4/78

Ingang museum / Entrée du musée		Educatieve Dienst / Service Educatif	
Ingang van een afdeling / Entrée de département		Reproduktie-, catalogusverkoop / Vente de reproductions / catalogues	
Verbinding tussen verdiepingen / Liaison entre étages		Bibliotheek / Bibliothèque	
Garderobe / Vestiaire		Rookkamer / Fumoir	
WC voor minder-validen / WC pour invalides		Lift	
Informatie / Renseignements			
Filmzaal / Films			

G eerste verdieping premier étage

**Schilderkunst
15de–17de eeuw
Peinture,
15ème–17ème siècle**

H eerste verdieping premier étage

**Beeldhouwkunst
& Kunstnijverheid
Sculpture &
Arts Décoratifs**

Stadhouderskade 42
telefoon / téléphone (020) 73 21 21
Open / Ouvert
10.00-17.00 ma-zat / lun-sam
13.00-17.00 zondags / le dimanche

copyright Rijksmuseum / verzorging Harry N Sierman en Karel Mul

All the paintings
of the Rijksmuseum
in Amsterdam

THE FIRST COMPLETE CATALOGUE
OF OBJECTS ON THE INVENTORY OF THE DEPARTMENT OF PAINTINGS
OF THE RIJKSMUSEUM IN AMSTERDAM,
INCLUDING PAINTINGS, MINIATURES, PASTELS, AQUARELLES, DRAWINGS
AND HERALDIC OBJECTS,
AS WELL AS A NUMBER OF OBJECTS ON THE INVENTORY
OF OTHER DEPARTMENTS OF THE MUSEUM

All the paintings
of the Rijksmuseum
in Amsterdam
A completely illustrated catalogue

BY THE DEPARTMENT OF PAINTINGS OF THE RIJKSMUSEUM

PIETER J J VAN THIEL *director*

CJ DE BRUYN KOPS

JOLA CLEVERINGA

WOUTER KLOEK

ANNEMARIE VELS HEIJN

WITH A FOREWORD BY ARTHUR VAN SCHENDEL *former director-general*

Amsterdam RIJKSMUSEUM
Maarssen GARY SCHWARTZ
1976

Copyright © 1976 by the Rijksmuseum, Amsterdam, and Gary Schwartz, Maarssen
No part of this book may be reproduced in any way, except for purposes of review and scholarly publication, without written permission from the publishers

ISBN 90 6179 010 7 (this edition)
ISBN 90 228 4046 8 (De Haan edition: Alle schilderijen van het Rijksmuseum te Amsterdam)

Designed by Alje Olthof

Translated from the Dutch and edited by Marianne Buikstra-de Boer and Gary Schwartz; some titles translated by Margaret Roche

Produced by Uitgeverij Gary Schwartz, Herengracht 22, Maarssen, The Netherlands

Typeset and printed by Koninklijke Drukkerij G J Thieme bv, Nijmegen

Half-tone films by Schwitter A G, Basle

Bound by Proost & Brandt nv, Amsterdam

Made in The Netherlands

Sold outside the Rijksmuseum by De Haan, Haarlem (The Netherlands and Belgium) and Uitgeverij Gary Schwartz (all other countries)

Orders in North America to: Abner Schram, 1860 Broadway, New York, NY 10023

Distributed in the United Kingdom, Australia, New Zealand and South Africa by Phaidon Press Limited, Littlegate House, St Ebbe's Street, Oxford

Contents

Foreword

In its origins, dating back to the late 18th century, the Rijksmuseum was a gallery of paintings. With the steady growth of the museum since those early days, its course has greatly changed, and it has developed into a general museum with several departments. Even so it is still considered by many as primarily a collection of pictures. Such is the fame of the Dutch paintings in the Rijksmuseum that for the public at large they dominate the image of the whole institution. And it must be admitted that nowhere else one can face such a wealth and such a variety of Dutch paintings. In this respect a walk through the rooms of the Rijksmuseum is a unique and rewarding experience.

When it started, the collection numbered about 350 paintings. Now, after so many years, the inventories of the department of paintings record about 5,000 entries. They are not all exhibited or stored in the Rijksmuseum. Many are lent to other institutions. But they all are part of the Rijksmuseum collection. In the course of time they were acquired through gifts, bequests, purchases or loans. Many parts of the collection have been published in the years that have passed and many catalogues and albums were issued. But so far not one of these publications ever contained a complete illustrated survey of the paintings of the Rijksmuseum collection. This meant that apart from the pictures on display, those in the store rooms and those on loan outside Amsterdam were not easily accessible to the public. It is exactly to facilitate this access for the scholar, the student and the general public that the present catalogue was conceived.

Though it is not a fully descriptive catalogue it is much more than a simple inventory. In condensed form it presents most of the facts now known about the paintings. Thus it forms a sort of data bank. A system of indexes opens the way to a wide range of cross-references.

Because of the size of the collections the preparations for this book took a long time and entailed much extra work on the part of those involved. The compilation of the catalogue was accomplished by a team headed by the director of the department of paintings, Dr P J J van Thiel, who also wrote the historical introduction. He was assisted by the other members of the department, Miss J L Cleveringa, Miss A A E Vels Heijn, Mr C J de Bruyn Kops and Mr W Th Kloek. It took them many years to go through the files of the 5,000 items, to examine them critically and to settle numerous questions

which earlier generations had left open. They courageously pursued their sometimes arduous task in order to make this publication as complete and as useful as possible. They are indebted to the staff members of the Amsterdam municipal archives and many other scholars for help and useful suggestions.

Hundreds of new negatives had to be made and many photographs had to be reprinted. Responsible for this important part of the work were the members of the photographic department of the Rijksmuseum, headed by Miss B Stokhuyzen. She was assisted by Miss M van Wijngaarden and our experienced photographers Messrs J van Zwol, G BH Bijl, H Bekker and P A Mookhoek.

I should like to warmly thank all the above and other members of the Rijksmuseum staff for their dedication and strenuous efforts in the long years before this book could appear. Dr S H Levie, director-general of the Rijksmuseum since November 1975, has given much attention to this work and has greatly stimulated its publication.

Materially the publication of this volume was not an easy matter for the Rijksmuseum. I should like to express my appreciation for all the professional assistance the co-publishers, Gary Schwartz and De Haan, have contributed to our joint venture. Close collaboration between the authors and Mr Gary Schwartz, Mrs Marianne Buikstra-de Boer, translators and editors, and Mr Alje Olthof, designer, did much to improve the composition and design of this complicated book.

Finally I wish to record with special pleasure the help given by Società Olivetti di Ivrea. By supporting the Rijksmuseum they have facilitated the printing of this book in its present form.

We, in the Rijksmuseum, believe that the following pages are rich in unpublished material and in new data. We therefore expect that they will stimulate research. We would be happy if to many specialists and art lovers this book would prove an instrument for furthering and refining the knowledge of the history of painting.

ARTHUR VAN SCHENDEL *former director-general of the Rijksmuseum*

September 1976

The Rijksmuseum painting collection

Chronological history of the Rijksmuseum painting collection

Introduction

As an institution, the Rijksmuseum is far older than the present Rijksmuseum building, which was completed in 1883, officially opened in 1885 and installed in final form in 1887. The new museum incorporated no fewer than five older collections and their combined libraries:

—Rijks Museum van Schilderijen (national painting museum)
—Rijks Verzameling van Kunstwerken van Moderne Meesters (national collection of works by modern masters)
—Nederlandsch Museum voor Geschiedenis en Kunst (Netherlands museum of history and art)
—Rijks Verzameling Gipsafgietsels van Beeldhouwwerken (national collection of plaster casts of statuary)
—Rijks Kabinet van Prenten en Teekeningen (national print- and drawing room), and
—the books and albums owned by each of them, which were to be integrated into one library.

The new museum was also charged with the care of loans from the city of Amsterdam (including the Museum Van der Hoop), scholarly societies (principally the Koninklijk Oudheidkundig Genootschap [royal antiquarian society]) and private individuals. The director of each collection was to retain autonomy in scholarly, artistic and educative matters, but was to be answerable for administrative affairs to a director-general.

The museum as we know it today has evolved from the 1883 plan. The initial collections have lost much of their old independence to become more completely subsumed in the Rijksmuseum, but the division of the collections into distinct departments–paintings, sculpture and applied arts, printroom, Dutch history, Asiatic art and a library – still betrays something of the museum's genesis. The department of Asiatic art did not come into being until as recently as 1965. In that year the collection of the Vereeniging van Vrienden der Aziatische Kunst (society of friends of Asiatic art, founded 1918), displayed in the

Rijksacademie van Beeldende Kunst in Amsterdam from 1928 to 1932 and, as the Museum van Aziatische Kunst, in the Stedelijk Museum from 1932 to 1952 and in the Rijksmuseum from 1952 on, was added as a loan to the museum's own sparse holdings in Asiatica, which until then had belonged to the department of sculpture and applied arts. The other departments, as they have been known since 1967, share between them the holdings of the former museums–except for the plaster casts of the Rijks Verzameling Gipsafgietsels van Beeldhouwwerken (founded 1879), which were disposed of in the years after 1925.

In compiling the following chronological history, grateful use has been made of older literature on the subject, especially the histories of the collection in the catalogues of 1858 (P L Dubourcq), 1880 (J W Kaiser), 1903 (B W F van Riemsdijk) and 1934 (F Schmidt-Degener & D C Röell), the annual reports from 1878 to the present, the study on the Nationale Konst-Gallery and the Koninklijk Museum written by E W Moes & Eduard van Biema in 1909, and Th H Lunsingh Scheurleer's publications of 1946, 1952, 1956, 1958 and 1967.

Nationale Konst-Gallery

[1795] On 18 January 1795, two years after the French had declared war on Holland, the last Dutch stadholder, Prince Willem v, fled to England. The Batavian Republic (1795-1806), the fond dream of the anti-Orange patriot party, became a reality. The prince had been forced to leave the stadholderly collections behind, in the building on the north corner of the Buitenhof in The Hague that had been purchased in 1766 to house the Kabinet van Natuur en Kunst (cabinet of nature and art) and the prince's library. The collection of paintings, less than 200 pieces in all, was hung in 1774 in the long gallery, a 25-meter room in two neighboring houses. (Buitenhof 34-35. The entire complex of Buitenhof 34-38, which had fallen into disrepair, was restored in 1971-75 and plans are being made to use the gallery for museum purposes.) Rembrandt was represented with *Simeon in the temple, Susannah*

and the elders, the 1629 *Self portrait* and the *Self portrait as an officer*; Gerard Dou with his *Mother and child*; Jan Steen with *The poultry yard* and several other works; and Paulus Potter with his famous *Young bull*. There were fine works by Piero di Cosimo (attributed at the time to Lucas van Leyden), Hans Holbein, Peter Paul Rubens and Anthony van Dyck. It was an interesting collection, though modest indeed compared with other princely galleries of Europe.

Before 1795 was out, the French had carted the Stadhouderlijk Kabinet (stadholderly cabinet) off to Paris as booty, to take its place in the Musée Central des Arts set up in the Louvre in 1793. The other possessions of the stadholders were left behind by the French, spread among various palaces. Among them were a considerable number of paintings, largely portraits. In the course of the next few years, they were confiscated and sold. In Amsterdam the sale was announced of 'several artful and extraordinarily common, ridiculous and barbaric paintings, most of them painted from life by Prussian and English masters, found in the cabinet of the deserted general Prince Willem v' ('eenige konstige en buitengemeene slegte belachlyke en barbaarsche schilderyen, meest alle naar het leven geschilderd door Pruissische en Engelsche meesters, gevonden in het kabinet van den gedeserteerden generaal Prins Willem v').

[1797] In 1797 more than 240 paintings and numerous other possessions were auctioned in Huis ten Bosch, the former palace in the woods outside The Hague. At first the Dutch took these disasters lying down; there were even some among the patriots who must have gloated over the liquidation of the princely estate. But those who looked further realized that the country had nothing to gain from this cultural bloodletting.

[1798] In 1798, management of the state and royal domains became the responsibility of Izaak Jan Alexander Gogel (1765-1821; fig 1), who decided to follow the French example in creating a national museum for Holland. Since the better paintings were already in Paris, he had to make do with the leftovers that were still in the various palaces and whatever else could be found in government buildings throughout the country. As the home for the new museum Gogel chose Huis ten Bosch (fig 3). This smallish palace had been built in 1645 by Pieter Post as a country home for Amalia van Solms, the wife of Prince Frederik Hendrik. Originally it was little more than a large central hall, called the Oranjezaal, decorated with paintings glorifying the prince, who died in 1647. The Oranjezaal was and is the great monument of Dutch classicism, with its paintings by Jacob van Campen, Salomon de Bray, Pieter de Grebber, Caesar van Everdingen, Christiaen van Couwenberg, Gerard van Honthorst and a group of Flemish artists including Jacob Jordaens. In 1734-37 the palace was renovated by Daniël Marot, who added wings on either side. The west wing, the Oranjezaal, the Chinese room and the Japanese room were reserved for the new museum. The available space consisted of eight rooms, three cabinets, a corridor and a vestibule.

[1799] In 1799 Cornelis Sebille Roos (1754-1820; fig 2) was appointed Inspecteur van de Zaal en Kunst-Gallery op het Huis in 't Bosch (inspector of the Oranjezaal and art gallery in Huis ten Bosch). Working closely with Gogel and

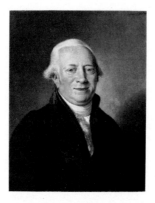

I Izaak Jan Alexander Gogel (1765-1821), minister of finance from 1805 to 1809. Gogel is the man who in 1798 took the first steps towards the creation of a national museum. Painting by Mattheus Ignatius van Bree (A 3136)

2 Cornelis Sebille Roos (1754-1820), from 1799 to 1806 inspector of the Oranjezaal and the Nationale Konst-Gallery in Huis ten Bosch near The Hague. Painting of 1815 by Adriaan de Lelie (A 3098)

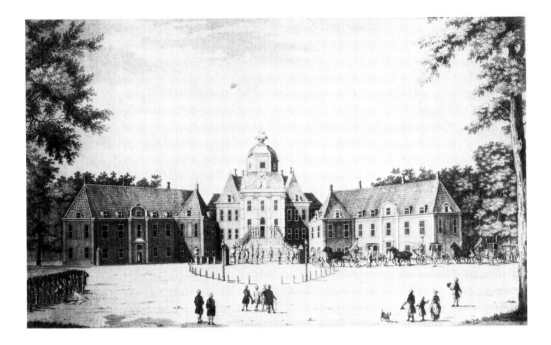

3 Huis ten Bosch near The Hague, built in 1645 by Pieter Post (1608-69). The wings were added in 1734-37 by Daniël Marot (ca 1663-1752). The right wing of this former palace of the stadholders housed the Nationale Konst-Gallery from 1798 to 1805. The museum was opened to the public in 1800. Engraving of 1782 by Cornelis Bogerts (1745-1817) after Hendrik Pothoven (1728-93). RPK

Everhardus Temminck (1758-1837), Inspecteur der Nationale Gebouwen herkomende van de Vorst van Nassau (inspector of government buildings formerly belonging to the prince of Nassau), Roos began filling the museum with paintings. Most of them came from the former princely possessions in Leeuwarden and Breda, the palaces Het Loo and Soestdijk, the Prinsenhof in Amsterdam, the building of the states-general in The Hague and the Zee-Comptoiren (maritime board) in Amsterdam and Rotterdam. On 31 **[1800]** May 1800 the Nationale Konst-Gallery, the first public museum in the Netherlands owned by the state, opened its doors. In it hung nearly 200 paintings.

The first room and the adjoining cabinet were devoted to portraits of Nassau princes, sea heroes and other national figures and to scenes from Dutch history. Among the latter was Jan Asselijn's *Threatened swan* (A 4), the first painting to be purchased, as we shall see. In the second room, at the far corner of the wing, were the larger history paintings by Italian and Netherlandish masters, including *The massacre of the innocents* by Cornelis Cornelisz van Haarlem (A 128). Following the two rooms were two smaller spaces, or cabinets. The *pièce de résistance* in the first was Bartholomeus van der Helst's portrait of *Princess Henrietta Maria Stuart* (A 142) and in the second a large still life by Jan Weenix (A 462). In the third room hung van Dyck's double portrait of *Willem II, prince of Orange, and Princess Henrietta Maria Stuart* (A 102), erroneously thought to represent King Charles II of England and his sister; in addition there were works by Melchior d'Hondecoeter and several genre paintings. Gerard Lairesse and Ferdinand Bol were the great names of the fourth room, which also housed Otto van Veen's *Claudius Civilis* series (A 421-A 432). The fifth room – the Monumenten Kamer (monuments room) – contained historical objects, among them the chair of Jacoba of Bavaria, and the sixth room – the present Japanese room – works of Rubens, van Dyck and Jordaens. The Chinese room was a

dead end in which no paintings were displayed. The visitor would double back through the sixth room to the vestibule, which opened into the Oranjezaal.

The decorative painter, draftsman and etcher Jan Gerard Waldorp (1740-1808) was appointed supervisor. Surviving mementos of his term of office are his groundplan of the Nationale Konst-Gallery (fig 4) and his drawings of all the walls in the museum, annotated to show which paintings hung where. In 1803 he designed a certificate (fig 5), conceived by Temminck and engraved by Reinier Vinkeles, to present to the donors of works of art, granting them free access to the museum.

The first purchase, made in the first year of the new museum's existence, was the above-mentioned *Threatened swan* by Jan Asselijn (A 4), bought by Roos at auction for 95 guilders. In the 18th century the painting had been provided with inscriptions that turned it into an allegory on the vigilance of Johan de Witt, the grand pensionary of the Republic who had paid with his life in 1672 for his resistance to the Orange party, who, he felt, were endangering Dutch independence. The painting was bought, in other words, because its presumed subject was a hero of the patriots, not because its creator was a good painter. This was not an isolated example. The museum was intended to be a monument to the history of the fatherland, and the acquisitions policy reflected this. The early accessions were nearly all portraits of national figures such as Prince Maurits, Oldenbarneveldt and Admirals Aert and Jan van Nes, or historical scenes such as Lieve Verschuier's *Keelhauling* (A 449), said to be the execution of Jan van Nes's ship's doctor, and the *Naval battle near Livorno* by Reinier Nooms **[1801]** (A 294). In 1801 there followed Pauwels van Hillegaert's *Disbanding of the 'waardgelders' by Prince Maurits on the Neude, Utrecht* (A 155) and Adriaen van Gaesbeeck's *Young man in a study* (A 113), then thought to be a youthful portrait of Hugo de Groot, or Grotius.

Subject matter was not the only consideration

in the purchasing policy, however. It was acknowledged that the glory of Dutch art had also contributed to the country's prestige, and representative works by the great masters were also welcome in the museum. The first attempt to add a Rembrandt to the collection resulted in the purchase of *The beheading of St John the Baptist*, which later turned out not to be by the master himself but a first-rate work from his school. It is now given to Carel Fabritius (A 91). In the same period the city of Amsterdam offered to sell *The sampling officials of the Amsterdam drapers' guild* (C 6) to the Nationale Konst-Gallery, but inspector Roos judged the painting too big and too dull, showing nothing but 'five gentlemen all in black, not doing a blessed thing but sitting to have their portrait painted.'

Donations found their way to the museum **[1803]** soon enough. In 1803 the Hague painter Dirk van der Aa (1731–1809) presented a painting from the estate of Aart Schouman, a painter who had died in 1792, representing the spot in the Prinsenhof in Delft where William the Silent had been murdered in 1584. At the time it was taken for the work of Johannes Vermeer, a name that did not then have the magic it has for us. The painting is attributed here to Egbert van der Poel (A 117).

[1804] In 1804 a curious transaction took place that brought some major works into the collection. In 1800 Haarlem had sold its own town hall to the Batavian Republic, and now, in order to regain possession of the building, the town was obliged to trade off five paintings that had hung for centuries in the Prinsenhof: *The massacre of the innocents*, *The wedding of Peleus and Thetis* and *The fall of man* by Cornelis Cornelisz van Haarlem (A 129; the two former paintings have been displayed in the Frans Halsmuseum in Haarlem, as loans from the Mauritshuis, since 1913), the *Battle between Dutch and Spanish ships on the Haarlemmermeer* by Hendrick Cornelisz Vroom (A 602) and *Mary Magdalene* by Jan van Scorel (A 372).

Although Huis ten Bosch, an historical and

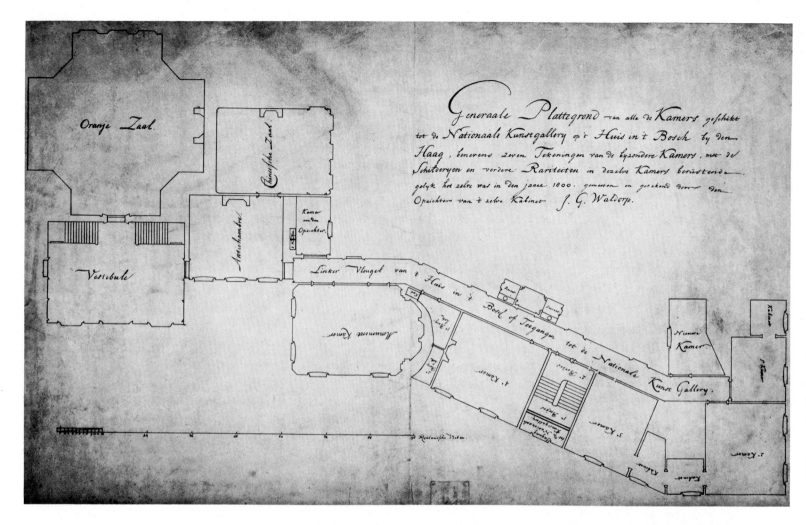

4 'Overall groundplan of all the rooms assigned to the Nationaale Kunstgallery in Huis ten Bosch near The Hague… as it was in the year 1800, measured and drawn by the supervisor of that gallery J G Waldorp.' Drawing of 1800 by Jan Gerard Waldorp (1740-1808). The Hague, Rijksarchief (state archives)

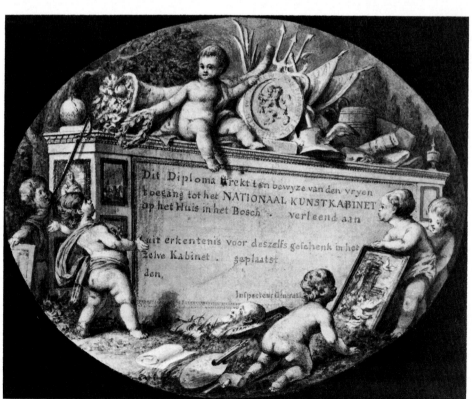

5 Diploma for donators of works of art, providing free access to the Nationale Konst-Gallery. Colored design (16 × 19.7) of 1803 by Jan Gerard Waldorp, engraved with slight changes by Reinier Vinkeles (1741-1816). RPK

6 The arrival of Louis Napoleon on 20 April 1808 at the former town hall of Amsterdam, remodeled by him as a palace. The town hall was built in 1648-55 by Jacob van Campen (1595-1657). From 1808 to 1815 the Koninklijk Museum was installed on the third floor. Aquatint in gray (26.7 × 36.8, proof printing) by Lodewijk Gottlieb Portman (1772-after 1828) after Franciscus Andreas Milatz (1764-1808). Amsterdam, municipal archives

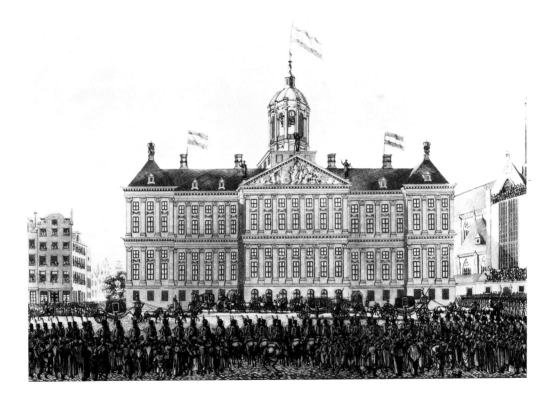

7 Groundplan of the third floor of the former town hall of Amsterdam, remodeled as a palace. The Koninklijk Museum was housed in the former large and small war council chambers and the adjoining rooms at the rear of the building. Drawing of 1808 by the adjunct municipal architect, Bartholomeus Wilhelmus Hendrikus Ziesenis (1762-1820). Amsterdam, municipal archives

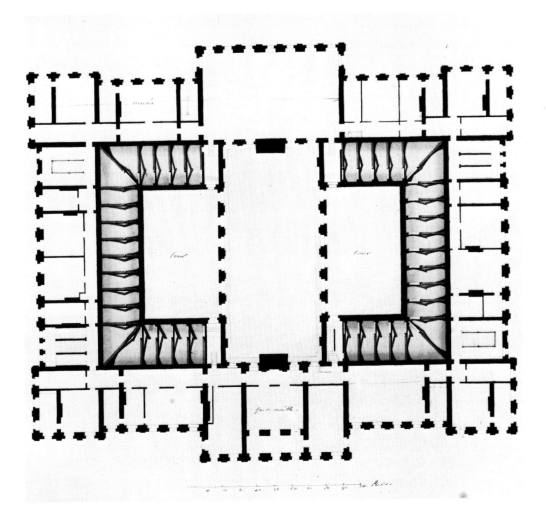

artistic monument in its own right, was an ideal home for the museum, the original state of affairs **[1805]** was not destined to last long. In 1805 the newly appointed grand pensionary, Rutger Jan Schimmelpenninck, decided to establish himself there, so the museum had to go. It was transferred to the building on the Buitenhof that had formerly housed the collection of Prince **[1806]** Willem v. In 1806 the grand pensionary was relieved of his post by Napoleon, who named his brother Louis Napoleon (fig 8) king of Holland (1806-10), bringing the French annexation of the country one step closer. Although the French were to disappear within the decade, many of the innovations they brought about in Dutch law and civic forms were to remain. One of these was Louis **[1807]** Napoleon's creation, in 1807, of a general directorate for the arts. The first one to fill this post, though for less than a year, was Carel Gerard Hultman (1752-1820). His commission from the king included directives that affected the structure of the Nationale Konst-Gallery. To begin with, its name was to be changed to the Koninklijk Museum (royal museum). From then on one room was to be reserved for works by living masters, and a cabinet for the safekeeping of prize paintings by protégés of the king–*pensionnaires* who had been awarded study grants for Rome or Paris; every other year an exhibition of works by living masters was to be held; a collection of plaster casts was to be put together; and a school for draftsmen was to be launched. In a word, the museum was to be transformed from a monument to the past into a school for living artists. This new approach was to exert a lasting influence on the development of the museum until our century, although the original, nationalistic impulse was by no means completely displaced.

During Hultman's brief tenure nothing at all was purchased. There were insufficient funds to take advantage of the opportunity to buy the

collection of Lucien Bonaparte, which was offered for sale at the time. Had that collection been acquired, the museum would have rocketed to international status overnight: besides a few Dutch paintings, Lucien Bonaparte owned about a hundred Italian, French and Spanish works, including many a masterpiece.

Koninklijk Museum

Hultman's successor Johan Meerman (1753-1815) was appointed director-general of sciences **[1808]** and arts in 1808. His budget for that year included the not inconsiderable sum of 10,000 guilders for acquisition. Upon command of the king he drew up regulations for the museum. The collection was to encompass paintings, drawings, sculptures, cut stone, antiquities and rare objects of all kinds. Prints, coins and medals were to be left to the Koninklijke Bibliotheek (royal library), but shortly afterwards it was decided that the coins and medals were to go to the museum of paintings. All works of art were to be arranged by school. One room was to be reserved for paintings of Dutch historical subjects and another for works by living Dutch masters. The director of the museum was to compile a catalogue. In 30 articles, the entire organization of the museum was taken care of; the only point left uncovered was where the museum was to be housed.

In the new unitary state, modelled after France, the largest city, Amsterdam, became the residence. It had no palace, but it did have a town hall, erected by Jacob van Campen on the Dam in the years 1648-55, that could vie with many a European royal palace. Louis Napoleon had the town hall vacated and re-installed as a royal palace (fig 6). As the residence and the seat of government, Amsterdam was also the only fit place, in the view of the king, for the public collections of art and science. On 21 April 1808, the day after his solemn entry into the city, the king ratified the regulations of the royal museum, fixing its location in Amsterdam. On 14 June it was announced that the museum was to be housed in the palace until a definitive site was found. The paintings were brought from the Buitenhof in The Hague to what were originally

the large and small war council chambers on the third floor in the rear of the Amsterdam town hall, rooms which had been used for similar purposes in the 18th century (fig 7). There and in the art room and art cabinet on the right front wing of the same floor, and in the chamber of rarities on the second mezzanine a number of important corporation pieces from the headquarters of various civic guards had formerly been hung. In 1715 *The nightwatch* was hung in the small war council chamber and *The syndics* in the art room in 1771. The offices had also long been hung full with paintings. When Louis Napoleon took over the town hall for his own use, these canvases were moved elsewhere, but the king continued to regard them as part of the inventory, and now had seven of them brought back: *The nightwatch* and *The syndics* by Rembrandt (C 5 & C 6; the latter is the same painting Roos had refused to buy in 1801), Bartholomeus van der Helst's *Celebration of the Peace of Münster* (C 2) and *The four governors of the archers' civic guard* (C 3), Govert Flinck's *Amsterdam civic guard celebrating the signing of the Peace of Münster* (C 1), Karel Dujardin's *Regents of the Spinhuis* (C 4) and Willem van de Velde's *The Y off Amsterdam* (C 7). No serious negotiations seem to have been conducted prior to the transfer, which took place on 15 August. The possibility was mentioned that the king would compensate the city of Amsterdam by improving the water supply. Nothing ever came of this, however, and the city retained legal ownership of the paintings.

In the same year, 1808, the collection was enriched with the purchase of 63 paintings at the auction of the estate of the Rotterdam collector Gerrit van der Pot. For a total of about 100,000 guilders the museum acquired all the important paintings. The most famous was Gerard Dou's *Night school* (A 87), for which 17,500 guilders was paid. For 210 guilders the museum bought *The holy kinship*, attributed then to Jan van Eyck. Now it is recognized as a masterwork of Geertgen tot Sint Jans (A 500), and remains the most important painting by him in the museum. Other major purchases at the van der Pot auction were *Isaac blessing Jacob* by Govert Flinck (A 110), *The*

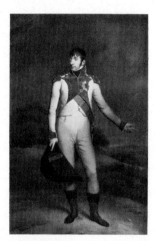

8 Louis Napoleon (1778-1846), king of the Netherlands from 1806 to 1810. Rechristened the national museum the Koninklijk Museum (royal museum) and moved it in 1808 to the former town hall on the Dam in Amsterdam, which he made his palace. Painting of 1809 by Charles Howard Hodges (A 653). Presumed to have been presented to the museum by the king in 1810

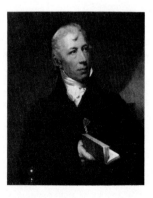

9 Cornelis Apostool (1762-1844), director of the Koninklijk Museum, later the Rijks Museum, from 1808 to 1844. Painting by Charles Howard Hodges (A 654)

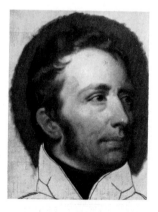

10 Willem I (1772-1843), king of the Netherlands from 1813/15 to 1840. It was Willem who gave the museum the name Rijks Museum in 1814 and moved it to the Trippenhuis in Amsterdam. Study for the state portrait of 1816 by Charles Howard Hodges (A 2125)

11 'Victory of arms, or the solemn return of the purloined works of art and science.' The arrival of a shipment of works from Paris in Antwerp in October 1815. The city maid of Antwerp conveys the joyous news to the mourning figure of Art. In the sky are King Willem I and, flanking him, Blücher and Wellington. To the right is the draftsman Jan Joseph Verellen (1788-1856) and, standing, the publisher J Groenewoud (active 1816-22 in Amsterdam). Engraving (56 × 67) by A G van Rooijen after J J Verellen, published in 1821 by J Groenewoud. R P K

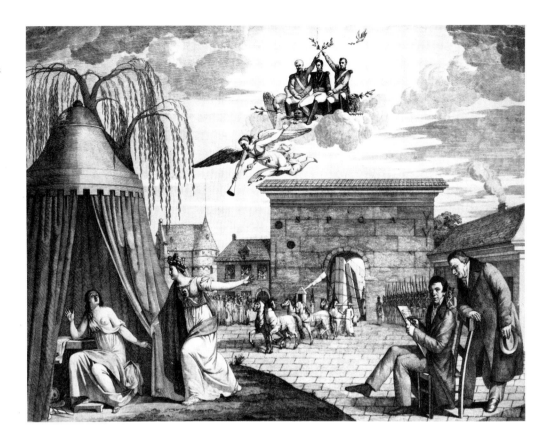

Leiden baker Arent Oostwaard and his wife Catharina Keizerswaard by Jan Steen (A 390), *The avenue of birches* by Jan Hackaert (A 130), *The painter's studio* by Adriaen van Ostade (A 298) and the *Boatmen moored on the shore of an Italian lake* by Adam Pynacker (A 321).

It took a whole year to install the royal museum in the palace. A report made up at the time identified the holdings of the museum as follows:
—225 paintings, several statues, antiquities and rarities from the Nationale Konst-Gallery, now the royal museum, in The Hague
—7 paintings on loan from the city of Amsterdam
—63 paintings purchased in 1808 from the collection of Gerrit van der Pot in Rotterdam
—6 paintings and two statues presented to the king in 1808 by J P G Baron van Spaen van Biljoen
—10 paintings purchased from living masters and several paintings remaining from the first exhibition of works by living masters held in the palace in Amsterdam in August 1808
—5 paintings by *pensionnaires*, sent from Paris, and a drawing by Aelbert Cuyp
—a large number of plaster statues and casts of medals and cut stones taken from originals in the Musée Napoléon in Paris, packed in 41 crates.

On 25 August 1808 Cornelis Apostool (1762-1844; fig 9), a well-traveled man with a broad range of interests, and something of a painter and draftsman himself, was appointed director of the museum, a post he retained until his death.

The two remaining years of Louis Napoleon's reign were prosperous ones for the museum. The king kept asking Apostool to report on potential purchases. Negative reports were submitted on the collections of Q van Amelsvoort of

's Hertogenbosch and F J O Boymans of Utrecht. (The latter collection was bequeathed to the city of Rotterdam in 1847, becoming the nucleus of the present Museum Boymans-van Beuningen.) Apostool also rejected the Panpoeticon Batavum by Arnoud van Halen, the remnants of which were to be purchased in Italy at the end of the century. He seems not to have been asked his opinion on the van Heteren collection, which the **[1809]** king decided to buy, in 1809, for about 100,000 guilders. The collection had been begun by Hendrik van Heteren (d 1749) in The Hague, and augmented with ten numbers by his son Adriaan Leonard (1722-1800) to a total of 137 paintings, which were left to the latter's nephew Adriaan Leonard van Heteren Gevers (b 1794), a page in the service of the king. Thanks to this purchase the museum acquired *The feast of St Nicholas* and *The parrot cage* by Jan Steen (A 385 & A 386), '*The paternal admonition*' by Gerard ter Borch (A 404), the *Man and woman sharing a meal* by Gabriël Metsu (A 249), the *Herd of cattle crossing a ford* by Nicolaas Berchem (A 30), *The Nieuwe Zijds Voorburgwal and the Martelaars-gracht, Amsterdam* by Jan van der Heyden (A 154) and Rubens's *Carrying of the cross* (A 344). With the purchase of a portrait of the receiver-general *Johannes Uyttenbogaert* from a family collection in Utrecht, the museum imagined itself in possession of a second Rembrandt. But this painting too is now assigned to the school, and has long been regarded as the work of Govert Flinck (A 582). The ambitious purchases from the van der Pot and van Heteren collections provided the museum in a short time with a solid basis for a representative collection of old Dutch masters.

The first printed catalogue appeared in 1809, compiled by Apostool. It lists 459 paintings, 72 antiquities and rarities and 50 drawings.

Groot Hollandsch Museum

[1810] In 1810 Louis Napoleon abdicated his throne and Holland was annexed to France. From 1810 to 1813 the country had as governor-general Charles François Lebrun, duc de Plaisance, who showed no interest whatever in the museum. All he did was change its name from royal museum to Groot Hollandsch Museum (great Dutch museum), as it was then called for a few years. All the efforts of Meerman and Apostool to advance the cause of the museum **[1812]** were to no avail. In 1812 there was even talk that the whole collection was to be ceded to the city of Amsterdam, a move which was certain to be followed by the confiscation of the best pieces by Napoleon, as he had done when the printroom, together with the royal library, had been 'donated' to the municipality of The Hague. The affair dragged on until the revolution of **[1813]** 1813 put an end to French rule in Holland.

's Lands Museum

Willem I (fig 10), son of Stadholder Willem v, became sovereign prince of the United Netherlands after the departure of the French. **[1814]** On 3 September 1814 he decreed that 's Lands Museum van schilderijen, oudheden, kunstwerken en penningen (state museum of paintings, antiquities, works of art and medals – a name it was to bear for not much longer than a year) and the Kabinet van Natuurlijke Historie (cabinet of natural history) were to remain in Amsterdam. They were to be removed from the palace to the Trippenhuis (former residence of

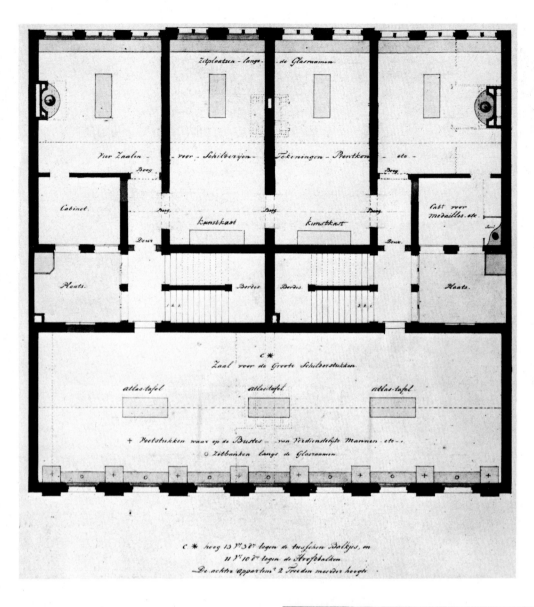

14→ Room in the Trippenhuis. In the upper left foreground hangs Rubens's *Cimon and Pero* (A 345; cat 1832, nr 269), and in the lower left the *Mary Magdalene* by Jan van Scorel (A 372; cat 1832, nr 282; incorrectly shown here in vertical format) and *The adoration of the magi* by Garofalo (A 114; cat 1832, nr 90, as Jan van Eyck). In the upper right is *The holy kinship* by Geertgen tot Sint Jans (A 500; cat 1832, nr 88, as 'a Gothic temple [with] a crowd of very strangely clad figures' by Hubert and Jan van Eyck) and the *Madonna and child with Sts Catherine, Cecilia, Barbara and Ursula* by the Master of the Virgo inter Virgines (A 501; cat 1832, nr 89, as Hubert and Jan van Eyck) and in the lower right *Fishing for souls* by Adriaen van de Venne (A 447; cat 1832, nr 13, as Hendrik van Balen and Jan Brueghel I). In the second room, half visible in the background, are *The bear hunt* by Paulus Potter (A 316; cat 1832, nr 247), with *The beheading of St John the Baptist* by Carel Fabritius (A 91; cat 1832, nr 255, as Rembrandt) above it to the right and beneath it *The death of Orion* attributed to Johann Carl Loth (A 71; cat 1832, nr 53, as *Diana and Endymion* by Caravaggio). On the side wall to the rear is *The massacre of the innocents* by Cornelis Cornelisz van Haarlem (A 128; cat 1832, nr 105) and closer to us we see half of *The Amsterdam civic guard celebrating the signing of the Peace of Münster* (C 1; cat 1832, nr 92). Along the top of the wall are small portraits from the Honselaarsdijk series. Colored drawing of 1838 by Gerrit Lamberts (1776-1850), first superintendent of the Rijks Museum, from 1824 to 1850. Amsterdam, municipal archives

12 Groundplan of the third floor of the Trippenhuis, the former quarters of the Rijks Museum. Project drawing for the 1814 remodeling by the city architect Abraham van der Hart (1747-1820). Amsterdam, Dienst van Publieke Werken (public works service)

13 The Trippenhuis on the Kloveniersburgwal, Amsterdam, with the Waag (weighing hall) in the background. The Trippenhuis was built in 1660-64 by Justus Vingboons (active third quarter of the 17th century). From 1815 to 1885 the Rijks Museum shared the premises with the academy of sciences, which has had the building to itself since the opening of the present Rijksmuseum building. Drawing of about 1850 by Willem Hekking Jr (1825-1904). Amsterdam, municipal archives

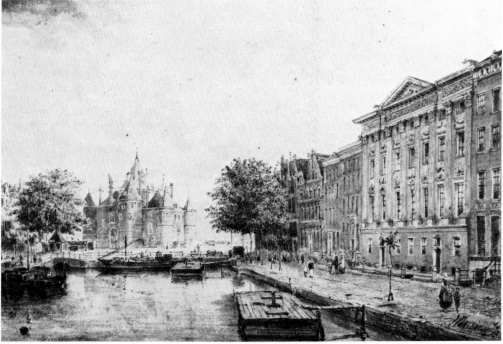

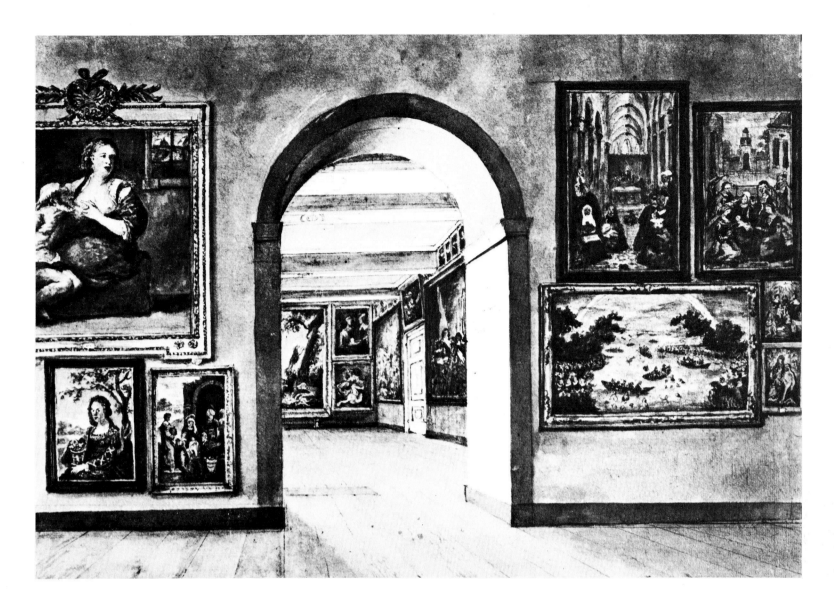

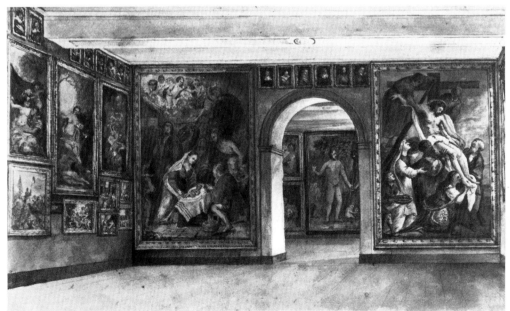

15 Room in the Trippenhuis. On the upper left wall hang, from left to right, *Odysseus and Calypso, Selene and Endymion* and *Mercury ordering Calypso to release Odysseus* by Gerard Lairesse (A 211, A 4210 & A 212; cat 1832, nrs 174-75 & 173). Below to the left is *The crucifixion* by Rubens (A 344; cat 1832, nr 270), with Adriaen van de Venne's tiny *Maurits, prince of Orange, lying in state* (A 446; cat 1832, nr 331) next to it, followed by five cabinet pictures by Hendrik van Balen, Hans Rottenhammer and others. On the dividing wall to the left is *The adoration of the shepherds* and to the right *The descent from the cross* by Casper de Crayer (A 74 & A 75; cat 1832, nrs 60-61). Along the top of the wall are small portraits from the Honselaarsdijk series. Through the passageway we see part of *The fall of man* by Cornelis Cornelisz van Haarlem (A 129; cat 1832, nr 104) on the right and on the upper left *A satyr* by Jacob Jordaens (A 198; cat 1832, nr 163), while the painting on the lower left is presumably the copy after Cristofano Allori's *Judith holding the head of Holofernes* (A 1; cat 1832, nr 1). Colored drawing of 1838 by Gerrit Lamberts (1776-1850), first superintendent of the Rijksmuseum, from 1824 to 1850. Amsterdam, municipal archives

16 The nightwatch on display in the Trippenhuis.
Painting of 1880 by August Jernberg (1826-96)
after a sketch of 1872. Malmö, Malmö Museum

the Trip family) 'for the benefit of the institute.'
The 'institute' was the Instituut van Weten-
schappen, Letterkunde en Schoone Kunsten
(institute of sciences, literature and fine arts),
which had been founded in the Trippenhuis in
1812.

The Rijks Museum in the Trippenhuis, 1815-85

[1815] In 1815 the prince, who had in the
meanwhile proclaimed himself king of the
Netherlands (that is to say of Holland and
Belgium both), sent Apostool to Paris to arrange
the return of all the works of art that had been
taken to France. At a given moment the duke of
Wellington had to be called upon to induce the
director of the Louvre, Vivant Denon, to part
with the paintings. Even then the matter was not
settled, though eventually Apostool did succeed
in recuperating most of the collection of Willem v
and 10,243 prints. Early in October the shipment
left Paris, and arrived in The Hague via Antwerp
(fig 11) and Bergen op Zoom, in the middle of
November. Apostool was unable to effect the
return of about 80 paintings that had been
assigned to French provincial museums. The
painter Charles Howard Hodges was
subsequently sent to Paris on the same errand,
but he too failed, and the paintings are still in
France. The repatriated prints went back to the
royal library. The paintings too remained in
The Hague, where they formed the nucleus of the
Koninklijk Kabinet van Schilderijen (royal
picture gallery), of which Jonkheer J Steengracht

van Oostkapelle was appointed director in 1816.
In 1817 the collection was re-installed in the
gallery of Prince Willem v, but in 1821 it found a
permanent home in the Mauritshuis.

The Trippenhuis (fig 13) on the Kloveniers-
burgwal in Amsterdam is a jewel of Dutch
classicism. It was built in 1660-64 by Justus
Vingboons for the immensely wealthy brothers
Louis and Hendrick Trip, the owners of iron
mines and cannon foundries in Sweden. Behind
the monumental façade were two symmetrical
houses, separated by a thick wall. Louis took the
northern house, on the left, and Hendrick the
southern. In 1808 the northern house had
become the property of the state; the southern
one had been owned by the city of Amsterdam
since 1771.

When in 1814 it was decided to move 's Lands
Museum (which was to be redubbed once more,
to Rijks Museum, in 1815) to the Trippenhuis,
the home of the institute of sciences, the
necessity arose of altering the curious
construction, with its thick central wall. The city
architect, Abraham van der Hart, was charged
with this task. The museum was assigned the
third floor of both houses (figs 12, 14 & 15), and
the institute, which had rented only the southern
house from the city, the second floor. On the
ground floor were the entrances – left that of the
museum, right that of the institute – and spare
rooms for both occupants. The museum used a
room in back of the left house, to the right of the
stairway, for the printroom, which had been
detached from the royal library in 1816. In
exchange the museum had released its medal
collection to the Koninklijk Penningkabinet
(royal medal cabinet), founded in 1816 and

housed, together with the royal library, in the
Mauritshuis. On the third floor of the Trippen-
huis the removal of the dividing wall (an
operation that entailed the demolition of two
handsome fireplaces) created a large hall which
was promptly named the Rembrandt hall. *The
nightwatch* was hung against one of the side walls
(fig 16), so that it would catch raking light from
the west, where the trees were cut down. The
rear of the house had two nearly square rooms
with three windows each, looking out on the large
garden. Between them were two rectangular
rooms with two windows on the short side. In
1817 the installation of the Rijks Museum in the
Trippenhuis was completed and it was opened to
the public. The space was cramped from the very
start, not only for the museum but also for the
institute, which only suffered from the arrival of
the museum, and enjoyed no benefits from it at
all. All attempts to seek alternative housing – at
first undertaken only by the institute – were
doomed to failure. In 1851 the institute, which
had borne the predicate 'royal' since 1815, was
dissolved and reconstituted as the Koninklijke
Academie van Wetenschappen (royal academy of
sciences).

Willem I shared Louis Napoleon's deep
interest in the museum, but spent much less
money on it than had his French predecessor.
Moreover, he was not consistent in applying the
policy of centralization that came so naturally to
the French. He allowed the cabinet of Willem v
to remain in The Hague, which was once more
elevated to royal residence. Not surprisingly,
there was a soft spot in his heart for the royal
picture gallery that had grown out of his father's
collection. Besides, he had other responsibilities

to the arts. There were also museums in Brussels and Antwerp, which were part of his domain until 1839. The king made donations to these museums only twice: in 1817 he gave 13 paintings, by modern Flemish masters, to the museum in Brussels and in 1823 three to that in Antwerp, among them Titian's *Jacopo Pesaro with Pope Alexander VI adoring St Peter* (cat 1958, nr 357). The paintings he judged the best tended to go to the museum in The Hague. It was Apostool's personal predilection that was behind the accession of Frans Hals's *Merry drinker* (A 135) for the Rijks Museum. The painting had been **[1816]** purchased for 325 guilders at the 1816 auction of the collection of Baroness van Leyden of Warmond; the other works bought in that auction, such as Jan Both's *Italian landscape*, which went for 5,610 guilders, were considered more important by the king and went to The Hague. What must have been regarded as a much more important acquisition than the Hals was *The beautiful shepherdess* by Paulus Moreelse (A 276), bought for 2,150 guilders at the auction of the collection of Father Ocke of Leiden in **[1817]** 1817. In the same year 4,010 guilders was paid for the *Woman with a child in a pantry* by Pieter de Hooch (A 182). Notable purchases of the following years were Jacob van Ruisdael's **[1818]** *Mountainous landscape with waterfall* **[1821]** (A 348) in 1818 and, in 1821, Jan Steen's *Self portrait* (A 383) and Willem Kalf's *Still life* **[1822]** *with silver jug* (A 199). 1822 could have been a great year for the collection if the king had only assigned Vermeer's *View of Delft*–purchased at Apostool's behest!–to the Rijks Museum instead of the Mauritshuis.

Although the day of the great bequests was yet to come, the arrival of the Balguerie-van **[1823]** Rijswijk bequest in 1823, consisting of 22 family portraits, was a welcome anticipation **[1824]** of them. A year later the museum was able to buy *The merry fiddler* by Gerard van Honthorst (A 180).

Early in his reign King Willem I also stimulated the acquisition of non-Netherlandish paintings, especially for the museum in The Hague. In 1818 and 1822 several paintings were purchased from the collection of Jean Adrien Snijers of Antwerp, and in 1821 from that of Vincent de Rainer of Brussels. The most important acquisition of this kind was the purchase in 1823 of 17 paintings from Countess Bourke in Paris. Holland gained two splendid Murillos in that transaction: a *Madonna and child* assigned to The Hague but since transferred to the Rijksmuseum (C 1366), and a *Holy family* kept by the king himself and now the property of Her Majesty the Queen.

[1825] In 1825 an exchange with the Mauritshuis was negotiated. The Rijks Museum traded seven paintings, among them the *Massacre of the innocents* acquired from Haarlem in 1804, for *The bear hunt* by Paulus Potter (A 316), *Cimon and Pero* by Rubens (A 345) and the portrait of *Nicolaes van der Borcht* by van Dyck (A 101). In the same year the antiquities and rarities were sent to the Museum van Oudheden (museum of antiquities) in Leiden.

[1828] In 1828, Apostool arranged for the auction of 38 paintings from the collection, partly in order to make space for works by modern masters, and partly in order to swell the acquisitions budget. The auctioned paintings

were by masters represented, in Apostool's opinion, by better work, and he intended to replace them with names still missing from the inventory. Sold were works by Ludolf Bakhuysen (1), Nicolaes Berchem (3) Jan Brueghel II (1), Gerard Dou (2), Anthony van Dyck (2), Aert de Gelder (1), Jan Griffier (1), Jan Davidsz de Heem (1), Jan van der Heyden (2), Melchior d'Hondecoeter (1), Jacob Jordaens (1), Gerard Lairesse (1), Jan Lievens (1), Frans van Mieris (1), Paulus Moreelse (1), Frederik de Moucheron (1), Eglon van der Neer (1), Adriaen van Ostade (1), Cornelis van Poelenburgh (3), Paulus Potter (1), Peter Paul Rubens (1), Pieter van Slingeland (1), David Teniers (2), Jacob van der Ulft (1), Willem van de Velde II (2) and Philips Wouwerman (4).

The paintings went under the hammer in Amsterdam on 4 August 1828 (Lugt 11819), and fetched a total of 22,700 guilders. The title page of the sale catalogue singled out for mention not any of the Rijks Museum paintings, but Rembrandt's *Anatomy lesson of Dr Nicolaas Tulp*, offered for sale by the impoverished surgeons' widow fund of Amsterdam. Shortly before the auction the king ordered the purchase of the Rembrandt. Although this was a deed of signal importance for the preservation of the Dutch cultural heritage, it must have galled Apostool that this Amsterdam painting par excellence, whose purchase price of 32,000 guilders was moreover partly paid with the proceeds of the paintings sold by the Rijks Museum, was placed by the king in the Mauritshuis. We do not know whether his feelings were soothed when Nicolaes Maes's *Girl at a window* (A 245) went to **[1829]** Amsterdam the following year.

In the first 15 years of his reign Willem I had spent about one-fourth as much money on paintings for the Rijks Museum and the Mauritshuis as Louis Napoleon, who was not notably prudent with the economy of the conquered territory he governed for France, had spent in only four years on one museum alone. Yet those 15 years were fat in comparison with the 45 that were to follow. The revolt of the Belgians in **[1830]** 1830, which was to end in a definitive secession in 1839, plunged the northern Netherlands into a difficult economic situation. Lack of funds, but also lack of interest on the part of the king, whose last ten years in power were so full of disappointment, were disastrous for the museum. It wasn't merely that Apostool's efforts were frustrated so consistently that he finally gave up trying–what was even worse is that the apathy was contagious. The lack of an active cultural policy seemed to paralyze everyone who was in a position to do something about it. Matters were not helped when the king abdicated in 1840 and Apostool died four years later. On the contrary. The new liberalism that was sweeping the country was inclined to disaffirm that art was a proper concern of the state. A maxim to that effect ('Kunst is geen regeringszaak') uttered by the Liberal prime minister Thorbecke, and which he meant less categorically than it sounds, actually passed into the language as a household word in the third quarter of the century. The writer EJ Potgieter (1808-75) wrote an indictment of the cultural indolence of the time in his article 'Het Rijks-Museum te Amsterdam' (*De Gids*, 1844), but his was a voice in the wilderness.

The reaction that finally set in did not come

from within the government apparatus but from private initiative, the motive force of 19th-century society. Gradually, bodies with practical cultural aims, like the Koninklijk Oudheidkundig Genootschap (royal antiquarian society) of 1858, arose and found their wings. But it wasn't until 1873 with the publication of Victor de Stuers's (1843-1916) passionate article 'Holland op zijn smalst' (Holland at its narrowest; *De Gids*), that changes began to occur. De Stuers gave a shocking picture of the destruction of monuments and swapping of art works, blaming the mercantile mentality of the upper classes for the state of affairs. ('A smile will appear on the lips of many when they hear that art and the colonies–Rembrandt's *Nightwatch* and Java coffee–are lumped together in our index of interests.') De Stuers's article had the desired effect, and the museum too benefitted. After nearly half a century of inertia, things began to move again.

[1831] But that was a long way away in 1831. The year began badly enough. The Romswinckel heirs had offered the king Rembrandt's portrait of *Nicolaes Ruts*. Apostool showed little interest: Rembrandt the portraitist, he believed, was well enough represented already. The king bought the painting for himself, and after the death of his son Willem II it was auctioned in 1850. In the years after 1831 Apostool submitted repeated requests for the acquisition of various paintings, but he was always refused. It went that way in **[1833]** 1833, when no purchases were made at the auctions of the collections of Jacob de Vos and Johan Goll van Frankenstein, where Apostool had hoped to acquire Vermeer's *Astronomer*, now in the Städelsches Kunstinstitut **[1834]** in Frankfurt. And in 1834 he tried in vain to acquire a landscape by Jacob van Ruisdael. After that he gave up completely.

[1838] The year 1838 saw a major change in the setup of the museum. Since 1808, upon the order of Louis Napoleon, the museum had been required to collect works by living masters. In the same year he had also decided to display those works in Welgelegen pavilion in Haarlem (figs 17 & 18), which he himself had bought. This palace-like building, beautifully situated in the Haarlemmer Hout (Haarlem woods), had been built in Neoclassical style between 1785 and 1788, most probably by Leendert Viervant (1752-1801), for the wealthy Amsterdam banker Henry Hope (1735-1811), the close friend of Prince Willem V, whom he followed to England in 1795. The monumental south wing was built to house Hope's picture collection. Louis Napoleon planned to turn this gallery, on the second floor of the building, into a museum of contemporary art, but nothing ever came of the project. It was in Welgelegen that he signed away the throne of Holland in 1810. From 1814 to 1820 the pavilion was the residence of Wilhelmina of Prussia, the mother of King Willem I, and his sister Louise, who died there in 1819. In 1828 the king decided to realize the plan of his predecessor, and decreed that Welgelegen was thenceforth to house the Koninklijke Verzameling van Schilderijen van Levende Meesters (royal collection of paintings by living masters). The museums of both Amsterdam and The Hague were to release the paintings in that category for the new collection. Their holdings of modern paintings were not

17 Welgelegen pavilion in Haarlem, built in
1785-88, most probably by Leendert Viervant.
Here, from 1838 to 1885, was housed 's Rijks
Verzameling van Kunstwerken van Moderne
Meesters (national collection of works of art by
modern masters). Engraving of 1791 by Christian
Haldenwang (1770-1831) after Hermanus Petrus
Schouten (1747-1822). RPK

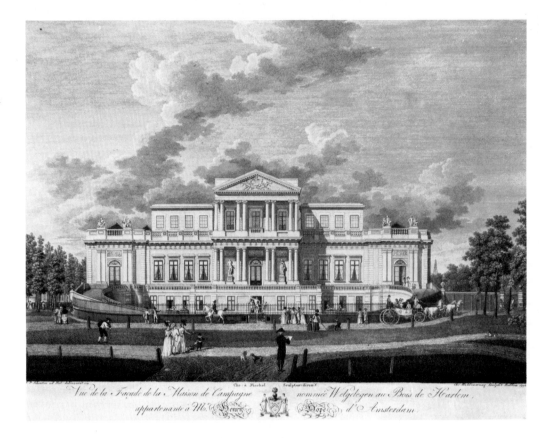

18 Groundplan of the second floor of
Welgelegen pavilion, Haarlem. Lithograph of
about 1880. Haarlem, municipal archives

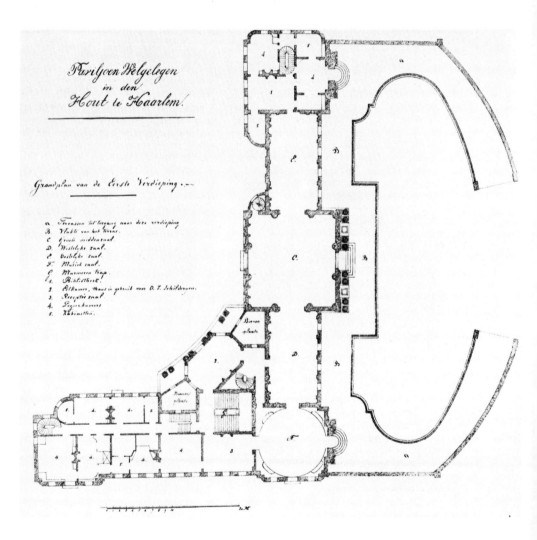

inconsiderable. In the course of the years they had been accumulating the prize works of the king's *pensionnaires* in Rome and Paris, and had been buying regularly at the biannual exhibitions of works of living masters, held in Amsterdam from 1808 to 1903 and in The Hague from 1811 to 1890. Exhibitions of this kind were also held in Antwerp, Brussels and Ghent in the 1820s, in Dordrecht in 1819, in Haarlem in 1825, in Rotterdam from 1832 to 1894 and in Utrecht from 1841 to 1861. The financial limitations which the government was forced to impose in 1830 meant that Amsterdam was unable from then on to purchase any paintings at all. The king continued to buy for The Hague, however, until 1840. Not until 1860 was the accession of modern works resumed.

Another consequence of the difficult political circumstances of 1830 was that Welgelegen was as yet unable to assume its new function. Finally, in 1838, 60 paintings from Amsterdam and 143 from The Hague were brought to Haarlem. The works were displayed in the large gallery giving onto the Haarlemmer Hout and later, temporarily, in the round concert hall at the southwest corner of the building as well. Later added to the museum area was the wing built out perpendicularly from the gallery, on the west, along the Dreef. The rooms there were originally living quarters and had been rented to Willem II from 1842 to 1849. The ground-floor rooms housed the Nederlandsch Geologisch Museum (Netherlands geological museum) from 1852 to 1865 and the Koloniaal Museum (colonial museum) from 1871 to 1925. In the rooms above, the Museum van Kunstnijverheid (museum of applied arts) was located from 1877 to 1926; the associated School voor Kunstnijverheid (school of applied arts) was in the stables. The colonial museum as well as the museum and school of applied arts were under control of the Nederlandsche Maatschappij ter Bevordering van Nijverheid (Netherlands society for the promotion of industry), founded in 1777. In 1879 plaster casts of the Greek statues excavated at Olympia – a gift of the Prussian government – were set up in the round concert hall. It was a loss to the Dutch museum world when this splendid building, in Dutch terms a veritable palace of the arts, more than half of which had been built as a private museum, was converted to bureaucratic use in our century. Since 1930 it has been the provincial hall of Noord-Holland.

When Welgelegen was still a popular museum for works by living artists, displays were allowed to remain there until five years after the death of their maker, when they were removed to one of the collections of old art. In 1848, however, the criterion 'living master' was replaced by 'modern master,' which covered everyone born after 1750. This change resulted in a second migration of paintings. In the interests of overall quality, the collection was pruned by the sale at auction of 65 paintings on 25 September 1860 in Amsterdam (Lugt 25744) and another 74 on 30 April 1878 (Lugt 38333). In 1885, by which time it had been rechristened 's Rijks Verzameling van Kunstwerken van Moderne Meesters (national collection of works of art by modern masters), the museum was transferred to the new Rijksmuseum in Amsterdam, where space had been reserved for it. Until then the Haarlem museum had been the joint

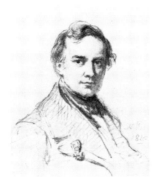

19 Jan Willem Pieneman (1779-1853), director of the Rijks Museum from 1844 to 1847 and chairman of the board of directors from 1847 to 1852. Drawing by the sitter's son Nicolaas Pieneman (1809-60). R P K

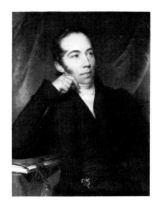

20 Pieter Ernst Hendrik Praetorius (1791-1876), chairman of the board of directors of the Rijks Museum from 1852 to 1876. Painting by Charles Howard Hodges (1764-1837). Private collection

responsibility of the directors of the Mauritshuis and the Rijksmuseum.

If the situation for works by living masters was improving, the old masters still were having **[1840]** hard times. In 1840 Willem II became king, succeeding his father. This could have been the best thing that ever happened to the Dutch museums. Willem II was the only prince of Orange to have had a true passion for art, and he could have been expected to pursue an active cultural policy. As early as the 1820s, in Brussels, he had begun to collect paintings. And when he assumed power he had a private neo-Gothic museum built in the garden of his palace on the Kneuterdijk in The Hague. (This Gotische Zaal [Gothic hall] still exists.) But any expectations that Willem II would further the cause of the public collections were doomed to disappoint-
[1841] ment. In 1841, at the same time that the plan to erect a monument to Rembrandt was launched in Amsterdam (it was not to be realized until 1852), the master's *Anatomy lesson of Dr Joan Deyman* was auctioned. The king did not react as his father had done in 1828, when *The anatomy lesson of Dr Nicolaas Tulp* was threatened with export. He blithely let it go. It was not until 40 years later, in 1882, when it once more came on the market in England, that a group of individuals seized the opportunity to buy it back for Holland.
[1844] Cornelis Apostool died in 1844 and was succeeded by the history painter Jan Willem Pieneman (1779-1853; fig 19). Pieneman had been underdirector of the Mauritshuis from 1816 to 1820 and thereafter director of the Koninklijke Academie van Beeldende Kunsten (royal academy of art) in Amsterdam, located originally in the stock exchange and from 1837 on in the former Oudemannenhuis (old men's home). He had done good work in these positions, and played an active role in the artistic world of Amsterdam. But his capacities were somehow unfit for his new task as director of a museum of old art. The year he assumed office a supervisory committee was appointed, in which
[1847] he had a seat. But in 1847 the director-ship and committee were both disbanded, and the running of the museum was turned over to a board of directors, a situation that prevailed until 1876. At first Pieneman headed the board of directors, but he was replaced in that function

in 1852 by Pieter Ernst Hendrik Praetorius (1791-1876; fig 20).

The board started out as a fairly apathetic body. They do deserve credit, however, for taking measures for the prevention of fire, a step that was certainly not uncalled for at a time when there was a kerosene storage plant a few doors from the Trippenhuis. Another classic missed
[1850] chance took place in 1850, when the collection of Willem II was auctioned a year after his death. The sale, which was held in the king's own Gothic hall, consisted of 192 old masters – largely 15th- and 16th-century Flemish, 17th-century Dutch, and Italian paintings – 162 paintings by modern masters, 370 drawings and 26 statues. The board of directors submitted the suggestion, modest to the point of embarrassment, to buy Hobbema's *Watermill* and Teniers' *Village fair*, but the government turned down even that request, and so nothing at all was bought. Two works by Teniers (C 298 & C 300) from the collection were to enter the Rijksmuseum years later with the van der Hoop bequest, as loans from the city of Amsterdam, and a triptych by Jacob Cornelisz van Oostsanen (C 1554) with the same provenance was lent by a friend of the museum in 1973. The only painting from this Dutch royal collection that the Rijksmuseum has been able to acquire since 1850 is W J J Nuyen's magnificent *Shipwreck on a rocky coast* (A 4644), which was bought at auction in Amsterdam in 1974. But the collection as a whole was lost to Holland, and the museum missed the chance to acquire Jan van Eyck's *Lucca Madonna* (now in Frankfurt, Städelsches Kunstinstitut), Dirk Bouts's justice panels (Brussels, Musées Royaux des Beaux-Arts), the wings of Simon Marmion's *St Bertinus retable* (Berlin-Dahlem, Gemäldegalerie), major works by Peter Paul Rubens and Anthony van Dyck, such Rembrandt portraits as *Nicolaes Ruts* (New York, The Frick Collection), *The noble Slav* (New York, The Metropolitan Museum of Art), *Titus* and the *Pellicorne family* (London, The Wallace Collection), Meindert Hobbema's *Watermill* (London, The Wallace Collection) and *The presentation of the bride* (Leningrad, Hermitage) by
[1852] Bartholomeus van der Helst. Two years later the board was able to convince the government to go so far as to provide 530 guilders for the purchase of Frans Hals's wedding portrait of

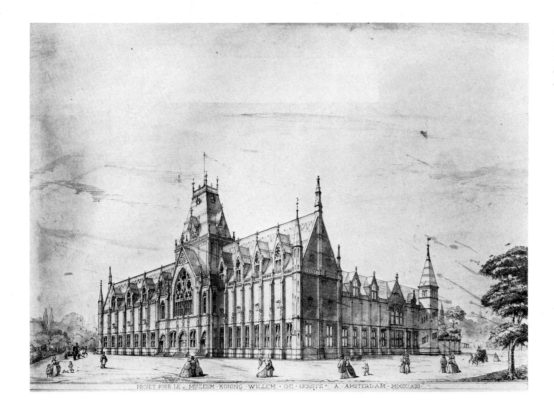

21 The second-prize winning entry for the Museum Koning Willem I (King Willem I museum), which was never built. Neo-Gothic design of 1864 by P J H Cuypers. Washed pen drawing (26.9 × 50.2). RPK

Isaac Massa and his wife (A 133) from the collection of H Six van Hillegom. Welcome donations to the collection in this unhappy period were made in 1849 by the painter Albertus Brondgeest (1786-1849) – Ferdinand Bol's *Self portrait* (A 42) – and in 1852 by Jonkheer J P Six van Hillegom – the *View of Antwerp* by Jan Wildens (A 616).

The perennial problem of accomodations in the Trippenhuis was never resolved. The 1828 sale and the transfer of the modern masters to Haarlem in 1838 and 1848 had brought insufficient relief. Meanwhile, although the collections of the museum had stopped growing, **[1855]** the academy had not. In 1855 the latter was enlarged with a second department, and at that point insisted on the right to hold two meetings a month in the Rembrandt hall, which had to be closed to the public on those occasions. The relations between the two occupants became badly strained. It was clear to everyone that one or another of them had to go, yet it took another 30 years before that was to come to pass. It **[1858]** seemed for a while in 1858 that a solution was at hand. In that year the Nederlandsche Handelsmaatschappij (Netherlands trading corporation) moved out of its spacious quarters on the Herengracht (the present nr 40), which had been the residence of Governor-general Charles François Lebrun in the French period. The king appointed an advisory committee to report on the suitability of the house as quarters for the museum or the academy. The museum was represented by Praetorius and Dubourcq, and the academy by Professor Willem Vrolijk (1801-63) and others. The committee found the building unsuitable for either institution, and in its report recommended that a new museum building be erected, leaving the Trippenhuis to the academy. This was the tentative start of a process that led to the present solution, reached in 1872. The king asked the

committee to recommend a location and general plan for the new building. The reply showed such a poor understanding of the needs of a museum that one can only be thankful it was not acted upon. In fact, no action at all was taken.

In the same year, W Bürger, in his *Musées de la Hollande: Amsterdam et La Haye*, specified three points concerning the Rijks Museum which he thought it a matter of honor for Holland to deal with: 'un nouveau local, un nouveau classement de tableaux, un nouveau catalogue détaillé' (a new location, a new arrangement of the paintings, a new detailed catalogue). It was many years before the first two matters were taken care of, but the third was provided for when Bürger wrote. P L Dubourcq (d 1873), member of the board of directors, replaced Apostool's catalogue of 1809 with a new one, modelled on the *Notices des tableaux du Musée Impérial du Louvre* by Fréderic Villot. The new catalogue, published in 1858, contained 432 numbers, and included for the first time facsimiles of signatures and a brief historical sketch of the museum.

[1862] In 1862 a fresh initiative was undertaken to build a new museum. A group of Amsterdam art lovers banded to form a Commissie ter Voorbereiding der Stichting van een Kunstmuzeum (committee for laying the groundwork for the foundation of an art museum), under the chairmanship of Professor Vrolijk. The vice chairman was C P van Eeghen and the secretary J A Alberdingk Thijm. The committee was playing on the wave of nationalism that was expected **[1863]** to break over Holland in 1863, upon the 50th anniversary of emancipation from French rule. They projected a Museum Koning Willem I (King Willem I museum) that was to be not only a museum but also – and that in the first place – a national monument to commemorate the events of 1813 and 1815. It was also to be a personal

memorial to King Willem I, in thanks for his activities as a statesman and a patron of the arts. A competition for the building was announced, and 21 entries were received. The first prize was awarded to the Munich architects Ludwig & Emil Lange and the second to the Dutchman P J H Cuypers, who submitted two designs for the façade, one in neo-Gothic style (fig 21) and the other with pronounced Renaissance features. Personal jealousies and official economies torpedoed the plans, which had never aroused the interest of Minister Thorbecke anyway. In **[1868]** 1868 the committee was disbanded.

And yet all this seemingly fruitless activity focussed people's attention on the museum, and in the 1870s the breakthrough came. The decade began unpromisingly enough. The irritation of enforced cotenancy reached such a point in **[1870]** 1870 that the academy resorted to an unsavory stunt to get its way. During one of the semi-monthly meetings in the Rembrandt hall a faked chimney fire produced enormous quantities of smoke, reviving old fears of a fire in the museum. The panicked museum directors consented to once more divide the hall in two, leaving the south half to the academy as a meeting hall.

More important than this incident was the receipt of the Dupper bequest (willed to the museum on 12 April 1862), the first of what was to be a long series of major bequests. Leendert Dupper Willemsz (1799-1870), the wealthy Dordrecht owner of a sugar refinery, inherited in 1850, through an uncle, the choice collection of his grandfather Jan Rombouts. He added to it, and by the time it came to the museum it included 64 paintings, among them the *Self portrait* of Gerard Dou (A 86), Nicolaes Maes's *Woman spinning* (A 246), Jan van Goyen's *Landscape with two oaks* (A 123), the *View of Haarlem* (A 351) and *Winter landscape* (A 349) by

Jacob van Ruisdael and a number of fine Italianate paintings.

The plan to build a new museum received **[1872]** fresh impetus in 1872 with the appointment of a new committee under the chairmanship of Josua van Eik. The committee achieved an important success in its first year of operation. On 4 December 1872, the second chamber of the Dutch parliament, voting on the budget submitted by Minister Geertsema, accepted with but one nay the amendment of S van Houten, proposing to enter the foundation of a new museum building as a tentative item on the budget. With that vote, the plans for the new museum became a proper concern of the state.

[1873] In 1873 the museum received a unique legacy consisting of 15 pastels by Jean-Etienne Liotard (A 228-A 243), left by Miss Marie Anne Liotard (1798-1873; testament of 27 June 1870), the artist's granddaughter. In 1885 six more pastels by the same artist were to be donated by J W R Tilanus on behalf of his wife Mrs Tilanus-Liotard, another granddaughter of the artist. Thanks to these acquisitions Amsterdam has a Liotard collection second only to that of Geneva, the artist's birthplace.

The same year saw the appearance of the above-mentioned article by Victor de Stuers in *De Gids*, exposing the lamentable state of Holland's cultural affairs. On a visit to the South Kensington Museum in London (now the Victoria & Albert Museum) he had been dismayed to come across the magnificent rood loft from the cathedral of St John in 's Hertogenbosch, which had left Holland, virtually unnoticed, in 1867. This most shocking instance of the dissipation of the national heritage was the direct instigation of de Stuers' extremely well-documented article. At long last, people began to grow convinced of the need to redress the balance.

The 'tentative item' was to remain on the budget until 1876, but as early as 1873 Minister Geertsema appointed a sub-committee to advise

the state concerning the projected museum. The sub-committee was chaired by C A J den Tex, burgomaster of Amsterdam, and the other members were Josua van Eik, L M Beels van Heemstede (both from the former van Eik committee), C P van Eeghen, Joh C Zimmerman (both from the former committee for a Museum Koning Willem I), P L Dubourcq (member of the board of directors of the Rijks Museum), Dr W J A Jonckbloet (for the Rijksacademie van Beeldende Kunsten) and L Lingeman (for the artistic society Arti et Amicitiae).

[1874] In 1874 the minister appointed a board of advisors to report to the government on the establishment and preservation of buildings with artistic or historical value. The members were C Fock, Dr C Leemans, A J Enschedé, E Gugel, Jonkheer J R T Ortt, C Vosmaer, P J H Cuypers and none other than Jonkheer Victor de Stuers. The board and sub-committee were to judge all new museum proposals jointly.

[1875] A year later, in 1875, de Stuers was given the influential post of referendary, under Minister J Heemskerk, of the newly constituted arts and sciences department of the ministry of the interior. In the meanwhile the city of Amsterdam had decided to give the government a plot of land on the Stadhouderskade, to contribute 100,000 guilders towards the costs of building a new museum and to make the city's paintings available for display there. The payment of 100,000 guilders was made in kind in 1884, with the transfer to the state of the southern half of the Trippenhuis, which now became wholly the property of the nation.

The government had gone ahead in the meanwhile to ask four architects to submit project designs: H P Vogel, L H Eberson, C Oudshoorn, who died within the year, however, and Cuypers. This time the plan of Petrus Josephus Hubertus Cuypers (1827-1921) was accepted. Again he had submitted alternative façades, one in a Renaissance style (fig 22) and the other with Gothic overtones. The

Renaissance version was chosen, though in a simplified form, without the central bay receding between two towers (figs 23 & 24). Funds were **[1876]** made available in 1876, and Cuypers was appointed architect of the museum. Work **[1877]** was begun the following year (fig 25), and six years later, in 1883, the building was completed (fig 26). 8,000 10-18 meter piles had been driven, 8,500,000 large bricks had been laid, and 1,500 cubic meters of blue granite (*petit granit de l'Ourthe*) and 2,000 cubic meters of white stone (*roche d'Euville* for the exterior and *savonnière* for the sculptures both inside and outside) had been used. The walls had a heavy load to bear: 920,000 kilograms of iron had been used for the roof and ceiling beams, 50,000 kilos of lead, 9,600 square meters of slate and 7,000 square meters of glass for the roofing and 2,500 kilos of zinc for roof ornaments. 16,000 square meters of floor was covered with mosaic, terrazzo, tiles or cement.

The new museum was the largest building in the country at the time of its construction. It stood on a plot of three hectares (about seven-and-a-half acres) – 11,850 square meters for the ground plan of the building and 18,150 for the garden, in 17th- and 18th-century style – surrounded by a wrought-iron fence 1,000 meters long. The large gardens, which kept traffic at a distance and gave the light around the building free play, were open to the public. The east and west gardens were joined by an underground tunnel.

The rectangular groundplan of the building (fig 27), with its 135-meter façade, is bisected at street level by a road traveling the 71 meters through the middle of the museum. This unfortunate situation was, as can be imagined, not the architect's idea: it was a demand of the city, which saw the road as an essential artery connecting the old and new parts of Amsterdam. But Cuypers knew how to make a virtue of necessity, and found a splendid way of incorporating the road, which he flanked with

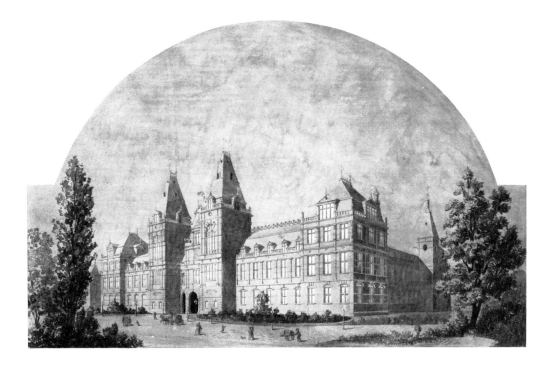

22 The winning entry in the prize competition for the Rijksmuseum, executed in this form, except for the central section. Renaissance design of 1876 by P J H Cuypers. Colored drawing (57 × 88.5) by Cuypers's bureau. Amsterdam, Nederlands Documentatiecentrum voor de Bouwkunst (Netherlands center for documentation of architecture)

23

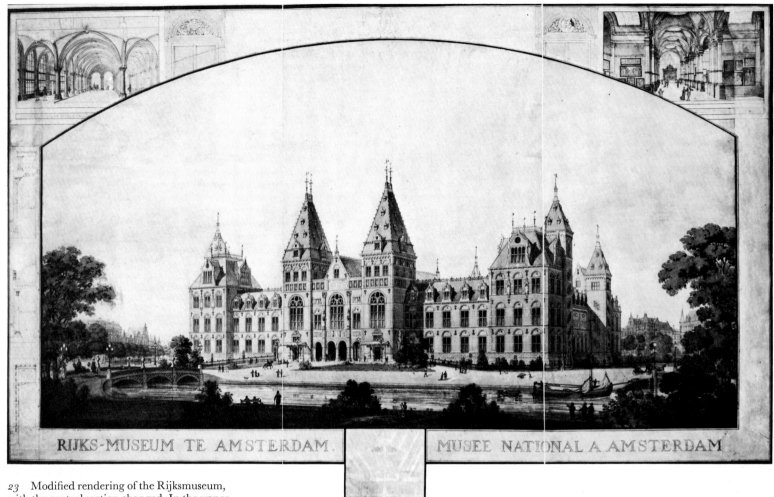

RIJKS-MUSEUM TE AMSTERDAM. MUSEE NATIONAL A AMSTERDAM

23 Modified rendering of the Rijksmuseum, with the central section changed. In the upper left is the through arcade, in the upper right the Eregalerij (gallery of honor). Renaissance design of about 1878 by P J H Cuypers. Colored drawing (100 × 194) by Cuypers's bureau. Amsterdam, Nederlands Documentatiecentrum voor de Bouwkunst (Netherlands center for documentation of architecture)

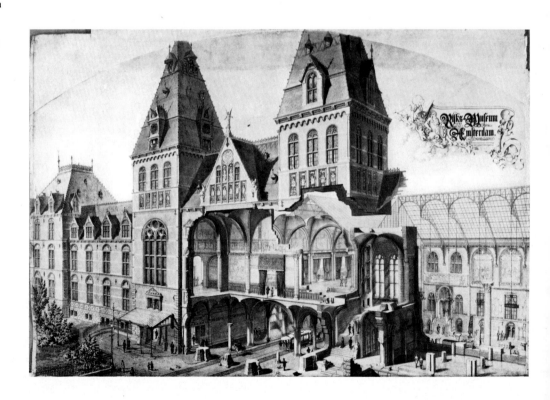

24 Perspective section of the Rijksmuseum. Colored drawing (161 × 208) of about 1878 by Cuypers's bureau. Amsterdam, Nederlands Documentatiecentrum voor de Bouwkunst (Netherlands center for documentation of architecture)

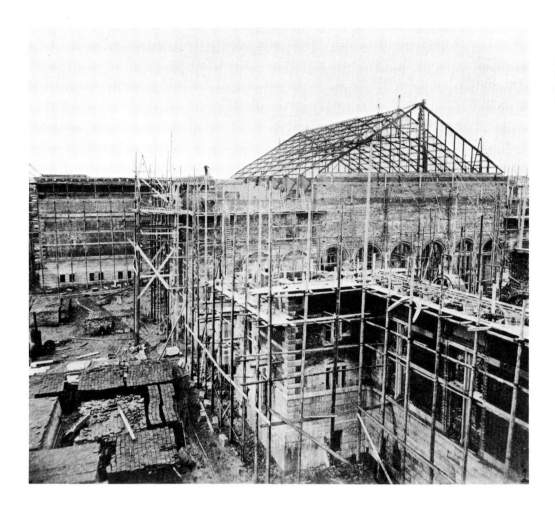

25 The Rijksmuseum in construction, about 1881. View of the rear façade with the towers flanking the central passageway, the ironwork of the roof over the west courtyard and, on the left, the rear of the printroom. Photograph in the museum archives

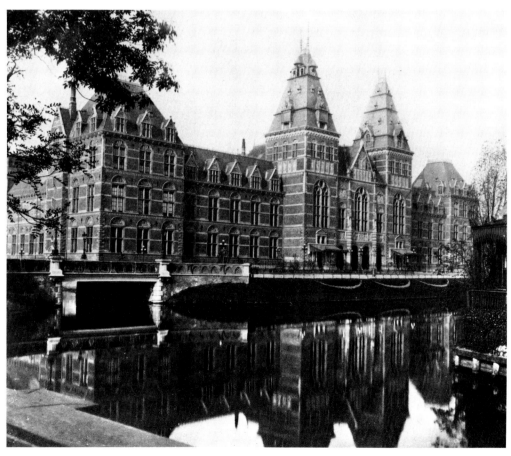

26 The Rijksmuseum upon its completion in 1883. Photograph in the museum archives

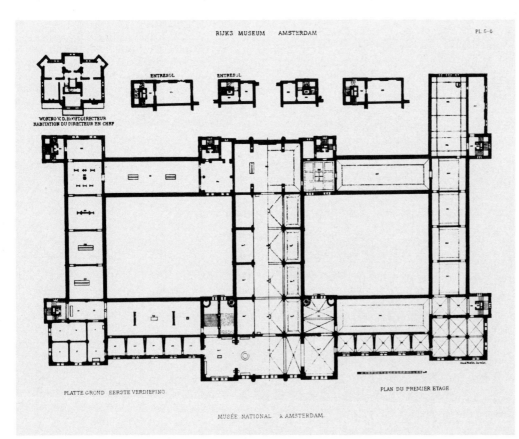

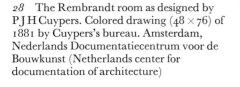

27 Groundplan of the main floor of the Rijksmuseum, housing the Rijksmuseum van Schilderijen (national painting museum). In the upper left is the director's residence, converted after the Second World War into executive offices. Plate 5-6 in Victor de Stuers, *Het Rijksmuseum te Amsterdam: platen van P J H Cuypers* (the Rijksmuseum in Amsterdam: plates by P J H Cuypers), Amsterdam 1897

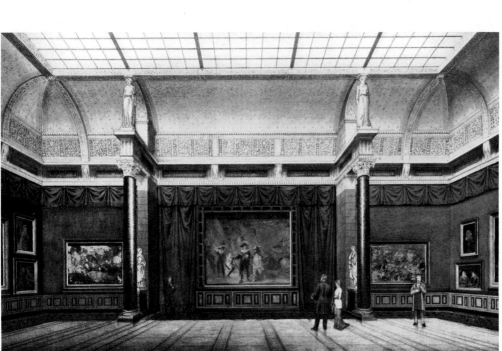

29 Jonkheer Victor Eugène Louis de Stuers (1843-1916) and Dr Petrus Josephus Hubertus Cuypers (1827-1921). Photograph in the museum archives

28 The Rembrandt room as designed by P J H Cuypers. Colored drawing (48 × 76) of 1881 by Cuypers's bureau. Amsterdam, Nederlands Documentatiecentrum voor de Bouwkunst (Netherlands center for documentation of architecture)

30 'The dedication of the bishop's palace, called "the Rijksmuseum in Amsterdam."' From left to right: Victor de Stuers, J A Alberdingk Thijm and P J H Cuypers. Satirical cartoon by Jan Pieter Holswilder (1850-90) in the Hague periodical *De Lantaarn*, vol 1 (1885) nr 14, opposite p 4

arcades, into his design: large windows on either side of the road allowed the passers-by to look into the large central courtyards, with their glass skylights, around which the galleries were laid out. The same arrangement prevailed on the main floor, which was nearly wholly illuminated with skylights. The central axis at this level was occupied by a front hall, a long gallery of honor and a Rembrandt room, which was seen as the culminating point of the architectural composition. The four corners of the building and the entry and exit of the road were accentuated by eight towers, the main ones 62 meters high and the others 43 meters.

The museum had 330 rooms – 141 in the basement, 70 on the ground floor, 67 on the second (main) floor, 32 on the third floor and 20 on the fourth. The courtyards, the ground floor and the main floor were the areas that were open to the public.

The interior as well as the exterior was richly decorated. The crucial moments and key monuments of Dutch history and art were visualized in historical and allegorical murals, tile paintings, stained-glass windows and reliefs, interlarded with appropriate texts and countless artist's names. The decoration outside is still intact, but inside it has been nearly totally removed in the name of modernization. Only room 168 (now room 106), a reconstruction of a 13th-century chapel from the abbey of Aduard in Groningen province, has been left in its original form. Rather than attempting to describe the entire, virtually encyclopedic decorative program, we can let the Rembrandt room (fig 28), where *The nightwatch* hung, stand for the whole. Four caryatids, representing Morning, Day, Evening and Night, in allusion to Rembrandt's mastery of light and dark, stood on columns of gray Hungarian marble and bore the vaults supporting the skylight. Their meaning was enriched with symbolic accessories: Morning had a crowing rooster and the heads of an awakening man and woman, Day an Egyptian woman (the south) and a lion, and so forth. The most important biographical data of Rembrandt were written in golden letters on the frieze, and the initials of his name worked into the mosaic floor and the walls, with those of Saskia. All of this has been covered up and hidden from view. Also gone is the Gulden Boek van het Museum (golden book of the museum), for the signatures of royal and other distinguished visitors. Once kept in a handsome oaken chest in the Rembrandt room, it is now preserved in the museum archive. The opening pages contain the official opening document, calligraphed by Jos Th J Cuypers, son of the architect.

De Stuers saw the museum not only as a monument to Dutch art and history of past ages, but also as a formative influence on the art of his own day. He intended it as a training school for artists, on the model of the South Kensington Museum. On the top floor of the east wing was the Rijksnormaalschool voor Teekenonderwijs (state high school for drawing instructors) and on that of the west wing the Rijksschool voor Kunstnijverheid (state school of applied arts), under the direction of W B G Molkenboer and J R de Kruijff, respectively. In 1891 the school for drawing instructors was enlarged with a handsome new annex in the museum garden, the Oefenschool (training school).

Cuypers and de Stuers (fig 29) were both Catholics, and adherents of Cuypers' brother-in-law Josephus Albertus Alberdingk Thijm (1820-89), writer, art theoretician and one of the great proponents of Catholic emancipation in Holland (fig 30), which had made such important social strides since the restoration of the hierarchy in 1853. Thijm's artistic theory was shot through with mysticism. Ideally, for Thijm, art should animate matter in three ways – through purpose, beauty and symbolism – an ideal he considered to have been realized in the ateliers of mediaeval church builders. Cuypers, who started off as an architect in his native Roermond, in the Catholic south of Holland, had been putting his brother-in-law's ideas into practice since 1850 in his churches and restorations of old churches. In 1864 Alberdingk Thijm had resigned from the committee for the King Willem I museum when it rejected Cuypers' 'Catholic' neo-Gothic project in favor of a classicizing one by a German architect. Cuypers had even submitted an alternative design, in which properly nationalistic 'Protestant' Renaissance features had been incorporated into the façade. Thijm continued to follow the progress of the museum as an interested observer, however. In 1876, the year when at long last Cuypers was appointed architect of the museum, Alberdingk Thijm became professor in aesthetics at the Rijksacademie van Beeldende Kunsten in Amsterdam. If de Stuers was the driving force behind the new museum, Alberdingk Thijm can be considered the author of the all-important decorative program for the building, which was after all Cuypers' very first major piece of profane architecture.

Thanks to the architect's breadth of vision, the building was more than equal to the demands made of it. In the early years it easily accommodated the 350,000 visitors the museum attracted each year, and today it can take, if less easily, 1,300,000. Despite the fits and starts with which the plans progressed over the decades, when it came to building the government was not cheap. The initial costs were estimated at no more than one million guilders, but in the end more than twice that much was spent.

The new government interest in the arts, expressed most conspicuously in the construction of the museum, stimulated a lot of private interest as well. Donations of paintings streamed in, which for the time being only aggravated the situation in the Trippenhuis. The museum had by then become the butt of jokes – it was referred to by the people of Amsterdam as 'the painting warehouse.' At the same time, purchasing was **[1879]** finally resumed. In 1879 Jan Mostaert's *Adoration of the magi* (A 671) was bought, as a work from the school of Jan van Eyck. In **[1880]** 1880 there followed *Princes Maurits and Frederik Hendrik of Orange at the Valkenburg horse fair* by Adriaan van de Venne (A 676). In the same year the museum received the bequest of Jonkheer Jacobus Salomon Hendrik van de Poll (1837-80), according to the terms of his testament of 25 December 1879. This scion of a well-known Amsterdam patrician family had inherited 52 paintings, most of which had been assembled by Henric Muilman, whose collection had been auctioned after his death in 1812. At the auction, 28 paintings were knocked down to the collector's son, Willem Ferdinand Mogge Muilman (d

1849), who left them, together with some family portraits, to his daughter Anna Maria Muilman. Through her marriage with Jonkheer Archibald Jan van de Poll, the collection passed into the possession of their son, who left the family's goods to the museum. One of Henric Muilman's greatest paintings, Vermeer's *Kitchen maid* (A 2344), was not purchased by his son at the auction. It entered the Kabinet Six, from whence it after all found its way to the Rijksmuseum in 1908. With the van de Poll bequest the museum acquired the portrait of *Elisabeth Bas*, then believed to be by Rembrandt but which has more recently been given to Ferdinand Bol (A 714), the equestrian portrait of *Pieter Schout* by Thomas de Keyser (A 697) and the *Dancing lesson* by Jan **[1881]** Steen (A 718). In 1881 the city received the bequest (testament of 19 May 1877) of Jonkvrouwe Jeanne Cathérine Bicker, dowager of Jonkheer Josua Jacob van Winter (1779-1878), consisting of 44 family portraits. The whole collection was given on loan to the museum, and place for it had to be found in the Trippenhuis. **[1882]** In 1882 the opportunity was seized to make good a missed chance of 1841. Rembrandt's *Anatomy lesson of Dr Joan Deyman* (C 85) appeared on the market in England, and upon the urging of Professor Jan Six it was bought by the city of Amsterdam, with help from some private individuals. Three years later the painting was given on loan to the museum.

In the meanwhile the museum management had undergone another transformation. In 1875 the directorate was reinstated, and in 1876 the board of directors was replaced by a board of supervisors, which in fact meant a return to the state of affairs of 1844. The new director was the engraver Johann Wilhelm Kaiser (1813-1900; fig 31), former director of the Graveerschool (school for engravers; 1859-75) and longtime member of the board. In 1880 he replaced the Dubourcq catalogue with a new edition, the first to contain fairly detailed biographies of artists. Kaiser's catalogue numbered 548 paintings. In **[1883]** 1883, with the completion of the new museum building, a new organization was also instituted (royal edict of 4 March 1883). From then on the overall administration was to be the province of a director-general, who was also to serve as director of the Rijksmuseum van Schilderijen. This position was entrusted to

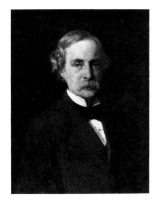

31 Johann Wilhelm Kaiser (1813-1900), director of the Rijks Museum from 1875 to 1883. Painting by Pantaleon Szyndler (A 2850)

32 Frederik Daniël Otto Obreen (1851-96), director-general of the Rijksmuseum and director of the Rijksmuseum van Schilderijen (national painting museum) from 1883 to 1896. Painting by Thérèse Schwartze (A 2724)

Frederik Daniël Otto Obreen (1851-96; fig 32) who, unlike all the previous directors, was not an artist but an art historian, known mainly for his *Archief voor Nederlandsche kunstgeschiedenis* (archive for Dutch art history) published in seven volumes in Rotterdam between 1877 and 1890. From 1879 to 1883 he had been director of the Museum Boymans in Rotterdam. Under him were appointed as directors of the Nederlandsch Museum voor Geschiedenis en Kunst (Netherlands museum of history and art) and the Rijksprentenkabinet (national printroom), both of which were housed in the Rijksmuseum, the brothers David van der Kellen Jr (1827-95) and Johan Philip van der Kellen (1831-1906). Another institution that found refuge in the new building was the museum of plasters, responsibility for which was assigned directly to the director-general.
[1884] In 1884 the museum received 26 family portraits from Jonkheer J H F R van Swinderen.

The Rijksmuseum from 1885 to 1945

The Rijksmuseum was officially opened (figs 33
[1885] & 34) on 13 July 1885 by the minister of the interior, Jan Heemskerk Az, in the name of King Willem III, who was represented by his niece Princess Maria of the Netherlands and her German husband Wilhelm, Prince von Wied. The ceremony took place in the east courtyard, with the prince and princess on golden chairs borrowed from the municipal theatre and the many guests seated opposite a dais on which an orchestra and chorus were placed. Speeches were held by the minister and the burgomaster of Amsterdam, G van Tienhoven. The orchestra and chorus then performed a cantata by J J L ten Kate, set to music by the conductor, Daniel de Lange. When the assembled guests, on a tour of the museum, reached *The nightwatch*, the painting was unveiled by the 68-year-old painter Johannes Bosboom at the same moment as, in the court-yard, the chorus took up Jan Pieter Heye's rhapsody *Rembrandt*, conducted by the composer, Johannes Verhulst. In closing, the banker and politician A C Wertheim paid homage to the architect, Cuypers, who was made a knight in the order of the Dutch lion. The reporter of the

Algemeen Handelsblad had this to say about the ceremony: 'The party in the Rijksmuseum today was not exactly what you would call exciting. The cantata was a bit on the long side; the speech of Mr Heemskerk was also quite long and not very gripping. Neither was the bestowal of the Dutch lion on the architect Cuypers [...] performed in a particularly impressive way; and seeing a prince in a German uniform representing the house of Orange did not contribute to the joy of the occasion.' The king's absence was not fortuitous. It was a public secret that he was profoundly annoyed that the museum was not named after Willem I or himself, as had been planned at one point.

At the opening only the Rijksmuseum van Schilderijen on the main floor was open. It consisted of the following component parts:
a 888 paintings from the former Rijks Museum in the Trippenhuis
b 41 paintings from the depot of the Mauritshuis, among them ceiling paintings, mantel paintings and decorated rooms
c 122 paintings from the Nederlandsch Museum voor Geschiedenis en Kunst, founded in 1875 at the instigation of Victor de Stuers and housed in a building on the Prinsengracht in The Hague. Aside from an important applied arts collection, the museum owned mainly paintings of historical subjects and the miniature collection of Prince Willem V. In 1876 the bequest of Jonkheer Jacob de Witte van Citters, consisting of numerous family portraits, was added to the collection. The nucleus of the museum came from the Koninklijk Kabinet van Zeldzaamheden (royal cabinet of rarities), which shared occupancy of the Mauritshuis with the Koninklijk Kabinet van Schilderijen since 1821. The objects in the Koninklijk Kabinet van Zeldzaamheden that were not transferred to the Nederlandsch Museum voor Geschiedenis en Kunst in 1875 were brought to a house on the Lange Vijverberg in The Hague. In 1883 this remnant was divided among the Rijksmuseum in Amsterdam, the Rijksmuseum voor Volkenkunde (national museum of ethnography) in Leiden and the medal cabinet in The Hague
d 35 family portraits, donated in 1885 by Jan Stanislaus Robert van de Poll (1805-88) of Arnhem. This donation, supplementing the J S H van de Poll bequest of family portraits, received in 1880, included Frans Hals's portraits of *Nicolaes Hasselaer* and *Sara Wolphaerts van Diemen* (A 1246 & A 1247)
e 190 paintings that had constituted the Rijks Verzameling van Kunstwerken van Moderne Meesters located since 1838 in Welgelegen pavilion, Haarlem
f 47 paintings assembled by the Vereeniging tot het vormen van eene openbare verzameling van Hedendaagsche Kunst (society for the formation of a public collection of contemporary art) founded in Amsterdam in 1874 by C P van Eeghen. The aim of this organization was to collect works of art, preferably by living Dutch artists, and to present them in some appropriate manner to the city of Amsterdam. Until 1885 the collection was housed in the Oudemannenhuis (old men's home). In 1895, by which time the collection had waxed to 82 paintings, it was transferred to the newly opened Stedelijk Museum (municipal museum)
g 165 paintings of the city of Amsterdam, from

the town hall and other public buildings. Most of these were group portraits of guild officers, governing bodies and civic guard companies. In 1889 this loan was augmented by the paintings belonging to the Felix Meritis society (founded in 1777 as a society for the advancement of knowledge of the arts and sciences), which was dissolved in that year. The works that entered the museum in that way included the *Old woman in prayer* by Nicolaes Maes (C 535) and Adriaen de Lelie's paintings of the Felix Meritis society itself (C 537-C 539). In 1891 there followed nine paintings presented to the city by Mrs Messchert van Vollenhoven, née van Lennep. In 1893 another group of new acquisitions was loaned by the city, and more followed in the years to come. By 1926, when the city of Amsterdam paintings in the Rijksmuseum were reviewed in connection with the foundation of the Amsterdams Historisch Museum (Amsterdam historical museum), the loan comprised 225 paintings
h 225 paintings belonging to the city of Amsterdam, constituting the Museum Van der Hoop. This formidable collection was put together by the banker Adriaan van der Hoop (1778-1854) largely after 1832, in a period when the Rijksmuseum was virtually out of the market. He willed it to the city on 22 November 1847 and on 3 July 1854 it became municipal property, thanks to the collector Carel Joseph Fodor (1801-60), who joined with some friends to pay the legacy duties of 50,000 guilders, which the city could not be troubled to raise. In the course of 1854 the Museum Van der Hoop was installed in the Oudemannenhuis, where the Academie van Beeldende Kunsten (academy of art) had been quartered since 1837 and which in 1875 also took in the paintings of the Vereeniging tot het vormen van eene openbare verzameling van Hedendaagsche Kunst (see above, under *f*). 24 more paintings were added to the Museum Van der Hoop in 1880, after the death of the collector's widow, who had them in her house. At that time it was decided that the Museum Van der Hoop was to have its own rooms in the Rijksmuseum, a stipulation that was long abided by.

Van der Hoop was not only blessed with wealth but also with taste, and he had assembled a truly choice collection of Dutch 17th-century masters and paintings by his contemporaries. The star pieces in the collection are Rembrandt's *Jewish bride* (C 216) and Vermeer's *Woman reading a letter* (C 251). Other highpoints are the large *Italian landscape with draftsman* by Jan Both (C 109), *The tailor's workshop* by Quiringh van Brekelenkam (C 112), the portrait of *Maritge Claesdr Voogt* by Frans Hals (C 139), the *Watermill* by Meindert Hobbema (C 144), three genre paintings by Pieter de Hooch (C 150, C 147 & C 149), *Peasants in an interior* by Adriaen van Ostade (C 200), *Two horses near a gate in a meadow* by Paulus Potter (C 205), *The windmill at Wijk bij Duurstede* and the *Landscape with waterfall* by Jacob van Ruisdael (C 211 & C 210), the *Interior of the church of St Odolphus in Assendelft* by Pieter Saenredam (C 217), *The merry family* and *The sick woman* by Jan Steen (C 229 & C 230), *The cannon shot* by Willem van de Velde II (C 244), the *Portrait of a couple in a landscape* by Adriaen van de Velde (C 248) and, from the Southern Netherlands, the portrait of *Helena Fourment* by Rubens (C 295)

33 The opening ceremony of the Rijksmuseum in the east courtyard on 13 July 1885: Prince and Princess von Wied and the invited guests, with depictions in the background of the Dutch maiden and, above it, 'Our pioneers,' painted in 1884 by Jonkheer Jacob Eduard van Heemskerck van Beest (C 429). Photograph in the museum archives

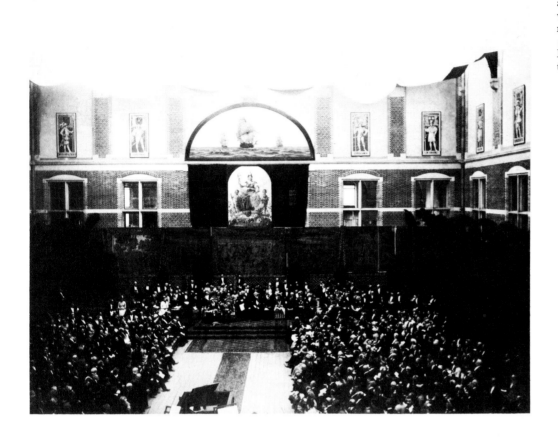

34 The other side of the east courtyard on 13 July 1885: the choir and orchestra under the direction of Daniël de Lange (1841-1918). Photograph in the museum archives

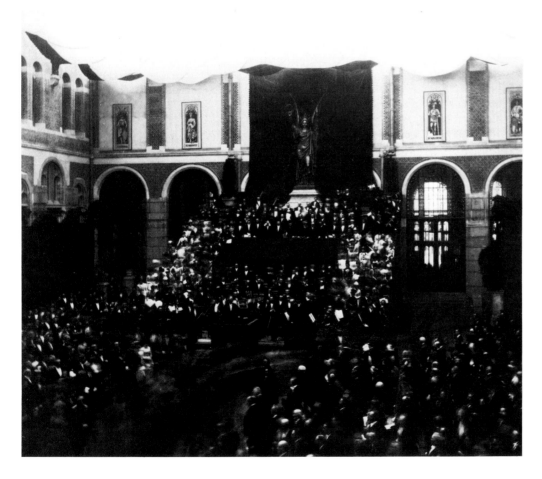

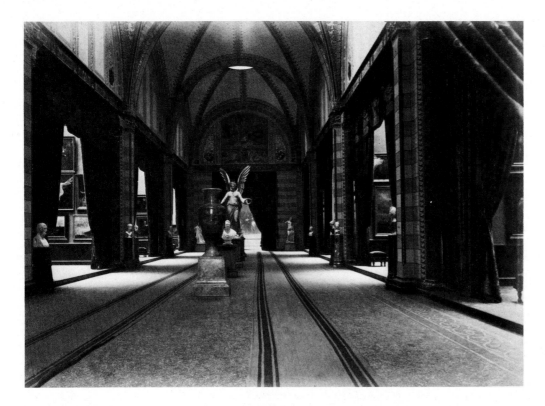

35 The gallery of honor (rooms 244-47) in 1887. We look towards *The nightwatch*, past the plaster modello for the bronze *Victoria* by Frans Vermeylen (1824-88) that crowns the entrance bay. Photograph in the museum archives

36 Groundplan of the main floor: Rijks Museum van Schilderijen (national painting museum), 1887. From Fr D O Obreen, *Wegwijzer door's Rijksmuseum te Amsterdam* (guide through the Rijksmuseum in Amsterdam), Schiedam 1887

i 34 paintings belonging to the Koninklijk Oudheidkundig Genootschap (royal antiquarian society; founded 1858), which had played a central role in the 1862 plans for a Museum Koning Willem I. The vice chairman and secretary of the responsible committee, C P van Eeghen and J A Alberdingk Thijm, were among the founders of the society, as were L M Beels van Heemstede, P L Dubourcq and L Lingeman, members of the 1873 subcommittee, and A J Enschedé and D van der Kellen Jr, members of the board of advisors in 1874. The Genootschap was housed in the Munttoren, but moved in 1917 to the Rijksmuseum, where since 1885 it had enjoyed the use of two exhibition rooms, joined in the so-called Regentenkamer (regents room; 248-49).

The augmentation of the collection with the more than 850 paintings listed under *b-i* nearly doubled it, bringing the total to about 1750. Kaiser's catalogue was replaced in 1885 by a new one compiled by Dr Abraham Bredius, under-director of the Nederlandsch Museum voor Geschiedenis en Kunst from 1880 to 1889, when he became director of the Mauritshuis.

The museum had – and still has – two main entrances, one on the left (east) and one on the right (west) of the dividing arcade. Both entrances lead to exhibition halls on the ground floor, which were occupied in the beginning mainly by the Nederlandsch Museum voor Geschiedenis en Kunst. The courtyard of the west wing was set aside for the Rijks Verzameling Gipsafgietsels, the plaster cast museum. The exhibition rooms of the printroom were also in the west wing.

The visitor to the Rijksmuseum van Schilde-rijen, which took in the entire main floor (fig 36), could choose between the two entrances. With Obreen's guide of 1887 in hand, one followed the stairway to the Voorhal (front hall; 212, now 237), which led to the Eregalerij (fig 35, gallery

of honor; 244-47, now devoted to the foreign schools and numbered 229-35). This gallery was lined with four spacious cabinets on either side, where the larger paintings, including most of the group portraits of governing bodies and civic guard companies, were hung. As soon as one entered the gallery of honor one was awarded a distant view of *The nightwatch* in the Rembrandt-zaal (fig 37, Rembrandt room; 243, now Nachtwachtzaal [Nightwatch room], 224). The painting hung on the south wall; on the others were group portraits of civic guard companies by Bartholomeus van der Helst, Govert Flinck, Frans Hals and Joachim von Sandrart as well as *The regents of the Spinhuis* by Karel Dujardin (C 4). From the Rembrandt room a door on the left, east wall led to the Karolingische zaal (Carolingian room; 236, now 223); this room, located under one of the towers and devoid of natural light, was a re-creation of Charlemagne's chapel in the porch of the church of St Servaas in Maastricht. Next came the large Internationale zaal (international room; 235, now divided into the early Rembrandt room, the Syndics room and the Rembrandt school room and numbered 220-22), with works by Flemish, Italian, French, Spanish and German masters. From there one went on to the 15th-century Dutch masters (228, now the Italianate room, 217) and those of the 16th century (227, now the Jan Steen room, 218). Following were the rooms housing the Dupper bequest (226, now the van der Helst room, 215) and the J S H van de Poll bequest (225, now the Ruisdael room, 214). An extension (now the de Momper room and miniature cabinet, 209 & 213) of the portrait room led to the Zaal der anatomiestukken (room of anatomy paintings; 220, now divided differently, into the present Mannerist rooms 206-08 & 210), where the highpoint was Rembrandt's *Anatomy lesson of Dr Joan Deyman* (C 85). Continuing, one came to the Portrettenzaal (portrait room; 214, now the

Frans Hals room and sales area, 211-12), where the Bicker bequest and Rembrandt's *Syndics* (C 6) were featured. Via four cabinets of 17th-century cabinet paintings (216-19) and one (215) with the family portraits of the de Witte van Citters bequest (now the Scorel room, Lucas van Leyden room, van Oostsanen room, Master of Alkmaar room and Geertgen room, 201-05) one returned to the front hall. Half of the route was now accomplished. Crossing the front hall, one entered the west cabinets, the first of which contained the Liotard bequest and nine pastels by J F A Tischbein, and the other four later 17th-century cabinet pictures (270-74, now devoted to mediaeval sculpture and applied arts, 238-42). The cabinets led to the Paviljoenzaal (pavilion room), originally installed as a service area but which by 1886 had to be converted into a painting gallery on account of the rapid growth of the collection. The family portraits of the J S R van de Poll donation shared this space with a large number of portraits of artists, mainly self portraits (268, now divided differently, and housing the applied arts rooms 243-47). From there an extension of the Museum Van der Hoop room led to that museum within a museum (fig 38; 269, now the new acquisitions room and Italian applied arts room, 248-49), with the splendid collection that Adriaan van der Hoop had left to the city of Amsterdam. The star painting was Rembrandt's *Jewish bride* (C 216). The same extension (now Schatkamer [treasury] 251A) led to room 263 (now 251), originally devoted to modern paintings belonging to the museum, and later to modern paintings from the van der Hoop bequest. There followed two rooms (261-62, now including the Lutma room, 254) of modern paintings belonging to the Vereeniging tot het vormen van eene openbare verzameling van Hedendaagsche Kunst. The next two rooms contained paintings by modern masters from Welgelegen in Haarlem, including Pieneman's

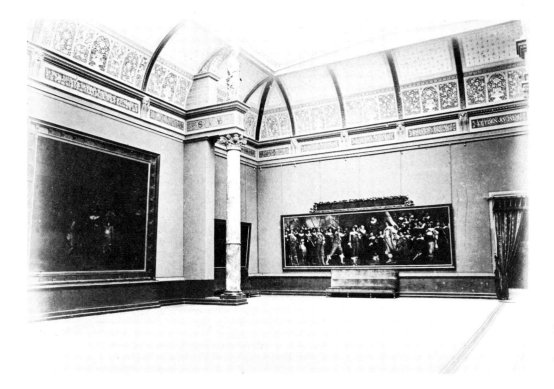

37 The Rembrandt room (243) in 1887. To the left is *The nightwatch*. On the side wall, where *The nightwatch* hangs today, is Bartholomeus van der Helst's *Company of Captain Roelof Bicker* (C 375). Photograph in the museum archives

38 The Museum Van der Hoop room (269) in
1887. To the right, behind the barrier, is
Rembrandt's *Jewish bride* (C 251). At the entrance
to the hall is the marble *Perseus* by F K A C
Leenhoff (1841-1914), bought at the Antwerp
world's fair in 1885 (see cat *Beeldhouwkunst*, 1973,
nr 527). Photograph in the museum archives

39 The Waterloo room (255) in 1887. At the
far left is part of *The battle of Waterloo* by Jan
Willem Pieneman (A 1115). In the background,
in the neighboring room 260, is the marble *Ecce
Homo* of 1826 by Louis Royer (1793-1868; cat
Beeldhouwkunst, 1973, nr 442). Photograph in the
museum archives

Battle of Waterloo (A 1115), after which the larger room was named (fig 39; 255 & 260, now not quite filled by the Delft blue room and the Verhulst room, 255, 257-59). Two rooms of the Koninklijk Oudheidkundig Genootschap followed – the Leprozenzaal (lepers' room), named for its ceiling, painted by Gerard Lairesse for the Leprozenhuis (lepers' asylum; C 382), and the small Goudleerkamer (gilt leather room) – installed as a 17th-century regents' chamber, which speedily came to be known as the Regentenkamer (248-49, now 17th-century furniture rooms, 260-61). These rooms adjoined the Rembrandt room, which led the visitor, via the gallery of honor, front hall and one of the staircases, to the exit.

Since 1885 much has changed in the museum. Paintings were frequently rehung from the start, and not long after the opening a building campaign made more space available. *The nightwatch* was moved twice, once in 1906 and again in 1926. The display of the entire collection was radically revised in the years after 1922 and again after 1945. These changes will be discussed below.

The old tradition of state purchase of works by living masters was soon to come to an end. In **[1886]** 1886 Breitner's *Horse artillery* (A 1328) was purchased, in 1887 Jacob Maris's *City view* (A 1404) and finally in 1889, P J C Gabriël's '*In the month of July*' (A 1505). In the meanwhile, a group of private individuals had set up in 1874 the above-mentioned society for modern art (see at 1885, under *f*). They bought works by living Dutch artists, with the intention of later displaying their collection in an appropriate public museum. From 1883 to 1895 the works hung in the Rijksmuseum. In the latter year, with the opening of the Amsterdam Stedelijk Museum, the 82 paintings they had accumulated were removed there. With such a large collection so nearby, the Rijksmuseum decided to abandon the field of modern art once and for all. For all practical purposes, the turn of the 20th century was to remain the collecting frontier of the Rijksmuseum, and later works were acquired only under special circumstances. The latest major component of the collection is formed by the Amsterdam and Hague schools of late 19th-century Holland, which was to grow to major importance through the donations of Mr & Mrs Drucker-Fraser and others.

The ground that had been lost after 1830, when acquisitions had come nearly to a stand-still, was partly regained by the reorganization of the 1880s – especially through the van der Hoop collection, even if it was only a loan. One could now admire four Rembrandts and one Vermeer in the collection, all five paintings loans. The museum did not own a single work by either of those masters, at least none that is accepted today as authentic. The acquisitions budget was simply not sufficient to allow the purchase of major works. When one came on the market, the museum had to turn to the Vereniging Rembrandt (Rembrandt society) for aid, invariably with success. This society 'for the preservation and augmentation of the art treasures in the Netherlands' was founded upon the initiative of Victor de Stuers in 1883 on the occasion of the auction of Jacob de Vos Jr's famous collection of drawings, which would otherwise have certainly been lost to foreign

40 Jonkheer Barthold Willem Floris van Riemsdijk (1850-1942), director-general of the Rijksmuseum and director of the Rijksmuseum van Schilderijen (national painting museum) from 1897 to 1921. Bronze relief made in 1899 by Johan Hendrik Baars (d 1899; cat *Beeldhouwkunst*, 1973, nr 552)

buyers. The society's financial aid is still of vital importance to the Rijksmuseum as for all other art museums in the country. The first major purchase made possible by the Vereniging Rembrandt was that of Vermeer's *Love letter* **[1893]** (A 1595) in 1893.

Towards the end of the 19th century and beginning of the 20th the Rijksmuseum regularly benefitted from donations, bequests and loans. Many of the works acquired in this way were by minor masters, interest in whom had recently been revived by discoveries in the archives made by practitioners of the new scholarly discipline of art history. Victor de Stuers donated about ten such works, and Abraham Bredius, the great benefactor of the Mauritshuis, gave 42 in all. Deserving of special mention is the purchase of **[1895]** the de Ruyter de Wildt collection in 1895, including 26 family portraits and many personal possessions of the famous admiral Michiel Adriaensz de Ruyter.

[1896] In 1896 the director-general of the Rijksmuseum and director of the Rijks-museum van Schilderijen, Fr D O Obreen, died and was succeeded by Jonkheer Barthold Willem Floris van Riemsdijk (1850-1942; fig 40), whose official appointment came the following year.

[1897] In 1897 the museum received Rembrandt's portrait of *Maria Trip* (C 597) on loan from the van Weede family foundation in **[1898]** Utrecht. In 1898 Daniël Franken Dzn (1838-98), banker and co-founder of the Koninklijk Oudheidkundig Genootschap, bequeathed the museum 49 paintings, including a number by Adriaan van de Venne. A year later **[1899]** came the bequest of Reinhard Baron van Lynden, comprising 39 modern and 4 old **[1900]** paintings. In 1900 his widow supplemented the bequest with a donation of 45 paintings by modern Dutch and foreign masters, supplying the museum with good works by Corot, Courbet, Daubigny, Daumier and others. Whistler's portrait of *Effie Deans* (A 1902) was also included in this donation. The great event of the year, however, was the purchase of Rembrandt's landscape *The stone bridge* (A 1935), made possible by the financial aid of the

Vereniging Rembrandt and Abraham Bredius. At last the museum owned a Rembrandt of its own. **[1903]** In 1903 the museum received the 22 paintings of the A A des Tombes bequest (the collector left his *Head of a young girl* by Vermeer to the Mauritshuis) and the second half of the bequest of des Tombes' brother-in-law Jonkheer Jacob de Witte van Citters, consisting of 24 family portraits that des Tombes had had in usufruct. A more important development in that year was the first contact with Mr & Mrs Drucker-Fraser, who made their first loan of Hague school paintings and drawings to the museum in 1903. Jean Charles Joseph Drucker (1862-1944), son of a wealthy financier, and his wife Maria Lydia Fraser, began collecting in 1885 and soon came to specialize in the Hague school. He and his wife gave the museum several groups of works on loan, and after the passage of time would convert the loans into donations. They stood in the closest contact with Jonkheer van Riemsdijk and after 1922 with his successor Schmidt-Degener. The 1903 loan consisted of 14 paintings, among them 8 by Anton Mauve, and 13 aquarelles. It was followed in 1904 by a loan of 21 paintings and 7 aquarelles by Jacob Maris. Both loans became gifts in 1909. In 1911 the Druckers lent 12 paintings and 7 aquarelles by Jozef Israels, converting the loan into a donation in 1912. In 1919 came another large loan of Hague school paintings, filled out with works by Breitner, Isaac Israels, Jongkind, van Gogh and others, while in 1928 Breitner's *The wooden shoes* (A 3061) and Prud'hon's portrait of the *Schimmelpenninck family* (A 3097) were donated directly. Mr & Mrs Drucker-Fraser died in Switzerland in 1944, and it wasn't until after the war, in 1947, that the museum received notice that the loan of 1919 and all later loans were now its property.

The Bredius catalogue was replaced in 1903 by van Riemsdijk with one he wrote himself. This became the standard model for all future catalogues, and it was repeatedly reprinted, with supplements. The last edition, revised by F Schmidt-Degener & D C Röell, appeared in 1934.

In the meanwhile the new museum building was being weighed in the balances. Although it was greeted enthusiastically at first by everyone except the anti-Catholics who saw it, not altogether wrongly, as a monument of the Catholic revival and dubbed it 'the bishop's palace' (*see* fig 30) – King Willem III is reported to have said of it 'Jamais je ne mettrai un pied dans ce monastère' (Never shall I set foot in this monastery) – other voices were soon raised in criticism. The foremost complaints were directed against the lack of system in the presentation, the intrusive decoration and the lighting, which was too bright everywhere except where it was too dim. The lighting of *The nightwatch* by skylight was a particular source of displeasure. Many felt that it had showed to better advantage in the Trippenhuis, where it had been illuminated from the side. The critics were proved right when in 1898 the painting was hung beside a window on the south side of the Stedelijk Museum for the Rembrandt exhibition. A committee was called into being: the Rijks Commissie tot het nemen van proeven betreffende de verlichting van Rembrandt's 'Nachtwacht' (state committee for experimenting with the lighting of Rembrandt's 'Nightwatch'). In 1901

41 *The nightwatch* in the new Rembrandt room, with southern light, as it hung from 1906 to 1926. This area is now the Vermeer room. Photograph in the museum archives

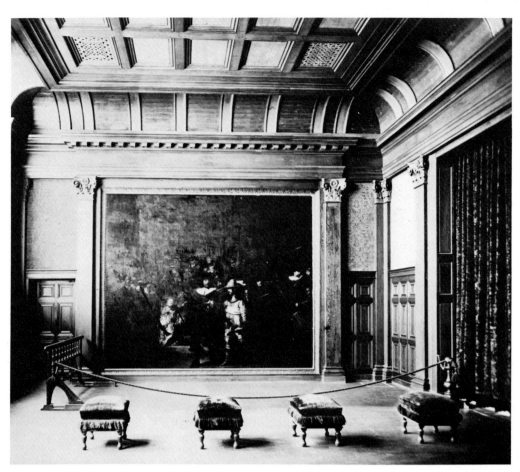

42 'Waarom juicht Cuypers niet bij 't Rembrandt-jubileum?: De man heeft nu een puist aan z'n eigen Rijksmuseum!' (Why doesn't Cuypers celebrate the Rembrandt jubilee? The fellow's grown a pimple on his own Rijks-museum!) Satirical cartoon by Albert Hahn (1877-1918) in his book *Het land van Rembrandt: prentjes van Albert Hahn* (Rembrandt country: cartoons by Albert Hahn), Amsterdam 1906

43 The new Rembrandt room, built in 1906 onto the existing Rembrandt room by P J H Cuypers. Photograph in the museum archives

44 The Fragmentengebouw (fragment building) in the garden, with the printroom on the left, in 1898. The fragment building was connected to the main building via a passage running along the rear of the printroom. Photograph in the museum archives

the painting was brought to a wooden shed built for the purpose behind the museum. (Before the construction of the museum similar tests had been performed, with Caspar de Crayer's *Adoration of the shepherds* [A 74] serving as a stand-in for *The nightwatch*.) Over the passionate protests of Victor de Stuers, the committee decided in favor of lighting from the side. Cuypers designed a new Rembrandt room behind the existing one (fig 42), to be built against the rear façade of the museum (fig 43). It was ready in time for the celebration of Rembrandt's 300th birthday in 1906. But although the painting was finally illuminated from the south side once more (fig 41), this solution too was to prove unsatisfying in the long run. In 1926 it was moved back to the original Rembrandt room, though now it was placed against the west wall rather than the south wall. The daylight (which has since been reinforced with a halogen lamp) came once more from above.

The museum had its first extension as early as 1898, with the construction of the so-called Fragmentengebouw (fragment building, fig 44), into which had been built a miscellany of remnants from demolished historical structures. It was connected to the main building by a long corridor that ran along the rear façade of the library and that, together with six new rooms, was reserved for the display largely of 19th-century paintings. When this part of the collection underwent a dramatic growth after the turn of the century, thanks in the first place to the Drucker-Fraser donations, the exhibition area had to be enlarged: in 1909 the new space was expanded, and in 1916 the so-called Drucker-uitbouw (Drucker extension) reached its present size. In 1917 the paintings were moved upstairs. In this way the modern paintings ended up in an area behind the library and printroom that does not communicate directly with the galleries of old art. The connecting corridor is on the ground floor, and the visitor to the main galleries had to descend the stairs in room 248 (now 260), cross the applied arts rooms 188-89 (now 162-66),

walk the corridor and climb another flight of stairs to get from the old paintings to the modern ones. This unfortunate situation has never been corrected.

[1905] In 1905 Miss Maria Elisabeth van den Brink, a descendant of the seascape painter Ludolf Bakhuysen, left the museum a number of paintings, among them several portraits of members of the Bakhuysen family, which included other artists beside Ludolf. In

[1907] 1907 the museum was enriched by the bequest of the painter and collector J B A M Westerwoudt (1849-1906), consisting of about 80 modern paintings and drawings. In the same year Cornelis Hoogendijk (1866/67-1911) lent his collection of no fewer than 260 paintings, including many remarkable works of the 15th and 17th centuries but distinguished mainly for its modern French masters. 126 of them were placed on exhibition in the Rijksmuseum and another 53 less important works in the Rijksmuseum Muiderslot, while about 80 more went into depot to await the opening of the first part of the Drucker extension. For some reason the modern paintings were not inscribed in the inventory of loans (the C-list). But twelve Cézannes and four van Goghs are known to have been on display (cat R M A 1911, nrs 688 A-I, K-M and 984 b-d, h, respectively) while another thirteen Cézannes and two van Goghs – not to mention ten Courbets, five Renoirs and two Monets – were placed in depot. A year after Hoogendijk's death his heirs donated 53 paintings to the museum, including some French works such as Daumier's *The singers* (A 2578), but not the Cézannes or the van Goghs. As for van Gogh: in 1909 Mrs J Cohen Gosschalk-Bonger lent three of his paintings, and in 1917 the H P Bremmer loan included four van Goghs as well as works by Verster, van Rijsselberghe, Gestel, Toorop and Mondriaan. Another advance into modern art was made with the loans by Conrad Kickert of a Braque and a Picasso drawing in 1911 and a Le Fauconnier in 1914. But all these loans were reclaimed, leaving the Dutch

Impressionists, after all, to bring up the chronological rear of the collection.

[1908] In 1908 the museum received the 39 paintings that had been bought from the Six collection the year before with help from the Rembrandt society. In this way one of the pearls of that famous Amsterdam collection – Vermeer's *Kitchen maid* (A 2344) – entered the Rijksmuseum, along with *The skaters* by Adriaen van Ostade (A 2332), the *Woman selling herrings* by Gabriël Metsu (A 2328) and *The serenade* by Judith Leyster (A 2326), to name only the most outstanding pieces.

No more noteworthy acquisitions were made

[1914] until 1914. In that year Misses A J Broedelet and S C Büchli Fest donated 13 paintings from the estate of W J van Randwijck. Most of them were Hague school works, most notably the *Souvenir d'Amsterdam* by Matthijs

[1915] Maris (A 2704). In 1915 Jonkheer J W Six of The Hague lent the museum two Rembrandts – *Joseph telling his dreams* and the portrait of *Dr Ephraïm Bueno* – which he took back five years later, but which were to come into the possession of the museum in 1946 and 1948, respectively (A 3477 & A 3982). In the same year the Vereniging Rembrandt lent the museum the *Emblematic still life* by Torrentius (A 2813), which was bought three years later. In

[1916] 1916 the art dealers B Asscher and H Koetser donated the *Heraclitus* and *Democritus* by Hendrick ter Brugghen (A 2783 & A 2784). In

[1918] 1918 *The seven works of charity* by the Master of Alkmaar (A 2815) was bought from the church of St Lawrence in Alkmaar, in a signal enrichment of the museum's scarce holdings in early northern Netherlandish paintings. Apart from the Hoogendijk loan several other major loans of old and modern masters entered the museum under van Riemsdijk, but nearly all of these temporary possessions had to be returned. The principal lenders were Th Baron Collot d'Escury (1904-24), A Tak van Poortvliet (1910-13), D Baron van Asbeck (1914-20), J R H Neervoort van de Poll (1915-

45 Frederik Schmidt-Degener (1881-1941), director-general of the Rijksmuseum and director of the Rijksmuseum van Schilderijen (national painting museum) from 1922 to 1941. Painting of 1936 by Harm Hendrik Kamerlingh Onnes (A 3268)

21), H van Weede (1916-21) and H P Bremmer (1916-22), the well-known advisor of Mrs **[1921]** Kröller-Müller. In 1921 the Rijksmuseum acquired its fourth, and in all likelihood last Vermeer: the *Street in Delft* (A 2860), which came, like *The kitchen maid*, from the Six collection. When this world-famous painting came under the hammer and might have been lost to Holland, Sir Henry Deterding (1866-1939), a native Amsterdammer who built the Koninklijke Petroleum Maatschappij (royal oil company) to a major financial power, surprised many by buying it at auction and donating it to the Rijksmuseum.

This exceptional acquisition was the last one to be recorded by van Riemsdijk (annual report, **[1922]** 1921). In 1922 he was succeeded by Dr Frederik Schmidt-Degener (1881-1941; fig 45), who had been director of the Museum Boymans in Rotterdam since 1908. In 1919 he had been appointed to the newly constituted Rijkscommissie voor het Museumwezen (state commission for museums), whose task it was to determine the extent to which the organizational forms of the Dutch museums could stand improvement. In that capacity he had been a warm adherent of the plan (which was never carried out) to build a 'toppenmuseum' (museum of masterpieces) behind the Rijksmuseum, in which would be displayed only those works which met the highest aesthetic standards. The old building would then be free for the exhibition of objects that were more interesting, in historical or art-historical terms, than beautiful. The wish to split up the collection was perfectly understandable, since in Cuypers' admittedly rather ornate building all the paintings of the Rijksmuseum were supposed to be displayed, earning it the nickname Rijksopslagplaats (state storage yard), just as the Trippenhuis had been called a warehouse. Van Riemsdijk had begun to exercise a certain degree of selectivity, a process that Schmidt-Degener carried much further. Numerous paintings disappeared into depots built for that purpose or were lent out to other museums, such as those of Utrecht, Leiden and Haarlem. The distracting decorations were hidden behind boarding or covered with paint, and overlarge spaces were broken up with walls or partitions, as had been done once before. The

entire presentation was reorganized, in the interest of a balanced and restful display of the best pieces in the collection. Careful attention was paid to the frames. Those that were not up to standard were replaced by old French frames, which were bought up regularly in Paris. In the new arrangement, the paintings were hung side by side, and almost never, as had been the rule before, one above the other. The composition of a wall would begin with the weighing of size and color of a group of paintings, but due consideration was also paid to the alternation of subject matter (fig 46). In many rooms the painting display was combined with furniture, ceramics and other *objets d'art*. This selective mixture (Schmidt-Degener always called it a 'selectieve gemengde opstelling') was inspired by Wilhelm von Bode's arrangement of the Kaiser-Friedrich Museum in Berlin. When Schmidt-Degener was finished, the paintings hung in a sensible chronological and geographical order, and the visitor who followed the prescribed route received a coherent impression of the development of Dutch painting.

The route itself was partly reversed (figs 47, 49). The visitor no longer left the front hall for the gallery of honor – he began with the five eastern cabinets (215-19, now 201-05), with the 15th- and early 16th-century Netherlandish paintings. In rooms 220-21 (now 206-08 and 210) hung the Netherlandish paintings of the latter half of the 16th century. Next came the large gallery 214 (now 211), formerly called the portrait room, which was now turned over mainly to Italian paintings and applied arts. In the following room (225, now 214), the development of Dutch painting was picked up again with the masters of the early 17th century. One continued to room 226 (now 215) with the early Amsterdam school, room 227 (now 216) with Frans Hals and the early Haarlem school and room 228 (now 217) with the Utrecht school. In the former storage space bordering on room 228 the Lutma and van Vianen silver was now displayed (229, now 218-19). What was first the large international room (235, now 220-22) was split in three. In the first and second rooms hung works of Rembrandt from his Leiden and early Amsterdam periods, with works by his master and pupils of that time. The third room was given to the van de Poll bequest. From there one entered the Carolingian chapel (236, now 223), with sculpture by Hendrick de Keyser, which led into the Nachtwachtzaal (Nightwatch room; 243, now 224; fig 48). *The nightwatch* itself hung on the west wall, and on the others the civic guard portraits by Bartholomeus van der Helst, Jacob Backer, Nicolaes Eliasz, Govert Flinck and Joachim von Sandrart which, like *The nightwatch*, were painted between 1638 and 1642 for the new headquarters of the arquebusiers' civic guard. The guild silver was also displayed here. The so-called Rembrandt-uitbouw (Rembrandt extension; 245, now 225-28), which had been built in 1906, was used for drawings. Crossing the Nightwatch room, the visitor entered the gallery of honor (fig 50), whose cabinets were hung with decorative paintings (244-47, now 229-36). Between the cabinets were large glass cases with the Loudon collection of Delft porcelain. Having walked up and back through the gallery of honor, in which 17th-century Dutch furniture was also displayed, the visitor returned once more to the

Nightwatch room, from where he entered the west wing, beginning with the former lepers' room (248-49, now 260-61), with sculptures by Quellinus and Verhulst. This led to the former Waterloo room (255, now 259-57), which like its counterpart in the east wing was also divided into three, devoted respectively to masters of the Southern Netherlands, Rembrandt's later works and the late Rembrandt school, and Jan Steen. In the following room (260, now 255) hung the Italianate painters, in room 261 (now 254) the later Haarlem school and in room 262 (now 252) Rembrandt's *Syndics* and a group of landscapes by Ruisdael and others. There followed room 263 (now 251) with the Amsterdam seascape painters and room 265a (now part of room 248), where Rembrandt's *Jewish bride* hung. Room 268a (now 246-47), with part of the glass collection, still lifes and some other paintings, provided something of an interlude, after which came eight cabinets (268b-d, 270-74, now 238-45), featuring in turn ter Borch, Dou, the Delft masters (in three cabinets, with Vermeer in the middle), the late Haarlem masters, including Wouwerman and Ostade, followed by Lairesse, van der Werff and van Mieris and finally van Huysum and Jacob de Wit. The last room was the truncated former van der Hoop room (269, now 248-49), with Flemish and Spanish masters, and from there one came back to the front hall. Those who wished to continue their visit were left to find their way to the Drucker extension, with its 18th- and 19th-century paintings.

Schmidt-Degener wrote an essay describing and motivating his rearrangement of the painting collection in the 1934 edition of the catalogue, under the title 'Het karakter der schilderijenverzameling' (the character of the painting collection). The chronological order was meant to reinforce the didactic side of the presentation, while the distinction between the aesthetically significant pieces and those of mere art-historical interest furthered the visitor's undisturbed delectation of the best of Dutch painting. The treatment of Rembrandt's work was clearly determined by Schmidt-Degener's well-known bisection of the painter's work, which he derived from Alfred Neumann's monograph of 1902. The successful painter of the wordly life, the pre-*Nightwatch* Rembrandt, was displayed in the east wing, and the misunderstood painter of the inner life, the painter of the soul, in the west.

Schmidt-Degener had changed the Rijksmuseum from a general collection with strong cultural-historical overtones to a museum of fine arts, where artistic pleasure was strictly separated from historical instruction. In keeping with this new concept, the Nederlandsch Museum voor Geschiedenis en Kunst was split up in 1927 into the Rijksmuseum voor Beeldhouwkunst en Kunstnijverheid (national museum of sculpture and applied arts) and the Nederlandsch Museum voor Geschiedenis (Dutch museum of history).

Schmidt-Degener's acquisition policy, which he carried out with great flair, was of profound significance for the future of the collection. The Vereniging Rembrandt, now under the chairmanship of M P Voûte, was as helpful as ever, and the funds it provided were now supplemented by those of the Commissie tot Verkoop van Photographieën (commission for the sale of photographs), an independent

foundation which had been set up in 1920 by van Riemsdijk. In 1922 two Italian and two Spanish paintings – including Goya's portrait of *Don Ramón Satué* (A 2963) – were bought, in a belated beginning of a collection of foreign paintings. King Willem I had bought in this area too, but many of his non-Dutch paintings had been assigned to the Mauritshuis. Neither museum, be it said, had followed up this part of the king's collecting policy, so that the Rijksmuseum's international room could boast of few significant works. Interest in collecting foreign paintings was now revived – among Dutch collectors as well, to the great good fortune of the **[1923]** museum. In 1923 the Vereeniging Rembrandt held her jubilee exhibition in the Rijksmuseum, devoting it to 'acquainting the visitor with a collection of old paintings, mainly by Italian masters, which we should like to preserve for our country.' It was the collection of the Augusteum in Oldenburg, built up between 1804 and 1870 by the reigning archdukes of that land and now thrown onto the market as a result of political events. Mr Voûte and his fellow board member E Heldring put up part of the purchase money, since the state was not able to buy the paintings at that point. In vain the queen mother requested the minister to do the impossible. With her financial support, and with the help of Jonkheer H Loudon, Messrs A F Philips, S van den Bergh Jr and others, the plan succeeded after all. In this way the museum acquired, in 1923-25, 16 Italian paintings, of which the *Madonna* by Fra Angelico (A 3011) undoubtedly is the most important. Ten years later, in 1934, a large exhibition of Italian art in Dutch collections (*Italiaansche kunst in Nederlandsch bezit*), including no fewer than 414 paintings, was held in the Stedelijk Museum. The largest lenders were the art dealer J Goudstikker, with 90 paintings, and Professor Otto Lanz, with 75. The Rijksmuseum was represented with 30 works. Many of the displayed paintings, notably those from the Lanz collection, were destined to find their way to the Rijksmuseum in later years.

In the preceding year, 1922, the 19th-century holdings were appreciably augmented by the bequest of A van Wezel, consisting of about 80 paintings of the Dutch and French schools. In 1923 a comparable bequest, that of C D Reich Jr, was received, but in the same year it had to be transferred, in the terms of the will, to the Vereeniging tot het vormen van een openbare verzameling van Hedendaagsche Kunst for placing in the Stedelijk Museum. The Reich collection, which was supplemented by a bequest by the widow Mrs A E Reich-Hohwü, in 1933, can thus be considered as an accession merely in name, and is not included in the present catalogue.

[1926] A splendid accession in 1926 was *Dignified couples courting*, one of the rare paintings of Willem Buytewech (A 3038). The loan from the city of Amsterdam underwent a minor change that year in connection with the opening of the Amsterdams Historisch Museum in the Waag, the old weighing station on the Nieuwmarkt. Twenty-five paintings were withdrawn from the loan to be installed there, and the Rijksmuseum added eight works from its own collection. In compensation, the city gave the museum eight additional paintings on loan, which brought the new total of the Amsterdam loan to about 420 items. A far more radical change was to follow in 1975, after the Amsterdams Historisch Museum moved from the Waag to much more spacious quarters in the Burgerweeshuis (civic orphanage).

The new display, with its selective chronological order, not only showed up the strong points of the collection to better advantage – it also revealed lacunae more mercilessly. One of the most serious gaps was the lack of a work by Hieronymus Bosch. A solution seemed to have **[1927]** been found in 1927. In 1923 it had been discovered that the *Still life with books in a niche*, formerly attributed to Quentin Massys, was actually a fragment of an altar wing by the 15th-century French Master of the Aix Annunciation (A 2399). This unique document of early French painting was somewhat out of place in the Rijksmuseum, but it was made to order for the Louvre, which had no paintings by this important French primitive on display. In 1927 both museums agreed to exchange, as loans, the Rijksmuseum *Still life* for the Bosch *Ship of fools* in the Louvre. Unfortunately for the Rijksmuseum, the loan lasted only three years. Since then repeated attempts have been made to add a Bosch to the collectoin, but without success.

[1928] In 1928 the museum acquired four masterworks. The *Portrait of a girl dressed in blue* by Johannes Verspronck (A 3064) was presented by the Vereeniging Rembrandt, which also made Rembrandt's *Prophetess Anna* (A 3066) available for a small sum. Both these works came from the estate of the society's chairman, M P Voûte, who had bought them in 1922 from the Augusteum in Oldenburg and loaned them to the museum with the intention of letting the museum take them over at a later date. *The sick child* by Gabriël Metsu (A 3059) was purchased in Berlin, after an unsuccessful attempt to buy it at the Paris auction of the Hague Steengracht van

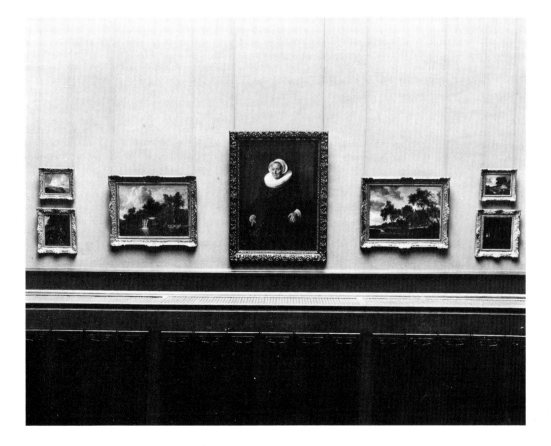

46 A wall of room 261 in 1929, with the paintings, in their French frames, arranged symmetrically. Photograph in the museum archives

47 Groundplan of the ground floor in 1938. From F Schmidt-Degener, *Rijksmuseum: gids met afbeeldingen* (illustrated guide), Amsterdam 1938 (2d printing)

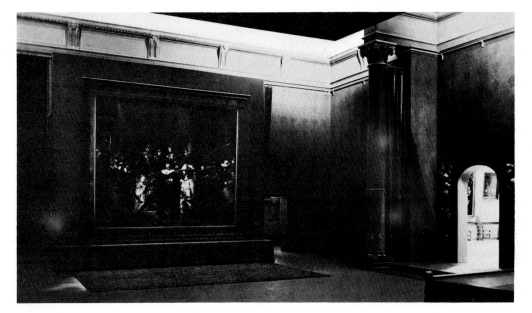

48 The Rembrandt room (243) in 1929. Next to *The nightwatch*, which was returned to its original room but not its original place there, is the passageway to room 248. On the far right we look through the entrance to the gallery of honor into room 244B. Photograph in the museum archives

HOOFDVERDIEPING, KUNST DER 15e, 16e, en 17e EEUW

49 Groundplan of the main floor in 1938. From the same publication as fig 47

50 The gallery of honor, with the porcelain of the Loudon collection, 1929. Photograph in the museum archives

51 *The nightwatch*, rolled onto a wooden
cylinder, transferred to the shelter in the dunes
near Heemskerk, November 1940. Photograph in
the museum archives

Duivenvoorde collection in 1913. Finally, the
Interior with women beside a linen chest by Pieter de
Hooch (C 1191) was acquired for the city of
Amsterdam at the auction of the Six collection.

One of the museum's most pressing desiderata
was that for a Rembrandt self portrait. In
[1929] 1929 a provisional solution was found
when the Rathenau family gave a late self
portrait on loan. The museum was able to keep it
until 1940; in 1947 it was purchased by the
Mauritshuis (inv nr 840).

In the terms of the last will and testament of
the art historian and collector Cornelis Hofstede
[1931] de Groot, the museum was able in 1931
to make a trade with the city of Groningen,
giving a seascape by Willem van de Velde II (the
former A 441) in exchange for the *River valley* by
Hercules Seghers (A 3120), thus filling another
gap in the collection. The decision of the Soviet
Union to place some of its paintings – works
which had seemed beyond reach for centuries –
on the market provided the Rijksmuseum with
the opportunity to acquire in 1931 Anthonis
Mor's portraits of *Sir Thomas and Lady Gresham*
(A 3118 & A 3119) from the Hermitage and in
[1933] 1933 *St Peter's denial* from the same
museum and from the Moscow museum the
portrait of *Titus van Rijn in monk's habit*, two major
Rembrandts (A 3237 & A 3138).
[1936] Sir Henry Deterding, who had donated

Vermeer's *Street in Delft* in 1921, presented in
1936 a group of 17 paintings, including *The
fishwife* by Adriaen van Ostade (A 3246), the
River view by moonlight by Aert van der Neer
(A 3245) and the *River view near Deventer* by
Salomon van Ruysdael (A 3259). In the same
year the museum received self portraits of Vincent
van Gogh (A 3262) and Emile Bernard (A 3263)
as donations from Mrs F W M Bonger, the widow
of André Bonger. Shortly before the outbreak of
[1939] the Second World War, in 1939, the
museum acquired Rembrandt's *Jeremiah
lamenting the destruction of Jerusalem* (A 3276), a
climax of the artist's early period, represented
until then only by the *Prophetess Anna* acquired
eleven years earlier.
[1940] In 1940 Mrs A C M H Kessler-
Hülsmann (1868-1947) contributed the larger
part of the collection she had accumulated
together with her husband, D A J Kessler (1855-
1939), consisting of about 80 paintings and
several aquarelles. Among the better works of
this rather uneven donation are the triptych
wings with *Sts Valerian and Cecilia* by the Master
of the Braunschweig Diptych (A 3505 & A 3506),
those with *Sts Sebastian and Anthony* from the upper
Rhenish school (A 3310 & A 3311), the
Florentine cassone with *Horatius Cocles defending
the head of the Sublician bridge* (A 3302) and
Rembrandt's *Oriental* (A 3340).

[1941] Schmidt-Degener died in November
1941. Under his invigorating 20-year director-
ship the museum had gained a new status in the
art world. The level of the 17th-century
holdings, particularly the Rembrandt collection,
had risen markedly. Like his predecessor van
Riemsdijk, Schmidt-Degener made it a policy to
attract large loans to the museum, in the hope
that some would take root and remain as
donations or bequests. The major loans during
his tenure were those given by the dowager of P
Gevers van Marquette, née Deutz van Lennep
(1925-39), V W van Gogh (1927-30; 1930-37), F
Koenigs (1930-38), F Buchanan (1934-39) and R
van Marle (1936-52). Thanks to the van Gogh
loan the museum was able to display for a period
of three years 31 van Goghs, two Gauguins, two
Lautrecs and a Manet. A more lasting
achievement to be reckoned to Schmidt-
Degener's credit is the de Bruijn-van der Leeuw
donation, which, although not received until
1961, was arranged entirely by him. He lived
just long enough to see the Rijksmuseum holdings
in foreign paintings, whose foundation he had
laid at the start of his career, but whose growth
had been frustrated by lack of funds, come to new
life with the receipt of the vom Rath bequest.
J W Edwin vom Rath (d 1940), a native
Amsterdammer who had made a fortune in
sugar, had been building up a collection of Italian

art since 1918, with the help of his friend, the collector Otto Lanz. The bequest included not only sculpture and *objets d'art* but also 74 paintings, among them *Judith with the head of Holofernes* by Botticelli (A 3381), *St Nicholas of Tolentino rescuing a hanged man* by Zanobi Machiavelli (A 3442), *St George and the dragon* by Signorelli (A 3430) and an attractive group of Venetian paintings whose climax is without question *Christ and the woman in adultery* by Jacopo Tintoretto (A 3439).

In the last two years of his tenure Schmidt-Degener had to preside over the dismantling of his life's work, when the museum was evacuated under the threat of approaching war. The removal of about 2,000 paintings and an immense number of prints, drawings and *objets d'art* was begun on 25 August 1939, six days before the German invasion of Poland, and was accomplished by 1 November. Underground shelters were built in various locations; most were still unfinished, though, when the Germans invaded Holland in May 1940. The perils of *The nightwatch* can give us an idea of the difficulties that had to be overcome by the Inspectie Kunstbescherming (inspectorate for the protection of art). The huge canvas was first brought to the knight's hall of Radboud Castle in Medemblik, which was provided with a provisional extra ceiling for protection against firebombs. On 13 May, when the fight for the nearby Afsluitdijk (Zuider Zee dike) reached its pitch, the painting was hastily loaded into a truck and, by cover of night, transported to a bombproof shelter that the city of Amsterdam had built in the dunes near Castricum. Because the entrance to the shelter had not been planned with anything the size of *The nightwatch* in mind, the painting had to be rolled onto a large wooden cylinder before it could be brought inside. In November 1940 it was

moved once more, to the recently completed state shelter in the dunes near Heemskerk (fig 51). When the Germans ordered the evacuation of the entire coast at the end of 1941, a new shelter had to be built in the Sint Pietersberg near Maastricht, a hilly area honeycombed with old tunnels and hideouts. That is where *The nightwatch* was brought in March 1942, and that is where it remained until the end of the war.

During the war years following 1941 the acting directors were M D Henkel (1879-1944), who served from 1941 until his death, and C M A A Lindeman (d 1948), from May 1944 until August 1946. In this period only a few paintings were acquired. Foremost among them was *The death of the Virgin*, the work which gave his name to the Master of the Amsterdam Death of the Virgin (A 3467), purchased in 1944 from the Hofje der Zeven Keurvorsten (almshouse of the seven electors) in Amsterdam. The largely vacant museum was put to use during the war for exhibitions of works by members of the Nazi-controlled Kultuurkamer (chamber of culture) and propagandistic shows like *Kunst der Front* (art of the front, 1941 & 1943) and *Frauen schaffen in Deutschland* (women at creative work in Germany, 1941). Some were opened by the governor of the occupied Netherlands himself, Arthur Seyss-Inquart.

[1944] In September 1944 the museum was closed altogether.

The Rijksmuseum since 1945

[1945] In June 1945, one month after the liberation of the Netherlands, *The nightwatch* was brought back to the Rijksmuseum and unrolled (fig 52). To the relief of all, neither it nor any of

the other evacuated paintings was damaged. The only losses were among paintings that had been on loan to the Dutch legation in Berlin, Doorwerth Castle and other buildings and museums around the country, notably in Middelburg, Arnhem, Zutphen and The Hague. About 40 paintings were lost in all, and fortunately no works of exceptional importance were among them.

The postwar history of the museum began on 15 July 1945, with the opening of the exhibition *Weerzien der meesters in het Rijksmuseum* (translated in the English catalogue as 'Return of the old masters in the Rijksmuseum'). *The nightwatch* was on display again for the first time in six years, and no fewer than 166,000 visitors came to see it, an unprecedented number for that time.

[1946] On 1 August 1946 a new director-general was appointed – Jonkheer David Cornelis Röell (1894-1961; fig 53). From 1922 to 1935 he had been an assistant and finally curator of the Rijksmuseum department of paintings, and from 1936 to 1946 director of the Stedelijk Museum in Amsterdam. In his new function he was able to apply his administrative talents and refined taste for the benefit not only of the painting collection (the 16th-century holdings were augmented considerably) but also, and especially, of the department of sculpture and applied arts, which grew immensely in quantity and quality under Röell. He tackled the modernization of the museum on a grand scale, and effected some drastic changes in the building. What was still left of the original decoration of the interior was removed virtually to the last piece. Röell's ability to carry out his plans was helped in no small measure by his talent for extracting large sums of money from the government.

The refurbishing of the museum took quite some time, and during this period, when the

52 The unrolling of *The nightwatch* in the east courtyard of the Rijksmuseum, June 1945. Photograph in the museum archives

53 Jonkheer David Cornelis Röell (1894-1961), director-general of the Rijksmuseum from 1946 to 1959 and director of the Rijksmuseum van Schilderijen (national painting museum) from 1946 to 1950. Photograph in the museum archives

museum was wholly or partially closed to the public, the opportunity to restore *The nightwatch* was eagerly seized. The painting was relined, and the thick layer of yellow varnish, which had successfully resisted all earlier attempts to render it transparent, was largely removed (fig 54). The cleaning amounted to a true metamorphosis. Many of the painting's more subtle qualities, which had been concealed for centuries, became visible again. The results were shown in spring 1947, and the public was generally enthusiastic.

The innovations that Schmidt-Degener had instituted were built upon as the visitor's route was changed once more. The department of paintings was now restricted to the main stories of the east wing, the Drucker extension and the corridor leading to it. The main story of the west wing was turned over entirely to the department of sculpture and applied arts. Mediaeval and 16th-century painting remained in the cabinets and the following rooms, 201-10. The Italian paintings were not returned to the large hall 211, which was now reserved for Frans Hals and the early Haarlem school. Room 214 became the Ruysdael room, 215 the van der Helst room, 216, where the Hals's had formerly hung, the Jan Steen and Jan van Goyen room, and 217, formerly for the Utrecht Caravaggists, was now given to the Italianate painters. The former silver room (Lutma and van Vianen) was now split in two (218-19) and used for cabinet paintings. All paintings by Rembrandt, except *The nightwatch*, and the works of his pupils, were concentrated in rooms 220-23. This group of rooms emptied into the Nightwatch room (224; fig 55), which was left unchanged except for the removal of the guild silver. From there one entered the Rembrandt extension (225-28), where the works of the Delft school, including Vermeer, and ter Borch were hung. Via the Nightwatch room, finally, the visitor entered the gallery of honor (fig 56), where the foreign paintings in the eight cabinets (229-35) were set off by the Italian furniture in the gallery itself as well as in the cabinets. The glass cases with the Loudon collection did not return to their old place here. Since then there have been only a few changes made in the installment of the collections, none of them very drastic.

In the years after the war, when so many art works from the destroyed churches and galleries of Europe were in depot, Röell managed to mount a unique series of exhibitions. Paintings that no one could ever have dreamt would hang in the Rijksmuseum graced its walls in *Van Jan van Eyck tot Rubens* (From Jan van Eyck to Rubens, 1946), *Kunstschatten uit Wenen* (Art treasures from Vienna, 1947), *Meesterwerken uit de Oude Pinacotheek te München* (Masterpieces from the Alte Pinakothek in Munich, 1948), *Uit de schatkamers van de Middeleeuwen* (From the treasures of the middle ages, 1949), *120 beroemde schilderijen uit het Kaiser-Friedrich-Museum te Berlijn* (120 famous paintings from the Kaiser-Friedrich-Museum in Berlin, 1950), *Bourgondische pracht* (Burgundian splendor, 1951) and *De Venetiaanse meesters* (The Venetian masters, 1953).

Directly after the war the stream of acquisitions resumed. In 1946 three paintings were purchased: *Joseph telling his dreams to his parents and his brothers* by Rembrandt (A 3477), a grisaille which had hung in the museum as a loan from 1915 to 1920 and 1931 to 1933; *The raising of Lazarus* by Aertgen van Leyden (A 3480); and the *Reclining* **[1947]** *Venus* by Lambert Sustris (A 3479). 1947 saw the accession of Jan Steen's *Adoration of the* **[1948]** *shepherds* (A 3509), and 1948 that of the splendid pendant portraits of a couple by Maerten van Heemskerck (A 3518 & A 3519), the latter donated by the art dealers D and N Katz of Dieren. A belated start was finally made in the collecting of fine examples of 16th-century portraiture, an area that was to be expanded considerably in years to come. A legacy of this period, of interest largely for its documentary value, was the contents of the studio of George Hendrik Breitner (1857-1923), which was received from the painter's widow.

In 1948 the relation between the Rijksmuseum and the Mauritshuis was reassessed. Each of these national museums, whose histories, especially during the reign of Willem I, were so closely intertwined, had old holdings which would, it was felt, be more in place in the other collection. Transfers had been made in the past, notably in the years 1825 and 1885. Now a long-term loan agreement was concluded, which stipulated that the Italian, Spanish and early Northern Netherlands paintings from both museums were to be displayed in the Rijksmuseum, and the 15th-17th-century Southern Netherlands school and the 18th-century French paintings in the Mauritshuis. Sixteen paintings and the most important items from Prince Willem v's splendid collection of miniatures, which had entered the Rijksmuseum through the Koninklijk Kabinet van Zeldzaamheden, went to the Mauritshuis. The Rijksmuseum received 31 paintings, including the portraits of *Francesco Giamberti* and his son *Giuliano da San Gallo* by Piero di Cosimo (C 1367 & C 1368), masterpieces of Italian Renaissance portraiture that also came from the cabinet of Willem v. It was further agreed at the same time that both museums would consider themselves bound by this division in their further accessions.

[1949] In 1949 Emanuel de Witte's *Interior of the Portuguese synagogue in Amsterdam* (A 3738) was purchased, after it had been de-acceded by the Kaiser-Friedrich-Museum in Berlin in 1926. Mr & Mrs de Bruijn-van der Leeuw also presented their collection in that year, reserving the

usufruct for the longest-living member of the pair. This magnificent donation was received in 1961.

In the 1950s special attention was paid to the Dutch Mannerists, who had been rather neglected until then. The first major purchase in this area was of Abraham Bloemaert's *Preaching* **[1950]** *of St John the Baptist* (A 3746) in 1950. After a lull in 1951 the collection experienced **[1952]** a very exciting year in 1952. The director of the department of paintings discovered in a Paris private collection and purchased the *Triptych with the adoration of the golden calf* by Lucas van Leyden (A 3841), a work that had been described by Carel van Mander in 1604 and which had long been thought lost. This fortunate find crowned the museum's efforts to acquire a major work by the Leiden master, who until then was not satisfactorily represented. In the same year the museum was lent Lucas's large tempera-on-canvas *Moses striking water from the rock*. The loan was not of long duration, however, and this remarkable work is now in the Museum of Fine Arts in Boston. The budding collection of 16th-century portraits was enriched with the purchase of the portraits of *Jan van Egmond* by Jacob Cornelisz van Oostsanen (A 3838) and of an unknown woman by Jan Mostaert (A 3843).

After the war a substantial number of paintings and *objets d'art* that had been illegally seized by the Germans, in large part from the collections of Jewish Dutchmen, returned to the country to be restored, insofar as possible, to the rightful owners. Works that had been purchased in the Netherlands during the war by German museums, art dealers and official bodies were declared Dutch government property. Beginning in 1948, these works were given on loan to the Rijksmuseum and several other museums by the Stichting Nederlands Kunstbezit (foundation for **[1953]** Dutch art holdings). In 1953, by which time the Stichting had been replaced by the Dienst voor 's Rijks Verspreide Kunstvoorwerpen (national service for state-owned works of art), the loan, numbering 48 paintings and many *objets d'art* at the time, was prolonged indefinitely. In 1960 and 1972 large groups of these works were transferred to the Rijksmuseum as property. The most significant gains were made by the department of sculpture and applied arts, which acquired a great number of very important works from the Mannheimer collection. But the department of paintings came out ahead as well, acquiring foreign canvases mainly from the collections of Otto Lanz and Fritz Mannheimer and Dutch ones from the collections of Mannheimer and J J M Chabot and the J Goudstikker gallery. The level of holdings in foreign paintings was raised overnight to a height which will probably never be substantially increased.

The Swiss surgeon Otto Lanz (1865-1935), who was appointed professor of medicine at the university of Amsterdam in 1902, had been building up an impressive collection of Italian art since the end of the 19th century. As we have already seen, he was one of the major contributors to the 1934 exhibition of Italian art in Dutch collections. Among the better pieces, which the museum now acquired from that collection, were *St Jerome in his study* and *St Francis of Assisi receiving the stigmata* by Lorenzo Monaco (A 3976 & A 4006), the *Madonna and child* and *Madonna* from the school and milieu,

54 The cleaning of *The nightwatch* by the chief restorer, H H Mertens, in 1946-47. Photograph in the museum archives

55 The Rembrandt room in 1959, with Bartholomeus van der Helst's *Company of Captain Roelof Bicker* (C 375) hanging on the original place of *The nightwatch*, which is itself seen on the right, in a new frame. The columns and decorations (*cf* fig 48) have been expunged. Photograph in the museum archives

56 The gallery of honor in 1959. The entrances to the cabinets have been narrowed. Photograph in the museum archives

43

respectively, of the same master (A 4005 & A 4004), *Christ on the cross* by Giovanni da Milano (A 4000), the *Portrait of a woman* by Carpaccio (A 3993), *The annunciation* by Tintoretto (A 3986 & A 3987), the portrait of *Daniele Barbaro* by Veronese (A 4011) and *The vision of St Francis of Assisi* by Lodovico Carracci (A 3992). From the collection of the Amsterdam banker Fritz Mannheimer (1890-1939) came the splendid *Mary Magdalene* by Carlo Crivelli (A 3989) and the portrait of *Dr Ephraïm Bueno* by Rembrandt (A 3982). From the Chabot collection came the *Still life with peacocks* by Rembrandt (A 3981), which had been present in the museum as a loan from 1923 to 1942, and the portrait of *Ernst van Beveren* by Aert de Gelder (A 3969). The Goudstikker gallery, finally, was the source of *The resurrection* by the Master of the Virgo inter Virgines (A 3975) and the *River landscape with ferry* by Salomon van Ruysdael (A 3983).

Since the end of the last century the Rijksmuseum has been in the habit of giving its depot paintings on loan to other museum and government buildings. In 1953 responsibility for these loans (with the exception of those to other state museums and the Amsterdam municipal museums) was assumed by the Dienst voor 's Rijks Verspreide Kunstvoorwerpen in The Hague. At the same time, 59 other paintings were added to the loan. Since 1953, all new loans from the Rijksmuseum to other bodies have been routed via the Dienst.

In 1953 the longstanding need for a journal in which to publish new acquisitions and the results of art-historical research on works in the collection was filled with the launching of the *Bulletin van het Rijksmuseum* (Rijksmuseum bulletin). The editorial board consisted of K G Boon, then an associate of the printroom and later its director, Dr A F E van Schendel, then director of the department of paintings and later director-general, and Th H Lunsingh Scheurleer, then director of the department of sculpture and applied arts and later professor in Leiden. The same year saw the museum acquire two major works: *Portrait of a man* by Jan van Scorel (A 3853) and the portrait of *Jeronimus Deutz* by Michael Sweerts (A 3855).

[1955] The little group of Dutch Mannerists was reinforced in 1955 with the purchase of Bartholomeus Spranger's *Venus and Adonis* (A 3888) and *Bathsheba in the bath* by his Haarlem follower Cornelis Cornelisz van Haarlem **[1956]** (A 3892). With the acquisition in 1956 of *The tree of Jesse* now attributed to Jan Mostaert (A 3901), the museum made a major addition to its sparse holdings in primitives of the Northern Netherlands. The group of Utrecht Caravaggists was augmented in the same year by Hendrick ter Brugghen's *Doubting Thomas* (A 3908). After the close of the 1956 Rembrandt exhibition, two paintings by the master stayed on in the museum as loans. Baroness Bentinck-Thyssen Bornemisza lent the magnificent, very early panel of *Tobias accusing Anna of stealing the kid* (C 1448) and the Louvre the portrait of *Titus van Rijn* (C 1450), in exchange for the *Still life with books in a niche* by the Master of the Aix Annunciation (A 2399) – the same painting that had been exchanged in 1927 for Bosch's *Ship of fools*. In the same year, Mrs J G de Bruijn-van der Leeuw agreed to leave Rembrandt's mighty *Self portrait as the apostle Paul* (A 4050) in the museum, after she had

donated it in 1949, reserving usufructuary rights. The Rembrandt year also saw the donation by Jonkheer John Loudon of a sum of money which **[1957]** was used in 1957 for the purchase of one of the great portraits of the 16th century, that of *Pompejus Occo* by Dirck Jacobsz (A 3924). The ranks of the primitives were reinforced once more in the form of the panel of *Geertruy Haeck-van Slingelandt van der Tempel kneeling in prayer before St Agnes* by a master of the Dordrecht school ca 1455 (A 3926).

[1958] In 1958 the 150th anniversary of the Rijksmuseum was celebrated. (For this purpose, Louis Napoleon's edict of 1808 was regarded as the founding document.) Among the activities was the forming of a jubilee fund for help in acquiring major works. With the purchase of the early Rembrandt *Self portrait* (A 3934) the museum finally could call a self portrait by the master its own. The large *River landscape with wild boar hunt* by Joos de Momper (A 3949) added a prime example of Mannerist landscape to the collection. Another lacuna was filled with the acquisition of two very early pieces by Jan van Goyen, a *Summer* and a *Winter* (A 3945 & A 3946). A fond wish finally came true with the purchase of a large and luxuriant *Still life* by Abraham van Beyeren (A 3944). The National Gallery in London provided the Rijksmuseum with an interesting document in the form of an old copy of *The nightwatch*, a loan that promptly found its way to the Nightwatch room (C 1453). The copy, usually ascribed to Gerrit Lundens, shows *The nightwatch* as it appeared before it was trimmed in the 18th century.

The acquisitions policy followed in the 1950s clearly reflected interests aroused by the museum's three most important painting exhibitions (not counting the Rembrandt exhibition) held during that decade. The accession of a splendid series of 16th-century and several important 17th-century portraits in the years 1948-59 was closely related to the exhibition *Drie eeuwen portret in Nederland* (three centuries of portraiture in the Netherlands, 1952). The purchase of the above-mentioned Bloemaert (1950), Spranger, Cornelis Cornelisz van Haarlem (1955) and de Momper (1958) was related to the organization of the exhibition *De*

57 Arthur François Emile van Schendel (b 1910), director of the Rijksmuseum van Schilderijen (national painting museum) since 1950 and director-general of the Rijksmuseum from 1959 to 1975. Photograph in the museum archives

triomf van het Maniërisme (the triumph of Mannerism, 1955). The exhibition *Middeleeuwse kunst der Noordelijke Nederlanden* (mediaeval art of the Northern Netherlands, 1958), finally, influenced the acquisition of the *Tree of Jesse* (1955) and the *St Agnes worshipped by Geertruy Haeck* (1957).

[1959] In 1959 Röell was succeeded as director-general by Dr Arthur François Emile van Schendel (b 1910; fig 57), who had come to the museum in 1933 as an assistant in the department of paintings and became its director in 1950. The most important acquisition of that year was probably *A woman at the spinning wheel and a man with a mug* by Pieter Pietersz (A 3962). In keeping with the terms of the 1948 agreement with the Mauritshuis, the portrait of *Lysbeth van Duvenvoorde*, an incunabulum of Dutch portraiture from about 1430 (C 1454), was placed in the Rijksmuseum.

Aert de Gelder's portrait of *Hermanus Boerhaave with his wife and daughter* (A 4034), present since 1932 in the museum as a loan of W A A J Baron Schimmelpenninck van der Oye, was purchased **[1960]** in 1960 at a London auction. An attractive addition to the Italian collection was the *Hagar and Ishmael in the wilderness* by Francesco Cozza (A 4035). The Amsterdam art dealer Pieter de Boer (1894-1974) placed an important loan with the museum in that year: Pieter Aertsen's *Adoration of the Magi* (C 1458), one of the few 16th-century altarpieces of high quality the museum can show its visitors.

[1961] 1961 will go down in the history of the Rijksmuseum first and foremost as the year in which the de Bruijn-van der Leeuw collection, donated in 1949 but kept by the collectors until their death, was finally received. Isaäc de Bruijn (1872-1953) had begun collecting in 1922 after retiring from business. Towards the end of the twenties he came into contact with the director-general of the Rijksmuseum, Dr F Schmidt-Degener, a meeting that was to be of great significance for the collection. Under Schmidt-Degener's guidance, de Bruijn applied himself to the acquisition of works that filled lacunae in the Rijksmuseum department of paintings, with the implicit understanding that the collection was later to be donated to the museum. From then on Schmidt-Degener could take this into account in determining his own acquisition tactics. Mr & Mrs de Bruijn-van der Leeuw helped the museum in other ways as well, providing financial aid for costly purchases and donating Rembrandt's portrait of *Saskia van Uylenburgh* (A 4057) on the occasion of the 50th anniversary of the Vereniging Rembrandt in 1933. The donation itself consisted of 19 paintings, 32 drawings, 500 etchings and 18 *objets d'art*. Rembrandt was heavily represented in the drawings and etchings, and the undisputed climax in the paintings was the master's late *Self portrait as the apostle Paul* (A 4050), which had been placed in the museum in 1956. This acquisition fulfilled the museum's old dream of owning a late Rembrandt self portrait. But nearly all the paintings in the de Bruijn-van der Leeuw donation were of outstanding quality and filled gaps in the collection. Think only of the *Ships at anchor on a quiet sea* and *Winter scene* by Jan van de Cappelle (A 4042 & A 4043), the *Seated girl in peasant costume* and *Woman at a mirror* by Gerard ter Borch (A 4038 & A 4039) and the two

magnificent church interiors by Emanuel de Witte (A 4054 & A 4055). Not all the paintings came in pairs. There were also splendid single works by Jan Steen – *A woman at her toilet* (A 4052) – and Nicolaes Maes – *Young woman at the cradle* (A 4047). As a result of the agreement with the Mauritshuis, several of the new accessions were given on loan to that museum, including *The smoker* by Adriaen Brouwer (A 4040) and a *Madonna and child* by Adriaen Isenbrant (A 4045). To all appearances, the de Bruijn-van der Leeuw donation, which in fact dates legally from 1949, marks the end of the epoch of great donations and bequests which began with the Dupper bequest in 1870.

Thanks to the keenness of E R Meijer, then a member of the museum staff, Claude Vignon's '*Feed my lambs*' (A 4068), which he came across in an Amsterdam church as a work by a Dutch master, could be acquired in 1961.

The reconstruction of the west courtyard, **[1962]** begun by Röell, was completed in 1962. By filling in this open area with floor space on two levels, the display area was tripled. With the renovated rooms surrounding the new space, the department of sculpture and applied arts now had adequate room for the display of its quickly growing collections. In the installation of this department wall space was also set aside for paintings whose subjects called for it, or whose frames could be considered works of sculpture in themselves.

The series of 16th-century Netherlandish portraits was augmented once more, magnificently, with the purchase of the portrait of *Erard de la Marck* by Jan Cornelisz Vermeyen (A 4069). The Abraham van Beyeren still life acquired some years before was joined in 1962 by

a *River view* by the same master (A 4073), so that this little-known side of his production was now represented in the collection as well. An exchange agreement with the museum of Douai, France, was concluded whereby the Rijksmuseum was able to display the portrait of *Constantijn Huygens* by the young Jan Lievens (C 1467), a masterpiece of Dutch portraiture and a prime document in the history of Dutch culture, not in the least because the courtier Huygens, who discerned the greatness of Lievens's friend Rembrandt at a very early date, discussed it extensively in his diary.

Still-life painting, one of the great areas of achievement in Dutch art, is relatively poorly represented in the Rijksmuseum, so that the **[1963]** acquisition in 1963 of an important *Vanitas still life* of the Leiden type, from the milieu of Rembrandt (A 4090), was doubly welcome. Rembrandt influence is also apparent in the lighting of the *Landscape with an old oak* by Adriaen van Ostade (A 4093), purchased in the same year. The foreign collection was enriched with the *St Sebastian nursed by Irene and her helpers* by Jacques Blanchard (A 4091).

A most charming document of 18th-century **[1964]** collecting was acquired in 1964: Adriaen de Lelie's *Art gallery of Jan Gildemeester Jansz* (A 4100), providing us with a glimpse in the cabinet from which Asselijn's *Threatened swan* (A 4) came, the very first purchase made by the state for the museum.

[1965] A memorable occurrence of 1965 was the purchase of the large *River landscape with riders* by Aelbert Cuyp (A 4118), a master whose more ambitious works could until then be admired only in English and American collections. Moreover, a new Rembrandt was acquired – *The*

holy family at night (A 4119). A worthy addition to the 19th-century collection was the *Meadow landscape with cattle* by Willem Roelofs (A 4114), donated by Mrs Th Laue-Drucker.

A television program mentioning the purchase two years earlier of Adriaen de Lelie's view in the Gildemeester cabinet led to the discovery of a similar work by the same master, depicting *The art gallery of Josephus Augustinus Brentano* (A 4122), **[1966]** which was purchased in 1966.

An acquisition rivalling the Cuyp in importance was the *Distant view, with cottages lining a road* by Philips Koninck (A 4133), **[1967]** purchased in 1967. Again the Rijksmuseum was able to bring back to Holland a masterpiece of a sort that had not been seen in a Dutch collection for 200 years. The Italian holdings gained a good example of early Roman Baroque in Giovanni Lanfranco's *The prophet Elijah awakened in the desert by an angel* (A 4129).

Through shortage of funds, no noteworthy acquisitions were made in the years 1968 or **[1969]** 1969, but in the latter year the renovation of the east courtyard, begun shortly after that on the west, saw its partial completion. Here too floor space was built in on two levels, and the upper one was now made available for display. The department of paintings gained two new rooms (fig 58) adjoining the existing display area, and the museum as a whole gained a space for temporary exhibitions. Until then such exhibitions were held in the same courtyard, usually the home of the study collection, which constantly had to be vacated for that purpose. The new area was inaugurated in great style with a large Rembrandt exhibition, the fifth to be held in Amsterdam, and the fourth in the Rijksmuseum. The first, legendary Rembrandt

exhibition, in honor of the installation of Queen Wilhelmina, was held in 1898 in the Stedelijk Museum, which had opened its doors in 1895. The second took place in 1932 in the Rijksmuseum on the occasion of the 300th anniversary of the university of Amsterdam, the third in 1935 to commemorate the official opening of the Rijksmuseum on 13 July 1885, and the fourth (which was also mounted in the Museum Boymans in Rotterdam) in 1956, the 350th anniversary of Rembrandt's birth. The 1969 exhibition marked the 300th anniversary of his death.

[1970] In 1970 *The adoration of the magi* by Hendrick ter Brugghen (A 4188) was purchased, as was the portrait of *Gozen Centen* by Govert Flinck (A 4166). The latter painting was an old possession of the Mennonite charity the Rijpenhofje in Amsterdam, and had been 'discovered' in 1900 to be a Rembrandt. Since then it had been on loan to the Rijksmuseum, where it was soon reassigned to Flinck. Also acquired were five large allegorical grisailles by Gerard Lairesse (A 4174-A 4178), painted for the vestibule of the house of the Amsterdam collector Philips de Flines.

In the meanwhile the east courtyard had been completely rebuilt, and, together with the surrounding spaces, the ground-floor area could **[1971]** be opened in 1971 as the redesigned department of Dutch history. Just as in the past, many paintings were made available for display here.

Conspicuously absent from this account has been the name of Cornelis Troost, Holland's best 18th-century painter, and one of the best-

represented masters in the museum. In 1971 his splendid theatrical painting *The spendthrift* (A 4209) was received, after it had been donated in 1954, with reservation of usufructuary rights, by Mr & Mrs Leopold Siemens-Ruyter in memory of Mrs Leopold Siemens' son G H G Ras, who had been killed in the resistance during the war. The painting had hung in the museum earlier, from 1909 to 1913, as a loan.

[1972] In 1972 Roelant Roghman's *Mountainous landscape with fisherman* (A 4218), on loan since 1968 from the London art dealer Daan Cevat, **[1973]** was purchased. In 1973 a Thomas de Keyser *Group portrait of an unidentified body* (A 4236), which was on the point of being sold outside the Netherlands, could be purchased and kept inside the country. In that year too the Troost collection was filled out with a self portrait (A 4225); an early Jan Toorop, *The sea* (A 4226), was presented by Miss I Lohr; and J William Middendorf II, departing United States ambassador to the Netherlands, gave the museum two precious loans – the *Portrait of a woman* by Rembrandt (C 1555) and the *Triptych with the adoration of the magi* by Jacob Cornelisz van Oostsanen (C 1554); the latter was once in the collection of King Willem II, which had been auctioned in the mid-19th century when nothing was bought by the nation.

[1974] In 1974 another painting which nearly left the Netherlands could be saved through timely purchase: the large early *Still life with turkey pie* by Pieter Claesz (A 4646). As always in the case of major purchases, considerable aid was given by the commission for the sale of photographs and the Vereniging

Rembrandt, the latter of which has long been the recipient of a yearly gift from the Prins Bernhardfonds (Prince Bernhard foundation). Two works by W J J Nuyen, a Dutch 19th-century romantic who died at a young age, were acquired; one of them, *Shipwreck on a rocky coast* (A 4644), had also once belonged to the collection of Willem II. Little mention has been made in this history of other 19th-century masters than those of the Hague and Amsterdam schools, which might leave the reader with the impression that they are poorly represented in the collection. Nothing could be further from the truth. We have already discussed the state purchase of works by living masters in the 19th century and the Rijks Verzameling van Kunstwerken van Moderne Meesters (state collection of works of art by modern masters), housed from 1838 to 1885 in Welgelegen pavilion in Haarlem. From that time on, it is true, little effort was made to purchase earlier 19th-century paintings until the 1950s. Now and then works of that period would be acceded through bequest or donation, such as the gift in 1934 by F G Waller of two landscapes near 's-Graveland by P G van Os (A 3229 & A 3230), and the 1956 bequest by Jonkheer W A van den Bosch of the *View of the Place de la Concorde, Paris, from the Batavian embassy* by J A Knip (A 3909), supplemented in 1959 with two landscapes from the same series (C 1455 & C 1456) lent by Jonkheer F J C Schimmelpenninck. More recently, purchases have been made of works by Gerard van Nijmegen, Abraham van Strij, Hendrikus van de Sande Bakhuyzen, Andreas Schelfhout, Bartholomeus Johannes van Hove and others.

59 The study collection on the ground floor of the renovated east courtyard, opened in 1974. Photograph in the museum archives

60 The east depot, renovated in 1967. The 64 steel racks have a total surface of 960 square meters. Photograph in the museum archives

Circumstances delayed the reopening of the study collection on the ground floor of the renovated east courtyard, an area that was completed in 1971, until 1974 (fig 59). A 'kunst-historische afdeling' (art history department) had been installed as early as 1926 on the top floor of the west wing, when that space was abandoned by the Rijksschool voor Kunstnijverheid (state school of applied arts). A long hall was rigged up with 61 sliding racks, on which were hung the reserve paintings from the 16th century and later. The 15th-century paintings were kept in a separate room. Both areas were easy to reach by elevator from the main floor. About 600 paintings from the depot, chosen in the first place for their art-historical significance, were displayed here in chronological order by school. After the war the east courtyard was used for the display of the study collection, a new selection of about 420 paintings from the reserve, dating from the 15th to the 19th century. This collection, which constantly had to be removed to make way for temporary exhibitions, was finally closed in 1964 in connection with the renovation of the courtyard. The ground floor now provided the museum with space for the display of about 800 paintings of the Netherlandish and foreign schools, with a group of about 60 portraits of artists as a special feature. This permanent study collection was opened to the public on 13 September 1974.

In 1969 the Amsterdams Historisch Museum moved from the Waag, where it had been housed since 1926, to the former Burgerweeshuis in the Kalverstraat. The restoration of the new building and its installation as a museum took until **[1975]** 1975. To help furnish the new museum building the city of Amsterdam took back 155 of the paintings on loan to the Rijksmuseum, which was left with about 260 paintings belonging to the city. Moreover, the state gave 70 Rijksmuseum paintings on loan to the Amsterdams Historisch Museum, making a total of about 225 paintings that were moved in 1975 from the Rijksmuseum to the Historisch Museum. Among them were Willem van de Velde's *The Y off Amsterdam* (C 7), Jan van der Heyden's *The Dam in Amsterdam* (C 571), Gerrit Adriaensz Berckheyde's *The Bloemmarkt, Amsterdam* (C 103), Nicolaes Maes's *Six governors of the Amsterdam surgeons' guild* (C 90) and Ferdinand Bol's *Four regents of the lepers' asylum in Amsterdam* (C 1176) as well as all the group portraits of civic guard companies and governing bodies that were not on display in the Rijksmuseum. Although the 155 returned loans have been scrapped from the Rijksmuseum inventory, they have nonetheless been included in the present catalogue, where many a reader ignorant of this great migration may very well look for them, even in the distant future. After all, some were in the Rijksmuseum for over 150 years.

May 1975 brought the retirement of Arthur van Schendel after 43 years in the Rijksmuseum, the last 17 as director-general. And in **[1976]** 1976 this catalogue, undertaken on his initiative, is due to be published.

Directors and staff members of the department of paintings since the administrative reorganization of 1883

Fr D O Obreen, head of the department, 1883-96
Jonkheer B W F van Riemsdijk, head of the department, 1897-1921
C G 't Hooft, 1897-98
W J Steenhoff, 1899-1924
F Schmidt-Degener, head of the department, 1922-41
Jonkheer D C Röell, 1922-35, head of the department, 1946-50
E H ter Kuile, 1928-29
Jonkheer Ch H de Stuers, 1931-48
A F E van Schendel, 1933-50, head of the department, 1950-59
A B de Vries, 1934-41
O L van der Aa, 1936-39
K E Schuurman, 1940-46
Miss A J de Hoop Scheffer, 1943-46
Miss J L Cleveringa, since 1946
Miss H van Hoorn, 1946-48
F S E Baudouin, 1949-50
J Bruyn, 1950-54
E R Meijer, 1952-53
B Haak, 1954-63
J Offerhaus, 1959-61
C J de Bruyn Kops, since 1961
P J J van Thiel, head of the department since 1964
Miss A A E Vels Heijn, 1967-72
W Th Kloek, since 1973

Catalogues of the collection

Koninklijk Museum and Rijksmuseum

[1808]
[C Apostool], *Koninklijk Museum : eerste catalogus*, Amsterdam 1808. Printed frontispiece (unique specimen) in Museum Meermanno-West-reenianum, The Hague, of an unpublished edition [*Bulletin van het Rijksmuseum* 6 (1958) p 20, fig 1]

1809
[C Apostool], *Catalogus der schilderijen, oudheden enz op het Koninklijk Museum te Amsterdam*, Amsterdam 1809 (19th and last edition 1853) ; French version ca 1825 (11th and last edition 1855)

1858
[P L Dubourcq], *Beschrijving der schilderijen op 's Rijks Museum te Amsterdam : met fac simile der naamteekens*, Amsterdam 1858 (6th and last edition 1876) ; French version 1858 (4th and last edition 1876)

1880
[J W Kaiser], *Beschrijving der schilderijen van het Rijksmuseum te Amsterdam met historische aanteekeningen en facsimile's der naamteekens*, The Hague 1880

1885
[A Bredius], *Catalogus van het Rijksmuseum van Schilderijen*, Amsterdam 1885 (5th and last edition 1897) ; French version 1885 (8th and last edition 1904)

1903
[B W F van Riemsdijk], *Catalogus der schilderijen, miniaturen, pastels, omlijste teekeningen, enz in het Rijks-Museum te Amsterdam*, Amsterdam 1903 (7th and last edition 1926) ; French version 1904 (2d and last edition 1911) ; English version 1905 (3d and last edition 1927) ; German version 1920

1934
[B W F van Riemsdijk, F Schmidt-Degener & D C Röell], *Catalogus der schilderijen, pastels, miniaturen, aquarellen tentoongesteld in het Rijks-museum te Amsterdam*, Amsterdam 1934

Alphabetische lijst der schilderijen, pastels, aquarellen tentoongesteld in het Rijksmuseum te Amsterdam, Amsterdam 1934 ; English version 1937 ; French/ German version 1937

1948
[D C Röell], *Catalogus van de tentoongestelde schilderijen, pastels en aquarellen* [in het] *Rijks-museum* [te] *Amsterdam*, Amsterdam 1948 (3d and last edition 1956) ; abridged English/French version 1949 (2d edition 1950)

1960
[A van Schendel, J L Cleveringa, B Haak & J Offerhaus], *Catalogue of paintings* [in the] *Rijks-museum* [at] *Amsterdam*, Amsterdam 1960

Rijks Verzameling van Moderne Meesters in Welgelegen pavilion, Haarlem

1880
[C J Gonnet], *Beschrijving der schilderijen in 's Rijks Verzameling van Kunstwerken van Moderne Meesters in het paviljoen 'Welgelegen' te Haarlem*, The Hague 1880 (preceded by seven Dutch and two French undated editions)

The loan from the city of Amsterdam

1653
G Schaep, 'Beschrijving van de schilderijen in de drie Doelens te Amsterdam,' in P Scheltema, *Aemstel's oudheid, of gedenkwaardigheden van Amsterdam*, 7 vols, Amsterdam 1855-85, vol 7 (1885) pp 121-41

1758
Jan van Dyk, *Kunst- en historie-kundige beschryving en aanmerkingen over alle de schilderyen op het Stadhuis van Amsterdam*, Amsterdam 1758 (3d and last edition 1790)

1855
Catalogus der schilderijen van het Museum Van der Hoop te Amsterdam, Amsterdam 1855

1864
[P Scheltema], *Aanwijzing der schilderijen, oudheden, modellen, enz zich bevindende op het Raadhuis der stad Amsterdam*, Amsterdam 1864

1865
[J W Kaiser], *Beschrijving der schilderijen in het Museum Van der Hoop*, Amsterdam 1865 (5th and last edition 1881) ; French version 1866 (5th and last edition 1883)

J W R Tilanus & J Gosschalk, *Beschrijving der schilderijen afkomstig van het Chirurgijnsgild te Amsterdam met eenige historische aanteekeningen enz*, Amsterdam 1865

1879
P Scheltema, *Historische beschrijving der schilderijen van het Stadhuis te Amsterdam*, Amsterdam 1879

1880
[J A Alberdingk Thijm], *Schilderijen afkomstig van het aloude Chirurgijns-Gild te Amsterdam*, Amsterdam 1880

1898
[J Six], *Catalogus van schilderijen, teekeningen en beelden in het Stedelijk Museum bijeengebracht door de 'Vereeniging tot het vormen van eene Openbare Verzameling van Hedendaagsche Kunst' te Amsterdam*, Amsterdam [1898] (3d and last edition 1922)

The loan from the Koninklijk Oudheidkundig Genootschap

1876
D van der Kellen Jr, *Catalogus van het Museum van het Koninklijk Oudheidkundig Genootschap gesticht in 1858*, Amsterdam 1876

1877
A D de Vries Az & D C Meyer Jr, *Catalogus van het Amsterdamsch Museum van het Koninklijk Oudheidkundig Genootschap in de zalen van het Oude-Mannen-huis*, Amsterdam 1877

Albums of the collection

1805
Bataafsche Kunstgalerij, Haarlem & The Hague 1805, 1st fascicule (not continued). Four engravings by J Bemme, J C Bendorp and R Vinkeles. Reviewed in *Algemeene Kunst- en Letter-bode* 19 (1806) pp 315-17

1870
Moderne kunst uit het Rijks-museum te Amsterdam, Haarlem 1870. 50 photographs

1875
Musée National d'Amsterdam, Amsterdam 1875-77. 32 etchings by W Unger, with text

Het Rijksmuseum te Amsterdam, Haarlem 1875-77. 25 etchings by A Boland, text by Jan ten Brink, J ter Gouw, Henry Havard, W J Hofdijk, P Scheltema, Victor de Stuers, J van Vloten, C N Wijbrands et al

W J Hofdijk, *Museum Van der Hoop*, Amsterdam 1875-76. 12 steel engravings by C L van Kesteren, text by W J Hofdijk, introduction by J van Lennep

1887
A Bredius, *Die Meisterwerke des Rijksmuseums zu Amsterdam : Photogravure-Prachtwerk mit erläuterndem Text*, Munich 1887-88

Fr D O Obreen, *Le Musée de l'Etat à Amsterdam* [avec] *photographies par Ad Braun & Co*, Dornach & Paris 1887

1898
Les chefs-d'oeuvre des peintres néerlandais anciens et modernes : Musée de l'Etat [à] *Amsterdam*, Amsterdam [1898]

1903
Karl Voll, *Die Meisterwerke des Rijksmuseum zu Amsterdam*, Munich 1903. 208 reproductions, with text

Het Rijksmuseum te Amsterdam : 30 afbeeldingen [in autotypie] *der beste schilderijen naar oude meesters*, Amsterdam [1903]

1905
C G 't Hooft, *Schilderijen uit de verzameling van het Rijks-Museum te Amsterdam*, Amsterdam 1905. 6 photoengravings, with text

1907
W J Steenhoff, *De meesterstukken in het Rijksmuseum te Amsterdam*, Leiden 1907. 40 color reproductions, with text

C G 't Hooft, *Verzameling J C J Drucker in het Rijks-museum*, Amsterdam 1907. 6 photoengravings, with text

1909
W J Steenhoff, *Nederlandsche meesters uit het Rijks-museum te Amsterdam*, Koog-Zaandijk 1909. 9 color reproductions

1912
W J Steenhoff, *Nederlandsche schilderkunst in het Rijksmuseum*, 6 vols, Amsterdam [1912-20]

1935
A F E van Schendel, *Onze gouden eeuw*, Baarn 1935

1948
Album [met 100 reproducties van] *schilderijen* [in het] *Rijksmuseum*, Amsterdam [1948] (2d edition 1949 with 120 ills; 3d edition 1952 with 256 ills; 4th edition 1967 with 100 ills; 5th edition 1972 with 100 ills)

1965
E R Meyer, *Het Rijksmuseum*, Amsterdam 1965

A F E van Schendel & B Haak, *Le Rijksmuseum* [à] *Amsterdam*, Paris 1965 ; Dutch version 1966

1967
H van Guldener, *Rijksmuseum* [te] *Amsterdam : Nederlandse schilderkunst*, Munich 1967 (also published in French, German, English, Spanish and Japanese)

A F E van Schendel, *Museo del Estado Amsterdam*, Madrid 1967

1968
G van der Hoek, Itsuji Yoshikawa & Yasuo Kamon, *Rijksmuseum Amsterdam*, Tokyo 1968

J van der Waals, *Rijksmuseum de Amsterdam*, Madrid 1968
1969
Giorgio T Faggin, Ugo Ruggeri & Raffaele Monti, *Rijksmuseum Amsterdam: paintings*, New York 1969
1970
Paolo Lecaldano, *The Rijksmuseum of Amsterdam and its paintings*, New York 1970

G van der Hoek, *Frans Hals, Jan Steen, Rembrandt, Vermeer* [in het] *Rijksmuseum*, Amsterdam 1970

A A E Vels Heijn, *Hollandse schilderkunst in de 17de eeuw* [in het] *Rijksmuseum* [te] *Amsterdam*, Amsterdam 1970

Guides to the collection

1886
J P Lamp'l, *Rijks-museum-gids*, Amsterdam 1886

Gratis-gids Rijksmuseum, Amsterdam 1886
1887
Fr D O Obreen, *Wegwijzer door 's Rijksmuseum te Amsterdam, met teekeningen door Wilm Steelink en plattegronden*, Schiedam 1887 (4th and last edition 1898); English version 1887 (4th and last edition 1898)
1902
Beknopte gids door 's Rijks Museum, Amsterdam 1902
1909
W Steenhoff, *Amsterdam: das Rijksmuseum*, Stuttgart 1909
1910
W P Brons, *Wegwijzer door 's Rijksmuseum*, Amsterdam 1910
1916
W P Brons, *Geïllustreerde gids door het Rijksmuseum te Amsterdam*, [Amsterdam 1916]
1927
[Lena Laurie], *Rijksmuseum: an illustrated guide to the principal pictures*, [Amsterdam 1927] (2d edition 1929)
1928
F S[chmidt]-Degener & D C Röell, *Rijksmuseum: gids met afbeeldingen*, [Amsterdam 1928] (2d edition 1931, 3d and last edition 1938); German version 1930
1962
E R Meijer, *Wegwijzer door het Rijksmuseum*, [Amsterdam 1962]; revised version 1972 in Dutch, French, German and English

Literature on the collection

1795
Notitie van eenige konstige en buitengemeene slegte belachlyke en barbaarsche schilderyen, meest alle naar het leven geschilderd door Pruisische en Engelsche meesters, gevonden in het kabinet van den gedeserteerden generaal Prins Willem V, Alle dewelke uit de hand te koop, en daaglyks te zien zyn … in de Kalverstraat …, Amsterdam [1795]

1801
[C S Roos], 'Korte beschryving der Nationale Kunst-Gallery op het Huis in 't Bosch by Den Haag,' *Algemeene Konst- en Letterbode* 14 (16 January 1801) pp 41-44 (reprinted in Moes & van Biema 1909, pp 36-38)
1826
'Museum in Amsterdam,' *Kunst-Blatt* 7 (1826) pp 413-16
1844
E J Potgieter, 'Het Rijks-Museum te Amsterdam,' *De Gids* 8 (1844) pp 7-26, 208-16, 391-423, 585-95, 599-609; published in book form, with introduction by Albert Verwey, Haarlem 1907
1858
P L Dubourcq, 'Korte geschiedenis van den oorsprong en de lotgevallen van 's Rijks Museum,' in *Beschrijving der schilderijen op 's Rijks Museum te Amsterdam*, Amsterdam 1858, pp XI-XV
1859
Maxime du Camp, *En Hollande: lettres à un ami; suivies des catalogues des musées de Rotterdam, La Haye et Amsterdam*, Paris 1859
1863
'Stichting van een kunstmuzeüm te Amsterdam,' *De Nederlandsche Spectator* 4 (1863) pp 145-46

[J A Alberdingk Thijm], *De 'Hoofdcommissie' voor 'het gedenkteeken enz' en het 'Muzeüm Koning Willem de Eerste': een blaadtjen lektuur voor de 'plaatselijke kommissiën,'* Amsterdam 1863
1864
J A Alberdingk Thijm, *Aan de leden der Kommissie tot voorbereiding der stichting van het Muzeüm 'Koning Willem de Eerste,'* [Amsterdam] 1864

'Het aanstaande nieuwe museum te Amsterdam: missive van wijlen den Heer van Effen aan den tegenwoordigen Spectator,' *De Nederlandsche Spectator* 5 (1864) pp 121-22

J Gosschalk, 'Museum Willem I,' *De Nederlandsche Spectator* 5 (1864) pp 130-32, 148-50, 164-65, see also pp 138, 178, 235
1866
J A Alberdingk Thijm, 'Het kunstmuzeüm te Amsterdam,' *De Dietsche Warande* 7 (1866) pp 70-90
1870
J C Zimmerman, 'Een schilderijenmuseüm en eene commissie,' *De Gids* 34 (1870) pp 352-57

[H A] Klinkhamer, *Academie of museum: eenige denkbeelden over de kunst in Nederland*, Amsterdam 1870

P L Dubourcq, ''s Rijks Museum te Amsterdam: het legaat van Leendert Dupper,' *Amsterdamsche Courant*, 17, 28 & 29 June 1870

C von Lützow, 'Die vormals Dupper'sche Sammlung,' *Zeitschrift für Bildende Kunst* 5 (1870) pp 227-30
1871
J A Alberdingk Thijm, 'Het Trippenhuis en zijne bewoners,' *De Dietsche Warande* 9 (1871) pp 491-550
1873
Victor de Stuers, 'Holland op zijn smalst,' *De Gids* 37 (1873) pp 320-403; published in book form, with introduction and commentary, by a group of staff and students of the Kunsthistorisch Instituut (institute for art history) of the university of Amsterdam, Bussum 1975

1875
Victor de Stuers, *Da capo: een woord over regeering, kunst en oude monumenten*, The Hague 1875

Victor de Stuers, 'Unitis viribus,' *De Gids* 39 (1875) pp 239-66
1877
'Het nieuwe Rijks-museum te Amsterdam,' *Eigen Haard* 3 (1877) pp 27-30
1879
Verslagen omtrent 's Rijks Verzamelingen van Geschiedenis en Kunst 1 (1878), The Hague 1879. Published annually since then
1880
'Le nouveau musée d'Amsterdam,' *La Chronique des Arts et de la Curiosité* 18 (1880) p 209

[J W Kaiser], 'Historische aanteekeningen betreffende het Museum (de verzameling; het bestuur; de catalogus; het gebouw),' in *Beschrijving der schilderijen van het Rijksmuseum te Amsterdam*, The Hague 1880, pp III-XXI

E H Koster, 'Korte geschiedenis van het Paviljoen Welgelegen en van de daarin geplaatste kunstverzameling,' in [C J Gonnet], *Beschrijving der schilderijen in 's Rijks Verzameling van Kunstwerken van Moderne Meesters in het Paviljoen 'Welgelegen' te Haarlem*, The Hague 1880, pp VII-XIII

V de Stuers, 'Het kabinet van J S H van de Poll,' *Nederlandsche Kunstbode* 2 (1880) pp 243-46, 276-77
1881
'De verzameling Bicker: familieportretten aan de Stad Amsterdam gelegateerd,' *Nederlandsche Kunstbode* 3 (1881) p 70
1883
Jaarverslag Vereeniging Rembrandt 1 (1883). Published annually since then
1885
Fr D O Obreen, 'Geschiedenis van het Rijks Museumgebouw: plechtige opening van het Rijksmuseum,' in *Verslagen omtrent 's Rijks Verzamelingen van Geschiedenis en Kunst* 8 (1885) pp 1-44

A Bredius, 'Korte inleiding,' in *Catalogus van het Rijks-Museum van Schilderijen*, Amsterdam 1885, pp VII-IX

A W Weissman, *Het Rijksmuseum te Amsterdam: geschiedenis, in- en uitwendige versiering, bouwstijl*, Arnhem 1885

[J A Alberdingk Thijm], *Toelichting der stoffeering van voorzaal en Rembrandtzaal van het Rijks-Museum*, Amsterdam 1885

'Het Rijksmuseum te Amsterdam,' *Het Lees-kabinet* 52 (1885) pp 146-53

Max Rooses, 'Het nieuwe Rijksmuseum te Amsterdam,' *De Gids* 49 (1885) pp 277-91

Taco H de Beer, 'De opening van het Rijks-museum,' *De Portefeuille* 7 (1885-86) pp 252-54

'De inwijding van het Rijksmuseum te Amsterdam op 13 Juli 1885,' *De Lantaarn* 1 (1885) nr 14, p 7

W Bode, 'Das neue Rijksmuseum zu Amsterdam,' *Der Kunstfreund* 1 (1885) pp 249-54

C Vosmaer, 'Het nieuwe museum te Amsterdam,' *De Nederlandsche Spectator* 26 (1885) pp 263-65, 269-72, 277-79, see also p 385
1886
Ch Ponsonailhe, 'Le Rijks-Muséum à Amsterdam et le nouveau Musée du Luxembourg,' *L'Artiste: Revue d'Art Contemporain* 56 (1886) pp 341-59

E Michel, 'Le Rijksmuseum d'Amsterdam,' *L'Art* 41 (1886) pp 41-46, 61-63

J de Vries, 'Het Rijksmuseum te Amsterdam,' *Eigen Haard* 12 (1886) pp 92-95, 108-10

'Het Rijksmuseum,' *De Nederlandsche Spectator* 27 (1886) p 275, see also p 371

[Redeker Bisdom], 'De verlichting van het Rijksmuseum te Amsterdam,' *Vademecum der Bouwvakken* 1 (1886) nr 8
1887
Victor de Stuers, *Beschrijving van de decoratie der zalen van het Nederlandsch Museum van Geschiedenis en Kunst te Amsterdam*, [The Hague] 1887; French version 1887
1888
Georg Galland, 'Das neue Reichsmuseum zu Amsterdam,' *Zeitschrift für Bildende Kunst* 23 (1888) pp 217-23, 241-45
1889
H C Rogge, 'Het Trippenhuis te Amsterdam en zijn lotgevallen,' *Eigen Haard* 15 (1889) pp 133-34, 144-47
1890
Fr D O Obreen, 'Rembrandts Anatomische Les van Prof Nicolaes Tulp,' *Obreen's Archief voor Nederlandsche Kunstgeschiedenis* 7 (1890) pp 195-244
1891
E W Moes, 'De nieuwe tegelschilderingen aan het Rijksmuseum te Amsterdam,' *De Nederlandsche Spectator* 32 (1891) p 294
1892
Victor de Stuers, *Mr N de Roever en de minister Heemskerk*, The Hague 1892

N de Roever, *Het schijnconcours voor 's Rijksmuseum: de waarheid volgehouden tegen Victor de Stuers*, Amsterdam 1892
1894
Jan Veth, *In het Rijksmuseum: met twee brieven van Jozef Israëls*, Amsterdam 1894
1895
Verslag… der Vereeniging tot het vormen van eene Openbare Verzameling van Hedendaagsche Kunst te Amsterdam 1894/95-1922/23, Amsterdam 1895-1923
1896
Eduard van Biema, 'De verhuizing van de Anatomische Les naar Den Haag,' *De Gids* 60 (1896) pp 560-64
1897
Victor de Stuers, *Het Rijksmuseum te Amsterdam: platen van P J H Cuypers*, Amsterdam 1897; French version 1897

Victor de Stuers, 'Dr P J H Cuypers,' in *Mannen en vrouwen van beteekenis in onze dagen*, Haarlem 1897

[K] Bes, *Kijkjes in 's Rijksmuseum te Amsterdam*, 2 vols, Amsterdam 1897
1900
Victor de Stuers, 'Dr P J H Cuypers,' *Elsevier's Geïllustreerd Maandschrift* 10 (1900) pp 1-13

1902
Th Molkenboer, 'In het Rijksmuseum,' *Van Onzen Tijd* 3 (1902-03) pp 183-89

Rapport aan H M de Koningin uitgebracht door de Rijks Commissie tot het nemen van proeven betreffende de verlichting van Rembrandt's 'Nachtwacht' met 6 bijlagen, [Amsterdam 1902]
1903
Victor de Stuers, *Een geheim rapport: onthulling*, The Hague 1903

B W F van Riemsdijk, 'Geschiedkundig overzicht der verzamelingen, – der catalogi, – van het beheer, – der gebouwen,' in *Catalogus der schilderijen … in het Rijksmuseum*, Amsterdam 1903, pp XI-XXVIII
1906
Inwijding der nieuwe Rembrandtzaal in het Rijksmuseum te Amsterdam op 16 Juli 1906, [Amsterdam] 1906
1908
W Steenhoff, 'De collectie Six en de aanwinst eruit door het Rijksmuseum,' *Onze Kunst* 13 (1908) pp 205-19
1909
E W Moes & Eduard van Biema, *De Nationale Konst-Gallery en het Koninklijk Museum: bijdrage tot de geschiedenis van het Rijksmuseum*, Amsterdam 1909

[A Pit], *De verzameling Otto Lanz, tentoongesteld in 't Rijksmuseum*, [Amsterdam 1909]

In en om het Rijksmuseum: 75 photographische opnamen van het gehele museum in volgorde afgebeeld, Koog-Zaandijk 1909; English version 1909
1910
K Bes, 'Het vijfentwintigjarige Rijksmuseum te Amsterdam,' *Morks' Magazijn* 12 (1910) pp 1-7

M D Henkel, 'Das Rijksmuseum für moderne Kunst zu Amsterdam,' *Kunstchronik* ns 21 (1910) pp 209-14

W P J Overmeer, 'Het buitenverblijf van Lodewijk Napoleon te Haarlem,' *De Navorscher* 59 (1910) pp 289-97

W Steenhoff, 'De collectie-Drucker in het Rijksmuseum,' *Elsevier's Geïllustreerd Maandschrift* 40 (1910) pp 361-74
1912
Adres met toelichting gericht aan den gemeenteraad van Amsterdam door het genootschap 'Architectura et Amicitia' ter zake van de voorgenomen uitbreiding van den Drucker-uitbouw aan het Rijksmuseum, [Amsterdam 1912]

Speratus, 'Museum-logika: nieuwe uitbouw aan het Rijksmuseum,' *Holland Express* 5 (1912) pp 255-56

'De Drucker-uitbouw aan het Rijksmuseum,' *De Bouwwereld* 11 (1912) pp 241-42, see also pp 329-30
1913
Max Eisler, 'De collectie Drucker in het Rijksmuseum te Amsterdam,' *Elsevier's Geïllustreerd Maandschrift* 46 (1913) pp 241-55, 323-35, 409-27
1915
R Bangel, 'Die Sammlung Hoogendijk im Rijksmuseum,' *Cicerone* 7 (1915) pp 171-89

W Steenhoff, 'De Randwijk-collectie in het Rijksmuseum,' *Onze Kunst* 27 (1915) pp 89-97

1918
Over hervorming en beheer onzer musea, Leiden 1918

[B Canter], 'De toekomst van het Rijksmuseum te Amsterdam,' *Holland Express* 11 (1918) pp 452-55

A le Comte, *Afscheidswoord aan Z E den Minister van Kunst en Wetenschap*, [Delft 1918]

Frits Lugt, *Het redderen van den nationalen kunstboedel*, Amsterdam 1918
1921
Rapport der Rijkscommissie van advies in zake reorganisatie van het museumwezen hier te lande, ingesteld bij K B van 5 Februari 1919, The Hague 1921

A J Luikinga, 'Reorganisatie van het museumwezen: naar aanleiding van het rapport der Staatskommissie,' *De Socialistische Gids* 6 (1921) pp 1004-18, 1134-52
1924
Corn[elis] Veth, 'Het Rijksmuseum en zijn inhoud,' *Haagsch Maandblad* 1 (1924) pp 468-75; *De Socialistische Gids* 9 (1924) pp 793-97

D C Röell, 'De verzameling Oldenburg in het Rijksmuseum, I-II,' *Maandblad voor Beeldende Kunsten* 1 (1924) pp 66-69, 135-38

F Schmidt-Degener, 'Een blik naar het Zuiden: naar aanleiding van den aankoop van schilderijen van Italiaanse meesters voor het Rijksmuseum te Amsterdam door de Vereeniging Rembrandt,' *Haagsch Maandblad*, July 1924
1926
Willem Eland, 'Groote veranderingen in het Rijksmuseum: rangschikking naar tijdsorde,' *Ons Eigen Tijdschrift* 5 (1926-27) pp 168-70
1927
F Schmidt-Degener, 'Dr P J H Cuypers en het Rijksmuseum,' *Maandblad Amstelodamum* 14 (1927) pp 46-48
1929
'Un essai d'éclairage au Rijksmuseum d'Amsterdam,' *Mouseion* 3 (1929) pp 97-98
1933
Vereeniging Rembrandt tot behoud en vermeerdering van kunstschatten in Nederland: gedenkboek 1883-1933, [Amsterdam 1933]

Gedenkboek ter gelegenheid van het 75-jarig bestaan [van het] Koninklijk Oudheidkundig Genootschap 1858-1933, Amsterdam 1933

A W Vinck, 'De kunstverzamelingen van stadhouder prins Willem v en hare lotgevallen sedert 1795,' *Die Haghe* 4 (1933) pp 54-134
1934
F Schmidt-Degener, 'Het karakter der schilderijenverzameling in het Rijksmuseum,' in *Catalogus der schilderijen … in het Rijksmuseum te Amsterdam*, Amsterdam 1934, pp VII-XVI

D C Röell, 'Geschiedkundig overzicht der verzamelingen, – der gebouwen,' in *Catalogus der schilderijen … in het Rijksmuseum te Amsterdam*, Amsterdam 1934, pp XIX-XXXIV

Jan Beerends, 'Een monument voor de schoonheid: bij het 50-jarig bestaan van het Rijksmuseum,' *Het R-K Bouwblad* 6 (1934-35) pp 401-03

1935
F Schmidt-Degener, 'Vijftig jaren Rijksmuseum,' in exhib cat *Rembrandt-tentoonstelling ter herdenking van de plechtige opening van het Rijksmuseum op 13 Juli 1885*, Amsterdam 1935, pp 5-10

Vox, 'Een gouden jubileum in de kunst,' *Eigen Haard* 61 (1935) pp 392-94, 408-09

R N Roland Holst, 'Bouwmeester Cuypers en het Rijksmuseum (1935),' in *In en buiten het tij*, Amsterdam 1940, pp 133-37

W Martin, 'Notice historique,' in *Catalogue raisonné des tableaux et sculptures* [du] *Musée Royal de Tableaux Mauritshuis à la Haye*, The Hague 1935, pp XII-XXXV
1936
C Veth, 'Sir Henry Deterding's schenking aan Nederlandsche musea,' *Maandblad voor Beeldende Kunsten* 13 (1936) pp 172-76

A van Schendel, 'Rijksmuseum te Amsterdam: Schenking van Henri Deterding,' *Mededeelingen van het Departement van Onderwijs, Kunsten en Wetenschappen* 3 (1936) pp 150-51, see also pp 227-28

F Schmidt-Degener, 'Het Rijksmuseum te Amsterdam' [address presented at the Koninklijk Museum voor Schone Kunsten te Antwerpen, 20 December 1936], in *Het blijvend beeld der Hollandse kunst: verzamelde studiën en essays van Dr F Schmidt-Degener*, Amsterdam 1949, pp 125-36
1937
Alb Heppner, 'Die vollendete Reorganisation des Rijksmuseums in Amsterdam,' *Internationale Kunstrevue* 1 (1937) pp 145-48
1939
H A van Goch, 'Nog iets over het Trippenhuis,' *Historia* 5 (1939) pp 11-17

E Boekman, *Overheid en kunst in Nederland*, Amsterdam 1939
1940
J G van Gelder, 'Het Rijksmuseum in oorlogstijd: nieuwe aanwinsten,' *Elsevier's Maandschrift* 50 (1940) pp 41-46

J Ubink, 'Onze kunst van heden,' *Eigen Haard* 66 (1940) pp 86-88

A B de V[ries], F S[chmidt]-D[egener], A v[an] S[chendel], 'Rijksmuseum te Amsterdam: schenking Kessler,' *Mededeelingen van het Departement van Onderwijs, Kunsten en Wetenschappen* 7 (1940) pp 420-23, 477-81; 8 (1941) pp 71-74
1941
A Muermans, *Het huis aan de kade: de roemvolle historie van het Rijksmuseum te Amsterdam en van al die zaken, waarin een klein volk groot kan zijn*, Amsterdam 1941

J Huizinga, 'Herdenking van Frederik Schmidt-Degener,' *Jaarboek der Koninklijke Nederlandsche Akademie van Wetenschappen*, Amsterdam 1941-42, pp 226-36

I de Bruijn, 'Over verzamelaars en musea,' *Maandblad van Beeldende Kunsten* 18 (1941) pp 84-86
1942
I de Bruijn, 'Herinneringen aan F Schmidt-Degener,' *Maandblad voor Beeldende Kunsten* 19 (1942) pp 93-94

'In memoriam Jhr B W F van Riemsdijk,' *Maandblad Amstelodamum* 29 (1942) pp 55-56

H E van Gelder, 'Haagsche kunstverzamelingen voor 1900,' *Die Haghe* 13 (1942) pp 1-36
1943
H E van Gelder, 'Frederik Schmidt-Degener (in memoriam),' *Jaarboek Maatschappij voor Nederlandse Letterkunde*, 1943-45, pp 207-24

H E van Gelder, Jan Kalf, Joseph Th J Cuypers, W Sprenger & F J van Lanschot, 'Jhr Mr Victor de Stuers' [in commemoration of his centennial], *Oudheidkundig Jaarboek* 12 (1943) pp 1-27
1945
H A van Goch & M E 't Hart, *Het Trippenhuis*, Amsterdam 1945 (second enlarged edition; first edition 1922)
1946
D F Slothouwer, *De paleizen van Frederik Hendrik*, Leiden 1946

W Martin, 'Abraham Bredius, 1855-1946: in memoriam,' *Maandblad voor Beeldende Kunsten* 22 (1946) p 71

H E van Gelder, 'Dr Abraham Bredius, 1855-1946,' *Oud-Holland* 61 (1946) pp 1-4

H P Baard, *Kunst in schuilkelders*, The Hague 1946

Th H Lunsingh Scheurleer, 'Het Koninklijk Kabinet van Zeldzaamheden en zijn betekenis voor het Rijksmuseum I,' *Oudheidkundig Jaarboek* 13 (1946) pp 50-67; II *Bulletin van de Koninklijke Nederlandse Oudheidkundige Bond* 9 (1956) pp 269-308
1947
A van Schendel & H H Mertens, 'De restauraties van Rembrandt's Nachtwacht,' *Oud-Holland* 62 (1947) pp 1-52
1948
J Knoef, 'De kunsttentoonstelling van 1808 en wat haar voorafging,' in *Tusschen Rococo en Romantiek*, The Hague 1948, pp 136-52

H E van Gelder, 'De kunstverzameling van koning Willem II,' *Maandblad voor Beeldende Kunsten* 24 (1948) pp 137-48

J Knoef, 'De verzameling A van der Hoop,' *Jaarboek Amstelodamum*, 1948, pp 51-72

J G van Gelder, 'De schilders van de Oranjezaal,' *Nederlands Kunsthistorisch Jaarboek*, 1948-49, pp 118-64
1950
G Panhuysen, 'Geschriften van en over Jhr Mr Victor Eugène de Stuers,' *De Maasgouw* 69 (1950) pp 112-17
1952
Th H Lunsingh Scheurleer, 'Geschiedenis van de verzameling,' in *Catalogus van meubelen en betimmeringen*, Amsterdam 1952, pp 9-11
1953
H E van Gelder, 'In memoriam Dr F Schmidt-Degener,' *Bulletin van het Rijksmuseum* 1 (1953) pp 45-49
1954
J Q van Regteren Altena, 'In memoriam Isaäc de Bruyn,' *Bulletin van het Rijksmuseum* 2 (1954) 27-28

1956
Th H Lunsingh Scheurleer, 'Rembrandt en het Rijksmuseum,' *Bulletin van het Rijksmuseum* 4 (1956) pp 27-41
1957
R van Luttervelt, 'Herinneringen aan Michiel Adriaenszoon de Ruyter in het Rijksmuseum,' *Bulletin van het Rijksmuseum* 5 (1957) pp 28-70
1958
Het Rijksmuseum 1808-1958: gedenkboek [*Bulletin van het Rijksmuseum* 6 (1958) vols 3-4], commemorative issue with the following articles:
 Th H Lunsingh Scheurleer, 'Geboorte en jeugdjaren van het Rijksmuseum,' pp 1-42
 Th H Lunsingh Scheurleer, 'Een eeuw Rijksmuseum in vogelvlucht,' pp 43-58
 J Verbeek, 'Bezoekers van het Rijksmuseum in het Trippenhuis 1844-85,' pp 59-71
 [A F E] v[an] S[chendel], 'Paul Verlaine in het Rijksmuseum,' p 72
 Ton Koot, 'Bespiegeling over de bezoekerscijfers,' pp 73-82
 D de Hoop Scheffer, 'Het Rijksmuseum en zijn begunstigers,' pp 83-100
 A van Schendel, 'Afbraak en opbouw, 1939-1958,' pp 101-10

K Blauw, 'Het provinciehuis van Noordholland,' *Jaarboek Haerlem*, 1958, pp 69-85

Th H Lunsingh Scheurleer, 'Historie en perspectief,' *Nieuws-Bulletin van de Koninklijke Nederlandse Oudheidkundige Bond* 11 (1958) cols 11-19
1959
A van Schendel, 'Bij het afscheid van de hoofddirecteur Röell,' *Bulletin van het Rijksmuseum* 7 (1959) pp 51-52
1960
[Editorial], 'Het Rijksmuseum 75 jaar,' *Bulletin van het Rijksmuseum* 8 (1960) pp 115-16

W A Keuzenkamp, 'De plannen voor het Rijksmuseum,' *Bulletin van het Rijksmuseum* 8 (1960) pp 117-34
1961
A van Schendel, 'De schenking De Bruijn-van der Leeuw aan het Rijksmuseum,' *Bulletin van het Rijksmuseum* 9 (1961) pp 43-44

E R Meijer, 'De schilderijen [van de schenking De Bruijn-van der Leeuw],' *Bulletin van het Rijksmuseum* 9 (1961) pp 45-58

J L Cleveringa, 'Catalogus van de schilderijen [van de schenking De Bruijn-van der Leeuw],' *Bulletin van het Rijksmuseum* 9 (1961) pp 63-67
1962
A van Schendel, 'In memoriam Jhr Dr D C Röell (1894-1961),' *Bulletin van het Rijksmuseum* 10 (1962) pp 3-4

A Staring, 'D C Röell,' *The Burlington Magazine* 104 (1962) pp 162-63
1963
E R Meyer, 'Bezoekers op de tweesprong,' *Bulletin van het Rijksmuseum* 11 (1963) pp 92-93

A F E van Schendel, 'Rijksmuseum: een verjongingskuur' [with contributions by J A F Bosschaart, Dick Elffers, Th Wijnalda, A Auer, B P Fondse, R Vosteen and C Groot], *Bouw* 18 (1963) pp 1710-26

1964

K G Boon, 'Korte geschiedenis van de verzamelingen,' in *Gids voor het Rijksprentenkabinet*, Amsterdam 1964, pp 11-31

1965

E P Engel, 'Het ontstaan van de verzameling Drucker-Fraser in het Rijksmuseum,' *Bulletin van het Rijksmuseum* 13 (1965) pp 45-66

C J de Bruyn Kops, 'De afdeling "moderne kunst" in het Rijksmuseum gedeeltelijk nieuw ingericht,' *Bulletin van het Rijksmuseum* 13 (1965) pp 67-71

1966

P van Vliet, 'Spaanse schilderijen in het Rijksmuseum afkomstig van schenkingen van Koning Willem I,' *Bulletin van het Rijksmuseum* 14 (1966) pp 131-49; *see also* J G van Gelder, 'Murillo's Heilige Familie uit de verzameling Bourke,' *Bulletin van het Rijksmuseum* 15 (1967) p 32

1967

Th H Lunsingh Scheurleer, 'De stadhouderlijke verzamelingen,' in *150 jaar Koninklijk Kabinet van Schilderijen, Koninklijke Bibliotheek* [en] *Koninklijk Penningkabinet*, The Hague 1967, pp 9-50

A B de Vries, 'Koninklijk Kabinet van Schilderijen,' in *150 jaar Koninklijk Kabinet van Schilderijen, Koninklijke Bibliotheek* [en] *Koninklijk Penningkabinet*, The Hague 1967, pp 51-90

1969

A A E Vels Heyn, 'Eerbetoon aan Rembrandt, 1852-1956,' *Spiegel Historiael* 4 (1969) p 450

1973

W Halsema-Kubes, 'History of the collection,' in *Beeldhouwkunst in het Rijksmuseum* [catalogue of sculpture], Amsterdam 1973, pp 20-26

1974

C J de Bruyn Kops, 'Aanwinsten in de gedeeltelijk gereorganiseerde afdeling 18de en 19de eeuwse schilderkunst,' *Bulletin van het Rijksmuseum* 22 (1974) pp 17-36

B P J Broos, 'Stukjes van een legpuzzel: Florentijnse schilderkunst in Nederlands bezit,' *Vrij Nederland*, 20 April 1974, p 26

Marten G Buist, *At spes non fracta; Hope & Co. 1770-1815: merchant bankers and diplomats at work*, [Amsterdam] 1974

M D Haga, 'Mannheimer, de onbekende verzamelaar,' *Bulletin van het Rijksmuseum* 22 (1974) pp 87-95

S W A Drossaers & Th H Lunsingh Scheurleer, *Inventarissen van de inboedels in de verblijven van de Oranjes en daarmede gelijk te stellen stukken, 1567-1795*, 3 vols, The Hague 1974-76

1975

F J Duparc, *Een eeuw strijd voor Nederlands cultureel erfgoed*, The Hague 1975

Ben van der Velden, 'Rijksmusea in oorlogstijd,' *NRC Handelsblad*, 11 July 1975

H de Lussanet de la Sablonière, 'De restauratie van Buitenhof 34 tot en met 38 te 's-Gravenhage ten behoeve van de Tweede Kamer der Staten-Generaal,' *Bulletin van de Koninklijke Oudheidkundige Bond* 74 (1975) pp 97-126

Statistical survey of the collection

Of the 5,100-odd items in the catalogue, about 4,950 are presently on the Rijksmuseum inventories, among them 87 pieces which are missing or lost. The great majority of these works – about 4,450 or 89.9 percent – are owned by the nation, and about 500, or 10.1 percent, are on loan.

The difference between the total of works catalogued and those on the inventories arose when about 155 paintings that were on loan from the city of Amsterdam were returned at the end of 1975 and stricken from the inventories (see below, p 55). Other catalogue numbers that are not on the department of paintings inventory are several painted objects from the departments of sculpture and applied arts, and Dutch history, included in the catalogue for the sake of completeness.

BREAKDOWN BY GROUPS

paintings	4410	89.1%
—general: 4050		
—Honselaarsdijk series: 50		
—Rotterdam East India Compagny series: 35		
—Governors-general series: 95		
—Panpoeticon Batavum: 80		
—Dutch costume series: 35		
—Vanmour series: 65		
miniatures	255	5.2
pastels	110	2.2
aquarelles and drawings	145	2.9
heraldic objects	30	0.6
	4950	100.0%

BREAKDOWN BY DISPOSITION

IN MUSEUM USE				50.5%
1 displayed in the Rijksmuseum			42.1%	
department of paintings		33.1%		
—main collection	16.8%			
Netherlands school 15–17 century: 7.9%				
Netherlands school 18–19 century: 6.9				
foreign schools: 2.0				
—study collection	16.3			
Netherlands school 15–19 century: 13.3				
portraits of artists: 1.2				
foreign schools: 1.8				
department of Dutch history		6.9		
department of sculpture and applied arts		2.1		
2 displayed in other museums			8.4	
loaned directly to		5.4		
Amsterdam, Stedelijk Museum: 1.0				
—, Amsterdams Historisch Museum: 1.4				
Enschede, Rijksmuseum Twenthe: 0.1				
The Hague, Mauritshuis: 1.9				
Muiden, Muiderslot: 0.6				
Velsen, Beeckestijn manor: 0.4				
loaned via the DRVK to other museums		3.0		
IN NON-MUSEUM USE				14.2
1 in Rijksmuseum and KOG offices		1.2		
2 loaned via the DRVK to other government buildings		13.0		
TOTAL PUT TO USE				64.7
IN DEPOT				35.3
				100.0%

Preface
to the catalogue

Introduction

The following catalogue includes every last item on the inventories of the Rijksmuseum department of paintings and virtually all the painted objects belonging to the other departments of Western art. All the works are illustrated, except for the few lost or missing ones of which no photograph is available. These are described in as great detail as possible.

The catalogue presents the latest state of scholarly knowledge concerning the paintings in the Rijksmuseum in as concise a form as possible. Not dealt with are the physical condition of the works, their stylistic, iconographical and technical relation to other works, preparatory studies and copies, early history prior to acquisition by the nation and exhibitions.

The form of the catalogue is discussed here under the following sections:
—groups of objects
—subdivisions of the groups
—order of works within each group
—structure of the entries

Groups of objects

The collection includes not only paintings but other kinds of objects as well. We have divided them into five groups:
—paintings, including *verres églomisés* (paintings on the backs of glass panes)
—miniatures, including enamels and silhouettes
—pastels
—aquarelles and drawings
—heraldic objects

Subdivisions of the groups

LISTING BY NAME Within each group the works are catalogued alphabetically by artist's name, if known, and if unknown by monogram, ad hoc name or school. In the paintings section the alphabetical listings are followed by thematic ones.

The main listing of painters by name, with which the catalogue opens, contains cross-references to the authors of works listed in all other sections of the catalogue, and thus doubles as a name index to artists. The spelling of artists' names and their biographical data are for the most part based on Thieme-Becker's *Künstler-lexikon*, P A Scheen, *Lexicon Nederlandse beeldende kunstenaars, 1750-1950*, 2d, revised edition, The Hague 1969-70, and F G Waller, *Biografisch woordenboek van Noord Nederlandsche graveurs*, The Hague 1938. Dutch usage is followed: the 'long y' of Dutch – ij – is not distinguished alphabetically from the normal y. (Anthony van Dyck, for example, is preceded by Abraham van Dijck and followed by Floris van Dijck.) The names of married Dutch women are composed of the husband's name followed by a hyphen and the woman's maiden name. (Laura Theresa Alma Tadema-Epps, for example, is the wife of a Mr Alma Tadema and the daughter of a Mr Epps.)

LISTING BY SCHOOL The schools are listed alphabetically by country, with each country subdivided, again alphabetically, into progressively smaller geographical units. All countries are called by their modern names, except for the Netherlands, where a more analytical distinction is drawn. The present Netherlands is called the Northern Netherlands, and the present Belgium the Southern Netherlands; the denomination Netherlands school is used for works which cannot be securely placed in the north or south. The terms Dutch school and Flemish school for the art of the Northern and Southern Netherlands respectively have been purposely avoided as being inaccurate. Likewise in the interest of terminological precision, 'Holland school' is used not for the modern Netherlands as a whole, but only for a subdivision of the Northern Netherlands school corresponding to the present provinces of Noord- and Zuid-Holland.

LISTING BY THEME Listings by theme occur only in the paintings section, where the following six series are catalogued:
—Honselaarsdijk series: portraits of military figures from the Eighty Years War
—Rotterdam East India Company series: portraits of the directors of the Rotterdam chamber of the Dutch East India Company
—Governor-general series: portraits of the governors-general of the former Dutch East Indies
—Panpoeticon Batavum: collection of portraits of Dutch poets, started by Arnoud van Halen
—Dutch costume series: illustrations of Dutch village costumes from the third quarter of the 16th century
—Vanmour series: paintings of Turkish subjects from the Calkoen bequest

Order of works within each group

If more than one work by an artist is present in the collection, the best documented works are catalogued first: signed and dated works (in chronological order) first, then works signed only, and finally unsigned works accepted as authentic. Works whose autograph quality is subject to more or less serious doubts or which can be definitely assigned to the studio, school or milieu of a particular master, are listed under his name, with one of the following qualifications:
—*attributed to*: probably or possibly authentic
—*studio of*: painted under the master's supervision
—*school of* or *milieu of*: close in style, place and time to the master's work
—*manner of*: close to the master's style, though probably made outside his direct sphere
—*copy after*: copied after a work by the master, irrespective of when and where

Structure of the entries

The entries are constructed according to the following scheme:
—illustration
—inventory number and title
—additional information concerning the subject and relation to other works
—support, dimensions, idiosyncrasies of format (e g octagonal, tondo) and technique (e g grisaille, pen painting), signature, date, inscriptions (generally excluding those on attached seals, labels and the like)
—provenance and present location
—literature

ILLUSTRATION The relative sizes of the original paintings are in no way reflected by the sizes of their illustrations in the catalogue. (The only exception to this rule is formed by the smaller miniatures, which are reproduced in their true size.) The main governing factor in determining the width of the illustrations (seven different width sizes were used) was the relation of the originals' height to their width. The aim has been to illustrate all the works as legibly as possible within the small space available for each.

For various reasons, it was not always possible to obtain uniform photographs of pendants. As a result, there are differences in size between the illustrations of some pendant paintings whose dimensions are reported as being identical. This unfortunate effect is most often due to the circumstance that one of the pendants was photographed in the frame and the other out of the frame. We have chosen to leave the more extreme examples as they are rather than to seek optical regularity at the expense of cropping out large parts of the painted surface.

INVENTORY NUMBER The publication of this catalogue has been seized upon by the museum as an opportunity to discontinue the old systems of catalogue numbers, which have been an annoying source of confusion for well over a century. The only numbers attached to the works from now on will be their inventory numbers. A-numbers indicate works owned by the museum, and remain unchanged forever once assigned. C-numbers indicate objects on loan, and are changed to A-numbers if the objects are eventually acquired.

Henceforth, paintings belonging to the Rijksmuseum are to be referred to by the name of the artist or school, followed by the inventory number (for example, Maerten van Heemskerck, A 3518). These components are printed in bold-face type in the catalogue. Works listed under the categories miniatures, pastels, and aquarelles and drawings are preceded by that information, for easy location in the catalogue (for example, Pastels: Johannes van Vilsteren, C 49). Heraldic objects are referred to only by category and inventory number since virtually all are anonymous productions from the Netherlands (for example, Heraldic objects: C 1580).

In 1886 three lists were instituted for the inventory of the collections of the Rijksmuseum van Schilderijen (national painting museum):

A paintings belonging to the nation
B *objets d'art* belonging to the nation
C paintings and *objets d'art* on loan

All works then in the museum were inscribed at that point in the lists, which have since been kept up to date year by year. The B-list, which was used mainly for sculpture and furniture displayed in the painting galleries, was discontinued when the items themselves were transferred to the departments they more properly belonged to.

In 1883, when the Nederlandsch Museum voor Geschiedenis en Kunst (Netherlands museum of history and art), located originally in The Hague, was moved to the Rijksmuseum building, the Rijksmuseum van Schilderijen received the paintings and miniatures of that collection. They were first inventoried with NM-numbers, but have since been given A-numbers. In 1927 the Nederlandsch Museum voor Geschiedenis en Kunst was divided into the Nederlandsch Museum voor Geschiedenis (Netherlands museum of history; now the Rijksmuseum department of Dutch history) and the Rijksmuseum voor Beeldhouwkunst en Kunstnijverheid (national museum [now Rijksmuseum department] of sculpture and applied arts). These departments use NM-numbers for the holdings they acquired in that way, while assigning NG-numbers and RBK-numbers, respectively, to subsequent accessions. The present catalogue contains various painted objects from the other departments of the museum which we felt could not be omitted from a publication of 'all the paintings of the Rijksmuseum.'

A sizeable portion of the important city of Amsterdam loan to the nation was recalled by Amsterdam in 1975 to take its place in the Amsterdams Historisch Museum. Although these paintings were stricken from the Rijksmuseum inventories when they left the premises, they are nonetheless included in the catalogue, since so many of them were present in the museum for a long period ending only in the very year this catalogue was completed.

TITLE The titles have been kept descriptive. Original and traditional titles (e g 'Prayer *without end*' by Nicolaes Maes, C 535) are enclosed within quotation marks.

DIMENSIONS All measurements in the catalogue are given in centimeters, height preceding width.

SIGNATURE When the initials in a signature are followed by periods, this indicates that on the painting they stand free from each other. The absence of points indicates that the initials are intertwined or superimposed to form a mono-gram of some kind, often together with the first letter of the painter's last name. No attempt has been made to reproduce the actual form of the signatures in the typography of the catalogue. A selection of 134 reproductions of photographs of signatures can be found in the 1960 English catalogue of paintings, pp 415-30. The older catalogues, from 1858 to 1934, contain many hand-drawn facsimiles of signatures.

PROVENANCE The information under the rubric PROV is limited to the identity of the previous owner or lender, the year and the circumstances of acquisition or loan by the nation, and the names of the state bodies, other than the Rijksmuseum, to which it may subsequently have belonged. If the painting has been lent out by the Rijksmuseum, this information follows behind an asterisk. Such loans may take one of two forms: the work may have been put in charge of the Dienst voor 's Rijks Verspreide Kunstvoorwerpen (DRVK; national service for state-owned works of art), The Hague,

for placing in non-state museums or non-museum premises of the state, a province, municipality or non-governmental body (in which case the location is only specified when the work is on loan to a public museum); or it may be on direct loan from the Rijksmuseum to another state museum or to one of the Amsterdam municipal museums (the location is then always specified). The names of museums that are mentioned frequently are abbreviated (see p 56 for the key).

The date following the abbreviation is the year when the object became the property of the institution whose name follows or, if no institution is named, of the Rijksmuseum. This rule has one exception: NM, 1808 means that the object was in the so-called Nationaal Museum (for an explanation of this unofficial name see NM in the key to abbreviations below) in 1808, according to the inventory drawn up that year (Moes & van Biema 1909, pp 99-103).

The Rijksmuseum not only has placed objects of its own in the care of the DRVK, it also has received objects from it, either in the form of long loans or outright transfers. The same reciprocality has been practiced with the Mauritshuis in The Hague (abbreviated KKS, for Koninklijk Kabinet van Schilderijen 'Het Mauritshuis,' the museum's official name).

LITERATURE Under LIT the reader will find a fairly complete list of scholarly references to the work concerned, including the more important exhibition catalogues. In many cases suggested datings for undated works and dissenting opinions as to attribution are reported in short. No references to the Rijksmuseum's earlier published catalogues are included, but the student will often be able to find in them more detailed information concerning provenances. Nor are the museum's own annual reports included, where additional information is often to be found on new acquisitions. The student can find these passages readily in the annual report of the year of acquisition.

Books are indicated by the author's last name and the year of publication. Articles are indicated by the author's initials and last name and the abbreviated name, volume and year of the periodical. For the complete references to books and the full titles of periodicals, the reader will have to consult the key to abbreviated literature on pp 57-75.

Public museums with paintings on loan from the Rijksmuseum

Amersfoort, Museum Flehite, Westsingel 50. Owner: Oudheidkundige Vereniging Flehite (Flehite antiquarian society)
Amsterdam, Stedelijk Museum (municipal museum), Paulus Potterstraat 13. Owner: municipality of Amsterdam
—Amsterdams Historisch Museum (Amsterdam historical museum), Kalverstraat 92. Owner: municipality of Amsterdam
—Museum Willet-Holthuysen, Herengracht 605. Owner: municipality of Amsterdam
—Museum 'Het Rembrandt-huis,' Jodenbree-straat 4-6. Owner: Stichting 'Het Rembrandt-huis' (Rembrandt house foundation)
—Museum Amstelkring, genaamd Ons' Lieve

Heer op Solder (Amstelkring museum, called Our Lord in the Attic), Oude Zijds Voorburgwal 40. Owner: Stichting Museum Amstelkring (Amstelkring foundation)
—Het Wijnkoopersgildehuys (the wine-merchants' guild house), Koestraat 10-12. Owner: Vereniging De Amsterdamsche Wijn-koopers (the Amsterdam wine merchants' society)
Arnhem, Gemeentemuseum (municipal museum), Utrechtseweg 87. Owner: municipality of Arnhem
—Rijksmuseum voor Volkskunde 'Het Nederlands Openluchtmuseum' (national folk museum 'Netherlands open air museum'), Schelmseweg 89. Owner: the nation
Bergen op Zoom, Markiezenhof Gemeente-museum (municipal museum), Steenbergse-straat 6. Owner: municipality of Bergen op Zoom
Den Briel, Trompmuseum, Venkelstraat 4. Owner: municipality of Den Briel and the Vereniging Vrienden van het Trompmuseum (society of friends of the Tromp museum)
Delft, Stedelijk Museum 'Het Prinsenhof' ('The prince's court' municipal museum), St Agathaplein 1. Owner: municipality of Delft
—Oranje Nassau Museum, St Agathaplein 1. Owner: Vereniging Oranje Nassau Museum (Orange Nassau museum society)
—Rijksmuseum 'Huis Lambert van Meerten' ('Lambert van Meerten house' national museum), Oude Delft 199. Owner: the nation
—Hofje van Gratie (mercy almshouse), Van der Mastenstraat. Owner: Stichting Hofje van Gratie (mercy almshouse foundation)
Doorwerth: see Leiden, Koninklijk Nederlands Leger- en Wapenmuseum
Dordrecht, Dordrechts Museum, Museumstraat 42. Owner: Vereniging Dordrechts Museum (Dordrecht museum society)
—Museum mr Simon van Gijn, Nieuwe Haven 29. Owner: municipality of Dordrecht
Douai, France, Musée de Douai, Ancienne Chartreuse, rue des Chartreux. Owner: municipality of Douai
Enschede, Rijksmuseum Twenthe, Lasonder-singel 129. Owner: the nation
Gouda, Stedelijk Museum 'Het Catharina-Gasthuis' ('St Catherine's hospital' municipal museum), Oosthaven 10. Owner: municipality of Gouda
Groningen, Groninger Museum, Praedinius-singel 59. Owner: Stichting Museum van Oudheden voor provincie en stad Groningen (foundation for the museum of antiquities of the province and town of Groningen) and Stichting Groninger Museum voor stad en lande (foundation for the Groningen museum of town and province)
Haarlem, Frans Halsmuseum, Groot Heiligland 62. Owner: municipality of Haarlem
The Hague, Koninklijk Kabinet van Schilderijen 'Het Mauritshuis' (royal picture gallery, the Mauritshuis), Korte Vijverberg 8, Owner: the nation
—Museum van de Kanselarij der Nederlandse Orden (museum of the chancery of the Netherlands orders of knighthood), Javastraat 50. Owner: Kanselarij der Nederlandse Orden (chancery of the Netherlands orders of knighthood)
Den Helder, Het Helders Marinemuseum (Den

Helder naval museum), Het Torentje, Hoofdgracht. Owner: the nation

Hoorn, Westfries Museum (West Frisian museum), Rode Steen 1. Owner: municipality of Hoorn

Laren, Singer Museum, Oude Drift 1. Owner: Stichting Singer Memorial Foundation

Leek, Nationaal Rijtuigmuseum 'Nienoord' ('Nienoord' national carriage museum). Owner: Stichting 'Paard en Karos' ('horse and coach' foundation)

Leeuwarden, Fries Museum (Frisian museum), Turfmarkt 24. Owner: Stichting Het Fries Museum (trustees of the Frisian museum foundation)

—Gemeentelijk Museum Het Princessehof (the princess's court municipal museum), Grote Kerkstraat 11. Owner: municipality of Leeuwarden

Leiden, Stedelijk Museum De Lakenhal (the cloth-hall municipal museum), Oude Singel 28-30. Owner: municipality of Leiden

—Koninklijk Nederlands Leger- en Wapenmuseum 'Generaal Hoefer' (royal Netherlands arms and army museum 'General Hoefer'), Pesthuislaan 7. Owner: Stichting Koninklijk Nederlands Leger- en Wapenmuseum 'Generaal Hoefer' (royal Netherlands arms and army museum 'General Hoefer' foundation)

—Rijksmuseum voor de Geschiedenis der Natuurwetenschappen (national museum of the history of science), Steenstraat 1A. Owner: the nation

Middelburg, Zeeuws Museum (Zeeland museum), Abdij 3-4. Owner: Koninklijk Zeeuwsch Genootschap der Wetenschappen (royal Zeeland society of science) and Zeeuwse Museumstichting (Zeeland museum foundation)

Muiden, Rijksmuseum Muiderslot (Muiden castle national museum), Herengracht 1. Owner: the nation

Naaldwijk, Westlands Streekmuseum (Westland regional museum), Heilige Geest Hofje 7. Owner: municipality of Naaldwijk

Oranienstein, Germany, Nassau-Museum Oranienstein, at Schloss Oranienstein near Diez an der Lahn. Owner: Stichting 'Je Maintiendrai Nassau' ('Je Maintiendrai Nassau' foundation)

Paris, France, Musée du Louvre. Owner: the French nation

Rotterdam, Museum Boymans-van Beuningen, Mathenesserlaan 18-20. Owner: municipality of Rotterdam

—Belastingmuseum 'Prof Dr Van der Poel' ('Prof Dr Van der Poel' museum of taxation), Parklaan 14 & 16. Owner: Stichting Belastingmuseum 'Prof Dr Van der Poel' ('Prof Dr Van der Poel' museum of taxation foundation)

Uden, Museum voor Religieuze Kunst (museum of religious art), Birgittinessenabdij (Brigittine abbey), Vorstenburg 1. Owner: Stichting Museum voor Religieuze Kunst (museum of religious art foundation)

Utrecht, Centraal Museum (central museum), Agnietenstraat 1. Owner: municipality of Utrecht

Vaassen, Kasteel de Cannenburch (De Cannenburch castle). Owner: Stichting Vrienden der Geldersche Kasteelen (foundation of friends of the castles of Gelderland)

Velsen, Landgoed Beeckestijn (Beeckestijn estate), Rijksweg 136. Owner: municipality of Velsen (since 1969 placed effectively at the disposal of the Rijksmuseum)

Vlissingen, Stedelijk Museum (municipal museum), Bellamypark 19. Owner: municipality of Vlissingen

Weesp, Gemeentemuseum (municipal museum), Nieuwstraat 41. Owner: municipality of Weesp

Zaltbommel, Maarten van Rossum Museum, Nonnenstraat 7. Owner: Stichting Maarten van Rossum Museum (Maarten van Rossum museum foundation)

Zutphen, Stedelijk Museum (municipal museum) and Oudheidkamer voor Stad en Graafschap Zutphen (antiquities chamber of the town and county of Zutphen), Rozengracht 3. Owner: municipality of Zutphen

Zwolle, Provinciaal Overijssels Museum (Overijssel provincial museum), Melkmarkt 41. Owner: Stichting Provinciaal Overijssels Museum (Overijssel provincial museum foundation)

For more information concerning the above museums, consult the official listing of Dutch museums, *De Nederlandse musea*, The Hague (Government Publishing Office) 1976 (6th edition).

Key to abbreviated museum names

AHM Amsterdams Historisch Museum (Amsterdam historical museum). Located from 1926 to 1969 in the Waag (weighing house) on the Nieuwmarkt, Amsterdam, and since 1969 in the former Burgerweeshuis (civic orphanage) on the Kalverstraat, Amsterdam; the restoration of the latter was completed, and its official opening celebrated, in 1975.

DRVK Dienst voor 's Rijks Verspreide Kunstvoorwerpen (national service for state-owned works of art). The Hague, established 1949. In 1975 the name was changed to Dienst Verspreide Rijkscollecties (DVR). *See also* SNK

KKS Koninklijk Kabinet van Schilderijen 'Het Mauritshuis' (royal picture gallery, the Mauritshuis). The Hague, from 1813 to 1821 on the Buitenhof and since then in the Mauritshuis.

KKZ Koninklijk Kabinet van Zeldzaamheden (royal cabinet of rarities). The Hague, 1815-21 on the Buitenhof, thereafter in the Mauritshuis. In 1875 part of the holdings were transferred to the Nederlandsch Museum voor Geschiedenis en Kunst. The rest was divided in 1883 between the Rijksmuseum, Amsterdam, the Rijksmuseum voor Volkenkunde (national museum of ethnography), Leiden, and the Koninklijk Penningkabinet (royal medal cabinet), The Hague.

KOG Koninklijk Oudheidkundig Genootschap (royal antiquarian society). Founded at Amsterdam in 1858. Before 1887 the offices, library and collection moved from one address to another – four in all. In that year the library and part of the collection were incorporated into the Rijksmuseum, though at first they were housed

in separate rooms. The seat of the society was located from 1887 to 1917 in the Muntgebouw and thereafter in the Rijksmuseum, where it has chambers of its own, including space for exhibitions and a conference room.

NM Nationaal Museum (national museum). The unofficial title of the Rijksmuseum's direct predecessor (1798-1815), founded as the Nationale Konst-Gallery (national art gallery) in The Hague (1798-1808) – first, until 1805, in the Huis ten Bosch, then on the Buitenhof – and housed thereafter in Amsterdam, in the former town hall on the Dam as the Koninklijk Museum (royal museum; 1808-10), Groot Hollandsch Museum (great Dutch museum; 1810-13) and 's Lands Museum (state museum; 1813-15). *See also* RMA

NMGK Nederlandsch Museum voor Geschiedenis en Kunst (Netherlands museum of history and art). Established 1875 in The Hague, moved to the Rijksmuseum, Amsterdam, in 1883, and split up in 1927 to form the Nederlandsch Museum voor Geschiedenis (now the Rijksmuseum department of Dutch history) and the Rijksmuseum voor Beeldhouwkunst en Kunstnijverheid (now the Rijksmuseum department of sculpture and applied arts).

RMA Rijksmuseum (national museum), Amsterdam. Located in the Trippenhuis from 1815 to 1885 and since 1885 in the new Rijksmuseum building, completed in 1883. *See also* NM

RPK Rijksprentenkabinet (national printroom) of the Rijksmuseum, Amsterdam. Originally the printroom of the Nationale Bibliotheek (national library; 1798-1807) on the Binnenhof, The Hague, continued as the Koninklijke Bibliotheek (royal library), located from 1807 to 1819 in The Mauritshuis and thereafter on the Lange Voorhout, The Hague. Brought in 1816 to the Rijksmuseum in the Trippenhuis, Amsterdam, and since 1885 installed in the new Rijksmuseum building.

RVMM Rijks Verzameling van Kunstwerken van Moderne Meesters (national collection of works of art by modern masters). Located from 1838 to 1885 in Welgelegen pavilion, Haarlem, and incorporated in 1885 into the Rijksmuseum voor Schilderijen (national painting museum) in the new Rijksmuseum building.

SMA Stedelijk Museum (municipal museum), Amsterdam. Established in 1895.

SNK Stichting Nederlands Kunstbezit (foundation for Dutch art holdings). Established in The Hague in 1945, and followed up in 1949 by the Dienst voor 's Rijks Verspreide Kunstvoorwerpen (DRVK).

VHK Vereeniging tot het vormen van eene openbare verzameling van Hedendaagsche Kunst (society for the formation of a public collection of contemporary art). Founded in Amsterdam in 1874 by C P van Eeghen and others. Until 1885 the collection of this society was housed in the Oudemannenhuis (old man's home), from 1885 to 1895 in the Rijksmuseum and since then in the Stedelijk Museum.

Key to abbreviated literature

Aachener Kunstbl
Aachener Kunstblätter : Jahresschrift des Museums-vereins. Aachen

Aanwijzing Raadhuis 1864
Aanwijzing der schilderijen, oudheden, modellen, enz. zich bevindende op het Raadhuis der Stad Amsterdam. Amsterdam 1864

Abry 1867
L Abry, *Les hommes illustres de la nation Liègeoise.* Liège (Publications de la Société des Bibliophiles Liègeois) 1867

Acropoli
Acropoli : Rivista d'Arte. Milan

Acta Hist Artium
Acta Historiae Artium Academiae Scientiarium Hungaricae. Budapest

Actes XVIIième Congr intern 1955
Actes du XVIIième Congrès International d'Histoire de l'Art, Amsterdam, juillet 1952. The Hague 1955

Adhémar 1954
J Adhémar, *Honoré Daumier.* Paris 1954

Aesculape
Aesculape : Revue Mensuelle (edition belge). Paris

AGNM
Anzeiger des Germanischen National Museums. Nürnberg

d'Ailly 1949
A F d'Ailly, *Historische gids van Amsterdam.* Amsterdam 1949

Alauzen & Ripert 1969
A M Alauzen & P Ripert, *Monticelli : sa vie et son œuvre.* Paris 1969

Alb amic J G van Gelder 1973
Album amicorum J G van Gelder. The Hague 1973

Alb disc J G van Gelder 1963
Album discipulorum aangeboden aan J G van Gelder ter gelegenheid van zijn 60ste verjaardag, 27 februari 1963. Utrecht 1963

Albertina Stud
Albertina Studien. Vienna

Aldenhove 1902
L Scheibler & C Aldenhove, *Geschichte der Kölner Malerschule.* Lübeck 1902

Alg Konst en Letterbode
Algemeene Konst- en Letter-Bode. Haarlem

Allen M A M Bull
Bulletin of the Allen Memorial Art Museum Oberlin College. Oberlin, Ohio

Allende Salazar 1925
J Allende Salazar, *Velazquez : des Meisters Gemälde.* Stuttgart & Leipzig (Klassiker der Kunst) 1925

Altena & van Thiel 1964
I Q van Regteren Altena & P J J van Thiel, *De portret-galerij van de Universiteit van Amsterdam en haar stichter Gerard van Papenbroeck 1673-1743.* Amsterdam 1964

Amour de l'Art
L'Amour de l'Art : Revue Mensuelle. Paris

Amsterdam in de 17de eeuw
Amsterdam in de zeventiende eeuw. The Hague 1897-1904

Amsterdamsch Jb
Amsterdamsch Jaarboekje. Amsterdam

Annuaire art et am
Annuaire des artistes et des amateurs. Paris

Annuaire Mus Roy Belgique
Annuaire des Musées Royaux des Beaux-Arts de Belgique. Brussels

Annual Report Smithsonian Inst
Annual Report of the Board of Regents of the Smithsonian Institution. Washington

Antichità
Antichità Viva : Rassegna d'Arte. Florence

Antiek
Antiek : Tijdschrift voor Liefhebbers en Kenners van Oude Kunst en Kunstnijverheid. Lochem

Apollo
Apollo : The Magazine of the Arts for Connoisseurs and Collectors. London

Apollo Mndbl
Apollo : Maandblad voor Literatuur en Beeldende Kunsten. The Hague

Applied Optics
Applied Optics : A Monthly Publication of the Optical Society of America. Easton

Aprà 1945
N Aprà, *Ambrogio da Fossano, detto il Bergognone.* Milan 1945

Araujo Sànchez 1889
Z Araujo Sànchez, *Goya.* Madrid 1889

Arch esp arte & arq
Archivo Español de Arte & Arqueologio. Madrid

Archivio stor
Archivio storico dell' arte. Rome

Armamentaria
Armamentaria : Publikatie van de Stichting Het Nederlands Leger- en Wapenmuseum 'Generaal Hoefer.' Leiden

Armstrong 1896
W Armstrong, *The life of Velazquez.* London 1896

Armstrong 1913
W Armstrong, *Lawrence.* London 1913

Arnau 1964
F Arnau, *Kunst der Fälscher – Fälscher der Kunst : 3000 Jahre Betrug mit Antiquitäten.* Munich & Zurich 1964

Arondéus 1939
W Arondéus, *Matthijs Maris : de tragiek van een droom.* Amsterdam 1939

von Arps-Aubert 1932
R von Arps-Aubert, *Die Entwicklung des reinen Tierbildes in der Kunst des Paulus Potter.* Halle 1932

Ars
Ars : Umeleckohistorická Revue Slovenskej Akadémie Vied. Bratislava

Arslan 1931
W Arslan, *J Bassano.* Bologna 1931

Arslan 1960
E Arslan, *J Bassano.* Milan 1960

Art in America
Art in America and Elsewhere. New York

Art Bull
The Art Bulletin : A Quarterly Published by the College Art Association of America. New York

l'Art fl & holl
L'Art Flamand et Hollandais. Antwerp & Paris

Art de France
Art de France : Revue Annuelle de l'Art Ancien et Moderne. Paris

Art J
The Art-Journal. London

Art News
Art News. New York

Art Q
The Art Quarterly : Published by the Detroit Institute of Arts. Detroit

Art Stud
Art Studies : Medieval, Renaissance and Modern. Cambridge, Massachusetts

l'Art et la Vie
L'Art et la Vie : Chronique Mensuelle de la Vie Artistique. Ghent & Brussels

Arta
Arta Plastica : Revista a Uniunii Artiştilor Plastici şi a Ministerului Culturii. Bucharest

l'Arte
L'Arte : Rivista Bimestriale di Storia dell' Arte Medievale e Moderna. Milan

Arte ant & mod
Arte Antica e Moderna : Rivista degli Istituti di Archeologia e di Storia dell' Arte dell' Università di Bologna e dei Musei del Commune di Bologna. Bologna

Arte ill
Arte Illustrata : Rivista d'Arte Antica e Moderna. Milan

Arte Ven
Arte Veneta : Rivista Trimestriale di Storia dell' Arte. Venice

Artes
Artes : Periodical of the Fine Arts. Copenhagen

Arts
Les Arts : Revue Mensuelle des Musées, Collections, Expositions. Paris

Auction
Auction. New York

Auerbach 1961
E Auerbach, *Nicholas Hilliard.* London 1961

Aulamé 1955
Chr Aulamé, *Histoire du Palais et du Musée du Louvre V : la petite Galerie, appartement d'Anne d'Autriche.* Paris 1955

Baard 1942
H P Baard, *Willem van de Velde de Oude en Willem van de Velde de Jonge.* Amsterdam 1942

Baard 1947
H P Baard, *Anton Mauve.* Amsterdam 1947

Baard 1949
H P Baard, *Frans Hals : schuttersstukken.* Amsterdam & Brussels 1949

Bacci 1966
M Bacci, *Piero di Cosimo.* Milan 1966

Bachmann 1966
F Bachmann, *Die Landschaften des Aert van der Neer.* Neustadt a/d Aisch 1966

de Balbian Verster & Kooy-van Zeggelen 1921
J F L de Balbian Verster & M C Kooy-van Zeggelen, *Batavia oud en nieuw.* Amsterdam 1921

von Baldass 1925
L von Baldass, *Joos van Cleve : der Meister des Todes Mariä.* Vienna 1925

von Baldass 1943
L von Baldass, *Jheronimus Bosch.* Vienna & Munich 1943

von Baldass 1959
2d edition of von Baldass 1943

von Baldass 1960
L von Baldass, *Hieronymus Bosch.* New York 1960

Baldaeus 1672
Ph Baldaeus, *Naauwkeurige beschryvinge van Malabar en Choromandel, der zelver aangrenzende ryken, en machtige eyland Ceylon.* Amsterdam 1672

Balet 1910
L Balet, *Der Frühholländer Geertgen tot Sint Jans.* The Hague 1910

Baltimore Ann
The Baltimore Museum of Art Annual. Baltimore

Banti & Boschetto 1953
A Banti & A Boschetto, *Lorenzo Lotto.* Florence 1953

Bardi 1956
P M Bardi, *The arts in Brazil.* Milan 1956

Bargellesi 1955
G Bargellesi, *Notizie di opere d'arte ferrarese.* Rovigo 1955

van Bastelaer & Hulin de Loo 1907
R van Bastelaer & G Hulin de Loo, *Peter Brueghel l'ancien : son œuvre et temps*. Brussels 1907
Bauch 1926
K Bauch, *Jacob Adriaensz Backer : ein Rembrandt-schüler aus Friesland*. Berlin 1926
Bauch 1933
K Bauch, *Die Kunst des jungen Rembrandt*. Heidelberg 1933
Bauch 1957
K Bauch, *Rembrandt van Rijn : die Nachtwache 1642*. Stuttgart 1957
Bauch 1960
K Bauch, *Die frühe Rembrandt und seine Zeit : Studien zur geschichtlichen Bedeutung seines Frühstils*. Berlin 1960
Bauch 1966
K Bauch, *Rembrandt : Gemälde*. Berlin 1966
Bauch 1967
K Bauch, *Studien zur Kunstgeschichte*. Berlin 1967
Baudouin 1972
F Baudouin, *Rubens en zijn eeuw*. Antwerp 1972
Bax 1949
D Bax, *Ontcijfering van Jeroen Bosch*. The Hague 1949
Bazin 1941
G Bazin, *Fra Angelico*. Paris 1941
Bazin 1956
G Bazin, *L'architecture réligieuse baroque au Brésil*. Paris 1956
Beaux-Arts
Beaux-Arts : Revue d'Information Artistique. Paris
Beck 1973
H-U Beck, *Jan van Goyen 1596-1656*. Amsterdam 1973
Beeldende Kunst
Beeldende Kunst. Utrecht
Beets 1913
N Beets, *Lucas de Leyde*. Brussels & Paris 1913
Beets 1940
N Beets, *Lucas van Leyden*. Amsterdam 1940
Beitr Jül Gesch
Beiträge zur Jülichter Geschichte. Jülich
Beitz 1922
E Beitz, *Christophorus und Christlicher Ritter*, Düsseldorf 1922
Belonje 1956
J Belonje, *De twee Nijenburgen bij Alkmaar*. Wormerveer 1956
Belvedere
Belvedere : Illustrierte Zeitschrift für Kunstsammler. Vienna
Bénédite 1910
L Bénédite, *De schilderkunst der XIXe eeuw in Frankrijk, Nederland en Italië*. Amsterdam 1910
Benesch 1935
O Benesch, *Rembrandt : Werk und Forschung*. Vienna 1935
von der Bercken 1927
E von der Bercken, *Malerei der Früh- und Hoch-renaissance in Oberitalien*. Potsdam 1927
von der Bercken 1942
E von der Bercken, *Die Gemälde des Jacopo Tintoretto*. Munich 1942
von der Bercken & Mayer 1923
E von der Bercken & A L Mayer, *Jacopo Tintoretto*. Munich 1923
Berckenhoff 1892
H L Berckenhoff, *Johannes Bosboom en A L G Bosboom-Toussaint*. Amsterdam 1892
Berenson 1897
B Berenson, *The Venetian painters of the Renaissance*. New York 1897

Berenson 1907
B Berenson, *North Italian painters of the Renaissance*. London 1907
Berenson 1909
B Berenson, *The Florentine painters of the Renaissance*. New York & Florence 1909
Berenson 1916
B Berenson, *The study and criticism of Italian art*, vol 2. London 1916
Berenson 1932
B Berenson, *Italian pictures of the Renaissance : Florentine school*. London 1932
Berenson 1936
B Berenson, *Pitture italiane del Rinascimento*. Milan 1936
Berenson 1957
B Berenson, *Italian pictures of the Renaissance : Venetian school*. London 1957
Berenson 1958
B Berenson, *Pitture italiane del Rinascimento : la scuolo veneta*. Milan 1958
Berenson 1963
B Berenson, *Italian pictures of the Renaissance : Florentine school*. London 1963
Berenson 1968
B Berenson, *Homeless paintings of the Renaissance*. Amsterdam 1968
van Beresteyn 1929
E A van Beresteyn, *Iconographie van Hugo Grotius*. The Hague 1929
van Beresteyn 1933
E A van Beresteyn, *De iconografie van Prins Willem I van Oranje*. Haarlem 1933
van Beresteyn & del Campo Hartman 1941-54
E A van Beresteyn & W F del Campo Hartman, *Genealogie van het geslacht van Beresteyn*. The Hague 1941-54
Berger 1964
K Berger, *Odilon Redon : Phantasie und Farbe*. Cologne 1964
Bergmans 1952
S Bergmans, *La peinture ancienne : ses mystères, ses secrets*. Brussels 1952
Bergström 1947
I Bergström, *Studier i holländskt stilleben-måleri under 1600-talet*. Göteborg 1947
Bergström 1956
I Bergström, *Dutch still-life painting in the seventeenth century*. London 1956
Bergström 1958
I Bergström, *Den symboliska nejlikan i senmedeltidens och renänsens konst*. Malmö 1958
Berichten R O B
Berichten van de Rijksdienst voor het Oudheidkundig Bodemonderzoek in Nederland. Amersfoort
Berl Mus
Berliner Museen : Berichte aus den Preussischen Kunstsammlungen. Berlin
Bernt 1960-62
W Bernt, *Die niederländischen Maler des 17. Jahr-hunderts*. Munich 1960-62
Bernt 1969-70
2d edition of Bernt 1960-62
Bertile 1932
M Bertile, *Il palazzo degli ambasciatori di Venezia a Costantinopoli e le sue antiche memorie*. Bologna 1932
Berto & Puppi 1968
G Berto & L Puppi, *Canaletto*. Milan 1968
de Beruete y Moret 1906
A de Beruete y Moret, *Velasquez*. London 1906
de Beruete y Moret 1909
A de Beruete y Moret, *The school of Madrid*. London 1909

de Beruete y Moret 1922
A de Beruete y Moret, *Goya as portrait painter*. London 1922
de Beruete y Moret 1924
A de Beruete y Moret, *Conferencias de arte*. Madrid 1924
Besson 1959
G Besson, *Daumier*. Paris 1959
Bettini 1942
S Bettini, *Botticelli*. Bergamo 1942
Bianconi 1953
P Bianconi, *All the paintings of Lorenzo Lotto*. London 1953
Bianconi 1963
P Bianconi, *All the paintings of Lorenzo Lotto*. London 1963
Bibl Sanct
Bibliotheca Sanctorum. Rome
Bidloo 1719
G Bidloo, *Mengel Poëzij*. Leiden 1719
de Bie 1661
C de Bie, *Het Gulden Cabinet van de edel vrij schilder const, inhoudende den lof vande vermarste schilders, architecten, beldthouwers ende plaetsnijders van deze eeuw*. Antwerp 1661
Bienfait 1943
A G Bienfait, *Oude Hollandsche tuinen*. The Hague 1943
Bild Kunst
Bildende Kunst : Zeitschrift für Malerei, Plastik, Graphik und Buchkunst, angewandte Kunst und Kunsthandwerk. Dresden
Bille 1961
C Bille, *De tempel der Kunst of het Kabinet van den Heer Braamcamp*. Amsterdam 1961
Birren 1965
F Birren, *History of color in painting*. New York 1965
Biul Hist Sztuki
Biuletyn Historii Sztuki i Kultury. Warszawa
Blätter f G
Blätter für Gemäldekunde. Vienna
Blanc 1862-63
Ch Blanc, *Histoire des peintres de toutes les écoles : école française I*. Paris 1862-63
van Bleyswyck 1667
D van Bleyswyck, *Beschrijving der Stadt Delft*. Delft 1667
Bloch 1954
V Bloch, *Tutta la pittura di Vermeer di Delft*. Milan 1954
Bloch 1968
V Bloch, *Michael Sweerts*. The Hague 1968
Blok 1897
same as Amsterdam in de 17de eeuw
Blok 1919-20
P J Blok, *Willem de Eerste, Prins van Oranje*. Amsterdam 1919-20
Blunt 1953
W Blunt, *Pietro's pilgrimage*. London 1953
Bo 1967
C Bo, *L'opera completa del Botticelli*. Milan 1967
Bode 1883
W Bode, *Studien zur Geschichte der holländischen Malerei*. Braunschweig 1883
Bode 1888
W Bode, *Die Grossherzogliche Gemälde Galerie zu Oldenburg*. Vienna 1888
Bode 1897-1901
W Bode, *L'œuvre complêt de Rembrandt*. Paris 1897-1901
Bode 1900
W Bode, *Gemäldesammlung des Herrn Rudolf Kann in Paris*. Vienna 1900

Bode 1906
W Bode, *Rembrandt und seine Zeitgenossen: Charakterbilder der grossen Meister der holländischen und vlämischen Malerschule im XVII. Jahrhundert.* Leipzig 1906

Bode 1909
W Bode, *Die Sammlung Oscar Huldschinsky.* Frankfurt am Main 1909

Bode 1913
W Bode, *Die Gemäldegalerie des weiland Herrn A de Ridder in seiner Villa zu Schönberg bei Cronberg im Taunus.* Berlin 1913

Bode 1914
W von Bode, *Frans Hals: sein Leben und seine Werke.* Berlin 1914

Bode 1917
W von Bode, *Die Meister der holländischen und flämischen Malerschule.* Leipzig 1917

Bode 1919
2d edition of Bode 1917

Bode 1921
W von Bode, *Sandro Botticelli.* Berlin 1921

Bode 1924
W von Bode, *Adriaen Brouwer: sein Leben und seine Werke.* Berlin 1924

Bode 1926
W von Bode, *Botticelli: des Meisters Werke.* Stuttgart (Klassiker der Kunst) 1926

Bode 1951
6th edition of Bode 1917

Bode 1953
7th edition of Bode 1917

Bode 1958
W von Bode, *Meisterwerke der holländischen und flämischen Malerschulen.* Leipzig 1958 (bearbeitet von E Plietzsch)

Bode & Hofstede de Groot 1897-1905
W Bode & C Hofstede de Groot, *Rembrandt: beschreibendes Verzeichnis seiner Gemälde, Geschichte seines Lebens und seiner Kunst.* Paris 1897-1905

von Bodenhausen 1905
E von Bodenhausen, *Gerard David und seine Kunst.* Munich 1905

Bodkin 1945
Th Bodkin, *Dismembered masterpieces: a plea for their reconstruction by international action.* London 1945

Bodmer 1939
H Bodmer, *Lodovico Carracci.* Burg b M 1939

Böhmer 1940
G Böhmer, *Der Landschafter Adriaen Brouwer.* Munich 1940

het Boek
Het Boek: tweede reeks van het Tijdschrift voor Boek- en Bibliotheekwezen. Ghent & The Hague

Börsch-Supan 1967
E Börsch-Supan, *Garten-, Landschafts- und Paradiesmotive.* Berlin 1967

Bol 1960
L J Bol, *The Bosschaert dynasty: painters of flowers and fruit.* Leighton-on-Sea 1960

Bol 1969
L J Bol, *Holländische Maler des 17. Jahrhunderts nahe den grossen Meistern.* Braunschweig 1969

Bol 1973
L J Bol, *Die holländische Marinemaler des 17. Jahrhunderts.* Braunschweig 1973

Bollafi arte
Bollafi Arte. Turin

Boll d'Arte
Bollettino d'Arte del Ministerio della Pubblica Istruzione. Rome

Boll Min Ed Naz
Bollettino d'Arte del Ministerio della Educazione Nazionale. Rome

Boll Piemontese
Bollettino della Società Piemontese di Archeologia e di Belle Arti. Turin

Boomkamp 1747
G Boomkamp, *Alkmaar en deszelfs geschiedenissen.* Rotterdam 1747

Boon 1942
K G Boon, *Schilders voor Rembrandt: de inleiding tot het bloeitijdperk.* Antwerp & Utrecht 1942

Boon 1942
K G Boon, *Quinten Massys.* Amsterdam 1942

Boon 1946
K G Boon, *Gerard David.* Amsterdam 1946

Boon 1947
K G Boon, *Het zelfportret in de Nederlandse en Vlaamse schilderkunst.* Amsterdam 1947

Boppe 1911
A Boppe, *Les peintres du Bosphore au dix-huitième siècle.* Paris 1911

Borea 1966
E Borea, *La diffusione del naturalismo in Europa.* Milan (Storia della Pittura 15) 1966

Borenius 1909
T Borenius, *The painters of Vicenza.* London 1909

Borghini 1584
R Borghini, *Il riposo in cui della pittura e della scultura si favella, di piu illustri pittori e scultori e delle piu famose opere loro si fa mentione.* Florence 1584

Boschetto 1963
A Boschetto, *Giovan Gerolamo Savoldo.* Milan 1963

Boschini 1664
M Boschini, *Le ricche minere della pittura veneziana, non solo delle pitture publiche di Venezia, ma dell' Isola ancora circonuicine.* Venice 1664

Boskovits 1964
M Boskovits, *Botticelli.* Budapest 1964

Boskovits 1966
M Boskovits, *Giovanni da Milano.* Florence 1966

de Bosschère 1907
J de Bosschère, *Quinten Metsys.* Brussels 1907

Bottari 1963
S Bottari, *Tutta la pittura di Giovanni Bellini.* Milan 1963

Bousquet 1964
J Bousquet, *La peinture manieriste.* Neuchâtel 1964

Bouwk Wkbld
Bouwkundig Weekblad: Orgaan van de Maatschappij tot Bevordering der Bouwkunst. Amsterdam

Bovero 1961
A Bovero, *Tutta la pittura di Crivelli.* Milan 1961

Boxer 1965
C R Boxer, *The Dutch seaborne empire 1600-1800.* London 1965

van Braam n d
F A van Braam, *Art treasures in the Benelux countries I: the Netherlands* [n p 1958]

Brabantia
Brabantia: Tweemaandelijks Tijdschrift van het Provinciaal Genootschap van Kunsten en Wetenschappen in Noord Brabant en de Stichting Brabantia Nostra. 's-Hertogenbosch

van den Branden 1883
F J van den Branden, *Geschiedenis der Antwerpsche schilderschool.* Antwerp 1883

Brander 1955
J Brander, *Jan Mayer in verleden en heden.* Middelburg 1955

Braun 1966
H Braun, *Gerard und Willem van Honthorst.* Göttingen 1966 (typescript)

Bredius 1887-88
A Bredius, *Die Meisterwerke des Rijksmuseum zu Amsterdam.* Munich 1887-88

Bredius 1904
same as Amsterdam in de 17de eeuw

Bredius 1909
A Bredius, *Johannes Torrentius.* The Hague 1909

Bredius 1918
A Bredius, *Künstler Inventare: Urkunden zur Geschichte der holländischen Kunst des XVIten, XVIIten und XVIIIten Jahrhunderts V.* The Hague 1918

Bredius 1927
A Bredius, *Jan Steen.* Amsterdam 1927

Bredius 1935
A Bredius, *Rembrandt: schilderijen.* Utrecht 1935

Bredius & Gerson 1969
A Bredius & H Gerson, *Rembrandt: the complete edition of the paintings.* London 1969

Bredius & Schmidt-Degener 1906
A Bredius & F Schmidt-Degener, *Die Grossherzogliche Gemälde-Galerie im Augusteum zu Oldenburg I.* Oldenburg 1906

Bremmer 1938
H P Bremmer, *Pieter Saenredam.* The Hague 1938

Brieger 1920
L Brieger, *Das Pastell: seine Geschichte und seine Meister.* Berlin 1920

Brieger 1922
L Brieger (ed), *Wilhelm Tischbein: aus meinem Leben.* Berlin 1922

Briganti 1962
G Briganti, *Pietro da Cortona o della pittura barocca.* Florence 1962

Briganti 1966
G Briganti, *Caspar van Wittel e l'origine della veduta settecentesca.* Rome 1966

Brochhagen 1958
E Brochhagen, *Karel Dujardin: ein Beitrag zum Italianismus in Holland im 17. Jahrhundert.* Cologne 1958

Bromig-Kolleritz 1955
K Bromig-Kolleritz von Novisance, *Die Selbstbildnisse Vincent van Goghs: Versuch einer kunsthistorischen Erfassung der Darstellungen.* Munich 1955 (typescript)

Broulhiet 1938
G Broulhiet, *Meindert Hobbema.* Paris 1938

Brugmans 1914
H Brugmans, *Het huiselijk en maatschappelijk leven onzer voorouders.* Amsterdam 1914

Brugmans 1930
H Brugmans, *Geschiedenis van Amsterdam I.* Amsterdam 1930

Brugmans 1970
J J Brugmans, *Stapvoets voorwaarts: sociale geschiedenis van Nederland in de 19de eeuw.* Bussum 1970

Buckley 1931
W Buckley, *Aert Schouman and the glasses that he engraved.* London 1931

Budde 1929
I Budde, *Die Idylle im holländischen Barock.* Cologne 1929

Bürger 1858-60
W Bürger, *Musées de la Hollande I: Amsterdam & La Haye.* Paris 1858-60

Bürger 1869
W Bürger, *Histoire des peintres de toutes les écoles: école espagnole (Mateo Cerezo).* Paris 1869

Bürger 1925
W Bürger, *Die Malerei in den Niederlanden 1400-1500.* Munich 1925

Buiten
Buiten: Geïllustreerd Weekblad. Amsterdam
Bull Ac Arch Belgique
Bulletins de l'Académie Royale d'Archéologie de Belgique. Brussels
Bull Ac Roy Belgique
Bulletins de l'Académie Royale des Sciences, des Lettres et des Beaux-Arts de Belgique. Brussels
Bull Boymans
Bulletin Museum Boymans (-van Beuningen), Rotterdam. Rotterdam
Bull Cal Pal Legion of Honor
Bulletin California Palace of the Legion of Honor. San Francisco
Bull Clev Mus of Art
Bulletin of the Cleveland Museum of Art. Cleveland
Bull KNOB
see Bull NOB
Bull Lab du Louvre
Bulletin du Laboratoire du Musée du Louvre. Paris
Bull Metrop Mus
Bulletin of the Metropolitan Museum of Art. New York
Bull MN Varsovie
Bulletin du Musée National de Varsovie. Warsawa
Bull Mus France
Bulletin des Musées de France. Paris
Bull Mus Hongrois
Bulletin du Musée Hongrois des Beaux Arts. Budapest
Bull Mus Roy Belg
Bulletin des Musées Royaux de Beaux-Arts de Belgique. Brussels
Bull NOB
Bulletin uitgegeven door de (Koninklijke) Nederlandse Oudheidkundige Bond. Amsterdam
Bull Oberlin
Bulletin of the Allen Memorial Art Museum Oberlin College. Oberlin
Bull Rhode Island
Bulletin of the Rhode Island School of Design. Rhode Island
Bull RM
Bulletin van het Rijksmuseum. The Hague
Bull Soc Hist Art Fr
Bulletin de la Société de l'Histoire de l'Art Français. Paris
Bull S R Vieux Liège
Bulletin de la S R Le Vieux Liège. Liège
Burckhardt 1898
J Burckhardt, *Beiträge zur Kunstgeschichte von Italien.* Basel 1898
Burckhardt 1898
J Burckhardt, *Der Cicerone: eine Anleitung zum Genuss der Kunstwerke Italiens.* Leipzig 1898 (7th edition)
Burckhardt 1901
8th edition of Burckhardt 1898
Burckhardt 1905
R Burckhardt, *Cima da Conegliano: ein Venezianer Maler des Uebergangs vom Quattrocento zum Cinquecento.* Leipzig 1905
Burl Mag
The Burlington Magazine for Connoisseurs. London
Burroughs 1938
A Burroughs, *Art criticism from a laboratory.* Boston 1938
Buscaroli 1935
R Buscaroli, *La pittura di paesaggio in Italia.* Bologna 1935
Byam-Shaw 1951
J J Byam-Shaw, *The drawings of Francesco Guardi.* London 1951

Bijdragen NOM
Bijdragen en Mededelingen van het Nederlands Openluchtmuseum. Arnhem
Bijdr Gesch Bisdom Haarlem
Bijdragen voor de Geschiedenis van het Bisdom Haarlem. Haarlem
Bijdr & Med Hist Gen Utrecht
Bijdragen en Mededelingen van het Historisch Genootschap Gevestigd te Utrecht. Utrecht
Bijdr Vad Gesch & Oudhk
Bijdragen voor Vaderlandsche Geschiedenis en Oudheidkunde. The Hague
Bijlsma 1918
R Bijlsma, *Rotterdams welvaren 1550-1650.* The Hague 1918

Cahiers de Belgique
Cahiers de Belgique: Peinture, Sculpture,… Cinéma. Brussels
Calvert 1908
A F Calvert, *Goya: an account of his life and works.* London 1908
Camón Aznar 1950
J Camón Aznar, *Dominico Greco.* Madrid 1950
Camón Aznar 1964
J Camón Aznar, *Velázquez.* Madrid 1964
Canova 1964
G Canova, *Paris Bordone.* Venice 1964
Caraceni 1966
A Caraceni, *Appunti su Pieter van Laer.* Rome 1966
Carli 1951
E Carli, *Les tablettes peintes de Sienne.* Milan 1951
Cary 1907
A C Cary, *The works of James McNeill Whistler.* New York 1907
Cassou 1949
J Cassou, *Daumier.* Lausanne 1949
Castelli 1966
E Castelli, *Simboli e imagini.* Rome 1966
Cavestany 1936-40
J Cavestany, *Floreros y bodegones en la pintura espanola.* Madrid 1936-40
Champfleury 1862
Champfleury, *Les peintres de la réalité sous Louis XIII: les frères Le Nain.* Paris 1862
Chastel 1957
A Chastel, *Botticelli.* Milan 1957
de Chennevières 1898
H de Chennevières, *Les Tiepolo.* Paris 1898
Christelijke Kunst
C Ed Taurel, *De Christelijke kunst in Holland en Vlaanderen.* Brussels 1881
Chron des Arts
La Chronique des Arts et de la Curiosité. Paris
Chron des Arts (GdB-A)
Chronique des Arts (supplément à la Gazette des Beaux-Arts). Paris
Chudzikowski 1957
A Chudzikowski, *Krajobraz holenderski.* Warsaw 1957
Ciaranfi 1952
A Ciaranfi, *Bozzetti delle gallerie di Firenze.* Florence 1952
Ciba
Ciba-Symposium. Arnhem
Cicerone
Der Cicerone: Halbmonatsschrift für die Interessen des Kunstforschers und Sammlers. Leipzig
Clapp 1916
F M Clapp, *Jacopo Carrucci da Pontormo.* New Haven 1916 (repr New York 1973)
Clark 1966
K Clark, *Rembrandt and the Italian Renaissance.* London 1966

Clausse 1900
G Clausse, *Les San Gallo.* Paris 1900
Clouzot 1924
H Clouzot, *Dictionnaire des miniatures sur émail.* Paris 1924
Clouzot 1927
H Clouzot, *La miniature sur émail en France.* Paris 1927
Cohen 1904
W Cohen, *Studien zu Quinten Metsys.* Bonn 1904
Colding 1953
T H Colding, *Aspects of miniature painting: its origins and development.* Copenhagen 1953
Colenbrander 1915
H Th Colenbrander, *Gedenkstukken der algemeene geschiedenis van Nederland van 1795 tot 1840, deel 7.* The Hague 1915
Colenbrander 1931
H Th Colenbrander, *Willem I, koning der Neder-landen, deel 1.* Amsterdam 1931
Coletti 1940
L Coletti, *Il Tintoretto.* Bergamo 1940
Coletti 1953
L Coletti, *Lorenzo Lotto.* Bergamo 1953
Coletti 1955
L Coletti, *Tutta la pittura di Giorgione.* Milan 1955
Coletti 1959
L Coletti, *Cima da Conegliano.* Venice 1959
Collins 1953
L C Collins, *Hercules Seghers.* Chicago 1953
Collins Baker 1912
C H Collins Baker, *Lely and the Stuart portrait painters: a study of English portraiture before and after van Dyck, vol 2.* London 1912
Collins Baker 1925
C H Collins Baker, *Pieter de Hooch.* London 1925
Commelin 1693-94
C Commelin, *Beschrijvinge van Amsterdam zijnde een naukeurige verhandelinge van desselfs eerste oorspronk uyt den Huyse der Heeren van Amstel en Amstellant, haar vergrootingen, rijkdom en wijze van regeeringe tot den jare 1691* and *Vervolg van de beschrijving der stadt Amsterdam.* Amsterdam 1693-94
Commentari
Commentari: Rivista di Critica e Storia dell' Arte. Florence & Rome
Connaissance d A
Connaissance des Arts: le Guide Mensuel de l'Amateur d'Art. Paris
Connoisseur
The Connoisseur: an Illustrated Magazine for Collectors. London
Constable 1962
W G Constable, *Canaletto: Giovanni Antonio Canal 1697-1768.* Oxford 1962
Constghesellen
De Constghesellen: Orgaan van de Nederlandsche Vereeniging van Kunsthandelaren. The Hague
Conway 1921
M Conway, *The van Eycks and their followers.* London 1921
Cook 1900
H Cook, *Giorgione.* London 1900
Coolhaas 1973
W Ph Coolhaas, *Het Huis 'De Dubbele Arend.'* Amsterdam 1973
le Corbeiller 1966
C le Corbeiller, *European and American snuffboxes 1730-1830.* London 1966
Cornelissen 1929
J Cornelissen, *Nederlandsche volkshumor op stad en dorp, land en volk.* Antwerp 1929-38

Country Life
Country Life: the Journal for All Interested in Country Life and Country Pursuits. London

Crit d'Arte
La Critica d'Arte: Rivista Bimestrale di Arti Figurative. Florence

Crone 1937
G C E Crone, *De jachten der Oranjes: historisch en scheeptechnisch overzicht van de jachten der stadhouders en vorsten uit het huis van Oranje-Nassau vanaf het einde der 16de eeuw.* Amsterdam 1937

Crowe & Cavalcaselle 1903-14
J A Crowe & G B Cavalcaselle, *A history of painting in Italy: Umbria, Florence and Siena from the second to the sixteenth century.* London 1903-14

Crowe & Cavalcaselle 1912
J A Crowe & G B Cavalcaselle, *A history of painting in North Italy: Venice, Padua, Vicenza, Verona, Ferrara, Milan, Friuli, Brescia from the fourteenth to the sixteenth century.* London 1912

Cruzada Villaamil 1885
G Cruzada Villaamil, *Anales de la vida y los obras de Diego de Silva Velazquez.* Madrid 1885

Cugini 1939
D Cugini, *Moroni.* Bergamo 1939

Curtis 1883
Ch B Curtis, *Velazquez and Murillo: a descriptive and historical catalogue of the works.* London & New York 1883

Cust 1900
L Cust, *Anthony van Dyck: an historical study of his life and works.* London 1900

van Daalen 1957
P K van Daalen, *Nederlandse beeldhouwers in de XIXe eeuw.* The Hague 1957

Dapper 1663
O Dapper, *Historische beschrijving der Stadt Amsterdam.* Amsterdam 1663

Dattenberg 1967
H Dattenberg, *Niederrhein Aussichten Holländischer Künstler des 17. Jahrhunderts.* Düsseldorf 1967

Davies 1902
G F Davies, *Frans Hals.* London 1902

Davies 1961
M Davies, *The earlier Italian schools (National Gallery catalogues).* London 1961

Dayot 1912
A Dayot, *Grands et petits maîtres hollandais du 17ième siècle à l'exposition à Paris 1911.* Paris 1912

Decoen 1951
J Decoen, *Vermeer-Van Meegeren: terug naar de waarheid. Twee authentieke schilderijen van Vermeer.* Rotterdam 1951

Dedalo
Dedalo: Revista de Arte e Arqueologia. Sao Paolo

Dek 1962
A W E Dek, *Graf Johann der Mittlere von Nassau-Siegen und seine 25 Kinder.* Rijswijk 1962

Dekker 1971
P Dekker, *De laatste bloeiperiode van de Nederlandse arctische walvis- en robbenvangst 1761-1775.* Zaltbommel 1971

Delacre 1934
M Delacre, *Recherches sur le rôle du dessin dans l'iconographie de van Dyck.* Brussels 1934

Delbanco 1928
G Delbanco, *Der Maler Abraham Bloemaert 1564-1651.* Strasbourg 1928

Delogu 1931
G Delogu, *Pittori minori liguri, lombardi, piemontesi del seicento e del settecento.* Venice 1931

Delta
Delta: a Review of Arts, Life and Thought in the Netherlands. Amsterdam

Der Kinderen 1878
T H Der Kinderen, *Gedenkboek van het Bataviaasch Genootschap van Kunsten en Wetenschappen gedurende de eerste eeuw van zijn bestaan 1778-1878.* Batavia 1878

Derkinderen 1933
J H Derkinderen-Besier, *Modemetamorphosen: de kleedij onzer voorouders in de 16e eeuw.* Amsterdam 1933

Derkinderen 1956
J H Derkinderen-Besier, *Spelevaart der mode: kledij onzer voorouders in de 17e eeuw.* Amsterdam 1956

Descamps 1753-64
J B Descamps, *La vie des peintres flamands, allemands et hollandais.* Paris 1753-64

Deshairs n d
L'Art des origines à nos jours, publié sous la direction de L Deshairs [Paris 1932-33]

Desparmet Fitz-Gerald 1950
X Desparmet Fitz-Gerald, *L'œuvre peint de Goya.* Paris 1950

Destrée 1914
J Destrée, *Hugo van der Goes.* Brussels & Paris 1914

Deutsche Rundschau
Deutsche Rundschau. Berlin

Dézallier d'Argenville 1762
A J Dézallier d'Argenville, *Abrégé de la vie des plus fameux peintres.* Paris 1762

Dhanens 1973
E Dhanens, *Van Eyck: the Ghent altarpiece.* London 1973

Dickens 1968
A G Dickens, *The Counterreformation.* London 1968

Diekerhoff 1967
F L Diekerhoff, *De oorlogsvloot in de zeventiende eeuw.* Bussum 1967

van Dillen 1941
J G van Dillen, *Amsterdam in 1585: het kohier der capitale impositie van 1585.* Amsterdam 1941

Dimier 1928
L Dimier, *Les peintres français du XVIIIième siècle, vol 1.* Paris & Brussels 1928

Dobrzycka 1966
A Dobrzycka, *Jan van Goyen.* Poznan 1966

Doen te weten
Doen te Weten: Officieel Orgaan voor de Burger(ess)en van Linschoten en Snelrewaard. Linschoten

Dohme 1877
R Dohme, *Kunst und Künstler Deutschlands und der Niederlände.* Leipzig 1877

Drey 1927
F Drey, *Carlo Crivelli und seine Schule.* Munich 1927

Dronkers 1968
J M G A Dronkers, *De generaals van het Koninkrijk Holland 1806-1810.* The Hague 1968

Drossaers & Lunsingh Scheurleer 1974-75
S W A Drossaers & Th H Lunsingh Scheurleer, *Inventarissen van de inboedels in de verblijven van de Oranjes en daarmede gelijk te stellen stukken 1567-1795.* The Hague (Rijks Geschiedkundige Publicatiën) 1974-75

Drost 1926
W Drost, *Barockmalerei in den germanischen Ländern.* Wildpark-Potsdam 1926

Du
Du: Kulturelle Monatsschrift. Zürich

Dülberg 1899
F Dülberg, *Die Leydener Malerschule.* Berlin 1899

Dülberg 1907
F Dülberg, *Frühholländer III: Frühholländer in Italien.* Haarlem 1907

Dülberg 1929
F Dülberg, *Niederländische Malerei der Spätgotik und Renaissance.* Potsdam 1929

Dülberg 1930
F Dülberg, *Frans Hals: ein Leben und ein Werk.* Stuttgart 1930

Duits Q
Duits Quarterly. London

Duret 1904
Th Duret, *Histoire de James McNeill Whistler et son œuvre.* Paris 1904

Duret 1918
Th Duret, *Courbet.* Paris 1918

Dussler 1926
L Dussler, *Signorelli.* Stuttgart (Klassiker der Kunst) 1926

Dussler 1935
L Dussler, *Giovanni Bellini.* Frankfurt am Main 1935

Dutuit 1883-85
E Dutuit, *Tableaux et dessins de Rembrandt: catalogue historique et descriptif.* Paris 1883-85

van Dijk 1790
J van Dijk, *Kunst- en historie-kundige beschryving over alle de schilderyen op het Stadhuis te Amsterdam.* Amsterdam 1790

van Dyke 1923
J C van Dyke, *Rembrandt and his school: a critical study of the master and his pupils with a new assignment of their pictures.* New York 1923

Eckardt 1971
G Eckardt, *Selbstbildnisse Niederländischer Maler des 17. Jahrhunderts.* Berlin 1971

Edwards 1954
R Edwards, *Early conversation pictures.* London 1954

Eemans 1964
M Eemans, *Jean Breughel de Velours.* Brussels 1964

Eigen Haard
Eigen Haard: Geïllustreerd Volkstijdschrift. Haarlem & Amsterdam

von Einem 1950
H von Einem, *Der Segen Jakobs.* Bonn 1950

Eisler 1918
M Eisler, *Rembrandt als Landschafter.* Munich 1918

Elias 1903-05
J E Elias, *De vroedschap van Amsterdam.* Haarlem 1903-05

Elsevier's GM
Elsevier's Geïllustreerd Maandschrift. Amsterdam

Emmens 1968
J A Emmens, *Rembrandt en de regels van de kunst.* Utrecht 1968

Emporium
Emporium: Rivista Mensile Illustrata d'Arte, Letteratura, Scienze e Varieta. Bergamo

Engel 1967
E P Engel, *Anton Mauve (1838-1888): bronnen-verkenning en analyse van zijn œuvre.* Utrecht 1967

Engelberts 1794
E M Engelberts (ed), *Gerard Brandt: het leven en bedrijf van den Heere Michiel de Ruiter.* Amsterdam 1794

Erasmus 1908
K Erasmus, *Roelant Saverij.* Halle a/S 1908

Erens 1912
F Erens, *Hollandsche schilders van dezen tijd: I Israels.* Amsterdam 1912

Erpel 1963
F Erpel, *Die Selbstbildnisse Vincent van Goghs.* Berlin 1963

Erpel 1967
F Erpel, *Die Selbstbildnisse Rembrandts.* Berlin 1967

Essays in hon of Panofsky
De artibus opuscula XL: essays in honor of Erwin Panofsky, edited by M Meiss. New York 1961

Essink 1973
H B M Essink, *Grave-Cuijk tussen 1481 en 1543*. Grave 1973

Etudes d'Art
Etudes d'Art: Publiées par le Musée National des Beaux-Arts de Alger. Algiers

Evelyn 1955
J Evelyn, *The diary (1620-1706): now first printed in full from the manuscripts belonging to John Evelyn and edited by E S de Beer*. Oxford 1955

Evers 1942
H G Evers, *Peter Paul Rubens*. Munich 1942

Evers 1943
H G Evers, *Rubens und sein Werk: neue Forschungen*. Brussels 1943

Ewald 1965
G Ewald, *Johann Carl Loth 1632-1689*. Amsterdam 1965

van Eynden & van der Willigen 1816-40
R van Eynden & A van der Willigen, *Geschiedenis der vaderlandsche schilderkunst sedert de helft der 18de eeuw*. Haarlem 1816-40

Faggin 1967
G Faggin, *Il Manierismo di Haarlem*. Milan 1967

Faggin 1968
G Faggin, *La pittura ad Anversa nel Cinquecento*. Florence 1968

de la Faille 1928
J B de la Faille, *L'œuvre de Vincent van Gogh: catalogue raisonné*. Paris & Brussels 1928

de la Faille 1970
J B de la Faille, *The works of Vincent van Gogh: his paintings and drawings*. Amsterdam 1970 (revised, augmented and annotated edition of de la Faille 1928)

von Falke 1912
O von Falke, *Die Kunstsammlung Eugen Guttman*. Berlin 1912

Fantin-Latour 1911
Madame Fantin-Latour, *Catalogue de l'œuvre complet de Fantin-Latour*. Paris 1911

Faré 1962
M Faré, *La nature morte en France*. Geneva 1962

Feestb M J Friedländer
Aan Max J Friedländer 1867 – 5 juni 1942 aangeboden door enkele vrienden en bewonderaars van zijn werk. The Hague 1942

Feestbundel Bredius
Feestbundel, Abraham Bredius aangeboden den achttiende April 1915. Amsterdam 1915

Fehm 1973
S A Fehm, *The collaboration of Niccolò Tegliacci and Luca di Tommè*. Los Angeles (Publication of the J Paul Getty Museum, 5) 1973

Ferrari 1961
M L Ferrari, *Il Romanino*. Milan 1961

Ferri 1922
A Ferri, *Alessandro Magnasco*. Rome 1922

Festschrift Badt
Festschrift Kurt Badt zum 60. Geburtstag. Berlin 1961

Festschrift Kurt Bauch
Festschrift Kurt Bauch: Kunstgeschichtliche Beiträge zum 25. November 1957. Munich & Berlin 1957

Festschrift von Einem
Festschrift für Herbert von Einem zum 16. Februar 1965. Berlin 1965

Festschrift Friedländer
Festschrift für Max J Friedländer zum 60. Geburtstage. Leipzig 1927

Festschrift A Goldschmidt
Festschrift für Adolph Goldschmidt zum 60. Geburtstag am 15. Januar 1923. Leipzig 1923

Festschrift Hager
Festschrift Werner Hager. Recklinghausen 1966

Festschrift Olaf Klose
Festschrift für Olaf Klose zum 65. Geburtstag. Neumünster 1968

Festschrift Redslob
Edwin Redslob zum 70. Geburtstag: eine Festgabe. Berlin 1954

Festschrift O Schmitt
Form und Inhalt: Kunstgeschichtliche Studien Otto Schmitt zum 60. Geburtstag am 13. Dezember 1950 dargebracht von seinen Freunden. Stuttgart 1950

Festschrift Winkler
Festschrift Friedrich Winkler. Berlin 1959

Fickaert 1648
F Fickaert, *Metamorphosis, ofte 'Wonderbaere Veranderingh' ende Leven vanden vermaerden Mr Quinten Matsijs*. Antwerp 1648

Fierens 1933
P Fierens, *Les Le Nain*. Paris 1933

Figura
Figura: Uppsala Studies in the History of Art. Uppsala

Filla 1959
E Filla, *Jan van Goyen*. Prague 1959

Fiocco 1928
G Fiocco, *Paolo Veronese 1528-1588*. Bologna 1928

Fiocco 1929
G Fiocco, *La pittura veneziana del sei e settecento*. Munich 1929

Fiocco 1931
G Fiocco, *Carpaccio*. Rome 1931

Fiocco 1941
G Fiocco, *Giorgione*. Bergamo 1941

Fiocco 1948
2d edition of Fiocco 1941

Fiocco 1958
G Fiocco, *Vittorio Carpaccio*. Novara 1958

Fontein 1966
J Fontein, *The pilgrimage of Sudhana*. The Hague 1966

Fosca 1956
F Fosca, *La vie, les voyages et les œuvres de Jean-Etienne Liotard, citoyen de Genève, dit le peintre turc*. Lausanne & Paris 1956

Foster 1903
J J Foster, *Miniature painters: British and foreign*. London 1903

Foster 1914-16
J J Foster, *Samuel Cooper and the English miniature painters of the seventeenth century*. London 1914-16

Foster 1926
J J Foster, *A dictionary of painters of miniatures 1525-1850*. London 1926

Foster 1931
W Foster, *British artists in India 1760-1820*. London (Walpole Society) 1931

Franken 1872
D Franken Dzn, *L'œuvre de Willem Jacobsz Delff*. Amsterdam 1872

Franken 1878
D Franken, *Adriaen van de Venne*. Amsterdam 1878

Franken & Obreen 1894
D Franken Dz & F D O Obreen, *L'œuvre de Charles Rochussen: essai d'un catalogue raisonné de ses tableaux, dessins, lithographies, eaux-fortes*. Rotterdam 1894

Franz 1969
H Franz, *Niederländische Landschaftsmalerei im Zeitalter des Manierismus*. Graz 1969

Frederiks 1943
J W Frederiks, *De meesters der plaquette-penningen*, The Hague 1943

Freise 1911
K Freise, *Pieter Lastman, sein Leben und seine Kunst*. Leipzig 1911

Frerichs 1947
L C J Frerichs, *Antonio Moro*. Amsterdam 1947

Friedländer 1903
M J Friedländer, *Die Brügger Leihausstellung von 1902*. Reimer 1903

Friedländer 1916
M J Friedländer, *Von Eyck bis Brueghel: Studien zur Geschichte der niederländischen Malerei*. Berlin 1916

Friedländer 1921
2d edition of Friedländer 1916

Friedländer 1924-37
M J Friedländer, *Die altniederländische Malerei*. Berlin 1924-37

Friedländer 1926
M J Friedländer, *Die Sammlung Von Pannwitz*. Munich 1926

Friedländer 1947
M J Friedländer, *Essays über die Landschaftsmalerei und andere Bildgattungen*. The Hague 1947

Friedländer 1963
M J Friedländer, *Lucas van Leyden*. Berlin 1963

von Frimmel 1899
Th von Frimmel, *Geschichte der Wiener Gemälde Sammlungen* (in *Galeriestudien*, 3d series). Leipzig 1899

von Frimmel 1913
Th von Frimmel, *Lexikon der Wiener Gemälde Sammlungen*. Munich 1913

Fritz 1932
R Fritz, *Das Stadt- und Strassenbild des 17. Jahrhunderts in der holländischen Malerei*. Stuttgart 1932

Frizzoni 1891
G Frizzoni, *Arte italiana del rinascimento*. Milan 1891

Fruin, Kernkamp & Japikse 1906-12
R Fruin, G W Kernkamp & N Japikse, *Johan de Witt: brieven*. Amsterdam 1906-12

Fuchs 1927
E Fuchs, *Der Maler Daumier*. Munich 1927

Fuchs 1968
R H Fuchs, *Rembrandt en Amsterdam*. Rotterdam 1968

von der Gabelentz 1922
H von der Gabelentz, *Fra Bartolommeo und die Florentinische Renaissance*. Leipzig 1922

Gamba 1936
C Gamba, *Botticelli*. Milan 1936

Gans 1971
M H Gans, *Memorboek: platenatlas van het leven der joden in Nederland van de Middeleeuwen tot 1940*. Baarn 1971

Gantner 1964
J Gantner, *Rembrandt und die Verwandlung klassischer Formen*. Bern & Munich 1964

Gardner 1911
E G Gardner, *The painters of the school of Ferrara*. London 1911

Garlick 1954
K J Garlick, *Sir Thomas Lawrence*. London 1954

Garlick 1964
K J Garlick, *A catalogue of the paintings, drawings and pastels by Sir Thomas Lawrence*. Glasgow 1964

Gault de Saint Germain 1818
P M Gault de Saint Germain, *Guide des amateurs de tableaux, pour les écoles allemande, flammande et hollandaise*, vol 2. Paris 1818

Gaunt 1926
W Gaunt, *Rome: past and present*. London 1926
Gavelle 1929
E Gavelle, *L'école de peinture de Leyde et le romantisme hollandais au début de la renaissance: Cornelis Engebrechtsz*. Lille 1929
Gavelle 1931
E Gavelle, *J Kock: le maître des spectres chevaliers*. Lille 1931
Gaya Nuño 1958
J A Gaya Nuño, *La pintura española fuera de Espana: historio y catalogo*. Madrid 1958
GdB-A
Gazette des Beaux-Arts: Courrier Européen de l'Art et de la Curiosité. Paris
Gedenkb A Vermeylen
Gedenkboek A Vermeylen. Bruges 1931
Gedenkboek Caecilia
Gedenkboek Koninklijke Zangvereniging Caecilia, 1930
Gedenkboek K O G
Gedenkboek ter gelegenheid van het 75-jarig bestaan van het Koninklijk Oudheidkundig Genootschap 1858-1933. Amsterdam 1933
Gedenkboek Rijksmuseum
Het Rijksmuseum 1808-1958: gedenkboek uitgegeven ter gelegenheid van het honderdvijftigjarig bestaan. The Hague 1959
Gedenkboek Ver Rembrandt
Vereeniging Rembrandt tot behoud en vermeerdering van kunstschatten in Nederland: gedenkboek 1883-1933, samengesteld bij gelegenheid van het halve eeuwfeest. Amsterdam 1933
Geiger 1923
B Geiger, *Alessandro Magnasco*. Vienna 1923
Geiger 1945
B Geiger, *I disegni del Magnasco*. Padua 1945
Geiger 1949
B Geiger, *Alessandro Magnasco*. Bergamo 1949
de Gelder 1921
J J de Gelder, *Bartholomeus van der Helst: een studie van zijn werk, zijn levensgeschiedenis, een beschrijvende catalogus van zijn œuvre*. Rotterdam 1921
van Gelder 1933
J G van Gelder, *Jan van de Velde 1593-1641, teekenaar-schilder: beschrijvende catalogus met een inleidende beschouwing over den teekenstijl en het landschap in het begin der XVIIe eeuw*. The Hague 1933
van Gelder 1939
H E van Gelder, *Matthijs Maris*. Amsterdam 1939
van Gelder 1940
H E van Gelder, *J H Weissenbruch*. Amsterdam 1940
van Gelder 1941
H E van Gelder, *WC Heda, A van Beijeren & W Kalf*. Amsterdam 1941
van Gelder 1946
H E van Gelder, *Rembrandt*. Amsterdam 1946
van Gelder 1947
H E van Gelder, *Jozef Israels*. Amsterdam 1947
van Gelder 1947
H E van Gelder, *Honderd jaar Haagsche schilderkunst in Pulchri Studio*. Amsterdam 1947
van Gelder 1953
J G van Gelder, *Rembrandt's vroegste ontwikkeling*. Amsterdam 1953
van Gelder 1957
H E van Gelder, *Ikonografie van Constantijn Huygens en de zijnen*. The Hague 1957
van Gelder 1958
J G van Gelder, *De schilderkunst van Jan Vermeer: voordracht voor het Kunsthistorisch Instituut te Utrecht*. Utrecht 1958

van Gelder 1958 (Pr & tek)
J G van Gelder, *Prenten en tekeningen*. Amsterdam 1958
van Gelder 1959
H E van Gelder, *Holland by Dutch artist in paintings, drawings, woodcuts, engravings and etchings*. Amsterdam 1959
Genava
Genava: publiée par le Musée d'Art et d'Histoire. Geneva
Gens Nostra
Gens Nostra – Ons Geslacht: Maandblad der Nederlandse Genealogische Vereniging. Amsterdam
Gent Bijdr
Gentsche Bijdragen tot de kunstgeschiedenis. Antwerp & The Hague
Gerson 1936
H Gerson, *Philips Koninck*. Berlin 1936
Gerson 1942
H Gerson, *Ausbreitung und Nachwirkung der holländischen Malerei des 17. Jahrhunderts*. Haarlem 1942
Gerson 1950
H Gerson, *Nederlandse schilderkunst I: van Geertgen tot Frans Hals*. Amsterdam 1950
Gerson 1952
H Gerson, *Nederlandse schilderkunst II: het tijdperk van Rembrandt en Vermeer*. Amsterdam 1952
Gerson 1953
H Gerson, *Introduction to Rembrandt's influence in the 17th century*. London 1953
Gerson 1961
H Gerson, *Nederlandse schilderkunst III: voor en na van Gogh*. Amsterdam 1961
Gerson 1968
H Gerson, *Rembrandt paintings*. Amsterdam 1968
Gerson 1973
H Gerson, *Rembrandt: la Ronde de nuit, Rijksmuseum*. Fribourg 1973
Gerson & ter Kuile 1960
H Gerson & E H ter Kuile, *Art and architecture in Belgium 1600-1800*. Harmondsworth (Pelican History of Art) 1960
Gerstenberg 1923
K Gerstenberg, *Die ideale Landschaftmalerei: ihre Begründung und Vollendung in Rom*. Halle 1923
Geurts 1968
P A M Geurts, *De Graaf van Horne: Filips van Montmorency 1524-1569*. Zaltbommel 1968
Gibbons 1968
F Gibbons, *Dosso and Battista Dossi*. Princeton 1968
de Gids
De Gids. Amsterdam
het Gildeboek
Het Gildeboek: Tijdschrift voor Kerkelijke Kunst en Oudheidkunde. Utrecht
Glück 1931
G Glück, *Van Dijck: des Meisters Gemälde*. Stuttgart & Berlin (Klassiker der Kunst) 1931
Glück 1932
G Glück, *Bruegels Gemälde*. Vienna 1932
Glück 1933
G Glück, *Rubens, van Dijck und ihr Kreis*, in *Gesammelte Aufsätze*, vol 1. Vienna 1933
Glück 1933
G Glück, *Aus drei Jahrhunderte europäischer Malerei*, in *Gesammelte Aufsätze*, vol 2. Vienna 1933
Godée-Molsbergen 1912
E C Godée-Molsbergen, *De stichter van Hollands-Zuid Afrika: Jan van Riebeeck 1618-1677*. Amsterdam 1912

Godée-Molsbergen & Visscher 1913
E C Godée-Molsbergen & J Visscher, *Zuid Afrika's geschiedenis in beeld*. Amsterdam 1913
Godfrey 1954
F M Godfrey, *Early Venetian painters*. London 1954
Goldscheider 1936
L Goldscheider, *500 Selbstporträts*. Vienna 1936
Goldscheider 1958
L Goldscheider, *Johannes Vermeer*. London 1958
Goldscheider 1967
2d edition of Goldscheider 1958
Gombrich 1960
E H Gombrich, *Art and illusion: a study in the psychology of pictorial representation*. London & New York 1960
Goodison & Robertson 1967
J W Goodison & G H Robertson, *Catalogue of paintings of the Fitzwilliam Museum, Cambridge*, vol 2. Cambridge 1967
van Gool 1750-51
J van Gool, *De nieuwe schouburg der Nederlantsche kunstschilders en schilderessen: waar in de levens- en kunstbedrijven der tans levende en reets overleedene schilders, die van Houbraken nog eenig ander schrijver zijn aengeteekend worden*. The Hague 1750-51
Goossens 1954
K Goosens, *David Vinckboons*. Antwerp & The Hague 1954
Gorissen 1962
F Gorissen, *B C Koekkoek 1803-1862: Werkverzeichnis der Gemälde*. Düsseldorf 1962
Gorissen 1964
F Gorissen, *Conspectus Cliviae, die klevische Residenz in der Kunst des 17. Jahrhunderts*. Kleve 1964
Gouirand 1901
A Gouirand, *Les peintres Provençaux*. Paris 1901
Gould 1962
C Gould, *The sixteenth century Italian school (National Gallery catalogues)*. London 1962
Gower 1885
R Gower, *The Northbrook Gallery: an illustrated, descriptive and historic account of the collection of the Earl of Northbrook*. London 1885
Gowing 1952
L Gowing, *Vermeer*. London 1952
Goya
Goya: Revista de Arte. Madrid
Gradmann & Cetto 1944
E Gradmann & A M Cetto, *Schweizer Malerei und Zeichnung im 17. und 18. Jahrhundert*. Basel 1944
Graefe 1909
F Graefe, *Jan Sanders van Hemessen und seine Identifikation mit dem Braunschweiger Monogrammisten*. Leipzig 1909
Granberg 1902
O Granberg, *Allart van Everdingen och hans 'Norska' landskap det Gamla Julita och Wurmbrandts Kanoner*. Stockholm 1902
Granberg 1911-12
O Granberg, *Inventaire général des trésors d'art, peintures et sculptures principalement de maîtres étrangers (non Skandinaves) en Suède*. Stockholm 1911-12
Granberg 1929
O Granberg, *Svenska konstsamlingarnas historia från Gustav Vasas tid till våra dagar*, vol 1. Stockholm 1929
Grant 1956
M H Grant, *Rachel Ruysch*. Leigh-on-Sea 1956
Graphischen Künste
Die Graphischen Künste: herausgegeben von der Gesellschaft für vervielfältigende Kunst. Vienna

Grappe 1937
G Grappe. *Goya*. Paris 1937
Grassi 1963
L Grassi, *Piero di Cosimo e il problema della conversione al '500 nella pittura fiorentina ed emiliana*. Rome 1963
Gratama 1943
G D Gratama, *Frans Hals*. The Hague 1943
Greindl 1956
E Greindl, *Les peintres flamands de nature morte au XVII-ième siècle*. Brussels 1956
Greve 1903
H E Greve, *De bronnen van Carel van Mander*. The Hague 1903
Grimm 1972
C Grimm, *Frans Hals: Entwicklung, Werkanalyse, Gesamtkatalog*. Berlin 1972
Grisebach 1974
L Grisebach, *Willem Kalf*. Berlin 1974
Gronau 1930
G Gronau, *Giovanni Bellini: des Meisters Gemälde*. Stuttgart & Berlin (Klassiker der Kunst) 1930
Gron Volksalm
Groninger Volksalmanak. Groningen
de Groot 1952
C W de Groot, *Jan Steen: beeld en woord*. Utrecht & Nijmegen 1952
Grosse 1936
R Grosse, *Niederländische Malerei des 17. Jahrhunderts*. Berlin 1936
Gruyer 1897
G Gruyer, *L'art Ferrarais à l'époque des Princes d'Este*. Paris 1897
de Gruyter 1968-69
W J de Gruyter, *De Haagse School*. Rotterdam 1968-69
Gudlaugsson 1938
S J Gudlaugsson, *Ikonographische Studien über die holländische Malerei und das Theater des 17. Jahrhunderts*. Berlin & Würzburg 1938
Gudlaugsson 1945
S J Gudlaugsson, *De komedianten bij Jan Steen en zijn tijdgenoten*. The Hague 1945
Gudlaugsson 1959-60
S J Gudlaugsson, *Katalog der Gemälde Gerard ter Borchs*. The Hague 1959-60
du Gue Trapier 1948
E du Gue Trapier, *Velazquez*. New York 1948
du Gue Trapier 1952
E du Gue Trapier, *Ribera*. New York 1952
du Gue Trapier 1964
E du Gue Trapier, *Goya and his sitters: a study of his style as a portraitist*. New York 1964
Guiffrey 1882
J Guiffrey, *A van Dyck: sa vie et son œuvre*. Paris 1882
van Guldener 1949
H van Guldener, *Het bloemstuk in de schilderkunst*. Amsterdam 1949
van Gijn 1908-12
S van Gijn, *Dordracum illustratum: verzameling van kaarten, teekeningen, prenten en portretten, betreffende de stad Dordrecht*. Dordrecht 1908-12

Haacke 1968
W Haacke, *Am Klavier*. Königstein im Taunus 1968
van der Haagen 1932
J K van der Haagen, *De schilders van der Haagen en hun werk*. Voorburg 1932
Haak 1968
B Haak, *Rembrandt: zijn leven, zijn werk, zijn tijd*. Amsterdam 1968

Haak 1972
B Haak, *Regenten en regentessen, overlieden en chirurgijns: Amsterdamse groepsportretten van 1600 tot 1835*. Amsterdam 1972, also published in *Antiek* 7 (1972) pp 81-117, 287-303
Haakman 1847
G C Haakman, *Rhenen en omstreken*. Amersfoort 1847
de Haan 1922-23
F de Haan, *Oud Batavia: Gedenkboek. Platenalbum*. Batavia 1922-23
de Haas 1928
K H de Haas, *Een meetkundige reconstructie van het oorspronkelijke formaat van Rembrandt's Nachtwacht*. Rotterdam 1928
de Haas 1941
C M de Haas, *David Pierre Giottin Humbert de Superville*. Leiden 1941
Haberfeld 1900
H Haberfeld, *Piero di Cosimo*. Breslau 1900
Hairs 1955
M L Hairs, *Les peintres flamands de fleurs au XVII-ième siècle*. Brussels & Paris 1955
Hale 1937
P L Hale, *Vermeer*. London 1937
van Hall 1963
H van Hall, *Portretten van Nederlandse beeldende kunstenaars*. Amsterdam 1963
Hamann 1948
R Hamann, *Rembrandt*. Berlin 1948
Hammacher 1932
A M Hammacher, *De levenstijd van Antoon Der Kinderen*. Amsterdam 1932
Hammacher 1941
A M Hammacher, *Amsterdamsche impressionisten en hun kring*. Amsterdam 1941
Hammacher 1946
2d edition of Hammacher 1941
Hammacher 1947
A M Hammacher, *Eduard Karsen en zijn vader Kaspar*. The Hague 1947
Handb Mij Ned Letterkunde
Handboek der Maatschappij van Nederlandsche Letterkunde. Leiden
Hannema 1952
D Hannema, *Kunst in oude sfeer*. Rotterdam 1952
Hannema 1955
D Hannema, *Catalogue raisonné of the pictures in the collection of J C H Heldring*. Rotterdam 1955
Hannema 1967
D Hannema, *Beschrijvende catalogus van de schilderijen, beeldhouwwerken, aquarellen en tekeningen, behorende tot de verzameling Stichting Hannema-de Stuers Fundatie in het Kasteel 't Nijenhuis bij Heino*. Rotterdam 1967
Hannema & van Schendel 1938
D Hannema & A van Schendel, *Noord- en Zuid-Nederlandse schilderkunst der XVIIe eeuw*. Amsterdam & Berlin 1938
Hargreaves-Mawdsley 1963
W N Hargreaves-Mawdsley, *A history of academical dress in Europe until the end of the eighteenth century*. Oxford 1963
Harsin 1957
P Harsin, *Etudes critiques sur l'histoire de la principauté de Liège 1477-1795*, vol 2: *La règne d'Erard de la Marck 1505-1538*. Liège 1957
Hartlaub 1912
G F Hartlaub, *Die Grossherzogliche Gemäldegalerie im Augusteum zu Oldenburg*. Oldenburg 1912
Hauptmann 1936
E Hauptmann, *Der Tondo*. Frankfurt am Main 1936

Hausenstein 1924
W Hausenstein, *Vermeer van Delft*. Munich 1924
Havard 1879-81
H Havard, *L'art et les artistes hollandais*. Paris 1879-81
Havard 1881
H Havard, *Histoire de la peinture hollandaise*. Paris 1881
Havard 1888
H Havard, *Van der Meer de Delft*. Paris 1888
Havelaar 1931
J Havelaar, *De Nederlandsche landschapskunst tot het einde der 17de eeuw*. Amsterdam 1931
Haverkamp Begemann 1959
E Haverkamp Begemann, *Willem Buytewech*. Amsterdam 1959
Haverkamp Begemann 1973
E Haverkamp Begemann, K G Boon & E Trautscholdt, *Hercules Seghers: the complete etchings*. Amsterdam 1973
Heckmanns 1965
F W Heckmanns, *Pieter Janszoon Saenredam: das Problem seiner Raumform*. Recklinghausen (Studien zur Münstersche Kunstgeschichte) 1965
Heckscher 1958
W S Heckscher, *Rembrandt's Anatomy of Dr. Nicolaas Tulp*. New York 1958
Heemkennis
Heemkennis Amsterdam. Amsterdam
Heemschut
Heemschut: Maandblad van de Bond Heemschut. Amsterdam
Hefting 1970
P H Hefting, *G H Breitner in zijn Haagse tijd*. Utrecht 1970
Hefting & Quarles van Ufford 1966
P H Hefting & C C G Quarles van Ufford, *Breitner als fotograaf*. Rotterdam 1966
Heidrich 1910
E Heidrich, *Altniederländische Malerei*. Jena 1910
Heinemann 1962
F Heinemann, *Giovanni Bellini e i belliniani*. Vienna 1962
Held 1964
J Held, *Farbe und Licht in Goya's Malerei*. Berlin 1964
Hellinga 1955
W G Hellinga, *Interpretatie van de Nachtwacht: een inleidende studie*. Amsterdam 1955
Hellinga 1956
W G Hellinga, *Rembrandt fecit; De Nachtwacht; Gijsbrecht van Aemstel*. Amsterdam 1956
Hendrick 1973
J Hendrick, *La peinture liègeoise au XVIIe siècle*. Gembloux 1973
Henkel 1942
M D Henkel, *Catalogus Rijksprentenkabinet I: tekeningen, Rembrandt en zijn school*. The Hague 1942
Hennus 1945
M F Hennus, *J B Jongkind*. Amsterdam 1945
Heppner 1938
A Heppner, *Weverswerkplaatsen geschilderd door Haarlemse meesters der 17de eeuw*. Haarlem 1938
't Herstelde Nederland
A N J Fabius (ed), *'t Herstelde Nederland: zijn opleven en bloei na 1813*. Amsterdam 1913
Hind 1912
A M Hind, *Rembrandt's etchings: an essay and a catalogue*. London 1912
Hirschmann 1916
O Hirschmann, *Hendrick Goltzius als Maler 1600-1617*. The Hague 1916

Historia
Historia : Maandschrift voor Geschiedenis. Utrecht
Hist Tijdschr
Historisch Tijdschrift. Utrecht
Historische beschrijving Felix Meritis 1800
Historische beschrijving van het gebouw der Maatschappij van Verdiensten ten spreuke voerende Felix Meritis. Amsterdam 1800
Höhne 1959
E Höhne, *Adriaen Brouwer.* Leipzig 1959
Hoet 1752
G Hoet, *Catalogus of naamlyst van schilderyen met derzelver pryzen … zoo in Holland als op andere plaatsen in het openbaar verkogt.* The Hague 1752
Hofdijk 1863
W J Hofdijk, *Historische schets ter opheldering der schilderij van J W Pieneman : de een-en-twintigste November 1813.* Amsterdam 1863
Hoffman 1928
W J Hoffman, *Geschiedenis der familie Hoffman.* n p 1928
Hofstede de Groot 1893
C Hofstede de Groot, *Arnold Houbraken und seine 'Groote Schouburgh' kritisch beleuchtet.* The Hague 1893
Hofstede de Groot 1899
C Hofstede de Groot, *Teekeningen en schilderijen van Pieter Saenredam.* Haarlem 1899
Hofstede de Groot 1903
C Hofstede de Groot, *Meisterwerke der Porträt-malerei auf der Ausstellung im Haag 1903.* Munich 1903
Hofstede de Groot 1906
C Hofstede de Groot, *Die Urkunden über Rembrandt neu herausgegeben und commentirt.* The Hague 1906
Hofstede de Groot 1907
C Hofstede de Groot, *Jan Vermeer van Delft en Carel Fabritius.* The Hague 1907
Hofstede de Groot 1907-28
C Hofstede de Groot, *Beschreibendes und kritisches Verzeichnis der Werke der hervorragendsten holländischen Maler des XVII. Jahrhunderts.* Erlingen & Paris 1907-28
van Hogendorp 1903
Gijsbert Karel van Hogendorp : Brieven en gedenkschriften, vol 3. The Hague 1903
Holländer 1913
E Holländer, *Die Medizin in der klassischen Malerei.* Stuttgart 1913
Holländer 1950
4th edition of Holländer 1913
Holland 1963
V Holland, *Goya.* The Hague 1963
Holland
Holland : Regionaal-Historisch Tijdschrift. The Hague
Hollstein 1949
F W H Hollstein, *Dutch and Flemish etchings, engravings and woodcuts ca 1450-1700.* Amsterdam 1949-
Honisch 1965
D Honisch, *Anton Raphael Mengs und die Bildform des Frühklassizismus.* Recklinghausen 1965
't Hooft 1907
C G 't Hooft, *Verzameling J C J Drucker-Fraser in het Rijksmuseum.* Amsterdam 1907
't Hooft 1912
C G 't Hooft, *Amsterdamsche stadsgezichten van Jan van der Heyden.* Amsterdam 1912
Hoogewerff 1912
G J Hoogewerff, *Nederlandsche schilders in Italië in de XVIe eeuw.* Utrecht 1912

Hoogewerff 1920
G J Hoogewerff, *De ontwikkeling der Italiaansche Renaissance.* Zutphen 1920
Hoogewerff 1923
G J Hoogewerff, *Jan van Scorel : peintre de la renaissance hollandaise.* The Hague 1923
Hoogewerff 1924
G J Hoogewerff, *Gerrit van Honthorst.* The Hague 1924
Hoogewerff 1936-47
G J Hoogewerff, *De Noord Nederlandsche schilderkunst.* The Hague 1936-47
Hoogewerff 1947
G J Hoogewerff, *De geschiedenis van de Sint Lucasgilden in Nederland.* Amsterdam 1947
Hoogewerff 1952
G J Hoogewerff, *De Bentvueghels.* The Hague 1952
Hoogewerff & Altena 1928
G J Hoogewerff & J Q van Regteren Altena, *Arnoldus Buchelius' 'Res Pictoriae.'* The Hague 1928
Horne 1908
H P Horne, *Botticelli.* London 1908
Houbraken 1718-21
A Houbraken, *De groote schouburgh der Nederlantsche konstschilders en schilderessen.* Amsterdam 1718-21
Hours 1973
M Hours, *Jean-Baptiste Camille Corot.* New York 1973
Huebner 1942
F M Huebner, *De Romantische schilderkunsten in de Nederlanden 1780-1840.* The Hague 1942
Hüttinger 1956
E Hüttinger, *Holländische Malerei im XVII. Jahrhundert.* Zürich 1956
Huizinga 1927
J Huizinga, *Leven en werken van Jan Veth.* Haarlem 1927
Huizinga 1935
J Huizinga, *Herfsttij der Middeleeuwen : studie over levens- en gedachtenvormen der veertiende en vijftiende eeuw in Frankrijk en de Nederlanden.* Haarlem 1935
Huldeboek Dr B Kruitwagen
Huldeboek Bonaventura Kruitwagen aangeboden op Sint Bonaventura 14 juli 1949 ter gelegenheid van zijn gouden priesterfeest en zijn 75ste verjaardag. The Hague 1949
d'Hulst 1956
R-A d'Hulst, *De tekeningen van Jakob Jordaens.* Brussels 1956
d'Hulst 1968
R-A d'Hulst, *Olieverfschetsen van Rubens uit Nederlands en Belgisch bezit.* Amsterdam & Antwerp (Openbaar Kunstbezit) 1968
Humbert, Revilliod & Tilanus 1897
Humbert, A Revilliod & J W R Tilanus, *La vie et les œuvres de Jean-Etienne Liotard (1702-1789) : étude biographique et iconographique.* Amsterdam 1897
Huyghe 1964
R Huyghe, *Delacroix ou le combat solitaire.* London 1964
Huyghe & de Vries 1948
R Huyghe & A de Vries, *Jan Vermeer de Delft.* Paris 1948
Hymans 1884
H Hymans, *Le livre des peintres*, vol 2. Paris 1884
Hymans 1920
H Hymans, *Antonio Moro, son œuvre et son temps.* Brussels 1920
Hijmans 1951
H Hijmans, *Wijk bij Duurstede.* Rotterdam 1951

Icones Leidenses 1973
Icones Leidenses : de portrettenverzameling van de Rijksuniversiteit te Leiden. Leiden 1973
Idea and form
Idea and Form : Studies in the History of Art. Stockholm (Figura ns)
Imago Mundi
Imago Mundi : a Review of Early Cartography. Berlin
Immerzeel 1842-43
J Immerzeel Jr, *De levens en werken der Hollandsche en Vlaamsche kunstschilders, beeldhouwers, graveurs en bouwmeesters.* Amsterdam 1842-43
Ingersoll-Smouse 1928
F Ingersoll-Smouse, *Pater : biographie et catalogue critique.* Paris 1928
Int J of Hypnosis
The International Journal of Clinical and Experimental Hypnosis. Baltimore
Isarlo 1941
G Isarlo, *Caravage et le caravagisme Européen.* Aix-en-Provence 1941
Italienische Malerei 1960
Italienische Malerei der Renaissance im Briefwechsel von Giovanni Morelli und Jean Paul Richter 1876-1899. Baden-Baden 1960
van Iterson 1960
W van Iterson, *De stad Rhenen.* Assen 1960

Jaarversl K O G
Jaarverslag van het Koninklijk Oudheidkundig Genootschap te Amsterdam. Amsterdam
Jaarversl R M A
Rijksmuseum te Amsterdam : Verslag van de Hoofddirecteur, in : *Verslagen omtrent 's Rijks Verzamelingen van Geschiedenis en Kunst.* The Hague
Jaarversl Ver Rembrandt
Verslag over…: Vereniging Rembrandt tot Behoud en Vermeerdering van Kunstschatten in Nederland. Amsterdam
900 Jahre Rottenbuch
900 Jahre Rottenbuch. Rottenbuch 1974
Janek 1968
A Janek, *Untersuchung über den holländischen Maler Pieter van Laer, genannt Bamboccio.* Würzburg 1968 (typescript)
Jantzen 1910
H Jantzen, *Das Niederländische Architekturbild.* Leipzig 1910
Japikse 1919
N Japikse, *Brieven aan Johan de Witt 1648-1672.* Amsterdam 1919
Jardin d A
Le Jardin des Arts : Revue Mensuelle. Paris
Jb Alberdingk Thijm
Het Jaarboekje van Jos Alb Alberdingk Thijm. 's Hertogenbosch, Amsterdam & Nijmegen
Jb Amstelodamum
Jaarboek van het Genootschap Amstelodamum. Amsterdam
Jb Berliner Museen
Jahrbuch der Berliner Museen : Neue Folge Jahrbuch Preussischen Kunstsammlungen. Berlin
Jb Die Haghe
Jaarboek Die Haghe. The Hague
Jb f Kunstw
Jahrbuch für Kunstwissenschaft. Leipzig & Berlin
Jb Genealogie
Jaarboek van het Centraal Bureau voor Genealogie. The Hague
Jb Haarlem
Haarlem Jaarboek. Haarlem

Jb Hamb Kunstsamml
Jahrbuch der Hamburger Kunstsammlungen.
Hamburg
Jb Köln Gesch Ver
Jahrbuch des Kölnischen Geschichtsvereins. Cologne
Jb Kon Mus SK België
*Jaarboek van de Koninklijke Musea voor Schone
Kunsten van België.* Brussels
Jb Ksamml Baden-Württemberg
*Jahrbuch der Staatlichen Kunstsammlungen in Baden-
Württemberg.* Munich
Jb Kunsth Samml AK
*Jahrbuch der Kunsthistorischen Sammlungen des
Allerhöchsten Kaiserhauses.* Vienna
Jb Kunsth Samml Wien
Jahrbuch der Kunsthistorischen Sammlungen in Wien.
Vienna
Jb Kunsthist Inst Graz
*Jahrbuch des Kunsthistorischen Instituts der Universität
Graz.* Graz
Jb Leiden
*Jaarboek voor Geschiedenis en Oudheidkunde van
Leiden en Omstreken.* Leiden
Jb Mus Antwerpen
*Jaarboek van het Koninklijk Museum voor Schone
Kunsten te Antwerpen.* Antwerp
Jb Mij Ned Letterkunde
*Jaarboek van de Maatschappij der Nederlandse
Letterkunde te Leiden.* Leiden
Jb Nifterlake
*Jaarboek van het Oudheidkundig Genootschap
'Nifterlake.'* Utrecht
Jb Oranjeboom
*Jaarboek van de Geschiedkundige en Oudheidkundige
Kring van Breda 'De Oranjeboom.'* Breda
Jb Oud Utrecht
*Jaarboekje van Oud Utrecht: Vereniging tot Beoefening
en ter Verspreiding van de Kennis der Geschiedenis van
Utrecht en Omstreken.* Utrecht
Jb Preusz Kunstsamml
Jahrbuch der Königlich Preussischen Kunstsammlungen.
Berlin
Jb Rhein Denkmalpfl
Jahrbuch der Rheinischen Denkmalpflege. Kevelaer
Jb Russ KHI
Jahrbuch des Russischen Kunsthistorischen Instituts.
Jeltes 1911
H F W Jeltes, *Willem Roelofs: bijzonderheden
betreffende zijn leven en zijn werk.* Amsterdam 1911
Jeltes 1917
H F W Jeltes, *Johannes Bosboom 1817-18 Februari
1891: korte schets van zijn ontwikkelingsgang.*
Amsterdam 1917
Jeltes 1947
H F W Jeltes, *Gerard Bilders.* The Hague 1947
João Couto 1971
João Couto: in memoriam. Lisbon 1971
Johannsen 1953
O Johannsen, *Geschichte des Eisens.* Düsseldorf
1953
de Jong 1972
C de Jong, *Geschiedenis van de oude Nederlandse
walvisvaart I: grondslagen, ontstaan en opkomst
1612-1642.* Pretoria 1972
de Jonge 1858-62
J C de Jonge, *Geschiedenis van het Nederlandse
zeewezen.* Haarlem 1858-62
de Jonge 1924
C H de Jonge, *Gids door het Museum der Stichting
Bisdom van Vliet.* Haarlem 1924
de Jonge 1938
C H de Jonge, *Paulus Moreelse, portret- en genre-
schilder te Utrecht 1571-1638.* Assen 1938

de Jonge 1939
C H de Jonge, *Jan Steen.* Amsterdam 1939
de Jonge 1940
C H de Jonge, *Jan van Scorel.* Amsterdam 1940
de Jongh 1966
J de Jongh, *De koningin Maria van Hongarije,
landvoogdes der Nederlanden 1505-1558.* Amsterdam
1966
de Jongh 1967
E de Jongh, *Zinne- en minnebeelden in de Nederlandse
schilderkunst van de 17de eeuw.* Amsterdam &
Antwerp (Openbaar Kunstbezit) 1967
Journ Aesth & Art Cr
*The Journal of Aesthetics and Art Criticism Published
by the American Society for Aesthetics.* Baltimore
Journ Am Mus Soc
Journal of the American Musicological Society.
Richmond
Journ WCI
Journal of the Warburg and Courtauld Institutes.
London
Judson 1959
J R Judson, *Gerrit van Honthorst.* The Hague 1959
Judson 1970
J R Judson, *Dirck Barendsz excellent painter from
Amsterdam.* Amsterdam 1970
Jugoslavya
Svoboda Jugoslavya: Kulturno-Politična Revija.
Munich
Justi 1888
C Justi, *Diego Velazquez und sein Jahrhundert.* Bonn
1888
Justi 1904
C Justi, *Murillo.* Leipzig 1904
Justi 1908
L Justi, *Giorgione.* Berlin 1908
Justi 1923
3d edition of Justi 1904
Jvsl Oranje-Nassau Mus
Jaarverslag van het Oranje-Nassau Museum te Delft.
Delft
Jvsl Scheepvaartmuseum
*Jaarverslag van de Vereniging Nederlands Historisch
Scheepvaartmuseum.* Amsterdam

Kaftal 1952
G Kaftal, *The iconography of the saints in Tuscan art.*
Florence 1952
van Kalcken & Six 1903-19
G van Kalcken & J Six, *Peintures ecclésiastiques du
moyen-âge de l'époque d'art de Jan van Scorel et P van
Oostzaanen 1490-1560.* Haarlem 1903-19
Kan 1946
A H Kan, *De jeugd van Constantijn Huygens door
hemzelf beschreven.* Rotterdam & Antwerp 1946
Kat Hist Verz Schutterij 1889
*Katalogus van de Historische Verzameling der
Schutterij te Amsterdam.* Amsterdam 1889
KdK
Klassiker der Kunst. Stuttgart and other places
1904-
Kehrer 1926
H Kehrer, *Spanische Kunst von Greco bis Goya.*
Munich 1926
Keramik-Freunde
Mitteilungsblatt der Freunde der Schweizer Keramik.
Basel
Kerkh Arch
Kerkhistorisch Archief. Amsterdam
Kermer 1967
W Kermer, *Studien zum diptichon in der sakralen
Malerei.* Tübingen 1967

Kessler 1930
J H H Kessler, *Geertgen tot Sint Jans.* Utrecht 1930
Kist 1971
J B Kist, *Jacob de Gheyn, 'The exercise of armes.'*
Lochem 1971
Kleinschmidt 1930
P B Kleinschmidt, *Die heilige Anna.* Düsseldorf
1930
Klönne 1894
B H Klönne, *Amstelodamensia.* Amsterdam 1894
van der Klooster & Bouman 1966
L J van der Klooster & J J Bouman, *Oranje in
beeld.* Zaltbommel 1966
Klossowski 1914
E Klossowski, *Honoré Daumier.* Munich 1914
Klossowski 1923
2d edition of Klossowski 1914
Knapp 1899
F Knapp, *Piero di Cosimo: ein Uebergangsmeister
von Florentiner Quattrocento zum Cinquecento.* Halle
1899
Knapp 1903
F Knapp, *Fra Bartolommeo della Porta und die
Schule von San Marco.* Halle 1903
Knipping 1939-40
J B Knipping, *Iconografie van de contra-reformatie
in de Nederlanden.* Hilversum 1939-40 (English
version Nieuwkoop 1974)
Knipping 1966
J B Knipping, *Kunstschatten van alle tijden.*
Amsterdam 1966
Knipping & Gerrits 1943-48
J B Knipping & M Gerrits, *Het kind in Neerlands
beeldende kunst.* Wageningen 1943-48
Knoef 1943
J Knoef, *Tussen Rococo en Romantiek: een bundel
kunsthistorische opstellen.* The Hague 1943
Knoef 1946
3d edition of Knoef 1943
Knoef 1947
J Knoef, *Van Romantiek tot Realisme: een bundel
kunsthistorische opstellen.* The Hague 1947
Knoef 1947
J Knoef, *Cornelis Troost.* Amsterdam 1947
Knoef 1948
J Knoef, *Een eeuw Nederlandse schilderkunst 1800-
1900.* Amsterdam 1948
Knuttel 1917
G Knuttel, *Das Gemälde des Seelen Fischfangs von
Adriaen Pietersz van de Venne.* The Hague 1917
Knuttel 1938
G Knuttel, *De Nederlandsche schilderkunst: van
van Eyck tot van Gogh.* Amsterdam 1938
Knuttel 1956
G Knuttel, *Rembrandt: de meester en zijn werk.*
Amsterdam 1956
Knuttel 1962
G Knuttel, *Adriaen Brouwer: the master and his work.*
The Hague 1962
Koch 1968
R A Koch, *Joachim Patinir.* Princeton 1968
Konsthist Tidskr
*Konsthistorisk Tidskrift: Revy för Konst och Konst-
forskning.* Stockholm
Koot 1947
T Koot, *Rembrandts Nachtwacht in nieuwer luister.*
Amsterdam 1947
Kramm 1857-64
Chr Kramm, *De levens en werken der Hollandsche en
Vlaamsche kunstschilders, beeldhouwers, graveurs en
bouwmeesters van de vroegsten tijd tot op heden.*
Amsterdam 1857-64

Kroniek Rembrandthuis
De Kroniek van de Vriendenkring van het Rembrandthuis. Amsterdam

Kruizinga 1948
J H Kruizinga, *Watergraafsmeer: eens een parel aan de kroon van Amsterdam*. Amsterdam 1948

Kubler & Soria 1959
G Kubler & M Soria, *Art and architecture in Spain and Portugal and their American dominions 1500-1800*. Harmondsworth 1959

Künstle 1926
K Künstle, *Iconographie der Heiligen*. Freiburg 1926

Kultzen 1954
R Kultzen, *Michael Sweerts 1624-1664*. Hamburg 1954 (typescript)

Kunoth-Leifels 1962
E Kunoth-Leifels, *Ueber die Darstellungen der 'Bathseba im Bade.'* Essen 1962

Kunst
Kunst: Tijdschrift voor Kunst en Letteren. Bruges

die Kunst
Die Kunst und das schöne Heim. Munich

Kunst dem Volke
Die Kunst dem Volke. Munich

Kunst der Ned
De Kunst der Nederlanden: Maandblad voor Oude en Nieuwe Beeldende Kunst. Amsterdam & Brussels

Kunst in Hessen
Kunst in Hessen und am Mittelrhein: Schriften der Hessischen Museen, Hessisches Landesmuseum Darmstadt. Darmstadt

Kunst und Künstler
Kunst und Künstler: Illustrierte Monatsschrift für Bildende Kunst und Kunstgewerbe. Berlin

Kunstblatt
Kunst-Blatt. Stuttgart

Kunstchronik
Kunstchronik: Beiblatt zur Zeitschrift für Bildende Kunst. Leipzig 1866-1918. Also *Kunstchronik und Kunstmarkt: Wochenschrift für Kenner und Sammler*. Leipzig

Kunstdenkm
Unsere Kunstdenkmäler: Mitteilungsblatt für die Mitglieder der Gesellschaft für Schweizerische Kunstgeschichte. Bern

Kunstgesch Anz
Kunstgeschichtliche Anzeigen: Beiblatt der Mitteilungen des Instituts für Österreichischen Geschichtsforschung. Innsbrück

Kunstgesch der Ned
Kunstgeschiedenis der Nederlanden. Utrecht 1954-56

Kunstgesch Studien 1943
Kunstgeschichtliche Studien. Breslau 1943

Kunsthist Congres London 1939
Congrès international d'histoire de l'art. Londres 24-29 Juillet 1939: résumés des communications. London 1939

Kunstkronijk
Kunstkronijk. The Hague & Leiden

Kunstmus Årsskrift
Kunstmuseets Årsskrift. Copenhagen

Kunstrip
Kunstrip: een Uitgave van de Educatieve Dienst van het Rijksmuseum te Amsterdam. Amsterdam

Kunstwanderer
Der Kunstwanderer: Halbmonatsschrift für Alte und Neue Kunst. Berlin

Kurtz 1956
G H Kurtz, *Kenau Simonsdochter van Haerlem*. Assen 1956

Kutter 1907
P Kutter, *Joachim von Sandrart als Künstler*. Strasbourg 1907

Lafond 1903
P Lafond, *Goya*. Paris 1903

Lafond 1914
P Lafond, *Hieronymus Bosch: son art, son influence, ses disciples*. Brussels & Paris 1914

Lafuente Ferrari 1946
E Lafuente Ferrari, *Breve historia de la pintura española*. Madrid 1946

Laignal-Lavastine & Guégan 1936-49
M Laignal-Lavastine & B Guégan, *Histoire générale de la médecine, de la pharmacie, de l'art dentaire et de l'art vétérinaire*. Paris 1936-49

Landsberger 1946
F Landsberger, *Rembrandt, the Jews and the bible*. Philadelphia 1946

Langendijk 1968
K Langendijk, *De portretten van de Medici tot omstreeks 1600*. Assen 1968

Langton Douglas 1946
R Langton Douglas, *Piero di Cosimo*. Chicago 1946

Lantern
Lantern: Tydskrif vir Kennis en Kultur. Pretoria

Larsen 1962
E Larsen, *Frans Post: interprète du Brasil*. Amsterdam & Rio de Janeiro 1962

Lassaigne 1933
J Lassaigne, *Daumier*. Paris 1933

Lassaigne 1948
J Lassaigne, *Goya*. London, Paris & New York 1948

Lauts 1962
J Lauts, *Carpaccio: paintings and drawings*. London 1962

Ledermann 1920
J Ledermann, *Beiträge zur Geschichte des romantischen Landschaftbildes in Holland und seines Einflusses auf die nationale Schule um die Mitte des 17. Jahrhunderts*. Berlin 1920 (typescript)

Leesberg-Terwindt 1960
J H M Leesberg-Terwindt, *Poppenhuizen (in het Rijksmuseum)*. Amsterdam (Facetten der Verzameling) 1960

Lefort 1888
P Lefort, *Velasquez*. Paris 1888

Legendre & Hartmann 1937
M Legendre & A Hartmann, *Domenico Theotocopouli dit El Greco*. Paris 1937

Legrand 1963
F-C Legrand, *Les peintres flamands de genre au XVIIe siècle*. Brussels 1963

Lendorff 1933
G Lendorff, *Giovanni Battista Moroni, der Porträtmaler von Bergamo*. Winterthur 1933

Lendorff 1939
G Lendorff, *Giovanni Battista Moroni: il ritrattista bergamasco*. Bergamo 1939

van Lennep 1962
F J E van Lennep, *Late regenten*. Haarlem 1962

Lewin 1958
I Lewin, *Goya*. Leningrad & Moscow 1958

Leymairie 1956
J Leymairie, *La peinture hollandaise*. Geneva 1956

Lilienfeld 1914
K Lilienfeld, *Arent de Gelder: sein Leben und seine Kunst*. The Hague 1914

Lindeboom 1963
G L Lindeboom, *Iconographia Boerhavii*. Leiden 1963

Lindeman 1929
C M A A Lindeman, *Joachim Anthonisz Wtewael*. Utrecht 1929

van der Linden 1957
M P van der Linden, *De burggraven van Montfoort in de geschiedenis van het Sticht Utrecht en het graafschap Holland ca 1260-1490*. Assen 1957

te Lintum 1909
C te Lintum, *Onze schuttersvendels en schutterijen van vroeger en later tijd 1550-1908*. The Hague 1909

Livrustkammaren
Livrustkammaren: Journal of the Royal Armoury. Stockholm

von Loga 1903
V von Loga, *Francisco de Goya*. Berlin 1903

von Loga 1914
V von Loga, *Velazquez: des Meisters Gemälde*. Stuttgart & Berlin (Klassiker der Kunst) 1914

von Loga 1923
V von Loga, *Die Malerei in Spanien vom 14. bis 18. Jahrhundert*. Berlin 1923

le Long 1729
I le Long, *Historische beschryvinge van de reformatie der stadt Amsterdam*. Amsterdam 1729

Long 1929
B S Long, *British miniaturists*. London 1929

Longhi 1934
R Longhi, *Officina ferrarese*. Rome 1934

Longhi 1952
R Longhi, *Viatico per cinque secoli di pittura veneziana*. Florence 1952

Longhi 1956
R Longhi, *Officina ferrarese 1934, seguita dagli ampliamenti 1940 e dai nuovi ampliamenti 1940-55*. Florence 1956

de Loos-Haaxman 1941
J A de Loos-Haaxman, *De landsverzameling schilderijen in Batavia*. Leiden 1941

de Loos-Haaxman 1968
J de Loos-Haaxman, *Verlaat rapport Indië*. The Hague 1968

de Loos-Haaxman 1972
J de Loos-Haaxman, *Dagwerk in Indië: hommage aan een verstild verleden*. Franeker 1972

López-Rey 1963
J López-Rey, *Velazquez: a catalogue raisonné of his œuvre*. London 1963

Lugt 1915
F Lugt, *Wandelingen met Rembrandt in en om Amsterdam*. Amsterdam 1915

Lugt 1917
F Lugt, *Le portrait-miniature*. Amsterdam 1917

Lugt 1927
F Lugt, *Les dessins de l'école du Nord de la collection Dutuit*. Paris 1927

Luns 1932
H Luns, *Spaanse schilders*. Amsterdam 1932

van Luttervelt 1947
R van Luttervelt, *Schilders van het stilleven*. n p 1947

van Luttervelt 1958
R van Luttervelt, *De 'Turkse' schilderijen van J B Vanmour en zijn school*. Istanbul 1958

Mabille de Poncheville 1938
A Mabille de Poncheville, *Philippe de Champaigne*. Paris 1938

MacLaren 1960
N MacLaren, *The Dutch school (National Gallery catalogues)*. London 1960

de Maeyer 1955
M de Maeyer, *Albrecht en Isabella en de schilderkunst*. Brussels 1955

Maison 1968
K E Maison, *Honoré Daumier*. London 1968

Mallé 1969
L Mallé, *Incontri con Gaudenzio*. Turin 1969

Malraux 1952
A Malraux, *Vermeer de Delft*. Paris 1952

van Mander 1604
C van Mander, *Het schilder-boeck waer in voor eerst de leerlustighe iueght den grondt der edel vrij schilderconst in verscheyden deelen wort voorghedraghen*. Haarlem 1604

Manke 1963
I Manke, *Emanuel de Witte*. Amsterdam 1963

Mankowski 1932
T Mankowski, *Galerja Stanisława Augusta*. Lvov 1932

Maquet-Tombu 1937
J Maquet-Tombu, *Colijn de Coter, peintre bruxellois*. Brussels 1937

Marb Jb
Marburger Jahrbuch für Kunstwissenschaft. Marburg

Maris 1943
M H W E Maris, *De geschiedenis van een schildersgeslacht*. Amsterdam 1943

Marius 1920
G H Marius, *De Hollandsche schilderkunst in de XIXe eeuw*. The Hague 1920

Marius & Martin 1917
G H Marius & W Martin, *Johannes Bosboom*. The Hague 1917

van Marle 1923-38
R van Marle, *The development of the Italian schools of painting*. The Hague 1923-38

van Marle 1932
R van Marle, *Iconographie de l'art profane au Moyen Age et à la Renaissance: allegories et symboles*. The Hague 1932

Marlier 1934
G Marlier, *Anthonis Mor van Dashorst (Antonio Moro)*. Brussels 1934

Marlier 1954
G Marlier, *Erasme et la peinture flamande de son temps*. Damme 1954

Marlier 1966
G Marlier, *Pierre Coeck d'Aelst*. Brussels 1966

Mar Mirror
The Mariner's Mirror: the Quarterly Journal of the Society for Nautical Research. London

Marsyas
Marsyas: a Publication by the Students of the Institute of Fine Arts, New York University. New York

Martin 1901
W Martin, *Het leven en de werken van Gerrit Dou beschouwd in verband met het schildersleven van zijn tijd*. Leiden 1901

Martin 1913
W Martin, *Gerard Dou: des Meisters Gemälde*. Stuttgart & Berlin (Klassiker der Kunst) 1913

Martin 1914
W Martin, *Albert Neuhuys, zijn leven en zijn kunst*. Amsterdam 1914

Martin 1920-21
W Martin, *Thérèse van Duyl-Schwartze 1851-1918: een gedenkboek*. Amsterdam 1920-21

Martin 1935-36
W Martin, *De Hollandsche schilderkunst in de zeventiende eeuw*. Amsterdam 1935-36

Martin 1942
2d edition of Martin 1935-36

Martin 1947
W Martin, *Van Nachtwacht tot feeststoet*. Amsterdam 1947

Martin 1954
W Martin, *Jan Steen*. Amsterdam 1954

Martin & Moes 1912-14
W Martin & E W Moes, *Oude schilderkunst in Nederland*. The Hague 1912-14

Master Drawings
Master Drawings: a Quarterly Published by the Master-Drawings Association. New York

Maumené & D'Harcourt 1928-31
Ch Maumené & L D'Harcourt, *Iconographie des rois de France*. Paris 1928-31

Mayer 1908
A L Mayer, *Juseppe de Ribera (Lo Spagnoletto)*. Leipzig 1908

Mayer 1910
A L Mayer, *Das Leben und die Werke der Brüder Matthäus und Paul Bril*. Leipzig 1910

Mayer 1913
A L Mayer, *Murillo: des Meisters Gemälde*. Stuttgart & Berlin (Klassiker der Kunst) 1913

Mayer 1922
A L Mayer, *Geschichte der spanischen Malerei*. Leipzig 1922

Mayer 1923
A L Mayer, *Francisco de Goya*. Munich 1923

Mayer 1936
A L Mayer, *Velazquez: a catalogue raisonné of pictures and drawings*. London 1936

Mayer 1947
A L Mayer, *Historia de la pintura española*. Madrid 1947

Med Dep O W & C
Mededelingen van het Departement van Onderwijs, Wetenschappen en Cultuur. The Hague

Med D K W Gem 's Grav
Mededeelingen van den Dienst voor Kunsten en Wetenschappen. The Hague

Med Ned Hist Inst Rome
Mededelingen van het Nederlandsch Historisch Instituut te Rome. The Hague

Med Ned Ver Zeegesch
Mededelingen van de Nederlandse Vereniging voor Zeegeschiedenis. The Hague

Med O K W
Mededelingen van het Department van Onderwijs, Kunsten en Wetenschappen. The Hague

Med R K D
Kunsthistorische Mededelingen van het Rijksbureau voor Kunsthistorische Documentatie, 's Gravenhage. The Hague

de Meester-Obreen 1912
A de Meester-Obreen, *Willem de Zwart*. Amsterdam 1912

Meesterwerken 1920-21
Meesterwerken der kunst in Holland. Vienna 1920-21

Meier-Graefe 1930
J Meier-Graefe, *Corot*. Berlin 1930

Meiss 1951
M Meiss, *Painting in Florence and Siena after the Black Death*. Princeton 1951

Meisterwerke 1920-21
Meisterwerke der Kunst in Holland. Vienna 1920-21

Mélanges Hulin de Loo
Mélanges Hulin de Loo. Brussels & Paris 1931

Meldrum 1923
D G Meldrum, *Rembrandt paintings*. London 1923

Menkman 1942
W R Menkman, *De Nederlanden en het Caraïbisch zeegebied*. Amsterdam 1942

Mercier & Vermeule 1962
Ch Mercier & C C Vermeule, *Alexander the Great*. n p 1962

Mesnil 1938
J Mesnil, *Botticelli*. Paris 1938

Meijer Jr 1876
D C Meijer Jr, *Wandeling door de zalen der Historische Tentoonstelling*. Amsterdam 1876

Mezzetti 1965
A Mezzetti, *Il Dosso e Battista Ferraresi*. Milan 1965

Michel 1893
E Michel, *Rembrandt, sa vie, son œuvre et son temps*. Paris 1893

Michel 1951
E Michel, *Les grands maîtres flamands*. Paris 1951

Michel 1953
E Michel, *Catalogue raisonné des peintures du Moyen Age, de la Renaissance et des temps modernes: peintures flamandes du XVe et du XVIe siècle*. Paris 1953

Michel 1970
M R Michel, *Anne Vallayer-Coster 1744-1818*. Paris 1970

Minkowski 1960
H Minkowski, *Aus dem Nebel der Vergangenheit steigt der Turm zur Babel*. Berlin 1960

Minneapolis Bull
The Bulletin of the Minneapolis Institute of Arts. Minneapolis

Miscellanea Bibl Hertz
Miscellanea Bibliotecae Hertzianae zu Ehren von Leo Bruhns, Franz Wolff Metternich, Ludwig Schudt. Munich 1961

Miscellanea van Puyvelde
Miscellanea Leo van Puyvelde. Brussels 1949

Miscellanea van Regteren Altena
Miscellanea J Q van Regteren Altena 16 V 1969. Amsterdam 1969

Mitchell 1968
P Mitchell, *Jan van Os 1744-1808*. Leigh-on-Sea 1968

Mitchell 1973
P Mitchell, *European flower painters*. London 1973

Mitt Kunsth Inst Florenz
Mitteilungen des Kunsthistorischen Instituts in Florenz. Berlin

Mitt und Ber D D R
Mitteilungen und Berichte der Kunstmuseen der Deutschen Demokratischen Republik. Leipzig

Mndbl Amstelodamum
Amstelodamum: Maandblad voor de Kennis van Amsterdam, Orgaan van het Genootschap Amstelodamum. Amsterdam

Mndbl B K
Maandblad voor Beeldende Kunsten. Amsterdam

Mndbl Oud Utrecht
Maandblad van 'Oud Utrecht' Vereniging tot Beoefening en Verspreiding van de Kennis der Geschiedenis van de Stad en de Provincie Utrecht. Utrecht

Moes 1897-1905
E W Moes, *Iconographia Batava: beredeneerde lijst van geschilderde en gebeeldhouwde portretten van Noord Nederlanders in vorige eeuwen*. Amsterdam 1897-1905

Moes 1909
E W Moes, *Frans Hals, sa vie et son œuvre*. Brussels 1909

Moes & van Biema 1909
E W Moes & E van Biema, *De Nationale Konstgallerij en het Koninklijk Museum: bijdrage tot de geschiedenis van het Rijksmuseum*. Amsterdam 1909

Moir 1967
A Moir, *The Italian followers of Caravaggio*. Cambridge, Massachusetts 1967

Mollema 1935
J C Mollema, *Eerste schipvaart der Hollanders naar Oost-Indië*. The Hague 1935

Mollema 1939-42
J C Mollema, *Geschiedenis van Nederland ter zee*. Amsterdam 1939-42

Molmenti 1909
P Molmenti, *Giovanni Battista Tiepolo*. Milan 1909

von Moltke 1965
J von Moltke, *Govert Flinck*. Amsterdam 1965
Mon f Kunstw
Monatshefte für Kunstwissenschaft. Leipzig
Morassi 1942
A Morassi, *Giorgione*. Milan 1942
Morassi 1962
A Morassi, *A complete catalogue of the paintings of G B Tiepolo including pictures by his pupils and followers wrongly attributed to him*. London 1962
Morassi 1973
A Morassi, *Guardi (Antonio e Francesco Guardi)*. Venice 1973
Moschini 1943
V Moschini, *Giambellino*. Bergamo 1943
Moschini 1956
V Moschini, *Pietro Longhi*. Milan 1956
Müller 1956
W J Müller, *Der Maler Georg Flegel und die Anfänge des Stillebens*. Frankfurt am Main 1956
Müller 1966
Th Müller, *Sculpture in the Netherlands, Germany, France and Spain 1400-1500*. Harmondsworth 1966
Münchn Jb
Münchner Jahrbuch der Bildenden Kunst. Munich
Muller 1853
F Muller, *Beschrijvende catalogus van 7000 portretten van Nederlanders*. Amsterdam 1853
F Muller
F Muller, *De Nederlandsche geschiedenis in platen*. Amsterdam 1863-1882
Muñoz 1911
A Muñoz, *Pièces de choix de la collection du comte Grégoire Stroganoff*. Rome 1911
Musées de France
Musées de France. Paris
Museum
Museum: a Quarterly Review. Paris
Museum Stud
Museum Studies: The Art Institute of Chicago. Chicago
Muther 1912
R Muther, *Geschichte der Malerei*. Berlin 1912
Muther 1922
4th edition of Muther 1912

Naber 1908
J W A Naber, *Prinses Wilhelmina, gemalin van Willem V, Prins van Oranje*. Amsterdam 1908
Nap Stud
Publicaties van het Genootschap voor Napoleontische Studiën. The Hague
Navorscher
De Navorscher: een Middel tot Gedachtenwisseling. Amsterdam
N Beitr Rembrandt Forsch 1973
Neue Beiträge zur Rembrandt Forschung. Berlin 1973
Ned Archief
Nederlandsch Archief voor Genealogie en Heraldiek. Amersfoort
Nederl Orgelpracht
Nederlandse orgelpracht: catalogus van een tentoonstelling in de Vleeshal te Haarlem, 3-30 juli 1961
Nederl Tijdschr Geneesk
Nederlands Tijdschrift voor Geneeskunde. Amsterdam
Ned Indië
Nederlandsch Indië Oud en Nieuw: Maandblad Gewijd aan Bouwkunst, Archaeologie, Land- en Volkenkunde… Amsterdam & The Hague
Ned Kunstbode
Nederlandsche Kunstbode tot Opwekking, Aankweking en Veredeling van den Nederlandschen Kunstsmaak en Schoonheidszin. Haarlem

Ned Leeuw
De Nederlandsche Leeuw: Maandblad van het Koninklijk Nederlandsch Genootschap voor Geslachts- en Wapenkunde. The Hague
Ned Post
Nederlandse Post: Maandblad voor Zuid-Afrika. Pretoria
Ned Spec
Nederlandsche Spectator. Arnhem, Rotterdam & The Hague
Nicolson 1958
B Nicolson, *Hendrick Terbrugghen*. The Hague 1958
Niemeijer 1968
J W Niemeijer, *Egbert van Drielst: 'De Drentse Hobbema.'* Assen 1968
Niemeijer 1973
J W Niemeijer, *Cornelis Troost 1696-1750*. Assen 1973
Nieuwbarn 1904
M C Nieuwbarn, *Sint Dominicus in de kunst*. Nijmegen 1904
Nieuwsbull K N O B
same as Bull N O B
Nikolenko 1966
L Nikolenko, *Francesco Ubertino called Il Bacchiacca*. New York 1966
N K J
Nederlands Kunsthistorisch Jaarboek. The Hague
Noach 1937
A Noach, *Het materiaal tot de geschiedenis der Oude Kerk te Amsterdam*. Amsterdam 1937
Noach 1939
A Noach, *De Oude Kerk te Amsterdam: biografie van een gebouw*. Amsterdam 1939
il Noncello
Il Noncello. Pordenone
Notes and Queries
Notes and Queries. London
Novotny 1970
F Novotny, *Painting and sculpture in Europe 1780-1880*. Harmondsworth 1970
Nübel 1972
O Nübel, *Pompejus Occo (1483 bis 1537): Fuggerfaktor in Amsterdam*. Tübingen 1972
Numaga
Numaga: Tijdschrift Gewijd aan Heden en Verleden van Nijmegen en Omgeving. Nijmegen
Nuova Ant
Nuova Antologia di Lettere, Scienze ed Arti. Rome
Nuyens 1865-70
W J F Nuyens, *Geschiedenis der Nederlandsche beroerten in de 16de eeuw*. Amsterdam 1865-70

Oberhuber 1958
K Oberhuber, *Die stilistische Entwicklung im Werk Bartholomäus Sprangers*. Vienna 1958
Obreen 1887
Fr D O Obreen, *Wegwijzer door 's Rijks Museum te Amsterdam*. Schiedam 1887
Obreen 1903
Fr D O Obreen, *Het geslacht van Wassenaer-Obdam*. n p 1903
Obreen's Archief
Archief voor Nederlandsche kunstgeschiedenis: verzameling van meerendeels onuitgegeven berichten en mededeelingen betreffende Nederlandsche schilders, plaatsnijders etc bijeengebracht door Fr D O Obreen. Rotterdam 1877-90
l'Oeil
L'Oeil: Revue d'Art Mensuelle. Paris
Oertel 1907
R Oertel, *Francisco de Goya*. Bielefeld 1907

O H
Oud Holland: Tweemaandelijks Nederlands Kunsthistorisch Tijdschrift. Amsterdam
O K
Openbaar Kunstbezit: Stichting voor Esthetische Vorming door Middel van de Radio, in Woord en Beeld. Amsterdam
O Ktv
Openbaar Kunstbezit: Televisie-cursus
Oldenbourg 1911
R Oldenbourg, *Thomas de Keysers Tätigkeit als Maler: ein Betrag zur Geschichte des holländischen Porträts*. Leipzig 1911
Oldenbourg 1921
R Oldenbourg, *P P Rubens: des Meisters Gemälde*. Stuttgart & Berlin (Klassiker der Kunst) 1921
Oldenbourg 1922
Peter Paul Rubens: Sammlung der von Rudolf Oldenburg veröffentlichten oder zur Veröffentlichung vorbereiteten Abhandlungen über den Meister. Munich & Berlin 1922
Oldewelt 1942
W F H Oldewelt, *Amsterdamse archiefvondsten*. Amsterdam 1942
Onghena 1959
M J Onghena, *De iconografie van Philips de Schone*. Brussels 1959
Ons Amsterdam
Ons Amsterdam: Maandblad van de Gemeentelijke Commissie Heemkennis. Amsterdam
Onze Eeuw
Onze Eeuw: Maandschrift voor Staatkunde, Letteren, Wetenschap en Kunst. Haarlem
Onze Kunst
Onze Kunst: Geïllustreerd Maandschrift voor Beeldende en Decoratieve Kunsten. Antwerp & Amsterdam
Op de Hoogte
Op de Hoogte: Geïllustreerd Maandschrift. Haarlem & Amsterdam
Op den Uitkijk
Op den Uitkijk: Christelijk Cultureel Maandblad. Wageningen
Opmerker
De Opmerker: Orgaan van het Genootschap Architectura et Amicitia, Weekblad voor Beeldende Kunst en Technische Wetenschap. Arnhem
Opstellen van de Waal
Opstellen voor H van de Waal. Amsterdam & Leiden 1970
Orlandi 1964
S Orlandi, *Beato Angelico: monografia storica della vita e delle opere con un' appendice di nuovi documenti inediti*. Florence 1964
Ortellani 1948
S Ortellani, *Il Pollaiuolo*. Milan 1948
van Os 1969
H W van Os, *Marias Demut und Verherrlichung in der Sienesischen Malerei 1300-1450*. The Hague 1969
van Os & Prakken 1974
H W van Os & M Prakken, *The Florentine paintings in Holland, 1300-1500*. Maarssen 1974
Osmond 1927
P H Osmond, *Paolo Veronese: his career and work*. London 1927
von der Osten & Vey 1969
G von der Osten & H Vey, *Painting and sculpture in Germany and The Netherlands 1500-1600*. Harmondsworth 1969
Ottani Cavina 1968
A Ottani Cavina, *Carlo Saraceni*. Milan 1968

Oudaen 1659
J Oudaen, *Bloemkrans van verscheyde gedichten.*
Amsterdam 1659

Oude Kunst
Oude Kunst: een Maandschrift voor Verzamelaars en Kunstzinnigen. Haarlem

Oud en Nieuw
Oud en Nieuw op het Gebied van Kunst en Kunst-nijverheid in Holland en België. Amsterdam

Oudh Jb
Oudheidkundig Jaarboek: 3e serie van het Bulletin van de Nederlandschen Oudheidkundigen Bond. Utrecht

Oudh Kring Antw
Jaarboek(je) van de Oudheidkundige Kring van Antwerpen. Antwerp

Oud Nederland
Oud Nederland: Tijdschrift Gewijd aan Volkscultuur en Oude Ambachtskunst. Leiden

Overvoorde & Martin 1902
J C Overvoorde & W Martin, *Stedelijk Museum te Leiden.* Leiden 1902

Ozinga 1929
M D Ozinga, *De protestantse kerkenbouw in Nederland van Hervorming tot Franschen tijd.* Amsterdam 1929

Ozinga 1940
M D Ozinga, *De Nederlandse monumenten van geschiedenis en kunst, vol 6 : de provincie Groningen.* Utrecht & The Hague 1940

Pallas Leid
Pallas Leidensis MCMXXV. Leiden 1925

Pallucchini 1943
R Pallucchini, *I disegni del Guardi al Museo Correr di Venezia.* Venice 1943

Pallucchini 1944
R Pallucchini, *La pittura veneziana del cinquecento.* Novara 1944

Pallucchini 1950
R Pallucchini, *La giovinezza del Tintoretto.* Milan 1950

Pallucchini 1959
R Pallucchini, *Giovanni Bellini.* Milan 1959

Pallucchini 1960
R Pallucchini, *La pittura veneziana del settecento.* Venice 1960

Pallucchini 1962
R Pallucchini, *I Vivarini (Antonio, Bartolomeo, Alvise).* Venice 1962

Pallucchini 1962
R Pallucchini, *Palladio, Veronese e Vittoria a Maser.* Milan 1962

Pallucchini 1968
A Pallucchini, *Giambattista Tiepolo.* Milan 1968

Panofsky 1953
E Panofsky, *Early Netherlandish painting : its origin and character.* Cambridge, Massachusetts 1953

Pantheon
Pantheon: Monatsschrift für Freunde und Sammler der Kunst. Munich

de Pantorba 1955
B de Pantorba, *La vida y la obra de Velazquez : estudio biografico y critico.* Madrid 1955

Paragone
Paragone: Rivista di Arte Figurativa e Letteratura. Florence

Pariset 1948
F G Pariset, *Georges de La Tour.* Paris 1948

Parthey 1863-64
G Parthey, *Deutscher Bildersaal: Verzeichnis der in Deutschland vorhandenen Ölbilder verstorbener Maler aller Schulen.* Berlin 1863-64

Peintre
Le Peintre: l'Officiel des Peintres et Graveurs. Paris

Pennell 1908
E R & J Pennell, *The life of James McNeill Whistler.* London & Philadelphia 1908

Pennell 1911
5th edition of Pennell 1908

Pennell 1921
E R Pennell, *The Whistler journal.* Philadelphia 1921

Percival 1969
V Percival, *The Duke of Wellington, a pictorial survey of his life (1769-1852).* London 1969

della Pergola 1955
P della Pergola, *Giorgione.* Milan 1955

Perocco 1960
G Perocco, *Tutta la pittura del Carpaccio.* Milan 1960

Philip 1971
L Brand Philip, *The Ghent altarpiece and the art of Jan van Eyck.* Princeton 1971

Philippot 1956
P Philippot, *Le maniérisme et l'art du portrait dans les Pays Bas.* Brussels 1956 (typescript)

Philips 1896
C Philips, *The picture gallery of Charles I.* London 1896

Phoenix
Phoenix: Maandblad voor Beeldende Kunsten. Amsterdam & Antwerp

Pierron 1912
S Pierron, *Les Mostaerts : Jean Mostaert, dit le Maître d'Oultremont, Gilles et François Mostaert, Michel Mostaert.* Brussels 1912

Pigler 1956
A Pigler, *Barockthemen.* Budapest & Berlin 1956

Pignatti 1955
T Pignatti, *Giorgione.* Milan 1955

Pignatti 1968
T Pignatti, *Pietro Longhi.* Venice 1968

Pignatti 1971
T Pignatti, *Giorgione.* London 1971

Pinacotheca
Pinacotheca: Studi di Storia dell' Arte. Rome

Pirovano 1973
C Pirovano, *La pittura in Lombardia.* Milan 1973

Pittaluga 1925
M Pittaluga, *Il Tintoretto.* Bologna 1925

Plasschaert 1920
A Plasschaert, *Jacob Maris.* Arnhem 1920

Plasschaert 1924
A Plasschaert, *Jozef Israëls.* Amsterdam 1924

Plietzsch 1910
E Plietzsch, *Die Frankenthaler Maler : ein Beitrag zur Entwicklungsgeschichte der niederländischen Landschaftsmalerei.* Leipzig 1910

Plietzsch 1911
E Plietzsch, *Vermeer van Delft.* Leipzig 1911

Plietzsch 1939
E Plietzsch, *Vermeer van Delft.* Leipzig 1939

Plietzsch 1944
E Plietzsch, *Gerard ter Borch.* Vienna 1944

Plietzsch 1960
E Plietzsch, *Holländische und Flämische Maler des XVII. Jahrhunderts.* Leipzig 1960

Pochat 1973
G Pochat, *Figur und Landschaft.* Berlin 1973

Pols 1942
A M Pols, *De Ruckers en de klavierbouw in Vlaanderen.* Antwerp 1942

Pols 1966
I V Pols, *G H Breitner.* Amsterdam 1966

Pol Wirtsch Kultur
Internationale Politik, Wirtschaft, Recht, Wissenschaft, Kultur. Belgrad

Ponsonailhe 1883
Ch Ponsonailhe, *Sébastien Bourdon : sa vie et son œuvre d'après des documents.* Paris 1883

Pont 1958
D Pont, *Barent Fabritius 1624-1673.* The Hague 1958

Pope-Hennessy 1952
J Pope-Hennessy, *Fra Angelico.* London 1952

Pope-Hennessy 1966
J Pope-Hennessy, *The portrait in the Renaissance.* London & New York 1966

Pospisil 1944
M Pospisil, *Magnasco.* Florence 1944

Posthumus Meyjes 1957
N Posthumus Meyjes, *Karakter en schoonheid van de Noordnederlandse schilderkunst in de zeventiende eeuw.* Amsterdam 1957

Pott 1962
P H Pott, *Naar wijder horizon : kaleidoscoop op ons beeld van de buitenwereld.* The Hague 1962

Praz 1971
M Praz, *Conversation pieces.* London 1971

Preibisz 1911
L Preibisz, *Martin van Heemskerck : ein Beitrag zur Geschichte des Romanismus in der Niederländischen Malerei des XVI. Jahrhunderts.* Leipzig 1911

Preston 1937
L Preston, *Sea and river painters of the Netherlands in the 17th century.* London 1937

Pronk-stukken
Pronk-stukken : Mededelingenblad van de Stichting Familiearchief Pronk. n p

Proporzioni
Proporzioni : Studi di Storia dell' Arte. Florence

di Provvido 1972
S di Provvido, *La pittura di Vittore Crivelli.* Teramo 1972

Pucci 1955
E Pucci, *Botticelli.* Milan 1955

Puppi 1962
L Puppi, *Bartolomeo Montagna.* Venice 1962

van Puyvelde 1912
L van Puyvelde, *Schilderkunst en tooneelvertooningen op het einde van de middeleeuwen.* Ghent 1912

van Puyvelde 1940
L van Puyvelde, *Les esquisses de Rubens.* Basel 1940

van Puyvelde 1947
L van Puyvelde, *The sketches of Rubens.* London 1947

van Puyvelde 1950
L van Puyvelde, *Van Dijck.* Amsterdam & Paris 1950

van Puyvelde 1952
L van Puyvelde, *Rubens.* Paris & Brussels 1952

van Puyvelde 1953
L van Puyvelde, *Jordaens.* Paris & Brussels 1953

van Puyvelde 1962
L van Puyvelde, *La peinture flamande au siècle de Bosch et Breughel.* Paris 1962

Q Rev Montreal Mus
A Quarterly Review of the Montreal Museum of Fine Arts. Montreal

Raczynski 1937
J A Raczynski, *Die flämische Landschaft vor Rubens : Beiträge zur Entwicklungsgeschichte der flämischen Landschaftmalerei in der Zeit von Brueghel bis zu Rubens.* Frankfurt am Main 1937

Raggi
Raggi : Zeitschrift für [italienische] *Kunstgeschichte und Archäologie.* Basel
Ramaer 1859
E H Ramaer, *Een merkwaardige schilderij aangaande C de Witt : nieuwe bijdrage tot de vaderlandsche geschiedenis.* Arnhem 1859
Rapp 1951
B Rapp, *Djur och stilleben i Karolinskt måleri.* Stockholm 1951
Rass d'Arte
Rassegna d'Arte. Milan
Réau 1956
L Réau, *Elie le prophète.* Bruges 1956
Réau 1958
L Réau, *Iconographie de l'art chrétien*, vol 3 : *iconographie des saints.* Paris 1958
Record Princeton
Record of the Art Museum of Princeton University. Princeton
RDK 1934-
Reallexikon zur Deutschen Kunstgeschichte. Stuttgart 1934-
Reesse 1908
J J Reesse, *De suikerhandel van Amsterdam : een bijdrage tot de handelsgeschiedenis des vaderlands*, vol 1. Haarlem & The Hague 1908
dalli Regoli 1966
G dalli Regoli, *Lorenzo di Credi.* Pisa 1966
van Regteren Altena 1936
J Q van Regteren Altena, *The drawings of Jacques de Gheyn*, vol 1. Amsterdam 1936
Rehorst 1939
A J Rehorst, *Torrentius.* Rotterdam 1939
Reinach 1905-23
S Reinach, *Répertoire des peintures du moyen âge et de la renaissance 1280-1580.* Paris 1905-23
Reisel 1967
J H Reisel, *Isaac Israëls.* Amsterdam 1967
Renaissance
La Renaissance : Chronique des Arts et de la Littérature. Brussels
Renger 1970
K Renger, *Lockere Gesellschaft : zur Ikonographie des Verlorenen Sohnes und von Wirtshausszenen in der niederländischen Malerei.* Berlin 1970
Rep f Kunstw
Repertorium für Kunstwissenschaft. Stuttgart, Vienna & Berlin
Rev Art anc & mod
Revue de l'Art Ancien et Moderne. Paris
Rev Esp de Arte
Revista Española de Arte : Publicacion de la Sociedad Española de Amigos del Arte. Madrid
Rev histoire pharm
Revue d'Histoire de la Pharmacie. Paris
Rev Inst Bras
Revista do Instituto Histórico e Geográfico Brasileiro. Rio de Janeiro
Revue belge d'Arch & d'hist de l'art
Revue Belge d'Archéologie et d'Histoire de l'Art Publié par l'Académie Royale de Belgique. Brussels & Paris
Revue belge numismatique
Revue Belge de Numismatique et de Sigillographie. Brussels
Revue de l'art
Revue de l'Art. Paris
Revue des arts
La Revue des Arts : Revue des Arts et des Musées. Paris
Revue du Louvre
La Revue du Louvre et des Musées de France. Paris

Revue litt comp Paris
Revue de Littérature Comparée. Paris
Reynolds 1781
J Reynolds, *Journey to Flanders and Holland 1781,* in : *The literary works.* London 1819
Reynolds 1931
E J Reynolds, *Some Brouwer problems.* Lausanne 1931
Reynolds 1952
G Reynolds, *English portrait miniatures.* London 1952
Reznicek 1961
E K J Reznicek, *Die Zeichnungen von Hendrick Goltzius.* Utrecht 1961
Richter 1889
J P Richter, *Catalogue of the Northbrook collection.* London 1889
Richter 1937
G M Richter, *Giorgio da Castelfranco.* Chicago 1937
de Ridder 1914
A de Ridder, *Pieter de Hoogh.* Brussels 1914
Ridolfi 1648 (ed 1924)
C Ridolfi, *La maraviglie dell' arte ovvero le vite degli illustri pittori veneti et dello stato 1648*, edited by D von Hadeln. Berlin 1914-24
Ried 1931
Fr Ried, *Das Selbstbildnis.* Berlin 1931
Riegl 1931
A Riegl, *Das holländische Gruppenporträt.* Vienna 1913
Ring 1913
G Ring, *Beiträge zur Geschichte niederländischer Bildnismalerei im 15. und 16. Jahrhundert.* Leipzig 1913
Ring 1949
G Ring, *A century of French painting 1400-1500.* London 1949
Ritz 1973
G M Ritz, *Hinterglasmalerei.* Munich 1973
Robaut 1965-66
A Robaut, *L'œuvre de Corot : catalogue raisonné et illustré.* Paris 1965-66
Röthlisberger 1961
M Röthlisberger, *Claude Lorrain : the paintings.* New Haven 1961
Röthlisberger-Bianco 1970
M Röthlisberger-Bianco, *Cavalier Pietro Tempesta and his time.* Newark, Delaware 1970
Roger-Marx 1960
Cl Roger Marx, *Rembrandt.* Paris 1960
Rogers 1970
P G Rogers, *The Dutch in the Medway.* London 1970
Rogge 1874-76
H C Rogge, *Johannes Wtenbogaert en zijn tijd.* Amsterdam 1874-76
Roh 1921
F Roh, *Holländische Malerei.* Jena 1921
Roli 1966
R Roli, *Il classicismo.* Milan (I maestri del colore) 1966
Rooses 1886-92
M Rooses, *L'œuvre de P P Rubens : histoire et description de ses tableaux.* Antwerp 1886-92
Rooses 1906
M Rooses, *Jordaens' leven en werken.* Amsterdam & Antwerp 1906
Rosenbaum 1928
H Rosenbaum, *Der junge van Dijck 1615-1621.* Munich 1928
Rosenberg 1897
A Rosenberg, *Ter Borch en Jan Steen.* Bielefeld & Leipzig 1897

Rosenberg 1904
A Rosenberg, *Rembrandt : des Meisters Gemälde.* Stuttgart & Leipzig (Klassiker der Kunst) 1904
Rosenberg 1906
J Rosenberg, *Rembrandt : des Meisters Gemälde.* Stuttgart & Leipzig (Klassiker der Kunst) 1906
Rosenberg 1928
J Rosenberg, *Jacob van Ruisdael.* Berlin 1928
Rosenberg 1948
J Rosenberg, *Rembrandt.* Cambridge 1948
Rosenberg 1964
2d edition of Rosenberg 1948
Rosenberg 1967
J Rosenberg, *On quality in art : criteria of excellence, past and present.* Princeton (Bollingen Series) 1967
Rosenberg, Slive & ter Kuile 1966
J Rosenberg, S Slive & E H ter Kuile, *Dutch art and architecture 1600-1800.* Harmondsworth 1966
Rossi 1974
P Rossi, *Jacopo Tintoretto : i ritratti.* Venice 1974
Rotterdamsch Jb
Rotterdamsch Jaarboekje. Rotterdam
Rouchès 1958
G Rouchès, *La peinture espagnole des origines au 20e siècle.* Paris 1958
Roy 1972
R Roy, *Studien zur Gerbrand van den Eeckhout.* Vienna 1972 (typescript)
Rushforth 1900
G McNeill Rushforth, *Carlo Crivelli.* London 1900
Russoli 1934
F Russoli, *The Berenson collection.* Milan 1934
van Rijckevorsel 1932
J van Rijckevorsel, *Rembrandt en de traditie.* Rotterdam 1932

Sack 1910
E Sack, *Giambattista und Domenico Tiepolo : ihr Leben und ihre Werke.* Hamburg 1910
Salmi 1953
M Salmi, *Luca Signorelli.* Novara 1953
Salmi 1958
M Salmi, *Il Beato Angelico.* Spoleto 1958
Salvini 1965
R Salvini, *All the paintings of Botticelli.* Milan 1965
Sanchez Canton 1930
F J Sanchez Canton, *Goya.* Paris 1930
von Sandrart 1683
J von Sandrart, *Academia nobilissima artis pictoriae.* Nürnberg 1683
Sanminiatelli 1967
D Sanminiatelli, *Domenico Beccafumi.* Milan 1967
Schaar 1958
E Schaar, *Studien zu Nicolaas Berchem.* Cologne 1958
Schäfer 1912
K Schäfer, *Führer durch die Grossherzogliche Gemäldegalerie zu Oldenburg.* Oldenburg 1912
Schaeffer 1904
E Schaeffer, *Das Florentiner Bildnis.* Munich 1904
Schaeffer 1905
E Schaeffer, *Botticelli.* Berlin 1905
Schaep 1653
G Schaep, *Beschrijving van de schilderijen in de drie Doelens te Amsterdam*, in : Scheltema 1855-85
Scharf 1935
A Scharf, *Filippino Lippi.* Vienna 1935
Schatborn & Szénássy 1971
P Schatborn & I L Szénássy, *Iconographie du notariat.* Groningen & Haarlem 1971
Scheen 1946
P A Scheen, *Honderd jaren Nederlandsche schilder- en teekenkunst.* The Hague 1946

Scheen 1969-70
P A Scheen, *Lexikon der Nederlandse beeldende kunstenaars 1750-1950*. The Hague 1969-70

Scheffer 1879
J H Scheffer, *Genealogie van het geslacht Steyn*. Rotterdam 1879

Scheffer & Obreen 1880
J H Scheffer & Fr D O Obreen, *Rotterdamsche Historiebladen*, deel 3:1. Rotterdam 1880

Scheffler 1916
K Scheffler, *Bildnisse aus drei Jahrhundert er deutschen und niederländischen Malerei*. Köningstein im Taunus 1916

Scheltema 1817
J Scheltema, *Rusland en de Nederlanden beschouwd in derzelver wederkeerige betrekkingen*, deel 1. Amsterdam 1817

Scheltema 1853
P Scheltema, *Rembrand : redevoering over het leven en de verdiensten van Rembrand van Rijn*. Amsterdam 1853

Scheltema 1855-85
P Scheltema, *Aemstel's oudheid, of gedenk-waardigheden van Amsterdam*. Amsterdam 1855-85

Scheltema 1864
P Scheltema, *Aanwijzing der schilderijen, oudheden, modellen enz zich bevindende op het Raadhuis der stad Amsterdam*. Amsterdam 1864

Scheltema 1879
P Scheltema, *Historische beschrijving der schilderijen van het stadhuis te Amsterdam*. Amsterdam 1879

van Schendel 1939
A van Schendel, *Breitner*. Amsterdam 1939

van Schendel 1948
A van Schendel, *Oog in oog met meesterwerken der Hollandse schilderkunst*. Amsterdam 1948

Scherjon 1928
W Scherjon, *Floris Verster 9 juni 1861-21 januari 1927*. Utrecht 1928

Scheurleer 1912
D F Scheurleer, *Onze mannen ter zee in dicht en beeld*, deel 1. The Hague 1912

Schidlof 1964
L R Schidlof, *The miniature in Europe in the 16th, 17th, 18th and 19th centuries*. Graz 1964

Schmidt 1873
W Schmidt, *Das Leben des Malers Adriaen Brouwer : kritische Beleuchtung der über ihn verbreiteten Sagen*. Leipzig 1873

Schmidt 1922
H Schmidt, *Jürgen Ovens : sein Leben und seine Werke*. Kiel 1922

Schmidt-Degener 1928
F Schmidt-Degener, *Rembrandt und die holländische Barock*. Leipzig & Berlin 1928

Schmidt-Degener 1942
F Schmidt-Degener, *Compositieproblemen in verband met Rembrandt's schuttersoptocht*. Amsterdam 1942

Schmidt-Degener 1949
F Schmidt-Degener, *Het blijvende beeld der Hollandse kunst*. Amsterdam 1949

Schmidt-Degener & van Gelder 1927
F Schmidt-Degener & H E van Gelder, *Veertig meesterwerken van Jan Steen*. Amsterdam 1927

Schneider 1932
H Schneider, *Jan Lievens : sein Leben und seine Werke*. Haarlem 1932

von Schneider 1933
A von Schneider, *Caravaggio und die Niederländer*, Marburg 1933

Schneider & Ekkart 1973
2d edition of Schneider 1932, revised by R E O Ekkart. Amsterdam 1973

Schönberger & Soehner 1959
A Schönberger & H Soehner, *Die Welt des Rokoko : Kunst und Kultur des 18. Jahrhunderts*. Munich 1959

Schottmüller 1924
F Schottmüller, *Fra Angelico da Fiesole : des Meisters Gemälde*. Stuttgart & Leipzig (Klassiker der Kunst) 1924

Schubert 1970
D Schubert, *Die Gemälde des Braunschweiger Monogrammisten*. Cologne 1970

Schubring 1915
P Schubring, *Cassoni : Truhen und Truhenbilder der italienischen Frührenaissance*. Leipzig 1915

Schuurman 1947
K E Schuurman, *Carel Fabritius*. Amsterdam 1947

Schweicher 1954
C Schweicher, *Daumier*. London 1954

Scriptorium
Scriptorium : Revue Internationale des Études Relatives aux Manuscrits. Antwerp

Second Dutch War 1967
The Second Dutch War (De Tweede Engelse Oorlog) 1665-1667. London (National Maritime Museum) 1967

Segard 1923
A Segard, *Jan Gossaert dit Mabuse*. Brussels & Paris 1923

Seguier 1870
F P Seguier, *A critical and commercial dictionary of the works of painters*. London 1870

Serra 1934
L Serra, *L'arte nelle Marche : il periodo del Rinascimento*. Rome 1934

Sérullaz 1963
M Sérullaz, *Mémorial de l'exposition Eugène Delacroix*. Paris 1963

Shorr 1954
D C Shorr, *The Christ child in devotional images*. New York 1954

von Sick 1930
I von Sick, *Nicolaes Berchem : ein Vorläufer des Rokoko*. Berlin 1930

Sievers 1908
J Sievers, *Pieter Aertsen*. Leipzig 1908

Simiolus
Simiolus : Kunsthistorisch Tijdschrift. Utrecht; later on *Simiolus : Netherlands Quarterly for the History of Art*. Bussum & Maarssen

Simon 1930
K E Simon, *Jacob van Ruisdael : eine Darstellung seiner Entwicklung*. Berlin-Lankwitz 1930

Simons 1974
C H F Simons, *Marine-justitie : ontwikkelingen in de strafrechtpleging bij de Nederlandse zeemacht gedurende de tweede helft van de 18de en het begin van de 19de eeuw*. Assen 1974

Sinibaldi 1933
G Sinibaldi, *I Lorenzetti*. Siena 1933

Sirèn 1905
O Sirèn, *Don Lorenzo Monaco*. Strasbourg 1905

Sirèn 1914
O Sirèn, *Nicodemus Tessin D Y : S Studieresor*. Stockholm 1914

Sitzungsberichte Berlin
Sitzungsberichte der Kunstgeschichtlichen Gesellschaft Berlin. Berlin

Sjöblom 1928
A Sjöblom, *Die koloristische Entwicklung in der niederländischen Malerei des 15. und 16. Jahrhunderts*. Berlin 1928

Slatkes 1963
L J Slatkes, *Dirck van Baburen (c 1595-1624) : a Dutch painter in Utrecht and Rome*. Utrecht 1963

Slive 1953
S Slive, *Rembrandt and his critics 1630-1730*. The Hague 1953

Slive 1970-74
S Slive, *Frans Hals*. London 1970-74

Smit 1938
J P W A Smit, *De legervlaggen uit de aanvang van de 80-jarige oorlog*. Assen 1938

Smith 1829-42
J Smith, *A catalogue raisonné of the works of the most eminent Dutch, Flemish and French painters*. London 1829-42

Smits 1933
K Smits, *De iconografie van de Nederlandse primitieven*. Amsterdam 1933

Snowman 1966
A K Snowman, *Eighteenth century gold boxes of Europe*. London 1966

van Someren 1888-91
J F van Someren, *Beschrijvende catalogus van gegraveerde portretten van Nederlanders*. Amsterdam 1888-91

van Someren n d
J F van Someren, *Oude Kunst in Nederland*. Amsterdam n d, with etchings by W Steelink

Son Spec
Sonorum Speculum : Mirror of Musical Life in Holland. Amsterdam

de Sousa-Leao 1937
J de Sousa-Leao, *Frans Post : sus quadros brasileiros*. Rio de Janeiro 1937

de Sousa-Leao 1948
J de Sousa-Leao, *Frans Post*. Rio de Janeiro 1948

de Sousa-Leao 1973
J de Sousa-Leao, *Frans Post 1612-1680*. Amsterdam 1973

Speth-Holterhoff 1957
S Speth-Holterhoff, *Les peintres flamands de cabinets d'amateurs au XVII-ième siècle*. Brussels 1957

Spiegel der Hist
Spiegel der Historie : Maandblad voor de Geschiedenis der Nederlanden. Zaltbommel

Spiegel Hist
Spiegel Historiael : Maandblad voor Geschiedenis en archeologie. Bussum

Städ Jb
Städel-Jahrbuch. Frankfurt am Main

Stange 1955
A Stange, *Deutsche Malerei der Gotik*, vol 7: *Oberrhein, Bodensee, Schweiz und Mittelrhein in der Zeit von 1450 bis 1500*. Berlin 1955

Stange 1960
A Stange, *Deutsche Malerei der Gotik*, vol 10: *Salzburg, Bayern und Tirol in der Zeit von 1400 bis 1500*. Munich & Berlin 1960

Stapel 1936
F W Stapel, *Cornelis Jansz Speelman 1628-1684*. The Hague 1936

Stapel 1938-40
F W Stapel, *Geschiedenis van Nederlandsch-Indië*. Amsterdam 1938-40

Stapel 1941
F W Stapel, *De Gouverneurs-generaal van Nederlandsch-Indië in beeld en woord*. The Hague 1941

Staring 1947
A Staring, *Fransche kunstenaars en hun Hollandsche modellen in de 18de en in de aanvang der 19de eeuw*. The Hague 1947

Staring 1948
A Staring, *Kunsthistorische verkenningen : een bundel kunsthistorische opstellen*. The Hague 1948

Staring 1951
A Staring, *De portretten van den Koning-Stadhouder.* The Hague 1951
Staring 1956
A Staring, *De Hollanders thuis: gezelschapstukken uit 3 eeuwen.* The Hague 1956
Staring 1958
A Staring, *Jacob de Wit 1695-1754.* Amsterdam 1958
Starye Gody
Starye Gody. Leningrad
Stechow 1938
W Stechow, *Salomon van Ruysdael: eine Einführung in seine Kunst.* Berlin 1938
Stechow 1966
W Stechow, *Dutch landscape painting of the 17th century.* London 1966
Stechow 1968
2d edition of Stechow 1966
Steenhoff 1908
W Steenhoff, *Album des Amsterdamer Rijksmuseums.* Leipzig 1908
Steenhoff 1920
W J Steenhoff, *Nederlandsche schilderkunst in het Rijksmuseum,* vol 3. Amsterdam 1920
Steinbart 1922
K Steinbart, *Die Tafelgemälde des Jakob Cornelisz van Amsterdam.* Strasbourg 1922
Steinmann 1925
E Steinmann, *Botticelli.* Leipzig 1925
Steland-Stief 1962-63
A C Steland-Stief, *Jan Asselijn.* Freiburg im Breisgau 1962-63
Steland-Stief 1971
A C Steland-Stief, *Jan Asselijn, nach 1610 bis 1652.* Amsterdam 1971
Steneberg 1955
K E Steneberg, *Kristinatidens Måleri.* Malmö 1955
Sterck 1923
J F M Sterck, *Valsche portretten van Vondel,* in: *Hoofdstukken over Vondel en zijn kring.* Amsterdam 1923
Sterck 1927-37
J F M Sterck et al, *De werken van Vondel.* Amsterdam 1927-37
Sterck 1928
J F M Sterck, *Van rederijkerskamer tot Muiderkring.* Amsterdam 1928
Sterling 1941
Ch Sterling, *Peintres du moyen âge.* Paris 1941
Sterling 1942
Ch Sterling, *La peinture française: les peintres du moyen âge.* Paris 1942
Stokes 1914
H Stokes, *Francisco Goya.* London 1914
Stoll 1923
A Stoll, *Der Maler Joh Friedrich August Tischbein und seine Familie: ein Lebensbild nach den Aufzeichnungen seiner Tochter Caroline.* Stuttgart 1923
Storia di Napoli
Storia di Napoli, vol 5. Naples 1972
Strömbom 1943
S Strömbom, *Svenska Kungliga porträtt i Svenska porträtterkivets samlingar.* Stockholm 1943
Strunk 1916
I M Strunk, *Fra Angelico aus dem Dominikanerorden.* München-Gladbach 1916
Stryienski 1913
C Stryienski, *La galerie du regent Philippe duc d'Orléans.* Paris 1913
Studia Muzealne
Studia Muzealne (Museum Studies). Poznan

Studies ded to Suida
Studies in the history of art dedicated to W E Suida on his 80th birthday. London 1959
Studio
The Studio: an Illustrated Magazine of Fine and Applied Art. London
Studi Romani
Studi Romani: Rivista Bimestrale dell' Istituto di Studi Romani. Rome
Stud op Godsd Geb
Studiën op Godsdienstig, Wetenschappelijk en Letterkundig Gebied. 's-Hertogenbosch
Suida 1953
W Suida, *Bramante pittore e il Bramantino.* Milan & Varese 1953
Sutton 1960
D Sutton, *Nocturnes of James McNeill Whistler.* London 1960
Sutton 1963
D Sutton, *James McNeill Whistler.* London 1963
Sutton 1966
D Sutton, *James McNeill Whistler.* London 1966
Svensk Slott och Herresäten 1908
Svensk Slott och Herresäten vid 1900-talets början Sodermanland. Stockholm 1908
Swillens 1935
P T A Swillens, *Pieter Janszoon Saenredam: schilder van Haarlem 1597-1665.* Amsterdam 1935
Swillens 1950
P T A Swillens, *Johannes Vermeer, painter of Delft 1632-1675.* Utrecht & Brussels 1950
Swillens 1961
P T A Swillens, *Jacob van Campen, schilder en bouwmeester 1595-1657.* Assen 1961
van Swinden 1789
J H van Swinden, *Redevoering en aanspraak ter inwijding van het gebouw der maatschappij Felix Meritis.* Amsterdam 1789
van Sypesteyn 1910
C H C A van Sypesteyn, *Oud-Nederlandsche tuinkunst.* The Hague 1910

Terlinden 1965
Ch Terlinden, *Carolus Quintus: Charles Quint empereur des deux mondes.* Paris 1965
Terrasse 1931
Ch Terrasse, *Goya y Lucientes 1746-1828.* Paris 1931
Testi 1915
L Testi, *Storia della pittura veneziana,* vol 2. Bergamo 1915
den Tex 1960-72
J den Tex, *Oldenbarnevelt.* Haarlem 1960-72
van Thienen 1930
Fr van Thienen, *Das kostüm der Blütezeit Hollands 1600-1660.* Berlin 1930
van Thienen 1939
Fr W S van Thienen, *Vermeer.* Amsterdam 1939
van Thienen 1945
Fr W S van Thienen, *Pieter de Hoogh.* Amsterdam 1945
van Thienen 1951
Fr W S van Thienen, *Het Noord Nederlandse costuum van de Gouden Eeuw.* Amsterdam 1951
Thiéry 1953
Y Thiéry, *Le paysage flamand au XVII-ième siècle.* Paris & Brussels 1953
Thuillier 1973
J Thuillier, *Tout l'œuvre peint de Georges de La Tour.* Milan & Paris 1973
Tidskr f Konstv
Tidskrift för Konstvetenskap. Lund

Tietze 1948
H Tietze, *Tintoretto: the paintings and drawings.* London 1948
Tilanus 1865
J W R Tilanus & J Gosschalk, *Beschrijving der schilderijen afkomstig van het Chirurgijnsgilde te Amsterdam.* Amsterdam 1865
Timmers 1942
J J M Timmers, *Gérard Lairesse.* Amsterdam 1942
Timmers 1961
J J M Timmers, *Bildatlas der niederländische Kultur.* Amsterdam 1961
de Tolnay 1943
Ch de Tolnay, *Hieronymus Bosch.* Vienna 1943
de Tolnay 1965
Ch de Tolnay, *Hieronymus Bosch.* Baden-Baden 1965
Trivas 1941
N S Trivas, *The paintings of Frans Hals.* New York 1941
Trudy Ėrmitaža
Trudy Gosudarstvennoge Ėrmitaža. Moscow
Tümpel 1968
Chr Tümpel, *Studien zur Ikonographie der Historien Rembrandts.* Hamburg 1968
Tijdschr Ind T L V
Tijdschrift voor Indische Taal-, Land- en Volkenkunde. Djakarta
Tijdschr Kon Aardr Gen
Tijdschrift van het Koninklijk Aardrijkskundig Genootschap te Amsterdam. Amsterdam
Tijdschr v Gesch
Tijdschrift voor Geschiedenis, Oudheden en Statistiek van Utrecht. Utrecht

von Uffenbach 1754
Z C von Uffenbach, *Merkwürdige Reisen durch Niedersachsen, Holland und Engeland.* Ulm 1754
Uit het Peperhuis
Uit het Peperhuis: Uitgave van de Vereniging van Vrienden van het Zuiderzeemuseum. Enkhuizen
Ungaretti & Bianconi
G Ungaretti & P Bianconi, *L'opera completa di Vermeer.* Milan 1967

Vaillat & Ratouis de Limay 1909
L Vaillat & P Ratouis de Limay, *J-B Perronneau 1715-1783: sa vie et son œuvre.* Paris & Brussels 1909
Vaillat & Ratouis de Limay 1923
2d edition of Vaillat & Ratouis de Limay 1909
Valabrèghue 1904
A Valabrèghue, *Les Frères Le Nain.* Paris 1904
Valentiner 1909
W R Valentiner, *Rembrandt: des Meisters Gemälde.* Stuttgart & Leipzig (Klassiker der Kunst) 1909
Valentiner 1914
W R Valentiner, *Aus der niederländischen Kunst.* Berlin 1914
Valentiner 1921
W R Valentiner, *Frans Hals: des Meisters Gemälde.* Stuttgart & Leipzig (Klassiker der Kunst) 1921
Valentiner 1921
W R Valentiner, *Rembrandt: wiedergefundene Gemälde 1910-1920.* Stuttgart & Berlin (Klassiker der Kunst) 1921
Valentiner 1923
2d edition of Valentiner 1921 (Frans Hals)
Valentiner 1924
W R Valentiner, *Nicolaes Maes.* Berlin & Leipzig 1924
Valentiner 1929
W R Valentiner, *Pieter de Hooch: des Meisters Gemälde.* Stuttgart & Leipzig (Klassiker der Kunst) 1929

Vallentin 1951
A Vallentin, *Goya*. Paris 1951
Vanbeselaere 1937
W Vanbeselaere, *De Hollandsche periode (1880-1885) in het werk van Vincent van Gogh 1853-1890*. Antwerp & Amsterdam 1937
Vanzype 1936
G Vanzype, *Les frères Stevens*. Brussels 1936
de Vecchi 1970
P de Vecchi, *Tintoretto*. Milan 1970
Vels Heijn 1974
N Vels Heijn, *Glorie zonder helden: de Slag bij Waterloo, waarheid en legende*. Amsterdam 1974
Vente 1958
M A Vente, *Die brabanter Orgel: zur Geschichte der Orgelkunst in Belgien und Holland im Zeitalter der Gotik und der Renaissance*. Amsterdam 1958
Venturi 1890
A Venturi, *La Galleria del Campidoglio*. Rome 1890
Venturi 1900
A Venturi, *La Galleria Crespi*. Milan 1900
Venturi 1901-40
A Venturi, *Storia dell'arte italiana*. Milan 1901-40
Venturi 1907
L Venturi, *Le origine della pittura veneziana 1300-1500*. Venice 1907
Venturi 1922-23
A Venturi, *Luca Signorelli*. Florence 1922-23
Venturi 1925
A Venturi, *Botticelli*. Rome 1925
Venturi 1927
A Venturi, *Studi del vero: attraverso le raccolte artistiche d'Europa*. Milan 1927
Venturi 1930
A Venturi, *North Italian painting of the Quattrocento*, vol 1. Florence & Paris 1930
Verbeek & Schotman 1957
J Verbeek & J W Schotman, *Hendrick ten Oever: een vergeten Overijssels meester uit de 17de eeuw*. Zwolle 1957
Verh Kon Vl Ac
Verhandelingen der Koninklijke Vlaamse Academie van Wetenschappen, Letteren en Schone Kunsten. Antwerp & Utrecht
VerHuell 1873
A VerHuell, *Cornelis Troost en zijn werken*. Arnhem 1873
VerHuell 1875
A VerHuell, *Jacobus Houbraken et son œuvre*. Arnhem 1875
Vermeulen 1928
F A J Vermeulen, *Handboek tot de geschiedenis der Nederlandsche bouwkunst*. The Hague 1928
Vermeulen 1932
F A J Vermeulen, *De Nederlandsche monumenten van geschiedenis en kunst*, vol 3: *de provincie Gelderland*. Utrecht & The Hague 1932
Verslagen CNO
Verslagen en Aanwinsten van de Stichting Cultuurgeschiedenis van de Nederlanders Overzee. Amsterdam
Versl der Rijksverz van Gesch en Kunst
Verslagen der Rijksverzamelingen van Geschiedenis en Kunst. The Hague
Vertova 1955
L Vertova, *Botticelli*. Milan 1955
Veth 1906
J Veth, *Rembrandts leven en kunst*. Amsterdam 1906
Veth 1908
J Veth, *Portretstudies en silhouetten*. Amsterdam 1908
Veth 1919
J Veth, *Beelden en groepen*. Amsterdam 1919

Veth 1921
C Veth, *Geschiedenis van de Nederlandsche caricatuur en van de scherts in de Nederlandsche beeldende kunst*. Leiden 1921
Vetter 1955
E M Vetter, *Der verlorene Sohn*. Düsseldorf (Lukas Bücherei zur Christlichen Ikonographie) 1955
Viale 1969
V Viale, *Gaudenzio Ferrari*. Turin 1969
de la Viñaza 1887
C Muñoz conde de la Viñaza, *Goya, su tiempo, su vida, sus obras*. Madrid 1887
Vis 1965
D Vis, *Rembrandt en Geertje Dircx*. Haarlem 1965
Visser 't Hooft 1947
W A Visser 't Hooft, *Rembrandt et la Bible*. Neuchâtel & Paris 1947
Visser 't Hooft 1956
W A Visser 't Hooft, *Rembrandts weg tot het evangelie*. Amsterdam 1956
Vita art
Vita Artistica: Studi di Storia dell'Arte. Rome
Vlieghe 1972
H Vlieghe, *Gaspard de Crayer: sa vie et ses œuvres*. Brussels 1972
Vogelsang 1909
W Vogelsang, *Holländische Möbel im Niederländischen Museum zu Amsterdam*. Amsterdam 1909
Vogelsang 1942
W Vogelsang, *Geertgen tot Sint Jans*. Amsterdam 1942
Volhard 1927
H Volhard, *Die Grundtypen der Landschaftsbilder des Jan van Goyens und ihre Entwicklung*. Frankfurt am Main 1927
Voll 1906
K Voll, *Die Altniederländische Malerei von Jan van Eyck bis Memling*. Leipzig 1906
Voll 1907
K Voll, *Gemälde Studien*. Munich & Leipzig 1907
Voll 1923
2d edition of Voll 1906
Vom Nachleben Dürers 1954
Vom Nachleben Dürers: Beiträge zur Kunst der Epoche von 1530 bis 1650. Berlin 1954
Voorl Lijst v Mon
Voorlopige lijst der Nederlandsche monumenten van geschiedenis en kunst. Utrecht 1908-33
Vorenkamp 1933
A P A Vorenkamp, *Bijdrage tot de geschiedenis van het Hollandsch stilleven in de 17de eeuw*. Leiden 1933
Vos 1662
J Vos, *Alle de gedichten*. Amsterdam 1662
Vos 1726
2d edition of Vos 1662
Vosmaer 1868
C Vosmaer, *Rembrandt Harmens van Rijn: sa vie et ses œuvres*. The Hague 1868
Vosmaer 1877
2d edition of Vosmaer 1868
de Vries 1934
A B de Vries, *Het Noord-Nederlandse portret in de tweede helft van de 16de eeuw*. Amsterdam 1934
de Vries 1939
A B de Vries, *Jan Vermeer van Delft*. Amsterdam 1939
de Vries 1948
2d edition of de Vries 1939
Vroom 1945
N R A Vroom, *De schilders van het monochrome banketje*. Amsterdam 1945
Vrijdagavond
Vrijdagavond: Joodsch Weekblad. Amsterdam

Vrije Fries
De Vrije Fries: Mengelingen Uitgegeven door het Friesch Genootschap van Friesche Geschied-, Oudheid- en Taalkunde. Leeuwarden
VTTT
Van Tijd tot Tijd: een Reeks Maandelijkse Beschouwingen met Afbeeldingen bij Kunstwerken uit het Rijksmuseum te Amsterdam. Amsterdam

Waagen 1850
G F Waagen, *Über Leben, Wirken und Werke der Maler Andrea Mantegna und Luca Signorelli*. Leipzig 1850
Waagen 1854
G F Waagen, *Treasures of art in Great Britain*. London 1854
Waagen 1862
G F Waagen, *Handbuch der deutschen und niederländischen Malerschulen*. Stuttgart 1862
Waagen 1863-64
G F Waagen, *Manuel de l'histoire de la peinture: écoles allemande, flamande et hollandaise*. Brussels 1863-64
van de Waal 1941
H van de Waal, *Jan van Goyen*. Amsterdam 1941
van de Waal 1952
H van de Waal, *Drie eeuwen vaderlandse geschied-uitbeelding 1500-1800*. The Hague 1952
Waddingham 1966
M R Waddingham, *I paesaggisti nordici italianizzanti del XVII secolo*, vol 1. Milan 1966
Wadsworth Ath Bull
Wadsworth Atheneum Bulletin. Hartford
Waffen-kunde
Waffen- und Kostümkunde: Zeitschrift der Gesellschaft für Historische Waffen- und Kostümkunde. Munich
Wagenaar 1760-88
J Wagenaar, *Amsterdam in zijne opkomst, aanwas, geschiedenissen....* Amsterdam 1760-88
Wagner 1967
A Wagner, *Isaac Israels*. Rotterdam 1967
Wagner 1971
H Wagner, *Jan van der Heyden 1637-1712*. Amsterdam & Haarlem 1971
Wallraf-R Jb
Wallraf-Richartz Jahrbuch herausgegeben von der Wallraf-Richartz Gesellschaft in Köln. Cologne
Walpole Society
Walpole Society for Promoting the Study of the History of British Art. Oxford
Wap 1842
J J F Wap, *Gedenkboek der inhuldiging en feesttogten van Zijne Majesteit Willem II 1840-1842*. 's-Hertogenbosch 1842
Wapenheraut
De Wapenheraut: Maandblad Gewijd aan Geschiedenis, Geslacht-, Wapen-, Oudheidkunde. The Hague & Brussels
Warmondse Bijdragen
Warmondse Bijdragen. Warmond
Warner 1928
R Warner, *Dutch and Flemish fruit and flower painters*. London 1928
Wassenbergh 1934
A Wassenbergh, *L'art du portrait en Frise au 16-ième siècle*. Leiden 1934
Wassenbergh 1967
A Wassenbergh, *De portretkunst in Friesland in de 17de eeuw*. Lochem 1967
Weale 1884
W H J Weale, *Bruges et ses environs*. Bruges 1884
Wedekind 1911
F Wedekind, *Cornelis Cornelisz van Haarlem*. Leipzig 1911

van Weerden 1967
J G van Weerden, *Spanningen en konflikten : verkenningen rond de afscheiding van 1831*. Groningen 1967

Wegner 1939
R N Wegner, *Das Anatomenbildnis : seine Entwicklung und Zusammenhang mit der anatomischen Abbildung*. Basel 1939

Weisbach 1919
W Weisbach, *Trionfi*. Berlin 1919

Weisbach 1926
W Weisbach, *Rembrandt*. Berlin & Leipzig 1926

Weissman 1912
A W Weissman, *Geschiedenis der Nederlandsche bouwkunst*. Amsterdam 1912

Weisz 1913
E Weisz, *Jan Gossaert gen Mabuse : sein Leben und seine Werke*. Parchim 1912

Welcker 1933
C Welcker, *Hendrick en Barent Avercamp, 'Schilders tot Campen.'* Zwolle 1933

Weltkunst
Die Weltkunst : Illustrierte Wochenschrift für Kunst, Buch, alle Sammelgebiete und ihren Markt. Berlin

Wescher 1945
P Wescher, *Jean Fouquet und seine Zeit*. Basel 1945

Westendorp Boerma 1950
J J Westendorp Boerma, *Een geestdriftig Nederlander : Johannes van den Bosch*. Amsterdam 1950

Westhoff-Krummacher 1965
H Westhoff-Krummacher, *Bartel Bruyn der Ältere als Bildnismaler*. Munich 1965

Westphal 1931
D Westphal, *Bonifazio Veronese (Bonifazio dei Pitati)*. Munich 1931

West-Vlaanderen
West-Vlaanderen : Tweemaandelijks Tijdschrift voor Kunst en Cultuur. Tielt

van de Wetering 1938
C van de Wetering, *Die Entwicklung der niederländischen Landschaftmalerei vom Anfang des 16. Jahrhunderts bis zur Jahrhundertmitte*. Berlin 1938

Wethey 1955
H E Wethey, *Alonso Cano : painter, sculptor, architect*. Princeton 1955

Wethey 1962
H E Wethey, *El Greco and his school*. Princeton 1962

Weijerman 1729
J C Weijerman, *De levens-beschrijvingen der Nederlandsche konst-schilders en konst-schilderessen met een uytbreyding over de schilder-konst der ouden*. The Hague & Dordrecht 1729-69

White 1964
Chr White, *Rembrandt*. The Hague (Biografieën in woord en beeld) 1964

Wichman 1923
H Wichman, *Leonard Bramer : sein Leben und seine Kunst*. Leipzig 1923

Wikor
Wikor : Algemeen Kunsttijdschrift voor Jonge Mensen. Tilburg

de Wild 1934
A M de Wild, *De schildertechniek van Johannes Torrentius*. n p 1934

Wildenstein 1923
G Wildenstein, *Le peintre Aved, sa vie et son œuvre*. Paris 1923

Wilenski 1960
R H Wilenski, *Flemish painters 1430-1830*. London 1960

Williamson 1904
G C Williamson, *The history of portrait miniatures*. London 1904

Willis 1911
F C Willis, *Die niederländische Marinemalerei*. Leipzig 1911

W Ind Gids
De West-Indische Gids. Amsterdam

Winkler 1924
F Winkler, *Die altniederländische Malerei : die Malerei in Belgien und Holland von 1400-1600*. Berlin 1924

Wiss Zeitschr Humboldt Un
Wissenschaftliche Zeitschrift der Humboldt Universität zu Berlin. Berlin

Wittop Koning 1966
D A Wittop Koning, *De oude apotheek*. Bussum 1966

Wolf-Heidegger & Cetto 1967
G Wolf-Heidegger & A M Cetto, *Die anatomischen Sektion in bildlicher Darstellung*. Basel & New York 1967

von Wolter 1929
F von Wolter, *Der junge Velazquez*. Munich 1929

Woltmann & Woermann 1879-88
A Woltmann & K Woermann, *Geschichte der Malerei*. Leipzig 1879-88

Worcester Mus Ann
Worcester Art Museum Annual. Worcester

Würtenberger 1937
F Würtenberger, *Das holländische Gesellschaftsbild*. Schramberg 1937

Würtenberger 1962
F Würtenberger, *Der Manierismus*. Vienna & Munich 1962

von Wurzbach 1886
A von Wurzbach, *Rembrandt Galerie : eine Auswahl von hundert Gemälde Rembrandts*. Stuttgart 1886

von Wurzbach 1904-11
A von Wurzbach, *Niederländisches Künstler-Lexikon*. Leipzig & Vienna 1904-11

Wijnaendts van Resandt 1944
W Wijnaendts van Resandt, *De gezaghebbers der Oost-Indische Compagnie op hare Buiten-Comptoiren in Azië*. Amsterdam 1944

Wijnbeek 1944
D Wijnbeek, *De nachtwacht*. Amsterdam 1944

van de Wijngaert 1943
F van de Wijngaert, *Antoon van Dijck*. Antwerp 1943

Wynne 1968
M Wynne, *Paintings from the Blessed Sacrament Chapel of St Paul's without-the-Walls, Rome, by Giovanni Lanfranco*. Dublin 1968

Yale Bulletin
Yale Art Gallery Bulletin. New Haven

Yashiro 1925
Y Yashiro, *Sandro Botticelli*. London & Boston 1925

Zaanlandsch Jaarboek
Zaanlandsch Jaarboek. Koog aan de Zaan

Zamboni 1968
S Zamboni, *Ludovico Mazzolino*. Milan 1968

Zampetti 1952
P Zampetti, *Carlo Crivelli nelle Marche*. Urbino 1952

Zampetti 1961
P Zampetti, *Carlo Crivelli*. Milan 1961

Zampetti 1968
P Zampetti, *Giorgione*. Milan 1968

Zarnowska 1929
E Zarnowska, *La nature-morte hollandaise : les principaux représentants, ses origines, son influence*. Brussels & Maastricht 1929

Zeitler 1966
R Zeitler, *Die Kunst des 19. Jahrhunderts*. Berlin 1966

Zeitschr BK
Zeitschrift für Bildende Kunst. Leipzig

Zeitschr f Chr Kunst
Zeitschrift für Christliche Kunst. Düsseldorf

Zeitschr f Kunstgesch
Zeitschrift für Kunstgeschichte. Berlin & Leipzig

Zeitschr f Kunstw
Zeitschrift für Kunstwissenschaft. Berlin

Zeitschr Schleswig-Holst Gesch
Zeitschrift der Gesellschaft für Schleswig-Holsteinische Geschichte

Zeri 1959
F Zeri, *La Galleria Pallavicini in Roma : catalogo dei dipinti*. Florence 1959

Zilber 1957
G Zilber, *Honoré Daumier*. Dresden 1957

Zilverberg 1968
S B J Zilverberg, *Ketters in de Middeleeuwen*. Bussum 1968

Zoege von Manteuffel 1927
K Zoege von Manteuffel, *Die Künstlerfamilie van de Velde*. Bielefeld & Leipzig 1927

Zuidholl Studiën
Zuidhollandse Studiën. Voorburg

Zwarts 1929
J Zwarts, *The significance of Rembrandt's The Jewish bride*. Batsford 1929

Zwollo 1973
A Zwollo, *Hollandse en Vlaamse vedute-schilders te Rome 1675-1725*. Assen 1973

Catalogue

attributed to **Dirk van der Aa**

The Hague 1731 – 1809 The Hague

A 1300 The Cupid seller. *De verkoop van Cupido's*

Pendant to A 1301

Canvas 114 × 98. Decorative painting in grisaille
PROV Office of the state architect, 2d district, The Hague, 1886 * DRVK since 1953

A 1301 Clipping the wings of Cupids. *Het kortwieken van Cupido's*

Pendant to A 1300

Canvas 114 × 98. Decorative painting in grisaille
PROV Same as A 1300 * DRVK since 1953

milieu of **Hans von Aachen**

Cologne 1552 – 1615 Prague

A 1412 Emperor Matthias (1557-1619). Emperor of the Holy Roman Empire. *Keizer van het Heilige Roomse Rijk*

Canvas 104 × 80
PROV Sale J H Cremer, Amsterdam, 21 June 1887, lot 85 (as portrait of Ferdinand II)
LIT *Cf* R A Peltzer, Jb Kunsth Samml AK 30 (1911-12) p 59ff

Jacobus Theodorus Abels

Amsterdam 1803 – 1866 Abcoude

A 998 Afternoon in a Gelderland meadow. *Gelderse weide in de middag*

Canvas 69 × 86. Signed *J. T. Abels f.* Staffage by Pieter Frederik van Os (1808-92)
PROV Purchased at exhib The Hague 1833, nr 1. RVMM, 1885 * DRVK since 1953
LIT Knoef 1943, pp 271-72

Acajou

see Miniatures: Rochard, Simon Jacques, called Acajou

Oswald Achenbach

Düsseldorf 1827 – 1905 Düsseldorf

A 1798 Market day in an Italian town. *Italiaanse marktdag*

Canvas 110 × 134. Signed *Osw. Achenbach*
PROV Bequest of Reinhard Baron van Lynden, The Hague, 1899 * DRVK since 1953

Alexander Adriaensen

Antwerp 1587 – 1661 Antwerp

A 1481 Still life with fish. *Stilleven met vis*

Panel 47 × 76. Signed and dated *Alexander Adriaenssen Fesit 1660*
PROV Sale Amsterdam, 4 Dec 1888, lot 1
LIT Greindl 1956, p 147

A 2544 Still life with wild fowl. *Stilleven met gevogelte*

Panel 74 × 114. Signed *Alex Adriaenssen fe. A° 1632*
PROV Lent by C Hoogendijk, The Hague, 1907. Presented by his estate, 1912
LIT R Bangel, Cicerone 7 (1915) p 189. Greindl 1956, p 147

Willem van Aelst

Delft 1627–1683 Amsterdam?

A 1669 Still life with poultry. *Stilleven met gevogelte*

Canvas 96 × 79. Signed and dated *Willem van Aelst alias de* [stick figure] *A°* *1658⁵₂₆*
PROV Purchased in London, 1895, with aid from the Rembrandt Society
LIT Vorenkamp 1933, p 90. Martin 1935-36, vol 2, p 432. Bol 1969, p 281

Hendrick Aerts

active ca 1600, presumably in the northern Netherlands

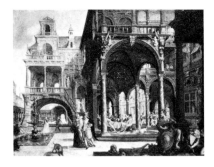

A 2528 Imaginary Renaissance palace. *Gefantaseerd renaissance paleis*

Canvas 93 × 127.5. Signed and dated *HAerts Inv. 1602*
PROV Purchased from O Granberg, Stockholm, 1911, with aid from the Rembrandt Society
LIT Granberg 1911-12, vol 1, p 127, nr 524, ill. K Lilienfeld, Mon f Kunstw 4 (1911) p 509, ill. H Jantzen, Mon f Kunstw 6 (1913) p 331. J P C M Ballegeer, Gent Bijdr 20 (1967) p 68, fig 38

Pieter Aertsen

Amsterdam 1509–1575 Amsterdam

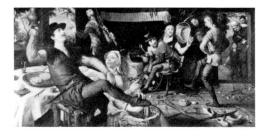

A 3 The egg dance. *De eierdans*

Panel 84 × 172. Dated *1557*
PROV Purchased from Colonel von Schepeler, Aachen, 1839
LIT N de Roever, OH 7 (1889) p 23. Sievers 1908, p 80, nr 21. L Baldass, in Meisterwerke, 1920. Winkler 1924, p 306. Friedländer 1924-37, vol 13 (1936) pp 117, 170, nr 329. Riegl 1931, pp 106-07. Martin 1935-36, vol 1, p 33. Hoogewerff 1936-47, vol 4 (1941-42) pp 531-34, fig 251. E Greindl, Pantheon 29 (1942) p 150, ill. R Genaille, GdB-A 96 (1954) pp 278, 283, nr 21. G Schiedlanski, AGNM, 1954-59, p 186, fig 15. D P Snoep, OK 11 (1967) nr 28, ill. R Genaille, Bull Mus Roy Belg 15 (1967) p 83. Faggin 1968, p 36, fig 92. Von der Osten & Vey 1969, p 306. D Kreidl, Jb Kunsth Samml Wien 68 (1972) p 44, fig 64

C 392 The adoration of the shepherds. *De aanbidding der herders*

Panel 90 × 60. Trapezoid pieced out to a rectangle. A fragment, probably of the high altar of the Nieuwe Kerk in Amsterdam, dedicated in 1559 and destroyed by the iconoclasts in 1566
PROV On loan from the city of Amsterdam, 1885-1975
LIT Wagenaar 1760-88, vol 2 (1765) p 22 (Rubens). Van Dijk 1790, nr 99 (Rubens). Scheltema 1879, nr 97 (Rubens?). J Six, Ned Spec, 1886, nr 12. N de Roever, OH 7 (1889) pp 17, 23. Sievers 1908, pp 57-63, nr 13. Hoogewerff 1912, p 97. Winkler 1924, p 304. Friedländer 1924-37, vol 13 (1936)

p 167, nr 300. Hoogewerff 1936-47, vol 4 (1941-42) pp 515-17, fig 243. E Greindl, Pantheon 29 (1942) p 154, ill. Bergmans 1952, p 24. R Genaille, GdB-A 96 (1954) p 283, nr 23. R Pallucchini, Arte Ven 11 (1957) p 102, fig 103. Van Puyvelde 1962, p 202

A 1909 The adoration of the magi; the presentation in the temple. *De aanbidding der koningen; de opdracht in de tempel*

Panel 188 × 71. Painted on two sides. The left wing of an altarpiece, probably from the Nieuwe Kerk in Delft
PROV Lent by Jonkheer J P Six, Amsterdam, 1885. Presented by his heirs, Jonkheer J Six and Jonkheer W Six, Amsterdam, 1900
LIT Van Bleyswyck 1667, pp 125-26. N de Roever, OH 7 (1889) p 23. Sievers 1908, p 75, nr 19. Friedländer 1924-37, vol 13 (1936) p 167, nr 296. Hoogewerff 1936-47, vol 4 (1941-42) pp 521-22, fig 246 (ca 1560). R Genaille, GdB-A 96 (1954) p 286, nr 47 (ca 1565). VTTT, 1960, nr 33. Van Hall 1963, p 1, nr 9. D Kreidl, Jb Kunsth Samml Wien 68 (1972) pp 95-96, fig 63

A 2398 Kitchen scene. *Keukenstuk*

Panel 92 × 215
PROV Purchased from Miss J F de Gelder, Montfoort, 1909
LIT Friedländer 1924-37, vol 13 (1936) p 170, nr 338. Hoogewerff 1936-47, vol 4 (1941-42) p 541. R Genaille, GdB-A 96 (1954) p 287, nr 49 (ca 1565)

C 1458 The adoration of the magi. *De aanbidding der koningen*

Panel 167.5 × 180. Middle panel of a triptych
PROV On loan from the P & N de Boer Foundation, Amsterdam, since 1960
LIT Sievers 1908, pp 61, 66, figs 15-16. Martin & Moes 1912-14, vol 1, nr 34. Winkler 1924, p 304, fig 180. Friedländer 1924-37, vol 13 (1936) pp 113, 167, nr 298, fig 59. Hoogewerff 1936-47, vol 4 (1941-42) p 527, fig 248. Gerson 1950, p 35, fig 94. R Genaille, GdB-A 96 (1954) pp 275, 282, nr 16. Von der Osten & Vey 1969, p 305. Judson 1970, p 52, fig 113. D Kreidl, Jb Kunsth Samml Wien 68 (1972) pp 92, 94-95, fig 64

Jean Eugène Charles Alberti

Maastricht 1781 – after 1843 Paris?

A 651 Warrior with lance and shield. *Krijgsman met lans en schild*

Canvas 91.5 × 72.5. Signed and dated *Alberti 1808*. Study from the model
PROV Mandatory entry by the artist, as a 'pensionnaire' of King Louis Napoleon in Paris, to exhib Amsterdam 1808 (nr 109), from whence it was automatically ceded to the state
LIT Moes & van Biema 1909, p 133

A 652 Warrior with drawn sword. *Krijgsman met getrokken zwaard*

Canvas 92.5 × 73. Signed and dated *Alberti 1808*. Study from the model
PROV Mandatory entry by the artist, as a 'pensionnaire' of King Louis Napoleon in Paris, to exhib Amsterdam 1808 (nr 110), from whence it was automatically ceded to the state
LIT Moes & van Biema 1909, p 133

A 641 Proculeius preventing Cleopatra from stabbing herself. *Proculejus weerhoudt Cleopatra ervan zich te doorsteken*

Canvas 122 × 160. Signed and dated *J. Alberti Roma 1810*
PROV Mandatory entry by the artist, as a 'pensionnaire' of King Louis Napoleon in Rome, to exhib Amsterdam 1810 (nr 68), from whence it was automatically ceded to the state * DRVK since 1961 (on loan to the Toneelmuseum, Amsterdam)
LIT Immerzeel 1842-43, vol 1, p 6. R van Luttervelt, Nap Stud 13 (1961) pp 568-70, fig 28

Abraham Alewijn

Amsterdam 1673 – 1735 Amsterdam

A 1726 Marine pageant on the Y off Amsterdam. *Het admiraalzeilen op het IJ voor Amsterdam*

Panel 116 × 147. Signed and dated *A. Alewyn 1701*
PROV Presented by F H Wente, Amsterdam, 1898

Augustus Allebé

Amsterdam 1838 – 1927 Amsterdam

A 3266 Portrait of a boy. *Portret van een jongen*

Canvas 86 × 57.5. Signed and dated *Allebé 56*
PROV Bequest of Mrs W M H Ramaer-Drognat Landré, widow of Gerard Allebé, Amsterdam, 1936

A 1799 'Early to church.' *'Vroeg ter kerke'*

Canvas 43 × 34. Signed and dated *A.A. 61*
PROV Bequest of Reinhard Baron van
Lynden, The Hague, 1899
LIT Marius 1920, p 94. VTTT, 1961-62,
nr 43. F J Dubiez, Ons Amsterdam 22
(1970) p 332, ill on p 334

A 1731 'Life's eventide.' *'Nadagen'*

Panel 29 × 22. Signed and dated *A.A. 63*
PROV Bequest of D Franken Dzn, Le
Vésinet, 1898
LIT Marius 1920, p 94. F J Dubiez, Ons
Amsterdam 22 (1970) p 332

A 1730 A young woman. *Een jonge vrouw*

Panel 35.5 × 23.5. Signed and dated
Allebé 1863
PROV Bequest of D Franken Dzn, Le
Vésinet, 1898
LIT F J Dubiez, Ons Amsterdam 22
(1970) p 332

A 2295 'The well-guarded infant.' *'Het
welbewaakte kind'*

Canvas 50.5 × 40.5. Signed and dated
A.A. 67
PROV Lent by J B A M Westerwoudt,
Haarlem, 1902. Bequeathed in 1907
LIT Marius 1920, pp 94-95, fig 51. F J
Dubiez, Ons Amsterdam 22 (1970) p 332

A 3095 'The butterflies.' *'De vlinders'*

Panel 35 × 50. Signed and dated *Allebé
71*
PROV Bequest of Mrs A M L
Westerwoudt-Klinger, Haarlem, 1929
LIT Knoef 1947, p 244, ill on p 240

A 1729 Still life with oriental slippers.
Stilleven met oosterse muilen

Canvas 36 × 43. Signed and dated *Allebé
73*
PROV Bequest of D Franken Dzn, Le
Vésinet, 1898
LIT G Knuttel Wzn, Med DKW Gem
's-Grav 2 (1926) p 26, fig 12. F J Dubiez,
Ons Amsterdam 22 (1970) p 332

A 3267 Old woman by the fireplace.
Oude vrouw bij de haard

Panel 21.7 × 16. Signed *Allebé*
PROV Bequest of Mrs W M H Ramaer-
Drognat Landré, widow of Gerard
Allebé, Amsterdam, 1936

attributed to **Alessandro Allori**

Florence 1535 – 1607 Florence

C 1344 Portrait of a woman. *Portret van
een vrouw*

Panel 95 × 73
PROV On loan from the KKS since 1948

copy after **Cristofano Allori**

Florence 1577–1621 Florence

A 1 Judith holding the head of Holofernes. *Judith met het hoofd van Holofernes*

Canvas 138 × 116
PROV Listed in the RMA catalogue from 1816 on * DRVK since 1953

Laurens Alma Tadema

Dronrijp 1836–1912 Wiesbaden

A 2289 & A 4173 Mary Magdalene. *Maria Magdalena*

Paper on panel. A 2289: 31 × 35, signed and dated *L. Alma Tadema 1854*. A 4173: 37 × 45, signed *L. A. T.* and inscribed on the verso *Alma Tadema. 't Kopje hiervan hangt in 't Rijksmuseum*. The artist finished the head of this study only after the lower part had been cut off

PROV A 2289: Lent by J BAM Westerwoudt, Haarlem, 1888. Bequeathed in 1907. A 4173: Presented by the widow of the painter Dirk Nijland, Bloemendaal, ca 1955
LIT A 2289: J Romijn, Antiek 7 (1974) p 730

A 2427 The Egyptian widow. *De Egyptische weduwe*

Panel 75 × 99. Signed and dated *L. Alma Tadema 1872*
PROV Lent by Mr & Mrs J C J Drucker-Fraser, London, 1903. Presented in 1909-10
LIT Exhib cat Ary Scheffer, Sir Lawrence Alma Tadema & Charles Rochussen, Rotterdam 1974, ill on p 22

A 2664 The death of the Pharaoh's first-born son. *De dood van de eerstgeborene van de Farao*

Canvas 77 × 124.5. Signed *L. Alma Tadema*. Painted in 1872
PROV Presented by the daughters of the painter from his estate, 1913
LIT Scheen 1946, fig 107. J Romijn, Antiek 7 (1974) p 179, ill. Exhib cat Ary Scheffer, Sir Lawrence Alma Tadema & Charles Rochussen, Rotterdam 1974, pp 21-22, ill

Laura Theresa Alma Tadema-Epps

London 1852–1909 London

A 2652 'Airs and graces'

Canvas 56.5 × 41. Signed *Laura Theresa Alma Tadema*. Inscribed *Op CX*
PROV Presented by Mrs E Gosse-Epps, London, 1913

Altena

see Regteren Altena

Sybrand Altmann

Den Burg, Texel 1822–1890 Amsterdam

A 1620 Johan Theodore Stracké (1817-91). Sculptor. *Beeldhouwer*.

The bust of the poet Hendrik Tollens (1780-1865) was made by the sitter about 1850

Canvas 120 × 85. Signed *S. Altmann ft*.
PROV Presented by F L Stracké, son of the sitter, Haarlem, 1894
LIT Van Hall 1963, p 320, nr 2021:1

Jurriaan Andriessen

Amsterdam 1742–1819 Amsterdam

see also under Pastels

A 2059 Self portrait. *Zelfportret*

Paper on panel 34 × 24. (Forged?)
signature *C. Hansen ft.*
PROV Presented by Jonkheer B W F van
Riemsdijk, Amsterdam, 1903
LIT Knoef 1943, p 15. Van Hall 1963,
p 4, nr 33:1. C J de Bruyn Kops, Bull
RM 13 (1965) p 107, fig 31

A 3921 Six putti with flowers and fruit
and attributes of the art of drawing. *Zes
putti met bloemen en vruchten en attributen van
de tekenkunst*

Canvas 79.5 × 201. Signed and dated
J. Andriessen 1782. Dessus-de-porte in
grisaille
PROV Purchased from the estate of the
painter Antoon van Welie, The Hague,
1957

Fra Angelico

active from 1417 on; d 1455 Rome

A 3011 Madonna with lily. *Madonna met
lelie*

Panel 74 × 52. Ends in a round arch; was
originally rectangular. The missing
upper left corner, with an angel, is now
in the Wadsworth Atheneum, Hartford,
Conn (cat 1958, p 30, ill)
PROV Purchased from the Augusteum,
Oldenburg, 1923, as a gift of the
Rembrandt Society
LIT Bode 1888, p 9. Berenson 1909, pp
11, 59, fig 31. Crowe & Cavalcaselle
1903-14, vol 4 (1911) p 97. Schäfer 1912,
p 33, ill. Hartlaub 1912, vol 2, nr 7, pl
12. Strunk 1916, p 98, fig 91. Cat
Jubileumtent Ver Rembrandt,
Amsterdam 1923, nr 156. Schottmüller
1924, p 261, fig 102 (1440-45, in
collaboration with a pupil). Venturi
1927, p 11 (ca 1440). Van Marle 1923-
38, vol 10 (1928) p 138, fig 92 (help of
Benozzo Gozzoli?). T Borenius, Burl
Mag 59 (1931) p 65. Gedenkb Ver
Rembrandt, 1933, p 96. A B de Vries,
Pantheon 14 (1934) p 312. R van Marle,
Boll d'Arte 28 (1935) p 305. Bazin 1941,
pp 23, 63, 181, fig 59 (ca 1440). Pope-
Hennessy 1952, p 197 (1440-45; executed
by a pupil under the guidance of the
master). Cat Mostra dell'Angelico,
Florence 1955, nr 27, fig 42. LC
Ragghianti, Crit d'Arte ns 2 (1955) p 392,
fig 301 (late studio production). C
Gómez-Moreno, Art Bull 39 (1957) pp
183-93, figs 1-2, 8 (1438-40; perhaps by
a good assistant). Salmi 1958, p 107.
Orlandi 1964, pp 59-60, fig 31 (after
1445). Van Os & Prakken 1974, pp 29-
31, nr 2, ill

Pieter van Anraedt

Utrecht? ca 1635–1678 Deventer

A 1960 The leavetaking of Captain
Hendrik de Sandra (1619-1707), sent off
by his wife and children. *Het afscheid van
de ritmeester Hendrik de Sandra, uitgeleide
gedaan door zijn vrouw en kinderen*

De Sandra's wife is Margareta Tortarolis
(1627-81) and his children are Anna
Maria (1647-81), Margareta Barbara
(1651-79) and Henricus Johannes (1654-
80). Behind the latter is the painter
himself

Canvas 154.5 × 245.5. The painting bore
a signature until as late as 1850, but was
subsequently provided with the forged
signature *G Ter Borch* and the year *1661*,
which have since been removed. The
dating was very probably correct
PROV Purchased from M H Colnaghi
gallery, London, 1901, with aid from
the Rembrandt Society
LIT H Hymans, GdB-A 34:2 (1886) p
431. V R[iemsdijk], Bull NOB 3 (1901-02)
p 84. Gudlaugsson 1959-60, vol 2, p 289
(ca 1660). Van Hall 1963, p 4, nr 37:1

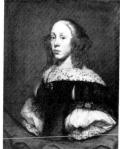

A 2 Portrait of a man. *Portret van een man*

Pendant to A 1350

Canvas 80 × 65. Signed and dated *Pieter
van Anraedt a 1671*
PROV Presumably purchased at the H J
Broers sale, Utrecht, 8-15 March 1873,
lot 3096 (as Bergman[?], Portrait of Jan
Evertsen)

A 1350 Portrait of a woman. *Portret van
een vrouw*

Pendant to A 2

Canvas 81 × 65.5. Signed and dated

Pieter van Anraedt 1671
PROV Presented by C F Roos & Co, art dealers, Amsterdam, 1886
LIT Bernt 1960-62, vol 4, nr 7

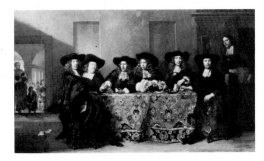

C 440 Six regents and the housemaster of the Oude Zijds institute for the outdoor relief of the poor, Amsterdam, 1675. *Zes regenten en de binnenvader van het Oude Zijds Huiszittenhuis te Amsterdam, 1675*

From left to right: Ferdinand Bol, Arnout van de Cruijs, Anthony Hoevenaer, Jan van Beuningen, Casparus Commelin, Aarnout Schuyt and housemaster Symon Leeman

Canvas 237 × 425. Signed and dated *Pieter van Anraadt an° 1675*
PROV Oude Zijds Huiszittenhuis (institute for the outdoor relief of the poor), Amsterdam. On loan from the city of Amsterdam, 1885-1975
LIT Houbraken 1718-21, vol 3 (1721) p 50. Wagenaar 1760-88, vol 2 (1765) p 264. Immerzeel 1842-43, vol 1, p 9. Kramm 1857-64, vol 1, p 19. J Six, OH 11 (1893) p 101. A Bredius, Burl Mag 42 (1923) p 72. Oldewelt 1942, p 17. Bernt 1960-62, vol 4, nr 6. Van Hall 1963, p 32, nr 201:25

attributed to **Pieter van Anraedt**

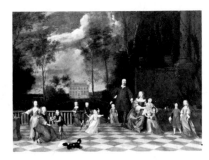

A 2416 The Amsterdam merchant Jeremias van Collen (1608-76) with his wife and their twelve children. *De Amsterdamse koopman Jeremias van Collen, zijn vrouw en hun twaalf kinderen*

Van Collen's wife is Susanna van

Uffelen (1622-74); the house in the background is the manor of Velserbeek

Canvas 107 × 155. Painted before the marriage of the eldest daughter, Susanna, in 1657
PROV Bequest of S Rendorp, Amsterdam, 1903. Received in 1910
LIT Martin 1935-36, vol 2, p 166. Gudlaugsson 1959-60, vol 2, p 286 (shortly before 1660)

Johannes Anspach

see under Pastels

Hendrick van Anthonissen

Amsterdam 1605 – after 1656
Amsterdam?

A 2126 Surprise attack on three Portuguese galleons in the Bay of Goa, 30 September 1639. *De verrassing van drie Portugese galjoenen in de Baai van Goa, 30 september 1639*

Canvas 152 × 275. Signed and dated *H. V. Anthonissen fesit A° 1653*
PROV Purchased through the intermediacy of J E van Someren-Brand, Amsterdam, 1903
LIT Baldaeus 1672, vol 2, p 50. J F L de Balbian Verster, Eigen Haard, 1904, pp 423, 437; idem, 1905, p 362. Willis 1911, p 42, pl IX. De Balbian Verster & Kooy-van Zeggelen 1921, p 69, fig 15. C R Boxer, Mar Mirror 12 (1930) p 5, ill. Preston 1937, p 33. Mollema 1939-42, vol 4 (1940) pp 380, 383. J K Oudendijk, Historia 7 (1941) p 114ff, ill. C R Boxer, Spiegel Hist 8 (1973) p 32, fig 6. Bol 1973, p 111

A 2970 Shipping on the East Schelde near the Zuidhavenpoort, Zierikzee. *Schepen op de Oosterschelde bij de Zuidhavenpoort van Zierikzee*

Canvas 99 × 133. Signed *H. V. A. F.*
PROV Presented by Mrs M L A Barnardiston-van Riemsdijk, from the estate of Jonkheer Th H F van Riemsdijk, The Hague, 1923 * DRVK since 1953
LIT Bol 1973, p 110, fig 111

Aert Anthonisz

Antwerp 1580 – 1620 Amsterdam

A 1367 Incident from the battle of the Spanish Armada. *Gevecht van Hollandse en Engelse schepen tegen de Spaanse Armada*

The flagship of Admiral Medina Sidonia, the 'San Martin,' attacked to port by the English 'Rainbow' and astern by the Dutch 'Gouden Leeuw,' 8 August 1588, in the roads of Dover

Panel 41 × 82.5. Signed and dated *Aert Ant Anno 1608* (barely legible)
PROV Sale Amsterdam, 28 April 1875, lot 3 (as Aert Antum)
LIT Steenhoff 1908, nr 26. Willis 1911, p 23. Bol 1973, pp 38-39, fig 35

A 1446 The 'Eendraght' off IJsselmonde, 1618. *Het schip 'De Eendraght' voor IJsselmonde, 1618*

The ship was on its return voyage after the discovery by Schouten and Le Maire of Cape Horn and the Strait of Le Maire

Panel 41 ×81. Signed and dated *Aert. An. To. Anno 1618*. Inscribed on the verso *passeren van 't Staten Yacht voorbij Iselmonde Augustus MD & CXVIII*
PROV Sale S B Bos (Harlingen), Amsterdam, 21 Feb 1888, lot 1 (as Aert Antum)
LIT S P L, Navorscher ns 4 (1864) p 79. Willis 1911, p 23. Preston 1937, p 13, fig 6. Bol 1973, pp 38-39, fig 37

Cornelis Anthonisz

Amsterdam ca 1499 – shortly after 1556 Amsterdam

C 1173 Banquet of seventeen members of the crossbowmen's civic guard (the St George guards), Amsterdam, 1533, known as the 'Banquet of the copper coin.' *Maaltijd van zeventien schutters van de Voetboog- (St Joris) doelen te Amsterdam, 1533, bekend als de 'Braspenningmaaltijd'*

In the upper left is the painter with a drawing stylus in his hand

Panel 130 ×206.5. Signed and dated *C.T. anno 1533* (between the letters *C* and *T* is the bell of St Anthony). Marked *D*
PROV Voetboogdoelen (headquarters of the crossbowmen's civic guard), Amsterdam. On loan from the city of Amsterdam, 1925-75
LIT Wagenaar 1760-88, vol 2 (1765) p 26. Van Dijk 1790, p 7, nr 1. Scheltema 1879, nr 1. Scheltema 1855-85, vol 7 (1885) p 134, nr 17. J F M Sterck, OH 43 (1926) p 257, fig 5. Sterck 1928, p 53. Riegl 1931, p 55, fig 10. De Vries 1934, p 37. N Beets, OH 57 (1939) p 21, fig 1. Hoogewerff 1936-47, vol 3 (1939) pp 480-84, fig 258. Bergström 1947, p 19. Gerson 1950, p 56, fig 152. Van Hall 1963, p 5, nr 41:1. M Picker, Journ Am Mus Soc 17 (1964) p 133 (on the sheet of music). Rosenberg, Slive & Ter Kuile

1966, p 33. E R M Taverne, OK 12 (1968) nr 2, ill. Judson 1970, p 24, note 6. Slive 1970, vol 1, p 109, fig 104. D G Carasso, Ons Amsterdam 24 (1972) p 54, ill. Haak 1972, p 15, fig 19. P Fischer, Son Spec 50-51 (1972) p 49

attributed to **Cornelis Anthonisz**

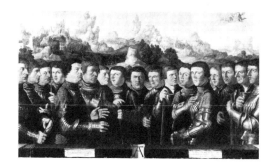

C 409 Seventeen members of Squad A of the arquebusiers' civic guard, Amsterdam, 1531. *Zeventien schutters behorende tot Rot A van de Kloveniersdoelen te Amsterdam, 1531*

Panel 115 × 195. Dated *Anno 1531*. Marked in the lower center *A*. Inscribed on the left *Wy zyn door deezen plechtighen eed verbonden de waereld|sche zaaken gheduldig te verdraaghen, en ons niet te laaten beroe|ren door die zaaken die wy niet in onse macht hebben om te vermyden. – Seneca.* Inscribed on the right *Ad h[unc] sacrame[n]t[u]m adacti sum[u]s ferre mortalia|et non p[er]turbari his quae n[ost]rae p[otenta]tis no[n] est, vitare. – Seneca in vit. beat. Cap. 15*
PROV Kloveniersdoelen (headquarters of the arquebusiers' civic guard), Amsterdam. On loan from the city of Amsterdam, 1925-75
LIT Scheltema 1879, nr 133 (style of Jan van Scorel). Scheltema 1855-85, vol 7 (1885) p 138, nr 24. W del Court & J Six, OH 21 (1903) p 81 (Scorel). Winkler 1924, p 285 (Cornelis Anthonisz?). J F M Sterck, OH 43 (1926) p 256, figs 3-4 (Scorel). G J Hoogewerff, OH 47 (1930) p 182, fig 7 (Master of Squad A). Riegl 1931, p 50, fig 9 (anonymous). Friedländer 1924-37, vol 12 (1935) p 203, nr 344 (Scorel). Hoogewerff 1936-47, vol 3 (1939) p 476, fig 256 (Master of Squad A)

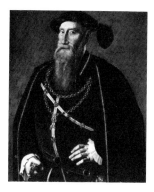

A 1619 Reinout III van Brederode (1493-1556), lord of Vianen. Deacon in the Order of the Golden Fleece, counselor and chamberlain to Charles V. *Heer van Vianen. Deken der Orde van het Gulden Vlies, raad en kamerheer van Karel V*

Panel 80 ×69
PROV Purchased from A Croiset gallery, The Hague, 1894
LIT N Beets, OH 56 (1939) p 200, fig 16. Hoogewerff 1936-47, vol 3 (1939) p 493, fig 264. E Schenk zu Schweinberg, OH 75 (1960) p 96, fig 3

José Antolinez

Madrid 1635 – 1675 Madrid

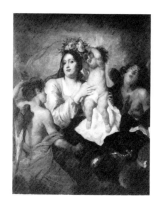

A 598 The apotheosis of the Virgin. *De verheerlijking van Maria*

Canvas 141 × 115
PROV Presented by King Willem I, 1822 (as Anthony van Dyck)
LIT Beruete y Moret 1909, p 225. Von Loga 1923, p 386. Rouchès 1958, p 347. P van Vliet, Bull RM 14 (1966) p 134, fig 3

Aert Antum

see Anthonisz, Aert

Lodewijk Franciscus Hendrik Apol

The Hague 1850–1936 The Hague

A 1164 A January evening in the woods of The Hague. *Een januari-avond in het Haagse Bos*

Canvas 92 × 121. Signed and dated *Louis Apol ft 75*
PROV Purchased at exhib The Hague 1875, nr 3. RVMM, 1885 * DRVK since 1953
LIT Marius 1920, p 225, fig 103

A 2691 An afternoon view of snowy woods. *Gezicht op een besneeuwd bos in de namiddag*

Canvas 120 × 90. Signed *Louis Apol ft*
PROV Presented by Jonkvrouwe H Hartsen, Beekbergen, from the estate of her uncle Jonkheer P Hartsen, 1913 * DRVK since 1952

studio of Apollonio di Giovanni

Florence ca 1415–1465 Florence

A 3999 The departure of Darius for the battle of Issus. *Het optrekken van Darius voor de slag bij Issus*

Panel 48.5 × 141.5. Cassone. Inscribed along the upper side above the figures, from left to right, *Sacrificium, Appollo, Dari rex* and *Mater et uxor Dari*
PROV O Lanz, Amsterdam. Lent by the DRVK, 1952. Transferred in 1960
LIT A Perate, Arts, Sep 1904, p 12, ill; idem, Oct 1904, p 12 (Tuscan). P Schubring, Burl Mag 22 (1912-13), p 202, pl IV. Schubring 1915, nrs 158-59, ill. Weisbach 1919, pp 30-32, fig 6. W G Constable, Burl Mag 47 (1925) p 28. Van Marle 1923-38, vol 10 (1928) p 565. Van Marle 1932, p 135. B Degenhart, Pantheon 27 (1941) nr 90. J Cornforth, Country Life, Feb 1965, p 409. Van Os & Prakken 1974, pp 31-33, nr 3, ill

Cornelis Apostool

Amsterdam 1762–1844 Amsterdam

A 1681 The Anio valley with the waterfalls of Tivoli. *Het dal van de Anio met de watervallen van Tivoli*

Canvas 78 × 107. Signed *C. Apostool ft*
PROV Purchased from S Frank, Amsterdam, 1896
LIT G J Hoogewerff, Med Ned Hist Inst Rome, 2d ser, vol 3 (1933) p 149. Scheen 1946, p 16, fig 327

Jacob Appel

Amsterdam 1680–1751 Amsterdam

A 4245 The dollhouse of Petronella Oortman (1655/56-1716). *Het poppenhuis van Petronella Oortman*

Vellum on canvas 87 × 69. Signed *Jacob Appel F.*
PROV KKZ, 1871. NMGK
LIT Scheen 1946, fig 182. I H van Eeghen, Mndbl Amstelodamum 40 (1953) p 117, ill. Leesberg-Terwindt 1960, fig 8. *Cf* cat RMA Meubelen 1952, nr 358, fig 63

attributed to Josaphat Araldi

active in Parma ca 1520

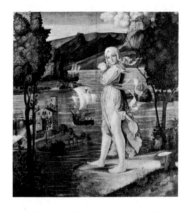

A 3967 Ariadne on Naxos. *Ariadne op Naxos*

Panel 128 × 119
PROV O Lanz, Amsterdam. Lent by the SNK, later DRVK, 1948. Transferred in 1960
LIT G Swarzenski, Münchn Jb, 1914-15, p 95, ill (Vincenzo Catena or Francesco Bonsignori). Schubring 1915, p 377, fig 162 (Bonsignori?). Von der Bercken 1927, p 108, pl VII (Catena). Van Marle 1923-38, vol 18 (1936) pp 371-72 (school of Vittore Carpaccio). E G Troche, Pantheon 25-26 (1940) p 20, ill. B Degenhart, Pantheon 27-28 (1941) p 36

Lodewijk Hendrik Arends

Amsterdam 1817–1873 Amsterdam

A 3844 A watermill in a woody landscape. *Watermolen in een bosachtig landschap*

Board 20 × 25. Signed and dated *L. H. A. 14 mei 1854*
PROV Bequest of Mrs M N Th Weddik-Lublink Weddik, widow of A L Weddik, Arnhem, 1919

Arent Arentsz *called* Cabel

Amsterdam ca 1585 – 1631 Amsterdam

A 1447 Fishermen and hunters. *Vissers en jagers*

Pendant to A 1448

Panel 27 × 52. Signed *AA*
PROV Sale S B Bos (Harlingen), Amsterdam, 21 Feb 1888, lot 3 * DRVK since 1959 (on loan to the Gemeentemuseum, Arnhem)
LIT G Poensgen, OH 41 (1923-24) p 122

A 1448 Fishermen and farmers. *Vissers en boeren*

Pendant to A 1447

Panel 27 × 52

PROV Sale S B Bos (Harlingen), Amsterdam, 21 Feb 1888, lot 4
LIT G Poensgen, OH 41 (1923-24) p 120, ill. A Bengtsson, Figura 3 (1952) p 19. Chudzikowski 1957, p 21, fig 12. Bernt 1960-62, vol 1, nr 12. Bernt 1969-70, vol 1, nr 20

A 2625 Fishermen on the bank of the Amstel near the Pauwentuin, Amsterdam. *Vissers aan de Amstel te Amsterdam in de nabijheid van het buiten 'De Pauwentuin'*

Panel 25.5 × 50.5. Signed *AA*
PROV Purchased from G Cohen, London, 1912. Lent to the AHM, 1975
LIT G Poensgen, OH 41 (1923-24) p 122. A Hoogendoorn, Med RKD 1 (1946) p 66ff. Bernt 1960-62, vol 1, nr 11. I H van Eeghen, Mndbl Amstelodamum 54 (1967) p 219, ill; idem 55 (1968) p 43, ill. Bernt 1969-70, vol 1, nr 19

A 4033 River landscape with gypsies. *Rivierlandschap met zigeuners*

Panel 47 × 87.5. Signed *AA*
PROV Sale C A van Hees (Reeuwijk), Amsterdam, 31 May 1960, lot 2
LIT A Heppner, Mndbl BK 17 (1940) p 242, fig 3

A 1969 The hunter. *De jager*

Panel 24 × 33. Signed *AA*
PROV Sale Amsterdam, 15 April 1902, lot 2 (as A Aertsen)
LIT G Poensgen, OH 41 (1923-24) p 117, ill. Boon 1942, p 37. A Bengtsson, Figura 3 (1952) p 19

Benjamin Arlaud

see under Miniatures

Pieter Florentius Nicolaas Jacobus Arntzenius

see under Aquarelles and drawings

David Adolphe Constant Artz

The Hague 1837 – 1890 The Hague

A 2378 'Lulled to sleep.' *'In slaap gesust'*

Canvas 56 × 39. Signed and dated *Artz 1871*
PROV Bequest of J B A M Westerwoudt, Haarlem, 1907. Received in 1909 *
DRVK since 1953

A 1187 'At grandmother's.' '*Bij groot-moeder*'

Canvas 131.5 × 91.5. Signed *Artz*.
Painted in 1883 (cat RMA 1887, nr 376)
PROV Purchased at exhib The Hague
1884, nr 10. RVMM, 1885 * DRVK since
1953

A 3067 Boy and girl in the dunes. *Jongen en meisje in het duin*

Canvas 95.2 × 140. Signed *Artz*
PROV Acquired from P Koster, Paris,
1929

A 3069 Seascape. *Zeegezicht*

Canvas 38.3 × 30. Signed *Artz*
PROV Bequest of J BA M Westerwoudt,
Haarlem, 1907. Received in 1929 *
DRVK since 1961

A 2292 In the orphanage at Katwijk-Binnen. *In het weeshuis te Katwijk-Binnen*

Canvas 97 × 130. Signed *Artz*
PROV Lent by J BA M Westerwoudt,
Haarlem, 1893. Bequeathed in 1907
LIT Scheen 1946, fig 111. De Gruyter
1968-69, vol 2, p 83, fig 107

Pieter Jansz van Asch

Delft 1603 – 1678 Delft

A 2106 Self portrait. *Zelfportret*

Panel 51.5 × 43.5
PROV Sale Vienna, 5 March 1903, lot
27, ill
LIT Moes 1897-1905, vol 1, nr 210a. Van
Hall 1963, p 7, nr 52:1

A 1970 River landscape. *Rivierlandschap*

Panel 26.5 × 40. Signed *P. v. As*
PROV Sale Amsterdam, 15 April 1902,
lot 3
LIT Bernt 1960-62, vol 1, nr 16

C 88 Wooded landscape. *Boomrijk land-schap*

Panel 100 × 73. Signed *PVA*
PROV On loan from the city of
Amsterdam (A van der Hoop bequest)
since 1885
LIT A Bredius, OH 6 (1888) p 294

Henry van Assche

Brussels 1774 – 1841 Brussels

A 999 River in the Ardennes at sunset. *Rivier in de Ardennen bij zonsondergang*

Panel 138 × 120. Signed and dated *H^ry van Assche 1821*
PROV Purchased in 1821. RVMM, 1885
* DRVK since 1959

Alphonse Asselbergs

Brussels 1839 – 1916 Brussels

A 985 Sunset in the Campine, Belgium. *Zonsondergang in de Kempen*

Canvas 123 × 202. Signed *Alp. Asselbergs*
PROV Presented by Miss A H H Horneman, Rijswijk, 1885 * DRVK since 1952

Jan Asselijn

Dieppe? after 1610 – 1652 Amsterdam

A 5 Cavalry attack at sunset. *Ruitergevecht bij zonsondergang*

Panel 49 × 74. Signed and dated *Jean Asselin F 1646*
PROV Bequest of L Dupper Wzn, Dordrecht, 1870 * DRVK since 1953
LIT Martin 1935-36, vol 2, p 325. Steland-Stief 1962-63, p 103ff, nr 19. Exhib cat Italianiserende landschapschilders, Utrecht 1965, nr 61, fig 65. Steland-Stief 1971, p 64, fig 38, cat nr 19

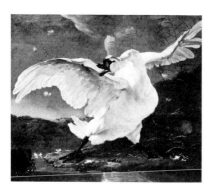

A 4 The threatened swan: interpreted later as an allegory on Johan de Witt. *De bedreigde zwaan ; later opgevat als allegorie op Johan de Witt*

Canvas 144 × 171. Signed *JA*. The inscriptions *de Raad-Pensionaris* (under the swan), *Holland* (on the egg) and *de viand van de staat* (above the dog) were added later
PROV Sale J Gildemeester Jzn, Amsterdam, 11 June 1800, lot 2. NM, 1808
LIT Moes & van Biema 1909, pp 29-30, 33, 37, 47, 175, 225. Ledermann 1920, p 47ff. Roh 1921, fig 138. Martin 1935-36, vol 2, pp 324-25, 442, fig 117. R van

Luttervelt, Bull RM 8 (1960) p 42, fig 12. Plietzsch 1960, p 135, fig 229. J Schouten, in Alb Disc J G van Gelder, 1963, p 140, fig 6. P J J van Thiel, OK 8 (1964) nr 1, ill. C J de Bruyn Kops, Bull RM 13 (1965) p 113, fig 42. Rosenberg, Slive & Ter Kuile 1966, p 178. De Jongh 1967, p 68, fig 53. Steland-Stief 1971, pp 97-98, fig 71, cat nr 244

C 89 Donkey drivers beside a ruin in Italy. *Ezeldrijvers bij een Italiaanse ruïne*

Canvas 67 × 82. Signed *JA*
PROV On loan from the city of Amsterdam (A van der Hoop bequest) since 1885
LIT Steland-Stief 1962-63, p 132, nr 104. Exhib cat Italianiserende landschapschilders, Utrecht 1965, nr 67, fig 70 (with list of copies and other versions). Stechow 1966, p 153, fig 298. A Blankert, OK 10 (1966) nr 21, ill. Steland-Stief 1971, p 80, fig 54, cat nr 104

A 2313 A waterside ruin in Italy. *Ruïne aan het water in Italië*

Panel 54.5 × 48
PROV Purchased from the heirs of Jonkheer P H Six van Vromade, Amsterdam, 1908, with aid from the Rembrandt Society
LIT Stechow 1966, p 160. Ch Steland-Stief, Raggi 7 (1967) p 102. Steland-Stief 1971, pp 92-93, fig 64, cat nr 209 (autograph replica). Bol 1973, p 253, fig 259

A 2314 Drovers with cattle under an arch of the Colosseum in Rome. *Herders met vee onder een gewelf van het Colosseum te Rome*

Panel 42 × 45. Signed *JAsselin*
PROV Purchased from the heirs of Jonkheer P H Six van Vromade, Amsterdam, 1908, with aid from the Rembrandt Society
LIT Steland-Stief 1971, p 81, fig 55, cat nr 68

Jan van Assen

Amsterdam 1635 – 1695 Amsterdam

A 1358 Portrait of a man. *Portret van een man*

Copper 12.5 × 10.5. Oval. Signed *J.v.A.* Inscribed *Aet. 23 A° 1666*
PROV Presented by Dr A Bredius, The Hague, 1887
LIT C Hofstede de Groot, OH 22 (1904) p 113 (Jan van Assen?)

Cornelis Albert van Assendelft

Middelburg 1870–1945 Amsterdam

A 3488 Shepherd with sheep. *Herder met schapen*

Canvas 35.5 × 45.5. Signed *C. van Assendelft*
PROV Bequest of Mrs ACMH Kessler-Hülsmann, widow of DAJ Kessler, Kapelle op den Bosch near Mechelen, 1947

Balthasar van der Ast

Middelburg 1593/94–1657 Delft

A 2103 Still life with flowers. *Stilleven met bloemen*

Panel 59 × 43. Signed *B. van der Ast*
PROV Bequest of AA des Tombe, The Hague, 1903
LIT W Steenhoff, Bull NOB 4 (1902-03) p 122. Van Luttervelt 1947, p 93, fig 47. Bergström 1947, p 75. LJ Bol, OH 70 (1955) pp 141, 153. Bergström 1956, p 68, fig 55. Bol 1960, p 70, nr 10

A 2152 Still life with fruits and flowers. *Stilleven met vruchten en bloemen*

Panel 40 × 70. Signed and dated in lower left *B. van der Ast 1620*; in lower right *B. van der Ast. fe. 1621*
PROV Sale Amsterdam, 21 Sep 1904, lot 51. Purchased with aid from the Rembrandt Society
LIT Warner 1928, nr 4a. Vorenkamp 1933, pp 116-17. Martin 1935-36, vol 1, pp 290, 292, fig 170. Bergström 1947, p 78. Van Guldener 1949, p 13, fig 11. LJ Bol, OH 70 (1955) pp 140, 142, 145, 152, nr 3. Bergström 1956, p 70, fig 61. Bol 1960, p 82, nr 96, fig 45b. Bol 1969, p 25

J Attama

active 1655-59 in Groningen

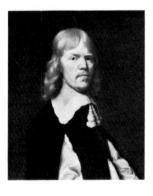

A 761 Portrait of a man. *Portret van een man*

Panel 72.5 × 61. Signed and dated *J. Attama f. 1655*. Inscribed *Aetat. 33*
PROV Sale Amsterdam, 13 Nov 1882, lot 1

Joost van Attevelt

see Heraldic objects: A 941

Jacobus Luberti Augustini

Haarlem 1748–1822 Haarlem

C 586 Four regents of the lepers' asylum in Amsterdam, 1773. *Vier regenten van het Leprozenhuis te Amsterdam, 1773*

The sitters, according to an inscription on the painting, are, from left to right, RJ van den Broeke, H van Veen, J Veening, M van Son, H Linteloo (house-master) and D Nolthenius

Canvas 172 × 208. Signed and dated *Jacobs Augustini Luberti Pinx. 1773* (over a remnant of a signature that was largely cut away when the canvas was reduced)
PROV Regents' chamber of the Lepro-zenhuis (lepers' asylum), Amsterdam. On loan from the city of Amsterdam since 1896
LIT Scheltema 1879, nr 72 (Luberti). Moes 1897-1905, vol 1, nr 1131; vol 2, nrs 4543, 5420, 7386, 8273, 8340 (Luberti). H van de Waal, OH 71 (1956) p 84, fig 17

Jacques André Joseph Aved

Douai 1702–1766 Paris

A 6 Willem IV (1711-51), prince of Orange-Nassau. *Prins van Oranje-Nassau*

Canvas 107.5 × 67.5. Signed and dated *J. Aved 1751*
PROV Purchased from PC Huybrechts, The Hague, 1806. NM, 1808
LIT Moes 1897-1905, vol 2, nr 9097:25. Moes & van Biema 1909, pp 84, 101, 105,

131, 204. Wildenstein 1923, vol 1, pp 77-83; vol 2, p 60, nr 40

A 872 Willem IV (1711-51), prince of Orange-Nassau. *Prins van Oranje-Nassau*

Canvas 225 × 173. Signed and dated *J. Aved f. 1751*
PROV NM, 1808. KKS, 1876
LIT Moes 1897-1905, vol 2, nr 9097:27.
Moes & van Biema 1909, pp 84, 204.
Wildenstein 1923, vol 1, pp 77-83; vol 2, p 60, nr 40

A 880 Willem IV (1711-51), prince of Orange-Nassau. *Prins van Oranje-Nassau*

Canvas 82.5 × 70.5
PROV KKS, 1876. NMGK, 1885 * DRVK since 1952 (on loan to Gemeentelijk Museum Het Princessehof, Leeuwarden)
LIT Moes 1897-1905, vol 2, nr 9097:41?
Wildenstein 1923, vol 2, p 62, nr 42

Barent Avercamp

Kampen 1612/13 – 1679 Kampen

A 3286 Enjoying the ice. *IJsvermaak*

Panel 40 × 53.5
PROV Presented by Mr & Mrs DAJ Kessler-Hülsmann, Kapelle op den Bosch near Mechelen, 1940

Hendrick Avercamp

Amsterdam 1585 – 1634 Kampen

A 1718 Winter landscape with iceskaters. *Winterlandschap met ijsvermaak*

Panel 77.5 × 132. Signed *HAenricus Av*
PROV Sale G de Clercq, Amsterdam, 1 June 1897, lot 1. Purchased with aid from the Rembrandt Society
LIT Welcker 1933, p 204, nr 10, fig 15.
Bernt 1960-62, vol 1, nr 28. Plietzsch 1960, p 86, fig 143. E van Uitert, OKTV 3 (1965) nr 20, ill. VTTT, 1965-66, nr 73. Dobrzycka 1966, p 20, fig 2. Bernt 1969-70, vol 1, nr 37

A 1320 Iceskating in a village. *IJsvermaak bij een dorp*

Panel 36 × 71. Signed *H.A.*
PROV Sale MM Snouck van Loosen, Enkhuizen, 29 April 1886, lot 5 * On loan to the KKS since 1924

LIT A Bredius, Zeitschr BK 21 (1886) p 644. Welcker 1933, p 204, nr 16, pl XVI-1. Plietzsch 1960, nr 143. Bernt 1969-70, vol 1, nr 39

A 3247 Enjoying the ice. *IJsvermaak*

Panel 25 × 37.5. Signed *H.A.*
PROV Presented by Sir Henry WA Deterding, London, 1936
LIT Van Gelder 1959, p 12, fig 8

Dirck van Baburen

Utrecht? 1590/95–1624 Utrecht

A 1606 Prometheus being chained by Vulcan. *Prometheus door Vulcanus geketend*

Canvas 202 × 184. Signed and dated *T. v. Baburen fecit An° 1623* (lower right) and *Teodoor* [or *Teodoer*] *de Babuer fecit An° 1623* (lower left)
PROV Presented by J van Loehr, German consul in Cairo, 1893
LIT Hoet 1752, vol 1, p 98, nr 15; p 563, nr 57 (Honthorst). P T A Swillens, OH 47 (1931) p 89. Von Schneider 1933, pp 42, 130, fig 20. Isarlo 1941, p 71. B Nicolson, Burl Mag 94 (1952) p 251. O Raggio, Journ WCI 21 (1958) p 44ff. Judson 1959, p 189, nr 91a. Slatkes 1965, pp 26, 38, 78-82, 85, 124-25, 139, 144, fig 21, nr A 21. L J Slatkes, OH 81 (1966) p 183

copy after **Dirck van Baburen**

C 612 The procuress. *De koppelaarster*

Canvas 100 × 96
PROV On loan from the city of Amsterdam (presented by G de Clercq) since 1898
LIT A Bredius, Rep f Kunstw 17 (1894) p 408 (ter Brugghen or Baburen). H Voss, Mon f Kunstw 5 (1912) pp 79-83, fig 21. P T A Swillens, OH 47 (1931) p 89 (Baburen). Von Schneider 1933, pp 43,

130. A Heppner, Pantheon 16 (1935) p 259. De Vries 1939, p 29. Van Thienen 1939, p 36. Isarlo 1941, p 27. A Heppner, Mndbl BK 24 (1948) p 80. Swillens 1950, pp 82, 164. A P de Mirimonde, GdB-A 103 (1961) p 32, fig 1. Slatkes 1965, pp 76, 116-17, 139, nr A 12, version A (17th-century copy after original in Boston, Museum of Fine Arts, nr 50.2721)

Francesco Ubertini *called* Bacchiacca

Florence 1494–1557 Florence

A 3104 Lodging the travellers, one of the seven works of charity. *Het herbergen der reizigers, één der zeven werken van barm-hartigheid*

Panel 85 × 71.5
PROV Purchased from R Langton Douglas gallery, London, 1930, with aid from the Photo Commission
LIT Berenson 1909, vol 1, p 19. E Cecchi, Pinacotheca 1 (1928) p 90, ill (ca 1550). A Scharf, Cicerone 21 (1929) p 115 (ca 1540). T Borenius, Burl Mag 59 (1930) p 66, ill (milieu of Pontormo). Ch Sterling, in Studies ded to Suida, 1959, p 287, fig 8. Nikolenko 1966, pp 24, 65, fig 80 (attributed to Bacchiacca, ca 1540-50). VTTT, 1968-69, nr 104

Adriaen Backer

Amsterdam 1635/36–1684 Amsterdam

A 7 Daniel Niellius (b 1610). Elder of the Remonstrant church and sampling official of Alkmaar. *Remonstrants ouderling en staalmeester te Alkmaar*

Canvas 107 × 89. Signed and dated *A Backer fe. 1671*. Inscribed *Ætatis Suae 61*
PROV Purchased from W N Hopman, Amsterdam, 1874
LIT Moes 1897-1905, vol 2, nr 5374

C 362 The chief commissioners of the Amsterdam harbor works, 1674. *De oppercommissarissen der Walen te Amsterdam, 1674*

The sitters are Dirck Claesz van Leeck, Jan Vlasblom, Wessel Smits and Hendrik Lynslager, the captain of the rescue brigade and the harbor master with his servant

Canvas 196 × 288. Dated *1674*
PROV Conference room of the chief commissioners of the Walen (harbor works) in the Schreierstoren, Amsterdam. On loan from the city of Amsterdam, 1885-1975
LIT Wagenaar 1760-88, vol 2 (1765) p 59 (Jacob Backer). Scheltema 1879, nr 9 (Jacob Backer). Moes 1897-1905, vol 2, nrs 4388, 4706, 7327, 8602. Bauch 1926, p 102, nr 22

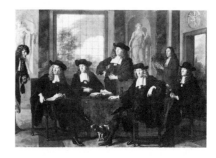

C 360 The superintendents of the Collegium Medicum in Amsterdam, 1683. *De inspecteurs van het Collegium Medicum te Amsterdam, 1683*

The sitters are the physicians Egbertus Veen, Bonaventura van Dortmont and Joan Verwout and the apothecaries Johannes de Vriest and Jacobus Danckertsz de Ry. Standing to the right

is the son of Johannes de Vriest and to the left the guild steward Sieuwert van Duynen

Canvas 261 × 378. Signed and dated *ABacker 1683*
PROV Meeting hall of the Geneeskundig Toevoorzicht (board of health), Amsterdam. On loan from the city of Amsterdam, 1885-1975
LIT Wagenaar 1760-88, vol 2 (1765) p 382. Scheltema 1879, nr 6. Moes 1897-1905, vol 1, nrs 1908, 2094:3, 2218; vol 2, nrs 8261, 8464, 8751. Martin 1935-36, vol 2, p 478

Jacob Adriaensz Backer

Harlingen 1608-1651 Amsterdam

A 3516 Jan Lutma (1584/85-1669). Amsterdam silversmith. *Zilversmid te Amsterdam*

Pendant to A 3517

Panel 91 × 71. Oval. Signed *JAB*
PROV On loan from A W M Mensing, Amsterdam, from 1925 to 1929 (inv nr C 1159). Purchased at sale H L Larsen, New York, 6 Nov 1947, lot 34
LIT C Hofstede de Groot, Gron Volks-almanak, 1895, pp 101-09. Moes 1897-1905, vol 2, nr 4668:1. A Bredius, OH 30 (1912) p 221. Bauch 1926, p 90, nr 151, ill. Martin 1935-36, vol 2, p 112. Frederiks 1943, p 23 (ca 1643). Plietzsch 1960, p 180, fig 330. Th M Duyvené de Wit-Klinkhamer, Bull RM 6 (1960) p 94, fig 18. Van Hall 1963, nr 1308:1

A 3517 Sara de Bie. Jan Lutma's second wife (1638). *Tweede echtgenote van Jan Lutma*

Pendant to A 3516

Panel 93 × 73. Oval. Signed *JAB*
PROV On loan from A W M Mensing, Amsterdam, from 1925 to 1929 (inv nr C 1160). Purchased at sale H L Larsen, New York, 6 Nov 1947, lot 35
LIT Moes 1897-1905, vol 2, nr 4667

(portrait of Mayke Roelantsdr). Bauch 1926, p 91, nr 156, ill; p 108, nr 67 (portrait of Mayken Rolandsdr)

C 1474 Johannes Uyttenbogaert (1557-1644). Remonstrant minister in The Hague. *Remonstrants predikant te 's-Gravenhage*

Canvas 122.5 × 98. Signed and dated *Backer A° 1638*. Inscribed *Æt 80*
PROV On loan from the Remonstrants-Gereformeerde Gemeente (Remonstrant-Reformed congregation), Amsterdam, since 1964
LIT Moes 1897-1905, vol 2, nr 9271:12. Martin & Moes 1912, nr 3. Bauch 1926, pp 31, 91, nr 159, ill. Martin 1935-36, vol 2, p 112, fig 61. A B de Vries, OKTV 3 (1965) nr 14, fig 5. Rosenberg, Slive & Ter Kuile 1966, p 90

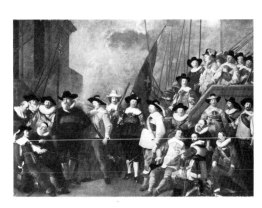

C 1174 The arquebusiers' civic guard company of Captain Cornelis de Graeff and Lieutenant Hendrick Lauwrensz, Amsterdam, 1642. *Officieren en manschappen van de Compagnie Kloveniers van kapitein Cornelis de Graeff en luitenant Hendrick Lauwrensz, Amsterdam, 1642*

The other sitters are Joachim Jansz Scheepmaker, ensign, Teunis Jansen Visch and Jan Gerritsz van Leeuwaerden, sergeants, Marten Canter, Hans van der Elst, Warnar Wiggertzen, Adam Gerritzen, Hendrick Janzen, Hendrick Rijckzen, Elias de Haes, Cornelis Cornelissen Karseboom, Barent van

Bruyninckwinckel, Willem Janzen van Middelum, Hendrick Pauwels, Jan Gerritzen Parys, Gerrit Brauningh Koeckebacker, Hendrick Aertzen de Keyzer, Jan Jacobsz Lantsman, Willem Janzen Buys, Jan Evertzen van Heerden and Jan Evertzen Mattys

Canvas 367 × 511. Dated *1642*
PROV Kloveniersdoelen (headquarters of the arquebusiers' civic guard), Amsterdam. On loan from the city of Amsterdam since 1925
LIT Wagenaar 1760-88, vol 2 (1765) p 19. Van Dijk 1790, p 99, nr 53. Scheltema 1855-85, vol 7 (1885) p 136, nr 6. Scheltema 1879, nr 4 (several of the details mentioned have been confused with those of nr 8). D C Meyer, OH 3 (1885) p 114ff. Bauch 1926, pp 41, 100, nr 232. W Martin, OH 50 (1933) pp 220-24, ill. Martin 1935-36, vol 1, pp 219-22, 224, fig 126; vol 2, p 114. Van Hall 1963, p 8, nr 61:3. Fuchs 1968, p 15, fig 24

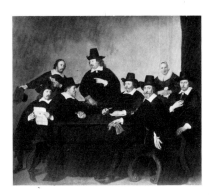

C 442 The regents of the Nieuwe Zijds institute for the outdoor relief of the poor, Amsterdam, ca 1650. *De regenten van het Nieuwe Zijds Huiszittenhuis te Amsterdam, ca 1650*

The sitters are Lucas Pietersz Conijn, Johan Steur, Rombout Kemp, Claes van Lith, Cornelis Metsue and Isaac Commelin. Behind them are the house-master and -mistress

Canvas 272 × 312. Signed *JABacker*
PROV Nieuwe Zijds Huiszittenhuis (institute for the outdoor relief of the poor), Amsterdam. On loan from the city of Amsterdam since 1885
LIT Commelin 1693-94, vol 2, pp 540, 542. Wagenaar 1760-88, vol 2, pp 267, 269 (1651). Bauch 1926, pp 49, 100, nr 233; p 110, nr 94, ill. Martin 1935-36, vol 1, pp 196, 198, fig 109; vol 2, p 114

attributed to **Jacob Adriaensz Backer**

A 157 The parable of the unworthy wedding guest. *De gelijkenis van de onwaardige bruiloftsgast*

Canvas 112 × 156
PROV Purchased from D van der Aa, The Hague, 1802 (as Gerbrandt van den Eeckhout). NM 1808
LIT C Hofstede de Groot, OH 17 (1899) p 167. Moes & van Biema 1909, pp 59, 212

Jan de Baen

Haarlem 1633–1702 The Hague

A 963 Hieronymus van Beverningk (1614-90), lord of Teylingen. Government paymaster. *Heer van Teylingen. Thesauriergeneraal*

Pendant to A 964

Canvas 156 × 121.5. Signed and dated *J. de Baen Fecit 1670*
PROV Sale Jonkvrouwe J J G Rutgers van Rozenburg, dowager of J M C Baron van Utenhove van Heemstede, Jutphaas (Groenendal), 21 Oct 1880, lot 205. NMGK, 1885
LIT Moes 1897-1905, vol 1, nr 610:1. Martin 1935-36, vol 2, p 163

A 964 Johanna le Gillon (1635-1706). Wife of Hieronymus van Beverningk. *Echtgenote van Hieronymus van Beverningk*

Pendant to A 963

Canvas 156.5 × 121.5. Signed *J. de Baen f.*
PROV Sale Jonkvrouwe J J G Rutgers van

Rozenburg, dowager of J M C Baron van Utenhove van Heemstede, Jutphaas (Groenendal), 21 Oct 1880, lot 206. NMGK, 1885
LIT Moes 1897-1905, vol 1, nr 2738. Martin 1935-36, vol 2, p 163. Bernt 1960-62, vol 1, nr 40. Bernt 1969-70, vol 1, nr 48

attributed to **Jan de Baen**

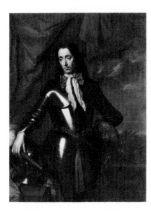

A 4162 Isaac de l'Ostal de Saint-Martin (ca 1629-96). Governor of the Dutch East Indies and commander of the garrison at Batavia. *Raad ordinair van Nederlands Oost Indië en commandant van het garnizoen in Batavia*

Canvas 132 × 102
PROV Purchased from J P Desbons, Paris, 1969
LIT J de Loos-Haaxman, Tijdschr Ind TLV 75 (1935) p 612ff. De Loos-Haaxman 1972, pp 48-50, fig 13

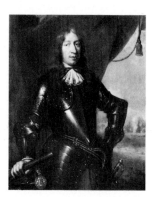

A 3126 Willem Joseph Baron van Ghent (1626-72). Vice admiral. *Luitenant-admiraal*

Canvas 111 × 92.5
PROV Purchased from R A Baron van Hardenbroek, The Hague, 1932
LIT Moes 1897-1905, vol 1, nr 2685. G A Evers, Historia 10 (1945) p 194, fig 2. L M Akerveld & J R Bruijn, Spiegel Hist 2 (1967) p 326, fig 8. Rogers 1970, pl v

A 15 The corpses of the de Witt brothers, Jan and Cornelis, hanging on the Groene Zoodje on the Vijverberg, The Hague, 1672. *De lijken van de gebroeders de Witt, opgehangen op het Groene Zoodje aan de Vijverberg te Den Haag, 1672*

Canvas 69.5 × 56
PROV Thought to have been bought from J I Jver, 1802. NM, 1808
LIT Moes & van Biema 1909, pp 58-59, 218. R van Luttervelt, Bull RM 8 (1960) p 59. J E Hayer, Spiegel Hist 2 (1967) p 417ff, ill

copy after **Jan de Baen**

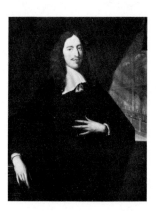

A 13 Johan de Witt (1625-72). Grand pensionary of Holland. *Raadpensionaris van Holland*

In the background is the assembly hall of the states of Holland and West Friesland

Pendant to A 14

Canvas 125 × 98
PROV Sale The Hague, 20 Aug 1806, lot 98. NM, 1808
LIT Houbraken 1718-21, vol 2 (1719) pp 305, 309. Moes 1897-1905, vol 2, nr 9185:11. Moes & van Biema 1909, pp 84, 209. A Dobrzycka, Biul Hist Sztuki 17 (1955) p 453, fig 9. R van Luttervelt, Bull RM 8 (1960) p 27, figs 1-2 (cites numerous other copies and calls the old attribution to de Baen in question)

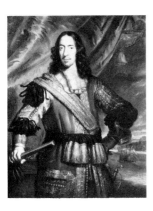

A 14 Cornelis de Witt (1623-72). Burgomaster of Dordrecht and lord lieutenant of Putten. *Burgemeester van Dordrecht en ruwaard van Putten*

In the background the victory over the 'Royal Charles' during the raid on Chatham in 1667

Pendant to A 13

Canvas 124 × 97
PROV Sale The Hague, 20 Aug 1806, lot 99. NM, 1808
LIT Moes 1897-1905, vol 2, nr 9173:11. Moes & van Biema 1909, pp 84, 209. R van Luttervelt, Bull RM 8 (1960) p 47, fig 13 (calls the old attribution to de Baen in question). L M Akerveld & J R Bruijn, Spiegel Hist 2 (1967) p 326, fig 11. Rogers 1970, p 125, pl XI

A 4648 The apotheosis of Cornelis de Witt, with the raid on Chatham in the background. *Verheerlijking van Cornelis de Witt, met op de achtergrond de tocht naar Chatham*

Canvas 75.5 × 102. Either a model for or a replica of the large painting in the town hall of Dordrecht, which was destroyed by rioters in 1672
PROV Purchased from Mr Eindhoven, The Hague, 1875. NMGK, 1885
LIT Houbraken 1718-21, vol 2 (1719) pp 309-10. Ramaer 1859. Moes 1897-1905, vol 2, nr 9173:7. Moes & van Biema 1909, p 128. R van Luttervelt, Bull RM 8 (1960) pp 49-52, fig 15. Rogers 1970, pl XI

David Bailly

Leiden 1584 – 1657 Leiden

A 16 Portrait of a woman, thought to be Maria van Reigersbergh (1589-1653), wife of Hugo de Groot. *Portret van een vrouw, vermoedelijk Maria van Reigersbergh, echtgenote van Hugo de Groot*

Copper 18.5 × 14. Signed and dated *D. Bailly fecit A° 1626*
PROV Purchased from P C Huybrechts, The Hague, 1806. NM, 1808
LIT Moes 1897-1905, vol 2, nr 6383:1. Moes & van Biema 1909, pp 84, 207. J Bruyn, OH 66 (1951) p 160 (rejects the identification of the sitter). R van Luttervelt, Jaarversl KOG 104-05 (1964) pp 52-53, fig 10

A 2717 Anthony de Wale (1573-1639). Professor of theology at the university of Leiden. *Hoogleraar in de theologie te Leiden*

Panel 71 × 60. Inscribed *Ætatis 63 A° 1636*
PROV Sale Crespi (Milan), Paris, 4 June 1914, lot 91, ill. Purchased with aid from the Rembrandt Society
LIT Moes 1897-1905, vol 2, nr 8824:1. J Bruyn, OH 66 (1951) p 214, fig 9

A 945 Portrait of a young man. *Portret van een jonge man*

Panel 35 × 27
PROV Purchased from Jonkheer J E van Heemskerck van Beest, 1877. NMGK, 1885
LIT J Bruyn, OH 66 (1951) p 219, fig 16

Gerrit Bakhuizen

Amsterdam 1721 – 1760 Rotterdam

A 2199 Self portrait. *Zelfportret*

Panel 30.5 × 25
PROV Bequest of Miss M E van den Brink, Velp, 1905
LIT Goldscheider 1936, p 44, fig 322. Boon 1947, p 70, fig 47. J W Niemeijer, Bull RM 10 (1962) p 147, ill. Van Hall 1963, nr 67. Exhib cat De schilder en zijn wereld, Delft-Antwerp 1965, nr 4 (with inaccurate data)

Ludolf Bakhuysen

Emden 1631 – 1708 Amsterdam

see also Helst, Bartholomeus van der,
A 140 Aert van Nes; A 141 Geertruida
den Dubbelde; A 832 Johan de Liefde

C 363 Self portrait. *Zelfportret*

Canvas 190 × 150. Signed and dated
L. Bakh... out L X V I I I I Anno 1699
PROV Presented by the artist to the Stads
Kunstkamer (art collection of the city of
Amsterdam), 1699. On loan from the
city of Amsterdam, 1885-1975
LIT Van Dijk 1790, p 146, nr 120.
Scheltema 1879, p 5, nr 10. Moes 1897-
1905, vol 1, nr 325:3. Hofstede de Groot
1907-28, vol 7 (1918) nr 42. Martin 1935-
36, vol 2, p 383. Van Hall 1963, nr 68:7.
N Popper-Voskuil, Pantheon 31 (1973) p
72, note 26

A 2186 Self portrait. *Zelfportret*

Pendant to A 2187

Panel 18.4 × 14.4
PROV Bequest of Miss M E van den
Brink, Velp, 1905
LIT Moes 1897-1905, vol 1, nr 325:8.
Hofstede de Groot 1907-28, vol 7 (1918)
nr 43. BAJ Renckens, OH 75 (1960) p
124. Van Hall 1963, nr 68:12

A 2187 Anna de Hooghe (1645-1717).
The painter's fourth wife. *Vierde echtgenote
van de schilder*

Pendant to A 2186

Panel 18.4 × 14.4
PROV Same as A 2186
LIT Moes 1897-1905, vol 1, nr 3687:2.
Hofstede de Groot 1907-28, vol 7 (1918)
nr 49. BAJ Renckens, OH 75 (1960) p
124

A 2188 Anna de Hooghe (1645-1717).
The painter's fourth wife. *Vierde echtgenote
van de schilder*

On the wall is a portrait of the sitter's son
Johannes (our A 2189)

Canvas 39 × 35.5
PROV Bequest of Miss M E van den
Brink, Velp, 1905
LIT Hofstede de Groot 1907-28, vol 7
(1918) nr 50. BAJ Renckens, OH 75
(1960) p 124

A 2189 Johannes Bakhuysen (1683-
1731). With a miniature portrait of his
father Ludolf. *Met een miniatuurportret van
zijn vader Ludolf*

The painting is depicted in A 2188

Canvas 65 × 55. Oval
PROV Bequest of Miss M E van den
Brink, Velp, 1905
LIT Moes 1897-1905, nr 324. Hofstede
de Groot 1907-28, vol 7 (1918) nr 52.
BAJ Renckens, OH 75 (1960) p 124. N
Popper-Voskuil, Pantheon 31 (1973) p
65, note 26

A 2197 Jan de Hooghe (1650-1731).
Anna de Hooghe's brother, dressed for
shooting. *Broer van Anna de Hooghe, in
jachtkostuum*

Canvas 99 × 82. Signed and dated
L. Bakh. 1700
PROV Bequest of Miss M E van den
Brink, Velp, 1905 * DRVK since 1950
LIT Hofstede de Groot 1907-28, vol 7
(1918) nr 56. BAJ Renckens, OH 75
(1960) p 124

A 2198 The Bakhuysen and de Hooghe
families dining at the Mosselsteiger
(mussel pier) on the Y, Amsterdam. *De
families Bakhuysen en de Hooghe aan de maal-
tijd op de Mosselsteiger aan het IJ te
Amsterdam*

Canvas 50.5 × 69.5. Signed and dated
L. Bakh. out 72 jaar a° 1702
PROV Bequest of Miss M E van den
Brink, Velp, 1905
LIT Hofstede de Groot 1907-28, vol 7
(1918) nr 48. BAJ Renckens, OH 75
(1960) p 124. Van Hall 1963, nr 68:8.
Bol 1973, pp 302, 304, fig 304

A 1465 An artist in his studio, painting the portrait of a lady. *Een schilder in zijn atelier, een dame portretterend*

Canvas 84 × 70. Signed and dated *Lud. Bak. 76 Aet 1707*
PROV Sale C J Terbruggen, Amsterdam, 12-13 June 1888, lot 5
LIT Hofstede de Groot 1907-28, vol 7 (1918) nr 44. Van Hall 1963, nr 68:10. Exhib cat Maler und Modell, Baden-Baden 1969, nr 70, ill

A 8 Dutch ships in the roads of Texel; in the middle the 'Gouden Leeuw,' the flagship of Cornelis Tromp. *Nederlandse schepen op de rede van Texel; in het midden de 'Gouden Leeuw,' het vlaggeschip van Cornelis Tromp*

Canvas 92 × 140. Signed and dated *L. Bakh. 1671*
PROV Purchased from C Josi, Amsterdam, 1805. NM, 1808
LIT Moes & van Biema 1909, pp 83, 218. Willis 1911, pp 108, 110. C G 't Hooft, in Feestbundel Bredius, 1915, p 104. Hofstede de Groot 1907-28, vol 7 (1918) nr 17

A 9 The Y at Amsterdam, seen from the Mosselsteiger (mussel pier). *Het IJ voor Amsterdam, van de Mosselsteiger gezien*

Canvas 81 × 67. Signed and dated *L. Backhuy... 1673*
PROV Sale G van der Pot van Groeneveld, Rotterdam, 6 June 1808, lot 2
LIT Moes & van Biema 1909, pp 112, 156, 186. Willis 1911, p 110. Hofstede de Groot 1907-28, vol 7 (1918) nr 64

A 2539 The man-of-war 'Koning William' on the Maas off Rotterdam. *Het oorlogsschip 'Koning William' op de Maas voor Rotterdam*

Canvas 130 × 197. Signed and dated *L. Bakh. Ft 1689*
PROV Purchased from Fr Muller, art dealers, Amsterdam, 1912
LIT Waagen 1854, vol 2, p 129. J F L de Balbian Verster, Eigen Haard, 1911, p 648. Hofstede de Groot 1907-28, vol 7 (1918) nr 143. Martin 1935-36, vol 2, p 383, fig 209

A 10 Rough sea with ships. *Woelige zee met schepen*

Canvas 53.5 × 69. Signed and dated *L. Bakh. 1692*
PROV Sale G van der Pot van Groeneveld, Rotterdam, 6 June 1808, lot 3
LIT Moes & van Biema 1909, pp 156, 181. Hofstede de Groot 1907-28, vol 7 (1918) nr 174 (cf nr 386)

A 11 Rough sea with a Dutch yacht under sail. *Woelige zee met Nederlands jacht onder zeil*

Canvas 37 × 46. Signed and dated *L. Bakhuizen 1694*
PROV Bequest of L Dupper Wzn, Dordrecht, 1870
LIT Hofstede de Groot 1907-28, vol 7 (1918) nr 175

A 2315 Rough sea with ships. *Woelige zee met schepen*

Pendant to A 2316

Canvas 31.5 × 39. Signed and dated *L.B. 1697*
PROV Purchased from the heirs of Jonkheer P H Six van Vromade, Amsterdam, 1908, with aid from the Rembrandt Society * DRVK since 1954
LIT Hofstede de Groot 1907-28, vol 7 (1918) nr 176

A 2316 Seas off the coast, with a spritsail barge. *Kustgezicht met tjalk*

Pendant to A 2315

Canvas 31.4 × 38.5. Signed and dated *L.B. 1697*
PROV Same as A 2315 * DRVK since 1954
LIT Hofstede de Groot 1907-28, vol 7 (1918) nr 177. Bernt 1960-62, vol 1, nr 35. Bernt 1969-70, vol 1, nr 43

A 12 The Y off Amsterdam. *Het IJ voor Amsterdam*

Canvas 61 × 75.5. Signed *L. B.*
PROV Bequest of L Dupper Wzn, Dordrecht, 1870 * DRVK since 1958
LIT Hofstede de Groot 1907-28, vol 7 (1918) nr 65

C 91 The Y at Amsterdam, with the frigate 'De Ploeg.' *Het IJ voor Amsterdam met het fregat 'De Ploeg'*

Canvas 68 × 81. Signed *L. Bakh.*
PROV On loan from the city of Amsterdam (A van der Hoop bequest) since 1885
LIT Willis 1911, p 110. Hofstede de Groot 1907-28, vol 7 (1918) nr 66. J Knoef, Jb Amstelodamum 42 (1946) p 5

A 2203 View of Egmond aan Zee. *Gezicht op Egmond aan Zee*

Panel 24 × 31.5. Signed *L. B.*
PROV Bequest of Miss M E van den Brink, Velp, 1905
LIT Hofstede de Groot 1907-28, vol 7 (1918) nr 477. BAJ Renckens, OH 75 (1960) p 124

C 92 The Haarlemmermeer. *Het Haarlemmermeer*

Canvas 43.5 × 62. Signed *L. Backh.*
PROV On loan from the city of Amsterdam (A van der Hoop bequest), 1885-1975
LIT Hofstede de Groot 1907-28, vol 7 (1918) nr 130. Bol 1973, p 303, fig 308

A 1428 The shipyard of the Amsterdam admiralty. *De scheepstimmerwerf der Admiraliteit van Amsterdam*

Panel 38 × 69. Pen painting. Signed *L. Backhuysen Ft.*
PROV Sale Amsterdam, 1 Nov 1887, lot 3
LIT Willis 1911, p 107. F G M Douwes, Ons Amsterdam 13 (1961), p 34ff, ill

Bakhuyzen

see Sande Bakhuyzen

Alexander Hugo Bakker Korff

The Hague 1824–1882 Leiden

see also under Aquarelles and drawings

A 1183 'Under the palms.' *'Onder de palmen'*

Panel 17.5 × 14. Signed and dated *A. H. Bakker Korff 1880*
PROV Purchased at exhib The Hague 1881, nr 12. RVMM, 1885
LIT A Crébas, Kunstrip 1 (1970-71) nr 2

A 3071 'The rag basket.' *'De lappenmand'*

Panel 21 × 16. Signed *A. H. Bakker Korff*
PROV Bequest of J B A M Westerwoudt, Haarlem, 1907. Received in 1929

A 3070 'The pastry chef.' *'De taarte-bakster'*

Panel 10.9 × 8.5. Signed *BK*

PROV Bequest of J BA M Westerwoudt, Haarlem, 1907. Received in 1929

A 2260 Two ladies at their sewing. *Twee dames bezig met naaiwerk*

Panel 24 × 20. Unfinished
PROV Bequest of J BA M Westerwoudt, Haarlem, 1907
LIT J Slagter, Elsevier's GM 34 (1924) ill opp p 364

milieu of **Alesso Baldovinetti**

Florence ca 1426–1499 Florence

C 1188 Tobias and the angel, with St Francis. *Tobias en de engel, met de heilige Franciscus*

Panel transferred to canvas 157 × 138
PROV On loan from J H van Heek, Lonneker, since 1928
LIT Van Marle 1923-38, vol 11 (1929) p 462 (related to the Master of the Florentine Picture Chronicle). T Borenius, Burl Mag 59 (1931) p 65 (school of Pollaiuolo). R van Marle, Boll d'Arte 28 (1935) p 306, fig 20. Berenson 1963, vol 1, p 217. Van Os & Prakken 1974, pp 33-34, nr 4, ill

Hendrick van Balen

Antwerp 1575–1632 Antwerp

A 17 Bacchus and Diana. *Bacchus en Diana*

Panel 39.5 × 52
PROV Purchased with the Kabinet van Heteren Gevers, The Hague-Rotterdam, 1809
LIT Moes & van Biema 1909, pp 145, 156. Legrand 1963, p 50

Pieter Balten

active 1540 in Antwerp; thought to have died there ca 1598

A 860 The St Martin's Day kermis. *Sint Maartenskermis*

Panel 110 × 148. Signed *Peeter Balten*
PROV Purchased through the intermediacy of J Ph van der Kellen, 1875.
NMGK, 1885
LIT G Marlier, Bull Mus Roy Belg 14 (1965) p 128

A 2554 A performance of the farce 'Een cluyte van Plaeyerwater' (A clod from Plaeyerwater) at a Flemish kermis. *Een opvoering van de klucht 'Een cluyte van Plaeyerwater' op een Vlaamse kermis*

Panel 112 × 157
PROV Lent by C Hoogendijk, The Hague, 1907. Presented by his estate in 1912 * DRVK since 1959 (on loan to the Toneelmuseum, Amsterdam)
LIT Van Bastelaer & Hulin de Loo 1907, p 372, nr 2. Van Puyvelde 1912, p 87. R Bangel, Cicerone 7 (1915) p 184. D Roggen, Gent Bijdr 6 (1939-40) p 107ff, ill. G Cohen, in Miscellanea van Puyvelde, 1949, pp 217-20. Gerson & Ter Kuile 1960, p 56. G Marlier, Bull Mus Roy Belg 14 (1965) pp 1-40. B Albach, Delta, winter 1967-68, p 22, ill. J E M van Autenboer, Spiegel Hist 3 (1968) p 65, ill on cover. R H C Vos, Kunstrip 3 (1972-73) nr 27

Gerbrandt Ban

Haarlem 1613–after 1652 Amsterdam

A 1345 Portrait of a young man. *Portret van een jonge man*

Copper 23 × 17.5. Oval. Signed and dated *GBan 1650*
PROV Sale J H Cremer, Amsterdam, 26 Oct 1886, lot 105

Pieter Barbiers Pietersz

Amsterdam 1738–1842 Amsterdam

A 1003 Farmhouse near Helvoirt. *Land-hoeve bij Helvoirt*

Panel 41 × 37. Signed *P. Barbiers*
PROV RVMM, 1885

Dirck Barendsz

Amsterdam 1534–1592 Amsterdam

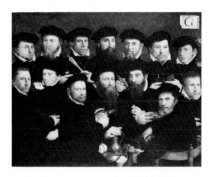

C 364 Fourteen guardsmen of Squad G, Amsterdam, 1562. *Veertien Amsterdamse schutters van Rot G, 1562*

Panel 143 × 183. Dated *Anno a Christo nato 1562*. Inscribed *G* and *In Vino Veritas*
PROV Voetboogdoelen (headquarters of the crossbowmen's civic guard), Amsterdam. On loan from the city of Amsterdam, 1885-1975
LIT Van Dijk 1790, p 9, nr 3. Scheltema 1879, p 5, nr 11. Scheltema 1855-85, vol 7 (1885) p 133, nr 10. AD de Vries, in Christelijke Kunst, 1881, p 190ff. J Six, OH 13 (1895) p 105. W del Court & J Six, OH 21 (1903) pp 74, 81. J Six, OH 29 (1911) p 133. Hoogewerff & Altena 1928, p 8, note 3. Riegl 1931, pp 94-99, fig 18. De Vries 1934, p 51. Hoogewerff 1936-47, vol 4 (1941-44) p 635, fig 305. Gerson 1950, p 57, fig 153. J Bruyn, Med RKD in OH 70 (1955) p 258. J R Judson, Bull Mus Roy Belg 11 (1962) p 82. Würtenberger 1962, p 203. G Bazin, Jardin d A, Nov 1968, p 80, ill. Judson 1970, pp 29-31, 44, 49, cat nr 46, figs 1-5

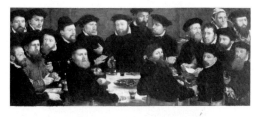

C 365 Banquet of eighteen guardsmen of Squad L, Amsterdam, 1566, known as 'The perch eaters.' *Maaltijd van achttien Amsterdamse schutters van Rot L, 1566, bekend als 'De poseters'*

Panel 120 × 295. Dated *Anno 1566*. Inscribed *L* (in the date, between *15* and *66*)

PROV Kloveniersdoelen (headquarters of the arquebusiers' civic guard), Amsterdam. On loan from the city of Amsterdam since 1885
LIT Van Mander 1604, fol 259v. Descamps 1753-64, vol 1, p 465ff. Van Dijk 1790, nr 9. Gault de Saint Germain 1818, p 28. Scheltema 1879, p 6, nr 12. AD de Vries, in Christelijke Kunst, 1881, p 189ff, nr 14. Hymans 1884, p 44, note. Scheltema 1855-85, vol 7 (1885) p 139, nr 34. G A Nauta, Navorscher 44 (1894) p 604 (on the kind of fish being eaten). J Six, OH 13 (1895) p 108. W del Court & J Six, OH 21 (1903) p 81. Greve 1903, p 212. J Six, OH 29 (1911) p 133. Riegl 1931, pp 95, 99, 101ff, 120, 123, 129, 133, fig 19. De Vries 1934, p 51. Hoogewerff 1936-47, vol 4 (1941-42) p 635. J Bruyn, Med RKD in OH 70 (1955) p 258. H van de Waal, OH 71 (1956) p 72, fig 5. J R Judson, Bull Mus Roy Belg 11 (1962) p 82, fig 3. Judson 1962, pp 97, 106, fig 3. Judson 1970, pp 21-22, 29-32, 39ff, cat nr 47, figs 16-19. Slive 1970, vol 1, p 55, fig 34 (detail)

milieu of **Dirck Barendsz**

A 2164 Willem I (1533-84), prince of Orange, called William the Silent. *Prins van Oranje, genaamd Willem de Zwijger*

Panel 49 × 33
PROV Purchased from E Constantini, Florence, 1905
LIT J J de Gelder, Med Ned Hist Inst Rome 8 (1928) p 154, fig 3 (anonymous). Beresteyn 1933, nr 72 (anonymous; lists variants). Hoogewerff 1936-47, vol 4 (1941-42) p 637, fig 307 (Barendsz). Judson 1970, p 155 (under rejected works). Gans 1971, p 19, ill

C 454 The company of Captain Reynst Pietersz and Ensign Claas Claasz Kruys, 1585. *Het korporaalschap van kapitein Reynst Pietersz en vaandrig Claas Claasz Kruys, 1585*

The sitters, insofar as they can be identified, are, from left to right: (above) *1* Klaas Engelen, *2* Claas Claasz Kruys, *10* Jan Banning, *14* Heereman, the steward, *15* Sybrant Bam; (below) *16* Willem Bitter, *17* Pieter Martsz Kodde, *18* Wm van Kampen, *19* Pieter Klaasz Boer, *20* Heindr van Marken, *21* Gerrit Jacobs Verwer, *22* Fredrik Fredriks Serwouters, *23* Laurens Jacobs Reael, *24* Reynst Pietersz, captain, *25* Cornelis Pietersz Hooft, *26* Dirk Thymansz, *27* Hans van Nes, *28* Cornelis Symons Joncheyn, *30* Jan de Bisschop, *31* Heindr Laurensz Spiegel

Panel 168 × 369. Dated *1585*
PROV Handboogdoelen (headquarters of the archers' civic guard), Amsterdam. On loan from the city of Amsterdam, 1885-1975
LIT Van Dijk 1790, nr 117 (Cornelis Ketel). Scheltema 1879, nr 76 (Paulus Moreelse). Scheltema 1855-85, vol 7 (1885) p 129, nr 11 (Barendsz). W del Court & J Six, OH 21 (1903) pp 67, 73, 81 (Barendsz). De Vries 1934, p 53 (Barendsz). Hoogewerff 1936-47, vol 4 (1941-42) p 639 (Barendsz?). Judson 1970, p 157 (not Barendsz)

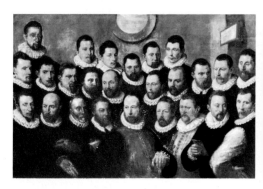

C 379 Twenty-five guardsmen of Squad A, Amsterdam, 1588, among them the bailiff Willem van der Does (1547-1624). *Vijfentwintig Amsterdamse schutters van Rot A, 1588, waaronder de schout Willem van der Does*

Panel 155 × 230. Formerly dated *1588* and inscribed *A* (between the *15* and *88*)
PROV Voetboogdoelen (headquarters of the crossbowmen's civic guard), Amsterdam. On loan from the city of Amsterdam, 1885-1975

LIT Van Dijk 1790, nr 4 (Cornelis Ketel). Scheltema 1855-85, vol 7 (1885) p 134, nrs 18, 141. Scheltema 1879, nr 54 (Ketel). Moes 1897-1905, vol 1, nr 2051. W del Court & J Six, OH 21 (1903) pp 77, 81 (Barendsz). De Vries 1934, p 53 (Barendsz). Hoogewerff 1936-47, vol 4 (1941-42) p 639 (Barendsz?). Judson 1970, p 157 (not Barendsz; possibly Ketel)

attributed to **Fra Bartolommeo**

Florence 1472 – 1517 Florence

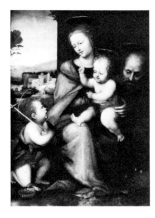

A 3376 The holy family with the infant John the Baptist. *De heilige familie met de kleine Johannes*

Panel 109 ×82.5
PROV Bequest of J W Edwin vom Rath, Amsterdam, 1941
LIT Gower 1885, p 5, fig 3. C J Ffoulkes, Archivio stor 7 (1894) p 170 (Perino del Vaga). Knapp 1903, p 264. Berenson 1909, p 112 (finished by Mariotto Albertinelli). Von der Gabelentz 1922, vol 1, p 193. Venturi 1901-40, vol 11:1 (1915) p 348, note. Venturi 1927, pp 75-76, fig 44. Berenson 1932, p 47. Berenson 1963, vol 1, p 22. Chr von Holst, Mitt Kunsth Inst Florenz 15 (1971) pp 17-19, fig 21 (ca 1509)

Willem Bartsius

Enkhuizen ca 1612 – after 1639 Amsterdam?

A 2214 A captain. *Een kapitein*

Panel 38.5 × 29. Signed *WB. f.*
PROV Sale Amsterdam, 21 Sept 1904, lot 65 (as Willem Buytewech). Purchased with aid from the Rembrandt Society

attributed to **Willem Bartsius**

A 818 Mrs Kettingh, née Speyart

Panel 63 × 51. Signed and dated *Bartz. S. Fecit A° 1630*. Inscribed *Ætatis 63*. Inscribed on the verso *Iuff^r Speijart Getrout met D Heer …lem Kettingh*
PROV Presented by Jonkheer J H F K van Swinderen, Groningen, 1884
LIT C Hofstede de Groot, OH 22 (1904) p 113 (not Bartsius). Moes 1897-1905, vol 2, nr 7441

Hendrick Bary

see Panpoeticon Batavum: A 4598 Johan de Witt, by Jan Maurits Quinkhard after Bary; A 4571 Willem de Groot, by Jan Maurits Quinkhard after Bary

Maria Konstantinowna Bashkirtseff

Gowronzi 1860 – 1884 Paris

A 1988 The artist's sister-in-law. *De schoonzuster van de schilderes*

Canvas 92 × 73. Signed and dated *M.B. 1881*
PROV Presented by Mrs M Bashkirtseff-Bananine, Nice, 1902

copy after **Jacopo Bassano**

active 1534; d 1592 Venice

A 2127 Lazarus and the rich man. *De rijke man en de arme Lazarus*

Copy after a print by Aegidius Sadeler after Jacopo Bassano

Canvas 99.5 × 138.5
PROV Purchased from J Rey, Texel, 1902
∗ On loan to the Rijksmuseum Muiderslot, Muiden, since 1905

Leandro Bassano

Bassano 1557–1622 Bassano

A 3006 Morosina Morosini. Wife of Marino Grimani, the doge of Venice. *Echtgenote van Marino Grimani, doge van Venetië*

Canvas 114 × 97.5
PROV Purchased from the Augusteum, Oldenburg, 1923, as a gift from a group of members of the Rembrandt Society
LIT Bode 1888, p 22. T Borenius, Burl Mag 28 (1913) p 35. Venturi 1901-40, vol 9:4 (1930) p 1319, fig 900. Arslan 1931, pp 257, 275. T Borenius, Burl Mag 59 (1931) p 72, ill. Berenson 1932, p 60. R van Marle, Boll d'Arte 28-29 (1935) p 400. Berenson 1957, vol 1, p 21. Arslan 1960, p 257. F Gibbons, Record Princeton 22 (1963) p 32

attributed to **Leandro Bassano**

A 3377 The exodus from Egypt. *De uittocht uit Egypte*

Canvas 95.5 × 125
PROV Bequest of J W Edwin vom Rath, Amsterdam, 1941
LIT Berenson 1932, p 55. Arslan 1960, pp 235, 257, fig 270 (Leandro Giovane, ca 1580, with the help of Jacopo)

Bartholomeus van Bassen

ca 1590–1652 The Hague

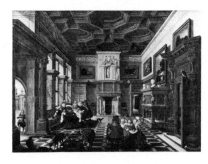

A 864 A company in an interior. *Gezelschap in interieur*

Panel 72 × 100. Signed *vBassen*
PROV Purchased in 1877. NMGK, 1885
LIT Jantzen 1919, pp 61, 158, nr 50, fig 20. Martin 1935-36, vol 1, pp 271, 275, fig 159

attributed to **Bartholomeus van Bassen**

A 4246 Five ladies in an interior. *Interieur met vijf dames*

Panel 95 × 140. Inscribed on the virginal *Cum tibi divitiae superant in fine se… munificus facito vivas, non parcus amit…*
PROV Unknown (was in the museum in 1881). NMGK
LIT Jantzen 1919, pp 64, 159, nr 55. E van Uitert, OKTV 12 (1968) p 1, ill. B Wander, Bijdragen NOM, 1972, p 11, fig 7

Madeleine Françoise Basseporte

see under Pastels

Syvert Nicolaas Bastert

Maarsseveen 1854–1939 Loenen aan de Vecht

see also under Aquarelles and drawings

A 2413 Summer landscape on the Vecht. *Zomerlandschap bij de Vecht*

Canvas 32 × 48. Signed *N. Bastert*
PROV Bequest of Mrs A E de Perrot-Hatwan, Amsterdam, 1910 * DRVK since 1953

Karel Batist

active Amsterdam 1659, Alkmaar 1663

A 732 Wreath of flowers encircling a niche. *Bloemenkrans rond een nis*

Canvas 121.5 × 106. Signed *K. Batist F.*
PROV Presented by Jonkheer O Smissaert, Haarlem, 1881
LIT Mitchell 1973, p 42, fig 47

Marius Alexander Jacques Bauer

The Hague 1867–1932 Amsterdam

see also under Aquarelles and drawings

A 3575 Oriental wedding. *Oosterse bruiloft*

Canvas 180 × 277. Signed and dated
M. Bauer 1911
PROV Lent by Mr & Mrs J C J Drucker-
Fraser, 1919. Bequeathed in 1944 *
DRVK since 1956

A 3572 Bridge near Toledo. *Brug bij
Toledo*

Panel 40 × 70. Signed *M. Bauer*
PROV Lent by Mr & Mrs J C J Drucker-
Fraser, 1919. Bequeathed in 1944

A 3573 Landscape in Spain. *Landschap in
Spanje*

Panel 30 × 47. Signed *M. Bauer*
PROV Lent by Mr & Mrs J C J Drucker-
Fraser, 1919. Bequeathed in 1944 *
DRVK since 1953

A 2875 Mountainous landscape in
Egypt. *Berglandschap in Egypte*

Canvas 41 × 61. Signed *M. Bauer*
PROV Bequest of A van Wezel,
Amsterdam, 1922

A 3571 Caravan. *Karavaan*

Canvas 50 × 70. Signed *M. Bauer*
PROV Lent by Mr & Mrs J C J Drucker-
Fraser, 1919. Bequeathed in 1944 *
DRVK since 1953

A 2876 A desert funeral. *Een woestijn-
begrafenis*

Canvas 55 × 75.5. Signed *M. Bauer*
PROV Bequest of A van Wezel,
Amsterdam, 1922 * DRVK since 1953

A 2261 Ambir Palace in Hindustan. *Het
paleis Ambir in Hindoestan*

Canvas 48 × 80. Signed *M. Bauer*
PROV Bequest of J B A M Westerwoudt,
Haarlem, 1907 * DRVK since 1961

A 3574 City wall in India. *Stadsmuur in
India*

Canvas 50 × 69. Signed *M. Bauer*
PROV Lent by Mr & Mrs J C J Drucker-
Fraser, 1919. Bequeathed in 1944

A 3570 Oriental street. *Oosterse straat*

Panel 81 × 19.5. Signed *M. Bauer*
PROV Lent by Mr & Mrs J C J Drucker-
Fraser, 1919. Bequeathed in 1944

Hendrikus Johan Antonius Baur

see under Pastels

Nicolaas Baur

Harlingen 1767–1820 Harlingen

A 1004 The navy's frigate 'Rotterdam' on the Maas off Rotterdam. *'s Lands fregat 'Rotterdam' op de Maas voor Rotterdam*

Pendant to A 1005

Canvas 80 × 106. Signed and dated *N. Baur 1807*
PROV Purchased by King Louis Napoleon, 1807. NM, 1808. RVMM, 1885
LIT Immerzeel 1842-43, vol 1, p 34. Moes & van Biema 1909, p 224. Marius 1920, fig 29. Huebner 1942, fig 44

A 1005 The navy's man-of-war 'Amsterdam' off the Westerlaag on the Y at Amsterdam. *'s Lands oorlogsschip 'Amsterdam' voor de Westerlaag op het IJ voor Amsterdam*

Pendant to A 1004

Canvas 82 × 103
PROV Same as A 1004
LIT Immerzeel 1842-43, vol 1, p 34. Moes & van Biema 1909, p 224. Huebner 1942, fig 45

A 1377 The Anglo-Dutch fleet in the Bay of Algiers backing up the ultimatum to release the white slaves, 26 August 1816. *De Engels-Nederlandse vloot in de Baai van Algiers ter ondersteuning van het ultimatum tot vrijlating van blanke slaven, 26 augustus 1816*

Panel 55 × 76. Signed and dated *N. Baur 1818*
PROV KKS, 1848. RVMM, 1885. NMGK, 1887

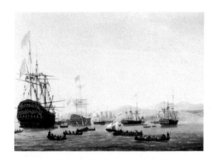

A 1379 Council of war on board the 'Queen Charlotte,' commanded by Lord Exmouth, prior to the bombardment of Algiers, 26 August 1816. *Krijgsraad aan boord van de 'Queen Charlotte' van Lord Exmouth voor het bombardement op Algiers, 26 augustus 1816*

Panel 55 × 76. Signed and dated *N. Baur 1818*
PROV KKS, 1848. RVMM, 1885. NMGK, 1887

A 1378 The fire on the wharves of Algiers, shortly after the commencement of the bombardment by the Anglo-Dutch fleet, 27 August 1816. *De brand op de werven van Algiers, kort na het begin van het bombardement door de Engels-Nederlandse vloot, 27 augustus 1816*

Panel 55 × 76. Signed *N. Baur*
PROV KKS, 1848. RVMM, 1885. NMGK, 1887
LIT Scheen 1946, fig 406. Exhib cat 150 jaar Nederlandse kunst, Amsterdam 1963, nr 4, fig 2

A 1380 The Anglo-Dutch fleet under Lord Exmouth and Vice admiral Jonkheer Theodorus Frederik van Capellen putting out the Algerian strongholds, 27 August 1816. *De Engels-Nederlandse vloot onder Lord Exmouth en vice-admiraal Jonkheer Theodorus Frederik van Capellen stelt de Algerijnse fortificaties buiten gevecht, 27 augustus 1816*

Panel 54 × 75. Signed and dated *N. Baur 1818*
PROV KKS, 1848. RVMM, 1885. NMGK, 1887
LIT Van Eynden & van der Willigen 1816-40, vol 3 (1820) p 136

copy after **Domenico Beccafumi**

Cortine 1486–1551 Siena

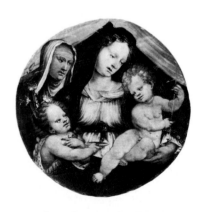

A 3378 Madonna and child with the infant John the Baptist and St Clara. *Maria met kind, Johannes de Doper en de heilige Clara*

Panel 62 cm in diam. Tondo
PROV Bequest of J W Edwin vom Rath, Amsterdam, 1941
LIT Berenson 1932, p 64. Sanminiatelli 1967, p 169 (after an original of ca 1530-40)

attributed to **Francesco Beccaruzzi**

active ca 1520-50 in Conegliano and Treviso

A 3990 Portrait of a woman with a squirrel. *Portret van een vrouw met een eekhoorntje*

Canvas 133.5 × 98
PROV O Lanz, Amsterdam. Lent by the DRVK, 1952. Transferred in 1960
LIT Berenson 1957, vol 1, p 119 (Francesco Montemezzano)

Jeronimus Becx II

see Heraldic objects: A 4643

Jan Simonsz van der Beeck

see Torrentius

Andries Beeckman

active 1651 in Deventer, thereafter in the Dutch East Indies, returning to Holland in or shortly after 1657

A 19 The castle of Batavia, seen from Kali Besar West, ca 1656. *Het kasteel van Batavia, gezien van Kali Besar West, ca 1656*

Canvas 108 × 151.5. Signed *ABeeckman Fecit*

PROV Conference room of East India House, Amsterdam. Purchased in 1859
LIT Dapper 1663, p 449. De Haan 1922-23, vol 1, p 275, pls L2, L2a, L2b. A Hallema, Historia 10 (1935-36) p 364, ill. Stapel 1938-40, vol 3, ill opp p 499. De Loos-Haaxman 1941, pp 64–66, fig 28. De Loos-Haaxman 1968, pp 10, 32, fig 2. G L Berk, Spiegel Hist 7 (1972) fig 3, p 552. Exhib cat Nederlandse schilders en tekenaars in de Oost, Amsterdam 1972, nr 1. W H Vroom, Ons Amsterdam 24 (1972) p 178, ill

Bernardus Antonie van Beek

Amsterdam 1875 – 1941 Kortenhoef

A 3520 Cows in the meadow. *Koeien in de wei*

Canvas 69 × 93.5. Signed *Bern. A. van Beek*
PROV Presented by Mrs Z Beversen-Siemons, Soestdijk, 1948 * DRVK since 1956

Adriaen Cornelisz Beeldemaker

Rotterdam 1618 – 1709 The Hague

A 750 The hunter. *De jager*

Canvas 185.5 × 224. Signed and dated *AC Beeldemaeker A° 1653*
PROV Sale W Gruyter, Amsterdam, 24-25 Oct 1882, lot 8

LIT Martin 1935-36, vol 2, p 367. Bernt 1960-62, vol 1, nr 46. Bol 1969, p 254. Bernt 1969-70, vol 1, nr 62

A 2676 Hunter with hounds at the edge of a wood. *Jager met honden aan bosrand*

Canvas 41 × 61. Signed and dated *ABeeldemaker f. 16..*
PROV Bequest of R Th Baron van Pallandt van Eerde, Ambt-Ommen, 1913

Cornelis Beelt

active ca 1660 in Haarlem; d before 1702

C 93 The proclamation of the Peace of Münster on the Grote Markt in Haarlem, 1648. *De afkondiging van de Vrede van Munster op de Grote Markt te Haarlem, 1648*

Canvas 103 × 147. Signed *K. Beelt*
PROV On loan from the city of Amsterdam (A van der Hoop bequest), 1885-1975
LIT Bernt 1960-62, vol 1, nr 47. Bol 1969, p 209, note 282. Bernt 1969-70, vol 1, nr 63

A 2692 The departure of Charles II of England from Scheveningen, 2 June 1660. *Het vertrek van Karel II, koning van Engeland, vanuit Scheveningen, 2 juni 1660*

Canvas 109 × 173.5. Signed *K. Beelt*
PROV Town hall, Franekeradeel, 1913 *
DRVK since 1952

A 1193 The Dutch herring fleet under sail. *De Hollandse haringvloot onder zeil*

Canvas 113.5 × 204.5. Signed *K. Beelt*
PROV Presented by W E van Pappelendam & Schouten, art dealers, Amsterdam, 1885
LIT Willis 1911, p 61. Bol 1973, p 140

Abraham Beerstraaten

thought to have been active ca 1635-65 in Amsterdam

A 3737 Battle of the combined Venetian and Dutch fleets against the Turks in the Bay of Foya, 1649. *Slag van de verenigde Venetiaanse en Nederlandse vloten tegen de Turken in de Baai van Foja, 1649*

Canvas 151.5 × 276.5. Signed and dated *AB 1656*
PROV Purchased from Fürst gallery, Amsterdam, 1949

A 679 The Blauwpoort in Leiden in the winter. *De Blauwpoort te Leiden in de winter*

Canvas 90 × 126. Signed *A. Beerstraaten*
PROV Bequest of Jonkheer J S H van de Poll, Amsterdam, 1880
LIT V de Stuers, Ned Kunstbode 2 (1880) p 244. C Hofstede de Groot, OH 22 (1904) p 114

Jan Abrahamsz Beerstraaten

Amsterdam 1622 – 1666 Amsterdam

A 21 The ruins of the old town hall of Amsterdam after the fire of 7 July 1652. *De puinhopen van het Oude Stadhuis te Amsterdam na de brand van 7 juli 1652*

Canvas 110 × 144. Signed *I. Beerstraaten*
PROV Sale Amsterdam, 17 Aug 1818, lot 5
LIT Willis 1911, p 84. F C Willis, Mon f Kunstw 6 (1913) p 160. Martin 1935-36, vol 2, pp 397-98. Van Hall 1963, p 16, nr 101:1. A Blankert, Simiolus 2 (1967-68) p 106 (ca 1652). Wagner 1971, p 23. Bol 1973, p 287

A 22 The battle of Terheide, 10 August 1653. *Slag bij Terheide, 10 augustus 1653*

Canvas 176 × 281.5. Signed *I. Beer-Straaten*
PROV Sale G van der Pot van Groeneveld, Rotterdam, 6 June 1808, lot 6
LIT Moes & van Biema 1909, pp 112, 156, 184. Willis 1911, p 100. C G 't Hooft, in Feestbundel Bredius, 1915, p 106. Martin 1935-36, vol 2, p 398. F L Dickerhoff, Spiegel Hist 5 (1970) p 22, fig 1. Bol 1973, pp 286, 290, fig 289

A 2678 Dutch ships in a foreign port. *Hollandse schepen in een vreemde haven*

Canvas 91 × 131. Signed and dated *I. Beerstraaten 1658*
PROV Bequest of R Th Baron van Pallandt van Eerde, Ambt-Ommen, 1913
LIT Bol 1973, p 286

C 94 View of Ouderkerk in the winter. *Gezicht op Ouderkerk in de winter*

Canvas 95 × 132.5. Signed and dated *J. Beerstraten 1659*
PROV On loan from the city of Amsterdam (A van der Hoop bequest), 1885-1975
LIT H Rosenau, OH 73 (1958) p 241, fig 2. Bol 1973, p 288 (probably Johannes Beerstraaten)

A 4134 View of the church of Sloten in the winter. *Gezicht op de kerk te Sloten in de winter*

Canvas 90 × 128. Signed *J. Beerstra…*
PROV Presented by Miss S E Dribbel, Amsterdam, 1967
LIT P J J van Thiel, Bull RM 16 (1968) p 51, ill (ca 1658-59)

A 20 The Paalhuis and the Nieuwe Brug, Amsterdam, in the winter. *Het Paalhuis en de Nieuwe Brug te Amsterdam in de winter*

Canvas 84 × 100. Signed *I. Beerestraten*
PROV Sale G van der Pot van Groeneveld, Rotterdam, 6 June 1808, lot 7
LIT Moes & van Biema 1909, pp 112, 156, 187. D J van Dissel, Ons Amsterdam 9 (1957) ill, p 10. Wagner 1971, p 23. W S da Costa & J Giphart, Ons Amsterdam 20 (1968) pp 227-28, ill

Johannes Beerstraaten

active 1663 in Amsterdam

C 1175 Skating on the Y near the Paal-

huis and the Nieuwe Brug, Amsterdam. *Het Paalhuis en de Nieuwe Brug te Amsterdam met ijsvermaak op het IJ*

Canvas 62.5 × 88.5. Signed and dated *Joannes Beerstraaten 1663*
PROV On loan from the city of Amsterdam, 1925-75
LIT Scheltema 1879, nr 14

attributed to **Osias Beert**

Antwerp? ca 1580–1623/24 Antwerp

A 2549 Still life. *Stilleven*

Panel 46.5 × 79
PROV Lent by C Hoogendijk, The Hague, 1907. Presented by his estate in 1912
LIT W Steenhoff, Bull NOB 2d ser 2 (1909) p 94 (L Moillon). Warner 1928, nr 68a (L Moillon). C Benedict, Amour de l'Art 19 (1938) p 310, fig 8 (replica of original in private collection, Paris, signed *O.B.*). M L Hairs, Revue belge d'Arch & d'Hist de l'Art 20 (1951) p 149 (Beert). Greindl 1956, p 149 (replica of original in Mestrallet collection, Paris). Müller 1956, p 142, fig 46 (Beert). Hairs 1955, p 122. A Chudzikowski, Bull MN Varsovie, 1962, p 19, fig 5

manner of **Osias Beert**

A 4247 Still life. *Stilleven*

Panel 64.5 × 115
PROV NMGK * DRVK since 1959 (on loan to Stedelijk Museum Het Catharina-gasthuis, Gouda)

Sybrand van Beest

The Hague? 1610–1674 Amsterdam

A 1732 Vegetable market. *Groentemarkt*

Panel 47 × 63. Signed and dated *S. V Beest 1646*
PROV D Franken Dzn, Le Vésinet, 1898

attributed to **Sybrand van Beest**

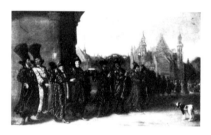

A 1633 The legation of the czar of Muscovy on its way to the meeting of the states-general in The Hague, 4 November 1631. *Het gezantschap van de Tsaar van Moscovië op weg naar de Staten-vergadering in Den Haag, 4 november 1631*

Panel 47.5 × 80.5
PROV Sale Mrs Storm-van der Chijs, Delft, 1 July 1895, lot 130 (as anonymous)
LIT Scheltema 1817, vol 1, pp 148-62

CD Beet

active 1652

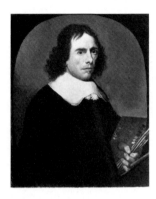

A 1597 Self portrait. *Zelfportret*

Canvas 75 ×60.5. Signed and dated
CDBeet fe 1652
PROV Sale Amsterdam, 25 April 1893,
lot 110 (as G D Beet)
LIT Moes 1897-1905, vol 1, nr 441 (de
Beel). Van Hall 1963, p 16, nr 104:1

Cornelis Bega

Haarlem 1631/32 – 1664 Haarlem

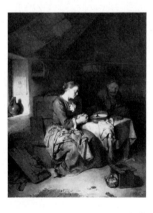

C 95 Saying grace. *Het gebed voor de
maaltijd*

Canvas 37.5 ×30. Signed and dated
C. Bega 1663
PROV On loan from the city of
Amsterdam (A van der Hoop bequest)
since 1885
LIT Martin 1935-36, vol 1, pp 400-01, fig
241

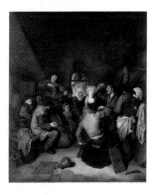

A 24 Peasants making music and
dancing. *Musicerende en dansende boeren*

Canvas 47 ×40.5. Signed *C. Bega*
PROV Purchased with the Kabinet van
Heteren Gevers, The Hague-
Rotterdam, 1809
LIT Moes & van Biema 1909, pp 145,
192

Abraham Begeyn

Leiden ca 1635 – 1697 Berlin

A 1497 Plundering. *De plundering*

Canvas 148 ×200. Signed *ABegeijn fe*
PROV Purchased from S E Goudstikker
gallery, Amsterdam, 1889

Carel Jacobus Behr

The Hague 1812 – 1895 The Hague

&

Gijsbertus Craeyvanger

Utrecht 1810 – 1895 Utrecht

A 1006 City wall with gunpowder
magazine. *Stadswal met kruitmagazijn*

Panel 49 ×61. Signed *C. J. Behr fec. figures
par G. Craeyenvanger 1830*
PROV Purchased at exhib The Hague
1830, nr 19. RVMM, 1885
LIT Huebner 1942, fig 43

Johann Philipp Behr

b Augsburg; d 1756 Frankfurt am Main

A 885 Maria Louisa of Hesse-Cassel
(1688-1765), called Maaike-Meu.
Widow of the stadholder of Friesland
John Willem Friso, prince of Orange-
Nassau. *Weduwe van de Friese stadhouder
Johan Willem Friso, prins van Oranje-
Nassau*

Canvas 84 ×68
PROV KKS, 1876. NMGK, 1885
LIT R van Luttervelt, Bull RM 9 (1961)
p 155

Jacob Bellevois

Rotterdam 1621 – 1676 Rotterdam

A 997 The mouth of a river in stormy weather. *Riviermonding bij stormachtig weer*

Panel 93.5 × 149.5. Signed *J. Bellevois*
PROV Presented by G P Rouffaer, Deventer, 1885 * DRVK since 1956

A 4248 A French squadron near a rocky coast. *Een Frans eskader bij een rotsachtige kust*

Panel 58.5 × 84.5. Signed *Bel*[le] *v*[o]*is*
PROV Purchased from the collection of Jonkheer J E van Heemskerck van Beest, 1877. NMGK * DRVK since 1964

A 2674 A French squadron near a rocky coast. *Een Frans eskader bij een rotsachtige kust*

Panel 54 × 97.5
PROV Purchased from the collection of Jonkheer J E van Heemskerck van Beest, 1877. NMGK, 1913 * On loan to the Rijksmuseum Muiderslot, Muiden, since 1923

attributed to **Giovanni Bellini**

Venice after 1430 – 1516 Venice

A 3379 Madonna and child. *Madonna met kind*

Panel 55 × 49
PROV Bequest of J W Edwin vom Rath, Amsterdam, 1941
LIT Van Marle 1923-38, vol 17 (1935) p 262, fig 157 (between 1475 and 1480). Exhib cat Giovanni Bellini, Venice 1949, nr 83. Berenson 1957, vol 1, p 29. Pallucchini 1959, p 139, fig 103. Bottari 1963, vol 1, p 38, fig 128

A 3287 Madonna and child. *Madonna met kind*

Panel 66 × 48
PROV Presented by Mr & Mrs D A J Kessler-Hülsmann, Kapelle op den Bosch near Mechelen, 1940
LIT Berenson 1916, p 67. G Gronau, Jb Preusz Kunstsamml 45 (1924) p 38. Van Marle 1923-38, vol 17 (1935) pp 221-24, fig 124 (before 1460). Gronau 1930, p 200 (ca 1471-72). A van Schendel, Mndbl BK 11 (1934) p 237. Dussler 1935, p 135 (ca 1470). Moschini 1943, p 12. Longhi 1946, p 55 (before 1460). Exhib cat Giovanni Bellini, Venice 1949, nr 25. Berenson 1957, vol 1, p 29. Pallucchini 1959, p 129, fig 15. Bottari 1963, vol 1, p 29, fig 56 (after 1462)

Nicolaas Berchem

Haarlem 1620 – 1683 Amsterdam

see also Dou, Gerard, A 90 Portrait of a couple; Ha(a)gen, Joris van der, A 33 Landscape with bathers

A 27 The city wall of Haarlem in the winter. *Stadswal van Haarlem in de winter*

Panel 39.5 × 48.5. Signed and dated *CBerghem 1647*
PROV Purchased with the Kabinet van Heteren Gevers, The Hague-Rotterdam, 1809 * DRVK since 1958 (on loan to the Frans Hals Museum, Haarlem)
LIT Moes & van Biema 1909, pp 145, 223. Hofstede de Groot 1907-28, vol 9 (1926) nr 802. Stechow 1966, p 91, fig 179. A C Steland-Stief, Kunst in Hessen 10 (1970) pp 62-63, fig 6

A 28 On the ice near a town. *IJsgezicht nabij een stad*

Panel 39.5 × 48.5. Unclearly signed and dated *C. Berchem 1647*
PROV Sale Amsterdam, 19 July 1809
LIT Moes & van Biema 1909, p 152. Hofstede de Groot 1907-28, vol 9 (1926) nr 803. Von Sick 1930, p 16. Plietzsch 1960, p 151, fig 264. A C Steland-Stief, Kunst in Hessen 10 (1970) pp 62-63, fig 7

A 30 A herd of cattle crossing a ford. *De ossendrift*

Panel 38 × 62.5. Signed and dated *Berchem f. 1656*

PROV Purchased with the Kabinet van Heteren Gevers, The Hague-Rotterdam, 1809
LIT Moes & van Biema 1909, pp 145, 194. Hofstede de Groot 1907-28, vol 9 (1926) nr 358. Bille 1961, vol 1, p 109. M Poch-Kalous, Albertina Stud, 1966, p 27

A 29 The three droves. *De drie kudden*

Canvas 44 × 66.5. Signed and dated *Berchem 1656*
PROV Sale G van der Pot van Groeneveld, Rotterdam, 6 June 1808, lot 11
LIT Smith 1829-42, vol 5 (1834) nrs 138, 274. Moes & van Biema 1909, pp 112, 156, 182. Hofstede de Groot 1907-28, vol 9 (1926) nr 469. Gerstenberg 1923, p 21, pl XLII-2. Von Sick 1930, p 36. Martin 1935-36, vol 2, pp 350-51, fig 190. Schaar 1958, pp 52, 56. Plietzsch 1960, p 150, fig 262. Exhib cat Italianiserende landschapschilders, Utrecht 1965, nr 78, fig 81

C 97 Italian landscape. *Italiaans landschap*

Canvas 88.5 × 70. Signed and dated *Berchem 1656*
PROV On loan from the city of Amsterdam (A van der Hoop bequest) since 1885
LIT Smith 1829-42, vol 5 (1834) nr 122, suppl nr 38. Hofstede de Groot 1907-28, vol 9 (1926) nr 282. Von Sick 1930, p 36, fig 29. Havelaar 1931, fig 203. Schaar 1958, pp 44, 83. Plietzsch 1960, p 150, fig 262. Exhib cat Italianiserende landschapschilders, Utrecht 1965, nr 79, fig 82. Stechow 1966, p 157, fig 317. VTTT, 1960, nr 30

A 680 Ruins in Italy. *Italiaanse ruïne*

Panel 51.5 × 41.5. Signed and dated *Berchem 1658*
PROV Bequest of Jonkheer J S H van de Poll, Amsterdam, 1880
LIT Smith 1829-42, vol 5 (1834) nr 168. V de Stuers, Ned Kunstbode 2 (1880) p 244. Ledermann 1920, p 74. Hofstede de Groot 1907-28, vol 9 (1926) nr 359. Von Sick 1930, p 37. Chr P van Eeghen, OH 62 (1947) p 92. Hoogewerff 1952, p 153, fig 34. Schaar 1958, pp 59, 64. Exhib cat Italianiserende landschapschilders, Utrecht 1965, nr 83, fig 87

A 32 Ruth and Boas. *Ruth en Boas*

Canvas 109.5 × 136. Signed *NCl Berighem*
PROV Purchased with the Kabinet van Heteren Gevers, The Hague-Rotterdam, 1809
LIT Hoet 1752, vol 2, p 452. Moes & van Biema 1909, pp 145, 192. Hofstede de Groot 1907-28, vol 9 (1926) nr 10. Bille 1961, vol 1, p 109

A 1936 Juno commanding Argus to keep watch on Io. *Juno geeft Argus opdracht Io te bewaken*

Panel 24.5 × 31.5. Signed *Berchem*
PROV Sale G de Clercq, Amsterdam, 1 June 1897, lot 5. Purchased through the intermediacy of the Rembrandt Society
LIT Hofstede de Groot 1907-28, vol 9 (1926) nr 41

A 31 The cattle ferry. *Het ponteveer*

Canvas 83.5 × 106. Signed *NBerchem*
PROV Sale Amsterdam, 19 July 1809, lot 3 * DRVK since 1953
LIT Moes & van Biema 1909, pp 152, 195. Hofstede de Groot 1907-28, vol 9 (1926) nr 325

A 26 Italian landscape. *Italiaans landschap*

Copper 14 × 17. Signed *Berchem*
PROV Sale G van der Pot van Groeneveld, Rotterdam, 6 June 1808, lot 12
LIT Moes & van Biema 1909, pp 112, 156, 184. Hofstede de Groot 1907-28, vol 9 (1926) nr 470

A 2317 Italian landscape. *Italiaans landschap*

Canvas 65 ×81. Signed *Berchem*
PROV Purchased from the heirs of Jonkheer P H Six van Vromade, Amsterdam, 1908, with aid from the Rembrandt Society
LIT Hofstede de Groot 1907-28, vol 9 (1926) nr 605

A 2505 Peasants dancing in a barn. *Dansende boeren in een schuur*

Panel 46 ×38. Signed *Berchem*. Brown monochrome
PROV Purchased from Parsons & Son gallery, London, 1910
LIT E Plietzsch, Zeitschr BK ns 27 (1916) p 138, fig 17. Hofstede de Groot 1907-28, vol 9 (1926) nr 835

C 98 Italian landscape. *Italiaans landschap*

Panel 30.5 ×37.5. Signed *Berchem*
PROV On loan from the city of Amsterdam (A van der Hoop bequest) since 1885

LIT Hofstede de Groot 1907-28, vol 9 (1926) nr 188

Gerrit Adriaensz Berckheyde

Haarlem 1638– 1698 Haarlem

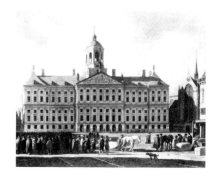

A 34 The town hall on the Dam, Amsterdam. *Het stadhuis op de Dam te Amsterdam*

Canvas 33.5 ×41.5. Signed and dated *Gerrit Berck Heyde 1672*
PROV Sale Amsterdam, 4 Aug 1828, lot 15
LIT K Fremantle, OH 77 (1962) p 210, fig 5

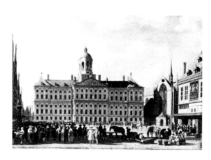

A 1733 The town hall on the Dam, Amsterdam. *Het stadhuis op de Dam te Amsterdam*

Panel 43 ×63. Signed and dated *Gerrit Berck Heyde 1673*
PROV Bequest of D Franken Dzn, Le Vésinet, 1898. Lent to the AHM, 1975
LIT Fritz 1932, p 87. Martin 1935-36, vol 2, pp 390, 396, fig 207

A 682 The bend in the Herengracht, Amsterdam. *De bocht van de Herengracht te Amsterdam*

Canvas 53 ×62. Signed and dated *Gerret Berck Heyde 1685*
PROV Bequest of Jonkheer J S H van de Poll, Amsterdam, 1880
LIT V de Stuers, Ned Kunstbode 2 (1880) p 245. Van Gelder 1959, p 17, fig 62. I H van Eeghen, Jb Amstelodamum 54 (1962) ill on p 172. W Stechow, Bull Clev Mus of Art 52 (1965) p 172. R Meiske, OK 15 (1973) pp 25-27

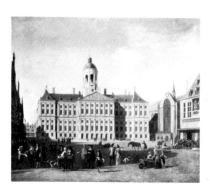

C 101 The town hall on the Dam, Amsterdam. *Het stadhuis op de Dam te Amsterdam*

Canvas 52 ×63. Signed and dated *Gerrit Berckheyde A° 1693*
PROV On loan from the city of Amsterdam (A van der Hoop bequest) since 1885
LIT Fritz 1932, p 87. B Haak, Antiek 4 (1969) p 141, fig 5

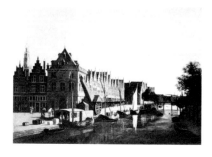

A 35 The Waag (weighing house) and

crane on the Spaarne, Haarlem. *De Waag en de kraan aan het Spaarne te Haarlem*

Panel 32 × 45.5. Signed *G. Berck Heyde*
PROV Bequest of L Dupper Wzn, Dordrecht, 1870
LIT Van Gelder 1959, p 17, fig 64

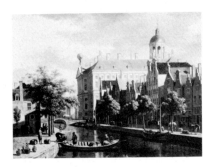

C 103 The Bloemmarkt, Amsterdam. *De Bloemmarkt te Amsterdam*

Canvas 45 × 61. Signed *Gerrit Berck Heyde*
PROV On loan from the city of Amsterdam (A van der Hoop bequest), 1885-1975
LIT Bernt 1960-62, vol 1, fig 71. Stechow 1966, p 127, fig 261. Borea 1966, fig 33. Bernt 1969-70, vol 1, nr 86. Wagner 1971, p 36

A 681 The Oude Zijds Herenlogement (gentlemen's hotel) in Amsterdam. *Het Oude Zijds Herenlogement te Amsterdam*

Panel 30 × 41. Signed *G. Berck Heyde*
PROV Bequest of Jonkheer J S H van de Poll, Amsterdam, 1880 * Lent to the AHM, 1975
LIT V de Stuers, Ned Kunstbode 2 (1880) p 245

C 104 The main gate to Egmond Castle. *De voorpoort van Kasteel Egmond*

Canvas 35.5 × 46. Signed *G. Berk Heyde*
PROV On loan from the city of Amsterdam (A van der Hoop bequest) since 1885

Job Berckheyde

Haarlem 1630–1693 Haarlem

C 100 Interior of the church of St Bavo in Haarlem. *De Sint Bavokerk te Haarlem van binnen*

Canvas 52 × 67.5. Signed and dated *J. Berck Heyde A° 1674*
PROV On loan from the city of Amsterdam (A van der Hoop bequest) since 1885
LIT Jantzen 1910, pp 87, 159, nr 74. Martin 1935-36, vol 2, p 396

attributed to **Job Berckheyde**

A 1790 Nicolaes Eichelberg (d 1699). Haarlem merchant, husband of Helena van der Schalcke. *Koopman te Haarlem, echtgenoot van Helena van der Schalcke*

see Borch, Gerard ter, A 1786 Helena van der Schalcke

Panel 34.5 × 28.5. Signed and dated *IB A° 1667*
PROV Francke gallery, Amsterdam, 1898
LIT H L Kruimel, Jb Genealogie 25 (1971) pp 224-29, ill

G W Berckhout

active 1653 in Alkmaar?

A 984 Egmond Castle. *Kasteel Egmond*

Canvas 96 × 160. Signed and dated *G. W. Berckhout 1653*
PROV Sale Amsterdam, 20 Jan 1885, lot 19 (as Anthonie van Croos)
LIT Bernt 1960-62, vol 4 (1962) nr 18. Bernt 1969-70, vol 1, nr 94

Hendrick Berckman

Klundert 1629–1679 Middelburg

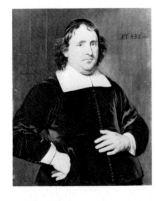

A 1643 Thomas Pots (1618-89). Minister at Vlissingen. *Predikant te Vlissingen*

Panel 83.5 × 69.5. Signed and dated *HBerckman Fecit 1661*. Inscribed *Aet. 43 A° 1661*
PROV Purchased from J C de Ruyter de

Wildt, Vlissingen, 1895 * DRVK since 1959 (on loan to the Stedelijk Museum, Vlissingen)
LIT Moes 1897-1905, vol 2, nr 6045

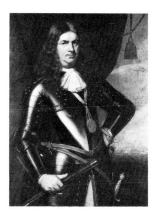

A 1644 Adriaen Banckert (ca 1620-84). Vice admiral of Zeeland. *Luitenant-admiraal van Zeeland*

Canvas 110 × 83.5. Signed and dated *HBerckman F. 1673*
PROV Purchased from J C de Ruyter de Wildt, Vlissingen, 1895

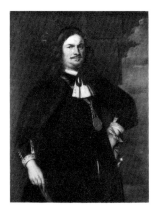

A 36 Adriaen Banckert (ca 1620-84). Vice admiral of Zeeland. *Luitenant-admiraal van Zeeland*

Canvas 114 × 84. Signed *HBerckman f.* Inscribed (apocryphally) *Aet. 46 1648*
PROV NM, 1808
LIT Moes 1897-1905, vol 1, nr 351:1

copy after **Hendrick Berckman**

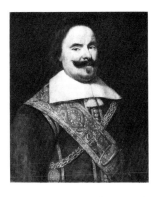

A 1602 Michiel Adriaensz de Ruyter (1607-76). Vice admiral. *Vice-admiraal*

Copy after a portrait in the Stedelijk Museum, Vlissingen

Panel 66 × 54
PROV Purchased from W A Hopman, Amsterdam, 1893
LIT Moes 1897-1905, vol 2, nr 6661:23. R van Luttervelt, Bull RM 5 (1957) p 56, ill

Johan Berens

see Weyden, Rogier van der, A 973 'Portrait of Charles the Bold,' copy by Berens

attributed to **Claes van Beresteyn**

Haarlem 1629 – 1684 Haarlem

A 785 Road in the dunes. *Duinweg*

Panel 33 × 34.5
PROV Sale Amsterdam, 14-15 Nov 1883, lot 7
LIT C Hofstede de Groot, OH 19 (1904) p 115 (van Beresteyn?). H Gerson, in van Beresteyn & del Campo Hartman 1941-54, appendix 2, pp 148, 155, nr 2, ill

Simon van den Berg

Overschie 1812 – 1891 Arnhem

A 1007 A summer morning. *Zomer-ochtend*

Canvas 50 × 83.5. Signed *S. van den Berg F.*
PROV Purchased at exhib Rotterdam 1870. RVMM, 1885 * DRVK since 1953

Willem Hendrik van den Berg

The Hague 1886 – 1970 Amsterdam

A 3288 Self portrait. *Zelfportret*

Canvas on panel 23 × 18. Signed *W. v. d. Berg*
PROV Presented by Mr & Mrs D A J Kessler-Hülsmann, Kapelle op den Bosch near Mechelen, 1940
LIT Van Hall 1963, p 20, nr 133:1

Dirck van den Bergen

Haarlem ca 1640 – ca 1690 Haarlem

A 37 Landscape with herdsmen and cattle. *Landschap met herdersvolk en vee*

Canvas 41 × 53. Signed *D. vand. Bergen*
PROV Bequest of L Dupper Wzn,
Dordrecht, 1870

A 38 Landscape with herdsman and
cattle. *Landschap met herder en vee*

Thought to be a pendant to A 39

Canvas 35 × 49. Signed *D. v. d. Bergen*
PROV Purchased in 1815

A 39 Landscape with fighting bulls.
Landschap met vechtende stieren

Thought to be a pendant to A 38

Canvas 37 × 48. Signed *D. v.d. Bergen*
PROV Purchased in 1815 ∗ DRVK since
1953

C 105 Landscape with herdsmen and
cattle near a tomb. *Landschap met herders-
volk en vee bij een graftombe*

Canvas 66 × 80. Signed *D. v. Berghen*
PROV On loan from the city of
Amsterdam (A van der Hoop bequest)
since 1885

Andries van den Bergh

see Governors-general series: A 3793
C Th Elout; A 3807 James Loudon;
A 3808 J W van Lansberge

Emile Bernard

Lille 1868–1941 Paris

A 3263 Self portrait. *Zelfportret*

Canvas 52 × 42. Signed and dated *Emile
Bernard 1897*. Inscribed *A nos amis de
Hollande*
PROV Presented by Mrs F W M Bonger,
née Baroness van der Borch van
Verwolde, widow of A Bonger,
Amsterdam, 1936
LIT M D Henkel, Cicerone 22 (1930) p
3, fig 3

Pietro Berrettini

see Cortona, Pietro da

Pieter Godfried Bertichen

Amsterdam 1796–after 1833

C 1539 The shipyard D'Hollandsche
Tuin on Bickers Eiland, Amsterdam. *De
scheepstimmerwerf 'D'Hollandsche Tuin' op
het Bickers Eiland te Amsterdam*

Pendant to C 1540

Canvas on panel 40 × 50. Signed and
dated *Bertichen 1823*. Inscribed on the
shed *D'Hollandsche Tuin*
PROV On loan from the KOG (purchased
in 1880) since 1973
LIT Jaarversl KOG 1932, ill opp p 43

C 1540 The shipyard St Jago on Bickers
Eiland, Amsterdam. *De scheepstimmer-
werf 'St Jago' op het Bickers Eiland te
Amsterdam*

Pendant to C 1539

Canvas on panel 40 × 50. Signed and
dated *Bertichen 1823*. Inscribed on the
shed *St Jago*, and on the stern of the ship
Anna en Maria. van Amsterdam
PROV On loan from the KOG (purchased
in 1880) since 1973

Nicolas Bertin

Paris ca 1667–1736 Paris

A 40 Joseph and Potiphar's wife. *Jozef en
de vrouw van Potifar*

Panel 38.5 × 32. Signed *Bertin in.*
PROV Purchased with the Kabinet van
Heteren Gevers, The Hague-Rotterdam,
1809
LIT Hoet 1752, vol 2, p 452. Moes & van
Biema 1909, pp 145, 156

A 41 Susanna and the elders. *Suzanna en de ouderlingen*

Panel 39 × 33. Signed *Bertin in.*
PROV Purchased with the Kabinet van Heteren Gevers, The Hague-Rotterdam, 1809
LIT Hoet 1752, vol 2, p 452. Moes & van Biema 1909, pp 145, 156

John Bettes

see under Miniatures

Charles van Beveren

Mechelen 1809– 1850 Amsterdam

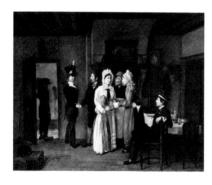

A 1501 The soldier's farewell. *Het afscheid van de soldaat*

Panel 45 × 55.5. Signed and dated *C. van Beveren 1828*
PROV Purchased in 1889 * DRVK since 1951
LIT Scheen 1946, fig 74

A 1523 Louis Royer (1793-1868). Sculptor. *Beeldhouwer*

Pendant to A 1524

Panel 25 × 20. Signed and dated *C. van Beveren fe. 1830.* Inscribed *Roma*
PROV Purchased from Mrs J A Alberdingk Thijm, Amsterdam, 1890 *
DRVK since 1952
LIT J Knoef, Historia 8 (1942) p 249. Van Daalen 1957, p 109, fig 10. Van Hall 1963, p 282, nr 1807:1

A 1524 Carolina Frederica Kerst (1803-83). Wife of Louis Royer. *Echtgenote van Louis Royer*

Pendant to A 1523

Panel 25 × 20. Signed *Ch. v. B. ft 1830*
PROV Same as A 1523 * DRVK since 1952
LIT Van Daalen 1957, p 108, fig 11

Jan de Beijer

see Zeuner, A 4230 Vreeland on the Vecht, after de Beijer

Abraham van Beyeren

The Hague 1620/21 – 1690 Overschie

A 3944 Still life. *Stilleven*

Canvas 126 × 106. Signed *AVB F.*

PROV Purchased from D A Hoogendijk gallery, Amsterdam, 1958
LIT B Haak, Bull RM 7 (1959) p 59, ill. B Haak, Antiek 2 (1968) p 410, figs 12-13

A 3828 Still life. *Stilleven*

Canvas 57 × 52.5. Signed *AVB f.*
PROV Sale N Katz, Paris, 7 Dec 1950, lot 5

A 355 Still life with flowers. *Stilleven met bloemen*

Canvas 64 × 46. Signed *AVB f.*
PROV Sale M C van Hall, Amsterdam, 27 April 1858, lot 399 (as Rachel Ruysch)
LIT Warner 1928, nr 6b. Vorenkamp 1933, p 128. Martin 1935-36, vol 2, pp 425-26, fig 224. Mitchell 1973, p 50, fig 64

A 25 Still life with fish. *Stilleven met vissen*

Canvas 74 × 87. Signed *AVB f.*
PROV Sale G van der Pot van
Groeneveld, Rotterdam, 6 June 1808,
lot 15 * On loan to the municipality of
Velsen (Beeckestijn Estate)
LIT Moes & van Biema 1909, pp 122,
186

A 4073 River view. *Riviergezicht*

Panel 71 × 95. Signed *AVB F.*
PROV Purchased from D A Hoogendijk
gallery, Amsterdam, 1962
LIT Bol 1973, p 161, fig 163

Cornelis de Bie

Amsterdam 1621/22 – ca 1664
Amsterdam

A 1419 Landscape with herdsmen and
their droves. *Landschap met herders en vee*

Panel 60 × 85. Signed and dated *Cornelis
Bie 1648*
PROV Presented by Dr A Bredius, The
Hague, 1887

Christiaen Jansz van Bieselingen

Delft 1557/58 – 1600 Middelburg

A 1631 The meeting of David and
Abigail. *De ontmoeting van David en
Abigaël*

Panel 142 × 195. Signed and dated
Carstiiaeni Biieselinge Feesit A° 1583
PROV Purchased from S Duits, art
dealer, Amsterdam, 1895 * On loan to
Rijksmuseum Lambert van Meerten,
later Museum Prinsenhof, Delft, since
1909 (from 1959 on via the DRVK)
LIT Hoogewerff 1936-47, vol 4 (1941-42)
p 486

Albert Gerard Bilders

Utrecht 1838 – 1865 Amsterdam

A 3073 Cows at a pond. *Koeien bij een plas*

Panel 27.5 × 45.3. Signed and dated
A. G. Bilders f. '56 ['58?]
PROV Bequest of J B A M Westerwoudt,
Haarlem, 1907. Received in 1929
LIT H F W Jeltes, Mndbl BK 21 (1944) p
6, fig 5. Scheen 1946, fig 314. Jeltes 1947,
pp 75-76, fig 39, cat nr 7

A 2298 Meadow near Oosterbeek.
Weiland bij Oosterbeek

Canvas 39 × 55. Signed and dated
A. G. Bilders 1860
PROV Lent by J B A M Westerwoudt,
Haarlem, 1902. Bequeathed in 1907
LIT Marius 1920, p 100, fig 53. H F W
Jeltes, Elsevier's GM 45 (1935) p 92, fig 4.
Jeltes 1947, pp 47-48, fig 2, cat nr 6.
Exhib cat 150 jaar Nederlandse kunst,
Amsterdam 1963, nr 49, fig 44. De
Gruyter 1968-69, vol 2, p 6, fig 4

A 2297 Swiss landscape. *Zwitsers
landschap*

Panel 24.5 × 34. Signed and dated
Gerard Bilders '60
PROV Lent by J B A M Westerwoudt,
Haarlem, 1902. Bequeathed in 1907
LIT H F W Jeltes, Elsevier's GM 45 (1935)
p 93, fig 5. Jeltes 1947, pp 48, 53, fig 4,
cat nr 60

A 3072 Pond in the woods at sunset.
Bosvijver bij zonsondergang

Panel 22 × 35. Signed *Gerard Bilders*.
Thought to have been painted in 1862
PROV Bequest of J B A M Westerwoudt,
Haarlem, 1907. Received in 1929
LIT H F W Jeltes, Mndbl BK 21 (1944) p
6, fig 6. Jeltes 1947, pp 76, 92, 101, fig
40, cat nr 44

A 2262 The goatherdess. *Geitenhoedster*

Canvas 61.5 × 53. Signed *Gerard Bilders*.
Thought to have been painted in 1864
PROV Lent by J BAM Westerwoudt,
Haarlem, 1902. Bequeathed in 1907
LIT H F W Jeltes, Elsevier's GM 45 (1935)
p 93, fig 11. Jeltes 1947, pp 43, 48, fig 5,
cat nr 49. De Gruyter 1968-69, vol 2, p 5,
ill

A 2263 Cows at a pond. *Koeien bij een plas*

Panel 27 × 35. Signed *Gerard Bilders*
PROV Lent by J BAM Westerwoudt,
Haarlem, 1902. Bequeathed in 1907
LIT H F W Jeltes, Elsevier's GM 45 (1935)
p 92, fig 8. Jeltes 1947, p 48, fig 3, cat nr
2

A 2264 Cows in the meadow. *Koeien in de
weide*

Canvas 47 × 70. Signed *Gerard Bilders*
PROV Lent by J BAM Westerwoudt,
Haarlem, 1902. Bequeathed in 1907
LIT H F W Jeltes, Elsevier's GM 45 (1935)
p 92, fig 6. Jeltes 1947, p 46, fig 1, cat nr
1. De Gruyter 1968-69, vol 2, p 10, fig 5

Johannes Warnardus Bilders

Utrecht 1811 – 1890 Oosterbeek

A 1008 The heath near Wolfheze. *De
heide bij Wolfheze*

Canvas 102.5 × 152.5. Signed and dated
J. W. Bilders 1866
PROV Purchased at exhib The Hague
1866, nr 34. RVMM, 1885
LIT VTTT, 1967-68, nr 94

A 3074 View in the woods. *Bosgezicht*

Canvas 27 × 22.3. Signed *JWBilders*
PROV Bequest of J BAM Westerwoudt,
Haarlem, 1907. Received in 1929
LIT VTTT 1967-68, nr 94

NO PHOTOGRAPH AVAILABLE

A 1734 The edge of the woods. *Bosrand*

A brook at the edge of the woods, with
bushes and pollard willows on the left
and on the right a meadow, bushes and
some ducks on the bank

Canvas 23 × 33.5. Signed *JW Bilders*
PROV Bequest of D Franken Dzn, Le
Vésinet, 1898 * Lent to the Stedelijk
Museum, Zutphen, 1924. Destroyed in
the war, 1945

Maria Philippina Bilders-van Bosse

Amsterdam 1837 – 1900 Wiesbaden

A 1922 Avenue of oaks in late summer.
Eikenlaan in de nazomer

Canvas 53.5 × 76. Signed *M. Bilders-van
Bosse*
PROV Benefit sale The Hague (Pulchri
Studio) 16 Oct 1900, lot 9 * DRVK since
1953

Christoffel Bisschop

Leeuwarden 1828 – 1904 Scheveningen

see also under Aquarelles and drawings

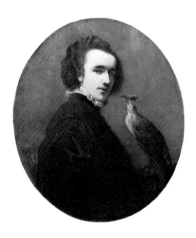

A 1801 The falconer. *De valkenier*

Canvas 80 × 68. Oval. Signed *C. Bisschop*
PROV Bequest of Reinhard Baron van
Lynden, The Hague, 1899 * DRVK since
1953

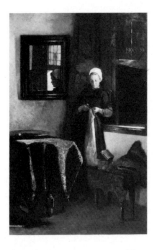

A 3060 A sunny corner. *Een zonnig plekje*

Canvas 135 × 88. Signed *C. Bisschop*
PROV Lent by Mr & Mrs J C J Drucker-Fraser, London, 1904. Presented in
1928 * DRVK since 1964
LIT 't Hooft 1907, p 2, fig 1

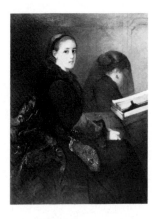

A 3726 The interrupted prayer. *Het gestoorde gebed*

Canvas 157 × 130
PROV Lent by Mr & Mrs J C J Drucker-Fraser, London, 1919. Bequeathed in
1944 * DRVK since 1953

Cornelis Bisschop

Dordrecht 1630–1674 Dordrecht

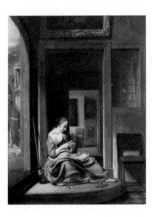

A 2110 Girl peeling an apple. *De appelschilster*

Panel 70 × 57. Signed and dated
C. Busschop fecit 1667
PROV Purchased from F Kleinberger
gallery, Paris, 1904
LIT G H Veth, OH 5 (1887) p 156. Martin
1935-36, vol 2, p 235. Hannema & van
Schendel 1938, fig 77. C Brière-Misme,
OH 65 (1950) p 231, fig 5. Plietzsch 1960,
p 72, fig 114. Bernt 1960-62, vol 1, nr 82.
Bernt 1969-70, vol 1, nr 113

A 1432 Allegory on the raid on Chatham
(1667), with a portrait of Cornelis de
Witt. *Allegorie op de tocht naar Chatham
(1667) met een portret van Cornelis de Witt*

Canvas 104 × 153.5. Signed and dated
C. Bischop Fecit 1668
PROV Purchased from J de Kuyper,
Rotterdam, 1887
LIT C Brière-Misme, OH 65 (1950) p
139ff, fig 1. R van Luttervelt, Bull RM 8
(1960) p 53, fig 16. Bernt 1969-70, vol 1,
nr 112

attributed to **Cornelis Bisschop**

A 983 Council of war of eleven
companies of the Dordrecht militia, ca
1675. *Krijgsraad van elf compagnieën van de
Burgerwacht te Dordrecht, ca 1675*

Canvas 291 × 567
PROV Purchased in Paris, 1877. NMGK,
1885 * DRVK since 1959 (on loan to the
Dordrechts Museum, Dordrecht)
LIT Bredius 1887-88, p 177. Hofstede de
Groot 1893, p 106, note 1. De Gelder
1921, pp 247-48, cat nrs 922, 943-44. C
Brière-Misme, OH 65 (1950) p 112ff, fig 7

Catharine Seaton Forman Bisschop-Swift

London 1834–1928 The Hague

A 1802 The widow of a painter. *De
schildersweduwe*

Canvas 79 × 52.5. Signed and dated *Kate
Bisschop-Swift 1870*
PROV Bequest of Reinhard Baron van
Lynden, The Hague, 1899

Gerrit Willem van Blaaderen

Nieuwer Amstel 1873–1935 Bergen

A 2715 The village of Sannois, France.
Het dorp Sannois, Frankrijk

Canvas 84 × 104. Signed *G. W. van
Blaaderen*
PROV Presented by the artist, 1914 *
DRVK since 1953

Jacques Blanchard

Paris 1600–1638 Paris

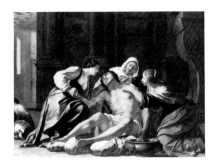

A 4091 St Sebastian nursed by Irene and her helpers. *De heilige Sebastiaan door Irene en haar helpsters verzorgd*

Canvas 153 × 202
PROV Purchased from Heim gallery, Paris, 1963
LIT Blanc 1862-63, vol 1, p 3, ill. Ch Sterling, Art de France 1 (1961) p 93, nr 57, fig 57 (attributed to Blanchard on the basis of a print by A Garnier inscribed *Iacobus Blanchar pin.*). E de Jongh, Bull RM 11 (1963) p 71ff, fig 2

Jan Theunisz Blanckerhoff

Alkmaar 1628–1669 Amsterdam

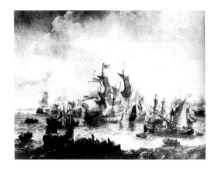

A 3235 The battle of the Zuider Zee, 1573. *De slag op de Zuiderzee, 1573*

Canvas 229 × 271.5. Signed *Jan Blancker...* Painted in 1663, commissioned by the admiralty of Hoorn
PROV Town hall, Hoorn. Transferred to the state in 1935, but left in its original location ∗ DRVK since 1952 (on loan to the municipality of Hoorn)

Louis Nicolas van Blarenberghe

Lille 1716/19–1794 Fontainebleau

A 4249 Four landscapes, representing the four seasons. *Vier landschappen, de vier jaargetijden voorstellend*

Gouache. Four panels in one frame, each 21 × 28. Signed *Van Blarenberghe fecit* (summer); *Van Blarenberghe in. et pinxit* (fall); *Van Blarenberghe in. pinxit* (winter)
PROV KKZ. NMGK

Dirck Bleecker

Haarlem 1622–after 1672 The Hague?

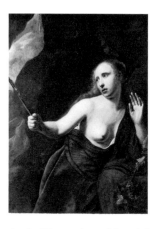

A 782 The penitent Mary Magdalene. *De boetvaardige Maria Magdalena*

Canvas 112 × 83. Signed and dated *D. Bleker 1651*
PROV Sale Count Rasponi (Ravenna), Amsterdam, 30-31 Oct 1883, lot 10

David Joseph Bles

The Hague 1821–1899 The Hague

A 1009 As the old sing, twitter the young. *Zo de ouden zongen, piepen de jongen*

Panel 49 × 67. Signed and dated *David Bles f. '69*
PROV Purchased at exhib The Hague 1869, nr 35 (under the title 'De vadermoorders,' with the motto: 'Het wil al wat muizen wat van katten komt').
RVMM, 1885

A 1803 The conversation. *De conversatie*

Panel 26 × 34. Signed *David Bles ft.*
PROV Bequest of Reinhard Baron van Lynden, The Hague, 1899

Herri met de Bles

Bouvignes-les-Dinant 1485/90–after 1550 Ferrara?

A 780 Paradise. *Het paradijs*

Panel 47 cm in diam. Tondo
PROV Sale HG van Otterbeek Bastiaans (Deventer), Amsterdam, 31 Jan 1882, lot

9 (as Velvet Brueghel) * On loan to the
KKS (cat 1968, vol 1, p 8, nr 959) since
1963
LIT Winkler 1924, p 309.·Friedländer
1924-37, vol 13 (1936) p 146, nr 57.
Duits Q 7 (1965) p 2, ill. A P de
Mirimonde, l'Oeil, Dec 1967, p 26, fig 4

Samuel Blesendorf

see under Miniatures

Daniel de Blieck

Middelburg? ca 1630 – 1673 Middelburg

A 1604 Church interior. *Kerkinterieur*

Panel 44 × 64. Signed and dated *C. [?] d.
Blieck 1652*
PROV Purchased from A H Davis,
Bournemouth, 1893
LIT Jantzen 1910, pp 108, 159, nr 79

Eugène François de Block

Grammont 1812 – 1893 Antwerp

C 576 Sunny room. *Zonnige kamer*

Panel 34 × 42. Signed *EB*
PROV On loan from the city of
Amsterdam since 1894

Abraham Bloemaert

Gorkum 1564 – 1651 Utrecht

A 3746 The preaching of St John the
Baptist. *Prediking van Johannes de Doper*

Canvas 139 × 188. Signed *A. Blommaert*
PROV Purchased from P & D Colnaghi
& Co gallery, London, 1950
LIT E R Meijer, Bull RM 1 (1953) p 72ff,
ill (1600-03). W Stechow, Bull Clev Mus
of Art 53 (1966) pp 375-76, fig 10. Bol
1969, p 158. H R Rookmaaker, NKJ 23
(1972) p 65

A 3743 Landscape with fruits and
vegetables in the foreground. *Landschap
met groenten en vruchten op de voorgrond*

Panel 39 × 50
PROV Purchased from J Néger gallery,
Paris, 1949

A 1990 The rest on the flight into Egypt.
Rust op de vlucht naar Egypte

Canvas 85 × 109.5. Signed and dated
A. Bloemaert fe. 1632
PROV Purchased from Dr A Bredius, The
Hague, 1902
LIT Delbanco 1928, p 77, nr 40. Von
Schneider 1933, p 55, fig 29c

Hendrick Bloemaert

Utrecht ca 1601 – 1672 Utrecht

A 674 Old man: an allegorical
representation of winter. *Oude man:
allegorische voorstelling van de winter*

Canvas 81 × 98. Signed and dated
HB fe. 1631
PROV Sale Utrecht, 16-20 Dec 1879, cat
p 133, lot 1 * Lent to the Commissaris
der Koningin (provincial governor) of
Zeeland, Middelburg, 1934. Destroyed
in the war, 1940
LIT Von Schneider 1933, p 56, fig 30b.
Martin 1935-36, vol 1, p 385

C 106 Old woman selling eggs. *De eieren-
koopvrouw*

Canvas 76 × 58. Signed and dated
HBloemaert 1632
PROV On loan from the city of
Amsterdam (A van der Hoop bequest)
since 1885
LIT Von Schneider 1933, p 56. Martin
1935-36, vol 1, pp 126-27, 384, fig 74

A 735 Johannes Puttkammer (1600-71). Licentiate in theology at the university of Utrecht, on his deathbed. *Licentiaat in de godgeleerdheid te Utrecht, op zijn doodsbed*

Canvas 67 × 82.5. Signed and dated *HBloemaert fe. A° 1671*
PROV Presented by W A Hopman, Amsterdam, 1882
LIT Moes 1897-1905, vol 2, nr 6094

Herman Antonie de Bloeme

The Hague 1802 – 1867 The Hague

see also Governors-general series: A 3803 A J Duymaer van Twist

A 1173 Antonie Frederick Jan Floris Jacob Baron van Omphal (1788-1860). Lieutenant general. *Luitenant-generaal*

Canvas 131 × 106. Signed and dated *H. A. de Bloeme pinx. A° 1854*
PROV Bequest of Jonkvrouwe C L M van Omphal, 1877. RVMM, 1885
LIT Marius 1920, p 50, fig 20. Scheen 1946, fig 34

Norbertus van Bloemen

Antwerp 1670 – ca 1746 Amsterdam

A 786 Jan Pietersz Zomer (1641-1724). Amsterdam art dealer. *Kunsthandelaar te Amsterdam*

Canvas on panel 37 × 29. Inscribed on the verso *Jan Pieterse Zomer, Nolbertus van Bloemen pinxit*
PROV Sale Amsterdam, 14-15 Nov 1883, lot 12
LIT Van Eynden & van der Willigen 1816-40, vol 1, p 195. Kramm 1857-64, vol 6 (1863) p 1902. Moes 1897-1905, vol 2, nr 7375. A Meilink, Mndbl Amstelodamum 29 (1942) p 35 (on J P Zomer). Van Hall 1963, p 310, nr 1973:1

attributed to **Pieter van Bloemen**

Antwerp 1657 – 1720 Antwerp

A 3478 Italian landscape. *Italiaans landschap*

Canvas 27.8 × 34
PROV Presented by Miss E M Lindsay, San Diego, Calif, 1946

Abraham de Blois

see Panpoeticon Batavum: A 4605 Joannes Vollenhove, by Arnoud van Halen after de Blois; A 4593 Nicolaas Heinsius, by Jan Maurits Quinkhard after de Blois

Bernardus Johannes Blommers

The Hague 1845 – 1914 Scheveningen

A 2296 The fisherman's children. *De kinderen van de visser*

Panel 41.5 × 40.5. Signed and dated *B. J. Blommers f. 68*
PROV Lent by J B A M Westerwoudt, Haarlem, 1902. Bequeathed in 1907 *
DRVK since 1953

A 3076 Neighborly gossip. *Buurpraatje*

Panel 22 × 17. Inscribed *Aan mijn vrienden Westerwoudt van Blommers*
PROV Bequest of J B A M Westerwoudt, Haarlem, 1907. Received in 1929

A 3075 Girl knitting in the dunes. *Breiend meisje op een duin*

Panel 30 × 20.7. Signed *Blommers*
PROV Bequest of J B A M Westerwoudt, Haarlem, 1907. Received in 1929

A 1327 Girl knitting. *Het breistertje*

Canvas 51 × 40.5. Signed *Blommers*
PROV Purchased at exhib Amsterdam 1886, nr 35 * DRVK since 1968
LIT De Gruyter 1968-69, vol 1, fig 126

le Blon

see Leblon

Pieter de Bloot

Rotterdam 1601 – 1658 Rotterdam

A 660 The lawyer's office. *Het kantoor van de advocaat*

Panel 57 × 83. Signed and dated *P. de Bloot 1628*. Inscribed *die wil rechten om een koe die brengter noch een toe*
PROV Purchased from the Bannier collection, Deventer, 1877
LIT A M van der Woude, Spiegel Hist 7 (1972) p 187, fig 7

A 1468 Country kermis. *Boerenkermis*

Panel 60 × 84. Signed and dated *P. de Bloot 1639*
PROV Purchased from A E André de la Porte Gzn, Arnhem, 1888 * DRVK since 1953

Abraham Blooteling

see Panpoeticon Batavum: A 4581 W J van Heemskerck, by Arnoud van Halen after Blooteling; A 4597 Tieleman Jsz van Bracht, by Jan Maurits Quinkhard after Blooteling; A 4614 Goverd Bidloo, by Arnoud van Halen after Blooteling

Zacharias Blijhooft

Middelburg? ca 1635 – ca 1681 Middelburg

A 825 François Leidecker (1651-88). Deputy of the exchequer of Zeeland. *Gedeputeerde ter Rekenkamer van Zeeland*

Pendant to A 826

Canvas 90 × 75. Signed and dated *Z. Blijhooft fe. 1674*
PROV Presented by Jonkheer J H F K van Swinderen, Groningen, 1884
LIT Moes 1897-1905, vol 2, nr 4468

A 826 Maria van der Burght. François Leidecker's first wife. *Eerste echtgenote van François Leidecker*

Pendant to A 825

Canvas 88 × 72
PROV Same as A 825
LIT Moes 1897-1905, vol 1, nr 1240

Théophile Emile Achille de Bock

The Hague 1851 – 1904 Haarlem

see also under Aquarelles and drawings

A 2493 Landscape. *Landschap*

Canvas 46 × 79.5. Signed *Th. de Bock*
PROV Lent by Mr & Mrs J C J Drucker-Fraser, London, 1909. Presented in 1910 * DRVK since 1956

A 2494 Sandy path. *Zandweg*

Canvas on panel 32 × 51. Signed *Th. de Bock*
PROV Lent by Mr & Mrs J C J Drucker-Fraser, London, 1909. Presented in 1910 * DRVK since 1951

A 3576 Autumn day. *Najaarsdag*

Panel 32 × 24. Signed *Th. de Bock*
PROV Lent by Mr & Mrs J C J Drucker-Fraser, 1919. Bequeathed in 1944 *
DRVK since 1953

A 3077 View in the woods. *Bosgezicht*

Canvas 46 × 38. Signed *Th. de Bock*
PROV Bequest of J B A M Westerwoudt, Haarlem, 1907. Received in 1929 *
DRVK since 1950

A 3577 Country lane. *Landweg*

Panel 43 × 36. Signed *Th. de Bock*
PROV Lent by Mr & Mrs J C J Drucker-Fraser, 1919. Bequeathed in 1944 *
DRVK since 1956

A 2495 Sunset. *Zonsondergang*

Canvas 32 × 45.5
PROV Lent by Mr & Mrs J C J Drucker-Fraser, London, 1909. Presented in 1910
* DRVK since 1953

du Bois

see Dubois

Charles Boit

see under Miniatures

Cornelis Bol

b Antwerp 1589, active in Haarlem before 1637; d after 1652

A 4250 Naval battle between Dutch men-of-war and Spanish galleys. *Zee-gevecht tussen Hollandse oorlogsschepen en Spaanse galeien*

Panel 39 × 73. Signed *C. Bol*
PROV Purchased from C F Roos & Co, art dealers, Amsterdam, 1870. NMGK, 1902
LIT Willis 1911, p 21. Bol 1973, pp 52-53

Ferdinand Bol

Dordrecht 1616–1680 Amsterdam

A 42 Self portrait. *Zelfportret*

Canvas 128 × 104
PROV Bequest of A Brondgeest, Amsterdam, 1849
LIT Scheltema 1855-85, vol 3 (1859) p 108. J Six, OH 11 (1893) p 101. Moes 1897-1905, vol 1, nr 833:1. A Bredius, Burl Mag 42 (1923) p 72. C Hofstede de Groot, Burl Mag 43 (1923) p 22. J Bruyn

& J A Emmens, Bull RM 4 (1956) p 3, fig 1 (on the frame with the sunflower motif). Van Hall 1963, p 32, nr 201 :24. K Hoffman, Zeitschr f Kunstgesch 31 (1968) p 37 (on the frame). Eckardt 1971, p 171, fig 13

C 1176 Four regents of the lepers' asylum in Amsterdam, 1649. *Vier regenten van het Leprozenhuis te Amsterdam, 1649*

The sitters are Augustijn Uyttenbogaert, Dr Joan van Hartogveld, Jacob Willemsz Hooft and Pieter Cleutrijn

Canvas 224 × 310. Signed and dated *F. Bol fec. 1649*
PROV Regents' chamber of the Leprozenhuis (lepers' asylum), Amsterdam. On loan from the city of Amsterdam, 1926-75
LIT Wagenaar 1760-88, vol 2 (1765) p 312. Scheltema 1855-85, vol 3 (1859) p 110. Scheltema 1879, nr 18. Moes 1897-1905, vol 1, nrs 1571, 3238, 3661; vol 2, nr 9270. Riegl 1931, pp 238-39, fig 68. Martin 1935-36, vol 1, pp 170, 173, 192, 195, fig 106; vol 2, p 120. Haak 1972, p 19, fig 24

A 683 Roelof Meulenaer (1618/19-91). Amsterdam mercantile courier or postmaster on the Antwerp route. *Koopmansbode of postmeester op Antwerpen te Amsterdam*

Pendant to A 684

Canvas 118 × 96.5. Signed and dated *F. Bol fec. 1650*
PROV Bequest of Jonkheer J S H van de Poll, Amsterdam, 1880
LIT V de Stuers, Ned Kunstbode 2

(1880) p 244. J G Frederiks, Obreen's
Archief 6 (1884-87) p 276. Moes 1897-
1905, vol 2, nr 5015. G Kolleman, Ons
Amsterdam 23 (1971) p 114ff, ill on p
115

A 684 Maria Rey (1630/31-1703). Wife
of Roelof Meulenaer. *Echtgenote van
Roelof Meulenaer*

Pendant to A 683

Canvas 118 × 96.5. Signed and dated
F. Bol fe. 1650
PROV Same as A 683
LIT J G Frederiks, Obreen's Archief 6
(1884-87) p 276. Moes 1897-1905, vol 2,
nr 6375. G Kolleman, Ons Amsterdam
23 (1971) p 114ff, ill on p 120

C 436 Six regents and the beadle of the
Nieuwe Zijds institute for the outdoor
relief of the poor, Amsterdam, 1657. *Zes
regenten en de bode van het Nieuwe Zijds
Huiszittenhuis te Amsterdam, 1657*

The sitters are Cornelus Metsue, Jan
Appelman, Abraham Ernst van Bassen,
Joachim Jansz Scheepmaker, Jan van
Halewijn and Tyman Veeneman

Canvas 143 × 192. Signed and dated
FBol A° 1657$\frac{7}{24}$
PROV Nieuwe Zijds Huiszittenhuis
(institute for the outdoor relief of the
poor), Amsterdam. On loan from the
city of Amsterdam since 1885
LIT Wagenaar 1760-88, vol 3 (1767) p
267. Scheltema 1855-85, vol 3 (1859) p
110. Riegl 1931, p 239

C 626 Naaman the Syrian and the
prophet Elisha. *Naäman de Syriër en de
profeet Elisa*

Canvas 151 × 248.5. Signed and dated
F. Bol 1661
PROV Leprozenhuis (lepers' asylum),
Amsterdam. On loan from the city of
Amsterdam, 1899-1975
LIT Wagenaar 1760-88, vol 2 (1765) p
312. Scheltema 1855-85, vol 3 (1859) p
111. Scheltema 1879, p 7, nr 9. H Goetz,
OH 54 (1937) p 226, note 7

A 46 Allegory of education. *Allegorie op
het onderwijs*

Belongs with A 45

Canvas 208 × 179. Signed and dated
F. Bol 1663
PROV From the Trippenhuis (the house
of the Trip family; mantel painting),
Amsterdam, in or before 1858
LIT Scheltema 1855-85, vol 3 (1859) p
109. Moes 1897-1905, vol 1, nr 2649
(identifies model as Johanna de Geer);
3545 (as Emerentia Hoefslager)

A 45 A mother, thought to be Johanna
de Geer (1627-91), and two children.
*Een moeder, vermoedelijk Johanna de Geer,
met twee kinderen*

Belongs with A 46

Canvas 169 × 154. Signed *F. Bol fecit*
PROV Same as A 46
LIT Scheltema 1855-85, vol 3 (1859) p
108. Moes 1897-1905, vol 1, nrs 2649,
3545; vol 2, nr 8081. J Białostocki, Bull
Mus Roy Belg 6 (1957) p 43ff (portrait
of Johanna de Geer, Hendrick Trip's
second wife)

A 43 Portrait of a man. *Portret van een man*

Canvas 124 × 100. Signed and dated
FBol 1663
PROV Purchased from J de Vries, art
dealer, Amsterdam, 1821 (as a portrait
of Jacob van Campen)
LIT Scheltema 1855-85, vol 3 (1859) p
107. CH de Jonge, in Huldeboek Dr B
Kruitwagen, 1959, p 211, ill. Van Hall
1963, pp 32, 56, nrs 201:24, 347:1. H
Kühn, Jb Ksamml Baden-Württemberg
2 (1965) p 205. Bernt 1969-70, vol 1, nr
134 (portrait of Artus Quellinus)

A 44 Michiel Adriaensz de Ruyter
(1607-76). Vice admiral. *Luitenant-
admiraal*

The seascape with the 'Zeven
Provinciën' in the background is thought
to have been painted by Willem van de
Velde II

Canvas 157 × 138. Signed and dated
FBol 1667
PROV Presented by the sitter in 1667 to
the admiralty of Zeeland in Middelburg.
Departement der Konvooyen en Licen-
ten (department of trade licensing and
customs), Vlissingen, 1795. NM, 1808
LIT Scheltema 1855-85, vol 3 (1859) p
107. Moes 1897-1905, vol 2, nr 6661:2.
Moes & van Biema 1909, pp 120, 187,
208. Willis 1911, p 86 (replica of the
version in the KKS [cat 1952, nr 585]). R
van Luttervelt, Bull RM 1 (1953) p 33;
idem 5 (1957) p 60, ill. J H Kruisinga,
Ons Amsterdam 9 (1957) ill on p 106.
L M Akerveld & J R Bruijn, Spiegel Hist
2 (1967) p 326, fig 9

C 107 Portrait of a naval officer. *Portret van een zeeoverste*

Canvas 116.5 × 93.5. Signed and dated *FBol 1667*
PROV On loan from the city of Amsterdam (A van der Hoop bequest) since 1885
LIT A D de Vries Azn, De Gids, 1876:3, pp 551-52. Moes 1897-1905, vol 2, nr 6661:5 (portrait of M A de Ruyter). J Knoef, Jb Amstelodamum 42 (1948) p 62

C 367 Three regentesses of the lepers' asylum in Amsterdam, 1668. *Drie regentessen van het Leprozenhuis te Amsterdam, 1668*

The sitters are Clara Abba, wife of Jan Lensen, Agatha Munter, wife of IJsbrand Valckenier, and Elisabeth van Duynen, widow of Dr Pelgrim ten Grootenhuijs

Canvas 170 × 208. Signed and dated *F. Bol 1668*
PROV Leprozenhuis (lepers' asylum), Amsterdam. On loan from the city of Amsterdam since 1885
LIT Wagenaar 1760-88, vol 2 (1765) p 313. Scheltema 1855-85, vol 3 (1859) p 110. Scheltema 1879, p 8, nr 20. Riegl 1931, pp 239, 266, fig 70. Martin 1935-36, vol 1, pp 200, 202, fig 113; vol 2, p 120

A 613 Consul Titus Manlius Torquatus beheading his son (Imperia Manliana). *Consul Titus Manlius Torquatus laat zijn zoon onthoofden*

Canvas 218 × 242
PROV Council chamber of the admiralty, Prinsenhof, Amsterdam, 1799. NM, 1808
* DRVK since 1953
LIT Wagenaar 1760-88, vol 3 (1767) p 79. Scheltema 1855-85, vol 3 (1859) p 107. Moes & van Biema 1909, pp 21, 38, 172, 216. W Stechow, OH 46 (1929) pp 136-37, fig 2. Van de Waal 1952, p 221, note 6

A 614 Aeneas at the court of Latinus. *Aeneas bij Latinus*

Canvas 218 × 232
PROV Council chamber of the admiralty, Prinsenhof, Amsterdam, 1799. NM, 1808
* DRVK since 1953
LIT Scheltema 1855-85, vol 3 (1859) p 107 (G Duilius Nepos returning to Rome in triumph after the naval battle against Carthage). Moes & van Biema 1909, pp 21, 38, 172, 216. Van de Waal 1952, p 221, note 6

A 1577, A 1579, A 1575, A 1578 & A 1576 Series of five wall paintings. *Serie van vijf kamerbeschilderingen*

A 1577 Abraham entertaining the three angels. *Abraham ontvangt de drie engelen*

Canvas 404 × 282.5. Signed *FBol*
PROV Belonged to the decoration of a room in the house at Nieuwe Gracht 6, Utrecht. Presented by the Royaards family, Utrecht, 1892 * On loan since 1912 (from 1952 on via the DRVK) to the Carnegie Foundation, The Hague
LIT A Bredius, OH 28 (1910) p 234, ill

A 1579 Joseph's cup discovered in Benjamin's sack. *Het vinden van Jozef's beker in de korenzak van Benjamin*

Canvas 408 × 409
PROV Same as A 1577 * On loan since 1912 (from 1952 on via the DRVK) to the Carnegie Foundation, The Hague

A 1575 Pharaoh's daughter discovers Moses in the rush basket. *Farao's dochter vindt Mozes in het biezen mandje*

Canvas 408 × 493
PROV Same as A 1577 * On loan since 1912 (from 1952 on via the DRVK) to the Carnegie Foundation, The Hague

A 1578 King Amaziah and the man of God. *Koning Amazia en de man Gods*

Canvas 408 × 273
PROV Same as A 1577 * On loan since 1912 (from 1952 on via the DRVK) to the Carnegie Foundation, The Hague

A 1576 Thetis presenting Achilles with a new suit of armor from the forge of Vulcan. *Achilles ontvangt van Thetis een nieuwe wapenrusting uit de smidse van Vulcanus*

Canvas 408 × 413
PROV Same as A 1577 * On loan since 1912 (from 1952 on via the DRVK) to the Carnegie Foundation, The Hague

attributed to **Ferdinand Bol**

A 714 Elisabeth Jacobsdr Bas (1571-1649). Widow of Jochem Hendricksz Swartenhont. *Weduwe van Jochem Hendricksz Swartenhont*

For a portrait of the sitter's husband, *see* Eliasz, Nicolaes, A 705

Canvas 118 × 91.5
PROV Bequest of Jonkheer J S H van de Poll, Amsterdam, 1880
LIT V de Stuers, Ned Kunstbode 2 (1880) p 244 (Rembrandt). A D de Vries & N de Roever, OH 2 (1884) p 82, note 1. J G Frederiks, Obreen's Archief 6 (1884-87) p 265ff (Rembrandt). C Vosmaer, Ned Spec, 1887, p 121ff. Moes 1897-1905, vol 1, nr 379 (Rembrandt). A Bredius, OH 29 (1911) p 193 (Bol). A Bredius, Burl Mag 20 (1911-12) p 330 (Bol). J Six, Bull NOB 2d ser, vol 4 (1911) p 311 (Rembrandt). C Hofstede de Groot, OH 30 (1912) p 74 (Rembrandt). A Bredius, OH 30 (1912) p 82 (Bol). C Hofstede de Groot, OH 30 (1912) p 174 (Rembrandt). A Bredius, OH 30 (1912) p 183 (Bol). C G 't Hooft, Rev Art Anc & Mod 31 (1912) p 459 (Bol). A Bredius, Burl Mag 21 (1913-14) p 217 (Bol). Bauch 1926, pp 33, 44, 68, fig 26, nr 137 (Rembrandt). C J Welcker, Mndbl Amstelodamum 14 (1927) p 68. A Bredius, in Festschrift M J Friedländer, 1927, p 156 (Bol). O Benesch, Kunstchronik 9 (1956) p 202. J Michelkowa, Biul Hist Sztuki 19 (1957) p 264, fig 7 (Bol). W R Valentiner, Art Q 20 (1959) p 49. Plietzsch 1960, pp 179, 325 (Rembrandt?). H Kühn, Jb Ksamml Baden-Württemberg 2 (1965) p 203 (Bol). A B de Vries, OKtv 3 (1965) nr 14, fig 6 (Bol). G Kolleman, Ons Amsterdam 19 (1967) pp 57-62, ill (Bol). Haak 1968, p 165, fig 258 (Bol?). B A Rifkin, Art News 68 (1969) p 32, ill on p 31 (Backer?). J R Judson, exhib cat Rembrandt after 300 years, Chicago, Minneapolis & Detroit 1969-70, nr 30. G Kolleman, Ons Amsterdam 23 (1971) p 114, ill on p 117

A 1937 Biblical scene. *Bijbelse voorstelling*

Canvas 165 × 177
PROV Purchased from the G de Clercq collection, Amsterdam, 1901, with aid from the Rembrandt Society * DRVK since 1952

copy after **Ferdinand Bol**

A 2736 Michiel Adriaensz de Ruyter (1607-76). Vice admiral. *Luitenant-admiraal*

Canvas 112 × 90
PROV NMGK, 1885 * DRVK since 1952
LIT Moes 1897-1905, vol 2, nr 6661:18

Hans Bollongier

Haarlem ca 1600 – after 1645 Haarlem

A 799 Still life with flowers. *Stilleven met bloemen*

Panel 68 × 54.5. Signed and dated
HBoulenger 1639
PROV Sale Amsterdam, 14-15 Nov 1883,
not in cat
LIT Warner 1928, nr 9c. Vorenkamp
1933, pp 120, 133. Martin 1935-36, vol
I, p 290. Bergström 1947, p 104, fig 88.
Bergström 1956, p 97, fig 88. Bernt 1960-
62, vol I, nr 103. Bernt 1969-70, vol I, nr
138. Mitchell 1973, p 28, fig 28

Benjamin Samuel Bolomey

Lausanne 1739 – 1819 Lausanne

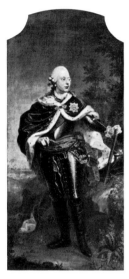

A 948 Willem V (1748-1806), prince of
Orange-Nassau. *Prins van Oranje-Nassau*

Pendant to A 949

Canvas 223 × 103. Signed and dated
Bolomey 1770
PROV Presented by the states of Zee-
land, Middelburg, 1878. NMGK, 1885 *
DRVK since 1952
LIT Moes 1897-1905, vol 2, nr 9098:16.
Scheen 1946, fig 23. R van Luttervelt,
Historia 15 (1950) p 269, fig 4

A 949 Frederika Sophia Wilhelmina of
Prussia (1751-1820). Wife of Prince
Willem V. *Echtgenote van Prins Willem V*

Pendant to A 948

Canvas 207 × 103
PROV Same as A 948 * DRVK since 1952

A 965 Frederika Sophia Wilhelmina of
Prussia (1751-1820). Wife of Prince
Willem V, in the temple of the arts. *Echt-
genote van Prins Willem V, in de tempel der
kunsten*

Panel 44.5 × 31. Inscribed on the verso
*Explication | du Sujet Allégorique | | S. A. R.
Mad : la Princesse | Douairière d'Orange
Nassau | (mère du Roi regnant des Pays-Bas),
| Environnée des graces, reçoit le pinceau des |
mains de la Peinture, Euterpe Deèsse de la |
Musique lui offre Sa Lire et Sa Couronne, |
l'Education d'un côté instruisant un
Adolescent, | d'un autre les graces reçoivent du
génie des Arts | une Couronne pour en orner Sa
Tête. | | La Scène se passe dans le Temple des
Arts. | | Ben. Bolomey invenit et pinxit.*
PROV Purchased from Mr Botgortscheck,
The Hague, 1880. NMGK, 1885
LIT Moes 1897-1905, vol I, nr 2581 : 22.
Scheen 1969-70, vol I, fig 3

Karel Frederik Bombled

Amsterdam 1822 – 1902 Chantilly

A 1735 Gypsies on the road. *Zigeuners op
weg*

Panel 28 × 37. Signed *K. Bombled 1881*
PROV Bequest of D Franken Dzn, Le
Vésinet, 1898
LIT Scheen 1946, fig 289

attributed to **Bonifazio Veronese**

Verona 1487 – 1553 Venice

C 1374 Head of a young woman. *Kop van
een jonge vrouw*

Canvas on panel 53 × 41. Oval
PROV Het Loo Palace, Apeldoorn. On
loan from the KKS since 1948
LIT Berenson 1897, p 85. Westphal 1931,
pp 66-67, 103, fig 22 (probably a
fragment)

Léon Joseph Florentine Bonnat

Bayonne 1833 – 1922 Paris

A 2246 Isaac Dignus Fransen van de
Putte (1822-1902). Colonial minister
(1863-66, 1872-74). *Minister van koloniën*

Canvas 144.5 × 105. Signed and dated
Ln Bonnat 1879
PROV Bequest of J H Fransen van de
Putte, The Hague, 1907 * DRVK since
1952

attributed to **Francesco Bonsignori**

Verona ca 1455–1519 Caldiero

A 3991 St Sebastian. *De heilige Sebastiaan*

Canvas 143 × 59
PROV O Lanz, Amsterdam. Lent by the
DRVK, 1952. Transferred in 1960
LIT G Swarzenski, Münchn Jb 9 (1915)
p 89, fig 5. R Longhi, Vita art 2 (1927) p
134 (Gentile Bellini). Van Marle
1923-38, vol 17 (1935) p 173, note 1. U B
Schmidt, Münchn Jb 3d ser, vol 12
(1961) p 129 (not Bonsignori; Venetian
ca 1480)

François Bonvin

Vaugirard 1817–1887 St Germain-en-
Laye

A 1859 Still life. *Stilleven*

Canvas 45.5 × 36. Signed and dated
F Bonvin. London 1871
PROV Presented by the dowager of R
Baron van Lynden, née M C Baroness
van Pallandt, The Hague, 1900

Daniel Boone

Burgerhout ca 1635–1698 London?

A 987 Peasants playing cards. *Kaart-
spelende boeren*

Panel 19.5 × 15. Signed *D. Boone*
PROV Purchased from C F Roos & Co,
art dealers, Amsterdam, 1885

A 1600 The porridge eater. *De papeter*

Panel 19.5 × 15. Signed *D. Boone*
PROV Presented by F Heusy, Kampen,
1893

Arnold Boonen

Dordrecht 1669–1729 Amsterdam

C 1468 Six regents of the Spinhuis
(house of correction) and the Nieuwe
Werkhuis (new workhouse) in
Amsterdam, 1699. *Zes regenten van het*

*Spinhuis en Nieuwe Werkhuis te Amsterdam,
1699*

The sitters are Sieuwert Witsen, Jan van
der Graaff, Josephus van de Putt,
Hendrick Mierinck, Hendrik Stok and
Aernout Schuyt

Canvas 191.5 × 297. Signed and dated
A. Boonen 1699
PROV Poorhouse, Roeterstraat,
Amsterdam. On loan from the city of
Amsterdam, 1885-1975

C 444 Six regents of the Oude Zijds
institute for the outdoor relief of the
poor, Amsterdam, 1705. *Zes regenten van
het Oude Zijds Huiszittenhuis te Amsterdam,
1705*

The sitters are Eduard Becker, Johannes
van Drogenhorst, Johannes Commelin,
Pieter Mierinck, Matthijs Gansneb,
called Tengnagel, and Arnoldus Dix

Canvas 175 × 375. Signed and dated
A. Boonen Pinx. 1705
PROV Oude Zijds Huiszittenhuis
(institute for the outdoor relief of the
poor), Amsterdam. On loan from the
city of Amsterdam, 1885-1975
LIT Oldewelt 1942, pp 17-18. Martin
1935-36, vol 2, pp 480-81, fig 249

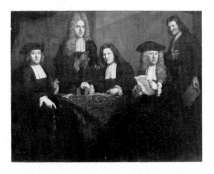

C 445 Four regents and the housemaster
of the Spinhuis (house of correction) in
Amsterdam, 1714. *Vier regenten en de
binnenvader van het Spinhuis te Amsterdam,
1714*

The sitters are Andries Hees, Tobias
Looten, 'Andries Carel Jongh, Jacob
Frederik du Fay and housemaster
Barend Mom

Canvas 178 × 235. Signed and dated
A. Boonen 1714

PROV Spinhuis (house of correction), Amsterdam. On loan from the city of Amsterdam, 1885-1975

attributed to **Arnold Boonen**

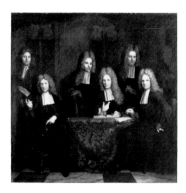

C 368 Four regents, the bookkeeper and the housemaster of the lepers' asylum in Amsterdam, 1715. *Vier regenten van het Leprozenhuis te Amsterdam met de boekhouder en de binnenvader, 1715*

The sitters are Hendrik Visser, Michiel du Fay, Willem Pijll, Wolfert Hendrik Drinkveld

Canvas 236 × 243. Signed and dated *A. Boonen 1715*
PROV Leprozenhuis (lepers' asylum), Amsterdam. On loan from the city of Amsterdam, 1885-1975
LIT Scheltema 1879, nr 21. Moes 1897-1905, vol 1, nrs 2152, 2495; vol 2, nrs 6104, 8536 (Cornelis Visscher)

A 1914 Portrait of a man. *Portret van een man*

Pendant to A 1915

Canvas 50 × 42.5
PROV Bequest of J H Schellwald, Zwolle, 1900
LIT Niemeijer 1973, pp 407-08

A 1915 Portrait of a woman. *Portret van een vrouw*

Pendant to A 1914

Canvas 50 × 42.5
PROV Same as A 1914
LIT Niemeijer 1973, pp 407-08

C 1567 Portrait of a man. *Portret van een man*

Pendant to C 1568

Canvas 89.5 × 71.4
PROV On loan from the KOG (presented by A J Enschedé) since 1973

C 1568 Portrait of a woman. *Portret van een vrouw*

Pendant to C 1567

Canvas 88.5 × 71
PROV Same as C 1567

Paulus Bor

Amersfoort ca 1600 – 1669 Amersfoort

A 1266 Jan van de Poll (1668-1745) and his son Harmen Hendrick (1697-1772). *Jan van de Poll en zijn zoon Harmen Hendrick*

Painted as a pendant to van der Werff, Adriaen, A 1267 Margaretha Rendorp

Canvas 48.5 × 39.5. Signed *A. Boonen*
PROV Presented by J S R van de Poll, Arnhem, 1885
LIT Moes 1897-1905, vol 2, nrs 5991:1, 5994

A 1263 Brechje Hooft (1640-1721). Widow of Harmen van de Poll. *Weduwe van Harmen van de Poll*

Canvas 50 × 41
PROV Presented by J S R van de Poll, Arnhem, 1885
LIT C Hofstede de Groot, OH 17 (1899) p 168 (Philip van Dijk)

manner of **Arnold Boonen**

A 852 Pharaoh's daughter discovers Moses in the rush basket. *Farao's dochter vindt Mozes in het biezen mandje*

Canvas 132.5 × 115.5
PROV Huygenshuis (house of Constantijn Huygens), Plein, The Hague, 1874. NMGK, 1885
LIT E Plietzsch, Jb Preusz Kunstsamml 37 (1916) pp 108-09, 112, fig 3. V Bloch, OH 45 (1928) p 25. Martin 1935-36, vol 1, p 132. V Bloch, OH 64 (1949) p 107, fig 1 (ca 1635-38). Th H Lunsingh Scheurleer, OH 77 (1962) p 182. Borea 1966, fig 4

A 4666 Mythological figure, thought to be Pomona. *Mythologische figuur, vermoedelijk Pomona*

Canvas 151 × 114
PROV On loan from J Dik, La Tour de Peilz, since 1972. Purchased in 1975
LIT V Bloch, OH 64 (1949) p 108, fig 5. J Q van Regteren Altena, OH 64 (1949) pp 108-09. J Walsh, Apollo, 1974, p 346, note 17

Gerard ter Borch

Zwolle 1617–1681 Deventer

see also Meegeren, Henricus Antonius van, A 4243 Portrait of a man

A 1784 Gerard Abrahamsz van der Schalcke (1609-67). Haarlem cloth merchant. *Lakenkoopman te Haarlem*

Pendant to A 1785

Panel 29.5 × 23.5. Oval. Signed and dated *GTB 1644*
PROV Purchased from Francke gallery, Amsterdam, 1898, with aid from the Rembrandt Society
LIT Hofstede de Groot 1907-28, vol 5 (1912) nr 265. Plietzsch 1944, pp 12, 39, nr 11. Gudlaugsson 1959-60, vol 1, p 47, fig 28; vol 2, p 68, nr 28. H L Kruimel, Jb Genealogie 25 (1971) pp 224-29, ill (new identification of the sitter)

A 1785 Johanna Bardoel (d after 1667).

Wife of Gerard van der Schalcke. *Echtgenote van Gerard van der Schalcke*

Pendant to A 1784

Panel 29.5 × 23.5. Oval
PROV Same as A 1784
LIT Hofstede de Groot 1907-28, vol 5 (1912) nr 266. Plietzsch 1944, pp 12, 39, nr 12. Gudlaugsson 1959-60, vol 1, p 47, fig 29; vol 2, p 68, nr 29 (1644). H J Kruimel, Jb Genealogie 25 (1971) pp 224-29, ill (new identification of the sitter)

A 1786 Helena van der Schalcke (1646-71). Daughter of Gerard van der Schalcke and Johanna Bardoel and the future wife of Nicolaes Eichelberg. *Dochter van Gerard van der Schalcke en Johanna Bardoel, later echtgenote van Nicolaes Eichelberg*

The sitter's parents are portrayed in A 1784 and A 1785, and her future husband in Berckheyde, Job, A 1790

Panel 34 × 28.5
PROV Same as A 1784
LIT Hofstede de Groot 1907-28, vol 5 (1912) nr 267. Plietzsch 1944, pp 12, 39, nr 10. Gudlaugsson 1959-60, vol 1, p 47, fig 30 (presumably 1644); vol 2, p 68, nr 30. L J Bol, OK 6 (1962) nr 32, ill. Rosenberg, Slive & Ter Kuile 1966, p 129, fig 106B. H L Kruimel, Jb Genealogie 25 (1971) pp 224-29, ill. Exhib cat Gerard Ter Borch, The Hague 1974, nr 6, ill

A 2417 François de Vicq (1646-1707).

Burgomaster of Amsterdam for several terms from 1697 on. *Sedert 1697 herhaaldelijk burgemeester van Amsterdam*

Pendant to A 2418

Canvas 38.5 × 31. Signed and dated *GTB 1670*. Inscribed *Aetatis 24* and on the verso, in a later hand, *Nicolaas Pancras*
PROV Bequest of S Rendorp, Amsterdam, 1910
LIT Moes 1897-1905, vol 2, nr 8476:1. Hofstede de Groot 1907-28, vol 5 (1912) nr 272. Plietzsch 1944, pp 18, 52, nr 84. Kruizinga 1948, p 94, fig 26. Gudlaugsson 1959-60, vol 1, p 149, fig 240; vol 2, p 216, nr 240

A 2418 Aletta Pancras (1649-1707). Wife of François de Vicq. *Echtgenote van François de Vicq*

Pendant to A 2417

Canvas 38.5 × 31. Signed and dated *GTB 1670*. Inscribed *Aetatis 21* and on the verso, in a later hand, *Petronella de Waart*
PROV Same as A 2417
LIT Hofstede de Groot 1907-28, vol 5 (1912) nr 273. Plietzsch 1944, pp 18, 52, nr 85. Kruizinga 1948, p 94, fig 27. Gudlaugsson 1959-60, vol 1, p 149, fig 241; vol 2, p 216, nr 241

A 3842 Godard van Reede (1588-1648), lord of Nederhorst. Delegate of the province of Utrecht at the peace conference at Münster (1646-48). *Heer van Nederhorst. Gevolmachtigde van de provincie Utrecht bij de vredesonderhandeling te Munster (1646-48)*

Copper 14.5 × 11. Oval
PROV Purchased from F C C Baron van Tuyll van Serooskerken, Zuylen Castle, Oud-Zuilen, 1952
LIT Gudlaugsson 1959-60, vol 1, p 58, fig 47; vol 2, p 77, nr 47 (probably 1646)

A 4038 Seated girl in peasant costume. Probably Gesina (1631-90), the painter's half-sister. *Zittende jonge vrouw in het costuum van een boerenmeisje. Waarschijnlijk Gesina, halfzuster van de schilder*

Panel 28 × 23
PROV Presented by Mr & Mrs I de Bruijn-van der Leeuw, Muri near Bern, 1961
LIT Smith 1829-42, vol 4 (1833) nr 62. Hofstede de Groot 1907-28, vol 5 (1912) nrs 102, 176c. Veth 1919, p 93. Plietzsch 1944, fig 27 (ca 1648). H L Jaffé, Du, 1944, p 42. ill. Gudlaugsson 1959-60, vol 1, p 78, fig 81; vol 2, p 99, nr 81 (ca 1650). E R Meijer, Bull RM 9 (1961) p 46, fig 1. J L Cleveringa, Bull RM 9 (1961) p 63, nr 1. Exhib cat Gerard Ter Borch, The Hague 1974, nr 20, ill (ca 1650)

A 4039 Woman at a mirror. *Vrouw voor een spiegel*

Panel 34.5 × 26
PROV Presented by Mr & Mrs I de Bruijn-van der Leeuw, Muri near Bern, 1961
LIT Hofstede de Groot 1907-28, vol 5 (1912) nr 52 = nr 64. Dayot 1912, p 153, nr 159, fig 94. Plietzsch 1944, fig 20. S J Gudlaugsson, N K J 2 (1948-49) p 245, nr 20 (shortly after 1650). Gudlaugsson 1959-60, vol 1, p 79ff, fig 83; vol 2, p 101, nr 83 (shortly after 1650). E R Meijer, Bull RM 9 (1961) p 46, fig 2. J L Cleveringa, Bull RM 9 (1961) p 63, nr 2. De Jongh 1967, p 78, fig 63. Exhib cat Gerard Ter Borch, The Hague 1974, nr 21, ill

A 404 Gallant conversation; known as 'The paternal admonition.' *Galante konversatie; bekend als 'De vaderlijke vermaning'*

Canvas 71 × 73
PROV Purchased with the Kabinet van Heteren Gevers, The Hague-Rotterdam, 1809
LIT Smith 1829-42, vol 4 (1833) p 4. Hofstede de Groot 1907-28, vol 5 (1912) nr 186. Moes & van Biema 1909, pp 150, 193. G Glück, in Meisterwerke, 1920. Martin 1935-36, vol 2, pp 170-71, 240, fig 132. Plietzsch 1944, pp 21, 28-29, 35, 45, nr 49. Gudlaugsson 1959-60, vol 1, p 96, fig 110; vol 2, nr 110:1 (ca 1653-54). Bille 1961, vol 1, pp 109-10. M Poch-Kalous, Albertina Stud 4 (1966) p 27. Rosenberg, Slive & Ter Kuile 1966, p 128. Exhib cat Gerard Ter Borch, The Hague 1974, nr 32, ill

A 402 Portrait of a man. *Portret van een man*

Pendant to A 403

Copper 35.5 × 29.5. Signed *GTB*
PROV Bequest of L Dupper Wzn, Dordrecht, 1870 * DRVK since 1959 (on loan to the Museum Boymans-van Beuningen, Rotterdam)
LIT C von Lützow, Zeitschr BK 5 (1870) pp 112, 229. Rosenberg 1897, p 9, fig 6 (self portrait). Hofstede de Groot 1907-28, vol 5 (1912) nr 285 = nr 345. Gudlaugsson 1959-60, vol 1, p 113, fig 136; vol 2, p 146, nr 136 (ca 1658)

A 403 Portrait of a woman. *Portret van een vrouw*

Pendant to A 402

Copper 35.5 × 29.5. Signed *GTB*
PROV Same as A 402 * DRVK since 1959 (on loan to the Museum Boymans-van Beuningen, Rotterdam)
LIT C von Lützow, Zeitschr BK 5 (1870) pp 112, 229. Rosenberg 1897, p 8, ill (ter Borch's wife). Hofstede de Groot 1907-28, vol 5 (1912) nr 371 = nr 423. Gudlaugsson 1959-60, vol 1, p 113, fig 135; vol 2, p 146, nr 135 (ca 1658)

A 3964 Portrait of a man in armor. *Portret van een man in harnas*

Copper 64 × 43. Signed *GTB*
PROV Lent by the SNK, later DRVK, 1948. Transferred in 1960
LIT Hofstede de Groot 1907-28, vol 5 (1912) nr 323. Plietzsch 1944, p 99. S J Gudlaugsson, Festschrift Winkler, 1958, p 310. Gudlaugsson 1959-60, vol 1, p 148, fig 228; vol 2, p 209, nr 228:1 (ca 1665-70)

A 3963 Jacob de Graeff (1642-90). In the uniform of an officer. *In officiersuniform*

Panel 45.5 × 34.5. Ends in a round arch. Signed *GBT*. Formerly inscribed on the

verso with biographical information concerning Jacob de Graeff, now covered by cradling
PROV Lent by the SNK, later DRVK, 1948. Transferred in 1960
LIT Hofstede de Groot 1907-28, vol 5 (1913) nr 228 (portrait of Andries de Graeff). A Bredius, OH 30 (1912) p 198. Bode 1913, fig 19. Plietzsch 1944, pp 18, 54, nr 94. Gudlaugsson 1959-60, vol 1, p 157, fig 265; vol 2, p 227, nr 265 (ca 1674). Exhib cat Gerard Ter Borch, The Hague 1974, nr 58, ill (ca 1674)

copy after **Gerard ter Borch**

A 405 Ratification of the Peace of Münster between Spain and the Dutch Republic in the town hall of Münster, 15 May 1648. *De beëdiging van het vredes-verdrag tussen Spanje en de Verenigde Nederlanden in het Raadhuis van Munster, 15 mei 1648*

Copy after the original in London, National Gallery (cat 1960, nr 896)

Copper 46 × 60
PROV Sale A C Putman (Deventer), Amsterdam, 17 Aug 1803, lot 80. NM, 1808
LIT F Muller, Navorscher 7 (1863) pp 147, 182. Moes & van Biema 1909, pp 64, 66, 196, 217. Hofstede de Groot 1907-28, vol 5 (1912) nr 6. J H Scholte, OH 63 (1948) p 9ff. Gudlaugsson 1959-60, vol 1, p 63; vol 2, p 84, nr 57a. Van Hall 1963, p 36, nr 226:5. C J A Genders, Spiegel Hist 8 (1973) pp 649-50, fig 10

C 242 Boy fleaing a dog. *Jongen bezig een hondje te vlooien*

Copy after the original in Munich, Alte Pinakothek (cat 1967, nr 589)

Panel 36.5 × 28.5
PROV On loan from the city of Amsterdam (A van der Hoop bequest) since 1885
LIT C von Lützow, Zeitschr BK 5 (1870) p 111. Gudlaugsson 1959-60, vol 2, p 131, nr 116a

Jan ter Borch

active 1624 in Utrecht; d after 1646

A 1331 The drawing lesson. *De tekenles*

Canvas 120 × 159. Signed and dated *J ter Borch 1634*
PROV Picture gallery of Prince Willem v, The Hague, 1795. NM, 1808?
LIT E W Moes, OH 4 (1886) p 158. Von Schneider 1933, pp 83, 140. Nicolson 1958, p 126. Gudlaugsson 1959-60, vol 2, p 42. B Nicolson, Burl Mag 102 (1960) p 473

Moses ter Borch

Zwolle 1645 – 1667 Harwich

A 2241 Self portrait. *Zelfportret*

Canvas 28 × 19

PROV Purchased from the estate of L F Zebinden, Zwolle, 1887. RPK, 1907
LIT Plietzsch 1944, p 33. A J Moes-Veth, Bull RM 6 (1958) p 17, ill (portrait of Moses ter Borch by his brother Gerard). Gudlaugsson 1959-60, vol 2, p 288, nr 2, pl XXV:2 (ca 1660-61). Van Hall 1963, p 37, nr 299:1

A 2118 Self portrait. The so-called 'Portrait of Jan Fabus.' *Zelfportret, zgn portret van Jan Fabus*

Paper 8 × 7
PROV Sale Amsterdam, 15 June 1886. RPK, 1907
LIT Plietzsch 1944, p 33. A J Moes-Veth, Bull RM 6 (1958) p 17, ill (portrait of Moses ter Borch by his brother Gerard). Gudlaugsson 1959-60, vol 2, p 288, nr 1, pl XXV:4 (self portrait of Moses; ca 1660-61). Van Hall 1963, p 37, nr 229:2

A 2240 Old woman. *Oude vrouw*
Canvas 24 × 19
PROV Purchased from the estate of L F Zebinden, Zwolle, 1887. RPK, 1907
LIT Plietzsch 1944, p 33. Gudlaugsson 1959-60, vol 2, p 288, nr 3, pl XXV:1 (ca 1660-61)

Nicolaes van Borculo

Utrecht ca 1575 – 1643 Utrecht

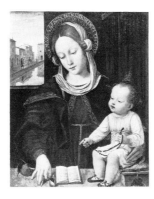

A 3031 Madonna and child. *Madonna met kind*

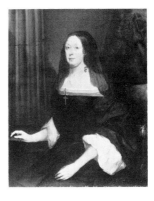

A 2397 Portrait of a woman. *Portret van een vrouw*

A 4251 Henricus van Zijl (1545-1627). Councillor to the court of Utrecht. *Raadsheer in het Hof van Utrecht*

Copper 16.5 × 11.5. Dated *Anno 1627*. Inscribed *Octo annis decies co[m]pletis atq. duobus Henrici Zyly talis imago fuit*
PROV Sale A van der Willigen, Haarlem, 20-21 April 1874, lot 21. NMGK
LIT Moes 1897-1905, vol 2, nr 4929. PTA Swillens, Jb Oud Utrecht, 1934, p 95ff, fig 1

Panel 50 × 42
PROV Purchased from the Augusteum, Oldenburg, 1925, with aid from the Rembrandt Society
LIT Bode 1888, p 11. Venturi 1901-40, vol 7 (1915) p 302, fig 603. A Venturi, Dedalo 1 (1920-21) p 527. Venturi 1927. p 339ff, fig 220 (late work). Venturi 1930, p 29. Berenson 1932, p 97. Aprà 1945, p 10. Pirovano 1973, p 83

Canvas 113 × 91. Signed *P. Borselaer fecit.* Inscribed *Aetat. Sue 53 1664*
PROV Purchased from W J Abraham, London, 1909
LIT Staring 1948, pp 39-40

Paris Bordone

Treviso 1500–1571 Treviso

Johannes Borman

b The Hague, active 1653-58 in Leiden; d after 1659 Amsterdam

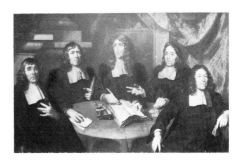

A 3457 Five regents of the Tuchthuis (house of correction) in Middelburg. *Vijf regenten van het Tuchthuis te Middelburg*

Canvas 147 × 132. Signed and dated *P. Borsselaer f 1683* (the 8 is unclear). Inscribed on the book *Regenten van … Joachim Leydecker, oudt 67 Jaer | Hendrick van den Bergen [?], oudt 56 Jaer | Anthonij Daillij, oudt 57 Jaer | Iman de Waiyer [?], oudt 62 Jaer | Pieter Crabbé, oudt 54 Jaer*
PROV Tuchthuis (house of correction), Middelburg. Property of the state for an indeterminate period. Inscribed in the RMA inventory, 1943 * DRVK since 1961

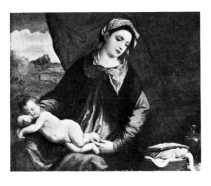

A 3380 Madonna with sleeping child. *Madonna met slapend kind*

Canvas 69.5 × 83.5
PROV Bequest of J W Edwin vom Rath, Amsterdam, 1941
LIT Berenson 1932, p 429. W Suida, Belvedere 12 (1934-36) p 208, fig 243. Berenson 1957, vol 1, p 45. Canova 1964, p 96, fig 118

A 754 Festoon of fruits. *Festoen van vruchten*

Canvas 60 × 74. Signed *Borman f.*
PROV Sale Jonkheer U W F van Panhuys, Amsterdam, 26 Sept 1882, lot 7

Jan Willem van Borselen

Gouda 1825–1892 The Hague

Ambrogio Borgognone

Milan? ca 1450–1523 Milan?

Pieter Borselaer

active 1664-87 in Middelburg

A 1010 Landscape near Schoonhoven. *Landschap in de buurt van Schoonhoven*

Canvas 80 × 130. Signed *J. W. van Borselen F.*
PROV Purchased at exhib Amsterdam 1868, nr 57. RVMM, 1885 * DRVK since 1950
LIT Scheen 1946, fig 347

Anthonie van Borssum

Amsterdam 1629/30 – 1677 Amsterdam

A 744 Moonlit landscape. *Landschap bij maneschijn*

Panel 38 × 49.5. Signed *A. Borssom f.*
PROV Sale Delbooy, The Hague, 1881
LIT A Mantner, OH 58 (1941) p 40. Bol 1969, p 230

A 1535 Animals and plants. *Dieren en planten*

Canvas 62 × 49. Signed *ABorssom*
PROV Presented by Dr A Bredius, The Hague, 1890
LIT Bol 1969, p 340, note 553

Johannes Bosboom

The Hague 1817 – 1891 The Hague

see also under Aquarelles and drawings

A 1011 The choir of the church of Our Lady in Breda with the tomb of Engelbert 11 of Nassau. *Het koor van de Onze Lieve Vrouwekerk te Breda met het grafmonument van Engelbert II van Nassau*

Panel 87 × 69. Signed and dated *J. Bosboom 1843*
PROV Purchased in 1843. RVMM, 1885
LIT Kunstkronijk, 1843-44, p 40. Marius & Martin 1917, pp 27, 127, fig 4. Scheen 1946, fig 188

A 3079 Church interior. *Kerkinterieur*

Canvas 56.7 × 41. Signed *J. Bosboom.* Inscribed on the verso *Bijdrage voor het album ter oprichting van het standbeeld voor Rembrandt ten jare 1848*
PROV Bequest of J B A M Westerwoudt, Haarlem, 1907. Received in 1929
LIT A A E Vels Heijn, Spiegel Hist 4 (1969) p 451, fig 2

A 3578 Vestry of the church of St Stephen in Nijmegen. *De consistoriekamer van de Sint Stevenskerk te Nijmegen*

Panel 47 × 36.5. Signed *J. Bosboom.*
PROV Lent by Mr & Mrs J C J Drucker-Fraser, 1919. Bequeathed in 1944
LIT Marius & Martin 1917, p 130 (1850). Berckenhoff 1892, ill on p 35 (preliminary study). J A B M de Jongh, Numaga 16 (1969) p 174. G F H M de Werd, Numaga 16 (1969) p 349, fig 20

A 2878 Interior of the Grote Kerk in Alkmaar. *Interieur van de Grote Kerk te Alkmaar*

Panel 19 × 14.5. Signed *J. Bosboom*
PROV Bequest of A van Wezel, Amsterdam, 1922 * DRVK since 1959

A 2877 The pulpit of the church in Hoorn. *De preekstoel van de kerk te Hoorn*

Paper on panel 25 × 14. Signed *J. Bosboom*
PROV Bequest of A van Wezel, Amsterdam, 1922
LIT Marius & Martin 1917, p 126 (ca 1842)

A 2380 Interior of the church in Maasland. *Interieur van de kerk te Maasland*

Panel 10.5 × 12.5. Signed *Bosboom*
PROV Bequest of J B A M Westerwoudt,
Haarlem, 1907. Received in 1909
LIT Marius & Martin 1917, pp 146-47,
ill on p 1

A 2700 Interior of the Dom in Trier.
Interieur van de Domkerk te Trier

Panel 40 × 30. Signed *Bosboom*
PROV Presented by the heirs of W J van
Randwijk, The Hague, 1914
LIT W Steenhoff, Onze Kunst 27 (1915)
p 29, ill; idem 32 (1917) p 36, ill. Marius
& Martin 1917, p 147, fig 36. Exhib cat
150 jaar Nederlandse kunst,
Amsterdam 1963, nr 51, fig 55. De
Gruyter 1968-69, vol 1, p 24, fig 20 (ca
1875)

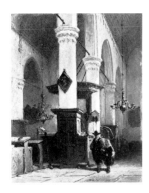

A 3078 Church interior. *Kerkinterieur*

Panel 18.5 × 14.5. Signed *J. Bosboom*
PROV Bequest of J B A M Westerwoudt,
Haarlem, 1907. Received in 1929

NO PHOTOGRAPH AVAILABLE

A 1804 Church interior. *Kerkinterieur*.

Side aisle of a Catholic church with oak
barrel vaulting. In the center is a group
of monks making music. Most of them
are sitting, but a few stand. The leader,
in a white toga, stands behind a table
with sheets of paper and a lectern. In the
shadow of the left wall a monk sits on a
bench; behind him another one walks
away. On the right, beyond the group,
are some paters dressed in black

Panel 88 × 68. Signed *J. Bosboom*
PROV Bequest of Reinhard Baron van
Lynden, The Hague, 1899 * Lent to the
Stedelijk Museum, Zutphen, 1924.
Destroyed in the war, 1945
LIT Marius & Martin 1917, p 135

Hendrik van den Bosch

see Governors-general series: A 3772
Christoffel van Swoll; A 3773 Hendrik
Swaardecroon; A 3775 Diederik van
Durven; A 3776 Dirk van Cloon; A 4541
Christoffel van Swoll; A 4542 Hendrik
Swaardecroon; A 4544 Diederik van
Durven; A 4545 Dirk van Cloon

school of Hieronymus Bosch

's-Hertogenbosch ca 1450–1516
's-Hertogenbosch

A 1601 'Removing the rocks in the head.'
Het snijden van de kei

Panel 41.5 × 32. Marked *B*
PROV Purchased from W A Hopman,
Bussum, 1893
LIT C Hofstede de Groot, OH 22 (1904)
p 115 (old copy). Lafond 1914, pp 58,
76, fig 64 (original). Friedländer 1924-
37, vol 5 (1927) p 153, nr 109a, fig 76 (ca

1550; perhaps by M Coffermans). Von
Baldass 1943, pp 21, 43 (Bosch school).
D Bax, Historia 10 (1945) p 121, fig 2.
Bax 1948, pp 75, 206. L Brand Philip,
NKJ 9 (1958) p 41ff. D Bax, NKJ 13
(1962) p 22ff. De Tolnay 1965, p 336
(copy). Exhib cat Jheronimus Bosch,
's-Hertogenbosch 1967, nr 31, ill.
P Gerlach, Brabantia 17 (1968) p 381

A 1795 The temptation of St Anthony.
*De verzoeking van de heilige Antonius de
Heremiet*

After the original in Lisbon, Museu
Nacional de Arte Antiga (cat 1956, nr
231): middle panel of a triptych

Panel 69 × 87
PROV Purchased from Fr Muller & Co,
art dealers, Amsterdam, 1899
LIT Lafond 1914, p 70, fig 53.
Friedländer 1924-37, vol 5 (1927) p 149,
nr 90e, figs 57-59. De Tolnay 1965, nr 42.
R C van Canegem, Spiegel Hist 4 (1969)
fig 3, p 49

copy after Hieronymus Bosch

A 3113 The arrest of Christ. *De gevangen-
neming van Christus*

Panel 51 × 81.5. Inscribed *B* (or *M*)
PROV Purchased from R W P de Vries,
Amsterdam, 1930, with aid from the
Rembrandt Society
LIT M D Henkel, Pantheon 4 (1931) p
273 (original). W Cohen, Pantheon 4
(1931) p 440 (copy). De Tolnay 1937, p
102, nr 43. Friedländer 1924-37, vol 14
(1937) p 101. Von Baldass 1943, p 43
(copy after a lost original). Von Baldass

1959-60, p 53. De Tolnay 1965, nr 43
(copy after a lost original). Exhib cat
Jheronimus Bosch, 's-Hertogenbosch
1967, nr 20, ill. P Gerlach, Brabantia 17
(1968) p 380

A 1673 Battle between Carnival and
Lent. *Gevecht tussen Carnaval en Vasten*

Panel 74 × 238. Inscribed later *Dit is den
dans van Luther met zyn nonne*
PROV Purchased from F Kleinberger
gallery, Paris, 1896 * On loan to the
Rijksmuseum Muiderslot, Muiden,
since 1949
LIT G Glück, in Gedenkboek A
Vermeylen, 1932, p 264. De Tolnay
1937, p 102, nr 41. Bax 1948, passim. R
Genaille, GdB-A 96 (1954) p 288 (copy
after a grisaille by Bosch in the Thyssen
collection, Schloss Rohoncz). De Tolnay
1965, nr 41. Exhib cat Jheronimus Bosch,
's-Hertogenbosch 1967, nr 39, ill. A P de
Mirimonde, GdB-A 77 (1971) p 34, fig
35

A 4252 Ecce homo

Copy after the original in Frankfurt,
Städelsches Kunstinstitut (cat 1963, inv
nr 1577)

Panel 77 × 55.5
PROV From the convent of Mariën-
water in Koudewater near 's-Hertogen-
bosch. Purchased from the Brigittine
convent in Uden, 1875. NMGK * DRVK
since 1973 (on loan to the Museum voor
Religieuze Kunst, Uden)
LIT Friedländer 1924-37, vol 5 (1927) p
146, nr 77a. Exhib cat Jheronimus Bosch,
's-Hertogenbosch 1967, nr 26, ill. P
Gerlach, Brabantia 17 (1968) p 380. P
Gerlach, Brabantia 20 (1971) ill on p 245

A 3240 The temptation of St Anthony.
*De verzoeking van de heilige Antonius de
Heremiet*

Panel 63 × 82. Inscribed *Jheronimus Bosch*
PROV Presented by F Schmidt-Degener,
Amsterdam, 1935
LIT Friedländer 1924-37, vol 5 (1927) p
150, nr 95. G Glück, Jb Kunsth Samml
Wien 9 (1935) p 151. De Tolnay 1937, p
102, nr 42, fig 118. Bax 1948, pp 40, 98.
J V L Brans, GdB-A 40 (1952) p 129, ill.
Combe 1957, nr 136 (copy after a lost
original). De Tolnay 1965, nr 42 (copy
after a lost original). Exhib cat
Jheronimus Bosch, 's-Hertogenbosch
1967, nr 6, ill. P Gerlach, Brabantia 17
(1968) p 378. J G Heymans, Numaga 15
(1968) p 164, ill on p 175. J van Lennep,
Bull Mus Roy Belg 17 (1968) p 127,
fig 11

A 124 The adoration of the magi. *De
aanbidding der koningen*

Copy after the original in the Prado,
Madrid (cat 1952, nr 2048)

Panel 57 × 45
PROV Purchased with the Kabinet van
Heteren Gevers, The Hague-Rotterdam,
1809
LIT Moes & van Biema 1909, pp 146,
158. Friedländer 1924-37, vol 5 (1927) p
144, nr 68b (copy)

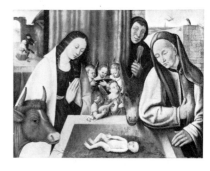

A 4131 The adoration of the child. *De
aanbidding van het kind*

Free copy after a painting in Cologne,
Wallraf-Richartz Museum (inv nr 474)

Panel 56 × 76
PROV Presented by A Andriesse,
Amsterdam, 1940

Ambrosius Bosschaert

Antwerp 1573 – 1621 The Hague

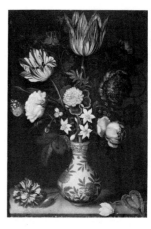

A 1522 Still life with flowers in a Wan-li
vase. *Stilleven met bloemen in een Wan li vaas*

Copper 31 × 22.5. Signed and dated
AB 1619
PROV Presented by Dr A Bredius, The
Hague, 1890
LIT Warner 1928, nr 11b. Vorenkamp
1933, p 116. Steenhoff 1920, vol 2, p 57,
fig 39. Bergström 1947, p 60, fig 30. L J
Bol, OH 70 (1955) pp 10, 104, 107, fig 8,
nr 6. Hairs 1955, pp 90-91, 196, fig 30.
Bergström 1956, p 62, fig 44. Bol 1960,
pp 31, 68, nr 47, fig 29b. VTTT, 1965-66,
nr 77

Bosse

see Bilders-van Bosse

Andries Both

Utrecht 1612/13 – 1641 Venice

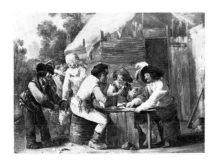

A 2557 The card players. *De kaartspelers*

Panel 32 × 44. Signed *ABoth*
PROV Lent by C Hoogendijk, The
Hague, 1907. Presented by his estate in
1912
LIT C Hofstede de Groot, Ned Spec,
1899, p 58. R Bangel, Cicerone 7 (1915)
p 178, fig 4. L de Bruyn, OH 67 (1952) p
110. M R Waddingham, Paragone
15:171 (1964) p 18, fig 19 (painted
during a stay in France, 1633-34)

Jan Both

Utrecht ca 1615 – 1652 Utrecht

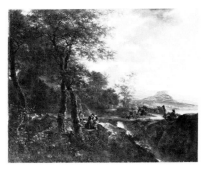

C 109 Italian landscape with draftsman.
Italiaans landschap met een tekenaar

Canvas 187 × 240. Signed *JBoth f.*
PROV On loan from the city of
Amsterdam (A van der Hoop bequest)
since 1885
LIT Smith 1829-42, vol 6 (1835) nr 1.
Ledermann 1920, p 97. Hofstede de
Groot 1907-28, vol 9 (1926) nr 87.
Plietzsch 1960, pp 152, 269. Exhib cat
Italianiserende landschapschilders,
Utrecht 1965, nr 56, fig 62 (late work).
Stechow 1966, pp 155, 158, fig 304.
Rosenberg, Slive & Ter Kuile 1966, p
176, fig 153A. Waddingham 1966, vol 1,
pls XIV-XV. VTTT, 1965-66, nr 74

A 1938 Street scene placed among
Roman ruins. *Volksscène tussen Romeinse
ruïnes*

Canvas 67 × 83.5. Signed *Both*
PROV Sale G de Clercq, Amsterdam, 1
June 1897, lot 9. Purchased through the
intermediacy of the Rembrandt Society
LIT Hofstede de Groot 1907-28, vol 9
(1926) nr 26. Gaunt 1926, p 15, fig 25.
Hoogewerff 1952, pp 90, 154, fig 37
(figures by Andries Both). W Stechow,
Actes 17ième congr intern, 1955, p
425ff. X de Salas, Goya, 1955, pp 128-
29, fig 9. Plietzsch 1960, p 154, fig 273.
Röthlisberger 1961, p 97, note 1. E Knab,
Bull Mus Boymans 13 (1962) p 48. M R
Waddingham, Paragone 15:171 (1964) p
36 (painted without collaboration of
Andries, presumably shortly after Jan's
return to Utrecht). Exhib cat
Italianiserende landschapschilders,
Utrecht 1965, nr 49, fig 53. Stechow
1966, pp 153-54, fig 297. Rosenberg,
Slive & Ter Kuile 1966, p 175

C 110 Italian landscape with mule
driver. *Italiaans landschap met muilezel-
drijver*

Panel 37.5 × 50.5. Signed *JBoth*
PROV On loan from the city of
Amsterdam (A van der Hoop bequest)
since 1885
LIT Smith 1829-42, vol 6 (1835) nr 19.
Hofstede de Groot 1907-28, vol 9 (1926)
nr 217. Exhib cat Italianiserende land-
schapschilders, Utrecht 1965, nr 53, fig
58

A 52 Italian landscape with ferry.
Italiaans landschap met overzetveer

Canvas 76 × 91. Signed *JBoth*
PROV Sale G van der Pot van
Groeneveld, Rotterdam, 6 June 1808,
lot 18 * DRVK since 1953
LIT Hoet 1752, vol 2, p 79, nr 43. Smith
1829-42, vol 6 (1835) nrs 5, 42. Hofstede
de Groot 1907-28, vol 9 (1926) nr 52.
Moes & van Biema 1909, pp 112, 157,
187. Bille 1961, vol 1, pp 32, 75, ill; vol 2,
pp 6, 90, nr 25. D G Burnett, Apollo,
1969, p 379, fig 20 (ca 1651-52)

A 49 Italian landscape with a view of
a harbor. *Italiaans landschap met gezicht op
een haven*

Panel 80.5 × 102.5. Signed *JBoth*
PROV Bequest of L Dupper Wzn,
Dordrecht, 1870
LIT C von Lützow, Zeitschr BK 5 (1870)
p 229. Hofstede de Groot 1907-28, vol 9
(1926) nr 51

A 51 Italian landscape with the Ponte
Molle. *Italiaans landschap met de Ponte
Molle*

Copper 45.5 × 58.5. Signed *JBoth*
PROV Purchased with the Kabinet van
Heteren Gevers, The Hague-Rotterdam,
1809 * DRVK since 1952
LIT Hofstede de Groot 1907-28, vol 9
(1926) nr 36. Moes & van Biema 1909,
pp 146, 157, 194. Bille 1961, vol 1, p 109

A 50 Farmyard. *Boerenerf*

Panel 62.5 × 50. Signed *JBoth f.*
PROV Sale Boreel, Amsterdam, 23 Sept
1814, lot 4
LIT Hofstede de Groot 1907-28, vol 9
(1926) nr 96

Alessandro Botticelli

Florence ca 1444– 1510 Florence

A 3381 Judith with the head of
Holofernes. *Judith met het hoofd van
Holofernes*

Panel 36.5 × 20. Probably cut down by
ca 7 cm on the right
PROV Bequest of J W Edwin vom Rath,
Amsterdam, 1941
LIT Frizzoni, l'Arte 5 (1902) p 292.

Schaeffer 1905, p 65. Horne 1908, p 264.
Venturi 1901-40, vol 7:1 (1911) p 642.
Crowe & Cavalcaselle 1903-14, vol 4
(1911) p 269. Bode 1921, p 158.
Steinmann 1925, p 111. Venturi 1925, p
107. Yashiro 1925, p 209, fig 259. Bode
1926, fig 71. Van Marle 1923-38, vol 12
(1931) p 178. J Byam Shaw, Belvedere 10
(1931) pp 163-66, ill. Berenson 1932, p
101. A van Schendel, Mndbl BK 11
(1934) p 235. R van Marle, Boll d'Arte
28 (1935) p 305. Gamba 1936, p 187, fig
64. Mesnil 1938, p 228, fig 94. Bettini
1942, p 132. K E Schuurman, Mndbl BK
19 (1942) p 99. Vertova 1955, p 318.
Pucci 1955, p 381. Chastel 1957, p 24.
Berenson 1963, vol 1, p 33; vol 2, fig
1091. Boskovits 1964, p 67. Salvini 1965,
vol 4, p 163, fig 101. Bo 1967, nr 140

attributed to **Francesco Botticini**

Florence 1446– 1497 Florence

A 3382 John the Baptist. *Johannes de
Doper*

Panel 105 × 53
PROV Bequest of J W Edwin vom Rath,
Amsterdam, 1941

school of **François Boucher**

Paris 1703– 1770 Paris

A 4014 The judgment of Paris. *Het oordeel
van Paris*

Canvas 135.5 × 191. Grisaille
PROV Transferred by the DRVK in 1960
* DRVK since 1971

Adriaen Frans Boudewijns

Brussels 1644– 1711 Brussels

A 986 Mountainous landscape. *Berg-
achtig landschap*

Panel 14 × 18.5. Signed *F. Bauduin fecit*
PROV Purchased from C F Roos & Co,
art dealers, Amsterdam, 1885

**Adriaan Johannes Petrus
Boudewijnse**

see Governors-general series: A 3811
Cornelis Pijnacker Hordijk

Auguste Boulard

Paris 1825– 1892 Paris

A 1860 The meal. *De maaltijd*

Canvas 88.5 × 73. Signed *A. Boulard*
PROV Presented by the dowager of R
Baron van Lynden, née M C Baroness
van Pallandt, The Hague, 1900 * DRVK
since 1952

Louise Bourdon

see Miniatures: German school ca 1810, A 4388

Sébastien Bourdon

Montpellier 1616–1671 Paris

A 53 The mystic marriage of St Catherine. *Het mystieke huwelijk van de heilige Catharina*

Canvas 86.5 × 103.5
PROV Purchased with the Kabinet van Heteren Gevers, The Hague-Rotterdam, 1809
LIT Hoet 1752, vol 2, p 452. Moes & van Biema 1909, pp 145, 157

Aimé Gabriel Adolphe Bourgoin

Paris 1824–1905 Paris?

A 1736 The dance. *De dans*

Panel 42 × 32. Signed and dated *A. Bourgoin 70*
PROV Bequest of D Franken Dzn, Le Vésinet, 1898

Esaias Boursse

Amsterdam 1631–1672 en route to the Indies

A 767 Interior with woman at the spinning wheel. *Interieur met vrouw aan spinnewiel*

Canvas 60 × 49. Dated *1661*
PROV Sale W Gruyter, Amsterdam, 24-25 Oct 1882, lot 40 (as Pieter de Hooch, with a false signature)
LIT Valentiner 1929, p 198. Martin 1935-36, vol 2, pp 209-10, fig 109. C Brière-Misme, OH 69 (1954) p 162, fig 12. Plietzsch 1960, p 78, fig 127. Bernt 1960-62, vol 1, nr 127. Bernt 1969-70, vol 1, nr 168

Peeter Bout

Brussels 1658–1719 Brussels

A 2558 The way station. *De halteplaats*

Panel 23.5 × 34.5. Signed *P. Bout*
PROV Lent by C Hoogendijk, The Hague, 1907. Presented by his estate in 1912
LIT R Bangel, Cicerone 7 (1915) p 186

attributed to **Peeter Bout**

A 2223 The annunciation to the shepherds. *De verkondiging aan de herders*

Pendant to A 2224

Panel 35.5 × 26. Signature illegible
PROV Purchased from A Th V A Deckers, Amsterdam, 1906 * DRVK since 1957 (on loan to the Museum Amstelkring, Amsterdam)

A 2224 The adoration of the shepherds. *De aanbidding der herders*

Pendant to A 2223

Panel 35.5 × 27. Signature illegible
PROV Same as A 2223 * DRVK since 1957 (on loan to the Museum Amstelkring, Amsterdam)

Gerard Bouttats

see Panpoeticon Batavum: A 4588 Willem Ogier, by Arnoud van Halen after Bouttats

Gottfried Boy

Frankfurt am Main 1701–after 1751 Hannover

A 971 Friedrich Christian (1722-63). Elector of Saxony and king of Poland. *Keurvorst van Saksen, koning van Polen*

Canvas 144 × 113. Signed and dated
Peint par Godefr. Boy Peintre du Roy 1751
PROV KKS, 1876. NMGK, 1885

Joseph Boze

see under Miniatures

Ferdinand de Braekeleer I

Antwerp 1792–1883 Antwerp

A 966 The citadel of Antwerp shortly
after the siege of 19 November-23
December 1832, and the surrender of the
Dutch garrison to the French. *De citadel
van Antwerpen kort na het beleg, 19 november-
23 december 1832, en de overgave van de
Nederlandse bezetting aan de Fransen*

Canvas 132 × 197. Signed and dated
Antwerpen 183. (nearly illegible) *F. de
Braekeleer*
PROV Sale Viruly, Amsterdam, 14 Dec
1880, lot 49. NMGK, 1885

C 281 Interior of an inn, with figures in
seventeenth-century costume. *Herberg-
interieur met figuren in zeventiende eeuws
kostuum*

Panel 57 × 49.5. Signed and dated
Ferdinand de Braekeleer A 1848 Anvers
PROV On loan from the city of
Amsterdam (A van der Hoop bequest)
since 1885

Richard Brakenburg

Haarlem 1650–1702 Haarlem

A 54 The feast of St Nicholas. *Het Sint
Nicolaasfeest*

Canvas 49 × 64.5. Signed and dated
R. Brakenburgh 1685
PROV Bequest of L Dupper Wzn,
Dordrecht, 1870

A 55 Country inn. *Boerenherberg*

Panel 35 × 28.5. Signed *R. Brakenb…*
PROV Purchased with the Kabinet van
Heteren Gevers, The Hague-Rotterdam,
1809
LIT Hoet 1752, vol 2, p 453. Moes & van
Biema 1909, pp 145, 157

attributed to **Bramantino**

North Italy ca 1470–1536 Milan

A 3383 The adoration of the shepherds.
De aanbidding der herders

Panel 50.5 × 43.5
PROV Bequest of J W Edwin vom Rath,
Amsterdam, 1941
LIT Berenson 1932, p 109. M R Gabrielli,
Boll d'Arte 27-28 (1934) p 569, ill on p
570. Suida 1953, p 135, pl CLXVI, nr 215
(Lombard school, early 16th century)

Leonard Bramer

Delft 1596–1674 Delft

A 2093 St Peter's denial. *De verloochening
van Petrus*

Canvas 126 × 141. Signed and dated
L. Bramer 1642
PROV Bequest of A A des Tombe, The
Hague, 1903
LIT W Steenhoff, Bull NOB 4 (1902-03) p
120. Wichmann 1923, nr 133. Von
Schneider 1933, pp 66, 131. Knipping
1939-40, vol 2, p 235, fig 173. Bernt
1969-70, vol 1, nr 177

A 845 Scuffle during a banquet of priests and monks in a temple of Jupiter. *Vecht-partij tijdens een maaltijd van priesters en monniken in een tempel van Jupiter*

Panel 47 × 62.5. Signed *L. Bramer*
PROV Sale Amsterdam, 31 Dec 1884
LIT Wichmann 1923, nr 172

Albertus Jonas Brandt

Amsterdam 1788–1821 Amsterdam

A 1012 Still life with flowers and fruits. *Stilleven van bloemen en vruchten*

Panel 71.5 × 55. Signed *AJBrandt*
PROV Purchased at exhib The Hague 1817, nr 4. RVMM, 1885
LIT Scheen 1946, fig 166

A 1013 Flowers in a terra cotta vase. *Bloemen in een terracotta vaas*

Panel 67 × 55
PROV Sale AJBrandt, Amsterdam, 29 Oct 1821, lot 13 (in unfinished state). The painting was finished in 1822 by EJ Eelkema (1788-1839). RVMM, 1885
LIT Exhib cat 150 jaar Nederlandse Kunst, Amsterdam 1963, nr 7, fig 13. Exhib cat Boeket in Willet, Amsterdam 1970, nr 3. Mitchell 1973, p 61, fig 80

Jacques Raymond Brascassat

Bordeaux 1804–1867 Paris

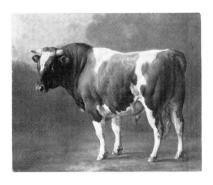

A 1326 Study of a bull. *Studie van een stier*

Canvas 43 × 52.5. Marked *J. R. Brascassat, don H. Krafft*
PROV Presented by H Krafft, Paris, 1886

Melchior Brassauw

Mechelen 1709–1757 Antwerp

A 57 A musical company. *Musicerend gezelschap*

Panel 58.5 × 67.5. Signed *Melchior Brassauw fecit*
PROV Bequest of L Dupper Wzn, Dordrecht, 1870
LIT AP de Mirimonde, Jb Mus Antwerpen, 1967, p 265, fig 74

Jan de Bray

Haarlem ca 1627–1697 Haarlem

A 2353 Judith and Holofernes. *Judith en Holofernes*

Panel 40 × 32.5. Signed and dated *Bray 1659*
PROV Purchased from H Deiters, Düsseldorf, 1908
LIT W Steenhoff, Bull NOB 2d ser 1 (1908) p 197. Martin 1935-36, vol 1, p 118. JW von Moltke, Marb Jb 11-12 (1938-39) p 451, nr 9, ill. JW von Moltke, Burl Mag 85 (1944) pp 178, 181, pl A (pendant, Jael killing Sisera, in the National Museum, Cape Town). Van Hall 1963, p 44, nr 267:3 (self portrait as Holofernes)

A 3280 The Haarlem printer Abraham Casteleyn (ca 1628-81) and his wife Margarieta van Bancken (d 1692/93). *De Haarlemse drukker Abraham Casteleyn en zijn echtgenote Margarieta van Bancken*

Canvas 84 × 108. A strip of about 30 cm has been cut off on the right. Signed and dated *JDBray 1663*
PROV Bequest of F E Blaauw, 's-Graveland, 1939
LIT J Dijserinck, OH 11 (1893) p 202 (portrait of Joan Blaeu and Geertruid Vermeulen). Grosse 1936, p 30, fig 80. JW von Moltke, Marb Jb 11-12 (1938-39) p 445, nr 179, ill (portrait of Joan Blaeu and Geertruyd Vermeulen or one of their sons with his wife). H van Hall, OH 73 (1958) p 51. Van Hall 1963, p 59, nr 361:1. L Hellinga-Querido, Spiegel Hist 5 (1970) ill on p 10

A 58 The governors of the guild of St Luke, Haarlem, 1675. *De overlieden van het Sint Lucasgilde te Haarlem, 1675*

From left to right Wouter Knyff, Jan de Bray, Gerrit Mulraet, Jan Golingh, Jan Claesz Marselis, Dirck de Bray and Jan de Jongh, standing

Canvas 130 × 184. Dated *1675*
PROV Purchased from J de Vries, art dealer, Amsterdam, 1821
LIT Van Eynden & van der Willigen 1816-40, vol 1, pp 401-02. Moes 1897-1905, vol 1, nrs 1065-66, 2805, 4034, 4241; vol 2, nr 5209. A Riegl, Jb Kunsth Samml AK 23 (1902) p 273ff. S Kalff, Oude Kunst 8 (1917) p 347. J Schmidt, Jb Russ KHI 1 (1922) pp 183-206, fig 2. Martin 1935-36, vol 1, p 27, fig 17. Goldscheider 1936, p 39, fig 267. J W von Moltke, Jb Haarlem, 1938, p 57. J W von Moltke, Marb Jb 11-12 (1938-39) pp 421, 443-44, 523, nr 189, ill. A Heppner, Mndbl BK 19 (1942) pp 181-84. Hoogewerff 1947, p 93, fig 11. Van Hall 1963, pp 43-44, 113, 159, 170, 198, 222, nrs 265:1, 267:1. A van der Marel, Ned Leeuw 81 (1964) col 6ff, ill; cols 283-84. Exhib cat De schilder in zijn wereld, Delft-Antwerp 1964-65, nr 14. Eckardt 1971, pp 172-73, fig 30. E Taverne, Simiolus 6 (1972-73) p 65

Jozef van Bredael

Antwerp 1688 – 1739 Paris

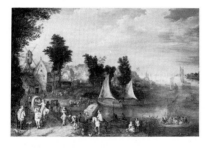

A 59 Village on the bank of a river. *Dorp aan de oever van een rivier*

Panel 38.5 × 56.5. Signed and dated *J. Breda F. 1723*
PROV Purchased with the Kabinet van Heteren Gevers, The Hague-Rotterdam, 1809

LIT Hoet 1752, vol 2, p 453. Moes & van Biema 1909, pp 145, 157

Mattheus Ignatius van Bree

Antwerp 1773 – 1839 Antwerp

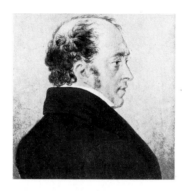

A 1172 Self portrait. *Zelfportret*

Panel 15 × 15. Signed on the verso
Mattheus Ignatius van Bree se ipse fecit
PROV Presented by Jonkheer Victor de Stuers, The Hague, 1877. RVMM, 1885
LIT P Eeckhout, Bull RM 16 (1968) p 114, fig 5

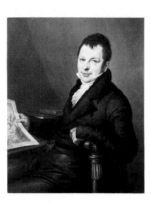

A 1540 Johannes Hermanus Molkenboer (1773-1834). Art collector. *Kunst-verzamelaar*

Canvas 89 × 72.5. Signed and dated *M. J. van Bree ft. 1815*
PROV Presented by the estate of J H Molkenboer, Amsterdam, 1891

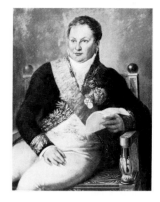

A 3136 Isaac Jan Alexander Gogel (1765-1821). Minister of finance. *Minister van financiën*

Canvas 95 × 75
PROV Bequest of W S Burger, Antwerp, 1933
LIT C H E de Wit, Spiegel Hist 3 (1968) p 399, fig 7

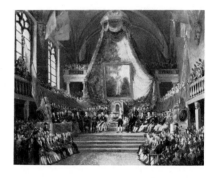

A 4088 The solemn inauguration of the university of Ghent by the prince of Orange in the throne room of the town hall on 9 October 1817. *De plechtige installatie van de Universiteit van Gent door de prins van Oranje in de troonzaal van het stadhuis op 9 oktober 1817*

Panel 52 × 66
PROV Purchased from F Hardy gallery, Bendorf-Rhein, 1962
LIT P Eeckhout, Bull RM 16 (1968) pp 107-21, ill

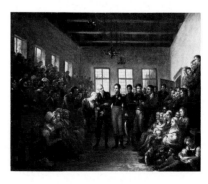

A 4253 The prince of Orange visiting flood victims at the almoners orphanage,

Amsterdam, on 14 February 1825. *De prins van Oranje bezoekt de slachtoffers van de watersnood in het Aalmoezeniersweeshuis te Amsterdam op 14 februari 1825*

Canvas 64.5 × 80. Study. Signed *M. J. v. B.* Inscribed *Eerste Schets.*
PROV Purchased in 1825. RVMM, 1877?
NMGK * Lent to the AHM, 1975
LIT P Eeckhout, Bull RM 16 (1968) p 119, fig 8

A 4234 An unidentified historical subject. *Ongeïdentificeerde historische voorstelling*

Panel 32.8 × 41.7. Sketch
PROV Sale Rotterdam, 20 Sept 1973, lot 83
LIT A Staring, Bull RM 17 (1969) p 178, fig 2

Adam van Breen

active 1611- after 1618 in The Hague and 1642-46 in Christiania?

A 2510 Winter recreation. *Wintervermaak*

Panel 52.5 × 90.5. Signed and dated *A. v. Breen 1611*
PROV Purchased from J Glen, London, 1910
LIT J G van Gelder & N F van Gelder-Schrijver, Oudh Jb 4th ser 1 (1932) pp 110-16. Fr W S van Thienen, Antiek 3 (1969) p 486. Bol 1969, p 157

A 955 The Vijverberg, The Hague, in the winter, with Prince Maurits and his retinue in the foreground. *Wintergezicht op de Vijverberg te Den Haag met op de voorgrond prins Maurits en zijn gevolg*

Panel 71.5 × 133.5. Original signature *A. van Breen* later falsified to *A. v. d. Venne.* Dated *1618*
PROV Purchased from Mr Ruppertshoven van Boll, Vienna, 1878. NMGK, 1885
LIT J G van Gelder & N F van Gelder-Schrijver, Oudh Jb 4th ser 1 (1932) p 113. Fr W S van Thienen & M Braun-Ronsdorf, Waffenkunde 12 (1970) p 62, fig 3

Bartholomeus Breenbergh

Deventer 1599-1657 Amsterdam

A 1724 Jacob wrestling with the angel. *Jacob worstelt met de engel*

Panel 50 × 68. Signed and dated *BB f. A° 1639*
PROV Purchased from J E Goedhart gallery, Amsterdam, 1898
LIT W Stechow, Jb Preusz Kunstsamml 51 (1930) p 135

attributed to **Bartholomeus Breenbergh**

A 1482 The adoration of the magi. *De aanbidding der koningen*

Copper 29 × 49
PROV Sale F Kayser (Frankfurt am Main), Amsterdam, 4 Dec 1888, lot 13

George Hendrik Breitner

Rotterdam 1857-1923 Amsterdam

see also under Aquarelles and drawings

A 3523 M C J (Marie) Jordan (1866-1948). The artist's wife. *De echtgenote van de schilder*

Panel 22.5 × 18. Signed *G. H. Breitner*
PROV Bequest of the painter's widow, Mrs M C J Breitner-Jordan, Zeist, 1948

A 3541 Marie Anne Henriette Breitner (b 1882). The painter's half-sister. *Halfzusje van de schilder*

Board 44 × 32.5. Signed *G. H. Breitner*
PROV Bequest of the painter's widow, Mrs M C J Breitner-Jordan, Zeist, 1948

A 3556 Dr van Hoorn

Panel 45 × 24.5. Signed *G. H. Breitner*
PROV Bequest of the painter's widow,
Mrs M CJ Breitner-Jordan, Zeist, 1948

A 3584 Girl in kimono (Geesje Kwak?).
Meisje in kimono

Canvas 59 × 57. Signed *G. H. Breitner*
PROV Lent by Mr & Mrs J CJ Drucker-
Fraser, 1919. Bequeathed in 1944
LIT Van Schendel 1939, p 38

A 3524 Study after the model (Geesje
Kwak?). *Modelstudie*

Panel 24.5 × 19. Signed *G. H. Breitner*

PROV Bequest of the painter's widow,
Mrs M CJ Breitner-Jordan, Zeist, 1948

A 3061 The wooden shoes. *De klompjes*

Canvas 92.5 × 63.5
PROV Presented by Mr & Mrs J CJ
Drucker-Fraser, Montreux, 1928
LIT Veth 1908, p 201. Knipping &
Gerrits 1943-48, fig 97. E P Engel, Bull
RM 13 (1965) p 56, fig 8. Hefting 1970,
nr 72, ill (1884-85)

A 3539 Hussars on maneuver. *Huzaren op
manœuvre*

Panel 9.5 × 23. Signed *G. H. Breitner*
PROV Bequest of the painter's widow,
Mrs M CJ Breitner-Jordan, Zeist, 1948

A 3538 Hussars in the open field. *Huzaren
in het open veld*

Panel 10.5 × 23.5. Signed *G. H. Breitner*
PROV Bequest of the painter's widow,
Mrs M CJ Breitner-Jordan, Zeist, 1948

A 2881 Hussar on horseback. *Huzaar te
paard*

Canvas 60 × 44. Signed *G. H. Breitner*
PROV Bequest of A van Wezel,
Amsterdam, 1922 * DRVK since 1956
LIT Hefting 1970, nr 21, ill

A 3583 Cavalry at repose. *Rustende
cavalerie*

Canvas 50 × 75. Signed *G. H. Breitner*
PROV Lent by Mr & Mrs J CJ Drucker-
Fraser, 1919. Bequeathed in 1944
LIT Hefting 1970, nr 92

A 2968 Cavalry at repose. *Rustende
cavalerie*

Panel 15.5 × 38. Signed *G. H. Breitner*
PROV Presented by Mrs W Korthals
Altes, Amsterdam, 1923

A 2880 Field artillery. *Veldartillerie*

Panel 27 × 37. Signed *G. H. Breitner*
PROV Bequest of A van Wezel,
Amsterdam, 1922 * DRVK since 1964

A 3582 Billeting the troops. *Inkwartiering*

Canvas 51 × 75
PROV Lent by Mr & Mrs J C J Drucker-
Fraser, 1919. Bequeathed in 1944
LIT Hefting 1970, nr 98, ill (ca 1885)

A 3531 A brown and a white horse in
Scheveningen. *Een bruin en een wit paard
te Scheveningen*

Panel 26.5 × 37. Signed *G. H. Breitner*
PROV Bequest of the painter's widow,
Mrs M C J Breitner-Jordan, Zeist, 1948

A 1328 Horse artillery. *Rijdende artillerie*

Canvas 115 × 77.5. Signed *G. H. Breitner*
PROV Purchased at exhib Amsterdam
1886, nr 50
LIT Veth 1908, p 201. Van Schendel
1939, p 25. Exhib cat 150 jaar Neder-
landse Kunst, Amsterdam 1963, nr 53,
fig 67. E P Engel, Bull RM 13 (1965) p 49.
Pols 1966, p 93. Hefting 1970, nr 87, ill
(1887?)

A 3547 View in The Hague? *Stadsgezicht
in Den Haag?*

Panel 24.5 × 32.5. Signed *G. H. B.*
PROV Bequest of the painter's widow,
Mrs M C J Breitner-Jordan, Zeist, 1948

A 3527 Neighborhood street in Rijswijk
near The Hague. *Buurtje in Rijswijk bij
Den Haag*

Panel 40 × 27. Signed *G. H. Breitner*
PROV Bequest of the painter's widow,
Mrs M C J Breitner-Jordan, Zeist, 1948

A 3537 Artillery on maneuver. *Artillerie
op manœuvre*

Panel 29.5 × 40.5. Signed *G. H. B.*
PROV Bequest of the painter's widow,
Mrs M C J Breitner-Jordan, Zeist, 1948

A 3528 Neighborhood street in The
Hague or Scheveningen. *Buurtje in Den
Haag of Scheveningen*

Panel 34.5 × 22. Signed *G. H. Breitner*
PROV Bequest of the painter's widow,
Mrs M C J Breitner-Jordan, Zeist, 1948

A 3530 View in the dunes near Dekkers-
duin, The Hague. *Duinlandschap bij
Dekkersduin, Den Haag*

Panel 20.5 × 39.5
PROV Bequest of the painter's widow,
Mrs M C J Breitner-Jordan, Zeist, 1948

A 3579 The Rokin, Amsterdam. *Het Rokin te Amsterdam*

Canvas 97 × 127. Signed and dated *G. H. Breitner '97*
PROV Lent by Mr & Mrs J C J Drucker-Fraser, 1919. Bequeathed in 1944

A 3542 The Rokin?, Amsterdam. *Het Rokin? te Amsterdam*

Panel 38 × 46. Inscribed on the verso *G. H. Breitner mei 1923*
PROV Bequest of the painter's widow, Mrs M C J Breitner-Jordan, Zeist, 1948

A 3289 The Rokin, Amsterdam. *Het Rokin te Amsterdam*

Canvas 68 × 90. Signed *G. H. Breitner*
PROV Presented by Mr & Mrs D A J Kessler-Hülsmann, Kapelle op den Bosch near Mechelen, 1940 * DRVK since 1956
LIT A van Schendel, Med Dep o w & c 8 (1941) p 73

A 3558 The Rokin, Amsterdam. *Het Rokin te Amsterdam*

Panel 27.5 × 39.5. Study
PROV Bequest of the painter's widow, Mrs M C J Breitner-Jordan, Zeist, 1948

A 3548 The Rokin, Amsterdam. *Het Rokin te Amsterdam*

Panel 29.5 × 40. Study
PROV Bequest of the painter's widow, Mrs M C J Breitner-Jordan, Zeist, 1948

A 2879 The Damrak, Amsterdam. *Het Damrak te Amsterdam*

Canvas 100 × 150. Signed *G. H. Breitner*
PROV Bequest of A van Wezel, Amsterdam, 1922
LIT Hammacher 1941, p 53. Van Schendel 1939, p 58, ill on p 54. Van Gelder 1959, p 20, fig 172. Hefting & Quarles van Ufford 1966, fig 51

A 3552 The old stock exchange in Amsterdam, at night. *De oude Beurs te Amsterdam bij avond*

Canvas 23.5 × 33.5. Study
PROV Bequest of the painter's widow, Mrs M C J Breitner-Jordan, Zeist, 1948. Missing since 1959

A 3580 The bridge over the Singel at the Paleisstraat, Amsterdam. *De Singelbrug bij de Paleisstraat te Amsterdam*

Canvas 100 × 152. Signed *G. H. Breitner*
PROV Lent by Mr & Mrs J C J Drucker-Fraser, 1919. Bequeathed in 1944
LIT Van Schendel 1939, p 57, ill on p 46. H van de Waal, OK I (1957) nr 26, ill. Gerson 1961, p 45, fig 112. Exhib cat 150 jaar Nederlandse kunst, Amsterdam 1963, nr 56, fig 68. Hefting & Quarles van Ufford 1966, p 23, fig 91. L C J Frerichs, Bull RM 21 (1973) pp 176-79, ill (winter 1896-97)

A 3553 The Singel at the Paleisstraat, Amsterdam, at night. *De Singel bij de Paleisstraat te Amsterdam bij avond*

Canvas 23.5 × 33.5. Study
PROV Bequest of the painter's widow, Mrs M C J Breitner-Jordan, Zeist, 1948. Missing since 1959

A 3526 The demolition of the Grand Bazar de la Bourse on the Nieuwendijk, Amsterdam. *Afbraak van de Grand Bazar de la Bourse aan de Nieuwendijk te Amsterdam*

Panel 25.5 × 47. Signed *G. H. Breitner*
PROV Bequest of the painter's widow, Mrs M C J Breitner-Jordan, Zeist, 1948

A 3545 The Leidsegracht, Amsterdam. *De Leidsegracht te Amsterdam*

Panel 24.5 × 32.5. Signed *G. H. B.*
PROV Bequest of the painter's widow, Mrs M C J Breitner-Jordan, Zeist, 1948

A 3543 Canal in Amsterdam. *Amsterdamse gracht*

Canvas 70 × 100. Signed *G. H. B.*
PROV Bequest of the painter's widow, Mrs M C J Breitner-Jordan, Zeist, 1948

A 3546 Neighborhood street in the Jordaan, Amsterdam. *Buurtje in de Amsterdamse Jordaan*

Panel 41 × 32.5. Signed *G. H. B.*
PROV Bequest of the painter's widow, Mrs M C J Breitner-Jordan, Zeist, 1948

A 3529 Neighborhood street in the Jordaan, Amsterdam. *Buurtje in de Amsterdamse Jordaan*

Panel 40 × 25. Signed *G. H. B.*
PROV Bequest of the painter's widow, Mrs M C J Breitner-Jordan, Zeist, 1948
* DRVK since 1952 (on loan to the Gemeentemuseum, Arnhem)

A 3559 Warehouses on the Teertuinen on the Prinseneiland, Amsterdam. *Pakhuizen aan de Teertuinen op het Prinseneiland te Amsterdam*

Panel 38 × 45.5
PROV Bequest of the painter's widow, Mrs M C J Breitner-Jordan, Zeist, 1948

A 3581 Midday break at a building site on the van Diemenstraat, Amsterdam. *Schafttijd in de bouwput aan de van Diemenstraat te Amsterdam*

Canvas 78 × 115. Signed *G. H. Breitner*
PROV Lent by Mr & Mrs J C J Drucker-Fraser, 1919. Bequeathed in 1944
LIT Van Schendel 1939, p 58, ill on p 51

A 3550 Building site. *Bouwterrein*

Panel 27.5 × 41
PROV Bequest of the painter's widow, Mrs M C J Breitner-Jordan, Zeist, 1948

A 3549 View in Amsterdam. *Amsterdams stadsgezicht*

Panel 26 × 36. Signed *G. H. B.*
PROV Bequest of the painter's widow, Mrs M C J Breitner-Jordan, Zeist, 1948

A 3544 View in Amsterdam. *Amsterdams stadsgezicht*

Panel 24.5 × 32.5. Signed *G. H. B.*
PROV Bequest of the painter's widow,
Mrs M C J Breitner-Jordan, Zeist, 1948
∗ DRVK since 1959

A 3560 Group of houses. *Groep huizen*

Canvas 38 × 45
PROV Bequest of the painter's widow,
Mrs M C J Breitner-Jordan, Zeist, 1948

A 3561 The edge of a city. *De buitenrand van een stad*

Panel 22 × 33
PROV Bequest of the painter's widow,
Mrs M C J Breitner-Jordan, Zeist, 1948

A 3585 Ships in the ice. *Schepen in het ijs*

Canvas 115 × 163. Signed *G. H. Breitner*
PROV Lent by Mr & Mrs J C J Drucker-
Fraser, 1919. Bequeathed in 1944
LIT Gerson 1961, p 46, fig 113

A 3525 The tower of Gorkum. *De toren van Gorkum*

Panel 47 × 25.5. Signed *G. H. Breitner*
PROV Bequest of the painter's widow,
Mrs M C J Breitner-Jordan, Zeist, 1948
LIT Veth 1908, p 190. Hefting 1970, nr
17 (Sep-Oct 1901)

A 3551 Street in Montmartre, Paris.
Straatje in Montmartre, Parijs

Panel 21.5 × 16
PROV Bequest of the painter's widow,
Mrs M C J Breitner-Jordan, Zeist, 1948

A 3536 Landscape near Waalsdorp, with
soldiers on maneuver. *Landschap bij
Waalsdorp met soldaten op manœuvre*

Panel 15.5 × 21. Signed *G. H. Breitner*
PROV Bequest of the painter's widow,
Mrs M C J Breitner-Jordan, Zeist, 1948

A 3533 A heath landscape, presumably
in Drenthe. *Heidelandschap, vermoedelijk in
Drenthe*

Panel 27 × 47.5
PROV Bequest of the painter's widow,
Mrs M C J Breitner-Jordan, Zeist, 1948

A 3535 View in the woods. *Bosgezicht*

Board 41 × 26. Signed *G. H. Breitner*
PROV Bequest of the painter's widow,
Mrs M C J Breitner-Jordan, Zeist, 1948

A 3534 Farmstead. *Boerenhofstede*

Board 24 × 40. Signed *G. H. Breitner*
PROV Bequest of the painter's widow,
Mrs M C J Breitner-Jordan, Zeist, 1948

A 3555 Blacksmith with gray. *Hoefsmid met schimmel*

Panel 22.5 × 33
PROV Bequest of the painter's widow,
Mrs M C J Breitner-Jordan, Zeist, 1948

A 3532 Meadow landscape. *Weide-landschap*

Board 22 × 40.5. Signed *G. H. Breitner*
PROV Bequest of the painter's widow,
Mrs M C J Breitner-Jordan, Zeist, 1948

A 3557 Four cows. *Vier koeien*

Board 36 × 41. Signed *G. H. Breitner*
PROV Bequest of the painter's widow,
Mrs M C J Breitner-Jordan, Zeist, 1948

A 3554 The funfair. *Kermis*

Panel 27 × 21.5
PROV Bequest of the painter's widow,
Mrs M C J Breitner-Jordan, Zeist, 1948

A 3540 Ginger pot with anemones.
Gemberpot met anemonen

Panel 23.5 × 36.5. Signed *G. H. Breitner*
PROV Bequest of the painter's widow,
Mrs M C J Breitner-Jordan, Zeist, 1948

A 3562 Vase with pink flowers. *Vaas met rose bloemen*

Panel 46 × 38
PROV Bequest of the painter's widow,
Mrs M C J Breitner-Jordan, Zeist, 1948

Quiringh Gerritsz van Brekelenkam

Zwammerdam ca 1620 – 1668 Leiden

A 62 The mousetrap. *De muizeval*

Panel 18.5 × 16.5. Signed and dated
Q. B. 1660
PROV Bequest of L Dupper Wzn,
Dordrecht, 1870

C 112 The tailor's workshop. *De kleer-makerswerkplaats*

Canvas 66 × 53. Signed and dated
Q. B. 1661
PROV On loan from the city of
Amsterdam (A van der Hoop bequest)
since 1885
LIT Bernt 1960-62, vol 1, nr 143.
Plietzsch 1960, pp 42-43, fig 51.
Rosenberg, Slive & Ter Kuile 1966, p
132. E van Uitert, OK tv 12 (1968) 2, ill
on p 1. Bernt 1969-70, vol 1, nr 187

A 685 A confidential chat. *Vertrouwelijk onderhoud*

Panel 47 × 36. Signed and dated
Q.B. 1661
PROV Bequest of Jonkheer J S H van de
Poll, Amsterdam, 1880
LIT V de Stuers, Ned Kunstbode 2
(1880) p 245. Chr P van Eeghen, OH 62
(1947) p 92. Plietzsch 1960, p 42, fig 54.
D P Snoep, Simiolus 3 (1968-69) p 79

C 113 A mother feeding porridge to her
child. *Een moeder die haar kind pap voert*

Panel 30.5 × 25.5. Oval. Signed and
dated *Q.B. 1661*
PROV On loan from the city of
Amsterdam (A van der Hoop bequest)
since 1885

A 60 Interior with fisherman and man
beside a bobbin and spool. *Interieur met
hengelaar en man bij spoelrad en haspel*

Thought to be a pendant to A 61

Panel 59 × 46. Signed and dated
Brekelenkam 1663
PROV Sale G van der Pot van
Groeneveld, Rotterdam, 6 June 1808,
lot 20
LIT Moes & van Biema 1909, pp 112,
157

A 61 Interior with two men by the fire-
side. *Interieur met twee mannen bij het vuur*

Thought to be a pendant to A 60

Panel 61 × 47. Signed and dated
Q. Brekelenkam 1664
PROV Same as A 60
LIT Moes & van Biema 1909, p 157

A 673 Reading aloud. *De voorlezer*

Panel 49 × 38
PROV Purchased from the collection of
Jonkheer J E van Heemskerck van Beest,
1878. NMGK, 1885
LIT M Heeren, Spiegel Hist 2 (1967) p
428, fig 2

attributed to **Quiringh Gerritsz van
Brekelenkam**

A 2698 The tenant farmer's rent. *De
pachtbetaling*

Panel 57 × 70
PROV Sale Amsterdam, 7 April 1914,
lot 2 (as Jan de Baen)
LIT Schatborn & Szénássy 1971, p 39,
nr 137

David van den Bremden

see Panpoeticon Batavum: A 4565
Adriaen Pietersz van de Venne, by
Arnoud van Halen after van den
Bremden

Emile Adélard Breton

Courrières 1831–1902 Courrières

A 1861 The breakers. *De branding*

Canvas 48 × 70.5. Signed and dated
Emile Breton 74
PROV Presented by the dowager of R
Baron van Lynden, née M C Baroness
van Pallandt, The Hague, 1900

Frans Arnold Breuhaus de Groot

Leiden 1824–1875 Brussels

A 1014 Jetties on the English coast.
Havenhoofden aan de Engelse kust

Canvas 46 × 69. Signed *F. A. Breuhaus de Groot F.*
PROV Purchased at exhib Amsterdam 1860, nr 222. RVMM, 1885 * DRVK since 1952
LIT Scheen 1946, fig 404

Ignace Brice

Brussels 1795 – 1866 Brussels

A 1015 The poultryman. *De poelier*

Canvas 99 × 124. Signed and dated *Brice 1827*
PROV RVMM, 1885 * DRVK since 1953

Paulus Bril

Antwerp 1554 – 1626 Rome

A 63 Landscape with Roman ruins.
Landschap met Romeinse ruïnes

Copper 41.5 × 57. Signed *P. Bril*

PROV Purchased with the Kabinet van Heteren Gevers, The Hague-Rotterdam, 1809
LIT Hoet 1752, vol 2, p 452. Mayer 1910, pp 37, 73, pl XXXV (ca 1600-02). Moes & van Biema 1909, pp 145, 147. Thiéry 1953, p 174. F F X Cerutti, Jb Oranje-boom 13 (1960) p 8, ill. Bille 1961, vol 1, p 110. A Chudzikowski, Bull MN Varsovie 13 (1972) p 21, note 7

A 2672 Winter landscape. *Winter-landschap*

Panel 58 × 78
PROV Sale Amsterdam, 6 May 1913, lot 68 (as J de Momper) * DRVK since 1959 (on loan to Stedelijk Museum Het Catharinagasthuis, Gouda)
LIT P T J J Reelick, OH 63 (1948) p 120

copy after **Paulus Bril**

A 1314 River view with large rock.
Riviergezicht met rotsen

Copy after a version in the Kunst-historisches Museum, Vienna (inv nr 5778)

Copper 23 × 29. Dated [1]*601*
PROV Sale D M Alewijn, Amsterdam, 16 Dec 1885, lot 10
LIT Mayer 1910, p 37, note 2, p 73

Cornelis Brisé

Haarlem 1622 – 1665/70 Amsterdam

A 1281 Vanitas still life. *Vanitas stilleven*

Canvas 107 × 90. Signed and dated *C. Brise f. A° 1665.* Inscribed *De doot stelt hoogh en laagh gelyk : | En 't middelbaar en Arm en Ryk. | Het sterven is 't gemeene lot, | De Boek Geleertheit en Marot | Zyn even schoon en wys in 't Graf | De Delvers Graaf en Bissopsstaf | De Zackpyp ende Tulbants-kroon | Staan al int uiterst even schoon | Laat woelen al wat woelen wil | Soo staat het al ten lesten stil*
PROV Presented by Dr A Bredius, The Hague, 1885
LIT Vorenkamp 1933, p 113. B J A Renckens, Med RKD 3 (1948) p 6. Bol 1969, p 358

Elias van den Broeck

Antwerp 1657 – 1708 Amsterdam

A 1463 Still life with roses. *Stilleven met rozen*

Canvas 49 × 33. Signed *Elias v. den Broeck*
PROV Presented by J B A M Westerwoudt, Haarlem, 1888
LIT Bol 1969, p 314, note 479

A 788 Still life with passionflowers. *Stil-leven met passiebloemen*

Canvas 41.5 × 33.5
PROV Sale Amsterdam, 14-15 Nov 1885, lot 23
LIT Bol 1969, p 314, note 479

Gerrit de Broen II

see Heraldic objects: A 1276

Jan Gerritsz van Bronckhorst

see Panpoeticon Batavum: A 4599 Matthijs van der Merwede, by Arnoud van Halen after van Bronckhorst

Albertus Brondgeest

see Cuyp, Aelbert, C 114 River view, copy by Brondgeest

attributed to **Agnolo Bronzino**

Monticelli 1503 – 1572 Florence

A 3344 Portrait of a boy, thought to be Giovanni de' Medici (1543-62). *Portret van een jongen, vermoedelijk Giovanni de' Medici*

Panel 24 × 18
PROV Presented by Mr & Mrs D A J Kessler-Hülsmann, Kapelle op den Bosch near Mechelen, 1940

Arnold van Brounckhurst

see under Miniatures

Adriaen Brouwer

Oudenaerde 1605/06 – 1638 Antwerp

A 64 Peasant drinking bout. *Boerendrink-partij*

Panel 19.5 × 26.5
PROV Purchased with the Kabinet van Heteren Gevers, The Hague-Rotterdam, 1809 * On loan to the KKS since 1948
LIT Immerzeel 1842-43, vol 1, p 106. Bürger 1858-60, vol 1, pp 95-96. Schmidt 1873, pp 36-37. W von Bode, Graph Künste 6 (1884) p 39. Hofstede de Groot 1907-28, vol 3 (1910) nr 102. Moes & van Biema 1909, pp 145, 157, 193. Bode 1924, p 40. Reynolds 1931, p 26, fig 1. Höhne 1959, p 25, fig 5. Bille 1961, vol 1, p 109. Knuttel 1962, p 87, figs 46-49, pl III (early work)

A 65 Peasant brawl. *Boerenvechtpartij*

Panel 25.5 × 34. Traces of a monogram
PROV Purchased with the Kabinet van Heteren Gevers, The Hague-Rotterdam, 1809 * On loan to the KKS since 1954
LIT Hofstede de Groot 1907-28, vol 3 (1910) nr 166. Moes & van Biema 1909, pp 145, 157, 193. Bode 1924, p 59, fig 29

(early work). Reynolds 1931, pp 25-26, fig 2. Böhmer 1940, pp 72-74, fig 14. Höhne 1959, p 25, fig 4. Bernt 1960-62, vol 1, nr 151. Bille 1961, vol 1, p 109. Knuttel 1962, pp 41-43, 78, fig 40 (early work). Bernt 1969-70, vol 1, nr 196

A 4040 The smoker. *De roker*

Panel 30.5 × 21.5
PROV Presented by Mr & Mrs I de Bruijn-van der Leeuw, Muri near Bern, 1961 * On loan to the KKS since 1963
LIT H L Jaffé, Du, 1944, p 45, ill. E R Meijer, Bull RM 9 (1961) p 46, fig 3. J L Cleveringa, Bull RM 9 (1961) p 63, nr 3. Knuttel 1962, p 140, fig 92 (late work). E de Jongh, Alb Amic J G van Gelder, 1973, p 204, note 41

manner of **Adriaen Brouwer**

A 3015 Musical company. *Musicerend gezelschap*

Panel 39 × 26
PROV Presented by J Goudstikker, Amsterdam, 1924 (as Buytewech)
LIT G Knuttel, Med D K W Gem 's-Grav 2 (1926-31) nr 5-6, p 188, note 3 (not Buytewech). Haverkamp Begemann 1959, cat nr XVI (not Buytewech). Knuttel 1962, pp 32, 167, ill (Painter of the Large Jars)

A 4041 The champion drinker. *De meesterdronk*

Panel 39.5 × 52.5
PROV Presented by Mr & Mrs I de Bruijn-van der Leeuw, Muri near Bern, 1961
LIT Hofstede de Groot 1907-28, vol 3 (1910) nr 128. F Schmidt-Degener, Onze Kunst 13 (1908) p 141, ill. F Schmidt-Degener, L'Art fl & holl 9 (1908) p 52 (ca 1636). Bode 1924, p 150, fig 103 (late work). E R Meijer, Bull RM 9 (1961) p 46. J L Cleveringa, Bull RM 9 (1961) p 63, nr 4. Knuttel 1962, p 56, fig 31 (not Brouwer)

A 3291 The drinker. *De drinker*

Panel 19.3 × 15.3. Signed (falsely) *AB*
PROV Presented by Mr & Mrs D A J Kessler-Hülsmann, Kapelle op den Bosch near Mechelen, 1940
LIT *Cf* Hofstede de Groot 1907-28, vol 2 (1910) nrs 200, 203. Höhne 1959, p 31

Willem Lodewijk Bruckman

The Hague 1866 – 1928 Laren

A 3068 View of Nantes. *Gezicht op Nantes*

Canvas 90.5 × 111. Signed *W.L. Bruckman*
PROV Presented by Mrs J van den Heuvell, Zeist, 1929 * DRVK since 1953

Abraham Brueghel

Antwerp 1631 – 1690 Naples

A 1433 Still life with fruit. *Stilleven met vruchten*

Canvas 67 × 50. Signed and dated *ABreugel F. Roma 1670*
PROV Sale Amsterdam, 15 Dec 1887, lot 11 * DRVK since 1953
LIT Greindl 1956, pp 118, 153

Jan Brueghel I

Brussels 1568 – 1625 Antwerp

A 67 View of a village on a river. *Gezicht op een dorp aan een rivier*

Copper 14.5 × 20.5. Signed and dated *Brueghel 1604*
PROV Sale G van der Pot van Groeneveld, Rotterdam, 6 June 1808, lot 21
LIT Moes & van Biema 1909, pp 146, 157, 182. E Wiersum, OH 48 (1931) p 211. Thiéry 1953, p 176. Wilenski 1960, vol 2, pl 480. Bille 1961, vol 1, p 110. M Winner, Jb Berliner Museen 3 (1961) p 215. Van Braam nd, nr 786

A 66 View of a town on a river. *Gezicht op een stad aan een rivier*

Copper 15.5 × 20.5
PROV Sale G van der Pot van Groeneveld, Rotterdam, 6 June 1808, lot 21
LIT Moes & van Biema 1909, pp 112, 157, 182. E Wiersum, OH 48 (1931) p 211. M Winner, Jb Berliner Museen 3 (1961) p 215. Van Braam nd, nr 787

A 70 Latona and the Lycian peasants. *Latona en de Lycische boeren*

Panel 37 × 56
PROV Purchased with the Kabinet van Heteren Gevers, The Hague-Rotterdam, 1809
LIT Hoet 1752, vol 2, p 451. Moes & van Biema 1909, pp 145, 157. Plietzsch 1910, p 67. Raczynski 1937, pp 53-54, fig 20. Thiéry 1953, p 175. Bernt 1960-62, vol 1, nr 162. Gerson & Ter Kuile 1960, p 59 (ca 1597/98-1607). Bille 1961, vol 1, p 110. Eemans 1964, p 20, fig 12

A 2102 Still life with flowers in a glass. *Stilleven met bloemen in een glas*

Copper 24.5 × 19
PROV Bequest of A A des Tombe, The Hague, 1903
LIT Hairs 1955, pp 32, 38, 203, fig 17. Eemans 1964, p 66, fig 37. M L Hairs, Bull Mus Roy Belg 16 (1967) p 105, fig 6. Van Braam nd, nr 790

studio of **Jan Brueghel I**

A 3290 Still life with flowers. *Stilleven met bloemen*

Panel 113 × 86
PROV Presented by Mr & Mrs D A J Kessler-Hülsmann, Kapelle op den Bosch near Mechelen, 1940
LIT Hairs 1955, pp 37, 207 (presumably not autograph). Ph Roberts-Jones, Bull Mus Roy Belg 1963, p 14 (studio work). Exhib cat Boeket in Willet, Amsterdam 1970, introduction, fig 6. G J van der Hoek, Kunstrip 3 (1972-73) nr 30. Van Braam nd, nr 789

manner of **Jan Brueghel I**

A 69 The rest on the flight into Egypt. *Rust op de vlucht naar Egypte*

Copper 16 × 12. Falsely signed *Bruegel*
PROV Purchased with the Kabinet van Heteren Gevers, The Hague-Rotterdam, 1809
LIT Hoet 1752, vol 2, p 451. Thiéry 1953, p 177. Gerson & Ter Kuile 1960, p 59. Bille 1961, vol 1, p 110. Van Braam nd, nr 791

copy after **Jan Brueghel I**

A 511 The sermon on the sea of Galilee. *De prediking op het Meer van Galilea*

Copper 29.5 × 41. Signed *J. B.*
PROV Presented by J P G Baron Spaen van Biljoen, 1808
LIT Moes & van Biema 1909, pp 129, 212

A 68 River bank. *Rivieroever*

Copper 20.5 × 27.5
PROV Purchased with the Kabinet van

Heteren Gevers, The Hague-Rotterdam, 1809
LIT Moes & van Biema 1909, p 157. Bille 1961, vol 1, p 110

Pieter Brueghel II

Brussels 1564 – 1638 Antwerp

A 731 The adoration of the magi. *De aanbidding der koningen*

Panel 41 × 57. Signed *P. Breughel*
PROV Sale Copes van Hasselt, Amsterdam, 20 April 1881, lot 9
LIT Van Bastelaer & Hulin de Loo 1907, p 362 (lists many replicas). Glück 1932, p 75. G J van der Hoek, Kunstrip 3 (1972-73) nr 30

Guillaume Anne van der Brugghen

Nijmegen 1811 – 1891 Ubbergen

A 2090 Four studies of a dog. *Vier studies van een hond*

Paper on panel 25 × 31.5. Signed and dated *G. A. v. d. B. f. 68*
PROV Bequest of A A des Tombe, The Hague, 1903

A 2087 Still life with wood pigeon and powder horn. *Stilleven met woudduif en kruithoorn*

Panel 35 × 27. Signed and dated *G. A. van der Brugghen f. 74*
PROV Bequest of AA des Tombe, The Hague, 1903 * DRVK since 1961

A 2088 Pigs in a barnyard. *Varkens bij een boerderij*

Canvas 24 × 34. Signed *G. A. v. d. B. f.*
PROV Bequest of AA des Tombe, The Hague, 1903

A 2089 A dog on a chair. *Een hondje op een stoel*

Panel 31 × 22.5. Signed *G. A. v. d. B. f.*
PROV Bequest of AA des Tombe, The Hague, 1903

A 2091 A dog on the leash. *Een hond aan de ketting*

Canvas 37 × 43. Signed *G. A. v. d. B.*
PROV Bequest of AA des Tombe, The Hague, 1903 * DRVK since 1961

A 2092 Portrait of a puppy. *Portret van een hondje*

Canvas on panel 15.5 × 18. Signed *G. A. v. d. B. f.*
PROV Bequest of AA des Tombe, The Hague, 1903

Hendrick ter Brugghen

Overijssel province 1588–1629 Utrecht

A 4188 The adoration of the magi. *De aanbidding der koningen*

Canvas 134 × 160. Signed and dated *HT-Brugghen fecit 1619*
PROV Purchased from B Cohen & Sons

gallery, London, 1970, as a gift of the Photo Commission and the Rembrandt Society in collaboration with the Prince Bernhard Foundation
LIT R Longhi, Paragone, 1966, nr 72, p 201, pl VII. Ottani Cavina 1968, pp 44, 56, 63, note 30, p 108, nr 38, fig 22. PJJ van Thiel, Jaarversl Ver Rembrandt 1970, pp 17-18, ill on p 19. PJJ van Thiel, Bull RM 19 (1971) pp 91-116, ill. L Kuiper, Bull RM 19 (1971) pp 117-35. Arteieri, Bolaffiarte 3 (1972) p 7, ill. B Nicolson, Alb Amic JG van Gelder, 1973, p 237

A 3908 Doubting Thomas. *De ongelovige Thomas*

Canvas 108.8 × 136.5
PROV Purchased from P & D Colnaghi gallery, London, 1956, as a gift of the Photo Commission
LIT B Nicolson, Burl Mag 98 (1956) p 103, fig 1 (ca 1621). A Slawska, Biul Hist Sztuki 19 (1957) p 273, fig 4. Nicolson 1958, p 44, nr A-2 (ca 1624-25). H Gerson, Kunstchronik 12 (1959) p 315. Plietzsch 1960, p 145. B Nicolson, Alb Amic JG van Gelder, 1973, p 239 (1623-25). G Harbison, Burl Mag 116 (1974) p 35, note 8

A 2784 Heraclitus

Pendant to A 2783

Canvas 85.5 × 70. Signed and dated *HT Brugghen fecit 1628*
PROV Presented by B Asscher & H Koetser, Amsterdam, 1916
LIT W Steenhoff, Onze Kunst 29-30 (1916) p 25ff. W Weisbach, Jb Preusz

Kunstsamml 49 (1928) p 151, fig 7. Von
Schneider 1933, pp 37, 141, fig 14b. W
Stechow, Art Q 7 (1944) pp 233-38.
Boon 1942, p 50, fig 27. B Nicolson, Burl
Mag 98 (1956) pp 108-10. Nicolson
1958, p 45, nr A-4. H Gerson, Kunst-
chronik 12 (1959) p 315. Plietzsch 1960,
p 146. B Nicolson, Burl Mag 102 (1960)
pp 469-70, note 19. A Blankert, N K J 18
(1967) p 99, nr 39

A 2783 Democritus

Pendant to A 2784

Canvas 85.5 × 70. Signed and dated
HTBrugghen fecit 1628
PROV Same as A 2784
LIT W Steenhoff, Onze Kunst 29-30
(1916) p 25ff. W Weisbach, Jb Preusz
Kunstsamml 49 (1928) p 151, fig 6. Von
Schneider 1933, pp 37, 141, fig 14a. E
Wind, Journ W C I I (1937-38) p 181, fig
24c. Boon 1942, p 50, fig 26. W Stechow,
Art Q 7 (1944) pp 233-38. B Nicolson,
Burl Mag 98 (1956) pp 108-10. Nicolson
1958, p 45, nr A-3. H Gerson, Kunst-
chronik 12 (1959) p 315. Plietzsch 1960,
p 146. B Nicolson, Burl Mag 102 (1960)
pp 469-70, note 19. A Blankert, N K J 18
(1967) p 99, nr 39

Bartholomæus Bruyn I

Wezel? 1493–1555 Cologne

A 2559 Portrait of a young woman.
Portret van een jonge vrouw

The sitter may be a daughter of Prof
Peter Bellinghausen, chancellor of
Cologne

Panel 31.5 × 21.5. Ends in a round arch
PROV Lent by C Hoogendijk, The
Hague, 1907. Presented by his estate in
1912 * On loan to the K K S (cat 1968, p
16, nr 889) since 1951
LIT R Bangel, Cicerone 7 (1915) p 171,

fig 1. H Vogts, Jb Köln Gesch Ver 29-30
(1954-55) p 325. Exhib cat Barthel
Bruyn, Cologne 1955, nr 110. J Bruyn,
O K 6 (1962) nr 6, ill. Westhoff-Krum-
macher 1965, pp 28, 81, 141, nr 65, ill on
frontispiece

manner of **Bartholomæus Bruyn I**

A 4228 Triptych with the adoration of
the magi. *Drieluik met de aanbidding der
koningen*

Left wing: the donor with his five sons
and St George (inside); the coat of arms
of the van Rooy family (outside). Right
wing: the donor's wife with her five
daughters and the Madonna and child
with St Anne (inside); the coat of arms
of the Francken or Vrancken family (out-
side)

Panel 84.5 × 62 (middle panel); 86 × 26
(each of the wings)
PROV Lent by F Duyvensz, Amsterdam,
1972. Bequeathed by F Duyvensz and
J Duyvensz-Nagel, Amsterdam, 1973

Cornelis de Bruijn

see Governors-general series: A 3770
Joan van Hoorn

Jacob de Bruijn

see Governors-general series: A 3880
A W L Tjarda van Starkenborgh
Stachouwer

Joachim Bueckelaer

Antwerp ca 1530–1573 Antwerp

A 1451 The well-stocked kitchen, with
Jesus in the house of Martha and Mary
in the background. *De welvoorziene keuken,
met op de achtergrond Jezus bij Martha en
Maria*

Panel 171 × 250. Signed and dated
JB 1566
PROV Sale S Bos (Harlingen),
Amsterdam, 21 Feb 1888, lot 18
LIT J Sievers, Jb Preusz Kunstsamml 32
(1911) p 206. E Greindl, Pantheon 29
(1942) p 155. Bergström 1947, p 21, fig
18. K Böstrom, O H 63 (1948) p 125ff. R
Genaille, Bull Mus Roy Belg 16 (1967) p
88. R Ehmke, Jb Rhein Denkmalpfl 27
(1967) pp 249-50, fig 236. V T T T, 1965-66,
nr 81

A 1496 Marketplace, with the flagel-
lation, the Ecce Homo and the bearing
of the cross in the background. *Marktplein,
met op de achtergrond de geseling, Ecce Homo
en de kruisdraging*

Panel 126.5 × 182
PROV Sale H F C ten Kate, Amsterdam,
15-16 May 1889, lot 74 (as Pieter
Aertsen)
LIT J Sievers, Jb Preusz Kunstsamml 32
(1911) p 207

copy after **Joachim Bueckelaer**

A 2251 Kitchen scene, with Jesus in the house of Martha and Mary in the background. *Keukenstuk, met op de achtergrond Jezus bij Martha en Maria*

Panel 110 × 140.5
PROV Purchased from W Vader Dzn, Schagen, 1907 * On loan to the Rijksmuseum Muiderslot, Muiden, since 1922

Jan Jansz Buesem

Amsterdam? ca 1600–after 1649 Amsterdam?

A 2555 Peasant meal. *Boerenmaaltijd*

Panel 20.5 × 29. Marked *B*
PROV Lent by C Hoogendijk, The Hague, 1907. Presented by his estate in 1912
LIT C Hofstede de Groot, Ned Spec, 1899, p 58. R Bangel, Cicerone 7 (1915) pp 177-78. J de Kleyn, OKtv 2 (1964) nr 6, fig 1

Willem Willemsz van den Bundel

Brussels ca 1577–1655 Delft

A 2835 View of a village. *Dorpsgezicht*

Panel 39.5 × 52. Signed and dated *WBundel 1623*
PROV Purchased from D Komter gallery, Amsterdam, 1920
LIT A Bredius, OH 38 (1920) p 66, ill. C Hofstede de Groot, Burl Mag 42 (1923) p 15. Bernt 1960-62, vol 4, nr 42. Bol 1969, p 150. Bernt 1969-70, vol 1, nr 208

manner of **Jacob Bunel**

Blois 1558–1614 Paris

A 1400 Henri IV (1553-1610), king of France. *Koning van Frankrijk*

Canvas 98 × 75. Dated *1592*. Inscribed *Henricus 4 D. G. Rex Francorum et Navarra Aetatis suae 40*
PROV KKS. NMGK, 1887
LIT *Cf* Maumené & d'Harcourt 1929-32, vol 1, nr 311

Louis de Burbure

b Schaerbeek 1837

C 534 The roads of Den Briel during the commemoration of the third centennial of the capture of the city, 1872. *Gezicht op de rede van Den Briel tijdens de 300-jarige herdenking van de inneming van de stad, 1872*

Canvas 95 × 188. Signed and dated *Louis de Burbure 1872*
PROV Lent by the heirs of B J Tideman, Amsterdam, 1889 * On loan to the Trompmuseum, Den Briel, since 1922

Hendricus Jacobus Burgers

Arnhem 1834–1899 Paris

A 1805 A Jewish funeral. *Joodse begrafenis*

Canvas 170 × 125. Signed *H. J. Burgers*
PROV Bequest of Reinhard Baron van Lynden, The Hague, 1899
LIT H Polak, Vrijdagavond 1 (1924) p 292, ill. Gans 1971, p 401, ill

R van Burgh

active 2d half of the 17th century

A 846 Still life with fish. *Stilleven met vissen*

Canvas 111.5 × 153. Signed *R. VBurgh*
PROV Sale Amsterdam, 31 Dec 1884, lot 222
LIT Vorenkamp 1933, p 80

Hendrick van der Burgh

active 1649-54 in Delft, 1658-59 in
Leiden and 1664 in Delft; d after 1669

A 2720 The conferring of a degree at the
university of Leiden about 1650. *Een
promotie aan de Leidse Universiteit omstreeks
1650*

Canvas 71.5 × 59. Signed *HVB*
PROV Purchased from J H Langeveldt,
Voorhout, 1915
LIT W Bürger, GdB-A 82 (1866) p 568,
nr 47 (Johannes Vermeer). B W F van
Riemsdijk, Eigen Haard, 1915, p 978. C
Hofstede de Groot, OH 39 (1921) p 125,
fig 3. P D Molhuysen, in Pallas Leid,
1925, p 315. Valentiner 1929, p 228.
Martin 1935-36, vol 2, p 210.
Hargreaves-Hawsley 1963, p 167. A van
den Berg, Spiegel Hist 3 (1968) fig 2. W
Schulz, Pantheon 28 (1970) p 421

C 1182 View of the Dam, Amsterdam,
showing the Nieuwe Kerk with its tower,
which was never erected. *Gezicht op de
Dam te Amsterdam, met de nimmer gebouwde
toren van de Nieuwe Kerk*

Canvas 110 × 135
PROV On loan from the KOG (bequest of
Mrs M A Domela Nieuwenhuis-Meijer)
since 1926

Hendrik van der Burgh

The Hague 1769 – 1858 The Hague

A 1016 After milking time. *Na het melken*

Panel 48 × 37. Signed *H. v. d. Burgh f.*
PROV Purchased at exhib The Hague
1827, nr 49. RVMM, 1885

Hendrik Adam van der Burgh

The Hague 1798 – 1877 The Hague

A 1017 Milking time. *Melktijd*

Panel 42 × 55. Signed *H. A. van der Burgh
Jr*
PROV Purchased at exhib The Hague
1827, nr 50. RVMM, 1885 * DRVK since
1961
LIT Scheen 1946, fig 297

Pieter Daniel van der Burgh

The Hague 1805 – 1879 Rijswijk

A 1368 The Gevangenpoort (prison
gate) and the Plaats, The Hague. *De
Gevangenpoort en de Plaats te Den Haag*

Panel 47 × 58.5. Signed *P. D. van der
Burgh*
PROV RVMM, 1877? NMGK, 1887 *
DRVK since 1959

Burgklij Glimmer

see Hoopstad

Busschop

see Bisschop

attributed to **Cornelis Buys II**

b Alkmaar; d 1546 Alkmaar

A 2392 Triptych with the lamentation.
Drieluik met de bewening van Christus

Left wing: the donor with St Francis?
Right wing: the donor's wife with St
Elizabeth

Panel 46.5 × 40 (middle panel); 48.5
× 18.5 (each of the wings)
PROV Sale Amsterdam, 30 June 1909,
lot 139 (as Jan van Scorel)
LIT R van Luttervelt, NKJ 13 (1962) p 66
(middle panel by Buys, wings by an-
other, perhaps somewhat later hand)

A 4219 The lamentation of Christ. *De bewening van Christus*

Panel 100 × 83.5
PROV Purchased from Mrs J de Bel-Paris, Amsterdam, 1972
LIT Bull RM 20 (1972) p 182, fig 1

Jacobus Buijs

Amsterdam 1724–1801 Amsterdam

A 2966 Scene from the play 'Lubbert Lubbertse of de geadelde boer' by M van Breda (1686). *Scène uit 'Lubbert Lubbertse of de geadelde boer' door M van Breda*

Panel 57 × 44.5. Signed and dated *J. Buys F. 1761*
PROV Purchased from D Komter gallery, Amsterdam, 1922, as a gift of the Photo Commision
LIT Niemeijer 1973, pp 121-22, fig 36

C 515 Cornelis Ploos van Amstel (1726-98). Art collector. *Kunstverzamelaar*

Panel 25.5 × 23. Signed and dated *J. Buys F. 1766*
PROV On loan from the KOG (gift of Jonkheer J Ploos van Amstel and Jonkheer J A G Ploos van Amstel) since 1878
LIT A Staring, in Kunstgesch der Ned, 1954, p 632. J W Niemeijer, NKJ 13 (1962) p 196, nr 1, fig 20. Van Hall 1963, p 251, nr 1668:1

Willem Pietersz Buytewech

Rotterdam 1591/92 – 1624 Rotterdam

A 3038 Dignified couples courting. *Voorname vrijage*

Canvas 56 × 70
PROV Purchased from N Beets gallery, Amsterdam, 1926, as a gift of the Photo Commission
LIT G Poensgen, Jb Preusz Kunstsamml 47 (1926) p 97. J Six, OH 43 (1926) p 97. I Q van Regteren Altena, Mndbl BK 3 (1926) pp 165-68. W J C Bijleveld, Ned Leeuw 44 (1926) pp 144-46. Martin 1935-36, vol I, pp 358-59, fig 207. C J Hudig, Historia 9 (1943) p 172, fig 5. Haverkamp Begemann 1959, cat nr IV. fig 35. Plietzsch 1960, p 35, fig 4. Fr W S van Thienen, OKTV I (1963) nr I, fig 1a. De Jongh 1967, p 25, figs 18-19

Jan van Bijlert

Utrecht 1597 – 1671 Utrecht

A 1596 Portrait of a woman. *Portret van een vrouw*

Canvas 82 × 67. Signed *J. v. Bijlert fec.*
PROV Purchased from B Kalf Dzn gallery, Amsterdam, 1893 * DRVK since 1957 (on loan to the Museum Amstelkring, Amsterdam)
LIT Martin 1935-36, vol I, p 131. G J Hoogewerff, OH 80 (1965) p 30, nr 92

A 1338 The lute player. *De luitspeler*

Panel 18 × 18. Signed *J. Bijlert fec.*
PROV Sale J H Cremer, Amsterdam, 26 Oct 1886, lot 14
LIT Von Schneider 1933, p 131. G J Hoogewerff, OH 80 (1965) p 28, nr 72

attributed to **Jan van Bijlert**

C 310 Woman praying. *Biddende vrouw*

Canvas 32.5 × 28.5
PROV On loan from the city of Amsterdam (A van der Hoop bequest) since 1885

A 1285 An oriental. *Een oosterling*

Panel 109 × 78
PROV Sale P VerLoren van Themaat, Amsterdam, 30 Oct 1885, lot 138 * DRVK since 1953

Arent Cabel

see Arentsz, Arent, called Cabel

Alexander Calame

Vevey 1810 – 1864 Menton

C 302 Landscape. *Landschap*

Canvas 57 × 82.5. Signed *A.Calame Genève*
PROV On loan from the city of Amsterdam (A van der Hoop bequest) since 1885

manner of **Jan Joest van Calcar**

active 1505-08 in Calcar and from 1509 on in Haarlem; d 1519 Haarlem

A 2596 The resurrection of Christ. *De verrijzenis van Christus*

Panel 70 × 37
PROV Lent by C Hoogendijk, The Hague, 1907. Presented by his estate in 1912

Maurits Calisch

Amsterdam 1819 – 1870 Amsterdam

C 117 Visit to a new mother. *Het bezoek bij de kraamvrouw*

Canvas 56.5 × 66. Signed and dated *M. Calisch fect 1835*
PROV On loan from the city of Amsterdam (A van der Hoop bequest) since 1885

C 116 'A mother's blessing.' '*Moeder-zegen*'

Canvas 120 × 96. Signed and dated *M. Calisch fect 1844*
PROV On loan from the city of Amsterdam (A van der Hoop bequest) since 1885

A 4181 Two women in Italian dress. *Twee vrouwen in Italiaanse dracht*

Canvas 118.5 × 90.5. Signed and dated *M.Calisch 1851*
PROV Unknown

A 1516 Johanna Christina Beelenkamp (1820-90). Wife of Cornelis van Outshoorn. *Echtgenote van Cornelis van Outshoorn*

Pendant to A 1515

Canvas 120 × 96. Signed *M.Calisch fect*
PROV Presented by the estate of C van Outshoorn, Amsterdam, 1890 * Lent to the AHM, 1975

A 1515 Cornelis van Outshoorn (1810-75). Engineer and architect. *Ingenieur en architect*

Pendant to A 1516

Canvas 120 × 99. Signed *M.Calisch fect*
PROV Same as A 1516 * Lent to the AHM, 1975
LIT Scheen 1946, fig 92

Abraham van Calraet

Dordrecht 1642 – 1722 Dordrecht

A 79 Cavalry skirmish. *Ruitergevecht*

Panel 50 × 65.5. Signed *A.C.*
PROV Sale J van der Linden van Slingelandt, Dordrecht, 22 Aug 1785, lot 98 (as Aelbert Cuyp). NM, 1808
LIT C Hofstede de Groot, OH 17 (1899) pp 164-65. Hofstede de Groot 1907-28, vol 2 (1908) nr 57 (Aelbert Cuyp). Moes & van Biema 1909, pp 146, 222

C 122 Cattle. *Veestuk*

Panel 39.5 × 55.5. Signed *A.C.*
PROV On loan from the city of
Amsterdam (A van der Hoop bequest)
since 1885
LIT CJH, Burl Mag 12 (1907) p 373
(Aelbert Cuyp). Hofstede de Groot
1907-28, vol 2 (1908) nr 180 (Cuyp). Bol
1969, p 236

Adam Camerarius

active 1644-65 in Amsterdam, Naarden
and Groningen

A 733 Christ and the centurion. *Christus
en de hoofdman over honderd*

Canvas 172.5 × 226.5. Signed
ACamerarius
PROV Sale Mrs Viruly-Mathijssen,
Amsterdam, 14 Dec 1880, lot 19 (as
Salomon Koninck)
LIT C Hofstede de Groot, Gron Volks-
almanak, 1893, p 27

Jacob van Campen

Haarlem 1595 – 1657 Amersfoort

A 4254 Three adjoining friezes of a room
decoration: Hercules hauling Cerberus
out of the underworld, flanked by two
still lifes (right wall); five niches with
fruit still lifes and garlands (back wall);
Hercules defeating the centaurs, flanked
by two still lifes (left wall). *Drie aaneen-
sluitende friezen van een kamerbeschildering:
Hercules haalt Cerberus uit de onderwereld,*

*geflankeerd door twee stillevens (rechter zij-
wand); vijf nissen met vruchtenstillevens en
guirlandes (achterwand); Hercules verslaat
de centauren, geflankeerd door twee stillevens
(linker zijwand)*

Panel ca 530 × 85 (back wall) and 355 ×
85 (side walls). Inscribed on the still life
on the left side of the right wall *Memoria
iusticum laude nomen impiopum putrescet* and
above a bookcase *El todo es nada*; on the
still life on the left side of the left wall is a
book with a Greek title page. The
mythological subjects are in grisaille
PROV From the painter's country home

Het Hoogerhuis near Randenbroek in
the neighborhood of Amersfoort, built
by himself in the years 1644-45. Acquired
1879. NMGK* Lent to the Museum
Flehite, Amersfoort, 1931. DRVK since
1959 (on loan to the Museum Flehite,
Amersfoort)
LIT Van Gelder 1933, p 47, note 2. R
van Luttervelt, De Gids, 1946, p 143ff
(ca 1626-36). HE van Gelder, OH 75
(1960) p 21, fig 10 (attributes the still lifes
to Albert Eckhout). Swillens 1961, pp
123-26, 261-63, cat nr 3a-b, figs 9-10 (ca
1645-46)

A 4254

Govert Dircksz Camphuijsen

Dokkum 1623/24–1672 Amsterdam

A 1303 Self portrait? *Zelfportret?*

Canvas 117 × 104. Signed on the letter
G.Camphuijsen Tot Amsterdam
PROV Purchased from J H Ward,
London, 1886
LIT A Bredius & E W Moes, OH 21 (1903)
p 216 (portrait of Govert Jochemsz, the
artist's cousin; the former was not born
until 1657/58, however). Mndbl BK 11
(1934) p 138. Rapp 1951, p 16, fig 1.
Van Hall 1963, p 58, nr 352:1 (accepts
identification of Bredius & Moes)

C 563 Flirtation in a cowshed. *Vrijage in
een koestal*

Panel 33 × 37. Signed
G.C[a]mph[u]ijsen; covered by the false
signature *P.Potter*
PROV On loan from the city of
Amsterdam (bequest of Mrs M C
Messchert van Vollenhoven-van
Lennep) since 1892
LIT A Bredius & E W Moes, OH 21 (1903)
p 210

Rafel Govertsz Camphuijsen

Gorkum 1598–1657 Amsterdam

A 1939 Landscape at sunset. *Landschap
bij zonsondergang*

Panel 46 × 63.5. Signed *R.Camphuijsen*
PROV Sale G de Clercq, Amsterdam, 1
June 1897, lot 11. Purchased with aid
from the Rembrandt Society
LIT A Bredius & E W Moes, OH 21 (1903)
p 198. Bol 1969, p 173, fig 165. F
Bachmann, OH 85 (1970) p 243. I V
Linnik, NKJ 23 (1972) p 243

school of **Antonio Canale** *called*
Canaletto

Venice 1697–1768 Venice

A 3384 Entrance to the Grand Canal
near the Punta della Dogana and Santa
Maria della Salute. *De ingang van het
Canal Grande bij de Punta della Dogana en de
Santa Maria della Salute*

Pendant to A 3385

Canvas 61 × 79.5
PROV Bequest of J W Edwin vom Rath,
Amsterdam, 1941
LIT Constable 1962, vol 2, p 252, nr 164a
(studio replica)

A 3385 The Grand Canal with the Rialto
Bridge and the Fondaco dei Tedeschi.
*Het Canal Grande met de Ponte Rialto en de
Fondaco dei Tedeschi*

Pendant to A 3384

Canvas 62 × 83
PROV Same as A 3384
LIT Constable 1962, vol 2, p 284, nr
236c (studio replica). Berto & Puppi
1968, p 107, nr 191B (copy of an original
in Sloane's Museum, London)

Jan van de Cappelle

Amsterdam 1626–1679 Amsterdam

A 453 The home fleet saluting the state
barge. *Begroeting van de regeringssloep door
de binnenvloot*

Panel 64 × 92.5. Signed and dated
J.v.Capel 1650
PROV Purchased in 1803. NM, 1808
LIT Hofstede de Groot 1907-28, vol 7
(1918) nr 17. Moes & van Biema 1909,
pp 64, 223. Willis 1911, p 79. C G 't
Hooft, in Feestbundel Bredius, 1915, p
103 (identifies occupants of the barge as
Frederik Hendrik and the future Willem
II). Martin 1935-36, vol 2, pp 385-86, fig
205. Crone 1937, pp 57-58, pl XVI. W R
Valentiner, Art Q 4 (1941) p 272.
Stechow 1966, p 117. Rosenberg, Slive &
Ter Kuile 1966, p 165, fig 148. Bol 1973,
p 224, figs 226-28

A 3248 Calm sea with fishing boats.
Kalme zee met vissersschepen

Canvas 54.5 × 66.5. Signed *J.v.Cappelle*

PROV Presented by Sir Henry W A
Deterding, London, 1936 * DRVK since
1954
LIT Hofstede de Groot 1907-28, vol 7
(1918) nr 120

A 4042 Ships at anchor on a quiet sea.
Schepen voor anker op een kalme zee

Canvas 47.5 × 60.5
PROV Presented by Mr & Mrs I de
Bruijn-van der Leeuw, Muri near Bern,
1961
LIT E R Meijer, Bull RM 9 (1961) p 47,
fig 6. J L Cleveringa, Bull RM 9 (1961) p
64, nr 5. H P Baard, OK 6 (1962) nr 3, ill.
Bol 1973, p 227, fig 233

A 4043 Winter scene. *Wintergezicht*

Canvas 51.5 × 67.4
PROV Presented by Mr & Mrs I de
Bruijn-van der Leeuw, Muri near Bern,
1961
LIT Hofstede de Groot 1907-28, vol 7
(1918) nr 160? H L Jaffé, Du, 1944, p 41,
ill. E R Meijer, Bull RM 9 (1961) p 47, fig
7. J L Cleveringa, Bull RM 9 (1961) p 64,
nr 6. Stechow 1966, p 96 (ca 1652-53)

attributed to **Vittore Carpaccio**

active 1472 in Venice; d 1525 Venice

A 3993 Portrait of a woman. *Portret van
een vrouw*

Panel 28.5 × 22.5
PROV O Lanz, Amsterdam. Lent by the
DRVK, 1952. Transferred in 1960
LIT Fiocco 1931, pp 17, 58, fig 8. G
Fiocco, Boll d'Arte 26 (1932) p 116. R
Longhi, Vita Art 3:1 (1932) p 5. Van
Marle 1923-38, vol 18 (1936) p 268 (ca
1505-10). B Degenhart, Pantheon 27
(1941) p 38. Longhi 1952, p 56. W
Arslan, Emporium 116 (1952) p 109.
Berenson 1957, vol 1, p 59 (follower of
Carlo Crivelli). Fiocco 1958, p 34.
Perocco 1960, p 85, fig 196 (attributed to
Carpaccio). Lauts 1962, p 237, nr 31, pl
1. Heinemann 1962, vol 1, p 232. F
Heinemann, Kunstchronik 16 (1963) p
243 (doubts attribution to Carpaccio). G
Robertson, Burl Mag 105 (1963) p 385
(closer to Bartolommeo Montagna).
Bottari 1963, vol 2, p 40, fig 170
(attributed to Giovanni Bellini)

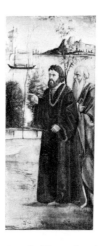

A 3387 Two saints(?) in a landscape.
Twee heiligen(?) in een landschap

Panel 99 × 44.5. Fragment
PROV Bequest of J W Edwin vom Rath,
Amsterdam, 1941
LIT Venturi 1927, pp 253, 255, fig 157.
Fiocco 1930, nr 200. Berenson 1932, p
133. Van Marle 1923-38, vol 18 (1936) p
280. Berenson 1957, vol 1, p 57. Perocco
1960, p 84, fig 190 (attributed). Lauts
1962, p 259 (milieu of Giovanni
Mansueti)

Ludovico Carracci

Bologna 1555–1619 Bologna

A 3992 The vision of St Francis of Assisi.
Het visioen van de heilige Franciscus van Assisi

Canvas 103 × 102
PROV O Lanz, Amsterdam. Lent by the
DRVK, 1952. Transferred in 1960
LIT Bodmer 1939, pp 43-44, 136. B
Degenhart, Pantheon 27 (1941) p 39, ill.
Ciaranfi 1952, pp 19-20, fig 25. F
Arcangeli, Paragone 79 (1956) p 34, fig 7
(ca 1585-86). F Mullaby, Apollo 65-66
(1957) p 75, fig 1 (ca 1583-84). A
Slawska, Biul Hist Sztuki 19 (1957) p
271. D Mahon, GdB-A 49 (1957) p 195,
nr 6. Burl Mag 102 (1960) p 52, note 15.
P Askew, Journ WCI 32 (1969) p 295,
note 66 (ca 1585). Exhib cat Natura ed
Espressione nell'arte Bolognese-
Emiliana, Bologna 1970, nr 50, ill. T
Graas, Bull RM 23 (1975) pp 173-75

Hendrik Carrée I

Amsterdam 1656–1721 The Hague

A 1493 Portrait of a young officer. *Portret
van een jonge officier*

Canvas 85 × 68. Oval. Signed and dated
on the verso *H. Carré 1697*
PROV Presented by Dr A Bredius, The
Hague, 1889

Hendrik Carrée II

The Hague 1696–1775 The Hague

A 2838 The catch. *De visvangst*

Canvas 177 × 98. Signed and dated
HCarré 1734. Grisaille
PROV Unknown

A 2837 Homage to Pomona. *Hulde aan
Pomona*

Canvas 177 × 98. Grisaille
PROV Unknown

attributed to **Juan Carreño de Miranda**

Avilés 1614–1685 Madrid

A 1425 St Sebastian. *De heilige Sebastiaan*

Canvas 76 × 64
PROV Presented by A Willet,
Amsterdam, 1887
LIT Luns 1932, p 151 (Antonio Cano).
Wethey 1955, p 189 (Madrid master of
the 2d half of the 17th century, possibly
Carreño de Miranda). Gaya Nuño 1958,
vol 2, nr 548. Kubler & Soria 1959, p
286 (ca 1655)

Hendrik Gerrit ten Cate

Amsterdam 1803–1856 Amsterdam

A 1018 The Torensluis (tower lock) and
the Jan Roodenpoortstoren in
Amsterdam. *De Torensluis met de Jan
Roodenpoortstoren te Amsterdam*

Canvas 63 × 81. Signed and dated
H. G. ten Cate fec. 1829
PROV RVMM, 1885
LIT Scheen 1946, fig 212

Siebe Johannes ten Cate

Sneek 1858–1908 Paris

see also under Pastels

A 2299 Zwijndrecht in the winter.
Gezicht op Zwijndrecht bij winter

Canvas 37.5 × 61. Signed and dated *ten
Cate 92*
PROV Lent by J B A M Westerwoudt,
Haarlem, 1902. Bequeathed in 1907 *
DRVK since 1956

Louis de Caullery

b Cambrai?; d after 1620

A 1956 Venus, Bacchus and Ceres with
mortals in a garden of love. *Venus,
Bacchus en Ceres met stervelingen in een minne-
tuin*

Panel 54.5 × 74
PROV Sale Amsterdam, 16 April 1901,
lot 21 (as Jan Brueghel and Frans
Francken)
LIT Van Sypesteyn 1910, pp 82-88, fig
37. E Michel, Bull Mus France 8 (1936)
pp 52-54. Michel 1951, pl 16. G Marlier,
Weltkunst, 15 May 1960, p 13, ill.
Legrand 1963, p 83

manner of **Louis de Caullery**

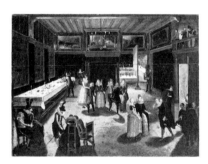

A 4292 Evening party. *Feestvierend
gezelschap bij avond*

Panel 66 × 88
PROV Sale Amsterdam, 5-6 Nov 1895,
lot 53? (as after Frans Francken). NMGK

Cornelis Cels

Lier 1778–1859 Brussels

see also Miniatures: Hari I, Johannes,
A 2817 Wilhelmina of Prussia, copy after
Cels

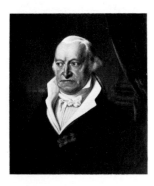

C 282 Joan Cornelis van der Hoop
(1742-1825). Minister of the navy.
Minister van Marine

Canvas 63 × 54. Signed and dated *C.Cels
1816*
PROV On loan from the city of
Amsterdam (A van der Hoop bequest),
1885-1975

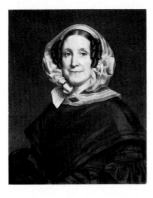

A 4172 Aryna van der Pot (b 1786). Wife
of N J A C Hoffmann. *Echtgenote van
N J A C Hoffmann*

Canvas 69 × 59.5. Signed and dated
C.Cels 1841. Inscribed on the verso *Aryna
van der Pot, Wed* N. J. A.C. Hoffmann, geb^n
te Rotterdam 21 April 1786*
PROV Bequeathed by Mrs M E
Goedkoop-Vanheerswijghels, The
Hague, 1969. Received in 1970
LIT Bull RM 19 (1971) p 32, fig 3

A 1019 Swiss peasant girl. *Zwitserse
boerin*

Canvas 110 × 88
PROV Purchased at exhib The Hague
1821? RVMM, 1885 * DRVK, 1961-70.
Badly damaged by fire in Eindhoven,
1970

Carlo Ceresa

San Giovanni Bianco 1609–1676
Bergamo

A 4103 Bernardo Gritti. Proprefect of
Bergamo. *Proprefect van Bergamo*

Canvas 114.2 × 100.5. Dated *1646*.
Inscribed *En faciem vere augustam vere previ.
tu dignam optimi optatissimi Bergomi
praetoris et pro praefecti Bernardi Gritti…
prudentia labore pervigili difficilis controversia
Civitatis cum pauperrimo D. Ursulae Collegio
faciliter celeriter laudabiliter fuit explicita
composita expedita. Tibi aeternas grates
agimus pro tua tuae late conspiquae familiae
incolumitate increme D. O. M. IV millimas
precis fundemus aeternum omnis omnas hocce
grati animi monum S. Ursulae Colleg. P.
MDCXLVI*
PROV Purchased from the Heim gallery,
Paris, 1964, with monies from the J W
Edwin vom Rath Fund
LIT Bull RM 13 (1965) p 129, fig 1

Mateo Cerezo

Burgos ca 1626–1666 Madrid

C 1347 The penitent Mary Magdalene.
De boetvaardige Maria Magdalena

Canvas 103.2 × 83. Signed and dated
Matheo zereço ft. añ de 1661
PROV Purchased by Willem I from
Countess Bourke, Paris, 1823. On loan
from the KKS since 1948
LIT Bürger 1858-60, vol I, p 310. Bürger
1869, p 2. E Tormo, Arch Esp Arte &
Arq 3 (1927) pp 113-28, 245-74, ill.
Lafuente Ferrari 1946, p 242. Mayer
1947, p 489, fig 380. Rouchès 1958, p
344. Gaya Nuño 1958, vol I, p 73; vol 2,
nr 587, fig 226. Kubler & Soria 1959, p
287. J Rogelio Buendia, Goya, 1966, p
284, ill. P van Vliet, Bull RM 14 (1966) p
134, fig 4

attributed to **Giacomo Ceruti**

active mid-18th century in Milan, Padua
and Brescia

A 3406 Portrait of an old lady. *Portret van
een oude dame*

Canvas 73 × 59
PROV Bequest of J W Edwin vom Rath,
Amsterdam, 1941
LIT G Fiocco, Emporium 59 (1953) p 52,
fig 3. VTTT, 1962-63, nr 60. H Olsen,
Kunstmus Årsskrift, 1963, p 88 (Pietro
Francesco Guala). E G G Bos, Antiek 1
(1966) p 10, fig 14

Hendrik Chabot

Sprang 1894–1949 Rotterdam

C 1485 Refugees in a cowshed.
Vluchtelingen in een koestal

Canvas 127 × 200. Signed *Chabot*
PROV On loan from the DRVK since 1970

C 1565 Fleeing with a blind boy, 1943.
Vlucht met blind jongetje, 1943

Canvas 151 × 135. Signed *Chabot*
PROV On loan from the DRVK since 1973

C 1566 The persecuted, 1944. *Vervolgden,
1944*

Canvas 46 × 64.5. Signed *Chabot*
PROV On loan from D Elffers,
Amsterdam, since 1973

Noël Challe

active mid-18th century in Amsterdam

A 2159 Sandrina van den Broecke. Wife
of George Lodewijk Matthes. *Echtgenote
van George Lodewijk Matthes*

Canvas 81 × 68. Signed and dated *Noel
Challe 1764*
PROV Presented by H Lepeltak Kieft,
Brummen, 1905

attributed to **Jean-Baptiste de Champaigne**

Brussels 1631–1681 Paris

A 3744 Philippe de la Trémoïlle (b 1596),
count of Olonne. *Graaf van Olonne*

Canvas 64 × 55
PROV Purchased from O Wertheimer
gallery, Paris, 1949
LIT B Dorival, GdB-A 75 (1970) p 321. B
Dorival, Bull RM 19 (1971) pp 16-24, fig 1

attributed to **Philippe de Champaigne**

Brussels 1602–1674 Paris

C 1183 Jacobus Govaerts (b 1635/36).
Appointed master of ceremonies and
clerk of the chapter of Antwerp in 1661.
*In 1661 benoemd tot ceremoniemeester en
notator van het Kapittel te Antwerpen*

Canvas 135 × 108. Inscribed *M. Episcop.*
and *Aet Suae 29 Ao 1665*
PROV Purchased by Willem I from
General Rottiers, 1823. On loan from
the KKS since 1927
LIT Mabille de Poncheville 1938, ill on p
60

attributed to **Nicolas-Toussaint Charlet**

Paris 1792–1845 Paris

A 2257 Head of a dog. *Hondekop*

Canvas 35 × 35
PROV Bequest of J B A M Westerwoudt,
Haarlem, 1907

Chattel

see Rossum du Chattel

George Chinnery

see Governors-general series: A 3792
Gilbert Elliot, earl of Minto

Carlo Cignani

see Miniatures: Ramelli, Felice, A 4363 Joseph and Potiphar's wife, copy after Cignani

attributed to **Giovanni Battista Cima da Conegliano**

Conegliano ca 1459–1517/18 Conegliano

A 1219 Madonna and child. *Maria met kind*

Panel transferred to canvas 83 × 68
PROV Purchased in 1831. KKS, 1885
LIT Burckhardt 1905, p 117. Crowe & Cavalcaselle 1912, p 252. Venturi 1901-40, vol 7:4 (1915) p 646. T Borenius, Burl Mag 57 (1930) p 71. L Venturi, L'Arte 37 (1934) p 495. R van Marle, Boll d'Arte 29 (1935) p 391. Van Marle 1923-38, vol 17 (1935) p 444ff. Berenson 1936, p 125. Berenson 1957, vol 1, p 65, fig 475. V Lasareff, Arte Ven 11 (1957) p 40. Berenson 1958, p 66. Coletti 1959, p 46, nr 119, ill (late work). Exhib cat Cima da Conegliano, Treviso 1962, nr 74, fig 81. F Heinemann, Kunstchronik 15 (1962) p 319 (Benedetto Diana, ca 1500-10)

manner of **Giovanni Battista Cima da Conegliano**

A 3389 Madonna and child. *Maria met kind*

Panel 23.5 × 19.5
PROV Bequest of J W Edwin vom Rath, Amsterdam, 1941

attributed to **Allaert Claesz**

active 1st half of the 16th century in Amsterdam

C 366 Eighteen guardsmen of the arquebusiers' civic guard, Amsterdam, 1534. *Achttien schutters van de Kloveniersdoelen te Amsterdam, 1534*

Panel 125 × 225. Dated *1534*
PROV Kloveniersdoelen (headquarters of the arquebusiers' civic guard), Amsterdam. On loan from the city of Amsterdam, 1885-1975
LIT J Six, OH 13 (1895) p 106. Sterck 1928, p 53. Riegl 1930, pp 68-71, fig 12 (Dirck Jacobsz). De Vries 1934, p 39 (Cornelis Anthonisz). Hoogewerff 1936-47, vol 3 (1939) p 518, figs 277-78 (Master Herman)

Pieter Claesz

Burg-Steinfurt 1597/98 – 1660 Haarlem

A 4646 Still life with turkey pie. *Stilleven met kalkoenpastei*

Panel 75 × 132. Signed and dated *PC A°
1627*
PROV Purchased from J C N Graaf van Lynden, St Michielsgestel, 1974, through the S Nijstad gallery, The Hague, with

aid from the Rembrandt Society, the Prince Bernhard Foundation and the Photo Commission
LIT Bergström 1956, pp 118-19, fig 104

A 3930 Vanitas still life with the Spinario. *Vanitas stilleven met de Doorn-uittrekker*

Panel 70.5 × 80.5. Signed and dated *P. Claesz. 1628*
PROV Purchased from A Brod gallery, London, 1958
LIT Van Gelder 1958, p 19, ill. P Gammelbo, Antichità 2 (1963) pp 30-31, ill. R Oertel, Münchn Jb, 1963, p 114, note 52. Fr W S van Thienen, OKtv 1 (1963) nr 1, fig 8. Exhib cat De schilder in zijn wereld, Delft-Antwerp 1964-65, nr 19

A 1857 Still life. *Stilleven*

Panel 64 × 82. Signed and dated *PC A°
1647*
PROV Purchased from H Bols, Groningen, 1900
LIT Martin 1935-36, vol 1, pp 407-08, fig 245. Vroom 1945, p 191, fig 178, nr 64. Bergström 1956, p 116. A Crébas, Kunstrip 3 (1972-73) nr 24

Jacques Grief *called* **de Claeu**

active 1642 in Dordrecht and The Hague; d after 1665

A 1444 Vanitas still life. *Vanitas stilleven*

Panel 54 ×71. Signed and dated
J.D.Claew f. 1650
PROV Presented by Dr A Bredius, The
Hague, 1888
LIT Vorenkamp 1933, p 105. Bergström
1937, p 184. J Buyck, Jb Mus
Antwerpen, 1962-63, p 172, fig 2. Bol
1969, p 96, fig 81

Hendrick de Clerck II

Brussels 1570 – 1629 Brussels

A 621 The contest between Apollo and
Marsyas. *De wedstrijd tussen Apollo en
Marsyas*

Copper 43 ×62
PROV Purchased with the Kabinet van
Heteren Gevers, The Hague-Rotterdam,
1809
LIT Moes & van Biema 1909, pp 146,
157. De Maeyer 1955, p 87, fig 19.
Vicomte Terlinden, Revue belge d'Arch
& d'Hist d'Art 21 (1952) p 104, fig 5

A 1461 Susanna and the elders. *Suzanna
en de ouderlingen*

Panel 172.5 ×196
PROV Sale J Hollender, Brussels, 10-12
April 1888, lot 141 (as Otto Vaenius) *
DRVK since 1953
LIT C Hofstede de Groot, OH 17 (1899) p
169

J de Clercq

biographical data unknown

C 1561 Still life. *Stilleven*

Canvas 48.5 ×57. Signed and dated *J. de
C 1860*. Inscribed on the verso *J de Clercq
ft 1860*
PROV On loan from the KOG (bequest of
S de Clercq, 1862) since 1973

attributed to **Joos van Cleve**

Kleve? ca 1464 – ca 1540 Antwerp

A 165 Portrait of a man. *Portret van een
man*

Panel 58.5 ×43.5
PROV Nationale Konst-Gallery, The
Hague, 1801 (as a Holbein portrait of
Maximilian of Austria). NM, 1808 * On
loan to the KKS (cat 1968, p 17, nr 895)
since 1951

LIT C Hofstede de Groot, OH 12 (1904)
pp 111-12. Moes & van Biema 1909, p
209. Ring 1913, p 67. Winkler 1924, p
252. Von Baldass 1925, p 28, cat nr 67,
fig 63. Friedländer 1924-37, vol 9 (1931)
p 141, nr 87 (ca 1525)

school of **Joos van Cleve**

A 3293 Maximilian I (1459-1519),
emperor of the Holy Roman Empire.
Keizer van het Heilige Roomse Rijk

Panel 34.5 ×24
PROV Presented by Mr & Mrs DAJ
Kessler-Hülsmann, Kapelle op den
Bosch near Mechelen, 1940
LIT Von Baldass 1925, p 7, cat nr 8, note
27. P Bautier, Onze Kunst 46 (1929) p
139. Friedländer 1924-37, vol 9 (1931) p
139, nr 71

copy after **Joos van Cleve**

A 3292 Joris W Vezeler

Copy after the original in the National
Gallery of Art, Washington (cat nr 1662)

Panel 58 ×38.5. Ends in a round arch

PROV Presented by Mr & Mrs D A J Kessler-Hülsmann, Kapelle op den Bosch near Mechelen, 1940
LIT Von Baldass 1925, nr 37. Friedländer 1924-37, vol 9 (1931) p 144, nr 117a. *Cf* Annual Report of the Smithsonian Inst, 1963, p 208, fig 12

attributed to **Maarten van Cleve**

Antwerp 1527–1581 Antwerp

A 836 Couples making love at a country inn. *Minnende paren bij een boerenherberg*

Panel 23.5 × 30.5. Signed *AR*
PROV Presented by Dr A Bredius, The Hague, 1884
LIT P Wescher, OH 46 (1929) p 163, fig 9 (Pieter Pietersz)

François Clouet

see Miniatures: French school ca 1500, A 4404 Louise of Savoy, perhaps by Clouet; French school ca 1550, A 4405 Henri II, copy after Clouet

attributed to **Jan Wellens de Cock**

active 1506-27 in Antwerp

A 1598 Triptych: Calvary, with donors (open); St Christopher with the Christ child on the road of life (closed). *Drieluik met Kruisberg en stichters (open); de heilige Christophorus met het Christuskind op de Weg des Levens (gesloten)*

Panel 37 × 25.5 (middle panel) 32.5 × 10 (each of the wings)
PROV Purchased from Durand Ruel gallery, Paris, 1893
LIT M J Friedländer, Zeitschr B K ns 29 (1918) p 67. Beitz 1922, p 21, fig 13. Winkler 1924, p 214. Gavelle 1931. Friedländer 1924-37, vol 11 (1933) pp 63, 126, nr 112. N Beets, OH 53 (1936) p 59, figs 49-50 (attributed to Lucas Cornelisz de Cock). Hoogewerff 1936-47, vol 3 (1939) p 374 (Cornelisz de Cock). L von Baldass, Jb Kunsth Samml Wien ns 11 (1937) p 125

Louis Bernard Coclers

Liège 1740–1817 Liège

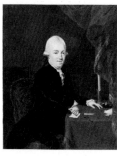

C 8 Jan Bernd Bicker (1746-1812). Amsterdam merchant and banker, chairman of the national assembly in 1796. *Koopman en bankier te Amsterdam, in 1796 voorzitter van de Nationale Vergadering*

Pendant to C 9

Panel 44.5 × 36. Signed and dated *L.B.Coclers ft. 1776*
PROV On loan from the city of Amsterdam (Bicker bequest), 1881-1975

C 9 Catharina Six (1752-93). Wife of Jan Bernd Bicker. *Echtgenote van Jan Bernd Bicker*

Pendant to C 8

Panel 44 × 36.5. Signed and dated *L.B.Coclers 1776*
PROV Same as C 8

A 642 A mother and her child. *Een moeder met haar kind*

Panel 36 × 45. Signed on the verso *L.B.Coclers 1794*
PROV Purchased at exhib Amsterdam 1808, nr 8
LIT Scheen 1946, fig 28

Cornelis de Cocq

see Governors-general series: A 3786 Sebastiaan Cornelis Nederburgh

Pieter Codde

Amsterdam 1599–1678 Amsterdam

see also Hals, Frans & Pieter Codde, C 374 The company of Captain Reynier Reael

C 1578 Cavaliers and ladies. *Galant gezelschap*

Panel 54 × 68. Signed and dated *PC 1635*
PROV Lent anonymously, 1974

LIT Granberg 1911-12, nr 485, ill 39. E de Jongh, Simiolus 3 (1968-69) pp 41, 43, ill 13

A 2836 Family group. *Familiegroep*

Panel 55 × 74. Signed and dated *PC 1642*
PROV Sale Amsterdam, 13 April 1920, lot 76

A 789 The adoration of the shepherds. *De aanbidding der herders*

Panel 55.5 × 46. Signed and dated *PC 1645*
PROV Sale Amsterdam, 14-15 Nov 1883, lot 29
LIT F Benoit, Rev Art Anc & Mod 35 (1914) p 16. P Brandt Jr, Historia 12 (1947) p 33, fig 8

studio of **Pieter Coecke van Aelst**

Aalst 1502 – 1550 Brussels

A 2594 Triptych with the adoration of the magi. *Drieluik met de aanbidding der koningen*

Panel 75 × 50 (middle panel); 75 × 21 (each of the wings)
PROV Lent by C Hoogendijk, The Hague, 1907. Presented from his estate in 1912
LIT *Cf* Marlier 1966, p 157, fig 92

copy after **Pieter Coecke van Aelst**

A 3464 The holy family. *De heilige familie*

Copy after a studio work

Panel 60 × 90
PROV Lent by the ministry of defense, The Hague, to the Oud Gorcum Society, Gorkum, ca 1935. On the inventory of the RMA since 1944 * DRVK since 1956
LIT *Cf* Marlier 1966, p 241, fig 180

Jacob Jansz Coeman

active 1656-76 in Amsterdam and Batavia

see also Governors-general series: A 3765 Joan Maetsuyker; A 4535 Joan Maetsuyker

A 4062 Pieter Cnoll. Senior merchant of Batavia, his wife Cornelia van Nieuwenrode, and their daughters Catharina (b 1653) and Hester (b 1659). *Eerste opperkoopman te Batavia, zijn echt-genote Cornelia van Nieuwenrode en hun dochters Catharina en Hester*

Canvas 130 × 190.5. Signed and dated *J. Coeman fec. Batᵃ 1665*
PROV Purchased from N Israël gallery, Amsterdam, 1961
LIT C Hofstede de Groot, Bull NOB 2d ser 1 (1908) p 241. C Hofstede de Groot, Cicerone 1 (1909) p 227. Starye Gody 1916, p 12, note 5, ill opp p 6. H Schneider, Ned Indië 6 (1921) fig 6. J de Loos-Haaxman, Tijdschr Ind TLV 27 (1937) p 592ff, ill. Stapel 1939, p 499. De Loos-Haaxman 1941, p 69, fig 30. CH de Jonge, Historia 8 (1947) p 195ff. Pott 1962, ill on p 67. De Loos-Haaxman 1968, pp 6, 11, 32, fig 3. G L Berk, Spiegel Hist 7 (1972) fig 2 on p 552. Exhib cat Nederlandse schilders en tekenaars in de Oost, Amsterdam 1972, nr 2

attributed to **Jacob Jansz Coeman**

A 807 Portrait of a girl, perhaps of the van Riebeeck family. *Portret van een meisje, wellicht uit de familie van Riebeeck*

Pendant to A 809

Canvas 118 × 83. Inscribed *Aetatis … Aᵒ 1663*. The age of the sitter was read by Godée Molsbergen (see LIT) as *3*
PROV Presented by Jonkheer J H F K van Swinderen, Groningen, 1884
LIT Moes 1897-1905, vol 2, nr 6425 (portrait of Geertruida van Riebeeck). Godée Molsbergen 1912, p 282. De Haan 1922-23, fig L 6. J de Loos-Haaxman, Tijdschr Ind TLV 27 (1937) p 590ff (portrait of Elisabeth van Riebeeck). De Loos-Haaxman 1941, p 71, fig 31. De Loos-Haaxman 1968, pp 11, 32. Exhib cat Nederlandse schilders en tekenaars in de Oost, Amsterdam 1972, nr 3, ill

A 809 Portrait of a boy, perhaps of the

van Riebeeck family. *Portret van een jongetje, wellicht uit de familie van Riebeeck*

Pendant to A 807

Canvas 118 × 83. Inscribed *Aetatis… A° 1663*. The age of the sitter was read by Godée Molsbergen (see LIT) as $1\frac{1}{2}$
PROV Same as A 807
LIT Moes 1897-1905, vol 2, nr 6429 (portrait of a brother of Geertruida van Riebeeck). Godée Molsbergen 1912, p 282. J de Loos-Haaxman, Tijdschr Ind TLV 27 (1937) p 590ff (portrait of Joanna van Riebeeck). De Loos-Haaxman 1941, p 71, ill 32. De Loos-Haaxman 1968, pp 11, 32. Exhib cat Nederlandse schilders en tekenaars in de Oost, Amsterdam 1972, nr 4, ill

Constantinus Fidelio Coene

Vilvoorde 1780–1841 Brussels?

A 1020 A collision at the Porte de Hal, Brussels. *Een aanrijding bij de Halpoort te Brussel*

Panel 95 × 124. Signed and dated *C. Coene 1823*
PROV Purchased in 1825. RVMM, 1885 * DRVK since 1957 (on loan to the Belastingmuseum, Rotterdam)

Jean Henri de Coene

Nederbrakel 1798–1866 Brussels?

A 1021 Market gossip. *Marktnieuws*

Canvas 109 × 128. Signed and dated *H. Decoene ft. 1827*
PROV Purchased at exhib Ghent 1829. RVMM, 1885 * DRVK since 1953

Johan George Colasius

active 1st half of the 18th century in Utrecht

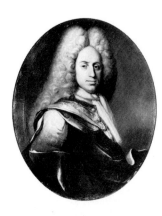

A 2105 Hieronymus Josephus Boudaen, lord of St Laurens and Popkensburg. *Heer van St Laurens en Popkensburg*

Canvas 77 × 64. Oval. Signed *Colasius fec.*
PROV Bequest of Jonkheer J de Witte van Citters, The Hague, 1876. Received in 1903

Edwaert Collier

b Breda, active Haarlem and Leiden; d between 1696 and 1702

A 3471 Vanitas still life. *Vanitas stilleven*

Canvas 102.5 × 132. Signed and dated *E. Collier 1662*
PROV Bequest of G H Kroon, Amsterdam, 1945

Richard Collins

see under Miniatures

Adam de Colonia

Rotterdam 1634–1685 London

A 1518 Fire by night in a village. *Nachtelijke brand in een dorp*

Panel 64.5 × 58. Signed *AD Colonia*
PROV Sale van Goethem de Soere, Amsterdam, 1 April 1890, lot 18

David Colijns

Rotterdam 1582–after 1668 Amsterdam?

A 1617 The ascension of Elijah. *De hemel-vaart van Elia*

Panel 40.5 × 73. Signed and dated *D. Colijns 1627*
PROV Presented by Dr A Bredius, The Hague, 1894
LIT A D de Vries Azn, OH 3 (1885) p 79. Bernt 1960-62, vol 4, nr 50. De Maeyer 1955, p 86, fig XV

Jan ten Compe

Amsterdam 1713–1761 Amsterdam

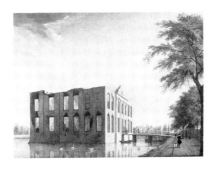

C 1529 Berckenrode Castle, Heemstede, after the fire of 4-5 May 1747: side view. *Het Slot Berckenrode te Heemstede na de brand van 4-5 mei 1747: zijaanzicht*

The castle was burnt to the ground during the illuminations honoring the accession of Prince Willem IV to the stadholdership

Pendant to C 1530

Panel 39 ×45. Signed and dated *J. T.Compe f. 1747* PROV On loan from the KOG (LMBeels van Heemstede bequest) since 1885

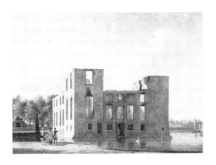

C 1530 Berckenrode Castle, Heemstede, after the fire of 4-5 May 1747: rear view. *Het Slot Berckenrode te Heemstede na de brand van 4-5 mei 1747: achteraanzicht*

Pendant to C 1529

Panel 39 ×52. Signed and dated *J. T.Compe f. 1747* PROV Same as C 1529

Adriaen van Conflans

active 1580-1607 in Amsterdam

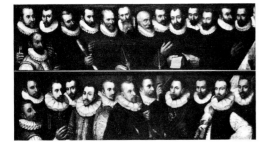

C 791 The company of Captain Dirck Thymansz Brouwer and Lieutenant Ryckert Ouwerol, Amsterdam, 1595. *Het korporaalschap van kapitein Dirck Thymansz Brouwer en luitenant Ryckert Ouwerol, Amsterdam, 1595*

The other sitters include Pieter Bas, ensign, Gillis Stokman, Reinier Klaas Reiniersz, Cornelis Krijnen, Claes Thymansz Visser, Jacob Smit, Tobias Martsz, Claes Garbransz and Jacob Cornelisz

Panel 138 × 261. Part of the panel at the right with nine guardsmen is missing. The remaining piece is sawn in three PROV Handboogdoelen (headquarters of the archers' civic guard), Amsterdam. On loan from the city of Amsterdam, 1885-1975 LIT Scheltema 1855-85, vol 7 (1885) p 129. W del Court & J Six, OH 21 (1903) p 73. J Six, OH 29 (1911) p 198. De Vries 1934, p 75. Hoogewerff 1936-47, vol 4 (1941-42) p 650

David de Coninck

Antwerp 1646–after 1699 Brussels

A 72 The deer hunt. *De hertenjacht*

Canvas 192 × 187. Signed *David de Coninck* PROV Sale G van der Pot van Groeneveld, Rotterdam, 6 June 1808, lot 24 * Lent to the Dutch legation, Berlin, 1924. Destroyed in the war, 1943 LIT Moes & van Biema 1909, pp 113, 183. G J Hoogewerff, Annuaire Mus Roy Belgique 4 (1943-44) p 94

A 73 The bear hunt. *De berenjacht*

Canvas 190 × 186. Signed *D. de Coninck* PROV Sale G van der Pot van Groeneveld, Rotterdam, 6 June 1808, lot 24 * Lent to the Dutch legation, Berlin, 1924. Destroyed in the war, 1943 LIT Moes & van Biema 1909, pp 113, 183. G J Hoogewerff, Annuaire Mus Roy Belgique 4 (1943-44) p 94

A 618 Hunting with the falcon. *De valkenjacht*

Canvas 185.5 × 189. Signed *David de Coninck f.* PROV Sale G van der Pot van Groeneveld, Rotterdam, 6 June 1808, lot 24 * Lent to the Dutch legation, Berlin, 1924. Destroyed in the war, 1943 LIT Moes & van Biema 1909, pp 113, 183. G J Hoogewerff, Annuaire Mus Roy Belgique 4 (1943-44) p 94, fig 1. Bernt 1960-62, vol 4, nr 51

NO PHOTOGRAPH AVAILABLE

A 617 Hunting dogs and dead game. *Jachthonden en dood wild*

A dead goose hangs in a tree, and on the ground is the rest of the bag–partridges, pheasants and a fox–and implements of the hunt–a horn, rifles and knives

Canvas 185.5 × 185

PROV Sale G van der Pot van
Groeneveld, Rotterdam, 6 June 1808, lot
24 * Lent to the Dutch legation, Berlin,
1924. Destroyed in the war, 1943
LIT Moes & van Biema 1909, pp 113,
183. G J Hoogewerff, Annuaire Mus Roy
Belgique 4 (1943-44) p 94

Jan Daemen Cool

Rotterdam 1589–1660 Rotterdam

A 1787 Pieter Pietersz Heijn (1588-
1629). Vice admiral of Holland.
Luitenant-admiraal van Holland

Panel 65 × 50. Dated *A° 1629*
PROV Sale Amsterdam, 8 Nov 1898, lot
19 (as Johannes Dane)
LIT Moes 1897-1905, nr 3498:1. R van
Luttervelt, Bull KNOB 6th ser 7 (1954)
p 147

Coolhaas

see Colasius

Alexander Cooper

see under Miniatures

Samuel Cooper

see under Miniatures

Adriaen S Coorte

active 1685-1707 in Middelburg?
174

A 2099 Still life with asparagus. *Stilleven met asperges*

Paper on panel 25 × 20.5. Signed and
dated *A.Coorte 1697*
PROV Bequest of AA des Tombe, The
Hague, 1903
LIT W Steenhoff, Bull NOB 4 (1902-03) p
121. Beeldende Kunst 4 (1919) nr 77.
Warner 1928, fig 23a. Zarnowska 1929,
p 11, fig 49. Vorenkamp 1933, p 72.
Martin 1935-36, vol 2, p 490, ill. Van
Luttervelt 1947, p 60. L J Bol, NKJ 6
(1952-53) p 215, nr 14. Leymarie 1956,
pp 175-76. Exhib cat Adriaen Coorte,
Dordrecht 1958, nr 6. G von der Osten,
Wallraf-R Jb 31 (1969) p 141, fig 97.
Bol 1969, p 360

Corneille de Lyon

b The Hague, active Lyon 1544-74

A 3037 Portrait of a man. *Portret van een man*

Panel 15.5 × 13
PROV Lent by M P Voûte, Amsterdam,
1924. Presented in 1926
LIT Faggin 1966, fig 4

A 3294 Portrait of a man. *Portret van een man*

Panel 20 × 17.2
PROV Presented by Mr & Mrs D A J
Kessler-Hülsmann, Kapelle op den
Bosch near Mechelen, 1940

Cornelis Cornelisz van Haarlem

Haarlem 1562–1638 Haarlem

A 128 The massacre of the innocents. *De kindermoord te Bethlehem*

Canvas 245 × 328. Signed and dated
C.Cornely H.fecit A° 1590
PROV NM, 1808
LIT V de Stuers, Ned Spec, 1874, p 330.
Moes & van Biema 1909, pp 37, 41, 49,
128, 159, 211. Wedekind 1911, pp vi, 16-
17. W Stechow, Elsevier's GM 45 (1935)
p 81. Gerson 1950, p 40, fig 105
(dimensions and owner listed wrongly).
Reznicek 1961, p 159. Würtenberger
1962, p 52, ill on p 61. Faggin 1967, p 3.
M Haraszti-Takacs, Bull Mus Hongrois
30 (1967) p 65

A 129 The fall of man. *De zondeval*

Canvas 273 × 220. Signed and dated
C.C.H. f. A° 1592
PROV Prinsenhof, Haarlem, 1804. NM,
1808
LIT Van Mander 1604, fol 293r. Van der
Willigen 1866, p 99. Moes & van Biema
1909, pp 77, 159, 176, 210. Wedekind
1911, pp vi, 20. C J Gonnet, OH 33 (1915)
p 140. L von Baldass, in Meisterwerke,
1920. W Stechow, Elsevier's GM 45 (1935)
p 81. H Kaufmann, in Vom Nachleben
Dürer's, 1954, p 42, fig 15. J Bruyn, Bull
RM 2 (1954) p 53 (on the provenance).
P J J van Thiel, Master Drawings 3
(1965) pp 128, 130-31. Faggin 1967, pp
3, 5. P J J van Thiel, Simiolus 2 (1967-68)
p 97, fig 8. A Heimann, Jb Ksamml
Baden-Württemberg 6 (1969) p 234, fig
33. Judson 1970, p 80, note 7

A 3892 Bathsheba in the bath. *Het toilet
van Bathseba*

Canvas 77.5 × 64. Signed and dated
CCH 1594
PROV Purchased from A Bloch gallery,
Paris, 1955
LIT P Mantz, GdB-A 10 (1965) pp 102-
03. Kunoth-Leifels 1962, pp 58-60, fig
48. Bousquet 1964, ill on p 197. Faggin
1967, p 5, pl VIII. M Haraszti-Takacs,
Bull Mus Hongrois 30 (1967) p 65. E K J
Reznicek, OK 11 (1967) nr 69, ill

A 1241 Pieter Jansz Kies (ca 1536-97).
Burgomaster of Haarlem. *Burgemeester
van Haarlem*

Panel 97 × 81. Dated *A° 1596 æ 60*.
Inscribed *Kiest het best*
PROV Presented by J S R van de Poll,
Arnhem, 1885
LIT Ver Huell 1875, nr 246. De Vries
1934, p 83

A 3016 Venus and Mars. *Venus en Mars*

Panel 31.5 × 42. Signed and dated
CH 1623
PROV Purchased from W Palte,
Rotterdam, 1924, as a gift of the Photo
Commission
LIT M Haraszti-Takacs, Bull Mus
Hongrois 30 (1967) p 68, fig 48

A 4015 Pomona receiving the harvest of
fruit. *Pomona ontvangt de fruitoogst*

Panel 44.5 × 32. Signed and dated
CH 1626
PROV Transferred by the DRVK in 1960

copy after **Cornelis Cornelisz van
Haarlem**

A 127 Dirck Volkertsz Coornhert (1522-
90). Writer and engraver. *Letterkundige en
graveur*

Panel 42 × 32.5
PROV Remonstrant Church, The Hague,
1804. NM, 1808
LIT Moes 1897-1905, vol 1, nr 1698:3. C
Hofstede de Groot, OH 19 (1901) p 138
(17th-century copy). Moes & van Biema
1909, pp 66-67, 176, 206. Wedekind
1911, pp vi, 14-15 (original). Ring 1913,
pp 58-59, 168. Van Hall 1963, p 65, nr
408:1

attributed to **Cornelis Cornelisz Kunst**

Leiden 1493 – 1544 Leiden

A 1725 Wing of an altarpiece: the
circumcision (front); grisaille of a sibyl
(back). *Altaarluik met besnijdenis en (op de
buitenkant in grisaille) een sibylle*

Panel 48 × 26
PROV Purchased from Fr Muller & Co,
art dealers, Amsterdam, 1898 * On loan
to the KKS (cat 1968, p 19, nr 880, ill [ca
1520]) since 1948
LIT Friedländer 1924-37, vol 11 (1933)
pp 66, 70, 126, nr 106 (Jan de Cock). N
Beets, OH 53 (1936) p 73 (Lucas Cornelisz
Kunst or Cornelis Cornelisz Kunst). L
von Baldass, Jb Kunsth Samml Wien ns
11 (1937) p 125, fig 132. Hoogewerff
1936-47, vol 3 (1939) p 374, figs 198-99
(Lucas Cornelisz Kunst)

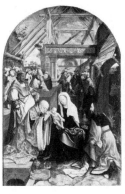

Jacob Cornelisz van Oostsanen

Oostzaan before 1470–1533 Amsterdam

C 1554 Triptych with the adoration of the magi. *Drieluik met de aanbidding der koningen*

Left wing: the donor and his six sons, St Jerome, a coat of the arms of his ancestors Heereman, Vanolles, Zeller and Baerland (inside); St Christopher and the coat of arms of the Heereman family (outside). Right wing: the donor's wife and her seven daughters, St Catherine, a coat of arms partly of the Heereman family and partly unidentified (inside); St Anthony and a coat of arms with an unidentified mark (outside)

Panel 83 × 56 (middle panel); 83 × 25 (each of the wings). Dated *1517*. Inscribed on the outside of the left wing *SCS Christoferus* and on the outside of the right wing *SCS Anthonius*
PROV On loan from J W Middendorf II since 1973
LIT J D Passavant, Kunstblatt, 1841, p 46 (Lucas van Leyden). L Scheibler, Jb Preusz Kunstsamml 3 (1882) p 22. Cat Kunsthistorische Ausstellung, Düsseldorf 1904, p 85, nr 197. Steinbart 1917/18-1922, pp 107, 157. J Six, OH 42 (1925) p 35 (Jan van Hout?). J Six, OH 43 (1926) p 141 (Jan van Hout). J F M Sterck, OH 43 (1926) p 249. K Steinbart, Marb Jb 5 (1929) p 234. Friedländer 1924-37, vol 12 (1935) nr 239. Hoogewerff 1936-47, vol 3 (1939) p 120. Exhib cat Middeleeuwse kunst der Noordelijke Nederlanden, Amsterdam 1958, p 99, nr 107. W Wegner, Kunstchronik 12 (1959) p 8

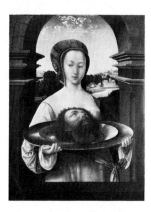

C 1349 Salome and the head of John the Baptist. *Salome met het hoofd van Johannes de Doper*

Panel 73 × 53.5. Signed and dated *I.A. 1524* (between the letters *I* and *A* is the painter's mark)
PROV Cabinet of Prince Willem V, The Hague, 1795. On loan from the KKS since 1948
LIT L Scheibler, Jb Preusz Kunstsamml 3 (1882) p 18. N Beets, Onze Kunst, 1914, p 86. Steinbart 1922, pp 125, 155, fig 11. Winkler 1924, p 232. Burger 1925, p 152, fig 264. Dülberg 1929, p 163. Friedländer 1924-37, vol 12 (1935) pp 104, 197, nr 284. Hoogewerff 1936-47, vol 3 (1939) p 126, fig 64. N Beets, in Kunstgesch der Ned, 1954-56, vol 1, p 438. VTTT, 1961-62, nr 45

A 668 Saul and the witch of Endor. *Saul bij de heks van Endor*

Panel 87.5 × 125. Signed and dated *I.A. A° 1526 noveb. 29* (between the

letters *I* and *A* is the painter's mark)
PROV Sale Beauvois, Valenciennes, 19 May 1879, lot 1 (as J W van Assen)
LIT W Bode, Rep f Kunstw 6 (1881) p 300. L Scheibler, Jb Preusz Kunstsamml 3 (1882) p 18. F Dülberg, Zeitschr BK 10 (1899) p 276. Hoogewerff 1912, p 34. N Beets, Onze Kunst 25-26 (1914) p 86. Steinbart 1922, pp 143, 152. Winkler 1924, p 228. J Six, OH 42 (1925) p 4, fig 2. Burger 1925, fig 263. Dülberg 1929, p 163. Smits 1933, p 26. Friedländer 1924-37, vol 12 (1935) pp 102, 194, nr 250, fig 1L. Hoogewerff 1936-47, vol 3 (1939) p 132, figs 66-67. N Beets, in Kunstgesch der Ned, 1954-56, vol 1, p 438. Von der Osten & Vey 1969, p 164. E M Schenk, Raggi 10 (1970) pp 48, 50, fig 7, note 38. K Strauss, Keramik-Freunde 84 (1972) p 37, pl 44, fig 7

A 1405 Self portrait. *Zelfportret*

Panel 38 × 30. Signed and dated *I.A. 1533* (between the letters *I* and *A* is the painter's mark)
PROV Purchased from A Myers & Son gallery, London, 1887
LIT Moes 1897-1905, vol 1, nr 1721. Ring 1913, pp 53, 71, 114. N Beets, Onze Kunst 25-26 (1914) p 86. Steinbart 1922, pp 143, 152, fig 1. Winkler 1924, p 228. J Six, OH 42 (1925) p 17, fig 17. C M A A Lindeman, Burl Mag 46 (1925) pp 29-30. K Steinbart, Marb Jb 5 (1929) p 247, fig 70 (probably a fragment). Dülberg 1929, p 162. De Vries 1934, p 12. Friedländer 1924-37, vol 12 (1935) pp 97, 197, nr 162, pl IV. Hoogewerff 1936-47, vol 3 (1939) p 133, fig 68 (fragment). H M Cramer, Med RKD 2 (1947) p 31. N Beets, in Kunstgesch der Ned, 1954-56, vol 1, p 438. C Müller-Hofstede, in Festschrift Winkler, 1959, p 234, fig 9. Van Hall 1963, nr 414:4. Exhib cat De schilder in zijn wereld, Delft-Antwerp 1964-65, nr 28, fig 4. Von der Osten & Vey 1969, p 164, fig 152

A 3838 Jan Gerritsz van Egmond (d 1523). Bailiff of Nieuwburg. *Baljuw van Nieuwburg*

Panel 41.5 × 33.5
PROV Purchased from E A Veltman, Bussum, 1952
LIT Friedländer 1924-37, vol 12 (1935) pp 110, 198, nr 293a (ca 1516). Hoogewerff 1936-47, vol 2 (1937) p 418, fig 203. Gerson 1950, p 21, fig 49. J Belonje, Jb Genealogie, 1955, p 6 (identification of the sitter). Belonje 1956, ill

attributed to **Jacob Cornelisz van Oostsanen**

C 1125 Korsgen Elbertszen (d 1503), his sons Dirck and Albert, aldermen of Amsterdam, and his son-in-law Heyman Jacobsz van Ouder-Amstel, burgomaster of Amsterdam, as donors. *Korsgen Elbertszen, zijn zoons Dirck en Albert, schepenen van Amsterdam, en zijn schoonzoon Heyman Jacobsz van Ouder-Amstel, burgemeester van Amsterdam, als schenkers*

Panel 90 × 57. Fragment of an altarpiece. The right half of another fragment, with female donors, is partially preserved in the Agnietenkapel, Amsterdam. The middle panel has been lost
PROV Agnietenkapel, Amsterdam. On

loan from the city of Amsterdam, 1923-75
LIT Le Long 1729, p 418, ill. L Scheibler, Jb Preusz Kunstsamml 3 (1882) p 17 (ca 1506). B J M de Bont, Jb Alberdingk Thijm 3 (1893) p 149. Klönne 1894, p 283. Moes 1897-1905, vol 1, nr 2311. J F M Sterck, OH 37 (1919) p 87 (attributed to Jan van Hout). Steinbart 1922, p 48. J Six, OH 42 (1925) p 13 (van Hout, before 1503). J H H Kessler, Oudh Jb 1 (1932) p 102 (Alkmaar master, perhaps Cornelis Buys). Friedländer 1924-37, vol 12 (1935) pp 112, 197, nr 287. Hoogewerff 1936-47, vol 3 (1939) p 137. N Beets, in Kunstgesch der Ned, 1954-56, vol 1, p 438

A 1967 Calvary. *Kruisberg*

Panel 104 × 88
PROV Sale Baron van den Bogaerde van ter Brugge, Heeswijk Castle near 's-Hertogenbosch, 24 March 1902, lot 1, ill. Purchased through the intermediacy of the Rembrandt Society
LIT F Dülberg, Rep f Kunstw 23 (1900) p 208. M J Friedländer, Rep f Kunstw 24 (1901) p 328. B W F van Riemsdijk, Bull NOB 3 (1901-02) p 87 (milieu of Jacob Cornelisz). C Hofstede de Groot, OH 22 (1904) pp 34, 38. N Beets, Bull NOB 6 (1905) p 182. N Beets, Onze Kunst, 1914, p 86. Steinbart 1922, pp 78, 152, pl VIII-2. Winkler 1924, p 230. J Six, OH 42 (1925) p 17 (Jan van Hout, before 1512). J Six, OH 43 (1926) p 142. K Steinbart, Marb Jb 5 (1929) p 227, fig 24. J H H Kessler, Oudh Jb 1 (1932) p 102 (Alkmaar master, perhaps Cornelis Buys). Friedländer 1924-37, vol 12 (1935) pp 110, 195, nr 264. Hoogewerff 1936-47, vol 3 (1939) p 89, fig 39 (ca 1510). T Gerszi, OH 75 (1960) p 231, figs 4-5

manner of **Jacob Cornelisz van Oostsanen**

A 4294 Triptych with the last supper. *Drieluik met het laatste avondmaal*

Left wing: Adriana Oem (d 1527), abbess of Terlee or Leeuwenhorst, with St James Major. Right wing: a priest with Mary Magdalene

Verre églomisé 45.2 × 39.2 (middle panel); 45.2 × 19.1 (each of the wings)
PROV Sale Spitzer, Paris, 17 April-16 June 1893, lot 2116. NMGK
LIT Moes 1897-1905, vol 2, nr 5507

copy after **Jacob Cornelisz van Oostsanen**

A 976 Edzard I (1462-1528), count of East Friesland. *Graaf van Oost-Friesland*

Copy after the original in Oldenburg, Landesmuseum

Canvas 150 × 113. Inscribed *Edzardus i Comes et Dominus Frisiae Orientalis Natus Anno 1462 die 15 Febr: Mortuus Anno 1528 die Febr:*
PROV Sale Jonkheer U W F van Panhuys, Amsterdam, 26 Sep 1882, lot 32 (as anonymous). NMGK, 1885 * DRVK since 1959 (on loan to the Groninger Museum voor Stad en Lande, Groningen)

Jacobus Ludovicus Cornet

Leiden 1815–1882 Leiden

A 1464 David Pierre Giottino Humbert de Superville (1770-1849). Painter and writer. *Schilder en schrijver*

Panel 20 × 16. Signed *J.L.C.*
PROV Presented by Mrs S E Kneppelhout van Sterkenburg-Drabbe, widow of K J F C Kneppelhout van Sterkenburg, Utrecht, 1888
LIT Van Hall 1963, p 149, nr 1004:1

Jean Baptiste Camille Corot

Paris 1796–1875 Paris

A 2883 Algérienne

Canvas 41 × 60. Signed *Corot*
PROV Bequest of A van Wezel, Amsterdam, 1922
LIT Meier-Graefe 1930, fig 139. M Hours, Bull Lab du Louvre 7 (1962) p 2, ill (x-ray). Robaut 1965-66, vol 3, nr 2140 (1871-73). Hours 1973, p 158, fig 46 (1871-73)

A 2882 Landscape with pollard willows. *Landschap met knotwilgen*

Panel 40 × 30.5. Signed *Corot*
PROV Bequest of A van Wezel, Amsterdam, 1922

A 1862 Pond in the woods. *Bosvijver*

Panel 32 × 52. Signed *Corot*
PROV Presented by the dowager of R Baron van Lynden, née M C Baroness van Pallandt, The Hague, 1900

attributed to **Pietro da Cortona**

Cortona 1596–1669 Rome

C 1345 The holy family. *De heilige familie*

Canvas 99 × 74.5
PROV Purchased by Willem I, 1823. On loan from the KKS since 1948
LIT Briganti 1962, p 277 (Benedetto Luti?)

attributed to **Lorenzo Costa**

Ferrara 1460–1535 Mantua

A 3034 The holy family. *De heilige familie*

Panel 50 × 40
PROV Purchased from the Augusteum, Oldenburg, 1925, with aid from the Rembrandt Society
LIT Venturi 1901-40, vol 7:3 (1914) p 1031 (Zaganelli). Berenson 1932, p 155

Colijn de Coter

ca 1455–after 1539; active in Brussels and Antwerp?

A 856 The lamentation. *De bewening van Christus*

Panel 35.5 × 43
PROV Purchased from Mr van Gelder, The Hague, 1875. NMGK, 1875
LIT Friedländer 1924-37, vol 4 (1926) p 148, nr 104, pl LXXIII. W F Douwes, Mndbl BK 9 (1932) pp 178-84. Maquet-Tombu 1937, pp 44-46, note 2, pl XII

Gustave Courbet

Ornans 1819–1877 La Tour de Peilz

A 1863 View in the forest of Fontainebleau. *Gezicht in het bos van Fontainebleau*

Canvas 82 × 102. Signed and dated *G.Courbet 55*
PROV Presented by the dowager of R Baron van Lynden, née MC Baroness van Pallandt, The Hague, 1900

A 1865 Still life with apples. *Stilleven met appels*

Canvas 59 × 48. Signed and dated *G.Courbet St. Pelagie 1872*
PROV Presented by the dowager of R Baron van Lynden, née MC Baroness van Pallandt, The Hague, 1900
LIT Duret 1918, p 106

A 1864 Landscape with rocky cliffs and a waterfall. *Landschap met rotsen en waterval*

Canvas 61 × 73. Signed and dated *G.Courbet 78*

PROV Presented by the dowager of R Baron van Lynden, née MC Baroness van Pallandt, The Hague, 1900

A 3295 Winter landscape. *Winterlandschap*

Canvas on panel 35 × 45. Signed *G.C.*
PROV Presented by Mr & Mrs DAJ Kessler-Hülsmann, Kapelle op den Bosch near Mechelen, 1940

Joseph Désiré Court

Rouen 1797–1865 Rouen

C 303 Countess de Pagès, née de Cornellan, as St Catherine. *Gravin de Pagès, née de Cornellan, als de heilige Catharina*

Canvas 83 × 66. Signed *Court*
PROV On loan from the city of Amsterdam (A van der Hoop bequest) since 1885

Pierre Coustain

see Heraldic objects: A 4641 & A 4642

Thomas Couture

Senlis 1815–1879 Villiers-le-Bel

A 1866 'Lust for gold.' *'De gouddorst'*

Canvas 35 × 45. Signed *T.C.* Preliminary study for a painting in the museum of Toulouse
PROV Presented by the dowager of R Baron van Lynden, née MC Baroness van Pallandt, The Hague, 1900

Abraham Johannes Couwenberg

Delft 1806–1844 Arnhem

A 1022 Frolicking on a frozen canal in a town. *IJsvermaak op een stadsgracht*

Canvas 74 × 100. Signed *A.J.Couwenberg*
PROV Purchased at exhib The Hague 1837, nr 67. RVMM, 1885 * DRVK since 1959

Francesco Cozza

Stilo 1605–1682 Rome

A 4035 Hagar and Ishmael in the wilderness. *Hagar en Ismaël in de woestijn*

Canvas 72 × 97. Signed and dated *Fran^cus Cozza Pin^t 1665*
PROV Purchased from G Cramer gallery, The Hague, 1960
LIT L Mortari, Arte ant e mod, 1961, p 374, figs 179a, 180. J Offerhaus, Bull RM 10 (1962) pp 5-15. Roli 1966, fig 5. J Offerhaus, OK 13 (1969) nr 36, ill. E Schleier, Arte ill 43-44:4 (1971) p 7, fig 17

Wouter Crabeth II

Gouda ca 1595 – 1644 Gouda

A 1965 Doubting Thomas. *De ongelovige Thomas*

Canvas 240 × 308
PROV Presented by the elders of the Old Catholic Church 'In de Driehoek,' Utrecht, 1902
LIT Voss 1927, p 471, fig 134. Von Schneider 1933, p 48, fig 26a

Dirck Craey

b Amsterdam, active 1648-65 in The Hague

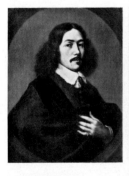 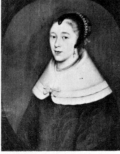

A 808 Johan Anthonisz van Riebeeck (1618-77). First commander of the Cape of Good Hope. *Eerste commandeur van Kaap de Goede Hoop*

Pendant to A 810

Panel 74 × 54
PROV Presented by Jonkheer J H F K van Swinderen, Groningen, 1884
LIT Moes 1897-1905, vol 2, nr 6428. Godée Molsbergen 1912, p 289ff, ill opp p 60. F Oudschans Dentz, Historia 10 (1945) p 164, ill. R van Luttervelt, Ned Post 5:11 (1952) pp 2-4. T Koot, Heemschut 45 (1968) p 46, ill

A 810 Maria de la Quevellerie (1629-64). Wife of Johan Anthonisz van Riebeeck. *Echtgenote van Johan Anthonisz van Riebeeck*

Pendant to A 808

Panel 74 × 59. Signed and dated *D.Craey F. 1650*
PROV Same as A 808
LIT Moes 1897-1905, vol 2, nr 6122. Godée Molsbergen 1912, p 280ff, ill opp p 60. F Oudschans Dentz, Historia 10 (1945) p 164, ill. T Koot, Heemschut 45 (1968) p 46, ill

Gijsbertus Craeyvanger

see Behr, Carel Jacobus & Gijsbertus Craeyvanger, A 1006 City wall

studio of **Lucas Cranach I**

Kronach 1472 – 1553 Weimar

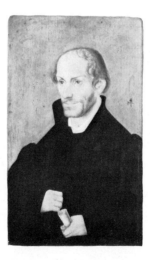

A 2561 Philip Melanchton (1497-1560). Leading figure of the Reformation. *Kerk-hervormer*

Panel 36 × 23. Signed *L* (crowned by Cranach's mark)
PROV Lent by C Hoogendijk, The Hague, 1907. Presented by his estate in 1912 * On loan to the KKS (cat 1968, p 21, nr 891, ill [ca 1545]) since 1951
LIT R Bangel, Cicerone 7 (1915) p 172. J Vercruysse, Spiegel Hist 4 (1969) p 290, fig 7

attributed to **Lucas Cranach II**

Wittenberg 1515 – 1586 Weimar

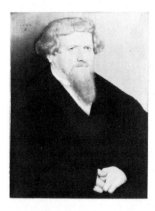

A 2560 Portrait of a man. *Portret van een man*

Panel 64 × 48. Marked with Cranach's mark and dated *1548*
PROV Lent by C Hoogendijk, The Hague, 1907. Presented by his estate in 1912 * On loan to the KKS (cat 1968, nr 890) since 1951

Crans

see Schmidt Crans

Casper de Crayer

Antwerp 1584 – 1669 Ghent

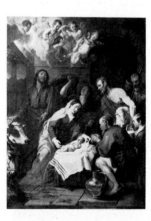

A 74 The adoration of the shepherds. *De aanbidding der herders*

Canvas 309 × 234
PROV Purchased from van Eyk gallery, The Hague, 1818 * DRVK since 1953
LIT Immerzeel 1842-43, vol 1, p 157. Drost 1926, p 83. Vlieghe 1972, p 161, nr A 105, fig 102

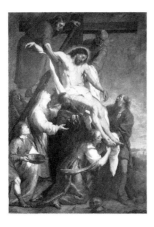

A 75 The descent from the cross. *De kruisafneming*

Canvas 309 × 224.5
PROV Purchased from van Eyk gallery, The Hague, 1818
LIT Immerzeel 1842-43, vol 1, p 157. Drost 1926, p 83. Knipping 1939-40, vol 2, p 191. Vlieghe 1972, p 162, nr A 106, fig 103

Carlo Crivelli

Venice 1435/40–after 1493 Venice

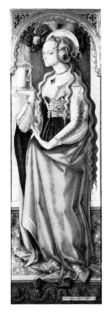

A 3989 Mary Magdalene. *Maria Magdalena*

Panel 152 × 49. Signed *Opus Karoli Crivelli Venet.*
PROV Coll F Mannheimer, Amsterdam. Lent by the SNK, later DRVK, 1949. Transferred in 1960
LIT W Bode, Jb Preusz Kunstsamml 11 (1890) p 63ff. Rushforth 1900, pp 27, 31, 58-59, 98. Crowe & Cavalcaselle 1912, vol 1, p 92. Venturi 1907, p 202. Drey

1927, pp 74, 88, 92, 107, 139, fig 54. Venturi 1930, vol 7, p 378, fig 290. Berenson 1932, p 138. Serra 1934, vol 2, p 390. Van Marle 1923-38, vol 18 (1936) pp 46, 60, ill on p 46. Zampetti 1952, p 58. Berenson 1952, vol 1, p 68. Godfrey 1954, pp 25, 41, fig 57. Berenson 1957, vol 1, p 68. R Pallucchini, Pantheon 19 (1961) p 279. Zampetti 1961, pp 36, 85, figs 78, 80. Exhib cat Crivelli e i Crivelleschi, Venice 1961, nr 23, ill. G Mariacher, Acropoli 2 (1961-62) p 46, ill. Bovero 1962, pp 37, 73, fig 89

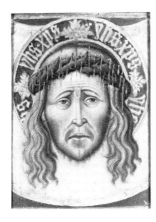

A 3994 St Veronica's cloth. *De zweetdoek van de heilige Veronica*

Panel 39.5 × 29
PROV O Lanz, Amsterdam. Lent by the DRVK, 1952. Transferred in 1960
LIT G Swarzenski, Münchn Jb, 1914-15, p 87, fig 1

Vittore Crivelli

active 1481-1501/02 in the Marches

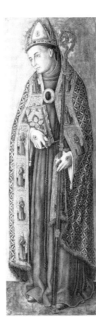
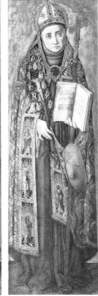

A 3390 St Louis of France. *De heilige Lodewijk van Frankrijk*

Belongs with A 3391

Panel 125.5 × 40
PROV Bequest of J W Edwin vom Rath, Amsterdam, 1941
LIT Crowe & Cavalcaselle 1912, vol 1, p 88. Berenson 1932, p 163. Van Marle 1923-38, vol 18 (1936) p 78. K E Schuurman, Mndbl BK 19 (1942) p 101, fig 2. Berenson 1952, vol 1, p 71. Di Provvido 1972, p 223, fig 73

A 3391 St Bonaventura. *De heilige Bonaventura*

Belongs with A 3390

Panel 125.5 × 40
PROV Same as A 3390
LIT Crowe & Cavalcaselle 1912, vol 1, p 88. Berenson 1932, p 163. Van Marle 1923-38, vol 18 (1936) p 78. K E Schuurman, Mndbl BK 19 (1942) p 101, fig 2. Berenson 1952, vol 1, p 71. Di Provvido 1972, p 223, fig 72

de la Croix

see Pastels: La Croix, de

attributed to **Adriaen van Cronenburg**

Schagen ca 1525 – 1604 or shortly thereafter Bergen

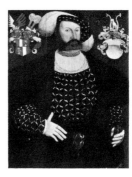
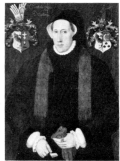

A 1993 Presumably posthumous portrait of Rudolph van Buynou (d 1542), high bailiff of Stavoren and 'grietman' of Gaasterland. *Vermoedelijk posthuum portret van Rudolph van Buynou, drost van Stavoren en grietman van Gaasterland*

Pendant to A 1994, which is dated 1553. Presumably painted in the same year

Panel 90 × 69. Inscribed *Rudolph van Buynou*
PROV Purchased from J J Boas Berg, Amsterdam, 1902 * DRVK since 1959 (on loan to the Fries Museum, Leeuwarden)
LIT Moes 1897-1905, vol 1, nr 1236

(portrait of Adolf van Bunau).
Wassenbergh 1935, p 94 (painted by
Adriaen van Cronenburg?)

A 1994 Cunera van Martena. Wife of
Rudolph van Buynou. *Echtgenote van
Rudolph van Buynou*

Pendant to A 1993

Panel 90 ×69. Inscribed *Aetatis suae 40
Anno 1553 Cunera van Martena*
PROV Same as A 1993 ∗ DRVK since
1959 (on loan to the Fries Museum,
Leeuwarden)
LIT Moes 1897-1905, vol 2, nr 4828.
Wassenbergh 1935, p 94 (painted by
Adriaen van Cronenburg?)

attributed to **Antonie Jansz van Croos**

ca 1606–after 1662 The Hague

RBK 15234 Decorated painter's box.
Beschilderd schilderskistje

Hunter in the woods (top of the lid; in
grisaille); shepherd beside a tree (inside
of the lid); view of a village with two
travellers (left side); view of a village
with one traveller (right side); duck
decoy (back). The cavalry skirmish on
the front and that on the sliding lid are
attributed to Jan Martszens II (1609?-
after 1647)

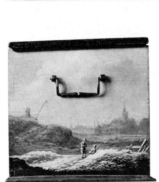

Dimensions of the box 21.2 ×36 ×23
PROV Presented by the Rembrandt
Society, 1938. Belongs to the department
of sculpture and applied arts
LIT C Veth, Mndbl BK 11 (1934) pp 45-
50

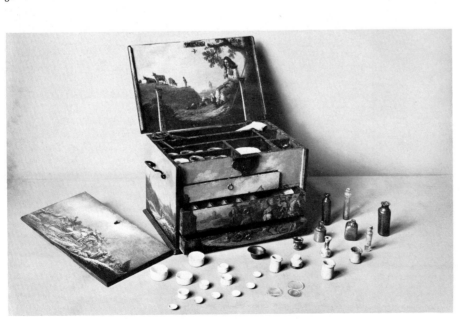

Conradijn Cunaeus

Dendermonde 1828–1895 Nieuwer-Amstel

A 1023 'Hunting companions.' '*Jacht-gezellen*'

Panel 45 × 61.5. Signed and dated
C. Cunaeus 1860
PROV Purchased at exhib Amsterdam
1860, nr 27. RVMM, 1885 * DRVK since
1961

A 2228 'The two friends.' '*De twee vrienden*'

Canvas 134 × 174. Signed *C. Cunaeus*
PROV Presented by the artist's widow,
Mrs M Cunaeus-Cnopius, Hoorn, 1906 *
DRVK since 1953

Cornelis van Cuijlenburg

Utrecht 1758–1827 The Hague

see also Heinsius, Johann Ernst, A 76
Willem Crul, copy by van Cuijlenburg;
and under Pastels

A 1374 Johan Arnold Zoutman (1724-93). Vice admiral. *Vice-admiraal*

Canvas 113 × 86. Signed and dated
C. van Cuylenburgh fecit A° 1801
PROV Purchased from the artist, 1801.
RVMM, 1877? NMGK, 1887
LIT Moes 1897-1905, vol 2, nr 9402:4.
Moes & van Biema 1909, pp 43, 46, 209.
R van Luttervelt, Historia 15 (1950) p
268, fig 3. Scheen 1969-70, vol 1, fig 5

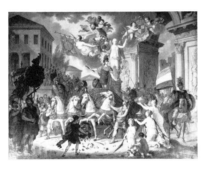

A 1216 Allegory of the triumphal
procession of the prince of Orange, the
future King Willem II, as the hero of
Waterloo, 1815. *Allegorie op de triomf-
tocht van de prins van Oranje, de latere
koning Willem II, als held van Waterloo, 1815*

Canvas 186 × 242. Signed and dated
C. van Cuylenburgh invt et pinxit A° 1815
PROV KKS, 1885

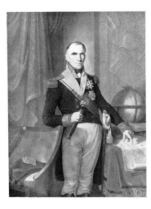

A 943 Jonkheer Theodorus Frederik van
Capellen (1762-1824). Vice admiral.
Vice-admiraal

Canvas 145 × 111. Signed and dated
C. van Cuijlenburgh pinxit ad vivum 1817
PROV RVMM, 1877? NMGK, 1887 *
DRVK since 1959
LIT Scheen 1946, fig 33

Aelbert Cuyp

Dordrecht 1620–1691 Dordrecht

A 77 Mountainous landscape with the
ruins of a castle. *Bergachtig landschap met
kasteelruïne*

Panel 66.5 × 91. Signed *A. Cuijp*
PROV Bequest of L Dupper Wzn,
Dordrecht, 1870
LIT C von Lützow, Zeitschr BK 5 (1870)
p 229. Hofstede de Groot 1907-28, vol 2
(1908) nr 406. Martin 1935-36, vol 2, p
342. W Stechow, OH 75 (1960) p 88.
Rosenberg, Slive & Ter Kuile 1966, p
159. VTTT, 1966-67, nr 86

A 4118 River landscape with riders.
Rivierlandschap met ruiters

Canvas 128 × 227.5. Signed *A. Cuijp*
PROV Purchased from Edmund de
Rothschild, Exbury, Hampshire, 1965,
with aid from the Rembrandt Society,
the Prince Bernhard Foundation and the
Photo Commission
LIT Smith 1829-42, vol 9, nr 35. Waagen
1854, vol 3, p 224. Seguier 1870, p 54.
Hofstede de Groot 1907-28, vol 2 (1908)
nr 458. S Reiss, Burl Mag 95 (1953) p 46
(ca 1655). C J de Bruyn Kops, Bull RM 13
(1965) pp 162-75, ill (ca 1655).
Dattenberg 1967, pp 64-66, ill. VTTT,
1966-67, nr 86. D G Burnett, Apollo,
1969, pp 377-79, fig 16 (ca 1655)

A 78 Landscape with herdsmen and cattle. *Landschap met herders en vee*

Canvas 105 × 103. Signed *A.Cuijp*
PROV Sale G van der Pot van Groeneveld, Rotterdam, 6 June 1808, lot 26
LIT Hofstede de Groot 1907-28, vol 2 (1908) nr 407. Moes & van Biema 1909, pp 113, 184. Martin 1935-36, vol 2, p 344. W Stechow, OH 75 (1960) p 90. CJ de Bruyn Kops, Bull RM 13 (1965) p 174, fig 7

A 3754 Landscape with cows and a young herdsman. *Landschap met koeien en herdersjongen*

Canvas 101.5 × 136. Signed *A.Cuyp*
PROV Purchased from P & D Colnaghi gallery, London, 1950, as a gift of the Photo Commission
LIT Cat Wallraf-Richartz Museum, Cologne, 1967, nr 2532. VTTT, 1966-67, nr 86

A 3957 River landscape with cows. *Rivierlandschap met koeien*

Panel 42.5 × 72. Signed *A.Cuijp*

PROV Purchased from E Speelman gallery, London, 1959, with aid from the Jubilee Fund 1958
LIT J Offerhaus, Bull RM 7 (1959) p 61, ill

C 120 Portrait of a young man. *Portret van een jonge man*

Panel 82 × 70. Oval
PROV On loan from the city of Amsterdam (A van der Hoop bequest) since 1885
LIT Hofstede de Groot 1907-28, vol 2 (1908) nr 127. Martin 1935-36, vol 2, p 348

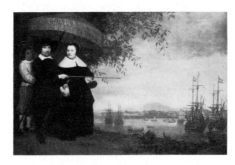

A 2350 A senior merchant of the Dutch East India Company, presumably Jacob Mathieusen, and his wife; in the background the fleet in the roads of Batavia. *Een opperkoopman van de VOC, vermoedelijk Jacob Mathieusen en zijn vrouw; op de achtergrond de retourvloot op de rede van Batavia*

Canvas 138 × 208
PROV Purchased from Fr Muller & Co, art dealers, Amsterdam, 1908, with aid from E van Deen, The Hague
LIT Hofstede de Groot 1907-28, vol 2 (1908) nr 81 (portrait of Barent Pietersz, called Grootebroeck, and his wife). De Haan 1922-23, pl L4. H Goetz, OH 54 (1937) pp 225-26, fig 1 (on the parasol). Stapel 1938-40, vol 3, pp 264-65. J Verseput, Spiegel Hist 5 (1970) ill on p 400

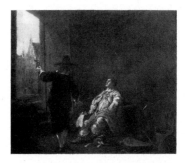

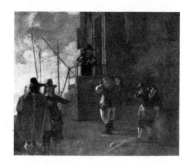

A 1457 Signboard of a wineshop: tasting the wine (one side); barreling the wine (other side). *Uithangbord van een wijnhandelaar: het proeven van de wijn (ene kant); het kuipen der wijnvaten (andere kant)*

Copper 45.5 × 52. Signed *Cuyp*
PROV Purchased from Ch Sedelmeyer gallery, Paris, 1888 * DRVK since 1959 (on loan to the Museum Mr Simon van Gijn, Dordrecht)
LIT Hofstede de Groot 1907-28, vol 2 (1908) nr 38. E Plietzsch, Zeitschr BK ns 27 (1916) p 141. Martin 1935-36, vol 1, p 427; vol 2, p 348

copy after **Aelbert Cuyp**

C 114 River view. *Riviergezicht*

Copy by Albertus Brondgeest (1786-1849) after the original in the earl of Northbrook collection, London (cat 1889, nr 44)

Panel 71 × 90.5
PROV On loan from the city of

Amsterdam (A van der Hoop bequest) since 1885
LIT *Cf* Hofstede de Groot 1907-28, vol 2 (1908) nr 31. J G van Gelder & I Jost, NKJ 23 (1972) p 231, note 33

C 123 View of Dordrecht at sunset. *Gezicht op Dordrecht bij zonsondergang*

18th-century copy after the left half of the view of Dordrecht in the de Rothschild collection, Waddesdon Manor, England

Canvas 68 × 84.5
PROV On loan from the city of Amsterdam (A van der Hoop bequest) since 1885
LIT J Six & A Bredius, Bull NOB 1 (1900) pp 154, 201. Hofstede de Groot 1907-28, vol 2 (1908) ad nr 164. J G van Gelder & I Jost, NKJ 23 (1972) p 223, note 6

Benjamin Gerritsz Cuyp

Dordrecht 1612 – 1652 Dordrecht

A 773 Joseph interpreting the dreams of the baker and the butler. *Jozef legt de bakker en de schenker hun dromen uit*

Panel 73.5 × 62. Signed *BG Cuijp*
PROV Sale Jonkheer W Gockinga, Amsterdam, 14 August 1883, lot 28
LIT G H Veth, OH 2 (1884) p 254

A 2857 The entombment. *De graflegging*

Canvas 75 × 60. Signed *B. Cuyp*
PROV Purchased from W Komter gallery, Amsterdam, 1921, as a gift of the Photo Commission

A 3297 Interior of a peasant hut. *Boeren-interieur*

Panel 51.5 × 67. Signed *B. Cuyp*
PROV Presented by Mr & Mrs D A J Kessler-Hülsmann, Kapelle op den Bosch near Mechelen, 1940

Jacob Gerritsz Cuyp

Dordrecht 1594 – 1651 Dordrecht

A 1793 The shepherdess. *De herderin*

Canvas 112 × 168. Signed and dated *IG Cuyp fecit 1628*
PROV Purchased from the Jacobson gallery, London, 1898
LIT Bernt 1960-62, vol 1, nr 219. Bernt 1969-70, vol 1, nr 293

A 611 Margaretha de Geer (1585-1672). Wife of Jacob Trip. *Echtgenote van Jacob Trip*

Panel 74 × 59. Signed and dated *JG Cuijp fecit 1651*. Inscribed *Aetatis 66*
PROV Sale G van der Voort, Amsterdam, 13 March 1877, lot 3
LIT C Hofstede de Groot, OH 45 (1928) pp 255-56, nr 2

attributed to **Jacob Gerritsz Cuyp**

C 121 The excursion. *De buitenpartij*

Panel 85.5 × 114.5
PROV On loan from the city of Amsterdam (A van der Hoop bequest) since 1885

Jaroslav Czermak

Prague 1831 – 1878 Paris

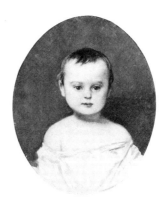

A 2718 Henri Bernard van der Kolk at the age of two. *Henri Bernard van der Kolk op 2-jarige leeftijd*

Canvas 53.5 × 44. Dated on the verso *6 Juni 1857*
PROV Presented by HB van der Kolk, The Hague, 1915

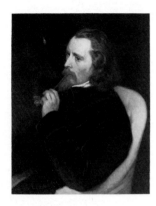

A 3481 Guillaume Anne van der Brugghen (1812-91). Painter. *Schilder*

Canvas 81 × 65. Signed and dated *Jaroslav Cermak 1857*
PROV Bequest of Mrs C van der Brugghen-van der Goes, widow of GA van der Brugghen, Blaricum, 1946

Alexander Joseph Daiwaille

Amsterdam 1818 – 1888 Brussels

C 124 Snow landscape. *Sneeuwlandschap*

Canvas 70 × 62. Signed and dated *A.J. Daiwaille 1845*
PROV On loan from the city of Amsterdam (A van der Hoop bequest) since 1885
LIT Scheen 1946, fig 240

Jean Augustin Daiwaille

Cologne 1786 – 1850 Rotterdam

see also under Pastels

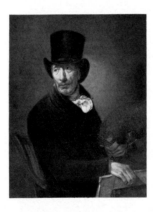

C 530 Pieter Barbiers Pz (1748-1842). Painter. *Schilder*

Canvas 79 × 62.5
PROV On loan from the KOG (presented by Mrs Krook van Harpen-de Burlett) since 1889
LIT [MF] H[ennus], Mndbl BK 7 (1930) p 23. Marius 1920, p 20 (self portrait). Huebner 1942, pp 72-73, fig 18 (self portrait). Scheen 1946, fig 39. Van Hall 1963, p 14, nr 85:2

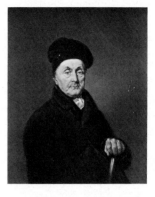

A 1952 Hendrik van Demmeltraadt (1736/37-1819)

For a portrait of the sitter's son, Clemens van Demmeltraadt, *see* Moritz, Louis, C 466

Canvas 77 × 61
PROV Bequest of Miss AJ Carp, Haarlem, 1901
LIT Marius 1920, p 20, fig 9

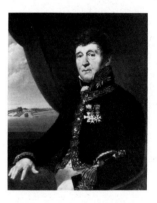

A 1845 Jan Blanken Jr (1755-1838). Superintendent of waterworks. *Inspecteur-generaal van Waterstaat*

Canvas 79 × 66
PROV Presented by JA Matthes, Amsterdam, 1899

attributed to **Cornelis van Dalem**

Antwerp 1530/35 – ca 1575 Antwerp

&

Jan van Wechelen

Antwerp ca 1530 – ca 1570 Antwerp

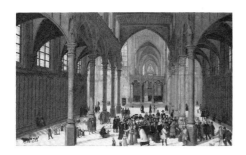

A 1991 Church interior with Christ preaching to a congregation. *Kerkinterieur met Christus predikend voor een menigte*

Panel 59 × 93. Inscribed *Matheus in 21 (Cap.)*
PROV Purchased from J A Hesterman, Amsterdam, 1902
LIT Jantzen 1910, p 172, nr 525 (Flemish, ca 1580). Ch Sterling, in Studies ded to Suida, 1959, p 280, fig 3. E Brochhagen, Münchn Jb, 1963, p 94

copy after **Cornelis van Dalem & Jan van Wechelen**

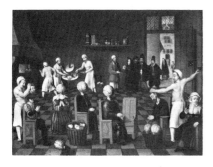

A 4293 The legend of the baker of Eekloo. *De legende van de bakker van Eekloo*

Panel 30 × 39.5
PROV Purchased from W B J Molkenboer, Amsterdam, 1883. NMGK * On loan to the Rijksmuseum Muiderslot, Muiden, since 1949
LIT Cornelissen 1929, vol 2, p 16. A Wijsman, OH 54 (1937) p 173, ill. Ch Sterling, in Studies ded to Suida, 1959, p 286

Cornelis van Dalen

see Panpoeticon Batavum: A 4586 Everard Meyster, by Arnoud van Halen after van Dalen

Dirck Dalens I

Dordrecht ca 1600 – 1676 Zierikzee

A 790 Arcadian landscape with herdsmen and cattle. *Arcadisch landschap met herders en vee*

Panel 34.5 × 45.5. Signed *Dirck Dalens*
PROV Sale Amsterdam, 14-15 Nov 1883, lot 38

Pieter Danckerts de Rij

Amsterdam 1605 – 1661 Rudnik

A 1593 Portrait of a young man with a javelin and a hunting horn. *Portret van een jonge man met spies en jachthoorn*

Canvas 110 × 88. Signed and dated *P. Danckerst fecit An° 1635*. Inscribed *Aetati sui 23*
PROV Purchased in 1892

Carel Bernardus (Charles) Dankmeyer

Amsterdam 1861 – 1923 The Hague

A 2229 Johannes Bosboom (1817-91). Painter. *Schilder*

Canvas 58 × 45. Signed *Ch. Dankmeyer*
PROV Presented by J J Biesing, The Hague, 1906
LIT Van Hall 1963, p 39, nr 232:3

Jan Dasveldt

Amsterdam 1770-1855 Amsterdam

C 125 Siberian greyhound. *Siberische windhond*

Canvas 142.5 × 177. Signed *J. Dasveldt*
PROV On loan from the city of Amsterdam (A van der Hoop bequest) since 1885
LIT J Knoef, Jb Amstelodamum 42 (1948) p 59

C 126 Two dogs. *Twee honden*

Panel 14.5 × 18
PROV On loan from the city of
Amsterdam (A van der Hoop bequest)
since 1885

Charles François Daubigny

Paris 1817–1878 Paris

A 2288 Landscape on the Oise. *Landschap aan de Oise*

Panel 35 × 58.5. Signed and dated
Daubigny 1872
PROV Lent by JBAM Westerwoudt,
Haarlem, 1888. Bequeathed in 1907

A 2884 Seascape. *Zeegezicht*

Canvas 100 × 200. Signed and dated
Daubigny 1876
PROV Bequest of A van Wezel,
Amsterdam, 1922 * DRVK since 1959

A 1867 A beach at ebb tide. *Strand bij eb*

Panel 35 × 55. Signed *Daubigny*
PROV Presented by the dowager of R
Baron van Lynden, née MCBaroness
van Pallandt, The Hague, 1900

A 1868 October. *Oktober*

Canvas 87.5 × 160.5. Marked on the
verso in red with a rubber stamp *Vente
Daubigny*
PROV Presented by the dowager of R
Baron van Lynden, née MCBaroness
van Pallandt, The Hague, 1900

A 2885 Orchard. *Boomgaard*

Canvas 55 × 107.5. Signed *Daubigny*
PROV Bequest of A van Wezel,
Amsterdam, 1922

A 2886 Landscape. *Landschap*

Panel 24.5 × 54.5. Signed *Daubigny*
PROV Bequest of A van Wezel,
Amsterdam, 1922

Honoré Daumier

Marseille 1808–1879 Valmondois

see also under Aquarelles and drawings

A 1869 Christ and his disciples. *Christus en zijn discipelen*

Canvas 65 × 81. Signed *h. D.*
PROV Presented by the dowager of R
Baron van Lynden, née MCBaroness
van Pallandt, The Hague, 1900
LIT Klossowski 1914, cat nr 80, fig 38.
Klossowski 1923, p 80, pl 64. Fuchs 1927,
p 152. Adhémar 1954, pl 48. Maison
1968, p 68, nr 30, pl 5

A 2578 The singers. *De zangers*

Canvas 37 × 28.5. Signed *h. D.*
PROV Presented by the estate of C
Hoogendijk, The Hague, 1912
LIT Fuchs 1927, p 281, note 33.
Lassaigne 1933, pl 37. Cassou 1949, pl 7.
Adhémar 1954, pl 106 (1856-60).
Schweicher 1954, pl 7. Zilber 1957, pl
89. Besson 1959. Maison 1968, p 58, nr
13, fig 71 (1846-50?). Novotny 1970, fig
114

Gerard David

Oudewater ca 1460–1523 Bruges

A 3134 & A 3135 View in a forest. *Bosgezicht*

Panel 90 × 30.5 each. The outsides of the wings of a triptych; the insides as well as the middle panel, with the adoration of the child, are in the Metropolitan Museum of Art, New York (cat 1947, nr L 44.23.20 A, B)
PROV Purchased from Duveen Brothers gallery, Paris, 1942, as a gift of the Photo Commission * On loan to the KKS (cat 1968, p 22, nr 843, ill [ca 1505-10]) since 1948
LIT A Mayer, Zeitschr BK ns 31 (1919-20) p 97. Friedländer 1924-37, vol 6 (1928) p 143, nr 160; vol 14 (1937) p 106, nr 160. L von Baldass, Jb Kunsthist Samml Wien ns 10 (1936) p 94. A Glavimans, Phoenix 1 (1946) p 46. P Nieburg, Constghesellen 1 (1946) p 16. Boon 1946, pp 51, 54-55, ill. Koch 1968, p 66. Von der Osten & Vey 1969, p 307

Alexandre Gabriel Decamps

Paris 1803 – 1860 Fontainebleau

A 1870 Searching for truffles. *De truffelzoeker*

Canvas 98.5 × 132.5. Signed *D.C.*
PROV Presented by the dowager of R

Baron van Lynden, née M C Baroness van Pallandt, The Hague, 1900

Cornelis Gerritsz Decker

Haarlem before 1625 – 1678 Haarlem

A 2562 Weaver's workshop. *Weverswerkplaats*

Panel 45 × 57. Signed and dated *C. Decker 1659*
PROV Lent by C Hoogendijk, The Hague, 1907. Presented by his estate in 1912
LIT C Hofstede de Groot, Ned Spec, 1899, p 58. A Heppner, in Festschrift A Goldschmidt, 1935, p 156. Heppner 1938, p 18, fig 8. Bol 1969, p 209

Frans Decker

Haarlem 1684 – 1751 Haarlem

C 1478 Willem Philip Kops (1695-1756). Merchant of Haarlem, with his wife and children. *Koopman te Haarlem, met zijn vrouw en kinderen.*

Kops' wife is Johanna de Vos (1702-58) and their children are Willem (1724-76), Catharina (1726-92), Jacobus de Vos Kops (1730-61), Philip (1731-91) and François (1733-40)

Canvas 148 × 146.5. Signed and dated

F. Decker Fecit 1738
PROV On loan from H A de Bruyn Kops, Amsterdam, since 1968

Hendrik Adriaan Christiaan Dekker

Amsterdam 1836 – 1905 Laag Soeren

NO PHOTOGRAPH AVAILABLE

A 2181 Interior of a stall. Against the wall are two antique chests. *Stalinterieur. Twee antieke kisten staan tegen een muur*

Panel 23.5 × 32. Signed *H. A. C. Dekker*
PROV Presented by the artist's widow, Mrs Dekker-Sartorius, Amsterdam, 1905 * Lent to the Stedelijk Museum, Zutphen, 1924. Destroyed in the war, 1945

Ferdinand Victor Eugène Delacroix

Charenton-Saint-Maurice 1798 – 1863 Paris

A 1871 The agony in the garden. *Christus in Gethsemané*

Canvas 34 × 42. Signed and dated *Eug. Delacroix 1861*
PROV Presented by the dowager of R Baron van Lynden, née M C Baroness van Pallandt, The Hague, 1900
LIT M P Georgel, Bull Soc Hist Art Fr, 1968-70, pp 171ff, 180, fig 3. Sérullaz 1963, nr 427. Huyghe 1964, p 497, fig 336

Dirck van Delen

Heusden 1605–1671 Arnemuiden

A 2352 A family beside the tomb of Willem I (William the Silent) in the Nieuwe Kerk, Delft. *Een familiegroep bij het praalgraf van prins Willem I in de Nieuwe Kerk te Delft*

Panel 74 × 110. Signed and dated *D.v. Delen Pinxt. Anno 1645*
PROV Purchased from Fr Muller & Co, art dealers, Amsterdam, 1908
LIT Jantzen 1910, pp 70, 161, nr 127. Martin 1935-36, vol 1, p 270

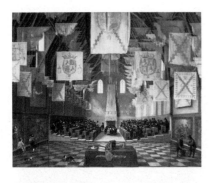

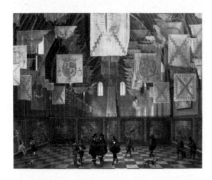

C 1350 The great hall of the Binnenhof, The Hague, during the great assembly of the states-general in 1651. *De grote zaal op het Binnenhof, Den Haag, tijdens de grote vergadering der Staten Generaal in 1651*

Panel 52 × 66. There is a painted metal flap attached to the panel. When it is closed, one sees figures in the foreground and a dividing partition behind them, blocking off the view of the rest of the hall. When the flap is open, the view of

the assembly is revealed in the background, and a table takes the place of the figures in the foreground
PROV Purchased from Mr Teissier, 1819. On loan from the KKS (cat 1935, nr 26) since 1948
LIT Jantzen 1910, p 161, nr 142. R van Luttervelt, Bull RM 8 (1960) p 38, fig 10. RDK, vol 6, col 122

A 3938

A 3936

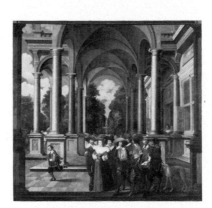

A 3937

A 3940 & A 3939

A 3941 & A 3942

A 3936 - A 3942 A seven-part decorative sequence: an interior (A 3938), two galleries (A 3936 & A 3937) and two outdoor stairways, each made up of two pieces (A 3939 & A 3940; A 3941 & A 3942), populated with many figures, including Prince Frederik Hendrik and Amalia van Solms, the stadholder of Friesland Ernst Casimir van Nassau-Dietz and his son Hendrik Casimir I (A 3936, left to right), Floris II van Pallandt, count of Culemborg, Frederick V of Bohemia (called the winter king), and Prince Maurits (A 3937, left to right). *Zevendelige kamerbeschildering met afbeeldingen van een interieur, twee galerijen en twee buitentrappen, bevolkt met talrijke personen waaronder prins Frederik Hendrik en Amalia van Solms, de Friese stadhouder Ernst Casimir van Nassau-Dietz en zijn zoon Hendrik Casimir I en van Floris II van Pallandt, graaf van Culemborg, de 'winterkoning' van Bohemen Frederik V, en prins Maurits*

Canvas 230 × 320 (A 3938); 317.5 × 350 (A 3936); 308.5 × 349 (A 3937); 310 × 121 (A 3939); 309 × 122 (A 3940); 309 × 109.5 (A 3942) and 309 × 124.5 (A 3941)
PROV Purchased from Mr & Mrs Everett through the C Marshall Spink gallery, London, 1958, as a gift of the Photo Commission
LIT A Oswald, Country Life 84 (1938) p 280 (A van de Venne). A Staring, Bull RM 13 (1965) pp 3-13, figs 1-5

Cornelis Jacobsz Delff

Delft 1571–1643 Delft

A 779 The poultry seller. *De hoenderkoopman*

Panel 90.5 × 143. Signed *C. Delff*
PROV Presented by Dr A Bredius, The Hague, 1883
LIT Bol 1969, p 5

Jacob Willemsz Delff I

Gouda ca 1550–1601 Delft

A 1907 Portrait of a little boy. *Portret van een jongetje*

Panel 61.5 × 47.5. Dated *An° Dnis 1581.* Inscribed *Ætatis suae 2*
PROV Sale Heeswijk ('s-Hertogenbosch), Amsterdam, 20 June 1900
LIT De Vries 1934, p 101. C J Hudig, Historia 9 (1943) p 169, fig 1. Hoogewerff 1936-47, vol 4 (1941-42) pp 608-10, fig 289. Gerson 1950, p 59, fig 151

A 841 Paulus Cornelisz van Beresteyn (1548-1625). Burgomaster of Delft. *Burgemeester van Delft*

Panel 115 × 83.5. Signed and dated *JW Delphius pinxit. An Dni 1592.* Inscribed *Aetatis 44*
PROV Sale van Beresteyn van Maurik, Vught, 22 Oct 1884, lot 33
LIT Moes 1897-1905, vol 1, nr 521. De Vries 1934, p 101. Hoogewerff 1936-47, vol 4 (1941-42) p 610, fig 290. Van Beresteyn & Del Campo Hartman 1941-54, vol 1, p 105; vol 2, nr 20, ill

A 1460 Self portrait of the painter and his family. *Zelfportret van de schilder met zijn gezin*

The painter is working on a portrait of his wife, Maria Joachimsdr Nagel. Behind him are his three sons, the painters Cornelis (1571-1643) and Rochus (1572/79-1617) and the engraver Willem (1580-1638)

Panel 83.5 × 109. Painted about 1594
PROV Sale J Hollender, Brussels, 10-12 April 1888, lot 139 (as Werner van den Valckert)
LIT B W F van Riemsdijk, OH 12 (1894) pp 233-37. De Vries 1934, p 102, fig 55. Hoogewerff 1936-47, vol 4 (1941-42) p 612. Van Hall 1963, p 76, nr 482:1. Exhib cat Maler und Modell, Baden-Baden 1969, ad nr 42, ill ad nr 44

Jacob Willemsz Delff II

Delft 1619–1661 Delft

A 843 Portrait of a man, thought to be Salomon van Schoonhoven (1617-53), lord lieutenant of Putten. *Portret van een man, vermoedelijk Salomon van Schoonhoven, ruwaard van Putten*

Panel 69.5 × 57.5. Signed and dated *J Delfius A° 1643.* Inscribed *Aetatis 27*
PROV Purchased from S Altmann, Amsterdam, 1884

copy after **Willem Jacobsz Delff II**

Delft 1580–1638 Delft

see also Panpoeticon Batavum: A 4557 Johannes Polyander à Kerckhoven, copy by Arnoud van Halen after W J Delff II

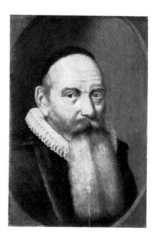

A 953 Jacobus Rolandus (1562-1632). Counter-Remonstrant minister in Amsterdam. *Contra-remonstrants predikant te Amsterdam*

Copy after the print by Willem Jacobsz Delff II

Panel 23.5 × 15.5. Grisaille
PROV Sale The Hague, 30 Jan 1878, lot 40. NMGK, 1885
LIT J Six, OH 5 (1887) pp 8-9. Moes 1897-1905, vol 2, nr 6485. J Six, OH 29 (1911) p 132

Edouard Delvaux

Brussels 1806–1862 Charleroi

A 1024 On the Sambre River. *Landschap bij de Sambre*

Canvas 66 × 82. Signed *Ed. Delvaux*
PROV Purchased at exhib Amsterdam
1828, nr 84 or 521. RVMM, 1885 * DRVK
since 1959

Demachy

see Machy

Demarne

see Marne

Balthasar Denner

Hamburg 1685–1749 Rostock

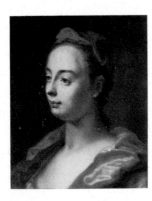

A 1442 Portrait of a woman. *Portret van een vrouw*

Canvas 42 × 34.5. Signed and dated
Denner 1731
PROV Presented by Dr A Bredius, The
Hague, 1888

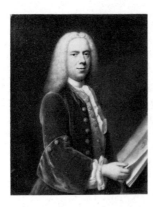

A 770 Portrait of a man, probably
Cornelis Troost (1696-1750). Painter.
Schilder

Canvas 87 × 70.5. Signed and dated
Denner 1737. Formerly signed and dated
falsely *C. Troost 1737*
PROV Sale Amsterdam, 13 Nov 1882, lot
49 * On loan to the municipality of
Velsen (Beeckestijn Estate) since 1969
LIT Moes 1897-1905, vol 2, nr 8099:1
(Cornelis Troost). Van Hall 1963, p 334,
nr 2106:3 (Troost). J W Niemeijer, NKJ
21 (1970) p 209, fig 10. Niemeijer 1973,
pp 408, 436. C J de Bruyn Kops, Bull RM
22 (1974) p 20

Antonius Johannes Derkinderen

's-Hertogenbosch 1859–1935
Amsterdam

A 3470 The building of the 'Argo.' *De
bouw van het schip 'Argo'*

Study for an unexecuted decoration in
the Amsterdam Stock Exchange

Canvas 65 × 95.3
PROV Bequest of the artist's widow, Mrs
J H Derkinderen-Besier, Amsterdam,
1944
LIT Hammacher 1932, pp 98, 127

Gijsbertus Derksen

Doesburg 1870–1920 Arnhem

A 2739 Johannes Gijsbert Vogel (1828-
1915). Painter. *Schilder*

Canvas 96 × 73. Signed and dated
G. Derksen 1910
PROV Bequest of J G Vogel, Velp, 1915
LIT Van Gelder 1947, pl IX, fig 22. Van
Hall 1963, p 357, nr 2253

Frans Wilhelm Maria Deutmann

Zwolle 1867–1915 Blaricum

A 2822 Landscape with a kid. *Landschap
met geitje*

Panel 22 × 27. Signed *Fr. Deutman*
PROV Presented by the artist's widow,
Mrs F W M Deutmann, 1919 * DRVK
since 1959

Willem Anthonie van Deventer

The Hague 1824–1893 The Hague

A 1025 View on the beach near Katwijk aan Zee. *Strandgezicht bij Katwijk aan Zee*

Canvas 77 × 102. Signed and dated
W. A. van Deventer A° 1860
PROV Purchased at exhib Amsterdam
1860, nr 32. RVMM, 1885 * DRVK since
1959

A 3846 Seascape near the coast. *Zee-gezicht aan de kust*

Panel 34.5 × 45.5. Signed *WA van Deventer ft.*
PROV Bequest of Mrs M N Th Weddik-Lublink Weddik, widow of A L Weddik, Arnhem, 1919 * DRVK since 1959

attributed to **Benedetto Diana**

Venice ca 1460 – 1525 Venice

A 3014 Madonna and child with the infant John the Baptist and Sts Peter and Anthony. *Maria met het kind, de kleine Johannes de Doper, Petrus en Antonius de Heremiet*

Panel 69 × 85.5
PROV Purchased from the Augusteum, Oldenburg, 1924, as a gift from a member of the Rembrandt Society
LIT T Borenius, Burl Mag 58 (1931) pp 71-72 (Marco Basaiti). Berenson 1932, p 169 (Diana). Van Marle 1923-38, vol 18 (1936) p 415, fig 230. Berenson 1957, vol I, p 73

attributed to **Giacinto Diana**

Pezzuoli 1730 – 1803 Naples

A 3465 The continence of Scipio. *De grootmoedigheid van Scipio*

Design for a ceiling painting in the Palazzo Serreoli Cassano, Naples, 1770

Canvas 63 × 77
PROV Purchased from T Mulder gallery, Amsterdam, 1944

Virgilio Narcisso Diaz de la Peña

Bordeaux 1808 – 1876 Menton

A 1872 Idyll. *Idylle*

Panel 38 × 55. Signed and dated *N. Diaz 53*
PROV Presented by the dowager of R Baron van Lynden, née M C Baroness van Pallandt, The Hague, 1900

A 2701 The forest of Fontainebleau. *Het bos van Fontainebleau*

Canvas 50.5 × 63.5. Signed and dated
N. Diaz 71
PROV Presented by the heirs of W J van Randwijk, The Hague, 1914
LIT W Steenhoff, Onze Kunst 27 (1915) p 90

A 2887 After the bath. *Na het bad*

Panel 24.5 × 18.5
PROV Bequest of A van Wezel, Amsterdam, 1922

A 1873 Still life with white and red roses. *Stilleven met witte en rode rozen*

Panel 27.5 × 22. Signed *N. Diaz*
PROV Presented by the dowager of R Baron van Lynden, née M C Baroness van Pallandt, The Hague, 1900

Ch van Dielaert

active 1666

A 2366 Still life. *Stilleven*

Canvas 135 × 115. Signed and dated
Ch. van Dielaert fecit A° 1666
PROV Presented by L Nardus, Paris,
1908
LIT Warner 1928, nr 27. Vorenkamp
1933, p 52. P Gammelbo, OH 72 (1957)
p 197, fig 1. Bernt 1960-62, vol 4, nr 69.
Bernt 1969-70, vol 1, nr 307

Abraham Diepraam

Rotterdam 1622 – 1670 Rotterdam

A 1574 The barroom. *De gelagkamer*

Canvas 46 × 52. Signed and dated
A. Diepraem 1665
PROV Purchased from S F Smith,
London, 1892

Jeronimus van Diest

The Hague 1631 – after 1675 The Hague?

A 1389 The seizure of the English flag-
ship 'Royal Charles,' captured during
the raid on Chatham, June 1667. *Het
opbrengen van het Engelse admiraalschip de
'Royal Charles,' buitgemaakt tijdens de tocht
naar Chatham, juni 1667*

Canvas 68 × 103.5. Signed *I. V. D.*
Inscribed *Huius quondam Britannicae et
Praetoriae Navis accuratissime picta Imago :|
… [pri]mo Superati regis Caroli I. et regii
victi Exercitus ad Nazebin :| Deinde regis
Caroli II. in sua Regna reducis : de cujus
nomine regius ap-| pellata a Carolus : Et
postremo a Batavis in ipsa Britannia capta|
ingentis Victoriae et simul optatissimae Pacis
monimentum extitit| D. D. Cornelio de Witt|
versae Classis Belgicae Imperatori et Victori
Batavo : Ejusque Liberis| Posteris paternae
avitaeque virtutis incitamento| D.*
PROV Purchased from W Hoog,
Noordwijkerhout, 1880. NMGK, 1887
LIT Willis 1911, p 56 (Monogrammist
IVD). CG 't Hooft, in Feestbundel
Bredius, 1915, p 102 (doubts attribution
to van Diest). Preston 1937, p 60, fig 86.
R van Luttervelt, Bull RM 8 (1960) pp
54-55, fig 17. Diekerhoff 1967, fig 23.
Rogers 1970, pl IX. Bol 1973, p 168, fig
172

A 2503 River view. *Riviergezicht*

Panel 31.5 × 37. Signed *I. V. D.*
PROV Presented by H J Pfungst, London,
1910

Johan van Diest

active ca 1700 in London

A 2804 Anna Margaretha van Petcum
(1676-1745). Wife of Johan Arnold
Zoutman. *Echtgenote van Johan Arnold
Zoutman*

For a portrait of the sitter's husband, *see*
Northern Netherlands school ca 1725,
A 2803

Canvas 80 × 64.5. Oval. The old
inscription on the verso was covered by
relining, but transcribed on the new
canvas: *V. Diest F* [or P]
PROV Presented by N S Rambonnet,
Elburg, 1917
LIT Moes 1897-1905, vol 2, nr 5892

attributed to **Willem van Diest**

The Hague? before 1610 – after 1663 The
Hague?

A 1382 Seascape on the beach at
Scheveningen. *Zeegezicht aan het strand te
Scheveningen*

Panel 37 × 73.5
PROV Purchased from Jonkheer J E
Heemskerck van Beest, 1877. NMGK,
1887
LIT C Hofstede de Groot, OH 22 (1904) p
112

Christian Wilhelm Ernst Dietrich

see Rembrandt, copy after, A 3298
Portrait of a man

Bartholomäus Dietterlin

Strasbourg ca 1590–after 1624

A 2844 Cavalry skirmish in a mountainous landscape. *Ruitergevecht in bergachtig landschap*

Paper 7 ×9.3. Signed *B. Dietterlin*
PROV Purchased from J Hop-Rietbergs, 1920, as a gift from the Photo Commission

Adolphe Diez

Mechelen 1801–1844 Mechelen

A 1026 Hebe with Jupiter in the guise of an eagle. *Hebe met Jupiter in de gedaante van een adelaar*

Canvas 183 × 130.5
PROV Thought to have been bought in 1827. RVMM, 1885

attributed to **Barend Dircksz**

active 1st half of the 17th century in Amsterdam

C 405 Eight guardsmen. *Schuttersstuk met acht figuren*

Panel 96 × 126
PROV Kloveniersdoelen (headquarters of the arquebusiers' civic guard), Amsterdam. On loan from the city of Amsterdam, 1885-1975
LIT Scheltema 1855-85, vol 7 (1885) p 139. J Six, OH 42 (1925) pp 166-68, ill. Riegl 1931, p 83 (Dirck Jacobsz?). De Vries 1934, pp 46-47 (Barend Dircksz?). Hoogewerff 1936-47, vol 3 (1939) p 511, fig 274 (Barend Dircksz or Master Herman)

Nicholas Dixon

see under Miniatures

attributed to **William Dobson**

London 1610–1646 London

A 3927 Prince Rupert (1619-82), count palatine of Rhine. *Prins Ruprecht, palts-graaf aan de Rijn*

Canvas 137.5 × 102. Thought to have been painted in 1636
PROV Sale London, 4 Nov 1957, lot 172 (as Anthony van Dyck)

A van Doeff

active mid-17th century

A 1407 Still life with fish. *Stilleven met vissen*

Canvas 104 ×92.5. Signed *AVDoeff*
PROV Sale Amsterdam, 19-20 April 1887
LIT Vorenkamp 1933, p 80

Simon van der Does

Amsterdam 1653–after 1718 Antwerp

A 84 Italian landscape with shepherdess and flocks. *Italiaans landschap met herderin en vee*

Canvas 83 ×96.5. Signed and dated *S. van der Does MDCCIII*
PROV Sale G van der Pot van Groeneveld, Rotterdam, 6 June 1808, lot 27 * DRVK since 1952
LIT Moes & van Biema 1909, pp 113, 186

A 82 Shepherdess reading. *Lezend herderinnetje*

Canvas 53.5 × 44.5. Signed and dated
S. v. Does 1706
PROV Sale Amsterdam, 19 July 1809,
lot 11
LIT Moes & van Biema 1909, p 158

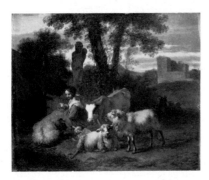

A 83 Italian landscape with shepherdess
and flocks. *Italiaans landschap met herderin
en vee*

Panel 32.5 × 41. Signed and dated
S. v. Does 1708
PROV Sale Amsterdam, 19 July 1809, lot
10
LIT Moes & van Biema 1909, pp 152, 195

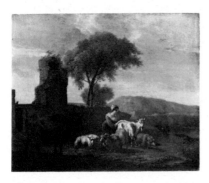

A 85 Italian landscape with shepherdess
and flocks. *Italiaans landschap met herderin
en vee*

Canvas 52 × 63. Signed and dated
S. v. Does 171[2]
PROV Bequest of L Dupper Wzn,
Dordrecht, 1870

Herman Mijnerts Doncker

b before 1620, active in Enkhuizen and
Haarlem; d after 1656

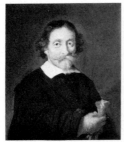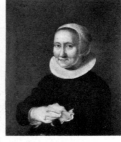

A 1689 Portrait of a man. *Portret van een
man*

Pendant to A 1690

Copper 32 × 28. Signed and dated
Doncker f. 1650
PROV Purchased from F L de Bruyn
Zegers, Roosendaal, 1897

A 1690 Portrait of a woman. *Portret van
een vrouw*

Pendant to A 1689

Copper 32 × 28. Signed and dated
Doncker f. 1650
PROV Same as A 1689

C 111 Portrait of a couple with their child
in a landscape. *Portret van een echtpaar met
kind in een landschap*

Canvas 68.5 × 57.5
PROV On loan from the city of
Amsterdam (A van der Hoop bequest)
since 1885

**Cornelis Theodorus Maria (Kees)
van Dongen**

Delfshaven 1877 – 1968 Monte Carlo

A 3039 Still life with flowers. *Stilleven met
bloemen*

Canvas 100 × 81. Signed *van Dongen*
PROV Presented by A Preyer gallery,
Paris, 1926 * On loan to the SMA since
1930

Lambert Doomer

Amsterdam 1622 – 1700 Alkmaar

A 1513 An inn in the neighborhood of
Nantes. *Herberg in de buurt van Nantes*

Panel 28 × 40.5. Signed *Doomer f.*
PROV Presented by Dr A Bredius, The
Hague, 1890
LIT Martin 1935-36, vol 2, p 131. Bernt
1960-62, vol 1, nr 235. Bernt 1969-70,
vol 1, nr 318

Gerard Dou

Leiden 1613 – 1675 Leiden

A 86 Self portrait. *Zelfportret*

Panel 48 × 37. Signed *GDou*
PROV Bequest of L Dupper Wzn, Dordrecht, 1870
LIT Hoet 1752, vol 2, p 407. C von Lützow, Zeitschr BK 5 (1870) p 229. C Hofstede de Groot, OH 10 (1892) p 235. Moes 1897-1905, vol 1, nrs 2096:12, 2096:15. Hofstede de Groot 1907-28, vol 1, nr 267. Martin 1913, p 16. E Tietze-Conrat, in Meisterwerke, 1920. Ried 1931, p 58. Martin 1935-36, vol 2, p 219. Goldscheider 1936, p 38, fig 214. Boon 1947, p 57, fig 39. P Reuterswärd, Konsthist Tidskr 25 (1956) p 107, fig 7. Plietzsch 1960, p 39, fig 43. Van Hall 1963, p 84, nr 527:47. Eckardt 1971, p 177, fig 25

A 686 Johan Wittert van der Aa (1604-70)

Panel 28 × 24. Oval. Signed and dated *GDou 1646*
PROV Bequest of Jonkheer J S H van de Poll, Amsterdam, 1880
LIT V de Stuers, Ned Kunstbode 2 (1880) p 244. Martin 1901, p 49, nr 146. Hofstede de Groot 1907-28, vol 1, nr 322. Martin 1913, p 32. Martin 1935-36, vol 2, p 219

C 127 A fisherman's wife. *Een vissers-vrouw*

Panel 32.5 × 22.8. Signed and dated *GDou 1653*. Inscribed *MDCLIII*

PROV On loan from the city of Amsterdam (A van der Hoop bequest) since 1885
LIT Martin 1901, p 229. Hofstede de Groot 1907-28, vol 1, nr 159. Martin 1913, p 103. Martin 1935-36, vol 2, p 219

C 128 A hermit. *Een kluizenaar*

Panel 33.5 × 27.5. Signed and dated *GDou 1664*
PROV On loan from the city of Amsterdam (A van der Hoop bequest) since 1885
LIT Martin 1901, p 16. Hofstede de Groot 1907-28, vol 1, nr 12. Martin 1913, p 8. Martin 1935-36, vol 2, pp 214-15, 219, fig 112. Rapp 1951, p 53, fig 26

A 2627 Old woman reading a lectionary: the so-called portrait of Rembrandt's mother, Neeltgen Willemsdr van Zuijdtbroeck (d 1640). *Oude vrouw lezend in een lectionarium; zogenaamd portret van Rembrandts moeder, Neeltgen Willemsdr van Zuijdtbroeck (gest 1640)*

Panel 71 × 55.5
PROV Bequest of A H Hoekwater, The Hague, 1912
LIT Martin 1901, p 34, nr 188. Moes 1897-1905, vol 2, nr 9404:18. Hofstede de Groot 1907-28, vol 1, nr 352. Martin 1913, p 37. Martin 1935-36, vol 2, p 214. Gombrich 1960, fig 164. Plietzsch 1960, p 38. A B de Vries, OKtv 3 (1965) nr 14, fig 3. H M Rotermund, NKJ 8 (1957) p 134, fig 6 (on the book which the woman

is reading). Rosenberg, Slive & Ter Kuile 1966, p 86, fig 65A. D Cevat, N Beitr Rembrandt Forsch, 1973, p 85, fig 40

A 87 The night school. *De avondschool*

Panel 53 × 40.3. Signed *GDou*
PROV Sale G van der Pot van Groeneveld, Rotterdam, 6 June 1808, lot 28
LIT Martin 1901, p 75, nr 320, appendix 4, p 171. Hofstede de Groot 1907-28, vol 1, nr 206. Moes & van Biema 1909, pp 113, 158, 182, 186. Martin 1913, p 170. E Wiersum, OH 48 (1931) pp 211, 214. Martin 1935-36, vol 2, pp 218-19, fig 115. Gerson 1952, pp 22, 34, fig 94. Plietzsch 1960, p 40, fig 45. BCG Gleistein, Kunstrip 2 (1972-73) nr 13

A 88 A hermit in prayer. *Een kluizenaar in gebed*

Panel 25 × 19. Signed *GD*
PROV Sale G van der Pot van Groeneveld, Rotterdam, 6 June 1808, lot 29
LIT Martin 1901, p 17. Hofstede de Groot 1907-28, vol 1, nr 13. Moes & van Biema 1909, pp 113, 181. Martin 1913, p 9. E Wiersum, OH 48 (1931) p 207

A 89 Girl with an oil lamp at a window. *Meisje met olielamp voor een venster*

Panel 22 × 17. Signed *GDou*
PROV Purchased with the Kabinet van Heteren Gevers, The Hague-Rotterdam, 1809
LIT Martin 1901, p 326. Hofstede de Groot 1907-28, vol 1, nr 227. Moes & van Biema 1909, pp 146, 158. Martin 1913, p 156. WG Hartstra, Antiek 4 (1969) p 315, fig 5

Gerard Dou

&

Nicolaas Berchem

Haarlem 1620 – 1683 Amsterdam

A 90 Portrait of a couple, thought to be Adriaen Wittert van der Aa and Maria Knotter. *Portret van een echtpaar, vermoedelijk Adriaen Wittert van der Aa en Maria Knotter*

Panel 76 × 62.5. Signed on a capital in the foreground, carved with Dou's portrait, *GDou* and, in the left foreground, *Berchem*
PROV Sale van Sluypwijk-van Moens, Amsterdam, 20 April 1803, lot 20. NM, 1808
LIT J Six, OH II (1893) p 104 (self portrait?). Moes 1897-1905, vol 1, nr 2096:32 (N Berchem and his wife?). Martin 1901, p 155. Moes & van Biema 1909, pp 63, 158, nr 72, 196, 209. Hofstede de Groot 1907-28, vol 1, p 334.

Martin 1913, p 56. Martin 1935-36, vol 2, p 219. Plietzsch 1960, p 41, fig 48. Van Hall 1963, p 80, nr 527:2. Rosenberg, Slive & Ter Kuile 1966, p 177

copy after **Gerard Dou**

A 2320 Triptych: allegory of art training. *Drieluik met allegorie op het kunstonderwijs*

The nursery (middle) symbolizes nature, the night school (left) education and the man cutting a quill (right) practice. Copy by Willem Joseph Laquy (1738-98) after an original that was lost in 1771 (Bille 1961, vol 1, pp 39-40, 46-47, 56, note 30)

Canvas 83 × 70 (middle) and panel 80 × 36 (each of the wings)
PROV Purchased from the heirs of Jonkheer PH Six van Vromade, Amsterdam, 1908, with aid from the Rembrandt Society
LIT Martin 1901, pp 77, 155-56, nr 304. Hofstede de Groot 1907-28, vol 1, nr 113. Martin 1913, p 93. Plietzsch 1960, p 36. Bille 1961, vol 1, fig 53; vol 2, pp 13, 94-95, note 53. JA Emmens, in Alb Disc JG van Gelder, 1963, pp 125-36, fig 1 (iconological interpretation)

A 2321 The doctor. *De dokter*

Copy by Jan Adriaensz van Staveren (before 1620-ca 1668) after the painting by Dou in the Kunsthistorisches Museum, Vienna (cat 1958, nr 126)

Copper 49 × 37
PROV Purchased from the heirs of Jonkheer PH Six van Vromade, Amsterdam, 1908, with aid from the Rembrandt Society * On loan to the Rijksmuseum voor de Geschiedenis der Natuurwetenschappen, Leiden, since 1959
LIT Hofstede de Groot 1907-28, vol 1, nr 143

C 243 A mother giving her child the breast. *Een moeder die haar kind de borst geeft*

Copy by Dominicus van Tol (ca 1635-76) after the painting by Dou in the duke of Westminster collection, London

Panel 49.5 × 37.5
PROV On loan from the city of Amsterdam (A van der Hoop bequest) since 1885
LIT Hofstede de Groot 1907-28, vol 1, nr 112

D J de Dowe *or* **de Douwe**

active ca 1647-60 in Leeuwarden

A 1357 Portraits of two boys in a landscape, one dressed as a hunter, the other as St John the Baptist. *Portretten van twee jongens in een landschap, de een gekleed als jager, de ander als Johannes de Doper*

Canvas 114.5 × 135. Signed and dated *Douwe A° 1647*

PROV Presented by Dr A Bredius, The Hague, 1887
LIT B J A Renckens, Med RKD I (1946) p 34ff. Wassenbergh 1967, p 48

Doyer

see Schoemaker Doyer

Drahonet

see Dubois Drahonet

attributed to **Johannes van Drecht**

Amsterdam 1737–1807 Amsterdam

A 3463 Bacchic scene. *Bacchantisch tafereel*

Canvas 96.5 × 140. Signed unclearly *I.V.D.* Dessus-de-porte or dessus-de-miroir in grisaille
PROV Sale Amsterdam, 16 Nov 1943, lot 4775

Christiaan Lodewijk Willem Dreibholtz

Utrecht 1799–1874 Utrecht

A 1028 View of Dordrecht seen from Papendrecht. *Gezicht op Dordrecht vanaf Papendrecht*

Canvas 77 × 102. Signed *C.L.W. Dreibholtz*

PROV Purchased at exhib The Hague 1837, nr 75. RVMM, 1885 * DRVK since 1959

A 3839 Stormy sea. *Woelige zee*

Canvas 64.5 × 92. Signed *C.L.W. Dreibholtz*
PROV Unknown * DRVK since 1952

Egbert van Drielst

see Lelie, Adriaan de, A 2231 General Daendels taking leave in Maarssen of Lieutenant colonel Krayenhoff

Johannes Adrianus van der Drift

The Hague 1808–1883 Weert

A 942 The Gevangenpoort (prison gate), The Hague. *De Gevangenpoort te Den Haag*

Panel 31.5 × 25.5. Signed *J.A. v.d. Drift*
PROV RVMM, 1877. NMGK, 1885 * DRVK since 1959
LIT Scheen 1946, fig 236

Cornelis Droochsloot

Utrecht 1630–1673 Utrecht

A 1920 Village street. *Dorpsstraat*

Panel 55 × 75. Signed and dated *C. Drooghsloot 1664*
PROV Purchased from W A Hopman, Bussum, 1900, with aid from the Rembrandt Society

Joost Cornelisz Droochsloot

Utrecht? 1586–1666 Utrecht

A 1930 St Martin cutting off part of his cloak for a beggar. *Sint Maarten snijdt een stuk van zijn jas af om aan een bedelaar te geven*

Panel 58 × 85. Signed and dated *Joost Cornel. Drooch Sloot 1623*
PROV Purchased from W Burrough Hill, Southampton, 1900
LIT R van Luttervelt, NKJ I (1947) p 122

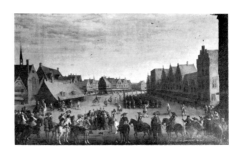

A 606 The disbanding of the 'waard-gelders' (mercenaries in the pay of the town government) by Prince Maurits in Utrecht, 31 July 1618. *Het afdanken der waardgelders door prins Maurits te Utrecht, 31 juli 1618*

Canvas 93 × 158. Signed and dated *Joost Cornelis Drooch Sloot f. A° 1625*

PROV NM, 1808 * DRVK since 1952
LIT Martin 1935-36, vol 2, p 391. R van
Luttervelt, NKJ I (1947) p 122

C 446 Housing the poor. *Het huisvesten van de armen*

Canvas 102 × 141. Signed and dated
JC DS 1647
PROV Oude Zijds Huiszittenhuis
(institute for the outdoor relief of the
poor), Amsterdam. On loan from the
city of Amsterdam since 1885
LIT R van Luttervelt, NKJ I (1947) p 117

A 3227 River view. *Riviergezicht*

Panel 57.5 × 87. Signed and dated
JC DS 1650
PROV Bequest of A A M Sträter,
Amsterdam, 1934

manner of **Joost Cornelisz Droochsloot**

C 438 The prodigal son. *De verloren zoon*

Canvas 103.5 × 152
PROV Thought to come from the Nieuwe
Zijds Huiszittenhuis (institute for the

outdoor relief of the poor), Amsterdam.
On loan from the city of Amsterdam
since 1885

Dirck Druyf

Leiden ca 1620 – after 1669 Leiden

A 2786 Portrait of a young man. *Portret van een jongeman*

Silver 14 × 10.5. Oval. Signed and dated
D. Druijf fe. 1659
PROV Presented by J R H Neervoort van
de Poll, Rijsenburg, 1916
LIT Hofstede de Groot 1903, p 7, nr 16a,
pl 11

Hendrick Jacobsz Dubbels

Amsterdam 1620/21 – 1676 Amsterdam

C 129 The fleet of Admiral van Wassenaer
van Obdam in the Texelse Gat, spring
1665. *De vloot van admiraal van Wassenaer
van Obdam in het Texelse Gat, voorjaar 1665*

Canvas 140 × 186. Signed *Dubbels*
PROV On loan from the city of
Amsterdam (A van der Hoop bequest),
1885-1975
LIT Willis 1911, p 76, pl XIX. C G 't
Hooft, in Feestbundel Bredius, 1915, p
107. Martin 1935-36, vol 2, p 373.
Preston 1937, p 54, fig 79. Bernt 1960-
62, vol 1, nr 246. Bernt 1969-70, vol 1, nr
334. Bol 1973, p 215, fig 222

A 687 Calm sea. *Kalme zee*

Canvas 48.5 × 62.5. Signed *Dubbels*
PROV Bequest of Jonkheer J S H van de
Poll, Amsterdam, 1880
LIT V de Stuers, Ned Kunstbode 2
(1880) p 244. Willis 1911, p 74

A 92 River view. *Riviergezicht*

Panel 38 × 49. Signed *Dubbels*
PROV Sale Amsterdam, 19 July 1809, lot
13 * DRVK since 1954
LIT Moes & van Biema 1909, pp 152,
158. Willis 1911, p 74

A 2513 View of Batavia. *Gezicht op
Batavia*

Canvas 65.5 × 84. Signed *Dubbels*
PROV Purchased from J R Sandersz,
London, 1910
LIT H Drake-Brockman, Spiegel Hist 6
(1971) fig 4 on p 839

Guillam Dubois

ca 1610 – 1680 Haarlem

A 3115 Mountainous landscape. *Berglandschap*

Panel 36 × 32. Signed and dated *G. de Bois 16[.4]*
PROV Purchased from Miss ENC Hasselman, Egmond aan de Hoef, 1930, as a gift of the Photo Commission

Simon Dubois

Antwerp 1632 – 1708 London

A 2062 Aernout van Citters (1661-1718). Son of Aernout van Citters and Christina de Brauw. *Zoon van Aernout van Citters en Christina de Brauw*

For a portrait of the sitter's father, *see* Kneller, Godfried, copy after, by Philip van Dijk, A 2060

Canvas 37 × 31. On the verso his coat of arms and those of his eight ancestors van Citters, van der Strenge, Velsen, Taelbout, de Brauw, ten Haaft, Huijssen, Jolijt, the inscription *d'h' Aernout van Citters Collonel van een regement infanterij Comandeur van Sas van gent geb tot middelb 25 maart 1661. gest Jul 1718* and the number *5*
PROV Bequest of Jonkheer J de Witte van Citters, The Hague, 1876. Received in 1903
LIT Moes 1897-1905, vol I, nr 1536 (Philip van Dijk)

A 2063 Anna van Citters (1664-94). Daughter of Aernout van Citters and Josina Parduyn. *Dochter van Aernout van Citters en Josina Parduyn*

For portraits of the sitter's father and mother, *see* Kneller, Godfried, copy after by Philip van Dijk, A 2060, and Schalcken, Godfried, A 2061, respectively

Canvas 37 × 32
PROV Same as A 2062 * DRVK since 1962
LIT Moes 1897-1905, vol I, nr 1537. P Haverkorn van Rijsewijk, OH 17 (1899) p 180

A 2064 Emerantia van Citters (1666-94). Sister of Anna van Citters. *Zuster van Anna van Citters*

Canvas 37 × 32. Signed and dated *S. du Bois fec. 1693*. On the verso her coat of arms and those of her eight ancestors van Citters, van der Strenge, Velsen, Taelbout, Parduijn, Salemons, Parduijn, Tirions, the inscription *Jongvrouw Emerentia van Citters geb : tot middelb : 4 Julij 1666 verongelukt 10 Julij 1694* and the number *7*
PROV Same as A 2062
LIT Moes 1897-1905, vol I, nr 1540. P Haverkorn van Rijsewijk, OH 17 (1899) p 180

A 2065 Josina Clara van Citters (1671-1753). Sister of Anna van Citters. *Zuster van Anna van Citters*

For another portrait of the sitter, *see* Schalcken, Godfried, A 899

Canvas 37 × 32. Signed and dated *S. du Bois fec. 1693*
PROV Same as A 2062 * DRVK since 1962
LIT Moes 1897-1905, vol I, nr 1544. P Haverkorn van Rijsewijk, OH 17 (1899) p 180

A 2066 Johanna van Citters (1672-1740). Sister of Anna van Citters. *Zuster van Anna van Citters*

Canvas 37 × 32. Signed and dated *S. du Bois fec. 1693*. On the verso her coat of arms and those of her eight ancestors (same as A 2064), the inscription *Jongvrouw Johana van Citters geb : tot middelb : 4 aug : 1672 namaels getr : gew. met d'h' admir. everts.*, and the number *9*
PROV Same as A 2062
LIT Moes 1897-1905, vol I, nr 1543. P Haverkorn van Rijsewijk, OH 17 (1899) p 180

Alexandre Jean Dubois Drahonet

Paris 1791 – 1834 Versailles

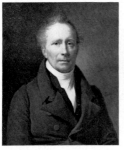

A 4153 Daniel Francis Schas (1772-1848). Member of the council for commerce and the colonies from 1814 to 1820. *Van 1814 tot 1820 lid van de Raad voor de koophandel en koloniën*

Pendant to A 4154

Canvas 63 × 53. Signed and dated *A J Dubois Drahonet 1826*
PROV Purchased from G Cramer gallery, The Hague, 1968

A 4154 Johanna Henriette Engelen (1789-1878). Second wife of Daniel Francis Schas. *Tweede echtgenote van Daniel Francis Schas*

Pendant to A 4153

Canvas 63 × 53. Signed and dated *A J Dubois Drahonet 1826*
PROV Same as A 4153

Pieter Dubordieu

Lille-Bouchard 1609 – after 1678 Leiden?

A 4221 Portrait of a woman. *Portret van een vrouw*

Panel 71 × 60.5. Signed and dated *P Dubordieu f a° 1637*
PROV Purchased in Amsterdam, 1972

LIT W Martin, Burl Mag 41 (1922) p 217, ill. Bull RM 20 (1972) p 182, fig 3 (portrait of Janneke des Planques)

A 2182 Portrait of a man. *Portret van een man*

Pendant to A 2183

Panel 76.5 × 61.5. Signed and dated *P Dubordieu f. A° 1638*. A label on the verso is inscribed *Frank van der Does | geboore 19 Jannuarij 1569 | obiit 30 mey 16[.]2 | troude met Anna Broers | 22 april 1606*. On another label he is called *Koopman en Opperhoofd op de Molukken en Ternate*. The man's suit has been visibly overpainted in accordance with a later fashion
PROV Bequest of Miss M E van den Brink, Velp, 1905
LIT B W F van Riemsdijk, Bull NOB 7 (1906) p 178

A 2183 Portrait of a woman. *Portret van een vrouw*

Pendant to A 2182

Panel 76.5 × 61.5. Signed and dated *P Dubordieu f. A° 1638*. A label on the verso is inscribed *Anna Boers | geboore te Antwerpe | 18 maart 1584 | obiit 30 mey 1642 | getrouwt met | Frank van der does | grootvader en moeder | van de schilder | Bakhuyse zyn vrouw*
PROV Same as A 2182

Pierre Louis Dubourcq

Amsterdam 1815 – 1873 Amsterdam

A 1029 The cemetery at Baden-Baden. *De begraafplaats te Baden-Baden*

Canvas 100 × 150. Signed and dated *Dubourcq 1855*
PROV Presented by the artist's widow, Mrs A J Dubourcq-Rochussen, Amsterdam, 1873. RVMM, 1885 * DRVK since 1961

Matthieu Dubus

South Flanders ca 1590 – 1665/66 The Hague

A 1539 A fortress. *Een fort*

Panel 47 × 64. Signed *Matiou Dubus*
PROV Sale S Altmann, Amsterdam, 18 Nov 1890, lot 19
LIT J Combe, Amour de l'Art 16 (1935) p 325, ill. V S[chendel], Mndbl BK 18 (1941) p 225, ill. Bernt 1960-62, vol 4 (1962) nr 75. Bernt 1969-70, vol 1, nr 337

Marie Duchatel

see under Miniatures

Duchattel

see Rossum du Chattel

Jacob Duck

Utrecht? ca 1600 – 1667 Utrecht

A 1940 The wine connoisseurs. *De wijn-proevers*

Panel 44 × 72. Signed *J. Duck*
PROV Purchased from the collection of G de Clercq, Amsterdam, 1899, through the intermediacy of the Rembrandt Society * DRVK since 1959 (on loan to the Wijnkoopersgildehuys Museum, Amsterdam)

A 93 Soldiers in a stable. *Krijgslieden in een paardestal*

Canvas 68 × 51
PROV Purchased with the Kabinet van Heteren Gevers, The Hague-Rotterdam, 1809
LIT Moes & van Biema 1909, pp 146, 158

Julien Joseph Ducorron

Ath 1770–1848 Ath

C 283 Landscape. *Landschap*

Panel 44 × 65
PROV On loan from the city of Amsterdam (A van der Hoop bequest) since 1885

copy after **Albrecht Dürer**

Nürnberg 1471–1528 Nürnberg

A 96 Willibald Pirkheimer (1470-1530)

Panel 18 × 12. Signed *AD*. Inscribed *Belibaldi MDXXIV*
PROV Sale M C van Hall, Amsterdam, 27 April 1858, lot 22

Gaspard Dughet

Rome 1615–1675 Rome

A 95 Landscape. *Landschap*

Canvas 74 × 99
PROV Purchased by King Willem I in Paris, 1823

A 94 Italian landscape. *Italiaans landschap*

Canvas 68.5 × 95
PROV Purchased by King Willem I in Paris, 1823

C 1351 Italian landscape. *Italiaans landschap*

Canvas 48.6 × 64
PROV Purchased by King Willem I from Chevalier V de Rainer, Brussels, 1821. On loan from the KKS since 1948

Guilliam Dujardin

Cologne? ca 1597–after 1647 Amsterdam?

A 1572 Pharaoh's daughter discovers Moses in the rush basket. *Farao's dochter vindt Mozes in het biezen mandje*

Panel 75 × 108. Signed *G. Du gardin*
PROV Presented by Dr A Bredius, The Hague, 1892

Karel Dujardin

Amsterdam 1622-1678 Venice

see also Panpoeticon Batavum: A 4592
Jan Vos, copy by Arnoud van Halen
after Dujardin

A 190 Self portrait. *Zelfportret*

Copper 28.5 × 22. Signed and dated
K. du Jardin fe. 1662
PROV Sale Amsterdam, 2 April 1827, lot
33
LIT Smith 1829-42, vol 5 (1834) nr 79.
Moes 1897-1905, vol 1, nr 4004:1.
Hofstede de Groot 1907-28, vol 9 (1926)
nr 370. Ried 1931, fig 46. Martin 1935-
36, vol 2, p 358. Goldscheider 1936, p 38,
fig 235. Brochhagen 1958, p 110. Bernt
1960-62, vol 1, nr 252. Van Hall 1963, p
87, nr 553:4. Bernt 1969-70, vol 1, nr
341. Eckardt 1971, p 179, fig 43

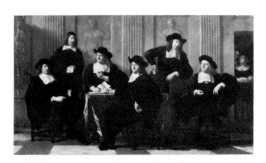

C 4 The regents of the Spinhuis (house
of correction) and the Nieuwe Werkhuis
(new workhouse) in Amsterdam, 1669.
*De regenten van het Spinhuis en Nieuwe
Werkhuis te Amsterdam, 1669*

The sitters are Michiel Tielensz, Joris
Croock, Hendrik Becker, Joannes
Commelin, Willem Muilman de Jonge
and a servant

Canvas 225 × 390. Signed and dated
Karel du Jardin fec. Anno 1669
PROV Spinhuis (house of correction),
Amsterdam. On loan from the city of
Amsterdam since 1808
LIT Smith 1829-42, vol 5 (1834) nr 86.
Obreen's Archief 1 (1877-78) p 166.

Scheltema 1879, p 21, nr 51. Moes
1897-1905, vol 1, nrs 430, 1665:1, 1828,
2321; vol 2, nrs 5202, 7976. Hofstede de
Groot 1907-28, vol 9 (1926) nr 407. Moes
& van Biema 1909, pp 120, 188. Martin
1935-36, vol 1, pp 97, 173, 200, fig 55;
vol 2, pp 165, 358. Brochhagen 1958, p
115. Haak 1972, p 29, fig 35

C 157 Portrait of a man, possibly Jacob
de Graeff (1642-90), alderman of
Amsterdam in 1672. *Portret van een man,
mogelijk Jacob de Graeff, schepen van
Amsterdam in 1672*

Canvas 130.5 × 106. Signed and dated
K. du Jardin fe. 1670
PROV On loan from the city of
Amsterdam (A van der Hoop bequest)
since 1885
LIT Hofstede de Groot 1907-28, vol 9
(1926) nr 387. Brochhagen 1958, p 113.
Gudlaugsson 1959-60, vol 2, p 228
(identifies the sitter as Jacob de Graeff)

A 191 Joan Reynst (1636-95), lord of
Drakenstein and the Vuursche. Captain
of the Amsterdam militia in 1672. *Heer
van Drakenstein en de Vuursche. Kapitein der
burgerij te Amsterdam in 1672*

Canvas 131 × 106. Signed *K. du Jardin fe*
PROV Purchased in 1815
LIT Smith 1829-42, vol 5 (1834) nr 382.
Moes 1897-1905, vol 2, nr 6404:2
(portrait of Gerard Reynst, 1599-1658).
Hofstede de Groot 1907-28, vol 9 (1926)
nr 382 (portrait of Gerard Reynst).
Brochhagen 1958, p 113

A 192 Italian landscape with girl milking
a goat. *Italiaans landschap met geiten-
melkster*

Panel 37 × 50. Signed and dated *K. du
Jardin fe 1652*
PROV Bequest of L Dupper Wzn,
Dordrecht, 1870
LIT Smith 1829-42, vol 5 (1834) nr 72.
Hofstede de Groot 1907-28, vol 9 (1926)
nr 44. Bernt 1960-62, vol 1, nr 254. Bernt
1969-70, vol 1, nr 343

A 195 Landscape with two donkeys,
goats and pigs. *Landschap met twee ezels,
geitjes en varkens*

Canvas 35.5 × 46. Signed and dated
K. du Jardin fe 1655
PROV Purchased with the Kabinet van
Heteren Gevers, The Hague-Rotterdam,
1809
LIT Smith 1829-42, vol 5 (1834) nr 84.
Hofstede de Groot 1907-28, vol 9 (1926)
nr 43. Moes & van Biema 1909, pp 146,
160. Exhib cat Italianiserende
landschapschilders, Utrecht 1965, ad nr
120. Rosenberg, Slive & Ter Kuile 1966,
p 179

A 194 Mule drivers at an inn. *Muilezel-
drijvers bij een herberg*

Copper 34 × 43.5. Signed *K. du Gardin f* and *Du Jardi* (on the donkey's bridle)
PROV Purchased with the Kabinet van Heteren Gevers, The Hague-Rotterdam, 1809 * DRVK since 1954
LIT Smith 1829-42, vol 5 (1834) nr 85. Hofstede de Groot 1907-28, vol 9 (1926) nr 309. Moes & van Biema 1909, pp 146, 160. Brochhagen 1958, p 56

A 193 Mounted trumpeter taking a drink. *Drinkende trompetter te paard*

Canvas 44 × 35. Signed *K. du Jardin fe.*
PROV Purchased with the Kabinet van Heteren Gevers, The Hague-Rotterdam, 1809
LIT Hoet 1752, vol 2, p 453. Smith 1829-54, vol 5 (1834) nr 87. Hofstede de Groot 1907-28, vol 9 (1926) nr 310. Moes & van Biema 1909, pp 146, 160. Brochhagen 1958, p 54 (ca 1653-54). Bille 1961, vol 1, p 109

C 158 Landscape with mule driver. *Landschap met muilezeldrijver*

Canvas 51 × 47. Signed *K. du Jardin f*
PROV On loan from the city of Amsterdam (A van der Hoop bequest) since 1885
LIT Smith 1829-42, vol 5 (1834) nr 90; suppl 18. Hofstede de Groot 1907-28, vol 9 (1926) nr 178. Brochhagen 1958, p 28 (ca 1652). A Blankert, OH 83 (1968) p 119, note 13

copy after **Karel Dujardin**

C 280 Italian landscape with soldiers. *Italiaans landschap met soldaten*

Copy after the painting in the Musées Royaux des Beaux-Arts, Brussels (cat 1949, nr 232)

Canvas 46 × 62
PROV On loan from the city of Amsterdam (A van der Hoop bequest) since 1885

Louis-Michel Dumesnil

Paris 1680 – after 1746 Paris

C 512 The reception of Cornelis Hop (1685-1762) as legate of the states-general at the court of Louis XV, 24 July 1719. *Ontvangst van Cornelis Hop als gezant der Staten Generaal aan het hof van Lodewijk XV, 24 juli 1719*

Canvas 104.5 × 163. Signed and dated *L. M. Dumes*[nil Pr.] *Regius* [Pinxit Anno 172.]. The inscriptions on the balustrades, right and left, are truncated and largely illegible
PROV On loan from the KOG (bequest of Jonkheer J M Pabst van Bingerden) since 1889
LIT Maumené & d'Harcourt 1932, vol 2, p 369, nr 232. R van Luttervelt, Jaarversl KOG 90-91 (1947-49) pp 80-104. Aulamé 1955, p 46, fig 18

copy after **Joseph Siffred Duplessis**

Carpentras 1725 – 1802 Versailles

A 3278 Louis XVI (1754-93), king of France. *Lodewijk XVI, koning van Frankrijk*

Copy after the painting in the Musée National de Versailles et des Trianons, dated 1775

Canvas 81 × 64.5. Oval
PROV Presented by B de Geus van den Heuvel, Amsterdam, 1939
LIT Maumené & d'Harcourt 1932, vol 2, p 471, nr 47, pl XXXV

Jules Dupré

Nantes 1811 – 1889 l'Isle-Adam

A 1874 'The broad way.' *'De brede weg'*

Canvas 91 × 118. Signed *Dupré*
PROV Presented by the dowager of R Baron van Lynden, née M C Baroness van Pallandt, The Hague, 1900 * DRVK since 1956

A 2888 A village by night. *Dorpsgezicht bij nacht*

Canvas 57 × 47. Signed *Jules Dupré*
PROV Bequest of A van Wezel, Amsterdam, 1922

A 1875 View in the woods. *Bosgezicht*

Canvas 34 × 24.5. Signed *Jules Dupré*
PROV Presented by the dowager of R Baron van Lynden, née MCBaroness van Pallandt, The Hague, 1900

Victor Dupré

Limoges 1816–1879 Paris

A 1876 Landscape. *Landschap*

Panel 32 × 41.5. Signed and dated *Victor Dupré 1869*
PROV Presented by the dowager of R

Baron van Lynden, née MCBaroness van Pallandt, The Hague, 1900

Christiaen Jansz Dusart

Antwerp 1618–1682/83 Amsterdam

A 1684 Young man by candlelight. *Jonge man bij kaarslicht*

Canvas 65 × 79. Signed and dated *C. Dusart fe 1645*
PROV Purchased from CHofstede de Groot, Amsterdam, 1897

Cornelis Dusart

Haarlem 1660–1704 Haarlem

A 98 Fish market. *Vismarkt*

Canvas 68.5 × 90.5. Signed and dated *Cor. Dusart f. 1683*
PROV Sale G van der Pot van Groeneveld, Rotterdam, 6 June 1808, lot 31
LIT Moes & van Biema 1909, pp 113, 186

A 100 Country inn. *Boerenherberg*

Panel 42 × 33. Signed and dated *Cor. Dusart 1690*
PROV From the Kabinet van Heteren Gevers, The Hague-Rotterdam. Already present in 1808
LIT Moes & van Biema 1909, pp 116, 158, 220. Martin 1935-36, vol 1, p 399, fig 240

A 688 A mother with her children. *Een moeder met haar kinderen*

Panel 32 × 25. Signed and dated *Cor. Dusart 1690*
PROV Bequest of Jonkheer JSH van de Poll, Amsterdam, 1880
LIT V de Stuers, Ned Kunstbode 2 (1880) p 245. Chr P van Eeghen, OH 62 (1947) p 92

A 99 Country kermis. *Boerenkermis*

Panel 36.5 × 32.5. Signed *K. Dusart*

PROV Bequest of L Dupper Wzn,
Dordrecht, 1870
LIT E Trautscholdt, NKJ 17 (1966) p 171

A 97 Street musicians. *Straatmuzikanten*

Canvas on panel 57 × 46. Signed *Corn.
Dusart fec.*
PROV Sale W Rijers, Amsterdam, 21
Sept 1814, lot 29. Purchased from J de
Vries, art dealer, 1814 * DRVK since 1953

manner of **Cornelis Dusart**

A 3273 The quack. *De kwakzalver*

Pendant to A 3274

Copper 9.7 × 12.7. Oval
PROV Belongs to the so-called doll-
house of Czar Peter (cat RMA Meubelen,
1952, nr 358). KKZ, 1821. NMGK, 1875

A 3274 The street seller. *De koopvrouw*

Pendant to A 3273

Copper 9.7 × 12.7. Oval
PROV Same as A 3273

Henri Joseph Duwée

active ca 1830-70 in Brussels

A 1808 Woman with a tambourine.
Vrouw met een tamboerijn

Canvas 117 × 83. Signed and dated
H. J. Duwée 58
PROV Bequest of Reinhard Baron van
Lynden, The Hague, 1899 * DRVK since
1953

Duyl-Schwartze

see Schwartze

Isaac van Duynen

Dordrecht? 1625/30 – 1677/81 The
Hague?

A 1466 Still life with fish. *Stilleven met
vissen*

Canvas 96 × 128
PROV Sale C J Terbruggen, Amsterdam,
12-13 June 1888, lot 28 * DRVK since
1959 (on loan to the Dordrechts
Museum, Dordrecht)
LIT Vorenkamp 1931, p 77

Willem Cornelisz Duyster

Amsterdam 1598/99 – 1635 Amsterdam

A 1427 The backgammon players. *De
triktrakspelers*

Canvas 30.5 × 40. Oval. Signed
WC Duyste.
PROV Presented by Dr A Bredius, The
Hague, 1887
LIT A Bredius, OH 6 (1888) p 194

C 514 A wedding feast, traditionally
called the wedding of Adriaen Ploos van
Amstel and Agnes van Bijlert, 1616.
*Bruiloftsfeest, van ouds bekend als de bruiloft
van Adriaen Ploos van Amstel en Agnes van
Bijlert, 1616*

Panel 76 × 106.5. Signed *WC Duyster
fecit*
PROV On loan from the KOG (bequest of
Jonkheer J Ploos van Amstel) since 1889
LIT A Bredius, OH 6 (1888) p 194. Moes
1897-1905, vol 1, nr 1359; vol 2, nr 5966.
Plietzsch 1960, p 31, fig 24. Fr W S van
Thienen, Antiek 3 (1969) p 486, fig 3 (ca
1628). Fr W S van Thienen & M Braun-
Ronsdorf, Waffenkunde 12 (1970) p 62,
fig 4

attributed to **Willem Cornelisz Duyster**

A 1791 Portrait of a man. *Portret van een man*

Pendant to A 1792

Copper 14.5 × 12. Oval. Dated *A° 1627.* Inscribed *out 40*
PROV Sale S W Josephus Jitta, Amsterdam, 9 Nov 1897, lot 58. Purchased with aid from the Rembrandt Society

A 1792 Portrait of a woman. *Portret van een vrouw*

Pendant to A 1791

Copper 14.5 × 12.5. Oval. Dated *A° 1629.* Inscribed *out 38*
PROV Same as A 1791

Abraham van Dijck

Alkmaar? 1636–1672 Amsterdam

A 3300 Old woman with a book. *Oude vrouw met boek*

Canvas 41 × 33
PROV Presented by Mr & Mrs DAJ Kessler-Hülsmann, Kapelle op den Bosch near Mechelen, 1941 * DRVK since 1953

Anthony van Dyck

Antwerp 1599–1641 Blackfriars, London

see also Miniatures: Cooper, Samuel, A 4305 George Gordon, after van Dyck; Hoskins, John, A 4326 & A 4327 Henrietta Maria of France, after van Dyck; Oliver, Peter, A 4353 François Duquesnoy, after van Dyck

A 103 The penitent Mary Magdalene. *De boetvaardige Maria Magdalena*

Canvas 169 × 148.5
PROV NM, 1808
LIT Smith 1829-42, vol 3 (1831) nr 422. Guiffrey 1882, p 199. Cust 1900, p 250. Moes & van Biema 1909, pp 54, 213. Bode 1917, p 369. Drost 1926, p 57. Rosenbaum 1928, pp 55, 62. Glück 1931, pp 139, 534. M Delacre, Bull Ac Roy Belgique 2d ser 3 (1934) p 177, ill. Van den Wijngaert 1943, p 75. Gerson & Ter Kuile 1960, p 117. Fr Bardon, Journ WCI 31 (1968) p 281, fig 76b

A 725 Portrait of a man from the van der Borght family, perhaps François van der Borght. *Portret van een man uit de familie van der Borght, misschien François van der Borght*

Canvas 205 × 136
PROV Bequest of Jonkheer J S H van de Poll, Amsterdam, 1880

LIT Smith 1829-42, vol 3 (1831) nr 352. V de Stuers, Ned Kunstbode 2 (1880) p 244. Guiffrey 1882, p 893. Cust 1900, p 253, nr 63. Glück 1931, pp 322, 554

A 101 Nicolaes van der Borght. Merchant of Antwerp. *Koopman te Antwerpen*

Canvas 201 × 141
PROV Acquired through exchange with the KKS, 1825 (as a portrait of François van der Borght)
LIT Smith 1829-42, vol 3 (1831) nr 137. Guiffrey 1882, p 893. Cust 1900, p 253, nr 16. Glück 1931, pp 323, 554. Van den Wijngaert 1943, p 94

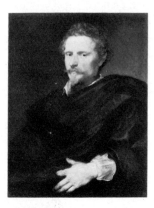

C 284 Johannes Baptista Franck (ca 1599-1663)

Canvas 75 × 59. Inscribed *Iohannes Bap^ta Franck Aetatis Suae XXXII*
PROV On loan from the city of Amsterdam (A van der Hoop bequest) since 1885
LIT Smith 1829-42, vol 3 (1831) nr 827. Moes & van Biema 1909, p 179. Glück 1931, pp 294, 551

studio of **Anthony van Dyck**

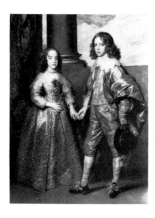

A 102 Willem II (1626-50), prince of Orange, and Princess Henrietta Maria Stuart (1631-60), daughter of Charles I of England. *Willem II, prins van Oranje, en prinses Henriette Maria Stuart, dochter van Karel I van Engeland*

Painted on the occasion of their marriage, 12 May 1641

Canvas 182.5 × 142
PROV NM, 1808
LIT Moes 1897-1905, vol 2, nr 9095:11. H Schneider, Zeitschr BK 61 (1927-28) p 44 (finished by Adriaan Hanneman). Glück 1931, pp 505, 576 (Hanneman). Martin 1935-36, vol 2, p 156. G Glück, Burl Mag 79 (1941) p 199 (Peter Lely). M R Toynbee, Burl Mag 82 (1943) pp 102-03 (possibly Lely). L van Puyvelde, Burl Mag 83 (1943) pp 205ff (van Dyck). H Rosenau, Burl Mag 83 (1943) p 207. M R Toynbee & L van Puyvelde, Burl Mag 83 (1943) pp 257-58. E K Waterhouse, Burl Mag 86 (1945) pp 50-51 (presumably a later copy [1650-60] by Lely after the original by van Dyck). Staring 1948, p 23 (heads painted in The Hague by Hanneman). O Millar, Burl Mag 92 (1950) p 233 (presumably a copy by Lely after van Dyck). Van Puyvelde 1950, pp 117, 157-58, 171. R van Luttervelt, OH 68 (1953) pp 159-69 (van Dyck with the help of Lely). A Staring, OH 70 (1955) pp 155-62. L van Puyvelde, Revue belge d'Arch & d'Hist de l'Art 24 (1955) p 42, fig 3. J G van Gelder, Bull Mus Roy Belg 8 (1959) p 67, fig 22. D Catton Rich, Worcester Mus Ann 7 (1959) p 1, fig 5. Gerson & Ter Kuile 1960, p 192, note 65 (studio of van Dyck). VTTT, 1962-63, nr 55. M Poch-Kalous, Albertina Stud 4 (1966) p 27. S Groenveld, Spiegel Hist 4 (1969) fig 2 on p 13. Th H Lunsingh Scheurleer, OH 84 (1969) p 56, fig 21. R H C Vos, OK 15 (1971) nr 18, ill. Gans 1971, p 48, ill (detail). R H C Vos, Kunstrip 3 (1972-73) nr 29

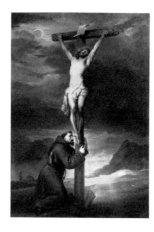

A 2318 Peter Paul Rubens (1577-1640). Painter and diplomat. *Schilder en diplomaat*

Panel 25.5 × 20. Grisaille
PROV Purchased from the heirs of Jonkheer P H Six van Vromade, Amsterdam, 1908, with aid from the Rembrandt Society
LIT Evers 1943, p 322, ill

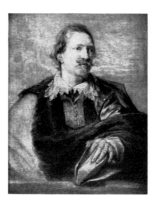

A 2319 Jan Caspar Gevaerts (1593-1666). Jurist, historian, philosopher and poet. *Rechtsgeleerde, geschiedschrijver, filosoof en dichter*

Panel 25.5 × 20. Grisaille
PROV Same as A 2318
LIT M Delacre, Bull Ac Roy Belg 2d ser 3 (1934) p 13 (studio work). Van Puyvelde 1950, pp 198, 202

manner of **Anthony van Dyck**

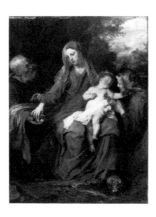

A 597 The holy family with Mary Magdalene. *De heilige familie met Maria Magdalena*

Canvas 100 × 76.5
PROV Purchased by King Willem I in Paris, 1823
LIT Glück 1931, pp 150, 536 (original)

A 104 St Francis at the foot of the cross. *De heilige Franciscus aan de voet van het kruis*

Canvas 175.5 × 123.5
PROV According to tradition, captured with the Spanish silver fleet on 9 Sep 1628. NM, 1808 * DRVK since 1961
LIT Cust 1900, p 66 (original). Moes & van Biema 1909, pp 27-28, 40, 48, 69, 122, 169, 212. R van Luttervelt, Bull NOB 6th ser 7 (1954) p 159, fig 9

copy after **Anthony van Dyck**

A 209 Sebastiaan Leerse. Merchant of Antwerp. *Koopman te Antwerpen*

Pendant to A 210
Copy by Willem Bartel van der Kooi (1768-1836) after the original in the Alte Pinakothek, Munich (cat 1957, nr 369)

Canvas 146 × 116
PROV Presented by H van der Kooi, Leeuwarden, 1869
LIT Marius 1920, p 63

A 210 The wife of Sebastiaan Leerse. *De vrouw van Sebastiaan Leerse*

Pendant to A 209
Copy by Willem Bartel van der Kooi (1768-1836) after the original in the Alte Pinakothek, Munich (cat 1957, nr 368)

Canvas 146 × 116
PROV Same as A 209
LIT Marius 1920, p 63

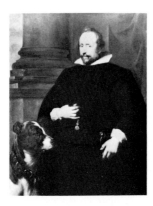

A 208 Wolfgang Wilhelm (1578-1653), count palatine of Neuburg, duke of Gulik and Berg. *Paltsgraaf van Neuburg, hertog van Gulik en Berg*

Copy by Willem Bartel van der Kooi (1768-1836) after the original in the Alte Pinakothek, Munich (cat 1957, nr 402)

Canvas 147 × 117
PROV Same as A 209 * DRVK since 1953
LIT Marius 1920, p 63

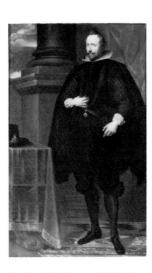

A 2872 Wolfgang Wilhelm (1578-1653), count palatine of Neuburg, duke of Gulik and Berg. *Paltsgraaf van Neuburg, hertog van Gulik en Berg*

Free copy after the original in the Alte Pinakothek, Munich (cat 1957, nr 402)

Canvas 197 × 120
PROV Helmond Castle, 1921 * DRVK since 1953

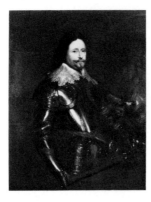

A 105 Frederik Hendrik (1584-1647), prince of Orange. *Prins van Oranje*

Copy after the original in the Prado, Madrid (cat 1952, nr 1482)

Canvas 125 × 101
PROV Purchased from Ch H Hodges, Amsterdam, 1810 * DRVK since 1952
LIT Moes 1897-1905, vol 1, nr 2582:44

A 205 Michel le Blon (1587-1657). Agent of Queen Christina of Sweden, goldsmith and engraver. *Agent van koningin Christina van Zweden, goudsmid en graveur*

Copy after the original in the Art Gallery of Ontario, Toronto (bequest of J J Vaughan, 1965)

Canvas 57 × 46
PROV Sale J A Brentano, Amsterdam, 13 May 1822, lot 174 (as a portrait of Hendrik Kasimir by Roelof Koets)
LIT Moes 1897-1905, vol 1, nr 746:2. Cust 1900, p 86. Van Hall 1963, p 28, nr 178:1. *Cf* H de la Fontaine Verwey, Jb Amstelodamum 61 (1969) pp 103-25

A 847 Andries van Eertvelt (1590-1652). Painter. *Schilder*

Copy after the original in the Staatsgalerie, Augsburg (cat 1899, nr 471)

Canvas 114 × 87
PROV Sale Amsterdam, 31 Dec 1884, lot 241 * DRVK since 1953

C 312 Henricus Liberti (1628-61). Composer and organist. *Componist en organist*

Copy after the original in the Alte Pinakothek, Munich (cat 1952, nr 375)

Canvas 114 × 83.5
PROV On loan from the city of Amsterdam (presented by the heirs of the dowager of W Baron Röell, née C C Hodshon) since 1885
LIT Moes 1897-1905, vol 2, nr 4491:5? Glück 1931, p 555

A 1224 Salvator mundi

Copy after the painting in Schloss
Sanssouci, Potsdam

Canvas 64.5 × 49.5
PROV KKS, 1885
LIT Moes & van Biema 1909, pp 63, 212

attributed to **Floris van Dijck**

Haarlem? 1575 – 1651 Haarlem

A 2058 Still life with fruit and vegetables,
with Christ at Emmaus in the back-
ground. *Stilleven met vruchten en groenten
met op de achtergrond Christus en de Emmaus-
gangers*

Canvas 113 × 200
PROV Purchased in Vogelenzang, 1903
LIT C Hofstede de Groot, OH 22 (1904) p
33. Warner 1928, p 66, nr 28e.
Vorenkamp 1933, p 53. Martin 1935-36,
vol 1, p 287. Hoogewerff 1936-47, vol 4
(1941-42) p 547 (Floris van Schooten or
Floris van Dijck). Bergström 1956, p 102,
note 12. Gammelbo 1960, p 12, nr 4 (van
Schooten). P Gammelbo, Antichità 2
(1963) p 24, ill (van Schooten). P
Gammelbo, NKJ 17 (1966) p 109, nr 1,
fig 2 (van Schooten)

Philip van Dijk

Amsterdam 1680 – 1753 The Hague

see also Kneller, Godfried, A 2060
Aernout van Citters, copy by Philip van

Dijk; Netscher, Caspar, A 901 Jan
Boudaen Courten & A 902 Anna Maria
Hoeufft, copies by Philip van Dijk –
Governors-general series: A 3780
Gustaaf Willem Baron van Imhoff

A 1647 Isaac Parker (1702-55).
Merchant of Middelburg. *Koopman te
Middelburg*

Pendant to A 1648

Canvas 51 × 41. Signed and dated
P. van Dijk 1734
PROV Purchased from J C de Ruyter de
Wildt, Vlissingen, 1895

A 1648 Justina Johanna Ramskrammer
(1702-98). Wife of Isaac Parker. *Echt-
genote van Isaac Parker*

Pendant to A 1647

Canvas 50 × 42
PROV Same as A 1647

A 1650 Willem Parker (1695-1754).
Burgomaster of Middelburg. *Burge-
meester van Middelburg*

Three-quarters length, standing beside a
table with a red cloth, facing front. With
a powdered wig and no hat, black velvet
robe, black silk camisole and long muslin
scarf. His right arm resting on a globe,
with a letter in his left hand. In the
background a bookcase
Pendant to A 1666

Canvas 50 × 40.5. Signed and dated
P. van Dijk 1741
PROV Purchased from J C de Ruyter de
Wildt, Vlissingen, 1895 * Lent to the
Stedelijk Museum, Middelburg, 1926.
Destroyed in the war, 1940

A 1666 Anna Maria Pottey (1695-1724).
Wife of Willem Parker. *Echtgenote van
Willem Parker*

Three-quarters length, standing beside a
stone pedestal, turned slightly to the left.
Powdered hair, purple velvet dress, a
lapdog on her left arm. Her head is seen
against the wall. To the right a red
drapery, in the left background a garden
Pendant to A 1650

Canvas 50 × 40. Signed and dated
P. v. Dijk 1741
PROV Same as A 1650 * Lent to the
Stedelijk Museum, Middelburg, 1926.
Destroyed in the war, 1940
LIT Moes 1897-1905, vol 2, nr 6053

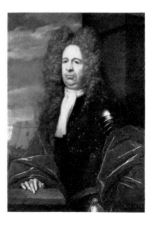

A 1649 Isaac Parker, his wife Justina
Johanna Ramskrammer and their son
Willem Alexander (1740-47). *Isaac
Parker, zijn echtgenote Justina Johanna
Ramskrammer en hun zoontje Willem
Alexander*

Panel 51.5 × 43. Signed and dated
P. van Dijk 1742
PROV Purchased from J C de Ruyter de
Wildt, Vlissingen, 1895

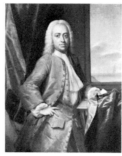

A 895 Adriaen Parduyn. Lieutenant

colonel, commandant of Retranchement and Rammekens, father of Caspar Adriaen Parduyn. *Luitenant-kolonel, commandant van Retranchement en Rammekens, vader van Caspar Adriaen Parduyn*

For a portrait of the sitter's son, *see* A 896

Canvas 105 × 77. Signed *P. v. Dijk*
PROV Bequest of Jonkheer J de Witte van Citters, The Hague, 1876. NMGK, 1885 * DRVK since 1950
LIT Moes 1897-1905, vol 2, nr 5734

A 896 Caspar Adriaen Parduyn (1685-1735). Bailiff of Middelburg. *Baljuw van Middelburg*

Pendant to A 897

Canvas 56.5 × 45. Signed *P. v. Dijk*
PROV Bequest of Jonkheer J de Witte van Citters, The Hague, 1876. NMGK, 1885 * DRVK since 1950
LIT Moes 1897-1905, vol 2, nr 5736

A 897 Maria van Citters (1684-1752). Wife of Caspar Adriaen Parduyn. *Echtgenote van Caspar Adriaen Parduyn*

Pendant to A 896

Canvas 55 × 45. Signed *P. van Dijk*
PROV Same as A 896 * DRVK since 1950
LIT Moes 1897-1905, vol 1, nr 1547

A 898 Adriaen Caspar Parduyn (1718-47). Councillor and alderman of Middelburg, son of Caspar Adriaen Parduyn and Maria van Citters. *Raad en schepen te Middelburg, zoon van Caspar Adriaen Parduyn en Maria van Citters*

For portraits of the sitter's parents, *see* A 896 & A 897

Canvas 54 × 44. Signed *P. van Dijk*. On the verso the sitter's coat of arms, the inscription *Adriaan Casper Parduijn Raad en Schepen te Middelburg Geb^r 1718 Gestorv. 1747* and the number *14*
PROV Bequest of Jonkheer J de Witte van Citters, The Hague, 1876. NMGK, 1885 * DRVK since 1950
LIT Moes 1897-1905, vol 2, nr 5735

A 1778 Berend van Iddekinge (1717-1801) with his wife Johanna Maria Sichterman (1726-56) and their son Jan Albert (b 1744). *Berend van Iddekinge met zijn echtgenote Johanna Maria Sichterman en hun zoontje Jan Albert*

Canvas 152 × 119. Signed *P. van Dijk*
PROV Bequest of FZ Reneman, Haarlem, 1898
LIT Moes 1897-1905, vol 2, nr 7190

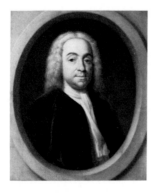

A 903 Abraham Boudaen (1688-1745), lord of Schellach. Town clerk of Walcheren. *Heer van Schellach. Griffier van Walcheren*

For portraits of the sitter's parents, *see* Netscher, Caspar, A 901 Jan Boudaen

Courten & A 902 Anna Maria Hoeufft, copies by Philip van Dijk

Canvas 36 × 31
PROV Bequest of Jonkheer J de Witte van Citters, The Hague, 1876. NMGK, 1885 * DRVK since 1950
LIT Moes 1897-1905, vol 1, nr 964

A 1435 The bird's nest. *Het vogelnestje*

Panel 33 × 26. Marked on the verso *Ph^s van Dijk*
PROV Presented by J A Smits van Nieuwerkerk, Dordrecht, 1888 * DRVK since 1959

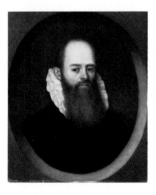

A 892 Cornelis van Ceters (1503-99)

Copy after an original of the 3d quarter of the 16th century. For a portrait of the sitter's son, *see* A 893

Canvas 38 × 31. On the verso his coat of arms, the inscription *Cornelis van Ceters geb^r 1503. gest^r 1599. wegens de Troubles na Middelburg geweeken* and the number *1*
PROV Bequest of Jonkheer J de Witte van Citters, The Hague, 1876. NMGK, 1885

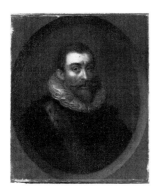

A 893 Aernout van Citters (1561-1634), lord of Gapinge. *Heer van Gapinge*

Copy after an original of the beginning of the 17th century. For a portrait of the sitter's son, *see* Kneller, Godfried, A 2060, copy by Philip van Dijk

Canvas 37 × 32. On the verso his coat of arms, the inscription *d'heer Aernout van Citters, hr van der gapinge. geb : tot Antwerpen 13 8br 1561. in 't Jaer 1632 voor d'vierd'mael getr : met Juffr Anna van der Strenge wede : kempe. tot middelb : gest : 29 7br : 1634* and the number 2
PROV Same as A 892. NMGK, 1885
LIT Moes 1897-1905, vol I, nr 1534

Gerrit Willem Dijsselhof

Zwollerkerspel 1866– 1924 Overveen

A 2890 Tulip fields. *Tulpenvelden*

Panel 20 × 35. Signed *GWD*
PROV Bequest of A van Wezel, Amsterdam, 1922 * DRVK since 1959

A 3586 Pike and perch in an aquarium. *Snoeken en baarzen in een aquarium*

Canvas 100 × 100. Signed *GWD*
PROV Lent by Mr & Mrs J C J Drucker-Fraser, 1920. Bequeathed in 1944

NO PHOTOGRAPH AVAILABLE

A 2891 Gurnard in an aquarium. *Ponen in een aquarium*

Panel 24.5 × 30. Signed *GWD*
PROV Bequest of A van Wezel, Amsterdam, 1922 * Lent to the Stedelijk Museum, Zutphen, 1924. Destroyed in the war, 1945

A 2889 Gold- and silverfish in an aquarium. *Goud- en zilvervisjes in een aquarium*

Canvas 32.5 × 46
PROV Bequest of A van Wezel, Amsterdam, 1922

A 3588 Meadow landscape on the Spaarne. *Weidelandschap aan het Spaarne*

Panel 17.5 × 29
PROV Lent by Mr & Mrs J C J Drucker-Fraser, 1919. Bequeathed in 1944

A 3587 Autumn day. *Najaarsdag*

Panel 19 × 23
PROV Lent by Mr & Mrs J C J Drucker-Fraser, 1919 * DRVK since 1959 (on loan to the Gemeentemuseum, Arnhem)

attributed to **Albert Eckhout**

Groningen ca 1610 – in or before 1666
Groningen

A 4070 A market stall in the Indies.
Oost-Indisch marktstalletje

Canvas 106 × 174.5. The names of the
fruits are inscribed in Malay in the
lower right corner, but are only partially
legible
PROV Presented by E Speelman gallery,
London, 1962

Gerbrandt van den Eeckhout

Amsterdam 1621 – 1674 Amsterdam

A 2507 The last supper. *Het laatste avond-
maal*

Canvas 100 × 142. Signed and dated
G.v. Eeckhout fe. A° 1664
PROV Purchased from Sully & Co
gallery, London, 1910
LIT W Sumowski, OH 77 (1962) p 32, fig
42. Gantner 1964, p 137, fig 38. Roy
1972, pp 72, 74, 181, cat nr 60

C 130 The hunter at rest. *De rustende
jager*

Canvas 36 × 45. Signed *G. v. Eeckhout f.*
PROV On loan from the city of
Amsterdam (A van der Hoop bequest),
1885-1975
LIT Martin 1935-36, vol 2, p 129. Roy
1972, p 145, cat nr 113

A 1612 Men bathing. *Badende mannen*

Panel 45.5 × 33. Signed *G. Eeckhout*
PROV Purchased from Dowdeswell &
Dowdeswell gallery, London, 1894
LIT Martin 1935-36, vol 2, p 130. Roy
1972, pp 144-45, cat nr 113

A 106 Christ and the woman in adultery.
Christus en de overspelige vrouw

Canvas 66 × 82
PROV Purchased from C Josi, London,
1828
LIT Martin 1935-36, vol 2, pp 129-30,
fig 72. Van de Waal 1952, p 217, note 3.
MacLaren 1960, p 309. W Sumowski,

OH 77 (1962) p 29, note 26. H Kühn, Jb
Ksamml Baden-Württemberg 2 (1965) p
206. Roy 1972, pp 74-75, cat nr 56

manner of **Gerbrandt van den
Eeckhout**

A 3489 The wrath of Ahasuerus. *De
woede van Ahasverus*

Canvas 61 × 74
PROV Bequest of Mrs A C M H Kessler-
Hülsmann, widow of D A J Kessler,
Kapelle op den Bosch near Mechelen,
1947

Jacobus Josephus Eeckhout

Antwerp 1793 – 1861 Paris

A 4059 Petronella de Lange (1779-1835).
Wife of Jonkheer Theodorus Frederik
van Capellen. *Echtgenote van Jonkheer
Theodorus Frederik van Capellen*

Panel 30.5 × 23.3. Signed and dated
J. J. Eeckhout 1835
PROV Presented by the dowager of
V C H J Baron de Constant Rebecque,
née F S C L M G Baroness van Zuylen
van Nyevelt, Breda, 1961 * DRVK since
1971 (on loan to the Museum van de
Kanselarij der Nederlandse Orden, The
Hague)

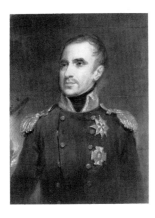

A 4058 Jonkheer Theodorus Frederik van Capellen (1762-1824). Vice admiral and commanding officer of the Dutch squadron off Algiers, 1816. *Vice-admiraal en bevelhebber van het Nederlandse eskader voor Algiers in 1816*

Copy after A 4639, pastel by Charles Howard Hodges

Panel 31 × 23.8. Signed *Eeckhout*
PROV Same as A 4059 * DRVK since 1971 (on loan to the Museum van de Kanselarij der Nederlandse Orden, The Hague)

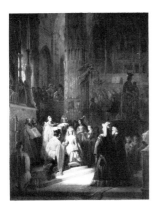

A 1030 The wedding of Jacoba of Bavaria, countess of Holland, and Jan IV, duke of Brabant, 10 March 1418. *Het huwelijk van Jacoba van Beieren, gravin van Holland, en Jan IV, hertog van Brabant, op 10 maart 1418*

Canvas 166 × 132. Signed and dated *J.J. Eeckhout 1839*
PROV Purchased at exhib The Hague 1839, nr 105. RVMM, 1885 * DRVK since 1952

Eelke Jelles Eelkema

Leeuwarden 1788 – 1839 Leeuwarden

see also Brandt, Albertus Jonas, A 1013 Flowers in a terra cotta vase

A 1031 Still life with flowers. *Stilleven met bloemen*

Canvas 74 × 60. Signed and dated *E.J. Eelkema 1817*
PROV Purchased at exhib Amsterdam 1818, nr 72. RVMM, 1885 * DRVK since 1953

A 1032 Still life with flowers and fruit. *Stilleven met bloemen en vruchten*

Canvas 91 × 76. Signed and dated *E.J. Eelkema 1824*
PROV RVMM, 1885 * DRVK since 1952

A 3454 Still life with flowers. *Stilleven met bloemen*

Canvas 71.5 × 52.5. Signed *E.J. Eelkema*
PROV Presented by Misses L & C Kramer, The Hague, 1942 * DRVK since 1961

C 131 Still life with flowers and fruit. *Stilleven met bloemen en vruchten*

Canvas 90.5 × 76. Signed *E.J. Eelkema*
PROV On loan from the city of Amsterdam (A van der Hoop bequest) since 1885
LIT Scheen 1946, fig 169

Otto Eerelman

Groningen 1839 – 1926 Groningen

A 1849 The Frederiksplein, Amsterdam, during the entry of Queen Wilhelmina, 5 September 1898. *Het Frederiksplein te Amsterdam tijdens de intocht van koningin Wilhelmina, 5 september 1898*

Canvas 139 × 195. Signed *Otto Eerelman den Haag*
PROV Presented by J J Biesing, 1900, on behalf of a group of art lovers * DRVK since 1961

attributed to **Andries van Eertvelt**

Antwerp 1590 – 1652 Antwerp

C 448 Ships in a storm. *Schepen in de storm*

Panel 38 × 106.5. Signed *v. E?*
PROV Oude Zijds Huiszittenhuis
(institute for the outdoor relief of the
poor), Amsterdam. On loan from the
city of Amsterdam since 1885
LIT P J J van Thiel, in Miscellanea van
Regteren Altena, 1969, p 109, fig 3
(attributed to Claes Claesz Wou)

l'Egaré

see Miniatures: Légaré

Ehrenstrahl

see Klöcker

Jan Ekels I

Amsterdam 1724–1781 Amsterdam

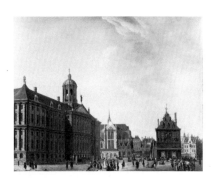

A 689 View of the Dam, Amsterdam.
Gezicht op de Dam te Amsterdam

Panel 48 × 62.5. Signed *I. Ekels*
PROV Bequest of Jonkheer J S H van de
Poll, Amsterdam, 1880
LIT V de Stuers, Ned Kunstbode 2
(1880) p 245. Scheen 1946, fig 207. Chr P
van Eeghen, OH 62 (1947) p 92

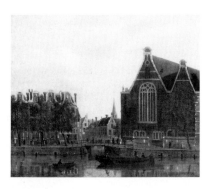

A 3475 The so-called Boerenverdriet on
the Spui, Amsterdam. *Het zogenaamde
Boerenverdriet aan het Spui te Amsterdam*

Canvas 40 × 48.5. Signed (apocryphally)
J. B. Heyde
PROV From the Robert May collection,
Amsterdam, 1946 * Lent to the AHM,
1975

Jan Ekels II

Amsterdam 1759–1793 Amsterdam

A 690 A writer trimming his pen. *Een
schrijver die zijn pen versnijdt*

Panel 27.5 × 23.5. Signed and dated
I. Ekels f. Ano 1784
PROV Bequest of Jonkheer J S H van de
Poll, Amsterdam, 1880
LIT V de Stuers, Ned Kunstbode 2
(1880) p 245. J Knoef, OH 45 (1928) p
49. Huebner 1942, fig 65. Knoef 1943, p
24, ill. Scheen 1946, fig 35. A Staring, in
Kunstgesch der Ned, 1954-56, p 651.
VTTT, 1958, nr 5. H P Baard, OK 4 (1960)
nr 31, ill. Gerson 1961, p 13. Rosenberg,
Slive & Ter Kuile 1966, p 214, fig 174.
C J de Bruyn Kops, Bull RM 16 (1968) p
62, fig 4. J W Niemeijer, Apollo 96 (1972)
p 394, fig 10

A 4130 A man writing at his desk. *Een
man schrijvend aan zijn lessenaar*

Panel 51.5 × 39.5. Signed and dated
I. Ekels Ano 1784
PROV Sale London, 21 April 1967, lot
28, ill

LIT C J de Bruyn Kops, Bull RM 16
(1968) p 38, fig 1

C 1537 A field officer of the Amsterdam
militia, perhaps Paulus van Pruyssen
Morisse. *Een hoofdofficier van de gewapende
Burgerwacht van Amsterdam, misschien
Paulus van Pruyssen Morisse*

Canvas 82.5 × 52. Signed and dated
.. Ekels. F 1787
PROV On loan from the KOG (who have
it on loan from the Commissie voor de
Verzameling betreffende Burger-
wapening en Schutterij) since 1973
LIT Kat Hist Verz Schutterij 1889, p 34.
Knoef 1943, p 25. G Kamphuis, Bull RM
21 (1973) p 25, ill

A 1846 Egbert van Drielst (1745-1818).
Painter. *Schilder*

Canvas 32 × 26.5
PROV Purchased from M van Duren Jr,
art dealer, Amsterdam, 1900
LIT Van Hall 1963, p 86, nr 536 (self
portrait of E van Drielst). C J de Bruyn
Kops, Bull RM 16 (1968) pp 56-66, fig 1

Nicolaes Eliasz *called* **Pickenoy**

Amsterdam 1590/91 – 1654/56
Amsterdam

C 383

C 386

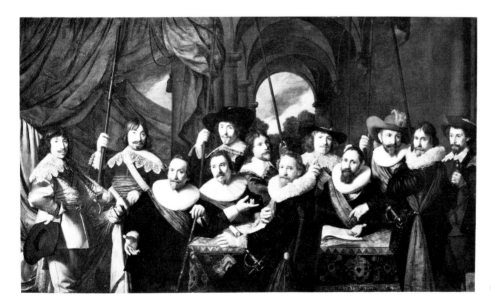

C 403

C 386 Banquet of the company of Captain Jacob Backer and Lieutenant Jacob Rogh, Amsterdam, 1632. *Schuttersmaaltijd van kapitein Jacob Backer en luitenant Jacob Rogh, Amsterdam, 1632*

The ensign, Roelof Bicker, is standing in front of the table, and Willem Backer is in the doorway

Canvas 198 × 531
PROV Voetboogdoelen (headquarters of the crossbowmen's civic guard), Amsterdam. On loan from the city of Amsterdam, 1885-1975
LIT Scheltema 1855-85, vol 7 (1885) p 133. DC Meyer Jr, OH 3 (1885) p 114. J Six, OH 4 (1886) p 92 (ca 1632). J Six, OH 9 (1891) p 92. Moes 1897-1905, vol 1, nr 278:2; vol 2, nr 6483:1. Riegl 1931, pp 226, 291. Martin 1935-36, vol 1, pp 164, 211, 224. H van de Waal, OH 71 (1956) p 70, fig 3

C 403 The company of Captain Dirck Theuling and Lieutenant Adriaen Pietersz Raep, Amsterdam, 1639. *Het korporaalschap van kapitein Dirck Theuling en luitenant Adriaen Pietersz Raep, Amsterdam, 1639*

Canvas 202 × 340.5. Dated *1639*
PROV Kloveniersdoelen (headquarters of the arquebusiers' civic guard), Amsterdam. On loan from the city of Amsterdam, 1885-1975
LIT Van Dijk 1758, p 138, nr 102 (lists 23 sitters). Scheltema 1879, p 46, nr 122 (says there are 12 sitters). Scheltema 1855-85, vol 7 (1885) p 136. DC Meyer Jr, OH 3 (1885) pp 112-13. J Six, OH 4 (1886) pp 96-97. Moes 1897-1905, vol 1, nr 371; vol 2, nr 6147:2. Van Hall 1963, p 139, nr 923:1

C 1177 The company of Captain Jan Claesz Vlooswijck and Lieutenant Gerrit Hudde, Amsterdam, 1642. *Het korporaalschap van kapitein Jan Claesz Vlooswijck en luitenant Gerrit Hudde, Amsterdam, 1642*

The other sitters are Jan Witsen, ensign, Hillebrant Bentes and Andries Dircksen van Saane, sergeants, Jan Bentes, Willem Simonsz Moons, Jan Huybertsen Codde, Roelof Roelofsen de Lange, IJsbrant van de Wouwer, Johannes Looten, Ulrich Petersen, Jacob Bleyenberch, Pieter Harpertsen, Pieter Tonneman, Evert Huibertsen Krieck, Hendrik Jansen van As and Nicolaes Kuysten

Canvas 340 × 527
PROV Kloveniersdoelen (headquarters of the arquebusiers' civic guard), Amsterdam. On loan from the city of Amsterdam since 1925
LIT Van Dijck 1790, p 62, nr 28 (Jacob Backer). DC Meyer Jr, OH 3 (1885) pp

C 383 The company of Captain Dr Matthijs Willemsz Raephorst and Lieutenant Hendrick Lauwrensz, Amsterdam, 1630. *Het korporaalschap van kapitein Dr Matthijs Willemsz Raephorst en luitenant Hendrick Lauwrensz, Amsterdam, 1630*

Canvas 272.5 × 484.5

PROV Voetboogdoelen (headquarters of the crossbowmen's civic guard), Amsterdam. On loan from the city of Amsterdam, 1885-1975
LIT Scheltema 1855-85, vol 7 (1885) p 133. J Six, OH 4 (1886) pp 89-91. Moes 1897-1905, vol 2, nr 6150

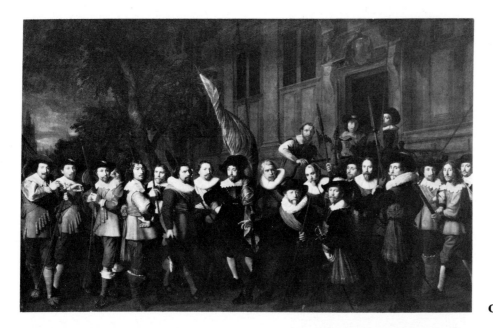

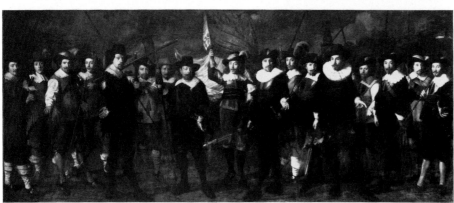

A 698 Maerten Rey (d 1632). Wine merchant and steward of the arquebusiers' civic guard. *Wijnkoper, kastelein van de Voetboogdoelen*

Pendant to A 699

Panel 99 × 74. Oval. Dated *1627*.
Inscribed *Aetª 32*
PROV Bequest of Jonkheer J S H van de Poll, Amsterdam, 1880
LIT J G Frederiks, in Obreen's Archief 6 (1884-87) p 265ff (Thomas de Keyser). J Six, OH 4 (1886) p 87. Moes 1897-1905, vol 2, nr 6374. G Kolleman, Ons Amsterdam 23 (1971) p 115

A 699 Maria Joachimsdr Swartenhont (1598-1631). Wife of Maerten Rey. *Echtgenote van Maerten Rey*

C 1177

Pendant to A 698

Panel 99 × 74. Oval. Dated *1627*.
Inscribed *Aetª 27*
PROV Same as A 698
LIT J G Frederiks, in Obreen's Archief 6 (1884-87) p 265ff (Thomas de Keyser). J Six, OH 4 (1886) p 87. Moes 1897-1905, vol 2, nr 7730. Martin 1935-36, vol I, pp 312, 314, fig 181. Boon 1942, p 66, fig 33. G Kolleman, Ons Amsterdam 23 (1971) p 115, ill on p 119

C 361

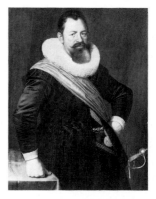

116-17. Scheltema 1855-85, vol 7 (1885) p 136. J Six, OH 4 (1886) pp 98-99. A Bredius, OH 13 (1895) p 180. Moes 1897-1905, vol 1, nr 3810; vol 2, nr 8620. Martin 1935-36, vol 1, pp 166, 210, 219, 224, fig 125. G 't Hart, OH 67 (1952) p 94, fig 16. Van Hall 1963, p 93, nr 600:3; p 191, nr 1295:1. M Kok, Bull RM 15 (1967) p 120

C 361 The company of Captain Jacob Rogh and Lieutenant Anthony de Lange, Amsterdam, 1645. *Het korporaalschap van kapitein Jacob Rogh en luitenant Anthony de Lange, Amsterdam, 1645*

The other sitters are Frans Bruyningh, ensign, Otto Cornelisz van Oever, Claes Pietersz van Hoorn, sergeants, Jan Verbeek, Jan Duyfken, Roelof Govertsz, Harman van Limburgh, Hendrick Willemsz Heems, Willem van Dalen, Dirck Douensz Koningh, Christoffel van Hartogveld, Jean le Couché, Willem Govaerts and Abraham Bull, master-at-arms

Canvas 243 × 581
PROV Voetboogdoelen (headquarters of the crossbowmen's civic guard), Amsterdam. On loan from the city of Amsterdam, 1885-1975
LIT Van Dijk 1758, p 33, nr 21. Scheltema 1879, nr 7 (Jacob Backer). Scheltema 1855-85, vol 7 (1885) p 131. D C Meyer Jr, OH 3 (1885) pp 114-15. J Six, OH 4 (1886) pp 99-100. Moes 1897-1905, vol 2, nrs 6483:2, 4347. Bauch 1926, p 102, nr 23

A 705 Jochem Hendricksz Swartenhont (1566-1627). Vice admiral of Holland, husband of Elisabeth Bas. *Luitenant-admiraal van Holland, echtgenoot van Elisabeth Bas*

For a portrait of the sitter's wife, *see* Bol, Ferdinand, A 714

Panel 119 × 90. Dated *An° 1627*.
Inscribed *Ætatis suae 62*
PROV Bequest of Jonkheer J S H van de Poll, Amsterdam, 1880 * Lent to the AHM, 1975
LIT J G Frederiks, in Obreen's Archief 6 (1884-87) p 265ff. J Six, OH 4 (1886) p 87, note 3 (probably by Werner van den Valckert). Moes 1897-1905, vol 2, nr 7729. Rosenberg 1964, p 58, fig 48. G

Kolleman, Ons Amsterdam 19 (1967) pp 57-62. G Kolleman, Ons Amsterdam 23 (1971) pp 114-15, ill on p 116

A 1245 Portrait of a woman, possibly Margriet Benningh (1565-1641). Second wife of Pieter Dircksz Hasselaer. *Portret van een vrouw, mogelijk Margriet Benningh. Tweede echtgenote van Pieter Dircksz Hasselaer*

Traditionally thought to be pendant to Pietersz, Aert, A 1244 Portrait of a man. For a portrait of the sitter's husband, *see* Voort, Cornelis van der, A 1249

Panel 56 × 46
PROV Presented by J S R van de Poll, Arnhem, 1885
LIT W E van Dam van Isselt, Oude Kunst 4 (1918-19) p 182

attributed to **Nicolaes Eliasz** *called* **Pickenoy**

A 1319 Reinier Ottsz Hinloopen (b 1609). Merchant of Hoorn. *Koopman te Hoorn*

Pendant to A 1313

Panel 123 × 91. Dated *An° 1631*. Inscribed *Æta 22*. Inscribed on the verso *Reijnier Ottsz Hinlopen*
PROV Sale D M Alewijn, Amsterdam, 16 Dec 1885, lot 90 (as Lambert Jacobsz)
LIT J Six, OH 4 (1886) p 91 (attributed to

Eliasz). Moes 1897-1905, vol 1, nr 3522. F G L O van Kretschmar, Jb Genealogie 21 (1967) pp 82-84

A 1313 Trijntje Tijsdr van Nooy (b 1607). Wife of Reinier Ottsz Hinloopen. *Echtgenote van Reinier Ottsz Hinloopen*

Pendant to A 1319

Panel 123 × 90. Dated *A° 1631*. Inscribed *Aetatis 24*. Inscribed on the verso *Trijntijen Tijsz van Nooij*
PROV Sale D M Alewijn, Amsterdam, 16 Dec 1885, lot 92 (as Lambert Jacobsz, pendant to lot 91 [RMA A 1312])
LIT J Six, OH 4 (1886) p 91 (attributed to Eliasz). Moes 1897-1905, vol 2, nr 5450. F G L O van Kretschmar, Jb Genealogie 21 (1967) pp 82-84

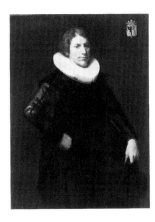

A 1312 Gerard Ottsz Hinloopen (1604-46)

Panel 123 × 90. Dated *A° 1631*. Inscribed *Aetatis 27*. Inscribed on the verso *Gerard Ottsz Hinloopen*
PROV Sale D M Alewijn, Amsterdam, 16 Dec 1885, lot 91 (as Lambert Jacobsz, pendant to lot 92 [RMA A 1313])
LIT J Six, OH 4 (1886) p 91 (attributed to Eliasz). Moes 1897-1905, vol 1, nr 3513

Ottomar Elliger I

Göteborg 1633 – 1679 Berlin

A 794 Still life with flowers and fruit. *Stilleven met bloemen en vruchten*

Panel 66 × 50. Signed and dated *Ottmar Elliger Fecit A° 1671*
PROV Sale Amsterdam, 14-15 Nov 1883, lot 52 * D R V K since 1959 (on loan to Stedelijk Museum Het Catharina-gasthuis, Gouda)
LIT D S van Zuiden, in Feestbundel Bredius, 1915, p 292. Warner 1928, nr 29a

C 215 Still life with flowers. *Stilleven met bloemen*

Canvas 86 × 68. Signed and dated *Ottmar Elliger fecit Anno 1673*
PROV On loan from the city of Amsterdam (A van der Hoop bequest) since 1885
LIT C Hofstede de Groot, OH 22 (1904) p 113 (copy after Rachel Ruysch). Warner 1928, nr 29b. Vorenkamp 1933, p 122

school of **Adam Elsheimer**

Frankfurt am Main 1572 – 1610 Rom

A 2650 Landscape with the good Samaritan. *Landschap met de barmhartige Samaritaan*

Copper 21 × 27. Traces of a signature
PROV Sale Amsterdam, 4-5 Dec 1912, lot 278
LIT Van Gelder 1959, p 10, fig 18. U Weisner, OH 79 (1964) p 226 (not Moyses van Uyttenbroeck)

Elven

see Tetar van Elven

Isack Elyas

active ca 1620, probably in Haarlem

A 1754 A party. *Feestvierend gezelschap*

Panel 47 × 63. Signed and dated *Isack Elyas f. 1620*
PROV Bequest of D Franken Dzn, Le Vésinet, 1898
LIT Würtemberger 1937, p 57. Martin 1935-36, vol 1, p 367. E Plietzsch, Wallraf-R Jb 18 (1956) p 175, fig 138. De Jongh 1967, p 6, fig 1. E de Jongh, in exhib cat Rembrandt en zijn tijd, Brussels 1971, pp 146, 150, 167. J Walsh, Bull Metrop Mus 31 (1973) fig 44

Cornelis Engebrechtsz

Leiden 1468 – 1533 Leiden

A 859 Christ on the cross, with Mary, John, Mary Magdalene and Sts Cecilia and Barbara (left) and Peter, Francis and Jerome (right). *Christus aan het kruis met Maria, Johannes, Maria Magdalena en de heiligen Caecilia en Barbara (links) en Petrus, Franciscus en Hieronymus (rechts)*

Panel 25 × 32.5
PROV From the convent of Mariënwater in Koudewater near 's-Hertogenbosch. Purchased from the Brigittine convent in Uden, 1875. NMGK, 1885
LIT Winkler 1924, p 226. Gavelle 1929, p 290. Friedländer 1924-37, vol 10 (1932) p 131, nr 91. Hoogewerff 1936-47, vol 3 (1939) p 201. E Pelinck, NKJ 2 (1948-50) p 53

A 1719 Christ taking leave of his mother. *Christus neemt afscheid van Maria*

Panel 55 × 43
PROV Purchased from F Kleinberger gallery, Paris, 1897, with aid from the Rembrandt Society
LIT Dülberg 1899, p 70. C Hofstede de Groot, OH 22 (1904) p 34. Winkler 1924, p 227, fig 136. P Wescher, Zeitschr BK 58 (1924-25) p 98. Gavelle 1929, p 290. Friedländer 1924-37, vol 10 (1932) p 131, nr 82. Hoogewerff 1936-47, vol 3 (1939) pp 179-183, fig 92. E Pelinck, NKJ 2 (1948-49) p 59. Gerson 1950, p 22, fig 55. Von der Osten & Vey 1969, p 166. J R J van Asperen de Boer, Delta, spring 1973, pp 56-57, ill. J R J van Asperen de Boer & A K Wheelock Jr, OH 87 (1973) pp 65, 67, 88-93, figs 32, 35-37

A 2232 Christ in the house of Mary and Martha. *Christus bij Maria en Martha*

Panel 54 × 44
PROV Purchased from F Kleinberger gallery, Paris, 1906
LIT B W F van Riemsdijk, Bull NOB 7 (1906) p 176. Winkler 1924, p 226. P Wescher, Zeitschr BK 58 (1924-25) p 99. Friedländer 1924-37, vol 10 (1932) p 131, nr 81. M D Henkel, OH 51 (1934) p 139. Hoogewerff 1936-47, vol 3 (1939) p 179, fig 93. E Pelinck, NKJ 2 (1948-49) p 59. Gerson 1950, p 22, fig 54. P K F Moxey, Journ WCI 34 (1971) p 335, note 3. J R J van Asperen de Boer & A K Wheelock Jr, OH 87 (1973) pp 65, 67, 88-93, figs 31, 33-34

Adolf Karel Maximiliaan Engel

Courtrai 1801 – 1833 Courtrai

C 285 Landscape with cattle. *Landschap met vee*

Panel 45 × 58. Signed and dated *A. Engel à Gand 1827*
PROV On loan from the city of Amsterdam (A van der Hoop bequest) since 1885

Willem Jodocus Mattheus Engelberts

Amsterdam 1809 – 1887 Aalst

A 4074 Self portrait in the uniform of the Rifles. *Zelfportret in het uniform van de Jagers*

Panel 31.5 × 26.5. Signed and dated *W. J. M. Engelberts 1831*
PROV Purchased from K Hoeksema, Hilversum, 1962

A 1033 The poultry stall. *De poelierster*

Panel 59 × 49. Signed *W. J. M. E.*
PROV Purchased at exhib The Hague 1830, nr 96. RVMM, 1885 * DRVK since 1953
LIT Scheen 1946, fig 63

Epps

see Alma Tadema-Epps

Vigilius Erichsen

Copenhagen? 1722 – 1782 Copenhagen

A 1929 Catherine II (1729-96), empress of Russia. *Keizerin van Rusland*

Canvas 62 × 48.5
PROV Purchased from J Coster, Utrecht, from the estate of Mrs E Hovy-van Vollenhoven, 1900

Jacob Esselens

Amsterdam 1626 – 1687 Amsterdam

A 2322 Landscape with hunters. *Landschap met jagers*

Canvas 103 × 158. Signed *J. Esselens*
PROV Purchased from the heirs of Jonkheer P H Six van Vromade, Amsterdam, 1908, with aid from the Rembrandt Society

A 2250 View on the beach. *Strandgezicht*

Canvas 41.5 × 51. Signed *J Esselens*
PROV Purchased from Fr Muller & Co, art dealers, Amsterdam, 1907
LIT Bol 1973, p 249, fig 254

William Charles Estall

London 1857 – 1897 London

A 3080 A flock of sheep. *Een kudde schapen*

Canvas 35.8 × 61.5. Signed *William Estall*
PROV Lent by J B A M Westerwoudt, Haarlem, 1907. Received in 1929 *
DRVK since 1950

Allart van Everdingen

Alkmaar 1621 – 1675 Amsterdam

A 691 Swedish landscape with a water-mill. *Zweeds landschap met een watermolen*

Canvas 66 × 60. Signed and dated *A V Everdingen 1655*
PROV Bequest of Jonkheer J S H van de Poll, Amsterdam, 1880 * DRVK since 1960
LIT V de Stuers, Ned Kunstbode 2 (1880) p 244. Stechow 1966, p 144, fig 286. A Blankert, Simiolus 2 (1967-68) p 104 (figures by Nicolaas Berchem)

A 107 Swedish landscape with a waterfall. *Zweeds landschap met waterval*

Canvas 105 × 89. Signed *A. v. Everdingen*
PROV Bequest of L Dupper Wzn, Dordrecht, 1870 * DRVK since 1959 (on loan to Stedelijk Museum Het Catharinagasthuis, Gouda)
LIT Martin 1935-36, vol 2, pp 309-10, fig 167

A 108 Swedish landscape. *Zweeds landschap*

Canvas 48 × 62.5. Signed *Everdingen*
PROV From the Trippenhuis (house of the Trip family), Amsterdam

C 132 Swedish landscape. *Zweeds landschap*

Canvas 121 × 105.5
PROV On loan from the city of Amsterdam (A van der Hoop bequest), 1885-1975

A 1510 Hendrick Trip's cannon foundry in Julitabroeck, Södermanland, Sweden.

De geschutgieterij van Hendrik Trip te Julitabroeck, Södermanland, Zweden

Canvas 192 × 254.5
PROV Trippenhuis (house of the Trip family), Amsterdam, 1890
LIT Granberg 1902, pp 11, 34, 42. Elias 1903-05, vol 2, p 547. G Upmark, in Svensk Slott och Herresäten, 1908, p 239, fig 90. Granberg 1929, vol 1, p 76, fig 49. Martin 1935-36, vol 2, pp 310, 466. J S Held, Konsthist Tidskr 6 (1937) p 41. Johannsen 1953, p 261. Steneberg 1955, p 119. Stechow 1966, p 143, fig 283. Bol 1969, pp 203 (note), 278. W H Vroom, Ons Amsterdam 24 (1972) pp 175-76, ill

Caesar Boëtius van Everdingen

Alkmaar 1617/21 – 1678 Alkmaar

A 1339 Willem Jacobsz Baert (1636-84). Burgomaster of Alkmaar and Amsterdam. *Burgemeester van Alkmaar en Amsterdam*

Pendant to A 1340

Canvas 110 × 90. Signed and dated *CVE Anno 1671*. Inscribed *Aetatis 35*
PROV Sale J H Cremer, Amsterdam, 26 Oct 1886, lot 23
LIT A R Kleyn, Gens Nostra 25 (1970) pp 127-28, ill

A 1340 Elisabeth van Kessel (1640-1717). Wife of Willem Jacobsz Baert. *Echtgenote van Willem Jacobsz Baert*

Pendant to A 1339

Canvas 109 × 90. Signed and dated *CVE Anno 1671*. Inscribed *Aetatis 31*
PROV Same as A 1339
LIT A R Kleyn, Gens Nostra 25 (1970) p 128, ill

C 1517 Pan and Syrinx. *Pan en Syrinx*

Panel 49.5 × 37. Signed *CvE*
PROV On loan from J K Luttikhuis, Abcoude, since 1972
LIT Bull RM 20 (1972) p 182, fig 5

A 2116 Lovers. *Liefdespaar*

Canvas 47 × 37.5
PROV Presented by Jonkheer Victor de Stuers, Amsterdam, 1903

Willem Eversdijck

Goes ca 1615 – 1671 Middelburg

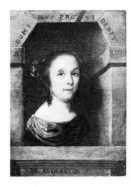 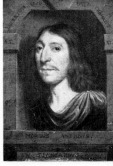

A 993 Nicolaes Blancardus (1624-1703). Professor at Franeker, privy councillor and personal physician to Princess Albertina Agnes. *Hoogleraar te Franeker,*

geheimraad, lijfarts van prinses Albertina Agnes

Pendant to A 994

Panel 16 × 11.5. Signed *W. Eversdijck fec.* Inscribed *Incertum quo fata trahant. N. Blancardus. Aet. XLII. Moribus Antiquis* PROV Purchased from Mrs G H E Balfour van Burleigh-Cantzlaar, widow of L H Balfour van Burleigh, Zutphen, 1885 LIT Moes 1897-1905, vol I, nr 705:1

A 994 Maria Eversdijck (b 1628). Wife of Nicolaes Blancardus. *Echtgenote van Nicolaes Blancardus*

Pendant to A 993

Panel 16 × 11.5. Dated *MDCLXVI.* Inscribed *Dominus providebit. M. Eversdijck. Aet XXXVIII* PROV Same as A 993 LIT Moes 1897-1905, vol I, nr 2423

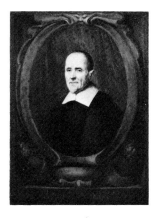

A 992 Cornelis Fransz Eversdijck (1586-1666). Mathematician, treasurer of Zeeland. *Wiskundige en rekenmeester van Zeeland*

Panel 36 × 26.5. Signed *W. Eversdijck fe.* PROV Purchased from Mrs G H E Balfour van Burleigh-Cantzlaar, widow of L H Balfour van Burleigh, Zutphen, 1885 LIT Moes 1897-1905, vol I, nr 2422

attributed to **Willem Eversdijck**

A 3829 Allegory on the flourishing of the Dutch fishery after the Second Anglo-Dutch War (1665-67). *Allegorie op de bloei van de Nederlandse visserij na de Tweede Engelse Zeeoorlog (1665-67)*

The sitters are, from left to right: (upper row) David Vlugh?, Aert van Nes?, unidentified, Tjerk Hiddes de Vries, I Sweers, Adriaen Banckert, Engel de Ruyter, Michiel Adriaensz de Ruyter, Pieter Florisz?, Cornelis Tromp?; (bottom row) unidentified, Cornelis Evertsen de Jonge, unidentified, Jan Cornelisz Meppel, Aucke Stellingwerff, Egbert M Cortenaer?, Johan Evertsen de Oude, unidentified, Pieter de Bitter and Jacob Benckers?

Canvas 114 × 162 PROV Sale N Katz (Basel), Paris, 7 Dec 1950, lot 3 (as Hendrick Berckman) LIT De Jonge 1858-59, vol I, pp 199, 664; vol 2, pp 235, 238. R van Luttervelt, Bull RM 5 (1957) pp 62-63, ill (attributed to Eversdijck, sitters identified)

Adèle Evrard

Ath 1792 – 1889 Ath

NO PHOTOGRAPH AVAILABLE

A 1034 Still life with flowers and fruit. *Stilleven met bloemen en vruchten*

On a tabletop an osier basket with various flowers. In front of it are three large peaches, a branch with three blue plums and in the middle a few bunches of blue grapes and one of white. To the side is a forget-me-not stem. On one of the peaches is a fly

Panel 69 × 47. Signed *Adèle Evrard* PROV Perhaps purchased at exhib The Hague 1827, nr 99. RVMM, 1885 * Hung in the residence of the provincial governor of Zuid-Holland, The Hague. Destroyed in the war, 1945

attributed to **Nicolaas I van Eyck**

Antwerp 1617 – 1679 Antwerp

A 619 Infantry battle at a bridge. *Infanteriegevecht bij een brug*

Canvas 59 × 83 PROV Purchased from P C Huybrechts, The Hague, 1803. NM, 1808 LIT Moes & van Biema 1909, p 217

Jan Baptist van Eycken

Brussels 1809 – 1853 Brussels

A 1035 'Becoming a painter.' '*Schilder worden*'

Panel 30 × 28.5. Signed *JB van Eycken* PROV Purchased at exhib The Hague 1827, nr 101. RVMM, 1885 * DRVK since 1964

Barent Fabritius

Midden-Beemster 1624–1673
Amsterdam

A 1304 Willem van der Helm (ca 1625-75). Municipal architect of Leiden, with his wife Belytgen Cornelisdr van der Schelt (d 1661) and their son Leendert (1655-64). *Stadsbouwmeester van Leiden, met zijn vrouw Belytgen Cornelisdr van der Schelt en hun zoontje Leendert*

Canvas 148 × 127.5. Signed and dated *B.Fabritius 1656 sep. 30.* Inscribed (on the medal hung on the baby's chain) *L.W.V.H. Ae 12/12*
PROV Purchased from J H Ward, London, 1886
LIT W Pleyte, Handb Mij Ned Letterk, 1886, pp 88-89. Woltmann & Woermann 1879-88, vol 3 (1888) p 720. Moes 1897-1905, vol 1, nr 3378. J C Overvoorde, Opmerker, 1908. J O Kronig, Oude Kunst, 1918, p 112. Steenhoff 1920, vol 3, p 171. W R Valentiner, Art Bull 14 (1932) p 239, fig 48. Martin 1935-36, vol 2, pp 135-36, fig 75. Derkinderen-Besier 1950, p 150. Van Thienen 1951, p 270. Pont 1958, pp 39, 115, nr 32. Van Hall 1963, p 133, nr 879. H Kühn, Jb Ksamml Baden-Württemberg 2 (1965) p 207. Rosenberg, Slive & Ter Kuile 1966, p 98. E Pelinck, Jb Leiden 1967, p 65, fig 2 (portrait of Adriaen Arentsz van 's-Gravenzande)

A 2958 The prodigal son. *De verloren zoon*
A 2959 The Pharisee and the publican. *De Farizeeër en de tollenaar*
A 2960 Lazarus and the rich man. *De rijke man en de arme Lazarus*

Canvas 95 × 287 each. Signed and dated on A 2958 *B.Fab...* Inscribed on A 2959 *qui se exaltat humiliabatur* and *Qui se humiliat exaltabitur.* Traces of a signature on A 2960
PROV From the Lutheran church of Leiden, 1866. Presented by M P Voûte, Amsterdam, 1922
LIT K Erasmus, Cicerone 3 (1911) p 380. G Biermann, Cicerone 6 (1914) p 116. F de Miomandre, Connoisseur 38 (1914) p 189. W A Valentiner, Art Bull 14 (1932) p 240. Martin 1935-36, vol 2, p 134. Knipping 1939-40, vol 1, pp 300-01. Schmidt-Degener 1949, pp 31-32. Kat 1952, p 58. Vetter 1955, fig 33. Pont 1958, pp 53, 109, 157, nrs 17-19, addendum 6

attributed to **Barent Fabritius**

A 4192 Colonnade giving onto a park. *Galerij met uitzicht op een park*

Mural canvas 308 × 148
PROV NMGK
LIT Börsch-Supan 1967, p 288, fig 194

Carel Fabritius

Midden-Beemster 1622–1654 Delft

A 1591 Abraham de Potter (1592-1650). Amsterdam silk merchant. *Zijdelaken-koopman te Amsterdam*

Canvas 68.5 × 57. Signed and dated *C.Fabritius 1640 f.* Inscribed *Abraham de Potter Ae 56*
PROV Purchased from M H Colnaghi gallery, London, 1892, through the intermediacy of the Rembrandt Society
LIT Waagen 1863-64, vol 2, p 237. Moes 1897-1905, vol 2, nr 5463. Hofstede de Groot 1907, pl XXXVIII. Hofstede de Groot 1907-28, vol 1, nr 6 (portrait of A de Notte). Bredius 1917, p 1438. HF Wijnman, OH 48 (1931) p 118, fig 5. W R Valentiner, Art Bull 14 (1932) p 203. F Schmidt-Degener, in Gedenkboek Ver Rembrandt, 1933, p 76. Martin 1935-36, vol 2, pp 179-80. Schuurman 1947, pp 43-44. Italienische Malerei 1960, pp 58, 62

A 91 The beheading of John the Baptist. *De onthoofding van Johannes de Doper*

Canvas 149 × 121
PROV Sale P Fouquet, Amsterdam, 13 April 1801, lot 61 (as Rembrandt). NM, 1808
LIT Hoet 1752, vol 1, p 37, nr 76. W Bürger, GdB-A 7 (1865) p 82. H Eisenmann, Zeitschr BK 16 (1881) p 404. Havard 1881, vol 4, p 61. Hofstede de Groot 1907-28, vol 1, nr 2. Moes & van Biema 1909, pp 44-45, 58, 213. Van Dyke 1923, p 79 (Fabritius?). H F Wijnman, OH 48 (1931) p 140, fig 12. W R Valentiner, Art Bull 14 (1932) p 210, nr 3, fig 5. Martin 1935-36, vol 2, p

508. K E Simon, Zeitschr f Kunstgesch 5
(1936) p 320. J Starzynski, Biul Hist
Sztuki 4 (1936) pp 95-113. A Heppner,
OH 55 (1938) p 73. Knuttel 1938, p 276.
Bredius, OH 56 (1939) pp 5, 8, fig 11.
Schuurman 1947, pp 10-17. H Gerson,
Burl Mag 98 (1956) p 283 (Fabritius?).
Th H Lunsingh Scheurleer, Bull RM 4
(1956) p 27, ill. Rosenberg, Slive & Ter
Kuile 1966, p 93. Borea 1966, fig 16.
B A Rifkin, Art News 68 (1969) ill on
p 31. Exhib cat Rembrandt after three
hundred years, Chicago 1969, nr 56
(not Fabritius)

Carel van Falens

Antwerp 1683–1733 Paris

A 2679 A hunting party. *Jachtgezelschap*

Canvas 55 × 65. Signed *C. van Falens*
PROV Bequest of R Th Baron van
Pallandt van Eerde, Ambt-Ommen,
1913
LIT V S[chendel], Mndbl BK 18 (1941) p
226, ill. C Brossel, Revue belge d'Arch &
d'Hist de l'Art 35 (1965) pp 221, 225, ill

Willem de Famars Testas

Utrecht 1834–1896 Arnhem

A 1184 The courtyard of a house in
Cairo. *Binnenplaats van een huis te Caïro*

Canvas 84 × 62. Signed *W. Testas*
PROV Purchased at exhib The Hague
1881, nr 349 ∗ DRVK since 1953

Henri Fantin-Latour

Grenoble 1836–1904 Buré

A 2892 Reclining nude. *Liggende naakte
vrouw*

Canvas 22.5 × 29. Signed *Fantin 74*
PROV Bequest of A van Wezel,
Amsterdam, 1922

A 2895 Still life with flowers. *Stilleven
met bloemen*

Canvas 72 × 60. Signed and dated
Fantin 87
PROV Bequest of A van Wezel,
Amsterdam, 1922
LIT Fantin-Latour 1911, nr 1306?

A 2893 Young woman under a tree at
sunset, called 'Autumn.' *Jonge vrouw
onder een boom bij zonsondergang, genaamd
'Herfst'*

Canvas 38 × 25. Signed *Fantin*
PROV Bequest of A van Wezel,
Amsterdam, 1922

A 2894 Hommage à Berlioz

Canvas 28 × 29. Traces of a signature
PROV Bequest of A van Wezel,
Amsterdam, 1922
LIT Fantin-Latour 1911, nr 772

Fargue

see La Fargue

Paolo Farinato

Verona 1524–1606 Verona

C 1352 The adoration of the magi. *De
aanbidding der koningen*

Canvas 115 × 161. Signed with the
artist's mark, a snail
PROV On loan from the KKS since 1948
LIT Berenson 1907, p 214. Berenson
1932, p 180

J Farncombe Sanders

active 1837; d 1878 Breda

A 951 Radboud Castle in Medemblik.
Het kasteel Radboud te Medemblik

Panel 28 × 41. Signed and dated
Farncombe Sanders 1837
PROV Presented by J Farncombe
Sanders, Breda, 1878. NMGK, 1885 *
DRVK since 1961

attributed to **Antoine de Favray**

Bagnolet 1706–1791/92 Malta

A 4127 David George van Lennep
(1712-97). Senior merchant of the Dutch
factory at Smyrna, with his wife and
children. *Opperkoopman van de Hollandse
factorij te Smyrna, met zijn vrouw en kinderen*

His wife is Anna Maria Leidstar (ca
1738-1803), and his children are
Elisabeth Clara (1760-1834, later Mrs
Morier), George Justinus (1761-88),
David (1762-82), Cornelia Jacoba
(1763-1839, later Lady Radstock),
Anna (1765-1839, later Marquise de
Chabannes), Hester Maria (b 1767, later
Mrs Lee), Jacob (1769-1855). On the
left is van Lennep's father-in-law,
Justinus Johannes Leidstar (b ca 1708)
and on the right the tutor, Monsieur
d'Antan

Canvas 172 × 248
PROV Lent by Jonkheer F J E van
Lennep, Amsterdam, 1954. Purchased
from him in 1967
LIT Van Luttervelt 1958, p 27, fig 35.
Van Lennep 1962, pp 208-11, ill. Bull
RM 15 (1967) p 35, fig 1

William Gowe Ferguson

Scotland 1632/33–after 1695 Scotland;
active in Utrecht, The Hague and
Amsterdam

A 1290 Still life with birds. *Stilleven met
vogels*

Panel 32 × 28. Signed and dated
WG Ferguson f. A° 1662
PROV Sale P Verloren van Themaat,
Amsterdam, 30 Oct 1885, lot 34
LIT Vorenkamp 1933, p 86

A 2154 Still life with birds and
implements of the hunt. *Stilleven met
vogels en jachtgerei*

Canvas 64 × 54. Signed and dated
WG Ferguson fecit A° 1684
PROV Sale A H H van der Burgh (The
Hague), Amsterdam, 21 Sep 1904, lot 8.
Purchased through the intermediacy of
the Rembrandt Society

Defendente Ferrari

Chivasso ca 1490–after 1535

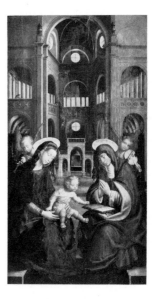

A 3394 The Madonna and child with St
Anne. *Anna te drieën*

Panel 166 × 87.5. Signed and dated
Fe 1528
PROV Bequest of J W Edwin vom Rath,
Amsterdam, 1941
LIT Berenson 1932, p 186. V Viale, Boll
Piemontese 1 (1947) p 52

attributed to **Defendente Ferrari**

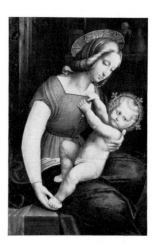

A 3395 Madonna and child. *Maria met
kind*

Panel 56 × 37. Dated *1526*
PROV Bequest of J W Edwin vom Rath,
Amsterdam, 1941
LIT Berenson 1932, p 187. V Viale, Boll
Piemontese 1 (1947) p 57, fig 35. Viale
1969, p 180. Mallé 1969, p 247, fig 121
(ca 1522/23)

attributed to **Gaudenzio Ferrari**

Valduggia ca 1480–1546 Milan

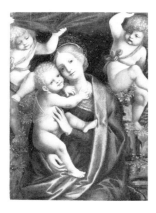

A 3032 Madonna and child. *Maria met kind*

Panel 76.5 × 59.5
PROV Purchased from the Augusteum, Oldenburg, 1925, with aid from the Rembrandt Society
LIT Bode 1888, p 15. Venturi 1927, p 358, fig 243 (Bernardo Lanino). Berenson 1932, p 190. A Bertini, Boll Piemontese ns 8-11 (1954-57) p 94. L Mallé, Boll Piemontese ns 8-11 (1954-57) p 123 (attributed to Eusebio Ferrari)

attributed to **Jacobello del Fiore**

Venice ca 1370–1439 Venice

A 4001 The martyrdom of St Lawrence, with two Dominican nuns. *Het martelaarschap van de heilige Laurentius, met twee Dominicanessen*

Panel 38 × 70.5. Inscribed *Martire Laurenti pie devote mei. Rogo tei grati | Mulla dulcis […] eige sit me advocato & fidele dei* and *fortitudo dulcis sit me iesu criste. Quia servus tuus et devote iste*
PROV O Lanz, Amsterdam. Lent by the DRVK, 1952. Transferred in 1960

Govert Flinck

Kleve 1615–1660 Amsterdam

A 4166 Portrait of a man, traditionally known as Gozen Centen, also called Gosse Senten or Sents (1611/12-77). *Portret van een man, bekend als Gozen Centen*

Panel 65.5 × 51
PROV From the Rijpenhofje, Amsterdam. Lent by the deacons of the Verenigde Doopsgezinde Gemeente (united Mennonite congregation), Amsterdam, 1900. Purchased from them, 1970, as a gift of the Photo Commission
LIT Meijer Jr 1876, p 216. A D de Vries, De Gids 3 (1876) p 551 (Rembrandt school). Moes 1897-1905, vol 1, nr 1515. A Bredius, OH 18 (1900) p 1, ill (Rembrandt). C Hofstede de Groot, OH 22 (1904) p 27 (Flinck). A Bredius, OH 22 (1904) p 129 (Flinck). J G van Gelder, Med RKD 1 (1946) p 27 (1636). Von Moltke 1965, p 106, nr 200, ill (ca 1639/40). Bull RM 18 (1970) p 34, fig 1

A 110 Isaac blessing Jacob. *Isaac zegent Jacob*

Canvas 117 × 141. A signature and date – *G. Flinck 1638* – disappeared when the painting was cleaned (*cf* facsimile in cat RMA 1880)
PROV Sale G van der Pot van Groeneveld, Rotterdam, 6 June 1808, lot 37
LIT Havard 1881, p 97, fig 17. O Benesch, in Meisterwerke, 1920. E Wiersum, OH 48 (1931) p 211, ill. Martin 1935-36, vol 2, pp 101, 116, fig 55. J G van Gelder, Med RKD 3 (1948) p 27. Von Einem 1950, p 28, fig 29. Gerson 1952, fig 38. Pigler 1956, vol 1,

p 55, ill. J Michalkowa, Biul Hist Sztuki 19 (1957) p 265. Plietzsch 1960, p 178, fig 324. Bernt 1960-62, vol 1, nr 283. VTTT, 1961-62, nr 39. A B de Vries, OKtv 3 (1965) nr 14, fig 7. Von Moltke 1965, pp 17ff, 66, nr 8, pls I-III. Rosenberg, Slive & Ter Kuile 1966, p 91, fig 68A. E Haverkamp Begemann, Kunstchronik 22 (1969) p 288. L Rosshandler, Weltkunst 39 (1969) p 234. Bernt 1969-70, vol 1, nr 381. Gans 1971, p 74, ill

C 370 Four governors of the arquebusiers' civic guard, Amsterdam, 1642. *Vier doelheren der Kloveniersdoelen, Amsterdam, 1642*

The sitters are Albert Coenraetsz Burgh, Jan Claesz Vlooswijck, Pieter Reael, Jacob Willekens and the steward

Canvas 203 × 278. Signed and dated *G. Flinck fe 1642*
PROV Kloveniersdoelen (headquarters of the arquebusiers' civic guard), Amsterdam. On loan from the city of Amsterdam since 1885
LIT Wagenaar 1760-88, vol 2 (1762) p 75. Scheltema 1855-85, vol 2 (1856) p 136. Scheltema 1879, p 12. Moes 1897-1905, vol 1, nr 1248:3; vol 2, nrs 8620:3, 6213, 9088. D C Meyer, OH 7 (1889) p 45. Riegl 1931, p 233, fig 66. Martin 1935-36, vol 1, pp 158, 219-20, 223, fig 128. Von Moltke 1965, pp 24-25, 166, nr 475, ill. M Kok, Bull RM 15 (1967) p 120. Chr Tümpel, N Beitr Rembrandt Forsch, 1973, p 170, fig 124

C 371 The company of Captain Albert Bas and Lieutenant Lucas Conijn, 1645. *Het korporaalschap van kapitein Albert Bas en luitenant Lucas Conijn, 1645*

Canvas 347 × 244. Signed and dated *G. Flinck f. A° 1645*
PROV Kloveniersdoelen (headquarters of the arquebusiers' civic guard), Amsterdam. On loan from the city of Amsterdam since 1885
LIT Wagenaar 1760-88, vol 2 (1762) p 75. Van Dijk 1790, p 98, nr 52. Scheltema 1855-85, vol 2 (1856) p 136. Scheltema 1879, p 13, nr 32. DC Meyer, OH 7 (1889) p 47. Moes 1897-1905, vol 1, nrs 376, 1684. Riegl 1931, p 238 (note). Martin 1935-36, vol 1, pp 162, 219-20, 222-24, fig 127. Van Hall 1963, p 100, nr 649:3. Von Moltke 1965, pp 28, 167, nr 477, pl 57. Rosenberg, Slive & Ter Kuile 1966, p 185. M Kok, Bull RM 15 (1967) p 120. Fuchs 1968, p 15, fig 25. R B F van der Sloot & J B Kist, Armamentaria 5 (1970) p 17, note 11

van 't krijgsgewaadt | Zoo waakt men aan het IJ na moorden en verwoesten | De wijzen laaten 't zwaardt wel rusten, maar niet roesten (poem by Jan Vos)
PROV Voetboogdoelen (headquarters of the crossbowmen's civic guard), Amsterdam. On loan from the city of Amsterdam, 1808-1975
LIT Wagenaar 1760-88, vol 2 (1762) p 27. Scheltema 1855-85, vol 2 (1856) p 135. Scheltema 1879, p 13, nr 33. DC Meyer, OH 7 (1889) p 48. Moes & van Biema 1909, pp 120, 188. Riegl 1931, p 234, fig 67. Martin 1935-36, vol 1, pp 160, 165, 173, 224-26, fig 129. Van Hall 1963, p 100, nr 649:4. CJ de Bruyn Kops, Bull RM 13 (1965) p 25, ill (on the self portrait). Von Moltke 1965, pp 32, 166, nr 476, pls 53, 56

nagedachtenis van Frederik Hendrik, prins van Oranje, met het portret van zijn weduwe Amalia van Solms

Canvas 307 × 189. Signed and dated *G. Flinck ft 1654*
PROV KKS, 1876. NMGK, 1885
LIT Moes & van Biema 1909, p 168. Martin 1935-36, vol 2, p 118, fig 63. A Heppner, Historia 6 (1940) p 254ff, ill. Van de Waal 1952, p 221, note 1. Von Moltke 1965, pp 39, 92, nr 118, pl 18. Th H Lunsingh Scheurleer, OH 84 (1969) pp 52-53, figs 16, 19

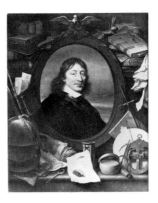

A 3103 Gerard Pietersz Hulft (1621-56). First councillor and director-general of the Dutch East India Company. *Eerste raad en directeur-generaal van de VOC*

Canvas 130 × 103. Signed and dated *G. Flinck f. 1654*. Inscribed *Nil adeo fuit unquam tam dispar sibi*
PROV Lent by Jonkvrouwe S J M Hulft, née Baronesse Taets van Amerongen, Utrecht, 1887-89 and 1898-1930, when the painting was bequeathed
LIT Moes 1897-1905, vol 1, nr 3819. Bauch 1926, p 55. JFL de Balbian Verster, Jb Amstelodamum 29 (1932) p 131, ill. Sterck 1927-37, vol 8 (1935) p 193, ill. H Rauws, Historia 2 (1936-37) p 260, ill. Von Moltke 1965, pp 35-36, 108, nr 207

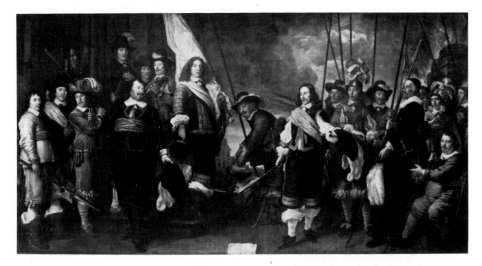

C 1 The Amsterdam civic guard celebrating the signing of the Peace of Münster, 1648. *Schuttersfeest bij het sluiten van de vrede van Munster, Amsterdam, 1648*

The sitters (not including the man with the wineglass and three figures only partially visible) are, from left to right: Jan Appelman, Rogier Ramsden, Pieter Waterpas, Joris de Wijze, Captain Jan Huydecoper van Maarseveen, the painter himself, Aart Jan van Lier, Nicolaes Oetgens van Waveren, ensign, Pieter Meffert, Frans Oetgens van Waveren, lieutenant, Nicolaas van Haag, Johannes van den Haag, Jan Stuurman, Jacob van Campen, Johannes Doavenne and Albert ten Brink

Canvas 265 × 513. Signed and dated *Flinck f. 1648*. Inscribed *Hier trekt van Maarseveen de eerst' in d' eeuwige vreede | Zoo trok zijn vaader d' eerst in 't oorlog voor de Staat | Vernuft en Dapperheid, de kracht der vrije steede' | Verwerpen 't oude wrok, inplaats*

A 869 Allegory on the memory of Frederik Hendrik (1584-1647), prince of Orange, with the portrait of his widow Amalia van Solms. *Allegorie op de*

A 3451 Rembrandt as shepherd with staff and flute. *Rembrandt als herder met staf en fluit*

Canvas 74.5 ×64. Signed *G.Flinck f.*
PROV Purchased from Jonas &
Kruseman, Amsterdam, 1942 * DRVK
since 1971 (on loan to the Rembrandt-
huis, Amsterdam)
LIT Mndbl BK 19 (1942) p 285. J G van
Gelder, Med RKD 1 (1946) pp 26-28.
Finck 1954, p 136. J Michalkowa, Biul
Hist Sztuki 19 (1957) p 264, fig 9. Van
Hall 1963, p 273, nr 1743:110. Von
Moltke 1965, pp 15, 94, nr 130 (errone-
ously as pendant to Flinck's painting of a
shepherdess in Braunschweig, dated
1636 [cat 1922, nr 252])

A 3133 Mercury, Argus and Io.
Mercurius, Argus en Io

Panel 31 ×47.5
PROV Purchased from N Beets gallery,
Amsterdam, 1932
LIT Valentiner 1921, p 115 (attributed
to Flinck). A Bredius, Zeitschr BK 56
(1921) p 152. J G van Gelder, Med RKD
1 (1946) p 27. J Michalkowa, Biul Hist
Sztuki 19 (1957) p 264. Von Moltke
1965, pp 21, 85, nr 98, ill (ca 1639)

A 218 Joost van den Vondel (1587-1679).
Poet. *Dichter*

Panel 42.5 ×38. Oval
PROV Purchased in 1815 * Lent to the
AHM, 1975
LIT Vos 1662, p 155. Navorscher 24
(1874) p 349ff (Jan Lievens). Alberdingk
Thijm 1876. A D de Vries, Ned Kunst-
bode 1 (1879) pp 57-58. J H W Unger,
OH 2 (1884) pp 129-30. Moes 1897-1905,
vol 2, nr 8651. Sterck 1927-37, vol 5
(1931) p 931. Schneider 1932, p 183, nr
LXXXIX. Von Moltke 1965, p 113, nr
233, ill (1653)

A 582 Portrait of a man, thought to be
Johannes Uyttenbogaert (1608-80),
receiver-general of the Amsterdam
district. *Portret van een man, vermoedelijk
Johannes Uyttenbogaert, ontvanger te
Amsterdam*

Panel 74.5 ×61
PROV Purchased from the van den
Heuvel collection, Utrecht, 1809 (as
Rembrandt)
LIT Moes 1897-1905, vol 2, nr 9272:2.
Moes & van Biema 1909, pp 152, 209.
Th H Lunsingh Scheurleer, Bull RM 4
(1956) p 27, ill. Von Moltke 1965, p 114,
nr 236, ill

attributed to **Govert Flinck**

A 1282 Hera hiding during the battle
of the gods and giants. *Hera verbergt zich
tijdens het gevecht van de goden met de giganten*

Canvas 88 ×69.5. Replica of the version
in the Pushkin Museum, Moscow (cat
1948, nr 496)
PROV Sale P Verloren van Themaat,
Amsterdam, 30 Oct 1885, lot 76
LIT Valentiner 1921, p XXVI, note 14
(Flinck). W Martin, OH 44 (1927) p 30,
ill (copy after Flinck). S Rosenthal, Jb f
Kunstw 6 (1928) p 108 (Salomon de Bray
or Flinck?). H Kaufmann, OH 48 (1931)
p 234. Von Moltke 1965, pp 20-21, 83,
nr 84, ill. H Kühn, Jb Ksamml Baden-
Württemberg 2 (1965) p 204

Hermanus Fock

see under Miniatures

Marcello Fogolino

active 1519-48 in Vicenza, Pordenone,
Udine and Triene

C 1129 Madonna and child with Sts
Catherine, Francis of Assisi, John the
Baptist, John the Evangelist, Anthony
of Padua and Mary Magdalene. *Maria
met het kind en heiligen*

Canvas 266 × 195. Signed *Marcellus
Vincentinus P.*
PROV Purchased by King Willem I from
the Reghellini collection, 1831. On loan
from the KKS since 1924
LIT Borenius 1909, p 211. Venturi 1901-
40, vol 7:4 (1915) p 648, ill. T Borenius,
Burl Mag 58 (1931) p 71. Berenson 1932,
p 197. P Zampetti, Boll d'Arte 34 (1949)
pp 218-19. Berenson 1957, vol 1, p 77

Adriaen Lucasz Fonteyn

active 1626; d 1661 in Rotterdam

A 1941 The mussel market near the
Roobrug, Rotterdam. *De Mosseltrap bij
de Roobrug te Rotterdam*

Panel 86 × 147. Signed and dated
A.Fonteyn 1657
PROV Purchased from the G de Clercq

collection, Amsterdam, 1899, through the intermediacy of the Rembrandt Society * DRVK since 1956
LIT P Haverkorn van Rijsewijk, OH 23 (1905) p 166

attributed to **Vincenzo Foppa**

Bagnolo 1427/30–1515/16 Brescia

A 3008 Portrait of a young woman. *Portret van een jonge vrouw*

Panel 45 × 31
PROV Purchased from the Augusteum, Oldenburg, 1923, as a gift of a group of members of the Rembrandt Society
LIT Bode 1888, p 11, ill on p 25. Venturi 1927, p 340, fig 221 (Ambrogio de Predis). Venturi 1930, pp 54-56, fig 39. T Borenius, Burl Mag 59 (1931) p 71 (de Predis). Berenson 1932, p 471 (de Predis). Gedenkboek Ver Rembrandt, 1933, p 102, ill. C L Ragghianti, Crit d'Arte ns 1 (1954) p 543, note 12, ill

Jean Fournier

Paris? ca 1700–1765 The Hague

see also Miniatures: Holland school ca 1750, A 4445 Willem IV, copy after Fournier

A 1273 Willem Sautijn (1703-43). Alderman of Amsterdam. *Schepen van Amsterdam*

Canvas 83.5 × 68. Signed and dated on the verso *Fournier fecᵗ 1734*
PROV Presented by J S R van de Poll, Arnhem, 1885 * Lent to the AHM, 1975
LIT Moes 1897-1905, vol 2, nr 6768. A J Stakenburg, Med RKD I (1946) p 44

A 1272 Margaretha Cornelia van de Poll (1726-98). Wife of Cornelis Munter. *Echtgenote van Cornelis Munter*

Canvas 83.5 × 68. Signed and dated *J. Fournier 1750*
PROV Presented by J S R van de Poll, Arnhem, 1885 * Lent to the AHM, 1975
LIT Moes 1897-1905, vol 2, nr 5998. A J Stakenburg, Med RKD I (1946) p 44. I H van Eeghen, Jb Amstelodamum 54 (1962) p 178

attributed to **Marco Antonio Franceschini**

Bologna 1648–1729 Bologna

C 1348 Adam and Eve. *Adam en Eva*

Canvas 234 × 158
PROV Cabinet of Willem V, The Hague, 1795. On loan from the KKS since 1948

Lucas Franchoys II

Mechelen 1616–1681 Mechelen

A 2323 François Vilain de Gand, baron de Rassenghem. Bishop of Tournai (1647-66). *Baron de Rassenghem. Bisschop van Doornik*

Panel 41 × 27.5. Grisaille
PROV Purchased from the heirs of Jonkheer P H Six van Vromade, Amsterdam, 1908, with aid from the Rembrandt Society
LIT F de Saligny, Bull Mus Roy Belg 16 (1967) p 218, fig 8

Christoffel Frederik Franck

Zwolle 1758–1818 Bennebroek

A 2155 Self portrait. *Zelfportret*

Panel 51 × 41.5. Signed *C. Franck*
PROV Purchased from J C H Beekman, 1905
LIT Van Hall 1963, p 102, nr 662:1

Frans Francken II

Antwerp 1581–1642 Antwerp

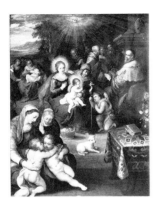

A 111 Allegory on the Christ child as the lamb of God. *Allegorie op het Christuskind als het lam Gods*

Copper 43 × 34. Signed and dated *D. M. F. Francken In. f. A° 1616*
PROV Purchased with the Kabinet van Heteren Gevers, The Hague-Rotterdam, 1809
LIT Moes & van Biema 1909, pp 129, 146, 158, 192

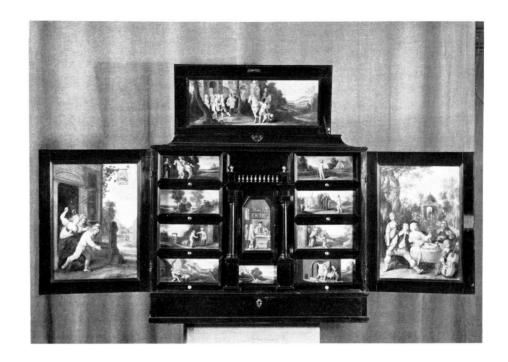

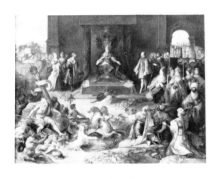

A 112 Allegory on the abdication of Emperor Charles v in Brussels, 25 October 1555. *Allegorie op de troonsafstand van keizer Karel V te Brussel, 25 oktober 1555*

Panel 134 × 172. Signed *F. F. Franck.* Inscribed *S. R. Imperii spontanea resignatio a Carolo V Imp. in Ferd. I Fr. regnorumq. haered. in Phlm. II Hisp. Regem Fil. Facta Brux. Ae 1555. Ex inven. D. Petri de Hannicart*
PROV Purchased from the George collection, 1806. NM, 1808
LIT Moes & van Biema 1909, pp 84, 216. Van de Waal 1952, p 1, fig 3. RDK, vol 5, cols 1135-36, fig 20. Legrand 1963, pp 28, 36, fig 8

NM 4190 Painted cabinet illustrating the story of the prodigal son. *Kunstkastje beschilderd met de geschiedenis van de verloren zoon*

Panel 18 × 52 (lid), 41 × 30 (left outer door), 41 × 29.2 (right outer door), 8.5 × 21.9 (drawers), 18.4 × 9.9 (middle panel), 6.5 × 14.5 (lower middle panel). Signed on the right door *D^io Ffranck in.*

PROV Purchased from Sarluis gallery, The Hague, 1877. Belongs to the department of sculpture and applied arts *
DRVK since 1956 (on loan to the Museum Amstelkring, Amsterdam)
LIT Cat RMA Meubelen 1952, nr 135. Speth-Holterhoff 1957, p 66, note 86

C 286 The story of the prodigal son. *De geschiedenis van de verloren zoon*

Panel 61 × 85. Middle panel in color, the rest in grisaille
PROV On loan from the city of Amsterdam (A van der Hoop bequest) since 1885
LIT Speth-Holterhoff 1957, p 66, note 86. Bauch 1960, p 32, fig 19. Bille 1961, vol 1, ill; vol 2, pp 15, 96, nr 62

dividing panel); after the fall (second pair of drawers); the expulsion from paradise, Eve with her children and Adam digging (third pair); Cain and Abel and their sacrifices (bottom pair and dividing panels)

Panel 28.2 × 75.6 (lid), 20.1 × 9.2 (small central doors), 46.4 × 38.3 (left outer door), 46.7 × 38.3 (right outer door), 12.3 × 10.7 (upper dividing panel), 7.3 × 14.2 (lower dividing panels), 9.2 × 22.7 (drawers)
PROV Sale B Th Baron van Heemstra van Froma en Eibersburen, The Hague, 16 Feb 1880, lot 528. Belongs to the department of sculpture and applied arts
LIT Vogelsang 1909, nr 80, pl XXXIII. Ch Herk, Oudh Kring Antwerpen 9 (1933) p 53. Ch Herk, Oudh Kring Antwerpen, 6th yearbook (1952) p 52. Cat RMA Meubelen 1952, nr 134. Speth-Holterhoff 1957, p 66, note 86

NM 4789 Painted cabinet with scenes from the book of Genesis. *Kunstkastje beschilderd met taferelen uit Genesis*

God dividing the waters from the earth (lid); the creation of the firmament (small central doors); God showing Adam and Eve the tree of knowledge (left outer door); the fall of man (right outer door); the creation of Adam and Eve (top drawers, left and right, and

Frank

see Niemantsverdriet

Joannes Henricus Franken

see Governors-general series: A 3815
Alexander Willem Frederik Idenburg

Desiré Oscar Leopold van Frankenberg en Proschlitz

Sas van Gent 1822–1907 The Hague

A 1807 A visit to the studio of Paulus Potter. *Bezoek aan het atelier van Paulus Potter*

To the right is Potter's famous *Young bull*, whose heavy curtain has just been drawn. In the middle are an old man, a young girl and an older lady seated on chairs. Behind the girl stands a boy. In the foreground is Potter himself, seen from behind. In the background an apprentice is busy grinding colors

Canvas 70 × 92. Signed and dated *Van Frankenberg 1853*
PROV Bequest of Reinhard Baron van Lynden, The Hague, 1899 * Lent to the ministry of arts and sciences, The Hague, 1942. Missing

233

Eduard Frankfort

Meppel 1864–1920 Laren

A 2685 The actress Esther de Boer-van Rijk (1854-1937) in the role of Kniertje in the play 'Op hoop van zegen' by Herman Heijermans (1864-1924). *De actrice Esther de Boer-van Rijk als Kniertje in 'Op hoop van zegen' van Herman Heijermans*

Canvas 211 × 151.5. Signed and dated *Ed. Frankfort 1913*
PROV Presented by friends and admirers of the actress on the occasion of the play's 400th performance, Amsterdam, 1913 * On loan to the Stadsschouwburg, Amsterdam, since 1923 (from 1953 on via the DRVK)
LIT Gans 1971, p 715, ill

Edouard Frère

Paris 1819–1886 Ecouen

A 3081 The evening prayer. *Het avondgebed*

Panel 46.5 × 38.5. Signed and dated *Ed.Frère 57*
PROV Bequeathed by J B A M Westerwoudt, Haarlem, 1907. Received in 1929

Franciscus Joseph Fricot

see Governors-general series: A 3783 Jeremias van Riemsdijk; A 3784 Reinier de Klerk; A 4552 Reinier de Klerk

Christian Friedrich Fritsch

see Panpoeticon Batavum: A 4620 Abraham de Haen, copy by Jan Maurits Quinkhard after Fritsch

Eugène Fromentin

La Rochelle 1820–1876 Saint-Maurice

A 3304 Farmyard with cattle. *Boerenerf met vee*

Canvas on panel 31.5 × 48. Signed and dated *Eug. Fromentin 1849*
PROV Presented by Mr & Mrs D A J Kessler-Hülsmann, Kapelle op den Bosch near Mechelen, 1940

copy after **Jan Fijt**

Antwerp 1611–1661 Antwerp

A 2928 Eagles on the cliffs. *Arenden op rotsen*

Copy by Matthijs Maris (1839-1917) after the original in the Museum voor Schone Kunsten, Antwerp (cat 1958, nr 171)

Paper on canvas 52 × 57. Signed and dated *MM 57*
PROV Bequest of A van Wezel, Amsterdam, 1922

Paul Joseph Constantin Gabriël

Amsterdam 1828–1903 Scheveningen

see also under Aquarelles and drawings

A 2265 Landscape near Kortenhoef. *Landschap bij Kortenhoef*

Panel 37 × 57.5. Signed and dated *Gabriël 77*
PROV Bequest of J B A M Westerwoudt, Haarlem, 1907

A 2290 A watercourse near Abcoude. *Een wetering bij Abcoude*

Panel 41 × 50. Signed and dated *Gabriel f. 78*
PROV Lent by J B A M Westerwoudt, Haarlem, 1888. Bequeathed in 1907

A 1505 'In the month of July': a windmill on a polder waterway. *'In de maand juli': een molen aan een poldervaart*

Canvas 102 × 66. Signed *Gabriel f.*
PROV Purchased in 1889
LIT Exhib cat 150 jaar Nederlandse
kunst, Amsterdam 1963, nr 59, fig 62.
E P Engel, Bull RM 13 (1965) p 49. De
Gruyter 1968-69, vol 1, p 78, note 9, 85,
fig 102 (ca 1888)

A 2266 Windmill on a pond. *Molen bij
een plas*

Canvas 28.5 × 46.5. Signed *Gabriel f.*
PROV Bequest of J B A M Westerwoudt,
Haarlem, 1907

A 3082 'Sunny day': a windmill on a
waterway. *'Zonnige dag': een molen aan een
wetering*

Panel 29.2 × 37.4. Signed *Gabriel f.*
PROV Bequest of J B A M Westerwoudt,
Haarlem, 1907. Received in 1929

A 3589 Landscape near Abcoude.
Landschap bij Abcoude

Panel 16.5 × 42. Signed *Gabriel*
PROV Lent by Mr & Mrs J C J Drucker-
Fraser, 1919. Bequeathed in 1944

A 3590 Landscape with windmills.
Landschap met molens

Canvas 65 × 100. Signed *Gabriel*. Sketch
PROV Lent by Mr & Mrs J C J Drucker-
Fraser, 1919. Bequeathed in 1944

A 2381 De Winkel near Abcoude. *In de
Winkel te Abcoude*

Canvas 52 × 82. Signed *Gabriël ft. de
Haas figur.* Staffage by Johannes
Hubertus Leonardus de Haas (1832-
1908)
PROV Bequest of J B A M Westerwoudt,
Haarlem, 1907. Received in 1909

Adriaen van Gaesbeeck

Leiden 1621/22 – 1650 Leiden

A 113 Young man in a study. *Jongeman
in een studeerkamer*

The sitter was traditionally identified as
Hugo de Groot (1583-1645)

Panel 100 × 76. Signed *A. van Gaesbeeck
fecit*
PROV Sale W F Taelman Kip,

Amsterdam, 16 March 1801, lot 14.
NM, 1808
LIT Moes & van Biema 1909, pp 44-45,
196, 210. Van Beresteyn 1929, pp 39, 57,
nr 40. A P de Mirimonde, GdB-A 109:1
(1967) p 319ff, fig 32

Emmanuel Gallard-Lepinay

Aulnay 1842 – 1885 Paris

A 1809 Venice. *Venetië*

Canvas 46 × 74. Signed *E. Gallard Lepinay*
PROV Bequest of Reinhard Baron van
Lynden, The Hague, 1899 * DRVK since
1953 (missing since 1972)

Pieter Gallis

Enkhuizen? 1633 – 1697 Hoorn

A 1634 Still life. *Stilleven*

Canvas 36 × 31. Signed *P...* (according
to cat RMA 1920 [where the facsimiles of
the signatures on A 1634 and A 1737
are switched] signed and dated *P Gallis
1667*)
PROV Sale Amsterdam, 5-6 Nov 1895,
lot 14
LIT Warner 1928, nr 34a. Vorenkamp
1933, p 63. Bernt 1960-62, vol 4, nr 92.
Bernt 1969-70, vol 1, nr 405 (dated 1673)

A 1737 Still life with fruit. *Stilleven met vruchten*

Canvas 39.5 × 34.2. Signed and dated *P Gallis 1673*
PROV Bequest of D Franken Dzn, Le Vésinet, 1898
LIT Warner 1928, nr 34b. Vorenkamp 1933, p 63. Bol 1969, p 320

Benvenuto Tisi da Garofalo

Ferrara 1481 – 1559 Ferrara

A 114 The adoration of the magi. *De aanbidding der koningen*

Panel 79 × 58
PROV Purchased by King Willem I from Countess Bourke, Paris, 1823
LIT P van Vliet, Bull RM 14 (1966) pp 136, 146

C 309 The holy family. *De heilige familie*

Panel 51 × 37.5
PROV On loan from the city of Amsterdam (A van der Hoop bequest) since 1885
LIT Berenson 1932, p 162

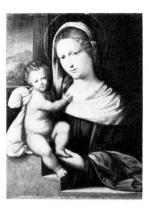

A 3400 Madonna and child. *Maria met kind*

Panel 61 × 46.5
PROV Bequest of J W Edwin vom Rath, Amsterdam, 1941

Pierre Jean Gauthier

see under Miniatures

Jacob Jacobsz van Geel

1584/85 – in or after 1638; active in Middelburg, Delft and Dordrecht

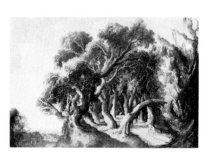

A 3968 Landscape. *Landschap*

Panel 49.5 × 72. Signed *Jacob v. Geel*
PROV Fedor Zschille, Cologne, 1889. On loan from the SNK, later DRVK, 1948-60. Transferred in 1960
LIT L J Bol, OH 72 (1957) pp 25, 34, 38, nr 19, fig 19 (ca 1637-38). Bousquet 1964, ill on p 273. L J Bol, OK 11 (1967) nr 12, ill. Bol 1969, p 115, fig 98

Joost van Geel

Rotterdam 1631 – 1698 Rotterdam

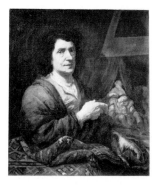

A 115 Self portrait. *Zelfportret*

Canvas 84.5 × 74.5
PROV Sale G van der Pot van Groeneveld, Rotterdam, 6 June 1808, lot 42
LIT Moes 1897-1905, vol 1, nr 2634:1? Moes & van Biema 1909, pp 113, 180. E Wiersum, OH 48 (1931) p 206, fig 4. Bernt 1960-62, vol 4, nr 95. Van Hall 1963, p 105, nr 689:1. Bernt 1969-70, vol 1, nr 410. Eckardt 1971, p 186, fig 34

Geertgen tot Sint Jans

Leiden? 1460/65 – 1488/93 Haarlem

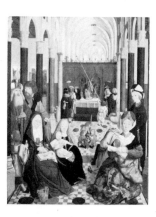

A 500 The holy kinship. *De heilige maagschap*

Panel 137.5 × 105
PROV Sale G van der Pot van Groeneveld, Rotterdam, 6 June 1808, lot 36 (as Hubert and Jan van Eyck)
LIT J A Alberdingk Thijm, in Christelijke Kunst, 1881, p 21, ill. A von Wurzbach, Kunstchronik 18 (1883) p 528 (attributed to Geertgen). Dülberg 1899, p 31. M J Friedländer, Jb Preusz Kunstsamml 24 (1903) p 67. E Durand-Gréville, Revue de l'Art 15-16 (1904) p 378, ill. Voll 1906, p 233. Moes & van Biema 1909, pp 113, 186. Jantzen 1910,

p 8, fig 2. Heidrich 1910, p 38, figs 92, 95. Balet 1910, p 45 (rather early). Valentiner 1914, p 53 (early). Voll 1923, p 220. Winkler 1924, p 176. Bürger 1925, p 92, fig 126. Friedländer 1924-37, vol 5 (1927) pp 29, 132, nr 10, pl XIII (early). Dülberg 1929, p 101, fig 73. Kessler 1930, p 24. Kleinschmidt 1930, p 272. Hoogewerff 1936-47, vol 2 (1937) pp 165, 170. M Davies, Burl Mag 70-71 (1937) p 98 (not Geertgen). K Oettinger, Jb Kunsth Samml Wien ns 12 (1938) p 68, note 20. Vogelsang 1942, p 37, ill (ca 1488). Panofsky 1953, vol 1, pp 327, 329, note 1, figs 439-40 (early). N Beets, in Kunstgesch der Ned, 1954-56, vol 1, p 283. J E Snyder, Bull RM 5 (1957) p 92, fig 5. Exhib cat Middeleeuwse kunst der Noordelijke Nederlanden, Amsterdam 1958, nr 15, fig 7. J E Snyder, Art Bull 42 (1960) p 128, fig 18. P Philippot, Bull Mus Roy Belg 11 (1962) p 31. U Finke, OH 77 (1963) p 41, fig 10. Van Hall 1963, p 105, nr 691:1. H W van Os, Bull Boymans 15 (1964) p 35ff, ill. H P Baard, OK 10 (1966) nr 54, fig 1. I Q van Regteren Altena, OH 80 (1966) p 76ff. Müller 1966, p 89, fig 105A. VTTT, 1969-70, nr 119. R de Keyser, Spiegel Hist 6 (1971) p 343, fig 9. E de Jongh, OK 15 (1971) nr 39, ill. J Snyder, Art Bull 53 (1971) p 453, figs 4-5. W S Gibson, Alb Amic J G van Gelder, 1973, p 129

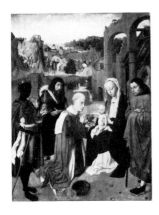

A 2150 The adoration of the magi. *De aanbidding der koningen*

Panel 90 × 70
PROV Sale W Hekking Jr, Amsterdam, 20 April 1904, lot 7
LIT E Durand-Gréville, Revue de l'Art 15-16 (1904) p 379, ill. Valentiner 1914, p 52 (early). L von Baldass, Jb Kunsth Samml Wien 1 (1920) p 24, fig 15 (middle period). Winkler 1924, p 176. Friedländer 1924-37, vol 5 (1927) pp 32, 131, nr 2, pl II. Dülberg 1929, p 100. Kessler 1930, p 21. Hoogewerff 1936-47, vol 2 (1937) p 170. M Davies, Burl Mag 70-71 (1937) p 91 (not Geertgen). K Oettinger, Jb Kunsth Samml Wien ns 12 (1938) p 68, note 20 (attributed to the Master of the Braunschweig Diptych). Vogelsang 1942, p 47, fig 29. Friedmann 1946, pp 56, 140. Panofsky 1953, vol 1,

p 329 (replica). N Beets, in Kunstgesch der Ned, 1954-56, vol 1, p 283. A van Schendel, OK 1 (1957) nr 37, ill. J E Snyder, Art Bull 42 (1960) p 121, fig 9 (begun by Geertgen, finished by another hand). VTTT, 1960, nr 26. E R Meijer, OKtv 2 (1964) nr 1, fig 5. I Q van Regteren Altena, OH 71 (1966) p 76ff (early). J R J van Asperen de Boer, Applied Optics 7 (1968) p 1711, figs 2-4. J R J van Asperen de Boer, Delta, spring 1973, pp 58-61, ill

Wybrand Symonsz de Geest

Leeuwarden 1592–after 1667
Leeuwarden

see also Honselaarsdijk series: A 528 Jan de Oude; A 523 Lodewijk, count of Nassau; A 522 Adolf, count of Nassau; A 524 Hendrik, count of Nassau; A 533 Hendrik Casimir I, count of Nassau-Dietz; A 530 Willem Frederik, prince of Nassau-Dietz; A 560 Johan Coenraad van Salm

A 1780 Self portrait. *Zelfportret*

Pendant to A 1781

Panel 71.5 × 55.5. Dated *CIC ICC XXIX*. Inscribed on the verso *Wibrant De Geest Geboren in 't Jaer 1592 den 16 van Oostmaent*
PROV Purchased from R Hoornsma Cannegieter, Donkerbroek, 1898 *
DRVK since 1959 (on loan to the Fries Museum, Leeuwarden)
LIT Bauch 1926, p 9, pl 5. Ried 1931, fig 29. Van Hall 1963, p 106, nr 692:1. Wassenbergh 1967, pp 33-34, nr 15, fig 55. H Kingmans, Vrije Fries 51 (1971) p 23, ill on p 24. Eckardt 1971, p 187, fig 3

A 1781 Hendrickje Uylenburgh (1600-ca 1682). The artist's wife. *Echtgenote van de kunstenaar*

Pendant to A 1780

Panel 71.5 × 55.5. Dated *MDCXXIX*. Inscribed on the verso *Hendrikien*

Ulenborch geboren in 't Jaer 1600 den 3 van Meert
PROV Same as A 1780 * DRVK since 1959 (on loan to the Fries Museum, Leeuwarden)
LIT Moes 1897-1905, vol 2, nr 8167. Wassenbergh 1967, pp 33, 35, nr 16, fig 56. H Kingmans, Vrije Fries 51 (1971) p 23

A 571 Ernst Casimir (1573-1632), count of Nassau-Dietz. *Graaf van Nassau-Dietz*

Pendant to A 572

Panel 67 × 59.5. Signed and dated *V. d. G. fe A° 1633*
PROV NM, 1808 * On loan to the Rijksmuseum Muiderslot, Muiden, since 1971
LIT Moes 1897-1905, vol 1, nr 2391:5. Moes & van Biema 1909, pp 169, 203. Wassenbergh 1967, p 35, nr 41, fig 74

A 572 Sophia Hedwig von Braunschweig-Wolfenbüttel (1592-1642). Wife of Ernst Casimir. *Echtgenote van Ernst Casimir*

Pendant to A 571

Panel 68.5 × 58
PROV Same as A 571 * On loan to the Rijksmuseum Muiderslot, Muiden, since 1971
LIT Moes 1897-1905, vol 2, nr 7407:1. Moes & van Biema 1909, pp 104, 169, 203. Wassenbergh 1967, p 35, nr 42, fig 64

A 1356 Portrait of a woman. *Portret van een vrouw*

Pendant in the museum of Lille (cat 1893, nr 327)

Canvas 243 × 165. Signed and dated *V. de Geest 1659*
PROV Presented by Dr A Bredius, The Hague, 1887
LIT Wassenbergh 1967, pp 33-34, 37, nr 85, fig 96 (portrait of Albertina Agnes van Nassau)

A 569 Hendrik Casimir I (1612-40), count of Nassau-Dietz. *Graaf van Nassau-Dietz*

Canvas 200 × 129. Signed *VdGeest f.* Inscribed on the verso *Graaff Henrijk Stadthouder van frieslant*
PROV NM, 1808
LIT Moes 1897-1905, vol 1, nr 3396:1. Moes & van Biema 1909, p 169. Wassenbergh 1967, p 35, nr 37. A W E Dek, Spiegel der Hist 3 (1968) ill on p 286. O ter Kuile, NKJ 20 (1969) p 10

A 570 Ernst Casimir (1573-1632), count of Nassau-Dietz. *Graaf van Nassau-Dietz*

Canvas 197 × 129

PROV NM, 1808
LIT Moes 1897-1905, vol 1, nr 2391:6. Moes & van Biema 1909, p 169. J Visser, Vrije Fries 47 (1966), ill opp p 24. Not listed in Wassenbergh 1967, but *cf* pp 32, 35 and nr 33

A 1908 Portrait of a boy with a golf club. *Portret van een jongen met kolfstok*

Panel 115 × 85.5. Dated *Anno 1631*
PROV Sale Heeswijk ('s-Hertogenbosch), Amsterdam, 20 June 1900
LIT Wassenbergh 1967, p 35, nr 23 (duplicate entry on p 36, nr 53). W J Müller, in Festschrift Olaf Klose, 1968, p 78, fig 3

A 4190 Portrait of an officer. *Portret van een officier*

Panel 56 × 47. Inscribed on the verso *Deze twee Portretten sijnde de Graven van Echmont en Hooren komen van wegens J.L. Trip en vrouwe A. W. Trip geb. Van Limburg Stirum zijnde oorspronkelijk uit het huis van de Graven van Limburg Stirum. Versonden van Breda na 's Hage aan het Nationaal Cabinet den 14 [?] Juni 1805*
PROV Presented by Jonkheer J L Trip and A W Trip, Countess van Limburg Stirum, Princenhage, 1805 (as a portrait of the count of Horn; given as a pair with J A van Ravesteyn, A 4191)
LIT Moes & van Biema 1909, pp 84, 167, 210

A 566 The four brothers of Willem I, prince of Orange: Jan (1536-1606), sitting, Hendrik (1550-74), Adolf (1540-68) and Lodewijk (1538-74), counts of Nassau. *De vier broeders van Willem I, prins van Oranje: de graven van Nassau Jan, zittend, Hendrik, Adolf en Lodewijk*

Canvas 186 × 144. Inscribed *P. Jan van Nassau; Graeff Lodewijck van Nassau out 36 j. Bij Moock gebleve A° 1574; Graeff Adolph van Nassau 24; Graeff Hendrick van Nassau*
PROV NM, 1808
LIT Moes 1897-1905, vol 1, nrs 27:2, 3395:2; vol 2, nr 4565:2. Moes & van Biema 1909, pp 104, 201. A Staring, OH 75 (1960) p 163, note 7. Wassenbergh 1967, pp 32, 35, nr 30, fig 63 (ca 1631, studio of de Geest). F W van den Berg, Spiegel Hist 6 (1971) p 371, fig 7

Aert de Gelder

Dordrecht 1645–1727 Dordrecht

A 3969 Ernestus van Beveren (1660-1722), lord of West-Ysselmonde and de Lindt. Alderman, burgomaster and from 1704 on postmaster of Dordrecht. *Heer van West-IJsselmonde en de Lindt. Schepen, burgemeester en sedert 1704 postmeester van Dordrecht*

Canvas 128 × 105. Signed and dated *ADe Gelder f. 1685*

PROV On loan from J J M Chabot, 1923-43. On loan from the SNK, later DRVK, 1948-60. Transferred in 1960
LIT Moes 1897-1905, vol I, nr 608. Hofstede de Groot 1903, p 12, nr 31, pl XIX. Van Gijn 1908-12, nr 3220. Lilienfeld 1914, nr 158

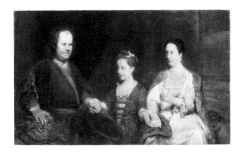

A 4034 Hermanus Boerhaave (1668-1738). Professor of medicine at the university of Leiden, with his wife Maria Drolenvaux (1686-1746) and their daughter Johanna Maria (1712-91). *Hoogleraar in de geneeskunde te Leiden met zijn vrouw en dochtertje*

Canvas 104.5 × 173. Signed *ADe Gelder f.*
PROV On loan from W A A J Baron Schimmelpenninck van der Oye, Voorschoten, 1932-60. Sale London, 22 June 1960, lot 21, ill
LIT Moes 1897-1905, vol I, nr 2153. Martin & Moes 1912-14, nr 25, ill. Lilienfeld 1914, pp 24, 66ff, nr 161. M G Wildeman, Oude Kunst 4 (1918-19) p 13, ill. W Martin, Bull NOB 12 (1919) p 26. C Brière-Misme, Beaux Arts 5 (1927) p 87. G Isarlov, Amour de l'Art 13 (1932) p 3, ill. Gerson 1952, fig 69. Lindeboom 1959, p 5. Plietzsch 1960, p 183, fig 338. Rosenberg, Slive & Ter Kuile 1966, p 100

A 2359 The arrest of Christ. *De gevangenneming van Christus*

Belongs with A 2360 to a series of the passion, other members of which are in the museum of Aschaffenburg

Canvas 73 × 59. Signed *ADe Gelder f.*
PROV Purchased from Mr Frenkner, Braunschweig, 1908

LIT Houbraken 1718-21, vol 3, p 208. Weijerman 1729-69, vol 3 (1729) p 41. Descamps 1753-64, vol 3 (1760) p 176. Lilienfeld 1914, pp 62, 155, nr 84. H Kühn, Jb Ksamml Baden-Württemberg 2 (1965) p 207

A 2360 Christ before Caiphas. *Christus voor Kajafas*

Belongs with A 2359 to a series of the passion, other members of which are in the museum of Aschaffenburg

Canvas 73 × 59. Signed *ADe Gelder f.*
PROV Same as A 2359
LIT Houbraken 1718-21, vol 3, p 208. Weijerman 1729-69, vol 3 (1729) p 41. Descamps 1753-64, vol 3 (1760) p 176. Lilienfeld 1914, pp 59, 155, nr 85

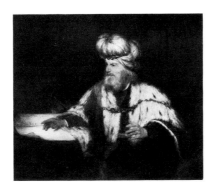

A 2695 King David. *Koning David*

Canvas 109.5 × 114.5
PROV Presented by M P Voûte, Amsterdam, 1913
LIT Lilienfeld 1914, nr 122. W Steenhoff, Onze Kunst 25-26 (1914) pp 117-19

Nicolaes van Gelder

Leiden? ca 1625 or 1635 – 1675/77 Amsterdam?

A 1536 Still life. *Stilleven*

Canvas 110.5 × 88. Signed and dated *N.v. Gelder f. Anno 1664*
PROV Purchased from M Cohen Stuart, Alkmaar, 1890
LIT Warner 1928, fig 34d. Vorenkamp 1933, p 68. Bernt 1960-62, vol I, nr 305. Bol 1969, p 303. Bernt 1969-70, vol I, nr 415

Gortzius Geldorp

Louvain 1553 – 1616 Cologne

A 912 Jean Fourmenois

Pendant to A 2072

Panel 96 × 72. Dated *An [1]590 90.* On the verso the inscription *Jean Fourmenois. Trouwt te Keulen Hortensia del Prado Geb : Overl :* and the number *34*
PROV Bequest of Jonkheer J de Witte van Citters, The Hague, 1876. NMGK, 1885

A 2072 Hortensia del Prado (d 1627). Wife of Jean Fourmenois. *Echtgenote van Jean Fourmenois*

Pendant to A 912. *See also* her portrait by Mesdach, Salomon, A 910

Panel 96 × 71. Signed and dated *GG.F. An° 1596.* On the verso the inscription *Hortensia del Prado. Trouwt 1°. Jean*

*Fourmenois 2°. Pieter Courten Geb : Overl :
18 Junij 1627.* and the number *35*
PROV Bequest of Jonkheer J de Witte
van Citters, The Hague, 1876. Received
in 1903
LIT Moes 1897-1905, vol 2, nr 6064:1.
Bernt 1960-62, vol 1, nr 306. Bernt 1969-
70, vol 1, nr 416

A 2081 Hortensia del Prado (d 1627)

see also her portrait by Mesdach,
Salomon, A 910

Panel 68 × 52. Signed and dated *GG.F.
An° 1599.* On the verso the inscription
*Hortensia del Prado. Trouwt 1°. Jean
Fourmenois 2°. Pieter Courten. Geb : , Overl :
18 Junij 1627.* and the number *32*
PROV Same as A 2072

A 2070 Catharina Fourmenois (1598-
1665)

see also her portrait by Mesdach,
Salomon, A 2069

Panel 82 × 64. Signed and dated *GG. F.
An° 1604.* On the verso the inscription
*Catharina Fourmenois. Trouwt Pieter Boudaen
Courten. Geb : 5 Dec : 1598. Overl :
16 Jan : 1665.* and the number *31*
PROV Same as A 2072
LIT Moes 1897-1905, vol 1, nr 2570:1

A 2071 A sister (b 1600) of Catharina
Fourmenois. *Een zuster van Catharina
Fourmenois*

Panel 86 × 64. Signed and dated *GG. F.
An 1606.* Inscribed *Aetatis 6.* On the verso
the inscription *Fourmenois. dochter van Jean
en Hortensia del Prado Geb : 1600. Overl :*
and the number *33*
PROV Same as A 2072
LIT Moes 1897-1905, vol 1, nr 2571

A 915 Gualtero del Prado (b 1535)

Panel 113 × 86. Dated *An° 1597.*
Inscribed *Aetatis 62.* On the verso the
inscription *Gualtero del Prado. Trouwt
Lucretia Pellicorne. Geb : 1535 Overl :*
and the number *38*
PROV Same as A 912

A 914 Lucretia Pellicorne (1550-1635).
Wife of Gualtero del Prado. *Echtgenote
van Gualtero del Prado*

Panel 69 × 55. Signed and dated *GG. F
An° 1608.* On the verso her coat of arms,
the inscription *Lucretia Pellicorne. Trouwt
Gualtero del Prado. Geb : 1550 Overl : te
Keulen 5 April 1635.* and the number *37*
PROV Same as A 912

A 916 Jeremias Boudinois

Pendant to A 917

Panel 103 × 81. Signed and dated *GG. F.
An° 1610.* On the verso the inscription
Jeremias Boudinois. Geb : Overl : and
the number *39*
PROV Same as A 912

A 917 Lucretia del Prado. Wife of
Jeremias Boudinois. *Echtgenote van
Jeremias Boudinois*

Pendant to A 916

Panel 105 × 80. Signed and dated *GG. F.
An° 1610.* On the verso her coat of arms,
the inscription *Lucretia del Prado. Trouwt
Jeremias Boudinois Geb : Overl :* and
the number *40*
PROV Same as A 912

Bernard te Gempt

Wijchen 1826 – 1879 Amsterdam

A 1337 A St Bernard dog. *Sint Bernards-
hond*

Canvas 179 × 248. Signed *B. te Gempt f¹*
PROV Bequest of J Hilman, Amsterdam, 1881

Abraham Genoels

Antwerp 1640 – 1723 Antwerp

A 1838 Landscape with Diana hunting. *Landschap met Diana op jacht*

Pendant to A 1839

Canvas 23 × 31.5. Signed *Genoels*
PROV Bequest of Reinhard Baron van Lynden, The Hague, 1899

A 1839 Landscape with Apollo and Calliope. *Landschap met Apollo en Kalliope*

Pendant to A 1838

Canvas 23 × 32
PROV Same as A 1838

François Pascal Simon Gérard

Rome 1770 – 1837 Paris

C 1525 Carolina Ferdinanda Louisa of Sicily (1798-1870). Wife of Charles Ferdinand, duc de Berry, in the park of Bagatelle in the Bois de Boulogne (near Paris). *Echtgenote van Karel Ferdinand, hertog van Berry, in het park van Bagatelle in het Bois de Boulogne bij Parijs*

Canvas 194.5 × 142.5
PROV On loan from the DRVK since 1973

copy after **François Pascal Simon Gérard**

C 1120 Emperor Napoleon I in coronation robes, 2 December 1804. *Keizer Napoleon I in kroningsgewaad, 2 december 1804*

Copy after the portrait in the museum of Versailles, dated 1805

Canvas 226.5 × 146
PROV On loan from the Museum Boymans, later Museum Boymans-van Beuningen, Rotterdam, since 1922
LIT R van Luttervelt, Nap Stud 13 (1961) pp 551-56, fig 12. WF Lichtenauer, Spiegel Hist 7 (1972) p 299, fig 6

Niccolò di Pietro Gerini

d Florence 1415

A 3401 Calvary. *De Kruisberg*

Panel 70 × 43
PROV Bequest of J W Edwin vom Rath, Amsterdam, 1941
LIT Berenson 1932, p 394. K E Schuurman, Mndbl BK 19 (1942) p 98, fig 1. Berenson 1963, vol 1, p 158. Van Os & Prakken 1974, pp 94-95, nr 56, ill (Niccolò di Pietro Gerini?)

Jacques de Gheyn II

Antwerp 1565 – 1629 The Hague

A 4255 A Spanish warhorse captured by Lodewijk Gunther van Nassau from Archduke Albert of Austria in the battle of Nieuwpoort and presented to Prince Maurits. *Spaanse strijdhengst, buitgemaakt door Lodewijk Gunther van Nassau op Aartshertog Albertus van Oostenrijk in de Slag bij Nieuwpoort en geschonken aan prins Maurits*

Canvas 228 × 269. Signed and dated *IDGheyn fe 1603.* Inscribed *HVnC dedIt aVstrIaCo teLLVs hIspana CreatrIX VICtorIqVe dedIt fLandrIa MaVrItIo*
PROV Presented by Jonkheer W LB van Panhuys, Leeuwarden, 1880

LIT Van Mander 1604, fol 294 verso.
Hirschmann 1916, p 68. Martin 1935-
36, vol 1, p 257. Bernt 1960-62, vol 4
(1962) nr 101. Bernt 1969-70, vol 1, nr
422

A 2395 Venus and Amor. *Venus en Amor*

Panel 132 × 112. Signed and dated
IDGheyn 16.. On the verso is the mark of
King William III of England
PROV Purchased from Kadol & Bodinot
gallery, The Hague, 1909
LIT Hirschmann 1916, p 69. I
Bergström, OH 85 (1970) p 153, note 28

attributed to **Giampietrino**

active ca 1500-50 in North Italy

A 3033 Madonna and child. *Maria met
kind*

Panel 67 × 54
PROV Purchased from the Augusteum,
Oldenburg, 1925, with aid from the
Rembrandt Society
LIT Bode 1888, p 14, ill (Giampietrino or
Marco d'Oggione). Hartlaub 1912, nr
45, fig 19. Venturi 1901-40, vol 7:4
(1915) pp 1046-47, fig 724. Suida 1929,
p 214. Berenson 1932, p 229

Joseph Gillis

see Governors-general series: A 3787
Pieter Gerardus van Overstraten;
A 3789 Albertus Henricus Wiese

Luca Giordano

Naples 1632 – 1705 Naples

C 1353 Four women making music. *Vier
musicerende vrouwen*

Canvas 57 × 101.5
PROV Purchased by King Willem I from
the collection of Vincent de Rainer,
1821. On loan from the KKS since 1948

attributed to **Giorgione**

Castelfranco 1477? – 1510 Venice

A 3970 St Justine(?) as a personification
of chastity. *De heilige Justine(?) als
personificatie van de kuisheid*

Canvas 28 × 39
PROV O Lanz, Amsterdam. Lent by the
SNK, later DRVK, 1948. Transferred in
1960
LIT Cook 1900, p 131. G Frizzoni, L'Arte
5 (1902) p 299, fig 17. U Monneret de
Villard, Emporium, 1903, p 86. Justi
1908, vol 1, p 267. Richter 1937, p 208,
nr 4, pl XXVII. B Degenhart, Pantheon
27-28 (1941) p 36. Fiocco 1941, p 32.
Morassi 1942, pp 57, 160, fig 26.
Pallucchini 1944, pl XII. Fiocco 1948, p
32. Exhib cat Giorgione, Venice 1955,
nr 29, ill. Della Pergola 1955, p 33
(follower). Coletti 1955, p 52, fig 20.

Pignatti 1955, p 114 (milieu). T
Pignatti, Nuova Ant, 1955, p 497. P
Zampetti, Arte Ven, 1955, p 66 (copy?).
Berenson 1957, vol 1, p 86, fig 664.
Zampetti 1968, p 59. Pignatti 1971, p
116, nr A-1, p 143, fig 143. Pochat 1973,
p 383, note 101

attributed to **Giovanni da Brescia (da
Asola)**

active ca 1512-31 in Venice

A 3995 St Jerome. *De heilige Hieronymus*

Canvas 77.5 × 116
PROV O Lanz, Amsterdam. Lent by the
DRVK, 1952. Transferred in 1960
LIT I Peelen, Elsevier's GM 22 (1912) p 6,
fig 4. G Swarzenski, Münchn Jb 9 (1915)
p 103, fig 19 (Dosso Dossi). O Lanz, Burl
Mag 43 (1923) p 184 (Dossi). Ch Holmes,
Burl Mag 43 (1923) p 253 (attributed to
Romanino). R Longhi, Vita Art 1 (1927)
p 33 (Dossi). Gould 1962, pp 18-19. MG
Antonelli Trenti, Arte ant & mod 25
(1964) p 406, fig 127b. Mezzetti 1965,
pp 51, note 7, 72, nr 6 (not Dossi).
Gibbons 1968, p 248, fig 189 (attributed
to Bernardino or Giovanni da Asola)

Giovanni da Milano

active 1350-66 in Florence

A 4000 Christ on the cross with Mary, Sts Mary Magdalene, John the Baptist, Ambrose of Milan(?) and Francis of Assisi. *Christus aan het kruis met heiligen*

Panel 51 × 30.5. Inscribed *Amor meus cru|cifisus est*
PROV O Lanz, Amsterdam. Lent by the DRVK, 1952. Transferred in 1960
LIT Van Marle 1923-38, vol 4 (1924) p 238, note 2. R van Marle, Burl Mag 46 (1925) p 188, pl A. Berenson 1932, p 243. R van Marle, Boll d'Arte 28 (1935) p 304. B Degenhart, Pantheon 27 (1941) p 35. Kaftal 1952, col 497. Berenson 1963, vol 1, p 89. A Marabottini, Commentari 16 (1965) p 30, fig 1. C Colfranceschi, in Bibl Sanct 7 (1966) col 664. Boskovits 1966, figs 28-29. M Boskovits, Revue de l'Art 11 (1971) pp 55, 57 (late 1350s). Van Os & Prakken 1974, pp 15, fig 10, 53-54, nr 24, ill

attributed to **Giovanni di Francia**

active 1429-39 in Venice

A 3432 Madonna of humility. *Madonna dell' umiltà*

Panel 53 × 42
PROV Bequest of J W Edwin vom Rath, Amsterdam, 1941
LIT Van Marle 1923-38, vol 7 (1926) pp 308, 310 (school work)

Hippolyte Girard

active 1883-91 in Paris?

A 1810 Heath with sheep. *Heide met schapen*

Canvas 63 × 92. Signed and dated *H. Girard 87*
PROV Presented by Reinhard Baron van Lynden, The Hague, 1899 * DRVK since 1952

attributed to **Girolamo da Santa Croce**

Venice? ca 1490 – 1556 Venice

A 3966 The young Mercury stealing cattle from the herd of Apollo. *De jonge Mercurius steelt runderen van Apollo's kudde*

Canvas 107 × 103
PROV O Lanz, Amsterdam. Lent by the SNK, later DRVK, 1948. Transferred in 1960
LIT B Degenhart, Pantheon 27-28 (1941) p 37, ill (milieu of Campagnola). Heinemann 1963, p 171, nr 570 bis, fig 675. L C J Frerichs, Bull RM 14 (1966) p 18, note 37 (1544-46)

Nicolaes de Giselaer

Dordrecht 1583 – before 1659 Amsterdam?

A 1527 The archangel Gabriel appearing to Zacharias. *De aartsengel Gabriël verschijnt aan Zacharias*

Panel 34 × 55.5. Signed and dated *ND Giselaer F 1625*
PROV Presented by Dr A Bredius, The Hague, 1890

LIT Jantzen 1910, p 162, nr 160. SWA Drossaers & C Hofstede de Groot, OH 47 (1930) p 202, nr 15. Bernt 1960-62, vol 4, nr 115. Bernt 1969-70, vol 1, nr 459

Johannes Glauber

Utrecht 1646 – ca 1726 Schoonhoven

see also Lairesse, Gerard, A 4213-A 4216 Mural canvases from the house of Jacob de Flines, Amsterdam

A 118 Arcadian landscape with Mercury and Io. *Arcadisch landschap met Mercurius en Io*

Mural canvas 124 × 90
PROV Thought to belong with nrs A 119, A 1200-A 1202, A 1217 and a painting in the KKS (cat 1935, nr 41) to a series of mural canvases that were transferred in 1799 from Soestdijk Palace to Huis ten Bosch (Nationale Konstgallery), The Hague. NM, 1808 * DRVK since 1956
LIT Moes & van Biema 1909, pp 20, 37, 214

A 119 Arcadian landscape with Diana bathing. *Arcadisch landschap met badende Diana*

Mural canvas 124 × 90
PROV Same as A 118
LIT Moes & van Biema 1909, pp 20, 37, 214

A 1217 Arcadian landscape with Salmacis and Hermaphroditus. *Arcadisch landschap met Salmacis en Hermaphroditus*

Mural canvas 123 × 90
PROV Same as A 118. KKS, 1885
LIT Moes & van Biema 1909, pp 20, 37, 214

A 1200 Arcadian landscape with Jupiter and Io. *Arcadisch landschap met Jupiter en Io*

Mural canvas 160 × 131
PROV Same as A 118. KKS, 1885
LIT Moes & van Biema 1909, pp 20, 37, 214

A 1201 Arcadian landscape. *Arcadisch landschap*

Mural canvas 173 × 152
PROV Same as A 118. KKS, 1885 * DRVK since 1953
LIT Moes & van Biema 1909, pp 20, 37, 214

A 1202 Arcadian landscape. *Arcadisch landschap*

Mural canvas 180 × 156
PROV Same as A 118. KKS, 1885
LIT Moes & van Biema 1909, pp 20, 37, 214

Hugo van der Goes

see Southern Netherlands school 1561, A 4488 The Gertz memorial tablet, middle panel, copy after van der Goes

Vincent Willem van Gogh

Groot-Zundert 1853 – 1890 Auvers-sur-Oise

see also under Aquarelles and drawings

A 3262 Self portrait. *Zelfportret*

Board 42 × 34. Painted in summer 1887 in Paris
PROV Presented by Mrs F W M Bonger, née Baroness van der Borch van Verwolde, widow of A Bonger, Amsterdam, 1936 * On loan to the SMA since 1950
LIT De la Faille 1928, nr 295, ill. M D Henkel, Cicerone 22 (1930) p 598, fig 1. Bromig-Kolleritz 1955, p 96 (1886). Erpel 1963, nr 9. De la Faille 1970, p 144, nr F 295, ill

A 3307 Farming village at twilight. *Boerendorp in de avond*

Canvas 57 × 82. Painted in 1884 in Nuenen
PROV Presented by Mr & Mrs D A J Kessler-Hülsmann, Kapelle op den Bosch near Mechelen, 1940
LIT R Jacobson, Onze Kunst, 1903:1, p 115. A Plasschaert, Onze Kunst, 1904:1, p 152. De la Faille 1928, nr 191, ill. Vanbeselaere 1937, pp 289-90, 396, 416. De la Faille 1970, p 102, nr F 190

Hendrick Goltzius

Mühlbrecht 1558 – 1617 Haarlem

A 1284 Dying Adonis. *Stervende Adonis*

Canvas 76.5 × 76.5. Lozenge-shaped. Signed and dated *HG 1603*
PROV Sale P Verloren van Themaat, Amsterdam, 30 Oct 1885, lot 136 (as Flemish master, 17th century)
LIT Hirschmann 1916, p 46ff, nr 4. E K J Reznicek, OH 75 (1960) p 38, note 14. Reznicek 1961, cat nr z w 8. P J J van Thiel, Master Drawings 3 (1965) p 147, note 41

A 2217 Vertumnus and Pomona. *Vertumnus en Pomona*

Canvas 90 × 149.5. Signed and dated *HG 1613*
PROV Purchased from Fr Muller & Co, art dealers, Amsterdam, 1906
LIT O Hirschmann, OH 33 (1915) p 130. Hirschmann 1916, nr 16. N N Nikouline, Trudy Ėrmitaža 8 (1964) p 56, fig 5. Rosenberg, Slive & Ter Kuile 1966, pp 15-16, fig 4

Johan van Gool

The Hague 1685?–1763 The Hague

A 1605 Milking time. *Het melkuur*

Panel 42 × 63. Signed *J.v. Gool ft*
PROV Purchased from M van Duren Jr, art dealer, Amsterdam, 1893
LIT Scheen 1946, fig 265

C 133 Arcadian landscape with shepherds and cattle. *Arcadisch landschap met herders en vee*

Panel 42.5 × 63. Signed *J.v. Gool ft*
PROV On loan from the city of Amsterdam (A van der Hoop bequest) since 1885

Gerrit van Goor

see Governors-general series: A 3768 & A 4538 Johannes Camphuys

Jan Gossaert van Mabuse

Maubeuge? ca 1478–1536 Middelburg

A 217 Floris van Egmond (1469-1539), count of Buren and Leerdam. *Graaf van Buren en Leerdam*

Panel 39 × 29.5
PROV NM, 1808 * On loan to the KKS (cat 1968, p 23, nr 841) since 1948
LIT C Justi, Zeitschr BK ns 6 (1895) p 199. Moes & van Biema 1909, pp 40, 68, 99, 105, 116, 161. Weisz 1913, pp 79-80, 114, note 64, 117, fig 49. Ring 1913, pp 22, 53, 65. Segard 1923, pp 140, 179, nr 15, fig 142. Friedländer 1923-37, vol 8 (1930) p 160, nr 54. Glück 1933, p 321. Exhib cat Jan Gossaert genaamd Mabuse, Rotterdam-Bruges 1965, nr 17. G von der Osten, in Essays in honor of Erwin Panofsky, 1961, pp 455, 465, 471, fig 4. P Wescher, Art Q 29 (1966) p 157, fig 9 (portrait of Johann van Brandenburg). Essink 1973, pl III

Anthonie Constantijn Govaerts

active 1821-27 in Antwerp and Brussels

A 1036 The camp follower. *De marketentster*

Panel 57 × 70.5
PROV Purchased at exhib The Hague 1827, nr 124. RVMM, 1885

Francisco José de Goya y Lucientes

Fuendetodos 1746–1828 Bordeaux

A 2963 Don Ramón Satué (1765-1824). Alcalde de Corte (judge of the fifth chamber of the council of Castile in La Corte). *Rechter van de vijfde kamer van de raad van Kastilië, gevestigd in La Corte*

Canvas 107 × 83.5. Signed and dated *Pr Goya 1823*. Inscribed *D. Ramon Satue Alcalde d corte*
PROV Purchased from Duveen gallery, New York, 1922, with aid from members of the Rembrandt Society
LIT De la Viñaza 1887, p 265, nr 127. Araujo Sánchez 1889, p 119, nr 272. Lafond 1903, p 137, nr 209, ill. Von Loga 1903, p 204, nr 331. L Amaudry, Burl Mag 6 (1904-05) p 185. Oertel 1907, fig 140. Calvert 1908, nr 232, fig 94. Stokes 1914, pp 277-78. Mayer 1922, p 484. A L Mayer, Zeitschr BK ns 33 (1922) p 68. De Beruete y Moret 1922, p 173, nr 282, pl 54. Mayer 1923, nr 418, fig 286. De Beruete y Moret 1924, p 328. Terrasse 1931, p 94. Sanchez Canton 1931, pp 77, 123. Grappe 1937, p 56, ill. Mayer 1947, p 535. Lassaigne 1948, p 65. Desparmet Fitz-Gerald 1950, vol 2, p 225, nr 514, ill on p 428. Vallentin 1951, p 392. Lafuente Ferrari 1953, pp 413-15. Delevoy 1954, fig 62. F J Sanchez Canton, Goya, 1954, pp 130-35. Rouchès 1958, p 438. Gaya Nuño 1958, vol 1, p 79; vol 2, nr 1123, fig 275. Lewin 1958, p 316, ill. E R Meijer, OK 4 (1960) nr 15, ill. V Bloch, Pantheon 20 (1962) p 179, fig 3. VTTT, 1962-63, nr 49. Holland, 1963, pp 117-18. Du Gué Trapier 1964, p 42, fig 80. Held 1964, pp 132-33, 135-36, 139, 141, ill. J Guidol, Arte ill 4 (1971) p 7, fig 4

Jan van Goyen

Leiden 1596–1656 The Hague

A 3945 Summer. *Zomer*

Pendant to A 3946

Panel 33.5 cm in diam. Signed and dated
I.v. Goien 1625
PROV Purchased from W Hallsborough
gallery, London, 1958, as a gift of the
Photo Commission
LIT Th Frimmel, Blätter fG, 1905, p 74.
Hofstede de Groot 1907-28, vol 8 (1923)
nr 357. Dobrzycka 1966, pp 24, 86, nr
13. J Bauch, D Eckstein & M Meier-
Siem, NKJ 23 (1972) p 488. Beck 1973,
vol 2, nr 108, ill

A 3946 Winter. *Winter*

Pendant to A 3945

Panel 33.5 cm in diam. Signed and dated
I.v. Goien 1625
PROV Same as A 3945
LIT Th Frimmel, Blätter fG, 1905, p 74,
ill. Hofstede de Groot 1907-28, vol 8
(1923) nr 1172. Dobrzycka 1966, pp 24,
86, nr 14. J Bauch, D Eckstein & M
Meier-Siem, NKJ 23 (1972) p 488. Beck
1973, nr 9, ill

A 123 Landscape with two oaks.
Landschap met twee eiken

Canvas 88.5 × 110.5. Signed and dated
IV G 1641
PROV Bequest of L Dupper Wzn,
Dordrecht, 1870
LIT C von Lützow, Zeitschr BK 5 (1870)
p 229. Hofstede de Groot 1907-28, vol 8

(1923) nr 267. Volhard 1927, p 111.
Martin 1935-36, vol 1, p 99, fig 57. N I
Romanov, OH 53 (1936) pp 189, 191.
Knuttel 1938, p 224. Gerson 1952, p 42,
fig 118. Van Gelder 1959, pl II. Filla
1959, fig 12. VTTT, 1961-62, nr 44. AB
de Vries, OKTV (1963) nr 15, fig 4.
Stechow 1966, pp 39, 43, fig 60.
Dobrzycka 1966, pp 43, 100, nr 93, fig
48. Beck 1973, vol 2, nr 1144, ill (view of
the Rhine with Wageningen and the
Grebbeberg in the left background)

A 122 The Valkhof in Nijmegen. *Het
Valkhof in Nijmegen*

Canvas 92 × 130. Signed and dated
V. Goyen 1641
PROV Purchased from the George
collection, The Hague, 1805-06. NM,
1808
LIT Hofstede de Groot 1907-28, vol 8
(1923) nr 168. Moes & van Biema 1909,
pp 84, 220. AB de Vries, Eigen Haard,
1914, p 318. Volhard 1927, p 127. Filla
1959, fig 25. Dobrzycka 1966, pp 76,
101, nr 103. Beck 1973, nr 348, ill

A 2133 Panoramic view of a river with
low-lying meadows. *Vergezicht over de
uiterwaarden van een rivier*

Panel 32 × 44.5. Signed and dated
VG 1641
PROV Purchased from the collection of
T Humphrey Ward, London, 1903, with
aid from the Rembrandt Society
LIT Hofstede de Groot 1907-28, vol 8
(1923) nr 497. Volhard 1927, pp 108,
177. Van de Waal 1941, pp 37-38. Filla
1959, fig 46. Dobrzycka 1966, pp 43, 100,
nr 94, fig 45. Stechow 1968, ill. Beck
1973, vol 2, p 972, ill. Bol 1973, p 124,
fig 128

A 3249 Polder landscape. *Polderlandschap*

Panel 22 × 33.5. Signed and dated
V. G. 1644
PROV Presented by Sir Henry W A
Deterding, London, 1936
LIT Dobrzycka 1966, pp 43, 107, nr 137.
J Bauch, D Eckstein & M Meier-Siem,
NKJ 23 (1972) p 488. Beck 1973, nr 979,
ill. Bol 1973, p 124

A 120 View of a town on a river. *Gezicht
op een dorp aan een rivier*

Canvas 131 × 166. Signed and dated
I. V Goyen 1645
PROV Sale G van der Pot van
Groeneveld, Rotterdam, 6 June 1808,
lot 44
LIT Moes & van Biema 1909, pp 113,
159, 183. Beeldende Kunst 4 (1917) nr
20, ill. Hofstede de Groot 1907-28, vol 8
(1923) nr 498. Volhard 1927, p 121.
Filla 1929, fig 80. Havelaar 1931, p 141,
ill. Dobrzycka 1966, nr 153. Beck 1973,
vol 2, nr 512, ill

A 3308 River view with sentry post.
Riviergezicht met wachtpost

Panel 46 × 66.5. Signed and dated
I. V. G. 1645
PROV Presented by Mr & Mrs D A J

Quality check: this is an illegible page.

Kessler-Hülsmann, Kapelle op den Bosch near Mechelen, 1940
LIT Weltkunst 21, nr 7 (1940) p 3. Dobrzycka 1966, nr 281. Beck 1973, vol 2, nr 761

A 3250 View of Arnhem. *Gezicht op Arnhem*

Panel 26 × 41.5. Signed *I.V.G.*
PROV Presented by Sir Henry W A Deterding, London, 1936
LIT Dobrzycka 1966, pp 52, 129, nr 274 (ca 1644). Beck 1973, vol 2, nr 288, ill

A 4044 Panoramic view of a wide river. *Vergezicht over een brede rivier*

Panel 22 × 31.5. Probably a fragment
PROV Presented by Mr & Mrs I de Bruijn-van der Leeuw, Muri near Bern, 1961
LIT J L Cleveringa, Bull RM 9 (1961) p 64, nr 7. Beck 1973, vol 2, nr 984, ill

manner of **Jan van Goyen**

A 121 View of the Merwede off Dordrecht. *Gezicht op de Merwede voor Dordrecht*

Panel 55.5 × 72
PROV Bequest of L Dupper Wzn, Dordrecht, 1870
LIT Roh 1921, fig 128. Hofstede de Groot 1907-28, vol 8 (1923) nr 36. Volhard 1927, p 120. Havelaar 1931, p 140, ill. Van de Waal 1941, p 52, ill. VTTT, 1958, nr 6. Filla 1959, fig 64. Dobrzycka 1966, pp 30, 46, nr 279 (ca 1646-48). R C, Jardin d A 208 (1972) p 36, ill. Beck 1973, vol 2, nr 316

A 952 View of the Valkhof in Nijmegen. *Gezicht op het Valkhof te Nijmegen*

Panel 25 × 31. Falsely signed *J. van Goyen*
PROV Sale The Hague, 31 Jan 1878, lot 10. NMGK, 1885

Barent Graat

Amsterdam 1628 – 1709 Amsterdam

A 1943 The prodigal son. *De verloren zoon*

Canvas 92 × 78. Signed and dated *B. Graat fe. 1652*
PROV Purchased from G de Clercq, Amsterdam, 1899, through the intermediacy of the Rembrandt Society *
DRVK since 1953
LIT [BWF] v[an] R[iemsdijk], Bull NOB 3 (1901-02) p 83

A 736 The prodigal son. *De verloren zoon*

Canvas 80 × 67. Signed and dated *B. Graat fe 1661*
PROV Sale D Bierens, Amsterdam, 15 Nov 1881, lot 7

A 3932 Company in a garden. *Een gezelschap in een tuin*

Canvas 85 × 75.5. Signed and dated *B. Graat f 1661*
PROV Purchased from Th Agnew & Sons gallery, London, 1958
LIT Frimmel 1914, vol 2, p 494. Mankowski 1932, p 296, nr 706, ill

A 1911 Family in a landscape. *Familiegroep in een landschap*

Canvas 55.5 × 50. Signed *B. G. fe*
PROV Bequest of J H Schellwald, Zwolle, 1900
LIT [BWF] v[an] R[iemsdijk], Bull NOB 3 (1901-02) p 82

attributed to **Timotheus de Graef**

active 1682-1718 in Amsterdam

A 1321 Italian landscape. *Italiaans landschap*

Canvas 51 × 64. Signed *De Graef*
PROV Sale M M Snouck van Loosen, Enkhuizen, 29 April 1886, lot 20

John Graham I

see under Miniatures

Grandmont-Hubrecht

see Hubrecht

David des Granges

see under Miniatures

Pieter Fransz de Grebber

Haarlem ca 1600 – 1652/53 Haarlem

A 2311 The descent from the cross. *De kruisafneming*

Canvas 232 × 193. Signed and dated *P.D G A° 1633*
PROV Purchased from H J Dierenbach, priest of the Old Catholic Church in Enkhuizen, 1907

C 522 The lamentation. *De bewening van Christus*

Canvas 164 × 174. Signed and dated *P. DG A 1640*
PROV On loan from the KOG (presented by the family of A D de Vries Azn) since 1889

A 2310 Self portrait (?) in oriental dress. *Zelfportret (?) in Oosters gewaad*

Canvas 103 × 89. Signed and dated *P. DG 1647*
PROV Purchased from H Thomas, Louvain, 1907
LIT Van Hall 1963, p 118, nr 754:1

Willem Grebner

see under Miniatures

school of **Domenico Theotokopoulos** *called* **El Greco**

Phódele 1541 – 1614 Toledo

A 3142 Christ on the cross. *Christus aan het kruis*

Canvas 46.5 × 32.5
PROV Lent by D G van Beuningen, Rotterdam, 1930. Presented in 1933
LIT Legendre & Hartmann 1937, p 493. Camòn Aznar 1950, vol 2, p 1366, nr 181. Exhib cat El Greco, Bordeaux 1953, nr 47, ill. Gaya Nuño 1958, nr 1353. Wethey 1962, vol 2, p 177, nr X-54 (school of El Greco, ca 1610-15). VTTT, 1966-67, nr 85

Johan Conrad Greive

Amsterdam 1837 – 1891 Amsterdam

A 1037 Midday break at a shipyard on the Maas. *Schafttijd op een scheepstimmer-werf aan de Maas*

Canvas 78 × 119. Signed *J.C. Greive Jr.*
PROV Purchased at exhib Amsterdam 1867, nr 54. RVMM, 1885 * DRVK since 1961 (on loan to the Museum der Koninklijke Marine, Den Helder)

Jean-Baptiste Greuze

Tournus 1725 – 1805 Paris

A 3906 Marquis de Saint Paul

Canvas 55 × 45. Oval
PROV Purchased from A de Heuvel
gallery, Brussels, 1956

Grief

see Claeu

Jan Griffier

Amsterdam 1652 or 1656–1718 London

A 125 River view. *Riviergezicht*

Panel 37 × 49. Signed *J. Griffier*
PROV Purchased with the Kabinet van
Heteren Gevers, The Hague-Rotterdam,
1809
LIT Hoet 1752, vol 2, p 454. Moes & van
Biema 1909, pp 146, 159

Pieter Anthonisz Groenewegen

active 1623-57 in Rome, Delft and The
Hague

A 3965 Roman landscape with the
Palatine (left) and parts of the Forum
Romanum (right). *Romeins landschap met
links de Palatinus en rechts gedeelten van het
Forum Romanum*

Panel 56 × 90.5
PROV Lent by the SNK, later DRVK,
1948. Transferred in 1960
LIT BJA Renckens, OH 75 (1960) p 243,
figs 2-3 (figures possibly by Esaias van
de Velde). Exhib cat Italianiserende
landschapschilders, Utrecht 1965, nr 33,
fig 36

Willem Gruijter Jr

Amsterdam 1817–1880 Amsterdam

A 1038 The roads of Bremerhaven. *De
rede van Bremerhaven*

Canvas 91 × 135. Signed and dated
Willem Gruijter jr. Julij 1868
PROV Purchased at exhib Amsterdam
1868, nr 202. RVMM, 1885 * DRVK since
1953

attributed to **Jacob de Gruyter**

active ca 1655-81 in Rotterdam

A 1381 Dutch ships off a northern coast.
Hollandse schepen voor een noordelijke kust

Panel 74 × 108. Signed and dated
P. Druyve... Anno 1689?
PROV Purchased from Jonkheer J E
Heemskerck van Beest, 1877. NMGK,
1887
LIT C Hofstede de Groot, OH 22 (1904)
p 112

Francesco Guardi

Venice 1712–1793 Venice

A 3251 Regatta on the Grand Canal,
near the Rialto bridge, Venice. *Regatta
op het Canal Grande bij de Rialtobrug te
Venetië*

Canvas 48 × 79
PROV Presented by Sir Henry W A
Deterding, London, 1936
LIT Pallucchini 1960, p 251. W R
Emmen-Riedel, Spiegel Hist 4 (1969) p
414, fig 3. Morassi 1973, vol 1, pp 203,
367, cat nr 303; vol 2, fig 333 (ca 1760-
70)

A 3252 A view on the Brenta canal near
Venice. *Gezicht op de oever van het Brenta-
kanaal bij Venetië*

Canvas 45 × 70
PROV Presented by Sir Henry W A
Deterding, London, 1936
LIT Morassi 1973, vol 1, pp 482-83, cat
nr 932

attributed to **Francesco Guardi**

A 3309 A lagoon near Venice. *Lagune bij Venetië*

Canvas 44 × 54.5
PROV Presented by Mr & Mrs D A J Kessler-Hülsmann, Kapelle op den Bosch near Mechelen, 1940
LIT A van Schendel, Mndbl B K I I (1934) p 245. Byam-Shaw 1951, p 78, nr 75. Morassi 1973, vol 1, p 484, cat nr 940; vol 2, fig 840

A 3899 Flowers. *Bloemen*

Canvas 53.5 × 76.5. Dessus-de-porte?
PROV Purchased from A de Castro gallery, Rome, 1956, as a gift from the Photo Commission

attributed to **Giacomo Guardi**

Venice 1764 – 1835 Venice

A 3403 View of the Isola di San Michele in Venice. *Gezicht op het Isola di San Michele in Venetië*

Canvas 14 × 21.5
PROV Bequest of J W Edwin vom Rath, Amsterdam, 1941
LIT Morassi 1973, vol 1, pp 431-32, cat nr 653

copy after **Francesco & Giacomo Guardi**

A 3402 The fire in the San Marcuola quarter of Venice, 28 November 1789. *De brand in de wijk van San Marcuola, Venetië, 28 november 1789*

Copy after a drawing by Francesco & Giacomo Guardi in the Museo Correr, Venice

Canvas 22 × 36. Inscribed *Incendio di S. Marcuola l'anno 1789 26 N.bre* (the day of the month should be 28; it was copied wrongly from the original)
PROV Bequest of J W Edwin vom Rath, Amsterdam, 1941
LIT P Wescher, Pantheon 4 (1929) pp 532, 535. Pallucchini 1943, p 50, nr 96. Kultzen 1968, p 12. *Cf* B Volk, Münchn Jb 3d ser 20 (1969) p 270, fig 4. Morassi 1973, vol 1, p 369, ad cat nr 312

attributed to **Jean Antoine Théodore Gudin**

Paris 1802 – 1880 Boulogne-sur-Seine

A 2832 View of a rocky coast by moonlight. *Gezicht op een rotsachtige kust bij maanlicht*

Canvas 42 × 51
PROV Bequest of Mrs M N Th Weddik-Lublink Weddik, widow of A L Weddik, Arnhem, 1919

studio of **Giovanni Francesco Barbieri** *called* **Il Guercino**

Cento 1591 – 1666 Bologna

A 3404 Caritas

Copper 42.5 × 37
PROV Bequest of J W Edwin vom Rath, Amsterdam, 1941
LIT Venturi 1927, pp 381–82, fig 258. D Mahon, Burl Mag 93 (1951) p 56 sub 1 (studio replica; *cf* the print by G B Pasqualini, dated 1622, after an unknown original)

copy after **Guercino**

A 593 Mary Magdalene. *Maria Magdalena*

Canvas 125 × 95
PROV NM, 1808 (as Jan van Scorel) *
DRVK since 1953
LIT Moes & van Biema 1909, p 213

Louis du Guernier

see under Miniatures

Pieter van Gunst

see Panpoeticon Batavum: A 4612
Balthasar Bekker, copy by Arnoud van
Halen after van Gunst

Gualterus Gijsaerts

Antwerp 1649–after 1674 Mechelen

A 800 Wreath of flowers encircling a
portrait of Hieronymus van Weert (d
1572), martyr of Gorkum. *Bloemenkrans
om het portret van Hieronymus van Weert,
martelaar van Gorkum*

Canvas 116 × 80. Signed *F. G. Gysaerts
Min. F.* and *D TF.* Inscribed *B Hieronymus
Werdanus*. The grisaille portrait was
painted by David Teniers II (1610-90) in
or after 1675, the year in which van
Weert was beatified
PROV Sale Count Andor de Festetits,
Amsterdam, 22-23 Jan 1884, lot 58
LIT Nuyens 1865-70, vol 2, p 54 (note).
Hairs 1955, pp 121, 225

Pieter Gijsels

Antwerp 1621–1690/91 Antwerp

A 126 Flemish village. *Vlaams dorp*

Copper 27.5 × 34. Signed *P. Gijssels*

PROV Purchased with the Kabinet van
Heteren Gevers, The Hague-Rotterdam,
1809
LIT Moes & van Biema 1909, pp 146, 159

A 2213 Still life near a fountain. *Stilleven
bij een fontein*

Copper 38 × 47. Signed *Peeter Gysels*
PROV Sale A H H van der Burgh (The
Hague), Amsterdam, 21 Sep 1904, lot
10, ill. Purchased through the inter-
mediacy of the Rembrandt Society
LIT Thiéry 1953, p 181. Greindl 1956,
pp 87, 170. Hairs 1965, p 378

G Haag

see under Miniatures

Tethart Philipp Christian Haag

Kassel 1737–1812 The Hague

A 1225 Frederika Sophia Wilhelmina of
Prussia (1751-1820). Equestrian portrait
of the wife of Prince Willem v. *Echtgenote
van prins Willem V, te paard*

Canvas 86 × 69. Signed and dated *TPC
Haag 1789*
PROV KKS, 1885
LIT Scheen 1946, fig 26

Rudolf Jurriaan Stephanus Haak

Zutphen 1862–1897 Zutphen

A 1566 Evening sun. *Avondzon*

Panel 22.5 × 33. Signed *Rud. Haak*
PROV Bequest of Jonkheer P A van den
Velden, The Hague, 1892

Meijer Isaac de Haan

Amsterdam 1852–1895 Amsterdam

A 1694 Petrus Franciscus Greive (1811-72). Painter. *Schilder*

Panel 14.5 × 11.5. Signed *MH*
PROV Presented by M W H Spijer, Amsterdam, 1897
LIT Van Hall 1963, p 119, nr 764:1. W Jaworska, NKJ 18 (1967) p 216, nr 2?

A 1987 Old Jewish woman. *Oude joodse vrouw*

Canvas 63 × 52. Signed and dated *M. I. de Haan 80*
PROV Presented by G C B Dunlop, Amsterdam, 1902
LIT W Jaworska, NKJ 18 (1967) p 216, nr 1

Adriana Johanna Haanen

Oosterhout 1814–1895 Oosterbeek

A 1471 Still life with flowers. *Stilleven met bloemen*

Canvas 98 × 85. Signed and dated *Adriana Haanen 1865*
PROV Bequest of W M J Desmons, Amsterdam, 1888 * DRVK since 1952

A 1472 Still life with fruit. *Stilleven met vruchten*

On a stone table a basket of grapes and a dish of apples. Beside them a melon cut in two and a plum branch

Canvas 97 × 85. Signed and dated *Adriana Haanen 1873*
PROV Bequest of W M J Desmons, Amsterdam, 1888 * Lent to the Gouvernementsgebouw (provincial capitol) of Gelderland, Arnhem, 1924. Destroyed in the war, 1944

A 1186 'Summer': still life with flowers. *'De zomer': stilleven met bloemen*

Canvas 132 × 102. Signed *Adriana Haanen*
PROV Presented by Miss M Vos, Oosterbeek, 1884 * DRVK since 1952

A 1039 Still life with fruit. *Stilleven met vruchten*

On a gray marble tabletop a cabbage leaf with three peaches on it, left a blue china bowl with raspberries and behind it a bunch of blue grapes with vine leaves

Panel 46 × 61. Signed *Adriana Haanen*
PROV Purchased at exhib Rotterdam 1867, nr 163. RVMM, 1885 * Lent to the Gouvernementsgebouw (provincial capitol) of Gelderland, Arnhem, 1924. Destroyed in the war, 1944

George Gillis Haanen

Utrecht 1807–1879 Bilsen

C 135 Old man in his study. *Oude man in zijn studeervertrek*

Pendant to C 136

Panel 32.5 × 26.5. Signed and dated *G. G. H. 1833*
PROV On loan from the city of Amsterdam (A van der Hoop bequest) since 1885
LIT Scheen 1946, fig 60

C 136 Old woman reading. *Lezende oude vrouw*

Pendant to C 135

Panel 31.5 × 25. Signed and dated *G. G. Haanen 1834*
PROV Same as C 135

C 134 The night school. *De avondschool*

Panel 64 × 50. Signed and dated
G. G. Haanen 1835
PROV On loan from the city of
Amsterdam (A van der Hoop bequest)
since 1885
LIT R Reinsma, Spiegel Hist 1 (1966) fig
3 on p 119

Remigius Adrianus Haanen

Oosterhout 1812 – 1894 Aussee

A 1639 Landscape with cottages on the
heath. *Landschap met hutten op de heide*

Canvas 32 × 54.5. Signed *R. Haanen*
PROV Bequest of Miss A J Haanen,
Oosterbeek, 1896 * DRVK since 1953

Haarlem

see Cornelisz van Haarlem

**Johannes Hubertus Leonardus de
Haas**

Hedel 1832 – 1908 Königswinter

see also Gabriël, Paul Joseph Constantin,
A 2381 De Winkel near Abcoude

A 1178 'Early morning': cows in a
meadow. *'Vroege morgen': koeien in een
weide*

Panel 90 × 127. Signed *J. H. L. de Haas*
PROV Purchased at exhib The Hague
1878, nr 166. RVMM, 1885 * DRVK since
1953
LIT Marius 1920, p 220, fig 100. De
Gruyter 1968-69, vol 2, fig 105

A 1556 Young bull. *Jonge stier*

Panel 30 × 38. Signed *J. H. L. de Haas*
PROV Bequest of J Jacobs, Roosendaal,
1892

Jan Hackaert

Amsterdam ca 1629 – in or after 1685
Amsterdam?

A 1709 The Lake of Zurich. *Het meer van
Zürich*

The motif was formerly thought to be the
Lake of Trasimeno

Canvas 82 × 145. Signed *Hackaert*
PROV Sale G de Clercq, Amsterdam, 1
June 1897, lot 31. Purchased through the
intermediacy of the Rembrandt Society
LIT Ledermann 1920, p 119.
Gerstenberg 1923, p 152, pl LVI.
Hofstede de Groot 1907-28, vol 9 (1926)
nr 8. Havelaar 1931, p 14. Martin
1935-36, vol 2, pp 321, 323, fig 174. W
Stechow, in Actes 17ème congr intern,
1955, p 432. Plietzsch 1960, p 137, fig
233. Exhib cat Italianiserende
landschapschilders, Utrecht 1965, nr
138, fig 136. Stechow 1966, p 158, fig
321. Rosenberg, Slive & Ter Kuile 1966,
p 179. Bol 1969, p 270, fig 259. M
Pfister, Bull RM 20 (1972) pp 177-81, ill
(identification of the subject). M
Pfister, Kunstdenkm 24 (1973) pp 262-
66, ill

C 137 Mountainous landscape. *Berg-
achtig landschap*

Canvas 65.5 × 75.5. Signed *Hackaert*
PROV On loan from the city of
Amsterdam (A van der Hoop bequest)
since 1885
LIT Hofstede de Groot 1907-28, vol 9
(1926) nr 70. Stechow 1966, p 156, fig
310

A 131 Hunters in the woods. *Bosgezicht
met jagers*

Canvas 58.5 × 46. Signed *Hackae...*
PROV Bequest of L Dupper Wzn,
Dordrecht, 1870
LIT Hofstede de Groot 1907-28, vol 9
(1926) nr 33. Bol 1969, p 269

A 130 The avenue of birches. *De berken-laan*

Traditionally called *De essenlaan* (The avenue of ash trees)

Canvas 66.5 × 53.5
PROV Sale G van der Pot van Groeneveld, Rotterdam, 6 June 1808, lot 47
LIT Zeitschr BK 10 (1875) p 320. Moes & van Biema 1909, pp 113, 181, 196. Hofstede de Groot 1907-28, vol 9 (1926) nr 32. E Wiersum, OH 48 (1931) p 209, fig 5. Martin 1935-36, vol 2, pp 322-23, fig 175. Plietzsch 1960, p 137, fig 232. Stechow 1966, p 81, fig 160. Rosenberg, Slive & Ter Kuile 1966, p 179. Bol 1969, p 269

A 692 Landscape with cattle drivers. *Landschap met veedrijvers*

Canvas 88.5 × 103
PROV Bequest of Jonkheer J S H van de Poll, Amsterdam, 1880
LIT V de Stuers, Ned Kunstbode 2 (1880) p 244. Hofstede de Groot 1907-28, vol 9 (1926) nr 69

G de Haen *possibly* **Gerrit de Haen**

active 1667-82 in The Hague

A 2651 St Jerome. *De heilige Hieronymus*

Panel 34 × 42.5. Signed *G. de Haen*
PROV Sale Amsterdam, 4 Dec 1912

Johan van Haensbergen

Gorkum or Utrecht 1642–1705 The Hague

see also Panpoeticon Batavum: A 4587 Joan van Paffenrode, copy by Arnoud van Halen after van Haensbergen

A 1291 Self portrait. *Zelfportret*

Panel 11 × 11. Signed *Joh. Haen...*
PROV Sale P Verloren van Themaat, Amsterdam, 30 Oct 1885, lot 40
LIT Moes 1897-1905, vol 1, nr 3061:1. Van Hall 1963, p 124, nr 811:1

C 1546 Harmen Lijnslager (1664-1704). Secretary of the admiralty of Amsterdam. *Secretaris van de admiraliteit van Amsterdam*

Pendant to C 1547

Canvas 61 × 50. Oval. Signed and dated *J. V.H. f. 1699*
PROV On loan from the KOG (purchased in 1881) since 1973
LIT Elias 1893-95, vol 2, pp 876-77. Moes 1897-1905, vol 1, nr 4708

C 1547 Judith Allijn (d 1702). Wife of Harmen Lijnslager. *Echtgenote van Harmen Lijnslager*

Pendant to C 1546

Canvas 60 × 50.5. Oval. Signed and dated *J. V.H. f. 1699*
PROV Same as C 1546
LIT Elias 1893-95, vol 2, pp 876-77. Moes 1897-1905, vol 1, nr 134

attributed to **Johan van Haensbergen**

A 1440 Portrait of a woman. *Portret van een vrouw*

Canvas 48 × 39
PROV Presented from the estate of J L de Bruyn Kops, The Hague, 1888

Joris van der Ha[a]gen

Dordrecht or Arnhem ca 1615–1669 The Hague

C 373 Mountainous landscape, possibly the St Pietersberg, with Lichtenberg

Castle, near Maastricht. *Bergachtig landschap, wellicht de St Pietersberg met het kasteel Lichtenberg bij Maastricht*

Canvas 174 × 232. Signed *JVHagen*
PROV On loan from the city of
Amsterdam since 1885
LIT Scheltema 1879, p 14, nr 35.
M J F W van der Haagen, OH 35 (1917) p
44. Van der Haagen 1932, nr 116

C 138 Landscape with the Schwanen-turm, Kleve. *Landschap met de Zwanen-burcht te Kleef*

Canvas 109 × 120. Signed *JVHagen*
PROV On loan from the city of
Amsterdam (A van der Hoop bequest)
since 1885
LIT Van der Haagen 1932, nr 142.
Gorissen 1964, nr 110, ill. Dattenberg
1967, nr 196, ill

A 33 Landscape with bathers. *Landschap met baders*

Canvas 70 × 85.5. Signed *Berchem*.
Staffage by Nicolaas Berchem (1620-83)
PROV Bequest of L Dupper Wzn,
Dordrecht, 1870 * DRVK since 1959 (on
loan to the Gemeentemuseum, Arnhem)
LIT Van der Haagen 1932, nr 157

C 108 Landscape with fisherman with a square net. *Landschap met visser met kruisnet*

Canvas 48 × 55.5
PROV On loan from the city of
Amsterdam (A van der Hoop bequest)
since 1885
LIT Van der Haagen 1932, nr 156

Georg Hainz

active 1666-1700 in Altona and
Hamburg

A 2550 Still life. *Stilleven*

Canvas 113 × 94.5. Signed *G. Hinz*
PROV Lent by C Hoogendijk, The
Hague, 1907. Presented from his estate
in 1912
LIT R Bangel, Cicerone 7 (1915) p 189
(Dutch school ca 1650). Bergström
1947, p 292, fig 236. Bergström 1956,
p 290, fig 236. BCG Gleistein, Kunstrip
I (1970-71) nr I. Grisebach 1974, nr
112d

Arnoud van Halen

see under Panpoeticon Batavum

Hall

see Teyler van Hall

Dirck Hals

Haarlem 1591 – 1656 Haarlem

A 1796 The fête champêtre. *De buiten-partij*

Panel 78 × 137. Signed and dated *DHals 1627*
PROV Purchased from Mrs P Driessen-Hooreman, Delft, 1899
LIT J de Vries, Eigen Haard, 1899, p
490. Martin 1935-36, vol I, pp 350, 360,
363, fig 203. Würtenberger 1937, p 60.
A Ellenius, in Idea and form, 1959, p
123. Plietzsch 1960, p 26, fig 6. F W S
van Thienen, OKTV I (1963) nr I, fig 7.
E de Jongh, OK 13 (1969) p 13

attributed to **Dirck Hals**

A 1722 An outdoor party. *Een feestvierend gezelschap buitenshuis*

Panel 18.5 × 21.5
PROV Sale Amsterdam, 30 Nov 1897, lot
41
LIT Würtenberger 1937, p 60

Frans Hals

Antwerp 1581/85–1666 Haarlem

see also Meegeren, Henricus Antonius van, A 4242 Malle Babbe, in the manner of Hals – Rotterdam East India Company series: A 4501 Paulus Verschuur, by Pieter van der Werff after Hals

A 133 Marriage portrait of Isaac Abrahamsz Massa (1586-1643) and Beatrix van der Laen (1592-1639), married in Haarlem 25 April 1622. *Huwelijksportret van Isaac Abrahamsz Massa en Beatrix van der Laen, getrouwd te Haarlem op 25 april 1622*

Canvas 140 × 166.5
PROV Sale H Six van Hillegom, Amsterdam, 25 Nov 1851, lot 15
LIT J Six, OH 11 (1893) p 101. Moes 1909, pp 29, 31-32, nr 90, ill. Hofstede de Groot 1907-28, vol 3 (1910) nr 427. Bode 1914, nr 96. Valentiner 1921, p 21. Valentiner 1923, nr 20 (ca 1621). Dülberg 1930, pp 65-68. Martin 1935-36, vol 1, pp 325, 339, fig 188. WR Valentiner, Art in America 23 (1935) pp 90-95. J LAAM van Rijckevorsel, Historia 3 (1937) p 175. Trivas 1941, nr 13 (ca 1624-27). Gratama 1943, p 32. JA Leerink, Phoenix 1 (1946) pp 1-7. H Kaufmann, in Festschrift O Schmitt, 1950, pp 257-74. J Keuning, Imago Mundi 10 (1953) p 65ff. H van de Waal, OK 5 (1961) nr 25, ill. E de Jongh & PJ Vinken, OH 76 (1961) p 117ff (1622). Exhib cat Frans Hals, Haarlem 1962, nr 10, fig 1. Van Hall 1963, p 125, nr 820:1. S Slive, in Miscellanea van Regteren Altena, 1969, p 115, fig 5. M Thierry de Bye Dólleman & O Schutte, Ned Leeuw 86 (1969) p 328, ill. Slive 1970-74, vol 1, pp 25-26, 51, 53-54, 57, 63, 66-68, 179; vol 2, pls 33-35 (ca 1622); vol 3, pp 11-12, nr 17. E de Jongh, in exhib cat Rembrandt en zijn wereld, Brussels 1971, p 155. Grimm 1972, nr 34, pp 20, 83-85, 124-25, 137, figs 51, 55. M Kahr, Art Bull 55 (1973) p 253, note 44. M Boot, Pantheon 31 (1973) p 422. F Suzman Jowell, Art Bull 56 (1974) pp 107, 109-11, fig 7

A 135 The merry drinker. *De vrolijke drinker*

Canvas 81 × 66.5. Signed *FH*
PROV Sale dowager of CP Baron van Leyden van Warmond, née HJ de Thoms, Leiden, 31 July 1816, lot 13
LIT Moes 1909, p 38, nr 264, ill. Hofstede de Groot 1907-28, vol 3 (1910) nr 63. Bode & Binder 1914, nr 53. Valentiner 1921, p 59 (ca 1627-30). Valentiner 1923, p 61 (ca 1627). Martin 1935-36, vol 1, p 339, ill. Trivas 1941, nr 32 (ca 1627). H Kaufmann, in Kunstgesch Studien, 1943, p 141, fig 22. Exhib cat Frans Hals, Haarlem 1962, nr 22, fig 25. ER Meijer, OKTV 1 (1963) nr 3, fig 3. Rosenberg, Slive & Ter Kuile 1966, pp 37-39, fig 21. Slive 1970-74, vol 1, pp 110-11; vol 2, pls 105-07 (1628-30), pp 38-39, nr 63; vol 3, pp 38-39, nr 63. Grimm 1972, nr 43, pp 64, 74, 76, 147 (ca 1627-28). F Suzman Jowell, Art Bull 56 (1974) pp 107-08, 111, fig 8

A 1246 Portrait of a man, possibly Nicolaes Hasselaer (1593-1635). Brewer and captain-major of a military body in Amsterdam. *Portret van een man, mogelijk Nicolaes Hasselaer. Brouwer, kapitein-majoor van het krijgsvolk binnen Amsterdam*

Pendant to A 1247

Canvas 79.5 × 66.5
PROV Presented by J SR van de Poll, Arnhem, 1885
LIT Moes 1897-1905, vol 1, nr 3254:2. Moes 1909, nr 42. Hofstede de Groot 1907-28, vol 3 (1910) nr 186. Valentiner 1921, pp 63-64. Trivas 1941, nr 60. CJ Hudig, Historia 9 (1943) p 172, fig 7. VTTT, 1959, nr 18. Slive 1970-74, vol 1, pp 117-18, 120; vol 2, pls 143, 145 (1630-33); vol 3, p 52, nr 86. Grimm 1972, nr 70, pp 91, 141, 155, fig 94 (ca 1634)

A 1247 Portrait of a woman, possibly Sara Wolphaerts van Diemen (1594-1667). Second wife of Nicolaes Hasselaer. *Portret van een vrouw, mogelijk Sara Wolphaerts van Diemen. Tweede echtgenote van Nicolaes Hasselaer*

Pendant to A 1246

Canvas 79.5 × 66.5
PROV Same as A 1246
LIT Moes 1909, nr 43. Hofstede de Groot 1907-28, vol 3 (1910) nr 187. Valentiner 1921, p 64. Trivas 1941, nr 61. Slive 1970-74, vol 1, pp 117-18, 120; vol 2, pls 144, 146 (ca 1630-33); vol 3, pp 52-53, nr 87. Grimm 1972, nr 71, pp 91, 141, fig 101 (ca 1634)

C 556 Lucas de Clercq (ca 1593-1652). Haarlem potash dealer. *Handelaar in potas te Haarlem*

Pendant to C 557

Canvas 126.5 × 93
PROV Lent by Mr & Mrs P de Clercq and Mr & Mrs P van Eeghen to the city of Amsterdam, 1891. On loan from the city of Amsterdam since 1891
LIT Moes 1897-1905, vol 1, nr 1563. Moes 1909, nr 24. Hofstede de Groot 1907-28, vol 3 (1910) nr 165. Trivas 1941, nr 22 (ca 1627). Slive 1970-74, vol 1, p 116; vol 2, pl 167 (ca 1635); vol 3, p 58, nr 104. Grimm 1972, nr 31, pp 67, 80, fig 52 (ca 1627)

C 557 Feyna van Steenkiste (1603/04-before 1645). Wife of Lucas de Clercq. *Echtgenote van Lucas de Clercq*

Pendant to C 556

Canvas 123 × 93. Dated *An° 1635*. Inscribed *Ætat suae 31*
PROV Same as C 556
LIT EW Moes, Oud en Nieuw, 1889-92, pp 127-30. Moes 1897-1905, vol 2, nr 7550. Moes 1909, nr 25. Hofstede de Groot 1907-28, vol 3 (1910) nr 166. Trivas 1941, nr 58. Rosenberg, Slive & Ter Kuile 1966, p 43. Slive 1970-74, vol 1, p 116; vol 2, pl 170 (ca 1635); vol 3, pp 58-59, nr 105. C Grimm, Münchn Jb 22 (1971) p 148, figs 3, 5 (Judith Leyster)

C 139 Maritge Voogt Claesdr (1577-1644). Wife of Pieter Jacobsz Olycan, burgomaster of Haarlem. *Echtgenote van Pieter Jacobsz Olycan, burgemeester van Haarlem*

Thought to be the pendant to the portrait in The John and Mable Ringling Museum of Art, Sarasota (cat 1949, nr 251)

Canvas 128 × 94.5. Dated *An° 1639*. Inscribed *Ætat suÆ 62*
PROV On loan from the city of Amsterdam (A van der Hoop bequest) since 1885
LIT Moes 1897-1905, vol 2, nr 8653:1. Moes 1909, p 57, nr 62, ill. Hofstede de Groot 1907-28, vol 3 (1910) nr 212. Bode & Binder 1914, p 182. Valentiner 1921, nr 170. Valentiner 1923, p 181. W R Valentiner, Art in America 16 (1928) pp 248-49. Dülberg 1930, pp 157, 224. W R Valentiner, Art in America 23 (1935) pp 85-86. K Erasmus, Burl Mag 75 (1939) p 236ff. Trivas 1941, p 73. Exhib cat Frans Hals, Haarlem 1962, nr 45, fig 46. Rosenberg 1964, p 77, fig 66. Slive 1970-74, vol 1, pp 115, 123; vol 2, pl 207; vol 3, pp 69-70, nr 129. Grimm 1972, p 100, nr 101, fig 121. F Suzman Jowell, Art Bull 56 (1974) p 108, fig 11

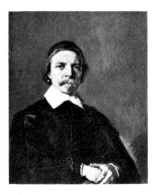

A 2859 Portrait of a minister? *Portret van een predikant?*

Panel 37 × 29.8. Signed *FH*
PROV Purchased from J B Luyckx, Hilversum, 1916, with aid from the Rembrandt Society

LIT C Hofstede de Groot, Oude Kunst 1 (1916) p 322, ill (1640-45). M D H[enkel], Kunstchronik ns 17 (1916) p 359. O Hirschmann, Kunstchronik ns 17 (1916) p 233. Jaarversl Ver Rembrandt 1916, pp 6-7. Valentiner 1921, p 254. Martin 1935-36, vol 1, p 338, fig 195. Trivas 1941, nr 88 (1641-44). Slive 1970-74, vol 1, p 198; vol 2, pl 321 (1655-60); vol 3, pp 106-07, nr 208. Grimm 1972, p 113, nr 151, fig 175 (ca 1656)

Frans Hals

&

Pieter Codde

Amsterdam 1599 – 1678 Amsterdam

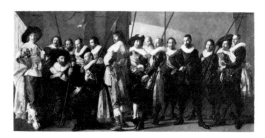

C 374 The company of Captain Reynier Reael and Lieutenant Cornelis Michielsz Blaeuw, Amsterdam, 1637, known as 'The meagre company.' *Het korporaalschap van kapitein Reynier Reael en luitenant Cornelis Michielsz Blaeuw, Amsterdam, 1637, bekend als 'De magere compagnie'*

Commissioned from Frans Hals in 1633, but in 1636, when he had not yet completed it, given to Pieter Codde to be finished

Canvas 209 × 429. Dated *A° 1637*
PROV Voetboogdoelen (headquarters of the crossbowmen's civic guard), Amsterdam. On loan from the city of Amsterdam since 1885
LIT Van Dijk 1790, pp 30-31. Scheltema 1855-85, vol 7, p 134, nr 23. Scheltema 1879, nr 36. D C Meyer Jr, OH 3 (1885) p 122. J Six, OH 11 (1893) pp 102-04. Moes 1897-1905, vol 1, nr 695; vol 2, nr 6214. Moes 1909, p 51, nr 5, ill. Hofstede de Groot 1907-28, vol 3 (1910) nr 428. A Bredius, OH 31 (1913) pp 81-84. Bode & Binder 1914, p 159. Valentiner 1921, p 112. Valentiner 1923, p 119. Riegl 1931, pp 252-54, fig 76. Martin 1935-36, vol 1, pp 162, 217, 329, 344. Würtenberger 1937, p 63. Gratama 1943, pp 40-41. M M van Dantzig, Phoenix 1 (1946) p 5ff, ill. P Brandt Jr, Historia 12 (1947) p 32, fig 3. Baard 1949, pp 23-24, figs E, 33-40. Rosenberg, Slive & Ter Kuile 1966, pp 43, 109, ill. Slive 1970-74, vol 1, pp 9, 17, 41-42, 62, 136-138, 210; vol 2, pls 129, 132-34 (ca 1633); vol 3, pp 48-50,

nr 80. Grimm 1972, pp 95, 97, 130, 141, nr 77, figs 108, 118. F Suzman Jowell, Art Bull 56 (1974) p 109

copy after **Frans Hals**

A 134 The fool. *De nar*

Old copy after the painting in the Alain de Rothschild collection, Paris

Canvas 67 × 60
PROV Bequest of L Dupper Wzn, Dordrecht, 1870
LIT C von Lützow, Zeitschr BK 5 (1870) p 229. Davies 1902, p 102 (Dirck Hals). Moes 1909, p 37 (attributed to one of the sons of Frans Hals). Martin 1935-36, vol 1, pp 339-40. K Borström, Konsthist Tidskr 18 (1949) pp 100, 104, fig 1. J Bruyn, OH 66 (1951) pp 219, 222 (before 1626, the year of Bailly's drawing after this copy). Rosenberg, Slive & Ter Kuile 1966, p 107 (Judith Leyster after Frans Hals)

A 950 Fisherboy. *Vissersjongen*

Copy after the painting in the Museum voor Schone Kunsten, Antwerp (cat 1958, nr 188)

Panel 40 × 29
PROV Presented by J Farncombe Sanders, Breda, 1878. NMGK, 1885

Eduard Michel Ferdinand Hamman

active 1880-89 in Paris

A 1811 A meadow near Réville, Normandy, on a rainy day. *Een weide bij Réville (Normandië) bij regen*

Canvas 65 × 80. Signed *Hamman fils*
PROV Bequest of Reinhard Baron van Lynden, The Hague, 1899 * DRVK since 1953

Louwrens Hanedoes

Woudrichem 1822 – 1905 Woudrichem

A 1814 Mountainous landscape. *Bergachtig landschap*

Canvas 57 × 71. Signed and dated *L. Hanedoes ft 1847*
PROV Bequest of Reinhard Baron van Lynden, The Hague, 1899 * DRVK since 1959

A 1815 Gelderland landscape. *Gelders landschap*

Canvas 57 × 71. Signed and dated *L. Hanedoes ft. 1847*
PROV Bequest of Reinhard Baron van Lynden, The Hague, 1899 * DRVK since 1953

A 1816 Mountainous landscape with a ruin. *Berglandschap met ruïne*

Canvas 43 × 65. Signed and dated *L. Hanedoes ft 49*
PROV Bequest of Reinhard Baron van Lynden, The Hague, 1899 * DRVK since 1953
LIT Scheen 1946, fig 326

A 1817 View in the woods at sunset. *Bos-gezicht bij zonsondergang*

Panel 18.5 × 26. Signed and dated *L. Hanedoes fct 49*
PROV Bequest of Reinhard Baron van Lynden, The Hague, 1899

A 1812 Heath landscape at sunset. *Heide-landschap bij zonsondergang*

Canvas 138 × 203. Signed and dated *L. Hanedoes fct 1851*

PROV Bequest of Reinhard Baron van Lynden, The Hague, 1899 * DRVK since 1953

A 1813 Forest landscape, known as 'An excursion to Gelderland.' *Boslandschap, bekend als 'Een uitstapje naar Gelderland'*

Canvas 100 × 135. Signed and dated *L. Hanedoes fct 1851*. Staffage by Charles Rochussen (1814-94)
PROV Bequest of Reinhard Baron van Lynden, The Hague, 1899 * DRVK since 1950

A 1040 Landscape in Kennemerland. *Landschap in Kennemerland*

Canvas 121 × 100. Staffage by Salomon Leonard Verveer (1813-76)
PROV Purchased at exhib The Hague 1869, nr 144. RVMM, 1885 * DRVK since 1953
LIT Marius 1920, fig 60

A 1818 The old fortress. *De oude burcht*

Panel 13.5 × 17. Signed *L. Hanedoes fct*
PROV Bequest of Reinhard Baron van
Lynden, The Hague, 1899

Adriaen Hanneman

The Hague ca 1601 – 1671 The Hague

see also Miniatures: Holland school ca
1665, A 4436 Willem Frederik, after
Hanneman; David des Granges, A 4314
Henrietta Maria Stuart, after
Hanneman; Nathaniel Thach, A 4369
Charles II, after Hanneman

A 3889 William III (1650-1702), prince
of Orange, as a child. *Willem III, prins
van Oranje, als kind*

Canvas 135 × 95. Signed and dated
Adr. Hanneman Fe An° 1654
PROV Purchased from C Reinheldt,
Berlin, 1955
LIT Moes 1897-1905, vol 2, nr 9096:3.
A Staring, NKJ 2 (1950-51) p 162, nr 3,
fig 3. R van Luttervelt, Jb Mus
Antwerpen, 1954-60, p 20, ill. R van
Luttervelt, Bull RM 5 (1957) pp 108-11,
fig 2

A 1622 Self portrait. *Zelfportret*

Canvas 81.5 × 64. Signed and dated *Adr.
Hanneman An° 1656*. Inscribed *Quaeris*

qui[s] [vu]ltus ductique sit oris imago | *[Qu]-
aere quis hanc talem duxerit inven[ie]s*;
covering an older inscription beginning
Effigies… (the rest illegible)
PROV Purchased from P & D Colnaghi
gallery, London, 1894
LIT A Bredius & E W Moes, OH 14 (1896)
p 214. Moes 1897-1905, vol 1, nr 3155:1.
C A Crommelin, Mndbl BK 21 (1944) p
126, fig 2. A Dobrzycka, Studia
Muzealne 1 (1953) p 95ff, fig 3. Van
Hall 1963, p 128, nr 830:2

A 1670 Cornelis van Aerssen (1600-62),
lord of Sommelsdijk. Colonel of cavalry.
Heer van Sommelsdijk. Kolonel bij de cavalerie

Canvas 124 × 99. Signed and dated *Adr.
Hanneman F An° 1658*. Inscribed *Corn. van
Aerssen Heere van Sommelsdijck van de ordre
der Ridderschap van Holland etc overleden
1662*
PROV Sale Mrs van Dam van Brakel-
Ditmars van IJsselvere, Amsterdam, 29
Oct 1895
LIT A Bredius & E W Moes, OH 14
(1896) p 214. Moes 1897-1905, vol 1, nr
66

Hannké

see Governors-general series: A 3814
Johannes Benedictus van Heutsz

Johannes Hannot

active 1650-83 in Leiden

A 1449 Still life with fruit. *Stilleven met
vruchten*

Panel 60 × 45.5. Signed and dated
J. Hannot 1668
PROV Sale S B Bos (Harlingen),
Amsterdam, 21 Feb 1888, lot 61

Pieter van Hanselaere

Ghent 1786 – 1862 Ghent

A 1042 Susanna and the elders. *Suzanna
en de ouderlingen*

Canvas 135 × 96. Signed and dated *Pre
Van Hanselaere ft. Romae 1820*
PROV Purchased at exhib Ghent 1829.
RVMM, 1885

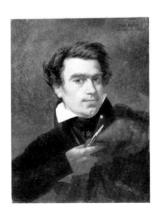

A 1041 Self portrait. *Zelfportret*

Canvas 65 × 50. Signed and dated *Par moi à Naples 1824*
PROV Purchased at exhib Haarlem 1825, nr 180. RVMM, 1885

Carel Lodewijk Hansen

Amsterdam 1765–1840 Vaassen

A 3925 The Rapenburg, Leiden, three days after the explosion of a powder ship on 12 January 1807. *Het Rapenburg te Leiden, drie dagen na de ontploffing van het kruitschip op 12 januari 1807*

Canvas 94.5 × 125.5. Signed *C.L. Hansen*. Inscribed *'t Raapenburg te Leyden zo als het was 15 January 1807*. Staffage partly by Jacob Smies (1764-1833)
PROV NM, 1808. RVMM. Lent by the RVMM in 1877 to Stedelijk Museum De Lakenhal, Leiden (cat 1949, nr 122) * DRVK since 1957
LIT Alg Konst en Letterbode I (1811) p 92. Van Eynden & van der Willigen 1816-40, vol 3 (1820), p 113. Moes & van Biema 1909, pp 132, 218. Knoef 1943, p 86. J W L Moerman, Jb Leiden 72 (1970) p 124, fig 21

Lambertus Johannes Hansen

Staphorst 1803–1859 Amsterdam

C 141 Woman selling vegetables. *De groentevrouw*

Canvas 57 × 50. Signed *L. J. Hansen*
PROV On loan from the city of Amsterdam (A van der Hoop bequest) since 1885

Pieter Hardimé

Antwerp 1678–ca 1758 The Hague

A 2734 Flowers and putti in a niche. *Bloemstuk met putti in een nis*

Canvas 89 × 129.5. Signed *P. Hardimé*. Dessus-de-porte
PROV From the Huygenshuis (house of Constantijn Huygens), Plein, The Hague, 1880. NMGK, 1915 * DRVK since 1961
LIT Hairs 1955, p 215

A 2732 A bust of Diana with a garland of flowers. *Diana-buste met bloemguirlande*

Canvas 90.5 × 126. Dessus-de-porte
PROV Same as A 2734 * DRVK since 1961

A 2733 A bust of Venus with a garland of flowers. *Venus-buste met bloemguirlande*

Canvas 90.5 × 126. Dessus-de-porte
PROV Same as A 2734 * DRVK since 1952

A 2735 A bust of Flora (?) with a garland of flowers. *Flora (?) buste met bloemguirlande*

Canvas 84 × 158. Dessus-de-porte
PROV Same as A 2734 * DRVK since 1961

Johannes Hari I

The Hague 1772–1849 The Hague

see also under Miniatures

A 1043 Bivouac at Molodechno, 3-4 December 1812: an episode from Napoleon's retreat from Russia. *Nachtkwartier te Molodetschno, 3-4 december 1812: episode uit de terugtocht van keizer Napoleon uit Rusland*

Panel 49 × 67
PROV Bequest of W P d'Auzon de Boisminart, Utrecht, 1870. RVMM, 1885

Daniel Haringh

The Hague ca 1636–1706 The Hague

A 1654 Johan van Bochoven (1624-93).

Public prosecutor and councillor at the court of Flanders. *Advocaat-fiscaal, raadsheer in het Hof van Vlaanderen*

Pendant to A 1655

Canvas 61 × 50. Signed *D. Haringh F.*
PROV Purchased from J C de Ruyter de Wildt, Vlissingen, 1895
LIT C Hofstede de Groot, OH 17 (1899) p 170

A 1655 Sara Pottey (1651-1705). Wife of Johan van Bochoven. *Echtgenote van Johan van Bochoven*

Pendant to A 1654

Canvas 60 × 49. Signed *D. Haringh F.*
PROV Same as A 1654
LIT C Hofstede de Groot, OH 17 (1899) p 170. Bernt 1960-62, vol 4, nr 120. F Rademacher, in Festschrift von Einem, 1965, p 209, note 24. Bernt 1969-70, vol 1, nr 479 (portrait of Catharine Pottey)

Ferdinand Hart Nibbrig

Amsterdam 1866 – 1915 Laren

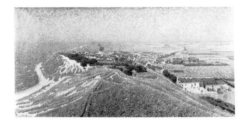

A 2540 View of Zoutelande on the island of Walcheren. *Gezicht op het dorp Zoutelande op Walcheren*

Canvas 80 × 159.5. Signed *Hart Nibbrig*
PROV Presented by B Hart Nibbrig, Hilversum, 1912

Frans Haseleer

Brussels 1804 – after 1869 Brussels?

A 1044 Esther appearing before Ahasuerus. *Esther voor Ahasverus*

Canvas 113 × 146
PROV Purchased at exhib The Hague 1827, nr 137. RVMM, 1885 * DRVK since 1961

Petrus van Hattich

active 1646-65 in Utrecht

C 452 Nymphs in a cave with antique ruins. *Nimfen in een grot met antieke ruïnes*

Copper 42 × 58. Signed and dated *Petrus van Hattich 164.*
PROV Nieuwe Zijds Huiszittenhuis (institute for the outdoor relief of the poor), Amsterdam, 1873. On loan from the city of Amsterdam since 1885

Augustus Christiaan Hauck

Mannheim 1742 – 1801 Rotterdam

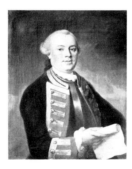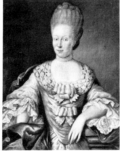

A 136 Johan Arnold Zoutman (1724-93). Vice admiral. *Vice-admiraal*

Pendant to A 633

Canvas 83 × 68
PROV Presented by J Zoutman, son of the sitter, 1803. NM, 1808
LIT Moes 1897-1905, vol 2, nr 9402:4. Moes & van Biema 1909, pp 66, 209. Scheen 1946, fig 24

A 633 Adriana Johanna van Heusden. Wife of Johan Arnold Zoutman. *Echtgenote van Johan Arnold Zoutman*

Pendant to A 136

Canvas 84.5 × 68.5. Signed and dated *A. C. Hauck pinx. 1770*
PROV Same as A 136
LIT Moes & van Biema 1909, pp 66, 209

Hendrik Johannes Haverman

see Governors-general series: A 3813 Willem Rooseboom

Arthur Hawksley

Nottingham 1842 – 1915 Streatham

A 1877 The lonesome bay. *De eenzame baai*

Canvas 36 × 54. Signed and dated *Arthur Hawksley 1886*
PROV Presented by the dowager of R Baron van Lynden, née M C Baroness van Pallandt, The Hague, 1900

A 4182 'At sundown.' *Avondschemering, genaamd 'At sundown'*

Canvas 21.8 × 29. Signed and dated *Hawksley 1889*
PROV Unknown

Nicolaas Jacobsz van der Heck

Alkmaar? 1575/81 – 1652 Alkmaar

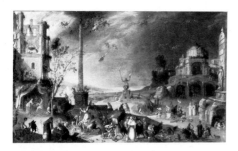

A 2373 Allegory on the vices. *Allegorie op de ondeugden*

Panel 57 ×97. Signed and dated *C. Heck fecit 1636*
PROV Presented by E Heldring, Amsterdam, 1909 * DRVK since 1953
LIT Th P H Wortel, OH 60 (1943) p 138, cat nr 17

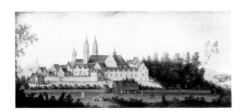

A 991 View of the abbey of Egmond-Binnen. *Gezicht op de abdij te Egmond-Binnen*

Pendant to A 990

Panel 32.5 ×72.5. Signed and dated *C. Heck fecit 1638*
PROV Sale Antwerp, 19 Feb 1885, lot 253 (as Pieter Saenredam)
LIT Th P H Wortel, OH 60 (1943) p 139, cat nr 23. J Bruyn, OH 81 (1966) p 147, fig 1

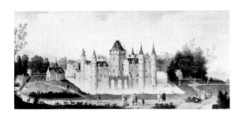

A 990 View of the castle of Egmond aan den Hoef. *Gezicht op het kasteel te Egmond aan den Hoef*

Pendant to A 991

Panel 32.5 ×72.5
PROV Sale Antwerp, 19 Feb 1885, lot 252 (as Pieter Saenredam)
LIT Th P H Wortel, OH 60 (1943) p 140, cat nr 32

Abraham van den Hecken II

b Antwerp, active 1635 to after 1655 in The Hague, Amsterdam and London

A 1410 Cornelis Jansz Meyer (1629-1701). Hydraulic engineer. *Waterbouwkundige*

Canvas 81 ×64. Signed *AB van der Heck*
PROV Sale J H Cremer, The Hague, 21 June 1887, lot 52
LIT Moes 1897-1905, vol 2, nr 5033. Bernt 1960-62, vol 4, nr 126. Van Hall 1963, p 208, nr 1403:1. Bernt 1969-70, vol 1, nr 486

A 1305 The slaughtered ox. *Het geslachte rund*

Canvas 114 ×98. Signed *AB v. Hecken*
PROV Presented by J H van Marwijk Kooy, Amsterdam, 1886

Gerrit Willemsz Heda

Haarlem? ca 1620 – before 1702 Haarlem

A 1549 Still life. *Stilleven*

Panel 82 ×60. Signed and dated *Jonge Heda 1642*
PROV Purchased from Dr A Bredius, The Hague, 1891 * DRVK since 1959 (on loan to the Wijnkoopersgildehuys, Amsterdam)
LIT Vorenkamp 1933, p 38. Vroom 1945, p 126, nr 147, fig 109. Bergström 1956, p 136, fig 120. Bernt 1960-62, vol 1, nr 348. Bol 1969, pp 68, 84. Bernt 1969-70, vol 1, nr 487

Willem Claesz Heda

Haarlem 1594 – 1680 Haarlem

A 137 Still life. *Stilleven*

Panel 44.5 ×62. Signed and dated *Heda 1634* and apocryphally *Johannes de Heem f.*
PROV Purchased with the Kabinet van Heteren Gevers, The Hague-Rotterdam, 1809
LIT Moes & van Biema 1909, pp 146, 159. Vroom 1945, pp 58, 72, nr 188, fig 47

C 610 Still life. *Stilleven*

Panel 58.5 × 67.5. Signed and dated
Heda 1642
PROV On loan from the city of
Amsterdam (presented by G de Clercq)
since 1898
LIT Vroom 1945, nr 203, p 83, fig 66

Cornelis de Heem

Leiden 1631 – 1695 Antwerp

A 2564 Still life. *Stilleven*

Canvas 153 × 166.5. Signed *C. de Heem f.*
PROV Lent by C Hoogendijk, The
Hague, 1907. Presented by his estate in
1912
LIT C Hofstede de Groot, Ned Spec,
1899, p 57. R Bangel, Cicerone 7 (1915)
p 186. Vorenkamp 1933, p 67. Bol 1969,
p 303. A P de Mirimonde, Jb Mus
Antwerpen, 1970, p 289, fig 45

David Davidsz de Heem

active 1668 in Utrecht

A 2566 Still life. *Stilleven*

Canvas 76.5 × 64.5. Signed *D. De Heem f.*
PROV Lent by C Hoogendijk, The
Hague, 1907. Presented by his estate in
1912
LIT R Bangel, Cicerone 7 (1915) p 186,
fig 12. MacLaren 1960, p 151, note 7

Jan Davidsz de Heem

Utrecht 1606 – 1683/84 Antwerp

A 2396 Self portrait. *Zelfportret*

Panel 24 × 19. Signed *J. D. Heem*
PROV Purchased from F Kleinberger
gallery, Paris, 1909
LIT H Schneider, Zeitschr BK 60 (1926-
27) p 272. Vorenkamp 1933, p 65.
Goldscheider 1936, p 37, nr 191. Boon
1947, p 55, fig 34. Van Hall 1963, nr
860:1. Exhib cat De schilder en zijn
wereld, Delft-Antwerp 1964-65, nr 60,
fig 26. A P de Mirimonde, Jb Mus
Antwerpen, 1970, p 248, fig 2. Eckardt
1971, p 189, fig 7

A 2565 Still life with books. *Stilleven met
boeken*

Panel 26.5 × 41.5. Signed *J. de Heem*
PROV Lent by C Hoogendijk, The
Hague, 1907. Presented by his estate in
1912
LIT C Hofstede de Groot, Ned Spec,
1899, p 57. Vorenkamp 1933, p 103.
Martin 1935-36, vol 1, p 417. Greindl
1956, p 171. Bergström 1956, pp 162-63,
308, notes 45-46. H Seifertová-Korecká,
OH 77 (1962) p 60, fig 5. A P de
Mirimonde, Jb Mus Antwerpen, 1970, p
257, fig 7

A 138 Festoon of fruits and flowers.
Festoen van vruchten en bloemen

Canvas 74 × 60. Signed *J. D. de Heem P*
PROV Unknown
LIT Moes & van Biema 1909, p 159.
Warner 1928, nr 43d. Bergström 1947, p
215, fig 176. Hairs 1955, pp 139, 219.
Bergström 1956, pp 211-12, fig 176

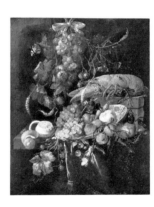

A 139 Still life with fruit and a lobster.
Stilleven met vruchten en een kreeft

Canvas 70 × 59
PROV Sale G van der Pot van
Groeneveld, Rotterdam, 6 June 1808, lot
48 * DRVK since 1953
LIT Moes & van Biema 1909, pp 113,
159. Warner 1928, nr 43c. E Wiersum,
OH 48 (1931) p 211. Greindl 1956, pp
105, 171

Egbert van Heemskerck

Haarlem ca 1634–1704 London

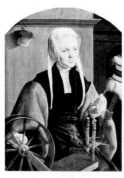

A 2180 An inn with backgammon players. *Herberg met triktrakspelers*

Canvas 40 × 53. Signed and dated *HKerck 1669*
PROV Presented by Jonkheer H Teixeira de Mattos, Vogelenzang, 1905

Maerten van Heemskerck

Heemskerk 1498–1574 Haarlem

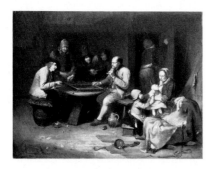

A 3518 Portrait of a man, formerly identified as Pieter Gerritsz Bicker (1497-1567). Mintmaster and alderman of Amsterdam. *Portret van een man, vroeger geïdentificeerd als Pieter Gerritsz Bicker. Muntmeester en schepen van Amsterdam*

Pendant to A 3519

Panel 84.5 × 65. Dated on the old frame *1529. A 34*
PROV Presented by D and N Katz, Dieren, 1948
LIT Martin & Moes 1912, nr 20 (Jan van Scorel). Ring 1913, pp 34, 92 (Scorel). W Cohen, Zeitschr f BK ns 25 (1914) p 33 (Master of the Kassel Family Portrait). N Beets, Onze Kunst 25-26 (1914) pp 89-91, ill. Friedländer 1921, p 168. Hoogewerff 1923, pp 77, 143 (not Scorel). Winkler 1923, pp 282-83 (Scorel). W Cohen, Cicerone 1 (1928) p 54 (Scorel). J Zwartendijk, Elsevier's GM 77 (1929) p 389. G J Hoogewerff, OH 46 (1929) pp 198, 200 (Jacob Nobel).

G J Hoogewerff, in Mélanges Hulin de Loo, 1931, pp 212-14 (Nobel). CH de Jonge, OH 49 (1932) pp 145-50, 240. De Vries 1934, p 25. Friedländer 1924-37, vol 12 (1935) p 207, nr 384 (Scorel). Hoogewerff 1936-47, vol 4 (1941-42) pp 230-37, fig 104; vol 5 (1947) p 103 (Master of the Bicker Portraits). CH de Jonge, OH 58 (1941) pp 1-5. Gerson 1950, pp 34, 54, fig 89. J Bruyn, Bull RM 3 (1955) p 27, nr 2, ill. Von der Osten & Vey 1969, p 184. Renger 1970, p 84. BCG Gleistein, Kunstrip 1 (1970-71) nr 5. I Markx-Veldman, OH 87 (1973) p 104

A 3519 Portrait of a woman, formerly identified as Anna Codde (b 1504). *Portret van een vrouw, vroeger geïdentificeerd als Anna Codde*

Pendant to A 3518

Panel 84.5 × 65. Dated on the old frame *1529. A 26*
PROV Same as A 3518
LIT *see under* A 3518

C 507 Johannes Colmannus (1471-1538). Rector of the convent of St Agatha in Delft. *Rector van het St Agatha-klooster te Delft*

Panel 77 × 60. Inscribed *67* (age of the sitter). Frame inscribed *Omnino ne sit fato Colmanus ademptus Martini fecit ingeniosa manus*
PROV On loan from the KOG (presented by Jonkheer J P Six) since 1889
LIT Van Bleyswyck 1667, p 129. Moes 1897-1905, vol 1, nr 1645. Preibisz 1911, pp 46, 70, nr 5. Ring 1913, pp 88, 94. Friedländer 1924-37, vol 13 (1936) p 160, nr 222. Hoogewerff 1936-47, vol 4 (1941-42) pp 330-32, fig 153. Von der Osten & Vey 1969, p 186

A 1910 Left wing of a triptych: the donor Matelief Dammasz and St Paul (front) and the Erythraean Sibyl (back). *Linkervleugel van een drieluik met portret van de stichter Matelief Dammasz en de heilige Paulus (voorkant) en de Sibylla Erythraea (achterkant)*

Panel 126 × 76.5. Signed and dated *Maertynus van Heemskerck, inventor A° 1564*
PROV Lent by Jonkheer J P Six, Amsterdam, 1885. Presented from his estate by Jonkheer J Six and Jonkheer W Six, Amsterdam, 1900
LIT Van Bleyswyck 1667, p 125. Moes 1897-1905, vol 1, nr 1905. Preibisz 1911, p 69, nr 4. J Six, OH 37 (1919) p 171ff. Friedländer 1924-37, vol 13 (1936) p 157, nr 185. Hoogewerff 1936-47, vol 4 (1941-42) pp 358-61, figs 170-71. VTTT, 1958, nr 9. E de Jongh, OK 8 (1964) nr 29, ill. Von der Osten & Vey 1969, p 186, fig 173. J Białostocki, Alb Amic J G van Gelder, 1973, p 186

A 3511-A 3514 Four panels from a series of twelve, depicting strong men from mythology and biblical history. *Vier panelen van een twaalfdelige serie met voorstellingen van sterke mannen, ontleend aan mythologie en bijbel*

A 3511 Samson shattering the pillars of the temple. *Simson verbrijzelt de zuilen van de tempel*

A 3512 Samson rending the lion. *Simson verscheurt de leeuw*

A 3513 Hercules destroying the centaur Nessus. *Hercules vernietigt de centaur Nessus*

A 3514 Neptune stabbing a sea horse with his trident. *Neptunus doorsteekt met zijn drietand een zeepaard*

The other panels are in the Allen Memorial Art Museum, Oberlin, Ohio (two); the Art Gallery, Yale University, New Haven (four) and the Wetzlar collection, Amsterdam (two)

Panels 47 × 15 each. Grisaille. Signed on the first panel *Martinus Heemskerck fecit*
PROV Purchased from P Cassirer & Co gallery, London, 1948
LIT Bull Oberlin 7 (1949) p 21. Yale Bull 26 (1961) p 48. Judson 1970, p 56, note 1

A 1306 Christ as the man of sorrows. *Christus als man van smarten*

Panel 99 × 78
PROV Sale D M Alewijn, Amsterdam, 16 Dec 1885, lot 1
LIT Preibisz 1911, p 79. Hoogewerff 1936-47, vol 4 (1941-42) p 383, fig 183

manner of **Maerten van Heemskerck**

C 1563 The holy trinity. *De allerheiligste drievuldigheid*

Verre églomisé 40 × 26.5. Ends in a round arch
PROV On loan from the KOG (presented by Mrs A F M Bodenheim-Rehrmann) since 1973

Jacob Eduard van Heemskerck van Beest

Kampen 1828 – 1894 The Hague

A 2726 Dutch, English, French and American squadrons in Japanese waters during the expedition led by the French commander Constant Jaurès, September 1864. *De Nederlandse, Engelse, Franse en Amerikaanse eskaders in de Japanse wateren tijdens de expeditie onder leiding van de Franse commandant Constant Jaurès, september 1864*

Pendant to A 2725

Canvas 68 × 107. Signed and dated *E. van Heemskerck van Beest f. 1864*
PROV Presented by the dowager of Jonkheer F F de Casembroot, née A T J van de Poll, The Hague, 1895. NMGK, 1915

A 2725 HMS 'Medusa' forcing the passage through Shimonoseki Strait between Kyūshū and Honshū, September 1864. *ZM Stoomschip 'Medusa' forceert de doorgang door de Straat van Simonoseki tussen Kioe-Sjioe en Hondo (Japan), september 1864*

Pendant to A 2726

Canvas 68 × 107. Signed *E. van Heemskerck v. Beest f.*
PROV Same as A 2726

A 1045 The Zuider Zee off Amsterdam. *De Zuiderzee voor Amsterdam*

Canvas 84 × 138. Signed *E. van Heemskerck v. B.*
PROV Purchased at exhib Amsterdam 1868, nr 222. RVMM, 1885 * DRVK since 1953

C 429 'Our pioneers': seventeenth-century ships at sea. *'Onze baanbrekers': zeventiende eeuwse schepen in volle zee*

Canvas 405 × 857.5. In the shape of the segment of a circle. Signed *E. van Heemskerck van Beest*

PROV Painted for the entrance to the Agricultural Fair, Amsterdam, 1884. On loan from the city of Amsterdam (presented by the artist) since 1885

Thomas Heeremans

active 1660-97 in Haarlem

A 1739 Winter scene. *Wintergezicht*

Canvas 41 × 49. Signed *THMans 1675*
PROV Bequest of D Franken Dzn, Le Vésinet, 1898

A 1944 Enjoying the ice. *IJsvermaak*

Panel 61 × 83.5. Signed and dated *THMans 1677*
PROV Purchased from the G de Clercq collection, Amsterdam, 1899, through the intermediacy of the Rembrandt Society

Hendrick Heerschop

Haarlem 1620/21 – after 1672 Haarlem?

A 1431 Rebecca receiving presents from Abraham's servant. *Rebecca ontvangt geschenken van Abrahams knecht*

Canvas 138 × 174. Signed and dated *H. Heerschop 1656*
PROV Purchased from C Triepel gallery, Berlin, 1887

A 774 Erichthonius found by the daughters of Cecrops. *De dochters van Cecrops vinden Erechthonius*

Canvas 110 × 121.5. Signed *H. Heerschop*
PROV Sale Jonkheer W Gockinga, Amsterdam, 14 Aug 1883, lot 50

copy after **Johann Ernst Heinsius**

Weimar? 1740 – 1812 Orléans

A 76 Willem Crul (1721-81). Rear admiral. *Schout bij nacht*

Copy by Cornelis van Cuijlenburg (1758-1827) after the original of 1763

Canvas 113 × 88
PROV Purchased from the copyist, Antwerp, 1801. NM, 1808
LIT Moes 1897-1905, vol 2, nr 4277:2. Moes & van Biema 1909, pp 46, 113, 206

Willem Hekking I

Amsterdam 1796 – 1862 Amsterdam

A 1698 Still life with fruit. *Stilleven met vruchten*

Panel 27 × 33. Signed *W. Hekking F.*
PROV Presented by W Hekking Jr, Haarlem, 1897

Franciscus Willem Helfferich

The Hague 1871 – 1941 The Hague

A 3490 Landscape. *Landschap*

Panel 30 × 31.5. Signed *Frans Helfferich*
PROV Bequest of Mrs A C M H Kessler-Hülsmann, widow of D A J Kessler, Kapelle op den Bosch near Mechelen, 1947

Bartholomeus van der Helst

Haarlem 1613–1670 Amsterdam

see also Tempel, Abraham van den,
C 241 Portrait of a woman, copy after
van der Helst – Pastels: Vilsteren,
Johannes van, C 49 Andries Bicker &
C 51 Catharina Gansneb, copies after
van der Helst

C 375 The company of Captain Roelof
Bicker and Lieutenant Jan Michielsz
Blaeuw in front of the de Haan brewery
at the corner of the Geldersekade and the
Boomsloot (called the Lastage),
Amsterdam, 1639. *Het vendel van kapitein
Roelof Bicker en luitenant Jan Michielsz
Blaeuw bij de bierbrouwerij de Haan op de
hoek van de Lastage (hoek Geldersekade en
Boomsloot) te Amsterdam, 1639*

Besides the captain, front center, and the
lieutenant, to his right, are portrayed:
Pieter Hulft, ensign, opposite the
lieutenant, Dirck de Lange, sergeant,
third from right, Jochem Rendorp,
sergeant, Hendrick Gerritsz Velthoen,
Jan Jorisz Eenhoorn, Coenraet
Rogiersz Ramsden, Johannes Rombouts,
Willem Jansz Steenwijck, Jan Hulft,
Claes Rotterdam, Clemens van Sorgen,
Jan Martensz Troost, Hendrick Jansz
Dommer, Paulus van Walbeeck, Jan
Cornelisz Moyaert, Hendrik Jorisz
Fuyck, Abraham Pietersz Kroock,
Cornelis Wilkens, Adriaen Jorisz
Eenhoorn, Isaac van de Venne, Jan
Cornelisz Pronk, Gerrit Jacobsz
Indischerave, Dirck Joosten Rijskamp,
Reynier Redinckhoven, Wynant Arentsz
Oppyn and Cornelis Wilkens Jr. On the
far left is the artist himself

Canvas 235 × 750. Signed and dated
B. van der Helst f. 163[9]
PROV Kloveniersdoelen (headquarters
of the arquebusiers' civic guard),
Amsterdam. On loan from the city of
Amsterdam since 1885
LIT Wagenaar 1760-88, vol 2 (1765) p
27. Van Dijk 1790, pp 35-36. Scheltema
1855-85, vol 1, p 168; vol 7 (1885) p 136.
Scheltema 1879, pp 15-16, nr 37. D C
Meyer, OH 4 (1886) p 226. D C Meyer,
Ned Spec, 1896, p 241. Moes 1897-1905,
vol 1, nrs 656, 698. J Six, OH 27 (1909)

pp 142, 146. De Gelder 1921, pp 41-58,
99, cat 835, pls VI-VII. Riegl 1931, pp
222-25, fig 63. Martin 1935-36, vol 1,
pp 153, 161, 173, 192, 216, 219, 222, fig
88; vol 2, pp 149-50. Plietzsch 1960, p
170, fig 302. Van Hall 1963, p 135, nr
881:22. C J de Bruyn Kops, Bull RM 13
(1965) p 20, ill. Rosenberg, Slive & Ter
Kuile 1966, pp 184-85, fig 158. M Kok,
Bull RM 15 (1967) p 120. Rosenberg
1967, pp 61, 64, 77, fig 49. Fuchs 1968,
p 15, fig 18. R B F van der Sloot & J B
Kist, Armamentaria 5 (1970) p 22, note
15. S E Pronk Czn, Pronkstukken, 1974,
p 124, ill

A 146 Andries Bicker (1586-1652).
Trader with Russia and burgomaster of
Amsterdam. *Koopman op Rusland en
burgemeester van Amsterdam*

The pendant portrait of his wife
Catharina Gansneb Tengnagel is in the
museum in Dresden (de Gelder 1921, nr
53). For a copy after A 146, *see* Pastels:
Vilsteren, Johannes van, C 49

Panel 93.5 × 70.5. Signed and dated
B. van der Helst 1642. Inscribed *Aetas 56*
PROV Sale Amsterdam, 10 Oct 1848,
lot 26
LIT Moes 1897-1905, vol 1, nr 631:1. De
Gelder 1921, pp 38-39, nr 51, pl IV.
Kruizinga 1948, fig 4

A 147 Gerard Andriesz Bicker (1622-66),
lord of Engelenburg. High bailiff of
Muiden. *Heer van Engelenburg. Drost van
Muiden*

For a portrait of the sitter's father, *see*
A 146

Panel 94 × 70.5
PROV Sale Amsterdam, 10 Oct 1848, lot
28
LIT Moes 1897-1905, vol 1, nr 639:1.
De Gelder 1921, p 40, nr 54. Martin
1935-36, vol 2, pp 147, 149, fig 81.
Plietzsch 1960, p 170, fig 304

A 143 Samuel van Lansbergen (d 1669).
Remonstrant minister in Rotterdam.
Remonstrants predikant te Rotterdam

Pendant to A 144

Panel 68 × 58. Traces of a signature
PROV Sale G van der Pot van Groeneveld,
Rotterdam, 6 June 1808, lot 50¹
LIT Moes & van Biema 1909, pp 113,
180. De Gelder 1921, p 61, nr 99. E
Wiersum, OH 48 (1931) p 207

A 144 Maria Pietersdr de Leest (d 1652).
Wife of Samuel van Lansbergen. *Echt-
genote van Samuel van Lansbergen*

Pendant to A 143

Panel 68 × 58. Signed and dated *B. van
der Helst 1646*
PROV Sale G van der Pot van Groeneveld,
Rotterdam, 6 June 1808, lot 50²
LIT Moes & van Biema 1909, pp 113,
180. Scheffer 1916, p 99. De Gelder
1921, p 61, nr 100. E Wiersum, OH 48
(1931) p 207. Martin 1935-36, vol 2, p
149, fig 82

C 2 The celebration of the Peace of Münster, 18 June 1648, in the headquarters of the crossbowmen's civic guard (St George guard), Amsterdam. *De schuttersmaaltijd in de Voetboog- (St Joris) doelen te Amsterdam ter viering van het sluiten van de vrede van Munster, 18 juni 1648*

The sitters are Captain Cornelis Jansz Witsen, with the silver drinking horn, Lieutenant Johan Oetgens van Waveren, shaking the captain's hand, Jacob Banning, ensign, seated beside the drum, Dirck Claesz Thoveling and Thomas Hartog, sergeants, Pieter van Hoorn, Willem Pietersz van der Voort, Adriaen Dirck Sparwer, Hendrick Calaber, Govert van der Mij, Johannes Calaber, Benedictus Schaeck, Jan Maes, Jacob van Diemen, Jan van Ommeren, Isaac Ooyens, Gerrit Pietersz van Anstenraadt, Herman Teunisz de Kluyter, Andries van Anstenraadt, Christoffel Poock, Hendrick Dommer Wz, Paulus Hennekijn, Lambregt van den Bos and Willem, the drummer

Canvas 232 × 547. Signed and dated *Bartholomeus Van der Helst fecit A° 1648*. The paper tucked under the snare of the drum is inscribed *Belloone walgt van bloedt | ja Mars vervloeckt het daveren | Van 't zwangere metaal, | en 't zwaardt bemint de scheê: | Dies biedt de dapp're Wits | aan d' eedele van Waveren | Op 't eeuwige verbondt, | den hooren van de Vreê* (poem by Jan Vos, 1620-67)
P R O V Voetboogdoelen (headquarters of the crossbowmen's civic guard), Amsterdam. On loan from the city of Amsterdam since 1808
L I T Wagenaar 1760-88, vol 2 (1765) p 20. Van Dijk 1790, p 40, nr 24. Scheltema 1855-85, vol 1, p 170. Scheltema 1879, nr 40. D C Meyer, O H 4 (1886) p 230. J Dyserinck, De Gids, 1894, pp 518-31. J Veth, De Gids, 1895, p 466. C Hofstede de Groot, Ned Spec, 1895, p 247. Moes 1897-1905, vol 1, nrs 168-69, 356. J Six, O H 27 (1909) p 142. De Gelder 1921, pp 64-81, 155, nr 836, pls XIII-XIV. Brieger 1922, p 86. Riegl 1931, pp 224-30, fig 64. Martin 1935-36, vol 1, pp 160-62, 165, 173, 192, 194, 197, 224, fig 108; vol 2, pp 149, 151. G Brom,

Mndbl B K 18 (1941) p 139, ill. Gerson 1952, p 25, fig 63. Plietzsch 1960, p 170, fig 303. Van Hall 1963, p 137, nr 891 : 1. V T T T, 1966-67, nr 89. Rosenberg, Slive & Ter Kuile 1966, p 185. Rosenberg 1967, p 77, fig 60. R B F van der Sloot & J B Kist, Armamentaria 5 (1970) p 16, note 10

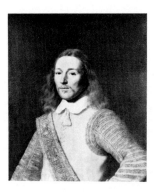

C 142 Portrait of an officer. *Portret van een officier*

Canvas 75 × 64.5. Signed and dated *B. van der Helst 1650*
P R O V On loan from the city of Amsterdam (A van der Hoop bequest), 1885-1975
L I T De Gelder 1921, nr 174

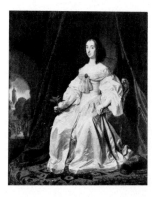

A 142 Princess Henrietta Maria Stuart (1631-60). Widow of Willem II, prince of Orange. *Weduwe van Willem II, prins van Oranje*

Canvas 199.5 × 170. Signed and dated *Bartholomeus van der Helst 1652 f*.
P R O V NM, 1808
L I T Moes 1897-1905, vol 2, nr 4803 :33. Moes & van Biema 1909, pp 37, 202. De Gelder 1921, pp 88-89, nr 104

C 3 The four governors of the archers' civic guard (the St Sebastian guard), Amsterdam, 1653. *De vier overlieden van de Handboog- (St Sebastiaan) doelen te Amsterdam, 1653*

From left to right: Frans Banning Cocq, Jan van de Poll, Albert Dircksz Pater and Jan Willemsz Blaeu. In the background there were originally three archers, one of whom has been painted out. Their names (P Blaeu, Harmen van de Poll and Dirck Pater) are written on the slate. For the original state of the painting, see the smaller version in the Louvre, painted by the artist in 1653, and the drawn copy by Julius Quinkhard in the Rijksprentenkabinet, Amsterdam

Canvas 183 × 268. Signed and dated *Bartholomeus van der Helst 1657* (the 7 is painted over a 3). Painted over an older signature
P R O V Handboogdoelen (headquarters of the archers' civic guard), Amsterdam. On loan from the city of Amsterdam since 1808
L I T Wagenaar 1760-88, vol 2 (1765) p 74. Van Dijk 1790, p 39. Scheltema 1855-85, vol 1, p 170; vol 7 (1885) pp 128-29. Scheltema 1879, nr 41. D C Meyer Jr, O H 4 (1886) p 232. J Dyserinck, O H 11 (1893) pp 193-210. Moes 1897-1905, vol 1, nrs 699 : 1, 1594 : 2; vol 2, nrs 5756 : 1, 5759, 5989 : 3, 5993 : 3. Moes & van Biema 1909, pp 120, 188. De Gelder 1921, pp 103-06, cat nr 838, pl XXI. Riegl 1931, pp 228-30, fig 65. Martin 1935-36, vol 1, pp 158, 162, 198-99, fig 110. Plietzsch 1960, p 171, fig 306. Van Hall 1963, p 25, nr 161 : 2. Rosenberg, Slive & Ter Kuile 1966, p 185. C Tümpel, N Beitr Rembrandt Forsch, 1973, p 169, fig 119

C 624 The four governors of the cross-bowmen's civic guard (the St George guard), Amsterdam, 1656. *De vier over-lieden van de Voetboog- (St Joris) doelen te Amsterdam, 1656*

The sitters are Hendrick Dircksz Spiegel, second from right, Jan Huydecoper van Maarseveen, far right, Joris Backer, an unknown man, and the steward Christoffel Poock, with an inkwell

Canvas 183 × 254. Signed and dated *B. van der Helst fecit 1656*
PROV Voetboogdoelen (headquarters of the crossbowmen's civic guard), Amsterdam. On loan from the city of Amsterdam, 1899-1975
LIT Wagenaar 1760-88, vol 2 (1765) p 19. Van Dijk 1790, p 96, nr 43. Scheltema 1855-85, vol 1, p 168. Scheltema 1879, nr 38. D C Meyer Jr, OH 4 (1886) p 236. Moes 1897-1905, vol 1, nrs 283, 3863:5; vol 2, nrs 6015:2, 7448:2. De Gelder 1921, pp 101, 237, nr 841, fig 26. Martin 1935-36, vol 1, pp 158, 200-01, fig 112. H van de Waal, OH 71 (1956) p 84, fig 15. Plietzsch 1960, p 171, fig 305. Rosenberg, Slive & Ter Kuile 1966, p 185

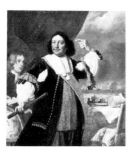

A 140 Aert van Nes (1626-93). Vice admiral. *Luitenant-admiraal*

Pendant to A 141

Canvas 139 × 125. Signed and dated *B. van der Helst 1668*. The naval battle in the background was painted by Ludolf Bakhuysen (1631-1708)
PROV Purchased from F Munnikhuizen, Rotterdam, 1800. NM, 1808
LIT Moes 1897-1905, vol 2, nr 5340:1. Moes & van Biema 1909, pp 34, 37, 76,

175, 207. De Gelder 1921, p 94, nr 109. E Wiersum, OH 51 (1934) pp 231-36, fig 1. Diekerhoff 1967, fig 24. R B F van der Sloot & J B Kist, Armamentaria 5 (1970) p 241, note 17

A 141 Geertruida den Dubbelde (1647-84). Wife of Aert van Nes. *Echtgenote van Aert van Nes*

Pendant to A 140

Canvas 139 × 125. Signed and dated *B. van der Helst f. 1668*. The harbor with men-of-war in the background was painted by Ludolf Bakhuysen (1631-1708)
PROV Same as A 140
LIT Moes 1897-1905, vol 1, nr 2170. Moes & van Biema 1909, pp 34, 37, 76, 175, 207. De Gelder 1921, p 97, nr 110, pl XXXVI. E Wiersum, OH 51 (1934) pp 231-36, fig 2

A 832 Johan de Liefde (ca 1619-73). Vice admiral. *Vice-admiraal*

Canvas 139 × 122. Signed and dated *B. van der Helst 1668*. The naval battle in the background was painted by Ludolf Bakhuysen (1631-1708)
PROV Purchased from Nathaniel Baron de Rothschild, London, 1884
LIT Scheffer & Obreen 1880, p 485. Moes 1897-1905, vol 2, nr 4494. De Gelder 1921, p 94, nr 102. R B F van der Sloot & J B Kist, Armamentaria 5 (1970) p 241

A 1255 Jacobus Trip (1627-70). Armaments dealer of Amsterdam and Dordrecht. *Wapenhandelaar te Amsterdam en Dordrecht*

For a portrait of the sitter's sister, *see* Rembrandt, C 597

Canvas 110 × 95. Signed *B. van der Helst f.*
PROV Presented by J S R van de Poll, Arnhem, 1885 * Lent to the AHM, 1975
LIT Moes 1897-1905, vol 2, nr 8069. De Gelder 1921, p 85, nr 132 (ca 1650)

A 145 Egbert Meeuwsz Cortenaer (1600-65). Vice admiral, admiralty of the Maas, Rotterdam. *Luitenant-admiraal der Admiraliteit van de Maze*

Panel 68 × 59
PROV NM, 1808
LIT Moes & van Biema 1909, p 286. De Gelder 1921, pp 95-96, nr 97, pl XXX (in or shortly after 1659). Second Dutch War, 1967, ill on p 11 (detail). F L Diekerhoff, Spiegel Hist 5 (1970) fig 5 on p 26

copy after **Bartholomeus van der Helst**

C 50 Gerard Andriesz Bicker (1623-66), lord of Engelenburg. High bailiff of Muiden. *Heer van Engelenburg. Drost van Muiden*

Copy by Anthony de Vries (1842-72) after A 147

Canvas 90 × 69
PROV On loan from the city of
Amsterdam (Bicker bequest), 1885-1975
* On loan to the Rijksmuseum Muider-
slot, Muiden, since 1949
LIT Moes 1897-1905, vol 1, nr 639:2. De
Gelder 1921, sub nr 54

Lodewijk van der Helst

Amsterdam 1642–after 1682
Amsterdam?

A 863 Adriana Jacobusdr Hinlopen (b
1646). Wife of Johannes Wijbrants (b
1639). *Echtgenote van Johannes Wijbrants*

Canvas 74 × 63. Signed and dated *L. VH
F 1667*
PROV Sale Amsterdam, 16 Dec 1875, lot
39. NMGK, 1885
LIT Moes 1897-1905, vol 1, nr 3512

A 148 Posthumous portrait of Aucke
Stellingwerff. Admiral of Friesland,
killed in 1665 at Lowestoft by a cannon-
ball. *Admiraal van de admiraliteit van
Friesland, gesneuveld in 1665 bij Lowestoft
door een kanonskogel*

Canvas 103 × 136. Signed and dated
L. van der Helst f. 1670. Inscribed *Æta 33*
PROV Purchased in 1803. NM, 1808
LIT Moes 1897-1905, vol 2, nr 7560:1.
Moes & van Biema 1909, pp 64, 209. R
van Luttervelt, Bull RM 2 (1954) p 92,
ill. Bernt 1969-70, vol 2, nr 509

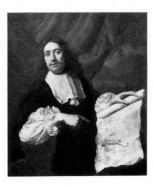

A 2236 Willem van de Velde II (1633-
1707). Painter. *Schilder*

Canvas 103 × 91. Inscribed on the
drawing *W. v. Velde*
PROV Purchased from Fr Muller & Co,
art dealers, Amsterdam, 1906
LIT Van Hall 1963, p 341, nr 2152:3.
PJJ van Thiel, Bull RM 17 (1969) p 14,
fig 10

Nicolaes van Helt Stockade

Nijmegen 1614–1669 Amsterdam

A 1926 Italian landscape with cattle.
Italiaans landschap met vee

Panel 27.5 × 32. Signed *NVHelt*
PROV Sale H I A Raedt van
Oldenbarneveldt, Amsterdam, 6-7 Nov
1900, lot 321
LIT C Hofstede de Groot, OH 22 (1904)
p 28 (doubts attribution to Helt
Stockade)

Pieter van der Hem

see Governors-general series: A 3822
Adriaan Neytzel de Wilde

Jan van Hemert

active 1645 in the northern Netherlands

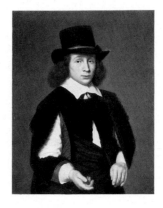

A 693 Dirck Hendrick Meulenaer

Canvas 88.5 × 69.5. Signed and dated
Jan v. Hemert fc. 1645
PROV Bequest of Jonkheer J S H van de
Poll, Amsterdam, 1880
LIT V de Stuers, Ned Kunstbode 2
(1880) p 244. G Kolleman, Ons
Amsterdam 23 (1971) p 118 (dated
1697, portrait of Dirck Meulenaer, son
of Maria Rey and Roelof Meulenaer, b
16 July 1656)

Catharina van Hemessen

Antwerp 1528–after 1587 Antwerp?

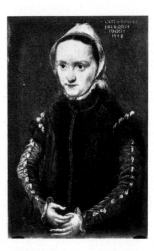

A 4256 Portrait of a woman, probably a
self portrait. *Portret van een vrouw,
waarschijnlijk een zelfportret*

Panel 24 × 17. Signed and dated
Catherina de Hemessen Pinxit 1548
PROV Bequest of F G S Baron van
Brakell, Arnhem, 1878. NMGK
LIT Winkler 1924, p 385

Barend Leonardus Hendriks

see Governors-general series: A 3805
L A J W Baron Sloet van de Beele

Frederik Hendrik Hendriks

Arnhem 1808-1865 Arnhem

A 1819 Landscape. *Landschap*

Canvas 86 × 114. Signed *F H Hendriks*
PROV Bequest of Reinhard Baron van
Lynden, The Hague, 1899 * DRVK since
1951
LIT W Steenhoff, Mndbl BK 5 (1928) p
35, ill

Sara Frederica Hendriks

Renkum 1846–1925 Naarden

A 1878 Still life with peaches and grapes.
Stilleven met perziken en druiven

Canvas 36 × 45. Signed and dated *Sara
Hendriks 81*
PROV Presented by the dowager of R
Baron van Lynden, née M C Baroness
van Pallandt, The Hague, 1900 * DRVK
since 1952

Wybrand Hendriks

Amsterdam 1744–1831 Haarlem

C 532 Wernerus Köhne (1725/26-88).
Notary of Haarlem, with his clerk Jan
Bosch. *Notaris te Haarlem, met zijn klerk
Jan Bosch*

Canvas 63 × 51. Signed and dated
Wd. Hendriks Pinxit 1787
PROV On loan from the KOG (presented
by P J Amersfoordt) since 1899
LIT Moes 1897-1905, vol 1, nrs 928,
4249. Marius 1920, p 65, fig 31. W
Steenhoff, Mndbl BK 5 (1928) p 37, ill.
J Knoef, Jaarversl KOG 78 (1935) pp 77-
78, ill. Gerson 1961, p 13. Schatborn &
Szénássy 1971, p 114, nr 514. Exhib cat
Wybrand Hendriks 1744-1831, Haarlem
1972, nr 8

A 1989 A painter with his wife. *Een
schilder met zijn vrouw*

Canvas 52 × 47. Formerly signed and
dated *W. Hendriks 1791* (now illegible)
PROV Presented by Jonkheer B W F van
Riemsdijk, Amsterdam, 1902
LIT Van Hall 1963, p 136, nr 889:1

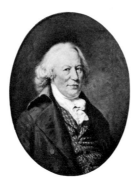

C 1482 Gerrit van der Aa (1744-1814).
Haarlem merchant. *Koopman te Haarlem*

Pendant to C 1483

Canvas 71 × 55. Oval. Signed and dated
W. Hendriks 1797. Inscribed on the verso
*Gerrit van der Aa overleden in Haarlem den
29ste September 1814 in den ouderdom van
70 jaren begraven den 5den oktober in de
Grooten Kerk St. Bavo. Menig mensch zal
Hem prijzen die mildadig is en hij zal een
geloofwaardige getuigenis bekomen wegens
Zijne deugd 31 vs. 28*
PROV On loan from O L van der Aa,
Amsterdam, since 1970
LIT CJ de Bruyn Kops, Bull RM 22
(1974) pp 28, 38, fig 11

C 1483 Johanna Brodden (1747-1813).
Wife of Gerrit van der Aa. *Echtgenote van
Gerrit van der Aa*

Pendant to C 1482

Canvas 71 × 55. Oval. Signed and dated
W. Hendriks 1797. Inscribed on the verso
*Johanna Brodde, Huisvrouw van Gerrit van
der Aa. Overleden den 24 Maart 1813 in de
ouderdom van 66 jaren en drie maanden
begraven den 30 Maart te Haarlem in de
Groote Kerk H. Bavo. Zij was geboren te Uden.
Zij heeft acht gegeven op de gangen van Haar
huisgezin en zij heeft haar brood niet in
ledigheid gegeten. XXXI vs. 2*
PROV Same as C 1482
LIT CJ de Bruyn Kops, Bull RM 22
(1974) pp 28, 38, fig 12

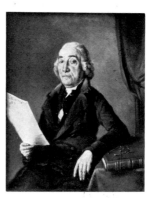

A 667 Jacob de Vos Sr (1735-1833).
Amsterdam art collector. *Kunst-
verzamelaar te Amsterdam*

Panel 34.5 × 29. Signed and dated
W. Hendriks ft. 1811
PROV Presented by Mrs A H de Vos-
Wurfbain, Amsterdam, 1879
LIT CJ de Bruyn Kops, Bull RM 13
(1965) p 70, ill. Exhib cat Wybrand
Hendriks 1744-1831, Haarlem 1972, nr
43, fig 57

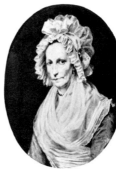

C 422 The four chief commissioners of the Amsterdam harbor works. *De vier oppercommissarissen der Walen te Amsterdam*

From left to right: Christiaan Scholten, Christiaan van Orsoy, Jan Petrus Scholten van Aschat and Frederik Alexander Vernède

Canvas 207 × 214. Painted between 1791 and 1795
PROV Conference room of the chief commissioners of the Walen (harbor works) in the Schreierstoren, Amsterdam. On loan from the city of Amsterdam since 1885
LIT Scheltema 1879, nr 150 (1791 or shortly thereafter). Moes 1897-1905, vol 2, nrs 5609, 6973, 6976, 8409. Exhib cat Wybrand Hendriks 1744-1831, Haarlem 1972, nr 20. Haak 1972, pp 29, 35, fig 40

A 3854 Woman sewing in an interior. *Interieur met naaiende vrouw*

Panel 34.4 × 29.3. Signed *W. Hendriks*
PROV Purchased from B Houthakker gallery, Amsterdam, 1953
LIT Exhib cat Wybrand Hendriks 1744-1831, Haarlem 1972, nr 56, fig 49

A 3943 View of the Nieuwe Gracht near the Bolwerk, Haarlem. *Gezicht op de Nieuwe Gracht bij het Bolwerk te Haarlem*

Panel 51.5 × 60. Signed *W. Hendriks*
PROV RVMM, 1877 * Lent to the Frans Halsmuseum, Haarlem, 1877. DRVK since 1958 (on loan to the Frans Halsmuseum, Haarlem)
LIT Gerson 1961, p 15, fig 22. Exhib cat Wybrand Hendriks 1744-1831, Haarlem 1972, nr 61, fig 76

Herman Frederik van Hengel

Nijmegen 1705 – 1785 Utrecht

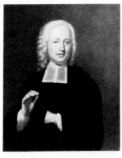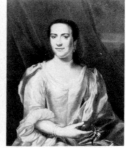

A 1473 Justus Tjeenk (1730-82). One of the founders of the Zeeuws Genootschap (Zeeland Society), minister in Vlissingen. *Een der oprichters van het Zeeuws Genootschap, predikant te Vlissingen*

Pendant to A 1474

Canvas 83 × 68. Signed and dated *H. Fredr. van Hengel 1756*
PROV Presented by H F Tjeenk, Amsterdam, 1888 * DRVK since 1959 (on loan to the Zeeuws Museum, Middelburg)
LIT Moes 1897-1905, vol 2, nr 8025

A 1474 Margaretha Leuveling (1738-83). Wife of Justus Tjeenk. *Echtgenote van Justus Tjeenk*

Pendant to A 1473

Canvas 83 × 68
PROV Same as A 1473 * DRVK since

1959 (on loan to the Zeeuws Museum, Middelburg)
LIT Moes 1897-1905, vol 2, nr 4453

Paulus Hennekyn

Amsterdam? 1611/14 – 1672 Amsterdam

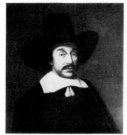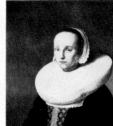

A 2184 Jan de Hooghe (1608-82). Father-in-law of the painter Ludolf Bakhuysen. *Schoonvader van de schilder Ludolf Bakhuysen*

Pendant to A 2185

Canvas 66.5 × 61. Signed and dated *P Hennekijn f. 1658*
PROV Bequest of Miss M E van den Brink, Velp, 1905 * DRVK since 1950

A 2185 Anna van der Does (1609-50). Wife of Jan de Hooghe. *Echtgenote van Jan de Hooghe*

Pendant to A 2184

Canvas 67 × 61.5
PROV Same as A 2184 * DRVK since 1950

H Th Hesselaar

ca 1821 – 1862 Pasuruan, Java

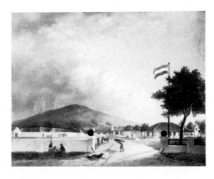

C 1519 The Kedawong sugar factory near Pasuruan, Java. *De suikerfabriek 'Kedawong' bij Pasoeroean op Java*

Panel 43 × 54. Signed and dated *H. T. Hesselaar ft 1849 Java*

PROV On loan from D F W Langelaan, Amsterdam, since 1972
LIT J de Loos-Haaxman, Verslagen CNO, 1968-69, p 48, fig 2

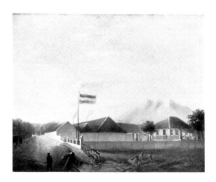

C 1520 A sugar factory (?) on Java. *Suikerfabriek (?) op Java*

Panel 43 × 54. Signed and dated *H. T. Hesselaar 1849 Java*
PROV Same as C 1519
LIT J de Loos-Haaxman, Verslagen CNO, 1968-69, p 48, fig 3

C 1521 A factory on Java. *Fabriek op Java*

Panel 49 × 54. Signed and dated *H. T. Hesselaar ft. 1851* (the last two figures are nearly illegible)
PROV Same as C 1519
LIT J de Loos-Haaxman, Verslagen CNO, 1968-69, p 48

Willem (Guilliam) de Heusch

Utrecht 1625 – 1692 Utrecht

A 151 Italian landscape with resting herdsman. *Italiaans landschap met rustende herder*

Canvas 40 × 56. Signed *GDHeusch f.*
PROV Bequest of L Dupper Wzn, Dordrecht, 1870

A 2324 Italian landscape with draftsman. *Italiaans landschap met tekenaar*

Panel 42 × 58. Signed *GDHeusch*
PROV Purchased from the heirs of Jonkheer P H Six van Vromade, Amsterdam, 1908, with aid from the Rembrandt Society * DRVK since 1953

A 149 Italian landscape at sunset. *Italiaans landschap bij zonsondergang*

Copper 22 × 28.5. Signed *GDHeusch*
PROV Bequest of L Dupper Wzn, Dordrecht, 1870 * DRVK since 1953

A 150 Italian landscape with herders. *Italiaans landschap met herders*

Copper 22 × 29. Signed *GDHeusch*
PROV Bequest of L Dupper Wzn, Dordrecht, 1870 * DRVK since 1953

Jan van der Heyden

Gorkum 1637 – 1712 Amsterdam

C 571 The Dam in Amsterdam with a view of the Nieuwe Kerk. *De Dam in Amsterdam met gezicht op de Nieuwe Kerk*

Panel 68 × 55. Signed *VHeyde*
PROV On loan from the city of Amsterdam (J F van Lennep bequest), 1893-1975
LIT A Bredius, OH 30 (1912) pp 132, 136. 't Hooft 1912, pp 11, 15. Hofstede de Groot 1907-28, vol 8 (1923) nr 6. Martin 1935-36, vol 2, pp 399, 401, fig 211. Exhib cat Jan van der Heyden, Amsterdam 1937, nr 2. H L C Jaffé, OKTV I (1963) nr 18, fig 1. Wagner 1971, pp 35, 67, cat nr 4, ill (figures by Adriaen van de Velde)

A 154 The Nieuwe Zijds Voorburgwal with the Oude Haarlemmersluis, Amsterdam (with topographical liberties). *De Nieuwe Zijds Voorburgwal met de Oude Haarlemmersluis te Amsterdam (met topografische vrijheden)*

Panel 44 × 57.5. Signed *VDHeyde*
PROV Purchased with the Kabinet van Heteren Gevers, The Hague-Rotterdam, 1809
LIT Hoet 1752, vol 2, p 455. 't Hooft 1912, pp 12, 15. Hofstede de Groot 1907-28, vol 8 (1923) nr 7. Moes & van Biema 1909, p 146. Exhib cat Jan van der Heyden, Amsterdam 1937, nr 4. Bode 1958, p 365ff. H W Alings, Ons Amsterdam, June 1960, p 188ff, ill. Wagner 1971, pp 32, 34, 60, 70, cat nr 15, ill (figures by Adriaen van de Velde)

A 3971 View of Nijenrode Castle on the Vecht. *Gezicht op kasteel Nijenrode aan de Vecht*

Panel 47 × 59. Signed *VDHeyde*
PROV Lent by the SNK, later DRVK, 1948. Transferred in 1960
LIT Hofstede de Groot 1907-28, vol 8 (1923) nr 231. M F Hennus, Mndbl BK 13 (1936) p 231. Exhib cat Jan van der Heyden, Amsterdam 1937, nr 9, ill. Wagner 1971, pp 45, 98, cat nr 143, ill (figures by Adriaen van de Velde)

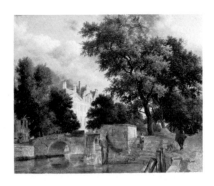

A 152 The stone bridge. *De stenen brug*

Pendant to A 153

Panel 37 × 44.5
PROV Sale G van der Pot van Groeneveld, Rotterdam, 6 June 1808, lot 53
LIT Moes & van Biema 1909, pp 113, 181. 't Hooft 1912, p 9. Hofstede de Groot 1907-28, vol 8 (1923) nr 200. Martin 1935-36, vol 2, p 400. Wagner 1971, pp 32, 86, cat nr 86, ill (figures by Adriaen van de Velde)

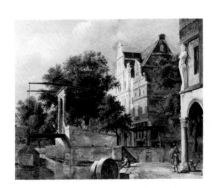

A 153 The drawbridge. *De ophaalbrug*

Pendant to A 152

Panel 36 × 44.5. Signed *VHeyde f.*
PROV Same as A 152
LIT Moes & van Biema 1909, pp 113, 118. A Bredius, OH 30 (1912) pp 132, 136. 't Hooft 1912, pp 9, 15. Hofstede de Groot 1907-28, vol 8 (1923) nr 201. Wagner 1971, pp 32, 86, cat nr 87, ill (figures by Adriaen van de Velde)

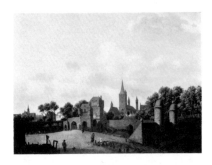

C 143 The church of St Severin in Cologne in an imaginary setting. *De Sankt Severin te Keulen opgenomen in een gefantaseerd stadsbeeld*

Panel 49 × 65. Signed *I. v.d. Heyde*
PROV On loan from the city of Amsterdam (A van der Hoop bequest) since 1885
LIT Hofstede de Groot 1907-28, vol 8 (1923) nr 5. Exhib cat Jan van der Heyden, Amsterdam 1937, nr 11. VTTT, 1964-65, nr 63. Dattenberg 1967, nr 243, ill. Wagner 1971, pp 58, 90, cat nr 105, ill (figures by Adriaen van de Velde)

A 3253 A country home. *Een landhuis*

Panel 23.5 × 29. Signed *J. v.d. Heyden f.*
PROV Presented by Sir Henry W A Deterding, London, 1936
LIT Wagner 1971, p 118 (doubts the attribution to van der Heyden)

A 2511 View in the woods. *Bosgezicht*

Verre églomisé 34 × 42.5. Signed *IVH*
PROV Purchased from Baron de Heusch, Valkenburg, 1910
LIT Th von Frimmel, Blätter fG 6 (1911) p 135. A Bredius, OH 31 (1913) pp 25-26, ill. Hofstede de Groot 1907-28, vol 8 (1923) nr 294. Bode 1958, p 365. Wagner 1971, pp 47, 55-56, 109, cat nr 102. E J Sluyter & H Wagner, OH 87 (1973) p 248, fig 3

manner of **Jan van der Heyden**

A 3491 Loenersloot Castle on the Angstel. *Kasteel Loenersloot aan de Angstel*

Canvas 34 × 61
PROV Bequest of Mrs A C M H Kessler-Hülsmann, widow of D A J Kessler, Kapelle op den Bosch near Mechelen, 1947

Marinus Heyl

Utrecht 1836– 1931 Amsterdam

A 3046 Evening landscape. *Avondlandschap*

Canvas 33 × 53. Signed *M. Heijl*
PROV Bequest of A Allebé, Amsterdam,
1927 * DRVK since 1953

Theodorus Hildebrand

Stettin 1804–1874 Düsseldorf

C 304 The Neva at St Petersburg
(Leningrad) in the winter. *De Newa bij
Sint Petersburg (Leningrad) in de winter*

Canvas 40 × 58.5. Signed and dated
Th. Hildebrand 1844
PROV On loan from the city of
Amsterdam (A van der Hoop bequest)
since 1885

Pauwels van Hillegaert

Amsterdam 1595/96–1640 Amsterdam

see also Heraldic objects: Shields, NM
2970

A 664 Prince Maurits at the Battle of
Nieuwpoort, 2 July 1600. *Prins Maurits
in de Slag bij Nieuwpoort, 2 juli 1600*

Panel 82.5 × 117.5. Signed *Pauwels
van Hillegaert*
PROV Sale Dowager van Loon-van
Winter, Amsterdam, 26 Feb 1878, lot 5

A 3125 Prince Maurits astride the white
warhorse presented to him after his
victory at Nieuwpoort. *Prins Maurits
gezeten op de witte strijdhengst hem
geschonken na de overwinning in de Slag bij
Nieuwpoort*

see also Gheyn II, Jacob de, A 4255

Panel 37 × 33.3
PROV Purchased from N Beets gallery,
Amsterdam, 1931 * On loan to the
Rijksmuseum Muiderslot, Muiden,
since 1971
LIT M Steif, Belvedere 7 (1925) p 41ff,
ill (Hendrick Pacx, portrait of William
of Orange)

A 155 The disbanding of the 'waard-
gelders' (mercenaries in the pay of the
town government) by Prince Maurits on
the Neude, Utrecht, 31 July 1618. *Het
afdanken der waardgelders door prins Maurits
op de Neude te Utrecht, 31 juli 1618*

Canvas 101 × 173.5. Signed and dated
Paulus van Hilligaert 1627
PROV NM, 1808
LIT Moes & van Biema 1909, pp 44, 217.
R B F van der Sloot, NKJ 10 (1959) p 119

A 452 Prince Maurits, accompanied by
Prince Frederik Hendrik, Frederick V of
Bohemia and his wife Elizabeth Stuart,
and others, on the Buitenhof, The Hague.
*Prins Maurits in gezelschap van o a prins
Frederik Hendrik, Frederik V en diens vrouw
Elizabeth Stuart, koning en koningin van
Bohemen, op het Buitenhof in Den Haag*

In the background are the Hofvijver and
the Binnenhof

Canvas 86.5 × 118
PROV Het Loo Palace, Apeldoorn,
1798. NM, 1808
LIT C Hofstede de Groot, OH 17 (1899)
p 165ff (attributed to Hendrick Pacx).
Moes & van Biema 1909, pp 17, 171, 201.
Bol 1969, p 245, fig 237

A 394 Prince Frederik Hendrik on horse-
back. *Prins Frederik Hendrik te paard*

Panel 35.5 × 28.5
PROV Sale M C van Hall, Amsterdam,
27 April 1858, lot 105 (as Anthonie
Palamedesz) * On loan to the Rijks-
museum Muiderslot, Muiden

A 4112 Prince Frederik Hendrik on
horseback outside the fortifications of
's-Hertogenbosch, 1629. *Prins Frederik
Hendrik te paard voor de vesting
's-Hertogenbosch, 1629*

Panel 37.5 × 33.5. Signed unclearly *Van
Hilligaert*
PROV Purchased from D Cevat gallery,
London, 1965
LIT Bull RM 13 (1965) p 135, fig 18

A 848 Prince Frederik Hendrik at the siege of 's-Hertogenbosch, 1629. *Prins Frederik Hendrik bij de belegering van 's-Hertogenbosch, 1629*

Canvas 107 × 178
PROV Purchased from J Hollender gallery, Brussels, 1885
LIT C Hofstede de Groot, OH 17 (1899) p 165 (attributed to Hendrick Pacx)

A 607 Prince Frederik Hendrik and Count Ernst Casimir at the siege of 's-Hertogenbosch, 1629. *Prins Frederik Hendrik en graaf Ernst Casimir bij het beleg van 's-Hertogenbosch, 1629*

Panel 48 × 64
PROV NM, 1808
LIT Moes & van Biema 1909, pp 168, 217. R BF van der Sloot, NKJ 10 (1959) p 119, fig 7. Bernt 1960-62, vol 4, nr 128. Bernt 1969-70, vol 2, nr 524

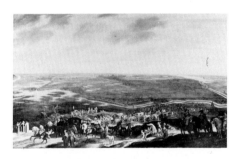

A 435 The defeated Spanish garrison leaving 's-Hertogenbosch, 17 September 1629. *De aftocht van het Spaanse garnizoen na de overgave van 's-Hertogenbosch, 17 september 1629*

Canvas 111.5 × 175
PROV NM, 1808

LIT C Hofstede de Groot, OH 17 (1899) p 166 (attributed to Hendrick Pacx). Moes & van Biema 1909, pp 64, 217

school of **Pauwels van Hillegaert**

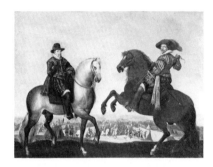

A 568 Princes Maurits and Frederik Hendrik on horseback. *Prins Maurits en prins Frederik Hendrik te paard*

Canvas 87 × 114.5
PROV NM, 1808
LIT Moes & van Biema 1909, p 201. CW Fock, OH 84 (1969) p 19, fig 10

Nicholas Hilliard

see under Miniatures

Eduard Alexander Hilverdink

Amsterdam 1846 – 1891 Amsterdam

C 1538 Rembrandt's house on the Jodenbreestraat in Amsterdam. *Het huis van Rembrandt in de Jodenbreestraat te Amsterdam*

Canvas 65 × 55. Signed and dated *E. Alexander Hilverdink Johz. 1867*
PROV On loan from the KOG (D Franken Dzn bequest) since 1889
LIT Scheen 1946, fig 215. Gans 1971, p 356, ill

A 1329 The Singel, Amsterdam, looking towards the mint. *Het Singel te Amsterdam naar de Munt gezien*

Canvas 47 × 76. Signed *E. Alex. Hilverdink*
PROV Purchased at exhib Amsterdam 1886, nr 135 * On loan to the AHM since 1926

Johannes Hilverdink

Groningen 1813 – 1902 Amsterdam

A 1046 The Channel coast, England. *De Engelse kust langs het Kanaal*

Canvas 80 × 130. Signed *Joh. Hilverdink*
PROV Purchased at exhib Amsterdam 1870, nr 103. RVMM, 1885 * DRVK since 1959

Hintzsch (Hintz, Hinz)

see Hainz

Peter Hoadley

see under Miniatures

Meindert Hobbema

Amsterdam 1638 – 1709 Amsterdam

A 156 A watermill. *Een watermolen*

Panel 60.5 ×85. Signed *M. Hobbema*
PROV Bequest of L Dupper Wzn,
Dordrecht, 1870 * On loan to the KKS
since 1950
LIT C von Lützow, Zeitschr BK 5 (1870)
p 229. Hofstede de Groot 1907-28, vol 4
(1911) nr 66. Lugt 1927, p 22, nr 42, pl
XIX. J Rosenberg, Jb Preusz Kunst-
samml 48 (1927) p 142, fig 9. Martin
1935-36, vol 2, pp 314-15. Broulhiet
1938, nr 20. Stechow 1966, p 77. G J van
der Hoek, Kunstrip 4 (1973-74) nr 32

C 144 A watermill. *Een watermolen*

Panel 62 ×85.5. Signed *M. Hobbema*
PROV On loan from the city of
Amsterdam (A van der Hoop bequest)
since 1885
LIT Hofstede de Groot 1907-28, vol 4
(1911) nr 67. Martin 1935-36, vol 2, pp
314-15. Broulhiet 1938, nr 17. G J van
der Hoek, Kunstrip 4 (1973-74) nr 32

C 145 A peasant cottage on a water-
course. *Een boerenwoning aan een wetering*

Panel 31.5 ×44. Signed *MHobbema*
PROV On loan from the city of
Amsterdam (A van der Hoop bequest),
1885-1975

LIT Hofstede de Groot 1907-28, vol 4
(1911) nr 253. Martin 1935-36, vol 2,
p 314. Broulhiet 1938, nr 381. W
Stechow, Art Q 22 (1959) p 3ff, fig 5 (ca
1659-60). Stechow 1966, p 60, fig 114

Charles Howard Hodges

Portsmouth 1764–1837 Amsterdam

see also Eeckhout, Jacobus Josephus,
A 4048 Jonkheer Theodorus Frederik
van Capellen, copy after Hodges –
Miniatures: C 45 Jan Bernd Bicker –
see also under Pastels

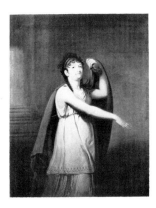

A 769 Joanna Cornelia Ziesenis, née
Wattier (1762-1827), as Epicharis in the
play of that name by G M J B Legouvé
(1764-1812). *Joanna Cornelia Ziesenis,
geb Wattier in de rol van Epicharis uit het
gelijknamige toneelstuk van G M J B Legouvé*

Canvas 74 ×47. Painted in 1804
FROV Sale Amsterdam, 13 Nov 1882,
lot 25 * DRVK since 1953 (on loan to the
Stadsschouwburg, Amsterdam)
LIT Marius 1920, p 6, fig 5. B Hout-
hakker, Mndbl BK 3 (1926) pp 326, 333

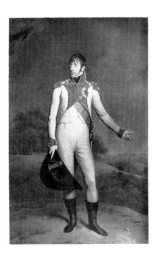

A 653 Louis Napoleon (1718-1846),
king of Holland from 1808 to 1810.
*Lodewijk Napoleon, koning van Holland van
1808 tot 1810*

Canvas 223 × 147. Signed and dated
C. H. Hodges fec. 1809
PROV Presumably presented by Louis
Napoleon in 1810
LIT B Houthakker, Mndbl BK 3 (1926) p
334. Knoef 1943, ill on p 136. J A Groen
Jr, Ons Amsterdam 10 (1958) ill on p
187. R van Luttervelt, Nap Stud 13
(1961) pp 545-47, figs 1-2

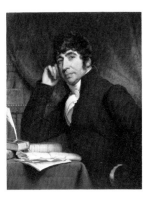

A 1453 Willem Bilderdijk (1756-1831).
Poet and historian. *Dichter en geschied-
schrijver*

Canvas 79 ×63. Dated *1810*. Signed and
dated on the verso *door C. H. Hodges in 't
Jaar MDCCCX*
PROV Purchased from Fr Muller & Co,
art dealers, Amsterdam, 1887
LIT B Houthakker, Mndbl BK 3 (1926) p
335. Scheen 1946, fig 1. J A Groen Jr,
Ons Amsterdam 10 (1958) ill on p 122.
Van Hall 1963, p 23, nr 151:3

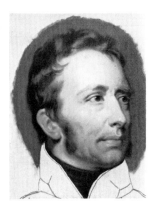

A 2125 Willem I (1772-1843), king of the
Netherlands. *Koning der Nederlanden*

Canvas 34.5 ×26. Study for the state
portrait of 1816 in the Amsterdam town
hall
PROV Lent by P C C Hansen,
Amsterdam, 1885. Purchased from his
estate in 1903
LIT Th H Lunsingh Scheurleer, in
Gedenkboek Rijksmuseum, 1958, ill on
p 32. Exhib cat 150 jaar Nederlandse
kunst, Amsterdam 1963, nr 12, fig 1

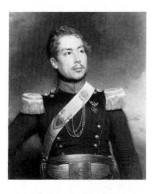

A 1569 Christian Edouard Fraser (1812-79). Second lieutenant of the 5th dragoon regiment. *Tweede luitenant van het 5de regiment der Dragonders*

For portraits of the sitter's parents, *see* A 1567 & A 1568

Canvas 72 × 61. Inscribed on the verso *C:E:Fraser, geb. 1812. C:H:Hodges pinxit 1834*
PROV Presented from the estate of the dowager of C H Baron van Pallandt, née C A Fraser, The Hague, 1892
LIT B Houthakker, Mndbl BK 3 (1926) p 337

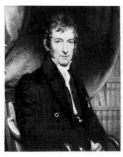

A 1567 Johan Fraser (1780-1843)

Pendant to A 1568

Canvas 72 × 60.5. Inscribed on the verso *J:Fraser: geb: 1780: obit 1843 C:H: Hodges pinxit 1835*
PROV Presented from the estate of the dowager of C H Baron van Pallandt, née C A Fraser, The Hague, 1892
LIT B Houthakker, Mndbl BK 3 (1926) p 337

A 1568 Maria Antoinette Charlotte Sanderson (1782-1859). Wife of Johan Fraser. *Echtgenote van Johan Fraser*

Pendant to A 1567

Canvas 72 × 60.5. Inscribed on the verso *M:A:C:Fraser. geb. Sanderson. 1782. obit 1859 C:H:Hodges pinxit 1835*
PROV Same as A 1567
LIT Marius 1920, fig 3. B Houthakker, Mndbl BK 3 (1926) p 337

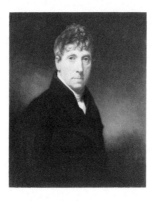

A 1047 Self portrait. *Zelfportret*

Canvas 72 × 60
PROV Bequest of the artist's daughter, Miss E J Hodges, Amsterdam, 1868. RVMM, 1885
LIT B Houthakker, Mndbl BK 3 (1926) p 333, ill. Van Hall 1963, p 140

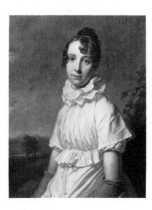

A 1048 Emma Jane Hodges (1789-1868). The artist's daughter. *Dochter van de schilder*

Canvas 77 × 62
PROV Bequest of the sitter, Amsterdam, 1868. RVMM, 1885
LIT B Houthakker, Mndbl BK 3 (1926) p 337

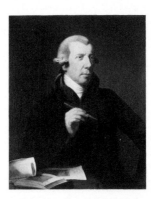

A 1517 Reinier Vinkeles (1741-1816). Draftsman and engraver. *Tekenaar en plaatsnijder*

Canvas 76 × 60
PROV Purchased from C M van Gogh gallery, Amsterdam, 1891
LIT Moes 1897-1905, vol 2, nr 8514. B Houthakker, Mndbl BK 3 (1926) p 335. Van Hall 1963, p 351, nr 2220:1

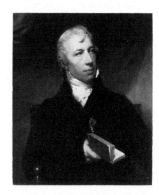

A 654 Cornelis Apostool (1762-1844). First director (1808-44) of the Koninklijk Museum, later Rijks Museum, Amsterdam. *Eerste directeur van het Koninklijk Museum, later Rijks Museum te Amsterdam*

Canvas 73 × 53
PROV Bequest of the sitter, Amsterdam, 1844
LIT Moes & van Biema 1909, p 120, ill. Th H Lunsingh Scheurleer, in Gedenkboek Rijksmuseum, 1958, ill on p 26. Van Hall 1963, p 6, nr 45:1

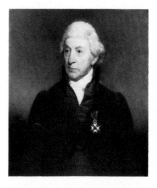

A 4161 Christiaan Everhard Vaillant (1746-1829). Government official. *'Raffinadeur van 't Salpeter' (1770), hoogheemraad van de Beemster (1775) en directeur der In- en Uitgaande rechten en lid van het Comité van Marine*

Canvas 73 × 61
PROV Presented by Jonkvrouwe C W van den Bosch, The Hague, 1969, in accordance with the wishes of the late Miss J Vaillant
LIT Bull RM 18 (1970) p 34, fig 2. M L Wurfbain, Jb Leiden 63 (1971) pp 174, 178, fig 22

A 4028 Suzanna Maria Crommelin (1780-1820). Wife of Egbert Johannes Koch. *Echtgenote van Egbert Johannes Koch*

Canvas 67 × 56
PROV Bequest of Mrs S M Büchner-Berns, Deventer, 1915. Received in 1960

A 661 Jacoba Vetter (1796-1830). Wife of Pieter Meijer Warnars, Amsterdam bookseller. *Echtgenote van Pieter Meijer Warnars, boekhandelaar te Amsterdam*

Canvas 73.5 × 60
PROV Bequest of Miss G Meijer Warnars, Zutphen, 1878 * On loan to the municipality of Velsen (Beeckestijn Estate)
LIT Scheen 1946, fig 38

C 1410 Suzanna Cornelia Veeckens (1787-1871). Wife of Isaac Tra Kranen (1790-1865), Amsterdam merchant. *Echtgenote van Isaac Tra Kranen, koopman te Amsterdam*

The pendant portrait of the sitter's husband is in care of the DRVK

Canvas 67 × 56.5
PROV On loan from the DRVK since 1951

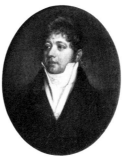

C 10 Jonkheer Hendrick Bicker (1777-1834)

Pendant to C 11

Canvas 30 × 25. Oval
PROV On loan from the city of Amsterdam (Bicker bequest), 1885-1975

C 11 Wilhelmina Jacoba van Hoorn (1776-1853). Wife of Jonkheer Hendrick Bicker. *Echtgenote van Jonkheer Hendrick Bicker*

Pendant to C 10

Canvas 30 × 25. Oval
PROV Same as C 10

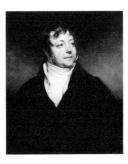

A 2267 Portrait of a man, perhaps J W Beynen. *Portret van een man, misschien J W Beynen*

Pendant to A 2268

Canvas 73 × 60
PROV Lent by J B A M Westerwoudt, Haarlem, 1907

A 2268 Portrait of a woman. *Portret van een vrouw*

Pendant to A 2267

Canvas 73 × 60
PROV Same as A 2267

copy after **Charles Howard Hodges**

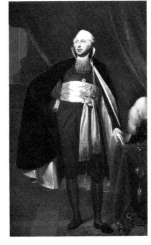

A 2971 Rutger Jan Schimmelpenninck (1761-1825). Grand pensionary of the Batavian Republic. *Raadpensionaris van de Bataafse Republiek*

Copy by Willem Stad (1873-1959) after the original in Nijenhuis Castle, Diepenheim

Canvas 220 × 140.5
PROV Presented anonymously, 1923
LIT C H E de Wit, Spiegel Hist 3 (1968) p 394, fig 1

attributed to **A van Hoef**

active mid-17th century

A 1753 Cavalry skirmish. *Ruitergevecht*

Panel 49 × 66
PROV Bequest of D Franken Dzn, Le Vésinet, 1898 * On loan to the Rijksmuseum 'Huis Lambert van Meerten,' Delft, since 1909

Gerard Hoet

Zaltbommel 1648–1733 The Hague

A 163 Willem Hadriaan van Nassau (1623-1705), lord of Odijk, with his wife and children. *Heer van Odijk, met zijn vrouw en kinderen*

His wife is Elisabeth van der Nisse (1639-98) and his children are Lodewijk (1664-1742), Cornelis (1667-1708) and Mauricia Margaretha. The deceased children Elisabeth (b 1668) and Elisabeth Wilhelmina (b 1671) are portrayed as cherubs

Copper 12 × 9.5. Oval. Signed *G. Hoet*
PROV Sale G van der Pot van Groeneveld, Rotterdam, 6 June 1808, lot 83 (as Karel de Moor, portrait of Michiel Adriaensz de Ruyter and his family)
LIT Moes & van Biema 1909, pp 169, 187. R van Luttervelt, Historia 13 (1948) p 76

A 161 The marriage of Alexander the Great and Roxane of Bactria. *Het huwelijk van Alexander de Grote met Roxane van Bactrië*

Pendant to A 162

Panel 32 × 41. Signed *G. Hoet*
PROV Purchased with the Kabinet van Heteren Gevers, The Hague-Rotterdam, 1809 * DRVK since 1959 (on loan to the Maarten van Rossum Museum, Zaltbommel)
LIT Hoet 1752, vol 2, p 455. Moes & van Biema 1909, pp 146, 160

A 162 Queen Cleophis offering wine to Alexander the Great after his conquest of Mazaka (Quintus Curtius Rufus 8.10. 34-45). *Koningin Kleophis biedt Alexander de Grote wijn aan na de verovering van Mazagae*

Pendant to A 161

Panel 32.5 × 41. Signed *G. Hoet*
PROV Same as A 161
LIT Hoet 1752, vol 2, p 455. Moes & van Biema 1909, pp 146, 160

A 159 Idyllic landscape with watchtower. *Idyllisch landschap met wachttoren*

Pendant to A 160

Panel 35.5 × 46. Signed *G. Hoet*
PROV Purchased with the Kabinet van Heteren Gevers, The Hague-Rotterdam, 1809 * DRVK since 1953
LIT Hoet 1752, vol 2, p 455. Moes & van Biema 1909, pp 146, 160

A 160 Idyllic landscape with fortress. *Idyllisch landschap met burcht*

Pendant to A 159

Panel 35.5 × 46. Signed *G. Hoet*
PROV Same as A 159 * DRVK since 1953
LIT Hoet 1752, vol 2, p 455. Moes & van Biema 1909, pp 146, 160

Willem Pieter Hoevenaar

Utrecht 1808–1863 Utrecht

C 1541 The Slijpsteenmarkt (whetstone market), Amsterdam. *De Slijpsteenmarkt te Amsterdam*

Canvas 63 × 54.5. Signed and dated *W. Hoevenaar 1835*
PROV On loan from the KOG since 1903

Georges Johannes Hoffmann

The Hague 1833–1873 The Hague

A 4202 Rough sea with sailing vessels. *Woelige zee met zeilschepen*

Panel 16.7 × 24.7. Signed and dated *G. J. Hoffmann 5*.
PROV Unknown

Samuel Hoffmann

Zürich 1592–1649 Frankfurt am Main

A 3333 Portrait of an old man. *Portret van een oude man*

Canvas 88 × 68. Dated *An° 1638*. Inscribed *Ætatis 80*
PROV Presented by Mr & Mrs DAJ Kessler-Hülsmann, Kapelle op den Bosch near Mechelen, 1940
LIT I Schlégl, Bull RM 14 (1966) p 11, fig 10

Jacob Hogers

Deventer 1614–after 1655 Deventer?

A 1498 The meeting of Jacob and Esau. *De ontmoeting tussen Jacob en Ezau*

Canvas 160 × 229. Signed and dated *JHogers 1655*
PROV Presented by AJ Enschedé, Haarlem, 1889
LIT G P Rouffaer, OH 4 (1886) p 53. A Bredius, Kunstchronik 23 (1888) p 613. G Isarlo, Renaissance, 1936, p 17, ill. BAJ Renckens, OH 70 (1955) p 60, fig 13, cat nr 8

A 804 Salome dancing for Herod. *Salome danst voor Herodes*

Canvas 176 × 133. Falsely signed and dated *F. Bol f. 16..*
PROV Sale Count Rasponi, Amsterdam, 30-31 Oct 1883, lot 13 (as Ferdinand Bol)
LIT C Hofstede de Groot, OH 22 (1904) p 31 (not Ferdinand Bol, perhaps Hendrik Heerschop). BAJ Renckens, OH 70 (1955) p 51, fig 1, cat nr 1 (attributed to Hogers, ca 1640). Bernt 1960-62, vol 4, nr 129. Bernt 1969-70, vol 2, nr 531

A 787 The idolatry of King Solomon. *De afgoderij van koning Salomo*

Canvas 124 × 197. Falsely signed and dated *L. Bramer A° 1654*
PROV Sale Amsterdam, 14-15 Nov 1883, lot 17
LIT C Hofstede de Groot, OH 19 (1901) p 135 (not Leonard Bramer); ibid 22 (1904) p 37. Wichman 1928, nr 28, pl XXVII. Martin 1935-36, vol 1, p 140 (Bramer). G Isarlo, Renaissance, 1936, ill on p 17 (Bramer). BAJ Renckens, OH 70 (1955) p 56ff, fig 8, cat nr 3 (attributed to Hogers). Van Hall 1963, p 141, nr 942:2

Hendrik Hollander Cz

Leeuwarden 1823–1884 Amsterdam

A 1489 Self portrait. *Zelfportret*

Paper 27 × 21. Signed and dated *HH. Cz. 1876*
PROV Purchased from Mrs H Hollander Cz, née Krebs, the artist's widow, Amsterdam, 1889
LIT Van Hall 1963, p 141, nr 945:1

Wenzel Hollar

see Panpoeticon Batavum: A 4582 Bonaventura Peeters, by Arnoud van Halen after Hollar; A 4595 Caspar van Kinschot, by Arnoud van Halen after Hollar

Pieter Holsteyn

see Panpoeticon Batavum: A 4578 Joannes Cool, by van Halen, after Holsteyn

Gillis Claesz d'Hondecoeter

Antwerp? ca 1580–1638 Amsterdam

A 1740 Rocky landscape with deer and goats. *Rotsachtig landschap met herten en geiten*

Panel 17.5 × 26. Signed and dated *G. DH 1620*
PROV Bequest of D Franken Dzn, Le Vésinet, 1898
LIT Bol 1969, p 130, fig 110

A 1502 The country road. *De landweg*

Panel 40.5 × 72. Signed *G. DH*
PROV Sale Fedor Zschille (Dresden), Cologne, 27-28 May 1889, lot 50 (as Gabriël de Heusch)

Gijsbert Gillisz d'Hondecoeter

Utrecht 1604–1653 Utrecht

A 751 Landscape with herdsmen. *Landschap met herders*

Canvas 92 × 116. Signed and dated *G. DHondecoeter 1652*
PROV Sale W Gruyter, Amsterdam, 24-25 Oct 1882, lot 39
LIT C Lewis, Marsyas 13 (1966-67) p 18ff, fig 4

A 1322 Waterfowl. *Watervogels*

Panel 39 × 104. Signed and dated *G. DH 1652*
PROV Sale M M Snouck van Loosen, Enkhuizen, 29 April 1886, lot 24
LIT Martin 1935-36, vol 2, p 435, fig 231. Bol 1969, p 133, note 186

Melchior d'Hondecoeter

Utrecht 1636–1695 Amsterdam

A 174 Two peacocks threatening a hen with chicks, known as 'The threatened hen.' *Een hen met kuikens bedreigd door twee pauwen, bekend als 'De bedreigde hen'*

Canvas 118 × 143. Signed and dated *M.d Hondecoeter A° 1681*
PROV Purchased with the Kabinet van Heteren Gevers, The Hague-Rotterdam, 1809
LIT Moes & van Biema 1909, pp 146, 194. Bille 1961, vol 1, p 109

A 2325 Birds in a park. *Vogels in een park*

Canvas 112 × 140. Signed and dated *MDHondecoeter A 1686*
PROV Purchased from the heirs of Jonkheer P H Six van Vromade, Amsterdam, 1908, with aid from the Rembrandt Society

A 173 The menagerie. *De menagerie*

Canvas 135 × 116.5. Signed *M. DHondecoeter*
PROV Soestdijk Palace, 1799. NM, 1808
LIT Moes & van Biema 1909, pp 18, 20, 37, 225

A 175 A pelican and other birds near a pool, known as 'The floating feather.' *Een pelikaan en ander gevogelte bij een waterbassin, bekend als 'Het drijvend veertje'*

Canvas 159 × 144. Signed *M. D. Hondecoeter*
PROV Soestdijk Palace, 1799. NM, 1808
LIT Moes & van Biema 1909, pp 18, 20, 37, 225. Martin 1935-36, vol 1, p 61, fig 36; vol 2, p 438. Plietzsch 1960, p 161, fig 286. Bol 1969, p 92

A 695 Birds on a balustrade. *Vogels op een balustrade*

Canvas 51 × 163. Signed *MD. Hondecoeter*
PROV Bequest of Jonkheer J S H van de Poll, Amsterdam, 1880

C 146 A hen with peacocks and a turkey. *Een hen met pauwen en een kalkoen*

Canvas 134 × 174.5. Signed *M. d Hondecoeter*

PROV On loan from the city of Amsterdam (A van der Hoop bequest) since 1885

C 581 A poultry yard. *Hoenderhof*

Canvas 92 × 109. Signed *MDHondecoeter*
PROV On loan from the city of Amsterdam (presented by the children of C P van Eeghen) since 1895

A 170 A hunter's bag, near a tree stump with a magpie, known as 'The contemplative magpie.' *Jachtbuit bij een ekster op een boomstronk, bekend als 'De filosoferende ekster'*

Pendant to A 171

Canvas 215 × 134. Ends in a round arch. Signed *M.D.H.*
PROV Soestdijk Palace, 1799. NM, 1808
LIT Moes & van Biema 1909, pp 18, 20, 37, 225

A 171 A hunter's bag on a terrace. *Jachtbuit bij een bordes*

Pendant to A 170

Canvas 215 × 134. Ends in a round arch
PROV Same as A 170
LIT Moes & van Biema 1909, pp 18, 20, 37, 225

A 694 A hunter's bag, with dead hare. *Jachtbuit met dode haas*

Canvas 110 × 88. Signed *M.D.Hondecoeter*
PROV Bequest of Jonkheer J S H van de Poll, Amsterdam, 1880 * DRVK since 1959 (on loan to De Cannenburgh Castle, Vaassen)
LIT V de Stuers, Ned Kunstbode 2 (1880) p 245. Chr P van Eeghen, OH 62 (1947) p 92

A 168 Dead birds. *Dode vogels*

Canvas 50 × 43. Signed *M.d.Hondecoete.*
PROV Purchased with the Kabinet van Heteren Gevers, The Hague-Rotterdam, 1809
LIT Moes & van Biema 1909, p 146

A 172 Ducks. *Eenden*

Canvas 93 × 116. Signed *M.d.Hondecoeter*
PROV Sale G van der Pot van Groeneveld, Rotterdam, 6 June 1808, lot 54 * DRVK since 1953
LIT Moes & van Biema 1909, pp 113, 181

A 169 Animals and plants. *Dieren en planten*

Canvas 66 × 52.5. Signed *M.d.Hondec…*
PROV Purchased with the Kabinet van Heteren Gevers, The Hague-Rotterdam, 1809
LIT Moes & van Biema 1909, pp 146, 192

A 2683 Poultry and ducks in a park. *Hoenders en eenden in een park*

Canvas 52 × 63.5
PROV Bequest of R Th Baron van Pallandt van Eerde, Ambt-Ommen, 1913 * DRVK since 1958

A 3312 A hunter's bag. *Jachtbuit*

Canvas 81 × 66
PROV Presented by Mr & Mrs D A J Kessler-Hülsmann, Kapelle op den Bosch near Mechelen, 1940 * DRVK since 1959 (on loan to De Cannenburgh Castle, Vaassen)
LIT Mndbl BK 13 (1926) p 22

Abraham Hondius

Rotterdam 1625–1695 London

A 1918 The annunciation to the shepherds. *De verkondiging aan de herders*

Pendant to A 1919

Panel 79 × 64. Signed and dated *Abraham Hondius A° 1663*
PROV Purchased from W A Hopman, Bussum, 1900, with aid from the Rembrandt Society
LIT A Bredius, OH 28 (1910) p 12. A Hentzen, Jb Hamb Kunstsamml 8 (1963) p 50, nr 17

A 1919 The adoration of the shepherds. *De aanbidding der herders*

Pendant to A 1918

Panel 79 × 63.5. Signed and dated *Abraham Hondius A° 1663*
PROV Same as A 1918
LIT A Bredius, OH 28 (1910) p 12. A Hentzen, Jb Hamb Kunstsamml 8 (1963) p 35, nr 18, fig 27

A 2677 The deer hunt. *De hertenjacht*

Canvas 63.5 × 76. Signed *Abraham Hondius*
PROV Bequest of R Th Baron van Pallandt van Eerde, Ambt-Ommen, 1913
LIT A Hentzen, Jb Hamb Kunstsamml 8 (1963) pp 37, 54, nr 75, fig 25

Isaac Hondius

d 1716 Rotterdam

C 1558 A calligraphic maxim, flanked by tulips. *Gecalligrafeerde spreuk geflankeerd door twee tulpen*

Panel 46.5 × 62. Signed and dated *I.Hondius pinxit 1667*. Inscribed *Kruyt, blom en lof | Verciert een hof | Des somers maer | Deugt ende eer | Verciert zijn heer | 't Geheele jaar*
PROV On loan from the KOG (presented anonymously, 1868) since 1973

attributed to **Lambert de Hondt II**

active 1679 in Brussels

A 4662 The troops of Louis XIV at Schenkenschans, 18 June 1672. *De troepen van Lodewijk XIV voor Schenkenschans, 18 juni 1672*

Pendant to A 4663

Canvas 62 × 85. Inscribed and dated *Schenken.schans 1672*
PROV Sale London, 25 Oct 1974, lot 57 (together with A 4663)

A 4663 The siege of Rijnberg by the French, 6 June 1672. *Het beleg van Rijnberg door de Fransen, 6 juni 1672*

Pendant to A 4662

Canvas 62 × 85. Inscribed and dated *Rinberg 1672*
PROV Same as A 4662

Gerard van Honthorst

Utrecht 1590–1656 Utrecht

see also Honthorst, Willem van, A 177
Willem II, replica after Gerard van
Honthorst–Honselaarsdijk series: A 519
Frederik Hendrik, copy after Honthorst;
A 520 Willem II, copy after Honthorst;
A 521 William III, copy after Honthorst –
Miniatures: Toutin, Henri, A 4371
Frederik Hendrik, after Honthorst;
Holland school ca 1635, A 4431 Frederik
Hendrik, after Honthorst; Holland
school ca 1650, A 4434 Willem II, after
Honthorst; A 4435 Willem II, after
Honthorst; Holland school ca 1675,
A 4437 Amalia van Solms, after
Honthorst

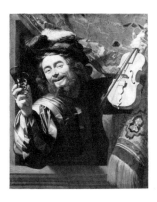

A 180 The merry fiddler. *De vrolijke
speelman*

Canvas 108 × 89. Signed and dated
GHonthorst fe. 1623
PROV Purchased from C Josi,
Amsterdam, 1824
LIT M Nissen, OH 32 (1914) p 75, ill. A
von Schneider, OH 40 (1922) p 170.
Hoogewerff 1924, p 12. Von Schneider
1933, pp 28, 134, fig 6a. Martin 1935-36,
vol 1, pp 130-31, fig 77. Gudlaugsson
1938, pp 30, 68. Isarlo 1941, p 151.
Boon 1942, p 50. B Nicolson, Burl Mag
94 (1952) p 251. Judson 1956, p 64, cat
nr 168. Nicolson 1958, p 68. Plietzsch
1960, p 129, fig 217. Rosenberg, Slive
& Ter Kuile 1966, p 28, fig 7B. Braun
1966, p 180, nr 49. Moir 1967, vol 1, p
120. Slive 1970, vol 1, p 84, fig 65. Bernt
1969-70, vol 2, nr 541

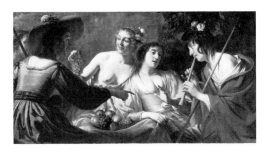

A 3270 Shepherd playing the flute, and
four nymphs. *Fluitspelende herder en vier
nimfen*

Canvas 92 × 174.5. Signed and dated
GHonthorst fe 1632

PROV Purchased from Mrs S Rodriguez-
de Jong, Brussels, 1937, as a gift of the
Rembrandt Society ∗ On loan to the
Rijksmuseum Muiderslot, Muiden, since
1949
LIT Hoogewerff 1924, p 13. Nicolson
1958, p 124, sub nr E 106. Judson 1959,
nr 144. Braun 1966, p 243, nr 96

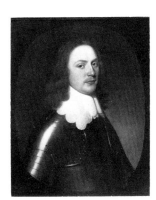

A 176 Portrait of an officer. *Portret van een
officier*

Panel 74.5 × 60. Signed and dated
GHonthorst 1644
PROV NM, 1808
LIT Moes 1897-1905, vol 2, nr 9095:19
(portrait of Prince Willem II). Moes &
van Biema 1909, pp 28, 196, 202.
Hoogewerff 1924, p 12

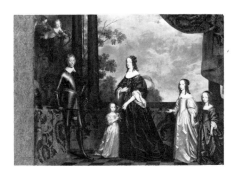

A 874 Frederik Hendrik (1584-1647),
prince of Orange, with his wife Amalia
van Solms (1602-75) and their three
youngest daughters Albertina Agnes
(1634-96), Henrietta Catharina (1637-
1708) and Maria (1642-88). *Prins van
Oranje, met zijn vrouw Amalia van Solms en
hun drie jongste dochters Albertina Agnes,
Henrietta Catharina en Maria*

Belongs with A 873 & A 871

Canvas 263.5 × 347.5
PROV Huis ten Bosch, The Hague. KKS,
1876. NMGK, 1885
LIT Moes 1897-1905, vol 1, nrs 111:3,
143:16, 2582:53; vol 2, nr 4804:3.
Hoogewerff 1924, p 12. R van Luttervelt,
OH 68 (1953) p 164, fig 3. Th H Lunsingh
Scheurleer, OH 84 (1969) p 60ff, figs
33-34 (painted in 1647; cut down,
especially on the top)

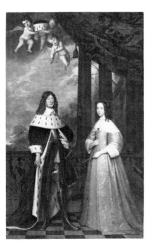

A 873 Friedrich Wilhelm (1620-88),
elector of Brandenburg, and his wife
Louisa Henrietta, countess of Nassau
(1627-67), daughter of Frederik Hendrik.
*Keurvorst van Brandenburg, met zijn vrouw
Louisa Henrietta, gravin van Nassau, dochter
van Frederik Hendrik*

Belongs with A 874 & A 871

Canvas 301 × 192. Signed and dated
GHonthorst fe. 1647
PROV Same as A 874
LIT Moes 1897-1905, vol 2, nr 4645:8.
Hoogewerff 1924, p 12. R van Luttervelt,
OH 68 (1953) p 164. Braun 1966, p 268,
nr 119. Th H Lunsingh Scheurleer, OH
84 (1969) p 60, figs 31-32

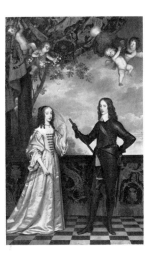

A 871 Willem II (1626-50), prince of
Orange, and his wife Henrietta Maria
Stuart (1631-60). *Prins van Oranje, en zijn
echtgenote Henriette Maria Stuart*

Belongs with A 874 & A 873

Canvas 300.5 × 193.5. Signed and dated
GHonthorst 1647
PROV Same as A 874
LIT Moes 1897-1905, vol 2, nrs 4803:27,
9095:21. Hoogewerff 1924, p 12. R van
Luttervelt, OH 68 (1953) p 164. Braun
1966, p 265, nr 118. Th H Lunsingh
Scheurleer, OH 84 (1969) p 60, figs 30, 32

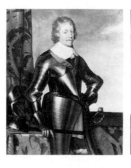

A 178 Frederik Hendrik (1584-1647), prince of Orange. *Prins van Oranje*

Pendant to A 179

Canvas 126 × 103.5. Signed and dated *GHonthorst 1650*
PROV NM, 1808
LIT Moes 1897-1905, vol 1, nr 2582:56. Moes & van Biema 1909, p 202. Hoogewerff 1924, p 12. R van Luttervelt, OH 68 (1953) p 164. Braun 1966, p 251 (copy after the version in the KKS [cat 1968, nr 104]). CW Fock, OH 84 (1969) p 19, note 61

A 179 Amalia van Solms (1602-75). Wife of Prince Frederik Hendrik. *Echtgenote van prins Frederik Hendrik*

Pendant to A 178

Canvas 126.5 × 103.5. Signed and dated *GHonthorst 1650*
PROV Same as A 178
LIT Moes 1897-1905, vol 1, nr 143:15. Moes & van Biema 1909, p 202. Hoogewerff 1924, p 12. R van Luttervelt, OH 68 (1953) p 164

A 1479 Self portrait. *Zelfportret*

Pendant to A 1480

Canvas 117 × 94.5. Dated *Feci A° 1655*. Inscribed *Æt MeÆ 67?*
PROV Purchased from Mrs Jansen, Alem, 1888
LIT Moes 1897-1905, vol 1, nr 3641:3. GJ Hoogewerff, Onze Kunst 31 (1917) p 91, fig 7. Hoogewerff 1924, p 12, ill. Martin 1935-36, vol 1, p 130. Boon 1947, p 50. Judson 1959, p 129, cat nr 204.

Van Hall 1963, p 143, nr 958:2. Braun 1966, p 231, nr 34 (not autograph). Bernt 1969-70, vol 2, nr 544. Eckardt 1971, p 190, fig 42. N Popper-Voskuil, Pantheon 31 (1973) p 65, fig 11

A 1480 Sophia Coopmans. Wife of Gerard van Honthorst. *Echtgenote van Gerard van Honthorst*

Pendant to A 1479

Canvas 117 × 94.5. Signed and dated *GH 1655*. Inscribed *Æt 54*
PROV Same as A 1479
LIT Moes 1897-1905, vol 1, nr 1694. Hoogewerff 1924, p 12

A 574 Louisa Christina (1606-69), countess of Solms-Braunfels. Second wife of Johan Wolfert van Brederode. *Gravin van Solms-Braunfels. Tweede echtgenote van Johan Wolfert van Brederode*

Panel 74 × 60
PROV NM, 1808
LIT Moes & van Biema 1909, pp 168, 205. Hoogewerff 1924, p 12

A 4171 Putti with a wreath of flowers. *Putti met een bloemenkrans*

Canvas 133 cm in diam. Ceiling painting
PROV Purchased from P Velona gallery, Florence, 1970, as a gift of the Photo Commission
LIT EKJ Reznicek, NKJ 23 (1972) pp 179-81, fig 8 (ca 1630)

studio of **Gerard van Honthorst**

A 573 Amalia van Solms (1602-75). Wife of Prince Frederik Hendrik. *Echtgenote van prins Frederik Hendrik*

Panel 74 × 60
PROV NM, 1808
LIT Hoogewerff 1924, p 12

Willem van Honthorst

Utrecht 1604 – 1666 Utrecht

A 855 Four generations of princes of Orange: Willem I, Maurits and Frederik Hendrik, Willem II and Willem III. *Vier generaties van de prinsen van Oranje*

Canvas 229 × 193
PROV Sale Schiffer van Bleiswijk, The Hague, 14 Dec 1874, lot 76. NMGK, 1885
LIT Moes 1897-1905, vol 1, nr 2582:67; vol 2, nrs 4896:122 (copy), 9094:91, 9095:33, 9096:20

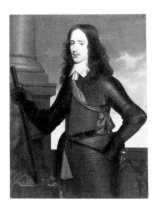

A 177 Willem II (1626-50), prince of Orange. *Prins van Oranje*

Replica of Honthorst, Gerard van, A 871

Canvas 112 × 87.5. Signed and dated *GHonthorst fe 1661*
PROV NM, 1808
LIT Moes 1897-1905, vol 2, nr 9095:32. Moes & van Biema 1909, p 202? R van Luttervelt, OH 68 (1953) p 164. Braun 1966, p 267. A W E Dek, Spiegel der Hist 3 (1968) ill on p 286

Carel (Charles) Cornelisz de Hooch

active 1627-38 in Utrecht

A 2218 Landscape with Christ on the way to Emmaus. *Landschap met de Emmausgangers*

Panel 46 × 66. Signed and dated *Chaerles D hooch 1627*
PROV Lent by the dowager of D J Zubli, née Jonkvrouwe M van den Berch van Heemstede, The Hague, 1899. Presented from her estate in 1906

Pieter de Hooch

Rotterdam 1629 – after 1683 Amsterdam

C 1191 Interior with women beside a linen chest. *Binnenhuis met vrouwen bij een linnenkast*

Canvas 72 × 77.5. Signed and dated *P.D.Hoogh 1663*
PROV On loan from the city of Amsterdam (sale Six, Amsterdam, 16 Oct 1928, lot 15; purchased through the intermediacy of the Rembrandt Society) since 1928
LIT Hofstede de Groot 1907-28, vol 1, nr 25. De Ridder 1914, pp 21, 54, 96. Collins Baker 1925, p 6. C Brière-Misme, GdB-A 69 (1927) p 72. Valentiner 1929, nr 69. Martin 1935-36, vol 2, p 198. MacLaren 1960, p 184. Rosenberg, Slive & Ter Kuile 1966, p 126, fig 103. F F Mendels, Spiegel Hist 4 (1969) p 543, fig 2

C 147 Man handing a letter to a woman in the front hall of a house. *Het aanreiken van een brief in een voorhuis*

Canvas 68 × 59. Signed and dated *P.d.Hooch f. 1670*
PROV On loan from the city of Amsterdam (A van der Hoop bequest) since 1885
LIT Hofstede de Groot 1907-28, vol 1, nr 173. De Ridder 1914, pp 23, 96. Collins Baker 1925, pp 6, 8, pl IX. C Brière-Misme, GdB-A 69 (1927) p 254. Valentiner 1929, nr 92. Martin 1935-36, vol 2, p 207. Van Thienen 1945, p 48, ill on p 58

A 182 Woman with a child in a pantry. *Een vrouw met een kind in een kelderkamer*

Canvas 65 × 60.5. Signed *P.D.H.*
PROV Sale Mrs A M Hogguer-Ebeling, Amsterdam, 18 Aug 1817, lot 19
LIT Hofstede de Groot 1907-28, vol 1, nr 1. De Ridder 1914, pp 21, 95. E Tietze-Conrat, in Meisterwerke, 1920-21. Collins Baker 1925, p 4. C Brière-Misme, GdB-A 69 (1927) p 58. Valentiner 1929, nr 50 (ca 1658). Martin 1935-36, vol 2, pp 175, 198, 200, 202, 207, fig 102. Würtenberger 1937, p 83. Van Thienen 1946, pp 32-33. Gerson 1952, p 38, fig 105. H P Baard, OK 3 (1959) nr 26, ill. Rosenberg, Slive & Ter Kuile 1966, p 125, fig 100A. J Walsh Jr, Bull Metrop Mus 31 (1973) fig 20

C 150 Three women and a man in the courtyard behind a house. *Een gezelschap op de plaats achter een huis*

Canvas 61 × 47. Signed *P.D.Hoog*
PROV On loan from the city of Amsterdam (A van der Hoop bequest) since 1885
LIT Hofstede de Groot 1907-28, vol 1, nr 286. De Ridder 1914, p 96. Collins Baker 1925, p 6 (ca 1664-65). C Brière-Misme, GdB-A 69 (1927) p 72. Valentiner 1929, nr 80 (ca 1665). Martin 1935-36, vol 2, p 207

C 149 Interior with a mother delousing her child's hair, known as 'A mother's duty.' *Binnenkamer met een moeder die het haar van haar kind reinigt, bekend als 'Moedertaak'*

Canvas 52.5 × 61. Signed *Pr. d.^e hooch*
PROV On loan from the city of Amsterdam (A van der Hoop bequest) since 1885
LIT Hofstede de Groot 1907-28, vol 1, nr 71. De Ridder 1914, p 96. Collins Baker 1925, p 4. C Brière-Misme, GdB-A 69 (1927) p 267. Van Thienen 1945, p 36. R C Hekker & W J Berghuis, Bull KNOB 12 (1959) p 81. Bille 1961, vol 1, pp 34, 76, ill; vol 2, pp 21, 100, nr 88. E van Uitert, OKtv 12 (1968) pp 6-7, ill

C 148 Interior with a mother and her baby beside the cradle, known as 'A mother's joy.' *Binnenhuis met een moeder met haar baby bij de wieg, bekend als 'Moedervreugd'*

Panel 36.5 × 42. Signed *PDHooch*
PROV On loan from the city of Amsterdam (A van der Hoop bequest), 1885-1975
LIT Hofstede de Groot 1907-28, vol 1, nr 2. De Ridder 1914, p 95. Collins Baker 1925, p 6 (ca 1663?). C Brière-Misme, GdB-A 69 (1927) p 265. Valentiner 1929, p 124 (ca 1670-75). Bille 1961, vol 1, p 121

attributed to **Pieter de Hooch**

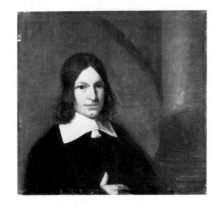

A 181 Self portrait? *Zelfportret?*

Panel 43 × 34. Fragment. Signed *P. D. H.* Inscribed *aetatis 19*
PROV Sale Amsterdam, 12 May 1834, lot 121
LIT Hofstede de Groot 1907-28, vol 1, p 569, note 3 (not de Hooch). C Brière-Misme, GdB-A 69 (1927) p 363. Valentiner 1929, p 265. Martin 1935-36, vol 2, p 207. Goldscheider 1936, p 38, fig 234. Van Thienen 1945, ill on p 3. Van Hall 1963, p 143, nr 960:1

Hoog

see Haag

Engel Hoogerheyden

Middelburg 1740 – 1809 Middelburg

A 4126 The Batavian fleet off Veere, 1800. *De Bataafse vloot voor Veere, 1800*

Panel 31 × 45. Grisaille. Signed *Fecit E. Hoogerheyde.* Inscribed *Gesigt van een gedeelte der 1ste Divisie s'Lands Cannonneerbooten op de Zeeuwsche stroomen, gecommandeert door den Capitain ter Zee Resterbooch; 't Verongelukken van de Logger de Jou Jou, en 't Over Boord vallen der Mast van een Deense Coopvaarder Brik strandende op Camperlandt. in den Storm van den 9. November 1800, te zien van Camperlandt*
PROV Purchased from A Pailloux gallery, Paris, 1966

Engel Hoogerheyden

&

Jacob Schwartzenbach

Veere 1763 – 1805 Veere

A 2405 Mustering the fleet in the harbor of Vlissingen, 1804. *Het bemannen van de vloot in de haven van Vlissingen, 1804*

Pendant to A 2406

Panel 41.5 × 52.5. Grisaille. Signed *Fecit E. Hoogerheyden & J. Schwartzenbach*
PROV Purchased from C W d'Huy, Middelburg, 1910

A 2406 The fleet leaving the harbor of Vlissingen, 1804. *De vloot verlaat de haven van Vlissingen, 1804*

Pendant to A 2405

Panel 41.5 × 53.5. Grisaille. Signed *Fecit E. Hoogerheyden & J. Schwartzenbach*
PROV Same as A 2405

Romeyn de Hooghe

Amsterdam 1645 – 1708 Haarlem

see also Panpoeticon Batavum: A 4577 Matthijs Balen Jansz, by Jan Maurits Quinkhard after de Hooghe

A 833 Allegory of coinage. *Zinnebeeldige voorstelling van het muntwezen*

Canvas 135 × 178
PROV State mint, Utrecht, 1884 *
DRVK since 1952

Dirck van Hoogstraten

Antwerp ca 1595 – 1640 Dordrecht

A 1500 Madonna and child with St Anne. *Maria met kind en de heilige Anna*

Panel 72 × 55.5. Signed and dated *D.V. Hoochstraten fecit 1630*
PROV Presented by Dr A Bredius, The Hague, 1889 * DRVK since 1959 (on loan to the Museum Amstelkring, Amsterdam)

Samuel van Hoogstraten

Dordrecht 1626 – 1678 Dordrecht

C 152 'The anemic lady.' '*De bleekzuchtige dame*'

Canvas 69.5 × 55. Signed *S.v.H.*
PROV On loan from the city of Amsterdam (A van der Hoop bequest) since 1885
LIT H Meige, Aesculape, 1928, p 64. B Bord, Aesculape, 1935, p 118. Martin 1935-36, vol 2, p 230. Gudlaugsson 1945, p 20. Plietzsch 1960, p 76, fig 120. H L Houtzager, Spiegel Hist 7 (1972) p 427, fig 7. B Dubbe, Antiek 7 (1972) p 304, fig 2

A 158 Mattheus van den Broucke (1620-85). Governor of the Indies, with the gold chain and medal presented to him by the Dutch East India Company in 1670. *Raad van Indië, getooid met de gouden keten en medaille die hem door de VOC in 1670 werden geschonken*

Canvas 142 × 111. Signed *S.v.H.*
PROV Bequest of L Dupper Wzn, Dordrecht, 1870
LIT S Kalff, Eigen Haard, 1897, pp 795-96. Moes 1897-1905, vol 1, nr 1129:1

Elisabeth Iosetta Hoopstad

Rio Demerary 1787 – 1847 Marseille

C 115 Still life. *Stilleven*

Canvas 72 × 91.5. Signed and dated *Mad^e Burgkly Glimmer née Hoopstad 1842*
PROV On loan from the city of Amsterdam (A van der Hoop bequest) since 1885

Johannes Franciscus Hoppenbrouwers

The Hague 1819 – 1866 The Hague

A 3847 View in the dunes. *Duinlandschap*

Canvas 41.5 × 55. Signed and dated *J.F. Hoppenbrouwers ft 1855*
PROV Bequest of Mrs M N Th Weddik-Lublink Weddik, widow of A L Weddik, Arnhem, 1919 * DRVK since 1949

A 3840 Winter landscape. *Winter-landschap*

Canvas 42 × 55. Signed and dated *J.F. Hoppenbrouwers ft 65*
PROV Unknown * DRVK since 1952

A 3848 'Souvenir du Rhin'

Panel 24.5 × 35. Signed *J.F. Hoppenbrouwers*. Inscribed *Souvenir du Rhin*
PROV Bequest of Mrs M N Th Weddik-Lublink Weddik, widow of A L Weddik, Arnhem, 1919 * DRVK since 1961

Jan Joseph Horemans II

Antwerp 1714–after 1790 Antwerp

A 1614 'The new song.' '*Het nieuwe lied*'

Panel 60 × 77. Signed *J. Horemans*
PROV Sale L Abels, Amsterdam, 17-18 April 1894, lot 10
LIT A P de Mirimonde, Jb Mus Antwerpen, 1967, p 241, fig 45. J de Kleyn, Antiek 7 (1973) pp 440-41, figs 6-7 (on the samovar)

A 1851 Merry company. *Vrolijk gezelschap*

Canvas 39.5 × 31.5. Signed *J. Horemans*
PROV Sale Amsterdam, 3 April 1900

Christian Hornemann

see Miniatures: Ploetz, Henrik, A 4361 Willem George Frederik

J (van) Horst

see under Dutch costume series

Johannes Petrus van Horstok

Overveen 1745–1825 Haarlem

A 643 The barroom of a village inn. *De gelagkamer van een dorpsherberg*

Canvas 63 × 79. Signed and dated *Horstok 1796*
PROV Purchased at an exhib in 1809 * DRVK since 1953

A 2204 A peasant wedding in Noord-Holland. *Noord-Hollandse boerenbruiloft*

Paper 39 × 57. Signed and dated *J. P. van Horstok inv. et fecit 1809*
PROV Bequest of Miss M E van den Brink, Velp, 1905 * On loan to the Rijksmuseum 'Nederlands Openlucht Museum,' Arnhem, since 1925

John Hoskins

see under Miniatures

Arnold Houbraken

Dordrecht 1660–1719 Amsterdam

A 2680 Romulus and Remus discovered by the herdsman Faustulus. *De herder Faustulus vindt Romulus en Remus*

Panel 61 × 50. Signed *A. Houbraken Fec.*
PROV Bequest of R Th Baron van Pallandt van Eerde, Ambt-Ommen, 1913 * DRVK since 1953

C 153 The painter and his model. *De schilder en zijn model*

Panel 28.5 × 19. Signed *AW Houbrake. pinxit*
PROV On loan from the city of Amsterdam (A van der Hoop bequest) since 1885
LIT C Hofstede de Groot, OH 17 (1899) p 168. *Cf* exhib cat Het schildersatelier in de Nederlanden, Nijmegen 1964, p 14, nr 36, fig 4. Exhib cat Maler und Modell, Baden-Baden 1969, ad nr 81, ill

Jacobus Houbraken

see Panpoeticon Batavum: A 4604 Joost van Geel, copy by Jan Maurits Quinkhard after J Houbraken

Gerrit Houckgeest

The Hague ca 1600–1661 Bergen op Zoom

A 1584 Interior of the Oude Kerk in Delft. *Interieur van de Oude Kerk te Delft*

Panel 49 × 41. Signed and dated *G H 165.*
PROV Sale Mrs M C Messchert van Vollenhoven-van Lennep, widow of J Messchert van Vollenhoven, Amsterdam, 29 March 1892, lot 4. Purchased through the intermediacy of the Rembrandt Society
LIT Jantzen 1910, pp 99, 162, nr 172, fig 47 (ca 1654). Martin 1935-36, vol 2, p 406. P Reuterswärd, Konsthist Tidskr 25 (1956) p 104, fig 10. H P Baard, in Nederl Orgelpracht, 1961, p 108, fig 13 (before 12 Oct 1654). Manke 1963, p 22, fig 14 (1654). H P Baard, OK 10 (1966) nr 54, ill. T Trent Blade, Museum Stud 6 (1971) p 41, fig 6 (1654?)

Houten

see Mesdag-van Houten

Bartholomeus Johannes van Hove

The Hague 1790–1880 The Hague

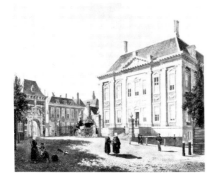

A 1369 The Mauritshuis in The Hague. *Het Mauritshuis te Den Haag*

Panel 62 × 72. Signed and dated *B. van Hove 1825*
PROV RVMM, 1877? NMGK, 1887

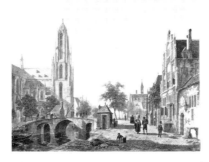

A 1049 City view. *Stadsgezicht*

Canvas 67 × 84. Signed and dated *B. van Hove 1827*
PROV RVMM, 1885 * DRVK since 1950

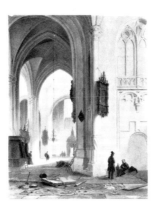

A 4661 Church interior. *Kerkinterieur*

Panel 55 × 42.5. Signed and dated *B. J. van Hove 1844*
PROV Sale Amsterdam, 10 Sept 1974, lot 231

Hubertus van Hove Bz

The Hague 1814–1864 Antwerp

A 3083 A Flemish kitchen. *Vlaamse keuken*

Canvas 61.5 × 79.5. Signed *HV Hove B Z*
PROV Bequest of J B A M Westerwoudt, Haarlem, 1907. Received in 1929 *
DRVK since 1953

Jan Hoynck van Papendrecht

Amsterdam 1858–1933 The Hague

A 2165 The Chassé division at the battle of Waterloo, 1815. *De divisie Chassé in de slag bij Waterloo, 1815*

Canvas 104 × 159. Signed *J. Hoynck van Papendrecht*
PROV Purchased at exhib Amsterdam 1905, nr 83 * DRVK since 1951

Theodoor van Hoytema

The Hague 1863–1917 The Hague

A 3017 Two Arabian vultures. *Twee monniksgieren*

Canvas 164.5 × 106
PROV Presented by the artist's widow, Mrs M van Hoytema-Hogervorst, Hilversum, 1924

Pierre Huaut I

see under Miniatures

Abrahamine Arnolda Louise (Bramine) Hubrecht

Rotterdam 1855–1913 Holinbury St Mary

see also under Pastels

A 2508 Professor Franciscus Donders (1818-89). Physiologist and opthalmologist. *Fysioloog en oogheelkundige*

Canvas 142 × 95. Signed and dated *Bramine Hubrecht fecit 1888*
PROV Presented by the artist, 1910 *
DRVK since 1953

A 2794 Alphonse Marie Antoine Joseph Grandmont (1837-1909). The artist's second husband, tutoring two Italian girls. *Tweede echtgenoot van de schilderes, les gevend aan twee Italiaanse meisjes*

Canvas 100 × 100. Signed *Bram. Grandmont-Hubrecht*
PROV Bequest of the artist, Doorn, 1916

Johan van Huchtenburg

Haarlem 1647–1733 Amsterdam

see also Netscher, Caspar, A 183 Willem III, copy by van Huchtenburg?

C 1226 Hendrik Casimir II (1657-96), prince of Nassau-Dietz. As commanding officer at a battle. *Vorst van Nassau-Dietz. Als aanvoerder bij een veldslag*

Canvas 121 × 165. Signed and dated *Hughtenburgh f. 1692*
PROV Het Loo Palace, Apeldoorn, 1818. On loan from the KKS since 1933
LIT Moes 1897-1905, vol 1, nr 3397:5

A 605 The Battle of the Boyne, Ireland, between James II and William III, 12 July 1690. *De slag aan de Boyne (Ierland) tussen Jacobus II en Willem III, 12 juli 1690*

Canvas 110 × 169. Signed *J. v. Hugtenburg F.*
PROV Purchased from P C Huybrechts gallery, The Hague, 1803. NM, 1808
LIT Moes & van Biema 1909, pp 62, 218. A J Hammerstein, Spiegel Hist 5 (1970) p 70

A 4061 The Battle of Ramillies between the French and the English, 23 May 1706. *De slag bij Ramillies tussen de Fransen en de Engelsen, 23 mei 1706*

Canvas 116 × 153
PROV Sale Amsterdam, 7 March 1961, lot 216

A 184 Cavalry attack. *Ruitergevecht*

Canvas 59.5 × 75. Signed *J. v. Huchtenburgh*
PROV Purchased in 1806. NM, 1808 *
DRVK since 1951
LIT Moes & van Biema 1909, pp 84, 222

A 2675 Casting the dice for life or death. *Het dobbelspel om het leven*

Canvas 67.5 × 76. Signed *J. v. Huchtenburgh*
PROV Bequest of R Th Baron van Pallandt van Eerde, Ambt-Ommen, 1913

Lambertus d'Hue

The Hague? 1623–1681 Amsterdam

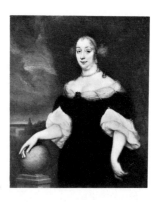

A 1256 Margaretha Munter (1639-1711). Second wife of Jacobus Trip. *Tweede echtgenote van Jacobus Trip*

For a portrait of the sitter's husband, *see* Helst, Bartholomeus van der, A 1255

Canvas 111 ×97. Signed and dated *Lambertus DHue fecit 1668*
PROV Presented by J S R van de Poll, Arnhem, 1885
LIT Moes 1897-1905, vol 2, nr 5224. A Bredius, OH 42 (1925) p 149, ill

Frans de Hulst

Haarlem ca 1600 – 1661 Haarlem

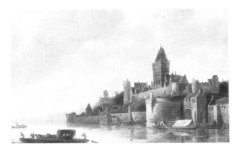

C 519 View of the Valkhof, Nijmegen. *Gezicht op het Valkhof te Nijmegen*

Panel 37 ×60. Signed *F. D. Hulst*
PROV On loan from the KOG (presented by S J Hingst) since 1889

Jean Baptist van der Hulst

Louvain 1790 – 1862 Brussels

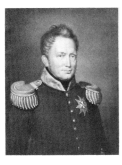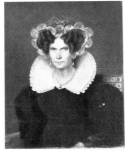

C 287 Willem I (1772-1843), king of the Netherlands. *Koning der Nederlanden*

Pendant to C 288

Canvas 75 ×62.5. Signed and dated *V. D. Hulst F. 1833*
PROV On loan from the city of Amsterdam (A van der Hoop bequest), 1885-1975

C 288 Frederica Louisa Wilhelmina of Prussia (1774-1837). Wife of King Willem I. *Echtgenote van koning Willem I*

Pendant to C 287

Canvas 76 ×62. Signed and dated *Van der Hulst 1833*
PROV Same as C 287
LIT Scheen 1946, fig 46

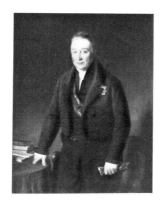

A 1495 Adam François Jules Armand (1771-1848), count van der Duyn van Maasdam. *Graaf van der Duyn van Maasdam*

Canvas 121 ×94. Signed and dated *J. B. van der Hulst fec. 1839*
PROV Bequest of F M Baron van der Duyn van Maasdam, The Hague, 1887. Received in 1889

Jan Hulswit

Amsterdam 1766 – 1822 Amsterdam

A 1051 City gate. *Stadspoort*

Panel 28 ×37. Signed and dated *J. Hulswit 1807*
PROV Purchased at exhib Amsterdam 1810, nr 62. RVMM, 1885

A 1050 Landscape in the Gooi district of Noord-Holland. *Landschap in het Gooi*

Panel 32 ×44.5. Signed and dated *IH 1807*
PROV Purchased at exhib Amsterdam 1820? RVMM, 1885

Jean Humbert

see Rotterdam East India Company series: A 4524 Adriaan du Bois

David Pierre Giottino Humbert de Superville

The Hague 1770 – 1849 Leiden

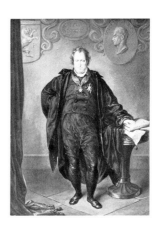

A 656 Johan Melchior Kemper (1776-1824). Jurist and statesman. *Rechtsgeleerde en staatsman*

Panel 38 ×29. Dated *Nov. MDCCCXIII*
PROV Presented from the estate of Jonkvrouwe E Kemper, 1871
LIT De Haas 1941, p 19. Knoef 1943, p 185. Scheen 1946, fig 32. J W Niemeijer, Bull RM 17 (1969) p 172, fig 1

Jan van Huysum

Amsterdam 1682–1749 Amsterdam

A 188 Still life with flowers. *Stilleven met bloemen*

Panel 81 ×61. Signed and dated *Jan Van Huysum fecit 1723*
PROV Purchased with the Kabinet van Heteren Gevers, The Hague-Rotterdam, 1809
LIT Hoet 1752, vol 2, p 455. Moes & van Biema 1909, p 147. Hofstede de Groot 1907-28, vol 10 (1928) nr 40. G Knuttel Wzn, Med DKW Gem 's Grav 2 (1926) p 20

C 154 Still life with flowers. *Stilleven met bloemen*

Canvas 80.5 ×62. Signed *Jan Van Huysum fecit.* Inscribed on the vase *Aenmerk*[t] *de lelien des velts | Salo*[mo in] *alle s*[y]*ne heer*[ly]*ck-heit ni*[et] *is bek*[leed] *gewe*[est gelijk ene van deze] (Matthew 7:28-29)
PROV On loan from the city of Amsterdam (A van der Hoop bequest), 1885-1975
LIT Hofstede de Groot 1907-28, vol 10 (1928) nr 41. J N van Wessem, OK 5 (1961) nr 21, ill. Rosenberg, Slive & Ter Kuile 1966, p 217. E de Jongh, in exhib cat Rembrandt en zijn tijd, Brussels 1971, p 153. Mitchell 1973, p 144, nr 198

C 155 Still life with flowers and fruit. *Stilleven met bloemen en vruchten*

Panel 66.5 ×52. Signed *Jan Van Huysum fecit*
PROV On loan from the city of Amsterdam (A van der Hoop bequest) since 1885
LIT Hofstede de Groot 1907-28, vol 10 (1928) nr 169

C 561 Still life with flowers and fruit. *Stilleven met bloemen en vruchten*

Panel 81 ×61. Signed *Jan Van Huysum fecit*
PROV On loan from the city of Amsterdam (bequest of Mrs M C Messchert van Vollenhoven-van Lennep, widow of J Messchert van Vollenhoven) since 1892
LIT Hofstede de Groot 1907-28, vol 10 (1928) nr 168. VTTT, 1958, nr 12. Exhib cat Boeket in Willet, Amsterdam 1970, nr 8, ill

A 187 Still life with fruit. *Stilleven met vruchten*

Copper 50.5 ×42.5. Signed *Jan Van Huysum fecit*
PROV Sale G van der Pot van Groeneveld, Rotterdam, 6 June 1808, lot 58 ∗ DRVK since 1954
LIT Moes & van Biema 1909, pp 113, 181. Hofstede de Groot 1907-28, vol 10 (1928) nr 200. Bergström 1947, p 232, fig 190. Bergström 1956, p 228, fig 190

A 185 Arcadian landscape with fishermen. *Arcadisch landschap met vissers*

Pendant to A 186

Copper 57 ×68. Signed *Jan van Huysum fecit*
PROV Purchased with the Kabinet van Heteren Gevers, The Hague-Rotterdam, 1809
LIT Moes & van Biema 1909, p 147. Hofstede de Groot 1907-28, vol 10 (1928) nr 19A. Stechow 1966, p 166, fig 338

A 186 Arcadian landscape with a sacrificial feast. *Arcadisch landschap met offerfeest*

Pendant to A 185

Copper 57 × 68. Signed *Jan V. Huysum fecit*
PROV Same as A 185
LIT Moes & van Biema 1909, p 147. Hofstede de Groot 1907-28, vol 10 (1928) nr 19B

manner of **Jan van Huysum**

A 620 Still life with flowers. *Stilleven met bloemen*

Panel 62 × 42
PROV NM, 1808 * DRVK since 1952

attributed to **Hans Hijsing**

Stockholm 1678 – 1752/53 London

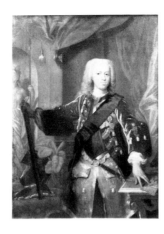

A 2377 Willem IV (1711-51), prince of Orange. *Prins van Oranje*

Canvas 76.5 × 58.5
PROV Purchased from G von Pirch, London, 1909

Wilhelmina Geertruida van Idsinga

see Kooi, Willem Bartel van der, C 1556
Jacobus Scheltema, copy by van Idsinga

Ignacio de Iriarte

Azcoita 1621 – 1685 Seville

C 1371 Landscape with hunters. *Landschap met jagers*

Canvas 109 × 82
PROV Purchased by King Willem I from Countess Bourke, Paris, 1823 (as Velasquez). On loan from the KKS since 1948
LIT Bürger 1858-60, vol 1, p 308 (Velasquez). Justi 1888, vol 2, p 150, note (not Velasquez). Kubler & Soria 1959, p 388, note 8 (attributed to de Iriarte). P van Vliet, Bull RM 14 (1966) p 134, fig 5

Isaac Isaacsz

Amsterdam 1599–after 1668 Amsterdam

A 1191 Abimelech, king of Gerar, gives Sarah back to Abraham. *Abimelech, koning van Gerar, geeft Sara aan Abraham terug*

Canvas 98 × 131. Signed and dated *Isaac Isacsen Fecit A° 1640*
PROV Presented by Dr A Bredius, The Hague, 1885
LIT Bernt 1960-62, vol 4, nr 146. Bernt 1969-70, vol 2, nr 579

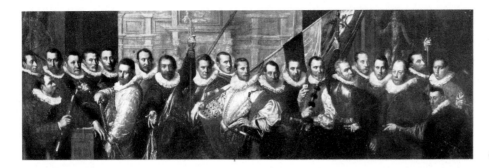

C 410

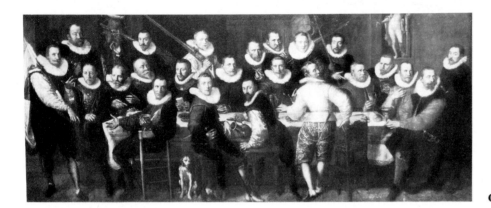

C 455

Adriaen Isenbrant

active ca 1510; d 1551 Bruges

A 4045 Madonna and child. *Maria met kind*

Panel 61 × 41.5
PROV Presented by Mr & Mrs I de
Bruijn-van der Leeuw, Muri near Bern,
1961 * On loan to the KKS (cat 1968, nr
958 [ca 1525]) since 1963
LIT Waagen 1854, vol 2, p 182 (Jan
Mostaert). Weale 1884, p 114 (Master
of the Mater Dolorosa in the Church of
Notre Dame at Bruges, ca 1515). Gower
1885, p 16 (early Netherlandish).
Friedländer 1903, p 24, nr 152. Von
Bodenhausen 1905, p 217, nr 79.
Friedländer 1924-37, vol 11 (1933) pp
83, 135, nr 173, pl LXVII. ER Meijer,
Bull RM 9 (1961) p 47, fig 10. J L
Cleveringa, Bull RM 9 (1961) p 64, nr 8

Pieter Isaacsz

Helsingør 1569–1625 Helsingør

C 410 The company of Captain Jacob
Hoynck and Lieutenant Wybrand Appel-
man, Amsterdam, 1596. *Het korporaal-
schap van kapitein Jacob Hoynck en luitenant
Wybrand Appelman, Amsterdam, 1596*

Canvas 171 × 502. Dated *1596*
PROV Kloveniersdoelen (headquarters
of the arquebusiers' civic guard),
Amsterdam. On loan from the city of
Amsterdam, 1885-1975
LIT Scheltema 1879, p 49, nr 134.
Scheltema 1855-85, vol 7 (1885) p 138.
J Six & W del Court, OH 21 (1903) p 77.
Riegl 1931, pp 124-27. De Vries 1934, p
87. Hoogewerff 1936-47, vol 4 (1941-42)
p 650

C 455 The company of Captain Gillis
Jansz Valckenier and Lieutenant Pieter
Jacobsz Bas, Amsterdam, 1599. *Het
korporaalschap van kapitein Gillis Jansz
Valckenier en luitenant Pieter Jacobsz Bas,
Amsterdam, 1599*

Canvas 218 × 526. Dated *1599*
PROV Voetboogdoelen (headquarters of
the crossbowmen's civic guard),
Amsterdam. On loan from the city of
Amsterdam since 1885
LIT Scheltema 1879, p 47, nr 129.
Scheltema 1855-85, vol 7 (1885) p 135,

nr 25. J Six & W del Court, OH 21 (1903)
p 77. Moes 1897-1905, vol 1, nr 384; vol
2, nr 8216:2. Riegl 1931, p 126, fig 36
(with caption of fig 28). De Vries 1934, p
87. Hoogewerff 1936-47, vol 4 (1941-42)
p 650. H van de Waal, OH 71 (1956) p
72, fig 6. Haak 1972, p 39, fig 47

A 1720 The rising of the women of Rome
on the Capitol on account of Papirius.
*De oploop der Romeinse vrouwen op het
Kapitool te Rome na het optreden van de kleine
Papirius*

Copper 41.5 × 62
PROV Purchased from the G de Clercq
collection, Amsterdam, 1898, through Fr
Muller & Co, art dealers
LIT Van Mander 1604, fol 205

Isaac Lazerus Israels

Amsterdam 1865–1934 The Hague

see also under Pastels *and* Aquarelles and
drawings

A 2914 Procession in the Old Catholic
Church in The Hague. *Processie in de
Oud-Katholieke kerk te Den Haag*

Depicted are the priests C H van Vlooten (1828-1903), with ciborium, J Verhey (1808-90), left, and Th van Vlooten (1821-99), right

Panel 35 × 26.5. Signed and dated *Isaac Israels 1881*
PROV Bequest of A van Wezel, Amsterdam, 1922
LIT Erens 1912, p 7ff, ill. Reisel 1967, p 59, note 46. Wagner 1967, p 11. Exhib cat 143 maal Isaac Israels, Zeist 1974, nr 3

A 3591 Two girls in the snow. *Twee meisjes in de sneeuw*

Panel 65 × 36. Signed *I. Israels*
PROV Lent by Mr & Mrs J C J Drucker-Fraser, 1919. Bequeathed in 1944
LIT Wagner 1967, p 54 (ca 1890). VTTT, 1968-69, nr 108. Exhib cat 143 maal Isaac Israels, Zeist 1974, nr 26

A 3595 Two donkeys. *Twee ezeltjes*

Board 46 × 61. Signed *Isaac Israëls*
PROV Lent by Mr & Mrs J C J Drucker-Fraser, 1919. Bequeathed in 1944 * On loan to the SMA since 1951
LIT Reisel 1967, p 54, note 30 (ca 1890-1900)

A 3594 Amsterdam household maids. *Amsterdamse dienstmeisjes*

Board 41 × 56. Signed *Isaac Israels*
PROV Lent by Mr & Mrs J C J Drucker-Fraser, 1919. Bequeathed in 1944
LIT Reisel 1967, p 22, note 36, ill on p 47 (1894). Wagner 1967, fig 61 (1895-96). J H Reisel, Spiegel Hist 2 (1967) ill 5 on p 367. Exhib cat 143 maal Isaac Israels, Zeist 1974, nr 52

A 3597 Donkey riding on the beach. *Ezeltje rijden langs het strand*

Canvas 51 × 70. Signed *Isaac Israels*
PROV Lent by Mr & Mrs J C J Drucker-Fraser, 1919. Bequeathed in 1944
LIT Reisel 1967, p 54, note 30 (ca 1898-1900). Wagner 1967, p 56 (ca 1900-01)

A 3596 Boy and girl on donkeys. *Jongen en meisje op ezeltjes*

Board 46 × 54. Signed *Isaac Israels*
PROV Lent by Mr & Mrs J C J Drucker-Fraser, 1919. Bequeathed in 1944
LIT E P Engel, Bull RM 13 (1965) p 51. Reisel 1967, ill on p 48 (1902)

A 3593 In the Bois de Boulogne near Paris. *In het Bois de Boulogne bij Parijs*

Canvas 33 × 46. Signed *Isaac Israels*
PROV Lent by Mr & Mrs J C J Drucker-Fraser, 1919. Bequeathed in 1944

A 3592 A shop window. *Etalage*

Canvas 59 × 64. Signed *Isaac Israels*
PROV Lent by Mr & Mrs J C J Drucker-Fraser, 1919. Bequeathed in 1944
LIT Reisel 1967, p 24, note 38

C 983 The lady drummer. *De trommelaarster*

Canvas 100 × 65. Signed *Isaac Israels*
PROV On loan from Th Baron Collot d'Escury, Oostvoorne, since 1910

A 2913 Portrait of a young woman. *Portret van een jonge vrouw*

Canvas 47.5 × 37. Signed *Isaac Israels*
PROV Bequest of A van Wezel, Amsterdam, 1922 * DRVK since 1961

A 2917 Portrait of a woman. *Portret van een vrouw*

Canvas 85 × 60. Signed *Isaac Israels*
PROV Bequest of A van Wezel, Amsterdam, 1922 * DRVK since 1964

A 2918 Portrait of a woman. *Portret van een vrouw*

Canvas 52 × 40. Signed *Isaac Israels*
PROV Bequest of A van Wezel, Amsterdam, 1922

A 2919 Girls smoking cigarettes. *Sigaretten rokende meisjes*

Canvas 60 × 44. Signed *Isaac Israels*
PROV Bequest of A van Wezel, Amsterdam, 1922 * DRVK since 1961

A 2920 In the theatre. *In het theater*

Panel 37.5 × 32. Signed *Isaac Israels*
PROV Bequest of A van Wezel, Amsterdam, 1922

NO PHOTOGRAPH AVAILABLE

A 2915 The Westertoren, Amsterdam, in stormy weather. *De Westertoren te Amsterdam bij stormachtig weer*

Canvas 68 × 38. Signed *Isaac Israels*
PROV Bequest of A van Wezel, Amsterdam, 1922 * Lent to the Stedelijk Museum, Zutphen, 1924. Destroyed in the war, 1945

Jozef Israels

Groningen 1824–1911 The Hague

see also under Aquarelles and drawings

A 2855 Sientje Nijkerk-Servaas at the age of 90, 1857. *Sientje Nijkerk-Servaas op 90-jarige leeftijd, 1857*

Canvas 62 × 47. Signed and dated *J. Israels 57*
PROV Bequest of M J Rosen, 1921
LIT *Cf* exhib cat Jozef Israels, Groningen-Arnhem 1961-62, nr 131

A 2382 'Children of the sea.' *'Kinderen der zee'*

Canvas 48.5 × 93.5. Signed and dated *Jozef Israels 1872*
PROV Bequest of J B A M Westerwoudt, Haarlem, 1907. Received in 1909
LIT Van Gelder 1947, p 14, ill on p 17

A 1179 'Alone in the world.' *'Alleen op de wereld'*

Canvas 90 × 39. Signed *Jozef Israels*. Painted in 1878
PROV Purchased at the Paris world's fair, 1878. RVMM, 1885
LIT Marius 1920, p 121. Plasschaert 1924, p 18. Van Gelder 1947, p 36, ill on p 31 (1878). Reisel 1967, p 13

A 2616 'The little seamstress.' '*Het naaistertje*'

Canvas 75 × 61. Signed *Jozef Israels*.
Painted before 1888
PROV Lent by Mr & Mrs J C J Drucker-
Fraser, London, 1911. Presented in 1912
LIT M Eisler, Elsevier's GM 46 (1913) p
241, ill on p 242

A 2597 'The joy of motherhood.'
'*Moederweelde*'

Canvas 106 × 129. Signed *Jozef Israels*.
Painted in 1890
PROV Lent by Mr & Mrs J C J Drucker-
Fraser, London, 1911. Presented in 1912
LIT M Eisler, Elsevier's GM 46 (1913) p
244, ill on p 245

A 2600 'The mother.' '*De moeder*'

Canvas 130 × 100. Signed *Jozef Israels*.
Painted ca 1890

PROV Lent by Mr & Mrs J C J Drucker-
Fraser, London, 1911. Presented in 1912
LIT M Eisler, Elsevier's GM 46 (1913) p
245, ill on p 247

C 570 Louis Jacques Veltman (1817-
1907). Actor. *Toneelspeler*

Canvas 82 × 62. Signed *Jozef Israels*.
Painted in 1893
PROV On loan from the city of
Amsterdam, 1893-1975
LIT Van Gelder 1947, p 51, ill on p 54
(ca 1892-93). VTTT, 1958, nr 7. Exhib
cat Jozef Israels, Groningen-Arnhem
1961-62, nr 26. Reisel 1967, p 14 (1893)

A 2601 'On country roads and fields.'
'*Langs velden en wegen*'

Canvas 128 × 185. Signed *Jozef Israels*.
Painted in 1893
PROV Lent by Mr & Mrs J C J Drucker-
Fraser, London, 1911. Presented in 1912
LIT M Eisler, Elsevier's GM 46 (1913) p
246, ill on p 43. Van Gelder 1947, p 44,
ill on p 43 (ca 1892). Exhib cat Jozef
Israels, Groningen-Arnhem 1961-62,
nr 23. E P Engel, Bull RM 13 (1965) p 47.
De Gruyter 1968-69, vol 1, p 50, fig 66

A 3599 'Meditation.' '*Overpeinzing*'

Canvas 50 × 61. Signed *Jozef Israels*.
Painted in 1896
PROV Lent by Mr & Mrs J C J Drucker-
Fraser, 1919. Bequeathed in 1944
LIT Exhib cat Jozef Israels, Groningen-
Arnhem 1961-62, nr 28. De Gruyter
1968-69, vol 1, fig 56 (1896)

A 2607 'Neighborly gossip.' '*Buurpraatje*'

Canvas 40 × 62.5. Signed *Jozef Israels*.
Painted in 1897
PROV Lent by Mr & Mrs J C J Drucker-
Fraser, London, 1911. Presented in 1912
LIT M Eisler, Elsevier's GM 46 (1913) p
250

A 2615 Study of a model. *Modelstudie*

Panel 61 × 46. Signed *Jozef Israels*.
Painted in or before 1899
PROV Lent by Mr & Mrs J C J Drucker-
Fraser, London, 1911. Presented in 1912
LIT M Eisler, Elsevier's GM 46 (1913) p
251

**A 3730, A 3731, A 4180, A 4198 &
A 3732** Five studies for a painting of
Saul and David. *Vijf studies voor een
schilderij van Saul en David*

The painting, made in 1899, is now in
the SMA (inv nr 2249)

A 3730 Saul

For a preparatory drawing, *see*
Aquarelles and drawings: Israels, Jozef,
A 3729

Canvas 57.5 × 77.5. Signed *Jozef Israels*
PROV Lent by Mr & Mrs J C J Drucker-
Fraser, 1919. Bequeathed in 1944

A 3731 David

Canvas 58.5 × 39.5. Signed *Jozef Israels*
PROV Same as A 3730

A 4180 David's legs. *De benen van David*

Canvas 47 × 34. Signed *Jozef Israels*
PROV Same as A 3730

A 4198 Saul's legs. *De benen van Saul*

Canvas 50 × 65. Signed *Jozef Israels*
PROV Same as A 3730

A 3732 Woman sitting. *Zittende vrouw*

Canvas 58.5 × 39.5. Signed *Jozef Israels*
PROV Same as A 3730

A 3313 Woman at a window. *Vrouw aan
een raam*

Panel 36.5 × 28.5. Signed *Jozef Israels*
PROV Presented by Mr & Mrs D A J
Kessler-Hülsmann, Kapelle op den
Bosch near Mechelen, 1940

A 2602 Adam and Eve. *Adam en Eva*

Canvas 84 × 116. Signed *Jozef Israels*.
Painted in 1903
PROV Lent by Mr & Mrs J C J Drucker-
Fraser, 1911. Presented in 1912
LIT M Eisler, Elsevier's GM 46 (1913) p
250, ill on p 249

A 2598 Jewish wedding. Thought to be
the wedding of the artist's daughter
Mathilde and G D Cohen Tervaert,
1903. *Joodse bruiloft. Vermoedelijk het
huwelijk van de dochter van de schilder,
Mathilde, met G D Cohen Tervaert, 1903*

Canvas 137 × 148. Signed *Jozef Israels*.
Painted in 1903

PROV Lent by Mr & Mrs J C J Drucker-Fraser, London, 1911. Presented in 1912
LIT M Eisler, Elsevier's GM 46 (1913) p 248, ill. M Eisler, in Meisterwerke, 1920-21. Van Gelder 1947, p 49, ill on p 47. Exhib cat Jozef Israels, Groningen-Arnhem 1961-62, nr 31. Reisel 1967, p 108, ill on p 12, note 4. Gans 1971, p 685, ill

A 2599 A scene of life in Laren. *Larens tafereel*

Canvas 132 × 103. Signed *Jozef Israels*. Painted in 1905
PROV Lent by Mr & Mrs J C J Drucker-Fraser, London, 1911. Presented in 1912
LIT M Eisler, Elsevier's GM 46 (1913) p 250. Exhib cat Jozef Israels, Groningen-Arnhem 1961-62, nr 32. De Gruyter 1968-69, vol 1, p 50, fig 64

A 2496 'Gazing into the distance.' *'Blik in de verte'*

Canvas 121 × 86. Signed *Jozef Israels*. Painted in 1907
PROV Lent by Mr & Mrs J C J Drucker-Fraser, London, 1909. Presented in 1909
* DRVK since 1959
LIT M Eisler, Elsevier's GM 46 (1913) p 243, ill

A 2605 'Old Isaac.' *'De oude Isaac'*

Canvas 56 × 37.5. Signed *Jozef Israels*
PROV Lent by Mr & Mrs J C J Drucker-Fraser, London, 1911. Presented in 1912
LIT M Eisler, Elsevier's GM 46 (1913) p 251. Gans 1971, p 407, ill

A 2606 'Melancholy.' *'Melancholie'*

Canvas 57 × 45.5. Signed *Jozef Israels*
PROV Lent by Mr & Mrs J C J Drucker-Fraser, London, 1911. Presented in 1912
LIT M Eisler, Elsevier's GM 46 (1913) p 251

A 2603 'After dark.' *'Het late uur'*

Canvas 92 × 168. Signed *Jozef Israels*
PROV Lent by Mr & Mrs J C J Drucker-Fraser, London, 1911. Presented in 1912
* DRVK since 1958
LIT M Eisler, Elsevier's GM 46 (1913) p 250, ill on p 251

A 2604 A boy and a girl in the dunes. *Een jongen en een meisje op een duintop*

Canvas 68 × 95. Signed *Jozef Israels*
PROV Lent by Mr & Mrs J C J Drucker-Fraser, London, 1911. Presented in 1912
* DRVK since 1953
LIT M Eisler, Elsevier's GM 46 (1913) p 242

A 3598 Country boy on a pole barrier. *Boerenjongen op een slagboom*

Panel 28 × 37. Signed *J. I.*
PROV Lent by Mr & Mrs J C J Drucker-Fraser, 1919. Bequeathed in 1944

A 2921 Interior of a peasant hut. *Boereninterieur*

Canvas 60 × 72. Signed *Jozef Israels*
PROV Bequest of A van Wezel, Amsterdam, 1922

A 2923 'Turning homewards.' '*Huis-waartskeren*'

Canvas 45 × 58. Signed *Jozef Israels*
PROV Bequest of A van Wezel,
Amsterdam, 1922
LIT Gerson 1960, p 30, fig 68

NO PHOTOGRAPH AVAILABLE

A 2922 Head of a woman, nearly full
face, turned slightly left. *Kop van een
vrouw, bijna recht van voren gezien, een weinig
naar links gewend*

Panel 35 × 29. Signed *Jozef Israels*
PROV Bequest of A van Wezel,
Amsterdam, 1922 * Lent to the Stedelijk
Museum, Zutphen, 1924. Destroyed in
the war, 1945

J Jackson II

see under Miniatures

Jurriaen Jacobson

Hamburg 1624–1685 Leeuwarden

A 2696 Michiel de Ruyter and his
family. *Michiel de Ruyter en zijn familie*

Sitting on the left are Michiel Adriaensz
de Ruyter (1607-76), vice admiral of
Holland at the time of the portrait, his
third wife Anna van Gelder (1614-87)
and her son by a previous marriage Jan
Pauwelsz van Gelder (1647-73). The
three children from de Ruyter's second
marriage are shown standing – Cornelia
(1639-1720) on the far right, with her
husband Jan de Witte (d 1683), Alida
(1642-79) in the middle and Engel
(1649-83) on the left, with a falcon. The
couple's two little daughters – on the
left Margaretha (1652-88) and on the
right Anna (1655-66) – are playing with
their cousin Cornelis de Witte (1660-
1701)

Canvas 269 × 406. Signed and dated
J. Jacobson fec. 1662
PROV Purchased from Jonkheer HA
Elias, Arnhem, 1911-12, through the
intermediacy of the Rembrandt Society
LIT Engelberts (ed) 1794, vol 1, preface
(Jan Baptist Weenix). Moes 1897-1905,
vol 2, nr 6661:30 (Weenix). BWF van
Riemsdijk, Jaarversl Ver Rembrandt,
1911, p 8. JFL de Balbian Verster,
Eigen Haard, 1912, pp 408-11. S Muller
Fzn, Bull NOB 2d ser 5 (1912) pp 137-40.
K Freise, Cicerone 4 (1912) p 657.
Martin 1935-36, vol 2, p 154. Der
Kinderen-Besier 1950, p 204. BJA
Renckens, OH 66 (1951) p 184. R van
Luttervelt, Bull RM 5 (1957) p 59, ill.
IH van Eeghen, Mndbl Amstelodamum
44 (1957) p 40, ill. JHKruisinga, Ons
Amsterdam 9 (1957) ill on p 107

Dirck Jacobsz

Amsterdam? 1496–1567 Amsterdam

C 402 A group of guardsmen, 1529. *Een
groep schutters, 1529*

Panel in three parts, 122 × 184 (middle
panel); 120 × 78 (each of the side panels).
Signed and dated *DI* (between the
initials is the painter's mark) *ANO DNI
1529*. The side panels were added later
by the artist
PROV Kloveniersdoelen (headquarters
of the arquebusiers' civic guard),
Amsterdam. On loan from the city of
Amsterdam since 1885
LIT Scheltema 1879, nr 117
(anonymous). Scheltema 1855-85, vol 7
(1885) p 139. J Six, OH 13 (1895) p 106.
GJHoogewerff, OH 32 (1914) pp 84-85,
ill. Roh 1921, p 7, fig 1. Winkler 1924,
pp 285, 388. Riegl 1931, pp 40-50, 84,
figs 7, 15 (side panels ca 1550).
Friedländer 1924-37, vol 13 (1936) pp
133, 177, nr 408, fig 78. De Vries 1934, p
41. Hoogewerff 1936-47, vol 3 (1939) p
536, figs 289-90; vol 5 (1947) pp 79, 97.
BHaak, Bull RM 6 (1958) p 33, ill. Van
Hall 1963, p 154, nr 1026:1. Judson
1970, p 24, note 6, p 42, note 5, fig 77.
Haak 1972, p 15, fig 1

C 377 Twelve guardsmen from Squad E of the arquebusiers' civic guard, Amsterdam, 1563. *Twaalf Amsterdamse schutters behorende tot Rot E van de Kloveniersdoelen, 1563*

Panel 92.5 × 179. Signed and dated *D I* (between the initials is the painter's mark) *1563*. Inscribed *E* and *Vreede Eendratigheidt Behaecht Gods Maiesteid*
PROV Kloveniersdoelen (headquarters of the arquebusiers' civic guard), Amsterdam. On loan from the city of Amsterdam, 1885-1975
LIT Scheltema 1879, p 21, nr 49. J Six, OH 13 (1895) pp 93, 107. Riegl 1931, pp 85-93, fig 17. De Vries 1934, p 44. Friedländer 1924-37, vol 13 (1936) pp 139, 177, nr 411, pl LXXIX. Judson 1970, p 30, note 3

A 3924 Pompeius Occo (1483-1537). Banker, merchant and humanist. *Bankier, koopman en humanist*

Panel 66 × 54. Thought to have been painted in 1531
PROV Purchased from Rosenberg & Stiebel gallery, New York, 1957, with funds from the bequest of Jonkheer J Loudon, Wassenaar
LIT Ring 1913, pp 94, 96. Steinbart 1922, p 96. J Six, OH 42 (1925) p 11. J F M Sterck, OH 43 (1926) p 251. J F M Sterck, Het Gildeboek, 1925, p 98, fig 1. Friedländer 1926, vol 1, nr 30, ill. J F M Sterck, OH 51 (1934) p 41, ill. De Vries 1934, p 42. Friedländer 1924-37, vol 13 (1936) pp 135, 177, nr 414, pl LXXXI. Hoogewerff 1936-47, vol 3 (1939) p 530, fig 287. B Haak, Bull RM 6 (1958) p 27 (1531). F J Dubiez, Ons Amsterdam 10 (1958) pp 159, 162. Bergström 1959, pp 104-06, fig 52. B Haak, Antiek 1 (1967) p 23, fig 1. D G Carasso, Ons Amsterdam 24 (1972) p 43, ill. Nübel 1972, pp 243-44, frontispiece

manner of **Dirck Jacobsz**

C 621 Sixteen guardsmen from Squad B of the arquebusiers' civic guard, Amsterdam, 1556. *Zestien Amsterdamse schutters behorende tot Rot B van de Kloveniersdoelen, 1556*

Panel 125 × 184. Dated *A DNI 1556*. Inscribed *B*
PROV Kloveniersdoelen (headquarters of the arquebusiers' civic guard), Amsterdam. On loan from the city of Amsterdam, 1885-1975
LIT Scheltema 1879, p 12, nr 30. Scheltema 1855-85, vol 7 (1885) p 138, nr 23. Riegl 1931, p 83. De Vries 1934, p 46 (studio of Dirck Barendsz). Hoogewerff 1936-47, vol 3 (1939) p 550 (Allaert Claesz?). P Philippot, Bull Mus Roy Belg 6 (1957) p 115 (Master of the Antwerp Family Portrait)

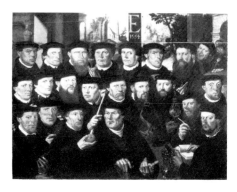

C 1178 Twenty-one guardsmen from Squad E of the crossbowmen's civic guard (the St George guard), Amsterdam, 1554. *Eenentwintig Amsterdamse schutters behorende tot Rot E van de Voetboog- (St Joris) doelen, 1554*

Panel 131.5 × 175.5. Dated *1554*. Inscribed *E*
PROV Voetboogdoelen (headquarters of the crossbowmen's civic guard), Amsterdam. On loan from the city of Amsterdam, 1926-75
LIT Scheltema 1879, p 20, nr 47. Scheltema 1855-85, vol 7 (1885) p 133, nr 14. Brugmans 1930, vol 1, p 296 (on the fool). Riegl 1931, pp 71-78, fig 13. Hoogewerff 1936-47, vol 3 (1939) p 548. P Philippot, Bull Mus Roy Belg 6 (1957) p 115 (Master of the Antwerp Family Portrait)

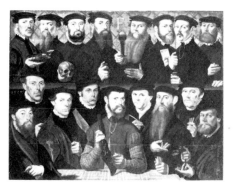

C 424 Seventeen guardsmen from Squad F of the arquebusiers' civic guard, Amsterdam, 1557. *Zeventien Amsterdamse schutters behorende tot Rot F van de Kloveniersdoelen, 1557*

Panel 133 × 169.5. Dated *1557*. Inscribed *F* and on the letter *Domio Cornelis van Dellef in Amsterdam*
PROV Kloveniersdoelen (headquarters of the arquebusiers' civic guard), Amsterdam. On loan from the city of Amsterdam, 1885-1975
LIT Scheltema 1855-85, vol 7 (1885) p 137, nr 16. Riegl 1931, pp 85-90, 99-101, fig 14 (anonymous, possibly Cornelis Anthonisz). De Vries 1934, p 46 (studio of Dirck Barendsz). P Philippot, Bull Mus Roy Belg 6 (1957) p 115 (Master of the Antwerp Family Portrait). Judson 1970, p 42 (unknown master). Chr Tümpel, N Beitr Rembrandt Forsch, 1973, p 171, figs 130-31

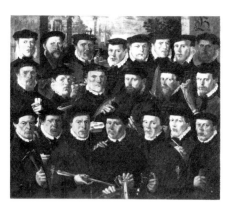

C 376 Twenty-one guardsmen from Squad B of the crossbowmen's civic guard (the St George guard), Amsterdam, 1559. *Eenentwintig Amsterdamse schutters behorende tot Rot B van de Voetboog- (St Joris) doelen, 1559*

Panel 142 × 169. Dated *A° 1559*. Inscribed *B* and *Sijse also*
PROV Voetboogdoelen (headquarters of the crossbowmen's civic guard), Amsterdam. On loan from the city of Amsterdam, 1885-1975
LIT Van Dijk 1790, p 14, nr 8. Scheltema 1879, p 21, nr 48. Scheltema 1855-85, vol 7 (1885) p 133, nr 15. De Vries 1934, p 46 (studio of Dirck Barendsz). Hoogewerff 1936-47, vol 3 (1939) p 550,

fig 298 (Allaert Claesz?). P Philippot, Bull Mus Roy Belg 6 (1957) p 115, fig 7 (Master of the Antwerp Family Portrait)

Lambert Jacobsz

Amsterdam ca 1598–1636 Leeuwarden

A 2814 The old prophet meets the man of God. *De oude profeet ontmoet de man Gods*

Canvas 82.5 × 111. Signed and dated *Lambert Jacobs fecit A° 1629*
PROV Sale Amsterdam, 28 May 1918, lot 149 * DRVK since 1971 (on loan to the Rembrandthuis, Amsterdam)
LIT J Six, OH 37 (1919) p 82. Bauch 1926, p 70, nr 4, ill. J Q van Regteren Altena, OH 42 (1925) p 142. HF Wijnman, OH 47 (1930) p 145ff. Bernt 1960-62, vol 2, nr 418. Bernt 1969-70, vol 2, nr 582

Diederik Franciscus Jamin

Amsterdam 1838–1865 Amsterdam

A 2286 Prayer for the deceased. *Het gebed voor de overledene*

Canvas 100 × 139.5. Signed and dated *D.F. Jamin 1864*
PROV Lent by J B A M Westerwoudt, Haarlem, 1888. Bequeathed in 1907
LIT Scheen 1946, fig 112

A 2269 The mourning widow. *De treurende weduwe*

Canvas 45 × 36.5. Signed *D.F. Jamin*
PROV Bequest of J B A M Westerwoudt, Haarlem, 1907

F Jansen

active ca 1635-40 in Amsterdam?

A 1842 A guardhouse. *Een kortegaard*

Panel 34 × 48.5. Signed *F. Iansen*
PROV Purchased from F Kleinberger gallery, Paris, 1899

Frederik Johannes Jansen

The Hague 1856–1928 Voorburg

A 1534 A summer afternoon. *Zomer-namiddag*

Canvas 34.5 × 53. Signed *Frits Jansen*
PROV Koninklijke Bibliotheek, The Hague, 1890

Hendrik Willebrord Jansen

Nijmegen 1855–1908 Zeist

A 2400 An Amsterdam wharf on a rainy day. *Een Amsterdamse werf op een regendag*

Canvas 123 × 180. Signed *H.W. Jansen*
PROV Presented by the artist's widow, Mrs S J W Jansen-Grothe, Zeist, 1909 *
DRVK since 1952

Johannes Janson

Ambon 1729–1784 Leiden

A 189 Heemstede Manor. *Het Huis te Heemstede*

Canvas 69 × 88.5. Signed and dated *J. Janson f. 1766*
PROV Purchased in 1803. NM, 1808
LIT Moes & van Biema 1909, pp 64, 219. C J de Bruyn Kops, Bull RM 22 (1974) p 22, fig 7

Johannes Christiaan Janson

Leiden 1763–1823 The Hague

C 156 A woman slicing bread. *Een vrouw die brood snijdt*

Panel 48 × 38.5. Signed *J.Chr.Jans..*
PROV On loan from the city of Amsterdam (A van der Hoop bequest) since 1885

A 1052 'Good neighbors.' '*Goede buren*'

Panel 62 × 47. Signed *J.C.Janson*
PROV RVMM, 1885
LIT Scheen 1946, fig 61

Janson van Ceulen

see Jonson van Ceulen

Louis Aimé Japy

Berne, France 1840–1916 Paris

A 1879 Landscape with watermill. *Landschap met watermolen*

Canvas 52.5 × 74. Signed and dated *Japy 74*
PROV Presented by the dowager of R Baron van Lynden, née M C Baroness van Pallandt, The Hague, 1900 * DRVK since 1953

du Jardin

see Dujardin

Johannes Jelgerhuis Rzn

Leeuwarden 1770–1836 Amsterdam

A 2504 The Rapenburg, Leiden, three days after the explosion of a powder ship on 12 January 1807. *Het Rapenburg te Leiden drie dagen na de ontploffing van het kruitschip op 12 januari 1807*

Canvas 86 × 114. Signed and dated *I. Jelgerhuis Rz. Acteur aan den Schouwburg te Amsterdam fecit. 15 Januari 1807.* Inscribed *Het Raepenburg te Leyden*
PROV Purchased from S F Smith & Co gallery, London, 1910
LIT Knoef 1943, p 151. Exhib cat Johannes Jelgerhuis, Nijmegen-Leiden-Amsterdam 1969-70, nr 5. I W L Moerman, Jb Leiden, 1970, pp 121-24

A 1055 The outer moat of Amsterdam, with the Leidse Poort, seen from the town theatre. *De Amsterdamse buitensingel bij de Leidse poort, gezien vanuit de Schouwburg*

Panel 36.5 × 45. Signed and dated *J. Jelgerhuis Rz. A 1813*
PROV Purchased at exhib Amsterdam 1814, nr 69. RVMM, 1885
LIT A E d'Ailly, Jb Amstelodamum 35 (1938) p 240, nr 36. H C de Bruijn, Op den Uitkijk 21 (1960) pp 474-75, ill on p 472. C J de Bruyn Kops, Bull RM 13 (1965) p 69. Exhib cat Johannes Jelgerhuis, Nijmegen-Leiden-Amsterdam 1969-70, p 27, ill on p 21, nr 6

A 2713 The distillery of apothecary A d'Ailly in the ramparts of the Zaag-molenpoort, Amsterdam. *Interieur van het 'Stoockhuys' van apotheker A d'Ailly bij het bolwerk aan de Zaagmolenpoort te Amsterdam*

Pendant to A 2714

Canvas 42 × 52. Signed and dated *J. Jelgerhuis Rz. 1818*
PROV Lent by the board of the Geschiedkundig Medisch-Pharmaceutisch Museum, Amsterdam, 1903. Presented by A J Rijk, Amsterdam, 1914 * On loan to the Rijksmuseum voor de Geschiedenis der Natuur-wetenschappen, Leiden, since 1960
LIT Marius 1920, p 64, fig 30. A E d'Ailly, Jb Amstelodamum 35 (1938) p 240. M J Schretlen, Mndbl BK 19 (1942) p 8. D F Lunsingh Scheurleer, Bull KNOB 8 (1955) cols 124-25. Wittop Koning 1966, pp 42-43. Exhib cat Johannes Jelgerhuis, Nijmegen-Leiden-Amsterdam 1969-70, p 26, ill on p 26 (detail), nr 9

A 2714 The distillery of apothecary A d'Ailly. *Interieur van het 'Stoockhuys' van apotheker A d'Ailly*

Pendant to A 2713

Canvas 42 × 52. Signed and dated
J. Jelgerhuis Rz. 1818
PROV Same as A 2713
LIT A E d'Ailly, Jb Amstelodamum 35
(1938) p 240. M J Schretlen, Mndbl BK
19 (1942) p 8. D F Lunsingh Scheurleer,
Bull KNOB 8 (1955) cols 124-25.
Wittop Koning 1966, pp 42-43, fig 24.
Exhib cat Johannes Jelgerhuis,
Nijmegen-Leiden-Amsterdam 1969-70,
p 26, ill on p 25 (detail), nr 8

A 662 The bookshop of Pieter Meijer
Warnars (1792-1869) on the Vijgen-
dam, Amsterdam. *De winkel van boek-
handelaar Pieter Meijer Warnars op de
Vijgendam te Amsterdam*

Canvas 48 × 58. Signed and dated
I. Jelgerhuis Rz. 1820
PROV Bequest of Miss G Meijer Warnars,
Zutphen, 1878
LIT J W Enschedé, Amsterdamsch
Jaarboekje, 1901, p 123, ill. Marius
1920, p 64, fig 30. W Steenhoff, Mndbl
BK 5 (1928) p 37, ill. A E d'Ailly, Jb
Amstelodamum 35 (1938) p 240.
Huebner 1942, fig 15. M J Schretlen,
Mndbl BK 19 (1942) p 8. Knuttel 1946,
p 400. H E van Gelder, in Kunstgesch
der Ned, 1954-56, vol 2, ill on p 366.
F J Dubiez, Ons Amsterdam 9 (1957) p
200, ill on p 194. VTTT, 1960, nr 25.
Gerson 1961, p 14, fig 29. E R Meijer,
OK 7 (1963) nr 6, ill. Exhib cat 150 jaar
Nederlandse kunst, Amsterdam 1963,
nr 16, fig 16. E R M Taverne, Antiek 4
(1969) p 66, fig 1. Exhib cat Johannes
Jelgerhuis, Nijmegen-Leiden-
Amsterdam 1969-70, p 26, ill on p 24, nr
10

A 1053 The small fish market on the
corner of the Brouwersgracht and
Singel, Amsterdam. *De kleine vismarkt op
de hoek van de Brouwersgracht en het Singel te
Amsterdam*

Canvas 41 × 51. Signed and dated
Jelgerhuis Rz. 1826
PROV Purchased at exhib Amsterdam
1828, nr 212. RVMM, 1885 * On loan to
the AHM since 1926
LIT A E d'Ailly, Jb Amstelodamum 35
(1938) p 240, nr 39. Hammacher 1946,
p 111, fig 2. Knoef 1948, p 50. H C de
Bruijn, Op den Uitkijk 21 (1960) pp
474-75. Exhib cat Johannes Jelgerhuis,
Nijmegen-Leiden-Amsterdam 1969-70,
nr 19. Ons Amsterdam 23 (1971) ill on
p 229

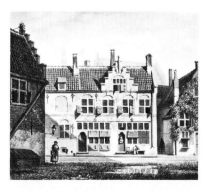

A 1054 A street in Amersfoort. *Een straat
in Amersfoort*

Canvas 33 × 37. Signed and dated
Jelgerhuis Rz. 1826
PROV Purchased at exhib Amsterdam
1826, nr 180. RVMM, 1885
LIT A E d'Ailly, Jb Amstelodamum 35
(1938) p 240, nr 43. Huebner 1942, fig
35. Exhib cat Johannes Jelgerhuis,
Nijmegen-Leiden-Amsterdam 1969-70,
p 19, nr 18

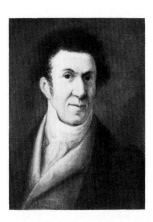

A 2389 Frits A Rosenveldt (1769-1847).
Actor and soldier. *Toneelspeler en militair*

Canvas 49 × 38. Signed and dated
J. Jelgerhuis Rz. 1827
PROV Presented by Mr & Mrs A

Lonsain-Rosenveldt, on behalf of the
Rosenveldt family, 1909 * DRVK since
1953
LIT S Duparc, Jb Amstelodamum 34
(1937) p 203. C te Lintum, in 't Herstelde
Nederland, 1913, p 306. Exhib cat
Johannes Jelgerhuis, Nijmegen-Leiden-
Amsterdam 1969-70, nr 23

Eugène Jettel

Moravia 1845–1901 Trieste

NO PHOTOGRAPH AVAILABLE

A 1880 River landscape. *Rivierlandschap*

The broad bend of a river begins on the
right and turns into the picture space,
flowing through meadowland. In the
background are trees in full bloom. In
the foreground are a boat moored on the
river bank; a bather; and some cows in
the meadow

Panel 45 × 77. Signed and dated *Eugène
Jettel 1870*
PROV Presented by the dowager of R
Baron van Lynden, née M C Baroness
van Pallandt, The Hague, 1900 * Lent
to the Gouvernementsgebouw
(provincial capitol of Gelderland),
Arnhem, 1924. Destroyed in the war,
1944

Sir Augustus Edwin John

Tenby 1879–1961 Fordingbride

A 3018 Man with a pipe. *Man met pijp*

Canvas 73 × 59.5
PROV Presented by F Stoop, London,
1924

Henry Jean Baptiste Jolly

Antwerp 1812–1853 The Hague

A 3472 The love letter. *De minnebrief*

Canvas 55 × 50. Signed and dated
H. J. B. Jolly 1844
PROV Bequest of Mrs J G Gohl-
Behrender, Amsterdam, 1945 * DRVK
since 1961

Jurjen de Jong

Harlingen 1807–1890 Harlingen

A 4257 J D B Wilkens. Lieutenant colonel
in the infantry. *Luitenant-kolonel van de
infanterie*

Canvas 66 × 56. Signed and dated
J. de Jong pinxit 1837
PROV Presented by C J W Wilkens,
Amsterdam, 1898. NMGK * DRVK since
1959 (on loan to the Nederlands Leger-
museum, Leiden)

Claude de Jongh

Utrecht ca 1605–1663 Utrecht

A 2842 Landscape. *Landschap*

Panel 43.5 × 69. Signed and dated
C. D. de Jongh 1633
PROV Presented by B Baron Ungern-
Sternberg, 1920, in grateful recollection
of the hospitality he enjoyed in the
Netherlands

Ludolph de Jongh

Rotterdam 1616–1679 Hillegersberg

A 196 Jan van Nes (1631-80). Vice
admiral of Holland and West-Friesland.
Vice-admiraal van Holland en West-Friesland

Pendant to A 197

Canvas 111.5 × 88.5. Signed and dated
L. D. Jongh A° 1666
PROV Purchased from F Munnikhuizen,
Rotterdam, 1800. NM, 1808
LIT P Haverkorn van Rijsewijk, OH 14
(1896) p 44. Moes 1897-1905, vol 2, nr
5346. Moes & van Biema 1909, pp 34,
37, 175, 207. E Wiersum, OH 51 (1934)
pp 231-36, fig 3. C J Hudig, Historia 9
(1943) p 173, fig 10

A 197 Aletta van Ravensberg (1635-77).
Wife of Jan van Nes. *Echtgenote van Jan
van Nes*

Pendant to A 196

Canvas 111.5 × 88.5. Signed and dated
L. D. Jongh f 1668
PROV Same as A 196
LIT P Haverkorn van Rijsewijk, OH 14
(1896) p 44. Moes 1897-1905, vol 2, nr
6192:2. Moes & van Biema 1909, pp
34, 37, 175, 207. E Wiersum, OH 51
(1934) pp 231-36, fig 4

A 1858 The fox hunt. *De vossejacht*

Canvas 51 × 71. Signed *L. D. Jongh*
PROV Purchased from F Smal, Paris,
1900
LIT C Hofstede de Groot, OH 22 (1904)
p 115. Bol 1969, pp 237, 253, fig 230

attributed to **Ludolph de Jongh**

C 190 Interior with couple and two
children. *Interieur met een echtpaar en twee
kinderen*

Canvas 72.5 × 63.5. Traces of a signature
PROV On loan from the city of
Amsterdam (A van der Hoop bequest),
1885-1975
LIT Bredius 1887-88, pp 165-66, ill
(discovery of a partly wiped out
signature and date 1673). P Haverkorn
van Rijsewijk, OH 14 (1896) pp 43-46

Jan Baptiste de Jonghe

Courtrai 1785–1844 Antwerp

A 1056 Market day in Courtrai. *Markt-dag in Kortrijk*

Panel 40 ×32.5. Signed and dated
J. B. de Jonghe 1828
PROV Purchased at exhib Amsterdam
1828, nr 219. RVMM, 1885 * DRVK since
1961

Johan Barthold Jongkind

Lattrop 1819–1891 La-Côte-Saint-André

see also under Aquarelles and drawings

A 2300 Windmills near Rotterdam. *Molens bij Rotterdam*

Canvas 42.5 ×55. Signed and dated
Jongkind 1857
PROV Lent by J BAM Westerwoudt,
Haarlem, 1902. Bequeathed in 1907
LIT Hennus 1945, ill on p 15

A 2924 Overschie in the moonlight. *Overschie bij maneschijn*

Canvas 22 ×27.5. Signed and dated
Jongkind 1871
PROV Bequest of A van Wezel,
Amsterdam, 1922

A 3317 Houses on a waterway near Crooswijk. *Huizen aan een vaart bij Crooswijk*

Canvas 25 ×32.5. Signed and dated
Jongkind 1874. Inscribed on the
stretcher *Krooswijk à Rotterdam, Hollande*
PROV Presented by Mr & Mrs DAJ
Kessler-Hülsmann, Kapelle op den
Bosch near Mechelen, 1940
LIT Hennus 1945, ill on p 49

A 2270 Rotterdam in the moonlight. *Rotterdam bij maneschijn*

Canvas 34 ×46. Signed and dated
Jongkind 1881
PROV Bequest of J BAM Westerwoudt,
Haarlem, 1907 * On loan to the SMA
since 1950

Cornelis Jonson van Ceulen I

London 1593–1661/62 Utrecht or
Amsterdam

C 1179 Jan Cornelisz Geelvinck (1579-
1651). Burgomaster of Amsterdam,
merchant and shipowner. *Burgemeester
van Amsterdam, koopman en reder*

Canvas 85 ×71.5. Signed and dated
*Cor^ns Jonson London^us fecit. Anno Dom
1646.* Inscribed *Aet suae 67*
PROV On loan from the city of
Amsterdam since 1926
LIT Moes 1897-1905, vol 1, nr 2639

A 1928 Joan Pietersz Reael (1625-59)

Canvas 98 × 78. Signed and dated *Cor^s
Jonson Londini fecit 1648*
PROV Purchased from CG 't Hooft,
Amsterdam, 1900

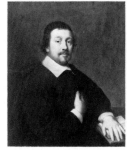 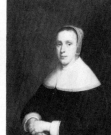

A 3857 Johan van Someren (1622-76).
Grand pensionary of Nijmegen. *Raad-
pensionaris van Nijmegen*

Pendant to A 3858

Canvas 85.5 × 73. Signed and dated
C. J. v. Ceulen fecit. 1650
PROV Presented by MC van Houten,
Doorn, 1933. Received in 1953

A 3858 Elisabeth Vervoorn (1617-73).
Wife of Johan van Someren. *Echtgenote
van Johan van Someren*

Pendant to A 3857

Canvas 85.5 × 73
PROV Same as A 3857

Cornelis Jonson van Ceulen II

London? after 1622–after 1698 Utrecht

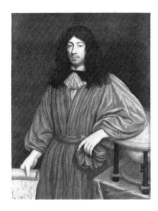

A 921 Jan Boudaen Courten (1635-1716), lord of St Laurens, Schellach and Popkensburg. Councillor of Middelburg and director of the Dutch East India Company. *Heer van St Laurens, Schellach en Popkensburg. Raad van Middelburg en bewindhebber der V OC*

For another portrait of the sitter, *see* Netscher, Caspar, A 901 – *see also* Heraldic objects: A 941

Canvas 116 × 94. Signed and dated *Cornelius Janson van Ceulen filius fecit 1668* PROV Bequest of Jonkheer J de Witte van Citters, The Hague, 1876. NMGK, 1885 * DRVK since 1950 LIT Moes 1897-1905, vol 1, nr 974:3

Jan Lodewijk Jonxis

Utrecht 1789–1867 Utrecht

A 4092 The toilet. *Het toilet*

Panel 56.5 × 45.5. Signed *J.L. Jonxis* PROV Presented by F Lugt, Paris, 1963

Jacob Jordaens

Antwerp 1593–1678 Antwerp

A 601 Marsyas ill-treated by the muses. *Marsyas door de muzen mishandeld*

Canvas 77 × 120 PROV Purchased with the Kabinet van Heteren Gevers, The Hague-Rotterdam, 1809 * On loan to the KKS since 1948 LIT Rooses 1906, p 155. Moes & van Biema 1909, pp 147, 161. Van Puyvelde 1953, p 198. D'Hulst 1956, pp 150, 201, 249, 355, fig 91. R A d'Hulst, Bull Mus Roy Belg 10 (1961) pp 34-36, fig 4. R A d'Hulst, Gent Bijdr 19 (1961-66) p 93, fig 9 (ca 1635). AP de Mirimonde, Jb Mus Antwerpen, 1969, p 212

C 439 The miracle of the obol in the mouth of the fish (Matt 17:27). *Het wonder van de stater in de bek van de vis*

Canvas 119 × 197.5. Signed *J. Jord. fc* PROV Thought to be from the Nieuwe Zijds Huiszittenhuis (institute for the outdoor relief of the poor), Amsterdam. On loan from the city of Amsterdam since 1885 LIT Rooses 1906, p 106. J Held, Revue belge d'Arch & d'Hist de l'Art 3 (1933) p 221. Knipping 1939-40, vol 1, p 259. K Madsen, Kunstmus Årsskrift, 1963, p 20, ill. Bernt 1960-62, vol 2, nr 433. Bernt 1969-70, vol 2, nr 600

A 198 A satyr. *Een satyr*

Canvas 135 × 176 PROV Sale S J Stinstra, Amsterdam, 22 May 1822, lot 94 LIT Rooses 1906, p 181. D'Hulst 1956, pp 144, 321. Bernt 1960-62, vol 2, nr 434. AP de Mirimonde, Jb Mus Antwerpen, 1969, p 213, fig 10. Bernt 1969-70, vol 2, nr 599

A 2367 Justice. *De gerechtigheid*

Canvas 176 × 242.5. Signed and dated *J. Jor. fec. et Inve 1663.* Inscribed *Deut. i v. 16 Verhoort Uwe Broederen Ghy Rechters en Rechtet Recht Tegens Eenen IJ* [gelyken] *En* [Synen] *Broeder En Den Vremdelinck. Lev 19* [v. 15] *Ghy En Sult Niet Onrecht Handelen Aen Den* [Gerichte] *Ende En Sult Niet Voor* [trekken] *Den Geringen Nog Den Groot* [en] [Ee]*ren* PROV Prison on the Prinsegracht, The Hague, 1908 * Lent to the courthouse, The Hague, 1937. Destroyed in the war, 1945 LIT Rooses 1906, p 211. D'Hulst 1956, pp 272, 299, 400

Pieter de Josselin de Jong

St Oedenrode 1861 – 1906 Amsterdam

see also Governors-general series: A 3809
Frederik s'Jacob – *see also under* Pastels

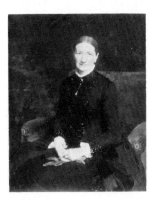

A 2785 Mrs A J Zubli-Maschhaupt

Canvas 108 × 84. Signed and dated
P. Josselin de Jong 1887
PROV Presented by J R H Neervoort van
de Poll, Rijsenburg, 1916

Auguste Jouve

Lyon 1846 – after 1877

A 1881 Still life with flowers. *Stilleven met
bloemen*

Canvas 116 × 64. Signed *A. Jouve*
PROV Presented by the dowager of R
Baron van Lynden, née M C Baroness
van Pallandt, The Hague, 1900 * DRVK
since 1952

Adriaen van der Kabel

Rijswijk 1630/31 – 1705 Lyon

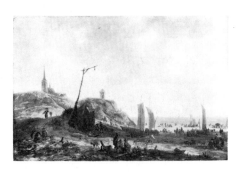

A 3318 The beach at Katwijk. *Strand te
Katwijk*

Panel 47 × 73.5. Signed *A. V. K.*
PROV Presented by Mr & Mrs D A J
Kessler-Hülsmann, Kapelle op den
Bosch near Mechelen, 1940
LIT Bol 1973, p 162

Jan Anthonie Kaldenbach

Zutphen 1760 – 1818 Zutphen

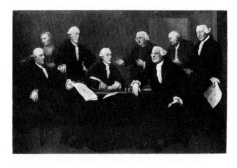

C 587 The regents of the old folk's home,
Amsterdam. *De regenten van het Oude
Mannen en Vrouwen Gasthuis te Amsterdam*

The regents depicted are Danker Jan de
Kempenaer, Arnoldus van Rijneveld,
George de Visscher and Jan Beeld-
snijder

Canvas 200 × 307.5. Signed and dated
J. A. Kaldenbach F 1781
PROV On loan from the city of
Amsterdam, 1896-1975
LIT Scheen 1946, fig 6

Willem Kalf

Rotterdam 1619 – 1693 Amsterdam

A 199 Still life with silver jug. *Stilleven
met zilveren schenkkan*

Canvas 71.5 × 62
PROV Sale Amsterdam, 29 Oct 1821, lot
96
LIT I Blok, Onze Kunst 35 (1919) p 93.
Roh 1921, fig 113. Warner 1928, fig 56a.
Vorenkamp 1933, p 51. Van Gelder
1941, p 55, note 2. Van Luttervelt 1947,
pp 50, 56, fig 27. Bergström 1947, p 279,
fig 229. Gerson 1952, p 60, fig 180.
Bergström 1956, p 278, fig 229. Duyvené
de Wit-Klinkhamer & Gans 1958, p 22,
fig 19. L J Bol, OK 6 (1962) nr 21, ill. M
Poch-Kalous, Albertina Stud 4 (1966)
p 27. E G Grimme, Aachener Kunstbl 35
(1968) p 19. Grisebach 1974, pp 124-25,
156, nr 80, fig 89

Harm Hendrick Kamerlingh Onnes

b Zoeterwoude 1893

A 3268 Frederik Schmidt-Degener
(1881-1941). Director-general of the
Rijksmuseum, Amsterdam (1922-41).
*Hoofddirecteur van het Rijksmuseum te
Amsterdam*

Canvas 96.5 × 83.5. Signed and dated
H. H. K. O. 1936
PROV Commissioned by the State
advisory committee for commissions to
artists, 1936

Menso Kamerlingh Onnes

Brussels 1860 – 1925 Oegstgeest

A 2896 Yellow roses in a carafe. *Gele rozen in een karaf*

Canvas 46 × 34. Signed and dated
M. Kamerlingh-Onnes '96
PROV Bequest of A van Wezel,
Amsterdam, 1922

Godaert Kamper

Düsseldorf 1613/14 – 1679 Leiden

A 837 Portrait of a woman. *Portret van een vrouw*

Panel 89 × 69. Signed and dated
G Kamper fe An° 1656. Inscribed *Aet 60*
PROV Presented by Dr A Bredius, The
Hague, 1884
LIT A Bredius, OH 40 (1922) p 5, ill.
Bernt 1960-62, vol 4, nr 149. Bernt
1969-70, vol 2, nr 611

Jan Kamphuijsen

Amsterdam 1760 – 1841 Amsterdam

A 4140 & A 4141 Ceiling painting with
scenes from the life of Hercules. *Plafond-schildering met Hercules-taferelen*

A 4140 The apotheosis of Hercules. *De
apotheose van Hercules*

Central scene. Oval

A 4141 Hercules fighting the bull;
Hercules fighting the Hydra. *Hercules
vechtend met de stier; Hercules vechtend met de
Hydra.* The main motifs of ornamental
corners and framing elements

From the salon of J A Brentano's
house on the Herengracht, Amsterdam.
Belongs with A 4142-A 4150. *Cf* Lelie,
Adriaan de, A 4122 The art gallery of J A
Brentano

Canvas, overall dimensions 630 × 735.
According to a partially legible
inscription on one of the corners – …
Maderna … 1791 [or *1790*] – probably
made after a design by Giambattista
Maderni (1758-1803)
PROV Purchased from A Nijstad gallery,
Lochem, 1967

A 4142-A 4150

A 4142-A 4150 Nine months of the year, with the appropriate zodiacal signs. *Negen maanden met de tekens van de dierenriem*

Grotesque decorations in plain or profiled frames from between the windows in the salon of J A Brentano's house on the Herengracht, Amsterdam. The months March, April and August are missing. Belongs with A 4140 & A 4141. *Cf* Lelie, Adriaan de, A 4122 The art gallery of J A Brentano. Thought to have been made after a design by Giambattista Maderni (1758-1803) PROV Same as A 4140 & A 4141

A 4142 January with the sign of Aquarius. *Januari met het teken van de waterman*

Panel and frame 333.5 × 33.5. Inscribed *Januarius*

A 4143 February with the sign of Pisces. *Februari met het teken van de vissen*

Panel and frame 330.5 × 29. Inscribed *Februarius*

A 4144 May with the sign of Gemini. *Mei met het teken van de Tweelingen*

Panel 285.5 × 23. Inscribed *Maius*

A 4145 June with the sign of Cancer. *Juni met het teken van de Kreeft*

Panel 285.5 × 23. Inscribed *Junius*

A 4146 July with the sign of Leo. *Juli met het teken van de Leeuw*

Panel 285.5 × 25.5. Inscribed *Julius*

A 4147 September with the sign of Libra. *September met het teken van de Weegschaal*

Panel and frame 329.5 × 28.5. Inscribed *September*

A 4148 October with the sign of Scorpio. *October met het teken van de Schorpioen*

Panel and frame 332 × 28. Inscribed *October.* Signed and dated *J. B. Maderna inv*^t *1791 J. Kamphuysen Pinx*^t

A 4149 November with the sign of Sagittarius. *November met het teken van de Boogschutter*

Panel and frame 332 × 28. Inscribed *November*

A 4150 December with the sign of Capricorn. *December met het teken van de Steenbok*

Panel and frame 333.5 × 28.5. Inscribed *December*

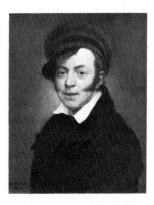

A 1632 Self portrait. *Zelfportret*

Canvas 66 × 55. Signed and dated *J. Kamphuisen P*^t *1825* PROV Purchased from J J Höpfer, Amsterdam, 1895 LIT Van Hall 1963, p 162, nr 1084:1

Johann Eduard Karsen

Amsterdam 1860 – 1941 Amsterdam

A 2581 The Spui, Amsterdam. *Het Spui te Amsterdam*

Canvas 40 × 54. Signed *Ed Karsen* PROV Presented from the estate of C Hoogendijk, The Hague, 1912 * DRVK since 1968 LIT Hammacher 1947, fig 28

A 2898 The Vinkenbuurt near Amsterdam. *De Vinkenbuurt bij Amsterdam*

Canvas 34 × 45. Signed *Ed Karsen* PROV Bequest of A van Wezel, Amsterdam, 1922 LIT Hammacher 1947, nr 29

A 2901 Enkhuizen

Canvas 37 × 45. Signed *Ed Karsen* PROV Bequest of A van Wezel, Amsterdam, 1922 LIT Marius 1920, fig 126. Hammacher 1947, fig 13

A 2905 Backstreet. *Achterbuurtje*

Canvas 35.5 × 25.5. Signed *Ed Karsen* PROV Bequest of A van Wezel, Amsterdam, 1922 * DRVK since 1961

A 2903 Farmstead. *Boerenhofstede*

Canvas 52 × 71. Signed *Ed Karsen*
PROV Bequest of A van Wezel,
Amsterdam, 1922

A 2582 Houses in a village. *Dorpshuisjes*

Canvas 34 × 44. Signed *Ed Karsen*
PROV Presented from the estate of C
Hoogendijk, The Hague, 1912
LIT Hammacher 1947, fig 27 (before
1900)

A 2897 View in a village. *Dorpsgezicht*

Canvas 36 × 45. Signed *Ed. Karsen*
PROV Bequest of A van Wezel,
Amsterdam, 1922
LIT Hammacher 1947, fig 26 (before
1900)

NO PHOTOGRAPH AVAILABLE

A 2904 Farm on a ditch at night.
Boerderij aan een sloot bij avond

Canvas 27 × 35.5. Signed *Ed. Karsen*
PROV Bequest of A van Wezel,
Amsterdam, 1922 * Lent to the Stedelijk
Museum, Zutphen, 1924. Destroyed in
the war, 1945

A 2902 Overcast day. *Grijze dag*

Canvas 34 × 45. Signed *Ed Karsen*
PROV Bequest of A van Wezel,
Amsterdam, 1922

A 2906 In the Harz Mountains. *In het
Harzgebergte*

Canvas 33.5 × 44. Signed *Ed. Karsen*
PROV Bequest of A van Wezel,
Amsterdam, 1922 * DRVK since 1959

A 2899 The Zuider Zee. *Zuiderzee*

Panel 19.5 × 30. Signed *Ed Karsen*
PROV Bequest of A van Wezel,
Amsterdam, 1922

A 2900 Watercourse with sail barges.
Vaart met zeilende scheepjes

Canvas 45 × 32. Signed *Ed. Karsen*
PROV Bequest of A van Wezel,
Amsterdam, 1922

Kaspar Karsen

Amsterdam 1810 – 1896 Bieberich

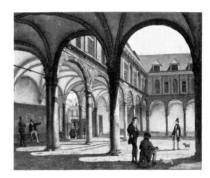

C 159 The inner court of the old stock
exchange, Amsterdam. *De binnenplaats
van de oude Beurs te Amsterdam*

Canvas 87 × 109. Signed and dated
K. Karsen 1836
PROV On loan from the city of
Amsterdam (A van der Hoop bequest),
1885-1975
LIT J Knoef, Jb Amstelodamum 42
(1948) p 21. CJ de Bruyn Kops, OK 8
(1964) nr 27, ill. VTTT, 1966-67, nr 84

A 2233 View of a town on a river. *Gezicht in een stad aan een rivier*

Panel 40.5 × 50.5. Signed and dated *K. Karsen 1846*
PROV Presented by H Th Karsen, Amsterdam, 1906

A 3243 View in a town. *Stadsgezicht*

Canvas 81 × 106.5. Signed *K. Karsen*
PROV Presented by J E Karsen, Amsterdam, 1935
LIT Scheen 1946, fig 211. Exhib cat 150 jaar Nederlandse kunst, Amsterdam 1963, nr 18, fig 28

A 3129 Imaginary view on the Rhine. *Rijn-fantasie*

Panel 37 × 48.5. Signed *K. Karsen*
PROV Presented by J E Karsen, Amsterdam, 1932

Herman Frederik Carel ten Kate

The Hague 1822 – 1891 The Hague

A 1057 Soldiers in a guardroom. *Wacht-kamer met soldaten*

Panel 64 × 92. Signed *Herman ten Kate ft*
PROV Purchased at exhib Amsterdam 1867, nr 103. RVMM, 1885 * DRVK since 1950

Johan Hendrik Keller

Zürich? ca 1698 – 1765 The Hague

A 1215 Five children making music. *Vijf musicerende kinderen*

Canvas 206 × 105. Signed and dated *JHKeller 1753*
PROV KKS, 1885 * DRVK since 1953

NO PHOTOGRAPH AVAILABLE

A 1232 Venus at Vulcan's forge. *Venus in de smidse van Vulcanus*

Canvas 235 × 200. Signed and dated *J. Keller 1753*
PROV KKS, 1885 * Lent to the states of Zeeland, Middelburg, 1912. Destroyed in the war, 1940

NO PHOTOGRAPH AVAILABLE

A 1237 Aeneas saving his father Anchises. *Aeneas redt zijn vader Anchises*

Canvas 246 × 84. Signed and dated *J. Keller 1753*

PROV KKS, 1885 * Lent to the states of Zeeland, Middelburg, 1912. Destroyed in the war, 1940

Jan van Kessel

Antwerp 1626 – 1679 Antwerp

A 793 Insects and fruit. *Insecten en vruchten*

Copper 11 × 15.5. Signed *I. V. Kessel F*
PROV Sale Amsterdam, 13 Nov 1882, lot 55
LIT Hairs 1955, p 225. Greindl 1956, p 176

Jan van Kessel

Amsterdam 1641/42 – 1680 Amsterdam

A 200 View in the woods. *Bosgezicht*

Canvas 58 × 73.5. Signed *J. van Kessel*
PROV Bequest of L Dupper Wzn, Dordrecht, 1870
LIT C Hofstede de Groot, OH 17 (1899) p 169

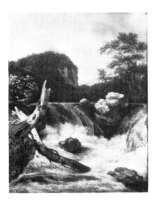

A 696 A waterfall. *Een waterval*

Canvas 94 × 74.5. Signed *J. v. Kessel*
PROV Bequest of Jonkheer J S H van de
Poll, Amsterdam, 1880
LIT V de Stuers, Ned Kunstbode 2
(1880) p 244. Chr P van Eeghen, OH 62
(1947) p 92

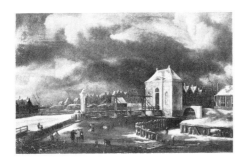

A 2506 The Heiligewegspoort,
Amsterdam, in the winter. *De Heilige-*
wegspoort te Amsterdam in de winter

Canvas 77 × 122. Signed *JVKessel*
PROV Purchased from J Goudstikker
gallery, Amsterdam, 1910
LIT J H Kruizinga, Ons Amsterdam 9
(1957) ill on p 260

Franz Kessler

see under Miniatures

Cornelis Ketel

Gouda 1548–1616 Amsterdam

A 4046 Portrait of a man. On the verso a
putto blowing bubbles. *Portret van een*
man. Op de keerzijde een bellenblazende putto

Panel 43 cm in diam. Round. Recto
signed and dated *CK An° D.NI 1574*.
Inscribed *Ætatis SuÆ 35* and (on the
frame) *Sermo Dei Æternus C Ætera*
Omnia Caduca. Verso signed *CK Inv. et pin.*
Inscribed ΠΟΜΦΟΓΥΞ Ο ΑΝΘΡΩΠΟΣ
PROV Presented by Mr & Mrs I de
Bruijn-van der Leeuw, Muri near Bern,
1961
LIT W Stechow, Zeitschr B K 63 (1929)
p 202, ill. O Götz, Städ Jb 7-8 (1932)
p 122, note 10, p 146, fig 102. De Vries
1934, p 55. W Stechow, Art Bull 20
(1938) p 227. Hoogewerff 1936-47, vol
4 (1941-42) p 641. E R Meijer, Bull R M 9
(1961) p 47, figs 8-9. J L Cleveringa, Bull
R M 9 (1961) p 64, nr 9. De Jongh 1967, p
82, fig 68. B Haak, Antiek 1 (1967) p 30,
figs 7-8

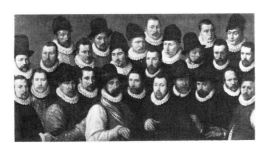

C 425 The company of Captain Dirck
Jacobsz Rosecrans and Lieutenant
Ruysch, Amsterdam, 1584. *Het korporaal-*
schap van kapitein Dirck Jacobsz Rosecrans
en luitenant Ruysch, Amsterdam, 1584

Panel 124 × 237. Dated *Anno Domini 1584*
PROV Kloveniersdoelen (headquarters
of the arquebusiers' civic guard),
Amsterdam. On loan from the city of
Amsterdam, 1885-1975
LIT Scheltema 1855-85, vol 7 (1885)
p 136, nr 12. Moes 1897-1905, vol 2, nrs
6541:1, 6648. Riegl 1931, p 110

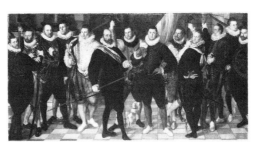

C 378 The company of Captain Dirck
Jacobsz Rosecrans and Lieutenant
Pauw, Amsterdam, 1588. *Het korporaal-*
schap van kapitein Dirck Jacobsz Rosecrans
en luitenant Pauw, Amsterdam, 1588

Canvas 208 × 410. Traces of a signature.
Dated *.588*

PROV Voetboogdoelen (headquarters
of the crossbowmen's civic guard),
Amsterdam. On loan from the city of
Amsterdam since 1885
LIT Van Mander 1604, fol 275. Van
Dijk 1790, p 22, nr 15. Scheltema 1879,
p 22, nr 53. Scheltema 1855-85, vol 7
(1885) p 134, nr 24. Moes 1897-1905,
vol 2, nrs 5815, 6541:2. Ring 1913, p 82.
F Schmidt-Degener, Onze Kunst 29-30
(1916) p 83. Winkler 1924, p 361. F
Schmidt-Degener, Zeitschr B K 59 (1925-
26) p 175. Riegl 1931, pp 111, 122, fig
23. De Vries 1934, pp 56-57. Martin
1935-36, vol 1, pp 43, 155, 158, 164, 211,
fig 23. Van Dillen 1941, p XXVIII.
Hoogewerff 1936-47, vol 4 (1941-42) pp
645-46, fig 311. P T A Swillens, Mndbl
B K 23 (1947) p 282, fig 25. Gerson 1950,
p 57, fig 154. E de Jongh, OK 7 (1963) nr
1, ill

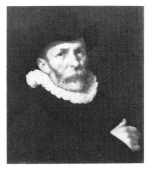

A 3462 Dirck Barendsz (1534-92).
Painter. *Schilder*

Canvas 53 × 47. Signed and dated *C. K.*
F. 1590. Inscribed *Ætatis 55* and
Swygende hoop ick
PROV Purchased from A J Rehorst,
Berkenwoude, 1943 * Lent to the A H M,
1975
LIT De Vries 1934, pp 54, 58-59, fig 13.
Hoogewerff 1936-47, vol 4 (1941-42)
pp 646-47, fig 312. Van Hall 1963, p 14,
nr 86:3. Judson 1970, p 32, fig 80

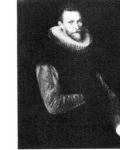

A 3121 Jacob Cornelisz Banjaert, called
van Neck (1564-1638). Admiral, burgo-
master and councillor of Amsterdam.
Admiraal, burgemeester en raad van
Amsterdam

Pendant to A 3122

Canvas 102 × 82. Signed and dated
C.K.f. An 1605. Inscribed *Aetatis 40*
PROV Lent by the dowager of P Gevers
van Marquette, née Deutz van Lennep,
Heemskerk, 1925. Bought in 1931
LIT Moes 1897-1905, vol 2, nr 5317. W
Stechow, Zeitschr BK ns 63 (1929) p 205,
fig 206. De Vries 1934, pp 60-61.
Hoogewerff 1936-47, vol 4 (1941-42) p
648. Boon 1942, p 24

A 3122 Griete Jacobsdr van Rhijn
(1585-1652). Wife of Jacob Cornelisz
Banjaert, called van Neck. *Echtgenote van
Jacob Cornelisz Banjaert, genaamd van Neck*

Pendant to A 3121

Canvas 102 × 82. Signed and dated *C.K.
f. An 1605.* Inscribed *Aetatis 20*
PROV Same as A 3121
LIT Moes 1897-1905, vol 2, nr 6690. W
Stechow, Zeitschr BK ns 63 (1929) p 205.
De Vries 1934, pp 60-61. Hoogewerff
1936-47, vol 5 (1941-42) p 648. Boon
1942, p 24, fig 7

A 244 Paulus van Vianen (1550-1613).
Goldsmith. *Goudsmid*

Canvas 56 × 50
PROV Sale M C van Hall, Amsterdam,
27 April 1858, lot 67 (as portrait of J
Lutma) * DRVK since 1959 (on loan to
the Centraal Museum, Utrecht)
LIT Moes 1897-1905, vol 2, nr 8475.
De Vries 1934, p 60. Hoogewerff 1936-
47, vol 5 (1947) p 173, nr 17. Van Hall
1963, p 350, nr 2210:2

Gerardus Laurentius Keultjes

Utrecht 1786–after 1818

A 644 St Peter. *De heilige Petrus*

Canvas 65 × 53. Signed and dated
G. L. Keultjes f 1806
PROV Unknown

A 1376 The attack of the combined
Anglo-Dutch squadron on Algiers, 1816.
*De aanval van het verenigd Engels-
Nederlands eskader op Algiers, 1816*

Canvas 61 × 86. Signed and dated
G. L. Keultjes 1817
PROV KKS, 1848. RVMM, 1885. NMGK
1887

Hendrik Keun

Haarlem 1738–1787 Haarlem

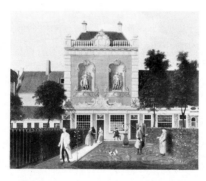

A 3831 The garden and coachhouse of
Keizersgracht 524, Amsterdam, when it
was the residence of Nicolaes Doekscheer
(d 1789) and Elisabeth Groen (d 1782).
*De stadstuin en het koetshuis behorende bij
het perceel Keizersgracht 524, Amsterdam,
destijds bewoond door Nicolaes Doekscheer en
Elisabeth Groen*

Panel 53 × 63.5. Signed and dated
Hᵉ Keun 1772
PROV Purchased from E M Jaarsma,
Amsterdam, 1951, as a gift of the Photo
Commission
LIT D'Ailly 1949, p 304. VTTT, 1964-65,
nr 65. I H van Eeghen, Mndbl
Amstelodamum 58 (1971) p 44. I H
van Eeghen, Bull RM 19 (1971) p 173-82,
ill

A 2247 View of the Herengracht near the
Leidsestraat, Amsterdam. *Gezicht op de
Herengracht bij de Leidsestraat te Amsterdam*

Panel 54 × 72.5. Signed and dated
H. Keun 1774
PROV Bequest of Mrs F A Gluysteen-van
Ommeren, 1907. NMGK, 1907
LIT Huebner 1942, fig 5. Van Gelder
1959, p 102. W Stechow, Bull Clev Mus
of Art, 1965, p 166, fig 5

C 119 The Keizersgracht, Amsterdam,
between the Molenpad and the Run-
straat, with the house later inhabited by
Adriaan van der Hoop. *De Keizersgracht
te Amsterdam tussen Molenpad en Runstraat
met onder andere het huis waar later Adriaan
van der Hoop woonde*

Canvas 54.5 × 46. Signed *Hᵏ Keun*
PROV On loan from the city of
Amsterdam (A van der Hoop bequest),
1885-1975
LIT J Knoef, Jb Amstelodamum 42
(1948) pp 10-11, ill. I H van Eeghen,
Mndbl Amstelodamum 45 (1958) p 53

A 3228 View of the Houtmarkt, Amsterdam. *Gezicht op de Houtmarkt te Amsterdam*

Panel 35.5 ×49. Signed *Keun*
PROV Bequest of A A M Sträter, Amsterdam, 1934

attributed to **Hendrik Keun**

A 2681 View of the Houtmarkt, Amsterdam. *Gezicht op de Houtmarkt te Amsterdam*

Panel 39 ×51. Signed *I. K.*
PROV Bequest of R Th Baron van Pallandt van Eerde, Ambt-Ommen, 1913

Jacob Simon Hendrik Kever

Amsterdam 1854 – 1922 Laren

A 2271 Domestic interior with country woman and child. *Gezicht in een binnen-huis met boerin en kind*

Canvas 54 ×56. Signed *Kever*
PROV Bequest of J B A M Westerwoudt, Haarlem, 1907

A 2907 Woman peeling potatoes. *De aardappelschilster*

Canvas 45 ×54. Signed *Kever*
PROV Bequest of A van Wezel, Amsterdam, 1922 * DRVK since 1951

A 2908 Children with a picture-book. *Kinderen met een prentenboek*

Canvas 52 ×67. Signed *Kever*
PROV Bequest of A van Wezel, Amsterdam, 1922

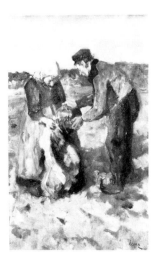

A 3319 Digging up potatoes. *Aardappel-rooien*

Canvas 51.5 ×34. Signed *Kever*
PROV Presented by Mr & Mrs D A J Kessler-Hülsmann, Kapelle op den Bosch near Mechelen, 1940 * DRVK since 1958

Adriaen Thomasz Key

Antwerp? ca 1544 – after 1589 Antwerp

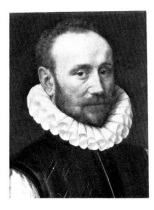

A 1700 Portrait of a man. *Portret van een man*

Panel 42 ×33. Marked and dated *ATK 1581*. Inscribed *Æ 38* and *Pacientia Spe*
PROV Purchased from Mrs Lowe-Timmer, Vreeswijk, 1897
LIT Ring 1913, p 156. P Philippot, Bull Mus Roy Belg 14 (1965) p 193

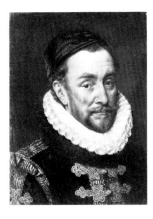

A 3148 Willem I (1533-84), prince of Orange, called William the Silent. *Prins van Oranje, genaamd Willem de Zwijger*

Panel 48 ×35
PROV Purchased from J H Gosschalk, The Hague, 1933, with aid from the William the Silent memorial committee
LIT Van Beresteyn 1933, p 13, nr 65, fig 11. J Bruyn, OH 75 (1960) p 112. A Staring, OH 75 (1960) p 165. P Philippot, Bull Mus Roy Belg 14 (1965) p 192 (ca 1580). A W E Dek, Spiegel der Hist 3 (1968) ill on p 233. G T Compagne, Spiegel Hist 4 (1969) fig 8 on p 690. J G S J van Maarseveen, Spiegel der Hist 4 (1971) ill on p 414

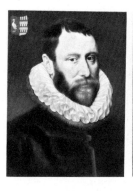

A 514 Jacob Bas Claesz (1536-89). Burgomaster of Amsterdam. *Burge-meester van Amsterdam*

Pendant to A 515

Panel 48.5 × 35.5
PROV Bequest of Mrs J Balguerie-van Rijswijk, widow of D Balguerie, Amsterdam, 1823 * Lent to the AHM, 1975
LIT Moes 1897-1905, vol 1, nr 380 (Cornelis Ketel). P Philippot, Bull Mus Roy Belg 14 (1965) p 193 (ca 1585)

A 515 Grietje Pietersdr Codde (d 1607). Wife of Jacob Bas. *Echtgenote van Jacob Bas*

Pendant to A 514

Panel 48.5 × 35.5
PROV Same as A 514 * Lent to the AHM, 1975
LIT Moes 1897-1905, vol 1, nr 1605 (Cornelis Ketel)

copy after **Willem Key**

Breda ca 1520 – 1568 Antwerp

A 18 Ferdinand Alvarez de Toledo (1507-82), duke of Alva. *Hertog van Alva*

Panel 49 × 38. Inscribed *Ferdinand Duc d'Alva* and *N 20*
PROV Het Loo Palace, Apeldoorn. NM, 1808

LIT AD de Vries, Christelijke Kunst, 1881, p 191, nr 16. Moes & van Biema 1909, pp 17, 170, 206. De Vries 1934, p 53. Friedländer 1924-36, vol 13 (1936) pp 105, 166, nr 287a. Judson 1970, p 155. R van der Heiden, Jb Kunsth Samml Wien ns 30 (1970) p 136, note 8

Nicaise de Keyser

Santvliet 1813 – 1887 Antwerp

C 290 Eberhard (1445-96), duke of Würtemberg, as a pilgrim in the Holy Land. *Hertog van Würtemberg als pelgrim in het Heilige Land*

Canvas 126 × 101. Signed and dated *NDe Keyser 1846*
PROV On loan from the city of Amsterdam (A van der Hoop bequest) since 1885

A 2863 King Willem II making his last will. *De laatste wilsbeschikking van koning Willem II*

Canvas 170 × 133
PROV Presented by G E J Baroness van Hardenbroek, née Countess van Limburg Stirum, Mrs J S Brantsen van Wielbergen, née Countess van Limburg Stirum, Mrs A C de Stuers, née Countess van Limburg Stirum, 1893 * DRVK since 1952
LIT Schatborn & Szénássy 1971, p 71, nr 313

Thomas de Keyser

Amsterdam 1596/97 – 1667 Amsterdam

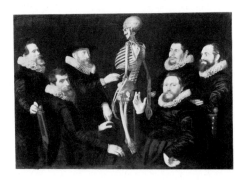

C 71 The anatomy lesson of Dr Sebastiaen Egbertsz de Vrij, 1619. *De anatomische les van dr Sebastiaen Egbertsz de Vrij, 1619*

The other sitters are Sebald J van Uyttenhoff, Dirck Koolvelt, Lambert Jacobs, Gerrit Indies and Jan de Wees, governors of the surgeons' guild

Canvas 135 × 186. Painted in 1619
PROV Chirurgijnsgildekamer (surgeons' guild chamber), Amsterdam. Sold in 1862. Presented by a committee of art lovers and physicians, 1864. On loan from the city of Amsterdam, 1885-1975
LIT Tilanus 1865, nr 2. D C Meijer Jr, OH 6 (1888) p 226. Moes 1897-1905, vol 1, nrs 1691, 2284:2, 3914, 3968; vol 2, nrs 8186, 8954. J O Kronig, Onze Kunst 16 (1909) p 78, ill. Oldenbourg 1911, pp 14-16, cat nr 3, pl 1. Riegl 1931, pp 169-71, fig 49. Martin 1935-36, vol 1, pp 172, 187, 314, fig 102. Würtenberger 1937, p 56. Boon 1942, p 71, fig 37. Rosenberg 1964, p 133, fig 119. Rosenberg, Slive & Ter Kuile 1966, pp 182-83, fig 156a. Fuchs 1968, p 25, fig 38. Haak 1972, pp 39-40, fig 51

A 1545 Portrait of three children and a man. *Portret van drie kinderen en een man*

Canvas 135 × 94. Signed and dated *T. D. Keyser F. An° 1622*. Composed of several fragments

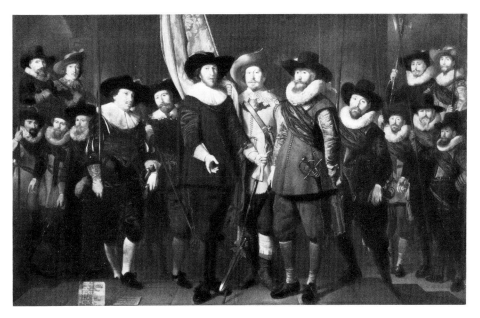

C 381

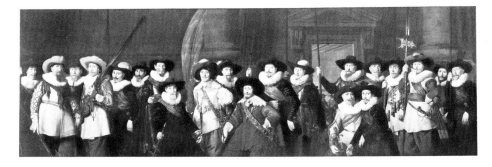

C 380

PROV Purchased in England, 1891, through the intermediacy of Dr A Bredius, The Hague
LIT Oldenbourg 1911, p 20, cat nr 6 (doubts attribution to de Keyser)

C 568 Portrait of a man. *Portret van een man*

Panel 66 × 53. Signed and dated *TDK 1631 january*. Inscribed *Æt˚ Su Æ 58*
PROV Thought to come from the Oude Mannen en Vrouwen Gasthuis (old folks' home), Amsterdam. On loan from the city of Amsterdam, 1885-1975
LIT Scheltema 1879, nr 170. Oldenbourg 1911, p 24, cat nr 7

C 381 The company of Captain Allaert Cloeck and Lieutenant Lucas Jacobsz Rotgans, Amsterdam, 1632. *Het korporaalschap van kapitein Allaert Cloeck en luitenant Lucas Jacobsz Rotgans, Amsterdam, 1632*

The other sitters are Claes Cloeck Nanningsz, Jan Vogelensang, Gerrit Pietersz Schagen, Michiel Colijn, Hans Walschaert, Jan Kuysten, Adolf Fortenbeeck, Aris Hendrick Hallewat, Hendrick Colijn, Hademan van Laer, Dirck Pietersz Pers, Frederick Schulenborch, Thomas Jacobsz Hoingh and Julius van den Bergen

Canvas 220 × 351. Signed and dated *TDK 1632*
PROV Kloveniersdoelen (headquarters of the arquebusiers' civic guard), Amsterdam. On loan from the city of Amsterdam since 1885
LIT Van Dijk 1790, p 34, nr 22. Scheltema 1879, p 23, nr 56. Scheltema 1855-85, vol 7 (1885) p 136, nr 8. DC Meijer Jr, OH 6 (1888) p 227. Moes 1897-1905, vol 1, nr 1579; vol 2, nr 6554:2. JO Kronig, Onze Kunst 16 (1909) p 111. Oldenbourg 1911, pp 42-45, cat nr 4, pl XVI. Riegl 1931, pp 171-74, fig 51. Martin 1935-36, vol 1, pp 156-57, 164, 212, fig 91. Boon 1942, p 72, fig 36. Rosenberg, Slive & Ter Kuile 1966, p 183. Gerson 1973, p 18, ill

C 380 The company of Captain Jacob Symonsz de Vries and Lieutenant Dirck de Graeff, Amsterdam, 1633. *Het korporaalschap van kapitein Jacob Symonsz de Vries en luitenant Dirck de Graeff, Amsterdam, 1633*

Canvas 198 × 604. Signed and dated *TDK Anno 1633*
PROV Voetboogdoelen (headquarters of the crossbowmen's civic guard), Amsterdam. On loan from the city of Amsterdam, 1885-1975
LIT Scheltema 1879, p 23, nr 55. Scheltema 1855-85, vol 7 (1885) p 134, nr 22. DC Meijer Jr, OH 6 (1888) p 130. Moes 1897-1905, vol 1, nr 2865:2; vol 2, nr 8739. Oldenbourg 1911, pp 46-47, cat nr 5. Riegl 1931, pp 174-77, fig 52. Martin 1935-36, vol 1, pp 209, 211, fig 120

A 697 Pieter Schout (1640-69). High bailiff of Hagestein. *Drost van Hagestein*

Copper 86 × 69.5. Signed and dated *TDK F. 1660*
PROV Bequest of Jonkheer J S H van de Poll, Amsterdam, 1880
LIT Vos 1726, vol 2, p 270. V de Stuers, Ned Kunstbode 2 (1880) p 244. DC Meijer Jr, OH 6 (1888) p 234. Moes 1897-1905, vol 2, nr 7025. JO Kronig, Onze Kunst 16 (1909) p 122. Oldenbourg 1911, pp 62-63, cat nr 9, pl XXIV. Martin 1935-36, vol 1, pp 76, 317, fig 42. R van Luttervelt, NKJ 8 (1957) p 201, fig 11. Plietzsch 1960, p 175, fig 317. Bernt 1960-62, vol 3, nr 448. Bernt 1969-70, vol 2, nr 621

A 4236 Group portrait of an unidentified body. *Groepsportret van een onbekend college*

Canvas 125 × 103
PROV The heirs of A Philips, Eindhoven. Purchased from H Cramer gallery, The Hague, 1973, as a gift of the Rembrandt Society, the Prince Bernhard Foundation and the Photo Commission

replica by **Thomas de Keyser**

C 567 Portrait of a man. *Portret van een man*

Autograph replica after the original in the Louvre, Paris (cat nr 2438-B)

Panel 67 × 52
PROV Thought to come from the Oude Mannen en Vrouwen Gasthuis (old folks' home), Amsterdam. On loan from the city of Amsterdam, 1885-1975
LIT Scheltema 1879, nr 172. Oldenbourg 1911, p 24, cat nr 8

school of **Thomas de Keyser**

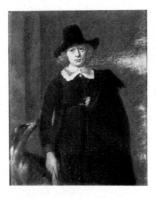

A 3493 Portrait of a man. *Portret van een man*

Copper 29 × 24.5
PROV Bequest of Mrs A C M H Kessler-Hülsmann, widow of D A J Kessler, Kapelle op den Bosch near Mechelen, 1947

A 3972 Godard Adriaen Baron van Reede van Amerongen (1621-91), on horseback. *Ruiterportret*

In the background is the village of Amerongen and its castle

Canvas 105 × 91.5
PROV N Katz gallery, Dieren. Lent by the SNK, later DRVK, 1948. Transferred in 1960

Simon Willemsz Kick

Delft 1603–1652 Amsterdam

A 2841 Portrait of an old man. *Portret van een oude man*

Panel 71 × 55. Signed and dated *Kick 1639*
PROV Purchased from Asscher & Koetser gallery, Amsterdam, 1920, with aid from the Rembrandt Society

Jan Kieft

De Rijp 1798–1870 Amsterdam

A 2356 Gijsbertus Martinus Cort Heyligers (1770-1849). Lieutenant general in the infantry. *Luitenant-generaal der infanterie*

Canvas 74.5 × 58. Signed and dated *J. Kieft Jr. 1831*
PROV Bequest of R W D Heyligers, The Hague, 1908 * DRVK since 1959 (on loan to the Nederlands Legermuseum, Leiden)
LIT Dronkers 1968, p 76, ill

Lucas Kilian

see Panpoeticon Batavum: A 4562 Theodorus Rodenburgh, copy by Arnoud van Halen after Kilian

Kinderen

see Derkinderen

Willem de Klerk

Dordrecht 1800–1876 Dordrecht

A 4087 View of the Meerzorg coffee plantation on the Taparoepi Canal in Surinam? *Gezicht op de koffieplantage 'Meerzorg' aan het Taparoepikanaal in Suriname?*

Canvas 75 ×97.5. Signed *W. de Klerk na de Teekening van A.L. Broekmann*
PROV Purchased from S Emmering gallery, Amsterdam, 1962
LIT F Oudschans Dentz, W Ind Gids, 1944-45, pp 147-80

Pieter Rudolph Kleyn

Hooge Zwaluwe 1785– 1816

A 645 View of the Plain of Montmorency near St Leu. *Gezicht op de vlakte van Montmorency bij St Leu*

Canvas 87 × 129. Signed and dated *PRKleyn 1808*
PROV Mandatory entry by the artist, as a 'pensionnaire' of King Louis Napoleon in Paris, to exhib Amsterdam 1808, nr 108, from whence it was automatically ceded to the state
LIT Moes & van Biema 1909, p 133. Knoef 1943, p 151, ill. Scheen 1946, fig 282. R van Luttervelt, Nap Stud 13 (1961) p 564, fig 23

A 646 The entrance to the Park of St Cloud, Paris. *De ingang van het Park van St Cloud te Parijs*

Canvas 100 × 130. Signed and dated *PRKleyn 1809.* Inscribed on the verso *Tableau de Mr P. R. Kleyn representant l'entrée du Parc de St. Cloud. Faict pour le Roi d'Hollande selon le règlement des pensionnaires le 2 Octobre 1809*
PROV Mandatory entry by the artist, as a 'pensionnaire' of King Louis Napoleon in Paris, to exhib Amsterdam 1810, nr 48, from whence it was automatically ceded to the state
LIT Moes & van Biema 1909, p 130. Knoef 1943, p 128. H R Bachofner, Du, June 1956, p 36, ill. E R Meijer, OK 3 (1959) nr 7, ill. Gerson 1961, p 16. R van Luttervelt, Nap Stud 13 (1961) pp 562-63, fig 22. Zeitler 1966, p 194, fig 13. VTTT, 1965-66, nr 78. Novotny 1970, p 140, fig 27B

A 647 The Aqua Cetosa near Rome. *De Aqua Cetosa bij Rome*

Canvas 90 × 128. Signed and dated *PRKleyn 1810*
PROV Mandatory entry by the artist, as a 'pensionnaire' of King Louis Napoleon in Rome, to exhib Amsterdam 1810, nr 67, from whence it was automatically ceded to the state
LIT Van Eynden & van der Willigen 1816-40, vol 2 (1817) p 494. R van Luttervelt, Nap Stud 13 (1961) p 564, fig 24

Johannes Christiaan Karel Klinkenberg

The Hague 1852– 1924 The Hague

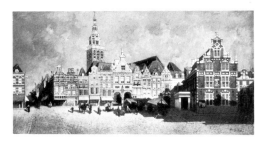

A 1175 The Markt, Nijmegen. *De Markt te Nijmegen*

Canvas 65.5 × 132. Signed *Klinkenberg*
PROV Purchased at exhib Amsterdam 1877, nr 278. RVMM, 1885 * DRVK since 1953

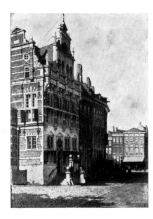

A 2383 The town hall in The Hague. *Het stadhuis in Den Haag*

Panel 45 × 32. Signed *Klinkenberg*
PROV Bequest of J BA M Westerwoudt, Haarlem, 1908

replica by **David Klöcker** *called* **Ehrenstrahl**

Hamburg 1629– 1698 Stockholm

A 1234 Charles XI (1665-97), king of Sweden. *Karel XI, koning van Zweden*

Canvas 320 × 275. Inscribed *Carolus XI R. Suec. In Praelio Lundensi D. 4 Dec. A° 1676*
PROV KKS, 1885
LIT Strömbom 1943, vol 1, p 311, ad nr 11g (as in the Trippenhuis, Amsterdam; prototype in Gripsholm, nr 459)

Johann Bernard Klombeck

Kleve 1815–1893 Kleve

A 3521 View in the woods in the winter. *Winters bosgezicht*

Canvas 91 × 125.5. Signed and dated *J.B. Klombeck ft. 1863 Eugène Verboeckhoven Figura*[vit]
PROV Presented by Mrs Z Beversen-Siemons, Soestdijk, 1948 * DRVK since 1950

Albert Jansz Klomp

ca 1618–1688? Amsterdam?

C 162 Landscape with cattle. *Landschap met vee*

Pendant to C 161

Canvas 27.5 × 35. Signed *A Klomp fe*
PROV On loan from the city of Amsterdam (A van der Hoop bequest) since 1885

C 161 Landscape with cattle. *Landschap met vee*

Pendant to C 162

Canvas 27 × 34. Signed *A.Klomp*
PROV Same as C 162

Sir Godfried Kneller

Lübeck 1646–1723 London

A 1280 Cornelis de Bruyn (1652-1727). Draftsman and traveller. *Tekenaar en reiziger*

Canvas 70.5 × 59
PROV Presented by A Willet, Amsterdam, 1885
LIT *Cf* W Blankwaard, Historia 10 (1944) p 69ff. Van Hall 1963, p 53, nr 315:1

copy after Sir Godfried Kneller

A 2060 Aernout van Citters (1633-96). Ambassador of the Dutch Republic in London. *Ambassadeur van de Verenigde Nederlanden te Londen*

Copy by Philip van Dijk (1680-1753) after the original in a private collection, The Hague, dated 1692

Canvas 45 × 35
PROV Bequest of Jonkheer J de Witte van Citters, The Hague, 1876. Received in 1903 * DRVK since 1950
LIT Moes 1897-1905, vol 1, nr 1535:2

François van Knibbergen

b 1597, active in The Hague; d in or after 1665

A 2361 Panorama in the countryside around Kleve. *Panorama in het Kleefse land*

Canvas 97 × 140. Signed *F. Knibbergen*
PROV Sale Mrs F Lemker-Muller, Kampen, 7 July 1908, lot 24
LIT Bernt 1960-62, vol 3, nr 453. Dattenberg 1967, nr 276. Bol 1969, p 180, fig 170. Bernt 1969-70, vol 2, nr 629

Knip

see Ronner-Knip

Josephus Augustus Knip

Tilburg 1777–1847 Berlicum

A 4220 The shelling of 's-Hertogenbosch by the French during the siege of 1794, presumably in the night of 25-26 September. *De beschieting van 's-Hertogenbosch door de Fransen tijdens het beleg van 1794, vermoedelijk in de nacht van 25 op 26 september*

Panel 47 × 62. Signed and dated
J. A. Knip 1800
PROV Sale Dordrecht, 13 June 1972, lot
121
LIT Bull RM 20 (1972) p 182, fig 4

A 3909 View of the Place de la Concorde,
Paris, from the Batavian embassy,
during the ambassadorship of Rutger
Jan Schimmelpenninck. *Het uitzicht van
de Bataafse Ambassade te Parijs op het Place de
la Concorde ten tijde van het ambassadeursschap
van Rutger Jan Schimmelpenninck*

Belongs with C 1455 & C 1456

Canvas 97 × 129.5. Signed and dated
J. A. Knip 1801
PROV Bequest of Jonkheer W A van den
Bosch, Doorn, 1956
LIT Staring 1947, p 122. A Staring, Nap
Stud 4 (1952) p 93. A Staring, OH 74
(1959) p 225. VTTT, 1961-62, nr 37

C 1455 The garden façade of the
Batavian embassy in Paris during the
ambassadorship of Rutger Jan
Schimmelpenninck. *De achterzijde van de
Bataafse Ambassade te Parijs ten tijde van het
ambassadeursschap van Rutger Jan
Schimmelpenninck*

Belongs with A 3909 & C 1456

Canvas 97 × 129.5
PROV On loan from Jonkheer F J C
Schimmelpenninck, Putten, since 1959
LIT Staring 1947, p 122. A Staring, Nap
Stud 4 (1952) p 93. A Staring, OH 74
(1959) p 225. CHE de Wit, Spiegel Hist
3 (1968) p 396, fig 3

C 1456 The Jardin de Bagatelle in
Auteuil, the property of Rutger Jan
Schimmelpenninck, ambassador of the
Batavian Republic in Paris. *De 'Jardin de
Bagatelle' in Auteuil van Rutger Jan
Schimmelpenninck, ambassadeur van de
Bataafse Republiek te Parijs*

Belongs with A 3909 & C 1455

Canvas 97 × 129.5
PROV Same as C 1455
LIT Staring 1947, p 122. A Staring, Nap
Stud 4 (1952) p 93. A Staring, OH 74
(1959) p 225

A 1058 The Gulf of Naples, with the
island Ischia in the background. *De golf
van Napels met op de achtergrond het eiland
Ischia*

Canvas 90 × 109. Signed and dated
J. A. Knip 1818
PROV Sale Amsterdam, 1818, lot 149.
RVMM, 1885
LIT Scheen 1946, fig 247. R van
Luttervelt, Nap Stud 13 (1961) p 565, fig
25. Exhib cat 150 jaar Nederlandse
kunst, Amsterdam 1963, nr 19, fig 10.
J Offerhaus, OK 12 (1968) nr 30, ill

Franciscus Cornelis Knoll

Rotterdam 1772 – 1827 Utrecht

A 1059 Still life in a stable. *Stilleven in een
stal*

Panel 42 × 49.5. Signed and dated
F. C. K. 1824
PROV Presented by the artist's daughter,
Mrs A E Visscher-Knoll, 1848. RVMM,
1885
LIT Scheen 1946, fig 180

H Knop

see Vanmour series: A 3947 View of
Smyrna

Nicolaus Knüpfer

Leipzig? ca 1603 – 1655 Utrecht

A 1458 The legates of Alexander the
Great investing the gardener
Abdalonymus with the insignia of the
kingship of Sidon (Quintus Curtius
Rufus 4.1.19-23). *De gezanten van
Alexander de Grote bekleden de tuinman
Abdalonymos met de insigniën der konings-
waardigheid van Sidon*

Panel 54.5 × 76. Signed *NKnupfer*
PROV Presented by Dr A Bredius, The
Hague, 1888
LIT L Mesnard, Chron des Arts 10
(1890) p 46. J I Kuznetsov, Trudy
Érmitaža 8 (1964) p 218, nr 100, fig 9

Wouter Knijff

Wesel ca 1607–after 1693 Bergen op Zoom?

C 451 View of Dordrecht. *Gezicht op Dordrecht*

Canvas 98.5 × 132. Signed and dated *W. Knijff 1643*
PROV Werkhuis (workhouse), Amsterdam. On loan from the city of Amsterdam since 1885
LIT C Hofstede de Groot, OH 17 (1899) pp 164-65. Bol 1969, p 186. Bernt 1969-70, vol 2, nr 632. Bol 1973, p 138, fig 141

Hendrik Kobell II

Rotterdam 1751–1779 Rotterdam

A 1218 The shipwreck. *De schipbreuk*

Canvas 92 × 134. Signed and dated *Kobell fec. 1775*
PROV Collection of Prince Willem V, The Hague, 1795. KKS, 1885
LIT Moes & van Biema 1909, pp 17, 171, 224

Jan (Baptist) Kobell II

Delftshaven 1778–1814 Amsterdam

C 164 Landscape with cattle. *Landschap met vee*

Panel 48 × 58. Signed and dated *J Kobell f 1804*
PROV On loan from the city of Amsterdam (A van der Hoop bequest) since 1885

A 1061 Oxen in the meadow. *Ossen in de weide*

Canvas 67 × 84. Signed and dated *J Kobell F 1806*
PROV Purchased in 1820. RVMM, 1885 * DRVK since 1953
LIT Scheen 1946, fig 286

A 1060 A herd of cattle crossing a ford. *De ossendrift*

Canvas 93 × 129.5. Signed *J Kobell*
PROV Purchased in or before 1809. RVMM, 1885 * DRVK since 1953
LIT Marius 1920, p 60, fig 26. Huebner 1942, fig 52

Jan Kobell III

Rotterdam 1800–1838 Rotterdam

A 1062 Cows in a stable. *Koeien op stal*

Panel 23.5 × 28.5. Signed *J. Kobell*
PROV Purchased in 1830. RVMM, 1885

Barend Cornelis Koekkoek

Middelburg 1803–1862 Kleve

C 542 Landscape with a rainstorm threatening. *Landschap bij opkomende regenbui*

Canvas 56 × 72. Inscribed *Niets zonder moeite* and *hierna beter*
PROV Awarded the first prize in 1829 by the drawing division of the Felix Meritis Society, Amsterdam, where the painting remained until the dissolution of the society in 1889. On loan from the city of Amsterdam since 1889
LIT Gorissen 1962, nr 29/56. CJ de Bruyn Kops, Bull RM 11 (1963) pp 39-40, 42, fig 1

A 1546 View in the woods. *Bosgezicht*

Canvas 136 × 160. Signed and dated
B.C.Koekkoek ft 1848
PROV Presented by CCA Baron du Bois
de Ferrières, Cheltenham, 1891
LIT Knoef 1947, pp 41-52. VTTT, 1961-
62, nr 46. HC de Bruijn Jr, Op den
Uitkijk, April 1962, p 321, ill. Gorissen
1962, nr 48/136. HC de Bruijn Jr, Antiek
2 (1967) p 3ff, fig 1

C 166 Italian landscape. *Italiaans
landschap*

Canvas 63 × 53. Signed and dated
B.C.Koekkoek ft 1848
PROV On loan from the city of
Amsterdam (A van der Hoop bequest)
since 1885
LIT Gorissen 1962, nr 48/63

C 165 Winter landscape. *Winterlandschap*

Canvas 62 × 75. Signed *B.C.Koekkoek f.*
PROV On loan from the city of Amsterdam
(A van der Hoop bequest) since 1885
LIT Gorissen 1962, nr 38/62

Roelof Koets II

Zwolle before 1650 – 1725 Zwolle

A 795 Portrait of a minister. *Portret van
een predikant*

Canvas 41 × 35.5. Signed and dated
R.Koets A° 1668. Inscribed *Ætat XXXV*
PROV Sale Amsterdam, 14 Nov 1883,
lot 80
LIT Gudlaugsson 1960, p 292, pl XXIX,
fig 3

Philips Koninck

Amsterdam 1619 – 1688 Amsterdam

A 4133 Distant view, with cottages
lining a road. *Vergezicht met hutten aan een
weg*

Canvas 133 × 167.5. Signed and dated
P.Koninck 1655
PROV Purchased from the earl of Derby,
Knowsley House, 1967, with aid from
the Rembrandt Society, the Prince
Bernhard Foundation and the Photo
Commission
LIT Gerson 1936, p 24, cat nr 26, pl 6.
PJJ van Thiel, Bull RM 15 (1967) pp
109-15, figs 1, 3-5. PJJ van Thiel, OK 12
(1968) nr 10, ill. HJaffé, NKJ 23 (1972)
p 365, fig 3

A 1904 Joost van den Vondel (1587-
1679). Poet. *Dichter*

Canvas on panel 55.5 × 47. Oval. Signed
and dated *P. k[o] 166[5]*
PROV Presented by Jonkheer P Hartsen
and the heirs of Jonkheer C Hartsen,
Amsterdam, 1900 * DRVK since 1959
(on loan to the Museum Amstelkring,
Amsterdam)
LIT Moes 1897-1905, vol 2, nr 8651:9.
BWF van R[iemsdijk], Bull NOB 3
(1901) pp 80-81. Sterck 1927-37, vol 4
(1930) pp 38-50, nr XX. Gerson 1936, p
53, cat nr 221, pl 24

A 1954 Joost van den Vondel (1587-
1679). Poet. *Dichter*

Canvas 62 × 54. Signed and dated on
the verso *P. ko. 1674*. Inscribed on the
verso *oudt 87 j.*
PROV Sale Amsterdam, 16 April 1901,
lot 82
LIT Moes 1897-1905, vol 2, nr 8651:14.
BWF van R[iemsdijk], Bull NOB 3
(1901) p 81. Schmidt-Degener 1928, pl
VIII. Sterck 1927-37, vol 4 (1930) pp
38-50, nrs XXII, XXIV. Gerson 1936, p
53, cat nr 222

A 206 River landscape. *Rivierlandschap*

Canvas 92.5 × 112. Signed and dated
P. Koninck 1676
PROV Bequest of L Dupper Wzn,
Dordrecht, 1870
LIT Gerson 1936, p 35, cat nr 2, pl 15.
Plietzsch 1960, p 111. H Kühn, Jb
Ksamml Baden-Württemberg 2 (1965) p
208

A 207 The entrance to the woods. *De in-
gang van het bos*

Canvas 138 × 166
PROV Sale G van der Pot van
Groeneveld, Rotterdam, 6 June 1808, lot
66
LIT Bürger 1858, vol 1, p 33. Waagen
1862, p 115. Moes & van Biema 1909, pp
113, 185. Gerson 1936, p 36, cat nr 3.
Plietzsch 1960, p 112, fig 189

Salomon Koninck

Amsterdam 1609–1656 Amsterdam

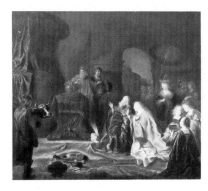

A 2220 The idolatry of King Solomon.
De afgoderij van koning Salomo

Canvas 155 × 171.5. Signed and dated
S. Koninck F A° 1644
PROV Purchased from Sulley & Co
gallery, London, 1905, through the
intermediacy of the Rembrandt Society
LIT De Bie 1661, p 250. Th M Duyvené
de Wit-Klinkhamer, NKJ 17 (1966) p
89

A 23 A scholar in his study. *Een geleerde
in zijn studeerkamer*

Panel 41 × 34.5
PROV Sale G van der Pot van
Groeneveld, Rotterdam, 6 June 1808,
lot 9 (as Cornelis Bega)
LIT Moes & van Biema 1909, pp 112,
156, 186

Willem Adriaan van Konijnenburg

The Hague 1868–1943 The Hague

A 3320 Plowing peasant. *Ploegende boer*

Panel 32 × 45. Signed *W. v. Konijnenburg*
PROV Presented by Mr & Mrs D A J
Kessler-Hülsmann, Kapelle op den
Bosch near Mechelen, 1940

Willem Bartel van der Kooi

Augustinusga 1768–1836 Leeuwarden

see also Dyck, Anthony van, A 208
Wolfgang Wilhelm, duke of Gulik and

Berg, copy by van der Kooi; A 209
Sebastiaan Leerse, copy by van der
Kooi; A 210 The wife of Sebastiaan
Leerse, copy by van der Kooi

A 1063 Self portrait, pointing at a
portrait of the artist's deceased colleague
Dirk Jacobsz Ploegsma (1769-91).
*Zelfportret, wijzend naar het portret van
zijn gestorven collega Dirk Jacobsz Ploegsma*

Canvas 122 × 96
PROV Presented by H van der Kooi,
Leeuwarden, 1869. RVMM, 1885 *
DRVK since 1959 (on loan to the Fries
Museum, Leeuwarden)
LIT Van Hall 1963, p 173, nr 1170:1,
p 251, nr 1667:3

A 1064 The love letter. *De minnebrief*

Canvas 131 × 108. Signed and dated on
the verso *W. B. van der Kooy pinxit 1808*.
Inscribed on the verso *Tu veteres Caesar
Revocas Artes, Horatius*
PROV Awarded a prize at exhib
Amsterdam, 1808. Presented by H van
der Kooi, Leeuwarden, 1869. RVMM,
1885 * DRVK since 1959 (on loan to the
Fries Museum, Leeuwarden)
LIT Moes & van Biema 1909, p 130.
Marius 1920, p 63. Knoef 1943, p 151,
ill. Scheen 1946, fig 55. Knoef 1948, p 32

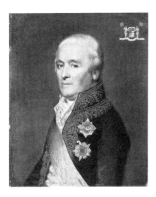

A 4139 Jonkheer Adriaen Pieter Twent (1745-1816), count of Rosenburg. Minister of inland waters, minister of the interior and chamberlain to King Louis Napoleon. *Graaf van Rosenburg. Minister van Waterstaat, minister van Binnenlandse Zaken, kamerheer van koning Lodewijk Napoleon*

Copper 36 × 29.5. Signed and dated on the verso *W.B. van de Kooi, pinxit 1809.* Inscribed on the verso *A.P. Twent Graaf van Rosenburg | Oud 65 Jaaren | Groot Kruis van de Koninklijke Orde der Unie van Holland | Groot Kruis van de Koninklijke Orde van Napels | Minister der Waterstaat van het Rijk van Holland | Kamerheer van Zijne Majesteit den Koning van Holland | Lid van het Capittel der Ordre van Unie 1810 | Graaf van het Keizerrijk 16 januarij 1811*
PROV Purchased from A van der Meer gallery, Amsterdam, 1967
LIT E Pelinck, Holland 2 (1970) p 164, fig 2

A 1170 Jan (Baptist) Kobell II (1778-1814). Painter, in the uniform of a member of the royal institute of science, literature and the fine arts. *Schilder, in het uniform van een lid van het Koninklijk Instituut van Wetenschappen, Letterkunde en Schoone Kunsten*

Canvas 88.5 × 70. Signed and dated *W.B. v.d. Kooi Pinx. 1811*
PROV Purchased in 1876. RVMM, 1885
LIT Van Hall 1963, p 170, nr 1145:1

A 1065 Piano practice interrupted. *Het gestoorde pianospel*

Canvas 147 × 121. Signed and dated on the verso *W.B. van der Kooi invent. et pinxit 1813*
PROV Presented by H van der Kooi, Leeuwarden, 1869. RVMM, 1885 * DRVK since 1959 (on loan to the Fries Museum, Leeuwarden)

copy after **Willem Bartel van der Kooi**

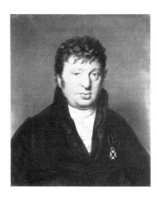

C 1556 Jacobus Scheltema (1767-1835). Historian. *Geschiedschrijver*

Copy by Wilhelmina Geertruida van Idsinga (1788-1819)

Canvas 66.5 × 54.5. Inscribed on the verso *W.J. Idsinga Pinxit*
PROV On loan from the KOG (presented by SJ Hingst, 1866) since 1973

Antonie Lodewijk Koster

Terneuzen 1859 – 1937 Haarlem

A 3565 Tulip fields. *Bollenvelden*

Panel 25.5 × 41. Signed *A.L. Koster*
PROV Bequest of Mrs M CJ Breitner-Jordan, widow of G H Breitner, Zeist, 1948

copy after **David von Krafft**

Hamburg 1655 – 1724 Stockholm

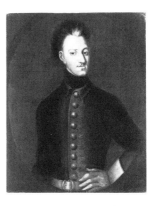

A 982 Charles XII (1682-1718), king of Sweden. *Karel XII, koning van Zweden*

Canvas 89 × 71
PROV Presented by J A Kramer, The Hague, 1884. NMGK, 1885

Hubertus Johannes Kramer

see Monogrammist H K

Josef Kreutzinger

see under Miniatures

Cornelis Kruseman

Amsterdam 1797–1857 Lisse

see also Governors-general series: A 3795
G A G Ph Baron van der Capellen;
A 3796 Hendrik Merkus de Kock; A 3800
Dominique Jacques de Eerens

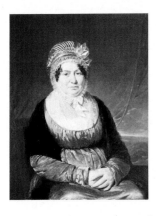

A 1067 Peasant family in their cottage. *Boerengezin in interieur*

Panel 49.5 × 40. Signed and dated
C. Kruseman f. 1817
P R O V Purchased at exhib The Hague
1817, nr 68. R V M M, 1885
L I T Knoef 1947, pp 17, 29, ill

A 2137 Mrs Brak-Haskenhoff

Canvas 77 × 61.5. Signed and dated
C. Kruseman 1818
P R O V Presented by Miss C M Bakker,
Baarn, 1904
L I T Scheen 1946, fig 29. Knoef 1947, p
18, ill

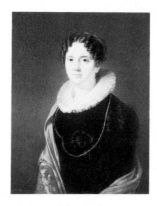

A 3050 Marie Allebé-Herckenrath.
Grandmother of the painter August
Allebé. *Grootmoeder van de schilder August
Allebé*

Canvas 77 × 62. Signed and dated
C. Kruseman 1820
P R O V Bequest of A Allebé, Amsterdam,
1927
L I T Knoef 1947, p 30

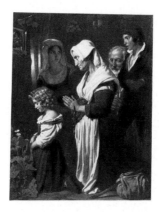

A 1069 'Piety.' *'Godsvrucht'*

Canvas 153 × 122.5. Signed *C. Kruseman
F. Roma*
P R O V Purchased in 1824. R V M M, 1885 *
D R V K since 1952
L I T T van Westrheene, Kunstkronijk 20
(1859) p 16a, nr 3:3 (ca 1821-25). G J
Hoogewerff, Med Ned Hist Inst Rome,
2d ser 3 (1933) p 160, fig 3 (confused
with another picture). Knoef 1947, pp
22, 31, 35, ill

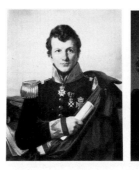

A 2166 Count Johannes van den Bosch
(1780-1844). Governor-general of the
Dutch East Indies (1828-33), colonial

minister (1834-39). *Gouverneur-generaal
van Nederlands Indië, minister van koloniën*

see also Governors-general series: A 3798,
free copy by Raden Saleh
Pendant to A 2167

Canvas 87 × 70. Signed and dated
C. Kruseman Fecit 1829
P R O V Presented by Jonkvrouwe J C C
van den Bosch, Brussels, 1905
L I T J J Westendorp Boerma, Historia 10
(1944-45) p 61, fig 2. W F J den Uyl,
Historia 10 (1944-45) p 226, fig 1.
Westendorp Boerma 1950, p 73,
frontispiece

A 2167 Rudolphina Wilhelmina
Elizabeth de Sturler (1798-1873).
Second wife of Count Johannes van den
Bosch, with their son Richard
Leeuwenhart (1815-1905). *Tweede
echtgenote van Johannes graaf van den Bosch
met hun zoon Richard Leeuwenhart*

Pendant to A 2166

Canvas 87 × 70. Signed *C. Kruseman*
P R O V Same as A 2166

A 1066 The entombment. *De graflegging*

Canvas 330 × 290. Signed and dated
C. Kruseman f. Hagae 1830
P R O V Purchased in November 1830.
R V M M, 1885 * D R V K since 1952
L I T T van Westrheene, Kunstkronijk 20
(1859) p 11, 16a, nr 1:5

A 1070 'Of one heart.' *'Een van zin'*

Canvas 102 × 120. Signed and dated
C. Kruseman f. 1830
PROV Purchased at exhib The Hague
1830?, nr 186. RVMM, 1885 * DRVK since
1953
LIT G J Hoogewerff, Med Ned Hist Inst
Rome 2d ser 3 (1933) p 159. Knoef 1947,
pp 33, 35

A 1068 Philip II accusing William the
Silent in Vlissingen upon his departure
from the Netherlands in 1559. *Philips
II beschuldigt prins Willem van Oranje te
Vlissingen bij zijn vertrek uit de Nederlanden
in 1559*

Canvas 270 × 200. Signed and dated
C. Kruseman ft. 1832
PROV Purchased in 1840. RVMM, 1885 *
DRVK since 1952
LIT T van Westrheene, Kunstkronijk 20
(1859) p 16a, nr 2:2. Knoef 1947, pp 26,
35, 37. Knoef 1948, p 72

A 2823 The prince of Orange, later King
Willem II, changing his wounded horse
during the Battle of Boutersem, 12
August 1831. *De vervanging van het gewonde
paard van de prins van Oranje, de latere
koning Willem II, tijdens de slag bij
Boutersem, 12 augustus 1831*

Sketch for the painting of 1839 in the
royal palace, Amsterdam

Canvas 31 × 39
PROV Purchased from Mrs W Ising,
Amsterdam, 1919
LIT Alg Konst en Letterbode, 1838, vol

2, pp 43, 45; 1839, vol 1, p 78.
Immerzeel 1842-43, vol 2 (1843) p 139.
Kunstkronijk ns 11 (1870) pp 51-60.
Marius 1920, p 21. Huebner 1942, p 65.
Knoef 1947, pp 23, 26-27, 35, ill. Knoef
1948, p 66, ill. Exhib cat 150 jaar
Nederlandse kunst, Amsterdam 1963, nr
23, fig 18

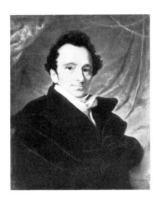

A 657 Gerrit Carel Rombach (1784-
1833). Actor. *Toneelspeler*

Canvas 74 × 61. Signed *C. Kruseman ft.*
PROV Presented by J M D Rombach,
Oudenhoorn, 1864, from the estate of his
father * DRVK since 1953
LIT Knoef 1947, p 35

C 167 Old woman reading. *Lezende oude
vrouw*

Panel 34.5 × 28.5. Signed *Kruseman f.*
PROV On loan from the city of
Amsterdam (A van der Hoop bequest)
since 1885

Jan Adam Kruseman

Haarlem 1804 – 1862 Haarlem

A 1071 The prophet Elisha and the
Shunamite woman. *De profeet Elisa en de
Sunamietische vrouw*

Canvas 117 × 113. Signed and dated
J. A. Kruseman Jz. van Haarlem F 1825
PROV Purchased at exhib Haarlem 1825,
nr 241. RVMM, 1885 * DRVK since 1953
LIT Knoef 1948, p 45

A 1072 Girl resting. *Rustend meisje*

Canvas 65.5 × 53. Signed and dated
J. A. Kruseman f. 1827
PROV Purchased at exhib Amsterdam
1827, nr 348. RVMM, 1885

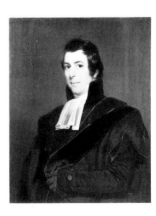

A 3950 Gijsbertus Johannes Rooyens
(1785-1846). Professor of theology and
church history at the university of
Amsterdam. *Hoogleraar in de theologie en
de kerkgeschiedenis te Amsterdam*

An autograph copy dated 1846 is in the
university of Amsterdam

Canvas 81.5 × 66.5. Signed and dated
J. A. Kruseman ft. 1828
PROV Presented by Mr & Mrs Hacke-
Oudemans, Putten, 1958
LIT J G Kam, Jb Amstelodamum 52
(1960) p 168, ad nr B 47. Altena & van
Thiel 1964, ad nr 108

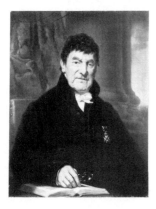

A 1613 Dr Cornelis Hendrik à Roy
(1751-1833). Physician and biographer.
Geneesheer en biograaf

Canvas 34 × 28. Painted in 1833
PROV Sale Amsterdam, 10 April 1894,
lot 120 * On loan to the Rijksmuseum
voor de Geschiedenis der Natuur-
wetenschappen, Leiden, since 1960
LIT J G Kam, Jb Amstelodamum 52
(1960) p 168, nr A 25

A 1570 Catharina Annette Fraser (1815-
92)

Canvas 73 × 62. Signed and dated on the
verso *J. Kruseman pinxit 1834*
PROV Presented from the estate of
Baroness C A van Pallandt-Fraser,
dowager of C H Baron van Pallandt,
The Hague, 1892
LIT J G Kam, Jb Amstelodamum 52
(1960) p 162, nr A 32

C 1123 Regents and regentesses of the
lepers' asylum, Amsterdam, 1834-35.
*Regenten en regentessen van het leprozenhuis te
Amsterdam, 1834-35*

The gentlemen sitters are Ludovicus
Hamerster Ameshoff, left, Jan van der
Meer de Wijs and Michiel Abraham van
Peene Pietersz, and the ladies Jacoba
Wilhelmina de Meyn, née van der
Meulen, Sara Maria Joanna van der
Poorten van Vollenhoven, née Berg, and
Catharina Elisabeth van Vloten, née
Bagman

Canvas 255 × 285. Painted in 1834-35
PROV Leprozenhuis (lepers' asylum),
Amsterdam. On loan from the city of
Amsterdam since 1923
LIT Scheltema 1879, nr 59 (some sitters
identified differently). J G Kam, Jb
Amstelodamum 52 (1960) p 165, nr
A 28. Haak 1972, p 36, fig 43

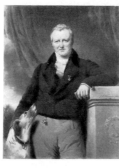

C 169 Adriaan van der Hoop (1778-
1854). Amsterdam banker and art
collector. *Bankier en kunstverzamelaar te
Amsterdam*

Pendant to A 3020

Canvas 125 × 99. Signed and dated
J. A. Kruseman f. 1835
PROV On loan from the city of
Amsterdam (A van der Hoop bequest),
1885-1975
LIT J Knoef, Jb Amstelodamum 42
(1948) p 21, ill. J G Kam, Jb
Amstelodamum 52 (1960) p 164, nr
A 33. Gerson 1961, p 18, fig 36. Exhib cat
150 jaar Nederlandse kunst, Amsterdam
1963, nr 25, fig 29

A 3020 Dieuwke Fontein (1800-79).
Second wife (married 1834) of Adriaan
van der Hoop. *Tweede echtgenote van
Adriaan van der Hoop*

Pendant to C 169
Painted in 1844 at the request of van der
Hoop to replace the original pendant of
1835, which was not to the collector's
taste

Canvas 126 × 97.5. Signed and dated
J. A. Kruseman f 1844
PROV Presented by Miss J G Fontein,
Santpoort, 1924, from the estate of Mrs
O E A E Wüste, née Baroness von Gotsch,
widow of J R Wüste, the sitter's grand-
daughter
LIT J G Kam, Jb Amstelodamum 52
(1960) p 164, nr B 35

C 170 Willem II (1792-1849), king of the
Netherlands. *Koning der Nederlanden*

Canvas 109.5 × 86. Painted in 1840
PROV On loan from the city of
Amsterdam (A van der Hoop bequest),
1885-1975
LIT J C van der Does, Historia 9 (1943) p
159, fig 4. J G Kam, Jb Amstelodamum
52 (1960) p 158, nr B 22. H C de Bruyn,
Op den Uitkijk, June 1961, p 432

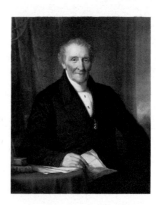

A 1499 Rodolphe le Chevalier (1777-
1865). Amsterdam merchant and one of
the three founders of the Holland Rail-
road Company. *Koopman te Amsterdam en
een der drie oprichters van de Hollandse
IJzeren Spoorweg Maatschappij*

Canvas 104 × 84. Signed and dated
J.A.Kruseman f. 1850
PROV Presented by Miss HM
Petitpierre, Haarlem, 1899
LIT J G Kam, Jb Amstelodamum 52
(1960) p 161, nr B 59

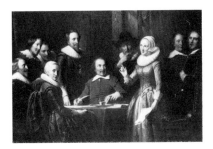

C 168 The Muiden circle. *De Muiderkring*

From left to right: Jacob Cats,
Constantijn Huygens, Laurens Reael,
Anna Roemers Visscher, Pieter
Cornelisz Hooft, Joost van den Vondel,
Roemer Visscher, Maria Roemers
Visscher, called Tesselschade, Caspar
van Baerle and Daniël Heinsius

Canvas 173 × 260. Signed and dated
J.A.Kruseman f. 1852
PROV On loan from the city of
Amsterdam (A van der Hoop bequest)
since 1885 * On loan to the Rijksmuseum
Muiderslot, Muiden, since 1943
LIT J G Kam, Jb Amstelodamum 52
(1960) p 153

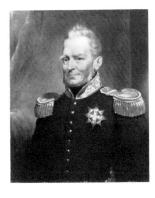

A 1621 Willem I (1772-1843), king of
the Netherlands. *Koning der Nederlanden*

Canvas 85 × 71. Inscribed on the frame
*Willem I, hersteller van den Koophandel,
Zeevaart, Scheepsbouw en Nijverheid*
PROV Purchased from Fr Muller & Co,
art dealers, Amsterdam, 1894 * DRVK
since 1950
LIT G A Evers, Historia 13 (1948) p 184,
fig 5. J G Kam, Jb Amstelodamum 52
(1960) p 158

NO PHOTOGRAPH AVAILABLE

A 4258 Gerrit Toelaer. First lieutenant
in the cuirassiers. *Eerste luitenant der
Kurassiers*

Head-and-shoulders portrait

Canvas 53 × 42
PROV Presented by J M Visbach Lobry,
Geneva, 1891. NMGK * Lent to the
Nederlandsch Legermuseum,
Doorwerth, 1925. Destroyed in the war,
1944

Kunst

see Cornelisz Kunst

Konrad Kuster

Winterthur ca 1730 – ca 1802

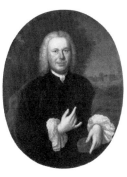

A 3859 Diederik van Bleyswijk (1711-
63), baron of Eethen and Meeuwen, lord
of Babiloniënbroek. Burgomaster of
Gorkum. *Vrijheer van Eethen en Meeuwen,
heer van Babiloniënbroek. Burgemeester van
Gorkum*

Pendant to A 3860

Canvas 84.5 × 67. Oval
PROV Presented by M C van Houten,
Doorn, 1936. Received in 1953

A 3860 Cornelia van Schuylenburgh
(1703-84). Wife of Diederik van
Bleyswijk. *Echtgenote van Diederik van
Bleyswijk*

Pendant to A 3859

Canvas 87.5 × 67. Oval. Signed and
dated on the verso *K.Kuster pinx. 1761*
PROV Same as A 3859

Gysbert van der Kuyl

Gouda ca 1600 – 1673 Gouda

A 835 A musical company. *Musicerend
gezelschap*

Canvas 99 × 131. Signed and dated
GVK 1651
PROV Presented by Dr A Bredius, The
Hague, 1884
LIT Von Schneider 1933, p 84. Bernt
1960-62, vol 4, nr 157. Bernt 1969-70,
vol 2, nr 648

A 3861 Guilliaam van Bleyswijk (1621-
1701)

Pendant to A 3862

Canvas 79.5 × 63.5
PROV Presented by M C van Houten,
Doorn, 1936. Received in 1953

A 3862 Catharina van Well (1626-1722).
Wife of Guilliaam van Bleyswijk. *Echt-
genote van Guilliaam van Bleyswijk*

Pendant to A 3861

Canvas 79.5 × 63.5. Signed *GVKuijl*
PROV Same as A 3861

Nicolaes Lachtropius

active 1656-1700 in Amsterdam and Alphen aan de Rijn

A 771 Still life with flowers. *Stilleven met bloemen*

Canvas 63 × 52. Signed and dated *N. Lachtropius An° 1667*
PROV Sale E Ruelens, Brussels, 17 April 1883, lot 151
LIT Warner 1928, nr 60a. Vorenkamp 1933, p 127. Bernt 1960-62, vol 2, nr 466. Bol 1969, p 328. Bernt 1969-70, vol 2, nr 649. Mitchell 1973, p 155, fig 213

La Croix

see under Pastels

Dirk Jan van der Laen

Zwolle 1759–1829 Zwolle

C 171 City view in the winter. *Stadsgezicht in de winter*

Panel 26.5 × 34.5. Inscribed *W. van Alpen Mr. Zalemaker* (above the door) and *Dit huis is te koop uit de han*[d] (on sign)
PROV On loan from the city of Amsterdam (A van der Hoop bequest) since 1885
LIT Marius 1920, p 59. W Steenhoff, Mndbl BK 5 (1928) p 35, ill. Huebner 1942, fig 42. Scheen 1946, fig 197

Pieter van Laer

Haarlem 1592/95–1642 Haarlem

A 1411 Harvesting the vines. *De wijnoogst*

Canvas 62.5 × 80. Formerly signed and dated *P. D. Laer 1650*
PROV Sale J H Cremer, Amsterdam, 21 June 1887, lot 71
LIT G J Hoogewerff, OH 50 (1933) p 113. Martin 1935-36, vol 2, p 456, fig 238

A 1945 A shepherd and washerwomen at a spring. *Een herder en wasvrouwen bij een bron*

Copper 29 × 43. Signed *V. Laer*
PROV Purchased from the G de Clercq collection, Amsterdam, 1899, through the intermediacy of the Rembrandt Society
LIT Ledermann 1920, p 187, note 11. G J Hoogewerff, OH 50 (1933) p 112, fig 28. G Briganti, Proporzioni 3 (1950) p 197. J Passavant, Pantheon 18 (1960) p 314, fig 4. Exhib cat Italianiserende landschapschilders, Utrecht 1965, nr 36, fig 40. R Roli, Arte ant e mod, 1965, p 108. Caraceni 1966 [p 9]. Janek 1968, p 69. J Michalkowa, OH 86 (1971) pp 193-94

Isaac Lodewijk La Fargue *called* van Nieuwland

The Hague 1726–1805 The Hague

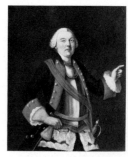 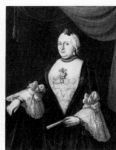

A 637 Jan Hendrik van Rijswijk (b 1717)

Pendant to A 638

Canvas 97 × 80. Signed and dated *I.L. la Fargue ad vivum pinx. 1754.* Inscribed *aetat. 27.* Inscribed on the verso *Hendrik Jan van Rijswijk Major van t' Regiment van Villegas. Nat 26 Sept 1717 Sedert 23 October 1755 Gouver Generaal over de Colon in de Berbice Revieren en Districten Colonel over de Melietie*
PROV Bequest of Mrs J Balguerie-van Rijswijk, widow of D Balguerie, Amsterdam, 1823
LIT Moes 1897-1905, vol 2, nr 6714

A 638 Johanna van Rijswijk (b 1715). Wife of Jan Hendrik van Rijswijk. *Echtgenote van Jan Hendrik van Rijswijk*

Pendant to A 637

Canvas 96 × 79. Inscribed on the verso *Johanna van Rijswijk Nat 30 November 1715*
PROV Same as A 637

Paulus Constantijn La Fargue

The Hague 1729–1782 The Hague

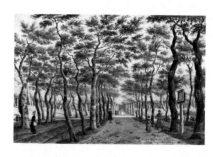

A 3959 The Scheveningen Woods near The Hague. *De Scheveningse Bosjes bij den Haag*

Panel 23 × 34. Signed and dated *Paulus Constantijn la Fargue pinx. 1778*
PROV Purchased from St Lucas gallery, Vienna, 1959

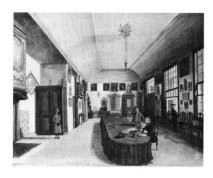

A 3834 The hall of the artistic society 'Kunst wordt door Arbeid verkregen' (Art is acquired through labor) in Leiden. *Interieur van de zaal van het genootschap 'Kunst wordt door Arbeid verkregen' te Leiden*

Canvas 57.3 × 73.8. Signed and dated *Paulus. Const. la Fargue pinx. 1780*
PROV Presented by R C Kneppelhout van Sterkenburg, The Hague, 1952 ∗ DRVK since 1959 (on loan to Stedelijk Museum De Lakenhal, Leiden)
LIT E Pelinck, Jb Leiden, 1956, pp 154-61, fig 2

Gerard Lairesse

Liège 1641–1711 Amsterdam

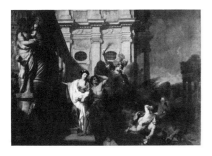

C 437 Allegory of virtue. *Allegorie op de deugd*

Canvas 134 × 195. Signed and dated *G.Laires in. et fecit Anno 1670*
PROV Werkhuis (workhouse), Amsterdam. On loan from the city of Amsterdam since 1885
LIT D P Snoep, Bull RM 18 (1970) p 160

A 213 Antiochus and Stratonice. *Antiochus en Stratonice*

Panel 31 × 47. Signed *G.Lairesse inv. fecit*
PROV Purchased with the Kabinet van Heteren Gevers, The Hague-Rotterdam, 1809 ∗ DRVK since 1954
LIT Hoet 1752, vol 2, p 456. Moes & van Biema 1909, pp 147, 161. Timmers 1942, p 10 (early work). W Stechow, Art Bull 27 (1945) pp 230-31, fig 9. Hendrick 1973, p 55

A 2115 Cleopatra's banquet. *Het feestmaal van Cleopatra*

Canvas 74 × 95.5. Signed *G.Lairesse inv. Pinx.*
PROV Bequest of Mrs H A Insinger-van Loon, dowager of M H Insinger, Amsterdam, 1903
LIT Timmers 1942, p 111, pl X. VTTT, 1966-67, nr 88. Hendrick 1973, p 55

A 211 Odysseus and Calypso. *Odysseus bij Calypso*

Canvas 125 × 94. Signed *G.Lairesse f.*
PROV Soestdijk Palace, 1799. NM, 1808
LIT Moes & van Biema 1909, pp 18, 20, 214. Timmers 1942, p 102. D P Snoep, Bull RM 18 (1970) p 198, fig 32. Hendrick 1973, p 56, fig 14

A 212 Mercury ordering Calypso to release Odysseus. *Mercurius gelast Calypso om Odysseus te laten vertrekken*

Canvas 132 × 96. Signed *G.Lairesse f.*
PROV Same as A 211
LIT Moes & van Biema 1909, pp 18, 20, 161, 214. Timmers 1942, pp 101, 113, pl XI. D P Snoep, Bull RM 18 (1970) p 198, fig 33

A 4210 Selene and Endymion. *Selene en Endymion*

Canvas 177 × 118.5
PROV Same as A 211
LIT Moes & van Biema 1909, pp 18, 20, 214. A Ryszkiewicz, OH 79 (1964) pp 230-32, fig 1. D P Snoep, Bull RM 18 (1970) p 198. Hendrick 1973, p 56, fig 13

A 615 Granida and Daiphilo. *Granida en Daifilo*

Canvas 122 × 147
PROV Unknown
LIT S J Gudlaugsson, Burl Mag 91 (1949) p 40, fig 16

A 1840 The last supper. *Het laatste avondmaal*

Canvas 42.5 × 55. Signed on the verso *Lairesse*
PROV Bequest of Reinhard Baron van Lynden, The Hague, 1899
LIT Hendrick 1973, p 50

A 4174-A 4178 Five allegories in grisaille, painted between 1675 and 1683 for the house of Philips de Flines in Amsterdam. *Vijf allegoriën, geschilderd in grisaille tussen 1675 en 1683 voor het huis van Philips de Flines te Amsterdam*

PROV Purchased from J C Hottinguer, Paris, 1970, as a gift of the Photo Commission
LIT Von Sandrart 1683, p 389. Houbraken 1718-21, vol 3 (1721) pp 117-18. Bidloo 1719, pp 175-76. Von Uffenbach 1754, vol 3, p 690. D P Snoep, Bull RM 18 (1970) pp 160, 172, 174, 176-89, figs 18-22. Hendrick 1973, p 54

A 4174 Allegory of riches. *Allegorie op de Rijkdom*

Canvas 288 × 153

A 4175 Allegory of charity. *Allegorie op de Milddadigheid*

Canvas 288 × 160

A 4176 Allegory of the arts. *Allegorie op de Kunsten*

Canvas 289 × 128

A 4177 Allegory of the sciences. *Allegorie op de Wetenschappen*

Canvas 289 × 161

A 4178 Allegory of fame. *Allegorie op de Roem*

Canvas 288 × 152. Signed *G.Laires*

A

B

C

D

E

F

G

H

C 382 Eight-part ceiling painting with allegorical representations of the care of lepers and the helpless, painted about 1675 for the lepers' asylum, Amsterdam. *Plafondschildering in acht delen met allegorische voorstellingen betreffende de verzorging van leprozen en onnozelen, geschilderd omstreeks 1675 voor het Leprozen-huis, Amsterdam*

A Caritas
B Saturnus
C Plutus
D Religio favoring Abondantia. *Religio begunstigt Abondantia*
E Fortitudo bridling foolishness. *Fortitudo breidelt de zotheid*
F Iustitia
G St Anthony. *De heilige Antonius de Heremiet*
H Protection or might. *Bescherming of Sterkheyt*

Canvas 476 × 573 (without frames);
A 117.5 × 185; B 117.5 × 170; C 117.5 × 131; D 183 × 233; E 182.5 × 290; F 170 × 185; G 130 × 170; H 176 × 131
PROV Leprozenhuis (lepers' asylum), Amsterdam. On loan from the city of Amsterdam since 1885
LIT Wagenaar 1760-88, vol 2 (1765) p 312. Scheltema 1879, p 25, nr 61. DP Snoep, Bull RM 18 (1970) pp 165, 169-70, figs 8-15 (with a plan of the ceiling attributed to Jacob Buys). Haak 1972, p 15, fig 17 (E). Hendrick 1973, p 53

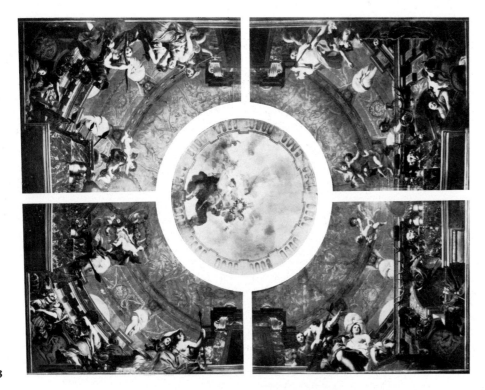

A 1233

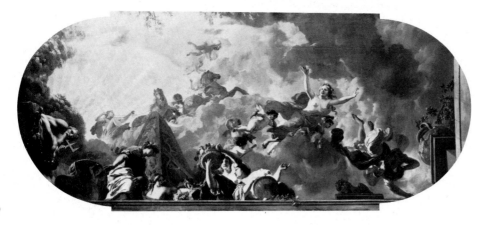

A 4259

Painted ca 1687, the figures by Gerard Lairesse and the landscapes by Johannes Glauber

PROV Passed from the Tutein Nolthenius collection to the so-called Raadzaal (council chamber) of the Rijksacademie voor Beeldende Kunsten, Amsterdam, ca 1910. Transferred to the RMA, 1971 * On loan to the municipality of Velsen (Beeckestijn Estate) since 1971
LIT Houbraken 1718-21, vol 3, p 219. Abry 1867, p 259. Sirèn 1914, p 71. CC van de Graft, Mndbl Oud Utrecht 15 (1942) pp 49-50. D P Snoep, Bull RM 18 (1970) pp 192-98, figs 28-31. Hendrick 1973, p 54

A 4213 Italian landscape with shepherd and shepherdess. *Italiaans landschap met herderspaar*

Mural canvas 290 × 212

A 4214 Italian landscape with three women making music. *Italiaans landschap met drie musicerende vrouwen*

Mural canvas 290 × 210

A 1233 Five-part ceiling decoration for the great hall of Soestdijk Palace, with Diana and her companions as the principal representation. *Plafond-schildering in vijf delen met als hoofdvoor-stelling Diana en haar gezellinnen, geschilderd voor de 'grote zaal' van Paleis Soestdijk*

Canvas 800 × 600 (four parts 400 × 300 each; central part 280 cm in diam)
PROV Soestdijk Palace, 1799. NM, 1808. KKS, 1885
LIT Moes & van Biema 1909, pp 20, 27, 38, 218. D P Snoep, Bull RM 18 (1970) pp 209, 211, fig 42 (central part presumably renewed or completely repainted at a later date). Hendrick 1973, pp 53-54

A 4259 Allegory of dawn. *Allegorie op de dageraad*

Canvas 290 × 680. Ceiling painting
PROV Presented by W F Piek, Amsterdam, 1878. NMGK
LIT D P Snoep, Bull RM 18 (1970) p 211, fig 43. Hendrick 1973, p 53

Gerard Lairesse

&

Johannes Glauber

Utrecht 1646 – ca 1726 Schoonhoven

A 4213-A 4216 Decoration for a room in the house of Jacob de Flines in Amsterdam. *Kamerbeschildering voor het huis van Jacob de Flines te Amsterdam*

A 4215 Italian landscape with two Roman soldiers. *Italiaans landschap met twee Romeinse soldaten*

Mural canvas 290 × 217

A 4216 Italian landscape with three women in the foreground. *Italiaans landschap met drie vrouwen op de voorgrond*

Mural canvas 290 × 212

Georg Lamprecht

see under Miniatures

George Lance

Little Easton 1802–1864 Sunnyside

A 2826 'Red cap'

Panel 31 × 38. Signed and dated
G.L. 1857
PROV Presented by Miss A C Lance,
Kelvedon, Sussex, 1919 * DRVK since
1961

Landsberghs

biographical data unknown

A 625 Portrait of a man of the Balguerie family. *Portret van een man uit de familie Balguerie*

Canvas 74 × 64. Oval. Signed and dated
on the verso *Landsberghs pinxit 1719*
PROV Bequest of Mrs J Balguerie-van
Rijswijk, widow of D Balguerie,
Amsterdam, 1823

Giovanni Lanfranco

Parma 1582–1647 Rome

A 4129 The prophet Elijah awakened in the desert by an angel. *De profeet Elia in de woestijn door een engel gewekt*

Canvas 212 × 230. Painted in 1624-25 for
the chapel of the sacraments in San
Paolo fuori le mura, Rome
PROV Purchased from Th Agnew &
Sons gallery, London, 1967

LIT Réau 1956, pp 233, 267. B de la
Penta, Boll d'Arte 48 (1963) pp 54-66.
E Schleier, Arte ant e mod, 1965, pp 62-
81, 188-201, 343-64. Wynne 1968. E
Schleier, Bull RM 18 (1970) pp 3-33. Cat
Paintings by old masters, London (P &
D Colnaghi) 21 May-22 June 1974, ad
nr 20

Willem Joseph Laquy

Brühl 1738–1798 Kleve

see also Dou, Gerard, A 2320 Triptych:
allegory of art training, copy by Laquy

A 1624 The kitchen. *De keuken*

Canvas 62.5 × 53. Signed *W. J. Laquy
pinx.*
PROV Presented by Dr A Bredius, The
Hague, 1895 * On loan to the
municipality of Velsen (Beeckestijn
Estate) since 1971

school of **Nicolas de Largillière**

Paris 1656–1746 Paris

A 3461 Portrait of a woman, according
to tradition Marie-Louise Elisabeth
d'Orléans (1695-1719), duchesse de
Berry, as Flora. *Portret van een vrouw, volgens
traditie Marie-Louise Elisabeth d'Orléans,
duchesse de Berry, als Flora*

Canvas 179 × 134. Traces of a signature and inscription
PROV Purchased from H F J Vreesmann, Amsterdam, 1943

Marcellus Laroon

The Hague 1653–1702 Richmond

A 1977 Merry company. *Vrolijk gezelschap*

Canvas 40 × 50. Falsely signed *J.Steen*
PROV Purchased from the G de Clercq collection, Amsterdam, 1899, through the intermediacy of the Rembrandt Society

Claes Pietersz Lastman

Amsterdam? ca 1586–1625 Amsterdam

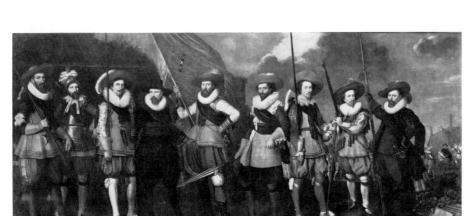

C 406 Captain Abraham Boom and Lieutenant Anthonie Oetgens van Waveren with seven members of the Amsterdam detachment sent off in 1622 to defend Zwolle, 23 September 1623. *Kapitein Abraham Boom en luitenant Anthonie Oetgens van Waveren met zeven schutters van het Amsterdamse vendel, dat in 1622 was uitgetrokken tot verdediging van Zwolle, 23 september 1623*

Canvas 245 × 572. The painting was completed after Lastman's death by

Pieter Pietersz Lastman

Amsterdam 1583–1633 Amsterdam

A 2354 Orestes and Pylades disputing at the altar. *De offerstrijd tussen Orestes en Pylades*

Panel 83 × 126. Signed and dated *Pietro Lastman fecit 1614*
PROV Purchased from F Gerstel gallery, Berlin, 1908
LIT Oudaen 1659, p 602. Vosmaer 1877, p 478, nr 43. W Unger, OH 2 (1884) p 130. K Freise, Bull NOB 2d ser 1 (1908) p 39. Freise 1911, pp 129-34, nr 98. Martin 1935-36, vol 1, p 143, fig 83. Boon 1942, p 44, fig 22. S H Levie, OK 14 (1970) p 17, ill

Adriaen van Nieulandt (1587-1658)
PROV Voetboogdoelen (headquarters of the crossbowmen's civic guard), Amsterdam. On loan from the city of Amsterdam, 1885-1975
LIT Van Dijk 1790, pp 27-28, nr 18. Scheltema 1855-85, vol 7 (1885) p 140. D C Meijer Jr, OH 3 (1885) p 120. Moes 1897-1905, vol 1, nr 852:1; vol 2, nr 5515:1. Martin 1935-36, vol 1, pp 158, 160. Chr Tümpel, N Beitr Rembrandt Forsch, 1973, p 171, fig 134

A 1533 Christ and the woman of Canaan. *Christus en de vrouw uit Kanaän*

Panel 78 × 108. Signed and dated *PL 1617*
PROV Purchased from the Beggi gallery, Florence, 1889, through the intermediacy of the Rembrandt Society
LIT E Jacobsen, Rep f Kunstw 24 (1901) p 178. Freise 1911, pp 137-39, nr 64. F Saxl, in Meisterwerke, 1920

A 1359 The sacrifice of Abraham. *Het offer van Abraham*

Panel 40 × 32. Grisaille. Signed *PL*
PROV Presented by Dr A Bredius, The Hague, 1887 * DRVK since 1959 (on loan to Het Rembrandthuis, Amsterdam)
LIT Michel 1893, pp 19-20. Freise 1911, nr 10. K Bauch, Münchn Jb, 1952-53, p 222, fig 6. J Bruyn, Simiolus 4 (1970) p 40, fig 13. B P J Broos, Kroniek Rembrandthuis 26 (1972) pp 140-41, fig 4

manner of **Georges de La Tour**

Vic-sur-Seille 1593–1652 Lunéville

A 3569 Christ seated on a stone block. *Christus op de koude steen*

Canvas 134 × 99
PROV Purchased from Professor Fiorentini, Rome, 1948, through the intermediacy of G J Hoogewerff
LIT Ch Sterling, Revue des Arts 3 (1951) p 155, note 10. G Frabetti, in Studies ded to Suida, 1959, p 271, fig 6. Thuillier 1973, p 99

Jacobus Johannes Lauwers

Bruges 1753 – 1800 Amsterdam

A 1073 Woman drawing water from a well. *Een vrouw bij een waterput*

Canvas 44 × 36. Signed and dated *J. Lauwers Ft 1799*
PROV Purchased in Amsterdam, 1829.
RVMM, 1885 * DRVK since 1961

Sir Thomas Lawrence

Bristol 1769 – 1830 London

A 728 Willem Ferdinand Mogge Muilman (1778-1849). President of the Bank of the Netherlands. *President van de Nederlandse Bank*

Canvas 76 × 64
PROV Bequest of Jonkheer J S H van de Poll, Amsterdam, 1880
LIT V de Stuers, Ned Kunstbode 2 (1880) p 244. Armstrong 1913, p 153. Garlick 1954, p 51. Garlick 1964, p 146

Jakob Christof Leblon

see under Miniatures

Anthony Leemans

The Hague 1631 – in or before 1673 Amsterdam

A 752 Still life with a copy of De Waere Mercurius, a broadsheet with the news of Tromp's victory over three English ships on 28 June 1639, and a poem telling the story of Apelles and the cobbler. *Stilleven met een exemplaar van De Waere Mercurius, een nieuwsblad over Tromp's overmeestering van drie Engelse schepen op 28 juni 1639, en een gedicht over de schoenmaker die het werk van Apelles misprijst*

Canvas 78 × 72. Signed and dated *Anthonius Leemans Fecit 1655*. Inscribed *Numero 8 Wekelycke waere | Mercurius | van het | gedenckwaerdichste| dat door | Europa… … verkregen tege… 1639. Mynheer|Soo*

terstont krijge ick hier ongetwijffelde Tijdingh uyt het schrijven van den Admirael Tromp selff, in dato den 29 Junij als dat hy den voorgaenden dagh, namentlick den acht-en-twinticghsten, siende aen-komen drie Enghelse schepen heeft den selven geboden om te strycken die sulcks weygerende, soo heeft hy haer doen blincken de Tanden van Emilia dewelcke sodanigen schrick causeerden, dat sy terstont in onmacht ende flaeuwigheyt zijn gevallen. Den Admirael sulcx siende heeft als een goet Medicus, haer sieckte laeten visiteren, ende bevonden dat sij den buyck vol Spanjaerden hadden, menende daer van binnen Duynkercken in de kraem te leggen. Maer de boven gemelde schrick heeft een misgeborte gecauseert, ende hebbe alsoo, op zee, aen de Werelt gebracht tien hondert en seventich Spanjaerden, die De hollantse Vroetwijfs ende Bakermoeren hebben terstont alsoo inde luyren gebonden, datse haest bequaem sullen zijn Rotterdams bier of water te drincken wordende alle uyre alhier verwacht. Vale. Rotterdam desen 2 Julij 1639
Venus en Cupido van Apelles hant ghewrocht worden hier besocht van vele (soo wij lesen) Eenen Schoenmaecker quam oock kijcken soo hij mocht 't Heeft hem al goet gedocht, dat hem eijgen mocht wesen Maer dat van sijn ambacht niet was heeft hij mispresen Apelles dit horende is tot hem gekeert En gaet over u leest niet sprack hij mits desen Maer elck mercke sijn ambacht dat hij heeft geleert Die een anders werck laeckt wort dicwils onteert. T 2 || Finis Coronat Opus ||
PROV Sale W Gruyter, Amsterdam, 24-25 Oct 1882, lot 59
LIT Vorenkamp 1933, p 94. Bernt 1960-62, vol 2, nr 476. Bernt 1969-70, vol 2, nr 666

Johannes Leemans

The Hague? ca 1633 – in or before 1688 The Hague

C 523 Still life with implements of the hunt. *Stilleven met jachtgerei*

Canvas 62 × 76.5. Trompe l'œil. Signed and dated *J. Leemans 1678*
PROV On loan from the KOG (presented by Dr A Bredius) since 1885
LIT Vorenkamp 1933, p 94

A 1946 Still life with implements of the hunt. *Stilleven met jachtgerei*

Canvas 73.5 × 59. Trompe l'œil
PROV Purchased from the G de Clercq collection, Amsterdam, 1899, through the intermediacy of the Rembrandt Society * On loan to the Rijksmuseum 'Huis Lambert van Meerten,' Delft, since 1909

Willem van Leen

Dordrecht 1753–1825 Delfshaven

A 4111 Still life with flowers and fruits. *Stilleven met bloemen en vruchten*

Verre églomisé 6.2 cm in diam. Signed *W Van Leen*
PROV Bequest of Mr & Mrs J C J Drucker-Fraser, Montreux, 1944

Gilles Légaré

see under Miniatures

Charles Henri Joseph Leickert

Brussels 1816–1907 Mainz

A 3922 Winter scene, with a city in the distance. *Wintergezicht met een stad in de verte*

Canvas 81 × 114. Signed and dated *Ch. Leickert f. 50*
PROV Purchased from P A Scheen gallery, The Hague, 1957

A 1074 Winter scene. *Wintergezicht*

Canvas 133 × 191. Signed and dated *Ch. Leickert f 67*
PROV Purchased at exhib Amsterdam 1867, nr 119. RVMM, 1885 * DRVK since 1953

A 3084 The old gate. *De oude poort*

Panel 23.5 × 18.8. Signed *Chr. Leickert*
PROV Bequest of J B A M Westerwoudt, Haarlem, 1907. Received in 1929

Adriaan de Lelie

Tilburg 1755–1820 Amsterdam

see also Governors-general series: A 3787 P G van Overstraten; A 3789 A H Wiese

A 4100 The art gallery of Jan Gildemeester Jansz (1744-99) in his house on the Herengracht, Amsterdam. *De kunstgalerij van Jan Gildemeester Jansz in zijn huis aan de Herengracht te Amsterdam*

Among the sitters are Jan Gildemeester Jansz, Bernardus de Bosch, Pieter Fouquet, Adriaan de Lelie and, presumably, Jurriaan Andriessen, Marianne Dull, née Dohrman, and C R T Krayenhoff

Panel 63.7 × 85.7. Signed and dated *A. de Lelie f. A° 1794-95*
PROV Purchased from F Lacorre, Les Eyzies, France, 1964
LIT Van Eynden & van der Willigen 1816-40, vol 3 (1820) p 70. Knoef 1943, pp 48-49. Bille 1961, vol 1, p 132, note 49. VTTT, 1964-65, nr 61. Th van Velzen, OKtv 3 (1965) nr 13, ill. C J de Bruyn Kops, Bull RM 13 (1965) pp 79-114, ill (identifies the sitters and the pictures on the wall). Th H Lunsingh Scheurleer, Jb Amstelodamum 59 (1967) pp 78ff, 88, fig 7. A van Schendel, in João Couto 1971, pp 163-69, ill. I H van Eeghen, Mndbl Amstelodamum 59 (1972) pp 25-32, ill. J W Niemeijer, Apollo 96 (1972) p 395, ill. G J van der Hoek, Kunstrip 2 (1971-72) nr 15

A 1075 Morning visit. *Morgenbezoek*

Panel 53 × 43. Signed and dated *A. de Lelie Ft 1796*
PROV Sale G van der Pot van Groeneveld, Rotterdam, 6 June 1808, lot 70. RVMM, 1885
LIT Moes & van Biema 1909, pp 113, 186. Scheen 1946, fig 27. C J de Bruyn Kops, Bull RM 13 (1965) p 104, fig 38

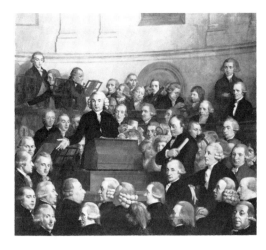

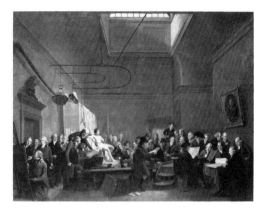

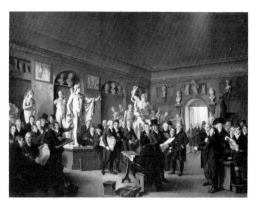

C 539 Dedication of the Felix Meritis Society building, Amsterdam, in the recital hall, 31 October 1788. *Inwijding van het gebouw der Maatschappij Felix Meritis te Amsterdam, in de muziekzaal, 31 oktober 1788*

The sitters are identified in a contour drawing by J C de Haen in the Rijksprentenkabinet as Professor Jean Henri van Swinden, the inaugural speaker; Joseph Schmidt, composer and conductor of the music written for the occasion; the board members Christiaan Everard Weits, Jan Pieterse, Daniel Bleecker, Frans Laurens Woldorff and Cornelis Sebille Roos, president, who had lain the first stone on 7 July 1787; members of the building committee Jan Lugt Dircksz, Johannes Marinus Verhoesen, Johannes Gerardus Fauvarcq, Jan Swart, Theodorus Johannes Weddik, Pieter Kerkhoven, Jacob Kuyper, Hidde Heeremiet, secretary, and Albert Strokkel, administrator; and further Dr Henricus Aeneae, Professor A Bonn, E M Engelberts, Professor Hendrik Constantijn Cras, D C Jamin, R W Linde van Dijk, H Steenbergen, Christoffel Leer, Steven Daniël Cartier, A C H Kaempff, P S Serné, Jacques Kuyper, J R Rigail, B Weddik Wendel, J Moll Jr, Joannes Lublink de Jonge, A de Haas, L Tersteeg, P H van Swinden, J G N Fauvarcq, Jan Schutte Hoyman, Philippus Taddel, Jan Anthonie van Hemert, J Ruloffs and Adriaan de Lelie himself

Canvas 167.5 × 189. Commissioned in 1800, unveiled in 1801. Reworked in places by de Lelie at a later date
PROV Felix Meritis Society, Amsterdam, 1889. On loan from the city of Amsterdam, 1889-1975
LIT Van Swinden 1789. Historische beschrijving Felix Meritis, 1800. J Knoef, Jb Amstelodamum 35 (1938) pp 207-11. J Knoef, Elsevier's GM 50 (1940) pp 389-90, 393. Knoef 1943, pp 42-43, ill on p 49. Van Hall 1963, p 184, nr 1253:2. C J de Bruyn Kops, Bull RM 13 (1965) pp 106-07, fig 30

C 538 The drawing room of the Felix Meritis Society in Amsterdam with portraits of artists, collectors of paintings and drawings, and some art dealers. *De tekenzaal van de Maatschappij Felix Meritis te Amsterdam, met portretten van kunstenaars, verzamelaars van schilder- en tekenkunst en enkele kunstmakelaars*

The sitters are identified in a contour drawing of 1822 by H W Caspari in the Rijksprentenkabinet as, from left to right, Pieter van Winter N Szn, Josephus Augustinus Brentano, Jacobus Lauwers, seated at the easel, Pieter de Smeth van Alphen, Gerrit Muller, unknown, Daniël Dupré, Jacques Kuyper, Adriaan de Lelie, seated and wearing a hat, Lambertus Antonius Claessens, above him, and, to the right of the model, Philippus van der Schley, Jan IJver, Jan Hulswit, Dirk Versteegh, with outstretched arm, Pieter Fouquet Jr, above him, Hermanus Fock, H Peereboom, pointing at the model, Cornelis van Heurn, Jan Evert Grave Jr, Jacob de Vos Wz, up front, wearing a hat, Gabriël van Rooijen, Jan Tersteeg, Jacob Smies, Chrétien du Bois, Jan Kamphuysen, Hermanus Numan, rising above the rest, Jan Ekels Jr, Pieter Barbiers Pz, Roelof Meurs Pruyssenaar, lower profile, Steven Goblé, upper profile, Jacob de Vos, Professor Andreas Bonn, Jodocus Clemens van Hall, Reinier Vinkeles, Johannes Goll van Frankenstein, Bernardus de Bosch, Hendrick van Eijl Sluyter, Jan Gildemeester Jansz, Jeronimo de Bosch, Cornelis Sebille Roos, and on the wall a portrait of Jean Grandjean

Canvas 100 × 131. Signed *A. de Lelie*. Painted in 1801
PROV Felix Meritis Society, Amsterdam, 1889. On loan from the city of Amsterdam since 1889
LIT J Knoef, Mndbl BK 13 (1936) p 341-47, ill. J Knoef, Jb Amstelodamum 35 (1938) p 211, ill. J Knoef, Elsevier's GM 50 (1940) p 390. Knoef 1943, pp 35, 44, 50, 67, ill. Van Hall 1963, p 184, nr 1353:3. Exhib cat De schilder en zijn wereld, Delft-Antwerp 1964-65, nr 70, fig 40. C J de Bruyn Kops, Bull RM 13 (1965) p 97ff, figs 21-23. C J de Bruyn Kops, OK 11 (1967) nr 24, ill

C 537 The sculpture gallery of the Felix Meritis Society in Amsterdam, with portraits of the commissioners and directors of the drawing, literature and commerce divisions and the secretaries of the society. *De beeldenzaal van de Maatschappij Felix Meritis te Amsterdam, met portretten van de commissarissen en directeuren van de Departmenten Teekenkunde, Letterkunde en Koophandel en de secretarissen der Maatschappij*

The sitters are identified in a contour drawing of 1822 by H W Caspari in the Rijksprentenkabinet as, from left to right, J Adami, J P Hibma, seated, M Kooy, standing, Hidde Heeremiet, W J Bruggemeyer, Hendrik de Flines, A Buyn, G Koek, Wouter Johannes van Troostwijk, Daniël Dupré, drawing, Dirk Versteegh and, in the middle group, J G Biben, G J Palthe, P Doublet, J Pennis, C Covens, Johannes Hermanus Molkenboer, A J Deyman, R Hoyman, Adriaan de Lelie, seen from the rear, at a drawing board, P Pietersz Iz, Hermanus Numan, M Romswinckel, G van Haarst Az, E P Offerman, G Swarth and, in the group to the right, C Tweehuisen, bedel, the foremost figure in the doorway, J W Berntz, G van der Voort, Barend Klijn Bz, Hendrik Harmen Klijn, J F Klinkhamer, F de Bozer, P J Uylenbroek, P Heimbach J Pz, A Bousquet, J L Weydeman and J Prins

Canvas 100 × 133. Signed *A. de Lelie*. Commissioned in 1806 as a pendant to C 538. Finished in 1809
PROV Felix Meritis Society, Amsterdam, 1889. On loan from the city of Amsterdam, 1889-1975
LIT J Knoef, Jb Amstelodamum 35 (1938) pp 214-18, ill. J Knoef, Elsevier's GM 50 (1940) p 392, ill. Knoef 1943, pp 46-47, 49, 52, ill. Van Hall 1963, p 184, nr 1253:4

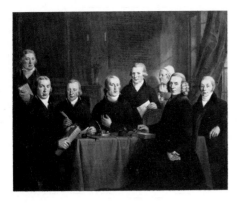

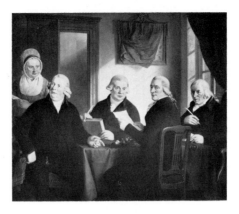

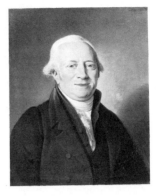

C 588 Six regents of the Nieuwe Zijds institute for the outdoor relief of the poor, Amsterdam, 1799. *Zes regenten van het Nieuwe Zijds Huiszittenhuis, Amsterdam, 1799*

The sitters are Johannes Ludovicus Farjon, Petrus Jacobus Noot, Carsten Petersen Jr, David de Mijn, Daniël Arbmann Daniels and Dirk van Bergen

Canvas 181 × 219. Signed *A. de Lelie*. The panegyric on the wall plaque is dated *20 December 1799*
PROV On loan from the city of Amsterdam, 1896-1975
LIT J Knoef, Elsevier's GM 50 (1940) p 390. Knoef 1943, pp 44, 46

C 589 Four regents of the Oude Zijds institute for the outdoor relief of the poor, Amsterdam, 1806. *Vier regenten van het Oude Zijds Huiszittenhuis te Amsterdam, 1806*

The sitters are Bernardus de Bosch, J H Bus, A Baart and P J le Jolle

Canvas 177 × 200. Signed and dated *A. de Lelie ft 1806*
PROV On loan from the city of Amsterdam, 1896-1975
LIT J Knoef, Elsevier's GM 50 (1940) p 391. Oldewelt 1942, p 18. Knoef 1943, pp 42, 46. Haak 1972, p 36, fig 41

A 3098 Cornelis Sebille Roos (1754-1820). Amsterdam art dealer and keeper of the Nationale Konst-Gallery in Huis ten Bosch, The Hague. *Kunstkoper en -makelaar te Amsterdam en inspecteur van de Nationale Konst-Gallery op het Huis ten Bosch te Den Haag*

Canvas 68 × 54.3. Signed and dated *A. de Lelie ft. A° 1815*
PROV Purchased from P F van Hamel Roos, Amsterdam, 1929

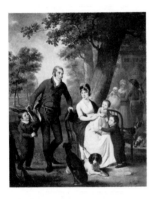

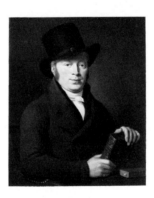

A 1355 Jonkheer Gijsbert Carel Rutger Reinier van Brienen van Ramerus (1771-1821). With his wife and four of their children. *Met zijn vrouw en vier van hun kinderen*

His wife is Geertruid Elisabeth de Graeff (1776-1857) and their children are Gerrit (b 1799), Jan Anne (b 1800), Christina (b 1802) and Carolina Gijsberta (b 1804). In the background is their country home at Craailoo

Canvas 84.5 × 71. Signed and dated *A. de Lelie ft. A° 1804*
PROV Presented by Jonkvrouwe A M van Brienen van Ramerus, Oosterbeek, 1887
LIT Knoef 1943, p 46

A 1541 Barend Klijn Barendsz (1774-1829). Poet. *Dichter*

Canvas 74.5 × 62. Formerly signed and dated *1813*. Inscribed on the verso *Portret van Barend Klijn Barendszoon op 39 jarigen leeftijd, geboren 21 December 1774, overleden 13 Januari 1829*
PROV Presented from the estate of J H Molkenboer, Amsterdam, 1891 * Lent to the AHM, 1975
LIT Knoef 1943, p 48 (dated 1815)

A 2294 Old woman making pancakes. *De koekebakster*

Panel 52.5 × 42. Signed *A. de Lelie fec.*
PROV Lent by J B A M Westerwoudt, Haarlem, 1902. Bequeathed in 1907
LIT Marius 1920, p 66, fig 32. Hannema 1967, nr 184

A 4122 The art gallery of Josephus Augustinus Brentano (1753-1821) in his house on the Herengracht, Amsterdam.

De kunstgalerij van Josephus Augustinus Brentano in zijn huis aan de Herengracht te Amsterdam

Panel 64.3 ×84.3
PROV Purchased from FJMWayenburg, Eindhoven, 1966
LIT Van Eynden & van der Willigen 1816-40, vol 3 (1820) pp 70-71. Knoef 1943, p 49. J Knoef, Med RKD 1 (1946) p 61. Bull RM 14 (1966) p 86, ill

A 2856 Jan Nieuwenhuyzen (1724-1806). Mennonite preacher and founder, in 1784, of the Dutch society for the promotion of the general good. *Doopsgezind predikant en in 1784 stichter van de Maatschappij tot Nut van 't Algemeen*

Canvas 63 ×50.5. Signed *A. de Lelie f.*
PROV Purchased from N van Rossum, Amsterdam, 1921

A 2234 Gerrit Verdooren (1757-1824). Vice admiral. *Vice-admiraal*

Presumably an autograph replica of the three-quarters length portrait in the Zeeuws Museum, Middelburg
Pendant to A 2235

Canvas 72.5 ×58.5
PROV Bequest of ELG Verdooren, Amsterdam, 1906 * DRVK since 1959 (on loan to the Museum van de Kanselarij der Nederlandse Orden, The Hague)

A 2235 Wilhelmina Maria Haack. Fourth wife of Gerrit Verdooren. *Vierde echtgenote van Gerrit Verdooren*

Pendant to A 2234

Canvas 72.5 ×58.5
PROV Same as A 2234

Adriaan de Lelie

&

Egbert van Drielst

Groningen 1745–1818 Amsterdam

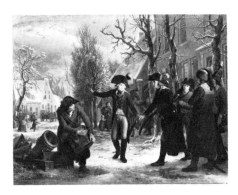

A 2231 General Daendels taking leave in Maarssen of Lieutenant colonel CRT Krayenhoff, whom he was despatching to Amsterdam to help depose the city government, 18 January 1795. *Generaal Daendels neemt te Maarssen afscheid van luitenant-kolonel CRT Krayenhoff, die naar Amsterdam wordt gezonden om een omwenteling in het stadsbestuur te bewerkstelligen, 18 januari 1795*

Panel 45 ×60. Signed and dated *E. van Drielst pinx. A. de Lelie A° 1795.* The figures are by de Lelie, the rest of the painting by van Drielst. A manuscript dated 1834 with an explication of the representation is attached to the verso
PROV Purchased from the Nagel family, Arnhem, 1906
LIT BWF van Riemsdijk, Bull NOB 7 (1906) p 177. J Knoef, Elsevier's GM 50 (1940) p 402. Knoef 1943, pp 59-60. Scheen 1946, fig 9. OL van der Aa & B van 't Hoff, Jb Genealogie 14 (1960) p 45, nr 6, fig d. AERientjes, Jb Nifterlake, 1951, p 7, ill. CJ de Bruyn Kops, Bull RM 13 (1965) p 107. JW Niemeijer, in exhib cat Egbert van Drielst, 1745-1818, Assen 1968, nr 2, ill. ERM Taverne, Antiek 4 (1969) p 67

Cornelis Lelienbergh

The Hague before 1626– after 1676 The Hague

A 1455 Still life with parrot and snipes. *Stilleven met papegaai en snippen*

Pendant to A 1454

Panel 47 ×37.5. Signed and dated *CL f. 1655*
PROV Sale Amsterdam, 13 March 1888, lot 48
LIT Bergström 1947, p 254. Bergström 1956, p 250

A 1454 Still life with woodpecker and snipes. *Stilleven met specht en snippen*

Pendant to A 1455

Panel 47 ×37.5. Signed and dated *CL F 1655*
PROV Same as A 1455
LIT Bergström 1947, p 254. Bergström 1956, p 250. Bol 1969, p 286

A 1710 Still life with black rooster and two rabbits. *Stilleven met zwarte haan en twee konijnen*

Canvas 93.5 ×84. Signed and dated *C. Lelienbergh f. 1659*
PROV Sale G de Clercq, Amsterdam, 1 June 1897, lot 45. Purchased with aid from the Rembrandt Society

A 1741 Still life with hare and black rooster. *Stilleven met haas en zwarte haan*

Canvas 101 ×85. Signed and dated *C.Lelienbergh f. A° 1659*
PROV Bequest of D Franken Dzn, Le Vésinet, 1898

studio of **Sir Peter Lely**

Soest 1618–1680 London

see also Miniatures: Richter, Christian, A 4365 Anthony van Dyck, after Lely

A 3832 George Monk (1608-69), first duke of Albemarle. English admiral and statesman. *Eerste hertog van Albemarle. Engels admiraal en staatsman*

Canvas 118 ×96
PROV Sale duke of Bedford, London, 19 Jan 1951, lot 121

Johann Philipp Lembke

see under Miniatures

Mathieu Lenain

Laon 1607–1677 Paris

A 3099 The dice shooters. *De dobbelaars*

Canvas 93 × 119.7
PROV Purchased from the J W Nienhuys collection, Bloemendaal, 1929, as a gift of the Photo Commission
LIT Champfleury 1862, p 146. Valabrègue 1904, p 119, note 3. P Jamot, GdB-A 65 (1923) pp 39, 100. Fierens 1933, p 51, pl XL

attributed to **Andrea de Leone**

Naples 1610–1685 Naples

C 1346 The peddlers. *De marskramers*

Canvas 98 × 132
PROV Purchased by King Willem I, 1831. On loan from the KKS (cat 1935, nr 289 as Sébastien Bourdon) since 1948
LIT Ponsonailhe 1883, p 299. V Lasareff, Städ Jb 6 (1930) pp 106-07 (Bourdon). Attributed orally to Leone by P Rosenberg, Paris (cf M S Soria, Art Q 23 [1960] p 23)

Eugène Modeste Edmond Lepoittevin

Paris 1806–1870 Paris

A 1823 A young herdsman. *Herders-jongen*

Board 16 ×21.5. Signed *ELP*
PROV Bequest of Reinhard Baron van Lynden, The Hague, 1899

Pieter Lesage

see under Miniatures

Jacob Levecq

Dordrecht 1634–1675 Dordrecht

A 2402 Portrait of a man. *Portret van een man*

Canvas 85 ×65. Signed and dated *J.L. f 1672*
PROV Purchased from Shepherd Bros, London, 1909 * DRVK since 1959 (on loan to the Dordrechts Museum, Dordrecht)

Aertgen van Leyden

Leiden 1498–1564 Leiden

A 3480 The raising of Lazarus. *De opwekking van Lazarus*

Panel 75.5 × 78.5
PROV Purchased from M Matthiesen gallery, London, 1946
LIT Gerson 1950, p 29, fig 79. J Bruyn, NKJ 11 (1960) p 79 (attributed to Aertgen). P Wescher, Wallraf-R Jb 30 (1968) p 215, fig 152. Von der Osten & Vey 1969, p 181

attributed to **Aertgen van Leyden**

A 1691 The calling of St Anthony. *De roeping van Sint Antonius*

Panel 133 × 97. Signed apocryphally *L*
PROV Purchased from P & D Colnaghi gallery, London, 1897, with aid from the Rembrandt Society
LIT E Bock, Mon f Kunstw 3 (1910) p 405. L Cust, Burl Mag 18 (1910-11) p 150, fig D. Ring 1913, pp 119, 162. Beets 1913, p 108 (Lucas van Leyden, ca 1530). Winkler 1924, p 269 (largely studio of Lucas). Friedländer 1924-37, vol 10 (1932) pp 92, 136, nr 134, pl LXXIX (Lucas and Pieter Cornelisz Kunst?). P Wescher, OH 51 (1934) p 60 (Lucas and helper). F W Hudig, OH 51 (1934) p 65 (Lucas, ca 1530). Goldscheider 1936, p 23, fig 99. Hoogewerff 1936-47, vol 3 (1939) p 261, fig 136 (Lucas 1518-19). I Q van Regteren Altena, OH 56 (1939) p 82

(Aertgen, ca 1530). Beets 1940, p 52 (Lucas). J B F van Gils, OH 61 (1946) p 70. J G van Gelder, OH 61 (1946) p 101 (Aertgen, ca 1530). Boon 1947, p 19, fig 7. Gerson 1950, pp 28, 68, fig 70 (Lucas). N Beets, OH 67 (1952) p 190, note 10 (Lucas). C Müller Hofstede, in Festschrift Winkler, 1959, p 232 (not Lucas). J Bruyn, NKJ 11 (1960) pp 37-119, ill (Aertgen). J Bruyn, Jb Mus Antwerpen, 1961, p 5, fig 4. Friedländer 1963, p 57, fig 47 (Lucas and Pieter Cornelisz Kunst). Van Hall 1963, p 177, nr 1199; p 186, nr 1262:2. K G Boon, in Miscellanea van Regteren Altena, 1969, pp 58-59. Von der Osten & Vey 1969, p 180

A 3903 St Jerome in his study by candlelight. *De heilige Hieronymus in zijn studeercel bij kaarslicht*

Panel 48 × 38. Signed on a tablet beneath the mirror *CI?* Inscribed *Respice fin[e]m*
PROV Purchased from P de Boer gallery, Amsterdam, 1955
LIT E Pelinck, Bull RM 8 (1960) p 135, fig 1 (attributed to Jan Vermeyen). J Bruyn, NKJ 11 (1960) pp 79, 93, fig 33. J Bruyn, Burl Mag 104 (1962) pp 291-94. O Millar, in exhib cat Dutch pictures from the royal collection, London 1971-72, p 9, note 8

Jan van Leyden

active 1667-69 in the northern Netherlands

A 1386 The Dutch firing English ships during the raid on Chatham, 20 June 1667. *De Hollanders steken Engelse schepen in brand tijdens de tocht naar Chatham, 20 juni 1667*

Panel 93 × 156.5. Signed *J. v. Leyden*
PROV Sale The Hague, 30 Jan 1878, lot 17. NMGK, 1887
LIT C Hofstede de Groot, OH 17 (1899) p 167. Willis 1911, p 100. Bol 1973, p 299. E Visser, Kunstrip 36 (1973-74)

Lucas van Leyden

Leiden 1494 – 1533 Leiden

A 3841 Triptych with the adoration of the golden calf. *Drieluik met de aanbidding van het gouden kalf*

Panel 93 × 67 (middle panel); 91 × 30 (each of the wings). The outsides of the wings are painted in imitation marble
PROV Purchased from Mrs Bignier, Paris, 1952
LIT Van Mander 1604, fol 136 recto. A Bredius, OH 31 (1913) p 203. N Beets, OH 67 (1952) pp 183-99 (1524-25). A van Schendel, Bull RM 1 (1953) pp 3-7 (1527-33). C Müller Hofstede, in Festschrift Winkler, 1959, p 230. Bille 1961, vol 1, p 144. Friedländer 1963, p 69, note 37, figs 54, 58. M L Wurfbain, OK 15 (1971) nr 17, ill. Von der Osten & Vey 1969, p 179. L A Silver, Art Bull 55 (1973) pp 407-08, fig 5. J R J van Asperen de Boer & A K Wheelock Jr, OH 87 (1973) p 80. I Markx-Veldman, OH 87 (1973) p 116

studio of **Lucas van Leyden**

A 3739 Madonna and child. *Maria met kind*

Panel 35 × 27.5
PROV Sale M A Schloss, Paris, 25 May 1949, lot 29
LIT Beets 1913, p 128. N Beets, Onze Kunst 25 (1914) p 59, fig 10. Winkler 1924, p 264. Friedländer 1924-37, vol 10 (1932) p 96 (after 1522), p 136, nr 126 (ca 1526), pl LXXV. Hoogewerff 1936-47, vol 3 (1939) pp 285-86 (1523-24). Beets 1940, p 38 (ca 1520). Gerson 1950, p 28, fig 72. N Beets, OH 67 (1952) p 183, fig 1. Friedländer 1963, p 69, fig 42 (ca 1521). E J Reznicek-Buriks, OH 80 (1965) p 245 (executed by a follower or by a pupil). Von der Osten & Vey 1969, p 178

manner of **Lucas van Leyden**

A 4260 Salome with the head of John the Baptist. *Salome met het hoofd van Johannes de Doper*

Verre églomisé 27 × 14

PROV Purchased from Fr Muller & Co, art dealers, Amsterdam, 1895
LIT Ritz 1972, pp 10, 154, nr 10, fig 10 (ca 1510)

Jan August Hendrik Baron Leys

Antwerp 1815 – 1869 Antwerp

C 291 Seventeenth-century interior. *Zeventiende-eeuws binnenhuis*

Panel 62 × 50. Signed and dated *HLeys 1838*
PROV On loan from the city of Amsterdam (A van der Hoop bequest) since 1885

Judith Leyster

Haarlem? 1600/10 – 1660 Heemstede

A 2326 The serenade. *De serenade*

Panel 45.5 × 35. Signed and dated *J* (followed by a star, referring to the artist's name, which can be interpreted to mean 'lodestar') *1629*
PROV Purchased from the heirs of Jonkheer P H Six van Vromade, Amsterdam, 1908, through the intermediacy of the Rembrandt Society
LIT W Steenhoff, Onze Kunst 13 (1908)

pp 216-17, ill. Moes 1909, p 91. J Harms, OH 44 (1927) p 115, fig 2. Von Schneider 1933, pp 65, 137. Martin 1935-36, vol 1, p 380. Slive 1971, vol 1, pp 71, 85-86, fig 68

A 1685 The jolly drinker. *De vrolijke drinker*

Canvas 89 × 85. Signed and dated *J* (followed by a star, referring to the artist's name, which can be interpreted to mean 'lodestar') *1629*
PROV Purchased from F Kleinberger gallery, Paris, 1897 * DRVK since 1959 (on loan to the Frans Halsmuseum, Haarlem)
LIT E Jacobson, Rep f Kunstw 18 (1895) p 435. A von Schneider, OH 40 (1922) p 170, ill. J Harms, OH 44 (1927) p 116. Von Schneider 1933, p 65. Martin 1935-36, vol 1, pp 343-44, 379, fig 199. Rosenberg, Slive & Ter Kuile 1966, p 107

copy after **Abraham Liedts**

active ca 1650 in Hoorn

A 854 Pieter Florisz (1605-58). Vice admiral of the northern district. *Vice-admiraal van het Noorderkwartier*

Canvas 119 × 92
PROV Sale J H Broers, Utrecht, 8 March 1873, lot 3108 (as 'F Liest'). NMGK, 1885
LIT Moes 1897-1905, vol 1, nr 2526:1

Willem Adriaan Alexander Liernur

The Hague 1856–1917 Deventer

A 1563 Interior of a cottage in Scheveningen. *Schevenings binnenhuis*

Panel 13 × 17. Signed and dated twice *A W A Liernur 1887*
PROV Bequest of Jonkheer P A van den Velden, The Hague, 1892

Jan Lievens

Leiden 1607–1674 Amsterdam

C 1467 Constantijn Huygens (1596-1687), lord of Zuylichem. Secretary of the stadholder, Prince Frederik Hendrik, and poet. *Heer van Zuylichem. Secretaris van stadhouder prins Frederik Hendrik en dichter*

Panel 99 × 84
PROV On loan from the Musée de la Chartreuse, Douai, since 1962, in exchange for Mignon, Abraham, A 266, and Witte, Emanuel de, A 474
LIT Moes 1897-1905, vol 1, nr 3873:5. Schneider 1932, nr 243. C Brière-Misme, OH 53 (1936) p 193ff. C Brière-Misme, Bull Mus France 9 (1936) p 28ff. H E van Gelder, Med DKW Gem 's-Grav, 1937, p 9, ill. K Bauch, Wallraf-R Jb ns 11 (1939) pp 239-68. Kan 1946, pp 81-82, 162. Van Gelder 1953, pp 18-19. J A Emmens, NKJ 7 (1956) p 154, fig 4. J Michalkowa, Biul Hist Sztuki 19 (1957) p 264, ill. Van Gelder 1957, p 20, nr 5,

fig 14. H Gerson, Kunstchronik 10 (1957) pp 122, 124. G Kamphuis, OH 73 (1958) p 106. HE van Gelder, OH 74 (1959) pp 75-76. Bauch 1960, pp 210, 265, note 178. Chr White, Apollo 76 (1962) p 180, ill. A van Schendel, Bull RM 11 (1963) p 5, ill (1627-28). Rosenberg, Slive & Ter Kuile 1966, p 85. K Bauch, Pantheon 25 (1967) p 264 (1630s). Gerson 1969, pp 22, 36, ill. H Gerson, OH 84 (1969) p 244. H Gerson, Miscellanea van Regteren Altena, 1969, p 138, note 3. A A E Vels Heijn, OK 14 (1970) nr 13, ill (1629-30). Schneider & Ekkart 1973, suppl, pp 308-12, nr 243

A 1627 Samson and Delilah. *Simson en Delila*

Canvas 131 × 111. Signed *IL* and, falsely, *Rembrandt f 1633*
PROV Purchased from J S Hensé, Bradford, 1895 * DRVK since 1971 (on loan to Het Rembrandthuis, Amsterdam)
LIT Hofstede de Groot 1906, p 19, nr 18. J Six, OH 37 (1919) p 84. S W A Drossaers, OH 47 (1930) p 203, nr 49. Schneider 1932, pp 30-31, nr 13. Martin 1935-36, vol 2, p 105. Burroughs 1938, pp 158, 162. W Sumowski, Wiss Zeitschr Humboldt Un 7 (1957) pp 233, 236, ill. Bauch 1960, p 216, fig 173a. Rosenberg 1964, p 18, fig 16. Gerson 1968, p 26, ill. A Tzeutschler-Lurie, Bull Clev Mus of Art 56 (1969) p 333, fig 3. M Kahr, Art Bull 55 (1973) p 240, fig 2. Schneider & Ekkart 1973, suppl nr 13

A 612 Allegory of peace. *Allegorie op de vrede*

Canvas 220 × 204. Signed and dated *I.L. 1652*
PROV From the offices of the ministry of finance in the Spinhuissteeg, Amsterdam, 1877
LIT Schneider 1932, nr 115

A 838 Maerten Harpertsz Tromp (1597-1653). Vice admiral. *Luitenant-admiraal*

Pendant to A 839

Canvas 134 × 101
PROV Sale G van Beresteyn van Maurik, Vught, 22 Oct 1884, lot 6
LIT Moes 1897-1905, vol 2, nr 8091:10. Schneider 1932, nr 265

A 839 Cornelia Teding van Berkhout (1614-80). Wife of Maerten Harpertsz Tromp. *Echtgenote van Maerten Harpertsz Tromp*

Pendant to A 838

Canvas 134 × 105
PROV Same as A 838
LIT Moes 1897-1905, vol 1, nr 552:3. Schneider 1932, nr 224

Jan Andries Lievens

Antwerp 1644–1680 Amsterdam

A 1660 Engel de Ruyter (1649-83). Vice admiral, son of Michiel Adriaensz de Ruyter. *Vice-admiraal, zoon van Michiel Adriaensz de Ruyter*

Canvas 147 × 123. Signed *IAL*.
Inscribed *R* (on the dog's collar)
PROV Purchased from J C de Ruyter de
Wildt, Vlissingen, 1895
LIT C Hofstede de Groot, OH 17 (1899)
p 169. Schneider 1932, p 280. R van
Luttervelt, Bull RM 5 (1957) p 67, ill.
L M Akveld & J R Bruijn, Spiegel Hist 2
(1967) p 322, fig 2 (detail)

A 1661 Jan van Gelder (1647-73). Naval
captain, stepson of Michiel Adriaensz de
Ruyter. *Kapitein ter zee, stiefzoon van
Michiel Adriaensz de Ruyter*

Canvas 147 × 124. Signed and dated
IAL 1668
PROV Same as A 1660
LIT *see under* A 1660

Hendrik van Limborch

The Hague 1681–1759 The Hague

A 1607 Self portrait. *Zelfportret*

Canvas 85 × 69. Signed and dated
H V Limborch 1708
PROV Purchased from Mrs A B van
Limborch van der Meersch-Spoelstra,
widow of W F van Limborch van der
Meersch, Amsterdam, 1894
LIT Moes 1897-1905, vol 2, nr 4514:1.
Van Hall 1963, p 188, nr 1272:1

A 219 Pastoral. *Pastorale*

Pendant to A 220

Canvas 68 × 55.5. Signed *HVLimborcht*
PROV Purchased with the Kabinet van
Heteren Gevers, The Hague-Rotterdam,
1809 * DRVK since 1953
LIT Van Gool 1750-51, vol 1, p 452.
Hoet 1752, vol 2, p 456. Moes & van
Biema 1909, pp 147, 161. Bille 1961, vol
1, p 109

A 220 Pastoral. *Pastorale*

Pendant to A 219

Canvas 67 × 54
PROV Same as A 219 * DRVK since 1953
LIT *see under* A 219

A 221 Putti playing. *Spelende putti*

Panel 27 × 34
PROV Purchased with the Kabinet van
Heteren Gevers, The Hague-Rotterdam,
1809
LIT Van Gool 1750-51, vol 1, p 452. Hoet
1752, vol 2, p 456. Moes & van Biema
1909, pp 147, 161. Scheen 1946, fig 2.
Bille 1961, vol 1, p 109

Johannes Lingelbach

Frankfurt am Main 1622–1674
Amsterdam

see also Looten, Jan, A 48 Path in the
woods

A 226 Marketplace in an Italian town,
with an itinerant toothpuller. *Italiaans
marktplein met een kiezentrekker*

Canvas 68.5 × 86. Signed and dated
J.Lingelbach A° 1651
PROV Bequest of L Dupper Wzn,
Dordrecht, 1870
LIT A Busiri Vici, Studi Romani 7 (1959)
p 45, pl II:2

A 223 Italian harbor with a fortified
tower. *Italiaanse haven met vestingtoren*

Canvas 78 × 66. Signed and dated
I.Lingelbach 1664
PROV Sale G van der Pot van
Groeneveld, Rotterdam, 6 June 1808,
lot 72
LIT Moes & van Biema 1909, pp 113,
182. Martin 1935-36, vol 2, p 389

C 1223 Charles II halting at the estate of
Wema on the Rotte during his journey
from Rotterdam to The Hague, 25 May
1660; or (less probably) the troops of
Prince Willem II halting at the estate of
Welna on the Amstel during their march
on Amsterdam, 31 May-4 August 1650.
Het halthouden van Karel II bij de buiten-

plaats Wema aan de Rotte tijdens zijn tocht van Rotterdam naar Den Haag, 25 mei 1660; of (minder waarschijnlijk) het halthouden van de oprukkende troepen bij de buitenplaats Welna aan de Amstel tijdens de aanslag van prins Willem II op Amsterdam, 31 mei-4 augustus 1650

Pendant to C 1224

Canvas 58 × 100. Signed *J. Lingelbach*
PROV Kabinet Willem v, The Hague, 1795. On loan from the KKS since 1933
LIT Martin 1935-36, vol 2, pp 459-60, fig 242. Bol 1969, p 252

C 1224 The departure of Charles II of England from Scheveningen, 2 June 1660. *Het vertrek van Karel II van Engeland, uit Scheveningen, 2 juni 1660*

Pendant to C 1223

Canvas 59 × 100. Signed *J. Lingelbach*
PROV Same as C 1223
LIT Martin 1935-36, vol 2, p 459. Bol 1969, p 252

A 3973 The climbing of the Capitol with the gray horse of the newly elected pope. *De opgang naar het Kapitool met de schimmel van de nieuw gekozen paus*

Canvas 115 × 91. Signed *J. Lingelbach fecet*
PROV N Beets gallery, Amsterdam. Lent by the SNK, later DRVK, 1948. Transferred in 1960
LIT A Busiri Vici, Studi Romani 7 (1959) p 47, pl X (ca 1665). VTTT, 1961-62, nr 42. Exhib cat Italianiserende landschapschilders, Utrecht 1965, nr 135, fig 137

A 224 The riding school. *De rijschool*

Canvas 68 × 82. Signed *J. Lingelbach*
PROV NM, 1808
LIT Moes & van Biema 1909, p 22. Bol 1969, p 252, fig 243

C 172 The return from the hunt. *De terugkomst van de jacht*

Panel 36 × 42.5. Signed *J. Lingelbach*
PROV On loan from the city of Amsterdam (A van der Hoop bequest) since 1885

A 222 Italian harbor. *Italiaanse haven*

Canvas 60 × 52.5. Signed *Lingelbach*
PROV Purchased with the Kabinet van Heteren Gevers, The Hague-Rotterdam, 1809
LIT Hoet 1752, vol 2, p 456. Moes & van Biema 1909, pp 148, 161. Martin 1935-36, vol 2, p 389

A 227 Country road with hunter and peasants. *Landweg met jager en landlieden*

Canvas 39 × 46. Signed *LB*
PROV Purchased with the Kabinet van Heteren Gevers, The Hague-Rotterdam, 1809 * DRVK since 1957 (on loan to the Museum Amstelkring, Amsterdam)
LIT Moes & van Biema 1909, pp 148, 161, 194. Bille 1961, vol 1, p 109

A 2327 Italian landscape with figures. *Italiaans landschap met figuren*

Canvas 34.5 × 36.5. Signed *J. Lingelbach*
PROV Purchased from the heirs of Jonkheer P H Six van Vromade, Amsterdam, 1908, with aid from the Rembrandt Society * DRVK since 1959 (on loan to Stedelijk Museum Het Catharinagasthuis, Gouda)

A 700 Landscape with riders, hunters and peasants. *Landschap met ruiters, jagers en landlieden*

Canvas 50 × 56. Signed *J. Lingelbach*
PROV Bequest of Jonkheer J S H van de
Poll, Amsterdam, 1880 * DRVK since
1958
LIT V de Stuers, Ned Kunstbode 2
(1880) p 244. Chr P van Eeghen, OH
62 (1947) p 92

A 225 Army camp. *Legerplaats*

Panel 44 × 65
PROV Bequest of L Dupper Wzn,
Dordrecht, 1870
LIT Bille 1961, vol 1, ill; vol 2, pp 27, 103,
nr 116

A 1391 The naval battle near Livorno,
14 March 1653: incident of the First
Anglo-Dutch War. *De zeeslag bij Livorno,
14 maart 1653, gebeurtenis uit de Eerste
Engels-Nederlandse Zeeoorlog*

Canvas on panel 114 × 216. Inscribed on
the monument *Bataglia secuita tra li vaseli
olandesi e inglesi il di 14 Marzo 1653.* The
ships are identified on the trompe-
l'oeil sheet of paper in the lower right
PROV Rijks Marinewerf (navy yard),
Rotterdam, 1832. Model room of the
ministry of marine, The Hague. NMGK,
1885
LIT P Haverkorn van Rijsewijk, OH 17
(1899) p 38

Lambertus Lingeman

Amsterdam 1829–1894 Abcoude

A 1076 Two men in a seventeenth-
century interior, called 'A conference.'
*Twee mannen in een zeventiende-eeuws
interieur, genaamd 'Eene conferentie'*

Panel 39 × 50. Signed and dated
Lingeman 1870
PROV Purchased at exhib Rotterdam
1870, nr 265. RVMM, 1885

Jacobus Linthorst

Amsterdam 1745–1815 Amsterdam

A 1077 Still life with fruit. *Stilleven met
vruchten*

Panel 84 × 66. Dated *1808*
PROV RVMM, 1885
LIT Moes & van Biema 1909, p 226?
Knoef 1943, p 151

Jean-Etienne Liotard

Geneva 1702–1789 Geneva

see also under Miniatures and Pastels

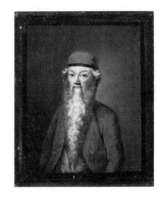

A 2656 Self portrait. *Zelfportret*

Canvas on panel 24 × 20
PROV Presented by H G C Leendertz,
Apeldoorn, 1913
LIT Van Hall 1963, p 189, nr 1281:2

copy after **Jean-Etienne Liotard**

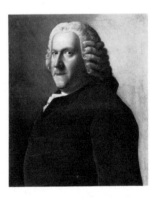

A 4155 Willem Bentinck (1704-74).
Diplomat in the service of Willem IV,
the regentess Anna and Willem V.
*Diplomaat in dienst van Willem IV, regentes
Anna en Willem V*

Canvas 59 × 49. Inscribed on the verso
*Honorable William Bentinck, died in 1774,
married 1732 to Charlotte Sophie Countess
Aldenburg.* On the frame *Cap^tn Bentinck's
Father*
PROV Sale London, 29 March 1968,
lot 38

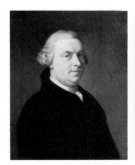

C 43 Hendrik Bicker (1722-83).
Alderman of Amsterdam. *Schepen te
Amsterdam*

Pendant to C 44

Canvas 63 × 49
PROV On loan from the city of
Amsterdam (Bicker bequest), 1885-1975
LIT Moes 1897-1905, vol 1, nr 644:2

C 44 Clara Magdalena Dedel (1727-78).
Wife of Hendrik Bicker. *Echtgenote van
Hendrik Bicker*

Pendant to C 43

Canvas 61 × 49
PROV Same as C 43
LIT Moes 1897-1905, vol 1, nr 1919:2

manner of **Filippino Lippi**

Prato ca 1457 – 1504 Florence

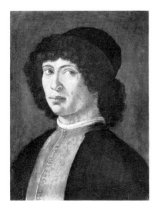

A 3030 Portrait of a young man. *Portret
van een jonge man*

Panel 40.5 × 30
PROV Purchased from the Augusteum,
Oldenburg, 1925, with aid from the
Rembrandt Society
LIT Bode 1888, p 9 (Alessandro
Botticelli or Filippino). Schäfer 1912,
p 35, ill. Hartlaub 1912, vol 2, nr 8, fig 14.
Jaarversl Ver Rembrandt, 1923, p 5.
Van Marle 1923-38, vol 11 (1927) p
350, fig 221 (Antonio Pollaiuolo). T
Borenius, Burl Mag 59 (1931) p 65
(early work of Filippino). Berenson 1932,
p 106 (Francesco Botticini). Scharf
1935, pp 38, 112, fig 138 (Filippino,
1485-88). Ortellani 1948, p 163.
Berenson 1963, vol 1, p 39 (Botticini).
Van Os & Prakken 1974, pp 67-68, nr
33, ill (style of Filippino)

Johann Liss

Oldenburg ca 1597 – 1629 Venice

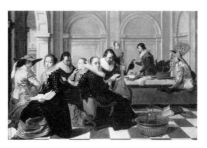

A 1403 The musical gathering. *De
muziekpartij*

Panel 42 × 63. Signed and dated *J.Lijs
1625*
PROV Purchased from J F Laisney, Paris,
1887 * On loan to the Rijksmuseum
Muiderslot, Muiden, since 1922
LIT C Hofstede de Groot, OH 19 (1901)
pp 135-36 (copy after Willem Duyster)

attributed to **Alejandro de Loarte**

d 1626 in Toledo

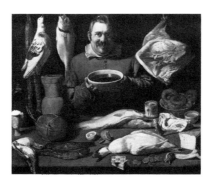

A 2962 Kitchen scene (bodegone).
Keukenstuk

Canvas 100 × 122
PROV Presented by a group of members
of the Rembrandt Society, 1922
LIT Ch Robinson, Burl Mag 10 (1906)
pp 172, 183, ill (Velazquez). A L Mayer,
Mon f Kunstw 4 (1915) p 124ff, ill (Juan
Sanchez Cotàn). Mayer 1922, pp 361-362
(Cotàn). A Mendes Casal, Rev Esp de
Arte, 1934, pp 187-98, pl VIII (ca 1626).
E Lafuente Ferrari, GdB-A 77 (1935) p
175, note 1. Cavestany 1935, p 151, nr
15, pl XV. Mayer 1947, pp 246, 298. J
Ainaud de Lasarte, Goya, 1955, p 116,
ill. Gaya Nuño 1958, p 219, nr 1574, fig
118. Kubler & Soria 1959, p 235, pl
122B (Juan van der Hamen y Leon, ca
1630). J Camón Aznar, Goya, 1963, p
285. Camón Aznar 1964, p 322. A W
Vliegenthart, OK 12 (1968) nr 25, ill

M Loebell

see Governors-general series: A 3816
Johan Paul Count van Limburg Stirum

Jacob Gerritsz Loef

Enkhuizen? ca 1607 – after 1648
Enkhuizen?

A 1383 Ships off the coast. *Schepen onder
de kust*

Panel 61 × 84. Signed *IGL*
PROV Purchased from Jonkheer J E van
Heemskerck van Beest, 1877. NMGK, 1887
LIT B J A Renckens, OH 73 (1958) pp
170, 175, nr 9, fig 9

A 4261 A man-of-war built in 1626 at a
Dutch shipyard for Louis XIII steering for
a Dutch port under escort of a Dutch
ship. *Een oorlogsschip, in 1626 op last van
Lodewijk XIII op een Hollandse werf
gebouwd, stevent onder geleide van een
Hollands schip een Hollandse haven binnen*

Panel 55 × 98
PROV Sale Amsterdam, 27-28 Sept 1881,
lot 305? (as anonymous)
LIT B J A Renckens, OH 73 (1958) pp
170, 175, nr 7, fig 7

Hillebrand Dirk Loeff

The Hague 1774 – 1845 The Hague

A 2791 Hermanus Martinus Eekhout (1772-1838). Lieutenant colonel. *Luitenant-kolonel*

Pendant to A 2792

Canvas 61.5 × 50. Signed *Loeff fect*
PROV Bequest of Mrs J J A Kraay-Eekhout, widow of E Kraay, Katwijk aan de Rijn, 1916 * DRVK since 1959 (on loan to the Nederlands Legermuseum, Leiden)

A 2792 Maria Adriana van der Sluys (b 1790). Wife of Hermanus Martinus Eekhout. *Echtgenote van Hermanus Martinus Eekhout*

Pendant to A 2791

Canvas 61.5 × 50. Signed *Loeff fect*
PROV Same as A 2791

Allaert van Loeninga

active in Middelburg; d 1649/50

A 3459 The regents of the Tuchthuis (house of correction) in Middelburg, 1643. *De regenten van het Tuchthuis te Middelburg, 1643*

The sitters are Jacques van Neuligem, alderman of Middelburg, Sijmen van Trijst, elector of Middelburg, Guillaume de Wolff, major, Cornelis Erckenbout and Matthias Molanus

Panel 147 × 220. Signed and dated *A. Loeninga F A° 1643*
PROV Huis van Bewaring (house of detention), Middelburg. Property of the state for an indeterminate period. Inscribed in the RMA inventory, 1943 * DRVK since 1961
LIT Voorl lijst v Mon, vol 6 (1922) p 116

Dirk van Lokhorst

Utrecht 1818–1893 Utrecht

A 1171 Sheep in a sheepcote, called 'At home.' *Schapen in een stal, genaamd 'Tehuis'*

Canvas 135 × 110. Signed and dated *D. van Lokhorst 1876*
PROV Purchased at exhib Rotterdam 1877 * DRVK since 1953
LIT Marius 1920, p 81

Jacob Lambrechtsz Loncke

Zierikzee ca 1580–after 1646 Zierikzee

A 906 Philippe le Mire (b 1596)

Pendant to A 907

Panel 66 × 53. Dated *Anno 1618*. Inscribed *Ætatis 22*. Inscribed on the verso '*Philippe le Mire Trouwt Antoinette Walleran Geb: ... Overl: ...*'
PROV Bequest of Jonkheer J de Witte van Citters, The Hague, 1876. NMGK, 1885
LIT Moes 1897-1905, vol 2, nr 5080. C Hofstede de Groot, OH 19 (1901) p 134. [A] v S[chendel], Mndbl BK 18 (1941) p 225, fig 226

A 907 Antoinette Walleran (b 1598). Wife of Philippe le Mire. *Echtgenote van Philippe le Mire*

Pendant to A 906

Panel 66.5 × 54. Dated *Anno 1618*. Inscribed *Ætatis 20* and, on the verso, '*Antoinette Walleran Echtgen: van Ph: Le Mire Geb: ... Overl: ...*'
PROV Same as A 906

LIT Moes 1897-1905, vol 2, nr 8833. C Hofstede de Groot, OH 19 (1901) p 134. [A] v S[chendel], Mndbl BK 18 (1941) p 225. A Staring, OH 62 (1947) p 102, fig 1

school of **Pietro Longhi**

Venice 1702–1785 Venice

A 3405 The gambling hall (Il ridotto). *De speelbank*

Canvas 85 × 101.5. Fragment
PROV Bequest of J W Edwin vom Rath, Amsterdam, 1941
LIT A van Schendel, Mndbl BK 11 (1934) p 245. K E Schuurman, Mndbl BK 19 (1942) p 141, fig 5. Moschini 1956, p 54. Pallucchini 1960, p 190, fig 487 (Maestro del Ridotto). F W S van Thienen, OK 8 (1964) nr 8, ill. M Braun-Ronsdorf, Waffenkunde, 1966, pp 87-94, fig 7. Pignatti 1968, p 131, fig 458 (Maestro del Ridotto)

Amédée van Loo

see Vanloo, Amédée

Jacob van Loo

Sluis 1614–1670 Paris

A 3483 Bacchic scene. *Bacchanten-scène*

Canvas 63 × 55. Signed and dated
I. V. Loo 1653
PROV Presented by H Schaeffer, New
York, 1947
LIT Von Moltke 1965, pp 48-49, 272, fig
223

attributed to **Jacob van Loo**

A 81 The Meebeeck Cruywagen family
near the gate of their country home on
the Uitweg near Amsterdam. *De familie
Meebeeck Cruywagen bij de poort van hun
buitenhuis aan de Uitweg bij Amsterdam*

From left to right: Cornelis (d 1674),
Pieter (d before 1674), Jan (d 1681),
Claas, on the wagon, Niesje Claesdr
(1568/9-1645), the maternal grand-
mother, Jacob, Rijckert, Barbara Jansdr,
née Mastenbroek (d 1650), the mother,
and father Hendrick Cruywagen (d
1659?)

Canvas 100 × 133.5. Inscribed on the
verso *De Familieportretten verbeeld voor
hunne hofstede aan den Hoge Dijk buiten den
Haarlemmerpoort te Amsterdam, van het
geslagt van Meebeek Kruywagen, huisvrouw
van Jan Troost, curator der desolate boedel-
kamer te Amsterdam. Zij is begraven den 15
december 1699 in de N. Kerk en was de
moeder van Cornelis Troost, kunstschilder.*
PROV Purchased from Mrs Schol,
Amsterdam, 1827
LIT Martin 1935-36, vol I, p 318. I H
van Eeghen, Mndbl Amstelodamum 49
(1962) pp 79-84, ill (ca 1642). I H van
Eeghen, Mndbl Amstelodamum 56
(1969) pp 219-20, ill. Niemeijer 1973, p 2

Jean-Baptiste van Loo

see Miniatures: English school ca 1725,
A 4397 Frederick Louis, prince of Wales,
after van Loo

Jan Looten

Amsterdam ca 1618 – 1681 England

A 48 Path in the woods. *Bosweg*

Canvas 97 × 82.4. Signed *F. Loote.*
Staffage presumably by Johannes
Lingelbach (1622-74)
PROV Bequest of L Dupper Wzn,
Dordrecht, 1870
LIT Bol 1969, p 223

Jacobus van Looy

Haarlem 1855 – 1930 Haarlem

A 4169 Anthonie Gerardus van der
Hout (1820-92)

Canvas 95 × 65. Signed *Jac. v. Looy.*
Inscribed on the verso *Doctor Anthonie
Gerardus van der Hout geb. 17 Januari 1820
te Amsterdam. Zoon van Anthonie en v.
Marª Chrª Nijssen overleden 30 Juni 1892
te Putten 72 j. Gehuwd m. Jacoba Diederica
Vorst, geb. 31 Dec. 1825 te Bodegraven
overleden 3 Juni 1884 te Santpoort (Gemeente
Velsen) dr. v. Huibert Adriaan en van Alyda
Elisabeth Muller. Kunstschilder: Jac. van
Looy*
PROV Bequest of W van der Hout,
Utrecht, 1970

A 2909 Partygoers in the streets.
Nachtelijke feestvierders op straat

Canvas 112 × 160. Signed *Jac v. Looy*
PROV Bequest of A van Wezel,
Amsterdam, 1922

A 2910 Clover in bloom. *Klaverbloemen*

Canvas 39 × 46. Signed *Jac. v. Looy*
PROV Bequest of A van Wezel,
Amsterdam, 1922

Lorenzo di Niccolò

active 1392-1411 in Florence

A 4007 The virgin of the annunciation.
De verkondiging aan Maria: Maria

Panel 23.5 cm in diam. Tondo. Possibly
part of a polyptych with a matching
tondo of the angel Gabriel
PROV O Lanz, Amsterdam. Lent by the
SNK, later DRVK, 1948. Transferred in
1960

LIT Van Marle 1923-37, vol 3 (1924) p 606, note 1 (Spinello Aretino); vol 9 (1927) p 177, note 1 (school of Lorenzo Monaco). R van Marle, Boll d'Arte 28 (1935) p 304 (school of Lorenzo Monaco). Van Os & Prakken 1974, pp 75-76, nr 39, ill

attributed to **Johann Carl Loth**

Munich 1632–1698 Venice

A 71 The death of Orion. *De dood van Orion*

Canvas 151 × 165
PROV Purchased from Mrs Liotard, Amsterdam, 1827
LIT H Voss, Zeitschr BK ns 23 (1912) p 71, ill. W Suida, Belvedere 5 (1924) p 71. Fiocco 1929, p 47. Ewald 1965, p 110, nr 433, pl 64

Lovera

active 1885 in Surinam

A 2252 Johan François Adriaan Cateau van Rosevelt (1823-91). Head of the department of construction and general director of immigration of Surinam. *Chef van het Bouwdepartement en Agent-generaal van de Immigratie in Suriname*

Canvas 135 × 93. Signed *Lovera*. Inscribed *Kaart der Kolonie Suriname … J. F. A. Cateau van Rosevelt … W. L. Loth*
PROV Presented by the colony of Surinam to the sitter to mark his fiftieth year of service, July 1885. Presented by the Misses Cateau van Rosevelt, Teteringen near Breda, 1907

Christoffel Lubienietzki

Stettin 1660/61–after 1729 Amsterdam?

A 1550 Arent van Buren (1670-1721). Naval captain. *Kapitein ter zee*

Pendant to A 1551

Canvas 102 × 84.5. Oval. Signed and dated *C. Lubienietzki 1721*
PROV Presented by J Fabius, Utrecht, 1891

A 1551 Sabina Agneta d'Acquet (1675-1726). Wife of Arent van Buren. *Echtgenote van Arent van Buren*

Pendant to A 1550

Canvas 102 × 84. Oval. Signed and dated *C. Lubienietzki 1721*
PROV Same as A 1550

attributed to **Christoffel Lubienietzki**

A 775 Portrait of a painter, presumably a self portrait. *Portret van een schilder, vermoedelijk een zelfportret*

Canvas 92 × 72.5
PROV Sale Jonkheer W Gockinga, Amsterdam, 14 August 1883, lot 77
LIT Van Hall 1963, p 192, nr 1300:1

Luca di Tommè

Siena? ca 1330–after 1389 Siena?

A 4003 The flagellation of Christ. *De geseling van Christus*

Panel 39 × 30
PROV O Lanz, Amsterdam. Lent by the DRVK, 1952. Transferred in 1960
LIT Van Marle 1923-38, vol 3 (1924) p 556 (Agnolo Gaddi). H Kiel, Pantheon 27 (1969) p 337. Exhib cat Sienese paintings in Holland, 1300-1500, Groningen-Utrecht-Florence 1969, nr 22, ill (part of a predella, ca 1362-66). Fehm 1973, pp 15-16, 18, 24-25, fig 26

P Luima

biographical data unknown

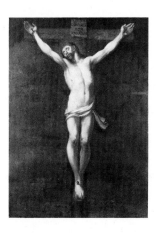

A 2514 Christ on the cross. *Christus aan het kruis*

Canvas 178 × 132. Signed *P. Luima fecit*
PROV Roman Catholic Church,
Veenhuizen, 1910 * DRVK since 1952

Gerrit Lundens

Amsterdam 1622 – after 1683
Amsterdam?

see also Rembrandt, C 1453 The
company of Captain Frans Banning
Cocq, copy by Lundens? ; *and under*
Miniatures

A 4262 Man with a drunken girl. *Man
met deerne*

Horn 9.5 × 6.5. Oval
PROV Presented by an unknown donor,
1899, through the intermediacy of C
Hofstede de Groot

Isaak Luttichuys

Austin Friars 1616 – 1673 Amsterdam

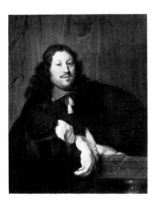

C 1522 Portrait of a man. *Portret van een
man*

Panel 96.5 × 75. Signed and dated
JLuttichuijs Fe. An° 1653
PROV On loan from J K Luttikhuis,
Abcoude, since 1972

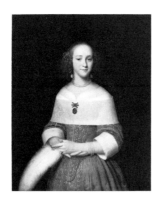

C 1477 Portrait of a young woman.
Portret van een jonge vrouw

Canvas 99 × 82. Signed and dated
JLuttichuis Fecit Anno 1656
PROV On loan from Mrs W I C Royer-
Bicker, Rotterdam, since 1966
LIT A Staring, OH 61 (1946) p 27, fig 2.
Staring 1948, p 33, fig 2. Bernt 1969-70,
vol 2, nr 709

Lyon

see Corneille de Lyon

Jacob Lyon

Amsterdam 1586/87 – after 1644
Amsterdam

see also Miereveld, Michiel van, A 2100
Maurits, copy by Lyon; A 2101
Frederik Hendrik, copy by Lyon

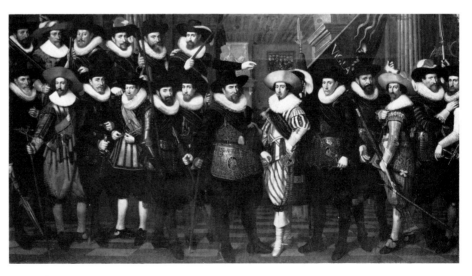

C 384 The company of Captain Jacob
Pietersz Hooghkamer and Lieutenant
Pieter Jacobsz van Rijn, Amsterdam,
1620. *Het korporaalschap van kapitein
Jacob Pietersz Hooghkamer en luitenant
Pieter Jacobsz van Rijn, Amsterdam, 1620*

Canvas 254 × 477.5. Signed and dated
A.Lont 1620 (inaccurate repainting of
J.Lion)
PROV Voetboogdoelen (headquarters
of the crossbowmen's civic guard),
Amsterdam. On loan from the city of
Amsterdam, 1885-1975
LIT Van Dijk 1790, p 25, nr 16.
Scheltema 1879, p 27, nr 71. D C Meijer
Jr, OH 3 (1885) pp 118-20. Moes 1897-
1905, vol 1, nr 3693; vol 2, nr 6692

Lijs

see Liss

Marius van der Maarel

The Hague 1857–1921 The Hague

A 3131 Adriaan Pit (1860-1944).
Director of the Netherlands Museum
of History and Art, Amsterdam
(1898-1918). *Directeur van het Nederlands
Museum voor Geschiedenis en Kunst te
Amsterdam*

Panel 35 × 25.5. Signed *M. van der Maarel*
PROV Presented by I Q van Regteren
Altena, Amsterdam, 1932

A 4063 Adriaan Pit (1860-1944).
Director of the Netherlands Museum
of History and Art, Amsterdam
(1898-1918). *Directeur van het Nederlands
Museum voor Geschiedenis en Kunst te
Amsterdam*

Canvas 49 × 31. Signed *M. v.d. Maarel*
PROV Presented by S B Slijper, Blaricum,
1961

A 3734 Tending the baby carriage on the
beach. *Bij de kinderwagen op het strand*

Panel 30.5 × 20. Signed *Maarel*
PROV Lent by Mr & Mrs J C J Drucker-
Fraser, 1919. Bequeathed in 1944

A 1883 Fisherman's wife. *Vissersvrouw*

Canvas 40 × 30. Signed *Van der Maarel*
PROV Presented by the dowager of R
Baron van Lynden, née M C Baroness
van Pallandt, The Hague, 1900

Mabuse

see Gossaert van Mabuse

attributed to **Zanobi Machiavelli**

Florence ca 1418–1479 Florence

A 3442 St Nicholas of Tolentino
rescuing a hanged man. *De heilige
Nicolaas van Tolentino redt een gehangene*

Panel 22 × 48
PROV Bequest of J W Edwin vom Rath,
Amsterdam, 1941
LIT Van Marle 1923-38, vol 10 (1928)
p 250, note 4 (Uccello). B Berenson,
Dedalo 12 (1932) pp 692, 698. K E
Schuurman, Mndbl BK 19 (1942) p 100.
Kaftal 1952, col 772, fig 871. Davies
1961, p 323. Berenson 1963, vol 1, p 124;
vol 2, pl 812. Berenson 1968, p 179, fig
323. Van Os & Prakken 1974, pp 76-77,
nr 40, ill

attributed to **Pierre Antoine de Machy**

Paris 1723–1807 Paris

A 3958 View of the Castel Sant'Angelo,
Rome. *Gezicht op de Engelenburcht te Rome*

Canvas 48 × 97.8
PROV Sale Vienna, 12 March 1959, lot
130, ill (as Caspar van Wittel)
LIT J Offerhaus, Bull RM 8 (1960) p 97,
ill (van Wittel). W Krönig, Miscellanea
Bibl Hertz, 1961, pp 400, 408 (van
Wittel). Exhib cat Italianiserende
landschapschilders, Utrecht 1965, nr
145, fig 148 (van Wittel). Briganti 1966,
nrs 99, 102 (attributed to P A Demachy).
Cat Kunsthistorisches Museum, Vienna,
Holl Meister, 1972, p 106

Giambattista Maderni

see Kamphuijsen, Jan, A 4140 & A 4141
Ceiling painting with scenes from the life
of Hercules; A 4142-A 4150 Nine months
of the year, after designs by Maderni

Jan Baptist Lodewijk Maes

Ghent 1794–1856 Rome

A 1078 The good Samaritan. *De barmhartige Samaritaan*

Canvas 251 × 200. Signed and dated
J. B. Maes Roma 1825
PROV Purchased at exhib Amsterdam
1826, nr 231. RVMM, 1885 * DRVK since
1952

Nicolaes Maes

Dordrecht 1634–1693 Amsterdam

See also Rotterdam East India Company
series: A 4505, Johan de Reus

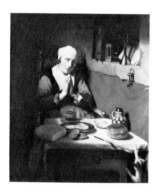

C 535 Old woman in prayer, known as
'Prayer without end.' *Oude vrouw in gebed,
bekend als 'Het gebed zonder end'*

Canvas 134 × 113. Signed *N. M. S.*
PROV Felix Meritis Society, Amsterdam,
1889. On loan from the city of
Amsterdam since 1889
LIT G H Veth, OH 8 (1890) p 138.
Hofstede de Groot 1907-28, vol 6 (1915)
nr 114. Valentiner 1924, pl 34. Martin
1935-36, vol 2, pp 171, 232. Bernt 1960-
62, vol 2, nr 503. Rosenberg, Slive &
Ter Kuile 1966, p 97, fig 69. Borea 1966,
fig 24. D van Fossen, Art Q 33 (1970) p
134. Bernt 1969-70, vol 2, nr 718

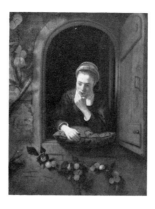

A 245 Girl at a window, known as 'The
daydreamer.' *Meisje aan het venster, bekend
als 'De peinzende'*

Canvas 123 × 96. Signed *N Mae.*
PROV Purchased from De Lelie &
Hulswit, art dealers, Amsterdam, 1829
LIT G H Veth, OH 8 (1890) p 137.
Hofstede de Groot 1907-28, vol 6 (1915)
nr 110. Valentiner 1924, pl 19. Martin
1935-36, vol 2, pp 230, 232, fig 125.
Rosenberg, Slive & Ter Kuile 1966, p
97, fig 72A. D van Fossen, Art Q 33
(1970) pp 134-35, fig 2

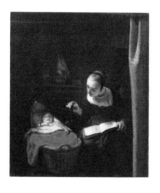

A 4047 Young woman at the cradle.
Jonge vrouw bij de wieg

Canvas 32.5 × 28
PROV Presented by Mr & Mrs I de
Bruijn-van der Leeuw, Muri near Bern,
1961
LIT Bode 1909, p 34, nr 17, pl XI.
Hofstede de Groot 1907-28, vol 6 (1915)
nr 81. Valentiner 1924, pl 23. H L Jaffé,
Du, 1944, p 45, ill. P Reuterswärd,
Konsth Tidskr 25 (1956) p 101, fig 3.
E R Meijer, Bull RM 9 (1961) p 48, fig 13.
J L Cleveringa, Bull RM 9 (1961) p 65,
nr 10

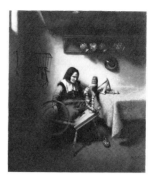

A 246 Woman spinning. *De spinster*

Canvas 63 × 55. Signed *N. Maes*
PROV Bequest of L Dupper Wzn,
Dordrecht, 1870
LIT C von Lützow, Zeitschr BK 5 (1870)
p 229. G H Veth, OH 8 (1890) p 137.
Hofstede de Groot 1907-28, vol 6 (1915)
nr 58. Valentiner 1924, pl 30. BCG
Gleistein, Kunstrip 1 (1971), nr 9.
A C A W van der Feltz, Antiek 8 (1974)
p 484, figs 11-12

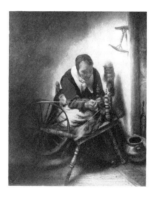

C 176 Woman spinning. *De spinster*

Panel 41.5 × 33.5. Signed *Maes*
PROV On loan from the city of
Amsterdam (A van der Hoop bequest)
since 1885
LIT G H Veth, OH 8 (1890) p 137.
Hofstede de Groot 1907-28, vol 6 (1915)
nr 57. Valentiner 1924, pl 32. Martin
1935-36, vol 2, pp 230-31, fig 124. BCG
Gleistein, Kunstrip 1 (1971) nr 9

A 3106 Portrait of a young woman.
Portret van een jonge vrouw

Canvas 73 × 59. Signed and dated
N. Maes 1665
PROV Bequest of P A Gildemeester,
Egmond aan den Hoef, 1930

A 701 Marten Meulenaer

Canvas 45 × 34. Signed and dated *Maes
1675*
PROV Bequest of Jonkheer J S H van de
Poll, Amsterdam, 1880 * DRVK since
1959 (on loan to Stedelijk Museum
Het Catharinagasthuis, Gouda)
LIT V de Stuers, Ned Kunstbode 2
(1880) p 244. Moes 1897-1905, vol 2, nr
5014. Hofstede de Groot 1907-28, vol 6
(1915) nr 213. G Kolleman, Ons
Amsterdam 23 (1971) p 118 (portrait of
Martinus Meulenaer, son of Maria Rey
and Roelof Meulenaer, b 16 Nov 1651)

A 1662 Cornelis Evertsen (1642-1706).
Vice admiral of Zeeland. *Luitenant-
admiraal van Zeeland*

Canvas 148 × 124. Signed and dated
N Maes 1680
PROV Purchased from J C de Ruyter de
Wildt, Vlissingen, 1895
LIT Hofstede de Groot 1907-28, vol 6
(1915) nr 164. Staring 1948, p 35

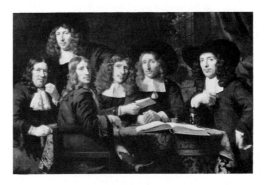

C 90 Six governors of the Amsterdam
surgeons' guild, 1680-81. *Zes overlieden
van het Chirurgijnsgilde te Amsterdam, 1680-
81*

The sitters are Jan Coenerding, Pieter
Muyser, Isaac Hartman, Gerrit Verhul,
Allardus Cyprianus and Goverd Bidloo,
seated on the chair in front of the table

Canvas 130.5 × 195.5
PROV On loan from the city of
Amsterdam (A van der Hoop bequest),
1885-1975
LIT Tilanus 1865, p 36. J Six, Ned Spec,
1882, p 170. Moes 1897-1905, vol 1, nrs
659:1, 3233, 4244:1; vol 2, nrs 5256,
8386. Hofstede de Groot 1907-28, vol 6
(1915) nr 549. Bauch 1926, p 102, nr 21
Riegl 1931, p 241, fig 71. Martin 1935-
36, vol 1, pp 173, 201, 203, fig 114.
J Knoef, Jb Amstelodamum 42 (1948)
p 15

A 1645 Willem Pottey (1666-94).
Lawyer and treasurer-general of
Vlissingen. *Advocaat en rekenmeester-
generaal te Vlissingen*

Pendant to A 1646

Canvas 61 × 49. Signed *Maes*
PROV Purchased from J C de Ruyter de
Wildt, Vlissingen, 1895 * DRVK since
1958
LIT Moes 1897-1905, vol 2, nr 6057.
Hofstede de Groot 1907-28, vol 6 (1915)
nr 234. A M Lubberhuizen-van Gelder,
OH 62 (1947) p 146

A 1646 Catharina Pottey (1641-1718).
Sister of Willem and Sara Pottey. *Zuster
van Willem en Sara Pottey*

Pendant to A 1645
For a portrait of Sara Pottey, *see* Haringh,
Daniel, A 1655

Canvas 61 × 49. Signed *Maes*
PROV Same as A 1645
LIT Moes 1897-1905, vol 2, nr 6056
(portrait of Sara Pottey). Hofstede de
Groot 1907-28, vol 6 (1915) nr 233

A 1259 Belichje Hulft (1656-1714). Wife
of Gerard Röver (1643-1711),
Amsterdam merchant and shipowner.
*Echtgenote van Gerard Röver, koopman en
reder te Amsterdam*

Canvas 44.5 × 33.5. Signed *Maes*
PROV Presented by J S R van de Poll,
Arnhem, 1885
LIT Hofstede de Groot 1907-28, vol 6
(1915) nr 195

attributed to **Nicolaes Maes**

A 3508 Portrait of a young man. *Portret
van een jonge man*

Panel 36.5 × 31
PROV Purchased from C L H Crommelin,
The Hague, 1947
LIT Hofstede de Groot 1907-28, vol 6
(1915) nr 371

school of **Nicolaes Maes**

A 3254 Vegetable market. *Groentemarkt*

Canvas 71 × 91
PROV Presented by Sir Henry W A
Deterding, London, 1936
LIT Hofstede de Groot 1907-28, vol 6
(1915) nr 38? E Plietzsch, Zeitschr f
Kunstw ns 4 (1950) p 76 (Reynier
Covijn?)

copy after **Nicolaes Maes**

A 702 Hendrick Wijnands (1601/02-76).
Amsterdam grocer. *Kruidenier te
Amsterdam*

Pendant to A 703
For portraits of the sitter's son, *see*
Noordt, Jan van, A 709 & A 710

Canvas 45 × 34
PROV Bequest of Jonkheer J S H van de
Poll, Amsterdam, 1880 * DRVK since
1968
LIT Moes 1897-1905, vol 2, nr 9336.
G Kolleman, Ons Amsterdam 23 (1971)
p 120

A 703 Aeltje Denijs (b 1598/99). Wife
of Hendrick Wijnands, mother of
Dionijs Wijnands. *Echtgenote van
Hendrick Wijnands, moeder van Dionijs
Wijnands*

Pendant to A 702
For portraits of the sitter's son, *see*
Noordt, Jan van, A 709 & A 710

Canvas 44.5 × 34
PROV Same as A 702 * DRVK since 1968
LIT Moes 1897-1905, vol 1, nr 1942

A 2840 Old woman in prayer. *Oude
vrouw in gebed*

Anonymous copy after Maes, Nicolaes,
C 535

Canvas 132 × 111
PROV Unknown * DRVK since 1952

Alessandro Magnasco

Genoa 1667–1749 Genoa

A 3407 Landscape with St Bruno?
Landschap met de heilige Bruno?

Pendant to A 3408

Canvas 98 × 74
PROV Bequest of J W Edwin vom Rath,
Amsterdam, 1941

A 3408 Carthusian monks in a land-
scape. *Karthuizer monniken in een landschap*

Pendant to A 3407

Canvas 99 × 75
PROV Same as A 3407

C 1358 Three Camaldolese monks in
ecstatic prayer. *Drie Camaldolenser
monniken in extatisch gebed*

Pendant to C 1359

Canvas 54.5 × 39
PROV Purchased from Snijers & Rottiers
gallery, Antwerp, 1822. On loan from
the KKS (cat 1968, nr 332) since 1948
LIT Kunstkronijk 13 (1873) nr 9
(Salvator Rosa). W R Valentiner,
Zeitschr BK ns 17 (1911) p 88, fig 4. A
Locatelli-Milesi, Emporium 42 (1915) p
421ff. Ferri 1922, pl XV. Geiger 1923, p
41, nr 38. Geiger 1945, p 13. Geiger
1949, p 67

C 1359 Three Capuchin monks in
meditative prayer. *Drie Capucijner
monniken in mediterend gebed*

Pendant to C 1358

Canvas 54.5 × 39
PROV Same as C 1358. On loan from
the KKS (cat 1968, nr 333) since 1948
LIT Kunstkronijk 14 (1873) fig 5
(Salvator Rosa). W R Valentiner,
Zeitschr BK ns 17 (1911) p 88, fig 5. A
Locatelli-Milesi, Emporium 42 (1915) p
421ff, ill. Ferri 1922, pl XV. Geiger 1923,
p 41, nr 38. Delogu 1931, fig 206. Geiger
1945, p 13. Geiger 1949, p 67

attributed to **Alessandro Magnasco**

C 1356 Landscape with hermit, pilgrim
and peasant woman. *Landschap met
kluizenaar, pelgrim en boerin*

Pendant to C 1357

Canvas 138.5 × 109.8. Oval
PROV Purchased in Brussels by King
Willem I (as Salvator Rosa), 1831. On
loan from the KKS (cat 1968, nr 328)
since 1948
LIT Geiger 1923, p 40, note 36. Geiger
1945, p 13. Geiger 1949, p 67, fig 23
(Marco Ricci)

C 1357 Landscape with monks, pilgrim
and peasant woman. *Landschap met
monniken, pelgrim en boerin*

Pendant to C 1356

Canvas 138.5 × 109.8. Oval
PROV Same as C 1356. On loan from
the KKS (cat 1968, nr 329) since 1948
LIT L Planiscig, Mon f Kunstw 8 (1915)
p 247, fig 64:13. Geiger 1923, nr 37.
Delogu 1931, p 110. Geiger 1945, pp 13-
14. Geiger 1949, p 67, fig 23 (Marco
Ricci)

C 1360 The massacre of the innocents.
De kindermoord te Bethlehem

Pendant to C 1361

Canvas 65.5 × 83.5
PROV Presented to the KKS by EJ
Philips, The Hague, 1935. On loan
from the KKS (cat 1968, nr 816) since
1948
LIT B Geiger, Belvedere 5-6 (1922) pls
63-64. Geiger 1923, nrs 91-92, pls 18-19
Delogu 1931, p 110, pls 233-34. Pospisil.
1944, XCIII, pl 273 (attributed to
Sebastiano Ricci). Geiger 1945, p 14.
Geiger 1949, p 67

C 1361 The raising of Lazarus. *De
opwekking van Lazarus*

Pendant to C 1360

Canvas 65.5 × 83.5
PROV Same as C 1360. On loan from
the KKS (cat 1968, nr 817) since 1948
LIT *see under* C 1360

Vincent Malo

active ca 1623-1645/49 in Antwerp and
Italy

A 781 Christ in the house of Martha and
Mary. *Christus bij Martha en Maria*

Canvas 149 × 231. Signed *VM*
PROV Purchased in 1883

A 590 Peasants playing cards at an inn.
Kaartende boeren bij een herberg

Panel 41.5 × 52. Signed *VM*
PROV Purchased with the Kabinet van
Heteren Gevers, The Hague-Rotterdam,
1809
LIT Moes & van Biema 1909, pp 146,
158, 192. Bille 1961, vol 1, p 109

T van Malsen

active 1692-94 in Gorkum

A 2307 Diana and Virtus punishing
Venus and Bacchus. *Diana en Virtus
bestraffen Venus en Bacchus*

Canvas 192 × 157. Signed and dated
Van Malsen inventor 1694
PROV Presented by the Schutters van
St Joris (St George civic guard),
Heusden, 1907 * DRVK since 1953

Cornelis de Man

Delft 1621 – 1706 Delft

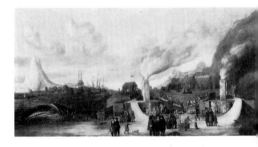

A 2355 The whale-oil factory of the
Amsterdam chamber of the Greenland
Company on Jan Mayen Island. *De
traankokerij van de Amsterdamse Kamer der
Groenlandse Compagnie op Jan Mayen
Eiland*

Canvas 108 × 205. Signed and dated
C. DMan 1639
PROV Sale duke of Sutherland, London,
8 Feb 1908, lot 66
LIT K Freise, Kunstchronik 19 (1908) p
366. C Brière-Misme, OH 52 (1935) p 7,
fig 2. Brander 1955, passim. C de Jong,
Ons Amsterdam 9 (1957) p 94, ill. De
Jong 1972, p 380, note 61, pl VI on p
335. W H Vroom, Ons Amsterdam 24
(1972) p 175. C de Jong, Med Ver
Zeegesch nr 26 (1973) pp 37-42, fig 2

manner of **Cornelis de Man**

C 151 Couple making music. *Het musicerende paar*

Canvas 83 × 66. Signed falsely *P. D. Hoog*
PROV On loan from the city of
Amsterdam (A van der Hoop bequest)
since 1885
LIT Bürger 1858-60, vol 2, pp 65-66
(Isaac Koedijck). C Hofstede de Groot,
OH 10 (1892) p 180, nr 9 (Koedijck);
OH 17 (1899) p 167, nr 687 (de Man?).C
Hofstede de Groot, Jb Preusz Kunst-
samml, 1903, p 40 (not de Man).
Hofstede de Groot 1907-28, vol 1, p 569,
nr 4 (fake Pieter de Hooch). G Falk,
Tidskr f Konstv, 1925, p 86 (Barent
Fabritius). Valentiner 1929, p 255
(Hendrik van der Burch). C Brière-
Misme, OH 52 (1935) p 102 (de Man?).
Pont 1958, p 132, nr 20 (Fabritius)

Antonio Mancini

Rome 1852–1930 Rome

A 1884 The poor child. *Het arme kind*

Canvas 148 × 81. Signed *A. Mancini*
PROV Presented by the dowager of R
Baron van Lynden, née M C Baroness
van Pallandt, The Hague, 1900

Jan Mankes

Meppel 1889–1920 Eerbeek

A 3321 Woman in front of her house.
Vrouwtje voor haar huis

Thought to be the mother of Jan
Mankes in front of her house in Kuijpe

Canvas 25.5 × 20. Signed *J. Mankes*
PROV Presented by Mr & Mrs D A J
Kessler-Hülsmann, Kapelle op den
Bosch near Mechelen, 1940
LIT Mankes-Zernike & Roland Holst
1923, p 28, ill. Plasschaert & Havelaar
1927, p 53, fig 22 (painted in 1914)

Carlo Maratti

see Miniatures: Ramelli, Felice, A 4364
Madonna on the crescent moon, after
Maratti

school of **Carlo Maratti**

Camerano 1625–1713 Rome

A 727 John the Evangelist on Patmos.
De evangelist Johannes op Patmos

Canvas 109 × 83
PROV Bequest of Jonkheer J S H van de
Poll, Amsterdam, 1880

Emile van Marcke de Lummen

Sèvres 1827–1890 Hyères

A 3085 Farmer with dogs. *Boer met honden*

Canvas 38 × 55. Signed *Em. van Marcke*
PROV Bequest of J B A M Westerwoudt,
Haarlem, 1907. Received in 1929

Joseph Marinkelle

see under Miniatures

Jacobus Hendrikus Maris

The Hague 1837–1899 Karlsbad

see also under Aquarelles and drawings

A 2274 The courtyard. *Achterplaatsje*

Panel 19.5 × 14. Signed and dated
J H Maris 1862
PROV Bequest of J B A M Westerwoudt,
Haarlem, 1907

A 2473 Praying monk. *Biddende monnik*

Copper 21.5 × 15.5. Signed and dated
J. H. Maris fc. 64
PROV Lent by Mr & Mrs J C J Drucker-
Fraser, London, 1907. Presented in
1909-10
LIT M Eisler, Elsevier's GM 46 (1913) p
323. Plasschaert 1920, p 24. De Gruyter
1968-69, vol 2, p 19, fig 12

A 2491 'Feeding the chickens.' *'Kippetjes
voeren'*

Canvas 33 × 21. Signed and dated
J Maris fe 1866
PROV Lent by Mr & Mrs J C J Drucker-
Fraser, London, 1907. Presented in
1909-10
LIT 't Hooft 1907, p 4, fig 2. W
Steenhoff, Elsevier's GM 40 (1910) p 364.
M Eisler, Elsevier's GM 46 (1913) pp 241,
323, ill on p 324. Plasschaert 1920, p 27,
ill. Scheen 1946, fig 128. E P Engel,
Bull RM 13 (1965) p 50. De Gruyter
1968-69, vol 2, p 19, fig 15

A 2500 Catharina Hendrika Horn
(1841-1905). The artist's wife. *Echtgenote
van de schilder*

Panel 19.5 × 16. Signed *J. M.* Inscribed
on the verso *Mijn portret in parijs
geschilderd door pa J. Maris.* Painted ca
1867
PROV Presented by Mr & Mrs L McSon-
Maris, The Hague, 1910
LIT De Gruyter 1968-69, vol 2, p 25, fig
13

A 2463 'Exhausted watching.' *'Moe
gewaakt'*

Canvas 42.5 × 61. Signed and dated
J. Maris fc 1869
PROV Lent by Mr & Mrs J C J Drucker-
Fraser, London, 1904. Presented in
1909-10
LIT W Steenhoff, Elsevier's GM 40 (1910)
pp 364-65, ill on p 362. M Eisler,
Elsevier's GM 46 (1913) pp 241, 323, 325.
Plasschaert 1920, p 28, ill

A 2703 A bleaching yard. *Een bleekveld*

Canvas 41 × 57. Signed and dated
J. Maris 1870

PROV Presented by the heirs of W J van
Randwijk, The Hague, 1914
LIT W Steenhoff, Onze Kunst 27 (1915)
p 93, ill

A 2458 'The truncated windmill.' *'De
afgesneden molen'*

Canvas 45 × 112.5. Signed and dated
J Maris fc 1872
PROV Lent by Mr & Mrs J C J Drucker-
Fraser, London, 1904. Presented in
1909-10
LIT W Steenhoff, Elsevier's GM 40 (1910)
p 366. M Eisler, Elsevier's GM 46 (1913)
p 325, ill on p 323. Plasschaert 1920, p
34. Maris 1943, p 171, ill. Gerson 1961,
p 28. De Gruyter 1968-69, vol 2, p 21,
fig 16

A 2926 Villagers. *Dorpelingen*

Canvas 41 × 25.5. Signed and dated
J Maris F 1872
PROV Bequest of A van Wezel,
Amsterdam, 1922

A 3600 'Portrait of Willem,' thought to be Willem Matthijs Maris Jbzn (1872-1929), son of J H Maris. '*Portret van Willem,*' *vermoedelijk Willem Matthijs Maris Jbzn, zoon van J H Maris*

Canvas on panel 14 × 11.8. Signed *J Maris*. Inscribed on the verso *Willem*. Painted ca 1876
PROV Lent by Mr & Mrs J C J Drucker-Fraser, 1920. Bequeathed in 1944
LIT De Gruyter 1968-69, vol 2, p 20, fig 20

A 2470 The wooden bridge. *Het houten bruggetje*

Panel 22 × 28. Signed *J Maris*. Painted ca 1878
PROV Lent by Mr & Mrs J C J Drucker-Fraser, London, 1904. Presented in 1909-10
LIT M Eisler, Elsevier's GM 46 (1913) p 330

A 2467 The Schreierstoren in Amsterdam. *De Schreierstoren te Amsterdam*

Canvas 27 × 35. Signed *J. Maris*. Painted ca 1880
PROV Lent by Mr & Mrs J C J Drucker-Fraser, London, 1904. Presented in 1909-10 * DRVK since 1958
LIT M Eisler, Elsevier's GM 46 (1913) p 331

A 2465 A waterway in the moonlight. *Vaart bij maanlicht*

Canvas 30 × 44.5. Signed *J Maris*. Painted in 1882
PROV Lent by Mr & Mrs J C J Drucker-Fraser, London, 1904. Presented in 1909-10
LIT M Eisler, Elsevier's GM 46 (1913) p 334. E P Engel, Bull RM 13 (1965) p 47

A 2464 Slums on the water. *Oud buurtje aan het water*

Canvas 46 × 32. Signed *J. Maris*. Painted in 1883
PROV Lent by Mr & Mrs J C J Drucker-Fraser, London, 1904. Presented in 1909-10
LIT M Eisler, Elsevier's GM 46 (1913) p 330

A 2456 The arrival of the boats. *Aankomst der boten*

Canvas 127 × 95. Signed *J. Maris*. Painted in 1884
PROV Lent by Mr & Mrs J C J Drucker-Fraser, London, 1904. Presented in 1909-10
LIT W Steenhoff, Elsevier's GM 40 (1910) p 364. M Eisler, Elsevier's GM 46 (1913) p 325, ill on p 326. E P Engel, Bull RM 13 (1965) p 47

A 2457 Gathering seashells. *Schelpenvissen*

Canvas 115 × 128. Signed *J. Maris*. Painted in 1885
PROV Lent by Mr & Mrs J C J Drucker-Fraser, London, 1904. Presented in 1909-10
LIT W Steenhoff, Elsevier's GM 40 (1910) p 367, ill on p 362. M Eisler, Elsevier's GM 46 (1913) p 328, ill on p 327

A 1404 City view. *Stadsgezicht*

Canvas 86 × 126. Painted ca 1885

PROV Purchased at exhib The Hague 1887, nr 271
LIT Novotny 1970, fig 135B

A 2471 Landscape with barge. *Landschap met schuit*

Panel 20 × 28. Signed *J. Maris*. Painted ca 1886
PROV Lent by Mr & Mrs J C J Drucker-Fraser, London, 1904. Presented in 1909-10
LIT M Eisler, Elsevier's GM 46 (1913) p 333

A 2469 Girl at the piano. *Meisje aan de piano*

Canvas 51.5 × 36. Painted ca 1889
PROV Lent by Mr & Mrs J C J Drucker-Fraser, London, 1904. Presented in 1909-10
LIT M Eisler, Elsevier's GM 46 (1913) p 325

A 2461 Summer. *Zomer*

Canvas 60 × 40.5. Signed *J. Maris*. Painted in 1889
PROV Lent by Mr & Mrs J C J Drucker-Fraser, London, 1904. Presented in 1909-10 * DRVK since 1953
LIT W Steenhoff, Elsevier's GM 40 (1910) p 368. M Eisler, Elsevier's GM 46 (1913) P 333

A 2460 Evening on the beach. *Strand bij avond*

Canvas 48.5 × 90.5. Signed *J. Maris*. Painted in 1890
PROV Lent by Mr & Mrs J C J Drucker-Fraser, London, 1904. Presented in 1909-10
LIT W Steenhoff, Elsevier's GM 40 (1910) p 367. M Eisler, Elsevier's GM 46 (1913) p 334. De Gruyter 1968-69, vol 2, p 22, fig 32

A 2925 Harbor view. *Havengezicht*

Canvas 51 × 78. Signed *J. Maris*. Painted ca 1890

PROV Bequest of A van Wezel, Amsterdam, 1922
LIT De Gruyter 1968-69, vol 2, fig 31

A 2468 Landscape in the outskirts of The Hague. *Landschap in de omgeving van Den Haag*

Canvas 45 × 47.5. Signed *J. Maris*. Painted in 1891
PROV Lent by Mr & Mrs J C J Drucker-Fraser, London, 1904. Presented in 1909-10
LIT W Steenhoff, Elsevier's GM 40 (1910) p 368. M Eisler, Elsevier's GM 46 (1913) P 333

A 2459 Towpath. *Jaagpad*

Canvas 50 × 79.5. Signed *J. Maris*. Painted in 1894
PROV Lent by Mr & Mrs J C J Drucker-Fraser, London, 1904. Presented in 1909-10
LIT W Steenhoff, Elsevier's GM 40 (1910) p 368, ill on p 365. M Eisler, Elsevier's GM 46 (1913) p 327

A 2455 City view. *Stadsgezicht*

Canvas 92.5 × 168.5. Signed *J. Maris*.
Painted in 1898
PROV Lent by Mr & Mrs J C J Drucker-
Fraser, London, 1904. Presented in
1909-10
LIT W Steenhoff, Elsevier's GM 40 (1910)
p 368. M Eisler, Elsevier's GM 46 (1913)
p 332, ill on p 328. De Gruyter 1968-69,
vol 2, pp 22-23, fig 30

A 2472 Houses on the Prins Hendrik-
kade, Amsterdam, on a misty day.
*Huizen aan de Prins Hendrikkade te
Amsterdam op een mistige dag*

Canvas 18.5 × 25. Signed *J. Maris*.
Painted in 1899
PROV Lent by Mr & Mrs J C J Drucker-
Fraser, London, 1904. Presented in
1909-10 * DRVK since 1959 (on loan to
the Gemeentemuseum, Arnhem)
LIT W Steenhoff, Elsevier's GM 40 (1910)
p 368. M Eisler, Elsevier's GM 46 (1913)
P 334

A 2462 A windmill by moonlight.
Molen bij maanlicht

Canvas 49 × 40.5. Signed *J. Maris*. The
painter's last work
PROV Lent by Mr & Mrs J C J Drucker-
Fraser, London, 1904. Presented in
1909-10
LIT W Steenhoff, Elsevier's GM 40 (1910)
p 368. M Eisler, Elsevier's GM 46 (1913)
p 334, ill on p 329

A 3322 Girl at a window. *Meisje bij het
venster*

Panel 41 × 20.5. Signed *J. Maris*
PROV Presented by Mr & Mrs D A J
Kessler-Hülsmann, Kapelle op den
Bosch near Mechelen, 1940

A 2810 Bluff-bowed fishing boat on the
beach at Scheveningen. *Bomschuit op het
Scheveningse strand*

Canvas 101.5 × 89.5. Signed *J. Maris*
PROV Presented by Mrs W C S Drucker-
de Koning, widow of H L Drucker, and
her children, The Hague, 1917
LIT E P Engel, Bull RM 13 (1965) p 64

A 2927 Ships in the harbor of Dordrecht.
Schepen in de haven van Dordrecht

Canvas 21.5 × 37.5. Signed *J. Maris*
PROV Bequest of A van Wezel,
Amsterdam, 1922

A 2273 Dordrecht by night. *Dordrecht
bij avond*

Canvas 45.5 × 47.5. Signed *J. Maris*
PROV Bequest of J B A M Westerwoudt,
Haarlem, 1907
LIT Maris 1943, ill on p 87

A 2702 The Schreierstoren on the
Buitenkant, Amsterdam. *De Schreierstoren
aan de Buitenkant te Amsterdam*

Canvas 83 × 111. Signed *J. Maris*
PROV Presented by the heirs of W J van
Randwijk, The Hague, 1914
LIT W Steenhoff, Onze Kunst 27 (1915)
p 93. Gerson 1961, p 28, fig 65

A 2466 The Schreierstoren and the
bridge over the Gelderse Kade,
Amsterdam. *De Schreierstoren met de brug
over de Gelderse Kade te Amsterdam*

Canvas 24.5 × 36.5. Signed *J. Maris*
PROV Lent by Mr & Mrs J C J Drucker-
Fraser, London, 1904. Presented in
1909-10

LIT W Steenhoff, Elsevier's GM 40 (1910) p 366. M Eisler, Elsevier's GM 46 (1913) p 331. Plasschaert 1920, p 93, ill

A 1885 Harbor view. *Havengezicht*

Canvas 48.5 × 77. Signed *J. Maris*
PROV Presented by the dowager of R Baron van Lynden, née M C Baroness van Pallandt, The Hague, 1900

A 2272 'Towards evening.' '*Tegen de avond*'

Panel 28 × 25. Signed *J. Maris*
PROV Bequest of J B A M Westerwoudt, Haarlem, 1907 * DRVK since 1950

A 1886 River view. *Riviergezicht*

Canvas 48 × 77.5. Signed *J. Maris*
PROV Presented by the dowager of R Baron van Lynden, née M C Baroness van Pallandt, The Hague, 1900 * DRVK since 1968

Matthijs Maris

The Hague 1839–1917 London

see also Fijt, Jan, A 2928 Eagles on the cliffs, copy by M Maris; *see also under* Aquarelles and drawings

A 3727 Study of an old woman. *Studie van een oude vrouw*

Paper on panel 31 × 36. Painted in 1855-58
PROV Lent by Mr & Mrs J C J Drucker-Fraser, 1919. Bequeathed in 1944 * On loan to the Stedelijk Museum, Zutphen, since 1924 (since 1954 through the DRVK)
LIT Exhib cat Matthijs Maris, The Hague 1974-75, nr 9

A 3019 Portrait study. *Portretstudie*

Panel 38.5 × 31.5. Signed and dated *M. Maris 1856*
PROV Presented by F C Stoop, Byfleet near London, 1924

A 2275 A brook in the woods near Oosterbeek. *Beekje in het bos bij Oosterbeek*

Panel 30 × 23.4. Signed *M M*. Painted ca 1860
PROV Bequest of J B A M Westerwoudt, Haarlem, 1907
LIT De Gruyter 1968-69, vol 2, pp 33, 35, fig 37. Exhib cat Matthijs Maris, The Hague 1974-75, nr 47

A 2276 The Noord-West-Buitensingel, The Hague. *De Noord-West-Buitensingel in Den Haag*

Panel 19.5 × 27.5. Signed *MM*. Painted ca 1864-66
PROV Bequest of J B A M Westerwoudt, Haarlem, 1907
LIT P Haverkorn van Rijsewijk, Onze Kunst 33-34 (1918) p 134, ill. Exhib cat Matthijs Maris, The Hague 1974-75, nr 56

A 2704 The Nieuwe Haarlemse Sluis on the Singel, called 'Souvenir

d'Amsterdam.' *De Nieuwe Haarlemse Sluis bij het Singel, genaamd 'Souvenir d'Amsterdam'*

Painted in Paris after a stereoscopic photograph

Canvas 46.5 × 35. Signed and dated *M.M. 71*
PROV Presented by the heirs of W J van Randwijk, The Hague, 1914
LIT W Steenhoff, Onze Kunst 27 (1915) p 92, ill. P Haverkorn van Rijsewijk, Onze Kunst 35 (1919) p 120, ill. Marius 1920, pp 142-43. Arondéus 1939, pp 42-43, 96-97, ill. Van Gelder 1939, p 20, ill on p 36. L J F Wijsenbeek, OK 1 (1957) nr 24, ill. H L C Jaffé, Ons Amsterdam 10 (1958) p 5, ill on p 3. Van Gelder 1959, p 20, fig 152. Gerson 1961, p 29, fig 64. A B de Vries, OKTV 1 (1963) nr 16, fig 10. De Gruyter 1968-69, vol 2, p 42. Novotny 1970, p 170, fig 139B. Exhib cat Matthijs Maris, The Hague 1974-75, nr 85

A 2705 Fairy tale. *Sprookje*

Panel 18 × 38. Signed *M. Maris*. Painted ca 1877
PROV Presented by the heirs of W J van Randwijk, The Hague, 1914
LIT W Steenhoff, Onze Kunst 27 (1915) p 92. De Gruyter 1968-69, vol 2, p 41 (1876 or 1877). Exhib cat Matthijs Maris, The Hague 1974-75, nr 95

C 1486 The shepherdess, called 'Monumental conception of humanity.' *De schaapherderin, genaamd 'Monumental conception of humanity'*

Canvas 200 × 135. Painted ca 1887
PROV Lent by W J G van Meurs, Haarlem, 1909-12. On loan from the van Meurs family, Amsterdam, since 1971
LIT Arondéus 1939, pp 154, 156-57. Exhib cat Matthijs Maris, The Hague 1974-75, p 25

A 2580 Head of a woman, called 'A fair beauty.' *Kop van een vrouw, genaamd 'A fair beauty'*

Canvas 39 × 28
PROV Presented by C Hoogendijk, The Hague, 1912
LIT Knoef 1948, p 109

Simon Willem Maris

The Hague 1873 – 1935 Amsterdam

A 2931 Negro girl. *Negerinnetje*

Canvas 41 × 29. Signed *Simon Maris*
PROV Bequest of A van Wezel, Amsterdam, 1922

Willem Maris

The Hague 1844 – 1910 The Hague

see also under Aquarelles and drawings

A 1887 Cows in a soggy meadow. *Koeien in een drassig weiland*

Canvas 48.5 × 100. Signed *Willem Maris*
PROV Presented by the dowager of R Baron van Lynden, née M C Baroness van Pallandt, The Hague, 1900
LIT De Gruyter 1968-69, vol 2, p 55, fig 64

A 2706 Cow beside a ditch. *Koe aan de slootkant*

Canvas 65 × 81. Signed *Willem Maris*
PROV Presented by the heirs of W J van Randwijk, The Hague, 1914
LIT W Steenhoff, Onze Kunst 27 (1915) p 93. De Gruyter 1968-69, vol 2, p 55, fig 65

A 2428 Meadow with cows beside the water. *Weide met koeien aan het water*

Canvas 87 × 108. Signed *Willem Maris*
PROV Lent by Mr & Mrs J C J Drucker-

Fraser, London, 1904. Presented in
1909-10
LIT 't Hooft 1907, p 6, fig 3. W Steenhoff,
Elsevier's GM 40 (1910) ill on p 371. M
Eisler, Elsevier's GM 46 (1913) p 334, ill
on p 333. De Gruyter 1968-69, vol 2, p
55, fig 72

A 2429 Cows. *Koeien*

Canvas 40 × 53. Signed *Willem Maris*
PROV Lent by Mr & Mrs J C J Drucker-
Fraser, London, 1904. Presented in
1909-10
LIT W Steenhoff, Elsevier's GM 40 (1910)
pp 373-74. M Eisler, Elsevier's GM 46
(1913) p 334

A 3107 Cows at a pond. *Koeien aan een
plas*

Canvas 86.5 × 127. Signed *Willem Maris*
PROV Bequest of P A Gildemeester,
Egmond aan den Hoef, 1930 * DRVK
since 1967

A 4104 Meadow with cows. *Weide met
koeien*

Panel 21.3 × 28.2. Signed *Willem Maris*
PROV Bequest of Mrs K Stanley
Wilkinson, Stone-in-Oxney, Kent, 1964

A 2930 'Summertime.' '*Zomertijd*'

Canvas 86.5 × 127. Signed *Willem Maris*
PROV Bequest of A van Wezel,
Amsterdam, 1922 * DRVK since 1950

A 2277 Ducks. *Eendjes*

Panel 19 × 27. Signed *Willem Maris*
PROV Bequest of J B A M Westerwoudt,
Haarlem, 1907

A 2525 Ducks. *Eenden*

Canvas 93 × 113. Signed *Willem Maris*
PROV Lent by Mr & Mrs J C J Drucker-
Fraser, London, 1904. Presented in
1909-10
LIT W Steenhoff, Elsevier's GM 40 (1910)
p 368. M Eisler, Elsevier's GM 46 (1913)
p 334, ill on p 332

A 2929 White duck with ducklets. *Witte
eend met kiekens*

Canvas 55 × 88. Signed *Willem Maris*
PROV Bequest of A van Wezel,
Amsterdam, 1922

Jean Louis Marne

Brussels 1754 – 1829 Battignolles

C 292 Italian landscape with herdsmen
and cattle at a watering place. *Italiaans
landschap met herders en vee bij een drenk-
plaats*

Canvas 52 × 66
PROV On loan from the city of
Amsterdam (A van der Hoop bequest)
since 1885

Jacob Marrel

Frankenthal 1614 – 1681 Frankfurt am
Main

A 772 Still life with a vase of flowers and a
dead frog. *Stilleven met bloemvaas en dode
kikvors*

Panel 40 × 30. Signed and dated *Iacobus
Marrellus Fecit Utreck Anno 1634*
PROV Presented by H W Mesdag, The
Hague, 1883
LIT Bergström 1947, p 90, ill on p 96.
Bergström 1956, p 83, fig 75. Bol 1969,
pp 41, 320

Otto Marseus van Schrieck

Nijmegen ca 1619–1678 Amsterdam

A 975 A forest floor, with a snake, lizards, butterflies and other insects. *Bosgrond met een slang, hagedissen, vlinders en andere insecten*

Canvas 76 × 62. Signed *OMVS F.*
PROV Purchased from the van der Kolff van Hoogeveen collection, Delft, 1882. NMGK, 1885
LIT C Hofstede de Groot, OH 22 (1904) p 116. Martin 1935-36, vol 2, pp 433-34, fig 230

Willem Martens

Semarang 1856–1927 The Hague

C 1544 Daniël Franken Dzn (1838-98). Banker and art collector. *Bankier en kunstverzamelaar*

Canvas 93.5 × 122.5. Signed and dated *Willy Martens 1888*
PROV On loan from the KOG (presented by CM van Gogh-Franken) since 1973
LIT Gedenkb Rijksmuseum, 1958, ill on p 89

A 1742 The holy family. *De heilige familie*

Canvas 132 × 165. Signed and dated *Willy Martens F 88*
PROV Bequest of D Franken Dzn, Le Vésinet, 1898 * DRVK since 1953

Louis Martinet

Paris 1810–1894 Paris

C 305 Still life with fruits and flowers. *Stilleven met vruchten en bloemen*

Panel 31.5 × 24. Signed *L. Martinet*
PROV On loan from the city of Amsterdam (A van der Hoop bequest) since 1885

Jan Martszen II

Haarlem 1609?–after 1647 Haarlem?

see also Croos, Antonie van, RBK 15234 Decorated painter's box

A 2153 Cavalry skirmish. *Ruitergevecht*

Panel 75.5 × 100. Signed and dated *JMD. Ionge 1629*
PROV Purchased from Fr Muller & Co, art dealers, Amsterdam, 1904, through the intermediacy of the Rembrandt Society
LIT Bol 1969, p 248

Jan Hendrik Maschhaupt

Amsterdam 1826–1903 Amsterdam

A 677 Jonkheer Archibald Jan van de Poll (1800-70)

Canvas 125 × 96
PROV Bequest of Jonkheer J S H van de Poll, Amsterdam, 1880
LIT V de Stuers, Ned Kunstbode 2 (1880) p 244. Scheen 1946, fig 94

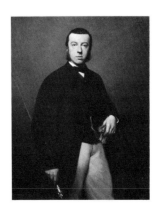

A 678 Jonkheer Jacobus Salomon Hendrik van de Poll (1837-80). Alderman of Velsen. *Wethouder van Velsen*

Canvas 126.5 ×98
PROV Bequest of the sitter, Amsterdam, 1880

Cornelis Massys

Antwerp ca 1508– after 1560 Antwerp

see also Miniatures: Northern Netherlands school ca 1615, A 4424

A 1286 The parable of the prodigal son. *De gelijkenis van de verloren zoon*

Panel 74.5 ×99.5. Signed and dated *Cor Met 1538*
PROV Sale P VerLoren van Themaat, Amsterdam, 30 Oct 1885, lot 153
LIT Hoogewerff 1912, p 21. L von Baldass, Jb Kunsth Samml Wien 34 (1918) p 143, fig 27. Winkler 1924, p 309. Friedländer 1924-37, vol 13 (1936) pp 33-34, 145, nr 50, pl XIV. Van Puyvelde 1962, p 233. E de Callatay, Bull Mus Roy Belg 14 (1965) p 49, ill. Franz 1969, vol 1, pp 93, 97; vol 2, fig 108

Quinten Massys

Louvain 1465/66– 1530 Antwerp

A 247 Madonna and child. *Maria met kind*

Panel 75 ×63
PROV Het Loo Palace, Apeldoorn, 1798. NM, 1808 * On loan to the KKS (cat 1968, p 39, nr 842) since 1948
LIT Fickaert 1648, p 15. Van den Branden 1883, pp 72-73. Cohen 1904, pp 36, 81, nr 902. De Bosschère 1907, pp 99, 101-02, fig 66. Moes & van Biema 1909, pp 17, 41, 49, 70, 108, 116, 161, 212. Hoogewerff 1912, p 24 (a follower). Winkler 1924, p 204 (copy). Friedländer 1924-37, vol 7 (1929) pp 124-25, nr 67, pl LIV (doubts the authenticity). Muls 1930-31, vol 1, p 152. L von Baldass, Jb Kunsth Samml Wien ns 7 (1933) pp 171-72. Van Puyvelde 1941, fig 81. Boon 1942, p 47, ill. I Bergström, Burl Mag 97 (1955) p 304, note 9, fig 4. De Maeyer 1955, p 57, note 2. Speth-Holterhoff 1957, pp 16, 100-02, fig 1. CG Stridbeck, Konsthist Tidskr 29 (1960) p 82, fig 1. Bille 1961, vol 1, p 110. I Bergström, Konsthist Tidskr 30 (1961) p 31, fig 1

A 4048 The carrying of the cross. *De kruisdraging*

Panel 83 ×59. Ends in a round arch
PROV Presented by Mr & Mrs I de Bruijn-van der Leeuw, Muri near Bern, 1961 * On loan to the KKS (cat 1968, p 38, nr 961) since 1963
LIT Friedländer 1924-37, vol 14 (1937) p 108, pl XXIV. Boon 1942, p 28, ill. Bodkin 1945, p 35. L Mallé, Commentari 6 (1955) pp 92, 94-95, fig 6. E R Meijer, Bull RM 9 (1961) p 47. J L Cleveringa, Bull RM 9 (1961) p 65, nr 11

copy after **Quinten Massys**

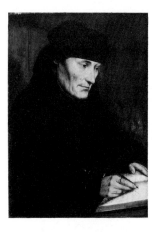

A 166 Desiderius Erasmus (1467-1536). Humanist. *Humanist*

Panel 39 ×27
PROV Purchased from H C van Molman, 1803 (as Hans Holbein). NM, 1808
LIT Moes 1897-1905, vol 1, nr 2385:52. Moes & van Biema 1909, pp 63, 206. Friedländer 1924-37, vol 7 (1929) p 120, nr 36a. Van Hall 1963, p 94, nr 612:6. H Brunin, Bull Mus Roy Belg 17 (1968) p 146

Herman van der Mast

Den Briel ca 1550– 1610 Delft

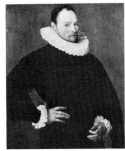

C 616 Portrait of a man. *Portret van een man*

Pendant to C 617

Panel 89 × 73.5. Signed and dated *HMast 1589*. Inscribed *Aeta Suae 33*
PROV On loan from the heirs of J P R M de Nerée van Babberich, The Hague, since 1899
LIT B W F van Riemsdijk, OH 17 (1899) p 124. De Vries 1934, p 102, fig 59. Hoogewerff 1936-47, vol 4 (1941-42) p 613, fig 292

C 617 Portrait of a woman. *Portret van een vrouw*

Pendant to C 616

Panel 89 × 73.5. Signed and dated
HM 1587. Inscribed *Æta Suae 24*
PROV Same as C 616
LIT *see under* C 616

Johan Hendrik van Mastenbroek

Rotterdam 1875 – 1945 Rotterdam

NO PHOTOGRAPH AVAILABLE

A 2278 The Wijnhaven, Rotterdam. *De Wijnhaven te Rotterdam*

In the foreground a spritsail barge is about to sail under a bridge

Canvas 35 × 54. Signed and dated
J. H. van Mastenbroek 1902
PROV Bequest of J B A M Westerwoudt,
Haarlem, 1907 * Lent to the Stedelijk
Museum, Zutphen, 1924. Destroyed in
the war, 1945

Jacob Matham

see Panpoeticon Batavum: A 4555
Dominicus Baudius, by Arnoud van
Halen after Matham

Theodor Matham

see Panpoeticon Batavum: A 4559
Theodorus Velius, by Jan Maurits
Quinkhard after Matham; A 4573 Dirck
Graswinckel, by Arnoud van Halen after
Matham

Anthonij (Anton) Mauve

Zaandam 1838 – 1888 Arnhem

see also under Aquarelles and drawings

A 4156 Pieter Frederik van Os (1808-92). Painter. *Schilder*

Paper on panel 20.8 × 17.4. Signed
A. Mauve. Inscribed on the verso *ce portret représent P.F. van Os peint par son éleve Anton Mauve a l'age de 17 ans en 1855 le jour de sa fête le 18 Septembre – décidé en 1888 – l'ayant vu peindre P. J.C. Gabriël*
PROV Sale Amsterdam, 5 Nov 1968, lot
313
LIT De Gruyter 1968-69, vol 2, p 63, fig
74. C J de Bruyn Kops, Bull RM 17
(1969) pp 37-43, figs 1-2

A 2436 The studio of the Haarlem
painter Pieter Frederik van Os (1808-92), Mauve's teacher. *Het atelier van de
Haarlemse schilder Pieter Frederik van Os,
de leermeester van Mauve*

Paper on canvas 49 × 61. Inscribed by
another hand *A. Mauve*. Inscribed on the
verso *Het atelier (thans de oudheidkamer op
het Stadhuis te Haarlem) van den Kunst-
schilder P. van Os door diens leerling A.
Mauve geschilderd*. Painted ca 1855-56
PROV Lent by Mr & Mrs J C J Drucker-
Fraser, London, 1903. Presented in 1910
LIT M Eisler, Elsevier's GM 46 (1913) p
241, ill. Baard 1947, ill on p 5. Gerson
1961, p 27. Engel 1967, nr 16, pl III. C J
de Bruyn Kops, Bull RM 17 (1969) pp
40-42, fig 5

A 3602 Morning ride on the beach.
Morgenrit langs het strand

Canvas 45 × 70. Signed *A. Mauve f.*
Painted in 1876
PROV Lent by Mr & Mrs J C J Drucker-
Fraser, Montreux, 1929. Bequeathed in
1944
LIT Illustrated Record of Barbizon

House, London, 1928, p 16, nr 20, ill.
Knoef 1947, p 270. Baard 1947, p 37, ill.
H P Baard, OK 3 (1959) nr 15, ill. Gerson
1961, p 27. Exhib cat 150 jaar
Nederlandse kunst, Amsterdam 1963, nr
82, pl IV. VTTT, 1964-65, nr 70. E P
Engel, Bull RM 13 (1965) pp 56, 64.
Engel 1967, nr 73a, ill. De Gruyter
1968-69, vol 2, p 61

A 2279 Horses at the gate. *Paarden bij het
hek*

Canvas 42.5 × 25. Signed and dated
A. Mauve f. 1878
PROV Bequest of J B A M Westerwoudt,
Haarlem, 1907

A 2523 The marsh. *Het moeras*

Canvas 60 × 90. Signed *A. Mauve f.*
Painted in 1885
PROV Lent by Mr & Mrs J C J Drucker-
Fraser, London, 1909. Presented in
1909-10
LIT W Steenhoff, Elsevier's GM 40 (1910)
p 372. M Eisler, Elsevier's GM 46 (1913)
p 410. Baard 1947, p 49, ill. Engel 1967,
nr III, pl XIV

A 3143 The Torenlaan, Laren. *De Toren-laan te Laren*

Canvas 52 × 38. Signed *A. Mauve.*
Painted in 1886
PROV Presented by Mrs B Hoyer-Wierdsma, Hilversum, 1933
LIT Engel 1967, nr 118, ill

A 2430 On the heath in Laren. *Heide te Laren*

Canvas 77 × 104. Signed *A. Mauve f.*
Painted in 1887
PROV Lent by Mr & Mrs J C J Drucker-Fraser, London, 1903. Presented in 1910
LIT W Steenhoff, Elsevier's GM 40 (1910) ill on p 370. M Eisler, Elsevier's GM 46 (1913) p 409, ill on p 411. E P Engel, Bull RM 13 (1965) p 47. Zeitler 1966, p 228, fig 140a. Engel 1967, nr 123, ill. A C J de Vrankrijker, Spiegel Hist 7 (1972) fig 7 on p 527

A 3601 Fishing boats on the beach. *Vissersschepen aan het strand*

Canvas 37 × 50. Signed *A. Mauve*

PROV Lent by Mr & Mrs J C J Drucker-Fraser, 1919. Bequeathed in 1944 *
DRVK since 1956

A 2433 Winter in the Scheveningen Woods. *Winter in de Scheveningse bosjes*

Canvas 47 × 31. Signed *A. Mauve*
PROV Lent by Mr & Mrs J C J Drucker-Fraser, London, 1903. Presented in 1910
LIT W Steenhoff, Elsevier's GM 40 (1910) p 372. M Eisler, Elsevier's GM 46 (1913) p 413

A 2432 Cottage on a ditch. *Huisje aan een sloot*

Canvas 36 × 49. Signed *A. Mauve f*
PROV Lent by Mr & Mrs J C J Drucker-Fraser, London, 1903. Presented in 1910
LIT W Steenhoff, Elsevier's GM 40 (1910) p 373. M Eisler, Elsevier's GM 46 (1913) p 411

A 2384 Shipping canal. *Trekvaart*

Canvas 42.5 × 25. Signed *A. Mauve f*
PROV Bequest of J B A M Westerwoudt, Haarlem, 1907

A 1542 Launching a fishing pink. *Het in zee brengen van een visserspink*

Canvas on panel 28.5 × 45. Signed *A.M.*
PROV Presented by G P Rouffaer, Nieuwer Amstel, 1892

A 2431 Cottage on a sandy path. *Huisje aan de zandweg*

Canvas 37 × 50.5. Signed *A. Mauve*
PROV Lent by Mr & Mrs J C J Drucker-Fraser, London, 1903. Presented in 1910
LIT W Steenhoff, Elsevier's GM 40 (1910) p 373. M Eisler, Elsevier's GM 46 (1913) p 411

A 1888 The milking yard. *De melkbocht*

Canvas 171 × 115. Signed *A. Mauve f*

PROV Presented by the dowager of R Baron van Lynden, née M C Baroness van Pallandt, The Hague, 1900

A 2524 The vegetable garden. *De moestuin*

Canvas 61 × 87. Signed *A. Mauve f*
PROV Lent by Mr & Mrs J C J Drucker-Fraser, London, 1909. Presented in 1909-10
LIT W Steenhoff, Elsevier's G M 40 (1910) p 372. M Eisler, Elsevier's G M 46 (1913) pp 411-12, ill on p 413

A 3323 Cow. *Koe*

Panel 27 × 41. Signed *A. Mauve*
PROV Presented by Mr & Mrs D A J Kessler-Hülsmann, Kapelle op den Bosch near Mechelen, 1940

A 2434 Cow. *Koe*

Canvas 49 × 61. Marked *Atelier A. Mauve*
PROV Lent by Mr & Mrs J C J Drucker-Fraser, London, 1903. Presented in 1910
* DRVK since 1953
LIT M Eisler, Elsevier's G M 46 (1913) p 413

A 2932 Lying cow. *Liggende koe*

Panel 15.5 × 25. Marked *Atelier A. Mauve*
PROV Bequest of A van Wezel, Amsterdam, 1922

A 2435 Horse. *Paard*

Canvas 25.5 × 33. Signed *A. Mauve*
PROV Lent by Mr & Mrs J C J Drucker-Fraser, London, 1903. Presented in 1910
LIT M Eisler, Elsevier's G M 46 (1913) p 413, ill on p 414

Jan Willem May

Amsterdam 1798 – 1826 Hoorn

 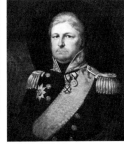

A 2423 Job Saeburne May (1765-1827). Rear admiral. *Schout-bij-nacht*

Pendant to A 2424

Canvas 61 × 51.5. Signed and dated *J. W. May f 1823*
PROV Bequest of H M C Baroness Collot d'Escury, The Hague, 1910 * DRVK since 1959 (on loan to the Museum van de Kanselarij der Nederlandse Orden, The Hague)

A 2424 Ann Brander (d 1837). Wife of Job Saeburne May. *Echtgenote van Job Saeburne May*

Pendant to A 2423

Canvas 61 × 51.5. Signed and dated *J. W. May f. 1823*
PROV Same as A 2423
LIT Scheen 1946, fig 43

attributed to **Juan Bautista Martínez del Mazo**

Beteta? 1612/16 – 1667 Madrid

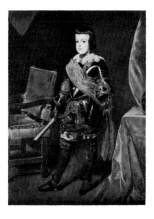

C 1362 Prince Balthasar Carlos (1629-46). Son of King Philip IV of Spain at about the age of eleven. *Zoon van de Spaanse koning Philips IV op ongeveer elf-jarige leeftijd*

Canvas 148.5 × 112.5
PROV Purchased from Chevalier Vincent de Rainer, Brussels, 1821, by King Willem I (as Velazquez). On loan from the K K S since 1948
LIT Kunstkronijk, 1847, ill opp p 70. Bürger 1858, p 307. Bürger 1865, nr 169. Curtis 1883, p 58, nr 139. Cruzada Villaamil 1885, nr 94. Lefort 1888, p 145. Armstrong 1896, p 48. De Beruete y Moret 1906, p 57. De Beruete y Moret 1909, pp 86-87. Von Loga 1914, nr 123. L Cust, Burl Mag 28 (1915) pp 56-60. A de Beruete y Moret, GdB-A 61 (1917) p 239. Justi 1923, vol 2, p 6. De Beruete y Moret 1924, p 147 (ca 1640-44). Allende Salazar 1925, nr 195. Mayer 1936, nr 285. Du Gué Trapier 1948, p 250, note 22. De Pantorba 1955, nr 78. Gaya Nuño 1958, nr 1720. Lopez Rey 1963, p 230, nr 316, fig 304. Camòn Aznar 1964, pp 618, 622, ill on p 621. P van Vliet, Bull R M 14 (1966) p 140, fig 8. E Harris, Journ W C I 30 (1967) p 415

A 433 Portrait of a boy, thought to be Prince Balthasar Carlos (1629-46), son of King Philip IV of Spain, at about the age of three. *Portret van een kind, vermoedelijk prins Balthasar Carlos, zoon van de Spaanse koning Philips IV, op ongeveer driejarige leeftijd*

Canvas 32 × 25
PROV Sale Amsterdam, 4 Aug 1828, lot 139 (as Velazquez)
LIT Bürger 1858, p 183. Curtis 1883, p 59. Justi 1888, vol 2, p 130, note 2. Gaya Nuño 1958, nr 1719. P van Vliet, Bull RM 14 (1966) p 140, fig 9

Ludovico Mazzolino

Ferrara ca 1480 – 1528/30 Ferrara

A 3409 Moses and the tables of the law, the cursing of the barren fig tree, and the parable of the widow's mite. *Mozes en de tafelen der Wet, de vervloeking van de verwelkte vijgenboom, en de gelijkenis van het penningske van de weduwe*

Panel 8.5 × 67. Predella
PROV Bequest of J W Edwin vom Rath, Amsterdam, 1941
LIT Berenson 1907, p 257. Longhi 1956, p 69. Zamboni 1968, nr 3, fig 61b

C 1363 The massacre of the innocents. *De kindermoord te Bethlehem*

Panel 31 × 38. Signed and dated apocryphally *1548 FE*
PROV Purchased from Chevalier Vincent de Rainer, Brussels, 1821, by King Willem I. On loan from the KKS since 1948
LIT Venturi 1890, pp 454, 456, 462. Gruyer 1897, p 253. Berenson 1907, p 257. Gardner 1911, p 229. Berenson 1936, p 307. Bargellesi 1955, p 65. Longhi 1956, p 69. Zamboni 1968, nr 2, fig 61a

Henricus Antonius van Meegeren

Deventer 1889 – 1947 Amsterdam

A 4239 Mary Magdalene washing Christ's feet. *De voetwassing*

In the manner of Johannes Vermeer

Canvas 122 × 102. Signed falsely *IVMeer*
PROV Purchased by the state, 1943
LIT Coremans 1949, pp 5-6, 9, 16, 18, 23, 28, 36-37, pls 15-16, 56. Decoen 1951, pls 20, 120, 142. Arnau 1964, pp 263-64. Ungaretti & Bianconi 1967, pp 100-01, ill (1942-43)

A 4240 Woman reading a letter. *Brieflezende vrouw*

In the manner of Johannes Vermeer

Canvas 58.5 × 57
PROV Deposited by the Amsterdam district court, 1947

LIT Coremans 1949, pp 5, 12-13, 19, 22, 28, 38, pls 21-22. Ungaretti & Bianconi 1967, p 102, ill (Nice 1935-36?). Exhib cat Fakes and forgeries, Minneapolis 1973, nr 82, ill

A 4241 Woman playing the cittern. *Cisterspelende vrouw*

In the manner of Johannes Vermeer

Canvas 58 × 47
PROV Deposited by the Amsterdam district court, 1947
LIT Coremans 1949, pp 5, 28, 38, pl 23. Ungaretti & Bianconi 1967, p 102, ill (Nice 1935-36?)

A 4242 Malle Babbe

In the manner of Frans Hals

Canvas 76 × 60
PROV Deposited by the Amsterdam district court, 1947
LIT Coremans 1949, pp 5, 28, 38, pl 25. Arnau 1964, p 249, ill (ca 1935-36)

A 4243 Portrait of a man. *Portret van een man*

In the manner of Gerard ter Borch

Canvas 28 ×23
PROV Deposited by the Amsterdam district court, 1947
LIT Coremans 1949, pp 5, 28, 38, pl 24. Arnau 1964, p 249, ill (ca 1935-36). Exhib cat Fakes and forgeries, Minneapolis 1973, nr 84, ill

Jan van der Meer II

Haarlem 1628–1691 Haarlem

A 2351 Landscape with a farm. *Landschap met boerderij*

Panel 53 ×66. Signed *JVMeer*
PROV Purchased from Fr Muller & Co, art dealers, Amsterdam, 1908, through the intermediacy of the Rembrandt Society * On loan to the KKS (pendant to cat nr 724, dated 1648) since 1933

Jan van der Meer III

Haarlem 1656–1705 Haarlem

A 248 The sleeping shepherd. *De slapende herder*

Canvas 65 ×83. Signed and dated *J.v. der Meer de Jonge A° 1678*
PROV Sale G van der Pot van Groeneveld, Rotterdam, 6 June 1808, lot 75 * On loan to the municipality of Velsen (Beeckestijn Estate)
LIT Moes & van Biema 1909, pp 113, 181

Johan Meerhout

b in Gorkum; d 1677 in Amsterdam?

A 1443 Mountainous landscape with river valley and castles. *Bergachtig landschap met rivierdal en kastelen*

Canvas 111.5 ×155. Signed and dated *Johan Meerhout 1661*
PROV Presented by Dr A Bredius, The Hague, 1888
LIT Bol 1969, p 185, note 257

Hendrik Meerman

active 1633–after 1650 in Amsterdam

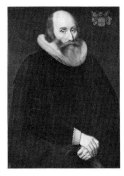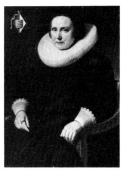

A 1543 Antonius Antonides van der Linden (1570-1633). Amsterdam physician. *Geneesheer te Amsterdam*

Pendant to A 1544

Panel 88 ×63. Dated *An° 1633*. Inscribed *Morientis Imago Ætat 63*
PROV Presented by Jonkheer Victor de Stuers, The Hague, 1891 * Lent to the AHM, 1975
LIT Moes 1897-1905, vol 2, nr 4528

A 1544 Sara Sweerts de Weert (b 1579). Second wife of Antonius Antonides van der Linden. *Tweede echtgenote van Antonius Antonides van der Linden*

Pendant to A 1543

Panel 88 ×63. Dated *An° 1636*. Inscribed *Ætatis 58*
PROV Same as A 1543 * Lent to the AHM, 1975

attributed to **Melozzo da Forlì**

Forlì 1438–1494 Forlì

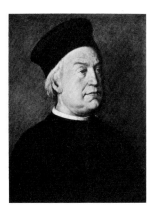

A 3315 Portrait of a man. *Portret van een man*

Panel 42.5 ×32
PROV Presented by Mr & Mrs DAJ Kessler-Hülsmann, Kapelle op den Bosch near Mechelen, 1940

Anton Raphael Mengs

Ústí (formerly Aussig) 1728 – 1779 Rome

see also under Pastels

A 3277 Isabel Parreño y Arce, marquesa de Llano. *Markiezin van Llano*

cf the version in the Real Academia de San Fernando, Madrid

Canvas 135 × 98.5
PROV Presented by B de Geus van den Heuvel, Amsterdam, 1939
LIT Honisch 1965, nr 73 (replica)

Jacob Fransz van der Merck

's-Gravendeel ca 1610 – 1664 Leiden

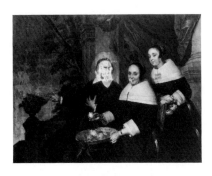

A 853 Family portrait. *Familieportret*

Canvas 151 × 195. Signed and dated *J. v. Merck 165.*
PROV Presented by A J Enschedé, Haarlem, 1874. NMGK, 1885 (in damaged condition)

Johannes Cornelis Mertens

see under Pastels

Salomon Mesdach

active 1617 – after 1628 in Middelburg

A 913 Willem Courten (1581-1630)

Panel 194 × 109. Dated *A° 1617*
PROV Bequest of Jonkheer J de Witte van Citters, The Hague, 1876. NMGK, 1885
LIT Moes 1897-1905, vol 1, nr 1771

A 2068 Pieter Boudaen Courten (1594-1663). Director of the Middelburg chamber of the Dutch East India Company. *Bewindhebber van de Middelburgse kamer der Verenigde Oostindische Compagnie*

Pendant to A 2069

Panel 105 × 74. Dated *A° 1619.* Inscribed *Aetatis suae 25.* On the verso his coat of arms, the inscription *Pieter Boudaen Courten Bewindhebber der O I Compagnie. Geb : te Rotterdam Oct : 1594. Overl : te Middelb : 5 Feb : 1668.*, and the number *27*
PROV Bequest of Jonkheer J de Witte van Citters, The Hague, 1876. Received in 1903
LIT Moes 1897-1905, vol 1, nr 977:2? Bernt 1960-62, vol 4, nr 200. Bernt 1969-70, vol 2, nr 749

A 2069 Catharina Fourmenois (1598-1665). Wife of Pieter Boudaen Courten. *Echtgenote van Pieter Boudaen Courten*

Pendant to A 2068
For another portrait of the sitter, *see* Geldorp, Gortzius, A 2070

Panel 104 × 73. Dated *A° 1619.* Inscribed *Aetatis suae 21.* On the verso her coat of arms and that of her husband, the inscription *Catharina Fourmenois. Trouwt 15 Julij 1618 te Middelb : Pieter Boudaen Courten. Geb : 5 Oct : 1598. Overl : 16 Jan : 1665.*, and the number *28*
PROV Same as A 2068
LIT Moes 1897-1905, vol 1, nr 2570:2. Bernt 1960-62, vol 4, nr 201

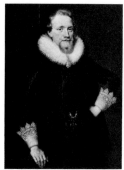

A 918 Jacob Pergens

Pendant to A 919

Panel 96 × 70. Dated *An° 1619.* On the verso his coat of arms, the inscription *Jacob Pergens van Keulen. Trouwt 15 Julij 1619 Anna Boudaen Courten. Geb : ….Overl : …*, and the number *41*
PROV Bequest of Jonkheer J de Witte van Citters, The Hague, 1876. NMGK, 1885
LIT Moes 1897-1905, vol 2, nr 5853

A 919 Anna Boudaen Courten (1599-1621). Wife of Jacob Pergens. *Echtgenote van Jacob Pergens*

Pendant to A 918

Panel 96 × 70. Dated *An° 1619.* On the verso her coat of arms and that of her husband, the inscription *Anna Boudaen Courten. Trouwt 15 Julij 1619 te London Jacob Pergens. Geb : te Rotterd : Febr. 1599. Overl : te London 15 Febr. 1621*, and the number *42*
PROV Same as A 918
LIT C J Hudig, Historia 9 (1943) p 169, fig 2

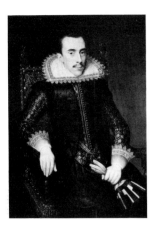

A 911 A man from the Boudaen Courten family. *Een man uit de familie Boudaen Courten*

Panel 96 × 70. Dated *An° 1620*. On the verso his coat of arms, the inscription *Boudaen Courten. Zoon van Mathias en Margarita Courten Geb: ... Overl: ...,* and the number *30*
PROV Bequest of Jonkheer J de Witte van Citters, The Hague, 1876. NMGK, 1885

A 2073 Margarita Courten (b 1564). Wife of Matthias Boudaen and Jean de Moncy. *Echtgenote van Matthias Boudaen en Jean de Moncy*

Panel 102.5 × 74. Dated *An° 1625*. On the verso her coat of arms, the inscription *Margarita Courten. Trouwt 1° Mathias Boudaen 2° in 1606 Jean de Moncij. Geb: 1564 Overl: ...,* and the number *43*
PROV Bequest of Jonkheer J de Witte van Citters, The Hague, 1876. Received in 1903
LIT Bernt 1969-70, vol 2, nr 750

A 910 Hortensia del Prado (d 1627). Wife of Jean Fourmenois and of Pieter Courten. *Echtgenote van Jean Fourmenois en van Pieter Courten*

For other portraits of the sitter, *see* Geldorp, Gortzius, A 2072 & A 2081

Panel 74 × 61. On the verso her coat of arms and those of her two husbands, the inscription *Hortensia del Prado. Trouwt 1.° Jean Fourmenois. 2.° Pieter Courten Geb: ... Overl: 18 Junij 1627.*, the number *29* and a vellum label inscribed *Hortensia del Prado moeder van mijn moeder z[al] Joh. Boudaen 16[78?]*
PROV Bequest of Jonkheer J de Witte van Citters, The Hague, 1876. NMGK, 1885
LIT Moes 1897-1905, vol 2, nr 6064:2

Hendrik Willem Mesdag

Groningen 1831 – 1915 The Hague

see also under Aquarelles and drawings

A 1165 Boats on the beach at Scheveningen. *Boten op het strand bij Scheveningen*

Canvas 62 × 131. Signed and dated *H W Mesdag 1874*
PROV Purchased in 1874. RVMM, 1885 *
DRVK since 1953

A 1891 Calm sea. *Kalme zee*

Canvas 123.4 × 97.5. Signed *H W Mesdag*
PROV Presented by the dowager of R Baron van Lynden, née M C Baroness van Pallandt, The Hague, 1900 *
DRVK since 1952

A 2474 Bluff-bowed Scheveningen fishing boats at anchor. *Scheveningse bommen voor anker*

Canvas 115.5 × 80. Signed *H. W. Mesdag*
PROV Lent by Mr & Mrs J C J Drucker-Fraser, London, 1904. Presented in 1909-10 * DRVK since 1959
LIT 't Hooft 1907, fig 4

A 2670 Fishing pinks in the breakers. *Pinken in de branding*

Canvas 90 × 181. Signed *H. W. Mesdag*
PROV Bequest of Miss A C Zegwaard, The Hague, 1913 * DRVK since 1956

A 2385 Beach with boats and seashell hunters. *Strand met boten en schelpenvissers*

Panel 40 × 51. Signed *H. W. Mesdag*
PROV Bequest of J B A M Westerwoudt, Haarlem, 1907 * DRVK since 1950

A 2301 The lighthouse of Scheveningen. *De vuurtoren van Scheveningen*

Canvas 74 × 83. Signed *H. W. Mesdag*
PROV Lent by J B A M Westerwoudt, Haarlem, 1902. Bequeathed in 1907 *
DRVK since 1953

A 3086 Moonlight at sea. *Maneschijn op zee*

Panel 44.2 × 31. Signed *H. W. Mesdag*
PROV Bequest of J B A M Westerwoudt, Haarlem, 1907. Received in 1929 *
DRVK since 1953

A 2938 Sea with ships. *Zee met schepen*

Canvas 46 × 38.5. Signed *H. W. Mesdag*
PROV Bequest of A van Wezel, Amsterdam, 1922 * DRVK since 1953

A 2280 Waves battering a lighthouse. *Vuurtoren in de branding*

Panel 52 × 40. Signed *H. W. M.*
PROV Bequest of J B A M Westerwoudt, Haarlem, 1907
LIT De Gruyter 1968-69, vol 1, p 96, fig 124

A 1553 Menno David Count van Limburg Stirum (1807-91). Royal adjutant, lieutenant general. *Adjudant des konings, luitenant-generaal*

Pendant to A 1554

Canvas 82.5 × 73.5. Signed and dated *H. W. Mesdag 28 Augustus 1874*. Inscribed *v. L. Stirum MD 30 Novr 1807*
PROV Bequest of the sitter, The Hague, 1891 * DRVK since 1960

A 1554 Maria Hermina Heemskerk (1827-1908). Wife of Menno David Count van Limburg Stirum. *Echtgenote van Menno David Graaf van Limburg Stirum*

Pendant to A 1553

Canvas 84 × 74. Signed and dated *H. W. Mesdag 1887*. Inscribed *Gravin van Limburg Stirum-Heemskerk 27 December 1827*
PROV Same as A 1553

Sina Mesdag-van Houten

Groningen 1834 – 1909 The Hague

A 1921 Still life with gourds and melons. *Stilleven met kalebassen en meloenen*

Canvas 69.5 × 89.5. Signed *S. Mesdag-van Houten*
PROV Sale The Hague, 16 Oct 1900, for the benefit of Pulchri Studio, lot 68 *
DRVK since 1953

Gabriël Metsu

Leiden 1629 – 1667 Amsterdam

A 2156 The armorer. *De wapensmid*

Canvas 101 × 85. Signed *G. Metsu*
PROV Purchased from F Kleinberger gallery, Paris, 1904, with aid from the Rembrandt Society
LIT Hofstede de Groot 1907-28, vol 1,

nr 209. O Kronig, Rev Art Anc & Mod 25 (1909) p 103, ill. Martin 1935-36, vol 2, p 226. S J Gudlaugsson, O H 83 (1968) p 23 (ca 1653). U M Schneede, O H 83 (1968) p 47 (mid or late 1650s)

C 177 The hunter's present. *Het geschenk van de jager*

Canvas 51 × 48. Signed *G. Metzu*
PROV On loan from the city of Amsterdam (A van der Hoop bequest) since 1885
LIT Immerzeel 1842-43, vol 2, p 218. Hofstede de Groot 1907-28, vol 1, nr 180. Martin 1935-36, vol 2, p 226. Exhib cat Gabriël Metsu, Leiden 1966, nr 27, ill. E de Jongh, Simiolus 3 (1968-69) p 35, fig 9. S J Gudlaugsson, O H 83 (1968) p 27 (ca 1658)

A 249 Man and woman sharing a meal. *Man en vrouw aan de maaltijd*

Canvas on panel 35.5 × 29. Signed *G. Metsu*
PROV Purchased with the Kabinet van Heteren Gevers, The Hague-Rotterdam, 1809
LIT Hofstede de Groot 1907-28, vol 1, nr 167. Moes & van Biema 1909, pp 148, 161, 193. Bille 1961, vol 1, pp 109, 113. Exhib cat Gabriël Metsu, Leiden 1966, nr 25, ill. S J Gudlaugsson, O H 83 (1968) p 25 (ca 1658)

A 2328 Woman selling herrings. *De haringkoopvrouw*

Panel 37 × 33. Signed *G Metsu*
PROV Purchased from the heirs of Jonkheer P H Six van Vromade, Amsterdam, 1908
LIT W Steenhoff, Onze Kunst 13 (1908) p 218, ill. Hofstede de Groot 1907-28, vol 1, nr 32. Bille 1961, vol 1, p 120, ill; vol 2, pp 31, 105. Exhib cat Gabriël Metsu, Leiden 1966, nr 30, ill. S J Gudlaugsson, O H 83 (1968) p 32 (ca 1661-62)

C 560 Woman eating, known as 'The cat's breakfast.' *Vrouw aan de maaltijd, bekend als 'Het ontbijt van de kat'*

Panel 33.5 × 27. Signed *G. Metsu*
PROV On loan from the city of Amsterdam (bequest of Mrs M C van Lennep-Messchert van Vollenhoven, widow of J Messchert van Vollenhoven) since 1892
LIT Hofstede de Groot 1907-28, vol 1, nr 133. Exhib cat Gabriël Metsu, Leiden 1966, nr 16, ill. S J Gudlaugsson, O H 83 (1968) p 34 (ca 1662)

A 250 The old drinker. *De oude drinker*

Panel 22 × 19.5
PROV Sale G Muller, Amsterdam, 2-3 April 1827, lot 44
LIT Hofstede de Groot 1907-28, vol 1, nr 193. Exhib cat Gabriël Metsu, Leiden 1966, nr 18, ill

A 672 Old woman meditating. *Oude vrouw in overpeinzing*

Panel 27 × 33. Signed *G. Metsu*
PROV Purchased from the van der Feltz collection, Oosterbeek, 1880
LIT Hofstede de Groot 1907-28, vol 1, nr 68. O Kronig, Rev Art Anc & Mod 25 (1909) p 214, fig 1. S J Gudlaugsson, O H 83 (1968) p 33 (1662 or somewhat later)

A 3059 The sick child. *Het zieke kind*

Canvas 32.2 × 27.2. Signed *G. Metsue*
PROV Sale Huldschinsky, Berlin, 10 May 1928, lot 20. Purchased with aid from the Rembrandt Society

LIT Hofstede de Groot 1907-28, vol 1, nr
111. O Kronig, Rev Art Anc & Mod 25
(1909) p 217, fig 3. K Lilienfeld,
Cicerone 5 (1913) p 327ff, ill on p 328.
Kunst und Künstler 12 (1914) ill on p
359. Collins Baker 1925, p 4, note 7.
Valentiner 1929, p 18, note 3. Martin
1935-36, vol 2, pp 171, 224-25, fig 120.
De Vries 1939, p 60. Bode 1953, p 119,
fig 128. E R Meijer, OK 2 (1958) nr 29,
ill. M Poch-Kalous, Albertina Stud 4
(1966) pp 30, 34. Rosenberg, Slive &
Ter Kuile 1966, p 131, fig 104. Exhib cat
Gabriël Metsu, Leiden 1966, nr 37, ill.
S J Gudlaugsson, OH 83 (1968) p 33 (ca
1663-64). E Snoep-Reitsma, Alb Amic
J G van Gelder 1973, p 290, note 52

Metsijs, Metsys

see Massys

Louis Mettling

Dijon 1847 – 1904 Neuilly

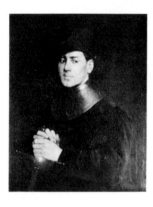

A 1889 The cavalier. *De cavalier*

Canvas 82.5 × 66. Signed *L. Mettling*
PROV Presented by the dowager of R
Baron van Lynden, née M C Baroness
van Pallandt, The Hague, 1900 * DRVK
since 1953

A 1890 Head of a girl. *Meisjeskopje*

Canvas 46 × 38.5. Signed *L. Mettling*
PROV Presented by the dowager of R
Baron van Lynden, née M C Baroness
van Pallandt, The Hague, 1900 * DRVK
since 1952

Coenraad Metzelaar

Amsterdam 1845 – 1881 Amsterdam

A 2281 On the bank of the Oise. *Aan de Oise*

Panel 45.5 × 27. Signed and dated
C. Metzelaar 1877
PROV Bequest of J B A M Westerwoudt,
Haarlem, 1907

Adriaan Meulemans

Rotterdam 1763 – 1835 The Hague

A 1174 A kitchen in lamplight. *Keuken bij lamplicht*

Panel 50 × 40. Signed and dated
A. Meulemans Fecit 1817
PROV Presented by J Kesler PMz,
Amsterdam, 1877. RVMM, 1885

C 179 Old woman reading. *Lezende oude vrouw*

Panel 25 × 20. Signed *A. Meulemans fecit*
PROV On loan from the city of
Amsterdam (A van der Hoop bequest)
since 1885

François Pieter ter Meulen

Bodegraven 1843 – 1927 The Hague

A 1330 In the woods. *In het bos*

Canvas 88 × 68. Signed *ter Meulen*
PROV Purchased at exhib Amsterdam
1886, nr 220 * DRVK since 1953

Adam Frans van der Meulen

Brussels 1632 – 1690 Paris

A 3753 Louis XIV crossing the Rhine near the tollhouse at Lobith, 12 June 1672. *Lodewijk XIV trekt bij het Tolhuis bij Lobith de Rijn over, 12 juni 1672*

Canvas 103 × 159
PROV Purchased from A Wiggins & Sons Ltd, London, 1950

A 3960 The troops of Louis XIV at Naarden, 20 July 1672. *De troepen van Lodewijk XIV voor Naarden, 20 juli 1672*

Canvas 52 × 93.5. Unfinished
PROV Purchased from H Baderou gallery, Paris, 1959

Pieter Meulener

Antwerp 1602 – 1654 Antwerp

A 803 Landscape with couple dancing. *Landschap met dansend paar*

Panel 51 × 174. Painted on the lid of a clavichord. Signed and dated *P. Meulener 1645*
PROV Purchased from J H Balfoort, Schoonhoven, 1883

Jacob van Meurs

see Panpoeticon Batavum: A 4591 Sibylle van Griethuysen, by Arnoud van Halen after van Meurs

Johan Hendrik Louis Meijer

Amsterdam 1809 – 1866 Utrecht

A 1406 Self portrait. *Zelfportret*

Canvas 136 × 120. Signed and dated *L. Meijer fecit 1838*
PROV Purchased in 1887
LIT Van Hall 1963, p 209, nr 1405:1

A 1820 Ships in open sea. *Schepen in volle zee*

Canvas 83 × 115. Signed and dated *Louis Meijer 1839*
PROV Bequest of Reinhard Baron van Lynden, The Hague, 1899 * DRVK since 1950

A 2239 The conquest of Palembang, Sumatra, by Lieutenant-general Baron de Kock, 24 June 1821. *De overmeestering van Palembang (Sumatra) door luitenant-generaal Baron de Kock, 24 juni 1821*

Panel 75 × 98. Signed and dated *Louis Meijer 1857*
PROV Lent by E Baroness de Kock, The Hague, 1900. Presented in 1907
LIT Jvsl Scheepvaartmus 4 (1920) p 72

A 1079 Storm in the Straits of Dover. *Storm in het Nauw van Calais*

Panel 65 × 88. Signed *Louis Meijer*
PROV Purchased from Mr de Ceva, 1869. RVMM, 1885 * DRVK since 1961

A 1821 On the coast. *Langs de kust*

Panel 23.5 × 34. Signed *L. Meijer*
PROV Bequest of Reinhard Baron van Lynden, The Hague, 1899

Hendrik de Meyer

active 1637-83 in Rotterdam

A 1511 The departure of the Spanish occupying force from Breda, 10 October 1637. *De uittocht van de Spaanse bezetting van Breda, 10 oktober 1637*

Panel 87 × 152. Signed and dated *H. de Meyer f… 16…* Signed falsely *A. Cuyp*
PROV Sale Amsterdam, 10-12 Dec 1889, lot 25

A 251 The capture of Hulst from the
Spanish, 5 November 1645. *De verovering
van de stad Hulst op de Spanjaarden, 5
november 1645*

Panel 94 × 154.5. Signed and dated
H. de Meyer f 1645. Inscribed *het over gaen
van de stadt Hulst op de 5 november 1645*
PROV NM, 1808
LIT Moes & van Biema 1909, p 217

A 252 The departure of Charles II of
England from Scheveningen, 2 July
1660. *Het vertrek van Karel II van Engeland
uit Scheveningen, 2 juli 1660*

Canvas 52 × 75. Signed *H. de Meyer fc*
PROV Purchased from H C van Molman,
1803. NM, 1808
LIT Moes & van Biema 1909, pp 63, 218

Jan de Meijer II

see Rotterdam East India Company
series: A 4515 Dirck de Raet

Gerrit Jan Michaëlis

Amsterdam 1775 – 1857 Haarlem

A 1080 Hilly landscape. *Heuvelachtig
landschap*

Canvas 51 × 61. Signed and dated
G. J. M. 1814
PROV Purchased at exhib The Hague
1833, nr 191. RVMM, 1885
LIT Scheen 1946, fig 279

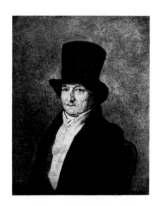

A 2141 Jean Bernard (1765-1833).
Amsterdam collector and painter.
Amsterdams verzamelaar en schilder

Paper on panel 21 × 16.5. Signed and
dated *G. J. M. 18¹¹⁄₅ 28*. Inscribed on a
sticker on the verso *Jean Bernard oud 64
jaar Geschilderd in Haarlem den 5 November
1828 door G. J. Michaelis*
PROV Bequest of J Bernard van
IJsseldijk, Amsterdam, 1904
LIT Van Hall 1963, p 21, nr 139:1. J W
Niemeijer, Bull RM 16 (1968) p 23, note 7

Hippolyte Michaud

Beaune 1813 – 1886 Paris

A 1743 The little art lovers. *De kleine
kunstliefhebbers*

Panel 16.5 × 14.5. Signed on the verso
H. Michaud Pinx.
PROV Bequest of D Franken Dzn, Le
Vésinet, 1898

A 1745 Spectators at the theatre.
Theaterpubliek

Canvas 22 × 27. Signed *HM*
PROV Bequest of D Franken Dzn, Le
Vésinet, 1898

A 1744 Woman bathing. *Badende vrouw*

Board 21.5 × 16
PROV Bequest of D Franken Dzn, Le
Vésinet, 1898

Jean Michelin

see under Miniatures

Michiel Jansz van Miereveld

Delft 1567 – 1641 Delft

see also under Honselaarsdijk series

A 253 Willem I (1533-84), prince of Orange, called William the Silent. *Prins van Oranje, genaamd Willem de Zwijger*

Canvas 112.5 × 88.5. Signed *Faciem huius ad principale Cornely de Vischer fecit M. a Miereveld*. Inscribed Ζεῦ μὴ λάθοι σε τῶνδ'|ός άίτιος κακῶν (O Zeus, may he who brought this misery about not escape you)
PROV Admiraliteit op de Maze (admiralty of the Maas), Rotterdam, 1800. NM, 1808 * DRVK since 1959 (on loan to the Oranje-Nassau Museum, Delft)
LIT E W Moes, OH 7 (1889) p 288. Moes 1897-1905, vol 2, nr 9094:20. Moes & van Biema 1909, pp 162, 201. Blok 1919-20, vol 2, p 206. S W A Drossaers, OH 47 (1930) p 255, sub 314. Van Beresteyn 1933, nr 52. H C Ebeling, Historia 13 (1948) p 173, fig 1

A 256 Philips Willem (1554-1618), prince of Orange. *Prins van Oranje*

Canvas 122 × 106. Signed *M. Miereveld*
PROV NM, 1808
LIT Moes 1897-1905, vol 2, nr 5905:2. Moes & van Biema 1909, pp 161, 201

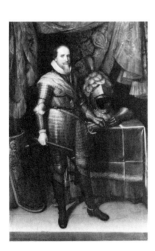

A 255 Maurits (1567-1625), prince of Orange. *Prins van Oranje*

Panel 221.5 × 146. Signed *M. Miereveld*

PROV Zeecomptoir (maritime board), Rotterdam, 1800. NM, 1808
LIT Moes & van Biema 1909, pp 33, 162, 201. R B F van der Sloot, NKJ 10 (1959) p 121, fig 8

A 254 Frederik Hendrik (1584-1647), prince of Orange. *Prins van Oranje*

Canvas 113 × 88.5
PROV Zeecomptoir (maritime board), Rotterdam, 1800. NM, 1808
LIT Moes 1897-1905, vol 1, nr 2582:6. Moes & van Biema 1909, pp 162, 202. C J Hudig, Historia 9 (1943) p 173, fig 12. Rosenberg, Slive & Ter Kuile 1966, fig 157A

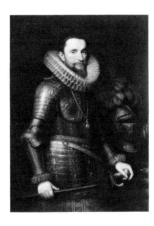

A 3953 Ambrogio Spinola (1569-1630). Commander in chief of the Spanish forces in the Southern Netherlands. *Opperbevelhebber der Spaanse troepen in de Zuidelijke Nederlanden*

Canvas 119 × 87. Signed and dated *Pitore Michiel Mierevelde 1609*. Inscribed *Effigie March Ambr. Spinolae Ætatis 39*
PROV Purchased from D A Hoogendijk gallery, Amsterdam, 1959

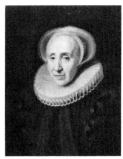

A 908 Paulus Cornelisz van Beresteyn (1548-1625). Burgomaster of Delft. *Burgemeester van Delft*

Pendant to A 909

Panel 64 × 51. On the verso his coat of arms, those of his four ancestors – Berestein, de Vries (a blank shield), Outschoten and a nameless shield – the inscription *Paulus van Berestein Burgerm^r te Delft Geb^r 1548 Gest^r 1625*, and the number *24*
PROV Bequest of Jonkheer J de Witte van Citters, The Hague, 1876. NMGK, 1885
LIT Moes 1897-1905, vol 1, nr 520:3. Van Beresteyn & Del Campo Hartman 1941-54, vol 2, p 18, nr 27

A 909 Volckera Claesdr Knobbert (1554-1634). Wife of Paulus van Beresteyn. *Echtgenote van Paulus van Beresteyn*

Pendant to A 908

Panel 63 × 51. Dated *A° 1617*. Inscribed *Aetatis 63*. On the verso her coat of arms and those of her four ancestors – Knobber, nameless, Duist and a blank, nameless shield – the inscription *Volkera Nicolai Knobber Huisvrouw van P. v. Berestein Geb^r 1554 Gest^r 1634*, and the number *25*
PROV Same as A 908
LIT Moes 1897-1905, vol 2, nr 4230:3. Van Beresteyn & Del Campo Hartman 1941-54, vol 2, p 26, nr 47

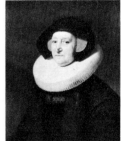 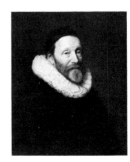

A 3875 Johannes Uyttenbogaert (1557-1644). Remonstrant minister in The Hague. *Remonstrants predikant te Den Haag*

Pendant to A 3876

Panel 70 × 59. Dated *A° 1632*. Inscribed
Ætatis 75
PROV Purchased from H Bekker,
Utrecht, 1953
LIT Rogge 1874-76, vol 3, p 317, note 7.
B Tideman, OH 21 (1903) p 126. Moes
1897-1905, vol 2, nr 9271:3

A 3876 Maria Petitpas (d 1640). Second
wife of Johannes Uyttenbogaert. *Tweede
echtgenote van Johannes Uyttenbogaert*

Pendant to A 3875

Panel 66.5 × 57. Dated *A° 1637*.
Inscribed *Ætatis 71*
PROV Same as A 3875
LIT B Tideman, OH 21 (1903) p 126.
Moes 1897-1905, vol 2, nr 5891:1

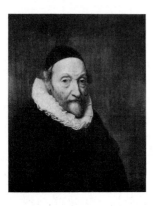

A 580 Johannes Uyttenbogaert (1557-
1644). Remonstrant minister in The
Hague. *Remonstrants predikant te Den Haag*

Panel 31.5 × 27
PROV Remonstrant congregation, The
Hague, 1804. NM, 1808
LIT B Tideman, OH 21 (1903) p 126.
Moes 1897-1905, vol 2, nr 9271:5. Moes
& van Biema 1909, pp 66, 176, 209

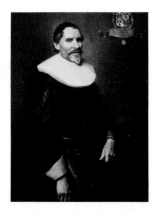

A 3833 François van Aerssen (1572-
1641), lord of Sommelsdijk, de Plaat and
Spijk. Diplomat in the service of the

Dutch Republic. *Heer van Sommelsdijk, de
Plaat en Spijk. Diplomaat in dienst van de
Verenigde Nederlanden*

Panel 112.2 × 86. Inscribed later *Franc.
van Aerssen, Heer van Sommelsdijk en van de
Ordre der Ridderschap van Holland.
Overleden 1641*
PROV Sale Paris, 7 Dec 1951, lot 33, ill *
DRVK since 1958
LIT Moes 1897-1905, vol 1, nr 70:2?
K Fremantle, OH 80 (1965) p 88, note
151, fig 6

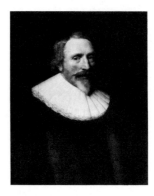

A 258 Jacob Cats (1577-1660).
Pensionary of Dordrecht and poet.
Pensionaris van Dordrecht en dichter

Panel 68.5 × 59.5. Signed and dated
A° 1634 M. Miereveld. Inscribed *Ætatis
56*
PROV NM, 1808
LIT Moes 1897-1905, vol 1, nr 1503:1.
Moes & van Biema 1909, pp 162, 206.
Martin 1935-36, vol 1, pp 303-04, 306,
fig 176

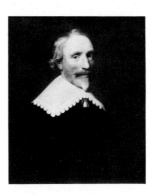

C 180 Jacob Cats (1577-1660). Grand
pensionary of Holland and West-
Friesland and poet. *Raadpensionaris van
Holland en Westfriesland en dichter*

Panel 67.5 × 57.5. Signed and dated
M. Miereveld A° 1639. Inscribed *Ætatis
61*
PROV On loan from the city of
Amsterdam (A van der Hoop bequest)
since 1885
LIT Moes 1897-1905, vol 1, nr 1503:2.
Plietzsch 1960, p 164, fig 291

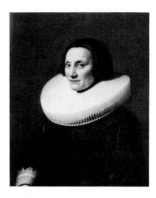

A 2067 Caecilia van Beresteyn (1589-
1661)

For portraits of her father and husband,
and possibly another portrait of the
sitter, *see* Miereveld, A 908, and
Palamedesz, Anthonie, A 1615, A 1616

Panel 71 × 60. Signed and dated
M. Miereveld A° 1640. Inscribed *Aetatis 51*.
On the verso her coat of arms, those of
her two husbands and her four
ancestors – Berestein, Oudschooten,
Nicolai and Duist – the inscription *Vrouw
Cicilia Paulusdogt*r* van Berest*n* geb. binne
Delft 8 feb. 1589 sterft 29 9 b*r* 1661
Begraven in den Briell. Troud' op 4 feb. 1614
Met d'h*r* Cornelis Briel. raad & rentm*r*
gene*r* van d' Graaflijke domeijnen van den
Lande van Voorn & op 26 octob*r* 1627 de
tweede maal met d h*r* Pieter de Witte.
Burgem*r* der Stad Z-Zee*, and the number
26
PROV Bequest of Jonkheer J de Witte
van Citters, The Hague, 1876. Received
in 1903
LIT Van Beresteyn & Del Campo
Hartman 1941-54, vol 2, p 52, nr 103, ill

A 1250 Hendrick Hooft (1617-78). Later
burgomaster of Amsterdam. *Later burge-
meester van Amsterdam*

Pendant to A 1251

Panel 69 × 59.5. Signed and dated
M. Miereveld A° 1640. Inscribed *Ætatis
23*
PROV Presented by J S R van de Poll,
Arnhem, 1885
LIT Moes 1897-1905, vol 1, nr 3655.
Kruizinga 1948, fig 3. M M Toth-
Ubbens, Antiek 6 (1971) p 373, fig 11

A 1251 Aegje Hasselaer (1617-64). Wife of Hendrick Hooft. *Echtgenote van Hendrick Hooft*

Pendant to A1250
For portraits of her parents, *see* Voort, Cornelis van der, A 1242 & A 1243

Panel 70 × 58.5. Signed and dated *M. Miereveld A° 1640*. Inscribed *Ætatis 22*
PROV Same as A 1250
LIT Moes 1897-1905, vol 1, nr 3248. Gerson 1952, p 23, fig 56

C 12 Portrait of a man. *Portret van een man*

Panel 72 × 61.5. Signed *M. Miereveld*
PROV On loan from the city of Amsterdam (Bicker bequest) since 1885

studio of or copy after **Michiel Jansz van Miereveld**

A 2731 Maurits (1567-1625), prince of Orange. *Prins van Oranje*

Panel 112 × 84.5
PROV NMGK, 1885 * DRVK since 1952
LIT Moes & van Biema 1909, p 204?

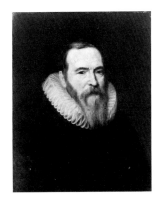

A 257 Johan van Oldenbarneveldt (1547-1619). Advocate of the states of Holland. *Landsadvocaat van Holland*

Panel 63 × 49
PROV Purchased from C S Roos, Amsterdam, 1800 (as Paulus Moreelse). NM, 1808
LIT Moes 1897-1905, vol 2, nr 5531:9. Moes & van Biema 1909, pp 161, 208

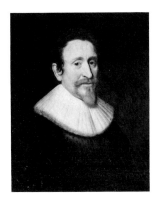

A 581 Hugo de Groot (1583-1645). Jurist. *Rechtsgeleerde*

Panel 63 × 55. Dated *A° 1631*. Inscribed *Aetatis 48*
PROV Purchased in 1803. NM, 1808
LIT Moes 1897-1905, vol 1, nr 2964:17. Van Beresteyn 1929, p 49, nr 18. A Hallema, Historia 10 (1945) p 210, ill. H A Ett, Historia 11 (1946) p 256, ill. Th J Hooning, Spiegel Hist 8 (1973) p 436, ill

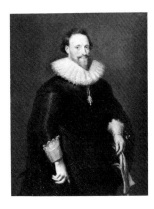

C 181 Pieter Cornelisz Hooft (1581-1647). Historian and poet. *Geschied-schrijver en dichter*

Panel 25 × 19
PROV On loan from the city of Amsterdam (A van der Hoop bequest) since 1885
LIT Moes 1897-1905, vol 1, nr 3668:3. Van Regteren Altena & van Thiel 1964, ad cat nr 34. J A Groen Jr, Ons Amsterdam 20 (1968) p 164, ill

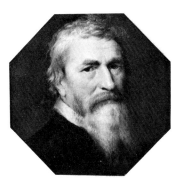

A 762 Lubbert Gerritsz (1535-1612). Mennonite minister in Amsterdam. *Leraar der Doopsgezinden te Amsterdam*

Panel 12 cm in diam. Round
PROV Sale Amsterdam, 13 Nov 1882, lot 13 (as Jacob Delff) * Lent to the AHM, 1975
LIT Moes 1897-1905, vol 1, nr 2706:2. Van Regteren Altena & van Thiel 1964, ad cat nr 21

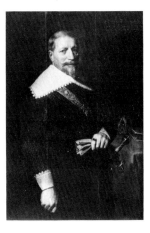

A 2665 Adam van Westerwolt (1580-1639). Governor extraordinary of the Dutch East Indies. *Raad Extra Ordinaris van Indië*

Panel 106 × 75.5. Dated *A° 1636*. Inscribed *Aetatis 56* and *Adam van Westerwoldt, Raad van Nederlandsch Indien An° 1638 admiraal van Holland en Zeeland*
PROV Purchased from P H A Martini Buys, Loenersloot, 1913
LIT Moes 1897-1905, vol 2, nr 9014

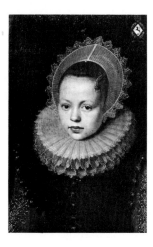

A 1450 Corvina van Hesenbroeck van Hofdijck (1602-67)

Panel 54 × 36. Dated *1618*. Inscribed *Ætat. 16*. Inscribed on the verso *Corvina van Hesenbroeck van Hofdijck. naderhant getrout met de Heer Cornelis van Beresteyn. Burgemeester der Stad Delft.*
PROV Sale S B Bos (Harlingen), Amsterdam, 21 Feb 1888, lot 183
LIT Moes 1897-1905, vol 1, nr 3460. Van Beresteyn & Del Campo Hartman 1941-54, vol 2, p 48, nr 94, ill

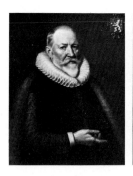 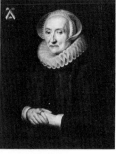

C 520 Maerten Ruychaver (1545-1626). Burgomaster of Haarlem. *Burgemeester van Haarlem*

Pendant to C 521

Panel 79 × 65
PROV On loan from the KOG (presented by D Henriques de Castro and G A Heineken, 1877) since 1889
LIT Moes 1897-1905, vol 2, nr 6631:3

C 521 Aletta van der Laen (1542-1626). Wife of Maerten Ruychaver. *Echtgenote van Maerten Ruychaver*

Pendant to C 520

Panel 78 × 64
PROV Same as C 520
LIT Moes 1897-1905, vol 2, nr 4308:3

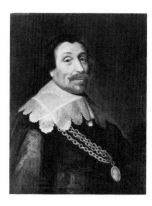

A 1418 Maerten Harpertsz Tromp (1597-1653). Vice admiral. *Luitenant-admiraal*

Canvas 72 × 59
PROV Sale J H Cremer, Amsterdam, 21 June 1887, lot 172?
LIT Moes 1897-1905, vol 2, nr 8091:4

A 260 Cornelia Teding van Berkhout (1614-80). Third wife of Maerten Harpertsz Tromp. *Derde echtgenote van Maerten Harpertsz Tromp*

Panel 70 × 61. Dated *Anno 1648*. Inscribed *Aetatis 36*
PROV NM, 1808
LIT Moes 1897-1905, vol 1, nr 552:2. Moes & van Biema 1909, p 208

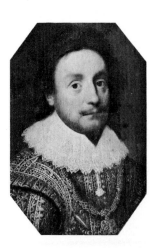

A 675 Frederick v (1596-1632), elector of the Palatinate, king of Bohemia, called the winter king. *Keurvorst van de Palts,*

koning van Bohemen, bijgenaamd de Winter-koning

Panel 24.5 × 18. Corners trimmed
PROV Sale Lamberts, Amsterdam, 18 Dec 1879, lot 18

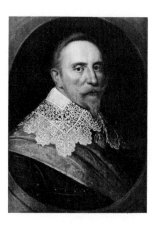

A 1723 Gustavus II Adolphus (1594-1632), king of Sweden. *Koning van Zweden*

Panel 38 × 27
PROV Sale Amsterdam, 30 Nov 1897, lot 69

C 1481 Gustavus II Adolphus (1594-1632), king of Sweden. *Koning van Zweden*

Panel 69 × 54.5. Inscribed on the verso *Gusta. Adolf Koning van Sweden*
PROV On loan from the van Sypesteyn Foundation, Loosdrecht, since 1970

A 2100 Maurits (1567-1625), prince of Orange. *Prins van Oranje*

Copy by Jacob Lyon (ca 1586/87-after 1644)
Pendant to A 2101

Copper 11 × 8.5. Signed on the verso
Jacob Lyon pinxt and *J. Lyon*
PROV Bequest of A A des Tombe, The Hague, 1903
LIT Moes 1897-1905, vol 2, nr 4896:83

A 2101 Frederik Hendrik (1584-1647), prince of Orange. *Prins van Oranje*

Copy by Jacob Lyon (ca 1586/87-after 1644)
Pendant to A 2100

Copper 11.4 × 8.5. Signed on the verso
Jacob Lyon Pinxt and *Jacob Lyon f*
PROV Bequest of A A des Tombe, The Hague, 1903
LIT Moes 1897-1905, vol 1, nr 2582:117

Frans van Mieris I

Leiden 1635 – 1681 Leiden

C 182 The flown bird: allegory on the loss of virginity. *De ontsnapte vogel: allegorie op de verloren kuisheid*

Panel 17.5 × 14. Signed and dated
F. van Mieris. 1676 f.
PROV On loan from the city of Amsterdam (A van der Hoop bequest) since 1885
LIT Hofstede de Groot 1907-28, vol 10 (1928) nr 30. Pigler 1956, vol 2, p 478. B Knüttel, OH 81 (1966) p 247. De Jongh 1967, pp 40-42, fig 24

C 184 A gentleman and a lady. *Een heer en een dame*

Panel 36 × 30. Signed and dated
F. van Mieris 1678
PROV On loan from the city of Amsterdam (A van der Hoop bequest) since 1885
LIT Hofstede de Groot 1907-28, vol 10 (1928) nr 336

A 261 Woman writing a letter. *De brief-schrijfster*

Panel 25 × 20. Signed and dated
F. van Mieris fecit Anno 1680
PROV Sale G van der Pot van Groeneveld, Rotterdam, 6 June 1808, lot 76
LIT Smith 1829-42, vol 1, nr 31. Immerzeel 1842-43, vol 2, p 227. Hofstede de Groot 1907-28, vol 10 (1928) nr 157. Moes & van Biema 1909, pp 11, 183. Gudlaugsson 1960, p 121, fig 2, pl XIII. Bille 1961, vol 1, p 74, ill; vol 2, pp 32, 106, nr 135

A 704 Jacob's dream. *Jacob's droom*

Panel 22 × 29.5. Signed *F. van Mieris*
PROV Bequest of Jonkheer J S H van de Poll, Amsterdam, 1880
LIT V de Stuers, Ned Kunstbode 2 (1880) p 245. C Hofstede de Groot, OH 22 (1904) p 116 (Arie de Vois)

A 263 Allegory of transitoriness. *Allegorie op de vergankelijkheid*

Panel 36 × 28
PROV Bequest of L Dupper Wzn, Dordrecht, 1870
LIT Hofstede de Groot 1907-28, vol 10 (1928) nr 24. B Haak, Antiek 2 (1968) p 411, fig 15

A 262 Tuning the lute. *Het stemmen van de luit*

Panel 22 × 17.5
PROV Purchased with the Kabinet van Heteren Gevers, The Hague-Rotterdam, 1809
LIT Descamps 1753-64, vol 3 (1760) p 21. Hofstede de Groot 1907-28, vol 10 (1928) nr 167. Moes & van Biema 1909, pp 148, 193. Bille 1961, vol 1, p 111

A 3327 Portrait of a man. *Portret van een man*

Copper 11.5 × 9.5. Oval
PROV Presented by Mr & Mrs DAJ Kessler-Hülsmann, Kapelle op den Bosch near Mechelen, 1940
LIT Hofstede de Groot 1907-28, vol 10 (1928) nr 398?

Frans van Mieris II

Leiden 1689–1763 Leiden

C 186 The apothecary. *De apotheker*

Panel 39.5 × 33.5. Signed and dated *F. v. Mieris Fecit A° 1714*
PROV On loan from the city of Amsterdam (A van der Hoop bequest), 1885-1975
LIT DA Wittop Koning, Antiek 3 (1968) p 269. Scheen 1969-70, vol 2, fig 6

C 185 The lady grocer. *De kruidenierster*

Panel 39 × 33.5. Signed and dated *F. van Mieris Fec. A° 1715*
PROV On loan from the city of Amsterdam (A van der Hoop bequest), 1885-1975
LIT Scheen 1946, fig 13

A 265 The hermit. *De kluizenaar*

Panel 16 × 14. Signed and dated *F. v. Mieris F. 1721*
PROV Sale G van der Pot van Groeneveld, Rotterdam, 6 June 1808, lot 79
LIT Moes & van Biema 1909, pp 113, 187

Jan van Mieris

Leiden 1660–1690 Rome

A 2122 Portrait of a young man. *Portret van een jonge man*

Panel 14.3 × 10.7. Oval. Signed on the verso *J. Mieris*
PROV Purchased from A Freyer, Berlin, 1903
LIT Van Hall 1963, p 214, nr 1421:5 (self portrait?)

Willem van Mieris

Leiden 1662–1747 Leiden

see also Slingeland, Pieter Cornelisz van, & Willem van Mieris, A 1983, Portrait tablet

C 183 Amarilli crowning Mirtillo with a wreath (Guarini, Il pastor fido 2.2). *Amarilli bekranst Mirtillo*

Panel 59 × 69.5. Signed and dated *W. van Mieris Fe 1722*
PROV On loan from the city of Amsterdam (A van der Hoop bequest) since 1885
LIT Hofstede de Groot 1907-28, vol 10 (1928) nr 133

A 264 The poultryman. *De poelier*

Panel 39 × 32.5. Signed and dated
W. van Mieris Fe Anno 1733
PROV Purchased with the Kabinet van
Heteren Gevers, The Hague-Rotterdam,
1809
LIT Moes & van Biema 1909, p 148.
Hofstede de Groot 1907-28, vol 10
(1928) nr 203. VTTT, 1960, nr 24. Bille
1961, vol 1, p 111

Abraham Mignon

Frankfurt am Main 1640–1679
Wetzlar?

A 266 Still life with fruit and a finch
drawing water. *Stilleven met vruchten en
een puttertje*

Canvas 78 × 67. Signed *A. Mignon fe*
PROV Sale G van der Pot van
Groeneveld, Rotterdam, 6 June 1808,
lot 80 * On loan to the Musée de la
Chartreuse, Douai, since 1962, in
exchange for Lievens, Jan, C 1467
LIT Moes & van Biema 1909, pp 113,
187. J Bergström, Konsth Tidskr 20
(1951) p 79, fig 1. Bergström 1956, p 219,
note 55. CJ de Bruyn Kops, Bull RM 13
(1965) p 113, fig 40. MM Toth-Ubbens,
in Miscellanea van Regteren Altena,
1969, p 158, fig 11

A 267 The overturned bouquet. *De
omvergeworpen ruiker*

Canvas 89 × 72. Signed *A. Mignon fe*.
PROV Purchased with the Kabinet van
Heteren Gevers, The Hague-Rotterdam,
1809
LIT Weyerman 1729, vol 2, p 393. Moes
& van Biema 1909, pp 148, 193. Warner
1928, nr 67c. Vorenkamp 1933, p 123.
Martin 1935-36, vol 2, pp 430-31, fig
228. Bergström 1947, pp 215, 219, fig
176. Bergström 1956, p 219, fig 182.
Bille 1961, vol 1, p 109

A 269 Still life with fruit and a beaker on
a cock's foot. *Stilleven met vruchten en
bokaal op hanepoot*

Canvas 76 × 60. Signed *A. Mignon fe*.
PROV Bequest of L Dupper Wzn,
Dordrecht, 1870
LIT Bernt 1969-70, vol 2, nr 772

A 268 Still life with flowers and watch.
Stilleven met bloemen en horloge

Canvas 75 × 60. Signed *A. Mignon fe*
PROV Bequest of L Dupper Wzn,
Dordrecht, 1870
LIT Warner 1928, nr 67d. Vorenkamp
1933, p 123. Bergström 1956, p 219, note
54. G Bott, Kunst in Hessen 10 (1970) p
54, fig 2

C 187 Still life with fruit and oysters.
Stilleven met vruchten en oesters

Canvas 60.5 × 75. Signed *A. Mignon fe*.
PROV On loan from the city of
Amsterdam (A van der Hoop bequest)
since 1885

A 2329 Still life with fruit, oysters and a
porcelain bowl. *Stilleven met vruchten,
oesters en een porseleinen kom*

Panel 55 × 45. Signed *Ab Mignon*
PROV Purchased from the heirs of
Jonkheer P H Six van Vromade,
Amsterdam, 1908, with aid from the
Rembrandt Society * DRVK since 1959
(on loan to the Gemeentemuseum,
Arnhem)
LIT Warner 1928, nr 66c

C 580 Still life with fruit, oysters and a wineglass. *Stilleven met vruchten, oesters en roemer*

Canvas 67 × 59. Signed *A. Mignon*
PROV On loan from the city of Amsterdam (presented by the children of C P van Eeghen) from 1895 on * On loan to the Museum Willet-Holthuysen, Amsterdam, since 1965

Jean François Millet

Gruchy 1814–1875 Barbizon

A 2707 Girl carrying water. *De water-draagster*

Canvas 41 × 33. Signed *J.F. Millet*
PROV Presented by the heirs of W J van Randwijk, The Hague, 1914
LIT W Steenhoff, Onze Kunst 27 (1915) p 89, ill

Anthonie Mirou

Frankenthal before 1586–after 1661 ?

A 755 Wooded landscape. *Bosrijk landschap*

Copper 33 × 50.5. Signed and dated *Mirou F. 1608*
PROV Sale Jonkheer U W F van Panhuys, Amsterdam, 26 Sept 1882, lot 69 (as M V Rael)
LIT Plietzsch 1910, p 103. Thiéry 1953, p 185. Bernt 1960-62, vol 2, nr 536. Bernt 1969-70, vol 2, nr 774

Joseph Jodocus Moerenhout

Eeckeren 1801–1874 Antwerp

A 1081 Cossack outpost. *Kozakkenvoorpost*

Panel 42 × 51.5. Signed and dated *J. Moerenhout 1827*
PROV Purchased at exhib Amsterdam 1828, nr 551. RVMM, 1885 * DRVK since 1951

A 1082 'The horse race.' '*De harddraverij*'

Panel 50 × 67. Signed and dated *Moerenhout F 1829*
PROV Purchased at exhib Ghent 1829. RVMM, 1885
LIT Scheen 1946, fig 135

C 293 A stable. *Paardestal*

Panel 39 × 34. Signed *J. Moerenhout*
PROV On loan from the city of Amsterdam (A van der Hoop bequest) since 1885

Hjalmar Mörner

Stockholm 1794–1837 Paris

C 306 Nicholas I (1796-1855), emperor of Russia. *Nicolaas I, keizer van Rusland*

Canvas 76.5 × 64.5
PROV On loan from the city of Amsterdam (A van der Hoop bequest) since 1885

Johannes Hendrikus Mösers

Someren 1826–1864 's-Hertogenbosch

NO PHOTOGRAPH AVAILABLE

A 2303 Johanna (1322-1406), duchess of Brabant and Limburg. *Hertogin van Brabant en Limburg*

Full-length portrait, standing. The duchess leans with her left hand on a lozenge-shaped coat of arms of Brabant

Canvas 243 × 183. Signed and dated
J. H. Mösers fec. 1859
PROV Presented by the Schutters van
St Joris (St George civic guard),
Heusden, 1907 * Lent to the town hall
of Heusden, 1908. Badly damaged in the
war, 1944

Nicolaes Moeyaert

Amsterdam 1592/93 – 1655 Amsterdam

A 270 The choice between old and
young. *De keuze tussen jong en oud*

Probably represents the four main
characters in G A Bredero's play 'Het spel
van de Moor' – left to right Kackerlack,
Mooi Aal, Ritsert and Roemert

Canvas 113.5 × 127.5. The original
signature has been changed to
GL. Metsu. Inscribed on the girl's collar
Mooy: aeltgen
PROV Presented by A S J Koch,
Amsterdam, 1874
LIT F Dülberg, in Meisterwerke, 1920.
Martin 1935-36, vol 1, pp 145-46, fig
85. Boon 1942, p 46. Bol 1969, p 166.
P J J van Thiel, Simiolus 6 (1972-73) pp
29-49, figs 10-11, 13

A 1485 The meeting of Jacob and
Rachel. *De ontmoeting van Jacob en Rachel*

Panel 41 × 60.5
PROV Sale F Kaijser (Frankfurt am
Main), Amsterdam, 4 Dec 1888, lot 68

Wouterus Mol

Haarlem 1785 – 1857 Haarlem

see also Raphael, A 271 Madonna della
Sedia, copy by Mol ; Rubens, Peter Paul,
A 272 Ecce homo, copy by Mol

A 648 Academy study of a man and
woman. *Academiestudie van een man en een
vrouw*

Canvas 96 × 83. Signed and dated *Mol
1808*
PROV Mandatory entry by the artist, as
a 'pensionnaire' of King Louis Napoleon
in Paris, to exhib Amsterdam 1808, nr
111, from whence it was automatically
ceded to the state
LIT Knoef 1947, p 5

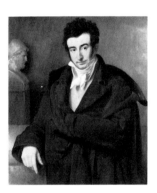

A 2121 Paulus Joseph Gabriël (1785-
1853). Sculptor. *Beeldhouwer*

Canvas 89 × 78. Signed *W. Mol.* Painted
ca 1818 (exhibited in Amsterdam, 1818,
cat nr 182)
PROV Bequest of P J C Gabriël, The
Hague, 1903
LIT Knoef 1947, pp 7-9. Van Daalen
1957, p 87, fig 3. Van Hall 1963, p 104,
nr 677:1. Exhib cat 150 jaar Nederlandse
kunst, Amsterdam 1963, nr 27, fig 11

Jan Miense Molenaer

Haarlem ca 1610 – 1668 Haarlem

C 188 Saying grace. *Het gebed voor de
maaltijd*

Panel 28.5 × 25. Signed *J. Molenaer*
PROV On loan from the city of
Amsterdam (A van der Hoop bequest)
since 1885

C 140 Woman playing the virginal. *De
virginaalspeelster*

Formerly thought to be a portrait of
Judith Leyster (1600/10-60), the
painter's wife, and her children

Panel 38.5 × 29.5
PROV On loan from the city of
Amsterdam (A van der Hoop bequest)
since 1885
LIT C Hofstede de Groot, Ned Spec,
1897, p 140. W Bode & A Bredius, Jb
Preusz Kunstsamml 11 (1890) p 74. A
Bredius, OH 26 (1908) p 42. Roh 1921, fig
173. G D Gratama, OH 47 (1930) p 74,
fig 2. Martin 1935-36, vol 1, p 376. Pols
1942, p 53. A Ellenius, in Idea and Form,
1959, p 118. Plietzsch 1960, p 29, fig 16.
Bernt 1960-62, vol 2, nr 542. Van Hall
1963, p 187, nr 1268:6. Haacke 1968,
ill. Bernt 1969-70, vol 2, nr 779

A 3023 Cheating at cards. *Het valse kaartspelen*

Panel 48.5 × 68.7
PROV Presented from the estate of Mrs O E A E Wüste, née Baroness von Gotsch, widow of J R Wüste, Santpoort, 1924

Pieter de Molijn

London 1595–1661 Haarlem

A 1942 Halting at a roadside inn. *Halte bij een herberg*

Copper 27 × 34.5. Signed and dated *P Molijn* [1]*657*
PROV Purchased from the G de Clercq collection, Amsterdam, 1899, through the intermediacy of the Rembrandt Society

Hendrik Mommers

Haarlem? ca 1623–1693 Amsterdam

A 1687 Interior of a peasant hut. *Boeren-interieur*

Canvas 76 × 68. Signed *Mommers*
PROV Purchased from M J van Gelder, Amsterdam, 1897

Mommorency

see Monmorency

Joos de Momper

Antwerp 1564–1635 Antwerp

A 3949 River landscape with wild boar hunt. *Rivierlandschap met everzwijnjacht*

Panel 121 × 196.5
PROV Purchased from Robert Finck gallery, Brussels, 1958, with aid from the Jubileumfonds
LIT J Offerhaus, Bull RM 7 (1959) p 57, ill. H Gerson, OK 12 (1968) nr 5. HG Franz, Jb Kunsth Inst Graz, 1968-69, p 59, fig 81. J Michalkowa, OH 86 (1971) p 193, note 14

A 3894 Hercules stealing Geryon's cattle. *Hercules rooft de kudde van Geryones*

Panel 87.4 × 117
PROV Purchased from P de Boer gallery, Amsterdam, 1955
LIT A Stheeman, Mndbl BK 12 (1935) p 11, ill. O Koester, Artes 2 (1966) p 13, note 19 (early work)

A 3100 Mountain view. *Berggezicht*

Panel 46.3 × 65
PROV Presented by P de Boer, Amsterdam, 1929
LIT O Koester, Artes 2 (1966) p 17, note 41, pl XX (ca 1631)

A 273 Landscape. *Landschap*

Panel 46 × 73.5
PROV Purchased with the Kabinet van Heteren Gevers, The Hague-Rotterdam, 1809 * D R V K since 1958
LIT Moes & van Biema 1909, pp 148, 162

manner of **Joos de Momper**

A 4263 The death of Euridice. *De dood van Euridice*

Panel 81 × 171. Painted on the lid of a clavichord. Formerly signed *J. B.*
PROV Sale Amsterdam, 1 Nov 1887, lot 13

Lorenzo Monaco

Siena? ca 1370/71–ca 1425 Florence

A 3976 St Jerome in his study. *De heilige Hieronymus in zijn studeervertrek*

Panel 23 × 18. Thought to be the right wing of a diptych whose left wing, with a Madonna of humility, is in the Thorvaldsen Museum, Copenhagen
PROV O Lanz, Amsterdam. Lent by the SNK, later DRVK, 1948. Transferred in 1960
LIT F Harck, Archivio stor 2 (1889) p 206. G Frizzoni, L'Arte 5 (1902) p 290. Sirèn 1905, pp 95-96, 143, 146-47, 186, pl XXXVI. Künstle 1926, p 304. Van Marle 1923-38, vol 9 (1927) p 150, fig 99. Berenson 1932, p 298. B Degenhardt, Pantheon 28 (1941) p 37, ill. H Schulte Nordholt, OK 5 (1961) nr 33, ill. P Murray, Apollo 76 (1962) p 284, pl v. Berenson 1963, vol 1, p 117. J Cornforth, Country Life 138 (Feb 1965) p 3, ill. K Roberts, Connoisseur, 1965, p 230, ill. R Longhi, Paragone 183 (1965) p 15, nr 29. Van Os & Prakken 1974, pp 68-70, nr 34, ill (ca 1408)

A 4006 St Francis of Assisi receiving the stigmata. *De stigmatisatie van de heilige Franciscus van Assisi*

Panel 87 × 61.5
PROV O Lanz, Amsterdam. Lent by the SNK, later DRVK, 1948. Transferred in 1960
LIT Van Marle 1923-37, vol 9 (1927) p 150, fig 100. Berenson 1932, p 298. R van Marle, Boll d'Arte 28 (1935) p 304. B Degenhart, Pantheon 27 (1941) p 35. F Zeri, Connoisseur 126 (1955) p 280.

Zeri 1959, nr 28. Berenson 1963, vol 1, p 117, fig 454. VTTT, 1962-63, nr 50. Van Os & Prakken 1974, pp 70-71, nr 35, ill

school of **Lorenzo Monaco**

A 4005 Madonna and child. *Maria met kind*

Canvas 150.5 × 78.5
PROV O Lanz, Amsterdam. Lent by the SNK, later DRVK, 1948. Transferred in 1960
LIT Van Marle 1923-37, vol 9 (1927) p 118, fig 77 (ca 1395). Berenson 1932, p 298. B Berenson, Dedalo 12 (1932) p 28. G Pudelko, Burl Mag 73 (1938) pp 237-38, note 8. A Heppner, Mndbl BK 17 (1940) p 311, ill. B Degenhart, Pantheon 27 (1941) p 35. H D Gronau, Burl Mag 92 (1950) p 221, notes 28-30. M J Eisenberg, Art Bull 39 (1957) pp 50, 52, note 11, fig 4. M Levi d'Ancona, Art Bull 40 (1958) p 184, note 40. Berenson 1963, vol 1, p 117, fig 429. F Zeri, Burl Mag 107 (1965) p 11. L Bellosi, Paragone 16 (1965) p 37, fig 35. Goodison & Robertson 1967, p 91, note 9. A Gonzalez-Palacios, Paragone 21 (1970) p 31. Van Os & Prakken 1974, pp 72-73, nr 37, ill

milieu of **Lorenzo Monaco**

A 4004 Madonna

Panel 36 × 29
PROV O Lanz, Amsterdam. Lent by the SNK, later DRVK, 1948. Transferred in 1960
LIT Muther 1922, vol 1, p 25, ill. M van Dantzig, Mndbl BK 11 (1934) p 296. R van Marle, Boll d'Arte 28 (1935) pp 302, 305, ill. B Degenhart, Pantheon 27 (1941) p 35, ill. H D Gronau, Burl Mag 92 (1950) p 221, note 32, fig 1. M Levi d'Ancona, Commentari 9 (1958) p 252, note 18 (Matteo Torelli). F Zeri, Burl Mag 107 (1965) p 11. Kermer 1967, p 231, note 68. Van Os & Prakken 1974, p 14, fig 6, pp 73-75, nr 38, ill

Claude Monet

Paris 1840 – 1926 Giverny

A 1892 La Corniche near Monaco. *La Corniche bij Monaco*

Canvas 75 × 94. Signed and dated *Claude Monet 84*
PROV Presented by the dowager of R Baron van Lynden, née M C Baroness van Pallandt, The Hague, 1900 * On loan to the SMA since 1948

A 2933 Flowers. *Bloemen*

Panel 91 × 48. Signed *Claude Monet*
PROV Bequest of A van Wezel,
Amsterdam, 1922

Louis de Moni

Breda 1698 – 1771 Leiden

A 274 Woman watering a plant. *Vrouw
een plant begietend*

Panel 37.5 × 28.5
PROV Purchased with the Kabinet van
Heteren Gevers, The Hague-Rotterdam,
1809
LIT Moes & van Biema 1909, pp 148,
194

Martin Monnickendam

Amsterdam 1874 – 1943 Amsterdam

C 1105 The artist's daughter Monarosa
as a fruitseller. *Monarosa, het dochtertje van
de schilder, als fruitverkoopstertje*

Canvas 99 × 66.5. Signed and dated
Martin Monnickendam 1914
PROV On loan from Mrs W CS Drucker-
de Koning, widow of H L Drucker, The
Hague, since 1917
LIT Exhib cat Martin Monnickendam
1874-1943, Amsterdam 1974, nr 19, ill

B Monmorency

active 1742 in Paris?

A 1658 Pieter Parker (1700-59). Alder-
man, councillor and burgomaster of
Goes. *Schepen, raad en burgemeester van Goes*

Canvas 85.5 × 69. Signed and dated on
the verso *Mr Pieter Parker fait par
B. Mommorency A 1742*. Inscribed on the
verso *Aetatis 42*
PROV Purchased from J C de Ruyter de
Wildt, Vlissingen, 1895

studio of **Bartolomeo Montagna**

Orzinuovi ca 1450 – 1523 Vicenza

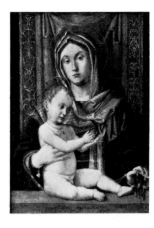

A 3448 Madonna and child. *Maria met
kind*

Panel 64 × 48.5. Signed *Bartolomeus
Montagna* and remnant of a date
PROV Lent by J W Edwin vom Rath,
Amsterdam, 1915. Bequeathed in 1941
LIT Venturi 1927, pp 248, 250, fig 153
(ca 1500). T Borenius, Burl Mag 58
(1931) p 71. Berenson 1932, p 366.
Berenson 1957, vol 1, p 115. Puppi 1962,
p 93, fig 166 (old replica of the original
in the Galleria Estense, Modena [cat
1945, nr 368])

Adolphe Monticelli

Marseille 1844 – 1886 Marseille

A 2579 Cliff on the water. *Kustgebergte*

Panel 46 × 62. Signed *Monticelli*
PROV Presented from the estate of C
Hoogendijk, The Hague, 1912 * On
loan to the SMA since 1948
LIT Alauzen & Ripert 1969, p 227, fig
345

A 3096 Landscape with an orchard in bloom. *Landschap met bloeiende boomgaard*

Panel 44.2 × 68.8. Signed *A. Monticelli*
PROV Bequest of Mrs A M L Westerwoudt-Klinger, widow of J B A M Westerwoudt, Haarlem, 1929 * On loan to the SMA since 1948
LIT Alauzen & Ripert 1969, p 222, fig 224

A 2935 Women in a forest. *Vrouwen in een bos*

Panel 45.5 × 66.5. Signed *Monticelli*
PROV Bequest of A van Wezel, Amsterdam, 1922

A 2937 Women in a park. *Vrouwen in een park*

Panel 39 × 47. Signed *Monticelli*
PROV Bequest of A van Wezel, Amsterdam, 1922 * DRVK since 1964

A 1893 Christ blessing the children. *Christus zegent de kinderen*

Panel 29.5 × 71.5. Signed *Monticelli*
PROV Presented by the dowager of R Baron van Lynden, née M C Baroness van Pallandt, The Hague, 1900

LIT Gouirand 1901, p 111. Alauzen & Ripert 1969, p 119, fig 140

A 2934 At the altar. *Aan het altaar*

Board 27 × 18. Signed *Monticelli*
PROV Bequest of A van Wezel, Amsterdam, 1922

NO PHOTOGRAPH AVAILABLE

A 2936 Ladies and gentlemen in a wood. *Heren en dames in een bos*

All the figures are in a single plane in the immediate foreground

Canvas 100 × 50. Signed *Monticelli*
PROV Bequest of A van Wezel, Amsterdam, 1922 * Lent to the Stedelijk Museum, Zutphen, 1924. Destroyed in the war, 1945

Carel de Moor

Leiden 1656–1738 Leiden

A 1746 Self portrait. *Zelfportret*

Panel 21.5 × 17. Oval. Signed *C. d. Moor*
PROV Bequest of D Franken Dzn, Le Vésinet, 1898
LIT Moes 1897-1905, vol 2, nr 5155:5. Van Hall 1963, p 219, nr 1448:5. A G van der Steur, Warmondse Bijdragen 6 (1972) p 74, fig 2

A 640 The fisherman. *De hengelaar*

Canvas 62 × 75. Signed *Car. d. Moor*
PROV Purchased with the Kabinet van Heteren Gevers, The Hague-Rotterdam, 1809
LIT C Hofstede de Groot, O H 22 (1904) p 116. Moes & van Biema 1909, p 148

attributed to **Carel de Moor**

A 3028 Scene of soldierly life. *Soldatenscène*

Panel 30.5 × 24.5
PROV Bequest of S van der Horst, Haarlem, 1925

Anthonis Mor van Dashorst

Utrecht 1519–1575 Antwerp

A 3118 Sir Thomas Gresham (1519-79). Merchant and financial agent of the English crown in the Netherlands, founder of the Royal Exchange and of Gresham College, London. *Koopman en financieel agent der Engelse kroon in de Nederlanden, stichter van de Londense beurs en van Gresham College te Londen*

Pendant to A 3119

Panel 90 × 75.5
PROV Purchased from the Hermitage, Leningrad, 1931, with aid from the Rembrandt Society
LIT Friedländer 1924-37, vol 13 (1936) pp 124, 175, nrs 404, 408 (1568). F Schmidt-Degener, Jaarversl Ver Rembrandt, 1930, p 11. H, Mndbl BK 8 (1931) p 220, ill. Marlier 1934, pp 84, 99, nr 22, 106. De Vries 1934, p 34. H van Guldener, Historia 1 (1937-38) p 38, ill. Frerichs 1947, pp 56-57

A 3119 Anne Fernely. Wife of Sir Thomas Gresham. *Echtgenote van Sir Thomas Gresham*

Pendant to A 3118

Panel transferred to canvas 88 × 75.5
PROV Same as A 3118
LIT *see under* A 3118. Faggin 1966, fig 14

copy after **Anthonis Mor van Dashorst**

A 2663 Philippe de Montmorency (1524-68), count of Hoorne. Admiral-general of the Netherlands, member of the council of state. *Graaf van Hoorne. Admiraal der Nederlanden, lid van de Raad van State*

Panel 108.5 × 78. Dated *A° 1562*
PROV Purchased from Fr Muller & Co, art dealers, Amsterdam, 1913
LIT R van Luttervelt, OH 74 (1959) p 194, fig 6. Geurts 1968, ill on p 2

A 1560 Philippe de Montmorency (1524-68), count of Hoorne. Admiral-general of the Netherlands, member of the council of state. *Graaf van Hoorne. Admiraal der Nederlanden, lid van de Raad van State*

Paper on panel 42 × 31
PROV Sale LAJW Baron Sloet van de Beele, Amsterdam, 9-10 Feb 1892

manner of **Anthonis Mor van Dashorst**

A 2873 Philip II (1527-98), king of Spain. *Philips II, koning van Spanje*

Panel transferred to canvas 99 × 73
PROV Helmond Castle, 1921

manner of **Pier Francesco Morazzone**

Morazzone 1571/73–1626 Piacenza

A 3433 St Catherine. *De heilige Catharina*

Panel 81.5 × 69. Oval
PROV Bequest of JW Edwin vom Rath, Amsterdam, 1941

Paulus Moreelse

Utrecht 1571–1638 Utrecht

see also Honselaarsdijk series: A 556 Anthonis van Utenhove

A 1423 Self portrait. *Zelfportret*

Panel 52 × 47
PROV Presented by Dr A Bredius, The Hague, 1887
LIT Moes 1897-1905, vol 2, nr 5161:2. De Jonge 1938, p 99, nr 124, fig 85. Van Hall 1963, p 221, nr 1453:3

A 275 Maria van Utrecht (1553-1629). Wife of Johan van Oldenbarneveldt. *Echtgenote van Johan van Oldenbarneveldt*

Panel 110 × 81. Signed and dated *PMo fe An° 1615*. Inscribed *Æta 63*
PROV Purchased in 1803 (as Michiel Jansz van Miereveld). NM, 1808
LIT Moes 1897-1905, vol 2, nr 8185:2. Moes & van Biema 1909, pp 63, 208. De Jonge 1938, pp 19, 82, nr 42, fig 33

C 623 The company of Captain Jacob Hoynck and Lieutenant Nanning Cloeck, Amsterdam, 1616. *Het korporaalschap van kapitein Jacob Hoynck en luitenant Nanning Cloeck, Amsterdam, 1616*

Canvas 169 × 333. Signed and dated *PMoreelse fecit ANo 1616*
PROV Kloveniersdoelen (headquarters of the arquebusiers' civic guard), Amsterdam. On loan from the city of Amsterdam since 1899
LIT Scheltema 1879, nr 123. Scheltema 1855-85, vol 8 (1885) p 138, nr 27. J Six, OH 4 (1886) p 93. Moes 1897-1905, vol 1, nrs 1581:1, 3799:1. Martin 1935-36, vol 1, p 208. De Jonge 1938, pp 20, 83, nr 44, fig 30

C 1440 Michiel Pauw (1590-1640), knight of San Marco, lord of Achttienhoven and Den Bosch. Merchant and alderman of Amsterdam, founder of the West India Company. *Ridder van San Marco, heer van Achttienhoven en Den Bosch. Koopman en schepen te Amsterdam, oprichter van de West Indische Compagnie*

Panel 127.5 × 94. Signed and dated *PM 1625*
PROV On loan from the heirs of M R Ridder Pauw van Wieldrecht since 1953
LIT De Jonge 1938, pp 26, 30, 55, 64, 89, nr 78, fig 65

A 276 The beautiful shepherdess. *De schone herderin*

Canvas 82 × 66. Signed and dated *PM 1630*
PROV Sale B Ocke, Leiden, 21 April 1817, lot 82
LIT Martin 1935-36, vol 1, pp 108-09, fig 63. De Jonge 1938, pp 39, 121, nr 275, fig 180. Plietzsch 1960, p 166, fig 295. Bernt 1960-62, vol 2, nr 559. Bernt 1969-70, vol 2, nr 803. M Louttit, Burl Mag 115 (1973) p 318, note 12

A 2330 Girl at the mirror. *Meisje bij een spiegel*

Canvas 87 × 73. Signed and dated *PM 1632*
PROV Purchased from the heirs of Jonkheer P H Six van Vromade, Amsterdam, 1908, with aid from the Rembrandt Society
LIT De Jonge 1938, p 40, nr 279, fig 182

C 623

A 277 Portrait of a girl, known as 'The princess,' thought to be Elisabeth (1620-28), countess of Nassau-Dietz, daughter of Ernst Casimir van Nassau-Dietz. *Portret van een meisje, bekend als 'Het prinsesje,' vermoedelijk Elisabeth, gravin van Nassau-Dietz, dochter van Ernst Casimir van Nassau-Dietz*

Canvas 79 ×62.5
PROV H Hilleveld Hzn collection, Amsterdam, 1865; acquired through the intermediacy of Miss J M Weigel
LIT Martin 1935-36, vol 1, pp 307-08, fig 175. De Jonge 1938, pp 24, 110, nr 210, pl v. Boon 1942, p 63, fig 32. C J Hudig, Historia 9 (1943) p 169, fig 4

copy after **Paulus Moreelse**

A 3455 Esau selling his birthright. *Ezau verkoopt zijn eerstgeboorterecht*

Copy after a print by Willem Swanenburgh II (active 1652-67) after a painting by Moreelse

Canvas 160.7 × 124
PROV Bequest of O A Peters, Amsterdam, 1942
LIT *Cf* De Jonge 1938, p 11, nr 3, fig 8

Jan Evert Morel

Amsterdam 1777 – 1808 Amsterdam

A 1083 Still life with flowers. *Stilleven met bloemen*

Panel 79 ×60. Signed *J. E. Morel ft. Amsterdam*
PROV RVMM, 1885 * DRVK since 1950
LIT Moes & van Biema 1909, pp 162, 226. Scheen 1946, fig 170

A 706 Still life with flowers and fruit. *Stilleven met bloemen en fruit*

Panel 40.5 ×32.5. Signed *J. E. Morel ft.*
PROV Bequest of Jonkheer J S H van de Poll, Amsterdam, 1880
LIT V de Stuers, Ned Kunstbode 2 (1880) p 245

Louis Moritz

The Hague 1773 – 1850 Amsterdam

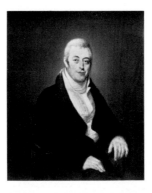

A 1324 Jonas Daniël Meijer (1780-1834). Jurist. *Rechtsgeleerde*

Canvas 98 ×81. Signed on the verso *L. Moritz f.* Inscribed on the verso *Aan Mr J. D. Meijer uit erkentelijkheid en hoogachting door B. A. Fallee*
PROV Bequest of Miss J E Meijer, Amsterdam, 1886 * Lent to the AHM, 1975
LIT Scheen 1946, fig 89. Gans 1971, p 299, ill

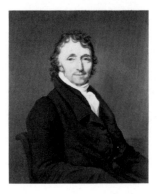

C 466 Clemens van Demmeltraadt (1777-1841). Amsterdam surgeon. *Chirurgijn te Amsterdam*

Canvas 80 ×65. Signed on the verso *L. Moritz f.*
PROV On loan from the city of Amsterdam since 1885

A 1512 The actor Andries Snoek (1766-1829) in the role of Achilles in the play of the same name (1719) by Balthasar Huydecoper (1695-1778). *De acteur Andries Snoek in de rol van Achilles in het gelijknamige toneelstuk van Balthasar Huydecoper*

Canvas 206 × 175. Signed *L. Moritz f^t*
PROV Sale Amsterdam, 4-8 Feb 1890, lot 45 * DRVK since 1953

A 2201 The actresses Joanna Cornelia Ziesenis-Wattier (1762-1827) and Geertruida Jacoba Grevelink-Hilverdink (1786-1827) in the play 'Iphigenia'

(1674) by Jean Racine (1639-99). *De actrices Joanna Cornelia Ziesenis-Wattier en Geertruida Jacoba Grevelink-Hilverdink in Iphigenia van Jean Racine*

Canvas 159 × 127
PROV Bequest of Miss M E van den Brink, Velp, 1905 * DRVK since 1959 (on loan to the Toneelmuseum, Amsterdam)

A 1953 Mrs Carp and her baby son. *Mevrouw Carp en haar zoontje*

Canvas 102 × 80
PROV Bequest of Miss A J Carp, Haarlem, 1901

A 2194 Hendrik Arend van den Brink (1783-1852) and his wife Lucretia Johanna van de Poll (1790-1850). *Hendrik Arend van den Brink met zijn vrouw Lucretia Johanna van de Poll*

Canvas 104 × 84
PROV Bequest of the sitter's daughter, Miss M E van den Brink, Velp, 1905 * DRVK since 1950

A 2195 Rudolf Johannes van den Brink (1819-1852). Eldest son of Hendrik Arend van den Brink. *Oudste zoon van Hendrik Arend van den Brink*

Paper on panel 33.5 × 27.5
PROV Bequest of Miss M E van den Brink, Velp, 1905 (in damaged condition)

A 1084 The mortally wounded Mark Anthony with Cleopatra. *De dodelijk gewonde Marcus Antonius bij Cleopatra*

Canvas 134 × 263. Signed *L. Moritz*
PROV Purchased in 1825. RVMM, 1885

A 4037 A musical company. *Musicerend gezelschap*

Panel 47 × 53. Signed *L. Moritz*
PROV Purchased from Roland, Browse & Delbanco gallery, London, 1960
LIT J W Niemeijer, OK 6 (1962) nr 37, ill

A 1370 Cossack bivouac, 1813. *Kozakken-nachtleger, 1813*

Canvas 68 × 84.5. Signed *L. Moritz*
PROV RVMM, 1877? NMGK, 1887

Giambattista Moroni

Albino ca 1525–1578 Albino

A 3410 Portrait of a man. *Portret van een man*

Canvas 87 × 66. Signed and dated *Giu. Batª Moroni Miii MDLXV.* Inscribed *Aet. Suae XXXV*
PROV Bequest of J W Edwin vom Rath, Amsterdam, 1941
LIT Berenson 1936, p 326

attributed to **Giambattista Moroni**

A 3036 Portrait of a young woman. *Portret van een jonge vrouw*

Canvas 73.5 × 65. Inscribed on the verso of the original canvas with a crown, the monogram *DGH*, *841* and *Caracciolo* (discovered during relining in 1951)
PROV Purchased from the Augusteum, Oldenburg, 1925, with aid from the Rembrandt Society
LIT Bode 1888, p 21. Venturi 1901-40, vol 9:4 (1930) p 259, fig 224. Bredius & Schmidt-Degener 1906, vol 2, p 2. T Borenius, Burl Mag 23 (1913) p 35. T Borenius, Burl Mag 58 (1931) p 72. Berenson 1932, p 379. Lendorff 1933, pp 48, 84, nr 92, fig 21 (Lolmo?). Gedenkboek Ver Rembrandt, 1933, p 110, ill. Cugini 1939, p 320 (Moroni?). Lendorff 1939, p 151, nr 92 (Lolmo?). W Suida, Emporium, 1949, pp 51-57. E GG Bos, Antiek 1 (1966) p 5, fig 1. VTTT, 1968-69, nr 107

C 1365 Vercellino Olivazzi. Senator of Bergamo. *Senator van Bergamo*

Canvas 98 × 81
PROV On loan from the KKS since 1948
LIT Cugini 1939, nr 99

Gillis Mostaert

Hulst ca 1534 – after 1598 Antwerp

A 972 Allegory of abuses by the authorities of church and state. *Allegorie op de wereldlijke en geestelijke misbruiken*

Panel 116 × 203
PROV NMGK, 1885
LIT Faggin 1968, p 73, fig 213

Jan Mostaert

Haarlem ca 1475–1555/56 Haarlem

A 671 The adoration of the magi. *De aanbidding der koningen*

Panel 49 × 35
PROV Sale Baron van Isendoorn à Blois, Amsterdam, 19 Aug 1879, lot 1 (as Flemish school, 15th century)
LIT G Glück, Zeitschr BK ns 7 (1896) p 271. C Benoît, GdB-A 41 (1899) p 370, ill. M J Friedländer, Rep f Kunstw 28 (1905) p 520. Pierron 1912, pp 61, 91. Hoogewerff 1912, p 38, fig 9. Friedländer 1916, p 189. Friedländer 1924-37, vol 10 (1932) p 120, nr 8. Bürger 1925, p 150, fig 254. Glück 1933, p 30, fig 11. Smits 1933, p 34. K Smits, Kunst 5 (1934) p 306. Hoogewerff 1936-47, vol 2 (1937) p 464, fig 228 (ca 1510). J G van Gelder, in Kunstgesch der Ned, 1954-56, vol 1, p 441. VTTT, 1959, nr 14. E K J Reznicek, OK 6 (1962) nr 40, ill. K G Boon, OH 81 (1966) p 63 (1510-15). Von der Osten & Vey 1969, p 162

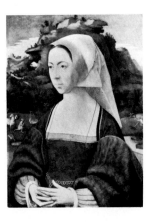

A 3843 Portrait of a woman. *Portret van een vrouw*

Panel 64 × 49.5
PROV Purchased from Schaeffer gallery, New York, 1952
LIT Friedländer 1924-37, vol 10 (1932) p

124, nr 42, pl XVIII. Hoogewerff 1936-47, vol 2 (1937) pp 489, 495. R van Luttervelt, NKJ 13 (1962) p 77, figs 15-16 (portrait of Claudine van Oranje [d 1521], second wife of Hendrik van Nassau?). VTTT, 1965-66, nr 76

 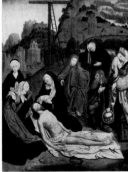

A 2123 Triptych with the lamentation. *Drieluik met de bewening*

Left wing: the donor with St Peter. Right wing: the donor's wife with St Paul. The middle panel, of poorer quality than the wings, is a free copy after Geertgen tot Sint Jans's Lamentation in Vienna, Kunsthistorisches Museum, inv nr 991

Panel 72.5 × 57.5 (middle panel); 72.5 × 21.5 (each of the wings). On the outsides of the wings, presumably added later, the coats of arms of the donor (Speyart van Woerden family) and his wife and the inscription *Anno 1577*
PROV Sale Brussels, 1 July 1903, lot 97 (as Maître d'Oultremont) ∗ Middle panel DRVK since 1958 (on loan to the Frans Halsmuseum, Haarlem)
LIT M J Friedländer, Rep f Kunstw 28 (1905) p 520. Pierron 1912, p 59, ill. Hoogewerff 1912, p 38. Friedländer 1916, p 189. Winkler 1924, p 236. Friedländer 1924-37, vol 10 (1932) pp 27, 119, nr 2. Dülberg 1929, p 160. Glück 1933, pp 39, 321. Hoogewerff 1936-47, vol 2 (1937) p 478, fig 237. F Winkler, Zeitschr f Kunstw 22 (1959) p 179, note 6. J Snyder, Art Bull 53 (1971) pp 454-55, figs 9-10 (wings by Mostaert, ca 1500; middle panel by a good follower of Geertgen; the donors are Willem Pietersz [d 1541], burgomaster of Haarlem, and his first wife Bella Borwoutsdr)

attributed to **Jan Mostaert**

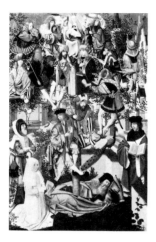

A 3901 The tree of Jesse. *De boom van Jesse*

Panel 89 × 59
PROV Purchased from the C von Pannwitz collection, Heemstede, 1956, with aid from the Rembrandt Society
LIT Dülberg 1899, p 31, note 1. M J Friedländer, Jb Preusz Kunstsamml 24 (1903) p 66 (not Geertgen tot Sint Jans). E Durand-Gréville, Revue de l'Art 15-16 (1904) p 377, ill. Voll 1906, p 237. E Firmenich-Richartz, Zeitschr f Chr Kunst 19 (1906) p 359, fig 4 (school of Geertgen). Dülberg 1907, vol 3, p 8, pl v. N Wrangel & A Troubnikoff, Starye Godye, 1909, p 127. Balet 1910, p 158 (school of Geertgen?). Muñoz 1911, pl XL (Geertgen). Valentiner 1914, pp 78-80 (Mostaert). Friedländer 1916, p 147 (Mostaert). Conway 1921, p 438 (Mostaert). Bürger 1925, p 149, fig 251 (Mostaert or Geertgen). Friedländer 1926, vol 1, p 13, nr 14. R Ligtenberg, Oudh Jb 9 (1929) p 3. Dülberg 1929, p 160 (Mostaert). Friedländer 1924-37, vol 10 (1932) p 28, nr 23 (early work of Mostaert). Hoogewerff 1936-47, vol 2 (1937) p 456 (Mostaert). M Davies, Burl Mag 70-71 (1937) p 89 (related to Geertgen). R van Luttervelt, Historia 13 (1948) p 265 (Mostaert). Gerson 1951, p 16 (Geertgen). A van Schendel, Bull RM 5 (1957) p 75 (Geertgen or milieu of Geertgen). J E Snyder, Bull RM 5 (1957) pp 85-94 (Geertgen). K G Boon, Burl Mag 100 (1958) p 376 (Mostaert). VTTT, 1958, nr 2. F Winkler, Zeitschr f Kunstw 22 (1959) p 179, fig 3 (early work of Mostaert). J E Snyder, Art Bull 42 (1960) p 129 (Geertgen). H W van Os, Bull Boymans 15 (1964) p 35. K G Boon, OH 71 (1966) p 61 ff (Mostaert, ca 1504-05). P J J van Thiel, OK 11 (1967) nr 50, ill (Mostaert). Von der Osten & Vey 1969, p 161 (Mostaert). J E Snyder, Art Bull 53 (1971) pp 445, 453-54, 456-58, figs 1, 3 (late work of Geertgen). R Grosshans, Berl Mus ns 12 (1972) p 10 (Geertgen)

manner of **Jan Mostaert**

A 743 Portrait of a man. *Portret van een man*

Panel 77 × 55.5. Ends in a round arch. Inscribed *Oř fide deo. Betrowetet A Y gode*. On the frame *anno dmi 1535* [or *1555*] *mru 85*
PROV Purchased in The Hague, 1881
LIT Ring 1913, pp 2, 89 (Mostaert). M J Friedländer, Rep f Kunstw 30 (1905) p 510 (Mostaert). Friedländer 1924-37, vol 10 (1932) p 123, nr 32 (Mostaert). F Winkler, Zeitschr f Kunstw 13 (1959) p 213, note 50 (related to Mostaert)

Frederik de Moucheron

Emden 1633 – 1686 Amsterdam

C 189 Italian landscape with round tower. *Italiaans landschap met ronde toren*

Canvas 69.5 × 84. Signed and dated *Moucheron fe 1667*
PROV On loan from the city of Amsterdam (A van der Hoop bequest) since 1885

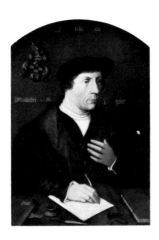

A 280 Italian landscape with hunters. *Italiaans landschap met jagers*

Canvas 39.5 × 32.5. Signed *Moucheron f.*
PROV Sale Boreel, Amsterdam, 23 Sep 1814, lot 11
LIT Stechow 1966, p 156, fig 311 (before 1672)

Isaac de Moucheron

Amsterdam 1667 – 1744 Amsterdam

C 388 Statues and buildings on the water in a park. *Waterpartij met beelden en gebouwen in een park*

Canvas 130 × 160. Signed *I. Moucheron Fecit*
PROV On loan from the city of Amsterdam, 1885-1975 * Placed in the Museum Willet-Holthuysen, Amsterdam, 1965
LIT Scheltema 1864, nr 137. Scheltema 1879, nr 79. Martin 1935-36, vol 2, pp 487-88, fig 255. Bienfait 1943, p 223, fig 297. A Staring, OH 65 (1950) p 94

A 796 View of Tivoli. *Gezicht op Tivoli*

Canvas 49.5 × 68. Probably painted in 1725
PROV Sale Amsterdam, 14-15 Nov 1883, lot 111 (the pendant, lot 112, was signed and dated 1725)
LIT Zwollo 1973, p 52, fig 66

Adolphe Mouilleron

Paris 1820–1881 Paris

A 1749 Still life with fruit. *Stilleven met vruchten*

Panel 110 × 80. Signed and dated *A Mouilleron 1879*
PROV Bequest of D Franken Dzn, Le Vésinet, 1898 * DRVK since 1953

A 1748 River view at night. *Riviergezicht bij avond*

Panel 19.5 × 28. Inscribed on the verso *AM 6 Août 1880. Reçu de Adolphe Mouilleron, Paris le 6 Août 1880*
PROV Bequest of D Franken Dzn, Le Vésinet, 1898

A 1750 Still life with bagpipes. *Stilleven met doedelzak*

Panel 70 × 55
PROV Bequest of D Franken Dzn, Le Vésinet, 1898 * DRVK since 1956

NO PHOTOGRAPH AVAILABLE

A 1426 Still life with books and musical instruments. *Stilleven met boeken en muziekinstrumenten*

A glass of beer, books and musical instruments on a table with a green cloth

Panel 101 × 75. Signed *Mouilleron*
PROV Presented by A Willet, Amsterdam, 1887 * Lent to the Gouvernementsgebouw (provincial capitol) of Gelderland, Arnhem, 1924. Destroyed in the war, 1944

Henry Muhrman

see under Pastels

Pieter Mulier I

Haarlem ca 1615–1670 Haarlem

A 2357 Fishing boat with the wind in the sails. *Vissersboot zeilend voor de wind*

Panel 38.5 × 60. Signed *PM*

PROV Sale Amsterdam, 28-29 April 1908, lot 267
LIT Willis 1911, p 61. Röthlisberger-Bianco 1970, p 6, nr 58, fig 57

Jacob Muller

b in Emden; d 1673 Utrecht

A 1445 Cavalry battle between Turkish troops and the troops of the Austrian emperor. *Ruitergevecht tussen Turkse troepen en troepen van de Oostenrijkse keizer*

Canvas 72 × 88. Signed *J. Muller f*
PROV Presented by Dr A Bredius, The Hague, 1888
LIT P T A Swillens, Jb Oud Utrecht, 1934, p 95ff, fig 2

Johannes van Munnickhuysen

see Panpoeticon Batavum: A 4575 Johannes Gronovius, by Jan Maurits Quinkhard after van Munnickhuysen

Emanuel Murant

Amsterdam 1622–ca 1700 Leeuwarden

A 1711 The watering place. *De pleisterplaats*

Canvas 65 × 77. Signed *E. M.*
PROV Sale G de Clercq, Amsterdam, 1 June 1897, lot 68. Purchased with aid from the Rembrandt Society

A 281 Farmhouse in ruins. *Vervallen boerderij*

Canvas 33 × 41
PROV Sale Amsterdam, 19 April 1819, lot 63. Purchased from J de Vries, art dealer, Amsterdam, 1819

Bartolomé Esteban Murillo

Seville 1618–1682 Seville

C 1366 Madonna and child. *Maria met kind*

Canvas 190 × 137
PROV Sale J A Snijers, Antwerp, 27 April 1818, lot 126. Purchased by King Willem I. On loan from the KKS since 1948
LIT Bürger 1858, p 308. Curtis 1883, p 150. Justi 1904, pp 43-45. Mayer 1913, p 34. Kehrer 1926, pp 237-38. Mayer 1947, p 368. Rouchès 1958, p 257, sub II. Gaya Nuño 1958, nr 1889. P van Vliet, Bull RM 14 (1966) p 131 ff, fig 2

A 282 The annunciation. *De verkondiging aan Maria*

Canvas 98 × 100
PROV Purchased by King Willem I from Countess Bourke, Paris, 1823
LIT Smith 1829-42, vol 2 (1830) nr 385 (Rubens). Bürger 1858, vol 1, p 183. Curtis 1883, p 144, nr 64. Mayer 1913, nr 46. Mayer 1922, p 342. Gaya Nuño 1958, nr 1893. P van Vliet, Bull RM 14 (1966) p 134, fig 6

Robert Mussard

see under Miniatures

Michiel van Musscher

Rotterdam 1645–1705 Amsterdam

A 4135 Michiel Comans (d 1687). Calligrapher, etcher, painter and schoolmaster, with his third wife Elisabeth van der Mersche. *Kalligraaf, etser, schilder en schoolmeester, met zijn derde vrouw Elisabeth van der Mersche*

Canvas 71 × 63. Signed and dated *M^l v. Musscher Pi...^t 1669.* Inscribed on the window *Michiel Comans en sijn Huysvrouw Elisabet vand^r Maersch.*; on the paper *Kent u Selven en Wacht u voor Gierigheyt*
PROV Purchased from H Cramer gallery, The Hague, 1967, as a gift from G Henle, Duisburg
LIT Moes 1897-1905, vol 2, nr 5239:4 (self portrait). H Schneider, Mon f Kunstw 12 (1919) p 132, note 9.

Goldscheider 1936, p 39, fig 261 (self portrait). Van Hall 1963, nr 1476:12 (self portrait). P J J van Thiel, Bull RM 17 (1969) pp 3-36, ill

A 2331 Portrait of a captain or shipowner. *Portret van een kapitein of een reder*

Canvas 43 × 38. Signed and dated *M^l v. Musscher Pinx A° 1678*
PROV Purchased from the heirs of Jonkheer P H Six van Vromade, Amsterdam, 1908, with aid from the Rembrandt Society

C 13 Hendrick Bicker (1649-1718). Burgomaster of Amsterdam. *Burgemeester van Amsterdam*

Pendant to C 14

Canvas 57.5 × 51. Signed and dated *M^l v. Musscher Pinx^t A° 1682*
PROV On loan from the city of Amsterdam (Bicker bequest) since 1881
LIT Moes 1897-1905, vol 1, nr 643. P J J van Thiel, Bull RM 17 (1969) p 3, fig 12

C 14 Maria Schaep (1658-1725). Wife of Hendrick Bicker. *Echtgenote van Hendrick Bicker*

Pendant to C 13

Canvas 57.5 × 51. Signed and dated *M^l v. Musscher Pinx^t A° 1682*
PROV Same as C 13
LIT *see under* C 13. Moes 1897-1905, vol 2, nr 6826

A 4232 Self portrait. *Zelfportret*

Pendant to A 4233

Canvas 20.5 × 17.8. Dated *A° 1685*.
Inscribed *Dus heeft hier Musschers handt,
deez Omtreck zelfs geg*[even] | *Tot een
geheugenis, hoe zijn gedaente was | De Tijdt
ondeckt hem wel, maer thoond' oock dat zijn
glas, | Al veel verloopen is en leerd ons 't brosze
leven*
PROV Purchased from Ch van der
Heyden gallery, Rotterdam, 1973
LIT Van Hall 1963, p 223, nr 1476:8
(with inaccurate data). P J J van Thiel,
Bull RM 22 (1974), p 131-149, fig 4

A 4233 Eva Visscher. Wife of Michiel
van Musscher. *Echtgenote van Michiel van
Musscher*

Pendant to A 4232

Canvas 20.5 × 17.8
PROV Same as A 4232
LIT P J J van Thiel, Bull RM 22 (1974),
pp 131-149, fig 5

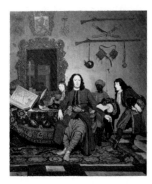

C 1215 Thomas Hees (b 1634/35).
Resident and commissioner of the states
general to the governments of Algiers,
Tunis and Tripoli, with his nephews Jan
(b 1670/71) and Andries (b 1662/63)
Hees, and a servant. *Resident en
commissaris der Staten Generaal bij de
regeringen te Algiers, Tunis en Tripolis, met
zijn neven Jan en Andries Hees, en een
bediende*

Canvas 76 × 63. Signed and dated
*Michiel van Musscher Pinxit Anno
MDCLXXXVII*. Inscribed on the
verso *Thomas Hees 52 jaar, Jan Hees 16
jaar, Andries Hees 24 jaar en Thomas de
neger 17 jaar*
PROV Presented by Jonkheers J H and
W Hora Siccama, 1914. On loan from
the KKS since 1932
LIT Moes 1897-1905, vol I, nr 3359.
W Martin, Bull NOB 2d ser 7 (1914) p
246. Edwards 1954, p 148, ill on p 97.
Staring 1956, p 98. Plietzsch 1960, p 74,
fig 117. P J J van Thiel, Bull RM 17
(1969) p 8. B Naderzad, GdB-A 79
(1972) p 37, note 19, fig 11. W H Vroom,
Ons Amsterdam 24 (1972) p 179

Nicolaas Muys

Rotterdam 1740 – 1808 Rotterdam

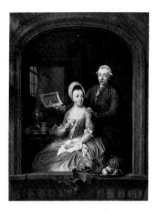

A 1587 The engraver Robert Muys
(1742-1825) and his wife Maria
Nozeman. *De graveur Robert Muys en zijn
echtgenote Maria Nozeman*

Panel 62 × 47. Signed and dated *N. Muys
P¹ A° MDCCLXXVIII*
PROV Sale Baroness Taets van
Amerongen van Natewisch, née S S M
Hodshon (Utrecht), Amsterdam, 1-2
Nov 1892, lot 601 (as a self portrait)
LIT Scheen 1946, fig 14. Van Hall 1963,
p 224, nr 1479:2

Hieronymus van der Mij

Leiden 1687 – 1761 Leiden

C 528 Johannes Hudde (1628-1704).
Burgomaster of Amsterdam and
mathematician. *Burgemeester van
Amsterdam en wiskundige*

Canvas 57 × 49. Signed and dated
Michiel v. Musscher pinxit A° 1686
PROV On loan from the KOG (presented
by Jonkheer C Dedel) since 1889
LIT Moes 1897-1905, vol I, nr 3812.
A M Lubberhuizen-van Gelder, O H 62
(1947) p 146, fig 3 (dated 1682). W H
Vroom, Ons Amsterdam 24 (1972) p
179, ill

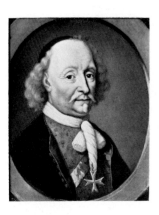

A 1676 Johan Maurits (1604-79), count
of Nassau-Siegen. Governor of Brazil.
*Graaf van Nassau-Siegen. Gouverneur van
Brazilië*

Copper 16.5 × 14
PROV Purchased from Fr Muller & Co,
art dealers, Amsterdam, 1896
LIT Moes 1897-1905, vol I, nr 4016:9

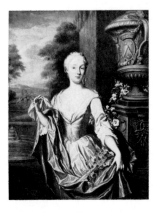

C 1526 Claudine van Royen (b 1712).
Wife of Pieter Teding van Berkhout.
Echtgenote van Pieter Teding van Berkhout

Panel 38 × 30.5. Signed and dated
H. van d. Mij fec A° 1757. Inscribed on the
verso *mevr Claudina van Royen geb. 1712, 10
Jan. 1734, 23 Febr. Pieter Teding v. Berkhout*
PROV On loan from the KOG (bequest of
Mrs M A Domela Nieuwenhuis-Meijer)
since 1902
LIT Scheen 1969-70, vol 2, fig 8

Cornelia van der Mijn

Amsterdam 1709–after 1772 London?

A 3907 Still life with flowers. *Stilleven met bloemen*

Canvas 76 × 64. Signed and dated *Cornelia van der Mijn 1762*
PROV Purchased from C Benedict gallery, Paris, 1956
LIT A Staring, NKJ 19 (1968) p 182, fig 6. Exhib cat Boeket in Willet, Amsterdam 1970, nr 16, ill. Mitchell 1973, p 182, fig 252

Frans van der Mijn

Antwerp? 1719–1783 London

A 2248 Jan Pranger (1700-73). Director-general of the Gold Coast (1730-34). *Directeur-generaal van de Goudkust*

Pendant to A 2249

Canvas 210 × 154.5. Signed and dated *F. Van der Mijn 1742*
PROV Purchased from Fr Muller & Co, art dealers, Amsterdam, 1907
LIT Moes 1897-1905, vol 2, nr 7718 (portrait of Adrianus Swalmius). Scheen 1946, fig 25. R van Luttervelt, Bull KNOB 6th ser 14 (1961) p 247. A van der Marel, Ned Leeuw 78 (1961) p 247. Boxer 1965, fig 9 (A van der Mijn). Fontein 1966, stelling 8 (doubts the identification of the sitter as Jan

Pranger). A Staring, NKJ 19 (1968) p 184, fig 8. B Koolen, Spiegel Hist 7 (1972) p 284, fig 6

A 2249 Machteld Muilman (1717/18-73). Second wife of Jan Pranger. *Tweede echtgenote van Jan Pranger*

Pendant to A 2248

Canvas 210 × 154.5. Signed *F. van der Mijn*
PROV Same as A 2248
LIT *see under* A 2248

A 4064 Group portrait of a family. *Familiegroep in een interieur*

Canvas 86 × 68. Signed and dated *F. Van der Mijn 1744*
PROV Sale London, 14 June 1961, lot 59
LIT A Staring, NKJ 19 (1968) p 188

C 1527 Portrait of a woman. *Portret van een vrouw*

Canvas 85 × 69. Signed and dated *F. van der Mijn 1748*
PROV On loan from the KOG (bequest of Mrs M A Domela Nieuwenhuis-Meijer) since 1902

A 3956 Portrait of a young woman. *Portret van een jonge vrouw*

Canvas 53.5 × 42.2. Grisaille. Signed and dated *F. V. M. 1756*
PROV Purchased from the Matthiesen gallery, London, 1959
LIT A Staring, NKJ 19 (1968) pp 179, 192, fig 13

A 2376 George van der Mijn (1726/27-63). Painter. *Schilder*

Canvas 34.5 × 29. Oval. Inscribed on a label on the verso *Het Portret van George van der Mijn. Geschilderd door Frans van der Mijn. Dit afgeschreven door mij C. Kramm*
PROV Sale A J Nijland, Amsterdam, 1909
LIT Van Hall 1963, p 224, nr 1482:3. A Staring, NKJ 19 (1968) p 183. A Staring, NKJ 20 (1969) p 202

A 1274 Maria Henriëtte van de Poll (1707-87). Wife of Willem Sautijn. *Echtgenote van Willem Sautijn*

Canvas 82 ×65
PROV Presented by J S R van de Poll, Arnhem, 1885
LIT Moes 1897-1905, vol 2, nr 5999

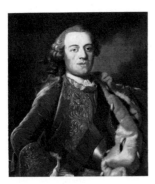

A 887 Willem IV (1711-51), prince of Orange-Nassau. *Prins van Oranje-Nassau*

Canvas 82.5 × 70.5
PROV KKS

George van der Mijn

London 1726/27 – 1763 Amsterdam

see also under Pastels

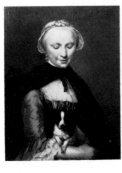 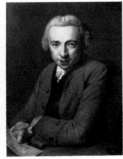

A 2139 Louis Metayer Phz (1728-99). Goldsmith and art collector. *Goudsmid en kunstverzamelaar*

Pendant to A 2140

Canvas 63.5 ×49. Signed and dated *G. Van der Mijn 1759*
PROV Bequest of J Bernard van IJsseldijk, Amsterdam, 1904
LIT J W Niemeijer, Bull RM 16 (1968) p 18, fig 7. A Staring, NKJ 20 (1969) p 204, fig 9

A 2140 Antoinette Metayer (1732-88). Eldest sister of Louis Metayer. *Oudste zuster van Louis Metayer*

Pendant to A 2139

Canvas 63.5 ×49. Signed *G. van de. ...*
PROV Same as A 2139
LIT Fr W S van Thienen, OK 7 (1963) nr 34, ill. J W Niemeijer, Bull RM 16 (1968) p 18, fig 6. A Staring, NKJ 20 (1969) p 204, fig 10

A 1360 Pieter Cornelis Hasselaer (1720-97). Governor of the Dutch East Indies and burgomaster of Amsterdam with his family. *Raad van Indië en burgemeester van Amsterdam met zijn gezin*

From left to right Hendrik Nicolaas (1749-1810), Cornelis Pieter (1741-67), Clara Suzanna (1752-1808), Geertruida Constantia (1746-94), Wendela Eleonora (b 1743) and Dirk Wijbrand (1754-78). On the chair the portrait of his wife Clara Wendela Sautijn (d 1756)

Canvas 249 × 288. Signed and dated *G. Van der Mijn 1763*
PROV Purchased from P C Sautijn Hasselaer, Amsterdam, 1887
LIT Moes 1897-1905, vol 1, nr 3259. J F L de Balbian Verster, Jb Amstelodamum 28 (1931) pp 73-76. Staring 1956, p 136, ill. A Staring, NKJ 20 (1969) pp 200, 215, fig 3

Daniël Mijtens II

The Hague 1644 – 1688 The Hague

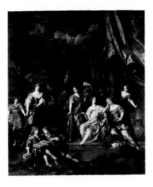

A 4222 Group portrait with allegorical

overtones of the children of Diederic Pietersz van Leyden (van Leeuwen; 1628-82), burgomaster of Leiden, and Alida Paets (1625-73). *Allegoriserende portretgroep van de kinderen van Diederic Pietersz van Leyden (van Leeuwen), burgemeester van Leiden, en Alida Paets*

In order of age Maria (b 1654), to the left, with the laurel branch, Alida (b 1660), seated, with a bridle, Theodora Catharina (b 1661), with a serpent and globe, Bernardina (ca 1662-1716), with shield, helmet, spear and golden cuirass, Suzanna (1664-1712), with a sword above a fire, Adriaan Willem (1667-88), at the far left, in Roman costume, Pieter (b 1666), in the foreground, with book, Lodewijk (1668-97), next to the latter, François Adriaan (1669-1726), with hourglass, and Philippina, who had died as a child, in the sky as a putto, with palm branch and wreath. These identifications are based on the apparent ages of the children, and three of the sisters who were born within two years of each other – Alida, Theodora Catharina, and Bernardina – may possibly have been interchanged

Canvas 178.3 × 156.3. Signed and dated *D Mytens f. 1679*
PROV Sale Amsterdam, 26 Sep 1972, lot 168, ill
LIT Bull RM 21 (1973) p 31, fig 1

Jan Mijtens

The Hague ca 1614 – 1670 The Hague

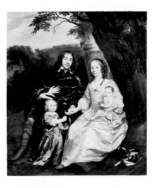

A 4013 Govert van Slingelandt (1623-90), lord of Dubbeldam. With his first wife Christina van Beveren (1632-57) and their two sons. *Heer van Dubbeldam. Met zijn eerste vrouw Christina van Beveren en hun beide zoontjes*

Canvas 99.5 ×86.5. Signed and dated *Joan Mijtens f. A° 1657*. Inscribed on the verso *Govert van Slingelandt Christina van Beveren met hun beide kinderen*
PROV Sale Amsterdam, 22 Dec 1942, lot 22, ill. Lent by the DRVK, 1954. Transferred in 1960

LIT Moes 1897-1905, vol 2, nr 7283:1?
R van Luttervelt, Bull RM 5 (1957) p
113, fig 4. Bernt 1969-70, vol 2, nr 823

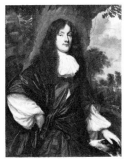 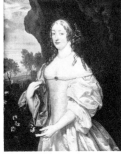

A 3021 Jacob de Witte (1628-79), lord of
Haamstede. *Heer van Haamstede*

Pendant to A 3022

Canvas 113 × 91. Signed and dated
JAMijtens A° 1660
PROV Presented from the estate of Mrs
O E A E Wüste, née Baroness von Gotsch,
widow of J R Wüste, Santpoort, 1924

A 3022 Jacoba van Orliens (1643-91).
Wife of Jacob de Witte van Haamstede.
Echtgenote van Jacob de Witte van Haamstede

Pendant to A 3021

Canvas 113 × 91. Signed *JAMijtens*
PROV Same as A 3021

A 746 Johan van Beaumont. Colonel in
the Holland guards and commander of
Den Briel. *Kolonel der Hollandse Gardes en
commandeur van Den Briel*

Pendant to A 747

Canvas 109 × 91. Signed and dated
JAMijtens F. A° 1661. Inscribed *Aet 52*
PROV Purchased from W A Hopman,
Bussum, 1881
LIT Moes 1897-1905, vol 1, nr 416

A 747 Maria de Witte Françoisdr (b
1616). Wife of Johan van Beaumont.
Echtgenote van Johan van Beaumont

Pendant to A 746

Canvas 110 × 90. Signed and dated
JAMijtens F. A° 1661. Inscribed *Aet. 45*
PROV Same as A 746
LIT Moes 1897-1905, vol 2, nr 9203

A 284 Cornelis Tromp (1629-91). Vice
admiral of the fleet. *Luitenant-admiraal-
generaal*

Pendant to A 285

Canvas 134 × 105. Signed and dated
JAMijtens F. A° 1668
PROV Purchased from P C Huybrechts,
The Hague, 1803. NM, 1808
LIT Moes 1897-1905, vol 2, nr 8086:7.
Moes & van Biema 1909, pp 62, 84, 98,
208. Rotterdamsch Jb 3d ser 7 (1929) p
116. Martin 1935-36, vol 2, p 162. H F
Wijnman, Bull Boymans 10 (1959) p 104,
fig 9

A 285 Margaretha van Raephorst (d
1690). Wife of Cornelis Tromp. *Echt-
genote van Cornelis Tromp*

Pendant to A 284

Canvas 136 × 104.5. Signed and dated
JAMijtens F A° 1668
PROV Same as A 284
LIT Moes 1897-1905, vol 2, nr 6149:1.
Moes & van Biema 1909, pp 62, 84, 98,
208. Rotterdamsch Jb 3d ser 7 (1929) p
116

A 1856 Double portrait of a young couple
as Granida and Daiphilo. *Dubbelportret
van een jong paar als Granida en Daifilo*

Canvas 112 × 143.5. Signed *JAMijtens F.*
PROV Bequest of Miss C J Amiabel, The
Hague, 1900
LIT Martin 1935-36, vol 1, p 162. S J
Gudlaugsson, Burl Mag 91 (1949) p 40,
fig 13

attributed to **Jan Mijtens**

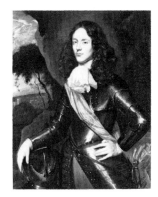

A 1239 A military officer. *Een officier*

Canvas 109 × 91
PROV KKS, 1885 * DRVK since 1951

Martinus Mijtens I

The Hague 1648 – 1736 Stockholm

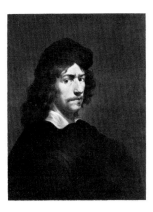

A 768 Self portrait. *Zelfportret*

Panel 63 × 49.5. Inscribed on the verso
*Martinus Mijtens, Hofschilder van de
Koninginne Christina van Sweeden*
PROV Sale W Gruyter, Amsterdam, 24-
25 Nov 1882, lot 31 (as anonymous)
LIT Moes 1897-1905, vol 2, nr 5271:1.
Van Hall 1963, p 225, nr 1488:1

Jan Jacob Nachenius

The Hague 1709–1752? Dutch East Indies

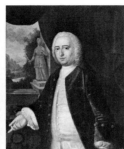

A 1656 Johan Willem Parker (1721-80), lord of Saamslag, Geersdijk, Wissekerke, Cats and Soelekerke. Burgomaster of Middelburg, delegate for Walcheren in the states of Zeeland. *Heer van Saamslag, Geersdijk, Wissekerke, Cats en Soelekerke. Burgemeester van Middelburg, gedeputeerde voor Walcheren in de Staten van Zeeland*

Pendant to A 1657

Canvas 42 × 36. Signed and dated *J.J.Nachenius Fecit 1746*
PROV Purchased from J C de Ruyter de Wildt, Vlissingen, 1895

A 1657 Jacoba Maria van Bueren gezegd van Regteren (1718-91). Wife of Johan Willem Parker. *Echtgenote van Johan Willem Parker*

Pendant to A 1656

Canvas 41 × 36. Signed and dated *J.J.Nachenius fecit 1746*
PROV Same as A 1656
LIT CJ Hudig, Historia 9 (1943) p 174, fig 17

attributed to **Jan Jacob Nachenius**

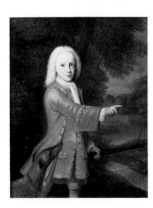

A 3863 Portrait of a boy. *Portret van een jongen*

Canvas 43 × 34.5
PROV Presented by M C van Houten, Doorn, 1933. Received in 1953

le Nain

see Lenain

Matthijs Naiveu

Leiden 1647–1721 Amsterdam

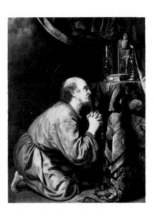

A 286 St Jerome. *De heilige Hieronymus*

Panel 37 × 29.5. Signed and dated *M.Naiveu Fecit A° 1676*
PROV NM, 1808
LIT Moes & van Biema 1909, p 214

A 1323 Theatrical performance in the open air. *Toneelvoorstelling in de open lucht*

Canvas 53 × 70
PROV Sale M M Snouck van Loosen, Enkhuizen, 29 April 1886, lot 48 * DRVK since 1959 (on loan to the Toneelmuseum, Amsterdam)

Robert Nanteuil

see Miniatures: French school ca 1665, A 4410 Marie, Marquise de Sévigné, after Nanteuil

attributed to **Francesco Napoletano**

active ca 1500 in Naples

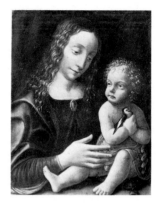

A 3399 Madonna and child. *Maria met kind*

Panel 39 × 29.5
PROV Bequest of J W Edwin vom Rath, Amsterdam, 1941
LIT S de Ricci, Burl Mag 18 (1910-11) p 27, fig A. Berenson 1932, p 205

Johannes Natus

active ca 1658-62 in Middelburg

A 1705 The card players. *De kaartspelers*

Canvas 53 × 46.5. Signed and dated *J Natus 1660*
PROV Presented in 1897 through the intermediacy of C Hofstede de Groot

François Joseph Navez

Charleroi 1787–1869 Brussels

see also Governors-general series: A 3797 L P J du Bus de Gisignies

A 1085 Elisha resurrecting the son of the Shunamite woman. *Elisa wekt de zoon van de Sunamitische vrouw op*

Canvas 254 × 320. Signed and dated *F. J. Navez Rome 1821*
PROV Purchased at exhib Brussels 1821. RVMM, 1885 * DRVK since 1952

NO PHOTOGRAPH AVAILABLE

A 1086 The first meeting of Isaac and Rebecca. *De eerste ontmoeting tussen Isaac en Rebecca*

In the center is Rebecca in a purple gown covered by a blue robe tied up with a greenish ribbon. From her yellow turbanlike headdress hangs a white veil interwoven with yellow, which she grasps in both hands. A yellow silk mantle is draped over her left arm. Isaac advances towards her, his right hand extended. In his left hand he holds a shepherd's crook. He wears a white tunic reaching to his knees, tied around his waist with a leather belt. A red woolen mantle is draped over his left arm. Behind Isaac and Rebecca stands Eliezer in a blue mantle. On his head is a blue turban with a brown rim, in his right hand a staff. To the left are two shepherds and a girl with two sheep-dogs. To the right is an old woman with a little boy; behind them are four female servants and one male one with a basket of gifts on his head. In the distance a train of camels descends a mountainside

Canvas 321 × 394. Signed and dated *F. J. Navez 1826*
PROV Purchased in Brussels, 1826. RVMM, 1885. Was probably rolled up on account of its size, then lost sight of and discarded or destroyed

Johan van Neck

Naarden 1635–1714 Amsterdam

A 1986 Cornelis Jacobsz de Boer (d 1673). Naval captain. *Kapitein ter zee*

Canvas 114.5 × 87.5. Signed and dated *J. v. Neck f 1674*
PROV Presented by the municipal government of Enkhuizen, 1902

Peter Neefs I

Antwerp ca 1578–1657/61 Antwerp

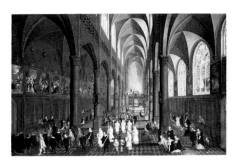

A 288 The interior of the Dominican church in Antwerp. *De Dominicanerkerk te Antwerpen van binnen gezien*

Panel 68 × 105.5. Signed and dated *Peeter Nefs Anno 1636*
PROV NM, 1808
LIT Moes & van Biema 1909, p 224. Jantzen 1910, pp 44, 165, nr 244. Baudouin 1972, p 77, fig 47

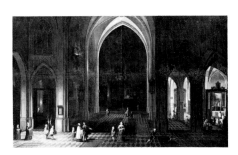

A 289 A church interior by candlelight. *Een kerkinterieur bij kaarslicht*

Panel 49 × 81. Signed and dated *Petrus Nefs 1636*

PROV Purchased with the Kabinet van Heteren Gevers, The Hague-Rotterdam, 1809
LIT Moes & van Biema 1909, pp 148, 162 (switched with A 287). Jantzen 1910, pp 44, 165, nr 245

Peter Neefs II

Antwerp 1620–after 1675 Antwerp

A 287 Church interior. *Een kerkinterieur*

Panel 24.5 × 35.5. Signed *Peeter Neeffs*
PROV NM, 1808
LIT Moes & van Biema 1909, pp 148, 162 (confused with A 289), 224. Jantzen 1910, p 167, nr 349

Aert van der Neer

Amsterdam 1603/04–1677 Amsterdam

A 1948 Landscape with watering place. *Landschap met pleisterplaats*

Panel 30.5 × 43. Signed and dated *A. v. der Neer 1639*
PROV Purchased from the G de Clercq collection, Amsterdam, 1899, through the intermediacy of the Rembrandt Society
LIT A Bredius, OH 18 (1900) p 78. Hofstede de Groot 1907-28, vol 7 (1918) nr 18. Bachmann 1966, p 9

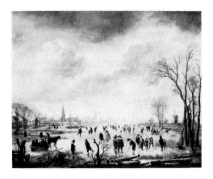

C 191 River view in the winter. *Rivier-gezicht bij winter*

Canvas 64 × 79. Signed *AV DN*
PROV On loan from the city of
Amsterdam (A van der Hoop bequest)
since 1885
LIT A Bredius, OH 18 (1900) p 80.
Hofstede de Groot 1907-28, vol 7 (1918)
nr 479. A van Schendel, OK 1 (1957) nr
5, ill. E van Uitert, OKtv 3 (1965) nr 20,
figs 6-7. Stechow 1966, pp 93, 107, fig
183 (ca 1655). Rosenberg, Slive & Ter
Kuile 1966, fig 128B. Bachmann 1966,
pp 52-53, fig 13

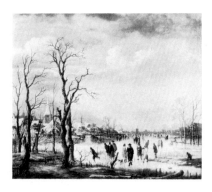

A 3256 River view in the winter. *Rivier-gezicht bij winter*

Canvas 55.5 × 64. Signed *AV DN*
PROV Presented by Sir Henry WA
Deterding, London, 1936 * Lent to the
AHM, 1975
LIT Hofstede de Groot 1907-28, vol 7
(1918) nr 517? Van Gelder 1959, p 15,
fig 80

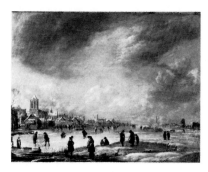

A 290 River view in the winter. *Rivier-gezicht bij winter*

Panel 53 × 67. Signed *AV DN*
PROV Sale Boreel, Amsterdam, 23 Sept
1814, lot 12
LIT A Bredius, OH 18 (1900) p 80.
Hofstede de Groot 1907-28, vol 7 (1918)
nr 478

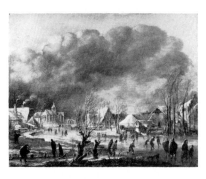

A 3329 Snowfall on a village beside a
frozen canal. *Dorp aan een bevroren vaart bij
een sneeuwbui*

Panel 41.5 × 53.5. Signed *AV DN*
PROV Presented by Mr & Mrs DAJ
Kessler-Hülsmann, Kapelle op den
Bosch near Mechelen, 1940

A 3245 River view by moonlight. *Rivier-gezicht bij maanlicht*

Panel 55 × 103. Signed *AV DN*
PROV Presented by Sir Henry WA
Deterding, London, 1936
LIT Hofstede de Groot 1907-28, vol 7
(1918) nr 155. C Veth, Mndbl BK 13
(1936) pp 172-73. Stechow 1966, p 178,
fig 357

A 2128 Landscape by moonlight.
Landschap bij maanlicht

Panel 31 × 43. Signed *AV N*
PROV Purchased from Mr Lampe,
Brussels, 1904
LIT Hofstede de Groot 1907-28, vol 7
(1918) nr 152

C 192 Landscape with hunter. *Landschap
met jager*

Panel 38 × 58.5. Signed *AV DN*
PROV On loan from the city of
Amsterdam (A van der Hoop bequest)
since 1885
LIT A Bredius, OH 18 (1900) p 80.
Hofstede de Groot 1907-28, vol 7 (1918)
nr 19

manner of **Aert van der Neer**

A 3330 River view at sunrise. *Rivier-gezicht bij zonsopgang*

Panel 15.6 × 28.5. Signed *AV DN*
PROV Presented by Mr & Mrs DAJ
Kessler-Hülsmann, Kapelle op den
Bosch near Mechelen, 1940
LIT Hofstede de Groot 1907-28, vol 7
(1918) nr 124? AB de V[ries], Med Dep
OW & C 7 (1940) p 480

A 3328 River view by moonlight. *Rivier-gezicht bij maanlicht*

Panel 42.5 × 57.5
PROV Presented by Mr & Mrs DAJ
Kessler-Hülsmann, Kapelle op den
Bosch near Mechelen, 1940

A 3496 River view by moonlight. *Rivier-gezicht bij maanlicht*

Canvas 69.5 × 104. Signed *AV DN*
PROV Bequest of Mrs ACMH Kessler-
Hülsmann, widow of DAJ Kessler,
Kapelle op den Bosch near Mechelen,
1947

Eglon van der Neer

Amsterdam 1634–1703 Düsseldorf

A 291 Tobias and the angel. *Tobias en de engel*

Panel 16.5 × 24. Signed and dated
E. H. van der Neer fe 1690
PROV Purchased with the Kabinet van
Heteren Gevers, The Hague-Rotterdam,
1809
LIT Moes & van Biema 1909, pp 148,
162. Hofstede de Groot 1907-28, vol 7
(1918) nr 6

Martinus Nellius

active 1674-after 1706 in Leiden and
The Hague

A 1751 Still life with pears, medlars and a glass. *Stilleven met peren, mispels en een glas*

Panel 41.5 × 34.5. Signed *Nellius fecit*
PROV Bequest of D Franken Dzn, Le
Vésinet, 1898
LIT Warner 1928, nr 71b. Bernt 1960-62,
vol 2, nr 593. Bol 1969, p 308, note 467.
Bernt 1969-70, vol 2, nr 844

Caspar Netscher

Heidelberg 1639–1684 The Hague

A 2666 Self portrait. *Zelfportret*

Panel 28 × 22
PROV Bequest of Mrs Netscher-Cornets
de Groot van Kraayenburg, widow of
JAH Netscher, The Hague, 1913
LIT Moes 1897-1905, vol 2, nr 5355:7.
Hofstede de Groot 1907-28, vol 5 (1912)
nr 160. AM Lubberhuizen-van Gelder,
OH 62 (1947) p 146. Van Hall 1963, p
227, nr 1498:13

A 2669 Margaretha Godin (d 1694). The artist's wife. *Echtgenote van de schilder*

Canvas 72 × 59.5
PROV Same as A 2666
LIT Moes 1897-1905, vol 1, nr 2764:8.
Hofstede de Groot 1907-28, vol 5 (1912)
nr 165

A 2668 Theodoor Netscher (1661-1732).
The artist's oldest son. *De oudste zoon van de schilder*

Canvas 47 × 38.5
PROV Same as A 2666
LIT Van Hall 1963, p 228, nr 1501:1

A 2667 A daughter and a son
(Constantijn?) of the artist. *Een dochtertje en een zoon (Constantijn?) van de schilder*

Canvas 37 × 45.5
PROV Same as A 2666
LIT Van Hall 1963, p 228, nr 1500:2

A 3977 Pieter de Graeff (1638-1707), lord of Zuid-Polsbroek, Purmerland and Ilpendam. Alderman of Amsterdam. *Heer van Zuid-Polsbroek, Purmerland en Ilpendam. Schepen van Amsterdam*

Pendant to A 3978

Panel 51 × 36. Ends in a round arch. Signed and dated *CNetscher 1663*. Inscribed *Aetat 25*
PROV Lent by the SNK, later DRVK, 1948. Transferred in 1960
LIT Hofstede de Groot 1907-28, vol 5 (1912) p 311, nr 203A. A Bredius, OH 30 (1912) p 198. Plietzsch 1960, p 60, fig 84

A 3978 Jacoba Bicker (1640-95). Wife of Pieter de Graeff. *Echtgenote van Pieter de Graeff*

Pendant to A 3977

Panel 51 × 36. Ends in a round arch. Signed *Netscher*. Inscribed *Aetat 23*
PROV Same as A 3977
LIT Hofstede de Groot 1907-28, vol 5 (1912) p 311, nr 203A. A Bredius, OH 30 (1912) p 198. Plietzsch 1960, p 60, fig 85

A 292 Constantijn Huygens (1596-1687), lord of Zuylichem. Secretary of Frederik Hendrik, Willem II and Willem III, and poet. *Heer van Zuylichem. Secretaris van Frederik Hendrik, Willem II en Willem III, en dichter*

Panel 27 × 23. Signed and dated *C.Netscher Fec. 1672*

PROV Purchased by King Willem I from Mr Wisalius, 1823
LIT Moes 1897-1905, vol 1, nr 3873:9. Hofstede de Groot 1907-28, vol 5 (1912) nr 210. F Schmidt-Degener, Onze Kunst 27-28 (1915) p 126. HE van Gelder, Med DKW Gem 's-Grav 9 (1954) p 92. Van Gelder 1957, p 33, fig 31. Plietzsch 1960, p 60

C 193 Coenraad van Beuningen (1622-93). Burgomaster of Amsterdam, statesman and diplomat. *Burgemeester van Amsterdam, staatsman en diplomaat*

Canvas 48 × 39.5. Signed and dated *C.Netscher Fecit 1673*
PROV On loan from the city of Amsterdam (A van der Hoop bequest), 1885-1975
LIT Hofstede de Groot 1907-28, vol 5 (1912) nr 177. W H Vroom, Ons Amsterdam 24 (1972) p 179

A 1693 Portrait of a woman, thought to be a member of the van Citters family. *Portret van een vrouw, vermoedelijk een lid van de familie van Citters*

Canvas 49 × 39. Signed and dated *C.Netscher fec. 1674*
PROV Bequest of A J W Farncombe Sanders, The Hague, 1887
LIT Hofstede de Groot 1907-28, vol 5 (1912) nr 191

A 1692 Portrait of a man, thought to be a member of the van Citters family. *Portret van een man, vermoedelijk een lid van de familie van Citters*

Canvas 49 × 39. Signed and dated *C.Netscher 1678*
PROV Bequest of A J W Farncombe Sanders, The Hague, 1887
LIT Hofstede de Groot 1907-28, vol 5 (1912) nr 190

A 707 Helena Catharina de Witte (1661-95). Wife of Iman Mogge, lord of Haamstede. *Echtgenote van Iman Mogge, heer van Haamstede*

Canvas 49 × 40. Signed and dated *C.Netscher 1678*
PROV Bequest of Jonkheer J S H van de Poll, Amsterdam, 1880
LIT V de Stuers, Ned Kunstbode 2 (1880) p 244. Moes 1897-1905, vol 2, nr 9202. Hofstede de Groot 1907-28, vol 5 (1912) nr 308

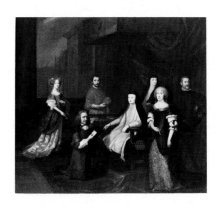

A 4128 Hieronymus van Beverningk
(1614-90). Extraordinary ambassador of
the Netherlands being received in secret
by the queen-regentess of Spain, Maria
Anna of Austria, on 2 March 1671.
*Nederlands buitengewoon ambassadeur, wordt
in geheime audiëntie ontvangen door de Spaanse
koningin-regentes Maria-Anna van Oostenrijk,
2 maart 1671*

Canvas 70 × 79. Signed *C. Netscher*
PROV Purchased from H Terry Engel
gallery, London, 1967
LIT Hofstede de Groot 1907-28, vol 5
(1912) nr 145a. Bull RM 15 (1967) p 94,
fig 1. Chron des Arts (GdB-A) 71 (1968)
p 118, nr 431

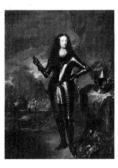

C 194 William III (1650-1702), prince of
Orange and, from 1689 on, king of
England. *Willem III, prins van Oranje en
sinds 1689 koning van Engeland*

Pendant to C 195

Canvas 80.5 × 63. Signed *C. Netscher*
PROV On loan from the city of
Amsterdam (A van der Hoop bequest)
since 1885
LIT Moes 1897-1905, vol 2, nr 9096:36.
Hofstede de Groot 1907-28, vol 5 (1912)
nr 283. A Staring, NKJ 3 (1951) p 175, fig
16 (1677)

C 195 Mary Stuart (1662-95). Wife of
Prince William III. *Maria Stuart, echt-
genote van prins Willem III*

Pendant to C 194

Canvas 80.5 × 63.5
PROV Same as C 194
LIT Hofstede de Groot 1907-28, vol 5
(1912) nr 297

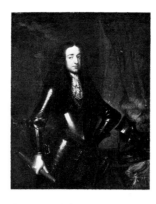

A 3331 William III (1650-1702), prince
of Orange and, from 1689 on, king of
England. *Willem III, prins van Oranje en
sinds 1689 koning van Engeland*

Canvas 49 × 39.5
PROV Presented by Mr & Mrs DAJ
Kessler-Hülsmann, Kapelle op den
Bosch near Mechelen, 1940
LIT Hofstede de Groot 1907-28, vol 5
(1912) nr 294j?

A 729 Cornelis Backer (1633-81).
Councillor, alderman and colonel of the
Amsterdam militia. *Raad, schepen en
kolonel der burgerij te Amsterdam*

Canvas 50 × 42
PROV Purchased in England in 1881
LIT Hofstede de Groot 1907-28, vol 5
(1912) nr 170

A 293 Interior with a mother combing
her child's hair. *Interieur met een moeder die
haar kind kamt*

Panel 44.5 × 38. Signed *C. Netscher Fec.*
PROV Purchased with the Kabinet van
Heteren Gevers, The Hague-Rotterdam,
1809
LIT Moes & van Biema 1909, pp 148,
162. Hofstede de Groot 1907-28, vol 5
(1912) nr 94. E Snoep-Reitsma, Alb
Amic J G van Gelder, 1973, p 288, fig 8

attributed to **Caspar Netscher**

A 2556 Family scene. *Familietafereel*

Panel 114 × 166.5
PROV Lent by C Hoogendijk, The
Hague, 1907. Presented from his estate
in 1912 * DRVK since 1959 (on loan to
the Provinciaal Overijssels Museum,
Zwolle)
LIT Hofstede de Groot 1907-28, vol 5
(1912) nr 454. Gudlaugsson 1959-60, vol
2, p 283, nr D 84, p 289, pl XXVI, nr 1
(early work of Netscher)

A 319 Trimming bales of hay. *De stro-
snijder*

Panel 29 × 24.5
PROV Presented by J P G Baron Spaen
van Biljoen, 1808 (as Paulus Potter)
LIT Bode 1883, p 168 (Pieter Potter). A
Bredius, OH 11 (1893) p 43 (Pieter
Potter). Moes & van Biema 1909, pp
129, 221. R Juynboll, in Thieme-Becker,
vol 27, 1933, p 308 (Netscher). Plietzsch
1960, p 61, fig 87

copy after **Caspar Netscher**

A 183 William III (1650-1702), prince of Orange and, from 1689 on, king of England. *Willem III, prins van Oranje en sinds 1689 koning van England*

Copy after C 194, presumably by Johan van Huchtenburg (1647-1733)

Canvas 80 × 64
PROV Sale M C van Hall, Amsterdam, 27 April 1858, lot 46 (as van Huchtenburg) * Lent to the AHM, 1975
LIT Moes 1897-1905, vol 2, nr 9096:47. Hofstede de Groot 1907-28, vol 5 (1912) nr 283. A Staring, NKJ 3 (1951) p 175 (copy or replica)

C 175 Johan de Witt (1625-72). Grand pensionary of Holland. *Raadpensionaris van Holland*

Canvas 32.5 × 29
PROV On loan from the city of Amsterdam (A van der Hoop bequest) since 1885
LIT Moes 1897-1905, vol 2, nr 9185:41. A Dobrzycka, Biul Hist Sztuki 17 (1955) p 453, fig 8. R van Luttervelt, Bull RM 8 (1960) p 32, fig 3

A 901 Jan Boudaen Courten (1635-1716), lord of St Laurens, Schellach and Popkensburg. Judge and alderman of Middelburg. *Heer van St Laurens, Schellach en Popkensburg. Raad van Middelburg en bewindhebber der VOC*

Copy by Philip van Dijk (1680-1753)
Pendant to A 902
see also Heraldic objects: A 941
For another portrait of the sitter, *see* Jonson van Ceulen II, Cornelis, A 921

Canvas 49 × 40
PROV Bequest of Jonkheer J de Witte van Citters, The Hague, 1876. NMGK, 1885 * DRVK since 1950
LIT Moes 1897-1905, vol 1, nr 974:2. Hofstede de Groot 1907-28, vol 5 (1912) nr 194b

A 902 Anna Maria Hoeufft (1646-1715). Wife of Jan Boudaen Courten. *Echtgenote van Jan Boudaen Courten*

Copy by Philip van Dijk (1680-1753)
Pendant to A 901
see also Heraldic objects: A 941

Canvas 49 × 40
PROV Same as A 901 * DRVK since 1950
LIT Moes 1897-1905, vol 1, nr 3557:3. Hofstede de Groot 1907-28, vol 5 (1912) nr 194c

A 1264 Pieter Rendorp (1648-99). Amsterdam brewer and owner of merchant ships trading with Norway and the Baltic Sea. *Brouwer te Amsterdam en reder op Noorwegen en de Oostzee*

Pendant to A 1265

Canvas on panel 48 × 39
PROV Presented by J S R van de Poll, Arnhem, 1885 * DRVK since 1952
LIT Moes 1897-1905, vol 2, nr 6319:3. Hofstede de Groot 1907-28, vol 5 (1912) nr 255

A 1265 Johanna Hulft (1649-98). Wife of Pieter Rendorp. *Echtgenote van Pieter Rendorp*

Pendant to A 1264

Canvas on panel 48 × 39
PROV Same as A 1264 * DRVK since 1952
LIT Moes 1897-1905, vol 1, nr 3822:1. Hofstede de Groot 1907-28, vol 5 (1912) nr 256

A 1552 Menno Baron van Coehoorn (1641-1704). General in the artillery and fortifications engineer. *Generaal der artillerie, vestingbouwkundige*

Copy after the original in the Rijksmuseum Twenthe, Enschede

Canvas 96 × 79
PROV Bequest of M D Count van Limburg Stirum, The Hague, 1891
LIT Hofstede de Groot 1907-28, vol 5 (1912) nr 194

Constantijn Netscher

The Hague 1668 – 1723 The Hague

C 15 Jacob Jan de Backer (1667-1718). Amsterdam lawyer. *Advocaat te Amsterdam*

Pendant to C 16

Canvas 52 × 42. Oval. Signed and dated *Consts Netscher 1694*
PROV On loan from the city of Amsterdam (Bicker bequest), 1881-1975
LIT Moes 1897-1905, vol 1, nr 289

C 16 Agatha Bicker (1671-1706). Wife of Jacob Jan de Backer. *Echtgenote van Jacob Jan de Backer*

Pendant to C 15

Canvas 52 × 42. Oval. Signed and dated *Consts Netscher 1694*
PROV Same as C 15
LIT Moes 1897-1905, vol 1, nr 629

Johannes Albert Neuhuys

Utrecht 1844 – 1914 Locarno

see also under Aquarelles and drawings

A 1181 'The fisherman's courting.' *'Vissersvrijage'*

Canvas 78 × 59.5. Signed and dated *Alb. Neuhuijs f 80*
PROV Purchased at exhib Amsterdam 1880, nr 300. RVMM, 1885 * DRVK since 1953
LIT Martin 1914, pp 31, 60, ill opp p 2 (Scheveningen, 1880)

A 2437 'At the cradle.' *'Bij de wieg'*

Canvas 78 × 90. Signed and dated *Albert Neuhuijs f 97*
PROV Lent by Mr & Mrs J C J Drucker-Fraser, London, 1903. Presented in 1909-10 * DRVK since 1953
LIT 't Hooft 1907, fig 5. M Eisler, Elsevier's GM 46 (1913) pp 252-53, ill on p 254

Jozef Hendrik Neuhuys

Utrecht 1841 – 1890 Warmond

A 1353 Wooded landscape under threatening skies. *Bosachtig landschap met opkomende bui*

Panel 27.5 × 36. Signed *Jozef Neuhuys*
PROV Koninklijke Bibliotheek, The Hague, 1887 * DRVK since 1953

Jan Hendrik Neuman

Cologne 1819 – 1898 The Hague

see also Governors-general series: A 3806 Pieter Mijer

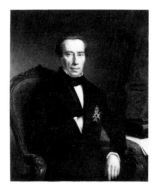

A 4120 Johan Rudolf Thorbecke (1796-1872). Minister of state and minister of the interior. *Minister van Staat en minister van Binnenlandse Zaken*

Canvas 100 × 84. Signed *J. H. Neuman f.* The letter on the table is dated *1852*
PROV Purchased from R Thorbecke, The Hague, 1965
LIT Bull RM 15 (1967) p 94, fig 6. R P van den Helm, Spiegel Hist 6 (1971) p 220, fig 4

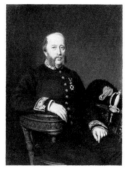

A 2824 Gerard Johan Verloren van Themaat (1809-90). Member of the provincial assembly of Utrecht. *Lid van de Gedeputeerde Staten van Utrecht*

Pendant to A 2825

Canvas 68 × 51. Signed and dated *J. H. Neuman f 1874*
PROV Bequest of E J C Verloren van Themaat-de Pesters, dowager of G J Verloren van Themaat, Utrecht, 1919
LIT Scheen 1969-70, vol 2, fig 51

A 2825 Wilhelmina Margaretha van den Bosch (1807-74). Wife of Gerard Johan Verloren van Themaat. *Echtgenote van Gerard Johan Verloren van Themaat*

Pendant to A 2824

Canvas 68 × 51. Signed and dated *J. H. Neuman f 1874*
PROV Same as A 2824
LIT Scheen 1946, fig 49

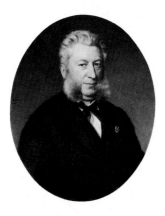

A 2215 Jan Jacob Lodewijk ten Kate
(1818-89). Poet. *Dichter*

Canvas 76 ×63. Oval. Signed and dated
J. H. Neuman f. 1875
PROV Presented by HFC ten Kate Jr,
Yokohama, 1906

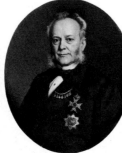

A 4159 Pieter Mijer (1812-81).
Governor-general of the Dutch East
Indies (1866-72). *Gouverneur-generaal van
Nederlands Oost Indië*

Pendant to A 4160

Canvas 75 ×62. Oval. Signed and dated
J. H. Neuman f 1875
PROV Purchased from KH Mijer,
Leidschendam, 1969

A 4160 Jeanette Antoinette Pietermaat
(1818-70). Wife of Pieter Mijer.
Echtgenote van Pieter Mijer

Pendant to A 4159

Canvas 75 ×62. Oval. Signed and dated
J. H. Neuman f 1876
PROV Same as A 4159

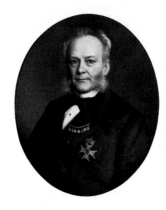

A 3242 Pieter Mijer (1812-81).
Governor-general of the Dutch East
Indies (1866-72). *Gouverneur-generaal van
Nederlands Oost Indië*

Canvas 75 ×62.5. Oval. Signed and
dated *J. H. Neuman f 1876*
PROV Presented by LPJ Michielsen,
The Hague, 1935

A 2807 Jacques Fabrice Herman Perk
(1859-81). Poet. *Dichter*

Canvas 80 ×60. Oval. Signed and dated
J. Neuman 1882
PROV Presented by the heirs of Reverend
MA Perk, Amsterdam, 1917 * Lent to
the AHM, 1975

A 3139 Jan Heemskerck Azn (1818-97).
Minister of the interior. Officially opened
the Rijksmuseum on 13 July 1885.

*Minister van Binnenlandse Zaken. Verrichtte
op 13 juli 1885 de opening van het Rijks-
museum*

Canvas 70.5 ×58. Signed and dated
J. H. Neuman f 1896
PROV Presented by CJ Heemskerck,
Dordrecht, 1933

A 2216 Herman Frederik ten Kate
(1822-91). Painter. *Schilder*

Canvas 56 ×47. Oval
PROV Presented by HFC ten Kate Jr,
Yokohama, 1906
LIT Van Hall 1963, p 163, nr 1090:1

attributed to **Pieter de Neyn**

Leiden 1597 – 1639 Leiden

A 2245 Frederik Hendrik's siege of
's-Hertogenbosch, 1629. *Het beleg van
's-Hertogenbosch door Frederik Hendrik, 1629*

Canvas 77.5 ×114
PROV Sale Amsterdam, 27-28 Nov 1906,
lot 143. Purchased through the inter-
mediacy of the Rembrandt Society
LIT *cf* H Gerson, NKJ I (1947) p 95

Niccolò de Liberatore

active ca 1456-1502 in Foligno

A 4008 The crucifixion. *Kruisiging*

Panel 33 × 21
PROV O Lanz, Amsterdam. Lent by the
DRVK, 1952. Transferred in 1960

Isaac van Nickelen

active since 1660; d 1703 Haarlem

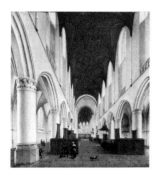

A 360 Interior of the church of St Bavo in
Haarlem. *Het interieur van de Sint Bavo-
kerk te Haarlem*

Canvas 49 × 43
PROV Purchased in 1808. NM, 1808
LIT Moes & van Biema 1909, pp 104,
164, 224. CW Bruinvis, OH 27 (1909) p
241. Jantzen 1910, pp 90, 168, nr 391

L Nicolas

active latter 19th century in Paris?

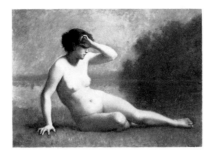

A 1894 Nymph. *Nimf*

Canvas 67.5 × 94. Signed and dated
L. Nicolas 86
PROV Presented by the dowager of R
Baron van Lynden, née M C Baroness
van Pallandt, The Hague, 1900

Joseph Christiaan Nicolié

Antwerp 1791 – 1854 Antwerp

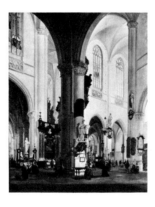

A 1087 The church of St James in
Antwerp. *De Sint Jacobskerk te Antwerpen*

Panel 66 × 52.5. Signed and dated
J.C. Nicolié 1825
PROV Purchased at exhib Haarlem
1825, nr 277. RVMM, 1885 * DRVK since
1951

Jan Frank Niemantsverdriet

see Governors-general series: A 3817
Dirck Fock; A 3819 B C de Jonge

Adriaen van Nieulandt

Antwerp 1587 – 1658 Amsterdam

see also Lastman, Claes Pietersz, C 406
Captain Abraham Boom and Lieutenant
Anthonie Oetgens van Waveren with
seven guardsmen

A 1995 Allegory of the Peace of Münster,
1648. *Allegorie op de Vrede van Munster,
1648*

Canvas 137 × 106. Signed and dated
Adriaen van Nieulandt Fecit Anno 1650
PROV Sale Amsterdam, 1902
LIT Van Hall 1963, p 230, nr 1517:1.
S Groenveld, Spiegel Hist 4 (1969) p 16,
fig 7

A 1582 The triumph of the sea goddess
Galathea? *De triomftocht van de zeegodin
Galathea?*

Canvas 156 × 200. Signed and dated
Adriaen van Nieuland f 1656
PROV Presented by Dr A Bredius, The
Hague, 1892

attributed to **Adriaen van Nieulandt**

NO PHOTOGRAPH AVAILABLE

A 2308 Venus and Neptune. *Venus en
Neptunus*

Venus is towed through the water in a
golden boat by tritons. Neptune stands
on the shore with his trident. To the
right is a rearing horse

Canvas 160 × 235
PROV Presented by the Schutters van

St Joris (St George civic guard), Heusden, 1907 * Lent to the town hall of Heusden, 1908. Destroyed in the war, 1944

Jacob van Nieulandt

Amsterdam? 1592/93–1634 Amsterdam

A 1788 Fish stall. *Visverkopers*

Canvas 156 ×207. Signed and dated *Jacob van Nieulandt F. 1617*
PROV Purchased from J Emerson Dowson, Chelsea, 1898
LIT Martin 1935-36, vol I, p 283. Bol 1969, p 6

Nieuwland

see La Fargue, Isaac Lodewijk, called van Nieuwland

Johannes Esaias Nilson

see under Miniatures

Peter Paul Joseph Noël

Waulsort-sur-Meuse 1789–1822 Sosoye

A 1089 Two drunkards at the market near the Westerkerk in Amsterdam. *Twee dronkaards op de markt bij de Westerkerk te Amsterdam*

Canvas 75 ×90. Signed and dated *Noel 1821*
PROV Purchased at exhib The Hague 1833 (?). RVMM, 1885 * DRVK since 1953
LIT Knoef 1947, p 239

A 1088 The impassioned grape picker. *De verliefde wijngaardenier*

Panel 22 ×18
PROV Purchased in 1826. RVMM, 1885

Pieter Nolpe

see Panpoeticon Batavum: A 4563 Jan van der Rosieren, by Arnoud van Halen after Nolpe

Reinier Nooms *called* **Zeeman**

Amsterdam 1623–1667/68 Amsterdam

A 759 Caulking ships at the Bothuisje (flounder shed) on the Y at Amsterdam. *Het kalefateren van schepen bij het Bothuisje op het IJ te Amsterdam*

Canvas 49 ×64. Signed *R. Zeeman*
PROV Sale W Gruijter, Amsterdam, 24-25 Oct 1882, lot 76
LIT Bol 1973, p 296, note 519

A 294 The naval battle near Livorno, 12 March 1653. *De zeeslag bij Livorno, 12 maart 1653*

Canvas 142 ×225. Signed *R. Zeeman*. Inscribed *Zeegevecht voor Livorno tusschen de nederlantsche en Engelsche vloten onder het bestier van de Commandeurs Jan van Galen en Sir Appleton. Voorgevallen den 14. maert 1653 | N° 1 – 'T Schip madonna della vigne – 't welck een schoot onder water krijgende, naer de wall liep | 2 – De maeght van Enckhuisen nemende den Levantschen Coopman van Armenien | 3 & 4 – De Son en Julius Caesar, die ten Com:er Appleton aborderen en veroveren | 5 & 6 – De Suzanna en de Swarten Arent, die de Pelgrim aborderen en veroveren | 7 – Den Com.er van Gaelen schiende den – Engelschen bonadvonture in de brant | 8 – Capn Tromp den Engelschen Samson een wijl aenboort gelegen hebbende doet hem door een brander verbranden | 9 – 'T Schip Maria, die het alleen ontscijlde | 10 – Den adm:l Bodley, met 8 schepen en een brander, boven windt zijnde dorst niet affcomen | 11 – Een brander van d'Engelsche door den Com.er van galen in de gront geschooten*
PROV Purchased from CS Roos, art dealer, Amsterdam, 1800. NM, 1808
LIT Moes & van Biema 1909, pp 33, 37, 217. Willis 1911, p 103. Martin 1935-36, vol 2, p 381. Stechow 1966, p 122, fig 249. Bol 1973, p 293

A 1399 View of Salee, Morocco. *Gezicht op Salee in Marokko*

Canvas 65.5 ×110. Signed *R. Zeeman*
PROV Admiralty, Amsterdam. Model room of the ministry of marine, The Hague. NMGK, 1887
LIT Willis 1911, p 104. CG 't Hooft, in Feestbundel Bredius, 1915, p 105. Bol 1973, p 296, note 519

A 1398 View of Tripoli. *Gezicht op Tripolis*

Canvas 63 × 110. Signed *R. Zeeman*
PROV Admiralty, Amsterdam. Model
room of the ministry of marine, The
Hague. NMGK, 1887
LIT Willis 1911, p 104. CG 't Hooft, in
Feestbundel Bredius, 1915, p 105. Bol
1973, p 296, note 519

A 1397 View of Tunis. *Gezicht op Tunis*

Canvas 63 × 110. Signed *R. Zeeman*
PROV Admiralty, Amsterdam. Model
room of the ministry of marine, The
Hague. NMGK, 1887
LIT Willis 1911, p 104. CG 't Hooft, in
Feestbundel Bredius, 1915, p 105

A 1396 View of Algiers with de Ruyter's
ship 'De Liefde,' 1662. *Gezicht op Algiers
met de Ruyter's schip 'De Liefde,' 1662*

Canvas 63 × 110. Signed *R. Zeeman*
PROV Admiralty, Amsterdam. Model
room of the ministry of marine, The
Hague. NMGK, 1887
LIT Willis 1911, p 104. CG 't Hooft, in
Feestbundel Bredius, 1915, p 105.
Gerson 1942, p 527. R van Luttervelt,
Bull RM 5 (1957) p 70. Bol 1973, p 296,
note 519

Hendrik Noorderwiel

active 1644-61 in The Hague

C 1550 The marriage trap: an allegory
of marriage. *De huwelijksfuik: allegorie op
het huwelijk*

Panel 117.5 × 175. Signed and dated
HNoorderwiel 1647
PROV On loan from the KOG (presented
by D van der Kellen Jr, 1865) since 1973
LIT Kramm 1857-60, vol 2, p 1208

Jan van Noordt

active ca 1644-76 in Amsterdam

A 709 Dionijs Wijnands (1628-73).
Amsterdam merchant, son of Hendrick
Wijnands and Aeltje Denijs. *Koopman te
Amsterdam, zoon van Hendrick Wijnands en
Aeltje Denijs*

For portraits of the sitter's parents, *see*
Maes, Nicolaes, A 702 & A 703

Canvas 124 × 103.5. Signed and dated
Joan v. Noordt f An° 1664
PROV Bequest of Jonkheer JSH van de
Poll, Amsterdam, 1880
LIT V de Stuers, Ned Kunstbode 2
(1880) p 245. C Hofstede de Groot, OH
10 (1892) pp 212, 216. Moes 1897-1905,
vol 2, nr 9335:1. A Staring, OH 61 (1946)
p 75, fig 2. Staring 1948, p 48, pl XVII:2.
G Kolleman, Ons Amsterdam 23 (1971)
p 120 (with wrong interpretation)

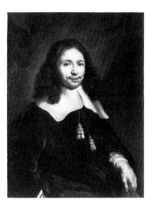

A 710 Dionijs Wijnands (1628-73).
Amsterdam merchant. *Koopman te
Amsterdam*

see also the preceding number

Copper 20.5 × 16. Dated *1664*. Inscribed
on the verso *Dionis Wijnands*
PROV Bequest of Jonkheer JSH van de
Poll, Amsterdam, 1880
LIT C Hofstede de Groot, OH 10 (1892)
pp 212, 216. Moes 1897-1905, vol 2, nr
9335:2. A Staring, OH 61 (1946) p 75.
Staring 1948, p 48, pl XVII. G Kolleman,
Ons Amsterdam 23 (1971) p 120 (with
wrong interpretation)

A 708 The continence of Scipio. *De
grootmoedigheid van Scipio*

Canvas 103 × 88. Signed and dated
Joan van Noordt An° 1672
PROV Bequest of Jonkheer JSH van de
Poll, Amsterdam, 1880
LIT C Hofstede de Groot, OH 10 (1892)
pp 213, 216. J Decoen, Cahiers de
Belgique, 1931, p 17, fig 11. A Pigler,
Acta Hist Art 2 (1955) p 184, fig 12.
Bernt 1969-70, vol 2, nr 869

Pieter van Noort

active 1626-48 in Leiden and thereafter
in Zwolle?

A 776 Still life with fish. *Stilleven met
vissen*

Canvas 68 × 77. Signed *P. v. Noort*
PROV Sale Jonkheer W Gockinga,
Amsterdam, 14 Aug 1883, lot 96 or 97
LIT Vorenkamp 1933, p 78. Bergström
1947, p 240. Bergström 1956, p 237.
Bernt 1960-62, vol 2, nr 610. Bernt 1969-
70, vol 2, nr 870

A 777 Still life with fish. *Stilleven met
vissen*

Canvas 66 × 79.5. Signed *P. v. Noort*
PROV Sale Jonkheer W Gockinga,
Amsterdam, 14 Aug 1883, lot 96 or 97
LIT Martin 1935-36, vol 1, p 425, fig 257.
Bergström 1947, p 240. Bergström 1956,
p 237

Pieter Frans de Noter II

Waelhem 1779–1843 Ghent

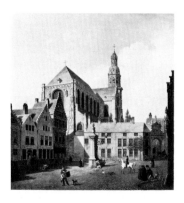

A 1091 The Veemarkt and church of St
Paul in Antwerp. *De Veemarkt met de Sint
Pauluskerk te Antwerpen*

Formerly identified erroneously as the
church of St Walpurgis in Oudenaerde

Panel 56 × 54. Signed and dated
P.F. de Noter 1825
PROV Purchased at exhib Haarlem
1825, nr 281 (as 'View in Ghent').
RVMM, 1885 (as 'The church of St
Michael in Ghent') * DRVK since 1953

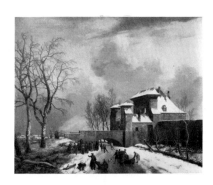

A 1090 The Sas gate, Ghent, in the
winter. *De Sassche poort te Ghent bij winter*

Panel 85.5 × 112. Signed and dated
P.F. de Noter 1827
PROV Presumably bought in 1827.
RVMM, 1885 * DRVK since 1952

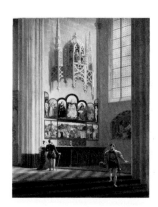

A 4264 The Ghent altarpiece by the van
Eyck brothers in the church of St Bavo
in Ghent. *Het Lam Gods van de gebroeders
van Eyck in de Sint Bavo te Gent*

Canvas 97 × 78. Signed and dated
P.F. de Noter 1829
PROV RVMM, 1877? NMGK
LIT Philip 1971, pp 30-31, 35, 51, figs 48,
52. E Dhanens, Gent Bijdr 22 (1969-72)
p 128, fig 10. W Kroenig, Boll d'Arte 57
(1972) p 174, fig 21. Dhanens 1973, p
134, fig 76

Michiel Nouts

active ca 1640-60 in Delft?

A 1847 Portrait of a woman. *Portret van
een vrouw*

Canvas 108 × 85.5. Signed and dated
Michiel Nouts Me fecit 1656
PROV Purchased from the G de Clercq
collection, Amsterdam, 1899, through
the intermediacy of the Rembrandt
Society
LIT A Bredius, OH 38 (1920) pp 180-83.
Valentiner 1929, pl XVIII. Bernt 1960-
62, vol 4, nr 212. Bernt 1969-70, vol 2,
nr 872

Hermanus Numan

Ezinge 1744–1820 Amsterdam

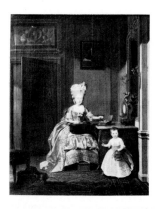

A 2419 Suzanna Cornelia Mogge (1753-
1806). Second wife of Hendrik Muilman
(1743-1812), with her daughter Johanna
Ferdinanda (1774-1833) from her

marriage with Ferdinand van Collen
(1741-73). *Tweede echtgenote van Hendrik Muilman, met haar dochtertje Johanna Ferdinanda uit haar huwelijk met Ferdinand van Collen*

Pendant in a private collection (exhib cat Binnen zonder kloppen in de pruiken-tijd, Amsterdam 1965, nr 17)

Canvas 80 × 64. Signed and dated
H.N.F. 1776
PROV Bequest of S Rendorp, Amsterdam, 1903. Received in 1910
LIT H F Heerkens Thijssen, Ned Archief, 1948, p 7ff, nr 1. Staring 1956, p 156, ill. Scheen 1969-70, vol 2, fig 7

Wijnandus Johannes Josephus Nuyen

The Hague 1813–1839 The Hague

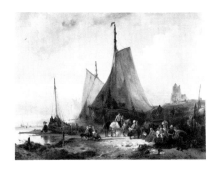

A 4645 Fishing boats on the beach, with fishermen and their wives sorting the catch. *Vissersschepen op het strand met vissers en vrouwen die de vangst sorteren*

Panel 62 × 84.5. Signed and dated
W.J.J.Nuyen Bz.f. 1835
PROV Sale Amsterdam, 18 Feb 1974, lot 51, ill

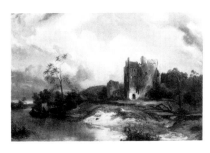

A 1092 River landscape with ruin.
Rivierlandschap met ruïne

Canvas 99 × 141.5. Signed and dated
W.J.J.Nuyen f. 36
PROV Purchased in 1877. RVMM, 1885
LIT Knoef 1947, p 72. Zeitler 1966, p 228, fig 139a. VTTT, 1958, nr 10. Exhib cat 150 jaar Nederlandse kunst, Amsterdam 1963, nr 28, fig 24

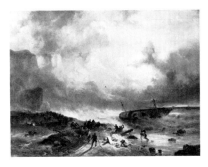

A 4644 Shipwreck on a rocky coast.
Schipbreuk op een rotsachtige kust

Canvas 154 × 206. Signed
W.J.J.Nuijen Bz.f.
PROV Sale Amsterdam, 18 Feb 1974, lot 50, ill
LIT Knoef 1947, p 71. Scheen 1969-70, vol 2, fig 233

Dionys van Nijmegen

Rotterdam 1705–1798 Rotterdam

see also Rotterdam East India Company series: A 4522 Adriaen Paets, A 4523 Hugo du Bois – Panpoeticon Batavum: A 4622 Cornelis van der Pot, A 4623 Frans de Haes, A 4624 Adriaan van der Vliet

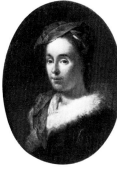

A 1933 Self portrait. *Zelfportret*

Pendant to A 1934

Copper 17 × 13. Oval. Inscribed on the verso *Dit is de Afbeelding van Dionijs van Nijmegen, kunstschilder en door hemzelve geschilderd. Hij is overl^n in Rotterdam 28 Aug. 1798 oud zijnde 93 Jaren en 6 maanden A° 1798*
PROV Sale Amsterdam, 27 Nov 1900, lot 42
LIT Van Hall 1963, p 234, nr 1542:1. J W Niemeijer, Bull RM 17 (1969) p 85, fig 34

A 1934 Sara Stiermans (1704-57). The artist's wife. *Echtgenote van de schilder*

Pendant to A 1933

Copper 17 × 13. Oval. Inscribed on the verso *Dit is de Afbeelding van Vrouwe Sara van Nijmegen, geb. Stiermans, Huisvrouw van Dionijs van Nijmegen en door denzelve geschilderd. Zij is overl^n in Rotterdam 31 Oct. A° 1757 oud zijnde ruim 53 Jaren*
PROV Same as A 1933
LIT Moes 1897-1905, vol 2, nr 7593

A 1459 Dionys Eliasz van Nijmegen (1779-1852). The artist's grandson.
Kleinzoon van de schilder

Canvas 80 × 66. Inscribed *Dionijs van Nijmegen Eliaszoon oud X I jaren geschildert door Dionijs van Nijmegen Eliaszoon oud 86 jaren, 1790*
PROV Sale J Hollender, Brussels, 10-12 April 1888, lot 106
LIT Scheen 1946, fig 19. J W Niemeijer, Bull RM 17 (1969) p 84

attributed to **Elias van Nijmegen**

Nijmegen 1667–1755 Rotterdam

RBK 16709 Ornamental ceiling painting with flower and plant motifs.
Ornamentale plafondschildering met bloem- en plantmotieven

Canvas 505 × 280. In the corners is a crowned monogram, presumably the initials of the stadholder of Friesland, Hendrik Casimir II, and his wife Amalia van Anhalt-Dessau, who commissioned the work
PROV From the Chinese lacquer cabinet, constructed in 1695, that stood in the palace of the stadholders of Friesland at Leeuwarden in 1880, when it was transferred, complete with panelling, to the RMA. Belongs to the department of sculpture and applied arts
LIT J W Niemeijer, Bull RM 17 (1969) pp 77-79, fig 27. Th H Lunsingh Scheurleer, in Opstellen voor H van de Waal, Amsterdam-Leiden 1970, pp 167-71, fig 4. Cf Cat RMA Meubelen, 1952, nr 54

A 4656 & A 4657 Ornamental ceiling painting with putti in the corners. *Ornamentale plafondschildering met in de hoeken voorstellingen van putti*

Canvas in two parts, each 485 × 265
PROV Unknown. Thought to come from the palace of the stadholders of Friesland in Leeuwarden, ca 1880; possibly identical with the ceiling painting mentioned by Obreen 1887, p 119, as being in hall 152

Gerard van Nijmegen

Rotterdam 1735–1808 Rotterdam

A 4223 Mountainous landscape with wagoners driving an oxcart over a wooden bridge. *Berglandschap met voerlieden, die een ossewagen over een houten brug drijven*

Panel 62 × 89. Signed and dated *G. van Nijmegen 1790*
PROV Sale London, 17 Nov 1972, lot 36, ill
LIT C J de Bruyn Kops, Bull RM 22 (1974) pp 26-38, fig 10

Anthony Oberman

Amsterdam 1781 – 1845 Amsterdam

C 196 Two riders in a landscape. *Twee ruiters in een landschap*

Panel 29 × 36. Signed and dated *A. Oberman 1817*
PROV On loan from the city of Amsterdam (A van der Hoop bequest) since 1885
LIT J Knoef, Mndbl BK 16 (1939) p 307. Scheen 1946, fig 290. Knoef 1943, p 247. J Knoef, Jb Amstelodamum 42 (1948) pp 10, 13

C 197 Adriaan van der Hoop's trotter 'De Vlugge' in the pasture. *De harddraver 'de Vlugge' van Adriaan van der Hoop in de weide*

Canvas 60 × 54. Signed and dated *A. Oberman 1828*
PROV On loan from the city of Amsterdam (A van der Hoop bequest) since 1885
LIT J Knoef, Mndbl BK 16 (1939) p 307, ill. Knoef 1943, p 247, ill, pp 249, 251, note 3. J Knoef, Jb Amstelodamum 42 (1948) pp 10, 13. Knoef 1948, p 31

C 198 Adriaan van der Hoop's trotter 'De Rot' near the coach house. *De harddraver 'de Rot' van Adriaan van der Hoop bij het koetshuis*

Canvas 61 × 54.5. Signed and dated *A. Oberman 1828*. Inscribed on the bucket *V.D.H.* (Van der Hoop)
PROV On loan from the city of Amsterdam (A van der Hoop bequest) since 1885
LIT J Knoef, Mndbl BK 16 (1939) p 307, ill. Knoef 1943, p 246, ill, pp 249, 251, note 3. J Knoef, Jb Amstelodamum 42 (1948) pp 10, 13. Knoef 1948, p 31. VTTT, 1959, nr 13. Gerson 1961, p 14, fig 30. C C G Quarles van Ufford, OK 14 (1970) nr 4, ill

Jacob Ochtervelt

Rotterdam 1634 – 1682 Amsterdam

C 390 Four regents of the lepers' asylum, Amsterdam, 1674. *Vier regenten van het Leprozenhuis, Amsterdam, 1674*

The sitters are Anthony de Haes, Dirk van Outshoorn, Dr Bonaventura van Dortmont, Isaac Hudde, the housemaster and a woman with two children

Canvas 156 × 204. Signed and dated *J. Ochtervelt f 1674*
PROV Regents' chamber of the Leprozenhuis (lepers' asylum), Amsterdam. On loan from the city of Amsterdam, 1885-1975
LIT Scheltema 1879, p 31, nr 84. Moes 1897-1905, vol 1, nrs 2094:1, 3091, 3811. S Donahue Kuretsky, OH 87 (1973) p 128, fig 3

A 2114 The players. *De speellieden*

Canvas 75 × 60. Signed *Jac. Ochtervelt f*
PROV Bequest of Mrs H A Insinger-van Loon, dowager of M H Insinger, Amsterdam, 1903
LIT E Plietzsch, Pantheon 19-20 (1937) p 370

Willem van Odekerken

active ca 1631 in The Hague, 1643-77 in Delft

A 1279 Woman scouring a vessel. *De ketelschuurster*

Panel 73 × 59. Signed *W. Odekercke*
PROV Presented by A Willet, Amsterdam, 1885

attributed to **Willem van Odekerken**

A 3334 The servant girl. *De dienstmaagd*

Panel 31 × 24
PROV Presented by Mr & Mrs D A J Kessler-Hülsmann, Kapelle op den Bosch near Mechelen, 1940

Joseph Dionysius Odevaere

Bruges 1778 – 1830 Brussels

A 1093 The last defenders of Missolonghi, 22 April 1826: an episode from the Greek war of independance. *De laatste verdedigers van Missolonghi, 22 april 1826: episode uit de Griekse vrijheidsoorlog*

Panel 58 × 86. Signed and dated *J. Odevaere 1826*
PROV RVMM, 1885 * DRVK since 1953
LIT L Wagner, Spiegel Hist 5 (1970) p 292, fig 4

Pieter Oets

Amsterdam 1720–1780 Amsterdam

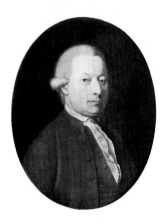

C 1325 Laurens Pieter van de Spiegel (1736-1800). Grand pensionary of Holland (1787-95). *Raadpensionaris van Holland*

The pendant portrait of his wife in the DJP Hoeufft collection is signed and dated *P. Oets 1780*

Canvas 40.5 × 32.5. Oval
PROV On loan from Jonkheer DJP Hoeufft, Dordrecht, since 1948
LIT Moes 1897-1905, vol 2, nr 7443

Hendrick ten Oever

Zwolle 1639–1716 Zwolle

A 295 A family on the terrace of a country house. *Familiegroep op het terras van een buitenverblijf*

Canvas 194 × 208. Signed and dated *H. Ten Oever A° 1669*
PROV Purchased in 1873 * DRVK since 1961 (on loan to the Provinciaal Overijssels Museum, Zwolle)
LIT Martin 1935-36, vol 2, p 155. E Plietzsch, Pantheon 29 (1942) p 136, ill. Verbeek & Schotman 1957, nr 3, fig 3. J Verbeek, Bull RM 16 (1968) p 24, ill (on the original frame)

A 2370 Still life with implements of the hunt and birds. *Stilleven van jachttuig en vogels*

Canvas 60.5 × 71. Signed and dated *H. Ten Oever. f. 1670*
PROV Sale Amsterdam, 15 Dec 1908, lot 103 * DRVK since 1958 (on loan to the Provinciaal Overijssels Museum, Zwolle)
LIT Vorenkamp 1933, p 92. E Plietzsch, Pantheon 29 (1942) p 136. Verbeek & Schotman 1957, nr 21, fig 15. Bol 1969, p 289

A 2697 Barend Hakvoort (1652-1735). Bookseller, church reader and catechism master in Zwolle. *Boekverkoper, voorlezer en catechiseermeester te Zwolle*

Canvas 65.5 × 55.5. Signed and dated *H. Ten Oever. f. 1686*. Inscribed *Aet. 34*
PROV Purchased from JA Hesterman & Son, Amsterdam, 1914 * DRVK since 1959 (on loan to the Provinciaal Overijssels Museum, Zwolle)
LIT Verbeek & Schotman 1957, nr 10, fig 10. Gudlaugsson 1959-60, vol 2, p 290

JA Oliphant

see Governors-general series: A 4548 Johannes Thedens

Jan Olis

Gorkum ca 1610–1676 Heusden

A 296 A kitchen. *Keukeninterieur*

Panel 68.5 × 81.5. Signed and dated *JOlis fecit 1645*
PROV Presented by AW Swart, 1801. NM, 1808 * DRVK since 1959 (on loan to the Dordrechts Museum, Dordrecht)
LIT Moes & van Biema 1909, pp 54, 220. Bol 1969, p 278

Isaac Oliver

see under Miniatures

Peter Oliver

see under Miniatures

Balthasar Paul Ommeganck

Antwerp 1755–1826 Antwerp

A 1094 Landscape with sheep and a hay wagon. *Landschap met schapen en een hooiwagen*

Panel 74 × 89. Signed *B.P. Ommeganck*
PROV Purchased at exhib Brussels 1824. RVMM, 1885 * DRVK since 1953

Onnes

see Kamerlingh Onnes

W Oosterdijk

active ca 1667 in Leiden?

NO PHOTOGRAPH AVAILABLE

A 1664 Portrait of a young man. *Portret van een jonge man*

A full-length portrait. The young man stands on a flight of steps, facing the beholder. His long blond hair is uncovered. He is dressed in a black velvet robe with gilt buttons, a red, white and purple striped camisole, a gold-embroidered belt around his waist, white socks and yellow leather gloves. In his right hand he holds a walking stick, in his left his hat. To the right are some steps and a balustrade, to the left a faded brown curtain. There are some trees in the right background

Canvas 153 × 122. Signed and dated *W. Oosterd... 1667*
PROV Purchased from J C de Ruyter de Wildt, Vlissingen, 1895 * Lent to the provincial governor of Zeeland, to be hung in the abbey of Middelburg, 1924. Destroyed in the war, 1940

NO PHOTOGRAPH AVAILABLE

A 1665 Portrait of a girl. *Portret van een meisje*

A full-length portrait. The girl stands on a terrace, facing left, her glance directed towards the beholder. Over her blond hair is a black hat with white feathers and yellow silk bows. She wears a brown silk dress with yellow silk ribbons. Beside her stands a large dog. To the right is a gathered-up brown curtain. To the left is a balustrade and beyond it a wooded landscape

Canvas 148 × 120. Signed and dated *W. O. 1667*
PROV Same as A 1664 * Lent to the provincial governor of Zeeland, to be hung in the abbey of Middelburg, 1924. Destroyed in the war, 1940

Dirk van Oosterhoudt

Tiel 1756– 1830 Tiel

A 3132 Jacoba van Wessem (1801-56). Wife of Mr Stumphius, burgomaster of Beverwijk. *Echtgenote van de heer Stumphius, burgemeester van Beverwijk*

Canvas 63.5 × 52. Signed *D. v. Oosterhoudt*
PROV Presented by C Th Scharten, Apeldoorn, 1932

Hermanus Adrianus van Oosterzee

Rotterdam 1863– 1933 Utrecht

A 3239 Landscape near Haamstede. *Landschap bij Haamstede*

Canvas 84.5 × 137.5. Signed *Van Oosterzee*
PROV Presented by the artist's widow, Mrs H G van Oosterzee-de Hartog, Doorn, 1935 * DRVK since 1953

Oostsanen

see Cornelisz van Oostsanen

Willem Johannes Oppenoorth

Amsterdam 1847– 1905 Utrecht

A 3087 The heath near Ede. *Heide bij Ede*

Canvas 47.5 × 63.7. Signed and dated *Willem Oppenoorth fec. 1890*
PROV Bequest of J B A M Westerwoudt, Haarlem, 1907. Received in 1929 *
DRVK since 1953

Jan Pietersz Opperdoes

b 1631/32 in Amsterdam

A 784 Farmstead with the gentleman farmer, his wife and the painter in the foreground. *Boerenhofstede met op de voorgrond de hereboer met zijn vrouw en de schilder*

Panel 39 × 38. Signed *Opperdoes*
PROV Sale Count Rasponi, Amsterdam, 30-31 Oct 1883, lot 231 (as E Murant)

Simon Opzoomer

Rotterdam 1819– 1878 Antwerp

A 1822 The last prayer of Johan van Oldenbarneveldt. *Het laatste gebed van Johan van Oldenbarneveldt*

Canvas 108 × 84. Signed *Simon Opzoomer*
PROV Bequest of Reinhard Baron van Lynden, The Hague, 1899
LIT Scheen 1946, fig 85

C 294 Magdalena Moons beseeching her fiancé Francisco Valdez to delay the storming of Leiden one more night, 1574: episode from the Eighty Years War. *Magdalena Moons smeekt haar verloofde Francisco Valdez de bestorming van Leiden nog een nacht uit te stellen, 1574: scène uit de Tachtigjarige Oorlog*

Panel 77.5 × 65
PROV On loan from the city of Amsterdam (A van der Hoop bequest) since 1885

attributed to **Barend van Orley**

Brussels ca 1488–1541 Brussels

A 2567 Madonna and child. *Maria met kind*

Panel 37.5 × 28
PROV Lent by C Hoogendijk, The Hague, 1907. Presented from his estate in 1912
LIT M J Friedländer, Jb Preusz Kunstsamml 30 (1909) p 26, fig 27. R Bangel,

Cicerone 7 (1915) p 176. Friedländer 1924-37, vol 8 (1930) p 176, nr 136a. L Baldass, Jb Kunsth Samml Wien ns 13 (1944) p 149

school of **Barend van Orley**

A 4265 The last judgment and the burial of the dead, the last of the seven works of charity. *Het laatste oordeel en het begraven der doden, het zevende werk van de Barmhartigheden*

Panel 218 × 190
PROV Aldermen's chamber, town hall, Tholen. Purchased in 1882. NMGK *
DRVK since 1957
LIT Van de Waal 1952, p 261, note 1

Willem Ormea

d 1673 in Utrecht

A 1789 Still life with fish. *Stilleven met vissen*

Panel 54.5 × 92. Signed and dated *W. Ormea fecit 1638*
PROV Purchased from Frenkel Brothers, Utrecht, 1898
LIT Vorenkamp 1933, p 80. Bernt 1960-62, vol 2, nr 619. Bernt 1969-70, vol 2, nr 885

George Jacobus Johannes van Os

Amsterdam 1805–1841 Amsterdam

A 1105 Still life with flowers in a Greek vase: allegory of spring. *Stilleven met bloemen in een griekse vaas: allegorie op de lente*

Canvas 149 × 116. Signed and dated *G. J. J. van Os 1816*
PROV Purchased in 1824. RVMM, 1885 *
DRVK since 1952

A 1104 Still life with a hunter's bag and a Greek stele: allegory of autumn. *Stilleven met jachtbuit en griekse stele: allegorie op de herfst*

Canvas 146 × 116. Signed and dated *G. J. J. van Os 1818*
PROV Purchased in 1824. RVMM, 1885 *
DRVK since 1952

C 199 Still life with flowers. *Stilleven met bloemen*

Panel 38 × 31. Signed *G. J. J. van Os*
PROV On loan from the city of Amsterdam (A van der Hoop bequest) since 1885

A 1106 Landscape near Hilversum. *Landschap in de omgeving van Hilversum*

Painted in collaboration with Pieter Gerardus van Os (1776-1839)

Canvas 81 × 100. Signed *G. J. J. van Os* and *P. G. van Os*
PROV RVMM, 1885 * DRVK since 1952
LIT Knoef 1943, p 271

Jan van Os

Middelharnis 1744 – 1808 The Hague

A 1095 Still life with flowers, fruit and birds. *Stilleven met bloemen, vruchten en gevogelte*

Panel 89 × 72. Signed and dated *J. van Os Fecit 1774*
PROV RVMM, 1885
LIT Moes & van Biema 1909, pp 148, 162, 194. Mitchell 1968, p 24, nr 33, fig 33

Maria Margaretha van Os

The Hague 1780 – 1862 The Hague

A 1107 Still life with lemon and cut glass. *Stilleven met citroen en geslepen glas*

Panel 27 × 23. Signed *M. M. van Os*
PROV Purchased at exhib Haarlem 1825, nr 300. RVMM, 1885
LIT Scheen 1946, fig 175

Pieter Frederik van Os

see Abels, Jacobus Theodorus, A 998 Afternoon in a Gelderland meadow

Pieter Gerardus van Os

The Hague 1776 – 1839 The Hague

see also Os, George Jacobus Johannes van, A 1106 Landscape near Hilversum

A 1096 Landscape with cattle. *Landschap met vee*

Panel 38 × 52. Signed and dated *PG van Os 1806*
PROV RVMM, 1885 * DRVK since 1961
LIT Knoef 1943, p 259

A 1100 A lion from the menagerie of King Louis Napoleon, 1808. *Een leeuw uit de menagerie van koning Lodewijk Napoleon, 1808*

Canvas 187 × 130. Signed *PG van Os f.*
PROV RVMM, 1885
LIT Knoef 1943, pp 151, 260ff

C 531 A Cossack outpost in 1813. *Kozakkenvoorpost in 1813*

Panel 22 × 27. Signed *PG van Os*
PROV On loan from the KOG (presented by Jonkheer J Ploos van Amstel) since 1889
LIT Marius 1920, p 68

A 4067 Cossacks on a country road near Bergen, Noord-Holland, 1813. *Kozakken op een landweg bij Bergen in Noord-Holland, 1813*

Panel 22.5 × 29.5. Signed *PG van Os fc*
PROV Sale Amsterdam, 15 Nov 1961, lot 611

A 1098 Breaking the ice on the Karnemelksloot, Naarden, January 1814. *Het doorijzen van de Karnemelksloot bij Naarden, januari 1814*

Canvas 99 × 131. Signed *P G van Os fecit*. Inscribed *Karnemelksloot January 1814*
PROV RVMM, 1885
LIT Knoef 1943, pp 261, 265, ill. Scheen 1946, fig 244. Exhib cat 150 jaar Nederlandse kunst, Amsterdam 1963, nr 32, fig 3

A 1099 The shelling of Naarden, April 1814. *Het beschieten van Naarden, april 1814*

Canvas 60 × 80. Signed *PG van Os fecit*. Inscribed *Kommerrust den 4e april 1814*
PROV RVMM, 1885

A 1103 The demilune constructed at the siege of Naarden, April 1814. *De halve maan voor Naarden bij het beleg, april 1814*

Canvas 98 × 132. Signed *PG van Os fecit*. Inscribed *Nationale Garde van Amsteldam op de Lunet voor Naarden Ochten VII April MDCCCXIV*
PROV RVMM, 1885
LIT Knoef 1943, p 265

A 1372 The casemates before Naarden, 1814. *De kazematten voor Naarden in 1814*

Canvas 55 × 65. Signed and dated *PG van Os f. 1814*
PROV RVMM, 1877? NMGK, 1887

A 1101 Landscape with cattle. *Landschap met vee*

Canvas 88 × 119. Signed and dated *PG van Os ft. 1816*
PROV Purchased at exhib Amsterdam 1816, nr 123. RVMM, 1885 ∗ DRVK since 1952

A 3229 Distant view of the meadows near 's-Graveland. *Vergezicht over de weiden bij 's-Graveland*

Pendant to A 3230

Canvas 111 × 89.5. Signed and dated *PG van Os f 1817*
PROV Presented by F G Waller, Amsterdam, 1934
LIT J Lauweriks, Mndbl BK 12 (1935) p 145, ill. M J Schretlen, Mndbl BK 19

(1942) p 9. Knoef 1943, p 266. Knoef 1948, p 50. Gerson 1961, p 16. Exhib cat 150 jaar Nederlandse kunst, Amsterdam 1963, p 85

A 3230 A watercourse near 's-Graveland. *De vaart bij 's-Graveland*

Pendant to A 3229

Canvas 111.5 × 89.5. Signed and dated *PG van Os f 1818*
PROV Same as A 3229
LIT J Lauweriks, Mndbl BK 12 (1935) p 145, ill. M J Schretlen, Mndbl BK 19 (1942) p 9. Knoef 1943, p 266. Knoef 1948, p 50. E R Meijer, OK 1 (1957) nr 22, ill. Van Gelder 1959, pl IV. Gerson 1961, p 16, fig 26. Exhib cat 150 jaar Nederlandse kunst, Amsterdam 1963, nr 33, fig 15

A 1097 Landscape with herdsmen and cattle. *Landschap met herders en vee*

Canvas 147 × 184.5. Signed and dated *PG van Os ft. 1820*
PROV Purchased at exhib Haarlem 1825, nr 297? RVMM, 1885 ∗ DRVK since 1953

A 1102 Landscape with herdsman, bullkeeper and cattle. *Landschap met herder, bulleman en vee*

Canvas 69 × 86. Signed *PG van Os f.*
PROV RVMM, 1885 * DRVK since 1959 (on loan to De Cannenburgh Castle, Vaassen)

Willem Ossenbeck

active ca 1632 in Rotterdam?

A 297 Mercury and Io. *Mercurius en Io*

Panel 37.5 × 56. Signed and dated *W. Ossenbeck F. 1632*
PROV Bequest of L Dupper Wzn, Dordrecht, 1870

A 2095 Landscape with shepherd, shepherdess and cattle. *Landschap met herderspaar en vee*

Panel 49 × 65. Signed *Ossenbeeck*
PROV Bequest of A A des Tombe, The Hague, 1903
LIT W Steenhoff, Bull NOB 4 (1902-03) p 122

Adriaen van Ostade

Haarlem 1610–1685 Haarlem

A 4093 Landscape with an old oak. *Landschap met oude eik*

Panel 34 × 46.5. Signed *A. v. Ostade*
PROV Sale J H C Heldring (Oosterbeek), London, 27 March 1963, lot 10, ill. Purchased with aid from the Rembrandt Society
LIT Hannema 1955, nr 20, pl 29 (ca 1645). Van Gelder 1959, fig 24. C J de Bruyn Kops, Jaarversl Ver Rembrandt, 1963, pp 35-36, ill. B Haak, Bull RM 12 (1964) p 5 (ca 1640). Rosenberg, Slive & Ter Kuile 1966, p 93. E Trautscholdt, Master Drawings 5 (1967) pp 161, ill, 164, nr 12. H Gerson, in Miscellanea van Regteren Altena, 1969, p 140

A 2568 Dancing couple. *Het dansende paar*

Panel 38 × 52
PROV Lent by C Hoogendijk, The Hague, 1907. Presented from his estate in 1912
LIT Hofstede de Groot 1907-28, vol 3 (1910) nr 16. R Bangel, Cicerone 7 (1915) p 181, fig 6

C 1127 Laughing peasant. *Lachende boer*

Panel 16 × 14. Signed and dated *AV Ostade 1646*
PROV On loan from the Museum Boymans, Rotterdam, since 1924
LIT Hofstede de Groot 1907-28, vol 3 (1910) nr 882. Martin 1935-36, vol 1, p 389, fig 232

A 300 The quack. *De kwakzalver*

Panel 27.5 × 22. Signed and dated *AV Ostade 1648*
PROV Bequest of L Dupper Wzn, Dordrecht, 1870 * DRVK since 1956 (on loan to the Frans Halsmuseum, Haarlem)
LIT C von Lützow, Zeitschr BK 5 (1870) p 229. Hofstede de Groot 1907-28, vol 3 (1910) nr 402

A 2332 'The skaters': peasants in an interior. *'De schaatsenrijders': boerengezelschap in interieur*

Panel 44 × 35.5. Signed and dated
AV Ostade 1650
PROV Purchased from the heirs of
Jonkheer P H Six van Vromade,
Amsterdam, 1908
LIT W Steenhoff, Onze Kunst 13 (1908)
pp 212-14, ill. Hofstede de Groot 1907-
28, vol 3 (1910) nr 621. Martin 1935-36,
vol 1, pp 392, 394, fig 233. J A Emmens,
OKtv 3 (1965) nr 3, fig 5. E van Uitert,
OK 12 (1968) tv, pp 3, 5, ill on p 4

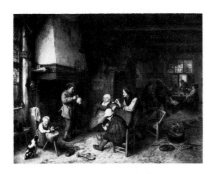

C 200 Peasants in an interior. *Boeren-
gezelschap binnenshuis*

Copper 37 × 47. Signed and dated
AV. Ostade 1661
PROV On loan from the city of
Amsterdam (A van der Hoop bequest)
since 1885
LIT Hofstede de Groot 1907-28, vol 3
(1910) nr 620. E Darier, GdB-A 41
(1949) p 66

A 3281 Portrait of a scholar. *Portret van
een geleerde*

Canvas 19 × 17.6. Signed and dated
AVOstade 1665
PROV Presented by K Arnhold & A
Arnhold, London, 1939

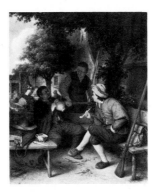

A 299 Travellers at rest. *Rustende reizigers*

Panel 36 × 30. Signed and dated
AV. Ostade 1671
PROV Purchased with the Kabinet van
Heteren Gevers, The Hague-Rotterdam,
1809
LIT Moes & van Biema 1909, pp 148,
162. Hofstede de Groot 1907-28, vol 3
(1910) nr 778. Martin 1935-36, vol 1,
p 394

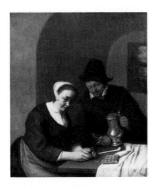

C 201 A confidential chat. *Het
vertrouwelijk onderhoud*

Panel 22 × 21.5. Signed and dated
AV Ostade 1672
PROV On loan from the city of
Amsterdam (A van der Hoop bequest)
since 1885
LIT Hofstede de Groot 1907-28, vol 3
(1910) nr 287

A 3246 The fishwife. *De visvrouw*

Canvas 36.5 × 39.5. Signed and dated
AV Ostade 1672

PROV Presented by Sir Henry W A
Deterding, London, 1936
LIT Smith 1829-42, vol 1, p 119, nr 42;
suppl vol, p 117, nr 126. Hofstede de
Groot 1907-28, vol 3 (1910) nr 130. C
Veth, Mndbl BK 13 (1936) p 173. Bille
1961, vol 1, p 86, ill; vol 2, pp 37, 109,
nr 155

A 298 The painter's studio. *Schilders-
atelier*

Panel 37 × 36. Signed *AO*
PROV Sale G van der Pot van
Groeneveld, Rotterdam, 6 June 1808, lot
96
LIT W Martin, Burl Mag 7 (1905) p 423.
Moes & van Biema 1909, pp 113, 184.
Hofstede de Groot 1907-28, vol 3 (1910)
nr 97. E Wiersum, OH 48 (1931) pp 210,
212, fig 6. Van Schendel 1948, pp 77,
149, fig 1. Gerson 1951, p 29, fig 77. Van
Hall 1963, p 239, nr 1584:1. Exhib cat
De schilder in zijn wereld, Delft-
Antwerp 1965, nr 89, fig 27. J A Emmens,
OKtv 3 (1965) nr 3. F van Leeuwen,
Kroniek Rembrandthuis 20 (1966) ill on
p 72

A 302 The merry peasant. *De vrolijke boer*

Panel 16.5 × 14.5. Signed *AV Ostade*
PROV Sale G van der Pot van
Groeneveld, Rotterdam, 6 June 1808, lot
98
LIT Moes & van Biema 1909, pp 113,
182. Hofstede de Groot 1907-28, vol 3
(1910) nr 138. E Wiersum, OH 48 (1931)
p 210

A 4049 Portrait of a boy. *Portret van een jongen*

Panel 10 cm in diam
PROV Presented by Mr & Mrs I de Bruijn-van der Leeuw, Muri near Bern, 1961
LIT J L Cleveringa, Bull RM 9 (1961) p 65, nr 12

A 301 A baker blowing his horn. *Een bakker blazend op zijn hoorn*

Panel 27.5 × 22
PROV Bequest of L Dupper Wzn, Dordrecht, 1870
LIT C von Lützow, Zeitschr BK 5 (1870) p 229. Hofstede de Groot 1907-28, vol 3 (1910) nr 29. L van Buyten, Spiegel Hist 2 (1967) ill on cover

copy after **Adriaen van Ostade**

C 564 A woman gutting herring in front of her house. *Een vrouw haring schoonmakend voor haar huis*

Panel 40 × 32.5. Signed and dated falsely *AV Ostade 1648*
PROV On loan from the city of Amsterdam (bequest of Mrs M C Messchert van Vollenhoven-van Lennep) since 1892
LIT C Hofstede de Groot, OH 17 (1899) p 169. Hofstede de Groot 1907-28, vol 3 (1910) nr 311a

Isaack van Ostade

Haarlem 1621 – 1649 Haarlem

A 303 Country inn with a horse at the trough. *Boerenherberg met paard aan de trog*

Panel 52 × 69. Signed and dated *Isack van Ostade 1643*
PROV Purchased with the Kabinet van Heteren Gevers, The Hague-Rotterdam, 1809
LIT Moes & van Biema 1909, pp 148, 163. Hofstede de Groot 1907-28, vol 3 (1910) nr 7

C 202 Country inn with horse and wagon. *Boerenherberg met paard en wagen*

Panel 56 × 47. Signed *Isack van Ostade*
PROV On loan from the city of Amsterdam (A van der Hoop bequest) since 1885
LIT Hofstede de Groot 1907-28, vol 3 (1910) nr 8

Jacobus Hermanus Otterbeek

The Hague 1839 – 1902 The Hague

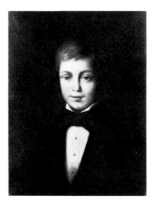

C 1571 Jacob van Eeghen (1818-34) at the age of twelve. *Op twaalfjarige leeftijd*

Canvas 64.5 × 50. Signed and dated *Otterbeek 1878*. Inscribed *naar een pastel van het jaar 1830*
PROV On loan from the KOG (presented by the dowager of H A van Karnebeek, née P Rochussen) since 1973

Johannes Dircksz van Oudenrogge

Leiden 1622 – 1653 Haarlem

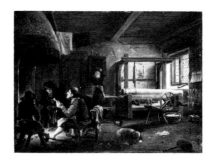

A 304 Weaver's workshop. *Weverswerkplaats*

Panel 41 × 56. Signed and dated *J. Oudenrogge 1652*
PROV Sale Amsterdam, 19 April 1819, lot 35
LIT Heppner 1938, p 20, fig 10. B J A Renckens, OH 73 (1958) p 110, fig 2. Bernt 1960-62, vol 4, nr 219. Bol 1969, p 209. Bernt 1969-70, vol 2, nr 896

Jean-Baptiste Oudry

see Miniatures: French school ca 1725, A 4417 Deer hunt, after Oudry

Pierre Justin Ouvrié

Paris 1806–1879 Rouen

A 2831 The town of Sankt Goar on the Rhine. *Het stadje Sankt Goar aan de Rijn*

Panel 31.5 ×46.5. Signed and dated *Justin Ouvrié 1856*
PROV Bequest of Mrs M N Th Weddik-Lublink Weddik, widow of A L Weddik, Arnhem, 1919 * DRVK since 1964

Isaak Ouwater

Amsterdam 1750–1793 Amsterdam

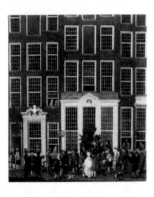

A 4026 The bookshop and lottery agency of Jan de Groot on the Kalverstraat, Amsterdam. *De boekhandel en het loterij-kantoor van Jan de Groot in de Kalverstraat te Amsterdam*

Canvas 38.5 ×33.5. Signed and dated *Ik Ouwater 10 $\frac{17}{79}$ 25* (25 October 1779). Inscribed above the storefront *Dum teritur cos literatis, usui et literis prosit bonis* (chronogram of the year 1728), above the portrait in the storefront *Hugo Grotius*, on the awning *Hier werdt Gecolletet… Ginnera … loterij*, on the plinth above the door to the left *De Graaf* [van] *Holland* and beneath the façade tablet to the right '*T Hof van Hollandt*
PROV Sale Amsterdam, 22 March 1960, lot 61
LIT E R Meijer, OK 4 (1961) nr 13, ill. Med OKW, 1965, p 24. Rosenberg, Slive & Ter Kuile 1966, p 218, fig 176A

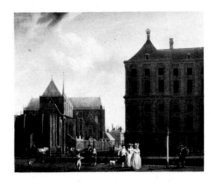

A 305 The partially erected (and never completed) tower of the Nieuwe Kerk and the rear façade of the town hall, Amsterdam. *De nimmer voltooide toren van de Nieuwe Kerk en de achterkant van het Stadhuis te Amsterdam*

Pendant to A 306

Canvas 59 ×73. Signed *Ik Ouwater*
PROV Sale G Schimmelpenninck, Amsterdam, 12 July 1819, lot 87 (as in collaboration with Hendrik Meyer)
LIT VTTT, 1960, nr 29

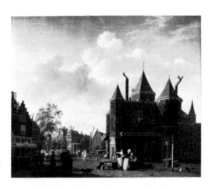

A 306 The St Anthony weighing house in Amsterdam. *De Sint Antoniuswaag te Amsterdam*

Pendant to A 305

Canvas 60 ×74. Signed *Ik Ouwater*
PROV Same as A 305 * On loan to the AHM since 1947
LIT Huebner 1942, fig 9. J W Niemeijer, Apollo 96 (1972) p 390, fig 5

Jürgen Ovens

Tönning 1623–1678 Friedrichstadt

C 17 Johan Bernard Schaep (1633-66). Alderman of Amsterdam, 1659. *Schepen van Amsterdam*

Canvas 115 ×86. Signed *J. Ovens fc*. On the verso his coat of arms and the inscription *Jan Bernd Schaap getrout met Margareta Backer*
PROV On loan from the city of Amsterdam (Bicker bequest), 1881-1975
LIT Meyer 1876, p 101. Moes 1897-1905, vol 2, nr 6825:1. Schmidt 1922, pp 33, 189, nr 257. M Sauerlandt, Cicerone 16 (1924) p 124

A 850 A couple with six children. *Een echtpaar met zes kinderen*

Canvas 113 ×173.5
PROV Sale van der Willigen, Haarlem, 20 April 1874, lot 104 (as J B Weenix, portrait of Rijcklof van Goens and his family). NMGK, 1885
LIT Moes 1897-1905, vol 1, nr 2773:4. Schmidt 1922, p 200, nr 314

A 1257 Portrait of a woman with four children, depicted as Caritas. *Portret van een vrouw met vier kinderen, voorgesteld als Caritas*

Canvas 118 × 102
PROV Presented by J S R van de Poll, Arnhem, 1885
LIT Schmidt 1922, p 200, nr 315

A 1680 Cornelis Nuyts (1574-1661). Amsterdam merchant. *Koopman te Amsterdam*

Canvas 163 × 128. Inscribed *Cornelis Nuyts gheportraiteert in 1658 oud 84 jaaren : na het af branden van sijne Suijcker Raffinaderije 't Amsterdam maeckte sijne Familije gheluckkich door groote Conquesten in Oost-Indien : Obijt in den ouderdom van 87 Jaaren den VII Junij A° 1661*
PROV Purchased from E Gaudouin, Paris, 1896
LIT Schmidt 1922, p 184, nr 238

A 2161 Jan Amos Comenius (Komenský) (1592-1670). Czech humanist and pedagogue. Exiled as a leader of the Moravian or Bohemian Brethren and settled in Amsterdam in 1656. *Tsjechisch humanist en pedagoog. Als voorganger van de Moravische of Boheemse Broedergemeente verdreven en sedert 1656 gevestigd te Amsterdam*

Canvas 64 × 56
PROV Sale Amsterdam, 27-29 June 1905, lot 78
LIT Schmidt 1922, p 177, nr 211. J M A van Rooyen, Historia 3 (1937) p 79. T den Herder, Ons Amsterdam 22 (1970) p 264, ill on p 261

manner of **Jürgen Ovens**

A 3749 Portrait of a man, thought to be Jan van Reygersbergh. *Portret van een man, vermoedelijk Jan van Reygersbergh*

Pendant to A 3750
see also Heraldic objects: A 3752

Canvas 128 × 95.5
PROV Presented by G J K Baron van Lynden van Horstwaerde, Doorwerth, 1950

A 3750 Portrait of a woman, thought to be Sara van Os (b 1610), wife of Jan van Reygersbergh. *Portret van een vrouw, vermoedelijk Sara van Os, echtgenote van Jan van Reygersbergh*

Pendant to A 3749
see also Heraldic objects: A 3751

Canvas 128 × 95.5
PROV Same as A 3749

Leendert Overbeek

Haarlem 1752 – 1815 Haarlem

A 4266 Shepherdess with sheep. *Herderin met schapen*

Pendant to A 4267

Verre églomisé in gold and black enamel 35.5 × 28.8. Signed *Leend Overbeek*

PROV Presented by the Misses J J and E S Kramer to the RMA department of sculpture and applied arts, 1942. Transferred to the department of paintings in 1973

A 4267 Shepherd near a farmstead. *Herder bij een boerenhoeve*

Pendant to A 4266

Verre églomisé in gold and black enamel 35.5 × 28.8. Signed *Leend t Overbeek*
PROV Same as A 4266

Pieter Oyens

Amsterdam 1842 – 1894 Brussels

A 4136 Hendrik Waller (1887-1951) at the age of three. *Op driejarige leeftijd*

Canvas 55 × 47. Signed and dated *P. Oyens f 1890*
PROV Bequest of Mrs E J F Waller-Nusselein, Heelsum, 1967
LIT Bull RM 16 (1968) p 38, fig 2

433

Joseph Paelinck

Oostacker 1781 – 1839 Brussels

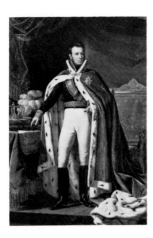

C 1460 Willem I (1772-1843), king of the Netherlands. *Koning der Nederlanden*

Canvas 227 × 155.5. Signed and dated *J. Paelinck Peintre de S. M. La Reine des Pays Bas à Bruxelles. 1819*. Inscribed on the map *Kaart van het Ryk van Bantam, Batavia [?] & Cheribon op het eylant Java* PROV Residence of the Dutch high commissioner, Djakarta, 1960. On loan from the DRVK since 1961 LIT Immerzeel 1842-43, vol 2 (1842) p 291. Th P M de Jong, Spiegel Hist 1 (1967) p 29, fig 1

A 1108 The toilet of Psyche. *Het toilet van Psyche*

Canvas 277 × 362. Signed and dated *J. Paelinck 1823* PROV Purchased at exhib Amsterdam 1823? RVMM, 1885 (in damaged condition)

Joos de Paepe

b Oudenaerde; d 1646 Rome

A 2961 Venus and Adonis. *Venus en Adonis*

Panel 114 × 104. Signed and dated *Joos de Paepe 1629* PROV Presented by a group of members of the Rembrandt Society, 1922

Anthonie Palamedesz

Delft 1601 – 1673 Amsterdam

A 1906 Merry company in a room. *Vrolijk gezelschap in een kamer*

Panel 54.5 × 88.5. Signed and dated *A. Palamedes 1633* PROV Purchased from Jonkheer J K J de Jonge, The Hague, 1900 LIT Würtenberger 1937, p 75. E Plietzsch, Wallraf-R Jb 18 (1956) p 180, fig 145. Plietzsch 1960, p 34, fig 33

A 3024 Soldiers in a guardroom. *Wachtlokaal met soldaten*

Panel 38 × 52. Signed and dated *A. Palamedes 1647*

PROV Presented from the estate of Mrs O E A E Wüste, Baroness von Gotsch, widow of J R Wüste, Santpoort, 1924 LIT Würtenberger 1937, p 78

A 4138 Jacobus Trigland (1583-1654). Theologian. *Theoloog*

Panel 30.5 × 23.8. Signed and dated *A Palamedes pinxit A° 1650*. Inscribed *Æt 66* PROV Sale Paris, 26 Nov 1967, lot 27

A 1615 Pieter de Witte (1588-1653). Burgomaster of Zierikzee. *Burgemeester van Zierikzee*

Pendant to A 1616

Canvas 82 × 67. Signed and dated *A. Palamedes pinxit A° 1652*. Inscribed *Æt: 64* PROV Purchased from J F van der Leck de Clercq, Rotterdam, 1894 LIT Moes 1897-1905, vol 2, nr 9204:2. Van Beresteyn & del Campo Hartmann 1941-54, vol 2, p 50, nr 99, ill

A 1616 Caecilia van Beresteyn (1589-1661). Wife of Pieter de Witte. *Echtgenote van Pieter de Witte*

Pendant to A 1615 For another portrait of the sitter, *see* Mierevelt, M J van, A 2067

Canvas 83 × 68. Signed and dated *A. Palamedes pinxit. A° 1652*. Inscribed *Æt: 64*

PROV Same as A 1615
LIT Van Beresteyn & del Campo
Hartmann 1941-54, vol 2, p 53, nr 104,
ill

A 3114 Portrait of a young woman.
Portret van een jonge vrouw

Canvas 82.5 × 69. Signed and dated
A. Palamedes pinxit A° 1654. Inscribed
Æt: 17
PROV Purchased from Miss E C N
Hasselman, Egmond aan den Hoef, 1930,
as a gift of the Photo Commission

manner of **Anthonie Palamedesz**

A 3335 Distinguished company in a
room. *Voornaam gezelschap in een kamer*

Panel 35 × 49
PROV Presented by Mr & Mrs D A J
Kessler-Hülsmann, Kapelle op den
Bosch near Mechelen, 1940

A 1623 Portrait of a woman. *Portret van
een vrouw*

Canvas 126.5 × 101. Dated *AN° 1641*
PROV Bequest of Mrs J Balguerie-van
Rijswijk, widow of D Balguerie,
Amsterdam, 1823

A 861 Portrait of three girls in a land-
scape. *Portret van drie meisjes in een land-
schap*

Canvas 195 × 188
PROV From the Delft post office (the
house named 'Spangien,' where Michiel
Jansz van Miereveld is said to have
lived), 1875. NMGK, 1885
LIT Havard 1879-81, vol 1, p 37, note

Martin Palin

see Governors-general series: A 3766,
A 4536 Ryclof van Goens; A 3767,
A 4537 Cornelis Speelman

copy after **Jacopo Palma il Vecchio**

Bergamo ca 1480–1528 Venice

A 594 The holy family. *De heilige familie*

Canvas 95 × 133
PROV Presented by J P G Baron Spaen
van Biljoen, 1808 * DRVK since 1961
LIT Moes & van Biema 1909, pp 129, 211

Jacopo Palma il Giovane

Venice 1544–1628 Venice

A 1235 Lot and his daughters. *Loth en zijn
dochters*

Canvas 118 × 163. Signed *Jacobus
Palma F.*
PROV NM before or after 1801 (as
Romanelli). KKS, 1885
LIT Moes & van Biema 1909, p 210

Jan Palthe

Deventer 1717–1769 Leiden

C 19 Pieter Cypriaan Testart (1717-98).
Secretary of Amsterdam, director of the

Dutch West India Company. *Secretaris van Amsterdam, bewindhebber van de West Indische Compagnie*

Pendant to C 20

Panel 86 × 63. Signed and dated
J. Palthe 1747
PROV On loan from the city of Amsterdam (Bicker bequest), 1881-1975
LIT Moes 1897-1905, vol 2, nr 7899

C 20 Agatha Hieronima Nobel (1728-1822). Wife of Pieter Cypriaan Testart. *Echtgenote van Pieter Cypriaan Testart*

Pendant to C 19

Panel 86 × 63. Signed and dated
I. Palthe 1740 (painted over and possibly changed). Inscribed *NO 52*
PROV Same as C 19
LIT Moes 1897-1905, vol 2, nr 5408:2

C 18 Theodora van der Marck (b 1693). Widow of Theodorus Nobel (1688?-1736) with her grandchildren Jan Baptist Theodoor, Geertruida Elisabeth (1747-1816) and Hieronyma Johanna (1749-1822), children of Agatha Hieronima Nobel and Pieter Cypriaan Testart. *Weduwe van Theodorus Nobel, met haar kleinkinderen Jan Baptist Theodoor, Geertruida Elisabeth en Hieronyma Johanna, kinderen van Agatha Hieronima Nobel en Pieter Cypriaan Testart*

Canvas 96 × 80. Signed and dated
J. Palthe pinx. 1750
PROV On loan from the city of Amsterdam (Bicker bequest), 1881-1975
LIT Moes 1897-1905, vol 2, nrs 7896-98

NO PHOTOGRAPHS AVAILABLE

A 1652 Johan Willem Parker (1721-80). Burgomaster of Middelburg. *Burgemeester van Middelburg*

Half-length portrait. Parker stands

beside a stone fountain on which his right arm rests. He wears no hat over his powdered wig. He has a blue velvet gown and a white silk camisole on, and grasps a walking stick in his right hand; his left hand is stuck in his bosom

Pendant to A 1653

Canvas 50 × 41.5. Signed and dated
J. Palthe 1756
PROV Purchased from J C de Ruyter de Wildt, Vlissingen, 1895 * Lent to the Stedelijk Museum, Middelburg, 1926. Destroyed in the war, 1940

A 1653 Jacoba Maria van Bueren, called van Regteren (1718-91). Wife of Johan Willem Parker with her seven-year-old son Willem. *Echtgenote van Johan Willem Parker met haar zevenjarig zoontje Willem*

Jacoba Maria is portrayed in half-length, sitting in a red velvet chair beside a column. She is bareheaded and wears a white satin gown. In her right hand is a rose twig. Next to her son is a dog. Behind them is a red velvet curtain

Pendant to A 1652

Canvas 50 × 41.5. Signed and dated
J. Palthe 1756
PROV Same as A 1652 * Lent to the Stedelijk Museum, Middelburg, 1926. Destroyed in the war, 1940

Alberto Pasini

Busseto 1826 – 1899 Cavoretto

NO PHOTOGRAPH AVAILABLE

A 1895 Horses in an Algerian pasture. *Paardenweide in Algerië*

In a pasture among the mountains a herd of horses is grazing. In the left foreground are some puddles. To the right are several tents beneath the high palms; nearby is the small figure of someone lighting a fire. There are some fleecy clouds in the bright blue sky

Canvas 59.5 × 95. Signed and dated
A. Pasini 1880
PROV Presented by the dowager of R Baron van Lynden, née M C Baroness van Pallandt, The Hague, 1900 * Lent to the Gouvernementsgebouw (provincial capitol) of Gelderland, Arnhem, 1924. Irreparably damaged in the war, 1944

Crispijn de Passe II

see Panpoeticon Batavum: A 4564 Jacobus Schotte, by Jan Maurits Quinkhard after de Passe; A 4613 David Lingelbach I, by Arnoud van Halen after de Passe

manner of **Joachim Patenir**

Dinant ca 1480 – 1524 Antwerp

A 3336 Landscape with the temptation of St Anthony. *Landschap met de verzoeking van de heilige Antonius de Heremiet*

Panel 57 × 29.5
PROV Presented by Mr & Mrs D A J Kessler-Hülsmann, Kapelle op den Bosch near Mechelen, 1940 * On loan to the KKS (cat 1968, p 43, nr 894, as milieu of Patinir, ca 1520) since 1951
LIT Friedländer 1947, p 62. Castelli 1966, p 27, pls V-VI

Jean-Baptiste Pater

Valenciennes 1695 – 1736 Paris

A 3257 Gallant company in a landscape. *Galant gezelschap in een landschap*

Canvas 50.5 × 60.5
PROV Presented by Sir Henry W A Deterding, London, 1936
LIT Ingersoll-Smouse 1928, nr 209

Louis Patru

Champel 1871 – 1905 Geneva

A 4165 Landscape. *Landschap*

Canvas 75 × 105. Signed *L. Patru*
PROV Unknown

Hendrik Paulides

see Governors-general series : A 3818
A C D de Graeff

Auguste Antoine Joseph Payen

Brussels 1792 – 1853 Tournai

A 3452 The house of the assistant
resident of Banjuwangi, East Java.
*Gezicht op het huis van de assistent-resident
te Banjoewangi (Oost-Java)*

Canvas 65 × 53. Signed and dated
A. A. J. Payen 1828
PROV Purchased from Mrs J Vuyk,
Amsterdam, 1942
LIT Exhib cat Nederlandse schilders en
tekenaars in de Oost, Amsterdam 1972,
nr 57

Pee

see Wolters-van Pee

Bonaventura Peeters I

Antwerp 1614 – 1652 Hoboken

A 1949 Ships near a pier. *Schepen bij een
steiger*

Panel 36.5 × 69. Signed *B. P.*
PROV Purchased from the G de Clercq
collection, Amsterdam, 1899, through
the intermediacy of the Rembrandt
Society

A 2518 Polar bear hunt on the coast of
Norway? *IJsberenjacht op de kust van
Noorwegen?*

Canvas 66 × 142.5. Signed *B. P.*
PROV Purchased from F Poupe Serrane,
Brussels, 1910

Clara Peeters

Antwerp 1589 – after 1657

A 2111 Still life with fish, oysters and
shrimps. *Stilleven met vissen, oesters en
garnalen*

Panel 25 × 35. Signed *Clara P.*
PROV Purchased from J Goudstikker
gallery, Amsterdam, 1903

LIT Vroom 1945, p 116, nr 240. Hairs
1955, pp 127, 230. Greindl 1956, p 178.
Bernt 1960-62, vol 2, nr 639. Bernt 1969-
70, vol 2, nr 909

Gilles Peeters

Antwerp 1612 – 1653 Antwerp

A 834 Landscape with a watermill.
Landschap met watermolen

Panel 43 × 59.5. Oval. Signed and dated
Gillis. Peeters 1633
PROV Presented by Dr A Bredius, The
Hague, 1884
LIT Thiéry 1953, p 188. Bernt 1960-62,
vol 4, nr 223. Bernt 1969-70, vol 2, nr
910

Arthur Douglas Peppercorn

London 1847 – 1926 London?

A 1896 A cow in the twilight. *Een koe in
de schemering*

Canvas 61 × 52. Signed *Peppercorn*
PROV Presented by the dowager of R
Baron van Lynden, née M C Baroness
van Pallandt, The Hague, 1900 * DRVK
since 1952

Perné

see van de Wall Perné

copy after Jean-Baptiste Perronneau

Paris 1715–1783 Amsterdam

see also under Pastels

A 3476 Antoni Warin (1712-64). Alder-man of Amsterdam. *Schepen van Amsterdam*

Anonymous copy after a pastel of 1763 in the Count van Lynden collection, Nederhorst Manor near Nigtevegt

Panel 62 × 46.5
PROV Purchased from PA Engelbrecht, Rotterdam, 1946

Reinier van Persijn

see Panpoeticon Batavum: A 4585 Hendrik Bruno, by Arnoud van Halen, after van Persijn

N le *or* NL Peschier

active 1659-61 in Leiden?

A 1686 Vanitas still life. *Vanitas stilleven*

Canvas 57 × 70. Signed and dated *Peschier Fecit 1660*
PROV Purchased from MJ van Gelder, Amsterdam, 1897
LIT Faré 1962, vol 2, fig 148. P Gammelbo, Studia Muzealne 4 (1964) p 74, fig 63. Bol 1969, p 358, note 615. Exhib cat IJdelheid der IJdelheden, Leiden 1970, nr 21

manner of Antoine Pesne

Paris 1683–1757 Berlin

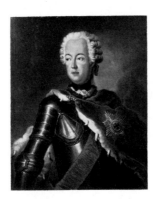

A 886 August Wilhelm (1722-58), prince of Prussia. *Prins van Pruisen*

Canvas 82 × 66.5
PROV KKS, 1876. NMGK, 1885

Jean Petitot

see under Miniatures

Phaff

see under Miniatures

Karel Frans Phlippeau

Amsterdam 1825–1897 Princenhage

A 2134 Two peasant women and a girl from the Roman Campagna near a lake.

Twee boerinnen en een meisje uit de Romeinse Campagna bij een meer

Panel 29.5 × 40. Signed and dated *Phlippeau 1866*
PROV Presented by FJMA Reekers, Amsterdam, 1904 * DRVK since 1952
LIT GJ Hoogewerff, Med Ned Hist Inst Rome 2d ser 3 (1933) p 181, fig 9

attributed to Giovanni Battista Piazzetta

Venice 1682–1754 Venice

A 3412 Girl selling fruit. *Het fruitmeisje*

Canvas 83 × 64.5
PROV Bequest of JW Edwin vom Rath, Amsterdam, 1941
LIT Venturi 1927, p 394, fig 270 (Piazzetta; the same author afterwards attributed the painting orally to Domenico Maggiotto). MA Bulgarelli, Arte Ven 27 (1973) p 223, ill (Maggiotto)

Pickenoy

see Eliasz, Nicolaes, called Pickenoy

Cornelis Picolet

Rotterdam 1626–1673 Rotterdam

A 1712 Two young men preparing to go horseback riding. *Twee jongemannen gereed voor een rit te paard*

Canvas 68.5 × 59. Signed and dated *C. Picolet fe 1664*
PROV Sale G de Clercq, 1 June 1897, lot 79. Purchased with aid from the Rembrandt Society * DRVK since 1959

Charles Picqué

Deynse 1799 – 1869 Brussels

A 1109 A St Bernard dog arriving to help a lost woman with a sick child. *Een Sint Bernardshond komt een verdwaalde vrouw met een ziek kind te hulp*

Canvas 136 × 113. Signed and dated *C. Picqué 1827*
PROV RVMM, 1885

Nicolas Piemont

Amsterdam 1659 – 1709 Vollenhoven

a

b

c & d

e

NM 1010 Painted decorations of the salon of Petronella Oortman's dollhouse. *Beschilderingen van de zaal van het poppenhuis van Petronella Oortman*

a Italian landscape with a broken tree
b Italian landscape with a muledriver
c Italian landscape with travelers flanking
d a flower piece framed in a fireplace
e a cloudy sky with birds (ceiling)

For the dollhouse as a whole, *see* cat RMA Meubelen, 1952, nr 358; for other parts of the decoration, *see* Royen, Hendrik Wilhelmus van, NM 1010, and Voorhout, Johannes, NM 1010; and for a painting of the dollhouse, *see* Appel, Jacob, A 4245

Panel 51.5 × 67 (a, b); 51.5 × 68.5 (c & d combined); 66 × 69 (e). Signed *Pimont* (a, b); *N.P.* (c). Above the flower piece (d) is a cartouche with the monogram *JE* or *EJ*
PROV KKZ, 1875. Belongs to the department of sculpture and applied arts
LIT Leesberg-Terwindt 1960, figs 13, 15. CJ de Bruyn Kops, Mndbl Amstelodamum 61 (1974) p 110

Jan Willem Pieneman

Abcoude 1779 – 1853 Amsterdam

A 4268 Allegory of the death of Willem V, prince of Orange, 1806. *Allegorie op de dood van Willem V, prins van Oranje, 1806*

Panel 53 × 41.5. Signed *J. W. Pieneman Fecit*. Painted in 1806
PROV RVMM, 1877? NMGK
LIT Knoef 1943, pp 100, 102, ill

A 4269 The voluntary sacrifice of Reverend Hambroeck on Taiwan, 1662. *De zelfopoffering van predikant Hambroeck op Formosa, 1662*

Canvas 102 × 114. Signed and dated *J. W. Pieneman 1810*
PROV RVMM, 1877? NMGK
LIT Knoef 1943, pp 103-04, fig on p 105. Knoef 1948, p 45

A 1110 Arcadian landscape. *Arcadisch landschap*

Canvas 70 × 84. Signed and dated
J. W. Pieneman Fecit 1813
PROV RVMM, 1885
LIT Knoef 1943, pp 103, 108, ill. Scheen 1946, fig 264

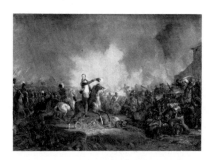

A 1520 The prince of Orange near Quatre Bras, 16 June 1815. *De prins van Oranje bij Quatre Bras, 16 juni 1815*

Canvas 54 × 77. Painted in 1817-18. Design for the painting in the collection of Her Majesty the Queen, Soestdijk Palace
PROV Sale van Goethem-de Soere, Amsterdam, 1 April 1890, lot 204? (as anonymous, The prince of Orange near Waterloo)
LIT Scheltema 1818 (description of the definitive version). J van Lennep, Kunstkronijk, 1853, pp 4-5. Marius 1920, pp 14, 17. Knoef 1943, pp 105-07, ill. Knoef 1948, p 45. Gerson 1961, p 18, fig 34

A 1111 Joanna Cornelia Ziesenis-Wattier (1762-1827). Actress. *Toneel-speelster*

Canvas 70 × 54. Signed and dated
J. W. Pieneman 1819
PROV RVMM, 1885 * DRVK since 1953

A 1113 The actress Joanna Cornelia Ziesenis-Wattier (1762-1827) as Agrippina in the play 'Britannicus' by Jean Racine (1639-99). *De toneelspeelster Joanna Cornelia Ziesenis-Wattier in de rol van Agrippina in 'Britannicus' van Jean Racine*

Canvas 259 × 202. Painted ca 1819
PROV Presented by the artist's daughter, Mrs C U Boelen-Pieneman, De Bilt, 1869. RVMM, 1885 * DRVK since 1953

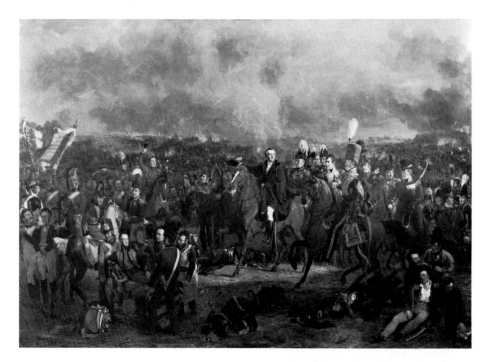

A 1115 The battle of Waterloo. *De slag bij Waterloo*

As the wounded prince of Orange is carried off the battlefield, Wellington orders the general attack. The main figures are, from left to right, Major-general Cambronne, second from left, Sergeant Ewart, with the eagle of the 45th French regiment, Captain Ch Graaf, adjutant of the prince of Orange. On the stretcher is Willem Frederik George Lodewijk, prince of Orange, later King Willem II. Behind him, mounted, is Major-general Count van Reede and

behind him is Lieutenant-colonel John William Fremantle, waving his cocked hat. To their right is Lieutenant-colonel Lord Fitzroy-Somerset, beside his horse, the commander-in-chief Arthur duke of Wellington, Major-general George Cooke, Colonel F E Hervey, Colonel Sir Colin-Campbell, Lieutenant-general Don Miguel de Alava, Lieutenant-colonel F C Ponsonby, Lieutenant-general Lord Uxbridge, Major William Thornhill, Lieutenant-general Sir Rowland Hill and Colonel Colborn. On the far right, in a single row, are Major-general Jean Victor Baron de Constant de Rebecque, Colonel Sir John Elley, Lieutenant-colonel F N L Aberson and Major-general A K J G d'Aubremé. In the right foreground are Colonel Sir William Howe de Lancey and, behind him, an English doctor

Canvas 576 × 836. Signed and dated
J. W. Pieneman 1824
PROV Purchased by King Willem I from the artist. RVMM, 1885. On loan from Her Majesty the Queen
LIT Beschrijving van de schilderij, voorstellende den veldslag bij Waterloo, op den 18 Junij 1815, vervaardigd door J W Pieneman, [Amsterdam 1824]. Colenbrander 1915, p 686. Marius 1920, pp 7, 14, 16-17, fig 4. Huebner 1942, p 64. Knoef 1943, pp 108-09. Scheen 1946, fig 133. Knoef 1947, pp 20, 151-52. Knoef 1948, pp 45, 47. J A Groen, Ons Amsterdam 9 (1957) ill on p 187. Gerson 1961, p 18. Percival 1969, ill on p 48, 49. A A E Vels Heijn, OK 15 (1972) nr 21. Vels Heijn 1974, pp 10-11, 260-61

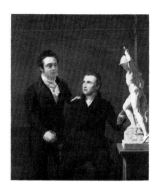

A 1114 Louis Royer (1787-1847), sculptor, and Albertus Bernardus Roothaan (1793-1868), stockbroker, art lover and patron of the sciences. *Louis Royer, beeldhouwer, en Albertus Bernardus Roothaan, makelaar in effecten, kunstvriend en bevorderaar der wetenschappen*

Canvas 175 × 146. Signed and dated *J.W.P. fecit 1825*
PROV Presented by G F Westerman and other art lovers, 1867. RVMM, 1885
LIT Ned Spec, 1867, p 225. Van Daalen 1957, p 99. VTTT, 1960, nr 22. E R Meijer, Bull RM 10 (1962) nr 17, ill. Van Hall 1963, p 282, nr 1807:2. E R Meijer, OK 8 (1964) nr 17, ill

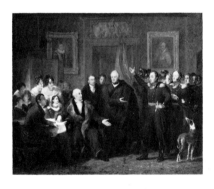

A 1558 The triumvirate assuming power in the name of the prince of Orange, 21 November 1813. *De aanvaarding van het Hoog Bewind door het Driemanschap in naam van de prins van Oranje, 21 november 1813.*

The event took place in The Hague at the house of Gijsbert Karel van Hogendorp, seated to the right of the table. Behind him stands van der Duyn van Maasdam and beside him Count van Limburg Stirum. On the right is the commander of the Hague militia, van Oldebarnevelt, called Witte Tullingh. Seated at the table on the left is Elias Canneman

Canvas 70 × 86.5. Signed *J.W.Pieneman*. Painted in or shortly before 1828. Inscribed on the resolution *Alzoo de Regeringloosheid veel is voorgekomen in de meeste steeden, door wijze voorzieningen van de notabelste Ingezetenen, maar het Algemeen Bestuur geheel verwaarloosd en in niemands handen is, terwijl het geroep van alle zijde om zulk een Bestuur tot redding van het Vaderland*

onze harten diep getroffen heeft, Zoo is het dat wij beslooten hebben hetzelve op te vat[ten] tot de komst van zijne Hoogheid toe – Bezwerende alle de brave Nederlanders om zich te vereenigen tot ondersteuning van dit ons Cordaat besluit. God helpt diegenen die zich zelve helpt – 's Hage den 20 Nov. 1813 – F. v.d. Duin Maasdam, G.K. v. Hoogendorp
PROV Presented by B van Marwijk Kooij, Amsterdam, 1892
LIT Hofdijk 1863. Exhib cat 150 jaar Nederlandse kunst, Amsterdam 1963, nr 34, fig 20

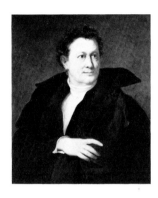

A 1112 Andries Snoek (1766-1829). Actor. *Toneelspeler*

Canvas 85 × 69. Signed and dated *JW Pieneman 1829*
PROV RVMM, 1885 * DRVK since 1953

A 4137 Portrait of a lady and a gentleman. *Portret van een dame en een heer*

Canvas 125.5 × 96.3. Signed and dated *J.W.Pieneman 1829*
PROV Purchased from A A M Stols, Taragona, 1967
LIT Bull RM 16 (1968) p 38, fig 3

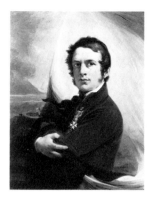

A 1371 Jacob Hobein (b 1810). Rescuer of the Dutch colors under enemy fire, 18 March 1831. *Redder der Nederlandse vlag onder vijandelijk vuur, 18 maart 1831*

Canvas 84 × 66. Signed and dated *J.W.Pieneman 1832*
PROV RVMM, 1877? NMGK, 1887 * DRVK since 1959

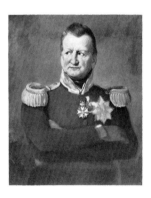

A 1373 David Hendrik Baron Chassé (1765-1849). Lieutenant-general. *Luitenant-generaal*

Canvas 98 × 79. Thought to have been painted in 1832
PROV RVMM, 1877? NMGK, 1887 * DRVK since 1959

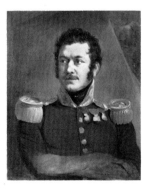

A 1538 Frederik Knotzer (1782-1853). Lieutenant-general. *Luitenant-generaal*

Canvas 78 × 65. Unfinished. Painted ca 1832
PROV Sale S Altmann, Amsterdam, 18 Dec 1890, lot 15

A 4123 Agatha Petronella Hartsen (1814-78). In the wedding gown she wore when she married Jan van der Hoop (1811-97) on 17 March 1841. *In bruidstoilet ter gelegenheid van haar huwelijk met Jan van der Hoop op 17 maart 1841*

Canvas 107.5 × 89. Signed and dated *J.W. Pieneman 1841*
PROV Purchased from Mrs S van der Hoop, Voorburg, 1966
LIT Bull RM 14 (1966) p 122, ill

A 944 Jacob Simonsz de Rijk getting the Spanish governor-general Requesens to release Marnix van Sint Aldegonde: an episode from the Eighty Years War, 1575. *Jacob Simonsz de Rijk bewerkstelligt bij de Spaanse gouverneur-generaal Requesens de vrijlating van Marnix van Sint Aldegonde: episode uit de Tachtigjarige oorlog, 1575*

Canvas 198 × 237. In poor condition
PROV RVMM, 1877? NMGK, 1887

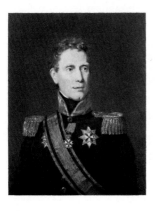

A 2219 Jonkheer Jan Willem Janssens (1762-1838). Governor of Cape Colony (1802-06) and governor-general of the Dutch East Indies (1811-12). *Gouverneur van de Kaapkolonie en gouverneur-generaal van Nederlands Oost Indië*

Canvas 77.5 × 62
PROV Bequest of Mrs W M Janssens-Arriëns, widow of Jonkheer H G Ch L Janssens, The Hague, 1906 * DRVK since 1959
LIT De Loos-Haaxman 1941, p 123

A 1905 Sara de Haan (1761-1832). Widow of the Amsterdam insurance broker Cornelis Hartsen (1751-1817). *Weduwe van de Amsterdamse assuradeur Cornelis Hartsen*

Canvas 77 × 63
PROV Presented by Jonkheer P Hartsen and the heirs of Jonkheer Cornelis Hartsen, 1900
LIT Marius 1920, fig 6

A 655 Hendrik Harmen Klijn (1773-1856). Poet. *Dichter*

Canvas 76 × 60
PROV Bequest of the sitter, Amsterdam, 1856 * Lent to the AHM, 1975

copy after **Jan Willem Pieneman**

see also Governors-general series: A 3791 Jan Willem Janssens; A 3801 Pieter Merkus

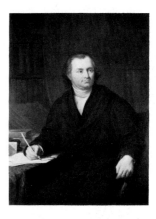

A 665 Dr Martinus Stuart (1756-1826). Historian. *Geschiedschrijver*

The original is the property of the Remonstrant congregation, Amsterdam

Canvas 121 × 94
PROV Bequest of Th Stuart, 1873 * DRVK since 1952

Nicolaas Pieneman

Amersfoort 1809 – 1860 Amsterdam

see also Governors-general series: A 3802 Jan Jacob Rochussen

A 3913 The battle of Bautersem, 12 August 1831, in the Ten Day Campaign. *De slag bij Bautersem, 12 augustus 1831, gedurende de Tiendaagse Veldtocht*

Canvas 46 × 60.5. Signed and dated *N. Pieneman 1833*
PROV Purchased from Bekker gallery, Zeist, 1957

A 2816 Lieutenant-general Frederik Knotzer (1782-1853) at the battle of Houthalen in the Ten Day Campaign, *1831. Luitenant-generaal Frederik Knotzer in de slag bij Houthalen, gedurende de Tiendaagse Veldtocht, 1831*

Canvas 85.5 × 71. Signed and dated *N. Pieneman 1834*
PROV Purchased from J F M Le Maître, Eefde, 1918

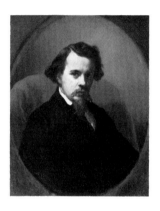

A 4164 Charles Henri Joseph Leickert (1818-1907). Painter. *Schilder*

Panel 38.3 × 30. Signed and dated *N. Pieneman 1853*. Inscribed on the verso *Portret van Ch. H. J. Leickert geschilderd door N. Pieneman. 1853*
PROV Sale Rotterdam, 29 Oct 1969, lot 77, as a gift of the Photo Commission
LIT C J de Bruyn Kops, Bull RM 22 (1974) pp 34, 38, fig 17

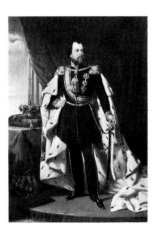

A 1701 Willem III (1817-90), king of the Netherlands. *Koning der Nederlanden*

Canvas 93 × 62.5. Signed and dated *N. Pieneman 1856*
PROV Presented by the family of F L W Baron de Kock, The Hague, 1897

A 1116 Jan Willem Pieneman (1779-1853). Painter, father of Nicolaas Pieneman. *Schilder, vader van Nicolaas Pieneman*

Canvas 136 × 101. Signed and dated *N. P. 1860*
PROV Bequest of the artist, Amsterdam, 1860. RVMM, 1885
LIT Van Hall 1963, p 249, nr 1645:3

A 2238 The submission of Diepo Negoro to Lieutenant-general Hendrik Merkus Baron de Kock, 28 March 1830, bringing to an end the Java War (1825-30). *De onderwerping van Diepo Negoro aan luitenant-generaal Hendrik Merkus Baron de Kock, 28 maart 1830, waarmee de Java-oorlog werd beëindigd*

Canvas 77 × 100
PROV Lent by E Baroness de Kock, The Hague, 1900. Presented from the estate of F L W Baron de Kock, The Hague, in 1907
LIT Marius 1920, fig 7. Scheen 1946, fig 138. Stapel 1938-40, vol 5, p 226. Historia 12 (1947) ill on p 284

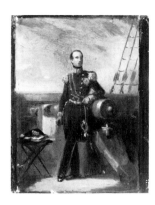

A 3961 Willem Frederik Hendrik (1820-79), prince of the Netherlands, known as Prince Hendrik. *Hendrik, prins der Nederlanden*

Panel 15 × 11.5
PROV Sale Amsterdam, 2 June 1959, lot 5520

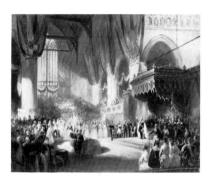

A 3852 The inauguration of King Willem II in the Nieuwe Kerk, Amsterdam, 28 November 1840. *De inhuldiging van koning Willem II in de Nieuwe Kerk te Amsterdam, 28 november 1840*

Panel 46.5 × 55.5. Signed *N. Pieneman*
PROV Purchased from M E van Welderen Baroness Rengers-van Pallandt, dowager of A van Welderen Baron Rengers, Heiloo, 1953
LIT Wap 1842, p 14ff. J G Berkhout, Bull RM 19 (1971) p 54, note 19

A 3877 An unidentified historical scene. *Ongeïdentificeerd historisch onderwerp*

Panel 73 × 101.5. Signed *N. P.*
PROV Presented by M C van Houten,

Doorn, 1953, to the Nederlands Leger-
museum, Leiden. Acquired subsequently
by the RMA through exchange

attributed to **Nicolaas Pieneman**

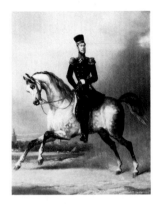

A 4270 Willem II (1792-1849), king of
the Netherlands, on horseback. *Willem
II, koning der Nederlanden, te paard*

Panel 293 × 235
PROV Presented by A C Baron
Snouckaert van Schouburg, The Hague,
1891. NMGK* Lent to the Legermuseum,
Doorwerth, 1925. Transferred to the
Nederlands Legermuseum, Leiden, ca
1939-40

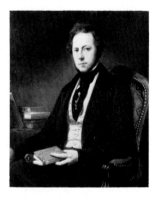

A 3466 Portrait of a man, perhaps Petrus
Augustus de Genestet (1829-61), poet.
*Portret van een man, misschien Petrus
Augustus de Genestet, dichter*

Panel 40 × 33
PROV Purchased from A J Rehorst,
Berkenwoude, 1944

Piero di Cosimo

Florence 1462 – 1521 Florence

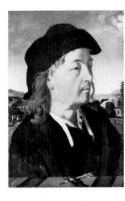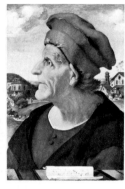

C 1368 Giuliano da San Gallo (1443-
1517). Architect and sculptor, son of
Francesco Giamberti. *Architect en beeld-
houwer, zoon van Francesco Giamberti*

Pendant to C 1367

Panel 47.5 × 33.5
PROV On loan from the KKS since 1948
LIT Vasari 1568, p 144. G Frizzoni,
Archivio stor 4 (1879) p 257. Frizzoni
1891, p 249. H Ulmann, Jb Preusz
Kunstsamml 17 (1896) p 134ff. Philips
1896, p 64. Burckhardt 1898, p 219.
Knapp 1899, p 70ff. Clausse 1900, vol 1,
p 284ff, ill. Haberfeld 1900, p 101ff.
Schaeffer 1904, p 107, ill. Reinach 1905-
23, vol 1, pp 125, 612. Venturi 1901-40,
vol 7 (1911) p 708. Crowe & Cavalcaselle
1903-14, vol 6 (1914) p 48. Hoogewerff
1920, p 257. G J Hoogewerff, Elsevier's
GM 59 (1920) p 369. Suida 1929, p 244.
Van Marle 1923-38, vol 13 (1931) p 367.
Berenson 1923, p 454. Buscaroli 1935, p
135. C Gamba, Boll d'Arte 30 (1936) p
45, figs 3-4. J Lipman, Art Bull 18 (1936)
p 92. Langton Douglas 1946, pp 73, 109.
P Morselli, L'Arte 22 (1957) p 146. P
Morselli, L'Arte 23 (1958) p 79. A van
Schendel, OK 3 (1959) nr 34, ill. E de
Jongh, Bull RM 9 (1961) p 123. Grassi
1963, p 64. R Hatfield, Art Bull 14
(1965) p 328. Bacci 1966, p 83, ill (ca
1500-04). Pope-Hennessy 1966, pp 33,
37, 40, 307, note 48, 308, note 60, fig 38.
W Prinz, Mitt Kunsth Inst Florenz 12
(1966) pp 13, 110, ill. Van Os & Prakken
1974, pp 97-99, nrs 58-59, ill

C 1367 Francesco Giamberti (1405-80).
Cabinetmaker, father of Giuliano da San
Gallo. *Schrijnwerker, vader van Giuliano da
San Gallo*

Pendant to C 1368

Panel 47.5 × 33.5
PROV Same as C 1368
LIT *see under* C 1368

Aert Pietersz

Amsterdam 1550 – 1612 Amsterdam

C 391 The company of Captain Jan de
Bisschop en Lieutenant Pieter Vinck,
Amsterdam, 1599. *Het korporaalschap van
kapitein Jan de Bisschop en luitenant Pieter
Vinck, Amsterdam, 1599*

Panel 133 × 362. Signed and dated
AP (with trident) *1599*
PROV Kloveniersdoelen (headquarters
of the arquebusiers' civic guard),
Amsterdam. On loan from the city of
Amsterdam, 1885-1975
LIT Wagenaar 1760-88, vol 2 (1765) p
26. Van Dijk 1790, p 21, nr 13 (Dirk
Cornelissen). Scheltema 1879, p 32, nr
87. J Six, OH 5 (1887) p 18. W del Court
& J Six, OH 21 (1903) p 78. Riegl 1931,
pp 127-30, fig 30. De Vries 1934, p 72.
Martin 1935-36, vol 1, p 208, fig 118.
Hoogewerff 1936-47, vol 4 (1941-42) p
537, figs 274 a-b

C 70 The anatomy lesson of Dr
Sebastiaen Egbertsz de Vrij (1563-1621),
1603. *De anatomische les van Dr Sebastiaen
Egbertsz de Vrij, 1603*

Canvas 147 × 392. Signed and dated *AP*
(with trident) *A° 1603*. Inscribed *De
namen van Alle de Meesters Chirurgijns die in
't Jaer 1603 in het Gildt waren 1. Dr. Sebast
Egbertsz.; 2. Cornelis Roos; 3. Claas C. Kist
de Oude; 4. Jan Sybrantz. Bont; 5. Hans
Pietersz. Vis; 6. Jan Laurentssz.; 7. Dirk A.
Koornkint; 8. Jeroen J. Waphelier; 9.
Pieter Wiggertsz.; 10. Dirk Warnaartz; 11.
Bartholmeus Willems; 12. Jacob Joachimsz.;
13. Albert Adriaansz. Koornkind; 14. Pieter
Splinter; 15. Jan Wiggertsz.; 16. Cornelis
de Vries; 17. Jan Laurentz; 18. Dirk
Tienen; 19. Hans de Lange; 20. Hendrik
Syb. de Bot; 21. Anthony Foreest; 22. Claes
Cz. Kist de Jonge; 23. Jacob C. Roos de
Jonge; 24. Barend Beenes; 25. Barent
Jansz.; 26. Albert Jansz. (Scherm); 27.
Coenraad (Stengerus); 28. Cornelis Bartholo;
29. Albert Gerritz. Hop*
PROV On loan from the city of
Amsterdam, 1885-1975
LIT Tilanus 1865, nr 1. Nuyens 1865-70,
p 17, fig 3. J Six, OH 5 (1887) p 19. Moes
1897-1905, vol 1, nrs 461, 844, 2284:1,
2537, 3731, 4206-07; vol 2, nrs 4357,
4384, 6523-24, 6916, 7470, 7977, 8525,
8735, 8856, 8872, 9054, 9056, 9106.
Riegl 1902, pp 162, 166. B W Th Nuyens,
Jaarversl KOG 70 (1928) p 45. Riegl
1931, p 131ff, fig 31. De Vries 1934, p 74.
Martin 1935-36, vol 1, pp 167, 172, fig
94. Wegner 1939, pp 59-60. Hoogewerff
1936-47, vol 4 (1941-42) p 573. Boon
1942, p 70. Holländer 1950, pp 52-56,
figs 35-36. Wolff-Heidegger & Cetto
1967, p 306, nr 255, fig 255. Haak 1972,
pp 38-39, fig 46

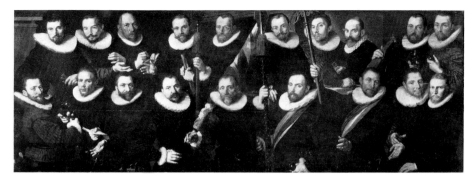

C 391

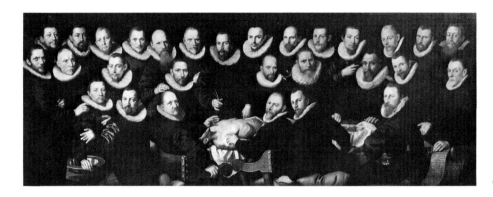

C 70

A 1244 Portrait of a man. *Portret van een man*

Traditionally thought to be pendant to Eliasz, Nicolaes, A 1245 Portrait of a woman, possibly Margriet Benningh

Panel 56 ×46
PROV Presented by JSR van de Poll, Arnhem, 1885

Gerrit Pietersz

Amsterdam 1566–after 1612
Amsterdam?

C 592 The company of Captain Jan Jansz Karel and Lieutenant Thijs Pietersz Schrijver, Amsterdam, 1604. *Het korporaalschap van kapitein Jan Jansz Karel en luitenant Thijs Pietersz Schrijver, Amsterdam, 1604*

The sitters are, from left to right: (sitting in front of the table) Jacob Egberts van Rhijn, Jan Jansz Karel, Lammert Jansz, Thijs Pietersz Schrijver, Hendrik Pietersz Schrijver; (sitting at the ends and behind the table) Hendrik Hendriks, Wouter Sieversz, IJsbrand Appelman, Jan Kuiper, Lieve Pietersz, Jan Cornelisz Vis, Daniël Hendriksz Schrijver, Sijmen Jansz Bout, Harmen IJsbrantsz Hem; (standing) Pieter Jansz Hollesloot, IJsbrand Hem, Wouter Berensteijn, Hans de Roy, Jacob Karstensz Wolff, Willem Jacobsz van Rhijn, Jan Olofsz, Jan Soop and David Dammans. On a piece that was sawn off from the right of the panel were portrayed Andries Harmensz Backer, Pieter Andriesz Korenbreek and the drummer

Panel 172 × 344
PROV Handboogdoelen (headquarters of the archers' civic guard), Amsterdam. On loan from the city of Amsterdam, 1897-1975
LIT Van Dijk 1790, p 31. Scheltema 1879, p 132. Moes 1897-1905, vol 1, nr 1484; vol 2, nr 7054. W del Court & J Six, OH 21 (1903) p 69. Riegl 1931, fig 28 (caption confused with that of fig 36). De Vries 1934, p 86. T Koopman, Mndbl

A 2538 The last judgment. *Het laatste oordeel*

Canvas 200 × 200. Signed and dated *AP* (with trident) *A. 1611*
PROV Purchased from C Wachtler gallery, Berlin, 1911
LIT Hoogewerff 1936-47, vol 4 (1941-42) p 556

attributed to **Aert Pietersz**

C 525 Pieter Dircksz (1528-1606), called Langebaard (Longbeard). Trustee of the orphanage of Edam. *Weesmeester van Edam*

Canvas 182 ×98. Dated *1583*. Inscribed *Aetatis 55*
PROV On loan from the KOG (purchased from the Boes family) since 1885
LIT Moes 1897-1905, vol 1, nr 2017:1. De Vries 1934, p 72, fig 26

copy after **Aert Pietersz**

445

C 592

Amstelodamum 58 (1971) p 193, note 4.
I H van Eeghen, Mndbl Amstelodamum
58 (1971) p 175

Pieter Pietersz

Antwerp ca 1543–1603 Amsterdam

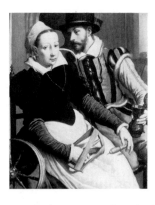

A 3962 A woman at the spinning wheel
and a man with a mug seated in an
interior. *Een vrouw bij een spinnewiel en een
man met een kan zittend in een interieur*

Panel 76 × 63. Signed *P* (with trident)
PROV Purchased from Nijstad gallery,
The Hague, 1959, with monies from the
Jubileumfonds, 1958
LIT B Haak, Bull RM 7 (1959) p 55, ill.
J R Judson, Bull Mus Roy Belg 11 (1962)
p 97, fig 11, notes 95-96. Judson 1970, p
59. Renger 1970, p 115, fig 79

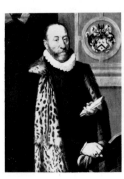 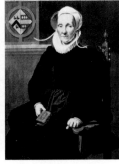

A 3864 Mattheus Augustijnsz Steijn
(1539-1606). Councillor of the admiralty
board of the northern quarter, Dokkum
(1589-1605). *Raad in het college ter
admiraliteit van het Noorder Quartier te
Dokkum*

Pendant to A 3865

Panel 107.5 × 85. Dated *An°. Dni 1588*.
Inscribed *Ætatis meae 49*
PROV Presented by M C van Houten,
Doorn, 1933. Received in 1953
LIT Scheffer 1879, p 7. De Vries 1934, p
68, fig 23. Hoogewerff 1936-47, vol 4
(1941-42) p 567, fig 270. Von der Osten
& Vey 1969, p 338

A 3865 Dirckje Tymansdr Gael, called
van der Graft (1539-1616). Wife of
Mattheus Steijn. *Echtgenote van Mattheus
Steijn*

Pendant to A 3864

Panel 107.5 × 85. Dated *A° Dni 1588*.
Inscribed *Æta meae 49*
PROV Same as A 3864
LIT Scheffer 1879, p 7. De Vries 1934, p
68, fig 24. Hoogewerff 1936-47, vol 4
(1941-42) p 567, fig 271. Von der Osten
& Vey 1969, p 338

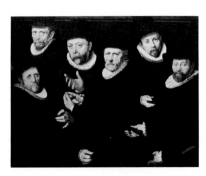

A 865 Six wardens of the drapers' guild,
Amsterdam, 1599. *Zes waardijns van de
Lakenen, Amsterdam, 1599*

The sitters are Jacob Jansz Benningh,
Lambert Pietersz, Hendrick Servaesz,
Gijsbert Michielsz and Hendrik Boelensz

Panel 108 × 143. Dated *In Martio A°
1599*. Inscribed on the frame *DOOR
GVNST OF HAET OF
EYGEBAET* (upper stanchion)
GEEN OORDEEL GEEFT (right
stanchion) | *BETREET VEEDT
INT GHVNT GHY WEET* (lower
stanchion) | *OPRECHTLICK LEEFT*
(left stanchion)
PROV Koloniaal Magazijn (colonial
warehouse), Amsterdam, 1857.
Transferred by the ministry of the
colonies, The Hague, 1876. NMGK, 1885
LIT J Six, OH 5 (1887) p 18 (Aert
Pietersz). Riegl 1931, pp 134-36, fig 31
(Aert Pietersz). De Vries 1934, p 70.
Martin 1935-36, vol 1, pp 154, 172, fig
89 (Aert Pietersz). Hoogewerff 1936-47,
vol 4 (1941-42) pp 572-73, fig 273. H
van de Waal, OH 71 (1956) p 75, fig 7.
Haak 1972, p 15, fig 20

milieu of **Pieter Pietersz**

C 404 The company of Captain Pieter
Dircksz Hasselaer and Lieutenant Jan
Gerritsz Hooft, Amsterdam. *Het
korporaalschap van kapitein Pieter Dircksz
Hasselaer en luitenant Jan Gerritsz Hooft,
Amsterdam*

Panel 97.5 × 106. Fragment
PROV Kloveniersdoelen (headquarters
of the arquebusiers' civic guard),
Amsterdam. On loan from the city of
Amsterdam since 1897
LIT Scheltema 1879, nr 119. Scheltema
1855-85, vol 7 (1885) p 136, nr 10. J Six,
OH 5 (1887) pp 7, 18 (Aert Pietersz).
Moes 1897-1905, vol 1, nrs 3256:4, 3663.
W E van Dam van Isselt, Oude Kunst 4
(1918-19) pp 183-184. Riegl 1931, p
136. De Vries 1934, p 73 (ca 1600)

A 3951 Portrait of a Dutch admiral. *Portret van een Hollandse vlootvoogd*

Panel 118.5 × 88
PROV Sale Amsterdam, 4 Nov 1958, lot 27. Purchased as a gift of the Photo Commission
LIT P Wescher, OH 46 (1929) p 167, fig 14 (Master of the Berlin Family Portrait). De Vries 1934, p 68. Hoogewerff 1936-47, vol 4 (1941-42) p 571. Von der Osten & Vey 1969, p 338

copy after **Sebastiano del Piombo**

Venice 1485-1547 Rome

A 3413 Pope Paul III (1468-1549). *Paus Paulus III*

Canvas 106 × 86
PROV Bequest of J W Edwin vom Rath, Amsterdam, 1941

Eduard Pistorius

Berlin 1796–1862 Karlsbad

C 307 Reading the Bible. *Bijbellezen*

Canvas 55.5 × 65.5. Signed and dated *Pistorius p. 1831*
PROV On loan from the city of Amsterdam (A van der Hoop bequest) since 1885

Pitloo

see Sminck Pitloo

David van der Plaes

Amsterdam 1647–1704 Amsterdam

see also Governors-general series: A 4539 Willem van Outhoorn

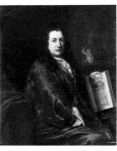

C 517 Casparus Commelin (1636-93). Bookseller, newspaper publisher and author of the official history of Amsterdam 'Beschrijvinghe van Amsterdam' of 1693. *Boekverkoper, courantier en stadshistorieschrijver met zijn 'Beschrijvinghe van Amsterdam' van 1693*

Pendant to C 518

Canvas 57.5 × 48.5. Signed *D. Vr Plaes f.*
PROV On loan from the KOG (presented by L M Beels van Heemstede) since 1889
LIT Moes 1897-1905, vol 1, nr 1659:1. J H Kruisinga, Mndbl Amstelodamum 30 (1943) p 64, ill

C 518 Margaretha Nelis (1652-1705). Second wife of Casparus Commelin. *Tweede echtgenote van Casparus Commelin*

Pendant to C 517

Canvas 56.5 × 48. Signed *D. vr Plaes fecit*
PROV Same as C 517

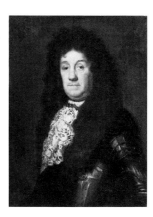

A 1413 Cornelis Tromp (1629-91). Vice admiral of Holland and West-Friesland. *Luitenant-admiraal van Holland en West-Friesland*

Canvas 80 × 64. Signed *D vr P f*
PROV Sale J H Cremer, Amsterdam, 21 June 1887, lot 119
LIT Moes 1897-1905, vol 2, nr 8086:14

Henrik Ploetz

see under Miniatures

Joannes Antonius Augustinus Pluckx

see under Miniatures

attributed to **Karel van der Pluym**

Leiden 1625–1672 Leiden

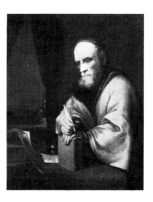

A 3337 An old scholar. *Een oude geleerde*

Canvas 29.5 × 24
PROV Presented by Mr & Mrs D A J Kessler-Hülsmann, Kapelle op den Bosch near Mechelen, 1940

447

Egbert van der Poel

Delft 1621 – 1664 Rotterdam

A 308 Interior of a barn. *Een boerendeel*

Panel 48 × 64.5. Signed and dated
Egbert van der Poel 1646
PROV Het Loo Palace, Apeldoorn, 1798.
NM, 1808
LIT Moes & van Biema 1909, pp 17, 171,
221. A Goldschmidt, OH 40 (1922) p 60,
ill

A 309 The explosion of the powder
magazine in Delft, 12 October 1654. *Het
springen van de kruittoren in Delft, 12
oktober 1654*

Panel 37 × 62. Signed and dated
E. van der Poel, 12 oct. 1654
PROV Het Loo Palace, Apeldoorn, 1798.
NM, 1808
LIT Moes & van Biema 1909, pp 64, 197,
217. J Walsh Jr, Bull Metrop Mus 21
(1973) fig 3

A 1755 Fish market at night. *Vismarkt bij
avond*

Panel 35 × 26.5. Signed *Egbert van der
Poel*
PROV Bequest of D Franken Dzn, Le
Vésinet, 1898

attributed to **Egbert van der Poel**

A 117 Portal of a stairway tower, with a
man descending the stairs : presumably
the moment before the assassination of
William the Silent in the Prinsenhof,
Delft. *Portaal in een traptoren met een
afdalende man, vermoedelijk de situatie vlak
voor de aanslag op prins Willem I in het
Prinsenhof te Delft*

Panel 49.5 × 40
PROV Presented by D van der Aa, The
Hague, 1803. NM, 1808
LIT W Bürger, GdB-A 8:2 (1866) p 569,
nr 51 (Johannes Vermeer). Moes & van
Biema 1909, pp 65, 195, 225. W
Valentiner, GdB-A 77 (1935) p 32
(Carel Fabritius). E P Richardson, Art in
America 25 (1937) p 151. P T A Swillens,
OH 61 (1946) p 141. Van de Waal 1952,
p 240, fig 89:1 (Carel Fabritius?). J W
Niemeijer, Bull RM 17 (1969) pp 135-39,
fig 1

Cornelis van Poelenburgh

Utrecht ca 1586 – 1667 Utrecht

A 313 Satyrs peeping at nymphs. *Nimfen
door satyrs bespied*

Copper 37.5 × 46
PROV Sale G van der Pot van
Groeneveld, Rotterdam, 6 June 1808, lot
101
LIT Moes & van Biema 1909, pp 113,
187. Plietzsch 1960, p 134, fig 225

A 312 The expulsion from paradise. *De
verdrijving uit het paradijs*

Panel 30 × 38. Signed *CP*
PROV Purchased with the Kabinet van
Heteren Gevers, The Hague-Rotterdam,
1809
LIT Moes & van Biema 1909, pp 149,
163. Bille 1961, vol I, p 111. J R Judson,
Wadsworth Ath Bull, 1966, p 8, note 37

A 310 Bathing men. *Badende mannen*

Pendant to A 311

Copper 14 × 17. Signed *CP*
PROV Purchased with the Kabinet van
Heteren Gevers, The Hague-Rotterdam,
1809
LIT Moes & van Biema 1909, pp 149,
163. Bille 1961, vol I, p 111

A 311 Bathing girls. *Badende meisjes*

Pendant to A 310

Panel 13.5 × 18. Signed *CP*
PROV Same as A 310
LIT *see under* A 310

attributed to **Cornelis van Poelenburgh**

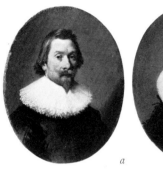

a *b*

c *d*

e

f *g*

A 1747 Portraits of a couple (a, b), their three daughters (c, d, e) and two sons (f, g). *Portretten van een echtpaar (a, b), hun drie dochtertjes (c, d, e) en twee zoontjes (f, g)*

Copper 15 × 12 each. Oval
PROV Bequest of D Franken Dzn, Le Vésinet, 1898 * DRVK since 1954
(A 1747d & A 1747e)
LIT De Jonge 1938, p 133, nr 30 (not Paulus Moreelse). Van Hall 1963, p 252, nr 1669:2

Pieter Frans Poelman

Ghent 1801 – 1826 Ghent

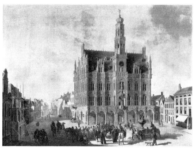

A 1118 The town hall of Oudenaarde. *Het stadhuis te Oudenaarde*

Panel 67 × 90. Signed and dated
P. J. Poelman A Gand P^t 1824
PROV Purchased at exhib Brussels 1824. RVMM, 1885 * DRVK since 1961

George Jan Hendrik Poggenbeek

Amsterdam 1853 – 1903 Amsterdam

see also under Aquarelles and drawings

A 3605 View in a village. *Dorpsgezicht*

Panel 19.5 × 30. Signed and dated
Geo Poggenbeek 81
PROV Lent by Mr & Mrs J C J Drucker-Fraser, 1919. Bequeathed in 1944 * DRVK since 1950

A 2708 Ducks beside a duck shelter on a ditch. *Slootrand met eenden bij een eendenkorf*

Canvas 33 × 49.5. Signed and dated
Geo Poggenbeek '84
PROV Presented by Miss A J Broedelet and Mrs S C Büchli-Fest from the estate of W J van Randwijk, The Hague, 1914
LIT W Steenhoff, Onze Kunst 27 (1915) p 96, ill. De Gruyter 1968-69, vol 2, p 89, fig 117

A 1564 A ditch with willows. *Sloot met wilgen*

Panel 29 × 43. Signed and dated
Geo Poggenbeek '90
PROV Bequest of Jonkheer P A van den Velden, The Hague, 1892 * DRVK since 1953

A 3604 Landscape with a watercourse. *Landschap met een vaart*

Canvas 49 × 71. Signed *Geo Poggenbeek*
PROV Lent by Mr & Mrs J C J Drucker-Fraser, 1919. Bequeathed in 1944

449

A 3603 Calves in an orchard. *Kalveren in een boomgaard*

Panel 21.5 × 31.5. Signed *Geo Poggenbeek*
PROV Lent by Mr & Mrs J C J Drucker-Fraser, London, 1919. Bequeathed in 1944 * DRVK since 1953

A 4106 An orchard. *Boomgaard*

Board 11.9 × 18
PROV Bequest of Mr & Mrs J C J Drucker-Fraser, Montreux, 1944

attributed to **Polidoro da Lanciano**

Lanciano ca 1515–1565 Venice

C 308 The holy family with St Catherine. *De heilige familie met de heilige Catharina.*

Canvas 136.5 × 179
PROV On loan from the city of Amsterdam (A van der Hoop bequest) since 1885
LIT Berenson 1932, p 579 (Francesco Torbido)

Paulus Pontius

see Panpoeticon Batavum: A 4570 Constantijn Huygens, by Jan Maurits Quinkhard after Pontius

manner of **Jacopo Pontormo**

Pontormo 1494–1557 Florence

A 3009 Portrait of a woman. *Portret van een vrouw*

Panel 114 × 78. Oval
PROV Purchased from the Augusteum, Oldenburg, 1923, as a gift from the Rembrandt Society
LIT Bredius & Schmidt-Degener 1906, p 8, fig 8. Clapp 1916, pp 86, 161-62, 235, fig 129. D C Röell, Mndbl BK 1 (1924) p 135, ill. T Borenius, Burl Mag 59 (1931) p 66. Berenson 1932, p 466. R Oertel, Kunstchronik 9 (1956) p 217. Berenson 1963, vol 1, p 179. K W Forster, Pantheon 23 (1965) p 217ff, fig 231 (Pier Francesco Foschi, ca 1560). P C Brokes, Burl Mag 108 (1966) p 564 (Maso da San Friano). A Tzeutschler Lurie, Bull Clev Mus of Art 61 (1974) p 5, note 6

A 3062 Alessandro de' Medici (1510-37)

Panel 46.5 × 31.2

PROV Presented by M M van Valkenburg, Laren, Gelderland, 1928
LIT F M Clapp, Rass d'Arte 13 (1913) pp 63-66. T Borenius, Burl Mag 59 (1931) p 66. Not listed by Langendijk, 1968

Bastiaan de Poorter

Meeuwen 1813–1880 Meeuwen

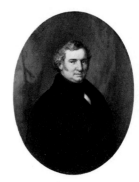

A 3866 Posthumous portrait of Hendrik André Cornelis Tierens (1794-1851). City official of Heusden. *Stadsfunctionaris van Heusden*

Pendant to A 3867

Canvas 87.5 × 68. Oval. Signed and dated *B. de Poorter ft. 1852*. Inscribed on the verso *Hendrik André Cornelis Tierens. Geboren 15 Junij 1794, Overleden 5 September 1851. In leven Directeur van het Postkantoor en Griffier bij het vredegerecht te Heusden. Zoon van Simon Tierens Segersz. en Antonia Adriana Hendrika van Bleyswijk, geb. 15 Juni 1794, gehuwd 8 Jan. 1817 met Joh^na Maria Parvé*
PROV Presented by M C van Houten, Doorn, 1936. Received in 1953

A 3867 Johanna Maria Parvé (1785-1861). Wife of Hendrik André Cornelis Tierens. *Echtgenote van Hendrik André Cornelis Tierens*

Pendant to A 3866

Canvas 88 × 68.5. Oval. Signed and dated *B. de Poorter ft. 1857*. Inscribed on the verso *Johanna Maria Parvé, geb. 8 Febr. 1785. Overl. 14 Maart 1861. Dochter van Hendrik André Parvé Jan Frederiksz. en Cornelia van Bleijswijk, gehuwd 8 Jan. 1817 met Hendrik André Corn. Tierens*
PROV Same as A 3866

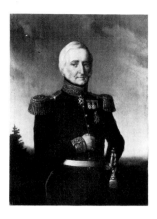

C 1564 Huibert Gerard Baron Nahuys van Burgst (1782-1858). Member of the Council of the Dutch East Indies, in the uniform of a brevet major-general. *Lid van de Raad van Nederlands Oost Indië, in het uniform van generaal-majoor titulair*

Panel 31.3 ×23. Signed and dated *B. de Poorter ft 1852*
PROV On loan from H G B Rissink, Amsterdam, since 1973

Willem de Poorter

Haarlem 1608 – after 1648 Haarlem?

A 757 The idolatry of King Solomon. *De afgoderij van koning Salomo*

Panel 63 ×49. Signed *W. D. P.*
PROV Sale Coster, Amsterdam, 1882

Jan Porcellis

Ghent ca 1584 – 1632 Zoeterwoude

A 3111 Fishing boats in choppy waters. *Vissersboten op onrustig water*

Panel 24 ×34.5
PROV Purchased from A Pauli, Amsterdam, 1930, as a gift of the Photo Commission

attributed to **Giovanni Antonio Pordenone**

Pordenone ca 1484 – 1539 Ferrara

A 3415 Judith holding the head of Holofernes. *Judith met het hoofd van Holofernes*

Canvas 103.5 ×86.5
PROV Bequest of J W Edwin vom Rath, Amsterdam, 1941
LIT Berenson 1936, vol 1, p 148. Berenson 1957, vol 1, p 144. I Furlan, Il Noncello, 1961, nr 16, p 14, ill (Francesco Floriani)

A 3414 Madonna and child. *Maria met kind*

Canvas 90 × 105. Unfinished
PROV Bequest of J W Edwin vom Rath, Amsterdam, 1941
LIT Berenson 1936, vol 1, p 148. Berenson 1957, vol 1, p 144. I Furlan, Il Noncello, 1961, nr 16, p 16 (Gasparo Narvesa)

Christiaan Julius Lodewijk Portman

Amsterdam 1799 – 1868 Beverwijk

A 4167 Anthonie van der Hout (1783-1859)

Pendant to A 4168

Canvas 85 ×67
PROV Bequest of W van der Hout, Utrecht, 1970
LIT Bull RM 19 (1971) p 32, fig 1

A 4168 Maria Christina Nijssen (1788-1870). Wife of Anthonie van der Hout. *Echtgenote van Anthonie van der Hout*

Pendant to A 4167

Canvas 85 ×67.5. Signed and dated *C. J. L. Portman 1826*
PROV Same as A 4167
LIT Bull RM 19 (1971) p 32, fig 2

C 203 Alexander II (1818-81), grand duke of Russia, visiting Czar Peter's house in Zaandam, 17 April 1839. *Alexander II, grootvorst van Rusland, bezoekt*

het Czaar Peterhuisje te Zaandam, 17 april 1839

Also portrayed are Prince Willem II of Orange-Nassau, Princess Anna Paulowna of Russia, Prince Willem Frederik Karel (Frederik) of the Netherlands, Princess Louise of Prussia, Princes Willem, Willem Frederik Hendrik (Hendrik) and Willem Alexander Frederik (Alexander) of Orange-Nassau, Elisa Martha Countess van Limburg Stirum, SophiaWilhelmina Petronella Countess van Wassenaer, née Baroness van Heeckeren van Kell, Count Orloff, Alexander's adjutant, Baron d'Ivoy, Andreas? Baron Mackay, Adriaan van der Hoop and his wife Dieuwke Fontein

Canvas 118.5 × 144. Inscribed on the stone *Ts Saerwitsch troono… grootvorst Alexander Nic… 17 April 1839*
PROV On loan from the city of Amsterdam (A van der Hoop bequest) since 1885
LIT Scheen 1946, fig 10

A 1119 An old man in seventeenth-century costume. *Een oude man in zeventiende-eeuws costuum*
Canvas 61 × 52. Signed *C. J. L. Portman f*
PROV RVMM, 1885

Frans Post

Leiden ca 1612 – 1680 Haarlem

A 4271 View of Itamaracá Island, Brazil. *Gezicht op het eiland Itamaracá, Brazilië*

Canvas 63.5 × 89.5. Signed and dated *F. Post 1637$_3^D$*. Inscribed on the verso of the original canvas *Het Eijlant I. Tamaraca gelijck hetselve int Zuijden verthoont, de stadt legt boven op den Berg beneden is het Fort Orangien ; het welcke leit inden mont van de Zee, op dese manier sitten de Portugisen de peert*
PROV Purchased from E Odinot, Paris, 1879. NMGK * On loan to the KKS since 1953
LIT J Combe, Amour de l'Art 12 (1931) pp 481-89, fig 37. De Sousa-Leão 1937, pl II. R C Smith, Art Q I (1938) pp 251, 262, nr 5. Beeldende Kunst, 1940, p 70, fig 1a. De Sousa-Leão 1948, pp I, 99, nr I, fig I. Bardi 1956, nr 44, ill. A Guimarães, Rev Inst Bras 235 (1957) nr 8. J de Sousa-Leão, GdB-A 103 (1961) p 102. Larsen 1962, nr 2, fig 23. H P Baard, OK 7 (1964) nr 5, ill. De Sousa-Leão 1973, nr I, ill

A 3224 Landscape in Brazil. *Landschap in Brazilië*

Canvas 282.5 × 210.5. Ends in a round arch. Signed and dated *F. Post 1652$_{22}^{12}$*
PROV Lent by A G N Swart, Wassenaar, 1932. Purchased in 1934 as a gift of the Photo Commission
LIT De Sousa-Leão 1937, pl I. R C Smith, Art Q I (1938) pp 259, 266, nr 54, fig I (undated). De Sousa-Leão 1948, pp 14, 99, nr 14. Bardi 1956, nr 43, ill. A Guimarães, Rev Inst Bras 235 (1957) nr 76. Plietzsch 1960, p 117, fig 199. Larsen 1962, pp 102, 147, nr 18, fig 42. J A Uitenhage de Mist-Verspijck, Bull RM 12 (1964) p 51ff, ill. Börsch-Supan 1967, p 286, fig 195. De Sousa-Leão 1973, nr 18, ill

A 1486 Brazilian landscape with the village of Igaraçú. To the left the church of Sts Cosmas and Damian. *Braziliaans landschap met het dorp Igaraçú. Links de Cosmas en Damianuskerk*

Panel 40 × 61. Signed and dated *F. Post 1659*
PROV Sale F Kaijser (Frankfurt am Main), Amsterdam, 4 Dec 1888, lot 80 (as View in Surinam)
LIT De Sousa-Leão 1937, pl VI. R C Smith, Art Q I (1938) pp 255-56, nr 40, figs 9-11 (undated). De Sousa-Leão 1948, p 99, nr 20. Bazin 1956, vol I, pp 54, 115. A Guimarães, Rev Inst Bras 235 (1957) nr 84. Larsen 1962, nr 37, fig 57. De Sousa-Leão 1973, nr 31, ill

A 742 View of Olinda, Brazil. *Gezicht op Olinda, Brazilië*

Canvas 107.5 × 172.5. Signed and dated *F. Post 1662*
PROV Sale Copes van Hasselt, Haarlem, 20 April 1880, lot 44
LIT De Sousa-Leão 1937, pl V. R C Smith, Art Q I (1938) p 262, nr 20. De Sousa-Leão 1948, p 99, nr 25, pl XX. A Guimarães, Rev Inst Bras 235 (1957) nr 98. Larsen 1962, nr 65, fig 69. De Sousa-Leão 1973, nr 36, ill

A 1585 Landscape in Brazil. *Landschap in Brazilië*

Canvas 66 × 88. Signed *F. Post*
PROV Purchased from Jonkheer Victor de Stuers, The Hague, 1892
LIT De Sousa-Leão 1937, pl III. R C Smith, Art Q I (1938) nr 16. De Sousa-Leão 1948, p 101, nr 66, pl XXX. A Guimarães, Rev Inst Bras 235 (1957) nr 118. Larsen 1962, nr 68, fig 66. E Stols, Spiegel Hist 5 (1970) p 424, fig 7. De Sousa-Leão 1973, nr 125, ill

A 2334 Landscape on the Senhor de Engenho River, Brazil. *Landschap bij de rivier Senhor de Engenho, Brazilië*

Pendant to A 2333

Panel 22.5 × 28. Signed *F. Post*
PROV Purchased from the heirs of Jonkheer PH Six van Vromade, Amsterdam, 1908
LIT De Sousa-Leão 1937, p 21. RC Smith, Art Q 1 (1938) p 265, nr 45. De Sousa-Leão 1948, p 51. A Guimarães, Rev Inst Bras 235 (1957) nr 119. Larsen 1962, nr 79, fig 95. De Sousa-Leão 1973, nr 131, ill

A 2333 Brazilian landscape. *Braziliaans landschap*

Pendant to A 2334

Panel 22.5 × 28. Signed *F. Post*
PROV Same as A 2334
LIT De Sousa-Leão 1948, p 101, nr 67. A Guimarães, Rev Inst Bras 235 (1957) nr 120. Larsen 1962, nr 80, fig 93. De Sousa-Leão 1973, nr 132, ill

A 4272 Brazilian village. *Braziliaans dorp*

Panel 20.5 × 26.5. Signed *F. Post*
PROV Presented by J Ph van der Kellen, Amsterdam, 1879. NMGK
LIT De Sousa-Leão 1948, nr 68. A Guimarães, Rev Inst Bras 235 (1957) nr 122. Larsen 1962, nr 82, fig 97. De Sousa-Leão 1973, nr 129, ill

A 4273 The house of a Dutch colonist in Brazil. *Het huis van een Hollandse kolonist in Brazilië*

Panel 16.5 × 25. Signed *F. Post*
PROV Presented by J Ph van der Kellen, Amsterdam, 1879. NMGK
LIT De Sousa-Leão 1937, pl IV. RC Smith, Art Q 1 (1938) p 265, nr 36. De Sousa-Leão 1948, pl XXXII. A Guimarães, Rev Inst Bras 235 (1957) nr 121. Larsen 1962, nr 82, fig 76. De Sousa-Leão 1973, nr 130, ill (landscape with a Franciscan monastery)

Hendrick Gerritsz Pot

Haarlem before 1585 – 1657 Amsterdam

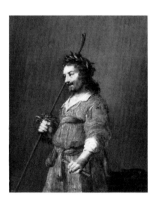

A 2135 Portrait of a man dressed as a shepherd: known as the portrait of Joost van den Vondel (1587-1679), poet. *Portret van een man, gekleed als herder, bekend als het portret van Joost van den Vondel, dichter*

Panel 34 × 26.5. Signed *HP*
PROV Purchased from E Warnecke, Paris, 1904
LIT Sterck 1923, pp 78-82. Martin 1935-

36, vol 1, pp 40, 346, fig 20. Bernt 1960-62, vol 2, nr 658. Bernt 1969-70, vol 2, nr 934

attributed to **Hendrick Gerritsz Pot**

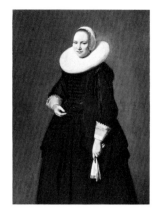

A 3301 Portrait of a woman. *Portret van een vrouw*

Panel 45 × 33.5. Dated *1638*. Inscribed *Ætatis 3*.
PROV Presented by Mr & Mrs DAJ Kessler-Hülsmann, Kapelle op den Bosch near Mechelen, 1940 * DRVK since 1959 (on loan to Stedelijk Museum Het Catharinagasthuis, Gouda)

Hendrik Pothoven

Amsterdam 1726 – 1807 The Hague

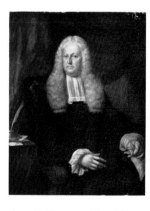

A 1268 Harmen Hendrik van de Poll (1697-1772). Burgomaster of Amsterdam. *Burgemeester van Amsterdam*

For the pendant portrait of Margaretha Trip, van de Poll's wife, *see* Quinkhard, Jan Maurits, A 1269

Canvas 50 × 39.5. Signed and dated *H. Pothoven 1749*
PROV Presented by J SR van de Poll, Arnhem, 1885 * Lent to the AHM, 1975
LIT Moes 1897-1905, vol 2, nr 5991:2

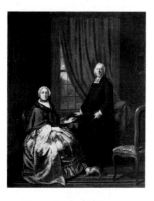

C 1475 Petrus Bliek (1706-97). Remonstrant minister in Amsterdam (1742-84), with his wife Cornelia Drost (d 1775). *Remonstrants predikant te Amsterdam, met zijn vrouw Cornelia Drost*

Canvas 89 × 74. Signed and dated *HPothoven f. A° 1771*
PROV On loan from the elders and deacons of the Remonstrants-Gereformeerde Gemeente (Remonstrant-Reformed congregation), Amsterdam, since 1964
LIT Moes 1897-1905, vol 1, nr 727. CJ de Bruyn Kops, Bull RM 22 (1974) pp 22, 37, fig 6

attributed to **Hendrik Pothoven**

A 663 Pieter Meijer (1718-81). Amsterdam publisher and bookseller. *Uitgever en boekverkoper te Amsterdam*

Canvas 37 × 34
PROV Bequest of Miss G Meijer Warnars, Zutphen, 1878
LIT J W Enschedé, Amsterdamsch Jaarboekje, 1901, p 123, ill. Moes 1897-1905, vol 2, nr 5035

Paulus Potter

Enkhuizen 1625 – 1654 Amsterdam

see also Pastels: Liotard, Jean-Etienne, A 1196 Landscape with cows and shepherdess, after Potter

A 315 A herdsman's hut. *Herdershut*

Panel 23 × 31. Signed and dated *Paulus Potter f 1645* (difficult to read)
PROV Purchased with the Kabinet van Heteren Gevers, The Hague-Rotterdam, 1809
LIT Moes & van Biema 1909, pp 149, 163. Hofstede de Groot 1907-28, vol 4 (1911) nr 125. Von Arps-Aubert 1932, nr 7

C 205 Two horses near a gate in a meadow. *Twee paarden in de weide bij een hek*

Panel 23.5 × 30. Signed and dated *Paulus Potter f. 1649*
PROV On loan from the city of Amsterdam (A van der Hoop bequest) since 1885
LIT Hofstede de Groot 1907-28, vol 4 (1911) nr 137. Von Arps-Aubert 1932, nr 31. J Verbeek, Antiek 8 (1974) p 858, fig 5

A 316 The bear hunt. *De berenjacht*

Canvas 305 × 338. Signed and dated *Paulus Potter f. 1649*
PROV Acquired through exchange with the KKS, 1825 * DRVK since 1952
LIT Hofstede de Groot 1907-28, vol 4 (1911) nr 160. Von Arps-Aubert 1932, nr 37

A 317 Orpheus charming the beasts. *Orpheus en de dieren*

Canvas 67 × 89. Signed and dated *Paulus Potter f. 1650*
PROV Purchased with the Kabinet van Heteren Gevers, The Hague-Rotterdam, 1809
LIT Moes & van Biema 1909, pp 149, 163, 193. Hofstede de Groot 1907-28, vol 4 (1911) nr 3. E Plietzsch, Zeitschr BK 27 (1916) p 134. Von Arps-Aubert 1932, nr 48. Martin 1935-36, vol 2, p 331. Bernt 1960-62, vol 2, nr 661. Bille 1961, vol 1, pp 109-10, 112. Rosenberg, Slive & Ter Kuile 1966, p 160. Bernt 1969-70, vol 2, nr 938

C 206 Four cows in a meadow. *Vier koeien in de weide*

Panel 25 × 30. Signed and dated *P. Potter f. 1651*
PROV On loan from the city of Amsterdam (A van der Hoop bequest) since 1885
LIT Hofstede de Groot 1907-28, vol 4 (1911) nr 38. Von Arps-Aubert 1932, nr 53

A 318 Herdsmen with their cattle. *Herders met hun vee*

Canvas 81 × 97.5. Signed and dated
Paulus Potter f. 1651
PROV Sale G van der Pot van
Groeneveld, Rotterdam, 6 June 1808, lot
103
LIT Moes & van Biema 1909, pp 11, 184.
Hofstede de Groot 1907-28, vol 4 (1911)
nr 118. E Wiersum, OH 48 (1931) p 212.
Von Arps-Aubert 1932, nr 50

A 711 Cows in the meadow near a farm. *Koeien in de weide bij een boerderij*

Panel 58 × 66.5. Signed and dated
Paulus Potter f. 1653
PROV Bequest of Jonkheer J S H van de
Poll, Amsterdam, 1880
LIT V de Stuers, Ned Kunstbode 2
(1880) p 245. Hofstede de Groot 1907-
28, vol 4 (1911) nr 89. Von Arps-Aubert
1932, nr 76. Martin 1935-36, vol 2, pp
329, 331, 333, fig 181. Van Gelder 1959,
p 16, fig 68

C 279 A spaniel. *Een patrijshond*

Panel 18 × 19.5. Signed and dated
Paulus Potter f. 1653
PROV On loan from the city of
Amsterdam (A van der Hoop bequest)
since 1885
LIT Hofstede de Groot 1907-28, vol 4
(1911) nr 131. Von Arps-Aubert 1932,
nr 68. Martin 1935-36, vol 2, p 333

Pieter Symonsz Potter

Enkhuizen 1597/1600 – 1652 Amsterdam

A 3338 A musical company in an
interior. *Musicerend gezelschap in een
interieur*

Panel 39.5 × 53. Signed and dated
P. Potter f. A° 1630
PROV Presented by Mr & Mrs D A J
Kessler-Hülsmann, Kapelle op den
Bosch near Mechelen, 1940

C 204 Vanitas still life. *Vanitas stilleven*

Panel 54 × 43. Signed and dated
P. Potter f. 1646
PROV On loan from the city of
Amsterdam (A van der Hoop bequest)
since 1885
LIT A Bredius, OH 11 (1893) p 44.
Vorenkamp 1933, p 104. Martin 1935-
36, vol 1, p 418. Bergström 1947, p 174,
fig 143. Bergström 1956, p 166, fig 144.
Exhib cat IJdelheid der IJdelheden,
Leiden 1970, nr 24

attributed to **Pieter Symonsz Potter**

A 3473 Perseus and Andromeda.
Allegory of the liberation of the
Netherlands by Prince Frederik Hendrik.
*Perseus en Andromeda. Allegorie op de
bevrijding van de Nederlanden door prins
Frederik Hendrik*

Panel 29 × 38. Grisaille. Model for an
engraving by Pieter Nolpe for the book
'Beschrivinge van de Blyde Inkoomste …
van Haare Majesteyt van Groot-
Britanien, Vrankryk en Ierland tot
Amsterdam, Den 20 May, 1642'
PROV Presented by E J M Douwes,
Amsterdam, 1945, in commemoration of
the liberation of the Netherlands in 1945
and the part played in it by the House of
Orange
LIT W H Vroom, Ons Amsterdam 24
(1972) p 174, ill

H Potuyl

active ca 1630-60

A 2790 Still life in a stable. *Stilleven in een
stal*

Canvas 77.5 × 65. Signed *H. Potuyl*
PROV Presented by H M Clark, London,
1916

A 3339 A housewife cleaning fish in a courtyard. *Een huisvrouw op een binnen-plaatsje bij het schoonmaken van vis*

Panel 45 ×36
PROV Presented by Mr & Mrs DAJ Kessler-Hülsmann, Kapelle op den Bosch near Mechelen, 1940 *DRVK since 1953

attributed to **Frans Pourbus I**

Bruges 1545–1581 Antwerp

A 3065 Portrait of a knight in the order of Calatrava, presumably a member of the Sorias or Soreau (Sorel) family. *Portret van een ridder in de orde van Calatrava, vermoedelijk van het geslacht Sorias of Soreau (Sorel)*

Panel 44 × 34.5. Inscribed on the verso
Jean Prince de Soreau, Prieur de Cosne
PROV From the Augusteum, Oldenburg. Lent by MP Voûte, Amsterdam, 1922. Bequeathed to the Rembrandt Society, which presented it to the RMA in 1928
LIT Bode 1888, pp 67-68 (school of Anthony Mor). Hymans 1920, p 176 (Mor). L Baldass, Städ Jb 6 (1930) p 82 (Mor). Philippot 1956, p 239 (manner of Frans Pourbus I). P Philippot, Bull Mus Roy Belg 14 (1965) p 175, fig 7 (ca 1560)

studio of **Frans Pourbus II**

Antwerp 1569–1622 Paris

A 870 Maria de' Medici (1573-1642). Wife of Henri IV, king of France (1553-1610). *Echtgenote van Hendrik IV, koning van Frankrijk*

Replica of the painting in the Louvre, Paris (cat 1953, nr 2072, fig 141; 1609/10)

Canvas 285 ×218
PROV KKS, 1876. NMGK, 1885
LIT Ring 1913, p 81. Michel 1953, p 240. FJ Dubiez, Ons Amsterdam 10 (1958) ill on p 267

attributed to **Pieter Pourbus**

Gouda ca 1510–1584 Bruges

A 962c Two wings of a triptych, with portraits of a man and woman accompanied by St John the Baptist and St Adrian, respectively. *Twee vleugels van een drieluik, met de portretten van een man en een vrouw, respectievelijk vergezeld van Johannes de Doper en de heilige Adrianus*

On the versos are portraits of Thomas Isaacq and his wife; *see* Master of the

Legend of Mary Magdalene, A 962b. The middle panel, with the Madonna and child, is in the collection of Mrs Mary van Berg, New York. For a copy after the latter, *see* Southern Netherlands school late 17th century, A 962a

Panel 91 ×29 each
PROV Presumably sale BTh Baron van Heemstra van Froma en Eibersburen, The Hague, 16 Feb 1880, lot 2. NMGK, 1885
LIT MJ Friedländer, Rep f Kunstw 23 (1900) p 256. Friedländer 1924-37, vol 12 (1935) pp 23, 166, nr 11. J Tombu, Onze Kunst 46 (1929) p 99. G Glück, Burl Mag 75 (1939) fig 33A. Exhib cat Anonieme Vlaamse Primitieven, Bruges 1969, nr 68

Johannes Huibert Prins

The Hague 1757–1806 Utrecht

A 1120 Imaginary city view with Romanesque church. *Gefantaseerd stads-gezicht met Romaanse kerk*

Panel 41 ×56. Signed and dated *J.H. Prins A° 1793*
PROV Purchased with the Kabinet van Heteren Gevers, The Hague-Rotterdam, 1809. RVMM, 1885
LIT Moes & van Biema 1909, pp 149, 163, 194. Bille 1961, vol 1, p 109

Cornelis Pronk

Amsterdam 1691–1759 Amsterdam

A 4274 Self portrait. *Zelfportret*

Copper 8.7 ×6.8. Oval. Signed on the verso *Cornelis Pronk, teekenaar en schilder, leerling van Boonen in zijnen jongen tijd se ipse fecit*
PROV KKS before 1876. NMGK
LIT Van Hall 1963, p 256, nr 2669:3

Albert Jurardus van Prooyen

Groningen 1834–1898 Amsterdam

A 1824 Landscape with cattle driver. *Landschap met veedrijver*

Canvas 44 ×65. Signed and dated *A. J. van Prooijen fec. 1864*
PROV Bequest of Reinhard Baron van Lynden, The Hague, 1899 * DRVK since 1953

attributed to **Jan Provoost**

Bergen ca 1465–1529 Bruges

A 2569 Madonna and child enthroned, with Sts Jerome and John the Baptist and a kneeling Carthusian monk. *Tronende madonna met de heiligen Hieronymus en Johannes de Doper en een knielende karthuizer monnik*

Panel 75.5 ×65
PROV Lent by C Hoogendijk, The Hague, 1907. Presented from his estate, 1912 * On loan to the KKS (cat 1968, p 46, nr 853) since 1948
LIT G Hulin de Loo, L'Art et la Vie,

1902, pp 19-20. R Bangel, Cicerone 7 (1915) p 172, fig 2. Winkler 1924, p 144. E Michel, GdB-A 17 (1928) pp 230-31, ill. Friedländer 1924-37, vol 9 (1931) pp 89, 150, nr 178 (ca 1505)

A 2570 Triptych with Madonna and child, St John the Evangelist (left wing), and Mary Magdalene (right wing). *Drie-luik met Maria en kind, Johannes de Evangelist (linker luik) en Maria Magdalena (rechter luik)*

Panel 44 ×31 (middle panel); 49.5 ×15 (each of the wings)
PROV Lent by C Hoogendijk, The Hague, 1907. Presented from his estate, 1912 * On loan to the KKS (cat 1968, p 46, nr 783) since 1924
LIT R Bangel, Cicerone 7 (1915) p 172

Pierre-Paul Prud'hon

Cluny 1758–1823 Paris

see also under Pastels

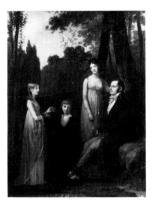

A 3097 Rutger Jan Schimmelpenninck (1761-1825). Legate of the Batavian Republic in Paris (1798-1802; 1803-05) with his wife Catharina Nahuys (1770-1844) and children Catharina (1790-1842) and Gerrit (1794-1863). *Gezant van de Bataafse Republiek te Parijs, met zijn vrouw Catharina Nahuys en zijn kinderen Catharina en Gerrit*

Canvas 263.5 ×200. Painted in 1801-02

PROV On loan from Jonkheer G J A Schimmelpenninck, Rhenen, 1924-29. Presented by Mr & Mrs J C J Drucker-Fraser, Montreux, 1929
LIT F Schmidt-Degener, GdB-A 72 (1930) pp 86-96. J F L de Balbian Verster, Jb Amstelodamum 31 (1934) p 137. Staring 1947, p 118ff, fig 40. Fr W S van Thienen, OK 7 (1963) nr 19, ill. E P Engel, Bull RM 13 (1965) pp 56, 64, fig 9. G H E de Wit, Spiegel Hist 3 (1968) p 398, fig 5

Pruisen

see Wilhelmina of Prussia

Pieter de Putter

Middelburg? ca 1605–1659 Beverwijk

A 1295 Still life with fish. *Stilleven met vissen*

Panel 69 ×58.5. Signed *PD V T'f*
PROV Presented by Dr A Bredius, The Hague, 1885
LIT Vorenkamp 1933, p 74. Martin 1935-36, vol 1, p 426, fig 258. Bergström 1947, p 237, fig 194. Bergström 1956, p 233

Christoffel Puytlinck

Roermond 1640–after 1671 Roermond

457

A 1452 Dead roosters. *Dode hanen*

Canvas 76 × 57. Signed and dated
C. Puytlinck alias Trechter fc A° 1671
PROV Sale S B Bos (Harlingen),
Amsterdam, 21 Feb 1888, lot 184
LIT Vorenkamp 1933, p 91. Bol 1969, pp
281, 291

A 2160 Still life with meat and dead
birds. *Stilleven met vlees en dode vogels*

Canvas 87 × 123. Signed
C. Puijtlinck alias Trechter fecit Rürmont
PROV Purchased from Well Castle,
Limburg, 1905
LIT Vorenkamp 1933, p 93

Adam Pynacker

Pijnacker 1622 – 1673 Delft

A 321 Boatmen moored on the shore of
an Italian lake; perhaps intended to
represent the flight into Egypt. *Schippers
met hun boten aan de oever van een Italiaans
meer; misschien bedoeld als de vlucht naar
Egypte*

Canvas on panel 97.5 × 85.5. Signed
APijnacker
PROV Sale G van der Pot van
Groeneveld, Rotterdam, 6 June 1808, lot
105
LIT Smith 1829-42, vol 6 (1835) nr 21.
Hofstede de Groot 1907-28, vol 9 (1926)
nr 18. E Wiersum, OH 48 (1931) p 211.
Exhib cat Italianiserende landschap-
schilders, Utrecht 1965, nr 116, fig 119.
Stechow 1966, p 160. L J Slatkes, Art Q
31 (1968) p 84

A 322 Landscape with cattle. *Landschap
met vee*

Panel 36 × 48. Signed *APijnacker*
PROV Bequest of L Dupper Wzn,
Dordrecht, 1870
LIT Hofstede de Groot 1907-28, vol 9
(1926) nr 85. Exhib cat Italianiserende
landschapschilders, Utrecht 1965, p 186,
note 1. A Blankert, OH 83 (1968) p 119,
note 13

A 2335 A boat on the bank of a river.
Een schuit aan de oever van een rivier

Panel 40 × 43. Signed *APijnacker*
PROV Purchased from the heirs of Jonk-
heer P H Six van Vromade, Amsterdam,
1908, with aid from the Rembrandt
Society
LIT Hofstede de Groot 1907-28, vol 9
(1926) nr 19. Stechow 1966, p 160. Bol
1973, p 258, fig 264

C 207 A waterfall. *Een waterval*

Canvas 49 × 42. Signed *A. Pijnacker*
PROV On loan from the city of

Amsterdam (A van der Hoop bequest)
since 1885
LIT Hofstede de Groot 1907-28, vol 9
(1926) nr 50

A 1976 A shepherdess with her flock in a
mountainous landscape. *Een herderin met
vee in een bergachtig landschap*

Canvas 100 × 86. Signed *APijna…*
PROV Purchased from the G de Clercq
collection, Amsterdam, 1899, through
the intermediacy of the Rembrandt
Society * DRVK since 1961
LIT Hofstede de Groot 1907-28, vol 9
(1926) nr 133

attributed to **Adam Pynacker**

A 323 Italian landscape with ancient
tempietto. *Italiaans landschap met tempeltje*

Canvas 69.5 × 60
PROV Bequest of L Dupper Wzn,
Dordrecht, 1870
LIT Hofstede de Groot 1907-28, vol 9
(1926) nr 86

A 279 Italian landscape with fortress on the rocks. *Italiaans landschap met burcht op rotsen*

Canvas 44 × 55.5
PROV Bequest of L Dupper Wzn, Dordrecht, 1870 * DRVK since 1968
LIT Bol 1969, p 270 (Frederik de Moucheron)

Jacob Symonsz Pynas

Haarlem ca 1585–after 1650 Delft

A 1586 Sts Paul and Barnabas worshipped as gods by the people of Lystra. *Paulus en Barnabas te Lystra door het volk als goden vereerd*

Panel 64 × 105. Signed and dated *Jac. Pynas f. 1628*
PROV Presented by Dr A Bredius, The Hague, 1892
LIT G von Terey, Cicerone 18 (1926) p 801. K Bauch, OH 53 (1936) p 87, fig 10. Martin 1935-36, vol 1, p 146. L von Baldass, Belvedere 13 (1938-43) pp 154-59. C C Cunningham, Wadsworth Ath Bull, 1959, p 10ff, ill. Bernt 1960-62, vol 4, nr 230. Rosenberg, Slive & Ter Kuile 1966, p 20. L Oehler, Städ Jb ns 1 (1967) p 160. Bernt 1969-70, vol 2, nr 951. M Waddingham, Burl Mag 114 (1972) p 602, note 13

Jan Symonsz Pynas

Haarlem 1583/84–1631 Amsterdam

A 1626 Moses changing the water of the Nile into blood. *Mozes verandert het water van de Nijl in bloed*

Panel 72 × 172. Signed and dated *J. Pynas fe 1610*
PROV Purchased from A G Brigg Jr, Nieuwer Amstel, 1895 * DRVK since 1959 (on loan to Museum Het Rembrandthuis, Amsterdam)
LIT K Bauch, OH 52 (1935) p 148, fig 5. Martin 1935-36, vol 1, p 146. Haverkamp Begemann 1973, p 37

attributed to **Jan Symonsz Pynas**

A 3510 The meeting of Jacob and Esau. *De ontmoeting van Jacob en Ezau*

Copper 24.5 × 31
PROV Sale The Hague, 4-5 Nov 1947, lot 69
LIT R Klessmann, Berl Mus ns 15 (1965) p 10, fig 6 (early work of Bartholomeus Breenbergh?). L Oehler, Städ Jb ns 1 (1967) p 165, fig 17

Pieter Jansz Quast

Amsterdam 1606–1647 Amsterdam

A 1756 The foot operation. *De voetoperatie*

Panel 30 × 41. Signed *PQ*. Fictive inscription on cartouche
PROV Bequest of D Franken Dzn, Le Vésinet, 1898
LIT A Bredius, OH 20 (1902) p 66ff. P Julien, Rev histoire pharm, 1967, p 390, ill

A 1298 Card players with woman smoking a pipe. *Kaartspelers met een pijprokende vrouw*

Panel 38.5 × 28. Signed *PQuast*
PROV Sale C F Berré, Leiden, 7 Sep 1885, lot 69 (as Jacob Ochtervelt)

Edmé Quenedey

see under Miniatures

Jan Maurits Quinkhard

Rees 1688–1772 Amsterdam

see also Governors-general series: A 3780 & A 4549 G W Baron van Imhoff, after and by Quinkhard respectively – Rotterdam East India Company series: A 4521 Walter Senserff – and Panpoeticon Batavum

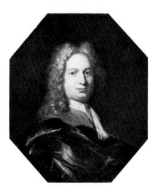

A 1354 Isaac Verburg (1680-1745). Rector of the Latin schools in Amsterdam. *Rector der Latijnse scholen te Amsterdam*

Canvas 37 × 30.5. Octagonal. Signed and dated *Quinkhard pinxit 1725*
PROV Presented by H T Karsten, Amsterdam, 1887 * Lent to the AHM, 1975
LIT Moes 1897-1905, vol 2, nr 8361

C 81 Six governors of the surgeons' guild, Amsterdam, 1732. *Zes overlieden van het chirurgijnsgilde, Amsterdam, 1732*

The sitters are Abraham Titsingh, deacon, A Vermey, Wichard van Wesik, Joannes de Bruyn, Willem Monnikhoff and Cornelis van der Swed. On the wall is a portrait of Professor Willem Röell

Canvas 176.5 × 273. Signed and dated *J. M. Quinkhard pinxit 1732.* Marked *XII*
PROV Surgeons' guild, Amsterdam. On loan from the city of Amsterdam, 1885-1975
LIT Tilanus 1865, p 17, nr XII. Moes 1897-1905, vol 1, nr 1206; vol 2, nrs 5130, 6470:3, 7736, 7992:1, 8405, 8997. P Geijl, OH 24 (1906) p 39. Scheen 1946, fig 4

C 82 Seven governors of the surgeons' guild, Amsterdam, 1737. *Zeven overlieden van het chirurgijnsgilde, Amsterdam, 1737*

The sitters are Pieter Plaatman, Abraham Titsingh, Leonard Coster, Augustinus Graver, Hermanus Meijer, Jan Bekker and Johannes Lakeman

Canvas 193 × 275. Marked *XIII*
PROV Surgeons' guild, Amsterdam. On loan from the city of Amsterdam, 1885-1975
LIT Tilanus 1865, nr XIII. Moes 1897-1905, vol 1, nrs 431, 1750, 2918; vol 2, nrs 4316, 5034, 5953, 7992:2

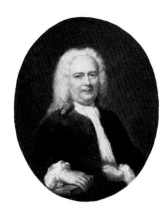

A 1509 Portrait of a man, perhaps a member of the Klinkhamer family. *Portret van een man, misschien een lid van de familie Klinkhamer*

Copper 16.5 × 14. Oval. Signed and dated *J. M. Quinkhard pinxit 1738.* Inscribed *Æt: 46* and on the verso *Klinkhamer*
PROV Sale Amsterdam, 10-12 Dec 1889, lot 34 (wrongly as a portrait of Govert Klinkhamer)
LIT Moes 1897-1905, vol 1, nr 4216:1

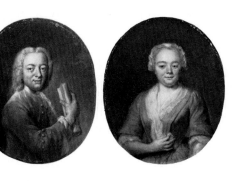

A 791 Bernardus de Bosch I (1709-86). Amsterdam poet and art patron. *Dichter en kunstbeschermer te Amsterdam*

Pendant to A 792
For another portrait of de Bosch by Quinkhard, *see* Panpoeticon Batavum: A 4625. A 791 & A 792 do not form part of the Panpoeticon

Copper 11 × 9.5. Oval. Grisaille
PROV Sale Amsterdam, 14-15 Nov 1883, lot 189

A 792 Margaretha van Leuvenigh (1705-85). Wife of Bernardus de Bosch. *Echtgenote van Bernardus de Bosch*

Pendant to A 791

Copper 11 × 9.5. Oval. Grisaille. Signed and dated *J. M. Quinkhard pinxit 1743*
PROV Same as A 791

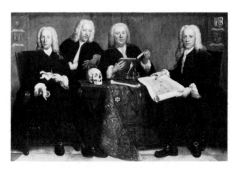

C 83 Four governors of the surgeons guild, Amsterdam, 1744. *Vier overlieden van het chirurgijnsgilde, Amsterdam, 1744*

The sitters are Johannes van Gorsel, Hendrik van der Ven, Hendrik Sak and Otto Ruysch

Canvas 162 × 239. Signed and dated *J. M. Quinkhard 1744.* Marked *XIV*
PROV Surgeons' guild, Amsterdam. On loan from the city of Amsterdam, 1885-1975
LIT Tilanus 1865, nr XIV. Moes 1897-1905, vol 1, nr 2828; vol 2, nrs 6645, 6734, 8338

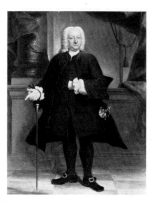

A 3954 Portrait of a man. *Portret van een man*

Copper 34 × 26.5. Signed and dated *J. M. Quinkhard fecit 1744*
PROV Bequest of FGS Baron van Brakell, Arnhem, 1878. NMGK

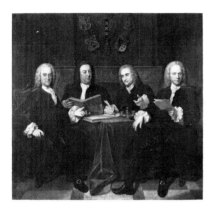

C 1469 The four chief commissioners of the Amsterdam harbor works, 1747. *De oppercommissarissen der Walen te Amsterdam, 1747*

The sitters are Jan Agges Scholten, Jacobus Dupeyrou Jansz, Karel Lijnslager and Hendrik van Castricum

Canvas 200 × 214. Signed and dated *J. M. Quinkhard pinxit 1747*
PROV Conference room of the chief commissioners of the Walen (harbor works) in the Schreierstoren, Amsterdam. On loan from the city of Amsterdam, 1885-1975
LIT Wagenaar 1760-88, vol 2 (1765) p 55. Aanwijzing Raadhuis, 1864, p 15, nr 86. Scheltema 1879, p 33, nr 90. Moes 1897-1905, vol 1, nrs 1499, 2175; vol 2, nrs 4709, 6975

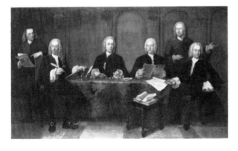

C 1471 Four regents and two other functionaries of the old folk's home, Amsterdam, 1750. *Vier regenten en twee andere functionarissen van het Oude Mannen en Vrouwen Gasthuis, Amsterdam, 1750*

The sitters are Pieter Karsseboom, Jacob de Leeuw, Pelgrom ten Grootenhuys Boendermaker and Jan Jacob Hartsinck

Canvas 207 × 350. Signed and dated *J. M. Quinkhard pinxit 1750*

PROV Regents' chamber, old folk's home, Amsterdam. On loan from the city of Amsterdam, 1885-1975
LIT Wagenaar 1760-88, vol 2 (1767) p 304. Aanwijzing Raadhuis, 1864, p 11, nr 61. Scheltema 1879, p 33, nr 89. Moes 1897-1905, vol 1, nrs 3240, 4091; vol 2, nr 4396

A 1269 Margaretha Trip (1699-1778). Wife of Harmen Hendrik van de Poll. *Echtgenote van Harmen Hendrik van de Poll*

For the pendant portrait of the sitter's husband, *see* Pothoven, Hendrik, A 1268

Canvas 50 × 39.5. Signed and dated *J. M. Quinkhard pinxit 1754*
PROV Presented by JSR van de Poll, Arnhem, 1885 * Lent to the AHM, 1975
LIT Moes 1897-1905, vol 2, nr 8075:1. M Heeren, Spiegel Hist 2 (1967) p 429, fig 3

A 1270 Jan van de Poll (1721-1801). Banker and burgomaster of Amsterdam (1787), with his son Harman (1751-99). *Bankier en burgemeester van Amsterdam met zijn zoontje Harman*

In the background is Spijk Manor near Velsen
For a presumed portrait of the sitter's wife Anna Maria Dedel, *see* Spinny, Guillaume de, A 1271

Canvas 50 × 40. Signed and dated *I. M. Quinkhard pinxit 1755*
PROV Presented by JSR van de Poll,

Arnhem, 1885 * Lent to the AHM, 1975
LIT Moes 1897-1905, vol 2, nrs 5990, 5995

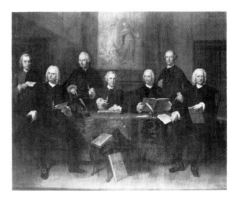

C 1470 Six regents and the housemaster of the Oude Zijds institute for the outdoor relief of the poor and the widows' home, Amsterdam, 1759. *Zes regenten en de binnenvader van het Oude Zijds Huiszitten-huis en het Weduwenhof, Amsterdam, 1759*

The sitters are Jacob Willink Meures, Jan Jacob van Beaumont, Jacob Guillot, Gijsbert van der Goot, Willem van der Meulen, Abraham Grommée and, on the left, the housemaster Hendrik Gorts

Canvas 267 × 336. Signed and dated *J. M. Quinkhard pinxit 1759 aetatis 71*
PROV On loan from the city of Amsterdam, 1885-1975
LIT Wagenaar 1760-88, vol 3 (1767) p 264. Moes 1897-1905, vol 1, nrs 415, 2822, 2951, 2991; vol 2, nrs 5010, 5017. Haak 1972, pp 34-35, fig 39

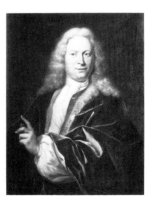

A 1436 Jan Henry van Heemskerck (1689-1730), count of the Holy Roman Empire, lord of Achttienhoven, den Bosch and Eyndschoten. Captain of the Amsterdam militia. *Graaf van het Heilige Roomse Rijk, heer van Achttienhoven, den Bosch en Eyndschoten. Kapitein der burgerij te Amsterdam*

Canvas 85 × 67. Signed *Quinkhard pinxit*
PROV Presented from the estate of JL

de Bruyn Kops, The Hague, 1888 * Lent
to the AHM, 1975
LIT Moes 1897-1905, vol I, nr 3318. AM
Hulkenberg, Jb Leiden, 1969, p 181, fig
26

Julius Quinkhard

Amsterdam 1736–1776 Amsterdam

A 325 A violinist and a flutist playing.
Een violist en een fluitist musicerend

Panel 51 × 41.5. Signed and dated *Julius
Quinkhard pinx 1755*
PROV Purchased from A J Brandt,
Amsterdam, 1821
LIT A Staring, in Kunstgesch der Ned,
1954-56, vol 2, p 341. VTTT, 1961-62, nr
41

A 324 Self portrait. Standing beside the
artist is Cornelis Ploos van Amstel J Czn
(1726-98). *Zelfportret met Cornelis Ploos van
Amstel JCzn naast hem staande*

Canvas 100 × 84. Signed and dated
Julius Quinkhard pinx 1757
PROV Purchased in 1876
LIT Scheen 1946, fig 17. J W Niemeijer,
NKJ 13 (1962) p 205, nr 5, fig 10. Van
Hall 1963, p 259, nr 1715:1

Johann Gualbert Raffalt

Murau 1836–1865 Rome

A 3088 The horsepond. *Het paardenwed*

Panel 26.2 × 33.9. Signed and dated
J. G. Raffalt [1]*858*
PROV Bequest of J BAM Westerwoudt,
Haarlem, 1907. Received in 1929

Felice Ramelli

see under Miniatures

Allan Ramsay

see Miniatures: English school ca 1770,
A 4399 George III, after Ramsay

copy after Raphael

Urbino 1483–1520 Rome

NO PHOTOGRAPH AVAILABLE

A 271 Madonna della Sedia

Copy by Wouterus Mol (1785-1857)
after the original in the Palazzo Pitti,
Florence

Canvas 72.5 cm in diam
PROV Mandatory entry by the artist, as
a subsidized art student in Paris, to exhib
Amsterdam 1810, nr 103, from whence it
was automatically ceded to the state *
Lent to the provincial assembly of
Zeeland, Middelburg, 1912. Destroyed
in the war, 1940
LIT Knoef 1947, p 7

Armand Rassenfosse

Liège 1862–1934 Liège

NO PHOTOGRAPH AVAILABLE

A 3282 Half-naked woman on a couch.
Halfnaakte vrouw op een rustbed

Board 35 × 45. Signed and dated
Rassenfosse 1920
PROV Presented by the artist's son,
A Rassenfosse, 1940. Missing

NO PHOTOGRAPH AVAILABLE

A 3283 'Au théâtre': two young women
in evening dress in a theatre loge. *Twee
jonge vrouwen in avondtoilet in een theaterloge*

Board 34 × 26.5. Signed and dated
Rassenfosse 1920
PROV Same as A 3282. Missing

NO PHOTOGRAPH AVAILABLE

A 3284 'Le journal': a young woman
sitting on a chair reading the newspaper.
*Een jonge vrouw zit op een stoel de krant te
lezen*

Board 44 × 34.5. Signed *A. R.*
PROV Same as A 3282. Missing

NO PHOTOGRAPH AVAILABLE

A 3285 A young woman, half undressed,
standing in front of a washbasin. *Een
jonge, half ontklede vrouw, staande voor een
wastafel*

Board 45 × 35. Signed and dated
Rassenfosse 1920
PROV Same as A 3282. Missing

Simon François Ravenet

see Miniatures: English school ca 1750-
51, Frederick Louis, prince of Wales,
after Ravenet

Jan van Ravenzwaay

Hilversum 1789–1869 Hilversum

A 1121 Cows in a stable. *Koeien op stal*

Canvas 40 × 46. Signed and dated
J. v. R. f. 1820
PROV Purchased at exhib Amsterdam
1820, nr 312. RVMM, 1885

C 209 Sheep and goats in a stable.
Schapen en geiten in de stal

Canvas 65 × 77. Signed and dated
J. v. Ravenzwaay Fecit 1821
PROV On loan from the city of
Amsterdam (A van der Hoop bequest)
since 1885

C 208 Meadow with cattle. *Weide met vee*

Canvas 96 × 122. Signed *J.v. Ravenzwaay
fec.*
PROV On loan from the city of
Amsterdam (A van der Hoop bequest)
since 1885

Jan Anthonisz van Ravesteyn

The Hague ca 1570–1657 The Hague

see also Honselaarsdijk series

C 1227 An officer in the army of Prince
Maurits. *Een officier uit het leger van prins
Maurits*

Canvas 116.5 × 97. Dated *A° 1611*
PROV Honselaarsdijk Manor. NM, 1809.
On loan from the KKS since 1933
LIT Moes & van Biema 1909, p 200

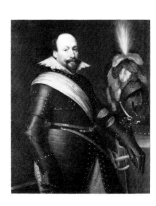

C 1229 An officer in the army of Prince
Maurits. *Een officier uit het leger van prins
Maurits*

Canvas 114.5 × 96.5. Dated *A 1612*
PROV Same as C 1227

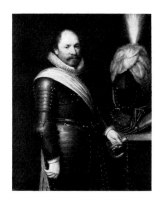

C 1230 An officer in the army of Prince
Maurits. *Een officier uit het leger van prins
Maurits*

Canvas 115 × 94.5. Dated *An° 1612*
PROV Same as C 1227

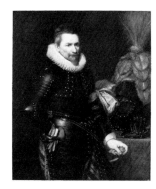

C 1228 An officer in the army of Prince
Maurits. *Een officier uit het leger van prins
Maurits*

Canvas 115 × 96.5. Signed and dated
VR A° 1615
PROV Same as C 1227

A 1950 Portrait of a man, thought to be
Jan Doublet, lord of Sint Annaland,
receiver-general of the states general.
*Portret van een man, vermoedelijk Jan Doublet,
heer van Sint Annaland, ontvanger-generaal
van de Generaliteit*

Panel 67.5 × 57.5. Signed and dated
VR Anno 1634
PROV Purchased from Fr Muller & Co,
art dealers, Amsterdam, 1901

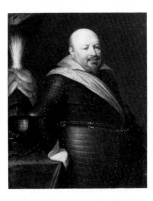

A 259 Nicolaas Smelsingh (1563-1629). Lieutenant governor of Overijssel. *Luitenant-gouverneur van Overijssel*

Canvas 109.5 ×85
PROV NM, 1808
LIT Moes & van Biema 1909, pp 104, 161, 200

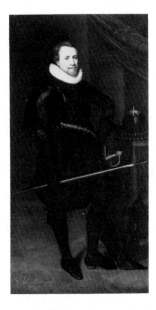

A 2527 Sir John Burroughs. Captain. *Veldoverste*

Canvas 212 × 107. Inscribed *Sr John Burroughs Capt.*
PROV Purchased from Fr Muller & Co, art dealers, Amsterdam, 1911, with aid from the Rembrandt Society
LIT J Veth, Jaarversl Ver Rembrandt, 1910, p 8. Martin 1935-36, vol I, p 308

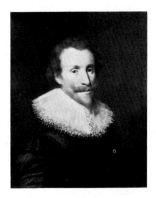

C 240 Portrait of a man. *Portret van een man*

Panel 67.5 ×53.5
PROV On loan from the city of Amsterdam (A van der Hoop bequest) since 1885 (as a portrait of Hugo de Groot)
LIT Van Beresteyn 1929, p 60, nr 54

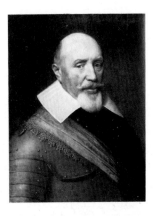

A 4191 Portrait of a man, thought to be Justinus of Nassau (1559-1631), natural son of Prince Willem I and Eva Elinx. *Portret van een man, vermoedelijk Justinus van Nassau, natuurlijke zoon van prins Willem I en Eva Elinx*

Panel 64 × 48
PROV Presented by Jonkheer J L Trip and A W Trip, née Countess van Limburg Stirum, Princenhage, 1805 (as a portrait of Count Egmond, together with Geest, Wybrand de, A 4190, as a portrait of Count Hoorne). NM, 1808
LIT Moes & van Biema 1909, pp 84, 204

attributed to **Giovanni Battista Recco**

Naples ca 1615– 1660 Naples

A 3884 Still life with chickens and eggs. *Stilleven met kippen en eieren*

Canvas 108 ×87
PROV Lent by E Heldring, Amsterdam, 1934. Bequeathed in 1954
LIT A L Mayer, Belvedere 3 (1923) pp 7, 13 (Velázquez). Beeldende Kunst 10 (1923) nr 7, p 51 (Velázquez). Kehrer 1926, p 104 (Velázquez). Von Wolter 1929, p 8, pl VI (Velázquez). Mayer 1936, p 39, nr 161, fig 66 (Velázquez). De Pantorba 1955, p 215, nr 131, fig 113 (Velázquez). J Ainaud de Lasarte, Goya, 1955, p 118 (Velázquez). S Bottari, Arte ant e mod, 1961, p 354, fig 159. Lopez Rey 1963, p 180, nr 167 (unknown 17th-century painter). Camón Aznar 1964, pp 188-89, ill (Velázquez). B de Pantorba, Goya, 1965, p 257, ill (Velázquez). R Causa, in Storia di Napoli 5 (1972) pp 1012, 1015, fig 390

Frédéric Reclam

Magdeburg 1734– 1774 Berlin

A 1222 Frederika Sophia Wilhelmina (Wilhelmina; 1751-1820), princess of Prussia, in a medallion, with details alluding to her marriage to Willem V, prince of Orange-Nassau, on 4 October 1767 in Berlin. *Prinses van Pruisen, in een medaillon, vergezeld van toespelingen op haar huwelijk te Berlijn, 4 october 1767, met Willem V, prins van Oranje-Nassau*

Panel 50 ×39. Signed and dated *Fr Reclam pinxit 1767*
PROV KKS, 1885

Odilon Redon

Bordeaux 1840–1916 Paris

A 3265 A M L Bonger-van der Linden. First wife of the collector André Bonger. *Eerste echtgenote van de verzamelaar André Bonger*

Canvas 72.5 × 59.5. Signed and dated *Odilon Redon 1905*
PROV Presented by C H Huguenot van der Linden and Miss E C van der Linden from the estate of André Bonger, Amsterdam, 1936 * On loan to the SMA since 1948
LIT Berger 1964, nr 189. Exhib cat André Bonger en zijn kunstenaars-vrienden, Amsterdam 1972, nr 20, fig 12

Hendrik Reekers

Haarlem 1815–1854 Haarlem

NO PHOTOGRAPH AVAILABLE

A 1704 Still life with fruits. *Stilleven met vruchten*

On a marble shelf are a half-peeled lemon, a peach, plums, white and blue grapes. In a vase are roses and other flowers. A yellow bird hangs in the middle of the picture space; to the left are a gray and a brown bird

Panel 60 × 46.5. Signed and dated *H. Reekers 1845*
PROV Presented by C C A Baron du Bois de Ferrières, Cheltenham, 1897 * Lent to the provincial governor of Zuid-Holland, The Hague, 1930. Destroyed in the war, 1944

Ignatius Josephus van Regemorter

Antwerp 1785–1873 Antwerp

A 1122 The fish market in Antwerp. *De vismarkt te Antwerpen*

Panel 59 × 49. Signed and dated *Ign. van Regemorter f. 1827*
PROV Probably purchased at exhib Amsterdam 1830, nr 280, or The Hague 1830, nr 255. RVMM, 1885

A 1123 Jan Steen sending his son out to trade paintings for beer and wine. *Jan Steen stuurt zijn zoon de straat op om schilderijen te ruilen voor bier en wijn*

Panel 55 × 44.5. Signed and dated *Ign. van Regemorter f. 1828*
PROV Purchased at exhib Amsterdam 1828, nr 365. RVMM, 1885 * DRVK since 1953
LIT A A E Vels Heijn, Kunstrip, 1973, nr 33

Martinus van Regteren Altena

Amsterdam 1866–1908 Nunspeet

A 2620 Farmer from Laren, Noord-Holland. *Boer uit Laren, Noord-Holland*

Canvas 42 × 32.5. Signed and dated *M. vR. Altena.* Inscribed in ink on the edge of the canvas *1902*
PROV Presented by the painter's widow, Mrs A van Regteren Altena-Pook van Baggen, Laren, 1912

Tibout Regters

Dordrecht 1710–1768 Amsterdam

A 2671 Jan Casper Philips (1700-65). Engraver. *Graveur*

Panel 35 × 30. Signed and dated *T. Regters pinxit 1747.* Inscribed on the engraving *J. C. Philips ... 1745*
PROV Sale Amsterdam, 6 May 1913, lot 85
LIT Van Hall 1963, p 248, nr 1642:1

A 2190 Ludolf Bakhuysen II (1717-82). Painter, in the uniform of the dragoons. *Schilder, in het uniform der Dragonders*

Panel 52.5 × 42.5. Signed and dated
T. Regters pinxit 1748
PROV Bequest of Miss M E van den Brink, Velp, 1905
LIT Van Gool 1750-51, vol 2, p 354. Van Eijnden & van der Willigen 1816-40, vol 2 (1817) pp 82-83. Moes 1897-1905, vol 1, nr 326. J W Niemeijer, Bull RM 10 (1962) p 148, fig 2. Van Hall 1963, p 12, nr 69:1

A 330 Jan ten Compe (1713-61). Amsterdam painter and art dealer. *Schilder en kunsthandelaar te Amsterdam*

Panel 28.5 × 24. Signed and dated
T. Regters f. 1751
PROV Sale J Immerzeel Jz, Amsterdam, 11-15 April 1842, lot 30
LIT Bürger 1858-60, vol 1, p 170. Moes 1897-1905, vol 1, nr 1667:2. Van Hall 1963, nr 402:4. S H Levie, Alb Amic J G van Gelder, 1973, p 219, note 9. H C de Bruijn, Antiek 8 (1974) p 616, fig 1

A 2136 The Brak family, Amsterdam Mennonites. *De Amsterdamse doopsgezinde familie Brak*

From left to right: Reverend Jan Brak (1717-61), his brother Pieter Brak (ca 1714-after 1778), his father Harmen Brak (d 1768), his sister-in-law Margaretha Hasselaar (1726-80/83) with her husband Cornelis Brak (1724-82); standing in the foreground is their oldest daughter. Their next to oldest daughter, Margaretha (d 1752), is sitting on her mother's lap

Canvas 67.5 × 84. Signed and dated
T. Regters pinxit 1752
PROV Presented by Miss C M Bakker, Baarn, 1904
LIT Scheen 1946, fig 7. P van Eeghen, Mndbl Amstelodamum 35 (1948) p 40, ill. Staring 1956, p 128

A 2422 Pieter Nicolaas Rendorp (1732-73). Amsterdam brewer. *Brouwer te Amsterdam*

For a portrait of the sitter's half brother Joachim Rendorp, *see* A 2420

Panel 16 × 14. Signed and dated
T. Regters Pᵗ 1756
PROV Bequest of S Rendorp, Amsterdam, 1910 * Lent to the AHM, 1975

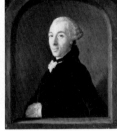

A 2420 Joachim Rendorp (1728-92), baron of Marquette. Brewer and burgomaster of Amsterdam. *Vrijheer van Marquette. Brouwer en meermalen burgemeester van Amsterdam*

Painted after a pastel of 1757 by Jean-Etienne Liotard in the collection of the heirs of Jonkheer H Boreel, Beverwijk Pendant to A 2421
For a portrait of the sitter's half brother Pieter Nicolaas Rendorp, *see* A 2422

Panel 16 × 14.5. Inscribed on the verso
Joachim Rendorp
PROV Same as A 2422 * Lent to the AHM, 1975

A 2421 Wilhelmina Hillegonda Schuyt (1728-1802). Wife of Joachim Rendorp. *Echtgenote van Joachim Rendorp*

Painted after a pastel of 1757 by Jean-Etienne Liotard in the collection of the heirs of Jonkheer H Boreel, Beverwijk Pendant to A 2420

Panel 16 × 14.5. Inscribed on the verso
Wilhelmina Hildegonde Schuyt
PROV Same as A 2422 * Lent to the AHM, 1975

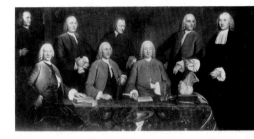

C 84 The anatomy lesson of Professor Petrus Camper, 1757. *De anatomische les van Professor Petrus Camper, 1757*

The other sitters are N van der Meulen, Loth Lothz, Pieter Jas, Coenraad Nelson, Abraham Richard, Joannes Stijger and, on the left, the guild steward van der Weert

Canvas 169 × 329. Signed *T. Regters*. Marked *XV*. Inscribed on the cupboard *Instrumenta Chirurgica A MDCCLVII*
PROV Surgeons' guild, Amsterdam. On loan from the city of Amsterdam, 1885-1975
LIT Van Eijnden & van der Willigen 1816-40, vol 2 (1817) p 73. Immerzeel 1842-43, vol 3, p 9. Tilanus 1865, p 35, note 43, nr XV. Moes 1897-1905, vol 1, nrs 1433:4, 4007; vol 2, nrs 4640, 5008, 5332, 6418, 7689. B W Th Nuyens, Jaarversl KOG 70 (1928) p 44, fig 21. Wegner 1939, pp 20, 22, 59, 73, 179. Holländer 1950, p 76, fig 50. Van Hall 1963, p 57, nr 350:5. Wolf-Heidegger & Cetto 1967, p 327, nr 275, ill. Haak 1972, p 48, fig 61

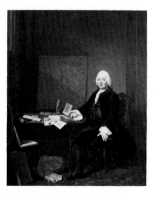

A 329 Jan Wagenaar (1709-76). Official historian of Amsterdam. *Stadshistorie-schrijver van Amsterdam*

Canvas 82 × 68. Signed and dated
T. Regters pinxit 1761

PROV Purchased from C F Roos & Co, art dealers, Amsterdam, 1821 * Lent to the AHM, 1975
LIT Moes 1897-1905, vol 2, nr 8817:1

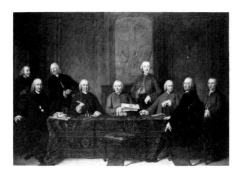

C 1472 Eight members of an unidentified Amsterdam board of officials and their steward. *Acht leden van een Amsterdams college en hun bediende*

Canvas 282 × 399. Dated on the minutes *1766*
PROV On loan from the city of Amsterdam, 1945/46-75
LIT Scheltema 1879, pp 35-36, nr 96 (with erroneous title and reference)

Rembrandt Harmensz van Rijn

Leiden 1606 – 1669 Amsterdam

see also Miniatures: Monogrammist W P, A 4377 Portrait of an old woman – Panpoeticon Batavum: A 4589 Jan Six, by Arnoud van Halen after Rembrandt

C 1448 Tobias accusing Anna of stealing the kid. *Tobias beschuldigt Anna van het stelen van een bokje*

Panel 39.5 × 30. Signed and dated *RH 1626*
PROV On loan from Baroness Bentinck-Thyssen Bornemisza, Paris, since 1956
LIT W Bode, Art in America I (1913) p 13. Hofstede de Groot 1907-28, vol 6 (1915) nr 64a. W Martin, OH 42 (1925) p 48, ill. Bauch 1933, pp 21-22. Martin

1935-36, vol 2, p 55. Bredius 1935, nr 486. W Martin, Jb Mij Ned Lett, 1936-37, p 57, fig 6. W Sumowski, OH 71 (1956) p 109, ill. Haverkamp Begemann 1959, pp 68, 83, 192. Bruyn 1959, p 24. Bauch 1960, p 213, fig 172. Bauch 1966, nr 2. Rosenberg, Slive & Ter Kuile 1966, pp 5, 51, fig 30 A. Gerson 1968, pp 24, 92, 174, 488, ill on pp 11, 174. Haak 1968, pp 29, 37, figs 34, 34 a-b. B R Wipper, Bild Kunst, 1969, p 468, fig 3. Chr Tümpel, NKJ 20 (1969) pp 113-14. Bredius & Gerson 1969, nr 486. A A E Vels Heijn, OK 15 (1971) nr 32, ill. J Bauch et alia, NKJ 23 (1972) pp 488, 491

A 3934 Self portrait. *Zelfportret*

Panel 41.2 × 33.8. Signed *RHL*
PROV Purchased from B Katz gallery, Dieren, 1958, with aid from the Rembrandt Society
LIT Hofstede de Groot 1903, p 38, nr 111, fig 49. Moes 1897-1905, vol 2, nr 6693:4. Rosenberg 1906, p 12. Hofstede de Groot 1907-28, vol 6 (1915) nr 531. Bauch 1933, pp 160, 178, 208. Benesch 1935, p 4. Bredius 1935, p 5. Goldscheider 1936, p 37, fig 202. Van Gelder 1946, P, p 9. Pinder 1950, p 28, ill. Bauch 1960, p 176. Van Hall 1963, p 263, nr 1743:8. Vis 1965, p 46, fig 15. Bauch 1966, nr 298. Gerson 1968, pp 196, 490, ill on pp 25, 196. Bredius & Gerson 1969, nr 5

A 3276 Jeremiah lamenting the destruction of Jerusalem. *Jeremia treurend over de verwoesting van Jeruzalem*

Panel 58 × 46. Signed and dated *RHL 1630*
PROV Purchased from H Rasch, Stockholm, 1939, with aid from private benefactors, the Rembrandt Society, the state of the Netherlands and the Photo Commission
LIT Smith 1829-42, vol 7 (1836) nrs 9, 190. Vosmaer 1868, pp 2-3. W Bode, Graphischen Künste 3 (1881) p 49ff. Bode 1897, vol I, nr 39. Hofstede de Groot, OH 41 (1923-24) pp 99-100, ill. Bredius 1935, p 604. Van Gelder 1946, L, pp 1, 13, 54, fig on p 2; HS, p 12. Landsberger 1946, p 109. Knuttel 1956, pp 76, 275, fig 2. R Wischnitzer, Art Bull 39 (1957) p 224ff. J G van Gelder, OK 7 (1963) nr 15, ill. Rosenberg 1964, pp 309-10. Bauch 1966, nr 127. Haak 1968, pp 48, 60, 63, figs 86, 86a. Gerson 1968, pp 18, 28, 190, 489. I Bergström, l'Oeil, 1969, p 7, ill. H Gerson, in Miscellanea van Regteren Altena, 1969, p 141, fig 7. J C van der Waals, Kroniek Rembrandt-huis 23 (1969) p 87. S H Levie, Connoisseur 171 (1969) p 2, fig 1. D Sutton, Apollo, 1969, p 421, fig 1. Chr Tümpel, NKJ 20 (1969) p 181. Bredius & Gerson 1969, p 604. VTTT, 1969-70, nr 114. J Bruyn, Simiolus 4 (1970) p 32ff, fig 4. E Huttinger, Arte ill 3 (1970) Jan-Feb, p 5. J Bauch et alia, NKJ 23 (1972) pp 488, 491

A 3066 An old woman, probably Rembrandt's mother, Neeltgen Willemsdr van Zuydtbroeck (d 1640), apparently in the guise of the prophetess Anna. *Een oude vrouw, waarschijnlijk Rembrandt's moeder, Neeltgen Willemsdr van Zuydtbroeck, vermoedelijk voorgesteld als de profetes Anna*

Panel 60 × 48. Signed and dated *RHL 1631*
PROV Lent by M P Voûte, Amsterdam, 1922. Purchased from his estate through the intermediacy of the Rembrandt Society, 1928
LIT Moes 1897-1905, vol 2, nr 9404:7. Bredius & Schmidt-Degener 1906, pp 12-13, ill. Rosenberg 1906, p 17. Valentiner 1909, p 38. Hofstede de Groot 1907-28, vol 6 (1915) nr 316. Bauch 1933, pp 107-08. Gedenkboek Ver Rembrandt, 1933, p 58, ill. Bredius

1935, p 69. Knuttel 1956, pp 78, 271.
H M Rotermund, NKJ 8 (1957) p 131,
figs 4-5. Fr W S van Thienen, OKTV I
(1963) nr 1, ill. Rosenberg 1964, p 9, fig
7. A B de Vries, OKTV 3 (1965) nr 14, fig
4. Rosenberg, Slive & Ter Kuile 1966,
p 51. Bauch 1966, nr 252, ill. Gerson
1968, pp 18, 30, 50, 193, 489, ill on p 193.
Fuchs 1968, p 13, fig 16. Haak 1968, fig
99. Gerson 1969, nr 69. Chr Tümpel,
NKJ 20 (1969) pp 178-79, fig 57. D Cevat,
N Beitr Rembrandt Forsch, 1973, p 85. J
Bauch et alia, NKJ 23 (1972) p 491. D de
Hoop Scheffer, Kroniek Rembrandthuis
26 (1972) p 132, fig 8

A 4057 Saskia van Uylenburgh (1612-
42). Rembrandt's wife from 1634 until
her death. *Saskia van Uylenburgh, met wie
Rembrandt trouwde in 1634*

Panel 65 × 48. Oval. Signed and dated
Rembrandt ft. 1633
PROV Presented by Mr & Mrs I de
Bruijn-van der Leeuw, Spiez, to the
Rembrandt Society, with reservation of
usufruct, for placing in the RMA, 1933.
Received in 1961
LIT Moes 1897-1905, vol 2, nr 8168:5.
Valentiner 1908, p 128. Hofstede de
Groot 1907-28, vol 6 (1915) nr 606.
Bredius 1935, nr 94, ill. Knuttel 1956, pp
251, 271. E R Meijer, Bull RM 9 (1961) p
59, fig 11. J L Cleveringa, Bull RM 9
(1961) p 65, nr 13. Van Hall 1963, p 267,
nr 1743:48. Bauch 1966, nr 473. Gerson
1968, pp 56, 271, 494, ill on pp 55, 271.
Fuchs 1968, p 12, fig 7. Bredius & Gerson
1969, nr 94

C 1555 Portrait of a woman. *Portret van
een vrouw*

Pendant to the portrait of a man in the
Thyssen-Bornemisza collection, Lugano
(Bredius 1935, nr 177)

Panel 69 × 55. Oval. Signed and dated
Rembrandt f. 1634
PROV On loan from J W Middendorf II
since 1973
LIT Bredius 1935, p 344. Bauch 1966, p
480. Gerson 1968, p 280, ill, nr 150.
Bredius & Gerson 1969, nr 344

A 3340 An oriental. *Een oosterling*

Panel 72 × 54.5. Signed and dated
Rembrandt f 1635
PROV Presented by Mr & Mrs D A J
Kessler-Hülsmann, Kapelle op den
Bosch near Mechelen, 1940
LIT Smith 1829-42, vol 7 (1836) nr 287.
C Hofstede de Groot, Onze Kunst 22
(1912) p 180, fig 6. Hofstede de Groot
1907-28, vol 6 (1915) nr 353. Valentiner
1921, p 8, fig 35. Meldrum 1923, p 191,
nr 144A. Benesch 1935, p 20. Bredius
1935, p 206. J G van Gelder, Elsevier's
GM 100 (1940) p 45ff, ill. Knuttel 1956,
pp 96, 274. Bauch 1966, nr 163, ill.
Gerson 1968, pp 290, 495, ill on p 290.
Bredius & Gerson 1969, nr 206. J Bauch
et alia, NKJ 23 (1972) pp 488, 491-92

A 3477 Joseph telling his dreams to his
parents and his brothers. *Jozef vertelt zijn
dromen aan zijn ouders en zijn broers*

Paper on panel 51 × 39. Grisaille. Signed
and dated *Rembrandt f. 163.*
PROV Lent by Jonkheer J W Six van
Vromade, The Hague, 1915-20. Lent by
A W Volz, The Hague, 1931-33.
Purchased from his estate, 1946, with aid
from the Rembrandt Society and the
Photo Commission
LIT Michel 1893, pp 236, 565. Bode &
Hofstede de Groot 1897-1905, vol 3
(1899) p 172, nr 212. Valentiner 1908,
p 175. Hind 1912, vol 1, p 83, nr 160.
Hofstede de Groot 1907-28, vol 6 (1915)
nr 14. A Bredius, GdB-A 63 (1921) p 218.
Bredius 1935, p 504. Martin 1935-36, vol
2, p 69. Knuttel 1956, pp 122, 275.
Bauch 1966, nr 19, ill. Gerson 1968, pp
241, 492, ill on p 241. Haak 1968, p 145,
fig 223. Bredius & Gerson 1969, nr 504.
J G van Gelder, N Beitr Rembrandt
Forsch, 1973, p 193

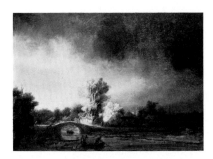

A 1935 The stone bridge. *De stenen brug*

Panel 29.5 × 42.5
PROV Sale J Reiss, London, 12 May
1900, lot 63. Purchased with aid from
Dr A Bredius and the Rembrandt
Society
LIT Hofstede de Groot 1907-28, vol 6
(1915) nr 939. Lugt 1915, p 126 (in the
neighborhood of Ouderkerk). Eisler
1918, p 192. Gedenkboek Ver
Rembrandt, 1933, p 60, ill. Bredius 1935,
p 440. Martin 1935-36, vol 2, p 37, fig 22.
Van Gelder 1946, L, pp 1, 17, 37ff, ill on
p 7. Hamann 1948, p 299. Gerson 1952,
p 42, fig 119. Knuttel 1956, pp 112, 279.
H van de Waal, OK 2 (1958) nr 26, ill.
Van Gelder 1959, pl III. Stechow 1966,

p 42, fig 108. Bauch 1966, nr 543, ill (ca 1637-38). A B de Vries, OKtV 1 (1963) nr 15, fig 3. Gerson 1968, p 307, ill, p 496. Haak 1968, p 149, fig 232. Fuchs 1968, p 61, fig 99. Bredius & Gerson 1969, nr 440. R Charmet, M Ochsé & D François, Jardin d A, nr 215, 1972, pp 24-25, ill

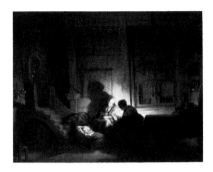

A 4119 The holy family at night. *De heilige familie bij avond*

Panel 66.5 × 78. Traces of a signature
PROV Purchased from Thos Agnew & Sons Ltd, London, 1965, with aid from the Rembrandt Society, the Prince Bernhard Foundation and the Photo Commission
LIT Smith 1829-42, vol 7 (1836) p 63, nr 145. Waagen 1854, vol 2, p 501. Dutuit 1883-85, vol 3, pp 9, 45, 59, nr 60. Von Wurzbach 1886, fig 157. Michel 1893, vol 1, pp 299, 555. Bode & Hofstede de Groot 1897-1905, vol 4 (1900) pp 15, 92, nr 250, ill. Valentiner 1909, p 280. Stryienski 1913, pp 108, 182, nr 398. Hofstede de Groot 1907-28, vol 6 (1915) nr 91. Weisbach 1926, pp 154-55, 386. Benesch 1935, p 36. Bredius 1935, nr 568, ill. Van Gelder 1946, HS, p 31, ill on p 34. Veth 1946, p 138. Hamann 1948, pp 288, 291-92, fig 197 (probably Nicolaes Maes). Pariset 1948, p 368. Slive 1953, p 149, fig 33. De Vries 1956, p 49. Knuttel 1956, pp 145, 276. J Rosenberg, Kunstchronik 9 (1956) p 347. X de Salas, Goya, 1956, p 144, ill. P J J van Thiel, Bull RM 13 (1965) pp 143-61. B Bakker, Kroniek Rembrandthuis 19 (1965) p 97, ill. Bauch 1966, p 49 (more likely in the manner of Nicolaes Maes). VTTT, 1965-66, nr 80. J G van Gelder, OK 10 (1966) nr 36, ill. J Q van Regteren Altena, OH 82 (1967) p 70. Bredius & Gerson 1969, nr 568 (studio work). R Charmet, M Ochsé & D François, Jardin d A, nr 215, 1972, p 20, ill

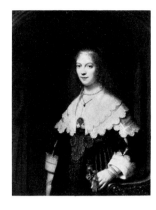

C 597 Maria Trip (1619-83). Sister of Jacobus Trip and future wife of Balthasar Coymans (1589-1657). *Zuster van Jacobus Trip en later echtgenote van Balthasar Coymans*

For a portrait of the sitter's brother, *see* Helst, Bartholomeus van der, A 1255

Panel 107 × 82. Signed and dated *Rembrandt f. 1639*
PROV On loan from the van Weede Family Foundation since 1897
LIT GdB-A 2 (1872) ill opp p 218. Hofstede de Groot 1907-28, vol 6 (1915) nr 845. Bredius 1935, p 356. Martin 1935-36, vol 2, p 64. C J Hudig, Historia 9 (1943) p 172, fig 8. I H van Eeghen, Mndbl Amstelodamum 43 (1956) pp 166-69. Knuttel 1956, pp 117, 274. Bauch 1966, p 498. Gerson 1968, pp 88, 304, 496, ill on p 304. Haak 1968, pp 155, 252, fig 242. Fuchs 1968, p 12, fig 5. Bredius & Gerson 1969, nr 356

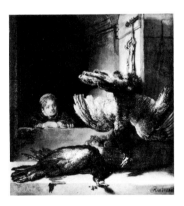

A 3981 Still life with peacocks. *Stilleven met pauwen*

Canvas 145 × 135.5. Signed *Rembrandt*
PROV Lent by J J M Chabot, Wassenaar, 1923-42. Lent by the SNK, later DRVK, 1948. Transferred in 1960
LIT Hoet 1752, vol 1, nr 419? A Bredius, OH 26 (1908) p 223. Valentiner 1909, p 309. Hofstede de Groot 1907-28, vol 6 (1915) nr 968. F Schmidt-Degener, Kunstchronik ns 30 (1918-19) p 3. Vorenkamp 1933, p 83. Bredius 1935, p 456. Bergström 1947, p 253, fig 207. Rosenberg 1948, pp 154-55. Bergström

1956, p 249, fig 207. Knuttel 1956, pp 106, 110, 279. H Kühn, Jb Ksamml Baden-Württemberg 2 (1965) p 200. Bauch 1966, nr 558, ill (ca 1636-37). Gerson 1968, pp 253, 492, ill on p 253. Haak 1968, pp 134, 136, fig 204. Bredius & Gerson 1969, nr 456. J G van Gelder, N Beitr Rembrandt Forsch, 1973, p 202

C 5 The company of Captain Frans Banning Cocq and Lieutenant Willem van Ruytenburch, known as 'The nightwatch.' *Het korporaalschap van kapitein Frans Banning Cocq en luitenant Willem van Ruytenburch, bekend als de 'Nachtwacht'*

Canvas 363 × 437. Signed and dated *Rembrandt f 1642*. Inscribed on cartouche, probably added later, *Frans Banning Cocq, heer van purmerlant en Ilpendam, Capiteijn, Willem van Ruijtenburch van Vlaerdingen, heer van Vlaerdingen, Lu[ij]tenant, Jan Visscher Cornelisen Vaendrich, Rombout Kemp Sergeant, Reijnier Engelen Sergeant, Barent Harmansen, Jan Adriaensen Keyser, Elbert Willemsen, Jan Clasen Leydeckers, Jan Ockersen, Jan Pietersen bronchorst, Harman Iacobsen wormskerck, Jacob Dircksen de Roy, Jan vander heede, Walich Schellingwou, Jan brugman, Claes van Cruysbergen, Paulus Schoonhoven*
PROV Great hall, Kloveniersdoelen (headquarters of the arquebusiers' civic guard), Amsterdam. On loan from the city of Amsterdam since 1808
LIT Wagenaar 1760-88, vol 2 (1765) p 26. Van Dijk 1790, p 58, nr 27. Scheltema 1853, pp 28, 101. Scheltema 1879, nr 98. A Bredius & N de Roever, OH 3 (1885) p 85. D C Meijer, Ned Spec, 1896, p 241ff. Moes 1897-1905, vol 1, nr 1594:1; vol 2, nr 6655. J Six, Bull NOB 3 (1901-02) p 199ff. A Pit, Bull NOB 4 (1902-03) p 45ff. E Durand-Gréville, OH 24 (1906) p 77. C Neumann, Kunstchronik ns 17 (1906) p 513. J F M Sterck, OH 25 (1907) p 65ff. A Bredius, OH 30 (1912) p 199. F Schmidt-Degener, Onze Kunst 21 (1912) p 1ff; idem 26 (1914) pp 1-17. J Veth, OH 33 (1915) pp 8, 10, ill. Hofstede de Groot 1907-28, vol 6 (1915) nr 926. F Schmidt-Degener, Onze Kunst 29 (1916) pp 61-84; idem 30 (1916) pp 29-56; idem 31 (1917) pp 1-32; idem 33 (1918) pp 91-94. J Six, Onze Kunst 33 (1918) p 141ff. J Six, Oude Kunst 35 (1919) pp 1-20. M Dvoràk, in Meisterwerke, 1920-21. W Martin, OH 41 (1923-24) p 8ff. De Haas 1928. H van Apeldoorn, De Gids 93 (1929) vol 2, p 133ff. Riegl 1931, pp 192, 206, 213-18, 220-26. J G van Dillen, Jb Amstelodamum 31 (1934) pp 97-110. Martin 1935-36, vol 1, pp 212-14, 219-20, 222, 224, fig 121; vol 2, pp 45, 52, 72-81, 103, fig 26a. Bredius 1935, nr 410. Schmidt-Degener 1942. Wijnbeek 1944. W Martin & M J Friedländer, Mndbl BK 22 (1946) p 197. Van Gelder 1946, N, pp 1, 18ff, ill on p 36, 39-44, T, 19. A van Schendel & H H Mertens, OH 62 (1947) p 1ff. A J Moes-Veth, OH 62 (1947) p

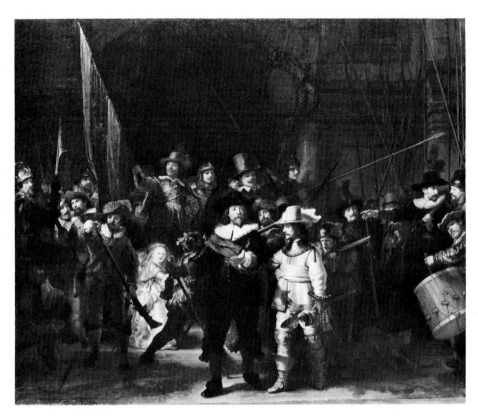

C 85 The anatomy lesson of Dr Joan Deyman (1620-66). *De anatomische les van Dr Joan Deyman*

The man holding the crown of the skull is Gijsbert Matthijsz Calckoen of the Amsterdam anatomy theatre

Canvas 100 × 134. Signed and dated *Rembrandt f. 1656*. Fragment of a painting most of which was destroyed by fire on 8 Nov 1723 and on which eleven figures were originally portrayed (*cf* Rembrandt's drawing in the Rijksprentenkabinet, Benesch nr 1175)
PROV Surgeons' guild, Amsterdam. Sold in 1841. Purchased by the city of Amsterdam, with aid from private benefactors, at the urging of Prof J Six, 1882. On loan from the city of Amsterdam since 1885
LIT Tilanus 1865, p 19, nr XVII, note 48. J Six, Ned Spec, 1882, p 168. Moes 1897-1905, vol 1, nrs 1376, 1962. J Six, OH 23 (1905) p 37. Voll 1907, p 180. Hofstede de Groot 1907-28, vol 6 (1915) nr 927. H Tietze, in Meisterwerke, 1920. Weisbach 1926, pp 581-84. Riegl 1931, pp 206-09, fig 59. Bredius 1935, p 414. Martin 1935-36, vol 1, p 202; vol 2, pp 19, 64, 79. Van Gelder 1946, N, p 43ff, ill on p 48; P, p 40. I H van Eeghen, Mndbl Amstelodamum 35 (1948) pp 34-36. I Q van Regteren Altena, OH 65 (1950) pp 171-78. Slive 1953, p 80. I H van Eeghen, OH 71 (1956) p 35ff, ill. Knuttel 1956, pp 40, 183, 273, fig 43. Heckscher 1958, p 190. A M Cetto, Ciba, 1958, pp 122-25. A M Cetto, Kroniek Rembrandthuis 13 (1959) pp 57-62, fig 2. Rosenberg 1964, pp 136-37, fig 121. White 1964, p 105, ill. H Kühn, Jb Ksamml Baden-Württemberg 2 (1965) p 199. Bauch 1966, nr 538, ill. Clark 1966, p 93, fig 85. Bauch 1967, p 140, note 27. Wolf-Heidegger 1967, p 313, nr 261, fig 261. Fuchs 1968, p 29, fig 40. Gerson 1968, pp 124, 128-29, 148, 150, 501, ill on p 398. Haak 1968, pp 266-67, 335, 445. C

188ff. Martin 1947. Koot 1947. L Münz, Burl Mag 89 (1947) pp 1-52, 253. H Gerson, Burl Mag 89 (1947) p 45. Rosenberg 1948, pp 74-80. W Martin, in Miscellanea van Puyvelde, 1949, pp 225-28. A van Schendel, Museum 3 (1950) pp 220-22. W Martin, OH 66 (1951) pp 1-9. Gerson 1952, p 10, fig 13. Slive 1953, pp 6, 86, 97, 108, 182. Hellinga 1955. I Q van Regteren Altena, Actes 17ième congr intern, 1955, pp 404-20. Knuttel 1956, pp 35, 128, 233, 273, fig 20. Hellinga 1956. Bauch 1957. A J Moes-Veth, OH 75 (1960) pp 143-56. H van der Tuin, Revue Litt Comp, 1960, p 456. Van Hall 1963, p 272, nr 1743:98. Rosenberg 1964, pp 138-43, fig 124. White 1964, pp 65-66, ill. Rosenberg, Slive & Ter Kuile 1966, pp 50, 54, 61-63, 83, 185, 268. H Gerson, OK 10 (1966) nr 1, ill. Clark 1966, pp 70, 85-86, 88, 160, 169, 172, 214, fig 77. Bauch 1966, nr 537, ill. M Imdahl, in Festschrift Hager, 1966, p 103ff. M Kok, Bull RM 15 (1967) pp 116-21. A Livermore, Apollo, 1967, p 240ff. Bauch 1967, p 140, note 27. Rosenberg 1967, pp 61, 64, 77-78, fig 501. VTTT, 1968-69, nr 99. Gerson 1968, pp 68, 72-84, 129, 136, 150, 152, 161, 338-39, 498, ill on p 73. Fuchs 1968, pp 14-16, figs 17, 19. Haak 1968, pp 128, 178-81, 184, 332-36, fig 282. H Lüdecke, Bild Kunst, 1969, p 457, fig 10. H van de Waal, in Miscellanea van Regteren Altena, 1969, p 145ff. M Brion, Jardin d A 176-77 (1969) p 8, ill on p 9. H Coulonges, Jardin d A 176-77 (1969) p 26ff. Bredius & Gerson 1969, nr 410, ill. R H Fuchs, Tijdschr v Gesch, 1969, p 488. Slive 1970, vol 1, p 121, fig 115. R Charmet, M Ochsé & D François, Jardin d A, nr

215, 1972, p 30, ill. H van de Waal, NKJ 23 (1972) p 98. E Haverkamp Begemann, Alb Amic J G van Gelder, 1973, pp 5, 8. Chr Tümpel, N Beitr Rembrandt Forsch, 1973, pp 162-75. Gerson 1973

A 3982 Dr Ephraïm Bueno (1599-1665). Jewish physician and writer of Amsterdam. *Joods geneesheer en letterkundige te Amsterdam*

Panel 19 × 15
PROV Lent by Jonkheer J W Six van Vromade, The Hague, 1915-20. F Mannheimer collection, Amsterdam. Lent by the SNK, later DRVK, 1948. Transferred in 1960
LIT Smith 1829-42, vol 7 (1836) p 258. Valentiner 1909, p 341. Hind 1912, vol I, pp 98, 226. Hofstede de Groot 1907-28, vol 6 (1915) nr 627. Bredius 1935, p 252. Landsberger 1946, pp 47, 49-50. Rosenberg 1948, p 217, note 14. J C Ebbinge Wubben, Bull Boymans 4

(1953-54) pp 65-66, fig 2. Knuttel 1956, pp 141, 272. Bille 1961, vol 1, p 34; vol 2, pp 43, 113, nr 178. Bauch 1966, nr 396, ill. Gerson 1968, pp 154, 349, 498, ill on p 349. Haak 1968, pp 53, 200, fig 328. Fuchs 1968, p 41, fig 65. Bredius & Gerson 1969, nr 252. Gans 1971, p 72, ill

Blotkamp & E van Uitert, OK 13 (1969)
tv fig 7. M Brion, Jardin d A 176-77
(1969) p 28, ill. Bredius & Gerson 1969,
nr 414. R H Fuchs, Tijdschr v Gesch,
1969, p 489. R Charmet, M Ochsé & D
François, Jardin d A, nr 215, 1972, p 26,
ill. Haak 1972, pp 44-45, fig 54.
Niemeijer 1973, p 25

A 3137 St Peter's denial. *De verloochening van Petrus*

Canvas 154 × 169. Nearly illegibly signed
and dated *Rembrandt 1660*
PROV Purchased from the Hermitage,
Leningrad, 1933, with aid from the
Rembrandt Society
LIT Valentiner 1909, p 383. Hofstede de
Groot 1907-28, vol 6 (1915) nr 121.
Weisbach 1926, p 465. M D Henkel,
Pantheon 6 (1933) p 292. J F Denne,
Mndbl BK 11 (1934) p 115. M D Henkel,
Burl Mag 64 (1934) pp 153-59. Bredius
1935, p 594. Martin 1935-36, vol 2, pp
85, 88, 90, fig 47. Van Gelder 1946, HS,
p 51ff, ill on p 50. Rosenberg 1948, pp
139-41. Gerson 1952, p 15, fig 31. Knuttel
1956, pp 197, 277. J R Judson, OH 79
(1964) p 141. Rosenberg 1964, p 226, fig
189. H Kühn, Jb Ksamml Baden-
Württemberg 2 (1965) p 202. Bauch
1966, nr 92. Rosenberg, Slive & Ter
Kuile 1966, p 80, fig 61. Gerson 1968, pp
134, 138, 418, 502, ill on p 418. Bredius
& Gerson 1969, nr 594. M Brion, Jardin
d A 176-77 (1969) p 16

A 3138 Titus van Rijn (1641-68).

Rembrandt's son in a monk's habit,
possibly in the guise of St Francis of
Assisi. *Rembrandt's zoon in monniksdracht,
mogelijk voorgesteld als de heilige Franciscus
van Assisi*

Canvas 79.5 × 67.7. Signed and dated
Rembrandt f. 1660
PROV Purchased from the museum in
Moscow, 1933, with aid from the
Rembrandt Society
LIT Valentiner 1909, p 460. Hofstede de
Groot 1907-28, vol 6 (1915) nr 193.
Weisbach 1926, p 581. M D Henkel,
Pantheon 6 (1933) p 292. Bredius 1935,
nr 306. Van Gelder 1946, T, p 44, ill on
p 45. Van Hall 1963, p 286, nr 1823:18.
H Kühn, Jb Ksamml Baden-
Württemberg 2 (1965) p 198. Bauch
1966, nr 227. L J Slatkes, Art Q 31 (1968)
p 89. Gerson 1968, pp 433, 503, ill on p
151, 433. Haak 1968, fig 480. Bredius &
Gerson 1969, nr 306. E de Jongh, in
Exhib cat Rembrandt en zijn tijd,
Brussels 1971, p 158

C 1450 Titus van Rijn (1641-68).
Rembrandt's son. *Rembrandt's zoon*

Canvas 72 × 56
PROV On loan from the Musée du
Louvre, Paris, since 1956, in exchange
for a painting by the Master of the Aix
Annunciation, A 2399
LIT Smith 1829-42, vol 7 (1836) p 113,
nr 308; vol 10 (1863) p 174, nr 825.
Vosmaer 1877, p 579. Dutuit 1883-85,
vol 3, p 39. Michel 1893, pp 456-57, 567.
Bode 1897-1901, vol 6 (1901) p 126, nr
447. Rosenberg 1904, p 228. Valentiner
1909, p 419. Hofstede de Groot 1907-28,
vol 6 (1915) nr 709. Bredius 1935, nr 22.
A van Schendel, Bull RM 4 (1956) p 62.
Biul Hist Sztuki 18 (1956) p 341. Roger-
Marx 1960, pp 53, 283. Van Hall 1963,
p 286, nr 1823:19. Rosenberg 1964, p
104, fig 92. Bauch 1966, nr 427. Gerson
1968, pp 432, 503, ill on p 432. Bredius
& Gerson 1969, nr 22

A 4050 Self portrait as the apostle Paul.
Zelfportret als de apostel Paulus

Canvas 91 × 77. Signed and dated
Rembrandt f. 1661. Inscribed on a
fragment of the former stretcher, built
into the new one, *From the Corsini Palace of
Rome | brought to England by William |
Buchanan Esq in Summer 1807*
PROV Presented by Mr & Mrs I de
Bruijn-van der Leeuw, Muri near Bern,
1949. Received in 1956
LIT Moes 1897-1905, vol 2, nr 6693:63.
Valentiner 1909, p 475. Hofstede de
Groot 1907-28, vol 6 (1915) nr 575. F
Schmidt-Degener, De Gids 83 (1919) p
222. W R Valentiner, Kunstchronik ns
32 (1920) p 19. Bredius 1935, p 59. Van
Gelder 1946, HS, p 28, P, p 57, ill on p 54.
Rosenberg 1948, p 32, fig 44. L Münz,
Burl Mag 90 (1948) p 64. Visser 't Hooft
1956, p 18, ill on p 101. Knuttel 1956, pp
187, 270. O Benesch, Art Q 19 (1956) pp
335-54. L Münz, Konsthist Tidskr 25
(1956) p 69, fig 10. E R Meijer, Bull RM 9
(1961) pp 47-48. J L Cleveringa, Bull RM
9 (1961) p 65, nr 14. Van Hall 1963, pp
271-72, nr 1743:89. White 1964, p 122.
Rosenberg 1964, pp 52, 287, fig 44. H
Kühn, Jb Ksamml Baden-Württemberg
2 (1965) p 194. Rosenberg, Slive & Ter
Kuile 1966, p 71, fig 51A. Clark 1966, p
130, fig 122. Bauch 1966, nr 338. Haak
1968, p 299, fig 504. Gerson 1968, pp
134, 140, 504, ill on p 444. P J J van Thiel,
OK 13 (1969) nr 2, ill. Bredius & Gerson
1969, nr 59. S H Levie, Connoisseur 172
(1969) p 4, fig 3. D Sutton, Apollo, 1969,
ill on p 424. E Huttinger, Arte Ill 3 (1970)
Jan-Feb, p 10, fig 7. E de Jongh, in exhib
cat Rembrandt en zijn tijd, Brussels
1971, p 158

C 6 The syndics: the sampling officials (wardens) of the Amsterdam drapers' guild. *De Staalmeesters: het college van staalmeesters (waardijns) van het Amsterdamse lakenbereidersgilde*

The sitters are probably, from left to right, Jacob van Loon (1595-1674), Volckert Jansz (1605/10-81), Willem van Doeyenburg (ca 1616-87), the servant Frans Hendricksz Bel (1629-1701), Aernout van der Mye (ca 1625-81) and Jochem de Neve (1629-81)

Canvas 191.5 × 279. Signed and dated *Rembrandt f. 1662* and later *Rembrandt f 1661*
PROV Staalhof (cloth sampling hall), Amsterdam, 1778. On loan from the city of Amsterdam since 1808
LIT Scheltema 1853, pp 28, 104. Scheltema 1879, p 99. J Six, OH 11 (1893) pp 100-01. J Six, OH 14 (1897) pp 65-67. Hofstede de Groot 1907-28, vol 6 (1915) nr 928. Riegl 1931, pp 209-17, 239-42, 264-66, 276-79. Martin 1935-36, vol 1, pp 2, 203, 205, figs 4, 115; vol 2, pp 79, 86, 90-94, 103, fig 49a. Bredius 1935, p 415. Ch de Tolnay, GdB-A 22 (1943) p 31ff. Van Gelder 1946, N, p 54ff, ill on pp 56-57; T, p 45. Rosenberg 1948, pp 80-83. Gerson 1952, p 14, fig 14. Slive 1953, p 80. A van Schendel, OH 71 (1956) pp 1-23. Idem, Konsthist Tidskr 25 (1956). H van de Waal, OH 71 (1956) pp 61-107. Knuttel 1956, pp 40, 190, 273. IH van Eeghen, Jb Amstelodamum 49 (1957) p 65. W Gs Hellinga, NKJ 8 (1957) pp 151-84. IH van Eeghen, OH 73 (1958) pp 80-84. Ch de Tolnay, OH 73 (1958) pp 85-86. H van de Waal, OH 73 (1958) pp 86-89. T Brunius, in Idea and Form, 1959, p 10, ill. Gantner 1964, p 175, fig 54. JG van Gelder, OK 8 (1964) nr 11, ill. White 1964, p 122, ill. Rosenberg 1964, pp 143-48, fig 126. Rosenberg, Slive & Ter Kuile 1966, pp 71-73, 185. Clark 1966, pp 61, 96-97, 100, fig 53. Rosenberg 1967, p 78. De Jongh 1967, p 63, figs 46-48. E van Uitert, OK 12 (1968) tv p 5, ill. Bauch 1967, p 140, note 27. Gerson 1968, pp 128-29, 131, 150, 154, 445, 504. Fuchs 1968, p 64, fig 111. Haak 1968, pp 308-10, 334, 336, figs 521-22. H Lüdecke, Bild Kunst, 1969, p 457. M Brion, Jardin d A, nr 176-77, 1969, p 17, ill. Bredius & Gerson 1969, nr 415. VTTT, 1969-70, nr 115. R H Fuchs, Tijdschr v Gesch, 1969, p 483, note 4. J Ploeger, Lantern 2 (Dec 1969) p 68. Haak 1972, p 20, fig 25. H van de Waal, NKJ 23 (1972) p 100, note 17. K Clark, Connaissance d A, 1974, p 73, ill

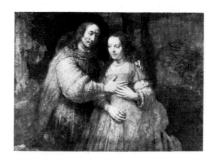

C 216 Portrait of a couple as figures from the Old Testament, known as 'The Jewish bride.' *Portret van een paar als Oud-Testamentische figuren, genaamd 'Het Joodse bruidje'*

Canvas 121.5 × 166.5. Signed and dated *Rembrandt f. 16..*
PROV On loan from the city of Amsterdam (A van der Hoop bequest) since 1885
LIT Bode 1883, p 553, note 1. A Jordan, Rep f Kunstw 7 (1884) p 183. J Veth, OH 24 (1906) pp 41-44. Ring 1913, p 74. J Veth, OH 33 (1915) p 12. Hofstede de Groot 1907-28, vol 6 (1915) nr 929. H Tietze, in Meisterwerke, 1920-21. W R Valentiner, Kunst und Künstler 22 (1923-24) p 17ff. Weisbach 1926, pp 591-93. J Zwarts, Onze Kunst 46 (1929) pp 11-42. Zwarts 1929. Van Rijckevorsel 1932, pp 210, 223-25, ill on p 220. Martin 1935-36, vol 2, pp 53, 70, 94-96, fig 52. Bredius 1935, p 416. F Lugt, Art in America 30 (1942) pp 174-78. Landsberger 1946, pp 54-55. Van Gelder 1946, T, p 47ff, ill on p 54, 55. Gerson 1952, p 16, fig 33. Slive 1953, p 185. Knuttel 1956, pp 44, 216-17, 235, 274. O Benesch, Art Q 29 (1956) p 352. W R Valentiner, in Festschrift K Bauch, 1957, pp 227-37. W Sumowski, Wiss Zeitschr Humboldt Un 7 (1957-58) p 225. H P Baard, OK 5 (1961) nr 6, ill. White 1964, p 125, ill. Rosenberg 1964, pp 88, 128, fig 112. Rosenberg, Slive & Ter Kuile 1966, p 68. Clark 1966, pp 39, 141-44, 216, fig 132. Bauch 1966, nr 38, ill. A Livermore, Apollo, 1967, pp 240-45. Rosenberg 1967, pp 78-81, fig 67. Tümpel 1968, p 302. Emmens 1968, p 23. Fuchs 1968, p 45, fig 73. Haak 1968, pp 228, 283, 310, 320-22, 326, 334, 336, figs 541, 541a. Gerson 1968, pp 132, 135, 156, 502, ill on p 421. Bredius & Gerson 1969, nr 416. H Lüdecke, Bild Kunst, 1969, p 458. J C van der Waals, Kroniek Rembrandthuis 23 (1969) p 97. S H Levie, Connoisseur 172 (1969) p 5, fig 5. I Caraion, Arta 17 (1969) p 13, ill. Chr Tümpel, NKJ 20 (1969) pp 162-67, fig 44. R H Fuchs, Tijdschr v Gesch, 1969, pp 482-93. J Ploeger, Lantern 2 (Dec 1969) p 69. M L Wurfbain, Jb Leiden 63 (1971) pp 173-78, fig 20 (perhaps B Vaillant and Elisabeth van Swanenburgh as Boas and Ruth). Gans 1971, p 62, ill. R Charmet, M Ochsé & D François, Jardin d A, nr 215, 1972, p 32, ill. K Clark, Connaissance d A, 1974, pp 75-76, ill

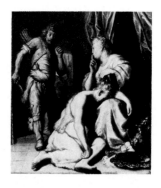

A 4096 Samson and Delilah. *Simson en Delila*

Panel 27.5 × 23.5. Grisaille
PROV Sale London, 3 July 1963, lot 14. Purchased with aid from the Photo Commission
LIT C Müller Hofstede, Kunstchronik 9 (1956) p 91 (Rembrandt and Jan Lievens). W Sumowski, Wiss Zeitschr Humboldt Un 7 (1957-58) pp 232-33, ill. Bauch 1960, p 214ff, fig 173 (Lievens). K Bauch, Wallraf-R Jb 24 (1962) p 329. K Bauch, Pantheon 21 (1967) p 166 (preliminary study by Lievens). J Bauch et alia, NKJ 23 (1972) pp 491, 494. M Kahr, Art Bull 55 (1973) pp 258-59, fig 22 (copy). Schneider & Ekkart 1973, suppl nr s 347 (probably Lievens)

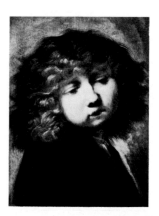

A 2391 Head of a boy. *Jongenskopje*

Panel 27.5 × 20. Inscribed *Rembrandt geretuceer... Lieve...* [traces of a date]
PROV Purchased from F Negele, Munich, 1909 * DRVK since 1959 (on loan to Stedelijk Museum De Lakenhal, Leiden)
LIT K Erasmus, Cicerone 1 (1909) p 571, ill. C Hofstede de Groot, OH 33 (1915) p 85. Valentiner 1921, p 101, ill. Schneider 1932, p 25, nr 221, fig 11. Bauch 1933, p 219. Martin 1935-36, vol 2, p 105. K

Bauch, Wallraf-R Jb 11 (1939) p 246, ill.
Gerson 1953. J Michalkowa, Biul Hist
Sztuki 19 (1957) p 263, fig 1. Bauch
1960, p 208. S Slive, Bull Oberlin 20
(1963) pp 136-37. A B de Vries, OKtv 3
(1965) nr 14, fig 1. Rosenberg, Slive &
Ter Kuile 1966, p 84. Bauch 1966, nr A2,
ill. Gerson 1968, pp 38, 64, ill. B P J
Broos, Kroniek Rembrandthuis 26
(1972) p 146, fig 11. Schneider &
Ekkart 1973, suppl p 308, nr 221 (not by
Lievens and not retouched by
Rembrandt)

A 4019 The raising of Lazarus. *De
opwekking van Lazarus*

Panel 62 × 35. Fragment
PROV Goudstikker & Miedl gallery,
Amsterdam. Lent by the SNK, later
DRVK. Transferred in 1960

milieu of **Rembrandt**

A 4090 Vanitas still life. *Vanitas stilleven*

Panel 91 × 120
PROV Purchased from H Jüngeling
gallery, The Hague, 1963, with aid from
the Photo Commission
LIT [B Haak], Versl der Rijksverz van

Gesch en Kunst 85 (1963) pp 18-20. J
Bergström, Apollo, 1963, p 453, figs 9-10.
K Bauch, Pantheon, 1967, p 261, fig 13
(Jan Lievens). Haak 1968, pp 68-69, figs
100-01 (Rembrandt?; the mug, glass and
plate with a roll are attributed to Jan
Jansz den Uyl). Bol 1969, pp 74-76, fig
62 (Rembrandt studio?). Exhib cat
IJdelheid der IJdelheden, Leiden 1970,
nr 25, ill. Schneider & Ekkart 1973,
suppl nr s 380 (very probably Lievens).
J Bauch et alia, NKJ 23 (1972) pp 491,
494

copy after **Rembrandt**

C 1453 The company of Captain Frans
Banning Cocq and Lieutenant Willem
van Ruytenburch, known as 'The night-
watch.' *Het korporaalschap van kapitein
Frans Banning Cocq en luitenant Willem van
Ruytenburch, bekend als de 'Nachtwacht'*

Copy after C 5; usually ascribed to Gerrit
Lundens (1622-83)

Panel 66.5 × 85.5. Later inscribed on the
verso *Naamen van de Hooftofficiers en
Gemeenen. Frans Banning Cock Heer van
Purmerland & Ilpendam. Capitein. Willem
van Ruijtenburg van Vlaardingen, Heere van
Vlaardingen, Leijtenant, Jan Visscher,
Vaandrig, Rombout Kemp, en Reijnier Engel,
Sergianten, Barent Harmense, Jan Adriaan
Kijser, Hendrik Willemse, Jan Ockerze, Jan
Melessen Bronkhorst, Harmen Jacob
Verraken, Jacob Dirkse de Boog, Jan van der
Hard, Johan Schellinger, Jan Bringman, Jan
van Kampoort, Tamboer*
PROV On loan from the National
Gallery, London (cat 1960, nr 289) since
1958
LIT A Bredius, Ned Spec, 1886, p 91. D C
Meijer Jr, Ned Spec, 1886, p 123. J
Goekoop de Jongh, Onze Kunst 11
(1907) p 123. J Veth, Onze Kunst 11
(1907) p 205. A Bredius, OH 30 (1912) p
197. Martin 1935-36, vol 1, p 215, fig
122. Van Gelder 1946, N, p 26ff, ill on p
37. MacLaren 1960, pp 343-49, nr 289
(rejects the traditional attribution to
Lundens). Rosenberg 1964, p 138, fig
123. Clark 1966, fig 78. E Haverkamp
Begemann, Alb Amic J G van Gelder,
1973, pp 5-6, fig 1. Gerson 1973, p 16, ill

A 358 Portrait of a man, perhaps
Rembrandt's father, Harmen Gerritsz
van Rijn (d 1630). *Portret van een man,
misschien Rembrandt's vader, Harmen
Gerritsz van Rijn*

Copy after the original in the collection
of Lord Samuel, Wychcross (Bredius
1935, nr 79)

Canvas on panel 62.5 × 47.5. Inscribed
Rembrandt f 1641
PROV NM, 1808
LIT Michel 1893, p 44, ill. Moes 1897-
1905, vol 2, nr 6687:8. Moes & van
Biema 1909, pp 129, 163, 208

A 3298 Portrait of a man, perhaps
Rembrandt's father, Harmen Gerritsz
van Rijn (d 1630). *Portret van een man,
misschien Rembrandt's vader, Harmen
Gerritsz van Rijn*

Copy, thought to be by Christian
Wilhelm Ernst Dietrich (1712-74)

Panel 18.3 × 14.5
PROV Presented by Mr & Mrs D A J
Kessler-Hülsmann, Kapelle op den
Bosch near Mechelen, 1940

imitation of **Rembrandt**

A 3341 Self portrait. *Zelfportret*

Canvas 21 × 17
PROV Presented by Mr & Mrs D A J
Kessler-Hülsmann, Kapelle op den
Bosch near Mechelen, 1940

A 946 Portrait of a rabbi. *Portret van een rabbijn*

Panel 24 × 20
PROV Purchased from the collection of
Jonkheer J E van Heemskerck van Beest,
1877. NMGK, 1885

Guido Reni

Bologna 1575–1642 Bologna

see Miniatures: Monogrammist W P,
A 4376 Madonna, after Reni

A 3416 The man of sorrows. *Man van Smarten*

Canvas 51.5 × 44.5. Painted oval
PROV Bequest of J W Edwin vom Rath,
Amsterdam, 1941

copy after **Guido Reni**

A 331 Mary Magdalene. *Maria Magdalena*

Copy after the original in a private
collection, Rome

Canvas 160 × 131
PROV Purchased with the Kabinet van
Heteren Gevers, The Hague-Rotterdam,
1809 * DRVK since 1953
LIT Moes & van Biema 1909, pp 149,
163. Bille 1961, vol I, p 110

Princess M H Reuss, *thought to be*
Princess Marie Henriette Augustine Reuss

b Greiz 1855

NO PHOTOGRAPH AVAILABLE

A 3051 Augustus Allebé (1838-1927).
Painter, director of the Rijksacademie
van Beeldende Kunsten, Amsterdam.
*Schilder, directeur van de Rijksacademie van
Beeldende Kunsten te Amsterdam*

Canvas 60 × 50. Signed and dated
M.H. Reuss VII … 1886
PROV Bequest of the sitter, Amsterdam,
1927. Missing

Nicolaas Reyers

see Panpoeticon Batavum: A 4619
Joannes Badon

Theodorus Justinus Rheen

see Governors-general series: A 3777
Abraham Patras; A 4546 Abraham
Patras, copy after Rheen? A 3778 &
A 4547 Adriaan Valckenier

attributed to **José de Ribera**

Játiba 1589–1652 Naples

A 3883 Philosopher with mirror. *Filosoof met spiegel*

Canvas 113 × 89
PROV Lent by E Heldring, Amsterdam,
1934. Bequeathed in 1954
LIT D Fitz Darby, Art in America 36
(1948) pp 113-26. Du Gué Trapier 1952,
p 234ff. D Fitz Darby, Art Bull 44 (1962)
pp 279, 300, fig 15. Country Life, 1965,
p 936

Augustin Théodule Ribot

Breteuil? 1823–1891 Colombes

A 1897 Woman sewing. *De naaister*

Canvas 46.5 × 38. Signed *t. Ribot*
PROV Presented by the dowager of R
Baron van Lynden, née M C Baroness
van Pallandt, The Hague, 1900

A 1898 Still life with fish and a lobster.
Stilleven met vissen en een kreeft

Canvas 60 × 74. Signed *t. Ribot*
PROV Presented by the dowager of R
Baron van Lynden, née M C Baroness
van Pallandt, The Hague, 1900

Christian Richter

see under Miniatures

Sebastiano Ricci

Cividale 1659–1734 Venice

A 3417 The adoration of the magi. *De
aanbidding der koningen*

Canvas 30.5 × 40
PROV Bequest of J W Edwin vom Rath,
Amsterdam, 1941
LIT K E Schuurman, Mndbl BK 19
(1942) p 139, fig 3

Nicolaas Riegen

Amsterdam 1827–1889 Amsterdam

A 1825 Seascape. *Zeegezicht*

Canvas 98 × 136. Signed *N. Riegen fec.*
PROV Bequest of Reinhard Baron van
Lynden, The Hague, 1899 * DRVK since
1953

Jan Claesz Rietschoof

Hoorn 1652–1719 Hoorn

A 333 Ships in the harbor in calm
weather. *Schepen in de haven bij kalm weer*

Pendant to A 334

Canvas 60 × 81. Signed *CR*
PROV NM, 1808
LIT Moes & van Biema 1909, pp 163,
224? Willis 1911, p 111. Bernt 1960-61,
vol 4, nr 234. Bernt 1969-70, vol 2, nr
962. Bol 1973, p 310

A 334 Ships in the harbor in gusty
weather. *Schepen in de haven bij een stevige
bries*

Pendant to A 333

Canvas 61 × 81. Signed *CR*
PROV NM, 1808
LIT Moes & van Biema 1909, pp 163,
224? Willis 1911, p 111. Bernt 1960-62,
vol 4, nr 235. Bernt 1969-70, vol 2, nr
963. Bol 1973, p 310

copy after **John Riley**

London 1646–1691 London

A 3303 Katherine Elliot (d 1688).
Dresser of Anne, duchess of York, and
first bedchamber woman of Mary of
Modena, the first and second wives of
James II of England. '*Dresser*' *van Anne,
duchess of York en* '*first bedchamber woman*'
*van Mary of Modena, respectievelijk de eerste
en tweede vrouw van Jacobus II van Engeland*

Copy after the version in Kensington
Palace, London

Canvas 76 × 63
PROV Presented by Mr & Mrs D A J
Kessler-Hülsmann, Kapelle op den
Bosch near Mechelen, 1940
LIT *cf* Collins Baker 1912, vol 2, pp 31-32

Pieter de Ring

Leiden 1615–1660 Leiden

A 335 Still life with a golden goblet. *Stilleven met een gouden bokaal*

Canvas 100 × 85. Signed on the table with a ring
PROV Purchased with the Kabinet van Heteren Gevers, The Hague-Rotterdam, 1809
LIT Moes & van Biema 1909, pp 149, 163. Warner 1928, nr 77. Bol 1969, p 302, fig 277

Jacoba Johanna (Coba) Ritsema

Haarlem 1876–1961 Amsterdam

A 3045 A bouquet of roses. *Een ruiker rozen*

Board 24 × 19. Signed *Coba Ritsema*
PROV Bequest of A Allebé, Amsterdam, 1927

Simon Jacques Rochard

see under Miniatures

Charles Rochussen

Kralingen 1814–1894 Rotterdam

see also Hanedoes, Louwrens, A 1813 An excursion to Gelderland – *see also under* Aquarelles and drawings

A 3923 The racetrack at Scheveningen, opened on 3 August 1846. *De renbaan te Scheveningen, geopend op 3 augustus 1846*

Panel 31.5 × 42. Signed *C. R.* Inscribed *Scheveningen 3 Augustus 1846*
PROV Purchased from P A Scheen gallery, The Hague, 1957
LIT Franken & Obreen 1894, suppl 25, nr 67*. H C de Bruijn Jr, Op den Uitkijk, 1959, p 507, ill on p 505. Gerson 1961, p 21, fig 44. VTTT, 1961, nr 34. Scheen 1969-70, vol 2, fig 122. H C de Bruijn, Antiek 6 (1972) p 476, fig 6

A 1759 Park in the neighborhood of Paris. *Park in de omgeving van Parijs*

Panel 43 × 62. Signed and dated *C. R. 48*
PROV Bequest of D Franken Dzn, Le Vésinet, 1898
LIT Franken & Obreen 1894, p 17, nr 96

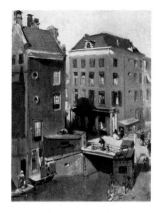

C 1548 The Osjessluis near the Kalverstraat, Amsterdam. *De Osjessluis bij de Kalverstraat te Amsterdam*

Panel 31.5 × 23.5. Signed and dated *C.R. 55*
PROV On loan from the KOG (presented by the artist, 1885) since 1973
LIT Jvsl KOG, 1934, ill opp p 63. Gerson 1961, p 21, fig 46

A 1760 A hunting party taking a rest in the woods. *Jagershalte in een bos*

Panel 19.5 × 29.5. Signed and dated *C.R.f. 59*
PROV Bequest of D Franken Dzn, Le Vésinet, 1898 * DRVK since 1959

A 1757 The requisition. *De requisitie*

Panel 21 × 28. Signed and dated *C.R.f. 72*
PROV Bequest of D Franken Dzn, Le Vésinet, 1898
LIT Franken & Obreen 1894, p 105, nr 730. Scheen 1946, fig 137

A 1758 Napoleon with his staff. *Napoleon met zijn staf*

Panel 20 × 15.5
PROV Bequest of D Franken Dzn, Le Vésinet, 1898
LIT Franken & Obreen 1894, p 2, nr 12

Johan de la Rocquette

active 1658–after 1694 in The Hague

A 1299 A European and a Sinhalese in a Ceylonese landscape. *Een Europeaan en een Singalees in een Ceylonees landschap*

Canvas 141 × 176. Signed and dated *DeLarocquete Fcit 1668*
PROV Purchased in Leiden, 1885

Niels Rode

Copenhagen 1742/43 – 1794 Leiden?

A 639 Nieuw Teylingen Manor. *Het Huis Nieuw Teylingen*

Canvas 23 × 50.5. Signed *N. Rode p.*
Inscribed on the verso *Dit schilderij present Gegeeven aan den Huijze van Tijlingen in October 1785 Door den Collonel van der Duijn, Heere van Maasdam & & & zijnde toen gedoodverwd en opgemaakt op ordre van Heeren Gecommitteerde Raeden*
PROV NM, 1808
LIT Moes & van Biema 1909, p 220

Willem Roelofs

Amsterdam 1822 – 1897 Berchem

A 4114 Meadow landscape with cattle. *Weidelandschap met vee*

Panel 49.2 × 77.3. Signed *W. Roelofs*
PROV Presented by Mrs Th Laue-Drucker, The Hague, 1965
LIT De Gruyter 1968-69, vol 1, ill on p 32. Scheen 1969-70, vol 2, fig 257

A 1166 Landscape in the neighborhood of The Hague. *Landschap in de omgeving van Den Haag*

Canvas 48 × 75. Signed *W. Roelofs*
PROV Purchased at exhib The Hague 1875, nr 340. RVMM, 1885
LIT Jeltes 1911, p 71

A 2386 The Gein River, near Abcoude. *In 't Gein bij Abcoude*

Canvas 45 × 68. Signed *W. Roelofs*
PROV Bequest of J B A M Westerwoudt, Haarlem, 1908
LIT VTTT, 1959, nr 19

A 3606 The bridge on the IJssel near Doesburg. *De brug over de IJssel bij Doesburg*

Canvas on panel 24.5 × 45.5. Signed and dated *W. Roelofs. Doesborgh 1889.* Inscribed on the verso *Schipbrug te Doesborgh*
PROV Lent by Mr & Mrs J C J Drucker-Fraser, 1919. Bequeathed in 1944
LIT W A L Beeren, OK 6 (1962) nr 14, ill

A 3607 Farmyard near Noorden. *Boeren-erf bij Noorden*

Panel 28 × 42.5. Signed *W. Roelofs*
PROV Lent by Mr & Mrs J C J Drucker-Fraser, 1919. Bequeathed in 1944 *
DRVK since 1959

A 3608 Willow trees. *Wilgebomen*

Panel 30 × 34. Signed *W. Roelofs*
PROV Lent by Mr & Mrs J C J Drucker-Fraser, 1919. Bequeathed in 1944

A 4207 The milking yard. *De melkbocht*

Panel 11 × 26. Signed *W. Roelofs*
PROV Unknown

Willem Elisa Roelofs

Schaerbeek 1874–1940 The Hague

A 1924 Still life with codfish. *Stilleven met kabeljauw*

Canvas 34 × 50. Signed and dated
Willem E. Roelofs Jr 96
PROV Sale The Hague, 16 Oct 1900, lot 84, for the benefit of Pulchri Studio

studio of **Marinus van Roemerswaele**

Zeeland 1493–after 1567

A 3123 St Jerome. *De heilige Hieronymus*

Panel 80.5 × 109
PROV Purchased from the estate of
MIEV Countess von Oberndorff-de
Stuers, Lausanne, 1931
LIT MJ Friedländer, Pantheon 13-14
(1934) p 33. *Cf* Friedländer 1924-37, vol
12 (1935) p 183, nr 162. Hoogewerff
1936-47, vol 4 (1941-42) p 459. L van
Puyvelde, Revue belge d'Arch & d'Hist

de l'Art 29 (1960) p 83, fig 11. HH van
Regteren Altena & HJ Zantkuyl,
Berichten ROB 19 (1969) p 257, pl
XXXVII

Coenraat Roepel

The Hague 1678–1748 The Hague

A 336 Still life with flowers. *Stilleven met bloemen*

Pendant to A 337

Canvas 66.5 × 52.5. Signed and dated
Coenraat Roepel fecit A° 1721
PROV Purchased with the Kabinet van
Heteren Gevers, The Hague-Rotterdam,
1809
LIT Hoet 1752, vol 2, p 459. Moes & van
Biema 1909, pp 149, 163. Warner 1928,
nr 79a. Bille 1961, vol 1, pp 108, 110.
Exhib cat Boeket in Willet, Amsterdam
1970, nr 27. Mitchell 1973, p 217, fig 307

A 337 Still life with fruit. *Stilleven met vruchten*

Pendant to A 336

Canvas 66.5 × 52.5. Signed and dated
Coenraet Roepel fecit A° 1721
PROV Same as A 336
LIT Hoet 1752, vol 2, p 459. Moes & van
Biema 1909, pp 149, 163. Warner 1928,
pl 79b. Bille 1961, vol 1, pp 108, 110

Pieter Gerritsz van Roestraeten

Haarlem ca 1630–1700 London

A 4189 Still life with a silver urn. *Stilleven met zilveren pot*

Panel 26 × 20. Signed *P. Roestra…*
PROV J Goudstikker gallery,
Amsterdam. Transferred by the DRVK in
1970

Roelant Roghman

Amsterdam 1627–1692 Amsterdam

A 4218 Mountainous landscape with
fisherman. *Bergachtig landschap met visser*

Canvas 80.5 × 100. Signed *R. Roghman*
PROV Lent by D Cevat, London, 1968.
Purchased in 1972
LIT Duits Q 5 (1964) p 3ff, ill; idem 6
(1965) p 14. E Haverkamp Begemann,
Kunstchronik 22 (1969) p 286, fig 6.
Bull RM 20 (1972) p 182, fig 5

A 2363 Forest landscape with lean-to. *Boslandschap met hut*

Pendant to A 2364

Canvas 116 × 97. Signed *R. Roghman f*
PROV Sale Dowager F Lemker-Muller, Kampen, 7 July 1908, lot 44

A 2364 Forest landscape with a woodsman's shed. *Boslandschap met houthakkerswoning*

Pendant to A 2363

Canvas 116 × 97. Signed *R. Roghman f*
PROV Sale Dowager F Lemker-Muller, Kampen, 7 July 1908, lot 43

A 760 Mountainous landscape with waterfall. *Berglandschap met waterval*

Canvas 123 × 151
PROV Sale W Gruijter, Amsterdam, 24-25 Oct 1882, lot 90
LIT Bernt 1960-62, vol 2, nr 679. Bernt 1969-70, vol 2, nr 970

Henricus Rol

b Amsterdam 1906

C 1462 Queen Juliana of the Netherlands in her coronation robes. *Koningin Juliana der Nederlanden in haar kroningsgewaad*

Canvas 207 × 121. Signed *H. Rol*.
Painted in 1951
PROV Dutch High Commission, Djakarta. Badly damaged in Djakarta in 1960. Deposited in the RMA via the DRVK, 1961

Gillis Rombouts

Haarlem 1630–before or in 1678 Haarlem?

A 753 Wooded landscape. *Boomrijk landschap*

Canvas 74 × 63.5. Signed *Rombouts*
PROV Sale W Gruijter, Amsterdam, 24-25 Oct 1882, lot 91 * DRVK since 1961

Salomon Rombouts

after 1650–before 1702, active in Haarlem and Florence

A 2529 Winter scene. *Wintergezicht*

Panel 42 × 66.7. Signed *S. Rombout*
PROV Purchased from L Nicholson, London, 1911

Willem Romeyn

Haarlem ca 1624–before or in 1694 Haarlem

A 340 Resting herd. *Rustende kudde*

Panel 30.5 × 37.5. Signed *W Romeyn*
PROV Sale Th Cremer, Rotterdam, 16 April 1816, lot 97

A 341 Italian landscape with cattle. *Italiaans landschap met vee*

Canvas 48 × 56. Signed *W Romeyn*
PROV Bequest of L Dupper Wzn, Dordrecht, 1870 * DRVK since 1956

A 338 Herd near a river. *Kudde bij een rivier*

Pendant to A 339

Panel 15 × 18.5. Signed *WRomeyn*
PROV Purchased with the Kabinet van Heteren Gevers, The Hague-Rotterdam, 1809
LIT Hoet 1752, vol 2, p 459. Moes & van Biema 1909, pp 149, 163

A 339 Herd near a fountain. *Kudde bij een fontein*

Pendant to A 338

Panel 15 × 18.5. Signed *WR*
PROV Same as A 338
LIT *See under* A 338

A 712 Landscape with cattle. *Landschap met vee*

Panel 35.5 × 32.5. Signed *WRomeyn*
PROV Bequest of Jonkheer J S H van de Poll, Amsterdam, 1880 * DRVK since 1972
LIT V de Stuers, Ned Kunstbode 2 (1880) p 245

attributed to **Nicolò Rondinello**

active ca 1500 in Ravenna

A 3388 Madonna and child. *Maria met kind*

Panel 77 × 57
PROV Bequest of J W Edwin vom Rath, Amsterdam, 1941
LIT Van Marle 1923-38, vol 17 (1935) p 444 (Cima da Conegliano). Berenson 1957, vol 1, p 150

Henriëtte Ronner-Knip

Amsterdam 1821 – 1909 Brussels

C 163 Cat with kittens. *Poes met jongen*

Panel 52 × 39. Signed and dated *Henriette Knip 1844*
PROV On loan from the city of Amsterdam (A van der Hoop bequest) since 1885

A 1124 'Three against one': a cat snarling at three dogs. '*Drie tegen één*': *een kat blazend tegen drie honden*

Canvas 82 × 127.5. Signed *Henriette Ronner*
PROV Purchased at exhib Amsterdam 1868, nr 445. RVMM, 1885

A 3089 The cat at play. *Katjesspel*

Panel 32.8 × 45.2. Signed *Henriette Ronner*
PROV Bequest of J B A M Westerwoudt, Haarlem, 1907. Received in 1929

Cornelis François Roos

Amsterdam 1802 – 1884 Amsterdam

A 1826 View in the Harz Mountains. *Gezicht in het Harzgebergte*

Canvas 74 × 85. Signed and dated *C. F. Roos f. 1840*
PROV Bequest of Reinhard Baron van Lynden, The Hague, 1899 * DRVK since 1959

Johann Melchior Roos

Frankfurt am Main 1659–1731
Frankfurt am Main

A 1625 Shepherd with ram and goats. *Herder met een bok en geiten*

Canvas 109.5 × 165. Signed and dated *JMRoos fecit 1683*
PROV Presented by D A Koenen, Nieuwer-Amstel, 1895

Roosenboom

see Vogel-Roosenboom

attributed to Cosimo Rosselli

Florence 1439–1507 Florence

A 3419 The adoration of the child. *De aanbidding van het kind*

Panel 114.5 cm in diam. Tondo
PROV Bequest of J W Edwin vom Rath, Amsterdam, 1941
LIT Berenson 1932, p 490. K E Schuurman, Mndbl BK 19 (1942) p 101. Berenson 1963, vol 1, p 189. Van Os & Prakken 1974, p 102, nr 62, ill

A 3420 St Dominic. *De heilige Dominicus*

On the splay of the frame are angels and cherubs, on the predella Sts Peter Martyr, Thomas and Matthew

Panel 80 × 40
PROV Bequest of J W Edwin vom Rath, Amsterdam, 1941

Jan van Rossum

active 1654-73 in Vianen

A 1283 Portrait of a woman, thought to be Anna of Burgundy, foundress of Windenburg Castle on Dryschor Island, Zeeland, and wife of Adolf of Cleves. *Portret van een vrouw, vermoedelijk Anna van Bourgondië, stichtster van Slot Windenburg op Dryschor (Schouwen), en echtgenote van Adolf van Kleef*

Canvas 117 × 93. Signed and dated *Johan V. Rossum fc. 1662*
PROV Sale P Verloren van Themaat, Amsterdâm, 30 Oct 1885, lot 78 * DRVK since 1964
LIT Moes 1897-1905, vol 1, nr 992

Jan Cornelis van Rossum

Amsterdam 1820–1905 Amsterdam

C 1549 Coenraad van Hulst (1774-1844). Actor, shown in his function as president of the v w society for promotion of the arts, Amsterdam (named for its founders Casper Vreedenberg and Jan van Well). *Toneelspeler, als president van de kunst-bevorderende maatschappij V W te Amsterdam (zo genoemd naar de oprichters Casper Vreedenberg en Jan van Well)*

Canvas 109 × 87. Signed and dated *J.C.v.R. 1839*
PROV On loan from the KOG (presented by the v w society, 1882) since 1973
LIT S Duparc, Jb Amstelodamum 34 (1937) p 174, ill on p 173

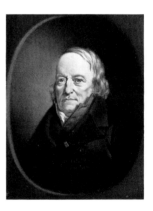

A 2874 Johannes Kinker (1764-1845). Amsterdam writer and philosopher, served as professor in Liège (1817-30). *Amsterdams letterkundige en wijsgeer, hoogleraar te Luik*

Panel 24 × 19
PROV Purchased from H B van der Linden, 1921

Fredericus Jacobus van Rossum du Chattel

The Hague 1856–1917 Yokohama

A 1806 The drawbridge. *De ophaalbrug*

Panel 35.5 × 26.5. Signed *Ferd. J. du Chattel f*
PROV Bequest of Reinhard Baron van Lynden, The Hague, 1899 * DRVK since 1960

Pietro Rotari

Verona 1707–1762 Leningrad

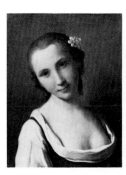

A 3421 A young woman. *Een jonge vrouw*

Pendant to A 3422

Canvas 46 × 36
PROV Bequest of J W Edwin vom Rath, Amsterdam, 1941

A 3422 A young woman with a book. *Een jonge vrouw met een boek*

Pendant to A 3421

Canvas 46 × 36
PROV Same as A 3421

George Andries Roth

Amsterdam 1809–1887 Amsterdam

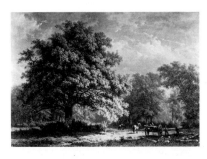

A 1125 View in the woods of Bentheim. *Gezicht in het Bentheimse bos*

Canvas 84 × 119. Signed and dated *G. A. Roth 1870*
PROV Purchased at exhib Amsterdam 1870, nr 198. RVMM, 1885 * DRVK since 1959

Jan Albertsz Rotius

Medemblik 1624–1666 Hoorn

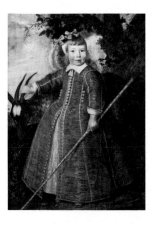

A 995 Portrait of a boy with a billygoat. *Portret van een jongetje met een bok*

Panel 116 × 87. Signed and dated *JAR ...fe A° 1652*. Inscribed *Aetatis Suae 4*
PROV Sale Dowager Quarles van Ufford (The Hague), Amsterdam, 24-25 March 1885, lot 89
LIT Knipping & Gerrits 1943-48, vol 1, p 91, ill. B J A Renckens, NKJ 2 (1948-49) pp 183, 227, nr 70

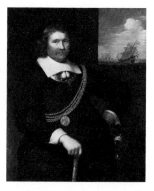

A 666 Jan Cornelisz Meppel (1609-69). Vice admiral of Holland and West-Friesland. *Luitenant-admiraal van Holland en West-Friesland*

Canvas 108 × 87.5. Signed and dated *JARootius 1661*. Inscribed *Aetatis 52*
PROV Sale S M C Schottelinck, Amsterdam, 4-5 March 1879, lot 87
LIT Moes 1897-1905, vol 2, nr 4964. B J A Renckens, NKJ 2 (1948-49) pp 189, 219, nr 18

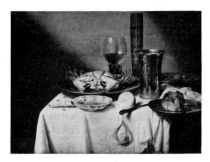

C 611 Still life. *Stilleven*

Panel 58 × 81.5. Signed and dated *Rotius 16..*
PROV On loan from the city of Amsterdam since 1898
LIT H F Wijnman, OH 47 (1930) p 60. Vorenkamp 1933, p 39. Vroom 1945, p 78, nr 248, fig 53. Bernt 1960-62, vol 4, nr 240. Bernt 1969-70, vol 3, nr 983

Johann Rottenhammer

Munich 1564–1623 Augsburg

A 343 Venus and Mars. *Venus en Mars*

Copper 29 × 38. Signed and dated
HRottenh F. in Venet 1604
PROV Purchased with the Kabinet van
Heteren Gevers, The Hague-Rotterdam,
1809
LIT Hoet 1752, vol 2, p 158. Moes & van
Biema 1909, pp 149, 163. R A Peltzer, Jb
Kunsth Samml AK 33 (1916) pp 322, 344

A 342 Madonna and child with the
infant John the Baptist and St Catherine.
*Maria met kind, de kleine Johannes en de
heilige Catharina*

Copper 35.5 × 28. Signed and dated
1604 IRott. F ... Venetia
PROV Purchased with the Kabinet van
Heteren Gevers, The Hague-Rotterdam,
1809
LIT Hoet 1752, vol 2, p 459. Moes & van
Biema 1909, pp 149, 164. R A Peltzer, Jb
Kunsth Samml AK 33 (1916) pp 317,
344. Bille 1961, vol 1, p 110. H Wagner,
Pantheon 28 (1970) p 518, fig 3

manner of **Johann Rottenhammer**

A 3952 Venus and Minerva. *Venus en
Minerva*

Copper 28.5 × 22
PROV Purchased from Ch E Slatkin
gallery, New York, 1959, with monies
from the J W Edwin vom Rath Foundation
LIT Bousquet 1964, ill on p 130

Pierre Etienne Théodore Rousseau

Paris 1812 – 1867 Barbizon

A 1899 'La Gorge aux Loups'

Canvas 35 × 46. Signed *Th. R.*
PROV Presented by the dowager of R
Baron van Lynden, née M C Baroness
van Pallandt, The Hague, 1900

A 2709 Twilight. *Avondschemering*

Canvas 42 × 63
PROV Presented by the heirs of W J van
Randwijk, The Hague, 1914
LIT W Steenhoff, Onze Kunst 27 (1915)
p 91

**Hendrik Wilhelmus (Willem) van
Royen**

Amsterdam 1672 – 1742 Amsterdam

NM 1010 Mantel painting in the salon
of Petronella Oortman's dollhouse: birds
in a park. *Schoorsteenstuk in de zaal van het*

*poppenhuis van Petronella Oortman: vogels in
een park*

The dollhouse is listed in cat RMA
Meubelen, 1952, nr 358
See also Appel, Jacob, A 4245; for other
parts of the decoration, *see* Piemont,
Nicolas, NM 1010, and Voorhout,
Johannes, NM 1010

Panel 14 × 12. Signed *W V Rooye*
PROV KKZ, 1875. Belongs to the
department of sculpture and applied arts
LIT Leesberg-Terwindt 1960, fig 15. C J
de Bruyn Kops, Mndbl Amstelodamum
61 (1974) pp 109-12, figs 1-2

Peter Paul Rubens

Siegen 1577 – 1640 Antwerp

A 344 The carrying of the cross. *Kruis-
draging*

Modello for the main altar of the abbey
church of Affligem (1634-37), now in the
Musées Royaux des Beaux-Arts, Brussels
(cat 1959, nr 374)

Panel 74 × 55
PROV Purchased with the Kabinet van
Heteren Gevers, The Hague-Rotterdam,
1809
LIT Hoet 1752, vol 2, p 458. Smith 1829-
42, vol 2 (1830) nr 384. Rooses 1886-92,
vol 2 (1888) pp 66-67, nr 274 bis. Moes
& van Biema 1909, pp 149, 164.
Oldenbourg 1921, p 471, *cf* p 419. F Antal,
Jb Preusz Kunstsamml 44 (1923) pp 63-
73 (attributed to Anthony van Dyck). J
Zarnowski, Jb Kon Mus SK België 1
(1938) pp 163-69, 179. Knipping 1939-
40, vol 2, pp 213-14. Van Puyvelde 1940,
pp 18-19, 47, 88, nrs 79-81, figs 79-81.
Evers 1942, pp 360-64. Van Puyvelde
1947, pp 19-20, 48, 90-91, figs 79-81. L
van Puyvelde, GdB-A 35 (1949) p 122.
Van Puyvelde 1952, p 172. Exhib cat
Olieverfschetsen van Rubens,
Rotterdam 1953, pp 98-100, nr 92, fig
81. E Haverkamp Begemann, Bull
Boymans 5 (1954) p 8. J Bruyn, Bull RM 7
(1959) pp 3-9, fig 1. Bille 1961, vol 1, p

110. VTTT, 1962-63, nr 51. ER Meijer, OKtv 2 (1964) nr 1, fig 2. D'Hulst 1968, nr 36, fig 19. HR Rookmaaker, NKJ 23 (1972) p 65

C 295 Helena Fourment (1614-73). The artist's second wife. *Tweede echtgenote van de schilder*

Panel 75 × 56
PROV On loan from the city of Amsterdam (A van der Hoop bequest) since 1885
LIT Rooses 1886-92, vol 4 (1890) p 164, nr 941 (ca 1630-32). Glück 1933, p 120 (excellent copy). L van Puyvelde, Rev Art Anc & Mod 71 (1937) p 14

C 296 Anne of Austria (1601-66). Wife of Louis XIII, king of France. *Anna van Oostenrijk, echtgenote van Lodewijk XIII, koning van Frankrijk*

Panel 105 × 74
PROV On loan from the city of Amsterdam (A van der Hoop bequest) since 1885
LIT Rooses 1886-92, vol 4 (1890) p 124 (replica of the version in the Louvre, Paris). Oldenbourg 1921, p 452 (studio work). Glück 1933, p 333 (studio replica). Van Puyvelde 1952, p 209, note 233 (portrait of Marie-Anne of Austria). Ph Erlanger, Connaissance d A, 1967, p 86 (replica)

A 345 Cimon and Pero. *Cimon en Pero*

Canvas 155 × 190
PROV Acquired through exchange with the KKS, 1825
LIT Rooses 1886-92, vol 4 (1890) pp 105-06, nr 869 (ca 1625). Oldenbourg 1921, pp 359, 470. Oldenbourg 1922, pp 85, 98, 197. Glück 1933, p 163 (ca 1635)

studio of **Peter Paul Rubens**

A 4051 Cadmus sowing dragon's teeth. *Cadmus zaait drakentanden*

Panel 25.5 × 40.5. Sketch
PROV Presented by Mr & Mrs I de Bruijn-van der Leeuw, Muri near Bern, 1961
LIT Dr WM, Weltkunst 7 (1933) p 3, nr 39. Van Puyvelde 1940, p 92 (copy). Exhib cat Olieverfschetsen van Rubens, Rotterdam 1953, ad nr 104. J L Cleveringa, Bull RM 9 (1961) p 66. M Jaffé, Revue du Louvre 14 (1964) p 321. H Vlieghe, Burl Mag 110 (1968) p 265 (attributed to Jacob Jordaens)

A 2336 'Noli me tangere': the meeting of Christ and Mary Magdalene. *'Noli me tangere': de ontmoeting van Christus en Maria Magdalena*

Canvas 200 × 177.5
PROV Purchased from the heirs of Jonkheer P H Six van Vromade, Amsterdam, 1908 * DRVK since 1953

school of **Peter Paul Rubens**

NO PHOTOGRAPH AVAILABLE

A 599 St Jerome. *De heilige Hieronymus*

Canvas 208 × 205
PROV Unknown * Lent to the Rijksuniversiteit, Utrecht, 1902. Destroyed by fire, 1942

NM 11906-1 Painted cabinet decorated with mythological scenes. *Kunstkastje beschilderd met mythologische taferelen*

The judgment of Midas (left door); Diana returning from the hunt (right door); Mars and Venus (left panel of the lid); Meleager and Atalanta (right panel of the lid); Erichthonius found by the daughters of Cecrops, Diana and Actaeon, Atalanta and the Calydonian swine, Cephalus and Procris? (left drawers, top to bottom); Daphnis and Chloë?, Callisto?, Diana hunting, Vertumnus and Pomona (right drawers, top to bottom); Narcissus (center drawer); and an allegory of abundance (center door)

Panel 47.3 × 37.7 (outer doors); 24.6 × 20 (panels in lid); 10.2 × 28.1 (drawers); 8.3 × 20.2 (center drawer); 22.3 × 15.5 (center door)
PROV Bequest of Miss M E van den Brink, Velp, 1906. Belongs to the department of sculpture and applied arts
LIT Vogelsang 1909, nr 79, pl XXXI. Cat RMA Meubelen, 1952, nr 136, fig 61

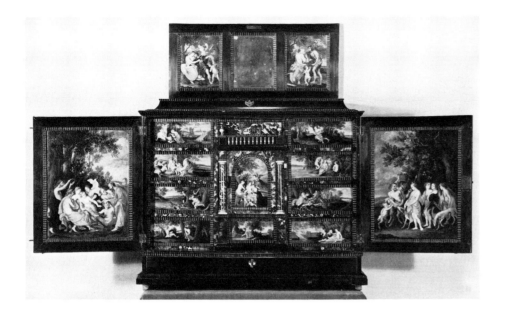

copy after **Peter Paul Rubens**

A 346 The reconciliation of Jacob and Esau. *De verzoening van Jacob en Ezau*

Copy after the version in the Alte Pinakothek, Munich, nr 1302

Panel 32 × 33
PROV NM, 1808 * On loan to the Rijksmuseum Muiderslot, Muiden, since 1922
LIT Rooses 1886-92, vol 1, p 137, nr 109 bis. Moes & van Biema 1909, pp 17, 170, 210. F Lugt, Jb Preusz Kunstsamml 52 (1931) p 44

NO PHOTOGRAPH AVAILABLE

A 600 The hippopotamus hunt. *De nijlpaardenjacht*

Copy after the version in the Alte Pinakothek, Munich, nr 4797

Canvas 198 × 300
PROV NM, 1808? * Lent to the Rijksuniversiteit, Utrecht, 1902. Destroyed by fire, 1942
LIT Moes & van Biema 1909, pp 67, 225

A 2516 The raising of Lazarus. *De opwekking van Lazarus*

Free copy after Oldenbourg 1921, ill on p 217

Canvas 120 × 92
PROV Roman Catholic Church, Veenhuizen, 1910 * DRVK since 1952

A 272 Ecce homo

Copy by Wouterus Mol (1785-1857) after Oldenbourg 1921, ill on p 50

Panel 125 × 95
PROV Unknown (was in the RMA by 1884) * DRVK since 1953 (on loan to Museum De Markiezenhof, Bergen op Zoom)
LIT Moes & van Biema 1909, p 157, nr 64?

Pieter des Ruelles

Amsterdam 1630 – 1658 Amsterdam

A 1573 The convent of St Agnes, Utrecht. *Het Agnietenklooster te Utrecht*

Panel 60 × 49. Signed *Ruelles*
PROV Presented by Dr A Bredius, The Hague, 1892 * DRVK since 1960 (on loan to the Centraal Museum, Utrecht)

Jacob Isaacksz van Ruisdael

Haarlem 1628/29 – 1682 Amsterdam

A 350 View in the woods. *Bosgezicht*

Panel 42 × 49. Signed and dated *JVRuisdael 1653*
PROV Bequest of L Dupper Wzn, Dordrecht, 1870
LIT C van Lützow, Zeitschr BK 5 (1870) p 228. Hofstede de Groot 1907-28, vol 4 (1915) nr 440. Rosenberg 1928, nr 256. Simon 1930, p 26. Stechow 1966, p 73, fig 139 (staffage by Nicolaes Berchem)

C 213 Landscape with watermill. *Landschap met watermolen*

Canvas 63 × 79. Signed and dated *JVRuisdael 1661*
PROV On loan from the city of Amsterdam (A van der Hoop bequest) since 1885
LIT Hofstede de Groot 1907-28, vol 4 (1915) nr 145. Simon 1927, p 41 (dated 1663). Rosenberg 1928, p 40, nr 93, fig 85. Simon 1930, pp 35-38, 41, 52. Broulhiet 1938, nr 31 (dated 1664). Stechow 1966, pp 75-76, fig 144

C 562 Sandy path in the dunes. *Zandweg in de duinen*

Panel 32 × 42.5. Signed *JVRuisdael*
PROV On loan from the city of
Amsterdam (bequest of Mrs M C
Messchert van Vollenhoven-van Lennep,
widow of J Messchert van Vollenhoven)
since 1892
LIT Hofstede de Groot 1907-28, vol 4
(1915) nr 876. Rosenberg 1928, p 33, nr
524, fig 67 (ca 1652). Simon 1930, pp 26-
27 (ca 1653-54). Martin 1935-36, vol 2,
pp 296, 298, fig 158. Van Gelder 1959, p
16, fig 76

C 212 Rocky landscape. *Rotsachtig
landschap*

Canvas 108.5 × 135. Signed *JVR*
PROV On loan from the city of
Amsterdam (A van der Hoop bequest)
since 1885
LIT Hofstede de Groot 1907-28, vol 4
(1915) nr 200. Rosenberg 1928, p 38, nr
122, fig 77 (ca 1660). Simon 1930, pp 43,
63 (ca 1660). Filla 1959, fig 89

C 211 The windmill at Wijk bij
Duurstede. *De molen bij Wijk bij Duurstede*

Canvas 83 × 101. Signed *Ruisdael*
PROV On loan from the city of
Amsterdam (A van der Hoop bequest)
since 1885
LIT Hofstede de Groot 1907-28, vol 4
(1915) nrs 105, 183? L Baldass, in
Meisterwerke, 1920-21. Rosenberg 1928,
p 52ff, nr 70, fig 111 (ca 1670). Simon
1930, p 41 (ca 1665). Martin 1935-36,
vol 1, p 53, fig 29; vol 2, pp 299-300.
Preston 1937, p 46, fig 66. Hymans 1951,
p 51, fig 17. Gerson 1952, p 45, fig 127.
Van Gelder 1959, p 16, fig 49. H E van
Gelder, OK 3 (1959) nr 13, ill. M Imdahl,

in Festschrift Badt, 1961, p 179, note 24.
Duits Q 1 (1963) pp 11-13. Rosenberg,
Slive & Ter Kuile 1966, pp 154, 157.
Stechow 1966, pp 59, 75, fig 115. W
Stechow, Bull Clev Mus of Art 55 (1968)
p 250. G J van der Hoek, Kunstrip, 1973-
74, p 32

A 351 View of Haarlem from the north-
west, with the bleaching fields in the
foreground. *Gezicht op Haarlem uit het
noordwesten, met de blekerijen op de voorgrond*

Canvas 43 × 38. Signed *JVRuisdael*
PROV Bequest of L Dupper Wzn,
Dordrecht, 1870
LIT C von Lützow, Zeitschr BK 5 (1870)
p 228. Hofstede de Groot 1907-28, vol 4
(1915) nr 55. Rosenberg 1928, p 57, nr
38 (ca 1670). Simon 1930, p 73. Van
Gelder 1959, p 16, fig 46. VTTT, 1959, nr
15. Stechow 1966, p 47. Rosenberg,
Slive & Ter Kuile 1966, p 157, fig 133.
M Ochsé, Jardin d A 208 (1972) p 33, ill.
J D Burke, Q Rev Montreal Mus 6
(1974-75) nr 1, pp 3, 9-10

C 210 Landscape with waterfall.
Landschap met waterval

Canvas 142 × 195. Signed *JVRuisdael*
PROV On loan from the city of
Amsterdam (A van der Hoop bequest)
since 1885
LIT Hofstede de Groot 1907-28, vol 4
(1915) nr 198. Rosenberg 1928, p 52, nr
120, fig 110 (ca 1670). Simon 1930, p 64

A 348 Mountainous landscape with
waterfall. *Berglandschap met waterval*

Canvas 111 × 99. Signed *JVRuisdael*
PROV Purchased from Mr Coclers, art
dealer, Amsterdam, 1818
LIT Moes & van Biema 1909, pp 64,
223? Hofstede de Groot 1907-28, vol 4
(1915) nr 199. Rosenberg 1928, p 51, nr
121 (ca 1670). Simon 1930, p 64 (1660s).
Martin 1935-36, vol 2, p 300

A 347 Bentheim Castle. *Kasteel Bentheim*

Canvas 68 × 54. Signed *JVRuisdael*
PROV Sale P de Smeth van Alphen,
Amsterdam, 1-2 Aug 1810, lot 86
LIT Hofstede de Groot 1907-28, vol 4
(1915) nr 21. Rosenberg 1928, p 62, nr
9, fig 133 (ca 1670-75). Simon 1930, p 64
(ca 1670)

A 349 Winter landscape. *Winterlandschap*

Canvas 42 × 49.7. Signed *JVRuisdael*
PROV Bequest of L Dupper Wzn,
Dordrecht, 1870

LIT Hofstede de Groot 1907-28, vol 4 (1915) nr 985. Rosenberg 1928, p 55, nr 602, fig 116 (ca 1670). Simon 1930, p 58. Filla 1959, fig 90. Stechow 1966, pp 96-97, fig 191. Rosenberg, Slive & Ter Kuile 1966, p 157, fig 132B. Bernt 1969-70, vol 3, nr 991

A 2337 The ford. *De voorde*

Canvas 67.5 × 85. Signed falsely? *JVR F*
PROV Purchased from the heirs of Jonkheer P H Six van Vromade, Amsterdam, 1908
LIT W Steenhoff, Onze Kunst 13 (1908) p 205ff. Hofstede de Groot 1907-28, vol 4 (1915) nr 441. Rosenberg 1928, nr 257 (staffage by Philip Wouwerman?). Simon 1930, pp 35, 38

A 3343 Landscape with ruins. *Landschap met ruïnes*

Canvas 53 × 66. Signed *JvRuisdael*
PROV Presented by Mr & Mrs D A J Kessler-Hülsmann, Kapelle op den Bosch near Mechelen, 1940 * DRVK since 1968
LIT Rosenberg 1928, p 105, nr 525

school of Jacob Isaacksz van Ruisdael

A 3498 Farm in a woody dune landscape. *Boerenhuis in een bosachtig duinlandschap*

Panel 24 × 28.5. Signed *JVR*
PROV Bequest of Mrs A C M H Kessler-Hülsmann, widow of D A J Kessler, Kapelle op den Bosch near Mechelen, 1949

Johan Adolph Rust

Amsterdam 1828 – 1915 Amsterdam

A 4275 View of the Hoge Sluis, Amsterdam, from the marina on the Amstel. *Gezicht op de Hoge Sluis te Amsterdam, vanaf de Amstel Jachthaven*

Panel 56 × 361. Lunette. Signed *J. A. Rust*. Painted in 1868. Inscribed *Om Amstels keurig schoon meer luister toe te voegen, Schonk de Achtbare Overheid aan ons het groot genoegen, Deez' haven tot vermaak en nut te doen ontstaan Dus elk die 't zeilen mint, hier zijn lust voldaan. Na honderd vijftig jaar den stroom des tijds te krachtig, Leeft, bloeit dit stads-geschenk in dubblen luister voort. Nog zijn wij sterk, nog zijn wij magtig: Gezegend blijve onze Amstelboord.* In the left margin *1718*
PROV Presented by C Jurrjens, on behalf of the former Amstel Jachthaven (marina on the Amstel), Amsterdam, 1894. NMGK

Simon Ruys

active 1679-88 in The Hague

A 2131 Johannes Camprich van Cronefelt. Knight in the order of Sts Maurice and Lazarus, imperial German legate to The Hague. *Ridder in de orde van Sint Mauritius en Sint Lazarus, keizerlijk Duits gezant in Den Haag*

Engraved in 1687 by Abraham Blooteling (1640-90)

Panel 36.5 × 28
PROV Purchased from Fr Muller & Co, art dealers, Amsterdam, 1904, through the intermediacy of Jonkheer Victor de Stuers

Rachel Ruysch

Amsterdam 1664 – 1750 Amsterdam

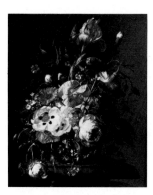

A 2338 Still life with flowers on a marble table top. *Stilleven met bloemen op een marmeren tafelblad*

Canvas 48.5 × 39.5. Signed and dated *Rachel Ruijsch 1716*
PROV Purchased from the heirs of Jonkheer P H Six van Vromade, Amsterdam, 1908
LIT W Steenhoff, Onze Kunst 13 (1908) pp 214-15, ill. Hofstede de Groot 1907-28, vol 10, nr 3A. Warner 1928, nr 83a. Grant 1956, nr 153, ill

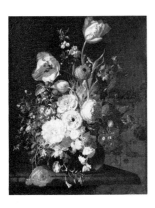

A 354 Still life with flowers in a glass vase. *Stilleven met bloemen in een glazen vaas*

Canvas 65 × 53.5. Signed *Rachel Ruijsch f*
PROV Sale Maria Boreel-Trip, dowager of Willem Boreel, Amsterdam, 23 Sep 1814, lot 18 * DRVK since 1953
LIT Hofstede de Groot 1907-28, vol 10, nr 3. Grant 1956, nr 117, ill

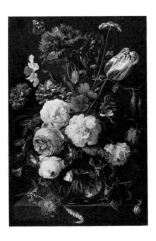

C 214 Still life with flowers in a glass vase. *Stilleven met bloemen in een glazen vaas*

Copper 54.5 × 36.5. Signed *Rachel Ruijsch*
PROV On loan from the city of Amsterdam (A van der Hoop bequest), 1885-1975
LIT Hofstede de Groot 1907-28, vol 10, nr 2. Grant 1956, nr 137, ill. Exhib cat Boeket in Willet, Amsterdam 1970, nr 28

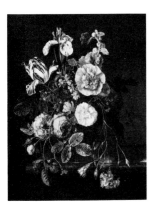

A 356 Still life with flowers. *Stilleven met bloemen*

Canvas 65 × 51.5
PROV Sale Amsterdam, 27 April 1858, lot 309
LIT Hofstede de Groot 1907-28, vol 10, nr 1. Grant 1956, nr 109, ill

Jacob Salomonsz van Ruysdael

Haarlem 1629/30-1681 Haarlem

A 1525 Landscape with herdsman and cattle. *Landschap met herder en vee*

Panel 80 × 107. Signed and dated *J vR 1665*
PROV Purchased from M Colnaghi gallery, London, 1890

Salomon Jacobsz van Ruysdael

Naarden 1600/03–1670 Haarlem

A 3259 River view near Deventer. *Riviergezicht bij Deventer*

Canvas 110 × 151.5. Signed and dated *S VR 1645*
PROV Presented by Sir Henry W A Deterding, London, 1936
LIT Stechow 1938, nr 458. Van Gelder 1959, p 14, fig 23. W Stechow, Bull Clev Mus of Art, Sep 1973, p 225, note 6

A 3983 River landscape with ferry. *Rivierlandschap met veerpont*

Canvas 99.5 × 133.5. Signed and dated *SVRuysdael 1649*
PROV J Goudstikker gallery, Amsterdam. Lent by the SNK, later DRVK, 1948. Transferred in 1960
LIT Stechow 1938, nr 358. Gerson 1952, p 44, fig 122. E R Meijer, OK 6 (1962) nr 35, ill

A 713 A village inn with stagecoach. *Dorpsherberg met reiswagen*

Panel 56 × 84.5. Signed and dated *S VR 1655*
PROV Bequest of Jonkheer J S H van de Poll, Amsterdam, 1880
LIT V de Stuers, Ned Kunstbode 2 (1880) p 244. Stechow 1938, nr 155

A 352 The watering place. *Pleisterplaats*

Panel 61 × 85. Signed and dated *SVRuysdael 1660*
PROV Bequest of L Dupper Wzn, Dordrecht, 1870
LIT C von Lützow, Zeitschr BK 5 (1870) p 229. Martin 1935-36, vol 1, pp 280-81, fig 150. Stechow 1938, nr 158

A 2571 View in a village. *Dorpsgezicht*

Canvas 105 × 150.5. Signed and dated
SVRuisdael 1663
PROV Lent by C Hoogendijk, The Hague,
1907. Presented from his estate in 1912
LIT C Hofstede de Groot, Ned Spec,
1899, p 58. R Bangel, Cicerone 7 (1915)
p 186, fig 9. Stechow 1938, nr 163

A 3258 Sailing vessels on an inland body
of water. *Zeilschepen op breed binnenwater*

Panel 50 × 69
PROV Presented by Sir Henry W A
Deterding, London, 1936 * DRVK since
1963
LIT Stechow 1938, nr 282

Jan de Ruyter

Amsterdam 1786 – 1831 Amsterdam

A 353 The kitchen maid. *De keukenmeid*

Canvas 38 × 31. Signed and dated
J. de Ruyter f 1820
PROV Purchased at exhib Amsterdam
1820, nr 320

Pieter Jansz van Ruyven

Delft 1651 – 1716 Delft

A 1315 A cock, a chicken and other
fowl. *Een haan, een kip en ander pluimvee*

Canvas 73 × 86. Signed *P. v. Ruijven f*[t]
PROV Sale D M Alewijn (Medemblik),
Amsterdam, 16 Dec 1885, lot 150

attributed to **Pieter Cornelisz van Rijck**

Delft 1568 – 1628

A 868 Kitchen scene with the parable of
Lazarus and the rich man. *Keuken-
interieur met de gelijkenis van de rijke man en
de arme Lazarus*

Canvas 198 × 272
PROV Purchased from M de Maan, The
Hague, 1876 (as probably Aert Pietersz).
NMGK, 1885
LIT Vorenkamp 1933, p 21. Martin
1935-36, vol 1, pp 34, 283, fig 165.
Hoogewerff 1936-47, vol 4 (1941-42) p
546. Bol 1969, p 5, fig 2 (ca 1615). Exhib
cat Vlaamse tekeningen uit de 17de
eeuw, Brussels, Rotterdam & Paris
1972-73, p 67. J A Emmens, Alb Amic
J G van Gelder, 1973, pp 93-94, fig 1
(Cornelis Jacobsz Delff)

David Ryckaert III

Antwerp 1612 – 1661 Antwerp

A 357 The cobbler's workshop. *De
schoenmakerswerkplaats*

Panel 53 × 69
PROV NM, 1808
LIT Moes & van Biema 1909, pp 61-62,
76, 221

James de Rijk

Hilversum 1806 – 1882 Hilversum

C 540 Stable adjoining a Dutch farm-
house. *Boerendeel*

Canvas 58 × 72
PROV Felix Meritis Society, Amsterdam,
1889. On loan from the city of
Amsterdam since 1889

Rijn

see Rembrandt

Georg Saal

Coblenz 1818–1870 Baden-Baden

A 1827 Forest landscape in the moonlight. *Boslandschap bij maanlicht*

Canvas 71 × 110. Signed and dated
G. Saal Paris 1861
PROV Bequest of Reinhard Baron van Lynden, The Hague, 1899 * DRVK since 1953

Philip Lodewijk Jacob Frederik Sadée

The Hague 1837–1904 The Hague

A 1167 Scheveningen women gleaning left-over potatoes. *Scheveningse vrouwen bij het nalezen van een gerooid aardappelveld*

Canvas 61 × 121. Signed and dated
Ph. Sadée f¹ 1874
PROV Purchased at exhib Amsterdam 1874, nr 448. RVMM, 1885 * DRVK since 1952
LIT Marius 1920, fig 99. Scheen 1946, fig 359

Aegidius Sadeler

see Southern Netherlands school ca 1607, A 740. The hall of the Hradschin, Prague

Jan Sadeler

see Winghe, Joos van, A 473 Nocturnal banquet with masqueraders

Pieter Jansz Saenredam

Assendelft 1597–1665 Haarlem

A 359 Interior of the church of St Bavo in Haarlem, seen from the south ambulatory, looking across the choir to the north ambulatory and the large organ. *Interieur van de Grote of Sint Bavo-kerk te Haarlem, gezien vanuit de zuidelijke kooromgang door het koor en de noordelijke kooromgang met het grote orgel*

Panel 95.5 × 57. Signed and dated
P. Saenredam 1636
PROV Purchased in 1806. NM, 1808
LIT A W Weissman, OH 20 (1902) p 134. H Jantzen, Onze Kunst 15 (1909) p 141, fig 1. Moes & van Biema 1909, p 104. Jantzen 1910, pp 82, 169, nr 404, fig 33. J W Enschedé, in Feestbundel Bredius, 1915, pp 25, 31, 35. Ozinga 1929, p 25. Swillens 1935, nr 95, fig 81. Hüttinger 1956, p 121, fig 67. Vente 1958, pl 39. Plietzsch 1960, p 121, fig 204. Bernt 1960-62, vol 3, nr 717. M A Vente, in exhib cat Nederlandse orgelpracht, Haarlem 1961, p 19, fig 2. Exhib cat P J Saenredam, Utrecht 1961, nr 38, fig 41. J Bruyn, Bull RM 11 (1963) p 31ff, ill. Heckmans 1965, pp 24-26, fig 13. G Schwartz, Simiolus 1 (1967) p 85ff, fig 11. BAR Carter, Burl Mag 109 (1967) p 594. VTTT, 1969-70, nr 120. Exhib cat Saenredam, Paris 1970, fig 11, nr 7. M A Vente, Spiegel Hist 5 (1970) p 434, fig 1. Bernt 1969-70, vol 3, nr 1019. J R J van Asperen de Boer, Bull RM 19 (1971) pp 26, 30, figs 4-8. W A Liedtke, OH 86 (1971) p 132, fig 8

A 858 The transept of the Mariakerk in Utrecht, seen from the northeast. *Het transept van de Mariakerk te Utrecht, gezien vanuit het noordoosten*

Panel 59 × 45. Signed and dated
Pʳ Saenredam Pinxit Anno 1637
PROV Purchased from Mr Colmette, Cahors, 1875. NMGK, 1885
LIT Jantzen 1910, pp 83, 169, nr 406. Swillens 1935, pp 30, 53, nr 145, fig 144. G Brinkgreve, Connaissance d A 95 (1960) p 38, nr 10. Exhib cat P J Saenredam, Utrecht 1961, nr 153. G Schwartz, Simiolus 1 (1967) p 79, note 21

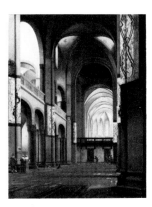

A 851 The nave and choir of the Mariakerk in Utrecht, seen from the west. *Het middenschip en koor van de Mariakerk te Utrecht, gezien vanuit het westen*

Panel 121.5 × 95. Signed and dated
Pieter Saenredam, ghemaeckt ende voleijndicht den 29 Januarij int Jaer 1641. Inscribed *Dit is de St. Mariae kerck, binnen uijttrecht* (above the signature) and *accipe posteritas quod per tua* [secula narres], *taurinis cutibus fundo solidata* [collumna est] (left on the column under the picture of a bull)
PROV From the Huygenshuis (house of Constantijn Huygens), Plein, The Hague. NMGK, 1885
LIT Hofstede de Groot 1899, nr 15. Jantzen 1910, p 84, nr 410, fig 34. J Six, Bull NOB 3 (1910) p 25. Weissman 1912, fig 9. Hoogewerff 1923, p 89, note 3, fig 62. Vermeulen 1928, vol 1, p 242, note 1. Martin 1935-36, vol 1, pp 278, 280-81, fig 163. Swillens 1935, cat nr 151, fig 133. N S Trivas, Apollo 27 (1938) p 155. J

Steppe, Verh Kon Vl Ac 7 (1952) p 342. S J Gudlaugsson, o h 69 (1954) p 68 (staffage by Pieter Post). G Brinkgreve, Connaissance d A 95 (1960) p 38, nr 12. Plietzsch 1960, p 122. Exhib cat P J Saenredam, Utrecht 1961, nr 149. Th H Lunsingh Scheurleer, o h 77 (1962) pp 181-82. H Halbertsma, Vrije Fries, 1964, p 78ff, fig 5. G Schwartz, Simiolus 1 (1967) p 69ff, ill

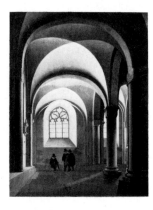

A 1189 The westernmost bays of the south aisle of the Mariakerk in Utrecht. *De westelijke traveeën van de zuidelijke beuk van de Mariakerk te Utrecht*

Panel 39 × 30
PROV Sale The Hague, 3 June 1885, lot 7
LIT Jantzen 1910, pp 83, 169, nr 424. Swillens 1935, pp 34, 36, 59, cat nr 167, fig 149 (ca 1645-50). G Brinkgreve, Connaissance d A 95 (1960) p 38, nr 11. Exhib cat P J Saenredam, Utrecht 1961, nr 166 (ca 1640)

C 217 Interior of the church of St Odulphus in Assendelft, seen from the choir to the west. *Interieur van de Sint Odulphuskerk te Assendelft, gezien vanuit het koor naar het westen*

Panel 50 × 76. Signed and dated *dit is de kerck tot Assendelft, een dorp in hollandt, van Pieter Saenredam, dese geschildert int jaer 1649. den 2. October.* Inscribed *Iohannis Saenredam sculptoris celeberrimi. Petri de Ionge XLIV annos Assendelphi praetoris. Gerardi de Ionge filii I.V.D. et advocati. Iacet hic quod fuit* (on the tombstone in the foreground) *en dit is de tombe ofte begraefplaets van heeren tot assendelft* (on the edge of the tomb) *en …kerck*

Assendelft een …p in Hollant … Saenredam 1649 volschildert (on the lower edge of the tomb)
PROV On loan from the city of Amsterdam (A van der Hoop bequest) since 1885
LIT Hofstede de Groot 1899, nr 2. Jantzen 1910, p 84, nr 412. J Six, Bull NOB 2d ser 3 (1910) p 24. F Vermeulen, Bull NOB 2d ser 13 (1920) p 179. Swillens 1935, pp 10, 35, 50, 66-67, nr 174, fig 47. Martin 1935-36, vol 1, pp 279, 281, 391, fig 162. Bremmer 1938, nr 4. Gerson 1952, p 55, fig 157. S J Gudlaugsson, o h 69 (1954) p 66, note 14. Leymairie 1956, p 150, ill. Hüttinger 1956, p 122, fig 68. G Brinkgreve, Connaissance d A 95 (1960) p 41, nr 17. Plietzsch 1960, p 121, fig 207. Exhib cat P J Saenredam, Utrecht 1961, nr 19. H P Baard, in exhib cat Nederlandse orgelpracht, Haarlem 1961, p 105, fig 12. J R J van Asperen de Boer, Bull RM 19 (1971) pp 25-26, figs 1-3. W A Liedtke, o h 86 (1971) pp 121 ff, fig 1

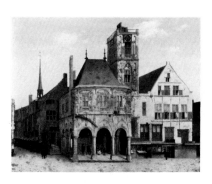

C 1409 The old town hall of Amsterdam. *Het oude stadhuis te Amsterdam*

Panel 64.5 × 83. Signed and dated *Pieter Saenredam, Heeft dit eerst naer 't Leeven Geteeckent, met al sijn Coleuren int Jaer 1641 en dit Geschildert, int jaer 1657.* Inscribed *Dit is het oude Raethuijs der stadt Amsterdam, welck afbrande int jaer 1651 den 7 julij, in 3 uren tyt sonder meer*
PROV Purchased from the artist by the burgomasters of Amsterdam. Burgomasters' chamber of the town hall. On loan from the city of Amsterdam since 1945
LIT Houbraken 1718-21, vol 1, p 175. Wagenaar 1760-88, vol 2 (1765) p 18. Van Dijk 1790, p 111, nr 68. Scheltema 1879, nr 100. Jantzen 1910, p 86, nr 416. J Six, Bull NOB 3 (1910) p 24. C G 't Hooft, Jb Amstelodamum 12 (1914) p 207ff. C G 't Hooft, Jb Amstelodamum 30 (1936) p 1. Martin 1935-36, vol 1, p 278. Swillens 1935, nr 204, fig 41. Bremmer 1938, nr 6. Gerson 1952, p 54, fig 158. S J Gudlaugsson, o h 69 (1954) p 66, note 13. Hüttinger 1956, p 123ff, fig 69. Leymairie 1956, p 155. Posthumus Meyjes 1957, p 18. G Brinkgreve, Connaissance d A 95 (1960) p 35, fig 7. Plietzsch 1960, p 124, fig 211. Swillens 1960, p 113. Exhib cat P J Saenredam,

Utrecht 1961, nr 13. K Fremantle, o h 77 (1962) p 208, fig 3. S H Levie, o k 10 (1966) nr 78, fig 1. Briganti 1966, p 36, ill. Stechow 1966, p 125, fig 250. Fuchs 1968, p 19, fig 27. Wagner 1971, p 22

Cornelis Saftleven

Gorkum 1607 – 1681 Rotterdam

A 715 A company of country folk. *Boerengezelschap*

Panel 63 × 83.5. Signed and dated *C. Saftleven 1642*
PROV Bequest of Jonkheer J S H van de Poll, Amsterdam, 1880
LIT V de Stuers, Ned Kunstbode 2 (1880) p 245. M Cloet, Spiegel Hist 5 (1970) p 282, ill on cover

A 797 Landscape with animals. *Landschap met dieren*

Panel 46.5 × 59.5. Signed and dated *C. Saftleven fe. 1652*
PROV Sale Amsterdam, 14-15 Nov 1883, lot 136
LIT Bol 1969, p 227, fig 219

A 1588 Satire on the trial of Johan van Oldenbarneveldt. *Satire op de berechting van Johan van Oldenbarneveldt*

The animals are traditionally identified as Nicolaes Kromhout, president of the Court (as the elephant), Reynier Pauw (as the peacock), Hendrick van Essen and Nicolaes de Voogt (as the lions), Hugo Muys van Holy (as the tiger), Gerard Beuckersz van Santen (as the crocodile), Pieter Jansz Schagen (as the donkey), Aelbrecht Bruyning (as the dog), Adriaen Ploos (as the ape) and Volckert Sloot (as the goat)

Canvas 63 × 86. Signed and dated *CS f A 1663*. Inscribed *Trucidata innocentia*
PROV Presented by G de Clercq, Amsterdam, 1892
LIT Martin 1935-36, vol 2, p 244. J C Boogman, Spiegel Hist 4 (1969) p 487, fig 2. Den Tex 1960-72, vol 4 (1970) pp 655-58

A 801 The annunciation to the shepherds. *De verkondiging aan de herders*

Panel 75 × 108. Signed falsely *G. Terburg*
PROV Sale Count Andor de Festetis, Amsterdam, 22 Jan 1884, lot 116
LIT E Plietzsch, Zeitschr BK ns 27 (1916) p 133. Bauch 1967, p 135, fig 54

Herman Saftleven

Rotterdam 1609–1685 Utrecht

A 363 Village on a river. *Dorp aan een rivier*

Panel 30.5 × 45. Signed and dated *HS 1654*
PROV Purchased with the Kabinet van Heteren Gevers, The Hague-Rotterdam, 1809
LIT Hoet 1752, vol 2, p 459. Moes & van Biema 1909, pp 149,167

A 1762 River view with ferry. *Rivier-gezicht met veerpont*

Panel 20.5 × 28. Signed and dated *HS 1655*
PROV Bequest of D Franken Dzn, Le Vésinet, 1898

A 361 River view. *Riviergezicht*

Panel 18 × 23.5. Dated *A 1655*
PROV Sale G van der Pot van Groeneveld, Rotterdam, 6 June 1808, lot 151

A 1761 Mountainous landscape near Boppard, on the Rhine. *Berglandschap bij Boppard aan de Rijn*

Copper 23 × 28. Signed and dated on the verso *Bij Popert Herman Saftleven f. A. Utrecht Anno 1660*
PROV Bequest of D Franken Dzn, Le Vésinet, 1898

A 716 Mountainous landscape with farm. *Berglandschap met boerderij*

Canvas 60 × 82. Signed and dated *HS 1663*
PROV Bequest of Jonkheer J S H van de Poll, Amsterdam, 1880 * DRVK since 1959 (on loan to De Cannenburch Castle, Vaassen)
LIT V de Stuers, Ned Kunstbode 2 (1880) p 244

A 362 River view with landing stage. *Riviergezicht met aanlegplaats*

Panel 27 × 37. Signed and dated *HS 1678*
PROV Purchased with the Kabinet van Heteren Gevers, The Hague-Rotterdam, 1809 * On loan to the Rijksmuseum Lambert van Meerten, Delft, since 1919

A 3029 River view near Kleve. *Rivier-gezicht bij Kleef*

Panel 32 × 40
PROV Bequest of S van der Horst, Haarlem, 1925
LIT Dattenberg 1967, nr 318, ill

C 218 River view in a mountainous region. *Riviergezicht in een bergachtige streek*

Canvas 67.5 × 91
PROV On loan from the city of Amsterdam (A van der Hoop bequest) since 1885

Le Sage

see under Miniatures

De Saint-Ligié

see under Miniatures

Raden Sarief Bastaman Saleh

Semarang 1814–1880 Buitenzorg

see also Governors-general series: A 3790 Herman Willem Daendels; A 3798 Johannes Graaf van den Bosch; A 3799 Jean Chrétien Baud

A 778 Fight between a lion, a lioness and a buffalo. *Gevecht tussen een leeuw, een leeuwin en een buffel*

Canvas 181 × 293. Signed and dated *Raden Saleh F 1848*
PROV Presented by the artist to King Willem III, 1850. RVMM, 1885. Destroyed by fire at the Colonial Exhibition, Paris, 1931
LIT Scheen 1946, fig 155. De Loos-Haaxman 1968, fig 61

Charles Louis Saligo

Grammont 1804–after 1848 Paris?

A 1126 Self portrait. *Zelfportret*

Canvas 91 × 74
PROV Purchased at exhib Ghent 1826. RVMM, 1885

Henri Sallembier

Paris ca 1753–1820 Paris

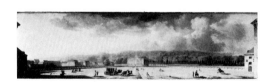

A 4276 View of a palace in a hilly landscape. *Gezicht op een paleis in een heuvellandschap*

Pendant to A 4277

Canvas 17 × 61. Signed *Sallembier*
PROV NMGK, 1898
LIT [A] v[an] S[chendel], Mndbl BK 18 (1941) p 226, ill

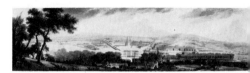

A 4277 View of the garden façade of a palace. *Gezicht op de achterzijde van een paleis*

Pendant to A 4276

Canvas 17 × 61. Signed *Sallembier*
PROV Same as A 4276
LIT [A] v[an] S[chendel], Mndbl BK 18 (1941) p 226

Engel Sam

Rotterdam 1699–1769 Amsterdam

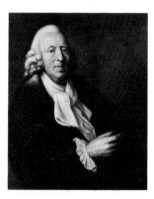

A 2694 Self portrait at about the age of sixty. *Zelfportret op ongeveer zestigjarige leeftijd*

Canvas 79.5 × 63.5
PROV Purchased from A van Oostveen, Amsterdam, 1913
LIT J W Niemeijer, Bull RM 11 (1963) p 58, fig 3

Gerardina Jacoba van de Sande Bakhuyzen

The Hague 1826–1895 The Hague

A 1002 Still life with flowers and fruit. *Stilleven met bloemen en vruchten*

Canvas 68.5 × 93. Signed and dated *G. J. v.d. S. Bakhuyzen 1869*
PROV Purchased at exhib The Hague 1869, nr 9. RVMM, 1885 * DRVK since 1952

A 3878 Still life with flowers in a crystal vase. *Stilleven met bloemen in een kristallen vaas*

Board 30.5 × 23. Signed *G. J. v.d. S. Bakhuyzen*
PROV Unknown

Hendrik van de Sande Bakhuyzen

The Hague 1795–1860 The Hague

A 1000 Gelderland landscape. *Gelders landschap*

Panel 55 × 47. Signed and dated *HBakhuyzen F. 1818*
PROV Purchased at exhib Amsterdam 1818, nr 15. RVMM, 1885

NO PHOTOGRAPH AVAILABLE

A 1001 The ruins of Brederode Castle, seen from the east side. *De ruïne van kasteel Brederode, gezien vanuit het oosten*

In the foreground is a narrow ditch, with a spotted white cow drinking from it. A bit further into the space are two red spotted cows, one standing and one lying, and a peasant talking to a peasant woman milking a goat on her knees. To their right are two sheep in the grass. The ruins of Brederode are in the middleground. In front of it are several trees, and among them some cattle

Canvas 113 × 148. Signed and dated *H. v.d. Sande Bakhuyzen F. 1827*
PROV Thought to have been purchased in 1831. RVMM, 1885 * Lent to the Gouvernementsgebouw (provincial capitol) of Gelderland, Arnhem, 1924. Destroyed in the war, 1944

A 4163 The artist painting a cow in a meadow landscape. *De schilder zelf, schilderend in een weidelandschap met vee*

Panel 73.2 × 96.7. Signed and dated *VDS Bakhuyzen fct 1850 Haga Comit*[is]. The tophat is marked *VD SB*
PROV Purchased from J de Caso, Berkeley, Calif, 1969
LIT CJ de Bruyn Kops, Bull RM 22 (1974) pp 33, 38, fig 16

A 3845 View on the Rhine. *Gezicht langs de Rijn*

Panel 24.5 × 29. Signed *Bakhuyzen*
PROV Bequest of Mrs MNTh Weddik-Lublink Weddik, widow of AL Weddik, Arnhem, 1919 * DRVK since 1961

Julius Jacobus van de Sande Bakhuyzen

The Hague 1835–1925 The Hague

A 1185 Landscape in Drenthe. *Landschap in Drenthe*

Canvas 55 × 95.5. Signed and dated *J. v.d. Sande Bakhuyzen 1882*
PROV Purchased at exhib Amsterdam 1882, nr 7 * DRVK since 1950

A 2379 Landscape with a turf hut. *Landschap met plaggenhut*

Panel 24 × 32. Signed *J. vdS Bakhuyzen*
PROV Bequest of JBAM Westerwoudt, Haarlem, 1907. Received in 1909 * DRVK since 1960

A 2259 A watermill near Twickel. *Water-molen bij Twickel*

Canvas 56 × 74. Signed *J. v.d. Sande Bakhuyzen*
PROV Bequest of J BA M Westerwoudt, Haarlem, 1907 * DRVK since 1953

Gerard Sanders

see Miniatures: Holland school ca 1750, A 4443 Willem IV, after Sanders

Hercules Sanders

Amsterdam 1606–after 1673
Amsterdam?

A 1492 Portrait of a woman. *Portret van een vrouw*

Canvas 123.5 × 104.5. Signed and dated *H. Sanders fe A° 1651*. Inscribed *Æ 67*
PROV Lent by Jonkheer H Teding van Berkhout, Haarlem, 1885. Purchased in 1889
LIT Bernt 1960-62, vol 4, nr 246. Bernt 1969-70, vol 3, nr 1029

Sanders

see Farncombe Sanders

Joachim von Sandrart

Frankfurt am Main 1606–1688
Nürnberg

C 393 The company of Captain Cornelis Bicker and Lieutenant Frederick van Banchem, waiting to welcome Maria de' Medici, dowager queen of France, on her visit to Amsterdam, September 1638. *De compagnie van kapitein Cornelis Bicker en luitenant Frederick van Banchem, gereed voor de ontvangst van Maria de' Medici, koningin-weduwe van Frankrijk, in september 1638*

Canvas 343 × 258. Inscribed *Het Corporaalschap des Heeren van Swieten. Geschildert door Sandrart* and *De Vaan van Swieten wacht om Medicis te onthalen | maar voor zo groot een ziel is dan een markt te kleen | En 't oog der Burgerij te zwak voor zulke Straalen | Die zon van 't Christenrijk, is vleesch, nog vel, nog been | Vergeef het dan Sandrart, dat hij haar maakt van steen. Vondel.* On the bust *Maria de Medicis*
PROV Kloveniersdoelen (headquarters of the arquebusiers' civic guard), Amsterdam. On loan from the city of Amsterdam since 1885
LIT Wagenaar 1760-88, vol 2 (1765) p 19. Van Dijk 1790, p 100, nr 54. Scheltema 1855-85, vol 2 (1856) p 97. Evelyn, ed 1955, vol 2, pp 43-44. Scheltema 1879, nr 101. D C Meijer Jr, OH 6 (1888) pp 236-37. Moes 1897-1905, vol 1, nrs 346, 633. Kutter 1907, p 46ff, 120, nr 86. Martin 1935-36, vol 1, pp 218-20, 223-24, fig 124. Van de Waal 1952, p 36, note 3, fig 4:2. F J Dubiez, Ons Amsterdam 10 (1958) p 277, ill on p 275. Van Hall 1963, p 289, nr 1837:1. B Albach, OH 85 (1970) p 98, fig 4. Gerson 1973, p 19, ill

of the Amsterdam militia. *Kapitein der burgerij te Amsterdam*

Pendant to C 27

Canvas 139 × 105. Signed and dated *Sandrart 1639*
PROV On loan from the city of Amsterdam (Bicker bequest), 1881-1975
LIT D C Meijer Jr, OH 6 (1888) p 238. Moes 1897-1905, vol 1, nr 642:1. Elias 1903-05, vol 1, p 360. Kutter 1907, pp 52, 73, note 283, 122, nr 88

C 27 Eva Geelvinck (1619-98). Wife of Hendrik Bicker. *Echtgenote van Hendrik Bicker*

Pendant to C 26

Canvas 139 × 105. Signed and dated *J. Sandrart f. 1639*
PROV Same as C 26
LIT D C Meijer Jr, OH 6 (1888) p 238. Moes 1897-1905, vol 1, nr 2637:1. Kutter 1907, p 122, nr 89

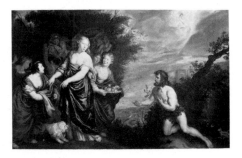

A 4278 Odysseus and Nausicaa. *Odysseus en Nausikaä*

Canvas 104 × 168.5. Signed *J. Sandrar*
PROV Presented by D Franken Dzn, Le Vésinet, 1898. NMGK
LIT Kutter 1907, p 121, nr 87. C Salvy, Jardin d A 176-77 (1969) p 50, ill

copy after **Joachim von Sandrart**

C 26 Hendrik Bicker (1615-51). Captain

A 364 Pieter Cornelisz Hooft (1581-1647). High bailiff of Muiden, historian and poet. *Drost van Muiden, geschied-schrijver en dichter*

Copy after the original in the university of Leiden (cat 1973, nr 60)

Panel 27 × 22.5
PROV Purchased in 1818 * Lent to the AHM, 1975
LIT DC Meijer Jr, OH 6 (1888) p 238. Moes 1897-1905, vol 1, nr 3668:6. Kutter 1907, p 123, nr 91a. Icones Leidenses, 1973, nr 60

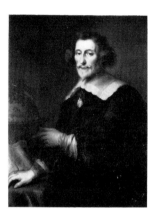

A 56 Pieter Cornelisz Hooft (1581-1647). High bailiff of Muiden, historian and poet. *Drost van Muiden, geschiedschrijver en dichter*

Copy after the original in the university of Leiden (cat 1973, nr 60)

Canvas 109 × 83
PROV Purchased in 1803 (as A Bloemaert). NM, 1808 * On loan to the Rijksmuseum Muiderslot, Muiden, since 1949
LIT Moes 1897-1905, vol 1, nr 3668:8 (copy by Leonard Bramer?). C Hofstede de Groot, OH 22 (1904) p 117. Moes & van Biema 1909, pp 64, 207. Schmidt 1922, p 179, nr 222 (Jurriaen Ovens?)

Ethel Sands

Newport (USA) 1873-1962 England?

A 3723 Corner of a bedroom. *Hoekje van een slaapkamer*

Board 44.5 × 36.5. Signed *E.S.*
PROV Bequest of Mr & Mrs J C J Drucker-Fraser, Montreux, 1944

Pieter Sane

see Panpoeticon Batavum: A 4609 Petrus Schaak

Hendrik Alexander Sangster

Nijkerk 1825 – 1901 Amsterdam

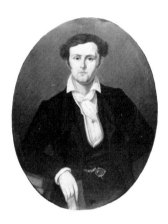

A 1678 Reinier Engelman (1795-1845). Actor and theatrical director. *Toneel-speler en toneeldirecteur*

Canvas 50 × 39. Oval
PROV Presented by Mrs J H Albregt-Engelman, Amsterdam, 1896, through the intermediacy of N van Harpen, Amsterdam * DRVK since 1953

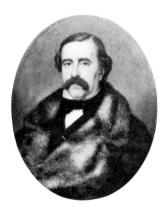

A 1677 Johan Eduard de Vries (1808-75). Director of the town theatre and the palace of industry, Amsterdam. *Directeur van de schouwburg en van het Paleis voor Volksvlijt te Amsterdam*

Canvas 68 × 57. Signed and dated *Sangster 1865*
PROV Same as A 1678 * DRVK since 1953

A 1679 Maria Francisca Bia (1809-89). Widow of Reinier Engelman and wife of Johan Eduard de Vries; actress and singer, in the role of Juffer Serklaas in the play of the same name (1852) by Hendrik Jan Schimmel (1823-1906). *Weduwe van Reinier Engelman, echtgenote van Johan Eduard de Vries, actrice en zangeres, in het kostuum van Juffer Serklaas uit het gelijknamige toneelstuk van Hendrik Jan Schimmel*

Canvas 70 × 57. Octagonal. Signed and dated *Sangster 1866*
PROV Same as A 1678 * DRVK since 1953

A 1966 Johannes Hermanus Albregt (1829-79). Actor. *Toneelspeler*

Canvas 79.5 × 62. Signed *Sangster*
PROV Bequest of the sitter's widow, Amsterdam, 1902 * DRVK since 1953

F Sant-Acker

active ca 1668 in Amsterdam?

A 2655 Still life with nautilus cup. *Stil-
leven met nautilusbeker*

Canvas 66 × 56.5. Signed *f. Sant Acker*
PROV Purchased from A Vecht & Co
gallery, Amsterdam, 1913
LIT Bol 1969, p 350. Bernt 1969-70, vol
3, nr 1030

Gerrit van Santen

active 1629-50 in The Hague

A 3893 The siege of Schenckenschans by
Prince Frederik Hendrik, April 1636.
*Het beleg van Schenckenschans door prins
Frederik Hendrik, april 1636*

Canvas 55 × 139.5
PROV Purchased from B Houthakker
gallery, Amsterdam, 1955
LIT Kramm 1857-64, appendix, p 132.
R van Luttervelt, Bull RM 4 (1956) p 78,
ill. Dattenberg 1967, nr 345, ill

Dirck Dircksz Santvoort

Amsterdam 1610-1680 Amsterdam

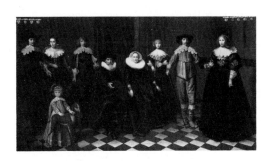

A 365 The family of Dirck Bas Jacobsz,
burgomaster of Amsterdam. *Het gezin
van Dirck Bas Jacobsz, burgemeester van
Amsterdam*

The sitters are, from left to right,
Abraham de Visscher (1605-67), his wife
Machteld Bas (d 1681) and their son
Jacob Bas Dircksz (1609-56), Dirck Bas
Jacobsz (1569-1637) with his second wife
Margriet Snoeck (1588-1645), Agatha
Bas (1611-58), Claes Bas (1616-35) and
Lysbeth Bas (1619-80)

Canvas 136 × 251. Painted in or before
1635
PROV Bequest of Mrs J Balguerie-van
Rijswijk, widow of D Balguerie,
Amsterdam, 1823 * Lent to the AHM,
1975
LIT Moes 1897-1905, vol 1, nrs 375, 377-
78, 381, 382:1, 383; vol 2, nrs 7349,
8553:1. E O G Haitsma Mulier, OK, Jan-
March 1973, ill

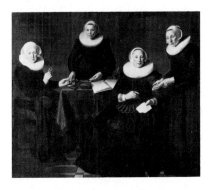

C 431 The regentesses Lijsbert
Hendricksdr Haecken and Stijntie
Thomas, sitting, and two housemistresses
of the Spinhuis (house of correction),
Amsterdam, 1638. *De regentessen Lijsbert
Hendricksdr Haecken en Stijntie Thomas
(zittend) en twee binnenmoeders van het Spin-
huis te Amsterdam, 1638*

Canvas 187.5 × 214. Signed and dated
D. D. Santvoort fc. 1638
PROV Werkhuis (workhouse),
Amsterdam. On loan from the city of
Amsterdam, 1885-1975
LIT Moes 1897-1905, vol 1, nr 3024; vol
2, nr 7935. Martin 1935-36, vol 1, pp 96,
186, 318, fig 54. Bernt 1960-62, vol 3, nr
726. Bernt 1969-70, vol 3, nr 1033

A 1317 Frederik Dircksz Alewijn (1603-
65). Alderman and councillor of
Amsterdam. *Schepen en raad van Amsterdam*

Pendant to A 1318

Panel 72 × 61. Signed and dated
D. D. Santvoort fe. 1640
PROV Sale D M Alewijn (Medemblik),
Amsterdam, 16 Dec 1885, lot 73
LIT Moes 1897-1905, vol 1, nr 126. J H
Scholte, Jb Amstelodamum 41 (1947) pp
83, 102-06, ill on p 103

A 1318 Agatha Geelvinck (1617-38).
First wife of Frederik Dircksz Alewijn.
Eerste echtgenote van Frederik Dircksz Alewijn

Pendant to A 1317

Panel 72 × 61
PROV Same as A 1317, lot 74
LIT Moes 1897-1905, vol 1, nr 2635. J H
Scholte, Jb Amstelodamum 41 (1947) p 104

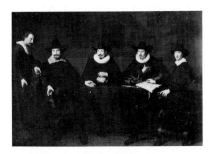

C 394 The directors of the serge cloth
industry, Amsterdam, 1643. *De hoofd-
lieden van de Saainering te Amsterdam, 1643*

The sitters are Jaques de Win, Pieter
Noordijck, Gerrit Kuycken, Gerrit
Anslo and, to the left, the servant Jan
Stockmans

Canvas 210 × 300. Signed and dated
D. D. Santvoort fec. 1643
PROV Kamer van de Hoofdlieden van de
Saainering (chamber of the directors of
the serge cloth industry), Amsterdam.
On loan from the city of Amsterdam
since 1885
LIT Wagenaar 1760-88, vol 2 (1765) p
43. Scheltema 1879, nr 102. Moes 1897-
1905, vol 1, nrs 166, 4292; vol 2, nrs
5437, 7600, 9128. H van de Waal, OH 71
(1956) p 102, fig 24

A 1310 Martinus Alewijn (1634-84). Son of Abraham Alewijn and Geertruid Hooftman. *Zoon van Abraham Alewijn en Geertruid Hooftman*

Pendant to A 1311

Canvas 124 × 91. Signed and dated *Santvoort fe. 1644*
PROV Sale D M Alewijn (Medemblik), Amsterdam, 16 Dec 1885, lot 79 (as Abraham van Santvoort)
LIT Martin 1935-36, vol 2, p 153

A 1311 Clara Alewijn (1635-74). Daughter of Abraham Alewijn and Geertruid Hooftman. *Dochter van Abraham Alewijn en Geertruid Hooftman*

Pendant to A 1310

Canvas 122 × 89.5
PROV Sale D M Alewijn (Medemblik), Amsterdam, 16 Dec 1885, lot 80 (as Abraham van Santvoort)
LIT *See under* A 1310

attributed to **Giovanni Battista Sassoferrato**

Sassoferrato 1605 – 1685 Rome

A 3423 Madonna and child. *Maria met kind*

Canvas 73 × 62
PROV Bequest of J W Edwin vom Rath, Amsterdam, 1941

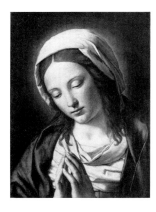

C 1370 Mary praying. *Biddende Maria*

Canvas 48 × 36.5
PROV On loan from the KKS since 1948

attributed to **Hans Savery I**

Courtrai ca 1564 – after 1626 Haarlem?

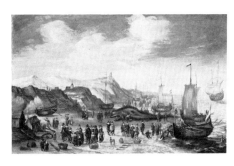

A 2526 A whale washed up on the beach at Noordwijk, 28 December 1614. *Een aangespoelde potvis op het strand bij Noordwijk, 28 december 1614*

Panel 53 × 85. Signed *Savery*
PROV Sale Amsterdam, 22 Nov 1910, lot 140
LIT Preston 1937, p 15. J W Niemeijer, Bull RM 12 (1964) p 20. Bol 1973, p 44, fig 43. B Haak, Antiek 9 (1974) p 73

Jacques Savery I

Courtrai ca 1545 – 1602 Amsterdam

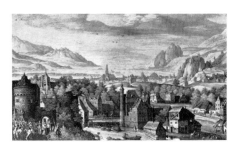

A 2117 Landscape with the story of Jephthah's daughter. *Landschap met de geschiedenis van de dochter van Jephta*

Gouache on vellum 18.5 × 31. Signed and dated *ISaveris 158.*
PROV Taken over from the RPK, 1903
LIT Franz 1969, vol 1, p 295; vol 2, fig 467 (ca 1584)

attributed to **Jacques Savery II**

Amsterdam ca 1592 – in or after 1627 Amsterdam?

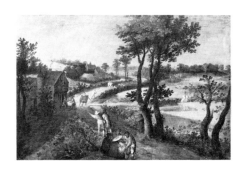

A 1980 Landscape with wheat fields. *Landschap met korenvelden*

Panel 28.5 × 42
PROV Purchased from the G de Clercq collection, Amsterdam, 1902, through the intermediacy of the Rembrandt Society

Roelant Savery

Courtrai 1576 – 1639 Utrecht

A 2211 Cows in a stable; witches in the four corners. *Koeien in een stal; in de vier hoeken heksen*

Panel 30.5 × 30.5. Signed and dated *R. Saveri 1615*
PROV Sale Amsterdam, 31 Oct 1905, lot 103
LIT Erasmus 1908, pp 35, 38, 60-61, nr 5. Thiéry 1953, p 191. R Klessmann, Jb Berliner Museen 2 (1960) p 112, fig 16

C 447 Wild boar hunt in a rocky land-scape. *Everzwijnjacht in een rotsachtig land-schap*

Panel 61.5 ×82. Signed and dated
R. Savery 1620
PROV Oude Zijds Huiszittenhuis
(institute for the outdoor relief of the
poor), Amsterdam. On loan from the city
of Amsterdam since 1885
LIT Erasmus 1908, pp 35, 61, nr 6. Bol
1969, p 127, fig 109

A 366 The poet crowned by two apes at
the feast of the animals. *De dichter op het
feest der dieren gekroond door twee apen*

Canvas 56.5 ×82. Signed and dated
Roeland Savery Fe 1623
PROV Purchased from L Hamming, 1875
LIT Bürger 1858-60, vol I, p 295.
Erasmus 1908, pp 36, 62, nr 7. Thiéry
1954, p 190

A 1297 Elijah fed by the ravens. *Elia door
de raven gevoed*

Copper 40 ×49. Signed and dated
Roeland Savery Fe 1634
PROV Sale C F Berré, Leiden, 7 Sep
1885, lot 59
LIT Erasmus 1908, pp 38, 62, nr 8

A 1488 Aesop's fable of the stag among
the cows. *De fabel van het hert tussen de
koeien (Aesopus)*

Panel 46.5 ×69.5. Signed *Roelandt
Savery Fe*
PROV Purchased from C L C Voskuil, art
dealer, Nieuwer Amstel, 1889
LIT Erasmus 1908, pp 62-63, nr 9.
Martin 1935-36, vol I, pp 233-34, fig 134.
Thiéry 1953, p 191. J Fechner, Jb
Kunsth Inst Graz, 1966-67, p 97

attributed to **Giovanni Girolamo
Savoldo**

Brescia ca 1480–after 1548 Venice

A 3269 Portrait of a man. *Portret van een
man*

Canvas 69 ×56.5
PROV Presented by E Heldring,
Amsterdam, 1937
LIT Berenson 1932, p 513. W Suida,
Pantheon 19-20 (1936) p 56 (Giovanni
Battista Moroni). C Gilbert, Arte Ven 3
(1949) pp 109-10 (Ritrattista Sala).
Berenson 1957, vol I, p 157. Boschetto
1963, p 223

B Schaak

active end 17th century in Rotterdam?

A 844 Vanitas still life. *Vanitas stilleven*

Canvas 47 ×40.5. Signed *B. Schaak f.*
PROV Purchased from C F Roos & Co,
art dealers, Amsterdam, 1884

Egbert Rubertus Derk Schaap

Nigtevecht 1862–1939 Ankeveen

A 2654 'Felsenmeer'

Canvas 34.5 ×46. Signed and dated
E. R. D. Schaap 1912. Inscribed on the
verso *Villa Nova*
PROV Presented by the artist, 1913

A 2653 Meadow in bloom. *Bloeiende weide*

Canvas 58.5 ×92. Signed and dated
E. R. D. Schaap 1912
PROV Presented by C F J Brands,
Amsterdam, 1913 * DRVK since 1953

Willem Henri van Schaik

Beetsterzwaag 1875 – 1938 Blaricum

A 3345 Farmstead. *Boerenhuis*

Canvas on panel 35 × 55. Signed
W. H. van Schaik
PROV Presented by Mr & Mrs DAJ
Kessler-Hülsmann, Kapelle op den
Bosch near Mechelen, 1940

Godfried Schalcken

Made 1643 – 1706 The Hague

A 2061 Josina Parduyn (1642-1718).
Second wife of Aernout van Citters.
Tweede echtgenote van Aernout van Citters

For a portrait of the sitter's husband, *see*
Kneller, Godfried, A 2060

Canvas on panel 44 × 35. Signed and
dated *G. Schalcken 1705*. On the verso her
coat of arms and those of her four
ancestors *Parduyn, Parduyn, Salomons,
Tirion*; the inscription *Vrouw Josina
parduijn geboren tot dort den 18 Mey 1642
trouwd Binnenen Middelburg den 29 octob^r*
*1663 den Heer Ambassadeur Aarnout van
Citters Heer van Gapinge. sterft 1 Novemb^r
1718 Binnen voornoemde stad* and the
number *4*
PROV Bequest of Jonkheer J de Witte
van Citters, The Hague, 1876. NMGK
1885
LIT Moes 1897-1905, vol 2, nr 5737:1.
Hofstede de Groot 1907-28, vol 5 (1912)
nr 317

A 899 Josina Clara van Citters (1671-
1753). Daughter of Josina Parduyn.
Dochter van Josina Parduyn

For a portrait of the sitter's mother, *see*
the preceding number

Canvas 30 × 25. Oval. Signed *G. Schalcken*
PROV Bequest of Jonkheer J de Witte
van Citters, The Hague, 1876. NMGK,
1885
LIT Moes 1897-1905, vol 1, nr 1544:1.
Hofstede de Groot 1907-28, vol 5 (1912)
nr 296

A 900 Miss van Gool, lady companion
of Josina Clara van Citters. *Mejuffrouw
van Gool, gezelschapsdame van Josina Clara
van Citters*

Canvas 30 × 25. Oval. Signed *G. Schalcken*
PROV Same as A 899
LIT Moes 1897-1905, vol 1, nr 2818.
Hofstede de Groot 1907-28, vol 5 (1912)
nr 305

A 367 William III (1650-1702), prince of
Orange. Stadholder and from 1689 on
king of England. *Willem III, prins van
Oranje. Stadhouder en sedert 1689 koning van
Engeland*

Canvas 76.5 × 65. Signed *G. Schalcken*
PROV NM, 1808
LIT Dezallier d'Argenville 1762, vol 4,
pp 216-17. G H Veth, OH 10 (1892) p 7.
Moes 1897-1905, vol 2, nr 9096:117.
Moes & van Biema 1909, pp 37, 203.
Hofstede de Groot 1907-28, vol 5 (1912)
nr 331. Martin 1935-36, vol 2, p 234. A
Staring, NKJ 2 (1950-51) p 186. O Millar,
in exhib cat Dutch pictures from the
Royal Collection, London 1971-72, p 17,
note 17

A 368 'Every one his fancy.' *'Elk zijn
meug'*

Pendant to A 369

Panel 42.5 × 31.5. Signed *G. Schalcken
pinxit*. Inscribed *Every one his fancy*
PROV Purchased with the Kabinet van
Heteren Gevers, The Hague-Rotterdam,
1809
LIT Hoet 1752, vol 2, p 459. G H Veth,
OH 10 (1892) p 8. Moes & van Biema
1909, pp 150, 164. Hofstede de Groot
1907-28, vol 5 (1912) nr 156

A 369 'Differing tastes.' *'Verschil van
smaak'*

Pendant to A 368

Panel 42.5 × 31. Signed *G. Schalck*
PROV Same as A 368
LIT Hoet 1752, vol 2, p 460. Moes & van
Biema 1909, pp 150, 164. Hofstede de
Groot 1907-28, vol 5 (1912) nr 242

A 2339 Young woman with lemon. *Jonge vrouw met citroen*

Panel 23 × 18. Signed *G.Schalcken*
PROV Purchased from the heirs of Jonkheer P H Six van Vromade, Amsterdam, 1908 * DRVK since 1959 (on loan to Stedelijk Museum Het Catharinagasthuis, Gouda)
LIT Hofstede de Groot 1907-28, vol 5 (1912) nr 120

A 2340 Woman selling herrings. *De haringverkoopster*

Panel 19 × 15.5. Signed *G.Schalcke*
PROV Purchased from the heirs of Jonkheer P H Six van Vromade, Amsterdam, 1908
LIT Hofstede de Groot 1907-28, vol 5 (1912) nr 116

attributed to **Godfried Schalcken**

A 371 A man with a pipe and a man filling his glass. *Een man met een pijp en een man, die zich een glas inschenkt*

Pendant to A 370

Canvas 45.5 × 38
PROV Purchased with the Kabinet van Heteren Gevers, The Hague-Rotterdam, 1809
LIT Hoet 1752, vol 2, p 459. Moes & van Biema 1909, pp 150, 164, 193. Hofstede de Groot 1907-28, vol 5 (1912) nr 243

A 370 A girl putting a candle in a lantern and a boy testing the fire in a footwarmer. *Een meisje plaatst een kaars in een lantaarn en een jongen verzorgt een vuurtest voor een stoof*

Pendant to A 371

Canvas 46 × 38
PROV Same as A 371
LIT Hoet 1752, vol 2, p 459. Moes & van Biema 1909, pp 150, 164. Hofstede de Groot 1907-28, vol 5 (1912) nr 237

Jean Frédéric Schall

Strassburg 1752 – 1825 Paris

A 3261 Evening toilet. *Avondtoilet*

Pendant to A 3260

Panel 23.5 × 17.5
PROV Presented by Sir Henry W A Deterding, London, 1936

A 3260 Morning toilet. *Morgentoilet*

Pendant to A 3261

Panel 23.5 × 17.5
PROV Same as A 3261

Johan Bernard Scheffer

Hamburg 1765 – 1809 Amsterdam

A 4151 Gerrit van der Pot (1732-1807), lord of Groeneveld. Rotterdam art collector. *Heer van Groeneveld. Kunstverzamelaar te Rotterdam*

Canvas 108 × 83.5. Signed *J.B.Scheffer*
PROV Purchased from the heirs of J E van der Pot, Rotterdam, 1968
LIT Moes & van Biema 1909, pp 179-87. E Wiersum, OH 48 (1931) pp 201-14, fig 1. E Wiersum, Rotterdamsch Jb, 1932, pp 4-17, ill. Bull RM 16 (1968) p 98, fig 1. F G L O van Kretschmar, Bull RM 16 (1968) p 186

A 1974 Joanna Cornelia Ziesenis-Wattier (1762-1827). Actress, as Elfride in the play of the same name, 1775, by Friedrich Justin Bertuch (1747-1822). *Toneelspeelster, in de rol van Elfride in het gelijknamige toneelstuk van Friedrich Justin Bertuch*

Canvas 102.5 × 84. Inscribed on the verso *Joanna Cornelia Ziesenis geboore Wattier in het karakter van Elfride, ons door deeze voortreffelijke kunstenaresse ten geschenke gegeeve in den jare 1822, F.Hart, A.Hart geb Diersen*
PROV Bequest of Miss G F A Martens, Renkum, 1902 * DRVK since 1953

Andreas Schelfhout

The Hague 1787 – 1870 The Hague

see also under Pastels

A 4197 Farmyard. *Boerenerf*

Paper on panel 29 × 28. Signed
A. Schelfhout f
PROV Sale The Hague, 20 April 1971,
lot 246A (not in the catalogue)
LIT C J de Bruyn Kops, Bull RM 22
(1974), pp 31, 38, fig 14

A 3887 The courtyard. *Binnenplaatsje*

Panel 44.8 × 40.3. Signed *A. Schelfhout f.*
PROV Purchased from H S F Baroness
Schimmelpenninck van der Oye, Doorn,
1955

A 1828 Wood gatherers on the ice. *IJs-
gezicht met houtsprokkelaars*

Panel 18.5 × 26.5. Signed and dated
A. Schelfhout 49
PROV Bequest of Reinhard Baron van
Lynden, The Hague, 1899

A 1127 Windmill beside a frozen river.
IJsgezicht met molen

Panel 47 × 72.5. Signed *A. Schelfhout*
PROV Purchased at exhib Rotterdam
1862, nr 367. RVMM, 1885

A 1128 A frozen waterway near the
Maas. *Een bevroren vaart bij de Maas*

Canvas 70 × 107. Signed *A. Schelfhout*
PROV Purchased at exhib Rotterdam
1867, nr 362? RVMM, 1885
LIT J de Vries, Eigen Haard, 1911, p 6

C 219 Landscape with the ruins of
Brederode Castle, Santpoort. *Landschap
met de ruïne van kasteel Brederode te
Santpoort*

Panel 32.5 × 41.5. Signed *A. Schelfhout f.*
Painted before March 1851, when it was
purchased by A van der Hoop
PROV On loan from the city of
Amsterdam (A van der Hoop bequest)
since 1885
LIT H C de Bruijn, Antiek 5 (1971) pp
632-33, fig 8

Willem Schellinks

Amsterdam 1627? – 1678 Amsterdam

A 2112 City wall in the winter. *Stadswal
in de winter*

Canvas 74 × 105. Signed *WS*
PROV Bequest of Mrs H A Insinger-van
Loon, dowager of M H Insinger,
Amsterdam, 1903
LIT Ledermann 1920, p 48ff. P T A
Swillens, Med RKD 4 (1949) p 19. Bernt
1960-62, vol 1, nr 21. A Ch Steland-
Stief, OH 79 (1964) p 100, fig 2. A C
Steland-Stief, Kunst in Hessen 10 (1970)
p 64, fig 8. Bernt 1969-70, vol 1, nr 27
(Jan Asselijn). Steland-Stief 1970, pp
102-03, cat nr 335, fig 72

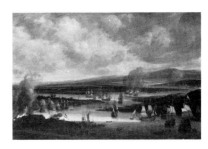

A 1393 The burning of the English fleet
near Chatham, June 1667, during the
second Anglo-Dutch war (1665-67). *Het
verbranden van de Engelse vloot bij Chatham,
juni 1667, tijdens de Tweede Engelse Zee-
oorlog (1665-67)*

Canvas 114 × 171
PROV Model room of the ministry of
marine, The Hague. NMGK, 1887
LIT C Hofstede de Groot, OH 22 (1904)
p 31. Preston 1937, p 62. Rogers 1970, fig
8. Bol 1973, p 297. E C Visser, Kunstrip 4
(1973-74) nr 36

Bernardus van Schendel

Weesp 1649–1709 Haarlem

C 173 Woman making pancakes. *De pannekoekenbakster*

Panel 48 ×39. Signed *BvS*
PROV On loan from the city of
Amsterdam (A van der Hoop bequest)
since 1885
LIT C Hofstede de Groot, OH 22 (1904)
p 29

C 174 The schoolmaster. *De schoolmeester*

Panel 50 ×41. Signed *BvS*
PROV On loan from the city of
Amsterdam (A van der Hoop bequest)
since 1885
LIT C Hofstede de Groot, OH 22 (1904) p
29

Petrus van Schendel

Terheyden 1806–1870 Brussels

A 1336 Adriana Johanna van Wijck
(1807-86). Wife of Johannes Ploos van
Amstel. *Echtgenote van Johannes Ploos van
Amstel*

Canvas 110 ×88. Signed and dated
P. van Schendel fec 1829
PROV Presented from the estate of Jonk-
heer J Ploos van Amstel, The Hague,
1886

C 297 Evening market in a Frisian town.
Avondmarkt in een Friese stad

Panel 46.5 ×39. Signed *P. van Schendel*
PROV On loan from the city of
Amsterdam (A van der Hoop bequest),
1885-1975

Cornelis Albertus Johannes Schermer

The Hague 1824–1915 The Hague

A 1829 Horse market on the Maliebaan,
The Hague. *Paardenmarkt op de Maliebaan
te Den Haag*

Canvas 65 ×96.5. Signed and dated
C. Schermer fec. 1858
PROV Bequest of Reinhard Baron van
Lynden, The Hague, 1899

Philip Schey

active 1st half 17th century in Flanders?

A 4279 Feast on a river bank. *Feestmaal
aan de oever van een rivier*

Panel 79.5 ×170. Painted on the lid of a
spinet. Signed and dated *Phil: Schei: In.
et Fe: Ao 1626*
PROV Purchased in 1877. NMGK

attributed to **Andrea Schiavone**

Zara? 1522–1563 Venice

A 3374 Nessus and Deianira. *Nessus en
Deianeira*

Panel 24 ×95
PROV Presented by the heirs of O Lanz,
Amsterdam, 1941
LIT G Swarzenski, Münchn Jb, 1914-15,
p 97, ill (not Schiavone). P Schubring,
Apollo 17 (1926) p 250, ill (Lorenzo
Lotto?). Banti & Boschetto 1953, p 105
(milieu of Schiavone). Bianconi 1953,
vol 2, p 102 (not Lotto). Berenson 1957,
vol 1, p 167 (Lambert Sustris)

A 4009 The rape of Europa. *De roof van
Europa*

Canvas 31 ×84

PROV O Lanz, Amsterdam. Lent by the
DRVK, 1952. Transferred in 1960
LIT Berenson 1957, vol I, p 167
(Lambert Sustris)

attributed to **Giorgio Schiavone**

Scadrin 1436/37 – 1504 Sebenico

A 3124 Madonna and child. *Maria met
kind*

Panel 103.5 × 102. Inscribed *Regina Celi*
PROV Presented from the estate of
M I V E Countess von Oberndorff-de
Stuers, Lausanne, 1931
LIT R van Marle, Boll Min Ed Naz,
1934. B Pzijatelj, Jugoslavya 18 (1959) p
102, ill

Natale Schiavone

see Miniatures: German school ca 1810,
A 4389 Francis I, after Schiavone

J G Schieblius

biographical data unknown

A 745 Italian landscape. *Italiaans
landschap*

Canvas 52 × 66.5. Signed *J. G. Schiebliu*[s]
PROV Sale H G van Otterbeek Bastiaans,
Amsterdam, 31 Jan 1882, lot 47

**George Friedrich Ferdinand (Frits)
Schiller**

Amsterdam 1886 – 1971 Amsterdam

A 3567 A building site. *Bouwput*

Canvas 40 × 59.5. Signed and dated
F. Schiller 1910
PROV Bequest of Mrs M C J Breitner-
Jordan, widow of G H Breitner, Zeist,
1948 * DRVK since 1961

George Adam Schmidt

Dordrecht 1791 – 1844 Dordrecht

A 1135 An old man and a girl reading,
called 'The Bible reading.' *Oude man en
lezend meisje, genaamd 'De bijbellezing'*

Panel 38 × 32. Signed *G. A. Schmidt*
PROV Purchased at exhib The Hague
1827, nr 256. RVMM, 1885 * DRVK since
1959 (on loan to the Dordrechts
Museum, Dordrecht)

Izaak Schmidt

see under Pastels

Willem Hendrik Schmidt

Rotterdam 1809 – 1849 Delft

A 3109 Self portrait. *Zelfportret*

Canvas 110 × 88. Signed *W. H. Schmidt*
PROV Bequest of Miss J J Schmidt, The
Hague, 1930
LIT Van Hall 1963, p 296, nr 1880:2

A 3110 The resurrection of the daughter
of Jairus. *De opwekking van het dochtertje van
Jaïrus*

Canvas 125 × 156. Signed *W. H. Schmidt*
PROV Bequest of Miss J J Schmidt, The
Hague, 1930 * DRVK since 1961

Johan Michaël Schmidt Crans

see under Miniatures

Johannes Schoeff

The Hague? 1608 – after 1666 Bergen op
Zoom

A 2230 River view. *Riviergezicht*

Panel 57 × 88.5. Signed and dated
J. Schoeff 1631
PROV Purchased from Fr Muller & Co,
art dealers, Amsterdam, 1906
LIT Bol 1969, p 182

Jacobus Schoemaker Doyer

Krefeld 1792 – 1867 Zutphen

A 1027 Payday. *Betaaldag*

Canvas 63 × 76
PROV Purchased at exhib Haarlem 1825.
RVMM, 1885 * DRVK since 1953

C 221 Jan van Speijk trying to decide
whether or not to put the spark to the
tinder, 5 February 1831. *Jan van Speijk
overlegt of hij de lont in het kruit zal steken,
5 februari 1831*

Canvas 89 × 75. Painted in 1834 for
A van der Hoop after eyewitness
accounts by survivors
PROV On loan from the city of
Amsterdam (A van der Hoop bequest)
since 1885

C 222 Jan van Speijk putting the spark
to the tinder, 5 February 1831. *Jan van
Speijk steekt de lont in het kruit, 5 februari
1831*

Canvas 26 × 21
PROV On loan from the city of
Amsterdam (A van der Hoop bequest)
since 1885

NO PHOTOGRAPH AVAILABLE

C 220 Kenau Simonsdr Hasselaer and
her women's brigade on the walls of
Haarlem in the thick of the Spanish
attack, 31 January 1573. *Kenau Simonsdr
Hasselaer op de wallen van Haarlem met haar
vrouwencorps bij de hevigste aanval der
Spanjaarden, 31 januari 1573*

Canvas 248 × 300. Painted in or before
1846 (exhib Amsterdam 1846, nr 87)
PROV Lent by the city of Amsterdam (A
van der Hoop bequest), 1885. Entered
the depot in damaged state. Probably
discarded

Johannes Schoenmakers Pzn

Dordrecht 1755 – 1842 Dordrecht

A 1434 View in a Dutch town. *Hollands
stadsgezicht*

Panel 38 × 54. Signed *J. Schoenmakers*
PROV Presented by J A Smits van
Nieuwerkerk, Dordrecht, 1888 * DRVK
since 1951

Johannes Schoenmakers Pzn

&

Johannes Christiaan Schotel

Dordrecht 1787 – 1838 Dordrecht

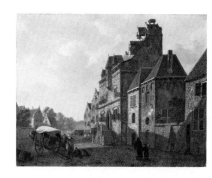

A 1129 View in Dordrecht. *Stadsgezicht
in Dordrecht*

The staffage is by Johannes Christiaan
Schotel

Panel 50 × 64. Signed *J. Schoenmakers*
and *J. C. Schotel*
PROV Purchased at exhib Haarlem 1825,
nr 373. RVMM, 1885

Hendrik Jacobus Scholten

Amsterdam 1824 – 1907 Heemstede

A 1830 Gerard van Honthorst showing
the drawings of his pupil Louisa of
Bohemia to Amalia van Solms. *Gerard van
Honthorst toont aan Amalia van Solms de
tekeningen van zijn leerlinge Louise van
Bohemen*

Panel 48 × 39.5. Signed and dated
H. J. Scholten ft 54
PROV Bequest of Reinhard Baron van
Lynden, The Hague, 1899 * DRVK since
1953

A 1130 Sunday morning. *Zondagmorgen*

Panel 55 ×66.5. Signed *H. J. Scholten F^t*
PROV Purchased at exhib Amsterdam
1868, nr 479. RVMM, 1885
LIT Scheen 1946, fig 82

Abraham van der Schoor

active 1643-50 in Amsterdam

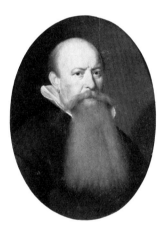

A 1424 Portrait of a man. *Portret van een man*

Panel 61 ×46. Oval. Signed and dated
AB v. Schoor 1647
PROV Presented by A Willet,
Amsterdam, 1887

A 1342 Vanitas still life. *Vanitas stilleven*

Canvas 63.5 × 73. Signed *AB van der Schoor*

PROV Sale J H Cremer, Amsterdam, 26
Oct 1886, lot 81
LIT Vorenkamp 1933, p 105. B Haak,
Antiek 2 (1968) p 402, fig 4. Bol 1969, p
94, fig 80. Exhib cat IJdelheid der
IJdelheden, Leiden 1970, nr 28, ill

Joris van Schooten

Leiden 1587–1651 Leiden

A 2374 Jacob Gerritsz van der Mij
(1560-1631). Trustee of the Leiden
orphanage. *Weesmeester te Leiden*

Panel 60.5 ×48.5. Signed and dated
JVS A° 1630. Inscribed *Ætat. 71*
PROV Purchased from Gaston von
Mallmann, Berlin, 1909

A 974 The adoration of the magi. *De
aanbidding der koningen*

Canvas 154 × 198. Signed and dated
J. v. Schooten fe. 1646
PROV Purchased from the van der Kolff
van Hoogeveen collection, Delft, 1882.
NMGK, 1885

Johannes Christiaan Schotel

Dordrecht 1787–1838 Dordrecht

see also Schoenmakers, Johannes &
Schotel, Johannes Christiaan, A 1129
View in Dordrecht

A 1131 Ships in a turbulent sea.
Schepen op een onstuimige zee

Canvas 163.5 ×218. Signed
J. C. Schotel F.
PROV RVMM, 1885
LIT Marius 1920, p 69, fig 34

A 1132 The beach of Rosenwerf on the
island of Marken. *Strandgezicht vanaf de
Rosenwerf op Marken*

Panel 36.5 × 50. Signed *J. C. Schotel*
PROV Sale Blokland, 1839. RVMM, 1885
* DRVK since 1956

Petrus Johannes Schotel

Dordrecht 1808–1865 Dresden

A 1133 The sea off Schouwen Island,
Zeeland. *De Zeeuwse wateren bij Schouwen*

Canvas 73 ×91.5. Signed *P. J. Schotel*
PROV Purchased at exhib The Hague
1827, nr 331. RVMM, 1885
LIT Scheen 1946, fig 383. Knoef 1948, fig
opp p 68

C 225 The Willemssluis, Amsterdam. *De Willemssluis bij Amsterdam*

Canvas 94.5 × 121. Signed *P. I. Schotel*. Painted in 1834 for A van der Hoop
PROV On loan from the city of Amsterdam (A van der Hoop bequest), 1885-1975
LIT Exhib cat 150 jaar Nederlandse kunst, Amsterdam 1963, nr 43, fig 31. CJ de Bruyn Kops, Bull RM 13 (1965) p 71, ill. HC de Bruijn Jr, Op den Uitkijk 39 (1966) p 97, ill on p 98

Aart Schouman

Dordrecht 1710–1792 The Hague

see also Panpoeticon Batavum: A 1968 Frans Greenwood

A 3458 Four regents and the housemaster of the Tuchthuis (house of correction), Middelburg, 1764. *Vier regenten en de binnenvader van het Tuchthuis te Middelburg, 1764*

The sitters are, according to the inscription on the letter, Samuel Radermacher (1693-1761), Johan Constant Mathias (d 1765), Anthony (?) de Schoesetter (b 1697/98), François de Kok (b 1696/97) and the housemaster Cornelis van Loysen (b 1686/87), standing

Canvas 132 × 192. Signed and dated *A. Schouman 1764 fec*.
PROV Huis van Bewaring (house of detention), Middelburg. For an indeterminate period property of the state; inscribed in the RMA inventory, 1943 * DRVK since 1961
LIT Voorl Lijst v Mon, vol 6 (1922) p 116

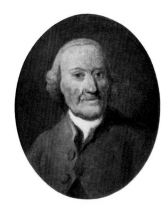

A 3897 Self portrait. *Zelfportret*

Panel 45 × 37. Oval. Signed and dated *A.S. 1787*
PROV Lent by Jonkheer BWF van Riemsdijk, Amsterdam, 1918-43. Sale Amsterdam, 8 Nov 1955, lot 1306
LIT Buckley 1931, p 25, fig 7. Van Hall 1963, p 297, nr 1894:4

A 2730 Fowl beside a tomb. *Gevogelte bij een tombe*

Canvas 95 × 158. Signed *A. Schouman*
PROV From the Huygenshuis (house of Constantijn Huygens), Plein, The Hague, 1879. NMGK * DRVK since 1958

A 4280 Pheasants. *Fazanten*

Canvas 99 × 151. Signed *A. Schouman*
PROV From the Huygenshuis (house of Constantijn Huygens), Plein, The Hague, 1879. NMGK

attributed to **Aart Schouman**

A 4157 Portrait of a painter, perhaps the artist himself. *Portret van een schilder, misschien de schilder zelf*

Panel 35.5 × 27. Dated on the verso $17\frac{7}{16}30$
PROV Purchased from PMJ Koning, Gorssel, 1969
LIT Van Hall 1963, p 297, nr 1894:1. CJ de Bruyn Kops, Bull RM 22 (1974) pp 21, 37, fig 5

Martinus Schouman

Dordrecht 1770–1848 Breda

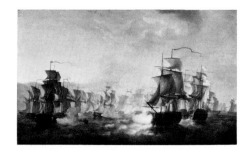

A 1394 The clash of the Dutch and English fleets during the Dutch raid on Boulogne, 1805. *Het treffen tussen de Hollandse en de Engelse vloot tijdens de tocht van de Hollandse flottille naar Boulogne, 1805*

Canvas 95 × 159. Signed and dated *M. Schouman 1806*
PROV Model room of the ministry of marine, The Hague. NMGK, 1887

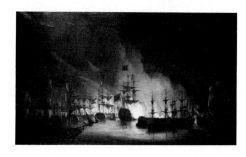

A 1395 The bombardment of Algiers

backing up the ultimatum to release the white slaves, 26-27 August 1816. *Het bombardement van Algiers, ter ondersteuning van het ultimatum tot vrijlating van blanke slaven, 26-27 augustus 1816*

Canvas 95 × 159.5. Signed and dated *M.Schouman f. 1823*
PROV Model room of the ministry of marine, The Hague. NMGK, 1887

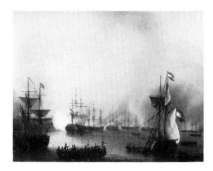

A 1134 The shelling of Palembang, Sumatra, 24 June 1821. *De beschieting van Palembang, Sumatra, 24 juni 1821*

Canvas 70.5 × 93. Signed *M.Schouman*
PROV RVMM, 1885
LIT Jvsl Scheepvaartmus 4 (1920) p 72

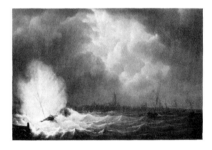

C 226 The explosion of cannonboat nr 2, under command of Jan van Speijk, off Antwerp, 5 February 1831. *De ontploffing voor Antwerpen van kanonneerboot nr 2 onder commando van Jan van Speijk, 5 februari 1831*

Canvas 53 × 75. Signed and dated *M.Schouman 1832*
PROV On loan from the city of Amsterdam (A van der Hoop bequest) since 1885

Schrieck

see Marseus van Schrieck

Theodoor Cornelisz van der Schuer

The Hague 1628–1707 The Hague

NM 4485 Ceiling with representations of morning and evening. *Plafond met voorstellingen van de Ochtend en de Avond*

Panel 305 × 506; the representations are 170 × 499 each. Vaulted
PROV From the bedroom of Mary Stuart (1662-95) in the stadholder's quarters, Binnenhof, The Hague

Jacob van Schuppen

Paris 1670–1751 Vienna

A 373 Eugene (1663-1736), prince of Savoy. *Eugenius, prins van Savoye*

Canvas 146 × 119. Formerly inscribed on the verso *Ad vivum Pinxit Jacobus van Schuppen Christianissimi Regis nec non Excelissimi ac Regii Ducis Lotharingiae Pictor Viennae 1718*
PROV Purchased in 1806. NM, 1808
LIT Moes & van Biema 1909, pp 84, 198, 204. ML Bataille, in Dimier, 1928, vol 1, p 291, nr 14

Hendrik van Schuylenburgh

Middelburg? ca 1620–1689 Middelburg?

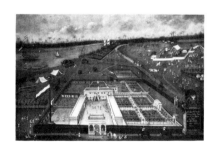

A 4282 The factory of the Dutch East India Company in Houghly, Bengal. *De factorij van de Verenigde Oostindische Compagnie te Hoegly in Bengalen*

Pendant to A 4283

Canvas 203 × 316. Signed *Schuijlenburgh deiln.* Inscribed *Afsbeeldinge vande Vereenighde Nederlantze Oostindische Comp-ᵃᵍ Logie, ofte Hooft Comptoir in Bengale, ter Stede Oügelij, Anno 1665*
PROV Acquired by the NMGK before or in 1881. NMGK

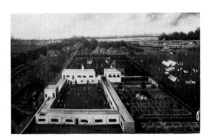

A 4283 Dutch plantation in Bengal. *Hollandse plantage in Bengalen*

Pendant to A 4282

Canvas 133 × 205
PROV Same as A 4282

M M van Schuylenburgh

see Sypesteyn

Johann Georg Schwartze

Amsterdam 1814 – 1874 Amsterdam

NO PHOTOGRAPH AVAILABLE

A 2820 Georgine Elisabeth Schwartze (1854-1935). The artist's daughter at the age of six. *Dochter van de schilder op zesjarige leeftijd*

Head and shoulders portrait in full face

Paper 42 × 34. Painted in 1860
PROV Presented by the sitter on behalf of her deceased sister Thérèse, Amsterdam, 1919 * Lent to the Stedelijk Museum, Zutphen, 1924. Destroyed in the war, 1945
LIT Martin 1920-21, p 173. Van Hall 1963, p 302, nr 1909:4

A 2819 Thérèse Schwartze (1851-1918). Daughter of the artist at the age of 16. *Dochter van de schilder op 16-jarige leeftijd*

Canvas 66 × 52. Signed *Schwartze*. Painted in 1868
PROV Presented by Miss G E Schwartze on behalf of her deceased sister Thérèse, Amsterdam, 1919
LIT Martin 1920-21, pp 18, 173, ill on p 7. Van Hall 1963, p 303, nr 1911:10

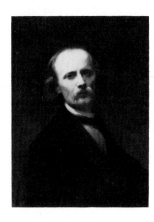

A 2818 Self portrait. *Zelfportret*

Canvas 78 × 58. Signed and dated *G.S. 1869*
PROV Same as A 2819
LIT Bénédite 1910, fig 223. Marius 1920, fig 24. Martin 1920-21, p 173. Knoef 1948, ill after p 84. Van Hall 1963, p 302, nr 1910:1

A 2821 Johann Joseph Hermann (1782-1857), the artist's father-in-law, and Ida,

his oldest daughter. *Schoonvader van de schilder, met zijn kleinkind Ida Schwartze, oudste dochter van de schilder*

Canvas 62.5 × 77.5
PROV Same as A 2819
LIT Martin 1920-21, p 173

attributed to **Johann Georg Schwartze**

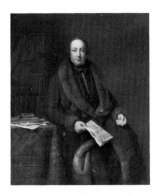

A 2170 Pieter Arnold Diederichs (1804-74). Amsterdam bookseller and founder, in 1828, of the Algemeen Handelsblad. *Boekhandelaar te Amsterdam en oprichter van het Algemeen Handelsblad in 1828*

For other family portraits, *see* Miniatures: Grebner, W, A 2173; Northern Netherlands school ca 1810, A 2175 & A 2176

Canvas 72 × 67.5
PROV Bequest of Mrs V E L Diederichs-Portman, widow of W G A Diederichs, Amsterdam, 1905

Thérèse Schwartze

Amsterdam 1851 – 1918 Amsterdam

see also under Pastels

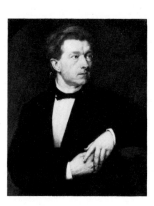

A 2788 Dr J L Dusseau

Canvas 81 ×65.5. Originally oval.
Signed *Thérèse Schwartze*. Painted in 1870
PROV Presented from the estate of Miss
H L van Pellecorn, Wageningen, 1916
LIT Martin 1920-21, pp 45, 162, 201, ill
on p 14

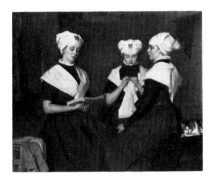

A 1190 Three girls from the Amsterdam
orphanage. *Drie meisjes uit het Amsterdamse
Burgerweeshuis*

Canvas 81.5 ×96. Signed and dated
Th.Schwartze 1885
PROV Purchased at exhib Rotterdam
1885, nr 391 * Lent to the AHM, 1975

C 745 Piet J Joubert (1831-1900).
Commander-in-chief of the Republic of
South Africa. *Commandant-generaal van de
Zuidafrikaanse Republiek*

Canvas 125 ×89. Signed *Thérèse
Schwartze, Amsterdam*. Inscribed *15 en 16
December 1890 Dingaansdag*
PROV On loan from the city of
Amsterdam since 1904
LIT Martin 1920-21, pp 101, 142, ill on p
62

A 1703 Young Italian woman with the
dog Puck. *Jonge Italiaanse vrouw met de
hond Puck*

Canvas 144 ×103. Signed *Th.Schwartze,
Paris, Amsterdam*. Inscribed *Puck*
PROV Bequest of A G van Anrooy,
Kampen, 1897 * DRVK since 1953
LIT Martin 1920-21, p 85

A 2724 Frederik Daniël Otto Obreen
(1840-96). Director-general of the Rijks-
museum, Amsterdam (1883-96). *Hoofd-
directeur van het Rijksmuseum, Amsterdam*

Canvas 87 ×80. Signed *Th. v. D.S.*
PROV Presented by Mrs A L H Obreen-
Pabst, Velp, 1915

Jacob Schwartzenbach

see Hoogerheyden, Engel, A 2405
Mustering the fleet in the harbor of
Vlissingen; A 2406 The fleet leaving the
harbor of Vlissingen

Johann Christian August Schwarz

see Monogrammist J J

Jan van Scorel

Schoorl 1495 – 1562 Utrecht

A 2843 The dying Cleopatra. *De stervende
Cleopatra*

Panel 36 ×61
PROV Bequest of A L E Ridder de Stuers,
Paris, 1920
LIT Hoogewerff 1923, p 135, nr 29. G J
Hoogewerff, Elsevier's GM 67 (1924) p
174, fig 23. Winkler 1924, p 277, fig 164.
L Baldass, Zeitschr BK 63 (1929-30) p
218, ill on p 217. Friedländer 1924-37,
vol 12 (1935) p 203, nr 342. De Jonge
1940, p 10, ill. Hoogewerff 1936-47, vol 4
(1941-42) p 56, fig 24. Exhib cat Jan van
Scorel, Utrecht 1955, nr 6 (ca 1523-24)

A 670 Bathsheba in the bath. *Het toilet
van Bathseba*

Panel 103 ×203
PROV Gouvernementsgebouw
(provincial capitol), Groningen, 1879
LIT C Hofstede de Groot, Gron
Volksalm, 1893, pp 24-25. Hoogewerff
1912, p 190, fig 44. Hoogewerff 1923, p
135, nr 33, fig 37. Winkler 1924, p 278.
G J Hoogewerff, Elsevier's GM 67 (1924)
p 89. Friedländer 1924-37, vol 12 (1935)
pp 139, 200, nr 310. P Wescher, Jb
Preusz Kunstsamml 59 (1938) p 223. De
Jonge 1940, p 22, ill (ca 1530).
Hoogewerff 1936-47, vol 4 (1941-42) p
120ff; vol 5, p 101 (ca 1530-38). Gerson
1950, p 32, nr 83. Exhib cat Jan van
Scorel, Utrecht 1955, nr 18 (ca 1527).
Franz 1969, vol 1, p 62; vol 2, fig 35
(ca 1527). Von der Osten & Vey 1969,
pp 182-83

A 372 Mary Magdalene. *Maria Magdalena*

Panel 67 × 76.5, including the strip of about 12 cm added later along the upper edge
PROV NM, 1808
LIT J van Vloten, Ned Kunstbode 1 (1874) p 12. Moes & van Biema 1909, pp 77-78, 83, 108, 115, 164, 213. Hoogewerff 1912, p 188, fig 43. Ring 1913, pp 32, 99. C J Gonnet, OH 33 (1915) p 188. L Baldass, in Meisterwerke, 1920. Friedländer 1921, p 165. Hoogewerff 1923, p 134, nr 24, fig 25. Winkler 1924, p 278. G J Hoogewerff, Med Ned Hist Inst Rome 4 (1924) p 199, fig 21, nr 43. Chr Huelsen, Med Ned Hist Inst Rome 7 (1927) pp 95-96. C H de Jonge, OH 46 (1929) p 270. Friedländer 1924-37, vol 12 (1935) p 203, nr 338. De Jonge 1940, p 39, ill. Hoogewerff 1936-47, vol 4 (1941-42) p 100, fig 43. J Bruyn, Bull RM 2 (1954) p 51, fig 1. Exhib cat Jan van Scorel, Utrecht 1955, nr 23 (ca 1527-29). VTTT, 1964-65, nr 69. J G van Gelder, OK 8 (1965) nr 8, ill. H F M Peeters, Spiegel Hist 1 (1967) p 658, fig 1. Von der Osten & Vey 1969, p 183. J M van Winter, Spiegel Hist 5 (1970) p 375, fig 3. A Crosthwait, Country Life 147 (1970) p 945, fig 5. I Q van Regteren Altena, Alb Amic J G van Gelder, 1973, p 253, note 2. J R J van Asperen de Boer, Delta, Spring 1973, pp 66-67, ill

A 3853 Portrait of a man. *Portret van een man*

Panel 47 × 34. Ends in a round arch.

Inscribed on the original frame *A° m v xxix Ætate vero XLVI*
PROV Purchased from the Nijenburgh Co., Inc., Heiloo, 1953
LIT Hoogewerff 1923, p 140, nr 2. L Baldass, Städ Jb 6 (1930) pp 83-84, pl XIX b. Friedländer 1924-37, vol 14 (1937) p 129. P Wescher, Jb Preusz Kunstsamml 59 (1938) p 225. Hoogewerff 1936-47, vol 4 (1941-42) p 104, fig 45. Gerson 1950, p 33, fig 87. J Bruyn, Bull RM 2 (1954) p 58, fig 4. S H Levie, OH 70 (1955) p 248. Exhib cat Jan van Scorel, Utrecht 1955, nr 33. I Geismeier, Mitt und Ber DDR 3 (1961) p 64. Von der Osten & Vey 1969, p 183. J G van Gelder, OH 87 (1973) p 170

studio of **Jan van Scorel**

A 1636 The baptism of Christ. *De doop van Christus*

Panel 130 × 100
PROV Presented by Jonkheer Victor de Stuers, The Hague, 1895 * DRVK since 1959 (on loan to the Westlands Streekmuseum, Naaldwijk)
LIT Hoogewerff 1923, p 140, nr 6. Hoogewerff 1936-47, vol 4 (1941-42) p 124, note 1 (milieu of van Scorel). Exhib cat Jan van Scorel, Utrecht 1955, nr 22 (studio of van Scorel, ca 1527-29)

school of **Jan van Scorel**

A 3468 The good Samaritan. *De barmhartige Samaritaan*

Panel 73 × 85. Dated *1537*. Inscribed *LVC. X.*
PROV Bequest of Mrs J H Derkinderen-Besier, widow of A Derkinderen, Amsterdam, 1944
LIT Beeldende Kunst 1 (1914) p 111, fig 74. W Cohen, Zeitschr BK ns 25 (1914) p 32 (Cornelis Buys). N Beets, Onze Kunst, 1914, p 89, note 2. Hoogewerff 1923, p 135, nr 26, fig 26. G J Hoogewerff, Elsevier's GM 67 (1924) p 86, figs 5-6. Winkler 1924, p 278, fig 166. C H de Jonge, OH 46 (1929) pp 92, 95, fig 9. G J Hoogewerff, OH 46 (1929) p 200. Friedländer 1924-37, vol 12 (1935) p 201, nr 320. J G van Gelder, in Kunsth Congres Londen, 1939, p 17 (Cornelis Buys II). De Jonge 1940, p 44, note 1. Hoogewerff 1936-47, vol 4 (1941-42) p 222, figs 99, 99 bis; vol 5, p 102 (Master of Valenciennes). P Wescher, OH 61 (1946) p 94 (Buys). R van Luttervelt, NKJ 1 (1947) p 121, fig 12. F J Dubiez, OH 65 (1950) p 72, fig 3. Exhib cat Jan van Scorel, Utrecht 1955, nr 55 (Buys?). VTTT, 1959, nr 21. J R J van Asperen de Boer, Spiegel Hist 7 (1972) pp 418-19, figs 2a, 2b

A 4284 The baptism of Christ. *De doop van Christus*

Panel 64 × 91
PROV Purchased from Jonkheer J P Six van Hillegom, Amsterdam, 1892
LIT Hoogewerff 1936-47, vol 4 (1941-42) p 124, note 1 (milieu of Scorel)

A 1855 Willem van Lokhorst (1514-64)

Panel 64 × 49. Inscribed *An° 1554 Etatis 40*
PROV Sale Amsterdam (Fr Muller & Co), 24 April 1900 (not in the catalogue)
LIT Hoogewerff 1936-47, vol 3 (1939) p 503, fig 270 (Cornelis Theunisz)

copy after **Jan van Scorel**

A 1532 Cornelis Aerentsz van der Dussen (1481-1556). Secretary of Delft from 1536 on. *Secretaris van Delft sedert 1536*

Copy after a lost original; *cf* version in Berlin, former Kaiser-Friedrich Museum (cat 1931, nr 644)

Panel 100 × 76. Inscribed *Sij gegeven aenden Eersame discreten ...elis aerentsz. secretarius tot delft*
PROV Purchased from G Bérardi, Brussels, 1890
LIT Moes 1897-1905, vol 1, nr 2190:2. Hoogewerff 1923, p 136, nr 43, fig 35. Friedländer 1924-37, vol 12 (1935) p 204, nr 351a (copy). De Jonge 1940, p 54. Hoogewerff 1936-47, vol 4 (1941-42) pp 180-82. Exhib cat Jan van Scorel, Utrecht 1955, nr 66 (copy; original ca 1540-45)

Pieter Willem Sebes

see Master of the Joseph Sequence, A 960 & A 961 Philip the Handsome and Joanna the Mad of Castile, copy by Sebes; Northern Netherlands school ca 1435, A 954 Jacoba of Bavaria, copy by Sebes

Giovanni Segantini

Arco 1858-1899 Pontresina

A 3346 A goat with her kid. *Een geit met haar jong*

Canvas 42 × 71.5. Formerly inscribed on the verso *G. Segantini, Savognino, 1890, 'Pasqua' Op. LXXXVII*
PROV Presented by Mr & Mrs D A J Kessler-Hülsmann, Kapelle op den Bosch near Mechelen, 1940

Gerard Seghers

Antwerp 1591 – 1651 Antwerp

A 374 Christ and the repentant sinners. *Christus en de boetvaardige zondaars*

Canvas 207 × 253
PROV Presented by J P G Baron Spaen van Biljoen, 1809
LIT Moes & van Biema 1909, p 129. Knipping 1939-40, vol 2, p 99

Hercules Pietersz Seghers

Haarlem? 1589/90 – in or before 1638 The Hague or Amsterdam

A 3120 River valley. *Rivierdal*

Panel 30 × 53.5. Signed *Hercules Seghers*
PROV Bequeathed by C Hofstede de Groot, 1931, on condition that a painting of commensurate value be donated to the municipality of Groningen. The work that was donated was Willem van de Velde II, A 441 Ships in a stormy sea
LIT W Bode, Jb Preusz Kunstsamml 24 (1903) p 192, fig 5. Bode 1906, p 110. K Freise, Mon f Kunstw 2 (1909) p 25, ill. A Bredius, Kunstchronik ns 17 (1916) p 83. Bode 1917, p 150, ill. W Bode, Rep f Kunstw 46 (1926) p 256. C Hofstede de Groot, OH 44 (1927) p 49ff. Ch Holmes, Burl Mag 52 (1928) p 215. Martin 1935-36, vol 1, p 239. E Trautscholdt, Pantheon 25 (1940) p 84, ill. Knuttel 1941, p 50, ill. Bode 1951, p 204, ill. Gerson 1952, p 46, fig 124. Collins 1953, pp 28, 117, 131, fig 25 (1607-11). J C Ebbinge Wubben, Bull Boymans 4 (1953) p 43, fig 11. J G van Gelder, OH 68 (1953) p 150 (before 1620). E Trautscholdt, Kunstchronik 7 (1954) p 3. Exhib cat Hercules Seghers, Rotterdam 1954, nr 1. Fr W S van Thienen, OKTV 1 (1963) nr 1. Stechow 1966, pp 38, 132, 135, fig 265. VTTT, 1966-67, nr 92. Haverkamp Begemann 1973, p 31

attributed to **Jacopo del Sellaio**

Florence 1441/42 – 1493 Florence

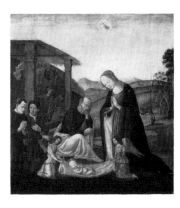

A 3428 The adoration of the child. *De aanbidding van het kind*

Panel 52.5 × 50.5
PROV Bequest of J W Edwin vom Rath, Amsterdam, 1941
LIT I Peelen, Elsevier's GM 22 (1912) p 2, fig 1

Harmanus Serin

active ca 1720-38 The Hague

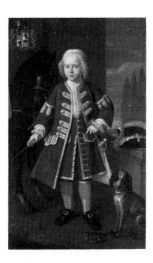

A 3868 Diederik van Hemert (1729-53), lord of Babiloniënbroek, at the age of six. *Heer van Babiloniënbroek op zesjarige leeftijd*

Canvas 137.5 ×83.5. Signed and dated *H. Serin F. 1735*. Inscribed on the verso *Diederik van Heemert, Heer van Babilonien-broek, overl. den 23 April 1753. Wiens wapen hangt te Meeuwen in de kerk*
PROV Presented by M C van Houten, Doorn, 1933. Received in 1953

attributed to **Giovanni Serodine**

Ascona ca 1594– 1631 Rome

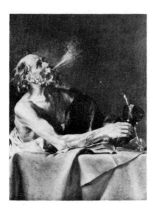

A 332 The smoker: allegory of transitoriness. *De roker; allegorie op de vergankelijkheid*

Canvas 128.5 × 101
PROV Het Loo Palace, Apeldoorn, 1798. NM, 1808 (as José Ribera)
LIT Mayer 1908, pp 99, 195. Moes & van Biema 1909, pp 17, 37, 170, 219

Ferdinand Carl Sierich

The Hague 1839– 1905 The Hague

A 2969 City view. *Stadsgezicht*

Canvas 51 ×42. Signed *Fr.Carl Sierig*
PROV Presented by Mrs CHM Korthals Altes-van Hengel, widow of W Korthals Altes, Amsterdam, 1923

attributed to **Luca Signorelli**

Cortona ca 1441– 1523 Cortona

A 3430 St George and the dragon. *Sint Joris en de draak*

Panel 55 × 77
PROV Bequest of J W Edwin vom Rath, Amsterdam, 1941
LIT Muther 1912, vol 1, p 182. Crowe & Cavalcaselle 1903-14, vol 5 (1914) p 115. Dussler 1926, p 213. Van Marle 1923-38, vol 16 (1937) pp 77-78, fig 49. Berenson 1932, p 529. B Berenson, GdB-A 75 (1933) p 279. A van Schendel, Mndbl BK 11 (1934) p 236. R van Marle, Boll Min Ed Naz, 1935, p 309. K E Schuurman, Mndbl BK 19 (1942) p 102, fig 4

Experiens Sillemans

Amsterdam ca 1611– 1653 Amsterdam

A 1366 Ships near a harbor. *Schepen bij een haven*

Panel 77 × 106. Pen painting. Signed and dated *Exs Silleman Fecit 1649*
PROV NMGK, 1887
LIT Willis 1911, p 33

attributed to **Michiel Simons**

Utrecht ca 1620– 1673 Utrecht

A 2083 Still life with fruit. *Stilleven met vruchten*

Canvas 89 × 113.5. Signed falsely *Corn. de Heem*
PROV Bequest of A A des Tombe, The Hague, 1903
LIT W Steenhoff, Bull NOB 4 (1902-03) pp 122-23. C Hofstede de Groot, OH 22 (1904) p 33

Karel Slabbaert

Zierikzee ca 1619– 1654 Middelburg

A 375 The breakfast. *Het ontbijt*

Panel 70 × 55. Signed *K. Slabba...*
PROV Sale Baroness van Leyden van
Warmond, Leiden, 31 July 1816, nr 33

Petrus Marinus Slager

's-Hertogenbosch 1841 – 1912
's-Hertogenbosch

A 3856 A veteran of the Battle of
Waterloo portrayed on the 60th
anniversary of the battle. *Een oud-strijder
van de Slag bij Waterloo, geportretteerd ter
gelegenheid van de 60-jarige herdenking van de
slag*

Canvas 83 × 71. Signed *PM Slager ft.*
PROV Unknown * DRVK since 1953

Pieter Cornelisz van Slingeland

Leiden 1640 – 1691 Leiden

A 377 Portrait of a man with watch.
Portret van een man met horloge

Panel 25.5 × 20. Signed and dated
P. v. Slingeland Fecit 1688
PROV Purchased with the Kabinet van
Heteren Gevers, The Hague-Rotterdam,
1809
LIT Moes & van Biema 1909, pp 150,
194. Hofstede de Groot 1907-28, vol 5
(1912) nr 139. Bille 1961, vol 1, p 109

A 376 Peasant family singing. *Zingende
boerenfamilie*

Panel 46.5 × 61.5. Signed *P. v. Slingerland
Fecit*
PROV Purchased with the Kabinet van
Heteren Gevers, The Hague-Rotterdam,
1809 * DRVK since 1959 (on loan to
Stedelijk Museum Het Catharina-
gasthuis, Gouda)
LIT Hoet 1752, vol 2, p 460. Moes & van
Biema 1909, pp 150, 164. Hofstede de
Groot 1907-28, vol 5 (1912) nr 92. Bernt
1960-62, vol 3, nr 762. Bernt 1969-70, vol
3, nr 1076

Pieter Cornelisz van Slingeland

&

Willem van Mieris

Leiden 1662 – 1747 Leiden

A 1983 Portrait tablet, with the portraits
of a man and a woman, two ornamental
friezes with shell motifs and a frieze with
the triumph of Amphitrite. *Portretstuk
samengesteld uit het portret van een man, het
portret van een vrouw, twee ornamentfriezen
met schelpmotief en een triomftocht van
Amphitrite*

The portraits are by van Slingeland, the
rest by Willem van Mieris

Copper 10.3 × 8.5 (portraits); 2 × 8.5
(friezes, in grisaille); 7 × 16 (frieze with
Amphitrite, in grisaille). Signed and
dated *P. v. Slingelant 1678* (on the man's

portrait) and *W. van Mieris Fe 1705* (on
the triumph of Amphitrite)
PROV Purchased from the G de Clercq
collection, Amsterdam, 1902, through
the intermediacy of the Rembrandt
Society
LIT Hofstede de Groot 1907-28, vol 5
(1912) pp 140, 159

Jan Willem Sluiter

see Governors-general series: A 3823
J C Koningsberger; A 3824 W M G
Schumann

Jacob Smies

Amsterdam 1764 – 1833 Amsterdam

see also Hansen, Carel Lodewijk, A 3925
The Rapenburg, Leiden, after the
explosion

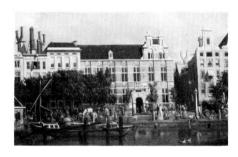

C 1536 The Latin school on the Singel,
Amsterdam. *De Latijnse school op het Singel
te Amsterdam*

Canvas 45 × 75. Signed and dated
I. Smies 1802
PROV On loan from the KOG (lent by
P C Librecht Lezwijn, 1879) since 1973
LIT J Knoef, Jaarversl KOG, 1931, pp
35-38, ill

Antonie Sminck Pitloo

Arnhem 1790 – 1837 Naples

A 1117 The church of San Giorgio in Velabro, Rome. *De kerk van San Giorgio in Velabro te Rome*

Canvas 100 × 75. Signed and dated *A.S. Pitloo 1820*
PROV Purchased by King Willem I. RVMM, 1885 * DRVK since 1952
LIT C Lorenzetti, Med Ned Hist Inst Rome 1st ser 9 (1929) p 223, fig 3. GJ Hoogewerff, Med Ned Hist Inst Rome 2d ser 3 (1933) p 156, ill. R van Luttervelt, Nap Stud 13 (1961) p 567, fig 27

Peter Snayers

Antwerp 1592 – after 1666 Brussels

A 1555 A battle. *Een veldslag*

Canvas 146 × 202
PROV Purchased from F Graf, Frankfurt am Main, 1891

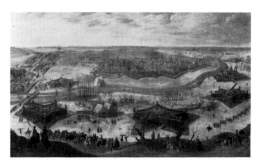

A 857 A siege of a city, thought to be the siege of Gulik by the Spanish under the command of Hendrik van den Bergh, 5 September 1621-3 February 1622. *Een belegering van een stad, vermoedelijk het beleg van Gulik door de Spanjaarden onder Hendrik van den Bergh, 5 september 1621-3 februari 1622*

Canvas 144 × 236
PROV Purchased from Rotteveel gallery, The Hague, 1874. NMGK, 1886
LIT H Neumann, Beitr Jül Gesch 39 (1972) pp 7-9

Frans Snijders

Antwerp 1579 – 1657 Antwerp

A 378 Still life with small game and fruits. *Stilleven met klein dood wild en vruchten*

Panel 57 × 88. Signed *F. Snijders fecit*
PROV Purchased with the Kabinet van Heteren Gevers, The Hague-Rotterdam, 1809
LIT Moes & van Biema 1909, pp 150, 194. Greindl 1956, pp 54, 179. H Robels, Wallraf-R Jb 31 (1969) p 52, fig 35. Bille 1961, vol 1, p 109

A 379 Still life with a deer, a boar's head, fruits and flowers. *Stilleven met groot dood wild, vruchten en bloemen*

Canvas 120.5 × 176.5
PROV Sale G van der Pot van Groeneveld, Rotterdam, 6 June 1808, lot 116
LIT Moes & van Biema 1909, pp 113, 181. E Wiersum, OH 48 (1931) p 209. Hairs 1955, pp 133, 241. Greindl 1956, pp 53, 182

Peter Snyers

Antwerp 1681 – 1752 Antwerp

A 726 The woman peddler. *De koopvrouw*

Canvas 59 × 44. Signed *P. Snijers*
PROV Bequest of Jonkheer J S H van de Poll, Amsterdam, 1880
LIT V de Stuers, Ned Kunstbode 2 (1880) p 245

Gerrit Jacobus van Soeren

Amsterdam 1859 – 1888 Amsterdam

A 1490 Apes in a cage, called 'Homesick.' *Apen in een kooi, genaamd 'Heimwee'*

Canvas 111.5 × 83. Signed and dated *G.J. van Soeren 1884*

PROV Presented by the artist's widow,
Mrs G J van Soeren-Huetink,
Amsterdam, 1889 * DRVK since 1953

Jacobus Loerenz Sörensen

Amsterdam 1812–1857 Amsterdam

A 3025 Ice scene with Mr and Mrs
Thijssen. *Portret van de heer en mevrouw
Thijssen op het ijs*

Canvas 44 × 51.5. Signed and dated
J. Sorensen 1845
PROV Bequest of K H Thijssen,
Amsterdam, 1925

copy after **Francesco Solimena**

Canale di Serino 1657–1747 Barra

A 996 The apotheosis of St Dominic. *De
verheerlijking van de heilige Dominicus*

Copy after the ceiling in the sacristy of
San Domenico Maggiore, Naples

Canvas 147 × 73
PROV Sale Dowager Quarles van Ufford,
Amsterdam, 24 March 1885, lot 90 (as in
the manner of Rubens)
LIT Nieuwbarn 1904, p 49. J Offerhaus,
Med Ned Hist Inst Rome 32 (1964) p 23,
fig 8

attributed to **Jan Frans van Son**

Antwerp 1658–in or before 1718 London

A 763-A 766 Marble portrait bust
encircled by a festoon of fruits. *Marmeren
borstbeeld omgeven door een festoen van
vruchten*

Canvas 139 × 120
PROV Sale Amsterdam, 13 Nov 1882, lot
21 (cut in four pieces)
LIT Greindl 1956, p 189

Hendrick Martensz Sorgh

Rotterdam ca 1611–1670 Rotterdam

A 495 The lute player. *De luitspeler*

Panel 51.5 × 38.5. Signed and dated
M. Sorgh 1661
PROV Bequest of L Dupper Wzn,
Dordrecht, 1870
LIT C von Lützow, Zeitschr BK 5 (1870)
p 229. Bernt 1960-62, vol 3, nr 779. E
Fromm, Int J of Hypnosis 13 (1965) pp
119-31, fig 1. Bernt 1969-70, vol 3, nr
1097

A 717 The vegetable market. *De groente-
markt*

Panel 51 × 71. Signed and dated
M. Sorgh 1662?
PROV Bequest of Jonkheer J S H van de
Poll, Amsterdam, 1880
LIT V de Stuers, Ned Kunstbode 2
(1880) p 245. P W Klein, Spiegel Hist 1
(1967) p 549, ill

A 494 Storm on the Maas. *Storm op de
Maas*

Panel 47.5 × 64.5. Signed and dated
M. Sorgh 1668
PROV Bequest of L Dupper Wzn,
Dordrecht, 1870
LIT Willis 1911, p 58, pl XIV. Bernt
1960-62, vol 3, nr 783. Bernt 1969-70, vol
3, nr 1101. Bol 1973, pp 191-92, fig 195

C 227 The fish market. *De vismarkt*

Panel 47.5 × 65. Signed *M. Sorgh*
PROV On loan from the city of
Amsterdam (A van der Hoop bequest)
since 1885
LIT D van der Kellen, Eigen Haard,
1876, p 326. Bernt 1969-70, vol 3, nr
1099

C 178 The fishwife. *De visvrouw*

Panel 30 × 26. Signed *...org*
PROV On loan from the city of
Amsterdam (A van der Hoop bequest)
since 1885
LIT CHofstede de Groot, OH 17 (1899) p
169 (Quiringh Gerritsz van
Brekelenkam)

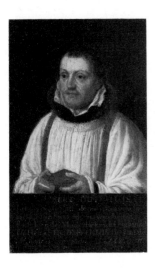

A 1682 Huybert Duyfhuys (1531-81).
Pastor of the church of St James, Utrecht.
Pastoor van de St Jacobskerk te Utrecht

Panel 19 × 12. Signed *M. Sorg ad Prototijp.*
Inscribed *M. Hubert Duifhuis | In 't wezen
straalt de minzaamheid | Gekant in 't woord en
't wijs beleid | En 't doen des Mans die kracht
betoonde | De Hemel-DUIF die 't HUIS
bewoonde | J. Oudaen*
PROV Sale Amsterdam, 10 Nov 1896, lot
40
LIT Moes 1897-1905, vol 1, nr 2209? A J
Teychiné Stakenburg, Rotterdamsch Jb,
1963, p 215, fig 41. N van der Blom, Bull
Boymans 15 (1964) p 43, fig 16

Johann Spilberg II

Düsseldorf 1619– 1690 Düsseldorf

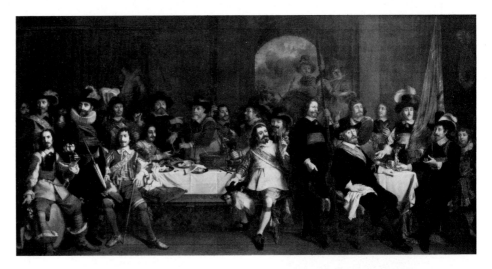

C 395 Feast of the civic guard in honor
of the appointment of Burgomaster Jan
van de Poll as colonel, 1650. *Schutters-
maaltijd ter ere van de benoeming van
burgemeester Jan van de Poll tot kolonel der
schutterij, 1650*

The sitters are from left to right:
(standing) the artist himself, Antony
Heindrickz Molenaer, Wouter
Lambertsz Heems, Cornelis Vliet,
Philips Willemsz Muyen, Jan
Hillebrantsz Kapel, Jonas Jonasz
Gekeer, Pieter Jacobsz Steur, Claes
Barentsz van Berken, Abraham Pietersz
Kroock, Eilard Bernhards, Joannis Pollis,
Jaspar Vlak, ensign, Harmen van de
Poll; (sitting) Jan Meures, Jacob
Calaber, Pieter van Gerven, Reinier
Blocq, Gijsbert van de Poll, lieutenant,
Jan van de Poll, captain

Canvas 297.5 × 589. Signed and dated
Johan Spilberg 1650
PROV Handboogdoelen (headquarters of
the archers' civic guard), Amsterdam.
On loan from the city of Amsterdam,
1885-1975
LIT Houbraken 1718-21, vol 3, p 43.
Wagenaar 1760-88, vol 2 (1765) p 74.
Scheltema 1879, nr 104. W del Court &
J Six, OH 21 (1903) p 71. Moes 1897-
1905, vol 2, nrs 5988, 5989:1, 5993:1

copy after **Johann Spilberg II**

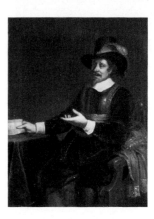

A 1258 Jan van de Poll (1597-1678).
Burgomaster of Amsterdam. *Burgemeester
van Amsterdam*

Copy after the portrait of Jan van de
Poll in C 395

Canvas 50.5 × 40
PROV Presented by J S R van de Poll,
Arnhem, 1885 * Lent to the AHM, 1975
LIT Moes 1897-1905, vol 2, nr 5993:2

A 1262 Harmen van de Poll (1641-73).
Son of Jan van de Poll. *Zoon van Jan van
de Poll*

For a portrait of the sitter's father, *see* the
preceding number

Copy after the portrait of Harmen van de Poll in C 395

Canvas 49 × 39
PROV Same as A 1258 * Lent to the AHM, 1975
LIT Moes 1897-1905, vol 2, nr 5989:2

Hendricus Spilman

Amsterdam 1721 – 1784 Haarlem

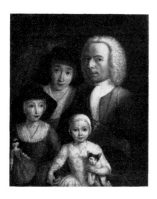

A 1583 Self portrait with his wife Sanneke van Bommel (b 1741) and their two children. *Zelfportret met zijn vrouw Sanneke van Bommel en hun twee kinderen*

Canvas 37 × 30
PROV Presented by J de Kuyper, Rotterdam, 1892
LIT J W Niemeijer, Bull RM 10 (1962) p 55, fig 1

Guillaume de Spinny

Brussels 1721 – 1785 The Hague

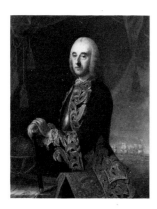

C 527 Hendrik Lijnslager (1693-1768). Vice admiral, son of Harmen Lijnslager and Judith Allijn. *Vice-admiraal, zoon van Harmen Lijnslager en Judith Allijn*

For portraits of the sitter's parents, *see* Haensbergen, Johan van, A 1546 & A 1547

Canvas 113 × 87. Signed and dated *Spinny f. 1759*
PROV On loan from the KOG since 1889
LIT Moes 1897-1905, vol 2, nr 4707:2

A 1271 Portrait of a lady from the van de Poll family, thought to be Anna Maria Dedel (1729-79), wife of Jan van de Poll. *Portret van een dame uit de familie van de Poll, vermoedelijk Anna Maria Dedel, echtgenote van Jan van de Poll*

For a portrait of the sitter's husband, *see* Quinkhard, Jan Maurits, A 1270

Canvas 49 × 39. Signed and dated *Spinnij fecit 1762*
PROV Presented by J S R van de Poll, Arnhem, 1885

 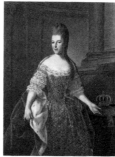

A 3826 Willem V (1748-1806), prince of Orange. *Prins van Oranje*

Pendant to A 3827

Canvas 135.5 × 105. Signed and dated *G^um Spinnÿ fecit 1775*
PROV Rijswijk Palace, Weltevreden (Java), 1950 * On loan to the Nassau Museum, Oranienstein near Dietz, Germany
LIT De Loos-Haaxman 1941, pp 144, 157. De Loos-Haaxman 1972, p 66

A 3827 Frederika Sophia Wilhelmina (Wilhelmina; 1751-1820), princess of Prussia. Wife of Prince Willem V. *Prinses van Pruisen. Echtgenote van prins Willem V*

Pendant to A 3826

Canvas 135.5 × 103.5. Signed and dated *G^m Spinnij fecit 1775*
PROV Same as A 3826 * On loan to the Nassau Museum, Oranienstein near Dietz, Germany
LIT De Loos-Haaxman 1941, pp 144, 157. De Loos-Haaxman 1972, p 66

Jacob Spoel

Rotterdam 1819/20 – 1868 Rotterdam

see also Governors-general series: A 3804 Ch F Pahud

A 2541 Mrs A J Schmidt-Keiser, widow of the artist Willem Hendrik Schmidt (1809-49), teacher of Jacob Spoel, with her brother J N Keiser and her son of ten. *Mevrouw A J Schmidt-Keiser, weduwe van de schilder Willem Hendrik Schmidt, de leermeester van Jacob Spoel, met haar broer J N Keiser en haar tienjarig zoontje*

Canvas 143.5 × 115. Signed and dated *J. Spoel '58*. Inscribed in the cartouche of the painting frame *W. H. Schmidt*
PROV Presented by the Misses J A and J J Schmidt, daughters of the sitter, Rotterdam, 1912

A 1964 Bernhard (1792-1862), duke of Saxe-Weimar. General in the service of the Netherlands. *Hertog van Saksen-Weimar. Generaal in Nederlandse dienst*

Canvas 133.5 × 100. Signed *J. Spoel*
PROV Bequest of His Highness Prince
Herman of Saxe-Weimar, 1901 * DRVK
since 1959 (on loan to the Nederlands
Legermuseum, Leiden)
LIT Van der Klooster & Bouman 1966,
fig 343

Bartholomeus Spranger

Antwerp 1546–1611 Prague

A 3888 Venus and Adonis. *Venus en Adonis*

Panel 135 × 109
PROV Purchased from the Arcade
Gallery, London, 1955
LIT Oberhuber 1958, pp 81, 219, nr 1.
K Oberhuber, Jb Ksamml Baden-
Württemberg 1 (1964) p 184, fig 151

Jacob van Spreeuwen

Leiden 1611–after 1650 Leiden?

A 1713 Philosopher in his study. *Filosoof in zijn studeervertrek*

Panel 35.5 × 32.5. Signed and dated
J. v. Spreuwen 1645
PROV Sale G de Clercq, Amsterdam, 1
June 1897, lot 93. Purchased with aid
from the Rembrandt Society
LIT Bernt 1960-62, vol 3, nr 784. Bernt
1969-70, vol 3, nr 1103

Cornelis Springer

Amsterdam 1817–1891 Hilversum

A 1136 The town hall and the vegetable
market, Veere. *Het raadhuis en de Groente-
markt te Veere*

Canvas 90 × 77. Signed and dated
C. Springer fec. 1861
PROV Purchased from the artist,
Amsterdam, 1861. RVMM, 1885 * Lent to
the Stedelijk Museum, Zutphen, 1924.
Destroyed in the war, 1945
LIT HC de Bruijn Jr, Antiek 2 (1967) p
15

A 2388 The Zuiderhavendijk,
Enkhuizen. *De Zuiderhavendijk in
Enkhuizen*

Panel 50 × 65. Signed and dated
C. Springer 1868. Inscribed on the verso
*De ondergeteekende verklaart dat deze schilderij
voorstellende de Havendijk te Enkhuizen Prov.
Noord Holland door hem is vervaardigd. 31
Dec. 1868. C. Springer*
PROV Bequest of J B A M Westerwoudt,
Haarlem, 1907. Received in 1909
LIT Scheen 1946, fig 226. Van Gelder
1959, fig 127

Willem Stad

see Hodges, Charles Howard, A 2971
Rutger Jan Schimmelpenninck, copy by
Stad

Adriaen van Stalbemt

Antwerp 1580–1662 Antwerp

A 756 Mountainous landscape. *Berg-
achtig landschap*

Panel 29.5 × 47. Signed *Av Stalbempt*
PROV Sale Jonkheer U W F van Panhuys,
Amsterdam, 26 Sep 1882, lot 72
LIT Thiéry 1953, p 196. L J Bol, OH 71
(1956) p 188, note 11. K Andrews, Burl
Mag 115 (1973) p 305, note 22

Pieter Stalpaert

Brussels ca 1572–before 1639
Amsterdam

A 1581 Hilly landscape. *Heuvelachtig
landschap*

Panel 67.5 × 116. Signed and dated
PSTA and *Stalpart 1635*
PROV Presented by Dr A Bredius, The
Hague, 1892
LIT Bernt 1960-62, vol 4, nr 256. Bernt
1969-70, vol 3, nr 1106. Bol 1973, p 40

Stap

see Woutersz Stap

attributed to **Gherardo Starnina**

active 1387; d 1409/13 Florence

A 3431 Madonna and child. *Maria met kind*

Panel 76.5 × 53.5
PROV Bequest of J W Edwin vom Rath, Amsterdam, 1941
LIT Van Marle 1923-38, vol 3 (1924) p 573. Berenson 1936, p 183 (Agnolo Gaddi). K E Schuurman, Mndbl BK 19 (1942) p 98. Shorr 1954, p 64. VTTT, 1962-63, nr 58. Berenson 1963, vol 1, p 66 (Gaddi). Van Os & Prakken 1974, p 48, nr 18, ill (school of Gaddi)

Jan Adriaensz van Staveren

Leiden ca 1625 – after 1668 Leiden

see also Dou, Gerard, A 2321 The doctor, copy by van Staveren

A 381 A hermit praying in a ruin. *Een biddende kluizenaar in een ruïne*

Panel 33 × 27. Signed *JAStaveren*
PROV NM, 1808
LIT Moes & van Biema 1909, p 214

C 228 A hermit in a ruin. *Een kluizenaar in een ruïne*

Panel 36.5 × 30.5. Signed *JAStaveren*
PROV On loan from the city of Amsterdam (A van der Hoop bequest) since 1885

copy after **Jan Adriaensz van Staveren**

A 382 The schoolmaster. *De schoolmeester*

Panel 50 × 42.5
PROV Bequest of L Dupper Wzn, Dordrecht, 1870 * DRVK since 1950

Jan Havicksz Steen

Leiden 1626 – 1679 Leiden

A 383 Self portrait. *Zelfportret*

Canvas 73 × 62. Signed *JSteen*
PROV Purchased from Ch H Hodges, Amsterdam, 1821
LIT Moes 1897-1905, vol 2, nr 7525:1. Hofstede de Groot 1907-28, vol 1, nr 860. E Plietzsch, Zeitschr BK ns 27 (1916) p 136. Bode 1917, p 124. Schmidt-Degener & van Gelder 1927, p 25. Bredius 1927, nr 1. Ried 1931, fig 59. Martin 1935-36, vol 1, p 15, fig 12; vol 2, pp 252, 266. Goldscheider 1936, p 38, fig 247. Boon 1947, p 66, fig 44. De Groot 1952, fig 1. Martin 1954, pp 16, 71, fig 1. W Stechow, Bull Oberlin 3 (1958) p 100. Exhib cat Jan Steen, The Hague 1958-59, nr 42, ill. Van Hall 1963, p 33, nr 1999:2. Eckardt 1971, p 209, fig 38. L de Vries, OH 87 (1973) p 229, fig 1

C 229 The merry family. *Het vrolijke huisgezin*

Canvas 110.5 × 141. Signed and dated *JSteen 1668*. Inscribed *Soo D[e] Oude Songen, Soo Pijpen De Jonge*
PROV On loan from the city of Amsterdam (A van der Hoop bequest) since 1885
LIT Hofstede de Groot 1907-28, vol 1, nr 88. Martin 1935-36, vol 2, pp 256, 264. Martin 1954, p 53. Van Hall 1963, p 316, nr 1999:53

A 3984 The sacrifice of Iphigenia. *Het offer van Iphigenia*

Canvas 135 × 173. Signed and dated (apocryphally) *Jan Steen 1671*
PROV Lent by the SNK, later DRVK, 1948. Transferred in 1960
LIT Hofstede de Groot 1907-28, vol 1, nr 74. O Hirschmann, Cicerone 15 (1923) p 135, ill. J B F van Gils, Op de Hoogte,

1937, p 92ff. Martin 1954, pp 23, 56, 71, fig 62. Exhib cat Jan Steen, The Hague 1958-59, not in the catalogue. A von Criegen, OH 86 (1971) p 27, note 37. L de Vries, OH 87 (1973) p 233, fig 4

A 388 A peasant wedding. *Boerenbruiloft*

Panel 38.5 × 50. Signed and dated *J Steen 1672*
PROV NM, 1808
LIT Hofstede de Groot 1907-28, vol 1, nr 454. Moes & van Biema 1909, pp 64, 198, 221. Martin 1954, p 80. J A F Doove, Spiegel Hist 4 (1969) p 146, fig 8

A 2572 Erysichthon selling his daughter Mestra. *Erysichthon verkoopt zijn dochter Mestra*

Canvas 66 × 64. Signed *J Steen*
PROV Presented from the estate of C Hoogendijk, The Hague, 1912
LIT C Hofstede de Groot, Ned Spec, 1899, p 57. Hofstede de Groot 1907-28, vol 1, nr 73. R Bangel, Cicerone 7 (1915) p 182. RDK, vol 5, col 1404

A 390 The Leiden baker Arent Oostwaard and his wife Catharina Keizerswaard. *Bakker Arent Oostwaard en zijn echtgenote Catharina Keizerswaard*

Panel 38 × 32. Signed *J Steen*. Inscribed on the verso *Dit is een Familiestukje, De Backer is 't portret van Arent Oostwaard. De vrou..... Catharina Keizerswaard, De Jonge is gedaan naar een jonge van J. Steen. Deze backer met zijn vrou hebben gewoond op den Rhyn, 3 à 4 huyzen van de vrouwebrugge, tussen de vrouwesteegh en Gasthuys binnen Leyden. Is nu, January 1738, ruim 79 jaar geleden, geschildert*
PROV Sale G van der Pot van Groeneveld, Rotterdam, 6 June 1808, lot 119
LIT Hoet 1770, vol 3, p 269. Moes 1897-1905, vol 1, nr 4168; vol 2, nr 5584. Hofstede de Groot 1907-28, vol 1, nr 872. Moes & van Biema 1909, pp 113, 181. CC van de Graft, Elsevier's GM 34 (1924) p 27, ill. E Wiersum, OH 48 (1931) p 209. Martin 1935-36, vol 2, pp 264, 266. Martin 1954, p 34, fig 16. L van Buyten, Spiegel Hist 2 (1967) p 67ff, fig 2

A 385 The feast of St Nicholas. *Het Sint Nicolaasfeest*

Canvas 82 × 70.5. Signed *J Steen*
PROV Purchased with the Kabinet van Heteren Gevers, The Hague-Rotterdam, 1809
LIT Hoet 1752, vol 2, p 459. Hofstede de Groot 1907-28, vol 1, nr 510. Martin 1935-36, vol 1, p 6, fig 3; vol 2, pp 256, 261, 266. De Groot 1952, p 79, fig 9. Gerson 1952, p 33, fig 87. Martin 1954, pp 50, 53, 63, fig 48. F W S van Thienen, OK 1 (1957) nr 32, ill. Bille 1961, vol 1, pp 109-10. Rosenberg, Slive & Ter Kuile 1966, p 135, fig 115. A A E Vels Heijn, Kunstrip 4 (1973-74) nr 33. Niemeijer 1973, p 67, fig 14

A 4052 Woman at her toilet. *Het toilet*

Panel 37 × 27.5. Ends in round corners. Signed *J Steen*
PROV Presented by Mr & Mrs I de Bruijn-van der Leeuw, Muri near Bern, 1961
LIT Smith 1829-42, suppl, p 482, nr 24. Bode 1900, vol 12, fig 18. Hofstede de Groot 1907-28, vol 1, nr 342. Bredius 1927, fig 71. Schmidt-Degener & van Gelder 1927, p 81, ill. De Jonge 1939, p 35. H L C Jaffé, Du, 1944, p 41, ill. Martin 1954, p 46, fig 40. Exhib cat Jan Steen, The Hague 1958-59, nr 20, ill. Bille 1961, vol 1, p 81; vol 2, p 76. E R Meijer, Bull RM 9 (1961) p 46, fig 4. J L Cleveringa, Bull RM 9 (1961) p 66, nr 10. J Guillerme, Peintre, 15 Dec (1964) p 23, ill. B Haak, Antiek 1 (1967) p 10, figs 3-4. E de Jongh, in exhib cat Rembrandt en zijn tijd, Brussels 1971, p 174, note 116

A 386 Interior with a woman feeding a parrot, two men playing backgammon and other figures, known as 'The parrot cage.' *Interieur met een vrouw, die een papegaai voert, twee trictracspelers en andere figuren, bekend als 'De papegaaiekooi'*

Canvas 50 × 40. Signed *J Steen*
PROV Purchased with the Kabinet van Heteren Gevers, The Hague-Rotterdam, 1809
LIT Hoet 1752, vol 2, p 459. Hofstede de Groot 1907-28, vol 1, nr 716. Moes & van Biema 1909, pp 150, 193. Bredius 1927, nr 22. Würtenberger 1937, p 91. Martin 1954, p 50. Exhib cat Jan Steen, The Hague 1958-59, nr 35 (ca 1665). VTTT, 1958, nr 3

A 718 Children teaching a cat to dance, known as 'The dancing lesson.' *Kinderen leren een poes dansen, bekend als 'De dansles'*

Panel 68.5 × 59. Signed *JSteen*
PROV Bequest of Jonkheer J S H van de Poll, Amsterdam, 1880
LIT V de Stuers, Ned Kunstbode 2 (1880) p 245. Hofstede de Groot 1907-28, vol I, nr 314. Martin 1954, p 67. A P de Mirimonde, GdB-A 106 (1964) p 272, fig 32

C 230 The sick woman. *De zieke vrouw*

Canvas 76 × 63.5. Signed *JSteen*
PROV On loan from the city of Amsterdam (A van der Hoop bequest) since 1885
LIT E Durand Gréville, GdB-A 40 (1898) pp 331-32. Hofstede de Groot 1907-28, vol I, nr 129. J B F van Gils, O H 38 (1920) p 200. J B F van Gils, Ned Tijdschr Geneesk, 1921, pp 2561, 2563. Bredius 1927, p 32. B Bord, Aesculape, 1935, p 113, fig 4. Martin 1935-36, vol 2, pp 257, 266, fig 141. De Jonge 1939, p 50. Gudlaugsson 1945, p 14, ill. De Groot 1952, p 52ff. Martin 1954, p 44, frontispiece. Exhib cat Jan Steen, The Hague 1958-59, nr 36, ill (ca 1665). M Putscher, Aachener Kunstbl 41 (1971) p 164, note 42. R H C Vos, Kunstrip 3 (1972-73) nr 27

A 3347 Interior of an inn with an old man amusing himself with the landlady and two men playing backgammon, known as 'Two kinds of games.' *Herberginterieur met een oude man, die zich amuseert met de waardin, en triktrakspelers, bekend als 'Tweeërlei spel'*

Canvas 63 × 69.5. Signed *JSteen*
PROV Presented by Mr & Mrs D A J Kessler-Hülsmann, Kapelle op den Bosch near Mechelen, 1940
LIT Hofstede de Groot 1907-28, vol I, nrs 718, 725. Schmidt-Degener & van Gelder 1927, pl XXXVII. J G van Gelder, Elsevier's GM 50 (1940) p 46, ill. Gudlaugsson 1945, p 27

A 387 The quack. *De kwakzalver*

Panel 37.5 × 52. Signed *JSteen*
PROV Kabinet Prince Willem V. NM, 1808
LIT Hofstede de Groot 1907-28, vol I, nr 177. Moes & van Biema 1909, pp 198, 221. Holländer 1913, vol 2, p 398ff. Veth 1921, pp 124-25. Schmidt-Degener & van Gelder 1927, pp 42-44. J B F van Gils, Ned Tijdschr Geneesk, 1940, nr 14, p 310ff. Bille 1961, vol I, p 112. P Julien, Rev Histoire Pharm, 1967, p 389, ill

A 384 Prince's day: celebrating the birth of Prince William III, 14 November 1660. *Prinsjesdag. Het gezelschap viert de geboorte van prins Willem III, 14 november 1660*

Panel 46 × 62.5. Signed *J. Steen*.
Inscribed (on the piece of paper) *Op de gesonheyt van het nasauss basie in de eene hant het rapier in de andere hant het glaesie*; (on the crown) *Salus patriae suprema lex esto*; (on the bedstead) *Wij screuve als leuwe*
PROV Bequest of L Dupper Wzn, Dordrecht, 1870
LIT Hofstede de Groot 1907-28, vol I, nr 516. Schmidt-Degener & van Gelder 1927, p 39. Martin 1935-36, vol 2, pp 256, 266. De Jonge 1939, p 31. A Heppner, Journ W C I 3 (1939-40) p 45. De Groot 1952, p 82. Martin 1954, pp 42, 64, fig 29. Exhib cat Jan Steen, The Hague 1958-59, nr 15. Van Hall 1963, p 317, nr 1999:61. VTTT, 1965-66, nr 82. Niemeijer 1973, p 93

A 3509 The adoration of the shepherds. *De aanbidding der herders*

Canvas 53 × 64. Signed *JSteen*
PROV Purchased from A A van Sandick, Amsterdam, 1947
LIT Weltkunst, Aug 1939, p 2. De Jonge 1939, p 15. H P Bremmer, Constghesellen I (1946) pp 164-66. H van Guldener, Phoenix 3 (1948) p 18. De Groot 1952, p 33. Martin 1954, p 73. Exhib cat Jan Steen, The Hague 1958-59, nr 10 (ca 1670). F van Leeuwen, Kroniek Rembrandthuis 20 (1966) pp 57-64

A 1932 The meal at Emmaus. *De Emmausgangers*

Canvas 134 × 104. Signed *JSteen*
PROV Purchased from the G de Clercq collection, Amsterdam, 1900, through the intermediacy of the Rembrandt Society
LIT Hofstede de Groot 1907-28, vol 1, nr 65. E Plietzsch, Zeitschr BK ns 27 (1916) p 131. Martin 1935-36, vol 2, p 260. Gerson 1952, p 33, fig 93. Martin 1954, pp 23, 71, fig 82. H A Höweler, Jb Leiden, 1965, pp 106, 111, fig 19. Rosenberg, Slive & Ter Kuile 1966, p 137, fig 116 B

C 232 The drunken couple. *Het dronken paar*

Panel 52.5 × 64. Signed *JSteen*. Inscribed *Wat Baeter Kaers of Bril Als den uijl niet sien en wil*
PROV On loan from the city of Amsterdam (A van der Hoop bequest) since 1885
LIT Hofstede de Groot 1907-28, vol 1, nr 100. Martin 1935-36, vol 2, pp 258, 266. Gudlaugsson 1938, pp 95-96. Martin 1954, p 54, fig 54. Rosenberg, Slive & Ter Kuile 1966, p 136. Renger 1970, p 130. RDK, vol 6, col 302

C 233 A couple drinking. *Een drinkend paar*

Panel 24.5 × 21
PROV On loan from the city of Amsterdam (A van der Hoop bequest) since 1885
LIT Hofstede de Groot 1907-28, vol 1, nr 822

A 389 The merry homecoming. *Het vrolijk huiswaartskeren*

Canvas 68.5 × 99. Signed *JSteen*
PROV NM, 1808
LIT Hofstede de Groot 1907-28, vol 1, nr 657. Moes & van Biema 1909, pp 198, 221. Bernt 1960-62, vol 3, nr 790. Bille 1961, vol 2, pp 52, 120, ill. Rosenberg 1967, fig 45. Bernt 1969-70, vol 3, nr 1113. A von Criegen, OH 86 (1971) pp 21-22, fig 7

C 231 Family scene. *Familietafereel*

Panel 48.5 × 40. Signed *JSteen*
PROV On loan from the city of Amsterdam (A van der Hoop bequest) since 1885

LIT Hofstede de Groot 1907-28, vol 1, nr 523. Martin 1954, pp 46, 62-63, 73, fig 39. VTTT, 1967-68, nr 101

A 391 Woman scouring metalware. *De ketelschuurster*

Panel 24.5 × 20. Signed *J. Steen*
PROV Sale G van der Pot van Groeneveld, Rotterdam, 6 June 1808, lot 121
LIT Hofstede de Groot 1907-28, vol 1, nr 352. Moes & van Biema 1909, pp 113, 186

attributed to **Jan Havicksz Steen**

A 392 The quack. *De kwakzalver*

Panel 27 × 22.5. Signed *JSteen*. Inscribed on the paper *Octroi*
PROV Bequest of L Dupper Wzn, Dordrecht, 1870
LIT Hofstede de Groot 1907-28, vol 1, nr 178

A 393 Man with a fiddle in bad company. *Man met een viool in slecht gezelschap*

Panel 30 × 25. Signed *JSteen*
PROV Bequest of L Dupper Wzn, Dordrecht, 1870
LIT C von Lützow, Zeitschr BK 5 (1870) p 228. C Hofstede de Groot, OH 22 (1904) p 30 (copy). Hofstede de Groot 1907-28, vol 1, nr 823

copy after **Jan Havicksz Steen**

A 1763 The bowlers. *De kegelaars*

Copy after the original in the National Gallery, London (cat 1960, nr 2560)

Panel 35 × 28. Inscribed *J.Steen 1672*
PROV Bequest of D Franken Dzn, Le Vésinet, 1898
LIT Hofstede de Groot 1907-28, vol 1, ad nr 737. MacLaren 1960, pp 401-02

Jan van der Steen

see Vanmour series

Harmen van Steenwyck

Delft 1612–after 1655 Delft?

A 1529 Still life with fish and fruit. *Stilleven met vissen en vruchten*

Pendant to A 1528

Panel 23 × 27. Signed and dated *H. Steenwijck 1652*
PROV Presented by Dr A Bredius, The Hague, 1890
LIT Vorenkamp 1933, p 74. Bol 1969, p 89

A 1528 Still life with an earthenware jug, fish and fruit. *Stilleven met aarden kruik, vissen en vruchten*

Pendant to A 1529

Panel 23 × 27. Signed *H. Steenwijck*
PROV Same as A 1529
LIT Bol 1969, p 89

Hendrik van Steenwyck I *or* **II**

I Steenwyck? ca 1550–1603 Frankfurt am Main

II ca 1580–before 1649 London

A 798 Vaulted interior by night, with men sleeping. *Slapende mannen in een ruimte met verlichte gewelven*

Panel 10.5 × 16. Signed *KVSteen*
PROV Sale Amsterdam, 14-15 Nov 1883, lot 151
LIT Jantzen 1910, p 39, nr 434

Alphonse Stengelin

Lyon 1852–1938 Satigny (near Geneva)

A 2498 Landscape in Drenthe. *Landschap in Drenthe*

Canvas 61 × 79. Signed *A. Stengelin*
PROV Presented by the artist, 1910, through the intermediacy of H W Mesdag, The Hague * DRVK since 1961

A 2499 Birches in a forest. *Bos met berkebomen*

Canvas 41 × 31. Sketch. Signed *Stengelin ft*
PROV Presented by the artist, 1910, through the intermediacy of H W Mesdag, The Hague

Alfred Stevens

Brussels 1823 – 1906 Paris

A 3609 The widow. *De weduwe*

Canvas 80 × 82. Signed *AStevens*
PROV Lent by Mr & Mrs J C J Drucker-
Fraser, 1919. Bequeathed in 1944
LIT Vanzijpe 1936, p 103, nr 91

Stevers

biographical data unknown

A 2358 Vanitas still life. *Vanitas stilleven*

Canvas 45 × 52. Signed *Stevers*
PROV Sale Hoogendijk, Amsterdam,
28-29 April 1908, lot 279

Hendrik Stokvisch

Loenen 1768 – 1823 Amsterdam

A 1137 Landscape with herdsman and
flock near Darthuizen. *Landschap met
herder en vee bij Darthuizen*

Panel 44 × 57. Signed and dated
H. Stokvisch 1814
PROV Purchased at exhib Amsterdam
1816, nr 157 or 158. RVMM, 1885

Jan Stolker

Amsterdam 1724 – 1785 Rotterdam

A 3830 Theodorus Bisdom van Vliet
(1698-1777). Burgomaster of Haastrecht
and chief dikereeve of the Krimpener-
waard, with his family in the garden of
his home in Haastrecht. *Burgemeester van
Haastrecht en hoogheemraad van de
Krimpenerwaard, met zijn gezin in de tuin
van zijn huis te Haastrecht*

The other sitters are Bisdom's wife Maria
van Harthals (1703-63) and his children
Cornelis (1737-73), Maria Theodora
(1739-1828) and Adriana Elisabeth
(1742-76), upper left, Agatha (1743-76),
Johanna Margaretha (1735-64) and
Johan de Wijs (1740-62), lower left, and
to the right, Elisabeth (1727-64) with
Marcellus (1729-1806), Adriaan Jacob
(1732-90) and Evert (1733-86), the
latter two on horseback

Canvas 185 × 150. Signed and dated
J. Stolker Pinx. 1757
PROV Purchased from M C Bisdom van
Cattenbroek, Bellavilliers, 1951
LIT Moes 1897-1905, vol 1, nrs 671-74,
677-78, 681-82, 685, 3326. De Jonge
1924, p 4

attributed to **Matthias Stomer**

ca 1600 – after 1650 Sicily

A 216 St John the Baptist. *Johannes de
Doper*

Canvas 73 × 60. Inscribed *ECXADEI*
PROV Het Loo Palace, Apeldoorn,
1798. NM, 1808
LIT Moes & van Biema 1909, pp 17, 171,
213. Von Schneider 1933, p 133 (Caesar
Boëtius van Everdingen). H Pauwels,
Gent Bijdr 14 (1953) p 176, fig 23
(Stomer)

Dirck Stoop

Utrecht 1610 – 1686 Utrecht

A 395 The hunting party. *Jachtpartij*

Panel 43 × 61. Signed and dated
D. Stoop f 1649
PROV Bequest of L Dupper Wzn,
Dordrecht, 1870
LIT P T A Swillens, OH 51 (1934) p 127,
fig 4

A 1714 Hunters resting. *Rustende jagers*

Panel 36.5 × 51. Signed *D. Stoop*

PROV Sale G de Clercq, Amsterdam, 1 June 1897, lot 97. Purchased with aid from the Rembrandt Society

attributed to **Dirck Stoop**

NM 9487 Couple taking a walk in a landscape. *Wandelaars in een landschap*

Panel 18 × 72.5. Painted on the lid of a clavichord
PROV Purchased from D Brugman, Amsterdam, 1892. Belongs to the department of sculpture and applied arts

Maerten Stoop

Rotterdam? 1618–1647 Utrecht

A 2573 An officer in billeted quarters. *Een ingekwartierde officier*

Panel 54 × 45
PROV Presented from the estate of C Hoogendijk, The Hague, 1912
LIT C Hofstede de Groot, Ned Spec, 1899, p 58. R Bangel, Cicerone 7 (1915) p 182. P T A Swillens, OH 51 (1934) p 176, fig 15

Abraham Storck

Amsterdam ca 1635–ca 1710 Amsterdam?

A 2132 The Muscovite legation visiting Amsterdam, 29 August 1697. *Bezoek van het Moskovisch Gezantschap aan Amsterdam, 29 augustus 1697*

Canvas on panel 33.5 × 42.8. Signed *A. Storck Fecit*
PROV Sale Amsterdam, 23 Feb 1904, lot 36 * Lent to the AHM, 1975
LIT W H Vroom, Ons Amsterdam 24 (1972) p 175

A 1521 The roads of Enkhuizen. *De rede van Enkhuizen*

Canvas 86 × 117.5. Signed *A. Storck*
PROV Presented from the estate of H J Baron van der Heim van Duivendijke, 1890
LIT Willis 1911, p 112, pl XXXII. Martin 1935-36, vol 2, p 384, fig 204. Bol 1973, p 322

A 4102 The whaling grounds. *Walvisvangst*

Canvas 50.5 × 66.8. Signed *A. Storck Fecit*
PROV Sale London, 8 July 1964, lot 17

C 235 Dutch merchantmen in a Mediterranean harbor. *Hollandse straatvaarders bij een Middellandse Zee-haven*

Pendant to C 236

Canvas 71 × 85. Signed *A. Storck F.*
PROV On loan from the city of Amsterdam (A van der Hoop bequest), 1885-1975
LIT Bol 1973, p 321, note 585

C 236 Dutch merchantmen in a Mediterranean harbor. *Hollandse straatvaarders bij een Middellandse Zee-haven*

Pendant to C 235

Canvas 71 × 85. Signed *A. Storck F*
PROV On loan from the city of Amsterdam (A van der Hoop bequest), 1885-1975

A 749 An Italian harbor. *Italiaanse zeehaven*

Canvas 50 × 64. Signed *A. Storck fecit*
PROV Purchased from Th Sirdey, Geneva, 1882 * DRVK since 1968

527

manner of **Abraham Storck**

A 739 Onrust Island near Batavia. *Het eiland Onrust bij Batavia*

Canvas 77 × 110. Dated *1699*
PROV Sale C J G Copes van Hasselt, Amsterdam, 20 April 1880 * Lent to the AHM, 1975
LIT C Hofstede de Groot, OH 22 (1904) p 117 (unrelated to Storck)

Jacobus Storck

active ca 1660-86 in Amsterdam

A 1289 Nijenrode Castle on the Vecht near Breukelen. *Het kasteel Nijenrode aan de Vecht bij Breukelen*

Panel 47 × 63. Signed *J. Storck*
PROV Sale P VerLoren van Themaat, Amsterdam, 30 Oct 1885, lot 33 (as Paulus Constantijn La Fargue)
LIT J Vuyck, OH 52 (1935) p 121ff, fig 1. Bol 1973, p 315, note 572

Louis Storm van 's-Gravesande

see Governors-general series: A 3812 C H A van der Wijck

Pieter Stortenbeker

The Hague 1828 – 1898 The Hague

A 1138 Early morning on the lakes. *Morgenstond aan de plassen*

Canvas 88 × 129. Signed *P. Stortenbeker*
PROV Purchased at exhib The Hague 1866, nr 343. RVMM, 1885 * DRVK since 1953

NO PHOTOGRAPH AVAILABLE

A 2628 Meadow landscape. *Weidelandschap*

In the foreground is a plank bridge over a ditch. On the horizon are several windmills

Board 30 × 44. Signed *P. Stortenbeker ft.*
PROV Presented by H L Klein, Amsterdam, 1912 * Lent to the Stedelijk Museum, Zutphen, 1924. Destroyed in the war, 1945

Johannes Anthonie Balthasar Stroebel

The Hague 1821 – 1905 Leiden

A 1831 Kitchen scene. *Keukeninterieur*

Canvas 52 × 65. Signed and dated *J Stroebel ft. 54*
PROV Bequest of Reinhard Baron van Lynden, The Hague, 1899 * DRVK since 1953

A 1139 The sampling officials of the Leiden serge hall. *De staalmeesters van de Leidse Saaihal*

Canvas 83.5 × 93. Signed and dated *J Stroebel ft 1866*
PROV Purchased at exhib The Hague 1866, nr 345. RVMM, 1885 * DRVK since 1953

Abraham van Strij

Dordrecht 1753 – 1826 Dordrecht

A 4195 Visit of a woman cherry peddler. *Een kersenverkoopster aan de deur*

Panel 72.7 × 59. Signed and dated *A. van Stry 1816*
PROV Purchased from Gebr Douwes gallery, Amsterdam, 1971, as a gift of the Photo Commission
LIT C J de Bruyn Kops, Bull RM 22 (1974) pp 29, 38, fig 13

A 396 The drawing lesson. *De tekenles*

Panel 25 × 20.5. Signed *A. van Strij*
PROV Purchased with the Kabinet van Heteren Gevers, The Hague-Rotterdam, 1809
LIT Moes & van Biema 1909, pp 150, 194. J Knoef, Historia 8 (1942) p 249. Bille 1961, vol 1, p 109

A 1143 Woman scouring the inside of a cauldron. *De ketelschuurster*

Panel 34 × 27. Signed *A. van Strij*
PROV Presumably purchased at exhib Amsterdam 1810, nr 6. RVMM, 1885
LIT Moes & van Biema 1909, p 221 (acquired in 1808)

C 237 The housewife. *De huisvrouw*

Panel 56.5 × 49. Signed *A. van Strij*
PROV On loan from the city of

Amsterdam (A van der Hoop bequest) since 1885
LIT Huebner 1942, fig 64

Jacob van Strij

Dordrecht 1756–1815 Dordrecht

A 1142 Landscape with cattle driver and shepherd. *Landschap met veedrijver en schaapherder*

Panel 57 × 83.5. Signed *J. van Strij ft*
PROV Purchased from the Gevers collection, Dordrecht, 1822. RVMM, 1885
LIT Marius 1920, p 58

A 1140 Milking time. *Melktijd*

Panel 73 × 96.5. Signed *J. van Strij*
PROV Purchased from the Gevers collection, Dordrecht, 1822. RVMM, 1885

A 1141 Landscape with cattle near a ruin. *Landschap met vee bij een ruïne*

Panel 72.5 × 96.5. Signed *J. van Strij*
PROV Purchased from the Gevers collection, Dordrecht, 1822. RVMM, 1885

C 613 Meadow landscape with cattle. *Weidelandschap met vee*

Panel 40 × 52.5. Signed *J. v. Strij*
PROV On loan from the city of Amsterdam (presented by G de Clercq) since 1898
LIT C J de Bruyn Kops, Bull RM 13 (1965) pp 68-69, ill

C 238 Landscape with peasants and their cattle and fishermen on the water. *Landschap met landlieden bij hun vee en hengelaars op het water*

Panel 69 × 91
PROV On loan from the city of Amsterdam (A van der Hoop bequest) since 1885

attributed to **Lambert Sustris**

Amsterdam 1515/20–after 1568 Padua?

A 3479 Reclining Venus. *Liggende Venus*

Canvas 116 × 186
PROV Purchased from Tomas Harris, London, 1946

LIT Waagen 1854, vol 2, p 244. Berenson 1957, vol 1, p 167, fig 1242. AP de Mirimonde, GdB-A 108 (1966) p 273, fig 12

A 3424-A 3427 Four allegorical female figures. *Vier allegorische vrouwenfiguren*

Panel 20 × 12; 19.5 × 12.3; 19.5 × 12.5; 19.5 × 12.5 respectively
PROV Bequest of J W Edwin vom Rath, Amsterdam, 1941
LIT Berenson 1957, vol 1, p 159

A 3424 Woman with water jug. *Vrouw met waterkruik*
A 3425 Woman with shield? *Vrouw met schild?*

A 3426 Woman with writing tablet. *Vrouw met schrijftafeltje*
A 3427 Woman with mirror. *Vrouw met spiegel*

Jonas Suyderhoef

see Panpoeticon Batavum: A 4560 Theodorus Schrevelius, by Arnoud van Halen after Suyderhoef; A 1503 Piërius Winsemius, by Jan Maurits Quinkhard after Suyderhoef; A 4566 Samuel Ampzing, by Arnoud van Halen after

Suyderhoef; A 4579 Marcus van Boxhorn, by Arnoud van Halen after Suyderhoef; A 4600 Franciscus Planté, by Arnoud van Halen after Suyderhoef

John Macallan Swan

Old Brentford 1847 – 1910 Isle of Wight

see also under Aquarelles and drawings

A 2490 A lioness nursing three cubs, called 'Motherly love.' *Een leeuwin met drie zogende welpen, genaamd 'Moederliefde'*

Canvas 153 × 227. Signed *John M. Swan*
PROV Lent by Mr & Mrs J C J Drucker-Fraser, London, 1906. Presented in 1909-10
LIT E P Engel, Bull RM 13 (1965) pp 50, 64

A 3610 Polar bears climbing into an empty drifting lifeboat. *IJsberen beklimmen een ronddrijvende sloep*

Canvas 152 × 276
PROV Lent by Mr & Mrs J C J Drucker-Fraser, 1919. Bequeathed in 1944 *
DRVK since 1953
LIT E P Engel, Bull RM 13 (1965) p 62

A 3614 Two panthers drinking, called 'Thirst.' *Twee drinkende panters, genaamd 'Dorst'*

Canvas 54 × 183. Signed and dated *John M. Swan 1896*
PROV Lent by Mr & Mrs J C J Drucker-Fraser, 1919. Bequeathed in 1944 *
DRVK since 1953

A 3613 A lioness and her cubs beside a dead Negro, called 'Nemesis.' *Een leeuwin met haar welpen bij een dode neger, genaamd 'Nemesis'*

Canvas 34 × 58. Signed *John M. Swan*
PROV Lent by Mr & Mrs J C J Drucker-Fraser, 1919. Bequeathed in 1944

A 3611 The sirens. *De Sirenen*

Canvas 67 × 56.5. Signed *John M. Swan*
PROV Lent by Mr & Mrs J C J Drucker-Fraser, 1919. Bequeathed in 1944

A 3612 A girl refugee. *Vluchtelinge*

Canvas 34 × 52. Signed *J. M. Swan*
PROV Lent by Mr & Mrs J C J Drucker-Fraser, 1919. Bequeathed in 1944

attributed to **Isaac Claesz van Swanenburgh**

Leiden? ca 1538 – 1614 Leiden

A 862 The parable of the tares among the wheat. *De gelijkenis van het onkruid onder het tarwe*

Panel 131 × 147. Inscribed *Math XIII*
PROV Sale Amsterdam, 16 Dec 1875, lot 30 (as anonymous). NMGK, 1885

Jacob Isaacsz Swanenburgh

Leiden ca 1571 – 1638 Leiden

A 730 The last judgment and the seven deadly sins. *Het laatste oordeel en de zeven hoofdzonden*

Panel 28 × 88
PROV Purchased in Doetinchem, 1881
LIT Van Regteren Altena 1936, vol 1, p 33

Willem Swanenburgh II

see Moreelse, Paulus, A 3455 Esau selling his birthright, copy after a print by Swanenburgh after a painting by Moreelse – Panpoeticon Batavum: A 4556 Petrus Bertius, by Arnoud van Halen after Swanenburgh; A 4558 Johan van der Does, by Arnoud van Halen after Swanenburgh

Herman van Swanevelt

Woerden ca 1600 – 1655 Paris

A 2497 Italian landscape. *Italiaans landschap*

Canvas 56 × 69. Signed and dated *H. Swanevelt Fs. Woerden 1643* (1648?)
PROV Sale Munich, 12 May 1910, lot 57
LIT W Stechow, OH 75 (1960) p 84.
Exhib cat Italianiserende landschapschilders, Utrecht 1965, nr 41, fig 45

attributed to **Jan Swart van Groningen**

Groningen 1490/1500 – 1553/58
Antwerp?

A 669 Solomon and the queen of Sheba. *Salomo en de koningin van Sheba*

Panel 98.5 × 196.5. Inscribed *III Reg. X/Math. XII/Luc. XI*
PROV Gouvernementsgebouw (provincial capitol), Groningen, 1879
* DRVK since 1959 (on loan to the Gronings Museum, Groningen)
LIT C Hofstede de Groot, Gron Volksalm, 1893, pp 24-25 (Jan van Scorel). Hoogewerff 1923, p 135, nr 34, fig 39 (Scorel). Winkler 1924, p 280 (Scorel). Friedländer 1924-37, vol 12 (1935) p 200, nr 309 (Scorel). Hoogewerff 1936-47, vol 3 (1939) p 457ff, fig 245; vol 5, p 78 (Dirck Crabeth). Van de Waal 1952, p 117, fig 40:1. Exhib cat Jan van Scorel, Utrecht 1955, nr 93

manner of **Jan Swart van Groningen**

NM 8184 The painted doors of an organ. Inside right door: the adoration of the shepherds; inside left door: the adoration of the magi; outsides: the tree of Jesse. *Beschildering van de deuren van een orgel. Binnenkant rechterluik: aanbidding der herders; binnenkant linkerluik: aanbidding der koningen; buitenkanten: de boom van Jesse*

Panel 645 × 300 (dimensions of the organ)
PROV Nederlands Hervormde Kerk (Dutch Reformed Church), Scheemda. Lent by J Verwer, Leeuwarden, 1886. Purchased in 1896, as a gift of the Rembrandt Society. Belongs to the department of sculpture and applied arts
LIT Vogelsang 1909, nr 38, pl XIX. AB de Vries, Feestb M J Friedländer, 1942, p 31

Michael Sweerts

Brussels 1624 – 1664 Goa

A 2574 Playing checkers. *De damspelers*

Canvas 48 × 38. Signed and dated
Michael Sweerts fecit an. 1652 Roma
PROV Lent by C Hoogendijk, The
Hague, 1907. Presented from his estate
in 1912
LIT C Hofstede de Groot, Ned Spec,
1893, nr 3. M J Friedländer, Rep f
Kunstw 20 (1897) p 252. C Hofstede de
Groot, Ned Spec, 1899, p 58. W Martin,
OH 25 (1907) pp 13, 150. R C Witt,
Beeldende Kunst 3-4 (1915-16) p 129.
R Bangel, Cicerone 7 (1915) p 183, fig 8.
Bredius 1918, vol 5, p 1499. Martin
1935-36, vol 2, pp 157, 458, fig 239.
Kultzen 1954, pp 67, 262, nr 28.
Plietzsch 1960, p 210, fig 387. Exhib cat
Michael Sweerts, Rotterdam 1958, nr
23. Bloch 1968, p 20, fig 10

A 1958 The card players. *De kaartspelers*

Canvas 71 × 74
PROV Purchased from Dr A Bredius,
The Hague, 1901
LIT W Martin, OH 25 (1907) p 149, nr
11. Kultzen 1954, pp 63, 260, nr 25.
M R Waddingham, Paragone 9 (1958) p
71. Exhib cat Michael Sweerts,
Rotterdam 1958, nr 20, fig 22. Bloch
1968, p 20

A 1957 A painter's studio. *Een schilders-
atelier*

Canvas 71 × 74
PROV Purchased from Dr A Bredius,
The Hague, 1901
LIT W Martin, Burl Mag 6-7 (1905) p
125ff. W Martin, OH 25 (1907) pp 139,
149, nr 10. G J Hoogewerff, Med Ned
Hist Inst Rome 4 (1924) p 159. W
Boeck, Kunstwanderer 14 (1932) p 378.
Van Rijckevorsel 1932, p 4. R Longhi,
OH 51 (1934) p 275. H Hang, Bull Mus
France 6 (1934) pp 102-04. Hoogewerff
1952, pp 14, 153, fig 30. G J
Hoogewerff, Med Ned Hist Inst Rome
3d ser 6 (1952) p 4; 3d ser 7 (1953) p 36.
Kultzen 1954, pp 24, 241, nr 5. F Roh,
Die Kunst 8 (1956) p 281, ill. Exhib cat
Michael Sweerts, Rotterdam 1958, nr 4.
M R Waddingham, Paragone 9 (1958)
pp 68, 70. Plietzsch 1960, p 209, fig 382.
Van Hall 1963, p 322, nr 2045:1. V
Bloch, Jb Ksamml Baden-Württemberg
1 (1965) p 164, fig 96. M Haraszti-
Takacs, Bull Mus Hongr B-A 30 (1967)
p 70. Bloch 1968, pp 20-22, figs 12, 12a

A 2845-A 2848 The seven works of
charity. *De zeven werken van barmhartigheid*

The other paintings in the cycle are in
the Wadsworth Atheneum, Hartford
(Burying the dead) and in two private
collections (Comforting captives and
Sheltering pilgrims)

Canvas 75 × 99; 72 × 97.5; 74 × 99;
75 × 99 respectively
PROV Purchased from Craddock and
Barnard gallery, Tunbridge Wells, 1920,
as a gift of the Photo Commission
LIT G Briganti, Proporzioni 3 (1950) p
192, pl CCXXX. Kultzen 1954, pp 70-74,
264-67, nrs 29-31, 34. F Roh, Die Kunst
8 (1956) p 283. Exhib cat Michael
Sweerts, Rotterdam 1958, nrs 24-26, 28.
M R Waddingham, Paragone 10 (1959)
p 70. Bernt 1960-62, vol 3, nr 813. Bloch
1968, p 20. Bernt 1969-70, vol 3, nr 1154

A 2845 Feeding the hungry. *De hongerigen
spijzen*

A 2846 Refreshing the thirsty. *De dorstigen
laven*

A 2847 Clothing the naked. *De naakten
kleden*

A 2848 Visiting the sick. *De zieken
bezoeken*

A 3855 Jeronimus Deutz (1622-81)

Canvas 99.5 × 74.5
PROV Purchased from J J H J van
Reenen, Bergen, Noord-Holland, 1953
LIT Moes 1897-1905, vol I, nr 1956. C
Hofstede de Groot, OH 19 (1901) p 138.
W Martin, OH 25 (1907) p 13, nr 2.
Kultzen 1954, pp 140, 298, nr 67. Exhib
cat Michael Sweerts, Rotterdam 1958,
nr 42. Plietzsch 1960, p 211, fig 388.
Bloch 1968, p 24

manner of **Michael Sweerts**

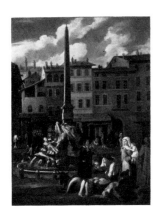

A 3896 Market scene in Rome. *Markt-
tafereel in Rome*

Canvas 65 × 49
PROV Purchased from M L de Boer
gallery, Amsterdam, 1955
LIT J O Kronig, Zeitschr B K 21 (1910) p
45, ill. Kultzen 1954, nr 129 (not
Sweerts). Exhib cat Michael Sweerts,
Rotterdam 1958, nr 58 (not Sweerts)

Swift

see Bisschop-Swift

Maria Machteld van Sypesteyn

see under Miniatures

Pantaleon Szyndler

Warsaw 1846–1905 Warsaw

A 2850 Johann Wilhelm Kaiser (1813-
1900). Graphic artist, director of the
school of graphic arts (1859-75) and of
the Rijksmuseum (1875-83). *Graficus,
directeur van de Graveerschool en van het
Rijksmuseum*

Canvas 69 × 55. Signed *P. Szyndler*
PROV Presented by R A Kaiser,
Amsterdam, 1921

Tadema

see Alma Tadema

F Taupel

active 19th century

A 3499 A monk in a cellar with a glass
in his hand. *Een monnik met een glas in de
hand in een kelder*

Canvas 47 × 34. Signed *F. Taupel*
PROV Bequest of Mrs A C M H Kessler-
Hülsmann, widow of D A J Kessler,
Kapelle op den Bosch near Mechelen,
1947

Kornelis Douwes Teenstra

Ruigezand 1813–1873 Groningen

A 3515 Portrait of Hendrick de Cock
(1801-42), minister in Ulrum, with his
wife, and seven other portraits. *Portret
van de predikant Hendrick de Cock te Ulrum,
met zijn vrouw, en zeven andere portretten*

Panel 30 × 23. Signed *K. D. Teenstra*.
Inscribed on the verso *Hendrick de Cock
(Ulrum) 1834*
PROV Purchased from Mr de Zwart,
Amsterdam, 1948
LIT Van Weerden 1967, frontispiece

Abraham Teerlink

Dordrecht 1776–1857 Rome

A 1144 The Cascata della Marmora near Terni. *De Cascata della Marmora bij Terni*

Pendant to A 1145

Canvas 101.5 × 143. Signed and dated *Teerlink F. Romae 1824*
PROV RVMM, 1885 * DRVK since 1952
LIT G J Hoogewerff, Med Ned Hist Inst Rome 2d ser 3 (1933) p 155, ill. Knoef 1948, p 38. R van Luttervelt, Nap Stud 13 (1961) p 566

A 1145 The waterfall of Tivoli. *De water-val van Tivoli*

Pendant to A 1144

Canvas 101 × 141. Signed and dated *Teerlink F. Romae 1824*
PROV RVMM, 1885
LIT A H L Hensen, Med Ned Hist Inst Rome 2 (1922) p 130. G J Hoogewerff, Med Ned Hist Inst Rome 2d ser 3 (1933) pp 148, 155. Knoef 1948, p 38. R van Luttervelt, Nap Stud 13 (1961) p 566, fig 26. C J de Bruyn Kops, Bull RM 13 (1965) p 68, ill. J Offerhaus, OK 11 (1967) nr 53, ill. Scheen 1969-70, vol 2, fig 127

Henriëtta Christina Temminck

The Hague 1813–1886 The Hague

C 239 Woman selling fruit. *De fruit-verkoopster*

Panel 42 × 35
PROV On loan from the city of Amsterdam (A van der Hoop bequest) since 1885

Leonardus Temminck

see under Miniatures

Abraham Lambertsz van den Tempel

Leeuwarden 1622/23–1672 Amsterdam

C 241 Portrait of a woman. *Portret van een vrouw*

Copy after a painting by Bartholomeus van der Helst in the Museum Boymans-van Beuningen, Rotterdam (cat 1962, nr 1295)

Canvas 76 × 66. Signed and dated *A. v. Tempel ft. 1646*. Inscribed on the verso *Aetatis 50 A 1646*
PROV On loan from the city of Amsterdam (A van der Hoop bequest) since 1885

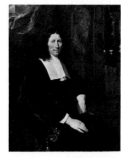 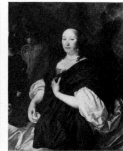

A 2243 Pieter de la Court (1620-85). Manufacturer and trader of linen, initially in Leiden, from 1673 on in Amsterdam, and political pamphleteer. *Fabrikant en lakenreder, eerst te Leiden, sedert 1673 te Amsterdam, politiek pamflettist*

Pendant to A 2244

Canvas 133 × 106. Signed and dated *A. van d. Tempel a° 1667*
PROV Sale De la Court, Amsterdam, 21 Sep 1904, lot 129, ill. Purchased through the intermediacy of the Rembrandt Society
LIT Moes 1897-1905, vol 1, nr 1768:2? F G L O van Kretschmar, Jb Mus Antwerpen, 1966, p 216. Th J Hooning, Spiegel Hist 8 (1973) p 437, ill. C W Fock, OH 87 (1973) p 35, note 25

A 2244 Catharina van der Voort (1622-74). Second wife of Pieter de la Court. *Tweede echtgenote van Pieter de la Court*

Pendant to A 2243

Canvas 133 × 106. Signed and dated *Tempel 1667*
PROV Same as A 2243
LIT Moes 1897-1905, vol 2, nr 8684:2. F G L O van Kretschmar, Jb Mus Antwerpen, 1966, p 216. C W Fock, OH 87 (1973) p 35, note 25

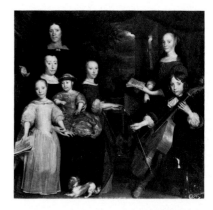

A 1972 David Leeuw (1631/32-1703). Amsterdam merchant with his family. *Koopman te Amsterdam, met zijn gezin*

The other sitters are Leeuw's wife

Cornelia Hooft (1631-1708) with their daughter Suzanna (1669-1726) on her lap. Standing beside her are Cornelia (1662/63-1716) and Weyntje (1659-1728) and opposite her Pieter (1656/57-77) and Maria (1652/53-1721)

Canvas 190 × 200. Signed and dated *A. van d. Tempel 1671*
PROV Presented by J H Willink van Bennebroek, Huize Oud-Poelgeest, Oegstgeest, 1902
LIT P van Eeghen, OH 68 (1953) p 170ff. Bernt 1960-62, vol 3, nr 815. Bernt 1969-70, vol 3, nr 1155. P Fischer, Son Spec 50-51 (1972) p 106

attributed to **Abraham Lambertsz van den Tempel**

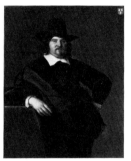

A 589 Abraham de Visscher (1605-67). Amsterdam merchant and director of the Dutch West India Company. *Koopman te Amsterdam en bewindhebber van de West Indische Compagnie*

Pendant to A 397

Canvas 127 × 100
PROV Bequest of Mrs J Balguerie-van Rijswijk, widow of D Balguerie, Amsterdam, 1823
LIT Moes 1897-1905, vol 2, nr 8553:2

A 397 Machteld Bas (d 1681). Wife of Abraham de Visscher. *Echtgenote van Abraham de Visscher*

Pendant to A 589

Canvas 127 × 100. Unfinished. Inscribed on the verso *Deze Machtelt Bas is afgeschildert naa Zij haar man Abraham de Visscher snagts dood naast haar zijde vondt*
PROV Same as A 589
LIT Moes 1897-1905, vol 1, nr 382:2

Jan Tengnagel

Amsterdam 1584/85 – 1635 Amsterdam

C 407 Banquet of seventeen members of the archers' civic guard company of Captain Geurt van Beuningen, Amsterdam, 1613. *Maaltijd van zeventien schutters van de Handboogdoelen onder kapitein Geurt van Beuningen, Amsterdam, 1613*

The sitters are from left to right: (upper row) Hans van der Voort, Jan Cornelisz Meulen, Gerrit Martsz Conijnenburgh, Willem Kik, Heindrik Hogendorp, Cornelis Gerritsz, Laurens Laurensz van Baalen, Cosmo de Moucheron, Pierre de Nimay; (bottom row) Klaas Bisschop, ensign, Geurt Dircksz van Beuningen, captain, Pieter Martsz Hoefijzer, lieutenant, Laurens Jansz van Lier, Heindrick Sybrantsz Voet, Adriaen van Nieulandt, Jan Tengnagel, sergeant, and Aert Keyser

Canvas 155 × 264. Dated *A° 1613*
PROV Handboogdoelen (headquarters of the archers' civic guard), Amsterdam. On loan from the city of Amsterdam since 1885
LIT Scheltema 1879, nr 126 (anonymous). DC Meijer Jr, OH 3 (1885) p 110. J Six, OH 4 (1886) p 92 (attributed to Frans Badens). J Six, OH 15 (1897) p 4 (Jan Tengnagel). Moes 1897-1905, vol 1, nr 587. A Riegl, Jb Kunsth Samml AK 18 (1902) p 178ff. W del Court & J Six, OH 21 (1903) pp 67, 75, 79. H Schneider, OH 39 (1921) pp 14, 26, nr 14, ill. Riegl 1931, pp 152, 282, fig 38. R BF van der Sloot, NKJ 10 (1959) p 114, fig 3. Van Hall 1963, nrs 1517:4, 2064:1. Rosenberg, Slive & Ter Kuile 1966, p 20

David Teniers II

Antwerp 1610 – 1690 Brussels

see also Gijsaerts, Gualterus, A 800 Wreath of flowers encircling a portrait of Hieronymus van Weert

A 398 Guardroom. *Soldatenwacht*

Canvas 61 × 94.5. Signed and dated *D. Teniers F. 1641*
PROV Purchased with the Kabinet van Heteren Gevers, The Hague-Rotterdam, 1809
LIT Moes & van Biema 1909, pp 150, 193. Bille 1961, vol 1, p 109

C 298 Country kermis. *Boerenkermis*

Canvas 78 × 106.5. Signed *D. Teniers. Fec*
PROV On loan from the city of Amsterdam (A van der Hoop bequest) since 1885
LIT Smith 1829-42, vol 3 (1831) p 272, nr 44

C 299 A peasant with his wife and child in front of the farmhouse. *Een boer met zijn vrouw en kind voor de boerderij*

Canvas 65 × 94.5. Signed *D. Teniers. Fec*
PROV On loan from the city of Amsterdam (A van der Hoop bequest) since 1885
LIT Smith 1829-42, vol 3 (1831) p 144. Bille 1961, vol 1, p 73, ill; vol 2, pp 53, 120, nr 219

C 300 The dice shooters. *De dobbelaars*

Panel 45 × 59. Signed *D. Teniers F.*
PROV On loan from the city of Amsterdam (A van der Hoop bequest) since 1885

A 399 Bricklayer smoking a pipe. *De rokende metselaar*

Panel 33 × 29. Signed *D. Teniers Fec.*
PROV Purchased with the Kabinet van Heteren Gevers, The Hague-Rotterdam, 1809
LIT Moes & van Biema 1909, p 150

A 400 The old beer drinker. *De oude bier-drinker*

Panel 35 × 32.5. Signed *DT*
PROV NM, 1808 * On loan to the KKS since 1948
LIT Moes & van Biema 1909, pp 129?, 165, 221

A 401 The temptation of St Anthony. *De verzoeking van de heilige Antonius de Heremiet*

Panel 31 × 23. Signed *D. Teniers*
PROV Sale Amsterdam, 19 July 1809, lot 55
LIT Hoet 1752, vol 2, p 509. Smith 1829-42, vol 3 (1831) p 143. Moes & van Biema 1909, p 214. Bille 1961, vol 1, p 74, ill; vol 2, pp 54, 121, nr 224

manner of **David Teniers II**

A 3226 Peasants dancing. *Dansende boeren*

Panel 46.5 × 63
PROV Bequest of Miss S Th Royer, Neuilly-sur-Seine, 1934

Terborch

see Borch, ter

Terbrugghen

see Brugghen, ter

Gerardus Terlaak

The Hague 1820–1865 Elburg

A 1832 A rich lady visiting a poor family. *Een rijke dame bezoekt een arm huisgezin*

Canvas 82 × 88. Signed and dated *G. Terlaak 1853*
PROV Bequest of Reinhard Baron van Lynden, The Hague, 1899
LIT Brugmans 1970, fig 8. F A M Messing, Spiegel Hist 9 (1974) ill on p 404

Augustin Terwesten II

The Hague 1711 – 1781 The Hague

NO PHOTOGRAPH AVAILABLE

A 2403 Science propelled by time. *De wetenschap voortgestuwd door de tijd*

A female figure with a shining sun in her hand, seated in the clouds and reading a book, is propelled by the flying Saturn, with a scythe in his hands

Canvas 455 × 333. Ceiling painting
PROV From the Vlaardingen post and telegraph agency, 1909 * Given on loan to that agency, but no longer present there

NO PHOTOGRAPH AVAILABLE

A 2404 Allegory of peace. *Allegorie op de vrede*

Canvas 148 × 150. Mantel painting. Signed and dated *A. Terwesten 1741*
PROV Same as A 2403

Mattheus Terwesten

The Hague 1670 – 1757 The Hague

A 4086 Allegory of freedom. *Allegorie op de vrijheid*

Canvas 126 × 105.5. Signed and dated *M : Terwesten f 1701*
PROV Sale Amsterdam, 16 Oct 1962, lot 327

Testas

see Famars Testas

Pierre Henri Théodore Tetar van Elven

Molenbeek 1828 – 1908 Milan

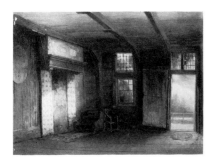

A 4286 Interior of Czar Peter's house, Zaandam. *Interieur van het Tsaar Peterhuisje te Zaandam*

Panel 22 × 29. Signed *Pierre T.v.E.* Signed and dated on the verso *Pierre T. van Elven 1851*
PROV Sale Amsterdam, 13 Nov 1882.
NMGK

Jan Jacob Teyler van Hall

Amsterdam 1794 – 1852 Amsterdam

C 1557 Batestein Castle near Vianen. *Slot Batestein bij Vianen*

Panel 16.5 × 21.3. Signed and dated *J. J. Teyler van Hall 1840*
PROV On loan from the KOG (presented by J Tideman, 1874) since 1973

Nathaniel Thach

see under Miniatures

Domenico Theotokopoulos

see Greco, El

Jan Philip van Thielen

Mechelen 1618 – 1667 Mechelen

A 407 Festoon of flowers encircling a

bust of Flora. *Festoen van bloemen om een buste van Flora*

Canvas 95 × 96. Signed and dated *I. P. Van Thielen F. A^{no} 1665*
PROV Bequest of L Dupper Wzn, Dordrecht, 1870 * DRVK since 1952
LIT Hairs 1955, pp 108, 243. Bernt 1960-62, vol 3, nr 828. Bernt 1969-70, vol 3, nr 1173

Willem Bastiaan Tholen

Amsterdam 1860 – 1931 The Hague

A 3090 A fishing pink on the beach. *Visserspink op het strand*

Panel 24.5 × 18. Signed and dated *WB. Tholen 96*
PROV Bequest of J BAM Westerwoudt, Haarlem, 1907. Received in 1929 *
DRVK since 1964

A 3615 Landing stage. *Landingsplaats*

Canvas 37 × 43. Signed and dated *WB. Tholen 99*
PROV Lent by Mr & Mrs J C J Drucker-Fraser, London, 1919. Bequeathed in 1944 * DRVK since 1953

A 3566 Seascape with fishing boats. *Zee-gezicht met vissersschuiten*

Panel 30 × 50.5. Signed and dated
Tholen '10
PROV Bequest of Mrs M C J Breitner-Jordan, widow of G H Breitner, Zeist, 1948

Theodoor van Thulden

's-Hertogenbosch 1606–1669
's-Hertogenbosch

A 4654 Allegory of William III's leave-taking from Amalia van Solms after the transferral of the regency to the states-general. *Allegorie op het afscheid van Willem III van Amalia van Solms na de overdracht van het regentschap aan de Staten-Generaal*

Canvas 115 × 97. Signed and dated
T. van Thulden Fecit 1661 (unclearly)
PROV Sale Vienna, 12 March 1974, lot 136
LIT R A d'Hulst, Alb Amic J G van Gelder, 1973, p 188, fig 7

attributed to **Pellegrino Tibaldi**

Puria 1527–1596 Milan

A 3955 The visitation, with Sts Jerome and Joseph and other figures. *De ontmoeting van Maria en Elisabeth in aanwezigheid van de heilige Hieronymus, de heilige Jozef en andere personen*

Canvas 76 × 102
PROV Purchased from Arcade gallery, London, 1959

Adolph Tidemand

Mandal 1814–1876 Kristiana

A 1833 The sick child. *Het zieke kind*

Canvas 93 × 114. Signed and dated
A. Tidemand Df. 1851
PROV Bequest of Reinhard Baron van Lynden, The Hague, 1899 * DRVK since 1953

Giovanni Battista Tiepolo

Venice 1696–1770 Madrid

A 2965 Telemachus and Mentor. *Telemachus en Mentor*

Canvas 110 × 72
PROV Purchased in 1922 with aid from the Rembrandt Society, presumably from P Cassirer gallery, Berlin
LIT De Chennevières 1898, p 114. Molmenti 1909, p 259, ill on p 255. Sack 1910, p 216, nr 483, ill on p 217. Venturi 1927, p 399, fig 275. Gedenkboek Ver Rembrandt, 1933, p 112, ill. Exhib cat Tiepolo, Venice 1951, p 60, fig 44. Morassi 1962, p 1, fig 236 (ca 1740-50, fragment). VTTT, 1962-63, nr 53. F W S van Thienen, OK 10 (1966) nr 48, ill. Pallucchini 1968, nr 195, ill

A 3437 Allegorical female figure with a club. *Allegorische vrouwenfiguur met een knots*

Pendant to A 3438. Two other pendants are in a private collection in Zurich and in the Balsan collection, New York

Canvas 81 × 65. Oval. Grisaille on a gold ground
PROV Bequest of J W Edwin vom Rath, Amsterdam, 1941
LIT Waagen 1854-57, vol 4 (1857) p 173. F J B Watson, Burl Mag 94 (1952) p 44, note 10. Morassi 1962, p 1, figs 379-80 (ca 1740-50). Pallucchini 1968, nrs 228 B & C, ill (ca 1755)

A 3438 Allegorical female figure with a shield. *Allegorische vrouwenfiguur met een schild*

Pendant to A 3437

Canvas 81 × 65. Oval. Grisaille on a gold ground
PROV Same as A 3437
LIT *See under* A 3437

A 3985 The vision of St Anne. *Het visioen van de heilige Anna*

Sketch for the altarpiece in the church of Santa Chiara, Cividale, now in the museum in Dresden (nr 580A)

Canvas 49 × 26. Inscribed on the verso *Modello originale d[i Ti]epolo per la tavola dell' altare nel Convento di S. Chiara in Cividale. Comprato della galeria Barlese Tiepolo per lire sessantatre li 23 maggio 1808*
PROV Collection of H W C Tietje, Amsterdam. R van Eyck gallery, The Hague. Lent by the SNK, later DRVK, 1948. Transferred in 1960
LIT Venturi 1900, p 179ff, ill on p 181. Molmenti 1909, p 147. Sack 1910, p 172. H Posse, Zeitschr B K 60 (1926-27) p 194, ill. Morassi 1962, p 1, fig 68 (1759, sketch). Pallucchini 1968, nr 257a, ill

circle of **Giovanni Battista Tiepolo**

A 3434 The flight into Egypt. *De vlucht naar Egypte*

Canvas 68 × 101
PROV Bequest of J W Edwin vom Rath, Amsterdam, 1941
LIT A Morassi, Burl Mag 67 (1935) p 149, pl III b (early work of Giovanni Battista Tiepolo). G Fiocco, Art in America 26 (1938) p 151. A Morassi, Emporium, 1941, p 87. K E Schuurman, Mndbl B K 19 (1942) p 141, fig 4. Morassi 1962, p 1 (not Giovanni Battista but Domenico Tiepolo)

Jacopo Tintoretto

Venice 1518–1594 Venice

A 3439 Christ and the woman in adultery. *Christus en de overspelige vrouw*

Canvas 160 × 225
PROV Bequest of J W Edwin vom Rath, Amsterdam, 1941
LIT Von der Bercken & Mayer 1923, pp 53, 201, fig 16. Berenson 1932, p 557. Coletti 1940, p 18. K E Schuurman, Mndbl B K 19 (1942) p 135, fig 1. Von der Bercken 1942, pp 44, 103, nr 9, fig 30. Tietze 1948, p 546, fig 15. Pallucchini 1950, pp 99, 107ff, fig 165. Camon Aznar 1950, vol 1, p 78, note 1. Berenson 1957, vol 1, p 167. J Maxon, Connoisseur 147-48 (1961) p 254ff (Master of the Corsini Adulteress). C Gould, Journ W C I, 1962, pp 62-63, ill. V T T T, 1962-63, nr 57. De Vecchi 1970, nr 50, ill (ca 1546). Judson 1970, p 41. P de Vecchi, l'Arte 5 (1972) p 105, fig 2

A 3986 & A 3987 The annunciation. *De verkondiging aan Maria*

Canvas 115 × 93 each. Two fragments of

an organ decoration from the church of San Benedetto, Venice
PROV O Lanz, Amsterdam. Lent by the SNK, later DRVK, 1948. Transferred in 1960
LIT Borghini 1584, p 552. Ridolfi 1648 (ed 1924, vol 2, p 17). Boschini 1664, p 123. D von Hadeln, Kunstchronik ns 22 (1910-11) p 337ff. G Swarzenski, München Jb, 1915, p 91, figs 8-9. Von der Bercken & Mayer 1923, vol 1, p 188; vol 2, p 42. Pittaluga 1925, p 261. Venturi 1901-40, vol 9:4 (1930) p 486, fig 338. Berenson 1932, p 557. B Degenhart, Pantheon 27 (1941) p 37. Von der Bercken 1942, p 103, nrs 7-8, fig 142. Tietze 1948, p 346. Berenson 1957, vol 1, p 169, fig 1286. H A van der Berg-Noë, O K 10 (1966) nr 32, ill. De Vecchi 1970, nr 229 C & D, ill (ca 1578)

A 3902 Ottavio Strada (1549/50-1612). Designer of jewelry, miniaturist and archaeologist; son of Jacopo Strada. *Ontwerper voor edelsmeedkunst, miniaturist en oudheidkundige, zoon van Jacopo Strada*

Canvas 128 × 101. Signed *Jac. Tentoret.* Inscribed *Octavius de Strada a Rosber Iac. Fil. Civ. Rom. Rodul. Imp. Nobil. Aulicus Æta XVIII An. Do. MDLXVII*
PROV Purchased from the heirs of D Wolff, The Hague, 1956, through A Nijstad & Zn gallery, The Hague, with monies from the J W Edwin vom Rath Fund
LIT D von Hadeln, Jb Preusz Kunstsamml 41 (1920) p 32. Berenson 1932, p 557. Von der Bercken 1942, nr 5, fig 147. Tietze 1948, p 346 (Tintoretto's daughter Mariette). Berenson 1957, vol 1, p 169, fig 1302. De Vecchi 1970, nr 173, ill. Rossi 1974, pp 58, 96, fig 140

A 4010 Muse with lute. *Muze met luit*

Canvas 119 × 84. Fragment
PROV O Lanz, Amsterdam. Lent by the
DRVK, 1952. Transferred in 1960
LIT D von Hadeln, Zeitschr BK ns 33
(1922) p 97, fig 6. D von Hadeln, Burl
Mag 43 (1923) p 293. Von der Bercken
& Mayer 1923, vol 1, p 247. Pittaluga
1925, p 261. Berenson 1932, p 557. Von
der Bercken 1942, nr 31, fig 334. Tietze
1948, nr 108, ill. Berenson 1957, vol 1,
p 169. De Vecchi 1970, nr E 7, ill
(attributed to Tintoretto)

A 2964 Portrait of a clergyman. *Portret
van een geestelijke*

Canvas 55 × 47
PROV Presented by a group of members
of the Rembrandt Society, 1922
LIT E von der Bercken, Pantheon 4
(1929) p 453. G Gronau, Pantheon 3
(1929) Beiblatt, p LV. Berenson 1932, p
557. Gedenkboek Ver Rembrandt, 1933,
p 108, ill. Von der Bercken 1942, p 103,
nr 4. Berenson 1957, vol 1, p 169. De
Vecchi 1970, nr F 76 (attributed to
Tintoretto). Rossi 1974, p 95, fig 76

attributed to **Jacopo Tintoretto**

A 3440 Portrait of a man. *Portret van een
man*

Canvas 63.5 × 57.5
PROV Bequest of J W Edwin vom Rath,
Amsterdam, 1941
LIT Berenson 1932, p 557. Berenson
1957, vol 1, p 167. Rossi 1974, p 96, fig 75

copy after **Jacopo Tintoretto**

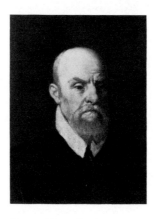

C 1373 Portrait of a man. *Portret van een
man*

Canvas 58 × 45
PROV On loan from the KKS since 1948

Johann Friedrich August Tischbein

Maastricht 1750 – 1812 Heidelberg

see also Governors-general series: A 3785
Willem Arnold Alting – *see also under*
Pastels

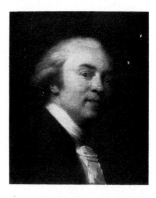

A 2084 Self portrait. *Zelfportret*

Canvas 46 × 38. Signed and dated
Fr. Tischbein se ipse pinxit Ann. 1782
PROV Bequest of A A des Tombe, The
Hague, 1903
LIT W Steenhoff, Bull NOB 4 (1902-03) p
122. Stoll 1923, p 200. Ried 1931, fig 90.
Van Hall 1963, p 329, nr 2091:1

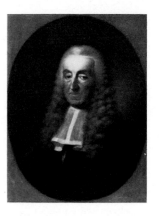

A 1275 Jan van de Poll (1721-1801).
Burgomaster of Amsterdam. *Burge-
meester van Amsterdam*

Canvas 73 × 55. Signed and dated
Tischbein p. 1791
PROV Presented by J S R van de Poll,
Arnhem, 1885

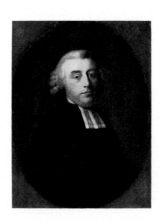

A 2256 Antonius Kuyper (1743-1822).
Amsterdam minister. *Predikant te
Amsterdam*

Canvas 72.5 × 54.5. Signed and dated
Tischbein p. 1791
PROV Bequest of Miss H W Vroom,
Amsterdam, 1907

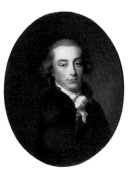

A 2414 Salomon Rendorp (1767-1824).
Amsterdam brewer. *Brouwer te Amsterdam*

Pendant to A 2415

Canvas 68 × 53. Oval. Signed and dated
Tischb. p. 1793. Inscribed on the verso
Salomon Rendorp Anno 1793
PROV Bequest of S Rendorp,
Amsterdam, 1910

A 2415 Johanna Ferdinanda van Collen
(1774-1833). Wife of Salomon Rendorp.
Echtgenote van Salomon Rendorp

Pendant to A 2414

Canvas 68 × 53. Oval. Inscribed on the
verso *Johanna Ferdinanda Rendorp Anno
1793*
PROV Same as A 2414

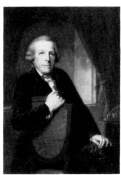

A 2827 Johannes Lublink II (1736-1816).
Philosopher, writer and statesman.
Filosoof, letterkundige en staatsman

Pendant to A 2828

Canvas 101 × 72
PROV Bequest of Mrs M N Th Weddik-
Lublink Weddik, widow of A L Weddik,
Arnhem, 1919

A 2828 Cornelia Rijdenius (b 1746).
Wife of Johannes Lublink. *Echtgenote van
Johannes Lublink*

Pendant to A 2827

Canvas 101 × 72
PROV Same as A 2827

attributed to **Johann Valentin
Tischbein**

Haina 1715 – 1768 Hildburghausen

see also Miniatures: Holland school ca
1750, A 4446 Anne of Hanover, after
Tischbein

A 406 Anne of Hanover (1709-59). Wife
of Prince Willem IV. *Anna van Hannover.
Echtgenote van prins Willem IV*

Canvas 48.5 × 38. Signed and dated
J. Tischbein 1753
PROV Purchased in 1818
LIT Staring 1948, p 108 (Johann
Valentin Tischbein or copy by Johann
Anton Tischbein?)

Tisi

see Garofalo

copy after **Titian (Tiziano Vecellio)**

Reve de Cadore 1474/82 – 1576 Venice

see also Pastels: Liotard, Jean-Etienne,
A 1194 Sleeping nymph spied on by
satyrs, after Titian

A 595 The penitent Mary Magdalene.
De boetvaardige Maria Magdalena

Copy after the original in the Hermitage,
Leningrad (cat 1958, vol 1, nr 117)

Canvas 114 × 97
PROV NM, 1808
LIT Moes & van Biema 1909, pp 76, 213

A 475 Francis I (1494-1547), king of
France. *Frans I, koning van Frankrijk*

Copy by Benjamin Wolff (1758-1825)
after the original in the Louvre, Paris
(cat 1926, nr 1588)

Canvas 118 × 90. Signed *B. Wolff fec.
après le Titien à Paris, 1809*
PROV Bequest of the artist, Amsterdam,
1825

school of **Titian**

A 3441 St Dominic. *De heilige Dominicus*

Canvas 94.5 × 77.5
PROV Bequest of J W Edwin vom Rath, Amsterdam, 1941

Louis Tocqué

Paris 1696–1772 Paris

A 3904 Isaac van Rijneveld (1706-92). Jeweler, partner in the firm Jan van Rijneveld & Sons. *Juwelier, firmant van het handelshuis Jan van Rijneveld en Zoonen*

Pendant to A 3905

Canvas 92 × 73.5
PROV Purchased from Jonkheer H J L Th van Theineck Leyssius, Voorburg, 1956
LIT Staring 1947, p 20. A Staring, Bull Soc Hist Art Fr, 1956, p 33. A Staring, Bull RM 5 (1957) p 11. A Staring, OH 74 (1959) p 225

A 3905 Arnoldus van Rijneveld (1715-98). Jeweler, brother of Isaac van Rijneveld. *Juwelier, broer van Isaac van Rijneveld*

Pendant to A 3904

Canvas 91.5 × 72. Signed and dated *L. Tocqué pinxit 173.*
PROV Purchased from Mrs Buma-Geisweit van der Netten, Doorn, 1956
LIT *See under* A 3904

Dominicus van Tol

Bodegraven ca 1635–1676 Leiden

see also Dou, Gerard, C 243 A mother giving her child the breast, copy by van Tol

C 21 An officer of the Leiden civic guard in front of the gate of the headquarters of the St George guards. *Een officier van de Leidse schutterij voor de poort van de Sint Jorisdoelen*

Panel 39 × 32. Signed and dated *D.V.Tol 1673*
PROV On loan from the city of Amsterdam (Bicker bequest) since 1881

A 2341 Interior with a man reading and a woman spinning yarn. *Binnenhuis met lezende man en haspelende vrouw*

Panel 53 × 42. Signed *D.V. Tol*
PROV Purchased from the heirs of Jonkheer P H Six van Vromade, Amsterdam, 1908

A 417 Children with a mousetrap. *Kinderen met een muizeval*

Panel 31 × 25. Signed *D.V. Tol*
PROV Purchased with the Kabinet van Heteren Gevers, The Hague-Rotterdam, 1809
LIT Moes & van Biema 1909, pp 150, 194. Bille 1961, vol 1, p 109

Jan Bedijs Tom

Boskoop 1813–1894 Leiden

A 1146 Sheep on the heath. *Schapen op de heide*

Panel 75 × 107.5. Signed and dated *JB Tom 1866*
PROV Purchased at exhib The Hague 1866, nr 359. RVMM, 1885 * DRVK since 1951

Jacob Toorenvliet

Leiden 1635/36–1719 Leiden

A 2254 Carel Quina (1620-89). Knight of the Holy Sepulchre, Amsterdam-born explorer of Asia. *Ridder van het Heilige Graf, Amsterdams reiziger naar Azië*

Copper 40 ×31. Signed and dated *JToorenvliet Fecit Anno 1669*. Inscribed on the insignia of the Order of the Holy Sepulchre *Betlehem* and *Jerusalem*
PROV Sale Mrs Cock Blomhoff-van de Poll, Amersfoort, 23 July 1907, lot 595

A 1978 The music lesson. *De muziekles*

Panel 27 ×20. Signed *J. Toornvliet f.*
PROV From the G de Clercq collection, Amsterdam. Taken over from the Rembrandt Society, 1899
LIT Bernt 1969-70, vol 3, nr 1187

Jean Theodoor (Jan) Toorop

Purworejo 1858–1928 The Hague

see also under Aquarelles and drawings

A 4226 The sea. *De zee*

Canvas 86 ×96. Signed and dated *J. Toorop 1887*
PROV Presented by Miss I Lohr, Basel, 1973, in memory of her father Herman Lohr
LIT CJ de Bruyn Kops, Bull RM 22 (1974) pp 34, 38, fig 18

A 3349 The seashell gatherer. *De schelpenvisser*

Canvas on panel 31.5 ×49.5. Signed and dated *J. Th. Toorop 1904 Domburg*
PROV Presented by Mr & Mrs DAJ Kessler-Hülsmann, Kapelle op den Bosch near Mechelen, 1940

A 3616 Women beside the sea. *Vrouwen aan zee*

Board 36 ×46. Signed *Jan Toorop*
PROV Lent by Mr & Mrs JCJ Drucker-Fraser, 1919. Bequeathed in 1944

Torrentius *born* **Jan Simonsz van der Beeck**

Amsterdam 1589–1644 Amsterdam

A 2813 Emblematic still life with flagon, glass, jug and bridle. *Emblematisch stilleven met kan, glas, kruik en breidel*

Panel 52 ×50.5. Round. Signed and dated *T. 1614*. Inscribed *ER* † [Eques Rosae Crucis] *Wat bu-ter maat be-staat, int on-maats qaat ver-ghaat*
PROV Purchased from the Sachse family, Enschede, 1918, with aid from the Rembrandt Society
LIT Bredius 1909. W Steenhoff, Onze Kunst 27 (1915) p 98, ill. BWF van Riemsdijk, in Feestbundel Bredius, 1915, pp 243-49. A Bredius, OH 35 (1917) p 219. A Bredius, Deutsche Rundschau, 1925, pp 35-52. Vorenkamp 1933, p 30. De Wild 1934. Martin 1935-36, vol 1, pp 413-14, fig 247. J LAAM van Rijckevorsel, Hist Tijdschr 14 (1935) pp 323-30. Würtenberger 1937, p 56. Rehorst 1939, pp 73-80, fig 2. JG van Gelder, OH 57 (1940) pp 140, 142. A Heppner, OH 57 (1940) pp 173, 180. Van Luttervelt 1947, pp 20, 31-32, fig 15. Bergström 1947, p 172. Bergström 1956, pp 165, 308, note 49. Bauch 1960, p 25, fig 13. Bernt 1960-62, vol 3, nr 839. H Schwarz, Pantheon 24 (1966) p 177, fig 12. AG van der Steur, Spiegel Hist 2 (1967) p 217ff, ill. Bauch 1967, p 70, fig 11. E de Jongh, OK 11 (1967) nr 29, ill. De Jongh 1967, pp 6, 59, fig 41. Slive 1970, vol 1, p 77, fig 50. Bernt 1969-70, vol 3, nr 1189. O Millar, in exhib cat Dutch pictures from the Royal Collection, London 1971-72, p 12, note 12. P Fischer, Son Spec 50-51 (1972) pp 75-86

de la Tour

see La Tour, de

Pierre Joseph Toussaint

Brussels 1822–1888 Brussels

A 1834 The young painter. *De jonge schilder*

Panel 25.5 × 21. Signed *P. J. Toussaint*
PROV Bequest of Reinhard Baron van Lynden, The Hague, 1899

Henri Toutin

see under Miniatures

Francesco Tozelli

see under Pastels

Jan Jansz Treck

Amsterdam ca 1606–1652 Amsterdam

A 2222 Still life with stoneware jug. *Stil-leven met kruik van steengoed*

Panel 49.5 × 37. Signed and dated *J Treck 1647*
PROV Sale Amsterdam, 3-5 April 1906, lot 977
LIT BWF van Riemsdijk, Bull NOB 7 (1906) p 177. Vorenkamp 1933, p 44. P

de Boer, OH 57 (1940) p 59. Vroom 1945, p 161, nr 264, fig 141. Bergström 1956, p 152. Bol 1969, p 76, fig 64

Tricot

see Fricot

Hendrik Albert van Trigt

Dordrecht 1829–1899 Heiloo

A 1147 Catechism in the Lutheran Church of Vik on Sogne Fjord, Norway. *Godsdienstonderwijs in de Lutherse kerk te Vik, Sogne Fjord, Noorwegen*

Canvas 75 × 102. Signed and dated *H. A. v. Trigt ft 1866*
PROV Purchased at exhib The Hague 1866, nr 365. RVMM, 1885 * DRVK since 1953

Cornelis Troost

Amsterdam 1696–1750 Amsterdam

see also under Pastels

A 418 Self portrait. *Zelfportret*

Copper 12.5 × 10. Oval
PROV Sale J I de Neufville Brants, Amsterdam, 23 March 1829, lot 42
LIT VerHuell 1873, p 77. Moes 1897-1905, vol 2, nr 8099:4. Knoef 1947, fig 2.

Van Hall 1963, p 334, nr 2106:5. Th van Velzen, OKtv 3 (1965) nr 6, fig 1. SAC Dudok van Heel, Jb Amstelodamum 65 (1973) ill on p 96. Niemeijer 1973, pp 83, 100, cat nr 1, ill

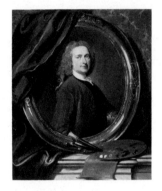

A 4225 Self portrait. *Zelfportret*

Canvas 103 × 83. Signed and dated *C. Troost ipse fecit 1739*
PROV Purchased from E Speelman gallery, London, 1973, as a gift of the Rembrandt Society, the Prince Bernhard Foundation and the Photo Commission
LIT Niemeijer 1973, cat nr 5, ill. CJ de Bruyn Kops, Bull RM 22 (1974) pp 20, 37, fig 4

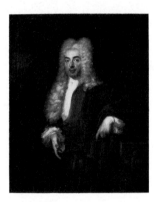

A 1439 Portrait of a man. *Portret van een man*

Canvas 63 × 50. Signed and dated *C. Troost 1723*
PROV Presented from the estate of J L de Bruyn Kops, The Hague, 1888
LIT Knoef 1947, pp 3, 16, ill. Niemeijer 1973, p 13, fig 2, cat nr 162

A 1635 The inspectors of the Collegium Medicum, Amsterdam, 1724. *De inspecteurs van het Collegium Medicum te Amsterdam, 1724*

Canvas 40 × 49. Modello for C 396
PROV Purchased from F Kleinberger gallery, Paris, 1895
LIT Niemeijer 1973, p 21, cat nr 139, ill

C 396 The inspectors of the Collegium Medicum, Amsterdam, 1724. *De inspecteurs van het Collegium Medicum te Amsterdam, 1724*

The sitters are from left to right: Hendrik van Bronkhorst, deacon, Jeronimo de Bosch, apothecary, Daniël van Buren, physician, Martinus Haesbaert, apothecary, Casparus Commelin, physician, and Joost ter Pelkwijk, guild steward

Canvas 245 × 315. Signed *C. Troost*
PROV On loan from the city of Amsterdam, 1885-1975
LIT Van Gool 1750-51, vol 2, pp 243, 254-58. Wagenaar 1760-88, vol 2 (1765) p 381; vol 3, p 268. VerHuell 1873, p 78. C Vosmaer, Zeitschr BK 8 (1873) p 21. Scheltema 1879, p 40, nr 106. Bredius 1887-88, p 85, ill. Moes 1897-1905, vol 1, nrs 936:1, 1154, 1242, 1660, 3099; vol 2, nr 5831. Scheen 1946, fig 3. Knoef 1947, pp 5, 16. Gerson 1961, p 8. Th van Velzen, OKtv 3 (1965) nr 6, ill. Rosenberg, Slive & Ter Kuile 1966, p 213. Haak 1972, pp 29, 32, fig 38. Niemeijer 1973, pp 12, 20-23, 53, 116, cat nr 138

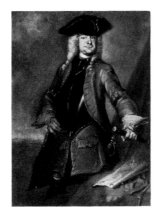

A 3933 Gerrit Sichterman (1688-1730). Quartermaster-general of the cavalry, colonel of the Oranje-Groningen infantry regiment, commander of Grave. *Generaal kwartiermeester der cavalerie, kolonel van het regiment infanterie Oranje-Groningen, commandant van Grave*

Paper on panel 38 × 31. Study for A 4200. Signed *C. Troost*. Inscribed on the verso *Gerrit Sichterman, Generaele Quartiermeester van H. Hoogmogenden Cavallerie. Collonel van een Regement Infanterie, broer van Jan Albert*
PROV Purchased from Old Masters gallery, London, 1958
LIT Niemeijer 1973, cat nr 72, ill. C J de Bruyn Kops, Bull RM 22 (1974) p 18

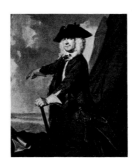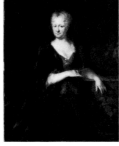

A 4200 Gerrit Sichterman (1688-1730). Quartermaster-general of the cavalry, colonel of the Oranje-Groningen infantry regiment, commander of Grave. *Generaal kwartiermeester der cavalerie, kolonel van het regiment infanterie Oranje-Groningen, commandant van Grave*

Pendant to A 4201

Canvas 69.5 × 56.5. Signed and dated *C. Troost 1725*. Inscribed on the verso *Gerrit Sichterman C. Troost Ft.*
PROV Sale Thomassen à Thuessink van der Hoop van Slochteren (Slochteren), Amsterdam, 10 May 1971, lot 272a. Purchased as a gift of the Photo Commission
LIT Moes 1897-1905, vol 2, nr 7187:2. Ozinga 1940, p 144. Niemeijer 1973, p 111, cat nr 126, color ill opp p 200. C J de Bruyn Kops, Bull RM 22 (1974) pp 18, 37, fig 2

A 4201 Louise Christina Trip (d 1733). Wife of Gerrit Sichterman. *Echtgenote van Gerrit Sichterman*

Pendant to A 4200

Canvas 69.5 × 56.5. Signed and dated *C. Troost 1725*. Inscribed on the verso *Louisa Christina Sichterman geb. Trip C. Troost ft.*
PROV Sale Thomassen à Thuessink van der Hoop van Slochteren (Slochteren), Amsterdam, 10 May 1971, lot 272b. Purchased as a gift of the Photo Commission
LIT Moes 1897-1905, vol 2, nr 8073:1. Ozinga 1940, p 144. Niemeijer 1973, p 111, cat nr 127, ill on p 199. C J de Bruyn Kops, Bull RM 22 (1974) pp 18, 37, fig 1

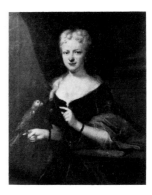

A 2078 Maria Magdalena Stavenisse (1700-83). Wife of Jacob de Witte van Elkerzee, councillor of Zierikzee. *Echtgenote van Jacob de Witte van Elkerzee, raad van Zierikzee*

see also Heraldic objects: A 936

Canvas 56 × 45. Signed and dated *C. Troost 1726*
PROV Bequest of Jonkheer J de Witte van Citters, The Hague, 1876. Received in 1903 * On loan to the municipality of Velsen (Beeckestijn Estate) since 1969
LIT Moes 1897-1905, vol 2, nr 7517. Niemeijer 1973, p 111, cat nr 74, ill

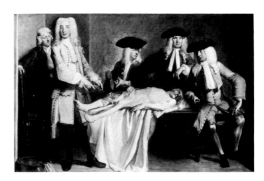

C 79 The anatomy lesson of Professor Willem Röell, 1728. *De anatomische les van professor Willem Röell, 1728*

The sitters are Dr Willem Röell (1700-75), Theodorus van Brederode, Anthonie Milaan, Bernardus van Vijve and Pieter Clevering, guild steward

Canvas 200 × 310. Signed and dated *Cornelis Troost inventor et fecit 1728.* Marked *X*
PROV On loan from the city of Amsterdam, 1885-1975
LIT Van Gool 1750-51, vol 2, p 244. Immerzeel 1842-43, vol 3, p 144. G Gosschalk, Ned Spec, 1864, p 61. Tilanus 1865, nr x, p 47. VerHuell 1873, p 78. C Vosmaer, Zeitschr BK 8 (1973) p 21. Moes 1897-1905, vol 1, nr 1572; vol 2, nrs 5072, 6470:2, 8782. B W Th Nuyens, Jaarversl KOG 70 (1928) p 40, fig 19. Laignel-Lavastine & Guégau 1936-49, vol 2 (1938) p 440, ill. Wegner 1939, p 59. Knoef 1947, pp 5, 17-18, ill. Holländer 1950, p 74, fig 48. A M Cetto, Ciba 9 (1961) pp 70-73, fig 1. Gerson 1961, p 8. Wolf-Heidegger & Cetto 1967, p 327, nr 274. Haak 1972, p 47, figs 60, 60a. Niemeijer 1973, pp 23-27, cat nr 145, ill

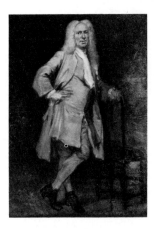

A 2158 Jan Lepeltak. Amsterdam lumber merchant, regent of the almoners' orphanage. *Houtkoper te Amsterdam, regent van het Aalmoezeniersweeshuis*

Paper on panel 58 × 43. Study for C 87
PROV Presented by H Lepeltak Kieft, Brummen, 1905, from the estate of his father, J Lepeltak Kieft
LIT Knoef 1947, p 18. VTTT, 1961-62, nr 48. Niemeijer 1973, p 29, cat nr 58

C 411 The regents of the almoners' orphanage, Amsterdam, 1729. *De regenten van het Aalmoezeniersweeshuis te Amsterdam, 1729*

Canvas 92.5 × 114. Modello for C 87
PROV Regents' chamber, Aalmoeze-niersweeshuis (almoners' orphanage), Amsterdam. On loan from the city of Amsterdam since 1885
LIT Knoef 1947, p 18. H E van Gelder, in Kunstgesch der Ned, 1954-56, vol 2, p 306, fig 7. VTTT, 1961-62, nr 48. Th van Velzen, OKTV 3 (1965) nr 6, fig 2. Niemeijer 1973, p 29, fig 5, cat nr 141

C 87 The regents of the almoners' orphanage, Amsterdam, 1729. *De regenten van het Aalmoezeniersweeshuis te Amsterdam, 1729*

The sitters are C van Westerhoff, Jan Lepeltak, standing to the left, Theodoor Rogge, L de Bas, J van Vliet, C Commelin II, W Swarth, in the middle, behind the table, Ph Schrijver, A van Bogaerde, bailiff, and J Capiteyn, book-keeper

Canvas 414 × 417. Signed and dated *C. Troost inventor et fecit 1729.* The names of the sitters are inscribed on a sheet of paper to the left
PROV Regents' chamber, Aalmoezeniersweeshuis (almoners' orphanage), Amsterdam. On loan from the city of Amsterdam since 1885
LIT Van Gool 1750-51, vol 2, p 244. Wagenaar 1760-88, vol 2 (1765) p 289; vol 3, p 268. VerHuell 1873, p 77. Scheltema 1879, nr 105. Moes 1897-1905, vol 1, nrs 385, 810, 4087; vol 2, nrs 4433, 6482, 7053, 7728, 8612, 9009. Knoef 1947, pp 18-20. VTTT, 1961-62, nr 48. Th van Velzen, OKTV 3 (1965) nr 6, fig 4. Rosenberg, Slive & Ter Kuile 1966, p 213. Niemeijer 1973, pp 14, 28-30, cat nr 140, ill on pp 206-07

C 80 Three governors of the surgeons' guild, Amsterdam, 1731. *Drie overlieden van het Chirurgijnsgilde te Amsterdam, 1731*

The sitters are from left to right: Isaac Hartman, Elias Huyzer and Adriaan Verduyn

Canvas 153 × 187. Signed and dated *C. Troost 1731.* Marked *XI*
PROV On loan from the city of Amsterdam, 1885-1975
LIT Wagenaar 1760-88, vol 3, p 268. G Gosschalk, Ned Spec, 1864, p 61. Tilanus 1865, nr xi. C Vosmaer, Zeitschr BK 8 (1873) p 21. VerHuell 1873, p 78. Moes 1897-1905, vol 1, nrs 3243, 3909; vol 2, nr 8370. Knoef 1947, p 6. Scheen 1969-70, vol 2, fig 11. Niemeijer 1973, pp 26-27, 30, cat nr 147, ill

A 2342 Hermanus Boerhaave (1668-1738). Physician, professor at the university of Leiden. *Geneeskundige, hoogleraar aan de universiteit te Leiden*

Canvas 90 × 70. Signed and dated *C. Troost 1735*
PROV Purchased from the heirs of Jonkheer P H Six van Vromade, Amsterdam, 1908 * On loan to the Rijksmuseum voor de Geschiedenis der Natuurwetenschappen, Leiden, since 1955
LIT Moes 1897-1905, vol 1, nr 798:1. Knoef 1947, p 21, ill on p 12. Lindeboom 1963, pp 7, 23, nr 3, pl IX. Niemeijer 1973, cat nr 21, ill

A 1608 Isaac Sweers (1707-77). High bailiff of Amsterdam and director of the Dutch East India Company. *Hoofd-schout van Amsterdam en bewindhebber van de Verenigde Oostindische Compagnie*

Canvas 59 × 47. Signed and dated
C. Troost 17..
PROV Bequest of Miss H A van Heukelom, Amsterdam, 1894
LIT Moes 1897-1905, vol 2, nr 7751. Knoef 1947, p 20, ill on p 8. Niemeijer 1973, p 14, cat nr 75, ill (ca 1735)

A 3948 Portrait of a music lover, perhaps Johannes van der Mersch (1707-73). *Portret van een muziekliefhebber, misschien Johannes van der Mersch*

Panel 72 × 57. Signed and dated
C. Troost 1736
PROV Purchased from E Speelman gallery, London, 1958
LIT Niemeijer 1973, p 14, cat nr 63, ill on p 179

A 719 Alexander the Great in the battle of the Granicus against the Persians. *Alexander de Grote in de slag tegen de Perzen bij de Granikos*

Canvas 110 × 132.5. Signed and dated
C. Troost 1737
PROV Bequest of Jonkheer J S H van de Poll, Amsterdam, 1880
LIT V de Stuers, Ned Kunstbode 2 (1880) p 245. Knoef 1947, pp 42-44, ill on p 48. Mercier & Vermeule, nd, p 58, color ill. Niemeijer 1973, pp 57-58, cat nr 490, ill. E de Jongh, Simiolus 6 (1972-73) p 78

A 3453 Family around the clavichord. *Familiegroep bij een clavecimbel*

Canvas 94 × 82.5. Signed and dated
C. Troost 1739
PROV Purchased from H M Wezelaar, Laren, 1942
LIT Staring 1956, p 112, ill. Knipping 1966, p 298, fig 541. Praz 1971, p 66. Niemeijer 1973, p 75, cat nr 237, ill on pp 229-30

C 1473 Four regents and the housemaster of the Oude Zijds institute for the outdoor relief of the poor, Amsterdam, 1740. *Vier regenten en de binnenvader van het Oude Zijds Huiszittenhuis te Amsterdam, 1740*

The sitters are Daniel van der Lip Michielsz, Jan van Marselis, Wybrand Wiltens and the housemaster de Somville

Canvas 175 × 184. Signed and dated
C. Troost 1740

PROV On loan from the city of Amsterdam, ca 1946-75
LIT Van Gool 1750-51, vol 2, p 244. Wagenaar 1760-88, vol 2 (1765) p 264; vol 3, p 268. VerHuell 1873, p 77. Voorl Lijst v Mon 5-2 (1928) p 30. Oldewelt 1942, pp 17-18. Niemeijer 1973, p 30, cat nr 149, ill

A 4209 'The spendthrift': act 3, scene 5 of Thomas Asselijn's play of 1693 of the same name. *De 'Spilpenning,' 3de bedrijf, 5de toneel uit het gelijknamige toneelstuk van Thomas Asselijn*

Panel 68.5 × 86. Signed and dated
C. Troost 1741
PROV Lent by Ch P H Ras, Leiden, 1909-13. Presented by Mr Leopold Siemens and Mrs Leopold Siemens-Ruyter, widow of Ch P H Ras, in memory of G H G Ras (1914-44), Amsterdam, 1954. Received in 1971
LIT Van Gool 1750-51, vol 2, pp 245-46. A Staring, in Deshairs, vol 2, p 142, ill. Gans 1971, p 178, ill on p 177. Editorial, Apollo 96 (1972) p 384, fig 18. Niemeijer 1973, p 109, cat nr 428, ill on p 280-81 (detail). C J de Bruyn Kops, Bull R M 22 (1974) pp 19, 37, fig 3

A 4023 The inspection of a cavalry regiment, perhaps by William of Hesse-Homburg. *Inspectie van een regiment cavalerie, wellicht door Willem van Hessen-Homburg*

Canvas 47.5 × 66. Signed and dated
C. Troost 1742
PROV Purchased from G Ryaux gallery, Paris, 1960
LIT R van Luttervelt, Versl der Rijksverz

van Gesch en Kunst 82 (1960) p 27, ill (Willem IV inspecting the cavalry). Niemeijer 1973, pp 75-76, 94, fig 29, cat nr 785

A 4115 Couple making music. *Musicerend paar*

Panel 49 × 68. Signed and dated *C. Troost 1743*
PROV Purchased from Schaeffer gallery, New York, 1965
LIT Bull RM 13 (1965) p 129, fig 2. J W Niemeijer, OH 71 (1966) p 36, fig 10. Niemeijer 1973, p 14, cat nr 235, ill

A 2191 Ludolf Bakhuysen II (1717-82). Painter and soldier, grandson of the seascape painter Ludolf Bakhuysen I. *Schilder en militair, kleinzoon van de zeeschilder Ludolf Bakhuysen I*

Paper on panel 21 × 15
PROV Bequest of Miss M E van den Brink, Velp, 1905 (as a self portrait of Ludolf Bakhuysen II)
LIT J W Niemeijer, Bull RM 10 (1962) p 147, fig 4. Van Hall 1963, p 12, nr 69:2. J W Niemeijer, Apollo 96 (1972) p 389, fig 4. Niemeijer 1973, cat nr 18, ill on p 160

A 2576 An Amsterdam house garden. *Een Amsterdamse stadstuin*

Canvas 66 × 56. Signed *C. Troost*
PROV Lent by C Hoogendijk, The Hague, 1907. Presented from his estate in 1912
LIT VerHuell 1873, p 106, nr 44. R Bangel, Cicerone 7 (1905) p 186. Knoef 1947, pp 39, 43, ill. Gerson 1961, p 9, fig 1. P J J van Thiel, OK 15 (1972) nr 22, ill. Niemeijer 1973, cat nr 691, ill on p 353

A 4099 'The inappropriate passion': perhaps the widower Joost visiting Lucia, in act 2 of C J van der Lijn's play of the same name. *'De wanhebbelijke liefde,' misschien de scène van de weduwnaar Joost bij Lucia, 2de toneel uit het gelijknamige stuk van C J van der Lijn*

Panel 45.4 × 33.6. Signed *C. Troost*
PROV Purchased from Nijstad gallery, The Hague, 1964
LIT VerHuell 1873, p 106. Bull RM 13 (1965) p 130, fig 3. Niemeijer 1973, p 100, cat nr 445

A 4089 'The dupes': the ambassador of the Labberlotten showing himself at the window of the Bokki Inn in the Haarlem woods. *'De misleyden': de ambassadeur der Labberlotten vertoont zich voor het venster van de herberg 't Bokki in de Haarlemmerhout*

Canvas 157 × 104
PROV Purchased from Clifford Duits gallery, London, 1963 * On loan to the municipality of Velsen (Beeckestijn Estate) since 1969
LIT Navorscher, 1856, p 390. VerHuell 1873, pp 28, 60. Niemeijer 1973, pp 83-85, cat nr 892, ill

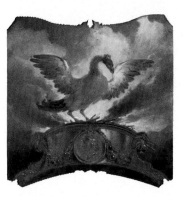

A 4287 The phoenix. *De vogel Phoenix*

Canvas 112 × 114. Dessus-de-porte? Ends in a convex arch below
PROV Uncertain. Possibly identical with a painting from the East India House, Amsterdam, that came to the RMA in 1876 through the ministry of the colonies, The Hague (NM 2863)
LIT Niemeijer 1973, cat nr 550, ill

Sara Troost

see under Pastels

Willem Troost

Arnhem 1812 – 1893 Barneveld

A 4024 The garden façade of Buitenzorg Palace, Batavia, before the earthquake of 10 October 1834. *De achterzijde van het Paleis Buitenzorg te Batavia vóór de aardbeving van 10 october 1834*

Pendant to A 4025

Canvas 52.5 × 77.5
PROV Presented by F E Knoote, Bussum, 1960
LIT De Loos-Haaxman 1972, p 95, fig 8 (after a drawing by Captain de Salis)

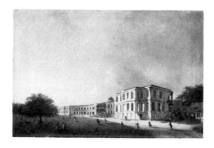

A 4025 The façade of Buitenzorg Palace, Batavia, after the earthquake of 10 October 1834. *De voorzijde van het Paleis Buitenzorg te Batavia na de aardbeving van 10 october 1834*

Pendant to A 4024

Canvas 52 × 77. Signed *W. Troost fec.*
PROV Same as A 4024
LIT De Loos-Haaxman 1972, p 100, fig 38 (after a drawing by Captain de Salis)

Wouter Johannes van Troostwijk

Amsterdam 1782 – 1810 Amsterdam

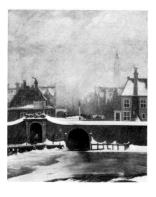

C 1535 The Raampoortje, Amsterdam. *Het Raampoortje te Amsterdam*

Canvas 57 × 48. Signed and dated *W. J. van Troostwijk 1809*
PROV On loan from the KOG (presented by J J C Biesmans Simons) since 1902
LIT W Steenhoff, Mndbl BK 5 (1928) p 41, ill. M H Bottenheim, in Gedenkboek KOG, 1933, p 223. Knoef 1943, pp 128, 265, ill on p 133. S J Gudlaugsson, OK 2 (1958) nr 33, ill. VTTT, 1958, nr 1. Van Gelder 1959, p 18, fig 125. Gerson 1961, p 20. Rosenberg, Slive & Ter Kuile 1966, p 218, fig 176B. S J Gudlaugsson, NKJ 21 (1970) p 373, note 2. Novotny 1970, p 139, fig 80

A 1168 A farm on the bank of a stream in Gelderland. *Een bouwhoeve aan de oever van een beek in Gelderland*

Canvas 52.5 × 63
PROV Sale W J van Troostwijk, Amsterdam, 18 March 1875, lot 14? RVMM, 1885
LIT Marius 1920, p 61, fig 27. Huebner 1942, fig 50. Knoef 1943, p 128, ill on p 130. Knoef 1948, p 27, ill. Gerson 1961, p 15, fig 32. AB de Vries, OKTV 1 (1963) nr 15, fig 7. Zeitler 1966, p 228, fig 139b. S J Gudlaugsson, NKJ 21 (1970) pp 373, 375, notes 2, 8

A 1169 A farm in Gelderland. *Een bouwhoeve in Gelderland*

Canvas on panel 45 × 40
PROV Sale W J van Troostwijk, Amsterdam, 18 March 1875, lot 16. RVMM, 1885
LIT Marius 1920, p 61. S J Gudlaugsson, NKJ 21 (1970) p 373, notes 2, 8

Constant Troyon

Sèvres 1810 – 1865 Paris

see also under Aquarelles and drawings

A 1900 View on the beach, with capstans. *Strandgezicht met kaapstanders*

Panel 36 × 47. Signed *C. Troyon*
PROV Presented by the dowager of R Baron van Lynden, née M C Baroness van Pallandt, The Hague, 1900

Alessandro Turchi

Verona 1578 – 1649 Rome

C 1372 Allegory of the power of love (Omnia Vincit Amor). *Allegorie op de macht van Amor*

Canvas 100 × 123
PROV Kabinet Willem v, The Hague, 1795. On loan from the KKS since 1948
LIT Hoet 1752, vol 1, p 150, nr 14 (Alexander Veronese). J G van Gelder, OH 86 (1971) p 214, note 54 (drawn copy by Jan de Bisschop)

Ubertini

see Bacchiacca

H Udemans

see Panpoeticon Batavum: A 4572
Cornelis Udemans, by Jan Maurits
Quinkhard after H Udemans

Jacob van der Ulft

Gorkum 1627–1689 Noordwijk

A 420 Italian city view. *Italiaans stads-
gezicht*

Pendant to A 419

Panel 12.5 × 20. Signed *J. v. Ulft*
PROV Purchased with the Kabinet van
Heteren Gevers, The Hague-Rotterdam,
1809
LIT Hoet 1752, vol 2, p 460. Moes & van
Biema 1909, p 150

A 419 Italian harbor view. *Italiaans
havengezicht*

Pendant to A 420

Panel 12.5 × 20. Signed *J. v. Ulft*
PROV Same as A 420
LIT *See under* A 420

A 720 Italian marketplace. *Italiaans
marktplein*

Canvas 41 × 38. Signed *v.d. Ulft ft.*
PROV Bequest of Jonkheer J S H van de
Poll, Amsterdam, 1880
LIT V de Stuers, Ned Kunstbode 2
(1880) p 244

attributed to **Jacob van der Ulft**

A 1916 The Dam, Amsterdam, with the
new town hall under construction. *De
Dam te Amsterdam met het nieuwe stadhuis in
aanbouw*

Canvas 81 × 100
PROV Presented by an unknown donor,
1900 * Lent to the AHM, 1975
LIT C Hofstede de Groot, OH 22 (1904) p
114 (attributed to Anthonie
Beerstraaten). Martin 1935-36, vol 2, p
394 (Johannes Lingelbach). Swillens
1961, p 217, note 570, ill (Lingelbach)

Harmanus Uppink

Amsterdam 1765–1791 Amsterdam

A 2293 Still life with flowers. *Stilleven met
bloemen*

Canvas 72 × 59.5. Signed and dated
Hs. Uppink 1789
PROV Lent by J B A M Westerwoudt,
Haarlem, 1902. Bequeathed in 1907
LIT Scheen 1946, fig 163. Exhib cat
Boeket in Willet, Amsterdam 1970, nr
38, ill. Mitchell 1973, p 248, fig 359

Willem Uppink

Amsterdam 1767–1849 Amsterdam

A 3055 Portrait of a painter, presumably
the artist himself. *Portret van een schilder,
vermoedelijk de kunstenaar zelf*

Pendant to A 3056

Panel 25 × 20. Signed and dated
Wm Uppink 1788
PROV Presented by W Mumm, Bussum,
1927, from the estate of Miss H J Uppink
LIT J Knoef, OH 53 (1936) pp 2-3, fig 1.
Van Hall 1963, p 336, nr 2116:1

A 3056 Portrait of a painter, presumably
Harmanus Uppink (1765-91). *Portret van
een schilder, vermoedelijk Harmanus Uppink*

Pendant to A 3055

Panel 25.5 × 20
PROV Same as A 3055
LIT J Knoef, OH 53 (1936) p 2. Van Hall
1963, p 336, nr 2115:1

A 3057 Portrait of a woman. *Portret van een vrouw*

Panel 33 × 29. Signed and dated
Wm. Uppink 1833
PROV Presented by W Mumm, Bussum, 1927, from the estate of Miss H J Uppink
LIT J Knoef, OH 53 (1936) p 3

Adriaen van Utrecht

Antwerp 1599–1652 Antwerp

C 301 Still life. *Stilleven*

Canvas 185 × 242.5. Signed and dated
Addriaen van Utrecht fc. 1644
PROV On loan from the city of
Amsterdam (A van der Hoop bequest)
since 1885
LIT Greindl 1956, p 190

Joachim Antonisz Uytewael

Utrecht 1566–1638 Utrecht

A 988 The meeting of David and Abigail. *De ontmoeting tussen David en Abigail*

Canvas 99 × 131. Signed and dated
J. Wtewael Fecit An° 1597
PROV Purchased from V Biermann,
Amsterdam, 1885
LIT Lindeman 1929, pp 43, 62, 101, 209, 233, 249, nr 3, pl II

A 1843 The annunciation to the shepherds. *De verkondiging aan de herders*

Canvas 170 × 136. Signed *Jo. Wtenwael fe*
PROV Purchased from Fr Muller & Co,
art dealers, Amsterdam, 1899
LIT Lindeman 1929, pp 79, 251, nr 24,
pl XVI

A 1697 The evangelist Mark. *De evangelist Marcus*

Pendant to A 1696

Canvas 68 × 50. Signed *Jo Wtewael fecit*
PROV Purchased from J Telbrach, Kleve,
1897 * On loan to the Rijksmuseum
Muiderslot, Muiden, since 1922
LIT Lindeman 1929, pp 82, 252, nr 27,
pl XVIII (ca 1600)

A 1696 The evangelist Luke. *De evangelist Lucas*

Pendant to A 1697

Canvas 68 × 50
PROV Same as A 1697 * On loan to the
Rijksmuseum Muiderslot, Muiden, since
1922
LIT Lindeman 1929, pp 82, 252, nr 26,
pl XVIII (ca 1600)

Moyses van Uyttenbroeck

The Hague 1595/1600–1648 The Hague

A 1462 Pan waylaying the nymph
Corysca? *Pan belaagt de nimf Corysca?*

Panel 59 × 51. Signed *M°. v. WB*
PROV Sale J Hollender, Brussels, 10-12
April 1888, lot 151 (as Michel van
Woreven)
LIT Budde 1929, p 72. H E van Gelder,
Med DKW Gem 's-Grav 3 (1932) p 244.
U Weisner, OH 79 (1964) pp 210, 219, nr
4, fig 26

Vaarzon Morel

see Morel

Vaenius

see Veen

Bernard Vaillant

Lille 1632 – 1698 Leiden

see also under Pastels

A 1663 Johannes Parker (1632-95).
Alderman and councillor of Middelburg.
Schepen en raad van Middelburg

Canvas 76 × 65. Signed and dated
Vaillant 1670
PROV Purchased from J C de Ruyter de
Wildt, Vlissingen, 1895
LIT M Vandalle, Revue belge d'Arch &
d'Hist de l'Art 7 (1937) p 349

Wallerand Vaillant

Lille 1623 – 1677 Amsterdam

see also Panpoeticon Batavum : A 4596
Jacob Heiblocq, by Arnoud van Halen
after Vaillant

A 1292 Maria van Oosterwijck (1630-
93). Flower painter. *Bloemenschilderes*

Canvas 96 × 78. Signed and dated
W. Vaillant 1671
PROV Sale P VerLoren van Themaat,
Amsterdam, 30 Oct 1885, lot 98
LIT Moes 1897-1905, vol 2, nr 5579.
M Vandalle, Revue belge d'Arch &
d'Hist de l'Art 7 (1937) p 348. A Czobor,
OH 73 (1958) p 244, fig 3. B J A Renckens,
OH 74 (1959) p 237, ill. Van Hall 1963,
p 237, nr 1571:2

C 22 Pieter de Graeff (1638-1707),
baron of Zuid-Polsbroek, Purmerland
and Ilpendam. Alderman of Amsterdam,
director of the Dutch East India
Company. *Vrijheer van Zuid-Polsbroek,
Purmerland en Ilpendam. Schepen van
Amsterdam, bewindhebber der Verenigde
Oostindische Compagnie*

Pendant to C 23

Canvas 72 × 60
PROV On loan from the city of
Amsterdam (Bicker bequest), 1881-1975
LIT Moes 1897-1905, vol 1, nr 2873:1. M
Vandalle, Revue belge d'Arch & d'Hist
de l'Art 7 (1937) p 349

C 23 Jacoba Bicker (1640-95). Wife of
Pieter de Graeff. *Echtgenote van Pieter
de Graeff*

Pendant to C 22

Canvas 73 × 60. Signed and dated
Vaillant fc 1674
PROV On loan from the city of
Amsterdam (Bicker bequest), 1881-1975
LIT Moes 1897-1905, vol 1, nr 647. M
Vandalle, Revue belge d'Arch & d'Hist
de l'Art 7 (1937) p 349

attributed to **Wallerand Vaillant**

C 39 Jan Gerritsz Bicker (1591-1653).
Merchant trading with Italy and the
Levant, burgomaster of Amsterdam.
*Koopman op Italië en de Levant, burgemeester
van Amsterdam*

Pendant to C 40

Canvas 72 × 58.5
PROV On loan from the city of
Amsterdam (Bicker bequest), 1881-1975
LIT P A Leerpe, Ned Spec, 1874, p 122.
Moes 1897-1905, vol 1, nr 648:1. Japikse
1919, vol 2, p 574. C J de Bruyn Kops,
Simiolus 4 (1970) p 61. Schneider &
Ekkart 1973, p 333, suppl nr 226
(perhaps old copy after Jan Lievens)

C 40 Agneta de Graeff (1603-56). Wife
of Jan Bicker. *Echtgenote van Jan Bicker*

Pendant to C 39

Canvas 71 × 59. Inscribed on the verso
*Agneta De Graeff, is Geboren op 10 Novnber
A° 1603, is op 18 Noven A° 1625 Getrouwd
met Johan Bicker A° 1648 Schepen A° 1653
Burgermester, zij is overleden snagts tusschen
den 3 en den 4 Maart A° 1656 en op 8 dito
Maart Begraven in de Westerkerk bij haa
overleden man Johan Bicker*
PROV Same as C 39
LIT Moes 1897-1905, vol 1, nr 2859:2.
Schneider & Ekkart 1973, p 333, suppl
nr 238 (perhaps old copy after Jan
Lievens)

A 1695 Reyer van der Burch (1630-95).
Ammunition officer attached to the
arsenal of the states-general, Delft, with
his wife and children. *Commies van de
Ammunitie aan de Generaliteitsmagazijnen te
Delft met zijn vrouw en kinderen*

His wife is Geertrui Graswinckel (1627-
1703) and his children are Frank (1658-

1715), Cornelis (1660-90), Reyer (1661-95), Maria (1667-1723) and Alida (1670-1727). In the background is the Tuighuis (arsenal) on the Geer Canal, Delft

Canvas 207 × 306
PROV Sale Amsterdam, 10 April 1894, lot 152 (as attributed to Nicolaes Maes). Purchased through the intermediacy of Jonkheer Victor de Stuers, The Hague. Received in 1897 * DRVK since 1952

A 1192 Portrait of a young woman with three children. *Portret van een jonge vrouw met drie kinderen*

Canvas 63 × 77
PROV Presented by C H de Swart, Arnhem, 1885
LIT A Czobor, OH 73 (1958) p 244, fig 5

A 1254 Portrait of a woman. *Portret van een vrouw*

Canvas 88 × 72
PROV Presented by J S R van de Poll, Arnhem, 1885
LIT A Czobor, OH 73 (1958) p 244, fig 4

Frederik van Valckenborgh

Antwerp 1565/66 – 1623 Nürnberg

A 1506 Mountainous landscape. *Bergachtig landschap*

Copper 27 × 35. Signed and dated
F. v. Falcke... 1605
PROV Purchased from C Wachtler gallery, Berlin, 1889
LIT Raczynski 1937, p 60, fig 27. Thiéry 1953, pp 24, 198. H G Franz, Jb Kunsthist Inst Graz, 1968-69, p 30, fig 6. Bernt 1969-70, vol 3, nr 1211

Lucas van Valckenborgh

Louvain in or after 1535 – 1597 Frankfurt am Main

A 1559 Mountainous landscape. *Bergachtig landschap*

Panel 25 × 35.5. Signed and dated
L.V.V. 1582
PROV Sale Amsterdam, 9-10 Feb 1892, lot 127
LIT Hoogewerff 1912, p 234, fig 55. Franz 1969, vol 1, p 203; vol 2, fig 248. A Wied, Jb Kunsth Samml Wien 67 (1971) pp 165, 168, 172, 199-200, 216, 220, cat nr 34, fig 124

Werner Jacobsz van den Valckert

The Hague? ca 1585 – 1627/28 Amsterdam?

A 3920 Portrait of a man with ring and touchstone. *Portret van een man met ring en toetssteen*

Panel 65 × 49.5. Signed and dated
W. v. Valckert fe 1617
PROV Purchased from the estate of A van Welie, The Hague, 1957

C 417 Four regents and the housemaster of the lepers' asylum, Amsterdam, 1624. *Vier regenten en de binnenvader van het leprozenhuis te Amsterdam, 1624*

The sitters are Sieuwerd Sem, Hendrick van Bronckhorst, Ernst Roeters and Dirck Vlack

Panel 137.5 × 209. Dated *1624*
PROV Leprozenhuis (lepers' asylum), Amsterdam. On loan from the city of Amsterdam since 1885
LIT Scheltema 1879, nr 142. Moes 1897-1905, vol 1, nr 1153; vol 2, nrs 6478, 7144, 8585. Hirschmann 1916, p 68. Riegl 1931, pp 161-63, fig 44. Martin 1935-36, vol 1, p 310. Boon 1942, p 71. Haak 1972, p 24, fig 30

C 419 Three regentesses and the house-mistress of the lepers' asylum, Amsterdam, 1624. *Drie regentessen en de binnenmoeder van het leprozenhuis te Amsterdam, 1624*

The regentesses are Trijntje ten Bergh, Anna Willekens and Trijntie Weelinx

Panel 134 × 192. Signed on a label on one of the moneybags *Valcke...* Dated *1624*
PROV Leprozenhuis (lepers' asylum), Amsterdam. On loan from the city of Amsterdam since 1885
LIT Scheltema 1879, nr 144. Hirschmann 1916, p 68, fig 14. Riegl 1931, pp 164, 276, 279, fig 45. Martin 1935-36, vol 1, p 186. Boon 1942, p 71, fig 35. Gerson 1950, p 58, fig 157. Bernt 1960-62, vol 3, nr 872. Bernt 1969-70, vol 3, nr 1223. Haak 1972, p 24, fig 31

C 397 The company of Captain Albert Coenraetsz Burgh and Lieutenant Pieter Evertsz Hulft, Amsterdam, 1625. *Het korporaalschap van kapitein Albert Coenraetsz Burgh en luitenant Pieter Evertsz Hulft, Amsterdam, 1625*

The other sitters are Arent van Buyl, ensign, Joris Adriaensz, Jan van Chanu,

Herman Rendorp, Nic van Strijen, Rombout Jacobsz, Pieter Croon, Lucas Jacobsz, Jacob Croon, Herman Cornelisz van Hoorn and Pieter Simonsz

Panel 169.5 × 270. Signed and dated *Warner v. Valckert f: 1625* and *Anno 1625*. Inscribed on the groundplan on the table *De Wael*
PROV Voetboogdoelen (headquarters of the crossbowmen's civic guard), Amsterdam. On loan from the city of Amsterdam, 1885-1975
LIT Wagenaar 1760-88, vol 2 (1765) p 27. Van Dijk 1790, p 28, nr 19. Scheltema 1879, nr 108. Scheltema 1855-85, vol 7 (1885) p 132, nr 6. Moes 1897-1905, vol 1, nrs 31, 1248:1, 1325. Riegl 1931, pp 164-65, fig 46. Kist 1971, p 37, pl 80. A Meyerson & B Hallström, Livrustkammaren 12:9 (1972) p 292, figs 52-53. Chr Tümpel, N Beitr Rembrandt Forsch, 1973, p 171, figs 132-33

H de Valk

active ca 1693-1717 in Friesland

A 1401 Hans Willem, baron of Aylva (1635-91). Major-general, called 'the formidable general.' *Baron van Aylva. Generaal-majoor, genoemd 'de ontzaglijke generaal'*

Pendant to A 1402

Copper 33.5 × 28.5. Oval. Signed *H. de Valk F*
PROV Purchased from C F Roos & Co, art dealers, Amsterdam, 1887
LIT Moes 1897-1905, vol 1, nr 245

A 1402 Frouck, baroness of Aylva. Wife of Hans Willem van Aylva from 1658 on. *Barones van Aylva. Sedert 1658 echtgenote van Hans Willem van Aylva*

Pendant to A 1401

Copper 33.5 × 28.5. Oval. Signed *H. de Valk Fc.*
PROV Same as A 1401
LIT Moes 1897-1905, vol 1, nr 243

Dirk Valkenburg

Amsterdam 1675–1721 Amsterdam

A 1240 Birds of the West Indies. *West-indische vogels*

Canvas 150 × 176. Signed and dated *Valckenburg Pinxit 1701*
PROV KKS, 1885 * DRVK since 1953
LIT Moes & van Biema 1909, p 127, nr 371. Chr P van Eeghen, OH 61 (1946) p 65, note 5

A 4075 Plantation in Surinam. *Plantage in Suriname*

Canvas 52.5 ×45.5. Signed and dated
Valkenburg Surin: 1707
PROV Purchased from Heim gallery,
Paris, 1962
LIT A van Schendel, Bull RM 11 (1963) p
80, ill

A 2097 Still life with hare and partridges.
Stilleven met dode haas en patrijzen

Canvas 100 ×80. Mantel painting.
Signed and dated *Valkenburg 1717*
PROV Bequest of AA des Tombe, The
Hague, 1903
LIT W Steenhoff, Bull NOB 4 (1902-03) p
122

Hendrik Valkenburg

Terwolde 1826–1896 Amsterdam

C 1559 Pieter Harme Witkamp (1816-
92). Historian and geographer. *Geschied-
schrijver en aardrijkskundige*

Canvas 80 ×61. Signed and dated
H. Valkenburg 1883
PROV On loan from the KOG (presented
by the heirs of the sitter) since 1973

attributed to **Dorothée Anne Vallayer-
Coster**

Paris 1744–1818 Paris

C 1523 Still life with coffeepot. *Stilleven
met koffiekan*

Canvas 57 ×91. Corners trimmed
PROV On loan from the DRVK since 1973
LIT Michel 1970, p 170, nr 231
(probably not Vallayer-Coster)

Jean François Valois

Paramaribo 1778–1853 The Hague

A 1148 The Kalvermarkt, The Hague.
De Kalvermarkt te Den Haag

Panel 45 ×61.5. Signed *J.F. Valois f.*
PROV RVMM, 1885 * DRVK since 1961
LIT Moes & van Biema 1909, p 219

A 1514 Landscape. *Landschap*

Panel 33 ×44. Signed *J.F. Valois f.*
PROV Presented by Mrs M Tamson-
Valois, 1890
LIT Scheen 1946, fig 268

attributed to **Amédée Vanloo**

Turin 1719–1795 Paris

A 888 Wilhelmine of Hesse-Cassel
(1726-1808). Wife of Prince Heinrich
of Prussia, portrayed as Hebe. *Wilhelmine
van Hessen-Cassel. Echtgenote van prins
Hendrik van Pruisen, voorgesteld als Hebe*

Canvas 145 ×111
PROV KKS, 1876. NMGK, 1885 * Lent to
the Dutch legation, Berlin, 1927.
Destroyed in the war, 1943

Jean-Baptiste Vanmour

see Vanmour series

Vanvitelli

see Wittel

Balthasar van der Veen

Amsterdam 1596/97–after 1657 Haarlem

A 1594 View of Haarlem from across the
Spaarne, near the Eendjespoort. *Gezicht
op de stad Haarlem over het Spaarne bij de
Eendjespoort*

Panel 75 ×110. Signed *BVD Veen*
PROV Presented by Dr A Bredius, The
Hague, 1893
LIT A Bredius, OH 12 (1894) p 57. Bernt
1960-62, vol 4, nr 276. Bernt 1969-70,
vol 3, nr 1226

Otto van Veen (Vaenius)

Leiden 1556 – 1629 Brussels

A 3911 The distribution of herring and white bread after the raising of the siege of Leiden, 3 October 1574. *De uitdeling van haring en wittebrood na de opheffing van het beleg van Leiden, 3 oktober 1574*

Panel 40 × 59.5. Signed and dated *OVV f 1574 3 10*. Inscribed on the verso *Men was in groot verdriet | want eten was er niet | En 't volck van Honger schreijden | Ten laest … God nedersiet | En sond door dese R. Vliet | Spijs, Brood en Dranck in Leijden* PROV Sale London, 28 Nov 1956, lot 8 LIT Overvoorde & Martin 1902, p 31, pl XII. R van Luttervelt, Jb Leiden, 1960, pp 77-81, fig 1

A 421-A 432 The revolt of the Batavians against the Romans, in twelve scenes. *De opstand van de Bataven tegen de Romeinen in twaalf taferelen*

Panels, 38 × 52 each. On the verso the numbers 1 through 12 and inscriptions identifying the scenes in Dutch and Latin PROV Purchased by representatives of the states-general, The Hague, 1613. NM, 1808 LIT Obreen's Archief 5 (1882-83) pp 66-67. Moes & van Biema 1909, pp 23-24, 37, 173, 216. Hoogewerff 1912, p 130. H van de Waal, OH 56 (1939) p 51. Van de Waal 1952, pp 210-15, figs 47:1, 73:1, 74:1, 74:3, 75:2, 77:2. H van de Waal, Konsthist Tidskr 25 (1956) pp 13-17, figs 4, 6. C Nordenfalk, Konsthist Tidskr 25 (1956) pp 76, 78, fig 5. Bauch 1960, p 119, fig 83a

A 421 The beheading of Julius Paulus and the capture of Claudius Civilis. *De onthoofding van Julius Paulus en de gevangenneming van Claudius Civilis*

A 422 The conspiracy of Claudius Civilis and the Batavians in the Schakerbos. *De samenzwering van Claudius Civilis met de Bataven in het Schakerbos*

A 423 Brinio raised upon the shield. *Brinio op het schild geheven*

A 424 The Batavians defeating the Romans on the Rhine. *De Bataven verslaan de Romeinen bij de Rijn*

A 425 The Batavians surround the Romans at Vetera. *De Bataven sluiten de Romeinen bij Vetera in*

A 426 The siege of Vetera. *De belegering van Vetera*

A 427 Claudius Civilis having his hair cut after the fall of Vetera, while his son kills some of the captives. *Na de val van Vetera laat Claudius Civilis zijn haar knippen, terwijl zijn zoontje enige gevangenen doodt*

A 428 The Gauls in conference at Reims. *De bijeenkomst van de Galliërs te Reims*

A 429 Valentinus taken prisoner. *Valentinus wordt krijgsgevangen gemaakt*

A 430 A banquet in the forest: unidentified scene. *Een avondmaal in een bos: ongeïdentificeerde voorstelling*

A 431 The Romans under Cerealis defeat Claudius Civilis through the treachery of a Batavian. *De Romeinen onder Cerealis verslaan Claudius Civilis door het verraad van een Bataaf*

A 432 The peace negotiations between Claudius Civilis and Cerealis. *De vredesonderhandelingen tussen Claudius Civilis en Cerealis*

Adriaen van de Velde

Amsterdam 1636–1672 Amsterdam

A 444 Hilly landscape with highroad. *Heuvelachtig landschap met hoge weg*

Panel 28 × 39. Signed and dated
A. v. Velde f. 1663
PROV Bequest of L Dupper Wzn, Dordrecht, 1870
LIT C Hofstede de Groot, OH 17 (1899) p 169. Hofstede de Groot 1907-28, vol 4 (1911) nr 176. Stechow 1966, p 31, fig 44

A 2343 Arcadian landscape with resting herdsmen and cattle. *Arcadisch landschap met rustende herders en vee*

Canvas on panel 41.5 × 51.5. Signed and dated *A. V. Velde 1664*
PROV Purchased from the heirs of Jonkheer P H Six van Vromade, Amsterdam, 1908, with aid from the Rembrandt Society
LIT Hoet 1752, vol 2, nr 183. Hofstede de Groot 1907-28, vol 4 (1911) nr 138

A 442 The cattle ferry. *Het pontveer*

Canvas 34 × 37.5. Signed and dated
A. v. Velde f. 1666
PROV Purchased with the Kabinet van Heteren Gevers, The Hague-Rotterdam, 1809
LIT Moes & van Biema 1909, pp 150, 165. Hofstede de Groot 1907-28, vol 4 (1911) nr 48. Bernt 1960-62, vol 3, nr 881

C 248 Portrait of a couple with two children and a nursemaid in a landscape. *Portret van een echtpaar met twee kinderen en een min in een landschap*

According to tradition a self portrait

Canvas 148 × 178. Signed and dated
A. v. Velde f. 1667
PROV On loan from the city of Amsterdam (A van der Hoop bequest) since 1885
LIT W Bode, Graphischen Künste 29 (1906) p 14. Hofstede de Groot 1907-28, vol 4 (1911) nr 29. Zoege von Manteuffel 1927, p 71. Martin 1935-36, vol 2, p 337. Goldscheider 1936, p 39. Van Hall 1963, p 340, nr 2146:1. Stechow 1966, p 32. Exhib cat Hollandse genre tekeningen uit de 17de eeuw, Amsterdam 1973, nr 97 (not a self portrait)

A 2688 The annunciation. *De verkondiging aan Maria*

Canvas 128 × 176. Signed and dated
A. v. Velde f. 1667
PROV Purchased from R Langton Douglas, London, 1913 * DRVK since 1959 (on loan to the Museum Amstelkring, Amsterdam)

LIT Hofstede de Groot 1907-28, vol 4 (1911) nr 3. A B de Vries, Eigen Haard, 1914, p 1018. E Plietzsch, Zeitschr BK ns 27 (1916) p 129, fig 7. Martin 1935-36, vol 1, pp 110, 112, fig 66. A Heppner, Mndbl BK 24 (1948) p 119, ill. H C de Wolf, Antiek 1 (1967) p 6, fig 5

C 249 The hunting party. *De jachtpartij*

Canvas 59.5 × 73. Signed and dated *A. v. Velde f. 1669*
PROV On loan from the city of Amsterdam (A van der Hoop bequest), 1885-1975
LIT Hofstede de Groot 1907-28, vol 4 (1911) nr 152

A 443 The hut. *De hut*

Canvas 76 × 65. Signed and dated *A. v. Velde f. 1671*
PROV Sale J A Brentano, Amsterdam, 13 May 1822, lot 344
LIT Hofstede de Groot 1907-28, vol 4 (1911) nr 79. A Blankert, OH 83 (1968) p 131, fig 11

C 250 Mountainous landscape with cattle. *Bergachtig landschap met vee*

Panel 31 × 36.5. Signed *A. v. Velde f.*
PROV On loan from the city of Amsterdam (A van der Hoop bequest) since 1885
LIT Hofstede de Groot 1907-28, vol 4 (1911) nr 177

Esaias van de Velde

Amsterdam ca 1591 – 1630 The Hague

A 1765 The fête champêtre. *De buiten-partij*

Panel 35 × 61. Signed and dated *E. van den Velde 1615*
PROV Bequest of D Franken Dzn, Le Vésinet, 1898
LIT Van Gelder 1933, p 36, note 3. Martin 1935-36, vol 1, pp 248, 359. Würtemberger 1937, p 44. Boon 1942, p 56. A Bengtsson, Figura 3 (1952) p 26. E Plietzsch, Wallraf-R Jb 18 (1956) p 181. Rosenberg, Slive & Ter Kuile 1966, p 105. Bol 1969, p 135, fig 120

C 1533 The robbery. *De overval*

Panel 36 × 50. Signed and dated *E. vanden Velde 1616*
PROV On loan from the KOG (bequest of Mrs Domela Nieuwenhuis-Meijer) since 1917

A 1293 The cattle ferry. *Het ponteveer*

Panel 75.5 × 113. Signed and dated *E. v. Velde 1622*
PROV Sale P VerLoren van Themaat, Amsterdam, 30 Oct 1885, lot 100
LIT Grosse 1925, p 46. Zoege von Manteuffel 1927, p 16, fig 9. Martin 1935-36, vol 1, pp 98, 247, fig 56. Boon 1942, p 31. A Bengtsson, Figura 3 (1952) p 69, ill. Van Gelder 1959, pp 10, 13, fig 19. Plietzsch 1960, p 96. Dobrzycka 1960, p 30, fig 4. Bernt 1960-62, vol 3, nr 884. H P Baard, OK 7 (1963) nr 12, ill. Stechow 1966, pp 52-53, fig 91. Bol 1969, p 139. Bernt 1969-70, vol 3, nr 1242

A 1764 Dune landscape. *Duinlandschap*

Panel 18 × 22.5. Signed and dated *E. v. Velde 1629*
PROV Bequest of D Franken Dzn, Le Vésinet, 1898
LIT Zoege von Manteuffel 1927, p 16. Van Gelder 1933, pp 39, 74. Martin 1935-36, vol 1, p 248, fig 143. Boon 1942, p 31, fig 13. J G van Gelder, Burl Mag 90 (1948) p 21. Gerson 1950, p 48, fig 131. A Bengtsson, Figura 3 (1952) p 73, ill. Chudzikowski 1957, p 25, fig 17. Van Gelder 1959, pp 10, 13, fig 25. Stechow 1966, p 21, fig 18. Rosenberg, Slive & Ter Kuile 1966, p 146. Dobrzycka 1967, p 23, fig 5. Bol 1969, p 139, fig 124

A 802 Frolicking on a frozen canal in a town. *IJsvermaak op een stadsgracht*

Panel 48.5 × 87
PROV Purchased from Mr Cordeil, Paris, 1884 (as Willem Buytewech)
LIT C Hugh Hildesley, Auction 3 (Dec 1969) p 44, fig 3

Jan van de Velde

Delft? 1593 – 1641 Enkhuizen

see also Panpoeticon Batavum: A 4567 Jan Starter, by Arnoud van Halen after van de Velde

A 3241 Winter landscape. *Winter-landschap*

Panel 9.1 × 11.5. Oval. Signed *I. V. V.*
PROV Presented by Mrs E Boas-Kogel, Baarn, 1935
LIT A Bengtsson, Figura 3 (1952) pp 27, 33, fig 33. J G van Gelder, OH 70 (1955) p 34, fig 17

milieu of **Jan van de Velde**

A 4288 Hilly landscape with travellers.

Heuvelachtig landschap met reizigers. Landscape with a river. *Landschap met een rivier*

Panel 178 × 84.5. Painted on the leaf and the lid of a clavichord
PROV Purchased in Wijk bij Duurstede, 1888. NMGK

Jan Jansz van de Velde

Haarlem 1619/20 – 1662 Enkhuizen?

A 2362 Still life with tall beer glass. *Stil-leven met hoog bierglas*

Panel 64 × 59. Signed and dated *Jan van de Velde 1647*
PROV Sale Dowager F Lemker-Muller, Kampen, 7 July 1908, lot 48
LIT Vroom 1945, p 169, nr 297, fig 152 (with inaccurate data)

A 3988 Still life with wineglass, flute glass, earthenware jug and pipes. *Stil-leven met roemer, fluit, aarden kruik en pijpen*

Canvas 69 × 89.5. Signed and dated *Jan van de Velde fecit Anno 1651*
PROV Lent by the SNK, later DRVK, 1948. Transferred in 1960

A 1766 Still life with wineglass, beer glass and pipe. *Stilleven met roemer, bierglas en pijp*

Panel 36 × 32.5. Signed and dated *J. van de Velde fecit An° 1658*
PROV Bequest of D Franken Dzn, Le Vésinet, 1898 * DRVK since 1959 (on loan to the Museum Boymans-van Beuningen, Rotterdam)
LIT Gerson 1952, p 59, fig 276

Willem van de Velde I

Leiden ca 1611 – 1693 London

A 1365 The Battle of Terheide, 10 August 1653: episode from the First Anglo-Dutch War (1652-54). *De zeeslag bij Terheide, 10 augustus 1653: episode uit de Eerste Engelse Zeeoorlog (1652-54)*

Canvas 170 × 289. Pen painting. Signed and dated *W. v. Velde f A° 1657 't galjoot van velde*
PROV NMGK, 1887
LIT P Haverkorn van Rijsewijk, OH 17 (1899) p 45. Willis 1911, p 30ff. Martin 1935-36, vol 2, p 374. Baard 1942, pp 26-27

A 1362 The naval battle against the Spaniards near Dunkerque, 18 February 1639. *De zeeslag tegen de Spanjaarden bij Duinkerken, 18 februari 1639*

Canvas 123 × 185. Pen painting. Signed and dated *W. v. Velde f. 1659*
PROV NMGK, 1887
LIT P Haverkorn van Rijsewijk, OH 16 (1898) p 75. Willis 1911, p 30. Martin 1935-36, vol 2, p 374. Baard 1942, pp 22-23

A 840 Episode from the Four Day Battle at Sea, 11-14 June 1666, in the Second Anglo-Dutch War (1665-67). *Episode uit de vierdaagse zeeslag, 11-14 juni 1666, in de Tweede Engelse Zeeoorlog (1665-67)*

Canvas 119 × 182. Pen painting. Signed and dated *W. v. Velde f. 1668*
PROV Sale Jonkheer G van Beresteyn van Maurik, Vught, 22 Oct 1884, lot 47
* Lent to the AHM, 1975
LIT P Haverkorn van Rijsewijk, OH 18 (1900) p 41. Willis 1911, p 30ff. Martin 1935-36, vol 2, p 376. Baard 1942, p 31. E Weber, Spiegel Hist 2 (1967) p 135, fig 4

A 1364 The Battle of Livorno, 14 March 1653: episode from the First Anglo-Dutch War (1652-54). *De zeeslag bij Livorno, 14 maart 1653: episode uit de Eerste Engelse Zeeoorlog (1652-54)*

Panel 114 × 160. Pen painting. Signed *W. v. Velde*
PROV NMGK, 1887
LIT P Haverkorn van Rijsewijk, OH 17 (1899) p 38. Willis 1911, p 30ff. Jvsl Scheepvaartmus 5 (1921) pp 78-85. Baard 1942, p 26. R M Vorstman, Med Ned Ver Zeegesch, 19 Sept 1969, ill opp p 14

A 1363 The Battle of the Downs against the Spanish Armada, 21 October 1639. *De zeeslag tegen de Spaanse Armada bij Duins, 21 october 1639*

Canvas 124 × 190. Pen painting. Signed and dated *W. v. Velde f. 1659*
PROV NMGK, 1887
LIT P Haverkorn van Rijsewijk, OH 16 (1898) p 75. Willis 1911, p 30ff. Martin 1935-36, vol 2, p 374. Baard 1942, pp 22-23. B N Teensma, Spiegel Hist 3 (1968) fig 6 on p 222

A 1384 The unsuccessful English attack against the returning Dutch fleet in the harbor of Bergen, Norway, 12 August 1665: episode from the Second Anglo-Dutch War (1665-67). *De mislukte aanslag van de Engelsen op de retourvloot in de haven van Bergen (Noorwegen), 12 augustus 1665: episode uit de Tweede Engelse Zeeoorlog (1665-67)*

Canvas 84 × 188. Pen painting. Signed and dated *W. v. d. Velde f. 1669*
PROV Right part (84 × 124) purchased from Dirksen gallery, The Hague, 1877. Received from NMGK, 1887. Left part (75 × 63.5) presented by the trustees of the National Maritime Museum, Greenwich, 1958. The two parts were joined in 1960
LIT P Haverkorn van Rijsewijk, OH 18 (1900) p 34. Willis 1911, p 30ff. Preston 1937, p 30, fig 33. Baard 1942, p 29. R van Luttervelt, Bull RM 10 (1962) pp 16-30, ill. B Haak, Antiek 1 (1967) p 10, figs 1-2. Second Dutch War, 1967, ill on p 14

A 1973 Episode from the Battle of the Sound between the Dutch and the Swedish fleets, 8 November 1658. *Episode uit de slag in de Sont tussen de Hollandse en de Zweedse vloot, 8 november 1658*

Canvas 106 × 155. Pen painting. Signed and dated *W. v. Velde f. 1665*
PROV Purchased from S Duits gallery, Amsterdam, 1902
LIT P Haverkorn van Rijsewijk, OH 18 (1900) p 24. Willis 1911, p 30ff, pl VI. Baard 1942, p 28

A 1388 Episode from the Battle of the Sound between the Dutch and Swedish fleets, 8 November 1658. *Episode uit de slag in de Sont tussen de Hollandse en Zweedse vloot, 8 november 1658*

Panel 97.5 × 141. Pen painting. Signed *W. v. Velde*
PROV NMGK, 1887 * Lent to the AHM, 1975
LIT P Haverkorn van Rijsewijk, OH 18 (1900) p 24. Willis 1911, p 30ff. Martin 1935-36, vol 2, pp 374, 376, fig 199. Baard 1942, p 28. B Haak, Antiek 9 (1974) p 72, fig 2

A 1385 The prince's yacht and the state yacht, presumably awaiting the arrival of Charles II of England near Moerdijk, 1660. *Het Prinsenjacht en het Statenjacht, vermoedelijk de komst van Karel II van Engeland afwachtend bij Moerdijk, 1660*

Panel 77.5 × 106.5. Pen painting. Signed *W. v.d. Velde*
PROV Purchased from Dirksen gallery, The Hague, 1877. NMGK, 1887
LIT Willis 1911, p 30ff. CG 't Hooft, in Feestbundel Bredius, 1915, p 102. Crone 1937, pp 59-60, pl XVIII

A 1589 The prince's yacht and the state yacht leaving Moerdijk with Charles II of England on board, 1660. *Het Prinsenjacht en het Statenjacht verlaten Moerdijk met Karel II van Engeland aan boord, 1660*

Panel 61 × 80. Pen painting. Signed *W. v. Velde*
PROV Presented by G de Clercq, Amsterdam, 1892
LIT Willis 1911, p 30ff. CG 't Hooft, in Feestbundel Bredius, 1915, p 102. Crone 1937, pp 59-60, pl XVIII. Baard 1942, p 10, note 11

A 3117 Ships after a battle. *Schepen na de slag*

Canvas 81.5 × 111. Pen painting. Signed *W. v. Velde*
PROV Purchased from I de Bruijn, Spiez, 1931, with aid from the Rembrandt Society
LIT Willis 1911, p 30ff

A 1390 Seascape with Dutch men-of-war. *Zeegezicht met Hollandse oorlogs-schepen*

Panel 70 × 90. Pen painting. Signed *W. v. Velde*
PROV NMGK, 1887
LIT Willis 1911, p 30ff

A 4289 The council of war before the Four Day Battle at Sea on board 'De Zeven Provinciën,' the flagship of Michiel Adriaensz de Ruyter, 10 June 1666: episode from the Second Anglo-Dutch War (1665-67). *De krijgsraad aan boord van 'De Zeven Provinciën,' het admiraalschip van Michiel Adriaensz de Ruyter, 10 juni 1666, voorafgaande aan de vierdaagse zeeslag: episode uit de Tweede Engelse Zeeoorlog (1665-67)*

Canvas 117 × 175. Pen painting
PROV Presented by a group of art lovers, 1910, with aid from the royal house.
NMGK
LIT J FL de Balbian Verster, Buiten, 1911, pp 193, 203-04. Willis 1911, p 30ff. Bintang Djaeoh, Eigen Haard, 1911, pp 279-82. Baard 1942, pp 30, 31, ill on pp 23, 25, 27. E Weber, Spiegel Hist 2 (1967) p 133, fig 3. Diekerhoff 1967, fig 1 (detail)

attributed to **Willem van de Velde I**

A 1392 Episode from the Four Day Battle at Sea, 11-14 June 1666, in the Second Anglo-Dutch War (1665-67). *Episode uit de vierdaagse zeeslag, 11-14 juni 1666, in de Tweede Engelse Zeeoorlog (1665-67)*

Canvas 151 × 235
PROV Model room of the ministry of marine, The Hague. NMGK, 1887
LIT P Haverkorn van Rijsewijk, OH 18 (1900) p 41. Willis 1911, p 30ff. Preston 1937, p 56, fig 83. Second Dutch War, 1967, p 21, ill (first day of the battle)

A 1467 Episode from the Battle of the Sound between the Dutch and Swedish fleets, 8 November 1658. *Episode uit de zeeslag in de Sont tussen de Hollandse en Zweedse vloten, 8 november 1658*

Canvas 100 × 142. Pen painting
PROV Sale Terbruggen, Amsterdam, 12-13 June 1888, lot 92
LIT Willis 1911, p 30ff

Willem van de Velde II

Leiden 1633 – 1707 London

see also Bol, Ferdinand, A 44 Michiel Adriaensz de Ruyter

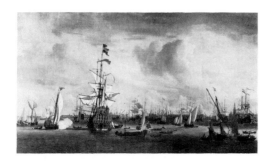

C 7 The Y off Amsterdam with the 'Gouden Leeuw,' the former flagship of Cornelis Tromp. *Het IJ voor Amsterdam met de 'Gouden Leeuw,' het voormalige vlaggeschip van Cornelis Tromp*

Canvas 179.5 × 316. Signed and dated *W. v. Velde J. 1686*
PROV Office of the Commissarissen der Walen (harbor commissioners), Schreierstoren, Amsterdam. On loan from the city of Amsterdam, 1808-1975
LIT Scheltema 1879, nr 110. Moes & van Biema 1909, pp 120, 180. Willis 1911, p 87, pl XXV. CG 't Hooft, in Feestbundel Bredius, 1915, p 107. Hofstede de Groot 1907-28, vol 7 (1918) nr 2. Martin 1935-36, vol 2, pp 368, 378, fig 198. Baard 1942, pp 48-50. Oldewelt 1942, pp 21-22. Van Gelder 1959, p 14, fig 7. R van Luttervelt, OK 3 (1959) nr 4, ill. Stechow 1966, p 121. Rosenberg, Slive & Ter Kuile 1966, p 162, fig 146B. VTTT, 1968-69, nr 106. J A van der Bergen, Antiek 6 (1972) pp 583-84, fig 6. J H M Verkuyl, Spiegel Hist 8 (1973) p 488, fig 2. Bol 1973, pp 240-41, figs 246-48

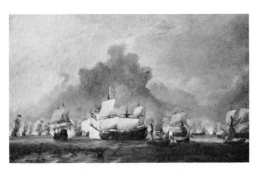

A 1716 Michiel Adriaensz de Ruyter fighting the duke of York, commanding the 'Royal Prince,' during the Battle of Solebay, 7 June 1672: episode from the Third Anglo-Dutch War (1672-74). *Het gevecht van Michiel Adriaensz de Ruyter tegen de Hertog van York op de 'Royal Prince' tijdens de zeeslag bij Solebay, 7 juni 1672: episode uit de Derde Engelse Zeeoorlog (1672-74)*

Canvas 112 × 182. Signed *W. vand. Velde Int.* and signed and dated on the verso *W. v. Velde J. 1691*

PROV Sale Amsterdam, 1 June 1897, lot 210. Purchased through the intermediacy of the Rembrandt Society
LIT Hofstede de Groot 1907-28, vol 7 (1918) nr 35. Martin 1935-36, vol 2, p 378. Bol 1973, p 238

C 244 The cannon shot. *Het kanonschot*

Pendant to A 1848

Canvas 78.5 × 67. Signed *W. v. Velde J.*
PROV On loan from the city of Amsterdam (A van der Hoop bequest) since 1885
LIT Willis 1911, p 85, pl XXVI. Hofstede de Groot 1907-28, vol 7 (1918) nr 79. Martin 1935-36, vol 2, pp 377, 380, fig 201. Baard 1942, p 44. Bernt 1960-62, vol 3, nr 888. Rosenberg, Slive & Ter Kuile 1966, p 165, fig 147. Bernt 1969-70, vol 3, nr 1247. R C, Jardin d A 208 (1972) p 37, ill. Bol 1973, pp 236-37, fig 241

A 1848 A ship on the high seas caught by a squall, known as 'The gust.' *Een schip in volle zee bij vliegende storm, bekend als 'De windstoot'*

Pendant to C 244

Canvas 77 × 63.5. Signed *W. v. Velde f.*
PROV Purchased from Ch Sedelmeyer gallery, Paris, 1900
LIT Willis 1911, p 87, pl XXV. Hofstede de Groot 1907-28, vol 7 (1918) nr 395.

Zoege von Manteuffel 1927, p 54, fig 52. Preston 1937, p 42, fig 52. Baard 1942, pp 44-45, ill on p 41. Van Braam vol 1, p 471, nr 5479

A 438 The capture of the English flagship the 'Royal Prince,' 13 June 1666, during the Four Day Battle at Sea, 11-14 June 1666: episode from the Second Anglo-Dutch War (1665-67). *De verovering van het Engelse admiraalschip de 'Royal Prince,' 13 juni 1666, tijdens de Vierdaagse Zeeslag, 11-14 juni 1666: episode uit de Tweede Engelse Zeeoorlog (1665-67)*

Pendant to A 439

Canvas 58.5 × 81. Signed *W.V.V.*
PROV Sale G van der Pot van Groeneveld, Rotterdam, 6 June 1808, lot 133
LIT Moes & van Biema 1909, pp 113, 182. Willis 1911, p 85. Hofstede de Groot 1907-28, vol 7 (1918) nr 25. E Wiersum, OH 48 (1931) p 211. Martin 1935-36, vol 2, pp 375, 378, fig 200. Crone 1937, pp 36-37. Baard 1942, pp 49, 52. J H Kruisinga, Ons Amsterdam 9 (1957) ill on p 109. Second Dutch War, 1967, ill on p 23. E Weber, Spiegel Hist 2 (1967) pp 130-38, ill on cover. Bol 1973, p 238, fig 242

A 439 The four captured men-of-war – 'Swiftsure,' 'Seven Oaks,' 'Loyal George' and 'Convertine' – brought into the Goereese Gat after the Four Day Battle at Sea, 11-14 June 1666: episode from the Second Anglo-Dutch War (1665-67). *De veroverde schepen 'Swiftsure,' 'Seven Oaks,' 'Loyal George' and 'Convertine' worden het Goereese Gat binnengebracht na de Vierdaagse Zeeslag, 11-14 juni 1666: episode uit de Tweede Engelse Zeeoorlog (1665-67)*

Pendant to A 438

Canvas 58 × 81. Traces of a signature
PROV Same as A 438
LIT Moes & van Biema 1909, pp 113,
182. Willis 1911, p 86, pl XXIV. Hofstede
de Groot 1907-28, vol 7 (1918) nr 32. E
Wiersum, OH 48 (1931) p 211. Martin
1935-36, vol 2, p 378. E Weber, Spiegel
Hist 2 (1967) p 138, fig 10

A 2393 The encounter between Cornelis
Tromp on the 'Gouden Leeuw' and Sir
Edward Spragg on the 'Royal Prince' in
the night of 21 August 1673, during the
Battle of Kijkduin: episode from the
Third Anglo-Dutch War (1672-74).
*Nachtelijk gevecht tussen Cornelis Tromp op
de 'Gouden Leeuw' en Sir Edward Spragg op
de 'Royal Prince' tijdens de zeeslag bij
Kijkduin, 21 augustus 1673: episode uit de
Derde Engelse Zeeoorlog (1672-74)*

Canvas 114 × 183
PROV Sale Amsterdam, 27 April 1909,
lot 151
LIT J F L de Balbian Verster, Eigen
Haard, 1907, p 198ff. Hofstede de Groot
1907-28, vol 7 (1918) nr 44. Martin
1935-36, vol 2, p 378. Baard 1942, pp 48-
50. J H M Verduyn, Spiegel Hist 8
(1973) p 488, fig 1. Bol 1973, p 238, fig
243

A 436 Ships in a calm. *Windstilte*

Canvas 36 × 43.5. Signed *W.V.V.*
PROV Bequest of L Dupper Wzn,
Dordrecht, 1870
LIT Hofstede de Groot 1907-28, vol 7
(1918) nr 178

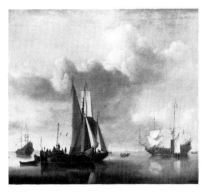

A 440 Ships off the coast. *Schepen voor de
kust*

Panel 42 × 46
PROV Purchased with the Kabinet van
Heteren Gevers, The Hague-Rotterdam,
1809
LIT Moes & van Biema 1909, pp 150,
165. Hofstede de Groot 1907-28, vol 7
(1918) nr 180. Bol 1973, p 234, fig 236
(late 1650s)

A 437 Harbor view. *Havengezicht*

Panel 34.5 × 30. Signed *W.V.V.*
PROV Purchased with the Kabinet van
Heteren Gevers, The Hague-Rotterdam,
1809
LIT H Jantzen, Onze Kunst 18 (1910) p
116, fig 8. Hofstede de Groot 1907-28,
vol 7 (1918) nr 179

A 722 Ships becalmed off the coast.
Schepen voor de kust tijdens windstilte

Panel 22.5 × 31. Signed *W.V.V.*
PROV Bequest of Jonkheer J S H van de
Poll, Amsterdam, 1880

LIT V de Stuers, Ned Kunstbode 2
(1880) p 244. Willis 1911, p 84. Hofstede
de Groot 1907-28, vol 7 (1918) nr 181.
Martin 1935-36, vol 2, pp 379-80, fig 202

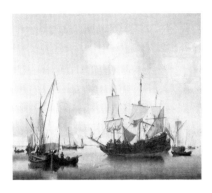

C 245 Ships anchored offshore. *Schepen
onder de kust voor anker*

Canvas 56.5 × 64. Signed *W.V.V.*
PROV On loan from the city of
Amsterdam (A van der Hoop bequest)
since 1885
LIT Hofstede de Groot 1907-28, vol 7
(1918) nr 99

C 246 Ships in a stiff breeze off the coast.
Schepen voor de kust bij straffe wind

Panel 51 × 47.5. Signed *W.V.V.*
PROV On loan from the city of
Amsterdam (A van der Hoop bequest),
1885-1975
LIT Willis 1911, p 88. Hofstede de Groot
1907-28, vol 7 (1918) nr 476

C 247 Fishing boats on the beach. *Vissers-
schepen aan het strand*

Canvas 36.5 ×46
PROV On loan from the city of
Amsterdam (A van der Hoop bequest)
since 1885
LIT Hofstede de Groot 1907-28, vol 7
(1918) nr 319

A 723 Ships near the shore in a stiff
breeze. *Schepen voor de kust bij flinke bries*

Panel 28.5 ×37. Signed *W.V.V.*
PROV Bequest of Jonkheer J S H van de
Poll, Amsterdam, 1880
LIT Willis 1911, p 84. Hofstede de Groot
1907-28, vol 7 (1918) nr 475

A 3350 Ships at anchor. *Schepen voor
anker*

Panel 35.5 in diam. Signed *W.V.V.*
PROV Presented by Mr & Mrs D A J
Kessler-Hülsmann, Kapelle op den
Bosch near Mechelen, 1940 * On loan to
the municipality of Velsen (Beeckestijn
Estate) since 1969

Peter van den Velde

Antwerp 1634–after 1687 Antwerp

A 3271 Naval battle near Elseneur in the
Sound between the Dutch and the
Swedish fleets, 8 November 1658. *Zee-
slag bij Elseneur in de Sont tussen de
Hollandse en de Zweedse vloot, 8 november
1658*

Panel 70 ×107.5. Signed and dated
P.V.V. 167.
PROV Presented by the heirs of W
Buckley, London, 1937
LIT F L Diekerhoff, Spiegel Hist 5
(1970) fig 4 on p 25

A 307 The burning of the English fleet
off Chatham, 20 June 1667. *Het
verbranden van de Engelse vloot voor
Chatham, 20 juni 1667*

Panel 73 ×108. Signed *P.V.V.*
PROV NM, 1808
LIT Moes & van Biema 1909, pp 104,
163, 218. Preston 1937, p 33 (Jan
Peeters). L M Akerveld & J R Bruijn,
Spiegel Hist 2 (1967) p 325, fig 7
(detail). Rogers 1970, fig 7

Petrus van der Velden

Rotterdam 1837–1915 Christchurch

A 1180 Fishermen playing dominoes,
called 'Double blank.' *Domino-spelende
vissers, genaamd 'Dubbel-blank'*

Canvas 76 × 100. Signed *P. van der Velden*
PROV Purchased at exhib Groningen
1880. RVMM, 1885 * DRVK since 1961
LIT Marius 1920, p 221. Scheen 1946, fig
132

copy after **Dirk Jacobsz Vellert**

active 1511-44 in Antwerp

A 849 The holy kinship. *De heilige
maagschap*

Copy after the middle panel of a
painting attributed to Dirk Vellert in
the Stiftsgalerie, Kremsmünster

Panel 40 ×42
PROV Sale van der Willigen, Haarlem,
20 April 1874, lot 45. NMGK, 1885
LIT Friedländer 1924-37, vol 12 (1935)
p 49

Henry van Velthuijsen

see Governors-general series: A 3825
J W Meijer Ranneft

Adriaen Pietersz van de Venne

Delft 1589–1662 The Hague

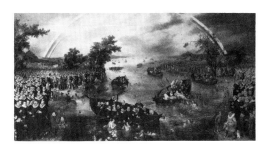

A 447 Fishing for souls: allegory of the jealousy between the various religious denominations during the Twelve Years Truce between the Dutch Republic and Spain. *De zielenvisserij : allegorie op de ijverzucht van de verschillende religies tijdens het Twaalfjarig Bestand tussen de Nederlandse Republiek en Spanje*

To the left are the Protestants and their allies, to the right the Roman Catholics. Among the many princes, politicians and theologians are, on the left, Prince Maurits, James I of England, Christian IV of Denmark and the young Louis XIII of France; and, on the right, Archduke Albert of Austria and his wife Isabella. The painter has probably included himself in the group to the left

Panel 98 × 189. Among the many inscriptions (see Knuttel 1917, p 20) is one reading *Evangelio Piscatores Optio Incomparabilis Anno 1614*
PROV Het Loo Palace, Apeldoorn. NM, 1808
LIT Franken 1878, pp 34-35, nr 3. Moes 1897-1905, vol 2, nr 8341:1. Moes & van Biema 1909, p 216. Knuttel 1917, passim, ill. Martin 1935-36, vol 1, pp 252-54, fig 146. Rehorst 1939, pp 196-99. Knipping 1939-40, vol 2, pp 155-56, fig 109. Boon 1942, p 59. LJ Bol, OH 73 (1958) pp 71, 76, 78. Plietzsch 1960, p 93. Bernt 1960-62, vol 3, nr 894. Van Hall 1963, p 342, nr 2163:1. Dickens 1968, fig 23. Bol 1969, p 117. Bernt 1969-70, vol 3, nr 1254. Th J Hooning, Spiegel Hist 8 (1973) p 430, ill. Bol 1973, p 59

A 676 Princes Maurits and Frederik Hendrik of Orange at the Valkenburg horse fair. *De prinsen van Oranje Maurits en Frederik Hendrik op de paardenmarkt te Valkenburg*

Panel 55.5 × 134.5. Signed and dated *AV Venne Ft 1618*
PROV Purchased from E Warnecke, Paris, 1880
LIT Franken 1878, pp 40-42, nr 8. D

Franken, Ned Kunstbode 2 (1880) p 93. Knuttel 1917, pp 64-65, nr 10. Martin 1935-36, vol 1, pp 252, 254-55, fig 147. Boon 1942, p 58, fig 30. Gerson 1950, p 47, fig 129. LJ Bol, OH 73 (1958) p 71. Van Gelder 1959, p 13, fig 14a. Plietzsch 1960, p 93, fig 152. Bol 1969, pp 118, 244. S Alpers, Simiolus 6 (1972/73) p 171, fig 5

C 606 'Utterly poor.' '*All-arm*'

Panel 37.5 × 30. Grisaille. Signed and dated *A. V. Venne 1621*. Inscribed *All-arm*
PROV On loan from the city of Amsterdam (presented by G de Clercq), 1898-1975
LIT LJ Bol, OH 73 (1958) p 131

C 607 'Wretched.' '*Jammerlijck*'

Panel 37 × 30.5. Grisaille. Signed and dated *A. V. Venne 1621*. Inscribed *Jammerlijck*
PROV On loan from the city of Amsterdam (presented by G de Clercq) since 1898
LIT LJ Bol, OH 73 (1958) pp 76, 131, fig 9

A 1770 'A miserable end.' '*Ellenden-eind*'

Panel 35.5 × 50. Grisaille. Signed and dated *Ad. v. Venne 1622*. Inscribed *Ellenden-eind*
PROV Bequest of D Franken Dzn, Le Vésinet, 1898
LIT Franken 1878, p 58, nr 34. LJ Bol, OH 73 (1958) pp 76, 131, fig 10. R Klessmann, Jb Berlin 2 (1960) pp 106-07, fig 11

A 1775 The harbor of Middelburg, possibly with the departure of Elizabeth Stuart, queen of Bohemia, called the 'winter queen,' on 12 May 1613. *De haven van Middelburg. Mogelijk is het vertrek van Elisabeth Stuart, koningin van Bohemen, de 'Winterkoningin,' voorgesteld, 12 mei 1613*

Panel 64 × 134. Formerly signed and dated *AV Venne 1625*
PROV Bequest of D Franken Dzn, Le Vésinet, 1898
LIT Franken 1878, pp 44-48, nr 12. Knuttel 1917, pp 68-70, nr 23. Martin 1935-36, vol 1, pp 252, 255. Crone 1937, p 36. LJ Bol, OH 73 (1958) pp 71-78, fig 1. Plietzsch 1960, p 93. Bol 1969, p 118, fig 101. J van Roey, Spiegel Hist 6 (1971) p 205, fig 7. Bol 1973, pp 58-59, figs 57-58

A 1767 Village kermis. *Dorpskermis*

Panel 35 × 55. Remnants of a signature. Dated *1625*. Falsely signed and dated *Breughel f 1625*
PROV Bequest of D Franken Dzn, Le Vésinet, 1898
LIT Knuttel 1917, pp 70-71, nr 24. Van Hall 1963, p 342, nr 2163:4

A 1771-A 1774 The four seasons. *De vier jaargetijden*

Panels 15 × 37.5 each. All four signed *Ad. v. Venne*. A 1773 dated *1625*
PROV Bequest of D Franken Dzn, Le Vésinet, 1898
LIT Knuttel 1917, pp 71-72, nrs 25-28. L J Bol, OH 73 (1958) p 143, ill. Van Gelder 1959, fig 14b. Bauch 1960, note 123. Bol 1969, p 121, fig 102. B Dubbe, Antiek 7 (1972) pp 305, 309, ill (on A 1774)

A 1772 Spring: 'the meeting.' *Lente: 'de ontmoeting'*

A 1771 Summer: 'the salute.' *Zomer: 'de begroeting'*

A 1773 Autumn: 'the conversation.' *Herfst: 'het gesprek'*

A 1774 Winter: 'frolicking on the ice.' *Winter: 'ijsvermaak'*

A 1768 Skaters. *Schaatsenrijders*

Panel 25.5 × 42.5. Signed and dated *Ad. van Venne 1625*
PROV Bequest of D Franken Dzn, Le Vésinet, 1898

A 446 Maurits (1567-1625), prince of Orange, lying in state, 1625. *Prins van Oranje, op zijn paradebed, 1625*

Copper 7.5 × 12.6
PROV NM, 1808
LIT Kramm 1857-64, vol 6 (1863) p 1697 (Cornelis Visscher). E W Moes, OH 7 (1889) p 37. Moes 1897-1905, vol 2, nr 4896:61. Moes & van Biema 1909, pp 64, 201. Knuttel 1917, p 73, nr 30. A Pigler, Acta Hist Artium, 1957, p 40, fig 50

A 958 Frederick V (1596-1632), elector of the Palatinate, king of Bohemia, and his wife Elizabeth Stuart (1596-1662) on horseback. *Keurvorst van de Palts, koning van Bohemen, en zijn echtgenote Elisabeth Stuart te paard*

Canvas 154.5 × 191. Grisaille. Signed and dated *Adri. van Venne 1628*
PROV Presented by the township of Heusden, 1879. NMGK, 1885
LIT M M Tóth-Ubbens, Antiek 6 (1971) p 372, fig 6 (detail)

C 609 Peasant dance. *Boerendans*

Panel 36 × 29. Grisaille. Signed and dated *A. v. Venne 1632*
PROV On loan from the city of Amsterdam (presented by G de Clercq) since 1898
LIT L J Bol, OH 73 (1958) p 146

C 608 'Mad misery.' *'Jammer-mall'*

Panel 35.5 × 29. Grisaille. Signed and dated *Ad. v. Venne 16...* Inscribed *Jammer-mall*
PROV On loan from the city of Amsterdam (presented by G de Clercq), 1898-1975
LIT L J Bol, OH 73 (1958) p 131

A 1769 A musical company. *Musicerend gezelschap*

Panel 35 × 56. Grisaille. Dated *Anno 163.*
PROV Bequest of D Franken Dzn, Le Vésinet, 1898

A 959 Boudewijn van Heusden (d 870) and his wife Sophia, daughter of King Edmund of East Anglia, who was once abducted by Boudewijn, receiving homage from the legate of King Edmund. *Boudewijn van Heusden en zijn echtgenote Sophia, dochter van de Engelse koning Edmund, die eens door Boudewijn ontvoerd was, ontvangen eerbewijzen van de gezant van koning Edmund*

Canvas 190 × 284. Grisaille
PROV Presented by the municipality of Heusden, 1879. NMGK, 1885

C 1343 Allegory of the stadholdership of Prince Frederik Hendrik of Orange. *Allegorie op het stadhouderschap van prins Frederik Hendrik*

Victory handing the laurel wreath to Stadholder Frederik Hendrik (1584-1647). Between them the young Prince Willem II (1626-50)

Panel 75 × 59. Grisaille. Inscribed *Victoria* and *Triumphal…*
PROV On loan from Stedelijk Museum 'Het Prinsenhof,' Delft, since 1948

A 1776 Princes Maurits (1567-1625) and Frederik Hendrik (1584-1647). *De prinsen Maurits en Frederik Hendrik*

Paper 12 × 9. Oval
PROV Bequest of D Franken Dzn, Le Vésinet, 1898

attributed to **Adriaen Pietersz van de Venne**

A 1931 Shrove Tuesday in a country village. *Boerenvastenavond*

Panel 73 × 92. Remnants of a signature
PROV Purchased from Jonkheer H Teding van Berkhout, Baarn, 1900
LIT Knuttel 1917, p 74, nr 33. A Bengtsson, Figura 3 (1952) p 70. Bernt 1960-62, vol 3, nr 895. Bernt 1969-70, vol 3, nr 1255

studio of **Adriaen Pietersz van de Venne**

A 445 Prince Maurits accompanied by his two brothers, Frederick V, elector of the Palatinate, and some counts of Nassau on horseback. *Prins Maurits vergezeld van zijn twee broeders, Frederik V van de Palts en enkele graven van Nassau te paard*

In the front row, left to right, are Maurits (1567-1625), prince of Orange, Frederik V (1596-1632), elector of the Palatinate, Philips Willem (1554-1618), prince of Orange, and Frederik Hendrik (1584-1647), prince of Orange; in the second row are, among others, Willem Lodewijk (1560-1620), count of Nassau, to the right of Prince Maurits; the first and second figures from the left are presumably Ernst Casimir (1573-1632), count of Nassau-Dietz, and Lodewijk Günther (1575-1604), count of Nassau. *Cf* the engraving 'Nassovii proceres' of 1621 by Willem Jacobsz Delff after Adriaen van de Venne (Franken 1872, nr 95)

Canvas 172 × 283
PROV NM, 1808
LIT Franken 1872, p 78. Moes 1897-1905, vol 1, nrs 2391:11, 2582:32; vol 2, nrs 4896:56, 5905:9, 9101:13. C Hofstede de Groot, OH 22 (1904) pp 117-18 (copy after or studio of van de Venne). Moes & van Biema 1909, p 200. Knuttel 1917, pp 60, 64, nr 3. Bol 1969, p 244

manner of **Adriaen Pietersz van de Venne**

A 434 Satire on Dutch politics about 1620. *Satirische voorstelling op de Hollandse politiek omstreeks 1620*

Panel 65.5 × 103
PROV Sale Bicker, Amsterdam, 19 July 1809, lot 59

LIT Moes & van Biema 1909, pp 152, 165, 217. Den Tex 1960-72, vol 3 (1966) pp 423-25

copy after **Adriaen Pietersz van de Venne**

NO PHOTOGRAPH AVAILABLE

A 2305 Boudewijn van Heusden (d 870) and his wife Sophia receiving homage from the legate of King Edmund of East Anglia. *Boudewijn van Heusden en zijn echtgenote Sophia ontvangen eerbewijzen van de gezant van de Engelse koning Edmund*

Copy after A 959, with colors added

Canvas 204 × 286
PROV Presented by the Schutters van Sint Joris (St George civic guard), Heusden * Lent to the municipality of Heusden, 1908. Destroyed in the war, 1944

Marcello Venusti

Como 1512 – 1579 Rome

A 3443 The annunciation. *De verkondiging aan Maria*

Canvas 41.7 × 30
PROV Bequest of J W Edwin vom Rath, Amsterdam, 1941

Eugène Joseph Verboeckhoven

Warneton 1799 – 1881 Brussels

see also Klombeck, Johann Bernard, A 3521 View in the woods in the winter

A 1150 Landscape with herdsman and flock near a tree. *Landschap met herder en vee bij een boom*

Panel 59 × 75. Signed and dated
E. J. Verboeckhoven F. à Gand, 1824
PROV Purchased at exhib Brussels 1824.
RVMM, 1885 * DRVK since 1953

A 1151 Landscape with herdsman and flock. *Landschap met herder en vee*

Canvas 95 × 127. Signed and dated
E. J. Verboeckhoven F. 1825
PROV Purchased at exhib Haarlem 1825, nr 449? RVMM, 1885 * DRVK since 1952

A 1149 Hungry wolves attacking a party of riders. *Hongerige wolven overvallen een groep ruiters*

Canvas 256 × 363. Signed and dated
Eugène Verboeckhoven Fe 1836
PROV Purchased from H J Molsbergen, Utrecht, 1861. RVMM, 1885 * DRVK since 1952

Adriaen Hendricksz Verboom

Rotterdam ca 1628 – 1670 Amsterdam

A 47 View in the woods. *Bosgezicht*

Canvas 230 × 333. Signed and dated
A.H.V.Boom fecit A° 1653
PROV Purchased with monies from the bequest of Mrs J Balguerie-van Rijswijk, widow of D Balguerie, Amsterdam, 1823
* DRVK since 1954
LIT C Hofstede de Groot, OH 17 (1899) p 169. Knoef 1943, p 272

attributed to **Dionijs Verburgh**

Rotterdam? ca 1655 – 1722 Rotterdam

A 3112 River view. *Riviergezicht*

Canvas 71.5 × 60.5
PROV Presented by H Schieffer, Amsterdam, 1930
LIT J Q van Regteren Altena, Kunst der Ned, vol 1 (1930-31) pp 277-78

Herman Verelst

The Hague 1641/42 – ca 1690 London

C 24 Portrait of a man. *Portret van een man*

Pendant to C 25

Canvas 127 × 104. Signed and dated
H. Verelst F. A° 1667
PROV On loan from the city of
Amsterdam (Bicker bequest) since 1881
LIT Moes 1897-1905, vol 2, nr 9185:8
(portrait of Johan de Witt). R van
Luttervelt, Bull RM 8 (1960) p 36, fig 8
(same identification). B Haak, Bull RM
14 (1966) p 117, fig 1

C 25 Portrait of a woman. *Portret van een vrouw*

Pendant to C 24

Canvas 127 × 104. Signed and dated
H. Verelst F. A° 1667
PROV Same as C 24
LIT Moes 1897-1905, vol 1, nr 657:1
(portrait of Wendela Bicker, wife of Johan
de Witt). R van Luttervelt, Bull RM 8
(1960) p 36, fig 9a (same identification).
B Haak, Bull RM 14 (1966) p 117, fig 2

Pieter Hermansz Verelst

Dordrecht? before 1618–after 1638

A 2206 Peasants drinking in a barn.
Drinkende boeren in een schuur

Panel 12.3 × 17. Oval
PROV Presented by Miss M E van den
Brink, Velp, 1905

A 3351 The herring eater. *De haringeter*

Panel 17 × 13.5
PROV Presented by Mr & Mrs D A J
Kessler-Hülsmann, Kapelle op den
Bosch near Mechelen, 1940

Dirck Verhaert

active 1631-64 in The Hague, Haarlem
and Leiden

A 989 River landscape. *Rivierlandschap*

Panel 41 × 56. Signed *DVH f*
PROV Sale Antwerp, 19 Feb 1885, lot
251 (as Dirck van Hoogstraten)
LIT C Hofstede de Groot, OH 17 (1899) p
165 (Monogrammist DVH)

Mattheus Verheyden

Breda 1700–after 1776 The Hague

A 1672 François van Aerssen (1669-
1740), lord of Sommelsdijk. Vice admiral
of Holland and West Friesland. *Heer van
Sommelsdijk. Vice-admiraal van Holland en
Westfriesland*

For a portrait of the sitter's father, *see*
Northern Netherlands school ca 1680,
A 1671

Canvas 134 × 106. Inscribed *François van
Aerssen van Sommelsdijk. Vice-Admiraal van
Hollandt en Westvrieslandt. Anno 1728*

PROV Sale Mrs van Dam van Brakel-
Ditmars van IJsselvere, Amsterdam, 29
Oct 1895
LIT Moes 1897-1905, vol 1, nr 71:1

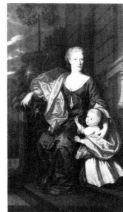

A 814 Joan van Riebeeck (1691-1735).
Alderman and councillor of Delft.
Schepen en raad van de stad Delft

Pendant to A 815
For a portrait of the sitter's son, *see*
Verheyden, Mattheus, A 816

Canvas 206 × 117. Signed on the verso
M. Verheyden ft
PROV Presented by Jonkheer J H F K
van Swinderen, Groningen, 1884 * DRVK
since 1953
LIT Moes 1897-1905, vol 2, nr 6427.
Apollo 96 (1972) p 383, fig 25

A 815 Charlotte Maria Leidecker (1695-
1746). Wife of Joan van Riebeeck, with
a child. *Echtgenote van Joan van Riebeeck,
met een kind*

Pendant to A 814
For portraits of the sitter's parents, *see*
Holland school ca 1690, A 824 & A 827

Canvas 206 × 117
PROV Same as A 814 * DRVK since 1953
LIT Moes 1897-1905, vol 2, nr 4466

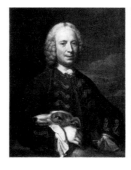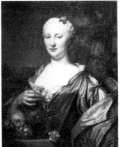

A 1438 Coenraad van Heemskerck
(1714-87), count of the Holy Roman

Empire, lord of Achttienhoven and den Bosch. *Graaf van het Heilige Roomse Rijk, heer van Achttienhoven en den Bosch*

Pendant to A 1437
For a portrait of the sitter's father, *see* Quinkhard, Jan Maurits, A 1436

Canvas 86 × 67. Signed and dated
M. Verheijden Fecit Hage 1750
PROV Presented from the estate of J L de Bruyn Kops, The Hague, 1888
LIT Moes 1897-1905, vol 1, nr 3314. Scheen 1946, fig 21

A 1437 Agnes Margaretha Albinus (1713-73). Wife of Coenraad van Heemskerck. *Echtgenote van Coenraad van Heemskerck*

Pendant to A 1438

Canvas 86 × 67. Signed and dated
M. Verheijden Fecit 1750
PROV Same as A 1438
LIT Moes 1897-1905, vol 1, nr 113. Scheen 1969-70, vol 2, fig 9

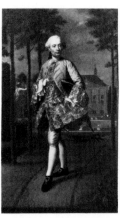

A 816 Gerard Cornelis van Riebeeck (1722-59). Secretary of Delft. *Secretaris van Delft*

Pendant to A 817
For portraits of the sitter's parents, *see* Verheyden, Mattheus, A 814 & A 815

Canvas 206 × 122. Signed and dated
M. Verheijden Fecit A° 1755
PROV Presented by Jonkheer J H F K van Swinderen, Groningen, 1884
LIT Moes 1897-1905, vol 2, nr 6426:1

A 817 Charlotte Beatrix Strick van Linschoten (b 1732). Second wife of Gerard Cornelis van Riebeeck. *Tweede echtgenote van Gerard Cornelis van Riebeeck*

Pendant to A 816

Canvas 206 × 122. Signed *M. Verheijden*

PROV Same as A 816
LIT Moes 1897-1905, vol 2, nr 7656

Albertus Verhoesen

Utrecht 1806–1881 Utrecht

A 830 A cock with hens and chickens. *Een haan met hennen en kuikens*

Canvas 61 × 80. Signed and dated
A. Verhoesen 1855
PROV Presented by Jonkheer J H F K van Swinderen, Groningen, 1884

Verhoeven

see Hoef

Jan Verkolje

Amsterdam 1650–1693 Delft

A 721 A musical company. *Musicerend gezelschap*

Canvas 44 × 53. Signed and dated
I. Vercolie 1673
PROV Bequest of Jonkheer J S H van de Poll, Amsterdam, 1880
LIT V de Stuers, Ned Kunstbode 2 (1880) p 245. Bernt 1960-62, vol 3, nr 914

A 2200 Margaretha Verkolje. Wife of Reinier Couturier. *Echtgenote van Reinier Couturier*

Panel 21 × 16.5. Dated *1682*
PROV Bequest of Miss M E van den Brink, Velp, 1905

A 1414 Portrait of a man. *Portret van een man*

Pendant to A 1415

Copper 58 × 50. Signed and dated
I. Verkolje 1685
PROV Sale J H Cremer, Amsterdam, 21 June 1887, lot 141

A 1415 Portrait of a woman. *Portret van een vrouw*

Pendant to A 1414

Copper 58 × 50. Signed and dated
I. Verkolje 1691
PROV Same as A 1414

A 1470 Portrait of a man, perhaps a self portrait. *Portret van een man, misschien een zelfportret*

Copper 19 × 14. Oval
PROV Presented by W E van Pappelendam & Schouten, art dealers, Amsterdam, 1888
LIT Moes 1897-1905, vol 2, nr 8390:1. Van Hall 1963, p 344, nr 2184:2

A 957 Anthonie van Leeuwenhoek (1632-1723). Delft physicist. *Natuur-kundige te Delft*

Canvas 56 × 47.5
PROV Sale Leiden, 19 June 1879, lot 8. NMGK, 1885 * On loan to the Rijks-museum voor de Geschiedenis der Natuurwetenschappen, Leiden, 1950
LIT Moes 1897-1905, vol 2, nr 4415:3. A M Lubberhuizen-van Gelder, OH 62 (1947) p 146, fig 4. A M Cetto, Bull Boymans 9 (1958) p 77, fig 35

Nicolaas Verkolje

Delft 1673 – 1746 Amsterdam

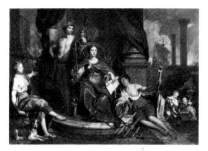

A 4290 Allegorical representation of the Amsterdam chamber of the Dutch East India Company. *Allegorische voorstelling van de Amsterdamse Kamer van de Verenigde Oost-Indische Compagnie*

Canvas 59.5 × 85. Signed *N. Verkolje fecit*. Painted after a medal struck in 1702 in honor of the centenary of the Dutch East India Company
PROV Koloniaal Magazijn (colonial warehouse), Amsterdam, 1857. NMGK
LIT Godée-Molsbergen & Visscher 1913, p 45

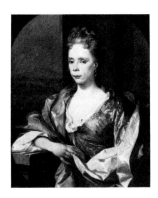

A 813 Elisabeth van Riebeeck (1693-1723). Daughter of Abraham van Riebeeck, wife of Gerard van Oosten (1693-1723). *Dochter van Abraham van Riebeeck, echtgenote van Gerard van Oosten*

For a portrait of the sitter's father, *see* Northern Netherlands school ca 1710, A 811

Panel 73.7 × 58.8
PROV Presented by Jonkheer J H F K van Swinderen, The Hague, 1884
LIT Moes 1897-1905, vol 2, nr 6424

Charles Verlat

Antwerp 1824 – 1890 Antwerp

A 2287 A bear attacking a woodsman, called 'Battle of life and death.' *Een beer overvalt een houthakker, genaamd 'Strijd op leven en dood'*

Panel 66 × 53. Signed *Charles Verlat*
PROV Lent by J BAM Westerwoudt, Haarlem, 1888. Bequeathed in 1907 *
DRVK since 1953

Vermeer

see also Meer

Johannes Vermeer

Delft 1632 – 1675 Delft

see also Meegeren, Henricus Antonius van, A 4239 Mary Magdalene washing Christ's feet; A 4240 Woman reading a letter; A 4241 Woman playing the cittern

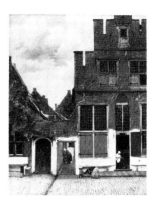

A 2860 View of houses in Delft, known as 'The little street.' *Gezicht op huizen in Delft, bekend als 'Het straatje'*

Canvas 54.3 × 44. Signed *J. v. Meer*
PROV Presented by Sir Henry W A Deterding, London, 1921
LIT W Bürger, GdB-A 21 (1866) pp 298, 303, 310, 463, 467, 568, nr 49. Havard 1888, nr 50. J de Vries, Eigen Haard, 1900, p 504ff. Hofstede de Groot 1906-08, pl XXXII. Hofstede de Groot 1907-28, vol 1, nr 47. Plietzsch 1911, nr 4, pl VIII. P Johansen, OH 38 (1920) p 189.

Batavus, Kunstwanderer, 1920-21, p 345. E Dacier, Rev Art Anc & Mod 39 (1921) p 275ff. A Bredius, OH 39 (1921) pp 59-62. W Martin, Oudh Jb I (1921) pp 107-08. Hausenstein 1924, fig 10. L G N Bouricius, OH 42 (1925) p 271. Martin 1935-36, vol 2, pp 184, 186, 190, 393. Van Thienen 1939, p 52, ill on p 11. De Vries 1939, pp 38-39, nr 8. Plietzsch 1939, nr 41. E Neurdenburg, OH 59 (1942) p 68. De Vries 1948, pp 42, 89, nr 7. Swillens 1950, pp 93-96, 130, 133, 176, nr 26, fig 26. Gerson 1952, pp 38, 110. Malraux 1952, nr x. Bloch 1954, p 31, figs 18-21. A J J M van Peer, OH 74 (1959) p 243. E R Meijer, OKTV 2 (1964) nr 17, figs 1-4. H Schwarz, Pantheon 24 (1966) p 175, ill. VTTT, 1966-67, nr 83. Goldscheider 1967, pp 19, 126, nr 7, figs 18-20. Rosenberg 1967, pp 85, 87, fig 66. Ungaretti & Bianconi 1967, p 89, nr 10, ill, pl XXVII. J Walsh Jr, Bull Metrop Mus 31 (1973) fig 11

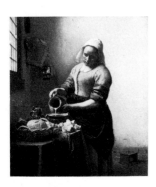

A 2344 The kitchen maid. *De keukenmeid*

Canvas 45.5 ×41
PROV Purchased from the heirs of Jonkheer P H Six van Vromade, Amsterdam, 1908, with aid from the Rembrandt Society
LIT Reynolds 1781. W Bürger, GdB-A 21 (1866) pp 298, 303, 306, 322-23, 328, 459, 467, 553-54, nr 25. Havard 1888, nr 28. Hofstede de Groot 1906-08, pl X. Hofstede de Groot 1907-28, vol 1, nr 17. J Six, Bull NOB 2d ser 1 (1908) p 1ff. W Steenhoff, Onze Kunst 13 (1908) pp 206-11, ill. C F L de Wild, Bull NOB 2d ser 4 (1911) p 58ff, 156ff. Plietzsch 1911, nr 3, fig 111. P Johansen, OH 38 (1920) p 192. H Jantzen, in Meisterwerke, 1920-21. Hausenstein 1924, fig 13. P T A Swillens, Oude Kunst 7 (1929-30) p 129. Martin 1935-36, vol 2, pp 184, 186, 192, 194, fig 96. Van Thienen 1939, p 52, figs 8-9. De Vries 1939, pp 40, 81, nr 10. Plietzsch 1939, nr 12. De Vries 1948, pp 37, 90, nr 9. Swillens 1950, pp 74, 85, 135, 140, nr 18, fig 18. Gowing 1952, p 109 ff, ill. Malraux 1952, pl XXX. Bloch 1954, p 31, fig 16. J G van Gelder, OK 2 (1958) nr 13, ill. Rosenberg, Slive & Ter Kuile 1966, pp 121-22, figs 88-89. Goldscheider 1967, pp 20, 127, nr 9, figs 22-25. Rosenberg 1967, pp 85, 87-88, fig 67. Ungaretti & Bianconi 1967, p 90, nr 12,

ill, pls XXX, XXXI, XXXII. R Charmet, Jardin d A 175 (1969) pp 38, 40, fig 4. J Walsh Jr, Bull Metrop Mus 31 (1973) fig 69

C 251 Woman reading a letter. *Brieflezende vrouw*

Canvas 46.5 ×39
PROV On loan from the city of Amsterdam (A van der Hoop bequest) since 1885
LIT W Bürger, GdB-A 21 (1866) pp 327, 459, 558, nr 32. Havard 1888, nr 35. Hofstede de Groot 1907-28, vol 1, nr 31. Hofstede de Groot 1906-08, pl XX. Plietzsch 1911, nr 1, pl X. P Johansen, OH 38 (1920) p 191. M Eisler, in Meesterwerken, 1920-21. Hausenstein 1924, fig 15. Collins Baker 1925, p 3, note 1. Martin 1935-36, vol 2, pp 184, 186, 190, 197, fig 100. Van Thienen 1939, p 22, ills on pp 34-35. Plietzsch 1939, nr 23. De Vries 1939, pp 46-47, 87, nr 25. De Vries 1948, pp 42, 95, nr 21. Swillens 1950, pp 67, 78, 83-84, 88, 140, 144, 175, nr 54, fig 11. Gerson 1952, p 40, fig 113. Bloch 1954, pp 33-34, figs 47-48. VTTT, 1960, nr 27. AB de Vries, OK 9 (1965) nr 39, ill. Rosenberg, Slive & Ter Kuile 1966, pp 116, 119, 121, 123, frontispiece. Goldscheider 1967, pp 14, 129, nr 17, figs 44, 47. Rosenberg 1967, pp 86-88, fig 68. Ungaretti & Bianconi 1967, p 92, nr 26, ill, pls XXXVII, XXXVIII. J Walsh Jr, Bull Metrop Mus 31 (1973) fig 58. K Clark, Connaissance d A, 1974, p 78, ill

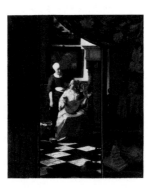

A 1595 The love letter. *De liefdesbrief*

Canvas 44 ×38.5. Signed *JVMeer*
PROV Sale J Messchert van Vollenhoven, Amsterdam, 29 March 1892, lot 14. Purchased in January 1893 with aid from the Rembrandt Society
LIT Hofstede de Groot 1907-28, vol 1, nr 32. P Johansen, OH 38 (1920) p 193. Oude Kunst, 1929-30, p 129. Martin 1935-36, vol 2, pp 184, 186. Hale 1937, p 177ff. Plietzsch 1939, nr 24. De Vries 1939, pp 51, 91, nr 35. Van Thienen 1939, p 56, ill. Wilenski 1945, p 184ff. A Hyatt Mayor, Bull Metrop Mus, 1946, p 19ff. De Vries 1948, p 98, nr 28. Huyghe & de Vries 1948, p XV, fig 24. Swillens 1950, pp 54, 71, 75, 79-80, 82, 84, 86-87, 117, nr 5, fig 5. Gowing 1952, p 152, ill. Bloch 1954, p 35, fig 58. Goldscheider 1958, p 141, figs 69-70. A P de Mirimonde, GdB-A 103 (1961) p 40, fig 7. A B de Vries, OK 10 (1966) nr 45, ill. Rosenberg, Slive & Ter Kuile 1966, p 119, fig 97B. Ungaretti & Bianconi 1967, p 95, nr 36, ill, pl XLVI. De Jongh 1967, p 133, fig 31. Goldscheider 1967, p 133, figs 71-72 (ca 1670). E van Uitert, OKTV 13 (1968) pp 7-8, ill on p 7. E de Jongh, in exhib cat Rembrandt en zijn tijd, Brussels 1971, pp 176-78. A F E van Schendel, Bull RM 20 (1972) pp 127-28. P J J van Thiel, Bull RM 20 (1972) pp 129-46. L Kuiper, Bull RM 20 (1972) pp 147-67. J Walsh Jr, Bull Metrop Mus 31 (1973) fig 58. Sh Guiton, Connoisseur 183 (1973) p 64, ill. P J J van Thiel & L Kuiper, Delta, Spring, 1973, pp 17-34. A A E Vels Heijn, Kunstrip 3 (1972-73) nr 21

Andries Vermeulen

Dordrecht 1763–1814 Amsterdam

C 252 Sledding on the ice. *Sledevaart op het ijs*

Panel 32.5 ×42.5. Signed *A. Vermeulen*
PROV On loan from the city of Amsterdam (A van der Hoop bequest) since 1885

Jan Cornelisz Vermeyen

Beverwijk ca 1500–1559 Brussels

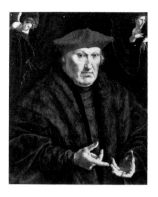

A 4069 Erard de la Marck (1472-1538).
Prince-bishop of Liège. *Prins-bisschop
van Luik*

Panel 64 ×54.5
PROV Purchased from Rosenberg
gallery, New York, 1962, with aid from
the Rembrandt Society
LIT J Houdoy, GdB-A 14 (1872) p 517.
W Cohen, Cicerone 2 (1910) p 221 (Jan
van Scorel). Friedländer 1926, p 6, nr 29
(Scorel). P Wescher, Cicerone 19 (1927)
p 115, fig 1 (Scorel). J Duverger, OH 45
(1928) p 214, note 5. O Benesch, Münchn
Jb ns 6 (1929) p 204, fig 1. K Steinbart,
Marb Jb 6 (1931) p 83. G Glück, Jb
Kunsth Samml Wien ns 7 (1933) p 197.
Friedländer 1924-37, vol 12 (1935) pp
157, 208. Hoogewerff 1936-47, vol 4
(1941-42) p 265, fig 119. M J
Friedländer, OH 59 (1942) p 12ff.
Gerson 1950, p 55, fig 148. L E Halkin,
Bull S R Vieux Liège, 1954, p 391ff, nr
107. Harsin 1955, p 2. P Harsin, Bull Ac
Roy Belgique 44 5th ser (1958) pp 366-
405. B Haak, Bull RM 11 (1963) pp 11,
87. C J de Bruyn Kops, OK 14 (1970) nr
30, ill. J K Steppe & G Delmarcel, Revue
de l'art 25 (1974) p 38, fig 2

manner of **Jan Cornelisz Vermeyen**

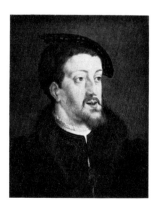

A 164 Charles V (1500-58), emperor of
the Holy Roman Empire. *Karel V, keizer
van het Heilige Roomse Rijk*

Panel 16.5 × 14
PROV Sale Amsterdam, 14 Nov 1825, lot
45 (as Hans Holbein II)

LIT G Glück, Jb Kunsth Samml A K ns 7
(1933) p 198; ibidem ns 11 (1937) p 166,
note 6

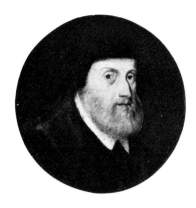

A 979 Charles V (1500-58), emperor of
the Holy Roman Empire. *Karel V, keizer
van het Heilige Roomse Rijk*

Panel 17.5 cm in diam
PROV NMGK, 1885 (as school of Hans
Holbein)

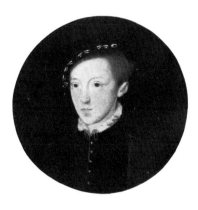

A 980 Philip II (1527-98), future king of
Spain, as a child. *Philips II, de latere
koning van Spanje, op jeugdige leeftijd*

Panel 17.5 cm in diam
PROV NMGK, 1885 (as school of Hans
Holbein)

Emile Jean Horace Vernet

Paris 1789–1863 Paris

A 3910 Emperor Napoleon I and his staff
on horseback. *Keizer Napoleon I en zijn
staf te paard*

Panel 30.5 ×39.5. Signed *Horace Vernet*
PROV Bequest of Jonkheer W A van den
Bosch, Doorn, 1956

Veronese, Bonifazio

see Bonifazio

Paolo Veronese

Verona 1528–1588 Venice

A 3444 The holy family with the infant
John the Baptist. *De heilige familie met de
kleine Johannes*

Canvas 60.5 ×63
PROV Bequest of J W Edwin vom Rath,
Amsterdam, 1941
LIT Berenson 1932, p 419. D von Hadeln,
Pantheon 13 (1934) p 112, ill. Berenson
1957, vol 1, p 129

A 4011 Daniele Barbaro (1513-70).
Theologian, translator of Vitruvius,
commissioner of the Villa Maser.
*Theoloog, vertaler van Vitruvius, bouwheer
van de Villa Maser*

Canvas 121 × 105.5
PROV O Lanz, Amsterdam. Lent by the
DRVK, 1952. Transferred in 1960

LIT O Lanz, Burl Mag 55 (1929) pp 88-93. Berenson 1932, p 419. Berenson 1957, vol 1, p 129. Pallucchini 1960, p 70

attributed to **Paolo Veronese**

A 3010 Venus and Amor. *Venus en Amor*

Canvas 97 × 71
PROV Purchased from the Augusteum, Oldenburg, 1923, as a gift of the Rembrandt Society
LIT Bode 1888, p 22. Bredius & Schmidt-Degener 1906, nr 3a. T Borenius, Burl Mag 24 (1913) p 35. Exhib cat Jubileumtentoonstelling Vereniging Rembrandt, Amsterdam 1923, nr 171. Osmond 1927, pp 89, 111. Fiocco 1928, p 201. T Borenius, Burl Mag 59 (1931) p 72. Berenson 1932, p 419. Berenson 1957, vol 1, p 129

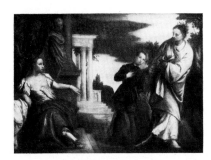

A 3445 The choice between virtue and passion. *De keuze tussen deugd en hartstocht*

Canvas 90 × 40
PROV Bequest of J W Edwin vom Rath, Amsterdam, 1941

copy after **Paolo Veronese**

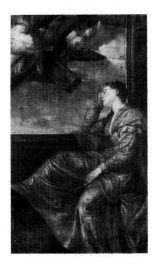

A 2515 The vision of St Helen. *Het visioen van de heilige Helena*

Copy after the version in the National Gallery, London (cat 1959, nr 1041)

Canvas 162 × 91
PROV Roman Catholic Church, Veenhuizen, 1910 * DRVK since 1952

Lieve Verschuier

Rotterdam ca 1630–1686 Rotterdam

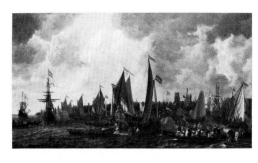

A 448 The arrival of Charles II of England in Rotterdam, 24 May 1660. *De aankomst van koning Karel II van Engeland te Rotterdam, 24 mei 1660*

Canvas 124 × 225. Signed *L. Verschuier*
PROV NM, 1808
LIT Moes & van Biema 1909, pp 61, 218. Willis 1911, p 106. CG 't Hooft, in Feestbundel Bredius, 1915, p 101. Martin 1935-36, vol 2, p 389. Crone 1937, p 70, pl XXII. Bol 1973, p 274

A 449 The keelhauling, according to tradition, of the ship's doctor of Admiral Jan van Nes. *Het kielhalen, volgens overlevering van de scheepschirurgijn van admiraal Jan van Nes*

Canvas 106 × 159. Signed *L. Verschuier*
PROV NM, 1808
LIT Moes & van Biema 1909, pp 36-37, 218. Willis 1911, p 106. Martin 1935-36, vol 2, p 389. Diekerhoff 1967, fig 15 (detail). Bol 1973, p 274. Simons 1974, fig 4. Van Braam nd, vol 1, p 477, nr 5546

C 253 Caulking a ship. *Het kalefateren van een schip*

Panel 37.5 × 49. Signed *L. Verschuier*
PROV On loan from the city of Amsterdam (A van der Hoop bequest) since 1885
LIT Willis 1911, p 106. Bernt 1960-62, vol 3, nr 924. Bernt 1969-70, vol 3, nr 1288. Bol 1973, p 274

Wouterus Verschuur I

Amsterdam 1812–1874 Vorden

C 254 Adriaan van der Hoop's horse 'De Koningin' winning the sleigh race held on the Zaan River at Zaandam, 27 January 1838. *Het paard 'De Koningin' van Adriaan van der Hoop wint de harddraverij met arresleden, gehouden op de Zaan te Zaandam, 27 januari 1838*

Canvas 78 × 106. Signed and dated *W. Verschuur ft. 1838*
PROV On loan from the city of Amsterdam (A van der Hoop bequest), 1885-1975
LIT J Knoef, Jb Amstelodamum 42 (1948) p 10. Brugmans 1970, fig 27

A 1152 Horses in the meadow in gusty weather. *Paarden in de weide tijdens buiig weer*

Panel 46 × 67. Signed *W. Verschuur*
PROV Purchased at exhib Amsterdam 1873, nr 260. RVMM, 1885 * DRVK since 1953
LIT Marius 1920, fig 43

C 541 Incident of the Ten Day Campaign against the rebellious Belgians, August 1831. *Tafereel uit de Tiendaagse Veldtocht tegen de in opstand gekomen Belgen, augustus 1831*

Canvas 56 × 71
PROV On loan from the city of Amsterdam (from the Felix Meritis Society) since 1889
LIT H van der Hoeven, Spiegel Hist 7 (1972) p 374, fig 6

Johannes Cornelisz Verspronck

Haarlem 1597–1662 Haarlem

A 3064 Portrait of a girl dressed in blue. *Portret van een meisje in het blauw*

Canvas 82 × 66.5. Signed and dated *J. VSpronck An° 1641*
PROV From the Augusteum, Oldenburg. Lent by M P Voûte, Amsterdam, 1922. Bequeathed to the Rembrandt Society, which presented it to the RMA in 1928
LIT Bredius & Schmidt-Degener 1906, p 23, ill. T Borenius, Pantheon 4 (1929) p 137, ill. Martin 1935-36, vol 1, pp 347-48, fig 202. Gerson 1952, p 24, fig 62. Plietzsch 1960, p 169, fig 300. E R Meijer, OKTV 1 (1963) nr 3, fig 4. Rosenberg, Slive & Ter Kuile 1966, p 184, fig 157B. O ter Kuile, Antiek 3 (1968) p 9, ill

A 380 Pieter Jacobsz Schout (d 1645). Burgomaster of Haarlem. *Burgemeester van Haarlem*

Canvas 78 × 65. Signed and dated *J. VSpronck an° 1641*
PROV Sale M C van Hall, Amsterdam, 27 April 1858, lot 131 (as a portrait of Burgomaster Kies)
LIT Moes 1897-1905, vol 2, nr 7023:2. Martin 1935-36, vol 1, p 347, fig 201

A 3352 Portrait of a man. *Portret van een man*

Canvas 86 × 65.5. Signed and dated *J. VSpronck an. 1646*
PROV Presented by Mr & Mrs D A J Kessler-Hülsmann, Kapelle op den Bosch near Mechelen, 1940

A 1253 Portrait of an old man. *Portret van een oude man*

Panel 77 × 62.5. Signed and dated *J. VSpronck an.° 1647*. Inscribed *Aetatis 83*
PROV Presented by J S R van de Poll, Arnhem, 1885

C 1414 Eduard Wallis (b 1621)

Pendant to C 1415

Panel 97 × 75. Signed and dated *Joh. C. VSpronck f. an.° 1652*
PROV On loan from Jonkvrouwe A H

van Reenen-van Reenen, widow of
Jonkheer G C J van Reenen, The Hague,
since 1952
LIT Plietzsch 1960, p 169, fig 297

C 1415 Maria van Strijp (b 1627). Wife
of Eduard Wallis. *Echtgenote van Eduard
Wallis*

Pendant to C 1414

Panel 97 × 75. Signed and dated
Joh.C.VSpronck f. an.° 1652
PROV Same as C 1414
LIT Plietzsch 1960, p 169, fig 298

Machiel Versteegh

Dordrecht 1756–1843 Dordrecht

A 1565 The night school. *De avondschool*

Panel 60 × 52. Signed and dated
M.Versteegh Fecit 1786
PROV Bequest of Jonkheer P A van den
Velden, The Hague, 1892

C 255 A musical company by candle-
light. *Musicerend gezelschap bij kaarslicht*

Panel 90 × 75. Signed *M.Versteegh fecit*
PROV On loan from the city of
Amsterdam (A van der Hoop bequest)
since 1885

C 256 A woman in a kitchen, by candle-
light. *Een vrouw in een keuken bij kaarslicht*

Panel 49 × 43. Signed *M.Versteegh fecit*
PROV On loan from the city of
Amsterdam (A van der Hoop bequest)
since 1885

**Floris Hendrik Verster van
Wulverhorst**

Leiden 1861–1927 Leiden

A 2941 Still life with zinnias in a ginger
pot. *Stilleven met zinnia's in een gemberpot*

Panel 24 × 19. Signed and dated *Floris
Verster '10*
PROV Bequest of A van Wezel,
Amsterdam, 1922
LIT Scherjon 1928, nr 192, ill

A 2942 Autumn flowers in a flaming red

pot on a pewter plate. *Najaarsbloemen in
vurig rode pot op een tinnen schotel*

Panel 25 × 30. Signed and dated *Floris
Verster '10*
PROV Bequest of A van Wezel,
Amsterdam, 1922 * Lent to the Stedelijk
Museum, Zutphen, 1924. Destroyed in
the war, 1945
LIT Scherjon 1928, nr 197, ill

Petrus Gerardus Vertin

The Hague 1819–1893 The Hague

A 1562 The Koepoort, Delft. *De Koepoort
te Delft*

Panel 15.5 × 21.5. Signed *P.G.Vertin*
PROV Bequest of Jonkheer P A van den
Velden, The Hague, 1892

Salomon Leonardus Verveer

The Hague 1813–1876 The Hague

see also Hanedoes, Louwrens, A 1040
Landscape in Kennemerland

A 1153 An imaginary city view based on
the Kolksluis, Amsterdam. *Stadsgezicht,
geïnspireerd op de Kolksluis te Amsterdam*

Canvas 104 × 125. Signed and dated
S.L.Verveer ft 1839
PROV Purchased at exhib The Hague
1839, nr 543. RVMM, 1885 * DRVK since
1953

A 1154 View of the beach near Noordwijk aan Zee. *Strandgezicht bij Noordwijk aan Zee*

Canvas 82 × 130. Signed and dated
S.L. Verveer ft. 65
PROV Purchased at exhib The Hague 1866, nr 378. RVMM, 1885 * DRVK since 1953
LIT Scheen 1946, fig 417

Franciscus Vervloet

Mechelen 1795–1872 Venice

A 1155 Interior of St Peter's in Rome. *Interieur van de Sint Pieterskerk te Rome*

Canvas 60 × 75. Signed and dated
F. Vervloet Roma 1824
PROV Purchased at exhib Brussels 1824. RVMM, 1885 * DRVK since 1952.
LIT S Sulzberger, OH 68 (1953) p 243. M Pittaluga, Antichità 9 (1970) pp 31, 33, fig 6

Abraham de Verwer

Amsterdam before 1600–1650 Amsterdam

A 603 The Battle of the Zuider Zee, 6 October 1573: episode of the Eighty Years War. *De slag op de Zuiderzee, 6 oktober 1573: episode uit de Tachtigjarige Oorlog*

Canvas 153 × 340. Signed and dated
A. D. Verwer in. fecit 1621
PROV NM, 1808
LIT Willis 1911, p 24. Preston 1937, p 15, fig 10. Bernt 1960-62, vol 4, nr 288. P J van Winter & K Sierksma, Spiegel Hist 5 (1970) p 605, fig 4. Bol 1973, p 85, fig 83

attributed to **Abraham de Verwer**

C 453 An Amsterdam East Indiaman. *Een Amsterdamse Oost-Indië-vaarder*

Panel 43 × 30
PROV Oude Zijds Huiszittenhuis (institute for the outdoor relief of the poor), Amsterdam. On loan from the city of Amsterdam, 1885-1975

François Verwilt

Rotterdam 1618–1691 Rotterdam

A 450 Portrait of a boy, called 'The son of Admiral van Nes.' *Portret van een jongen, genaamd 'Het zoontje van admiraal Van Nes'*

Canvas 114 × 92.5. Signed and dated
F. Verwilt 1669
PROV NM, 1808
LIT Moes & van Biema 1909, pp 37, 175, 208. E Wiersum, OH 51 (1934) p 231ff, ill. Bernt 1960-62, vol 3, nr 934. Bernt 1969-70, vol 3, nr 1299

attributed to **François Verwilt**

A 3500 A man dancing with a dog. *Een man dansend met een hond*

Panel 66 × 22
PROV Bequest of Mrs A C M H Kessler-Hülsmann, widow of D A J Kessler, Kapelle op den Bosch near Mechelen, 1947

Jan Pieter Veth

Dordrecht 1864–1925 Amsterdam

see also under Aquarelles and drawings

A 2124 Johannes Martinus Messchaert (1857-1922). Singer and voice teacher. *Zanger en zangpedagoog*

Canvas 82 × 72. Signed and dated
JV 1903
PROV Presented by friends and admirers of the sitter, 1903 * DRVK since 1955
LIT Huizinga 1927, p 225, nr 495

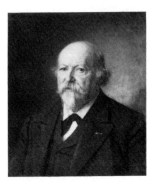

A 2138 Johan Philip van der Kellen (1831-1906). Director of the Rijks-prentenkabinet (1876-96). *Directeur van het Rijksprentenkabinet*

Canvas 65 × 56. Signed and dated *JV 1904*. Inscribed *Æt 72*
PROV Presented by friends and admirers of the sitter, 1904
LIT Huizinga 1927, p 226, nr 521. Van Hall 1963, p 164, nr 1099:1

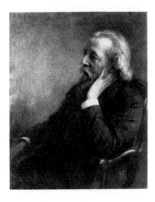

A 3449 Reverend P H Hugenholtz II (1834-1911), founder of the Free Congregation. *Ds P H Hugenholtz II, oprichter van de Vrije Gemeente*

Canvas 82.5 × 65. Signed and dated *JV 1908*. Inscribed *Æt 73*
PROV Presented by Miss M A Hugenholtz, The Hague, 1942
LIT Huizinga 927, p 230, nr 637

A 3837 Adelheid Emma Wilhelmina Theresia (1858-1934), princess of Waldeck-Pyrmont, widow of Willem III, king of the Netherlands. *Koningin Emma, prinses van Waldeck-Pyrmont. Weduwe van koning Willem III*

Canvas 99 × 70. Signed and dated *Jan Veth 1918*
PROV Purchased from the heirs of P Hofstede de Groot, Amsterdam, 1952

Hendrik Vettewinkel Dzn

Amsterdam 1809 – 1878 Amsterdam

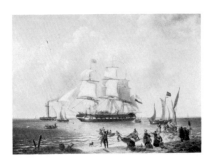

C 257 The merchantman 'Flevo' sailing out of the Nieuwe Diep after being set afloat by the tugboat 'Noord-Holland.' *Het koopvaardijschip 'Flevo' bij het uitzeilen van het Nieuwe Diep, nadat de sleepboot 'Noord-Holland' heeft losgemaakt*

Canvas 65.5 × 94.5. Signed and dated *H. Vettewinkel ft. 1837*
PROV On loan from the city of Amsterdam (A van der Hoop bequest), 1885-1975

A 1475 Ships in a river, near a light. *Schepen op een rivier bij een lichtbaken*

Panel 37.5 × 47. Signed and dated *H. V. 1847*
PROV Presented by D H Vettewinkel, Amsterdam, 1888

Paulus van Vianen II

Prague before 1613 – 1652 Utrecht

A 1557 The rest on the flight into Egypt. *Rust op de vlucht naar Egypte*

Canvas 84 × 110. Signed and dated *Vianen F. 1643*
PROV Presented by Dr A Bredius, The Hague, 1892
LIT Bernt 1960-62, vol 4, nr 291. Bernt 1969-70, vol 3, nr 1300

P Vianey(?)

active 18th century

C 1542 Allegory of free love: a gentleman, a monk and a beggar talking to two fishermen who have just caught a woman in their net. *Allegorie op de vrije liefde: een heer, een monnik en een bedelaar sprekend met twee vissers die een vrouw in een net gevangen hebben*

Canvas 58.5 × 81.5. Signed and dated *P. Vianey [?] f. 1761*. Inscribed *Wij hebben deez list zoo wel bedagt | Dat dit visje 's in ons net gebragt || Vissers hebt gij van die vis te veel | Soo verkoopt mij daarvan ook een deel || Och had ik zulken vis in 't clooster 't eten | Hoe haast zoud ik dan alle vleesch vergeten || Zulken soort van visjes hebben 't mij gedaan | Dat ik daardoor moet op dees krukken gaan*
PROV On loan from the KOG (presented by Dr A Bredius, 1880) since 1973

Jacobus Victors

Amsterdam? 1640 – 1705 Amsterdam

A 1674 A rooster with chickens, pigeons and a marmot. *Een haan met kippen, duiven en een marmot*

Canvas 128 × 111. Signed and dated *Jacomo Victor f 1674*
PROV Sale Baroness A W C F C van Verschuer-van Riemsdijk, widow of B F J A Baron van Verschuer, Amsterdam, 31 March-2 April 1896, lot 76
LIT Martin 1935-36, vol 2, p 442, fig 235

Jan Victors

Amsterdam 1620–in or after 1676 Dutch East Indies

A 451 Joseph interpreting the dreams of the baker and the butler. *Jozef legt de bakker en de schenker hun dromen uit*

Canvas 120 × 134. Signed and dated *Johanes Victors fe. 1648*
PROV NM, 1808
LIT Martin 1935-36, vol 2, p 127

C 259 The swine butcher. *De varkens-slachter*

Canvas 79.5 × 99.5. Signed and dated *Jan Victors fe 1648*
PROV On loan from the city of Amsterdam (A van der Hoop bequest) since 1885

A 2345 The greengrocer at the sign of 'De Buyskool.' *De groentewinkel 'De Buyskool'*

Canvas 91.5 × 110. Signed and dated *Jan Victoors fe. 1654*. Inscribed on sign-board *de buys kool*
PROV Purchased from the heirs of Jonk-heer P H Six van Vromade, Amsterdam, 1908 * DRVK since 1953

C 258 The itinerant dentist. *De tand-meester*

Canvas 76 × 94.5. Signed and dated *Jan Victoors fe. 1654*
PROV On loan from the city of Amsterdam (A van der Hoop bequest), 1885-1975
LIT Martin 1935-36, vol 2, p 128, fig 71

Elisabeth Vigée-Lebrun

see under Pastels

Claude Vignon

Tours 1593–1670 Paris

A 4068 Christ commanding St Peter 'Feed my lambs.' *Christus draagt Petrus op: 'Weid mijn schapen'*

Canvas 124 × 105. Signed and dated *Vignon In. Fecit 1624*. Inscribed *Petre amas me* and *Pasce oves meas*
PROV Purchased from the elders of the church of St Willibrord (H Willibrordus buiten de Veste), Amsterdam, 1961
LIT E R Meijer, NKJ 7 (1956) p 121, fig 1. W Fischer, NKJ 13 (1962) pp 147-48, fig 27. VTTT, 1962-63, nr 54. P Rosenberg, Minneapolis Bull 57 (1968) p 11

Johannes van Vilsteren

see under Pastels

François André Vincent

Paris 1746–1816 Paris

A 3931 Portrait of a man, possibly Monsieur Baillon. *Portret van een man, wellicht Monsieur Baillon*

Cf the smaller version with pendant of the sitter's wife in the Montreal Museum of Fine Arts, Montreal (bequest of Lady Davis, 1964)

Canvas 117 × 89.5. Signed *Vincent*
PROV Purchased from C Duits gallery, London, 1958

David Vinckboons

Mechelen 1576–1632? Amsterdam

A 1351 The peasant's misfortune. *Boeren-verdriet*

Pendant to A 1352

Panel 26.5 × 42
PROV Presented by Dr A Bredius, The Hague, 1887
LIT Goossens 1954, p 85, fig 45 (ca 1609). Legrand 1963, p 123. A Czobor, OH 78 (1963) p 152. Bernt 1969-70, vol 3, nr 1312

A 1352 The peasant's pleasure. *Boeren-vreugd*

Pendant to A 1351

Panel 26.5 × 42
PROV Same as A 1351
LIT Goossens 1954, p 89, fig 45 (ca 1609). Legrand 1963, p 123, fig 47 (detail). A Czobor, OH 78 (1963) p 152

A 1782 The preaching of St John the Baptist. *Johannes de Doper predikend*

Panel 28 × 43.5
PROV Purchased from F le Cocq,

Brussels, 1898, through the intermediacy of the Rembrandt Society
LIT Goossens 1954, p 114, fig 62 (ca 1610). H Gerson, OH 70 (1955) p 131, fig 4. Legrand 1963, p 123

A 2401 The hurdy-gurdy player. *De liereman*

Panel 33.5 × 62.5
PROV Purchased from Steinmeyer & Stephan Bourgeois gallery, Paris, 1909
LIT E W Moes, OH 19 (1901) p 54. Goossens 1954, p 107, fig 58 (ca 1610). Legrand 1963, p 123. F Grossmann, Burl Mag 115 (1973) p 582

A 2109 The fête champêtre. *De buiten-partij*

Panel 28.5 × 44
PROV Sale Amsterdam, 31 March 1903, lot 26 (as Dirck Hals)
LIT Würtenberger 1937, p 39, pl XIV. Goossens 1954, p 95, fig 50 (shortly after 1610). Haverkamp Begemann 1959, pp 23-24. Legrand 1963, p 123. VTTT, 1964-65, nr 66. I Bergström, NKJ 17 (1966) pp 143-69. K Goossens, Jb Antwerpen, 1966, p 89

Lambert Visscher

see Panpoeticon Batavum: A 4584 Alexander Morus, by Arnoud van Halen after Visscher

Adrianus de Visser

see under Miniatures

attributed to **Bartolomeo Vivarini**

Murano ca 1432–ca 1499

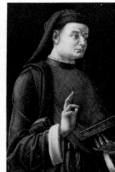

A 4012 St Damian. *De heilige Damianus*

Pendant to A 4235

Panel 43.5 × 30
PROV O Lanz, Amsterdam. Lent by the DRVK, 1952. Transferred in 1960 *
DRVK since 1964 (on loan to Stedelijk Museum Het Catharinagasthuis, Gouda)
LIT G Swarzenski, Münchn Jb 9 (1914-15) p 88, ill. Berenson 1932, p 601. R van Marle, Boll d'Arte 28 (1935) p 394, fig 5. Van Marle 1923-38, vol 18 (1936) p 117. Longhi 1956, p 138. Berenson 1957, vol I, pp 200-01, figs 116-17. Pallucchini 1962, nr 173, ill. F Heinemann, Kunst-chronik 16 (1963) p 63

A 4235 St Cosmas. *De heilige Cosmas*

Pendant to A 4012

Panel 49 × 33
PROV Same as A 4012 * DRVK since 1964 (on loan to Stedelijk Museum Het Catharinagasthuis, Gouda)
LIT Longhi 1956, p 138. Pallucchini 1962, nr 172, ill

copy after **Joseph Vivien**

Lyon 1657–1734 Bonn

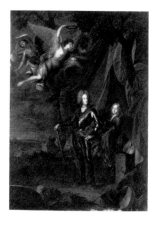

A 4016 Maximilian II Maria Emanuel (1662-1726). Elector of Bavaria, in the Battle of Harzan against the Turks. *Keurvorst van Beieren, in de slag bij Harzan tegen de Turken*

Copy after a painting signed and dated 1710, formerly in the Residenz, Munich, that was burnt in 1944

Copper 65 × 45
PROV Transferred by the DRVK in 1960
LIT *Cf* H Börsch-Supan, München Jb 3d ser 14 (1963) pp 176, 184, nr 68

Simon de Vlieger

Rotterdam 1601 – 1653 Weesp

A 454 The battle on the Slaak between the Dutch and Spanish fleets during the night of 12-13 September 1631. *De slag op het Slaak tussen de Nederlandse en Spaanse vloten in de nacht van 12 op 13 september 1631*

Canvas 104 × 179. Signed and dated *S. De Vlieger 1633*
PROV NM, 1808
LIT Moes & van Biema 1909, p 217. Willis 1911, pp 47-48. Martin 1935-36, vol 1, p 265. Crone 1937, pp 38, 54-55

A 1981 The falconer's homecoming. *De thuiskomst van de valkenier*

Panel 71 × 95. Signed and dated *S. De Vlieger f 1637*
PROV Purchased from the G de Clercq collection, Amsterdam, 1899, through the intermediacy of the Rembrandt Society
LIT A Heppner, OH 47 (1930) p 88, fig 7. A Heppner, OH 55 (1938) p 141, fig 8. Bernt 1960-62, vol 3, nr 946. E Plietzsch, Zeitschr BK ns 27 (1916) p 140, fig 22. Bernt 1969-70, vol 3, nr 1317. J Bauch et alia, NKJ 23 (1972) p 488

A 1982 River view. *Riviergezicht*

Panel 88 × 121. Signed *S. de Vlieger*
PROV Purchased from the G de Clercq collection, Amsterdam, 1899, through the intermediacy of the Rembrandt Society * Lent to the Gemeentemuseum, Weesp, 1953 (from 1959 on via the DRVK). Destroyed by fire, 1968
LIT H Jantzen, Onze Kunst 18 (1910) p 110, fig 4. Willis 1911, p 47, pl x. Preston 1937, p 26, fig 20. Baard 1942, p 38, fig 31. Bol 1973, p 182

attributed to **Simon de Vlieger**

A 2086 Rocky coast. *Rotsachtige kust*

Canvas 83 × 144
PROV Bequest of A A des Tombe, The Hague, 1903
LIT W Steenhoff, Bull NOB 4 (1902-03) p 121

C 449 Ships in danger. *Schepen in nood*

Canvas 111 × 182. Dated *1640*
PROV Oude Zijds Huiszittenhuis (institute for the outdoor relief of the poor), Amsterdam. On loan from the city of Amsterdam, 1888-1975
LIT T Krielaart, Antiek 8 (1973-74) p 568, ill

A 1777 Beach with fishermen. *Strand met vissers*

Panel 64 × 106.5
PROV Bequest of D Franken Dzn, Le Vésinet, 1898 * On loan to the Rijksmuseum Lambert van Meerten, Delft, since 1909

Hendrick Cornelisz van (der) Vliet

Delft 1611/12–1675 Delft

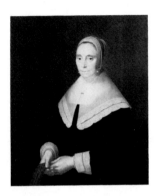

A 2531 Portrait of a woman. *Portret van een vrouw*

Panel 79.5 ×66.5. Signed and dated
H. van der Vliet 1650
PROV Purchased from Mason & Philips gallery, London, 1911

A 455 View in the Oude Kerk, Delft. *Gezicht in de Oude Kerk te Delft*

Panel 74 ×60. Signed and dated
H. van Vliet f 1654
PROV NM, 1808
LIT Moes & van Biema 1909, pp 59, 224. Jantzen 1910, pp 102, 172, nr 527

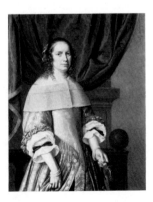

A 1343 Portrait of a woman. *Portret van een vrouw*

Canvas 105.5 ×87. Signed and dated
H. van Vliet $\frac{8}{28}$ A. 1663. Inscribed *Æta 27*
PROV Sale J H Cremer, Amsterdam, 26 Oct 1886, lot 97

attributed to **Hendrick Cornelisz van (der) Vliet**

A 1971 Interior of the Oude Kerk, Delft, with the tomb of Pieter Pietersz Heijn (1588-1629), vice admiral of Holland. *Interieur van de Oude Kerk te Delft met de graftombe van Pieter Pietersz Heijn, luitenant-admiraal van Holland*

Canvas 68 × 56
PROV Sale Amsterdam, 15 April 1903, lot 201
LIT Jantzen 1910, pp 97, 163, nr 184, fig 45 (Gerrit Houckgeest). T Trent Blade, Museum Stud 6 (1971) p 48, note 5 (not Houckgeest)

Willem Willemsz van Vliet

Delft? ca 1584–1642 Delft

A 2577 Portrait of a boy. *Portret van een jongetje*

Panel 93 ×76. Signed and dated
W. van der Vliet fecit a° 1638. Inscribed *Æta 1½*
PROV Lent by C Hoogendijk, The Hague, 1907. Presented from his estate in 1912
LIT R Bangel, Cicerone 7 (1915) p 177

Jan Voerman I

see under Aquarelles and drawings

attributed to **Jakob Ferdinand Voet**

Antwerp 1639–1700 Paris

A 3236 Maria Mancini (1639-1715), duchess of Bouillon. *Hertogin van Bouillon*

Canvas 72.5 ×62.5
PROV Lent by F G Waller, Amsterdam, 1928-29 (as Pierre Mignard). Bequeathed in 1935
LIT P Bautier, Annuaire Mus Roy Belgique 2 (1939) p 179. P Bautier, Revue belge d'Arch & d'Hist de l'Art 25 (1956) p 153. G Poisson, Revue du Louvre 13 (1963) p 38, fig 6. J Wilhelm, Connoisseur, Aug 1966, p 253, fig 11

Cornelis Johannes de Vogel

Dordrecht 1824–1879 Dordrecht

A 1177 Autumn in the woods of The Hague. *Herfst in het Haagse Bos*

Canvas 79 × 138. Signed *C. J. de Vogel, Dordrecht*
PROV Purchased at exhib Amsterdam 1877, nr 557. RVMM, 1885 * DRVK since 1953

Johannes Gijsbert Vogel

Hooge Zwaluwe 1828–1915 Velp

A 1156 On the heath in Noord-Brabant. *Noord-Brabantse heide*

In the center of the composition is a carrier with a two-wheeled oxcar on the shoulder of a broad sunken road. Nearby a woman squats at a turf fire, over which an iron pot is suspended. Further in the distance the ground falls away towards a small house in the trees, of which we see only the roof. In the left background is a large open field with a flock; to the right a hilly forest landscape

Canvas 81 × 123.5. Signed and dated *J. G. Vogel 66*
PROV Purchased at exhib The Hague 1866, nr 386. RVMM, 1885 * Lent to the Gouvernementsgebouw (provincial capitol) of Gelderland, Arnhem, 1924. Destroyed in the war, 1944

A 2721 Landscape on the waterway near Hilversum. *Landschap aan de vaart bij Hilversum*

Canvas 30 × 68. Signed *J. G. Vogel*
PROV Presented by Mr & Mrs HPMA Vogel-Molenkamp, Haarlem, 1915

Margaretha Cornelia Johanna Wilhelmina Henriëtta Vogel-Roosenboom

The Hague 1843 – 1896 Voorburg

A 1182 Still life with spring flowers. *Stilleven met voorjaarsbloemen*

Canvas 53 × 43. Signed *Marguerite Roosenboom*
PROV Purchased at exhib Amsterdam 1880. RVMM, 1885 * DRVK since 1961

A 2723 Still life with strawberries on a white plate. *Stilleven met aardbeien in een witte schaal*

Canvas 45 × 58. Oval. Signed *M. R.*
PROV Presented by Mr & Mrs HPMA Vogel-Molenkamp, Haarlem, 1915

A 2740 Still life with guitar and roses. *Stilleven met gitaar en rozen*

Canvas 60 × 120. Signed *Margt. Roosenboom*
PROV Bequest of the artist's husband, JG Vogel, Velp, 1915 * DRVK since 1961

A 2722 Still life with fruit. *Stilleven met vruchten*

Canvas 20 × 30. Signed *M. R V.*
PROV Presented by Mr & Mrs HPMA Vogel-Molenkamp, Haarlem, 1915 * DRVK since 1953

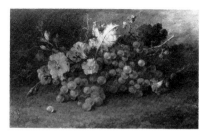

A 2387 Still life with grapes. *Stilleven met druiven*

Canvas 34 × 54. Signed *Marguérite Roosenboom*
PROV Bequest of JBAMWesterwoudt, Haarlem, 1907. Received in 1909 * DRVK since 1959

Pieter Vogelaer

Zierikzee 1641 – 1720 Zierikzee

C 524 The Dutch herring fleet. *De Hollandse haringvloot*

Panel 84 × 114. Pen painting. Signed *P. Vogelaer*
PROV Lent by the KOG (presented by JH Marlof), 1889 * Lent to the AHM, 1975

Willem Vogels

Brussels 1836 – 1896 Brussels

A 3091 A city marketplace. *Markt op een stadsplein*

Canvas 40.7 × 61.5. Signed and dated *G. Vogels 75*
PROV Bequest of JBAMWesterwoudt, Haarlem, 1907. Received in 1929 * DRVK since 1953

Arie de Vois

Utrecht ca 1632 – 1680 Leiden

A 457 The merry fiddler. *De vrolijke speelman*

Panel 26 × 21. Signed *AD Vois f.*
PROV NM, 1808

A 456 A man with a vial of medicine. *Een man met een medicijnflesje*

Canvas 16 × 12. Signed *AD Vois*
PROV Purchased with the Kabinet van Heteren Gevers, The Hague-Rotterdam, 1809
LIT Moes & van Biema 1909, pp 150, 194. Bille 1961, vol 1, p 109

C 260 The smoker. *De roker*

Panel 14 × 10.5. Oval. Signed *AD Vois*

PROV On loan from the city of Amsterdam (A van der Hoop bequest) since 1885

A 458 A young woman with a parrot. *Een jonge vrouw met een papegaai*

Panel 27 × 21. Signed *AD Vois f.*
PROV Bequest of L Dupper Wzn, Dordrecht, 1870
LIT Bernt 1960-62, vol 3, nr 953. Bernt 1969-70, vol 3, nr 1325

A 2512 Portrait of a man. *Portret van een man*

Canvas 82 × 64. Signed *AD Vois f.*
PROV Purchased from C Brunner, Paris, 1910

attributed to **Arie de Vois**

A 3237 Adriaan van Beverland (ca 1652-ca 1712). Writer of theological works and satires, with a wanton woman. *Schrijver van theologische werken en hekelschriften, met een dame van lichte zeden*

Panel 35 × 27.5. Inscribed *Beverlandus de Prostibulis Veterum*
PROV Bequest of F G Waller, Amsterdam, 1935
LIT Th J Meijer, Jb Leiden 63 (1971) pp 43, 64

Lancelot Volders

see Miniatures: Arlaud, Benjamin, A 4295 Christian V, after Volders; Holland school ca 1690, A 4439 Hendrik Casimir II, after Volders; Holland school ca 1710, A 4440, A 4441 Johan Willem Friso, after Volders

Herman van Vollenhoven

active 1611-27 in Utrecht

A 889 The painter in his studio painting the portrait of a couple. *De schilder in zijn werkplaats bezig met het portretteren van een echtpaar*

Canvas 89 × 112. Signed and dated *H. Vollenhove An° 1612 in Wtre…*
PROV Purchased from the collection of D van der Kellen Jr, 1873. NMGK, 1885
LIT Van Hall 1963, p 358, nr 2258. Birren 1965, p 35, figs 2-8. B Haak, Antiek 2 (1968) p 399, fig 1. Exhib cat Maler und Modell, Baden-Baden 1969, nr 42, ill. N Popper-Voskuil, Pantheon 31 (1973) pp 63, 67, fig 7. B Hinz, Städ Jb ns 4 (1973) p 210, fig 3

Jan Vollevens I

Geertruidenberg 1649 – 1728 The Hague

A 1325 Portrait of an army officer. *Portret van een krijgsoverste*

Canvas 124 × 97.5. Signed *Jan Vollevens f.*
PROV Presented by W E Pappelendam & Schouten, art dealers, Amsterdam, 1886
LIT Martin 1935-36, vol 2, p 482, fig 250

copy after **Jan Vollevens I**

A 283 Caspar Fagel (1634-88). Grand pensionary of Holland from 1672 on, with the assembly hall of the states of Holland on the Binnenhof, The Hague, in the background. *Raadpensionaris van Holland sedert 1672, met op de achtergrond de vergaderzaal van de Staten van Holland op het Binnenhof te Den Haag*

Copy after the signed version in the Haags Gemeentemuseum, The Hague (on loan from the DRVK)

Canvas 67 × 54
PROV Sale The Hague, 27 April 1863, lot 21
LIT C Hofstede de Groot, OH 22 (1904) p 29 (rejects the older attribution to Michiel van Musscher)

Jan Vollevens II

The Hague 1685 – 1758 The Hague

A 1630 Gerard Callenburgh (1642-1722). Vice admiral of Holland and West-Friesland. *Luitenant-admiraal van Holland en West-Friesland*

Canvas 121 × 95. Signed and dated *Jan Vollevens f 1718*
PROV Presented from the estate of Mrs Kallenberg van den Bosch-van Lelyveld, widow of R J A Kallenberg van den Bosch, according to the wishes of her husband and through the intermediacy of Jonkheer T van Eysinga, 1895 *
DRVK since 1973

Antoine Vollon

Lyon 1833 – 1900 Paris

A 1901 Harbor view in Dunkerque. *Havengezicht in Duinkerken*

Panel 62 × 36. Signed *A. Vollon*
PROV Presented by the dowager of R Baron van Lynden, née M C Baroness van Pallandt, The Hague, 1900

A 3092 View of the church of Notre Dame de Lorette and the Rue Fléchier, Paris. *Gezicht op de Notre Dame de Lorette en de Rue Fléchier te Parijs*

Canvas 73.5 × 60. Signed *A. Vollon*. Inscribed *Esquisse à mon ami Albert Wolff*
PROV Bequest of J B A M Westerwoudt, Haarlem, 1907. Received in 1929

A 2302 Flowers in a red earthenware pot. *Bloemen in een rood aarden pot*

Canvas 79.5 × 60. Signed *A. Vollon*
PROV Lent by J B A M Westerwoudt, Haarlem, 1902. Bequeathed in 1907 *
DRVK since 1961

Elias Vonck

Amsterdam 1605 – 1652 Amsterdam

A 1951 Still life with a hare, a heron and other birds. *Stilleven met een haas, een reiger en ander gevogelte*

Canvas 100 × 92. Signed *Elias Vonck fe.*
PROV Purchased from F Kleinberger gallery, Paris, 1901

Jan Vonck

Amsterdam ca 1630 – in or after 1662 Amsterdam

A 1344 Dead birds. *Dode vogels*

Panel 34 × 52. Signed *Jan Vonck f.*
PROV Sale J H Cremer, Amsterdam, 26 Oct 1886, lot 99
LIT Vorenkamp 1933, p 82

A 1487 Still life with a haddock and a gurnard. *Stilleven met een schelvis en een knorhaan*

Panel 54.5 × 48. Signed *J. Vonck Fecit*
PROV Sale F Kayser (Frankfurt am Main), Amsterdam, 4 Dec 1888, lot 110
* DRVK since 1959 (on loan to Stedelijk Museum Het Catharinagasthuis, Gouda)

Hendrik Voogd

Amsterdam 1768 – 1839 Rome

A 4094 Italian landscape with pine trees. *Italiaans landschap met pijnbomen*

Canvas 72.5 × 90. Signed and dated *H. Voogd fect Roma 1795*
PROV Sale Amsterdam, 9 April 1963, lot 66, ill
LIT C J de Bruyn Kops, Bull RM 13 (1965) p 68, fig 1. C J de Bruyn Kops, NKJ 21 (1970) pp 320, 348, 361, fig 1

attributed to **Hendrik Voogd**

C 1524 Overgrown rocks and waterfall in Italy, perhaps near Tivoli. *Begroeide rotsen met een waterval in Italië, misschien bij Tivoli*

Canvas 30.1 × 35.5. Fragment
PROV On loan from the DRVK since 1973
LIT J Knoef, Mndbl BK 20 (1943) pp 89-90, ill on p 89 (Josephus Augustus Knip)

Henri Voordecker

Brussels 1779 – 1861 Brussels

A 1157 The home of a hunter. *Jagers-woning*

Panel 62 × 78. Signed and dated *H. Voordecker fecit 1826*
PROV Purchased at exhib Amsterdam 1828, nr 516. RVMM, 1885 * DRVK since 1953

Johannes Voorhout

Uithoorn 1647 – 1723 Amsterdam

A 2371 Allegory of the Treaty of Rijswijk, 1697. *Allegorie op de Vrede van Rijswijk, 1697*

Canvas 146 × 121.5. Signed and dated *J. Voorhout Ft A 1698*
PROV Purchased from C Wachter gallery, Berlin, 1908

NM 1010 a

NM 1010 c

NM 1010 b cannot be photographed

NM 1010 Painted decorations of the nursery (a & b) and the tapestry room (c) in Petronella Oortman's dollhouse: Pharao's daughter discovers Moses (a, mantel painting); Moses with the tables of the law (b, ceiling painting); Christ blessing the children (c, mantel painting). *Beschilderingen van de kraam-kamer en de tapijtkamer in het poppenhuis van Petronella Oortman: Farao's dochter vindt Mozes (a, schoorsteenstuk); Mozes met de tafelen der wet (b, plafondstuk); Christus zegent de kinderen (c, schoorsteenstuk)*

For the dollhouse itself, *see* cat RMA Meubelen, 1952, nr 358; for other parts of the decoration, *see* Piemont, Nicolas, NM 1010; Royen, Hendrik Wilhelmus van, NM 1010; and for a painting of the dollhouse, *see* Appel, Jacob, A 4245

Panels, respectively 13.5 × 11.5 (a); 66 × 56.5 (b); 18.5 × 16.5 (c). Signed *I. V. Hout* (on a) and *J. v. hout* (on c) PROV KKZ, 1875. Belongs to the department of sculpture and applied arts LIT Leesberg-Terwindt 1960, figs 16, 24. CJ de Bruyn Kops, Mndbl Amstelodamum 61 (1974) p 110

Cornelis van der Voort

Antwerp? ca 1576–1624 Amsterdam

C 748 The company of Captain Jonas Cornelisz Witsen and Lieutenant Volckert Overlander, ca 1612/14. *Het korporaalschap van kapitein Jonas Cornelisz Witsen en luitenant Volckert Overlander, ca 1612/14*

The sitters are Jonas Witsen, captain, in the middle, Volckert Overlander, lieutenant, Dirck Hasselaer, ensign, with banner, Pieter Hasselaer, sergeant, Jan van Vlooswijck, sergeant, Pieter Symonsz van der Schellingh, Dirck Claesz Schepel, Jacob Pieters Nachtglas, Hendrick Lens, Jan Beths Roodenburch, Huyg Jansz Crayesteyn, Jan Heyckens, Cornelis Schellinger, Dirck Thollincx and the painter himself, upper right

Canvas 172 × 338
PROV Kloveniersdoelen (headquarters of the arquebusiers' civic guard), Amsterdam. On loan from the city of Amsterdam, 1904-75
LIT Scheltema 1879, nr 124? J Six, OH 5 (1887) pp 12-13. Moes 1897-1905, vol 2, nrs 5668:1, 9163. J Six, OH 29 (1911) p 130, ill. G 't Hart, OH 67 (1952) p 93, fig 14. Van Hall 1963, p 358, nr 2265:1

A 1242 Dirck Hasselaer (1581-1645). Amsterdam merchant, director of the Dutch East India Company. *Koopman te Amsterdam, bewindhebber der Verenigde Oostindische Compagnie*

Pendant to A 1243
For a portrait of the sitter's daughter, *see* Miereveld, Michiel Jansz van, A 1251

Panel 116 × 84.5. Dated *Anno 1614*. Inscribed *Aetatis Suae 33*
PROV Presented by J S R van de Poll, Arnhem, 1885
LIT J Six, OH 5 (1887) pp 9-10. Moes 1897-1905, vol 1, nr 3250:1. WE van Dam van Isselt, Oude Kunst 4 (1918-19) p 182

A 1243 Brechtje van Schoterbosch (1592-1618). Wife of Dirck Hasselaer. *Echt-genote van Dirck Hasselaer*

Pendant to A 1242

Panel 115 × 84.5. Dated *Anno 1614*. Inscribed *Aetatis Suae 22*
PROV Same as A 1242
LIT J Six, OH 5 (1887) pp 9-10. Moes 1897-1905, vol 2, nr 7015. WE van Dam van Isselt, Oude Kunst 4 (1918-19) p 182

C 1108 The regents of the Binnengast-huis (hospital), Amsterdam, 1617. *De regenten van het Binnengasthuis, Amsterdam, 1617*

The sitters are Cornelis Jansz Geelvinck, Lambert Pietersz, IJsbrandt Harmensz, Pieter Egbertsz Vink, Dirck Wuytiers and Warnar Ernst van Bassen

Canvas 197 × 239. Signed and dated *CVV f. Anno 1617*
PROV Binnengasthuis (hospital), Amsterdam. On loan from the city of Amsterdam, 1918-75
LIT J Six, OH 5 (1887) p 8. Moes 1897-1905, vol 1, nrs 392, 2636, 3214; vol 2, nrs 5928, 8508, 9292. J Six, OH 29 (1911) pp 130-31, ill. J Six, OH 36 (1918) pp 243-46, ill (transcription of monogram and inscriptions). Haak 1972, p 17

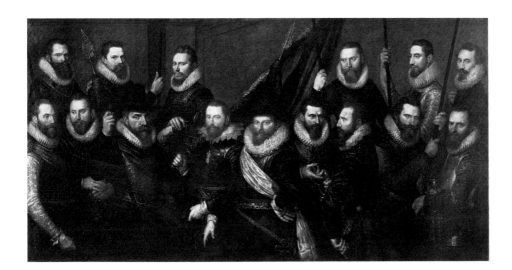

C 399 The regents of the old folk's home, Amsterdam, 1618. *De regenten van het Oude Mannen- en Vrouwengasthuis, Amsterdam, 1618*

Among the sitters are Pelgrom van Dronckelaer, Hendrick Hendricksz Tholinx, Hendrick Tholinx and the beadle

Canvas 152 × 200. Signed and dated *CVV. f.* [Ann]*o 1618*
PROV Oude Mannen- en Vrouwen-gasthuis (old folk's home), Amsterdam. On loan from the city of Amsterdam, 1885-1975
LIT Scheltema 1879, p 10, nr 112 (Cornelis de Wael). J Six, OH 5 (1887) pp 6-7. Moes 1897-1905, vol 1, nr 2155:2; vol 2, nr 7951. J Six, OH 29 (1911) p 131, ill. Riegl 1931, pp 155-56, fig 40. Martin 1935-36, vol 1, pp 186-87, fig 101. Haak 1972, p 17, fig 21

A 1416 Cornelis Pietersz Hooft (1546-1626). Burgomaster of Amsterdam. *Burgemeester van Amsterdam*

The pendant portrait of his wife Anna Jacobsdr Blaeu is the property of the AHM (inv nr A 23544)

Panel 124 × 90.5. Dated *Ann. 1622* (now reads 1642). Inscribed *Aetatis Suae 76*
PROV Sale J H Cremer, Amsterdam, 21 June 1887, lot 147 * Lent to the AHM, 1975
LIT J Six, OH 5 (1887) p 2. Moes 1897-

1905, vol 1, nr 3647:1. J Six, OH 29 (1911) p 132. Martin 1935-36, vol 1, p 311, fig 179. Boon 1942, p 64, fig 31

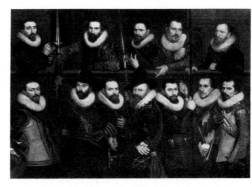

C 408 The company of Lieutenant Pieter Pietersz Hasselaer, 1623. *Het korporaal-schap van luitenant Pieter Pietersz Hasselaer, 1623*

The sitters are from left to right: (top row) Allard Garbrantsz Schilt, master-at-arms, Willem Adriaensz Raep, Jan Lucasz Hooft, Dirck Pietersz Brugman, Barend Willemsz Prins; (bottom row) Samuel Blommert, Pieter Hasselaer, lieutenant, Hendrick Lens, Claes Hendrickz Pot, Jacob Dircksz Brouwer, Heindrik Seulijns and Jacob van Nieulandt

Canvas 184 × 259
PROV Handboogdoelen (headquarters of the archers' civic guard), Amsterdam. On loan from the city of Amsterdam, 1885-1975
LIT Scheltema 1879, nr 27. Scheltema 1855-85, vol 7 (1885) p 128, nr 5. J Six, OH 5 (1887) pp 3-5, 7. Moes 1897-1905, vol 1, nr 3257:3. W del Court & J Six, OH 21 (1903) p 68. Riegl 1931, p 157, fig 64. Martin 1935-36, vol 1, p 160. F Daniels & W Wijnaendts van Resandt, Jb Genealogie 27 (1973) p 71, ill opp p 70

A 3741 Laurens Reael (1583-1637). Governor-general of the Dutch East Indies (1616-19), director of the

Amsterdam chamber of the Dutch East India Company from 1625 on. *Gouverneur-generaal van Nederlands Oost-Indië, sedert 1625 bewindhebber der Verenigde Oostindische Compagnie te Amsterdam*

Pendant to A 3742

Canvas 223 × 127
PROV Lent by the SNK, 1948. Purchased in 1949
LIT H van Rijn, OH 5 (1887) p 150. D C Meijer Jr, OH 6 (1888) pp 226-27. G P Rouffaer, OH 12 (1894) p 195. Moes 1897-1905, vol 2, nr 6211:1. J Six, OH 29 (1911) pp 129-30, ill. Scheurleer 1912, vol 1, ill opp p 124 (Thomas de Keyser). De Loos-Haaxman 1941, p 23, fig 5

A 3742 Suzanna Moor (1608-57). Wife of Laurens Reael from 1629 on. *Sinds 1629 echtgenote van Laurens Reael*

Pendant to A 3741

Canvas 223 × 127
PROV Same as A 3741
LIT D C Meijer Jr, OH 6 (1888) pp 226-27 (not van der Voort). G P Rouffaer, OH 12 (1894) p 195. Moes 1897-1905, vol 2, nr 5157 (Thomas de Keyser?). J Six, OH 29 (1911) p 129. De Loos-Haaxman 1941, p 23

attributed to **Cornelis van der Voort**

C 622 Eleven guardsmen. *Schutterstuk met elf personen*

Canvas 172 × 233
PROV Kloveniersdoelen (headquarters of the arquebusiers' civic guard), Amsterdam. On loan from the city of Amsterdam, 1899-1975
LIT Scheltema 1879, nr 130. J Six, OH 5 (1887) pp 13-14 (Cornelis van der Voort)

manner of **Cornelis van der Voort**

A 1249 Pieter Dircksz Hasselaer (1554-1616). Councillor and alderman of Amsterdam, one of the nine founders of the Compagnie van Verre (overseas trade company) in 1594. *Raad en schepen van Amsterdam, een der negen oprichters van de Compagnie van Verre in 1594*

For a presumed portrait of the sitter's second wife, *see* Eliasz, Nicolaes, A 1245

Panel 67 × 51
PROV Presented by JSR van de Poll, Arnhem, 1885 * Lent to the AHM, 1975
LIT J Six, OH 5 (1887) p 20, note 1 (not Werner van der Valckert but Hendrik Goltzius). Moes 1897-1905, vol 1, nr 3256:1 (Goltzius?). WE van Dam van Isselt, Oude Kunst 4 (1918-19) pp 180-82

copy after **Cornelis van der Voort**

C 1553 Portrait of a man. *Portret van een man*

Panel 71 × 61. Dated on the verso *1619*. Inscribed on the verso *Aet. 54*
PROV On loan from the KOG since 1889

Maria Vos

Amsterdam 1824 – 1906 Oosterbeek

A 1158 Still life with ornate goblet. *Stilleven met een pronkbokaal*

Canvas 91 × 74. Signed and dated *M. Vos 1870*
PROV Purchased at exhib Rotterdam 1870, nr 461. RVMM, 1885 * Lent to the Gouvernementsgebouw (provincial capitol) of Gelderland, Arnhem, 1924. Destroyed in the war, 1944
LIT Scheen 1946, fig 176

A 3456 Still life with stoneware mug. *Stilleven met kan van steengoed*

Canvas 78.5 × 58. Signed and dated *M. Vos 1878*
PROV Bequest of Mrs Weber-van Bosse, widow of AA Weber, Eerbeek, 1942 *
DRVK since 1953

Maerten de Vos

Antwerp 1532 – 1603 Antwerp

A 1717 Gillis Hooftman (1521-81). Shipowner, and his wife Margaretha van Nispen (b 1545). *Reder, en zijn echtgenote Margaretha van Nispen*

Panel 116 × 140.5. Inscribed *Aegidio Hoftman et Margaritae van Nispen eius coniugi pingebat Martinus De Vos Antverpiae mense Iulio ann. A.R.S.CIƆIƆLXX*; above the man *Ætatis sue XXXXVII*; above the woman *Aetatis suae XXV*
PROV Sale G de Clercq, Amsterdam, 1 June 1897, lot 213. Purchased through the intermediacy of the Rembrandt Society
LIT Moes 1897-1905, vol 2, nr 5400. Ring 1913, p 156. S Sulzberger, Revue belge d'Arch & d'Hist de l'Art 6 (1936) pp 121-32. P Philippot, Bull Mus Roy Belg 14 (1965) pp 187, 194, fig 15. L Smolderen, Rev belge numismatique 114 (1968) p 105, pl XVIII. Von der Osten & Vey 1969, p 331. BHinz, Städel Jb ns 4 (1973) p 209, note 20

Johan Jacob Voskuil

b Breda 1897

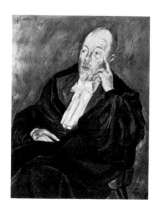

A 4229 Professor Jan Romein (1893-1962). Professor of history at the university of Amsterdam. *Hoogleraar in de geschiedenis aan de universiteit van Amsterdam*

Canvas 116 × 88. Signed and dated *J.J. Voskuil 57*. Inscribed on the verso *Portret van Dr. Jan Romein door J.J. Voskuil '57 maat 116 × 88*
PROV Sale Amsterdam, 1 May 1973, lot 257

Huygh Pietersz Voskuyl

Amsterdam 1592/93 – 1665 Amsterdam

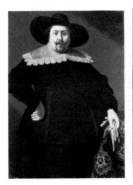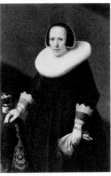

A 2368 Philip Denijs (b 1602). Amsterdam brewer. *Brouwer te Amsterdam*

Pendant to A 2369

Panel 123.5 × 90. Signed and dated *HP Voskuijl fecit Anno 1640*. Inscribed *Aetatis suae 38*
PROV Sale Amsterdam, 15 Dec 1908, lot 150

A 2369 Geertruy Reael (1601-66). Wife of Philip Denijs. *Echtgenote van Philip Denijs*

Pendant to A 2368

Panel 123.5 × 90. Signed and dated *HP Voskuyl fecit Anno 1640*. Inscribed *Aetatis suae 40*
PROV Same as A 2368
LIT Moes 1897-1905, vol 2, nr 6208. Bernt 1960-62, vol 4, nr 296. Bernt 1969-70, vol 3, nr 1339

Sebastiaen Vrancx

Antwerp 1573 – 1647 Antwerp

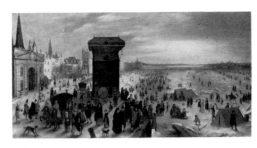

A 1699 The Kranenhoofd on the Schelde, Antwerp. *Het Kranenhoofd aan de Schelde te Antwerpen*

Panel 58.5 × 113. Signed and dated *SV A. 1622*
PROV Purchased from Mrs Lowe-Timmer, Vreeswijk, 1897

LIT J S Held, GdB-A 99 (1957) pp 62, 65, 73, fig 8. Speth-Holterhoff 1957, figs 32-33. Legrand 1963, p 191

C 510 Market day in a Flemish town. *Marktdag in een Vlaamse stad*

Panel 42 × 55. Signed *SV*
PROV On loan from the KOG (presented by A Willet) since 1889
LIT Legrand 1963, p 191, fig 72

A 1637 The robber punished. *De gestrafte rover*

Panel 45.5 × 65. Signed *SV*
PROV Presented by Jonkheer Victor de Stuers, The Hague, 1895

attributed to **Sebastiaen Vrancx**

A 2699 Avenue of trees. *De oprijlaan*

Panel 16.5 × 34
PROV Purchased from A Schlüter gallery, Amsterdam, 1914
LIT M Ihmdahl, in Festschrift Badt, 1961, p 173. Stechow 1966, p 32

copy after **Sebastiaen Vrancx**

A 1409 The battle between Bréauté and Leckerbeetje on the heath outside Vught, 5 February 1600. *Het gevecht tussen Bréauté en Leckerbeetje op de Vughterheide, 5 februari 1600*

Panel 74 × 108
PROV Sale J H Cremer, Amsterdam, 21 June 1887, lot 40 * On loan to the Rijksmuseum Muiderslot, Muiden, since 1949
LIT C Hofstede de Groot, OH 17 (1899) p 170 (Gerrit van Santen). R van Luttervelt, Historia 8 (1942) p 253ff

Vredeman de Vries

see Vries

Jacobus Vrel

active 1654-62, presumably in Holland

A 1592 City view. *Stadsgezicht*

Panel 36 × 28. Signed *I. Vrel*
PROV Purchased from A H H van der Burgh, The Hague, 1892
LIT C Hofstede de Groot, Rep f Kunstw 16 (1893) p 116. C Hofstede de Groot, OH 22 (1904) p 32. C Hofstede de Groot, Oude Kunst, 1916, p 211. W R Valentiner, Art in America 17 (1929) p 91, ill on p 93. Valentiner 1929, pp XXXII-XXXV, ill on p 204. C Brière-Misme, Rev Art Anc & Mod, 1935, p

109. Martin 1935-36, vol 2, p 208. A
Heppner, OH 55 (1938) pp 71, 142, fig 4.
G Régnier, GdB-A 71 (1968) p 281, fig 14

A 3127 Woman at the hearth. *Vrouwtje
bij de schouw*

Panel 36 × 27.5
PROV Purchased from H Schäffer
gallery, Berlin, 1931, as a gift of the
Photo Commission
LIT W Bürger, Annuaire art et am, 1860,
p 293. W R Valentiner, Art in America,
1929, p 92. C Brière-Misme, Rev Art Anc
& Mod, 1935, pp 113, 164, fig 11.
Martin 1935-36, vol 2, p 208

Abraham de Vries

Rotterdam ca 1590–1650/62 The
Hague?

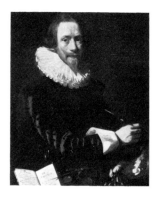

A 2157 Self portrait. *Zelfportret*

Canvas 79 × 65. Signed and dated *Hanc
suam imaginem propria manu depictam
pergula huic iconibus viventi ut parergon
libenter apposuit A. de Vries Batavus anno
1621*. Inscribed on the book *De Arte
Picturae*, followed by a Latin ode and
*De Symetria et Flexuris Partium Humani
Corporis Libri*
PROV Purchased from R Langton
Douglas, London, 1905, through the
intermediacy of the Rembrandt Society
LIT Van Hall 1963, p 361, nr 2289:1

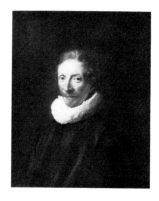

A 758 David de Moor

Panel 71.5 × 61. Signed and dated *A. de
Vries Rotterdam Anno 1640*. Inscribed on
the verso *David de Moor*
PROV Sale W Huydecoper-van den
Heuvel, dowager of W Huydecoper
(Utrecht), Amsterdam, 20 Oct 1880, lot
204
LIT Kramm 1857-64, vol 6 (1863) p 1803

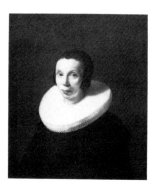

A 4053 Portrait of a woman. *Portret van
een vrouw*

Panel 68.5 × 58. Signed and dated
A. de Vries … 16[42]
PROV Bequest of Mr & Mrs I de Bruijn-
van der Leeuw, Muri near Bern, 1960
LIT J L Cleveringa, Bull RM 9 (1961) p
66, nr 17, fig 14

Anthony de Vries

see Helst, Bartholomeus van der, C 50
Gerard Andriesz Bicker, copy by de Vries

Hans Vredeman de Vries

Leeuwarden 1527–ca 1606

A 2390 Formal garden of a palace, with
Lazarus in the foreground. *Parkaanleg bij
een paleis met op de voorgrond de arme
Lazarus*

Panel 42 × 66. Traces of a signature
PROV Sale Amsterdam, 27 April 1909,
lot 209
LIT Van de Wetering 1938, p 69.
Rosenberg, Slive & Ter Kuile 1966, p
188. U M Schneede, NKJ 18 (1967) p
156, nr V, fig 22

Joghem de Vries

active 1750-90 in Zaandam

A 4065 The Greenlandman 'Zaandam'
of the Zaandam shipowners Claes Taan
& Son in the whaling grounds. *De
Groenlandvaarder 'Zaandam' van rederij
Claes Taan en Zn, Zaandam, op de walvis-
vangst*

Canvas 98.5 × 127. Signed and dated
Joghem de Vries 1772. Inscribed on the
rowboat *Klaas Taan Zaandam*
PROV Purchased from H Sokolowski,
Stockholm, 1961
LIT *Cf* Zaanlandsch Jaarboek, 1847,
p 59. Dekker 1971, fig 52

Michiel van Vries

active ca 1650 – before 1702 in Zaandam

A 1507 Old country cottage on the water. *Oude boerenwoning aan het water*

Panel 43 × 62.5. Signed and dated
M. v. Vries 1656
PROV Purchased from S Kesnar,
Amsterdam, 1899
LIT Bernt 1969-70, vol 3, nr 1354

Roelof van Vries

Haarlem 1631 – after 1681 Amsterdam?

A 459 Landscape with falconer. *Landschap met valkenier*

Canvas 63 × 85. Signed *R. v. Vries*
PROV Purchased in Amsterdam, 1814
LIT Bernt 1960-62, vol 4, nr 300. Bol
1967, p 213

Hendrick Cornelisz Vroom

Haarlem ca 1566 – 1640 Haarlem

A 460 Dutch ships ramming Spanish galleys off the Flemish coast, 3 October 1602. *Hollandse schepen overzeilen Spaanse galeien onder de Vlaamse kust, 3 october 1602*

Canvas 117.5 × 146. Signed and dated
Vroom 1617
PROV NM, 1808
LIT Moes & van Biema 1909, pp 37, 317.
Willis 1911, pl IV. S W A Drossaers, OH
47 (1930) p 232, nr 244. Martin 1935-36,
vol 1, pp 48, 258, fig 26. Bernt 1960-62,
vol 3, nr 981. Diekerhoff 1967, fig 16.
Bol 1973, p 28, note 64

A 602 Battle between Dutch and Spanish ships on the Haarlemmermeer, 26 May 1573. *Gevecht tussen Hollandse en Spaanse schepen op het Haarlemmermeer, 26 mei 1573*

Canvas 190 × 268. Signed *Vroom F.*
PROV Town hall, Haarlem. NM, 1808.
's Rijks Marinewerf (navy yard),
Amsterdam, 1866
LIT Moes & van Biema 1909, pp 77, 177,
216. Willis 1911, p 19. C J Gonnet, OH 33
(1915) p 141. Martin 1935-36, vol 1, p
258. Boon 1942, p 39, fig 19. J Bruyn,
Bull RM 2 (1954) p 54. J A van der
Bergen, Antiek 6 (1972) pp 580-81, fig 4.
J J Temminck, Spiegel Hist 8 (1973) p
266, frontispiece. Bol 1973, pp 24-25, fig
19

A 1361 The Amsterdam fourmaster 'De Hollandse Tuyn' and other ships entering the Y on their return from Brazil under command of Paulus van Caerden. *De Amsterdamse viermaster 'De Hollandse Tuyn' en andere schepen bij het binnenvaren van het IJ na terugkeer uit Brazilië onder bevel van Paulus van Caerden*

Canvas 144 × 279. Signed *Vroom*
PROV East India House, Amsterdam.
NMGK, 1887
LIT Martin 1935-36, vol 1, p 258. R van
Luttervelt, OK 1 (1957) nr 34, ill. Bernt
1960-62, vol 3, nr 980. P J van Winter &
K Sierksma, Spiegel Hist 5 (1970) p 606,
frontispiece. Bernt 1969-70, vol 3, nr
1362. Bol 1973, p 26, note 53

A 3108 The 'Mauritius' and other East Indiamen sailing out of the Marsdiep. *Het uitzeilen van een aantal Oost-Indiëvaarders uit het Marsdiep. In het midden het schip 'Mauritius'*

Canvas 103.5 × 198.5. Signed *Vroom*
PROV Presented by J W I Jzerman,
Wassenaar, 1930
LIT Bol 1973, p 26. J Heniger, Jb Leiden
65 (1973) p 33, fig 1

A 2858 The return to Amsterdam of the second expedition to the East Indies, 19 July 1599. *De terugkomst in Amsterdam van de tweede expeditie naar Oost-Indië, 19 juli 1599*

Canvas 110 × 220. Inscribed on the frame *Den eersten Mey anno 1598 ∗ Mauritius, Hollant, Overijssel en Vrieslant; Vier schepen syn geseylt om specery te halen, naar Bantam, hebben oock den handel daer geplant en quamen rijcklijc weer voor d'Amsterdamsche palen ∗ Den negentienden Iuly anno 1599*
PROV Purchased from the dowager of
Jonkheer G J Th Beelaerts van Blokland,

née J M Kneppelhout van Sterkenburg, The Hague, 1921 * Lent to the AHM, 1975
LIT Baard 1942, p 8, ill on p 7. Bol 1973, p 26

A 2163 The explosion of the Spanish flagship during the Battle of Gibraltar, 25 April 1607. *Het ontploffen van het Spaanse admiraalschip tijdens de zeeslag bij Gibraltar, 25 april 1607*

Canvas 137.5 × 188
PROV Sale Jonkheer H Teding van Berkhout, Amsterdam, 27-29 July 1905, lot 120
LIT H Jantzen, Onze Kunst 18 (1910) p 105. Jvsl Scheepvaartmus, 1922, pp 47-56. Preston 1937, p 12, fig 4. Smit 1938, pp 47, 68. Stechow 1966, p 112, fig 222. Rosenberg, Slive & Ter Kuile 1966, p 163, fig 145A. Bernt 1969-70, vol 3, nr 1363. Bol 1973, pp 17-18, fig 10

attributed to **Hendrick Cornelisz Vroom**

A 2661 A seagoing vessel sailing into an inland waterway. *Een zeeschip vaart een binnenwater op*

Panel 43.5 × 71
PROV Purchased from A Vecht & Co gallery, Amsterdam, 1913
LIT Bol 1973, p 28, note 64

Isaak Vroomans

Delft? ca 1655 – 1719 Delft?

A 2530 Grapes, flowers and animals. *Druiven, bloemen en dieren*

Canvas 65 × 53. Signed *I. Vroomans*
PROV Purchased from Mason & Philips gallery, London, 1911
LIT Bernt 1960-62, vol 4, nr 301. Bol 1969, p 340. Bernt 1969-70, vol 3, nr 1358

Gerrit van Vught

active 1658-97 in Schiedam

A 2205 Vanitas still life. *Vanitas stilleven*

Panel 9.3 × 12
PROV Bequest of Miss M E van den Brink, Velp, 1905
LIT B Haak, OH 72 (1957) pp 117, 120. Bol 1969, p 83, fig 71

Nicolaas van der Waay

Amsterdam 1855 – 1936 Amsterdam

A 2789 Willem Steelink II (1856-1928). Graphic artist. *Graficus*

Canvas 63.5 × 42. Signed *N. v.d. Waay*
PROV Presented by the sitter, Laren, 1916
LIT Van Hall 1963, p 313, nr 1997:1

A 3144 Amsterdam orphan girl. *Amsterdams weesmeisje*

Canvas 69 × 43.5. Signed *N. v.d. Waay*
PROV Bequest of F de Fremery, The Hague, 1933

Philip van der Wal

active ca 1810 in Rome

NO PHOTOGRAPH AVAILABLE

A 1348 Scene from Roman history. *Tafereel uit de Romeinse geschiedenis*

Canvas 292 × 352. Signed and dated *Van der Wal Roma 1810*
PROV Discovered in the small attic room of the Trippenhuis in 1884/85 when the collection was transferred to the Rijksmuseum. Probably discarded on account of poor condition

NO PHOTOGRAPH AVAILABLE

A 1349 Scene from Roman history. *Tafereel uit de Romeinse geschiedenis*

Canvas 258 × 242
PROV Same as A 1348. Probably discarded on account of poor condition

Antonie Waldorp

The Hague 1803 – 1866 Amsterdam

A 3849 One of the bridges over the Seine, Paris, in the moonlight. *Gezicht op een Seinebrug te Parijs bij maanlicht*

Panel 35 × 43.5. Signed and dated *A. Waldorp 1835*[?]
PROV Bequest of Mrs M N Th Weddik-Lublink Weddik, widow of A L Weddik, Arnhem, 1919 * DRVK since 1961

A 3850 River view with a tower on the water, modelled after the Camperveerse Tower, Veere. *Riviergezicht met een*

waltoren geïnspireerd op de Camperveerse toren te Veere

Panel 23 × 30.5. Signed and dated *A. Waldorp 1855.* Inscribed on the mainsail *Veere*
PROV Bequest of Mrs M N Th Weddik-Lublink Weddik, widow of A L Weddik, Arnhem, 1919 * DRVK since 1961

C 261 Fishing boats in calm water. *Vissersboten op kalm water*

Panel 48.5 × 60. Signed *A. Waldorp*
PROV On loan from the city of Amsterdam (A van der Hoop bequest) since 1885
LIT Scheen 1946, fig 378

Gustaaf Frederik van de Wall Perné

Apeldoorn 1877 – 1911 Amsterdam

A 2626 'Mystic paths': forest view. '*Mystieke paden': bosgezicht*

Canvas 129 × 177. Signed and dated *Gust. van de Wall Perné 1907*
PROV Presented by the artist's widow, Mrs E C van de Wall Perné-van Vooren, Amsterdam, 1912

Isaak Walraven

Amsterdam 1686 – 1765 Amsterdam

A 461 The deathbed of Epaminondas, commander of the Theban army in its battle against Sparta, 371-62 BC. *Het sterfbed van Epaminondas, bevelhebber van het Thebaanse leger in de strijd tegen Sparta*

Panel 61 × 80. Signed and dated *Isaak Walraven Fecit A° 1726.* Inscribed on the verso *A° 1783 op de verkoping van Leyden is dit schilderij door Gildemeester gekocht voor 1200,– guldens en kosten de Heer Locquet op de verkoping van Walraven 1560 guld. A° 1800 verkogt...*
PROV Purchased from J de Brauwere gallery, Brussels, 1871
LIT Scheen 1946, fig 108. C J de Bruyn Kops, Bull RM 13 (1965) p 113, fig 41

Jacob van Walscapelle

Dordrecht 1644 – 1727 Amsterdam

A 2346 Still life with fruit. *Stilleven met vruchten*

Canvas 68 × 63. Signed *J. W. F.*
PROV Purchased from the heirs of Jonkheer P H Six van Vromade, Amsterdam, 1908 * On loan to the municipality of Velsen (Beeckestijn Estate) since 1969
LIT Warner 1928, nr 110b. Vorenkamp 1933, p 64. Bergström 1947, p 226, fig 186. Bergström 1956, p 226, fig 187. Bernt 1960-62, vol 3, nr 983. Bol 1969, p 317. Bernt 1969-70, vol 3, nr 1370

Maria Wilhelmina Wandscheer

Amsterdam 1856 – 1936 Ede

NO PHOTOGRAPH AVAILABLE

A 3044 Portrait of a woman. Bust. *Portret van een vrouw. Borstbeeld.*

Canvas 67 × 48. Signed and dated
M. Wandscheer 1886
PROV Bequest of A Allebé, Amsterdam,
1927. Missing

Egide Charles Gustave **Wappers**

Antwerp 1803 – 1874 Paris

A 1159 Anthony van Dyck wooing his model. *Anthonie van Dijck verliefd op zijn model*

Panel 58 × 47.5. Signed and dated
G^{ve} Wappers 1827
PROV Purchased at exhib The Hague
1827, nr 341. RVMM, 1885 * DRVK since
1953

Elisabet Geertruda **Wassenbergh**

Groningen 1729 – 1781 Groningen

A 3740 The doctor's visit. *Het dokters-bezoek*

Canvas 40 × 49.5
PROV Sale A Schlosz, Paris, 25 May
1949, lot 67, ill

LIT Van Eynden & van der Willigen
1816-40, vol 2 (1817) pp 245-46. A
Wassenbergh, OH 62 (1947) pp 195-98.
CJ de Bruyn Kops, NKJ 12 (1961) pp
128-32, 145, nr 7d, fig 5

Jan Abel **Wassenbergh**

Groningen 1689 – 1750 Groningen

A 1799 Louise Christina Trip (d 1733).
Wife of Gerrit Sichterman. *Echtgenote van Gerrit Sichterman*

For other portraits of the sitter and her
husband, *see* Troost, Cornelis, A 3933,
A 4200, A 4201

Canvas 171 × 141. Signed
J.A. Wassenbergh fecit
PROV Bequest of FZReneman, Haarlem,
1898
LIT Scheen 1946, fig 22

attributed to **Antonie Waterloo**

Utrecht? ca 1610 – 1690 Utrecht?

A 734 Wooded landscape. *Boomrijk landschap*

Canvas 52 × 62
PROV Purchased from CFRoos & Co,
art dealers, Amsterdam, 1881 * DRVK
since 1952

Jan van **Wechelen**

see Dalem, Cornelis van, and Jan van
Wechelen, A 1991 Church interior;
A 4293 The legend of the baker of Eekloo

Jan **Weenix**

Amsterdam 1642 – 1719 Amsterdam

C 262 Abraham van Bronckhorst (b
1656)

Canvas 87 × 73.5. Signed and dated
J. Weenix A. 1688. Inscribed on the letter
*Mijnheer…n heer A. Bronckhorst C…sman
tot Amsterdam.*
PROV On loan from the city of
Amsterdam (A van der Hoop bequest),
1885-1975

A 464 Still life with hare and other small
game. *Stilleven met haas en andere jachtbuit*

Canvas 114.5 × 96. Signed and dated
J. Weenix f. 1697
PROV Sale G van der Pot van
Groeneveld, 6 June 1808, lot 135
LIT Moes & van Biema 1909, pp 113,
166, 182. Vorenkamp 1933, p 93

A 463 A monkey and a dog beside dead game and fruits. *Een aap en een hond bij dood wild en vruchten*

Canvas 123 × 99. Signed and dated *J. Weenix f. 1704*
PROV Purchased with the Kabinet van Heteren Gevers, The Hague-Rotterdam, 1809 * On loan to the KKS since 1925
LIT Moes & van Biema 1909, pp 155, 166

A 462 A monkey and a dog beside dead game and fruits, with the estate of Rijxdorp near Wassenaar in the background. *Een aap en een hond bij dood wild en vruchten met op de achtergrond het buitenverblijf Rijxdorp bij Wassenaar*

Canvas 172 × 160. Signed and dated *J. Weenix f. 1714*
PROV NM, 1808
LIT Moes & van Biema 1909, p 226

C 264 A dog near a dead goose and peacock. *Een hond bij een dode gans en een pauw*

Canvas 139 × 170
PROV On loan from the city of Amsterdam (A van der Hoop bequest) since 1885

C 263 Portrait of a greyhound and a spaniel. *Portret van een hazewindhond en een patrijshond*

Canvas 84 × 103.5
PROV On loan from the city of Amsterdam (A van der Hoop bequest) since 1885

A 4098 Park with country home. *Park met buitenhuis*

Part of a six-piece decorative suite. Another part, with a hunting scene, is in the Musée de la Chartreuse, Douai

Canvas 302 × 215
PROV Purchased from Th Agnew & Sons gallery, London, 1963, as a gift of the Photo Commission
LIT J Guillouet, Revue du Louvre 14 (1964) p 238. Connaissance d A, June 1967, p 108, ill

Jan Baptist Weenix

Amsterdam 1621 – ca 1660 Utrecht

A 3879 Johan van Twist (d 1643). The ambassador of the Dutch fleet on his way to the sultan of Visiapur, with the blockade of Goa, January-February 1637, in the background. *Als ambassadeur van de Hollandse vloot op weg naar de sultan van Visiapoer. Op de achtergrond de blokkade van Goa, januari-februari 1637*

Canvas 101 × 179. Signed *Gio Batt Weenix*
PROV Purchased from G Kurz, Vienna, 1953
LIT R van Luttervelt, Bull RM 3 (1955) pp 9-16, ill

A 591 A dog and a cat near a disembowelled deer. *Een hond en een kat bij een half geslachte ree*

Canvas 180 × 162. Signed *Gio. Batti. Weenix*
PROV NM, 1808
LIT C Hofstede de Groot, OH 22 (1904) p 32. B W F van Riemsdijk, Bull NOB 8 (1907) p 124. Vorenkamp 1933, p 84. Martin 1935-36, vol 2, pp 461-62, fig 243. Bergström 1947, p 257. Bergström 1956, p 253, fig 210. Plietzsch 1960, p 140, fig 239. Rosenberg, Slive & Ter Kuile 1966, p 201

A 1417 A ram sitting on the ground. *Liggende bok*

Canvas 84 × 132.5. Signed *Gio. Batti.*
Weenix
PROV Sale J H Cremer, Amsterdam, 26
Oct 1886, lot 102

Hendrik Johannes (JH) Weissenbruch

The Hague 1824–1903 The Hague

see also under Aquarelles and drawings

A 2291 'View near the Geestbrug': the
shipping canal of Rijswijk, with the
Binckhorst left and the Laakmolen
right. *'Gezicht bij de Geestbrug': de trekvaart
in de richting van Rijswijk gezien met links de
Binckhorst en rechts de Laakmolen*

Panel 31 × 50. Signed and dated
J. Hendrik Weissenbruch f. 68
PROV Lent by J B A M Westerwoudt,
Haarlem, 1888. Bequeathed in 1907
LIT M Delitzscher, Die Kunst, 1960, p
14, ill. De Gruyter 1968-69, vol 1, p 67,
fig 75

A 3618 Basement of the artist's home in
The Hague. *Doorkijkje in het onderhuis van
Weissenbruch's woning in Den Haag*

Canvas 39 × 51. Signed and dated
J. H. Weissenbruch f 88
PROV Lent by Mr & Mrs J C J Drucker-
Fraser, 1919. Bequeathed in 1944
LIT *Cf* van Gelder 1940, p 50, ill on p 34.
De Gruyter 1968-69, vol 1, pp 66, 73,
note 21

A 3617 Interior of a stable. *Stalinterieur*

Panel 32.5 × 43.5. Signed and dated
J. H. Weissenbruch 95
PROV Lent by Mr & Mrs J C J Drucker-
Fraser, 1919. Bequeathed in 1944
LIT M Delitzscher, Die Kunst, 1960, p
15, ill. De Gruyter 1968-69, vol 1, p 66,
67, fig 82

A 1923 Forest view near Barbizon. *Bos-
gezicht in de omgeving van Barbizon*

Canvas 48.5 × 64. Signed and dated
J. H. Weissenbruch f 1900. Inscribed
Barbizon
PROV Sale The Hague, 16 Oct 1900, lot
104, for the benefit of Pulchri Studio
LIT M Delitzscher, Die Kunst, 1960, p
45, ill. De Gruyter 1968-69, vol 1, p 71,
fig 91

A 2438 The mill. *De molen*

Panel 41 × 30.5. Signed
J. H. Weissenbruch f.
PROV Lent by Mr & Mrs J C J Drucker-

Fraser, London, 1903. Presented in
1909-10 * DRVK since 1959 (on loan to
the Gemeentemuseum, Arnhem)
LIT M Eisler, Elsevier's GM 46 (1913) p
424, ill on p 423. M Delitzscher, Die
Kunst, 1960, p 14, ill

A 2439 Dune landscape. *Duinlandschap*

Panel 21 × 34. Signed *J. H. Weissenbruch f.*
PROV Lent by Mr & Mrs J C J Drucker-
Fraser, London, 1903. Presented in 1910
LIT W Steenhoff, Elsevier's GM 40 (1910)
ill on p 373. M Eisler, Elsevier's GM 46
(1913) p 422, ill. M Delitzscher, Die
Kunst, 1960, p 17, ill

A 2710 Landscape with farm near a
pond. *Landschap met boerderij bij een plas*

Canvas 46 × 67. Signed *J. H. Weissenbruch*
PROV Presented by the heirs of W J van
Randwijk, The Hague, 1914
LIT W Steenhoff, Onze Kunst 14 (1915)
p 94, ill

A 3619 Peasant cottage on a waterway.
Boerenhuis aan een vaart

Panel 17.5 × 24. Signed
J. H. Weissenbruch f
PROV Lent by Mr & Mrs J C J Drucker-
Fraser, 1919. Bequeathed in 1944

A 3355 Interior of a peasant hut. *Boeren-interieur*

Panel 34 × 43.5. Signed *J. H. Weissenbruch*
PROV Presented by Mr & Mrs DAJ
Kessler-Hülsmann, Kapelle op den
Bosch near Mechelen, 1940
LIT M Delitzscher, Die Kunst, 1960, p
17, ill

A 3093 Autumn landscape. *Herfst-landschap*

Canvas 41.3 × 66.5. Signed
J. H. Weissenbruch f.
PROV Bequest of J B A M Westerwoudt,
Haarlem, 1909. Received in 1929

Johannes Weissenbruch

The Hague 1822–1880 The Hague

A 1160 A city gate in Leerdam. *Een stadspoort te Leerdam*

Canvas 77 × 104. Signed *Jan
Weissenbruch f.*
PROV Purchased at exhib Rotterdam
1870, nr 465. RVMM, 1885
LIT VTTT, 1960, nr 31

A 1835 The church of St Denis, Liège.
De kerk van St Denis te Luik

Canvas 95 × 77. Signed
Jan Weissenbruch f
PROV Bequest of Reinhard Baron van
Lynden, The Hague, 1899
LIT Scheen 1946, fig 216

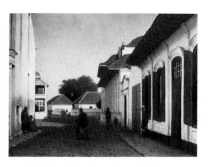

A 2830 A street in the old quarter of
Batavia. *Een straatje in het oude gedeelte van
Batavia*

Panel 22.5 × 30.5
PROV Bequest of Mrs M N Th Weddik-
Lublink Weddik, widow of A L Weddik,
Arnhem, 1919

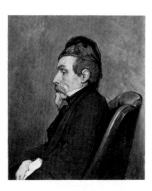

A 1526 Johan Hendrik Louis Meijer
(1809-66). Seascape painter. *Zeeschilder*

Paper 31 × 28.5
PROV Presented by Jonkheer Victor de
Stuers, The Hague, 1890
LIT Gerson 1961, p 26. Van Hall 1963, p
209, nr 1405:2

Johannes Antonius van Welie

Druten 1866–1956 The Hague

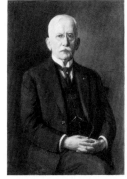

A 3356 Dominicus Antonius Josephus
Kessler (1855-1939)

The paintings collected by Mr & Mrs
Kessler-Hülsmann were presented to the
Rijksmuseum in 1940 and 1947

Pendant to A 3357

Canvas 101.5 × 71. Signed and dated
Antoon van Welie Ft 1925. Inscribed
Æt Suae 70
PROV Presented by Mr & Mrs DAJ
Kessler-Hülsmann, Kapelle op den
Bosch near Mechelen, 1940 * DRVK
since 1958

A 3357 Anna Christina Maria Helene
Hülsmann (1868-1947). Daughter of
Mr & Mrs Hülsmann-Sonnenschein,
wife of DAJ Kessler. *Dochter van de heer en
mevrouw Hülsmann-Sonnenschein, echtgenote
van D A J Kessler*

Pendant to A 3356
For a portrait of the sitter's parents, *see*
A 3358, A 3359

Canvas 101.5 × 71. Signed and dated
Antoon van Welie Ft 1926
PROV Same as A 3356 * DRVK since 1958

A 3358 Johann Heinrich Hermann
Hülsmann. Father of Mrs ACMH
Kessler-Hülsmann. *Vader van mevrouw
ACMH Kessler-Hülsmann*

Pendant to A 3359

Canvas 62 × 53. Signed and dated
Antoon van Welie Ft 1937
PROV Same as A 3356

A 3359 J M C J (Julia) Sonnenschein.
Wife of J H H Hülsmann, mother of Mrs
A C M H Kessler-Hülsmann. *Echtgenote
van J H H Hülsmann, moeder van mevrouw
A C M H Kessler-Hülsmann*

Pendant to A 3358

Canvas 63 × 53. Signed and dated
Antoon van Welie Ft 1926
PROV Same as A 3356

Wellens de Cock

see Cock

Adriaen van der Werff

Kralinger-Ambacht 1659 – 1722
Rotterdam

see also Miniatures: Petitot, Jean, A 4356
John Churchill, after van der Werff

A 1267 Margaretha Rendorp (1673-
1730). Wife of Jan van de Poll. *Echt-
genote van Jan van de Poll*

Pendant to Boonen, Arnold, A 1266 Jan
van de Poll and his son Harmen
Hendrick

Canvas 48 × 39. Signed and dated
Ad^n vand^r Werff fec. 1692
PROV Presented by J S R van de Poll,
Arnhem, 1885
LIT Moes 1897-1905, vol 2, nr 6318.
Hofstede de Groot 1907-28, vol 10, nr
192

C 265 A couple making love in a park
spied upon by children. *Liefkozend paar
in een park door kinderen bespied*

Panel 37 × 30. Signed and dated
Adr^n v. Werff fec. A° 1694
PROV On loan from the city of
Amsterdam (A van der Hoop bequest)
since 1885
LIT Hofstede de Groot 1907-28, vol 10,
nr 148. Martin 1935-36, vol 1, p 103, fig
61. E Plietzsch, Art Q 14 (1951) p 146.
Plietzsch 1960, p 191. Exhib cat Adriaen
van der Werff, Rotterdam 1973, nr 23,
fig 11 (probably depicts Paris and
Oenone; ca 1685-95)

A 469 The entombment. *De graflegging*

Canvas 102.5 × 83. Signed and dated
A. v.d. Werf 1696
PROV Bequest of L Dupper Wzn,
Dordrecht, 1870 * DRVK since 1959 (on
loan to the Museum Amstelkring,
Amsterdam)
LIT Hofstede de Groot 1907-28, vol 10,
nr 70. Exhib cat Adriaen van der Werff,
Munich 1972, p 18, nr 16. Exhib cat
Adriaen van der Werff, Rotterdam 1973,
nr 21

A 465 Self portrait with the portrait of
his wife Margaretha van Rees (1669-
1732) and their daughter Maria (1692-
1731). *Zelfportret met het portret van zijn
vrouw Margaretha van Rees en hun dochtertje
Maria*

Canvas 81 × 65.5. Signed and dated
Adr. v. Werff fec. 1699
PROV Sale A Gevers, Rotterdam, 24
July 1827, lot 1
LIT Houbraken 1718-21, vol 3, p 398?
Van Gool 1750-51, vol 2, p 398. N de
Roever, OH 5 (1887) p 70. Moes 1897-
1905, vol 2, nrs 6286:2, 8985:4, 8985:13,
8988:1. E Wiersum, Rotterdamsch Jb 3d
ser 5 (1927) pp 10-11. Hofstede de
Groot 1907-28, vol 10, nr 172. Ried 1931,
fig 72. Goldscheider 1936, p 39, fig 284.
Boon 1947, p 62, fig 42. Bernt 1960-62,
vol 3, nr 993. Van Hall 1963, p 367, nr
2339:8. Exhib cat De schilder en zijn
wereld, Delft 1964-65, nr 118.
Rosenberg, Slive & Ter Kuile 1966, p
212. Bernt 1969-70, vol 3, nr 1381.
Eckardt 1971, p 213, fig 49. N Popper-
Voskuil, Pantheon 31 (1973) p 65, fig 10.
Exhib cat Adriaen van der Werff,
Rotterdam 1973, nr 33, fig 5

A 468 The holy family. *De heilige familie*

Panel 36 × 29. Signed and dated
A. V^n dr Werff ft. 1714
PROV Sale G van der Pot van
Groeneveld, Rotterdam, 6 June 1808, lot
137 * DRVK since 1959 (on loan to the
Museum Amstelkring, Amsterdam)
LIT Moes & van Biema 1909, pp 113,
166, 183. E Wiersum, Rotterdamsch Jb

3d ser 5 (1927) p 12. Hofstede de Groot
1907-28, vol 10, nr 143. E Plietzsch, Art
Q 14 (1951) pp 144-45, fig 4. Plietzsch
1960, p 190, fig 348. Rosenberg, Slive &
Ter Kuile 1966, p 213, fig 172a

A 467 A nymph dancing to a shepherd's
flute. *Een nimf dansend op het fluitspel van
een herder*

Panel 44 × 33. Signed and dated
Chev^r v^r Werff fe 1718
PROV Purchased with the Kabinet van
Heteren Gevers, The Hague-Rotterdam,
1809
LIT Hoet 1752, vol 2, p 461. Moes & van
Biema 1909, pp 151, 192. Hofstede de
Groot 1907-28, vol 10, nr 161. E
Plietzsch, Art Q 14 (1951) p 146.
Plietzsch 1960, p 191. Bernt 1960-62, vol
3, nr 994. Bernt 1969-70, vol 3, nr 1382.
Exhib cat Adriaen van der Werff,
Rotterdam 1973, nr 26, fig 10

A 1715 A young painter. *Een jonge
schilder*

Panel 17 × 12.5. Signed *A. van der Werf fec.*
Formerly dated *1678*
PROV Sale G de Clercq, Amsterdam, 1
June 1897, lot 118. Purchased with aid
from the Rembrandt Society
LIT Houbraken 1718-21, vol 3, p 312.
Hofstede de Groot 1907-28, vol 10, nr
173. Van Hall 1963, p 367, nr 2339:1.
Exhib cat Adriaen van der Werff,
Rotterdam 1973, nr 41, fig 8. N Popper-
Voskuil, Pantheon 31 (1973) pp 58-74

A 3935 Godard van Reede (1644-1703),
lord of Amerongen. Lieutenant-general.
Heer van Amerongen. Luitenant-generaal

Canvas 130 × 101
PROV Purchased from Leger gallery,
London, 1958

A 466 Amor kissing Venus. *Venus door
Amor gekust*

Panel 25 × 35
PROV NM, 1808
LIT Moes & van Biema 1909, p 215.
Hofstede de Groot 1907-28, vol 10, nr
122. E Plietzsch, Art Q 14 (1951) p 146.
Plietzsch 1960, p 191

manner of **Adriaen van der Werff**

A 2347 Vanitas still life with a girl
blowing bubbles. *Bellenblazend meisje bij
een vanitas stilleven*

Copper 15 × 11.5. Inscribed on the book
I. Sterte [J Starter] *Boertighede...*
PROV Purchased from the heirs of
Jonkheer P H Six van Vromade,
Amsterdam, 1908
LIT Hofstede de Groot 1907-28, vol 10,
nr 143

copy after **Adriaen van der Werff**

A 623 Cimon and Pero. *Cimon en Pero*

Canvas 56 × 68
PROV Unknown
LIT *See* Moes & van Biema 1909, p 216.
Hofstede de Groot 1907-28, vol 10, nrs
129-31

Pieter van der Werff

Kralinger-Ambacht 1665 – 1722
Rotterdam

see also Rotterdam East India Company
series

A 2657 Portrait of Mr Brust. *Portret van
de heer Brust*

Pendant to A 2658

Canvas 80 × 68. Oval. Signed and dated
P v^r Werff fecit Anno 1710
PROV Presented by H G C Leendertsz,
Apeldoorn, 1913 * On loan to the
municipality of Velsen (Beeckestijn
Estate) since 1969

A 2658 Portrait of Mrs Brust-Batailhy. *Portret van mevrouw Brust-Batailhy*

Pendant to A 2657

Canvas 80 × 68. Oval. Signed and dated *P. vr Werff fecit anno 1710*
PROV Same as A 2657 * On loan to the municipality of Velsen (Beeckestijn Estate) since 1969

A 470 St Jerome. *De heilige Hieronymus*

Panel 46 × 36. Signed and dated *P. vr Werff fe Anno 1710*
PROV Purchased with the Kabinet van Heteren Gevers, The Hague-Rotterdam, 1809
LIT Hoet 1752, vol 2, p 461. Moes & van Biema 1909, pp 151, 166. Bille 1961, vol 1, p 109. Exhib cat Adriaen van der Werff, Rotterdam 1973, nr 71, fig 44

A 471 Two girls with flowers at a statue of Cupid. *Twee meisjes met bloemen bij een beeld van Cupido*

Panel 38.5 × 29. Signed and dated *P. vr Werff fecit Anno 1713*
PROV Purchased with the Kabinet van Heteren Gevers, The Hague-Rotterdam, 1809
LIT Hoet 1752, vol 1, p 449; vol 2, p 461. Moes & van Biema 1909, pp 151, 192. Exhib cat Adriaen van der Werff, Rotterdam 1973, nr 74, fig 43

A 472 A statue of Venus, with a girl drawing and a boy. *Een tekenares en een jongen bij een beeld van Venus*

Panel 38.5 × 29. Signed and dated *P. vr Werff fect Anno 1715*
PROV Purchased with the Kabinet van Heteren Gevers, The Hague-Rotterdam, 1809
LIT Hoet 1752, vol 1, p 449; vol 2, p 461. Moes & van Biema 1909, pp 151, 192. Bille 1961, vol 1, p 109. VTTT, 1961, nr 36. F Gorissen, Spiegel Hist 4 (1969) pp 231-32, ill. Exhib cat Adriaen van der Werff, Rotterdam 1973, nr 75, fig 42

C 267 The infant Hercules with the snakes. *De jonge Hercules met de slangen*

Pendant to C 268

Panel 34.5 × 43
PROV On loan from the city of Amsterdam (A van der Hoop bequest) since 1885

C 268 The infant Bacchus. *De jonge Bacchus*

Pendant to C 267

Panel 34.5 × 43.5
PROV Same as C 267

attributed to **Pieter van der Werff**

A 631 Portrait of a man, thought to be Theodorus Rijswijk (1668-1729), alderman of Amsterdam. *Portret van een man, vermoedelijk Theodorus Rijswijk, schepen te Amsterdam*

Pendant to A 632

Canvas 73 × 62. Oval
PROV Bequest of Mrs J Balguerie-van Rijswijk, widow of D Balguerie, Amsterdam, 1823 * On loan to the municipality of Velsen (Beeckestijn Estate) since 1969

A 632 Portrait of a woman, thought to be Elisabeth Hollaer, wife of Theodorus Rijswijk. *Portret van een vrouw, vermoedelijk Elisabeth Hollaer, echtgenote van Theodorus Rijswijk*

Pendant to A 631

Canvas 74 × 60. Oval
PROV Same as A 631 * On loan to the municipality of Velsen (Beeckestijn Estate) since 1969

C 266 Blowing bubbles. *Bellen blazen*

Panel 40.5 × 33
PROV On loan from the city of
Amsterdam (A van der Hoop bequest)
since 1885
LIT Hofstede de Groot 1907-28, vol 10,
nr 160. Exhib cat Adriaen van der Werff,
Rotterdam 1973, nr 73, fig 12 (attributed
to Pieter van der Werff; after 1712)

Johannes Hendrik van West

The Hague 1803–1881 The Hague

C 269 The love letter. *Het minnebriefje*

Canvas 40.5 × 34.5. Signed and dated
J. H. van West 1838
PROV On loan from the city of
Amsterdam (A van der Hoop bequest)
since 1885

George Pieter (P G) Westenberg

Nijmegen 1791–1873 Brummen

A 1161 The Slijpsteenmarkt (whetstone
market) with the 'Zeerecht' building,
Amsterdam, in the winter. *De Slijpsteen-
markt in Amsterdam met het gebouw 'Het
Zeerecht' in de winter*

Canvas 52 × 68. Signed and dated
P. G. Westenberg 1817
PROV Purchased at exhib Amsterdam
1818, nr 293. RVMM, 1885 * Lent to the
AHM since 1926

LIT Marius 1920, p 62, fig 28. Scheen
1946, fig 233. Knoef 1948, p 27. Ons
Amsterdam 23 (1971) ill on p 229

Jan Jansz Westerbaen

The Hague ca 1600–1686 The Hague

A 1478 Sophia van Overmeer (1608-84).
Wife of Adriaen van Persijn. *Echtgenote
van Adriaen van Persijn*

Panel 68 × 57. Signed and dated
I. W. A° 1650
PROV Sale M van Galen, Amsterdam,
30-31 Oct 1888, lot 448 (as attributed to
Jan Wijckersloot)
LIT C Hofstede de Groot, OH 22 (1904) p
118. Bernt 1960-62, vol 4, nr 308. Bernt
1969-70, vol 3, nr 1384

Cornelis Westerbeek I

Sassenheim 1844–1903 The Hague

A 1836 Cows at a lake. *Koeien aan een plas*

Canvas 57 × 107. Signed and dated
C. Westerbeek f. 85
PROV Bequest of Reinhard Baron van
Lynden, The Hague, 1899 * DRVK since
1953

**Johannes Barnardus Antonius
Maria Westerwoudt**

Amsterdam 1849–1906 Arnhem

A 2282 The Noordermarkt, Amsterdam
De Noordermarkt te Amsterdam

Panel 33.5 × 40
PROV Bequest of J BA M Westerwoudt,
Haarlem, 1907

A 3094 Bluff-bowed fishing boat on the
beach. *Bomschuit op het strand*

Panel 24.3 × 15.8
PROV Bequest of J BA M Westerwoudt,
Haarlem, 1907. Received in 1929

Gerrit de Wet

active 1640-74 in Haarlem and Leiden

A 1854 Saul honoring David after his
victory over Goliath. *Saul begroet David
als overwinnaar van Goliath*

Panel 61 × 84.5. Signed and dated

G. d. Wet f. 1640
PROV Sale Amsterdam, 24 April 1900,
lot 46

Jacob Willemsz de Wet I

Haarlem ca 1610–1671/72 Haarlem

A 1530 Christ blessing the children.
Christus zegent de kinderen

Panel 55 ×45. Signed *J. d. Wet*
PROV Presented by Dr A Bredius, The
Hague, 1890

A 1853 The assumption. *De hemelvaart van Maria*

Canvas 76.5 ×62.5. Signed *J. de Wet*
PROV Sale Amsterdam, 3 April 1900, lot
93 * DRVK since 1959 (on loan to the
Museum Amstelkring, Amsterdam)

Johannes Embrosius van de Wetering de Rooij

Woudrichem 1877–1972 The Hague

A 3522 Peasant cottages in a wooded
countryside. *Boerenwoningen in een bosrijke
streek*

Panel 58 × 79. Signed *Wetering de Rooy*
PROV Presented by Mrs Z Beversen-
Siemons, Soestdijk, 1948

Cornelis Wever

active 1771-92 in Amsterdam

A 1531 Jan Maurits Quinkhard (1688-
1772). Painter. *Schilder*

Canvas 48 ×41. Signed and dated
C. Wever Pinx. 1771. Inscribed *J. M.
Quinkhardt Aet. 84 Suae*
PROV Presented by Jonkheer B W F van
Riemsdijk, Amsterdam, 1890
LIT Moes 1897-1905, vol 2, nr 6125:5.
Van Hall 1963, p 259, nr 1714:7

Jacob Gerrit (Jaap) Weijand

Amsterdam 1886–1960 Castricum

A 3101 Jonkheer Barthold Willem Floris
van Riemsdijk (1850-1942). Director-
general of the Rijksmuseum (1897-
1922). *Hoofddirecteur van het Rijksmuseum*

Canvas 138.5 × 133.5. Signed and dated
Jaap Weyand 1921
PROV Presented by friends of the sitter,
1921

copy after **Rogier van der Weyden**

Tournai? ca 1399–1464 Brussels

NO PHOTOGRAPH AVAILABLE

A 973 The so-called portrait of Charles
the Bold (1433-77), duke of Burgundy.
*Het zogenaamde portret van Karel de Stoute,
hertog van Bourgondië*

Copy by Johan Berens (1858-1925) after
the version in the Musées des Beaux-
Arts, Brussels (cat nr 190)

Panel 47 ×36.5
PROV Presented by J Berens, Brussels,
1883. NMGK, 1885 * Lent to the states of
Zeeland, Middelburg, 1922. Destroyed
in the war, 1940

Jacob Campo Weyerman

Breda 1677–1747 The Hague

A 1302 Still life with flowers. *Stilleven met
bloemen*

Panel 52 ×41. Signed *Weyermans*
PROV Presented by Jonkheer Victor de
Stuers, The Hague, 1886
LIT Warner 1928, nr 113a. Exhib cat
Boeket in Willet, Amsterdam 1970, nr
42, ill. Mitchell 1973, p 259, fig 381

James Abbott MacNeill Whistler

Lowell, Massachusetts 1834–1903
Chelsea

A 1902 Effie Deans: 'Arrangement in yellow and grey'

Canvas 194 × 93. Signed with a butterfly. Inscribed *She sunk her head upon her hand, and remained seemingly, unconscious as a statue – Walter Scott – The heart of Mid Lothian*
PROV Presented by the dowager of R Baron van Lynden, née M C Baroness van Pallandt, The Hague, 1900 * On loan to the Singer Museum, Laren, since 1964 (since 1975 through the DRVK)
LIT Duret 1904, ill on p 157. Cary 1907, p 497. Pennell 1908, vol 1, p 201; vol 2, pp 88-89, 281, ill on p 88. Pennell 1911, pp 276-77. Pennell 1921, pp 163, 245, 247. Sutton 1960, nr 41. Sutton 1963, p 77. Sutton 1966, pp 191-92, ill. Exhib cat James McNeill Whistler, Chicago-Utica 1968, nr 25, ill

Harmen Willems Wieringa

active 1632-50 in Leeuwarden

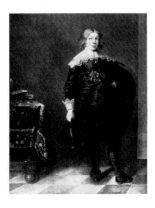

A 2221 Portrait of a boy. *Portret van een jongen*

Panel 42 × 32.5. Signed and dated *Willems A° 1636*. Inscribed *Aetatis 13*
PROV Purchased from Fr Muller & Co, art dealers, Amsterdam, 1904, through the intermediacy of the Rembrandt Society
LIT Wassenbergh 1967, p 43, nr 5

attributed to **Harmen Willems Wieringa**

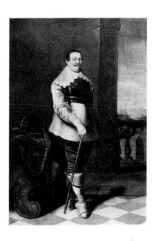

A 204 Portrait of an officer. *Portret van een officier*

Panel 57.5 × 40
PROV NM, 1808
LIT Moes & van Biema 1909, p 207. Wassenbergh 1967, p 33 (attributed to Wybrand de Geest and a helper, ca 1632-44)

Nicolaas Wieringa

active 1644-81 in Leeuwarden

A 1641 Portrait of an officer. *Portret van een krijgsoverste*

Canvas 100 × 81.5. Signed and dated *Wieringa fec. A° MDCLXVIII*

PROV Sale M Vlierboom van Hoboken, Amsterdam, 18 Feb 1896, lot 86 (as 'Bicringa')
LIT H Martin, Oude Kunst 3 (1917-18) pp 38-42, ill. Wassenbergh 1967, p 46, nr 8

Cornelis Claesz van Wieringen

Haarlem? ca 1580–1643 Haarlem

A 1629 The Spanish Armada off the English coast. *De Spaanse Armada voor de Engelse kust*

Canvas 104 × 206. Signed *C.CW*
PROV Purchased from W A Hopman, Bussum, 1895
LIT Willis 1911, p 21. Bernt 1960-62, vol 4, nr 311. Bernt 1969-70, vol 3, nr 1390. Bol 1973, p 33, fig 30

Henricus Franciscus Wiertz

Amsterdam 1784–1858 Nijmegen

A 2202 Shells and sea plants. *Schelpen en zeegewassen*

Canvas 106.5 × 86. Signed and dated *H. W. Wiertz 1809*
PROV Bequest of Miss M E van den Brink, Velp, 1905

Dirk Wiggers

Amersfoort 1866–1933 The Hague

A 3722 Pollard willows on a knoll overlooking a valley. *Knotwilgen op een heuvel met uitzicht op een vallei*

Canvas 93 × 131. Signed *D. Wiggers*
PROV Lent by Mr & Mrs J C J Drucker-Fraser, 1919. Bequeathed in 1944 *
DRVK since 1953

Jan Wildens

Antwerp 1586–1653 Antwerp

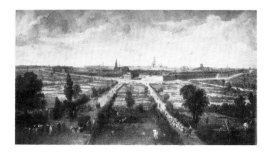

A 616 View of Antwerp. *Gezicht op Antwerpen*

Canvas 197.5 × 367. Signed and dated
I. Wildens fecit 1656
PROV Presented by Jonkheer J P Six van Hillegom, Amsterdam, 1852 * DRVK since 1951
LIT Thiéry 1953, pp 114, 200. Gerson & Ter Kuile 1960, p 152

Frederika Sophia Wilhelmina (Wilhelmina), princess of Prussia

see under Miniatures

Abraham Willaerts

Utrecht ca 1603–1669 Utrecht

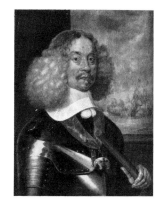

A 579 Jacob Baron van Wassenaer (1616-65), lord of Obdam. Vice admiral of Holland and West-Friesland. *Heer van Obdam. Luitenant-admiraal van Holland en West-Friesland*

Panel 39.5 × 30.5. Signed *A. W.*
PROV Sale M C van Hall, Amsterdam, 27 April 1858, lot 159
LIT Moes 1897-1905, vol 2, nr 8893:1

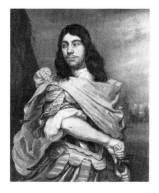

A 1683 Cornelis Tromp (1629-91). Vice admiral, in Roman costume. *Luitenant-admiraal, in Romeins kostuum*

Panel 40 × 33. Signed *A. W.*
PROV Sale Cologne, 4-5 June 1894, lot 161
LIT J B Kist, Spiegel Hist 7 (1972) p 669, figs 7a, 7b

Adam Willaerts

Antwerp 1577–1664 Utrecht

A 1955 Shipwreck off a rocky coast. *Schipbreuk op een rotsachtige kust*

Panel 65 × 86.5. Oval. Signed and dated
AD Wilarts fe 1614
PROV Sale Amsterdam, 16 April 1901, lot 165
LIT Willis 1911, pp 25-26. C G 't Hooft, OH 33 (1915) p 97. Martin 1935-36, vol 1, p 268, fig 153. Bol 1973, p 64, fig 61. J Walsh Jr, Burl Mag 116 (1974) p 657, note 19, fig 26. Van Braam nd, vol 1, p 495, nr 5815

A 1387 The defeat of the Spaniards at Gibraltar by a Dutch fleet under command of Admiral Jacob van Heemskerck, 25 April 1607. *De overwinning op de Spanjaarden bij Gibraltar door een vloot onder bevel van Jacob van Heemskerck, 25 april 1607*

Canvas 93 × 187. Signed and dated
AD Willarts 1617
PROV Sale The Hague, 30 Jan 1878, lot 41. NMGK, 1887
LIT Willis 1911, p 25. Martin 1935-36, vol 1, p 268. Preston 1937, p 14, fig 8. Gerson 1942, p 528. Bol 1973, p 65, figs 63-64

A 1927 Ships off a rocky coast. *Schepen bij een rotsachtige kust*

Panel 62 × 122.5. Signed and dated
A. Willarts f. 1621
PROV Sale Amsterdam, 6 Nov 1900, lot 351
LIT H Jantzen, Onze Kunst 18 (1910) p 108. Bol 1973, p 77, note 180

A 1430 Ships off the coast. *Schepen voor de kust*

Panel 45 × 82. Signed and dated in the lower right *AW 1628* and in the middle *Ad Willarts, AW 1628*
PROV Sale Amsterdam, 1 Nov 1887, lot 52 * DRVK since 1964
LIT Bol 1973, p 71, fig 68

A 2162 The defeat of the Spaniards at Gibraltar by a Dutch fleet under command of Admiral Jacob van Heemskerck, 25 April 1607. *De overwinning op de Spanjaarden bij Gibraltar door een vloot onder bevel van Jacob van Heemskerck, 25 april 1607*

Canvas 136 × 204.5. Signed and dated *A. Willarts 1639*
PROV Sale Amsterdam, 27 June 1905, lot 125
LIT Willis 1911, p 25. Bol 1973, p 73, fig 71

A 4116 Allegory of the Dutch victory over the Spanish fleet at Gibraltar, 25 April 1607. *Allegorie op de overwinning van de Hollandse op de Spaanse vloot bij Gibraltar, 25 april 1607*

Panel 38.2 × 55.8

PROV Sale Amsterdam, 18 May 1965, lot 606
LIT Bull RM 13 (1965) p 135, fig 17

attributed to **Adam Willaerts**

A 502 Kenau Simonsdr Hasselaer (1526-88). Widow of Nanning Borst. *Weduwe van Nanning Borst*

Panel 44 × 34.5. Ends in a round arch. Marked *AW*. Inscribed *K. H. Siet hier een vrou, genamt Kenou. | Vroom als een man ; die taldertyt, |vromelyck bestryt, den Spaensen tiran. Aetatis 47.1573*
PROV NM, 1808
LIT Moes 1897-1905, vol I, nr 3253:2. Moes & van Biema 1909, pp 64, 167, 207. Kurtz 1956, p 35, ill opp p 25

Thomas Willeboirts

Bergen-op-Zoom 1613/14–1654 Antwerp

C 400 Allegorical depiction of Mars (Friedrich Wilhelm, elector of Brandenburg?) receiving the weapons of Venus (Louisa Henrietta, countess of Nassau?) and Vulcan. *Mars ontvangt de wapens van Venus en Vulcanus: allegorie*

Canvas 218.5 × 225. Signed *T. Will…*
PROV On loan from the city of

Amsterdam since 1885
LIT C Vosmaer, Kunstkronijk, 1861, p 37. Scheltema 1879, p 43, nr 114. A Bredius, OH 52 (1935) p 36, ill. J G van Gelder, OH 64 (1949) p 43, note 1, fig 4. H Börsch-Supan, Zeitschr f Kunstgesch 30 (1967) p 186, note 55

P W Windtraken

biographical data unknown

A 2737 Still life with flowers. *Stilleven met bloemen*

Canvas 57.5 × 49. Signed *P. W. Windtraken*
PROV Unknown * DRVK since 1961

A 2738 Still life with fruit. *Stilleven met vruchten*

Canvas 57.5 × 49. Signed *P. W. Windtraken*
PROV Unknown * DRVK since 1961

copy after **Joos van Winghe**

Brussels 1544–1603 Frankfurt am Main

A 473 Nocturnal banquet with masqueraders. *Nachtbanket en maskerade*

Copy after a print by Jan Sadeler (1550-1600) after a design by van Winghe, with the background changed

Panel 117 × 154.5
PROV Purchased from Colonel von Schepeler, Aachen, 1839
LIT Hoogewerff 1912, p 132. G Poensgen, Zeitschr BK 59 (1925-26) pp 324-30. K Bauch, Münchn Jb 3d ser 2 (1951) p 236, fig 17 (copy by Pieter Lastman after a print after van Winghe). R A d'Hulst, Bull Mus Roy Belg 4 (1955) p 239, ill. E Holzinger, Münchn Jb 3d ser 6 (1955) p 236, fig 17. G Poensgen, Pantheon 28 (1970) p 510. K Renger, Jb Berliner Museen, 1972, p 161, fig 3

Abraham Hendrik Winter

Utrecht ca 1800 – 1861 Amsterdam

A 1162 Stable with sheep and goats. *Stal met schapen en geiten*

Panel 40.5 × 50.5. Signed *A. Winter F.*
PROV RVMM, 1885 * DRVK since 1961
LIT Scheen 1946, fig 149

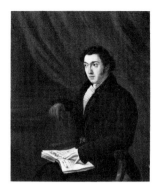

A 1917 Johannes Petrus Schouburg (1798-1863). Die engraver at the state mint. *Stempelsnijder aan 's Rijks Munt te Utrecht*

Panel 24 × 10.5
PROV Presented by J Ph van der Kellen, Bussum, 1900

Franz Xaver Winterhalter

Menzenschwand 1805 – 1873 Frankfurt am Main

A 1702 Sophia Frederika Mathilda (1818-77), princess of Württemberg. First wife of Willem III, king of the Netherlands. *Prinses van Württemberg. Eerste echtgenote van Willem III, koning der Nederlanden*

Canvas 74 × 60. Oval. Signed *F. Winterhalter*
PROV Presented by the de Kock family, 1897
LIT R van Luttervelt, Apollo Mndbl 1 (1945) p 69, fig 5

manner of **Willem Wissing**

Amsterdam ca 1656 – 1687 Burleigh

see also Miniatures: Holland school ca 1675, A 4438 William III, after Wissing

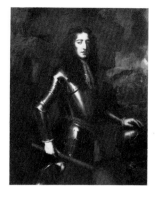

A 879 William III (1650-1702), prince of Orange. Stadholder and from 1689 on king of England. *Willem III, prins van Oranje. Stadhouder, sedert 1689 tevens koning van Engeland*

Canvas 130 × 103
PROV KKS, 1876. NMGK, 1885
LIT Moes 1897-1905, vol 2, nr 9096:54. A Staring, NKJ 3 (1951) p 180, fig 23

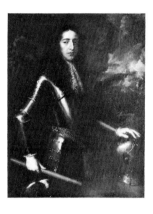

A 1228 William III (1650-1702), prince of Orange. Stadholder and from 1689 on king of England. *Willem III, prins van Oranje. Stadhouder, sedert 1689 tevens koning van Engeland*

Canvas 113 × 89
PROV KKS, 1885 * DRVK since 1953

Jacob de Wit

Amsterdam 1696 – 1754 Amsterdam

A 3885 Jupiter disguised as Diana seducing the nymph Callisto. *Jupiter vermomd als Diana verleidt de nimf Callisto*

Belongs with A 3886

Canvas 240 × 205. Part of a room decoration. Signed and dated *JdWit 1727*
PROV Purchased from D A Hoogendijk gallery, Amsterdam, 1955
LIT Staring 1958, p 146, fig 94

A 3886 Diana and Endymion. *Diana en Endymion*

Belongs with A 3885

Canvas 240 × 205. Part of a room decoration. Signed and dated *JdWit 1727*
PROV Same as A 3885
LIT Staring 1958, p 146, fig 92 (Jupiter and Mnemosyne?)

C 1221 Apollo enthroned in the clouds, with Minerva and the nine muses. *Apollo tronend op de wolken met Minerva en de negen muzen*

Canvas 427 cm in diam. Ceiling painting. Painted in 1730, commissioned by Dirk van der Meer for his home at Keizersgracht 401, Amsterdam
PROV Lent by A L E Ridder de Stuers, Paris, to the NMGK, 1898-1923. Purchased at the sale of his collection, Amsterdam, 12 April 1932, lot 276, by the KOG. On loan from the KOG since 1932

LIT Mndbl Amstelodamum 19 (1932) pp 79-80. Staring 1958, pp 89, 148, fig 73. A Staring, OH 74 (1959) p 57, fig 3

A 4291 Allegory of navigation. *Allegorie op de zeevaart*

Canvas 111 × 113. Signed and dated *J. de Wit 173[5 or 2]*
PROV Koloniaal Magazijn (colonial warehouse), Amsterdam, 1831. NMGK * DRVK since 1958

A 1783 Moses appointing the seventy elders. *Mozes verkiest de zeventig oudsten*

Modello for the painting in the Moses hall of the former town hall (now palace) on the Dam, Amsterdam

Panel 32 × 73. Signed *J.d.Wit*. Painted in 1736-37
PROV Purchased from A M Reckers gallery, Rotterdam, 1898
LIT R van Luttervelt, in Heemkennis 8, p 56, figs 21-22. Staring 1958, pp 18, 125 (autograph replica). VTTT, 1959, nr 17. A Czobor, Bull Mus Hongr BA, 1965, pp 39, 46, fig 17. J W Niemeijer, OK 12 (1968) nr 7, ill. R Mandle, Apollo 96 (1972) pp 418-20, fig 4

C 1577 Paris and Oenone. *Paris en Oenone*

Canvas 99.5 × 146.5. Signed and dated *J. d. Wit 1737*. Inscribed *Enone*
PROV On loan from Jonkheer F E Teixeira de Mattos, 1928, later from Mrs J M Drost-Nanning
LIT Staring 1958, pp 99, 195, fig 111

A 3231 The summer. *De zomer*

Canvas 109 × 110.5. Irregular hexagon. Presumably a dessus-de-porte. Grisaille. Signed and dated *J. de Wit 1740*
PROV Lent by Miss M C C Reynvaan, Elspeet, 1926. Bequeathed in 1934

A 3232 The autumn. *De herfst*

Canvas 109 × 110.5. Irregular hexagon. Presumably a dessus-de-porte. Grisaille. Signed and dated *J. de Wit 1740*
PROV Same as A 3231
LIT A Vis, Uit het Peperhuis, 1973, pp 45, 97, fig 10

A 3233 The winter. *De winter*

Canvas 88 cm in diam. Round. Grisaille
PROV Same as A 3231

A 3872 The autumn. *De herfst*

Panel 64 × 180. The lower edge is
concave. Grisaille. Signed and dated
J. de Wit 1746
PROV Bequest of PG van Tienhoven,
Amsterdam, 1953

RBK 1958-81 The autumn. *De herfst*

Canvas 160 × 90. Irregularly curving
form. Grisaille. Signed and dated
J. de Wit 1746
PROV From the house at Keizersgracht
293, Amsterdam. Purchased from the
department of public works of the city of
Amsterdam, 1958, with the mantelpiece
for which it was made. Belongs to the
department of sculpture and applied arts
LIT Staring 1958, p 154

RBK 16558 Pictura; the symbols of
painting. *Pictura; de symbolen van de
schilderkunst*

Panel 169 × 76. Door of a painted
cabinet. Both paintings signed and dated
J. de Wit 1750
PROV Presented by HS Nienhuis (Mak
van Waay NV), Amsterdam, 1952.
Belongs to the department of sculpture
and applied arts
LIT Th H Lunsingh Scheurleer, Bull RM
2 (1954) pp 19-21, fig 1. E Pelinck, Jb
Amstelodamum 46 (1954) p 105. Staring
1956, p 180, pl LVII. Staring 1958, pp
99-100. B Haak, Antiek 1 (1966) p 21.
Th H Lunsingh Scheurleer, Alb Amic
J G van Gelder, 1973, pp 226, 232, fig 3

C 401 Allegory of the works of Ptolemy.
Allegorie op de werken van Ptolemaeus

Canvas 295 × 105. Signed and dated
J. de Wit F 1754. Inscribed *Ptolomaeus
Philadelphus Rex Aegipti II*
PROV On loan from the city of
Amsterdam (presented by Jonkheer
M H Six van Hillegom), 1885-1965. On
loan to the Museum Willet-Holthuysen,
Amsterdam, since 1965

LIT Scheltema 1879, nr 116. Staring
1958, pp 93, 157, fig 99. Bille 1961, vol 1,
p 85, ill; vol 2, pp 63, 128, nr 263

A 3900 Putti with mirrors. *Putti met
spiegels*

Canvas 30 × 35
PROV Purchased from A de Heuvel
gallery, Brussels, 1956
LIT Staring 1958, p 192, fig 80 (modello
for the signboard of a frame maker)

A 4659 Design for a ceiling painting,
with Mercury bringing a hero before
Venus; in the corners the four seasons in
brown monochrome. *Ontwerp voor een
plafondstuk met Mercurius, die een held naar
Venus voert. In de hoeken de vier jaargetijden
in brunaille*

Canvas 51.5 × 69.5
PROV Purchased from A Stein gallery,
Paris, 1974

Matthias Withoos

Amersfoort 1627–1703 Hoorn

A 1925 The Grashaven near Hoorn. *De Grashaven bij Hoorn*

Canvas 66 × 102.5. Signed and dated *M.Withoos 1675*
PROV Sale H J A Raedt van Oldenbarnevelt, 6 Nov 1900, lot 145 *
DRVK since 1959 (on loan to the Westfries Museum, Hoorn)
LIT Briganti 1966, p 95. Bernt 1969-70, vol 3, nr 1405 (Enkhuizen). Bol 1973, pp 310-11, fig 314

Willem Arnold Witsen

Amsterdam 1860–1923 Amsterdam

see also under Aquarelles and drawings

A 2948 Andries van Wezel (1856-1922). Antwerp merchant who bequeathed his painting collection to the Rijksmuseum in 1922. *Koopman te Antwerpen, legateerde in 1922 zijn schilderijenverzameling aan het Rijksmuseum*

Pendant to A 2949

Canvas 70 × 59. Signed and dated *WW 1912*. Inscribed *Æt suae L V I*
PROV Bequest of the sitter, Amsterdam, 1922

A 2949 The wife of Andries van Wezel. *De echtgenote van Andries van Wezel*

Pendant to A 2948

Canvas 70 × 59. Signed and dated *WW 1912*
PROV Same as A 2948

A 2955 Portrait of a girl. *Portret van een meisje*

Panel 26 × 21. Signed *Witsen*
PROV Bequest of A van Wezel, Amsterdam, 1922

A 2952 Warehouses on an Amsterdam canal in the Uilenburg quarter. *Pakhuizen aan een Amsterdamse gracht op Uilenburg*

Canvas 52 × 42. Signed *Witsen*
PROV Bequest of A van Wezel, Amsterdam, 1922 * DRVK, 1953-75. On loan to the AHM since 1975

A 3568 Landscape with the windmill of Wijk bij Duurstede. *Landschap met de molen van Wijk bij Duurstede*

Panel 14 × 23.5. Signed *W. W.*
PROV Bequest of Mrs M C J Breitner-Jordan, widow of G H Breitner, Zeist, 1948

A 2954 Landscape with fields. *Landschap met akkervelden*

Canvas 33 × 66. Signed *Witsen*
PROV Bequest of A van Wezel, Amsterdam, 1922

A 2953 Winter landscape. *Winterlandschap*

Canvas 45 × 52. Signed *Witsen*
PROV Bequest of A van Wezel, Amsterdam, 1922

A 2951 Vegetable garden. *Moestuin*

Panel 27.5 × 35.5. Signed *Witsen*
PROV Bequest of A van Wezel, Amsterdam, 1922

A 2950 Fluffy flowers in a jug. *Kruikje met pluisbloemen*

Canvas 44 × 37. Signed *Witsen*
PROV Bequest of A van Wezel, Amsterdam, 1922 * DRVK since 1951

A 2956 African marigolds in a blue vase. *Afrikaantjes in een blauw vaasje*

Canvas 39.5 × 31. Signed *Witsen*
PROV Bequest of A van Wezel, Amsterdam, 1922

Emanuel de Witte

Alkmaar 1616/18 – 1692 Amsterdam

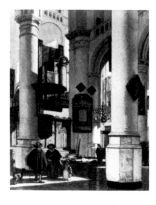

A 4054 Interior of a Protestant Gothic church with motifs from the Oude and the Nieuwe Kerk in Amsterdam. *Interieur van een protestantse gotische kerk met motieven van de Oude en de Nieuwe Kerk te Amsterdam*

Pendant to A 4055

Panel 44.5 × 33.5. Signed and dated *E. De Witte A° 1669*
PROV Presented by Mr & Mrs I de Bruijn-van der Leeuw, Muri near Bern, 1961
LIT Waagen 1857, vol 2, p 188. Weale 1889, nr 52. Jantzen 1910, p 123, fig 64, nr 633. Roh 1921, fig 116. C Brière-Misme, GdB-A 65 (1923) p 144. D Hannema, Oudh Jb 4th ser 1 (1932) p 117. M F Hennus, Mndbl BK 13 (1936) p 11. J L Cleveringa, Bull RM 9 (1961) p 66, nr 18. Manke 1963, pp 103-04, nr 109, fig 69

A 4055 Interior of a Protestant Gothic church with motifs from the Oude Kerk in Amsterdam. *Interieur van een protestantse gotische kerk met motieven van de Oude Kerk te Amsterdam*

Pendant to A 4054

Panel 44.5 × 33.5. Signed and dated *E. De Witte A° 1669*
PROV Same as A 4054
LIT Waagen 1857, vol 2, p 188. Jantzen 1910, p 123, nr 632, fig 63. C Brière-Misme, GdB-A 65 (1923) p 144. D Hannema, Oudh Jb 4th ser 1 (1932) p 117. M F Hennus, Mndbl BK 13 (1936) p 11. Noach 1937, p 84, nr 8. E R Meijer, Bull RM 9 (1961) p 47, fig 5. J L Cleveringa, Bull RM 9 (1961) p 65, nr 19. Manke 1963, nr 94, fig 70

A 474 Interior of a Protestant Gothic church with motifs from the Oude and the Nieuwe Kerk in Amsterdam. *Interieur van een protestantse gotische kerk met motieven van de Oude en de Nieuwe Kerk te Amsterdam*

Panel 47.5 × 37. Signed and dated *E. De Witte A° 1677*
PROV Sale G van der Pot van Groeneveld, Rotterdam, 6 June 1808, lot 141 * On loan to the Musée de la Chartreuse, Douai, since 1962, in exchange for Lievens, Jan, C 1467
LIT Moes & van Biema 1909, pp 113, 180. Jantzen 1910, pp 125, 175, nr 527. E Wiersum, OH 48 (1931) p 207. E P Richardson, Art Q 1 (1938) p 14, fig 12. Noach 1939, p 125. Manke 1963, p 104, nr 111, fig 87. J G van Gelder, OH 80 (1965) p 202

A 3738 Interior of the Portuguese synagogue in Amsterdam. *Interieur van de Portugese synagoge te Amsterdam*

Canvas 110 × 99. Formerly signed and dated *1680*
PROV Purchased from W E Duits gallery, London, 1949
LIT Parthey 1863-64, vol 2, p 792, nr 1. Jantzen 1910, nr 691. Bode 1919, p 278. M F Hennus, Mndbl BK 13 (1936) p 3ff, ill. Manke 1963, pp 58, 121, nr 206, figs 95-96. Rosenberg, Slive & Ter Kuile 1966, p 247. Gans 1971, p 105, ill

A 1642 The choir of the Nieuwe Kerk in Amsterdam with the tomb of Michiel de Ruyter. *Het koor van de Nieuwe Kerk te*

Amsterdam met het praalgraf van Michiel de Ruyter

Canvas 123.5 × 105. Signed and dated *E. de Witte A° 1683*
PROV Purchased from J C de Ruyter de Wildt, Vlissingen, 1895 * Lent to the AHM, 1975
LIT Houbraken 1718-21, vol I, p 283. Jantzen 1910, pp 125, 176, nr 637. Bredius 1918, vol 5, pp 1845-47. Martin 1935-36, vol 2, p 404. R van Luttervelt, Bull RM 7 (1957) p 66, ill. Manke 1963, pp 42, 98, nr 88

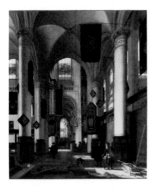

C 270 Interior of a Protestant Gothic church with motifs from the Oude and the Nieuwe Kerk in Amsterdam. *Interieur van een protestantse gotische kerk met motieven van de Oude en de Nieuwe Kerk te Amsterdam*

Canvas 122 × 104
PROV On loan from the city of Amsterdam (A van der Hoop bequest) since 1885
LIT Jantzen 1910, pp 126, 176, nr 656. E P Richardson, Art Q I (1938) p 14, fig 13. Noach 1939, pp 122-23. Manke 1963, pp 43, 56, nr 102, fig 94 (1680-82). W Stechow, Bull Clev Mus of Art, 1972, p 232, fig 11

A 2536 The Nieuwe Vismarkt (new fish market), Amsterdam. *De Nieuwe Vismarkt te Amsterdam*

Canvas 52 × 62
PROV Sale Amsterdam, 28 Nov 1911, lot 98
LIT Bode 1917, p 271. C Brière-Misme,

GdB-A 65 (1923) p 137. M F Hennus, Mndbl BK 13 (1936) p 3ff, ill. P van Eeghen, Mndbl Amstelodamum 45 (1958) ill on p 220. Manke 1963, p 126, nr 226, fig 80 (ca 1677)

A 3244 Harbor at sunset. *Haven bij zonsondergang*

Canvas 44 × 66.5
PROV Purchased from J Goudstikker gallery, Amsterdam, 1936, as a gift of the Photo Commission
LIT Preston 1937, p 52, fig 74. Hannema 1952, p 83. Van Gelder 1959, p 17, fig 72. Bernt 1960-62, vol 3, nr 1013. Manke 1963, pp 55-56, 128, nr 234, fig 89 (1678-80). Stechow 1966, p 121, fig 244 (ca 1664?). A Blankert, Simiolus 2 (1967-68) p 104 (de Witte?). Bernt 1969-70, vol 3, nr 1409. Bol 1973, pp 249-50, fig 255

circle of **Gaspar Adriaansz van Wittel** *called* **Vanvitelli**

Amersfoort 1647–1736 Rome

A 2659 View of Naples. *Gezicht op Napels*

Pendant to A 2660

Copper 20 × 50.5. Signed *Vanvitelli*
PROV Purchased from Brother Barbier, Nancy, 1913, through the intermediacy of A Vecht gallery, Amsterdam

A 2660 View of the Bay of Naples. *Gezicht op de Golf van Napels*

Pendant to A 2659

Copper 20 × 50.5. Traces of a signature *G.v.W.*
PROV Same as A 2659

Hermanus Gerhardus Wolbers

Heemstede 1856–1926 The Hague

A 3501 Man in a rowboat. *Man in een roeiboot*

Panel 22 × 66. Signed *H. Wolbers*[?]
PROV Bequest of Mrs A C M H Kessler-Hülsmann, widow of D A J Kessler, Kapelle op den Bosch near Mechelen, 1947

Jan Baptist Wolfert

Antwerp 1625–1687?

A 1494 Pastoral scene with a man playing the shepherd's reed. *Herderstafereel met een schalmeispeler*

Canvas 75 × 67.5. Signed and dated *B. Wolfert 1646*
PROV Presented by Dr A Bredius, The Hague, 1889
LIT Bernt 1960-62, vol 4, nr 321. Bernt 1969-70, vol 3, nr 1415

Benjamin Wolff

Dessau 1758–1825 Amsterdam

see also Titian, A 475 Francis I, copy by Wolff

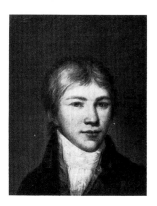

A 2193 Hendrik Arend van den Brink (1783-1852). At the age of seventeen. *Op zeventienjarige leeftijd*

For a portrait of the sitter's mother, *see* the following number

Canvas 46 × 37. Painted in 1800
PROV Bequest of the sitter's daughter, Miss M E van den Brink, Velp, 1905 *
DRVK since 1950
LIT B W F van Riemsdijk, Bull NOB 7 (1906) p 178

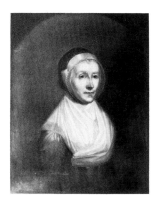

A 2192 Christina Sebilla Charlotte Bakhuizen (1750-1810). Wife of Joannes van den Brink (1743-1806), Amsterdam broker. *Echtgenote van Joannes van den Brink, commissionair te Amsterdam*

Canvas 80 × 62.5. Signed and dated *B. Wolff Fec. 1802*
PROV Bequest of Miss M E van den Brink, Velp, 1905 * DRVK since 1950

NO PHOTOGRAPH AVAILABLE

A 658 The death of Sophonisba, queen of Numidia. *De dood van Sophonisba, koningin van Numidië*

Canvas 270 × 400. Signed and dated *Wolff f 1816*
PROV Bequest of the artist to King Willem I, 1825. Never exhibited. The canvas was rolled up, so that the painting eventually disintegrated and was discarded
LIT Van Eynden & van der Willigen 1816-40, vol 4, p 22

NO PHOTOGRAPH AVAILABLE

A 659 Massinissa, king of Numidia. *Massinissa, koning van Numidië*

Canvas 265 × 380. Signed *Wolff*
PROV Bequest of the artist to King Willem I, 1825. Never exhibited. The canvas was rolled up, so that the painting eventually disintegrated and was discarded
LIT Van Eynden & van der Willigen 1816-40, vol 4, p 22

Hermanus Wolters

see under Miniatures

Henrietta Wolters-van Pee

see under Miniatures

Pieter Christoffel Wonder

Utrecht 1780 – 1852 Amsterdam

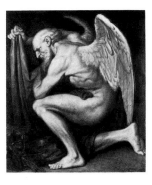

A 1163 Time. *De Tijd*

Canvas 124 × 107. Signed and dated *P.C. Wonder F. 1810*
PROV Bequest of the artist, 1853. RVMM, 1885 * DRVK since 1953

LF (J?) Woutersin

active ca 1630 in Friesland

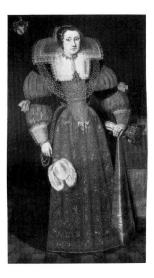

A 2693 Saepke or Sophia van Vervou

Canvas 174 × 102.5. Signed *L.F. Woutersin*. Inscribed *Sophia van Vervou Ætatis Suae 17*
PROV Town hall, Franekeradeel, 1913 *
DRVK since 1952
LIT Wassenbergh 1967, p 45, fig 125 (dated 1630)

Johan Woutersz *called* **Stap**

Amsterdam? 1599 – 1663? Amsterdam

A 1341 The landlord's steward. *Het kantoor van de rentmeester*

Canvas 76 × 107.5. Signed *Iohan. i woute...* Dated on the book *1.29*
PROV Sale J H Cremer, Amsterdam, 26 Oct 1886, lot 48
LIT Winkler 1924, p 380. Martin 1935-36, vol 1, p 336. A van Schendel, OH 54 (1937) pp 270, 274, nr 8, fig 9. Bernt 1960-62, vol 4, nr 329. Schatborn & Szénássy 1971, p 38, nr 131

A 2426 The notary in his office. *De notaris in zijn kantoor*

Panel 83 × 68. Inscribed on the document *April 1636* and *By my P. Vlasch openbaer notaris*
PROV Presented by H J Pfungst, London, 1910
LIT A van Schendel, OH 54 (1937) pp 270, 274, nr 11, fig 12. Bernt 1969-70, vol 3, nr 1423. Schatborn & Szénássy 1971, p 38, nr 132, fig 28

Jan Wouwerman

Haarlem 1629–1666 Haarlem

A 1850 The spotted horse. *Het bonte paard*

Panel 36 × 41.5. Signed *J. W.*
PROV Sale Amsterdam, 3 April 1900, lot 96

Philips Wouwerman

Haarlem 1619–1668 Haarlem

A 476 A peasant free-for-all near a village. *Vechtende boeren bij een dorp*

Canvas 66 × 87. Signed *Phils W.*
PROV Sale G van der Pot van Groeneveld, Rotterdam, 6 June 1808, lot 145
LIT Hofstede de Groot 1907-28, vol 2 (1908) nr 1036. Moes & van Biema 1909, pp 113, 183. E Wiersum, OH 48 (1931) p 212

A 482 The victory of the peasants. *De overwinning der boeren*

Canvas 59 × 78. Signed *Phils W.*
PROV Sale G van der Pot van Groeneveld, Rotterdam, 6 June 1808, lot 142 * On loan to the municipality of Velsen (Beeckestijn Estate) since 1969
LIT Hofstede de Groot 1907-28, vol 2 (1908) nr 794. Moes & van Biema 1909, pp 113, 182. E Wiersum, OH 48 (1931) p 210

A 483 The bucking gray. *De slaande schimmel*

Panel 37 × 49. Signed *Phils W*
PROV Sale Dowager Boreel, Amsterdam, 23 Sep 1814, lot 23
LIT Hofstede de Groot 1907-28, vol 2 (1908) nr 43

A 477 The riding school. *De rijschool*

Canvas 48 × 62. Signed *Phils W.*
PROV Purchased with the Kabinet van Heteren Gevers, The Hague-Rotterdam, 1809
LIT Hoet 1752, vol 2, p 461. Hofstede de Groot 1907-28, vol 2 (1908) nr 44. Moes & van Biema 1909, pp 151, 166. Martin 1935-36, vol 2, pp 359, 362, fig 195

A 485 Horsepond near a boundary stone. *Paardenwed bij een grenspaal*

Panel 34 × 41. Signed *Phils W.*
PROV NM, 1808
LIT Hofstede de Groot 1907-28, vol 2 (1908) nr 69. Moes & van Biema 1909, pp 59, 76, 223

C 271 Horsepond on a river. *Paardenwed bij een rivier*

Panel 46 × 64. Signed *Phils W.*
PROV On loan from the city of Amsterdam (A van der Hoop bequest) since 1885
LIT Hofstede de Groot 1907-28, vol 2 (1908) nr 70. W Stechow, Baltimore Ann 4 (1972) p 51, fig 2

A 484 An army camp. *Een legerkamp*

Panel 36 × 42. Signed *Phils W.*
PROV Bequest of L Dupper Wzn,
Dordrecht, 1870
LIT Hofstede de Groot 1907-28, vol 2
(1908) nr 843

C 272 An army camp. *Een legerkamp*

Panel 42 × 49
PROV On loan from the city of
Amsterdam (A van der Hoop bequest)
since 1885
LIT Hofstede de Groot 1907-28, vol 2
(1908) nr 836

A 2348 A stable. *Een paardestal*

Panel 47 × 64.5. Signed *Phils W.*
PROV Purchased from the heirs of Jonk-
heer P H Six van Vromade, Amsterdam,
1908
LIT Hofstede de Groot 1907-28, vol 2
(1908) nr 476

A 478 Blacksmith shoeing a horse. *De
hoefsmid*

Canvas 62 × 55. Signed *Phils W.*
PROV Sale G van der Pot van
Groeneveld, Rotterdam, 6 June 1808, lot
144
LIT Hofstede de Groot 1907-28, vol 2
(1908) nr 116. Moes & van Biema 1909,
pp 113, 181. E Wiersum, OH 48 (1931)
p 209

A 1610 The gray. *De schimmel*

Panel 43.5 × 38. Signed *Phils W.*
PROV Sale Mrs M C Messchert van
Vollenhoven-van Lennep, Amsterdam,
29 March 1892, lot 15. Purchased
through the intermediacy of the
Rembrandt Society
LIT Hofstede de Groot 1907-28, vol 2
(1908) nr 207

C 273 Landscape with sandy path beside
a river. *Landschap met zandweg langs een
rivier*

Canvas 62 × 80. Signed *Phils W.*

PROV On loan from the city of
Amsterdam (A van der Hoop bequest)
since 1885
LIT Hofstede de Groot 1907-28, vol 2
(1908) nr 1045

A 479 Landscape with signal post.
Landschap met seinpaal

Panel 22.5 × 28.5. Signed *Phils W.*
PROV NM, 1809 * DRVK since 1954
LIT Hofstede de Groot 1907-28, vol 2
(1908) nr 1044. Moes & van Biema
1909, pp 151, 166

A 480 The stag hunt. *Hertenjacht*

Copper 28 × 34. Signed *Phils W.*
PROV Purchased with the Kabinet van
Heteren Gevers, The Hague-Rotterdam,
1809
LIT Hofstede de Groot 1907-28, vol 2
(1908) nr 614. Moes & van Biema 1909,
pp 151, 194. Bille 1961, vol 1, p 109

A 481 The heron hunt. *Reigerjacht*

Copper 26 × 30. Signed *Phils W.*
PROV Sale G van der Pot van
Groeneveld, Rotterdam, 6 June 1808, lot
143 * DRVK since 1958
LIT Hofstede de Groot 1907-28, vol 2
(1908) nr 587. Moes & van Biema 1909,
pp 113, 187

Pieter Wouwerman

Haarlem 1623–1682 Amsterdam

A 486 The storming of Coevorden, 30
December 1672. *De bestorming van
Coevorden, 30 december 1672*

Canvas 65.5 × 80.5. Signed *P. W.*
PROV NM, 1808
LIT Moes & van Biema 1909, p 218.
Spiegel Hist 6 (1971) ill on p 380

A 487 Hunting party at a fountain.
Jachtgezelschap bij een fontein

Canvas 66 × 80.5. Signed *P. W.*
PROV Bequest of L Dupper Wzn,
Dordrecht, 1870 * DRVK since 1952

manner of **Pieter Wouwerman**

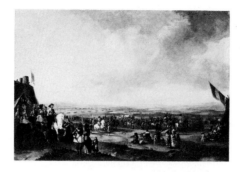

A 1794 Frederik Hendrik at the surrender
of Maastricht, 22 August 1632. *Frederik
Hendrik bij de overgave van Maastricht, 22
augustus 1632*

Canvas 138 × 201
PROV Purchased from J D Stevens,
Brussels, 1899 * DRVK since 1959 (on
loan to Museum Het Prinsenhof,
Delft)
LIT B W F van Riemsdijk, Bull NOB I
(1899-1900) p 9. C Hofstede de Groot,
Bull NOB I (1899-1900) p 39

John Michael Wright

see Miniatures: Cooper, Samuel, A 4310
James of Cambridge, after Wright

Wttenbroeck

see Uyttenbroeck

Wttewael

see Uytewael

Mathijs Wulfraet

Arnhem 1648–1727 Amsterdam

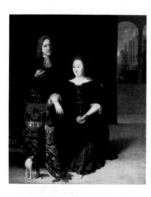

A 1912 Portrait of a lady and a gentle-
man in an interior. *Portret van een dame en
een heer in een interieur*

Canvas 63 × 53. Signed and dated
M. Wulfraet F. 1694
PROV Bequest of J H Schellwald, Zwolle,
1900 * DRVK since 1959 (on loan to the
Gemeentemuseum, Arnhem)
LIT Gudlaugsson 1959-60, vol 2, p 294

Thomas Wijck

Beverwijk ca 1616–1677 Haarlem

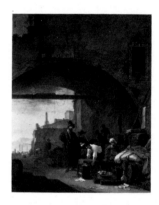

A 2113 A Levantine harbor city.
Levantijnse haven

Canvas 72.5 × 59.5. Signed *T Wijck*
PROV Bequest of Mrs H A Insinger-van
Loon, widow of M H Insinger,
Amsterdam, 1903
LIT Exhib cat Italianiserende landschap-
schilders, Utrecht 1965, nr 72, fig 74

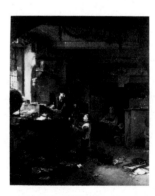

A 489 The alchemist. *De alchimist*

Panel 43 × 37.5. Signed *T Wijck*
PROV Bequest of L Dupper Wzn,
Dordrecht, 1870
LIT J van Lennep, Revue belge d'Arch
& d'Hist de l'Art 35 (1966) p 161, note 4

A 488 Peasant woman spinning. *Spinnende boerin*

Panel 37 × 35. Signed *T Wijck*
PROV Purchased from J van Ravenzwaay, Hilversum, 1829 * DRVK since 1961

attributed to **Jan van Wijckersloot**

active 1643-83 in Utrecht

A 748 Playing cards over the cradle: an allegory. *Het kaartspel op de wieg: allegorie*

Canvas 98 × 121
PROV Presented by J J van Torenbergen, 1882

Jan Wijnants

Haarlem 1631/32 – 1684 Amsterdam

A 492 A peasant cottage. *Een boeren-woning*

Panel 30 × 37. Signed *J. Wijnants*
PROV Sale Amsterdam, 19 July 1809, lot 65
LIT Moes & van Biema 1909, pp 152, 223. Hofstede de Groot 1907-28, vol 8 (1923) nr 26. W Stechow, Bull Clev Mus of Art, 1965, p 167 (shortly after 1656). Bol 1969, p 213, fig 208

C 277 Landscape with peddler and woman resting. *Landschap met marskramer en rustende vrouw*

Canvas 29.5 × 35. Signed and dated *J. Wijnants 1669*
PROV On loan from the city of Amsterdam (A van der Hoop bequest) since 1885
LIT Hofstede de Groot 1907-28, vol 8 (1923) nr 427

C 276 Landscape with donkey rider. *Landschap met ezelrijder*

Canvas 29 × 36. Signed *J. Wijnants f.*
PROV On loan from the city of Amsterdam (A van der Hoop bequest) since 1885
LIT Hofstede de Groot 1907-28, vol 8 (1923) nr 426

A 493 Landscape with cattle on a country road. *Landschap met vee op een landweg*

Panel 26.5 × 34.5. Signed *J. Wijnants*
PROV Sale G H Trochel, Amsterdam, 11 May 1801, lot 113. NM, 1808
LIT Moes & van Biema 1909, pp 198, 223. Hofstede de Groot 1907-28, vol 8 (1923) nr 351

A 2349 Dune landscape with resting hunters. *Duinlandschap met rustende jagers*

Canvas 52 × 60.5. Signed *J. Wijnants*
PROV Purchased from the heirs of Jonkheer P H Six van Vromade, Amsterdam, 1908, through the intermediacy of the Rembrandt Society * DRVK since 1959 (on loan to de Cannenburch Castle, Vaassen)
LIT Hofstede de Groot 1907-28, vol 8 (1923) nr 132

C 274 Landscape with a hunter and other figures. *Landschap met een jager en andere figuren*

Canvas 67 × 63. Signed *J. Wijnants*
PROV On loan from the city of
Amsterdam (A van der Hoop bequest)
since 1885
LIT Hofstede de Groot 1907-28, vol 8
(1923) nr 212

A 490 Landscape with two hunters.
Landschap met twee jagers

Canvas 37 × 34. Signed *J. W.*
PROV Purchased with the Kabinet van
Heteren Gevers, The Hague-Rotterdam,
1809
LIT Moes & van Biema 1909, pp 151,
167. Hofstede de Groot 1907-28, vol 8
(1923) nr 213

A 491 Hilly landscape with a rider on a
country road. *Heuvelachtig landschap met
een ruiter op een landweg*

Canvas 23.5 × 29.5. Signed *JW*
PROV Bequest of L Dupper Wzn,
Dordrecht, 1870 * DRVK since 1958
LIT Hofstede de Groot 1907-28, vol 8
(1923) nr 263

C 275 Landscape with a rider watering
his horse. *Landschap met een ruiter, die zijn
paard drenkt*

Panel 23.5 × 30.5. Signed *J. W.*
PROV On loan from the city of
Amsterdam (A van der Hoop bequest),
1885-1975
LIT Hofstede de Groot 1907-28, vol 8
(1923) nr 425

Dirck Wijntrack

Drenthe province? before 1625 – 1678
The Hague

A 2304 The annunciation to the
shepherds. *De verkondiging aan de herders*

Canvas 112 × 155. Signed and dated
D. Wijntrack F. 1670
PROV Presented by the Schutters van
St Joris (St George civic guard),
Heusden, 1907 * DRVK since 1953

A 2682 A buzzard attacking two ducks.
Een buizerd valt twee eenden aan

Panel 50.5 × 57
PROV Bequest of R Th Baron van
Pallandt van Eerde, Ambt-Ommen,
1913
LIT M J F W van der Haagen, OH 35
(1917) p 44

Jan Hillebrand Wijsmuller

Amsterdam 1855 – 1925 Amsterdam

A 1963 Waterway near the Baarsjes,
Amsterdam. *Wetering bij de Baarsjes bij
Amsterdam*

Canvas 60 × 100. Signed *J. H. Wijsmuller*
PROV Presented by the heirs of A J
Potter, Amsterdam, 1901

A 3026 Landscape with bridge. *Land-
schap met brug*

Canvas 76 × 100
PROV Presented by the Arti et Amicitiae
society, Amsterdam, 1925 * DRVK since
1959

attributed to **Adrianus van Ysselstein**

active 1653-84 in Utrecht

A 3928 Johan Servaes van Limburg (1632-98). Deacon of the chapter of St Mary, Utrecht. *Deken van het kapittel van Sinte Marie te Utrecht*

Pendant to A 3929

Canvas 122 × 104
PROV Purchased from A Nijstad gallery, Lochem, 1958

A 3929 Cornelia Craen van Haeften (1622-78), lady of Schorrestein. Wife of Johan Servaes van Limburg. *Vrouwe van Schorrestein. Echtgenote van Johan Servaes van Limburg*

Pendant to A 3928

Canvas 122 × 104
PROV Same as A 3928

manner of **Zacchia il Vecchio**

Vezzano? ca 1495–after 1561 Lucca?

A 503 The clavichord player. *De clavichordspeler*

Panel 88 × 62
PROV Purchased by King Willem I from Countess Bourke, Paris, 1823 (as Bronzino)
LIT Ring 1913, pp 92, 163 (not by Jan van Scorel). F Schmidt-Degener, Jaarversl RMA, 1923, p 20. T Borenius, Burl Mag 59 (1931) p 71. J Pope-Hennessy, Burl Mag 72 (1938) p 217, note 21 (not Zacchia). Haacke 1968, p 17, fig 25

attributed to **Bernardino Zaganelli**

Cotignola 1460/70–1510/12 Cotignola

A 783 The lamentation. *De bewening van Christus*

Panel 69 × 62.5
PROV Sale Count Rasponi (Ravenna), Amsterdam, 30-31 Oct 1883, lot 68 (as Andrea Mantegna)
LIT Crowe & Cavalcaselle 1912, vol 3, p 312. Venturi 1901-40, vol 7:3 (1914) p 1032, fig 773. T Borenius, Burl Mag 59 (1931) p 71. R Roli, Arte ant e mod 31-32 (1965) p 225, fig 79a (Bernardino Zaganelli)

attributed to **Francesco Zaganelli**

Cotignola 1470/80–1531 Ravenna

A 3446 St Catherine. *De heilige Catharina*

Panel 44 × 33
PROV Bequest of J W Edwin vom Rath, Amsterdam, 1941

Jan Adam Zandleven

Koog aan de Zaan 1868–1923 Rhenen

A 3502 Pool on the heath. *Vennetje op de heide*

Panel 33 × 49.5. Signed *J. A. Zandleven*
PROV Bequest of Mrs A C M H Kessler-Hülsmann, widow of D A J Kessler, Kapelle op den Bosch near Mechelen, 1947

Cornelis de Zeeuw

active 1540-65 in Antwerp, thereafter presumably in England

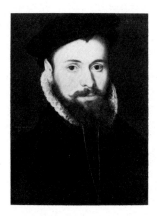

A 2849 Portrait of a young man. *Portret van een jonge man*

Panel 43 × 32.5. Signed and dated *Cornelis de Zeeu pinxit*. Inscribed *An° 1563 Aetatis 23*
PROV Purchased from Asscher & Koetser gallery, Amsterdam, 1920, as a gift of the Photo Commission
LIT Winkler 1924, p 388. De Vries 1934, p 104, fig 62. Hoogewerff 1936-47, vol 4 (1941-42) p 481, fig 226. P Philippot, Bull Mus Roy Belg 14 (1965) p 193

attributed to **Cornelis de Zeeuw**

A 1537 Pierre de Moucheron (1508-67). Merchant of Middelburg and Antwerp, his wife Isabeau de Berbier (1518-68), their eighteen children, their son-in-law Allard de la Dale and their first grandchild. *Koopman te Middelburg en Antwerpen, zijn echtgenote Isabeau de Berbier, hun achttien kinderen, hun schoonzoon Allard de la Dale en hun eerste kleinkind*

Panel 108 × 246. Dated *1563*. Inscribed (above the man) *Etatis sue 55* and (above

the woman) *Etatis sue 45* and above each of the children its age
PROV Purchased from F B Meylink, Haarlem, 1890
LIT Moes 1897-1905, vol 2, nr 5182, ill. De Vries 1934, p 104, fig 61. Hoogewerff 1936-47, vol 4 (1941-42) pp 478-81, fig 227. Edwards 1954, p 135, ill on p 72. P Philippot, Bull Mus Roy Belg 14 (1965) pp 182, 193, fig 13. J de Roey, Spiegel Hist 6 (1971) p 206, fig 8. B C G Gleistein, Kunstrip 3 (1972-73) nr 25. E Snoep-Reitsma, NKJ 24 (1973) p 240, note 160

Jonas Zeuner

1724-1814

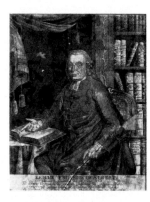

C 1569 Ericus Fridericus Alberti (b 1724). Lutheran minister in Amsterdam, pointing at the text John 1:17. *Luthers predikant te Amsterdam, wijzend op de tekst Johannes 1, vers 17*

Verre églomisé in gold and black enamel 35 × 28.5. Glass broken. Signed and dated *Zeuner. inv: 1771*. Inscribed *Ericus Fridericus Alberti Gebooren te Emmerik den 26 Maij 1724. Tot Leeraar beroepen in de Gemeente Toegedaan de Onveranderde Augsburgse Geloofs belijdenis te Zirikzee den 7 Maart 1744. Te Dordrecht den 16 feb: 1746. Te Amsteldam den 25 Jan: 1768.*
PROV On loan from the KOG (presented by J W Pfeiffers) since 1973

C 1534 The Jan Roodenpoortstoren, Amsterdam. *De Jan Roodenpoortstoren te Amsterdam*

Verre églomisé in gold, silver, black and other colors 42 × 52. Signed *Zeuner*
PROV On loan from the KOG since 1904
LIT Ritz 1972, pp 11, 154 ad nr 26, fig 26

C 1531 Houses near a river. *Huizen bij een rivier*

Verre églomisé in gold, silver, black and other colors 21.5 × 26.5. Signed *Zeuner. fec.*
PROV On loan from the KOG (presented by R D Benten, 1885) since 1973

C 1532 Mill on a river. *Molen bij een rivier*

Verre églomisé in gold, silver, black and other colors 20 × 26. Signed *Zeuner. fec.*
PROV On loan from the KOG since 1904

A 4117 Exchange of fire between the Utrecht patriots, right, and the troops of the stadholder, left, on the banks of the Vaartse Rijn near Jutphaas, at ten o'clock of the evening of 9 May 1787. *Vuurgevecht aan de Vaartse Rijn bij Jutphaas op 9 mei 1787, 's avonds om tien uur. Rechts de Utrechtse patriotten, links de troepen van de stadhouder*

Verre églomisé in gold, silver, black and other colors 27 ×33. Signed and dated *Zeuner fec. den 9. Mey 1787*
PROV Purchased from A van der Berg, Boskoop, 1965

A 4230 Vreeland on the Vecht. *Vreeland aan de Vecht*

After a drawing by Jan de Beijer (1703-ca 1785)

Verre églomisé in gold and black enamel 13.1 ×21.4. Glass broken. Signed *Zeuner*
PROV Unknown

Félix Ziem

Beaune 1821 – 1911 Paris

A 1903 Moorish oarsmen off Constantinople. *Moorse roeiers bij Constantinopel*

Canvas 67 × 138. Signed *Ziem*
PROV Presented by the dowager of R Baron van Lynden, née M C Baroness van Pallandt, The Hague, 1900 * DRVK since 1961

Johann Georg Ziesenis

Copenhagen 1716 – 1776 Hannover

see also Miniatures: Holland school ca 1770, A 4453 Wilhelmina of Prussia, after Ziesenis

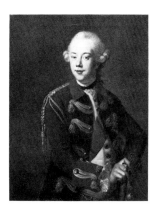

A 882 Willem V (1748-1806), prince of Orange-Nassau. *Prins van Oranje-Nassau*

Canvas 92 ×71
PROV KKS, 1876. NMGK, 1885
LIT Moes 1897-1905, vol 2, nr 9098:2

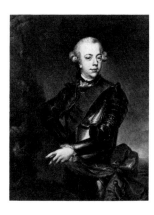

A 1229 Willem V (1748-1806), prince of Orange-Nassau. *Prins van Oranje-Nassau*

Canvas 113 ×91
PROV KKS, 1876. NMGK, 1885 * DRVK since 1959 (on loan to the Oranje-Nassau Museum, Delft)
LIT Moes 1897-1905, vol 2, nr 9098:22

A 881 Willem V (1748-1806), prince of Orange-Nassau. *Prins van Oranje-Nassau*

Canvas 144 × 104
PROV KKS, 1876. NMGK, 1885 * Lent to the provincial governor of Zeeland, Middelburg, 1924. Destroyed in the war, 1940
LIT Moes 1897-1905, vol 2, nr 9098:21

Charles Louis Philippe Zilcken

see under Pastels

Christian Friedrich Zincke

see under Miniatures

attributed to **Francesco Zuccarelli**

Pitigliano 1702 – 1788 Florence

A 3447 Landscape with figures. *Landschap met figuren*

Canvas 59 × 73
PROV Bequest of J W Edwin vom Rath, Amsterdam, 1941

Francesco Zugno

Venice 1709–1787 Venice

A 3435 Mars sleeping. *Slapende Mars*

Pendant to A 3436

Canvas 50.5 × 120
PROV Bequest of J W Edwin vom Rath,
Amsterdam, 1941
LIT Pallucchini 1960, p 165

A 3436 Abraham and the three angels.
Abraham en de drie engelen

Pendant to A 3435

Canvas 50.5 × 120
PROV Same as A 3435
LIT Pallucchini 1960, p 165

Johannes Wilhelm Cornelis Anton Zürcher

Amsterdam 1851–1905 The Hague

A 2535 The preacher in the wilderness.
De woudprediker

Canvas 72 × 96
PROV Presented by the artist's widow,
Mrs J Zürcher-Bijleveld van
Serooskerken, Wilmersdorf, 1911

Bernardus Zwaerdecroon

Utrecht 1617–1654 Utrecht

A 828 François Leydecker. Burgomaster
of Tholen, 1686. *Burgemeester van Tholen*

Pendant to A 829

Panel 75 × 60. Signed *B. Z.* Inscribed on
the verso *DHeer Francois Leijdekker
Burgermeester Van Thoole.*
PROV Presented by Jonkheer J H F K
van Swinderen, Groningen, 1884
LIT Moes 1897-1905, vol 2, nr 4469
(anonymous)

A 829 Digna de Maets. Wife of François
Leydecker. *Echtgenote van François
Leydecker*

Pendant to A 828

Panel 75 × 60. Signed *B. Z.* Inscribed on
the verso *Iuffr Digna De Maats Dogter Van
den Heer Carolus De Maats Getrout met
Den Heer Francois Leijdekker Burgermeester
Van Thoole.*
PROV Same as A 828
LIT Moes 1897-1905, vol 2, nr 4740

Wilhelmus Hendrikus Petrus Johannes (Willem) de Zwart

The Hague 1862–1931 The Hague

A 3503 Meadow with cows. *Weide met
koeien*

Canvas 68 × 105. Signed *W. de Zwart*

PROV Bequest of Mrs A C M H Kessler-
Hülsmann, widow of D A J Kessler,
Kapelle op den Bosch near Mechelen,
1947 * DRVK since 1956
LIT De Meester-Obreen 1912, p 14, ill

A 3504 Meadow with cows. *Weide met
koeien*

Canvas 80 × 105. Signed *W. de Zwart*
PROV Bequest of Mrs A C M H Kessler-
Hülsmann, widow of D A J Kessler,
Kapelle op den Bosch near Mechelen,
1947 * DRVK since 1956

A 2957 Coaches and waiting drivers.
Rijtuigen met wachtende koetsiers

Canvas 31.5 × 43. Signed *W. de Zwart*
PROV Bequest of A van Wezel,
Amsterdam, 1922

A 3362 Street in Montmartre, Paris, in
the winter. *Straat in Montmartre, Parijs,
bij winter*

Canvas 50.5 × 65.5. Signed *W. de Zwart*
PROV Presented by Mr & Mrs D A J

Kessler-Hülsmann, Kapelle op den Bosch near Mechelen, 1940 * DRVK since 1968

A 3364 Hay wagon. *Hooiwagen*

Panel 17.5 × 24.7
PROV Presented by Mr & Mrs DAJ Kessler-Hülsmann, Kapelle op den Bosch near Mechelen, 1940 * DRVK since 1959

A 3363 In the barn. *In de schuur*

Panel 23.8 × 30.5
PROV Presented by Mr & Mrs DAJ Kessler-Hülsmann, Kapelle op den Bosch near Mechelen, 1940

A 3361 Still life with apples in a Delft blue bowl. *Stilleven met appels op een Delfts blauwe schaal*

Canvas 48.5 × 79. Signed *W. de Zwart*
PROV Presented by Mr & Mrs DAJ Kessler-Hülsmann, Kapelle op den Bosch near Mechelen, 1940 * DRVK since 1959 (on loan to the Gemeentemuseum, Arnhem)

A 2283 Head of a boy. *Jongenskop*

Panel 27 × 19.5. Signed *W. de Zwart*
PROV Bequest of J BAM Westerwoudt, Haarlem, 1907

A 3368 The fallen angel. *De gevallen engel*

Panel 20 × 17.5
PROV Presented by Mr & Mrs DAJ Kessler-Hülsmann, Kapelle op den Bosch near Mechelen, 1940

A 3365 - A 3367, A 3505 - A 3507
Painted screen in three sections, each in two parts. *Beschildering van een driedelig kamerscherm met telkens twee voorstellingen*

Canvas 15.5 × 44.5 and 82.5 × 45 respectively. Each section signed *W. de Zwart*
PROV A 3365-A 3367 presented by Mr

& Mrs DAJ Kessler-Hülsmann, Kapelle op den Bosch near Mechelen, 1940; A 3505-A 3507 bequeathed by Mrs ACMH Kessler-Hülsmann, widow of DAJ Kessler, Kapelle op den Bosch near Mechelen, 1947

A 3367 The deluge. *De zondvloed*
A 3505 Adam and Eve in paradise. *Adam en Eva in het paradijs*
A 3365 The crucifixion. *De kruisiging*
A 3507 Cain and Abel. *Kaïn en Abel*

A 3366 The destruction of Sodom and Gomorrah. *De verdelging van Sodom en Gomorra*
A 3506 The expulsion from paradise. *De verdrijving uit het paradijs*

Cornelis van Zwieten

active 1648-61 in Leiden

A 2834 Hilly landscape with peasant cottage. *Heuvelachtig landschap met boeren-woning*

Panel 41.5 × 60. Signed and dated *C.v. Zwieten 1653*
PROV Purchased from H Hoffmann, Aachen, 1920

attributed to **Roelof van Zijl**

active 1608-28 in Utrecht

A 1611 Elisha mocked by the little children. *Elisa door de kinderen bespot*

Canvas 143 × 160. Fragment. Falsely signed *F.H.f.* (Frans Hals)
PROV Purchased from F Kleinberger gallery, Paris, 1894 * DRVK since 1953
LIT A Bredius, OH 26 (1908) p 42, note 1 (Jan Miense Molenaer)

Monogrammists

Monogrammist AS

Southern Netherlands school mid-17th century

A 737 A young woman near a table with fruits. *Een jonge vrouw bij een tafel met vruchten*

Copper 22 × 29. Signed *AS*
PROV Purchased from Mrs D Thijgesen-Rensburg, 1882

Braunschweig Monogrammist

see under Masters with ad hoc names

Monogrammist BVDA

Northern Netherlands school mid-17th century

A 1721 Still life with fish. *Stilleven met vissen*

Canvas 51 × 62. Signed *BvdA*
PROV Purchased from the estate of N de Roever, Amsterdam, 1898 * On loan to the Museum Amstelkring, Amsterdam, since 1956; from 1957 on via the DRVK

Monogrammist DB

Southern Netherlands school first half 17th century

NM 8041 Partygoers and figures from the Commedia dell'Arte in a gallery. *Feestvierend gezelschap en figuren uit de Commedia dell' Arte in een galerij*

Perspective box painted on glass, isinglass and copper; the background is paper on panel 32 × 36 × 3. Signed and dated *D.B. 1634*
PROV Presented by Dr A Bredius, The Hague, 1885. Belongs to the department of sculpture and applied arts

Monogrammist HK

Netherlands school mid-19th century

A 1844 Pieter Janson (1765-1851). Painter and etcher, retired major in the cuirassiers. *Schilder en etser, majoor der Kurassiers buiten dienst*

Canvas 40 × 31. Signed and dated *HK x 1842* (possibly Hubertus Johannes Kramer, 1808-80)
PROV Presented by P E Boele, The Hague, 1899
LIT Van Hall 1963, p 155, nr 1034:1 (Hubertus Johannes Kramer?)

Monogrammist IB

Holland school second quarter 17th century

A 2253 Still life with implements of war. *Stilleven met krijgstuig*

Panel 24 × 21.5. Signed with a monogram composed of the letters *I* and *B*
PROV Purchased from Mr Maas Geesteranus, Amsterdam, 1907

Monogrammist IL

Netherlands school 18th century

C 160 Landscape with cattle. *Landschap met vee*

Canvas 69.5 × 56.5. Signed with a monogram composed of the letters *I* and *L* or *J* and *L*
PROV On loan from the city of Amsterdam (A van der Hoop bequest) since 1885

copy after Monogrammist ISH

Northern Netherlands school first half 17th century

C 529 Willem III, count of Holland, ordering the beheadal of the bailiff of Zuid Holland, 1336. *Willem III, graaf van Holland, geeft opdracht de baljuw van Zuid-Holland te onthoofden, 1336*

Copy after the version in the town hall of Naarden

Canvas 153 × 195. Falsely signed and dated *F. Francke Ao 1617*
PROV On loan from the KOG (presented by A D de Vries Azn) since 1885
LIT Van de Waal 1952, p 273, fig 106:2. Nicolson 1958, p 65

Monogrammist IVA

German school? 1645

A 1706 Herman Gijsbert van der Hem van Niederstein (d 1671)

Canvas 74 × 62. Signed with monogram composed of the letters *I, V* and *A* followed by *f.* and the date *A° 1645*
PROV Purchased from A G Brigg Jr, Amsterdam, 1897

Monogrammist JJ

see under Pastels

Monogrammist Johann GM

active 1678 in Germany

A 4460 Calligraphic maxim: Das Blut Jesu Christi des Sohnes Gottes macht uns rein von allen Sünden. *Gecalligrafeerde spreuk*

Verre églomisé 27.3 × 35. Signed and dated *Johann G. M. 1678*
PROV Presented by H Quint, Amsterdam, 1895. NMGK

Monogrammist JVR

Northern Netherlands school first half 17th century

A 1456 Still life with pig's head, pig's knuckles and sausage. *Stilleven met varkenskop, varkenspootjes en worst*

Panel 57 × 72. Signed *JVR F.* Inscribed *T is al vant Vercken*
PROV Sale Amsterdam, 13 March 1888, lot 73 (as Hubert van Ravesteyn) * On loan to the Rijksmuseum Muiderslot, Muiden, since 1949

Monogrammist WP

see under Miniatures

Masters with ad hoc names

Because the Dutch names of the masters in this section may differ considerably from the English ones under which they are alphabetized, we give first a list of the names in Dutch, followed by the English equivalent

Brunswijkse Monogrammist. *Braun-schweig Monogrammist*
Meester van de Abdij van Afflighem. *Master of the Abbey of Afflighem*
Meester van het Adie Lambertsz-portret. *Master of the Portrait of Adie Lambertsz*
Meester van Alkmaar. *Master of Alkmaar*
Meester Allegro. *Master Allegro*
Meester van het Amsterdamse Sterfbed van Maria. *Master of the Amsterdam Death of the Virgin*
Meester van de Anghiari-slag. *Master of the Battle of Anghiari*
Meester van de Bambino Vispo. *Master of the Bambino Vispo*
Meester van de Barbara-legende. *Master of the Legend of St Barbara*
Meester der Barmhartigheden. *Master of the Seven Works of Charity*
Meester van de Brunswijkse diptiek. *Master of the Braunschweig Diptych*
Meester van de Carrand-triptiek. *Master of the Carrand Triptych*
Meester van de Conversazione di Santo Spirito. *Master of the Conversazione di Santo Spirito*
Meester van Delft. *Master of Delft*
Meester van de Elisabeth-panelen. *Master of the St Elizabeth Panels*
Meester van de Jarves-cassoni. *Master of the Jarves Cassoni*
Meester van de Johannes-taferelen. *Master of the St John Panels*
Meester van de Kruisafneming in de Verzameling Figdor. *Master of the Figdor Deposition*
Meester van het Leven van Jozef. *Master of the Joseph Sequence*
Meester van de Magdalena-legende. *Master of the Legend of Mary Magdalene*
Meester met de Papegaai. *Master with the Parrot*
Meester van Pietro a Ovile. *Master of Pietro a Ovile*
Meester van Rhenen. *Master of Rhenen*
Meester van het Salemer Altaar. *Master of the Salem Altar*
Meester van San Miniato. *Master of the San Miniato Altarpiece*
Meester van de Spes Nostra. *Master of the Spes Nostra*
Meester van de Ursula-legende. *Master of the Legend of St Ursula*
Meester van de Verkondiging van Aix. *Master of the Aix Annunciation*
Meester van de Virgo inter Virgines. *Master of the Virgo inter Virgines*
Meester van de Vorstenportretten. *Master of the Portraits of Princes*
Meester van de Vrouwelijke Half-figuren. *Master of the Female Halflengths*

Braunschweig Monogrammist.
Brunswijkse Monogrammist

active second quarter 16th century in the Southern Netherlands

A 1561 A public house. *Gezelschap in een bordeel*

Copy after the version in the Städelsches Kunstinstitut, Frankfurt am Main (cat 1924, nr 249)

Panel 33.5 × 47.5. Signed with a monogram composed of the letters *G* and *L*
PROV Sale Amsterdam, 9-10 Feb 1892, lot 134
LIT Friedländer 1924-37, vol 12 (1935) p 192, nr 236a. Hoogewerff 1936-47, vol 4 (1941-42) p 496. Von der Osten & Vey 1969, p 299. P Wescher, Jb Berliner Museen 12 (1970) pp 50-51, 53, 58, fig 13. Schubert 1970, pp 184-85, fig 24. Renger 1970, p 98. D Kreidl, Jb Kunsth Samml Wien 68 (1972) pp 53, 70, 72, fig 46

A 1603 Ecce homo

Panel 55 × 89.5
PROV Purchased from L Dirix van Aubel, Maastricht, 1893 * On loan to the KKS (cat 1968, p 13, nr 960) since 1963
LIT F Haberditzl, Kunstgesch Anz, 1909, p 92. E Dietz, Sitzungsberichte Berlin, vol 7 (1909) p 9. Graefe 1909, pp 28-29, pl VI. P de Mont, Elsevier's GM 45 (1913) p 139, ill. L von Baldass, Jb Kunsth Samml AK, 1918, p 136. Winkler 1924, p 306 (Jan van Amstel). Sjöblom 1928, p 179. Glück 1933, p 149 (van Amstel). Friedländer 1924-37, vol 12 (1935) pp 38, 191, nr 229. Hoogewerff 1936-47, vol 4 (1941-42) p 493, fig 232 (van Amstel).

R Genaille, Revue belge d'Arch & d'Hist de l'Art (1950) p 148. R Genaille, GdB-A 39 (1952) p 245. Marlier 1954, p 290. S Bergmans, Revue belge d'Arch & d'Hist de l'Art 27 (1958) p 81. G F Faggin, Paragone 175 (1964) p 44, note 5. S Bergmans, Bull Mus Roy Belg 14 (1965) p 161, fig 17. Faggin 1968, p 34, fig 82. Graz 1969, vol I, p 90, fig 122. Von der Osten & Vey 1969, p 299. Franz 1969, vol I, p 90; vol 2, fig 122. Schubert 1970, p 191, nr 14, fig 38. J Bruyn, OK 14 (1970) nr 8, ill. Th H Lunsingh Scheurleer, Alb Amic J G van Gelder, 1973, pp 98-99, fig 16

Master of the Abbey of Afflighem.
Meester van de Abdij van Afflighem

see Master of the Joseph Sequence

Master of the Portrait of Adie Lambertsz

alphabetized under Portrait

Master of the Aix Annunciation.
Meester van de Verkondiging van Aix

active 2d quarter 15th century in the Provence

A 2399 Still life with books in a niche. *Stilleven met boeken in een nis*

Upper part of the left wing of a triptych with the prophet Isaiah in Museum Boymans-van Beuningen, Rotterdam (cat 1962, p 87, nr 2463). The right wing with the prophet Jeremiah is in the Musées des Beaux-Arts, Brussels (cat 1957, p 64, nr 950); the middle panel with the annunciation is in the church of Ste Madeleine, Aix-en-Provence

Panel 30 × 56
PROV From the church of the Saint Sauveur, Aix-en-Provence. Sale Amsterdam, 30 Nov 1909, lot 23 * On loan to the Musée du Louvre, Paris, since 1956, in exchange for Rembrandt, C 1450
LIT Rev Art Anc & Mod 43 (1923) pp 81-100, 174-78, 287-306. L Dimier, OH

44 (1927) pp 211-13. J Guiffrey,
Renaissance, 1927, p 271-74. P Jamot,
Rev Art Anc & Mod 52 (1927) pp 155-
62. Hevesey, Pantheon 3 (1930) p 57. M
Demonts, in Mélanges Hulin de Loo,
1931, pp 123-27. L H Labande, GdB-A
74 (1932) p 392. L Dimier, OH 50 (1933)
p 263. Sterling 1941, p 48, figs 25-26, nr
43. R Kömstedt, Pantheon 29 (1942) p
25ff. Wescher 1945, pp 57-62. S
Sulzberger, Revue belge d'Arch &
d'Hist de l'Art 16 (1946) p 113. Ring
1949, p 205, nr 94, pl 49. J Dupont,
Musées de France, 1950, p 106, figs 4-5.
Panofsky 1953, pp 133, 307, notes 277:1,
305:2. L Ph May, Revue des Arts 3
(1953) pp 21-26 (de Clerc or d'Eyck in
collaboration with Roux or Ruffi). L van
Puyvelde, GdB-A 96 (1954) p 145
(Master of Flémalle). Ch Sterling, Revue
des Arts 5 (1955) p 35. L Ninane, Bull
Mus Roy Belg 5 (1956) p 139. J Boyer,
GdB-A 101 (1959) p 301; idem 102
(1960) p 137 (Dombet?)

Master of Alkmaar. *Meester van
Alkmaar*

active first half 16th century in Alkmaar
and Haarlem

A 2815 The seven works of charity. *De
zeven werken van barmhartigheid*

Panel; the outer panels 101 × 54 each;
the others 101 × 55.5. Dated on the old
frame, which also bears the inscriptions
cited, *Gheschildert Anno 1504*. The second
panel is dated *Ano mccccc en iiii*. On the
first panel is a master's mark (?) and on
the second the word *Gloria*
PROV Purchased from the church of St
Lawrence in Alkmaar, 1918, with aid
from the Rembrandt Society
LIT Boomkamp 1747, p 387. Dülberg
1899, p 24. Van Kalcken & Six 1903-19,
vol 2. Binder 1908, p 16 (Haarlem,
Willem Cornelisz?). C H de Jonge, Bull
NOB 2d ser 6 (1913) p 200. Valentiner
1914, p 76. N Beets, Onze Kunst 25-26
(1914) p 60, ill. W R Valentiner,
Cicerone 10 (1918) p 256. W J Steenhoff,
Jaarversl Ver Rembrandt, 1918, p 6, ill.
O Hirschmann, Mon f Kunstw 12 (1919)
p 88, ill. Winkler 1924, p 379. N F van
Gelder-Schrijver, OH 47 (1930) p 103.
Friedländer 1924-37, vol 10 (1932) pp
33, 126, nr 55, pls XXVI-XXIX
(Haarlem?, Cornelis Buys?).
Hoogewerff 1936-47, vol 2 (1937) p 346,
ill (Cornelis Buys). Gerson 1950, p 20,
figs 110-11. A B de Vries, OK I (1957) nr
25, ill. Exhib cat Middeleeuwse kunst
der Noordelijke Nederlanden,
Amsterdam 1958, nr 87, fig 52. Van
Gelder 1959, p 9, fig 4. G M de Meyer,
Spiegel Hist 2 (1967) pp 654-55, figs 3-4.
Von der Osten & Vey 1969, p 163.
VTTT, 1968-69, nr 103. M A van

Dongen, Jb Leiden 72 (1970) p 85, fig
12. Haak 1972, p 11, fig 9. D Kreidl, Jb
Kunsth Samml Wien 68 (1972) p 103

1 Feeding the hungry. *Het spijzen van de
hongerigen*

Inscribed on the frame *Deelt mildelick den
armen, God zal u weder ontfarmen*

2 Refreshing the thirsty. *Het laven van de
dorstigen*

Inscribed on the frame *Van spijs ende*

*drank in dit leven, duisentfout zal u weder
werden gegeven*

3 Clothing the naked. *Het kleden van de
naakten*

Inscribed on the frame *Uwen evenmensche
zijn naektheyt wilt decken, op dat god wijt doe
uwer so[n]den vlecken*

4 Burying the dead. *Het begraven van de
doden*

Inscribed on the frame *Van de dooden te begraven so wij lesen, wert thobias van god gepresen*

5 Lodging the travellers. *Het herbergen van de reizigers*

Inscribed on the frame *Die heer spreekt Wilt mij verstaen, wat Ghij den minsten doet wert mij gedaen*

6 Visiting the sick. *Het bezoeken van de zieken*

Inscribed on the frame *Wilt ziecken ende crancken vysenteren, u loon zal ewelick vermeren*

7 Comforting captives. *Het vertroosten van de gevangenen*

Inscribed on the frame *Die gevangen verlost met caritaten, het komt hier nae zijn[d]er zielen te baten*

A 1307 & A 1308 Two panels of an altarpiece. *Twee panelen van een altaarstuk*

Panels 132 × 82 each
PROV Sale D M Alewijn (Medemblik), Amsterdam, 16 Dec 1885, lots 44-45 (as Hans Memlinc)
LIT Dülberg 1899, p 23. Valentiner 1914, p 77. Winkler 1924, p 379. Bürger 1925, p 94, fig 136. NF van Gelder-Schrijver, OH 47 (1930) p 112. Friedländer 1924-37, vol 10 (1932) p 125, nr 54. L Fröhlich-Bum, OH 51 (1934) p 186. Hoogewerff 1936-47, vol 2 (1937) pp 384-87, figs 184, 186 (follower of Cornelis Buys). J E Snyder, OH 76 (1961) p 63, ill

A 1308 The circumcision (recto); the resurrection (verso). *De besnijdenis (recto); de opstanding (verso)*

A 1307 Jesus disputing with the doctors in the temple (recto); Christ appearing to the Virgin (verso). *Jezus lerende in de tempel (recto); Christus verschijnt aan Maria (verso)*

A 1188 Two wings of a memorial tablet with eight male and nine female portraits, accompanied by Sts James the Greater and Mary Magdalene respectively. *Twee zijluiken van een memoriestuk met acht portretten van mannen en negen van vrouwen, respectievelijk vergezeld van de heiligen Jacobus Major en Maria Magdalena*

The coats of arms identify the sitters in the foreground as Willem Jelysz van Soutelande (d 1515/16) and his wife Kathrijn van der Graft Willemsdochter (d 1490/91). Van Soutelande was alderman and later trustee of the Haarlem orphanage. He is depicted here as a knight in the Confraternity of the Holy Land. Hovering angels bear the coats of arms of Jacob de Wael van Rozenburg (d 1524), a citizen of Haarlem, and his wife Margriet van Waveren. On the versos are the arms of the van Soutelandes and those of the van der Grafts in alliance with van Soutelande

Panel 102 × 36 each
PROV Sale L H van der Hoop Tilanus, The Hague, 1885
LIT NF van Gelder-Schrijver, OH 47 (1930) p 109. Friedländer 1924-37, vol 10 (1932) pp 41, 125, nr 53. Hoogewerff 1936-47, vol 2 (1937) pp 378, 380, fig 182 (studio of Cornelis Buys). P Wescher, OH 61 (1946) p 92 (Jacob Cornelisz). M Thierry de Bye Dólleman, Jb Genealogie, 1965, p 133ff, ill

milieu of **Master of Alkmaar**

C 1364 Triptych with the adoration of the magi. *Drieluik met de aanbidding der koningen*

Left wing: the departure of the three magi. Right wing: a group of riders. On the versos of the wings are Sts Anthony (left) and Adrian (right) in grisaille

Panel 48 × 36.8 (middle panel); 48.5 × 14 (each of the wings). Marked on the middle panel, in the lower left and right, and on the versos of the wings with a master's mark composed of an *A*? and a *V*
PROV Presented by J H van Heek, Lonneker, 1926. On loan from the KKS since 1948
LIT NF van Gelder-Schrijver, OH 47 (1930) p 115. Friedländer 1924-37, vol 10 (1932) pp 36, 125, nr 49, pls XXI-XXII. Hoogewerff 1936-47, vol 2 (1937) p 369 (studio of Cornelis Buys)

A 3324 The adoration of the magi. *De aanbidding der koningen*

Panel 64.5 × 45. Ends in a round arch
PROV Presented by Mr & Mrs D A J Kessler-Hülsmann, Kapelle op den Bosch near Mechelen, 1940

C 57 Hendrik IV van Naaldwijk (ca 1430-96). Knight and hereditary marshall of Holland. *Ridder en erfmaarschalk van Holland*

Belongs to a series of six, of which three others were on loan in the Rijksmuseum until 1935 (cat 1927, nrs 134-35, 137) and two until 1975 (cat 1927, nrs 132-33)

Panel 82 × 56.5. Inscribed *Heer henric van naeldwijc, wille*[m]*s zoon, zijn wijff was machtelt van raephorst.* Marked *VI*
PROV On loan from the municipality of Naaldwijk since 1884
LIT Moes 1897-1905, vol 2, nr 5274. S Muller Fz, OH 38 (1920) p 72ff. NF van Gelder-Schrijver, OH 47 (1930) p 102 (attributed to Master of Alkmaar). De Vries 1934, p 6. Hoogewerff 1936-47, vol 2 (1937) p 423ff, fig 209 (not Master of Alkmaar). M A van Andel, Ned Tijdschr Geneesk 82 (1938) pp 1099-1102, ill. A van der Marel, Zuidholl Studiën 4 (1954) p 93ff, fig 15

Master Allegro. *Meester Allegro*

active end 15th century in Florence

A 3007 The adoration of the child. *De aanbidding van het kind*

Panel 88 cm in diam. Tondo
PROV Purchased from the Augusteum, Oldenburg, 1923, as a gift of a group members of the Rembrandt Society
LIT Bode 1888, p 10 (Sebastiano Mainardi). Hartlaub 1912, vol 2, nr 10, fig 17 (Mainardi). Jaarversl Ver Rembrandt, 1923, pp 5, 14, ill (Mainardi). Van Marle 1923-38, vol 13 (1931) p 254, fig 174 (Bartolommeo di Giovanni). T Borenius, Burl Mag 59 (1931) p 64 (Piero di Cosimo). Berenson 1932, p 196 (Jacopo del Indaco?, ca 1500). Hauptmann 1936, p 231 (Mainardi). F Zeri, Boll d'Arte 47 (1962) p 315, fig 4. Berenson 1963, vol 1, p 220 (Jacopo del Indaco?, ca 1500). Bacci 1966, p 117 (not Piero di Cosimo). Van Os & Prakken 1974, pp 81-82, nr 45, ill

Master of the Amsterdam Death of the Virgin. *Meester van het Amsterdamse Sterfbed van Maria*

active ca 1500 in Utrecht or Amsterdam

A 3467 The death of the virgin. *Het sterf-bed van Maria*

Panel 58 × 78
PROV Purchased from the regents of the Hofje van de Zeven Keurvorsten (alms-

house of the seven electors), Amsterdam, 1944, through the intermediacy of A Douwes gallery, Amsterdam
LIT Friedländer 1924-37, vol 10 (1932) pp 114, 138, nr 148, pl XC. Hoogewerff 1936-47, vol 1, p 518 (not Amsterdam). Gerson 1950, p 20, fig 39. KG Boon, OK 2 (1958) nr 32, ill. Exhib cat Middel-eeuwse kunst der Noordelijke Neder-landen, Amsterdam 1958, nr 44, fig 32. VTTT, 1961-62, nr 38. SE Pronk Czn, Pronk-stukken, 1974, p 124, ill

A 2129 & A 2130 Two panels of an altar-piece. *Twee panelen van een altaarstuk*

Panel 51.5 × 63.5 (A 2129); 53 × 65.6 (A 2130)
PROV Purchased from Fr Muller & Co, art dealers, Amsterdam, 1904
LIT Friedländer 1924-37, vol 10 (1932) pp 117, 138, nr 145, pl LXXXVIII. Hoogewerff 1936-47, vol 1, p 524, fig 291 (Master of the Lantern). DF Scheurleer, Oud Nederland 4 (1950) p 113, fig 7. G Schiedlanski, AGNM, 1954-59, p 186

A 2129 The last supper. *Het laatste avond-maal*

A 2130 The resurrection. *De opstanding van Christus*

Master of the Battle of Anghiari

alphabetized under Battle

attributed to **Master of the Bambino Vispo.** *Meester van de Bambino Vispo*

active first quarter 15th century in Florence

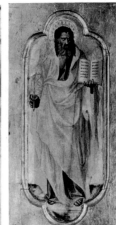

A 3979 Evangelist. *Evangelist*

Pendant to A 3980

Panel 35 × 14
PROV O Lanz, Amsterdam. Lent by the SNK, later DRVK, 1948. Transferred in 1960
LIT Van Marle 1923-38, vol 9 (1927) p 72, fig 42 (Giovanni a Ponte, before 1410). Berenson 1932, p 339. B Degenhart, Pantheon 27-28 (1941) p 35. Berenson 1963, vol 1, p 138. JJ van Waadenoijen, Burl Mag 116 (1974) p 85 (Gherardo Starnina?). Van Os & Prakken 1974, p 55, nrs 25-26, ill (Giovanni del Ponte)

A 3980 Evangelist. *Evangelist*

Pendant to A 3979

PROV Same as A 3979
LIT *See under* A 3979

Master of the Legend of St Barbara

alphabetized under Legend

Master of the Battle of Anghiari. *Meester van de Anghiari-slag*

active ca 1450 in Florence

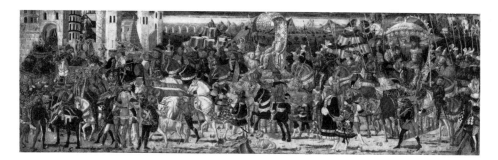

A 3974 The triumph of Aemilius Paulus after the battle of Pydna, 168 BC. *De triomftocht van Aemilius Paulus na de slag bij Pydna, 168 voor Chr*

Panel 58 × 150. Cassone
PROV J Goudstikker gallery, Amsterdam. Lent by the SNK, later DRVK, 1948. Transferred in 1960
LIT Schubring 1915, nr 116, ill. Weisbach 1919, p 37. Van Marle 1923-38, vol 10 (1928) p 558. R van Marle, Cicerone 21 (1929) p 181. Van Os & Prakken 1974, p 85, nr 48, ill

Master of the Braunschweig Diptych. *Meester van de Brunswijkse Diptiek*

active ca 1490 in Haarlem and possibly Amsterdam

A 2563 The nativity. *De geboorte van Christus*

Panel 46 × 35
PROV Lent by C Hoogendijk, The Hague, 1907. Presented from his estate in 1912
LIT Balet 1910, p 157 (school of Geertgen tot Sint Jans). R Bangel, Cicerone 7 (1915) p 176, fig 3. Winkler 1924, p 176 (Geertgen). Friedländer 1924-37, vol 5 (1927) pp 53, 134, nr 18, pl XIX. Dülberg 1929, p 103 (school of Geertgen). Kessler 1930, p 8 (Geertgen). Hoogewerff 1936-47, vol 2 (1937) p 197, fig 88. Vogelsang 1942, p 56. Exhib cat Middeleeuwse kunst der Noordelijke Nederlanden, Amsterdam 1958, nr 25. J Q van Regteren Altena, OH 81 (1966) p 81 (early)

A 3305 & A 3306 Versos of wings of a triptych. *Buitenkanten van luiken van een drieluik*

Panels 65 × 23.5 each. Inscribed *Valeman[u]s* and *[S]po[n]s[us] Cecilie*
PROV Presented by Mr & Mrs D A J Kessler-Hülsmann, Kapelle op den Bosch near Mechelen, 1940
LIT Friedländer 1924-37, vol 5 (1927) pp 53, 135, nr 21. T Borenius, Pantheon 2 (1929) p 134, ill. Kessler 1930, p 13, pls II-III (Geertgen tot Sint Jans). J K van der Haagen, in Gedenkboek Caecilia, 1930, p 19, ill. J K van der Haagen, Het Gildeboek 13 (1930) p 145. Hoogewerff 1936-47, vol 2 (1937) p 200. Vogelsang 1942, p 56, figs 12-13. Gerson 1950, p 15 (Geertgen). R van Luttervelt, OH 66 (1951) p 81, fig 3. N Beets, in Kunstgesch der Ned, 1954-56, vol 1, p 284 (Geertgen). Exhib cat Middeleeuwse kunst der Noordelijke Nederlanden, Amsterdam 1958, nr 28, fig 10

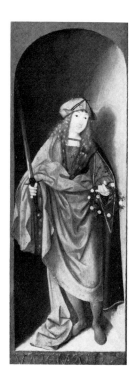

A 3305 St Valerian (left). *De heilige Valerianus (links)*

A 3306 St Cecilia (right). *De heilige Cecilia (rechts)*

Master of the Carrand Triptych. *Meester van de Carrand-triptiek*

active 1450-60 in Florence

A 4022 Frame painted with the annunciation, the baptism of Christ, the entry into Jerusalem, Sts Cecilia and Catherine, the seat of mercy and four angels making music. *Lijst beschilderd met de verkondiging, de doop van Christus, de intocht in Jeruzalem, de heiligen Cecilia en Catharina, de genadestoel en vier musicerende engelen*

Composite wooden frame 158 × 69
PROV Bachstitz gallery, The Hague, 1939. SNK. Transferred by the DRVK in 1960
LIT Burl Mag 75 (1939) p 83, fig B

Master of the Seven Works of Charity. *Meester der Barmhartigheden*

see Master of Alkmaar

Master of the Conversazione di Santo Spirito. *Meester van de Conversazione di Santo Spirito*

active first quarter 16th century in Florence

A 3012 Madonna and child with St John the Baptist. *Maria met kind en Johannes de Doper*

Panel 77 cm in diam. Tondo
PROV Purchased from the Augusteum, Oldenburg, 1923, as a gift of the Rembrandt Society
LIT Bode 1888, p 10 (follower of Lorenzo di Credi). Venturi 1901-40, vol 7:1 (1911) p 818 (school of Lorenzo di Credi). Schäfer 1912, p 35. Hartlaub 1912, vol 2, nr 8, pl 14. Reinach 1905-23, vol 5 (1922) p 347. Exhib cat Jubileum-tentoonstelling Ver Rembrandt, Amsterdam 1923, nr 162. Jaarversl Ver Rembrandt, 1923, pp 4-5, ill. Van Marle 1923-38, vol 13 (1931) p 315, fig 216 (studio of Lorenzo di Credi). B Degenhart, Münchn Jb 9 (1932) p 577 (Tommaso di Stefano). Hauptmann 1936, p 203. Berenson 1963, vol 1, p 207 (Tommaso). Dalli Regoli 1966, p 191, nr 241, fig 272 (attributed to Maestro della Conversazione di S Spirito = Giovanni Cianfanini?). Van Os & Prakken 1974, pp 87-88, nr 50, ill

Master of Delft. *Meester van Delft*

active ca 1510 in Delft

A 3141 Triptych with Madonna and child and saints. *Drieluik met Maria met kind en heiligen*

Left wing: the donor with St Martin. Right wing: the donor's wife with St Cunera. On the outsides of the wings the annunciation in grisaille

Panel 84.5 ×68 (middle panel); 84.5 ×30 (each of the wings). The wings have been sawn in half so that the recto and verso are now separate
PROV Lent by J H van Heek, Lonneker, 1926. Presented in 1933 through the intermediacy of the Rembrandt Society
LIT M J Friedländer, Burl Mag 23 (1913) p 107. M J Schretlen, OH 40 (1922) p 16, fig 2. D Th Enklaar, Jb Oud Utrecht, 1931, p 36 (before 1496). Friedländer 1924-37, vol 10 (1932) pp 47, 127, nr 62, pls XXXIV-XXXVI. Hoogewerff 1936-47, vol 1, p 578, figs 327-28. Gerson 1950, p 19, fig 36. R Berliner, Münchn Jb, 1955, p 72, fig 22. Exhib cat Middeleeuwse kunst der Noordelijke Nederlanden, Amsterdam 1958, nr 61. Zilverberg 1968, fig 25

A 3325 The Virgin and St John lamenting over the body of Christ. *Maria en Johannes wenend bij het lichaam van Christus*

Panel 23.5 × 18.5. Fragment
PROV Presented by Mr & Mrs D A J Kessler-Hülsmann, Kapelle op den Bosch near Mechelen, 1940
LIT M J Schretlen, OH 40 (1922) p 17, fig 7. Friedländer 1924-37, vol 10 (1932) p 127, nr 66; vol 16, p 121, nr 66

Master of the St Elizabeth Panels. *Meester van de Elisabeth-panelen*

active end 15th-beginning 16th century in Utrecht

A 3145, A 3146 & A 3147a-b Two panels, painted on both sides, with scenes from the life of St Elizabeth of Hungary (1207-31) and the St Elizabeth's Day Flood, 18-19 November 1421. *Twee panelen, aan weerskanten beschilderd met voorstellingen uit het leven van de heilige Elisabeth van Hongarije (1207-31) en de Sint Elisabethsvloed, 18-19 november 1421*

Left panel: The engagement of St Elizabeth and Louis of Thuringia; the wedding feast on the Wartburg (A 3145). Right panel: St Elizabeth tending the sick in Marburg; the death of St Elizabeth (A 3146). Versos of both panels: The St Elizabeth's Day Flood, with the city of Dordrecht in the background (A 3147a & A 3147b)

Panel 127 × 110 each. Both panels have been sawn in half so that the rectos and versos are now separate
PROV The Grote Kerk, Dordrecht. Purchased from J Goudstikker gallery, Amsterdam, 1933, with aid from the Rembrandt Society
LIT Tijdschr Kon Aardr Gen 42 (1925) pp 133-38. Jaarversl Ver Rembrandt, 1933, p 19ff, ill. Hoogewerff 1936-47, vol I, pp 502, 504. Van de Waal 1952, pp 255-56, fig 96:1. F Popelier, Bull Mus Roy Belg 18 (1969) p 144, note 9. G L Berk, Spiegel Hist 5 (1970) p 411, fig 3. M K E Gottschalk, Spiegel Hist 6 (1971) p 670, fig 1

A 1727 The conquest of Rhenen by John II of Cleves in 1499. *De verovering van Rhenen door Jan II van Kleef in 1499*

Panel 182 × 143. Inscribed on the frame *Die inneminghe van rienen geschiet in t jaer 1499*
PROV Presented by the municipality of Rhenen, 1898
LIT Haakman 1847, pp 23, 32, 64-65, 72. N C Kist, Kerkh Arch 2 (1859) pp 45-46. Hoogewerff 1936-47, vol I, p 508, fig 277. J H P Kemperink, Zeitschr Schleswig-Holst Gesch 72 (1958) pp 253-54, ill. Van Iterson 1960, ill. C Boschma, OH 76 (1961) pp 91-92. Timmers 1961, fig 225. M E Deelen, Bull RM 15 (1967) p 91, ill

Master of the Female Halflengths.
Meester van de Vrouwelijke Halffiguren

active ca 1520-40 in the Southern Netherlands

A 3130 Madonna and child. *Maria met kind*

Panel 19 × 24
PROV Sale A Ridder de Stuers, Amsterdam, 12 April 1932, lot 255 * On loan to the KKS (cat 1968, p 36, nr 845, ill) since 1948
LIT Winkler 1924, p 382. Friedländer 1924-37, vol 12 (1935) p 172

milieu of **Master of the Female Half-lengths**

A 3255 The judgment of Paris. *Het oordeel van Paris*

Panel 10 × 15.6. Signed and dated *L.D.H. (?) 1532*
PROV Presented by Sir Henry W A Deterding, London, 1936 * On loan to the KKS (cat 1968, p 37, nr 846, ill) since 1948
LIT Koch 1968, p 56, note 3, p 61

Master of the Figdor Deposition.
Meester van de Kruisafneming in de Verzameling Figdor

active end 15th-beginning 16th century in Haarlem and Amsterdam

A 1688 The martyrdom of St Lucy. *Het martelaarschap van de heilige Lucia*

Panel 132.5 × 101.5
PROV Purchased from H O Miethke, Vienna, 1897, with aid from the Rembrandt Society
LIT Dohme 1877, vol I, nrs XII-XIII, p 15. K Altz, Rep f Kunstw 15 (1892) p 183. Von Frimmel 1899, vol I, p 69. Dülberg 1899, p 35 (school of Geertgen tot Sint Jans). E Durand-Gréville, Revue de l'Art 15-16 (1904) p 388. B W F van Riemsdijk, Bull NOB 7 (1906) p 174. Voll 1906, p 237. Balet 1910, p 156 (school of Geertgen). Valentiner 1914, p 69, fig 15. Winkler 1924, p 378. Bürger 1925, p 94, fig 135. Friedländer 1924-37, vol 5 (1927) pp 56, 136, nr 27

(follower of Geertgen, ca 1500). K
Steinbart, Marb Jb 5 (1929) p 217.
Dülberg 1929, p 103. Smits 1933, p 205.
Hoogewerff 1936-47, vol 2 (1937) p 216,
fig 100; vol 5, p 54. L von Baldass, Jb
Kunsth Samml Wien ns 11 (1937) p 119.
M J Schretlen, OH 55 (1938) p 149, fig 3
(early work of Lucas Cornelisz). I Kunze,
Berl Mus 60 (1939) p 8, fig 1. Vogelsang
1942, fig 53. Gerson 1950, p 20, fig 39.
Exhib cat Middeleeuwse kunst der
Noordelijke Nederlanden, Amsterdam
1958, nr 32

A 2212 Christ on the cross. *Christus aan
het kruis*

Panel 104.5 × 85.5
PROV Purchased from Sir Henry H
Howorth, London, 1905
LIT M J Friedländer, Rep f Kunstw 23
(1900) p 257. B W F van Riemsdijk, Bull
NOB 7 (1906) p 174, ill. Balet 1910, p
157 (school of Geertgen tot Sint Jans).
Valentiner 1914, p 69, fig 16.
Friedländer 1924-37, vol 5 (1927) pp 57,
136, nr 28. Dülberg 1927, p 103.
Hoogewerff 1936-47, vol 2 (1937) p 211,
fig 97. M J Schretlen, OH 55 (1938) p
149, fig 4 (early work of Jacob Cornelisz).
I Kunze, Berl Mus 60 (1939) p 10.
Vogelsang 1942, p 58, fig 57.
Hoogewerff 1936-47, vol 5, p 55. J E
Snyder, Art Bull 42 (1960) p 126, fig 16
(copy after Geertgen?)

Master of the Jarves Cassoni. *Meester
van de Jarves-cassoni*

see Florentine school ca 1450, A 3302

Master of the St John Panels.
Meester van de Johannes-taferelen

active end 15th-beginning 16th century
in Gouda and Leiden

A 4125 The Madonna and child with St
Anne, donors and saints. *De heilige Anna
te Drieën met stichters en heiligen*

Panel 54.5 × 53.5
PROV Purchased from P de Boer gallery,
Amsterdam, 1966
LIT K G Boon, Bull RM 16 (1968) pp 3-
12, ill (ca 1485-95)

copy after **Master of the Joseph
Sequence.** *Meester van het Leven van Jozef*

active ca 1500 in Brussels

A 960 Philip the Handsome (1478-1506),
archduke of Austria, duke of Burgundy.
*Philips de Schone, aartshertog van Oostenrijk,
hertog van Bourgondië*

Copy by Pieter Willem Sebes (1827-
1906) after the original in the Musées
des Beaux-Arts, Brussels (inv nr 2406)
Pendant to A 961

Panel 125 × 49
PROV Painted in 1879 upon commission
of the government of the Netherlands.
NMGK, 1885

A 961 Joanna the Mad of Castile (1482-

1555). Wife of Philip the Handsome.
*Johanna de Waanzinnige van Castilië. Echt-
genote van Philips de Schone*

Copy by Pieter Willem Sebes (1827-
1906) after the original in the Musées
des Beaux-Arts, Brussels (inv nr 2406)
Pendant to A 960

Panel 125 × 49
PROV Same as A 960

**Master of the Portrait of Adie
Lambertsz**

alphabetized under Portrait

Master of the Legend of St Barbara.
Meester van de Barbara-legende

active ca 1445-70 in the territory of the
duke of Burgundy

A 2057 Episode from the life of a saint,
probably St Géry, bishop of Cambrai.
*Episode uit het leven van een heilige,
vermoedelijk St Géry, bisschop van Kamerijk*

Panel 97 × 69. Indecipherable, and
possibly fictive inscriptions on the foot
and rim of the pedestal
PROV Sale Middelburgse Teken-
academie, Amsterdam, 9 Dec 1902, lot
37 * On loan to the KKS (cat 1968, p 31,
nr 844, ill) since 1948
LIT Winkler 1924, p 374. M J
Friedländer, Jb f Kunstw 1 (1924) pp
22, 25, fig 4. Friedländer 1924-37, vol 4
(1926) pp 111, 140, nr 66, pl LIII. O van
de Castijne, Revue belge d'Arch &
d'Hist de l'Art 5 (1935) pp 319-25, ill.
O van de Castijne, Revue belge d'Arch
& d'Hist de l'Art 6 (1936) pp 63-65. G
de Tervarent, GdB-A 79 (1936) pp 52-
56, fig 3. Hoogewerff 1936-47, vol 1, pp
493-96, fig 270. P Lefèvre & O Proem,
Revue belge d'Arch & d'Hist de l'Art 6
(1936) p 359. Réau 1958, vol 3, p 591

Master of the Legend of Mary Magdalene. *Meester van de Magdalena-legende*

active end 15th-beginning 16th century in Brussels

A 2854 Philip the Handsome (1478-1506), archduke of Austria, duke of Burgundy. *Philips de Schone, aartshertog van Oostenrijk, hertog van Bourgondië*

Panel 32 × 21
PROV Purchased from Asscher & Koetser gallery, Amsterdam, 1921, as a gift of the Photo Commission
LIT J Tombu, GdB-A 71 (1929) p 284. Friedländer 1924-37, vol 12 (1935) p 169, nr 32 (ca 1500). Onghena 1959, pp 54, 87, note 1, 95-97, fig 13

A 962b Two wings of a triptych: Thomas Isaacq (d 1539/40), king of arms of the Order of the Golden Fleece, decorated with the arms of Philip the Handsome, accompanied by St Thomas;

the wife of Thomas Isaacq, accompanied by St Margaret. *Twee vleugels van een drieluik : Thomas Isaacq, wapenkoning van het Gulden Vlies, getooid met het wapen van Philips de Schone, vergezeld door de heilige Thomas ; de echtgenote van Thomas Isaacq, vergezeld door de heilige Margaretha*

For the portraits on the versos, *see* Pourbus, Pieter, A 962c. The original middle panel, with the Madonna and child, is in the collection of Mrs Mary van Berg, New York. For the middle panel added later, *see* Southern Netherlands school late 17th century, A 962a

Panel 91 × 29 each
PROV Presumably sale B Th Baron van Heemstra van Froma en Eibersburen, The Hague, 16 Feb 1880, lot 2. NMGK, 1885
LIT M J Friedländer, Rep f Kunstw 23 (1900) p 256. J Tombu, Onze Kunst 46 (1929) p 99. Friedländer 1924-37, vol 12 (1935) pp 23, 166, nr 11. G Glück, Burl Mag 75 (1939) p 31, fig 33A. Exhib cat Anonieme Vlaamse primitieven, Bruges 1969, nr 68

Master of the Legend of St Ursula. *Meester van de Ursula-legende*

active ca 1480-90 in Bruges

A 3326 Left wing of a triptych: a donor, his two sons and St John the Evangelist. *Linkerluik van een drieluik : een schenker met twee zonen en Johannes de Evangelist*

Panel 50 × 29
PROV Presented by Mr & Mrs D A J Kessler-Hülsmann, Kapelle op den Bosch near Mechelen, 1940
LIT A B de V[ries], Med Dep o w & c 7 (1940) p 422, ill. G Marlier, Jb Antwerpen, 1964, p 40, nr 53 (not Master of the Legend of St Ursula)

Master with the Parrot. *Meester met de Papegaai*

active first quarter 16th century in Antwerp

A 3225 The suicide of Lucretia. *De zelfmoord van Lucretia*

Panel 41.5 × 32.5. Inscribed on the hem of the cloak *Lvcresia Romana imr* and *s...tas romana*
PROV Presented by R van Marle, Perugia, 1934
LIT Marlier 1966, p 288, note 37. D Schuberl, Jb Kunsth Inst Graz 6 (1971) p 104, fig 15

Master of Pietro a Ovile. *Meester van Pietro a Ovile*

active mid-14th century in Siena

A 4002 Madonna of humility. *Madonna dell'humiltà*

Panel 57 × 24.5
PROV O Lanz, Amsterdam. Lent by the
DRVK, 1952. Transferred in 1960
LIT E T Dewald, Art Stud 1 (1923) p 45;
7 (1929) p 154. Van Marle 1923-38, vol
2 (1923) p 370, note 2 (early work of
Pietro Lorenzetti). M Meiss, Art Bull 13
(1931) p 388, fig 27 (studio of Ugolino
Lorenzetti). Berenson 1932, p 41.
Sinibaldi 1933, p 182 (school of
Lorenzetti). Russoli 1934, nr XVIII. M
Meiss, Art Bull 18 (1936) p 437, note 9
(studio of Bartolommeo Bulgarini).
Meiss 1951, p 134 (school of Bulgarini).
Van Os 1969, pp 108, 113, 131, fig 9.
Exhib cat Sienese schilderijen in
Nederlands bezit, Groningen-Utrecht-
Florence 1969, nr 27, ill. H Kiel,
Pantheon 27 (1969) p 337, ill on p 338

follower of **Master of the Portrait of Adie Lambertsz.** *Meester van het Adie Lambertsz-portret*

active ca 1600 in Friesland

A 970 Portrait of a woman from the Holdringa family. *Portret van een vrouw uit het geslacht Holdringa*

Panel 189 × 91. Inscribed *Aetatis suae 28*
PROV Purchased from Dirksen gallery,
The Hague, 1881. NMGK, 1885
LIT Wassenbergh 1967, p 15, fig 5

Master of the Portraits of Princes.
Meester van de Vorstenportretten

active ca 1490, presumably in Brussels

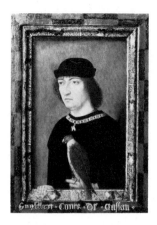

A 3140 Engelbert II (1451-1504), count
of Nassau, lord of Breda. Regent of all
the Netherlands in the name of Philip
the Handsome. *Graaf van Nassau, heer
van Breda. Regent over alle Nederlanden in
naam van Philips de Schone*

Panel 33.5 × 24. Dated *1487*. Inscribed
on the original frame *Engelbert Conte de
Nassau*
PROV Presented by H W C Tietje,
Amsterdam, 1933
LIT M J Friedländer, Rep f Kunstw 23
(1909) p 251. Friedländer 1924-37, vol 4
(1926) p 106. J Tombu, GdB-A, 1929, p
281 (Master of the Legend of Mary
Magdalene). J Tombu, GdB-A 72 (1930)
p 90 (idem). A C R Carter, Burl Mag 63
(1933) p XVI (Master of Zwolle?). P
Wescher, Pantheon 27 (1941) p 274, ill
on p 273. A A Moerman, West-
Vlaanderen 11 (1962) pp 310-12. Exhib
cat Anonieme Vlaamse primitieven,
Bruges 1969, nr 60. P Gerlach, Brabantia
18 (1969) ill on p 157. A A Arkenbout,
Holland 3 (1971) p 68. R Grosshans,
Berl Mus ns 22 (1972) p 8, note 38

Master of Rhenen. *Meester van Rhenen*

see Master of the St Elizabeth Panels

Master of the Salem Altar. *Meester
van het Salemer Altaar*

active ca 1500 in south Germany

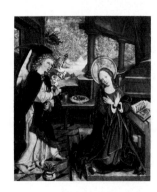

A 2547 The annunciation. *De
verkondiging aan Maria*

Probably belonged to an altarpiece with
scenes from the life of the Virgin

Panel 103 × 91
PROV Lent by C Hoogendijk, The
Hague, 1907. Presented from his estate
in 1912
LIT R Bangel, Cicerone 7 (1915) p 171
(south German). Stange 1955, p 49,
fig 106. K Strauss, Keramik-Freunde,
Dec 1972, pp 28, 36, pls 18, 42, figs 3, 10

**Master of the San Miniato Altar-
piece.** *Meester van San Miniato*

active ca 1460-80 in Florence

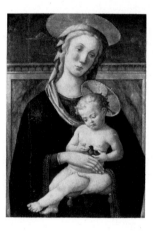

A 3013 Madonna and child. *Maria met
kind*

Panel 66.5 × 48
PROV Purchased from the Augusteum,
Oldenburg, 1923, as a gift of J H van
Heek, Lonneker
LIT Bode 1888, p 11 (follower of Filippo
Lippi). Schäfer 1912, p 35. Hartlaub
1912, vol 2, nr 8, pl 14. Jaarversl Ver
Rembrandt, 1923, pp 4-5, ill. J H H
Kessler, Burl Mag 46 (1925) pp 230-31,
fig IID. Berenson 1932, p 347. Gedenk-
boek Ver Rembrandt, 1933, p 98, ill.
Van Marle 1923-38, vol 16 (1934) p 202,
fig 110. R van Marle, Boll d'Arte 28
(1935) p 308. Friedmann 1946, p 148.
Berenson 1963, vol 1, p 145. Van Os &
Prakken 1974, pp 88-89, nr 51, ill

**Master of the Seven Works of
Charity.** *Meester der Barmhartigheden*

see Master of Alkmaar

Master of the Spes Nostra. *Meester van de Spes Nostra*

active end 15th century in Delft or Gouda

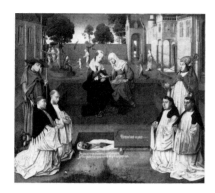

A 2312 Four Augustinian canons regular meditating beside an open grave on the transitoriness of human life in the presence of Sts Augustine and Jerome and Mary and Elizabeth, enacting the visitation. *Vier reguliere kanunniken van St Augustinus mediterend bij een geopend graf over de vergankelijkheid van het aards bestaan in aanwezigheid van St Augustinus, St Hieronymus en Maria, die Elisabeth ontmoet*

Panel 88 × 104.5. Inscribed on the tombstone *Requiescant in pace*; on the edge of the tomb *Si quis eris qui transieris hoc respice plora. Sum quod eris quod es ipse fui pro me precor ora*
PROV From the convent of Holy Mary, mother of God in Sion, near Delft. Purchased from F Kleinberger gallery, Paris, 1907, through the intermediacy of the Rembrandt Society
LIT Aldenhove 1902, p 300 (Master of the Legend of St Ursula). Friedländer 1924-37, vol 10 (1932) p 127 (presumably Master of Delft). Hoogewerff 1936-47, vol 2 (1937) p 278, fig 135. R van Luttervelt, Bull Boymans 3 (1952) p 70, fig 11. H Schulte Nordholt, OK 7 (1963) nr 35, ill. K R van Kooy, Spiegel Hist 4 (1969) p 391, ill

Master of the Legend of St Ursula

alphabetized under Legend

Master of the Virgo inter Virgines. *Meester van de Virgo inter Virgines*

active ca 1470-1500 in Delft

A 501 Madonna and child with Sts Catherine, Cecilia, Barbara and Ursula. *Maria met kind en de heiligen Catharina, Cecilia, Barbara en Ursula*

Panel 123 × 102
PROV NM, 1808
LIT M J Friedländer, Rep f Kunstw 20 (1897) p 415. Dülberg 1899, p 18 (milieu of Albert Ouwater). M J Friedländer, Rep f Kunstw 26 (1903) p 168. M J Friedländer, Onze Kunst, 1906, p 39. Moes & van Biema 1909, pp 158, 211, nr 88. M J Friedländer, Jb Preusz Kunstsamml 31 (1910) p 66, nr 4. N Beets, Onze Kunst 25-26 (1914) p 42, fig 1. L von Baldass, in Meisterwerke, 1920. Winkler 1924, p 150. Friedländer 1924-37, vol 5 (1927) pp 70, 142, nr 63, pl XLI. Dülberg 1929, p 103. Smits 1933, p 153. Hoogewerff 1936-47, vol 2 (1937) p 241, fig 111. R van Luttervelt, Bull Boymans 3 (1952) p 59, fig 5. Panofsky 1953, p 323. N Beets, in Kunstgesch der Ned, 1954-56, vol 1, p 265. Exhib cat Middeleeuwse kunst der Noordelijke Nederlanden, Amsterdam 1958, nr 54, fig 24. P Philippot, Bull Mus Roy Belg 11 (1962) p 26, fig 11. VTTT, 1964-65, nr 62

A 3975 The resurrection. *De opstanding van Christus*

Panel 88 × 51
PROV J Goudstikker gallery,

Amsterdam. Lent by the SNK, later DRVK, 1948. Transferred in 1960
LIT Friedländer 1924-37, vol 14, p 98. Hoogewerff 1936-47, vol 2 (1937) p 272, fig 130 (related to Master of the Virgo inter Virgines)

attributed to **Pseudo Ambrodigio di Baldese**

active first quarter 15th century in Florence

A 2589 Madonna and child. *Maria met kind*

Panel 111 × 54
PROV Lent by C Hoogendijk, The Hague, 1907. Presented from his estate in 1912

Anonymous paintings

The schools are listed alphabetically by country, with each country subdivided, again alphabetically, into progressively smaller geographical units – regions, provinces and localities.

'Netherlands school' refers to works that may have been made either in the Northern or Southern Netherlands.

'Holland school,' in distinction to 'Northern Netherlands school,' is used to refer only to the painters of the former province of Holland, now divided into the provinces of Noord- and Zuid-Holland.

Danish school ca 1760

A 978 Charlotte Amalie (1706-82). Daughter of Frederick IV, king of Denmark. *Dochter van Frederik IV, koning van Denemarken*

Cf the version in Frederiksborg Castle, Hillerød, Denmark (inv nr A 7766)

Canvas 150 × 116
PROV Model room of the ministry of marine, The Hague, 1883. NMGK, 1885

English school 2d half 16th century

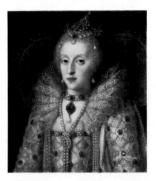

C 1466 Elizabeth I (1533-1603), queen of England. *Elisabeth I, koningin van Engeland*

Panel 34.5 × 30.5
PROV On loan from the DRVK since 1962

English school ca 1585

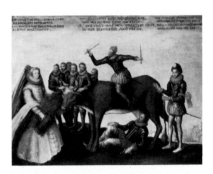

A 2684 The milch cow: satire on the exploitation of the Netherlands by the prince of Orange. *Het melkkoetje: satire op het uitbuiten der Nederlanden door de prins van Oranje*

Panel 52 × 67. Inscribed *Not longe time since I sawe a cowe | did Flaunders represente | upon whose backe Kinge Phillip rode | as being malecontnt. | The Queene of England giving hay | wheareon the cow did feede | as one that was her greatest helpe | in her distresse and neede. | The Prince of Orange milkt the cow and made his purse the payle. | The cow did shyt in monsieurs hand | while hie did hold her tayle*
PROV Bequest of R Th Baron van Pallandt van Eerde, Ambt-Ommen, 1913

English school mid-19th century

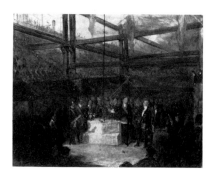

A 4217 A ceremony of Scottish Free-masons. *Plechtigheid van Schotse vrij-metselaars*

Board 35.5 ×45.7
PROV Purchased from H Marcus gallery, Amsterdam, 1971

French school 1454

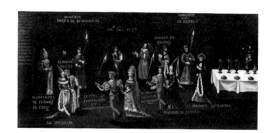

A 4212 'Le voeu du faisan'

Late copy after an unknown model

Canvas 39.3 ×85. Dated *An° D NI 1454*.
Inscribed *Banquet fait a Lille le 18 Fevrier 1454 sous la direc : tion du côte d'estampes pour le bon duc Philippe de Bourgogne et Isabelle de Portugal sa femme ; ou se firent les voeux pour reconquerire la terre sainte.*
Also inscribed with the names of those portrayed
PROV Bequest of L G van Hoorn, Bloemendaal, 1970

French school 16th century

A 504 Gaston de Foix (1489-1512). Commander-in-chief of the French army. *Frans legeraanvoerder*

Late copy after an unknown original

Panel 53 ×46. Inscribed *Gasto Foisseius*
PROV NM, 1808
LIT Moes & van Biema 1909, pp 167, 207

French school ca 1720

C 1324 Madame Violente

Canvas 65 ×56
PROV On loan from Miss J E van Nierop, Amsterdam, since 1938

French school ca 1750

A 3279 Portrait of a woman. *Portret van een vrouw*

Canvas 84 ×63.5
PROV Presented by B de Geus van den Heuvel, Amsterdam, 1939

French school ca 1775

A 3916, A 3918, A 3919 & A 3917 Four decorative paintings with plants and

animals. *Vier decoratieve schilderingen met planten en dieren*

Canvas 218.5 × 48.5; 219 × 46; 219 × 47; 218.5 × 47 respectively
PROV Purchased from A Nijstad gallery, Lochem, 1957

School of Avignon ca 1505-10

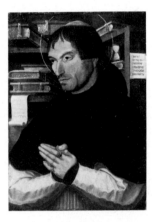

A 3116 St Dionysius the Areopagite in prayer. *De heilige Dionysius de Areopagiet in gebed*

Panel 49 × 35. Inscribed *Divus Dionysius Parisior. Episcopus Theologus Ariopagita* and *Magnum Mysterium et Mirabile Sacramentum*
PROV Purchased from Miss ENC Hasselman, Egmond aan den Hoef, 1930
* On loan to the KKS (cat 1968, vol 1, p 22, nr 896, ill) since 1951
LIT Sterling 1942, nr 90, fig 105 (Provençal, ca 1500). Ring 1949, nr 275, fig 174 (school of Avignon, ca 1500-10)

School of Fontainebleau 3d quarter 16th century

A 320 Portrait of a lady, said to be Elizabeth I, queen of England. *Portret van*

een dame, zogenaamd Elisabeth I, koningin van Engeland

Panel 44 × 32.5. On the verso the crowned initials *CR* (mark of Charles I of England)
PROV NM, 1808
LIT Moes & van Biema 1909, p 205

German school? 1st half 17th century

A 4097 Satire on celibacy. *Satire op het celibaat*

Panel 29.7 × 41.5
PROV Presented by M Bodkin, Dublin, 1963

German school 1603

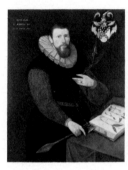

A 968 Portrait of a botanist. *Portret van een botanicus*

Pendant to A 969

Panel 104 × 83. Dated *A° 1603*. Inscribed *Quid Flos. Aetatis 25*
PROV Purchased from Sarluis gallery, The Hague, 1881. NMGK, 1885

A 969 Portrait of a woman. *Portret van een vrouw*

Pendant to A 968

Panel 104 × 83. Dated *Anno 1603*. Inscribed *Lilia Verna Docent* and *Nata A. 1582*
PROV Same as A 968

German school ca 1765

A 1223 Paul I (1754-1801), emperor of Russia, at an early age. *Keizer van Rusland, op jeugdige leeftijd*

Canvas 57 × 46
PROV KKS, 1885

North German school 2d quarter 15th century

A 2553 The crucifixion with Sts Cosmas and Damian. *Kruisiging met de heiligen Cosmas en Damianus*

Panel 157.5 × 157.5
PROV Lent by C Hoogendijk, The Hague, 1907. Presented from his estate in 1912
LIT R Bangel, Cicerone 7 (1915) p 171

North German school ca 1500

A 2593 Three apostles. *Drie apostelen*

Panel 134 × 57
PROV Lent by C Hoogendijk, The Hague, 1907. Presented from his estate in 1912

South German school early 16th century

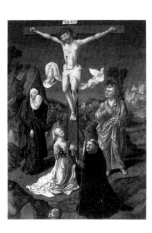

A 2595 The crucifixion with Mary, John, Mary Magdalene and a donor. *Kruisiging met Maria, Johannes, Maria Magdalena en een schenker*

Panel 109 × 77
PROV Lent by C Hoogendijk, The Hague, 1907. Presented from his estate in 1912

South German school ca 1500

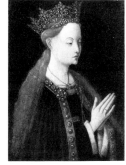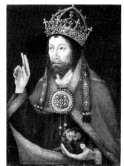

A 497 Mary. *Maria*

Pendant to A 496

Panel 17.5 × 13
PROV NM, 1808
LIT Moes & van Biema 1909, pp 99, 106, 121, 132, 167, 212

A 496 Christ as savior. *Christus als zaligmaker*

Pendant to A 497

Panel 17.5 × 13
PROV Same as A 497
LIT Moes & van Biema 1909, pp 99, 106, 121, 132, 167, 212

Upper Rhenish school ca 1450

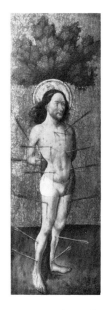

A 3311 St Sebastian. *De heilige Sebastiaan*

Pendant to A 3310

Panel 68.5 × 22.5. Left wing of an altarpiece
PROV Presented by Mr & Mrs D A J Kessler-Hülsmann, Kapelle op den Bosch near Mechelen, 1940

LIT J Schouten, Antiek 8 (1973) p 226, ill

A 3310 St Anthony. *De heilige Antonius de Heremiet*

Pendant to A 3311

Panel 68.5 × 22.5. Right wing of an altarpiece
PROV Same as A 3311

Lower Rhenish school ca 1490

A 2799 The family of Zebedee. On the verso remnants of the angel Gabriel of the annunciation? *Het gezin van Zebedeus. In dorso restanten van de engel Gabriël van een verkondiging aan Maria?*

Panel 85 × 51. Left wing of a triptych
PROV NMGK, 1916

Bavarian school last quarter 15th century

A 2548 The crucifixion. *Kruisiging*

Belonged to an altarpiece from the former Augustinerchorherrenstift Rottenbuch. Three panels are in the Bayerische Staatsgemäldesammlungen, Munich (inv nrs 6240, 6241, 6243)

Panel 123 × 103
PROV Lent by C Hoogendijk, The Hague, 1907. Presented from his estate in 1912
LIT Stange 1960, p 120, fig 195. A Miller, in 900 Jahre Rottenbuch, 1974, pp 26-33, fig 9

Westphalian school ca 1500

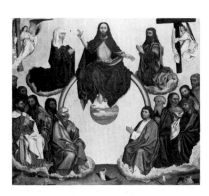

A 2588 The last judgment. *Het laatste oordeel*

Panel 149 × 175
PROV Lent by C Hoogendijk, The Hague, 1907. Presented from his estate in 1912

Cologne school? ca 1575

A 3891 Portrait of a woman, probably Anna Jagellonia (1522-96), queen of Poland. *Portret van een vrouw, waarschijnlijk Anna Jagellonia, koningin van Polen*

Panel 19.2 × 14.2
PROV Purchased from A Weinberger gallery, Paris, 1955
LIT R van Luttervelt, Bull RM 5 (1957) p 108, fig 1 (as portrait of Juliana van Stolberg)

Italian school 2d half 13th century

A 3996 Madonna and child. *Maria met kind*

Panel 64 × 41.5
PROV Lent by the DRVK, 1952.
Transferred in 1960

Italian school 15th century

A 3997 Madonna of humility. *Madonna dell'humiltà*

Panel 26 × 16.5. Inscribed *S. Maria de Umilitade*
PROV O Lanz, Amsterdam. Lent by the DRVK, 1952. Transferred in 1960

Italian school 17th century

A 1220 Justitia

Canvas 74 × 57. Inscribed on the verso *Giustitia*
PROV KKS, 1885

Italian school 2d half 17th century

A 596 The mystic marriage of St Catherine. *Het mystieke huwelijk van de heilige Catharina*

Canvas 41 × 32.5
PROV NM, 1808
LIT Moes & van Biema 1909, p 158 (Ciro Ferri)

A 4020 Portrait of a man. *Portret van een man*

Canvas 68 × 46
PROV Transferred by the DRVK in 1960
LIT Mndbl BK, 1942, p 264 (Salvator Rosa, self portrait). Suggested attributions to Nicola Grassi, Andrea de Leone and Ghislandi

North Italian school 2d half 15th century

A 2590 A saint, presumably Bonaventura. *Een heilige, vermoedelijk Bonaventura*

Panel 50 × 36
PROV Lent by C Hoogendijk, the Hague, 1907. Presented from his estate in 1912

North Italian school 2d quarter 16th century

A 3411 Portrait of a woman. *Portret van een vrouw*

Panel 66.5 × 49.5
PROV Bequest of J W Edwin vom Rath, Amsterdam, 1941
LIT K E Schuurman, Mndbl BK 19 (1942) p 137, fig 2 (Lorenzo Lotto). Coletti 1953, p 48, fig 198 (Lotto?). Bianconi 1963, vol 2, p 102 (not Lotto)

North Italian school? 1st half 18th century

A 3218 Portrait of a woman. *Portret van een vrouw*

Canvas 77.5 × 60
PROV From the Rijksarchief (state archives), Haarlem, 1934

North Italian school 18th century

A 3386 Portrait of a painter. *Portret van een schilder*

Canvas 50 × 37
PROV Bequest of J W Edwin vom Rath, Amsterdam, 1941

Lombard school 1st half 16th century

A 2801 The baptism of Christ. *De doop van Christus*

Panel 150 × 115
PROV Sale Hekking, Amsterdam, 16-18 Feb 1897, lot 864. NMGK, 1916

Brescian school 1st half 16th century

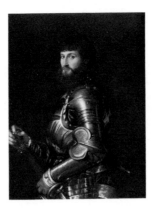

A 3035 Portrait of a nobleman in armor. *Portret van een edelman in harnas*

Canvas 92.5 × 70. Inscribed on the breastplate …*Oies*
PROV Purchased from the Augusteum, Oldenburg, 1925, with aid from the Rembrandt Society
LIT Bode 1888, p 21 (Lorenzo Lotto). T Borenius, Burl Mag 59 (1931) p 72 (Romanino). Berenson 1932, p 173 (Dosso Dossi?). Gedenkboek Ver Rembrandt, 1933, p 104, ill (Lotto). Longhi 1934, p 149, note 156, fig 207 (copy after Titian). W Suida, Pantheon 14 (1934) p 325 (Girolamo Savoldo?). W Suida, Pantheon 17 (1937) p 52 (Savoldo). C Gilbert, Arte Ven 3 (1949) pp 107-08 (Romanino). Banti & Boschetto 1953, p 105 (doubts attribution to Lotto). J Roh, Die Kunst, 1955, p 7 (Giorgione). Longhi 1956, p 88 (copy after Titian). Ferrari 1961, p 305 (copy after Titian). Boschetto 1963, p 223 (presumably copy after Titian). Bianconi 1963, vol 2, p 102 (not Lotto). Gibbons 1968, pp 248-49, fig 190 (attributed to Romanino, after 1540)

Ferrarese school 2d half 15th century

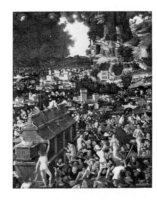

A 3418 The deluge. *De zondvloed*

Panel 122 × 98
PROV Bequest of J W Edwin vom Rath, Amsterdam, 1941

Ferrarese school 2d quarter 16th century

A 109 The marriage of Mary and Joseph. *Het huwelijk van Maria met Jozef*

Canvas 49.5 × 58.5
PROV NM, 1808
LIT Moes & van Biema 1909, p 211

Florentine school ca 1375

A 1294 Madonna and child with four saints. *Maria met kind en vier heiligen*

Panel 75 × 39
PROV Presented by Dr A Bredius, The Hague, 1886

Florentine school 1st half 15th century

A 3396 Scene from a tale of chivalry. *Tafereel uit een ridderlegende*

Panel 40 × 42. Fragment of a cassone
PROV Bequest of J W Edwin vom Rath, Amsterdam, 1941

Florentine school ca 1450

A 3302 Horatius Cocles defending the head of the Sublician bridge. *Horatius Cocles verdedigt de Pons Sublitius*

Panel 40 × 128. Cassone
PROV Presented by Mr & Mrs DAJ Kessler-Hülsmann, Kapelle op den Bosch near Mechelen, 1940
LIT H F W Jeltes, Elsevier's GM 33 (1923) p 4, ill. A van Schendel, Mndbl BK 11 (1934) p 233. J G van Gelder, Elsevier's GM 50 (1940) p 43ff, ill. Van Os & Prakken 1974, p 47, nr 17, ill

Florentine school 1486

A 3398 St Ignatius of Antioch. *De heilige Ignatius van Antiochië*

Belongs with A 3397

Panel 116 × 45. Fragment of an altarpiece. Inscribed *Scs Ignazius Pischapus e Martirus. 1486*
PROV Bequest of J W Edwin vom Rath, Amsterdam, 1941

A 3397 St Sebastian. *De heilige Sebastiaan*

Belongs with A 3398

Panel 115.5 × 45. Fragment of an altarpiece. Inscribed *Scs Bastianusu Martirus 1486*
PROV Same as A 3398

Florentine school 2d quarter 16th century

A 1226 St John the Baptist. *Johannes de Doper*

Panel 65 × 51
PROV KKS, 1885 * DRVK since 1952

Neapolitan school mid-17th century

A 3342 Man with urinal in his hand. *Man met urinaal in de hand*

Canvas 72 × 61
PROV Presented by Mr & Mrs DAJ Kessler-Hülsmann, Kapelle op den Bosch near Mechelen, 1940

Pisan school ca 1250

A 3392 The descent from the cross. *De kruisafneming*

Belongs with A 3393

Panel 18.5 × 18. Fragment of an altar-
piece
PROV Bequest of J W Edwin vom Rath,
Amsterdam, 1941

A 3393 The entombment. *De graflegging*

Belongs with A 3392

Panel 18.5 × 18. Fragment of an altar-
piece
PROV Same as A 3392

Sienese school ca 1450

A 3998 The payment of the night watch-
men (berrovieri) of Siena in the Camera
del Comune. *Het uitbetalen van de gemeente-
salarissen aan de nachtwakers in de 'Camera
del Comune' te Siena*

Thought to be the binding of a ledger
of the Gabella (import duty office),
Siena

Panel 28.5 × 25
PROV O Lanz, Amsterdam. Lent by the
DRVK, 1952. Transferred in 1960
LIT J Offerhaus, Wikor, 1960, p 338, fig
2. Exhib cat Sienese paintings in
Holland, Groningen-Utrecht-Florence
1969, nr 46, ill

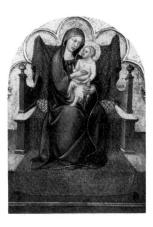

A 3375 Madonna and child. *Maria met
kind*

Panel 49 × 35.5
PROV Bequest of J W Edwin vom Rath,
Amsterdam, 1941
LIT Exhib cat Sienese paintings in
Holland, Groningen-Utrecht-Florence
1969, nr 44, ill

Sienese school 1451-52

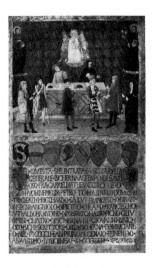

A 3429 The office of the tax collector of
Siena (il Biccherna). *Het kantoor van de
belastingontvanger van Siena*

Binding for the records of the year 1451-
52 of the Biccherna, Siena

Panel 48.5 × 30.5. Inscribed *Questa
Sielentrata e uscita della generale Bicherna al
tenpo di Savioso Fra Gabriel Matheuccio e
desavi huomini missr Petro Tomasini
Lodovicho Trichierchi Ricchardo Salvi
Franciescho Dinani insegni Angniolo Dipietro
Orafo Franciescho Luti Aldobrandino dimissr
Tomasso Pichoglivomini quatro dibicherna di
Giovanni Dinocholo Bichi scrittore della
Bicherna cominciando nel MCCCCLI
eadiprimo di Genaio efinendo adi ultimo
didicienbre MCCCCLII*
PROV Bequest of J W Edwin vom Rath,
Amsterdam, 1941

LIT Katalog der alter Ital Meister in der
Samml J A Ramboux, Cologne 1862, p
63, nr 31. Carli 1951, p 80. J Offerhaus,
Wikor, 1960, p 338, fig 1. Exhib cat
Sienese paintings in Holland,
Groningen-Utrecht-Florence 1969, nr
45, ill. H Kiel, Pantheon 27 (1969) p 338

**Venetian school 1st quarter 16th
century**

C 1354 Venus

Canvas 67.5 × 51.5
PROV Purchased from Chevalier
Vincent de Rainer, Brussels, 1821, by
King Willem I. On loan from the KKS
(cat 1968, p 74, nr 349) since 1948

**Venetian school 1st half 16th
century**

A 1296 The judgment of Paris. *Het
oordeel van Paris*

Canvas 71 × 77. Inscribed on the apple
Pulchriori detur
PROV From the riding academy behind
the Kloosterkerk, The Hague, 1886 *
DRVK since 1953

Venetian school ca 1590

A 2242 Portrait of a man. *Portret van een man*

Canvas 25.5 × 19
PROV From the RPK

Venetian-Byzantine school late 13th century

A 4461 Christ on the cross with Mary and John. *Christus aan het kruis met Maria en Johannes*

Panel 42 × 21.5
PROV KKS, 1885. NMGK
LIT Exhib cat Sienese paintings in Holland, Groningen-Utrecht-Florence 1969, nr 14, ill

Netherlands school early 16th century

NO PHOTOGRAPH AVAILABLE

A 4650 Ecce homo

Beside Christ kneels St Brigit. In the background are the flagellation and crowning with thorns

Panel 59.5 × 45 (with frame)
PROV From the convent of Mariënwater in Koudewater near 's-Hertogenbosch. Purchased from the Brigittine convent, Uden, 1875. NMGK * Missing

Netherlands school ca 1515

A 867 The rain of manna (recto); Ecclesia (verso). *De mannaregen (voorkant) en Ecclesia (achterkant)*

Belongs with A 866

Panel 101 × 71. Right wing of an altarpiece
PROV Purchased in The Hague, 1876.

NMGK, 1885 * On loan to the KKS (cat 1968, nr 945, ill) since 1960
LIT Winkler 1924, p 221 (Antwerp, ca 1500). Bürger 1925, p 147, fig 244. Hoogewerff 1936-47, vol 3 (1939) pp 43-44, fig 15 (Utrecht Mannerist, ca 1530)

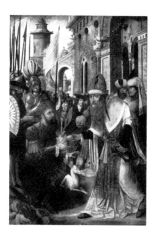

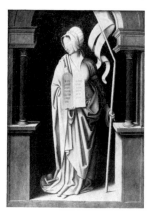

A 866 The meeting of Abraham and Melchizedek (recto); Synagoga (verso). *De ontmoeting van Abraham en Melchisedek (voorkant) en Synagoge (achterkant)*

Belongs with A 867

Panel 101 × 71. Left wing of an altarpiece
PROV Same as A 867 * On loan to the KKS (cat 1968, nr 944, ill) since 1960
LIT Winkler 1924, p 221 (Antwerp, ca 1500). Bürger 1925, p 147, fig 245. Hoogewerff 1936-47, vol 3 (1939) pp 43-44 (Utrecht Mannerist ca 1530)

Netherlands school? 1542

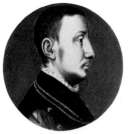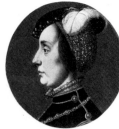

A 4462 René de Châlon (ca 1518-44), prince of Orange. *Prins van Oranje*

Later copy
Pendant to A 4027

Panel 15 cm in diam. Inscribed on the frame *Rene de Chalon Prince Dorenges, Conte de Nassou ec̄ aige de XXIII ans 1542*
PROV KKZ, 1874-75. NMGK
LIT Moes 1897-1905, vol 2, nr 6326:2. R van Luttervelt, NKJ 13 (1962) p 6off, fig 3

A 4027 Anne of Lorraine (1522-68). Wife of René de Châlon. *Anna van Lotharingen, echtgenote van René de Châlon*

Later copy
Pendant to A 4462

Panel 14 cm in diam
PROV Purchased from Miss J Verhulden, Antwerp, 1960
LIT R van Luttervelt, NKJ 13 (1962) p 74ff, fig 12

Netherlands school ca 1550

A 3215 Allert Boelisse (1523-59)

Copy

Panel 49.5 × 33. Inscribed *Allert Boelisse, soon van Dirck Boelisse. Obijt Anno 1559 Aetatis 36*
PROV From the Rijksarchief (state archives), Haarlem, 1934 * DRVK since 1959 (on loan to the Westfries Museum, Hoorn)

Netherlands school? ca 1550

A 4463 Mary of Hungary (1505-58). Governess of the Netherlands. *Maria van Hongarije, landvoogdes der Nederlanden*

Panel 9 cm in diam. Inscribed on the verso *Marie par la grace de dieu rogne de hongrie de hol....n Soeur de l'empereur Charles 5, qui fut gouvernante des Pays-Bas*
PROV Purchased from I P Menger, Utrecht, in or before 1881. NMGK
LIT W Suida, Burl Mag 44 (1934) pp 277-78. G Glück, Jb Kunsth Samml AK ns 8 (1934) p 194, fig 106. Terlinden 1965, p 213, fig 133. De Jongh 1966, fig 24 opp p 273

A 977 David Jorisz (1501-56). Glass painter of Delft who became a fanatical Anabaptist and settled in Basel in 1544. *Glasschilder te Delft, fanatiek wederdoper, sedert 1544 te Bazel*

Later copy

Panel 36 × 28. Inscribed *David Joris*
PROV Sale Amsterdam, 13 Nov 1882, lot 83. NMGK, 1885

LIT Moes 1897-1905, vol 1, nr 4065:2. Van Hall 1963, p 161, nr 1071:2. *Cf* Altena & van Thiel 1964, nr 17

Netherlands school 2d half 16th century

A 3460 The adoration of the shepherds. *De aanbidding der herders*

Panel 205 × 142
PROV Presented by H A Wetzlar, Amsterdam, 1943

Netherlands school 1573

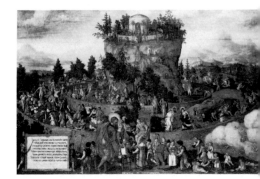

A 2372 Tabula Cebetis

Panel 119.5 × 177. Dated *1573*. Inscribed *Inclyta Thebigenae spectās monumēta Cebetis Humanae biviū vitae, errores que malignos, Mortales que quibus sensus irretiat. illex Impostura modis, Circeia que pocula disce Rursus inaccessos pandat quae semita calles, Ardua qua virtus habitat, diis proxima, turbae Non residi aeternū nomen, vitam que beatā, Vatibus et lauros frōdētia praemia donās*
PROV Purchased from the heirs of the owner of the tavern Het Hof van Holland, Noordwijk, 1908
LIT M Boas, Het Boek 9 (1920) p 14. Knipping 1939-40, vol 1, pp 95-97, fig 60. RDK 3 (1954) col 388, fig 2

Netherlands school? 3d quarter 16th century

A 3914 The parable of Lazarus and the rich man. On the verso the statues of St Peter and the Virgin on a terrace, in grisaille. *De gelijkenis van de rijke man en de arme Lazarus. Op de achterzijde de beelden van de heilige Petrus en Maria met kind op een terras, in grisaille*

Left wing of an altarpiece. The middle panel is probably a last judgment
Belongs with A 3915

Panel 208 × 122. Inscribed on the verso *Memento mori* and a barely legible Greek inscription
PROV Purchased from A Nijstad gallery, Lochem, 1957
LIT Cat Centraal Museum, Utrecht 1952, nr 1324 (Lambert Sustris). Haverkamp Begemann 1959, p 85 (Gouda school?). Antiek 3 (1968) p 16, ill. Schatborn & Szénássy 1971, p 62, nr 254, fig 49. H L Houtzager, Spiegel Hist 7 (1972) p 432, fig 2. Haak 1972, p 14, figs 13-14

A 3915 The deathbed of the rich man. On the verso the statues of Sts Andrew and Michael on a terrace, in grisaille. *Het sterfbed van de rijke man. Op de achter-*

zijde de beelden van de heiligen Andreas en Michael op een terras, in grisaille

Right wing of an altarpiece
Belongs with A 3914

Panel 208 × 122. On the verso an illegible Greek inscription
PROV Same as A 3914
LIT *See under* A 3914

Netherlands school ca 1580

A 4464 The office of a tax receiver. *Het kantoor van een ontvanger*

Panel 33 × 55. Signboard. Inscribed *hier ontfangmē t' schoorstien gelt*
PROV Sale Hekking, Amsterdam, 16-18 Feb 1897, lot 863. NMGK * On loan to the Belastingmuseum, Rotterdam, since 1956; from 1974 on via the DRVK

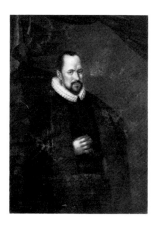

A 922 Steven van Dalen (d 1586)

Later copy

Canvas 113 × 85. Inscribed *Fides una salus*. On the verso his coat of arms and the inscription *Dheer Steven Van Dalen, Geb. Sterft Januarij 1586*
PROV Bequest of Jonkheer J de Witte van Citters, The Hague, 1876. NMGK, 1885

Netherlands school ca 1590

C 1222 Pleasure garden. *Lusthof*

Panel 64 × 136. Presumably the lid of a clavier
PROV On loan from the KOG since 1933

Netherlands school? 17th century

A 512 Adonis

Panel 150 × 112
PROV NM, 1808
LIT Moes & van Biema 1909, pp 49, 69, 107, 164

A 2094 Still life with flowers in the foreground of a landscape. *Stilleven met bloemen voor een landschap*

Canvas 67 × 87
PROV Bequest of A A des Tombe, The Hague, 1903 * DRVK since 1953
LIT W Steenhoff, Bull NOB 4 (1902-03), p 122

Netherlands school 1st quarter 17th century

A 4152 Peace urging the churches to be tolerant. *De Vrede maant de kerken tot verdraagzaamheid*

At the table are seated Calvin (*Calf fijn:* good veal), the pope (*dees pap:* this porridge) and Luther (*Ick raecke de luyt teer aen:* I handle the lute gently). To the right is an Anabaptist (*Ick herdoop er mijn brood:* I rebaptize my bread)

Canvas 131.5 × 162.5. Inscribed
Willecom vrinden alte samen | Neempt de vrede metter Hant | Soo en mach v niemant pramen | Oft vyant comen in v lant
Van hondert die dit lesen. | Qūalyck tien diet sūllen verstaen. | Dus latet ongeūonnist wesen. | Op dat dit vry mach blijūen staen.
Dit Calf fijn ist met desen sappe Van Oraignen. | Des ick noijt beter spijse en vāūt. | Maer moet mij Wachten van Calangien. | Oft soūde moeten rūymen t'lant.
Eij dēs pap is bitter gebrockt met schellen van oraignen. | Daerom mijn Catte lecken niet als sij plagen: | Maer compt, mijnen oūden kock wērwt Spaignen. | Soū al t'geselschap willen veriaghen.
Ick raecke de lūijt teer aan- | En soūde geeren hoūden goeij mae[te] | Maer niemant en wilt mijn spel verstae[n] | Soo ist best dat ick t'late. Ick herdōper mijn broot vrij sonder… | En acht op all dit gheselschap niet… | Want hadden sij … [The rest illegible]
Waer de liefde int herte ghedaen. | Soo en hoefde ick op't tresoir, niet te staen
PROV Presented by J W Bosman, Brussels, 1968

Netherlands school ca 1600

A 1309 Portrait of a woman. *Portret van een vrouw*

Panel 125 × 85
PROV Sale D M Alewijn (Medemblik), Amsterdam, 16 Dec 1885, lot 55 (as Paulus Moreelse) * On loan to the Rijksmuseum 'Huis Lambert van Meerten,' Delft, since 1909
LIT A M, Ned Spec, 1886, p 19

Netherlands school ca 1615

A 1441 Elegant party on a terrace in Venice-like surroundings. *Elegant gezelschap op een terras in een op Venetië geinspireerde omgeving*

Panel 51 × 172. Thought to be the lid of a clavier
PROV Presented from the estate of J L de Bruyn Kops, The Hague, 1888
LIT E Jacobsen, Rep f Kunstw 24 (1901) p 188 (Pieter Schey)

Netherlands school ca 1620

A 201 A couple and four children. *Een echtpaar met vier kinderen*

Panel 51 × 46. Falsely signed *TDK* (Thomas de Keyser)
PROV Purchased from P C Huybrechts, The Hague, 1803. NM, 1808
LIT C Hofstede de Groot, OH 17 (1899) p 168 (not Thomas de Keyser; Flemish?). Oldenbourg 1911, p 36 (not de Keyser)

Netherlands school 2d half 17th century

C 428 Twelfth night. *Driekoningenfeest*

Panel 40 × 65.5
PROV On loan from the city of Amsterdam since 1885
LIT Scheltema 1879, nr 159

Netherlands school ca 1665

A 1979 Southern landscape with the ruins of a castle. *Zuidelijk landschap met kasteelruïne*

Canvas 26.5 × 36
PROV Purchased from the G de Clercq collection, Amsterdam, 1902, through the intermediacy of the Rembrandt Society * DRVK since 1968

Netherlands school 4th quarter 17th century

A 2629 Peace putting out the torch of war. *De Vrede blust de oorlogsfakkel*

Canvas 162.5 × 93.5
PROV From the Huygenshuis (house of Constantijn Huygens), Plein, The Hague. NMGK, 1912 * DRVK since 1952

Netherlands school ca 1820

A 4664 Dutch troops marching in a town in the Southern Netherlands. *Hollandse troepen marcherend in een Zuidnederlandse stad*

Canvas 58 × 74
PROV Bequest of Mrs E Houtsma-Westenberg, widow of N Houtsma, Bunnik, 1965. Received in 1975

Northern Netherlands school ca 1380

A 831 Memorial tablet for the lords of Montfoort. *Gedachtenistafel van de Heren van Montfoort*

Kneeling before the Madonna are Jan I van Montfoort, his great-uncle Roelof de Rover, his uncle Willem de Rover and a figure who may be Hendrik de Rover Willemsz

Panel 69 × 142. Inscribed *int jaer ons heeren dusent drie hondert vijf en veertich op sante cosmas en damianus dach doe bleven doot op die vriezen bij grave willem van heynegouwen van hollant en van Zeland en heer van Vrieslant heer jan van Montfoorde heer roeloff van Montfoorde heer willem van Montfoorde met veel hare magen vrienden en onderhebbenden. bidt voor haer allen zielen.* Added later *dit is verlicht anno 1608* and *voor die derde maal verlicht 1770*. Painted for the altar of the Virgin in the Sint Jans-kerk in Linschoten
PROV Presented from the estate of H van der Lee, Woerden, 1884
LIT Obreen's Archief 6 (1884-87) p 75, fig 1. Ring 1913, p 46. I Blok, Bull NOB 2d ser 7 (1914) p 185. Dülberg 1929, p 19, fig 13. Hoogewerff 1936-47, vol 1, pp 92-98, ill; vol 5, p 17 (ca 1375, Utrecht school?). Gerson 1950, p 8, fig 4. K G Boon, Mndbl BK 26 (1950) p 263. Panofsky 1953, p 92 (ca 1390). G J Hoogewerff, in Kunstgesch der Ned, 1954-56, vol 1, p 181, fig 2 (1365-70). Van der Linden 1957, p 28, note 1. Exhib cat Middeleeuwse kunst der Noordelijke Nederlanden, Amsterdam 1958, nr 1. RDK 5 (1958) cols 875-76, 890, fig 2. J G M B, Doen te Weten, Feb 1963. Bauch 1967, p 105, fig 38

Northern Netherlands school ca 1430

C 1454 Lysbeth van Duvenvoorde (d 1472)

Oil on vellum 32.5 × 20.5. Inscribed *mi verdriet lange te hopen, wie is hi die sijn hert hout open.* Inscribed on the verso *Afbeeltsel van Juffer Lijsbeth van Duvenvoorde, Heer Dircks dochter. Sij troude den 19. Meert anno 1430 aen Symon van Adrichem, Ridder, Heer Floris soon, en stierf op ons Heeren Hemelvaerts Avond anno 1472, en is begraven in de Beverwijck int Reguliersconvent voor het H. Cruys Autaer dat hy hadde doen maken.* Left wing of an engagement(?) diptych; the right wing (location unknown), portraying Symon van Adrichem, is inscribed *mi banget seret, wi is hi, die mi met minne eeret*
PROV On loan from the KKS since 1959
LIT M Nahuys, Bull Ac Arch Belgique 2 (1875) p 199, ill. Obreen 1903. G D Gratama, Onze Kunst, 1915, p 78. Beeldende Kunst, 1916, nr 57. Huizinga 1935, p 448, ill. Hoogewerff 1936-47, vol 2, p 50, fig 23 (ca 1430). Gerson 1950, p 8, fig 5. Panofsky 1953, p 92. G J Hoogewerff, in Kunstgesch der Ned, 1954-56, vol 1, p 198, fig 15. Exhib cat Middeleeuwse kunst der Noordelijke Nederlanden, Amsterdam 1958, nr 3. Bauch 1967, p 107, fig 19. M Tóth-Ubbens, OK 12 (1968) nr 2, ill

Northern Netherlands school ca 1435

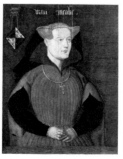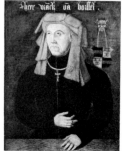

A 498 Jacoba of Bavaria (1401-36), countess of Holland and Zeeland. *Jacoba van Beieren, gravin van Holland en Zeeland*

16th-century copy
Pendant to A 499

Panel 64 × 50. Inscribed *vrau jacobe*
PROV Nieuw Teylingen Castle. NM, 1808
LIT W Pleyte, Bijdr Vad Gesch & Oudhk, 1885, p 225. Moes 1897-1905, vol 1, nr 3960:4. Moes & van Biema 1909, pp 38, 195, 206. Hoogewerff 1936-47, vol 1, p 49 (Holland or Zeeland school). R van Luttervelt, OH 72 (1957) p 221, fig 36 (16th-century replica of a portrait of 1435). J van Lennep, Bull Mus Roy Belg 17 (1968) p 117

A 499 Frank van Borselen (d 1470). Fourth husband of Jacoba of Bavaria. Stadholder of Zeeland. *Vierde echtgenoot van Jacoba van Beieren. Stadhouder van Zeeland*

16th-century copy
Pendant to A 498

Panel 64 × 50. Inscribed *heer vräck vã borssel*
PROV Same as A 498
LIT W Pleyte, Bijdr Vad Gesch & Oudhk, 1885, p 225. Moes 1897-1905, vol 1, nr 906:2. Moes & van Biema 1909, pp 38, 195, 206. Hoogewerff 1936-47, vol 1, p 49 (Holland or Zeeland school). R van Luttervelt, OH 72 (1957) pp 143, 223, fig 30 (16th-century replica of a painting from 1435). A A Arkenbout, OH 83 (1968) p 143, figs 1-2. J van Lennep, Bull Mus Roy Belg 17 (1968) p 117, fig 1. A A Arkenbout, Jb Die Haghe, 1970, ill opp p 82

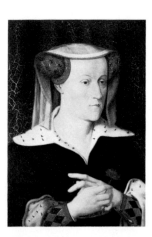

A 954 Jacoba of Bavaria (1401-36), countess of Holland and Zeeland. *Jacoba van Beieren, gravin van Holland en Zeeland*

Copy by Pieter Willem Sebes (1827-1906)

Panel 66 × 45

PROV Painted in 1879 upon commission of the government of the Netherlands. NMGK, 1885

Northern Netherlands school ca 1500

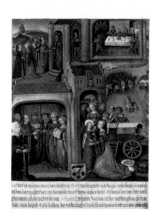

A 2237 Four scenes from the legend of St Elizabeth of Hungary. *Vier taferelen uit de legende van de heilige Elisabeth van Hongarije*

Panel 82.5 × 61. Inscribed *Hier wert vã andries coninc van hõgheren Elisabe noch ligghēde in de wieghe opgheslaghē de ambaliatē van düeringhen voer een toecomēde bruyt huers jöghen heerē. En binnē drie jare daerna sy ghecomen ghedeputeerde om S. Elisabeth te halen. Worden eerlijc ontfanghen getracteert ende begift. Ende hebben Eerwerdigh Elisabeth met groten scatte met hem ghevoert*
PROV Purchased from CF Roos & Co, art dealers, Amsterdam, 1906

Northern Netherlands school ca 1510

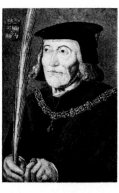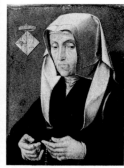

A 1547 Jan (1438/41-1516), count of Egmond. Called the Lame. Banneret of Bahr and Lathum, stadholder of Holland, Zeeland and West Friesland, depicted as a pilgrim to Jerusalem. *Graaf van Egmond. Genaamd Manke Jan. Banner-heer van Bahr en Lathum, stadhouder van*

Holland, Zeeland en West-Friesland, als Jeruzalemvaarder

Old copy
Pendant to A 1548

Paper on panel 19.5 × 13.5
PROV Presented by Jonkheer Victor de Stuers, The Hague, 1891
LIT Moes 1897-1905, vol 1, nr 2292:1. Ring 1913, p 95. Hoogewerff 1936-47, vol 2 (1937) p 414. W J Thijl, Historia 3 (1937) p 161

A 1548 Magdalena van Waardenborgh (1464-1538). Wife of Jan van Egmond. *Echtgenote van Jan van Egmond*

Old copy
Pendant to A 1547

Paper on panel 18 × 14
PROV Same as A 1547
LIT *See under* A 1547

Northern Netherlands school ca 1525

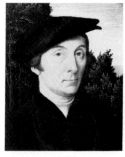

A 2107 Portrait of a man. *Portret van een man*

Pendant to A 2108

Panel 27.5 × 22.5
PROV Purchased from F Kleinberger gallery, Paris, 1903
LIT Ring 1913, p 30. Hoogewerff 1936-47, vol 2 (1937) p 502 (Pieter Gerritsz?)

A 2108 Portrait of a woman. *Portret van een vrouw*

Pendant to A 2107

Panel 27.5 × 22.5
PROV Same as A 2107
LIT *See under* A 2107

Northern Netherlands school ca 1530

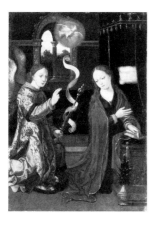

A 2592 The annunciation. *De verkondiging aan Maria*

Panel 44 × 31
PROV Lent by C Hoogendijk, The Hague, 1907. Presented from his estate in 1912

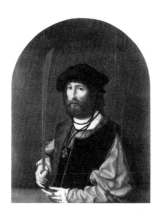

A 894 Ruben Parduyn. Knight of the Order of St John. *Ridder van de Johannieter-orde*

Later copy

Panel 75 × 60. On the verso his coat of arms, that of his wife, the inscription *DHeer Rubijn Perduijns Ridder van Jerusalem, trouwde Anno 1520 Vrouwe Barbara Floris dogter Michiels Ende van Juffr Magdalena Fossez* and the number *10*
PROV Bequest of Jonkheer J de Witte van Citters, The Hague, 1876. NMGK
LIT Ring 1913, p 95

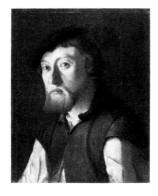

A 4056 Portrait of a man. *Portret van een man*

Panel 26 × 20.5
PROV Presented by Mr & Mrs I de Bruijn-van der Leeuw, Muri near Bern, 1961
LIT Hoogewerff 1936-47, vol 4 (1941-42) p 639, fig 308 (Dirck Barendsz?). HJ Jaffé, Du, 1944, p 38, ill (Jan van Scorel). J L Cleveringa, Bull RM 9 (1961) p 67, nr 20. Judson 1970, p 156

Northern Netherlands school 1557

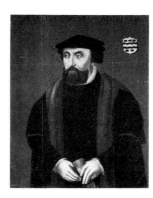

A 4196 Portrait of a man, possibly Willem Simon-Maertensz (1498-1557), lord of Stavenisse and Cromstrijen, burgomaster of Zierikzee for several terms. *Portret van een man, wellicht Willem Simon-Maertensz, ambachtsheer van Stavenisse en Cromstrijen, herhaaldelijk burgemeester van Zierikzee*

Panel 79 × 64. Inscribed *Ætatis Suae 59 Anno 1557*
PROV Unknown
LIT Cf Moes 1897-1905, vol 2, nr 7204

Northern Netherlands school ca 1570

A 1599 Two wings of an altarpiece: the circumcision (left); the adoration of the shepherds (right). *Twee zijluiken van een altaarstuk met de besnijdenis (links) en de aanbidding der herders (rechts)*

On the versos of the wings are St John the Baptist (left) and six kneeling noblemen with their coats of arms (right). From left to right Jan Baptist van Taxis, a lord of Ensse, Tiete van Cammingha, Jarich van Liauckema, Jacob van Claerhout and a lord of Boisot

Panels 236 × 104 each
PROV According to tradition from the church in Huissen, Gelderland. Purchased from H Gildemeester, 1893
LIT Moes 1897-1905, vol 1, nr 1409; vol 2, nr 4489:2? J Vuyck, OH 45 (1928) p 161. P Wescher, OH 45 (1928) p 271 (not Anthonie Blocklandt). J Vuyck, OH 46 (1929) p 159; OH 48 (1931) p 76 (Blocklandt). De Vries 1934, p 90 (not Blocklandt). Hoogewerff 1936-47, vol 4 (1941-42) p 588 (not Blocklandt)

Northern Netherlands school 4th quarter 16th century

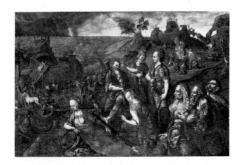

A 2624 Noah's ark. *De ark van Noach*

Panel 129 × 200
PROV Purchased from J S Zilverberg, Amsterdam, 1912

Northern Netherlands school 1578

C 1560 Willem Ploos van Amstel (1529-1603). Bailiff of Loosdrecht. *Schout van Loosdrecht*

Lozenge-shaped canvas on panel 22 × 18.7. Inscribed (on a piece of canvas added later?) *Aet. 49, An° 1578* with the family coat of arms
PROV On loan from the KOG (presented by D A Koenen, 1880) since 1973

Northern Netherlands school 1590

A 575 Charles de Heraugières (1556-1601). Captain, commander of Breda. *Kapitein, commandant van Breda*

Later copy?

Panel 69.5 × 58.5. Inscribed *Breda a servitute Hispana vindicata 4 Mart 1590*
PROV NM, 1808
LIT Moes 1897-1905, vol 1, nr 3426:1. Moes & van Biema 1909, pp 168, 207

Northern Netherlands school ca 1590

A 636 Portrait of a woman. *Portret van een vrouw*

Panel 71 × 53.5. Oval
PROV Bequest of Mrs J Balguerie-van Rijswijk, widow of D Balguerie, Amsterdam, 1823 * On loan to the Rijksmuseum 'Huis Lambert van Meerten,' Delft, since 1909

A 4468 Portrait of a young woman. *Portret van een jonge vrouw*

Copper 6.8 × 5.4
PROV Purchased from the collection of Jonkheer J E van Heemskerck van Beest, 1877. NMGK

Northern Netherlands school 17th century

NO PHOTOGRAPH AVAILABLE

A 1236 A faun and a nymph with two children in a landscape. *Een faun met een nimf en twee kinderen in een landschap*

Canvas 205 × 154
PROV KKS, 1885 * Lent to the states of Zeeland, Middelburg, 1912. Destroyed in the war, 1940

NO PHOTOGRAPH AVAILABLE

A 1231 Mythological subject? A woman and two men kneeling. *Mythologisch onderwerp? Een vrouwefiguur bij twee geknielde mannen*

Canvas 213 × 143
PROV KKS, 1885 (badly damaged) * Lost sight of and discarded or destroyed

Northern Netherlands school ca 1600

A 577 Joost de Moor (1550-1610). Vice admiral of Zeeland. *Vice-admiraal van Zeeland*

Panel 63 × 49
PROV Sale J H Broers, Utrecht, 8 March 1873, lot 3107 (as Michiel van Miereveld)
LIT Moes 1897-1905, vol 2, nr 5153:1

A 1469 Pieter Willemsz Verhoeff (ca 1560-1609). Captain (1600) and commander (1607) of the Dutch East India Company. Murdered on Banda. *Kapitein en commandeur bij de Verenigde Oost-Indische Compagnie. Vermoord op Banda*

Canvas 56 × 48
PROV Purchased from A A Vorsterman van Oyen, The Hague, 1888
LIT Moes 1897-1905, vol 2, nr 8283

A 3216 Klaes van Boelisse. Bailiff of Hoorn. *Schout van Hoorn*

Copy

Panel 49.3 × 33. Inscribed *Klaes Boelisse*
PROV From the Rijksarchief (state archives), Haarlem, 1934 * DRVK since 1959 (on loan to the Westfries Museum, Hoorn)

A 2867 Portrait of a man. *Portret van een man*

Canvas 178 × 116
PROV Helmond Castle. Acquired through exchange with Jonkheer H Trip, The Hague, 1921 * DRVK since 1953

Northern Netherlands school 1st half 17th century?

A 4170 Willem I (1533-84), prince of Orange, called William the Silent, on his deathbed. *Willem I, genaamd de Zwijger, prins van Oranje, op zijn ziekbed*

Canvas 49 × 72.7. Grisaille. Inscribed *Houd het mijn Leiden*; on the verso *Prins Albrechts van Pruisen [?] fol 17 Slot Reinhardtshausen*
PROV Purchased from Reinhardtshausen Castle, Erbach am Rhein, 1970

Northern Netherlands school? 1st half 17th century

NO PHOTOGRAPH AVAILABLE

A 4649 Portrait of a man. *Portret van een man*

Canvas 80 × 70
PROV Presented anonymously. NMGK * Missing

Northern Netherlands school 1601

A 3912 Francisco Hurtado de Mendoza (1546-1623). Admiral of Aragon. *Admiraal van Aragon*

For another portrait of the sitter, *see* Honselaarsdijk series: A 555

Canvas 97 × 76. Inscribed *Currente A° Ætatis Suae 55 captivitatis 2° Domini Vero 1601*
PROV Purchased from the Helmich family, Baak, 1957

Northern Netherlands school 1604

A 956 Portrait of a boy, perhaps Lodewijk van Nassau (d 1665), later lord of Beverweerd, de Leck, Odijk and Lekkerkerk, illegitimate son of Maurits, prince of Orange, and Margaretha van Mechelen. *Portret van een jongetje, misschien Lodewijk van Nassau, later heer van Beverweerd, de Leck, Odijk en Lekkerkerk, onechte zoon van Maurits, prins van Oranje, en Margaretha van Mechelen*

Panel 90 × 69. Inscribed *Aetatis Suae 18. mens A° 1604*
PROV Presented by Mrs A de Pinto, The Hague, 1875. NMGK, 1885
LIT R van Luttervelt, Historia 10 (1945) pp 222-24, ill (as a portrait of Lodewijk van Nassau)

Northern Netherlands school 1608

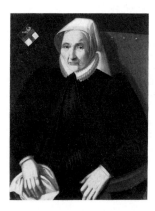

C 506 Portrait of a woman, thought to be an aunt or elder sister of Isabeau de Halinck (Haling), grandmother of Louys de Geer (1587-1652). *Portret van een vrouw, vermoedelijk een tante of oudere zuster van Isabeau de Halinck (Haling), grootmoeder van Louys de Geer*

Panel 74 × 58.5. Inscribed *Ætaᵗ Suae 97 A° 1608*
PROV On loan from the KOG since 1889

Northern Netherlands school ca 1610

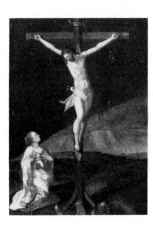

A 3497 Mary Magdalene at the foot of the cross. *Maria Magdalena bij het kruis*

Panel 42 × 32
PROV Bequest of Mrs A C M H Kessler-Hülsmann, widow of D A J Kessler, Kapelle op den Bosch near Mechelen, 1947

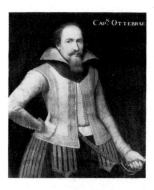

A 876 Otto Brahe. Captain of a Danish troop in the pay of Zeeland in 1607; went over to the Brandenburgs in 1610. *Kapitein van een compagnie Denen ter repartitie van Zeeland; trad in 1610 in Brandenburgse dienst*

Canvas 96 × 84. Inscribed *Capⁿ Ottebrae*
PROV KKS, 1876. NMGK, 1885 * DRVK since 1959 (on loan to the Nederlands Legermuseum, Leiden)

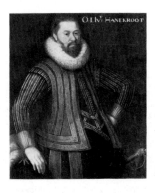

A 875 Eberhard Hanecroth (d 1637). Captain of a company from the regiment of Ernst Casimir van Nassau. *Kapitein van een compagnie van het regiment van Ernst Casimir van Nassau*

Canvas 96 × 84.5. Inscribed *O. Luiᵗ Hanekroot*
PROV KKS, 1876. NMGK, 1885 * DRVK since 1959 (on loan to the Nederlands Legermuseum, Leiden)
LIT *Cf* Moes & van Biema 1909, p 200

A 877 Karel van den Hoeven. Sergeant major. *Sergeant-majoor*

Canvas 121 × 95. Inscribed *Capⁿ vander Hoef*
PROV KKS, 1876. NMGK, 1885 * DRVK since 1959 (on loan to the Nederlands Legermuseum, Leiden)

A 587 Portrait of a man from the van Rijswijk family. *Portret van een man uit het geslacht van Rijswijk*

Panel 27 × 20. Inscribed on the verso *Pieter Rijswijk, geb. 1615, overleede 27 Febr. 1687, getrouwt 20 Dec. 1637 aan Trijntje Jacobse van Dijk, geb. 1617 (1613?) overleede 4 April 1677 vader en moeder van Jaques Rijswijck* (the date of the sitter's costume makes this identification unlikely)
PROV Bequest of Mrs J Balguerie-van Rijswijk, widow of D Balguerie, Amsterdam, 1823
LIT Moes 1897-1905, vol 2, nr 6711 (portrait of Pieter Rijswijck)

Northern Netherlands school ca 1615

A 738 Portrait of a man, said to be Justinus van Nassau (1559-1631), son of Prince Willem I and Eva Elinx. *Portret van een man, zogenaamd Justinus van Nassau, zoon van prins Willem I en Eva Elinx*

Panel 109 × 76
PROV Purchased from Fr Muller & Co,
art dealers, Amsterdam, 1882

A 1230 Bartolomeus Andrio Walsdorffer
(d 1622). Captain of a Swiss troop in the
pay of Friesland. Killed at Bergen op
Zoom. *Kapitein van een compagnie Zwitsers
ter repartitie van Friesland. Gesneuveld bij
Bergen op Zoom*

Canvas 122 × 96. Inscribed *Cap^n
Walsdorp*
PROV KKS, 1876. NMGK, 1885 * DRVK
since 1959 (on loan to the Nederlands
Legermuseum, Leiden)

A 576 Focco, Unico or Eggerich Adriaen
van Ripperda. Captain in the service of
the states-general. *Kapitein in Staatse dienst*

Canvas 124 × 93.5. Inscribed *Capteyn
Ripperda*
PROV NM, 1808 * DRVK since 1959 (on
loan to the Nederlands Legermuseum,
Leiden)
LIT G Murray Bakker, OH 16 (1898) p
30. Moes 1897-1905, vol 2, nr 6457.
Moes & van Biema 1909, pp 159, 208.
JJ Temminck, Spiegel Hist 8 (1973) p
267, fig 2

A 2871 Portrait of a man. *Portret van een
man*

Canvas 119 × 87
PROV Helmond Castle. Acquired
through exchange with Jonkheer H
Trip, The Hague, 1921 * DRVK since
1953

Northern Netherlands school 1616

A 905 Margarita Cassier. Wife of
Guilliam Courten. *Echtgenote van
Guilliam Courten*

For a portrait of the sitter's husband,
see Southern Netherlands school 1575,
A 904

Panel 131 × 96. Dated *A° 1616*. On the
verso her coat of arms, the inscription
*Margarita Cassier, Trouwt Junij 1563
Gilliam Courten* and the number *21*
PROV Bequest of Jonkheer J de Witte
van Citters, The Hague, 1876. Received
in 1903

Northern Netherlands school ca
1620

A 2727 Frederik de Houtman (1571-
1627). Governor of Ambon (1605-11).
Gouverneur van Amboina

Canvas 129 × 95
PROV Presented by JWIJzerman, The
Hague, 1915

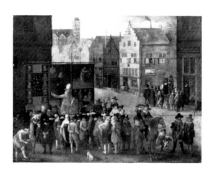

A 1429 The quack. *De kwakzalver*

Panel 69 × 91. Inscribed (left) *Ooc Kan
Ick Genesen Veel Heymelycke Ghebreken AEn
Man Ende Vrou, Allen Deese Ende Meer An
Der Hebbe Ick Genesen Alst Blyck By Mynne
Brieven Ende Serteficacien*; (right) *Desse
Vrouwe Hebbe Ick Van Eener Blientheijt
Ghenesen Soo Lubeck 1618 Den 9 Appril*;
(on the portrait in the middle) *Ætatis
Sua 39 Anno 1617*; and (on the building
to the right) *Francois Ende Ooc Duijtse
Schole*
PROV Sale Amsterdam, 1 Nov 1887, lot
47 (as Adriaen Pietersz van de Venne,
1617)
LIT G Snyder, Boehringer Zeitung 4
(1961) p 18ff, ill

Northern Netherlands school 1622

A 1316 Grietje Adriaensdr Groote (b 1587/88)

Panel 111 × 89. Inscribed *Aetatis 34. 1622*
PROV Sale D M Alewijn (Medemblik), Amsterdam, 16 Dec 1885, lot 56 (as school of Paulus Moreelse)
LIT Moes 1897-1905, vol 1, nr 2975

A 2075 Johan van Citters (1602-29). Son of Aernout van Citters and Anna van der Hooghe. *Zoon van Aernout van Citters en Anna van der Hooghe*

For a portrait of the sitter's father, *see* Dijk, Philip van, A 893

Panel 105 × 77. Inscribed *Aetas Sua 20, 1622*. On the verso *Jehan van Ceters. Zoon van Aernout en Anna van der Hooge, Geb: 1 Aug: 1602. Overl: 7 Dec: 1629* and the number *45*
PROV Bequest of Jonkheer J de Witte van Citters, The Hague, 1876. Received in 1903
LIT Moes 1897-1905, vol 1, nr 1542

Northern Netherlands school 1623

A 2076 Martrijntje van Citters (1609-29). Sister of Johan van Citters. *Zuster van Johan van Citters*

For a portrait of the sitter's brother, *see* the preceding number

Panel 103.5 × 76. Inscribed *Æt. Sua 14 An 1623*
PROV Bequest of Jonkheer J de Witte van Citters, The Hague, 1876. Received in 1903 * DRVK since 1962
LIT Moes 1897-1905, vol 1, nr 1548

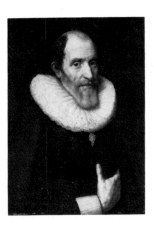

A 823 Portrait of a man from the Kettingh family. *Portret van een man uit de familie Kettingh*

Panel 67 × 51.5. Inscribed *Aetatis 63 A° 1623*. On the verso *Hʳ Kettingh*
PROV Presented by Jonkheer J H F K van Swinderen, Groningen, 1884
LIT Moes 1897-1905, vol 1, nr 4150

Northern Netherlands school 1624

NO PHOTOGRAPH AVAILABLE

A 2309 Solomon and the queen of Sheba. *Salomo en de koningin van Sheba*

Canvas 205 × 230. Dated *1624*
PROV Presented by the Schutters van St Joris (St George civic guard), Heusden, 1907. Irreparably damaged in the war, Heusden, 1944

Northern Netherlands school ca 1625

C 1551 Allegory on the tyranny of the duke of Alva in the Netherlands. *Allegorie op de tyrannie van de hertog van Alva in de Nederlanden*

Free copy after a print of 1622 by Willem Jacobsz Delff (1580-1638) (Fr Muller 514). Complete versions in the Zeeuws Museum, Middelburg, and Museum 'Het Prinsenhof,' Delft

Panel 76.5 × 117.5. Fragment. Inscribed *[H]ier siet ghy lustich wt gestreke[n] ducdalba in synen tyrannigen troon met sweerden boven stroppen beste[k]en scheurende met der hant slants prevelegen | ..elle die vlytich arbeyt om duvelsloon blaest hem d' ooren vol deur wrekende* [or: braekende, smekende] *haet die haer den duvel elck laet sien een croon te verdienen deur 't v[er]staen | .. en sta[e]t by hem staen scherprechter en syn bloetraet voor hem knielen als slaeven in banden 17 Jonc-vrouwe seer desolaet die werpen godts woort wt | .. [allen] de[ur] vreese hem te voe[t] haer vrome dere .. sietmen w[org]en .. horen .. emont en die vant .. b[o]nt die wieren onthalst | catie het ... |*
PROV On loan from the KOG (presented by J J Boas Berg, Amsterdam, 1890) since 1973

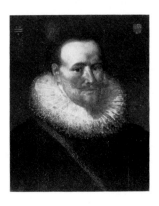

A 328 Joris van Cats, lord of Coulster. Rear admiral (1639). *Heer van Coulster. Schout-bij-nacht*

Panel 63 × 50
PROV Sale H J Broers, Utrecht, 8 March 1873, lot 3138
LIT Moes 1897-1905, vol 1, nr 1507 (Jan van Ravesteyn)

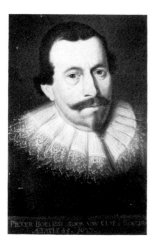

A 3217 Pieter Boelisse (1582-1627)

Copy

Panel 49.8 × 33. Dated *1627*. Inscribed *Pieter Boelisse, soon van Claes Boelisse Aetatis 45*
PROV From the Rijksarchief (state archives), Haarlem, 1934 * DRVK since 1959

Northern Netherlands school 1626

C 1528 Dirck Hendricksz van Swieten

Canvas 73.5 × 58. Inscribed *Ætatis Suae 67 anno 1626*
PROV On loan from the KOG since 1889
LIT Moes 1897-1905, vol 2, nr 7765

A 1975 Giant radish. *Een reuzenradijs*

Panel 53.5 × 87.5. Dated *Anno 1626*. Inscribed *Aanschout dees Radisfiguer nu allen van lengt en dicht hier gestelt net gewassen binne fredriks Stad Wallen en gesaait naer St. Jan. hier wel op let hie woech Sevendehalf pond en noch een bet*
PROV Presented by Fr Muller, Amsterdam, 1902 * On loan to the Rijksmuseum Muiderslot, Muiden, since 1949

Northern Netherlands school 1627

A 4469 Family portrait. *Familieportret*

Panel 122 × 191. Dated *Anno 1627*
PROV Purchased from A Greebe, 1880.
NMGK

A 2079 Portrait of a man. *Portret van een man*

Belongs with Northern Netherlands school 1645, A 2080

Paper on panel 13 × 10. Oval. Inscribed *Aetat. 35 1627*
PROV Bequest of Jonkheer J de Witte van Citters, The Hague, 1876. Received in 1903
LIT P J J van Thiel, in Miscellanea van Regteren Altena, 1969, p 109, fig 4 (on the frame)

Northern Netherlands school 1629

A 2077 Nicolaas de Witte (1603-29)

Canvas 72 × 54. Dated *1629*
PROV Bequest of Jonkheer J de Witte van Citters, The Hague, 1876. Received in 1903
LIT Moes 1897-1905, vol 2, nr 9204:1 (Pieter de Witte)

Northern Netherlands school 1630

A 2196 Paul de Hooghe (1611-74)

Panel 71.5 × 48. Inscribed *Anno 1630 Aetatis suae 18*
PROV Bequest of Miss M E van den Brink, Velp, 1905 * DRVK since 1957 (on loan to the Museum Amstelkring, Amsterdam)

A 2074 Pieter Courten (1581-1630). Second husband of Hortensia del Prado. *Tweede echtgenoot van Hortensia del Prado*

For a portrait of the sitter's wife, *see* Mesdach, Salomon, A 910

Panel 72 × 59. Dated *1630*. On the verso his coat of arms, the inscription *Pieter Courten. Trouwt Hortensia del Prado. Geb: 8 Maart 1581. Overl: te Middelb: 12 Jan: 1630* and the number *44*
PROV Bequest of Jonkheer J de Witte van Citters, The Hague, 1876. Received in 1903
LIT Moes 1897-1905, vol 1, nr 1770

Northern Netherlands school ca 1630

A 1752 Fortuna distributing her largesse. *Fortuna deelt haar gaven uit*

Panel 74 × 105
PROV Bequest of D Franken Dzn, Le Vésinet, 1898
LIT E K Grootes, Spiegel Hist 3 (1968) p 471, fig 8

Northern Netherlands school 1633

A 326 Portrait of a man. *Portret van een man*

Pendant to A 327

Panel 71 × 56. Inscribed on the verso *Jan Pieterze Snoek getroud aan Margriet Goverse Bal vader en moeder van Margriet Snoek huysvrouw van Dirk Bas* (the date of the sitter's costume makes this identification unlikely)
PROV Bequest of Mrs J Balguerie-van Rijswijk, widow of D Balguerie, Amsterdam, 1823
LIT Moes 1897-1905, vol 2, nr 7347

A 327 Portrait of a woman. *Portret van een vrouw*

Pendant to A 326

Panel 71.5 × 56. Inscribed *Aetatis Suae 37, Anno 1633*. Inscribed on the verso *Margriet Goverse Bal huysvrouw van Jan Pieterse Snoek moeder van Margriet Snoek die was huysvrouw van Dirk Bas* (the date of the sitter's costume makes this identification unlikely)
PROV Same as A 326
LIT Moes 1897-1905, vol 1, nr 327 (Jan van Ravesteyn?)

Northern Netherlands school ca 1635

A 3316 River view. *Riviergezicht*

Panel 29.5 × 47.5
PROV Presented by Mr & Mrs D A J Kessler-Hülsmann, Kapelle op den Bosch near Mechelen, 1940 * DRVK since 1964

A 585 Ursula (1594-1657), countess of Solms-Braunfels. Wife of Christoph, burgrave of Dohna. *Gravin van Solms-Braunfels. Echtgenote van Christoffel, burggraaf van Dohna*

Canvas 123 × 105
PROV NM, 1808
LIT C Hofstede de Groot, OH 17 (1899) p 168, nr 981 (Paulus Moreelse?). B W F van Riemsdijk, Bull NOB 8 (1907) p 126. De Jonge 1938, p 133, nr 26

Northern Netherlands school 1639

A 4101 Portrait of a man. *Portret van een man*

Canvas 111 × 85. Inscribed *An° DNI 1639 Æ Suae 63* and *De Madrasta | El nombre de basta*
PROV Sale Amsterdam, 26 May 1964, lot 156, ill

Northern Netherlands school ca 1640

A 203 Family portrait, thought to be the family of Joos van Trappen, called Banckers (1599-1647), vice admiral of Zeeland. *Familieportret, vermoedelijk het gezin van Joos van Trappen, genaamd Banckers, vice-admiraal van Zeeland*

Panel 57 × 72
PROV Purchased in 1866
LIT Moes 1897-1905, vol I, nr 3498:5 (the family of Piet Heyn by Thomas de Keyser). C Hofstede de Groot, OH 17 (1899) p 168 (Willem Duyster?). R van Luttervelt, Bull KNOB 6th ser 7 (1954) p 160

Northern Netherlands school 1643

A 920 Portrait of a man. *Portret van een man*

Panel 73.5 × 59.5. Dated *1643*
PROV Bequest of Jonkheer J de Witte van Citters, The Hague, 1876. NMGK, 1885

Northern Netherlands school 1644

A 1252 Jacoba Bontemantel (b 1643). Daughter of the Amsterdam merchant Frederik Bontemantel (b 1608) and Agatha Hasselaer (b 1624), whom he married in 1642. *Dochter van de Amsterdamse koopman Frederik Bontemantel en Agatha Hasselaer met wie hij in 1642 trouwde*

Canvas 73 × 56. Inscribed *Ætatis An° 1644*. On the verso *jacoba bontemantel dochter van fredrick bontemantel en agata hasselars*
PROV Presented by J S R van de Poll, Arnhem, 1885
LIT Moes 1897-1905, vol I, nr 849. C Hofstede de Groot, OH 22 (1904) p 113 (presumably a copy after Aelbert Cuyp)

Northern Netherlands school 1645

A 2080 Portrait of a woman. *Portret van een vrouw*

Belongs with Northern Netherlands school 1627, A 2079

Panel 13 × 10. Oval. Inscribed *Aetat 50. 1645*
PROV Bequest of Jonkheer J de Witte van Citters, The Hague, 1876. Received in 1903
LIT P J J van Thiel, in Miscellanea van Regteren Altena, 1969, p 109, fig 4 (on the frame)

Northern Netherlands school ca 1645

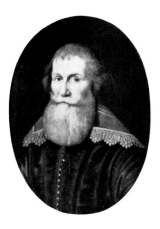

C 1225 Cornelis Haga (1578-1654). Dutch legate at the Turkish court. *Nederlands gezant bij het Turkse hof*

Panel 62 × 46.5. Oval
PROV Presented by Mrs A J S Dibbets-Kaas, 1873. On loan from the KKS since 1933
LIT Moes 1897-1905, vol I, nr 3103

C 427 A cavalry attack. *Een ruitergevecht*

Panel 20 × 28
PROV On loan from the city of Amsterdam since 1885
LIT Scheltema 1879, nr 158

Northern Netherlands school mid-17th century

A 2306 View of Heusden. *Gezicht op de stad Heusden*

Canvas 76 × 130
PROV Presented by the Schutters van St
Joris (St George civic guard), Heusden,
1907

A 4470 View of Heusden. *Gezicht op de stad Heusden*

Canvas 85.5 × 147
PROV Presented by C Leemans, Leiden,
1873?

NO PHOTOGRAPH AVAILABLE

A 1203, A 1204, A 1205 & A 1206 Four
decorative paintings with a festoon of
flowers. *Vier decoratiestukken met een bloem-festoen*

Canvas 216 × 81 (A 1203, A 1204);
163 × 68 (A 1205, A 1206)
PROV KKS, 1885 * DRVK since 1956
(A 1203 is missing)

A 2522a, A 2522b & A 2522c Three
decorative paintings with garlands. *Drie
decoratiestukken met guirlandes*

Paper on canvas 55 × 111; 55 × 113;
55 × 155 respectively. Grisaille
PROV From the vestibule of the former
arsenal, Amsterdam, 1910 * On loan to
the Academie voor Hoger Bouwkundig
Onderwijs (housed in the former
arsenal), Amsterdam, since 1911

A 2521a & A 2521b Two decorative
paintings with garlands. *Twee decoratie-stukken met guirlandes*

Paper on canvas 55 × 115 each. Grisaille
PROV Same as A 2522a * On loan to the
Academie voor Hoger Bouwkundig
Onderwijs, Amsterdam, since 1911

A 2520a, A 2520b, A 2520c & A 2520d
Four decorative paintings with laurel
wreaths. *Vier decoratiestukken met lauwer-kransen*

Canvas 55 × 55 each. Grisaille
PROV Same as A 2522a * On loan to the
Academie voor Hoger Bouwkundig
Onderwijs, Amsterdam, since 1911

662

A 2519a, A 2519b, A 2519c & A 2519d
Portrait busts of Jupiter, Juno, Venus and
Antinous. *Borstbeelden van Jupiter, Juno
Venus en Antinous*

Canvas 125 × 50 each. Grisaille
PROV Same as A 2522a * On loan to the
Academie voor Hoger Bouwkundig
Onderwijs, Amsterdam, since 1911
(A 2519b missing since 1972)

**Northern Netherlands school 2d
half 17th century**

A 1882 Still life with lemons and bread.
Stilleven met citroenen en brood

Canvas 42.5 × 59
PROV Presented by the dowager of R
Baron van Lynden, née M C Baroness
van Pallandt, The Hague, 1900 * DRVK
since 1952

A 1211, A 1212, A 1213 & A 1214 Four
decorative paintings, each with two
children: Christian allegories. *Vier
decoratiestukken met op elk twee kinderen:
christelijke allegorieën*

Canvas 115 × 76
PROV KKS, 1885

NO PHOTOGRAPH AVAILABLE

A 1238 A wreath of flowers. *Een krans van
bloemen*

Canvas 181 × 130. One section of a wall
covering
PROV KKS, 1885. Rolled up and
damaged; lost sight of and discarded or
destroyed

**Northern Netherlands school? 2d
half 17th century**

A 2551 Still life with fruits and plates
and dishes on a Turkey carpet. *Stilleven
met vruchten en vaatwerk op een smyrna kleed*

Canvas 128 × 136
PROV Lent by C Hoogendijk, The
Hague, 1907. Presented from his estate
in 1912
LIT R Bangel, Cicerone 7 (1915) p 188,
fig 13

**Northern Netherlands school ca
1650**

A 3881 Charles I (1600-49), king of
England. In a frame with allegorical
figures and historical subjects. *Karel I,
koning van Engeland, in een omlijsting met
allegorische figuren en historische voor-
stellingen*

Pendant to A 3882

Panel 42 × 41.5. Inscribed *D'klagende
Koninck Carolus Stuart Over sijn ongeluck,
dat hem den tijt nu toont, En dat voor vreught
nu druck, bij hem achter fortuin woont* and
other texts
PROV Sale Amsterdam, 17 March 1954,
lot 42

A 3882 Oliver Cromwell (1599-1658). In a frame with allegorical figures and historical subjects. *In een omlijsting met allegorische figuren en historische voorstellingen*

Pendant to A 3881

Panel 41.5 × 41.5. Inscribed *D'verwaenden Protecteur Olivier Kromwel, Die t'onrecht staet groot acht, en schijnt te glorieeren, over verkreghen macht, maer 't fortuijn kan verkeeren* and other texts
PROV Same as A 3881

A 4471 View of Cochin, on the Malabar coast, India. *Gezicht op Cochin, aan de kust van Malabar*

Canvas 97 × 140. Inscribed *Couchyn*
PROV Thought to come from the conference room of East India House, Amsterdam. Ministry of the colonies, The Hague, 1831-76. NMGK

A 4472 View of the city Cannanore on the Malabar coast, India. *Gezicht op de stad Cananor aan de kust van Malabar*

Canvas 97 × 140. Inscribed *Cananor*
PROV Same as A 4471

A 4473 View of Raiebagh in Visiapur, India. *Gezicht op de stad Raiebagh in Visiapoer, India*

Canvas 97 × 140. Inscribed *Raiebaagh*
PROV Same as A 4471

A 4474 View of Canton, China. *Gezicht op Canton, China*

Canvas 97 × 140. Inscribed *Canton*
PROV Same as A 4471

A 4477 View of Ayuthaya, the former capital of Siam. *Gezicht op Judea, de oude hoofdstad van Siam*

Canvas 97 × 140. Inscribed *Iudea*
PROV Same as A 4471

A 4475 View of the Dutch settlement at Lawec, near Martapura, Borneo. *Gezicht op de Hollandse nederzetting op Lawec bij Martapoera (Borneo)*

Canvas 97 × 140. Inscribed *De logie op Lawec*
PROV Thought to come from the West India House, Amsterdam. Ministry of colonies, The Hague, 1857-76. NMGK

A 4476 View of Banda Neira. *Gezicht op Banda Neira*

Canvas 97 × 140. Inscribed *Neyra*
PROV Same as A 4475

Northern Netherlands school 1655

A 3354 Portrait of a man. *Portret van een man*

Panel 74 × 60. Inscribed *Aetatis 95 An° 1655*
PROV Presented by Mr & Mrs DAJ Kessler-Hülsmann, Kapelle op den Bosch near Mechelen, 1940

Northern Netherlands school ca 1655

A 1638 Portrait of a painter. *Portret van een schilder*

Panel 30 × 26
PROV Presented by F Kleinberger, Paris, 1896

A 842 Portrait of a couple with child, members of the van Beresteyn family. *Portret van een echtpaar met kind, leden van de familie van Beresteyn*

Canvas 120 × 135
PROV Sale G van Beresteyn van Maurick, Vught, 22 Oct 1884, lot 46b
LIT Moes 1897-1905, vol 1, nr 525. C Hofstede de Groot, OH 17 (1899) p 167 (Isaac Luttichuys?). W R Valentiner, Art Q 1 (1938) pp 157-58, 177, nr 6 (Luttichuys). Van Beresteyn & del Campo Hartman 1941-54, vol 2, p 134, nr 266, ill (Cornelis Willaerts?). De Jongh 1967, p 60, fig 44 (Zeeland school?)

A 2866 Portrait of a woman. *Portret van een vrouw*

Canvas 200 × 119
PROV Helmond Castle. Acquired through exchange with Jonkheer H Trip, The Hague, 1921 * DRVK since 1953

Northern Netherlands school ca 1660

A 132 Landscape with rolling bridge. *Landschap met overtoom*

Canvas 120 × 168.5
PROV Sale G van der Pot van Groeneveld, Rotterdam, 6 June 1808, lot 46 (as Joris van der Haagen)
LIT C Hofstede de Groot, OH 19 (1901) p 126 (attributed to Jan Vermeer van Haarlem). Moes & van Biema 1909, pp 113, 159, 182

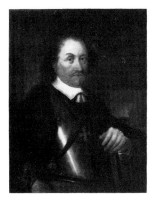

A 2967 Johan Maurits (1604-97), count of Nassau-Siegen. Governor of Brazil. *Graaf van Nassau-Siegen. Gouverneur van Brazilië*

Canvas 82 × 60
PROV Donated by the Dutch government, 1922, in substitution for another portrait of Johan Maurits (cat 1914, nr 1901; inv nr A 314), given to the Brazilian government

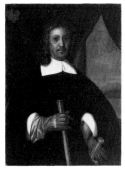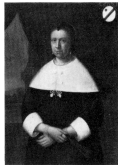

A 805 Portrait of a man, known as the portrait of Anthony van Riebeeck (d 1639). *Portret van een man, bekend als het portret van Anthony van Riebeeck*

Pendant to A 806

Canvas 91 × 61. Inscribed on the verso *Antony Joansz van Riebeek obiit Maij 1639 begraven in Brezie in Phernambucq op 't recif Olinda in de kerk St. Paulo*
PROV Presented by Jonkheer J H F K van Swinderen, Groningen, 1884
LIT Moes 1897-1905, vol 2, nr 6423. Godée Molsbergen 1912, p 6, note 3, p 280ff, fig 1 (portrait of Joan van Riebeeck). J de Loos-Haaxman, Tijdschr Ind TLV 27 (1937) pp 295, 590ff (Jacob Jansz Coeman). D Bax, Zuid Afrika, 1952, nr 4, p 51, ill (portrait of Joan van Riebeeck). T Koot, Heemschut 45 (1968) p 46, ill. De Loos-Haaxman 1968, p 11 (portrait of Joan van Riebeeck by Jacob Jansz Coeman)

A 806 Portrait of a woman, known as the portrait of Elisabeth van Gaesbeek (d 1629), wife of Anthony van Riebeeck.

Portret van een vrouw, bekend als het portret van Elisabeth van Gaesbeek, echtgenote van Anthony van Riebeeck

Pendant to A 805

Canvas 91 × 61. Inscribed on the verso *Govertsdr. Elisabeth van Gaesbeek, Huis-vrouw van Anthony van Riebeeck. Obiit de 7 November 1629. Begraven te Schiedam*
PROV Same as A 805
LIT Moes 1897-1905, vol I, nr 2611. Godée Molsbergen 1912, p 28off, ill (portrait of Maria Scipio). De Haan 1922-23, fig L 5 (presumably a portrait of Maria Scipio). J de Loos-Haaxman, Tijdschr Ind TLV 27 (1937) pp 396, 59off (Jacob Jansz Coeman). De Loos-Haaxman 1968, p 11 (portrait of Maria Scipio by Jacob Jansz Coeman)

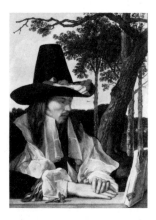

A 4018 A man reading. *Een lezende man*

Canvas 88 × 66.5. Unclearly signed
PROV From the H E ten Cate collection, Almelo. SNK. Transferred by the DRVK in 1960
LIT De Vries 1939, p 50, pl III, p 91, nr 34 (Vermeer, ca 1665). Plietzsch 1939, pp 33-34, 51, nr 33, fig 38 (Vermeer, ca 1670). G Adriani, Kunst dem Volk 12 (1941) nr 5 (Vermeer). Martin 1942, vol 2, p 185 (Vermeer). A Welcker, OH 61 (1946) p 150, ill (presumably Haarlem school). De Vries 1948, pp 73, 103, nr 39, ill (Jan Baptist Weenix or Karel Dujardin?). Swillens 1950, p 64, nr c (not Vermeer). Ungaretti & Bianconi 1967, p 99, nr 64, ill (not Vermeer)

A 1913 Portrait of a young woman. *Portret van een jonge vrouw*

Canvas 34 × 26.5
PROV Bequest of J H Schellwald, Zwolle, 1900

Northern Netherlands school ca 1665

A 1260 Nicolaas Klopper (1636-81). Owner of whaling vessels and trader in whale oil, Amsterdam. *Reder ter walvis-vangst en traankoper te Amsterdam*

Pendant to A 1261

Canvas 50 × 39.5
PROV Presented by J S R van de Poll, Arnhem, 1885 * DRVK since 1950
LIT Moes 1897-1905, vol I, nr 4222

A 1261 Margaretha Le Gouche (1636-1727). Wife of Nicolaas Klopper. *Echtgenote van Nicolaas Klopper*

Pendant to A 1260

Canvas 50 × 39.5
PROV Same as A 1260 * DRVK since 1950
LIT Moes 1897-1905, vol I, nr 2836

Northern Netherlands school ca 1670

A 1640 Splitting the chain across the Thames, 22 June 1667: episode from the raid on Chatham. *Het stukzeilen van de ketting over de Theems op 22 juni 1667; episode uit de tocht naar Chatham*

Panel 56 × 80
PROV Sale Amsterdam, 4 Feb 1896, lot 24 (as Hendrick de Meyer); purchased for the RMA by an unknown donor *
DRVK since 1953

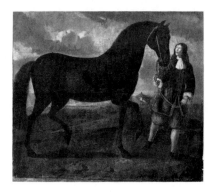

A 4478 Groom leading a black horse. *Zwart paard door een stalknecht geleid*

Canvas 226 × 286
PROV Purchased in 1884. NMGK
LIT Martin 1935-36, vol I, p 257

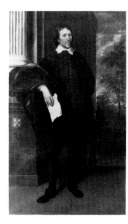

A 819 Willem Kettingh

Pendant to A 820

Canvas 208 × 121
PROV Presented by Jonkheer J H F K

van Swinderen, Groningen, 1884 *
DRVK since 1957
LIT Moes 1897-1905, vol 1, nr 4149

A 820 Maria Hartmansdr de Kuster.
Wife of Willem Kettingh. *Echtgenote van
Willem Kettingh*

Pendant to A 819

Canvas 207 × 122
PROV Same as A 819 * DRVK since 1953
LIT Moes 1897-1905, vol 1, nr 1867

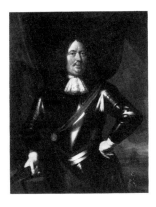

A 609 Portrait of an admiral, thought to
be Adriaen Banckert (ca 1615-84), vice
admiral of Zeeland. *Portret van een
admiraal, vermoedelijk Adriaen Banckert,
vice-admiraal van Zeeland*

Canvas 122 × 98
PROV Unknown

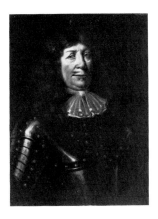

A 1422 Carel Rabenhaupt (1602-75).
Lieutenant-general. *Luitenant-generaal*

Canvas 69 × 53
PROV Purchased from Scholtens & Zn
gallery, Groningen, 1887
LIT Moes 1897-1905, vol 2, nr 6830:2

**Northern Netherlands school ca
1675**

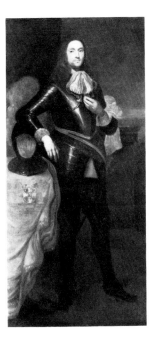

A 2868 Ferdinand Carolus Gonzaga,
duke of Mantua. *Hertog van Mantua*

Canvas 195 × 91. Inscribed *Ferdinan.
Conzaga Princeps Marchionibus Mantue
Marchio…..*
PROV Helmond Castle. Acquired
through exchange with Jonkheer H Trip,
The Hague, 1921 * DRVK since 1953

**Northern Netherlands school ca
1680**

A 3895 Portrait of a gold- and silver-
smith. *Portret van een edelsmid*

Panel 45.5 × 38
PROV Purchased from A Nijstad gallery,
The Hague, 1955

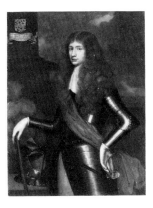

A 1671 Cornelis van Aerssen (1637-88),
lord of Sommelsdijk. Governor of
Surinam from 1683 on. *Heer van
Sommelsdijk. Sedert 1683 gouverneur van
Suriname*

For a portrait of the sitter's father, *see*
Hanneman, Adriaen, A 1670; for a
portrait of the sitter's son, *see* Verheyden,
Mattheus, A 1672

Canvas 121 × 91. Inscribed beneath the
coat of arms *Corn: van Aerssen Heer van
Sommelsdijck etc Colonel te Paert Heer voor
eenderde en gouverneur van Suriname overleden
1688*
PROV Sale Mrs van Dam van Brakel-
Ditmars van IJsselvere, Amsterdam, 29
Oct 1895
LIT Moes 1897-1905, vol 1, nr 67:2

A 1628 Portrait of an admiral, thought
to be Willem van Ewijck (1645-86).
*Portret van een admiraal, vermoedelijk Willem
van Ewijck*

Canvas 135 × 110
PROV Purchased from Hamburger
gallery, Amsterdam, 1895

Northern Netherlands school ca 1690

A 741 The roads of Vlissingen. *De rede van Vlissingen*

Canvas 96 × 146
PROV Sale Amsterdam, 20-22 Dec 1881, lot 86* (as Bonaventura Peters)

Northern Netherlands school? ca 1695

A 4479 William III (1650-1702), prince of Orange and, from 1689 on, king of England. *Willem III, prins van Oranje, sedert 1689 koning van Engeland*

Pendant to A 4480

Tin 9.4 × 7.5. Oval
PROV Bequest of FGS Baron van Brakell, Arnhem, 1878. NMGK

A 4480 Mary Stuart (1662-95). Wife of William III. *Maria Stuart. Echtgenote van Willem III*

Pendant to A 4479

Tin 9.4 × 7.5. Oval
PROV Same as A 4479

Northern Netherlands school? late 17th century

A 4121 Meleager and Atalanta. *Meleager en Atalanta*

Copper 23.2 × 27.3
PROV Bequest of Mrs J E F E de Kleyn-von Artner, Amsterdam, 1965

Northern Netherlands school 18th century

C 1582 Signboard with a herring boat on either side. *Uithangbord, aan weerszijden beschilderd met een haringbuis*

Copper 70.5 × 78. Inscribed on both sides 'D'Haringbuys'
PROV On loan from the KOG (purchased 1886) since 1974
LIT A G M B[oost], Heemschut 26 (1949) p 28

A 1347 Decorative painting with birds. *Decoratiestuk met gevogelte*

Canvas 75 × 140
PROV Presented by an unknown donor, Leiden, 1886

NO PHOTOGRAPH AVAILABLE

A 1346 Decorative painting with a parrot, a heron and a duck. *Decoratiestuk met een papegaai, een reiger en een eend*

Canvas 96 × 104
PROV Same as A 1347 * Given on loan to the state architect's office, 2d district, The Hague, ca 1910. Missing

A 2534 Decorative painting with birds in a landscape. *Decoratiestuk met vogels in een landschap*

Canvas 163.5 × 69
PROV NMGK, 1911 * On loan to the ministry of inland waters since 1916 (from 1959 on via the DRVK)

A 4179 *Ceres, Bacchus and Amor.* Ceres, Bacchus en Amor

Canvas 248 × 120 (with frame). Grisaille
PROV Unknown * DRVK since 1953

Northern Netherlands school? 18th century

A 610 *Tarquinius and Lucretia.* Tarquinius en Lucretia

Canvas 104 × 90
PROV Presented by J P G Baron Spaen van Biljoen, 1808

Northern Netherlands school ca 1700

A 630 *Portrait of a woman of the Balguerie family.* Portret van een vrouw uit de familie Balguerie

Canvas 73 × 62. Oval
PROV Bequest of Mrs J Balguerie-van Rijswijk, widow of D Balguerie, Amsterdam, 1823 * DRVK since 1958

Northern Netherlands school ca 1705

A 1947 *Naval battle in the Estuary of Vigo, 23 October 1702: episode from the War of Spanish Succession.* Zeeslag in de baai van Vigo, 23 october 1702. Episode uit de Spaanse Successie-oorlog

Panel 59 × 82.5
PROV Purchased from the G de Clercq collection, Amsterdam, 1899, through the intermediacy of the Rembrandt Society
LIT C R Boxer, Spiegel Hist 8 (1973) p 34, fig 8

Northern Netherlands school ca 1710

A 626 *Portrait of a young woman of the Rijswijk family.* Portret van een jonge vrouw uit de familie Rijswijk

Canvas 73 × 65. Oval
PROV Bequest of Mrs J Balguerie-van Rijswijk, widow of D Balguerie, Amsterdam, 1823 * DRVK since 1953

A 634 *Jacoba Magtelda Rijswijk. Daughter of the Amsterdam merchant Theodoor Rijswijk (1668-1729) and Elisabeth Hollaer.* Dochter van de Amsterdamse koopman Theodoor Rijswijk en Elisabeth Hollaer

Canvas 73 × 64. Oval. Inscribed on the verso *Jacoba Magtelda Ryswyk, Dogter van Theodorus Ryswyk en Elisabeth Hollaer*
PROV Same as A 626 * DRVK since 1958

A 628 *Jacques Rijswijk blowing bubbles.* Jacques Rijswijk bellen blazend

Canvas 73 × 62. Oval
PROV Same as A 626 * DRVK since 1953

669

A 629 Cornelia Rijswijk

Canvas 73 × 62. Oval
PROV Same as A 626 * DRVK since 1953

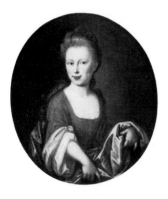

A 627 Portrait of a young woman of the
Rijswijk family. *Portret van een jonge vrouw
uit de familie Rijswijk*

Canvas 73 × 62. Oval
PROV Same as A 626 * DRVK since 1953

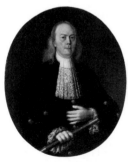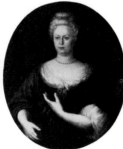

A 811 Abraham van Riebeeck (1653-
1713). Governor-general of the Dutch
East Indies (1709-13). *Gouverneur-
generaal van Nederlands Oost Indië*

Pendant to A 812

Canvas 95 × 78.5. Oval
PROV Presented by Jonkheer J H F K
van Swinderen, Groningen, 1884
LIT Moes 1897-1905, vol 2, nr 6422:1.
De Loos-Haaxman 1941, p 94, fig 56

A 812 Elisabeth van Oosten (1660-
1714). Wife of Abraham van Riebeeck.
Echtgenote van Abraham van Riebeeck

Pendant to A 811

Canvas 96 × 79. Oval
PROV Same as A 811
LIT Moes 1897-1905, vol 2, nr 5566.
De Loos-Haaxman 1941, p 94

**Northern Netherlands school ca
1725**

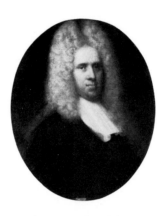

A 2803 Johan Arnold Zoutman (1676-
1745). Lawyer, husband of Anna
Margaretha van Petcum. *Advocaat,
echtgenoot van Anna Margaretha van Petcum*

For a portrait of the sitter's wife, *see*
Diest, Johan van, A 2804

Canvas 72 × 59.5. Oval
PROV Presented by N S Rambonnet,
Elburg, 1917
LIT Moes 1897-1905, vol 2, nr 9401
(Johan van Diest)

**Northern Netherlands school ca
1730**

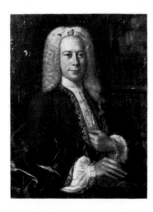

C 1570 Portrait of an historian. *Portret
van een geschiedkundige*

Canvas 88.5 × 66.5. The title of the book
on the table is *Wassenaar Hist. Verh. |
1.2.3.4 Deel* (Claes Wassenaer,
Historisch verhael alder ghedenck-
weerdichste geschiedenissen die hier en
daer in Europa... van den beginne des
jaers 1621 ... voorgevallen zyn, 21 vols,
Amsterdam 1622-35)
PROV On loan from the KOG since 1973

**Northern Netherlands school ca
1745**

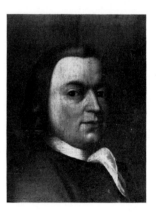

C 1575 Gerrit Schnetzler

Canvas on panel 40.5 × 29
PROV On loan from the KOG since 1973

**Northern Netherlands school? mid-
18th century**

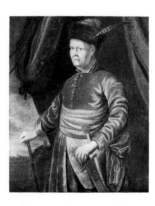

A 2870 Portrait of a Hungarian legate.
Portret van een Hongaars gezant

Canvas 124 × 100
PROV Helmond Castle. Acquired
through exchange with Jonkheer H Trip,
The Hague, 1921 * DRVK since 1953

**Northern Netherlands school 2d
half 18th century**

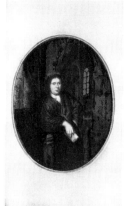

A 1332 Portrait of a man in seventeenth-century costume. *Portret van een man in zeventiende-eeuwse kleding*

Pendant to A 1333

Verre églomisé 77 × 47. The oval portrait measures 49.5 × 39
PROV Discovered in the Trippenhuis in 1884/85 when the collection was transferred to the Rijksmuseum

A 1333 Portrait of a woman in seventeenth-century costume. *Portret van een vrouw in zeventiende-eeuwse kleding*

Pendant to A 1332

Verre églomisé 77 × 47. The oval portrait measures 49.5 × 39
PROV Same as A 1332

A 1334 Portrait of a man in seventeenth-century costume. *Portret van een man in zeventiende-eeuwse kleding*

Verre églomisé 77 × 47. The oval portrait measures 49.5 × 39
PROV Same as A 1332

NO PHOTOGRAPH AVAILABLE

A 1335 Portrait of a woman in eighteenth-century costume. *Portret van een vrouw in achttiende-eeuwse kleding*

Verre églomisé 77 × 47. The oval portrait measures 49.5 × 39
PROV Same as A 1332 * Irreparably damaged

Northern Netherlands school ca 1760

A 926 Portrait of a man. *Portret van een man*

Canvas 54 × 46
PROV Bequest of Jonkheer J de Witte van Citters, The Hague, 1876. NMGK, 1885

Northern Netherlands school 1772

A 4194 Allegorical representation of the birth of Willem Frederik (1772-1843), prince of Orange-Nassau, later King Willem I. *Allegorische voorstelling op de geboorte van Willem Frederik, prins van Oranje-Nassau, de latere koning Willem I*

Canvas 36.3 × 28.5. Inscribed *Den hemel*

schenkt ons nog dit geluk. Den 24 Augustus 1772
PROV Unknown

Northern Netherlands school ca 1775

A 1476 Willem Frederik (1772-1843), prince of Orange-Nassau (later King Willem I), as a child. *Prins van Oranje-Nassau (later koning Willem I), als kind*

Pendant to A 1477

Canvas 46 × 39
PROV Presented by E Baron van Lynden, Vaassen, 1888

A 1477 Willem George Frederik (1774-99), prince of Orange-Nassau, as a child. Brother of the preceding. *Prins van Oranje-Nassau als kind. Broer van voorgaande*

Pendant to A 1476

Canvas 46 × 39
PROV Same as A 1476

Northern Netherlands school 1st half 19th century

A 2833 Seascape. *Zeegezicht*

Panel 31 × 39
PROV Bequest of Mrs M N Th Weddik-Lublink Weddik, widow of A L Weddik, Arnhem, 1919 * DRVK since 1953

Northern Netherlands school ca 1815

A 1519 Willem I (1772-1843), sovereign prince of the United Netherlands, later king of the Netherlands. *Souverein vorst der Verenigde Nederlanden, later koning der Nederlanden*

Canvas 69 × 55. Painted between 2 December 1813 and 16 March 1815
PROV Sale van Goethem (former de Soere collection, Bruges), Amsterdam, 1 April 1890, lot 203?

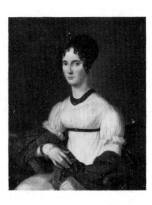

C 1323 Jonkvrouwe Rebecca Teixeira (1793-1835). Wife of Jonkheer Abraham Salvador (1782-1866) from 1812 on. *Sinds 1812 echtgenote van Jonkheer Abraham Salvador*

Canvas 79 × 64
PROV On loan from Miss J E van Nierop, Amsterdam, since 1938

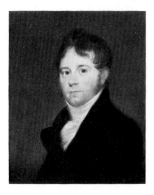

A 925 Portrait of a man. *Portret van een man*

Panel 23 × 19
PROV Bequest of Jonkheer J de Witte van Citters, The Hague, 1876. NMGK, 1885

Northern Netherlands school? ca 1820

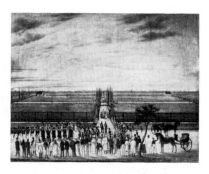

A 4481 A Catholic funeral in the West Indies. *Katholieke begrafenis in West-Indië*

Canvas 53.5 × 70
PROV Acquired in 1896. NMGK

Northern Netherlands school ca 1830

A 2798 Portrait of a painter. *Portret van een schilder*

Canvas 99 × 82
PROV Presented by an unknown donor, 1916

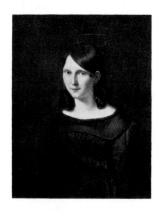

A 2171 Portrait of a girl, thought to be Miss Sligting. *Portret van een meisje, vermoedelijk mejuffrouw Sligting*

Thought to be a pendant to A 2172

Canvas 68 × 52.5
PROV Bequest of Mrs V E L Diederichs-Portman, widow of W G A Diederichs, Amsterdam, 1905

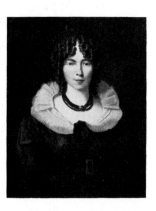

A 2172 Portrait of a young woman. *Portret van een jonge vrouw*

Thought to be a pendant to A 2171

Canvas 67.5 × 52.5
PROV Same as A 2171

Northern Netherlands school? 1844

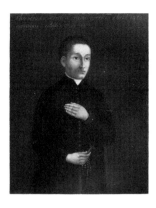

A 4158 Charles van der Meulen (1826-44). Missionary on Curaçao. *Missionaris te Curaçao*

Panel 36 × 28.5. Inscribed *Charles van der Meulen Missionaris obiit 1844 curacao aetaitis vero 18*
PROV Purchased from C Meuleman gallery, Amsterdam, 1969

Northern Netherlands school? ca 1850

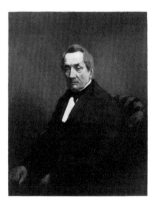

A 1961 J C de Brunett. Consul-general of Russia in Amsterdam. *Consul-generaal van Rusland te Amsterdam*

Panel 41 × 31.4
PROV Presented by Mrs Herpel-Völcker, Bussum, 1901

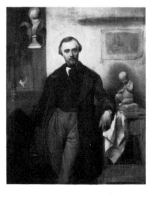

A 4193 Portrait of a sculptor, perhaps

Johannes Antonius van der Ven (1799-1866). *Portret van een beeldhouwer, misschien Johannes Antonius van der Ven*

Canvas 58 × 44
PROV Unknown

Northern Netherlands school mid-19th century

A 4208 Rough sea with sailing vessels. *Woelige zee met zeilschepen*

Pendant to A 4647

Panel 13 × 17.5. Traces of a signature
PROV Unknown

A 4647 Harbor view. *Havengezicht*

Pendant to A 4208

Panel 12.3 × 17.6
PROV Unknown

Northern Netherlands school 1858

A 4105 The bombardment of the palace of the sultan of Djambi by the Dutch navy vessels 'Celebes,' 'Admiraal van Kinsbergen' and 'Onrust,' 8 September 1858. *De beschieting van de Kraton van de Sultan van Djambi door de gouvernements-marineschepen 'Celebes,' 'Admiraal van Kinsbergen' en 'Onrust' op 8 september 1858*

Canvas 70.5 × 100
PROV Purchased from A van der Meer gallery, Amsterdam, 1964
LIT Bull RM 15 (1967) p 94, fig 8

Northern Netherlands school 3d quarter 19th century

A 1837 Windmill on a bluff beside a watercourse. *Molen op de hoge kant van een vaart*

Canvas 121 × 91.5. Unclearly signed
PROV Bequest of Reinhard Baron van Lynden, The Hague, 1899 * DRVK since 1952

Northern Netherlands school ca 1948

C 1461 Wilhelmina (1880-1963), queen of the Netherlands. *Koningin der Nederlanden*

Canvas 281 × 191
PROV Transferred to the DRVK by the Dutch High Commission, Djakarta, 1960, in damaged condition. On loan from the DRVK since 1961

Provincial schools of the Northern Netherlands

Frisian school 1542

A 1992 Worp van Ropta (1504-51). 'Grietman' of Oost-Dongeradeel. *Grietman van Oost-Dongeradeel*

Panel 195 × 100. Inscribed *Worp Ropta van wegen Römischer Keiserlicher Maiestaet Grietman over Doncardeel zra sue etates 38 ipsa die qua factum A° 1542 den 20sten Octobris*
PROV Purchased from JJBoas Berg, Amsterdam, 1902 * DRVK since 1959 (on loan to the Fries Museum, Leeuwarden)
LIT Moes 1897-1905, vol 2, nr 6531. Ring 1913, p 79. Wassenbergh 1935, p 53. Renger 1970, pp 97-98

Gelderland school ca 1435

A 1491 Eighteen scenes from the life of Christ, known as the Roermond passion. *Achttien taferelen uit het leven van Christus, bekend als de Roermondse passie*

Upper row: the annunciation, the nativity, the circumcision, the adoration of the magi, the presentation in the temple, the entry into Jerusalem. Middle row: the last supper, the agony in the garden, the betrayal, Christ before Pilate, the crowning with thorns, the flagellation. Bottom row: the carrying of the cross, the crucifixion, the lamentation, the resurrection, the ascension and Pentecost

Canvas on panel 103 × 167.5. Each scene 33 × 27.5
PROV Lent by the elders of the Onze Lieve Vrouwe Munster, Roermond, 1880. Purchased in 1889
LIT F Winkler, Jb Preusz Kunstsamml 44 (1923) p 136, fig 1 (ca 1420-30, influence of van Eyck and Cologne masters). Winkler 1924, p 167, figs 104-05 (not later than 1430, influenced by van Eyck miniatures). Friedländer 1924-37, vol 3 (1925) pp 63, 113, nr 39 (ca 1450). Dülberg 1929, p 76. Smits 1933, pp 120, 126, fig 52. Hoogewerff 1936-47, vol 1, pp 177-88, ill (ca 1435, related to the Cologne and Westphalia schools and to van Eyck). Gerson 1950, p 8, figs 2-3. Panofsky 1953, vol 1, pp 104, 125, note 4, p 235, note 2. GJ Hoogewerff, in Kunstgesch der Ned, 1954-56, vol 1, p 194, figs 9-10 (1425-30). Exhib cat Middeleeuwse kunst der Noordelijke Nederlanden, Amsterdam 1958, nr 4

Holland school ca 1485

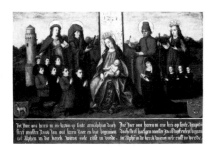

C 509 Memorial tablet of Jacob Jan van Assendelft (1396-1478) and his wife Haesgen van Outshoorn (d 1471). *Gedachtenistafel van Jacob Jan van Assendelft en zijn echtgenote Haesgen van Outshoorn*

Panel 61 × 91. Inscribed on the left *Int Jaer ons heren MCCCCLXXVIII op Sinte Arnulphus dach sterf meester Jan Jacob out LXXXI jaer en legt begraven tot Alphen in die kerck wiens ziele rust in vrede*; on the right *Int Jaer ons heren MCCCCLXXI op Sinte Agapitus dach sterf Haesgen meester Jacob⁵ wijf en leyt begravē tot Alphē in de kerck wiens ziele rust in vrede*
P R O V On loan from the K O G (presented by F de Wildt) since 1889
L I T Moes 1897-1905, vol 1, nr 222; vol 2, nr 5656

Holland school ca 1500

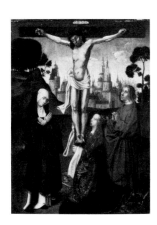

A 1508 The crucifixion. *Kruisiging*

Panel 38 × 28
P R O V Sale O A Spitzen, Zwolle, 15 Oct 1889, lot 6

Holland school? ca 1595

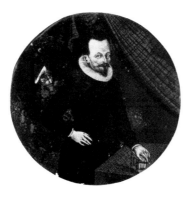

A 4484 Portrait of a man. *Portret van een man*

Verre églomisé 9 cm in diam. Remnants of a signature and date *GISOW GS … Æ 16*
P R O V Purchased from S Duits gallery, Amsterdam, 1896. N M G K
L I T Ritz 1972, pp 11, 154, nr 11, fig 11 (late 16th century)

Holland school 1597

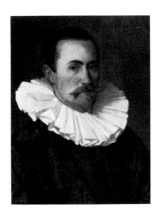

A 1841 Portrait of a man. *Portret van een man*

Panel 52 × 41. Inscribed *Aeta 30 1597*
P R O V Bequest of Reinhard Baron van Lynden, The Hague, 1899

Holland school 1601

A 1580 Mother and child in Noord-Holland costume. *Moeder en kind in Noordhollandse dracht*

Panel 107 × 77. Inscribed *Aetatis suae 22 Anno 1601*
P R O V Sale Amsterdam, 29 March 1892, lot 51 * On loan to the Nederlands Openluchtmuseum, Arnhem, since 1968
L I T De Vries 1934, p 78 (Hoorn school?; follower of Pieter and Aert Pietersz)

Holland school 1617

A 4482 Bird's-eye view of Ambon with a portrait of Frederik de Houtman (1571-1627), governor of Ambon from 1605 to 1611, in a cartouche. *Gezicht op Amboina in vogelperspectief met in cartouche het portret van Frederik de Houtman, gouverneur van Amboina*

Canvas 150 × 265. Dated *1617*. Inscribed *Aet. Suae 46*
P R O V N M G K
L I T P A Tiele, Bijdr & Med Hist Gen Utrecht 6 (1883) pp 281-376. Mollema 1935, p 52. Stapel 1938-40, vol 3, ill opp p 88. W H Vroom, Ons Amsterdam 24 (1972) p 179, ill

A 981 Twins in swaddling clothes: the children of Jacob de Graeff and Aeltge Boelens, who died in infancy. *Een ingebakerde tweeling: vroeg gestorven kinderen van Jacob de Graeff en Aeltge Boelens*

Panel 71 × 54. Dated *den 7 April 1617*
P R O V Sale Amsterdam, 3 Dec 1872, lot

51. NMGK, 1885 * On loan to the Rijks-museum Muiderslot, Muiden, since 1949

Holland school ca 1620

A 1852 Interior with gamblers and drinkers. *Interieur met drinkende en spelende mensen*

Panel 57 × 92. Falsely signed *T. Keyzer*
PROV Sale Amsterdam, 3 April 1900, lot 42 * On loan to the Rijksmuseum Muiderslot, Muiden, since 1922

Holland school 2d quarter 17th century

A 3492 River view. *Riviergezicht*

Panel 63 × 93
PROV Bequest of Mrs A C M H Kessler-Hülsmann, widow of D A J Kessler, Kapelle op den Bosch near Mechelen, 1947

Holland school ca 1630

A 4066 Prisoners of the Tupinamba Indians: three scenes. *De behandeling van krijgsgevangenen door de Tupinamba-indianen, in drie taferelen*

Panel 33.5 × 189. Probably the frieze of a mantlepiece, presumably from West India House, Amsterdam
PROV Koloniaal Magazijn (colonial warehouse), Amsterdam, 1857. Ministry of the colonies, The Hague, 1885. NMGK, 1962
LIT Pott 1962, p 33, ill, p 34

Holland school 1633

A 2258 Vanitas still life with books. *Vanitas stilleven met boeken*

Panel 73.5 × 70. Dated *An° 1633*
PROV Bequest of J B A M Westerwoudt, Haarlem, 1907 * On loan to the Rijks-museum Muiderslot, Muiden, since 1949
LIT A Bredius, Burl Mag 41 (1921) p 176ff (Constantijn Verhout)

Holland school 1634

A 578 Willem van Oldenbarneveldt (1590-1634), lord of Stoutenburg. Cavalry officer for Spain and the states-general. *Heer van Stoutenburg. Ritmeester in Spaanse en in Staatse dienst*

Panel sawed down to an oval 38.3 × 28.7. Dated *An° 1634*
PROV Sale M C van Hall, Amsterdam, 27 April 1858, lot 34
LIT Moes 1897-1905, vol 2, nr 5532:2

Holland school ca 1635

A 567 Portrait of a man. *Portret van een man*

Panel 18.5 × 15
PROV NM, 1808

Holland school 1637

A 1675 Willem Usselinx (1567-after 1647). Merchant and founder of the Dutch West India Company. *Koopman en stichter van de West Indische Compagnie*

Panel 17.5 × 14. Inscribed *W. Wsselinx, Auteur van Westindise Compangi. Æ Suae 69 A° 1637*
PROV Purchased from Fr Muller & Co, art dealers, Amsterdam, 1896
LIT Moes 1897-1905, vol 2, nr 8180. J C Mollema, Historia 10 (1945) p 149, fig 1

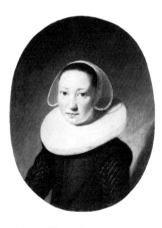

A 3299 Portrait of a young woman. *Portret van een jonge vrouw*

Panel 25 × 19. Oval. Signed and dated *P. [van G] ... 1637*
PROV Presented by Mr & Mrs D A J Kessler-Hülsmann, Kapelle op den Bosch near Mechelen, 1940

Holland school ca 1640

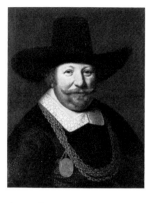

A 202 Joos van Trappen (1599-1647), called Banckers. Vice admiral of Zeeland. *Vice-admiraal van Zeeland*

Canvas 60 × 46
PROV Sale M C van Hall, Amsterdam, 27 April 1858, lot 53 (as a portrait of Piet Hein by Thomas de Keyser)
LIT C Hofstede de Groot, OH 17 (1899) p 168. R van Luttervelt, Bull NOB 6th ser 7 (1954) p 160

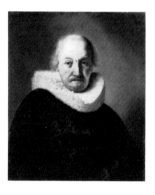

A 1248 Portrait of a man. *Portret van een man*

Copy?

Canvas 71.5 × 59.5
PROV Presented by J S R van de Poll, Arnhem, 1885

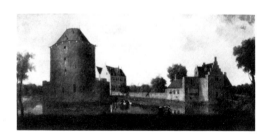

A 608 Teylingen Castle. *Het slot Teylingen*

Canvas 98 × 204
PROV NM, 1808 * On loan to the Rijksmuseum Muiderslot, Muiden, since 1947
LIT Moes & van Biema 1909, pp 39, 52, 105, 167, 220

Holland school 1641

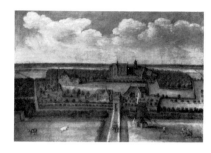

A 4483 The abbey of Leeuwenhorst in Rijnland. *De abdij Leeuwenhorst in Rijnland*

Canvas 73 × 106. Dated *1641*
PROV Presented by Mr van der Meer Jansen, Alem, 1880. NMGK

Holland school mid-17th century

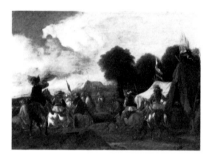

C 426 The army camp. *Het legerkamp*

Panel 35 × 48
PROV On loan from the city of Amsterdam since 1885
LIT Scheltema 1879, nr 157

Holland school ca 1650

C 289 Portrait of a man. *Portret van een man*

Panel 26 × 20
PROV On loan from the city of
Amsterdam (A van der Hoop bequest)
since 1885

Holland school 1656-57

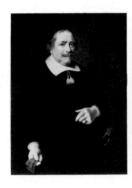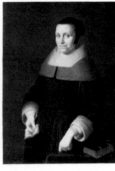

A 583 Portrait of a man, thought to be
Willem van de Velden (1600-63),
secretary of Hugo de Groot. *Portret van
een man, vermoedelijk Willem van de Velden,
secretaris van Hugo de Groot*

Pendant to A 584

Panel 99 × 74.5. Inscribed *Ætatis 57
AN° 1657*
PROV Sale Utrecht, 27 June 1825, lot
154 (as Jan Lievens or Gerbrandt van
den Eeckhout)
LIT Engraving by P Velijn, in Almanak
voor het Schoone en Goede, 1823, opp
p 48. Moes 1897-1905, vol 2, nr 8313.
Schneider 1932, nr LXXXVIII

A 584 Portrait of a woman, thought to be
Elsje van Houweningen (1601-81), wife
of Willem van de Velden. *Portret van een
vrouw, vermoedelijk Elsje van Houweningen,
echtgenote van Willem van de Velden*

Pendant to A 583

Panel 99 × 74.5. Inscribed *Ætatis 56
AN° 1656*
PROV Same as A 583
LIT Engraving by P Velijn, in Almanak
voor het Schoone en Goede, 1823, fron-
tispiece. Moes 1897-1905, vol 1, nr
3781:1. Schneider 1932, nr LXXXVIII

Holland school 1657

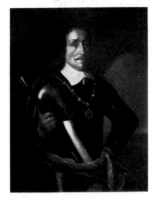

A 586 Witte Cornelisz de With (1599-
1658). Vice admiral of Holland and
West-Friesland. *Vice-admiraal van Holland
en West-Friesland*

Canvas 93 × 78.5. Inscribed on the verso
*Witte Cornelisz de With, vice-admiraal van
Holland en West-Friesland Gesneuveld 1658
Aetatis 57 Ao 1657*
PROV NM, 1808
LIT Moes 1897-1905, vol 2, nr 9157:4
(dated 1654). Moes & van Biema 1909, p
209

Holland school ca 1660

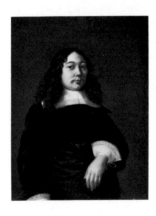

A 724 Wijnand Wijnands

Copper 20 × 15.7. Inscribed on the verso
Wynand Wynands
PROV Bequest of J S R van de Poll,
Arnhem, 1885
LIT Moes 1897-1905, vol 2, nr 9338

Holland school ca 1675

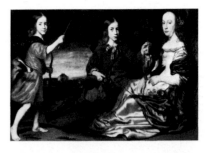

A 2869 Two boys dressed as hunters and
a girl in a landscape with a country
house in the background. *Twee jongens,
gekleed als jagers, en een meisje in een land-
schap met op de achtergrond een buitenhuis*

Canvas 108 × 165
PROV Helmond Castle. Acquired
through exchange with Jonkheer H Trip,
The Hague, 1921 * DRVK since 1953

Holland school ca 1680

A 2716 Allegory on the glory of
navigation? *Allegorie op de roem van de
scheepvaart?*

Canvas 250 × 380. Ceiling painting or
wall covering
PROV From Oudaen Castle on the
Vecht. Presented by the Misses J M E
and M E Willink van Collen, Breukelen,
1914 * On loan to the ministry of the
navy, 1914, since 1958 through the
DRVK

Holland school ca 1690

A 822 Diederik van Hogendorp (1625-

1702), lord of Cromstrijen. Councillor and treasurer of the domains of the stadholder-king William III. *Heer van Cromstrijen. Raad en rekenmeester der domeinen van de stadhouder-koning Willem III*

Pendant to A 821
For a portrait of the sitter's daughter, *see* A 827

Canvas 86 ×68
PROV Presented by Jonkheer J H F K van Swinderen, Groningen, 1884
LIT Moes 1897-1905, vol 1, nr 3595

A 821 Petronella Kettingh (d 1707). Wife of Diederik van Hogendorp. *Echtgenote van Diederik van Hogendorp*

Pendant to A 822

Canvas 86 ×68
PROV Same as A 822
LIT Moes 1897-1905, vol 1, nr 4148

A 824 François Leidecker (1651-88). Zeeland delegate to the treasury of the states-general. *Gedeputeerde ter Generaliteitsrekenkamer wegens Zeeland*

Pendant to A 827
For a portrait of the sitter's daughter, *see* Verheyden, Mattheus, A 815

Canvas 86 ×67.5. Inscribed on the verso *D'Heer Fransois Leydecker Gediputeert ter Generaliteits Rekenkamer Wegens de Provintie van Zeeland*
PROV Presented by Jonkheer J H F K van Swinderen, Groningen, 1884
LIT Moes 1897-1905, vol 2, nr 4468:2

A 827 Anna Maria van Hogendorp. Second wife of François Leidecker. *Tweede echtgenote van François Leidecker*

Pendant to A 824
For portraits of the sitter's parents, *see* A 822 & A 821

Canvas 86 ×67
PROV Same as A 824
LIT Moes 1897-1905, vol 1, nr 3593

A 2805 & A 2806 Two decorative paintings, each with three putti. *Twee decoratiestukken met elk drie putti*

Canvas 111 × 122.5 each. Grisaille
PROV Unknown * DRVK since 1953

Holland school late 17th century?

A 3296 Pleasure yacht and man-of-war. *Speeljacht en oorlogsschip*

Imitation in the manner of Jan van de Cappelle or Aelbert Cuyp

Panel 32 × 39. Falsely signed *A.Cuyp f.*
PROV Presented by Mr & Mrs D A J Kessler-Hülsmann, Kapelle op den Bosch near Mechelen, 1940

Holland school 18th century

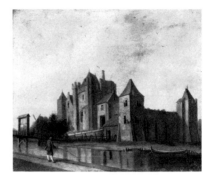

A 890 Purmerend Manor: front view. *Het Huis te Purmerend, voorzijde*

Canvas 40 ×47
PROV Presented by A J Enschedé, Haarlem, 1876. NMGK, 1885

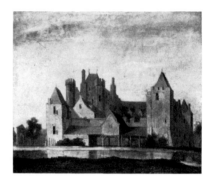

A 891 Purmerend Manor: rear view. *Het Huis te Purmerend, achterzijde*

Canvas 40 ×47. Inscribed *A° 1592*
PROV Same as A 890

Holland school 18th or 19th century

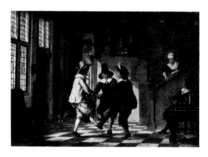

C 278 Three men in seventeenth-century costume dancing in the front hall of a house. *Drie mannen in zeventiende-eeuws kostuum dansend in een voorhuis*

Panel 36 ×52. Inscribed on the poor box beside the door *Gedenk den arme* and on the placard near the stairs *Waarschouwing*
PROV On loan from the city of Amsterdam (A van der Hoop bequest) since 1885

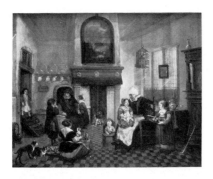

A 592 The feast of St Nicholas. *Sint Nicolaasfeest*

Canvas 58.5 × 75. Falsely signed
Rembrandt f 1636
PROV Bequest of L Dupper Wzn, Dordrecht, 1870

Holland school ca 1700

A 4655 Ceiling painting with the apotheosis of a ruler being brought by Mars and Minerva to Jupiter. *Plafond-stuk met de apotheose van een vorst, die door Mars en Minerva tot Jupiter wordt gevoerd*

Canvas 250 × 430. Oval
PROV Unknown. Thought to have been present in the collection by 1885; possibly identical with the ceiling mentioned by Obreen 1887, p 120, as being in hall 151

Holland school 1st quarter 18th century

A 2839 Landscape with playing putti and parrots. *Landschap met spelende putti en papegaaien*

Canvas 86 × 80. Mantel painting
PROV From the NMGK * DRVK since 1952

Holland school 1720

C 526 Hendrik Lijnslager (1693-1768). Naval captain in the service of the Amsterdam admiralty. *Kapitein ter zee bij de Admiraliteit van Amsterdam*

Canvas 55 × 44. Inscribed on the verso *Hendrik Lijnslager Captn ter zee onder het ressort van 't Eed.moog. Collegie ter Admiraliteit tot Amsterdam A° 1720, oud 27 jaaren*
PROV On loan from the KOG since 1889
LIT Moes 1897-1905, vol 2, nr 4707:1

Holland school ca 1730

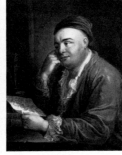

A 3219 A man with a drawing of flowers, the so-called portrait of Jacob Feitama Jr (1698-1774), Amsterdam merchant. *Een man met een tekening van bloemen, zogenaamd portret van Jacob Feitama Jr, koopman te Amsterdam*

Pendant to A 3220
see also Heraldic objects: A 3221

Canvas 80.5 × 66
PROV From the Rijksarchief (state archives), Haarlem, 1934

A 3220 A woman with a birdcage, the so-called portrait of Susanna van Collen (1692-1745), wife of Jacob Feitama from 1727 on. *Een vrouw met een vogelkooi, zogenaamd portret van Susanna van Collen, sedert 1727 echtgenote van Jacob Feitama*

Pendant to A 3219
see also Heraldic objects: A 3222

Canvas 80.5 × 66
PROV Same as A 3219 * DRVK since 1950

Holland school ca 1745

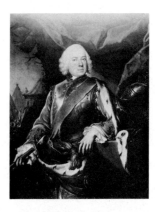

A 884 Willem IV (1711-51), prince of Orange-Nassau. *Prins van Oranje-Nassau*

Pendant to A 883

Canvas 127 × 102
PROV KKS, 1876. NMGK, 1885 * Lent to the provincial governor of Zeeland, Middelburg, 1924. Destroyed in the war, 1940
LIT Moes 1897-1905, vol 2, nr 9097:41?

NO PHOTOGRAPH AVAILABLE

A 883 Anne of Hanover (1709-59). Wife of Prince Willem IV, with her daughter Anna. *Anna van Hannover, echtgenote van prins Willem IV, met haar dochtertje Anna*

Pendant to A 884

Canvas 127 × 95
PROV Same as A 884 * Lent to the provincial governor of Zeeland, Middelburg, 1924. Destroyed in the war, 1940

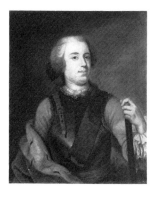

A 1797 Willem IV (1711-51), prince of Orange-Nassau. *Prins van Oranje-Nassau*

Canvas 82 × 69
PROV Presented by Count Leopold von Schlitz, 1899
LIT Moes 1897-1905, vol 2, nr 9097:42

Holland school mid-18th century

A 2686 Four putti carrying a basket of fruit. *Vier putti die een vruchtenmand dragen*

Pendant to A 2687

Canvas 86 × 98. Decorative painting
PROV From the Huygenshuis (house of Constantijn Huygens), Plein, The Hague, 1881. NMGK, 1913

A 2687 Four putti with grapes. *Vier putti met druiven*

Pendant to A 2686

Canvas 86 × 98. Decorative painting
PROV Same as A 2686

Holland school 4th quarter 18th century

A 1207, A 1208, A 1209 & A 1210 Four decorative paintings of flowers in a vase. *Vier decoratiestukken met bloemen in een vaas*

Canvas 137 × 80 each
PROV KKS, 1885 * DRVK since 1953

Holland school late 18th century

A 4281 Flowers in a vase. *Bloemen in een vaas*

Canvas 118 × 105. Square with scalloped sides. Dessus-de-porte? In damaged condition
PROV Unknown

Holland school ca 1850

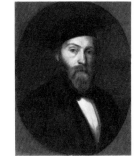

A 2861 Willem Frederik Wehmeyer (1819-54). Engraver. *Graveur*

Pendant to A 2862

Canvas 64.5 × 52
PROV Presented by H Boock, Amsterdam, 1921

A 2862 Anna Charlotte Koppelaar (b 1821). Wife of Willem Frederik Wehmeyer from 1850 on. *Sedert 1850 echtgenote van Willem Frederik Wehmeyer*

Pendant to A 2861

Canvas 64.5 × 52
PROV Same as A 2861

Zeeland school 1664

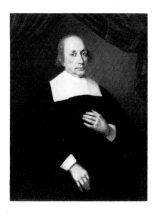

A 923 Cornelis Verheye (1601-82). Burgomaster and councillor of Zierikzee. *Burgemeester en raad van Zierikzee*

Canvas 115 × 85. Inscribed *Æ 63 A 1664*
PROV Bequest of Jonkheer J de Witte

van Citters, The Hague, 1876. NMGK,
1885 * DRVK since 1952
LIT Moes 1897-1905, vol 2, nr 8377

Zeeland school ca 1665

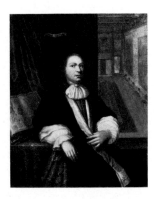

A 4124 Justus de Huybert (1610-82).
Secretary of the states and admiralty of
Zeeland. *Secretaris van de Staten en de
Admiraliteit van Zeeland*

Canvas 53 × 44
PROV Sale H J Broers, Utrecht, 8 March
1873, lot 3132
LIT Moes 1897-1905, vol 1, nr 3849

Zeeland school ca 1760

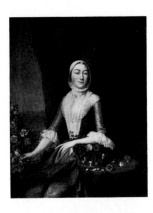

A 924 Magdalena van Citters (b 1737).
Wife of Adriaen Isaac Hurgronje.
Echtgenote van Adriaen Isaac Hurgronje

Canvas 60 × 47. On the verso her coat of
arms and those of her eight ancestors *van
Citters, Verheye, Parduyn, de Ionge van
Ellemet, Boudaan, Sandra, Hoeuft* and *Stipel*,
the inscription *vrouw Magdalena van
Citters Gebr te Middelb : 14 July 1737
Trouwt 4 Septembr 1760 dheer Mst
Adriaan Isaac Hurgronie Raad der stad
Vlissingen* and the number *53*
PROV Bequest of Jonkheer J de Witte van
Citters, The Hague, 1876. NMGK, 1885
LIT Moes 1897-1905, vol 1, nr 1546.
Attributed orally to Jan Appelius (active
1760-90 in Middelburg) by R E Ekkart

Local schools of the Northern Netherlands

Amsterdam school 1560

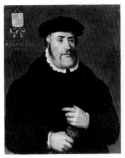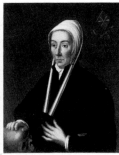

C 33 Pieter Gerritsz Bicker (1497-1567).
Soapmaker, mintmaster and alderman
of Amsterdam. *Zeepzieder, muntmeester en
schepen van Amsterdam*

Later copy
Pendant to C 34
Cf Heemskerck, Maerten van, A 3518

Canvas 74 × 61. Inscribed *Mr. Pieter
Bijcker. aetatis. LXIII. 1560*
PROV On loan from the city of
Amsterdam (Bicker bequest), 1881-1975
LIT Moes 1897-1905, vol 1, nr 654. J F L
de Balbian Verster, Mndbl Amstelo-
damum 17 (1930) p 100

C 34 Anna Codde (b 1504). Wife of
Pieter Bicker. *Echtgenote van Pieter Bicker*

Later copy
Pendant to C 33
Cf Heemskerck, Maerten van, A 3519

Canvas 74 × 61. Inscribed *out LVI iaer.
An. 1560*
PROV Same as C 33
LIT Moes 1897-1905, vol 1, nr 1604

Amsterdam school 1573

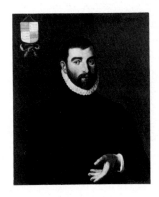

C 35 Pieter Pietersz Bicker (1532-85).
Amsterdam brewer. *Brouwer te Amsterdam*

Later copy
For portraits of the sitter's parents, *see*
Amsterdam school 1560, C 33-C 34

Canvas 74 × 61. Inscribed *Pieter Bijcker
Aetatis suae 41, 1573*. On the verso *Pieter
Bicker is getrouwd geweest met Lijsbeth
Banninck*
PROV On loan from the city of
Amsterdam (Bicker bequest), 1881-1975
LIT Moes 1897-1905, vol 1, nr 655

Amsterdam school 1583

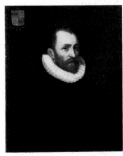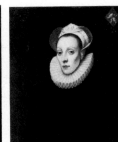

C 36 Gerrit Pietersz Bicker (1554-1604).
Amsterdam merchant and brewer, one
of the founders of the Compagnie van
Verre (overseas trade company) in 1594,
later a director of the Dutch East India
Company. *Koopman en brouwer te
Amsterdam, één der oprichters in 1594 van
Compagnie van Verre, later bewindhebber van
de Verenigde Oostindische Compagnie*

Pendant to C 37
For a portrait of the sitter's father, *see*
Amsterdam school 1573, C 35; for
portraits of the sitter's sons, *see* Helst,
Bartholomeus van der, A 146; Vaillant,
Wallerand, C 39, and Amsterdam
school 1654, C 38

Canvas 74 × 61. Inscribed *An. 1583 Aeta.
29*
PROV On loan from the city of
Amsterdam (Bicker bequest), 1881-1975

C 37 Alyda Boelens (1557-1630). Wife of
Gerrit Bicker. *Echtgenote van Gerrit Bicker*

Pendant to C 36

Canvas 74 × 61. Inscribed *An. 1583 Aeta
25*
PROV Same as C 36

Amsterdam school 1593

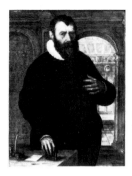 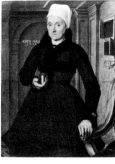

A 1984 Bartholomeus van der Wiere (1534-1603). Pensionary of Amsterdam in 1578. *Pensionaris van Amsterdam in 1578*

Pendant to A 1985

Panel 107 ×82. Inscribed *Aetatis: suae 59: 1593; * on the letter *Eersamen seer dicreten … Tot Amsterdam. Actum 1593*
PROV Purchased from F Kleinberger gallery, Paris, 1902 * On loan to the AHM since 1972
LIT De Vries 1934, p 75, fig 29 (closely related to Pieter and Aert Pietersz)

A 1985 Lysbeth Hendriksdr (1536-after 1603). Wife of Bartholomeus van der Wiere. *Echtgenote van Bartholomeus van der Wiere*

Pendant to A 1984

Panel 107 ×82. Inscribed *Aetatis Suae 55 1593*
PROV Same as A 1984 * On loan to the AHM since 1972
LIT De Vries 1934, p 75, fig 30 (closely related to Pieter and Aert Pietersz)

Amsterdam school 1606

C 387 An arquebusiers' civic guard company, thought to be the company of Captain Albert Joncheyn (Jonkhein),

Amsterdam, 1606. *Een schutterstuk, vermoedelijk het korporaalschap van kapitein Albert Joncheyn, Amsterdam, 1606*

Scheltema 1855-85 (see LIT) identifies this as a painting mentioned by Gerard Schaep in 1653

Canvas 186 ×362
PROV Kloveniersdoelen (headquarters of the arquebusiers' civic guard), Amsterdam. On loan from the city of Amsterdam, 1885-1975
LIT Scheltema 1879, nr 77 (Paulus Moreelse). Scheltema 1855-85, vol 7, p 138, nr 28. J Six, OH 5 (1887) pp 10-12 (Cornelis van der Voort). W del Court & J Six, OH 21 (1903) pp 78-79. Riegl 1931, pp 158-60, fig 42 (not van der Voort, possibly Tengnagel). RBF van der Sloot, NKJ 10 (1959) p 114

Amsterdam school ca 1645

A 588 Portrait of a woman, said to be Theodora de Visscher (1641-1722), wife of Jacob Rijswijk. *Portret van een vrouw, zogenaamd Theodora de Visscher, echtgenote van Jacob Rijswijk*

For a portrait of the sitter's husband, *see* Amsterdam school ca 1670, A 635

Panel 73 ×60.5. Inscribed on the verso

Theodora de Visscher huysvrouw van Jaques Rijswijck, dogter van Abraham de Visscher en Magteldt Bas
PROV Bequest of Mrs J Balguerie-van Rijswijk, widow of D Balguerie, Amsterdam, 1823
LIT Moes 1897-1905, vol 2, nr 8559

Amsterdam school ca 1650

C 42 Johan Bernard Schaep (1633-66). Councillor of the admiralty in the northern district (1661-66), alderman of Amsterdam (1659). *Raad der Admiraliteit in het Noorderkwartier, schepen van Amsterdam*

Iron 10.5 ×8.5. Oval.
PROV On loan from the city of Amsterdam (Bicker bequest), 1881-1975
LIT Moes 1897-1905, vol 2, nr 6825:2

Amsterdam school 1654

C 38 Cornelis Bicker (1592-1654), lord of Swieten. Merchant and burgomaster of Amsterdam. *Heer van Swieten. Koopman en burgemeester van Amsterdam*

For portraits of the sitter's parents, *see* Amsterdam school 1583, C 36 & C 37

Canvas 74 ×61. Inscribed *Corn. Bicker H.V. Swieten 1654*

PROV On loan from the city of
Amsterdam (Bicker bequest), 1881-1975
LIT Blok 1897, vol 1, p 69, ill. Moes 1897-
1905, vol 1, nr 633:2. Von Moltke 1965,
p 105, nr 196 (weak painting by Govert
Flinck)

Amsterdam school 1655

C 1172 Jacob de Vogelaer (1625-97),
secretary of Amsterdam, and his clerk.
Secretaris van Amsterdam, met zijn klerk

Canvas 64.5 × 54. Dated *1655*
PROV On loan from the city of
Amsterdam, 1925-75
LIT Moes 1897-1905, vol 2, nr 8633

Amsterdam school ca 1670

A 635 Jacob Rijswijk (1641-96)

Panel 74 × 60. Inscribed on the verso
*Jaques Ryswijck zoon van Pieter Ryswyck en
Tryntje jacobse van Dijk geb. 28 maart 1641
obiit 15 May 1696 begraaven in de Oude
Kerk May 21. 1696. getrouwt 2 Nov. 1666
aan Theodora de Visscher dogter van
abraham de Visscher en Magtelt Bas. was
commississaris der stad Amsterdam. Capiteyn
der Burgerije & Regent van 't Tugthuijs 1666
alwaar ook is uytgeschildert staande in regents
kleederen. vader en moeder van Dirk of
theodorus Ryswyck scheepen tot Amsterdam
1722*

PROV Bequest of Mrs J Balguerie-van
Rijswijk, widow of D Balguerie,
Amsterdam, 1823

Amsterdam school ca 1726

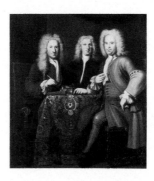

C 418 Three regents of the lepers'
asylum. *Drie regenten van het leprozenhuis*

Canvas 174 × 158
PROV Leprozenhuis (lepers' asylum),
Amsterdam. On loan from the city of
Amsterdam, 1885-1975
LIT Scheltema 1879, nr 143. Haak 1972,
p 51

Amsterdam school 2d half 18th century

C 1562 The Brouwersgracht,
Amsterdam. *De Brouwersgracht te
Amsterdam*

Canvas on panel 19.5 × 30.5
PROV On loan from the KOG since 1973

Amsterdam school ca 1775

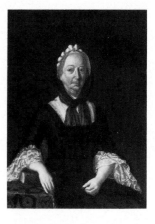

C 41 Johanna Sara Pels (1702-91). Wife
of the Amsterdam merchant and banker
Jan Bernd Bicker. *Echtgenote van de
Amsterdamse koopman en bankier Jan Bernd
Bicker*

Canvas 89 × 66. Inscribed on the verso
*Johanna Sara Pels, dochter van Andries Pels
en Agneta Bouwens, get: 6 Nov: 1720 met
Mr. Jan Bernd Bicker* and [… Jan Bernd
Bicker] *geb. 12 Aug. 1695, overl. 1 Nov.
1750, Thesaurier, schepen te Amsterdam,
Drost van Muiden, Baljuw van Gooijland.
Zij was dochter van Andries Pels en Agneta
Bouwens*
PROV On loan from the city of
Amsterdam (Bicker bequest), 1881-1975
LIT Moes 1897-1905, vol 2, nr 5836

Amsterdam school mid-19th century

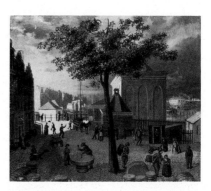

C 1545 The Slijpsteenmarkt (whetstone
market) and the Zeerecht building,
Amsterdam. *De Slijpsteenmarkt met het
gebouw 'Het Zeerecht' te Amsterdam*

Panel 15 × 18
PROV On loan from the KOG (presented
by W L J Bos, 1878) since 1973

Amsterdam school ca 1875

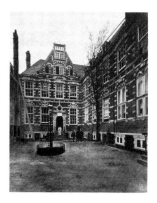

C 1576 Courtyard of East India House, Amsterdam. *Binnenplaats van het Oost Indisch Huis te Amsterdam*

Panel 43 ×34
PROV On loan from the KOG (presented by J van Eik Jz, 1893) since 1973

Dordrecht school ca 1455

A 3926 Geertruy Haeck-van Slingelandt van der Tempel kneeling in prayer before St Agnes. *Geertruy Haeck-van Slingelandt van der Tempel knielt in gebed voor de heilige Agnes*

Panel 62.8 ×48.3. Inscribed *sancta agneta ora pro me* and on the flagstones the letters *A*, *M* and *R* (Agnes Martyra Romana?)
PROV Purchased from A Kauffmann gallery, London, 1957
LIT Exhib cat Middeleeuwse kunst der Noordelijke Nederlanden, Amsterdam 1958, nr 5, fig 2. K Strauss, Keramik-Freunde, Dec 1972, p 23, pl 4, fig 2

Haarlem school? ca 1660

A 4017 Female figure, perhaps Erminia, from Torquato Tasso, La Gerusalemme Liberata. *Vrouwenfiguur, misschien Erminia uit Torquato Tasso, La Gerusalemme Liberata*

Panel 74.5 ×55
PROV From the V Bloch collection, The Hague. Transferred by the DRVK in 1960

Leiden school ca 1515

A 1483 Christ with the crown of thorns. *Christus met doornenkroon*

Pendant to A 1484

Panel 26.5 ×21.5. Signed and dated apocryphally *AD 1511*
PROV Sale Amsterdam, 4 Dec 1888, lot 25 (as Albrecht Dürer)

A 1484 The Virgin Mary. *De maagd Maria*

Pendant to A 1483

Panel 26.5 ×21.5
PROV Same as A 1483

Leiden school ca 1630

A 2365 Still life with the skulls of suckling pigs. *Stilleven met speenvarken-schedeltjes*

Panel 27 ×53
PROV Sale Mrs Lemker-Muller, widow of F Lemker, Kampen, 7 July 1908, lot 42 (as Pieter Potter)
LIT Vorenkamp 1933, pp 91, 101 (Gabriel Metsu or David Bailly). Martin 1935-36, vol 1, p 452, note 573 (milieu of Bailly). Exhib cat IJdelheid der IJdelheden, Leiden 1970, nr 38, ill (Pieter Potter?)

Nijmegen school ca 1483

A 2545 Balthasar, one of the three magi, with a servant. *Balthasar, één van de drie koningen, met een bediende*

Belongs with A 2546

Panel 40 ×24. Fragment of an altarpiece
PROV Lent by C Hoogendijk, The Hague, 1907. Presented from his estate in 1912 * DRVK since 1959 (on loan to the Gemeentemuseum, Arnhem)
LIT R Bangel, Cicerone 7 (1915) p 171 (lower Rhenish, ca 1480). G de Werd & G Lemmens, Numaga 17 (1970) p 119, fig 5

A 2546 Caspar or Melchior, one of the three magi. *Caspar of Melchior, één van de drie koningen*

Belongs with A 2545

Panel 26.5 × 21. Fragment of an altar-piece
PROV Same as A 2545 * DRVK since 1959 (on loan to the Gemeentemuseum, Arnhem)
LIT R Bangel, Cicerone 7 (1915) p 171 (lower Rhenish, ca 1480). G de Werd & G Lemmens, Numaga 17 (1970) p 119, fig 6

Utrecht school ca 1435

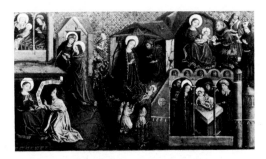

A 2649 Triptych with scenes from the life of the Virgin. *Drieluik met taferelen uit het leven van Maria*

Left wing: Joachim with his herd; the rejection of Joachim's sacrifice; the annunciation to St Anne; the meeting at the Golden Gate. Central panel: the birth of the Virgin; the annunciation; the visitation; the nativity; the adoration of the magi; the circumcision. Right wing: Jesus in the Temple; the death of the Virgin. Versos of the wings: eight scenes from the passion of Christ

Panel 84 × 152 (middle panel); 84 × 61 (each of the wings)
PROV Sale Amsterdam, 4 Dec 1912, lot 207 * On loan to the Rijksmuseum Twenthe, Enschede, since 1930
LIT Friedländer 1924-37, vol 3 (1925) pp 63, 113, nr 40 (ca 1450). Dülberg 1929, p 76. Hoogewerff 1936-47, vol 1, pp 411-16, 587, figs 206-10 (ca 1430-35, Utrecht province or the east of Holland; cf the Amoz Master)

Utrecht school ca 1460

A 1408 Triptych with the crucifixion. *Drieluik met de kruisiging*

Left wing: the mass of St Gregory. Right wing: St Christopher. Versos of the wings: the annunciation

Panel 73 × 48 (middle panel); 73 × 20 (each of the wings)
PROV Sale J H Cremer, Amsterdam, 21 June 1887, lot 34 * On loan to the Centraal Museum, Utrecht, from 1924 to 1942 and from 1946 on, since 1959 through the DRVK
LIT F Winkler, Jb Preusz Kunstsamml 44 (1923) p 139, fig 2 (Master of Gijsbrecht van Brederode?; ca 1475). Winkler 1924, p 155, fig 94. Friedländer 1924-37, vol 3 (1925) p 112, nr 38. Dülberg 1929, p 76. A W Bijvanck, Oudh Jb 10 (1930) p 137, fig 40 (1460-65, presumably the Master of Soudenbalch). Smits 1933, p 119, fig 48. Hoogewerff 1936-47, vol 1, pp 564-71, figs 321-23 (Master Zeno in collaboration with Master Zenobius). J Por, OH 54 (1937) p 36, ill. L W J Delaissé, Scriptorium 3 (1950) p 230. Panofsky 1953, p 323, fig 437. Exhib cat Middeleeuwse kunst der Noordelijke Nederlanden, Amsterdam 1958, nr 7. K G Boon, OH 76 (1961) pp 51-60, fig 4 (Master of the Buurkerk Tree of Jesse, ca 1460-65). D G Carter, Bull Rhode Island 48 (1962) p 11ff, ill (ca 1457-67, the Soudenbalch group). A de Bosque, Arch Esp Arte & Arq 185 (1974) p 6, fig 5

Utrecht school ca 1520

A 513 Pope Hadrian VI (1459-1523). *Paus Adrianus VI*

Later copy

Canvas 78.5 × 65
PROV NM, 1808 * DRVK since 1960 (on loan to the Centraal Museum, Utrecht) LIT Moes 1897-1905, vol 1, nr 28:8. GJ Hoogewerff, Med Ned Hist Inst Rome 3 (1923) p 16. Friedländer 1924-37, vol 12 (1935) p 204, nr 350. F Schmidt-Degener, Burl Mag 101 (1939) p 234, fig c. Hoogewerff 1936-47, vol 4 (1941-42) p 62, note 1 (copy after Jan van Scorel). Exhib cat Paus Adrianus VI, Utrecht & Louvain 1959, nr 357

Utrecht school mid-16th century

A 4485 Memorial tablet of Lubbert Bolle (d 1398). *Memorietafel voor Lubbert Bolle*

Panel 74.5 × 51. Inscribed *Hier leit begraven Mr Lubbert Bol die Domdekn t' Utrecht was ende werde priester van der Duytschen Oerden ende stirf int iaer ons Herē MCCCXCVIII op alre zielē dach. Bit voer D. zyl*
PROV Submitted by the provincial archivist of Utrecht, 1874. NMGK

Utrecht school 2d half 16th century

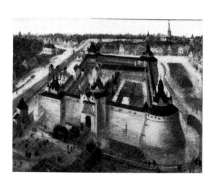

A 1728 Bird's-eye view of Vredenburch Castle, Utrecht. *Het kasteel Vredenburch te Utrecht in vogelvlucht*

Panel 39 × 50
PROV Sale J Zürcher, Amsterdam, 1 March 1898, lot 26

Utrecht school 1554

A 4486 Triptych with the stoning of St Stephen and the legend of the discovery of his tomb. *Drieluik met de steniging van Stephanus en de legende van het vinden van zijn graf*

Left wing: Noli me tangere. Right wing: St Maria Aegyptiaca receiving communion in the wilderness

Panel 59 × 73 (middle panel); 59 × 39

(fixed wings). In the original architectonic frame. Inscribed on the frame (on the frieze) *Huius altaris dedicatio altera pasche celebrabitur*; (on the basement) *Altare p̄ns ā° 1532 cōsecratū ī laudē Dei ōīpotētis eīque genitricis Marie V̄ginis, ac scōr Stephani, Mā Maḡ, Mā Egiptiace, ōīmque scōr, suo Arnesī a Scayck Canōic hoc decoravit epithaphio ā° 1554*
PROV Sint Pieterskerk (church of St Peter), Utrecht, 1875. NMGK * DRVK since 1971
LIT GJ Hoogewerff, Oudh Jb 3 (1923) p 28ff, ill. CH de Jonge, OH 50 (1933) pp 159-67, figs 1-3 (possibly by Ernst II van Schayck). Hoogewerff 1936-47, vol 4 (1941-42) p 202 (perhaps Everardus van Schayck). Jb Oud Utrecht 43 (1970) p 79, ill

Southern Netherlands school 2d half 15th century

A 3836 Charles the Bold (1433-77), duke of Burgundy. *Karel de Stoute, hertog van Bourgondië*

Pendant to A 3835

Panel 31 cm in diam. Inscribed *Autre Navray*
PROV Presented by G Wildenstein gallery, New York, 1952

A 3835 Philip the Good (1419-69), duke of Burgundy. *Philips de Goede, hertog van Bourgondië*

Pendant to A 3836

Panel 31 cm in diam. Inscribed *Ie Lay Emprins*
PROV Same as A 3836

Southern Netherlands school? 16th century?

A 4184 Pharaoh's daughter discovers Moses in the rush basket. *Farao's dochter vindt Mozes in het biezen mandje*

Panel 48 × 63.5
PROV Unknown

A 4185 The adoration of the magi. *De aanbidding der koningen*

Panel 47.5 × 63
PROV Unknown

A 4186 The adoration of the shepherds. *De aanbidding der herders*

Panel 47.5 × 63
PROV Unknown

Southern Netherlands school ca 1500

A 2552 Madonna and child. *Maria met kind*

Panel 37 × 28.5
PROV Lent by C Hoogendijk, The Hague, 1907. Presented from his estate in 1912
LIT R Bangel, Cicerone 7 (1915) p 172. Winkler 1924, p 85 (copy after Rogier van der Weyden). Friedländer 1924-37, vol 2 (1924) p 131, nr 108n (ca 1500).

Cf M J Friedländer, OH 61 (1946) pp 11-12. D de Vos, Jb Berliner Museen 13 (1971) pp 139-40 (Bruges, ca 1500)

Southern Netherlands school ca 1530

A 2591 The entombment. *Graflegging*

Panel 89 × 87
PROV Lent by C Hoogendijk, The Hague, 1907. Presented from his estate in 1912

Southern Netherlands school ca 1535-40

A 167 Portrait of a young minister. *Portret van een jonge geestelijke*

Panel 42.5 × 31
PROV Purchased with the Kabinet van Heteren Gevers, The Hague-Rotterdam, 1809 (as a portrait of Robert Sidney by Hans Holbein II) * On loan to the KKS (cat 1968, p 12, nr 881 [Bruges school]) since 1948
LIT Moes & van Biema 1909, pp 145, 147, 160. Ring 1913, pp 57, 88, 91. Winkler 1924, p 290. Bille 1961, vol 1, p 110

Southern Netherlands school 1557

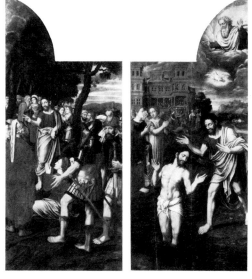

A 2587 Triptych with scenes from the life of St John the Baptist. *Drieluik met taferelen uit het leven van Johannes de Doper*

Left wing: The preaching of St John the Baptist. Central panel: St John pointing Christ out to the Pharisees. Right wing:

The baptism. Versos of the wings: St John the Baptist (left) and St Barbara with the donor Berbel van der Noot (right)

Panel 194 × 192 (middle panel); 194 × 87 (each of the wings). Inscribed on the versos of the wings *Dese tafel heeft doē maekē ioffrou Berbel vāder Noot en Relegiose i es clooster v̄a grootē Bijgaerdē Aō XVCLVII*
PROV Lent by C Hoogendijk, The Hague, 1907. Presented from his estate in 1912

Southern Netherlands school ca 1560

C 508 Arma Christi

Panel 59 × 46. Inscribed on the frame *Non est aliud nomen sub caelo datum hominibus In quo oporteat nos salvos fieri. Act 4 capite*
PROV On loan from the KOG since 1889

A 4487 Moses showing the tables of the law with the ten commandments in calligraphy. *De Tafelen der Wet met de tien geboden in schoonschrift getoond door Mozes*

Panel 112 × 68. Inscribed on the frame *Siet toe ende hoort alle deese woorden die ick*

U ghebiede op dat het U wel ghae ende Uwen kinderen naer U eewiglijck. Deut. XII. XXVIII
PROV Sale Amsterdam, 19-20 Feb 1889, lot 102. NMGK

Southern Netherlands school 1561

A 4488 The Gertz memorial tablet. *De Gertz memorietafel*

Triptych with the deposition (middle

panel), with portraits of Willem Gertz and his sons presented by St John the Evangelist (left wing); and his wife Styntgen Dirck Claesgens and her daughters presented by the Madonna and child (right wing). On the versos of the wings are Sts Peter (left) and Mary Magdalene (right) in grisaille.
The deposition is a copy after a lost original by Hugo van der Goes (ca 1440-82); *cf* Friedländer (see LIT)

Panel 84 × 105 (middle panel); 86 × 46 (each of the wings). Dated on the verso of the wings *1561*. Inscribed on the original frame *Hier legghen begraven willem gertz die starf āno m cccc eñ xxxxiiii den xiii marcij stijntgen dirck claessens starf anno xxxi den vi septembris maria willemz starf āno xxxviii den v aprilis anna willemz starf āno xxxvii den xiiii septēbris. bidt voer die zielen*
PROV Purchased from the estate of J Bosboom, The Hague, 1892. NMGK
LIT Destrée 1914, pp 47-48 (1543-48). Friedländer 1924-37, vol 4 (1926) pp 67, 130, nr 23f. K Goossens, Jb Mus Antwerpen, 1964, p 145ff. C Eisler, Bull Mus.Roy Belg 16 (1967) p 65, figs 11-12

Southern Netherlands school 1565

A 4071 Antoine Perrenot (1517-86). Cardinal de Granvelle, minister of Charles V and Philip II. *Kardinaal van Granvelle, minister van Karel V en Philips II*

Panel 57.5 × 35.6. Dated *1565*
PROV Purchased from L Reis-Santos, Coimbra (Portugal), 1962

Southern Netherlands school ca 1570

A 3851 Viglius ab Zuychem (1507-77). Frisian jurist, chairman of the blood council and member of the council of state. *Fries rechtsgeleerde, voorzitter van de Geheime Raad en lid van de Raad van State*

Panel 56 × 45. Inscribed *Natus 1507. Denatus 1577. Vita mortalium vigilia*
PROV Purchased from A J Rehorst, Berkenwoude, 1953
LIT E Dhanens, Bull Mus Roy Belg 14 (1964) p 197. E H Waterbolk, Spiegel Hist 3 (1968) p 206, fig 10

C 1579 Christ blessing the children. *Christus zegent de kinderen*

Panel 62 × 52
PROV On loan from the KOG since 1974 (in damaged condition)

Southern Netherlands school 1575

A 904 Guilliam Courten (b 1540). Husband of Margarita Cassier. *Echtgenoot van Margarita Cassier*

For a portrait of the sitter's wife, *see* Northern Netherlands school 1616, A 905

Panel 46 × 34. Inscribed *Aeta. 35. 1575.* and *WCH* (monogram of the sitter). On the verso his coat of arms, the inscription *Den 2 Marcij in meenen 1567 dacht ducdalve Ghuilliame Courten te beroven zijn leven. Maer godt heeft den 29 Marcij 1567 door sijn huijsvroue Marghueriete Cassier: Victorie ghegheven* and the number *20*
PROV Bequest of Jonkheer J de Witte van Citters, The Hague, 1876. NMGK, 1885

Southern Netherlands school? ca 1575

A 1287 Tarquinius and Lucretia. *Tarquinius en Lucretia*

Pendant to A 1288

Panel 104.5 × 160
PROV Sale P VerLoren van Themaat, Amsterdam, 30 Oct 1885, lot 31 (as Cornelis Engelbertsz)
LIT E de Jongh, Simiolus 3 (1968-69) pp 45, 47, note 52 (follower of Vincent Sellaer)

A 1288 Joseph and Potiphar's wife. *Jozef en de vrouw van Potifar*

Pendant to A 1287

Panel 104.5 × 160
PROV Sale P VerLoren van Themaat, Amsterdam, 30 Oct 1885, lot 32 (as Cornelis Engelbertsz)

Southern Netherlands school ca 1580

A 4465 Allegory on falsehood. *Allegorie op de kuiperij*

Panel 20.5 cm in diam. Dinner plate. Inscribed along the rim *Ick ete op een tonne 't en baet geen nijghen. Ghij en sult uwen voet niet onder de tafel crijgen*
PROV NMGK, 1881

A 4466 The toothpuller. *De tandetrekker*

Panel 16 cm in diam. Dinner plate. Inscribed along the rim *Is. dat. tant.wt.al. lachende.t | is.de.plage. ick.en.schreyde.noyt. soo.seer.van.alle.mijn.daghe.vroet.*
PROV Sale Amsterdam, 10 Nov 1896

A 4467 The impotent fisherman. *De impotente visser*

Panel 16 cm in diam. Dinner plate. Inscribed along the rim *Waey.visser.in.u. vissche.en.heb.ick.gee.vreucht.sit.want.u. engelroey.is.slap.en.u.aes.e.deucht.niet.*
PROV Sale Amsterdam, 10 Nov 1896

Southern Netherlands school 17th century

NO PHOTOGRAPH AVAILABLE

A 4651 St Theresa inflamed with love for Jesus. *De heilige Theresa in liefde ontstoken voor Jezus*

To the left are Joseph and the Virgin

Copper 16.5 × 13.5
PROV From the convent of Mariënwater in Koudewater near 's-Hertogenbosch. Purchased from the Brigittine convent, Uden, 1875. NMGK. Missing

Southern Netherlands school? 17th century

A 3353 The apostle Paul. *De apostel Paulus*

Canvas 65 × 51.5
PROV Presented by Mr & Mrs D A J Kessler-Hülsmann, Kapelle op den Bosch near Mechelen, 1940

Southern Netherlands school 1st half 17th century

A 622 Two playing children. *Twee spelende kinderen*

Canvas 41 × 34
PROV Unknown

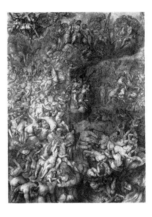

C 1484 The last judgment. *Het laatste oordeel*

Paper on canvas 83 × 62. Grisaille
PROV On loan from the DRVK since 1970

Southern Netherlands school ca 1600

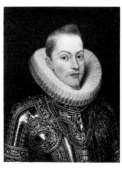

A 507 Philip III (1578-1621), king of Spain. *Philips III, koning van Spanje*

Pendant to A 508

Copper 28.5 × 22.5
PROV Purchased from Ch H Hodges, The Hague, 1829

A 508 Margaret of Austria (1584-1611). Wife of Philip III. *Margaretha van Oostenrijk. Echtgenote van Philips III*

Pendant to A 507

Copper 28.5 × 22.5
PROV Same as A 507

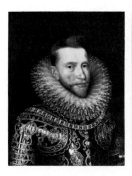 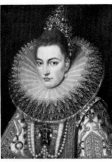

A 509 Albert of Habsburg (1559-1621), archduke of Austria. *Albertus van Habsburg, aartshertog van Oostenrijk*

Pendant to A 510

Copper 28.5 × 22.5
PROV Same as A 507

A 510 Isabella Clara Eugenia of Habsburg (1566-1633). Wife of arch-duke Albert of Austria. *Echtgenote van aartshertog Albertus van Oostenrijk*

Pendant to A 509

Copper 28.5 × 22.5
PROV Same as A 507
LIT G Glück, Jb Kunsth Samml Wien ns 7 (1933) p 183

Southern Netherlands school? ca 1600?

A 1221 The death of St Cecilia. *De dood van de heilige Cecilia*

Schist 44 × 35
PROV KKS, 1885

Southern Netherlands school ca 1607

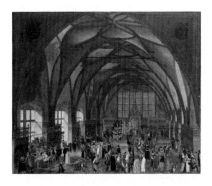

A 740 The great hall in the Hradschin in Prague. *De grote zaal in het Hradschin te Praag*

After Aegidius Sadeler's print of 1607

Panel 66 × 76.5
PROV Sale C J G Copes van Hasselt, Amsterdam, 20 April 1880, lot 43 (as Peter Neeffs)

Southern Netherlands school ca 1615

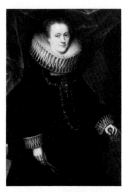

A 2864 Portrait of a woman. *Portret van een vrouw*

Thought to be a pendant to A 2865

Canvas 108 × 73
PROV Helmond Castle. Acquired through exchange with Jonkheer H Trip, The Hague, 1921 * DRVK since 1953

A 2865 Portrait of a woman. *Portret van een vrouw*

Thought to be a pendant to A 2864

Canvas 108 × 73
PROV Same as A 2864 * DRVK since 1953

Southern Netherlands school ca 1640

A 2575 Farmyard. *Boerenerf*

Panel 32 × 45.5. Falsely (?) signed *DT*
PROV Lent by C Hoogendijk, The Hague, 1907. Presented from his estate in 1912
LIT R Bangel, Cicerone 7 (1915) p 186, fig 10 (school of David Teniers). Böhmer 1940, pp 118-19, fig 50 (doubts attribution to Charles de Hooch)

Southern Netherlands school 2d quarter 17th century

A 3027 The apotheosis of commerce and science. *Verheerlijking van handel en wetenschap*

Canvas 70 × 92
PROV Bequest of S van der Horst, Haarlem, 1925 * DRVK since 1953
LIT J van Lennep, Revue belge d'Arch & d'Hist de l'Art 35 (1966) p 153, note 1. A P de Mirimonde, GdB-A III (1969) p 351, fig 19

Southern Netherlands school? 2d quarter 17th century?

A 947 An old man. *Een oude man*

Panel 16 × 12
PROV Purchased from the collection of
Jonkheer J E van Heemskerck van
Beest, 1877. NMGK, 1885

**Southern Netherlands school 2d
half 17th century**

A 4021 Allegorical female figure with
two putti. *Allegorische vrouwenfiguur met
twee putti*

Panel 24 × 30.3
PROV Goudstikker-Miedl gallery,
Amsterdam. Lent by the SNK, later
DRVK. Transferred in 1960

Southern Netherlands school ca 1655

A 80 Birds fighting. *Vechtende vogels*

Canvas 127 × 158
PROV NM, 1808
LIT C Hofstede de Groot, OH 17 (1899) p
165

Southern Netherlands school ca 1680

A 2096 Company in a wooded land-
scape. *Gezelschap in een boomrijk landschap*

Canvas 88 × 107
PROV Bequest of A A des Tombe, The
Hague, 1903

**Southern Netherlands school late
17th century**

A 962a Christ on the cross. *Christus aan
het kruis*

Thought to be a copy. Acquired as the
middle panel to two old wings (Master
of the Legend of Mary Magdalene,
A 962b, and Pourbus, Pieter, A 962c)

Canvas 104 × 86
PROV Sale B Th Baron van Heemstra
van Froma en Eibersburen, The Hague,
16 Feb 1880, lot 2. NMGK, 1885

Brabant school 2d half 15th century

A 2800 The mass of St Gregory. *De mis
van de heilige Gregorius*

Panel 58.5 × 54
PROV From the convent of Mariënwater
in Koudewater near 's-Hertogenbosch.
Purchased from the Brigittine convent,
Uden, 1875. NMGK, 1916 * DRVK since
1973 (on loan to the Museum voor
Religieuze Kunst, Uden)

**Antwerp school 1st half 17th
century**

ILLUSTRATED ON PAGE 694

NM 1014 Painted cabinet decorated
with scenes from the life of the Virgin.
*Kunstkastje beschilderd met taferelen uit het
leven van Maria*

The visitation, Jesus and the infant John
the Baptist, the holy family in the
carpenter's shop, the annunciation (left
drawers); Christ appearing to the Virgin,
the mystic marriage of St Catherine, the
Virgin with her parents Joachim and St
Anne, the presentation of the Virgin in
the temple (right drawers); the flight
into Egypt (lid); the coronation of the
Virgin, Mary and Joseph with Jesus on
the way to the temple (middle drawers);
Madonna and child enthroned (middle
door); the adoration of the shepherds
(left outer door); the adoration of the
magi (right outer door)

Panel 4.7 × 14.5 (left and right drawers);
17.6 × 41.8 (lid); 4.7 × 14.8 (middle
drawers); 8.8 × 8.7 (middle door);
26 × 19.8 (outer doors)
PROV Purchased with the Lupus
collection, Brussels, 1819. Received in
1823. KKZ, 1875. Belongs to the
department of sculpture and applied
arts
LIT Cat RMA Meubelen, 1952, nr 137

NM 1014

Antwerp school? ca 1650

RBK 16434 Painted cabinet decorated with scenes from the Old Testament.
Kunstkastje beschilderd met taferelen uit het Oude Testament

Aaron in the tabernacle (fronton); Judah and Tamar, the death of the firstborn, Joshua's spies, Rebecca and Eliezer (left drawers); Balaam and the ass, David and Abigail, the discovery of Moses, Esau selling his birthright (right drawers); Lot and his daughters, Moses and the burning bush, Hagar and Ishmael, unidentified subject (lower drawers); Moses receiving the tables of the law (upper oval); the adoration of the golden calf, the bronze serpent (doors); Noah's prayer after the deluge, Noah sees the rainbow (panels under the doors); Adam, Eve and Seth?, Abraham and Lot on the mountain, Cain and Abel (lowermost panels)

Marble 18.8 × 10.8 (fronton); 6.5 × 21.3, 7.5 × 21, 6.8 × 21, 7.3 × 21 (left drawers); 7 × 21 (all the right drawers); 5.4 × 18.8 (lower drawers); 5.7 × 13.9 (upper oval); 22.7 × 13 (doors); 6.1 × 13.7 (panels under the doors); 4.2 × 15.8, 4.8 × 15.9, 3.9 × 15.6 (lowermost panels)
PROV Sale A J Olthoff, Hilversum, 7-13 Feb 1950, lot 505. Belongs to the department of sculpture and applied arts
LIT Cat RMA Meubelen, 1952, nr 140

Illustrations continued on page 696

Bruges school ca 1450-70

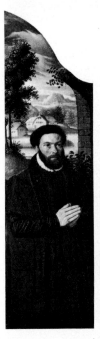

A 2851 The tower of Babel. *De toren van Babel*

Panel 19.7 × 17
PROV Purchased from N Beets gallery, Amsterdam, 1921 * On loan to the KKS (cat 1968, vol 1, p 12, nr 784, ill) since 1924
LIT P Wescher, Art Q 9 (1946) p 190. F Winkler, Festschrift Redslob, 1954, pp 91-95, ill (milieu of Hubert van Eyck?, 1400-50). Minkowski 1960, p 49, fig 138 (ca 1520)

Bruges school 1584

A 1668 Two wings of a triptych: portraits of Julien de Brouckere (d 1603) and his wife Elisabeth Canneel. *Twee vleugels van een drieluik met de portretten van Julien de Brouckere en zijn vrouw Elisabeth Canneel*

On the versos their coat of arms

Panels 83 × 25.5 each. Dated on the versos *Anno 1584*
PROV Purchased in 1894 through the intermediacy of the Rembrandt Society
LIT J Th E Canneel, OH 25 (1907) pp 61-63, ill

Russian school? 1st half 18th century

A 116 Peter the Great (1672-1725), czar of Russia. *Peter de Grote, tsaar van Rusland*

Canvas 110 × 91
PROV Sale Guttenbrun, Amsterdam, 30 April 1821, lot 319
LIT J Veth, OH 6 (1888) p 186 (attributed to Aert de Gelder). C Hofstede de Groot, OH 19 (1901) p 37 (attribution to de Gelder unconvincing). Lilienfeld 1914, nr 167 (probably not de Gelder)

Spanish school? 17th century

A 2394 The meal at Emmaus. *De Emmausgangers*

Canvas 148 × 202.5
PROV Purchased from Fr Muller & Co, art dealers, Amsterdam, 1909
LIT J O Kronig, Onze Kunst 26 (1914) p 93 (attributed to Joannes Cordua)

Spanish school? ca 1615

C 311 Portrait of a man on horseback. *Portret van een man te paard*

Canvas 306 × 169.5
PROV On loan from the city of Amsterdam (A van der Hoop bequest) since 1885

Spanish school 2d half 17th century

A 4489 Black Madonna. *Zwarte Madonna*

Copper 5.4 × 4.4. Mounted on the inside of a round wooden box. Inscribed later *Effigies Montezumae imperatoris Mexici per Ferdinandum del Campo ad vivam imaginem facta*
PROV KKS, 1885. NMGK

Aragonese school last quarter 15th century

A 3469 A saintly bishop. *Een heilige bisschop*

Panel 86.8 × 35.7
PROV Bequest of Mrs J H Derkinderen-Besier, widow of A J Derkinderen, Amsterdam, 1944

Catalan school last quarter 15th century

A 3105 Calvary. *Calvarieberg*

Panel 176.8 × 186. Top of an altarpiece
PROV Bequest of P A Gildemeester, Egmond aan den Hoef, 1930

Honselaarsdijk series

Portraits of military figures from the Eighty Years War. *Portretten van militairen uit de Tachtigjarige Oorlog*

There are important gaps in our information concerning this series of military portraits. The Rijksmuseum now owns 52 pieces in the series – A 505-A 506, A 516-A 565, C 1516 – but there are similar portraits in other collections that may have belonged to it as well. For that matter, we do not know whether the portraits concerned formed one series or more than one.

In Drossaers and Lunsingh Scheurleer's 1974 publication of the inventories of the house of Orange, what we call the Honselaarsdijk series was identified as the 'kleine borststucken' (small head-and-shoulders portraits) listed in the 1633 inventory of the court at Leeuwarden. The correspondence is not perfect, however. One difficult point is that several of the portraits in the Rijksmuseum are dated after 1633. Another is that there is nothing in their provenance that points to the Frisian court. According to our scarce data, all the portraits catalogued here (with the exception of A 505 and A 506, whose pedigree cannot be traced earlier than the year 1808) were transferred bit by bit about 1800 from the former palace at Honselaarsdijk near The Hague to the Nationale Konst-Gallery.

The portraits are painted on panels of 30 × 25 cm. The authors of some remain unknown; a few are signed by Wybrand de Geest (A 530, A 533), Michiel van Miereveld (A 534, A 548, A 554), Paulus Moreelse (A 556) and Jan van Ravesteyn (A 544, A 553, A 555); the rest are attributed to one or another of these masters or their studios, or are considered copies after them or after Gerard van Honthorst

LIT G Murray Bakker, 'De portretten, afkomstig van het huis Honselaarsdijk, in 's Rijks Museum te Amsterdam,' OH 16 (1898) pp 12-31

The painters are all listed in the alphabetical section of the catalogue above, with cross-references to the Honselaarsdijk series

The portraits are divided into five groups, and within the groups are arranged chronologically by the sitter's date of birth:

1 Members of the house of Nassau
2 Commanders-in-chief of the forces of the states-general
3 Foreigners in the service of the states-general
4 Adversaries of the Republic
5 Others

In order to facilitate the search for a specific painting in the series, there follows a list by inventory number, indicating the group under which each portrait can be found:

A 505 Robert Dudley, earl of Leicester, b 1532, group 3
A 506 Gaspard de Coligny, b 1517, group 5
A 516 Willem I of Orange, b 1533, group 1
A 517 Philips Willem of Orange, b 1554, group 1
A 518 Maurits of Orange, b 1567, group 1
A 519 Frederik Hendrik of Orange, b 1584, group 1
A 520 Willem II of Orange, b 1626, group 1
A 521 William III of Orange, b 1650, group 1
A 522 Adolf of Nassau, b 1540, group 1
A 523 Lodewijk of Nassau, b 1538, group 1
A 524 Hendrik of Nassau, b 1550, group 1
A 525 Willem Lodewijk of Nassau, b 1560, group 1
A 526 Lodewijk Günther of Nassau, b 1575, group 1
A 527 Philips of Nassau, b 1566, group 1
A 528 Lodewijk of Nassau?, b 1538, group 1
A 529 Ernst Casimir of Nassau-Dietz, b 1573, group 1
A 530 Willem Frederik of Nassau-Dietz, b 1613, group 1
A 531 Johan Ernst of Nassau-Siegen, b 1582, group 1
A 532 Albert of Nassau-Dillenburg, b 1596, group 1
A 533 Hendrik Casimir of Nassau-Dietz, b 1612, group 1
A 534 Jan de Jongere of Nassau-Siegen, b 1583, group 1
A 535 Adolf of Nassau-Siegen, b 1586, group 1
A 536 Justinus of Nassau, b 1559, group 1
A 537 George Frederik of Nassau-Siegen, b 1606, group 1
A 538 Jan de Oude of Nassau, b 1535, group 1
A 539 Jan de Jongere of Nassau-Siegen, b 1583, group 1
A 540 Jan de Middelste of Nassau-Siegen, b 1561, group 1
A 541 Lodewijk Hendrik of Nassau-Dillenburg, b 1594, group 1
A 542 Philips of Nassau, b 1566, group 1
A 543 Willem of Nassau-Siegen, b 1592, group 1
A 544 Philips of Hohenlohe zu Langenburg, b 1550, group 3
A 545 Philip Ernst of Hohenlohe zu Langenburg, b 1585, group 3
A 546 Gaspard de Coligny, b 1584, group 3
A 547 Charles de Levin, d 1592, group 2
A 548 Syrius de Bethune, d 1649, group 3
A 549 Willem de Zoete de Laeke, d 1637, group 2

A 550 Nicolaas Schmelsingh, b 1561, group 2
A 551 François de la Noue, b 1531, group 3
A 552 Joost de Zoete, d 1589, group 2
A 553 Olivier van den Tempel, b 1540, group 2
A 554 Ambrogio de Spinola, b 1569, group 4
A 555 Francisco Hurtado de Mendoza, b 1546, group 4
A 556 Anthonis van Utenhove, d 1625, group 2
A 557 Horace Vere, b 1565, group 3
A 558 Robert Henderson of Tunnegask, d 1622, group 3
A 559 William Brog, d 1636, group 3
A 560 Johann Conrad von Salm, b 1590, group 3
A 561 Willem Adriaen van Hornes, d 1625, group 2
A 562 Adolf of Nassau-Siegen, b 1586, group 1
A 563 portrait of a man, group 5
A 564 Daniël de Hertaing, d 1625, group 2
A 565 portrait of a man, group 5
C 1516 Nicolaas Schmelsingh, b 1561, group 2

1
Members of the house of Nassau

NO PHOTOGRAPH AVAILABLE

A 516 Willem I (1533-84), prince of Orange, called William the Silent. *Prins van Oranje, genaamd Willem de Zwijger*

Copy after Michiel Jansz van Miereveld (1567-1641)

Inscribed *Prins Wilhelm van Orangien, de Oude, Aetatis 52 tot Delft vermoort 1584*
* Missing
LIT Moes 1897-1905, vol 2, nr 9094:16. Moes & van Biema 1909, p 168. Van Beresteyn 1933, nr 11

A 538 Jan de Oude (1535-1606), count of Nassau. *Graaf van Nassau*

Studio of Jan Anthonisz van Ravesteyn (1572-1657)

Inscribed on the verso *Johan Graf zu Nassau Catzenelb.*
LIT Moes 1897-1905, vol 1, nr 4015:3. Moes & van Biema 1909, pp 168, 199. AWE Dek, Spiegel der Hist 3 (1968) ill on p 237

A 523 Lodewijk (1538-74), count of Nassau. *Graaf van Nassau*

Studio of Wybrand Symonsz de Geest (1592-after 1660)

Inscribed *Graef Lodewijck van Nassau, Ætatis 36 gebleven bij Moock A° 1574*
LIT Moes 1897-1905, vol 2, nr 4565:3. Moes & van Biema 1909, p 199. R van Luttervelt, OH 67 (1952) p 199, ill (copy after Daniël van den Queeckborne?). A Staring, OH 75 (1960) p 163, fig 5. AWE Dek, Spiegel der Hist 3 (1968) ill on p 237. GT Campagne, Spiegel Hist 4 (1969) p 685, fig 3

A 528 Portrait of a man, thought to be Lodewijk (1538-74), count of Nassau. *Portret van een man, vermoedelijk Lodewijk, graaf van Nassau*

Studio of Wybrand Symonsz de Geest (1592-after 1660)

Inscribed *Graef Johan van Nassau Aetatis 71. obijt op Dillenborgh A° 1606*
* On loan to the Rijksmuseum Muiderslot, Muiden, since 1947
LIT Moes 1897-1905, vol 1, nr 4015:4. Moes & van Biema 1909, p 199. R van Luttervelt, OH 67 (1952) p 199, ill (copy after Daniël van den Queeckborne?)

A 522 Adolf (1540-68), count of Nassau. *Graaf van Nassau*

Studio of Wybrand Symonsz de Geest (1592-after 1660)

Inscribed *Graef Adolph van Nassau, Ætatis 28 gebleven bij Heyligerlee A° 1568*

LIT Moes 1897-1905, vol 1, nr 27:4. Moes & van Biema 1909, p 199. J Mulder, Spiegel der Hist 3 (1968) ill on p 192. AWE Dek, Spiegel der Hist 3 (1968) ill on p 237

A 524 Hendrik (1550-74), count of Nassau. *Graaf van Nassau*

Studio of Wybrand Symonsz de Geest (1592-after 1660)

Inscribed *Graef Hendrick van Nassau, Aetatis 24 gebleven bij Moock A° 1574*
LIT Moes 1897-1905, vol 1, nr 3395:3. Moes & van Biema 1909, p 199. AWE Dek, Spiegel der Hist 3 (1968) ill on p 237

A 517 Philips Willem (1554-1618), prince of Orange. *Prins van Oranje*

Copy by Jan Anthonisz van Ravesteyn (1572-1657) after Michiel Jansz van Miereveld (1567-1641)

Inscribed *Prins Philips Wilhellm van Orangien, Aetatis 64 obijt A°. 1617 in Brussell*
LIT Moes 1897-1905, vol 2, nr 5905:8. Moes & van Biema 1909, pp 168, 199

A 536 Justinus of Nassau (1559-1631). Son of Prince Willem I and Eva Elinx. *Zoon van prins Willem I en Eva Elinx*

Studio of Jan Anthonisz van Ravesteyn (1572-1657)

Inscribed *Justinus Nassou*
LIT Moes 1897-1905, vol 2, nr 5303:1. Moes & van Biema 1909, p 168. K E Oudendijk, Historia 9 (1943) p 182, fig 3. A W E Dek, Spiegel der Hist 3 (1968) ill on p 244

A 525 Willem Lodewijk (1560-1620), count of Nassau, nicknamed in Frisian 'us heit' (our father). *Graaf van Nassau, genaamd 'us heit'*

Attributed to Michiel Jansz van Miereveld (1567-1641)

Dated *A° 1609*. Inscribed *Æta 50* and *Graef Wilhelm Lodewijck van Nassau, Stadhouder; Aetatis 60 Obijt in Leeuwarden A° 1604*
LIT Moes 1897-1905, vol 2, nr 9101:5. Moes & van Biema 1909, pp 168, 197

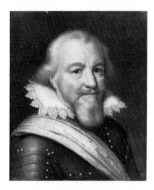

A 540 Jan de Middelste (1561-1623), count of Nassau-Siegen. *Graaf van Nassau-Siegen*

Attributed to Jan Anthonisz van Ravesteyn (1572-1657)

Inscribed on the verso *Johan Graf zu Nassau Catzenlb.*
LIT Moes & van Biema 1909, p 169

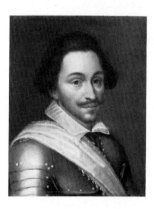

A 542 Philips (1566-95), count of Nassau. *Graaf van Nassau*

Studio of Jan Anthonisz van Ravesteyn (1572-1657)

Inscribed on the verso *Pilip Graf zu Nassau C. A.*
LIT Moes & van Biema 1909, p 169

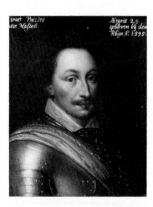

A 527 Philips (1566-95), count of Nassau. *Graaf van Nassau*

Holland school 1st half 17th century

Inscribed *Graef Philips van Nassau, Ætatis 29 gebleven bij den Rhijn A° 1595*
∗ On loan to the Rijksmuseum Muiderslot, Muiden, since 1947
LIT Moes & van Biema 1909, p 199. A W E Dek, Spiegel der Hist 3 (1968) ill on p 258

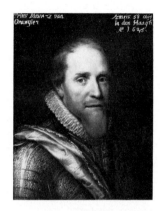

A 518 Maurits (1567-1625), prince of Orange. *Prins van Oranje*

Attributed to Jan Anthonisz van Ravesteyn (1572-1657)

Inscribed *Prins Mauriz van Orangien, Aetatis 58 obijt in den Haagh A° 1625*
LIT Moes 1897-1905, vol 2, nr 4896:46 (copy after Michiel Jansz van Miereveld). Moes & van Biema 1909, pp 168, 199. A W E Dek, Spiegel der Hist 3 (1968) ill on p 244

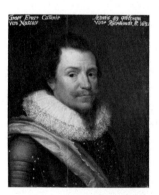

A 529 Ernst Casimir (1573-1632), count of Nassau-Dietz. *Graaf van Nassau-Dietz*

Attributed to Jan Anthonisz van Ravesteyn (1572-1657)

Inscribed *Graef Ernst Casimir van Nassau, Aetatis 59, gebleven voor Ruermondt A° 1632*
LIT Moes 1897-1905, vol 1, nr 2391:13. Moes & van Biema 1909, pp 168, 199

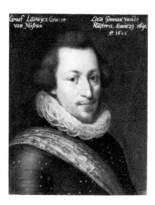

A 526 Lodewijk Günther (1575-1604), count of Nassau. *Graaf van Nassau*

Attributed to Jan Anthonisz van Ravesteyn (1572-1657)

Inscribed *Graef Lodewijck Gunther van Nassau, Lieut. Generaal van de Ruijterie, Aetatis 29, obijt A° 1604*
LIT Moes & van Biema 1909, p 169

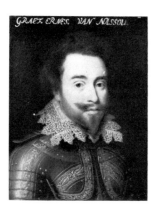

A 531 Johan Ernst I (1582-1617), count of Nassau-Siegen. *Graaf van Nassau-Siegen*

Attributed to Jan Anthonisz van Ravesteyn (1572-1657)

Inscribed *Graef Ernes van Nassou*
LIT Moes & van Biema 1909, p 200

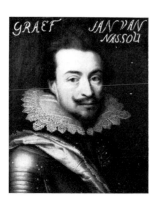

A 534 Jan de Jongere (1583-1638), count of Nassau-Siegen. *Graaf van Nassau-Siegen*

By Michiel Jansz van Miereveld (1567-1641)

Signed *M. Mirevelt*. Inscribed … *Jean de Nassau* and *Graef Jan van Nassou*
LIT Moes & van Biema 1909, pp 169, 197

A 539 Jan de Jongere (1583-1638), count of Nassau-Siegen. *Graaf van Nassau-Siegen*

Attributed to Jan Anthonisz van Ravesteyn (1572-1657)

Inscribed on the verso *Johan G. Z. N.*
LIT Moes & van Biema 1909, p 169

A 519 Frederik Hendrik (1584-1647), prince of Orange. *Prins van Oranje*

Copy after Gerard van Honthorst, A 178

Inscribed *Prins Frederick Hendrick van Orangien, Aetatis 64 obijt in den Haagh 1647*
LIT Moes 1897-1905, vol 1, nr 2582:63. Moes & van Biema 1909, p 168. Braun 1966, p 252

A 535 Adolf (1586-1608), count of Nassau-Siegen. *Graaf van Nassau-Siegen*

Attributed to Jan Anthonisz van Ravesteyn (1572-1657)

Inscribed *Graef Adolf van Nassau*
LIT Moes & van Biema 1909, pp 167, 199

A 562 Adolf (1586-1608), count of Nassau-Siegen. *Graaf van Nassau-Siegen*

Attributed to Jan Anthonisz van Ravesteyn (1572-1657)

Inscribed on the verso *Adolf Gr. Zw. Nassau Kazenele*
* Missing
LIT Moes & van Biema 1909, p 169

A 543 Willem (1592-1642), count of Nassau-Siegen. *Graaf van Nassau-Siegen*

Copy by Jan Anthonisz van Ravesteyn after Michiel Jansz van Miereveld (1567-1641)

Inscribed on the verso *Wilen Gr. Zu Nassau K. Elepogen*
LIT Moes & van Biema 1909, p 169. Dek 1962, fig 20. A W E Dek, Spiegel der Hist 3 (1968) ill on p 266

A 541 Lodewijk Hendrik (1594-1661), prince of Nassau-Dillenburg. *Vorst van Nassau-Dillenburg*

Holland school 1st half 17th century

Inscribed on the verso *Ludowic z.n.ke*

A 532 Albert (1596-1626), count of Nassau-Dillenburg. *Graaf van Nassau-Dillenburg*

Studio of Jan Anthonisz van Ravesteyn (1572-1657)

Inscribed *Graef Albert van Nassau*
LIT C Hofstede de Groot, OH 17 (1899) p 169 (Wybrand de Geest)

A 537 George Frederik (1606-74), prince of Nassau-Siegen. *Vorst van Nassau-Siegen*

Holland school 1636

Dated *1636*. Inscribed on the verso *Gorg fri gun.ke*

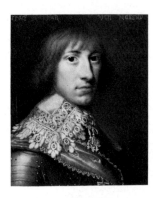

A 533 Hendrik Casimir I (1612-40), count of Nassau-Dietz. *Graaf van Nassau-Dietz*

By Wybrand Symonsz de Geest (1592-after 1660)

Signed and dated *V. de Geest f. A° 1632.* Inscribed *Graef Hindrick van Nassau*
LIT Moes & van Biema 1909, p 205? Wassenbergh 1967, p 35, nr 38, fig 72

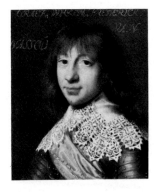

A 530 Willem Frederik (1613-64), prince of Nassau-Dietz. *Vorst van Nassau-Dietz*

By Wybrand Symonsz de Geest (1592-after 1660)

Signed and dated *V. de Geest f. A° 1632.* Inscribed *Graef Willem Frederick van Nassou*
LIT Moes 1897-1905, vol 2, nr 9100:2. Moes & van Biema 1909, p 203? Wassenbergh 1967, p 35, nr 39, fig 73

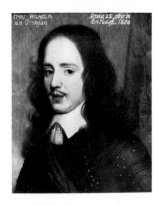

A 520 Willem II (1626-50), prince of Orange. *Prins van Oranje*

Copy after Gerard van Honthorst, A 871

Inscribed *Prins Wilhelm van Orangien. Aetatis 25 obijt in den Haagh 1650*
LIT Moes & van Biema 1909, p 168

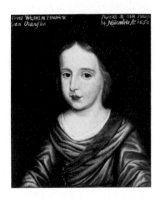

A 521 William III (1650-1702), prince of Orange. *Willem III, prins van Oranje*

Copy after Gerard van Honthorst (1590-1656)

Inscribed *Prins Wilhelm Hendrick van Orangien. Natus in den Haagh 14 Novembris A° 1650*
LIT Moes 1897-1905, vol 2, nr 9096:14. Moes & van Biema 1909, p 168

2

Commanders-in-chief of the forces of the states-general

A 553 Olivier van den Tempel (1540-1603), lord of Corbeecke. *Heer van Corbeecke*

By Jan Anthonisz van Ravesteyn (1572-1657)

Signed *M. Ravestein*. Inscribed *Mons. de Temple*. Marked *M. d. Tempel*
LIT G Murray Bakker, OH 16 (1898) p 16. Moes & van Biema 1909, pp 169, 200

C 1516 Nicolaas Schmelsingh (1561-1629)

Attributed to Jan Anthonisz van Ravesteyn (1572-1657)

Inscribed *Mons. Smelsin.*
PROV On loan from J W Niemeijer, Broek in Waterland, since 1972

NO PHOTOGRAPH AVAILABLE

A 550 Nicolaas Schmelsingh (1561-1629)

Attributed to Jan Anthonisz van Ravesteyn (1572-1657)

Inscribed *Mons. Smelsin*
* Missing
LIT Moes 1897-1905, vol 2, nr 7310:3 (copy after van Ravesteyn). G Murray Bakker, OH 16 (1898) p 13, note 1

A 552 Joost de Zoete (d 1589), lord of Villers. *Heer van Villers*

Studio of Jan Anthonisz van Ravesteyn (1572-1657)

Inscribed *Mons^r Viles Maresc: Dij Camp*
LIT G Murray Bakker, OH 16 (1898) pp 14-15. Moes 1897-1905, vol 2, nr 9397. Moes & van Biema 1909, pp 169, 200

A 547 Charles de Levin (d 1592), lord of Famars, Forimont and Lousart. *Heer van Famars, Forimont en Lousart*

Studio of Jan Anthonisz van Ravesteyn (1572-1657)

Inscribed *Mons^r de Hama*
LIT G Murray Bakker, OH 16 (1898) pp 17-20. Moes & van Biema 1909, pp 169, 200

A 556 Anthonis van Utenhove (d 1625), lord of Rijnesteyn. *Heer van Rijnesteyn*

By Paulus Moreelse (1571-1638)

Signed and dated *PM 1619*. Inscribed *Coronel Wyten Hoghe*
LIT G Murray Bakker, OH 16 (1898) p 27. Moes 1897-1905, vol 2, nr 8181. Moes & van Biema 1909, pp 168, 200. De Jonge 1938, p 84, nr 53, fig 39

A 564 Daniël de Hertaing (d 1625), lord of Marquette. *Heer van Marquette*

Attributed to Jan Anthonisz van Ravesteyn (1572-1657)

Inscribed *Mons^r de Mar^q*

A 561 Willem Adriaen (d 1625), count of Hornes, lord of Kessel and Westwezel. *Graaf van Hornes, heer van Kessel en Westwezel*

Attributed to Jan Anthonisz van Ravesteyn (1572-1657)

Inscribed *D'Heer van Kessel*
LIT G Murray Bakker, OH 16 (1898) p 29. Moes & van Biema 1909, pp 167, 200

A 549 Willem de Zoete de Laeke (d 1637), lord of Hautain. *Heer van Hautain*

Studio of Jan Anthonisz van Ravesteyn (1572-1657)

Inscribed *Mons De Houtin*
LIT G Murray Bakker, OH 16 (1898) p 15. Moes 1897-1905, vol 2, nr 9399:1. Moes & van Biema 1909, pp 169, 200

3
Foreigners in the service of the states-general

A 551 François de la Noue (1531-91), lord of Teligny, called 'Bras de Fer' and 'le Bayard Huguenot.' *Heer van Teligny, genaamd 'Bras de Fer' en 'le Bayard Huguenot'*

Holland school 1st half 17th century

Inscribed *Mons de la Nove*
LIT Moes & van Biema 1909, p 200. R van Luttervelt, OH 67 (1952) p 199, ill (copy after Daniël van den Queeckborne?)

A 505 Robert Dudley (1532-88), earl of Leicester. *Graaf van Leicester*

Studio of Jan Anthonisz van Ravesteyn (1572-1657)

Inscribed *Comte de Lysester*
LIT Moes & van Biema 1909, pp 167, 200. E van Hall-Nijhoff, Spiegel Hist 7 (1972) pp 675, 677, fig 10

A 544 Philips (1550-1606), count of Hohenlohe zu Langenburg. *Graaf van Hohenlohe zu Langenburg*

By Jan Anthonisz van Ravesteyn (1572-1657)

Signed *JA Ravestein*. Inscribed *Le Comte de Hohenloe* and *Den ouden Graef Philijps van Holack*
LIT Moes & van Biema 1909, pp 168, 200

A 559 Sir William Brog (d 1636)

Studio of Jan Anthonisz van Ravesteyn (1572-1657)

Inscribed *Colonel Brock*
LIT G Murray Bakker, OH 16 (1898) pp 23, 25-27. Moes & van Biema 1909, pp 168, 200

A 557 Sir Horace Vere (1565-1635)

Attributed to Michiel Jansz van Miereveld (1567-1641)

Inscribed *Coronel Veer*
LIT G Murray Bakker, OH 16 (1898) pp 21-23. Moes & van Biema 1909, pp 168, 200

A 546 Gaspard de Coligny (1584-1646), count of Châtillon sur Loing. *Graaf van Châtillon sur Loing*

Studio of Jan Anthonisz van Ravesteyn (1572-1657)

Inscribed *Monsʳ Chan: tillon Maresc. de France*
LIT G Murray Bakker, OH 16 (1898) p 14. Moes & van Biema 1909, pp 168, 200

A 545 Philip Ernst (1585-1629), count of Hohenlohe zu Langenburg. *Graaf van Hohenlohe zu Langenburg*

Studio of Jan Anthonisz van Ravesteyn (1572-1657)

Inscribed *Graef Philips Ernst van Holack*
LIT Moes & van Biema 1909, pp 168, 200

A 558 Sir Robert Henderson of Tunnegask (d 1622)

Studio of Jan Anthonisz van Ravesteyn (1572-1657)

Inscribed *Coronel Hendersom*
LIT G Murray Bakker, OH 16 (1898) pp 23-24

A 548 Syrius de Bethune (d 1649), lord of Cogni, Mareuil, le Beysel, Toulon, Conegory and Chastillon. *Heer van Cogni, Mareuil, le Beysel, Toulon, Conegory en Chastillon*

By Michiel Jansz van Miereveld (1567-1641)

Signed *M. M. Mireveld*. Inscribed *Monsʳ De Betune*
LIT G Murray Bakker, OH 16 (1898) p 21. Moes & van Biema 1909, pp 168, 200

A 560 Johann Conrad von Salm (1590-1622), waldgrave and Rhinegrave of the Holy Roman Empire. *Wild- en Rijngraaf van het Heilige Roomse Rijk*

Attributed to Wybrand Symonsz de Geest (1592-after 1660)

Dated *A° 1622*. Inscribed *D. Rijn. Gref*
LIT Moes & van Biema 1909, p 168. Wassenbergh 1967, p 34, nr 3

4
Adversaries of the Republic

A 555 Francisco Hurtado de Mendoza (1546-1623). Admiral of Aragon. *Admiraal van Aragon*

By Jan Anthonisz van Ravesteyn (1572-1657)

For another portrait of the sitter, *see* Northern Netherlands school 1601: A 3912

Inscribed *L'Admirant D'Daragon*. Marked *M. Ravenstei*
LIT Moes & van Biema 1909, pp 168, 200

A 554 Ambrogio (1569-1630), marquess de Spinola. *Markies de Spinola*

By Michiel Jansz van Miereveld (1567-1641)

Signed *M. Mirevelt*. Inscribed *Marquis Spinola*
LIT Moes & van Biema 1909, pp 169, 200

5
Others

A 506 Gaspard de Coligny (1517-72)

Attributed to Jan Anthonisz van Ravesteyn (1572–1657)

Inscribed *Caspar de Coligny, Admiral de France*
LIT Moes & van Biema 1909, pp 167, 200

NO PHOTOGRAPH AVAILABLE

A 563 Portrait of a man. *Portret van een man*

Northern Netherlands school 1st half 17th century

* Missing

NO PHOTOGRAPH AVAILABLE

A 565 Portrait of a man. *Portret van een man*

Northern Netherlands school 1st half 17th century

* Missing

Rotterdam East India Company series

Portraits of the directors of the Rotterdam chamber of the Dutch East India Company (1602-1742). *Portretten van de bewindhebbers van de Rotterdamse Kamer der Verenigde Oost-Indische Compagnie (VOC)*

The series was made for the Nieuw Oost-Indisch Huis (New East India House) on the Boompjes in Rotterdam (destroyed 1940), which was built as the headquarters of the Rotterdam chamber of the East India Company in 1698.

The series contained at least 47 portraits, of which 38 are still preserved. All the portraits are oval, are painted on canvas (82 × 68 cm) and are in uniform, contemporary frames. The 35 paintings catalogued here (A 4490-A 4524) were transferred in 1877 to the Nederlandsch Museum voor Geschiedenis en Kunst in The Hague (which was moved to the Rijksmuseum in 1883) by the colonial ministry, under whose care they had been since the dissolution of the East India Company in 1798. In 1972 the series was given on loan to the Historisch Museum in Rotterdam.

For the most part, the series consists of unsigned copies by Pieter van der Werff, who was commissioned to make them in the closing years of the 17th century. He presumably painted the then living directors from life. After van der Werff's death in 1722, the series was set forth by Jan de Meijer II, Jan Maurits Quinkhard, Dionys van Nijmegen, Jean Humbert and other, unknown painters.

The painters are listed in the alphabetical section of the catalogue above, with cross-references to the Rotterdam East India Company series.

The portraits are catalogued in chronological order by the date of the sitters' assumption of office. (Once elected, a director of the company served for the rest of his life. Originally there were nine directors, and in later times seven.) This order corresponds to that of the paintings' inventory numbers.

By way of exception, the paintings of the Rotterdam East India Company series are reproduced in their (original) frames.

A 4490 Johan van der Veecque, elected in 1602

Copy by Pieter van der Werff (1655-1722)

Inscribed on the frame *Johan van d'Veecque. 1602*
LIT Moes 1897-1905, vol 2, nr 8251.
A J M Alkemade & B Wolderink, Rotterdamsch Jb 7th ser 6 (1968) p 247, fig 58

A 4491 Cornelis Matelieff de Jonge (1570-1632), elected in 1602

Copy by Pieter van der Werff (1655-1722)

Inscribed on the frame *Corn. Matelief de Jonge. 1602*
LIT Moes 1897-1905, vol 2, nr 4871

A 4492 Ewoud Pietersz van der Horst (d before 1624), elected in 1618

Copy by Pieter van der Werff (1655-1722)

Inscribed on the frame *Ewoud Piet van d'Horst. 1618*
LIT Moes 1897-1905, vol 1, nr 3757

A 4493 Claes Maertensz Thoveling, elected in 1619

Copy by Pieter van der Werff (1655-1722)

Inscribed on the frame *Cla' Maart' Thoveling*
LIT Moes 1897-1905, vol 2, nr 7958

A 4494 Hendrik Nobel (1567-1649), elected in 1625

Copy by Pieter van der Werff (1655-1722)

Inscribed on the frame *Hendrick Nobel. 1625*
LIT Moes 1897-1905, vol 2, nr 5410

A 4495 Joost van Coulster (d 1649), elected in 1630

Copy by Pieter van der Werff (1655-1722)

Inscribed on the frame *Joost van Coulster. 1630*
LIT Moes 1897-1905, vol 1, nr 1762

A 4496 Pieter Sonmans (d 1660), elected in 1631

Copy by Pieter van der Werff (1655-1722)

Inscribed on the frame *Peter Sonmans. 1631*
LIT Moes 1897-1905, vol 2, nr 7395

A 4497 Cornelis Jansz Hartigsvelt (before 1586-1641), elected in 1639

Copy by Pieter van der Werff (1655-1722)

Inscribed on the frame *Corn. Jansz. Hartigsvelt. 1639*
LIT Moes 1897-1905, vol 1, nr 3227

A 4498 Adriaen Besemer, elected in 1642

Copy by Pieter van der Werff (1655-1722)

Inscribed on the frame *Adriaen Besemer. 1642*
LIT Moes 1897-1905, vol 1, nr 547

A 4499 Cornelis de Koningh, elected in 1649

Copy by Pieter van der Werff (1655-1722)

Inscribed on the frame *Cornelis de Koningh*

A 4500 Jan van der Burgh, elected in 1649

Copy by Pieter van der Werff (1655-1722)

Inscribed on the frame *Jan van der Burght. 1649*
LIT Moes 1897-1905, vol 1, nr 1258

A 4501 Paulus Verschuur (1606-67), elected in 1651

Free copy after Frans Hals (Metropolitan Museum of Art, New York; cat 1954; nr 26.101.11) by Pieter van der Werff (1655-1722)

Inscribed on the frame *Paulus Verschuur. 1651*
LIT Moes 1897-1905, vol 2, nr 8429. Bijlsma 1918, ill opp p 120. Hoffman 1928, vol 2, ill opp p 246. SJ Gudlaugsson, OH 69 (1954) p 235, ill. Slive 1970-74, vol 3, p 75

A 4502 Gerard van Bergen (d 1663), elected in 1653

Copy by Pieter van der Werff (1655-1722)

Inscribed on the frame *Gerard van Bergen. 1653*

A 4503 Jacob Sonmanus, elected in 1657

Copy by Pieter van der Werff (1655-1722)

Inscribed on the frame *Jacob Sonmanus. 1657*

A 4504 Willem Hartigsvelt (d 1664), elected in 1657

Copy by Pieter van der Werff (1655-1722)

Inscribed on the frame *Willem Hartigsvelt. 1657*
LIT Moes 1897-1905, vol 1, nr 3228

A 4505 Johan de Reus (ca 1600-85), elected in 1657

Copy after Nicolaes Maes (National Gallery, London; cat 1960, nr 2581) by Pieter van der Werff (1655-1722)

Inscribed on the frame *Johans de Reus*
LIT Moes 1897-1905, vol 2, nr 6368. SJ
Gudlaugsson, Med RKD 1 (1946) p 32.
MacLaren 1960, pp 233-34

A 4506 Cornelis van den Bergh, elected
in 1659

Copy by Pieter van der Werff (1655-
1722)

Inscribed on the frame *Cornelis van
D'Bergh*
LIT Moes 1897-1905, vol 1, nr 531

A 4507 Johan Hennekin, elected in 1664

Copy by Pieter van der Werff (1655-
1722)

Inscribed on the frame *Johan Bennekin.
1654*
LIT Moes 1897-1905, vol 1, nr 3417

A 4508 Johan Kieviet (d 1692), elected
in 1664

Copy by Pieter van der Werff (1655-
1722)

Inscribed on the frame *Mr Jan Kieviet*
LIT Moes 1897-1905, vol 1, nr 4184.
D J Roorda, Rotterdamsch Jb 8th ser 1
(1973) fig 59

A 4509 Johan de Vries (1607-77),
elected in 1667

Copy by Pieter van der Werff (1655-
1722)

Inscribed on the frame *Mr Johan de
Vries. 1667*
LIT Moes 1897-1905, vol 2, nr 8741

A 4510 Cornelis van Couwenhove,
elected in 1667

Copy by Pieter van der Werff (1655-
1722)

Inscribed on the frame *Corns van
Couwenhove. 1667*
LIT Moes 1897-1905, vol 1, nr 1776

A 4511 Adriaen Paets (1631-86), elected
in 1668

Copy by Pieter van der Werff (1655-
1722)

Inscribed on the frame *Adriaen Paats.
1668*

A 4512 Dominicus Rosmale, elected in
1677

Copy by Pieter van der Werff (1655-
1722)

Inscribed on the frame *Dominicus Rosmale*

A 4513 Matthias van den Brouck Jr,
elected in 1685

By Pieter van der Werff (1655-1722)

Signed *P. vr Werff fecit*. Inscribed on the
frame *Matths van den Brouck. 1685*

A 4514 Jacob Dane (ca 1638-99), elected in 1689

By Pieter van der Werff (1655-1722)

Signed and dated *P. v. Werff fecit Anno 1700*. Inscribed on the frame *Jacob Dane*

A 4517 Sebastiaen Schepers, elected in 1702

By Pieter van der Werff (1655-1722)

Signed *P. v^r Werff fe^t*. Inscribed on the frame *M^r Sebastiaen Schepers. 1702*

A 4520 Hendrik Braats, elected in 1729

By an unknown painter

Inscribed on the frame *M^r Hendrick Braats. 1729*

A 4515 Dirck de Raet (1649-1708), elected in 1689

By Jan de Meijer II (1711-40)

Signed and dated *De Meyer 1722*. Inscribed on the frame *M^r Dirck de Raet. 1689*
LIT Moes 1897-1905, vol 2, nr 6163

A 4518 Adriaen Paets (1657-1712), elected in 1703

Attributed to Pieter van der Werff (1655-1722)

Inscribed on the frame *M^r Adriaen Paets. 1703*
LIT Moes 1897-1905, vol 2, nr 5687:3

A 4521 Walter Senserff (1685-1752), elected in 1731

By Jan Maurits Quinkhard (1688-1772)

Signed *J. M. Quinkhard fecit*. Inscribed on the frame *Walter Senserf. 1731*
LIT Moes 1897-1905, vol 2, nr 7157:1

A 4516 Willem van Hogendorp (1656/57-1733), elected in 1692

By an unknown painter

Inscribed on the frame *M^r Will' van Hogendorp. 1692*

A 4519 Engelbert van Berckel (1686-1768), elected in 1715

By an unknown painter

Inscribed on the frame *M^r Engelbert van Berckel. 1715*

A 4522 Adriaen Paets (1697-1765), elected in 1734

By Dionys van Nijmegen (1705-98)

Signed *D. van* [Nijmegen]. Inscribed on the frame *M^r Adriaen Paets. 1734*
LIT Van Eynden & van der Willigen

1816-40, vol 2 (1820) p 58. Moes 1897-
1905, vol 2, nr 5688. J W Niemeijer, Bull
RM 17 (1969) p 86, note 23, fig 37

A 4523 Hugo du Bois, elected in 1734

By Dionys van Nijmegen (1705-98)

Inscribed on the frame *Hugo du Bois. 1734*
LIT Van Eynden & van der Willigen
1816-40, vol 2 (1820) p 58. Moes 1897-
1905, vol 1, nr 825

A 4524 Adriaan du Bois (1713-74),
elected in 1742

By Jean Humbert (1734-94)

Signed and dated *Humbert fecit 1760.*
Inscribed on the frame *Mr Adr. du Bois.
1742*

Governors-general series

Portraits of the governors-general of the
former Dutch East Indies. *Portretten van
de gouverneurs-generaal van het voormalige
Nederlands Oost-Indië*

1 A The complete and most authentic
series, containing 65 portraits (A 3755-
A 3819). Transferred in 1950 to the
Rijksmuseum from Rijswijk Palace in
Weltevreden on the island of Java,
together with group 2. It was completed
in 1954 with the addition of the portrait
of the last governor-general (A 3880).

Two royal portraits by G J J Spinny
(A 3826 & A 3827) which do not belong
to the governors-general series also
come from Rijswijk Palace in Wel-
tevreden, and were acquired at the
same time as series 1 A and 2. They are
listed under Spinny in the alphabetical
section of the catalogue.

Many of the portraits in series 1 A have
suffered seriously from their lengthy stay
in the tropics. The history of the series
is treated extensively by J de Loos-
Haaxman, De landsverzameling
schilderijen in Batavia : landvoogds-
portretten en compagnieschilders,
Leiden 1941, vol 1, pp 17-139. See also
F W Stapel, De gouverneurs-generaal
van Nederlandsch-Indië in beeld en
woord, The Hague 1941.

1 B Incomplete series of 28 portraits
(A 4525-A 4552), thought to come from
the Dutch East India Company. These
portraits are for the most part copies
after those in group 1 A, and are
catalogued accordingly.

Transferred in 1876 by the colonial
ministry to the Nederlandsch Museum
voor Geschiedenis en Kunst in The
Hague, which was moved to the Rijks-
museum in 1883.

For this series and others, see de Loos-
Haaxman, op cit, pp 147-50.

2 In 1950 the Rijksmuseum acquired
four portraits (A 3822-A 3825) of
chairmen of the Volksraad (people's
council) of the former Dutch East
Indies, from the seat of that council in
Djakarta (formerly Batavia).

The painters that could be identified
are listed in the alphabetical section of
the catalogue above, with cross-
references to the governors-general
series.

The portraits are catalogued in
chronological order by the date of the
sitters' assumption of office. In order to
facilitate the search for a particular
portrait, there follows a list of the
paintings, with the sitters' dates, by
inventory number:

A 3755 Pieter Both (1610-14)
A 3756 Gerard Reynst (1614-15)
A 3757 Laurens Reael (1616-19)
A 3758 Jan Pietersz Coen (1619-23;
1627-29)
A 3759 Pieter de Carpentier (1623-27)
A 3760 Jacques Specx (1629-32)
A 3761 Hendrik Brouwer (1632-36)
A 3762 Antonio van Diemen (1636-45)
A 3763 Cornelis van der Lijn (1645-50)
A 3764 Karel Reyniersz (1650-53)
A 3765 Joan Maetsuyker (1653-78)
A 3766 Rycklof van Goens (1678-81)
A 3767 Cornelis Speelman (1681-84)
A 3768 Johannes Camphuys (1684-91)
A 3769 Willem van Outhoorn (1691-
1704)
A 3770 Joan van Hoorn (1704-09)
A 3771 Abraham van Riebeeck (1709-
13)
A 3772 Christoffel van Swoll (1713-18)
A 3773 Hendrik Swaardecroon (1718-
25)
A 3774 Mattheus de Haan (1725-29)
A 3775 Diederik van Durven (1729-30)
A 3776 Dirk van Cloon (1730-35)
A 3777 Abraham Patras (1735-37)
A 3778 Adriaan Valckenier (1737-41)
A 3779 Johannes Thedens (1741-43)
A 3780 Gustaaf Willem Baron van
Imhoff (1743-50)
A 3781 Jacob Mossel (1750-61)
A 3782 Petrus Albertus van der Parra
(1761-75)
A 3783 Jeremias van Riemsdijk (1775-
77)
A 3784 Reinier de Klerk (1777-80)
A 3785 Willem Arnold Alting (1780-97)
A 3786 Sebastiaan Cornelis Nederburgh
(director-general 1791-99)
A 3787 Pieter Gerhardus van
Overstraten (1797-1801)
A 3788 Johannes Siberg (1801-05)
A 3789 Albertus Henricus Wiese (1805-
08)
A 3790 Herman Willem Daendels
(1808-10)
A 3791 Jonkheer Jan Willem Janssens
(1811-12)
A 3792 Gilbert Elliot, earl of Minto
(1812-14)
A 3793 C Th Elout (director-general
1816-19)
A 3794 Arnold Adriaan Buyskes
(director-general 1816-19)
A 3795 Godart Alexander Gerard
Philip Baron van der Capellen (1816-
26)
A 3796 Hendrik Merkus Baron de Kock
(lieutenant governor-general after
1826)
A 3797 Léonard Pierre Joseph Burgrave
du Bus de Gisignies (director-general
1826-30)
A 3798 Johannes Count van den Bosch
(1830-33)
A 3799 Jean Chrétien Baud (1833-35)
A 3800 Dominique Jacques de Eerens
(1835-40)
A 3801 Pieter Merkus (1841-44)
A 3802 Jan Jacob Rochussen (1845-51)
A 3803 Albertus Jacob Duymaer van
Twist (1851-55)

A 3804 Charles Ferdinand Pahud (1855-61)
A 3805 L A J W Baron Sloet van de Beele (1861-66)
A 3806 Pieter Mijer (1866-71)
A 3807 James Loudon (1871-75)
A 3808 J W van Lansberge (1875-1880)
A 3809 Frederik s'Jacob (1880-84)
A 3810 Otto van Rees (1884-88)
A 3811 Cornelis Pijnacker Hordijk (1888-93)
A 3812 Carel Herman Aert van der Wijck (1893-99)
A 3813 Willem Rooseboom (1899-1904)
A 3814 Johannes Benedictus van Heutsz (1904-09)
A 3815 Alexander Willem Frederik Idenburg (1909-16)
A 3816 Johan Paul Count van Limburg Stirum (1916-21)
A 3817 Dirck Fock (1921-26)
A 3818 Andries Cornelis Dirk de Graeff (1926-31)
A 3819 Jonkheer Bonifacius Cornelis de Jonge (1931-36)
A 3822 Adriaan Neytzel de Wilde (chairman of the people's council 1925-29)
A 3823 Jacob Christiaan Koningsberger (chairman of the people's council 1918-19)
A 3824 Willem Martinus Godfried Schumann (chairman of the people's council 1919-25)
A 3825 Jan Willem Meijer Ranneft (chairman of the people's council 1929-33)
A 3880 Jonkheer Alidius Warmoldus Lambertus Tjarda van Starkenborgh Stachouwer (1936-45)
A 4525 Pieter Both (1610-14)
A 4526 Gerard Reynst (1614-15)
A 4527 Laurens Reael (1616-19)
A 4528 Jan Pietersz Coen (1619-23; 1627-29)
A 4529 Pieter de Carpentier (1623-27)
A 4530 Jacques Specx (1629-32)
A 4531 Hendrik Brouwer (1632-36)
A 4532 Antonio van Diemen (1636-45)
A 4533 Cornelis van der Lijn (1645-50)
A 4534 Karel Reyniersz (1650-53)
A 4535 Joan Maetsuyker (1653-78)
A 4536 Rycklof van Goens (1678-81)
A 4537 Cornelis Speelman (1681-84)
A 4538 Johannes Camphuys (1684-91)
A 4539 Willem van Outhoorn (1691-1704)
A 4540 Abraham van Riebeeck (1709-13)
A 4541 Christoffel van Swoll (1713-18)
A 4542 Hendrik Swaardecroon (1718-25)
A 4543 Mattheus de Haan (1725-29)
A 4544 Diederik van Durven (1729-30)
A 4545 Dirk van Cloon (1730-35)
A 4546 Abraham Patras (1735-37)
A 4547 Adriaan Valckenier (1737-41)
A 4548 Johannes Thedens (1741-43)
A 4549 Gustaaf Willem Baron van Imhoff (1743-50)
A 4550 Jacob Mossel (1750-61)
A 4551 Petrus Albertus van der Parra (1761-75)
A 4552 Reinier de Klerk (1777-80)

1 A & B
Governors-general

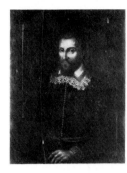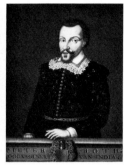

A 3755 Pieter Both (1550-1615). Governor-general (1610-14)

By a Dutch painter in Batavia, mid-17th century

Panel 98 × 77.5
LIT G P Rouffaer, OH 12 (1894) p 193ff. Moes 1897-1905, vol 1, nr 954:1. De Loos-Haaxman 1941, p 20, fig 2. Stapel 1941, p 9, ill

A 4525 Pieter Both (1550-1615). Governor-general (1610-14)

Copy after A 3755

Panel 33 × 25. Inscribed *Pieter Both Gouvʳ Generˡ van India*
LIT Moes 1897-1905, vol 1, nr 954:3. De Loos-Haaxman 1941, p 21, note 1

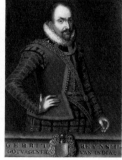

A 3756 Gerard Reynst (d 1615). Governor-general (1614-15)

By a Dutch painter in Batavia, mid-17th century

Panel 98.5 × 78
LIT Moes 1897-1905, vol 2, nr 6403:2. De Loos-Haaxman 1941, p 28, fig 3. Stapel 1941, p 11, ill

A 4526 Gerard Reynst (d 1615). Governor-general (1614-15)

Copy after A 3756

Panel 33 × 25. Inscribed *Gerrit Reynst Gouvʳ Generˡ van India*
LIT Moes 1897-1905, vol 2, nr 6403:5. De Loos-Haaxman 1941, p 29, note 1

A 3757 Laurens Reael (1583-1637). Governor-general (1616-19)

By a Dutch painter in Batavia, mid-17th century

Panel 98 × 77.5
LIT Moes 1897-1905, vol 2, nr 6211:3. De Loos-Haaxman 1941, p 23, fig 4. Stapel 1941, p 13, ill. CH de Jonge, Historia 8 (1942) p 194

A 4527 Laurens Reael (1583-1637). Governor-general (1616-19)

Copy after A 3757

Panel 33 × 25. Inscribed *Laurens Reaal Gouvʳ Generˡ van India*
LIT Moes 1897-1905, vol 2, nr 6211:6. De Loos-Haaxman 1941, p 23, note 2. Coolhaas 1973, ill on p 15

A 3758 Jan Pietersz Coen (1587-1629). Governor-general (1619-23; 1627-29)

By a Dutch painter in Batavia, mid-17th century

Panel 97.5 × 77.5
LIT Moes 1897-1905, vol 1, nr 1613:3. J de Loos-Haaxman, Tijdschr Ind T L V 74 (1934) p 3ff. De Loos-Haaxman 1941, p 25, fig 6. Stapel 1941, p 15, ill. CH de

Jonge, Historia 8 (1942) p 194. Exhib cat Nederlandse schilders en tekenaars in de Oost, Amsterdam 1972, nr 7, ill

A 4528 Jan Pietersz Coen (1587-1629). Governor-general (1619-23; 1627-29)

Copy after A 3758

Panel 33 × 25. Inscribed *Jan Pieterszoon Coen Gouvᵣ Generˡ van India*
LIT Moes 1897-1905, vol 1, nr 1613:6. De Loos-Haaxman 1941, p 28, note 2. J P Sigmond, Spiegel Hist 9 (1974) p 362, fig 5

A 3759 Pieter de Carpentier (1588-1659). Governor-general (1623-27)

By a Dutch painter in Batavia, mid-17th century

Panel 97.5 × 77.5
LIT Moes 1897-1905, vol 1, nr 1489:1. De Loos-Haaxman 1941, p 24, fig 9. Stapel 1941, p 17, ill

A 4529 Pieter de Carpentier (1588-1659). Governor-general (1623-27)

Copy after A 3759

Panel 33 × 25. Inscribed *Pieter de Carpentier Gouvᵣ Generˡ van India*
LIT Moes 1897-1905, vol 1, nr 1489:4. De Loos-Haaxman 1941, p 25, note 3

A 3760 Jacques Specx (b 1588). Governor-general (1629-32)

By a Dutch painter in Batavia, mid-17th century

Panel 97.5 × 77.5
LIT Moes 1897-1905, vol 2, nr 7435:4. De Loos-Haaxman 1941, p 22, fig 10. Stapel 1941, p 19, ill

A 4530 Jacques Specx (b 1588). Governor-general (1629-32)

Copy after A 3760

Panel 33 × 25. Inscribed *Jaques Specks Gouvᵣ Generˡ van India*
LIT Moes 1897-1905, vol 2, nr 7435:7. De Loos-Haaxman 1941, p 22, note 5. Coolhaas 1973, p 54, ill on p 34

A 3761 Hendrik Brouwer (1581-1643). Governor-general (1632-36)

By a Dutch painter in Batavia, mid-17th century

Panel 97.5 × 78.5
LIT Moes 1897-1905, vol 1, nr 1177:1. De Loos-Haaxman 1941, p 29, fig 11. Stapel 1941, p 21, ill

A 4531 Hendrik Brouwer (1581-1643). Governor-general (1632-36)

Copy after A 3761

Panel 33 × 25. Inscribed *Hendrik Brouwer Gouvᵣ Generˡ van India*
LIT Moes 1897-1905, vol 1, nr 1177:4. De Loos-Haaxman 1941, p 29, note 3

A 3762 Antonio van Diemen (1593-1645). Governor-general (1636-45)

By a Dutch painter in Batavia, mid-17th century

Panel 100 × 77
LIT Moes 1897-1905, vol 1, nr 1975:2. De Loos-Haaxman 1941, p 30, fig 12. Stapel 1941, p 23, ill

A 4532 Antonio van Diemen (1593-1645). Governor-general (1636-45)

Copy after A 3762

Panel 33 × 25. Inscribed *Antonio van Dimen Gouvᵣ Generˡ van India*
LIT Moes 1897-1905, vol 1, nr 1975:5. De Loos-Haaxman 1941, p 32, note 3. J Verseput, Spiegel Hist 5 (1970) fig 4 on p 403

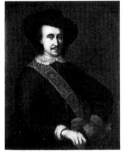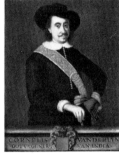

A 3763 Cornelis van der Lijn (1608?-79). Governor-general (1645-50)

By a Dutch painter in Batavia, mid-17th century

Panel 97.5 × 78.5
LIT Moes 1897-1905, vol 2, nr 4681:1. De Loos-Haaxman 1941, p 32, fig 13. Stapel 1941, p 25, ill

A 4533 Cornelis van der Lijn (1608?-79). Governor-general (1645-50)

Copy after A 3763

Panel 33 × 25. Inscribed *Cornelis van der Lyn Gouvᵣ Generˡ van India*
LIT Moes 1897-1905, vol 2, nr 4681:4. De Loos-Haaxman 1941, p 33, note 4

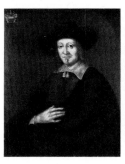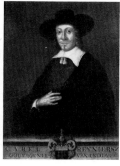

A 3764 Karel Reyniersz (1604-53). Governor-general (1650-53)

By a Dutch painter in Batavia, mid-17th century

Panel 97.5 × 78
LIT Moes 1897-1905, vol 2, nr 6390:1.
De Loos-Haaxman 1941, p 33, fig 14.
Stapel 1941, p 27, ill (Philip Angel?). De Loos-Haaxman 1968, p 9, fig 4

A 4534 Karel Reyniersz (1604-53). Governor-general (1650-53)

Copy after A 3764

Panel 33 × 25. Inscribed *Carel Reyniersz. Gouv^r Gener^l van India*
LIT Moes 1897-1905, vol 2, nr 6390:3.
De Loos-Haaxman 1941, p 34, note 2

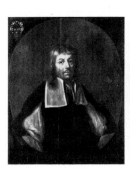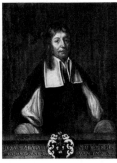

A 3765 Joan Maetsuyker (1606-78). Governor-general (1653-78)

By Jacob Jansz Coeman (active 1663-76 in Batavia)

Panel 97.5 × 78
LIT Moes 1897-1905, vol 2, nr 4741:4. J de Loos-Haaxman, Tijdschr Ind TLV 77 (1937) p 599, ill. De Loos-Haaxman 1941, pp 69, 73-74, fig 35. Stapel 1941, p 29, ill. CH de Jonge, Historia 8 (1942) p 194, fig 1. De Loos-Haaxman 1968, pp 11, 32, fig 7. Exhib cat Nederlandse schilders en tekenaars in de Oost, Amsterdam 1972, p 14 (Jacob Jansz Coeman?)

A 4535 Joan Maetsuyker (1606-78). Governor-general (1653-78)

Copy after A 3765

Panel 33 × 25. Inscribed *Joan Maatsuyker Gouv^r Gener^l van India*
LIT Moes 1897-1905, vol 2, nr 4741:7. J de Loos-Haaxman, Tijdschr Ind TLV 77 (1937) p 599, note 2. De Loos-Haaxman 1941, p 74, note 1

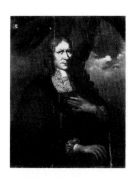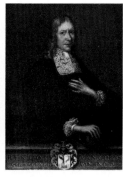

A 3766 Rycklof van Goens (1619-82). Governor-general (1678-81)

Attributed to Martin Palin (active ca 1680-90 in Batavia)

Panel 98 × 79
LIT Moes 1897-1905, vol 1, nr 2773:6.
De Loos-Haaxman 1941, p 77, fig 39.
Stapel 1941, p 31, ill. De Loos-Haaxman 1968, p 32, fig 6 (copy after Govert Flinck?)

A 4536 Rycklof van Goens (1619-82). Governor-general (1678-81)

Copy after A 3766

Panel 33 × 25. Inscribed *Ryklof van Goens Gouv^r Gener^l van India*
LIT Moes 1897-1905, vol 1, nr 2773:9.
De Loos-Haaxman 1941, p 78, note 2

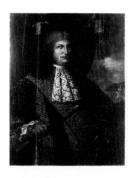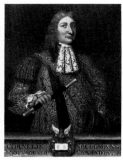

A 3767 Cornelis Speelman (1628-84). Governor-general (1681-84)

Copy, attributed to Martin Palin (active ca 1680-90 in Batavia)

Panel 100 × 79
LIT Moes 1897-1905, vol 2, nr 7437:2.
Stapel 1936, p 144. J de Loos-Haaxman,
Tijdschr Ind TLV 78 (1938) p 192, fig 1.
De Loos-Haaxman 1941, p 79. Stapel 1941, p 33, ill (Martin Palin)

A 4537 Cornelis Speelman (1628-84). Governor-general (1681-84)

Copy after A 3767

Panel 33 × 25. Inscribed *Cornelis Speelman Gouv^r Gener^l van India*
LIT Moes 1897-1905, vol 2, nr 7437:5.
De Loos-Haaxman 1941, p 80, note 1

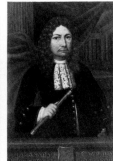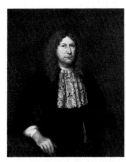

A 3768 Johannes Camphuys (1634-95). Governor-general (1684-91)

By Gerrit van Goor (active 1674-85 in Batavia)

Panel 97.5 × 78.5. Signed and dated *G. van Goor ft. A. 1685*
LIT Moes 1897-1905, vol 1, nr 1434:1. J de Loos-Haaxman, Tijdschr Ind TLV 75 (1935) p 612, ill. De Loos-Haaxman 1941, p 84, fig 47. Stapel 1941, p 35, ill. De Loos-Haaxman 1968, p 13, fig 11. De Loos-Haaxman 1972, pp 46, 49, fig 15. Exhib cat Nederlandse schilders en tekenaars in de Oost, Amsterdam 1972, nr 5, ill

A 4538 Johannes Camphuys (1634-95). Governor-general (1684-91)

Free copy after A 3768

Canvas 33 × 25. Inscribed *Iohannes Camphuijs Gouver^r Gener^l van India*
LIT Moes 1897-1905, vol 1, nr 1434:4.
De Loos-Haaxman 1941, p 85, note 4

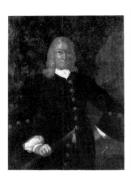
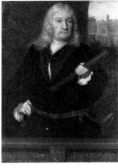

A 3769 Willem van Outhoorn (1635-1720). Governor-general (1691-1704)

By a Dutch painter in Batavia, ca 1700

Panel 99 × 78.5
LIT Moes 1897-1905, vol 2, nr 5653:2.
De Loos-Haaxman 1941, p 91, fig 50.
Stapel 1941, p 37, ill

A 4539 Willem van Outhoorn (1635-1720). Governor-general (1691-1704)

Copy by David van der Plaes (1647-1704)

Canvas 33.5 × 24.5. Signed *D. vʳ Plaes*.
Inscribed *Wilh. van Outshoorn gouv. Generaal van Indië*
LIT Moes 1897-1905, vol 2, nr 5653:5.
De Loos-Haaxman 1941, p 91

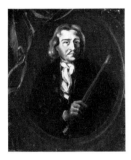

A 3770 Joan van Hoorn (1653-1711). Governor-general (1704-09)

Copy after a lost original by Cornelis de Bruijn (1652-1726/27)

Canvas on board 85 × 70.5
LIT De Loos-Haaxman 1941, p 92, fig 53 (on the original). Stapel 1941, p 39, ill

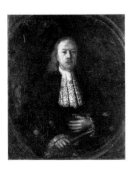
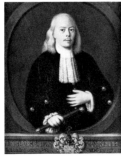

A 3771 Abraham van Riebeeck (1653-1713). Governor-general (1709-13)

By a Dutch painter in Batavia, ca 1711

Canvas on board 89 × 80.5
LIT Moes 1897-1905, vol 2, nr 6422:2.
De Loos-Haaxman 1941, p 94, fig 55.
Stapel 1941, p 41, ill

A 4540 Abraham van Riebeeck (1653-1713). Governor-general (1709-13)

Copy after A 3771

Copper 34.5 × 27. Inscribed *De Hr. Abraham van Riebeeck. Gouvernʳ Generael oud 58 jaeren A° 1711*
LIT Moes 1897-1905, vol 2, nr 6422:4.
De Loos-Haaxman 1941, p 95

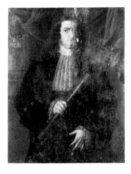
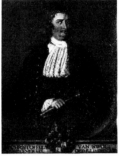

A 3772 Christoffel van Swoll (1663-1718). Governor-general (1713-18)

By Hendrik van den Bosch (active 1692-1736 in Batavia)

Panel 99 × 77. Signed *Hendrik van den Bosch van Batavia fecit*
LIT Moes 1897-1905, vol 2, nr 7776:1.
De Loos-Haaxman 1941, p 95, fig 57.
Stapel 1941, p 43, ill

A 4541 Christoffel van Swoll (1663-1718). Governor-general (1713-18)

Copy after A 3772

Canvas 35 × 26.5. Inscribed *De Hr. Christoffel van Swol Gouwerʳ Generael Oud 53 jaeren A° 1715*
LIT Moes 1897-1905, vol 2, nr 7776:4.
De Loos-Haaxman 1941, p 95, note 3

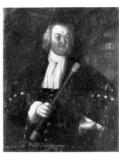
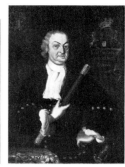

A 3773 Hendrik Swaardecroon (1667-1728). Governor-general (1718-25)

By Hendrik van den Bosch (active 1692-1736 in Batavia)

Panel 98.5 × 80.5. Signed and dated *H. vn. dn. Bosch Fecit A° 1723*
LIT Moes 1897-1905, vol 2, nr 7717:1.
De Loos-Haaxman 1941, p 96, fig 58.
Stapel 1941, p 45, ill

A 4542 Hendrik Swaardecroon (1667-1728). Governor-general (1718-25)

Copy after A 3773

Copper 33.5 × 26. Inscribed *India Belgarum Dulce Decus Batavis*
LIT Moes 1897-1905, vol 2, nr 7717:4.
De Loos-Haaxman 1941, p 96, note 3

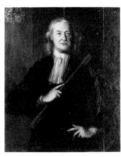
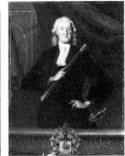

A 3774 Mattheus de Haan (1663-1729). Governor-general (1725-29)

By a Dutch painter in Batavia, 1726

Panel 101.5 × 83.5. Inscribed on the verso *Mattheus de Haan ernʳ Generˡ van Nederlands India October A° 1726 Ætatis 63 Jaaren*
LIT Moes 1897-1905, vol 1, nr 3058:1.
De Loos-Haaxman 1941, p 97, fig 59.
Stapel 1941, p 47, ill

A 4543 Mattheus de Haan (1663-1729). Governor-general (1725-29)

Copy after A 3774

Copper 33 × 25. Inscribed *Mattheus de*

*Haan Gouvern' Gen' van India van den 7
Aug A° 1725 tot.* On the verso *den 14
October A° 1726; Aetatis 63 Jaaren*
LIT Moes 1897-1905, vol 1, nr 3058:4.
De Loos-Haaxman 1941, p 97

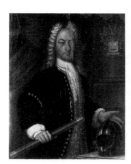

A 3775 Diederik van Durven (1676-
1740). Governor-general (1729-30)

By Hendrik van den Bosch (active 1692-
1736 in Batavia)

Panel 98.5 ×80.5
LIT Moes 1897-1905, vol 1, nr 2183:3.
De Loos-Haaxman 1941, pp 96, 98, fig
60. Stapel 1941, p 49, ill

A 4544 Diederik van Durven (1676-
1740). Governor-general (1729-30)

By Hendrik van den Bosch (active 1692-
1736 in Batavia)

Copper 33 ×25. Signed and dated
Hendrik van den Bosch. fecit 1736.
Inscribed *Mr. Diderik Durven Gouvr.
Generl. van India*
LIT De Loos-Haaxman 1941, p 96

A 3776 Dirk van Cloon (1684-1735).
Governor-general (1730-35)

By Hendrik van den Bosch (active 1692-
1736 in Batavia)

Panel 99 ×81.5. Signed and dated
Hk. van den Bosch ten Batavia Fecit 1733
LIT Moes 1897-1905, vol 1, nr 1585:1.
De Loos-Haaxman 1941, p 99, fig 61.
Stapel 1941, p 51, ill

A 4545 Dirk van Cloon (1684-1735).
Governor-general (1730-35)

Free copy after A 3776

Copper 33.5 ×26.5. Inscribed *Mr. Dirk
van Cloon. Bat. Ind.*
LIT Moes 1897-1905, vol 1, nr 1585:4.
De Loos-Haaxman 1941, p 99, note 7

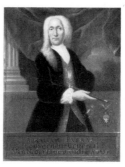

A 3777 Abraham Patras (1671-1737).
Governor-general (1735-37)

By Theodorus Justinus Rheen (active
1737-45 in Batavia)

Copper 102 ×84.5
LIT Moes 1897-1905, vol 2, nr 5763:1.
De Loos-Haaxman 1941, pp 100, 102,
fig 62. Stapel 1941, p 53, nr XXIII, ill

A 4546 Abraham Patras (1671-1737).
Governor-general (1735-37)

Copy after or replica of A 3777

Copper 34 ×27. Inscribed *T. J. Rheen*
and *Abraham Patras Gouverneur Generaal.
van Nederlands. India A° 1735*
LIT Moes 1897-1905, vol 2, nr 5763:4

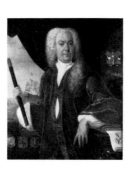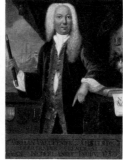

A 3778 Adriaan Valckenier (1695-1751).
Governor-general (1737-41)

By Theodorus Justinus Rheen (active
1737-45 in Batavia)

Brass 102.5 ×85.5. Signed and dated
Th. J. Rheen 1737
LIT Moes 1897-1905, vol 2, nr 8209:1.
De Loos-Haaxman 1941, p 100, fig 63.
Stapel 1941, nr 24, ill

A 4547 Adriaan Valckenier (1695-1751).
Governor-general (1737-41)

Copy after A 3778

Copper 34 ×26.5. Inscribed *Adriaan
Valckenier van Amsterd. Gouverneur
Generaal Van Nederlands India 1737*
LIT Moes 1897-1905, vol 2, nr 8209:4

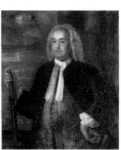

A 3779 Johannes Thedens (1680-1748).
Governor-general (1741-43)

By a Dutch painter in Batavia, ca 1742

Canvas 107.5 ×91
LIT Moes 1897-1905, vol 2, nr 7929:1.
De Loos-Haaxman 1941, p 102, fig 64.
Stapel 1941, p 57, ill. De Loos-Haaxman
1968, pp 12, 15, 32

A 4548 Johannes Thedens (1680-1748).
Governor-general (1741-43)

Free copy after A 3779 by J A Oliphant
(biographical data unknown)

Copper 35 ×24. Signed and dated *Jaˢ
Oliphant Pinxit 1742.* Inscribed *Johannes
Thedens. Gouw. Gen. van Nederland. Indië
Etatis Suae 64*
LIT De Loos-Haaxman 1941, p 103, note
2

A 3780 Gustaaf Willem Baron van
Imhoff (1705-50). Governor-general
(1743-50)

Copy after Philip van Dijk (1680-1753)
and Jan Maurits Quinkhard (1688-
1772)

Brass 110 ×92.5
LIT Moes 1897-1905, vol 1, nr 3913:3
(Philip van Dijk). De Loos-Haaxman
1941, p 104, fig 66. Stapel 1941, p 59, ill

A 4549 Gustaaf Willem Baron van
Imhoff (1705-50). Governor-general
(1743-50)

By Jan Maurits Quinkhard (1688-1772)

Copper 34 ×27. Signed and dated *J. M.
Quinkhard pinxit 1742*. Inscribed *Gustaaf
Willem Baron van Imhoff aetat XXXVIII
G. G. van N. I.*
LIT Moes 1897-1905, vol 1, nr 3912

A 3781 Jacob Mossel (1704-61).
Governor-general (1750-61)

By a Dutch painter in Batavia, ca 1755

Canvas on board 112.5 ×96
LIT Moes 1897-1905, vol 2, nr 5175:1.
De Loos-Haaxman 1941, p 105, fig 67.
Stapel 1941, p 61, ill. CH de Jonge,
Historia 8 (1942) p 195, fig 4. De Loos-
Haaxman 1968, pp 15-16

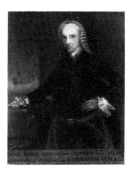

A 4550 Jacob Mossel (1704-61).
Governor-general (1750-61)

Copy by an unknown painter

Copper 33.5 ×26.5. Inscribed *Jacob
Mossel Generaal over d'Infanterye van den
Staat en Gouverneur Generaal van Nederlands
India*
LIT Moes 1897-1905, vol 2, nr 5175:4.
De Loos-Haaxman 1941, p 106

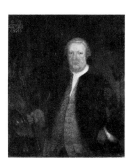 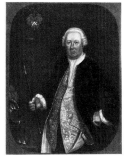

A 3782 Petrus Albertus van der Parra
(1714-75). Governor-general (1761-75)

By a Dutch painter in Batavia, ca 1762

Brass 108.5 ×93
LIT Moes 1897-1905, vol 2, nr 5743:1.
De Loos-Haaxman 1941, p 107, fig 68.
Stapel 1941, p 63, ill

A 4551 Petrus Albertus van der Parra
(1714-75). Governor-general (1761-75)

Copy after A 3782

Copper 35 ×27. Inscribed *P. A. van der
Parre Gouverneur Generael van Nederlands
Indiën*
LIT Moes 1897-1905, vol 2, nr 5743:4.
De Loos-Haaxman 1941, p 107, note 2

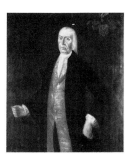

A 3783 Jeremias van Riemsdijk (1712-
77). Governor-general (1775-77)

By 'Tricot' or 'Fricot,' possibly
Franciscus Joseph Fricot (active ca 1777
in Batavia)

Brass 108.5 ×93
LIT Moes 1897-1905, vol 2, nr 6435:1.
De Loos-Haaxman 1941, p 109, fig 70.
Stapel 1941, p 65, ill

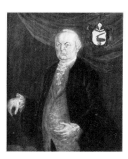 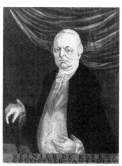

A 3784 Reinier de Klerk (1710-80).
Governor-general (1777-80)

By 'Tricot' or 'Fricot,' possibly
Franciscus Joseph Fricot (active ca 1777
in Batavia)

Brass on panel 105 ×90. Signed and
dated *Tricot 1777*
LIT Moes 1897-1905, vol 1, nr 1564:1.
De Loos-Haaxman 1941, p 108, note 3,
p 109, fig 71. Stapel 1941, p 67, ill

A 4552 Reinier de Klerk (1710-80).
Governor-general (1777-80)

By 'Tricot' or 'Fricot,' possibly
Franciscus Joseph Fricot (active ca 1777
in Batavia)

Copper 35 ×27. Signed *Tricot 1779*.
Inscribed *Reinier de Klerk Gouv^r Gener^l
van India*
LIT Moes 1897-1905, vol 1, nr 1564:4.
De Loos-Haaxman 1941, p 109, note 4

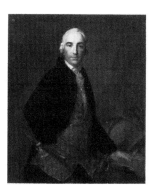

A 3785 Willem Arnold Alting (1724-
1800). Governor-general (1780-97)

By Johann Friedrich August Tischbein
(1750-1812)

Brass 108 ×91.5. Signed and dated
Tischbein pinx. 1788
LIT J de Loos-Haaxman, Tijdschr Ind
TLV 78 (1938) pp 57-64. De Loos-
Haaxman 1941, p 112, fig 72. Stapel
1941, p 69, nr 21, ill. CH de Jonge,
Historia 8 (1942) p 195

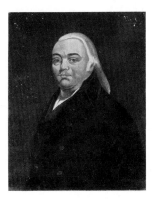

A 3786 Sebastiaan Cornelis Nederburgh (1762-1811). Director-general (1791-99). *Commissaris-generaal*

Copy by Cornelis de Cocq (active 1843 in The Hague)

Canvas on board 80.5 ×65. Signed and dated *C. de Cock 1862.* Inscribed on the verso *Mr. Sebastiaan Cornelis Nederburgh, geboren den 7 Maart 1762, Commissaris-Generaal over geheel Nederlandsch Indië en Kaap de Goede Hoop. Daartoe benoemd den 19 Augustus 1791, als zoodanig afgetreden in October 1799. Het oorspronkelijke dezer copie is geschilderd in 1800*
LIT De Loos-Haaxman 1941, pp 115, 139

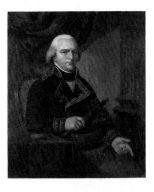

A 3787 Pieter Gerhardus van Overstraten (1755-1801). Governor-general (1797-1801)

Thought to be by Adriaan de Lelie (1755-1820). The facial features are modelled after a miniature portrait made in Batavia by Joseph Gillis (b Antwerp? active ca 1802-08 in Batavia), now preserved in the Stichting Historische Verzamelingen van het Huis Oranje-Nassau (historical collections foundation of the house of Orange-Nassau) in The Hague

Copper 106.5 ×91.5
LIT Moes 1897-1905, vol 2, nr 5675:2. De Loos-Haaxman 1941, p 115, fig 77 (Joseph Gillis). Stapel 1941, p 71, ill

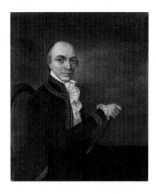

A 3788 Johannes Siberg (1740-1817). Governor-general (1801-05)

By a Dutch painter in Batavia, ca 1800

Copper 107 ×90
LIT De Loos-Haaxman 1941, p 118, fig 80. Stapel 1941, p 73, ill

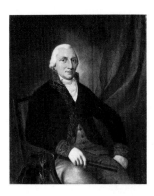

A 3789 Albertus Henricus Wiese (1761-1810). Governor-general (1805-08)

By the same hand as A 3787

Copper 105 ×91
LIT De Loos-Haaxman 1941, pp 116, 119, fig 79 (Joseph Gillis). Stapel 1941, p 75, ill

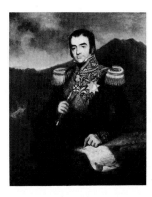

A 3790 Posthumous portrait of Herman Willem Daendels (1762-1818). Governor-general (1808-10)

By Raden Sarief Bastaman Saleh (1814-80)

Canvas 119 ×98. Signed and dated *Raden Saleh f. 1838*
LIT De Loos-Haaxman 1941, p 121, fig 83. Stapel 1941, p 77, ill. CH de Jonge, Historia 8 (1942) p 196, fig 5. Dronkers 1968, p 86, ill. M Zappey, Spiegel Hist 4 (1969) p 33

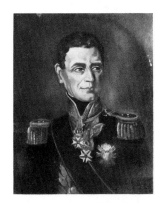

A 3791 Jonkheer Jan Willem Janssens (1762-1838). Governor-general (1811-12)

Free copy after Jan Willem Pieneman, A 2219

Canvas on board 79.5 ×61.5
LIT De Loos-Haaxman 1941, p 123, fig 84

A 3792 Gilbert Elliot, first earl of Minto (1751-1814). Viceroy of British India and governor-general of the Dutch East Indies (1812-14). *Onderkoning van Brits-Indië en gouverneur-generaal van Nederlands Oost Indië*

By George Chinnery (1748-1847)

Canvas on board 238 ×149
LIT Der Kinderen 1878, p 148, note 3. G P Rouffaer, OH 12 (1894) p 198. R R M See, Connoisseur 53-54 (1919) pp 141-45. J Orange, Studio 79-80 (1920) pp 82-93. W H Welply, Notes and Queries, 1927, pp 21ff, 39ff, 58ff, 75ff. J de Loos-

Haaxman, Ned Indië 12 (1928) p 215.
Foster 1931, p 16. De Loos-Haaxman
1941, p 123, fig 85. CH de Jonge,
Historia 8 (1942) p 195. De Loos-
Haaxman 1972, p 46

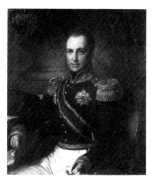

A 3795 Godart Alexander Gerard
Philip Baron van der Capellen (1778-
1848). Governor-general (1816-26)

By Cornelis Kruseman (1797-1857)

Canvas on board 103.5 × 89.5
LIT De Loos-Haaxman 1941, p 126, fig
86. Stapel 1941, p 81, ill

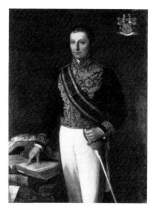

A 3793 Cornelis Theodorus Elout (1767-
1841). Director-general (1816-19).
Commissaris-generaal

Painted ca 1883 by Andries van den
Bergh (1852-1944) after models by
Charles Howard Hodges and L A
Vincent

Canvas 134 × 97.5. Signed *A. v.d. Berg ft.*
LIT De Loos-Haaxman 1941, p 127, fig
90

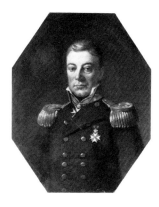

A 3794 Arnold Adriaan Buyskes (1771-
1838). Director-general (1816-19).
Commissaris-generaal

By an unknown artist; painted ca 1865
in the Netherlands

Canvas 80 × 60
LIT De Loos-Haaxman 1941, p 127, fig 91

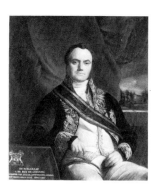

A 3797 Léonard Pierre Joseph Burgrave
du Bus de Gisignies (1780-1849).
Director-general (1826-30). *Commissaris-
generaal*

By François Joseph Navez (1787-1869)

Canvas 113.5 × 98. Signed and dated
F. J. Navez 1836. Inscribed *De Burggraaf
L. Du Bus de Gisignies. Minister van Staat,
Kommissaris-Generaal over Nederlandsch
Indië 1826-30*
*DRVK since 1971 (Museum 'Bronbeek,'
Arnhem)
LIT De Loos-Haaxman 1941, p 128, fig
92. Stapel 1941, p 83, ill

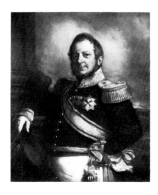

A 3796 Hendrik Merkus Baron de Kock
(1779-1845). Commander of the army
and after 1826 lieutenant governor-
general. *Legercommandant en na 1826
luitenant-gouverneur-generaal*

By Cornelis Kruseman (1797-1857)

Canvas 106 × 90. Signed *C. Kruseman f.*
*DRVK since 1960 (Museum van de
Kanselarij der Nederlandse Orden,
The Hague)
LIT De Loos-Haaxman 1941, p 127, fig
88. Knoef 1948, ill opp p 72

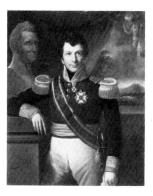

A 3798 Johannes Count van den Bosch
(1780-1844). Governor-general (1830-
33)

By Raden Sarief Bastaman Saleh (1814-
80)
For another portrait of the sitter, *see*
Kruseman, Cornelis, A 2166

Canvas 115 × 97. Signed and dated
R. Saleh ft 1836
LIT De Loos-Haaxman 1941, p 129, fig
93. Stapel 1941, p 85, ill. CH de Jonge,
Historia 8 (1942) p 196

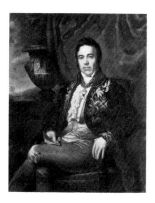

A 3799 Jean Chrétien Baud (1789-1859).
Governor-general ad interim (1833-35)

By Raden Sarief Bastaman Saleh (1814-
80)

Canvas 119.5 × 97.5
LIT De Loos-Haaxman 1941, p 130, fig
94. Stapel 1941, p 87, ill. CH de Jonge,
Historia 8 (1942) p 196

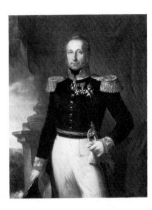

A 3800 Dominique Jacques de Eerens (1781-1840). Governor-general (1835-40)

Copy after Cornelis Kruseman (1797-1857)

Canvas 132.5 × 101.5
LIT De Loos-Haaxman 1941, p 130, fig 95. Stapel 1941, p 89, ill

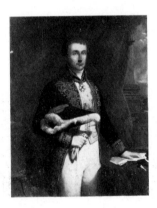

A 3801 Pieter Merkus (1787-1844). Governor-general (1841-44)

Copy after Jan Willem Pieneman (1779-1853)

Canvas 141.5 × 109.5
LIT De Loos-Haaxman 1941, p 131, fig 96. Stapel 1941, p 91, ill

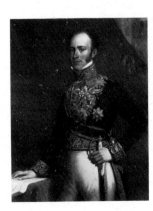

A 3802 Jan Jacob Rochussen (1797-1871). Governor-general (1845-51)

By Nicolaas Pieneman (1809-60)

Canvas 119.5 × 93. Signed and dated *N. Pieneman 1845*
LIT Kramm 1857-64, vol 3 (1859) p 1283. De Loos-Haaxman 1941, p 131, fig 97. Stapel 1941, p 93, ill

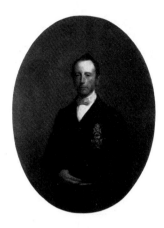

A 3803 Albertus Jacob Duymaer van Twist (1809-87). Governor-general (1851-55)

By Herman Antonie de Bloeme (1802-67)

Canvas 120 × 91.5. Oval. Signed and dated *H. A. de Bloeme 1861*
LIT De Loos-Haaxman 1941, p 131, fig 98. Stapel 1941, p 95, ill. CH de Jonge, Historia 8 (1942) p 196

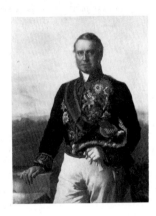

A 3804 Charles Ferdinand Pahud (1803-73). Governor-general (1855-61)

By Jacob Spoel (1819/20-68)

Canvas 120.5 × 92.5. Signed *J. Spoel*
LIT De Loos-Haaxman 1941, p 132, fig 99. Stapel 1941, p 97, ill

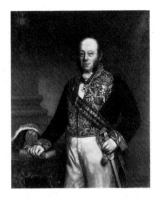

A 3805 Ludolph Anne Jan Wilt Baron Sloet van de Beele (1806-90). Governor-general (1861-66)

By Barend Leonardus Hendriks (1830-99)

Canvas 133.5 × 106. Signed and dated *BL Hendriks f 1867*
LIT De Loos-Haaxman 1941, p 132, fig 100. Stapel 1941, p 99, ill

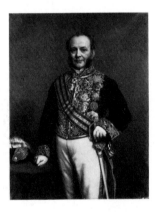

A 3806 Pieter Mijer (1812-81). Governor-general (1866-71)

By Jan Hendrik Neuman (1819-98)

Canvas 125 × 95. Signed and dated *Jan Hendrik Neuman f 1874*
LIT De Loos-Haaxman 1941, p 133, fig 101. Stapel 1941, p 101, ill

A 3807 James Loudon (1824-1900). Governor-general (1871-75)

By Andries van den Bergh (1852-1944)

Canvas 134.5 × 97.5. Signed *A. v.d. Berg fecit*
* DRVK since 1971 (Museum 'Bronbeek,' Arnhem)
LIT De Loos-Haaxman 1941, p 133, fig 102. Stapel 1941, p 102, ill

A 3808 Johan Willem van Lansberge (1830-1906). Governor-general (1875-80)

By Andries van den Bergh (1852-1944)

Canvas 123.5 × 98
* DRVK since 1971 (Museum 'Bronbeek,' Arnhem)
LIT De Loos-Haaxman 1941, p 133, fig 103. Stapel 1941, p 105, ill

A 3809 Frederik s'Jacob (1822-1901). Governor-general (1880-84)

By Pieter de Josselin de Jong (1861-1906)

Canvas 129 × 105. Signed *P. d.J.d.J.*
LIT De Loos-Haaxman 1941, p 133, fig 104. Stapel 1941, p 107, ill

A 3810 Otto van Rees (1823-92). Governor-general (1884-88)

By an unknown artist

Canvas on board 106 × 92.5
LIT De Loos-Haaxman 1941, p 134, fig 105. Stapel 1941, p 109, ill

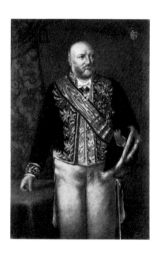

A 3811 Cornelis Pijnacker Hordijk (1847-1908). Governor-general (1888-93)

By Adriaan Johannes Petrus Boudewijnse (1862-1909)

Canvas 143.5 × 94. Signed and dated *P. Boudewijnse 1895*
LIT De Loos-Haaxman 1941, p 134, fig 106. Stapel 1941, p 111, ill

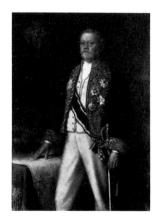

A 3812 Carel Herman Aart van der Wijck (1840-1914). Governor-general (1893-99)

By Louis Storm van 's-Gravesande (1861-1930)

Canvas 153 × 108. Signed and dated *Louis Storm v. 's Gravesande 1900*
LIT De Loos-Haaxman 1941, p 134, fig 107. Stapel 1941, p 113, ill

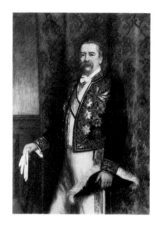

A 3813 Willem Rooseboom (1843-1920). Governor-general (1899-1904)

By Hendrik Johannes Haverman (1858-1928)

Canvas 152 × 107. Signed and dated *Haverman 1905*
LIT De Loos-Haaxman 1941, p 134, fig 108. Stapel 1941, p 115, ill

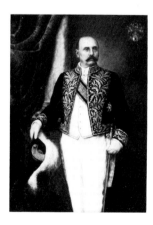

A 3814 Johannes Benedictus van Heutsz (1851-1924). Governor-general (1904-09)

By Hannké (active 1909 in Batavia)

Canvas 140.5 × 101. Signed and dated *Hannké Batavia 1909*
* DRVK since 1960 (Museum van de Kanselarij der Nederlandse Orden, The Hague)
LIT De Loos-Haaxman 1941, p 134, fig 109. Stapel 1941, p 117, ill

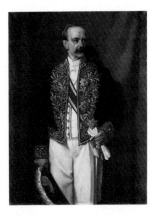

A 3815 Alexander Willem Frederik Idenburg (1861-1935). Governor-general (1909-16)

By Johannes Henricus Franken (1878-1959)

Canvas 145.5 × 107. Signed *Jan Franken*
LIT De Loos-Haaxman 1941, p 135, fig 110. Stapel 1941, p 119, ill

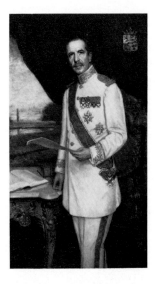

A 3816 Johan Paul Count van Limburg Stirum (1873-1948). Governor-general (1916-21)

By M Loebell, a German artist (biographical data unknown)

Canvas 168 × 98. Signed and dated *M. Loebell 1920*
LIT De Loos-Haaxman 1941, p 135, fig 111. Stapel 1941, p 121, ill

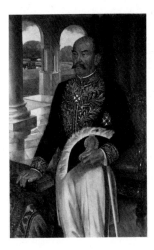

A 3817 Dirk Fock (1858-1941). Governor-general (1921-26)

By Jan Frank Niemantsverdriet (1885-1945)

Canvas 150 × 96.5. Signed and dated *J. Frank Weltevreden 1925*
LIT De Loos-Haaxman 1941, p 135, fig 112. Stapel 1941, p 123, ill. CH de Jonge, Historia 8 (1942) p 196

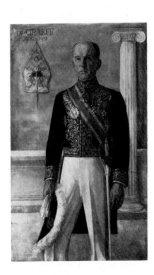

A 3818 Jonkheer Andries Cornelis Dirk de Graeff (1872-1936). Governor-general (1926-31)

By Hendrik Paulides (1892-1967)

Canvas 168 × 100.5. Signed and dated *HP fec. 1930*. Inscribed *De Graeff 1926-1931*
LIT De Loos-Haaxman 1941, p 135, fig 113. Stapel 1941, p 125, ill

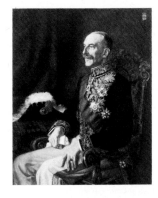

A 3819 Jonkheer Bonifacius Cornelis de Jonge (1875-1958). Governor-general (1931-36)

By Jan Frank Niemantsverdriet (1885-1945)

Canvas 124.5 × 104
LIT De Loos-Haaxman 1941, p 135, fig 114. Stapel 1941, nr 127, ill. CH de Jonge, Historia 8 (1942) p 196

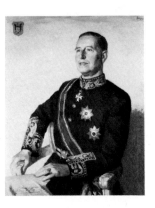

A 3880 Jonkheer Alidius Warmoldus Lambertus Tjarda van Starkenborgh Stachouwer (b 1888). Governor-general (1936-1945)

By Jacob Bruyn (b 1906)

Canvas 100 × 80. Signed *Bruyn*
PROV Commissioned in 1953 to round off the series of portraits of the governors-general * DRVK since 1971 (Museum 'Bronbeek,' Arnhem)

2
Chairmen of the people's council

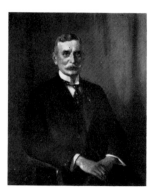

A 3823 Jacob Christiaan Koningsberger
(1871-1951). Chairman of the people's
council (1918-19)

By Jan Willem Sluiter (1873-1949)

Canvas 99.5 ×81.5. Signed and dated
Willy Sluiter, Den Haag, Sept. 1925

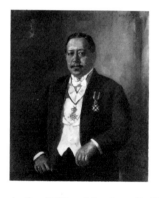

A 3824 Willem Martinus Godfried
Schumann (1877-1952). Chairman of
the people's council (1919-25)

By Jan Willem Sluiter (1873-1949)

Canvas 98 ×80.5. Signed and dated
Willy Sluiter 1924

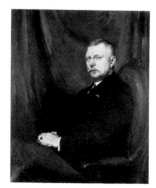

A 3822 Adriaan Neytzel de Wilde
(1877-1939). Chairman of the people's
council (1925-29)

By Pieter van der Hem (1885-1961)

Canvas 99 ×81. Signed and dated *P. van
der Hem 1929*

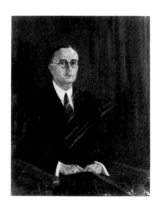

A 3825 Jan Willem Meijer Ranneft (b
1887). Chairman of the people's council
(1929-33)

By Henry van Velthuijsen (1881-1954)

Canvas 98 ×80.5. Signed *H. v. Velthuysen*

Panpoeticon Batavum

Collection of portraits of Dutch poets.
*Verzameling portretten van Nederlandse
dichters*

This collection of portraits, which is no
longer complete, was begun in the first
decade of the 18th century by the
Amsterdam painter, engraver of
mezzotints, sculptor, ivory carver and
poet Arnoud van Halen (1673-1732).
He was probably inspired in this labor
by the publication of Adriaan Pars's
Index Batavicus of naamrol van de
Batavise en Hollandse schrijvers van
Julius Cesar af tot deze tijden toe, met
kopere afbeeldsels (Index Batavicus or
roll of the Batavian and Dutch writers
from Julius Caesar to our times, with
copperplate illustrations), Leiden 1701.
 Van Halen painted his oval portraits
of Dutch poets himself, after prints and
drawings. For the four poets of whom he
could find no authentic portrait – Melis
Stoke, Anna Roemers Visscher, her sister
Maria Tesselschade Visscher and
Catharina Lescailje – he made
'cenotaphs.' Hugo de Groot and
Lambert Bidloo are each represented
with two portraits, at different ages.
 In 1719 van Halen had a walnut
cabinet made for the collection, after a
design by Simon Schijnvoet. He himself
had modelled a gilt statuette of Apollo
to crown the cabinet, and busts of
Melpomene and Thalia for the niches on
either side of the door. On the inside of
the door he painted Apollo and the
muses. The cabinet had 82 removable
trays of various sizes, on which the
miniatures were mounted in gilt leaden
frames. In the cartouche on each frame
was pasted a slip of paper with the name
of the portrayed written in ink. Seven of
the trays and a number of frames have
been preserved. The cabinet itself,
which has since been lost, can be seen in
the background of the self portrait that
van Halen added to the collection
(A 1738) and on the title print etched by
Jan Goeree for the first publication
devoted to it: Lambert Bidloo's
Panpoeticon Batavum: kabinet waar in
de afbeeldingen van voornaame Neder-
landsche dichteren, versameld en
konstig geschildert door Arnoud van
Halen en onder uitbreyding en aan-
merkingen over de Hollandsche
rymkonst geopendt door Lamb. Bidloo
(Panpoeticon Batavum: cabinet with
illustrations of prominent Dutch poets,
collected and artfully painted by
Arnoud van Halen and opened, with
additions and notes on Dutch poetry, by
Lamb[ert] Bidloo), Amsterdam 1720.
 After van Halen's death in 1732 the
collection was purchased by Michiel de
Roode (1685-1771), an Amsterdam
broker with a passion for the theater. He
had 22 of the less attractive portraits

replaced by better ones and added 113 new miniatures. Two of them – those of Joost van den Vondel and Reinier Anslo – duplicated portraits of the same poets by van Halen, though at different ages, and sixteen more show eight poets at two ages. In all, then, de Roode added 103 new figures to van Halen's Panpoeticon.

De Roode assigned work to the following artists: Jan Maurits Quinkhard (21 replacements and 92 new portraits); Dionys van Nijmegen (1 replacement and 7 new portraits); Aart Schouman (7 portraits); Nicolaas Verkolje (4 portraits); Hieronymus van der Mij, Hendrik Pothoven and Cornelis Greenwood (1 portrait each).

The portraits de Roode had duplicated and those he added in two versions are:

Reinier Anslo, by Verkolje, duplicating van Halen
Johannes Braam, by Quinkhard and Schouman
Caspar Brandt, painted twice by Quinkhard
Johannes Brandt, by Quinkhard and Verkolje
Herman van der Burgh, painted twice by Quinkhard
Frans Greenwood, by Schouman and Cornelis Greenwood
Constantijn Huygens, painted twice by Quinkhard
Jan de Marre, painted twice by Quinkhard
Anna Maria Schuurman, painted twice by Quinkhard
Joost van den Vondel, by Quinkhard, duplicating van Halen

Quinkhard was moreover responsible for paintings of himself with de Roode, a double portrait of de Roode with his friend the actor Jan Punt and a portrait of Jan Punt.

Van Halen's original decoration of the inside of the door was replaced by de Roode in 1738 with a painting made for this purpose by Jacob de Wit, representing the Vereniging van Dicht-en Schilderkunst (Union of poetry and painting; a preliminary study is preserved in the Teylers Stichting, Haarlem). Following the death of de Roode, the Panpoeticon was put on the auction block in Amsterdam on 29 March 1771, but remained unsold. The executor of de Roode's estate, Arnoud de Jongh, kept it for a few months, in which time he had several of the miniatures restored and added three new ones, one by Hendrik Pothoven and two by an unidentified painter.

In 1772, finally, the cabinet was sold to the Leiden cultural society Kunst wordt door Arbeid verkregen (Art is acquired through labor), where it was given a place in the auditorium. The Leiden painter Nicolaas Reyers (1719-96) was put in charge of the collection. He

painted the top of the chest with putti and the coats of arms of the four patrons of the society, added eight new portraits and replaced the 'cenotaph' of Catharina Lescailje with a portrait of her. Within a short time, the society executed de Roode's abortive plan to publish the captions and panegyrics that formed an integral part of the collection: Arnoud van Halen's Pan Poëticon Batavum verheerlijkt door lofdichten en bijschriften, grootendeels getrokken uit het Stamboek van Michiel de Roode en nu eerst in 't licht gebragt door het Genootschap onder de spreuk: Kunst wordt door arbeid verkregen (Arnoud van Halen's Pan Poëticon Batavum adorned with panegyrics and captions largely extracted from Michiel de Roode's record book and now published for the first time by the society that bears the motto Art is acquired through labor), Leiden 1773.

In 1807 the cabinet was damaged by the powder ship explosion on the Rapenburg in Leiden. The statuette of Apollo was lost at that time. After several vain attempts were made to interest King Louis Napoleon in the acquisition of the cabinet it was put up for public sale in Amsterdam on 9 April 1818 and bought by Anthonie Kluijtenaar. It remained with his family until the auction of the estate of Anthonia Kluijtenaar-Raidt on 16 October 1849. The new owner was a dealer, and he seems to have disposed of the collection in parts. The cabinet itself has been missing since then. Remarkably enough, a few years later, in 1852, a correspondent to the magazine De Navorscher (p 188) inquired concerning the whereabouts of the Panpoeticon. His letter elicited two responses in the following volume of the journal (pp 187-88), neither of which could answer his question.

In 1849 the cabinet contained a number of books and panegyrics, Michiel de Roode's record book, the manuscript of Lambert Bidloo's book and 350 portraits. The following enumeration of the Panpoeticon Batavum in 1849 shows how many of the portraits have ended up in the Rijksmuseum:

Arnoud van Halen: 199 portraits
Rijksmuseum 46: A 1504, A 4555-A 4558, A 4560-A 4563, A 4565-A 4569, A 4573, A 4574, A 4578-A 4582, A 4584-A 4592, A 4594-A 4596, A 4599-A 4601, A 4603, A 4605, A 4606, A 4608, A 4610-A 4615
Jan Maurits Quinkhard: 113 portraits
Rijksmuseum 25: A 1503, A 4553, A 4554, A 4559, A 4564, A 4570-A 4572, A 4575-A 4577, A 4583, A 4586, A 4593, A 4597, A 4598, A 4602, A 4604, A 4607, A 4609, A 4616, A 4618, A 4620, A 4621, A 4625, A 4626
Dionys van Nijmegen: 8 portraits
Rijksmuseum 3: A 4622-A 4624
Aart Schouman: 7 portraits

Rijksmuseum 1: A 1968
Nicolaas Reyers: 5 portraits
Rijksmuseum 1: A 4619
Nicolaas Verkolje: 4 portraits
Hendrik Pothoven: 2 portraits
Hieronymus van der Mij: 1 portrait
Unknown painter: 7 portraits
Rijksmuseum 1: A 4617

Total: 346 portraits of poets
Rijksmuseum 77

Arnoud van Halen: self portrait
Rijksmuseum 1: A 1738
Jan Maurits Quinkhard: self portrait
The same: portrait of Michiel de Roode
The same: portrait of Jan Punt

Overall total: 350 portraits
Rijksmuseum 78

If one subtracts from the overall total of 350 the portraits of van Halen, Quinkhard, de Roode and Jan Punt, the 22 improved versions of van Halen portraits by Quinkhard and van Nijmegen and the 13 portraits that duplicate poets already represented, the Panpoeticon Batavum is left with portraits of no fewer than 311 Dutch poets.

The enumeration above is based largely on data from the 1849 sales catalogue and the publication of 1773 put out by the Leiden society Kunst wordt door Arbeid verkregen. The latter has proved a relatively reliable source, but it leaves some questions, especially concerning exact numbers and the authorship of several portraits, unanswered. Some errors may have crept into our account that way.

The lion's share of the Rijksmuseum holdings in the Panpoeticon Batavum were bought in Venice in 1880 through the intermediacy of A J Enschedé for the Nederlandsch Museum voor Geschiedenis en Kunst (NMGK). This purchase consisted of six trays of eleven portraits apiece and one of ten portraits. The portraits were still in their frames; to all appearances, the trays were acquired in virtually the same state as when they were removed from the cabinet. Upon arrival at the museum, the miniatures were inventoried under nrs NM 3100a et seq, NM 3101a et seq, NM 3102a et seq, NM 3103a et seq, NM 3104a et seq, NM 3105a et seq and NM 3106a et seq. In 1883 the collection was transferred to the Rijksmuseum where the portraits were inventoried under nrs A 4553-A 4626.

The inventory of the former Nederlandsch Museum voor Geschiedenis en Kunst mentions that two portraits were missing – those of Johannes van Neyenburg (NM 3104d) and Jacobus Heyblocq (NM 3104h); it does not mention the absence of a third portrait, that of G Ogier (NM 3104l). Moreover, the portrait of Gijsbert Tijssens was inadvertently not

inventoried, while two other portraits were entered twice. As it now seems, a total of 77 miniatures were paid for in 1880, of which only 72 were actually received: N M 3100a-i, k-l; N M 3101a-i, k-l; N M 3102a-i, k-l; N M 3103a-i, k-l; N M 3104a-c, e-g, i, k-l; N M 3105a, c-e, g-i, k; N M 3106a-i, k-l.

Five portraits could subsequently be added to the collection, bringing the present total to 77: in 1889 Quinkhard's portrait of Winsemius (A 1503) and van Halen's of Jeremias de Decker (A 1504) were purchased; in 1898 D Franken Dzn bequeathed van Nijmegen's portraits of van der Vliet (A 4624) and de Haas (A 4623); and in 1902 Schouman's portrait of Frans Greenwood was bought (A 1968). Finally, the van Halen self portrait (A 1738) that the artist appended to the Panpoeticon was bequeathed by D Franken Dzn in 1898.

The fate of the rest of the Panpoeticon Batavum is largely unknown. The present locations are known of only ten other pieces from the collection:

Gerbrand Adriaensz Bredero, Jan Goeree, Arnold Houbraken, Gerardus Outhof and Adriaan Reland, by van Halen: Amsterdam, V Rappard collection
Hendrik van der Zande, by Quinkhard: ibidem
Jacob de Witt, by Schouman: Dordrecht, Museum Mr Simon van Gijn
Mattheus Brouerius van Nidek, by van Halen: Heino, Stichting Hannema-de Stuers (cat 1967, nr 286, fig 53, as Godfried Schalcken)
Jan de Marre, by Quinkhard: Vorden, A Staring collection
Theodoor Snakenburg, by Frans van der Mijn: ibidem

In the course of the years the following miniatures have been noted in private collections and in the art market:

Hermanus Angelkot I & II, both by van Halen: H D Willink van Collen collection, Breukelen, 1919
Gerard Brandt, by van Halen: sale Amsterdam, 6 Nov 1900, lot 380
Frans Greenwood, by Cornelis Greenwood: sale Amsterdam, 23 Feb 1909, lot 2812 (as Schouman)
Romyn de Hooghe, by Verkolje: sale Amsterdam, 24 Feb 1930, lot 65 (as Willem Troost)
Adriaan Hoppesteyn, by van Halen: C Boywer collection, 1865
Jan Harmensz Krul, by van Halen: sale Amsterdam, 24 Feb 1930, lot 61
Joost Lambrechts, by Quinkhard: sale Amsterdam, 5 June 1916, lot 15c
Christina Leonora de Neufville, by Verkolje: sale Amsterdam, 5 June 1916, lot 15j (as van der Mij)
Dirck Pietersz Pers, by van Halen: sale Amsterdam, 24 Feb 1930, lot 61
George Henri Petri, by Quinkhard: sale

The Hague, 9 June 1931, lot 781; C Hofstede de Groot collection
Willem van der Pot, by Quinkhard: sale Amsterdam, 5 June 1916, lot 15d (as van der Mij)
Pieter de la Rue, by Quinkhard: J A Schorer collection, The Hague, nd
Josephus Justus Scaliger, by van Halen: sale Amsterdam, 24 Feb 1930, lot 61; sale The Hague, 9 June 1931, lot 783; C Hofstede de Groot collection
Joannes Stalpaert van der Wielen, by van Halen: sale The Hague, 11 April 1969, lot 230
Joan Steengracht, by Quinkhard: sale Amsterdam, 5 June 1916, lot 15h; de Nijs gallery, Amsterdam, 1961
Philip Sweerts, by Quinkhard: sale Vienna, 17 May 1921, lot 391
Ysbrand Vincent, by Quinkhard: sale Amsterdam, 5 June 1916, lot 15e; de Nijs gallery, Amsterdam, 1961
Roemer Visscher, by van Halen: sale Amsterdam, 24 Feb 1930, lot 61
Unknown man: sale Amsterdam, 5 June 1916, lot 15k

Van Halen's portraits are painted with a sparing use of color on oval, somewhat convex tin plates measuring ca 11 × 9 cm. Quinkhard and the other artists who worked on the cabinet after 1732 painted on similar plates of copper. Quinkhard and van Nijmegen worked in straight grisaille, while Schouman, Reyers and in all likelihood the other later artists as well used color.

As far as can be determined, van Halen worked exclusively from prints and drawings. Quinkhard and the later contributors to the cabinet, on the other hand, painted their contemporaries from life.

LIT Lambert Bidloo, Panpoëticon Batavum ..., Amsterdam 1720 (see above). Arnoud van Halen's Pan Poeticon Batavum ..., Leiden 1773 (see above). J C K, 'Arnoud van Halen's Pan Poëticon,' De Navorscher 2 (1852) p 188. L J and W, ibidem 3 (1853) pp 187-88. C & A and C K, 'Arnold van Halen's Pan Poëticon,' Navorscher's Bijblad 3 (1853) p CXXXVI. J J M Heeren, 'Het Panpoëticon Batavum,' OH 37 (1919) pp 230-40. F Wijnman, 'Arnoud van Halen,' OH 43 (1926) p 96. E Pelinck, 'De vergaderzaal van Kunst Wordt Door Arbeid Verkregen,' Jb Leiden 47 (1956) p 156. Pauline I de Haan, 'Het Panpoeticon Batavum van Arnoud van Halen,' Utrecht (unpublished doctoral paper) 1969. Th H Lunsingh Scheurleer, 'Jacob de Wit beschildert kunstkasten,' Alb Amic J G van Gelder, 1973, p 227, figs 1-2

The painters are all listed in the alphabetical section of the catalogue above, with cross-references to the Panpoeticon Batavum.

The portraits are arranged

chronologically by the year of birth of the person portrayed, in an order corresponding to that of inventory numbers A 4553-A 4626, with the following exceptions:

A 1503 Piërius Winsemius, b 1586
A 1504 Jeremias de Decker, b 1609
A 1738 Arnoud van Halen, b 1673 (heads the series)
A 1968 Frans Greenwood, b 1680
A 4594 Anthony Janssen van ter Goes, b 1625-26
A 4600 Franciscus Planté, b ca 1610
A 4613 David Lingelbach I, b 1592-93
A 4618 Frans van Steenwijk, b 1715

Unless otherwise specified, all the portraits come from the Nederlandsch Museum voor Geschiedenis en Kunst, which acquired them in 1880

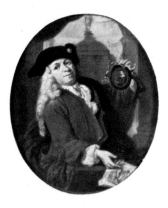

A 1738 Self portrait. *Zelfportret*

By Arnoud van Halen (1673-1732)

Copper 14.5 × 12.5. Oval. Inscribed on
the verso *Arnoud van Halen Pict.
Panpoëticon Batavum*
PROV Bequest of D Franken Dzn, Le
Vésinet, 1898
LIT Moes 1897-1905, vol 1, nr 3123:1.
J J M Heeren, OH 37 (1919) p 233. Van
Hall 1963, p 125, nr 819:2

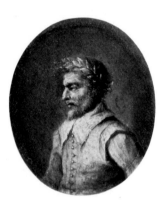

A 4553 Matheus de Casteleyn (1485-
1550). Oudenaarde priest and
rhetorician. *Priester en rederijker te
Oudenaarde*

By Jan Maurits Quinkhard (1688-1772)
after an unknown model

Inscribed on the verso *Math de
Castelyn circa 1566*

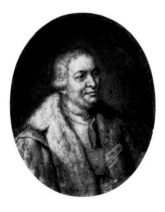

A 4554 Jason Pratensis (1486-1558).
Zierikzee physician. *Geneesheer te
Zierikzee*

By Jan Maurits Quinkhard (1688-
1772) after an unknown model

Inscribed on the verso *Iason Pratensis ob.
1558*
* On loan to the Rijksmuseum voor de
Geschiedenis der Natuurwetenschappen,
Leiden, since 1959

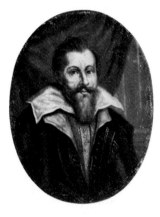

A 4555 Dominicus Baudius (1561-1613).
Professor of rhetoric, history and law at
the university of Leiden. *Hoogleraar in de
welsprekendheid, de geschiedenis en de
rechten te Leiden*

By Arnoud van Halen (1673-1732) after
a print by Jacob Matham (1571-1631)

Inscribed on the verso *Dominicus
Baudius Nat 1561 Obt 1613*
* On loan to the municipality of Delft
since 1949 (from 1959 on via the DRVK)
LIT Moes 1897-1905, vol 1, nr 398:2

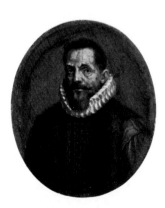

A 4556 Petrus Bertius (1565-1629).
Professor at the university of Leiden.
Hoogleraar te Leiden

By Arnoud van Halen (1673-1732) after
a print by Willem Swanenburgh II
(active 1652-67)

Inscribed on the verso *P. Bertius Nat.
1565/Obt 1629*
LIT Moes 1897-1905, vol 1, nr 573

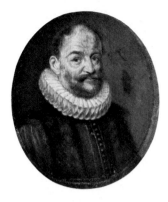

A 4557 Johannes Polyander à
Kerckhoven (1568-1646). Professor of
theology at the university of Leiden.
Hoogleraar in de godgeleerdheid te Leiden

By Arnoud van Halen (1673-1732) after
a print by Willem Jacobsz Delff II
(1580-1638)

Inscribed on the verso *Joannes Poliander.
Nat. 1568/Obt 1646*
LIT Moes 1897-1905, vol 1, nr 4122:5

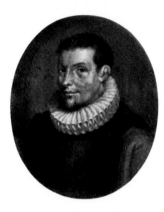

A 4558 Johan van der Does de Jonge
(1571-96). Librarian of the university of
Leiden. *Bibliothecaris te Leiden*

By Arnoud van Halen (1673-1732) after
a print by Willem Swanenburgh II
(active 1652-67)

Inscribed on the verso *Janus Dousa.
Filius. Nat. 1570/Obt 1596/1597*
LIT Moes 1897-1905, vol 1, nr 2043:3

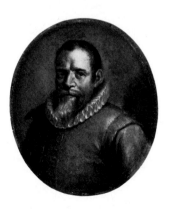

A 4559 Theodorus Velius (1572-1630). Author of the 'Chroniek van Hoorn.' *Schrijver van de 'Chroniek van Hoorn'*

By Jan Maurits Quinkhard (1688-1772) after a print by Theodor Matham (1605/06-76)

Inscribed on the verso *Th. Velius Natus A° 1572 $\frac{1}{10}$, Obt A° 1630 $\frac{4}{23}$* LIT Moes 1897-1905, vol 2, nr 8318:2 (Arnoud van Halen). J J M Heeren, OH 37 (1919) p 239 (presumably Jan Maurits Quinkhard)

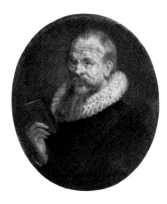

A 4560 Theodorus Schrevelius (1572-1653). Rector of the Latin School in Leiden. *Rector van de Latijnse School te Leiden*

By Arnoud van Halen (1673-1732) after a print by Jonas Suyderhoef (ca 1613-86)

Inscribed on the verso *Theod. Schrevelius. 1572*

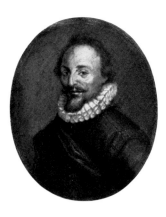

A 4561 Jacob van den Eynde (1575-1614). Governor of Woerden. *Gouverneur van Woerden*

By Arnoud van Halen (1673-1732) after an unknown model

Inscribed on the verso *Jacobus Eyndius. Nat. | Obt 1614* LIT Moes 1897-1905, vol 1, nr 2457

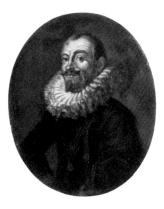

A 4562 Theodorus Rodenburgh (ca 1578-1644). Diplomat and playwright. *Diplomaat en toneeldichter*

By Arnoud van Halen (1673-1732) after a print by Lucas Kilian (1579-1637)

Inscribed on the verso *T. Rodenburg.A° 1566*

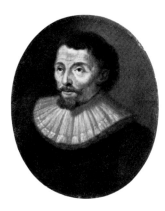

A 4563 Jan van der Rosieren (b 1581)

By Arnoud van Halen (1673-1732) after a print by Pieter Nolpe (1613/14-52/53)

Inscribed on the verso *Joannes van Rosieren.Circa 1565*

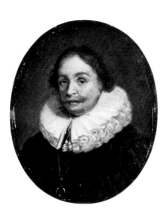

A 1503 Piërius Winsemius (1586-1641). Professor of rhetoric and history at the university of Franeker. *Hoogleraar in de welsprekendheid en de geschiedenis te Franeker*

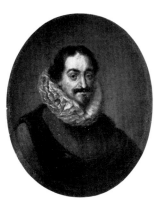

By Jan Maurits Quinkhard (1688-1772) after a print by Jonas Suyderhoef (ca 1613-86)

Inscribed on the verso *Pierius Winsemius. A° 1586* PROV Sale Amsterdam, 11-12 June 1889, lot 191 (as Arnold Houbraken) LIT Moes 1897-1905, vol 2, nr 9140:2

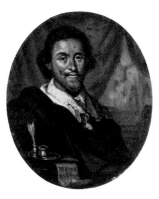

A 4564 Jacobus Schotte (ca 1586-1641). Burgomaster of Middelburg. *Burgemeester van Middelburg*

By Jan Maurits Quinkhard (1688-1772) after a print by Crispijn de Passe II (ca 1597-in or after 1670)

Inscribed on the verso *Iacob Scotte.circa 1570* LIT Moes 1897-1905, vol 2, nr 7016

A 4565 Adriaen Pietersz van de Venne (1589-1662). Painter and poet. *Schilder en dichter*

By Arnoud van Halen (1673-1732) after a print by David van den Bremden (ca 1609/10-after 1650)

Inscribed *Ik Soek En Vind* and, on the verso, *Adriaan van Venne A° 1589* LIT Moes 1897-1905, vol 2, nr 8341:2. Van Hall 1963, p 343, nr 2163:5

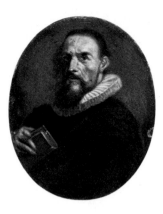

A 4566 Samuel Ampzing (ca 1591-1632). Haarlem minister and poet. *Predikant en dichter te Haarlem*

By Arnoud van Halen (1673-1732) after a print by Jonas Suyderhoef (ca 1613-86)

Inscribed on the verso *Samuel Ampsing. Circa 1594*

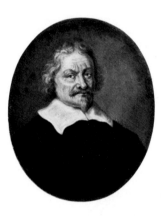

A 4613 David Lingelbach I (1592/93-1653). Founder of the amusement park De Nieuwe Doolhof, Amsterdam. *Oprichter van de Nieuwe Doolhof, Amsterdam*

By Arnoud van Halen (1673-1732) after a print by Crispijn de Passe II (ca 1597-in or after 1670)

Inscribed on the verso *Daniel Lingelbach. Circa 1625*
∗ Lent to the AHM, 1975
LIT Moes 1897-1905, vol 2, nr 4540 (portrait of Daniel Lingelbach)

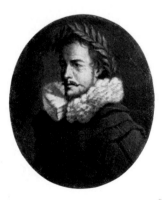

A 4567 Jan Jansz Starter (1594-1626). Poet in Leeuwarden and Amsterdam. *Dichter te Leeuwarden en Amsterdam*

By Arnoud van Halen (1673-1732) after a print by Jan van de Velde (ca 1593-1641)

Inscribed on the verso *Jan Janz Starter. 1594*
LIT Moes 1897-1905, vol 2, nr 7514

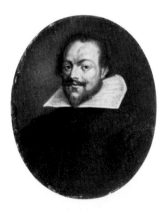

A 4568 Florentius Schoonhoven (1594-1648). Latin poet, burgomaster of Gouda. *Latijns dichter, burgemeester van Gouda*

By Arnoud van Halen (1673-1732) after an anonymous print

Inscribed on the verso *Florentius Schoonhovius. A° 1594*
LIT Moes 1897-1905, vol 2, nr 6985

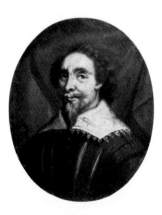

A 4569 Petrus Baard (ca 1595-after 1647). Leeuwarden physician and poet. *Geneesheer en dichter te Leeuwarden*

By Arnoud van Halen (1673-1732) after an unknown model

Inscribed on the verso *Petrus Baard. circa 1600*
LIT Moes 1897-1905, vol 1, nr 317

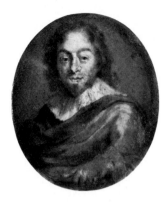

A 4570 Constantijn Huygens (1596-1687). Poet, secretary of Prince Frederik Hendrik and Prince Willem II, first councillor and treasurer of Prince William III. *Dichter, secretaris van prins Frederik Hendrik en prins Willem II en eerste raad en rekenmeester van prins Willem III*

By Jan Maurits Quinkhard (1688-1772) after a print by Paulus Pontius (1603-58)

Inscribed on the verso *C. Huigens A° 1596*
LIT Moes 1897-1905, vol 1, nr 3873:18 or 19

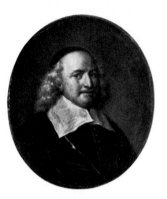

A 4571 Willem de Groot (1597-1662). Jurist and writer. *Rechtsgeleerde en letterkundige*

By Jan Maurits Quinkhard (1688-1772) after a print by Hendrick Bary (ca 1640-1707)

Inscribed on the verso *Wilh. Grotius A° 1597*
LIT Moes 1897-1905, vol 1, nr 2973:2

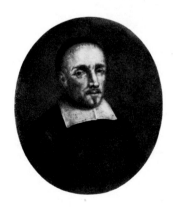

A 4572 Cornelis Hendriksz Udemans (1598-ca 1672). Veere poet. *Dichter te Veere*

By Jan Maurits Quinkhard (1688-1772) after a print by H Udemans (active ca 1660)

Inscribed on the verso *C. Udemans Nat. 1598*
LIT Moes 1897-1905, vol 2, nr 8162

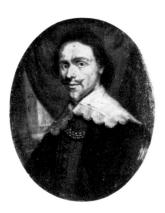

A 4573 Dirck Graswinckel (1600-66). Jurist and writer. *Rechtsgeleerde en letter-kundige*

By Arnoud van Halen (1673-1732) after a print by Theodor Matham (1605/06-1676)

Inscribed on the verso *Theodorus Graswinkel A° 1600*
* On loan to the municipality of Delft since 1949 (from 1959 on via the DRVK)
LIT Moes 1897-1905, vol 1, nr 2912:5

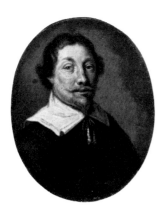

A 4574 Jan van der Veen (ca 1600-59). Deventer apothecary and poet. *Apotheker en dichter te Deventer*

By Arnoud van Halen (1673-1732) after an unknown model

Inscribed on the verso *..n van der Veen. Circa 1595*
LIT Moes 1897-1905, vol 2, nr 8284:2

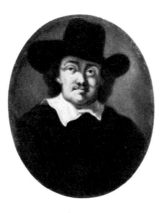

A 1504 Jeremias de Decker (1609-66). Amsterdam poet. *Dichter te Amsterdam*

By Arnoud van Halen (1673-1732) after an anonymous print

Inscribed on the verso *Jerem\\s de Dekker. 1609*
PROV Sale Amsterdam, 11-12 June 1889, lot 192 (as Arnold Houbraken)
* Lent to the AHM, 1975
LIT Moes 1897-1905, vol 1, nr 1917:2.
K H de Raaf, OH 30 (1912) p 3, ill

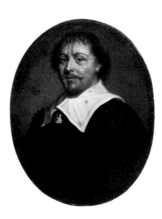

A 4600 Franciscus Planté (ca 1610?-90). Minister in Zevenbergen and in Brazil. *Predikant te Zevenbergen en in Brazilië*

By Arnoud van Halen (1673-1732) after a print by Jonas Suyderhoef (ca 1613-86)

Inscribed on the verso *Franciscus Plante. Circa 1610*
LIT Moes 1897-1905, vol 2, nr 5954:2

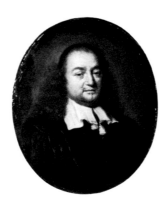

A 4575 Johannes Fredericus Gronovius (1611-71). Philologist and jurist, professor at the university of Leiden. *Filoloog en jurist, hoogleraar te Leiden*

By Jan Maurits Quinkhard (1688-1772) after a print by Johannes van Munnickhuysen (1654/55-after 1701)

Inscribed on the verso *Joh. Fred\\r Gronovius. 1611*
LIT Moes 1897-1905, vol 1, nr 2953:2

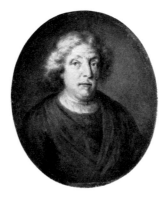

A 4576 Jacob Lescaille (1611-77). Amsterdam bookseller and poet. *Boekhandelaar en dichter te Amsterdam*

By Jan Maurits Quinkhard (1688-1772) after an unknown model

Inscribed on the verso *J\\b Lescailje. 1611*
* Lent to the AHM, 1975
LIT Moes 1897-1905, vol 2, nr 4436

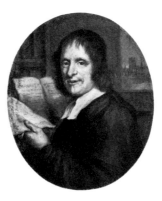

A 4577 Matthijs Balen Jansz (1611-91). Dordrecht poet and city chronicler. *Dichter en stedebeschrijver te Dordrecht*

By Jan Maurits Quinkhard (1688-1772) after a print by Romyn de Hooghe (1645-1708)

Inscribed on the verso *Mathys Balen. 1611*
LIT Moes 1897-1905, vol 1, nr 332:3

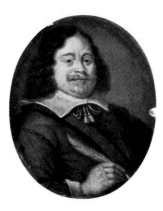

A 4578 Joannes Cools (b 1611). Jurist, historian and Latin poet in Hoorn. *Rechtsgeleerde, geschiedschrijver en Latijns dichter te Hoorn*

By Arnoud van Halen (1673-1732) after a print by Pieter Holsteyn II (ca 1614-87)

Inscribed on the verso *Joh Cools. R.Z. Hᵉ van Tetterode. Circa 1615* LIT Moes 1897-1905, vol 1, nr 1689

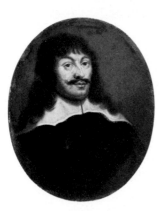

A 4579 Marcus Zuërius van Boxhorn (1612-53). Historian and professor at the university of Leiden. *Geschiedschrijver en hoogleraar te Leiden*

By Arnoud van Halen (1673-1732) after a print by Jonas Suyderhoef (ca 1613-86)

Inscribed on the verso *Marcus Zweri Boxhornius 1612* LIT Moes 1897-1905, vol 1, nr 1001:4

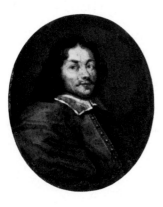

A 4580 Matthijs Gansneb, called Tengnagel (1613-before 1657). Amsterdam poet. *Dichter te Amsterdam*

By Arnoud van Halen (1673-1732) after an unknown model

Inscribed on the verso *M. Tengnagel. 1613* * Lent to the AHM, 1975 LIT Moes 1897-1905, vol 2, nr 7883

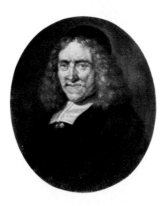

A 4581 Willem Jacobsz van Heemskerck (1613-92). Poet and glass etcher. *Dichter en glasetser*

By Arnoud van Halen (1673-1732) after a print by Abraham Blooteling (1640-90)

Inscribed on the verso *Wilh. Heemskerk 1613* LIT Moes 1897-1905, vol 1, nr 3326:3. Van Hall 1963, p 132, nr 865:2

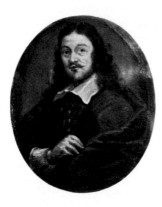

A 4582 Bonaventura Peeters I (1614-52). Painter. *Schilder*

By Arnoud van Halen (1673-1732) after a print by Wenzel Hollar (1607-77)

Inscribed on the verso *B Peters 1614*

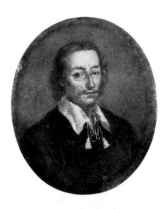

A 4583 Jacob Jacobsz Steendam (1615-73). Poet and historian in Amsterdam, New Amsterdam and Batavia. *Dichter en historicus te Amsterdam, Nieuw-Amsterdam en Batavia*

By Jan Maurits Quinkhard (1688-1772) after an unknown model

Inscribed on the verso *J. Steendam. circa 1615* LIT Moes 1897-1905, vol 2, nr 7534

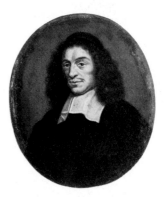

A 4584 Alexander Morus (1616-70). Professor at the university of Amsterdam. *Hoogleraar te Amsterdam*

By Arnoud van Halen (1673-1732) after a print by Lambert Visscher (1633?-after 1690)

Inscribed on the verso *Alexander Morus. 1616* * Lent to the AHM, 1975 LIT Moes 1897-1905, vol 2, nr 5172:2

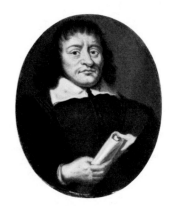

A 4585 Hendrik Bruno (1617-64). Poet and conrector of the Latin School in Hoorn. *Dichter en conrector van de Latijnse school te Hoorn*

By Arnoud van Halen (1673-1732) after a print by Reinier van Persijn (before 1614-68)

Inscribed on the verso *Hendrik Bruno. Circa 1618*
LIT Moes 1897-1905, vol 1, nr 1195

A 4586 Everard Meyster (1617-79). Utrecht poet. *Dichter te Utrecht*

By Arnoud van Halen (1673-1732) after a print by Cornelis van Dalen (ca 1602-65)

Inscribed on the verso *R Meyst..*
LIT Moes 1897-1905, vol 2, nr 5044:2

A 4587 Joan van Paffenrode (1618-73), baron of Ghussigny. Playwright. *Vrijheer van Ghussigny, toneeldichter*

By Arnoud van Halen (1673-1732) after a print by Johan van Haensbergen (1642-1705)

Inscribed on the verso *J. Vryheer van Paffenrode Circa 1622*
LIT Moes 1897-1905, vol 2, nr 5696:2

A 4588 Willem Ogier (1618-89). Antwerp playwright. *Toneeldichter te Antwerpen*

By Arnoud van Halen (1673-1732) after a print by Gerard Bouttats (ca 1630-after 1655)

Inscribed on the verso *G. Ogier Circa 1620*

A 4589 Jan Six (1618-1700). Poet and burgomaster of Amsterdam. *Dichter en burgemeester van Amsterdam*

By Arnoud van Halen (1673-1732) after the etching by Rembrandt (1606-69)

Inscribed on the verso *Jan Six. Burgermeester. 1618*
* Lent to the AHM, 1975
LIT Moes 1897-1905, vol 2, nr 7228:5

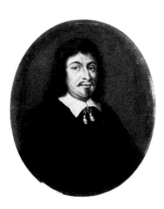

A 4590 Johan van Nijenborgh (1620-70). Groningen poet. *Dichter te Groningen*

By Arnoud van Halen (1673-1732) after an anonymous print

Inscribed on the verso *Joh. Van Neyenburg. 1621*
LIT Moes 1897-1905, vol 2, nr 5472

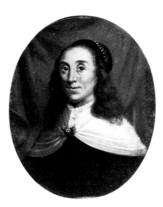

A 4591 Sibylle van Griethuysen (ca 1620-after 1662). Groningen poetess. *Dichteres te Groningen*

By Arnoud van Halen (1673-1732) after a print by Jacob van Meurs (1619-before 1680)

Inscribed on the verso *Sibilla van Griethuyse. Circa 1620*
LIT Moes 1897-1905, vol 1, nr 2934:3

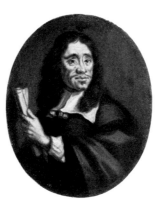

A 4592 Jan Vos (ca 1620-67). Amsterdam poet. *Dichter te Amsterdam*

By Arnoud van Halen (1673-1732) after a print by Karel Dujardin (1622-1678)

Inscribed on the verso *Jan Vos. Circa 1620*
* Lent to the AHM, 1975
LIT Moes 1897-1905, vol 2, nr 8702:3

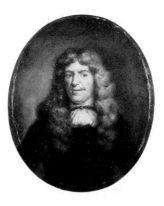

A 4593 Nicolaas Heinsius I (1620-81).
Poet and professor at the university of
Leiden, legate of Christine of Sweden.
*Dichter en hoogleraar te Leiden, gezant van
Christina van Zweden*

By Jan Maurits Quinkhard (1688-1772)
after a print by Abraham de Blois (ca
1655-after 1720)

Inscribed on the verso *N. Heinsius
Gebooren A° 1620 Ob. 7 9ᵇ 1681*
LIT Moes 1897-1905, vol I, nr 3371:3
(Arnoud van Halen)

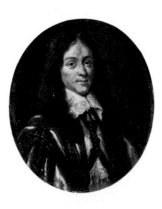

A 4595 Caspar van Kinschot (1622-49).
Poet. *Dichter*

By Arnoud van Halen (1673-1732) after
a print by Wenzel Hollar (1607-77)

Inscribed on the verso *Casper Kingschot.
1621*
LIT Moes 1897-1905, vol I, nr 4192:3

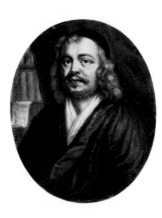

A 4596 Jacob Heiblocq (1623-90).
Rector of the Latin School in
Amsterdam. *Rector van de Latijnse school
te Amsterdam*

By Arnoud van Halen (1673-1732) after
a print by Wallerand Vaillant (1623-77)

Inscribed on the verso *Jacobus Hyblok.
Circa 1630*
∗ Lent to the AHM, 1975
LIT Moes 1897-1905, vol I, nr 3486

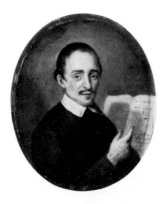

A 4597 Tieleman Jansz van Bracht
(1625-64). Dordrecht minister and poet.
Predikant en dichter te Dordrecht

By Jan Maurits Quinkhard (1688-1772)
after a print by Abraham Blooteling
(1640-90)

Inscribed on the verso *Tilem. Van Bracht
1625*
LIT Moes 1897-1905, vol I, nr 1016

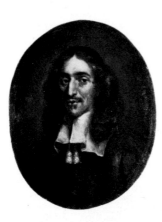

A 4598 Johan de Witt (1625-72).
Grand pensionary. *Raadpensionaris*

By Jan Maurits Quinkhard (1688-1772)
after a print by Hendrick Bary (ca 1640-
1707)

Inscribed on the verso *Jan De Wit 1625*
LIT Moes 1897-1905, vol 2, nr 9185:47.
R van Luttervelt, Bull RM 8 (1960) p 33,
fig 4. J E Haijer, Spiegel Hist 2 (1967) p
418, fig 2

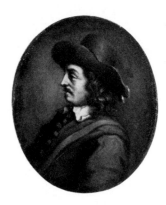

A 4599 Matthijs van de Merwede (1625-
after 1677), lord of Clootwijck.
Dordrecht poet. *Heer van Clootwijck.
Dichter te Dordrecht*

By Arnoud van Halen (1673-1732) after
a print by Jan Gerritsz van Bronckhorst
(ca 1603-61)

Inscribed on the verso *M.V. Merwede
Hʳ van Clootwyk. Circa 1615*
LIT Moes 1897-1905, vol 2, nr 4996

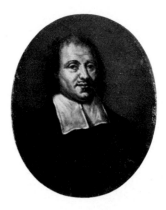

A 4594 Anthony Janssen van ter Goes
(1625/26-99). Amsterdam poet. *Dichter te
Amsterdam*

By Arnoud van Halen (1673-1732). *Cf*
an anonymous drawing in the Teylers
Stichting, Haarlem (Panpoeticon of
Willem Kops)

Inscribed on the verso *Antoni Jansze. 1621*
LIT Moes 1897-1905, vol I, nr 3981:2

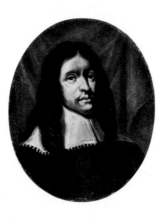

A 4601 Simon Abbes Gabbema (1628-88). Historian of Friesland, from Leeuwarden. *Geschiedschrijver van Friesland te Leeuwarden*

By Arnoud van Halen (1673-1732) after an unknown model

Inscribed on the verso *Simon Abbes Gabbema Circa 1615*
LIT Moes 1897-1905, vol 1, nr 2597

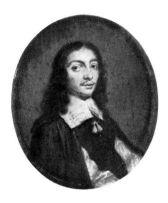

A 4602 Frans Godin (ca 1628-61). Brussels poet. *Dichter te Brussel*

By Jan Maurits Quinkhard (1688-1772) after an unknown model

Inscribed on the verso *F Goduin 1616*
LIT Moes 1897-1905, vol 1, nr 2762

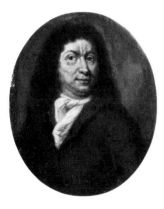

A 4603 Andries Pels (1631-81). Amsterdam playwright. *Toneeldichter te Amsterdam*

By Arnoud van Halen (1673-1732) after an unknown model

Inscribed on the verso *Andries Pels. Circa 1632*
* Lent to the AHM, 1975
LIT Moes 1897-1905, vol 2, nr 5834

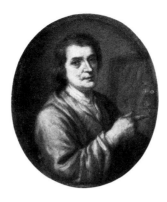

A 4604 Joost van Geel (1631-98). Rotterdam poet and painter. *Schilder en dichter te Rotterdam*

By Jan Maurits Quinkhard (1688-1772) after a print by Jacobus Houbraken (1698-1780)

Inscribed on the verso *Joost. v. Geel. 1631/1698*
LIT Moes 1897-1905, vol 1, nr 2634:2. Van Hall 1963, p 105, nr 689:2

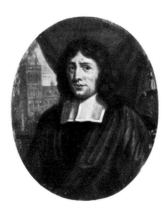

A 4605 Joannes Vollenhove (1631-1708). Minister and poet in The Hague. *Predikant en dichter te Den Haag*

By Arnoud van Halen (1673-1732) after a print by Abraham de Blois (ca 1655-after 1720)

Inscribed on the verso *Joannes Vollenhoven. 1631*
LIT Moes 1897-1905, vol 2, nr 8642:5

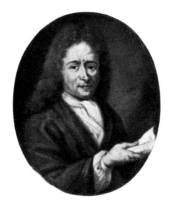

A 4606 Christoffel Pierson (1631-1714). Gouda poet. *Dichter te Gouda*

By Arnoud van Halen (1673-1732) after an unknown model

Inscribed on the verso *Christ... Piersson. 1631/1714*
LIT Moes 1897-1905, vol 2, nr 5924. Van Hall 1963, p 250, nr 1650:1

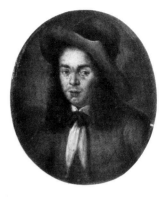

A 4607 Aernout van Overbeke (1632-74). Traveller and poet. *Reiziger en dichter*

By Jan Maurits Quinkhard (1688-1772) after an unknown model

Inscribed on the verso *A. V. Overbeek 1632*
LIT Moes 1897-1905, vol 2, nr 5661:5

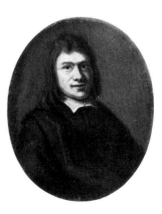

A 4608 Frans van Hoogstraten (1632-96). Poet and bookseller in Rotterdam and Dordrecht. *Dichter en boekhandelaar te Rotterdam en Dordrecht*

By Arnoud van Halen (1673-1732) after an unknown model

Inscribed on the verso *Frans van Hoogstraten. 1632/1696*
LIT Moes 1897-1905, vol 1, nr 3699

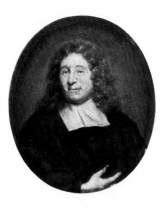

A 4609 Petrus Schaak (1633-78). Amsterdam minister and scholar. *Predikant en geleerde te Amsterdam*

By Jan Maurits Quinkhard (1688-1772) after a print by Pieter Sane (active Amsterdam 1666-69)

Inscribed on the verso *D⁰ P. Schaak. 1633⁴⁄₈*
∗ Lent to the AHM, 1975
LIT Moes 1897-1905, vol 2, nr 6818:2

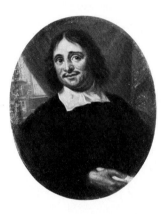

A 4610 Karel Verloove (1633-after 1695). Amsterdam poet. *Dichter te Amsterdam*

By Arnoud van Halen (1673-1732) after an unknown model

Inscribed on the verso *Carel Verlove.1633*
LIT Moes 1897-1905, vol 2, nr 8396

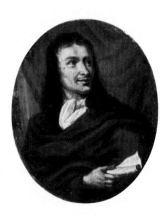

A 4611 Pieter Verhoek (1633-1702).

Amsterdam poet and marble painter. *Dichter en marmerschilder te Amsterdam*

By Arnoud van Halen (1673-1732) after an anonymous print

Inscribed on the verso *Pieter Verhoek. 1633/1702*
LIT Moes 1897-1905, vol 2, nr 8385. Van Hall 1963, p 344, nr 2176:1

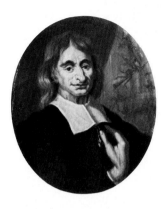

A 4612 Balthasar Bekker (1634-98). Amsterdam minister and writer. *Predikant en letterkundige te Amsterdam*

By Arnoud van Halen (1673-1732) after a print by Pieter van Gunst (1659-1724)

Inscribed on the verso *Balthʳ Bekker. 1634*
∗ Lent to the AHM, 1975
LIT Moes 1897-1905, vol 1, nr 429:3.
Th J Hooning, Spiegel Hist 8 (1973) p 437, ill

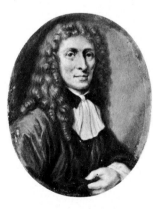

A 4614 Goverd Bidloo (1649-1713). Poet and professor of medicine at the university of Leiden. *Dichter en hoogleraar in de geneeskunde te Leiden*

By Arnoud van Halen (1673-1732) after a print by Abraham Blooteling (1640-90)

Inscribed on the verso *Govert Bidlo 1649*
∗ On loan to the Rijksmuseum van de Geschiedenis der Natuurwetenschappen, Leiden, since 1959
LIT Moes 1897-1905, vol 1, nr 659:4

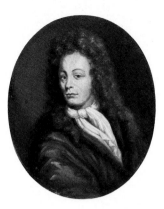

A 4615 Tobias Gutberleth (1675-1703). Leeuwarden writer. *Letterkundige te Leeuwarden*

By Arnoud van Halen (1673-1732) after an unknown model

Inscribed on the verso *Tobias Gutberlet. Circa 1650*
LIT Moes 1897-1905, vol 1, nr 2998

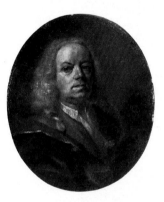

A 1968 Frans Greenwood (1680-1761/62). Dordrecht miniaturist, glass engraver and poet. *Miniaturist, glasgraveur en dichter te Dordrecht*

By Aart Schouman (1710-92)

Signed *A S*. Inscribed on the verso *Frans Greenwood Gebooren den 17 April 1680/1740³⁰⁄₄*
PROV Purchased from C F Roos & Co, art dealers, Amsterdam, 1902
LIT Moes 1897-1905, vol 1, nr 2925:2
J J M Heeren, OH 37 (1919) p 239

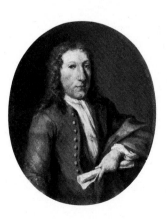

A 4616 Gijsbert Tijssens (ca 1700-ca 1750). Amsterdam playwright. *Toneel-schrijver te Amsterdam*

By Jan Maurits Quinkhard (1688-1772)? *Cf* a drawing attributed to Aart Schouman (1710-92) in the Teylers Stichting, Haarlem (Panpoeticon of Willem Kops

Inscribed on the verso *Tysse*
LIT Moes 1897-1905, vol 2, nr 8159 (Arnoud van Halen). J J M Heeren, OH 37 (1919) p 239 (van Halen)

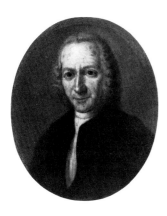

A 4617 Adrianus van Royen (1704-79). Professor of medicine and botany at the university of Leiden. *Hoogleraar in de geneeskunde en kruidkunde te Leiden*

By an unknown painter

Inscribed on the verso *A. van Roijen 1747*
∗ On loan to the Rijksmuseum voor de Geschiedenis der Natuurwetenschappen, Leiden, since 1959
LIT J J M Heeren, OH 37 (1919) p 240 (presumably Nicolaas Reyers)

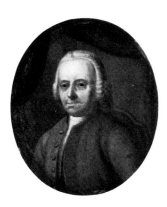

A 4619 Joannes Badon (1706-90). Vlaardingen poet. *Dichter te Vlaardingen*

By Nicolaas Reyers (1719-96)

Signed and dated on the verso *N. Reyers pinx. 1774.* Inscribed on the verso *Joh. Badon.*

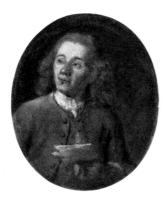

A 4620 Abraham de Haen (1707-48). Amsterdam draftsman, etcher and poet. *Tekenaar, etser en dichter te Amsterdam*

By Jan Maurits Quinkhard (1688-1772). Possibly after a print by Christian Friedrich Fritsch (1719-before 1774)

Inscribed on the verso *Abᵐ de Haen*
LIT Moes 1897-1905, vol 1, nr 3054. Van Hall 1963, p 124, nr 809:1

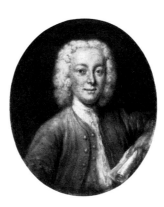

A 4621 Lucas Pater (1707-81). Amsterdam merchant and poet. *Koop-man en dichter te Amsterdam*

By Jan Maurits Quinkhard (1688-1772)

Inscribed on the verso *Lucas Pater. A° 1707*
∗ Lent to the AHM, 1975
LIT Moes 1897-1905, vol 2, nr 5762:2

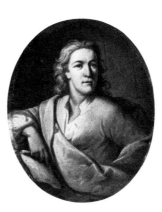

A 4622 Cornelis van der Pot (1707- after 1799). Rotterdam merchant and poet. *Koopman en dichter te Rotterdam*

By Dionys van Nijmegen (1705-98)

Signed *D.V. Nijmegen. Pinx.* Inscribed on the verso *Corn. Van der Pot. 1707*
LIT Moes 1897-1905, vol 2, nr 6039. J W Niemeijer, Bull RM 17 (1969) p 94, note 23

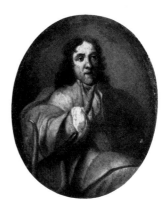

A 4623 Frans de Haes (1708-61). Rotterdam poet and philologist. *Dichter en taalgeleerde te Rotterdam*

By Dionys van Nijmegen (1705-98)

Signed *DVNijmegen Pinx.* Inscribed on the verso *F. de Haas.1708*
PROV Bequest of D Franken Dzn, Le Vésinet, 1898
LIT Moes 1897-1905, vol 1, nr 3096:2

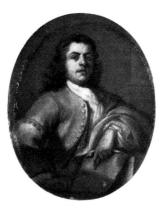

A 4624 Adriaan van der Vliet (1708-77). Rotterdam poet. *Dichter te Rotterdam*

By Dionys van Nijmegen (1705-98)

Inscribed on the verso *A.V.Vliet. 1707*
PROV Bequest of D Franken Dzn, Le Vésinet, 1898
LIT Moes 1897-1905, vol 2, nr 8615. J W Niemeijer, Bull RM 17 (1969) p 94, note 23

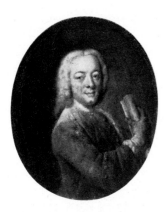

A 4625 Bernardus de Bosch I (1709-86). Amsterdam poet and art patron. *Dichter en kunstbeschermer te Amsterdam*

By Jan Maurits Quinkhard (1688-1772) For another portrait of the sitter, *see* Quinkhard, Jan Maurits, A 791

Inscribed on the verso *B. de Bosch A°* *1709*
∗ Lent to the AHM, 1975
LIT Moes 1897-1905, vol 1, nr 933:1

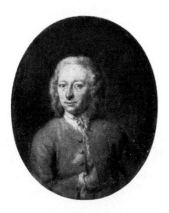

A 4618 Frans van Steenwijk (1715-88). Amsterdam poet and playwright. *Dichter en toneelschrijver te Amsterdam*

By Jan Maurits Quinkhard (1688-1772)

Inscribed on the verso *F. Steenwyk 1715*
∗ Lent to the AHM, 1975
LIT Moes 1897-1905, vol 2, nr 7557

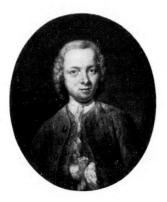

A 4626 Nicolaas Willem op den Hooff (ca 1715-65). Amsterdam physician and translator. *Medicus en vertaler te Amsterdam*

By Jan Maurits Quinkhard (1688-1772)

Inscribed on the verso *Opdenhoof A° 1715*
LIT Moes 1897-1905, vol 1, nr 3644

Dutch costume series

Illustrations of Dutch village costumes from the third quarter of the sixteenth century. *Afbeeldingen van Nederlandse klederdrachten uit het derde kwart van de zestiende eeuw*

1 Twelve paintings (A 4627-A 4638) from a series attributed to J (van) Horst (active ca 1570 in Noord- or Zuid-Holland), which was undoubtedly larger originally. Purchased in 1889 from a businessman named Etienne in Amsterdam. Given on loan in 1925 to the Rijksmuseum 'Nederlands Open-luchtmuseum' in Arnhem, where they were destroyed in the war in 1944

LIT H Brugmans, Het huiselijk en maatschappelijk leven onzer voorouders, vol 1, Amsterdam 1914, p 313. F van Thienen, Volk van Nederland, Amsterdam 1943, pp 117, 119. J G van Gelder, 'J (van) Horst,' OH 75 (1960) pp 51-53, with 9 figs (attributed to J [van] Horst). F van Thienen & J Duyvetter, Klederdrachten, Amsterdam 1962, pp 117, 119. J Duyvetter, Ars Folklorica Belgica, Antwerp nd, p 183

2 A more completely preserved series of 24 paintings (C 1491-C 1514) that departs in details from the panels attributed to Horst. Received on loan in 1971 from the Bayerische Staatsgemäldesammlungen, Munich

LIT Von Reber, 'Die Gemälde der herzoglichen bayerischen Kunstkammer nach dem Fickler'schen Inventar von 1598,' Sitzungsberichte der philosophisch-philologischen Runde der historischen Classe der kgl Akademie der Wissenschaften zu München, 1892, pp 160-61. S J van der Molen, 'Klederdrachtpaneeltjes uit omstreeks 1550: een herwonnen documentatie,' Antiek 7 (1973) pp 621-44, ill

Both series illustrate the costume of girls and women from various Dutch villages, identified by inscription. All are painted on panel, series 1 measuring 43.5 × 31.5 and series 2 42 × 29 cm. The two series are catalogued together, alphabetically by place name

To facilitate the finding of a particular painting, there follows a list of paintings by inventory number:

A 4627 Woman from Benningbroek
A 4628 Woman from Brouwershaven
A 4629 Girl from Edam
A 4630 Girl from Goeree
A 4631 Woman from Heiloo
A 4632 Woman from Hensbroek
A 4633 Woman from Hoogwoud
A 4634 Girl from Monnikendam
A 4635 Girl from Oudendijk
A 4636 Woman from Oudendijk

C 1498 Girl from Beets. *Meisje uit Beets*

Inscribed *Beetser Maecht*

C 1510 Woman from Benningbroek. *Vrouw uit Benningbroek*

Inscribed *Benningbroecker Vrou*

A 4627 Woman from Benningbroek. *Vrouw uit Benningbroek*

Inscribed *Bēningbroecker Vrou*

C 1496 Woman from Broek. *Vrouw uit Broek*

Inscribed *Broker Vrou*

NO PHOTOGRAPH AVAILABLE

A 4628 Woman from Brouwershaven. *Vrouw uit Brouwershaven*

Inscribed *Brouers Haeuen*

A 4629 Girl from Edam. *Meisje uit Edam*

Inscribed *Edamer Maecht*

737

C 1509 Girl from Edam. *Meisje uit Edam*

Inscribed *Edammer Maecht*

Inscribed *Enchuser Vrou*

C 1491 Woman from Harderwijk. *Vrouw uit Harderwijk*

Inscribed *Harderwijker Vrou*

C 1500 Woman from Edam. *Vrouw uit Edam*

Inscribed *Edamer Vrou*

A 4630 Girl from Goeree. *Meisje uit Goeree*

Inscribed *Goeree Maecht*

NO PHOTOGRAPH AVAILABLE

A 4631 Woman from Heiloo. *Vrouw uit Heiloo*

Inscribed *Heiloo*

C 1499 Girl from Enkhuizen. *Meisje uit Enkhuizen*

Inscribed *Enchuser Maecht*

C 1492 Woman from Graft. *Vrouw uit Graft*

Inscribed *Grafter Vrou*

C 1497 Woman from Heiloo. *Vrouw uit Heiloo*

Inscribed *Heiloer Vrou*

C 1503 Woman from Enkhuizen. *Vrouw uit Enkhuizen*

C 1512 Girl from Harderwijk. *Meisje uit Harderwijk*

Inscribed *Harderwijker Maecht*

A 4632 Woman from Hensbroek. *Vrouw uit Hensbroek*

Inscribed *Hensbroecker Vrou*

C 1508 Woman from Hoogwoud. *Vrouw uit Hoogwoud*

Inscribed *Hoechtwouder Vrou*

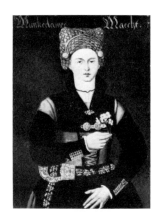

A 4634 Girl from Monnikendam. *Meisje uit Monnikendam*

Inscribed *Munkedamer Maecht*

C 1513 Woman from Hensbroek. *Vrouw uit Hensbroek*

Inscribed *Hensbroecker Vrou*

C 1505 Woman from Jisp. *Vrouw uit Jisp*

Inscribed *Jisper Vrou*

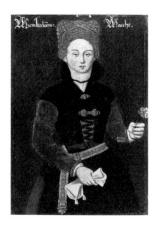

C 1493 Girl from Monnikendam. *Meisje uit Monnikendam*

Inscribed *Mumkedamer Maecht*

A 4633 Woman from Hoogwoud. *Vrouw uit Hoogwoud*

Inscribed *Hoechtwouder Vrou*
LIT Brugmans 1914, vol 1, ill on p 313

C 1507 Woman from Landsmeer. *Vrouw uit Landsmeer*

Inscribed *Lansmoer Vrou*

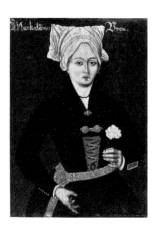

C 1506 Woman from Monnikendam. *Vrouw uit Monnikendam*

Inscribed *Munkedamer Vrou*

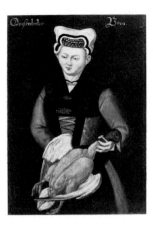

C 1511 Woman from Oosterleek. *Vrouw uit Oosterleek*

Inscribed *Ooesterleecker Vrou*

A 4636 Woman from Oudendijk. *Vrouw uit Oudendijk*

Inscribed *Oudēdijcker Vrou*

C 1514 Woman from Schagen. *Vrouw uit Schagen*

Inscribed *Skoager Vrou*

C 1494 Woman from Oosthuizen. *Vrouw uit Oosthuizen*

Inscribed *Ooesthuijser Vrou*

C 1495 Woman from Oudendijk. *Vrouw uit Oudendijk*

Inscribed *Oudendiker Vrou*

C 1504 Woman from Staveren. *Vrouw uit Staveren*

Inscribed *Staverse Vrou*

A 4635 Girl from Oudendijk. *Meisje uit Oudendijk*

Inscribed *Oudendijcker Maecht*

C 1501 Girl from Schagen. *Meisje uit Schagen*

Inscribed *Schaegher Maecht*

C 1502 Woman from Wadwaay. *Vrouw uit Wadwaay*

Inscribed *Watwaeier Vrou*

A 4637 Woman from Westerblokker. *Vrouw uit Westerblokker*

Inscribed *Westerbloecker Vrou*

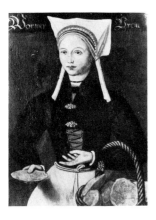

A 4638 Woman from Wormer. *Vrouw uit Wormer*

Inscribed *Wormer Vrou*

Vanmour series

Paintings of Turkish subjects from the Calkoen bequest. *Schilderijen met Turkse onderwerpen uit het legaat Calkoen*

Jean-Baptiste Vanmour (Valenciennes 1671 – 1737 Constantinople) settled in Constantinople in 1688, where he worked for the French ambassadors de Ferriol, de Bonnac and de Villeneuve, the Swedish diplomat Gustaf Celsing and for Cornelis Calkoen (1696-1764), ambassador of the Dutch Republic at the Porte from 1725 to 1743.

Cornelis Calkoen left his collection of 'Turkish' paintings to his nephew Abraham Calkoen. The latter's son Nicolaas bequeathed it in 1817 to the Directie van de Levantsche Handel (bureau of Levantine trade) in Amsterdam. At the time of the bureau's dissolution in 1827, the paintings hung in its headquarters in the town hall of Amsterdam, together with seven other 'Turkish' paintings which probably did not belong to the Calkoen bequest. From there the entire collection passed to the Koninklijk Kabinet van Zeldzaamheden in The Hague. The main part of the latter collection was transferred in 1875 to the Nederlandsch Museum voor Geschiedenis en Kunst, founded that year in The Hague. This museum's holdings were transferred to the Rijksmuseum in Amsterdam in 1883. The remaining 'Turkish' paintings in the Koninklijk Kabinet van Zeldzaamheden were assigned to other museums in the same year. A large part of the Calkoen bequest, as well as the other 'Turkish' paintings, were given to the Rijks Ethnografisch Museum in Leiden (A 1996-A 2056). Numbers A 3947 & A 4076-A 4085 went to the Nederlandsch Museum in the Rijksmuseum. In 1902 all 72 paintings were brought together in the Rijksmuseum.

The Calkoen bequest numbers 65 paintings. Seven other paintings, which probably did not belong to the bequest (A 2053-A 2056, A 3947, A 4083 & A 4085), are catalogued at the end of this section, because of their common provenance from the bureau of Levantine trade.

Most of the paintings from the Calkoen bequest can be regarded as original works by Vanmour, with the exception of the view of Constantinople from the Dutch embassy (A 4084), the representation of the building itself (A 1997) and the series of figure studies in the format 33.5 × 26, which were probably made in his studio.

LIT A Boppe, Les peintres du Bosphore au dix-huitième siècle, Paris 1911. R van Luttervelt, 'De "Turkse" schilderijen van J B Vanmour en zijn school,' Istanbul (Nederlands Historisch Archeologisch Instituut in het Nabije Oosten) 1958

Calkoen bequest

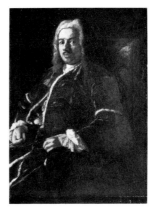

A 1996 Cornelis Calkoen (1696-1764). Ambassador to the Porte (1725-43), Constantinople. *Ambassadeur bij de Hoge Porte te Constantinopel*

Canvas 106 × 76.5. Signed *I.B. Vanmour P.*
LIT Boppe 1911, p 44, nr IX. Van Luttervelt 1958, p 7, fig 6. J Watelet, Etudes d'Art 14 (1959) p 43

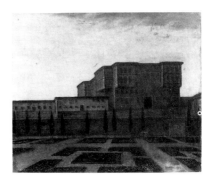

A 1997 The Dutch embassy in Pera near Constantinople. *De Nederlandse ambassade te Pera bij Constantinopel*

Studio of Jean-Baptiste Vanmour

Canvas 66.5 × 82
LIT Boppe 1911, p 48, nr XVI. Van Luttervelt 1958, p 11, fig 26

A 4084 View of Constantinople from the

Dutch embassy in Pera. *Gezicht op Constantinopel vanuit de Nederlandse ambassade te Pera*

Studio of Jean-Baptiste Vanmour

Canvas 142 × 214
LIT Boppe 1911, p 48, nr XV. Van Luttervelt 1958, pp 11, 28, fig 25. A Petrová-Pleskotová, Ars, 1971, p 176, fig 9

A 4076 Ambassador Cornelis Calkoen crossing the second court of the palace, where the janissaries are eating, to attend an audience with Sultan Ahmed III, 14 September 1727. *Ambassadeur Cornelis Calkoen doorschrijdt de tweede binnenhof van het paleis, waar een maaltijd van de Janitsjaren plaatsvindt, op weg naar de audiëntie bij sultan Achmed III, 14 september 1727*

Canvas 91.5 × 125
LIT Boppe 1911, p 47, nr X. Van Luttervelt 1958, p 12. J Watelet, Etudes d'Art 14 (1959) p 42

A 4078 Ambassador Cornelis Calkoen in audience with Sultan Ahmed III, 14 September 1727. *Ambassadeur Cornelis Calkoen op audiëntie bij sultan Achmed III, 14 september 1727*

Canvas 90 × 121
LIT Boppe 1911, p 47, nr XII. Bertile 1932, p 161. Blunt 1953, p 21. Van Luttervelt 1958, p 12, fig 29

A 4077 The meal presented to Ambassador Cornelis Calkoen by the grand vizier in the name of Sultan Ahmed III, 14 September 1727. *De maaltijd aangeboden aan ambassadeur Cornelis Calkoen door de groot-vizier namens sultan Achmed III, 14 september 1727*

Canvas 90 × 120
LIT Boppe 1911, pp 30-31, 47, nr XI. Van Luttervelt 1958, p 12, fig 27. J Watelet, Etudes d'Art 14 (1959) p 42. A Petrová-Pleskotová, Ars, 1971, p 175, fig 2

A 4079 Ambassador Cornelis Calkoen received by the grand vizier in his yali (waterside residence) on the Bosphorus, ca 1728. *Ambassadeur Cornelis Calkoen op audiëntie bij de groot-vizier in diens yali aan de Bosporus, ca 1728*

Canvas 92.5 × 129.5
LIT Boppe 1911, p 48, nr XIII. Van Luttervelt 1958, p 17, fig 28. J Watelet, Etudes d'Art 14 (1959) p 42. E R Gallagher, Bull Cal Pal Legion of Honor 24, Sep/Oct 1966, p 17, fig 3

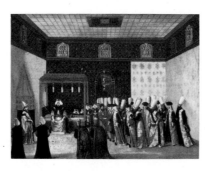

A 4080 An ambassador received by Sultan Ahmed III. *Een ambassadeur op audiëntie bij sultan Achmed III*

Canvas 88 × 121
* DRVK since 1962
LIT Boppe 1911, p 48, nr XIV. Van Luttervelt 1958, p 17

A 2032 The ambassador's servant Çokadar. *Tchoadar, dienaar van de ambassadeur*

Canvas 39.5 × 30. Inscribed on the verso *Chezodax oft Ambassadeur*
LIT Boppe 1911, p 52, nr XLVII

A 2013 Sultan Ahmed III (1703-30). *Sultan Achmed III*

Canvas 33.5 × 27
LIT Boppe 1911, p 51, nr XXXV?

A 2015 Sultan Ahmed III (1703-30). *Sultan Achmed III*

Copy after A 2013

Canvas 38 × 31. Inscribed on the verso
Den Grooten Heer
LIT Van Luttervelt 1958, p 8, fig 9

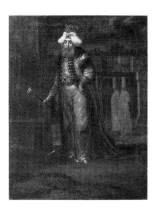

A 2014 Sultan Ahmed III (1703-30).
Sultan Achmed III

Canvas 33.5 × 26.5

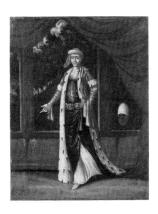

A 2016 The sultan's mother. *De sultane-moeder*

Canvas 39 × 31. Inscribed on the verso
Sultane
LIT Boppe 1911, p 51, nr XXXIX. Van
Luttervelt 1958, p 8 (A 2041 is illustrated
erroneously as fig 7)

A 2017 The grand vizier. *De groot-vizier*

Canvas 33.5 × 26
LIT Boppe 1911, p 51, nr XL? Van
Luttervelt 1958, pp 7-8, fig 8

A 2018 The grand vizier. *De groot-vizier*

Canvas 38.5 × 31. Inscribed on the verso
Den Primo Vizir
∗ DRVK since 1962
LIT Boppe 1911, p 51, nr XL?

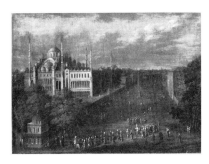

A 1998 The grand vizier crossing the
Atmeidan (Hippodrome), with the Blue
Mosque on the left. *De groot-vizier
begeeft zich over de Atmeidan; links de
Blauwe Moskee*

Canvas 61 × 84.5
LIT Boppe 1911, p 49, nr XXII. Van
Luttervelt 1958, p 10, fig 24

A 2024 Mehmet reis effendi. Head of the

chancery and second lieutenant of the
grand vizier. *Hoofd van de kanselarij en
tweede luitenant van de groot-vizier*

Canvas 34.5 × 27. Inscribed on the
verso *Mehemet Reis Effendi*
LIT Van Luttervelt 1958, p 9

A 2025 Ağa. Commander-in-chief of the
janissaries. *Opperbevelhebber der Janits-
jaren*

Canvas 39 × 31. Inscribed on the verso
Capitijn Pacha
LIT Boppe 1911, p 51, nr XXXVII. Van
Luttervelt 1958, p 8

A 2026 Mehmet kâhya or Kul Kâhyāsî.
Adjutant to the agha. *Adjudant van de Ağa*

Canvas 34.5 × 27.5. Inscribed on the
verso *Mehemmet Chiaia*
LIT Boppe 1911, p 52, nr XLI?

A 2027 A soldier in the janissaries. *Een soldaat van de Janitsjaren*

Canvas 39.5 × 31. Inscribed on the verso *Janitzar off Deurwachter van den Grooten Heer*
LIT Boppe 1911, p 52, nr XLIII. Van Luttervelt 1958, p 8, fig 10

A 2021 The kapîcî başï, head doorkeeper of the seraglio, or the ikbrikdar ağasï, agha of the ewer. *De Capoudji Bachi, opperdeurbewaarder van het Serail, of de Ibriktar Aghassi, de officier die de sultan het waswater aanreikt*

Canvas 39 × 31. Inscribed *Den Seraskier of Onder Visir*
LIT Boppe 1911, p 51, nr XXXVIII. Van Luttervelt 1958, p 8

A 2019 The kïzlar ağasï, chief of the black eunuchs and intendant of the

imperial harem. *De Kislar Aghassi, hoofd der zwarte eunuchen en intendant van de harem van de sultan*

Canvas 39 × 31. Inscribed on the verso *Eunuchus of Dienaar van de vrouwen van den G. Heer*
LIT Boppe 1911, p 52, nr XLIV. Van Luttervelt 1958, p 8

A 2020 The kapu ağasï, chief of the white eunuchs and intendant of the imperial household. *De Capou Aghassi, hoofd der blanke eunuchen en intendant van de dienaren van de huishouding van de sultan*

Canvas 39.5 × 31.5. Inscribed on the verso *Kamerdienaar van den G. Heer. Ferriol no. 5, G. Scotin sc.*
LIT Boppe 1911, nr XLII. Van Luttervelt 1958, p 8

A 2028 The sïlïhdar ağasï, chief sword-bearer to the sultan. *De Seliktar Aghassi, opperwapendrager van de sultan*

Canvas 38.5 × 30.5. Inscribed on the verso *Wapendrager van den Groten Heer*
LIT Boppe 1911, p 52, nr XLV

A 2031 The çavuş basï, chief pursuivant, commander of the corps of imperial messengers, and lieutenant of the grand vizier in his judicial capacity, in command of the detachment that escorted the foreign legates to their audience with the sultan. *De Tchavouch Bachi, opperheraut, commandant van de boodschappers van de sultan en luitenant van de groot-vizier in zijn hoedanigheid van rechter, tevens overste van het detachement dat de buitenlandse gezanten op hun tocht naar de audiëntie van de sultan vergezelt*

Canvas 38.5 × 30.5 Inscribed on the verso *Chaous Bazzi off Oversten der Rijks-bezendelingen*
LIT Boppe 1911, p 51, nr XXXVI

A 2029 A çavuş, member of the corps of imperial messengers. *Een Tchavouch, een boodschapper van de sultan*

Canvas 39 × 51. Inscribed on the verso *Chanous of Postlooper*
LIT Boppe 1911, p 52, nr XLVI

A 2022 A Turkish court functionary.
Een hofdignitaris

Canvas 34 × 27

A 2023 A Turkish court functionary. *Een hofdignitaris*

Canvas 34 × 26

A 4082 Halil Patrona, a former sailor in the sultan's fleet, who deposed Ahmed III and placed Mahmut I on the throne in his place, 28 February 1730. *Khalil Patrona, voormalig zeesoldaat, die sultan Achmed III van de troon stootte en Mahmud I voor hem in de plaats verhief, 28 februari 1730*

Canvas 120 × 90. Inscribed *Kalil Patrona Chef de Révolte arrivée à Constantinople le 28 7bre de l'année 1730*. Signed *I.B. Vanmour pinxit*

LIT Boppe 1911, pp 18-20, 49, nr XVIII. Van Luttervelt 1958, pp 9, 18, fig 1. A Petrová-Pleskotová, Ars, 1971, p 175, fig 6

A 2012 The assassination of the ministers during the revolt of Halil Patrona, 1730.
De moord op de ministers tijdens de opstand van Khalil Patrona, 1730

Canvas 75 × 101
LIT Boppe 1911, p 49, nr XIX. Van Luttervelt 1958, p 18, fig 33

A 2046 One of Halil Patrona's rebels.
Eén van Khalil Patrona's opstandelingen

Canvas 39 × 31. Inscribed on the verso *Patrona off Rebell*
LIT Boppe 1911, p 49, nr XVII

A 2008 The reservoirs in the forest of Belgrade, known as the Bends. *De water-reservoirs, de zogenaamde Bends, in het bos van Belgrado*

Canvas 60.5 × 75
LIT Boppe 1911, p 49, nr XX. Van Luttervelt 1958, pp 9-10, fig 23

A 2030 Dervish. *Derwisch*

Canvas 39.5 × 31.5. Inscribed on the verso *Derweys of Turxen Heilige*
LIT Boppe 1911, p 52, nr LII

A 4081 Dervishes dancing in the Mevlevi monastery in Pera, Constantinople. *Dansende derwischen in het Mevleviklooster te Pera*

Canvas 76 × 101
LIT Boppe 1911, pp 24-25, 50, nr XXIII. Van Luttervelt 1958, p 9, fig 14. AP de Mirimonde, Revue du Louvre 19 (1969) p 238, fig 8

A 1999 Dervishes at table. *Derwischen aan de maaltijd*

Canvas 33 × 43
LIT Boppe 1911, p 50, nr XXIV. Van Luttervelt 1958, p 9, fig 15. AP de

Mirimonde, Revue du Louvre 19 (1969) p 238, fig 9. A Petrová-Pleskotová, Ars, 1971, p 175, fig 7

A 2041 Turkish woman. *Turkse vrouw*

Canvas 47 × 35.5
LIT Boppe 1911, p 53, nr LXVI. Van Luttervelt 1958, p 8, fig 7 (misidentified)

A 2042 Turkish woman at her embroidery frame. *Turkse vrouw voor haar borduurraam*

Canvas 33.5 × 26.5

A 2003 The nursery of a distinguished Turkish woman. *Kraamkamer van een voorname Turkse vrouw*

Canvas 55.5 × 90
LIT Boppe 1911, p 50, nr XXIX. Van Luttervelt 1958, p 9, fig 17

A 2005 Turkish boy on his first day of school. *Eerste schoolgang van een Turkse jongen*

Canvas 38.5 × 53
LIT Boppe 1911, p 50, nr XXVII. Van Luttervelt 1958, fig 18

A 2006 Turkish women in the country-side near Constantinople looking at a vision in the sky. *Turkse vrouwen in de omgeving van Constantinopel bekijken een verschijning in de lucht*

Canvas 44 × 58
LIT Boppe 1911, p 50, nr XXXII. Van Luttervelt 1958, p 9, fig 22

A 2007 Women's party at Hunkiar Iskêléci on the Bosphorus. *Damesfeest te Hunkiar Iskêléci aan de Bosporus*

Canvas 78 × 101
LIT Boppe 1911, p 49, nr XXI. Van Luttervelt 1958, p 9

A 2004 Banquet of distinguished Turkish women. *Maaltijd van voorname Turkse vrouwen*

Canvas 45 × 58.5
LIT Boppe 1911, p 51, nr XXXIII. Van Luttervelt 1958, p 9

A 2011 Fête champêtre of Turkish courtiers. *Feestende Turkse hovelingen voor een tent*

Canvas 51.5 × 90
LIT Boppe 1911, p 51, nr XXXIV. Van Luttervelt 1958, p 9, fig 20. A P de Mirimonde, Revue du Louvre 19 (1969) p 238, fig 10

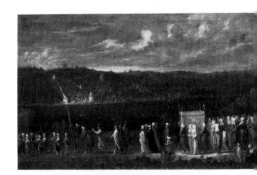

A 2000 Turkish wedding. *Turkse bruiloft*

Canvas 56 × 90
LIT Boppe 1911, p 50, nr XXV? Van Luttervelt 1958, p 9, fig 16. A P de Mirimonde, Revue du Louvre 19 (1969) p 238, fig 7

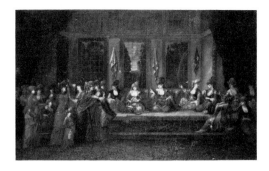

A 2002 Greek wedding. *Griekse bruiloft*

Canvas 55.5 × 90
LIT Boppe 1911, p 50, nr XXVIII. Van
Luttervelt 1958, p 9

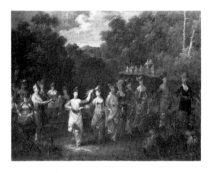

A 2009 Greek men and women dancing
the khorra. *Griekse mannen en vrouwen de
Khorra dansend*

Canvas 44.5 × 58
LIT Boppe 1911, p 50, nr XXXI. Van
Luttervelt 1958, p 9, fig 21. A P de
Mirimonde, Revue du Louvre 19 (1969)
p 238, fig 12. A Petrová-Pleskotová, Ars,
1971, p 176, fig 8

A 2043 Greek clergyman. *Griekse
geestelijke*

Canvas 39 × 31. Inscribed on the verso
Pape Grec and *Een Griekske Paap of
Priester*
LIT Boppe 1911, p 52, nr LI

A 2044 Jewish moneychanger. *Joodse
geldwisselaar*

Canvas 39.5 × 30.5. Inscribed on the
verso *Juif* and *Saraff of Wisselaar van den
Grooten Heer*
LIT Boppe 1911, p 52, nr XLVIII

A 2049 Man from the Albanian coast.
Man van de Albanese kust

Canvas 39 × 31. Inscribed on the verso
Arbanes and *Een man van de kust Arbano*
LIT Boppe 1911, p 53, nr LXII. *Cf* van
Luttervelt 1958, fig 11

A 2050 Woman from the Albanian
coast. *Vrouw van de Albanese kust*

Canvas 39.5 × 31. Inscribed on the verso
Een vrouw van de kust Arbano and *Vanmour*
LIT Boppe 1911, p 53, nr LXI. Van
Luttervelt 1958, fig 28

A 2040 Albanian shepherd. *Albanese
herder*

Canvas 39 × 31. Inscribed on the verso
Pasteur Albanes and *Arbanees Herder*
LIT Boppe 1911, p 53, nr LXIII

A 2045 Albanian soldier. *Albanees
soldaat*

Canvas 39 × 31.5. Inscribed on the verso
Arbanes and *Een Arbanees Soldaat*
LIT Boppe 1911, p 53, nr LX. Van
Luttervelt 1958, p 8, ill

A 2001 Armenian wedding. *Armeense
bruiloft*

Canvas 44.5 × 58.5
LIT Boppe 1911, p 50, nr XXVI. Van
Luttervelt 1958, p 9. A P de Mirimonde,
Revue du Louvre 19 (1969) p 238, fig 11

A 2010 Armenians playing cards.
Armeens gezelschap bij het kaartspel

Canvas 44.5 × 58.5
LIT Boppe 1911, p 50, nr XXX. Van
Luttervelt 1958, p 9, fig 19

A 2051 Man from the Bulgarian coast.
Bulgaar van de kust

Canvas 39 × 31. Inscribed on the verso
Boulgar and *Een man van de kust Bolgardo*
LIT Boppe 1911, p 52, nr XLIX

A 2052 Bulgarian girl. *Bulgaars meisje*

Canvas 39.5 × 31. Inscribed on the verso
Femme de Boulgar, Vanm. and *Een vrouw
van de kust Bolgardo*
LIT Boppe 1911, p 52, nr L

A 2047 Man from the island of Kythnos
(Thermia). *Man van het eiland Kythnos
(Thermia)*

Canvas 39 × 31. Inscribed on the verso
Termiote and *Een man van het eiland Termio*
* DRVK since 1962
LIT Boppe 1911, p 53, nr LIX

A 2048 Woman from the island of
Kythnos (Thermia). *Vrouw van het eiland
Kythnos (Thermia)*

Canvas 39 × 31. Inscribed on the verso
Femme de Termiote and *Een vrouw van 't
Eylandt Termio*
* DRVK since 1962
LIT Boppe 1911, p 53, nr LVIII. Van
Luttervelt 1958, fig 13

A 2033 Man from the island of Patmos.
Man van het eiland Patmos

Canvas 39 × 30.5. Inscribed on the verso
Eilanden van Patino (Pays Patiniote)
LIT Boppe 1911, p 53, nr LXIV

A 2034 Woman from the island of
Patmos. *Vrouw van het eiland Patmos*

Canvas 39.5 × 31. Inscribed on the verso
Femme de Patiniote and *Vrouw van 't
Eiland Patino*
LIT Boppe 1911, p 53, nr LXV

A 2035 Man from the island of Tenos.
Man van het eiland Tinos

Canvas 39.5 × 31. Inscribed *Tinioter* and
Eilander van Tino
LIT Boppe 1911, p 53, nr LIV

A 2036 Woman from the island of Tenos.
Vrouw van het eiland Tinos

Canvas 39 × 30.5. Inscribed on the verso
Vrouw van het eiland Tino
LIT Boppe 1911, p 53, nr LIII

A 2037 Man from the island of Mykonos.
Man van het eiland Mykonos

Canvas 39 × 31. Inscribed on the verso
Miconiote and *Man van het Eiland Mykono*
LIT Boppe 1911, p 53, nr LV

A 2038 Woman from the island of
Mykonos. *Vrouw van het eiland Mykonos*

Canvas 39 × 30.5. Inscribed on the verso
Miconeese vrouw and *Miconiote*
LIT Boppe 1911, p 53, nr LVI

A 2039 Man from the island of Serifos.
Man van het eiland Serifos

Canvas 39 × 31. Inscribed on the verso
Serifiote and *Eilanden van Serifo*
LIT Boppe 1911, p 53, nr LVII

'Turkish' paintings probably not from the Calkoen bequest

H Knop

biographical data unknown

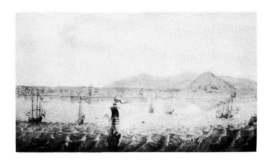

A 3947 View of Smyrna. *Gezicht op
Smyrna*

Canvas 77 × 138. Signed and dated *H.
Knop f 1779*
LIT Van Luttervelt 1958, p 39, fig 38

Jan van der Steen

active in Constantinople, d before 1784
in Bengal

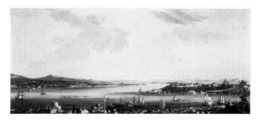

A 2056 View of Constantinople and the
seraglio from the Swedish embassy in
Pera. *Gezicht op Constantinopel en het
Serail vanuit de Zweedse ambassade te Pera*

Canvas 94 × 221

A 2054 View of the Bosphorus at the
village of Beykoz, looking northwest,
with the aqueduct of Justinian in the
background. *Gezicht op de Bosporus,
genomen ter hoogte van Beykoz naar het
noordwesten, met op de achtergrond het
aquaduct van Justinianus*

Canvas 75 × 106

A 2053 View of the Dardanelles. *Gezicht
op de Dardanellen*

Canvas 75 × 106

Unknown Italian painter

A 4083 View of Constantinople and the
Seraglio from the Dutch embassy. *Gezicht
op Constantinopel en het Serail vanuit de
Hollandse ambassade*

Canvas 74 × 214. Inscribed *1 S... del
palazo di ...uanda ... il quale e il jardino | 2
palazo di .uncia | 3 Serraglio del gr. Signori
S.tuatoal Norodipena | 4 La deitta di Sairar | 5
La torre di leandro | 6 Il Serraglio di Scudar | 7
Calcidonia | 8 il Sanar di Calcidonia | 9 ... | 10
... di Asia | 11 Il gran Serraglio del grand
Signore | 12 La Mosqua di S¹ Sophia | 13
Sarre del porto di Constantinopoli | 14
Coppana e Magazino ove Si fundano le
canone | 15 una barca overo Griche del grand
Signore.* The numbers correspond with
numbers on the painting
∗ DRVK since 1962
LIT Van Luttervelt 1958, pp 11-12, 28

Turkish school or painted after a Turkish model

A 2055 View of Ankara. *Gezicht op Ankara*

Canvas 117 × 198

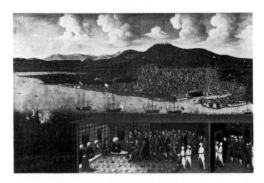

A 4085 View of Smyrna with the reception of the Dutch consul, Daniël Jan Baron de Hochepied (1657-1723), in the Divan. *Gezicht op Smyrna met op de voorgrond de ontvangst van de Nederlandse consul Daniël Jan Baron de Hochepied in de Divan*

Canvas 155 × 242
LIT Gerson 1942, p 525 (ca 1740). Van Luttervelt 1958, p 35ff, pl 37 (ca 1720)

Miniatures

Pastels

Aquarelles and drawings

Heraldic objects

The inventories of the Rijksmuseum department of paintings include not only canvases and panels, but other kinds of painted objects as well. We have divided the total holdings into five groups. The first and largest (pp 78-750), here ended, consists mainly of canvases and panels, with verres églomisés (*achter-glas-schilderingen*) and painted cabinets added.

The groups to follow are:
—miniatures, including enamels and silhouettes (pp 750-86)
—pastels (pp 787-803)
—aquarelles and drawings (pp 803-20)
—heraldic objects (pp 821-30)

For a separate listing of the verres églomisés, enamels and silhouettes, see the index of objects in unusual techniques (p 832)

Miniatures

Acajou

see Rochard, Simon Jacques, called Acajou

Benjamin Arlaud

Geneva ca 1670–after 1731 England

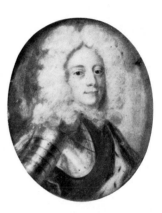

A 4295 Christian V (1646-99), king of Denmark. *Christiaan V, koning van Denemarken*

Copy after an original by Lancelot Volders (active ca 1660-70 in Brussels)

Board 5.8 × 4.6. Oval. Signed and dated on the verso *Benjamin Arlaud pinxit 1706*
PROV KKZ. NMGK
LIT L Hagedoorn, Op de Hoogte 14 (1917) ill on p 496. Foster 1926, p 5. Long 1929, p 6. Schidlof 1964, vol 1, p 48

attributed to **Benjamin Arlaud**

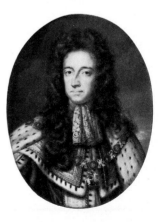

A 4296 William III (1650-1702), prince of Orange. From 1689 on king of England. *Willem III, prins van Oranje. Sedert 1689 koning van Engeland*

Board 9.5 × 7.3. Oval
PROV KKZ. NMGK* On loan to the KKS
(cat 1968, p 170, nr 997) since 1951
LIT Williamson 1904, vol 1, pl XLVII, nr
2 (Lawrence Crosse). Moes 1897-1905,
vol 2, nr 9096:121 (Crosse). L
Hagedoorn, Op de Hoogte 14 (1917) ill
on p 490 (Crosse). Long 1929, p 108.
Schidlof 1964, vol 1, p 174. Exhib cat
Twintig miniaturen, Delft (antique fair)
1966, nr 19, ill

attributed to **John Bettes**

London? ca 1530 – after 1580

A 4297 Edward VI (1537-53), the future
king of England, as a child. *De latere
koning van Engeland als kind*

Board 4.8 × 3.6. Oval
PROV KKZ. NMGK* On loan to the KKS
(cat 1968, p 173, nr 982, English school)
since 1951
LIT Williamson 1904, vol 1, pl XLVII, nr
4

attributed to **Samuel Blesendorf**

Berlin 1633 – 1706 Berlin

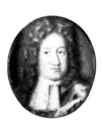

A 4298 Portrait of a man, probably
Frederick I (1657-1713), king of Prussia.
*Portret van een man, waarschijnlijk Frederik I,
koning van Pruisen*

Enamel on copper 2.6 × 2.3. Oval
PROV KKZ. NMGK
LIT L Hagedoorn, Op de Hoogte 14
(1917) ill on p 497

Blon

see Leblon

Charles Boit

Stockholm 1662 – 1727 Paris

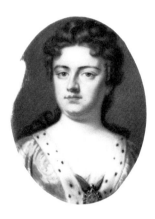

A 4299 Anne Stuart (1665-1714), queen
of England. Wife of George of Denmark.
*Koningin van Engeland. Echtgenote van
George van Denemarken*

Enamel on copper 4.7 × 3.7. Oval.
Signed *C. Boit pinx.*
PROV KKZ. NMGK
LIT H Clouzot, Revue de l'Art 30 (1911)
p 185, ill on p 123. L Hagedoorn,
Op de Hoogte 14 (1917) p 494,
ill on p 495. Clouzot 1924, p 25.
Long 1929, p 36. Cat Mauritshuis, The
Hague 1968, nr 1028

attributed to **Charles Boit**

A 4300 William III (1650-1702), prince
of Orange. From 1689 on king of
England. *Willem III, prins van Oranje.
Sedert 1689 koning van Engeland*

Pendant to A 4301

Enamel on gold 3.4 × 2.8. Oval. The
setting is monogrammed *WR*
PROV KKZ. NMGK
LIT Moes 1897-1905, vol 2, nr 9096:133

A 4301 Mary Stuart (1662-95). Wife of
William III. *Maria Stuart. Echtgenote van
Willem III*

Pendant to A 4300

Enamel on copper? 3.2 × 2.7. Oval
PROV KKZ. NMGK
LIT L Hagedoorn, Op de Hoogte 14
(1917) ill on p 497

Louise Bourdon

see Miniatures: German school ca 1810,
A 4388 Alexander I, after Bourdon

Joseph Boze

Martigues ca 1744 – 1826 Paris

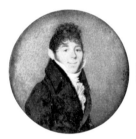

A 3869 Gerrit Jan van Houten (b 1774).
Burgomaster of Amersfoort. *Burgemeester
van Amersfoort*

Pendant to A 3870

Ivory 5.7 cm in diam. Signed *Boze*
PROV Presented by M C van Houten,
Doorn, 1933. Received in 1953

A 3870 Maria Cornelia Pull (d 1809).
Wife of Gerrit Jan van Houten.
Echtgenote van Gerrit Jan van Houten

Pendant to A 3869

Ivory 5.8 cm in diam. Signed *Boze*
PROV Same as A 3869

A 3871 Maria Cornelia Pull (d 1809).
Wife of Gerrit Jan van Houten.
Echtgenote van Gerrit Jan van Houten

Ivory 5.5 cm in diam. Set in the cover of
a tortoiseshell box. Signed *Boze*
PROV Same as A 3869

copy after **Joseph Boze**

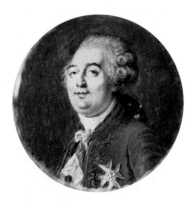

A 4320 Louis XVI (1754-93), king of
France. *Lodewijk XVI, koning van
Frankrijk*

Ivory 7.4 cm in diam
PROV KKZ. NMGK

attributed to **Arnold van Brounckhurst**

active ca 1565-80 in England and
Scotland

A 4302 James I (1556-1625), the future
king of England, as a child. *Jacobus I,
de latere koning van Engeland, als kind*

Board 5 × 3.8. Oval
PROV KKZ. NMGK * On loan to the KKS
(cat 1968, p 171, nr 983) since 1951
LIT Williamson 1904, vol I, pl XLVII, nr
6 (portrait of Edward VI, attributed to
Stretes). Auerbach 1961, nr 274, pl 239

Richard Collins

Gosport 1755 – 1831 London

A 2639 Portrait of a woman. *Portret van
een vrouw*

Ivory 8.5 × 7.3. Oval. Signed on the
verso *Rd. Collins pinxit, Principal Painter
in Enamel to the King, by His Majesty's
special appointement*
PROV Formed part of an unclaimed
estate, Paramaribo, 1912

attributed to **Alexander Cooper**

London ca 1605 – 1660 Stockholm

A 4303 James II (1633-1701), the future
king of England, as a young man.
*Jacobus II, de latere koning van Engeland,
als jongeman*

Board 4.5 × 3.4. Oval
PROV KKZ. NMGK * On loan to the KKS
(cat 1968, p 172, nr 1008, as Samuel
Cooper) since 1951
LIT Williamson 1904, vol I, pl XLVI,
nr 10 (probably by John Hoskins).
L Hagedoorn, Op de Hoogte 14 (1917) p
488, ill on p 491 (Hoskins). Long 1929, p
225. A Staring, Oudh Jb 12 (1943) pp
93-94, pl XXIV, fig 9 (portrait of
Willem II, prince of Orange, by
Hoskins?). Staring 1948, p 22, pl III, fig 9
(portrait of Willem II, prince of
Orange?)

A 4304 Elizabeth Stuart (1596-1662).
Widow of Frederick V, elector of the
Palatinate, king of Bohemia. *Weduwe van
Frederik V, keurvorst van de Palts, koning van
Bohemen*

Board 4.5 × 3.6. Oval. On the back of
the enamelled setting is a crowned *E* in a
mirror monogram
PROV KKZ. NMGK
LIT Long 1929, p 79 (portrait of
Christina of Sweden). A Staring, Oudh
Jb 12 (1943) p 93, pl XXIV, fig 7
(portrait of Christina of Sweden).
Staring 1948, p 21, pl II, fig 7 (portrait of
Christina of Sweden). L Weltman, Pol
Wirtsch Kultur, 1961, p 55, ill. CJ de
Bruyn Kops, Bull RM 19 (1971) pp 3-6,
figs 1-2

Samuel Cooper

London 1609-1672 London

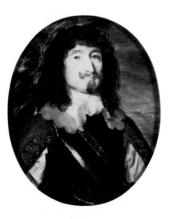

A 4305 George Gordon (d 1649), 2d
marquess of Huntley

After an original by Anthony van Dyck
(1599-1641) in the duke of Buccleuch
collection, Drumlanrig Castle, Scotland

Vellum 5.6 × 4.6. Oval. Signed and
dated *S C 16..*
PROV KKZ, 1875. NMGK * On loan to
the KKS (cat 1968, p 172, nr 992) since
1951
LIT Williamson 1904, vol I, pl XLVI, nr
I. L Hagedoorn, Op de Hoogte 14
(1917) p 488, ill on p 493. Long 1929, p

89 (unfinished). Exhib cat Twintig miniaturen, Delft (antique fair) 1966, nr 16, ill. Foskett 1974, p 111. Exhib cat Samuel Cooper and his contemporaries, London 1974, nr 10

A 4306 Portrait of a woman. *Portret van een vrouw*

Vellum 6.8 × 5.5. Oval. Signed and dated *S C : fe : 1643*
PROV KKZ. NMGK * On loan to the KKS (cat 1968, p 172, nr 991) since 1951
LIT Williamson 1904, vol 1, pl XLVI, nr 3. L Hagedoorn, Op de Hoogte 14 (1917) p 488, ill on p 493. Long 1929, pp 88-89. Foskett 1974, p 108. Exhib cat Samuel Cooper and his contemporaries, London 1974, nr 13

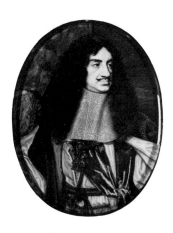

A 4307 Charles II (1630-85), king of England. *Karel II, koning van Engeland*

Vellum 17.2 × 13.4. Oval. Signed and dated *SC 1665*
PROV KKZ, 1875. NMGK * On loan to the KKS (cat 1968, p 172, nr 993) since 1951
LIT Williamson 1904, vol 1, pl XLI, nr 1. P Lambotte, Onze Kunst 21 (1912) p 198, ill. Foster 1914-16, p 21. L Hagedoorn, Op de Hoogte 14 (1917) p 488, ill after p 500. Long 1929, p 89. Staring 1948, p 13. J P W van der Werff, Spiegel Hist 2 (1967) fig 6 opp p 440. L de Vries, Spiegel Hist 4 (1969) p 169, ill

on cover. Foskett 1974, p 117. Exhib cat Samuel Cooper and his contemporaries, London 1974, nr 112

A 4308 Frances Teresa Stuart (1647-1702), duchess of Richmond and Lennox, in male costume. *Hertogin van Richmond en Lennox, in travestie*

Vellum 8.6 × 7. Oval. Signed and dated *SC F 1 …*
PROV KKZ, 1875. NMGK * On loan to the KKS (cat 1968, p 172, nr 996) since 1951
LIT Williamson 1904, vol 1, pl XLVI, nr 5. P Lambotte, Onze Kunst 21 (1912) p 198, ill. L Hagedoorn, Op de Hoogte 14 (1917) p 488, ill on p 493. Long 1929, p 89 (unfinished). Exhib cat Twintig miniaturen, Delft (antique fair) 1966, nr 17, ill. L de Vries, Spiegel Hist 4 (1969) p 168, fig 10. LC de Ranitz, Bull RM 19 (1971) p 8, fig 2 (ca 1664-65). Foskett 1974, p 117, fig 13. Exhib cat Samuel Cooper and his contemporaries, London 1974, nr 119

A 4309 Portrait of a woman. *Portret van een vrouw*

Board 6.8 × 5.7. Oval. Signed and dated *SC 1670*
PROV KKZ, 1875. NMGK * On loan to the KKS (cat 1968, p 172, nr 995) since 1951
LIT Williamson 1904, vol 1, pl XLVI, nr 2. L Hagedoorn, Op de Hoogte 14 (1917) p 488, ill on p 493. Long 1929, p 89. Colding 1953, p 117, fig 88. Exhib

cat Twintig miniaturen, Delft (antique fair) 1966, nr 14, ill. L de Vries, Spiegel Hist 4 (1969) p 168, fig 11. Foskett 1974, p 118, fig 70. Exhib cat Samuel Cooper and his contemporaries, London 1974, nr 130

school of **Samuel Cooper**

A 4310 James, duke of Cambridge (1661-67). Son of James II. *Hertog van Cambridge. Zoon van Jacobus II*

After an original by John Michael Wright (ca 1623-1700)

Vellum 3 × 2.6. Oval
PROV KKZ, 1816. NMGK
LIT Williamson 1904, vol 1, pl XLVII, nr 11. LC de Ranitz, Bull RM 19 (1971) p 8, fig 4

A 4311 Charles II (1630-85), the future king of England, as a young man. *Karel II, de latere koning van Engeland, als jongeman*

Board 5.1 × 4.3. Oval
PROV KKZ. NMGK
LIT Cat Mauritshuis, The Hague 1968, p 173, nr 988 (English school)

Crans

see Schmidt Crans

attributed to **Nicholas Dixon**

active ca 1665–1708 in London

A 4312 Mary Stuart (1662-95), the future wife of William III, as a child. *Maria Stuart, de latere echtgenote van Willem III, als kind*

Board 5.2 × 4.9. Oval
PROV KKZ. NMGK * On loan to the KKS (cat 1968, p 172, nr 994) since 1951
LIT Williamson 1904, vol I, pl XLVI, nr 9 (portrait of Mary, daughter of Charles I, by John Hoskins). L Hagedoorn, Op de Hoogte 14 (1917) p 488, ill on p 491 (portrait of Henrietta Maria Stuart, wife of Willem II, by Hoskins). Long 1929, p 225 (very likely by Hoskins). Exhib cat Twintig miniaturen, Delft (antique fair) 1966, nr 12, ill

Marie Duchatel

active ca 1681-97 in The Hague, Brussels and Düsseldorf

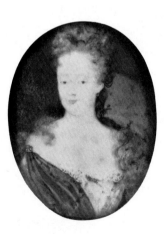

A 4313 Henriette Amalia van Anhalt-Dessau (1666-1726). Wife of Hendrik Casimir II, prince of Nassau-Dietz. *Echtgenote van Hendrik Casimir II, vorst van Nassau-Dietz*

Pendant to A 4439 (Miniatures: Holland school ca 1690)

Board 5.5 × 4.2. Oval. Inscribed on the verso *Amélie, Princesse de Nassau, née Princesse d'Anhalt facit par Mlle du Chatel à Bruxelles, 1689*
PROV KKZ. NMGK
LIT Staring 1948, p 69

Égaré

see Légaré

Hermanus Fock

Amsterdam 1766–1822 Franeker

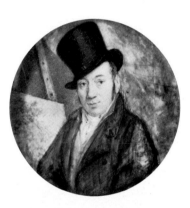

A 2120 Self portrait. *Zelfportret*

Ivory 8.8 cm in diam
PROV RPK, 1903
LIT L Hagedoorn, Op de Hoogte 14 (1917) ill on p 485. Van Hall 1963, p 101, nr 652:1

Pierre Jean Gauthier

active ca 1810-15 in Franeker

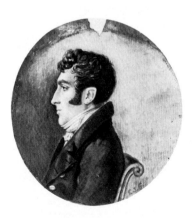

A 4031 Portrait of a young man of the van Limburg Stirum family. *Portret van een jongeman uit de familie van Limburg Stirum*

Paper 7 cm in diam. Signed *P.J.G.*
PROV Bequest of Jonkvrouwe ACAJ Clifford, The Hague, 1960
LIT CJ de Bruyn Kops, Bull RM 14 (1966) pp 38-41, fig 1; 120-21, fig 2

John Graham I

London ca 1705–after 1775 London

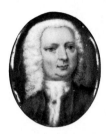

A 2689 Portrait of a man. *Portret van een man*

Enamel on copper 3.1 × 2.5. Oval. Signed and dated on the verso *'s Hage I. Graham F. 1737*
PROV Purchased from Th Rikoff, Munich, 1913

attributed to **David des Granges**

London 1611/13–ca 1675 London

A 4314 Henrietta Maria Stuart (1631-60). Wife of Willem II. *Henriette Maria Stuart. Echtgenote van Willem II*

After an original by Adriaen Hanneman? (ca 1601-71)

Board 4.5 × 3.9. Oval
PROV KKZ. NMGK * On loan to the KKS (cat 1968, p 173, nr 998) since 1951
LIT Williamson 1904, vol I, pl XLVI, nr 4. L Hagedoorn, Op de Hoogte 14 (1917) p 490, ill on p 492. Long 1929, p 123 (related to the work of John Hoskins)

A 4315 Albertina Agnes (1634-87), countess of Nassau. Wife of Willem Frederik van Nassau-Dietz. *Gravin van Nassau. Echtgenote van Willem Frederik van Nassau-Dietz*

Board 4.7 × 3.7. Oval
PROV KKZ. NMGK * On loan to the KKS (cat 1968, p 174, nr 999) since 1951
LIT Williamson 1904, vol 1, pl XLVI, nr 6. L Hagedoorn, Op de Hoogte 14 (1917) p 490, ill on p 492. Long 1929, p 123 (related to the work of John Hoskins)

Willem Grebner

Vreeland 1784–1866 Amsterdam

A 2173 The Diederichs family. *De familie Diederichs*

The sitters are the Amsterdam book-seller Pieter Arnold Diederichs (1804-74), his wife Alida Elisabeth Sligting (1801-71) and their children Willem George Albrecht (1829-1901) and Bertha

For a portrait of Pieter Arnold Diederichs, *see* Schwartze, Johann Georg, A 2170; for portraits of his parents, *see* Miniatures: Northern Netherlands school ca 1810, A 2175 & A 2176

Ivory 14.3 × 18.6. Signed and dated *Grebner 1836*
PROV Bequest of Mrs V E L Diederichs-Portman, widow of W G A Diederichs, Amsterdam, 1905

A 2174 George Frederik Diederichs (1799-1862). Amsterdam bookseller. *Boekhandelaar te Amsterdam*

For portraits of the sitter's parents, *see* Miniatures: Northern Netherlands school ca 1810, A 2175 & A 2176

Ivory 8 × 6.5. Oval
PROV Same as A 2173

Louis du Guernier

Paris 1614–1659 Paris

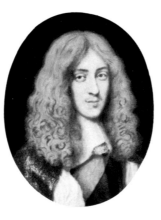

A 4316 James II (1633-1701), the future king of England, as a young man. *Jacobus II, de latere koning van Engeland, als jongeman*

Board 7 × 5.8. Oval. Signed and dated on the verso *Du Guernier pinxit 1656*. On the back of the enamelled setting is the crowned monogram *DL*
PROV KKZ. NMGK
LIT Williamson 1904, vol 1, pl XLIV, nr 9. L Hagedoorn, Op de Hoogte 14 (1917) p 494, ill. Foster 1926, p 98. Long 1929, p 79. A Staring, Oudh Jb 12 (1943) p 94. Staring 1948, p 23

attributed to **Louis du Guernier**

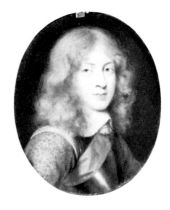

A 4317 James II (1633-1701), the future king of England, as a child. *Jacobus II, de latere koning van Engeland, op jeugdige leeftijd*

Board 6.2 × 5.1. Oval
PROV KKZ, 1875. NMGK
LIT Foster 1903, p 57, pl XXI. L Hagedoorn, Op de Hoogte 14 (1917) p 490, ill (Alexander Cooper). Long 1929, p 79 (presumably James II). A Staring, Oudh Jb 12 (1943) p 94 (David des Granges?). Staring 1948, p 23, note 39 (des Granges?). Cat Mauritshuis, The Hague 1968, p 171, nr 990 (Alexander Cooper)

G Haag *or* **Hoog**

active ca 1750-75 in Holland

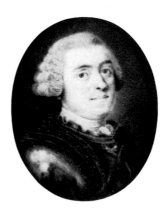

A 4318 Willem IV (1711-51), prince of Orange-Nassau. *Prins van Oranje-Nassau*

Ivory 4.7 × 3.8. Oval. Signed *G. Haag*
PROV KKZ. NMGK
LIT Moes 1897-1905, vol 2, nr 9097:36

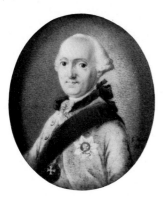

A 4319 Karl Wilhelm Ferdinand (1735-1806), duke of Braunschweig-Luneburg. *Hertog van Brunswijk-Luneburg*

Ivory 5.3 × 4.6. Oval. Signed and dated *G. Haag 1763*
PROV KKZ. NMGK

Johannes Hari I

The Hague 1772 – 1849 The Hague

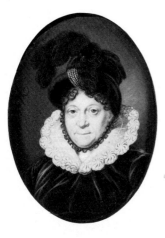

A 2817 Frederika Sophia Wilhelmina (1751-1820), princess of Prussia. Dowager princess of Orange after the death of Prince Willem v in 1806. *Prinses van Pruisen. Sedert de dood van prins Willem V Prinses Douairière van Oranje*

After an original of 1817 by Cornelis Cels (1778-1859) in the Stichting Historische Verzamelingen van het Huis Oranje-Nassau, The Hague

Ivory 8 × 6. Oval. Signed *J. Hari na C. Cels*
PROV Purchased from J Hari de Meur, Watergraafsmeer, 1918
LIT A Staring, Oude Kunst 4 (1918-19) p 226

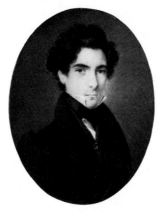

A 4030 Frederik Adrian (1804-74), Count van Limburg Stirum or Thomas Henry (1804-42), Count van Limburg Stirum. *Frederik Adrian, graaf van Limburg Stirum of Thomas Henry, graaf van Limburg Stirum*

Vellum 8 × 6.5. Oval. Signed and dated *J. Hari 1837* (or 1827)
PROV Bequest of Jonkvrouwe ACAJ Clifford, The Hague, 1960

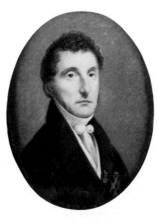

A 3102 Pieter de Riemer (1769-1831). Professor of anatomy and obstetrics, consulting surgeon of King Willem I. *Professor in de ontleed- en verloskunde, consulent chirurgijn van koning Willem I*

Ivory 8.6 × 6.6. Oval
PROV Presented by Jonkheer BWF van Riemsdijk, Amsterdam, 1929
LIT A Staring, Oude Kunst 4 (1918-19) p 227, ill

Nicholas Hilliard

Exeter 1547 – 1619 London

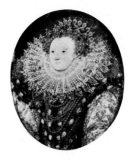

A 4321 Elizabeth I (1533-1603), queen of England. *Koningin van Engeland*

Vellum 4 × 3.2. Oval
PROV KKZ. NMGK * On loan to the KKS (cat 1968, p 174, nr 1000) since 1951
LIT Williamson 1904, vol I, pl XVII, nr 3. L Hagedoorn, Op de Hoogte 14 (1917) p 487, ill on p 486. Auerbach 1961, pl 296, nr 54. L de Vries, Spiegel Hist 4 (1969) p 166, fig 3

attributed to **Nicholas Hilliard**

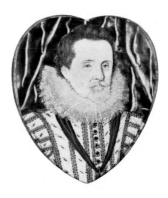

A 4322 James I (1566-1625), king of England. *Jacobus I, koning van Engeland*

Board 5.2 × 4.7. Heart-shaped
PROV KKZ. NMGK * On loan to the KKS (cat 1968, p 174, nr 1015) since 1951
LIT Williamson 1904, vol I, pl XVII, nr 11 (attributed to Isaac Oliver). P Lambotte, Onze Kunst 21 (1912) p 196, ill. L Hagedoorn, Op de Hoogte 14 (1917) p 488, ill (attributed to Oliver). Long 1929, p 318 (probably an old copy after Oliver). Colding 1953, p 109 (attributed to Oliver). G Reynolds, Walpole Society 34 (1959) nr A 14. Auerbach 1961, pp 164-65, nr 173. FWS van Thienen, OK 9 (1965) nr 10, ill. L de Vries, Spiegel Hist 4 (1969) p 166, fig 4

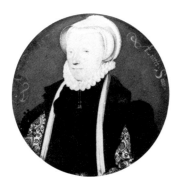

A 4323 Portrait of a lady, perhaps Lady Margaret Douglas (1515-78), mother of Lord Darnley. *Portret van een dame, misschien Lady Margaret Douglas, moeder van Lord Darnley*

Board 4.5 cm in diam. Dated *Anô. Dni. 1575.Ætatis.Suae*
PROV KKZ* On loan to the KKS (cat 1968, p 174, nr 1023) since 1951
LIT Williamson 1904, vol 1, pl XVII, nr 5 (portrait of Lady Hunston). L Hagedoorn, Op de Hoogte 14 (1917) ill on p 498 (portrait of a lady, by Levina Teerlinck-Beninck). Long 1929, p 432 (attribution to Levina Teerlinck uncertain). Auerbach 1961, nr 25, pl 28. L de Vries, Spiegel Hist 4 (1969) p 166, fig 2

Peter Hoadley

b London? ca 1700; died at an early age near Hoorn

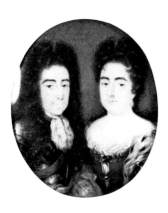

A 4324 William III (1650-1702), prince of Orange and from 1689 on king of England, with his wife Mary Stuart (1662-95). *Willem III, prins van Oranje en sinds 1689 koning van Engeland met zijn vrouw Maria Stuart*

Board 6.1 ×5.2. Oval. Signed *PH*
PROV KKZ. NMGK
LIT Williamson 1904, vol 1, p 97, pl XLVII, nr 5. Moes 1897-1905, vol 2, nr 9096:122. Foster 1926, p 150. Long 1929, p 212 (copy after another portrait). Cat Mauritshuis, The Hague 1968, p 175, nr 1003

copy after **Charles Howard Hodges**

Portsmouth 1764– 1837 Amsterdam

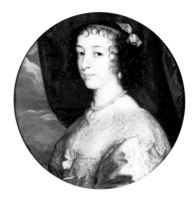

C 45 Jan Bernd Bicker (1746-1812). Amsterdam merchant and banker, chairman of the national assembly in 1796. *Koopman en bankier te Amsterdam, in 1796 voorzitter van de Nationale Vergadering*

Reduced copy after a pastel portrait by Hodges. *Cf* the version in the AHM

Paper 19 ×15.5
PROV On loan from the city of Amsterdam (Bicker bequest), 1881-1975

Hoog

see Haag

Christian Hornemann

see Ploetz, Henrik, & Christian Hornemann

John Hoskins

London? ca 1600 – 1664 London

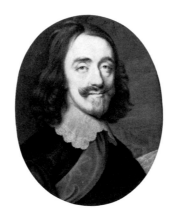

A 4325 Charles I (1600-49), king of England. *Karel I, koning van Engeland*

Board 8 ×6.4. Oval. Signed *H. fe*
PROV KKZ. NMGK* On loan to the KKS (cat 1968, p 176, nr 1006) since 1951
LIT Williamson 1904, vol 1, pl XLVI, nr 8. F Lugt, Oude Kunst 1 (1915-16) p 152, note 1. L Hagedoorn, Op de Hoogte 14 (1917) p 488, ill on p 491. Long 1929, p 225. Exhib cat Twintig miniaturen, Delft (antique fair) 1966, nr 8, ill. L de Vries, Spiegel Hist 4 (1969) p 168, fig 9

A 4326 Henrietta Maria of France (1609-1669). Wife of Charles I of England. *Henriëtte Maria van Frankrijk. Echtgenote van Karel I van Engeland*

After an original by Anthony van Dyck (1599-1641). *Cf* the version in Windsor Castle (Glück 1931, nr 376)

Vellum 17.8 cm in diam. Signed and dated *IH 1632*. Marked with crowned monogram *HMR*
PROV KKZ. NMGK* On loan to the KKS (cat 1968, p 176, nr 1004) since 1951
LIT Williamson 1904, vol 1, pl XLI, nr 2. P Lambotte, Onze Kunst 21 (1912) p 199, ill. Schidlof 1914, vol 1, p 337. Long 1929, p 225. Reynolds 1952, p 47. Colding 1953, p 115. L de Vries, Spiegel Hist 4 (1969) p 168, fig 1. Exhib cat Samuel Cooper and his contemporaries, London 1974, nr 145

A 4327 Henrietta Maria of France

(1609-69). Wife of Charles I of England. *Henriëtte Maria van Frankrijk. Echtgenote van Karel I van Engeland*

After the painting by Anthony van Dyck (1599-1641) in Windsor Castle (Glück 1931, nr 383)

Board 6.2 × 5.3. Oval. Signed *H.f.* Marked with crowned monogram *HMR* PROV KKZ. NMGK * On loan to the KKS (cat 1968, p 176, nr 1005) since 1951 LIT Williamson 1904, vol I, pl XLVI, nr 7. F Lugt, Oude Kunst 1 (1915-16) p 158. L Hagedoorn, Op de Hoogte 14 (1917) p 488, ill on p 491. Long 1929, p 225. L de Vries, Spiegel Hist 4 (1969) p 168, fig 8

A 4328 Henrietta Maria of France (1609-69). Wife of Charles I of England. *Henriëtte Maria van Frankrijk. Echtgenote van Karel I van Engeland*

Board 6.2 × 5.1. Oval. Signed *IH* PROV KKZ. NMGK * On loan to the KKS (cat 1968, p 176, nr 1007) since 1951 LIT L Hagedoorn, Op de Hoogte 14 (1917) p 488, ill on p 491 (portrait of Elizabeth Stuart, wife of Frederick V of the Palatinate). Long 1929, p 225 (portrait of Elizabeth Stuart). F W S van Thienen, OK 9 (1965) nr 10, ill (portrait of Elizabeth Stuart). Exhib cat Twintig miniaturen, Delft (antique fair) 1966, nr 13, ill (portrait of Elizabeth Stuart)

Pierre Huaut I

Châtellerault 1612-1680 Geneva

A 4329 Portrait of a woman, thought to be Anne Stuart (1665-1714), queen of

England, wife of George of Denmark. *Portret van een vrouw, vermoedelijk Anna Stuart, koningin van Engeland, echtgenote van George van Denemarken*

Enamel on copper 2.6 × 2.1. Oval. Signed and dated *P. Huaut primo nata pinxit Berline 1694* PROV KKZ. NMGK LIT L Hagedoorn, Op de Hoogte 14 (1917) pp 494, 496, ill on p 497 (anonymous)

attributed to **J Jackson II**

active 1816-35 in Oxford and London

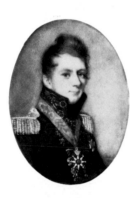

A 4330 J Dommering

On the verso an oval detail from a lithograph showing an urn and ruins

Ivory 9 × 7. Oval. Signed and dated *Jackson 1819.* Inscribed on an enclosed slip of paper *A. Belle. Uit achting en Vriendschap. J. Dommering. Dat steeds dit klein geschenk van mij. Herinnering onzer [vriendsch]ap zij.* PROV Bequest of F G S Baron van Brakell, Arnhem, 1878. NMGK * DRVK since 1959 (Museum van de Kanselarij der Nederlandse Orden, The Hague)

attributed to **Franz Kessler**

Wetzlar ca 1580-after 1650 Dantzig

A 4331 Portrait of a young man. *Portret van een jonge man*

Copper 11.8 × 9.1. Oval PROV KKS. NMGK

Josef Kreutzinger

see German school ca 1810, A 4389 Francis I, after Kreutzinger

Georg Lamprecht

active 1772-1814 in Clignancourt, Sèvres and Vienna

A 4332 Frederika Sophia Wilhelmina (Wilhelmina; 1751-1820), princess of Prussia. Wife of Prince Willem V. *Prinses van Pruisen. Echtgenote van prins Willem V*

Ivory 7.7 × 6.2. Oval. Signed *G. Lamprecht.* Inscribed on the verso *G. Lamprecht ad vivum pinxit* PROV KKZ. NMGK

attributed to **Jakob Christof Leblon**

Frankfurt am Main 1667-1741 Paris

A 3873 Portrait of a woman. *Portret van een vrouw*

Ivory 7.6 × 5.8. Oval
PROV Bequest of P G van Tienhoven, Amsterdam, 1953
LIT Staring 1948, pl XLIV, fig 11

A 3874 Portrait of a woman. *Portret van een vrouw*

Ivory 7.7 × 5.8. Oval
PROV Same as A 3873

attributed to **Gilles Légaré**

Chaumont ca 1610 – after 1685 Paris

A 4333 Henrietta Maria Stuart (1631-60). Wife of Willem II. *Henriëtte Maria Stuart. Echtgenote van Willem II*

Enamel on gold 2.5 cm in diam. In the case is a crowned violet in clouds, and under it the inscription *j'aime une seul*
PROV KKZ. NMGK

LIT L Hagedoorn, Op de Hoogte 14 (1917) pp 494, 496, ill on p 497. EGG Bos, Antiek 1 (1966) p 9, figs 8-10

Johann Philipp Lembke

Nürnberg 1631 – 1713 Stockholm

A 4334 Self portrait with his wife. *Zelfportret met zijn vrouw*

Painted on the inside of a screw-threaded silver 1632 half-crown (schroefdaalder) 3.9 cm in diam
PROV Presented by Dr A Bredius, The Hague, 1881 or before. NMGK

Pieter Lesage

active from before 1772 to after 1793 in Amsterdam and The Hague

A 4335 Willem V (1748-1806), prince of Orange-Nassau, with his wife Frederika Sophia Wilhelmina of Prussia and their children Frederica Louisa Wilhelmina, Willem Frederik and Willem George Frederik. *Prins van Oranje-Nassau, met zijn vrouw Frederika Sophia Wilhelmina van Pruisen en hun kinderen Frederica Louisa Wilhelmina, Willem Frederik en Willem George Frederik*

Ivory 16.2 × 11.6. Signed and dated *Le Sage 1779*
PROV KKZ. NMGK
LIT Moes 1897-1905, vol 2, nr 9098:36.

L Hagedoorn, Op de Hoogte 14 (1917) ill on p 500. A Staring, Oude Kunst 4 (1918-19) p 228. Schidlof 1964, vol 2, p 439

A 4237 Willem Frederik (1772-1843), prince of Orange-Nassau, with his cousin Ludwig Ferdinand of Prussia (1772-1806). *Prins van Oranje-Nassau met zijn neef Ludwig Ferdinand van Pruisen*

Ivory 8.5 cm in diam. Signed and dated *Le Sage 1793*
PROV Purchased from B Osthoff gallery, Bielefeld, 1958

Jean-Etienne Liotard

Geneva 1702 – 1789 Geneva

A 239 Maria Theresia (1717-80), empress of Austria, queen of Hungary and Bohemia. *Keizerin van Oostenrijk, koningin van Hongarije en Bohemen*

Although this object is certainly not a miniature, it is listed here because it is painted in enamel

Enamel on copper 62 × 51. Inscribed on the verso *Marie Therese Imperatrice Reine de hongrie & de Boheme, peinte par Liotard de Geneve a Lion 1747*
PROV Bequest of Miss M A Liotard, Amsterdam, 1873
LIT Humbert, Revilliod & Tilanus 1897, p 141, nr 119. Long 1929, p 274

attributed to **Jean-Etienne Liotard**

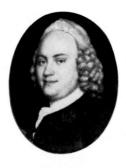

A 4336 Pieter van Bleiswijk (1724-90). Grand pensionary of Holland. *Raad-pensionaris van Holland*

Board 3.7 × 3. Oval
PROV KKZ. NMGK
LIT A Staring, Oude Kunst 4 (1918-19) p 228. Staring 1947, p 38. Staring 1948, p 84

Gerrit Lundens

Amsterdam 1622–after 1683
Amsterdam?

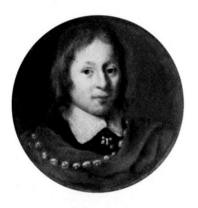

A 4337 Portrait of a young man. *Portret van een jonge man*

Forms one piece with A 4338

Painted on the inside of a screw-threaded silver 1607 half-crown (schroefdaalder) 4.8 cm in diam. Signed *G. Lundens ft*
PROV Purchased from the collection of D van der Kellen Jr, 1873. NMGK
LIT Williamson 1904, vol I, pl XLVII, nr I. Staring 1948, p 80

A 4338 Portrait of a woman. *Portret van een vrouw*

Forms one piece with A 4337

Painted on the inside of a screw-threaded silver medal depicting the battle of Nieuwpoort (1600) 4.8 cm in diam. Signed and dated *GLundens ft 1650*
PROV Same as A 4337
LIT Williamson 1904, vol I, pl XLVII, nr 3. Staring 1948, p 80, pl XLI, nr 5

Joseph Marinkelle

Rotterdam 1742–ca 1780 Amsterdam?

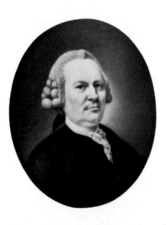

A 4224 Portrait of a man, thought to be a member of the Collot d'Escury or van Rappard family. *Portret van een man, vermoedelijk een lid van de familie Collot d'Escury of van Rappard*

Ivory 7.4 × 5.7. Oval. Signed and dated *Marinkelle Pinx: 1768*
PROV Presented by Jonkheer J C Martens van Sevenhoven, Almen, 1972. Received in 1973

attributed to **Joseph Marinkelle**

NM 5885 Portrait of a woman, perhaps Anna van Barnevelt (1725-89), wife of Abraham del Court, lord of Krimpen. *Portret van een vrouw, misschien Anna van Barnevelt, echtgenote van Abraham del Court, heer van Krimpen*

Decoration of a golden snuffbox (cat RMA Goud- en Zilverwerken, 1952, nr 311)

Ivory 3.8 × 3.2. Oval
PROV On loan since 1883 from MGP del Court, Haarlem; Mrs HW Creutzberg, née Jonkvrouwe J I del Court, IJmuiden; Rev HW Creutzberg and Miss A E H Creutzberg, IJmuiden, in turn. Presented in 1953. Belongs to the department of sculpture and applied arts

Jean Michelin

Langres 1623–1696 Jersey

A 4339 Georg Wilhelm (1625-1705), duke of Braunschweig-Luneburg. *Hertog van Brunswijk-Luneburg*

Board 4.2 × 3.7. Oval. Signed and dated on the verso *Michelin fecit 1674*
PROV KKZ. NMGK

Robert Mussard

Geneva 1713–1777 Paris

A 4340 Willem V (1748-1806), prince of Orange-Nassau, as a child. *Prins van Oranje-Nassau, als kind*

Vellum 5.8 × 7.7. Inscribed on the verso *R. Mussard pinxit agé de 3 ans e-demi dans l'année 1751*
PROV KKZ. NMGK * On loan to the KKS (cat 1968, p 176, nr 1010) since 1951
LIT Moes 1897-1905, vol 2, nr 9098:2. L Hagedoorn, Op de Hoogte 14 (1917) ill on p 496

A 4341 Frederika Sophia Wilhelmina (Wilhelmina; 1751-1820), princess of Prussia. Wife of Willem V. *Prinses van Pruisen. Echtgenote van Willem V*

Vellum 3.3 × 2.7. Oval. Signed and dated on the verso *R. Mussard 1768*
PROV KKZ. NMGK
LIT Moes 1897-1905, vol 2, nr 9098:3

A 4342 Wilhelmina Carolina (Carolina; 1743-87), princess of Orange-Nassau, daughter of Willem IV and sister of Willem V. *Prinses van Oranje-Nassau, dochter van Willem IV en zuster van Willem V*

Board 5.6 × 7.5. Formerly signed *R. Mussard*

PROV KKZ. NMGK * On loan to the KKS (cat 1968, p 177, nr 1012) since 1951
LIT L Hagedoorn, Op de Hoogte 14 (1917) ill on p 496

A 4343 Willem V (1748-1806), prince of Orange-Nassau, as a child. *Prins van Oranje-Nassau, als kind*

Vellum 5.3 × 7.1
PROV KKZ. NMGK * On loan to the KKS (cat 1968, p 176, nr 1011) since 1951
LIT Moes 1897-1905, vol 2, nr 9098:3

Johannes Esaias Nilson

Augsburg 1721 – 1788 Augsburg

A 4107 Frederica Carolina of Brandenburg (1735-91). Daughter of Duke Franz Josias of Saxe-Coburg-Saalfeld. *Dochter van hertog Franz Josias van Saksen Coburg Saalfeld*

Vellum 8.7 × 6.8. Oval. Signed *Palat.* Inscribed on the verso *Frederica Carolina March. Brandenb. N.d. 24 Juni 1735*
PROV Bequest of Mr & Mrs J C J Drucker-Fraser, Montreux, 1944

Isaac Oliver

Rouen ca 1560 – 1617 London

A 4344 Arabella Stuart (d 1615). Daughter of Charles Lennox. *Dochter van Charles Lennox*

Vellum 7 × 5.6. Oval. Signed *IO*
PROV KKZ. NMGK * On loan to the KKS (cat 1968, p 177, nr 1014, as a portrait of an unknown lady) since 1951
LIT Williamson 1904, vol 1, pl XVII, nrs 7, 9. L Hagedoorn, Op de Hoogte 14 (1917) p 488, ill. Exhib cat Nicholas Hilliard and Isaac Oliver, London 1947, nr 171

attributed to **Isaac Oliver**

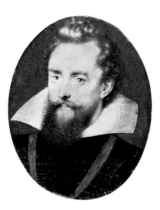

A 4345 Ludivic Stuart (1574-1623/24), first duke of Richmond and second duke of Lennox, or Thomas Howard (1561-1628), count of Suffolk. *Eerste hertog van Richmond en tweede hertog van Lennox of Thomas Howard, graaf van Suffolk*

Vellum 5 × 4. Oval
PROV KKZ. NMGK * On loan to the KKS (cat 1968, p 177, nr 1013) since 1951
LIT Williamson 1904, vol 1, pl XVII, nr 4 (probably a portrait of Robert Devereux, earl of Essex). L Hagedoorn, Op de Hoogte 14 (1917) p 488, ill (portrait of Robert Devereux). Long 1929, p 318 (portrait of Robert Devereux). Exhib cat Nicholas Hilliard and Isaac Oliver, London 1947, nr 168 (portrait of Robert Devereux). Auerbach 1961, p 245, nr 248, pl 213. Fr W S van Thienen, OK 9 (1965) nr 10, ill (portrait of an

unknown man, sometimes called Essex).
L de Vries, Spiegel Hist 4 (1969) p 166,
fig 6

Peter Oliver

London ca 1594–1647 London

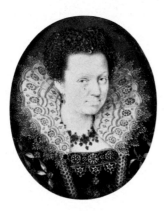

A 4346 Portrait of a woman. *Portret van een vrouw*

Vellum 5.2 × 4.5. Oval
PROV KKZ. NMGK * On loan to the KKS
(cat 1968, p 177, nr 1002) since 1951
LIT Williamson 1904, vol 1, pl XVII, nr
1 (Nicholas Hilliard). L Hagedoorn, Op
de Hoogte 14 (1917) p 487, ill on p 486
(Hilliard). Exhib cat Nicholas Hilliard
and Isaac Oliver, London 1947, nr 148.
Auerbach 1961, pl 205. L de Vries,
Spiegel Hist 4 (1969) p 166, fig 5

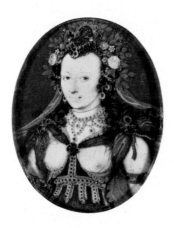

A 4347 Portrait of a woman as Flora.
Portret van een vrouw als Flora

Vellum 5.3 × 4.1. Oval
PROV KKZ (as a portrait of Elizabeth I).
NMGK * On loan to the KKS (cat 1968, p
177, nr 1001) since 1951
LIT Williamson 1904, vol 1, pl XVII, nr 2
(portrait of Queen Elizabeth in fancy
costume, by Nicholas Hilliard). P
Lambotte, Onze Kunst 21 (1912) p 197,
ill opp p 194 (portrait of Queen
Elizabeth by Hilliard). L Hagedoorn,
Op de Hoogte 14 (1917) p 487, ill on p
486 (portrait of Queen Elizabeth? by
Hilliard). Long 1929, p 211 (attributed
to Hilliard). Exhib cat Nicholas
Hilliard and Isaac Oliver, London 1947,
nr 181. L de Vries, Spiegel Hist 4 (1969)
p 166, fig 7

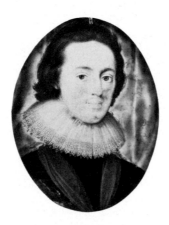

A 4348 Charles Stuart (1600-49), prince
of Wales. The future King Charles I of
England. *Karel Stuart, prins van Wales. De
latere koning Karel I van Engeland*

Vellum 5.5 × 4.4. Oval. Signed and
dated *PO 1621*
PROV KKZ. NMGK * On loan to the KKS
(cat 1968, p 178, nr 1016) since 1951
LIT Williamson 1904, vol 1, pl XVII, nr
6. F Lugt, Oude Kunst 1 (1915-16) p
152. L Hagedoorn, Op de Hoogte 14
(1917) ill on p 489. Long 1929, p 322

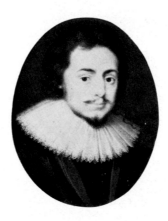

A 4349 Frederick V (1596-1632), elector
of the Palatinate, king of Bohemia.
*Frederik V, keurvorst van de Palts, koning van
Bohemen*

Board 5.2 × 4.1. Oval. Signed *PO*
PROV KKZ. NMGK * On loan to the KKS
(cat 1968, p 178, nr 1019) since 1951
LIT Williamson 1904, vol 1, pl XVII, nr
10. L Hagedoorn, Op de Hoogte 14
(1917) ill on p 489. Long 1929, p 322.
Colding 1953, p 115

attributed to **Peter Oliver**

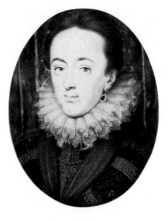

A 4350 Charles Stuart (1600-49), prince
of Wales. The future King Charles I of
England. *Karel Stuart, prins van Wales. De
latere koning Karel I van Engeland*

Board 5.5 × 4.1. Oval
PROV KKZ. NMGK * On loan to the KKS
(cat 1968, p 178, nr 1020, as Isaac
Oliver) since 1951
LIT Williamson 1904, vol 1, pl XVII, nr 8
(portrait of Henry Frederick, prince of
Wales). L Hagedoorn, Op de Hoogte 14
(1917) ill on p 489 (portrait of Henry
Frederick, prince of Wales). Long 1929,
p 322

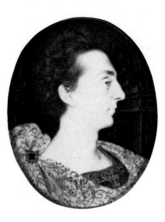

A 4351 Henry Frederick (1594-1612),
prince of Wales. Eldest son of James I.
Prins van Wales. Oudste zoon van Jacobus I

Board 5.1 × 4.1. Oval
PROV KKZ. NMGK * On loan to the KKS
(cat 1968, p 177, nr 1018, as Isaac
Oliver) since 1951
LIT Williamson 1904, vol 1, pl XVII, nr
13 (possibly a portrait of the duke of
Buckingham). L Hagedoorn, Op de
Hoogte 14 (1917) ill on p 489. Long
1929, p 322

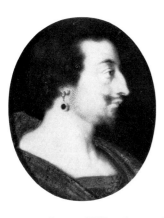

A 4352 George Villiers (1592-1628), duke of Buckingham. *Hertog van Buckingham*

Board 5.1 ×4.1. Oval
PROV KKZ. NMGK * On loan to the KKS (cat 1968, p 178, nr 1017, as a portrait of Frederick V, elector of the Palatinate?) since 1951
LIT Williamson 1904, vol 1, pl XVII, nr 12. L Hagedoorn, Op de Hoogte 14 (1917) ill on p 489. Long 1929, p 322

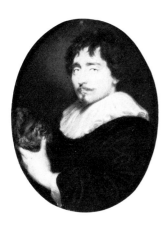

A 4353 François Duquesnoy (1594-1643). Sculptor. *Beeldhouwer*

After an original by Anthony van Dyck (1599-1641) in the Musée des Beaux Arts, Brussels (cat nr 3928)

Board 7.8 ×6.2. Oval. Inscribed on the verso in a later hand *Paintet by Oliver 1613*
PROV KKZ. NMGK * On loan to the KKS (cat 1968, p 178, nr 1021) since 1951
LIT L Hagedoorn, Op de Hoogte 14 (1917) ill on p 489 (Peter Oliver). Long 1929, p 322 (presumably not Oliver). L C de Ranitz, Bull RM 19 (1971) pp 9-10, fig 5

Pee

see Wolters-van Pee

attributed to **Jean Petitot**

Geneva 1607 – 1691 Geneva

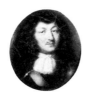

A 4354 Louis XIV (1638-1715), king of France. *Lodewijk XIV, koning van Frankrijk*

Enamel on copper 2.2 ×2. Oval
PROV KKZ. NMGK
LIT L Hagedoorn, Op de Hoogte 14 (1917) p 494, ill on p 495. Long 1929, p 340

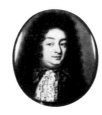

A 4355 Louis de Bourbon (1661-1711), dauphin of France. Son of Louis XIV. *Lodewijk van Bourbon, dauphin van Frankrijk. Zoon van Lodewijk XIV*

Enamel on copper 2.7 ×2.3. Oval
PROV Thought to come from the KKS. NMGK
LIT L Hagedoorn, Op de Hoogte 14 (1917) p 494, ill on p 495. Long 1929, p 340

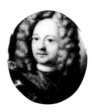

A 4356 John Churchill (1650-1722), duke of Marlborough. *Hertog van Marlborough*

After the original by Adriaen van der Werff (1659-1722) in the Palazzo Pitti, Florence (cat 1961, nr 76)

Enamel on copper? 2.5 ×2.2. Oval
PROV Thought to come from the KKS. NMGK
LIT L Hagedoorn, Op de Hoogte 14 (1917) p 494, ill on p 495. Long 1929, p 340

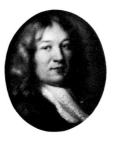

A 4357 Portrait of a man. *Portret van een man*

Enamel on copper 3.1 ×2.8. Oval
PROV Bequest of F G S Baron van Brakell, Arnhem, 1878. NMGK
LIT L Hagedoorn, Op de Hoogte 14 (1917) pp 494, 496, ill on p 495. Long 1929, p 340

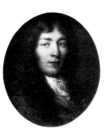

A 4358 Portrait of a man. *Portret van een man*

Enamel on copper 3.1 ×2.7. Oval
PROV Bequest of F G S Baron van Brakell, Arnhem, 1878
LIT L Hagedoorn, Op de Hoogte 14 (1917) pp 494, 496, ill on p 495. Long 1929, p 340

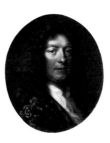

A 4359 Portrait of a man. *Portret van een man*

Enamel on copper 3.2 ×2.8. Oval
PROV Bequest of F G S Baron van Brakell, Arnhem, 1878
LIT L Hagedoorn, Op de Hoogte 14 (1917) pp 494, 496, ill on p 495. Long 1929, p 340

manner of **Jean Petitot**

NM 9882 Portrait of a woman. *Portret van een vrouw*

Enamel on copper 3.2 × 2.5. Oval. Ornament of a piece of silver jewelry
PROV Purchased from Dr A Bredius, The Hague, 1894. Belongs to the department of sculpture and applied arts

Loch Phaff

biographical data unknown

A 4360 Frederika Sophia Wilhelmina (Wilhelmina; 1747-1820), princess of Prussia. Wife of Prince Willem v. *Prinses van Pruisen. Echtgenote van prins Willem V*

Ivory 10 × 7.8. Oval. Signed *Loch. Phaff*
PROV KKZ. NMGK ∗ On loan to the KKS (cat 1968, p 178, nr 1022) since 1951

A 649 Historia

Ivory 20.5 × 14.5. Signed *Phaff fec.*
PROV Purchased in 1809

Henrik Ploetz

Rellingen 1748–1810 Copenhagen

&

Christian Hornemann

Copenhagen 1765–1844 Copenhagen

A 4361 Willem George Frederik (Frederik; 1774-99), prince of Orange-Nassau. Youngest son of Prince Willem v. *Prins van Oranje-Nassau. Jongste zoon van prins Willem V*

Vellum 9.3 × 7.7. Signed *Plötz et Horneman*
PROV KKZ. NMGK
LIT Colding 1953, pp 165, 208, fig 202 (ca 1797-98)

attributed to **Henrik Ploetz**

A 4238 Willem George Frederik (Frederik; 1774-99), prince of Orange-Nassau. Youngest son of Prince Willem v. *Prins van Oranje-Nassau. Jongste zoon van prins Willem V*

Ivory 7.3 cm in diam
PROV Purchased from B Osthoff gallery, Bielefeld, 1958

Joannes Antonius Augustinus Pluckx

Courtrai 1786–1837 Amsterdam

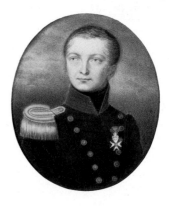

A 4362 Jan Carel Josephus van Speijk (1802-31). Naval officer. *Zeeofficier*

Ivory 12 × 11. Oval
PROV Presented by the artist to King Willem I, 1832. KKZ. NMGK

Pruisen

see Wilhelmina van Pruisen

Edmé Quenedey

Ricey-le-Haut 1756–1830 Paris

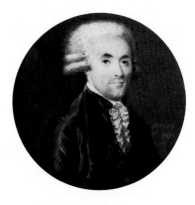

A 4206 Portrait of a man. *Portret van een man*

Ivory 5.4 cm in diam. Signed and dated *Quenedey pt. 1787*
PROV Bequest of F G S Baron van Brakell, Arnhem, 1878

Felice Ramelli

Asti 1666–1741 Rome

A 4363 Joseph and Potiphar's wife. *Jozef en de vrouw van Potifar*

After an original by Carlo Cignani (1628-1719). *Cf* the version in the Gemäldegalerie, Dresden (cat nr 387)

Ivory 19.5 × 15.2. Inscribed on the verso *Opera Singularissima del famoso Padre Abate Ramelli fatto nel l'anno 1725*
PROV KKZ. NMGK
LIT Foster 1926, p 246. Colding 1953, pp 140, 206, fig 145

A 4364 Madonna on the crescent moon. *Madonna op de maansikkel*

After an original by Carlo Maratti (1625-1713) in the Galleria Capitolina, Rome

Ivory 16.6 × 12.3. Oval
PROV KKZ. NMGK

Christian Richter

Sweden ca 1682–1732 London

A 4365 Anthony van Dyck (1599-1641). Painter. *Schilder*

After an original by Sir Peter Lely (1618-80)

Board 9.3 × 7.3. Oval. Inscribed on the verso *C. Richter pinxit 1711*
PROV KKZ. NMGK
LIT Foster 1914-16, p 251. L Hagedoorn, Op de Hoogte 14 (1917) ill on p 499. Long 1929, p 363. G Glück, Burl Mag 79 (1941) pp 194, 196

Simon Jacques Rochard *called* Acajou

Paris 1788–1872 Brussels

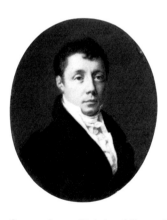

C 1459 Anton Reinhard Baron Falck (1777-1843). Minister of education, industry and the colonies. *Minister van onderwijs, nijverheid en koloniën*

Ivory 8 × 7.2. Oval. Signed and dated *Rochard mai 1819*
PROV On loan from FSCLMG Baroness de Constant Rebecque-van Zuylen van Nijevelt, dowager of VCHJ Baron de Constant Rebecque, Breda, since 1961

Sage

see Lesage

De Saint-Ligié

active ca 1783 in The Hague

A 4366 Portrait of a woman. *Portret van een vrouw*

Ivory 5.8 cm in diam. Signed *d Sᵗ Ligié*
PROV KKZ. NMGK

Johan Michaël Schmidt Crans

Rotterdam 1830–1907 The Hague

A 4367 Baruch de Spinoza (1632-77). Philosopher. *Filosoof*

Board 14.5 × 12
PROV NMGK
LIT FJ Dubiez, Ons Amsterdam 21 (1969) ill on p 5

Schuylenburch-van Sypesteyn

see Sypesteyn

Maria Machteld van Sypesteyn

Haarlem 1724–1774 Heemstede

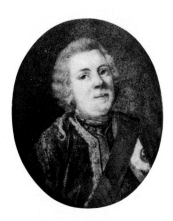

A 4368 Willem IV (1711-51), prince of Orange-Nassau. *Prins van Oranje-Nassau*

Ivory 17.7 × 5.9. Oval. Inscribed on the verso *Wilhelmus Carolus Henricus Friso Princeps Auriaci Nassouique Gubernator Summus Septem Unitarum Provinciarum Delineatus est a M.M. Schuylenburch a Moermont Nata a Sypesteyn 17 $\frac{5}{20}$ 48*
PROV KKZ. NMGK
LIT Moes 1897-1905, vol 2, nr 9097:46. Schidlof 1964, vol 2, p 739

Leonardus Temminck

The Hague 1746–1813 Amsterdam

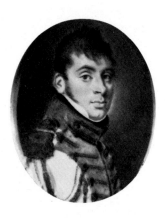

A 3272 Willem Jacob Verkouteren (1779-1861). Lieutenant in the artillery, stationed in Delft. *Luitenant der artillerie te Delft*

Ivory 5.6 × 4.5. Oval. Signed *LT*
PROV Bequest of Miss L E C Verkouteren, Epe, 1938

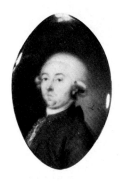

A 4072 Rudolf van Olden (1746-1813). Councillor and treasurer, later paymaster of Prince Willem V. *Raad- en rekenmeester van prins Willem V*

Ivory 4.2 × 2.9. Oval. Signed *LT*. On the verso the monogram *RVO*
PROV Purchased from Miss E Bogaerts, Bennekom, 1962

Nathaniel Thach

Barrow 1617–after 1650

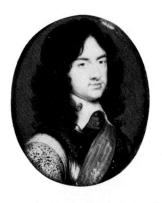

A 4369 Charles Stuart (1630-85), prince of Wales. The future King Charles II of England. *Karel Stuart, prins van Wales. De latere koning Karel II van Engeland*

After the original by Adriaen Hanneman (ca 1601-71)

Board 4.6 × 3.9. Oval. Signed and dated *N Thach F 165*.
PROV KKZ. NMGK * On loan to the KKS (cat 1968, p 179, nr 1009) since 1951
LIT Williamson 1904, vol 1, pl XLVII, nr 10. Staring 1948, p 58. Reynolds 1952, pp 70-71. Schidlof 1964, vol 2, p 807. L C de Ranitz, Bull RM 19 (1971) pp 7-8, fig 1 (wrong ill)

Henri Toutin

Châteaudun 1614–after 1683 Paris

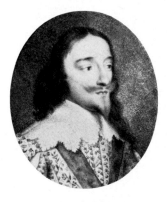

A 4370 Charles I (1600-49), king of England. *Karel I, koning van Engeland*

Enamel on copper 6.5 × 5.5. Signed and dated on the verso *henry Toutin | Orphevre a paris a fait ce cy lan. | 1636*
PROV KKZ. NMGK * On loan to the KKS (cat 1968, p 179, nr 1029) since 1951
LIT F Lugt, Oude Kunst 1 (1915-16) pp 152, 157. L Hagedoorn, Op de Hoogte 14 (1917) p 494, ill on p 495. Clouzot 1924, p 196. Clouzot 1927, pp 24-25, pl 1. R W Lightbown, Connoisseur 167-68 (1968) pp 84-85, 89, fig 7

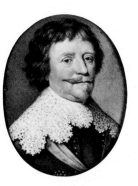

A 4371 Frederik Hendrik (1584-1647), prince of Orange. *Prins van Oranje*

After the original by Gerard van Honthorst (1590-1656)

Enamel on gold 4.3 × 3.4. Oval. On the back of the enamelled setting the crowned monogram *H*[endrik] *A*[malia] *V*[an Solms] crossed twice by the *O* of Orange
PROV Thought to come from the KKS. NMGK * On loan to the KKS (cat 1968, p 179, nr 1030) since 1951
LIT H Clouzot, Revue de l'Art 30 (1911) ill on p 187 (Paul Prieur). L Hagedoorn, Op de Hoogte 14 (1917) p 494, ill on p 495 (attributed to Prieur). Exhib cat Twintig miniaturen, Delft (antique fair) 1966, nr 20, ill

Adrianus de Visser

Rotterdam 1762–1837 Alkmaar

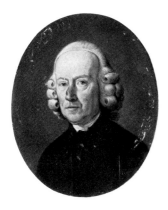

A 3058 Portrait of a man. *Portret van een man*

Copper 10.6 ×8.8. Oval. Signed and dated *A. de Visser Fecit 1795*
PROV Purchased from G Knuttel Wzn, The Hague, 1928

Frederika Sophia Wilhelmina (Wilhelmina), princess of Prussia

Berlin 1751 – 1820 Apeldoorn

A 4372 Willem Frederik (1772-1843), prince of Orange-Nassau. The future King Willem I, eldest son of Willem V and Wilhelmina of Prussia. *Prins van Oranje-Nassau. De latere koning Willem I, oudste zoon van Willem V en Wilhelmina van Pruisen, als kind*

Ivory 2.2 × 1.8. Oval
PROV KKZ. NMGK

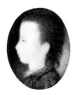

A 4373 Willem George Frederik (Frederik; 1774-99), prince of Orange-Nassau. Son of Willem V and Wilhelmina of Prussia as a child. *Prins van Oranje-Nassau. Zoon van Willem V en Wilhelmina van Pruisen, als kind*

Ivory 2.2 × 1.8. Oval
PROV KKZ. NMGK

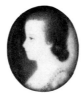

A 4374 Frederica Louisa Wilhelmina (Louise; 1770-1819), princess of Orange-Nassau. Daughter of Willem V and Wilhelmina of Prussia, as a child. *Prinses van Oranje-Nassau. Dochter van Willem V en Wilhelmina van Pruisen, als kind*

Ivory 2.2 × 1.9. Oval
PROV KKZ. NMGK

Hermanus Wolters

Zwolle 1682 – 1756 Haarlem

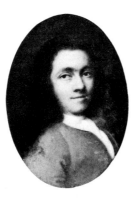

A 2407 Self portrait. *Zelfportret*

Pendant to A 2408

Ivory 8.5 ×6. Oval. Inscribed on the verso *Herm. Wolters hem zelf het eerst in Mignatuur geschildert 1717. Geboren 1682*
PROV Purchased from S Duits & Sons gallery, Amsterdam, 1910
LIT Van Hall 1963, p 378, nr 2408:1

A 2408 Henriëtta van Pee (1692-1741). Wife of Hermanus Wolters. *Echtgenote van Hermanus Wolters*

Pendant to A 2407

Ivory 8 × 5.5. Oval. Inscribed on the verso *Herman Wolters zijn vrouw in Mignatuur geschildert 1719 geboren … Gestorven 3 oct. 1741*
PROV Same as A 2407
LIT L Hagedoorn, Op de Hoogte 14 (1917) p 499, ill. Van Hall 1963, p 246, nr 1619:3

Henriëtta Wolters-van Pee

Amsterdam 1692 – 1741 Amsterdam

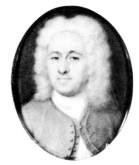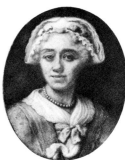

A 2409 Hermanus Wolters (1682-1756). The artist's husband. *Echtgenoot van de schilderes*

Pendant to A 2410

Ivory 6.8 ×5.5. Oval. Inscribed on the verso *Harm. Wolters. Geboren den 9 Jannu 1682 en van zijn waarde Vrouw Henriëtte van Pee geschildert 1726*
PROV Purchased from S Duits & Sons gallery, Amsterdam, 1910
LIT A Staring, Oude Kunst 4 (1918-19) p 201, ill. Van Hall 1963, p 378, nr 2408:2

A 2410 Self portrait. *Zelfportret*

Pendant to A 2409

Ivory 6.8 ×5.5. Oval. Inscribed on the verso *Henriëtta Wolters. Geboren den 5 December 1692. Haar selven geschildert 1732 Gestorven den 3 Octob. 1741*
PROV Same as A 2409
LIT Moes 1897-1905, vol 2, nr 5821:1. L Hagedoorn, Op de Hoogte 14 (1917) p 499, ill. Colding 1953, pp 141, 205, fig 141. Van Hall 1963, p 246, nr 1619:1

attributed to **Christian Friedrich Zincke**

Dresden 1683/84–1767 Dresden?

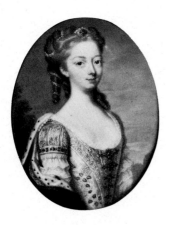

A 4375 Portrait of an English princess. *Portret van een Engelse prinses*

Enamel on copper 7.6 × 6. Oval
PROV KKZ * On loan to the KKS (cat 1968, p 180, nr 1025) since 1951

Monogrammists

Monogrammist WP

A 4376 Madonna

After an original by Guido Reni (1575-1642). *Cf* the painting in the Gemälde-galerie, Kassel (cat 1929, nr 574)

Ivory 11 × 9. Signed and dated *WP 74*
PROV KKZ. NMGK

A 4377 Portrait of an old woman, called Rembrandt's mother. *Portret van een oude vrouw, zogenaamd Rembrandt's moeder*

Copy after a painting by Rembrandt (1606-69) in Windsor Castle, known in the 18th century as the portrait of Countess Desmond

Vellum 11.3 × 8.6. Signed *WP*
PROV KKZ. NMGK

Anonymous miniatures

English school ca 1565

A 4390 James Stuart (1556-1625), the future king James I of England, at about the age of ten. *Jacobus Stuart, de latere koning Jacobus I van Engeland, op ongeveer tienjarige leeftijd*

Board 4.6 × 3.6. Oval
PROV KKZ. NMGK * On loan to the KKS (cat 1968, p 173, nr 984) since 1951
LIT Williamson 1904, vol I, pl XLVII, nr 11

A 4392 Portrait of a woman, thought to be Mary Stuart (1542-87), queen of Scots. *Portret van een vrouw, vermoedelijk Maria Stuart, koningin van Schotland*

Probably a 19th-century copy after an original in the Uffizi, Florence

Board 4.9 × 4. Oval
PROV KKZ. NMGK * On loan to the KKS (cat 1968, p 173, nr 985) since 1951
LIT Williamson 1904, vol I, pl XLVII, nr 9. L Cust & K Martin, Burl Mag 10 (1906) p 44, ill

A 4391 Portrait of a woman, perhaps Mary Stuart (1542-87), queen of Scots. *Portret van een vrouw, misschien Maria Stuart, koningin van Schotland*

Vellum 3.7 cm in diam
PROV KKZ. NMGK * On loan to the KKS (cat 1968, p 174, nr 986, attributed to Nicholas Hilliard) since 1951
LIT Williamson 1904, vol I, pl XLVII, nr 8

A 4393 Henry Stewart (1546-67), Lord Darnley. Husband of Mary Stuart. *Echtgenoot van Maria Stuart*

Board 5.2 × 4.1. Oval
PROV KKZ. NMGK * On loan to the KKS (cat 1968, p 173, nr 987) since 1951
LIT Williamson 1904, vol I, pl XLVII, nr 7. L Cust & K Martin, Burl Mag 10 (1906) p 44, ill

English school ca 1635

A 4395 Portrait of a man. *Portret van een man*

Board 6 × 5. Oval
PROV KKZ. NMGK * On loan to the KKS (cat 1968, p 173, nr 989) since 1951

English school ca 1665-70

A 4396 Portrait of a woman, perhaps Anne Hyde (1637-71), first wife of James II of England. *Portret van een vrouw, misschien Anne Hyde, eerste echtgenote van Jacobus II van Engeland*

Enamel on copper 4.2 × 3.6. Oval. On the back of the setting the monogram *LD* under a royal crown
PROV KKZ. NMGK
LIT L Hagedoorn, Op de Hoogte 14 (1917) pp 494, 496, ill on p 497

English school ca 1725

A 4397 Frederick Louis (1707-51), prince of Wales. Son of King George II. *Prins van Wales. Zoon van koning George II*

After an original by Jean-Baptiste van Loo (1684-1745)

Ivory 7.5 × 5.7. Oval
PROV KKZ. NMGK

English school ca 1750-51

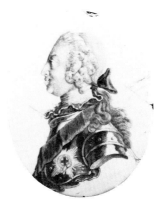

A 4402 Frederick Louis (1707-51), prince of Wales. *Prins van Wales*

After an engraving by Simon François Ravenet I (1706-74)

Battersea enamel on copper 8.9 × 7.2. Oval
PROV Bequest of F GS Baron van Brakell, Arnhem, 1878. NMGK

English school ca 1755

A 4398 Charles Edward Stuart (1720-88). Bonnie Prince Charlie in the dress of his maidservant Betty Burke on his flight from Benbecula, Hebrides, to the Isle of Skye, 1746. *In travestie in de japon van het dienstmeisje Betty Burke bij zijn vlucht van Benbecula (Hebriden) naar Skye in 1746*

Battersea enamel on copper 8.8 × 7. Oval
PROV KKZ, 1885. NMGK

English school ca 1770

A 4399 George III (1738-1820), king of England. *Koning van Engeland*

After an original of 1760 by Allan Ramsay (1713-84)

Ivory 2.5 cm in diam. Inscribed along the rim *Long live the king*
PROV KKZ. NMGK

A 4400 Portrait of a girl, thought to be a daughter of George III of England. *Portret van een meisje, vermoedelijk een dochter van George III, koning van Engeland*

Ivory 2.4 × 2. Oval
PROV KKZ. NMGK

A 4401 Portrait of a girl, thought to be a daughter of George III of England. *Portret van een meisje, vermoedelijk een dochter van George III, koning van Engeland*

Ivory 2.4 × 2. Oval
PROV KKZ. NMGK

English school ca 1790

A 4108 Portrait of a woman. *Portret van een vrouw*

Ivory 6.2 × 4.9. Oval. On the verso the monogram *CS*
PROV Bequest of Mr & Mrs J CJ Drucker-Fraser, Montreux, 1944

English school ca 1800

A 4403 George III (1738-1820), king of England. *Koning van Engeland*

Enamel on copper 5.5 × 4.8. Oval
PROV KKZ. NMGK

English school ca 1810

A 4109 Portrait of a woman. *Portret van een vrouw*

Ivory 8.3 × 6.3. Oval
PROV Bequest of Mr & Mrs J CJ Drucker-Fraser, Montreux, 1944

French school ca 1500

A 4404 Louise of Savoy (1467-1531/32), duchess of Angoulême, mother of Francis I. *Louise van Savoye, hertogin van Angoulême, moeder van Frans I*

Perhaps after an original by François Clouet (before 1522-1572)

Vellum 8.1 × 6.5. Inscribed *Louise Duchesse d'Engoulesme*
PROV KKZ. NMGK

French school ca 1550

A 4405 Henri II (1518-59), king of France. *Hendrik II, koning van Frankrijk*

18th-century copy after an original by François Clouet (before 1522-1572)

Board 8.8 × 7.4. Oval. Inscribed *Henri II, Roi de France*
PROV KKZ. NMGK

French school ca 1570

A 4406 Don Juan of Austria (1547-87). Regent of the Netherlands. *Don Juan van Oostenrijk. Landvoogd der Nederlanden*

Board 4.8 × 3.5. Oval
PROV KKZ, 1875. NMGK

French school ca 1580

A 4407 Henri I of Lorraine (1550-88), duc de Guise. *Hendrik I van Lotharingen, hertog van Guise*

Board 6 × 4.8. Oval
PROV KKZ. NMGK

A 4408 Portrait of a young woman, thought to be Margaret of Valois (1553-1615), daughter of Henri II of France. *Portret van een jonge vrouw, vermoedelijk Marguerite van Valois, dochter van Hendrik II*

Ivory 9.2 × 7.7
PROV KKZ. NMGK

French school ca 1650

A 4409 Portrait of a man. *Portret van een man*

Enamel on copper 3 × 2.4. Oval
PROV KKZ. NMGK
LIT L Hagedoorn, Op de Hoogte 14 (1917) pp 494, 496, ill on p 497

French school ca 1665

A 4410 Marie, marquise de Sévigné (1626-96). *Markiezin van Sévigné*

After an original by Robert Nanteuil (1623-78)

Board 3.1 × 2.7. Oval
PROV KKZ. NMGK

A 4411 Portrait of a woman, thought to

be Françoise d'Aubigny (1635-1719), marquise de Maintenon. *Portret van een vrouw, vermoedelijk Françoise d'Aubigny, markiezin van Maintenon*

Board 4.7 × 3.9. Oval
PROV KKZ. NMGK

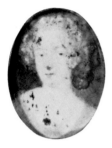

A 4412 Hortense Mancini (1639-1715), duchesse de Mazarin. *Hertogin van Mazarin*

Vellum 3.5 × 2.8. Oval
PROV KKZ. NMGK

French school ca 1675

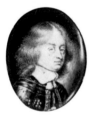

A 4413 Portrait of a man, perhaps Louis II de Bourbon (1621-86), prince de Condé. *Portret van een man, misschien Louis II van Bourbon, prins van Condé*

Enamel on copper 2.6 × 2.2. Oval
PROV KKZ. NMGK
LIT L Hagedoorn, Op de Hoogte 14 (1917) pp 494, 496, ill on p 497

French school? 18th century

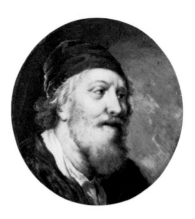

A 4414 Head of an old man. *Kop van een oude man*

Ivory 6 cm in diam
PROV KKZ. NMGK

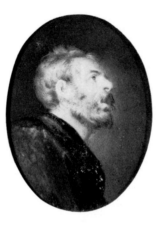

A 4415 Head of an old man. *Kop van een oude man*

Vellum 6.9 × 4.9. Oval
PROV KKZ. NMGK

A 4416 Head of an old man. *Kop van een oude man*

Vellum 6.4 × 5. Oval
PROV KKZ. NMGK

A 2809 Portrait of an Indian prince. *Portret van een Indische prins*

Ivory 7.5 × 6.2. Oval
PROV Presented by an unknown donor, 1917

French school ca 1725

RBK 17200 Portrait of a man. *Portret van een man*

Ivory 4.4 × 3.1. Oval. Decoration of a golden box
PROV F Mannheimer collection, Amsterdam. Transferred by the DRVK, 1952. Belongs to the department of sculpture and applied arts

A 4417 Deer hunt. *Hertenjacht*

After an original by Jean-Baptiste Oudry (1686-1755)

Board 4.7 × 6.4
PROV KKZ. NMGK

French school ca 1750

A 4418 A young woman distracting a soldier while one of her children robs him. *Een jonge vrouw die een krijgsman afleidt terwijl een van haar kinderen hem berooft*

Vellum 5.2 × 7.2. Grisaille
PROV KKZ. NMGK

French school 2d half 18th century

RBK 17156 Portrait of a woman. *Portret van een vrouw*

Ivory 4 × 3.1. Oval. Decoration of a golden box
PROV F Mannheimer collection, Amsterdam. Transferred by the DRVK, 1953. Belongs to the department of sculpture and applied arts

French school ca 1785

A 4419 Portrait of a young woman. *Portret van een jonge vrouw*

Ivory 5.8 × 4.8. Oval
PROV KKZ. NMGK

French school ca 1790

A 4420 Portrait of a lady. *Portret van een dame*

Ivory 6.2 × 5.4. Oval
PROV KKZ. NMGK

A 4421 Portrait of a young woman. *Portret van een jonge vrouw*

Ivory 6.4 cm in diam
PROV KKZ. NMGK

French school ca 1805

A 4110 Portrait of an old and a young woman. *Portret van een oude en een jonge vrouw*

Vellum 10.6 cm in diam
PROV Bequest of Mr & Mrs J C J Drucker-Fraser, Montreux, 1944

French school? ca 1810

A 650 Christ as the man of sorrows. *Christus als man van smarten*

Ivory 10.5 × 9.3. Signed on the verso with pencil *Lz*
PROV Presumably bought at an exhib in 1809

German school? 18th century?

NO PHOTOGRAPH AVAILABLE

A 4652 Portrait of an archduke of Austria. *Portret van een aartshertog van Oostenrijk*

Enamel on copper 4.9 × 3.7. In a silver setting with two clasps
PROV KKS. NMGK. Missing

German school ca 1700

A 4378 Christian V (1646-99), king of Denmark. *Christiaan V, koning van Denemarken*

Ivory 2.5 × 2. Oval
PROV KKZ. NMGK

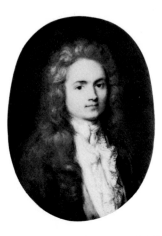

A 4032 Christoffer Bernard Julius von Schwartz, lord of Ansen. *Heer van Ansen*

Ivory 7 × 5. Oval. Inscribed on the verso *Christoffer Bernard Julius von Schwartz, Herr von Ansen*
PROV Bequest of Jonkvrouwe ACAJ Clifford, The Hague, 1960 * DRVK since 1964

German school ca 1730

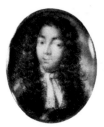

A 4379 Portrait of a man and, on the verso, a woman, thought to be Wilhelm Friedrich (1686-1723), margrave of Brandenburg-Anspach, and his wife Christiane Charlotte of Württemberg (1694-1729). *Portret van een man en een vrouw (keerzijde), vermoedelijk Willem Frederik Markgraaf van Brandenburg-Anspach en zijn vrouw Christiane Charlotte van Württemberg*

Ivory 2.8 × 2.4. Oval
PROV KKZ. NMGK

A 4380 Portrait of a woman, thought to be Christiane Charlotte of Württemberg (1694-1729). *Portret van een vrouw, vermoedelijk Christiane Charlotte van Württemberg*

Ivory 2.8 × 2.4. Oval
PROV KKZ. NMGK

A 4381 Portrait of a woman, thought to be Christiane Charlotte of Württemberg (1694-1729). *Portret van een vrouw, vermoedelijk Christiane Charlotte van Württemberg*

Ivory 2.8 × 2.4. Oval
PROV KKZ. NMGK

A 4382 Portrait of a woman. *Portret van een vrouw*

Ivory 2.6 × 2.2. Oval
PROV KKZ. NMGK

German school ca 1750

A 4383 Portrait of a ruler? *Portret van een vorst?*

Copper 3.7 × 3. Oval
PROV KKZ. NMGK

German school ca 1760

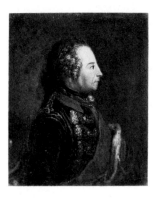

A 4384 Frederick II (1713-86), king of Prussia, called Frederick the Great. *Frederik II de Grote, koning van Pruisen*

Copper 8.4 × 7
PROV KKZ. NMGK

German school 1770

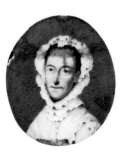

A 4385 Mary of Braunschweig (1723-72). Wife of Frederick, landgrave of Hesse-Cassel. *Maria van Brunswijk. Echtgenote van Frederik, landgraaf van Hessen-Cassel*

Enamel on copper 3.5 × 3. Oval. Inscribed on the verso *...Ldgr. de H. Cassel, fille de George II, Roi de la gr. Br. agé de 48 ans 1770*
PROV KKZ. NMGK

German school ca 1770

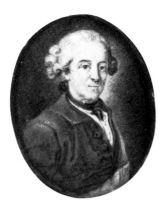

A 4386 Portrait of a man, thought to be Frederick II (1712-86), king of Prussia, called Frederick the Great. *Portret van een man, vermoedelijk Frederik II de Grote, koning van Pruisen*

Board 4.5 × 3.8. Oval
PROV KKZ. NMGK

German school ca 1780

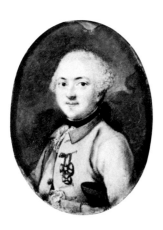

A 4387 Portrait of an Austrian officer. *Portret van een Oostenrijkse officier*

Board 4.9 × 3.9. Oval
PROV Bequest of F G S Baron van Brakell, Arnhem, 1878. NMGK

German school ca 1810

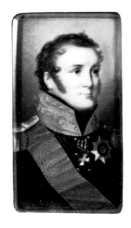

A 4388 Alexander I (1777-1825), emperor of Russia. *Keizer van Rusland*

After an original by Louise Bourdon (ca 1790-ca 1810)

Ivory 7.4 × 4.5
PROV KKZ. NMGK

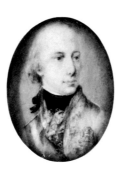

A 4389 Francis I (1768-1835), emperor of Austria. *Frans I, keizer van Oostenrijk*

After an original by Josef Kreutzinger (1757-1829) or Natale Schiavone (1777-1829)

Ivory 3.5 × 2.9. Oval
PROV KKZ. NMGK

German school ca 1830

A 2638 Portrait of a woman. *Portret van een vrouw*

Vellum 6.4 × 4.8
PROV Formed part of an unclaimed estate, Paramaribo, 1912

Netherlands school ca 1575

A 4394 Portrait of a woman. *Portret van een vrouw*

Copper 4.4 × 3.3. Oval
PROV KKS, 1885. NMGK

A 4422 Portrait of a man. *Portret van een man*

Copper 4.6 × 3.4. Oval
PROV KKS. NMGK

Netherlands school ca 1610

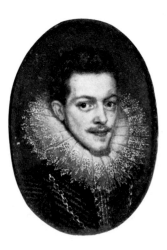

A 4095 Portrait of a man. *Portret van een man*

Copper 6.5 × 4.7. Oval
PROV Purchased from O Geveke gallery, Baexen, Limburg, 1963

Northern Netherlands school 17th century?

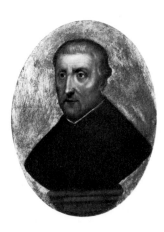

A 4423 Petrus Canisius (1521-97). Nijmegen priest and writer. *Geestelijke en schrijver te Nijmegen*

Copper 13.6 × 10.4. Oval. Inscribed *V.P.Petrus Canisius*
PROV KKS, 1885. NMGK
LIT L van Miert, in Stud op Godsd Geb 91 (1919) p 144. B Schneider, Numaga 18 (1971) ill on p 90

Northern Netherlands school 1614

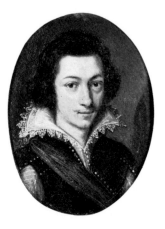

A 2104 Portrait of a young man. *Portret van een jonge man*

Copper 8.6 × 6.3. Oval. Dated *Ao 1614*
PROV Bequest of A A des Tombe, The Hague, 1933

Northern Netherlands school ca 1615

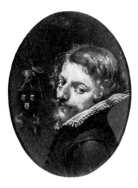

A 4424 Portrait of a painter (self portrait?). *Portret van een schilder (een zelfportret?)*

Copper 6.1 × 5.1. Oval. Painted on the back of a trimmed copper plate on which is engraved an unpublished copy after an engraving by Cornelis Massys (ca 1508-after 1560), Hollstein, vol 11, nr 141
PROV Purchased from Jonkheer J van Heemskerck van Beest, 1877. NMGK

Northern Netherlands school ca 1630

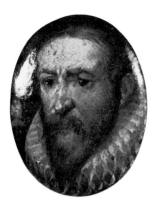

A 4204 Portrait of a man. *Portret van een man*

Silver 4.7 × 3.7. Oval
PROV Unknown

Northern Netherlands school? ca 1635

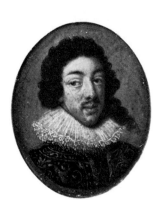

A 278 Frederick v (1596-1632), elector of the Palatinate, king of Bohemia. *Frederik V, keurvorst van de Palts, koning van Bohemen*

Copper 4.5 × 3.8. Inscribed on the verso *Frederik Koning van Bohemen, overleden a° 1632 geschilderd door P. Moreelse* PROV Purchased in 1803. NM, 1808 LIT Moes & van Biema 1909, pp 64, 169, 205

Northern Netherlands school ca 1640

A 2207 Portrait of a lute player. *Portret van een luitspeler*

Copper 6.3 × 5.1. Oval PROV Bequest of Miss ME van den Brink, Velp, 1905

Northern Netherlands school ca 1645

A 4425 Portrait of a woman, called a self portrait of Anna Maria van Schurman (1607-78). *Portret van een vrouw, zogenaamd zelfportret van Anna Maria van Schurman*

Copper 9.5 × 7.5. Oval. Inscribed on the verso *Marie Brughel peinte par son fils le Vieux en 1554* (incised) and *Schuerman*

savante Utrecht, par elle même written over it in ink PROV Bequest of D Franken Dzn, Le Vésinet, 1898. NMGK

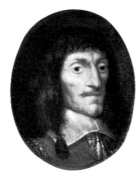

A 4426 Portrait of a man and a woman. *Portret van een man en een vrouw*

Painted directly into a silver locket 6 × 4.8. Oval PROV KKS, 1875. NMGK

Northern Netherlands school ca 1655

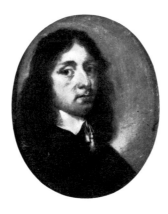

A 2085 Portrait of a man. *Portret van een man*

Copper 7.5 × 6. Oval PROV Bequest of AA des Tombe, The Hague, 1903

Northern Netherlands school ca 1675

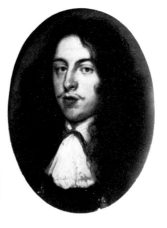

A 2098 Portrait of a young man. *Portret van een jonge man*

Copper 10.5 × 8. Oval. The verso is inscribed *Admiraal Melchior van de Kerckhove* and engraved with the number 7 and *Majoor Storm* PROV Bequest of AA des Tombe, The Hague, 1903 LIT Moes 1897-1905, vol I, nr 4129:2 (portrait of Melchior van den Kerckhoven)

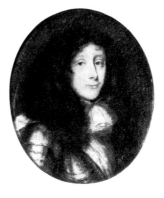

A 4203 Portrait of a man. *Portret van een man*

Board 5.6 × 4.7 PROV Bequest of FGS Baron van Brakell, Arnhem, 1878. NMGK

Northern Netherlands school ca 1690

A 4427 Portrait of a woman. *Portret van een vrouw*

Vellum 2.2 × 1.9. Oval PROV KKS, 1885. NMGK

Northern Netherlands school ca 1700

A 2812 Portrait of a woman. *Portret van een vrouw*

Ivory 2.8 × 2.2. Oval
PROV Purchased from W Jacobson, Amsterdam, 1918

Northern Netherlands school ca 1710

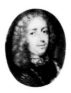

A 4428 Portrait of a man. *Portret van een man*

Board 2.1 × 1.7. Oval
PROV KKZ. NMGK

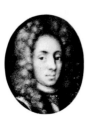

A 4429 Portrait of a man. *Portret van een man*

Board 2.5 × 2.2. Oval
PROV Presented by HAGE Kempers, Amsterdam, 1898. NMGK

A 2208 Portrait of a woman. *Portret van een vrouw*

Panel 8 × 5.6. Oval
PROV Bequest of Miss M E van den Brink, Velp, 1905

Northern Netherlands school ca 1725

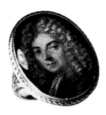

NM 12896 Portrait of a man. *Portret van een man*

Paper 2.5 × 1.9. Oval. Decoration of a golden ring from the mid-19th century
PROV Bequest of J G de Groot Jamin, Amsterdam, 1921. Belongs to the department of sculpture and applied arts

Northern Netherlands school ca 1730

NM 11444 Nicolaas Pancras (1696-1739). Alderman of Amsterdam (1728). *Schepen te Amsterdam*

Vellum 2.3 × 2.1. Oval. In an elaborate golden box (cat RMA Goud- en zilver-werken, 1952, nr 247)

PROV Presented by S Rendorp, Amsterdam, 1900. Belongs to the department of sculpture and applied arts

Northern Netherlands school ca 1745

A 4430 Anne of Hanover (1709-59). Wife of Prince Willem IV. *Anna van Hannover. Echtgenote van prins Willem IV*

Mother-of-pearl 6.7 × 4.8. Oval
PROV KKS. NMGK

A 2209 Portrait of a young man. *Portret van een jonge man*

Copper 6.5 × 5
PROV Bequest of Miss M E van den Brink, Velp, 1905

A 2210 Portrait of a woman. *Portret van een vrouw*

Copper 5.9 cm in diam
PROV Bequest of Miss M E van den Brink, Velp, 1905

Northern Netherlands school ca 1775

A 2177 Portrait of a man. *Portret van een man*

Pendant to A 2178

Black silhouette 8 × 6.5. Oval
PROV Bequest of Mrs V E L Diederichs-Portman, widow of W G A Diederichs, Amsterdam, 1905

A 2178 Portrait of a woman. *Portret van een vrouw*

Pendant to A 2177

Black silhouette 8 × 6.5. Oval
PROV Same as A 2177

Northern Netherlands school late 18th century

NO PHOTOGRAPH AVAILABLE

A 4653 Portrait of an army officer with baton and an orange ribbon. *Portret van een legeroverste met bevelhebbersstaf en oranje lint*

Enamel on copper 4.9 × 3.7. In a pressed copper frame
PROV KKS. Missing

Northern Netherlands school ca 1790

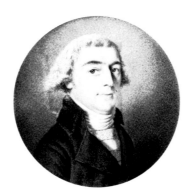

A 4211 Portrait of a man. *Portret van een man*

Ivory 6.5 cm in diam
PROV Unknown

A 2631 Portrait of a woman. *Portret van een vrouw*

Silhouette on paper 11.7 × 9.3. Oval. Inscribed on the verso *in de boedel Wed. Ringeling, geb. Maynarel gevonden, 25 Febr. 1831*
PROV Formed part of an unclaimed estate, Paramaribo, 1912

A 2642 Portrait of a man. *Portret van een man*

Pendant to A 2643

Silhouette on paper 9 × 7. Oval
PROV Formed part of an unclaimed estate, Paramaribo, 1912

A 2643 Portrait of a woman. *Portret van een vrouw*

Pendant to A 2642

Silhouette on paper 9 × 7. Oval
PROV Same as A 2642

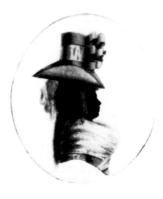

A 2634 Portrait of a woman. *Portret van een vrouw*

Silhouette on vellum 5 × 4.5. Oval. Signed *HWC*
PROV Formed part of an unclaimed estate, Paramaribo, 1912

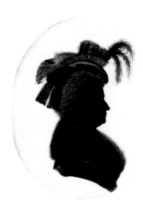

A 2645 Portrait of a woman. *Portret van een vrouw*

Silhouette on ivory 5.4 × 4.5. Oval
PROV Formed part of an unclaimed estate, Paramaribo, 1912

A 2646 Portrait of a woman. *Portret van een vrouw*

Silhouette on ivory 2.5 × 1.5. Octagonal brooch
PROV Formed part of an unclaimed estate, Paramaribo, 1912

Northern Netherlands school? ca 1800

NO PHOTOGRAPH AVAILABLE

A 2640 Portrait of a young girl. *Portret van een jong meisje*

Half-length, the head turned three-quarters to the right, wearing a dress with a low décolleté

Ivory 7 × 5.7. Oval
PROV Formed part of an unclaimed estate, Paramaribo, 1912. Missing

Northern Netherlands school ca 1805

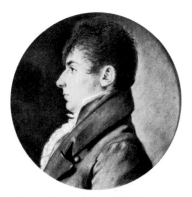

A 2082 Jonkheer Laurens de Witte van Citters (1781-1862)

Colored chalk on paper 17.5 cm in diam.

Inscribed on the verso *Laurens de Witte van Citters, geboren 21 Juni 1781, zoon van Jacob Verheye van Citters en Anna Jacoba de Witte, gehuwd met Wilhelmina van Hogendorp, dochter van Gijsbert Karel en Hester Clifford*
PROV Bequest of A A des Tombe, The Hague, 1876. Received in 1903

A 2673 Mrs Titsingh-Weber

Ivory 5.5 × 4.5. Oval
PROV Purchased from Mrs H J C Hübscher-Schenk, 1913

A 2633 Portrait of a woman. *Portret van een vrouw*

Ivory 7.6 × 5.7. Oval. Inscribed on a loose slip of paper *in de nagelaten goederen van wijlen J. H. Schlarhorst*
PROV Formed part of an unclaimed estate, Paramaribo, 1912

A 2636 Portrait of a young woman. *Portret van een jonge vrouw*

Ivory 5 × 3.4. Oval
PROV Formed part of an unclaimed estate, Paramaribo, 1912

A 2637 Portrait of a Surinamese girl. *Portret van een Surinaams meisje*

Ivory 4.8 cm in diam
PROV Formed part of an unclaimed estate, Paramaribo, 1912

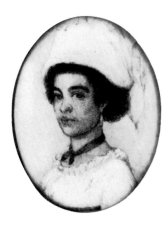

A 2641 Portrait of a Surinamese woman. *Portret van een Surinaamse vrouw*

Ivory 5.7 × 4. Oval
PROV Formed part of an unclaimed estate, Paramaribo, 1912

Northern Netherlands school ca 1810

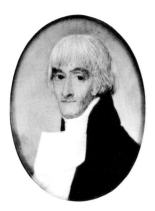

A 2647 Portrait of a man. *Portret van een man*

Ivory 4.5 × 3.7. Oval
PROV Formed part of an unclaimed estate, Paramaribo, 1912

A 2648 Portrait of a woman. *Portret van een vrouw*

Ivory 7 × 5.5. Oval
PROV Formed part of an unclaimed estate, Paramaribo, 1912

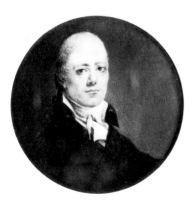

A 2632 Portrait of a man. *Portret van een man*

Ivory 6.1 cm in diam. Signed on the verso *JL*
PROV Formed part of an unclaimed estate, Paramaribo, 1912

A 2175 Georg Albrecht Diederichs (1751-1816). Amsterdam bookseller. *Boekhandelaar te Amsterdam*

Pendant to A 2176
For portraits of the sitter's sons, *see* Schwartze, Johann Georg, A 2170 – Miniatures: Grebner, Willem, A 2173 & A 2174. For portraits of the sitter's parents, *see* Pastels: Mertens, Johannes Cornelis, A 2168 & A 2169

Ivory 8 × 6.5. Oval
PROV Bequest of Mrs V E L Diederichs-Portman, widow of W G A Diederichs, Amsterdam, 1905

A 2176 Maria Elisabeth Schreiber (1765-1822). Wife of Georg Albrecht Diederichs. *Echtgenote van Georg Albrecht Diederichs*

Pendant to A 2175

Ivory 8 × 6.5. Oval
PROV Same as A 2175

A 2644 Portrait of an old lady. *Portret van een oude dame*

Ivory 8.2 × 6.8. Oval
PROV Formed part of an unclaimed estate, Paramaribo, 1912

A 2635 Portrait of a Surinamese girl. *Portret van een Surinaams meisje*

Ivory 6.4 × 4.9. Oval. On the verso is a lock of hair
PROV Formed part of an unclaimed estate in Paramaribo, 1912

Northern Netherlands school ca 1820

A 3063 Suzanna de Roth (1789-1822). Wife of Jonkheer Isaäc Pierre Graafland (1789-1825), justice in the supreme court of Surinam. *Echtgenote van Jonkheer Isaäc Pierre Graafland, raadsheer in het hooggerechtshof van Suriname*

Ivory 9 × 7.5. Oval
PROV Presented from the estate of Mrs Chr H Graafland-de Graaf, dowager of Jonkheer J P C Graafland, 1928

Holland school ca 1580

C 32 Jacob Pietersz Bicker (1555-87). Treasurer of Amsterdam. *Commissaris-thesaurier van Amsterdam*

Presumably a later copy

Copper 4 cm in diam
PROV On loan from the city of Amsterdam (Bicker bequest), 1881-1975
LIT Moes 1897-1905, vol 1, nr 645

Holland school ca 1635

A 4431 Frederik Hendrik (1584-1647), prince of Orange. *Prins van Oranje*

After an original by Gerard van Honthorst (1590-1656)

Board 4.8 × 3.9. Oval. Unclearly signed
PROV KKZ. NMGK
LIT L Hagedoorn, Op de Hoogte 14 (1917) p 490 (attributed to Thomas Flatman). Long 1929, p 155 (copy, not Flatman)

A 4432 Frederik Hendrik (1584-1647), prince of Orange. *Prins van Oranje*

Copper 3.2 cm in diam
PROV Purchased in 1896. NMGK

A 4433 Portrait of a man. *Portret van een man*

Vellum 3.7 × 3.1. Oval. Inscribed on the verso *..loving ..g.. van Prins Willem I. Graaf van ..*
PROV KKZ. NMGK
LIT Moes 1897-1905, vol 2, nr 5905:22 (portrait of Philips Willem, prince of Orange)

Holland school ca 1650

A 4434 Willem II (1626-50), prince of Orange. *Prins van Oranje*

After Honthorst, Gerard van, A 871

Board 3.8 × 2.3. Oval
PROV KKZ. NMGK
LIT Moes 1897-1905, vol 2, nr 9095:37?

A 4435 Willem II (1626-50), prince of Orange. *Prins van Oranje*

After an original by Gerard van Honthorst (1590-1656)

Board 4.6 × 4.1. Oval
PROV KKZ. NMGK
LIT Moes 1897-1905, vol 2, nr 9095:37? L Hagedoorn, Op de Hoogte 14 (1917) p 490, ill on p 492 (attributed to Thomas Flatman). Long 1929, p 155 (copy, not Flatman)

Holland school ca 1665

A 4436 Willem Frederik (1613-64), prince of Orange-Nassau. *Prins van Oranje-Nassau*

After an original by Adriaen Hanneman (ca 1601-71)

Enamel on gold? 7 × 6.1
PROV KKZ. NMGK * On loan to the KKS (cat 1968, p 175, nr 1024) since 1951
LIT Moes 1897-1905, vol 2, nr 9100:15. L Hagedoorn, Op de Hoogte 14 (1917) ill on p 498. Exhib cat Twintig miniaturen, Delft (antique fair) 1966, nr 18, ill

Holland school ca 1675

A 4437 Amalia van Solms (1602-75). Widow of Prince Frederik Hendrik. *Weduwe van prins Frederik Hendrik*

On the verso a skull and crossbones. After an original by Gerard van Honthorst (1590-1656)

Board 4.7 × 3.8. Oval. Inscribed on the verso *Amelie Orange*
PROV KKZ. NMGK * On loan to the KKS (cat 1968, p 175, nr 981) since 1951

A 4438 William III (1650-1702), prince of Orange. *Willem III, prins van Oranje*

After an original by Willem Wissing (1656-87). *Cf* Wissing, Willem, A 879

Board 2.4 × 2. Oval
PROV KKZ. NMGK
LIT Moes 1897-1905, vol 2, nr 9096

Holland school ca 1690

A 4439 Hendrik Casimir II (1657-96), prince of Nassau-Dietz. *Vorst van Nassau-Dietz*

After an original by Lancelot Volders (active ca 1660-70 in Brussels)
Pendant to A 4313 (Miniatures: Duchatel, Marie)

Board 5.1 × 4. Oval
PROV KKZ. NMGK

Holland school ca 1710

A 4440 Johan Willem Friso (1687-1711), prince of Orange-Nassau. *Prins van Oranje-Nassau*

After an original by Lancelot Volders (active ca 1660-70 in Brussels)

Ivory 8.5 × 5.8. Oval
PROV KKZ. NMGK

A 4441 Johan Willem Friso (1687-1711), prince of Orange-Nassau. *Prins van Oranje-Nassau*

After an original by Lancelot Volders (active 1660-70 in Brussels)

Board 4.7 × 3.7. Oval
PROV KKZ. NMGK

Holland school ca 1715

A 4442 Portrait of a child, thought to be Willem IV (1711-51), prince of Orange-Nassau. *Portret van een kind, vermoedelijk Willem IV, prins van Oranje-Nassau*

Board 4 × 3. Oval
PROV KKZ. NMGK

Holland school ca 1750

A 4443 Willem IV (1711-51), prince of Orange-Nassau. *Prins van Oranje-Nassau*

Perhaps after an original by Gerard Sanders (ca 1702-67)

Ivory 5 × 4. Oval
PROV KKZ. NMGK
LIT Moes 1897-1905, vol 2, nr 9097: 44, 45 or 46. Staring 1947, p 38

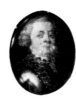

A 4444 Willem IV (1711-51), prince of Orange-Nassau. *Prins van Oranje-Nassau*

Ivory 2.1 × 1.8. Oval
PROV KKZ. NMGK
LIT Moes 1897-1905, vol 2, nr 9097: 44, 45 or 46

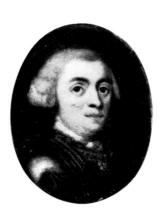

A 4445 Willem IV (1711-51), prince of Orange-Nassau. *Prins van Oranje-Nassau*

After an original by Jean Fournier (ca 1700-65) in the town hall of Delft

Ivory 5 × 4. Oval
PROV KKZ. NMGK
LIT Moes 1897-1905, vol 2, nr 9097: 44, 45 or 46

A 4446 Anne of Hanover (1709-59). Wife of Prince Willem IV. *Anna van Hannover. Echtgenote van prins Willem IV*

After Tischbein, Johann Valentin, A 406

Ivory 4 × 3.6. Oval
PROV KKZ. NMGK

A 4447 Portrait of an English princess, probably Anne of Hanover (1709-59), daughter of George II of England and wife of Prince Willem IV. *Portret van een Engelse prinses, waarschijnlijk Anna van Hannover, dochter van koning George II, echtgenote van prins Willem IV*

Enamel on gold? 4 × 3.3. Oval
PROV KKZ. NMGK
LIT L Hagedoorn, Op de Hoogte 14 (1917) pp 494, 496, ill on p 497

Holland school ca 1760

A 4448 Wilhelmina Carolina (Carolina; 1743-87), princess of Orange-Nassau. Daughter of Prince Willem IV. *Prinses van Oranje-Nassau. Dochter van prins Willem IV*

On the verso a small monument, with the letter C, is depicted in paint and embroidery on a piece of vellum

Ivory 2.8 × 2.4. Oval
PROV KKZ. NMGK

Holland school ca 1770

A 4452 Frederika Sophia Wilhelmina (Wilhelmina; 1751-1820), princess of Prussia. Wife of Prince Willem V. *Prinses van Pruisen. Echtgenote van prins Willem V*

Ivory 5.2 × 7.5
PROV KKZ. NMGK

A 4453 Frederika Sophia Wilhelmina (Wilhelmina; 1751-1820), princess of Prussia. Wife of Prince Willem V.

Prinses van Pruisen. Echtgenote van prins Willem V

After the painting of 1760 by Johann Georg Ziesenis (1716-76) in the KKS (cat nr 463)

Ivory 11 × 7.2
PROV KKZ. NMGK

Holland school ca 1775

A 4449 Frederica Louisa Wilhelmina (Louise; 1770-1819), princess of Orange-Nassau. Daughter of Prince Willem V as a child. *Prinses van Oranje-Nassau. Dochter van prins Willem V, als kind*

Ivory 6.5 cm in diam
PROV KKZ. NMGK

A 4458 Portrait of a lady, thought to be Frederika Sophia Wilhelmina (1751-1820), princess of Prussia, wife of Prince Willem V. *Portret van een dame, vermoedelijk Frederika Sophia Wilhelmina prinses van Pruisen, echtgenote van prins Willem V*

Enamel on copper 3.9 × 3.2. Oval
PROV KKZ. NMGK * On loan to the KKS (cat 1968, p 175, nr 1026) since 1951
LIT L Hagedoorn, Op de Hoogte 14 (1917) pp 494, 496, ill on p 497

Holland school ca 1780

A 4450 Willem v (1748-1806), prince of Orange-Nassau. *Prins van Oranje-Nassau*

Ivory 4.4 × 3.5. Oval
PROV KKZ. NMGK
LIT Moes 1897-1905, vol 2, nr 9098:49

A 4451 Willem v (1748-1806), prince of Orange-Nassau. *Prins van Oranje-Nassau*

Ivory 3.2 × 2.6. Oval
PROV KKZ. NMGK
LIT Moes 1897-1905, vol 2, nr 9098:50

A 4454 Willem v (1748-1806), prince of Orange-Nassau. *Prins van Oranje-Nassau*

Silhouette on ivory 5.6 × 4.7. Oval
PROV KKZ. NMGK

A 4455 Willem Frederik (1772-1843), prince of Orange-Nassau. Oldest son of Willem v. *Prins van Oranje-Nassau. Oudste zoon van Willem V*

Silhouette on paper 6 × 4.3. Oval
PROV KKZ. NMGK

A 4456 Frederica Louisa Wilhelmina (Louise; 1770-1819), princess of Orange-Nassau, future wife of Carel George August of Braunschweig-Wolfenbüttel. *Prinses van Oranje-Nassau. De latere echtgenote van Carel George August van Brunswijk-Wolfenbüttel*

Silhouette on paper 6 × 4.2. Oval
PROV KKZ. NMGK

Holland school ca 1785

A 4457 Willem George Frederik

(Frederik; 1774-99), prince of Orange-Nassau. Son of Prince Willem v. *Prins van Oranje-Nassau. Zoon van prins Willem V*

Cf Pastels: Tischbein, Johann Friedrich August, A 414

Ivory 3 × 1.8. Octagonal, set in a ring
PROV Purchased in 1892. NMGK

Holland school ca 1795

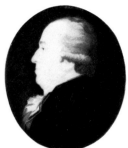

C 46 Jan Bernd Bicker (1746-1812). Amsterdam merchant and banker, chairman of the national assembly in 1796. *Koopman en bankier te Amsterdam, in 1796 voorzitter van de Nationale Vergadering*

Pendant to C 47

Ivory 5 × 4.5. Oval
PROV On loan from the city of Amsterdam (Bicker bequest), 1881-1975

C 47 Catharina Six (1752-93). Wife of Jan Bernd Bicker. *Echtgenote van Jan Bernd Bicker*

Pendant to C 46

Ivory 5 × 5.4. Oval
PROV Same as C 46

Holland school ca 1810

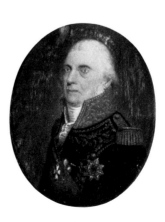

A 4658 Jan Hendrik van Kinsbergen (1735-1819). Vice admiral, marshall extraordinary of the Dutch navy. *Vice-admiraal, buitengewoon maarschalk der Hollandse zeemacht*

Ivory 9.5 × 7.5. Oval
PROV Purchased from G C Helbers, Gouda, 1952

Holland school ca 1840

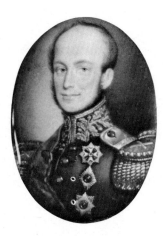

A 1959 Willem II (1792-1849), king of the Netherlands. *Koning der Nederlanden*

Ivory 5.2 × 4. Oval
PROV Purchased from M van Duren Jr, art dealer, 1901

Holland school ca 1850

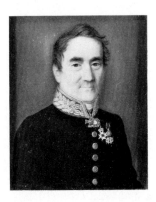

A 1962 J C de Brunett. Consul-general of Russia in Amsterdam. *Consul-generaal van Rusland te Amsterdam*

Ivory 9.6 × 8.3. Oval
PROV Presented by Mrs Herpel-Völcker, Bussum, 1901

Amsterdam school 1696

NG 1974 R 30 Neptune quieting the waves. *Neptunus brengt de golven tot bedaren*

Ivory 7.5 cm in diam. Lid of an ivory box. Inscribed along the rim *… praestat componere flctus.* Inscribed on the verso *…onibus redugt | natus Amstelod | civibus quis hoc | antiquae virtutis | …s.ectataeq fidei | praemium largitur || MDC XC VI.* Inscribed on a fragmentary label *In deze doos werd door de Regering der Stad Amsterdam aan hen die (waarschijnlijk ter walvischvaart) naar de IJszee waren geweest en vandaar teruggekomen een geschenk aangeboden, misschien een medaille, een geschenk in geld of een te brief. Op het deksel staat: De Regering der Stad Amsterdam heeft aan hare burgers, die uit het Noorden zijn teruggekeerd, uit aanmerking van hunne meer-malen aan den dag gelegde onverschrokkenheid en hunne beproefde trouw, dit geschenk vereerd. || 1696 … Hij (Neptunus de God en beheerscher der Zee) beyvert zich om de golven der zee tot bedaren te brengen. – No: 86*
PROV Unknown. Belongs to the department of Dutch history

Spanish school ca 1650

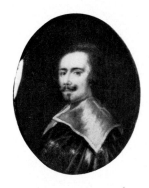

A 4459 Portrait of a man, thought to be Don Louis de Haro (1598-1661), minister and favorite of Philip IV of Spain. *Portret van een man, vermoedelijk Don Louis de Haro, minister en gunsteling van Philips IV van Spanje*

Ivory 4.4 × 3.7. Oval
PROV KKZ. NMGK

Pastels

Not included are pastels belonging to the Rijksprentenkabinet, including works by P F de La Croix (1709-82), Ph Endlich (ca 1700-after 1748), Ch H Hodges (1764-1837), R Jelgerhuis (1729-1806), Bernard Vaillant (1634/35-after 1675), Wallerand Vaillant (1623-77) and other earlier masters. The bulk of their holdings in this area, however, is of more recent date.

The pastels catalogued here are sometimes executed in a mixed technique, the pastel chalks being used in combination with body color. This is especially apparent in the works by Cornelis Troost, for one. Such technical departures have not been specified.

Jurriaan Andriessen

Amsterdam 1742 – 1819 Amsterdam

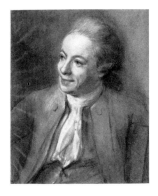

A 3048 Dirk Versteegh (1751-1822). Amsterdam art collector, patron and amateur draftsman. *Amsterdams kunst-verzamelaar en -bevorderaar en amateur-tekenaar*

Paper 26.7 × 22. Signed and dated on the verso *J. Andriessen del ad viv 1772* and, on the old mount *'t Portrait van D V oud 21 Jaaren A° 1772 Jur^n Andriessen*
PROV Bequest of A Allebé, Amsterdam, 1927
LIT Knoef 1943, p 15. CJ de Bruyn Kops, NKJ 21 (1970) p 323, ill on p 324

Johannes Anspach

Nieder-Ingelheim 1752 – 1823 Rotterdam

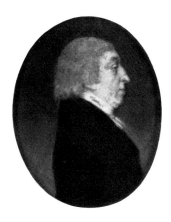

A 2630 Portrait of a man. *Portret van een man*

Vellum 14.5 × 11.5. Oval. Signed and dated on the verso of the wooden backing *Joh. Anspach 1802 $\frac{5}{14}$ gemaalt* and inscribed *Mamin*
PROV Formed part of an unclaimed estate, Paramaribo, 1912

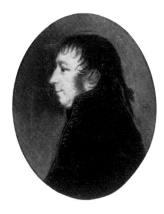

A 4660 Albert Kikkert (1762-1819). Vice admiral and governor-general of Curaçao, Aruba and Bonaire. *Vice-admiraal en gouverneur-generaal van Curaçao, Aruba en Bonaire*

Vellum 12.4 × 9.6. Oval
PROV Presented from the estate of A van der Vies, Amsterdam, 1974

Madeleine Françoise Basseporte

Paris 1701 – 1780 Paris

A 2119 Portrait of a young woman. *Portret van een jonge vrouw*

Paper 44.5 × 37. Inscribed on the verso *Peinte par Madeleine Basseporte 1727*
PROV Sale Amsterdam, 30 April 1900 (as by Rosalba Carriera)

attributed to Hendrikus Johan Antonius Baur

Huckeswagen 1736 – 1817 Harlingen

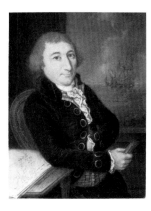

A 3223 Portrait of an admiral, thought to be Vice Admiral Hermanus Reijntjes (1744-97). *Portret van een vlootvoogd, misschien vice-admiraal Hermanus Reijntjes*

Vellum 35 × 28
PROV From the Rijksarchief (state archives), Haarlem, 1934
LIT R van Luttervelt, Bull RM 7 (1959) p 23, ill (portrait of J W de Winter or H Reijntjes)

Siebe Johannes ten Cate

Sneek 1858–1908 Paris

A 2284 Market in Beauvais. *De markt te Beauvais*

Paper 26 × 34. Signed and dated *ten Cate Beauvais 97*
PROV Bequest of J B A M Westerwoudt, Haarlem, 1907

A 2285 A pond in the woods. *Een bos-vijver*

Paper 25 × 33.5. Signed *ten Cate*
PROV Bequest of J B A M Westerwoudt, Haarlem, 1907

Croix

see la Croix, de

Cornelis van Cuijlenburg

Utrecht 1758–1827 The Hague

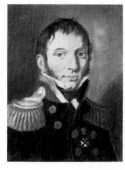

A 2622 Willem Augustus (or Anton?) van der Hart (died in or after 1824). Naval officer. In 1813, as colonel, charged with the supervision of the wharves and harbors of Rotterdam. *Zee-officier, in 1813 als kolonel belast met het opzicht over werven en havens te Rotterdam*

Pendant to A 2623

Vellum 23.5 × 18. Signed and dated on the verso *Cs. van Cuylenburgh in 's Hage pinx 1815*
PROV Purchased from W A van Duynen, Amsterdam, 1912

A 2623 Willem Augustus van der Hart's wife. *De echtgenote van Willem Augustus van der Hart*

Pendant to A 2622

Vellum 23.5 × 18
PROV Same as A 2622

Jean Augustin Daiwaille

Cologne 1786–1850 Rotterdam

A 1618 Self portrait. *Zelfportret*

Vellum 38.5 × 31
PROV Presented by W Roelofs, The Hague, 1894
LIT C J de Bruyn Kops, Bull RM 11 (1963) pp 52-53, fig 10

Duyl-Schwartze

see Schwartze

Grandmont-Hubrecht

see Hubrecht

Charles Howard Hodges

Portsmouth 1764–1837 Amsterdam

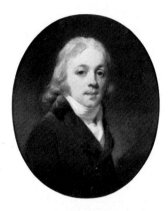

A 4029 Portrait of a man, thought to be a member of the Clifford family. *Portret van een man, waarschijnlijk een lid van de familie Clifford*

Vellum. The exposed area measures 27 × 21.8. Oval
PROV Bequest of Jonkvrouwe A C A J Clifford, The Hague, 1960

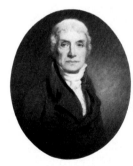

A 2542 Jacob Carel Abbema (1749-1835). Major-general and state councillor for war and the navy. *Generaal-majoor en staatsraad van oorlog en marine*

Pendant to A 2543

Vellum. The exposed area measures 26.7 × 22. Oval
PROV Purchased from J F Abbema Copes van Hasselt, Rotterdam, 1912, through the intermediacy of H Vas Dias
LIT Dronkers 1968, p 38, ill

A 2543 Isabella Maria Smissaert (1752-1824). Widow of Willem Backer and, from 1813 on, second wife of Jacob Carel Abbema. *Tweede echtgenote, sedert 1813, van Jacob Carel Abbema, weduwe van Willem Backer*

Pendant to A 2542

Vellum. The exposed area measures 26.4 × 21.8. Oval
PROV Same as A 2542

A 4639 Jonkheer Theodorus Frederik van Capellen (1762-1824). Vice admiral. *Vice-admiraal*

For another portrait of the sitter, *see* Eeckhout, Jacobus Josephus, A 4058

Vellum. The exposed area measures 29 × 23.5. Oval
PROV Bequest of Jonkheer H Th Hora Siccama, The Hague, 1922. NMGK

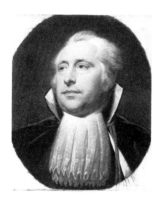

A 4227 Rutger Jan Schimmelpenninck (1761-1825). Grand pensionary of the Batavian Republic. *Raadpensionaris van de Bataafse Republiek*

For another portrait of the sitter, *see* Hodges, Charles Howard, copy after, A 2971

Vellum. The exposed area measures 50.5 × 39.3. Oval
PROV Presented by Jonkheer G Schimmelpenninck, Olst, 1973

Abrahamine Arnolda Louise (Bramine) Hubrecht

Rotterdam 1855–1913 Holinbury St Mary

A 2797 Self portrait. *Zelfportret*

Paper 52.5 × 48. Signed *B.A.G.Ht*
PROV Bequest of the artist, Doorn, 1916 * Lent to Miss M Hubrecht, Doorn, 1928-50. On loan to J B Hubrecht, Doorn, since 1950
LIT Van Hall 1963, nr 991:1

A 2795 Maria Pruys van der Hoeven (1824-1901). Wife of Paul François Hubrecht (1829-1902) and mother of the artist. *Echtgenote van Paul François Hubrecht en moeder van de kunstenares*

Paper 94 × 73.5
PROV Same as A 2797 * Lent to Miss M Hubrecht, Doorn, 1928-50. On loan to J B Hubrecht, Doorn, since 1950

A 2796 Maria Hubrecht (1865-1950). Painter, sister of the artist. *Schilderes, zuster van de kunstenares*

Paper 71 × 57. Signed *B.G.Ht.*
PROV Same as A 2797 * Lent to Miss M Hubrecht, Doorn, 1928-50. On loan to J B Hubrecht, Doorn, since 1950

Isaac Lazerus Israels

Amsterdam 1865 – 1934 The Hague

A 3664 In the Bois de Boulogne near Paris. *In het Bois de Boulogne bij Parijs*

Paper 49 × 36. Signed *Isaac Israels*
PROV Lent by Mr & Mrs J C J Drucker-Fraser, 1919. Bequeathed in 1944

A 3665 Gust of wind in a city square. *Rukwind op een plein*

Paper 29 × 44. Signed *Isaac Israels*

PROV Lent by Mr & Mrs J C J Drucker-
Fraser, 1919. Bequeathed in 1944
LIT Wagner 1967, p 29, fig 36 (1893-95)

A 3667 A milliner's atelier. *Modisten-
atelier*

Paper 62.5 ×47. Signed *Isaac Israels*
PROV Lent by Mr & Mrs J C J Drucker-
Fraser, 1919. Bequeathed in 1944
LIT E P Engel, Bull RM 13 (1965) ill on p
61

A 3668 The funfair. *De kermis*

Paper 51 ×70.5. Signed *Isaac Israels*
PROV Lent by Mr & Mrs J C J Drucker-
Fraser, 1919. Bequeathed in 1944

A 2911 Javanese dancers. *Dansende
Javanen*

Paper 50.5 × 37.5. Signed *Isaac Israels*
PROV Bequest of A van Wezel,
Amsterdam, 1922

A 2912 The chess players. *De schaak-
spelers*

Paper 40 × 57.5. Signed *Isaac Israels*
PROV Bequest of A van Wezel,
Amsterdam, 1922

A 2916 Girl before a mirror. *Meisje voor
een spiegel*

Paper 72 ×49. Signed *Isaac Israels*
PROV Bequest of A van Wezel,
Amsterdam, 1922

Pieter de Josselin de Jong

St Oedenrode 1861 – 1906 Amsterdam

A 3672 Woman gleaning ears of grain.
Een arenlezende vrouw

Paper 35 ×26.5. Signed *de Josselin de
Jong*
PROV Lent by Mr & Mrs J C J Drucker-
Fraser, 1919. Bequeathed in 1944

A 3673 Interior of an iron foundry.
Interieur van een ijzergieterij

Paper 75 × 112. Signed *de Josselin de
Jong*
PROV Same as A 3672

attributed to **Susanna de La Croix**

active ca 1800 in The Hague

A 1609 Portrait of a woman. *Portret van
een vrouw*

Paper 33 ×25. Signed and dated with an
unclear initial and *de la Croix fecit 1793*.
Inscribed *Oud 82*
PROV Bequest of Miss H A van
Heukelom, Amsterdam, 1894

Jean-Etienne Liotard

Geneva 1702 – 1789 Geneva

A 228 Portrait of Mlle Lavergne, the artist's niece, known as 'La liseuse.'
Portret van Mlle Lavergne, een nicht van de kunstenaar, bekend als 'La liseuse'

Vellum 54 × 42. Signed and dated *J. E. Liotard lion 1746.* Inscribed on the verso *Mad^elle Lavergne de Lion peint par Liotard*
PROV Bequest of Miss M A Liotard, Amsterdam, 1873
LIT Humbert, Revilliod & Tilanus 1897, p 105, nr 2, ill. L Vaillat, Les Arts, 1911, p 10, ill. Fosca 1928, p 36. Fosca 1956, pp 30, 46, 51, 187. Garland 1957, p 92. Schönberger & Soehner 1959, fig 237. Fr W S van Thienen, OKTV I (1963) nr 13, fig 6

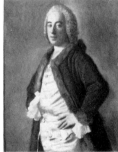

A 232 Monsieur Boère. Genoese merchant. *Koopman te Genua*

Pendant to A 233

Vellum 61 × 48. Signed and dated *par Liotard 1746.* Inscribed on the verso *M. Boere, negociant à Gênes, né et décédé à Genève, peint par J.E. Liotard en 1746*
PROV Bequest of Miss M A Liotard, Amsterdam, 1873
LIT Humbert, Revilliod & Tilanus 1897, p 113, nr 31. Fosca 1928, p 35. Staring 1947, p 42. Fosca 1956, pp 30, 129

A 233 Madame Boère

Pendant to A 232

Vellum 61 × 48. Signed and dated *par J.E. Liotard 1746.* Inscribed on the verso

Madame Boere, Epouse du négociant de Gênes décédée à Génève, peint par J. Et. Liotard en 1746
PROV Same as A 232
LIT Humbert, Revilliod & Tilanus 1897, p 113, nr 32. L Vaillat, Les Arts, 1911, p 6, ill on p 13. Fosca 1928, p 35, ill opp p 24. C J Hudig, Historia 9 (1943) p 147, fig 18. Staring 1947, p 42. Fosca 1956, pp 30, 52, 131, 187, pl XVIII

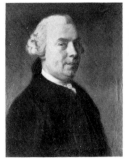

C 30 Hendrick Bicker (1722-83). Amsterdam merchant and banker. *Koopman en bankier te Amsterdam*

Pendant to C 31

Paper 53 × 44.5
PROV On loan from the city of Amsterdam (Bicker bequest), 1881-1975
LIT Humbert, Revilliod & Tilanus 1897, p 112, nr 29. Moes 1897-1905, vol 1, nr 644:2. Staring 1947, p 30

C 31 Clara Magdalena Dedel (1727-78). Wife of Hendrick Bicker. *Echtgenote van Hendrick Bicker*

Pendant to C 30

Vellum 53 × 43.5. Signed and dated *par Liotard 1756*
PROV Same as C 30
LIT Humbert, Revilliod & Tilanus 1897, p 112, nr 30. Moes 1897-1905, vol 1, nr 1919:1. Staring 1947, p 30. E G G Bos, Antiek 1 (1966) p 12, fig 15

A 231 Portrait of Marie Congnard-

Batailhy, grandmother of the artist's wife, known as 'La dame aux dentelles.'
Portret van Marie Congnard-Batailhy, grootmoeder van de vrouw van de kunstenaar, bekend als 'La dame aux dentelles'

Vellum 56.5 × 45. Inscribed on the verso *Marie Cognard Ayeule de Marie Fargues Epouse de Jean Etienne Liotard qui l'a peinte en 1757*
PROV Bequest of Miss M A Liotard, Amsterdam, 1873
LIT Humbert, Revilliod & Tilanus 1897, p 115, nr 37, ill. L Vaillat, Les Arts, 1911, p 16. Brieger 1920, ill on p 110. Fosca 1928, pp 56-57. Staring 1947, pp 30, 42. Fosca 1956, p 67

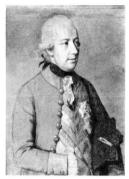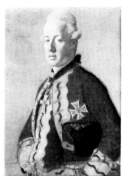

A 1198 Joseph II (1741-90), emperor of Austria, king of Hungary and Bohemia. *Keizer van Oostenrijk, koning van Hongarije en Bohemen*

Pendant to A 1199

Gray paper 66 × 48. Unfinished. Inscribed on the verso *Joseph II Empereur des Romains, Roi d'Hongrie et de Bohème, fils ainé de Marie Thérese et de Francois 2 en 1776-7. Esquisse d'après nature par J.Et.Liotard*
PROV Presented by J W R Tilanus, Amsterdam, 1885, on behalf of his wife, Mrs J V Tilanus-Liotard
LIT Humbert, Revilliod & Tilanus 1897, p 106, nr 7, ill on p 31. *Cf* Fosca 1928, pp 94-95. Fosca 1956, p 108

A 1199 Maximilian (1756-1801), archduke of Austria, elector of Cologne. *Maximiliaan, aartshertog van Oostenrijk, keurvorst van Keulen*

Pendant to A 1198

Blue paper 66 × 48. Unfinished. Inscribed on the verso *Maximilien d'Autriche, Coadjuteur de Treves, Cologne & Munster &., 3e fils de Marie Thérèse et Francois D. de Lorraine, Empereur en 1776-7. Esquisse d'apres nature par J. Et. Liotard*
PROV Same as A 1198
LIT Humbert, Revilliod & Tilanus 1897, p 107, nr 8, ill. Fosca 1928, p 94. Fosca 1956, p 107

A 230 Maria Theresia (1717-80), empress of Austria, queen of Hungary and Bohemia. *Keizerin van Oostenrijk, koningin van Hongarije en Bohemen*

Vellum 59 × 47.5. Inscribed on the verso *Marie Therese d'Autriche, Impératrice reine d'Hongrie & de Bohème, peinte d'après nature par Liotard*
PROV Bequest of Miss M A Liotard, Amsterdam, 1873
LIT Humbert, Revilliod & Tilanus 1897, p 106, ad nr 4 (drawn in 1762)

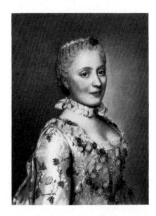

A 238 Marie Josèphe of Saxony (1731-67), dauphiness of France. Wife of Louis de Bourbon. *Marie Josèphe van Saksen, dauphine van Frankrijk. Echtgenote van Louis de Bourbon*

Vellum 40 × 31
PROV Same as A 235
LIT Humbert, Revilliod & Tilanus 1897, p 109, nr 16, ill. Fosca 1956, pp 46, 51, 131, 193, pl XVI

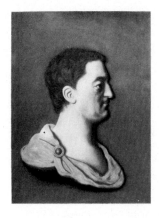

A 237 Sir William Ponsonby (1704-93). Later earl of Bessborough, friend and travel companion of Liotard. *Later earl van Bessborough, vriend en reisgenoot van Liotard*

Vellum 60 × 48. Inscribed on the verso *Milord Besborough ami de & peint par Liotard*
PROV Bequest of Miss M A Liotard, Amsterdam, 1873
LIT Humbert, Revilliod & Tilanus 1897, p 111, nr 27, ill on p 7. Fosca 1928, p 53. Fosca 1956, p 59

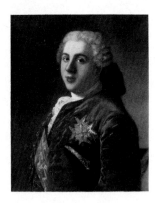

A 235 Louis de Bourbon (1729-65), dauphin of France. Son of Louis XV, father of Louis XVI, Louis XVIII and Charles X. *Dauphin van Frankrijk. Zoon van Lodewijk XV, vader van Lodewijk XVI, Lodewijk XVIII en Karel X*

Paper 60 × 49
PROV Bequest of Miss M A Liotard, Amsterdam, 1873
LIT Humbert, Revilliod & Tilanus 1897, p 108, nr 15, ill

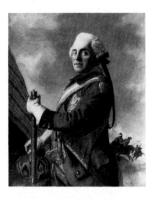

A 229 Count Hermann Maurice de Saxe (1696-1750). Marshal of France. *Graaf Herman Maurits van Saksen, maarschalk van Frankrijk*

Vellum 62 × 51. Inscribed on the verso *Le Maréchal de Saxe inhumé à Strasbourg d'après nature par Liotard*
PROV Bequest of Miss M A Liotard, Amsterdam, 1873
LIT Humbert, Revilliod & Tilanus 1897, p 122, nr 59. Fosca 1928, pp 45-46. Fosca 1956, p 187

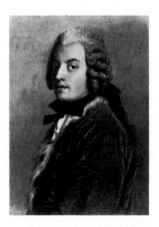

A 234 Francesco Algarotti (1712-64). Venetian writer at the court of Frederick the Great. *Venetiaans letterkundige aan het hof van Frederik de Grote*

Vellum 41 × 31.5. Inscribed on the verso *Le Comte Algarotti, peint par Liotard*
PROV Bequest of Miss M A Liotard, Amsterdam, 1873
LIT P Seidel, Jb Preusz Kunstsamml 15 (1894) p 122. Humbert, Revilliod & Tilanus 1897, p 110, nr 23, ill. Fosca 1928, pp 34-35. Fosca 1956, pp 30, 129

A 240 Portrait of a woman in Turkish costume, perhaps Mary Gunning (1733-60), countess of Coventry. *Portret van een vrouw in Turks kostuum, misschien Mary Gunning, gravin van Coventry*

Vellum 100 × 75
PROV Bequest of Miss M A Liotard, Amsterdam, 1873
LIT Humbert, Revilliod & Tilanus 1897, p 116, nr 39, ill. L Vaillat, Les Arts, 1911, p 14, ill. Brieger 1920, ill on p 108. Fosca 1928, p 54, ill opp p 48. Fosca 1956, pp 34, 39-41, 103, 150, pl IV. Fr W S van Thienen, OK 4 (1960) nr 17, ill. VTTT, 1964-65, nr 72. Previtali 1966, pl IX. R Watson, Apollo 89 (1969) p 184ff, fig 2

A 236 Jeanne-Elisabeth de Sellon (b 1705). Wife of Charles Tyrell, English consul in Constantinople. *Echtgenote van Charles Tyrell, Engels consul te Constantinopel*

Vellum 61 × 47. Inscribed on the verso *Mad. Tyrell Epouse du Consul Anglais née à Constantinople peint par Liotard*
PROV Bequest of Miss M A Liotard, Amsterdam, 1873
LIT Humbert, Revilliod & Tilanus 1897, p 131, nr 82. Fosca 1928, p 27, ill opp p 16. Fosca 1956, p 20 pl XXVIII. J Watelet, Etudes d'Art, 1959, p 61

A 243 Portrait of a boy. *Portret van een jongen*

Paper 44 × 33.5
PROV Bequest of Miss M A Liotard, Amsterdam, 1873
LIT Humbert, Revilliod & Tilanus 1897, p 133, nr 89

A 241 Portrait of a young girl, thought to be Caroline Russell (d 1811), daughter of the fourth duke of Bedford, who was to marry George, fourth duke of Marlborough, in 1762. *Portret van een jong meisje, waarschijnlijk Caroline Russell, dochter van de vierde hertog van Bedford, die in 1762 huwde met George, vierde hertog van Marlborough*

Vellum 58 × 44.5. Inscribed on the verso *La Duchesse de Marlborough dans sa jeunesse par Liotard*
PROV Bequest of Miss M A Liotard, Amsterdam, 1873
LIT Humbert, Revilliod & Tilanus 1897, p 121, nr 56

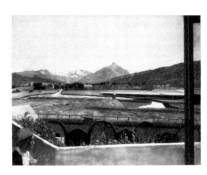

A 1197 View from the artist's studio near Geneva, with self portrait. *Uitzicht uit het atelier van de kunstenaar bij Genève met zelf-portret*

Vellum 45 × 58. Inscribed on the verso *Vue de Genève du Cabinet peinte par Liotard*
PROV Presented by J W R Tilanus, Amsterdam, 1885, on behalf of his wife Mrs J V Tilanus-Liotard
LIT Humbert, Revilliod & Tilanus 1897, pp 47, 133, nr 90, ill. Brieger 1920, ill on p 102. Fosca 1928, p 120, ill. Goldscheider 1936, p 43, fig 310. Gradmann & Cetto 1944, p 59. Fosca 1956, pp 104, 187, pl XIV. Van Hall 1963, nr 1281:15. C Gottlieb, Journ Aesth & Art Cr 22 (1964) p 402, fig 16. Previtali 1966, pl XV. E van Uitert, OK 14 (1970) nr 24, ill. M Sandoz, Genava ns 19 (1971) pp 201-04, fig 8

A 1194 Sleeping nymph spied on by satyrs. *Slapende nimf bespied door saters*

Vellum 30 × 40. Inscribed on a sticker on the verso *d'après le Titien par Liotard*
PROV Presented by J W R Tilanus, Amsterdam, 1885, on behalf of his wife Mrs J V Tilanus-Liotard
LIT Humbert, Revilliod & Tilanus 1897, pp 61, 132, nr 86. Fosca 1928, p 17. Fosca 1956, pp 13, 187

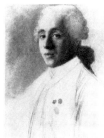

A 1196 Landscape with cows and shepherdess. *Landschap met koeien en herderin*

Copy after Paulus Potter (1625-54), with the shepherdess added. On the verso is an unfinished portrait of a man

Vellum 36 × 45. Inscribed *d'après P. Potter, ajouté la figure par J.E. Liotard*
PROV Bequest of J W R Tilanus,

Amsterdam, 1885, on behalf of his wife
Mrs J V Tilanus-Liotard
LIT Humbert, Revilliod & Tilanus 1897,
p 134, nr 91. Fosca 1956, p 187

A 242 The three graces. *De drie Gratiën*

After the antique group in the Galleria
Borghese, Rome

Vellum 38 × 43
PROV Bequest of Miss M A Liotard,
Amsterdam, 1873
LIT Humbert, Revilliod & Tilanus 1897,
p 138, nr 87, ill. Fosca 1928, p 17. Fosca
1956, pp 13, 187

A 1195 Apollo and Daphne. *Apollo en
Daphne*

After the group by Gian Lorenzo
Bernini (1598-1680) in the Galleria
Borghese, Rome

Paper 64 × 50. Inscribed on the verso
*Apollon et Daphné d'après le groupe Antique
de Palais Borghese par Liotard*
PROV Presented by J W R Tilanus,
Amsterdam, 1885, on behalf of his wife
Mrs J V Tilanus-Liotard
LIT Humbert, Revilliod & Tilanus 1897,
p 133, nr 88, ill. Fosca 1928, p 17. Fosca
1956, pp 13, 187

Anton Raphael Mengs

Ustí (formerly Aussig) 1728-1779 Rome

A 4199 Portrait of a young girl,
probably Julie Carlotta Mengs, the
artist's sister. *Portret van een jong meisje,
waarschijnlijk Julie Carlotta Mengs, zuster
van de kunstenaar*

Paper 43.7 × 33.2
PROV Sale Amsterdam, 20 April 1971,
nr 423
LIT C J de Bruyn Kops, Bull RM 22
(1974) pp 24-26, 38, fig 9

Johannes Cornelis Mertens

Amsterdam 1743-1821 Amsterdam

A 2168 Michiel Diederichs

Pendant to A 2169
For a portrait of the sitter's son, *see*
Miniatures: Northern Netherlands
school ca 1810, A 2175

Vellum 62 × 50. Signed and dated *J.C.
Mertens Fecit 1772*
PROV Bequest of Mrs V E L Diederichs-
Portman, widow of W G A Diederichs,
Amsterdam, 1905

A 2169 Helena Siebels. Wife of Michiel
Diederichs. *Echtgenote van Michiel
Diederichs*

Pendant to A 2168

Vellum 62 × 50. Signed and dated *J.C.
Mertens Fecit 1774*
PROV Same as A 2168

Henry Muhrman

Cincinnati 1854-1916 Meissen

A 3702 View of a valley with a brook.
Gezicht op een dal met een beekje

Paper 27.5 × 21. Signed and dated
H. Muhrman '91
PROV Lent by Mr & Mrs J C J Drucker-
Fraser, 1919. Bequeathed in 1944

attributed to **George van der Mijn**

London 1726/27-1763 Amsterdam

A 2375 Catharina Dulac. Widow of
Charles Bernard. *Weduwe van Charles
Bernard*

Vellum 65.5 × 53. Inscribed on the book
Pseaume XXXIX followed by a rhymed
French version of Psalms 39:5-6
PROV Bequeathed by J Bernard van
IJsseldijk, Amsterdam, 1904. Received
in 1909
LIT A Staring, OH 40 (1922) p 69. J W

Niemeijer, Bull RM 16 (1968) p 23, note
7. A Staring, NKJ 20 (1969) pp 205-06,
fig 11

Jean-Baptiste Perronneau

Paris 1715 – 1783 Amsterdam

A 3747 Arent van der Waeyen (1685-
1767). Amsterdam merchant and
member of the city council. *Koopman en
raad in de vroedschap van Amsterdam*

Pendant to A 3748

Paper pasted on canvas 58.5 × 46. Signed
perronneau. Inscribed (partly illegibly) on
the verso *gecrayonneert door Perronneau
Maart 1763*
PROV Purchased from G J K Baron van
Lynden van Horstwaerde, Doorwerth,
1950
LIT Moes 1897-1905, vol 2, nr 8804.
Vaillat & Ratouis de Limay 1909, pp 39,
99, nr 88, pl 9. Staring 1947, p 54. J Q
van Regteren Altena, OK 13 (1969) nr 5,
ill

A 3748 Sara Hinloopen (1689-1775).
Wife of Arent van der Waeyen.
Echtgenote van Arent van der Waeyen

Pendant to A 3747

Vellum 58.5 × 46. Signed *perronneau*.
Inscribed (partly illegibly) on the verso
.... *gecrayonneert door Perronneau Maart 1763*
PROV Same as A 3747
LIT Moes 1897-1905, vol 1, nr 3523.
Vaillat & Ratouis de Limay 1923, pp 39,
99, nr 89, pl 10. Staring 1947, p 54. J Q
van Regteren Altena, OK 13 (1969) nr
5, ill

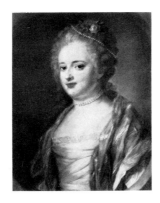

A 2142 Catherine Elisabeth Metayer (b
1744)

Vellum 59 × 46
PROV Bequest of J Bernard van
IJsseldijk, Amsterdam, 1904
LIT Vaillat & Ratouis de Limay 1923, p
233, pl 45. Staring 1947, pp 48, 69.
J W Niemeijer, Bull RM 16 (1968) p 17,
fig 5 (1771?)

Pierre-Paul Prud'hon

Cluny 1758 – 1823 Paris

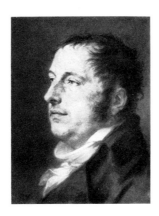

C 1487 Rutger Jan Schimmelpenninck
(1761-1825). Legate of the Batavian
Republic in Paris. *Gezant van de Bataafse
Republiek in Parijs*

Study for the artist's painted group
portrait of the Schimmelpenninck
family, A 3097

Vellum 40.5 × 31.5
PROV On anonymous loan since 1935
LIT F Schmidt-Degener, GdB-A 72
(1930) p 90, fig 2. J F L de Balbian
Verster, Jb Amstelodamum 31 (1934)
pp 141-46, ill opp p 140. Staring 1947, p
118

C 1488 Catharina Nahuys (1770-1844).
Wife of Rutger Jan Schimmelpenninck.
Echtgenote van Rutger Jan Schimmelpenninck

Study for the artist's painted group
portrait of the Schimmelpenninck
family, A 3097

Vellum 40 × 30.5
PROV Same as C 1487
LIT F Schmidt-Degener, GdB-A 72
(1930) p 90, fig 3. J F L de Balbian
Verster, Jb Amstelodamum 31 (1934)
pp 141-46, ill on p 142. Staring 1947, p
118

C 1489 Catharina Schimmelpenninck
(1790-1842). Daughter of Rutger Jan
Schimmelpenninck and Catharina
Nahuys. *Dochter van Rutger Jan
Schimmelpenninck en Catharina Nahuys*

Study for the artist's painted group
portrait of the Schimmelpenninck
family, A 3097

Vellum 41 × 32.5
PROV Same as C 1487
LIT F Schmidt-Degener, GdB-A 72
(1930) p 90, fig 4. J F L de Balbian
Verster, Jb Amstelodamum 31 (1934)
pp 141-46, ill on p 145. Staring 1947, p
118

C 1490 Gerrit Schimmelpenninck (1794-1863). Son of Rutger Jan Schimmelpenninck and Catharina Nahuys. *Zoon van Rutger Jan Schimmelpenninck en Catharina Nahuys*

Study for the artist's painted group portrait of the Schimmelpenninck family, A 3097

Vellum 40.5 × 31.5
PROV Same as C 1487
LIT F Schmidt-Degener, GdB-A 72 (1930) p 90, fig 5. J F L de Balbian Verster, Jb Amstelodamum 31 (1934) pp 141-46, ill on p 145. Staring 1947, p 118

A 2151 Portrait of a woman. *Portret van een vrouw*

Vellum. The exposed area measures 18 × 14. Oval. The pendant, a man's portrait, missing since 1904, bore the name of the artist
PROV From the Eckhardt family, The Hague, 1904. Purchased in Amsterdam in 1904

A 4231 Alida Elizabet Grevers (1888-1973), at the age of one. *Op één-jarige leeftijd*

Paper 51.5 × 38.5. Signed and dated *Th.S. 1889*. Inscribed *Ada*. Inscribed on the verso *Ada. Elizabet Grevers. geb. 14 juli 1888 oud 13 maanden*
PROV Bequest of the sitter, Haarlem, 1973

Andreas Schelfhout

The Hague 1787-1870 The Hague

A 4665 A rocky coast. *Een rotsachtige kust*

Paper 37 × 47. Signed and dated *A. Schelfhout 52*
PROV Purchased from the Koninklijk Huisarchief (archives of the royal house), The Hague, 1975

Izaak Schmidt

Amsterdam 1740–1818 Amsterdam

A 3238 Elisabeth van Vollenhoven (1781-1816). Daughter of the Amsterdam merchant Jan Messchert van Vollenhoven and Elisabeth van der Poorten, later wife of Frederik van de Poll (1780-1853). *Dochter van de Amsterdamse koopman Jan Messchert van Vollenhoven en Elisabeth van der Poorten, later echtgenote van Frederik van de Poll*

Vellum 25 × 19.5. Octagonal. Signed *Schmidt fecit*
PROV Presented from the estate of Miss C C E Reynvaan, Amsterdam, 1935

Thérèse Schwartze

Amsterdam 1851–1918 Amsterdam

A 3054 Paul Joseph Constantin Gabriël (1828-1903). Painter. *Schilder*

Paper 56 × 46. Signed and dated *Th.S. '99 à Gabriel*
PROV Bequest of the sitter's widow, Mrs V H C A Gabriël-Urbain, The Hague, 1927
LIT Martin 1920-21, pp 106, 142, ill on p 102. H F W Jeltes, OH 43 (1926) p 126

A 3450 Amelia Eliza van Leeuwen (1862-1923). Wife of Christiaan Bernard Tilanus, Amsterdam surgeon and orthopedist. *Echtgenote van Christiaan Bernard Tilanus, chirurg en orthopedist te Amsterdam*

Paper 73.5 × 59. Signed and dated *Th. Schwartze 1900*
PROV Bequest of the sitter's husband, Amsterdam, 1942

A 3564 Marie Catharina Josephina Jordan (1866-1948). Wife of the painter George Hendrik Breitner. *Echtgenote van de schilder George Hendrik Breitner*

Paper 106 × 78. Signed and dated *Th. v. Duyl-Schwartze 1902*
PROV Bequest of the sitter, Zeist, 1948

Johann Friedrich August Tischbein

Maastricht 1750 – 1812 Heidelberg

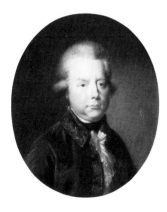

A 408 Willem V (1748-1806), prince of Orange-Nassau. *Prins van Oranje-Nassau*

Vellum. The exposed area measures 62.5 × 52. Oval. Signed and dated *Tischbein 1789*
PROV NM, 1808
LIT Moes & van Biema 1909, pp 56, 204. CHE de Wit, Spiegel Hist 1 (1966) p 43, ill

A 409 Frederika Sophia Wilhelmina (Wilhelmina; 1751-1820), princess of Prussia. Wife of Prince Willem V. *Prinses van Pruisen. Echtgenote van prins Willem V*

Vellum. The exposed area measures 63 × 52. Oval
PROV Same as A 408
LIT Marius 1920, p 5, fig 2

A 415 Frederica Louisa Wilhelmina (Louise; 1770-1819), princess of Orange-Nassau. Daughter of Prince Willem V, wife of Carel George August, prince of Braunschweig-Wolfenbüttel. *Prinses van Oranje-Nassau. Dochter van prins Willem V, echtgenote van Carel George August, erfprins van Brunswijk-Wolfenbüttel*

Vellum. The exposed area measures 60.5 × 48.5. Oval
PROV Same as A 408
LIT Staring 1948, pl LVI. EGD, Jvsl Oranje-Nassau Mus, 1972, p 19. M Roland-Michel, Revue du Louvre 23 (1973) p 174, ill, p 176-77

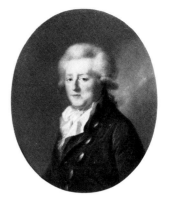

A 411 Carel George August (1766-1807), prince of Braunschweig-Wolfenbüttel. Husband of Frederica Louisa Wilhelmina (Louise), princess of Orange-Nassau. *Erfprins van Brunswijk-Wolfenbüttel. Echtgenoot van Frederica Louisa Wilhelmina (Louise), prinses van Oranje-Nassau*

Vellum. The exposed area measures 62.5 × 52. Oval
PROV Same as A 408

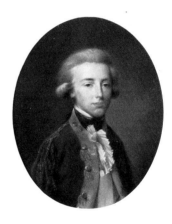

A 412 Willem Frederik (1772-1843), prince of Orange-Nassau. Eldest son of Prince Willem V, later Willem I, king of the Netherlands. *Prins van Oranje-Nassau. Oudste zoon van prins Willem V, later Willem I, koning der Nederlanden*

Vellum. The exposed area measures 61.5 × 49.5. Oval. Signed and dated *Tischbein 1788*
PROV Same as A 408
LIT DH Couvée, OK 12 (1968) nr 22, ill

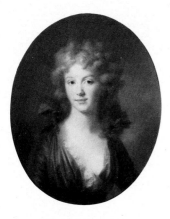

A 413 Frederica Louisa Wilhelmina (1774-1837), princess of Prussia. From 1791 on wife of Willem Frederik, prince of Orange-Nassau. *Prinses van Pruisen. Sedert 1791 echtgenote van Willem Frederik, prins van Oranje-Nassau*

Vellum. The exposed area measures 61.5 × 49.5. Oval
PROV Same as A 408
LIT Brieger 1920, ill on p 62

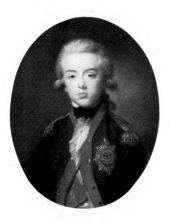

A 414 Willem George Frederik (Frederik; 1774-99), prince of Orange-Nassau. Son of Prince Willem v. *Prins van Oranje-Nassau. Zoon van prins Willem V*

For another portrait of the sitter, *see* Miniatures: Holland school ca 1785, A 4457

Vellum. The exposed area measures 60.5 × 48.5. Oval. Signed and dated *Tischbein 1788*
PROV Same as A 408

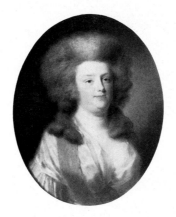

A 410 Augusta Maria Carolina of Nassau-Weilburg (1764-1802). Niece of Willem v, prince of Orange-Nassau, daughter of his sister Carolina. *Nicht van Willem V, prins van Oranje-Nassau, dochter van zijn zuster Carolina*

Vellum. The exposed area measures 61.5 × 50. Oval
PROV Same as A 408

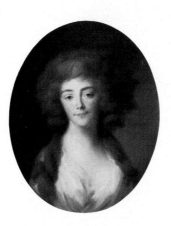

A 416 Louisa Isabella Alexandrina Augusta von Kirchberg (1772-1827). Wife of Frederik Willem, prince of Nassau-Weilburg and sister-in-law of Augusta Maria Carolina of Nassau-Weilburg (see the preceding number). *Echtgenote van Frederik Willem, vorst van Nassau-Weilburg, en schoonzuster van Augusta Maria Carolina van Nassau-Weilburg*

Vellum. The exposed area measures 60.5 × 48.5. Oval
PROV Same as A 408

Francesco Tozelli

active 1794 – 1822 in Amsterdam

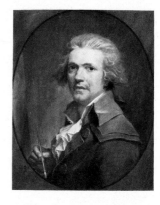

C 543 Self portrait. *Zelfportret*

Vellum 61 × 48. Signed and dated *F. Tozelli F. A. 1794*
PROV On loan from the city of Amsterdam (Felix Meritis Society) since 1889
LIT A Staring, OH 40 (1922) p 80. Van Hall 1963, nr 2103:1

Cornelis Troost

Amsterdam 1697 – 1750 Amsterdam

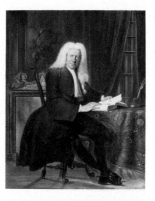

C 1193 Carel Bouman (1673-1747). Amsterdam tobacco factor and poet. *Tabaksfactor te Amsterdam en dichter*

Paper 61.5 × 48.5. Signed and dated *C. Troost 1739*
PROV On loan from the KOG (bequest of Miss H S Bouman, Amsterdam) since 1928
LIT Moes 1897-1905, vol I, nr 986. A Staring, OH 40 (1922) pp 46-47. Gedenkboek KOG, 1933, p 156. Knoef 1947, p 20, ill on p 9. A Staring, in Kunstgesch der Ned, 1954-56, vol 2 (1955) p 329, ill. Niemeijer 1973, pp 14, 109, nr 39, ill on p 168. C J de Bruyn Kops, Bull RM 22 (1974) p 24, fig 8

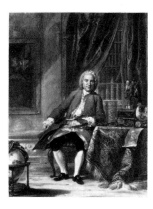

A 4060 Joan Jacob Mauricius (1692-1768). Governor-general of Surinam, poet and theatre enthusiast. *Gouverneur-generaal van Suriname, dichter en toneel-minnaar*

Paper 73 × 58. Signed and dated *Cornelis Troost. Amsterdam 1741*
PROV Purchased from J Breton, Grenoble, 1961
LIT J Offerhaus, OH 77 (1962) pp 113-125, fig 1. Niemeijer 1973, p 14, nr 62, ill

A 1707 'Crocodile tears': act 1, scene 11, from David Lingelbach's comedy 'De ontdekte schijndeugd' (Pretended virtue unmasked; 1687). *'De geveinsde droef-heid': eerste bedrijf, elfde toneel van het blijspel 'De ontdekte schijndeugd' van David Lingelbach*

Paper 66 × 53.5. Signed and dated *C. Troost 1743*
PROV Presented by the heirs of S W Josephus Jitta, 1897
LIT Niemeijer 1973, p 101, nr 401

A 1708 The bribery scene from the second act of Johan van Paffenrode's comedy 'Hopman Ulrich of de bedrogen gierigheid' (Captain Ulrich, or greed deceived; 1661). *De omkopingsscène uit het tweede bedrijf van het blijspel 'Hopman Ulrich of de bedrogen gierigheid' van Johan van Paffenrode*

Vellum 62 × 50. Signed and dated *C. Troost 1745*
PROV Same as A 1707
LIT Knoef 1947, p 25. Niemeijer 1973, nr 322, ill on p 250

A 3745 The landscape painter Dirk Dalens III (1688-1753) with his second wife Maria Schaack (d 1766) and the children Anna (b 1725), Willem (1737-60) and Jacobus (1741-63). *De landschap-schilder Dirk Dalens III met zijn tweede echtgenote Maria Schaack en de kinderen Anna, Willem en Jacobus*

Vellum 73 × 59. Signed and dated *C. Troost 1746*
PROV Purchased from B Houthakker, Amsterdam, 1949
LIT Staring 1956, p 116, ill (portrait of Arnout Rentinck and his family?). Van Hall 1963, nr 1747:1 (Rentinck?). J W Niemeijer, Bull RM 12 (1964) pp 24-27. Praz 1971, p 187. Niemeijer 1973, pp 18, 121, nr 128, ill

Sara Troost

Amsterdam 1732 – 1803 Amsterdam

C 1407 Portrait of a man. *Portret van een man*

Pendant to C 1408

Vellum 43 × 33. Signed and dated *Sara Troost Fecit 1757*
PROV On loan from the RPK (purchased in 1910) since 1950

C 1408 Portrait of a woman. *Portret van een vrouw*

Pendant to C 1407

Vellum 43 × 33
PROV Same as C 1407

Bernard Vaillant

Lille 1632 – 1698 Leiden

A 3484 Vincent Paets (1658-1702). Ambassador to China (1685-87). *Ambassadeur in China*

Pendant to A 3485

Paper 43 × 33. Oval. Inscribed on the verso on a sticker *Vincent Paets Azn. ob^t 13 Aug^s 1702 in 1688 ambassadeur in China geh^d Geertruida Johanna van der Wolff overl. 13 Juny 1717. ouders van Adriaan Paets Vzn. geh^d Elisabeth Cornelia Crookcens ft. 1684 AB Vaillant*
PROV Presented by Mrs J de Wolf, Ede, 1947

A 3485 Geertruida Johanna van der Wolff (d 1717). Wife of Vincent Paets. *Echtgenote van Vincent Paets*

Pendant to A 3484

Paper 43 × 33. Oval. Inscribed on the verso on a sticker *Geertruida Johanna van der Wolff overleden 13 Juny 1717 ge h^d met Vincent Paets Azn. Ouders van Adriaan Paets Vzn*
PROV Same as A 3484

A 3486 Adriaen Paets (1657-1712). Lord of Schotelbosch. *Ambachtsheer van Schotelbosch*

Paper 43 × 33. Oval. Inscribed on the verso on a sticker *Adriaan Paets Az. ambachtsheer van Schotelbosch, vader van Elisabeth Paets die ong^d overleden is 14 febr. 1778 Geschilderd anno 1648 [1684] door B. Vaillant.*
PROV Same as A 3484

A 3487 Sophia Paets (d 1711)

Paper 43 × 33. Oval. Inscribed on the verso on a sticker *Sophia Paets ong^d overleden 26 November 1711 ft. A°. 1684 B Vaillant*
PROV Same as A 3484

A 1651 Thomas Parker (1656-1737). Leiden merchant. *Koopman te Leiden*

For a portrait of the sitter's father, *see* Vaillant, Bernard, A 1663

Paper 41 × 32. Oval. Signed and dated *B. Vaillant f. 1695.* Inscribed on the verso on a sticker *Thomas Parker geb. 1656, zoon van Johannes Parker en Anne van Beursteen (oudere broeder van Pieter Parker) B Vaillant fec. 1695*
PROV Purchased from J C de Ruyter de Wildt, Vlissingen, 1895

Vau...ons

active 1778

C 1574 Hendrick van Leendt (1732-80)

Paper 51 × 38.5. Signed and dated (nearly illegibly) *Vau...ons Fecit 1778*
PROV On loan from the KOG since 1973

Elisabeth Vigée-Lebrun

Paris 1755–1842 Paris

A 3898 Yolande Gabrielle Martine (1749-93), duchesse de Polignac

Paper 39.5 × 28
PROV Purchased from B Houthakker gallery, Amsterdam, 1955

Johannes van Vilsteren

active 1723-63 in The Hague and Amsterdam

C 49 Andries Bicker (1586-1652). Trader with Russia and burgomaster of Amsterdam. *Koopman op Rusland en burgemeester van Amsterdam*

Copy after the painting by Bartholomeus van der Helst (1613-70), A 146
Pendant to C 51

Paper 52 × 41
PROV On loan from the city of Amsterdam (Bicker bequest), 1881-1975

C 51 Catharina Gansneb, called Tengnagel (1595-1652). Wife of Andries Bicker. *Echtgenote van Andries Bicker*

Copy after the painting by Bartholomeus van der Helst (1613-70) in the Gemäldegalerie, Dresden (cat 1961, nr 1595)
Pendant to C 49

Paper 52 × 41
PROV Same as C 49

Charles Louis Philippe Zilcken

The Hague 1857–1930 Villefranche

A 2690 Moorish house in Bir Madris near Algiers. *Moors huis te Bir-Mandries bij Algiers*

Paper 43 × 51. Signed *Ph. Zilcken*
PROV Transferred from the RPK, 1913

Monogrammists

Monogrammist J J

active ca 1805

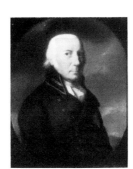

A 2412 Carl Wilhelm Ferdinand (1735-1806), duke of Braunschweig-Wolfenbüttel. Father-in-law of Princess Louise. *Hertog van Brunswijk-Wolfenbüttel. Schoonvader van prinses Louise*

Copy after a pastel portrait by Johann Christian August Schwarz (1756-1814) in Braunschweig Palace
Belongs with the following number

Vellum 36.5 × 29.5. Signed *J.J.*
PROV Purchased from R W P de Vries, art dealer, Amsterdam, 1910

A 2411 Frederica Louisa Wilhelmina (Louise; 1770-1819), princess of Orange-Nassau. Wife of Carel George August of Braunschweig-Wolfenbüttel. *Prinses van Oranje-Nassau. Echtgenote van Carel George August van Brunswijk-Wolfenbüttel*

Copy after a pastel portrait by Johann Christian August Schwarz (1756-1814) in Braunschweig Palace. *Cf* Brieger 1920, ill on p 305
Belongs with the preceding number

Vellum 36.5 × 29.5. Signed *J.J.*
PROV Same as A 2412

Anonymous pastels

German school ca 1808

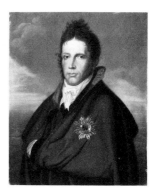

A 4113 Willem Frederik (1772-1843), prince of Orange-Nassau. Later King Willem I. Known as 'The overcoat portrait.' *Erfprins van Oranje-Nassau. Later koning Willem I. Genaamd 'Het mantelportret'*

Vellum 70 × 54. Inscribed on the verso [S]*eptember 1812, Caroline*
PROV Purchased from B Arnold, Mutschellen, Aargau, 1965
LIT Van Hogendorp 1903, p 97. Naber 1908, p 259ff. Colenbrander 1931, p 115. Bull RM 13 (1965) p 136, fig 19. E Pelinck, Bull RM 19 (1971) pp 11-14 (second version in Soestdijk Palace, ill on p 12)

Northern Netherlands school ca 1750

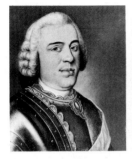

C 1572 Willem IV (1711-51), prince of Orange-Nassau. *Prins van Oranje-Nassau*

Pendant to C 1573

Vellum 45 × 37.5
PROV On loan from the KOG (presented by H H Momma) since 1973

C 1573 Anne of Hanover (1709-59). Wife of Prince Willem IV. *Anna van Hannover. Echtgenote van prins Willem IV*

Pendant to C 1572

Vellum 45 × 37.5
PROV Same as C 1572

Northern Netherlands school ca 1775

A 1667 Willem Parker (1747-1808), lord of Saemslag, lord of Wissekerke, Cats and Geersdijk. *Heer van Saemslag. Ambachtsheer van Wissekerke, Cats en Geersdijk*

Paper 42.6 × 32.5. On the collar of the dog *Parker*. Inscribed on the verso on a sticker *Jonkheer Mr. Wilhem Parker, heer van Saamslagh Ambachtsheer in Wissekerke Cats Geersdijk geboren te Middelburg den 17 November 1747 zoon van Jkhr Mr Johan Wilhem Parker, Heer van Saemslagh*

Geersdijk, Wissekerke, Cats enz. Bugemeester der stad Middelburg, Bewindhebber der O.I. Compagnie, en van Jonk[vrouwe] Jacoba Maria van Bueren.
PROV Purchased from J C de Ruyter de Wildt, Vlissingen, 1895

Northern Netherlands school ca 1780

A 1421 Johan Arnold Zoutman (1724-93). Vice admiral. *Vice-admiraal*

Paper 53 × 42
PROV Presented by Jonkheer Victor de Stuers, The Hague, 1887

Northern Netherlands school ca 1790

A 2829 Maria Lublink (1772-1819). From 1791 on wife of Theodorus Johannes Weddik (1754-1815). *Sedert 1791 echtgenote van Theodorus Johannes Weddik*

For painted portraits of the sitter's parents, *see* Tischbein, Johann Friedrich August, A 2827 & A 2828

Vellum 31 × 25.5. Oval
PROV Bequest of Mrs M N Th Weddik-Lublink Weddik, widow of A L Weddik, Arnhem, 1919

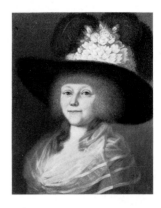

A 1571 Anna Geertruida van Rappard (1752-1831). Wife of Eduard Sanderson. *Echtgenote van Eduard Sanderson*

Paper 40 × 33.5
PROV Presented from the estate of C A Baroness van Pallandt-Fraser, dowager of C H Baron van Pallandt, The Hague, 1892

Northern Netherlands school ca 1805

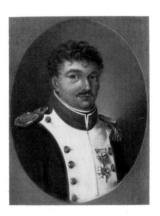

A 2793 Diederik Hendrik van der Sluis (d 1812)

Vellum 31 × 23. Inscribed on the verso *Dit is mijn waardige vader Diederik Henderik van der Sluys* [gestorven?] *oud 49 jaren*
PROV Bequest of Mrs J J A Kraay-Eekhout, widow of E Kraay, Katwijk aan de Rijn, 1916

Northern Netherlands school ca 1815

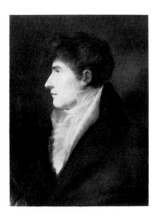

C 1552 Portrait of a man. *Portret van een man*

Vellum 27.5 × 22.5
PROV On loan from the KOG since 1973

Northern Netherlands school ca 1820

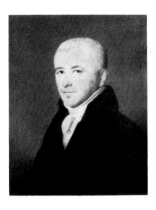

A 4132 Portrait of a man. *Portret van een man*

Vellum laid down on glass 38.7 × 32
PROV Unknown

Northern Netherlands school ca 1890

NO PHOTOGRAPH AVAILABLE

A 4640 Albert Carel Snouckaert van Schauburg (1841-1902). Donor of the Rijksmuseum's collection of military uniforms. *Schenker van de verzameling militaire uniformen in het Rijksmuseum*

Paper 55 × 40
PROV Presented by W A P E L van Exter, 1895. NMGK * Lent to the Legermuseum, Doorwerth Castle, 1925. Destroyed in the war, 1944-45

Aquarelles and drawings

Aquarelles and drawings from the Drucker-Fraser donation and bequest and aquarelles and drawings from other sources, now transferred to the printroom.
Aquarellen en tekeningen van de schenking en het legaat Drucker-Fraser en aquarellen en tekeningen van andere herkomst, thans overgedragen aan het prentenkabinet

The collection of Mr & Mrs Drucker-Fraser consisted not only of paintings from the Hague School, but also of aquarelles and drawings. The collectors realized that the 'papieren kunst' (paper art; that is, prints and drawings) of the Hague School artists they admired so much could not be divorced from their paintings. For that reason the aquarelles and drawings from the Drucker-Fraser collection, as well as the paintings, pastels and miniatures, are listed in the inventory of the Rijksmuseum department of paintings, and are included in this catalogue. Other parts of the collection, such as the Chinese porcelain, the carpets, furniture and silver are on the inventories of other departments.

The aquarelles and drawings of the Drucker-Fraser collection entered the Rijksmuseum in stages:

given on loan in 1903, donated in 1909:
 A 2440-A 2454
given on loan in 1904, donated in 1909:
 A 2475-A 2489
given on loan in 1907, donated in 1909:
 A 2492
given on loan in 1911, donated in 1912:
 A 2608-A 2614; A 2617-A 2619
given on loan in 1919, bequeathed in
 1944: A 3620-A 3663; A 3666; A
 3669-A 3671; A 3674-A 3701; A
 3703-A 3721; A 3724 & A 3725; A
 3728 & A 3729; A 3733

Finally, in 1960 Mrs Th Laue-Drucker donated A 4036, an aquarelle by H J Weissenbruch.

This information is not repeated under the individual numbers. All the works in this section of the catalogue are on paper, so we have not specified that in each case. Tinted papers are noted, however. The medium of the drawings is given but not that of the aquarelles. Our use of the term aquarelle, it should be noted, does not eliminate the possibility of a mixed technique, such as aquarelle and body color.

For literature on the collection as a whole, *see* D de Hoop Scheffer, 'Het Rijksmuseum en zijn begunstigers,' Bull RM 6 (1958) pp 99-100 (on J C J Drucker) and E P Engel, 'Het ontstaan van de verzameling Drucker-Fraser in het Rijksmuseum,' Bull RM 13 (1965) pp 45-66.

The artists are listed in the alphabetical section of the catalogue above, with cross-references to the Aquarelles and drawings section.

The department of paintings was formerly in possession of aquarelles and drawings from other sources than the Drucker-Fraser donation and bequest, namely donations and bequests of A Allebé, J C J Arriëns, M C J Breitner-Jordan, J Cohen Gosschalk-Bonger, J F S Esser, E R Harkema, Mrs Hart Nibbrig-Moltzer, J Hidde Nijland, C Hoogendijk, Mr & Mrs D A J Kessler-Hülsmann, O Lanz, H V G Le Fauconnier, L MacSon-Maris, J H R Neervoort van de Poll, W J van Randwijk, J C de Ruyter de Wildt, H W J Schaap van der Plek, J G Vogel, L W R Wenckebach and A van Wezel, as well as a loan from the D R V K. These have all been transferred to the print-room, but since they were once the property of the department of paintings, they are listed here, with their former catalogue numbers in brackets:

Aquarelles

A 3563 (2925 T 7) G H Breitner, Scheveningen girl at the washtub

A 2742 (2926 D 1) G Derksen, Study of a farmer's wife, called 'Oude Marry'

A 3314 (2926 P 11) J Israels, Old fisherman's wife sleeping at the window

A 3494 (2950 G 22) A Mauve, The bleaching field

A 3495 (2950 ME 1) W H van der Nat, Plowing the fields in the winter

A 2940 (2950 P 1) J Neuhuys, The barge canal

A 2711 (2950 N 2) J A Neuhuys, A mother nursing her child, called 'The Norwegian Madonna'

A 3332 (2950 N 4) J A Neuhuys, A girl ironing

A 2939 (2950 N 5) J A Neuhuys, Two peasant children at a cradle

A 2741 (2954 B 1) M Roosenboom, Roses in a vase

A 2584 (2970 G 1) J Voerman, Cows grazing

A 2585 (2970 G 2) J Voerman, View of Hattem

A 2586 (2970 G 3) J Voerman, Pink roses

A 2943 (2970 G 4) J Voerman, Idyl

A 2944 (2970 K 3) J H Weissenbruch, Village on a lake

A 3047 (2970 KB 1) B W Wierink, Head of a lioness

A 2945 (2970 L 1) W Witsen, Venice

A 2946 (2970 L 2) W Witsen, Venice

A 2947 (2970 L 4) W Witsen, Venice

A 3369 (2970 N 1) W de Zwart, The sandpit

A 3370 (2970 N 2) W de Zwart, The cattle market

A 3371 (2970 N 3) W de Zwart, Coach waiting in a park

A 3372 (2970 N 4) W de Zwart, Farm in the winter

Drawings

A 931 (2922) Unknown master of the 18th century, Lieven Jacobsz de Huybert with his wife Catharina Imansdr and their three daughters

A 2729 (2925 V 1) Ch Bouten, Misery

A 2621 (2925 V 1) J Cohen Gosschalk, Portrait of Ferdinand J Hart Nibbrig (1866-1915), painter

A 2662 (2925 V 2) J Cohen Gosschalk, A girl from Laren

C 1439 (2926 GM 1) P L Ghezzi, A flutist

A 2227 (2926 H 1) V W van Gogh, A sower

A 2225 (2926 H 2) V W van Gogh, Country lane behind the vicarage at Nuenen

A 2226 (2926 H 3) V W van Gogh, Landscape with farm in the Provence

A 2509 (2926 K 1) H F de Grijs, Self portrait

A 2728 (2927 F 1) H V G Le Fauconnier, Portrait of Albert Verwey (1865-1937), poet

A 2501 & A 2502 (2950 B 8) J H Maris, Two sheets with 9 and 10 sketches respectively

A 3275 (2950 D 2) M Maris, View of Lausanne

A 2712 (2950 L 1) J F Millet, Shepherdess

A 2537 (2951 E 1) N Pieneman, Portrait of Willem (1840-79), prince of Orange, at the age of seven

A 2787 (2951 H 1) J Quinkhard, The four directors of the St Sebastian guards, Amsterdam

A 2532 (2951 K 1) A G A van Rappard, Workshop for the blind

A 2583 (2954 D 1) F Rops, The absinthe drinker

A 1659 (2969) B Vaillant, Portrait of Michiel Adriaensz de Ruyter (1607-76), vice admiral

A 2743 (2970 H 1) J G Vogel, A wood near Delden

A 2744 (2970 H 2) J G Vogel, Seven sketches

A 2746 (2970 H 3) J G Vogel, Country estate near Hilversum

A 2745 (2970 H 4) J G Vogel, Seven sketches

Pieter Florentius Nicolaas Jacobus Arntzenius

Surabaja 1864–1925 The Hague

A 3724 Market with flower stalls. *Markt met bloemenstalletjes*

Aquarelle 40 × 52. Signed *Fl. Arntzenius* (left) and *G. H Breitner* (right)
LIT Hefting 1970, p 57, nr 132, ill (possibly left unfinished by Breitner and completed by Arntzenius)

Alexander Hugo Bakker Korff

The Hague 1824–1882 Leiden

A 3620 'Ecureuse': a maidservant seated at a table polishing metalware. *Een dienstmeisje, dat aan tafel zit te poetsen*

Pen and brown ink 20.7 × 15.7. Signed and dated *A.H. Bakker Korff. fct 71.* Inscribed *Ecureuse*

A 3621 'Intérieur paisible': an old woman knitting in a chair. *Breiende oude dame*

Pen and brown ink 16 × 15.2. Signed and dated *A.H. Bakker Korff. fct 71*. Inscribed *Intérieur paisible*

A 3622 'Lecture du matin': an old woman reading. *Lezende oude dame*

Pen and brown ink 19.7 × 16. Signed and dated *A.H. Bakker Korff fec[1] 71*. Inscribed *Lecture du matin*

Syvert Nicolaas Bastert

Maarsseveen 1854–1939 Loenen aan de Vecht

A 3623 A pond in the meadows. *Een waterplas in het weiland*

Aquarelle 43 × 86. Signed *N. Bastert*

Marius Alexander Jacques Bauer

The Hague 1867–1932 Amsterdam

A 3626 View in the cathedral of Seville. *Gezicht in de kathedraal te Sevilla*

Aquarelle 85 × 60. Signed *M. Bauer*

A 3627 The Kremlin in Moscow. *Het Kremlin te Moskou*

Aquarelle 58 × 55. Signed *M. Bauer*

A 3628 Courtyard of a fortress in Cairo. *Binnenplaats van een burcht te Caïro*

Aquarelle 65 × 62. Signed *M. Bauer*

A 3624 Soldiers outside an Eastern city. *Krijgslieden voor een Oosterse stad*

Aquarelle 47.5 × 38. Signed *M. Bauer*
* On loan to the Gemeentemuseum, Arnhem, 1952 (since 1959 through the DRVK)

A 3629 The Taj Mahal by moonlight. *De Taj-Mahal bij maanlicht*

Aquarelle 53 × 61. Signed *M. Bauer*

A 3631 Courtyard of a mosque. *Binnenplaats van een moskee*

Charcoal 78 × 58. Signed *M. Bauer*

A 3625 A slave trader. *Een slavenhandelaar*

Aquarelle 38 × 50. Signed *M. Bauer*

A 3630 A group of orientals in lively discussion. *Een groep oosterlingen in druk gesprek*

Pen and brush and India ink 22.7 × 16. Signed *M Bauer*

Christoffel Bisschop

Leeuwarden 1828 – 1904 Scheveningen

A 3632 'The sunny corner': a young woman in a house in Hindelopen. '*Het*

zonnige hoekje' : *jonge vrouw in een kamer te Hindelopen*

see also Bisschop's painting A 3060

Aquarelle 75 × 49.5. Signed *C. Bisschop*
LIT Mrs van Westrheene, in M Rooses, Het Schildersboek I (1898) p 201, ill on p 204 (1882)

Théophile Emile Achille de Bock

The Hague 1851 – 1904 Haarlem

A 3634 View in the dunes. *Duinlandschap*

Black and colored chalk on gray paper 30.5 × 44.5. Signed *ThdeBock* (initials in monogram)

A 3635 Landscape near Nijmegen. *Landschap bij Nijmegen*

Red chalk 30.5 × 45. Signed *ThdeBock* (initials in monogram). Inscribed *Nijmegen*

A 3636 Autumn landscape. *Herfstlandschap*

Black and colored chalk on gray paper 27.5 × 41. Signed *Th. de Bock*. Inscribed *Winterswijk* (?)

A 3633 Sandy road at Wijhe, under heavy clouds. *Zandweg te Wijhe onder een zware lucht*

Black and colored chalk 18.5 × 43.5. Inscribed *Wijhe*
* Missing

Johannes Bosboom

The Hague 1817 – 1891 The Hague

A 3647 Interior of the church of Oosthuizen. *Interieur van de kerk te Oosthuizen*

Aquarelle 26 × 39. Signed *J.B.* Inscribed *Oosthuizen*
* On loan to the Gemeentemuseum, Arnhem, since 1952 (from 1959 on through the DRVK)
LIT *Cf* Marius & Martin 1917, pp 38, 129, fig 7 (1846)

A 3655 A rococo portal in the town hall of The Hague, with a man in seventeenth-century costume. *Rococo portaal in het stadhuis in Den Haag met een man in zeventiende-eeuws kostuum*

Aquarelle 20 × 14. Signed *J. Bosboom*
LIT *Cf* De Gruyter 1968-69, vol 1, fig 11
(ca 1846)

A 3643 View of the rood loft of the church
of St John in 's Hertogenbosch. *Gezicht
op het oxaal van de St Janskerk te
's-Hertogenbosçh*

Aquarelle 13 × 8.5. Signed *Bosboom*.
Presumably painted in 1851

A 3644 Interior of a Gothic church.
Interieur van een gotische kerk

Belongs with A 3643

Aquarelle 13 × 8.5. Signed *JBosboom*.
Presumably painted in 1851

A 3654 Interior of a church. *Interieur van
een kerk*

Belongs with A 3643

Aquarelle 13 × 8.5. Signed *J. Bosboom*.
Presumably painted in 1851

A 3656 Interior of a church. *Interieur van
een kerk*

Belongs with A 3643

Aquarelle 13 × 8.5. Signed *J. Bosboom*.
Presumably painted in 1851

A 3640 'Payday': the aldermen's
chamber in the courthouse of Nieuw-
Loosdrecht, with figures in seventeenth-

century costume. *'Betaaldag': de schepen-
kamer in het Rechthuis te Nieuw-Loosdrecht,
gestoffeerd met zeventiende-eeuwse figuren*

Aquarelle 37.5 × 55. Signed *JBosboom*
LIT Marius & Martin 1917, pp 55, 140
(1863-70)

A 3639 Interior of a barn near
Hilversum. *Een boerendeel bij Hilversum*

Aquarelle 39 × 57. Signed *JBosboom*.
Inscribed *Hilversum*
LIT Marius & Martin 1917, p 139?
(interior of a barn in Nieuw-Loosdrecht,
1863-67)

A 3648 Peter (1672-1725), czar of Russia,
as a carpenter in Zaandam. *Tsaar van
Rusland, als timmerman in Zaandam*

Aquarelle 69.5 × 60.5. Signed *J.B.*
LIT Marius & Martin 1917, p 145 (1871).
Jeltes 1917, p 70

A 3646 The beach at Scheveningen.
Het strand te Scheveningen

Aquarelle 35 × 55. Signed *J. Bosboom*

LIT Marius & Martin 1917, pp 77, 146 (1873). Exhib cat 150 jaar Nederlandse kunst, Amsterdam 1963, nr 50, fig 53

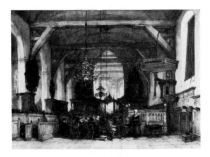

A 3642 Interior of the church of Maasland. *Interieur van de kerk te Maasland*

Aquarelle 46 × 48. Signed *Bosboom*
LIT Marius & Martin 1917, pp 80, 146 (1873)

A 3637 Fishing boats on the beach (Scheveningen?). *Vissersboten op het strand (Scheveningen?)*

Aquarelle 26 × 36.5. Signed *JBosboom*. Presumably painted in 1873

A 3653 The south aisle of the Grote Kerk in The Hague, with figures in seventeenth-century costume. *De zuidelijke zijbeuk van de Grote Kerk in Den Haag gestoffeerd met zeventiende- eeuwse figuren*

Aquarelle 51 × 38. Signed *J. Bosboom*
LIT Marius & Martin 1917, p 148 (ca 1875?)

A 3650 The archives of Veere, with figures in seventeenth-century costume. *Het archief te Veere met figuren in zeventiende-eeuws kostuum*

Aquarelle 51 × 42. Signed *J. Bosboom*. Inscribed *Archief Veere*
LIT Marius & Martin 1917, p 88, note 2, 149 (1880)

A 3641 View of the rood loft of the church of St John in 's Hertogenbosch. *Gezicht op het oxaal van de St Janskerk te 's-Hertogenbosch*

Charcoal 107 × 80
LIT Jeltes 1917, p 102. Marius & Martin 1917, p 150 (ca 1880). J Bosboom Nzn, Onze Eeuw, 1917, p 275

A 3645 The Doelenpoort in Hoorn. *De Doelenpoort te Hoorn*

Aquarelle 50.5 × 34. Signed *J. Bosboom*. Inscribed *Hoorn*
LIT Marius & Martin 1917, pp 86, 150 (ca 1880)

A 3652 The stairway in the Prinsenhof in Delft where Prince Willem I was murdered in 1584. *De trap in het Prinsenhof te Delft, waar prins Willem I werd vermoord in 1584*

Aquarelle 28 × 17. Signed *J.B.*
Inscribed *Prinsen Hof, Delft*
LIT Marius & Martin 1917, p 152 (1884)

A 3651 Courtyard of the Nieuwkoop charity home in The Hague. *Binnenplaats van het Hofje van Nieuwkoop in Den Haag*

Aquarelle 15.5 × 26.5. Signed *Bosboom*
LIT Marius & Martin 1917, p 104 (1887)

A 3649 Landing of a stairway. *Trap-portaal*

Aquarelle 28 × 21. Signed *J. Bosboom*

A 3638 City square. *Stadspleintje*

Aquarelle 19 × 27. Signed *JBosboom*

George Hendrik Breitner

Rotterdam 1857–1923 Amsterdam

see also Aquarelles and drawings: Arntzenius, Pieter Florentius Nicolaas Jacobus, A 3724

A 3657 Cavalry at ease on a square. *Rustende cavalerie op een plein*

Aquarelle 23 × 47. Signed *G.H. Breitner*
LIT Hefting 1970, p 56, nr 140

A 3658 Tram horses on the Dam, Amsterdam. *Trampaarden op de Dam te Amsterdam*

Aquarelle 53 × 75. Signed *G.H. Breitner*
LIT Van Schendel 1939, p 45, ill

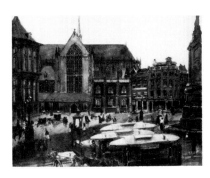

A 3659 The Dam, Amsterdam. *De Dam te Amsterdam*

Aquarelle 38 × 50. Signed *G.H. Breitner*

Honoré Daumier

Marseille 1808–1879 Valmondois

A 3660 Man reading. *Lezende man*

Pen and brush and India ink 16 × 20. Signed *h.D.*

Paul Joseph Constantin Gabriël

Amsterdam 1828–1903 Scheveningen

A 3661 Pond with reeds. *Waterplas met riet*

Black chalk 33 × 58. Signed *Gabriel*

Vincent Willem van Gogh

Groot-Zundert 1853–1890 Auvers-sur-Oise

A 3662 Vegetable garden on the Schenkweg, The Hague. *Moestuin aan de Schenkweg te Den Haag*

Pencil, India ink and water color 23 × 32. Signed *Vincent*. Drawn in March 1882 in The Hague
∗ On loan to the SMA since 1957
LIT De la Faille 1928, nr 923, ill. Vanbeselaere 1937, pp 79, 81, 128-29, 408 (end of April 1882). De la Faille 1970, pp 344, 646, nr F 923, ill

Isaac Lazerus Israels

Amsterdam 1865–1934 The Hague

A 3663 Maidservant. *Dienstmeisje*

Aquarelle 67 × 21. Signed *Isaac Israels*
LIT Wagner 1967, fig 46 (ca 1894)

A 3669 Worker at a whetstone. *De slijper*

Aquarelle 61 × 42. Signed *Isaac Israels*

A 3666 A nanny with a child in a pram. *Een kindermeisje met een kinderwagen*

Aquarelle 32 × 46. Signed *Isaac Israels*
LIT Reisel 1967, ill on p 48 (painted in 1894)

A 3670 A tram conductor with three little girls on a bench. *Een tramconducteur met drie meisjes op een bank*

Aquarelle 43 × 28. Signed *Isaac Israels*
LIT *Cf* Wagner 1967, p 30, fig 57

A 3728 Jozef Israels in his studio. *Jozef Israels in zijn atelier*

Pencil 43.5 × 27.5
∗ On loan to the Groninger Museum voor Stad en Lande, Groningen, since 1924 (from 1975 on through the DRVK)

Jozef Israels

Groningen 1824–1911 The Hague

A 2619 Interior of a peasant cottage. *Boerenbinnenhuis*

Aquarelle 27 × 33. Signed *Jozef Israels*
LIT M Eisler, Elsevier's GM 46 (1913) p 251. Exhib cat Jozef Israels, Groningen-Arnhem 1961-62, nr 54 (1874-80)

A 2618 The seamstress. *Het naaistertje*

Aquarelle 39 × 27.5. Signed *Jozef Israels*
LIT M Eisler, Elsevier's GM 46 (1913) p 251. Exhib cat Jozef Israels, Groningen-Arnhem 1961-62, nr 55 (1880 or later)

A 2617 The cobbler. *De schoenmaker*

Aquarelle 46.5 × 31. Signed *Jozef Israels*
LIT M Eisler, Elsevier's GM 46 (1913) p

251, ill on p 252. Exhib cat Jozef Israels, Groningen-Arnhem 1961-62, nr 56, ill (1880 or later)

A 2609 The rabbi. *De rabbi*

Aquarelle 50 × 34. Signed *Jozef Israels*
LIT M Eisler, Elsevier's GM 46 (1913) p 251. Exhib cat Jozef Israels, Groningen-Arnhem 1961-62, nr 58 (1886)

A 2608 'A son of the chosen people.' '*Zoon van het oude volk*'

Aquarelle 56 × 43. Signed *Jozef Israels*
LIT M Eisler, Elsevier's GM 46 (1913) p 251. Van Gelder 1947, p 42, ill on p 38 (portrait of Jacob Stedel with the artist's grandchild). Exhib cat Jozef Israels, Groningen-Arnhem 1961-62, nr 59 (1888). Exhib cat 150 jaar Nederlandse kunst, Amsterdam 1963, nr 63, fig 64. De Gruyter 1968-69, vol 1, p 53, fig 61 (1888)

A 2611 Reapers. *Maaiers*

Aquarelle 37 × 57. Signed *Jozef Israels*
LIT M Eisler, Elsevier's GM 46 (1913) p 251. Exhib cat Jozef Israels, Groningen-Arnhem 1961-62, p 9, nr 60 (1890-1900)

A 3733 Self portrait with sore foot. *Zelf-portret met zieke voet*

Aquarelle 24 × 34. On the verso a letter dated 19 October 1898 '*Dear Mrs Drucker, my sick foot is not quiet, till he is in your possession, therefore you will accept this souvenir of ill days with the pleasure of your recovered servant Jozef Israels.*'
* On loan to the Groninger Museum voor Stad en Lande, Groningen, since 1924 (from 1975 on through the DRVK)
LIT Exhib cat Jozef Israels, Groningen-Arnhem 1961-62, nr 64

A 3729 Saul

Preparatory study for a painting of Saul and David in the SMA (inv nr 2249)
For a painted study of this detail, *see* Israels, Jozef, A 3730

Black and white chalk 53 × 78.5. Signed *Jozef Israels*

A 2610 Fishergirl on the beach. *Vissers-meisje op het strand*

Aquarelle 45 × 70. Signed *Jozef Israels*.
Painted in 1903
LIT M Eisler, Elsevier's GM 46 (1913) p 251

A 2613 'Alone in the world.' '*Alleen op de wereld*'

Aquarelle 32 × 48.5. Signed *Jozef Israels*
LIT M Eisler, Elsevier's GM 46 (1913) p 251

A 2612 'The sick neighbor.' '*De zieke buurman*'

Aquarelle 58 × 88. Signed *Jozef Israels*
LIT M Eisler, Elsevier's GM 46 (1913) p 251

A 2614 A fisherman. *Een hengelaar*

Aquarelle 73 × 59.5. Signed *Jozef Israels*
LIT M Eisler, Elsevier's GM 46 (1913) p
251, ill on p 253

Johan Barthold Jongkind

Lattrop 1819–1891 La-Côte-Saint-
André

A 3671 Landscape near Nevers. *Land-
schap bij Nevers*

Aquarelle 23.5 × 46.5. Signed and dated
Jongkind, Nevers 25 Sept. 71
LIT Exhib cat Dutch drawings,
Washington etc 1958-59, nr 129, ill.
Exhib cat Jongkind, Paris 1971, nr 76, ill.
Exhib cat Jongkind, Enschede 1971, nr
90, ill

Jacobus Hendrikus Maris

The Hague 1837–1899 Karlsbad

A 2478 The Buitenkant with the
Schreierstoren, Amsterdam. *De Buiten-
kant met de Schreierstoren te Amsterdam*

Aquarelle 19 × 33. Signed and dated
J. Maris 1875
LIT W Steenhoff, Elsevier's GM 40 (1910)
ill on p 264. M Eisler, Elsevier's GM 46
(1913) pp 330, 334. Exhib cat Dutch
drawings, Washington etc 1958-59, nr
136, ill

A 3674 The Buitenkant with the
Schreierstoren, Amsterdam. *De Buiten-
kant met de Schreierstoren te Amsterdam*

Charcoal 21 × 37.5. Signed *J. Maris*
LIT Van Gelder Pr & tek 1958, fig 170

A 3675 The windmill and the bridge on
the Noord-West-Binnensingel, The
Hague. *De molen en de brug bij de Noord-
West-Binnensingel in Den Haag*

Aquarelle 29 × 21. Signed and dated
J. Maris 1877

A 3681 A fishing pink on the beach.
Visserspink aan het strand

Aquarelle 37 × 28. Signed *J. Maris*
LIT Cf De Gruyter 1968-69, vol 2, fig 25
(1878)

A 2475 View of a city. *Gezicht op een stad*

Aquarelle 60 × 84.5. Signed and dated
J. Maris 1882

A 2476 Willem Matthijs Maris (1872-
1929). The artist's oldest son with a
violin. *De oudste zoon van de schilder, met
een viool*

Aquarelle 39 × 55.5. Signed *J. Maris*
LIT M Eisler, Elsevier's GM 46 (1913) p
334, ill on p 331. Exhib cat Meesters van
de Haagse school, The Hague 1965, nr
53, ill (ca 1882, identification of the
sitter). De Gruyter 1968-69, vol 2, pp
20, 28, note 17

A 3678 City view at night. *Stadsgezicht
bij avond*

Aquarelle 48 × 43. Signed *J.Maris*
LIT Exhib cat 150 jaar Nederlandse
kunst, Amsterdam 1963, nr 76, fig 58.
De Gruyter 1968-69, vol 2, fig 24

A 2479 View of a city. *Gezicht op een stad*

Aquarelle 22.5 × 32.5. Signed *J.Maris*
LIT M Eisler, Elsevier's GM 46 (1913) p
334

A 2481 Landscape with windmill in the
moonlight. *Landschap met molen bij maan-
licht*

Aquarelle 42.5 × 24. Signed *J.Maris*
LIT M Eisler, Elsevier's GM 46 (1913) p
334

A 3684 A windmill in the winter. *Een
molen in de winter*

Aquarelle 53 × 40. Signed *J.Maris*

A 2480 Landscape with windmill in the
snow. *Landschap met molen in de sneeuw*

Aquarelle 16.5 × 32. Signed *J.Maris*

A 3686 View in the dunes. *Duinlandschap*

Aquarelle 29 × 42. Signed *J.Maris*

A 3685 A mounted towman on the tow-
path. *Een jager te paard op het jaagpad*

Aquarelle 37 × 26. Signed *J.Maris*

A 3683 Landscape with plowing peasant.
Landschap met ploegende boer

Aquarelle 17 × 33. Signed *J.Maris*

A 2477 Plowing peasant. *Ploegende boer*

Aquarelle 31 × 22. Signed *J.Maris*
LIT W Steenhoff, Elsevier's GM 40
(1910) p 369. M Eisler, Elsevier's GM
46 (1913) p 334

A 3677 Two girls blowing bubbles. *Twee
meisjes aan het bellen blazen*

Aquarelle 45 × 32. Signed *J.Maris*

A 3680 A girl with flowers on the grass. *Een meisje met bloemen in het gras*

Aquarelle 37 × 24.5. Signed *J.Maris*
LIT De Gruyter 1968-69, vol 2, p 20, fig 26. Hefting 1970, p 46, fig 29, ad nr 105

A 3679 Seashell gatherer on the beach. *Schelpenvisser op het strand*

Aquarelle 32 × 33. Signed *J.Maris*

A 3676 A fisherman's wife, with her little daughter dressed as a bride for her first communion, lighting a candle in church. *Een vissersvrouw met haar dochtertje als 'bruidje' steekt een kerkkaars aan*

Aquarelle 30 × 19. Signed *J.Maris*
LIT De Gruyter 1968-69, vol 2, fig 23

A 3682 Two girls at the piano. *Twee meisjes bij de piano*

Aquarelle 34 × 22.5. Signed *J.Maris*

Matthijs Maris

The Hague 1839– 1917 London

A 3687 The pawnbrokerage. *Het pandjeshuis*

Pencil and aquarelle 22 × 35. Unfinished. Signed *M.M.*

Willem Maris

The Hague 1844–1910 The Hague

A 3689 Cows at a pond. *Koeien bij een plas*

Aquarelle 16 × 24. Signed *W. Maris*

A 3690 Sunset. *Zonsondergang*

Charcoal 30 × 57

A 3692 Milking time. *Melktijd*

Aquarelle 65 × 48. Signed *Willem Maris*

A 3693 The milking yard. *De melkbocht*

Aquarelle 43 × 58.5. Signed *Willem Maris*

A 3691 Ducks beside a ditch. *Eenden aan de slootkant*

Aquarelle 22 × 46. Signed *Willem Maris*

A 3688 Ducks under the willows. *Eenden onder wilgen*

Aquarelle 28 × 17.5. Signed *Willem Maris*
LIT De Gruyter 1968-69, vol 2, fig 70

A 3694 A rowboat in a ditch. *Een roeiboot in een sloot*

Aquarelle 42.5 × 57.5. Signed *Willem Maris*

Anthonij (Anton) Mauve

Zaandam 1838–1888 Arnhem

A 3697 A horse's harness. *Paardetuig*

Pen and brown ink, black chalk and brush in brown and gray wash 40.5 × 24.5. Signed *A. Mauve f*
LIT Engel 1967, nr 25 (1858)

A 2452 A chat on a country lane. *Praatje op een landweg*

Aquarelle 33 × 48.5. Signed *A. Mauve f*.
LIT M Eisler, Elsevier's GM 46 (1913) p 415, ill. Engel 1967, nr 48, ill (1859)

A 2492 Plowing peasant. *Ploegende boer*

Aquarelle 44.5 × 59. Signed *A. Mauve f*.
LIT M Eisler, Elsevier's GM 46 (1913) p 415, ill on p 418. E P Engel, Bull RM 13 (1965) p 50. Engel 1967, nr 85, ill (1878)

A 2443 Riders in the snow in the woods

of The Hague. *Ruiters in de sneeuw in het Haagse bos*

Aquarelle 44 × 27. Signed *A. Mauve f*
LIT W Steenhoff, Elsevier's GM 40 (1910) pp 371-72, ill on p 367. M Eisler, Elsevier's GM 46 (1913) p 419, ill. Van Gelder 1959, fig 146. Engel 1967, nr 90 (1879)

A 3699 Water at the edge of the woods. *Bosrand aan het water*

Aquarelle 60 × 38. Signed *A. Mauve f*.
LIT Engel 1967, nr 101a (1879)

A 3695 Woman herding cows on a country road in the rain. *Koeien en een herderin op een landweg in de regen*

Aquarelle 34.5 × 54. Signed *A. Mauve f*.
LIT De Gruyter 1968-69, vol 2, p 65 (ca 1879)

A 2444 Shearing a sheep. *De schapenscheerder*

Aquarelle 45.5 × 37. Signed *A. Mauve f*
LIT M Eisler, Elsevier's GM 46 (1913) p
417. Engel 1967, nr 94 (1880)

A 2445 Elisabeth Mauve (b 1875). The
artist's daughter, standing on a garden
path. *Dochtertje van de kunstenaar, staande
op een tuinpad*

Aquarelle 34 × 21. Signed *A. Mauve*
* On loan to the Gemeentemuseum,
Arnhem, since 1952 (from 1959 on
through the DRVK)
LIT M Eisler, Elsevier's GM 46 (1913) p
419. Engel 1967, nr 102, ill
(identification of the sitter; 1882). De
Gruyter 1968-69, vol 2, p 61, fig 83
(1882). Hefting 1970, ad nr 105

A 3696 Interior of a cottage in Laren.
Larens binnenhuis

Aquarelle 49 × 59.5. Signed *A. Mauve*
LIT Engel 1967, nr 107, ill (1884)

A 2447 Woman hanging out the wash.
Vrouw bij een waslijn

Aquarelle 23.5 × 33.5. Signed *A. Mauve*
LIT W Steenhoff, Elsevier's GM 40 (1910)
p 371, ill on p 369. M Eisler, Elsevier's
GM 46 (1913) p 418. Engel 1967, nr 108,
ill (1884)

A 2441 The timber wagon. *De mallejan*

Aquarelle 42 × 57.5. Signed *A. Mauve f.*
LIT M Eisler, Elsevier's GM 46 (1913) p
417. E P Engel, Bull RM 13 (1965) fig 9.
Engel 1967, nr 115, ill (1885)

A 2440 A flock of sheep on the heath
near Laren. *Schapenkudde op de heide bij
Laren*

Aquarelle 46 × 72. Signed *A. Mauve f*
LIT M Eisler, Elsevier's GM 46 (1913) p
419

A 2442 A flock of sheep in a wood.
Schapenkudde in een bos

Aquarelle 46 × 34. Signed *A. Mauve*
LIT M Eisler, Elsevier's GM 46 (1913) p
417

A 3700 Young bull reclining. *Liggende
jonge stier*

Aquarelle 44 × 68. Signed *A. Mauve f*

A 2450 Peasant cart on a country road.
Boerenkar op een landweg

Aquarelle 18 × 24. Signed *A. Mauve*
LIT M Eisler, Elsevier's GM 46 (1913) p
418

A 2449 The sand barge. *De zandschuit*

Aquarelle 17 × 28.5. Signed *A. Mauve*
LIT M Eisler, Elsevier's GM 46 (1913) p
418

A 2446 Digging up potatoes. *Aardappel-rooiers*

Aquarelle 33 × 44.5. Signed *A. Mauve*
LIT M Eisler, Elsevier's GM 46 (1913) p
417

A 2448 Woman at a washline in the
dunes. *Vrouw bij een waslijn in de duinen*

Aquarelle 27.5 × 39.5. Signed *A. Mauve*
LIT M Eisler, Elsevier's GM 46 (1913) p
418

A 3698 The edge of a wood. *Bosrand*

Black and white chalk on brown paper
24 × 33

A 2451 Old couple in a new park. *Oud
paar in een nieuw park*

Aquarelle 19.5 × 32. Signed *A. Mauve f.*
LIT M Eisler, Elsevier's GM 46 (1913) pp
415-16, ill on p 417. Baard 1947, p 54,
note 10. Knoef 1947, p 107. De Gruyter
1968-69, vol 2, p 62, fig 79

Hendrik Willem Mesdag

Groningen 1831 – 1915 The Hague

A 3701 Fishing boats in the breakers.
Vissersschepen in de branding

Aquarelle 48 × 63.5. Signed *H.W.
Mesdag*

Johannes Albert Neuhuys

Utrecht 1844 – 1914 Locarno

A 2482 The midday meal in a peasant
household. *Middagmaal in een boerengezin*

Aquarelle 55.5 × 75.5. Signed and dated
Albert Neuhuys f 95
LIT M Eisler, Elsevier's GM 46 (1913) pp
254-55. Martin 1914, p 64. De Gruyter
1968-69, vol 2, fig 108

A 3703 A mother giving her child the
breast by the fireplace. *Een moeder haar
kind zogend bij de haard*

Aquarelle 43 × 31.5. Signed *Albert
Neuhuys f.*

George Jan Hendrik Poggenbeek

Amsterdam 1853 – 1903 Amsterdam

A 2483 On a waterway. *Aan de vaart*

Aquarelle 46.5 × 76. Signed *Geo
Poggenbeek*
LIT M Eisler, Elsevier's GM 46 (1913) p
425, ill

A 2487 Pollard willows beside a ditch. *Knotwilgen aan een sloot*

Aquarelle 33.5 × 53.5. Signed *Geo Poggenbeek*
LIT M Eisler, Elsevier's GM 46 (1913) p 427

A 2485 Ducks near the water. *Eenden bij het water*

Aquarelle 27 × 47.5. Signed and dated *Geo Poggenbeek 88*
LIT 't Hooft 1907, fig 6. W Steenhoff, Elsevier's GM 40 (1910) ill on p 372. M Eisler, Elsevier's GM 46 (1913) p 425, ill on p 426

A 3704 Ducks near a clump of willows. *Eenden bij een wilgenbosje*

Aquarelle 27 × 46.5. Signed *Geo Poggenbeek*

A 2486 Meadow with a cow reclining beside a ditch. *Weiland met liggende koe bij een sloot*

Aquarelle 34.5 × 52. Signed *Geo Poggenbeek*
LIT M Eisler, Elsevier's GM 46 (1913) p 425

A 2489 The milking yard. *De melkbocht*

Aquarelle 20 × 29. Signed and dated *Geo Poggenbeek 87*
LIT M Eisler, Elsevier's GM 46 (1913) p 426. De Gruyter 1968-69, vol 2, fig 118

A 2488 High water in the meadows. *Hoog water in het weiland*

Aquarelle 25.5 × 39. Signed *Geo Poggenbeek*
LIT M Eisler, Elsevier's GM 46 (1913) p 425

A 2484 Country road in the twilight. *Landweg in de schemering*

Aquarelle 26.5 × 42. Signed *Geo Poggenbeek*
LIT M Eisler, Elsevier's GM 46 (1913) p 426

Charles Rochussen

Kralingen 1814–1894 Rotterdam

A 3705 French troops crossing a frozen river: probably a scene from the invasion of Holland in 1795. *Franse troepen trekken over een bevroren rivier: waarschijnlijk is bedoeld de invasie van Holland in 1795*

Aquarelle 27 × 47. Signed and dated *C.R. ft 88*

John Macallan Swan

Old Brentford 1847–1910 Isle of Wight

A 3706 Tigress. *Tijgerin*

Black and colored chalk and charcoal on gray paper 23.5 × 36.5. Signed *John M. Swan*

A 3707 Head of a polar bear. *Kop van een ijsbeer*

Black chalk on brown paper 9.5 × 17. Signed *J.M.S.*

A 3708 Head of a polar bear. *Kop van een ijsbeer*

Black chalk on brown paper 9.5 × 17. Signed and dated *5 Jan 85 J.M.S.*

A 3709 Head of a polar bear. *Kop van een ijsbeer*

Black chalk on brown paper 9.5 × 17. Signed *J.M.S.* Inscribed *Samson*

A 3710 Study of a standing leopard. *Studie van een staande luipaard*

Black chalk on gray paper 15 × 13. Signed *J.M. Swan*

A 3711 Studies of a leopard. *Studies van een luipaard*

Black chalk on gray paper 14.5 × 22. Signed *J.M. Swan*

A 3712 Study of a leopard lying on a branch. *Studie van een luipaard, liggend op een tak*

Black chalk on gray paper 14 × 22. Signed *J.M. Swan*

A 3713 Studies of a reclining polar bear. *Studies van een liggende ijsbeer*

Black and colored chalk on gray paper 24 × 36. Signed and dated *John M. Swan 1903*

Jean Theodoor (Jan) Toorop

Purworejo 1858–1928 The Hague

A 3714 'Mauvais salaire': two working men. *Twee werklieden*

Black chalk and charcoal 167 × 88.

Signed *Jan Toorop*. Inscribed *Fragment* and *Mauvais Salaire*
LIT Ph Mertens, Bull Mus Roy Belg 18 (1969) p 164, fig 11

Constant Troyon

Sèvres 1810–1865 Paris

A 3715 Man with a team of oxen. *Man met een span ossen*

Black chalk 14 × 21.5. Signed *C.T.*

Jan Pieter Veth

Dordrecht 1864–1925 Amsterdam

A 3716 Jacob Hendrikus Maris (1837-99). Painter. *Schilder*

Black chalk 32 × 23.5. Drawing for a lithograph. Signed *JV*
LIT Huizinga 1927, nr 184-85, 197. Van Hall 1963, p 199, nr 1342:19 (1891)

A 3725 Petrus Josephus Hubertus Cuypers (1827-1921). Architect of the Rijksmuseum. *Architect van het Rijksmuseum*

Black and a little white chalk 23 × 22.5. Signed *JV*
LIT Van Hall 1963, p 72, nr 448:6

NO PHOTOGRAPH AVAILABLE

A 3717 Willem Maris (1844-1910). Painter. *Schilder*

Black chalk 30 × 23. Drawing for a lithograph
*Missing
LIT Huizinga 1927, nr 258?, 270. Van Hall 1963, p 200, nr 1345:9 (1893)

Jan Voerman I

Kampen 1857–1941 Hattem

A 3735 The bank of the IJssel river. *De oever van de IJssel*

Aquarelle 38 × 51. Signed *JV*

A 3736 White roses. *Witte rozen*

Body color 26 × 48.5. Signed *J. Voerman*

Hendrik Johannes (J H) Weissenbruch

The Hague 1824–1903 The Hague

A 2453 Drawbridge near Noorden. *Ophaalbrug bij Noorden*

Aquarelle 52 × 71. Signed *JH. Weissenbruch f.*
LIT M Eisler, Elsevier's GM 46 (1913) p 420, ill

A 2454 City view with ships, thought to be in Haarlem. *Stadsgezicht met schepen, vermoedelijk in Haarlem*

Aquarelle 52.5 × 72. Signed *J.H. Weissenbruch f.*
LIT M Eisler, Elsevier's GM 46 (1913) p 421, ill. *Cf* De Gruyter 1968-69, vol 1, fig 89

A 3719 View on a pier. *Gezicht op een kade*

Black chalk, washed, on gray paper 25.5 × 40. Signed *J.H. Weissenbruch*

A 3718 Courtyard. *Binnenplaats*

Aquarelle 29 × 42. Signed *J.H. Weissenbruch*

A 3720 Corner of a courtyard. *Hoek van een binnenplaats*

Aquarelle 47 × 33. Signed *J.H. Weissenbruch*

A 4036 View on the beach. *Strandgezicht*

Aquarelle 29 × 40. Signed *J.H. Weissenbruch f.*
PROV Presented by Mrs Th Laue-Drucker, The Hague, 1960

Willem Arnold Witsen

Amsterdam 1860 – 1923 Amsterdam

A 3721 The Kromboomsloot, Amsterdam. *De Kromboomsloot te Amsterdam*

Aquarelle 51 × 63. Signed *Witsen*
LIT Van Gelder 1959, p 20, fig 171

Heraldic objects

Coats of arms

Coats of arms from the G J K Baron van Lynden van Horstwaerde donation, Doorwerth, 1950. *Wapens behorend bij de schenking G J K Baron van Lynden van Horstwaerde, Doorwerth, 1950*

A 3752 The coats of arms of Jan van Reygersbergh and his eight ancestral families Reyghersbergh, Nicolaey, Voxdael, Maelstede, Veth, Rosenburch, de Haen and Luycx. *Het wapen van Jan van Reygersbergh met zijn acht kwartieren*

Pendant to A 3751
For a portrait of Jan van Reygersbergh, *see* Ovens, Jürgen, A 3749

Canvas 46 × 36

A 3751 The coats of arms of Sara van Os, wife of Jan van Reygersbergh, and her eight ancestral families van Os, van der Piet, Dockters, Kivit Wijs, Berrewijns, Webbe, van Eekere. *Het wapen van Sara van Os, echtgenote van Jan van Reygersbergh, met haar acht kwartieren*

Pendant to A 3752
For a portrait of Sara van Os, *see* Ovens, Jürgen, A 3750

Canvas 46.5 × 37

Coats of arms from the J S R van de Poll donation, Arnhem, 1885. *Wapens behorend bij de schenking J S R van de Poll, Arnhem, 1885*

A 1277 Chart of the sixteen ancestral lines of Jan van de Poll (1668-1745): van de Poll, de Vroede, Duivel, Dommer, van Gerwen, van Maren, van Warmond, Brouwer, Hooft, Haak, Houtlook, Boswinkel, Hasselaar, Persijn, van Schoterbosch and Kies. *Kwartierstaat met wapens van de zestien kwartieren van Jan van de Poll*

For a portrait of Jan van de Poll, see Boonen, Arnold, A 1266

Ink and water color on vellum 57 × 70

A 1278 Chart of the sixteen ancestral lines of Margaretha Rendorp (1673-1730), wife of Jan van de Poll: Rendorp, Bicker, van Ingen, Buyters, Hulft, Smit, Hasselaar, Persijn, Hulft, Smit, Hasselaer, Persijn, Cloeck, Koning, Hooft and Blaauw. *Kwartierstaat met wapens van de zestien kwartieren van Margaretha Rendorp*

For a portrait of Margaretha Rendorp, *see* Werff, Adriaen van der, A 1267

Ink and water color on paper 64 × 74.5

A 1276 Pedigree chart ornamented with coats of arms of the six children of Jan van de Poll (1668-1745) and Margaretha Rendorp (1673-1730) and that of their husbands and wifes: Trip, Bors van Waveren, van de Poll, van den Bempden, Trip and Sautijn and the chart of their eight ancestral lines: van de Poll, van Gherwen, Hooft, Hasselaer, Rendorp, Hulft, Hulft and Cloek. *Wapenkaart met de wapens van de zes kinderen van Jan van de Poll en Margaretha Rendorp en die van hun echtgenoten; en hun kwartierstaat met acht kwartieren*

By Gerrit de Broen II (active 1715-60 in Amsterdam)

Ink and water color on vellum 69 × 78. Signed and dated *Gerred de Broen Junior Scripsit 1738*

Coats of arms from the Jonkheer J de Witte van Citters donation, The Hague, 1876. *Wapens behorend bij de schenking Jonkheer J de Witte van Citters, Den Haag, 1876*

A 940 The van Citters coat of arms. *Het wapen van Citters*

Water color on paper 33 × 25. Signed and dated *VH v. C. 77*. Thought to be the initials of Jacob Verheye van Citters (1753-1823), husband of Anna Jacoba de Witte (*see* A 934)

A 938 The Verheye coat of arms. *Het wapen Verheye*

Possibly drawn for Jacob Verheye, great-grandfather of Jacob Verheye van Citters (*see* A 940)

Water color on vellum 38 × 30

A 941 The combined arms of Jan Boudaen Courten (1635-1716) and Anna Maria Hoeufft (1646-1715), great-grandparents of Jacob Verheye van Citters (*see* A 940) in a carved wooden frame with the arms of the couple's sixteen ancestral families. *De alliantie-wapens van Jan Boudaen Courten en Anna Maria Hoeufft, overgrootouders van Jacob Verheye van Citters, in een gesneden houten lijst met de wapens van de zestien kwartieren van het echtpaar*

The families whose coats-of-arms are inscribed on the frame are: left, from top to bottom: *1* Boudaen, *3* Courten, *2* ?, *4* Cassier, *5* Fourmenois, *7* Del Prado (or Del Prato), *6* Hureau, *8* Pellicorne. Right, from top to bottom: *1* Hoeufft, *3* Luls, *2* van Wessem, *4* van Hoven, *5* Deutz, *7* Coymans, *6* Schoeff, *8* de Pickere (the numbers are added to indicate the proper order of ancestry of the husband and wife respectively) For portraits of Jan Boudaen Courten and Anna Maria Hoeufft, *see* Netscher, Caspar, A 901 & A 902; *see also* cat RMA Meubelen, 1952, nrs 313, 340-41

By Joost van Attevelt (b 1621; active ca 1645-80 in Utrecht)

Water color on vellum 30.5 × 25. Signed *J. v. Atteveld ft* and dated *A° M.DC.LXXV.*

A 929 Shield with the arms of the Boudaen and (reversed) Fourmenois families in 1623. *Wapenbord met de wapens van Boudaen en Fourmenois, 1623 (het wapen van Fourmenois omgewend)*

Copper 24 × 36.5. Dated *Anno 1623*

A 928 Shield with the arms of the husband and wife Pieter Courten (1581-1630) and Hortensia del Prado (d 1627), 1625. *Wapenbord met de wapens van het echtpaar Pieter Courten en Hortensia del Prado, 1625*

For a portrait of Pieter Courten, *see* Northern Netherlands school 1630, A 2074; for portraits of Hortensia del Prado, *see* Geldorp, Gortzius, A 2072 & A 2081

Panel 26 × 44. Dated *Anno 1625*

A 934 The coat of arms of Anna Jacoba de Witte (1758-1796), wife of Jacob Verheye van Citters (*see* A 940), with the coats of arms of her four grandparents: de Witte, Stavenisse, van Gelre and Ockersse. *Het wapen van Anna Jacoba de Witte, echtgenote van Jacob Verheye van Citters, met de wapens van haar vier grootouders*

Water color on paper 22 × 16.5

A 935 The coat of arms of Laurens Jacobsz de Witte (1733-1761), father of Anna Jacoba de Witte (see the preceding number), with the coats of arms of his four grandparents: de Witte, de Jonge, Stavenisse and de Keyser. *Het wapen van Laurens Jacobsz de Witte, vader van Anna Jacoba de Witte, met de wapens van zijn vier grootouders*

Water color on paper 22 × 16.5

A 933 The coat of arms of Jacob de Witte, father of Laurens Jacobsz de Witte (see the preceding number), with the coats of arms of his four grandparents: de Witte, [de] Huybert, de Jonge and [de] Coq. *Het wapen van Jacob de Witte, vader van Laurens Jacobsz de Witte, met de wapens van zijn vier grootouders*

Water color on paper 22 × 16.5

A 936 The coat of arms of Maria Magdalena Stavenisse (1700-83), wife of Jacob de Witte (see the preceding number), with the coats of arms of her four grandparents: Stavenisse, Stoutenburg, de Keyser and Bolle. *Het wapen van Maria Magdalena Stavenisse, echtgenote van Jacob de Witte, met de wapens van haar vier grootouders*

For a portrait of Maria Magdalena Stavenisse, *see* Troost, Cornelis, A 2078

Water color on paper 22 × 16.5

A 937 The coat of arms of Anna Digna van Gelre, wife of Laurens Jacobsz de Witte (see A 935), with the coats of arms of her four grandparents: van Gelre, de Keyser, Ockersse and de Witte. *Het wapen van Anna Digna van Gelre, echtgenote van Laurens Jacobsz de Witte, met de wapens van haar vier grootouders*

Water color on paper 22 × 16.5

A 932 The coat of arms of a female member of the Ockersse family, married to a van Gelre and mother of Anna Digna van Gelre (see the preceding number), with the coats of arms of her four grandparents: Ockersse, Pous, de Witte and van Orliens. *Het wapen van een vrouwelijk lid van de familie Ockersse, gehuwd met van Gelre en moeder van Anna Digna van Gelre, met de wapens van haar vier grootouders*

Water color on paper 22 × 16.5

A 939 Coat of arms of the de Witte family, after a lozenge-shaped memorial tablet with the initials I W flanking the shield and the date 1590. *Wapen van de familie de Witte, naar een ruitvormig rouw-bord met de initialen I W aan weerskanten van het schild en het jaartal 1590*

Water color on paper 32.5 × 25

A 930 Shield with the arms of Laurens Jacobsz de Witte (d 1636) and his eight ancestors: de Witte, Couwenburg, la Bluin, Domits, Hollaer, de Swart, Dagh and van der Lisse. *Wapenbord met het wapen van Laurens Jacobsz de Witte en zijn acht kwartieren*

Panel 35 × 31.5. Inscribed *d'Heer Laurens Iacobsz de Witte, Heer van Elkerzee, Schepen van Z'zee, begraven in de groote kerk tot Zierickzee op den 14 maert 1636.*

Coats of arms not belonging to a donation or bequest. *Wapens, niet behorend bij een schenking of legaat*

A 4641 Shield of Edward IV (1442-83), king of England, in his capacity as knight in the Order of the Golden Fleece. *Wapenbord van Eduard IV, koning van Engeland, in zijn hoedanigheid van ridder in de orde van het Gulden Vlies*

Attributed to Pierre Coustain (active 1453-87 in Bruges and Brussels)

Panel 112 × 68. Inscribed *Tres hault Et Tres puissant Prince Edouart Par la Grace De dieu Roy dengletre Et Seignr Dyrlande* PROV Sale Jonkheer van den Bogaerde van Moergestel, 's Hertogenbosch, 26-31 Feb 1896. NMGK

A 4642 Shield of Jacob of Luxemburg, lord of Fiennes, in his capacity as knight in the Order of the Golden Fleece. *Wapenbord van Jacob van Luxemburg, heer van Fiennes, in zijn hoedanigheid van ridder in de orde van het Gulden Vlies*

Attributed to Pierre Coustain (active 1453-87 in Bruges and Brussels)

Panel 93 × 58. Inscribed *Jaques. de luxembō Seignr. De Fiennes* PROV Same as A 4641

A 4643 The coats of arms of the Dutch East India Company and of the city of Batavia. *De wapens van de Verenigde Oost-Indische Compagnie en van de stad Batavia*

By Jeronimus Becx II (active 1649 in Middelburg)

Panel 63 × 97. Signed and dated *J. Becx de Jonge fecit 1651.* Inscribed *Wapen. Vande.Stadt. Batavia. gelegen. opt Eijlandt. Groot. Java. int. Coninckrijck. Van Jacatra. bijde. Generale. Nederlandsche Geoctroyeerde. Oostindische. Compagnie Verovert. den 30 Maij. Anno 1619* PROV NMGK LIT C Hofstede de Groot, OH 22 (1904) pp 119-20

NM 10500 Hatchments of Tjerk Hiddes de Vries (1622-66), vice admiral of Friesland. *Wapenbord van Tjerk Hiddes de Vries, luitenant-admiraal van Friesland*

Panel 86 × 86 (measured diagonally). Inscribed *D'Heer Admerael, De Vrise Obijt 27 Julius 1666 Oude Stijl* PROV Sale Jonkheer van den Bogaerde van Moergestel, 's Hertogenbosch, 26-31 Feb 1896. Belongs to the department of Dutch history

A 3221 The coat of arms of Jacob Feitama II (1698-1774). *Het wapen van Jacob Feitama II*

Pendant to A 3222
For a portrait of Jacob Feitama II, *see* Holland school ca 1730, A 3219

Water color on vellum 38 × 28.5
PROV From the Rijksarchief (state archives), Haarlem, 1934

A 3222 The coat of arms of Susanna van Collen (1692-1745), wife of Jacob Feitama. *Het wapen van Susanna van Collen, echtgenote van Jacob Feitama*

Pendant to A 3221
For a portrait of Susanna van Collen, *see* Holland school ca 1730, A 3220

Water color on vellum 38 × 28.5
PROV Same as A 3221

C 513 The combined arms of Jacob Ploos van Amstel and Margaretha Tol, 1683. *De alliantie-wapens van Jacob Ploos van Amstel en Margareta Tol, 1683*

Canvas 54 × 44.5. Inscribed *Jacobus Ploos van Amstel en Margareta Tol. 1683*
PROV On loan from the KOG since 1889

C 513a The combined arms of Jacobus Loohoff and Johanna Pierraert, 1684. *De alliantie-wapens van Jacobus Loohoff en Johanna Pierraert, 1684*

Canvas 54 × 44.5. Inscribed *Johanna Pierraert.1684. Jacobus Loohof*
PROV Same as C 513

A 4205 Shield with the coat of arms of the Snoeck family (Amsterdam). *Wapenbord met het wapen van de familie Snoeck (Amsterdam)*

Panel 23.8 × 18.9. Oval
PROV Unknown

NM 5339 Shield with quartered coat of arms. *Wapenbord met wapen in vier kwartieren*

Panel 48.2 × 40.8. Oval
PROV From Sint Maartensdijk. Purchased from Mr Peter, 1881. Belongs to the department of Dutch history

NM 5340 Heraldic shield. *Wapenbord*

Panel 48.5 × 41. Oval
PROV Same as NM 5339. Belongs to the department of Dutch history

NM 5341 Heraldic shield. *Wapenbord*

Panel 48.5 × 41. Oval
PROV Same as NM 5339. Belongs to the department of Dutch history

NM 5342 Heraldic shield. *Wapenbord*

Panel 48.5 ×41. Oval
PROV Same as NM 5339. Belongs to the
department of Dutch history

NM 5343 Heraldic shield. *Wapenbord*

Panel 48.5 ×41. Oval
PROV Same as NM 5339. Belongs to the
department of Dutch history

NM 5344 Heraldic shield. *Wapenbord*

Panel 48.5 ×41. Oval
PROV Same as NM 5339. Belongs to the
department of Dutch history

Memorial tablets

NG 87 Memorial tablet of Frans Banning
Cocq (1605-55), lord of Purmerland and
Ilpendam. *Grafbord van Frans Banning
Cocq, heer van Purmerland en Ilpendam*

Panel 111.5 ×80.5. Inscribed *D.O.M.*
and nearly illegibly *O BIIT I Januari
MDCLV*
PROV Presented by J L de Boer, Elburg,
1948. Belongs to the department of
Dutch history
LIT R van Luttervelt, Mndbl
Amstelodamum 38 (1951) pp 24-26

NM 8359 Memorial tablet of Laurentius
de Blau (1648/49-74). *Grafbord van
Laurentius de Blau*

Panel 113 × 113 (measured diagonally).
Inscribed *Laurentius de Blau Luitenant van
een comp^ie te voet, door een vijantlijcke koegel
voor de Graeff geschoten, den 3 Octob 1674,
Aetatis 25*
PROV Purchased in 1887. Belongs to the
department of Dutch history

NG 105-NG 118 These numbers are
from a church built by the Dutch in
Chinsura, India, in 1767. They were
presented by the bishop of Calcutta,
1949, through the intermediacy of P de
Josselin de Jong and belong to the
department of Dutch history.
Catalogued in chronological order

NG 105 Memorial tablet of Rogier van
Heijningen (d 1665), director of Bengal
(1663-65). *Grafbord van Rogier van
Heijningen, directeur van Bengalen*

Panel 122 × 121 (measured diagonally).
Inscribed *Obijt R. V. H. den 9 Juni Anno
1665*
LIT DG van Epen, Wapenheraut 1
(1897) p 174. Wijnaendts van Resandt
1944, p 28

NG 106 Memorial tablet of WA,
probably Arnoldus van Wachtendonck
(d 1668), deputy director of Bengal
(1665-68). *Grafbord van W A,
waarschijnlijk Arnoldus van Wachtendonck,
plaatsvervangend directeur van Bengalen*

Panel 115 × 114.5 (measured
diagonally). Inscribed *Obyt W.A. Den
13 August An° 1668*
LIT DG van Epen, Wapenheraut 1
(1897) p 173. Wijnaendts van Resandt
1944, p 29

NG 117 Memorial tablet of François de Haze (d 1676), director of Bengal (1673-76). *Grafbord van François de Haze, directeur van Bengalen*

Panel 123 × 125 (measured diagonally). Inscribed *Obijt Den 26 October Anno 1676* and *De Hasen, Velter, Van Wissel* and *Van Esse*
LIT DG van Epen, Wapenheraut 1 (1897) p 174. Wijnaendts van Resandt 1944, p 30

NG 107 Memorial tablet of Nicolaas Baukes (d 1683), director of Bengal (1681-83). *Grafbord van Nicolaas Baukes, directeur van Bengalen*

Panel 119 × 119 (measured diagonally). Inscribed *N.B. Obiit 19 May A° 1683*
LIT DG van Epen, Wapenheraut 1 (1897) p 174. Wijnaendts van Resandt 1944, p 32

NG 108 Memorial tablet of Marten Huysman (d 1685), director of Bengal (1683-85). *Grafbord van Marten Huysman, directeur van Bengalen*

Panel 125 × 129 (measured diagonally). Inscribed *M.H. Obijt 5 Iuny AN° 1685*
LIT DG van Epen, Wapenheraut 1 (1897) p 174. Wijnaendts van Resandt 1944, pp 32, 84

NG 109 Memorial tablet of Pieter van Dishoeck (1653-1701), director of Bengal (1696-1701). *Grafbord van Pieter van Dishoeck, directeur van Bengalen*

Panel 128 × 129.5 (measured diagonally). Inscribed *P. V. D. O B I I T 12 Ianu A° 1701*
LIT Wijnaendts van Resandt 1944, pp 34-35

NG 110 Memorial tablet of Rogier Beernards (d 1733), director of Bengal (1731-33). *Grafbord van Rogier Beernards, directeur van Bengalen*

Panel 120 × 118.5 (measured diagonally). Inscribed *R.B. Obyt 28 gbo[?] A° 1733*
LIT DG van Epen, Wapenheraut 1 (1897) p 174. Wijnaendts van Resandt 1944, p 41

NG 113 Memorial tablet of Boudewijn Versewel Faure (1734-70), director of Bengal (1769-70). *Grafbord van Boudewijn Versewel Faure, directeur van Bengalen*

Belongs with NG 112

Panel 100.5 × 100 (measured diagonally). Inscribed *Boudewijn Verselewel Faure in Leeven Oud Eerste Secretaris van de Hooge Regering en Directeur Van Bengalen. Geboren tot Dendermonde Den 25 Januarij Anno 1734. Obiit tot Bengalen Den 6 Meij A° 1770 Oud 36 Jaaren, 3 Maann en 11 Daagen*
LIT DG van Epen, Wapenheraut 1 (1897) p 174. Wijnaendts van Resandt 1944, pp 47-48

NG 112 Memorial tablet of Theodora Hendrica Piekenbroek (1746-70), wife of Boudewijn Versewel Faure. *Grafbord van Theodora Hendrica Piekenbroek, echtgenote van Boudewijn Versewel Faure*

Belongs with NG 113

Panel 100 × 100 (measured diagonally). Inscribed *Theodora Hendrica Piekenbroek in Leeven Huijsvrouw van D. Agtbr Heer Boudewijn Verselewel Faure, Oud Eerste Secretaris van D. Hooge Regering en Directeur van Bengalen, Geboren tot Batavia Den 21 Julij Anno 1746 Obiit tot Bengalen Den 27 Maart A° 1770 Oud 23 Jaaren 8 Maann en 6 Daagen*
LIT Same as NG 113

NG 114 Memorial tablet of Theodora Antoinette Bodle (1729-74). *Grafbord van Theodora Antoinette Bodle*

Panel 124 × 123 (measured diagonally). Inscribed *T. A. Bodle, ob: 15:Decr 1774 Aetat 45*
LIT DG van Epen, Wapenheraut 1 (1897) p 174

NG 115 Memorial tablet of George Lodewijk Vernet (1711-75), director of Bengal (1763-69). *Grafbord van George Lodewijk Vernet, directeur van Bengalen*

Panel 100 × 99.5 (measured diagonally). Inscribed *Den Weledelen Achtbaeren Heer George Lous Vernet. In leven Directeur van Bengalen Gebooren tot scraven Hage Dn 11 Jan An° 1711 Obiit tot Batavia Den 13 December An 1775 oud 64 Jaar* LIT DG van Epen, Wapenheraut 1 (1897) p 174. Wijnaendts van Resandt 1944, p 47

NO PHOTOGRAPH AVAILABLE

NG 116 Memorial tablet of Tammerus Canter Visscher (1729-78), chief of Cossimbazar. *Grafbord van Tammerus Canter Visscher (1729-78), opperhoofd van Cassimbesaar*

Metal 135 × 136 (measured diagonally). Inscribed *Tammerus Canter Visscher: in leeven Opper Koopman secunde der Bengaalsche Directie en Opperhoofde te Cassimbesaar. Geb. te Penjum Vriesland den 11. Augustus Anno 1729 Overl. te Cassimbesaar den 31 Januarij Anno 1778 Oud 48 Jaaren 5 Maanden en 20 dagen* * Missing LIT DG van Epen, Wapenheraut 1 (1897) p 175

NG 118 Memorial tablet of Pieter de Brueys (1750-83), senior merchant and chief administrator of Chinsura. *Graf-*

bord van Pieter de Brueys, opperkoopman en hoofd-administrateur te Chinsura

Panel 104 × 103 (measured diagonally). Inscribed *Pieter Brueys van I.A. Opper koopman en Hoofd administrateur Overleeden te Chintsurah den 23 August Anno 1783 in den Ouderdom van 52 Jaaren 9 Maanden 17 Dagen* LIT DG van Epen, Wapenheraut 1 (1897) p 175

NO PHOTOGRAPH AVAILABLE

NG 111 Memorial tablet thought to be of Jeronimo Isinck. *Grafbord, vermoedelijk van Jeronimo Isinck*

Metal 151.5 × 150 (measured diagonally). Inscribed *INO Isinck Geb. 9 July, 1709 te Groningen Gestorven 25 September 17..* * Missing LIT DG van Epen, Wapenheraut 1 (1897) p 175

Shields

C 1580 Fifteenth-century German shield, painted with the coat of arms of the city of Cologne. *Vijftiende-eeuws Duits schild, beschilderd met het wapen van de stad Keulen*

Wood covered with leather ca 110 × 45 PROV On loan from the KOG since 1974 LIT J B Kist, Jaarversl KOG 108-10 (1965-68) pp 48-50, ill

C 1581 Fifteenth-century Burgundian shield with a red St Andrew's cross on a white and blue field, surrounded by four yellow steels, four black-and-white flints and red flames. *Vijftiende-eeuws Bourgondisch schild met een rood Andreas-*

kruis op wit en blauw fond, omgeven door vier
gele vuurslagen, vier wit-zwarte vuurstenen en
rode vlammen

Wood covered with leather ca 110 × 45
PROV On loan from the KOG since 1974
LIT *See under* C 1580

NM 11421 Fifteenth-century German
shield, presumably of a foot soldier,
painted with a pelican and its young.
Vijftiende-eeuws Duits schild, vermoedelijk
een voetknechtenschild, beschilderd met een
pelikaan met haar jongen

Panel covered in leather and linen on
the front 66 × 41
PROV Sale Amsterdam, 7-12 Aug 1899.
Belongs to the department of Dutch
history

NM 9313 Seventeenth-century Northern
Netherlands shield (?) painted with the
four sons of Aymon. *Zeventiende-eeuws*
Noord-Nederlands schild (?) beschilderd.
met de vier Heemskinderen

Iron 60 cm in diam
PROV Presented by P de Clercq and P
van Eeghen, Amsterdam, 1891. Belongs
to the department of Dutch history

NM 11649-w Shield painted with a
guardsman of the Delft civic guard
standing beside an altar, 1766. *Schild*
beschilderd met een schutter, van een Delftse
schutterij, staande naast een altaar, 1766

Metal covered with leather 64 cm in
diam. Inscribed (over an older
inscription) *Pro Aris Et Focis* and *It Rt It*
Wt Vt het 3 Quart Ano 1766. To the left the
Delft coat of arms with the legend *Honi*
Soit Qui Mal Y Pense
PROV On loan from the Koninklijke
Militaire Academie, Breda (Roosdorp
collection) since 1901. In care of the
department of Dutch history
LIT Te Lintum 1909, pl 31:8

NM 2970 Tortoise shell painted with a
portrait of Frederik Hendrik (1584-
1647), prince of Orange, on horseback.
Schild van een schildpad beschilderd met een
portret van Frederik Hendrik, prins van
Oranje, te paard

Manner of Pauwels van Hillegaert
(1595/96-1640)

Tortoise shell 117 × 68
PROV Sale L J A Scheltens van
Kampferbeke, Rotterdam, 24-25 July
1876. Belongs to the department of
Dutch history
LIT D van der Kellen, Eigen Haard,
1879, p 12

Drums

NG 47 Eighteenth-century Northern
Netherlands drum painted with a scene
of two soldiers playing cards on a table
and a trophy made up of a cannon,
drums, rifles and pieces of armor. *Acht-*
tiende eeuwse Noord Nederlandse trommel,
beschilderd met een scène van twee kaartende
soldaten aan een tafel en met een trofee
bestaande uit een kanon, trommels, geweren en
onderdelen van harnassen

Copper 40.5 cm in diam
PROV Presented by J A Z Count van
Rechteren Limpurg, 1937. Belongs to
the department of Dutch history

NM 9310 Late eighteenth-century Nor-
thern Netherlands drum, painted with a
trophy made up of a drum, two cannons
with two ramrods and cannonballs,
seven flags, two rifles with bayonets,
three pikes, sabres, a helmet, a cartridge
pouch, a staff with a cap of liberty and a
lion with a sheaf of arrows and a scimitar
in its claws. *Laat achttiende-eeuwse*
Noord Nederlandse trommel, beschilderd met
een trofee bestaande uit een trommel, twee
kanonnen met twee kruitpels en kogels, zeven
vlaggen, twee geweren met bajonetten, drie
pieken, sabels, een helm, een patroontas, een
stok met vrijheidshoed en een leeuw met in zijn
klauwen een pijlenbundel en een kromzwaard

Wood 33 cm high and 46 in diam.
Inscribed *CC. NCO...DIA*
PROV Thought to come from the
collection of A C Baron Snouckaert van
Schouburg, The Hague, 1891. Belongs
to the department of Dutch history

Lists, indexes and concordances

Introduction

The alphabetical listing of painters by name, with which the catalogue opens, contains cross-references to the authors of works listed in all other sections of the catalogue, and thus doubles as a name index to artists represented in the collection.

The inventory numbers following an artist's name in the indexes are given in the order in which they occur in the catalogue. This system has not been followed in the list of inventory numbers, where considerations of space led us to adopt a strictly numerical order.

Besides the abbreviations used throughout the catalogue, the following additional abbreviations have been used in the lists, indexes and concordances:

A QU Aquarelles and drawings, pp 803-21
COST Dutch costume series, pp 736-41
GOV Governors-general series, pp 711-23
HER Heraldic objects, pp 821-29
HON Honselaarsdijk series, pp 698-706
MIN Miniatures, pp 750-86
PAN Panpoeticon Batavum, pp 723-37
PAST Pastels, pp 787-802
ROT Rotterdam East India Company series, pp 706-11
VANM Vanmour series, pp 741-50

Survey of foreign schools

The following survey lists all artists other than those from the Northern Netherlands represented in the collection with an autograph work, one attributed to them or their school, or an early copy after one of their works. Artists represented only by late copies are not included, nor are graphic artists whose works may have served as the model for a painting.

To locate the entries on the works by artists in the list, consult the main section of the catalogue – painters by name – which includes cross-references to all other sections.

America
Muhrman, H
Whistler, J A M

Czechoslovakia
Jettel, E
Raffalt, J Q

Denmark
Erichsen, V
Hornemann, Chr
Isaacsz, P
Ploetz, H
see also under Paintings: Danish school

England
Alma Tadema, L
Alma Tadema-Epps, L Th
Bettes, J
Bisschop-Swift, C S F
Boone, D
Brounckhurst, A van
Collins, R
Cooper, A
—, S
Dixon, N
Dobson, W
Estall, W Ch
Ferguson, W G
Graham I, J
Granges, D des
Hawksley, A
Hilliard, N
Hoadley, P
Hoskins, J
Jackson II, J
John, A E
Kneller, G
Lance, G
Lawrence, Th
Lely, P
Oliver, I
—, P
Peppercorn, A D
Riley, J
Sands, E
Swan, J M
Thach, N
see also under Paintings: English school, and Miniatures: English school

France
Aved, J A J
Bashkirtseff, M K
Basseporte, M F
Bernard, E
Bertin, N
Blanchard, J
Blarenberghe, L N van
Bonnat, L J F
Bonvin, F
Boucher, F
Boulard, A
Bourdon, S
Bourgoin, A G A
Boze, J
Brascassat, J R
Breton, E A
Bunel, J
Champaigne, J B de
—, Ph de
Charlet, N T
Clouet, F
Corneille de Lyon
Corot, J B C
Courbet, G
Court, J D
Coustain, P
Couture, Th
Czermak, J
Daubigny, Ch F

Daumier, H
Decamps, A G
Delacroix, F V E
Diaz de la Peña, V N
Dubois Drahonet, A J
Dughet, G
Dumesnil, L M
Duplessis, J S
Dupré, J
—, V
Fantin-Latour, H
Favray, A de
Frère, E
Fromentin, E
Gallard-Lepinay, E
Gauthier, P J
Gérard, F P S
Girard, H
Greuze, J B
Gudin, J A Th
Guernier, L du
Hamman, E M F
Japy, L A
Jouve, A
Lamprecht, G
Largillière, N de
La Tour, G de
Légaré, G
Lenain, M
Lepoittevin, E M E
Machy, P A de
Marcke de Lummen, E van
Martinet, L
Mettling, L
Michaud, H
Michelin, J
Millet, J F
Monet, C
Monmorency, B
Monticelli, A
Mouilleron, A
Nicolas, L
Noël, P P J
Ouvrié, P J
Pater, J B
Perronneau, J B
Prud'hon, P P
Quenedey, E
Redon, O
Ribot, A Th
Rochard, S J
Rousseau, P E Th
Saligo, Ch L
Sallembier, H
Schall, J F
Schuppen, J van
Stengelin, A
Tocqué, L
Toutin, H
Troyon, C
Vallayer-Coster, D A
Vanloo, A
Vanmour, J B
Vernet, E J H
Vigée-Lebrun, E
Vignon, C
Vincent, F A
Vivien, J
Vollon, A
Ziem, F
Master of the Aix Annunciation
see also under Paintings: French school, and Miniatures: French school

Germany
Aachen, H von
Achenbach, O
Behr, J Ph
Blesendorf, S
Bourdon, L
Boy, G
Bruyn I, B
Calcar, J J van
Cranach I, L
Cranach II, L
Denner, B
Dietrich, Ch W E
Dietterlin, B
Dürer, A
Elliger I, O
Elsheimer, A
Hainz, G
Hildebrand, Th

Kessler, F
Klombeck, J B
Krafft, D von
Leblon, J Ch
Lembke, J Ph
Liss, J
Loebell, M
Loth, J C
Lubienietzki, Ch
Marrel, J
Mengs, A R
Nilson, J E
Ovens, J
Pesne, A
Pistorius, E
Reclam, F
Reuss, H A
Roos, J M
Rottenhammer, J
Saal, G
Sandrart, J von
Spilberg II, J
Tischbein, J F A
Tischbein, J V
Winterhalter, F X
Ziesenis, J G
Zincke, Ch F
Monogrammist I V A
Monogrammist Johann G M
Master of the Salem Altar
see also under Paintings: German school, Miniatures: German school, and Pastels: German school

Indonesia
Saleh, S B

Ireland
Chinnery, G

Italy
Allori, A
—, C
Angelico, Fra
Apollonio di Giovanni
Araldi, J
Bacchiacca
Baldovinetti, A
Bartolommeo, Fra
Bassano, J
—, L
Beccafumi, D
Beccaruzzi, F
Bellini, G
Bonifazio Veronese
Bonsignori, F
Bordone, P
Borgognone, A
Botticelli, A
Botticini, F
Bramantino
Bronzino, A
Canaletto, A
Carpaccio, V
Carracci, L
Ceresa, C
Ceruti, G
Cima da Conegliano, G B
Cortona, P da
Costa, L
Cozza, F
Crivelli, C
—, V
Diana, B
—, G
Farinato, P
Ferrari, D
—, G
Fiore, J del
Fogolino, M
Foppa, V
Franceschini, M A
Garofalo
Gerini, N di P
Giampietrino
Giordano, L
Giorgione
Giovanni da Brescia
Giovanni di Francia
Giovanni da Milano
Girolamo da Santa Croce
Guardi, F
—, G
Guercino

Lanfranco, G
Leone, A de
Lippi, F
Longhi, P
Lorenzo di Niccolò
Luca di Tommè
Machiavelli, M
Maderni, G B
Magnasco, A
Mancini, A
Maratti, C
Mazzolino, L
Melozzo da Forlì
Monaco, L
Montagna, B
Morazzone, P F
Moroni, G
Napoletano, F
Niccolò de Liberatore
Palma il Giovane, J
Palma il Vecchio, J
Pasini, A
Piazzetta, G B
Piero di Cosimo
Piombo, S del
Polidoro da Lanciano
Pontormo, J
Pordenone, G A
Ramelli, F
Recco, G B
Reni, G
Ricci, S
Rondinello, N
Rosselli, C
Rotari, P
Sassoferrato, G B
Savoldo, G G
Schiavone, A
—, G
Segantini, G
Sellaio, J del
Serodine, G
Signorelli, L
Solimena, F
Starnina, G
Tibaldi, P
Tiepolo, G B
Tintoretto, J
Titian
Tozelli, F
Turchi, A
Venusti, M
Veronese, P
Vivarini, B
Zacchia il Vecchio
Zaganelli, B
—, F
Zuccarelli, F
Zugno, F
Master Allegro
Master of the Bambino Vispo
Master of the Battle of Anghiari
Master of the Carrand Triptych
Master of the Conversazione di Santo Spirito
Master of Pietro a Ovile
Master of the San Miniato Altarpiece
Pseudo-Ambrodigio di Baldese
see also under Paintings: Italian school

Norway
Tidemand, A

Poland
Szyndler, P

Russia
see under Paintings: Russian school

Southern Netherlands
Adriaensen, A
Assche, H van
Asselbergs, A
Balen, H van
Balten, P
Beert, O
Beveren, Ch van
Bles, H met de
Block, E F de
Bloemen, N van
—, P van
Boudewijns, A F
Bout, P
Braekeleer I, F de

Brassauw, M
Bredael, J van
Bree, M I van
Brice, I
Bril, P
Brouwer, A
Brueghel, A
Brueghel I, J
Brueghel II, P
Bueckelaer, J
Burbure, L de
Caullery, L de
Cels, C
Clerck II, H de
Cleve, J van
—, M van
Cock, J W de
Coclers, L B
Coecke van Aelst, P
Coene, C F
—, J H de
Coninck, D de
Coter, C de
Crayer, C de
Dalem, C van
Dalen, C van
David, G
Delvaux, E
Diez, A
Ducorron, J J
Duwée, H J
Dyck, A van
Eeckhout, J J
Eertvelt, A van
Engel, A K M
Evrard, A
Eyck, N van
Eycken, J B van
Falens, C van
Franchoys II, L
Francken II, F
Fijt, J
Geldorp, G
Genoels, A
Goes, H van der
Gossaert van Mabuse, J
Govaerts, A C
Gijsaerts, G
Gijsels, P
Hanselaere, P van
Haseleer, F
Hemessen, C van
Horemans II, J J
Hulst, J B van der
Isenbrant, A
Jolly, H J B
Jonghe, J B de
Jordaens, J
Kessel, J van
Key, A Th
Keyser, N de
Leys, J A H B
Maes, J B L
Malo, V
Marne, J L
Massys, C
—, Q
Meulen, A F van der
Meulener, P
Mirou, A
Moerenhout, J J
Momper, J de
Mostaert, G
Navez, F J
Neefs I, P
Neefs II, P
Nicolié, J Chr
Noter II, P F de
Odevaere, J D
Ommeganck, B P
Orley, B van
Paelinck, J
Paepe, J de
Patenir, J
Payen, A A J
Peeters, B
—, C
—, G
Picqué, Ch
Pluckx, J A A
Poelman, P
Pourbus I, F
Pourbus II, F

Missing and lost objects

Objects said in the catalogue to be 'missing' occur in the inventory
but cannot be located in the collection. Some of these cases are
doubtless due to administrative errors. One period when such
errors were likely to have been made was 1940-45, when the
museum had to be evacuated and effective stocktaking was
impossible.

Objects said to be 'lost' are known to have been destroyed or
damaged beyond repair. The cause of such losses is specified
under the catalogue entry.

Missing

Lost

Religious subjects

Old Testament and apocrypha

Aaron in the tabernacle: Antwerp school? ca 1650, RBK 16434
Abraham, Abimelech gives Sarah to: Isaacsz, I, A 1191
—entertaining the three angels: Bol, F, A 1577; Zugno, F, A 3436
—, sacrifice of: Lastman, P, A 1359
—and Lot on the mountain: Antwerp school? ca 1650,
 RBK 16434
—and Melchizedek, meeting of: Netherlands school ca 1515,
 A 866
Adam and Eve: Cornelisz van Haarlem, C, A 129; Franceschini,
 MA, A 1348; Israels, J, A 2602; Zwart, W H P J de, A 3505
—, expulsion from paradise of: Poelenburgh, C van, A 312;
 Zwart, W H P J de, A 3506
Adam, Eve and Seth: Antwerp school? ca 1650, RBK 16434
Ahasuerus, Esther appearing before: Haseleer, F, A 1044
—, wrath of: Eeckhout, G van den, A 3489
Amaziah and the man of God: Bol, F, A 1578
Babel, tower of: Bruges school ca 1450-70, A 2851
Balaam and the ass: Antwerp school? ca 1650, RBK 16434
Bathsheba in the bath: Cornelisz van Haarlem, C, A 3892;
 Scorel, J van, A 670
Benjamin's sack, Joseph's cup discovered in: Bol, F, A 1579
Cain and Abel: Zwart, W H P J de, A 3507; Antwerp school? ca
 1650, RBK 16434

David: Gelder, A de, A 2695; Israels, J, A 3731
—and Abigail, meeting of: Bieselingen, C J van, A 1631;
 Uytewael, J A, A 988; Antwerp school? ca 1650, RBK 16434
—after his victory over Goliath, Saul honoring: Wet, G de,
 A 1854
deluge: Zwart, W H P J de, A 3367
Elijah, ascension of: Colijns, D, A 1617
—awakened in the desert by an angel: Lanfranco, G, A 4129
—fed by the ravens: Savery, R, A 1297
Elisha mocked by the little children: Zijl, R van, A 1611
—, Naaman the Syrian and: Bol, F, C 626
—, and the Shunamite woman: Kruseman, J A, A 1071
—resurrecting the son of the Shunamite woman: Navez, F J,
 A 1085
Esau selling his birthright: Moreelse, P, A 3455; Antwerp school?
 ca 1650, RBK 16434
exodus from Egypt: Bassano, L, A 3377
Esther: see Ahasuerus
Genesis, scenes from the book of: Francken II, F, NM 4789
golden calf, adoration of the: Leyden, L van, A 3841; Antwerp
 school? ca 1650, RBK 16434
Hagar and Ishmael in the wilderness: Cozza, F, A 4035;
 Antwerp school? ca 1650, RBK 16434
Isaac blessing Jacob: Flinck, G, A 110
—and Rebecca, first meeting of: Navez, F J, A 1086
Jacob wrestling with the angel: Breenbergh, B, A 1724
—and Esau, meeting of: Hogers, J, A 1498; Pynas, Jan S, A 3510;
 Rubens, P P, A 346
—and Rachel, meeting of: Moeyaert, N, A 1485
Jacob's dream: Mieris I, F van, A 704
Jephthah's daughter: Savery I, J, A 2117
Jeremiah lamenting the destruction of Jerusalem: Rembrandt,
 A 3276
Joseph telling his dreams to his parents and his brothers:
 Rembrandt, A 3477
—interpreting the dreams of the baker and the butler: Cuyp,
 B G, A 773; Victors, J, A 451
—and Potiphar's wife: Bertin, N, A 40; Southern Netherlands
 school? ca 1575, A 1288; MIN Ramelli, F, A 4363
Judah and Tamar: Antwerp school? ca 1650, RBK 16434
Judith and Holofernes: Bray, J de, A 2353
—holding the head of Holofernes: Allori, C, A 1; Botticelli,
 A 3381; Pordenone, G A, A 3415
Lot and his daughters: Palma il Giovane, J, A 1235; Antwerp
 school? ca 1650, RBK 16434
man of God, the old prophet meets the: Jacobsz, L, A 2814
manna, rain of: Netherlands school ca 1515, A 867
Moses in the rush basket, Pharaoh's daughter discovers:
 Dujardin, G, A 1572; Voorhout, J, NM 1010; Southern
 Netherlands school? 16th century?, A 4184; Antwerp school?
 ca 1650, RBK 16434
—and the burning bush: Antwerp school? ca 1650, RBK 16434
—changing the water of the Nile into blood: Pynas, Jan S, A 1626
—appointing the seventy elders: Wit, J de, A 1783
—receiving the tablets of the law: Antwerp school? ca 1650,
 RBK 16434
—and the tablets of the law: Mazzolino, L, A 3409; Voorhout,
 J, NM 1010; Southern Netherlands school ca 1560, A 4487;
 Antwerp school? ca 1650, RBK 16434
—and the bronze serpent: Antwerp school? ca 1650, RBK 16434
Noah's ark: Northern Netherlands school last quarter 16th
 century, A 2624; Ferrarese school 2d half 15th century, A 3418
—prayer after the deluge: Antwerp school? ca 1650, RBK 16434
Noah sees the rainbow: Antwerp school? ca 1650, RBK 16434
Paradise: Bles, H met de, A 780; see also Adam and Eve
Pharaoh's first born son: Alma Tadema, L, A 1664; Antwerp
 school? ca 1650, RBK 16434
Rebecca receiving presents from Abraham's servant: Heerschop,
 H, A 1431; Antwerp school? ca 1650, RBK 16434
Ruth and Boas: Berchem, N, A 32
Samson and Delilah: Lievens, J, A 1627; Rembrandt, A 4096
—rending the lion: Heemskerck, M van, A 3512
—shattering the pillars of the temple: Heemskerck, M van,
 A 3511
Saul: Israels, J, A 3730; AQU Israels, J, A 3729
—and the witch of Endor: Cornelisz van Oostsanen, J, A 668
Sodom and Gomorrah, destruction of: Zwart, W H P J de, A 3366
Solomon, idolatry of: Hogers, J, A 787; Koninck, S, A 2220;
 Poorter, W de, A 757
—and the queen of Sheba: Swart van Groningen, J, A 669;
 Northern Netherlands school 1624, A 2309
Susanna and the elders: Bertin, N, A 41; Clerck, H de, A 1461;
 Hanselaere, P van, A 1042
Tobias and the angel: Baldovinetti, A, C 1188; Neer, E van der,
 A 291
Tobit accusing Anna of stealing the kid: Rembrandt, C 1448

New Testament

GENERAL

Christ, eighteen scenes from the life of: Gelderland school ca
 1435, A 1491

evangelists: Fogolino, M, C 1129; Maratti, C, A 727; Provoost, J,
 A 2570; Uytewael, J A, A 1697 & A 1696; Master of the
 Bambino Vispo, A 3979 & A 3980; Master of the Legend of
 St Ursula, A 3326; Southern Netherlands school 1561, A 4488;
 see also under Saints
Jesse, tree of: Mostaert, J, A 3901; Swart van Groningen, J,
 NM 8184
Zebedee, family of: Lower Rhenish school ca 1490, A 2799

THE LIFE OF ST JOHN THE BAPTIST; see also under Saints

beheading of St John the Baptist: Fabritius, C, A 91
preaching of St John the Baptist: Bloemaert, A, A 3746;
 Vinckboons, D, A 1782
Salome dancing for Herod: Hogers, J, A 804
—with the head of St John the Baptist: Cornelisz van Oostsanen,
 J, C 1349; Leyden, L van, A 4260
Zacharias, archangel Gabriel appearing to: Giselaer, N de,
 A 1527

THE BIRTH AND YOUTH OF CHRIST

adoration of the child: Bosch, J, A 4131; Rosselli, C, A 3419;
 Sellaio, J del, A 3428; Master Allegro, A 3007; Master of the
 Braunschweig Diptych, A 2563; Gelderland school ca 1435,
 A 1491; Utrecht school ca 1435, A 2649
—of the magi: Aertsen, P, A 1909 & C 1458; Bosch, J, A 124;
 Breenbergh, B, A 1482; Brueghel II, P, A 731; Brugghen,
 H ter, A 4188; Bruyn I, B, C 1515; Coecke van Aelst, P,
 A 2594; Cornelisz van Oostsanen, J, C 1554; Farinato, P,
 C 1352; Garofalo, B T da, A 114; Geertgen tot Sint Jans,
 A 2150; Mostaert, J, A 671; Ricci, S, A 3417; Schooten, J van,
 A 974; Swart van Groningen, J, NM 8184; Master of Alkmaar,
 C 1364 & A 3324; Gelderland school ca 1435, A 1491;
 Nijmegen school ca 1483, A 2545 & A 2546; Utrecht school
 ca 1435, A 2649; Southern Netherlands school? 16th century?,
 A 4185
—of the shepherds: Aertsen, P, C 392; Bout, P, A 2224;
 Bramantino, A 3383; Codde, P, A 789; Crayer, C de, A 74;
 Hondius, A, A 1919; Steen, J H, A 3409; Swart van
 Groningen, J, NM 8184; Netherlands school 2d half 16th
 century, A 3460; Northern Netherlands school ca 1570,
 A 1599; Southern Netherlands school 16th century?, A 4186
Anna, prophetess: Rembrandt, A 3066; South German school
 ca 1525, A 849
annunciation: Lorenzo di Niccolò, A 4007; Murillo, B E, A 282;
 Tintoretto, J, A 3986 & A 3987; Velde, A van de, A 2688;
 Venusti, M, A 3443; Master of the Carrand Triptych, A 4022;
 Master of Delft, A 3141; Master of the Salem Altar, A 2547;
 Northern Netherlands school ca 1530, A 2592; Gelderland
 school ca 1435, A 1491; Utrecht school ca 1435, A 2649;
 Utrecht school ca 1460, A 1408
—to the shepherds: Bout, P, A 2223; Hondius, A, A 1918;
 Saftleven, C, A 801; Uytewael, J A, A 1843; Wijntrack, D,
 A 2304
Balthasar: Nijmegen school ca 1483, A 2546
Caspar: Nijmegen school ca 1483, A 2546
circumcision: Cornelisz Kunst, C, A 1725; Master of Alkmaar,
 A 1308; Northern Netherlands school ca 1570, A 1599;
 Gelderland school ca 1435, A 1491; Utrecht school ca 1435,
 A 2649
flight into Egypt, rest on the: Bloemaert, A, A 1990; Brueghel I, J,
 A 69; Pynacker, A, A 321; Tiepolo, G B, A 3434; Vianen II,
 P van, A 1557
holy family: Coecke van Aelst, P, A 3464; Cortona, P da, C 1345;
 Costa, L, A 3034; Garofalo, B T da, C 309; Martens, W,
 A 1742; Palma il Vecchio, J, A 594; Rembrandt, A 4119;
 Veronese, P, A 3444; Werff, A van der, A 468
—with St Catherine: Bourdon, S, A 53; Polidoro da Lanciano,
 C 308
—with the infant John the Baptist: Bartolomeo, Fra, A 3376
—with Mary Magdalene: Dyck, A van, A 597
holy kinship: Geertgen tot Sint Jans, A 500; Vellert, D, A 849
innocents, massacre of the: Cornelisz van Haarlem, C, A 128;
 Magnasco, A, C 1360; Mazzolino, L, C 1363
Melchior: Nijmegen school ca 1483, A 2546
presentation in the temple: Aertsen, P, A 1909; Gelderland
 school ca 1435, A 1491
temple, Jesus disputing with the doctors in the: Master of
 Alkmaar, A 1307; Utrecht school ca 1435, A 2649
visitation: Tibaldi, P, A 3955; Master of the Spes Nostra, A 2312;
 Utrecht school ca 1435, A 2649

THE PUBLIC LIFE OF CHRIST

baptism of Christ: Scorel, J van, A 1636 & A 4284; Master of the
 Carrand Triptych, A 4022; Lombard school 1st half 16th
 century, A 2801
blessing the children, Christ: Monticelli, A, A 1893; Voorhout, J,
 NM 1010; Wet I, J W de, A 1530; Southern Netherlands school
 ca 1570, C 1579
centurion, Christ and the: Camerarius, A, A 733
disciples, Christ and his: Daumier, H, A 1869

Mary

Saints and sibyls

education: Bol, F, A 46; Bolomey, B, A 965; Dou, G & Laquy, WJ, A 2320
events, historical
—tyranny of the duke of Alva: Northern Netherlands school ca 1625, C 1551
—Amsterdam chamber of the Dutch East India Company: Verkolje, N, A 4290
—Dutch politics about 1620: Venne, AP van de, A 434
—Dutch victory over the Spanish fleet at Gibraltar: Willaerts, A, A 4116
—Peace of Münster: Nieulandt, A van, A 1995
—Treaty of Rijswijk: Voorhout, J, A 2371
—William III's leavetaking from Amalia van Solms after transferring the regency to the states-general: Thulden, Th van, A 4654
falsehood: Southern Netherlands school ca 1580, A 4465
fame: Lairesse, G, A 4178
female figure, allegorical: Southern Netherlands school 2d half 17th century, A 4021
fisherman, impotent: Southern Netherlands school ca 1580, A 4467
fishery: Eversdijck, W, A 3829
fishing for souls: Venne, AP van de, A 447
Fortitudo: Lairesse, G, C 382
Fortuna distributing her largesse: Northern Netherlands school ca 1630, A 1752
freedom: Terwesten, M, A 4086
gold, lust for: Couture, T, A 1866
history: MIN Phaff, L, 649
justice: Jordaens, J, A 2367; Lairesse, G, C 382
kingship, satire on: Wyckersloot, J van, A 748
love, free: Vianey, P, C 1542
—, power of: Turchi, A, C 1372
marriage trap: Noorderwiel, H, C 1550
memento mori: Master of the Spes Nostra, A 2312; Netherlands school? 3d quarter 16th century, A 3914 & A 3915
months of the year: Kamphuijsen, J, A 4142-A 4150
nature: Dou, G & Laquy, WJ, A 2320
navigation: Wit, J de, A 4291; Holland school ca 1680, A 2716
passion, choice between virtue and: Veronese, P, A 3445
peace: Lievens, J, A 612; Terwesten II, A, A 2404
—putting out the torch of war: Netherlands school 4th quarter 17th century, A 2629
—urging the churches to be tolerant: Netherlands school 1st quarter 17th century, A 4152
persons
—Alva: Northern Netherlands school ca 1625, C 1551
—Amalia van Solms: Thulden, Th van, A 4654
—Charles I of England: Northern Netherlands school ca 1650, A 3881
—Charles V: Francken II, F, A 112
—Cromwell, Oliver: Northern Netherlands school ca 1650, A 3882
—Frederik Hendrik: Flinck, G, A 869; Potter, PS, A 3473; Venne, AP van de, C 1343
—Oldenbarneveldt: Saftleven, C, A 1588
—Ptolemy: Wit, J de, C 401
—Willem I, king of the Netherlands: Northern Netherlands school 1792, A 4194
—Willem II, king of the Netherlands: Cuijlenburgh, C van, A 1216
—Willem V of Orange: Pieneman, JW, A 4268
—William III of Orange, king of England: Thulden, Th van, A 4654
—William the Silent of Orange: English school ca 1585, A 2684
—Witt, Cornelis de: Baen, J de, A 4648; Bisschop, C, A 1432
—Witt, Johan de: Asselijn, J, A 4
Pictura: Bolomey, B, A 965; Wit, J de, RBK 16558
poet crowned by two apes at the feast of the animals, satire: Savery, R, A 366
political satire: Saftleven, C, A 1588; Venne, AP van de, A 434; English school ca 1585, A 2684
practice: Dou, G & Laquy, WJ, A 2320
protection: Lairesse, G, C 382
Religio favoring Abondantia: Lairesse, G, C 382
riches: Lairesse, G, A 4174
satirical allegories: Saftleven, C, A 1588; Savery, R, A 366; Venne, AP van de, A 434; Wyckersloot, J van, A 748; English school ca 1585, A 2684; German school? 1st half 17th century, A 4097
seasons, the four: Blarenberghe, LN van, A 4249; Bloemaert H, A 674; Goyen, J van, A 3945 & A 3946; Os, GJJ van, A 1105 & A 1104; Venne, AP van de, A 1771-A 1774; Wit, J de, A 3231-A 3233, A 3872, RBK 1958-81 & A 4659
science, commerce and: Southern Netherlands school 2d quarter 17th century, A 3027
—propelled by time: Terwesten II, A, A 2403
sciences, the: Lairesse, G, A 4177
senses, the: Schalcken, G, A 368 & A 369; Vois, A de, A 456
state and church, abuses of by the authorities of: Mostaert, G, A 972
time: Wonder, PC, A 1163
—, science propelled by: Terwesten II, A, A 2403
times of the day: Lairesse, G, A 4259; Schall, JF, A 3260 & A 3261; Schuer Th C van der, A 4281

transitoriness: Mieris I, F van, A 263; Serodine, G, A 332; Master of the Spes Nostra, A 2312; see also Vanitas
Vanitas: Brisé, C, A 1281; Claesz, P, A 3930; Claeu, J de, A 1444; Collier, E, A 3471; Ketel, C, A 4046; Peschier, NL, A 1686; Potter, PS, C 204; Rembrandt, A 4090; Schaak, B, A 844; Schoor, A van der, A 1342; Stevers, A 2358; Vucht, G van, A 2205; Werff, A van der, A 2347; Holland school 1633, A 2258; see also transitoriness
vices: Heck, NJ van der, A 2373
victory: Venne, AP van de, C 1343
virtue: Lairesse, G, C 437
—and passion, choice between: Veronese, P, A 3445
—: see also under mythology and legend: Diana
war, peace putting out the torch of: Netherlands school 4th quarter 17th century, A 2629

Social life

alderman's chamber: AQU Bosboom, J, A 3640
Algérienne: Corot, JBC, A 2883
art
—architect: see under professions and trades
—art collection: Lelie, A de, A 4100 & A 4122
—art lover: Michaud, H, A 1743
—draftsman: see under professions and trades
—drawing lesson: Borch, J ter, A 1331; Strij, A van, A 396; Werff, P van der, A 472
—gold- and silversmith: see under professions and trades
—painter: see under professions and trades
—painter, becoming a: Eycken, JB van, A 1035
—studies from the model: Alberti, JE Ch, A 651 & A 652; Mol, W, A 648
—see also under craft and industry: painter's studio; see also under painter's anecdotes
bookshop: Jelgerhuis, J, A 662; Ouwater, I, A 4026
building activities: Breitner, GH, A 3526, A 3518 & A 3550; Fabritius, B, A 1304; Schiller, GFF, A 3567; Ulft, J van der, A 1916; Bruges school ca 1570, A 2851
capstan: Troyon, C, A 1900
caravan: Bauer, MAJ, A 3571
coach: Keun, H, A 3228; Meyer, H de, A 251; Ruysdael, SJ van, A 352 & A 713; Stoop, D, NM 9487; Venne, A van de, A 1771 & A 1772; Wildens, J, A 616; Zwart, W de, A 2957
collision: Coene, CF, A 1020
costume, village: West, JH van, C 269; see also COST
craft and industry
—cannon foundry: Everdingen, A van, A 1510
—cooperage: Cuyp, A, A 1457
—distillery, apothecary's: Jelgerhuis, J, A 2713 & A 2714
—forge: Smits, G, A 2156
—iron factory: PAST Josselin de Jong, P de, A 3673
—laboratory: Jelgerhuis, J, A 2713 & A 2714; Wijck, Th, A 489;
—painter's studio: Bakhuysen, L, A 1465; Houbraken, A, C 153; Mauve, A, A 2436; Musscher, M van, A 4135; Ostade, A van, A 298; Schouman, A, A 4157; Sweerts, M, A 1957; Vollenhove, H van, A 889; see also under painter's anecdotes
—sugar factory: Hesselaar, Th, C 1519 & C 1520
—watermill: Arends, LH, A 3844; Everdingen, A van, A 691 & A 107; Hobbema, M, A 156 & C 144; Japy, LA, A 1879; Peeters, G, A 834; Ruisdael, JI van, C 213
—whale-oil factory: Man, C de, A 2355
—see also windmill
dance: Alma Tadema-Epps, L Th, A 2652; Berchem, N, A 2505; Bourgoin, AGA, A 1736; Duyster, WC, C 415; Meulener, P, A 803; Ostade, A van, A 2568; Teniers II, D, C 298 & A 3226; Venne, AP van de, C 609; Verwilt, F, A 3500; Vinckboons, D, A 2109; Werff, A van der, A 467; Holland school 18th or 19th century, C 278; VANM A 4081 & A 2009; PAST Israels, IL, A 2911
—, egg: Aertsen, P, A 3
dancing cat: Steen, JH, A 718
—dog: Verwilt, F, A 3500
deathbed: Bloemaert, H, A 735; Israels, J, A 1179; Jamin, DF, A 2286; Venne, AP van de, A 446; AQU Israels, J, A 2613
dervish: VANM A 2030, A 4081 & A 1999
dinner party: Caullery, L de, A 1956 & A 4292; Elyas, I, A 1754; Hals, D, A 1796; Schey, Ph, A 4279; Velde, E van de, A 1765; Vinckboons, D, A 2109; Winghe, J van, A 473
dollhouse: Appel, J, A 4245
drunkenness: Steen, JH, C 232
education
—conferring of a degree: Burgh, H van der, A 2720
—inauguration of the university: Bree, MI van, A 4088
—going to school: VANM A 2005
—school: Dou, G, A 87; Dou, G & Laquy, J, A 2320; Haanen, GG, C 134; Schendel, B van, C 174; Staveren, JA van, A 382; Versteegh, M, A 1565
—see also under art: drawing lesson; see also music lesson
explosion: Poel, E van der, A 309
feast
—carnival: Bosch, H, A 1673
—Shrove Tuesday: Venne, AP van de, A 1931
—St Martin's Day: Balten, P, A 860

—St Nicholas: Brakenburg, R, A 54; Steen, JH, A 385; Holland school 18th or 19th century, A 592
—Twelfth Night: Netherlands school 2d half 17th century, C 428
ferry: Berchem, N, A 31; Ruysdael, SJ van, A 3983; Velde, E van de, A 1293
fire: Colonia, A de, A 1518; Guardi, F & G, A 3402
fool: Hals, F, A 134; Meegeren, HA van, A 4242
funeral: Bauer, MAJ, A 2876; Burgers, HJ, A 1805; Northern Netherlands school? ca 1820, A 4481
garden: Keun, H, A 3831; Troost, C, A 2576; see also park; vegetable garden
gypsy: Arentsz, A, A 4033; Bombled, KF, A 1735
hay wagon: Zwart, W de, A 3364
horse: see under nature: fauna
horseback riding: see under occupation and recreation
horse fair: Schermer, CAJ, A 1829; Venne, AP van de, A 676
horse racing: see under occupation and recreation
horse's harness: AQU Mauve, A, A 3697
hunt: Arentsz, A, A 1447 & A 1448; Beeldemaker, AC, A 750 & A 2676; Danckerts de Rij, P, A 1593; Eeckhout, G van den, C 130; Falens, C van, A 2679; Hackaert, J, A 130; Lelie, A de, A 1355; Lingelbach, J, C 172; Metsu, G, C 177; Picolet, C, A 1712; Rochussen, Ch, A 1760; Rocquette, J de la, A 1299; Stoop, D, A 395 & A 1714; Velde, A van de, C 249; Voordecker, H, A 1157; Wouwerman, P, A 487
—bear hunt: Coninck, D de, A 73; Peeters, B, A 2518; Potter, P, A 316
—duck shooting: Coninck, D de, A 617; Croos, A van, RBK 15234
—falconer: Bisschop, Ch, A 1801; Coninck, D de, A 618; Falens, C van, A 2679; Vlieger, S de, A 1981; Vries, R van, A 459
—fox hunt: Jongh, L de, A 1858
—heron hunting: Arentsz, A, A 1969; Hondecoeter, GC d', A 1502; Wouwerman, Ph, A 481
—implements of the hunt: Coninck, D de, A 617; Ferguson, WG, A 2154; Hondecoeter, M d', A 170, A 171, A 694 & A 3312; Leemans, J, C 523 & A 1946; Oever, H ten, A 2370; Os, GJJ van, A 1104
—stag hunting: Coninck, D de, A 72; Hondius, A, A 2677; Wouwerman, Ph, A 480; MIN French school ca 1725, A 4417
—wild boar hunt: Momper, D, A 3848; Savery, R, C 447
Indian prince: MIN French school? 18th century, A 2809
Jew: Burgers, HJ, A 1805; Haan, MI de, A 1987; Israels, J, A 2598
keelhauling: Verschuier, L, A 449
kermis: Balten, P, A 860 & A 2554; Bloot, PP de, A 1468; Breitner, GH, A 3554; Teniers II, D, A 198; Venne, AP van de, A 1767; PAST Israels, IL, A 3668
kitchen: Aertsen, P, A 3 & A 2398; Bakker Korff, AH, A 3070; Bueckelaer, J, A 1451 & A 2251; Horstok, JP van, A 643; Hove, H van, A 3083; Laquy, WJ, A 1624; Lelie, A de, A 1075 & A 2294; Loarte, A de, A 2962; Meulemans, A, A 1174; Odekerken, W van, A 3334; Olis, J, A 296; Rijck, PC van, A 868; Stroebel, JAB, A 1831; Versteegh, M, C 256
lighthouse: Gudin, JA Th, A 2832; Mesdag, HW, A 3301; Vettewinkel, H, A 1475
linen chest: Hooch, P de, C 1191
lottery agency: Ouwater, I, A 4026
marine pageant: Alewijn, A, A 1726
market: Bueckelaer, J, A 1496; Jonghe, JB, A 1056; Schendel, P van, C 297; Vogels, W, A 3091; Vrancx, S, C 510; Westerwoudt, JBAM, A 2282; PAST Cate, SJ ten, A 2284; AQU Arntzenius, PFNJ, A 3724
—fish market: Dusart, C, A 98; Jelgerhuis, J, A 1053; Nieulandt, A van, A 1788; Ostade, A van, A 3246; Regemorter, IJ van, A 1122; Sorgh, HM, C 247; Witte, E de, A 2536
—vegetable market: Beest, S van, A 1732
—see also under professions and trades: merchants and vendors
marsh: Mauve, A, A 2523
melancholy: Israels, J, A 2606
military
—armorer: Metsu, G, A 2156
—army camp: Lingelbach, J, A 225; Wouwerman, Ph, A 484 & C 272; Holland school mid-17th century, C 426
—artillery: Breitner, GH, A 2880, A 1328 & A 3537
—battle: Eyck, N van, A 619; Snayers, P, A 1545
—billeting: Breitner, GH, A 3582; Stoop, M, A 2573
—camp follower: Govaerts, AC, A 1036
—cavalry: Breitner, GH, A 3583, A 2968, A 2881, A 3539 & A 2538; Cuyp, A, A 4118; Troost, C, A 4023; AQU Breitner, GH, A 3657
—cavalry attack: Asselijn, J, A 5; Calraet, A van, A 79; Croos, AJ van, RBK 15234; Dietterlin, B, A 2844; Hoef, A van, A 1753; Huchtenburg, J van, A 184; Martszen II, J, A 2153; Muller, J, A 1445; Northern Netherlands school ca 1645, C 427
—Cossack outpost: Moerenhout, JJ, A 1081; Moritz, L, A 1370; Os, PG van, C 531
—fight: Vinckboons, D, A 1351 & A 1352
—fortress: Dubus, M, A 1539
—guardroom: Jansen, F, A 1842; Kate, HFC ten, A 1057; Palamedesz, A, A 3024; Teniers II, D, A 398
—gunpowder magazine: Behr, CJ & Craeyvanger, G, A 1006

Coopmans, Sophia: Honthorst, G van, A 1480
Coornhert, Dirck Volkertsz: Cornelisz van Haarlem, C, A 127
Cornelisz, Jacob: Conflans, A van, C 791
Cornelisz van Oostsanen, Jacob: Cornelisz van Oostsanen, J, A 1405
Cort-Heyligers, Gijsbertus Martinus: Kieft, J, A 2356
Cortenaer, Egbert Meeuwsz: Eversdijck, W, A 3829; Helst, B van der, A 145
Coster, Leonard: Quinkhard, J M, C 82
Couché, Jean le: Eliasz, N, C 361
Coulster, Joost van: R O T A 4495
Court, Pieter de la: Tempel, A L van den, A 2243
Courten, Guilliam: Southern Netherlands school 1575, A 904
—, Margarita: Mesdach, S, A 2073
—, Pieter: Northern Netherlands school 1630, A 2074; H E R A 928
—, Willem: Mesdach, S, A 913
—: see also Boudaen Courten
Couwenhove, Cornelis van: R O T A 4510
Covens, C: Lelie, A de, C 537
Coventry, Mary Gunning, duchess of: P A S T Liotard, J-E, A 240
Craen van Haeften, Cornelia: Ysselstein, A van, A 3929
Cramprich van Cronefelt, Johannes: Ruys, S, A 2131
Cras, Hendrik Constantijn: Lelie, A de, A 539
Crayesteyn, Huyg Jansz: Voort, C van der, C 748
Crommelin, Suzanna Maria: Hodges, Ch H, A 4028
Cromwell, Oliver: Northern Netherlands school ca 1650, A 3882
Cronefelt: see Cramprich van Cronefelt
Croock, Joris: Dujardin, K, C 4
Croon, Jacob: Valckert, W J van den, C 397
—, Pieter: Valckert, W J van den, C 397
Crul, Willem: Heinsius, J E, A 76
Cruijs, Arnout van de: Anraedt, P van, C 440
Cruysbergen, Claes van: Rembrandt, C 5
Cruywagen, Claas Hendricksz: Loo, J van, A 81
—, Cornelis Hendricksz: Loo, J van, A 81
—, Hendrick Jansz: Loo, J van, A 81
—, Jacob Hendricksz: Loo, J van, A 81
—, Jan Hendricksz: Loo, J van, A 81
—, Pieter Hendricksz: Loo, J van, A 81
—, Rijckert Hendricksz: Loo, J van, A 81
Cuypers, Petrus Josephus Hubertus: A Q U Veth, J P, A 3725
Cyprianus, Allardus: Maes, N, C 90

Daendels, Herman Willem: Lelie, A de, A 2231; G O V A 3790
Daiwaille, Jean Augustin: P A S T Daiwaille, J A, A 1618
Dale, Allard de la: Zeeuw, C de, A 1537
Dalen, Steven van: Netherlands school ca 1580, A 922
—, Willem van: Eliasz, N, C 361
Dalens, Anna: P A S T Troost, C, A 3745
Dalens I I I, Dirk: P A S T Troost, C, A 3745
Dalens, Jacobus: P A S T Troost, C, A 3745
—, Willem: P A S T Troost, C, A 3745
Dammans, David: Pietersz, G, C 592
Dammasz, Matelief: Heemskerck, M van, A 1910
Dane, Jacob: R O T A 4514
Daniels, Daniël Arbmann: Lelie, A de, C 588
Darnley, Henry Stewart Lord: M I N English school ca 1565, A 4393
Deans, Effie: Whistler, J A M, A 1902
Decker, Jeremias de: P A N A 1504
Dedel, Anna Maria: Spinny, G de, A 1271
—, Clara Magdalena: Liotard, J-E, C 43; P A S T Liotard, J-E, C 31
Demmeltraadt, Clemens van: Moritz, L, C 466
—, Hendrik van: Daiwaille, J A, A 1952
Denijs, Aeltje: Maes, N, A 703
—, Philip: Voskuyl, H P, A 2368
Desmond, Countess: M I N Monogrammist W P, A 4377
Deutz, Jeronimus: Sweerts, M, A 3855
Deyman, A J: Lelie, A de, C 537
—, Joan: Rembrandt, C 85
Diederichs, Bertha: M I N Grebner, W, A 2173
—, Georg Albrecht: M I N Northern Netherlands school ca 1810, A 2175
—, George Frederik: M I N Grebner, W, A 2174
—, Michiel: P A S T Mertens, J C, A 2168
—, Pieter Arnold: Schwartze, J G, A 2170; M I N Grebner, W, A 2173
—, Willem George Albrecht: M I N Grebner, W, A 2173
Diemen, Antonio van: G O V A 3762 & A 4532
—, Jacob van: Helst, B van der, C 2
—, Sara Wolphaerts van: Hals, F, A 1247
Dirck Claesgens, Styntgen: Southern Netherlands school 1561, A 4488
Dircksz, Pieter, called Langebaard: Pietersz, A, C 525
Dishoeck, Pieter van: H E R NG 109
Dix, Arnoldus: Boonen, A, C 444
Doavenne, Johannes: Flinck, G, C 1

Does, Anna van der: Hennekyn, P, A 2185
—, Frank van der: Dubordieu, P, A 2182
—, Willem van der: Barendsz, D, C 379
Does II, Johan van der: P A N A 4558
Doeyenburg, Willem van: Rembrandt, C 6
Dohrman, Marianne: Lelie, A de, A 4100
Dommer, Hendrick Jansz: Helst, B van der, C 375
Dommer Wz, Hendrick: Helst, B van der, C 2
Dommering, J: M I N Jackson II, J, A 4330
Donders, Franciscus Cornelis: Hubrecht, A A L, A 2508
Dortmont, Bonaventura van: Backer, A, C 360; Ochtervelt, J, C 390
Dou, Gerard: Dou, G, A 86
Doublet, Jan: Ravesteyn, J A van, A 1950
—, P: Lelie, A de, C 537
Douglas, Margaret: M I N Hilliard, N, A 4323
Driellst, Egbert van: Ekels II, J, A 1846
Drinkveld, Wolfert Hendrik: Boonen, A, C 368
Drogenhorst, Johannes van: Boonen, A, C 444
Drolenvaux, Maria: Gelder, A de, A 4034
Dronckelaer, Pelgrom van: Voort, C van der, C 399
Drost, Cornelia: Pothoven, H, C 1475
Dubbelde, Geertruida den: Helst, B van der, A 141
Du Bois, Adriaan: R O T A 4524
Du Bois, Chrétien: Lelie, A de, C 538
Du Bois, Hugo: R O T A 4523
Du Bus de Gisignies, Léonard Pierre Joseph: G O V A 3797
Dudley, Robert, earl of Leicester: H O N A 505
Dujardin, Karel: Dujardin, K, A 190
Dulac, Catharina: P A S T Mijn, G van der, A 2375
Dull-Dohrman: see Dohrman, Marianne
Dupeyrou Jansz, Jacobus: Quinkhard, J M, C 1469
Dupré, Daniël: Lelie, A de, C 538 & C 537
Duquesnoy, François: M I N Oliver, P, A 4353
Durven, Diederik van: G O V A 3775; A 4544
Dusseau, J L: Schwartze, Th, A 2788
Dussen, Cornelis Aerentsz van der: Scorel, J van, A 1532
Duvenvoorde, Lysbeth van: Northern Netherlands school ca 1430, C 1454
Duyfhuys, Huybert: Sorgh, H M, A 1682
Duyfken, Jan: Eliasz, N, C 361
Duymaer van Twist, Albertus Jacob: G O V A 3803
Duyn van Maasdam, Adam François Jules Armand Count van der: Hulst, J B van der, A 1495; Pieneman, J W, A 1558
Duynen, Elisabeth van: Bol, F, C 367
—, Sieuwert van: Backer, A, C 360
Dyck, Anthony van: Wappers, E Ch G, A 1159; M I N Richter, C, A 4365

Eberhard of Württemberg: Keyser, N de, C 290
Edward I V of England: H E R A 4641
Edward V I of England: M I N Bettes, J, A 4297
Edzard I of East Friesland: Cornelisz van Oostsanen, J, A 976
Eeghen, Jacob van: Otterbeek, J H, C 1571
Eekhout, Hermanus Martinus: Loeff, H D, A 2791
Eenhoorn, Adriaen Jorisz: Helst, B van der, C 375
—, Jan Jorisz: Helst, B van der, C 375
Eerens, Dominique Jacques de: G O V A 3800
Eertvelt, Andries van: Dyck, A van, A 847
Egmond, Floris van: Gossaert van Mabuse, J, A 217
—, Jan van: Northern Netherlands school ca 1510, A 1547
—, Jan Gerritsz van: Cornelisz van Oostzanen, J, A 3838
Eichelberg, Nicolaes: Berckheyde, J, A 1790
Ekels II, Jan: Lelie, A de, C 538
Elbertszen, Korsgen: Cornelisz van Oostsanen, J, C 1125
Elizabeth I of England: English school 2d half 16th century, C 1466; English school ca 1585, A 2684; School of Fontainebleau 3d quarter 16th century, A 320; M I N Hilliard, N, A 4321
Elizabeth Stuart of Bohemia: Hillegaert, P van, A 452; Venne, A P van de, A 1775 & A 958; M I N Cooper, A, A 4304
Elley, John: Pieneman, J W, A 1115
Elliot, Gilbert: G O V A 3792
—, Katherine: Riley, J, A 3303
Elout, C Th: G O V A 3793
Elst, Hans van der: Backer, J A, C 1174
Emma van Waldeck-Pyrmont: Veth, J P, A 3837
Engelberts, Engelbert Matthias: Lelie, A de, C 539
Engelberts, Willem Jodocus Mattheus: Engelberts, W J M, A 4074
Engelen, Johanna Henriette: Dubois Drahonet, A J, A 4154
—, Klaas: Barendsz, D, C 454
—, Reijnier: Rembrandt, C 5 & C 1453
Engelman, Johannes: Sangster, H A, A 1678
Engelman-Bia: see Bia, Maria Francisca
Ensse, lord of: Northern Netherlands school ca 1570, A 1599
Erasmus, Desiderius: Massys, Q, A 166
Erckenhout, Cornelis: Loeninga, A van, A 3459
Ernst Casimir of Nassau-Dietz: see Nassau-Dietz, Ernst Casimir of
Essen, Hendrick van: Saftleven, C, A 1588
Eugene of Savoy: Schuppen, J van, A 373
Eversdijck, Cornelis Fransz: Eversdijck, W, A 992
—, Maria: Eversdijck, W, A 994
Evertsen I, Cornelis: Maes, N, A 1662

—, Johan: Eversdijck, W, A 3829
Evertsen II, Cornelis: Eversdijck, W, A 3829
Ewart, Sergeant: Pieneman, J W, A 1115
Ewijck, Willem van: Northern Netherlands school ca 1680, A 1628
Eijl Sluyter, Hendrick van: Lelie, A de, C 538
Eynde, Jacob van den: P A N A 4561

Fabus, Jan: Borch, M ter, A 2118
Fagel, Caspar: Vollevens I, J, A 283
Falck, Anton Reinhard Baron: M I N Rochard, S J, C 1459
Farjon, Johannes Ludovicus: Lelie, A de, C 588
Faure, Boudewijn Versewel: H E R NG 113
Fauvarcq, J G N: Lelie, A de, C 539
—, Johannes Gerardus: Lelie, A de, C 539
Fay, Jacob Frederik du: Boonen, A, C 445
—, Michiel du: Boonen, A, C 368
Feitama II, Jacob: Holland school ca 1730, A 3219; H E R A 3221
Fernely, Anne: Mor van Dashorst, A, A 3119
Fitzroy-Somerset, Lord: Pieneman, J W, A 1115
Flinck, Govert: Flinck, G, C 1
Flines, Hendrik de: Lelie, A de, C 537
Florisz, Pieter: Eversdijck, W, A 3829; Liedts, A, A 854
Fock, Dirk: G O V A 3817
Fock, Hermanus: Lelie, A de, C 538; M I N Fock, H, A 2120
Foix, Gaston de: French school 16th century, A 504
Fontein, Dieuwke: Kruseman, J A, A 3020; Portman, Chr J L, C 203
Foreest, Anthony: Pietersz, A, C 70
Fortenbeeck, Adolf: Keyser, Th de, C 381
Fouquet Jr, Pieter: Lelie, A de, C 538 & A 4100
Fourmenois, Geldorp, G, A 2071; H E R A 929
—, Catharina: Geldorp, G, A 2070; Mesdach, S, A 2069
—, Jean: Geldorp, G, A 912
Fourment, Helena: Rubens, P P, C 295
Francis I of Austria: M I N German school ca 1810, A 4389
Francis I of France: Titian, A 475
Franck, Christoffel Frederik: Franck, Chr F, A 2155
Franck, Johannes Baptista: Dyck, A van, C 284
Franken Dzn, Daniël: Martens, W, C 1544
Fransen van de Putte, Isaac Dignus: Bonnat, L J F, A 2246
Fraser, Catharina Annette: Kruseman, J A, A 1570
—, Christian Edouard: Hodges, Ch H, A 1569
—, Johan: Hodges, Ch H, A 1567
Frederick I of Prussia: M I N Blesendorff, S, A 4298
Frederick II the Great of Prussia: M I N German school ca 1760, A 4384; M I N German school ca 1770, A 4386
Frederick V of Bohemia: Delen, D van, A 3936-A 3942; Hillegaert, P van, A 452; Miereveld, M J van, A 675; Venne, A P van de, A 958 & A 445; M I N Oliver, P, A 4349 & A 4352; M I N Northern Netherlands school? ca 1635, A 278
Frederick Louis, prince of Wales: M I N English school ca 1725, A 4397; M I N English school ca 1750-51, A 4402
Frederik, prince of the Netherlands: Portman, Chr J L, C 203
Frederik of Orange-Nassau: see Orange-Nassau, Willem George Frederik of
Frederik Hendrik: see Orange, Frederik Hendrik of
Fremantle, John William: Pieneman, J W, A 1115
Friedrich Christian of Poland: Boy, G, A 971
Friedrich Wilhelm of Brandenburg: Honthorst, G van, A 873; Willeboirts, Th, C 400
Fuyck, Hendrik Jorisz: Helst, B van der, C 375

Gabbema, Simon Abbes: P A N A 4601
Gabriël, Paul Joseph Constantin: P A S T Schwartze, Th, A 3054
—, *Paulus Joseph*: Mol, W, A 2121
Gael, Dirckje Tymansdr, called van der Graft: Pietersz, P, A 3865
Gaesbeek, Elisabeth van: Northern Netherlands school ca 1660, A 806
Gand: see Vilain de Gand, François
Gansneb, Catharina, called Tengnagel: P A S T Vilsteren, J van, C 51
—, Matthijs, called Tengnagel: Boonen, A, C 444; P A N A 4580
Garbransz, Claes: Conflans, A van, C 791
Geel, Joost van: Geel, J van, A 115; P A N A 4604
Geelvinck, Agatha: Santvoort, D D, A 1318
—, Cornelis Jansz: Voort, C van der, C 1108
—, Eva: Sandrart, J von, C 27
—, Jan Cornelisz: Jonson van Ceulen I, C, C 1179
Geer, Johanna de: Bol, F, A 45
—, Margaretha de: Cuyp, J G, A 611
Geest, Wybrand Symonsz de: Geest, W S de, A 1780
Gekeer, Jonas Jonasz: Spilberg II, J, C 395
Gelder, Anna van: Jacobson, J, A 2696
—, Jan van: Lievens, J A, A 1661
—, Jan Pauwelsz van: Jacobson, J, A 2696
Gelre, Anna Digna van: H E R A 937
Genestet, Petrus Augustus de: Pieneman, N, A 3466
George III of England: M I N English school ca 1770, A 4399; M I N English school ca 1800, A 4403
Gerritsz, Cornelis: Tengnagel, J, C 407
—, Lubbert: Miereveld, M J van, A 762
Gerritzen, Adam: Backer, J A, C 1174

ANONYMOUS ARTISTS, COLLECTORS AND ART DEALERS

collectors: Pieneman, J W, A 4137
painters: Bakhuysen, L, A 1465; Hendriks, W, A 1989; Werff, A van der, A 1715; Italian school 2d half 17th century, A 4020; North Italian school 18th century, A 3386; Northern Netherlands school ca 1655, A 1638; Northern Netherlands school ca 1830, A 2798; MIN Northern Netherlands school ca 1615, A 4424
sculptors: Northern Netherlands school? ca 1850, A 4193
silversmiths: Northern Netherlands school ca 1680, A 3895

GROUP PORTRAITS OF CIVIC GUARD COMPANIES

All the portraits of this type in the Rijksmuseum are of Amsterdam civic guard companies

Handboogdoelen (archers' civic guard)
—1585: Barendsz, D, C 454
—1595: Conflans, A van, C 791
—1604: Pietersz, G, C 592
—1613: Tengnagel, J, C 407
—1623: Voort, C van der, C 408
—1650: Spilberg II, J, C 395
—1653: Helst, B van der, C 3
Kloveniersdoelen (arquebusiers' civic guard)
—1529: Jacobsz, D, C 402
—1531: Anthonisz, C, C 409
—1534: Claesz, A, C 366
—1556: Jacobsz, D, C 621
—1557: Jacobsz, D, C 424
—1563: Jacobsz, D, C 377
—1566: Barendsz, D, C 365
—1584: Ketel, C, C 425
—1588: Barendsz, D, C 379
—1596: Isaacsz, P, C 410
—1599: Pietersz, A, C 391
—1600: Pietersz, P, C 404
—1606: Amsterdam school 1606, C 387
—1612/14: Voort, C van der, C 748
—1616: Moreelse, P, C 623
—1632: Keyser, Th de, C 381
—1638: Sandrart, J von, C 393
—1639: Helst, B van der, C 375; Eliasz, N, C 403
—1642: Backer, J A, C 1174; Eliasz, N, C 1177; Flinck, G, C 370; Rembrandt, C 5
—1645: Flinck, G, C 371
Voetboogdoelen (crossbowmen's civic guard)
—1533: Anthonisz, C, C 1173
—1554: Jacobsz, D, C 1178
—1559: Jacobsz, D, C 376
—1562: Barendsz, D, C 364
—1588: Ketel, C, C 378
—1599: Isaacsz, P, C 455
—1620: Lyon, J, C 384
—1623: Lastman, CP, C 406
—1625: Valckert, W J van den, C 397
—1630: Eliasz, N, C 383
—1632: Eliasz, N, C 386
—1633: Keyser, Th de, C 380
—1637: Hals, F and Codde, P, C 374
—1645: Eliasz, N, C 361
—1648: Flinck, G, C 1; Helst, B van der, C 2
—1656: Helst, B van der, C 624

GROUP PORTRAITS OF GUILD OFFICERS

The Rijksmuseum has never had on loan all the group portraits of guild officers and other governing bodies belonging to the city of Amsterdam. For a complete publication of these paintings, see B Haak, Regenten en regentessen, overlieden en chirurgijns: Amsterdamse groepsportretten van 1600 tot 1835, Amsterdam 1972, pp 50-52

Amsterdam
—, Collegium Medicum
—1683: Backer, A, C 360
—1724: Troost, C, A 1635 & C 396

van, A 2205; Wiertz, HF, A 2202; Wolff, B, A 2192 & A 2193;
Northern Netherlands school 1630, A 2196; MIN Northern
Netherlands school ca 1640, A 2207; MIN Northern Netherlands
school ca 1710, A 2208; MIN Northern Netherlands school ca
1745, A 2209 & A 2210
Broedelet, AJ: Poggenbeek, GJH, A 2708
Broers, HJ: see sale Utrecht, 8-15 March 1873
Brondgeest, A: Bol, F, A 42
Brunner, C: Vois, A de, A 2512
Bruijn-van der Leeuw, Mr & Mrs I de: Borch, G ter, A 4038 &
A 4039; Brouwer, A, A 4040 & A 4041; Cappelle, J van de,
A 4042 & A 4043; Goyen, J van, A 4044; Isenbrant, A, A 4045;
Ketel, C, A 4046; Maes, N, A 4047; Massys, Q, A 4048;
Ostade, A van, A 4049; Rembrandt, A 4050 & A 4057; Rubens
PP, A 4051; Steen, JH, A 4052; Velde I, W van de, A 3117;
Vries, A de, A 4053; Witte, E de, A 4054 & A 4055; Northern
Netherlands school ca 1530, A 4056
Bruyn Kops, HA de: Decker, F, C 1478
—, JL de: Haensbergen, J van, A 1440; Quinkhard, JM, A 1436;
Troost, C, A 1439; Verheyden, M, A 1437 & A 1438;
Netherlands school ca 1615, A 1441
Bruyn Zegers, FL de: Doncker, HM, A 1689 & A 1690
Büchli-Fest, SC: Poggenbeek, GJH, A 2708
Büchner-Berns, SM: Hodges, ChH, A 4028
Buckley, W: Velde, P van de, A 3271
Burger, WS: Bree, MI van, A 3136
Burgh, AHH van der: Vrel, J, A 1592; see also sale Amsterdam
21 Sep 1904
Burrough Hill, W: Drooghsloot, JC, A 1930

C...: see sale Amsterdam, 13-14 March 1888
Calcutta, bishop of: see Institutions: Chinsura, India
Calkoen, C: VANM; see also Institutions: The Hague, Koninklijk
Kabinet van Zeldzaamheden
Campen, J van: Campen, J van, A 4254
Carp, AJ: Daiwaille, JA, A 1952; Moritz, L, A 1953
Casembroot-van de Poll, Dowager ATJ: Heemskerck van Beest,
JE van, A 2725 & A 2726
Caso, J de: Sande Bakhuyzen, H van de, A 4163
Cate, HE ten: Northern Netherlands school ca 1655, A 4018
Cateau van Rosevelt, JFA: Lovera, A 2252
Chabot, JJM: Gelder, A de, A 3969; Rembrandt, A 3981
Chijs, J van der: see sale Amsterdam, 10-12 Dec 1889
Clark, HM: Potuyl, H, A 2790
Clavé-Bouhaben: see sale Cologne, 4-5 June 1894
Clercq, G de: Bol, F, A 1937; Duck, J, A 1940; Fonteyn, AL,
A 1941; Goyen, J van, A 1943; Heda, WC, C 610; Heeremans,
Th, A 1944; Isaacsz, P, A 1720; Laer, P van, A 1945; Laroon,
M, A 1977; Leemans, J, A 1946; Molijn, P de, A 1942; Neer,
A van der, A 1948; Nouts, M, A 1847; Peeters, B, A 1949;
Pynacker, A, A 1976; Saftleven, C, A 1588; Savery II, J,
A 1980; Slingeland, PC van, A 1983; Steen, JH, A 1932;
Toorenvliet, J, A 1978; Velde I, W van de, A 1589; Vlieger, S
de, A 1981 & A 1982; Netherlands school ca 1665, A 1979;
Northern Netherlands school ca 1705, A 1947; see also sale
Amsterdam, 1 June 1897
—, P de: Hals, F, C 556 & C 557; HER NM 9313
—, S de: Clercq, J de, C 1561
Clifford, Jonkvrouwe ACAJ: MIN Gauthier, PJ, A 4031; MIN
Hari I, J, A 4030; MIN German school ca 1700, A 4032; PAST
Hodges, ChH, A 4029
Cock Blomhoff-van de Poll: see sale Amersfoort, 23-24 July 1907
Coclers, LB: see sale Amsterdam, 19ff April 1819
Cocq, F le: Vinckboons, D, A 1782
Cohen, G: Arentsz, A, A 2625
Cohen Gosschalk-Bonger, J: see AQU Introduction
Cohen Stuart, M: Gelder, N van, A 1536
Collot d'Escury, HMC Baroness: May, JW, A 2423 & A 2424
—, Th Baron: Israels, IL, C 983
Colmette, Mr: Saenredam, PJ, A 858
Constant Rebecque-van Zuylen van Nyevelt, Dowager
FSCLMG de: Eeckhout, JJ, A 4058 & A 4059; MIN
Rochard, SJ, C 1459
Constantini, E: Barendsz, D, A 2164
Copes van Hasselt, CJG: see sale Amsterdam, 20 April 1880
Cordeil, Mr: Velde, E van de, A 802
Coster, Mr: Poorter, W de, A 757
Coster, J: Erichsen, V, A 1929
Court, de la: see sale Amsterdam, 21 Sep 1904
Cr..., V v d: see sale Amsterdam, 1 Nov 1887
Cremer, JH: see sales Amsterdam, 15ff June 1886, 26 Oct 1886
& 21 June 1887
—, Th Th: see sale Rotterdam, 16-17 April 1816
Crespi: see sale Paris, 4 June 1914
Croes van Hasselt: see sale Haarlem, 20 April 1880
Croiset, A: see sale Amsterdam, 10 Dec 1902
Crommelin, CLH: Maes, N, A 3508
Cunaeus-Cnopius, M: Cunaeus, C, A 2228
Cuijlenburg, C van: Cuijlenburg, C van, A 1374; Heinsius,
JE, A 76

Dam van Brakel-Ditmars van IJsselvere: see sale Amsterdam,
29 Oct 1895
Davis, AH: Blieck, D de, A 1604
De Ceva: Meyer, JHL, A 1079
Deckers, AThVA: Bout, P, A 2223 & A 2224
Dedel, Jonkheer C: Musscher, M van, C 528
Deiters, H: Bray, J de, A 2353
Dekker-Sartorius, S: Dekker, HAC, A 2181
Delbooy, Mr: Borssum, A van, A 744
Derby, earl of: Koninck, Ph, A 4133
Derkinderen-Besier, JH: Derkinderen, AJ, A 3470; Scorel, J van,
A 3468; Aragonese school last quarter 15th century, A 3469
Desbons, JP: Baen, J de, A 4162
Desmons, WMJ: Haanen, AJ, A 1471 & A 1472
Deterding, Sir Henry WA: Avercamp, H, A 3247; Cappelle, J
van de, A 3248; Goyen, J van, A 3249 & A 3250; Guardi, F,
A 3251 & A 3252; Heyden, J van der, A 3253; Maes, N,
A 3254; Neer, A van der, A 3245 & A 3256; Ostade, A van,
A 3246; Pater, JB, A 3257; Ruysdael, SJ van, A 3258 &
A 3259; Schall, JF, A 3260 & A 3261; Vermeer, J, A 2860;
Master of the Female Halflengths, A 3255
Deutmann, Mrs FWM: Deutmann, FWM, A 2822
Dibbets-Kaas, AJS: Northern Netherlands school ca 1645,
C 1225
Diederichs-Portman, VEL: Schwartze, JG, A 2170; Northern
Netherlands school ca 1830, A 2171 & A 2172; MIN Grebner,
W, A 2173 & A 2174; MIN Northern Netherlands school ca
1775, A 2177 & A 2178; MIN Northern Netherlands school ca
1810, A 2175 & A 2176; PAST Mertens, JC, A 2168 & A 2169
Dierenbach, HJ: Grebber, PF de, A 2311
Dirix van Aubel, L: Braunschweig Monogrammist, A 1603
Domela Nieuwenhuis-Meijer, MA: Burgh, H van der, C 1182;
Mij, H van der, C 1526; Mijn, F van der, C 1527; Velde, E
van de, C 1533
Donati-Martini: see sale Amsterdam, 8 Nov 1898
Douwes, EJM: Potter, PS, A 3473
Dribbel, SE: Beerstraaten, JA, A 4134
Driessen-Hooreman, P: Hals, D, A 1796
Drost-Nanning, JM: Wit, J de, C 1577
Drucker-Fraser, Mr & Mrs JCJ: Alma Tadema, L, A 2427;
Bauer, N, A 3570-A 3575; Bisschop, Ch, A 3060 & A 3726;
Bock, ThEA de, A 2493-A 2495, A 3576 & A 3577; Bosboom,
J, A 3578; Breitner, GH, A 3061, A 3579-A 3585; Dijsselhof,
GW, A 3586-A 3588; Gabriël, PJC, A 3589 & A 3590; Israels,
IL, A 3591-A 3597; Israels, J, A 2496, A 2597-A 2599, A 2600-
A 2607, A 2615, A 2616, A 3598, A 3599, A 3730-A 3732,
A 4180 & A 4198; Leen, W van, A 4111; Maarel, M van der,
A 3734; Maris, JH, A 2455-A 2473, A 2491 & A 3600; Maris,
M, A 3727; Maris, W, A 2428, A 2429 & A 2525; Mauve, A,
A 2430-A 2436, A 2523, A 2524, A 3601 & A 3602; Mesdag,
HW, A 2474; Neuhuys, JA, A 2437; Poggenbeek, GJH,
A 3603-A 3605 & A 4106; Prud'hon, PP, A 3097; Roelofs, W,
A 3606-A 3608; Sande, E, A 3723; Stevens, A, A 3609; Swan,
JM, A 2490, A 3610-A 3614; Tholen, WB, A 3615; Toorop,
JTh, A 3616; Weissenbruch, HJ, A 2438, A 2439, A 3617-
A 3619; Wiggers, D, A 3722; MIN Nilson, JE, A 4107; MIN
English school ca 1790, A 4108; MIN English school ca 1810,
A 4109; MIN French school ca 1805, A 4110; PAST Israels, IL,
A 3664, A 3665, A 3667 & A 3668; PAST Josselin de Jong, P
de, A 3672 & A 3673; PAST Muhrman, H, A 3702; AQU
Arntzenius, PFNJ, A 3724; AQU Bakker Korff, AH, A 3620-
A 3622; AQU Bastert, SN, A 3623; AQU Bauer, MAJ, A 3624-
A 3631; AQU Bisschop, Ch, A 3632; AQU Bock, ThEA de,
A 3633-A 3636; AQU Bosboom, J, A 3637-A 3656; AQU
Breitner, GH, A 3657-A 3659; AQU Daumier, H, A 3660; AQU
Gabriël, PJC, A 3661; AQU Gogh, VW van, A 3662; AQU
Israels, IL, A 3663, A 3666, A 3669, A 3670 & A 3728; AQU
Israels, J, A 2608-A 2614, A 2617-A 2619, A 3729 & A 3733;
AQU Jongkind, JB, A 3671; AQU Maris, JH, A 2475-A 2481;
AQU Maris, M, A 3687; AQU Maris, W, A 3688-
A 3694; AQU Mauve, A, A 2440-A 2452, A 2492, A 3695-
A 3700; AQU Mesdag, HW, A 3701; AQU Neuhuys, JA,
A 2482 & A 3703; AQU Poggenbeek, GJH, A 2483-A 2489 &
A 3704; AQU Rochussen, Ch, A 3705; AQU Swan, JM, A 3706-
A 3713; AQU Toorop, JTh, A 3714; AQU Troyon, C, A 3715;
AQU Veth, JP, A 3716, A 3717 & A 3725; AQU Voerman I,
J, A 3735 & A 3736; AQU Weissenbruch, HJ, A 2453, A 2454,
A 3718-A 3720 & A 4036; AQU Witsen, WA, A 3721
Drucker-de Koning, HL: Maris, JH, A 2810; Monnickendam,
M, C 1105
Du Bois, HC: see sale Amsterdam, 27-28 Nov 1906
Dubourcq-Rochussen, AJ: Dubourcq, PL, A 1029
Dunlop, GCB: Haan, MI de, A 1987
Duport, JE: see sale Amsterdam, 4-8 Feb 1890
Dupper Wzn, L: Asselijn, J, A 5; Bakhuysen, L, A 11 & A 12;
Berckheyde, GA, A 35; Bergen, D van den, A 37; Borch, G ter,
A 402 & A 403; Both, J, A 49; Brakenburg, R, A 54; Brassauw,
M, A 57; Brekelenkam, QG, A 62; Cuyp, A, A 77; Does, S
van der, A 85; Dou, G, A 86; Dujardin, K, A 192; Dusart, C,
A 99; Everdingen, A van, A 107; Goyen, J van, A 121 &
A 123; Hackaert, J, A 131; Haagen, J van der, A 33; Hals, F,
A 134; Heusch, W de, A 149-A 151; Hobbema, M, A 156;
Hoogstraten, S van, A 158; Kessel, J van, A 200; Koninck,

Ph, A 206; Lingelbach, J, A 225 & A 226; Looten, J, A 48;
Maes, N, A 246; Mieris I, F van, A 263; Mignon, A, A 268 &
A 269; Ossenbeck, W, A 297; Ostade, A van, A 300 & A 301;
Pynacker, A, A 279, A 322 & A 323; Romeyn, W, A 341;
Ruisdael, JI van, A 349-A 351; Ruysdael, SJ van, A 352;
Sorgh, HM, A 494 & A 495; Staveren, JA van, A 382; Steen,
JH, A 384, A 392 & A 393; Stoop, D, A 395; Thielen, JPh
van, A 407; Velde, A van de, A 444; Velde II, W van de,
A 436; Vois, A de, A 458; Werff, A van der, A 469;
Wouwerman, P, A 487; Wouwerman, Ph, A 484; Wijck, Th,
A 489; Wijnants, J, A 491; Holland school 18th or 19th
century, A 592
Duyn van Maasdam, FM Baron van der: Hulst, JB van der,
A 1495
Duynen, WA van: PAST Cuijlenburg, C van, A 2622 & A 2623
Duyvensz, F: Bruyn I, B, A 4228
Duyvensz-Nagel, J: Bruyn I, B, A 4228

Ebeling, AM: see sale Amsterdam, 18-21 August 1817
Eckhardt, family: PAST Schmidt, I, A 2151
—, CH: see sale Amsterdam, 10-11 Nov 1896
Eeghen, P van: Hals, F, C 556 & C 557; HER NM 9313
Eik Jz, J van: Amsterdam school ca 1875, C 1576
Elffers, D: Chabot, H, C 1566
Elias, Jonkheer HA: Jacobson, J, A 2696
Embden, J van: see sale Amsterdam, 10-11 Nov 1896
Emerson Dowson, J: Nieulandt, J van, A 1788
Engelberts, WJM: see sale Amsterdam, 28 April 1875
Engelbrecht, PA: Perronneau, J-B, A 3476
Engelbronner, d': see sale Amsterdam, 17-18 April 1894
Engelenberg, CHA van: see sale Amsterdam, 29 March 1892
Enschedé, AJ: Boonen, A, C 1567 & C 1568; Hogers, J, A 1498;
Merck, JF van der, A 853; Holland school 18th century,
A 890 & A 891
Esser, JFS: see AQU Introduction
Everett, Mr: Delen, D van, A 3936-A 3942
Exter, WAPEL van: PAST Northern Netherlands school ca
1890, A 4640
Eyk, I van: see sale Amsterdam, 29ff Oct 1821

Fabius, J: Lubienietzki, Ch, A 1550 & A 1551
Fages, EP: see sale Amsterdam, 7-12 August 1899
Farncombe Sanders, AJW: Netscher, Casp, A 1692 & A 1693
—, J: Farncombe Sanders, J, A 951; Hals, F, A 950
Feltz, van der: Metsu, G, A 672
Festetits, Count Andor de: see sale Amsterdam, 22 Jan 1884
Fiorentini, Mr: La Tour, G de, A 3568
Fontein, JG: Kruseman, JA, A 3020
Fouquet Jr, P: see sale Amsterdam, 13-14 March 1801
Frank, S: Apostool, C, A 681
Franken Dzn, D: Allebé, A, A 1729-A 1731; Beest, S van, A 1732;
Berckheyde, GA, A 1733; Bilders, JW, A 1734; Bombled, KF,
A 1735; Bourgoin, AGA, A 1736; Eliasz, I, A 1754; Gallis, P,
A 1737; Heeremans, Th, A 1739; Hilverdink, EA, C 1538;
Hoef, A van, A 1753; Hondecoeter, GCd', A 1740;
Lelienbergh, C, A 1741; Martens, W, A 1742; Michaud, H,
A 1743-A 1745; Moor, C de, A 1746; Mouilleron, A, A 1748-
A 1750; Nellius, M, A 1751; Poel, E van der, A 1755;
Poelenburgh, C van, A 1747; Quast, PJ, A 1756; Rochussen,
Ch, A 1757-A 1760; Saftleven, H, A 1761 & A 1762;
Sandrart, J von, A 4278; Steen, JH, A 1763; Velde, E van de,
A 1764 & A 1765; Velde, JJ van de, A 1766; Venne, AP van
de, A 1767-A 1776; Vlieger, S de, A 1777; Northern
Netherlands school ca 1630, A 1752; PAN A 1738, A 4616 &
A 4623; MIN Northern Netherlands school ca 1645, A 4425
Fransen van de Putte, JH: Bonnat, LJF, A 2246
Fremery, F de: Waay, N van der, A 3144
Frenkner, Mr: Gelder, A de, A 2359 & A 2360
Freyer, A: Mieris, J van, A 2122
Furstner: see sale Amsterdam, 30 June-2 July 1909

G...: see sale Amsterdam, 13-14 March 1888
GA...: see sale Munich, 12 May 1910
Gabriel, PJC: Mol, W, A 2121; PAST Schwartze, Th, A 3054
Galen, MM van: see sale Amsterdam, 30-31 Oct 1888
Gaudouin, E: Ovens, J, A 1680
Gelder, JF de: Aertsen, P, A 2398
—, Mr van: Coter, C de, A 856
—, MJ van: Mommers, H, A 1687; Peschier, NL, A 1686
George, Mr: Francken II, F, A 112; Goyen, J van, A 122
Geus van den Heuvel, B de: Duplessis, JS, A 3278; Mengs, AR,
A 3277; French school ca 1750, A 3279
Gevers, Mr: Strij, J van, A 1140-A1142
Gevers Arnz, A: see sale Rotterdam, 24 July 1827
Gevers van Marquette-Deutz van Lennep, Dowager PA: Ketel,
C, A 3121 & A 3122
Gildemeester, H: Northern Netherlands school ca 1570, A 1599
—, PA: Maes, N, A 3106; Maris, W, A 3107; Catalan
school last quarter 15th century, A 3105
Gildemeester Jzn, J: Asselijn, J, A 4
Glen, J: Breen, A van, A 2510
Gluysteen-van Ommeren, FA: Keun, H, A 2247
Gockinga, Jonkheer W: see sale Amsterdam, 14 August 1883

Josselin de Jong, P de: *see* Chinsura, India
Jurrjens, C: Rust, J A, A 4275

Kaathoven, C W H van: *see* sale Leiden, 19 June 1879
Kaiser, R A: Szyndler, P, A 2850
Kallenberg van den Bosch-van Lelyveld, R J A: Vollevens II, J, A 1630
Karnebeek-Rochussen, Dowager P van: Otterbeek, J H, C 1571
Karsen, H Th: Karsen, K, A 2233
—, J E: Karsen, K, A 3129 & A 3243
Karsten, H T: Quinkhard, J M, A 1354
Kate, H F C ten: Neuman, J H, A 2215 & A 2216; *see also* sale Amsterdam, 15-16 May 1889
Kaijser, F: *see* sale Amsterdam, 4-5 Dec 1888
Kellen, D van der: Noorderwiel, H, C 1550; Vollenhoven, H van, A 889; MIN Lundens, G, A 4337 & A 4338
Kellen, J van der: *see* sale Amsterdam, 31 March-2 April 1896 & 10-11 Nov 1896
—, J Ph van der: Post, F, A 4272 & A 4273; Winter, A H, A 1917
Kemper, Jonkvrouwe E: Humbert de Superville, D P G, A 656
Kempers, H A G E: MIN Northern Netherlands school ca 1710, A 4429
Kerkhoff, D: *see* sale Amsterdam, 29ff Oct 1821
Kesler Pmz, J: Meulemans, A, A 1174
Kesnar, M: Vries, M de, A 1507
Kessler-Hülsmann, Mr & Mrs D A J: Assendelft, C A van, A 3488; Avercamp, B, A 3286; Bellini, G, A 3287; Berg, W H van den, A 3288; Breitner, G H, A 3289; Bronzino, A, A 3344; Brouwer, A, A 3291; Brueghel I, J, A 3290; Cleve, J van, A 3292 & A 3293; Corneille de Lyon, A 3294; Courbet, G, A 3295; Cuyp, B G, A 3297; Dijck, Abr van, A 3300; Eeckhout, G van den, A 3489; Fromentin, E, A 3304; Gogh, V W van, A 3307; Goyen, J van, A 3308; Guardi, F, A 3309; Helfferich, F W, A 3490; Heyden, J van der, A 3491; Hoffmann, S, A 3333; Hondecoeter, M d', A 3312; Israels, J, A 3313; Jongkind, J B, A 3317; Kabel, A van der, A 3318; Kever, J S H, A 3319; Keyser, Th de, A 3493; Konijnenburg, W A van, A 3320; Mankes, J, A 3321; Maris, J H, A 2273 & A 3322; Mauve, A, A 3323; Melozzo da Forli, A 3315; Mieris I, F van, A 3327; Neer, A van, A 3328-A 3330 & A 3496; Netscher, Casp, A 3331; Odekerken, W van, A 3334; Palamedesz, A, A 3335; Patenir, J, A 3336; Pluym, K van der, A 3337; Pot, H G, A 3301; Potter, P S, A 3338; Potuyl, H, A 3339; Rembrandt, A 3298, A 3340 & A 3341; Riley, J, A 3303; Ruisdael, J I van, A 3343 & A 3498; Schaik, W H van, A 3345; Segantini, G, A 3346; Steen, J H, A 3347; Taupel, F, A 3499; Toorop, J Th, A 3349; Velde II, W van de, A 3350; Verelst, P H, A 3351; Verspronck, J C, A 3352; Verwilt, F, A 3500; Weissenbruch, H J, A 3355; Welie, J van, A 3356-A 3359; Wolbers, H G, A 3501; Zandleven, J A, A 3502; Zwart, W H P J de, A 3361-A 3368, A 3503-A 3507; Master of Alkmaar, A 3324; Master of the Braunschweig Diptych, A 3305 & A 3306; Master of Delft, A 3325; Master of the Legend of St Ursula, A 3326; Upper Rhenish school ca 1450, A 3310 & A 3311; Florentine school mid-15th century, A 3302; Neapolitan school mid-17th century, A 3342; Northern Netherlands school ca 1610, A 3497; Northern Netherlands school ca 1635, A 3316; Northern Netherlands school 1655, A 3354; Holland school 1637, A 3299; Holland school 2d quarter 17th century, A 3492; Holland school late 17th century?, A 3296; Southern Netherlands school? 17th century, A 3353; *see also* AQU Introduction
Kinderen, der: *see* Derkinderen
Klein, H L: Stortenbeker, P, A 2628
Kleyn-von Artner, J E F E de: Northern Netherlands school? late 17th century, A 4121
Klijn, H H: Pieneman, J W, A 655
Kneppelhout van Sterkenburg, R C: La Fargue, P C, A 3834
Kneppelhout van Sterkenburg-Drabbe, S E: Cornet, J L, A 1464
Knoote, F E: Troost, W, A 4024 & A 4025
Knuttel Wzn, G: MIN Visser, A de, A 3058
Koch, A S J: Moeyaert, N, A 270
Kock, F L W Baron de: Pieneman, N, A 1701; Winterhalter, F X, A 1702
—, E Baroness de: Meyer, J H L, A 2239
—, F L M Baron de: Pieneman, N, A 2238
Koenen, D A: Roos, J M, A 1625; Northern Netherlands school 1578, C 1560
Kolff van Hoogeveen, Mr van der: Marseus van Schrieck, O, A 975; Schooten, J van, A 974
Kolk, H B van der: Czermak, J, A 2718
Koning, P M J: Schouman, A, A 4157
Kooi, H van der: Dyck, A van, A 208-A 210; Kooi, W B van der, A 1063-A 1065
Korthals Altes-van Hengel, C H M: Breitner, G H, A 2968; Sierich, F C, A 2969
Koster, P: Artz, D A C, A 3067
Koudachef: *see* sale Amsterdam, 27 April 1909
Kraay-Eekhout, J J A: Loeff, H D, A 2791 & A 2792; PAST Northern Netherlands school ca 1805, A 2793
Krafft, H: Brascassat, J R, A 1326
Kramer, C: Eelkema, E J, A 3454

—, E S: Overbeek, L, A 4266 & A 4267
—, J A: Krafft, D von, A 982
—, J J: Overbeek, L, A 4266 & A 4267
—, L: Eelkema, E J, A 3454
Krook van Harpen-de Burlett, J J M: Daiwaille, J A, C 530
Kroon, G H: Collier, E, A 3471
Kurz, G: Weenix, J B, A 3879
Kuyper, J de: Bisschop, C, A 1432; Spilman, H, A 1583
Kuijpers, J: *see* sale Amsterdam, 10 April 1894

Lacorre, F: Lelie, A de, A 4100
Laisney, J F: Liss, J, A 1403
Lamberts, H: *see* sale Amsterdam, 18 Dec 1879
Lamme, D A: *see* sale Leiden, 19 June 1879
Lampe, Mr: Neer, A van der, A 2128
Lance, A C: Lance, G, A 2826
Langelaan, D F W: Hesselaar, H Th, C 1519-C 1521
Langeveldt, J H: Burgh, H van der, A 2720
Langton Douglas, R: Bacchiacca, A 3104; Velde, A van de, A 2688; Vries, A de, A 2157
Lanz, O: Apollonio di Giovanni, A 3999; Araldi, J, A 3967; Beccaruzzi, F, A 3990; Bonsignori, F, A 3991; Carpaccio, V, A 3993; Carracci, L, A 3992; Crivelli, C, A 3994; Fiore, J del, A 4001; Giorgione, A 3970; Giovanni da Brescia, A 3995; Giovanni da Milano, A 4000; Girolamo da Santa Croce, A 3966; Lorenzo di Niccolò, A 4007; Luca di Tommè, A 4003; Monaco, L, A 3976 & A 4004-A 4006; Niccolò de Liberatore, A 4008; Schiavone, A, A 3374 & A 4009; Tintoretto, J, A 3986, A 3987 & A 4010; Veronese, P, A 4011; Vivarini, B, A 4012 & A 4235; Master of the Bambino Vispo, A 3979 & A 3980; Master of Pietro a Ovile, A 4002; Italian school 15th century, A 3997; Sienese school ca 1450, A 3998; *see also* AQU Introduction
Laue-Drucker, Th: Roelofs, W, A 4114; AQU Weissenbruch, H J, A 4036
Leck de Clercq, J F van der: Palamedesz, A, A 1615 & A 1616
Ledeboer: *see* sale Amsterdam, 13 Dec 1887
Lee, H van der: Northern Netherlands school ca 1380, A 831
Leemans, C: Northern Netherlands school mid-17th century, A 4470
Leembruggen: *see* sale Amsterdam, 13-19 April 1920
Leendertz, H C C: Liotard, J-E, A 2656; Werff, P van der, A 2657 & A 2658
Leeuw, G J van: *see* sale Amsterdam, 14 Nov 1825
Leeuwen Boomkamp, Mr van: Voort, C van der, A 3741 & A 3742
Le Fauconnier, H V G: *see* AQU Introduction
Le Maître, J F M: Pieneman, N, A 2816
Lemker-Muller, F: *see* sale Kampen, 7 July 1908
Lennep, Jonkheer F J E van: Favray, A de, A 4127
—, I F van: Heyden, J van der, C 571; *see also* sale Amsterdam, 25 April 1893
—, P van: Vermeer, J, A 1595; Wouwerman, Ph, A 1610
Leopold Siemens-Ruyter, Mr & Mrs: Troost, C, A 4209
Lepeltak Kieft, H & J: Challe, N, A 2159; Troost, C, A 2158
Lerius, van: *see* sale Antwerp, 19 Feb 1885
Leyden, Baron van: *see* sale Warmond, 31 July 1816
Librecht Lezwijn, P C: Smies, J, C 1536
Limbeek, J J van: *see* sale Amsterdam, 12ff May 1834
Limborch van der Meersch-Spoelstra, A B: Limborch, H van, A 1607
Limburg Stirum, M D Count van: Mesdag, H W, A 1553 & A 1554; Netscher, Casp, A 1552
Linden, E C van der: *see* Bonger, A
—, H B van der: Rossum, J C van, A 2874
Linden van Slingelandt, J van der: *see* sale Dordrecht, 22 August 1785
Lindsay, E M: Bloemen, P van, A 3478
Lintz, F E: *see* sale Amsterdam, 27 April 1909
Liotard, Mrs: Loth, J H, A 71
—, M A: MIN Liotard, J-E, A 239; PAST Liotard, J-E, A 228-A 238, A 240-A 243, A 1196 & A 1197
Lodewijk Napoleon: *see* Louis Napoleon
Loehr, J von: Baburen, D van, A 1606
Lohr, I: Toorop, J Th, A 4226
Lonsain-Rosenveldt, A: Jelgerhuis Rzn, J, A 2389
Louis Napoleon: Hodges, Ch H, A 653
Lowe-Timmer, Mrs: Key, A Th, A 1700; Vrancx, S, A 1699
Lugt, F: Jonxis, J L, A 4092
Luttikhuis, J K: Everdingen, C B van, C 1517; Luttichuys, I, C 1522
Luyckx, J B: Hals, F, A 2859
Lynden, E Baron van: Northern Netherlands school ca 1775, A 1476 & A 1477
—, J C N Count van: Claesz, P, A 4646
—, Reinhard Baron van: Achenbach, O, A 1798; Allebé, A, A 1799; Bisschop, Ch, A 1801; Bisschop-Swift, C S F, A 1802; Bles, D J, A 1803; Bosboom, J, A 1804; Burgers, H J, A 1805; Chattel, F J van Rossum du, A 1806; Duwée, H J, A 1808; Frankenberg en Proschlitz, D O L van, A 1807; Gallard-Lepinay, E, A 1809; Genoels, A, A 1838 & A 1839; Girard, H, A 1810; Hamman, E M F, A 1811; Hanedoes, L, A 1812-A 1818; Hendriks, F H, A 1819; Lairesse, G, A 1840;

Lepoittevin, E M E, A 1823; Meyer, J H L, A 1820 & A 1821; Opzoomer, S, A 1822; Prooyen, A J van, A 1824; Riegen, N, A 1825; Roos, C F, A 1826; Saal, G, A 1827; Schelfhout, A, A 1828; Schermer, C A J, A 1829; Scholten, H J, A 1830; Stroebel, J A B, A 1831; Terlaak, G, A 1832; Tidemand, A, A 1833; Toussaint, P J, A 1834; Weissenbruch, J, A 1835; Westerbeek I, C, A 1836; Northern Netherlands school 3d quarter 19th century, A 1837; Holland school 1597, A 1841
Lynden-van Pallandt, Dowager M C: Bonvin, F, A 1859; Boulard, A, A 1860; Breton, E A, A 1861; Corot, J B C, A 1862; Courbet, G, A 1863-A 1865; Couture, Th, A 1866; Daubigny, Ch F, A 1867 & A 1868; Daumier, H, A 1869; Decamps, A G, A 1870; Delacroix, F V E, A 1871; Diaz de la Peña, V N, A 1872 & A 1873; Dupré, J, A 1874 & A 1875; Dupré, V, A 1876; Hawksley, A, A 1877; Hendriks, S F, A 1878; Japy, L A, A 1879; Jettel, E, A 1880; Jouve, A, A 1881; Maarel, M van der, A 1883; Mancini, A, A 1884; Maris, J H, A 1885 & A 1886; Maris, W, A 1887; Mauve, A, A 1888; Mesdag, H W, A 1891; Mettling, L, A 1889 & A 1890; Monet, C, A 1892; Monticelli, A, A 1893; Nicolas, L, A 1894; Pasini, A, A 1895; Peppercorn, A D, A 1896; Ribot, A Th, A 1897 & A 1898; Rousseau, P E Th, A 1899; Troyon, C, A 1900; Vollon, A, A 1901; Whistler, J A M, A 1902; Ziem, F, A 1903; Northern Netherlands school 2d half 17th century, A 1882
Lynden van Horstwaerde, G J K Baron van: Ovens, J, A 3749 & A 3750; PAST Perronneau, J-B, A 3747 & A 3738; HER A 3751 & A 3752

M…, de: *see* sales Amsterdam, 23 Feb 1904 & 3 April 1906
Maan, M de: Rijck, P C van, A 868
Maas Geesteranus, Mr: Monogrammist I B, A 2253
Macalester Loup: *see* sale The Hague, 20 Aug 1806
MacSon-Maris, L: Maris, J H, A 2500; *see also* AQU Introduction
Mallman, G von: Schooten, J van, A 2374
Mannheimer, F: Crivelli, C, A 3989; Rembrandt, A 3982; MIN French school 2d half 18th century, RBK 17156
Marle, R van: Master with the Parrot, A 3225
Marlof, J H: Vogelaer, P, C 524
Martens, G F A: Scheffer, J B, A 1974
Martens van Sevenhoven, Jonkheer J C: MIN Marinkelle, J, A 4224
Martini Buys, Jonkheer P H A: Miereveld, M J van, A 2665
Marwijk Kooij, B van: Pieneman, J W, A 1558
—, J H van: Hecken II, A van der, A 1305
Mathijssen: *see* sale Amsterdam, 14 Dec 1880
Matthes, J A: Daiwaille, J A, A 1845
May, R: Ekels I, J, A 3475
Meer Jansen, Mr van der: Holland school 1641, A 4483
Menger, I P: Netherlands school? ca 1550, A 4463
Mesdag, H W: Marrel, J, A 772
Messchert van Vollenhoven: *see* sale Amsterdam, 29 March 1892
Messchert van Vollenhoven-van Lennep, M C: Camphuijsen, G D, C 563
Meuleman, C: Northern Netherlands school? 1844, A 4158
Meulen, D G H van der: *see* sale Amsterdam, 3-4 April 1900
Meulen-Trakranen, ter: *see* sale Amsterdam, 30 June-2 July 1909
Meurs, W J G: Maris, M, C 1486
Meijer, J E: Moritz, L, A 1324
Meyer Warnars, G: Hodges, Ch H, A 661; Jelgerhuis Rzn, J, A 662; Pothoven, H, A 663
Meylink, F B: Zeeuw, C de, A 1537
Michielsen, L P J: Neuman, J H, A 3242
Middendorf II, J W: Cornelisz van Oostsanen, J, C 1554; Rembrandt, C 1555
Miethke, H O: Master of the Figdor Deposition, A 1688
Mock, H G T: *see* sale Amsterdam, 4 Dec 1912
Molkenboer, J H: Bree, M I van, A 1540; Lelie, A de, A 1541
—, W B J: Dalen, C van, A 5675
Moll Sr, Evert: *see* sale Amsterdam, 15-16 Dec 1908
Moll, J C C D W de: *see* sale Amsterdam, 28 April 1875
Molman, H C van: Massys, Q, A 166; Meyer, H de, A 252
Molsbergen, H J: Verboeckhoven, E J, A 1149
Momma, H H: Northern Netherlands school ca 1750, C 1572 & C 1573
Moons: *see* sale Antwerp, 19 Feb 1885
Muller, G: *see* sale Amsterdam, 2-3 April 1827
Mumm, W: Uppink, H, A 3056; Uppink, W, A 3055 & A 3057
Munnikhuizen, F: Helst, B van der, A 140 & A 141; Jongh, L de, A 196 & A 197
Mijer, K H: Neuman, J H, A 4159 & A 4160
Myrtil-Schleisinger: *see* sale Amsterdam, 6 May 1913

Nagel, Mr: Lelie, A de, A 2231
Nahuys, P C Baron: *see* sale Amsterdam, 14-15 Nov 1883
Nanninga Uiterdijk, J: *see* sale Amsterdam, 10 Dec 1902
Nardus, L: Dielaert, Ch van, A 2366
Neervoort van de Poll, J R H: Druyf, D, A 2786; Josselin de Jong, P de, A 2785; *see also* AQU Introduction
Negele, F: Rembrandt, A 2391
Nerée van Babberich, J P R M de: Mast, H van der, C 616 & C 617
Nesselrode, Ch R de: *see* sale Amsterdam, 27 April 1909
Netscher-Cornets de Groot van Kraayenburg, J A H: Netscher, Casp, A 2666-A 2669

Neufville Brants, J I de: *see sale Amsterdam, 23 March 1829*
Nicholson, L: Rombouts, S, A 2529
Nienhuis, H S: Wit, J de, RBK 16558
Nienhuys, J W: Lenain, M, A 3099
Nierop, J E van: French school ca 1720, C 1324; Northern
 Netherlands school ca 1815, C 1323
Nijenburgh: *see* Institutions: Heiloo
Nijland, A J: *see sale Amsterdam, 14 April 1911*
Nyland, Mrs D: Alma Tadema, L, A 4173
Nijland, J Hidde: *see* AQU Introduction

Oberndorff-de Stuers, M I E V Countess von: Roemerswaele, M
 van, A 3123; Schiavone, G, A 3124
Obreen, C N C: *see sale Amsterdam, 4 Dec 1912*
Obreen-Pabst, A M G S: Schwartze, Th, A 2724
Ocke, B: *see sale Leiden, 21-22 April 1817*
Odinot, Eug: Post, F, A 4271
Omphal, Jonkvrouwe C L M van: Bloeme, H A de, A 1173
Oosterzee-de Hartog, H G van: Oosterzee, H A van, A 3239
Oostveen, A van: Sam, E, A 2694
Otterbeek Bastiaans, H G van: *see sale Amsterdam, 31 Jan 1882*
Outshoorn, C van: Calisch, M, A 1515 & A 1516
Overgauw-Beetz, P: *see sale Amsterdam, 24-25 April 1900*

Pabst van Bingerden, Jonkheer J M: Dumesnil, L M, C 512
Pallandt-Fraser, Dowager C A: Hodges, Ch H, A 1567-A 1569;
 Kruseman, J A, A 1570; PAST Northern Netherlands school
 ca 1790, A 1571
Pallandt van Eerde, R Th Baron van: Beeldemaker, A C, A 2676;
 Beerstraaten, J A, A 2678; Falens, C van, A 2679; Hondecoeter,
 M d', A 2683; Hondius, A, A 2677; Houbraken, A, A 2680;
 Huchtenburg, J van, A 2675; Keun, H, A 2681; Wijntrack,
 D, A 2682; English school ca 1585, A 2684
Palte, W: Cornelisz van Haarlem, C, A 3016
Panhuys, Jonkheer H W F van: *see sale Amsterdam, 26 Sep 1882*
—, Jonkheer W L B van: Gheyn II, J de, A 4255
Pannemaeckers, C E: *see sale Amsterdam, 19-20 April 1887*
Pannwitz, C von: Mostaert, J, A 3901
Pauli, A: Porcellis, J, A 3111
Pauw van Wieldrecht, M R Ridder: Moreelse, P, C 1440
Pellecorn, H L van: Schwartze, Th, A 2788
Peltzer: *see sale Amsterdam, 28 May 1918*
Penninck Hoofd, A M: *see sale Amsterdam, 19ff April 1819*
Perk, M A: Neuman, J H, A 2807
Perrot-Hatwan, A E de: Bastert, S N, A 2413
Pesters, Jonkvrouwe E J C: *see* Verloren van Themaat
Peter, Mr: HER NM 5339-5344
Peters, O A: Moreelse, P, A 3455
Petitpierre, H M: Kruseman, J A, A 1499
Pfeiffers, J W: Zenner, G, A 1569
Pfungst, H J: Diest, J van, A 2503; Woutersz, J, A 2426
Philips, A: Keyser, Th de, A 4236
Piek, W F: Lairesse, G, A 4259
Pieneman, N: Pieneman, N, A 1116
Pinto, A de: Northern Netherlands school 1604, A 956
Pirch, G von: Hijsing, H, A 2377
Ploos van Amstel, Jonkheer J: Buijs, J, C 515; Duyster, W C,
 C 514; Os, P G van, C 531; Schendel, P van, A 1336
—, Jonkheer J A G: Buijs, J, C 515
Pluckx, J A A: MIN Pluckx, J A A, A 4362
Poll, Jonkheer J S H van de: Beerstraaten, A, A 679; Berchem, N,
 A 680; Berckheyde, G A, A 681 & A 682; Bol, F, A 683,
 A 684 & A 714; Brekelenkam, Q G, A 685; Dou, G, A 686;
 Dubbels, H J, A 687; Dusart, C, A 688; Dyck, A van, A 725;
 Ekels, I, J, A 689; Ekels II, J, A 690; Eliasz, N, A 698, A 699
 & A 705; Everdingen, A van, A 691; Hackaert, J, A 692;
 Hemert, J van, A 693; Hondecoeter, M d', A 694 & A 695;
 Kessel, J van, A 696; Keyser, Th de, A 697; Lawrence, Th,
 A 728; Lingelbach, J, A 700; Maes, N, A 701-A 703; Maratti,
 C, A 727; Maschhaupt, J H, A 677 & A 678; Mieris I, F van,
 A 704; Morel, J E, A 706; Netscher, Casp, A 707; Noordt,
 J van, A 708-A 710; Potter, P, A 711; Romeyn, W, A 712;
 Ruysdael, S J van, A 713; Saftleven, C, A 714; Saftleven, H,
 A 716; Snyers, P, A 726; Sorgh, H M, A 717; Steen, J H,
 A 718; Troost, C, A 719; Ulft, J van der, A 720; Velde II, W
 van de, A 722 & A 723; Verkolje, J, A 721; Holland school ca
 1660, A 724
—, J S R van de: Boonen, A, A 1263 & A 1266; Cornelisz van
 Haarlem, C, A 1241; Eliasz, N, A 1245; Fournier, J, A 1272 &
 A 1273; Hals, F, A 1246 & A 1247; Helst, B van der, A 1255;
 Hue, L d', A 1256; Maes, N, A 1259; Miereveld, M J van,
 A 1250 & A 1251; Mijn, F van der, A 1274; Netscher, Casp,
 A 1264 & A 1265; Ovens, J, A 1257; Pietersz, A, A 1244;
 Pothoven, H, A 1268; Quinkhard, J M, A 1269 & A 1270;
 Spilberg II, J, A 1258 & A 1262; Spinny, G de, A 1271;
 Tischbein, J F A, A 1275; Vaillant, W, A 1254; Verspronck,
 J C, A 1253; Voort, C van der, A 1242, A 1243 & A 1249;
 Werff, A van der, A 1267; Northern Netherlands school 1644,
 A 1252; Northern Netherlands school 1665, A 1260 &
 A 1261; Holland school ca 1640, A 1248; HER A 1276-A 1278
Pot (van Groeneveld), G van der: *see sale Rotterdam, 6ff June*
 1808
Pot, J E van der: Scheffer, J B, A 4151

Potter, A J: Wijsmuller, J H, A 1963
Poupe Serrane, F: Peeters, B, A 2518
Praetorius, G: *see sale Amsterdam, 13-19 April 1920*
Putman, A C: *see sale Amsterdam, 17 Aug 1803*
Pijl, P G W van der: *see sale Amsterdam, 31 March 1903*

Quarles van Ufford: *see sale Amsterdam, 24-25 March 1885*
Quint, H: Monogrammist Johann G M, A 4460

Raedt van Oldenbarnevelt, H I A: *see sales Amsterdam, 6-9 Nov*
 1900 & 15-16 April 1902
Rainer, V de: Dughet, G, C 1351; Giordano, L, C 1353; Mazo,
 J B M del, C 1362; Mazzolino, L, C 1363; Venetian school 1st
 quarter 16th century, C 1354
Ramaer-Drognat Landré, W M H: Allebé, A, A 3266 & A 3267
Rambonnet, N S: Diest, J van, A 2804; Northern Netherlands
 school ca 1725, A 2803
Randwijk, W J van: Bosboom, J, A 2700; Diaz de la Peña, V N,
 A 2701; Maris, J H, A 2702 & A 2703; Maris, M, A 2704 &
 A 2705; Maris, W, A 2706; Millet, J F, A 2707; Poggenbeek,
 G J H, A 2708; Rousseau, P E Th, A 2709; Weissenbruch, H J,
 A 2710; *see also* AQU Introduction
Ras, Ch P H: Troost, C, A 4209
—, G H G: Troost, C, A 4209
Rasch, H: Rembrandt, A 3276
Rasponi, Count F: *see sale Amsterdam, 30-31 Oct 1883*
Rassenfosse, A: Rassenfosse, A, A 3282-A 3285
Rath, J W Edwin von: Fra Bartolommeo, A 3376; Bassano, L,
 A 3377; Beccafumi, D, A 3378; Bellini, G, A 3379; Bordone,
 P, A 3380; Botticelli, A, A 3381; Botticini, F, A 3382;
 Bramantino, A 3383; Canaletto, A 3384 & A 3385; Carpaccio,
 V, A 3387; Ceruti, G, A 3406; Cima da Conegliano, G B,
 A 3389; Crivelli, V, A 3390 & A 3391; Ferrari, D, A 3394 &
 A 3395; Gaddi, A, A 3431; Garofalo, A 3400; Gerini, N di P,
 A 3401; Giovanni da Francia, A 3432; Guardi, F, A 3402;
 Guardi, G, A 3403; Guercino, A 3404; Longhi, P, A 3405;
 Machiavelli, Z, A 3442; Magnasco, A, A 3407 & A 3408;
 Mazzolino, L, A 3409; Montagna, B, A 3448; Morazzone, P F,
 A 3433; Moroni, G, A 3410; Napoletano, F, A 3399; Piazzetta,
 G B, A 3412; Piombo, S del, A 3413; Pordenone, G A, A 3414
 & A 3415; Reni, G, A 3417; Ricci, S, A 3417; Rondinello, N,
 A 3388; Rosselli, C, A 3419 & A 3420; Rotari, P, A 3421 &
 A 3422; Sassoferrato, G B, A 3423; Sellaio, J del, A 3428;
 Signorelli, L, A 3430; Sustris, L, A 3424-A 3427; Tiepolo, G B,
 A 3434, A 3437 & A 3438; Tintoretto, J, A 3439 & A 3440;
 Titian, A 3441; Venusti, M, A 3443; Veronese, P, A 3444 &
 A 3445; Zaganelli, F, A 3446; Zuccarelli, F, A 3447; Zugno, F,
 A 3435 & A 3436; North Italian school 2d quarter 16th
 century, A 3411; North Italian school 18th century, A 3386;
 Ferrarese school 2d half 15th century, A 3416; Florentine
 school 1st half 15th century, A 3396; Florentine school 1486,
 A 3397 & A 3398; Pisan school ca 1250, A 3392 & A 3393;
 Sienese school ca 1450, A 3375; Sienese school 1451-52, A 3429
Ravenzwaay, J van: Wijck, Th, A 488
Rechteren Limpurg, J A Z Count van: HER NG 47
Reede van ter Aa en Aastein, J P C Baron van: *see sale*
 Amsterdam, 16 Dec 1875
Reekers, F J M A: Phlippeau, K F, A 2134
Reenen, J J H J van: Sweerts, M, A 3855
Reenen-van Reenen, A H van: Verspronck, J C, C 1414 & C 1415
Regteren Altena, I Q van: Maarel, M van der, A 3131
Regteren Altena-Pook van Baggen, A van: Regteren Altena, M
 van, A 2620
Rehorst, A J: Ketel, C, A 3462; Pieneman, N, A 3466; Southern
 Netherlands school ca 1570, A 3851
Reinheldt, C: Hanneman, A, A 3889
Reis-Santos, L: Southern Netherlands school 1565, A 4071
Reiss, J: *see sale London, 12 May 1900*
Rendorp, S: Anraedt, P van, A 2416; Borch, G ter, A 2417 &
 A 2418; Numan, H, A 2419; Regters, T, A 2420-A 2422;
 Tischbein, J F A, A 2414 & A 2415
Reneman, F Z: Dijk, Ph van, A 1778; Wassenbergh, J A, A 1779
Révon: *see sale Amsterdam, 27 April 1909*
Rey, J: Bassano, J, A 2127
Reynvaan, C C E: PAST Schmidt, I, A 3238
—, M C C: Wit, J de, A 3231-A 3233
Riemsdijk, van: *see sale Amsterdam, 31 March-2 April 1896*
—, Jonkheer B W F van: Andriessen, J, A 2059; Hendriks, W,
 A 1989; Schouman, A, A 3897; Wever, C, A 1531; MIN
 Hari I, J, A 3102
—, B W F van, friends of: Weijand, J G, A 3101
Rikoff, Th: MIN Graham I, J, A 2689
Rissink, H G B: Poorter, B de, C 1564
Rochussen, Ch: Rochussen, Ch, C 1548
Rodriguez-de Jong, S: Honthorst, G van, A 3270
Röell-Hodshon, Dowager C C: Dyck, A van, C 312
Roelofs, W: PAST Daiwaille, A, A 1618
Roest van Limburg: *see sale Amsterdam, 13 Dec 1887*
Roever, N de: Monogrammist B V D A, A 1721
Rombach, J M D: Kruseman, C, A 657
Romondt, W G F van: *see sale Utrecht, 16-20 Dec 1879*
Rosen, M J: Israels, J, A 2855
Rossum, N van: Lelie, A de, A 2856

Rothschild, E de: Cuyp, A, A 4118
—, N Baron de: Helst, B van der, A 832
Rottiers, General: Champaigne, Ph de, C 1183
Rouffaer, G P: Bellevois, J, A 997; Mauve, A, A 1542
Royaards, family: Bol, F, A 1575-A 1579
Royer, S Th: Teniers II, D, A 3226
Royer-Bicker, W I C: Luttichuys, I, C 1477
Royer-Kerst, C F: *see sale Amsterdam, 14-15 Nov 1883*
Ruelens, E: *see sale Brussels, 17-21 April 1883*
Ruppertshoven van Boll, Mr: Breen, A van, A 955
Ruyter de Wildt, J C de: Berckman, H, A 1643 & A 1644; Dijk,
 Ph van, A 1647-A 1650 & A 1666; Haringh, D, A 1654 &
 A 1655; Lievens, J A, A 1660 & A 1661; Maes, N, A 1645,
 A 1646 & A 1662; Monmorency, B, A 1658; Nachenius, J J,
 A 1656 & A 1657; Oosterdijk, W, A 1664 & A 1665; Palthe, J,
 A 1652 & A 1653; Vaillant, B, A 1663; Witte, E de, A 1642;
 PAST Vaillant, B, A 1651; PAST Northern Netherlands school
 ca 1775, A 1667
Rijers, W: *see sale Amsterdam, 21 Sep 1814*
Rijk, A J: Jelgerhuis Rzn, J, A 2713 & A 2714
Rijnbout, C J: *see sale Utrecht, 16-20 Dec 1879*

S...: *see sale Amsterdam, 30 June-2 July 1909*
Sachse, family: Torrentius, A 2813
Sandersz, J R: Dubbels, H J, A 2513
Sandick, A A van: Steen, J H, A 3509
Sautijn Hasselaer, P C: Mijn, G van der, A 1360
Saxe-Weimar, Prince Herman of: Spoel, J, A 1964
Schaap, E R D: Schaap, E R D, A 2654
Schaap van der Plek, H W J: *see* AQU Introduction
Schaft, Fern v d: *see sale Amsterdam, 19ff April 1819*
Scharten, C Th: Oosterhoudt, D van, A 3132
Schellwald, J H: Boonen, A, A 1914 & A 1915; Graat, B, A 1911;
 Wulfraet, M, A 1912; Northern Netherlands school ca 1655,
 A 1913
Scheltus van Kampferbeke, L J A: *see sale Rotterdam, 24-25 July*
 1876
Schepeler, Colonel von: Aertsen, P, A 3; Winghe, J van, A 473
Schieffer, H: Verburgh, D, A 3112
Schiffer van Bleiswijk: *see sale Amsterdam, 10-12 Dec 1889*
—, C: *see sale The Hague, 14-15 Dec 1874 & 2 Jan 1875*
Schimmelpenninck, Jonkheer F J C: Knip, J A, C 1455 & C 1456
—, Jonkheer G: PAST Hodges, Ch H, A 4227
—, Jonkheer G J A: Prud'hon, P P, A 3097
Schimmelpenninck Gsz, G: *see sale Amsterdam, 12 July 1819*
Schimmelpenninck van der Oye, H S F Baroness: Schelfhout, A,
 A 3887
—, W A A J Baron: Gelder, A de, A 4034
Schlitz called Görtz und Wrisberg, Count L von: Holland school
 ca 1745, A 1797
Schloss, M A: *see sale Paris, 25 May 1949*
Schmidt, J A: Spoel, J, A 2541
Schmidt, J J: Schmidt, W H, A 3109 & A 3110; Spoel, J, A 2541
Schmidt-Degener, F: Borsch, J, A 3240
Schol, Mrs: Loo, J van, A 81
Schottelink, S M C: *see sale Amsterdam, 4-5 March 1879*
Schuylenburch van Bommenede, Jonkheer F L van: English
 school 2d half 16th century, C 1466
Schwartze, G E: Schwartze, J G, A 2818-A 2821
Sigault Czn, J F: *see sale Amsterdam, 12ff May 1834*
Sirdey, Th: Storck, A, A 749
Six, Jonkheer J: Aertsen, P, A 1909; Heemskerck, M van, A 1910
—, Jonkheer W: Aertsen, P, A 1909; Heemskerck, M van,
 A 1910
Six van Hillegom, H: *see sale Amsterdam, 25 Nov 1851*
—, Jonkheer J P: Aertsen, P, A 1909; Heemskerck, M van,
 A 1910 & C 507; Scorel, J van, A 4284; Wildens, J, A 616
Six van Vromade, Jonkheer J W: Rembrandt, A 3477 & A 3982
—, Jonkheer P H: Asselijn, J, A 2313 & A 2314; Bakhuysen,
 L, A 2315 & A 2316; Berchem, N, A 2317; Dou, G,
 A 2320 & A 2321; Dyck, A van, A 2318 & A 2319; Esselens, J,
 A 2322; Franchoys II, L, A 2323; Heusch, W de, A 2324;
 Hondecoeter, M d', A 2325; Leyster, J, A 2326; Lingelbach, J,
 A 2327; Metsu, A, A 2328; Mignon, A, A 2329; Moreelse, P,
 A 2330; Musscher, M van, A 2331; Ostade, A van, A 2332;
 Post, F, A 2333 & A 2334; Pynacker, A, A 2335; Rubens, P P,
 A 2336; Ruisdael, J I, A 2337; Ruysch, R, A 2338; Schalcken,
 G, A 2339 & A 2340; Tol, D van, A 2341; Troost, C, A 2342;
 Velde, A van de, A 2343; Vermeer, J, A 2344; Victors, J,
 A 2345; Walscapelle, J van, A 2346; Werff, A van der, A 2347;
 Wouwerman, Ph, A 2348; Wijnants, J, A 2349
Sloet van de Beele, L A J W Baron: *see sale Amsterdam, 9-10 Feb*
 1892
Sluypwijk, M M van: *see sale Amsterdam, 20 April 1803*
Slijper, S B: Maarel, M van der, A 4063
Smal, F: Jongh, L de, A 1858
Smallenburg van Stellendam-'t Hooft, N J W: *see sale Amsterdam,*
 6 May 1913
Smeth van Alphen, P de: *see sale Amsterdam, 1-2 August 1810*
Smissaert, Jonkheer O: Batist, K, A 732
Smith, S F: Diepraam, A, A 1574
Smits van Nieuwerkerk, J A: Dijk, Ph van, A 1435; Schoenmakers
 Pzn, J, A 1434

Snouck van Loosen, M M: *see* sale Enkhuizen, 29 April 1886
Snouckaert van Schouburg, A C Baron: Pieneman, N, A 4270; HER NM 9310
Snijers, J A: *see* sale Antwerp, 27 April 1818
Soere, de: *see* sale Amsterdam, 1 April 1890
Soeren-Huetink, Mrs G J van: Soeren, G J van, A 1490
Sokolowski, H: Vries, J de, A 4065
Someren-Brand, J E van: Anthonissen, H van, A 2126
Souget, H: *see* sale Amsterdam, 13-19 April 1920
Spaen van Biljoen, J P G Baron van: Brueghel 1, J, A 511; Francken 11, F, A 111; Netscher, Casp, A 319; Palma il Vecchio, J, A 594; Seghers, G, A 374; Northern Netherlands school? 18th century, A 610
Spitzen, O A: *see* sale Zwolle, 15 Oct 1889
Spitzer, A: *see* sale Paris, 17 April-16 June 1893
Springer, C: Springer, C, A 1136
Spijer, M W H: Haan, M I de, A 1694
Stanley Wilkinson, K: Maris, W, A 4104
Steelink Jr, W: Waay, N van der, A 2789
Stengelin, A: Stengelin, A, A 2498 & A 2499
Stevens, J D: Wouwerman, P, A 1794
Stinstra, S J: *see* sale Amsterdam, 22 May 1822
Stols, A A M: Pieneman, J W, A 4137
Stoop, F C: John, A E, A 3018; Maris, M, A 3019
Storm-van der Chijs: *see* sale Delft, 1-10 July 1895
Stracké, F L: Altmann, S, A 1620
Straelen, van der: *see* sale Antwerp, 19 Feb 1885
Sträter, A A M: Droochsloot, J C, A 3227; Keun, H, A 3228
Stuart, Th: Pieneman, J W, A 665
Stuers, A L E Ridder de: Scorel, J van, A 2843; *see also* sale Amsterdam, 12 April 1932
—, Jonkheer Victor de: Bree, M I van, A 1172; Everdingen, C B van, A 2116; Meerman, M, A 1543 & A 1544; Post, F, A 1585; Scorel, J van, A 1636; Vrancx, S, A 1637; Weissenbruch, J, A 1526; Weyerman, J C, A 1302; Northern Netherlands school ca 1510, A 1547 & A 1548; PAST Northern Netherlands school ca 1780, A 1421
Stuers-van Limburg Stirum, A C de: Keyser, N de, A 2863
Sutherland, duke of: *see* sale London, 8 Feb 1908
Swaab, L: *see* sale Amsterdam, 6-9 Nov 1900
Swart, A G N: Post, F, A 3224
—, A W: Olis, J, A 296
—, C H de: Vaillant, W, A 1192
Swinderen, Jonkheer J H F K van: Bartsius, W, A 818; Blijhooft, Z, A 825 & A 826; Coeman, J J, A 807 & A 809; Craey, D, A 808 & A 810; Verheyden, M, A 814 & A 817; Verhoesen, A A 830; Verkolje, N, A 813; Zwaerdecroon, B, A 828 & A 829; Northern Netherlands school 1623, A 823; Northern Netherlands school ca 1655, A 805 & A 806; Northern Netherlands school ca 1670, A 819 & A 820; Northern Netherlands school ca 1710, A 811 & A 812; Holland school ca 1690, A 821, A 822, A 824 & A 827
Sypesteyn: *see* Institutions: Loosdrecht

Taelman Kip, W F: *see* sale Amsterdam, 16ff March 1801
Taets van Amerongen van Natewisch, S S M Baroness: *see* sale Amsterdam, 1-2 Nov 1892
Tamson-Valois, M: Valois, J F, A 1514
Teding van Berkhout, Jonkheer H: Sanders, H, A 1492; Venne, A P van de, A 1931; *see also* sale Amsterdam, 27 July 1905
Teissier, Mr: Delen, D van, C 1350
Teixeira de Mattos, Jonkheer F E: Wit, J de, C 1577
—, Jonkheer H: Heemskerck, E van, A 2180
Telbrach, J: Uytewael, J A, A 1697 & A 1698
Terbrugge, C J: *see* sale Amsterdam, 12-13 June 1888
Theineca Leyssius, Jonkheer H J L Th van: Tocqué, L, A 3904 & A 3905
Thomas, H: Grebber, P F de, A 2310
Thomassen à Thuessink van der Hoop: *see* sale Amsterdam, 10 May 1971
Thom's, de: *see* sale Warmond, 31 July 1816
Thorbecke, R: Neuman, J H, A 4120
Thijgesen, Mrs D: Monogrammist A S, A 737
Thijssen, K H: Sörensen, J L, A 3025
Tideman, B J: Burbure, L de, C 534
—, J: Teyler van Hall, J J, C 1557
Tienhoven, P G van: Wit, J de, A 3872; MIN Le Blon, J Ch, A 3873 & A 3874
Tietje, H W C: Tiepolo, G B, A 3985; Master of the Portraits of Princes, A 3140
Tilanus, C B: PAST Schwartze, Th, A 3450
Tilanus-Liotard, J V: PAST Liotard, J-E, A 1194, A 1195, A 1198 & A 1199
Tjeenk, H F: Hengel, H F van, A 1473 & A 1474
Tombe, A A des: Ast, B van der, A 2103; Bramer, L, A 2093; Brueghel 1, J, A 2102; Brugghen, G A van der, A 2087-A 2092; Coorte, A S, A 2099; Lyon, J, A 2100 & A 2101; Ossenbeck, W, A 2095; Simons, M, A 2083; Tischbein, J F A, A 2082; Valckenburg, D, A 2097; Vlieger, S de, A 2086; Netherlands school? 17th century, A 2094; Southern Netherlands school ca 1680, A 2096; MIN Northern Netherlands school 1614, A 2104; MIN Northern Netherlands school ca 1655, A 2085; MIN Northern Netherlands school ca 1675, A 2098; MIN Northern

Netherlands school ca 1805, A 2082
Torenbergen, J J van: Wijckersloot, J van, A 748
Trip, Jonkheer H: Northern Netherlands school ca 1600, A 2867; Northern Netherlands school ca 1615, A 2871; Northern Netherlands school ca 1655, A 2866; Northern Netherlands school ca 1675, A 2868; Northern Netherlands school? mid-18th century, A 2870; Holland school ca 1675, A 2869; Southern Netherlands school ca 1615, A 2864 & A 2865
—, Jonkheer J L: Geest, W S de, A 4190; Ravesteyn, J A van, A 4191
Trip-van Limburg Stirum, A W Countess: Geest, W S de, A 4190; Ravesteyn, J A van, A 4191
Trochel, G H: *see* sale Amsterdam, 11ff May 1801
Troostwijk, W J van: *see* sale Amsterdam, 18 March 1875
Tutein Nolthenius, Mr: Lairesse, G, A 4213-A 4216
Tuyll van Serooskerken, F C C Baron van: Borch, G ter, A 3842

Ungern-Sternberg, B Baron: Jongh, C de, A 2842
Uppink, H J: Uppink, H, A 3056; Uppink, W, A 3055 & A 3057
Utenhove van Heemstede, Baroness van: *see* sale Jutphaas, 21-22 Oct 1880

Vader Dzn, W: Bueckelaer, J, A 2251
Vaillant, J: Hodges, Ch H, A 4161
Valkenburg, M M van: Pontormo, J, A 3062
Velden, Jonkheer P A van den: Haak, R J S, A 1566; Liernur, W A A, A 1563; Poggenbeek, G J H, A 1564; Versteegh, M, A 1565; Vertin, P G, A 1562
Veltman, E A: Cornelisz van Oostsanen, J, A 3838
Verdooren, E L G J: Lelie, A de, A 2234 & A 2235
Verhoesen, A: *see* sale Amsterdam, 22 Nov 1910
Verhulden, J: Netherlands school? 1542, A 4027
Verkouteren, L E C: MIN Temminck, L, A 3272
Verloren van Themaat, P: *see* sale Amsterdam, 30 Oct 1885
Verloren van Themaat-de Pesters, Dowager E J C: Neuman, J H, A 2824 & A 2825
Verschuer, van: *see* sale Amsterdam, 31 March-2 April 1896
Verveer, E L: *see* sale Amsterdam, 27-29 Nov 1900
Verwer, J: Swart van Groningen, J, NM 8184
Vettewinkel, D H: Vettewinkel, H, A 1475
Vies, A van der: PAST Anspach, A 4660
Vinkenstein, J J C: *see* sale Amsterdam, 31 March 1903
Viruly: *see* sale Amsterdam, 14 Dec 1880
Visbach Lobry, J M: Kruseman, J A, A 4258
Visscher-Knoll, A E: Knoll, F C, A 1059
Visser, A G de: *see* sale The Hague, 3 June 1885
Vlierboom van Hoboken, M: *see* sale Amsterdam, 18 Feb 1896
Vogel, J G: Derksen, G, A 2739; Vogel-Roosenboom, M C J W H, A 2740; *see also* AQU Introduction
Vogel-Molenkamp, H P M A: Vogel, J G, A 2721; Vogel-Roosenboom, M C J W H, A 2722 & A 2723
Volz, A W: Rembrandt, A 3477
Voort, G van der: *see* sale Amsterdam, 13 March 1877
Vorsterman van Oyen, A A: Northern Netherlands school ca 1600, A 1469
Vos, G de: *see* sale Amsterdam, 25 April 1893
—, M: Haanen, A J, A 1186
Vos-Wurfbain, A H de: Hendriks, W, A 667
Voûte, M P: Corneille de Lyon, C 3037; Fabritius, B, A 2958-A 2960; Gelder, A de, A 2695; Pourbus 1, F, A 3065; Rembrandt, A 3066; Verspronck, J C, A 3064
Vries Azn, A D de: Grebber, P F de, C 522; Monogrammist I S H, C 529
Vroom, H W: Tischbein, J F A, A 2256
Vuyk, J: Payen, A A J, A 3452

W…, O: *see* sale Amsterdam, 1 Nov 1887
Wall Perné-van Vooren, E C van de: Wall Perné, G F van de, A 2626
Waller, F G: Os, P G van, A 3229 & A 3230; Voet, J F, A 3236; Vois, A de, A 3237
Waller-Nusselein, Mrs E J F: Oyens, P, A 4136
Walter, A H: *see* sale Amsterdam, 4-8 Feb 1890
Ward, J H: Camphuijsen, G D, A 1303; Fabritius, B, A 1304
Warnecke, E: Pot, H G, A 2135; Venne, A P van de, A 676
Wayenburg, F J M: Lelie, A de, A 4122
Weber-van Bosse, Mrs A A: Vos, M, A 3456
Weddik-Lublink Weddik, M N Th: Arends, L H, A 3844; Deventer, W A van, A 3846; Gudin, J A Th, A 2832; Hoppenbrouwers, J F, A 3847 & A 3848; Ouvrié, P J, A 2831; Sande Bakhuyzen, H van de, A 3845; Tischbein, J F A, A 2827 & A 2828; Waldorp, A, A 3849 & A 3850; Weissenbruch, J, A 2830; Northern Netherlands school 1st half 19th century, A 2833; PAST Northern Netherlands school ca 1790, A 2829
Weede Family Foundation, van: Rembrandt, C 597
Weigel, J M: Moreelse, P, A 277
Welderen Baron Rengers-van Pallandt, Dowager A van: Pieneman, N, A 3852
Welie, A van: Andriessen, J, A 3921; Valckert, W van den, A 3920
Wenckebach, L W R: *see* AQU Introduction
Wente, F H: Alewijn, A, A 1726
Westerman, G F: Pieneman, J W, A 1114

Westerwoudt, J B A M: Allebé, A, A 2295; Alma Tadema, L, A 2289; Artz, D A C, A 2292, A 2378 & A 3069; Bakker Korff, A H, A 3060, A 3070 & A 3071; Bauer, N, A 2261; Bilders, A G, A 2262-A 2264, A 2297, A 2298, A 3072 & A 3073; Bilders, J W, A 3074; Blommers, B J, A 2296, A 3075 & A 3076; Bock, Th E A de, A 3077; Bosboom, J, A 2380, A 3078 & A 3079; Broeck, E van den, A 1463; Cate, S J ten, A 2299; Charlet, N T, A 2257; Daubigny, Ch F, A 2288; Estall, W Ch, A 3080; Frère, E, A 3081; Gabriel, P J C, A 2265, A 2266, A 2290, A 2381 & A 3082; Hodges, Ch H, A 2267 & A 2268; Hove Bzn, H van, A 3083; Israels, J, A 2382; Jamin, D F, A 2269 & A 2286; Jongkind, J B, A 2270 & A 2300; Kever, J S H, A 2271; Klinkenberg, J Ch K, A 2383; Leickert, Ch H J, A 3084; Lelie, A de, A 2294; Marcke de Lummen, E van, A 3085; Maris, J H, A 2272 & A 2274; Maris, M, A 2275 & A 2276; Maris, W A 2277; Mastenbroek, J H van, A 2278; Mauve, A, A 2279 & A 2384; Mesdag, H W, A 2280, A 2301, A 2385 & A 2386; Metzelaar, C, A 2281; Oppenoorth, W J, A 3087; Raffalt, J G, A 3088; Roelofs, W, A 2386; Ronner-Knip, H, A 3089; Sande Bakhuyzen, J J van de, A 2259 & A 2379; Springer, C, A 2388; Tholen, W B, A 3090; Uppink, H, A 2293; Verlat, Ch, A 2287; Vogel-Roosenboom, M C J W H, A 2387; Vogels, W, A 3091; Vollon, A, A 2302 & A 3092; Weissenbruch, H J, A 2291 & A 3093; Westerwoudt, J B A M, A 2282 & A 3094; Zwart, W H P J de, A 2283; Holland school 1633, A 2258; PAST Cate, S J ten, A 2284 & A 2285
Westerwoudt-Klinger, A M L: Allebé, A, A 3095; Monticelli, A, A 3096
Wetzlar, H A: Netherlands school 2d half 16th century, A 3460
Wezel, A van: Bauer, N, A 2875 & A 2876; Bosboom, J, A 2877 & A 2878; Breitner, G H, A 2879-A 2881; Corot, J B C, A 2882 & A 2883; Daubigny, Ch F, A 2884-A 2886; Diaz de la Peña, V N, A 2887; Dupré, J, A 2888; Dijsselhof, G W, A 2889-A 2891; Fantin Latour, H, A 2892-A 2895; Israels, I L, A 2913-A 2915, A 2917-A 2920; Israels, J, A 2921-A 2923; Jongkind, J B, A 2924; Kamerlingh Onnes, M, A 2896; Karsen, J E, A 2897-A 2906; Kever, J S H, A 2907 & A 2908; Looy, J van, A 2909 & A 2910; Maris, J H, A 2925-A 2927; Maris, M, A 2928; Maris, S W, A 2931; Maris, W, A 2929 & A 2930; Mauve, A, A 2932; Mesdag, H W, A 2938; Monet, C, A 2933; Monticelli, A, A 2934-A 2937; Verster van Wulverhorst, F H, A 2941 & A 2942; Witsen, W A, A 2948-A 2956; Zwart, H W P J de, A 2957; PAST Israels, I L, A 2911, A 2912 & A 2916; *see also* AQU Introduction
Wezelaar, H M: Troost, C, A 3453
Widener, P: *see* sale Amsterdam, 30 June-2 July 1909
Wildt, F de: Holland school ca 1485, C 509
Wilkens, C J W: Wilkens, J D B, A 4257
Willem I, king of the Netherlands: Antolinez, J, A 598; Dughet, G, A 94 & A 95; Dyck, A van, A 597; Fogolino, M, C 1129; Garofalo, B T, A 114; Iriarte, I de, C 1371; Magnasco, A, A 1356 & A 1357; Mazo, J B M del, C 1362; Mazzolino, L, C 1363; Murillo, B E, C 1366 & A 1282; Netscher, Casp, A 292; Pieneman, J W, A 1115; Sminck Pitloo, A, A 1117; Wolff, B, A 658 & A 659; Zacchia il Vecchio, A 503; Italian school mid-17th century, C 1346; MIN Pluckx, J A A, A 4362
Willem III, king of the Netherlands: Saleh, S B, A 778
Willem V, Prince: Borch, J ter, A 1331; Cornelisz van Oostsanen, J, C 1349; Kobell Jr, H, A 1218; Lingelbach, J, C 1223 & C 1224; Steen, J H, A 387; Turchi, A, C 1372
Willet, A: Carreño de Miranda, J, A 1425; Kneller, G, A 1280; Mouilleron, A, A 1426; Odekerken, W van, A 1279; Schoor, A van der, A 1424; Vrancx, S, C 510
Willigen, A van der: *see* sale Haarlem, 20-21 April 1874
Willink van Bennebroek, J H: Tempel, A L van den, A 1972
Willink van Collen, Misses J M E & M E: Holland school ca 1680, A 2716
Winter-Bicker, Dowager J C: Coclers, L B, C 8 & C 9; Helst, B van der, C 50; Hodges, Ch H, C 10 & C 11; Liotard, J-E, C 43 & C 44; Miereveld, M J van, C 12; Musscher, M van, C 13 & C 14; Netscher, Con, C 15 & C 16; Ovens, J, C 17; Palthe, J, C 18-C 20; Sandrart, J von, C 26 & C 27; Tol, D van, C 21; Vaillant, W, C 22 & C 23, C 39 & C 40; Verelst, H, C 24 & C 25; Amsterdam school 1560, C 33 & C 34; Amsterdam school 1573, C 35; Amsterdam school 1583, C 36 & C 37; Amsterdam school ca 1650, C 42; Amsterdam school 1654, C 38; Amsterdam school ca 1775, C 41; MIN Hodges, Ch H, C 45; MIN Holland school ca 1580, C 32; MIN Holland school ca 1795, C 46 & C 47; PAST Liotard, J-E, C 30 & C 31; PAST Vilsteren, J van, C 49 & C 51
Wisalius, Mr: Netscher, Casp, A 292
Wisselingh, H J: *see* sale Amsterdam, 9-10 Feb 1892
Witkamp, P H: Valkenburg, H, C 1559
Witte van Citters, Jonkheer J de: Appelius, J, A 924; Colasius, J G, A 2105; Dubois, S, A 2062-A 2066; Dijk, Ph van, A 892, A 893, A 895-A 898, A 903 & A 2060; Geldorp, G, A 912, A 914-A 917, A 2070-A 2072 & A 2081; Jonson van Ceulen 11, C, A 921; Loncke, J L, A 906 & A 907; Mesdach, S, A 910, A 911, A 913, A 918, A 919, A 2068, A 2069 & A 2073; Miereveld, M J van, A 908, A 909 & A 2067; Netscher, Casp, A 901 & A 902; Schalcken, G, A 899, A 900 & A 2061; Troost, C, A 2078; Netherlands school ca 1580, A 922; Northern Netherlands school ca 1530, A 894; Northern Netherlands

school 1616, A 905; Northern Netherlands school 1622, A 2075;
Northern Netherlands school 1623, A 2076; Northern
Netherlands school 1627, A 2079; Northern Netherlands school
1629, A 2077; Northern Netherlands school 1630, A 2074;
Northern Netherlands school 1643, A 920; Northern
Netherlands school 1645, A 2080; Northern Netherlands school
ca 1760, A 926; Northern Netherlands school ca 1815, A 925;
Zeeland school 1664, A 923; HER A 928-A 930, A 932-A 940
Wolff, J de: PAST Vaillant, B, A 3484-A 3487
Wolff, B: Titian, A 475; Wolff, B, A 658 & A 659
—, D: Tintoretto, J, A 3902
Wonder, P C: Wonder, P C, A 1163
Wreesman: see sale Amsterdam, 17 Aug 1818
Wreesmann, H F J: Largillière, N de, A 3461
Wüste-von Gotsch, O E A E Baroness: Kruseman, J A, A 3020;
Molenaer, J M, A 3023; Mijtens, J, A 3021 & A 3022;
Palamedesz, A, A 3024
Wijkersloot: see sale Amsterdam, 19 July 1809

IJsseldijk, J B van: Michaëlis, G J, A 2141; Mijn, G van der,
A 2139 & A 2140; PAST Perronneau, J-B, A 2142
IJzerman, J W: Vroom, H C, A 3108; Northern Netherlands
school ca 1620, A 2727

Zanoli: see sale Cologne, 4-5 June 1894
Zebinden, L T: Borch, M ter, A 2240 & A 2241; see also sale
Amsterdam, 15ff June 1886
Zeggelen, W J van: see sale Amsterdam, 10 April 1894
Zegwaard, A C: Mesdag, H W, A 2670
Zilverberg, J S: Northern Netherlands school last quarter 16th
century, A 2624
Zoutman, J: Hauck, A Ch, A 136 & A 633
Zschille, Fédor: Geel, J J van, A 3968; see also sale Cologne,
27-28 May 1889
Zubli-van den Berch van Heemstede, Dowager M: Hooch, C C
de, A 2218
Zürcher, J: see sale Amsterdam, 1-2 March 1898
Zürcher-Bijleveld van Serooskerken, J: Zürcher, J W C A, A 2535
Zwart, Mr de: Teenstra, K D, A 3515

Anonymous lenders and previous owners: Codde, P, C 1578;
Dubordieu, P, A 4221; Hodges, Ch H, A 2971; Northern
Netherlands school ca 1830, A 2798; MIN French school? 18th
century, A 2809; PAST Prud'hon, P P, C 1487-C 1490

Unknown provenance: Allori, C, A 1; Bassen, B van, A 4246;
Beert, O, A 4247; Bergen, D van den, A 38 & A 39; Beveren,
Ch van, A 1501; Bree, M I van, A 4253; Calisch, M, A 4181;
Carrée II, H, A 2837 & A 2838; Danckerts de Rij, P, A 1593;
Dreibholz, Ch L W, A 3839; Dujardin, K, A 191; Dijck, F
van, A 2058; Gabriël, P J C, A 1505; Hawksley, A, A 4182;
Heem, J D de, A 138; Hoffman, G J, A 4202; Keultjes, G L,
A 644; Knip, H, A 3947; Lairesse, G, A 615; Loarte, A de,
A 2962; Maes, N, A 2840; Meyer, J H L, A 1406; Mostaert, J,
A 743; Netscher, Casp, A 729; Oever, H ten, A 295; Paepe, J
de, A 2961; Patru, L, A 4165; Quinkhard, J, A 324; Rocquette,
J de la, A 1299; Roelofs, W, A 4207; Rubens, P P, A 599 &
A 272; Sande Bakhuyzen, G J van de, A 3878; Sandrart, J von,
A 364; Schey, Ph, A 4279; Slager, P M, A 3856; Swanenburgh,
II van, A 730; Tintoretto, J, A 2969; Tischbein, J V, A 406;
Ulft, J van der, A 1916; Uytewael, J A, A 1696; Velde I, W
van de, A 4289; Vries, R de, A 459; Werff, A van der, A 623;
Windtraken, P W, A 2737 & A 2738; Zeuner, J, A 4230; Vene-
tian school ca 1590, A 2242; Northern Netherlands school 1557,
A 4196; Northern Netherlands school ca 1640, A 203;
Northern Netherlands school ca 1670, A 609; Northern
Netherlands school 18th century, A 4179; Northern
Netherlands school 1792, A 4194; Northern Netherlands
school 18th century, A 1347; Northern Netherlands school ca
1820, A 4481; Northern Netherlands school ca 1850, A 4193;
Northern Netherlands school mid-19th century, A 4208 &
A 4647; Holland school ca 1690, A 2805 & A 2806; Holland
school ca 1700, A 4655; Holland school mid-18th century, A
4281; Southern Netherlands school 1st half 17th century,
A 622; Southern Netherlands school? 16th century?, A 4184-
A 4186; Bruges school 1584, A 1668; MIN Schmidt Crans, J M,
A 4367; MIN French school? ca 1810, A 650; MIN Northern
Netherlands school ca 1630, A 4204; MIN Northern
Netherlands school ca 1790, A 4211; MIN Holland school ca
1635, A 4432; MIN Holland school ca 1785, A 4457; MIN
Amsterdam school 1696, NG 1974-R-30; PAST Northern
Netherlands school ca 1820, A 4132; HER A 4205, A 4643 &
NM 8359

ART DEALERS

Aa, D van der (Amsterdam): Backer, J A, A 157; Poel, E van der,
A 117
Agnew & Sons, Th (London): Graat, B, A 3932; Lanfranco, G,
A 4129; Rembrandt, A 4119; Weenix, J, A 4098
Arcade (London): Spranger, B, A 3888; Tibaldi, P, A 3955
Asscher & Koetser (Amsterdam): Brugghen, H ter, A 2783 &
A 2784; Kick, S W, A 2841; Zeeuw, C de, A 2849; Master of
the Legend of Mary Magdalene, A 2854

Bachstitz (The Hague): Master of the Carrand Triptych, A 4022
Baderou, H (Paris): Meulen, A F van der, A 3960
Beets, N (Amsterdam): Buytewech, W P, A 3038; Flinck, G,
A 3133; Hillegaert, P van, A 3125; Lingelbach, J, A 3973;
Bruges school ca 1450-70, A 2851
Beggi (Florence): Lastman, P P, A 1533
Bekker (Zeist): Pieneman, N, A 3913
Benedict, C (Paris): Mijn, C van der, A 3907
Bloch, A (Paris): Cornelisz van Haarlem, C, A 3892
—, V (The Hague): Haarlem school? ca 1660, A 4017
Boer, M L de (Amsterdam): Sweerts, M, A 3896
—, P de (Amsterdam): Leyden, A van, A 3903; Momper, J de,
A 3100 & A 3894; Master of the St John Panels, A 4125
Brauwere, Jules de (Brussels): Walraven, I, A 461
Brod, A (London): Claesz, P, A 3930
Cassirer & Co, P (Amsterdam): Heemskerck, M van, A 3511-
A 3514; Tiepolo, G B, A 2965
Castro, Alberto di (Rome): Guardi, F, A 3899
Cevat, D (London): Hillegaert, P van, A 4112; Roghman, R,
A 4218
Coclers (Amsterdam): Ruisdael, J I van, A 348
Cohen & Sons, B (London): Brugghen, H ter, A 4188
Colnaghi, M H (London): Anraedt, P van, A 1960; Fabritius, C,
A 1591; Ruysdael, J S van, A 1525
Colnaghi & Co, P & D (London): Aelst, W van, A 1669;
Bloemaert, A, A 3746; Brugghen, H ter, A 3908; Cuyp, A,
A 3754; Hanneman, A, A 1622; Leyden, A van, A 1691;
Craddock and Barnard (Tunbridge Wells): Sweerts, M, A 2845-
A 2848
Cramer, G (The Hague): Cozza, F, A 4035; Dubois Drahonet,
A J, A 4153 & A 4154; Musscher, M van, A 4135
Croiset, A (Amsterdam): Anthonisz, C, A 1619
Dik, J (Lausanne): Bor, P, C 1518
Dirksen (The Hague): Velde I, W van de, A 1384 & A 1385;
Master of the Portrait of Adie Lambertsz, A 970
Douwes, E (Amsterdam): Strij, A van, A 4195
Dowdeswell & Dowdeswell (London): Eeckhout, G van den,
A 1612
Duits, C (London): Troost, C, A 4089; Vincent, F A, A 3931
—, S (Amsterdam): Bieselingen, C J van, A 1631; Velde I, W
van de, A 1973; Holland school? ca 1595, A 4484; MIN
Wolters, H, A 2407 & A 2408; MIN Wolters-van Pee, H,
A 2409 & A 2410
—, W E (London): Witte, E de, A 3738
Durand Ruel (Paris): Cock, J W de, A 1598
Duren Jr, M van (Amsterdam): Ekels II, J, A 1846; Gool, J van,
A 1605; MIN Holland school ca 1840, A 1959
Duveen (New York): Goya, A 2963
Duveen Brothers (Paris): David, G, A 3134 & A 3135
Emmering, S (Amsterdam): Klerk, W de, A 4087
Etienne (Amsterdam): COST A 4627-A 4638
Eyck, R van (The Hague): Tiepolo, G B, A 3985
Eyk, van (The Hague): Crayer, C de, A 74 & A 75
Finck, R (Brussels): Momper, J de, A 3949
Francke (Amsterdam): Berckheyde, J, A 1790; Borch, G ter,
A 1784-A 1786
Frenkel, Gebroeders (Utrecht): Ormea, W, A 1789
Fürst (Amsterdam): Beerstraaten, A, A 3737
Gerstel, F (Berlin): Lastman, P P, A 2354
Geveke, O (Baexen): MIN Northern Netherlands school ca 1610, A 4095
Goedhart, J E (Amsterdam): Breenbergh, B, A 1724
Gogh, C M van (Amsterdam): Hodges, Ch H, A 1517
Goudstikker, J (Amsterdam): Brouwer, A, A 3015; Kessel, J van,
A 2506; Peeters, C, A 2111; Roestraeten, P G van, A 4189;
Ruysdael, J S van, A 3983; Steen, J H, A 3984; Witte, E de,
A 3244; Master of the Battle of Anghiari, A 3974; Master of
the St Elizabeth Panels, A 3145-A 3147; Master of the Virgo
inter Virgines, A 3975
—, S E (Amsterdam): Begeyn, A, A 1497
Goudstikker-Miedl (Amsterdam): Rembrandt, A 4019;
Southern Netherlands school 2d half 17th century, A 4021
Hallsborough, W (London): Goyen, J van, A 3945 & A 3946
Hamburger (Amsterdam): Northern Netherlands school ca 1680,
A 1628
Hardy, F (Bendorf-Rhein): Bree, M I van, A 4088
Heim (Paris): Blanchard, J, A 4091; Ceresa, C, A 4103;
Valkenburg, D, A 4075
Hesterman & Zn, J A (Amsterdam): Dalen, C van, A 1991;
Oever, H ten, A 2697
Heuvel, A de (Brussels): Greuze, J B, A 3906; Wit, J de, A 3900
Heyden, Ch van der (Rotterdam): Musscher, M van, A 4232 &
A 4233
Hollender, J (Brussels): Hillegaert, P van, A 848
Hoogendijk, D A (Amsterdam): Beyeren, A van, A 3944 &
A 4073; Miereveld, M J van, A 3953; Wit, J de, A 3885 &
A 3886
Hopman, W A (Amsterdam): Berckman, H, A 1602; Bloemaert,
H, A 735; Bosch, J, A 1601; Droochsloot, C, A 1920; Hondius,
A, A 1918 & A 1919; Mijtens, J, A 746 & A 747; Wieringen,
C C van, A 1629
Houthakker, B (Amsterdam): Hendriks, W, A 3854; Santen, G
van, A 3893; PAST Troost, C, A 3745; PAST Vigée-Lebrun, E,
A 3898

Huybrechts, P C (The Hague): Baen, J de, A 13 & A 14; Eyck,
N van, A 619
Israël, N (Amsterdam): Coeman, J J, A 4062
Jacobson (London): Cuyp, J G, A 1793
Jonas & Kruseman (Amsterdam): Flinck, G, A 3451
Josi, C (Amsterdam): Bakhuysen, L, A 8; Eeckhout, G van den,
A 106; Honthorst, G van, A 180
Jüngeling, H (The Hague): Rembrandt, A 4090
Kadol & Bodinot (The Hague): Gheyn II, J de, A 2395
Kalf Dzn, B (Amsterdam): Bijlert, J van, A 1596
Katz, B (Dieren): Rembrandt, A 3934
—, N (Dieren): Heemskerck, M van, A 3518 & A 3519;
Keyser, Th de, A 3972
Kauffmann, A (London): Dordrecht school ca 1455, A 3926
Kleinberger, F (Paris): Bisschop, C, A 2110; Bosch, J, A 1673;
Engebrechtsz, C, A 1719 & A 2232; Heem, J D de, A 2396;
Jansen, F, A 1842; Leyster, J, A 1685; Metsu, G, A 2156;
Troost, C, A 1635; Vonck, E, A 1951; Zijl, R van, A 1611;
Master of the Spes Nostra, A 2312; Northern Netherlands
school 1525, A 2107 & A 2108; Northern Netherlands school
ca 1655, A 1638; Amsterdam school 1593, A 1984 & A 1985
Komter, D (Amsterdam): Bundel, W W van den, A 2835; Buijs,
J, A 2966
—, W (Amsterdam): Cuyp, B G, A 2857
Leger (London): Werff, A van der, A 3935
De Lelie & Hulswit (Amsterdam): Maes, N, A 245
Marcus, H (Amsterdam): English school mid-19th century,
A 4217
Marshall Spink, C (London): Delen, D van, A 3936-A 3942
Mason & Philips (London): Vroom, H C, A 2530
Matthiesen, M (London): Leyden, A van, A 3480; Mijn, F van
der, A 3956
Meer, A van der (Amsterdam): Kooi, W B van der, A 4139;
Northern Netherlands school 1858, A 4105
Meyers & Son, A (London): Cornelisz van Oostsanen, J, A 1405
Mulder, T (Amsterdam): Diana, G, A 3465
Muller & Co, Fr (Amsterdam): Bakhuysen, L, A 2539; Bosch, J,
A 1795; Cornelisz Kunst, C, A 1725; Cuyp, A, A 2350; Delen,
D van, A 2352; Esselens, J, A 2250; Goltzius, H, A 2217; Helst,
L van der, A 2236; Hodges, Ch H, A 1453; Isaacsz, P, A 1720;
Kruseman, J A, A 1621; Leyden, L van, A 4260; Martzen II, J,
A 2153; Meer II, J van der, A 2351; Mor van Dashorst, A,
A 2663; Musscher, M van, A 1676; Mijn, F van der, A 2248 &
A 2249; Ravesteyn, J A van, A 1950 & A 2527; Ruys, S, A 2131;
Schoeff, J, A 2230; Scorel, J van, A 1855; Uytewael, J A,
A 1843; Wieringa, H W, A 2221; Master of the Amsterdam
Death of the Virgin, A 2129 & A 2130; Northern Netherlands
school ca 1615, A 738; Northern Netherlands school ca 1625,
A 1975; Holland school 1637, A 1675; Spanish school? 17th
century, A 2394
Nason & Philips (London): Vliet, H C van, A 2531
Néger, J (Paris): Bloemaert, A, A 3743
Nijstad, A (Lochem & The Hague): Claesz, P, A 4244;
Kamphuijsen, J, A 4140-A 4150; Pietersz, P, A 3962;
Tintoretto, J, A 3902; Troost, C, A 4099; IJsselstein, A van,
A 3928 & A 3929; French school ca 1775, A 3916-A 3919;
Netherlands school? 3d quarter 16th century, A 3914 & A 3915;
Northern Netherlands school ca 1680, A 3895
Old Masters Galleries Ltd (London): Troost, C, A 3933
Osthoff (Bielefeld): MIN Lesage, P, A 4237; MIN Ploetz, H,
A 4238
Pailloux, A (Paris): Hoogerheyden, E, A 4126
Pappelendam & Schouten, W E van (Amsterdam): Beelt, C,
A 1193; Verkolje, J, A 1470; Vollevens I, J, A 1325; see also sale
Amsterdam, 11-12 June 1889
Parson & Son (London): Berchem, N, A 2505
Preyer, A (The Hague): Dongen, C Th M van, A 3039
Reckers, A M (Rotterdam): Wit, J de, A 1783
Roland, Browse & Delbanco (London): Moritz, L, A 4037
Roos & Co, C F (Amsterdam): Anraedt, P van, A 1350; Bol, C,
A 4250; Boone, D, A 987; Boudewijns, A F, A 986; Halen, A
van, A 1968; Regters, T, A 329; Schaak, B, A 844; Valk, H de,
A 1401 & A 1402; Waterloo, A, A 734; Northern Netherlands
school ca 1500, A 2237
Roos, C S (Amsterdam): Miereveld, M J van, A 257; Nooms, R,
A 294
Rosenberg & Stiebel (New York): Jacobsz, D, A 3924;
Vermeyen, J C, A 4069
Rotteveel (The Hague): Snayers, P, A 857
Ryaux, G (Paris): Troost, C, A 4023
St Lucas (Vienna): La Fargue, P C, A 3959
Schäffer, H (Berlin): Vrel, J, A 3127
Schaeffer (New York): Loo, J van, A 3483; Mostaert, J, A 3843;
Troost, C, A 4115
Scheen, P A (The Hague): Leickert, Ch H J, A 3922; Rochussen,
Ch, A 3923
Schlüter, Ad (Amsterdam): Vrancx, S, A 2699
Scholtens & Zn (Groningen): Northern Netherlands school ca
1670, A 1422
Sedelmeyer, Ch (Paris): Cuyp, A, A 1457; Velde II, W van de,
A 1848
Shepherd Bros (London): Levecq, J, A 2402
Slatkin, Ch E (New York): Rottenhammer, J, A 3952

Smith & Co, SF (London): Jelgerhuis Rzn, J, A 2504
Snijers & Rottiers (Antwerp): Magnasco, A, C 1358 & C 1359
Speelman, E (London): Cuyp, A, A 3957; Eckhout, A, A 4070; Troost, C, A 3948 & A 4225
Stein, A (Paris): Wit, J de, A 4659
Steinmeyer & Stephan Bourgois (Paris): Vinckboons, D, A 2401
Sully & Co (London): Eeckhout, G van den, A 2507; Koninck, S, A 2220
Terry Engel, H (London): Netscher, Casp, A 4128
Triepel, C (Berlin): Heerschop, H, A 1431
Vecht & Co, A (Amsterdam): Sant-Acker, P, A 2655; Vroom, H C, A 2661
Velona, P (Florence): Honthorst, G van, A 4171
Voskuil, C L C (Nieuwer Amstel): Savery, R, A 1488
Vries, J de (Amsterdam): Bol, F, A 43; Bray, J de, A 58; Murant, E, A 281
—, R W P de (Amsterdam): Bosch, J, A 3113; PAST Monogrammist J J, A 2411 & A 2412
Wachtler, C (Berlin): Pietersz, A, A 2538; Valckenborgh, F van, A 1506; Voorhout, J, A 2371
Weinberger, A (Paris): Cologne school ca 1575, A 3891
Wertheimer, O (Paris): Champaigne, J B de, A 3744
Wiggings & Sons, A (London): Meulen, A F van der, A 3753
Wildenstein, G (New York): Southern Netherlands school 2d half 15th century, A 3835 & A 3836
IJver, J (Amsterdam): Baen, J de, A 15

INSTITUTIONS (by place name)

Aix-en-Provence, Saint-Sauveur: Master of the Aix Annunciation, A 2399
Alkmaar, St Laurenskerk (church of St Lawrence): Master of Alkmaar, A 2815
Amersfoort, Het Hoogerhuis near Randenbroek: Campen, J van, A 4254
Amsterdam, Admiraliteit (admiralty), navy model room: Nooms, R, A 1396-A 1399
—, Agnietenkapel: Cornelisz van Oostsanen, J, C 1125
—, Amstel Jachthaven (marina on the Amstel): Rust, J A, A 4275
—, Arrondissements-Rechtbank (district court): Meegeren, H A van, A 4240-A 4243
—, Arsenaal (arsenal): Northern Netherlands school mid-17th century, A 2519a-A 2522c
—, Arti et Amicitiae: Wijsmuller, J H, A 3026
—, Chirurgijns-Weduwenfonds (pension fund for surgeons' widows): see sale Amsterdam, 4ff Aug 1828
—, city of: Aertsen, P, C 392; Anraedt, P van, C 440; Anthonisz, C, C 409 & C 1173; Asch, P J van, C 88; Asselijn, J, C 89; Augustini, J L, C 586; Baburen, D van, C 612; Backer, A, C 360 & C 362; Backer, J, C 442 & C 1174; Bakhuysen, L, C 91, C 92 & C 363; Barendsz, D, C 364, C 365, C 454 & C 379; Beelt, C, C 93; Beerstraaten, J, C 1175; Beerstraaten, J A, C 94; Bega, C, C 95; Berchem, N, C 97 & C 98; Berckheyde, G A, C 101, C 103 & C 104; Berckheyde, J, C 100; Bergen, D van den, C 104; Block, E F de, C 576; Bloemaert, H, C 106; Bol, F, C 107, C 367, C 436, C 626 & C 1176; Boonen, A, C 368, C 444, C 445 & C 1468; Borch, G ter, C 242; Both, J, C 109 & C 110; Braeckeleer, F de, C 281; Brekelenkam, Q G van, C 112 & C 113; Bijlert, J van, C 310; Calame, A, C 302; Calisch, M, C 116 & C 117; Calraet, A van, C 122; Camphuijsen, G D, C 563; Cels, C, C 282; Claesz, A, C 366; Coclers, L B, C 8 & C 9; Conflans, A van, C 791; Cornelisz van Oostsanen, J, C 1125; Court, J D, C 303; Cuyp, A, C 114, C 120 & C 123; Cuyp, J G, C 121; Daiwaille, A J, C 124; Dasveldt, J, C 125 & C 126; Dircksz, B, C 405; Doncker, H M, C 111; Dou, G, C 127, C 128 & C 243; Droochsloot, J C, C 438 & C 446; Dubbels, H J, C 129; Ducorron, J J, C 283; Dujardin, K, C 4, C 157, C 158 & C 280; Dyck, A van, C 284 & C 312; Eeckhout, G van den, C 130; Eelkema, E J, C 131; Eertvelt, A van, C 361, C 383, C 386, C 403 & C 1177; Elliger I, O, C 215; Engel, A K M, C 285; Everdingen, A van, C 132; Flinck, G, C 1, C 370 & C 371; Francken II, F, C 286; Garofalo, B T da, C 309; Gool, J van, C 133; Haagen, J van der, C 108, C 138 & C 373; Haanen, G G, C 134-C 136; Hackaert, J, C 137; Hals, F, C 139, C 374, C 556 & C 557; Hansen, L J, C 141; Hattich, P van, C 452; Heda, W C, C 610; Heemskerck van Beest, J E van, C 429; Helst, B van der, C 2, C 3, C 50, C 142, C 375 & C 624; Hendricks, W, C 422; Heyden, J van der, C 143 & C 571; Hildebrand, Th, C 304; Hobbema, M, C 144 & C 145; Hodges, Ch H, C 10 & C 11; Hondecoeter, M d', C 146 & C 581; Hooch, P de, C 148-C 150 & C 1191; Hoogstraten, S van, C 152; Hoopstad, E I, C 115; Houbraken, A, C 153; Hulst, J B van der, C 287 & C 288; Huysum, J van, C 154, C 155 & C 561; Isaacsz, P, C 410 & C 455; Israels, J, C 570; Jacobsz, D, C 376, C 377, C 402, C 424, C 621 & C 1178; Janson, J Ch, C 156; Jongh, L de, C 190; Jonson van Ceulen I, C, C 1179; Jordaens, J, C 439; Kaldenbach, J A, C 587; Karsen, K, C 159; Ketel, C, C 378 & C 425; Keun, H, C 119; Keyser, N de, C 290; Keyser, Th de, C 71, C 380, C 381, C 567 & C 568; Klomp, A J, C 161 & C 162; Knijff, W, C 451; Kobell II, J, C 164; Koekkoek, B C, C 165, C 166 & C 542; Kruseman, C, C 167; Kruseman, J A, C 168-C 170 & C 1123;

Laen, D J van der, C 171; Lairesse, G, C 382 & C 437; Lastman, C P, C 406; Lelie, A de, C 537-C 539, C 588, C 589 & C 1131; Leys, J A H Baron, C 291; Lingelbach, J, C 172; Liotard, J-E, C 43 & C 44; Lyon, J, C 384; Maes, N, C 90, C 176 & C 535; Man, C de, C 151; Marne, J L, C 292; Martinet, L, C 305; Metsu, G, C 177 & C 560; Meulemans, A, C 179; Miereveld, M J van, C 12, C 180 & C 181; Mieris I, F van, C 182 & C 184; Mieris 11, F van, C 185 & C 186; Mieris, W van, C 183; Mignon, A, C 187 & C 580; Moerenhout, J J, C 293; Molenaer, J M, C 140 & C 188; Moreelse, P, C 623; Moritz, L, C 466; Mörner, H, C 306; Moucheron, A de, C 189; Moucheron, I de, C 388; Musscher, M van, C 13 & C 14; Neer, A van der, C 191 & C 192; Netscher, Casp, C 175, C 193-C 195; Netscher, Con, C 15 & C 16; Oberman, A, C 196-C 198; Ochtervelt, J, C 390; Opzoomer, S, C 294; Os, G J J van, C 199; Ostade, A van, C 200, C 201 & C 564; Ostade, I van, C 202; Ovens, J, C 17; Palthe, J, C 18-C 20; Pietersz, A, C 70 & C 391; Pietersz, G, C 592; Pietersz, P, C 404; Pistorius, E, C 307; Polidoro da Lanciano, C 308; Portman, Chr J L, C 203; Potter, P, C 205, C 206 & C 279; Potter, P S, C 204; Pynacker, A, C 207; Quinkhard, J M, C 81-C 83, C 1469-C 1471; Ravenzwaay, J van, C 208 & C 209; Ravesteyn, J A van, C 240; Regters, T, C 84 & C 1472; Rembrandt, C 5, C 6, C 85 & C 216; Ronner-Knip, H, C 592; Rotius, J A, C 611; Rubens, P P, C 295 & C 296; Ruisdael, J I van, C 210-C 213 & C 562; Ruysch, R, C 214; Rijk, J de, C 540; Saenredam, P J, C 217 & C 1409; Saftleven, H, C 218; Sandrart, J von, C 26, C 27 & C 393; Santvoort, D D, C 394 & C 431; Savery, R, C 447; Schelfhout, A, C 219; Schendel, B van, C 173 & C 174; Schendel, P van, C 297; Schoemaker Doyer, J, C 220-C 222; Schotel, P J, C 225; Schouman, M, C 226; Schwartze, Th, C 745; Sorgh, H M, C 178 & C 227; Spilberg 11, J, C 395; Staveren, J A van, C 228; Steen, J H, C 229-C 233; Storck, A, C 235 & C 236; Strij, A van, C 237; Strij, J van, C 238 & C 613; Temminck, H C, C 239; Tempel, A L van den, C 241; Tengnagel, J, C 407; Teniers 11, D, C 298-C 300; Tol, D van, C 21; Troost, C, C 79, C 80, C 87, C 596, C 411 & C 1473; Utrecht, A van, C 301; Vaillant, W, C 22, C 23, C 39 & C 40; Valckert, W J van den, C 397, C 417 & C 419; Velde, A van de C 248-C 250; Velde 11, W van de, C 7, C 244-C 247; Venne, A P van de, C 606-C 608; Verelst, H, C 24 & C 25; Vermeer, J, C 251; Vermeulen, A, C 252; Verschuier, L, C 253; Verschuur I, W, C 254 & C 541; Versteegh, M, C 255 & C 256; Verwer, A de, C 453; Vettewinkel, H, C 257; Victors, J, C 258 & C 259; Vlieger, S de, C 449; Vois, A de, C 260; Voort, C van der, C 262-C 264, C 399, C 408, C 622, C 748 & C 1108; Werff, A van der, C 265 & C 266; Werff, P van der, C 267 & C 268; West, J H van, C 269; Willeboirts, Th, C 400; Wit, J de, C 401; Witte, E de, C 270; Wouwerman, Ph, C 271-C 273; Wijnants, J, C 274-C 277; Monogrammist I L, C 160; Netherlands 2d half 17th century, C 428; Northern Netherlands school ca 1645, C 427; Holland school mid-17th century, C 426; Holland school ca 1650, C 289; Holland school 18th or 19th century, C 278; Amsterdam school 1560, C 33 & C 34; Amsterdam school 1573, C 35; Amsterdam school 1583, C 36 & C 37; Amsterdam school 1606, C 387; Amsterdam school ca 1650, C 42; Amsterdam school 1654, C 38; Amsterdam school 1655, C 1172; Amsterdam school ca 1726, C 418; Amsterdam school 1775, C 41; Spanish school? ca 1615, C 311; MIN Hodges, Ch H, C 45; MIN Holland school ca 1650, C 32; MIN Holland school ca 1795, C 46 & C 47; PAST Liotard, J-E, C 30 & C 31; PAST Tozelli, F, C 543; PAST Vilsteren, J van, C 49 & C 51
The Bicker and van der Hoop bequests are also indexed under the names of the bequeathers
—, Dienst Publieke Werken (department of public works): Wit, J de, RBK 1958-81
—, Directie van de Levantse handel (bureau of Levantine trade): VAN M A 2053-A 2056, A 3947, A 4083 & A 4085; see also The Hague, Koninklijk Kabinet van Zeldzaamheden
—, district court: see Arrondissements-Rechtbank
—, Doopsgezinde Gemeente: see Verenigde Doopsgezinde Gemeente
—, Groot Hollandsch Museum: see The Hague & Amsterdam, Nationaal Museum (NM)
—, Hofje van de Zeven Keurvorsten (almshouse of the seven electors): Master of the Amsterdam Death of the Virgin, A 3467
—, Keizersgracht 293: Wit, J de, RBK 1958-81
—, Koloniaal Magazijn (colonial warehouse): Pietersz, P, A 865; Verkolje, N, A 4290; Wit, J de, A 4291; Holland school 1617, A 4482; Holland school ca 1630, A 4066
—, Koninklijk Museum: see The Hague & Amsterdam, Nationaal Museum (NM)
—, Koninklijk Oudheidkundig Genootschap (KOG; royal antiquarian society): Bertichen, P G, C 1539 & C 1540; Boonen, A, C 1567 & C 1568; Burgh, H van der, C 1182; Buijs, C 515; Clercq, J de, C 1561; Compe, J ten, C 1529 & C 1530; Daiwaille, J A, C 530; Dumesnil, L M, C 512; Duyster, W C, C 514; Ekels 11, J, C 1537; Grebber, P F de, C 522; Haensbergen, J van, C 1546 & C 1547; Heemskerck, M van, C 507 & C 1563; Hendriks, W, C 532; Hilverdink, E A, C 1538; Hoevenaar, W P, C 1541; Hondius, I, C 1558; Hulst, F de, C 519; Kooi, W B van der, C 1556; Leemans, J, C 523;

Martens, W, C 1544; Mierevald, M J van, C 520 & C 521; Musscher, M van, C 528; Mij, H van der, C 1526; Mijn, F van der, C 1527; Noorderwiel, H, C 1550; Os, PG van, C 531; Otterbeek, J H, C 1571; Pietersz, A, C 525; Plaes, D van der, C 517 & C 518; Rochussen, Ch, C 1548; Rossum, J C van, C 1549; Smies, J C, C 1536; Spinny, G de, C 527; Teyler van Hall, J J, C 1557; Troostwijk, W J van, C 1535; Valkenburg, H, C 1559; Velde, E van de, C 1533; Vianey, P, C 1542; Vogelaer, P, C 524; Voort, C van der, C 1553; Vrancx, S, C 510; Wit, J de, C 1221; Zeuner, J, C 1531, C 1532, C 1534 & C 1569; Monogrammist I S H, C 529; Northern Netherlands school ca 1590, C 1222; Northern Netherlands school 1578, C 1560; Northern Netherlands school 1608, C 506; Northern Netherlands school ca 1625, C 1528 & C 1551; Northern Netherlands school 18th century, C 1582; Northern Netherlands school ca 1730, C 1570; Northern Netherlands school ca 1745, C 1575; Holland school ca 1485, C 509; Holland school 1720, C 526; Amsterdam school 2d half 18th century, C 1562; Amsterdam school mid-19th century, C 1545; Amsterdam school ca 1875, C 1576; Southern Netherlands school ca 1560, C 508; Southern Netherlands school ca 1570, C 1579; PAST Troost, C, C 1193; PAST Vau...ons, C 1574; PAST Northern Netherlands school ca 1750, C 1572 & C 1573; PAST Northern Netherlands school ca 1815, C 1552; HER C 513, C 513a, C 1580 & C 1581
—, 's Lands Museum: see The Hague & Amsterdam, Nationaal Museum (NM)
—, Ministerie van Financiën (ministry of finance), agency: Lievens, J, A 612
—, Museum Van der Hoop: see private persons: Hoop, A van der
—, Nationaal Museum (NM): see The Hague & Amsterdam
—, Nederlandsch Museum voor Geschiedenis en Kunst (NMGK): see The Hague & Amsterdam
—, Oost-Indië Huis (East India House): Beeckman, A, A 19; Troost, A, A 4287; Vroom, H C, A 1361; Northern Netherlands school ca 1650, A 4471-A 4474 & A 4477
—, Oud-Rosenburgh: see sale Amsterdam, 27-29 June 1905
—, Prinsenhof: Bol, F, A 613 & A 614
—, Remonstrants-Gereformeerde Gemeente (Remonstrant-Reformed congregation): Backer, J A, C 1474; Pothoven, H, C 1475
—, Rijksacademie voor Beeldende Kunsten (national academy of art): Lairesse, G & Glauber, J, A 4213-A 4216
—, Rijks Marinewerf (navy yard): Vroom, H C, A 602
—, Rijksprentenkabinet van het Rijksmuseum (RPK; Rijksmuseum printroom): Borch, M ter, A 2118; Savery 1, J, A 2117; MIN Fock, H, A 2120; PAST Carriera, R, A 2119; PAST Troost, S, C 1407 & C 1408; PAST Zilcken, Ch L Ph, A 2690; see also AQU Introduction
—, Rijpenhofje: Flinck, G, A 4166
—, Stads Kunstkamer (city art room): Bakhuysen, L, C 363
—, Stichting P en N de Boer (P & N de Boer foundation): Aertsen, P, C 1458
—, Trippenhuis (house of the Trip family): Bol, F, A 45 & A 46; Everdingen, A van, A 108 & A 1510; Van der Wal, Ph, A 1348 & A 1349; Northern Netherlands school 2d half 18th century, A 1332-A 1335
—, Verenigde Doopsgezinde Gemeente (united Mennonite congregation), deacons: Flinck, G, A 4166
—, West-Indië Huis (West India House): Northern Netherlands school ca 1650, A 4475 & A 4476
—, H Willibrorduskerk buiten de veste (church of St Willibrord): Vignon, C, A 4068
—: see also Index of portraits and persons: group portraits of civic guard companies; group portraits of guild officers; group portraits of other governing bodies
Apeldoorn, paleis Het Loo (Het Loo palace): Bonifazio Veronese, C 1374; Hillegaert, P van, A 452; Huchtenburg, J van, C 1226; Key, W, A 18; Massys, Q, A 247; Poel, E van der, A 308 & A 309; Serodine, G, A 332; Stomer, M, A 216; Venne, A P van de, A 447
Batavia: see Djakarta
Brazil, government: Northern Netherlands school ca 1660, A 2967
Breda, Koninklijke Militaire Academie (royal military academy): HER NM 11640-w
Breukelen, Kasteel Oudaen (Oudaen castle): Holland school ca 1680, A 2716
Chinsura, India: HER NG105-NG 118
Delft, the house named 'Spangien': Palamedesz, A, A 861
—, Maria Moeder des Heren in Sion-klooster (convent of Holy Mary, Mother of God in Zion): Master of the Spes Nostra, A 2312
—, Stedelijk Museum 'Het Prinsenhof': Venne, A P van de, C 1343
Djakarta, Gebouw van de Volksraad (seat of the people's council): GOV A 3822-A 3825
—, Nederlandse Hoge Commissaris (Dutch high commission): Paelinck, J, C 1460; Rol, H, C 1462
Douai, Musée de la Chartreuse: Lievens, J, C 1467
Enkhuizen, municipality: Neck, J van, A 1986
—, Oud-Katholieke Kerk (Old Catholic church): Grebber, P F de, A 2311

Erbach am Rhein, Reinhardtshausen Castle: Northern Netherlands school 1st half 17th century?, A 4170

Franekeradeel, town hall: Beelt, C, A 2692; Woutersin, LF, A 2693

Gorkum, Vereniging 'Oud-Gorcum' (Oud-Gorcum society): Coecke van Aelst, P, A 3464

Greenwich, National Maritime Museum: Velde I, W van de, A 1384

Groningen, Gouvernementsgebouw (provincial capitol): Scorel, J van, A 670; Swart van Groningen, J, A 669

Haarlem, Prinsenhof: Cornelisz van Haarlem, C, A 129

—, Rijksarchief (state archives): North Italian school? 1st half 18th century, A 3218; Netherlands school ca 1550, A 3215; Northern Netherlands school ca 1600, A 3216; Northern Netherlands school ca 1625, A 3217; Holland school ca 1730, A 3219 & A 3220; PAST Baur, HJA, A 3223; HER A 3221 & A 3222

—, 's Rijks Verzameling van Moderne Meesters (RVMM; state collection of modern masters): Abels, J Th, A 998; Apol, LFH, A 1164; Artz, DAC, A 1187; Assche, H van, A 999; Bakker Korff, AH, A 1183; Barbiers, P, A 1003; Bauer, N, A 1004, A 1005, A 1377-A 1380; Behr, CJ, A 1006; Berg, S van den, A 1007; Bilders, JW, A 1008; Bles, DJ, A 1009; Bloeme, HA de, A 1173; Borselen, JW van, A 1010; Bosboom, J, A 1011; Brandt, AJ, A 1012 & A 1013; Bree, MI van, A 1172 & A 4253; Breuhaus de Groot, FA, A 1014; Brice, I, A 1015; Burgh, H van der, A 1016 & A 1017; Burgh, PD van der, A 1368; Cate, HG ten, A 1018; Cels, C, A 1019; Coene, CF, A 1020; Coene, JH de, A 1021; Couwenberg, AJ, A 1022; Cunaeus, C, A 1023; Cuijlenburg, C van, A 943 & A 1374; Delvaux, E, A 1024; Deventer, WA van, A 1025; Diez, A, A 1026; Dreibholtz, CLW, A 1028; Drift, JA van der, A 942; Dubourcq, PL, A 1029; Eeckhout, JJ, A 1030; Eelkema, EJ, A 1031 & A 1032; Engelberts, WJM, A 1033; Evrard, A, A 1034; Eycken, JB van, A 1035; Famars Testas, W de, A 1184; Govaerts, AC, A 1036; Greive, JC, A 1037; Gruijter I, W, A 1038; Haanen, AJ, A 1039 & A 1186; Haas, JHL de, A 1178; Hanedoes, L, A 1040; Hanselaere, P van, A 1041 & A 1042; Hansen, CL, A 3925; Hari I, J, A 1043; Haseleer, F, A 1044; Heemskerck van Beest, JE van, A 1045; Hendriks, W, A 3943; Hilverdink, J, A 1046; Hodges, Ch H, A 1047 & A 1048; Hove, BJ van, A 1049 & A 1369; Hulswit, J, A 1050 & A 1051; Israels, J, A 1179; Janson, J Ch, A 1052; Jelgerhuis Rzn, J, A 1053-A 1055; Jonghe, J B de, A 1056; Kate, H FC ten, A 1057; Keultjes, GL, A 1376; Klinkenberg, J Ch K, A 1175; Knip, JA, A 1058; Knoll, FC, A 1059; Kobell II, J, A 1060 & A 1061; Kobell III, J, A 1062; Kooi, WB van der, A 1063-A 1065 & A 1170; Koster, E, A 1176; Kruseman, C, A 1066-A 1070; Kruseman, JA, A 1071 & A 1072; Lauwers, JJ, A 1073; Leickert, CH J J, A 1074; Lelie, A de, A 1075; Lingeman, L, A 1076; Linthorst, J, A 1077; Lokhorst, D van, A 1171; Maes, J BL, A 1078; Mesdag, HW, A 1165; Meulemans, A, A 1174; Meyer, JHL, A 1079; Michaëlis, GJ, A 1080; Moerenhout, JJ, A 1081 & A 1082; Morel, JE, A 1083; Moritz, L, A 1084 & A 1370; Navez, FJ, A 1085 & A 1086; Neuhuys, JA, A 1181; Nicolié, J Ch, A 1087; Noël, PPJ, A 1088 & A 1089; Noter II, PF de, A 1090, A 1091 & A 4264; Nuyen, WJJ, A 1092; Odevaere, JD, A 1093; Ommeganck, BP, A 1094; Os, GJJ van, A 1104-A 1106; Os, J van, A 1095; Os, MM van, A 1107; Os, PG van, A 1096-A 1103 & A 1372; Paelinck, J, A 1108; Picqué, Ch, A 1109; Pieneman, JW, A 944, A 1110-A 1115, A 1371, A 1373, A 1375, A 4268 & A 4269; Pieneman, N, A 1116; Poelman, PF, A 1118; Portman, Chr J L, A 1119; Prins, JH, A 1120; Ravenzwaay, J van, A 1121; Regemorter, IJ van, A 1122 & A 1123; Roelofs, W, A 1166; Ronner-Knip, H, A 1124; Roth, GA, A 1125; Sadée, Ph L J F, A 1167; Saleh, SB, A 778; Saligo, Ch L, A 1126; Sande Bakhuyzen, H van de, A 1000 & A 1001; Sande Bakhuyzen, GJ van de, A 1002; Sande Bakhuyzen, JJ van de, A 1185; Schelfhout, A, A 1127 & A 1128; Schmidt, GA, A 1135; Schoemaker Doyer, J, A 1027; Schoenmakers Pzn, J, A 1129; Scholten, HJ, A 1130; Schotel, J Ch, A 1131 & A 1132; Schotel, PJ, A 1133; Schouman, M, A 1134; Sminck Pitloo, A, A 1117; Springer, C, A 1136; Stokvisch, H, A 1137; Stortenbeker, P, A 1138; Stroebel, J AB, A 1139; Strij, A van, A 1143; Strij, J van, A 1140-A 1142; Teerlink, A, A 1144 & A 1145; Tom, JB, A 1146; Trigt, HA van, A 1147; Troostwijk, WJ van, A 1168 & A 1169; Valois, JF, A 1148; Velden, P van der, A 1180; Verboeckhoven, EJ, A 1149-A 1151; Verschuur I, W, A 1152; Verveer, SL, A 1153 & A 1154; Vervloet, F, A 1155; Vogel, JG, A 1156; Vogel-Roosenboom, MCJWH, A 1182; Vogel, CJ de, A 1177; Voordecker, H, A 1157; Vos, M van, A 1158; Wappers, E Ch G, A 1159; Weissenbruch, J, A 1160; Westenberg, GP, A 1161; Winter, AH, A 1162; Wonder, PC, A 1163

The Hague, Bureau Rijksbouwmeester (office of the state architect): Aa, D van der, A 1300 & A 1301

—, Departement van Defensie (ministry of defense): Coecke van Aelst, P, A 3464

—, Departement van Koloniën (ministry of the colonies): Pietersz, P, A 865; Troost, C, A 4287; Northern Netherlands school ca 1650, A 4471-A 4477; Holland school 1617, A 4482; Holland school ca 1630, A 4066; ROT see Rotterdam, Oost-Indisch Huis; GOV A 4525-A 4552

—, Departement van Marine (ministry of marine), model room: Lingelbach, J, A 1391; Nooms, R, A 1396-A 1399; Schellinks, W, A 1393; Schouman, M, A 1394 & A 1395; Velde I, W van de, A 1392; Danish school ca 1760, A 978

—, Dienst voor 's Rijks Verspreide Kunstvoorwerpen (DRVK; national service for state-owned works of art): Apollonio di Giovanni, A 3999; Araldi, J, A 3967; Beccaruzzi, F, A 3990; Bonsignori, F, A 3991; Borch, G ter, A 3963 & A 3964; Boucher, F, A 4014; Carpaccio, V, A 3993; Carracci, L, A 3992; Chabot, H, C 1485 & C 1565; Cornelisz van Haarlem, C, A 4015; Crivelli, C, A 3989 & A 3994; Fiore, J del, A 4001; Geel, JJ van, A 3968; Gelder, A de, A 3969; Gérard, F, C 1525; Giorgione, A 3970; Giovanni da Brescia, A 3995; Giovanni da Milano, A 4000; Girolamo da Santa Croce, A 3966; Groenewegen, PA, A 3965; Heyden, J van der, A 3971; Hodges, Ch H, C 1410; Lingelbach, J, A 3973; Keyser, Th de, A 3972; Luca di Tommè, A 4003; Monaco, L, A 3976, A 4004-A 4007; Mijtens, J, A 4013; Netscher, Casp, A 3977 & A 3978; Niccolò di Liberatore, A 4008; Paelinck, J, C 1460; Rembrandt, A 3981, A 3982 & A 4019; Roestraeten, RG van, A 4189; Rol, H, C 1462; Ruysdael, SJ van, A 3983; Schiavone, A, A 4009; Steen JH, A 3984; Tiepolo, GB, A 3985; Tintoretto, J, A 3986, A 3987 & A 4010; Vallayer-Coster, A, C 1523; Velde, JJ van de, A 3988; Veronese, P, A 4011; Vivarini, B, A 4012; Vivien, A, A 4016; Voogd, H, C 1524; Voort, C van der, A 3741 & A 3742; Master of the Battle of Anghiari, A 3974; Master of the Bambino Vispo, A 3979 & A 3980; Master of the Carrand Triptych, A 4022; Master of Pietro a Ovile, A 4002; Master of the Virgo inter Virgines, A 3975; English school 2d half 16th century, C 1466; Italian school 2d half 13th century, A 3996; Italian school 15th century, A 3997; Italian school 2d half 17th century, A 4020; Sienese school ca 1450, A 3998; Northern Netherlands school ca 1575, A 4018; Northern Netherlands school ca 1948, C 1461; Haarlem school? ca 1660, A 4017; Southern Netherlands school 1st half 17th century, C 1484; Southern Netherlands school 2d half 17th century, A 4021; MIN French school 2d half 18th century, RBK 17156

—, Groot Hollandsch Museum: see Nationaal Museum

—, Huis ten Bosch: Honthorst, G van, A 871, A 873 & A 874

—, Huygenshuis (house of Constantijn Huygens): Bor, P, A 852; Hardimé, P, A 2732-A 2735; Saenredam, PJ, A 851; Schouman, A, A 2730 & A 4280; Netherlands school 4th quarter 17th century, A 2629; Holland school mid-18th century, A 2686 & A 2687

—, Koninklijke Bibliotheek (royal library): Jansen, FJ, A 1534; Neuhuys, JH, A 1353

—, Koninklijk Kabinet van Schilderijen (KKS; royal picture cabinet, called Het Mauritshuis): Aved, JAJ, A 872; Bunel, J, A 1400; Cima da Conegliano, GB, A 1219; Cuijlenburg, C van, A 1216; Dyck, A van, A 101 & A 1224; Flinck, G, A 869; Haag, T Ph Ch, A 1225; Honthorst, G van, A 871, A 873 & A 874; Keller, JH, A 1215, A 1232 & A 1237; Keultjes, GL, A 1376; Klöcker, D, A 1234; Kobell II, H, A 1218; Lairesse, G, A 1233; Mijn, F van der, A 887; Mijtens, J, A 1239; Palma il Giovane, J, A 1235; Pesne, A, A 886; Potter, P, A 316; Pourbus II, F, A 870; Pronk, C, A 4274; Reclam, F, A 1222; Rubens, PP, A 345; Valkenburg, D, A 1240; Vanloo, A, A 888; Wissing, W, A 879 & A 1228; Ziesenis, JG, A 881, A 882 & A 1229; German school ca 1765, A 1223; Italian school 17th century, A 1220; Florentine school 2d quarter 16th century, A 1226; Venetian-Byzantine school late 13th century, A 4461; Northern Netherlands school 17th century, A 1231 & A 1236; Northern Netherlands school ca 1610, A 875-A 877; Northern Netherlands school ca 1615, A 1230; Northern Netherlands school mid-17th century, A 1203-A 1206; Northern Netherlands school 2d half 17th century, A 1211-A 1214 & A 1238; Holland school 4th quarter 18th century, A 1207-A 1210; Holland school ca 1745, A 883 & A 884; Southern Netherlands school? ca 1600?, A 1221; Spanish school 2d half 17th century, A 4489; MIN Petitot, J, A 4355 & A 4356; MIN English school ca 1575, A 4394; MIN German school? 18th century?, A 4652; MIN Netherlands school ca 1575, A 4422; MIN Northern Netherlands school 17th century?, A 4423; MIN Northern Netherlands school ca 1645, A 4426; MIN Northern Netherlands school ca 1690, A 4427; MIN Northern Netherlands school ca 1745, A 4430; MIN Northern Netherlands school late 18th century, A 4653

The following works are on loan from the KKS: Allori, A, C 1344; Bonifazio Veronese, C 1374; Cerezo, M, C 1347; Champaigne, Ph de, C 1183; Cornelisz van Oostsanen, J, C 1349; Cortona, P da, C 1345; Delen, D van, C 1350; Dughet, G, C 1351; Farinato, P, C 1352; Fogolino, M, C 1129; Franceschini, MA, C 1348; Giordano, L, C 1353; Huchtenburg, J van, C 1226; Iriarte, I de, C 1371; Lingelbach, J, C 1223 & C 1224; Magnasco, A, C 1356-A 1361; Mazo, J BM del, C 1362; Mazzolino, L, C 1363; Moroni, G, C 1365; Murillo, BE, C 1366; Musscher, M van, C 1215; Piero di Cosimo, C 1367 & C 1368; Ravesteyn, JA van, C 1227-C 1230; Sassoferrato, GB, C 1370; Tintoretto, J, C 1373; Turchi, A, C 1372; Master of Alkmaar, C 1364; Italian school mid-17th century, C 1346; Venetian school 1st quarter 16th century, C 1354; Northern Netherlands school ca 1430, C 1454; Northern Netherlands school 1645, C 1225

—, Koninklijk Kabinet van Zeldzaamheden (KKZ; royal cabinet of curiosities): Appel, J, A 4245; Blarenberghe, L N van, A 4249; Piemont, N, NM 1010; Royen, WF van, NM 1010; Voorhout, J, NM 1010; Netherlands school? 1542, A 4462; VAN M A 1996-A 2056, A 4076-A 4085; MIN Arlaud, B, A 4295 & A 4296; MIN Bettes, J, A 4297; MIN Blesendorff, S, A 4298; MIN Boit, Ch, A 4299-A 4301; MIN Boze, J, A 4320; MIN Brounckhurst, A van, A 4302; MIN Cooper, A, A 4303 & A 4304; MIN Cooper, S, A 4305-A 4311; MIN Dixon, N, A 4312; MIN Duchatel, M, A 4313; MIN Granges, D des, A 4314 & A 4315; MIN Guernier, L du, A 4316 & A 4317; MIN Haag, G, A 4318 & A 4319; MIN Hilliard, N, A 4321-A 4323; MIN Hoadley, P, A 4324; MIN Hoskins, J, A 4325-A 4328; MIN Huaut I, P, A 4329; MIN Kessler, F, A 4331; MIN Lamprecht, G, A 4332; MIN Légaré, G, A 4333; MIN Le Sage, P, A 4335; MIN Liotard, J-E, A 4336; MIN Michelin, J, A 4339; MIN Mussard, R, A 4340-A 4343; MIN Oliver, I, A 4344-A 4347; MIN Oliver, P, A 4348-A 4353; MIN Petitot, J, A 4354; MIN Phaff, L, A 4360; MIN Ploetz, H, A 4361; MIN Pluckx, J AA, A 4362; MIN Ramelli, F, A 4363 & A 4364; MIN Richter, Ch, A 4365; MIN De Saint Ligié, A 4366; MIN Sypesteyn, MM van, A 4368; MIN Thach, N, A 4369; MIN Toutin, H, A 4370 & A 4371; MIN Wilhelmina, princess of Prussia, 4372-4374; MIN Zincke, Ch F, A 4375; MIN Monogrammist WP, A 4376 & A 4377; MIN English school ca 1565, A 4390-A 4393; MIN English school ca 1635, A 4395; MIN English school ca 1665-70, A 4396; MIN English school ca 1725, A 4397; MIN English school ca 1755, A 4398; MIN English school ca 1770, A 4399-A 4401; MIN English school ca 1800, A 4403; MIN French school 1500, A 4404; MIN French school ca 1550, A 4405; MIN French school ca 1570, A 4406; MIN French school ca 1580, A 4407 & 4408; MIN French school ca 1650, A 4409; MIN French school ca 1665, A 4410-A 4412; MIN French school ca 1675, A 4413; MIN French school 18th century, A 4414-A 4416; MIN French school 2d half 18th century, A 4417; MIN French school 1750, A 4418; MIN French school ca 1785, A 4419; MIN French school ca 1790, A 4420 & A 4421; MIN German school ca 1700, A 4378; MIN German school ca 1730, A 4379-A 4382; MIN German school ca 1750, A 4383; MIN German school ca 1760, A 4384; MIN German school ca 1770, A 4385; MIN German school ca 1770, A 4386; MIN German school ca 1810, A 4388 & A 4389; MIN Netherlands school ca 1575, A 4394; MIN Northern Netherlands school ca 1710, A 4428; MIN Holland school ca 1635, A 4431 & A 4433; MIN Holland school ca 1650, A 4434 & A 4435; MIN Holland school ca 1665, A 4436; MIN Holland school ca 1675, A 4437 & A 4438; MIN Holland school ca 1690, A 4439; MIN Holland school ca 1710, A 4440 & A 4441; MIN Holland school ca 1715, A 4442; MIN Holland school ca 1750, A 4443-A 4447; MIN Holland school ca 1760, A 4448; MIN Holland school ca 1770, A 4452 & A 4453; MIN Holland school ca 1775, A 4448 & A 4449; MIN Holland school ca 1780, A 4450, A 4451, A 4454-A 4456; MIN Spanish school 1650, A 4459

—, Koninklijk Museum: see The Hague & Amsterdam, Nationaal Museum

—, Mauritshuis: see Koninklijk Kabinet van Schilderijen

—, Nationaal Museum: see under The Hague & Amsterdam

—, Nationale Konst-Gallery: see The Hague & Amsterdam, Nationaal Museum

—, Nederlandsch Museum voor Geschiedenis en Kunst: see under The Hague & Amsterdam

—, prison on the Prinsegracht: Jordaens, J, A 2367

—, Pulchri Studio: see sale The Hague, 16 Oct 1900

—, Remonstrantse kerk (Remonstrant church): Cornelisz van Haarlem, C, A 127; Miereveld, M J van, A 580

—, riding academy behind the Kloosterkerk: Venetian school 1st half 16th century, A 1296

—, Stadhouderlijk Kwartier (the stadholder's quarters on the Binnenhof): Schuer, Th C van der, NM 4485

—, Staten Generaal (states-general): Veen, O van, A 421-A 432

—& Amsterdam, Nationaal Museum (NM; national museum; the works in the following list were acquired between 1798 and 1815 either for the Koninklijk Museum or its predecessor the Nationale Konst-Gallery. The collections of G van der Pot van Groeneveld and A L van Heteren Gevers, which were also acquired in this period, are indexed separately; see private persons: Heteren Gevers, A L van, and sale Rotterdam, 1808 6 June): Asselijn, J, A 4; Aved, JAJ, A 6; Backer, JA, A 157; Baen, J de, A 13-A 15; Bakhuysen, L, A 8; Bailly, D, A 16; Berchem, N, A 28 & A 31; Berckman, H, A 36; Bol, F, A 44, A 613 & 614; Borch, G ter, A 405; Borch, J ter, A 1331; Both, J, A 50; Calraet, A van, A 79; Cappelle, J van de, A 453; Cleve, J van, A 165; Cornelisz van Haarlem, C, A 127-A 129; Does, S van der, A 82 & A 83; Dou, G & Berchem, N, A 90; Droochsloot, J C, A 606; Dubbels, H J, A 92; Dusart, C, A 97; Dyck, A van, A 102-A 104; Eyck, N van, A 619; Fabritius, C, A 91; Francken II, F, A 112; Gaesbeeck, A van, A 113; Geest, W S de, A 566, A 569- A 572 & A 4190; Glauber, J, A 118, A 119, A 1200-A 1202 & A 1217; Gossaert van Mabuse, A 217; Goyen, J van, A 122; Guercino, A 593; Hansen, CL, A 3925; Hauck, A Ch, A 136 & A 633; Helst, B van der, A 140-A 142 & A 145; Helst, L van der, A 148; Heinsius, JE, A 76; Hillegaert, P van, A 155, A 435, A 452, A 568 & A 607; Hondecoeter,

M d', A 170, A 171, A 173 & A 175; Honthorst, G van, A 176, A 178, A 179, A 573 & A 574; Honthorst, W van, A 177; Huchtenburg, J van, A 184 & A 605; Huysum, J van, A 620; Janson, J, A 189; Jongh, L de, A 196 & A 197; Key, W, A 18; Lairesse, G, A 211, A 212, A 214, A 215, A 1233 & A 4210; Lingelbach, J, A 224; Massys, Q, A 166 & A 247; Meyer, H de, A 251 & A 252; Miereveld, M J van, A 253-A 258, A 260, A 580 & A 581; Mol, W, A 271; Moreelse, P, A 275; Moucheron, F de, A 280; Mijtens, J, A 284 & A 285; Naiveu, M, A 286; Neefs I, P, A 288; Neefs II, P, A 287; Neer, A van der, A 290; Nickelen, I van, A 360; Nooms, R, A 294; Olis, J, A 296; Palma il Giovane, J, A 1235; Poel, E van der, A 117, A 308 & A 309; Ravesteyn, J A van, A 259, A 4191, C 1227-C 1230; Rembrandt, A 358; Rietschoof, J C, A 333 & A 334; Rode, N, A 639; Rubens, P P, A 346 & A 600; Ruisdael, J I van, A 347; Ruysch, R, A 354; Ryckaert III, D, A 357; Saenredam, P J, A 359; Sandrart, J von, A 56; Schalcken, G, A 367; Schuppen, J van, A 373; Scorel, J van, A 372; Serodine, G, A 332; Staveren, J A van, A 381; Steen, J H, A 387-A 389; Stomer, M, A 216; Teniers II, D, A 400 & A 401; Titian, A 595; Veen, O van, A 421-A 432; Velde, P van den, A 307; Venne, A P van de, A 434, A 445-A 447; Verschuier, L, A 448 & A 449; Verwer, A de, A 603; Verwilt, F, A 450; Victors, J, A 451; Vlieger, S de, A 454; Vliet, H C van, A 455; Vois, A de, A 457; Vroom, H C, A 460 & A 602; Weenix, J, A 462; Weenix, J B, A 591; Werff, A van der, A 466; Wieringa, H W, A 204; Willaerts, A, A 502; Wouwerman, P, A 486; Wouwerman, Ph, A 479, A 483 & A 485; Wijnants, J, A 492 & A 493; Master of the Virgo inter Virgines, A 501; French school 16th century, A 320; School of Fontainebleau 3d quarter 16th century, A 320; South German school ca 1500, A 496 & A 497; Italian school 2d half 17th century, A 596; Ferrarese school 2d quarter 16th century, A 109; Netherlands school ca 1620, A 201; Netherlands school? 17th century, A 512; Northern Netherlands school ca 1435, A 498 & A 499; Northern Netherlands school 1590, A 575; Northern Netherlands school ca 1615, A 576; Northern Netherlands school ca 1635, A 585; Holland school ca 1635, A 567; Holland school ca 1640, A 608; Holland school 1657, A 586; Utrecht school ca 1520, A 513; Southern Netherlands school ca 1655, A 80; HON A 505 & A 506, see also Honselaarsdijk, Huis; MIN Northern Netherlands school? ca 1635, A 278; PAST Tischbein, J F A, A 408-A 416

—, Nederlandsch Museum voor Geschiedenis en Kunst (NMGK; Netherlands museum of history and art): Appel, J, A 4245; Appelius, J, A 924; Aved, J A J, A 880; Baen, J de, A 4648; Balten, P, A 860; Bassen, B van, A 864 & A 4246; Bauer, N, A 1377-A 1380; Beert, O, A 4247; Behr, J Ph, A 885; Bellevois, J, A 4248; Bisschop, C, A 983; Blarenberghe, L N van, A 4249; Bol, F, A 2736 & A 4250; Bolomey, B S, A 948 & A 949; Bor, P, A 852; Borculo, N van, A 4251; Bosch, J, A 4252; Bree, M I van, A 4253; Breen, A van, A 955; Bunel, J, A 1400; Burgh, P D van der, A 1368; Campen, J van, A 4254; Caullery, L de, A 4292; Coter, C de, A 856; Cuijlenburg, C van, A 943 & A 1374; Dalen, C van, A 4493; Delff II, J W, A 953; Diest, J van, A 1389; Diest, W van, A 1382; Drift, J A van der, A 942; Dijk, Ph van, A 892, A 893, A 895-A 898 & A 903; Engebrechtsz, C, A 859; Fabritius, B, A 4192; Farncombe Sanders, J, A 951; Flinck, G, A 869; Francken II, F, NM 4190, NM 4789; Gheyn II, J de, A 4255; Gruyter, J de, A 1381; Hardimé, P, A 2732-A 2735; Heemskerck van Beest, J E van, A 2726; Hemessen, C van, A 4256; Honthorst, G van, A 871, A 873 & A 874; Honthorst, W van, A 855; Hove, B J van, A 1369; Jonson van Ceulen II, C, A 921; Krafft, D von, A 982; Kruseman, J, A 4258; Lairesse, G, A 4259; Leyden, J van, A 1386; Leyden, L van, A 4260; Liedts, A, A 854; Lingelbach, J, A 1391; Loef, J G, A 1383 & A 4261; Lundens, G, A 4262; Marseus van Schrieck, O, A 975; Mesdach, S, A 910, A 911, A 913, A 918 & A 919; Miereveld, M J van, A 908, A 909 & A 2731; Momper, J de, A 4263; Moritz, L, A 1370; Mostaert, G, A 972; Netscher, Casp, A 901 & A 902; Nooms, R, A 1396-A 1399; Noter II, P F de, A 4264; Orley, B van, A 4265; Ovens, J, A 850; Palamedesz, A, A 861; Pesne, A, A 886; Piemont, N, NM 1010; Pieneman, J W, A 944, A 1371, A 1373, A 4268 & A 4269; Pieneman, N, A 4270; Pietersz, P, A 865; Post, F, A 4271-A 4273; Pourbus I, F, A 870; Pourbus, P, A 962c; Pronk, C, A 4274; Quinkhard, J M, A 3954; Royen, W F van, NM 1010; Rust, J A, A 4275; Rijck, P C van, A 868; Saenredam, P J, A 851 & A 858; Sallembier, H, A 4276 & A 4277; Sandrart, J von, A 4278; Schalcken, G, A 899, A 900 & A 2061; Schellinks, W, A 1393; Schey, Ph, A 4279; Schouman, A, A 2730 & A 4280; Schouman, M, A 1394 & A 1395; Schuer. Th C van der, NM 4485; Schuylenburgh, H van, A 4282 & A 4283; Scorel, J van, A 4284; Sillemans, E, A 1366; Snayers, P, A 857; Stoop, D, NM 9487; Swanenburgh, I C van, A 862; Tetar van Elven, P H Th, A 4286; Troost, C, A 4287; Vanloo, A, A 888; Velde, J van de, A 4288; Velde I, W van de, A 1362-A 1365, A 1384, A 1385, A 1388, A 1390, A 1392 & A 4289; Venne, A P van de, A 958 & A 959; Verkolje, J, A 957; Verkolje, N, A 4290; Vermeyen, J C, A 979 & A 980; Vollenhoven, H van, A 889; Voorhout, J, NM 1010; Vroom, H C, A 1361; Weyden, R van der, A 973; Wilkens, J D B, A 4257; Willaerts, Adam, A 1387; Wissing, W, A 879; Wit, J

de, A 4291; Ziesenis, J G, A 881, A 882 & A 1229; Monogrammist Johann G M, A 4460; Master of the Joseph Sequence, A 960 & A 961; Master of the Legend of Mary Magdalene, A 970; Danish school ca 1760, A 978; German school 1603, A 968 & A 969; Lower Rhenish school ca 1490, A 2799; Venetian-Byzantine school late 13th century, A 4461; Netherlands school ca 1515, A 866 & A 867; Netherlands school? 1542, A 4462; Netherlands school? ca 1550, A 977 & A 4463; Netherlands school ca 1580, A 4464; Northern Netherlands school ca 1435, A 954; Northern Netherlands school ca 1530, A 894; Northern Netherlands school ca 1590, A 4468; Northern Netherlands school? 1st half 17th century, A 4649; Northern Netherlands school ca 1604, A 956; Northern Netherlands school ca 1610, A 875-A 877; Northern Netherlands school ca 1615, A 1230; Northern Netherlands school 1627, A 4469; Northern Netherlands school ca 1643, A 920; Northern Netherlands school mid-17th century, A 4470; Northern Netherlands school ca 1650, A 4471-A 4477; Northern Netherlands school ca 1670, A 4478; Northern Netherlands school? ca 1695, A 4479 & A 4480; Northern Netherlands school 18th century, A 2534; Northern Netherlands school ca 1760, A 926; Northern Netherlands school ca 1820, A 2481; Holland school? ca 1595, A 4484; Holland school 1617, A 981 & A 4482; Holland school ca 1630, A 4066; Holland school 1641, A 4483; Holland school 18th century, A 890 & A 891; Holland school 1st quarter 18th century, A 2839; Holland school ca 1745, A 883 & A 884; Holland school mid-18th century, A 2686 & A 2687; Utrecht school mid-16th century, A 4485; Utrecht school ca 1554, A 4486; Southern Netherlands school ca 1525, A 849; Southern Netherlands school ca 1560, A 4487; Southern Netherlands school 1561, A 4488; Southern Netherlands school 1575, A 904; Southern Netherlands school ca 1580, A 4465; Southern Netherlands school 17th century, A 4651; Southern Netherlands school late 17th century, A 962a; Spanish school 2d half 17th century, A 4489; ROT A 4490-A 4524; GOV A 4525-A 4552; PAN A 4553-A 4623, A 4625 & A 4626; COST A 4627-A 4638; VANM A 4076-A 4085; MIN Arlaud, B, A 4295 & A 4296; MIN Bettes, J, A 4297; MIN Blesendorff, S, A 4298; MIN Boit, Ch, A 4299-A 4301; MIN Boze, J, A 4320; MIN Brounckhurst, A van, A 4302; MIN Cooper, A, A 4303 & A 4304; MIN Cooper, S, A 4305-A 4311; MIN Dixon, N, A 4312; MIN Duchatel, A, A 4313; MIN Granges, D des, A 4314 & A 4315; MIN Guernier, L du, A 4316 & A 4317; MIN Haag, G, A 4318 & A 4319; MIN Hilliard, N, A 4321-A 4323; MIN Hoadley, P, A 4325-A 4328; MIN Huaut I, P, A 4329; MIN Jackson II, J, A 4330; MIN Kessler, F, A 4331; MIN Lamprecht, G, A 4332; MIN Légaré, G, A 4333; MIN Lembke, J Ph, A 4334; MIN Le Sage, P, A 4335; MIN Liotard, J-E, A 4336; MIN Lundens, G, A 4337 & A 4338; MIN Michelin, J, A 4339; MIN Mussard, R, A 4340-A 4343; MIN Oliver, I, A 4344-A 4347; MIN Oliver, P, A 4348-A 4353; MIN Petitot, J, A 4354-A 4359; MIN Phaff, L, A 4360; MIN Ploetz, H, A 4361; MIN Pluckx, J A A, A 4362; MIN Ramelli, F, A 4363 & A 4364; MIN Richter, Chr, A 4365; MIN De Saint Ligié, G, A 4366; MIN Schmidt Crans, J M, A 4367; MIN Sypesteyn, M M van, A 4368; MIN Thach, N, A 4369; MIN Toutin, H, A 4370 & A 4371; MIN Wilhelmina, princess of Prussia, A 4372-A 4374; MIN Zincke, Ch F, A 4375; MIN Monogrammist W P, A 4376 & A 4377; MIN English school ca 1565, A 4390-A 4393; MIN English school ca 1635, A 4395; MIN English school ca 1665-70, A 4396; MIN English school ca 1725, A 4397; MIN English school ca 1750-51, A 4402; MIN English school ca 1755, A 4398; MIN English school ca 1770, A 4399-A 4401; MIN English school ca 1800, A 4403; MIN French school ca 1500, A 4404; MIN French school ca 1550, A 4405; MIN French school ca 1570, A 4406; MIN French school ca 1580, A 4407 & A 4408; MIN French school ca 1650, A 4409; MIN French school ca 1665, A 4410-A 4412; MIN French school ca 1675, A 4413; MIN French school? 18th century, A 4414-A 4416; MIN French school 2d half 18th century, A 4417; MIN French school ca 1750, A 4418; MIN French school ca 1785, A 4419; MIN French school ca 1790, A 4420 & A 4421; MIN German school ca 1700, A 4378; MIN German school? 18th century? A 4652; MIN German school ca 1730, A 4379-A 4382; MIN German school ca 1750, A 4383; MIN German school ca 1760, A 4384; MIN German school 1770, A 4385; MIN German school ca 1770, A 4386; MIN German school ca 1780, A 4387; MIN German school ca 1800, A 4388 & A 4389; MIN Netherlands school ca 1575, A 4394 & A 4422; MIN Northern Netherlands school 17th century?, A 4423; MIN Northern Netherlands school ca 1615, A 4424; MIN Northern Netherlands school ca 1645, A 4425 & A 4426; MIN Northern Netherlands school ca 1690, A 4427; MIN Northern Netherlands school ca 1710, A 4428 & A 4429; MIN Northern Netherlands school 1745, A 4430; MIN Holland school ca 1635, A 4431-A 4433; MIN Holland school ca 1650, A 4434 & A 4435; MIN Holland school ca 1665, A 4436; MIN Holland school ca 1675, A 4437 & A 4438; MIN Holland school ca 1690; MIN Holland school ca 1710, A 4440 & A 4441; MIN Holland school ca 1715, A 4442; MIN Holland school ca 1750, A 4443-A 4447; MIN Holland school ca 1760, A 4448; MIN Holland school ca 1770, A 4452 & A 4453; MIN Holland school ca 1775, A 4449 & A 4458; MIN Holland school ca 1780, A 4450, A 4451,

A 4454-A 4456; MIN Holland school ca 1785, A 4457; MIN Spanish school ca 1650, A 4459; PAST Hodges, Ch H, A 4639; PAST Northern Netherlands school ca 1890, A 4640; HER A 4641-A 4643

Heeswijk, Slot (Heeswijk castle): see sale's Hertogenbosch, 20-22 June 1900 and 24 March 1902

Heiloo, N v Mij Nijenburgh (Nijenburgh Co, Inc): Scorel, J van, A 3853

Helmond, Kasteel (Helmond castle): Dyck, A van, A 2872; Mor van Dashorst, A, A 2873; Northern Netherlands school ca 1600, A 2867; Northern Netherlands school ca 1615, A 2871; Northern Netherlands school ca 1655, A 2866; Northern Netherlands school ca 1675, A 2868; Northern Netherlands school? mid-18th century, A 2870; Holland school ca 1675, A 2869; Southern Netherlands school ca 1615, A 2864 & A 2865

Heusden, municipality: Venne, A P van de, A 958 & A 959

—, Schutters van Sint Joris (St George civic guard): Malsen, T van, A 2307; Mösers, J H, A 2303; Nieulandt, A van, A 2308; Venne, A P van de, A 2305; Wijntrack, D, A 2304; Northern Netherlands school 1624, A 2309; Northern Netherlands school mid-17th century, A 2306

Honselaarsdijk, Huis (Honselaarsdijk manor): Ravesteyn, J A van, C 1227-C 1230; HON A 516-A 565 & C 1516

Hoorn, town hall: Blanckerhoff, J Th, A 3235

Huissen, church: Northern Netherlands school ca 1570, A 1599

Ilpenstein, Kasteel (Ilpenstein castle): see sale Amsterdam, 3 Dec 1872

Koudewater, klooster Mariënwater: see Uden, Birgittinessenklooster

Leeuwarden, paleis der Friese stadhouders (palace of the stadholders of Friesland): Nijmegen, E van, A 4656, A 4657 & NM 16709

Leiden, Nederlands Leger- en Wapenmuseum (Netherlands army and arms museum): Pieneman, N, A 3877

—, Rijks Ethnografisch Museum (state ethnographic museum): VANM 1996-A 2052; VANM Steen, J van der, A 2053, A 2054 & A 2056; VANM Turkish school A 2055

Leningrad, Hermitage: Mor van Dashorst, A, A 3118 & A 3119; Rembrandt A 3137

London, National Gallery: Rembrandt C 1453

Loosdrecht, Van Sypesteyn Stichting (van Sypesteyn foundation): Miereveld, M J van, C 1481

Middelburg, house of detention: Borselaer, P, A 3457; Loeninga, A van, A 3459; Schouman, A, A 3458

—, Provinciale Staten van Zeeland (states of Zeeland): Bolomey, B S, A 948 & A 949

—, Raad van Zeeland (admiralty of Zeeland): Bol, F, A 44

—, Tekenacademie: see sale Amsterdam, 10 Dec 1902

—: see also Index of portraits and persons: group portraits of other governing bodies

Moscow, museum: Rembrandt, A 3138

Munich, Bayerische Staatsgemäldesammlungen: COST C 1491-C 1514

Naaldwijk, municipality: Master of Alkmaar, C 57

Nieuw Teylingen, kasteel (castle): Northern Netherlands school ca 1435, A 498 & A 499

Noordwijk, Hof van Holland: Netherlands school 1573, A 2372

Oldenburg, Augusteum: Fra Angelico, A 3011; Bassano, L, A 3006; Borgognone, A, A 3031; Costa, L, A 3034; Diana, B, A 3014; Ferrari, G, A 3032; Foppa, V, A 3008; Giampietrino, A 3033; Lippi, F, A 3030; Moroni, G, A 3036; Pontormo, J, A 3009; Rembrandt, A 3066; Veronese, P, A 3010; Verspronck, J C, A 3064; Master Allegro, A 3007; Master of the Conversazione di Santo Spirito, A 3012; Master of the San Miniato Altarpiece, A 3013; Brescian school 1st half 16th century, A 3035

palaces: see Apeldoorn, The Hague, Honselaarsdijk, Leeuwarden, Soestdijk & Weltevreden

Paramaribo, onbeheerde Surinaamse boedels (unclaimed estates): MIN Collins, R, A 2639; MIN German school ca 1830, A 2638; MIN Northern Netherlands school ca 1790, A 2631, A 2634, A 2642, A 2643, A 2645 & A 2646; MIN Northern Netherlands school? ca 1800, A 2640; MIN Northern Netherlands school ca 1805, A 2632, A 2633, A 2636, A 2637, A 2641, A 2647 & A 2648; MIN Northern Netherlands school ca 1810, A 2635 & A 2644; MIN Northern Netherlands school ca 1825, A 2638; PAST Anspach, J, A 2630

Paris, Louvre: Rembrandt, C 1450

Randenbroek: see Amersfoort

Rhenen, municipality: Master of the St Elizabeth Panels, A 1727

Roermond, Onze Lieve Vrouwe Munster-kerk (church of Our Lady): Gelderland school ca 1435, A 1491

Rotterdam, Admiraliteit op de Maze (admiralty of the Maas): Miereveld, M J van, A 253

—, Museum Boymans-van Beuningen: Gérard, F P S, C 1120; Ostade, A van, C 1127

—, Oost-Indisch Huis (East India House): ROT A 4490-A 4524

—, Rijks Marinewerf (navy yard): Lingelbach, J, A 1391

—, Zeecomptoir (maritime board): Miereveld, M J van, A 254 & A 255

Scheemda, Nederlands Hervormde Kerk (Dutch Reformed Church): Swart van Groningen, J, NM 8184

Sint Maartensdijk: HER NM 5339-5344

Soestdijk, paleis (palace): Glauber, J, A 118, A 119, A1200-
A 1202 & A 1217; Hondecoeter, M d', A 170, A 171, A 173 &
A 175; Lairesse, G, A 211, A 212, A 1233 & A 4210
Teylingen: see Nieuw Teylingen
Tholen, stadhuis, schepenzaal (town hall, aldermen's chamber):
Orley, B van, A 4265
Uden, Birgittinessenklooster (Brigittine convent): Bosch, J,
A 4252; Engebrechtsz, C, A 859; Netherlands school early
16th century, A 4650; Southern Netherlands school 17th
century, A 4651; Brabant school 2d half 15th century, A 2800
Utrecht, Nieuwe Gracht 6: Bol, F, A 1575-A 1579
—, Oud-Katholieke Gemeente (Old Catholic congregation):
Crabeth 11, W, A 1965
—, Sint Pieterskerk (church of St Peter): Utrecht school 1554,
A 4486
—, Rijksarchief (state archives): Utrecht school mid-16th century,
A 4485
—, 's Rijks Munt (state mint): Hooghe, R de, A 833
Veenhuizen, Roomskatholieke kerk (Roman Catholic church):
Luima, P, A 2514; Rubens, P P, A 2516; Veronese, P, A 2515
Vlaardingen, post and telegraph office: Terwesten 11, A, A 2403
& A 2404
Vlissingen, Departement der Konvooyen en Licenten
(department of trade licensing and customs): Bol, F, A 44
Well Castle: Puytlinck, Ch, A 2160
Weltevreden, Paleis Rijswijk (Rijswijk palace): Spinny, G de,
A 3826 & A 3827; GOV A 3755-A 3819
Wijk bij Duurstede: Velde, J van de, A 4288
Zeist, 'De Breul': see sale Amsterdam, 4 Dec 1912

Sales

Wherever possible, sales have been identified by the number
assigned to them in F Lugt, *Répertoire des catalogues de ventes
publiques*, 3 vols, The Hague 1938-64.

Amersfoort 1907, 23-24 July, Mrs Cock Blomhoff-van de Poll:
Toorenvliet, J, A 2254
Amsterdam 1801, 16ff March, W F Taelman Kip, a o (Lugt
6216): Gaesbeeck, A van, A 113
—13-14 April, Pierre Fouquet Jr (Lugt 6231): Fabritius, C,
A 91
—11ff May, Giorgius Henricus Trochel (Lugt 6261):
Wijnants, J, A 493
—1803, 20 April, Maria Magdalena van Sluijpwijk, Countess van
Moens (Lugt 6605): Dou, G & Berchem, N, A 90
—17 Aug, Anna Catharina Putman (Lugt 6681): Borch, G ter,
A 405
—1809, 19 July, J B Bicker & Wijkersloot (Lugt 7623):
Berchem, N, A 28 & A 31; Does, S van der, A 82 & A 83;
Dubbels, H J, A 92; Teniers 11, D, A 401; Venne, A P van de,
A 434; Wijnants, J, A 492
—1810, 1-2 Aug, Pieter de Smeth van Alphen (Lugt 7842):
Ruisdael, J I van, A 347
—1814, 21 Sep, Wessel Rijers (Lugt 8584): Dusart, C, A 97
—23 Sep, Dowager L Boreel (Lugt 8586): Both, J, A 50;
Moucheron, F de, A 280; Neer, A van der, A 290; Ruysch, R,
A 354; Wouwerman, Ph, A 483
—1817, 18-21 Aug, Anna Maria Ebeling, widow of Paul Iwan
Hogguer (Lugt 9204): Hooch, P de, A 182
—1818, 17 Aug, Wreesman (Lugt 9429): Beerstraaten, J A, A 21
—1819, 19ff April, Fern v d Schaft, L B Coclers & A M Penninck
Hoofd (Lugt 9568): Murant, E, A 281; Oudenrogge, J D van,
A 304
—12 July, Gerrit Schimmelpenninck Gsz (Lugt 9629):
Ouwater, I, A 305 & A 306
—1821, 30 April, Guttenbrun a o (Lugt 10020): Russian school
1st half 18th century, A 116
—29ff Oct, Albertus Jonas Brandt, Daniel Kerkhoff and Isaac
van Eyk (Lugt 10122): Brandt, A J, A 1013; Kalf, W, A 199
—1822, 13ff May, Josephus Augustus Brentano (Lugt 10249):
Dyck, A van, A 205; Velde, A van de, A 443
—22 May, S J Stinstra (Lugt 10255): Jordaens, J, A 198
—1825, 14 Nov, Baron de Beehr & Gerrit Johan van Leeuwen
(Lugt 10988): Vermeyen, J C, A 164
—1827, 2-3 April, Gerrit Muller (Lugt 11399): Dujardin, K,
A 190; Metsu, G, A 250
—1828, 4ff Aug, Chirurgijns-Weduwenfonds (pension fund for
surgeons' widows; Lugt 11819): Berckheyde, G A, A 34; Mazo,
J B M del, A 433
—1829, 23 March, Jan Isaac de Neufville Brants (Lugt 11974):
Troost, C, A 418
—1834, 12ff May, J F Sigault Czn & J J van Limbeek (Lugt
13672): Hooch, P de, A 181
—1842, 11-15 april, Johannes Immerzeel Jz (Lugt 16550):
Regters, T, A 330
—1848, 10-13 Oct, anon (Lugt 19144): Helst, B van der, A 146 &
A 147
—1851, 25 Nov, Jonkheer H Six van Hillegom (Lugt 20537):
Hals, F, A 133
—1858, 27-29 April, M C van Hall (Lugt 24208): Beyeren, A van,
A 355; Dürer, A, A 96; Hillegaert, P van, A 394; Ketel, C,
A 244; Netscher, Casp, A 183; Ruysch, R, A 356; Verspronck,

J C, A 380; Willaerts, Abr, A 579; Holland school 1634, A 578;
Holland school ca 1640, A 202
—1872, 3 Dec, Kasteel Ilpenstein (Ilpenstein castle; Lugt
33487): Holland school 1617, A 981
—1875, 18 March, W J van Troostwijk (Lugt 35458): Troostwijk,
W J van, A 1168-A 1169
—28 April, J C C D W de Moll & W J M Engelberts (Lugt
35604): Anthonisz, A, A 1367
—16 Dec, J P C Baron van Reede van ter Aa en Aastein (Lugt
35996): Helst, L van der, A 863; Swanenburgh, I C van, A 862
—1877, 13 March, Gillis van der Voort a o (Lugt 37205): Cuyp,
J G, A 611
—1879, 4-5 March, S M C Schottelink, widow of Mr Beerekamp
(Lugt 39022): Rotius, J A, A 666
—19 Aug, Baron d'Isendoorn à Blois van den Cannenburg
(Lugt 39523): Mostaert, J, A 671
—18 Dec, H Lamberts a o (Lugt 39729): Miereveld, M J van,
A 675
—1880, 20 April, C J G Copes van Hasselt (Lugt 40097): Brueghel
11, P, A 731; Post, F, A 742; Storck, A, A 739; Southern
Netherlands school 1607, A 740
—20 Oct, W van den Heuvel, widow of Mr Huydecoper (Lugt
40418): Vries, A de, A 758
—14 Dec, Dowager Viruly van Vuren en Dalem, née
Mathijssen (Lugt 40560): Braekeleer 1, F de, A 966;
Camerarius, A, A 733
—1881, 27-28 Sep, anon (Lugt 41299): Loef, J G, A 4261
—15 Nov, David Bierens (Lugt 41366): Graat, B, A 736
—20-21 Dec, anon (Lugt 41503): Northern Netherlands school
ca 1690, A 741
—1882, 31 Jan, H G van Otterbeek Bastiaans (Lugt 41610):
Bles, H met de, A 780; Schieblius, J G, A 745
—26 Sep, Jonkheer H W F van Panhuys (Lugt 42242):
Borman, J, A 754; Cornelisz van Oostsanen, J, A 976; Mirou,
A, A 755; Stalbemt, A van, A 756
—13 Nov, P A Borger & D J H Joosten (Lugt 42321): Attama, J,
A 761; Denner, B, A 770; Hodges, Ch H, A 769; Kessel, J van,
A 793; Miereveld, M J van, A 762; Son, J F van, A 763-A 766;
Tetar van Elven, P H Th, A 4286; Netherlands school? ca 1550,
A 977
—24-25 Oct, W Gruyter Jr (Lugt 42268): Beeldemaker, A C,
A 750; Boursse, E, A 767; Hondecoeter, G G d', A 751;
Mijtens 1, M, A 768; Nooms, R, A 759; Roghman, R, A 760;
Rombouts, G, A 753
—1883, 14 Aug, Jonkheer W Gockinga a o (Lugt 43225): Cuyp,
B G, A 773; Heerschop, H, A 774; Lubienietzki, Chr, A 775;
Noort, P van, A 776 & A 777
—30-31 Oct, Count Ferdinand Rasponi, a o (Lugt 43287):
Bleecker, D, A 782; Hogers, J, A 804; Opperdoes, J P, A 784;
Zaganelli, B, A 783
—14-15 Nov, F M Hodgson, widow of P C Baron Nahuys, C F
Royer-Kerst a o (Lugt 43320): Beresteyn, C van, A 785;
Bloemen, N van, A 786; Bollongier, H, A 799; Broeck, E van
den, A 788; Codde, P, A 789; Dalens 1, D, A 790; Elliger 1, O,
A 794; Hogers, J, A 787; Koets 11, R, A 795; Moucheron, I de,
A 796; Quinkhard, J M, A 791 & A 792; Saftleven, C, A 797;
Steenwyck 1, H, A 798
—1884, 22-23 Jan, Count Andor de Festetits (Lugt 43534):
Gijsaerts, G, A 800; Saftleven, C, A 801
—31 Dec (not in Lugt): Bramer, L, A 845; Burgh, R van,
A 846; Dyck, A van, A 847
—1885, 20 Jan, anon (Lugt 44486): Berckhout, G W, A 984
—24-25 March, Quarles van Ufford (Lugt 44710): Rotius,
J A, A 995; Solimena, F, A 996
—30 Oct, P Verloren van Themaat a o (Lugt 45156): Bijlert,
J van, A 1285; Ferguson, W G, A 1290; Flinck, G, A 1282;
Goltzius, H, A 1284; Haensbergen, J van, A 1291; Massys, J,
A 1286; Rossum, J van, A 1283; Storck, J, A 1289; Vaillant,
W, A 1292; Velde, E van de, A 1293; Southern Netherlands
school? ca 1575, A 1287 & A 1288
—16 Dec, D M Alewijn (Lugt 45274): Bril, P, A 1314; Eliasz,
N, A 1312, A 1313 & A 1319; Moelenbeeck, M van, A 1306;
Ruyven, J P van, A 1315; Santvoort, D D, A 1310, A 1311,
A 1317 & A 1318; Master of Alkmaar, A 1307 & A 1308;
Netherlands school ca 1600, A 1309; Northern Netherlands
school 1622, A 1316
—1886, 15ff June, J H Cremer & L T Zebinden (Lugt 45864):
Borch, M ter, A 2118
—26 Oct, J H Cremer (Lugt 45985): Ban, G, A 1345; Bijlert,
J van, A 1338; Everdingen, C B van, A 1339 & A 1340;
Schoor, A van der, A 1342; Vliet, H C van, A 1343; Vonck, J,
A 1344; Weenix, J B, A 1417; Netherlands school, A 1341
—1887, 19-20 April, C E Pannemaeckers (Lugt 46480): Doeff,
A van, A 1407
—21 June, J H Cremer (Lugt 46716): Aachen, H von, A 1412;
Laer, P van, A 1411; Miereveld, M J van, A 1418; Plaes, D
van der, A 1413; Verkolje, J, A 1414 & A 1415; Voort, C van
der, A 1416; Vrancx, S, A 1409; Utrecht school ca 1460,
A 1408
—1 Nov, V v d Cr... & O W... (Lugt 46826): Northern
Netherlands school ca 1620, A 1429
—13 Dec, Ledeboer & Roest van Limburg (Lugt 46947):
Brueghel, A, A 1433

—1888, 21 Feb, S B Bos (Lugt 47093): Anthonisz, A, A 1446;
Arentsz, A, A 1447 & A 1448; Bueckelaer, J, A 1451; Hannot,
J, A 1449; Miereveld, M J van, A 1450; Puytlinck, Ch, A 1452
—13-14 March, C... & G... (Lugt 47161): Lelienbergh, C,
A 1454 & A 1455; Monogrammist J V R, A 1456
—12-13 June, C J Terbrugge (Lugt 47513): Bakhuysen, L,
A 1465; Duynen, I van, A 1466; Velde 1, W van de, A 1467
—30-31 Oct, M M van Galen (Lugt 47659): Westerbaen, J J,
A 1478
—4-5 Dec, F Kaijser (Lugt 47762): Adriaensen, A, A 1481;
Moeyaert, N, A 1485; Post, F, A 1486; Vonck, J, A 1487;
Leiden school ca 1515, A 1483 & A 1484
—1889, 19-20 Feb, anon (Lugt 47970): Southern Netherlands
school ca 1560, A 4487
—15-16 May, Herman F C ten Kate (Lugt 48264): Bueckelaer,
J, A 1496
—11-12 June, W E van Pappelendam & Schouten (Lugt
48361): PAN A 1503 & A 1504
—10-12 Dec, J A Alberdingk Thijm, Schiffer van Bleiswijk,
C K Breet, J van der Chijs a o (Lugt 48626): Meyer, H de,
A 1511; Quinkhard, J M, A 1509
—1890, 4-8 Feb, A H Walter & J E Duport (Lugt 48741): Moritz,
L, A 1512
—1 April, van Goethem, de Soere a o (Lugt 48963): Pieneman,
J W, A 1520; Northern Netherlands school ca 1815, A 1519
—18 Dec, S Altmann a o (Lugt 49523): Dubus, M, A 1539;
Pieneman, J W, A 1538
—1892, 9-10 Feb, L A J W Baron Sloet van de Beele, H J
Wisselingh a o (Lugt 50457): Mor van Dashorst, A, A 1560;
Valckenborgh, L van, A 1559; Braunschweig Monogrammist,
A 1561
—29 March, Messchert van Vollenhoven & C H A van
Engelenberg (Lugt 50649): Houckgeest, G, A 1584; Vermeer,
J, A 1595; Wouwerman, Ph, A 1610; Holland school 1601,
A 1580
—1-2 Nov, Baroness Taets van Amerongen van Natewisch
(Lugt 51058): Muys, N, A 1587
—1893, 25 April, I F van Lennep & G de Vos (Lugt 51663):
Beet, C D, A 1597
—1894, 10 April, W J van Zeggelen & Jan Kuijpers (Lugt 52448):
Kruseman, J A, A 1613; Vaillant, W, A 1695
—17-18 April, L Abels & d'Engelbronner, widow of P T van
Hoorn (Lugt 52486): Horemans 11, J J, A 1614
—1895, 29 Oct (not in Lugt): Hanneman, A, A 1670; Verheyden,
M, A 1672; Northern Netherlands school ca 1680, A 1671
—5-6 Nov, anon (Lugt 53797): Caullery, L de, A 4292;
Gallis, P, A 1634
—1896, 4-7 Feb, anon (Lugt 54056): Northern Netherlands
school ca 1670, A 1640
—18 Feb, Marius Vlierboom van Hoboken (Lugt 54092):
Wieringa, N, A 1641
—26 Feb (not in Lugt): HER NM 10500
—31 March-2 April, van Riemsdijk, widow of van Verschuer,
J van der Kellen a o (Lugt 54263): Victors, J, A 1674
—10-11 Nov, J van Embden, C H Eckhardt & J van der Kellen
(Lugt 54727): Sorgh, H M, A 1682; Southern Netherlands
school ca 1580, A 4466 & A 4467
—1897, 16-18 Feb, anon [Hekking] (Lugt 55030): Lombard
school 1st half 16th century, A 2801; Netherlands school ca
1580, A 4464
—1 June, Gijsbert de Clercq (Lugt 55451): Avercamp, H,
A 1718; Berchem, N, A 1936; Both, J, A 1938; Camphuijsen,
R G, A 1939; Hackaert, J, A 1709; Lelienbergh, C, A 1710;
Murant, E, A 1711; Picolet, C, A 1712; Spreeuwen, J van,
A 1713; Stoop, D, A 1714; Velde 11, W van de, A 1716; Vos,
M de, A 1717; Werff, A van der, A 1715
—9-11 Nov, S W Josephus Jitta (Lugt 55674): Duyster, W C,
A 1791 & A 1792
—30 Nov, P C Haemacher, F L Berré a o (Lugt 55733): Hals,
D, A 1722; Miereveld, M J van, A 1723
—1898, 1-2 March, J Zürcher a o (Lugt 56005): Utrecht school
2d half 16th century, A 1728
—8 Nov, Donati-Martini a o (Lugt 56603): Cool, J D, A 1787
—1899, 7-12 Aug, E P Fages & G M A J Heeswijk (Lugt 57467):
HER NM 11421
—1900, 3-4 April, G v d B... v L..., D G H van der Meulen a o
(Lugt 58011): Wet 1, J W de, A 1853; Wouwerman, J, A 1850;
Holland school ca 1620, A 1852
—24-25 April, P Overgauw-Beetz a o (Lugt 58081): Horemans
11, J J, A 1851; Scorel, J van, A 1855; Wet, G de, A 1854
—30 April (not in Lugt): PAST Basseporte, M F, A 2119
—6-9 Nov, H A Raedt van Oldenbarnevelt, L Hardenberg &
L Swaab (Lugt 58501): Helt Stockade, N van, A 1926;
Willaerts, Adam, A 1927; Withoos, M, A 1925
—27-29 Nov, Elchanon Verveer, J Avis Jzn, K van Bree a o
(Lugt 58567): Nijmegen, D van, A 1933 & A 1934
—1901, 16-17 April, anon: Caullery, L de, A 1956; Koninck, Ph,
A 1954; Willaerts, Adam, A 1715
—1902, 15-16 April, H I A Raedt van Oldenbarnevelt, J D
Hoekwater a o: Arentsz, A, A 1969; Asch, P J van, A 1970;
Nieulandt, A van, A 1748
—10 Dec, A Croiset, J Nanninga Uitterdijk a o: Nieulandt, A
van, A 1995; Master of the Legend of St Barbara, A 2057

—1903, 31 March, P G W van der Pijl, J J C Vinkenstein a o: Vinckboons, D, A 2109
—15 April: Vliet, H van, A 1971
—1904, 23 Feb, de M... a o: Storck, A, A 2132
—20 April, W Hekking Jr: Geertgen tot St Jans, A 2150
—21 Sep, A H H van der Burgh and portraits of the de la Court family: Ast, B van der, A 2152; Bartsius, W, A 2214; Ferguson, W G, A 2154; Gijsels, P, A 2213; Tempel, A L van den, A 2243 & A 2244
—1905, 27-29 June, Oud-Rosenburgh a o: Ovens, J, A 2161; Willaerts, Adam, A 2162
—27 July: Vroom, H C, A 2163
—31 Oct, Adriaan Holtzman: Savery, R, A 2211
—1906, 3 April, de M... a o: Treck, J J, A 2222
—27-28 Nov, v I v D [van Iddekinge van Drogershorst] & H C Du Bois: Neyn, P de, A 2245
—1908, 28-29 April, H[oogendijk] a o: Mulier I, P, A 2357; Stevers, A 2358
—15-16 Dec, Evert Moll Sr & W M Helmich: Oever, H ten, A 2370; Voskuyl, H P, A 2368 & A 2369
—1909, 27 April, Charles Robert de Nesselrode, Révon, F E Lintz, Koudachef a o: Velde II, W van de, A 2393; Vries, H V de, A 2390
—30 June-2 July, P W[idener], Furstner, widow Ter Meulen-Trakranen and S...: Buys II, C, A 2392
—30 Nov, anon: Master of the Aix Annunciation, A 2399
—1910, 22 Nov, J J van Alen, F Seymour Haden, A Verhoesen: Savery I, H, A 2526
—1911, 14 April: Mijn, F van der, A 2376
—28 Nov, Joh Bosscha a o: Witte, E de, A 2536
—1912, 4 Dec, Grimaldi, C N C Obreen, H G T Mock, 'De Breul' (Zeist): Elsheimer, A, A 2650; Haen, G de, A 2651; Utrecht school ca 1435, A 2649
—1913, 6 May, N J W Smallenburg van Stellendam-'t Hooft, Myrtil-Schleisinger a o: Bril, P, A 2672; Regters, T, A 2671
—1914, 7 April: Brekelenkam, Q G van, A 2698
—1918, 28 May, Peltzer: Jacobsz, L, A 2814
—1920, 13-19 April, Bramlot, G Praetorius, Leembruggen, H Souget, W P Ingenegeren a o: Codde, P, A 2836
—12 April: Master of the Female Halflengths, A 3130
—1932, 12 April: Master of the Female Halflengths, A 3130
—1942, 22 Dec: Mijtens, J, A 4013
—1943, 16 Nov: Drecht, J van, A 3463
—1954, 17 March: Northern Netherlands school ca 1650, A 3881 & A 3882
—1955, 8 Nov: Schouman, A, A 3897
—1958, 4 Nov: Pietersz, P, A 3951
—1959, 2 June: Pieneman, N, A 3961
—1960, 22 March: Ouwater, I, A 4026
—31 May: Arentsz, A, A 4033
—1961, 7 March: Huchtenburg, J van, A 4061
—15 Nov: Os, P G van, A 4067
—1962, 16 Oct: Terwesten, M, A 4086
—1963, 9 April: Voogd, H, A 4094
—1964, 26 May: Northern Netherlands school 1639, A 4101
—1965, 18 May: Willaerts, Adam, A 4116
—1968, 5 Nov: Mauve, A, A 4156
—1971, 20 April: P A S T Mengs, A R, A 4199
—10 May: Troost, C, A 4200 & A 4201
—1972, 26 April: Mijtens III, D, A 4222
—1973, 1 May: Voskuil, J J, A 4229
—1974, 18 Feb: Nuyen, W J J, A 4644 & A 4645
—10 Sep: Hove, B J van, A 4661
Antwerp 1818, 27 April, Jean Adrien Snijers (Lugt 9359): Murillo, B E, C 1366
—1885, 19 Feb, van der Straelen, Moons & van Lerius (Lugt 44590): Heck, N J van der, A 990 & A 991; Verhaert, D, A 989
Berlin 1928, 10 May: Metsu, G, A 3059
Brussels 1883, 17-21 April, Edmond Ruelens (Lugt 42899): Lachtropius, N, A 771
—1888, 10-12 April, J Hollender (Lugt 47258): Clerck II, H de, A 1461; Delff, W J, A 1460; Nijmegen, D van, A 1459; Uyttenbroeck, M van, A 1462
—1903, 1 July, anon: Mostaert, J, A 2123
Cologne 1889, 27-28 May, Fédor Zschille (Lugt 48311): Hondecoeter, G C d', A 1502
—1894, 4-5 June, Zanoli, widow of Clavé-Bouhaben a o (Lugt 52692): Willaerts, Abr, A 1683
Delft 1895, 1-10 July, Storm-van der Chijs (Lugt 53685): Beest, S van, A 1633
Dordrecht 1785, 22ff Aug, Johan van der Linden van Slingeland (Lugt 3936): Calraet, A van, A 79
—1942, 22 Sep: Rosa, S, A 4020
—1972, 13 June: Knip, J A, A 4220
Enkhuizen 1886, 29 April, Jonkvrouwe M M Snouck van Loosen (Lugt 45693): Avercamp, H, A 1320; Graef, Th de, A 1321; Hondecoeter, G G d', A 1322; Naiveu, M, A 1323
Haarlem 1874, 20-21 April, A van der Willigen & A van der Willigen Pzn (Lugt 34788): Borculo, N van, A 4251; Ovens, J, A 850; Vellert, D, A 849
The Hague 1806, 20 Aug, Macalester Loup a o (Lugt 7146): Baen, J de, A 13 & A 14
—1863, 27 April, anon (Lugt 27296): Vollevens I, J, A 283

—1874, 14-15 Dec, C Schiffer van Bleiswijk & G J Hoffmann (Lugt 35206): Honthorst, W van, A 855
—1878, 30 Jan, anon (Lugt 37957): Delff II, J W, A 953; Goyen, J van, A 952; Leyden, J van, A 1386; Willaerts, Adam, A 1387
—1880, 16-19 Feb, Balthasar Theodorus Baron van Heemstra en Eibersburen (Lugt 39890): Pourbus, P, A 962b; Master of the Legend of Mary Magdalene, A 962c; Southern Netherlands school late 17th century, A 962a
—1885, 3 June, A G de Visser (Lugt 44992): Saenredam, P J, A 1189
—1900, 16 Oct, works by members of Pulchri Studio (Lugt 58454): Bilders-van Bosse, M Ph, A 1922; Mesdag-van Houten, S, A 1921; Roelofs, W E, A 1924; Weissenbruch, H J, A 1923
—1947, 4 Nov: Pynas, Jan S, A 3510
—1971, 20 April: Schelfhout, A, A 4197
's Hertogenbosch 1900, 20-22 June, Andreas Joannes Ludovicus Baron van den Bogaerde van Terbruggen, Kasteel Heeswijk (Lugt 58330): Delff I, J W, A 1907; Geest, W S de, A 1908
—1902, 24 March, Slot Heeswijk: Cornelisz van Oostsanen, J, A 1967
Jutphaas (Groenedaal) 1880, 21-22 Oct, Baron van Utenhove van Heemstede (Lugt 40421): Baen, J de, A 963 & A 964
Kampen 1908, 7 July, F Lemker-Muller a o: Knibbergen, F van, A 2361; Roghman, R, A 2363 & A 2364; Velde, J J van de, A 2362; Leiden school ca 1630, A 2365
Leiden 1817, 21-22 April, B Ocke (Lugt 9106): Moreelse, P, A 276
—1879, 19 June, C W H van Kaathoven & Dirk A Lamme (Lugt 39430): Verkolje, J, A 957
—1885, 7 Sep, C F Berré (Lugt 45118): Quast, P J, A 1298; Savery, R, A 1297
London 1900, 12 May, James Reiss (Lugt 58179): Rembrandt, A 1935
—1908, 8 Feb, Duke of Sutherland: Man, C de, A 2355
—1951, 19 Jan: Lely, P, A 3832
—1956, 28 Nov: Veen, O van, A 3911
—1957, 4 Dec: Dobson, W, A 3927
—1960, 22 June: Gelder, A de, A 4034
—1961, 14 June: Mijn, F van der, A 4064
—1963, 27 March: Ostade, A van, A 4093
—3 July: Rembrandt, A 4096
—1964, 8 July: Storck, A, A 4102
—1967, 21 April: Ekels II, J, A 4130
—1968, 29 March: Liotard, J-E, A 4155
—1972, 17 Nov: Nijmegen, G van, A 4223
—1974, 25 Oct: Hondt II, L de, A 4662 & A 4663
Munich 1910, 12 May, G A ...: Swanevelt, H van, A 2497
New York 1947, 6 Nov: Backer, J A, A 3516 & A 3517
Paris 1893, 17 April-16 June, A Spitzer (Lugt 51629): Cornelisz van Oostsanen, J, A 4294
—1914, 4 June, Crespi: Bailly, D, A 2717
—1949, 25 May: Leyden, L van, A 3739; Wassenbergh, E G, A 3740
—1950, 7 Dec: Beyeren, A van, A 3828; Eversdijck, W, A 3829
—1951, 7 Dec: Miereveld, M J van, A 3833
—1967, 26 Nov: Palamedesz, A, A 4138
Rotterdam 1808, 6ff June, Gerrit van der Pot (Lugt 7424): Bakhuysen, L, A 9 & A 10; Beerstraaten, J A, A 20 & A 22; Berchem, N, A 26 & A 29; Beyeren, A van, A 25; Both, J, A 52; Brekelenkam, Q G van, A 60 & A 61; Brueghel I, J, A 66 & A 67; Coninck, D de, A 72 & A 73, A 617 & A 618; Cuyp, A, A 78; Does, S van der, A 84; Dou, G, A 87 & A 88; Dusart, C, A 98; Flinck, G, A 110; Geel, J van, A 115; Geertgen tot Sint Jans, A 500; Goyen, J van, A 120; Hackaert, J, A 130; Heem, J D de, A 139; Helst, B van der, A 143 & A 144; Heyden, J van der, A 152 & A 153; Hoet, G, A 163; Hondecoeter, M d', A 172; Huysum, J van, A 187; Koninck, Ph, A 207; Koninck, S, A 23; Lelie, A de, A 1075; Lingelbach, J, A 223; Meer III, J van der, A 248; Mieris I, F van, A 261; Mieris II, F van, A 265; Mignon, A, A 266; Ostade, A van, A 298 & A 302; Poelenburgh, C van, A 313; Potter, P, A 318; Pynacker, A, A 321; Saftleven, H, A 379; Snijders, F, A 482; Steen, J H, A 390 & A 391; Velde II, W van de, A 438 & A 439; Weenix, J, A 464; Werff, A van der, A 468; Witte, E de, A 474; Wouwerman, Ph, A 476, A 481 & A 482; Northern Netherlands school ca 1655, A 132
—1816, 16-17 April, Thomas Theodoor Cremer (Lugt 8862): Romeyn, W, A 340
—1827, 24 July, Abraham Gevers Arnsz (Lugt 11523): Werff, A van der, A 465
—1876, 24-25 July, L J A Scheltus van Kampferbeke (Lugt 36746): H E R NM 2970
—1969, 3 Nov: Pieneman, N, A 4164
—1973, 20 Sep: Bree, M I van, A 4234
Utrecht 1825, 27ff June, H A van den Heuvel a o (Lugt 10935): Holland school 1617, A 583 & A 584
—1873, 8-15 March, H J Broers (Lugt 33745): Anraedt, P van, A 2; Liedts, A, A 854; Northern Netherlands school ca 1600, A 577; Northern Netherlands school ca 1625, A 328; Zeeland school ca 1665, A 4124
—1879, 16-20 Dec, W G F van Romondt & C J Rijnbout (Lugt 39723): Bloemaert, H, A 674
Valenciennes 1879, 19 May, Beauvois (Lugt 39354): Cornelisz van Oostsanen, J, A 668

Vienna 1903, 5 March: Asch, P J van, A 2106
—1959, 12 March: Machy, P A de, A 3958
—1974, 12 March: Thulden, Th van, A 4654
Vught 1884, 22-25 Oct, Jonkheer G van Beresteijn van Maurick (Kasteel van Maurick; Lugt 44253): Delff I, J W, A 841; Lievens, J, A 838 & A 839; Velde I, W van de, A 840; Northern Netherlands school ca 1655, A 842
Warmond 1816, 31 July, Countess de Thoms, widow of Baron van Leyden (Lugt 8948): Hals, F, A 135; Slabbaert, K, A 375
Zwolle 1889, 15 Oct, O A Spitzen (Lugt 48477): Holland school ca 1500, A 1508

Exhibitions

Modern paintings were bought regularly from 1808 to 1886 at the biannual exhibitions of works by living Dutch and Belgian masters which were held in Amsterdam, Antwerp, Brussels, Dordrecht, Ghent, Haarlem, The Hague, Rotterdam and Utrecht within this period. *See* the chronological history under the years 1838, 1885 at *e*, and 1886; *see also* the *Catalogus der kunsthistorische bibliotheek in het Rijksmuseum te Amsterdam*, 3 vols with index vol, Amsterdam 1934-36, vol 3 (1935) pp 711-31.

Amsterdam 1808: Alberti, J E Ch, A 651 & A 652; Coclers, L B, A 642; Kleyn, P R, A 645-A 647; Kooi, W B van der, A 1064; Mol, W, A 648
—1810: Alberti, J E Ch, A 641; Hulswit, J, A 1051; Mol, W, A 271; Strij, A van, A 1143
—1814: Jelgerhuis Rzn, J, A 1055
—1816: Os, P G van, A 1101; Stokvisch, H, A 1137
—1818: Eelkema, E J, A 1031; Knip, J A, A 1058; Sande Bakhuyzen, H van de, A 1000; Westenberg, G P, A 1161
—1820: Hulswit, J, A 1050; Ravenzwaay, J van, A 1121; Ruyter, J de, A 353
—1823: Paelinck, J, A 1108
—1826: Jelgerhuis Rzn, J, A 1054; Maes, J B L, A 1078
—1827: Kruseman, J A, A 1072
—1828: Delvaux, E, A 1024; Jelgerhuis Rzn, J, A 1053; Jonghe, J B de, A 1056; Moerenhout, J J, A 1081; Regemorter, I J van, A 1123; Voordecker, H, A 1157
—1830: Regemorter, I J van, A 1122
—1860: Breuhaus de Groot, F A, A 1014; Cunaeus, C, A 1023; Deventer, W A van, A 1025
—1867: Greive, J C, A 1037; Kate, H F C ten, A 1057; Leickert, Ch H J, A 1074
—1868: Borselen, J W van, A 1010; Gruijter II, W, A 1038; Heemskerck van Beest, J E van, A 1045; Ronner-Knip, H, A 1124; Scholten, H J, A 1130
—1870: Hilverdink, J, A 1046; Roth, G A, A 1125
—1873: Verschuur I, W, A 1152
—1874: Sadée, Ph L J F, A 1167
—1877: Klinkenberg, J Ch K, A 1175; Koster, E, A 1176; Vogel, C J, A 1177
—1880: Neuhuys, J A, A 1181; Vogel-Roosenboom, M C J W H, A 1182
—1886: Blommers, B J, A 1327; Breitner, G H, A 1328; Hilverdink, E A, A 1329; Meulen, F P ter, A 1330
—1905: Hoynck van Papendrecht, J, A 2165
Brussels 1821: Navez, F J, A 1085
—1824: Ommeganck, B P, A 1094; Poelman, P F, A 1118; Verboeckhoven, E J, A 1150; Vervloet, F, A 1155
—1826: Navez, F J, A 1086
Ghent 1826: Saligo, Ch L, A 1126
—1829: Coene, J H de, A 1021; Hanselaere, P van, A 1042; Moerenhout, J J, A 1082
Groningen 1880: Velden, P van der, A 1180
Haarlem 1825: Hanselaere, P van, A 1041; Kruseman, J A, A 1071; Nicolié, J Ch, A 1087; Noter II, P F de, A 1091; Os, M M van, A 1107; Os, P G van, A 1097; Schoemaker Doyer, J, A 1027; Schoenmakers Pzn, J, A 1129; Verboeckhoven, E J, A 1151
The Hague 1817: Brandt, A J, A 1012; Kruseman, C, A 1067
—1821: Cels, C, A 1019
—1827: Burgh, H van der, A 1016 & A 1017; Evrard, A, A 1034; Eycken, J B van, A 1035; Govaerts, A, A 1036; Haseleer, F, A 1044; Sande Bakhuyzen, H van de, A 1001; Schmidt, G A, A 1135; Schotel, P J, A 1133; Wappers, E Ch G, A 1159
—1830: Hoeksema, W J M, A 1033; Kruseman, C, A 1070; Regemorter, I G, A 1122
—1833: Abels, J Th, A 998; Michaëlis, G J, A 1080; Noël, P P J, A 1089
—1837: Couwenberg, A J, A 1022; Dreibholtz, Ch L W, A 1028
—1839: Eeckhout, J J, A 1030; Verveer, S L, A 1153
—1866: Bilders, J W, A 1008; Stortenbeker, P, A 1138; Stroebel, J A B, A 1139; Tom, J B, A 1146; Trigt, H A van, A 1147; Verveer, S L, A 1154; Vogel, J G, A 1156
—1869: Bles, D J, A 1009; Hanedoes, L, A 1040; Sande Bakhuyzen, G J van de, A 1002
—1875: Apol, L F H, A 1164; Roelofs, W, A 1166
—1878: Haas, J H L de, A 1178
—1881: Bakker Korff, A H, A 1183; Famars Testas, W de, A 1184
—1884: Artz, D A C, A 1187
—1887: Maris, J H, A 1404

Paris 1878: Israels, J, A 1179
Rotterdam 1862: Schelfhout, A, A 1127
—1867: Haanen, A J, A 1039; Schelfhout, A, A 1128
—1870: Berg, S van den, A 1007; Lingeman, L, A 1076; Vos, M,
 A 1158; Weissenbruch, J, A 1160
—1877: Lokhorst, D van, A 1171
—1882: Sande Bakhuyzen, J J van de, A 1185
—1885: Schwartze, Th, A 1190

Concordance of inventory numbers with listings in the catalogue

In the following lists all the objects in the catalogue are filed in order of inventory number, followed by the heading under which they can be found in the catalogue itself. The A- and c-lists form a comprehensive register of all the objects owned by or on loan to the Rijksmuseum department of paintings now or in the past. The present inventories were begun in 1886 with the registration of all the objects brought together in 1885 to form the Rijksmuseum van Schilderijen (national painting museum). For a description of the various components, see pp 28-31, under 1885, a-i.

The N G-, N M- and R B K-lists include only those painted objects from other departments of the museum that we felt could not be omitted from a publication of 'all the paintings of the Rijksmuseum.'

A Department of paintings inventory of objects owned by the nation now or in the past

C Department of paintings inventory of objects on loan to the nation now or in the past

N G Painted objects on the inventory of the department of Dutch history acquired after 1927

N M Painted objects on the joint inventory of the departments of Dutch history and sculpture and applied arts acquired in 1927 from the Nederlandsch Museum voor Geschiedenis en Kunst

R B K Painted objects on the inventory of the department of sculpture and applied arts acquired after 1927

Department of paintings inventory of objects owned by the nation now or in the past

A 1: Allori, C
A 2: Anraedt, P van
A 3: Aertsen, P
A 4 & A 5: Asselijn, J
A 6: Aved, J A J
A 7: Backer, A
A 8-A 12: Bakhuysen, L
A 13-A 15: Baen, J de
A 16: Bailly, D
A 17: Balen, H van
A 18: Key, W
A 19: Beeckman, A
A 20-A 22: Beerstraaten, J A
A 23: Koninck, S
A 24: Bega, C
A 25: Beyeren, A van
A 26-A 32: Berchem, N
A 33: Haagen, J van der
A 34 & A 35: Berckheyde, G A
A 36: Berckman, H
A 37-A 39: Bergen, D van den
A 40 & A 41: Bertin, N
A 42-A 46: Bol, F
A 47: Verboom, A H
A 48: Looten, J
A 49-A 52: Both, J
A 53: Bourdon, S
A 54 & A 55: Brakenburg, R
A 56: Sandrart, J von
A 57: Brassauw, M
A 58: Bray, J de
A 59: Bredael, J van
A 60-A 62: Brekelenkam, Q G van
A 63: Bril, P
A 64 & A 65: Brouwer, A
A 66-A 70: Brueghel I, J
A 71: Loth, J C
A 72 & A 73: Coninck, D de
A 74 & A 75: Crayer, C de
A 76: Heinsius, J E
A 77 & A 78: Cuyp, A
A 79: Calraet, A van
A 80: Southern Netherlands school ca 1655
A 81: Loo, J van
A 82-A 85: Does, S van der
A 86-A 90: Dou, G
A 91: Fabritius, C
A 92: Dubbels, H J
A 93: Duck, J
A 94 & A 95: Dughet, G
A 96: Dürer, A
A 97-A 100: Dusart, C
A 101-A 105: Dyck, A van
A 106: Eeckhout, G van den
A 107 & A 108: Everdingen, A van
A 109: Ferrarese school 2d quarter 16th century

A 110: Flinck, G
A 111 & A 112: Francken II, F
A 113: Gaesbeeck, A van
A 114: Garofalo
A 115: Geel, J van
A 116: Russian school? 1st half 18th century
A 117: Poel, E van der
A 118 & A 119: Glauber, J
A 120-A 123: Goyen, J van
A 124: Bosch, J
A 125: Griffier, J
A 126: Gijsels, P
A 127-A 129: Cornelisz van Haarlem, C
A 130 & A 131: Hackaert, J
A 132: Northern Netherlands school ca 1660
A 133-A 135: Hals, F
A 136: Hauck, A Chr
A 137: Heda, W C
A 138 & A 139: Heem, J D de
A 140-A 147: Helst, B van der
A 148: Helst, L van der
A 149-A 151: Heusch, W de
A 152-A 154: Heyden, J van der
A 155: Hillegaert, P van
A 156: Hobbema, M
A 157: Backer, J A
A 158: Hoogstraten, S van
A 159-A 163: Hoet, G
A 164: Vermeyen, J C
A 165: Cleve, J van
A 166: Massijs, Q
A 167: Southern Netherlands school ca 1535-40
A 168-A 175: Hondecoeter, M d'
A 176: Honthorst, G van
A 177: Honthorst, W van
A 178-A 180: Honthorst, G van
A 181 & A 182: Hooch, P de
A 183: Netscher, Casp
A 184: Huchtenburg, J van
A 185-A 188: Huysum, J van
A 189: Janson, J
A 190-A 195: Dujardin, K
A 196 & A 197: Jongh, L de
A 198: Jordaens, J
A 199: Kalf, W
A 200: Kessel, J van
A 201: Netherlands school ca 1620
A 202: Holland school ca 1640
A 203: Northern Netherlands school ca 1640
A 204: Wieringa, H W
A 205: Dyck, A van
A 206 & A 207: Koninck, Ph
A 208-A 210: Dyck, A van
A 211-A 213: Lairesse, G
A 214 & A 215: Lairesse, G: de-acceded in 1920 (presented to the
 city of Rotterdam)
A 216: Stomer, M
A 217: Gossaert van Mabuse, J
A 218: Flinck, G
A 219-A 221: Limborch, H van
A 222-A 227: Lingelbach, J
A 228-A 238: P A S T Liotard, J E
A 239: M I N Liotard, J E
A 240-A 243: P A S T Liotard, J E
A 244: Ketel, C
A 245 & A 246: Maes, N
A 247: Massys, Q
A 248: Meer III, J van der
A 249 & A 250: Metsu, G
A 251 & A 252: Meyer, H de
A 253-A 258: Miereveld, M J van
A 259: Ravesteyn, J A van
A 260: Miereveld, M J van
A 261-A 263: Mieris I, F van
A 264: Mieris, W van
A 265: Mieris II, F van
A 266-A 269: Mignon, A
A 270: Moeyaert, N
A 271: Raphael
A 272: Rubens, P P
A 273: Momper, J de
A 274: Moni, L de
A 275-A 277: Moreelse, P
A 278: M I N Northern Netherlands school? ca 1635
A 279: Pynacker, A
A 280: Moucheron, F de
A 281: Murant, E
A 282: Murillo, B E
A 283: Vollevens I, J
A 284 & A 285: Mijtens, J
A 286: Naiveu, M
A 287: Neefs II, P
A 288 & A 289: Neefs I, P

A 290: Neer, A van der
A 291: Neer, E van der
A 292 & A 293: Netscher, Casp
A 294: Nooms, R
A 295: Oever, H ten
A 296: Olis, J
A 297: Ossenbeck, W
A 298-A 302: Ostade, A van
A 303: Ostade, I van
A 304: Oudenrogge, J D van
A 305 & A 306: Ouwater, I
A 307: Velde, P van den
A 308 & A 309: Poel, E van der
A 310-A 313: Poelenburgh, C van
A 314: Post, F: de-acceded in 1922 (presented to the Brazilian government)
A 315-A 318: Potter, P
A 319: Netscher, Casp
A 320: Fontainebleau school 3d quarter 16th century
A 321-A 323: Pynacker, A
A 324 & A 325: Quinkhard, Julius
A 326 & A 327: Northern Netherlands school 1633
A 328: Northern Netherlands school ca 1625
A 329 & A 330: Regters, T
A 331: Reni, G
A 332: Serodine, G
A 333 & A 334: Rietschoof, J C
A 335: Ring, P de
A 336 & A 337: Roepel, C
A 338-A 341: Romeyn, W
A 342 & A 343: Rottenhammer, J
A 344-A 346: Rubens, P P
A 347-A 351: Ruisdael, J I van
A 352: Ruysdael, S J van
A 353: Ruyter, J de
A 354: Ruysch, R
A 355: Beyeren, A van
A 356: Ruysch, R
A 357: Ryckaert III, D
A 358: Rembrandt
A 359: Saenredam, P J
A 360: Nickelen, I van
A 361-A 363: Saftleven, H
A 364: Sandrart, J von
A 365: Santvoort, D D
A 366: Savery, R
A 367-A 371: Schalcken, G
A 372: Scorel, J van
A 373: Schuppen, J van
A 374: Seghers, G
A 375: Slabbaert, K
A 376 & 377: Slingeland, P C van
A 378 & A 379: Snijders, F
A 380: Verspronck, J C
A 381 & A 382: Staveren, J A van
A 383-A 393: Steen, J H
A 394: Hillegaert, P van
A 395: Stoop, D
A 396: Strij, A van
A 397: Tempel, A L van den
A 398-A 401: Teniers II, D
A 402-A 405: Borch, G ter
A 406: Tischbein, J V
A 407: Thielen, J Ph van
A 408-A 416: PAST Tischbein, J F A
A 417: Tol, D van
A 418: Troost, C
A 419 & A 420: Ulft, J van der
A 421-A 432: Veen, O van
A 433: Mazo, J B M del
A 434: Venne, A P van de
A 435: Hillegaert, P van
A 436-A 440: Velde II, W van de
A 441: Velde II, W van de: de-acceded in 1931 (exchanged for H Seghers, A 3120)
A 442-A 444: Velde, A van de
A 445-A 447: Venne, A P van de
A 448 & A 449: Verschuier, L
A 450: Verwilt, F
A 451: Victors, Jan
A 452: Hillegaert, P van
A 453: Cappelle, J van de
A 454: Vlieger, S de
A 455: Vliet, H C van
A 456-A 458: Vois, A de
A 459: Vries, R van
A 460: Vroom, H C
A 461: Walraven, I
A 462-A 464: Weenix, J
A 465-A 469: Werff, A van der
A 470-A 472: Werff, P van der
A 473: Winghe, J van
A 474: Witte, E de

A 475: Titian
A 476-A 485: Wouwerman, Ph
A 486 & A 487: Wouwerman, P
A 488 & A 489: Wijck, Th
A 490-A 493: Wijnants, J
A 494 & A 495: Sorgh, H M
A 496 & A 497: South German school ca 1500
A 498 & A 499: Northern Netherlands school ca 1435
A 500: Geertgen tot Sint Jans
A 501: Master of the Virgo inter Virgines
A 502: Willaerts, Adam
A 503: Zacchia il Vecchio
A 504: French school 16th century
A 505 & A 506: Honselaarsdijk series
A 507-A 510: Southern Netherlands school ca 1600
A 511: Brueghel I, J
A 512: Netherlands school? 17th century
A 513: Utrecht school ca 1520
A 514 & A 515: Key, A Th
A 516-A 565: Honselaarsdijk series
A 566: Geest, W S de
A 567: Holland school ca 1635
A 568: Hillegaert, P van
A 569-A 572: Geest, W S de
A 573 & A 574: Honthorst, G van
A 575: Northern Netherlands school 1590
A 576: Northern Netherlands school ca 1615
A 577: Northern Netherlands school ca 1600
A 578: Holland school 1634
A 579: Willaerts, Abr
A 580 & A 581: Miereveld, M J van
A 582: Flinck, G
A 583 & A 584: Holland school 1656-57
A 585: Northern Netherlands school ca 1635
A 586: Holland school 1657
A 587: Northern Netherlands school ca 1610
A 588: Amsterdam school ca 1645
A 589: Tempel, A L van den
A 590: Malo, V
A 591: Weenix, J B
A 592: Holland school 18th or 19th century
A 593: Guercino
A 594: Palma il Vecchio, J
A 595: Titian
A 596: Italian school 2d half 17th century
A 597: Dyck, A van
A 598: Antonilez, J
A 599 & A 600: Rubens, P P
A 601: Jordaens, J
A 602: Vroom, H C
A 603: Verwer, A de
A 604: Verwer, A de: de-acceded in 1902 (exchanged for J van Neck, A 1986)
A 605: Huchtenburg, J van
A 606: Droochsloot, J C
A 607: Hillegaert, P van
A 608: Holland school ca 1640
A 609: Northern Netherlands school ca 1670
A 610: Northern Netherlands school? 18th century
A 611: Cuyp, J G
A 612: Lievens, J
A 613 & A 614: Bol, F
A 615: Lairesse, G
A 616: Wildens, J
A 617 & A 618: Coninck, D de
A 619: Eyck, N van
A 620: Huysum, J van
A 621: Clerck, H de
A 622: Southern Netherlands school 1st half 17th century
A 623: Werff, A van der
A 624: anonymous: de-acceded in 1890 (given to the Koninklijke Nederlandse Academie van Wetenschappen, Amsterdam)
A 625: Landsberghs
A 626-A 629: Northern Netherlands school ca 1710
A 630: Northern Netherlands school ca 1700
A 631 & A 632: Werff, P van der
A 633: Hauck, A Chr
A 634: Northern Netherlands school ca 1710
A 635: Amsterdam school ca 1670
A 636: Northern Netherlands school ca 1590
A 637 & A 638: La Fargue, I L
A 639: Rode, N
A 640: Moor, C de
A 641: Alberti, J E Ch
A 642: Coclers, L B
A 643: Horstok, J P van
A 644: Keultjes, G L
A 645-A 647: Kleyn, P R
A 648: Mol, W
A 649: MIN Phaff, L
A 650: MIN French school? ca 1810
A 651 & A 652: Alberti, J E Ch
A 653 & A 654: Hodges, Ch H

A 655: Pieneman, J W
A 656: Humbert de Superville, D P G
A 657: Kruseman, C
A 658 & A 659: Wolff, B
A 660: Bloot, P de
A 661: Hodges, Ch H
A 662: Jelgerhuis, J
A 663: Pothoven, H
A 664: Hillegaert, P van
A 665: Pieneman, J W
A 666: Rotius, J A
A 667: Hendriks, W
A 668: Cornelisz van Oostsanen, J
A 669: Swart van Groningen, J
A 670: Scorel, J van
A 671: Mostaert, J
A 672: Metsu, G
A 673: Brekelenkam, Q G van
A 674: Bloemaert, H
A 675: Miereveld, M J van
A 676: Venne, A P van de
A 677 & A 678: Maschhaupt, J H
A 679: Beerstraaten, A
A 680: Berchem, N
A 681 & A 682: Berckheyde, G A
A 683 & A 684: Bol, F
A 685: Brekelenkam, Q G van
A 686: Dou, G
A 687: Dubbels, H J
A 688: Dusart, C
A 689: Ekels I, J
A 690: Ekels II, J
A 691: Everdingen, A van
A 692: Hackaert, J
A 693: Hemert, J van
A 694 & A 695: Hondecoeter, M d'
A 696: Kessel, J van
A 697: Keyser, Th de
A 698 & A 699: Eliasz, N
A 700: Lingelbach, J
A 701-A 703: Maes, N
A 704: Mieris I, F van
A 705: Eliasz, N
A 706: Morel, J E
A 707: Netscher, Casp
A 708-A 710: Noordt, J van
A 711: Potter, P
A 712: Romeyn, W
A 713: Ruysdael, S J van
A 714: Bol, F
A 715: Saftleven, C
A 716: Saftleven, H
A 717: Sorgh, H M
A 718: Steen, J H
A 719: Troost, C
A 720: Ulft, J van der
A 721: Verkolje, J
A 722 & A 723: Velde II, W van de
A 724: Holland school ca 1660
A 725: Dyck, A van
A 726: Snyers, P
A 727: Maratti, C
A 728: Lawrence, Th
A 729: Netscher, Casp
A 730: Swanenburgh, J I
A 731: Brueghel II, P
A 732: Batist, K
A 733: Camerarius, A
A 734: Waterloo, A
A 735: Bloemaert, H
A 736: Graat, B
A 737: Monogrammist A S
A 738: Northern Netherlands school ca 1615
A 739: Storck, A
A 740: Southern Netherlands school ca 1607
A 741: Northern Netherlands school ca 1690
A 742: Post, F
A 743: Mostaert, J
A 744: Borssum, A van
A 745: Schieblius, J G
A 746 & A 747: Mijtens, J
A 748: Wijckersloot, J van
A 749: Storck, A
A 750: Beeldemaker, A C
A 751: Hondecoeter, G G d'
A 752: Leemans, A
A 753: Rombouts, G
A 754: Borman, J
A 755: Mirou, A
A 756: Stalbemt, A van
A 757: Poorter, W de
A 758: Vries, A de
A 759: Nooms, R

A 760: Roghman, R
A 761: Attama, J
A 762: Miereveld, M J van
A 763-A 766: Son, J F van
A 767: Boursse, E
A 768: Mijtens, M
A 769: Hodges, Ch H
A 770: Denner, B
A 771: Lachtropius, N
A 772: Marrel, J
A 773: Cuyp, B G
A 774: Heerschop, H
A 775: Lubienietzky, Chr
A 776 & A 777: Noordt, P van
A 778: Saleh, S B
A 779: Delff, C J
A 780: Bles, H met de
A 781: Malo, V
A 782: Bleecker, D
A 783: Zaganelli, B
A 784: Opperdoes, J P
A 785: Beresteyn, C van
A 786: Bloemen, N van
A 787: Hogers, J
A 788: Broeck, E van den
A 789: Codde, P
A 790: Dalens I, D
A 791 & A 792: Quinkhard, J M
A 793: Kessel, J van
A 794: Elliger, O
A 795: Koets II, R
A 796: Moucheron, I de
A 797: Saftleven, C
A 798: Steenwyck I, H van
A 799: Bollongier, H
A 800: Gijsaerts, G
A 801: Saftleven, C
A 802: Velde, E van de
A 803: Meulener, P
A 804: Hogers, J
A 805 & A 806: Northern Netherlands school ca 1660
A 807: Coeman, J J
A 808: Craey, D
A 809: Coeman, J J
A 810: Craey, D
A 811 & A 812: Northern Netherlands school ca 1710
A 813: Verkolje, N
A 814-A 817: Verheyden, M
A 818: Bartius, W
A 819 & A 820: Northern Netherlands school ca 1670
A 821 & A 822: Holland school ca 1690
A 823: Northern Netherlands school 1623
A 824: Holland school ca 1690
A 825 & A 826: Blijhooft, Z
A 827: Holland school ca 1690
A 828 & A 829: Zwaerdecroon, B
A 830: Verhoesen, A
A 831: Northern Netherlands school ca 1380
A 832: Helst, B van der
A 833: Hooghe, R de
A 834: Peeters, G
A 835: Kuyl, G van der
A 836: Cleve, M van
A 837: Kamper, G
A 838 & A 839: Lievens, J
A 840: Velde I, W van de
A 841: Delff I, J W
A 842: Northern Netherlands school ca 1655
A 843: Delff II, J W
A 844: Schaak, B
A 845: Bramer, L
A 846: Burgh, R van
A 847: Dyck, A van
A 848: Hillegaert, P van
A 849: Vellert, D
A 850: Ovens, J
A 851: Saenredam, P J
A 852: Bor, P
A 853: Merck, J F van der
A 854: Liedts, A
A 855: Honthorst, W van
A 856: Coter, C de
A 857: Snayers, P
A 858: Saenredam, P J
A 859: Engebrechtsz, C
A 860: Balten, P
A 861: Palamedesz, A
A 862: Swanenburgh, I C
A 863: Helst, L van der
A 864: Bassen, B van
A 865: Pietersz, P
A 866 & A 867: Netherlands school ca 1515
A 868: Rijck, P C van

A 869: Flinck, G
A 870: Pourbus II, F
A 871: Honthorst, G van
A 872: Aved, J A J
A 873 & A 874: Honthorst, G van
A 875-A 877: Northern Netherlands school ca 1610
A 878: Miereveld, M J van: de-acceded in 1888 (given to the Prinsenhof, Delft)
A 879: Wissing, W
A 880: Aved, J A J
A 881 & A 882: Ziesenis, J G
A 883 & A 884: Holland school ca 1745
A 885: Behr, J Ph
A 886: Pesne, A
A 887: Mijn, F van der
A 888: Vanloo, A
A 889: Vollenhoven, H van
A 890 & A 891: Holland school 18th century
A 892 & A 893: Dijk, Ph van
A 894: Northern Netherlands school ca 1530
A 895-A 898: Dijk, Ph van
A 899 & A 900: Schalcken, G
A 901 & A 902: Netscher, Casp
A 903: Dijk, Ph van
A 904: Southern Netherlands school 1575
A 905: Northern Netherlands school 1616
A 906 & A 907: Loncke, J L
A 908 & A 909: Miereveld, M J van
A 910 & A 911: Mesdach, S
A 912: Geldorp, G
A 913: Mesdach, S
A 914-A 917: Geldorp, G
A 918 & A 919: Mesdach, S
A 920: Northern Netherlands school 1643
A 921: Jonson van Ceulen, C
A 922: Netherlands school ca 1580
A 923: Zeeland school 1664
A 924: Zeeland school ca 1760
A 925: Northern Netherlands school ca 1815
A 926: Northern Netherlands school ca 1760
A 927: Hellemans, C: print, transferred to the RPK
A 928-A 930: HER Witte van Citters, de
A 931: anonymous: drawing, transferred to the RPK
A 932-A 941: HER Witte van Citters, de
A 942: Drift, J A van der
A 943: Cuijlenburg, C van
A 944: Pieneman, J W
A 945: Bailly, D
A 946: Rembrandt
A 947: Southern Netherlands school? 2d quarter 17th century?
A 948 & A 949: Bolomey, B S
A 950: Hals, F
A 951: Farncombe Sanders, J
A 952: Goyen, J van
A 953: Delff, W J
A 954: Northern Netherlands school ca 1435
A 955: Breen, A van
A 956: Northern Netherlands school 1604
A 957: Verkolje, J
A 958 & A 959: Venne, A P van de
A 960 & A 961: Master of the Joseph Sequence
A 962a: Southern Netherlands school late 17th century
A 962b: Master of the Legend of Mary Magdalene
A 962c: Pourbus, P
A 963 & A 964: Baen, J de
A 965: Bolomey, B S
A 966: Braeckeleer, F de
A 967: Queborn, D van den: de-acceded in 1891 (given to the Prinsenhof, Delft)
A 968 & A 969: German school 1603
A 970: Master of the Portrait of Adie Lambertsz
A 971: Boy, G
A 972: Mostaert, G
A 973: Weyden, R van der
A 974: Schooten, J van
A 975: Marseus van Schrieck, O
A 976: Cornelisz van Oostsanen, J
A 977: Netherlands school? ca 1550
A 978: Danish school ca 1760
A 979 & A 980: Vermeyen, J C
A 981: Holland school 1617
A 982: Krafft, D von
A 983: Bisschop, C
A 984: Berckhout, G W
A 985: Asselbergs, A
A 986: Boudewijns, A F
A 987: Boone, D
A 988: Uytewael, J A
A 989: Verhaert, D
A 990 & A 991: Heck, N J van der
A 992-A 994: Eversdijck, W
A 995: Rotius, J A
A 996: Solimena, F

A 997: Bellevois, J
A 998: Abels, J Th
A 999: Assche, H van
A 1000 & A 1001: Sande Bakhuyzen, H van de
A 1002: Sande Bakhuyzen, G J van de
A 1003: Barbiers, P P
A 1004 & A 1005: Baur, N
A 1006: Behr, C J
A 1007: Berg, S van den
A 1008: Bilders, J W
A 1009: Bles, D J
A 1010: Borselen, J W van
A 1011: Bosboom, J
A 1012 & A 1013: Brandt, A J
A 1014: Breuhaus de Groot, F A
A 1015: Brice, I
A 1016: Burgh, Hendrik van der
A 1017: Burgh, H A van der
A 1018: Cate, H G ten
A 1019: Cels, C
A 1020: Coene, C F
A 1021: Coene, J H de
A 1022: Couwenberg, A J
A 1023: Cunaeus, C
A 1024: Delvaux, E
A 1025: Deventer, W A van
A 1026: Diez, A
A 1027: Schoemaker Doyer, J
A 1028: Dreibholtz, Chr L W
A 1029: Dubourcq, P L
A 1030: Eeckhout, J J
A 1031 & A 1032: Eelkema, E J
A 1033: Engelberts, W J M
A 1034: Evrard, A
A 1035: Eycken, J B van
A 1036: Govaerts, A C
A 1037: Greive, J C
A 1038: Gruijter, W
A 1039: Haanen, A J
A 1040: Hanedoes, L
A 1041 & A 1042: Hanselaere, P van
A 1043: Hari, J
A 1044: Haseleer, F
A 1045: Heemskerck van Beest, J E van
A 1046: Hilverdink, J
A 1047 & A 1048: Hodges, Ch H
A 1049: Hove, B J van
A 1050 & A 1051: Hulswit, J
A 1052: Janson, J Chr
A 1053-A 1055: Jelgerhuis, J
A 1056: Jonghe, J B de
A 1057: Kate, H F C ten
A 1058: Knip, J A
A 1059: Knoll, F C
A 1060 & A 1061: Kobell II, J B
A 1062: Kobell III, J
A 1063-A 1065: Kooi, W B van der
A 1066-A 1070: Kruseman, C
A 1071 & A 1072: Kruseman, J A
A 1073: Lauwers, J J
A 1074: Leickert, Ch H J
A 1075: Lelie, A de
A 1076: Lingeman, L
A 1077: Linthorst, J
A 1078: Maes, J B L
A 1079: Meijer, J H L
A 1080: Michaëlis, G J
A 1081 & A 1082: Moerenhout, J J
A 1083: Morel, J E
A 1084: Moritz, L
A 1085 & A 1086: Navez, F J
A 1087: Nicolié, J Chr
A 1088 & A 1089: Noël, P P J
A 1090 & A 1091: Noter II, P F de
A 1092: Nuyen, W J J
A 1093: Odevaere, J D
A 1094: Ommeganck, B P
A 1095: Os, J van
A 1096-A 1103: Os, P G van
A 1104-A 1106: Os, G J J van
A 1107: Os, M M van
A 1108: Paelinck, J
A 1109: Picqué, Ch
A 1110-A 1115: Pieneman, J W
A 1116: Pieneman, N
A 1117: Sminck Pitloo, A
A 1118: Poelman, P F
A 1119: Portman, Chr J L
A 1120: Prins, J H
A 1121: Ravenswaay, J van
A 1122 & A 1123: Regemorter, I J van
A 1124: Ronner-Knip, H
A 1125: Roth, G A

A 1464: Cornet, J L
A 1465: Bakhuysen, L
A 1466: Duynen, I van
A 1467: Velde I, W van de
A 1468: Bloot, P de
A 1469: Northern Netherlands school ca 1600
A 1470: Verkolje, J
A 1471 & A 1472: Haanen, A J
A 1473 & A 1474: Hengel, H F van
A 1475: Vettewinkel Dzn, H
A 1476 & A 1477: Northern Netherlands school ca 1775
A 1478: Westerbaen, J J
A 1479 & A 1480: Honthorst, G van
A 1481: Adriaensen, A
A 1482: Breenbergh, B
A 1483 & A 1484: Leiden school ca 1515
A 1485: Moeyaert, N
A 1486: Post, F
A 1487: Vonck, J
A 1488: Savery, R
A 1489: Hollander Cz, H
A 1490: Soeren, G J van
A 1491: Gelderland school ca 1435
A 1492: Sanders, H
A 1493: Carrée I, H
A 1494: Wolfert, J B
A 1495: Hulst, J B van der
A 1496: Bueckelaer, J
A 1497: Begeyn, A
A 1498: Hogers, J
A 1499: Kruseman, J A
A 1500: Hoogstraten, D van
A 1501: Beveren, Ch van
A 1502: Hondecoeter, G C d'
A 1503 & A 1504: PAN
A 1505: Gabriël, P J C
A 1506: Valckenborgh, F van
A 1507: Vries, M van
A 1508: Holland school ca 1500
A 1509: Quinkhard, J M
A 1510: Everdingen, A van
A 1511: Meyer, H de
A 1512: Moritz, L
A 1513: Doomer, L
A 1514: Valois, J F
A 1515 & A 1516: Calisch, M
A 1517: Hodges, Ch H
A 1518: Colonia, A de
A 1519: Northern Netherlands school ca 1815
A 1520: Pieneman, J W
A 1521: Storck, A
A 1522: Bosschaert, A
A 1523 & A 1524: Beveren, Ch van
A 1525: Ruysdael, J S van
A 1526: Weissenbruch, J
A 1527: Giselaer, N de
A 1528 & A 1529: Steenwyck, Harm van
A 1530: Wet I, J W de
A 1531: Wever, C
A 1532: Scorel, J van
A 1533: Lastman, P P
A 1534: Jansen, F J
A 1535: Borssum, A van
A 1536: Gelder, N van
A 1537: Zeeuw, C de
A 1538: Pieneman, J W
A 1539: Dubus, M
A 1540: Bree, M I van
A 1541: Lelie, A de
A 1542: Mauve, A
A 1543 & A 1544: Meerman, H
A 1545: Keyser, Th de
A 1546: Koekkoek, B C
A 1547 & A 1548: Northern Netherlands school ca 1510
A 1549: Heda, G W
A 1550 & A 1551: Lubienietzky, Chr
A 1552: Netscher, Casp
A 1553 & A 1554: Mesdag, H W
A 1555: Snayers, P
A 1556: Haas, J H L de
A 1557: Vianen II, P van
A 1558: Pieneman, J W
A 1559: Valckenborgh, L van
A 1560: Mor van Dashorst, A
A 1561: Braunschweig Monogrammist
A 1562: Vertin, P G
A 1563: Liernur, W A A
A 1564: Poggenbeek, G J H
A 1565: Versteegh, M
A 1566: Haak, R J S
A 1567-A 1569: Hodges, Ch H
A 1570: Kruseman, J A
A 1571: PAST Northern Netherlands school ca 1790

A 1572: Dujardin, G
A 1573: Ruelles, P des
A 1574: Diepraam, A
A 1575-A 1579: Bol, F
A 1580: Holland school 1601
A 1581: Stalpaert, P
A 1582: Nieulandt, A van
A 1583: Spilman, H
A 1584: Houckgeest, G
A 1585: Post, F
A 1586: Pynas, Jac S
A 1587: Muys, N
A 1588: Saftleven, C
A 1589: Velde I, W van de
A 1590: anonymous: purchased for the frame
A 1591: Fabritius, C
A 1592: Vrel, J
A 1593: Danckerts de Rij, P
A 1594: Veen, B van der
A 1595: Vermeer, J
A 1596: Bijlert, J van
A 1597: Beet, C D
A 1598: Cock, J W de
A 1599: Northern Netherlands school ca 1570
A 1600: Boone, D
A 1601: Bosch, J
A 1602: Berckman, H
A 1603: Braunschweig Monogrammist
A 1604: Blieck, D de
A 1605: Gool, J van
A 1606: Baburen, D van
A 1607: Limborch, H van
A 1608: Troost, C
A 1609: PAST La Croix, S de
A 1610: Wouwerman, Ph
A 1611: Zijl, R van
A 1612: Eeckhout, G van den
A 1613: Kruseman, J A
A 1614: Horemans II, J J
A 1615 & A 1616: Palamedesz, A
A 1617: Colijns, D
A 1618: PAST Daiwaille, J A
A 1619: Anthonisz, C
A 1620: Altmann, S
A 1621: Kruseman, J A
A 1622: Hanneman, A
A 1623: Palamedesz, A
A 1624: Laquy, W J
A 1625: Roos, J M
A 1626: Pynas, Jan S
A 1627: Lievens, J
A 1628: Northern Netherlands school ca 1680
A 1629: Wieringen, C C van
A 1630: Vollevens II, J
A 1631: Bieselingen, Chr J van
A 1632: Kamphuijsen, J
A 1633: Beest, S van
A 1634: Gallis, P
A 1635: Troost, C
A 1636: Scorel, J van
A 1637: Vrancx, S
A 1638: Northern Netherlands school ca 1655
A 1639: Haanen, R A
A 1640: Northern Netherlands school ca 1670
A 1641: Wieringa, N
A 1642: Witte, E de
A 1643 & A 1644: Berckman, H
A 1645 & A 1646: Maes, N
A 1647-A 1650: Dijk, Ph van
A 1651: PAST Vaillant, B
A 1652 & A 1653: Palthe, J
A 1654 & A 1655: Haringh, D
A 1656 & A 1657: Nachenius, J J
A 1658: Monmorency, B
A 1659: Vaillant, B: drawing, transferred to the RPK
A 1660 & A 1661: Lievens, J A
A 1662: Maes, N
A 1663: Vaillant, B
A 1664 & A 1665: Oosterdijk, W
A 1666: Dijk, Ph van
A 1667: PAST Northern Netherlands school ca 1775
A 1668: Bruges school 1548
A 1669: Aelst, W van
A 1670: Hanneman, A
A 1671: Northern Netherlands school ca 1680
A 1672: Verheyden, M
A 1673: Bosch, J
A 1674: Victors, Jac
A 1675: Holland school 1637
A 1676: Musscher, M van
A 1677-A 1679: Sangster, H A
A 1680: Ovens, J
A 1681: Apostool, C

A 1682: Sorgh, H M
A 1683: Willaerts, Abr
A 1684: Dusart, Chr J
A 1685: Leyster, J
A 1686: Peschier, N L
A 1687: Mommers, H
A 1688: Master of the Figdor Deposition
A 1689 & A 1690: Doncker, H M
A 1691: Leyden, A van
A 1692 & A 1693: Netscher, Casp
A 1694: Haan, M I de
A 1695: Vaillant, W
A 1696 & A 1697: Uytewael, J A
A 1698: Hekking I, W
A 1699: Vrancx, S
A 1700: Key, A Th
A 1701: Pieneman, N
A 1702: Winterhalter, F X
A 1703: Schwartze, Th
A 1704: Reekers, H
A 1705: Natus, J
A 1706: Monogrammist I V A
A 1707 & A 1708: PAST Troost, C
A 1709: Hackaert, J
A 1710: Lelienbergh, C
A 1711: Murant, E
A 1712: Picolet, G
A 1713: Spreeuwen, J van
A 1714: Stoop, D
A 1715: Werff, A van der
A 1716: Velde II, W van de
A 1717: Vos, M de
A 1718: Avercamp, H
A 1719: Engelbrechtsz, C
A 1720: Isaacsz, P
A 1721: Monogrammist B V D A
A 1722: Hals, D
A 1723: Miereveld, M J van
A 1724: Breenbergh, B
A 1725: Cornelisz Kunst, C
A 1726: Alewijn, A
A 1727: Master of the St Elizabeth Panels
A 1728: Utrecht school 2d half 16th century
A 1729-A 1731: Allebé, A
A 1732: Beest, S van
A 1733: Berckheyde, G A
A 1734: Bilders, J W
A 1735: Bombled, K F
A 1736: Bourgoin, A G A
A 1737: Gallis, P
A 1738: PAN
A 1739: Heeremans, Th
A 1740: Hondecoeter, G C d'
A 1741: Lelienbergh, C
A 1742: Martens, W
A 1743-A 1745: Michaud, H
A 1746: Moor, C de
A 1747a-A 1747g: Poelenburgh, C van
A 1748-A 1750: Mouilleron, A
A 1751: Nellius, M
A 1752: Netherlands school ca 1630
A 1753: Hoef, A van
A 1754: Elyas, I
A 1755: Poel, E van der
A 1756: Quast, P J
A 1757-A 1760: Rochussen, Ch
A 1761 & A 1762: Saftleven, H
A 1763: Steen, J H
A 1764 & A 1765: Velde, E van de
A 1766: Velde, J J van de
A 1767-A 1776: Venne, A P van de
A 1777: Vlieger, S de
A 1778: Dijk, Ph van
A 1779: Wassenbergh, J A
A 1780 & A 1781: Geest, W S de
A 1782: Vinckboons, D
A 1783: Wit, J de
A 1784-A 1786: Borch, G ter
A 1787: Cool, J D
A 1788: Nieulandt, J van
A 1789: Ormea, W
A 1790: Berckheyde, J
A 1791 & A 1792: Duyster, W C
A 1793: Cuyp, J G
A 1794: Wouwerman, P
A 1795: Bosch, J
A 1796: Hals, D
A 1797: Holland school ca 1745
A 1798: Achenbach, O
A 1799: Allebé, A
A 1800: Sande Bakhuizen, G J van de: de-acceded in 1899
(returned to the heirs of the donor)
A 1801: Bisschop, Chr

A 1802: Bisschop-Swift, C S F
A 1803: Bles, D J
A 1804: Bosboom, J
A 1805: Burgers, H J
A 1806: Rossum du Chattel, F J van
A 1807: Frankenberg en Proschlitz, D O L van
A 1808: Duwée, H J
A 1809: Gallard-Lepinay, E
A 1810: Girard, H
A 1811: Hamman, E M F
A 1812-A 1818: Hanedoes, L
A 1819: Hendriks, F H
A 1820 & A 1821: Meijer, J H L
A 1822: Opzoomer, S
A 1823: Lepoittevin, E M E
A 1824: Prooyen, A J van
A 1825: Riegen, N
A 1826: Roos, C F
A 1827: Saal, G
A 1828: Schelfhout, A
A 1829: Schermer, C A J
A 1830: Scholten, H J
A 1831: Stroebel, J A B
A 1832: Terlaak, G
A 1833: Tidemand, A
A 1834: Toussaint, P J
A 1835: Weissenbruch, J
A 1836: Westerbeek, C
A 1837: Northern Netherlands school 3d quarter 19th century
A 1838 & A 1839: Genoels, A
A 1840: Lairesse, G
A 1841: Holland school 1597
A 1842: Jansen, F
A 1843: Uytewael, J A
A 1844: Monogrammist H K
A 1845: Daiwaille, J A
A 1846: Ekels II, J
A 1847: Nouts, M
A 1848: Velde II, W van de
A 1849: Eerelman, O
A 1850: Wouwerman, J
A 1851: Horemans II, J J
A 1852: Holland school ca 1620
A 1853: Wet I, J W de
A 1854: Wet, G de
A 1855: Scorel, J van
A 1856: Mijtens, J
A 1857: Claesz, P
A 1858: Jongh, L de
A 1859: Bonvin, F
A 1860: Boulard, A
A 1861: Breton, E A
A 1862: Corot, J B C
A 1863-A 1865: Courbet, G
A 1866: Couture, Th
A 1867 & A 1868: Daubigny, Ch F
A 1869: Daumier, H
A 1870: Decamps, A G
A 1871: Delacroix, F V E
A 1872 & A 1873: Diaz de la Peña, N V
A 1874 & A 1875: Dupré, J
A 1876: Dupré, V
A 1877: Hawksley, A
A 1878: Hendriks, S F
A 1879: Japy, L A
A 1880: Jettel, E
A 1881: Jouve, A
A 1882: Northern Netherlands school 2d half 17th century
A 1883: Maarel, M van der
A 1884: Mancini, A
A 1885 & A 1886: Maris, J H
A 1887: Maris, W
A 1888: Mauve, A
A 1889 & A 1890: Mettling, L
A 1891: Mesdag, H W
A 1892: Monet, C
A 1893: Monticelli, A
A 1894: Nicolas, L
A 1895: Pasini, A
A 1896: Peppercorn, A D
A 1897 & A 1898: Ribot, A Th
A 1899: Rousseau, P E Th
A 1900: Troyon, C
A 1901: Vollon, A
A 1902: Whistler, J A M
A 1903: Ziem, F
A 1904: Koninck, Ph
A 1905: Pieneman, J W
A 1906: Palamedesz, A
A 1907: Delff I, J W
A 1908: Geest, W S de
A 1909: Aertsen, P
A 1910: Heemskerck, M van

A 1911: Graat, B
A 1912: Wulfraet, M
A 1913: Northern Netherlands school ca 1660
A 1914 & A 1915: Boonen, A
A 1916: Ulft, J van der
A 1917: Winter, A H van
A 1918 & A 1919: Hondius, A
A 1920: Droochsloot, C
A 1921: Mesdag-van Houten, S
A 1922: Bilders-van Bosse, M Ph
A 1923: Weissenbruch, H J
A 1924: Roelofs, W E
A 1925: Withoos, M
A 1926: Helt Stockade, N van
A 1927: Willaerts, Adam
A 1928: Jonson van Ceulen I, C
A 1929: Erichsen, V
A 1930: Droochsloot, J C
A 1931: Venne, A P van de
A 1932: Steen, J H
A 1933 & A 1934: Nijmegen, D van
A 1935: Rembrandt
A 1936: Berchem, N
A 1937: Bol, F
A 1938: Both, J
A 1939: Camphuijsen, R G
A 1940: Duck, J
A 1941: Fonteyn, A L
A 1942: Molijn, P de
A 1943: Graat, B
A 1944: Heeremans, Th
A 1945: Laer, P van
A 1946: Leemans, J
A 1947: Northern Netherlands school ca 1705
A 1948: Neer, A van der
A 1949: Peeters, B
A 1950: Ravesteyn, J A van
A 1951: Vonck, E
A 1952: Daiwaille, J A
A 1953: Moritz, L
A 1954: Koninck, Ph
A 1955: Willaerts, Adam
A 1956: Caullery, L de
A 1957 & A 1958: Sweerts, M
A 1959: MIN Holland school ca 1840
A 1960: Anraedt, P van
A 1961: Northern Netherlands school ca 1850
A 1962: MIN Holland school ca 1850
A 1963: Wijsmuller, J H
A 1964: Spoel, J
A 1965: Crabeth II, W
A 1966: Sangster, H A
A 1967: Cornelisz van Oostsanen, J
A 1968: PAN
A 1969: Arentsz, A
A 1970: Asch, P J van
A 1971: Vliet, H C van
A 1972: Tempel, A L van den
A 1973: Velde I, W van de
A 1974: Scheffer, J B
A 1975: Northern Netherlands school 1626
A 1976: Pynacker, A
A 1977: Laroon, M
A 1978: Toorenvliet, J
A 1979: Netherlands school ca 1665
A 1980: Savery II, J
A 1981 & A 1982: Vlieger, S de
A 1983: Slingeland, P C van
A 1984 & A 1985: Amsterdam school 1593
A 1986: Neck, J van
A 1987: Haan, M I de
A 1988: Bashkirtseff, M K
A 1989: Hendriks, W
A 1990: Bloemaert, A
A 1991: Dalem, C van
A 1992: Friesland school 1542
A 1993 & A 1994: Cronenburg, A van
A 1995: Nieulandt, A van
A 1996-A 2052: VANM
A 2053 & A 2054: VANM Steen, J van der
A 2055: VANM
A 2056: VANM Steen, J van der
A 2057: Master of the Legend of St Barbara
A 2058: Dijck, F van
A 2059: Andriessen, J
A 2060: Kneller, G
A 2061: Schalcken, G
A 2062-A 2066: Dubois, S
A 2067: Miereveld, M J van
A 2068 & A 2069: Mesdach, S
A 2070-A 2072: Geldorp, G
A 2073: Mesdach, S
A 2074: Northern Netherlands school 1630

A 2075: Northern Netherlands school 1622
A 2076: Northern Netherlands school 1623
A 2077: Northern Netherlands school 1629
A 2078: Troost, C
A 2079: Northern Netherlands school 1627
A 2080: Northern Netherlands school 1645
A 2081: Geldorp, G
A 2082: MIN Northern Netherlands school ca 1805
A 2083: Simons, M
A 2084: Tischbein, J F A
A 2085: MIN Northern Netherlands school ca 1655
A 2086: Vlieger, S de
A 2087-A 2092: Brugghen, G A van der
A 2093: Bramer, L
A 2094: Netherlands school? 17th century
A 2095: Ossenbeck, W
A 2096: Southern Netherlands school ca 1680
A 2097: Valkenburg, D
A 2098: MIN Northern Netherlands school ca 1675
A 2099: Coorte, A S
A 2100 & A 2101: Miereveld, M J van
A 2102: Brueghel I, J
A 2103: Ast, B van der
A 2104: MIN Northern Netherlands school 1614
A 2105: Colasius, J G
A 2106: Asch, P J van
A 2107 & A 2108: Northern Netherlands school ca 1525
A 2109: Vinckboons, D
A 2110: Bisschop, C
A 2111: Peeters, C
A 2112: Schellinks, W
A 2113: Wijck, Th
A 2114: Ochtervelt, J
A 2115: Lairesse, G
A 2116: Everdingen, C B van
A 2117: Savery I, J
A 2118: Borch, M ter
A 2119: PAST Basseporte, M F
A 2120: MIN Fock, H
A 2121: Mol, W
A 2122: Mieris, J van
A 2123: Mostaert, J
A 2124: Veth, J P
A 2125: Hodges, Ch H
A 2126: Anthonissen, H van
A 2127: Bassano, J
A 2128: Neer, A van der
A 2129 & A 2130: Master of the Amsterdam Death of the Virgin
A 2131: Ruys, S
A 2132: Storck, A
A 2133: Goyen, J van
A 2134: Phlippeau, K F
A 2135: Pot, H G
A 2136: Regters, T
A 2137: Kruseman, C
A 2138: Veth, J P
A 2139 & A 2140: Mijn, G van der
A 2141: Michaëlis, G J
A 2142: PAST Perronneau, J B
A 2143: Koets, R: de-acceded in 1921 (given to Jonkheer H Trip, The Hague)
A 2144: Holland school: de-acceded in 1921 (same as A 2143)
A 2145-A 2147: Wassenbergh, J A: de-acceded in 1921 (same as A 2143)
A 2148 & A 2149: Dubois Drahonet, A J: de-acceded in 1921 (same as A 2143)
A 2150: Geertgen tot Sint Jans
A 2151: PAST Schmidt, I
A 2152: Ast, B van der
A 2153: Martszen II, J
A 2154: Ferguson, W G
A 2155: Franck, Chr F
A 2156: Metsu, G
A 2157: Vries, A de
A 2158: Troost, C
A 2159: Challe, N
A 2160: Puytlinck, Chr
A 2161: Ovens, J
A 2162: Willaerts, Adam
A 2163: Vroom, H C
A 2164: Barendsz, D
A 2165: Hoynk van Papendrecht, J
A 2166 & A 2167: Kruseman, C
A 2168 & A 2169: PAST Mertens, J C
A 2170: Schwartze, J G
A 2171 & A 2172: Northern Netherlands school ca 1830
A 2173 & A 2174: MIN Grebner, W
A 2175 & A 2176: MIN Northern Netherlands school ca 1810
A 2177 & A 2178: MIN Northern Netherlands school ca 1775
A 2179: Northern Netherlands school: de-acceded in 1964 (choir vault, returned to the church in Kerkwijk)
A 2180: Heemskerck, E van
A 2181: Dekker, H A Chr

A 2182 & A 2183: Dubordieu, P
A 2184 & A 2185: Hennekyn, P
A 2186-A 2189: Bakhuysen, L
A 2190: Regters, T
A 2191: Troost, C
A 2192 & A 2193: Wolff, B
A 2194 & A 2195: Moritz, L
A 2196: Northern Netherlands school 1630
A 2197 & A 2198: Bakhuysen, L
A 2199: Bakhuizen, G
A 2200: Verkolje, J
A 2201: Moritz, L
A 2202: Wiertz, HF
A 2203: Bakhuysen, L
A 2204: Horstok, JP van
A 2205: Vught, G van
A 2206: Verelst, PH
A 2207: MIN Northern Netherlands school ca 1640
A 2208: MIN Northern Netherlands school ca 1710
A 2209 & A 2210: MIN Northern Netherlands school ca 1745
A 2211: Savery, R
A 2212: Master of the Figdor Deposition
A 2213: Gijsels, P
A 2214: Bartius, W
A 2215 & A 2216: Neuman, JH
A 2217: Goltzius, H
A 2218: Hooch, CC de
A 2219: Pieneman, JW
A 2220: Koninck, S
A 2221: Wieringa, HW
A 2222: Treck, JJ
A 2223 & A 2224: Bout, P
A 2225-A 2227: Gogh, VW van: drawings, transferred to the RPK
A 2228: Cunaeus, C
A 2229: Dankmeyer, CB
A 2230: Schoeff, JP
A 2231: Lelie, A de
A 2232: Engebrechtsz, C
A 2233: Karsen, K
A 2234 & A 2235: Lelie, A de
A 2236: Helst, L van der
A 2237: Northern Netherlands school ca 1500
A 2238: Pieneman, N
A 2239: Meijer, JHL
A 2240 & A 2241: Borch, M ter
A 2242: Venetian school ca 1590
A 2243 & A 2244: Tempel, AL van den
A 2245: Neyn, P de
A 2246: Bonnat, JJF
A 2247: Keun, H
A 2248 & A 2249: Mijn, F van der
A 2250: Esselens, J
A 2251: Bueckelaer, J
A 2252: Lovera
A 2253: Monogrammist IB
A 2254: Toorenvliet, J
A 2255: Holland school: de-acceded in 1951 (returned to the Landhuis, Hellevoetsluis)
A 2256: Tischbein, JFA
A 2257: Charlet, NT
A 2258: Holland school 1633
A 2259: Sande Bakhuyzen, JJ van de
A 2260: Bakker Korff, AH
A 2261: Bauer, MAJ
A 2262-A 2264: Bilders, AG
A 2265 & A 2266: Gabriël, PJC
A 2267 & A 2268: Hodges, ChH
A 2269: Jamin, DF
A 2270: Jongkind, JB
A 2271: Kever, JSH
A 2272-A 2274: Maris, JH
A 2275 & A 2276: Maris, M
A 2277: Maris, W
A 2278: Mastenbroek, JH van
A 2279: Mauve, A
A 2280: Mesdag, HW
A 2281: Metzelaar, C
A 2282: Westerwoudt, JBAM
A 2283: Zwart, WHPJ de
A 2284 & A 2285: PAST Cate, SJ ten
A 2286: Jamin, DF
A 2287: Verlat, Ch
A 2288: Daubigny, ChF
A 2289: Alma Tadema, L
A 2290: Gabriël, PJC
A 2291: Weissenbruch, HJ
A 2292: Artz, DAC
A 2293: Uppink, H
A 2294: Lelie, A de
A 2295: Allebé, A
A 2296: Blommers, BJ
A 2297 & A 2298: Bilders, AG

A 2299: Cate, SJ ten
A 2300: Jongkind, JB
A 2301: Mesdag, HW
A 2302: Vollon, A
A 2303: Mösers, JH
A 2304: Wijntrack, D
A 2305: Venne, AP van de
A 2306: Northern Netherlands school mid-17th century
A 2307: Malsen, T van
A 2308: Nieulandt, A van
A 2309: Northern Netherlands school 1624
A 2310 & A 2311: Grebber, PF de
A 2312: Master of the Spes Nostra
A 2313 & A 2314: Asselijn, J
A 2315 & A 2316: Bakhuysen, L
A 2317: Berchem, N
A 2318 & A 2319: Dyck, A van
A 2320 & A 2321: Dou, G
A 2322: Esselens, J
A 2323: Franchoys, E
A 2324: Heusch, W de
A 2325: Hondecoeter, M d'
A 2326: Leyster, J
A 2327: Lingelbach, J
A 2328: Metsu, G
A 2329: Mignon, A
A 2330: Moreelse, P
A 2331: Musscher, M van
A 2332: Ostade, A van
A 2333 & A 2334: Post, F
A 2335: Pynacker, A
A 2336: Rubens, PP
A 2337: Ruisdael, JI van
A 2338: Ruysch, R
A 2339 & A 2340: Schalcken, G
A 2341: Tol, D van
A 2342: Troost, C
A 2343: Velde, A van de
A 2344: Vermeer, J
A 2345: Victors, Jan
A 2346: Walscapelle, J van
A 2347: Werff, A van der
A 2348: Wouwerman, Ph
A 2349: Wijnants, J
A 2350: Cuyp, A
A 2351: Meer II, J van der
A 2352: Delen, D van
A 2353: Bray, J de
A 2354: Lastman, PP
A 2355: Man, C de
A 2356: Kieft, J
A 2357: Mulier I, P
A 2358: Stevers
A 2359 & A 2360: Gelder, A de
A 2361: Knibbergen, F van
A 2362: Velde, JJ van de
A 2363 & A 2364: Roghman, R
A 2365: Leiden school ca 1630
A 2366: Dielaert, Ch van
A 2367: Jordaens, J
A 2368 & A 2369: Voskuyl, HP
A 2370: Oever, H ten
A 2371: Voorhout, J
A 2372: Netherlands school 1573
A 2373: Heck, NJ van der
A 2374: Schooten, J van
A 2375: PAST Mijn, G van der
A 2376: Mijn, F van der
A 2377: Hijsing, H
A 2378: Artz, DAC
A 2379: Sande Bakhuyzen, JJ van de
A 2380: Bosboom, J
A 2381: Gabriël, PJC
A 2382: Israels, J
A 2383: Klinkenberg, JChrK
A 2384: Mauve, A
A 2385: Mesdag, HW
A 2386: Roelofs, W
A 2387: Vogel-Roosenboom, MCJWH
A 2388: Springer, C
A 2389: Jelgerhuis, J
A 2390: Vries, HV de
A 2391: Rembrandt
A 2392: Buys II, C
A 2393: Velde II, W van de
A 2394: Spanish school? 17th century
A 2395: Gheyn II, J de
A 2396: Heem, JD de
A 2397: Borselaer, P
A 2398: Aertsen, P
A 2399: Master of the Aix Annunciation
A 2400: Jansen, HW
A 2401: Vinckboons, D

A 2402: Levecq, J
A 2403 & A 2404: Terwesten II, A
A 2405 & A 2406: Hoogerheyden, E
A 2407 & A 2408: MIN Wolters, H
A 2409 & A 2410: MIN Wolters-van Pee, H
A 2411 & A 2412: PAST Monogrammist JJ
A 2413: Bastert, SN
A 2414 & A 2415: Tischbein, JFA
A 2416: Anraedt, P van
A 2417 & A 2418: Borch, G ter
A 2419: Numan, H
A 2420-A 2422: Regters, T
A 2423 & A 2424: May, JW
A 2425: May, JS: map, transferred to the state archives, The Hague, 1910
A 2426: Woutersz, J
A 2427: Alma Tadema, L
A 2428 & A 2429: Maris, W
A 2430-A 2436: Mauve, A
A 2437: Neuhuys, JA
A 2438 & A 2439: Weissenbruch, HJ
A 2440-A 2452: AQU Mauve, A
A 2453 & A 2454: AQU Weissenbruch, HJ
A 2455-A 2473: Maris, JH
A 2474: Mesdag, HW
A 2475-A 2481: AQU Maris, JH
A 2482: AQU Neuhuys, JA
A 2483-A 2489: AQU Poggenbeek, GJH
A 2490: Swan, JM
A 2491: Maris, JH
A 2492: AQU Mauve, A
A 2493-A 2495: Bock, ThEA de
A 2496: Israels, J
A 2497: Swanevelt, H van
A 2498 & A 2499: Stengelin, A
A 2500: Maris, JH
A 2501 & A 2502: Maris, JH: drawings, transferred to the RPK
A 2503: Diest, Jer van
A 2504: Jelgerhuis, J
A 2505: Berchem, N
A 2506: Kessel, J van
A 2507: Eeckhout, G van den
A 2508: Hubrecht, AAL
A 2509: Grijs, HF de: drawing, transferred to the RPK
A 2510: Breen, A van
A 2511: Heyden, J van der
A 2512: Vois, A de
A 2513: Dubbels, HJ
A 2514: Luima, P
A 2515: Veronese, P
A 2516: Rubens, PP
A 2517: anonymous: de-acceded in 1910 (destroyed)
A 2518: Peeters, B
A 2519-A 2522: Northern Netherlands school mid-17th century
A 2523 & A 2524: Mauve, A
A 2525: Maris, W
A 2526: Savery I, H
A 2527: Ravesteyn, JA van
A 2528: Aerts, H
A 2529: Rombouts, S
A 2530: Vroomans, I
A 2531: Vliet, HC van
A 2532: Rappard, AGA van: drawing, transferred to the RPK
A 2533: anonymous: photo, transferred to the RPK
A 2534: Northern Netherlands school 18th century
A 2535: Zürcher, JWCA
A 2536: Witte, E de
A 2537: Pieneman, N: drawing, transferred to the RPK
A 2538: Pietersz, A
A 2539: Bakhuysen, L
A 2540: Hart Nibbrig, F
A 2541: Spoel, J
A 2542 & A 2543: PAST Hodges, ChH
A 2544: Adriaensen, A
A 2545 & A 2546: Nijmegen school ca 1483
A 2547: Master of the Salem Altar
A 2548: Bavarian school last quarter 15th century
A 2549: Beert, O
A 2550: Hainz, J
A 2551: Northern Netherlands school? 2d half 17th century
A 2552: Southern Netherlands school ca 1500
A 2553: North German school 2d quarter 15th century
A 2554: Balten, P
A 2555: Buesem, JJ
A 2556: Netscher, Casp
A 2557: Both, A
A 2558: Bout, P
A 2559: Bruyn I, B
A 2560: Cranach II, L
A 2561: Cranach I, L
A 2562: Decker, CG
A 2563: Master of the Braunschweig Diptych
A 2564: Heem, C de

A 2565: Heem, J D de
A 2566: Heem, D D de
A 2567: Orley, B van
A 2568: Ostade, A van
A 2569 & A 2570: Provoost, J
A 2571: Ruysdael, S J van
A 2572: Steen, J H
A 2573: Stoop, M
A 2574: Sweerts, M
A 2575: Southern Netherlands school ca 1640
A 2576: Troost, C
A 2577: Vliet, W W van
A 2578: Daumier, H
A 2579: Monticelli, A
A 2580: Maris, M
A 2581 & A 2582: Karsen, J E
A 2583: Rops, F: drawing, transferred to the R P K
A 2584-A 2586: Voerman, J: drawings, transferred to the R P K
A 2587: Southern Netherlands school 1557
A 2588: Westphalian school ca 1500
A 2589: Pseudo-Ambrodigio di Baldese
A 2590: North Italian school 2d half 15th century
A 2591: Southern Netherlands school ca 1530
A 2592: Northern Netherlands school ca 1530
A 2593: North German school ca 1500
A 2594: Coecke van Aelst, P
A 2595: South German school early 16th century
A 2596: Calcar, J J van
A 2597-A 2607: Israels, J
A 2608-A 2614: A Q U Israels, J
A 2615 & A 2616: Israels, J
A 2617-A 2619: A Q U Israels, J
A 2620: Regteren Altena, M van
A 2621: Cohen Gosschalk, J: drawing, transferred to the R P K
A 2622 & A 2623: P A S T Cuylenburg, C van
A 2624: Northern Netherlands school last quarter 16th century
A 2625: Arentsz, A
A 2626: Wall Perné, G F van de
A 2627: Dou, G
A 2628: Stortenbeker, P
A 2629: Netherlands school 4th quarter 17th century
A 2630: P A S T Anspach, J
A 2631: M I N Northern Netherlands school ca 1790
A 2632 & A 2633: M I N Northern Netherlands school ca 1805
A 2634: M I N Northern Netherlands school ca 1790
A 2635: M I N Northern Netherlands school ca 1810
A 2636 & A 2637: M I N Northern Netherlands school ca 1805
A 2638: M I N German school ca 1830
A 2639: M I N Collins, R
A 2640: M I N Northern Netherlands school? ca 1800
A 2641: M I N Northern Netherlands school ca 1805
A 2642 & A 2643: M I N Northern Netherlands school ca 1790
A 2644: M I N Northern Netherlands school ca 1810
A 2645 & A 2646: M I N Northern Netherlands school ca 1790
A 2647 & A 2648: M I N Northern Netherlands school ca 1805
A 2649: Utrecht school ca 1435
A 2650: Elsheimer, A
A 2651: Haen, G de
A 2652: Alma Tadema-Epps, L Th
A 2653 & A 2654: Schaap, E R D
A 2655: Sant-Acker, F
A 2656: Liotard, J E
A 2657 & A 2658: Werff, P van der
A 2659 & A 2660: Wittel, G van
A 2661: Vroom, H C
A 2662: Cohen Gosschalk, J: drawing, transferred to the R P K
A 2663: Mor van Dashorst, A
A 2664: Alma Tadema, L
A 2665: Miereveld, M J van
A 2666-A 2669: Netscher, Casp
A 2670: Mesdag, H W
A 2671: Regters, T
A 2672: Bril, P
A 2673: M I N Northern Netherlands school ca 1805
A 2674: Bellevois, J
A 2675: Huchtenburg, J van
A 2676: Beeldemaker, A C
A 2677: Hondius, A
A 2678: Beerstraaten, J A
A 2679: Falens, C van
A 2680: Houbraken, A
A 2681: Keun, H
A 2682: Wijntrack, D
A 2683: Hondecoeter, M d'
A 2684: English school ca 1585
A 2685: Frankfort, E
A 2686 & A 2687: Holland school mid-18th century
A 2688: Velde, A van de
A 2689: M I N Graham I, J
A 2690: P A S T Zilcken, Ch L Ph
A 2691: Apol, L F H
A 2692: Beelt, C
A 2693: Woutersin, L F

A 2694: Sam, E
A 2695: Gelder, A de
A 2696: Jacobson, J
A 2697: Oever, H ten
A 2698: Brekelenkam, Q G van
A 2699: Vrancx, S
A 2700: Bosboom, J
A 2701: Diaz de la Peña, N V
A 2702 & A 2703: Maris, J H
A 2704 & A 2705: Maris, M
A 2706: Maris, W
A 2707: Millet, J F
A 2708: Poggenbeek, G J H
A 2709: Rousseau, P E Th
A 2710: Weissenbruch, H J
A 2711: Neuhuys, A: drawing, transferred to the R P K
A 2712: Millet, J F: drawing, transferred to the R P K
A 2713 & A 2714: Jelgerhuis, J
A 2715: Blaaderen, G W van
A 2716: Holland school ca 1680
A 2717: Bailly, D
A 2718: Czermak, J
A 2719: Israels, J: photo of, transferred to the R P K
A 2720: Burgh, Hendrick van der
A 2721: Vogel, J G
A 2722 & A 2723: Vogel-Roosenboom, M C J W H
A 2724: Schwartze, Th
A 2725 & A 2726: Heemskerck van Beest, J E van
A 2727: Northern Netherlands school ca 1620
A 2728: Le Fauconnier, H V G: drawing, transferred to the R P K
A 2729: Bouten, Ch: drawing, transferred to the R P K
A 2730: Schouman, A
A 2731: Miereveld, M J van
A 2732-A 2735: Hardimé, P
A 2736: Bol, F
A 2737 & A 2738: Windtraken, P W
A 2739: Derksen, G
A 2740: Vogel-Roosenboom, M C J W H
A 2741: Vogel-Roosenboom, M C J W H: aquarelle, transferred to the R P K
A 2742: Derksen, G: aquarelle, transferred to the R P K
A 2743-A 2747: Vogel, J G: drawings, transferred to the R P K
A 2748: Vogel-Roosenboom, M C J W H: aquarelle, transferred to the R P K
A 2749: Vogel, J G
A 2750-A 2782: Vogel, J G: aquarelles, drawings and lithographs, transferred to the R P K
A 2783 & A 2784: Brugghen, H ter
A 2785: Josselin de Jong, P de
A 2786: Druyf, D
A 2787: Quinkhard, J: drawing, transferred to the R P K
A 2788: Schwartze, Th
A 2789: Waay, N van der
A 2790: Potuyl, H
A 2791 & A 2792: Loeff, H D
A 2793: P A S T Northern Netherlands school ca 1805
A 2794: Hubrecht, A A L
A 2795-A 2797: P A S T Hubrecht, A A L
A 2798: Northern Netherlands school ca 1830
A 2799: Lower Rhenish school ca 1490
A 2800: Brabant school 2d half 15th century
A 2801: Lombard school 1st half 16th century
A 2802: anonymous ceiling painting: probably same as Holland school ca 1680, A 2716
A 2803: Northern Netherlands school ca 1725
A 2804: Diest, Joh van
A 2805 & A 2806: Holland school ca 1690
A 2807: Neuman, J H
A 2808: Both, J: de-acceded in 1924 (exchanged for A Brouwer, A 3015)
A 2809: M I N French school? 18th century
A 2810: Maris, J H
A 2811: Maris, W: litho, transferred to the R P K
A 2812: M I N Northern Netherlands school ca 1700
A 2813: Torrentius, J S
A 2814: Jacobsz, L
A 2815: Master of Alkmaar
A 2816: Pieneman, N
A 2817: M I N Hari Sr, J
A 2818-A 2821: Schwartze, J G
A 2822: Deutmann, F W M
A 2823: Kruseman, C
A 2824 & A 2825: Neuman, J H
A 2826: Lance, G
A 2827 & A 2828: Tischbein, J F A
A 2829: P A S T Northern Netherlands school ca 1790
A 2830: Weissenbruch, J
A 2831: Ouvrié, J J
A 2832: Gudin, J A Th
A 2833: Northern Netherlands school 1st half 19th century
A 2834: Zwieten, C van
A 2835: Bundel, W W van den
A 2836: Codde, P

A 2837 & A 2838: Carrée II, H
A 2839: Holland school 1st quarter 18th century
A 2840: Maes, N
A 2841: Kick, S W
A 2842: Jongh, C de
A 2843: Scorel, J van
A 2844: Dietterlin, B
A 2845-A 2848: Sweerts, M
A 2849: Zeeuw, C de
A 2850: Szyndler, P
A 2851: Bruges school ca 1450-70
A 2852 & A 2853: Japanese school: silk paintings, transferred to the department of Dutch history
A 2854: Master of the Legend of Mary Magdalene
A 2855: Israels, J
A 2856: Lelie, A de
A 2857: Cuyp, B G
A 2858: Vroom, H C
A 2859: Hals, F
A 2860: Vermeer, J
A 2861 & A 2862: Holland school ca 1850
A 2863: Keyser, N de
A 2864 & A 2865: Southern Netherlands school ca 1615
A 2866: Northern Netherlands school ca 1655
A 2867: Northern Netherlands school ca 1600
A 2868: Northern Netherlands school ca 1675
A 2869: Holland school ca 1675
A 2870: Northern Netherlands school? mid-18th century
A 2871: Northern Netherlands school ca 1615
A 2872: Dyck, A van
A 2873: Mor van Dashorst, A
A 2874: Rossum, J C van
A 2875 & A 2876: Bauer, M A J
A 2877 & A 2878: Bosboom, J
A 2879-A 2881: Breitner, G H
A 2882 & A 2883: Corot, J B C
A 2884-A 2886: Daubigny, Ch F
A 2887: Diaz de la Peña, N V
A 2888: Dupré, J
A 2889-A 2891: Dijsselhof, G W
A 2892-A 2895: Fantin-Latour, H
A 2896: Kamerlingh Onnes, M
A 2897-A 2906: Karsen, J E
A 2907 & A 2908: Kever, J S H
A 2909 & A 2910: Looy, J van
A 2911 & A 2912: P A S T Israels, I L
A 2913-A 2915: Israels, I L
A 2916: P A S T Israels, I L
A 2917-A 2920: Israels, I L
A 2921-A 2923: Israels, J
A 2924: Jongkind, J B
A 2925-A 2927: Maris, J H
A 2928: Fijt, J
A 2929 & A 2930: Maris, W
A 2931: Maris, S W
A 2932: Mauve, A
A 2933: Monet, C
A 2934-A 2937: Monticelli, A
A 2938: Mesdag, H W
A 2939: Neuhuys, A: aquarelle, transferred to the R P K
A 2940: Neuhuys, J: aquarelle, transferred to the R P K
A 2941 & A 2942: Verster, F H
A 2943: Voerman, J: aquarelle, transferred to the R P K
A 2944: Weissenbruch, J H: aquarelle, transferred to the R P K
A 2945-A 2947: Witsen, W A: aquarelle, transferred to the R P K
A 2948-A 2956: Witsen, W A
A 2957: Zwart, W H P J de
A 2958-A 2960: Fabritius, B
A 2961: Paepe, J de
A 2962: Loarte, A de
A 2963: Goya, F
A 2964: Tintoretto, J
A 2965: Tiepolo, G B
A 2966: Buijs, J
A 2967: Northern Netherlands school ca 1660
A 2968: Breitner, G H
A 2969: Sierig, F C
A 2970: Anthonissen, H van
A 2971: Hodges, Ch H
A 2972-A 3005: Reich bequest, technical accession, transferred to the S M A in 1923
A 3006: Bassano, L
A 3007: Master Allegro
A 3008: Foppa, V
A 3009: Pontormo, J
A 3010: Veronese, P
A 3011: Angelico, Fra
A 3012: Master of the Conversazione di Santo Spirito
A 3013: Master of the San Miniato Altarpiece
A 3014: Diana, B
A 3015: Brouwer, A
A 3016: Cornelisz van Haarlem, C
A 3017: Hoytema, Th van

A 3018: John, A E
A 3019: Maris, M
A 3020: Kruseman, J A
A 3021 & A 3022: Mijtens, J
A 3023: Molenaer, J M
A 3024: Palamedesz, A
A 3025: Sörensen, J L
A 3026: Wijsmuller, J H
A 3027: Southern Netherlands school 2d quarter 17th century
A 3028: Moor, C de
A 3029: Saftleven, H
A 3030: Lippi, Filippino
A 3031: Borgognone, A
A 3032: Ferrari, G
A 3033: Giampietrino
A 3034: Costa, L
A 3035: Brescian school 1st half 16th century
A 3036: Moroni, G B
A 3037: Corneille de Lyon
A 3038: Buytewech, W P
A 3039: Dongen, C Th M van
A 3040: stamp collection in 8 vols, transferred to the Nederlands
 Postmuseum, The Hague, in 1930
A 3041: family papers, transferred to the RMA archives
A 3042 & A 3043: illuminated manuscripts, transferred to the
 RPK
A 3044: Wandscheer, M W
A 3045: Ritsema, J
A 3046: Heyl, M
A 3047: Wierink, B W: aquarelle, transferred to the RPK
A 3048: PAST Andriessen, J
A 3049: Kruseman, C: drawing, transferred to the RPK
A 3050: Kruseman, C
A 3051: Reuss, princess M H
A 3052: Leenhoff, F: etching, transferred to the RPK
A 3053: Tollenaar-Ermeling, J: photographs of a statue,
 transferred to the RBK
A 3054: PAST Schwartze, Th
A 3055-A 3057: Uppink, W
A 3058: MIN Visser, A de
A 3059: Metsu, G
A 3060: Bisschop, Chr
A 3061: Breitner, G H
A 3062: Pontormo, J
A 3063: MIN Northern Netherlands school ca 1820
A 3064: Verspronck, J C
A 3065: Pourbus I, F
A 3066: Rembrandt
A 3067: Artz, D A C
A 3068: Bruckman, W L
A 3069: Artz, D A C
A 3070 & A 3071: Bakker Korff, A H
A 3072 & A 3073: Bilders, A C
A 3074: Bilders, J W
A 3075 & A 3076: Blommers, B J
A 3077: Bock, Th E A de
A 3078 & A 3079: Bosboom, J
A 3080: Estall, W Ch
A 3081: Frère, E
A 3082: Gabriël, P J C
A 3083: Hove Bz, H van
A 3084: Leickert, Ch H J
A 3085: Marcke de Lummen, E van
A 3086: Mesdag, H W
A 3087: Oppenoorth, W J
A 3088: Raffelt, J G
A 3089: Ronner-Knip, H
A 3090: Tholen, W B
A 3091: Vogels, W
A 3092: Vollon, A
A 3093: Weissenbruch, H J
A 3094: Westerwoudt, J B A M
A 3095: Allebé, A
A 3096: Monticelli, A
A 3097: Prud'hon, P P
A 3098: Lelie, A de
A 3099: Lenain, M
A 3100: Momper, J de
A 3101: Weijand, J
A 3102: MIN Hari I, J
A 3103: Flinck, G
A 3104: Bacchiacca
A 3105: Catalan school last quarter 15th century
A 3106: Maes, N
A 3107: Maris, W
A 3108: Vroom, H C
A 3109 & A 3110: Schmidt, W H
A 3111: Porcellis, J
A 3112: Verburgh, D
A 3113: Bosch, J
A 3114: Palamedesz, A
A 3115: Dubois, G
A 3116: Avignon school ca 1505-10

A 3117: Velde I, W van de
A 3118 & A 3119: Mor van Dashorst, A
A 3120: Seghers, H P
A 3121 & A 3122: Ketel, C
A 3123: Roemerswaele, M van
A 3124: Schiavone, G
A 3125: Hillegaert, P van
A 3126: Baen, J de
A 3127: Vrel, J
A 3128: Grégoire, J: de-acceded after 1932
A 3129: Karsen, K
A 3130: Master of the Female Halflengths
A 3131: Maarel, M van der
A 3132: Oosterhoudt, D van
A 3133: Flinck, G
A 3134 & A 3135: David, G
A 3136: Bree, M I van
A 3137 & A 3138: Rembrandt
A 3139: Neuman, J H
A 3140: Master of the Portraits of Princes
A 3141: Master of Delft
A 3142: Greco, El
A 3143: Mauve, A
A 3144: Waay, N van der
A 3145-A 3147: Master of the St Elizabeth Panels
A 3148: Key, A Th
A 3149-A 3214: Reich-Hohwü bequest, technical accession,
 transferred to the SMA in 1933
A 3215: Netherlands school ca 1550
A 3216: Northern Netherlands school ca 1600
A 3217: Northern Netherlands school ca 1625
A 3218: North Italian school? 1st half 18th century
A 3219 & A 3220: Holland school ca 1730
A 3221 & A 3222: HER
A 3223: PAST Baur, H J A
A 3224: Post, F
A 3225: Master with the Parrot
A 3226: Teniers II, D
A 3227: Drooschloot, J C
A 3228: Keun, H
A 3229- A 3230: Os, P G van
A 3231-A 3233: Wit, J de
A 3234: mirror, transferred to the RBK
A 3235: Blanckerhoff, J Th
A 3236: Voet, J F
A 3237: Vois, A de
A 3238: PAST Schmidt, I
A 3239: Oosterzee, H A van
A 3240: Bosch, J
A 3241: Velde, J van de
A 3242: Neuman, J H
A 3243: Karsen, K
A 3244: Witte, E de
A 3245: Neer, A van der
A 3246: Ostade, A van
A 3247: Avercamp, H
A 3248: Cappelle, J van de
A 3249 & A 3250: Goyen, J van
A 3251 & A 3252: Guardi, F
A 3253: Heyden, J van der
A 3254: Maes, N
A 3255: Master of the Female Halflenghts
A 3256: Neer, A van der
A 3257: Pater, J B
A 3258 & A 3259: Ruysdael, S J van
A 3260 & A 3261: Schall, J F
A 3262: Gogh, V W van
A 3263: Bernard, E
A 3264: Bernard, E: tapestry, transferred to the RBK
A 3265: Redon, O
A 3266 & A 3267: Allebé, A
A 3268: Kamerlingh Onnes, H H
A 3269: Savoldo, G G
A 3270: Honthorst, G van
A 3271: Velde, P van den
A 3272: MIN Temminck, L
A 3273 & A 3274: Dusart, C
A 3275: Maris, M: drawing, transferred to the RPK
A 3276: Rembrandt
A 3277: Mengs, A R
A 3278: Duplessis, J S
A 3279: French school ca 1750
A 3280: Bray, J de
A 3281: Ostade, A van
A 3282-A 3285: Rassenfosse, A
A 3286: Avercamp, B
A 3287: Bellini, G
A 3288: Berg, W H van den
A 3289: Breitner, G H
A 3290: Brueghel I, J
A 3291: Brouwer, A
A 3292 & A 3293: Cleve, J van
A 3294: Corneille de Lyon

A 3295: Courbet, G
A 3296: Holland school late 17th century?
A 3297: Cuyp, B G
A 3298: Rembrandt
A 3299: Holland school 1637
A 3300: Dijck, Abr van
A 3301: Pot, H G
A 3302: Florentine school ca 1450
A 3303: Riley, J
A 3304: Fromentin, E
A 3305 & A 3306: Master of the Braunschweig Diptych
A 3307: Gogh, V W van
A 3308: Goyen, J van
A 3309: Guardi, F
A 3310 & A 3311: Upper Rhenish school ca 1450
A 3312: Hondecoeter, M d'
A 3313: Israels, J
A 3314: Israels, J: aquarelle, transferred to the RPK
A 3315: Melozzo da Forlí
A 3316: Northern Netherlands school ca 1635
A 3317: Jongkind, J B
A 3318: Kabel, A van der
A 3319: Kever, J S H
A 3320: Konijnenburg, W van
A 3321: Mankes, J
A 3322: Maris, J H
A 3323: Mauve, A
A 3324: Master of Alkmaar
A 3325: Master of Delft
A 3326: Master of the Legend of St Ursula
A 3327: Mieris I, F van
A 3328-A 3330: Neer, A van der
A 3331: Netscher, Casp
A 3332: Neuhuys, A: aquarelle, transferred to the RPK
A 3333: Hoffmann, S
A 3334: Odekerken, W van
A 3335: Palamedesz, A
A 3336: Patinier, J
A 3337: Pluym, K van der
A 3338: Potter, P S
A 3339: Potuyl, H
A 3340 & A 3341: Rembrandt
A 3342: Neapolitan school mid-17th century
A 3343: Ruisdael, J I van
A 3344: Bronzino, A
A 3345: Schaik, W H van
A 3346: Segantini, G
A 3347: Steen, J H
A 3348: Thoma, H: drawing, transferred to the RPK
A 3349: Toorop, J Th
A 3350: Velde II, W van de
A 3351: Verelst, P H
A 3352: Verspronck, J C
A 3353: Southern Netherlands school? 17th century
A 3354: Northern Netherlands school 1655
A 3355: Weissenbruch, H J
A 3356-A 3359: Welie, J A van
A 3360: Welti, A: de-acceded in 1955 (sold to the Gottfried-
 Keller-Stiftung, Switzerland)
A 3361-A 3368: Zwart, W H P J de
A 3369-A 3372: Zwart, W H P J de: aquarelles, transferred to
 the RPK
A 3373: Wassenbergh, J A: de-acceded in 1953 (exchanged with
 the city of Groningen for an ivory mirror)
A 3374: Schiavone, A
A 3375: Sienese school ca 1450
A 3376: Bartolommeo, Fra
A 3377: Bassano, L
A 3378: Beccafumi, D
A 3379: Bellini, G
A 3380: Bordone, P
A 3381: Botticelli
A 3382: Botticini, F
A 3383: Bramantino
A 3384 & A 3385: Canaletto, A
A 3386: North Italian school 18th century
A 3387: Carpaccio, V
A 3388: Rondinello, N
A 3389: Cima da Conegliano, G B
A 3390 & A 3391: Crivelli, V
A 3392 & A 3393: Pisan school ca 1250
A 3394 & A 3395: Ferrari, D
A 3396: Florentine school 1st half 15th century
A 3397 & A 3398: Florentine school 1486
A 3399: Napoletano, F
A 3400: Garofalo
A 3401: Niccolo di Pietro Gerini
A 3402 & A 3403: Guardi, F
A 3404: Guercino
A 3405: Longhi, P
A 3406: Ceruti, G
A 3407 & A 3408: Magnasco, A
A 3409: Mazzolino, L

A 3410: Moroni, G B
A 3411: North Italian school 2d quarter 16th century
A 3412: Piazzetta, G B
A 3413: Piombo, S del
A 3414 & A 3415: Pordenone, G A
A 3416: Reni, G
A 3417: Ricci, S
A 3418: Ferrarese school 2d half 15th century
A 3419 & A 3420: Rosselli, C
A 3421 & A 3422: Rotari, P
A 3423: Sassoferrato, G B
A 3424–A 3427: Sustris, L
A 3428: Sellaio, J del
A 3429: Sienese school 1451-52
A 3430: Signorelli, L
A 3431: Starnina, G
A 3432: Giovanni di Francia
A 3433: Morazzone, P F
A 3434: Tiepolo, G B
A 3435 & A 3436: Zugno, F
A 3437 & A 3438: Tiepolo, G B
A 3439 & A 3440: Tintoretto, J
A 3441: Titian
A 3442: Machiavelli, Z
A 3443: Venusti, M
A 3444 & A 3445: Veronese, P
A 3446: Zaganelli, F
A 3447: Zuccarelli, F
A 3448: Montagna, B
A 3449: Veth, J P
A 3450: PAST Schwartze, Th
A 3451: Flinck, G
A 3452: Payen, A A J
A 3453: Troost, C
A 3454: Eelkema, E J
A 3455: Moreelse, P
A 3456: Vos, M
A 3457: Borselaer, P
A 3458: Schouman, A
A 3459: Loeninga, A
A 3460: Netherlands school 2d half 16th century
A 3461: Largillière, N de
A 3462: Ketel, C
A 3463: Dregt, J van
A 3464: Coecke van Aelst, P
A 3465: Diana, G
A 3466: Pieneman, N
A 3467: Master of the Amsterdam Death of the Virgin
A 3468: Scorel, J van
A 3469: Aragonese school 4th quarter 15th century
A 3470: Kinderen, A J der
A 3471: Collier, E
A 3472: Jolly, H J B
A 3473: Potter, P S
A 3474: Nolpe, P: engraving, transferred to the RPK
A 3475: Ekels I, J
A 3476: Perronneau, J B
A 3477: Rembrandt
A 3478: Bloemen, P van
A 3479: Sustris, L
A 3480: Leyden, A van
A 3481: Czermak, J
A 3482: Segaer, P: de-acceded in 1947 (exchanged for an armchair with the city of Middelburg)
A 3483: Loo, J van
A 3484–A 3487: PAST Vaillant, B
A 3488: Assendelft, C A van
A 3489: Eeckhout, G van den
A 3490: Helfferich, F W
A 3491: Heyden, J van der
A 3492: Holland school 2d quarter 17th century
A 3493: Keyser, Th de
A 3494: Mauve, A: aquarelle, transferred to the RPK
A 3495: Nat, W H van der: aquarelle, transferred to the RPK
A 3496: Neer, A van der
A 3497: Northern Netherlands school ca 1610
A 3498: Ruisdael, J I van
A 3499: Taupel, F
A 3500: Verwilt, F
A 3501: Wolbers, H G
A 3502: Zandleven, J A
A 3503–A 3507: Zwart, W H P J de
A 3508: Maes, N
A 3509: Steen, J H
A 3510: Pynas, Jan S
A 3511–A 3514: Heemskerk, M van
A 3515: Teenstra, K D
A 3516 & A 3517: Backer, J A
A 3518–A 3519: Heemskerk, M van
A 3520: Beek, B A van
A 3521: Klombeck, J B
A 3522: Wetering de Rooy, J E van de
A 3523–A 3562: Breitner, G H

A 3563: Breitner, G H: aquarelle, transferred to the RPK
A 3564: PAST Schwartze, Th
A 3565: Koster, A L
A 3566: Tholen, W B
A 3567: Schiller, G F F
A 3568: Witsen, W A
A 3569: Tour, G de la
A 3570–A 3575: Bauer, M A J
A 3576 & A 3577: Bock, Th E A de
A 3578: Bosboom, J
A 3579–A 3585: Breitner, G H
A 3586–A 3588: Dijsselhof, G W
A 3589 & A 3590: Gabriël, P J C
A 3591–A 3597: Israels, I L
A 3598 & A 3599: Israels, J
A 3600: Maris, J H
A 3601 & A 3602: Mauve, A
A 3603–A 3605: Poggenbeek, G J H
A 3606–A 3608: Roelofs, W
A 3609: Stevens, A
A 3610–A 3614: Swan, J M
A 3615: Tholen, W B
A 3616: Toorop, J Th
A 3617–A 3619: Weissenbruch, H J
A 3620–A 3622: AQU Bakker Korff, A H
A 3623: AQU Bastert, S N
A 3624–A 3631: AQU Bauer, M A J
A 3632: AQU Bisschop, Chr
A 3633–A 3636: AQU Bock, Th E A de
A 3637–A 3656: AQU Bosboom, J
A 3657–A 3659: AQU Breitner, G H
A 3660: AQU Daumier, H
A 3661: AQU Gabriël, P J C
A 3662: AQU Gogh, V W van
A 3663: AQU Israels, I L
A 3664 & A 3665: PAST Israels, I L
A 3666: AQU Israels, I L
A 3667 & A 3668: PAST Israels, I L
A 3669 & A 3670: AQU Israels, I L
A 3671: AQU Jongkind, J B
A 3672 & A 3673: PAST Josselin de Jong, P de
A 3674–A 3686: AQU Maris, J H
A 3687: AQU Maris, M
A 3688–A 3694: AQU Maris, W
A 3695–A 3700: AQU Mauve, A
A 3701: AQU Mesdag, H W
A 3702: PAST Muhrman, H
A 3703: AQU Neuhuys, J A
A 3704: AQU Poggenbeek, G J H
A 3705: AQU Rochussen, Ch
A 3706–A 3713: AQU Swan, J M
A 3714: AQU Toorop, J Th
A 3715: AQU Troyon, C
A 3716 & A 3717: AQU Veth, J P
A 3718–A 3720: AQU Weissenbruch, H J
A 3721: AQU Witsen, W A
A 3722: Wiggers, D
A 3723: Sands, E
A 3724: AQU Arntzenius, P F N J
A 3725: AQU Veth, J P
A 3726: Bisschop, Chr
A 3727: Maris, M
A 3728: AQU Israels, I L
A 3729: AQU Israels, J
A 3730–A 3732: Israels, J
A 3733: AQU Israels, J
A 3734: Maarel, M van der
A 3735 & A 3736: AQU Voerman I, J
A 3737: Beerstraaten, A
A 3738: Witte, E de
A 3739: Leyden, L van
A 3740: Wassenbergh, E G
A 3741 & A 3742: Voort, C van der
A 3743: Bloemaert, A
A 3744: Champaigne, J B de
A 3745: PAST Troost, C
A 3746: Bloemaert, A
A 3747 & A 3748: PAST Perronneau, J B
A 3749 & A 3750: Ovens, J
A 3751 & A 3752: HER Lynden van Horstwaerde, van
A 3753: Meulen, A F van der
A 3754: Cuyp, A
A 3755–A 3819: GOV
A 3820 & A 3821: Wignjosoewarno: omitted in accordance with the wishes of the sitters
A 3822–A 3825: GOV
A 3826 & A 3827: Spinny, G de
A 3828: Beyeren, A van
A 3829: Eversdijck, W
A 3830: Stolker, J
A 3831: Keun, H
A 3832: Lely, P
A 3833: Miereveld, M J van

A 3834: La Fargue, P C
A 3835 & A 3836: Southern Netherlands school 2d half 15th century
A 3837: Veth, J P
A 3838: Cornelisz van Oostsanen, J
A 3839: Dreibholtz, Chr L W
A 3840: Hoppenbrouwers, J F
A 3841: Leyden, L van
A 3842: Borch, G ter
A 3843: Mostaert, J
A 3844: Arends, L H
A 3845: Sande Bakhuyzen, H van de
A 3846: Deventer, W A van
A 3847 & A 3848: Hoppenbrouwers, J F
A 3849 & A 3850: Waldorp, A
A 3851: Southern Netherlands school ca 1570
A 3852: Pieneman, N
A 3853: Scorel, J van
A 3854: Hendriks, W
A 3855: Sweerts, M
A 3856: Slager, P M
A 3857 & A 3858: Jonson van Ceulen I, C
A 3859 & A 3860: Kuster, K
A 3861 & A 3862: Kuyl, G van der
A 3863: Nachenius, J J
A 3864 & A 3865: Pietersz, P
A 3866 & A 3867: Poorter, B de
A 3868: Serin, H
A 3869–A 3871: MIN Boze, J
A 3872: Wit, J de
A 3873 & A 3874: MIN Le Blon, J Chr
A 3875 & A 3876: Miereveld, M J van
A 3877: Pieneman, N
A 3878: Sande Bakhuyzen, G J van de
A 3879: Weenix, J B
A 3880: GOV
A 3881 & A 3882: Northern Netherlands school ca 1650
A 3883: Ribera, J de
A 3884: Recco, G B
A 3885 & A 3886: Wit, J de
A 3887: Schelfhout, A
A 3888: Spranger, B
A 3889: Hanneman, A
A 3890: Beyeren, A van: de-acceded in 1958 (sold and proceeds spent on A van Beyeren, A 3944)
A 3891: Cologne school ca 1575
A 3892: Cornelisz van Haarlem, C
A 3893: Santen, G van
A 3894: Momper, J de
A 3895: Northern Netherlands school ca 1680
A 3896: Sweerts, M
A 3897: Schouman, A
A 3898: PAST Vigée-Lebrun, E
A 3899: Guardi, F
A 3900: Wit, J de
A 3901: Mostaert, J
A 3902: Tintoretto, J
A 3903: Leyden, A van
A 3904 & A 3905: Tocqué, L
A 3906: Greuze, J B
A 3907: Mijn, C van der
A 3908: Brugghen, H ter
A 3909: Knip, J A
A 3910: Vernet, E J H
A 3911: Veen, O van
A 3912: Northern Netherlands school 1601
A 3913: Pieneman, N
A 3914 & A 3915: Netherlands school? 3d quarter 16th century
A 3916–A 3919: French school ca 1775
A 3920: Valckert, W J van den
A 3921: Andriessen, J
A 3922: Leickert, Ch H J
A 3923: Rochussen, Ch
A 3924: Jacobsz, D
A 3925: Hansen, C L
A 3926: Dordrecht school ca 1455
A 3927: Dobson, W
A 3928 & A 3929: Ysselstein, A van
A 3930: Claesz, P
A 3931: Vincent, F A
A 3932: Graat, B
A 3933: Troost, C
A 3934: Rembrandt
A 3935: Werff, A van der
A 3936–A 3942: Delen, D van
A 3943: Hendriks, W
A 3944: Beyeren, A van
A 3945 & A 3946: Goyen, J van
A 3947: Knop, H
A 3948: Troost, C
A 3949: Momper, J de
A 3950: Kruseman, J A
A 3951: Pietersz, P

A 3952: Rottenhammer, J
A 3953: Miereveld, M J van
A 3954: Quinkhard, J M
A 3955: Tibaldi, P
A 3956: Mijn, F van der
A 3957: Cuyp, A
A 3958: Machy, P A de
A 3959: La Fargue, P C
A 3960: Meulen, A F van der
A 3961: Pieneman, N
A 3962: Pietersz, P
A 3963 & A 3964: Borch, G ter
A 3965: Groenewegen, P A
A 3966: Girolamo da Santa Croce
A 3967: Araldi, J
A 3968: Geel, J J van
A 3969: Gelder, A de
A 3970: Giorgione
A 3971: Heyden, J van der
A 3972: Keyser, Th de
A 3973: Lingelbach, J
A 3974: Master of the Battle of Anghiari
A 3975: Master of the Virgo inter Virgines
A 3976: Monaco, L
A 3977 & A 3978: Netscher, Casp
A 3979 & A 3980: Master of the Bambino Vispo
A 3981 & A 3982: Rembrandt
A 3983: Ruysdael, S J van
A 3984: Steen, J H
A 3985: Tiepolo, G B
A 3986 & A 3987: Tintoretto, J
A 3988: Velde, J J van de
A 3989: Crivelli, C
A 3990: Beccaruzzi, F
A 3991: Bonsignori, F
A 3992: Carracci, L
A 3993: Carpaccio, V
A 3994: Crivelli, C
A 3995: Giovanni da Brescia
A 3996: Italian school 2d half 13th century
A 3997: Italian school 15th century
A 3998: Sienese school ca 1450
A 3999: Apollonio di Giovanni
A 4000: Giovanni da Milano
A 4001: Fiore, J del
A 4002: Master of Pietro a Ovile
A 4003: Luca di Tommè
A 4004-A 4006: Monaco, L
A 4007: Lorenzo di Niccolò
A 4008: Niccolò de Liberatore
A 4009: Schiavone, A
A 4010: Tintoretto, J
A 4011: Veronese, P
A 4012: Vivarini, B
A 4013: Mijtens, J
A 4014: Boucher, F
A 4015: Cornelisz van Haarlem, C
A 4016: Vivien, J
A 4017: Haarlem school? ca 1660
A 4018: Northern Netherlands school ca 1660
A 4019: Rembrandt
A 4020: Italian school 2d half 17th century
A 4021: Southern Netherlands school 2d half 17th century
A 4022: Master of the Carrand Triptych
A 4023: Troost, C
A 4024 & A 4025: Troost, W
A 4026: Ouwater, I
A 4027: Netherlands school? 1542
A 4028: Hodges, Ch H
A 4029: PAST Hodges, Ch H
A 4030: MIN Hari Sr, J
A 4031: MIN Gauthier, P J
A 4032: MIN German school ca 1700
A 4033: Arentsz, A
A 4034: Gelder, A de
A 4035: Cozza, F
A 4036: AQU Weissenbruch, H J
A 4037: Moritz, L
A 4038 & A 4039: Borch, G ter
A 4040 & A 4041: Brouwer, A
A 4042 & A 4043: Cappelle, J van de
A 4044: Goyen, J van
A 4045: Isenbrant, A
A 4046: Ketel, C
A 4047: Maes, N
A 4048: Massijs, Q
A 4049: Ostade, A van
A 4050: Rembrandt
A 4051: Rubens, P P
A 4052: Steen, J H
A 4053: Vries, A de
A 4054 & A 4055: Witte, E de
A 4056: Northern Netherlands school ca 1530

A 4057: Rembrandt
A 4058 & A 4059: Eeckhout, J J
A 4060: PAST Troost, C
A 4061: Huchtenburg, J van
A 4062: Coeman, J J
A 4063: Maarel, M van der
A 4064: Mijn, F van der
A 4065: Vries, J de
A 4066: Holland school ca 1630
A 4067: Os, P G van
A 4068: Vignon, C
A 4069: Vermeyen, J C
A 4070: Eckhout, A
A 4071: Southern Netherlands school 1565
A 4072: MIN Temminck, L
A 4073: Beyeren, A van
A 4074: Engelberts, W J M
A 4075: Valkenburg, D
A 4076-A 4085: VAN M
A 4086: Terwesten, M
A 4087: Klerk, W de
A 4088: Bree, M I van
A 4089: Troost, C
A 4090: Rembrandt
A 4091: Blanchard, J
A 4092: Jonxis, J L
A 4093: Ostade, A van
A 4094: Voogd, H
A 4095: MIN Netherlands school ca 1610
A 4096: Rembrandt
A 4097: German school? 1st half 17th century
A 4098: Weenix, J
A 4099: Troost, C
A 4100: Lelie, A de
A 4101: Northern Netherlands school 1639
A 4102: Storck, A
A 4103: Ceresa, C
A 4104: Maris, W
A 4105: Northern Netherlands school 1858
A 4106: Poggenbeek, G J H
A 4107: MIN Nilson, J E
A 4108: MIN English school ca 1790
A 4109: MIN English school ca 1810
A 4110: MIN French school ca 1805
A 4111: Leen, W van
A 4112: Hillegaert, P van
A 4113: PAST German school ca 1808
A 4114: Roelofs, W
A 4115: Troost, C
A 4116: Willaerts, Adam
A 4117: Zeuner, J
A 4118: Cuyp, A
A 4119: Rembrandt
A 4120: Neuman, J H
A 4121: Northern Netherlands school? late 17th century
A 4122: Lelie, A de
A 4123: Pieneman, J W
A 4124: Zeeland school ca 1665
A 4125: Master of the St John Panels
A 4126: Hoogerheyden, E
A 4127: Favray, A de
A 4128: Netscher, Casp
A 4129: Lanfranco, G
A 4130: Ekels II, J
A 4131: Bosch, J
A 4132: PAST Northern Netherlands school ca 1820
A 4133: Koninck, Ph
A 4134: Beerstraaten, J A
A 4135: Musscher, M van
A 4136: Oyens, P
A 4137: Pieneman, J W
A 4138: Palamedesz, A
A 4139: Kooi, W B van der
A 4140-A 4150: Kamphuijsen, J
A 4151: Scheffer, J B
A 4152: Netherlands school 1st quarter 17th century
A 4153 & A 4154: Dubois Drahonet, A J
A 4155: Liotard, J-E
A 4156: Mauve, A
A 4157: Schouman, A
A 4158: Northern Netherlands school? 1844
A 4159 & A 4160: Neuman, J H
A 4161: Hodges, Ch H
A 4162: Baen, J de
A 4163: Sande Bakhuyzen, H van de
A 4164: Pieneman, N
A 4165: Patru, L
A 4166: Flinck, G
A 4167 & A 4168: Portman, Chr J L
A 4169: Looy, J van
A 4170: Northern Netherlands school 1st half 17th century?
A 4171: Honthorst, G van
A 4172: Cels, C

A 4173: Alma Tadema, L
A 4174-A 4178: Lairesse, G
A 4179: Northern Netherlands school 18th century
A 4180: Israels, J
A 4181: Calisch, M
A 4182: Hawksley, A
A 4183: see C 1579
A 4184-A 4186: Southern Netherlands school? 16th century
A 4187: Dubourg, L F: de-acceded in 1974 (returned to the rightful heir of J Knoef)
A 4188: Brugghen, H ter
A 4189: Roestraeten, P G van
A 4190: Geest, W S de
A 4191: Ravesteyn, J A van
A 4192: Fabritius, B
A 4193: Northern Netherlands school ca 1845
A 4194: Northern Netherlands school 1792
A 4195: Strij, A van
A 4196: Northern Netherlands school 1557
A 4197: Schelfhout, A
A 4198: Israels, J
A 4199: PAST Mengs, A R
A 4200 & A 4201: Troost, C
A 4202: Hoffmann, G J
A 4203: MIN Northern Netherlands school ca 1675
A 4204: MIN Northern Netherlands school ca 1630
A 4205: HER
A 4206: MIN Quenedey, E
A 4207: Roelofs, W
A 4208: Northern Netherlands school mid-19th century
A 4209: Troost, C
A 4210: Lairesse, G
A 4211: MIN Northern Netherlands school ca 1790
A 4212: French school 1454
A 4213-A 4216: Lairesse, G
A 4217: English school mid-19th century
A 4218: Roghman, R
A 4219: Buys II, C
A 4220: Knip, J A
A 4221: Dubordieu, P
A 4222: Mijtens II, D
A 4223: Nijmegen, G van
A 4224: MIN Marinkelle, J
A 4225: Troost, C
A 4226: Toorop, J Th
A 4227: PAST Hodges, Ch H
A 4228: Bruyn I, B
A 4229: Voskuyl, J J
A 4230: Zeuner, J
A 4231: PAST Schwartze, Th
A 4232 & A 4233: Musscher, M van
A 4234: Bree, M I van
A 4235: Vivarini, B
A 4236: Keyser, Th de
A 4237: MIN Le Sage, P
A 4238: MIN Ploetz, L
A 4239-A 4243: Meegeren, H A van
A 4244: see A 4646
A 4245: Appel, J
A 4246: Bassen, B van
A 4247: Beert, O
A 4248: Bellevois, J
A 4249: Blarenberghe, L N van
A 4250: Bol, C
A 4251: Borculo, N van
A 4252: Bosch, J
A 4253: Bree, M I van
A 4254: Campen, J van
A 4255: Gheyn II, J de
A 4256: Hemessen, C van
A 4257: Jong, J de
A 4258: Kruseman, J A
A 4259: Lairesse, G
A 4260: Leyden, L van
A 4261: Loef, J G
A 4262: Lundens, G
A 4263: Momper, J de
A 4264: Noter II, P F de
A 4265: Orley, B van
A 4266 & A 4267: Overbeek, L
A 4268 & A 4269: Pieneman, J W
A 4270: Pieneman, N
A 4271-A 4273: Post, F
A 4274: Pronk, C
A 4275: Rust, J A
A 4276 & A 4277: Sallembier, H
A 4278: Sandrart, J von
A 4279: Schey, Ph
A 4280: Schouman, A
A 4281: Holland school late 18th century
A 4282 & A 4283: Schuylenburgh, H van
A 4284: Scorel, J van
A 4285: see NM 9487

A 4286: Tetar van Elven, PHTh
A 4287: Troost, C
A 4288: Velde, J van de
A 4289: Velde I, W van de
A 4290: Verkolje, N
A 4291: Wit, J de
A 4292: Caullery, L de
A 4293: Dalem, C van
A 4294: Cornelisz van Oostsanen, J
A 4295 & A 4296: MIN Arlaud, B
A 4297: MIN Bettes, J
A 4298: MIN Blesendorff, S
A 4299-A 4301: MIN Boit, Ch
A 4302: MIN Brounckhurst, A van
A 4303 & A 4304: MIN Cooper, A
A 4305-A 4311: MIN Cooper, S
A 4312: MIN Dixon, N
A 4313: MIN Duchatel, M
A 4314 & A 4315: MIN Granges, D des
A 4316 & A 4317: MIN Guernier, L du
A 4318 & A 4319: MIN Haag, G
A 4320: MIN Boze, J
A 4321-A 4323: Hilliard, N
A 4324: MIN Hoadley, P
A 4325-A 4328: MIN Hoskins, J
A 4329: MIN Huaut I, P
A 4330: MIN Jackson II, J
A 4331: MIN Kessler, F
A 4332: MIN Lamprecht, G
A 4333: MIN Légaré, G
A 4334: MIN Lembke, J Ph
A 4335: MIN Le Sage, P
A 4336: MIN Liotard, J E
A 4337 & A 4338: MIN Lundens, G
A 4339: MIN Michelin, J
A 4340-A 4343: MIN Mussard, R
A 4344-A 4347: MIN Oliver, I
A 4348-A 4353: MIN Oliver, P
A 4354-A 4359: MIN Petitot, J
A 4360: MIN Phaff, L
A 4361: MIN Ploetz, H
A 4362: MIN Pluckx, J A A
A 4363 & A 4364: MIN Ramelli, F
A 4365: MIN Richter, Chr
A 4366: MIN Saint Ligié, de
A 4367: MIN Schmidt Crans, J M
A 4368: MIN Sypesteyn, M M van
A 4369: MIN Thach, N
A 4370 & A 4371: MIN Toutin, H
A 4372-A 4374: MIN Wilhelmina, princess of Prussia, F S
A 4375: MIN Zincke, Chr Fr
A 4376 & A 4377: MIN Monogrammist W P
A 4378: MIN German school ca 1700
A 4379-A 4382: MIN German school ca 1730
A 4383: MIN German school ca 1750
A 4384: MIN German school ca 1760
A 4385: MIN German school 1770
A 4386: MIN German school ca 1770
A 4387: MIN German school ca 1780
A 4388 & A 4389: MIN German school ca 1810
A 4390-A 4393: MIN English school ca 1565
A 4394: MIN English school ca 1575
A 4395: MIN English school ca 1635
A 4396: MIN English school ca 1665-70
A 4397: MIN English school ca 1725
A 4398: MIN English school ca 1755
A 4399-A 4401: MIN English school ca 1770
A 4402: MIN English school ca 1750-51
A 4403: MIN English school ca 1800
A 4404: MIN French school ca 1500
A 4405: MIN French school ca 1550
A 4406: MIN French school ca 1575
A 4407 & A 4408: MIN French school ca 1580
A 4409: MIN French school ca 1650
A 4410-A 4412: MIN French school ca 1665
A 4413: MIN French school ca 1675
A 4414-A 4416: MIN French school? 18th century
A 4417: MIN French school ca 1725
A 4418: MIN French school ca 1750
A 4419: MIN French school ca 1785
A 4420 & A 4421: MIN French school ca 1790
A 4422: MIN Netherlands school ca 1575
A 4423: MIN Northern Netherlands school 17th century?
A 4424: MIN Northern Netherlands school ca 1615
A 4425 & A 4426: MIN Northern Netherlands school ca 1645
A 4427: MIN Northern Netherlands school ca 1690
A 4428 & A 4429: MIN Northern Netherlands school ca 1710
A 4430: MIN Northern Netherlands school ca 1745
A 4431-A 4433: MIN Holland school ca 1635
A 4434 & A 4435: MIN Holland school ca 1650
A 4436: MIN Holland school ca 1665
A 4437 & A 4438: MIN Holland school ca 1675
A 4439: MIN Holland school ca 1690

A 4440 & A 4441: MIN Holland school ca 1710
A 4442: MIN Holland school ca 1715
A 4443-A 4447: MIN Holland school ca 1750
A 4448: MIN Holland school ca 1760
A 4449: MIN Holland school ca 1775
A 4450 & A 4451: MIN Holland school ca 1780
A 4452 & A 4453: MIN Holland school ca 1770
A 4454-A 4456: MIN Holland school ca 1780
A 4457: MIN Holland school ca 1785
A 4458: MIN Holland school ca 1775
A 4459: MIN Spanish school ca 1650
A 4460: Monogrammist Johann G M
A 4461: Venetian-Byzantine school late 13th century
A 4462: Netherlands school? 1542
A 4463: Netherlands school? ca 1550
A 4464: Netherlands school ca 1580
A 4465-A 4467: Southern Netherlands school ca 1580
A 4468: Northern Netherlands school ca 1590
A 4469: Northern Netherlands school 1627
A 4470: Northern Netherlands school mid-17th century
A 4471-A 4477: Northern Netherlands school ca 1650
A 4478: Northern Netherlands school ca 1670
A 4479 & A 4480: Northern Netherlands school? ca 1695
A 4481: Northern Netherlands school? ca 1820
A 4482: Holland school 1617
A 4483: Holland school 1641
A 4484: Holland school? ca 1595
A 4485: Utrecht school mid-16th century
A 4486: Utrecht school 1554
A 4487: Southern Netherlands school ca 1560
A 4488: Southern Netherlands school 1561
A 4489: Spanish school 2d half 17th century
A 4490-A 4524: ROT
A 4525-A 4552: GOV
A 4553-A 4626: PAN
A 4627-A 4638: COST
A 4639: PAST Hodges, Ch H
A 4640: PAST Northern Netherlands school ca 1890
A 4641-A 4643: HER
A 4644 & A 4645: Nuyen, W J J
A 4646: Claesz, P
A 4647: Northern Netherlands school mid-19th century
A 4648: Baen, J de
A 4649: Northern Netherlands school? 1st half 17th century
A 4650: Netherlands school early 16th century
A 4651: Southern Netherlands school 17th century
A 4652: MIN German school? 18th century
A 4653: MIN Northern Netherlands school late 18th century
A 4654: Thulden, Th van
A 4655: Holland school ca 1700
A 4656 & A 4657: Nijmegen, E van
A 4658: MIN Holland school ca 1810
A 4659: Wit, J de
A 4660: PAST Anspach, J
A 4661: Hove, B J van
A 4662 & A 4663: Hondt II, L de
A 4664: Netherlands school ca 1820

Department of paintings inventory of objects on loan to the nation now or in the past

Inventory numbers beginning with c are used for objects on loan now or in the past to the department of paintings. In the following list, objects on current loan are entered with the artist's name only. These objects can be looked up in the catalogue. Terminated loans are provided with the name of the lender and the period of the loan. A large group of objects that were returned to the Amsterdams Historisch Museum (AHM) in 1975 are nonetheless included in the catalogue (see above, p 55). The entries of those objects in the following list indicate that the 'loan ends in 1975.'

The listing of former loans that subsequently became the property of the nation are provided with the A-number they were assigned upon acquisition.

The objects other than paintings in the c-list – sculpture, *objets d'art*, furniture and the like – were once installed in the Rijksmuseum painting galleries, and for that reason were placed in care of the department of paintings.

C 1: Flinck, G: loan ends in 1975
C 2 & C 3: Helst, B van der
C 4: Dujardin, K
C 5 & C 6: Rembrandt
C 7: Velde II, W van de: loan ends in 1975
C 8 & C 9: Coclers, L B: loan ends in 1975
C 10 & C 11: Hodges, Ch H: loan ends in 1975
C 12: Miereveld, M J van
C 13 & C 14: Musscher, M van
C 15 & C 16: Netscher, Const: loan ends in 1975
C 17: Ovens, J: loan ends in 1975
C 18-C 20: Palthe, J: loan ends in 1975
C 21: Tol, D van
C 22 & C 23: Vaillant, W: loan ends in 1975
C 24 & C 25: Verelst, H

C 26 & C 27: Sandrart, J von: loan ends in 1975
C 28 & C 29: Sandrart, J von: city of Amsterdam, 1885-1952
C 30 & C 31: PAST Liotard, J E: loan ends in 1975
C 32: MIN Holland school ca 1580: loan ends in 1975
C 33 & C 34: Amsterdam school 1560: loan ends in 1975
C 35: Amsterdam school 1573: loan ends in 1975
C 36 & C 37: Amsterdam school 1583: loan ends in 1975
C 38: Amsterdam school 1654: loan ends in 1975
C 39 & C 40: Vaillant, W: loan ends in 1975
C 41: Amsterdam school ca 1775: loan ends in 1975
C 42: Amsterdam school ca 1650: loan ends in 1975
C 43 & C 44: Liotard, J E: loan ends in 1975
C 45: MIN Hodges, Ch H: loan ends in 1975
C 46 & C 47: MIN Holland school ca 1795: loan ends in 1975
C 48: Helst, B van der: city of Amsterdam, 1885-1947
C 49: PAST Vilsteren, J van: loan ends in 1975
C 50: Helst, B van der: loan ends in 1975
C 51: PAST Vilsteren, J van: loan ends in 1975
C 52: Beerstraaten, A: Mrs P M N van Holthe tot Echten, 1883-1957
C 53 & C 54: Master of Alkmaar: municipality of Naaldwijk, 1884-1975
C 55 & C 56: Master of Alkmaar: municipality of Naaldwijk, 1884-1935
C 57: Master of Alkmaar
C 58: Master of Alkmaar: same as C 55
C 59: Netherlands school: Mr Garnier Heldewier, 1885-1962
C 60: now A 1491
C 61: Kuyl, G van der: municipality of Gorkum, 1880-1925
C 62: Brueghel II, P: Jonkheer A L E de Stuers, 1885-1889
C 63: now A 2125
C 64: now A 1492
C 65: Troost, C: Jonkheer H Teding van Berkhout, 1885-1905
C 66 & C 67: Maes, N: same as C 65
C 68 & C 69: French school: same as C 65
C 70: Pietersz, A: loan ends in 1975
C 71: Keyser, Th de: loan ends in 1975
C 72: Eliasz, N: city of Amsterdam, 1885-1964
C 73: Backer, A: city of Amsterdam, 1885-1935
C 74: Neck, J van der: city of Amsterdam, 1885-1926
C 75: Amsterdam school: same as C 73
C 76: Pool, J: same as C 74
C 77: Amsterdam school: same as C 74
C 78: Boonen, A: same as C 74
C 79 & C 80: Troost, C: loan ends in 1975
C 81-C 83: Quinkhard, J M: loan ends in 1975
C 84: Regters, T: loan ends in 1975
C 85: Rembrandt
C 86: Bree, M I van: city of Amsterdam, 1885-92
C 87: Troost, C
C 88: Asch, P J van
C 89: Asselijn, J
C 90: Maes, N: loan ends in 1975
C 91: Bakhuysen, L
C 92: Bakhuysen, L: loan ends in 1975
C 93: Beelt, C: loan ends in 1975
C 94: Beerstraaten, J A: loan ends in 1975
C 95: Bega, C
C 96: Berchem, N: same as C 74
C 97 & C 98: Berchem, N
C 99: Berckheyde, J: same as C 73
C 100: Berckheyde, J
C 101: Berckheyde, G A
C 102: Berckheyde, G A: same as C 73
C 103: Berckheyde, G A: loan ends in 1975
C 104: Berckheyde, G A
C 105: Bergen, D van den
C 106: Bloemaert, H
C 107: Bol, F
C 108: Hagen, J van der
C 109 & C 110: Both, J
C 111: Doncker, H M
C 112 & C 113: Brekelenkam, Q G van
C 114: Cuyp, A
C 115: Hoopstad, E I
C 116 & C 117: Calisch, M
C 118: Kate, H G ten: same as C 74
C 119: Keun, H: loan ends in 1975
C 120: Cuyp, A
C 121: Cuyp, J G
C 122: Calraet, A van
C 123: Cuyp, A
C 124: Daiwaille, A J
C 125 & C 126: Dasveldt, J
C 127 & C 128: Dou, G
C 129: Dubbels, H J: loan ends in 1975
C 130: Eeckhout, G van den: loan ends in 1975
C 131: Eelkema, E J
C 132: Everdingen, A van: loan ends in 1975
C 133: Gool, J van
C 134-C 136: Haanen, G G
C 137: Hackaert, J
C 138: Hagen, J van der

C 139: Hals, F
C 140: Molenaer, J M
C 141: Hansen, L J
C 142: Helst, B van der: loan ends in 1975
C 143: Heyden, J van der
C 144: Hobbema, M
C 145: Hobbema, M: loan ends in 1975
C 146: Hondecoeter, M d'
C 147: Hooch, P de
C 148: Hooch, P de: loan ends in 1975
C 149 & C 150: Hooch, P de
C 151: Man, C de
C 152: Hoogstraten, S van
C 153: Houbraken, A
C 154: Huysum, J van: loan ends in 1975
C 155: Huysum, J van
C 156: Janson, J Chr
C 157 & C 158: Dujardin, K
C 159: Karsen, K: loan ends in 1975
C 160: Monogrammist I L
C 161 & C 162: Klomp, A J
C 163: Ronner-Knip, H
C 164: Kobell II, J B
C 165 & C 166: Koekkoek, B C
C 167: Kruseman, C
C 168: Kruseman, J A
C 169 & C 170: Kruseman, J A: loan ends in 1975
C 171: Laen, D J van der
C 172: Lingelbach, J
C 173 & C 174: Schendel, B van
C 175: Netscher, Casp
C 176: Maes, N
C 177: Metsu, G
C 178: Sorgh, H M
C 179: Meulemans, A
C 180: Miereveld, M J van
C 181: Miereveld, M J van: loan ends in 1975
C 182: Mieris I, F van
C 183: Mieris, W van
C 184: Mieris I, F van
C 185: Mieris II, F van
C 186: Mieris II, F van: loan ends in 1975
C 187: Mignon, A
C 188: Molenaer, J M
C 189: Moucheron, F de
C 190: Jongh, L de: loan ends in 1975
C 191 & C 192: Neer, A van der
C 193: Netscher, Casp: loan ends in 1975
C 194 & C 195: Netscher, Casp
C 196–C 198: Oberman, A
C 199: Os, G J J van
C 200 & C 201: Ostade, A van
C 202: Ostade, I van
C 203: Portman, Chr J L
C 204: Potter, P S
C 205 & C 206: Potter, P
C 207: Pynacker, A
C 208 & C 209: Ravenzwaay, J van
C 210–C 213: Ruisdael, J I van
C 214: Ruysch, R: loan ends in 1975
C 215: Elliger, O
C 216: Rembrandt
C 217: Saenredam, P J
C 218: Saftleven, H
C 219: Schelfhout, A
C 220–C 222: Schoemaker Doyer, J
C 223 & C 224: Schotel, J C: city of Amsterdam, 1885-1927
C 225: Schotel, P J: loan ends in 1975
C 226: Schouman, M
C 227: Sorgh, H M
C 228: Staveren, J A van
C 229–C 233: Steen, J H
C 234: Storck, A: same as C 73
C 235 & C 236: Storck, A: loan ends in 1975
C 237: Strij, A van
C 238: Strij, J van
C 239: Temminck, H Chr
C 240: Ravesteyn, J A van
C 241: Tempel, A L van den
C 242: Borch, G ter
C 243: Dou, G
C 244 & C 245: Velde II, W van de
C 246: Velde II, W van de: loan ends in 1975
C 247: Velde II, W van de
C 248: Velde, A van de
C 249: Velde, A van de: loan ends in 1975
C 250: Velde, A van de
C 251: Vermeer, J
C 252: Vermeulen, A
C 253: Verschuier, L
C 254: Verschuur I, W: loan ends in 1975
C 255 & C 256: Versteegh, M
C 257: Vettewinkel Dzn, H: loan ends in 1975

C 258: Victors, Jan: loan ends in 1975
C 259: Victors, Jan
C 260: Vois, A de
C 261: Waldorp, A
C 262: Weenix, J: loan ends in 1975
C 263 & C 264: Weenix, J
C 265 & C 266: Werff, A van der
C 267 & C 268: Werff, P van der
C 269: West, J H van
C 270: Witte, E de
C 271–C 273: Wouwerman, Ph
C 274: Wijnants, J
C 275: Wijnants, J: loan ends in 1975
C 276 & C 277: Wijnants, J
C 278: Holland school 18th or 19th century
C 279: Potter, P
C 280: Dujardin, K
C 281: Braeckeleer, F de
C 282: Cels, C: loan ends in 1975
C 283: Ducorron, J J
C 284: Dyck, A van
C 285: Engel, A K M
C 286: Francken II, F
C 287 & C 288: Hulst, J B van der: loan ends in 1975
C 289: Holland school ca 1650
C 290: Keyser, N de
C 291: Leys, J A H
C 292: Marne, J L de
C 293: Moerenhout, J J
C 294: Opzoomer, S
C 295: Rubens, P P
C 296: Rubens, P P
C 297: Schendel, P van: loan ends in 1975
C 298–C 300: Teniers II, D
C 301: Utrecht, A van
C 302: Calame, A
C 303: Court, J D
C 304: Hildebrand, Th
C 305: Martinet, L
C 306: Mörner, H
C 307: Pistorius, E
C 308: Polidoro da Lanciano
C 309: Garofalo
C 310: Bijlert, J van
C 311: Spanish school? ca 1615
C 312: Dyck, A van
C 313: Altmann, S: VHK, 1885-95
C 314: Apol, L: same as C 313
C 315: Sande Bakhuizen, J van de: same as C 313
C 316: Beers, J van: same as C 313
C 317: Heemskerck van Beest, J E van: same as C 313
C 318: Bilders, J W: same as C 313
C 319: Bisschop, C: same as C 313
C 320: Bles, D: same as C 313
C 321 & C 322: Bosboom, J: same as C 313
C 323: Brondgeest, A: same as C 313
C 324: Rossum du Chattel, F J van: same as C 313
C 325: Czermak, J: same as C 313
C 326: Gempt, B te: same as C 313
C 327: Greive Jr, J C: same as C 313
C 328: Greive, P F: same as C 313
C 329: Haanen, A: same as C 313
C 330: Haas, J H L de: same as C 313
C 331: Haverman, H J: same as C 313
C 332: Hilverdink, J: same as C 313
C 333: Hulswit, J: same as C 313
C 334 & C 335: Israels, J: same as C 313
C 336: Kellen, D van der: same as C 313
C 337: Klinkenberg, K: same as C 313
C 338 & C 339: Meijer, L: same as C 313
C 340: Nakken, W C: same as C 313
C 341: Rochussen, Ch: same as C 313
C 342: Roelofs, W: same as C 313
C 343: Sadée, Ph: same as C 313
C 344: Saint-Jean, S: same as C 313
C 345: Scheltema, F: same as C 313
C 346: Scholten, H J: same as C 313
C 347 & C 348: Schwartze, Th: same as C 313
C 349: Springer, C: same as C 313
C 350: Tetar van Elven, P: same as C 313
C 351: Trigt, H A van: same as C 313
C 352: Valkenburg, H: same as C 313
C 353: Verschuur, W: same as C 313
C 354: Verveer, S L: same as C 313
C 355: Vos, M: same as C 313
C 356: Waldorp, A: same as C 313
C 357: Weissenbruch, J H: same as C 313
C 358: Witkamp, E: same as C 313
C 359: Wolterbeek, A: same as C 313
C 360: Backer, A: loan ends in 1975
C 361: Eliasz, N: loan ends in 1975
C 362: Backer, A: loan ends in 1975
C 363: Bakhuysen, L: loan ends in 1975

C 364: Barendsz, D: loan ends in 1975
C 365: Barendsz, D
C 366: Claesz, A: loan ends in 1975
C 367: Bol, F
C 368: Boonen, A: loan ends in 1975
C 369: Cornelisz, J: city of Amsterdam, 1885-1933
C 370 & C 371: Flinck, G
C 372: Graat, B: same as C 74
C 373: Hagen, J van der
C 374: Hals, F & Codde, P
C 375: Helst, B van der
C 376 & C 377: Jacobsz, D: loan ends in 1975
C 378: Ketel, C
C 379: Barendsz, D: loan ends in 1975
C 380: Keyser, Th de: loan ends in 1975
C 381: Keyser, Th de
C 382: Lairesse, G: loan ends in 1975
C 383: Eliasz, N: loan ends in 1975
C 384: Lyon, J: loan ends in 1975
C 385: Bol, F: same as C 74
C 386: Eliasz, N: loan ends in 1975
C 387: Amsterdam school 1606: loan ends in 1975
C 388: Moucheron, I de: loan ends in 1975
C 389: Moeyaert, N: same as C 74
C 390: Ochtervelt, J: loan ends in 1975
C 391: Pietersz, A: loan ends in 1975
C 392: Aertsen, P: loan ends in 1975
C 393: Sandrart, J von
C 394: Santvoort, D D
C 395: Spilberg II, J
C 396: Troost, C: loan ends in 1975
C 397: Valckert, W van den: loan ends in 1975
C 398: Valckert, W van den: city of Amsterdam, 1885-1923
C 399: Voort, C van der: loan ends in 1975
C 400: Willeboirts, Th
C 401: Wit, J de: loan ends in 1975
C 402: Jacobsz, D
C 403: Eliasz, N: loan ends in 1975
C 404: Pietersz, P
C 405: Dircksz, B: loan ends in 1975
C 406: Lastman, C P: loan ends in 1975
C 407: Tengnagel, J
C 408: Voort, C van der: loan ends in 1975
C 409: Anthonisz, C: loan ends in 1975
C 410: Isaacsz, P: loan ends in 1975
C 411: Troost, C
C 412–C 416: Valckert, W van den: same as C 74
C 417: Valckert, W van den
C 418: Amsterdam school ca 1726: loan ends in 1975
C 419: Valckert, W van den
C 420: Eliasz, N: same as C 74
C 421: Voort, C van der: same as C 398
C 422: Hendriks, W
C 423: Aertsen, P: same as C 74
C 424: Jacobsz, D: loan ends in 1975
C 425: Ketel, C: loan ends in 1975
C 426: Holland school mid-17th century
C 427: Northern Netherlands school ca 1645
C 428: Netherlands school 2d half 17th century
C 429: Heemskerck van Beest, J E van
C 430: Ovens, J: same as C 74
C 431: Santvoort, D D: loan ends in 1975
C 432: Holsteijn, C: same as C 74
C 433: Loo, J van: same as C 74
C 434 & C 435: Bronckhorst, J van: same as C 74
C 436: Bol, F
C 437: Lairesse, G: loan ends in 1975
C 438: Droochsloot, J C
C 439: Jordaens, J
C 440: Anraedt, P van: loan ends in 1975
C 441: Eliasz, N: loan ends in 1975
C 442: Backer, J A
C 443: Baen, J de: same as C 398
C 444 & C 445: Boonen, A: loan ends in 1975
C 446: Droochsloot, J C
C 447: Savery, R
C 448: Eertvelt, A van
C 449: Vlieger, S de: loan ends in 1975
C 450: Vroom, H C: same as C 48
C 451: Knijff, W
C 452: Hattich, P van
C 453: Verwer, A de: loan ends in 1975
C 454: Barendsz, D: loan ends in 1975
C 455: Isaacsz, P
C 456: Alewijn, M W: same as C 313
C 457: Calame, A: same as C 313
C 458: Diday, F: same as C 313
C 459: Schwartze, J G: same as C 313
C 460: now A 1910
C 461: now A 1909
C 462: Holland school: Jonkheer J P Six, 1886-1932
C 463: Bilders, J W: VHK, 1886-95
C 464: Hove, B van: same as C 463

C 465: Pieneman, N: Mrs P K van Diermen-Wins, 1886-1925
C 466: Moritz, L
C 467: Lingeman, J: same as C 463
C 468: now A 1489
C 469: Kamper, G: municipality of Utrecht, 1886-1921
C 470: Bronckhorst, J G van: municipality of Utrecht, 1886-1919
C 471: Utrecht school: municipality of Utrecht, 1886-1902
C 472: Northern Netherlands school: same as C 470
C 473: Drooschloot, J C: same as C 470
C 474 & C 475: Northern Netherlands school: same as C 470
C 476: Cock, J C de: sculpture, cat RMA Beeldhouwkunst 1973, nr 339a
C 477: Landelle, Ch: VHK, 1887-91
C 478: Mauve, A: VHK, 1887-95
C 479: Honthorst, G van: Amsterdam, church of St Dominic, 1887-89
C 480: now A 3103
C 481: Vos, H: W E van Pappelendam & Schouten, 1887-89
C 482: Demont-Breton, V: same as C 478
C 483: Constant, B: same as C 478
C 484: Hove, B van: same as C 478
C 485: Mesdag, H W: same as C 478
C 486: Buijs, J: city of Amsterdam, 1887-1926
C 487-C 492: now A 2286-A 2291
C 493: Sande Bakhuizen, J J van de: VHK, 1888-95
C 494: Bosboom, J: same as C 493
C 495: Israels, J: same as C 493
C 496: Klinkenberg, J C K: same as C 493
C 497: Mauve, A: same as C 493
C 498: Mesdag, H W: same as C 493
C 499: Roelofs, W: same as C 493
C 500: Roosenboom, M: same as C 493
C 501: Springer, C: same as C 493
C 502: Blommers, B J: VHK, 1889-95
C 503: Deventer, W A van: same as C 502
C 504 & C 505: Bilders, J W: same as C 502
C 506: Northern Netherlands school 1608
C 507: Heemskerck, M van
C 508: Southern Netherlands school ca 1560
C 509: Holland school ca 1485
C 510: Vrancx, S
C 511: Jacobsz, C: KOG, 1889-1974
C 512: Dumesnil, L M
C 513 & C 513a: HER
C 514: Duyster, W C
C 515: Buijs, J
C 516: Amsterdam school: KOG, 1889-1934
C 517 & C 518: Plaes, D van der
C 519: Hulst, F de
C 520 & C 521: Miereveld, M J van
C 522: Grebber, P F de
C 523: Leemans, J
C 524: Vogelaer, P
C 525: Pietersz, A
C 526: Holland school 1720
C 527: Spinny, G de
C 528: Musscher, M van
C 529: Monogrammist I S H
C 530: Daiwaille, J A
C 531: Os, P G van
C 532: Hendriks, W
C 533: now A 2627
C 534: Burbure, L de
C 535: Maes, N
C 536: Lelie, A de: loan ends in 1975
C 537 & C 538: Lelie, A de
C 539: Lelie, A de: loan ends in 1975
C 540: Rijk, J de
C 541: Verschuur I, W
C 542: Koekkoek, B C
C 543: PAST Tozelli, F
C 544: Tozelli, F: city of Amsterdam, 1889-1935
C 545: Israels, J: same as C 502
C 546: Hals, F: city of Amsterdam, 1889-1958
C 547: Hove, B J W M van: sculpture, former inv nr B 64, returned
C 548: Leenhoff, F: sculpture, cat RMA Beeldhouwkunst 1973, nr 528
C 549: Schwartze, J G: Mrs F W Rive-Fuchs, 1890-1926
C 550: Brizé, C: H D Willink-van Collen, 1890-1956
C 551: Allebé, A: VHK, 1890-95
C 552: Maris, W: VHK, 1891-95
C 553 & C 554: Israels, J: same as C 552
C 555: Bosboom, J: same as C 552
C 556 & C 557: Hals, F
C 558: Maris, J: A Bredius, 1891-95
C 559: Mercié, A: sculpture, returned
C 560: Metsu, G
C 561: Huysum, J van
C 562: Ruisdael, J I van
C 563: Camphuijsen, G D
C 564: Ostade, A van
C 565 & C 566: Keyser, Th de: city of Amsterdam, 1892-1926
C 567 & C 568: Keyser, Th de: loan ends in 1975

C 569: Hesselink, A: sculpture, cat RMA Beeldhouwkunst 1973, nr 544
C 570: Israels, J: loan ends in 1975
C 571: Heyden, J van der: loan ends in 1975
C 572: Stracké, F: sculpture, city of Amsterdam, 1893-1956
C 573: Greive Jr, J C: VHK 1893-95
C 574: now A 2292
C 575: Maris, J: same as C 573
C 576: Block, E F de
C 577: Maris, J: same as C 573
C 578: Verdonck, J J F: sculpture, M G F Verdonck, 1895-98
C 579: Schwartze, G: sculpture, returned
C 580: Mignon, A: loan ends in 1975
C 581: Hondecoeter, M d'
C 582 & C 583: Schotel, P J: Grand duchess of Saxe-Weimar, 1896-1929
C 584 & C 585: Meijer, L: same as C 582
C 586: Augustini, J L
C 587: Kaldenbach, J A: loan ends in 1975
C 588 & C 589: Lelie, A de: loan ends in 1975
C 590: Buys II, C: G C V Schöffer, 1896-1922
C 591: Bosch-Reitz, M: sculpture, returned
C 592: Pietersz, G: loan ends in 1975
C 593: Coignet, G: city of Amsterdam, 1897-1926
C 594: Nieulant, A van: same as C 593
C 595: Israels, J: H Helweg, 1897-1912
C 596: Blondeel, L: Jonkheer B W F van Riemsdijk, 1897-1924
C 597: Rembrandt
C 598: Netscher, C: van Weede-Family Foundation, 1897-1958
C 599: Breitner, G H: J G Pott, 1898-1909
C 600: Steen, J H: F H Wente, 1898-1911
C 601: Beyeren, A van: same as C 600
C 602: Victors, J: same as C 600
C 603: Schut, C: same as C 600
C 604: Leenhoff, F: sculpture, F Leenhoff, 1898-1928
C 605: now A 3103
C 606: Venne, A P van de: loan ends in 1975
C 607: Venne, A P van de
C 608: Venne, A P van de: loan ends in 1975
C 609: Venne, A P van de
C 610: Heda, W C
C 611: Rotius, J A
C 612: Baburen, D van
C 613: Strij, J van
C 614: anonymous, ivory statue, KOG, 1899-1928
C 615: Northern Netherlands school: I P R M de Nerée tot Babberich, 1899-1909
C 616 & C 617: Mast, H van der
C 618 & C 619: Miereveld, M J van: I P R M de Nerée tot Babberich, 1899-1906
C 620: Ravesteyn, H van: I P R M de Nerée tot Babberich, 1899-1968
C 621: Jacobsz, D: loan ends in 1975
C 622: Voort, C van der
C 623: Moreelse, P
C 624: Helst, B van der: loan ends in 1975
C 625: Helst, B van der: city of Amsterdam, 1899-1926
C 626: Bol, F: loan ends in 1975
C 627: now A 2218
C 628: Velde II, W van de: city of Amsterdam, 1899-1906
C 629 & C 630: Graat, B: Jonkheer J van Ortt van Schonauen, 1899-1921
C 631: Lubienietsky, Chr: Amsterdam, united Mennonite congregation, 1899-1952
C 632: Lubienietsky, Chr: Amsterdam, united Mennonite congregation, 1899-1934
C 633: Holland school: same as C 631
C 634: Flinck, G: same as C 631
C 635: anonymous: same as C 631
C 636: anonymous: same as C 631
C 637: anonymous: same as C 632
C 638: Key, W: same as C 632
C 639: Southern Netherlands school: Jonkheer B W F van Riemsdijk, 1899-1900
C 640: Stuers, A de: sculpture, cat RMA Beeldhouwkunst 1973, nr 533
C 641: Koninck, Ph: M J van Lennep, 1900-13
C 642 & C 643: now A 2238 & A 2239
C 644: now A 4166
C 645: banisters, returned
C 646 & C 647: Borch, G ter: P W van Doorninck, 1901-04
C 648-C 657: Lacomblé, E: sculptures, cat RMA Beeldhouwkunst 1973, nrs 497, 484? 479? 464, 498, 471, 503, 478?, 516
C 658: David d'Angers, P J: sculpture, returned
C 659: Maes, D: G C V Schöffer, 1902-08
C 660-C 669: now A 2293-A 2302
C 670 & C 671: now A 2713 & A 2714
C 672: Goes, H van der: J Leembruggen, 1903-19
C 673: Monogrammist R K: Zwolle, regents of the Emmanuels-huizen, 1903-24
C 674: Bray, D de: same as C 673
C 675: baptismal font, Th Stuart 1903-?
C 676-C 680: now A 2427-A 2431

C 681: Mauve, A: J C J Drucker 1903-07
C 682-C 704: now A 2432-A 2454
C 705: Stomme, J J de: Jonkheer B W F van Riemsdijk, 1904-21
C 706: Holland school: same as C 705
C 707: oak door, Broek in Waterland, Dutch Reformed church, 1904-65
C 708: Israels, J: S Maris, 1904-08
C 709: Maris, M: same as C 708
C 710-C 712: Holland school: Th Baron Collot d'Escury, 1904-24
C 713: anonymous: same as C 710
C 714-C 716: Spinny, G de: same as C 710
C 717 & C 718: Tischbein, J F A: same as C 710
C 719: Holland school: same as C 710
C 720 & C 721: Ravesteyn, J A van: same as C 710
C 722: & C 723: Gelder, A de: same as C 710
C 724 & C 725: Schalcken, G: same as C 710
C 726-C 737: Holland school: same as C 710
C 738-C 740: Ravesteyn, J A van: same as C 710
C 741: Janson van Ceulen, C: same as C 710
C 742: Hanneman, A: same as C 710
C 743 & C 744: Holland school: same as C 710
C 745: Schwartze, Th
C 746: Bilders, J W: F H Wente, 1904-11
C 747: Springer, C & Karsen, K: same as C 746
C 748: Voort, C van der: loan ends in 1975
C 749: now A 3060
C 750-C 765: now A 2455-A 2470
C 766 & C 767: Maris, J: J C J Drucker 1904-07
C 768-C 786: now A 2471-A 2489
C 787: Vrolijk, J: B J D Zubli, 1905-12
C 788: Bock, Th de: same as C 787
C 789: Segantini, G: drawing, same as C 787
C 790: Royer, L: sculpture, F H Wente, 1905-11
C 791: Conflans, A van: loan ends in 1975
C 792: Valckert, W van den: G C V Schöffer, 1906-22
C 793: Israels, I L: J G Pot, 1906-09
C 794: Israels, J: Mrs J Slagmulder-van Gent, 1906-24
C 795: Israels, I L: Mrs J Slagmulder-van Gent, 1906-25
C 796: Josselin de Jong, P de: drawing, B J D Zubli, 1906-19
C 797: Allebé, A: same as C 792
C 798: now A 2490
C 799: Falise, A: sculpture, A Falise, 1906-?
C 800 & C 801: now A 2491 & A 2492
C 802: Schwartze, Th: Mrs J Slagmulder-van Gent, 1907-24
C 803: Leenhoff, F: sculpture, F Leenhoff, 1907-11
C 804: Mauve, A: M W Savry, 1907-51
C 805: now A 2544
C 806: German school: C Hoogendijk, 1907-11
C 807-C 810: now A 2545-A 2548
C 811 & C 812: German school: same as C 806
C 813: French school: same as C 806
C 814: now A 2549
C 815-C 818: Holland school: same as C 806
C 819 & C 820: now A 2550 & A 2551
C 821-C 823: Holland school: same as C 806
C 824: Southern Netherlands school: same as C 806
C 825: now A 2552
C 826-C 834: Southern Netherlands school: same as C 806
C 835: now A 2553
C 836: anonymous: same as C 806
C 837: Antonello da Messina: same as C 806
C 838: now A 2554
C 839: Bega, C P: same as C 806
C 840 & C 841: now A 2555 & A 2556
C 842: Bosch, J: same as C 806
C 843 & C 844: now A 2557 & A 2558
C 845: Bouts, A: same as C 806
C 846: Brekelenkam, Q G: same as C 806
C 847: Brueghel II, P: same as C 806
C 848: now A 2559
C 849 & C 850: Chardin, J B S: same as C 806
C 851: Claesz, P: same as C 806
C 852 & C 853: now A 2560 & A 2561
C 854 & C 855: Cranach I, L: same as C 806
C 856: Cuyp, B G: same as C 806
C 857: now A 2562
C 858: Duck, J: same as C 806
C 859: now A 2563
C 860: Gheyn, J de: same as C 806
C 861: Goyen, J van: same as C 806
C 862: now A 2564
C 863: Heem, C de: same as C 806
C 864 & C 865: now A 2565 & A 2566
C 866: Marseus van Schrieck, O: same as C 806
C 867: Neufchatel, N: same as C 806
C 868: now A 2567
C 869: Ostade, A van: same as C 806
C 870-C 872: now A 2568-A 2570
C 873: Rubens, P P: same as C 806
C 874: Ruisdael, J I van: same as C 806
C 875: Ruysdael, S van: same as C 806
C 876: now A 2571
C 877: Ruysdael, S van: same as C 806

C 878: Savery, R: same as C 806
C 879: Son, J F van: same as C 806
C 880: now A 2572
C 881 & C 882: Steen, J H: same as C 806
C 883 & C 884: now A 2573 & A 2574
C 885 & C 886: Teniers II, D: same as C 806
C 887 & C 888: now A 2575 & A 2576
C 889: Vliet, H C van: same as C 806
C 890: now A 2577
C 891: Wouwerman, J: same as C 806
C 892: Wijck, Th: same as C 806
C 893: Southern Netherlands school: drawing, same as C 806
C 894: German school: same as C 806
C 895: Holland school: same as C 806
C 896 & C 897: Claeu, A de: same as C 806
C 898-C 900: now A 2587-A 2589
C 901: Southern Netherlands school: same as C 806
C 902-C 908: now A 2590-A 2596
C 909: Southern Netherlands school: same as C 806
C 910: Chardin, J B S: same as C 806
C 911: Southern Netherlands school: same as C 806
C 912: Mignon, A: same as C 806
C 913: Holland school: same as C 806
C 914: Teniers II, D: same as C 806
C 915: Steen, J H: same as C 806
C 916 & C 917: Teniers II, D: same as C 806
C 918: Balten, P: same as C 806
C 919: Teniers II, D: same as C 806
C 920: Fijt, J: same as C 806
C 921: Steen, J H: same as C 806
C 922: Jonson, C: same as C 806
C 923: Neer, A van der: same as C 806
C 924: Holland school: same as C 806
C 925: Jonson, C: same as C 806
C 926: Ruisdael, J I van: same as C 806
C 927: Goyen, J van: same as C 806
C 928: Neer, A van der: same as C 806
C 929: Pynacker, A: same as C 806
C 930: Boone, D: same as C 806
C 931: anonymous: same as C 806
C 932: Neer, B van der: same as C 806
C 933: Holland school: same as C 806
C 934: Southern Netherlands school: same as C 806
C 935: Rubens, P P: same as C 806
C 936: Goyen, J van: same as C 806
C 937: Holland school: same as C 806
C 938: Fijt, J: same as C 806
C 939: Moreelse, P: same as C 806
C 940: Jordaens, J: same as C 806
C 941: Steen, J H: same as C 806
C 942: Goyen, J van: same as C 806
C 943: Steen, J H: same as C 806
C 944: Bor, P: same as C 806
C 945: French school: same as C 806
C 946: Southern Netherlands school: same as C 806
C 947: anonymous: same as C 806
C 948: Keyser, Th de: same as C 806
C 949: Everdingen, A van: same as C 806
C 950: Spanish school: same as C 806
C 951: cast iron stove, A H Wertheim, 1909-?
C 952: Israels, J: M Hijmans van Wadenoyen, 1909-23
C 953: now C 1486
C 954: now A 4209
C 955: Scorel, J van: Jonkheer B W F van Riemsdijk, 1909-24
C 956-C 959: now A 2493-A 2496
C 960: table, transferred to the RBK
C 961-C 968: chairs, same as C 960
C 969: two Chinese vases: same as C 960
C 970-C 972: Gogh, V W van: Mrs J Cohen Gosschalk-Bonger, 1909-26
C 973: now A 2524
C 974: now A 2523
C 975: Konijnenburg, W A van: M M van Valkenburg, 1910-15
C 976: Maris, M: M M van Valkenburg, 1910
C 977: Maris, M: M M van Valkenburg, 1910-17
C 978.1: Mesdag, H W: A Tak van Poortvliet, 1910-13
C 978.2: Bock, Th de: same as C 978.1
C 978.3: Knip, J A: same as C 978.1
C 978.4: Sadée, Ph L J F: same as C 978.1
C 978.5: Bosboom, J: same as C 978.1
C 978.6: Essen, J van: same as C 978.1
C 978.7: Artz, D A C: same as C 978.1
C 978.8: Offermans, T: same as C 978.1
C 978.9-10: Voort, C van der: same as C 978.1
C 978.11: Ovens, J: same as C 978.1
C 978.12: Blieck, D de: same as C 978.1
C 978.13: Maes, N: same as C 978.1
C 978.14: Haensbergen, J: same as C 978.1
C 978.15-23: Holland school: same as C 978.1
C 978.24-25: Luttichuys, J: same as C 978.1
C 978.26: Holland school: same as C 978.1
C 978.27-28: Appelius, J: same as C 978.1
C 978.29-32: Holland school: same as C 978.1

C 979: now A 2525
C 980: Wiggers, D: drawing, Jonkheer B W F van Riemsdijk, 1910-21
C 981: Maes, N: same as C 978.1
C 982: Schwartze, Th: pastel, P J H Cuypers, 1910-49
C 983: Israels, I L
C 984: Smith, H: C J K van Aalst, 1910-13
C 985: Weenix, J B: Oudewater, Dutch Reformed orphanage, 1910-24
C 986 & C 987: Borch, G ter: W E Luyken Glashorst, 1911-41
C 988: Berckmans, H: Mrs van Riemsdijk-de Kock, 1911-30
C 989-C 1006: now A 2597-A 2614
C 1007: Zürcher, J W C A: Mrs J Zürcher-Bijleveld van Serooskerken, 1911-24
C 1008: Lastman, P: J Allard, 1911-20
C 1009: Braque, G: Amsterdam, De Moderne Kunstkring, 1911-26
C 1010: Picasso, P: drawing, Amsterdam, De Moderne Kunstkring
C 1011-C 1015: now A 2615-A 2619
C 1016: Slingeland, P C van: J Allard, 1913-20
C 1017: Maks, C J: G W van Blaaderen, 1913-23
C 1018: Gauguin, P: Mrs J Cohen Gosschalk-Bonger, 1913-26
C 1019: Shee, M A: H W de Joncheere, 1913-14
C 1020: Le Fauconnier, H V G: C Kickert, 1914-26
C 1021 & C 1022: Bol, F: D Baron van Asbeck, 1914-20
C 1023: Palamedesz, A: same as C 1021
C 1024: Le Ducq, J: same as C 1021
C 1025: Holland school: same as C 1021
C 1026: Ravesteyn, A van: same as C 1021
C 1027 & C 1028: Maton, B: same as C 1021
C 1029: anonymous: same as C 1021
C 1030: Valckert, W van den: same as C 1021
C 1031 & C 1032: Boonen, A: same as C 1021
C 1033: Holland school: same as C 1021
C 1034 & C 1035: Huyssen, M: same as C 1021
C 1036-C 1038: Holland school: same as C 1021
C 1039: Huyssen, M: same as C 1021
C 1040-C 1043: anonymous: same as C 1021
C 1044: Leenhoff, F: sculpture, cat RMA Beeldhouwkunst 1973, nr 529
C 1045: Holland school: H P Bremmer, 1914-22
C 1046: now A 3982
C 1047: now A 3477
C 1048: Ruisdael, J I van: Jonkheer J W Six, 1915-20
C 1049: Steen, J H: same as C 1048
C 1050-C 1052: Israels, I L: L Bessie, 1915-22
C 1053: Goyen, J van: C A Piek, 1915-?
C 1054: Bosboom, J: J R H Neervoort van de Poll, 1915-21
C 1055 & C 1056: Corot, J B C: same as C 1054
C 1057: Daumier, H: same as C 1054
C 1058: Diaz de la Peña, N V: same as C 1054
C 1059: Dupré, J: same as C 1054
C 1060-C 1062: Israels, J: same as C 1054
C 1063: Josselin de Jong, P de: same as C 1054
C 1064-C 1079: Maris, J: same as C 1054
C 1080 & C 1081: Maris, W: same as C 1054
C 1082-C 1086: Mauve, A: same as C 1054
C 1087: Millet, J F: same as C 1054
C 1088 & C 1089: Neuhuys, J: same as C 1054
C 1090-C 1092: Poggenbeek, G: same as C 1054
C 1093: Toorop, J: same as C 1054
C 1094: now A 3448
C 1095: Sluyters, J: M Kaufmann, 1916-26
C 1096: Raden Saleh: J G Dom, 1916-24
C 1097.1-2: Holland school: Jonkheer H van Weede, 1916-21
C 1097.3-4: Flinck, G: same as C 1097.1
C 1097.5-6: Victors, J: same as C 1097.1
C 1097.7-8: Luttichuys, J: same as C 1097.1
C 1097.9-12: Holland school: same as C 1097.1
C 1097.13: Troost, C: same as C 1097.1
C 1097.14: Holland school: same as C 1097.1
C 1097.15: Victors, J: same as C 1097.1
C 1097.16: Flinck, G: same as C 1097.1
C 1097.17: Lalaing, J de: same as C 1097.1
C 1098.1-2: Holland school: Count van Heerdt tot Eversberg, 1916-17
C 1098.3-4: Miereveld, M J van: same as C 1098.1
C 1098.5-6: Holland school: same as C 1098.1
C 1099.1-2: Bruyn II, B: H P Bremmer, 1916-22
C 1100.1-4: Gogh, V W van: H P Bremmer, 1917-50
C 1100.5: Mondriaan, P C: same as C 1100.1
C 1100.6-8: Toorop, J Th: same as C 1100.1
C 1100.9-10: Gestel, L: same as C 1100.1
C 1100.11: Rijsselberghe, Th van: same as C 1100.1
C 1100.12-13: Verster, F: same as C 1100.1
C 1101.1-27: Altorf, J; Mendes da Costa, J M; Minne, G & Zijl, L: sculptures, same as C 1100.1
C 1102: genealogical register of the lords and ladies of Purmerlandt and Ilpendam, 2 vols, transferred to the RMA library
C 1103 & C 1104: Toorop, J Th: drawings, C Henny, 1917-19
C 1105: Monnickendam, M

C 1105a: panelling of a Chinese room (imitation): transferred to the RBK
C 1106.1: Verburgh, D: A Philips, 1918-19
C 1106.2: Croos, P van der: same as C 1106.1
C 1106.3: Anthonissen, H van: same as C 1106.1
C 1106.4: anonymous: same as C 1106.1
C 1106.5-6: Both, J: same as C 1106.1
C 1106.7-8: Holland school: same as C 1106.1
C 1107: Robertson, S: Amsterdam, Maatschappij voor Beeldende Kunsten, 1918-22
C 1108: Voort, C van der: loan ends in 1975
C 1109: Tibetan paintings: W van Meurs, 1918-19
C 1110.A-B: Maris, W: S Benima, 1918-20
C 1111: now A 3897
C 1112: Cézanne, P: Mrs M van Blaaderen-Hoogendijk, 1918-20
C 1113: Ruysdael, S J van: Mr & Mrs A C J Begeer-de Ridder, 1920-21
C 1114: Heem, J D de: same as C 1113
C 1115: Ruisdael, J I van: Mr & Mrs A C J Begeer-de Ridder, 1920-23
C 1116: Rembrandt: same as C 1115
C 1117: Ravesteyn, J A van: Mrs A Bakels, 1921-23
C 1118: Holland school: same as C 1117
C 1119: Perronneau, J B: pastel, A W M Mensing, 1922-29
C 1120: Gérard, F P S Baron
C 1121: now A 3302
C 1122: four tapestries, acquired in 1934 for the RBK
C 1123: Kruseman, J A
C 1124.I: now A 3981
C 1124.II: now A 3969
C 1124.III: Steen, J H: J J M Chabot, 1923-42
C 1124.IV: Beyeren, A H van: same as C 1124.III
C 1124.V: Momper, J de: J J M Chabot, 1923-43
C 1125: Cornelisz van Oostsanen, J: loan ends in 1975
C 1126: now A 3097
C 1127: Ostade, A van
C 1128: Keyser, Th de: Utrecht, Centraal Museum, 1924-58
C 1129: Fogolino, M
C 1130: Troost, C: Jonkheer B W F van Riemsdijk, 1924-43
C 1131: Lelie, A de: city of Amsterdam, 1924-?
C 1131.a: now A 3037
C 1132: Greco, El: D G van Beuningen, 1925-30
C 1133: Rembrandt: Mrs E de Ridder, 1925-27
C 1134: Seghers, H: F Koenigs, 1925
C 1135 & C 1136: Menendez, L: P Smidt van Gelder, 1925-37
C 1137: tapestry: same as C 1135
C 1138: Kickert, C: W Chr Vaezer, 1925-34
C 1139 & C 1140: Niehaus, K: K Niehaus, 1925-26
C 1141: Seghers, H: F Enthoven, 1925-31
C 1142: now A 4236
C 1143: furniture, dowager P A Gevers van Marquette-Deutz van Lennep, 1925-30
C 1144-C 1146: furniture, dowager P A Gevers van Marquette-Deutz van Lennep, 1925-39
C 1147: furniture, dowager P A Gevers van Marquette-Deutz van Lennep, 1925-28
C 1148 & C 1149: now A 3121 & A 3122
C 1150 & C 1151: Nijmegen, D van: same as C 1144
C 1152: Mierevelt, M J van: dowager P A Gevers van Marquette-Deutz van Lennep, 1925-33
C 1153-C 1157: Holland school: same as C 1144
C 1157a-b: Tischbein, J F A: same as C 1143
C 1158: Flinck, G: D Andreson, 1925-27
C 1159 & C 1160: now A 3516 & A 3517
C 1161-C 1167: Rembrandt; Lutma, J & Smith, J: prints, A W M Mensing, 1925-29
C 1168: now A 3141
C 1169-C 1171: now A 3231-A 3233
C 1172: Amsterdam school 1655: loan ends in 1975
C 1173: Anthonisz, C: loan ends in 1975
C 1174: Backer, J A
C 1175: Beerstraaten, J: loan ends in 1975
C 1176: Bol, F: loan ends in 1975
C 1177: Eliasz, N
C 1178: Jacobsz, D: loan ends in 1975
C 1179: Jonson van Ceulen, C: loan ends in 1975
C 1180: Vroom, H C: city of Amsterdam, 1926-47
C 1181: Quellinus I, A: sculpture, cat RMA Beeldhouwkunst 1973, nr 303
C 1182: Burgh, Hendrick van der
C 1183: Champaigne, Ph de
C 1184.1-31: Gogh, V W van: paintings and two drawings, V W van Gogh, 1927-30
C 1184.32-34: Gauguin, P: same as C 1184.1
C 1184.35-36: Toulouse-Lautrec, H de: one drawing, same as C 1184.1
C 1184.37: Manet, E: drawing, same as C 1184.1
C 1185: now A 3602
C 1186: Bosch, J: Paris, Musée du Louvre, 1927-30
C 1187: now A 3236
C 1188: Baldovinetti, A
C 1189: Hals, F: E Rathenau, 1928-35
C 1190: Beyeren, A H van: Mrs B Nathusius, 1928-51

C 1191: Hooch, P de
C 1192: Rembrandt: drawing, transferred to the R P K
C 1193: P A S T Troost, C
C 1194: Kalf, W: Jonkheer Ph F van de Poll, 1929-33
C 1195: Tintoretto, J: J P Kleiweg de Zwaan, 1929-30
C 1195a: Rembrandt: E Rathenau, 1929-40
C 1196 & C 1197: Cézanne, P: G F Reber, 1930-33
C 1198.1-2: Cézanne, P: one aquarelle, F Koenigs, 1930-38
C 1198.3: Corot, J B C: F Koenigs, 1930-40
C 1198.4-8: Degas, H G E: pastels and one painting, same as
 C 1198.1
C 1198.9: Forain, J L: drawing, same as C 1198.1
C 1198.10-12: Manet, E: one aquarelle, same as C 1198.1
C 1198.13-14: Renoir, A: same as C 1198.1
C 1198.15-22: Toulouse-Lautrec, H de: one pastel, same as
 C 1198.1
C 1199: Gauguin, P: A Bonger, 1930-40
C 1200: now A 3142
C 1201.1-5: Gogh, V W van: V W van Gogh 1930-37
C 1202: Bonington, R P: Mrs J P M Klever-Kemps, 1931-48
C 1203: now A 3477
C 1204: Bakhuysen, L: K K S, 1931-56
C 1205: Brouwer, A: E Rathenau, 1931-35
C 1206: Hobbema, M: same as C 1205
C 1207: Neer, A van der: same as C 1205
C 1208: Potter, P: same as C 1205
C 1209-C 1213: Rembrandt: drawings, same as C 1205
C 1214: Cappelle, J van de: H Schieffer, 1931-36
C 1215: Musscher, M van
C 1216: ambassador's pouch, transferred to the N G
C 1217: Brouwer, A: H Bromberg, 1932-36
C 1218: Rembrandt: Mrs Dübi-Müller, 1932-59
C 1219: now A 3224
C 1220: now A 4034
C 1221: Wit, J de
C 1222: Netherlands school ca 1590
C 1223 & C 1224: Lingelbach, J
C 1225: Northern Netherlands school ca 1645
C 1226: Huchtenburg, J van
C 1227-C 1230: Ravesteyn, J A van
C 1231: Alsloot, D van: Mrs E Boas-Kogel, 1933-40
C 1232: Pisa, G da: sculpture, Mrs A Jaarsma-de Lange, 1933-44
C 1233: Italian school: same as C 1232
C 1234: Teniers II, D: Mrs P Meyer-Cohn, 1933-38
C 1235: Zorn, A: same as C 1234
C 1236: Lieberman, M: Mrs P Meyer-Cohn, 1933-42
C 1237: Lotto, L: Amsterdam, Nederlandsche Standaard Bank,
 1933-39
C 1238: Piero di Cosimo: Amsterdam, Nederlandsche Standaard
 Bank, 1933-37
C 1239: Angelico, Fra: same as C 1238
C 1240: Tintoretto, J: same as C 1237
C 1241: Holland school: R A Baron van Hardenbroek, 1933-39
C 1242: Berckheyde, G: F Buchenau, 1934-39
C 1243: Beyeren, A van: same as C 1242
C 1244: Brekelenkam, Q G van: F Buchenau, 1934-38
C 1245-C 1248: Brouwer, A: same as C 1242
C 1249: Cappelle, J van de: same as C 1242
C 1250: Coques, G: same as C 1242
C 1251: Fijt, J: same as C 1242
C 1252 & C 1253: Goyen, J van: same as C 1242
C 1254: Heem, J D de: same as C 1244
C 1255: Heem, J D de: same as C 1242
C 1256: Heyden, J van der: same as C 1242
C 1257: Hondecoeter, M d': same as C 1242
C 1258: Kalf, W: same as C 1242
C 1259: Keyser, Th de: same as C 1242
C 1260: Koninck, Ph: same as C 1242
C 1261: Koninck, S: same as C 1242
C 1262: Maes, N: same as C 1242
C 1263: Metsu, G: same as C 1242
C 1264-C 1266: Neer, A van der: same as C 1242
C 1267: Netscher, Casp: same as C 1242
C 1268-C 1270: Ostade, A van: same as C 1242
C 1271 & C 1272: Rembrandt: same as C 1242
C 1273-C 1275: Rubens, P P: same as C 1242
C 1276: Ruisdael, J I van: same as C 1244
C 1277: Ruysdael, S J van: same as C 1244
C 1278 & C 1279: Seghers, H: same as C 1242
C 1280 & C 1281: Steen, J H: same as C 1242
C 1282 & C 1283: Teniers II, D: same as C 1242
C 1284: Borch, G ter: same as C 1244
C 1285-C 1287: Borch, G ter: same as C 1242
C 1288 & C 1289: Velde II, W van de: same as C 1242
C 1290: Witte, E de: same as C 1244
C 1291: Wouwerman, Ph: same as C 1242
C 1292: Lohman, Th: drawing, Amsterdam, Nederlandsch
 Kunstverbond, 1934-?
C 1293 & C 1294: Tintoretto, J: Amsterdam, Nederlandsche
 Standaard Bank, 1934-39
C 1295: Tintoretto, D: same as C 1293
C 1296 & C 1297: Titian: E Heldring, 1934-37
C 1298: now A 3883

C 1299: now A 3269
C 1300: now A 3884
C 1301: now C 1458
C 1302: Francesco di Vannucci: R van Marle, 1936-52
C 1303: Sano di Pietro: same as C 1302
C 1304: Gerini, P: same as C 1302
C 1305: Orcagna, A: same as C 1302
C 1306: Martino di Bartolommeo: same as C 1302
C 1307: Guariento: same as C 1302
C 1308: Vinci, L da: same as C 1302
C 1309: Sellaio, J del: same as C 1302
C 1310: Giampietrino: same as C 1302
C 1311: Italian school: same as C 1302
C 1312: Giovanni di Bartolommeo Cristiani: same as C 1302
C 1313: Maestro Paolo: same as C 1302
C 1314: Paolo di Giovanni Fei: same as C 1302
C 1315 & C 1316: Andrea di Bartolo: same as C 1302
C 1317: Vanni, A: same as C 1302
C 1318: Vanni, L: same as C 1302
C 1319: Jacopo di Cione: same as C 1302
C 1320: Fontainebleau school: same as C 1302
C 1321: French school: same as C 1302
C 1322: Rembrandt: P Smidt van Gelder, 1937-39
C 1323: Northern Netherlands school ca 1815
C 1324: French school ca 1720
C 1325: Oets, P
C 1326: Vrijmoet, J: C Baron van Breugel Douglas, 1948-53
C 1327: Holland school: Jonkheer M N van Loon, 1948-52
C 1328 & C 1329: Miereveld, M J van: same as C 1327
C 1330 & C 1331: Molenaer, J M: Jonkheer M N van Loon,
 1948-73
C 1332: Ovens, J: same as C 1327
C 1333 & C 1334: Quinkhard, J M: same as C 1327
C 1335: Santvoort, D D: same as C 1330
C 1336: Vaillant, W: same as C 1327
C 1337: Vries, A de: same as C 1327
C 1338 & C 1339: Miereveld, M J van: Amsterdam, Deutzen-
 hofje, 1948-51
C 1340: Appel, J: Jonkheer F J E van Lennep, 1950-65
C 1341: now A 3742
C 1342: Mor van Dashorst, A: city of Amsterdam, 1948-56
C 1343: Venne, A P van de
C 1344: Allori, A
C 1345: Cortona, P da
C 1346: Leone, A de
C 1347: Cerezo, M
C 1348: Franceschini, M A
C 1349: Cornelisz van Oostsanen, J
C 1350: Delen, D van
C 1351: Dughet, G
C 1352: Farinato, P
C 1353: Giordano, L
C 1354: Venetian school 1st quarter 16th century
C 1355: Keyser, Th de: K K S, 1948-58
C 1356-C 1361: Magnasco, A
C 1362: Mazo, J B M del
C 1363: Mazzolino, L
C 1364: Master of Alkmaar
C 1365: Moroni, G B
C 1366: Murillo, B E
C 1367 & C 1368: Piero di Cosimo
C 1369: Ruisdael, J I van: K K S, 1948-50
C 1370: Sassoferrato, G B
C 1371: Iriarte, I de
C 1372: Turchi, A
C 1373: Tintoretto, J
C 1374: Bonifazio Veronese
C 1375: Barbari, J de': same as C 1369
C 1376-C 1380: now A 3963-A 3967
C 1381: Cranach I, L: K K S, 1948-51
C 1382-C 1384: now A 3968-A 3970
C 1385: now A 3972
C 1386: now A 3971
C 1387: Kulembach, H S von: same as C 1381
C 1388-C 1404: now A 3973-A 3989
C 1405: Hulst, J B van der: D R V K, 1950-72
C 1406: Rembrandt: anonymous, 1950-65
C 1407 & C 1408: P A S T Troost, S
C 1409: Saenredam, P J
C 1410: Hodges, Ch H
C 1411 & C 1412: Hodges, Ch H: D R V K, 1951-53
C 1413: Loo, J van: Jonkheer G C J van Reenen, 1952-68
C 1414 & C 1415: Verspronck, J C
C 1416-C 1419: now A 3990-A 3993
C 1420: now A 3996
C 1421 & C 1422: now A 3994 & A 3995
C 1423-C 1438: now A 3997-A 4012
C 1439: Ghezzi, P L: drawing, D R V K, 1952-54
C 1440: Moreelse, P
C 1441: Vroom, H C: Mrs Theunisse-Oosterhaven, 1954
C 1442 & C 1443: Aved, J A J: Jonkheer F J E van Lennep,
 1954-65
C 1444: Lorrain, C: F Lugt, 1954-60

C 1445: now A 4127
C 1446: Tiepolo, G B: W O Koenigs, 1955-65
C 1447: now A 4013
C 1448: Rembrandt
C 1449: now A 4050
C 1450: Rembrandt
C 1451: Quinkhard, J: Amsterdam, Rotterdamsche Bank-
 vereniging, 1957-60
C 1452: Regters, T: J P Bijl, 1957-58
C 1453: Rembrandt
C 1454: Northern Netherlands school ca 1430
C 1455 & C 1456: Knip, J A
C 1457: Rembrandt: D H Cevat, 1960-71
C 1458: Aertsen, P
C 1459: M I N Rochard, S J
C 1460: Paelinck, J
C 1461: Holland school ca 1948
C 1462: Rol, H
C 1463: Fabritius, C: D H Cevat, 1962-70
C 1464 & C 1465: Hodges, Ch H: pastels, L H Baroness
 Schimmelpenninck van der Oye, 1962-65
C 1466: English school 2d half 16th century
C 1467: Lievens, J
C 1468: Boonen, A: loan ends in 1975
C 1469-C 1471: Quinkhard, J M: loan ends in 1975
C 1472: Regters, T: loan ends in 1975
C 1473: Troost, C: loan ends in 1975
C 1474: Backer, J A
C 1475: Pothoven, H
C 1476: Gheyn, J de: Amsterdam, P & N de Boer foundation
 collection, 1966-71
C 1477: Luttichuys, I
C 1478: Decker, F
C 1479: now A 4218
C 1480: Fontaine, L de: D R V K, 1969-71
C 1481: Miereveld, M J van
C 1482 & C 1483: Hendriks, W
C 1484: Southern Netherlands school 1st half 17th century
C 1485: Chabot, H
C 1486: Maris, M
C 1487-C 1490: P A S T Prud'hon, P P
C 1491-C 1514: C O S T
C 1515: now A 4228
C 1516: H O N
C 1517: Everdingen, C B van
C 1518: Bor, P
C 1519-C 1521: Hesselaar, H Th
C 1522: Luttichuys, I
C 1523: Vallayer-Coster, D A
C 1524: Voogd, H
C 1525: Gérard, F P S Baron
C 1526: Mij, H van der
C 1527: Mijn, F van der
C 1528: Northern Netherlands school 1626
C 1529 & C 1530: Compe, J ten
C 1531 & C 1532: Zeuner, J
C 1533: Velde, E van de
C 1534: Zeuner, J
C 1535: Troostwijk, W J van
C 1536: Smies, J
C 1537: Ekels II, J
C 1538: Hilverdink, E A
C 1539 & C 1540: Bertichen, P G
C 1541: Hoevenaar, W P
C 1542: Vianey, P
C 1543: Leemans, J: K O G, 1973-74
C 1544: Martens, W
C 1545: Amsterdam school mid-19th century
C 1546 & 1547: Haensbergen, J van
C 1548: Rochussen, Ch
C 1549: Rossum, J C van
C 1550: Noorderwiel, H
C 1551: Northern Netherlands school ca 1625
C 1552: P A S T Northern Netherlands school ca 1815
C 1553: Voort, C van der
C 1554: Cornelisz van Oostsanen, J
C 1555: Rembrandt
C 1556: Kooi, W B van der
C 1557: Teyler van Hall, J J
C 1558: Hondius, I
C 1559: Valkenburg, H
C 1560: Northern Netherlands school 1578
C 1561: Clercq, J de
C 1562: Amsterdam school 2d half 18th century
C 1563: Heemskerck, M van
C 1564: Poorter, B de
C 1565 & C 1566: Chabot, H
C 1567 & C 1568: Boonen, A
C 1569: Zeuner, J
C 1570: Northern Netherlands school ca 1730
C 1571: Otterbeek, J H
C 1572 & C 1573: P A S T Northern Netherlands school ca 1750
C 1574: P A S T Vau...ons

C 1575: Northern Netherlands school ca 1745
C 1576: Amsterdam school ca 1875
C 1577: Wit, J de
C 1578: Codde, P
C 1579: Southern Netherlands school ca 1570
C 1580 & C 1581: HER shields
C 1582: Northern Netherlands school 18th century

Painted objects on the inventory of the department of Dutch history acquired after 1927

NG 47: HER drums
NG 87: HER memorial tablets
NG 105-NG 118: HER memorial tablets
NG 1974-R-30: MIN Amsterdam school 1696

Painted objects on the joint inventory of the departments of Dutch history and sculpture and applied arts acquired in 1927 from the Nederlandsch Museum voor Geschiedenis en Kunst

NM 1010: Piemont, N; Royen, W F van & Voorhout, J
NM 1014: Antwerp school 1st half 17th century
NM 2970: HER shields
NM 4190: Francken II, F
NM 4485: Schuer, Th C van der
NM 4789: Francken II, F
NM 5339-NM 5344: HER
NM 5885: MIN Marinkelle, J
NM 8041: Monogrammist D B
NM 8184: Swart van Groningen, J
NM 8359: HER memorial tablets
NM 9310: HER drums
NM 9313: HER shields
NM 9487: Stoop, D
NM 9882: MIN Petitot, J
NM 10500: HER memorial tablets
NM 11421: HER shields
NM 11444: MIN Northern Netherlands school ca 1730
NM 11649-w: HER shields
NM 11906-1: Rubens, P P
NM 12896: MIN Northern Netherlands school ca 1725
NM 16709: Nijmegen, E van

Painted objects on the inventory of the department of sculpture and applied arts acquired after 1927

RBK 15234: Croos, A J van
RBK 16434: Antwerp school? ca 1650
RBK 16558: Wit, J de
RBK 16709: Nijmegen, E van
RBK 17156: MIN French school 2d half 18th century
RBK 17200: MIN French school ca 1725
RBK 1958-81: Wit, J de

Concordance of former catalogue numbers with listings in the present catalogue

All catalogue numbers assigned by the museum since 1903 are listed, irrespective of whether they ever appeared in a printed catalogue.

1: Abels, J Th, A 998
2: Achenbach, O, A 1798
3: Adriaensen, A, A 1481
3a = 3 A 1: Adriaensen, A, A 2544
4: Aelst, W van, A 1669
4a = 4 B 1: Aerts, H, A 2528
5: Aertsen, P, A 3
6: Aertsen, P, C 392
7: Aertsen, P, A 1909
7a = 7 A 1: Aertsen, P, A 2398
7 A 2: Aertsen, P, C 1458
8: Aertsen, P: returned loan
8a: Alberti, J E Ch, A 641
8b: Alberti, J E Ch, A 651
8c: Alberti, J E Ch, A 652
8 H 1: Alberti, J E Ch, A 641
8 H 2: Alberti, J E Ch, A 651
8 H 3: Alberti, J E Ch, A 652
9: Alewijn, A, A 1726
10: Allebé, A, A 1799
11: Allebé, A, A 1731
12: Allebé, A, A 1730
13: Allebé, A, A 2295
13 A 1: Allebé, A, A 3095
13 A 2: Allebé, A, A 3266
13 A 3: Allebé, A, A 3267
13 A 4: Allebé, A: returned loan
14: Allebé, A, A 1729
14a: Allebé, A: returned loan
14b: Allebé, A, A 3266
14c: Allebé, A, A 3267
14d: Allebé, A, A 3095
14 M 1: Allori, A, C 1344
15: Allori, C, A 1
15a: Regteren Altena, M van, A 2620
15 G 1: Alsloot, D: returned loan
15 M 1: Regteren Altena, M van, A 2620
16: Altmann, S, A 1620
16 B 1 & 2: Andrea di Bartolo: returned loan
17: Andriessen, J, A 2059
17a: German school: returned loan
17A: Goyen, J van: returned loan
17 A 1: Andriessen, J, A 3921
17b: Nijmegen school ca 1483, A 2545
17 B 1: Angelico, Fra, A 3011
17 B 2: Angelico, Fra: returned loan
17c: Nijmegen school ca 1483, A 2546
17d: Master of the Salem Altar, A 2547
17f: German school: returned loan
17 F 1: Nijmegen school ca 1483, A 2545
17g: German school: returned loan
17 G 1: Nijmegen school ca 1483, A 2546
17h: Westphalian school ca 1500, A 2588
17 H 1: Master of the Salem Altar, A 2547
17i: Lower Rhenish school ca 1490, A 2799
17 K 1: Bavarian school last quarter 15th century, A 2548
17 L 1: Westphalian school ca 1500, A 2588
17 M 1: Lower Rhenish school ca 1490, A 2799
17 T 1: Upper Rhenish school ca 1450, A 3310
17 T 2: Upper Rhenish school ca 1450, A 3311
18: Vellert, D, A 849
19: Leiden school ca 1515, A 1483
20: Leiden school ca 1515, A 1484
20a = 20 A 1: North German school ca 1500, A 2593
21: Cleve, J van, A 165
21 E 1: Cologne school ca 1575, A 3891
22: Aachen, H von, A 1412
23: German school 1603, A 968
24: German school 1603, A 969
25: Pesne, A, A 886
25a: Hoffmann, S, A 3333
26: MIN German school ca 1760, A 4384
27: MIN German school ca 1750, A 4383
27a: Master of the Portraits of Princes, A 3140
27 A: Holland school ca 1730, A 3219
27 B: Holland school ca 1730, A 3220
27 C: North Italian school? 1st half 18th century, A 3218
27 D: North French school: returned loan
27 M 1: Northern Netherlands school ca 1775, A 1476
27 M 2: Northern Netherlands school ca 1775, A 1477
27 S 1: French school 1454, A 4212
28: French school 16th century, A 504
28a: School of Avignon ca 1505-10, A 3116
29: Vermeyen, J C, A 164
30: Vermeyen, J C, A 979
31: Vermeyen, J C, A 980

32: Bunel, J, A 1400
33: Southern Netherlands school ca 1680, A 2096
34 & 35: French school: returned loans
36: Maratti, C, A 727
36a: French school: returned loan
36b: Northern Netherlands school ca 1850, A 1961
36c: Riley, J, A 3303
36d: French school ca 1750, A 3279
36e: Charlet, N T, A 2257
36 G 1: French school ca 1775, A 3916
36 G 2: French school ca 1775, A 3917
36 G 3: French school ca 1775, A 3918
36 G 4: French school ca 1775, A 3919
37: Northern Netherlands school ca 1380, A 831
38: Northern Netherlands school: returned loan
39: Gelderland school ca 1435, A 1491
39a: Northern Netherlands school ca 1450: de-acceded
39b: Utrecht school ca 1435, A 2649
39c: Upper Rhenish school ca 1450, A 3310
39d: Upper Rhenish school ca 1450, A 3311
40: Southern German school ca 1500, A 496
41: Southern German school ca 1500, A 497
42: Holland school ca 1485, C 509
43: Master of the Virgo inter Virgines, A 501
43a: Master of the Spes Nostra, A 2312
44: Utrecht school ca 1460, A 1408
44a: Holland school: returned loan
45: Master of Alkmaar, A 1308
45a: Northern Netherlands school ca 1500, A 2237
46: Master of Alkmaar, A 1307
46a: Master of Alkmaar, A 2815
46b: Master of Alkmaar, A 3324
47: Cock, J W de, A 1598
48: Master of Alkmaar, A 1188
49: Engebrechtsz, A. A 1719
50: Netherlands school: returned loan
51: Holland school ca 1508, A 1508
52: Cornelisz Kunst, C, A 1725
52a: Netherlands school early 16th century, C 4650
53: Netherlands school ca 1515, A 867
54: Netherlands school ca 1515, A 866
54b: Southern Netherlands school ca 1560, C 508
54 M 1: Coecke van Aelst, P, A 3464
55: Utrecht school 1554, A 4486
55a: Holland school: returned loan
56: Orley, B van, A 4265
56a: Northern Netherlands school ca 1530, A 2592
57: Lombard school 1st half 16th century, A 2801
58: Northern Netherlands school ca 1570, A 1599
58 F 1: Netherlands school? 3d quarter 16th century, A 3914
58 F 2: Netherlands school? 3d quarter 16th century, A 3915
58 M 1: Northern Netherlands school last quarter 16th century, A 2624
59: Bruges school 1584, A 1668
59a: Unknown school 17th century: de-acceded
59b: Southern Netherlands school? ca 1600?, A 1221
59 K: Southern Netherlands school ca 1560, A 4487
60: Master of the St Elizabeth panels, A 1727
61: Netherlands school? 17th century, A 512
62-64: Unknown school: returned loan
65: COST A 4627
66: COST A 4629
67: COST A 4631
68: COST A 4632
69: COST A 4633
70: COST A 4630
71: COST A 4634
72: COST A 4636
73: COST A 4635
74: COST A 4637
75: COST A 4638
76: COST A 4628
77: Jacobsz, C: returned loan
78: Utrecht school 2d quarter 16th century, A 1728
78a: Bassano, J, A 2127
78 D 1: Netherlands school 1st quarter 17th century, A 4152
78 M 1: Northern Netherlands school ca 1625, C 1551
79: Southern Netherlands school ca 1580, A 4465
80: Southern Netherlands school ca 1580, A 4466
81: Southern Netherlands school ca 1580, A 4467
81a: Netherlands school 1573, A 2372
82: Netherlands school ca 1580, A 4464
83: Holland school 1617, A 4482
84: Northern Netherlands school ca 1650, A 4473
85: Northern Netherlands school ca 1650, A 4472
86: Northern Netherlands school ca 1650, A 4471
87: Northern Netherlands school ca 1650, A 4477
88: Northern Netherlands school ca 1650, A 4475
89: Northern Netherlands school ca 1650, A 4476
90: Northern Netherlands school ca 1650, A 4474
91: VANM A 4083
92: Caullery, L de, A 4292
93: Netherlands school 2d half 17th century, C 428

94: Beert, O, A 4247
95: Netherlands school ca 1615, A 1441
95a = 95 A 1: Netherlands school ca 1590, C 1222
96: Northern Netherlands school 1626, A 1975
96a: Holland school: returned loan
97: Venne, A P van de, A 434
98: Monogrammist I S H, C 529
99: Northern Netherlands school ca 1620, A 1429
100: Netherlands school ca 1630, A 1752
100a: Northern Netherlands school 1624, A 2309
101: Holland school ca 1640, A 608
102: Holland school 1641, A 4483
103: Holland school: returned loan
104: Holland school 1620, A 1852
104a: Holland school 1933, A 2258
105: Netherlands school? 17th century, A 2094
106: Holland school: returned loan
107: Zijl, R van, A 1611
107a: Holland school: returned loan
107 A 1 = 107b: Leiden school ca 1630, A 2365
107d: Netherlands school 4th quarter 17th century, A 2629
107 E 1: Northern Netherlands school 1st half 17th century?, A 4170
108: Poel, E van der, A 117
109: Man, C de, C 151
109 E 1: Haarlem school? ca 1660, A 4017
109 E 2: Holland school ca 1630, A 4066
110: Bijlert, J van, C 310
111: Bijlert, J van, A 1285
112: Holland school 18th or 19th century, C 278
112a: Hainz, G, A 2550
112b: Northern Netherlands school? 2d half 17th century, A 2551
112c-d: Holland school: returned loan
113: Holland school 18th or 19th century, A 592
114: Loef, J G, A 4261
115: Eyck, N van, A 619
116: Diest, W van, A 1382
116a: Holland school mid-17th century, C 426
116b: Holland school 2d quarter 17th century, A 3492
117: Hoef, A van, A 1753
118: Gruyter, J de, A 1381
118a: Northern Netherlands school 18th century, A 2534
118 A 1: Northern Netherlands school mid-17th century, A 1205 & A 1206
118 A 2: Northern Netherlands school mid-17th century, A 1203 & A 1204
118 A 3: Northern Netherlands school mid-17th century, A 2522a-c
118 A 4: Northern Netherlands school mid-17th century, A 2521a-b
118 A 5: Northern Netherlands school mid-17th century, A 2520a-d
118 A 6: Northern Netherlands school mid-17th century, A 2519a-d
118 A 7: Northern Netherlands school 17th century, A 1236
118 A 8: Northern Netherlands school 17th century, A 1231
118 A 9: Northern Netherlands school mid-17th century, A 2306
118 A 10: Northern Netherlands school mid-17th century, A 4470
118 A 11: Northern Netherlands school 2d half 17th century, A 1211-A 1214
118 A 12: Northern Netherlands school 2d half 17th century, A 1238
118 A 13: Holland school ca 1680, A 2716
118 A 14: Northern Netherlands school ca 1670, A 1640
118 A 15: Eversdijck, W, A 3829
118 A 16: Northern Netherlands school? late 17th century, A 4121
118b: Northern Netherlands school 2d half 17th century, A 1238
118c: Northern Netherlands school mid-17th century, A 1205 & A 1206
118d: Northern Netherlands school mid-17th century, A 1203 & A 1204
118e: Northern Netherlands school mid-17th century, A 2522a-c
118f: Northern Netherlands school mid-17th century, A 2521a-b
118g: Northern Netherlands school mid-17th century, A 2520a-d
118h: Northern Netherlands school 17th century, A 1236
118i: Northern Netherlands school mid-17th century, A 2519a-d
118k: Northern Netherlands school 17th century, A 1231
118m: Northern Netherlands school mid-17th century, A 2306
119: Northern Netherlands school ca 1705, A 1947
119a = 119 A 1: Northern Netherlands school ca 1690, A 741
119b: VANM A 4085
119c: VANM A 2055
120: Elliger, O, C 215
121: Northern Netherlands school 2d half 17th century, A 1882
121a: Holland school 1st quarter 18th century, A 1207-A 1210
121b: Northern Netherlands school 18th century, A 1347
121 B 1: Holland school 4th quarter 18th century, A 1207-A 1210
121 B 2: Northern Netherlands school 18th century, A 1347
121 B 3: Northern Netherlands school 18th century, A 1346
121 B 4: Northern Netherlands school? 18th century, A 610
121 B 5: Aa, D van der, A 1300
121 B 6: Aa, D van der, A 1301

121 B 7: Northern Netherlands school 1st half 19th century, A 2833
121 B 8: Holland school 1st quarter 18th century, A 2839
121 B 9: Holland school mid-18th century, A 2686
121 B 10: Holland school mid-18th century, A 2687
121 B 11: Holland school ca 1690, A 2805 & A 2806
121 B 12: Northern Netherlands school 18th century, A 2534
121 B 13: Holland school 18th century, A 891
121 B 14: Holland school 18th century, A 890
121 B 15: Northern Netherlands school 18th century, A 4179
121 B 16: Northern Netherlands school 1792, A 4194
121 B 17: Amsterdam school 2d half 18th century, C 1562
121c: Northern Netherlands school 18th century, A 1346
121d: Northern Netherlands school? 18th century, A 610
121e: Aa, D van der, A 1300
121f: Aa, D van der, A 1301
121g: Northern Netherlands school 1st half 19th century, A 2833
121h: Holland school mid-18th century, A 2686
121i: Holland school mid-18th century, A 2687
121k: Holland school ca 1690, A 2805 & A 2806
121m: Northern Netherlands school 18th century, A 2534
121n: Holland school 18th century, A 891
122: Northern Netherlands school? ca 1820, A 4481
122 F 1: English school mid 19th century, A 4217
122 M 1: Northern Netherlands school 1858, A 4105
122 S 1: Northern Netherlands school mid-19th century, A 4208
122 S 2: Northern Netherlands school mid-19th century, A 4647
122 T 1: Amsterdam school mid-19th century, C 1545
122 U 1: Amsterdam school ca 1875, C 1576
122 W 1: Netherlands school ca 1820, A 4664
123: Northern Netherlands school 3d quarter 19th century, A 1837
124: Girard, H, A 1810
125: Amsterdam school 1606, C 387
126: Holland school: returned loan
126a: Bisschop, C, A 983
127: Holland school: returned loan
128: Holland school: returned loan
129: Amsterdam school ca 1726, C 418
129a: Borselaer, P, A 3457
129 F 1: Northern Netherlands school ca 1430, C 1454
130: Northern Netherlands school ca 1435, A 498
131: Northern Netherlands school ca 1435, A 499
131 H 1: Dordrecht school ca 1455, A 3926
132: Master of Alkmaar, C 53
133: Master of Alkmaar, C 54
134: Holland school: returned loan
135: Holland school: returned loan
136: Master of Alkmaar, C 57
137: Holland school: returned loan
138: Northern Netherlands school ca 1510, A 1547
139: Northern Netherlands school ca 1510, A 1548
140: Utrecht school ca 1520, A 513
141: Northern Netherlands school ca 1525, A 2107
142: Northern Netherlands school ca 1525, A 2108
143: Cronenburg, A van, A 1993
144: Cronenburg, A van, A 1994
145: Mostaert, J, A 743
146: Netherlands school? 1542, A 4462
146 A 1: Netherlands school? 1542, A 4027
147: Friesland school 1542, A 1992
148: Netherlands school? ca 1550, A 4463
149: Netherlands school? ca 1550, A 977
150: Northern Netherlands school ca 1530, A 894
150 M 1: Northern Netherlands school ca 1530, A 4056
151: Scorel, J van, A 1855
151 M 1: Northern Netherlands school 1557, A 4196
152: Zeeuw, C de, A 1537
152a-b: Holland school: returned loan
153: Willaerts, Adam, A 502
154: Dijk, Ph van, A 892
155: Southern Netherlands school 1575, A 904
155a: Holland school: returned loan
155 M 1: Northern Netherlands school 1578, C 1560
156: Dijk, Ph van, A 893
157: Amsterdam school 1560, C 33
158: Amsterdam school 1560, C 34
159: Amsterdam school 1573, C 35
160: Amsterdam school 1583, C 36
161: Amsterdam school 1583, C 37
162: MIN Holland school ca 1580, C 32
162a-f: Holland school: returned loan
163: MIN Netherlands school ca 1575, A 4422
164: MIN Netherlands school ca 1575, A 4394
165: MIN Northern Netherlands school 17th century?, A 4423
166: Pietersz, A, C 525
166a: Barendsz, D, A 2164
167: Master of the Portrait of Adie Lambertsz, A 970
168: Mor van Dashorst, A, A 1560
169: Amsterdam school 1593, A 1984
170: Amsterdam school 1593, A 1985
171: Netherlands school ca 1580, A 922
172: Holland school 1597, A 1841

173: Northern Netherlands school ca 1610, A 587
174 & 175: Holland school: returned loan
175a: Venetian school ca 1590, A 2242
175b: Northern Netherlands school ca 1615, A 2871
176: Holland school: returned loan
177: HON A 528
178: HON A 523
179: HON A 522
180: HON A 524
181: HON A 527
182: HON A 537
183: HON A 541
184: HON A 551
185: HON A 563
186: Northern Netherlands school 1590, A 575
187: Miereveld, M J van, A 260 & A 1723
188: MIN Holland school ca 1635, A 4432
189: Northern Netherlands school ca 1600, A 577
190: Northern Netherlands school ca 1615, A 576
191: Northern Netherlands school ca 1610, A 875
192: Northern Netherlands school ca 1610, A 876
193: Northern Netherlands school ca 1615, A 1230
194: Northern Netherlands school ca 1610, A 877
195: Northern Netherlands school ca 1600, A 1469
196: Holland school 1637, A 1675
197: Northern Netherlands school ca 1615, A 738
198: Northern Netherlands school ca 1625, A 328
199: Holland school 1601, A 1580
199 A 1: Northern Netherlands school 1601, A 3912
199 D 1: MIN Netherlands school ca 1610, A 4095
200: Northern Netherlands school? 1st half 17th century, A 4649
201: Northern Netherlands school 1604, A 956
202: Northern Netherlands school 1608, C 506
202 D 1: Holland school: returned loan
203: MIN Northern Netherlands school ca 1645, A 4425
204: MIN Northern Netherlands school 1614, A 2104
205: Holland school 1617, A 981
205a = 205 A 1: Northern Netherlands school ca 1620, A 2727
206: Northern Netherlands school 1616, A 905
207: Mesdach, S, A 913
208: Northern Netherlands school 1622, A 2075
209: Northern Netherlands school 1623, A 2076
210: Northern Netherlands school 1627, A 2079
211: Northern Netherlands school 1629, A 2077
212: Northern Netherlands school 1630, A 2074
213: Northern Netherlands school 1645, A 2080
214: Netherlands school ca 1600, A 1309
215: Northern Netherlands school 1622, A 1316
216: Holland school ca 1650, C 289
217: Holland school ca 1635, A 567
218: Northern Netherlands school ca 1590, A 4468
219: Northern Netherlands school 1623, A 823
220: MIN Kessler, F, A 4331
221: Northern Netherlands school 1626, C 1528
221a = 221 A 1: Northern Netherlands school ca 1645, C 1225
222: Holland school 1634, A 578
223: Holland school: returned loan
224: Northern Netherlands school 1627, A 4469
225: Northern Netherlands school ca 1640, A 203
226: Northern Netherlands school ca 1655, A 842
227: Holland school ca 1640, A 1248
227a: Northern Netherlands school 1630, A 2196
228: Amsterdam school ca 1650, C 42
229: MIN Northern Netherlands school ca 1645, A 4426
230: Northern Netherlands school ca 1590, A 636
231: Northern Netherlands school 1633, A 326
232: Northern Netherlands school 1633, A 327
232 E 1: Northern Netherlands school 1639, A 4101
233: Northern Netherlands school 1643, A 920
234: Northern Netherlands school 1644, A 1252
234a: Amsterdam school 1655, C 1172
235: Vaillant, W, C 39
236: Vaillant, W, C 40
236b: Northern Netherlands school ca 1660, A 2967
236c: Northern Netherlands school ca 1600, A 2867
236d: Northern Netherlands school ca 1600, A 3216
236 D 1: Holland school: returned loan
236 D 2: Northern Netherlands school ca 1660, A 2967
236 D 3: Northern Netherlands school ca 1600, A 2867
236 D 4: Northern Netherlands school ca 1600, A 3216
236 D 5: Netherlands school ca 1550, A 3215
236 D 6: Northern Netherlands school ca 1625, A 3217
236 D 7: Southern Netherlands school ca 1615, A 2864
236 D 8: Southern Netherlands school ca 1615, A 2865
236e: Netherlands school ca 1550, A 3215
236 E 1: Northern Netherlands school ca 1650, A 3881
236 E 2: Northern Netherlands school ca 1650, A 3882
236f: Northern Netherlands school ca 1625, A 3217
236g: Southern Netherlands school ca 1610, A 2864
236 G 1: Utrecht school mid-16th century, A 4485
236h: Southern Netherlands school ca 1625, A 2865
236 M 1: Italian school 17th century, A 1220
237: Amsterdam school ca 1670, A 635

238: Amsterdam school ca 1645, A 588
239: Amsterdam school 1654, C 38
240: Holland school 1656-57, A 583
241: Holland school 1656-57, A 584
242: Holland school 1657, A 586
243: Northern Netherlands school ca 1670, A 819
244: Northern Netherlands school ca 1670, A 820
244a=244 A 1: Northern Netherlands school ca 1660, A 805
244 A 2=244b: Northern Netherlands school ca 1660, A 806
245: Coeman, J J, A 807
246: Coeman, J J, A 809
246a=246 A 1: Holland school ca 1675, A 2869
247: MIN Northern Netherlands school 1655, A 2085
247a=247 A 1: MIN Northern Netherlands school ca 1640, A 2207
248: MIN Northern Netherlands school ca 1675, A 2098
249: HON A 565
250: Netscher, Casp, C 175
251: Zeeland school 1664, A 923
252: Jonson van Ceulen II, C, A 921
253: Northern Netherlands school ca 1660, A 1913
254: Northern Netherlands school ca 1670, A 609
255: Northern Netherlands school ca 1670, A 1422
256: Northern Netherlands school ca 1680, A 1671
256a-e: Holland school: returned loan
256 E 3: Northern Netherlands school ca 1660, A 4018
256f: Holland school: returned loan
257: Northern Netherlands school ca 1680, A 1628
257a: Holland school: de-acceded
257b: Northern Netherlands school? ca 1695, A 4479
257c: Northern Netherlands school? ca 1695, A 4480
258: Holland school ca 1660, A 724
259: Northern Netherlands school ca 1665, A 1260
260: Northern Netherlands school ca 1665, A 1261
261: Holland school: returned loan
261 M 1: Zeeland school ca 1665, A 4124
262: Holland school ca 1690, A 822
263: Holland school ca 1690, A 821
264: Holland school ca 1690, A 824
265: Holland school ca 1690, A 827
266: Boonen, A, A 1263
266a: Holland school: de-acceded
266b: Northern Netherlands school ca 1675, A 2868
266c: Northern Netherlands school ca 1655, A 2866
267: Northern Netherlands school ca 1710, A 811
268: Northern Netherlands school ca 1710, A 812
269: Verkolje, N, A 813
270: Holland school 1720, C 526
270a=270 A 1: MIN Northern Netherlands school ca 1700, A 2208
271: Northern Netherlands school ca 1700, A 630
272: Werff, P van der, A 631
273: Werff, P van der, A 632
274: Northern Netherlands school ca 1710, A 626
275: Northern Netherlands school ca 1710, A 634
276: Northern Netherlands school ca 1710, A 628
276a: Northern Netherlands school ca 1725, A 2803
277: Northern Netherlands school ca 1710, A 629
278: Northern Netherlands school ca 1710, A 627
279: ROT A 4516
280: ROT A 4519
281: ROT A 4520
282: PAN A 4617
282 M 1: Northern Netherlands school ca 1730, C 1570
282 M 2: Northern Netherlands school ca 1745, C 1575
283: Behr, J Ph, A 885
284: MIN Northern Netherlands school ca 1745, A 4430
285: Holland school 1745, A 884
286: Holland school ca 1745, A 883
287: Holland school 1745, A 1797
287 D 1: Danish school ca 1760, A 978
288: Aved, J A J, A 880
289: Pothoven, H, A 663
290: Zeeland school ca 1760, A 924
291: Amsterdam school ca 1775, C 41
292: Liotard, J-E, C 43
293: Liotard, J-E, C 44
293a: MIN Northern Netherlands school ca 1745, A 2209
293b: MIN Northern Netherlands school ca 1745, A 2210
294: Northern Netherlands school ca 1775, A 1476
295: Northern Netherlands school ca 1755, A 1477
295b: Northern Netherlands school ca 1760, A 926
295c: MIN Northern Netherlands school ca 1775, A 2177
295d: MIN Northern Netherlands school ca 1775, A 2178
295e: Northern Netherlands school 2d half 18th century, A 1332
295f: Northern Netherlands school 2d half 18th century, A 1334
295g: Northern Netherlands school 2d half 18th century, A 1333
295 G 1: Oets, P, C 1325
295h: Northern Netherlands school 2d half 18th century, A 1335
295 H 1: Krafft, D von, A 982
295i: Northern Netherlands school? mid-18th century, A 2870
296: Northern Netherlands school ca 1815, A 1519
297: Pieneman, J W, A 1520
298: Northern Netherlands school ca 1815, A 925
298a: Sangster, H A, A 1678

298b: Northern Netherlands school ca 1830, A 2171
298c: Northern Netherlands school ca 1830, A 2172
298d: Schwartze, J G, A 2170
298e: Holland school: de-acceded
298 M 1: Holland school 1948, C 1461
299: Ketel, C, A 244
300: MIN Northern Netherlands school ca 1615, A 4424
301: Northern Netherlands school ca 1655, A 1638
302: Asch, P J van, A 2106
303: Hooch, P de, A 181
303a: Liotard, J-E, A 2656
303b: Sam, E, A 2694
303 B 1: Liotard, J-E, A 2656
303 E 1: Northern Netherlands school ca 1680, A 3895
304: Spilman, H, A 1583
305: Ekels II, J, A 1846
305a: Northern Netherlands school ca 1830, A 2798
305b: Holland school ca 1850, A 2861
305c: Holland school ca 1850, A 2862
305 M 1: Northern Netherlands school? ca 1850, A 4193
306: GOV A 4525
307: GOV A 4526
308: GOV A 4527
309: GOV A 4528
310: GOV A 4529
311: GOV A 4530
312: GOV A 4531
313: GOV A 4532
314: GOV A 4533
315: GOV A 4534
316: GOV A 4535
317: GOV A 4536
318: GOV A 4537
319: GOV A 4538
320: GOV A 4540
321: GOV A 4541
322: GOV A 4542
323: GOV A 4543
324: GOV A 4545
325: GOV A 4547
326: GOV A 4550
327: GOV A 4551
328: GOV A 4552
328 B 1: GOV A 3755
328 B 2: GOV A 3756
328 B 3: GOV A 3757
328 B 4: GOV A 3758
328 B 5: GOV A 3759
328 B 6: GOV A 3760
328 B 7: GOV A 3761
328 B 8: GOV A 3762
328 B 9: GOV A 3763
328 B 10: GOV A 3764
328 B 11: GOV A 3766
328 B 12: GOV A 3767
328 B 13: GOV A 3769
328 B 14: GOV A 3771
328 B 15: GOV A 3774
328 B 16: GOV A 3779
328 B 17: GOV A 3780
328 B 18: GOV A 3781
328 B 19: GOV A 3782
328 B 20: GOV A 3788
328 B 21: GOV A 3794
329: Florentine school ca 1375, A 1294
329a: Venetian school 1st half 16th century, A 1296
329 A 1: Pisan school ca 1250, A 3392
329 A 2: Pisan school ca 1250, A 3393
329 B 1: Pseudo Ambrodigio di Baldese, A 2589
329 B 2: Venetian-Byzantine school end 13th century, A 4461
329 D 1: Machiavelli, Z, A 3442
329 D 2: Sienese school 1451-52, A 3429
329 D 3: North Italian school 2d half 15th century, A 2590
329 D 4: Sienese school 1450, A 3998
329 E 1: Venetian school 1st half 16th century, A 1296
329 G 2: North Italian school 2d quarter 16th century, A 3411
329 H 1: Brescian school 1st half 16th century, A 3035
329 K 1: Ceruti, G, A 3406
330: Polidoro da Lanciano, C 308
331: Ferrarese school 2d quarter 16th century, A 109
331a: Italian school: returned loan
332: Stomer, M, A 216
332a: Florentine school 2d quarter 16th century, A 1226
332 BM 1: Russian school 1st half 18th century, A 116
332 D 1: Catalan school last quarter 15th century, A 3105
332 D 2: Aragonese school last quarter 15th century, A 3469
333: Carreño de Miranda, J, A 1425
334: Italian school 2d half 17th century, A 596
335: Mazo, J B M del, A 433
336: Spanish school? ca 1615, C 311
337: Serodine, G, A 332
337 S 1: VANM, A 4085
338: Northern Netherlands school ca 1435, A 954

339: Southern Netherlands school 1561, A 4488
340: Coter, C de A 856
340a: Southern Netherlands school: returned loan
340b: Southern Netherlands school ca 1500, A 2552
340c & 341: Southern Netherlands school: returned loan
342: Master of the Legend of St Barbara, A 2057
342a: Master of the Amsterdam Death of the Virgin, A 2129
342aa: Master of the Legend of St Ursula, A 3326
342b: Master of the Amsterdam Death of the Virgin, A 2130
343: Master of the Joseph Sequence, A 960
344: Master of the Joseph Sequence, A 961
344a: Southern Netherlands school 2d half 15th century, A 3835
344b: Southern Netherlands school 2d half 15th century, A 3836
344 E 1: Southern Netherlands school 2d half 15th century, A 3835
344 E 2: Southern Netherlands school 2d half 15th century, A 3836
345: Bosch, J, A 1673
346: Southern Netherlands school late 17th century, A 962a
346a-b: Southern Netherlands school: returned loan
346c: Master of the Aix Annunciation, A 2399
346d: Master of the Female Halflengths, A 3130
346dd: Master of the Female Halflengths, A 3255
346e: Master with the Parrot, A 3225
346 E 1: Southern Netherlands school 1557, A 2587
346 E 4: Brabant school 2d half 15th century, A 2800
346 E 5: Southern Netherlands school 17th century, A 4651
346f: Bruges school ca 1450-70, A 2851
346g: Southern Netherlands school 1557, A 2587
346h: South German school early 16th century, A 2595
346 H: Southern Netherlands school ca 1530, A 2591
347: Dalem, C van, A 1991
347a: Bruges school 1584, A 1668
347b: Southern Netherlands school 1561, A 4488
347 M 1: Southern Netherlands school ca 1570, C 1579
348: Southern Netherlands school? ca 1575, A 1287
349: Southern Netherlands school? ca 1575, A 1288
349a: Dalem, C van, A 4293
349 A: School of Fontainebleau: returned loan
349 B 1: Zeeuw, C de, A 1537
350: Swanenburgh, J I, A 730
351: Mostaert, G, A 972
351b: Southern Netherlands school: returned loan
351c: English school ca 1585, A 2684
351f: Southern Netherlands school ca 1570, A 3851
352: Southern Netherlands school ca 1607, A 740
352 E 1: Southern Netherlands school ca 1570, A 3851
352 E 2: Southern Netherlands school 1565, A 4071
353: Southern Netherlands school ca 1600, A 507
354: Southern Netherlands school ca 1600, A 508
355: Southern Netherlands school ca 1600, A 509
356: Southern Netherlands school ca 1600, A 510
357: Caullery, L de, A 1956
357a: Southern Netherlands school: returned loan
357 A: Southern Netherlands school? 17th century, A 3353
357b-c: Southern Netherlands school: returned loan
357d: Northern Netherlands school 1655, A 3354
358: Brueghel I, J, A 2102
358a: Southern Netherlands school: returned loan
358b: Solimena, F, A 996
358c: Southern Netherlands school 2d quarter 17th century, A 3027
358 E 1: Southern Netherlands school 1st half 17th century, C 1484
359: Spanish school 2d half 17th century, A 4489
359a: North German school 2d quarter 15th century, A 2553
359b: Southern Netherlands school: returned loan
359c: Spanish school? 17th century, A 2394
359 F 1: English school 2d half 16th century, C 1466
359 M 1: German school? 1st half 17th century, A 4097
359 M 2: Southern Netherlands school? 16th century, A 4184
359 M 3: Southern Netherlands school? 16th century, A 4185
359 M 4: Southern Netherlands school? 16th century, A 4186
360: Eriksen, V, A 1929
361: German school ca 1765, A 1223
361a: Rubens, P P, A 2516
361b: Northern Netherlands school ca 1645, C 427
361c: Northern Netherlands school ca 1815, C 1323
361d: French school ca 1720, C 1324
361e: Holland school ca 1680, A 2716
361f: Southern Netherlands school? 2d quarter 17th century? A 947
361g: Luima, P, A 2514
361 M 1: Northern Netherlands school? 1844, A 4158
362: Anraedt, P van, C 440
363: Anraedt, P van, A 1960
363a: Anraedt, P van, A 2416
364: Anraedt, P van, A 2
364 A 1: Anraedt, P van, A 2416
365: Anraedt, P van, A 1350
365 A 1: Anraedt, P van, A 2416
366: Anthonisz, C, C 409
366a: Anthonissen, H van, A 2126

505 A 1: Beyeren, A van: returned loan
505 A 2: Beyeren, A van, A 3828
505 A 3: Beyeren, A van: de-acceded
505 A 4: Beyeren, A van, A 3944
505 A 5: Beyeren, A van: returned loan
505 A 6: Beyeren, A van, A 4073
506: Beyeren, A van, A 355
506a: Beyeren, A van: returned loan
506b: Beyeren, A van: returned loan
507: Bie, C de, A 1419
508: Bieselingen, Chr J van, A 1631
509: Bilders, A G, A 2297
509 A 1: Bilders, A G, A 2262
509 A 2: Bilders, A G, A 2263
509 A 3: Bilders, A G, A 2264
509 A 4: Bilders, A G, A 3072
509 A 5: Bilders, A G, A 3073
510: Bilders, A G, A 2298
510a: Bilders, A G, A 2262
510b: Bilders, A G, A 2263
510c: Bilders, A G, A 2264
510d: Bilders, A G, A 3072
510e: Bilders, A G, A 3073
511: Bilders, J W, A 1008
511 A 1: Bilders, J W, A 3074
512: Bilders, J W, A 1734
513: Bilders-van Bosse, M Ph, A 1922
514: Bisschop, C, A 2110
515: Bisschop, C, A 1432
516: Bisschop, Chr, A 1801
516a = 516 A 1: Bisschop, Chr, A 3060
516 A 2: Bisschop, Chr, A 3726
517: Bisschop-Swift, C S F, A 1802
517a = 517 B 1: Diana, B, A 3014
518: Blaaderen, G W van, A 2715
518 G 1: Blanchard, J, A 4091
518 M 1: Blanckerhoff, J Th, A 3235
519: Bleecker, D, A 782
520: Bles, D J, A 1009
521: Bles, D J, A 1803
522: Bles, H met de, A 780
522 B 1: Coecke van Aelst, P, A 2594
523: Blieck, D de, A 1604
524: Block, E F de, C 576
525: Bloemaert, A, A 1990
525 A 1: Bloemaert, A, A 3743
525 A 2: Bloemaert, A, A 3746
526: Bloemaert, H, A 674
527: Bloemaert, H, C 106
528: Bloemaert, H, A 735
529: Bloeme, H A de, A 1173
529 A 1: G O V A 3803
530: Bloemen, N van, A 786
531: Blommers, B J, A 2296
531 A 1: Blommers, B J: de-acceded
531 A 2: Blommers, B J, A 3075
531 A 3: Blommers, B J, A 3076
532: Blommers, B J, A 1327
533: Blondeel, L: returned loan
534: Bloot, P de, A 660
534 A 1: Buesum, J J, A 2555
535: Bloot, P de, A 1468
535a: Buesum, J J, A 2555
535b: Bega, C: returned loan
536: Blijhooft, Z, A 825
537: Blijhooft, Z, A 826
537a: Bock, Th E A de: returned loan
537b = 537 B 1: Bock, Th E A de, A 2493
537 B 2: Bock, Th E A de, A 2494
537 B 3: Bock, Th E A de, A 2495
537 B 4: Bock, Th E A de, A 3576
537 B 5: Bock, Th E A de, A 3577
537 B 6: Bock, Th E A de: technical accession
537 B 7: Bock, Th E A de, A 3077
537 B 8: Bock, Th E A de: returned loan
537c: Bock, Th E A de, A 2494
537d: Bock, Th E A de, A 2495
537e: Bock, Th E A de, A 3576
537f: Bock, Th E A de, A 3577
537g: Bock, Th E A de: technical accession
537h: Dubois, G, A 3115
538: Bol, C, A 4250
539: Bol, F, A 42
540: Bol, F, C 436
541: Bol, F: returned loan
542: Bol, F, C 367
543: Bol, F, A 683
544: Bol, F, A 684
545: Bol, F, A 43
546: Bol, F, A 46
547: Bol, F, A 45
548: Bol, F, C 107
549: Bol, F, A 44

550: Bol, F, C 626
551: Hogers, J, A 804
552: Bol, F, A 1577
552a = 552 A 1: Bol, F, C 1176
552 A 2: Bol, F, A 714
552 A 3: Bol, F, A 1575
552 A 4: Bol, F, A 1576
552 A 5: Bol, F, A 1578
552 A 6: Bol, F, A 1579
552 A 7: Bol, F, A 1577
552 A 8: Bol, F, A 1937
552 A 9: Bol, F, A 613
552 A 10: Bol, F, A 614
552b: Bol, F, A 1575
552c: Bol, F, A 1576
552d: Bol, F, A 1578
552e: Bol, F, A 1579
552f: Bol, F, A 1937
553: Bol, F, A 2736
553a: Bol, F, A 613
553b: Bol, F, A 614
554: Bollongier, H, A 799
555: Bolomey, B S, A 965
556: Bolomey, B S, A 948
557: Bolomey, B S, A 949
558: Bombled, K F, A 1735
558a: Bonnat, L J F, A 2246
558 A: Bonington, R P: returned loan
558 D 1: Bonifazio Veronese, C 1374
558 E 1: Bonnat, L J F, A 2246
558 F 1: Bonsignori, F, A 3991
559: Bonvin, F, A 1859
560: Boone, D, A 987
561: Boone, D, A 1600
562: Boonen, A, C 444
563: Boonen, A, C 368
563 A 1: Boonen, A, C 1468
564: Boonen, A: returned loan
565: Boonen, A, C 445
565 A 1: Boonen, A, A 1914
565 A 2: Boonen, A, A 1915
565 A 3: Boonen, A, A 1263
565 A 4: Boonen, A, C 1567
565 A 5: Boonen, A, C 1568
566: Boonen, A, A 1266
566a: Boonen, A, A 1263
566b: Boonen, A, A 1914
566c: Boonen, A, A 1915
567: Bor, P, A 852
567 A 1: Bor, P, C 1518
568: Borch, G ter, A 402
569: Borch, G ter, A 403
569a: Netscher, Casp, A 2556
570: Borch, G ter, A 404
571: Borch, G ter, A 1784
572: Borch, G ter, A 1785
573: Borch, G ter, A 1786
573a = 573 A 1: Borch, G ter, A 2417
573 A 2: Borch, G ter, A 2418
573 A 3: Netscher, Casp, A 2556
573 A 4: Borch, G ter, A 3963
573 A 5: Borch, G ter, A 3964
573 A 6: Borch, G ter, A 3842
573 A 7: Borch, G ter, A 4039
573 A 8: Borch, G ter, A 4038
573b: Borch, G ter, A 2418
574: Borch, G ter: returned loan
575: Borch, G ter: returned loan
576: Borch, G ter, A 405
577: Borch, G ter, C 242
578: Borch, J ter, A 1331
578a: Borch, M ter, A 2118
578b: Borch, M ter, A 2240
578 B 1: Borch, M ter, A 2118
578 B 2: Borch, M ter, A 2240
578 B 3 = 578c: Borch, M ter, A 2241
579: Borculo, N van, A 4251
579a: Borgognone, A, A 3031
579 B 1: Bordone, P, A 3380
579 D 1: Borgognone, A, A 3031
580: Borman, J, A 754
580a = 580 G 1: Borselaer, P, A 2397
581: Borselen, J W van, A 1010
582: Borssum, A van, A 744
583: Borssum, A van, A 1535
584: Bosboom, J, A 1011
584a = 584 A 1: Bosboom, J, A 2380
584 A 2: Bosboom, J, A 2700
584 A 3: Bosboom, J, A 2877
584 A 4: Bosboom, J, A 2878
584 A 5: Bosboom, J, A 3578
584 A 6: Bosboom, J: technical accession
584 A 7: Bosboom, J, A 3078

584 A 8: Bosboom, J, A 3079
584b: Bosboom, J, A 2700
584c: Bosboom, J, A 2877
584d: Bosboom, J, A 3578
585: Bosboom, J, A 1804
585 Z 1: G O V A 3772
585 Z 2: G O V A 3773
586: G O V A 4544
586 A 1: G O V A 3775
586 A 2: G O V A 3776
587: Bosch, J, A 1601
588: Bosch, J, A 1795
588 A 1: Bosch, J, A 4252
588 A 2: Bosch, J, A 3113
588 A 3: Bosch, J, A 3240
588 A 4: Bosch, J, A 4131
589: Bosch, J, A 124
589a: Bosch, J, A 3113
589b: Bosch, J, A 3240
590: Bosschaert, A, A 1522
590a = 590 D 1: Both, A, A 2557
591: Both, J, C 109
592: Both, J, A 49
593: Both, J, A 52
594: Both, J, C 110
595: Both, J, A 50
596: Both, J, A 51
596a = 596 A 1: Both, J: de-acceded
597: Both, J, A 1938
597 B 1: Botticelli, A, A 3381
597 D 1: Botticini, F, A 3382
597 G 1: Boucher, F, A 4014
597 M 1: G O V A 3811
598: Boulard, A, A 1860
599: Bourdon, S, A 53
599 A 1: Leone, A de, C 1346
600: Bourgoin, A G A, A 1736
601: Boursse, E, A 767
601a: Bout, P, A 2558
601b: Bouts, A: returned loan
601 G 1: Bout, P, A 2558
601 L 1: Bouts, A: returned loan
602: Boy, G, A 971
602a = 602 G 1: Braque, G: returned loan
603: Braekeleer, F de, C 281
604: Braekeleer, F de, A 966
605: Brakenburg, R, A 54
606: Brakenburg, R, A 55
606 D 1: Bramantino, A 3383
607: Bramer, L, A 845
608: Bramer, L, A 2093
609: Hogers, J, A 787
610: Brandt, A J, A 1012
611: Brandt, A J, A 1013
612: Brascassat, J R, A 1326
613: Brassauw, M, A 57
613a = 613 G 1: Bray, D de: returned loan
614: Bray, J de, A 58
614a = 614 A 1: Bray, J de, A 2353
614 A 2: Bray, J de, A 3280
615: Bredael, J van, A 59
616: Bree, M I van, A 1172
617: Bree, M I van, A 1540
617 A 1: Bree, M I van, A 3136
617 A 2: Bree, M I van: returned loan
617 A 3: Bree, M I van, A 4088
617 A 4: Bree, M I van, A 4234
618: Bree, M I van, A 4253
618a: Bree, M I van, A 3136
619: Breen, A van, A 955
619a = 619 A 1: Breen, A van, A 2510
620: Breenbergh, B, A 1724
620 A 1: Groenewegen, P A van, A 3965
621: Breenbergh, B, A 1482
622: Breitner, G H, A 1328
622a = 622 A 1: Breitner, G H, A 2879
622 A 2: Breitner, G H, A 2880
622 A 3: Breitner, G H, A 2881
622 A 4: Breitner, G H, A 3579
622 A 5: Breitner, G H, A 3580
622 A 6: Breitner, G H, A 3581
622 A 7: Breitner, G H, A 3582
622 A 8: Breitner, G H, A 3583
622 A 9: Breitner, G H, A 3584
622 A 10: Breitner, G H, A 3585
622 A 11: Breitner, G H, A 3061
622 A 12: Breitner, G H, A 3289
622 A 13: Breitner, G H, A 2968
622 A 14-16: Breitner, G H: technical accession
622 A 17: Breitner, G H, A 3523
622 A 18: Breitner, G H, A 3524
622 A 19: Breitner, G H, A 3525
622 A 20: Breitner, G H, A 3526

622 A 21 : Breitner, G H, A 3527
622 A 22 : Breitner, G H, A 3528
622 A 23 : Breitner, G H, A 3529
622 A 24 : Breitner, G H, A 3530
622 A 25 : Breitner, G H, A 3531
622 A 26 : Breitner, G H, A 3532
622 A 27 : Breitner, G H, A 3533
622 A 28 : Breitner, G H, A 3534
622 A 29 : Breitner, G H, A 3535
622 A 30 : Breitner, G H, A 3536
622 A 31 : Breitner, G H, A 3537
622 A 32 : Breitner, G H, A 3538
622 A 33 : Breitner, G H, A 3539
622 A 34 : Breitner, G H, A 3540
622 A 35 : Breitner, G H, A 3541
622 A 36 : Breitner, G H, A 3542
622 A 37 : Breitner, G H, A 3543
622 A 38 : Breitner, G H, A 3544
622 A 39 : Breitner, G H, A 3545
622 A 40 : Breitner, G H, A 3546
622 A 41 : Breitner, G H, A 3547
622 A 42 : Breitner, G H, A 3548
622 A 43 : Breitner, G H, A 3549
622 A 44 : Breitner, G H, A 3550
622 A 45 : Breitner, G H, A 3551
622 A 46 : Breitner, G H, A 3552
622 A 47 : Breitner, G H, A 3553
622 A 48 : Breitner, G H, A 3554
622 A 49 : Breitner, G H, A 3555
622 A 50 : Breitner, G H, A 3556
622 A 51 : Breitner, G H, A 3557
622 A 52 : Breitner, G H, A 3558
622 A 53 : Breitner, G H, A 3559
622 A 54 : Breitner, G H, A 3560
622 A 55 : Breitner, G H, A 3561
622 A 56 : Breitner, G H, A 3562
622b : Breitner, G H, A 2880
622c : Breitner, G H, A 2881
622d : Breitner, G H, A 3579
622e : Breitner, G H, A 3580
622f : Breitner, G H, A 3581
622g : Breitner, G H, A 3582
622h : Breitner, G H, A 3583
622i : Breitner, G H, A 3584
622k : Breitner, G H, A 3585
622l : Breitner, G H, A 3061
622m : Breitner, G H, A 3289
623 : Breitner, G H : returned loan
624 : Brekelenkam, Q G van, A 673
625 : Brekelenkam, Q G van, A 62
626 : Brekelenkam, Q G van, A 685
627 : Brekelenkam, Q G van, C 113
628 : Brekelenkam, Q G van, C 112
629 : Brekelenkam, Q G van, A 60
629 A 1 : Brekelenkam, Q G van, A 2698
630 : Brekelenkam, Q G van, A 61
630a & b : Brekelenkam, Q G van, A 2698
631 : Breton, E A, A 1861
632 : Breuhaus de Groot, F A, A 1014
632a = 632 A 1 : Brice, I, A 1015
633 : Bril, P, A 63
633 A 1 : Bril, P, A 2672
634 : Bril, P, A 1314
635 : Brisé, C : returned loan
636 : Brisé, C, A 1281
637 : Broeck, E van den, A 1463
638 : Broeck, E van den, A 788
639 : Bronckhorst, J J van : returned loan
640 : Bronckhorst, J J van : returned loan
640a = 640 B 1 : Bronzino, A, A 3344
641 : Brouwer, A, A 64
641a = 641 A 1 : Brouwer, A, A 3291
641 A 2 : Brouwer, A, A 4040
641 A 3 : Brouwer, A, A 4041
642 : Brouwer, A, A 65
642a = 642 G 1 : Bruckman, W L, A 3068
643 : Brueghel, A, A 1433
644 : Brueghel I, J, A 67
645 : Brueghel I, J, A 66
646 : Brueghel I, J, A 70
646a = 646 A 1 : Brueghel I, J, A 3290
646 A 2 : Brueghel I, J, A 2102
647 : Brueghel I, J, A 69
648 : Brueghel I, J, A 511
649 : Brueghel I, J, A 68
650 : Brueghel II, P, A 731
651 : Brugghen, G A van der, A 2089
652 : Brugghen, G A van der, A 2090
653 : Brugghen, G A van der, A 2087
654 : Brugghen, G A van der, A 2088
655 : Brugghen, G A van der, A 2092
656 : Brugghen, G A van der, A 2091
656a : Bruyn I, B, A 2559

656 A = 656 A 1 : Brugghen, H ter, A 2783
656 A 2 : Brugghen, H ter, A 2784
656 A 3 : Brugghen, H ter, A 3908
656 A 4 : Brugghen, H ter, A 4188
656 B : Brugghen, H ter, A 2784
656 B 1 : Bruyn I, B, A 2559
656 B 2 : Bruyn I, B, A 4228
656 E 1 : G O V A 3770
656 G 1 : G O V A 3880
657 : Bueckelaer, J, A 1451
657 A 1 : Bueckelaer, J, A 2251
658 : Bueckelaer, J, A 1496
658a : Bundel, W W van den, A 2835
658 AF 1 : Buesum, J J, A 2555
658 B 1 : Bundel, W W van den, A 2835
659 : Burbure, L de, C 534
660 : Burgers, H J, A 1805
660a = 660 B 1 : Burgh, Hendrick van der, C 1182
660 B 2 : Burgh, Hendrick van der, A 2720
661 : Burgh, Hendrik van der, A 1016
662 : Burgh, H A van der, A 1017
663 : Burgh, P D van der, A 1368
664 : Burgh, R van, A 846
665 : Hoopstad, E I, C 115
665a & b = 665 F 1 & 2 : Buys II, C : returned loan
666 : Buys II, C : returned loan
666a = 666 A 1 : Buys II, C, A 2392
666 A 2 : Buys II, C, A 4219
667 : Buijs, J, C 515
667 A 1 : Buijs, J, A 2966
668 : Buijs, J : returned loan
668a : Buijs, J, A 2966
668b : Brouwer, A, A 3015
668 B 1 : Buytewech, W P, A 3038
668 B 2 : Brouwer, A, A 3015
668c : Buytewech, W P, A 3038
669 : Bijlert, J van, A 1338
670 : Bijlert, J van, A 1596
671 : Calame, A, C 302
671a = 671 F 1 : Calcar, J J van, A 2596
672 : Calisch, M, C 117
673 : Calisch, M, C 116
673 A 1 : Calisch, M, A 4181
674 : Calisch, M, A 1515
675 : Calisch, M, A 1516
675 B 1 : Calraet, A van, A 79
675 B 2 : Calraet, A van, C 122
676 : Camerarius, A, A 733
676 B 1 : Girolamo da Sante Croce, A 3966
677 : Campen, J van, A 4254
678 : Camphuijsen, G D, A 1303
679 : Camphuijsen, G D, C 563
680 : Camphuijsen, R G, A 1939
680 B 1 : North Italian school 18th century, A 3386
680 B 2 : Canaletto, A, A 3384
680 B 3 : Canaletto, A, A 3385
680 D 1 : Carreño de Miranda, J, A 1425
681 : Cappelle, J van de, A 453
681a = 681 A 1 : Cappelle, J van de, A 3248
681 A 2 : Cappelle, J van de, A 4042
681 A 3 : Cappelle, J van de, A 4043
682 : Loth, J C, A 71
682 B 1 : Araldi, J, A 3967
682 E 1 : Carpaccio, V, A 3387
682 E 2 : Carpaccio, V, A 3993
682 G 1 : Carracci, L, A 3992
683 : Carrée I, H, A 1493
683 A 1 : Carrée II, H, A 2837
683 A 2 : Carrée II, H, A 2838
683 M 1 : Carreño de Miranda, J, A 1425
684 : Cate, H G ten, A 1018
685 : Cate, H G ten : returned loan
686 : Cate, S J ten, A 2299
686 B 1 : Rondinello, N, A 3388
686 E 1 : Caullery, L de, A 1956
687 : Cels, C, A 1019
688 : Cels, C, C 282
688a : Challe, N, A 2159
688 A 1 : Cels, C, A 4172
688 AS 1 : Ceresa, C, A 4103
688b : Champaigne, Ph de, C 1183
688 B 1 : Cerezo, M, C 1347
688 BE 1 : Ceruti, G, A 3406
688 BF 1 : Chabot, H, C 1485
688 BF 2 : Chabot, H, C 1565
688 BF 3 : Chabot, H, C 1566
688 BK 1 : Challe, N, A 2159
688 D 1 : Champaigne, Ph de, C 1183
688 D 2 : Champaigne, J B de, A 3744
689 : Rossum du Chattel, F J van, A 1806
689 D 1 : G O V A 3792
689 H 1 : Franceschini, M A, C 1348
690 : Cima da Conegliano, G B, A 1219

690a : Jacopo di Cione : returned loan
690 A 1 : Cima da Conegliano, G B, A 3389
690 F 1 : Italian school 2d half 13th century, A 3996
691 : Claesz, A, C 366
692 : Heda, W C, A 137
692 A 1 : Claesz, P : returned loan
692 A 2 : Claesz, P, A 3930
692 A 3 : Claesz, P, A 4646
693 : Claesz, P, A 1857
693a : Claesz, P : returned loan
694 : Claeu, J de, A 1444
694a : Cleve, J van, A 3292
694b : Cleve, J van, A 3293
695 : Clerck, H de, A 621
696 : Clerck, H de, A 1461
696 AG 1 : Clercq, J de, C 1561
696 B 1 : Cleve, J van, A 165
696 B 2 : Cleve, J van, A 3292
696 B 3 : Cleve, J van, A 3293
696 D 1 : Cleve, M van, A 836
697 : Coclers, L B, C 8
698 : Coclers, L B, C 9
699 : Coclers, L B, A 642
699 AB 1 : G O V A 3786
699 B 1 : Cock, J W de, A 1598
699 B 2 : Cornelisz Kunst, C, A 1725
700 : Codde, P, A 789
700a = 700 A 1 : Codde, P, A 2836
701 : Duyster, W C, A 1791
702 : Duyster, W C, A 1792
702 E 1 : G O V A 3765
702 E 2 : Coeman, J J, A 4062
703 : Coene, C F, A 1020
704 : Coene, J H de, A 1021
705 : Coignet, G : returned loan
705 E 1 : Collier, E, A 3471
706 : Colonia, A de, A 1518
707 : Colijns, D, A 1617
708 : Colasius, J G, A 2105
709 : Keun, H, C 119
710 : Compe, J ten, C 1529
711 : Compe, J ten, C 1530
711a = 711 B 1 : Conflans, A van, C 791
712 : Coninck, D de, A 72
713 : Coninck, D de, A 73
714 : Coninck, D de, A 618
715 : Coninck, D de, A 617
716 : Cool, J D, A 1787
717 : Coorte, A S, A 2099
717a : Corneille de Lyon, A 3037
717b : Corneille de Lyon, A 3294
717 B 1 : Corneille de Lyon, A 3037
717 B 2 : Corneille de Lyon, A 3294
718 : Cornelisz van Haarlem, C, A 128
719 : Cornelisz van Haarlem, C, A 129
719 A 1 : Cornelisz van Haarlem, C, A 3016
719 A 2 : Cornelisz van Haarlem, C, A 1241
719 A 3 : Cornelisz van Haarlem, C, A 3892
719 A 4 : Cornelisz van Haarlem, C, A 4015
720 : Cornelisz van Haarlem, C, A 127
720a : Cornelisz van Haarlem, C, A 3016
721 : Cornelisz van Oostsanen, J, A 1405
722 : Cornelisz van Oostsanen, J, A 668
722 A 1 : Cornelisz van Oostsanen, J, C 1125
722 A 2 : Cornelisz van Oostsanen, J, C 1349
722 A 3 : Cornelisz van Oostsanen, J, A 3838
722 A 4 : Cornelisz van Oostsanen, J, C 1554
723 : Cornelisz van Oostsanen, J, A 1967
723a : Cornelisz van Oostsanen, J, C 1125
724 : Buys II, C : de-acceded
725 : Cornet, J L, A 1464
726 : Corot, J B C, A 1862
726a = 726 A 1 : Corot, J B C, A 2882
726 A 2 = 726b : Corot, J B C, A 2883
726c = 726 D 1 : Costa, L, A 3034
726 H 1 : Coter, C de, A 856
727 : Courbet, G, A 1863
728 : Courbet, G, A 1864
728 A 1 : Courbet, G, A 3295
729 : Courbet, G, A 1865
729a : Courbet, G, A 3295
730 : Court, J D, C 303
731 : Couture, Th, A 1866
732 : Couwenberg, A J, A 1022
732 G 1 : Cozza, F, A 4035
733 : Crabeth II, W, A 1965
734 : Craey, D, A 808
735 : Craey, D, A 810
735a : Cranach II, L, A 2560
735b : Cranach I, L, A 2561
735 B 1 : Cranach I, L : returned loan
735 B 2 : Cranach I, L, A 2561
735 D 1 : Cranach II, L, A 2560

736: Crayer, C de, A 74
737: Crayer, C de, A 75
737a = 737 B 1: Master of the Conversazione di Santo Spirito, A 3012
737 D 1: Crivelli, C, A 3989
737 D 2: Crivelli, C, A 3994
737 E 1: Crivelli, V, A 3390
737 E 2: Crivelli, V, A 3391
738: Cunaeus, C, A 1023
738a = 738 A 1: Cunaeus, C, A 2228
739: Heinsius, J E, A 76
740: Cuijlenburg, C van, A 943
741: Cuijlenburg, C van, A 1374
742: Cuijlenburg, C van, A 1216
743: Calraet, A van, A 79
744: Cuyp, A, A 77
745: Cuyp, A, A 78
746: Calraet, A van, C 122
746a: Cuyp, A, A 2350
747: Cuyp, A, C 123
748: Cuyp, A, C 120
748a: Holland school late 17th century?, A 3296
748 A 1: Cuyp, A, A 2350
748 A 3: Cuyp, A, A 3754
748 A 4: Cuyp, A, A 3957
748 A 5: Cuyp, A, A 4118
748 B 1: Holland school late 17th century?, A 3296
749: Cuyp, A, A 1457
750: Southern Netherlands school ca 1655, A 80
751: Cuyp, A, C 114
752: Cuyp, BG, A 773
752a = 752 A 1: Cuyp, BG, A 2857
752 A 2 = 752b: Cuyp, BG, A 3297
753: Cuyp, J G, A 1793
754: Cuyp, J G, A 611
755: Cuyp, J G, C 121
755a = 755 M 1: Czermak, J, A 2718
755 M 2: Czermak, J, A 3481
756: Daiwaille, A J, C 124
757: Daiwaille, J A, C 530
758: Daiwaille, J A, A 1845
759: Daiwaille, J A, A 1952
759 M 1: Dalem, C van, A 1991
760: Dalens I, D, A 790
761: Danckerts de Rij, P, A 1593
761a = 761 E 1: Dankmeyer, C B, A 2229
762: Dasveldt, J, C 125
763: Dasveldt, J, C 126
764: Daubigny, Ch F, A 2288
765: Daubigny, Ch F, A 1867
765 A 1: Daubigny, Ch F, A 2884
765 A 2: Daubigny, Ch F, A 2885
765 A 3: Daubigny, Ch F, A 2886
766: Daubigny, Ch F, A 1868
766a: Daubigny, Ch F, A 2884
766b: Daubigny, Ch F, A 2885
766c: Daubigny, Ch F, A 2886
767: Daumier, H, A 1869
767a = 767 A 1: Daumier, H, A 2578
767b = 767 B 1: David, G, A 3134
767 B 2 = 767c: David, G, A 3135
768: Decamps, A G, 1870
768a: Dekker, H A Chr, A 2181
768A = 768 B 1: Decker, C G, A 2562
768 L 1: Decker, F, C 1478
769: Delacroix, F V E, A 1871
769 B 1: Delen, D van, A 2352
769 B 2: Delen, D van, C 1350
769 B 3: Delen, D van, A 3936-A 3942
769c: Delen, D van, A 2352
770: Delff, C J, A 779
770 A 1: Rijck, P C van, A 868
771: Delff I, J W, A 1460
772: Delff I, J W, A 841
773: Delff I, J W, A 1907
774: Delff II, J W, A 843
774a: Master of Delft, A 3141
774b: Master of Delft, A 3325
775: Delvaux, E, A 1024
776: Denner, B, A 1442
776a: Derksen, G, A 2739
776 A: Deutmann, F W M, A 2822
776 A 1: Denner, B, A 770
776 E 1: Derkinderen, A J, A 3470
776 F 1: Derksen, G, A 2739
776 G 1: Deutmann, F W M, A 2822
776 H 1: Deventer, W A van, A 3846
777: Deventer, W A van, A 1025
777 M 1: Diana, G, A 3465
778: Diaz de la Peña, N V, A 1872
778a = 778 A 1: Diaz de la Peña, N V, A 2701
778 A 2 = 778b: Diaz de la Peña, N V, A 2887
779: Diaz de la Peña, N V, A 1873

779a = 779 E 1: Dielaert, Ch van, A 2366
780: Diepraem, A, A 1574
780a: Diest, Jer van, A 2503
780b: Diest, Jer van, A 1389
780c: Diest, Joh van, A 2804
780d: Rembrandt, A 3298
780 H 1: Diest, Jer van, A 2503
780 H 2: Diest, Jer van, A 1389
780 K 1: Diest, Joh van, A 2804
780 P 1: Rembrandt, A 3298
781: Diez, A, A 1026
781 B 1: Dircksz, B, C 405
781 M 1: Dobson, W, A 3927
782: Doeff, A, A 1407
783: Does, S van der, A 84
784: Does, S van der, A 82
785: Does, S van der, A 83
786: Does, S van der, A 85
786 D 1: Machiavelli, Z, A 3442
787: Doncker, H M, A 1689
788: Doncker, H M, A 1690
789: Doncker, H M, C 111
789a = 789 B 1: Dongen, C Th M van, A 3039
790: Doomer, L, A 1513
790 D 1: Giovanni da Brescia, A 3995
791: Dou, G, A 86
791a: Dou, G, A 2627
792: Dou, G, A 686
793: Dou, G, C 127
794: Dou, G, A 90
795: Dou, G, A 87
796: Dou, G, A 89
797: Dou, G, C 128
798: Dou, G, A 88
798a-c: Dou, G, A 2320
798 A 1: Dou, G, A 2627
798 B 1-3: Dou, G, A 2320
798 B 4: Dou, G, A 2321
799: Dou, G, C 243
799a: Dou, G, A 2321
800: Douwe, J D de, A 1357
801: Schoemaker Doyer, J, A 1027
802: Schoemaker Doyer, J, C 222
803: Schoemaker Doyer, J, C 221
803 H 1: Dregt, J van, A 3463
804: Dreibholtz, Chr L W, A 1028
804 A 1: Dreibholtz, Chr L W, A 3839
805: Drift, J A van der, A 942
806: Droochsloot, C, A 1920
807: Droochsloot, J C: returned loan
808: Droochsloot, J C, A 1930
808a: Droochsloot, J C, A 3227
809: Droochsloot, J C, A 606
809 A 1: Droochsloot, J C, A 3227
809 A 2: Droochsloot, J C, C 438
810: Droochsloot, J C, C 446
810a = 810 H 1: Druyf, D, A 2786
811: Dubbels, H J, A 92
812: Dubbels, H J, A 687
812 A 1: Dubbels, H J, A 2513
813: Dubbels, H J, C 129
813a: Dubbels, H J, A 2513
813 G 1: Dubois, G, A 3115
814: Dubois, S, A 2062
815: Dubois, S, A 2063
816: Dubois, S, A 2064
817: Dubois, S, A 2065
818: Dubois, S, A 2066
818a-b: Dubois Drahonet, A J: de-acceded
818c: Dubordieu, P, A 2182
818d: Dubordieu, P, A 2183
818 D 1: Dubois Drahonet, A J, A 4153
818 D 2: Dubois Drahonet, A J, A 4154
818 E 1-2: Dubois Drahonet, A J: de-acceded
818 M 1: Dubordieu, P, A 2182
818 M 2: Dubordieu, P, A 2183
818 M 3: Dubordieu, P, A 4221
819: Dubourcq, P L, A 1029
819 M 1: Dubourg, L F: de-acceded
820: Dubus, M, A 1539
821: Duck, J, A 93
822: Duck, J, A 1940
823: Ducorron, J J, C 283
824: Dughet, G, A 94
824 A 1: Dughet, G, C 1351
825: Dughet, G, A 95
826: Dujardin, G, A 1572
827: Dujardin, K, A 190
828: Dujardin, K, C 4
829: Dujardin, K, A 191
830: Dujardin, K, C 157
831: Dujardin, K, A 195
832: Dujardin, K, A 194

833: Dujardin, K, A 193
834: Dujardin, K, C 158
835: Dujardin, K, A 192
836: Dujardin, K, C 280
837: Dumesnil, L M, C 512
837a = 837 D 1: Duplessis, J S, A 3278
838: Dupré, J, A 1874
838 A 1: Dupré, J, A 2888
839: Dupré, J, A 1875
839a: Dupré, J, A 2888
840: Dupré, V, A 1876
841: Dürer, A, A 96
842: Dusart, Chr J, A 1684
843: Dusart, C, A 97
844: Dusart, C, A 98
845: Dusart, C, A 99
846: Dusart, C, A 100
846 A 1: Dusart, C, A 3273
846 A 2: Dusart, C, A 3274
847: Dusart, C, A 688
847a: Dusart, C, A 3273
847b: Dusart, C, A 3274
848: Duwée, H J, A 1808
849: Duynen, I van, A 1466
850: Duyster, W C, A 1427
851: Duyster, W C, C 514
851 A 1: Duyster, W C, A 1791
851 A 2: Duyster, W C, A 1792
852: Liss, J, A 1403
852 B 1: Dijck, Abr van, A 3300
853: Dyck, A van, A 103
853a: Dyck, A van: returned loan
854: Dyck, A van, A 725
855: Dyck, A van, C 284
856: Dyck, A van, A 101
857: Dyck, A van, A 102
857a = 857 A 1: Dyck, A van, A 2318
857 A 2: Dyck, A van, A 2319
857 A 3: Dyck, A van: returned loan
857 A 4: Dyck, A van: de-acceded
857b: Dyck, A van, A 2319
858: Dyck, A van, A 105
859: Dyck, A van, A 847
860: Dyck, A van, A 205
861: Dyck, A van, C 312
862: Dyck, A van, A 208
862a: Dyck, A van, A 1224
862 A: Dyck, A van, A 209
862 B: Dyck, A van, A 210
863: Dyck, A van, A 104
863a: Southern Netherlands school 1st half 17th century, A 622
863 A 3: Dyck, A van, A 209
863 A 4: Dyck, A van, A 210
863 A 5: Dyck, A van, A 1224
863 A 6: Southern Netherlands school 1st half 17th century, A 622
863 A 7: Dyck, A van, A 2872
863b: Dyck, A van, A 2872
864: Dyk, A van, A 597
865: Dijk, F van, A 2058
866: Dijk, Ph van, A 895
867: Dijk, Ph van, A 896
868: Dijk, Ph van, A 897
869: Dijk, Ph van, A 898
870: Dijk, Ph van, A 903
871: Dijk, Ph van, A 1647
872: Dijk, Ph van, A 1648
873: Dijk, Ph van, A 1649
874: Dijk, Ph van, A 1650
875: Dijk, Ph van, A 1666
875 A 1: Dijk, Ph van, A 1435
876: Dijk, Ph van, A 1778
876a: Dijsselhof, G W, A 2889
876b: Dijsselhof, G W, A 3586
876c: Dijsselhof, G W, A 3587
876d: Dijsselhof, G W, A 3588
876e: Dijsselhof, G W, A 2890
876f: Dijsselhof, G W, A 2891
876 F 1: Dijsselhof, G W, A 2889
876 F 2: Dijsselhof, G W, A 3586
876 F 3: Dijsselhof, G W, A 3587
876 F 4: Dijsselhof, G W, A 3588
876 F 5: Dijsselhof, G W, A 2890
876 F 6: Dijsselhof, G W, A 2891
876 M 1: Eckhout, A, A 4070
877: Eeckhout, G van den, A 106
877a: Eeckhout, G van den, A 2507
878: Eeckhout, G van den, C 130
878 A 1: Eeckhout, G van den, A 2507
878 B 1: Eeckhout, G van den, A 3489
879: Eeckhout, G van den, A 1612
880: Eeckhout, J J, A 1030
880 A 1: Eeckhout, J J, A 4058
880 A 2: Eeckhout, J J, A 4059

881: Eelkema, E J, A, 1031
882: Eelkema, E J, A 1032
882 A 1: Eelkema E J, A 3454
883: Eelkema, E J, C 131
884: Eerelman, O, A 1849
884 B 1: Eertvelt, A van, C 448
885: Klöcker, D, A 1234
886: Ekels 1, J, A 689
886 A 1: Ekels 1, J, A 3475
887: Ekels 11, J, A 690
887 A 1: Ekels 11, J, A 4130
887 A 2: Ekels 11, J, A 1846
887 A 3: Ekels 11, J, C 1537
888: Eliasz, N: returned loan
889: Eliasz, N: returned loan
889 A 1: Eliasz, N, C 1177
890: Eliasz, N, C 383
891: Eliasz, N, C 386
892: Eliasz, N, C 403
893: Eliasz, N, C 361
894: Eliasz, N, A 698
895: Eliasz, N, A 699
896: Eliasz, N, A 1245
897: Eliasz, N, A 1312
898: Eliasz, N, A 1313
899: Eliasz, N, A 1319
900: Eliasz, N, A 705
900a: Eliasz, N, C 1177
901: Elyas, I, A 1754
902: Elliger, O, A 794
902a: Tetar van Elven, P H Th, A 4286
902 A 1: Elliger, O, C 215
902 G 1: Pynas, Jan S, A 3510
902 N 1: Tetar van Elven, P H Th, A 4286
903: Engel, A K M, C 285
904: Engelberts, W J M, A 1033
904a: Engebrechtsz, C, A 1719
904 A 1: Engelberts, A 4074
905: Engebrechtsz, C, A 859
905a: Engebrechtsz, C, A 2232
905 A 1: Engebrechtsz, C, A 1719
905 A 2: Engebrechtsz, C, A 2232
905 AL 1: G O V A 3810
905b = 905 B 1: Erichsen, V, A 1929
905c: Esselens, J, A 2322
905d: Esselens, J, A 2250
905 D 1: Esselens, J, A 2322
905 D 2: Esselens, J, A 2250
905f = 905 M 1: Estall, W Ch, A 3080
906: Everdingen, A van, A 1510
907: Everdingen, A van, C 132
908: Everdingen, A van, A 691
909: Everdingen, A van, A 107
910: Everdingen, A van, A 108
911: Everdingen, C B van, A 1339
912: Everdingen, C B van, A 1340
913: Everdingen, C B van, A 2116
913 A 1: Everdingen, C B van, C 1517
914: Eversdijck, W, A 992
914 A 1: Eversdijck, W, A 3829
915: Eversdijck, W, A 993
916: Eversdijck, W, A 994
917: Evrard, A, A 1034
918: Eycken, J B van, A 1035
919: Fabritius, B, A 1304
919a-c = 919 A 1-3: Fabritius, B, A 2958-A 2960
919d = 919 A 4: Fabritius, B, A 4192
920: Fabritius, C, A 1591
920 A 1: Fabritius, C: returned loan
921: Fabritius, C, A 91
921 A: Fantin-Latour, H, A 2894
921 B: Fantin-Latour, H, A 2895
921 B 1 = 921c: Falens, C van, A 2679
921d: Voet, J F, A 3236
921dd: Paolo di Giovanni Fei: returned loan
921 D 1: Fantin-Latour, H, A 2894
921 D 2: Fantin-Latour, H, A 2895
921 D 3: Fantin-Latour, H, A 2892
921 D 4: Fantin-Latour, H: technical accession
921 D 5: Fantin-Latour, H, A 2893
921 DA 1: Farinato, P, C 1352
921 E: Fantin-Latour, H, A 2893
921 M 1: Favray, A de, A 4127
921 P 1: Paolo di Giovanni Fei: returned loan
922: Ferguson, W G, A 1290
922a = 922 A 1: Ferguson, W G, A 2154
922b: Ferrari, D, A 3032
922 B 1: Ferrari, D, A 3394
922 B 2: Ferrari, D, A 3395
922 D 1: Ferrari, G, A 3032
922 E 1: Beert, O, A 2549
923: Flinck, G, C 370
924: Flinck, G, C 371

925: Flinck, G, C 1
926: Flinck, G: returned loan
926a: Flinck, G, A 4166
927: Flinck, G, A 110
928: Flinck, G, A 218
929: Flinck, G, A 869
930: Flinck, G, A 3103
930 A 1: Flinck, G, A 4166
930 A 2: Flinck, G, A 3133
930 A 3: Flinck, G, A 3451
931: Flinck, G, A 582
931a: Flinck, G, A 3133
931b: Fogolino, M, C 1129
931 B 1: Machiavelli, Z, A 3442
931 B 2: North Italian school 2d quarter 16th century, A 3411
931 B 3: Florentine school 1486, A 3397
931 B 4: Florentine school 1486, A 3398
931 B 5: Sienese school ca 1450, A 3998
931 B 6: Apollonio di Giovanni, A 3999
931 B 7: Florentine school 1st half 15th century, A 3396
931 M 1: Fogolino, M, C 1129
931 S 1: Fontaine, L de: returned loan
932: Fonteyn, A L, A 1941
933: Fournier, J, A 1273
934: Fournier, J, A 1272
934a = 934 M 1: Franck, Chr F, A 2155
935: Francken 11, F, A 112
936: Francken 11, F, A 111
937: Francken 11, F, C 286
938: Francken 11, F, NM 4190
939: Francken 11, F, NM 4789
939a: Franchoys, L, A 2323
939b: Fromentin, E, A 3304
939 D 1: Franchoys, L, A 2323
939 G 1: G O V A 3815
940: Frankenberg en Proschlitz, D O L van, A 1807
940a = 940 D 1: Frankfort, E, A 2685
940 G 1: Frère, E, A 3081
940 P 1: G O V A 3783
940 P 2: G O V A 3784
940 W 1: Fromentin, E, A 3304
941: Gabriël, P J C, A 2290
941 A 1: Gabriël, P J C, A 2265
941 A 2: Gabriël, P J C, A 2266
941 A 3: Gabriël, P J C, A 2381
941 A 4: Gabriël, P J C, A 3589
941 A 5: Gabriël, P J C, A 3590
941 A 6: Gabriël, P J C, A 3082
942: Gabriël, P J C, A 1505
942a: Gabriël, P J C, A 2265
942b: Gabriël, P J C, A 2266
942c: Gabriël, P J C, A 2381
942d: Gabriël, P J C, A 3589
942e: Gabriël, P J C, A 3590
943: Gaesbeeck, A van, A 113
944: Gallard-Lepinay, E, A 1809
945: Gallis, P, A 1634
946: Gallis, P, A 1737
947: Garofalo, C 309
947 A 1: Garofalo, A 3400
948: Garofalo, A 114
948a = 948 F 1: Gauguin, P: returned loan
948 M 1: Geel, J J van, A 3968
949: Geel, J van, A 115
950: Geertgen tot Sint Jans, A 500
950a = 950 A 1: Geertgen tot Sint Jans, A 2150
950 A 2: Mostaert, J, A 3901
950b: Master of the Braunschweig Diptych, A 2563
951: Master of the Figdor Deposition, A 1688
951a: Master of the Figdor Deposition, A 2212
951b: Master of the Braunschweig Diptych, A 3305
951c: Master of the Braunschweig Diptych, A 3306
952: Geest, W S de, A 1780
953: Geest, W S de, A 1781
954: Geest, W S de, A 570
955: Geest, W S de, A 569
956: H O N A 533
957: H O N A 530
958: H O N A 560
959: Geest, W S de, A 571
960: Geest, W S de, A 572
961: Geest, W S de, A 1356
962: Wieringa, H W, A 204
963: Geest, W S de, A 566
964: Geest, W S de, A 1908
965: Geest, W S de, A 4190
965a-b: Gelder, A de: returned loan
965c: Gelder, A de, A 2695
965d: Gelder, A de, A 2359
965e: Gelder, A de, A 2360
965f: Gelder, A de, A 3969
965g: Gelder, A de, A 4034
966: Russian school? 1st half 18th century, A 116

966 B 1-2: Gelder, A de: returned loan
966 B 3: Gelder, A de, A 2695
966 B 4: Gelder, A de, A 2359
966 B 5: Gelder, A de, A 2360
966 B 6: Gelder, A de, A 3969
966 B 7: Gelder, A de, A 4034
967: Gelder, N van, A 1536
968: Geldorp, G, A 915
969: Geldorp, G, A 914
970: Geldorp, G, A 2072
971: Geldorp, G, A 912
972: Geldorp, G, A 2081
973: Geldorp, G, A 916
974: Geldorp, G, A 917
975: Geldorp, G, A 2070
976: Geldorp, G, A 2071
976 F 1: Lorrain, C: returned loan
977: Gempt, B te, A 1337
978: Genoels, A, A 1838
979: Genoels, A, A 1839
979a-b: Gestel, L: returned loan
979 A = 979 B 1: Gérard, F P S, C 1120
979 B 2: Gérard, F P S, C 1525
979 D 1: Niccolo di Pietro Gerini, A 3401
979 D 2: Niccolo di Pietro Gerini: returned loan
979 E 1-2: Gestel, L: returned loan
980: Gheyn 11, J de, A 4255
980 A 1: Gheyn 11, J de, A 2395
980 A 2: Gheyn 11, J de: returned loan
981: Northern Netherlands school ca 1670, A 4478
981b: Gheyn 11, J de, A 2395
981 B 1: Giampietrino: returned loan
981 D 1: G O V A 3787
981 D 2: G O V A 3789
981 G 1: Giordano, L, C 1353
981 M 1: Giorgione, A 3970
981 N 1: Giovanni di Bartolommeo Cristiani: returned loan
981 P 1: Giovanni da Milano, A 4000
981 T 1: Fiore, J del, A 4001
982: Giselaer, N de, A 1527
982a: Glauber, J, A 1201
982b: Glauber, J, A 1200
982 G 1: Glauber, J, A 1201
982 G 2: Glauber, J, A 1200
982 G 3: Glauber, J, A 1202
983: Glauber, J, A 118
983a = 983 A 1: Glauber, J, A 1217
984: Glauber, J, A 119
984a: Southern Netherlands school 1561, A 4488
984b: Gogh, V van: returned loan
984 B 1-4: Gogh, V van: returned loan
984 D 1: Southern Netherlands school 1561, A 4488
984e-g: Gogh, V van: returned loan
984 G 1: Gogh, V van, A 3262
984 G 2: Gogh, V van, A 3307
984h-n: Gogh, V van: returned loan
985: Goltzius, H, A 1284
985a = 985 A 1: Goltzius, H, A 2217
986: Gool, J van, C 133
987: Gool, J van, A 1605
987 E 1: G O V A 3768
988: Govaerts, A C, A 1036
988a = 988 B 1: Goya, F, A 2963
989: Goyen, J van, A 121
989a: Goyen, J van, A 2133
990: Goyen, J van, A 123
991: Goyen, J van, A 122
991 A 1: Goyen, J van, A 2133
991 A 2: Goyen, J van, A 3249
991 A 3: Goyen, J van, A 3250
991 A 4: Goyen, J van, A 3308
991 A 5: Goyen, J van, A 3945
991 A 6: Goyen, J van, A 3946
991 A 7: Goyen, J van, A 4044
992: Goyen, J van, A 120
992a: Goyen, J van, A 3249
992b: Goyen, J van, A 3250
992c: Goyen, J van, A 3308
993: Knijff, W, C 451
994: Graat, B, A 1911
995: Graat, B, A 1943
996: Graat, B, A 736
996 A 1: Graat, B, A 3932
997-999: Graat, B: returned loan
1000: Graef, Th de, A 1321
1001: Grebber, P F de, C 522
1001a = 1001 A 1: Grebber, P F de, A 2310
1001 A 2 = 1001b: Grebber, P F de, A 2311
1001 B 1: Greco, El, A 3142
1001 B 2 = 1001c: Greco, El: returned loan
1001d: Greco, El, A 3142
1002: Greive, J C, A 1037
1002 H 1: Greuze, J B, A 3906

1003: Griffier, J, A 125
1003 H 1: Groenewegen, PA, A 3965
1004: Gruijter, W, A 1038
1004a: Guardi, F, A 3251
1004 B 1: Guardi, F, A 3251
1004 B 2: Guardi, F, A 3252
1004 B 3: Guardi, F, A 3309
1004 B 4: Guardi, F, A 3899
1004 B 5: Guardi, F, A 3403
1004 B 6: Guardi, F, A 3402
1004c: Guardi, F, A 3309
1004 M 1: Guariento: returned loan
1004 T 1: Gudin, J A Th, A 2832
1005: Guercino, A 593
1005a: Gudin, J A Th, A 2832
1005 A 1: Guercino, A 3404
1006: Gijsaerts, G, A 800
1007: Gijsels, P, A 126
1007a = 1007 A 1: Gijsels, P, A 2213
1008: Haag, T Ph Chr, A 1225
1008 H 1: Haak, R J S, A 1566
1009: Haan, M I de, A 1694
1010: Haan, M I de, A 1987
1011: Haanen, A J, A 1039
1012: Haanen, A J, A 1186
1013: Haanen, A J, A 1472
1014: Haanen, A J, A 1471
1015: Haanen, G G, C 134
1016: Haanen, G G, C 135
1017: Haanen, G G, C 136
1018: Haanen, R A, A 1639
1019: Haas, J H L de, A 1178
1020: Haas, J H L de, A 1556
1021: Hackaert, J, A 130
1022: Hackaert, J, A 131
1023: Hackaert, J, A 692
1024: Hackaert, J, C 137
1025: Hackaert, J, A 1709
1025a = 1025 M 1: Haen, G de, A 2651
1026: Haensbergen, J van, A 1291
1026 A 1: Haensbergen, J van, C 1546
1026 A 2: Haensbergen, J van, C 1547
1027: Hagen, J van der, C 373
1028: Hagen, J van der, C 108
1029: Hagen, J van der, C 138
1030: Hagen, J van der, A 33
1030 D 1: Hainz, G, A 2550
1031: PAN A 1738
1032: PAN A 4557
1033: PAN A 4555
1034: PAN A 4556
1035: PAN A 4562
1036: PAN A 4558
1037: PAN A 4559
1038: PAN A 4560
1039: PAN A 4561
1040: PAN A 4563
1041: PAN A 1503
1042: PAN A 4565
1043: PAN A 4613
1044: PAN A 4566
1045: PAN A 4568
1046: PAN A 4567
1047: PAN A 4569
1048: PAN A 4574
1049: PAN A 4573
1050: PAN A 4579
1051: PAN A 1504
1052: PAN A 4578
1053: PAN A 4600
1054: PAN A 4580
1055: PAN A 4581
1056: PAN A 4582
1057: PAN A 4584
1058: PAN A 4585
1059: PAN A 4589
1060: PAN A 4592
1061: PAN A 4594
1062: PAN A 4590
1063: PAN A 4588
1064: PAN A 4595
1065: PAN A 4591
1066: PAN A 4586
1067: PAN A 4596
1068: PAN A 4599
1069: PAN A 4587
1070: PAN A 4601
1071: PAN A 4605
1072: PAN A 4603
1073: PAN A 4606
1074: PAN A 4608
1075: PAN A 4611

1076: PAN A 4610
1077: PAN A 4612
1078: PAN A 4614
1079: PAN A 4615
1080: PAN A 4620
1081: PAN A 1968
1081 M 1: Teyler van Hall, J J, C 1557
1082: Hals, D, A 1796
1083: Hals, D, A 1722
1084: Hals, F, A 133
1085: Hals, F, C 374
1086: Hals, F, C 556
1087: Hals, F, C 557
1088: Hals, F, C 139
1089: Hals, F, A 1246
1090: Hals, F, A 1247
1090a: Hals, F, A 2859
1091: Hals, F, A 135
1091 A 1: Hals, F, A 2859
1091 B 1: Hals, F: returned loan
1091 B 2: Hals, F, A 950
1092 & 1093: Hals, F: returned loans
1094: Hamman, EMF, A 1811
1095: Hanedoes, L, A 1040
1096: Hanedoes, L, A 1812
1097: Hanedoes, L, A 1813
1098: Hanedoes, L, A 1814
1099: Hanedoes, L, A 1815
1100: Hanedoes, L, A 1816
1101: Hanedoes, L, A 1817
1102: Hanedoes, L, A 1818
1103: Hanneman, A, A 1622
1103 A 1: Hanneman, A, A 3889
1104: Hanneman, A, A 1670
1104 E 1: GOV A 3814
1105: Hannot, J, A 1449
1106: Hanselaere, P van, A 1041
1107: Hanselaere, P van, A 1042
1107 F 1: Hansen, C L, A 3925
1108: Hansen, L J, C 141
1108a = 1108 G 1: Hardimé, P, A 2734
1108 G 2: Hardimé, P, A 2732
1108 G 3: Hardimé, P, A 2733
1108 G 4: Hardimé, P, A 2735
1109: Hari, J, A 1043
1110: Haensbergen, J van, A 1440
1111: Haringh, D, A 1654
1112: Haringh, D, A 1655
1112 G 1: Haseleer, F, A 1044
1113: Hattich, P van, C 452
1114: Hauck, A Chr, A 136
1115: Hauck, A Chr, A 633
1115 E 1: GOV A 3813
1116: Hawksley, A, A 1877
1116 A 1: Hawksley, A, A 4182
1117: Heck, N J van der, A 990
1118: Heck, N J van der, A 991
1118a = 1118 A 1: Heck, N J van der, A 2373
1119: Hecken II, A van der, A 1305
1120: Hecken II, A van der, A 1410
1120a: Heda, W C, A 137
1121: Heda, W C, C 610
1121 A 1: Heda, W C, A 137
1122: Heda, G W, A 1549
1122a = 1122 A 1: Vught, G van, A 2205
1122b = 1122 B 1: Heem, C de, A 2564
1122d = 1122 D 1: Heem, D D de, A 2566
1123: Heem, J D de, A 138
1123a: Heem, J D de, A 2565
1123 A 1 = 1123 A 1: Heem, J D de, A 2396
1123 A 2: Heem, J D de, A 2565
1124: Heem, J D de, A 139
1124a = 1124 M 1: Heemskerck, E van, A 2180
1125: Heemskerck van Beest, J E van, A 1045
1125a = 1125 A 1: Heemskerck van Beest, J E van, A 2725
1125b = 1125 A 2: Heemskerck van Beest, J E van, A 2726
1126: Heemskerck van Beest, J E van, C 429
1127: Heemskerck, M van, A 1910
1128: Heemskerck, M van, C 507
1128 A 1: Heemskerck, M van, A 3518
1128 A 2: Heemskerck, M van, A 3519
1128 A 3: Heemskerck, M van, A 3511
1128 A 4: Heemskerck, M van, A 3512
1128 A 5: Heemskerck, M van, A 3513
1128 A 6: Heemskerck, M van, A 3514
1129: Heemskerck, M van, A 1306
1130: Heeremans, Th, A 1739
1131: Heeremans, Th, A 1944
1132: Heerschop, H, A 774
1133: Heerschop, H, A 1431
1133 K 1: Hekking I, W, A 1698
1133 S 1: Helfferich, FW, A 3490
1134: Helst, B van der, C 375

1135: Helst, B van der, C 2
1136: Helst, B van der, C 3
1137: Helst, B van der: returned loan
1138: Helst, B van der, C 624
1139: Helst, B van der, A 146
1140: Helst, B van der, A 147
1141: Helst, B van der, A 143
1142: Helst, B van der, A 144
1143: Helst, B van der, C 142
1144: Helst, B van der, A 142
1145: Helst, B van der, A 145
1146: Helst, B van der, A 140
1147: Helst, B van der, A 141
1148: Helst, B van der, A 832
1149: Helst, B van der, A 1255
1150: Helst, B van der: returned loan
1151: Helst, B van der, C 50
1153: Helst, L van der, A 148
1153 A 1: Helst, L van der, A 2236
1154: Helst, L van der, A 863
1154a: Helst, L van der, A 2236
1154b = 1154 F 1: Helt Stockade, N van, A 1926
1154 M 1: GOV A 3822
1155: Hemert, J van, A 693
1156: Hemessen, C van, A 4256
1157: Braunschweig Monogrammist, A 1603
1158: Braunschweig Monogrammist, A 1561
1158 M 1: GOV A 3805
1159: Hendriks, F H, A 1819
1160: Hendriks, S F, A 1878
1161: Hendriks, W, C 532
1162: Hendriks, W, A 667
1163: Hendriks, W, A 1989
1163 A 1: Hendriks, W, A 3854
1163 A 2: Hendriks, W, A 3943
1163 A 3: Hendriks, W, C 1482
1163 A 4: Hendriks, W, C 1483
1164: Hendriks, W, C 422
1165: Hengel, H F van, A 1473
1166: Hengel, H F van, A 1474
1166a: Hennekyn, P, A 2184
1166b: Hennekyn, P, A 2185
1166 M 1: Hennekyn, P, A 2184
1166 M 2: Hennekyn, P, A 2185
1166 S 1: Hesselaar, H Th, C 1519
1166 S 2: Hesselaar, H Th, C 1520
1166 S 3: Hesselaar, H Th, C 1521
1167: Heusch, W de, A 149
1168: Heusch, W de, A 150
1168a = 1168 A 1: Heusch, W de, A 2324
1169: Heusch, W de, A 151
1170: Heyden, J van der, C 143
1171: Heyden, J van der, A 154
1172: Heyden, J van der, A 152
1173: Heyden, J van der, A 153
1173 A 1: Heyden, J van der, A 3253
1173 A 2: Heyden, J van der, A 3971
1173 A 3: Heyden, J van der, A 3491
1174: Heyden, J van der, C 571
1174a: Heyden, J van der, A 3253
1174 F 1: Heyl, M, A 3046
1175: Hildebrand, Th, C 304
1176: Hillegaert, P van, A 664
1177: Hillegaert, P van, A 155
1178: Hillegaert, P van, A 607
1179: Hillegaert, P van, A 394
1180: Hillegaert, P van, A 452
1181: Hillegaert, P van, A 848
1182: Hillegaert, P van, A 435
1182 A 1: Hillegaert, P van, A 3125
1182 A 2: Hillegaert, P van, A 4112
1183: Hillegaert, P van, A 568
1184: Hilverdink, E A, A 1329
1185: Hilverdink, E A, C 1538
1186: Hilverdink, J, A 1046
1187: Hobbema, M, A 156
1188: Hobbema, M, C 144
1189: Hobbema, M, C 145
1190: Hodges, Ch H, A 1047
1191: Hodges, Ch H, A 2125
1192: Hodges, Ch H, A 653
1193: Hodges, Ch H, A 1048
1194: Hodges, Ch H, A 1453
1195: Hodges, Ch H, A 654
1196: Hodges, Ch H, A 1517
1197: Hodges, Ch H, A 769
1198: Hodges, Ch H, A 661
1199: Hodges, Ch H, C 10
1200: Hodges, Ch H, C 11
1201: Hodges, Ch H, A 1567
1202: Hodges, Ch H, A 1568
1202 A 1: Hodges, Ch H, A 2267
1202 A 2: Hodges, Ch H, A 2268

1202 A 3: Hodges, Ch H, C 1410
1202 A 4: Hodges, Ch H: returned loan
1202 A 5: Hodges, Ch H: returned loan
1202 A 6: Hodges, Ch H, A 4028
1202 A 7: Hodges, Ch H, A 4161
1203: Hodges, Ch H, A 1569
1203a: Hodges, Ch H, A 2267
1203 A 1: Hodges, Ch H, A 2971
1203b: Hodges, Ch H, A 2268
1203c: Hodges, Ch H, A 2971
1204: Hoet, G, A 159
1205: Hoet, G, A 160
1206: Hoet, G, A 161
1207: Hoet, G, A 162
1208: Hoet, G, A 163
1208a = 1208 M 1: Hoevenaar, W P, C 1541
1208 P 1: Hoffmann, G J, A 4202
1208 S 1: Hoffmann, S, A 3333
1209: Hogers, J, A 1498
1209 A 1: Hogers, J, A 787
1209 A 2: Hogers, J, A 804
1210: Southern Netherlands school ca 1535-40, A 167
1211: Hollander Cz, H, A 1489
1212: Holsteyn, C: returned loan
1213: Hondecoeter, G C d', A 1502
1214: Hondecoeter, G C d', A 1740
1215: Hondecoeter, G G d', A 1322
1216: Hondecoeter, G G d', A 751
1217: Hondecoeter, M d', A 168
1218: Hondecoeter, M d', A 169
1219: Hondecoeter, M d', A 170
1220: Hondecoeter, M d', A 171
1221: Hondecoeter, M d', A 172
1222: Hondecoeter, M d', A 174
1223: Hondecoeter, M d', A 173
1224: Hondecoeter, M d', A 175
1225: Hondecoeter, M d', A 694
1226: Hondecoeter, M d', A 695
1227: Hondecoeter, M d', C 146
1227 A 1: Hondecoeter, M d', A 2325
1227 A 2: Hondecoeter, M d', A 2683
1227 A 3: Hondecoeter, M d', A 3312
1228: Hondecoeter, M d', C 581
1228a: Hondecoeter, M d', A 2325
1228b: Hondecoeter, M d', A 2683
1228c: Hondecoeter, M d', A 3312
1229: Hondius, A, A 1918
1230: Hondius, A, A 1919
1230a = 1230 A 1: Hondius, A, A 2677
1230 M 1: Hondius, I, C 1558
1231: Honthorst, G van, A 1479
1232: Honthorst, G van, A 1480
1233: Honthorst, G van, A 180
1234: Honthorst, G van, A 176
1235: Honthorst, G van, A 874
1236: Honthorst, G van, A 873
1237: Honthorst, G van, A 871
1238: Honthorst, G van, A 178
1239: Honthorst, G van, A 179
1240: Honthorst, G van, A 573
1241: Honthorst, G van, A 574
1241 A 1: Honthorst, G van, A 3270
1242: HON A 519
1243: HON A 520
1244: HON A 521
1244a: Honthorst, G van, A 3270
1244 A 1: Honthorst, G van, A 4171
1245: Honthorst, W van, A 177
1246: Honthorst, W van, A 855
1247: Hooch, C C de, A 2218
1247 A 1: Southern Netherlands school ca 1640, A 2575
1248: Hooch, P de, A 182
1249: Hooch, P de, C 147
1250: Hooch, P de, C 149
1251: Hooch, P de, C 150
1251 A 1: Hooch, P de, C 1191
1251 A 2: Hooch, P de, A 181
1252: Hooch, P de, C 148
1252a: Hooch, P de, C 1191
1252c: Hoogerheyden, E, A 2405
1252d: Hoogerheyden, E, A 2406
1252 M 1: Hoogerheyden, E, A 2405
1252 M 2: Hoogerheyden, E, A 2406
1252 M 3: Hoogerheyden, E, A 4126
1253: Hooghe, R de, A 833
1254: Hoogstraten, D van, A 1500
1255: Hoogstraten, S van, A 158
1256: Hoogstraten, S van, C 152
1256 D 1: Hoppenbrouwers, J F, A 3840
1256 D 2: Hoppenbrouwers, J F, A 3847
1256 D 3: Hoppenbrouwers, J F, A 3848
1257: Horemans II, J J, A 1614
1258: Horemans II, J J, A 1851

1258a: Horstok, J P van, A 643
1258b: Horstok, J P van, A 2204
1258 D 1: COST A 4627
1258 D 2: COST A 4628
1258 D 3: COST A 4629
1258 D 4: COST A 4630
1258 D 5: COST A 4631
1258 D 6: COST A 4632
1258 D 7: COST A 4633
1258 D 8: COST A 4634
1258 D 9: COST A 4635
1258 D 10: COST A 4636
1258 D 11: COST A 4637
1258 D 12: COST A 4638
1258 D 13: COST C 1491
1258 D 14: COST C 1492
1258 D 15: COST C 1493
1258 D 16: COST C 1494
1258 D 17: COST C 1495
1258 D 18: COST C 1496
1258 D 19: COST C 1497
1258 D 20: COST C 1498
1258 D 21: COST C 1499
1258 D 22: COST C 1500
1258 D 23: COST C 1501
1258 D 24: COST C 1502
1258 D 25: COST C 1503
1258 D 26: COST C 1504
1258 D 27: COST C 1505
1258 D 28: COST C 1506
1258 D 29: COST C 1507
1258 D 30: COST C 1508
1258 D 31: COST C 1509
1258 D 32: COST C 1510
1258 D 33: COST C 1511
1258 D 34: COST C 1512
1258 D 35: COST C 1513
1258 D 36: COST C 1514
1258 E 1: Horstok, J P van, A 643
1258 E 2: Horstok, J P van, A 2204
1259: Houbraken, A, C 153
1259a = 1259 A 1: Houbraken, A, A 2680
1260: Houckgeest, G, A 1584
1260a = 1260 A 1: Vliet, H C van, A 1971
1261: Hove, B J van, A 1049
1262: Hove, B J van, A 1369
1262a: Hoynk van Papendrecht, J, A 2165
1262b: Hoytema, Th van, A 3017
1262c: Hubrecht, A A L, A 2508
1262d: Hubrecht, A A L, A 2794
1262 F 1: Hove Bz, H van, A 3083
1262 K 1: Hoynk van Papendrecht, J, A 2165
1262 N 1: Hoytema, Th van, A 3017
1262 R 1: Hubrecht, A A L, A 2508
1262 R 2: Hubrecht, A A L, A 2794
1263: Huchtenburg, J van, A 184
1263a = 1263 A 1: Huchtenburg, J van, A 2675
1263 A 2: Huchtenburg, J van, C 1226
1263 A 3: Huchtenburg, J van, A 4061
1264: Huchtenburg, J van, A 605
1264a: Huchtenburg, J van, C 1226
1265: Hue, L d', A 1256
1266: Hulst, F de, C 519
1267: Hulst, J B van der, C 287
1268: Hulst, J B van der, C 288
1268 A 1: Hulst, J B van der: returned loan
1269: Hulst, J B van der, A 1495
1270: Hulswit, J, A 1050
1271: Hulswit, J, A 1051
1272: ROT A 4524
1273: Humbert de Superville, D P G, A 656
1274: Huysum, J van, C 561
1275: Huysum, J van, A 187
1276: Huysum, J van, A 188
1277: Huysum, J van, C 154
1278: Huysum, J van, C 155
1278 B 1: Huysum, J van, C 620
1279: Huysum, J van, A 185
1280: Huysum, J van, A 186
1280a = 1280 E 1: Hijsing, H, A 2377
1280 M 1: Kooi, W B van der, C 1556
1281: Isaacsz, I, A 1191
1282: Isaacsz, P, C 410
1283: Isaacsz, P, C 455
1284: Isaacsz, P, A 1720
1284a: Israels, I L: returned loan
1284 A: Israels, I L, A 3591
1284 A 1: Isenbrant, A, A 4045
1284b: Israels, I L, C 983
1284bb: Israels, I L, A 2914
1284 B: Israels, I L, A 3592
1284 B 1: Israels, I L, C 983
1284 B 2: Israels, I L, A 2914

1284 B 3: Israels, I L, A 3591
1284 B 4: Israels, I L, A 3592
1284 B 5: Israels, I L, A 3593
1284 B 6: Israels, I L, A 3594
1284 B 7: Israels, I L, A 3595
1284 B 8: Israels, I L, A 3596
1284 B 9: Israels, I L, A 3597
1284 B 10: Israels, I L, A 2913
1284 B 11: Israels, I L, A 2917
1284 B 12: Israels, I L, A 2918
1284 B 13: Israels, I L, A 2919
1284 B 14: Israels, I L, A 2920
1284 B 15: Israels, I L, A 2915
1284c: Israels, J: returned loan
1284 C: Israels, I L, A 3593
1284d: Israels, J, A 2382
1284 D: Israels, I L, A 3594
1284e: Israels, J: returned loan
1284 E: Israels, I L, A 3595
1284f: Israels, J, A 2496
1284 F: Israels, I L, A 3596
1284g: Israels, J, A 2597
1284 G: Israels, I L, A 3597
1284h: Israels, J, A 2598
1284i: Israels, J, A 2599
1284k: Israels, J, A 2600
1284l: Israels, J, A 2601
1284m: Israels, J, A 2602
1284n: Israels, J, A 2603
1284o: Israels, J, A 2604
1284p: Israels, J, A 2605
1284q: Israels, J, A 2606
1284r: Israels, J, A 2607
1284s: Israels, J, A 2616
1284t: Israels, J, A 2615
1284u: Israels, J, A 2921
1284v: Israels, J, A 2923
1284w: Israels, J, A 3598
1284x: Israels, J, A 3599
1285: Israels, J, A 1179
1285a: Israels, J, A 3313
1286: Israels, J: returned loan
1286a: Israels, J: returned loan
1286 A 1: Israels, J, A 2382
1286 A 2: Israels, J, A 2496
1286 A 3: Israels, J, A 2597
1286 A 4: Israels, J, A 2598
1286 A 5: Israels, J, A 2599
1286 A 6: Israels, J, A 2600
1286 A 7: Israels, J, A 2601
1286 A 8: Israels, J, A 2602
1286 A 9: Israels, J, A 2603
1286 A 10: Israels, J, A 2604
1286 A 11: Israels, J, A 2605
1286 A 12: Israels, J, A 2606
1286 A 13: Israels, J, A 2607
1286 A 14: Israels, J, A 2616
1286 A 15: Israels, J, A 2615
1286 A 16: Israels, J, A 2855
1286 A 17: Israels, J, A 2921
1286 A 18: Israels, J, A 2922
1286 A 19: Israels, J, A 2923
1286 A 20: Israels, J: technical accession
1286 A 21: Israels, J, A 3598
1286 A 22: Israels, J, A 3599
1286 A 23: Israels, J, A 3730
1286 A 24: Israels, J, A 3731
1286 A 25: Israels, J, A 3732
1286 A 26: Israels, J, A 3313
1286 A 27: Israels, J, A 4180
1286 A 28: Israels, J, A 4198
1287: Israels, J, C 570
1287a: Jacobson, J, A 2696
1287 D 1: Italian school 15th century, A 3997
1287 D 2: Venetian school 1st quarter 16th century, C 1354
1287 E 1: Jacobson, J, A 2696
1288: Jacobsz, D, A 402
1289: Jacobsz, D, C 377
1290: Dircksz, B, C 405
1290 A 1: Jacobsz, D, A 3924
1291: Jacobsz, D, C 621
1292: Jacobsz, D, C 424
1292 A 1: Jacobsz, D, C 1178
1293: Jacobsz, D, C 376
1293a: Jacobsz, L, A 2814
1293 A 1: Jacobsz, D, C 1178
1293 A 1: Jacobsz, L, A 2814
1294: Jamin, D F, A 2286
1294a = 1294 A 1: Jamin, D F, A 2269
1294c: Jansen, H W, A 2400
1294 F 1: Jansen, F J, A 1534
1294 M 1: Jansen, H W, A 2400
1295: Jansen, F, A 1842

1296: Jonson van Ceulen I, C, A 1928
1296a: Jonson van Ceulen I, C: returned loan
1296 A 1: Jonson van Ceulen I, C, C 1179
1296 A 2: Jonson van Ceulen I, C, A 3857
1296 A 3: Jonson van Ceulen I, C, A 3858
1296 A 4: Jonson van Ceulen I, C: returned loan
1296b: Jonson van Ceulen I, C, C 1179
1296 B 1: Jonson van Ceulen II, C, A 921
1297: Janson, J, A 189
1298: Janson, J Chr, C 156
1299: Janson, J Chr, A 1052
1300: Japy, LA, A 1879
1301: Jelgerhuis, J, A 2713
1302: Jelgerhuis, J, A 2714
1302a: Jelgerhuis, J, A 2504
1303: Jelgerhuis, J, A 662
1304: Jelgerhuis, J, A 1055
1305: Jelgerhuis, J, A 1054
1305 A 1: Jelgerhuis, J, A 2504
1305 A 2: Jelgerhuis, J, A 2389
1306: Jelgerhuis, J, A 1053
1306a: Jelgerhuis, J, A 2389
1307: Jettel, E, A 1880
1307a = 1307 M 1: John, AE, A 3018
1307 R 1: Jolly, H J B, A 3472
1308: Jong, J de, A 4257
1308a: Jongh, C de, A 2842
1308b: Verburgh, D, A 3112
1308c: Northern Netherlands school ca 1635, A 3316
1308 F 1: Jongh, C de, A 2842
1308 F 2: Verburgh, D, A 3112
1308 F 3: Northern Netherlands school ca 1635, A 3316
1309: Jongh, L de, A 196
1310: Jongh, L de, A 197
1311: Jongh, L de, C 190
1312: Jongh, L de, A 1858
1313: Jonghe, J B de, A 1056
1314: Jongkind, J B, A 2300
1314a = 1314 A 1: Jongkind, J B, A 2270
1314 A 2: Jongkind, J B, A 2924
1314 A 3: Jongkind, J B, A 3317
1314b: Jongkind, J B, A 2924
1314c: Jongkind, J B, A 3317
1314 M 1: Jonxis, J L, A 4092
1315: Jordaens, J, A 198
1316: Jordaens, J, C 439
1317: Jordaens, J, A 601
1317a: Jordaens, J, A 2367
1317 B 1: Josselin de Jong, P, A 2785
1317 B 2: G O V A 3809
1317c: Josselin de Jong, P, A 2785
1318: Jouve, A, A 1881
1318 B 1: Kabel, A van der, A 3318
1319: Kaldenbach, J A, C 587
1320: Kalf, W, A 199
1321: Kamper, G, A 837
1322: Kamper, G: returned loan
1323: Kamphuijsen, J, A 1632
1323a: Karsen, J E, A 2581
1323b: Karsen, J E, A 2582
1323 B 1: Karsen, J E, A 2581
1323 B 2: Karsen, J E, A 2582
1323 B 3: Karsen, J E, A 2897
1323 B 4: Karsen, J E, A 2898
1323 B 5: Karsen, J E, A 2899
1323 B 6: Karsen, J E, A 2900
1323 B 7: Karsen, J E, A 2901
1323 B 8: Karsen, J E, A 2902
1323 B 9: Karsen, J E, A 2903
1323 B 10: Karsen, J E, A 2905
1323 B 11: Karsen, J E, A 2906
1323 B 12: Karsen, J E: technical accession
1323 B 13: Karsen, J E, A 2904
1323c: Karsen, J E, A 2902
1323d: Karsen, J E, A 2898
1323e: Karsen, J E, A 2901
1324: Karsen, K, C 159
1324a = 1324 A 1: Karsen, K, A 2233
1324 A 2: Karsen, K, A 3129
1324 A 3: Karsen, K, A 3243
1324b: Karsen, K, A 3129
1324c: Karsen, K, A 3243
1325: Kate, H F C ten, A 1057
1326: Keller, J H, A 1215
1326 A 1: Keller, J H, A 1232
1326 A 2: Keller, J H, A 1237
1327: Kessel, J van, A 793
1328: Kessel, J van, A 200
1328 A 1: Kessel, J van, A 2506
1329: Kessel, J van, A 696
1329a: Kessel, J van, A 2506
1330: Ketel, C, C 378
1331: Ketel, C, C 425

1332: Key, A Th, A 514
1333: Key, A Th, A 515
1333a = 1333 A 1: Ketel, C, A 3121
1333 A 2: Ketel, C, A 3122
1333 A 4: Ketel, C, A 3462
1333 A 5: Ketel, C, A 244
1333 A 6: Ketel, C, A 4046
1333b: Ketel, C, A 3122
1334: Cornelisz van Haarlem, C, A 1241
1335: Keultjes, G L, A 1376
1335a: Keun, H, A 2247
1335aa: Keun, H, A 3228
1335b: Kever, J S H, A 2271
1335 B 1: Keun, H, A 2247
1335 B 2: Keun, H, A 3228
1335 B 3: Keun, H, A 3831
1335 B 4: Keun, H, C 119
1335 B 5: Keun, H, A 2681
1335c: Kever, J S H, A 3319
1335 E 1: Kever, J S H, A 2271
1335 E 2: Kever, J S H, A 2907
1335 E 3: Kever, J S H, A 2908
1335 E 4: Kever, J S H, A 3319
1336: Key, A Th, A 1700
1336a = 1336 A 1: Key, A Th, A 3148
1336 A 2: Key, A Th, A 514
1336 A 3: Key, A Th, A 515
1337: Key, W: returned loan
1337a = 1337 A 1: Key, W, A 18
1338: Keyser, N de, C 290
1338a = 1338 A 1: Keyser, N de, A 2863
1339: Keyser, Th de, C 71
1340: Keyser, Th de, C 381
1341: Keyser, Th de, C 380
1341 A 1: Keyser, Th de, A 4236
1342: Keyser, Th de, A 1545
1343: Holland school ca 1645, A 202
1344: Keyser, Th de, C 568
1345: Keyser, Th de, C 567
1346 & 1347: Keyser, Th de: returned loans
1348: Netherlands school ca 1620, A 201
1349: Loo, J van, A 81
1349a = 1349 A 1: Keyser, Th de: returned loan
1349 A 2: Keyser, Th de, A 3493
1349 A 3: Keyser, Th de: returned loan
1349 A 4: Keyser, Th de, A 3972
1350: Keyser, Th de, A 697
1350a: Kieft, J, A 2356
1350 D 1: Kick, SW, A 2841
1350 M 1: Kieft, J, A 2356
1350 S 1: Klerk, W de, A 4087
1351: Kleyn, P R, A 646
1351 A 1: Kleyn, P R, A 645
1351 A 2: Kleyn, P R, A 647
1352: Klinkenberg, J Chr K, A 1175
1352a = 1352 A 1: Klinkenberg, J Chr K, A 2383
1352 B 1: Klombeck, J B, A 3521
1353: Klomp, A J, C 162
1354: Klomp, A J, C 161
1355: Kneller, G, A 1280
1356: Kneller, G, A 2060
1356a = 1356 B 1: Knibbergen, F van, A 2361
1357: Knip, J A, A 1058
1357 A 1: Knip, J A, A 3909
1357 A 2: Knip, J A, C 1455
1357 A 3: Knip, J A, C 1456
1357 A 4: Knip, J A, A 4220
1358: Knoll, F C, A 1059
1358 F 1: VAN M Knop, H, A 3947
1359: Knüpfer, N, A 1458
1359a: Kobell II, H, A 1218
1359 D 1: Knijff, W, C 451
1359 M 1: Kobell II, H, A 1218
1360: Kobell III, J, A 1062
1361: Kobell II, J B, A 1060
1362: Kobell II, J B, A 1061
1363: Kobell II, J B, C 164
1364: Koekkoek, B C, C 165
1365: Koekkoek, B C, C 166
1366: Koekkoek, B C, C 542
1367: Koekkoek, B C, A 1546
1368: Koets II, R, A 795
1368a = 1368 A 1: Koets II, R: de-acceded
1368b: Konijnenburg, W van, A 3320
1368d: Konijnenburg, W van: returned loan
1369: Koninck, Ph, A 206
1370: Koninck, Ph, A 207
1370 A 1: Koninck, Ph, A 4133
1371: Koninck, Ph, A 1904
1372: Koninck, Ph: returned loan
1373: Koninck, Ph, A 1954
1374: Koninck, Ph: returned loan
1375: Koninck, S, A 23

1375a = 1375 A 1: Koninck, S, A 2220
1375 G 1: Konijnenburg, W van, A 3320
1375 G 2: Konijnenburg, W van: returned loan
1376: Kooi, W B van der, A 1063
1377: Kooi, W B van der, A 1064
1378: Kooi, W B van der, A 1170
1379: Kooi, W B van der, A 1065
1379 A 1: Kooi, W B van der, A 4139
1379 G 1: Koster, A L, A 3565
1380: Koster, E: de-acceded
1381: Krafft, D von, A 982
1381a = 1381 G 1: Keultjes, G L, A 644
1382: Kruseman, C, C 167
1383: Kruseman, C, A 1067
1383a: Kruseman, C, A 2137
1384: Kruseman, C, A 1070
1385: Kruseman, C, A 1068
1386: Kruseman, C, A 1069
1386 A 1: Kruseman, C, A 2137
1386 A 2: Kruseman, C, A 2166
1386 A 3: Kruseman, C, A 2167
1386 A 4: Kruseman, C, A 2823
1386 A 5: Kruseman, C, A 1066
1386 A 6: Kruseman, C, A 3050
1386 A 7: G O V A 3795
1386 A 8: G O V A 3796
1386 B 1: G O V A 3800
1387: Kruseman, C, A 657
1387a: Kruseman, C, A 2166
1387b: Kruseman, C, A 2167
1387c: Kruseman, C, A 2823
1388: Kruseman, J A, A 1071
1389: Kruseman, J A, A 1072
1390: Kruseman, J A, C 168
1391: Kruseman, J A, C 169
1391 A 1: Kruseman, J A, A 3020
1392: Kruseman, J A, C 170
1393: Kruseman, J A, A 1499
1394: Kruseman, J A, A 1570
1395: Kruseman, J A, A 1621
1396: Kruseman, J A, A 1613
1396 A 1: Kruseman, J A, C 1123
1396 A 3: Pieneman, N, A 3466
1396 A 4: Kruseman, J A, A 3950
1397: Kruseman, J A, A 4258
1397a: Kruseman, J A, C 1123
1397 B 1: Kulmbach, H S von: returned loan
1397 E 1: Kuster, K, A 3859
1397 E 2: Kuster, K, A 3860
1398: Kuyl, G van der: returned loan
1398 A 1: Kuyl, G van der, A 3861
1398 A 2: Kuyl, G van der, A 3862
1399: Kuyl, G van der, A 835
1400: Lachtropius, N, A 771
1401: Laen, D J van der, C 171
1402: Laer, P van, A 1411
1402 A 1: Bloemen, P van, A 3478
1403: Laer, P van, A 1945
1403a: Master of the Legend of Mary Magdalen, A 2854
1403 M 1: La Fargue, P C, A 3834
1403 M 2: La Fargue, P C, A 3959
1404: La Fargue, I L, A 637
1405: La Fargue, I L, A 638
1406: Lairesse, G, A 213
1407: Lairesse, G, A 2115
1408: Lairesse, G, A 1840
1409: Lairesse, G, A 211
1410: Lairesse, G, A 212
1411: Lairesse, G, C 437
1412: Lairesse, G, A 4210
1413: Lairesse, G, A 615
1414: Lairesse, G: de-acceded
1415: Lairesse, G: de-acceded
1416: Lairesse, G, A 1233
1417: Lairesse, G, C 382
1418: Lairesse, G, A 4259
1418a: Lance, G, A 2826
1418 A 1: Lairesse, G, A 4174
1418 A 2: Lairesse, G, A 4175
1418 A 3: Lairesse, G, A 4176
1418 A 4: Lairesse, G, A 4177
1418 A 5: Lairesse, G, A 4178
1418 A 6: Lairesse, G, A 4213
1418 A 7: Lairesse, G, A 4214
1418 A 8: Lairesse, G, A 4215
1418 A 9: Lairesse, G, A 4216
1418 G 1: Lance, G, A 2826
1421: Landsberghs, A 625
1421 M 1: Lanfranco, G, A 4129
1422: Laquy, W J, A 1624
1422 D 1: Largillière, N de, A 3461
1423: Laroon, M, A 1977
1424: Lastman, C P, C 406

1425: Lastman, PP, A 1359
1425 A 1: Lastman, PP, A 2354
1425 A 2: Lastman, PP: returned loan
1426: Lastman, PP, A 1533
1426a: Lastman, PP, A 2354
1426 D 1: La Tour, G de, A 3569
1427: Lauwers, JJ, A 1073
1428: Lawrence, Th, A 728
1429: Leemans, A, A 752
1430: Leemans, J, C 523
1430 A 1: Leemans, J, A 1946
1431: Leemans, J: returned loan
1432: Leemans, J, A 1946
1432 G 1: Leenhoff, F: returned loan
1433: Leickert, Ch HJ, A 1074
1433 A 1: Leickert, Ch HJ, A 3084
1433 A 2: Leickert, Ch HJ, A 3922
1433 H 1: Leyden, A van, A 3903
1434: Lelje, A de, C 539
1435: Lelie, A de, C 538
1436: Lelie, A de, C 537
1437: Lelie, A de: returned loan
1438: Lelie, A de, C 588
1439: Lelie, A de, C 589
1440: Lelie, A de, A 1355
1441: Lelie, A de, A 2294
1442: Lelie, A de, A 1075
1442 A 1: Lelie, A de, A 2231
1442 A 2: Lelie, A de, A 2234
1442 A 3: Lelie, A de, A 2235
1442 A 4: Lelie, A de, A 2856
1442 A 5: Lelie, A de: returned loan
1442 A 6: Lelie, A de, A 3098
1442 A 7: Lelie, A de, A 4100
1442 A 8: Lelie, A de, A 4122
1443: Lelie, A de, A 1541
1443a: Lelie, A de, A 2231
1443b: Lelie, A de, A 2234
1443c: Lelie, A de, A 2235
1443d: Lelie, A de, A 2856
1444: Lelienbergh, C, A 1455
1445: Lelienbergh, C, A 1454
1446: Lelienbergh, C, A 1710
1447: Lelienbergh, C, A 1741
1447 D 1: Lely, P, A 3832
1448: MIN Lembke, J Ph, A 4334
1448a = 1448 B 1: Lenain, M, A 3099
1448 M 1: Leonardo da Vinci: returned loan
1449: Lepoittevin, EME, A 1823
1449a = 1449 B 1: Levecq, J, A 2402
1449 D 1: Leyden, A van, A 3480
1449 D 2: Leyden, A van, A 1691
1451: Leyden, J van, A 1386
1452: Leyden, A van, A 1691
1452 A 1: Leyden, L van, A 3739
1452 A 2: Leyden, L van, A 3841
1453: Cornelisz van Oostsanen, J, A 976
1453a: Leyden, L van: returned loan
1453 A 1: Leyden, L van: returned loan
1453 A 2: Leyden, L van: returned loan
1453 A 3: Leyden, L van: returned loan
1453b: Leyden, L van: returned loan
1453c: Leyden, L van: returned loan
1454: Leys, JAH, C 291
1455: Leyster, J, A 1685
1455a = 1455 A 1: Leyster, J, A 2326
1455 A 2: Hals, F, A 134
1456: Liedts, A, A 854
1457: Liernur, WAA, A 1563
1458: Lievens, J, A 1627
1459: Lievens, J, A 612
1460: Lievens, J, A 838
1461: Lievens, J, A 839
1461a = 1461 A 1: Rembrandt, A 2391
1461 A 2: Lievens, J, C 1467
1462: Lievens, JA, A 1660
1463: Lievens, JA, A 1661
1464: Limborch, H van, A 1607
1465: Limborch, H van, A 219
1466: Limborch, H van, A 220
1467: Limborch, H van, A 221
1468: Lingelbach, J, A 226
1469: Lingelbach, J, A 225
1470: Lingelbach, J, A 224
1471: Lingelbach, J, A 700
1472: Lingelbach, J, C 172
1473: Lingelbach, J, A 1391
1473a: Lingelbach, J, C 1223
1473b: Lingelbach, J, C 1224
1474: Lingelbach, J, A 222
1475: Lingelbach, J, A 223
1475a: Lingelbach, J, A 2327
1475 A 1: Lingelbach, J, C 1223

1475 A 2: Lingelbach, J, C 1224
1475 A 3: Lingelbach, J, A 2327
1475 A 4: Lingelbach, J, A 3973
1476: Lingelbach, J, A 227
1477: Lingeman, L, A 1076
1478: Linthorst, J, A 1077
1478a: Loeff, H D, A 2791
1478 A: Lippi, Filippino, A 3030
1478 AM 1: Liotard, JE, A 4155
1478b: Loeff, H D, A 2792
1478 B 1: Lippi, Filippino, A 3030
1478 D 2: Loarte, A de, A 2962
1478 M 1: G O V A 3816
1478 P 1: Loef, JG, A 1383
1478 P 2: Loef, JG, A 4261
1478 R 1: Loeff, H D, A 2791
1478 R 2: Loeff, H D, A 2792
1478 V 1: Loeninga, A, A 3459
1479: Lokhorst, D van, A 1171
1480: Loncke, JL, A 906
1481: Loncke, JL, A 907
1481 B 1: Longhi, P, A 3405
1482: Loo, J van: returned loan
1482 A 1: Loo, J van, A 81
1482 A 2: Loo, J van, A 3483
1482 A 3: Loo, J van: returned loan
1483: Looten, J, A 48
1483a: Lovera, A 2252
1483 A: Loth, JC, A 71
1483b: Brescian school 1st half 16th century, A 3035
1483 E 1: Looy, J van, A 2909
1483 E 2: Looy, J van, A 2910
1483 E 3: Looy, J van, A 4169
1483 K 1: Master of Pietro a Ovile, A 4002
1483 O 1: Loth, JC, A 71
1483 T 1: Lovera, A 2252
1484: Augustini, JL, A 586
1485: Lubienietzky, Chr, A 775
1486: Lubienietzky, Chr: returned loan
1487: Lubienietzky, Chr: returned loan
1488: Lubienietzky, Chr, A 1550
1489: Lubienietzky, Chr, A 1551
1489 E 1: Luca di Tommè, A 4003
1490: MIN Lundens, G, A 4337
1491: MIN Lundens, G, A 4338
1492: Lundens, G, A 4262
1492 M 1: Luttichuys, I, C 1477
1492 M 2: Luttichuys, I, C 1522
1493: Lyon, J, C 384
1494: Miereveld, MJ van, A 2100
1495: Miereveld, MJ van, A 2101
1496: Maarel, M van der, A 1883
1496 A 1: Maarel, M van der, A 3734
1496 A 2: Maarel, M van der, A 3131
1496 A 3: Maarel, M van der, A 4063
1497: Maas, D: returned loan
1498: Gossaert van Mabuse, J, A 217
1498 M 1: Machiavelli, Z, A 3442
1499: Maes, JBL, A 1078
1500: Maes, N, C 90
1501: Maes, N, C 535
1501 A 1: Maes, N, A 2840
1502: Maes, N, A 245
1503: Maes, N, C 176
1504: Maes, N, A 246
1504a: Maes, N, A 3254
1505: Maes, N, A 701
1506: Maes, N, A 1662
1507: Maes, N, A 1645
1508: Maes, N, A 1646
1509 & 1510: Maes, N: returned loans
1511: Maes, N, A 1259
1511 A 1: Maes, N, A 3254
1511 A 2: Maes, N, A 3106
1511 A 3: Maes, N, A 3508
1511 A 4: Maes, N, A 4047
1512: Maes, N, A 702
1513: Maes, N, A 703
1513a: Maks, CJ: returned loan
1513A: Master Allegro, A 3007
1513 B 1: Magnasco, A, A 3407
1513 B 2: Magnasco, A, A 3408
1513 B 3: Magnasco, A, C 1356
1513 B 4: Magnasco, A, C 1357
1513 B 5: Magnasco, A, C 1360
1513 B 6: Magnasco, A, C 1361
1513 B 7: Magnasco, A, C 1358
1513 B 8: Magnasco, A, C 1359
1513 G 1: Master Allegro, A 3007
1514: Malo, V, A 590
1515: Malo, V, A 781
1515a: Man, C de, A 2355
1515 B 1: Malsen, T van, A 2307

1515 D 1: Man, C de, A 2355
1515 D 2: Man, C de, C 151
1516: Mancini, A, A 1884
1516a = 1516 F 1: Mankes, J, A 3321
1516 M 1: Marcke de Lummen, E van, A 3085
1517: Maris, JH, A 1404
1517a: Maris, JH, A 2272
1517b: Maris, JH, A 2273
1518: Maris, JH, A 1885
1518a: Maris, JH, A 2274
1518 A 1: Maris, JH, A 2272
1518 A 2: Maris, JH, A 2273
1518 A 3: Maris, JH, A 2500
1518 A 4: Maris, JH, A 2274
1518 A 5: Maris, JH, A 2491
1518 A 6: Maris, JH, A 2703
1518 A 7: Maris, JH, A 2702
1518 A 8: Maris, JH, A 2925
1518 A 9: Maris, JH, A 2926
1518 A 10: Maris, JH, A 2927
1518 A 11: Maris, JH, A 3600
1518 A 12: Maris, JH, A 2473
1518 A 13: Maris, JH, A 2463
1518 A 14: Maris, JH, A 2458
1518 A 15: Maris, JH, A 2466
1518 A 16: Maris, JH, A 2470
1518 A 17: Maris, JH, A 2467
1518 A 18: Maris, JH, A 2465
1518 A 19: Maris, JH, A 2464
1518 A 20: Maris, JH, A 2456
1518 A 21: Maris, JH, A 2471
1518 A 22: Maris, JH, A 2457
1518 A 23: Maris, JH, A 2469
1518 A 24: Maris, JH, A 2461
1518 A 25: Maris, JH, A 2460
1518 A 26: Maris, JH, A 2468
1518 A 27: Maris, JH, A 2459
1518 A 28: Maris, JH, A 2455
1518 A 29: Maris, JH, A 2472
1518 A 30: Maris, JH, A 2462
1518 A 31: Maris, JH, A 2810
1518 A 32-40: Maris, JH: technical accession
1518 A 41: Maris, JH, A 3322
1518b: Maris, JH, A 2491
1518c: Maris, JH, A 2703
1518d: Maris, JH, A 2702
1519: Maris, JH, A 1886
1519a: Maris, JH, A 2473
1519aa: Maris, M: returned loan
1519A: Maris, JH, A 2925
1519bb: Maris, M, A 2704
1519B: Maris, JH, A 2926
1519 B 1: Maris, M, A 2275
1519 B 2: Maris, M, A 2276
1519 B 3: Maris, M, A 2580
1519 B 4: Maris, M, A 2704
1519 B 5: Maris, M, A 2705
1519 B 6: Maris, M, A 3019
1519 B 7: Fijt, J, A 2928
1519 B 8: Maris, M, A 3727
1519 B 9-10: Maris, M: technical accession
1519 B 11: Maris, M: returned loan
1519 B 12: Maris, M, C 1486
1519c: Maris, JH, A 2463
1519cc: Maris, M, A 2705
1519C: Maris, JH, A 2927
1519d: Maris, JH, A 2458
1519dd: Maris, M, A 3019
1519D: Maris, JH, A 3600
1519 D 1: Maris, SW, A 2931
1519e: Maris, JH, A 2466
1519ee: Fijt, J, A 2928
1519g: Maris, JH, A 2470
1519h: Maris, JH, A 2467
1519i: Maris, JH, A 2465
1519k: Maris, JH, A 2464
1519l: Maris, JH, A 2456
1519m: Maris, JH, A 2471
1519n: Maris, JH, A 2457
1519o: Maris, JH, A 2469
1519p: Maris, JH, A 2461
1519q: Maris, JH, A 2460
1519r: Maris, JH, A 2468
1519s: Maris, JH, A 2459
1519t: Maris, JH, A 2455
1519u: Maris, JH, A 2472
1519v: Maris, JH, A 2462
1519w: Maris, JH, A 2810
1519wa: Maris, JH, A 3322
1519x: Maris, M, A 2275
1519y: Maris, M, A 2276
1519z: Maris, M, A 2580
1520: Maris, W, A 1887

1520a = 1520 A 1: Maris, W, A 2428
1520 A 2: Maris, W, A 2429
1520 A 3: Maris, W, A 2277
1520 A 4: Maris, W, A 2525
1520 A 5: Maris, W, A 2706
1520 A 6: Maris, W, A 2929
1520 A 7: Maris, W, A 2930
1520 A 8-9: Maris, W: technical accession
1520 A 10: Maris, W, A 3107
1520 A 11: Maris, W, A 4104
1520b: Maris, W, A 2429
1520c: Maris, W, A 2277
1520e: Maris, W, A 2525
1520of: Maris, W, A 2706
1520g: Maris, W, A 2929
1520h: Maris, W, A 2930
1521: Marne, J L de, C 292
1522: Marrel, J, A 772
1523: Marseus van Schrieck, O, A 975
1524: Martens, W, A 1742
1524 A 1: Martens, W, C 1544
1525: Martinet, L, C 305
1525a: Martszen II, J, A 2153
1525 E 1: Martino di Bartolommeo: returned loan
1525 G 1: Martszen II, J, A 2153
1526: Maschhaupt, J H, A 677
1527: Maschhaupt, J H, A 678
1528: Massijs, C, A 1286
1529: Massijs, Q, A 247
1529 A 1: Massijs, Q, A 4048
1530: Massijs, Q, A 166
1531: Mast, H van der, C 616
1532: Mast, H van der, C 617
1532a: Mastenbroek, J H van, A 2278
1532A: Mauve, A: returned loan
1532 B 1: Mastenbroek, J H van, A 2278
1533: Mauve, A, A 1542
1533a: Mauve, A, A 2523
1533 A 1: Mauve, A: returned loan
1533 A 2: Mauve, A, A 2523
1533 A 3: Mauve, A, A 2524
1533 A 4: Mauve, A, A 2430
1533 A 5: Mauve, A, A 2431
1533 A 6: Mauve, A, A 2432
1533 A 7: Mauve, A, A 2433
1533 A 8: Mauve, A, A 2434
1533 A 9: Mauve, A, A 2435
1533 A 10: Mauve, A, A 2436
1533 A 11: Mauve, A, A 2279
1533 A 12: Mauve, A, A 2384
1533 A 13: Mauve, A, A 3601
1533 A 14: Mauve, A, A 3602
1533 A 15: Mauve, A, A 2932
1533 A 16: Mauve, A: technical accession
1533 A 17: Mauve, A, A 3143
1533 A 18: Mauve, A, A 3323
1533 A 19: Mauve, A, A 4156
1533b: Mauve, A, A 2524
1534: Mauve, A, A 1888
1534a: Mauve, A, A 2430
1534aa: Meer II, J van der, A 2351
1534b: Mauve, A, A 2431
1534 B 1: May, J W, A 2423
1534 B 2: May, J W, A 2424
1534d: Mauve, A, A 2432
1534 D 1: Mazo, J B M del, A 433
1534 D 2: Mazo, J B M del, C 1362
1534e: Mauve, A, A 2433
1534 E 1: Mazzolino, L. A 3409
1534 E 2: Mazzolino, L, C 1363
1534f: Mauve, A, A 2434
1534g: Mauve, A, A 2435
1534h: Mauve, A, A 2436
1534i: Mauve, A, A 2279
1534k: Mauve, A, A 2384
1534l: Mauve, A, A 3601
1534m: Mauve, A, A 3602
1534n: Mauve, A, A 3143
1534y: May, J W, A 2423
1534z: May, J W, A 2424
1535: Meer III, J van der, A 248
1535 E 1: Meer II, J van der, A 2351
1536: Meerhout, J, A 1443
1537: Meerman, H, A 1543
1538: Meerman, H, A 1544
1538a-b: Melendez, L: returned loan
1538 B 1: Master of Alkmaar, A 2815
1538 B 2: Master of Alkmaar, A 1188
1538 B 3: Master of Alkmaar, C 1364
1538 B 4: Master of Alkmaar, A 1308
1538 B 5: Master of Alkmaar, A 1307
1538 B 6: Master of Alkmaar, A 3324
1538 D 1: Master of the Amsterdam Death of the Virgin, A 3467

1538 D 2: Master of the Amsterdam Death of the Virgin, A 2129
1538 D 3: Master of the Amsterdam Death of the Virgin, A 2130
1538 E 1: Master of the Battle of Anghiari, A 3974
1538 G 1: Master of the Legend of St Barbara, A 2057
1538 H 1: Master of the Braunschweig Diptych, A 2563
1538 H2: Master of the Braunschweig Diptych, A 3305
1538 H 3: Master of the Braunschweig Diptych, A 3306
1538 J 1: Master of the Carrand Triptych, A 4022
1538 K 1: Florentine school ca 1450, A 3302
1538 L 1: Master of Delft, A 3141
1538 L 2: Master of Delft, A 3325
1538 M 1: Master of the Figdor Deposition, A 2212
1538 M 2: Master of the Figdor Deposition, A 1688
1538 ME 1: Master of the St John Panels, A 4125
1538 N 1: Master of the Legend of Mary Magdalene, A 2854
1538 N 2: Master of the Legend of Mary Magdalene, A 962b
1538 P 1: Master with the Parrot, A 3225
1538 R 1: Master of the St Elizabeth Panels, A 1727
1538 R 2: Master of the St Elizabeth Panels, A 3145
1538 R 3: Master of the St Elizabeth Panels, A 3146
1538 R 4: Master of the St Elizabeth Panels, A 3147
1538 S 1: Master of the San Miniato Altarpiece, A 3013
1538 T 1: Master of the Spes Nostra, A 2312
1538 TG 1: Master of the Legend of St Ursula, A 3326
1538 U 1: Master of the Aix Annunciation, A 2399
1538 V 1: Master of the Virgo inter Virgines, A 501
1538 V 2: Master of the Virgo inter Virgines, A 3975
1538 W 1: Master of the Portraits of Princes, A 3140
1538 X 1: Master of the Female Halflengths, A 3130
1538 X 2: Master of the Female Halflengths, A 3255
1538 Z 1: Melozzo da Forlì, A 3315
1538 ZB 1: Zugno, F, A 3435
1538 ZB 2: Zugno, F, A 3436
1538 ZD 1: Mengs, A R, A 3277
1539: Merck, J F van der, A 853
1539a: Mesdach, S, A 913
1540: Mesdach, S, A 918
1541: Mesdach, S, A 919
1542: Mesdach, S, A 911
1543: Mesdach, S, A 910
1544: Mesdach, S, A 2073
1545: Mesdach, S, A 2068
1546: Mesdach, S, A 2069
1546 A 1: Mesdach, S, A 913
1547: Mesdag, H W, A 1165
1548: Mesdag, H W, A 1891
1548a: Mesdag, H W, A 2670
1549: Mesdag, H W, A 2301
1549a: Mesdag, H W, A 1891
1549 A 1: Mesdag, H W, A 2670
1549 A 2: Mesdag, H W, A 2474
1549 A 3: Mesdag, H W, A 2280
1549 A 4: Mesdag, H W, A 2385
1549 A 5: Mesdag, H W, A 2938
1549 A 6: Mesdag, H W, A 3086
1549b: Mesdag, H W, A 2280
1549c: Mesdag, H W, A 2385
1550: Mesdag, H W, A 1553
1551: Mesdag, H W, A 1554
1552: Mesdag-van Houten, S, A 1921
1552a: Metsu, G, A 2156
1553: Metsu, G, A 249
1554: Metsu, G, A 250
1555: Metsu, G, A 672
1556: Metsu, G, C 177
1556a = 1556 A 1: Metsu, G, A 2328
1556 A 2: Metsu, G, A 2156
1556 A 3: Metsu, G, A 3059
1557: Metsu, G, C 560
1557a: Metsu, G, A 3059
1558: Mettling, L, A 1889
1559: Mettling, L, A 1890
1559a = 1559 F 1: Metzelaar, C, A 2281
1560: Meulemans, A, C 179
1561: Meulemans, A, A 1174
1562: Meulen, F P ter, A 1330
1562 E 1: Meulen, A F van der, A 3753
1562 E 2: Meulen, A F van der, A 3960
1563: Meulener, P, A 803
1564: ROT A 4515
1565: Meyer, H de, A 251
1566: Meyer, H de, A 252
1567: Meyer, H de, A 1511
1568: Meijer, J H L, A 1406
1569: Meijer, J H L, A 1079
1570: Meijer, J H L, A 1820
1571: Meijer, J H L, A 1821
1572 & 1573: Meijer, J H L: returned loans
1574: Meijer, J H L, A 2239
1575: Michaëlis, G J, A 1080
1575a = 1575 A 1: Michaëlis, G J, A 2141
1576: Michaud, H, A 1745
1577: Michaud, H, A 1743

1578: Michaud, H, A 1744
1579: Miereveld, M J van, A 253
1580: Miereveld, M J van, A 256
1581: Miereveld, M J van, A 255
1582: Miereveld, M J van, A 254
1583: Miereveld, M J van, A 675
1584: Miereveld, M J van, A 258
1585: Miereveld, M J van, C 180
1586: Miereveld, M J van, A 580
1587: Miereveld, M J van, A 257
1588: Miereveld, M J van, A 908
1589: Miereveld, M J van, A 909
1590: Miereveld, M J van, A 2067
1591: Miereveld, M J van, A 1250
1592: Miereveld, M J van, A 1251
1593 & 1594: Miereveld, M J van: returned loans
1595: Miereveld, M J van, A 1450
1595a: Miereveld, M J van, A 2665
1596: HON A 525
1597: HON A 534
1598: HON A 554
1599: HON A 548
1600: HON A 557
1601: Miereveld, M J van, C 520
1602: Miereveld, M J van, C 521
1603: Miereveld, M J van, A 1418
1604: Miereveld, M J van, A 581
1605: Miereveld, M J van, A 260
1606: Miereveld, M J van, A 762
1607: Miereveld, M J van, C 12
1607 A 1: Miereveld, M J van, A 2665
1607 A 2: Miereveld, M J van: de-acceded
1607 A 3-6: Miereveld, M J van: returned loans
1607 A 7: Miereveld, M J van, A 3833
1607 A 8: Miereveld, M J van, A 3875
1607 A 9: Miereveld, M J van, A 3876
1607 A 10: Miereveld, M J van, A 3953
1607 A 11: Miereveld, M J van, A 2731
1608: Miereveld, M J van, C 181
1609: Miereveld, M J van, A 1723
1609 A 1: Miereveld, M J van, C 1481
1610: Mieris I, F van, C 182
1611: Mieris I, F van, A 262
1612: Mieris I, F van, A 263
1613: Mieris I, F van, A 704
1614: Mieris I, F van, A 184
1614 A 1: Mieris I, F van, A 3327
1615: Mieris I, F van, A 261
1615a = 1615 D 1: Mieris, J van, A 2122
1616: Mieris, W van, C 183
1617: Mieris, W van, A 264
1618: Mieris II, F van, C 186
1619: Mieris II, F van, C 185
1620: Mieris II, F van, A 265
1621: Mignon, A, A 266
1622: Mignon, A, A 267
1623: Mignon, A, A 269
1624: Mignon, A, A 268
1625: Mignon, A, C 187
1625a = 1625 A 1: Mignon, A, A 2329
1626: Mignon, A, C 580
1626a = 1626 E 1: Millet, J F, A 2707
1627: Mirou, A, A 755
1628: Moerenhout, J J, C 293
1629: Moerenhout, J J, A 1081
1630: Moerenhout, J J, A 1082
1631: Moeyaert, N: returned loan
1632: Moeyaert, N, A 270
1633: Moeyaert, N, A 1485
1634: Backer, J A, A 157
1634a: Mol, W, A 2121
1634A: Beert, O, A 2549
1634 E 1: Mol, W, A 2121
1634 E 2: Mol, W, A 648
1635: Molenaer, J M, C 140
1635 A 1: Molenaer, J M, A 3023
1635 A 2-3: Molenaer, J M: returned loan
1636: Molenaer, J M, C 188
1636a: Molenaer, J M, A 3032
1637: Molijn, P de, A 1942
1638: Mommers, H, A 1687
1639: Mommorency, B, A 1658
1640: Goyen, J van, A 952
1641: Momper, J de, A 273
1641a = 1641 A 1: Bril, P, A 2672
1641 A 2: Momper, J de: returned loan
1641 A 3: Momper, J de, A 3100
1641 A 4: Momper, J de, A 3894
1641 A 5: Momper, J de, A 3949
1641 A 6: Momper, J de, A 4263
1641b: Momper, J de: returned loan
1641 B 1: Monaco, L, A 3976
1641 B 2: Monaco, L, A 4004

1641 B 3 : Monaco, L, A 4005
1641 B 4 : Monaco, L, A 4006
1641 B 5 : Lorenzo di Niccolo, A 4007
1641c : Momper, J de, A 3100
1642 : Monet, C, A 1892
1642a = 1642 A 1 : Monet, C, A 2933
1643 : Moni, L de, A 274
1643a = 1643 F 1 : Monnickendam, M, C 1105
1644 : Cleve, M van, A 836
1644a : Monogrammist RK : returned loan
1644b : Bartsius, W, A 818
1645 : Monogrammist JVR, A 1456
1645a : Eertvelt, A van, C 448
1645b : Bartsius, W, A 2214
1646 : Monogrammist IVA, A 1706
1646a : Bout, P, A 2223
1646b : Bout, P, A 2224
1646 B 1 : Bout, P, A 2223
1646 B 2 : Bout, P, A 2224
1647 : Verhaert, D, A 989
1648 : Monogrammist BVDA, A 1721
1648a : Monogrammist IB, A 2253
1648b : Stevers, A 2358
1648 B 1 : Monogrammist IB, A 2253
1648c : Burgh, H van der, A 2720
1649 : Diest, Jer van, A 1389
1650 : Loef, J G, A 1383
1651 : Monogrammist IL, C 160
1651a : Keun, H, A 2681
1652 : Monogrammist HK, A 1844
1652 D 1 : Arends, LH, A 3844
1652 E 1 : Braunschweig Monogrammist, A 1561
1652 E 2 : Braunschweig Monogrammist, A 1603
1653 : Monogrammist AS, A 737
1653a = 1653 B 1 : Montagna, B, A 3448
1654 : Monticelli, A, A 1893
1654a = 1654 A 1 : Monticelli, A, A 2579
1654 A 2 : Monticelli, A, A 2935
1654 A 3 : Monticelli, A, A 3096
1654 A 4 : Monticelli, A, A 2934
1654 A 5 : Monticelli, A, A 2937
1654 A 6 : Monticelli, A : technical accession
1654 A 7 : Monticelli, A, A 2936
1654b : Monticelli, A, A 2935
1654c : Monticelli, A, A 3096
1655 : Moor, C de, A 1746
1655 A 1 : Moor, C de, A 3028
1656 : Moor, C de, A 640
1657 : Moreelse, P, A 1423
1658 : Moreelse, P, C 623
1659 : Moreelse, P, A 275
1660 : Moreelse, P, A 277
1661 : Moreelse, P, A 276
1661a : Moreelse, P, A 2330
1662 : HON A 556
1663 : Northern Netherlands school ca 1635, A 585
1664 A 1–6 : Poelenburgh, C van, A 1747
1664 A 7 : Moreelse, P, A 2330
1664 A 8 : Moreelse, P, A 3455
1664 A 9 : Moreelse, P, C 1440
1665 : MIN Northern Netherlands school? ca 1635, A 278
1666 : Morel, J E, A 1083
1667 : Morel, J E, A 706
1668 : Moritz, L, A 1084
1669 : Moritz, L, A 1370
1670 : Moritz, L, A 1324
1671 : Moritz, L, C 466
1671a : Moritz, L, A 2194
1671 A 1 : Moritz, L, A 1953
1671 A 2 : Moritz, L, A 2201
1671 A 3 : Moritz, L, A 2194
1671 A 4 : Moritz, L, A 2195
1671 A 5 : Moritz, L, A 4037
1672 : Moritz, L, A 1512
1673 : Mörner, H, C 306
1673a : Mor van Dashorst, A, A 2663
1673b = 1673 B 1 : Mor van Dashorst, A, A 3118
1673 B 2 : Mor van Dashorst, A, A 3119
1673 B 3 : Pourbus I, F, A 3065
1673 B 4 : Mor van Dashorst, A, A 2663
1673 B 5 : Mor van Dashorst, A, A 2873
1673 B 6 : Mor van Dashorst, A : returned loan
1673c : Mor van Dashorst, A, A 3119
1673d = 1673 D 1 : Moroni, G B, A 3036
1673 D 2 : Moroni, G B, A 3410
1673 D 3 : Moroni, G B, C 1365
1673 G 1 : Mösers, J H, A 2303
1673 N 1 : Mostaert, G, A 972
1674 : Mostaert, J, A 671
1674 A 1 : Mostaert, J, A 3843
1675 : Mostaert, J, A 2123
1676 : Pynacker, A, A 279
1677 : Moucheron, F de, C 189

1678 : Moucheron, F de, A 280
1679 : Moucheron, I de, A 796
1680 : Moucheron, I de, C 388
1681 : Mouilleron, A, A 1426
1682 : Mouilleron, A, A 1749
1683 : Mouilleron, A, A 1750
1684 : Mouilleron, A, A 1748
1684a = 1684 B 1 : Mulier I, P, A 2357
1685 : Muller, J, A 1445
1685 B 1 : Diana, G, A 3465
1686 : Murant, E, A 281
1687 : Murant, E, A 1711
1688 : Murillo, BE, A 282
1688 A 1 : Murillo, BE, C 1366
1689 : Vollevens I, J, A 283
1689a : Musscher, M van, A 2331
1689 A 1 : Musscher, M van, A 4232
1689 A 2 : Musscher, M van, A 4233
1690 : Musscher, M van, C 528
1691 : Musscher, M van, C 13
1692 : Musscher, M van, C 14
1692 A 1 : Musscher, M van, A 2331
1692 A 2 : Musscher, M van, C 1215
1692 A 3 : Musscher, M van, A 4135
1693 : Musscher, M van, A 1676
1693a : Musscher, M van, C 1215
1694 : Muys, N, A 1587
1695 : Mij, H van der, C 1526
1695 H 1 : Mijn, C van der, A 3907
1696 : Mijn, F van der, C 1527
1696a = 1696 A 1 : Mijn, F van der, A 2248
1696 A 2 : Mijn, F van der, A 2249
1696 A 3 : Mijn, F van der, A 2376
1696 A 4 : Mijn, F van der, A 887
1696 A 5 : Mijn, F van der, A 3956
1696 A 6 : Mijn, F van der, A 4064
1696b : Mijn, F van der, A 2249
1696c : Mijn, F van der, A 2376
1697 : Mijn, F van der, A 1274
1697a : Mijn, F van der, A 887
1698 : Mijn, G van der, A 1360
1698a = 1698 A 1 : Mijn, G van der, A 2139
1698 A 2 = 1698b : Mijn, G van der, A 2140
1698 G 1 : Mijtens II, D, A 4222
1699 : Mijtens, J, A 284
1700 : Mijtens, J, A 285
1701 : Mijtens, J, A 746
1702 : Mijtens, J, A 747
1703 : Mijtens, J, A 1856
1703a = 1703 A 1 : Mijtens, J, A 3021
1703 A 2 : Mijtens, J, A 3022
1703 A 3 : Mijtens, J, A 4013
1703b : Mijtens, J, A 3022
1704 : Mijtens, J, A 1239
1705 : Mijtens, M, A 768
1706 : Nachenius, J J, A 1656
1707 : Nachenius, J J, A 1657
1707 A 1 : Nachenius, J J, A 3863
1708 : Naiveu, M, A 286
1709 : Naiveu, M, A 1323
1709 B 1 : Serodine, G, A 332
1709 D 1 : Napoletano, F, A 3399
1710 : Natus, J, A 1705
1711 : Navez, F J, A 1085
1711 A 1 : GOV A 3797
1712 : Navez, F J, A 1086
1713 : Neck, J van : returned loan
1714 : Neck, J van, A 1986
1715 : Neefs I, P, A 288
1716 : Neefs I, P, A 289
1717 : Neefs II, P, A 287
1718 : Neer, A van der, A 1948
1719 : Neer, A van der, A 290
1720 : Neer, A van der, C 191
1720 A 1 : Neer, A van der, A 2128
1720 A 2 : Neer, A van der, A 3245
1720 A 3 : Neer, A van der, A 3256
1720 A 4 : Neer, A van der, A 3328
1720 A 5 : Neer, A van der, A 3329
1720 A 6 : Neer, A van der, A 3330
1720 B 1 : Neer, A van der, A 3496
1721 : Neer, A van der, C 192
1721a : Neer, A van der, A 2128
1721b : Neer, A van der, A 3245
1721c : Neer, A van der, A 3256
1721d : Neer, A van der, A 3328
1721e : Neer, A van der, A 3329
1721f : Neer, A van der, A 3330
1722 : Neer, E van der, A 291
1723 : Nellius, M, A 1751
1723a : Netscher, Casp, A 2666
1723b : Netscher, Casp, A 2669
1723c : Netscher, Casp, A 2668

1723d : Netscher, Casp, A 2667
1724 : Netscher, Casp, A 293
1724a : Netscher, Casp, A 319
1725 : Netscher, Casp : returned loan
1726 : Netscher, Casp, A 292
1727 : Netscher, Casp, C 193
1728 : Netscher, Casp, A 707
1729 : Netscher, Casp, A 1692
1730 : Netscher, Casp, A 1693
1731 : Netscher, Casp, A 729
1732 : Netscher, Casp, C 194
1732a : Netscher, Casp, A 3331
1733 : Netscher, Casp, C 195
1733 A 1 : Netscher, Casp, A 319
1733 A 2 : Netscher, Casp, A 2666
1733 A 3 : Netscher, Casp, A 2669
1733 A 4 : Netscher, Casp, A 2668
1733 A 5 : Netscher, Casp, A 2667
1733 A 6 : Netscher, Casp, A 3331
1733 A 7 : Netscher, Casp, A 3977
1733 A 8 : Netscher, Casp, A 3978
1733 A 9 : Netscher, Casp, A 4128
1733 A 10 : Netscher, Casp, A 2556
1734 : Netscher, Casp, A 183
1735 : Netscher, Casp, A 1552
1736 : Netscher, Casp, A 1264
1737 : Netscher, Casp, A 1265
1738 : Netscher, Casp, A 901
1739 : Netscher, Casp, A 902
1740 : Netscher, Con, C 15
1741 : Netscher, Con, C 16
1742 : Neuhuys, J A, A 1181
1742a = 1742 A 1 : Neuhuys, J A, A 2437
1743 : Neuhuys, J H, A 1353
1743a : Neuman, J H, A 2215
1743aa : Neuman, J H, A 3139
1743b : Neuman, J H, A 2215
1743bb : Neuman, J H, A 3242
1743 B 1 : Neuman, J H, A 2215
1743 B 2 : Neuman, J H, A 2216
1743 B 3 : Neuman, J H, A 2807
1743 B 4 : Neuman, J H, A 2824
1743 B 5 : Neuman, J H, A 2825
1743 B 6 : Neuman, J H, A 3139
1743 B 7 : Neuman, J H, A 3242
1743 B 8 : GOV A 3806
1743 B 9 : Neuman, J H, A 4120
1743 B 10 : Neuman, J H, A 4159
1743 B 11 : Neuman, J H, A 4160
1743c : Neuman, J H, A 2807
1743d : Hart Nibbrig, F, A 2540
1743 D 1 : Neyn, P de, A 2245
1743 G 1 : Hart Nibbrig, F, A 2540
1743 L 1 : Niccolò de Liberatore, A 4008
1744 : Nickelen, I van, A 360
1745 : Nicolas, L, A 1894
1746 : Nicolié, J Chr, A 1087
1746 E 1 : GOV A 3817
1746 E 2 : GOV A 3819
1747 : Nieulandt, A van : returned loan
1748 : Nieulandt, A van, A 1995
1748 A 1 : Nieulandt, A van, A 2308
1749 : Nieulandt, A van, A 1582
1750 : Nieulandt, J van, A 1788
1751 : Noël, P P J, A 1089
1752 : Noël, P P J, A 1088
1752a : Neyn, P de, A 2245
1753 : Nooms, R, A 294
1754 : Nooms, R, A 759
1755 : Nooms, R, A 1399
1756 : Nooms, R, A 1398
1757 : Nooms, R, A 1397
1758 : Nooms, R, A 1396
1759 : Schellinks, W, A 1393
1759 AM 1 : Noorderwiel, H, C 1550
1759 B 1 : Brescian school 1st half 16th century, A 3035
1759 B 2 : Ceruti, A 3406
1760 : Noordt, J van, A 709
1761 : Noordt, J van, A 710
1762 : Noordt, J van, A 708
1763 : Noordt, P van, A 776
1764 : Noordt, P van, A 777
1765 : Noter II, P F de, A 1090
1766 : Noter II, P F de, A 1091
1767 : Noter II, P F de, A 4264
1768 : Nouts, M, A 1847
1768a = 1768 B 1 : Numan, H, A 2419
1769 : Nuyen, W J J, A 1092
1769 A 1 : Nuyen, W J J, A 4644
1769 A 2 : Nuyen, W J J, A 4645
1770 : Nijmegen, D van, A 1933
1771 : Nijmegen, D van, A 1934
1772 : Nijmegen, D van, A 1459

1773: PAN A 4623
1774: PAN A 4622
1775: PAN A 3624
1776: ROT A 4522
1777: ROT A 4523
1777 M 1: Nijmegen, G van, A 4223
1778: Oberman, A, C 196
1779: Oberman, A, C 197
1780: Oberman, A, C 198
1781: Ochtervelt, J, C 390
1782: Ochtervelt, J, A 2114
1783: Odekerken, W van, A 1279
1783a = 1783 A 1: Odekerken, W van, A 3334
1784: Odevaere, J D, A 1093
1784 K 1: Oets, P, C 1325
1785: Oever, H ten, A 295
1785a = 1785 A 1: Oever, H ten, A 2370
1785 A 2 = 1785b: Oever, H ten, A 2697
1785 B 1 = 1785c: Giampietrino, A 3033
1786: GO V A 4548
1787: Olis, J, A 296
1788: Ommeganck, BP, A 1094
1788a = 1788 E 1: Kamerlingh Onnes, M, A 2896
1788 E 2: Kamerlingh Onnes, HH, A 3268
1789: Oosterdijk, W, A 1664
1790: Oosterdijk, W, A 1665
1790a = 1790 E 1: Oosterhoudt, D van, A 3132
1790 H 1: Oosterzee, HA van, A 3239
1790 N 1: Oppenoorth, WJ, A 3087
1791: Opperdoes, JP, A 784
1792: Opzoomer, S, C 294
1793: Opzoomer, S, A 1822
1793a: Orley, B van, A 2567
1793 B 1: Orcagna, A: returned loan
1793 D 1: Orley, B van, A 2567
1794: Ormea, W, A 1789
1795: Os, GJJ van, C 199
1796: Os, GJJ van, A 1106
1797: Os, GJJ van, A 1105
1798: Os, GJJ van, A 1104
1799: Os, J van, A 1095
1800: Os, MM van, A 1107
1801: Os, PG van, A 1096
1802: Os, PG van, A 1101
1803: Os, PG van, A 1102
1804: Os, PG van, A 1097
1805: Os, PG van, C 531
1806: Os, PG van, A 1098
1807: Os, PG van, A 1099
1808: Os, PG van, A 1103
1809: Os, PG van, A 1372
1809a = 1809 A 1: Os, PG van, A 3229
1809 A 2: Os, PG van, A 3230
1809 A 3: Os, PG van, A 4067
1809b: Os, PG van, A 3230
1810: Os, PG van, A 1100
1811: Ossenbeck, W, A 297
1812: Ossenbeck, W, A 2095
1813: Ostade, A van, A 298
1814: Ostade, A van, A 300
1815: Ostade, A van, A 301
1816: Ostade, A van, A 302
1816a: Ostade, A van, A 2332
1817: Ostade, A van, C 200
1818: Ostade, A van, A 299
1819: Ostade, A van, C 201
1819a: Ostade, A van, A 3246
1820 A 1: Ostade, A van, A 2332
1820 A 2: Ostade, A van, A 3246
1820 A 3: Ostade, A van, A 2568
1820 A 4: Ostade, A van, C 1127
1820 A 5: Ostade, A van, A 3281
1820 A 6: Ostade, A van, A 4049
1820 A 7: Ostade, A van, A 4093
1821: Ostade, A van, C 564
1821b: Ostade, A van, A 2568
1821c: Ostade, A van, C 1127
1822: Ostade, I van, A 303
1823: Ostade, I van, C 202
1824: Oudenrogge, JD van, A 304
1824a = 1824 B 1: Ouvrié, PJ, A 2831
1825: Ouwater, I, A 305
1825 A 1: Ouwater, I, A 4026
1826: Ouwater, I, A 306
1827: Ovens, J: returned loan
1828: Ovens, J, C 17
1829: Ovens, J, A 850
1830: Ovens, J, A 1257
1831: Ovens, J, A 1680
1831a = 1831 A 1: Ovens, J, A 2161
1831 A 2: Ovens, J: returned loan
1831 B 1: Ovens, J, A 3749
1831 B 2: Ovens, J, A 3750

1832: Sandrart, J von, A 56
1832 M 1: Oyens, P, A 4136
1833: Paelinck, J, A 1108
1833a: Paepe, J de, A 2961
1833 A 1: Paelinck, J, C 1460
1833 E 1: Paepe, J de, A 2961
1834: Palamedesz, A, A 1906
1835: Palamedesz, A, A 1615
1836: Palamedesz, A, A 1616
1837: Palamedesz, A, A 1623
1837a = 1837 A 1: Palamedesz, A, A 3024
1837 A 2: Palamedesz, A, A 3114
1837 A 3: Palamedesz, A, A 3335
1837 A 4: Palamedesz, A, A 4138
1837b: Palamedesz, A, A 3114
1837c: Palamedesz, A, A 3335
1838: Palamedesz, A, A 861
1839: Palma il Giovane, J, A 1235
1840: Palma il Vecchio, J, A 594
1841: Palthe, J, C 18
1842: Palthe, J, C 19
1843: Palthe, J, C 20
1844: Palthe, J, A 1652
1845: Palthe, J, A 1653
1845 E 1: Maestro Paolo: returned loan
1846: Pasini, A, A 1895
1846a: Pater, JB, A 3257
1846b: Patinir, J, A 3336
1846 F 1: Pater, JB, A 3257
1846 M 1: Patinir, J, A 3336
1846 N 1: Patru, L, A 4165
1846 R 1: GO V A 3818
1846 W 1: Payen, AAJ, A 3452
1847: Peeters, B, A 1949
1847a = 1847 A 1: Peeters, B, A 2518
1848: Peeters, C, A 2111
1848a: Brueghel I, J, A 2102
1849: Peeters, G, A 834
1850: Velde, P van den, A 307
1851: Peppercorn, AD, A 1896
1851a = 1851 B 1: Wall Perné, GF van de, A 2626
1851 D 1: Perronneau, JB, A 3476
1852: Peschier, NL, A 1686
1852a: Phlippeau, KF, A 2134
1852A = 1852 B 1: Pesne, A, A 886
1852 D 1: Phlippeau, KF, A 2134
1852 E 1: Piazzetta, GB, A 3412
1853: Picolet, G, A 1712
1854: Picqué, Ch, A 1109
1855: Pieneman, JW, A 4268
1856: Pieneman, JW, A 4269
1857: Pieneman, JW, A 1110
1858: Pieneman, JW, A 1112
1859: Pieneman, JW, A 1113
1860: Pieneman, JW, A 1111
1861: Pieneman, JW, A 1114
1862: Pieneman, JW, A 1115
1862a: Pieneman, JW, A 1520
1863: Pieneman, JW, A 1371
1864: Pieneman, JW, A 1373
1865: Pieneman, JW: de-acceded
1866: Pieneman, JW, A 1538
1867: Pieneman, JW, A 1558
1868: Pieneman, N, A 4270
1869: Pieneman, JW, A 655
1870: Pieneman, JW, A 1905
1870 A 1: Pieneman, JW, A 1520
1870 A 2: Pieneman, JW, A 2219
1870 A 3: Pieneman, JW, A 944
1870 A 4: Pieneman, JW, A 4123
1870 A 5: Pieneman, JW, A 4137
1870 B 1: GO V A 3791
1870 B 2: GO V A 3801
1871: Pieneman, JW, A 665
1871a: Pieneman, JW, A 2219
1872: Pieneman, N, A 1116
1873: Pieneman, N, A 1701
1874: Pieneman, N, A 2238
1874a = 1874 A 1: Pieneman, N, A 2816
1874 A 2: GO V A 3802
1874 A 3: Pieneman, N, A 3852
1874 A 4: Pieneman, N, A 3877
1874 A 5: Pieneman, N, A 3913
1874 A 6: Pieneman, N, A 3961
1874 A 7: Pieneman, N, A 4164
1875: Pieneman, N: returned loan
1875 B 1: Piero di Cosimo, C 1367
1875 B 2: Piero di Cosimo, C 1368
1876: Pietersz, A, C 391
1877: Pietersz, A, C 70
1878: Pietersz, P, A 865
1879: Pietersz, P, C 404
1879a = 1879 A 1: Pietersz, A, A 2538

1880: Pietersz, A, A 1244
1881: Pietersz, G, C 592
1881 B 1: Pietersz, P, A 865
1881 B 2: Pietersz, P, A 3864
1881 B 3: Pietersz, P, A 3865
1881 B 4: Pietersz, P, A 3951
1881 B 5: Pietersz, P, A 3962
1881 H 1: Piombo, S del, A 3413
1882: Pistorius, E, C 307
1883: Pitloo, AS, A 1117
1884: Plaes, D van der, C 517
1885: Plaes, D van der, C 518
1886: GO V A 4539
1887: Plaes, D van der, A 1413
1887a = 1887 G 1: Pluym, K van der, A 3337
1888: Poel, E van der, A 308
1889: Poel, E van der, A 309
1889 A 1: Poel, E van der, A 117
1890: Poel, E van der, A 1755
1891: Poelenburgh, C van, A 310
1892: Poelenburgh, C van, A 311
1893: Poelenburgh, C van, A 312
1893 A 1-7: Poelenburgh, C van, A 1747a-g
1894: Poelenburgh, C van, A 313
1895: Poelman, PF, A 1118
1895a: Poggenbeek, GJH, A 3603
1895b: Poggenbeek, GJH, A 3604
1895c: Poggenbeek, GJH, A 3605
1896: Poggenbeek, GJH, A 1564
1896a: Poggenbeek, GJH, A 2708
1896 A 1: Poggenbeek, GJH, A 3603
1896 A 2: Poggenbeek, GJH, A 3604
1896 A 3: Poggenbeek, GJH, A 3605
1896 A 4: Poggenbeek, GJH, A 2708
1896 A 5-10: Poggenbeek, GJH: technical accession
1896 A 11: Poggenbeek, GJH, A 4106
1896 AG 1: Polidoro da Lanciano, C 308
1896b = 1896 B 1: Baldovinetti, A, C 1188
1896c: Pontormo, J, A 3009
1896d: Pontormo, J, A 3062
1896 D 1: Master of the Bambino Vispo, A 3979
1896 D 2: Master of the Bambino Vispo, A 3980
1896 E 1: Pontormo, J, A 3009
1896 E 2: Pontormo, J, A 3062
1897 F 1: Poorter, B de, A 3866
1897 F 2: Poorter, B de, A 3867
1897 F 3: Poorter, B de, C 1564
1897: Pool, J: returned loan
1898: Poorter, W de, A 757
1898a = 1898 G 1: Porcellis, J, A 3111
1898 P 1: Pordenone, GA, A 3414
1898 P 2: Pordenone, GA, A 3415
1899: Portman, Chr JL, C 203
1900: Portman, Chr JL, A 1119
1900 A 1: Portman, Chr JL, A 4167
1900 A 2: Portman, Chr JL, A 4168
1901: Post, F: de-acceded
1902: Post, F, A 742
1903: Post, F, A 1585
1904: Post, F, A 4271
1904a: Post, F, A 2334
1904b: Post, F, A 2333
1905: Post, F, A 1486
1905a: Post, F, A 3224
1906: Post, F, A 4273
1906 A 1: Post, F, A 2334
1906 A 2: Post, F, A 2333
1906 A 3: Post, F, A 3224
1907: Post, F, A 4272
1907a: Pot, HG, A 2135
1907b: Pot, HG, A 3301
1907 G 1: Pot, HG, A 2135
1907 G 2: Pot, HG, A 3301
1908: Pothoven, H, A 1268
1908 A 1: Pothoven, H, C 1475
1909: Potter, P, A 315
1910: Potter, P, A 316
1911: Potter, P, C 205
1912: Potter, P, A 317
1913: Potter, P, C 206
1914: Potter, P, A 318
1915: Potter, P, A 711
1916: Potter, P, C 279
1917: Potter, PS, C 204
1917a = 1917 A 1: Potter, PS, A 3338
1917 A 2: Potter, PS, A 3473
1918: Netscher, Casp, A 319
1918a: Potuyl, H, A 2790
1918b: Potuyl, H, A 3339
1918 F 1: Potuyl, H, A 2790
1918 F 2: Potuyl, H, A 3339
1919: School of Fontainebleau 3d quarter 16th century, A 320
1919 A 1: Southern Netherlands school ca 1535-40, A 167

1920: Pourbus 11, F, A 870
1920a: Southern Netherlands school ca 1535-40, A 167
1920 B 1 = 1920c: Foppa, V, A 3008
1921: Prins, J H, A 1120
1922: Pronk, C, A 4274
1923: Prooyen, A J van, A 1824
1923a: Provoost, J, A 2569
1923b: Provoost, J, A 2570
1923 B 1: Provoost, J, A 2569
1923 B 2: Provoost, J, A 2570
1923c = 1923 D 1: Prud'hon, P P, A 3097
1924: Putter, P de, A 1295
1925: Puytlinck, Chr, A 1452
1925a = 1925 A 1: Puytlinck, Chr, A 2160
1926: Pynacker, A, A 321
1927: Pynacker, A, A 322
1928: Pynacker, A, A 323
1929: Pynacker, A, C 207
1929a = 1929 A 1: Pynacker, A, A 2335
1930: Pynacker, A, A 1976
1931: Pynas, Jac S, A 1586
1931 A 1: Northern Netherlands school ca 1610, A 3497
1932: Pynas, Jan S, A 1626
1932 A 1: Pynas, Jan S, A 3510
1933: Quast, P J, A 1756
1933 A 1: Bartsius, W, A 2214
1934: Quast, P J, A 1298
1934 B 1: Queeborne, D van den: de-acceded
1935: Quinkhard, J M, C 81
1936: Quinkhard, J M, C 82
1937: Quinkhard, J M, C 83
1937 A 1: Quinkhard, J M, C 1469
1937 A 2: Quinkhard, J M, C 1470
1937 A 3: Quinkhard, J M, C 1471
1938: Quinkhard, J M, A 1354
1939: ROT A 4521
1940: Quinkhard, J M, A 1509
1941: GOV A 4549
1942: Quinkhard, J M, A 1269
1943: Quinkhard, J M, A 1270
1944: Quinkhard, J M, A 1436
1944a = 1944 A 1: Quinkhard, J M, A 3954
1944 A 2-3: Quinkhard, J M: returned loan
1945: Quinkhard, J M, A 791
1946: Quinkhard, J M, A 792
1947: PAN A 4554
1948: PAN A 4553
1949: PAN A 4564
1950: PAN A 4570
1951: PAN A 4571
1952: PAN A 4572
1953: PAN A 4576
1954: PAN A 4575
1955: PAN A 4577
1956: PAN A 4583
1957: PAN A 4602
1958: PAN A 4593
1959: PAN A 4597
1960: PAN A 4598
1961: PAN A 4604
1962: PAN A 4607
1963: PAN A 4609
1964: PAN A 4621
1965: PAN A 4625
1966: PAN A 4616
1967: PAN A 4618
1968: PAN A 4626
1969: Quinkhard, Julius, A 325
1970: Quinkhard, Julius, A 324
1970a: Raphael, A 271
1970 A 1: Quinkhard, Julius: returned loan
1970 G 1: Raffalt, J G, A 3088
1970 M 1: Raphael, A 271
1970 S 1: Rassenfosse, A, A 3282
1970 S 2: Rassenfosse, A, A 3283
1970 S 3: Rassenfosse, A, A 3284
1970 S 4: Rassenfosse, A, A 3285
1971: Ravenzwaay, J van, C 208
1972: Ravenzwaay, J van, C 209
1973: Ravenzwaay, J van, A 1121
1974: Ravesteyn, H van: returned loan
1975: Ravesteyn, J A van, A 1950
1975a: Ravesteyn, J A van: returned loan
1975A: Ravesteyn, J A van, A 2527
1975b-d: Ravesteyn, J A van: returned loans
1976: Ravesteyn, J A van, A 259
1977: Ravesteyn, J A van, C 240
1978: Ravesteyn, J A van, A 4191
1978a = 1978 A 1: Ravesteyn, J A van, C 1127
1978 A 2: Ravesteyn, J A van, C 1228
1978 A 3: Ravesteyn, J A van, C 1229
1978 A 4: Ravesteyn, J A van, C 1230
1978 A 5: Ravesteyn, J A van, A 2527

1978b: Ravesteyn, J A van, C 1228
1978c: Ravesteyn, J A van, C 1229
1978d: Ravesteyn, J A van, C 1130
1979: HON A 516
1980: HON A 538
1981: HON A 535
1982: HON A 517
1983: HON A 518
1984: HON A 544
1985: HON A 536
1986: HON A 540
1987: HON A 542
1988: HON A 529
1989: HON A 526
1990: HON A 545
1991: HON A 531
1992: HON A 539
1993: HON A 562
1994: HON A 543
1995: HON A 532
1996: HON A 506
1997: HON A 505
1998: HON A 555
1999: HON A 552
2000: HON A 549
2001: HON A 553
2002: HON A 547
2003: HON A 558
2004: HON A 559
2005: HON A 561
2006: HON A 546
2007: HON A 564
2008: HON A 550
2008 A 1: HON C 1516
2008 M 1: Recco, G B, A 3884
2009: Reclam, F, A 1222
2009a = 2009 D 1: Redon, O, A 3265
2010: Reekers, H, A 1704
2011: Regemorter, I J van, A 1122
2012: Regemorter, I J van, A 1123
2013: Regters, T, C 84
2013a: Regters, T, A 2420
2013 A 1: Regters, T, C 1472
2013b: Regters, T, A 2421
2013c: Regters, T, A 2422
2014: Regters, T, A 330
2014a: Regters, T, A 2136
2014 A 3: Regters, T, A 2136
2014 A 4: Regters, T, A 2190
2014 A 5: Regters, T, A 2671
2014 A 6: Regters, T, A 2420
2014 A 7: Regters, T, A 2421
2014 A 8: Regters, T, A 2422
2014 A 9: Regters, T: returned loan
2014b: Regters, T, A 2190
2015: Regters, T, A 329
2015a: Regters, T, A 2671
2016: Rembrandt, C 5
2016 A 1: Rembrandt, C 1453
2017: Rembrandt, C 6
2018: Rembrandt, C 85
2019: Rembrandt, C 216
2020: Rembrandt, A 1935
2021: Flinck, G, A 4166
2022: Rembrandt, C 597
2023: Bol, F, A 714
2024: Flinck, G, A 1282
2024 A 1: Rembrandt, A 3066
2024 A 2: Rembrandt, A 3981
2024 A 3: Rembrandt, A 3137
2024 A 4: Rembrandt, A 3138
2024 A 5: Rembrandt, A 3276
2024 A 6: Rembrandt, A 3340
2024 A 7: Rembrandt, A 3477
2024 A 8: Rembrandt, A 3982
2024 A 9-10: Rembrandt: returned loans
2024 A 11: Rembrandt, C 1450
2024 A 12: Rembrandt, C 1448
2024 A 13: Rembrandt, A 4050
2024 A 14: Rembrandt, A 3934
2024 A 15: Rembrandt: returned loan
2024 A 16: Rembrandt, A 4057
2024 A 17: Rembrandt, A 4090
2024 A 18: Rembrandt, A 4096
2024 A 19: Rembrandt, A 4119
2024 A 20: Rembrandt, C 1555
2024 B 1: Flinck, G, A 1282
2024 B 2: Rembrandt, A 946
2024 B 3: Rembrandt, A 3341
2024 B 4: Rembrandt, A 4019
2025: Rembrandt, A 358
2025a: Rembrandt, A 3066
2025d: Rembrandt, A 3137

2025e: Rembrandt, A 3138
2025f: Rembrandt, A 3276
2025g: Rembrandt, A 3340
2025h: Rembrandt, A 3341
2026: Reni, G, A 331
2026 A 1: Reni, G, A 3416
2026 M 1: Reuss, Princess M H, A 3051
2027: PAN A 4619
2028: GOV A 4546
2028a: Master of the St Elizabeth Panels, A 3145
2028 A 1: GOV A 3777
2028 A 2: GOV A 3778
2028b: Master of the St Elizabeth Panels, A 3146
2028c: Master of the St Elizabeth Panels, A 3147
2028d: Neapolitan school mid-17th century, A 3342
2028 D 1: Ribera, J de, A 3883
2028 D 2: Neapolitan school mid-17th century, A 3342
2029: Ribot, A Th, A 1897
2030: Ribot, A Th, A 1898
2030 B 1: Ricci, S, A 3417
2031: Riegen, N, A 1825
2032: Rietschoof, J C, A 333
2033: Rietschoof, J C, A 334
2033 F 1: Riley, J, A 3303
2034: Ring, P de, A 335
2034 B 1: Ritsema, J, A 3045
2034 D 1: Ferrarese school 2d half 15th century, A 3418
2035: Rochussen, Ch, A 1757
2036: Rochussen, Ch, A 1758
2037: Rochussen, Ch, A 1759
2037 A 1: Rochussen, Ch, A 3923
2037 A 2: Rochussen, Ch, C 1548
2038: Rochussen, Ch, A 1760
2039: Rocquette, J de la, A 1299
2040: Rode, A 639
2041: Roelofs, W, A 1166
2041a = 2041 A 1: Roelofs, W, A 2386
2041 A 2: Roelofs, W, A 3606
2041 A 3: Roelofs, W, A 3607
2041 A 4: Roelofs, W, A 3608
2041 A 5: Roelofs, W, A 4114
2041 A 6: Roelofs, W, A 4207
2041b: Roelofs, W, A 3606
2041c: Roelofs, W, A 3607
2041d: Roelofs, W, A 3608
2042: Roelofs, W E, A 1924
2042a = 2042 B 1: Roemerswaele, M van, A 3123
2043: Roepel, C, A 336
2044: Roepel, C, A 337
2044 D 1: Roestraeten, P G van, A 4189
2045: Roghman, R, A 760
2045a = 2045 A 1: Roghman, R, A 2363
2045 A 2: Roghman, R, A 2364
2045 A 3: Roghman, R, A 4218
2045b: Roghman, R, A 2364
2045 M 1: Rol, H, C 1462
2046: Rombouts, G, A 753
2046a = 2046 D 1: Rombouts, S, A 2529
2047: Romeyn, W, A 338
2048: Romeyn, W, A 339
2049: Romeyn, W, A 340
2050: Romeyn, W, A 341
2051: Romeyn, W, A 712
2051 M 1: Rondinello, N, A 3388
2052: Ronner-Knip, H, C 163
2052 A 1: Ronner-Knip, H, A 3089
2053: Ronner-Knip, H, A 1124
2054: Roos, J M, A 1625
2055: Roos, C F, A 1826
2055 Z 1: Vogel-Roosenboom, M C J W H, A 2387
2055 Z 2: Vogel-Roosenboom M C J W H, A 2740
2055 Z 3: Vogel-Roosenboom M C J W H, A 2722
2055 Z 4: Vogel-Roosenboom M C J W H, A 2723
2056: Vogel-Roosenboom, M C J W H, A 1182
2056a: Vogel-Roosenboom, M C J W H, A 2387
2056 AM 1: Italian school 2d half 17th century, A 4020
2056b: Vogel-Roosenboom, M C J W H, A 2740
2056 B 1: Rosselli, C, A 3419
2056 B 2: Rosselli, C, A 3420
2056 BM 1: Rossum, J C van, A 2874
2056 BM 2: Rossum, J C van, C 1549
2056 BP 1: Rossum, J van, A 1283
2056c: Vogel-Roosenboom, M C J W H, A 2723
2056 C: Vogel-Roosenboom, M C J W H, A 2722
2056 D 1: Rotari, P, A 3421
2056 D 2: Rotari, P, A 3422
2057: Rotius, J A, A 666
2058: Rotius, J A, A 995
2059: Rotius, J A, C 611
2060: Rossum, J van, A 1283
2061: Roth, G A, A 1125
2062: Rottenhammer, J, A 342
2062 A 1: Rottenhammer, J, A 3952

2063: Rottenhammer, J, A 343
2064: Rousseau, P E Th, A 1899
2064a = 2064 A 1: Rousseau, P E Th, A 2709
2065: Rubens, P P, A 344
2066: Rubens, P P, A 345
2066a: Rubens, P P, A 2336
2067: Rubens, P P, C 295
2068: Rubens, P P, C 296
2068 A 1: Rubens, P P, A 2336
2068 A 2: Rubens, P P, A 4051
2068 B 1: Rubens, P P, A 272
2068 B 2: Rubens, P P, A 599
2068 B 3: Rubens, P P, A 600
2068 B 4: Rubens, P P, A 2516
2069: Rubens, P P, A 346
2070: Ruelles, P des, A 1573
2071: Ruisdael, J I van, A 351
2072: Ruisdael, J I van, A 350
2073: Ruisdael, J I van, C 562
2073a: Ruisdael, J I van, A 2337
2074: Ruisdael, J I van, C 211
2075: Ruisdael, J I van, C 210
2076: Ruisdael, J I van, A 348
2077: Ruisdael, J I van, C 213
2078: Ruisdael, J I van, C 212
2079: Ruisdael, J I van, A 349
2080: Ruisdael, J I van, A 347
2080 A 1: Ruisdael, J I van, A 2337
2080 A 2: Ruisdael, J I van, A 3343
2080 A 4: Ruisdael, J I van: returned loan
2080 B 1: Ruisdael, J I van, A 3498
2081: Northern Netherlands school ca 1660, A 132
2081a: Ruisdael, J I van, A 3343
2082: Ruysdael, S J van, A 1525
2083: Ruysdael, S J van, A 352
2083 A 1: Ruysdael, S J van, A 2571
2083 A 2: Ruysdael, S J van, A 3258
2083 A 3: Ruysdael, S J van, A 3259
2083 A 4: Ruysdael, S J van, A 3983
2084: Ruysdael, S J van, A 713
2084a: Ruysdael, S J van, A 2571
2084b: Ruysdael, S J van, A 3258
2084c: Ruysdael, S J van, A 3259
2085: Rust, J A, A 4275
2085a = 2085 M 1: Ruys, S, A 2131
2086: Ruysch, R, A 356
2087: Ruysch, R, C 214
2087 A 1: Ruysch, R, A 2338
2088: Ruysch, R, A 354
2088a: Ruysch, R, A 2338
2089: Ruyter, J de, A 353
2090: Ruyven, P J van, A 1315
2091: Rijck, P C van, A 868
2092: Ryckaert II, D, A 357
2093: Rijk, J de, C 540
2093a = 2093 D 1: Rijsselberghe, Th van: returned loan
2094: Saal, G, A 1827
2095: Sadée, Ph L J F, A 1167
2096: Saenredam, P J, A 359
2097: Saenredam, P J, A 858
2098: Saenredam, P J, A 1189
2099: Saenredam, P J, A 851
2099 A 1: Saenredam, P J, C 1409
2100: Saenredam, P J, C 217
2101: Saftleven, C, A 715
2102: Saftleven, C, A 797
2103: Saftleven, C, A 801
2104: Saftleven, C, A 1588
2105: Saftleven, H, A 363
2106: Saftleven, H, A 361
2107: Saftleven, H, A 1762
2108: Saftleven, H, A 1761
2109: Saftleven, H, A 716
2110 = 2110 A 1: Saftleven, H, A 362
2110 A 2: Saftleven, H, A 3029
2111: Saftleven, H, C 218
2112: Saleh, S B, A 778
2112a: Saleh, S B: returned loan
2112 A 1: G O V A 3790
2112 A 2: G O V A 3798
2112 A 3: G O V A 3799
2112 A 4: Saleh, S B: returned loan
2113: Saligo, Ch L, A 1126
2113 M 1: Fiore, J del, A 4001
2114: Sallembier, H, A 4276
2115: Sallembier, H, A 4277
2115 E 1: Sam, E, A 2694
2115 M 1: Farncombe Sanders, J, A 951
2116: Sanders, D I, A 1492
2117: Sandrart, J von, C 393
2118: Sandrart, J von, A 364
2119: Sandrart, J von, C 26
2120: Sandrart, J von, C 27

2121: Sandrart, J von: returned loan
2122: Sandrart, J von: returned loan
2123: Sandrart, J von: A 4278
2123 F 1: Sands, E, A 3723
2123 M 1: Sangster, H A, A 1677
2123 M 2: Sangster, H A, A 1678
2123 M 3: Sangster, H A, A 1679
2123 M 4: Sangster, H A, A 1966
2123 N 1: Sano di Pietro: returned loan
2124: Master of the San Miniato Altarpiece, A 3013
2125: Sant-Acker, F, A 2655
2126: Sangster, H A, A 1966
2126 E 1: Santen, G van, A 3893
2127: Santvoort, D D, C 431
2128: Santvoort, D D, C 394
2129: Santvoort, D D, A 365
2129 A 1: Santvoort, D D: returned loan
2130: Santvoort, D D, A 1317
2131: Santvoort, D D, A 1318
2132: Santvoort, D D, A 1310
2133: Santvoort, D D, A 1311
2133 F 1: Sassoferrato, G B, A 3423
2133 F 2: Sassoferrato, G B, C 1370
2134: Savery II, J, A 1980
2134a: Savery, R, A 2211
2135: Savery, R, C 447
2136: Savery, R, A 366
2137: Savery, R, A 1297
2137 A 1: Savery, R, A 2211
2138: Savery, R, A 1488
2138b: Savery I, H, A 2526
2138 B 1 = 2138c: Savoldo, G G, A 3269
2138 D 1: Savery I, H, A 2526
2138 M 1: Savoldo, G G, A 3269
2139: Schaak, B, A 844
2139a: Schaap, E R D, A 2653
2139b: Schaap, E R D, A 2654
2139c: Schaik, W H van, A 3345
2139 E 1: Schaap, E R D, A 2653
2139 E 2: Schaap, E R D, A 2654
2139 M 1: Schaik, W H van, A 3345
2140: Schalcken, G, A 367
2141: Schalcken, G, A 368
2142: Schalcken, G, A 369
2143: Schalcken, G, A 370
2144: Schalcken, G, A 371
2144a = 2144 A 1: Schalcken, G, A 2339
2144 A 2: Schalcken, G, A 2340
2144 A 3: Schalcken, G: returned loan
2144 A 4: Schalcken, G: returned loan
2144b: Schalcken, G, A 2340
2145: Schalcken, G, A 899
2146: Schalcken, G, A 900
2147: Schalcken, G, A 2061
2147a: Schalcken, G: returned loan
2147b: Schalcken, G: returned loan
2147c: Schall, J F, A 3260
2147d: Schall, J F, A 3261
2147 E 1: Schall, J F, A 3260
2147 E 2: Schall, J F, A 3261
2148: Scheffer, J B, A 1974
2148 A 1: Scheffer, J B, A 4151
2149: Schelfhout, A, A 1828
2150: Schelfhout, A, C 219
2151: Schelfhout, A, A 1127
2151 A 1: Schelfhout, A, A 3887
2151 A 2: Schelfhout, A, A 4197
2152: Schelfhout, A, A 1128
2152 E 1: Schellinks, W, A 1393
2152 E 2: Schellinks, W, A 2112
2153: Schendel, B van, C 173
2154: Schendel, B van, C 174
2155: Schendel, P van, C 297
2156: Schendel, P van, A 1336
2157: Schermer, C A J, A 1829
2158: Schey, Ph, A 4279
2158a: Schiavone, G, A 3124
2158 B 1: Schiavone, A, A 3374
2158 B 2: Sustris, L, A 3424
2158 B 3: Sustris, L, A 3425
2158 B 4: Sustris, L, A 3426
2158 B 5: Sustris, L, A 3427
2158 B 6: Schiavone, A, A 4009
2158 D 1: Schiavone, G, A 3124
2159: Schieblius, J G, A 745
2159 G 1: Schiller, G F F, A 3567
2160: Schmidt, G A, A 1135
2160a: Schoeff, J P, A 2230
2160 D 1: Schmidt, W H, A 3109
2160 D 2: Schmidt, W H, A 3110
2160 M 1: Schoeff, J P, A 2230
2161: Schoenmakers Pzn, J, A 1129
2162: Schoenmakers Pzn, J, A 1434

2163: Scholten, H J, A 1130
2164: Scholten, H J, A 1830
2165: Schoor, A van der, A 1342
2166: Schoor, A van der, A 1424
2167: Schooten, J van, A 974
2167a = 2167 A 1: Schooten, J van, A 2374
2168: Schotel, J Chr: returned loan
2169: Schotel, J Chr: returned loan
2170: Schotel, J Chr, A 1131
2171: Schotel, J Chr, A 1132
2172: Schotel, P J, A 1133
2173: Schotel, P J, C 225
2174: Schotel, P J: returned loan
2175: Schotel, P J: returned loan
2175a: Schouman, A, A 2730
2176: Schouman, A, A 4280
2176a: Schouman, A, A 3897
2176 A 1: Schouman, A, A 2730
2176 A 2: Schouman, A, A 3458
2176 A 3: Schouman, A, A 3897
2176 A 4: Schouman, A, A 4157
2177: Schouman, M, C 226
2178: Schouman, M, A 1394
2179: Schouman, M, A 1395
2180: Schouman, M, A 1134
2181: Schuer, Th C van der, NM 4485
2182: Schuppen, J van, A 373
2183: Schut, C: returned loan
2184: Schuylenburgh, H van, A 4282
2185: Schuylenburgh, H van, A 4283
2186: Schwartze, J G: returned loan
2186a: Schwartze, Th: returned loan
2186 A = 2186 A 1: Schwartze, J G, A 2818
2186 A 2: Schwartze, J G, A 2819
2186 A 3: Schwartze, J G, A 2821
2186 A 4: Schwartze, J G, A 2820
2186 B: Schwartze, J G, A 2819
2196 C: Schwartze, J G, A 2820
2186 D: Schwartze, J G, A 2821
2187: Schwartze, Th, A 1190
2187 A 1: Schwartze, Th: returned loan
2187 A 2: Schwartze, Th, C 745
2187 A 3: Schwartze, Th, A 2724
2187 A 4: Schwartze, Th, A 2788
2188: Schwartze, Th, A 1703
2188a: Schwartze, Th, C 745
2188b: Schwartze, Th, A 2724
2188c: Schwartze, Th, A 2788
2189: Scorel, J van, A 372
2190: Swart van Groningen, J, A 669
2191: Scorel, J van, A 670
2192: Anthonisz, C, A 1619
2193: Scorel, J van: de-acceded
2194: Zacchia il Vecchio, A 503
2195: Scorel, J van, A 1532
2196: Scorel, J van, A 1636
2196 A 1: Scorel, J van, A 2843
2196 A 2: Scorel, J van, A 1855
2196 A 3: Scorel, J van, A 3853
2196 A 4: Scorel, J van: returned loan
2197: Scorel, J van, A 4284
2197a: Scorel, J van: returned loan
2197 A 1: Scorel, J van, A 3468
2197b: Scorel, J van, A 2843
2197c: Segantini, G, A 3346
2197 K 1: Segaer, P: de-acceded
2197 M 1: Segantini, G, A 3346
2198: Seghers, G, A 374
2198a = 2198 B 1: Seghers, H P, A 3120
2198 G 1: Sellaio, J: returned loan
2198 G 2: Sellaio, J del, A 3428
2199: Serin, H: returned loan
2199 A 1: Serin, H, A 3868
2199 B 1: Sierig, F C, A 2969
2199 D 1: Signorelli, L, A 3430
2200: Sillemans, E, A 1366
2201: Simons, M, A 2083
2202: Slabbaert, K, A 375
2202 G 1: Slager, P M, A 3856
2203: Slingeland, P C van, A 376
2203a = 2203 A 1: Slingeland, P C van: returned loan
2204: Slingeland, P C van, A 377
2205: Slingeland, P C van, A 1983
2205a: Sluyters, J: returned loan
2205 E 1: G O V A 3823
2205 E 2: G O V A 3824
2205 M 1: Smies, J, C 1536
2206: Snayers, P, A 1555
2207: Snayers, P, A 857
2208: Snijders, F, A 378
2209: Snijders, F, A 379
2210: Snyers, P, A 726
2211: Soeren, G J van, A 1490

2211 M 1: Solimena, F, A 996
2212: Son, J F van, A 763
2212: Son, J F van, A 764
2212: Son, J F van, A 765
2212: Son, J F van, A 766
2212 M 1: Sörensen, J L, A 3025
2213: Sorgh, H M, A 495
2214: Sorgh, H M, A 717
2215: Sorgh, H M, A 494
2216: Sorgh, H M, C 227
2217: Sorgh, H M, C 178
2217 A 1: Holland school 1637, A 3299
2218: Sorgh, H M, A 1682
2218a: Holland school 1637, A 3299
2218 B 2: Iriarte, I de, C 1371
2219: Spilberg 11, J, C 395
2220: Spilberg 11, J, A 1258
2221: Spilberg 11, J, A 1262
2221 M 1: Spilman, H, A 1583
2222: Spinny, G de, C 527
2222 A 1: Spinny, G de, A 3826
2222 A 2: Spinny, G de, A 3827
2222 A 3: Spinny, G de: returned loan
2222 A 4: Spinny, G de: returned loan
2222 A 5: Spinny, G de: returned loan
2222 A 6: Spinny, G de: returned loan
2223: Spinny, G de, A 1271
2223a: Spinny, G de: returned loan
2223b: Spinny, G de: returned loan
2223c: Spinny, G de: returned loan
2223d: Spinny, G de: returned loan
2224: Spoel, J, A 1964
2224a = 2224 A 1: Spinny, G de, A 2541
2224 A 2: G O V A 3804
2224 E 1: Spranger, B, A 3888
2225: Spreeuwen, J van, A 1713
2226: Springer, C, A 1136
2226 A = 2226 A 1: Springer, C, A 2388
2227: Stalbemt, A van, A 756
2228: Stalpaert, P, A 1581
2228 B 1 = 2228 G 1: Starnina, G, A 3431
2229: Staveren, J A van, A 381
2230: Staveren, J A van, C 228
2231: Staveren, J A van, A 382
2232: Steen, J H, A 383
2233: Steen, J H, A 390
2234: Steen, J H, C 232
2235: Steen, J H, A 384
2236: Steen, J H, C 231
2237: Steen, J H, A 385
2238: Steen, J H, C 229
2239: Steen, J H, A 389
2240: Steen, J H, A 388
2241: Steen, J H, A 387
2242: Steen, J H, A 391
2243: Steen, J H, C 233
2244: Steen, J H, A 718
2245: Steen, J H, A 386
2246: Steen, J H, C 230
2247: Steen, J H, A 392
2248: Steen, J H, A 393
2249: Steen, J H: returned loan
2250: Steen, J H, A 1932
2250a = 2250 A 1: Steen, J H, A 2572
2250 A 2: Steen, J H: returned loan
2250 A 3: Steen, J H, A 3347
2250 A 4: Steen, J H, A 3509
2250 A 5: Steen, J H, A 3984
2250 A 6: Steen, J H, A 4052
2250b: Steen, J H: returned loan
2250c: Steen, J H, A 3347
2251: Steen, J H, A 1763
2252: VAN M Steen, J van der, A 2056
2253: VAN M Steen, J van der, A 2053
2254: VAN M Steen, J van der, A 2054
2255: Steenwyck, Harm van, A 1529
2256: Steenwyck, Harm van, A 1528
2257: Steenwyck 1, Hendr van, A 798
2257a: Stengelin, A, A 2498
2257b: Stengelin, A, A 2499
2257 B 1: Steenwyck 1, Hendr van, A 798
2257c: Stevens, A, A 3609
2257 E 1: Vught, G van, A 2205
2257 G 1: Giovanni di Francia, A 3432
2257 H 1: Stengelin, A, A 2498
2257 H 2: Stengelin, A, A 2499
2257 K 2: Stevens, A, A 3609
2257 L 1: Stevens, A, A 2358
2258: Helt Stockade, N van, A 1926
2259: Stokvisch, H, A 1137
2259a: Stomme, J J de: returned loan
2259 E 1: Stolker, J, A 3830
2259 M 1: Stomer, M, A 216

2260: Stoop, D, A 395
2260 A 1: Stoop, D, NM 9487
2261: Stoop, D, A 1714
2261a: Stoop, D, NM 9487
2261b = 2261 H 1: Stoop, M, A 2573
2262: Storck, A, A 749
2263: Storck, A: returned loan
2264: Storck, A, C 235
2265: Storck, A, C 236
2266: Storck, A, A 1521
2266a = 2266 A 1: Storck, A, A 2132
2266 A 2: Storck, A, A 4102
2267: Storck, A, A 739
2268: Storck, J, A 1289
2268 E 1: G O V A 3812
2269: Stortenbeker, P, A 1138
2269a = 2269 E 1: Stortenbeker, P, A 2628
2270: Stroebel, J A B, A 1831
2271: Stroebel, J A B, A 1139
2271 F 1: Morazzone, P F, A 3433
2272: Strij, A van, A 396
2273: Strij, A van, C 237
2274: Strij, A van, A 1143
2274 A 1: Strij, A van, A 4195
2275: Strij, J van, A 1140
2276: Strij, J van, A 1141
2277: Strij, J van, A 1142
2278: Strij, J van, C 238
2279: Strij, J van, C 613
2279a: Swan, J M, A 2490
2279b: Swan, J M, A 3610
2279 B 1: Sustris, L, A 3479
2279c: Swan, J M, A 3611
2279d: Swan, J M, A 3612
2279e: Swan, J M, A 3613
2279f: Swan, J M, A 3614
2279 G 1: Swan, J M, A 2490
2279 G 2: Swan, J M, A 3610
2279 G 3: Swan, J M, A 3611
2279 G 4: Swan, J M, A 3612
2279 G 5: Swan, J M, A 3613
2279 G 6: Swan, J M, A 3614
2280: Swanenburgh, I C, A 862
2280a: Swanevelt, H van, A 2497
2280 A 1: Swanenburgh, J I, A 730
2280 F 1: Swanevelt, H van, A 2497
2281: Sweerts, M, A 1957
2282: Sweerts, M, A 1958
2282a = 2282 A 1: Sweerts, M, A 2574
2282 A 2: Sweerts, M, A 2845
2282 A 3: Sweerts, M, A 2846
2282 A 4: Sweerts, M, A 2847
2282 A 5: Sweerts, M, A 2848
2282 A 6: Sweerts, M, A 3855
2282 A 7: Sweerts, M, A 3896
2282b: Sweerts, M, A 2845
2282c: Sweerts, M, A 2846
2282d: Sweerts, M, A 2847
2282e: Sweerts, M, A 2848
2282 G 1: Szyndler, P, A 2850
2283: Alma Tadema, L, A 2289 & A 4173
2283a = 2283 A 1: Alma Tadema, L, A 2427
2283 A 2 = 2283b: Alma Tadema, L, A 2664
2283 B 1: Alma Tadema-Epps, L Th, A 2652
2283 D 1: Taupel, F, A 3499
2283h: Alma Tadema-Epps, L Th, A 2652
2283 K 1: Teenstra, K D, A 3515
2284: Teerlink, A, A 1144
2285: Teerlink, A, A 1145
2286: Temmink, H Chr, C 239
2287: Tempel, A L van den, A 589
2288: Tempel, A L van den, A 397
2289: Tempel, A L van den, A 1972
2289 A 1: Tempel, A L van den, A 2243
2289 A 2: Tempel, A L van den, A 2244
2290: Tempel, A L van den, C 241
2290a: Tempel, A L van den, A 2243
2290b: Tempel, A L van den, A 2244
2291: Tengnagel, J, C 407
2292: Teniers 11, D, A 398
2293: Teniers 11, D, A 399
2294: Teniers 11, D, A 400
2295: Teniers 11, D, A 401
2296: Teniers 11, D, C 298
2297: Teniers 11, D, C 299
2297 B 1: Teniers 11, D, A 3226
2298: Teniers 11, D, C 300
2298c: Southern Netherlands school ca 1640, A 2575
2299: Terlaak, G, A 1832
2299 F 1: Terwesten 11, A, A 2403
2299 F 2: Terwesten 11, A, A 2404
2299 K 1: Terwesten, M, A 4086
2300: Famars Testas, W de, A 1184

2300 M 1: Teyler van Hall, J J, C 1557
2301: Thielen, J Ph van, A 407
2301a = 2301 F 1: Tholen, W B, A 3615
2301 F 2: Tholen, W B, A 3090
2301 F 3: Tholen, W B, A 3566
2301 J 1: Thulden, Th van, A 4654
2301 K 1: Tibaldi, P, A 3955
2302: Tidemand, A, A 1833
2302a: Tiepolo, G B, A 2965
2302b: Tintoretto, J, A 2964
2302 B 1: Tiepolo, G B, A 2965
2302 B 2: Tiepolo, G B, A 3985
2302 B 3: Tiepolo, G B: returned loan
2302 B 4: Tiepolo, G B, A 3437
2302 B 5: Tiepolo, G B, A 3438
2302 D 1: Tiepolo, G B, A 3434
2302 E 1: Tintoretto, J, A 2964
2302 E 2: Tintoretto, J, A 3439
2302 E 3: Tintoretto, J, A 3440
2302 E 4: Tintoretto, J, A 3986 & A 3987
2302 E 5: Tintoretto, J, C 1373
2302 E 6: Tintoretto, J, A 4010
2302 E 7: Tintoretto, J, A 3902
2303: Tischbein, J F A, A 2084
2303a = 2303 A 1: Tischbein, J F A, A 2827
2303 A 2: Tischbein, J F A, A 2828
2303 A 3: Tischbein, J F A, A 2256
2303 A 4: Tischbein, J F A, A 2414
2303 A 5: Tischbein, J F A, A 2415
2303 A 6: G O V A 3785
2303 A 7-8: Tischbein, J F A: returned loans
2303b: Tischbein, J F A, A 2828
2304: Tischbein, J F A, A 1275
2304 a-b: Tischbein, J F A: returned loans
2304c: Tischbein, J F A, A 2256
2304d: Tischbein, J F A, A 2414
2304e: Tischbein, J F A, A 2415
2305: Tischbein, J V, A 406
2306: Titian, A 595
2306 A 1: Titian, A 3441
2307: Titian, A 475
2307 G 1: Tocqué, L, A 3904
2307 G 2: Tocqué, L, A 3905
2308: Tol, D van, A 417
2308a = 2308 A 1: Tol, D van, A 2341
2309: Tol, D van, C 21
2310: Tom, J B, A 1146
2311: Toorenvliet, J, A 1978
2311a = 2311 A 1: Toorenvliet, J, A 2254
2311b = 2311 B 1: Toorop, J Th: returned loan
2311 B 2: Toorop, J Th, A 3616
2311 B 3: Toorop, J Th, A 3349
2311 B 4: Toorop, J Th, A 4226
2311c: Toorop, J Th, A 3616
2311cc: Toorop, J Th, A 3349
2311d = 2311 D 1: Torrentius, J S, A 2813
2312: Toussaint, P J, A 1834
2312a = 2312 B 1: Treck, J J, A 2222
2313: Trigt, H A van, A 1147
2314: Denner, B, A 770
2315: Troost, C, A 418
2315 A 1: Troost, C, A 4225
2316: Troost, C, A 396
2317: Troost, C, A 1635
2318: Troost, C, C 79
2319: Troost, C, C 87
2320: Troost, C, C 411
2320a = 2320 A 1: Troost, C, A 2158
2321: Troost, C, C 80
2321 A 1: Troost, C, C 1473
2322: Troost, C, A 1608
2323: Troost, C, A 1439
2323a: Troost, C, A 2576
2324: Troost, C: returned loan
2325: Troost, C, A 2078
2325a: Troost, C, A 2342
2325b: Troost, C: returned loan
2326: Troost, C, A 719
2326 A 1: Troost, C, A 2342
2326 A 2: Troost, C, A 2576
2326 A 3: Troost, C, A 3453
2326 A 4: Troost, C, A 3933
2326 A 5: Troost, C, A 3948
2326 A 6: Troost, C, A 4023
2326 A 7: Troost, C, A 2191
2326 A 8: Troost, C, A 4089
2326 A 9: Troost, C, A 4099
2326 A 10: Troost, C, A 4115
2326 A 11: Troost, C, A 4200
2326 A 12: Troost, C, A 4201
2326 A 13: Troost, C, A 4287
2326 A 14: Troost, C, A 4209
2327: Boonen, A, A 1914

2539: Versteegh, M, C 255
2540: Versteegh, M, C 256
2540a: Verster, F H: returned loan
2540b: Verster, F H, A 2941
2540 D 1: Verster, F H: returned loan
2540 D 2: Verster, F H, A 2941
2540 D 3: Verster, F H, A 2942
2541: Vertin, P G, A 1562
2542: Verveer, S L, A 1153
2543: Verveer, S L, A 1154
2544: Vervloet, F, A 1155
2545: Verwer, A de, A 603
2546: Verwer, A de, C 453
2546a: Verwer, A de: de-acceded
2547: Verwilt, F, A 450
2547a: Veth, J P, A 2124
2547 A 1: Verwilt, F, A 3500
2547b: Veth, J P, A 2138
2547 B 1: Veth, J P, A 2124
2547 B 2: Veth, J P, A 2138
2547 B 3: Veth, J P, A 3449
2547 B 4: Veth, J P, A 3837
2548: Vettewinkel Dzn, H, C 257
2549: Vettewinkel Dzn, H, A 1475
2550: Vianen II, P van, A 1557
2550 M 1: Vianey, P, C 1542
2551: Victors, Jac, A 1674
2552: Victors, Jan, A 451
2553: Victors, Jan, C 259
2553a: Victors, Jan, A 2345
2554: Victors, Jan: returned loan
2554 A 1: Victors, Jan, A 2345
2555: Victors, Jan, C 258
2555 E 1: Vignon, C, A 4068
2555 H 1: Vincent, F A, A 3931
2556: Vinckboons, D, A 1351
2557: Vinckboons, D, A 1352
2557a: Vinckboons, D, A 2401
2558: Vinckboons, D, A 1782
2558 A 1: Vinckboons, D, A 2401
2558 A 2: Netherlands school ca 1620, A 201
2559: Vinckboons, D, A 2109
2559 F 1: Vivarini, B, A 4012
2559 F 2: Vivarini, B, A 4235
2559 M 1: Vivien, J, A 4016
2560: Vlieger, S de, A 454
2561: Vlieger, S de, A 1981
2562: Vlieger, S de, A 1982
2563: Vlieger, S de, A 2086
2564: Vlieger, S de, C 449
2565: Vlieger, S de, A 1777
2566: Vliet, H C van, A 455
2566a: Vliet, H C van, A 2531
2567: Vliet, H C van, A 1971
2567 A 1: Vliet, H C van, A 2531
2568: Vliet, H C van, A 1343
2568a = 2568 D 1: Vliet, W W van, A 2577
2568 N 1: Voet, J F, A 3236
2569: Vogel, C J de, A 1177
2570: Vogel, J G, A 1156
2570a = 2570 A 1: Vogel, J G, A 2721
2571: Vogelaer, P, C 524
2571 E 1: Vogels, W, A 3091
2572: Vois, A de, A 456
2573: Vois, A de, A 457
2574: Vois, A de, A 458
2574 A 1: Vois, A de, A 2512
2575: Vois, A de, C 260
2575a: Vois, A de, A 2512
2575b = 2575 B 1: Vois, A de, A 3237
2576: Vollenhoven, H van, A 889
2577: Vollevens I, J, A 1325
2577a = 2577 A 1: Vollevens I, J, A 283
2578: Vollevens II, J, A 1630
2579: Vollon, A, A 1901
2579 A 1: Vollon, A, A 3092
2580: Vollon, A, A 2302
2580a: Vollon, A, A 3092
2581: Vonck, E, A 1951
2582: Vonck, J, A 1344
2583: Vonck, J, A 1487
2583 M 1: Voogd, H, A 4094
2583 M 2: Voogd, H, C 1524
2584: Voordecker, H, A 1157
2584a: Voort, C van der, C 748
2584A = 2584 F 1: Voorhout, J, A 2371
2585: Voort, C van der, C 408
2586: Voort, C van der, C 622
2586a: Voort, C van der, C 1108
2586 A 1: Voort, C van der, C 748
2586 A 2: Voort, C van der, C 1108
2587: Voort, C van der, C 399
2588: Voort, C van der: returned loan

2589: Voort, C van der, A 1242
2590: Voort, C van der, A 1243
2591: Voort, C van der, A 1416
2591 A 1: Voort, C van der, A 3741
2591 A 2: Voort, C van der, A 3742
2592: Delff, W J, A 953
2593: Voort, C van der, C 1553
2594: Vos, M, A 1158
2594 A 1: Vos, M, A 3456
2595: Vos, M de, A 1717
2595a: Voskuyl, H P, A 2368
2595b: Voskuyl, H P, A 2369
2595 E 1: Voskuil, J J, A 4229
2595 G 1: Voskuyl, H P, A 2368
2595 G 2: Voskuyl, H P, A 2369
2596: Vrancx, S, A 1637
2597: Vrancx, S, C 510
2598: Vrancx, S, A 1699
2598 A 1: Vrancx, S, A 2699
2599: Vrancx, S, A 1409
2599a: Vrel, J, A 3127
2600: Vrel, J, A 1592
2600 A 1: Vrel, J, A 3127
2601: Vries, A de, A 758
2601a: Vries, H V de, A 2390
2601 A 1: Vries, A de, A 2157
2601 A 2: Vries, A de: returned loan
2601 A 3: Vries, A de, A 4053
2601 B 1: Vries, H V de, A 2390
2601 M 1: Vries, J de, A 4065
2602: Vries, M van, A 1507
2603: Vries, R van, A 459
2603 F 1 = 2604: Vroom, H C, A 460
2604a: Vroom, H C, A 2163
2605: Vroom, H C: returned loan
2606: Vroom, H C, A 1361
2606a: Vroom, H C, A 2661
2606 A 1: Vroom, H C, A 2163
2606 A 2: Vroom, H C, A 2661
2606 A 3: Vroom, H C, A 2858
2606 A 4: Vroom, H C: returned loan
2606 A 5: Vroom, H C, A 3108
2606 A 6: Vroom, H C: returned loan
2606b: Vroom, H C, A 2858
2606bb: Vroom, H C: returned loan
2606c: Vroom, H C, A 3108
2607: Vroom, H C, A 602
2607a: Waay, N van der, A 2789
2607A = 2607 B 1: Vroomans, I, A 2530
2607 D 1: Vrijmoet, J: returned loan
2607 L 1: Vught, G van, A 2205
2607 O 1: Waay, N van der, A 2789
2607 O 2: Waay, N van der, A 3144
2607 S 1: Wal, Ph van der, A 1348
2607 S 2: Wal, Ph van der, A 1349
2608: Waldorp, A, C 261
2608 A 1: Waldorp, A, A 3849
2608 A 2: Waldorp, A, A 3850
2609: Walraven, I, A 461
2609a = 2609 B 1: Walscapelle, J van, A 2346
2609 M 1: Wandscheer, M W, A 3044
2610: Wappers, E Ch G, A 1159
2610 D 1: Wassenbergh, E G, A 3740
2611: Wassenbergh, J A, A 1779
2611a-c = 2611 A 1-3: Wassenbergh, J A: de-acceded
2611 A 4: Wassenbergh, J A: de-acceded
2612: Waterloo, A, A 734
2613: Weenix, J, C 262
2614: Weenix, J, A 464
2615: Weenix, J, A 463
2616: Weenix, J, A 462
2617: Weenix, J, C 264
2618: Weenix, J, C 263
2618 A 1: Weenix, J, A 4098
2619: Weenix, J B, A 1417
2619 A 1: Weenix, J B: returned loan
2620: Weenix, J B, A 591
2620a: Weenix, J B: returned loan
2620 A 1: Weenix, J B, A 3879
2621: Weissenbruch, J, A 1160
2622: Weissenbruch, J, A 1835
2623: Weissenbruch, J, A 1526
2623a: Weissenbruch, J, A 2830
2624: Weissenbruch, H J, A 2291
2624 A 1: Weissenbruch, H J, A 2438
2624 A 2: Weissenbruch, H J, A 2439
2624 A 3: Weissenbruch, H J, A 2710
2624 A 4: Weissenbruch, H J, A 3617
2624 A 5: Weissenbruch, H J, A 3618
2624 A 6: Weissenbruch, H J, A 3619
2624 A 7: Weissenbruch, H J, A 3355
2624 A 8: Weissenbruch, H J, A 3093

2625: Weissenbruch, H J, A 1923
2625a: Weissenbruch, H J, A 2438
2625b: Weissenbruch, H J, A 2439
2625 B 1: Weissenbruch, J, A 1160
2625 B 2: Weissenbruch, J, A 1835
2625 B 3: Weissenbruch, J, A 1526
2625 B 4: Weissenbruch, J, A 2830
2625c: Weissenbruch, H J, A 2710
2625d: Weissenbruch, H J, A 3617
2625 D 1: Welie, J A van, A 3356
2625 D 2: Welie, J A van, A 3357
2625 D 3: Welie, J A van, A 3358
2625 D 4: Welie, J A van, A 3359
2625e: Weissenbruch, H J, A 3618
2625 E 1: Welti, A: de-acceded
2625f: Weissenbruch, H J, A 3619
2625g: Weissenbruch, H J, A 3355
2625h: Welie, J A van, A 3356
2625j: Welie, J A van, A 3358
2625k: Welie, J A van, A 3359
2625l: Welti, A: de-acceded
2626: Werff, A van der, A 465
2627: Werff, A van der, A 1715
2628: Werff, A van der, A 1267
2629: Werff, A van der, C 265
2630: Werff, A van der, A 469
2631: Werff, A van der, A 468
2632: Werff, A van der, A 467
2632a: Werff, A van der, A 2347
2633: Werff, A van der, C 266
2633 A 1: Werff, A van der, A 2347
2633 A 2: Werff, A van der, A 3935
2633 A 3: Vivien, J, A 4016
2633 B 1: Werff, A van der, A 623
2634: Werff, A van der, A 466
2634a: Werff, A van der, A 2347
2635: Werff, P van der, A 470
2636: Werff, P van der, A 471
2637: Werff, P van der, A 472
2638: Werff, P van der, C 267
2639: Werff, P van der, C 268
2639a = 2639 A 1: Werff, P van der, A 2657
2639 A 2: Werff, P van der, A 2658
2639 A 3: Werff, P van der, A 631
2639 A 4: Werff, P van der, A 632
2639b: Werff, P van der, A 2658
2640: R O T A 4490
2641: R O T A 4491
2642: R O T A 4492
2643: R O T A 4494
2644: R O T A 4493
2645: R O T A 4495
2646: R O T A 4496
2647: R O T A 4497
2648: R O T A 4498
2649: R O T A 4499
2650: R O T A 4500
2651: R O T A 4501
2652: R O T A 4502
2653: R O T A 4503
2654: R O T A 4504
2655: R O T A 4505
2656: R O T A 4506
2657: R O T A 4507
2658: R O T A 4508
2659: R O T A 4509
2660: R O T A 4510
2661: R O T A 4511
2662: R O T A 4513
2663: R O T A 4514
2664: R O T A 4512
2665: R O T A 4517
2666: R O T A 4518
2667: West, J H van, C 269
2667a: Westerbaen, J J, A 1478
2668: Westenberg, G P, A 1161
2668 F 1: Westerbaen, J J, A 1478
2669: Westerbeek, C, A 1836
2669c: Westerwoudt, J B A M, A 2282
2669 F 1: Westerwoudt, J B A M, A 2282
2669 F 2: Westerwoudt, J B A M, A 3094
2670: Wet, G de, A 1854
2671: Wet I, J W de, A 1530
2672: Wet I, J W de, A 1853
2672 C 1: Wetering de Rooy, J E van de, A 3522
2673: Wever, C, A 1531
2673 F 1: Weijand, J G, A 3101
2674: Weyden, R van der, A 973
2675: Weyerman, J C, A 1302
2676: Whistler, J A M, A 1902
2676 T 1: Wieringa, H W, A 2221
2677: Wieringa, N, A 1641
2678: Wieringen, C C van, A 1629

2678a = 2678 D 1: Wiertz, H F, A 2202
2678 F 1: Wiggers, D, A 3722
2679: Wildens, J, A 616
2680: Willaerts, Abr, A 579
2681: Willaerts, Abr, A 1683
2682: Willaerts, Adam, A 1387
2682a: Willaerts, Adam, A 2162
2683: Willaerts, Adam, A 1927
2684: Willaerts, Adam, A 1430
2684 A 1: Willaerts, Adam, A 2162
2684 A 2: Willaerts, Adam, A 4116
2685: Willaerts, Adam, A 1955
2686: Willeboirts, Th, C 400
2686 A 1: Willeboirts Bosschaert, T: de-acceded
2686 F 1: Windtraken, P W, A 2737
2686 F 2: Windtraken, P W, A 2738
2687: Winghe, J van, A 473
2688: Winter, A H van, A 1162
2689: Winter, A H van, A 1917
2690: Winterhalter, F X, A 1702
2691: Wissing, W, A 879
2691 A 1: Wissing, W, A 1228
2692: Wit, J de, C 401
2693: Wit, J de, A 1783
2694: Wit, J de, A 4291
2694 A 1: Wit, J de, A 3231
2694 A 2: Wit, J de, A 3232
2694 A 3: Wit, J de, A 3233
2694 A 4: Wit, J de, A 3872
2694 A 5: Wit, J de, A 3885
2694 A 6: Wit, J de, A 3886
2694 A 7: Wit, J de, A 3900
2694 A 8: Southern Netherlands school 2d half 17th century,
 A 4021
2694 A 9: Wit, J de, RBK 1958-81
2694 A 10: Wit, J de, RBK 16558
2694 A 11: Wit, J de, C 1577
2694 A 12: Wit, J de, A 4659
2695: Wit, J de, C 1221
2695a: Wit, J de, A 3231
2696: Withoos, M, A 1925
2696a: Witsen, W A, A 2925
2696b: Witsen, W A, A 2953
2696 B 1: Witsen, W A, A 2952
2696 B 2: Witsen, W A, A 2951
2696 B 3: Witsen, W A, A 2953
2696 B 4: Witsen, W A, A 2954
2696 B 5: Witsen, W A, A 2948
2696 B 6: Witsen, W A, A 2949
2696 B 7: Witsen, W A, A 2950
2696 B 8: Witsen, W A, A 2955
2696 B 9: Witsen, W A, A 2956
2696 B 10: Witsen, W A, A 3568
2696c: Witsen, W A, A 2953
2696d: Witsen, W A, A 2954
2697: Witte, E de, C 270
2698: Witte, E de, A 474
2698 A 1: Witte, E de, A 2536
2698 A 2: Witte, E de, A 3244
2698 A 3: Witte, E de, A 3738
2698 A 4: Witte, E de, A 4054
2698 A 5: Witte, E de, A 4055
2699: Witte, E de, A 1642
2699a: Witte, E de, A 2536
2699aa: Witte, E de, A 3244
2699b: Wittel, G van, A 2659
2699c: Wittel, G van, A 2659
2699 G 1: Wittel, G van, A 2659
2699 G 2: Wittel, G van, A 2660
2699 G 3: Machy, P A de, A 3958
2699 R 1: Wolbers, H G, A 3501
2700: Wolfert, J B, A 1494
2700a: Wolff, B, A 2192
2700b: Wolff, B, A 2193
2700 B 1: Wolff, B, A 2192
2700 B 2: Wolff, B, A 2193
2700 B 3: Wolff, B, A 659
2700 B 4: Wolff, B, A 658
2700c: Wolff, B, A 659
2700d: Wolff, B, A 658
2701: Wonder, P Chr, A 1163
2701 M 1: Woutersin, L F, A 2693
2702: Woutersz, J, A 1341
2702a = 2702 A 1: Woutersz, J, A 2426
2703: Wouwerman, J, A 1850
2704: Wouwerman, P, A 486
2705: Wouwerman, P, A 487
2706: Wouwerman, P, A 1794
2707: Wouwerman, Ph, A 476
2708: Wouwerman, Ph, A 482
2709: Wouwerman, Ph, A 484
2710: Wouwerman, Ph, A 483
2711: Wouwerman, Ph, A 479

2712: Wouwerman, Ph, A 480
2713: Wouwerman, Ph, A 477
2714: Wouwerman, Ph, A 481
2715: Wouwerman, Ph, A 478
2716: Wouwerman, Ph, A 485
2717: Wouwerman, Ph, C 271
2718: Wouwerman, Ph, C 272
2719: Wouwerman, Ph, C 273
2719a = 2719 A 1: Wouwerman, Ph, A 2348
2720: Wouwerman, Ph, A 1610
2721: Uyttenbroeck, M van, A 1462
2722: Elsheimer, A, A 2650
2723: Uytewael, J A, A 1696
2723 A 1: Uytewael, J A, A 1697
2724: Uytewael, J A, A 988
2725: Uytewael, J A, A 1843
2726: Wulfraet, M, A 1912
2727: Wijck, Th, A 489
2728: Wijck, Th, A 488
2729: Wijck, Th, A 2113
2730: Westerbaen, J J, A 1478
2731: Wijckersloot, J van, A 748
2731a = 2731 F 1: Wieringa, H W, A 2221
2732: Wijnants, J, A 492
2733: Wijnants, J, C 275
2734: Wijnants, J, A 491
2735: Wijnants, J, A 493
2736: Wijnants, J, C 274
2737: Wijnants, J, A 490
2738: Wijnants, J, C 276
2738a: Wijnants, J, A 2349
2739: Wijnants, J, C 277
2739a: Wijntrack, D, A 2304
2739 A 1: Wijnants, J, A 2349
2739 E 1: Wijntrack, D, A 2682
2739 E 2: Wijntrack, D, A 2304
2740: Wijsmuller, J H, A 1963
2740 A 1: Wijsmuller, J H, A 3026
2740 K 1: Ysselstein, A van, A 3928
2740 K 2: Ysselstein, A van, A 3929
2740 P 1: Zacchia il Vecchio, A 503
2741: Zaganelli, B, A 783
2741a: Zeeuw, C de, A 2849
2741 A 1: Zaganelli, F, A 3446
2741 AB 1: Zandleven, J A, A 3502
2741 B 1: Zeeuw, C de, A 2849
2741 B 2: Zeeuw, C de, A 1537
2742: Ziem, F, A 1903
2743: Ziesenis, J G, A 882
2744: Ziesenis, J G, A 881
2745: Ziesenis, J G, A 1229
2745a: Zürcher, J W C A, A 2535
2745b: Zürcher, J W C A: returned loan
2745 E 1: Zuccarelli, F, A 3447
2745 G 1: Zugno, F, A 3435
2745 G 2: Zugno, F, A 3436
2745 M 1: Zürcher, J W C A, A 2535
2745 M 2: Zürcher, J W C A: returned loan
2746: Zwaerdecroon, B, A 828
2747: Zwaerdecroon, B, A 829
2747a: Zwart, W H P J de, A 2283
2747b: Zwart, W H P J de, A 2957
2747bb: Zwieten, C van, A 2834
2747 B 1: Zwart, W H P J de, A 2283
2747 B 2: Zwart, W H P J de, A 2957
2747 B 3: Zwart, W H P J de, A 3361
2747 B 4: Zwart, W H P J de, A 3362
2747 B 5: Zwart, W H P J de, A 3363
2747 B 6: Zwart, W H P J de, A 3364
2747 B 7: Zwart, W H P J de, A 3365
2747 B 8: Zwart, W H P J de, A 3366
2747 B 9: Zwart, W H P J de, A 3367
2747 B 10: Zwart, W H P J de, A 3368
2747 B 11: Zwart, W H P J de, A 3503
2747 B 12: Zwart, W H P J de, A 3504
2747 B 13: Zwart, W H P J de, A 3505
2747 B 14: Zwart, W H P J de, A 3506
2747 B 15: Zwart, W H P J de, A 3507
2747c: Zwart, W H P J de, A 3363
2747d: Zwart, W H P J de, A 3362
2747 D 1: Zwieten, C van, A 2834
2747e: Zwart, W H P J de, A 3363
2747f: Zwart, W H P J de, A 3364
2747g: Zwart, W H P J de, A 3365
2747h: Zwart, W H P J de, A 3366
2747i: Zwart, W H P J de, A 3367
2747j: Zwart, W H P J de, A 3368
2748: MIN Holland school ca 1635, A 4433
2749: MIN Holland school ca 1675, A 4437
2750: MIN Holland school ca 1650, A 4434
2751: MIN Holland school ca 1675, A 4438
2752: MIN Holland school ca 1690, A 4439
2753: MIN Holland school ca 1710, A 4440

2754: MIN Holland school ca 1710, A 4441
2755: MIN Holland school ca 1750, A 4443
2756: MIN Holland school ca 1750, A 4445
2757: MIN Holland school ca 1750, A 4444
2758: MIN Holland school ca 1750, A 4446
2759: MIN Holland school ca 1715, A 4442
2760: MIN Holland school ca 1760, A 4448
2761: MIN Holland school ca 1780, A 4450
2762: MIN Holland school ca 1780, A 4451
2763: MIN Holland school ca 1770, A 4452
2764: MIN Holland school ca 1770, A 4453
2765: MIN Holland school ca 1775, A 4449
2766: MIN Wilhelmina, F S, princess of Prussia, A 4374
2767: MIN Wilhelmina, F S, princess of Prussia, A 4372
2768: MIN Wilhelmina, F S, princess of Prussia, A 4373
2769: MIN Holland school ca 1785, A 4457
2770: MIN Holland school ca 1840, A 1959
2771: MIN Bettes, J, A 4297
2772: MIN Brounckhurst, A van, A 4302
2773: MIN English school ca 1565, A 4390
2774: MIN English school ca 1565, A 4392
2775: MIN English school ca 1565, A 4391
2776: MIN English school ca 1565, A 4393
2777: MIN Cooper, S, A 4310
2778: MIN Cooper, S, A 4311
2779: MIN German school ca 1730, A 4382
2780: MIN German school ca 1730, A 4379
2781: MIN German school ca 1730, A 4380
2782: MIN German school ca 1730, A 4381
2783: MIN English school ca 1725, A 4397
2784: MIN English school ca 1770, A 4399
2785: MIN English school ca 1770, A 4400
2786: MIN English school ca 1770, A 4401
2787: MIN French school ca 1500, A 4404
2788: MIN French school ca 1570, A 4405
2789: MIN French school ca 1580, A 4407
2790: MIN Boze, J, A 4320
2791: MIN French school ca 1570, A 4406
2792: MIN German school ca 1810, A 4389
2793: MIN German school ca 1810, A 4388
2794: MIN Cooper, A, A 4304
2795: MIN German school ca 1700, A 4378
2796: MIN Spanish school ca 1650, A 4459
2797: MIN English school ca 1635, A 4395
2797a: MIN Northern Netherlands school ca 1675, A 4203
2798: MIN French school ca 1665, A 4410
2799: MIN French school ca 1665, A 4411
2800: MIN French school ca 1665, A 4412
2800a: MIN Northern Netherlands school ca 1700, A 2812
2800 B 1: MIN Northern Netherlands school ca 1690, A 4427
2800 D 1: MIN Northern Netherlands school ca 1700, A 2812
2801: MIN Northern Netherlands school ca 1710, A 4428
2802: MIN Northern Netherlands school ca 1710, A 4429
2802 D 1: MIN German school ca 1700, A 4032
2803: MIN Liotard, J-E, A 4336
2804: MIN Holland school ca 1795, C 46
2805: MIN Holland school ca 1650, A 4434
2806: MIN French school ca 1785, A 4419
2807: MIN French school ca 1790, A 4421
2808: MIN French school ca 1790, A 4420
2809: MIN French school ca 1580, A 4408
2810: MIN German school ca 1770, A 4386
2811: MIN German school ca 1780, A 4387
2811a: MIN French school? 18th century, A 2809
2811 F 1: MIN Northern Netherlands school ca 1790, A 4211
2811 M 1: MIN English school ca 1790, A 4108
2811 S 1: MIN English school ca 1810, A 4109
2811 T 1: MIN French school ca 1805, A 4110
2811 W 1: MIN Holland school ca 1810, A 4658
2812: MIN Holland school ca 1850, A 1962
2813: MIN Ramelli, F, A 4364
2814: MIN French school? 18th century, A 4414
2815: MIN French school ca 1725, A 4417
2815 M 1: MIN French school 2d half 18th century, RBK 17156
2816: MIN French school ca 1750, A 4418
2816a: MIN French school? ca 1810, A 650
2817: MIN French school? 18th century, A 4415
2818: MIN French school? 18th century, A 4416
2818a: MIN Northern Netherlands school ca 1805, A 2632
2818b: MIN Northern Netherlands school ca 1805, A 2633
2818c: MIN Northern Netherlands school ca 1810, A 2635
2818d: MIN Northern Netherlands school ca 1805, A 2636
2818e: MIN Northern Netherlands school ca 1805, A 2637
2818f: MIN German school ca 1830, A 2638
2818 F: MIN Northern Netherlands school? ca 1800, A 2640
2818g: MIN Northern Netherlands school ca 1805, A 2641
2818h: MIN Northern Netherlands school ca 1805, A 2647
2818i: MIN Northern Netherlands school ca 1805, A 2648
2818k: MIN Northern Netherlands school ca 1805, A 2673
2818l: MIN Northern Netherlands school ca 1810, A 2175
2818m: MIN Northern Netherlands school ca 1810, A 2176
2818n: MIN Northern Netherlands school ca 1810, A 2644
2818o: MIN Northern Netherlands school ca 1820, A 3063

2819: MIN Arlaud, B, A 4295
2820: MIN Cooper, S, A 4308
2821: Blarenberghe, L N van, A 4249
2821a: MIN Collins, R, A 2639
2821 D 1: MIN Boze, J, A 3869
2821 D 2: MIN Boze, J, A 3870
2821 D 3: MIN Boze, J, A 3871
2821 G 1: MIN Collins, R, A 2639
2822: MIN Guernier, L du, A 4317
2823: MIN Guernier, L du, A 4316
2824: MIN Cooper, S, A 4306
2825: MIN Cooper, S, A 4305
2826: MIN Cooper, S, A 4307
2826a = 2826 A 1: MIN Dixon, N, A 4312
2826 A 2: MIN Cooper, S, A 4308
2827: MIN Cooper, S, A 4309
2827a: MIN Cooper, S, A 4308
2828: MIN Arlaud, B, A 4296
2828a = 2828 E 1: Dietterlin, B, A 2844
2829: MIN Duchatel, M, A 4313
2830: MIN Holland school ca 1635, A 4431
2831: MIN Holland school ca 1650, A 4435
2832: MIN Fock, H, A 2120
2833: MIN Granges, D des, A 4314
2834: MIN Granges, D des, A 4315
2834a = 2834 B 1: MIN Grebner, W, A 2173
2834 B 2: MIN Grebner, W, A 2174
2834c = 2834 D 1: MIN Guernier, L du, A 4316
2835: MIN Haag, G, A 4318
2836: MIN Haag, G, A 4319
2836 E 1: MIN Hari I, J, A 2817
2836 E 2: MIN Hari I, J, A 3102
2836 E 3: MIN Hari I, J, A 4030
2837: MIN Hilliard, N, A 4321
2838: MIN Oliver, I, A 4347
2839: MIN Oliver, I, A 4346
2840: MIN Hilliard, N, A 4323
2841: MIN Hoadley, P, A 4324
2842: MIN Hoskins, J, A 4326
2843: MIN Hoskins, J, A 4327
2844: MIN Hoskins, J, A 4325
2845: MIN Hoskins, J, A 4328
2846: MIN Dixon, N, A 4312
2847: MIN Cooper, A, A 4303
2848: MIN Lamprecht, G, A 4332
2848 F 1: MIN Leblon, J Chr, A 3873
2848 F 2: MIN Leblon, J Chr, A 3874
2849: MIN Lesage, P, A 4335
2849 A 1: MIN Lesage, P, A 4237
2849 M 1: MIN Marinkelle, J, A 4224
2850: MIN Michelin, J, A 4339
2851: MIN Thach, N, A 4369
2852: MIN Jackson II, J, A 4330
2853: MIN Monogrammist WP, A 4377
2854: MIN Monogrammist WP, A 4376
2855: MIN Mussard, R, A 4340
2856: MIN Mussard, R, A 4343
2857: MIN Mussard, R, A 4342
2858: MIN Mussard, R, A 4341
2858 M 1: MIN Nilson, J E, A 4107
2859: MIN Oliver, I, A 4345
2860: MIN Oliver, I, A 4344
2861: MIN Hilliard, N, A 4322
2862: MIN Oliver, P, A 4348
2863: MIN Oliver, P, A 4352
2864: MIN Oliver, P, A 4351
2865: MIN Oliver, P, A 4349
2866: MIN Oliver, P, A 4350
2867: MIN Oliver, P, A 4353
2868: MIN Phaff, L, A 4360
2869: MIN Phaff, L, A 649
2870: MIN Ploetz, H, A 4361
2870a: MIN Quenedey, E, A 4206
2870 A 1: MIN Ploetz, H, A 4238
2870 AB 1: MIN Pluckx, J A A, A 4362
2870 B 1: MIN Quenedey, E, A 4206
2871: MIN Ramelli, F, A 4363
2872: MIN Richter, Chr, A 4365
2872 G 1: MIN Rochard, S J, C 1459
2873: MIN Saint Ligié, de, A 4366
2874: Savery I, J, A 2117
2874 B 1: MIN Schmidt Crans, J M, A 4367
2875: MIN Sypesteyn, M M van, A 4368
2875a: MIN Hilliard, N, A 4323
2875aa: MIN Temminck, L, A 3272
2875 B 1: MIN Hilliard, N, A 4323
2875d: MIN Wolters, H, A 2407
2875 D 1: MIN Temminck, L, A 3272
2875 D 2: MIN Temminck, L, A 4072
2875e: MIN Wolters, H, A 2408
2875 E 1: MIN Thach, N, A 4369
2875f: MIN Wolters-van Pee, H, A 2409
2875g: MIN Wolters-van Pee, H, A 2410

2875 G 1: MIN Visser, A de, A 3058
2875 H 1: MIN Wolters, H, A 2407
2875 H 2: MIN Wolters, H, A 2408
2875 L 1: MIN Wolters-van Pee, H, A 2409
2875 L 2: MIN Wolters-van Pee, H, A 2410
2876: MIN Légaré, G, A 4333
2877: MIN Boit, Ch, A 4300
2878: MIN Boit, Ch, A 4301
2879: MIN Holland school ca 1665, A 4436
2880: MIN Zincke, Chr Fr, A 4375
2881: MIN Holland school ca 1750, A 4447
2882: MIN Holland school ca 1775, A 4458
2883: MIN Huaut I, P, A 4329
2884: MIN Blesendorff, S, A 4298
2885: MIN English school ca 1800, A 4403
2886: MIN German school 1770, A 4385
2887: MIN English school ca 1665-70, A 4396
2888: MIN French school ca 1675, A 4413
2889: MIN French school ca 1650, A 4409
2889a: MIN Petitot, J, A 4357
2889b: MIN Petitot, J, A 4358
2889c: MIN Petitot, J, A 4359
2890: Buys, J: returned loan
2891: MIN English school ca 1750-51, A 4402
2892: MIN English school ca 1755, A 4398
2892 B 1: MIN German school? 18th century?, A 4652
2892 B 2: MIN Northern Netherlands school late 18th century, A 4653
2893: MIN Boit, Ch, A 4299
2893a = 2893 G 1: MIN Graham I, J, A 2689
2893 M 1: MIN Huaut I, P, A 4329
2894: MIN Liotard, J E, A 239
2895: MIN Petitot, J, A 4354
2896: MIN Petitot, J, A 4355
2897: MIN Petitot, J, A 4356
2898: MIN Petitot, J, A 4357
2899: MIN Petitot, J, A 4358
2900: MIN Petitot, J, A 4359
2901: MIN Toutin, H, A 4370
2902: MIN Toutin, H, A 4371
2902-2908: MIN transferred to RPK
2909: MIN Holland school ca 1780, A 4454
2910: MIN Holland school ca 1780, A 4455
2911: MIN Holland school ca 1780, A 4456
2911a: Josselin de Jong, P de: transferred to the department of sculpture and applied arts
2912: transferred to the department of sculpture and applied arts
2912 M 1: MIN Northern Netherlands school ca 1630, A 4204
2913: transferred to RPK
2913a: MIN Northern Netherlands school ca 1790, A 2631
2913 A = 2913 A 1: MIN Holland school ca 1780, A 4455
2913 A 2: MIN Holland school ca 1780, A 4456
2913b: MIN Northern Netherlands school ca 1790, A 2634
2913 B: MIN Holland school ca 1780, A 4456
2913c: MIN Northern Netherlands school ca 1790, A 2642
2913d: MIN Northern Netherlands school ca 1790, A 2643
2913e: MIN Northern Netherlands school ca 1790, A 2645
2913f: MIN Northern Netherlands school ca 1790, A 2646
2914: Holland school? ca 1595, A 4484
2915: Cornelisz van Oostsanen, J, A 4294
2915a: Heyden, J van der, A 2511
2915 K 1: MIN Heemskerck, M van, C 1563
2915 M 1: Heyden, J van der, A 2511
2915 S 1: Leen, W van, A 4111
2916: Leyden, L van, A 4260
2916a: Zeuner, J, C 1534
2916b: Zeuner, J, C 1532
2916 B 1: Overbeek, L, A 4266
2916 B 2: Overbeek, L, A 4267
2916 D 1: Zeuner, J, C 1534
2916 D 2: Zeuner, J, C 1532
2916 D 3: Zeuner, J, A 4117
2916 D 4: Zeuner, J, C 1531
2916 D 5: Zeuner, J, A 4230
2916 D 6: Zeuner, J, C 1569
2917: PAST Vilsteren, J van, C 49
2918: PAST Mijn, G van der, A 2375
2919: PAST Northern Netherlands school ca 1780, A 1421
2920: PAST Northern Netherlands school ca 1790, A 1571
2921: PAST Northern Netherlands school ca 1775, A 1667
2922: transferred to RPK
2922a: PAST Monogrammist JJ, A 2411
2922b: PAST Monogrammist JJ, A 2412
2922 G 1: PAST Northern Netherlands school ca 1750, C 1572
2922 G 2: PAST Northern Netherlands school ca 1750, C 1573
2922 M 1: PAST Vau...ons, C 1574
2923: MIN Hodges, Ch H, C 45
2924: MIN Northern Netherlands school ca 1805, A 2082
2924a: PAST Northern Netherlands school ca 1790, A 2829
2924b: PAST Northern Netherlands school ca 1805, A 2793
2924c-d: AQU: transferred to RPK
2924e: AQU Arntzenius, P F N J, A 3724
2924 E 1: PAST German school ca 1808, A 4113

2924f: AQU Bakker Korff, A H, A 3620
2924g: AQU Bakker Korff, A H, A 3621
2924 G 1: PAST Northern Netherlands school ca 1815, C 1552
2924h: AQU Bakker Korff, A H, A 3622
2924 M 1: PAST Northern Netherlands school ca 1820, A 4132
2925: PAST Northern Netherlands school ca 1890, A 4640
2925a: PAST Basseporte, M F, A 2119
2925aa: AQU Bosboom, J, A 3647
2925 A: PAST Anspach, J, A 2630
2925b: AQU Bastert, S N, A 3623
2925bb: AQU Bosboom, J, A 3648
2925 B: PAST Cate, S J ten, A 2284
2925 B 1: PAST Andriessen, J, A 3048
2925c: AQU Bauer, M A, A 3624
2925cc: AQU Bosboom, J, A 3649
2925 C: PAST Cate, S J ten, A 2285
2925d: AQU Bauer, M A, A 3625
2925dd: AQU Bosboom, J, A 3650
2925 D 1: PAST Anspach, J, A 2630
2925e: AQU Bauer, M A, A 3626
2925ee: AQU Bosboom, J, A 3651
2925 E: PAST Cuylenburg, C van, A 2622
2925 E 1: AQU Arntzenius, P F N J, A 3724
2925f: AQU Bauer, M A, A 3627
2925ff: AQU Bosboom, J, A 3652
2925 F: PAST Cuylenburg, C van, A 2623
2925g: AQU Bauer, M A, A 3628
2925gg: AQU Bosboom, J, A 3653
2925 G: PAST Cuylenburg, C van, A 2622
2925 G 1: AQU Bakker Korff, A H, A 3620
2925 G 2: AQU Bakker Korff, A H, A 3621
2925 G 3: AQU Bakker Korff, A H, A 3622
2925h: AQU Bauer, M A, A 3629
2925hh: AQU Bosboom, J, A 3654
2925 H: PAST Cuylenburg, C van, A 2623
2925 H 1: PAST Basseporte, M F, A 2119
2925i: AQU Bauer, M A, A 3630
2925ii: AQU Bosboom, J, A 3655
2925k: AQU Bauer, M A, A 3631
2925kk: AQU Bosboom, J, A 3656
2925 K 1: AQU Bastert, S N, A 3623
2925l: AQU Bisschop, Chr, A 3632
2925ll: AQU Breitner, G H, A 3659
2925 L 1: AQU Bauer, M A, A 3624
2925 L 2: AQU Bauer, M A, A 3625
2925 L 3: AQU Bauer, M A, A 3626
2925 L 4: AQU Bauer, M A, A 3627
2925 L 5: AQU Bauer, M A, A 3628
2925 L 6: AQU Bauer, M A, A 3629
2925 L 7: AQU Bauer, M A, A 3630
2925 L 8: AQU Bauer, M A, A 3631
2925 LK 1: PAST Baur, H J A, A 3223
2925m: AQU Bock, Th E A de, A 3633
2925mm: AQU Breitner, G H, A 3659
2925 M 1: AQU Bisschop, Chr, A 3632
2925n: AQU Bock, Th E A de, A 3634
2925nn: AQU Breitner, G H, A 3659
2925 o: AQU Bock, Th E A de, A 3635
2925 oo: Bock, Th E A de: transferred to RPK
2925p: AQU Bock, Th E A de, A 3636
2925pp: Bock, Th E A de: transferred to RPK
2925 P 1: AQU Bock, Th E A de, A 3633
2925 P 2: AQU Bock, Th E A de, A 3634
2925 P 3: AQU Bock, Th E A de, A 3635
2925 P 4: AQU Bock, Th E A de, A 3636
2925q: AQU Bosboom, J, A 3637
2925qq: AQU Daumier, H, A 3660
2925r: AQU Bosboom, J, A 3638
2925rr: AQU Gabriël, P J C, A 3661
2925 R 1: AQU Bosboom, J, A 3637
2925 R 2: AQU Bosboom, J, A 3638
2925 R 3: AQU Bosboom, J, A 3639
2925 R 4: AQU Bosboom, J, A 3640
2925 R 5: AQU Bosboom, J, A 3641
2925 R 6: AQU Bosboom, J, A 3642
2925 R 7: AQU Bosboom, J, A 3643
2925 R 8: AQU Bosboom, J, A 3644
2925 R 9: AQU Bosboom, J, A 3645
2925 R 10: AQU Bosboom, J, A 3646
2925 R 11: AQU Bosboom, J, A 3647
2925 R 12: AQU Bosboom, J, A 3648
2925 R 13: AQU Bosboom, J, A 3649
2925 R 14: AQU Bosboom, J, A 3650
2925 R 15: AQU Bosboom, J, A 3651
2925 R 16: AQU Bosboom, J, A 3652
2925 R 17: AQU Bosboom, J, A 3653
2925 R 18: AQU Bosboom, J, A 3654
2925 R 19: AQU Bosboom, J, A 3655
2925 R 20: AQU Bosboom, J, A 3656
2925s: AQU Bosboom, J, A 3639
2925 S 1: AQU Bouten, Ch: transferred to RPK
2925t: AQU Bosboom, J, A 3640
2925 T 1: AQU Breitner, G H, A 3657

2925 T 2: AQU Breitner, GH, A 3658
2925 T 3: AQU Breitner, GH, A 3659
2925 T 4-6: Breitner, GH: technical accession
2925 T 7: Breitner, GH: transferred to RPK
2925u: AQU Bosboom, J, A 3641
2925 U 1: PAST Cate, SJ ten, A 2284
2925 U 2: PAST Cate, SJ ten, A 2285
2925v: AQU Bosboom, J, A 3642
2925 V 1: Cohen Gosschalk, J: transferred to RPK
2925 VD 1: PAST La Croix, S de, A 1609
2925w: AQU Bosboom, J, A 3643
2925 W 1: PAST Cuylenburg, C van, A 2622
2925 W 2: PAST Cuylenburg, C van, A 2623
2925x: AQU Bosboom, J, A 3644
2925ij: AQU Bosboom, J, A 3645
2925z: AQU Bosboom, J, A 3646
2926: PAST Daiwaille, JA, A 1618
2926^1: AQU Israels, J, A 2608
2926^2: AQU Israels, J, A 2609
2926^3: AQU Israels, J, A 2610
2926^4: AQU Israels, J, A 2611
2926^5: AQU Israels, J, A 2612
2926^6: AQU Israels, J, A 2613
2926^7: AQU Israels, J, A 2614
2926^8: AQU Israels, J, A 2619
2926^9: AQU Israels, J, A 2617
2926^{10}: AQU Israels, J, A 2618
2926^{10a}: Israels, J: transferred to RPK
2926^{11}: AQU Jongkind, JB, A 3671
2926^{12}: PAST Josselin de Jong, P de, A 3672
2926^{13}: PAST Josselin de Jong, P de, A 3673
2926a: Gogh, VW van: transferred to RPK
2926 A: Derksen, G: transferred to RPK
2926ab: PAST Hodges, Ch H, A 2542
2926ac: PAST Hodges, Ch H, A 2543
2926b: Gogh, VW van: transferred to RPK
2926 B: PAST Hubrecht, AAL, A 2797
2926 B 1: AQU Daumier, H, A 3660
2926c: Gogh, VW van: transferred to RPK
2926 C: PAST Hubrecht, AAL, A 2795
2926d: AQU Gogh, VW van, A 3662
2926 D: PAST Hubrecht, AAL, A 2796
2926 D 1: Derksen, G: transferred to DRVK
2926e: PAST Hodges, Ch H, A 2542
2926f: PAST Hodges, Ch H, A 2543
2926g: AQU Israels, IL, A 3663
2926 G 1: AQU Gabriël, PJC, A 3661
2926 GE 1: MIN Gauthier, PJ, A 4031
2926 GM 1: Ghezzi, PL: returned loan
2926h: PAST Israels, IL, A 3664
2926 H 1–3: Gogh, VW van: transferred to RPK
2926 H 4: AQU Gogh, VW van, A 3662
2926i: PAST Israels, IL, A 3665
2926k: AQU Israels, IL, A 3666
2926 K 1: Grijs, HF de: transferred to RPK
2926l: PAST Israels, IL, A 3667
2926 L 1: PAST Hodges, Ch H, A 2542
2926 L 2: PAST Hodges, Ch H, A 2543
2926 L 3: PAST Hodges, Ch H, A 4029
2926 L 4: PAST Hodges, Ch H, A 4639
2926 L 5: PAST Hodges, Ch H, A 4227
2926m: PAST Israels, IL, A 3668
2926 M 1: PAST Hubrecht, AAL, A 2797
2926 M 2: PAST Hubrecht, AAL, A 2795
2926 M 3: PAST Hubrecht, AAL, A 2796
2926n: AQU Israels, IL, A 3669
2926 N 1: AQU Israels, IL, A 3663
2926 N 2: PAST Israels, IL, A 3664
2926 N 3: PAST Israels, IL, A 3665
2926 N 4: AQU Israels, IL, A 3666
2926 N 5: PAST Israels, IL, A 3667
2926 N 6: PAST Israels, IL, A 3668
2926 N 7: AQU Israels, IL, A 3669
2926 N 8: AQU Israels, IL, A 3670
2926 N 9: PAST Israels, IL, A 2911
2926 N 10: PAST Israels, IL, A 2912
2926 N 11: PAST Israels, IL, A 2916
2926 N 12: AQU Israels, IL, A 3728
2926o: AQU Israels, IL, A 3670
2926 P 1: AQU Israels, J, A 2608
2926 P 2: AQU Israels, J, A 2609
2926 P 3: AQU Israels, J, A 2610
2926 P 4: AQU Israels, J, A 2611
2926 P 5: AQU Israels, J, A 2612
2926 P 6: AQU Israels, J, A 2613
2926 P 7: AQU Israels, J, A 2614
2926 P 8: AQU Israels, J, A 2619
2926 P 9: AQU Israels, J, A 2617
2926 P 10: AQU Israels, J, A 2618
2926 P 11: Israels, J: transferred to RPK
2926 P 12 & 13: AQU Israels, J: technical accession
2926 P 14: AQU Israels, J, A 3729
2926 P 15: AQU Israels, J, A 3733

2926 R 1: AQU Jongkind, JB, A 3671
2926 S 1: PAST Josselin de Jong, P de, A 3672
2926 S 2: PAST Josselin de Jong, P de, A 3673
2926 S 3: Josselin de Jong, P de: returned loan
2926 T 1: Knip, JA: transferred to RPK
2927: La Fargue, IL: transferred to RPK
2927a = 2927 F 1: Le Fauconnier, HVG: transferred to RPK
2928: PAST Liotard, J-E, A 228
2929: PAST Liotard, J-E, A 230
2930: PAST Liotard, J-E, A 1198
2931: PAST Liotard, J-E, A 1199
2932: PAST Liotard, J-E, A 235
2933: PAST Liotard, J-E, A 234
2934: PAST Liotard, J-E, A 238
2935: PAST Liotard, J-E, A 237
2936: PAST Liotard, J-E, C 30
2937: PAST Liotard, J-E, C 31
2938: PAST Liotard, J-E, A 232
2939: PAST Liotard, J-E, A 233
2940: PAST Liotard, J-E, A 231
2941: PAST Liotard, J-E, A 240
2942: PAST Liotard, J-E, A 241
2943: PAST Liotard, J-E, A 229
2944: PAST Liotard, J-E, A 236
2945: PAST Liotard, J-E, A 1194
2946: PAST Liotard, J-E, A 242
2947: PAST Liotard, J-E, A 1195
2948: PAST Liotard, J-E, A 243
2949: PAST Liotard, J-E, A 1197
2950: PAST Liotard, J-E, A 1196
2950a: AQU Mauve, A, A 2440
2950aa: AQU Mauve, A, A 2492
2950A: AQU Maris, JH, A 2478
2950b: AQU Mauve, A, A 2441
2950B: AQU Maris, JH, A 2479
2950 B 1: AQU Maris, JH, A 2478
2950 B 2: AQU Maris, JH, A 2479
2950 B 3: AQU Maris, JH, A 2477
2950 B 4: AQU Maris, JH, A 2475
2950 B 5: AQU Maris, JH, A 2481
2950 B 6: AQU Maris, JH, A 2480
2950 B 7: AQU Maris, JH, A 2476
2950 B 8: AQU Maris, JH: transferred to RPK
2950 B 9: AQU Maris, JH, A 3674
2950 B 10: AQU Maris, JH, A 3675
2950 B 11: AQU Maris, JH, A 3676
2950 B 12: AQU Maris, JH, A 3677
2950 B 13: AQU Maris, JH, A 3678
2950 B 14: AQU Maris, JH, A 3679
2950 B 15: AQU Maris, JH, A 3680
2950 B 16: AQU Maris, JH, A 3681
2950 B 17: AQU Maris, JH, A 3682
2950 B 18: AQU Maris, JH, A 3683
2950 B 19: AQU Maris, JH, A 3684
2950 B 20: AQU Maris, JH, A 3685
2950 B 21: AQU Maris, JH, A 3686
2950c: AQU Mauve, A, A 2442
2950 C: AQU Maris, JH, A 2477
2950d: AQU Mauve, A, A 2443
2950 D: AQU Maris, JH, A 2475
2950 D 1: AQU Maris, M, A 3687
2950 D 2: Maris, M: transferred to RPK
2950e: AQU Mauve, A, A 2444
2950 E: AQU Maris, JH, A 2481
2950 E 1: AQU Maris, W, A 3688
2950 E 2: AQU Maris, W, A 3689
2950 E 3: AQU Maris, W, A 3690
2950 E 4: AQU Maris, W, A 3691
2950 E 5: AQU Maris, W, A 3692
2950 E 6: AQU Maris, W, A 3693
2950 E 7: AQU Maris, W, A 3694
2950f: AQU Mauve, A, A 2445
2950 F: AQU Maris, JH, A 2480
2950 F 1: Maris, W: transferred to RPK
2950g: AQU Mauve, A, A 2446
2950 G: AQU Maris, JH, A 2476
2950 G 1: AQU Mauve, A, A 2492
2950 G 2: AQU Mauve, A, A 2440
2950 G 3: AQU Mauve, A, A 2441
2950 G 4: AQU Mauve, A, A 2442
2950 G 5: AQU Mauve, A, A 2443
2950 G 6: AQU Mauve, A, A 2444
2950 G 7: AQU Mauve, A, A 2445
2950 G 8: AQU Mauve, A, A 2446
2950 G 9: AQU Mauve, A, A 2447
2950 G 10: AQU Mauve, A, A 2448
2950 G 11: AQU Mauve, A, A 2449
2950 G 12: AQU Mauve, A, A 2450
2950 G 13: AQU Mauve, A, A 2451
2950 G 14: AQU Mauve, A, A 2452
2950 G 15: AQU Mauve, A, A 3695
2950 G 16: AQU Mauve, A, A 3696
2950 G 17: AQU Mauve, A, A 3697

2950 G 18: AQU Mauve, A, A 3698
2950 G 19: AQU Mauve, A, A 3699
2950 G 20: AQU Mauve, A, A 3700
2950 G 21: Mauve, A: technical accession
2950 G 22: Mauve, A: transferred to RPK
2950 GM 1: PAST Mengs, AR, A 4199
2950h: AQU Mauve, A, A 2447
2950 H 1: PAST Mertens, JC, A 2168
2950 H 2: PAST Mertens, JC, A 2169
2950i: AQU Mauve, A, A 2448
2950 I: AQU Maris, JH, A 3674
2950k: AQU Mauve, A, A 2449
2950 K: AQU Maris, JH, A 3675
2950 K 1: AQU Mesdag, HW, A 3701
2950l: AQU Mauve, A, A 2450
2950 L: AQU Maris, JH, A 3676
2950 L 1: Millet, JF: transferred to RPK
2950m: AQU Mauve, A, A 2451
2950 M: AQU Maris, JH, A 3677
2950 M 1: PAST Muhrman, H, A 3702
2950 ME 1: Nat, WH van der: transferred to RPK
2950n: AQU Mauve, A, A 2452
$2950n^a$: PAST Mertens, JC, A 2168
$2950n^b$: PAST Mertens, JC, A 2169
2950 N: AQU Maris, JH, A 3678
2950 N 1: AQU Neuhuys, JA, A 2482
2950 N 2: Neuhuys, JA: transferred to RPK
2950 N 3: AQU Neuhuys, JA, A 3703
2950 N 4: Neuhuys, JA: transferred to RPK
2950 N 5: Neuhuys, JA: transferred to RPK
2950o: AQU Mauve, A, A 3695
$2950o^1$: AQU Neuhuys, JA, A 2482
2950 O: AQU Maris, JH, A 3679
2950p: AQU Mauve, A, A 3696
2950 P: AQU Maris, JH, A 3680
2950 P 1: Neuhuys, J: transferred to RPK
2950 Q: AQU Maris, JH, A 3681
2950r: AQU Mauve, A, A 3697
2950 R: AQU Maris, JH, A 3682
2950 S: AQU Maris, JH, A 3683
2950t: AQU Mauve, A, A 3698
2950 T: AQU Maris, JH, A 3684
2950u: AQU Mauve, A, A 3699
2950 U: AQU Maris, JH, A 3685
2950v: AQU Mauve, A, A 3700
2950 V: AQU Maris, JH, A 3686
2950w: AQU Mesdag, HW, A 3701
2950 W: AQU Maris, M, A 3687
2950Ww: Maris, M: transferred to RPK
2950 WW: AQU Maris, W, A 3688
2950x: Millet, JF: transferred to RPK
2950xx: PAST Muhrman, H, A 3702
2950 X: AQU Maris, W, A 3689
2950 XX: AQU Maris, W, A 3690
2950y: AQU Neuhuys, JA, A 2482
2950yy: Neuhuys, JA: transferred to RPK
2950 Y: AQU Maris, W, A 3691
2950 YY: AQU Maris, W, A 3692
2950z: AQU Neuhuys, JA, A 3703
2950za: Neuhuys, JA: transferred to RPK
2950zz: Neuhuys, J: transferred to RPK
2950 Z: AQU Maris, W, A 3693
2950 ZZ: AQU Maris, W, A 3694
2951: Orley, B van: transferred to RPK
2951a: AQU Poggenbeek, GJH, A 2483
2951aa: Picasso, PR: returned loan
2951 A: PAST Perronneau, JB, A 2142
2951b: AQU Poggenbeek, GJH, A 2484
2951 B: Pieneman, N: transferred to DRVK
2951 B 1: PAST Perronneau, JB, A 2142
2951 B 2: PAST Perronneau, JB, A 3747
2951 B 3: PAST Perronneau, JB, A 3748
2951c: AQU Poggenbeek, GJH, A 2485
2951d: AQU Poggenbeek, GJH, A 2486
2951 D 1: Picasso, PR: returned loan
2951e: AQU Poggenbeek, GJH, A 2489
2951 E 1: Pieneman, N: transferred to DRVK
2951f: AQU Poggenbeek, GJH, A 2487
2951g: AQU Poggenbeek, GJH, A 2488
2951 G 1: AQU Poggenbeek, GJH, A 2483
2951 G 2: AQU Poggenbeek, GJH, A 2484
2951 G 3: AQU Poggenbeek, GJH, A 2485
2951 G 4: AQU Poggenbeek, GJH, A 2486
2951 G 5: AQU Poggenbeek, GJH, A 2489
2951 G 6: AQU Poggenbeek, GJH, A 2487
2951 G 7: AQU Poggenbeek, GJH, A 2488
2951 G 8: AQU Poggenbeek, GJH, A 3704
2951 GD 1: PAST Prud'hon, PP, C 1487
2951 GD 2: PAST Prud'hon, PP, C 1488
2951 GD 3: PAST Prud'hon, PP, C 1489
2951 GD 4: PAST Prud'hon, PP, C 1490
2951h: AQU Poggenbeek, GJH, A 3704
2951hh = 2951 H 1: Quinkhard, J: transferred to RPK

2951k: Rappard, A G A van: transferred to R P K
2951 K 1: Rappard, A G A van: transferred to R P K
2951l: A Q U Rochussen, Ch, A 3705
2951 L 1: A Q U Rochussen, Ch, A 3705
2952-2954: Reimer, C F: transferred to R P K
2954a: Rops, F: transferred to R P K
2954 A = 2954 B 1: Roosenboom, M: transferred to R P K
2954 D 1: Rops, F: transferred to R P K
2955: P A S T Basseporte, M F, A 2119
2955a: P A S T Schmidt, I, A 2155
2955aa: P A S T Schmidt, I, A 3238
2955b: Schwartze, Th; returned loan
2955 B 1: P A S T Schmidt, I, A 2151
2955 B 2: P A S T Schmidt, I, A 3238
2955c: A Q U Swan, J M, A 3706
2955d: A Q U Swan, J M, A 3707
2955 D 1: P A S T Schwartze, Th, A 3054
2955 D 2: P A S T Schwartze, Th, A 3450
2955 D 3: P A S T Schwartze, Th, A 3564
2955 D 4: P A S T Schwartze, Th, A 4231
2955e: A Q U Swan, J M, A 3708
2955 E 1: A Q U Swan, J M, A 3706
2955 E 2: A Q U Swan, J M, A 3707
2955 E 3: A Q U Swan, J M, A 3708
2955 E 4: A Q U Swan, J M, A 3709
2955 E 5: A Q U Swan, J M, A 3710
2955 E 6: A Q U Swan, J M, A 3711
2955 E 7: A Q U Swan, J M, A 3712
2955 E 8: A Q U Swan, J M, A 3713
2955f: A Q U Swan, J M, A 3709
2955g: A Q U Swan, J M, A 3710
2955h: A Q U Swan, J M, A 3711
2955i: A Q U Swan, J M, A 3712
2955k: A Q U Swan, J M, A 3713
2956: P A S T Tischbein, J F A, A 408
2957: P A S T Tischbein, J F A, A 409
2958: P A S T Tischbein, J F A, A 412
2959: P A S T Tischbein, J F A, A 413
2960: P A S T Tischbein, J F A, A 414
2961: P A S T Tischbein, J F A, A 415
2962: P A S T Tischbein, J F A, A 410
2963: P A S T Tischbein, J F A, A 411
2964: P A S T Tischbein, J F A, A 416
2964a-b: Toorop, J Th: returned loans
2964 B 1-2: Toorop, J Th: returned loans
2964 B 3: A Q U Toorop, J Th, A 3714
2964 B 4-5: Toorop, J Th: returned loans
2964e: A Q U Toorop, J Th, A 3714
2965: P A S T Tozelli, F, C 543
2966: Tozelli, F: returned loan
2967: P A S T Troost, C, A 1707
2968: P A S T Troost, C, A 1708
2968a = 2968 A 1: P A S T Troost, C, C 1193
2968 A 2: P A S T Troost, C, A 3745
2968 A 3: P A S T Troost, C, A 4060
2968 B 1: P A S T Troost, S, C 1407
2968 B 2: P A S T Troost, S, C 1408
2968 C = 2968 D 1: A Q U Troyon, C, A 3715
2969: Vaillant, B: transferred to R P K
2970: P A S T Vaillant, B, A 1651
2970a: A Q U Weissenbruch, H J, A 2453
2970 A: Verster, F: returned loan
2970 A 1: P A S T Vaillant, B, A 3484
2970 A 2: P A S T Vaillant, B, A 3485
2970 A 3: P A S T Vaillant, B, A 3486
2970 A 4: P A S T Vaillant, B, A 3487
2970b: A Q U Weissenbruch, H J, A 2454
2970 B: A Q U Veth, J P, A 3716
2970 BB: A Q U Veth, J P, A 3717
2970 B 1: Verster, F: returned loan
2970c: Weissenbruch, J H: transferred to R P K
2970cc: A Q U Weissenbruch, H J, A 3718
2970 C: Voerman I, J: transferred to R P K
2970d: A Q U Weissenbruch, H J, A 3719
2970d: P A S T Zilcken, Ch L Ph, A 2690
2970dd: A Q U Weissenbruch, H J, A 3720
2970 D: Voerman I, J: transferred to R P K
2970 D 1: A Q U Veth, J P, A 3716
2970 D 2: A Q U Veth, J P, A 3717
2970 D 3: A Q U Veth, J P, A 3725
2970 DK 1: P A S T Vigée-Lebrun, E, A 3898
2970e: Witsen, W: transferred to R P K
2970 E: Voerman I, J: transferred to R P K
2970 EE: Voerman I, J: transferred to R P K
2970 E 1: A Q U Vilsteren, J van, C 49
2970 E 2: A Q U Vilsteren, J van, C 51
2970of: Witsen, W: transferred to R P K
2970 F: Vogel, J G: transferred to R P K
2970og: A Q U Witsen, W A, A 3721
2970 G: Vogel, J G: transferred to R P K
2970 G 1-4: Voerman I, J: transferred to R P K
2970 G 5: A Q U Voerman I, J, A 3735
2970 G 6: A Q U Voerman I, J, A 3736

2970oh: Zwart, W de: transferred to R P K
2970 H: Vogel, J G: transferred to R P K
2970 H 1-4: Vogel, J G: transferred to R P K
2970i-k: Zwart, W de: transferred to R P K
2970 K 1: A Q U Weissenbruch, H J, A 2453
2970 K 2: A Q U Weissenbruch, H J, A 2454
2970 K 3: Weissenbruch, J H: transferred to R P K
2970 K 4: A Q U Weissenbruch, H J, A 3718
2970 K 5: A Q U Weissenbruch, H J, A 3719
2970 K 6: A Q U Weissenbruch, H J, A 3720
2970 K 7: A Q U Weissenbruch, H J, A 4036
2970 KB 1: Wierink, B W: transferred to R P K
2970 KD 1: Wiggers, D: returned loan
2970 L 1: Witsen, W: transferred to R P K
2970 L 2: Witsen, W: transferred to R P K
2970 L 3: A Q U Witsen, W A, A 3721
2970 L 4: Witsen, W: transferred to R P K
2970 M 1: P A S T Zilcken, Ch L Ph, A 2690
2970 N 1-4: Zwart, W de: transferred to R P K
2971: H E R A 4641
2972: H E R A 4642
2973: H E R A 929
2974: H E R A 928
2975: H E R C 513
2976: H E R C 513a
2976 M 1: H E R A 4205
2977: H E R A 930
2978: H E R A 940
2979: H E R A 938
2980: H E R A 932
2981: H E R A 937
2982: H E R A 936
2983: H E R A 934
2984: H E R A 933
2985: H E R A 935
2986: H E R A 939
2986 D 1: H E R A 3221
2986 D 2: H E R A 3222
2986 D 3: H E R A 3751
2986 D 4: H E R A 3752
2987: H E R A 941
2988: H E R A 4643
2989: H E R A 1276
2990: H E R A 1277
2991: H E R A 1278
2991 P 1: Israels, J: transferred to R P K

List of changed attributions

Works attributed in earlier Rijksmuseum catalogues to masters other than those to whom they are given in this catalogue are listed here under the name of the artist to whom they were formerly given. To find the present listing of an anonymous work whose attribution has been changed, look up its inventory or catalogue number in the appropriate concordance

Aertsen, P: Bueckelaer, J, A 1496
Anthonisz, C: Claesz, A, C 366
Ashville, E: M I N Cooper, S, A 4308
Asselijn, J: Schellinks, W, A 2112
Bakhuysen II, L: Troost, C, A 2191
Barendsz, D: Key, W, A 18; Netherlands school 2d half 16th century, A 3460
Bartolo di Fredi: Sienese school ca 1450, A 3375
Bassano, J: Bassano, L, A 3006
Beerstraaten, A: Ulft, J van der, A 1916
Bega, C: Koninck, S, A 23
Bening, S: Bruges school ca 1450-70, A 2851
Bissolo, F: Diana, B, A 3014
Blankerhoff, J Th: Northern Netherlands school ca 1690, A 741
Bles, H met de: Coecke van Aelst, P, A 2594
Bloemaert, A: Cleve, M van, A 836
Bloot, P de: Buesem, J J, A 2555; Netherlands school ca 1620, A 1429
Bol, F: Hogers, J, A 804
Borch, G ter: Netscher, Casp, A 2556
Bourdon, S: Leone, A de, C 1346
Bramer, L: Hogers, J, A 787; Sandrart, J von, A 56
Breenbergh, B: Groenewegen, P A, A 3965
Bronckhorst, J G van: Bor, P, A 852
Brueghel I, P: Bles, H met de, A 780
Brueghel II, P: Swanenburg, J I, A 730
Bueckelaer, J: Rijck, P C van, A 868
Buytewech, W P: Brouwer, A, A 3015; Velde, E van de, A 802
Campagnola, D: Girolamo da Santa Croce, A 3966
Canaletto, A: North Italian school 18th century, A 3386
Cano, A: Carreño de Miranda, J, A 1425
Caravaggio: Loth, J C, A 71
Caroto, G F: Araldi, J, A 3967
Carriera, R: P A S T Basseporte, M F, A 2119
Catena, V: Rondinello, N, A 3388
Champaigne, Ph de: Champaigne, J B de, A 3744
Cignani, C: Franceschini, M A, C 1348
Cimabue: Italian school 2nd half 13th century, A 3996
Claesz, P: Heda, W C, A 137
Clouet, F: Pourbus I, F, A 3065
Cock, J W de: Cornelisz Kunst, C, A 1725
Codde, P: Duyster, W C, A 1791 & A 1792
Compe, J ten: Keun, H, C 119
Cooper, A: M I N Guernier, L du, A 4316
Cooper, S: M I N Dixon, N, A 4312; M I N Guernier, L du, A 4317
Credi, L di: Master of the Conversazione di Santo Spirito, A 3012
Croos, A J van der: Berckhout, G W, A 984
Crosse, L: M I N Arlaud, B, A 4296
Cuyp, A: Calraet, A van, A 79 & C 122; Holland school late 17th century?, A 3296; Southern Netherlands school ca 1655, A 80
Cuyp, J G: Loo, J van, A 81
Delff, C J: Rijck, P C van, A 868
Delff I, J W: Miereveld, M J van, A 762
Domenico di Michelino: Machiavelli, Z, A 3442
Donck, G: Holland school 1637, A 3299
Dossi, D: Giovanni da Brescia, A 3995
Drost, W: Fabritius, C, A 91
Duyster, W C: Liss, J, A 1403
Dyck, A van: Southern Netherlands school 1st half 17th century, A 622
Egmont, J van: Levecq, L, A 2402
Eliasz, N: Pot, H G, A 3301
Elsheimer, A: Pynas, Jan S, A 3510
Fabritius, C: Poel, E van der, A 117
Fauchier, L: Voet, J F, A 3236
Ferri, C: Ferrarese school 2d quarter 16th century, A 109
Fiorentino, P F: Master of the San Miniato Altarpiece, A 3013
Flatman, Th: M I N Holland school ca 1635, A 4431; M I N Holland school ca 1650, A 4435
Flegel, G: Beert, O, A 2549
Fredi, B di: Sienese school ca 1450, A 3375
Geertgen tot Sint Jans: Mostaert, J, A 3901; Master of the Braunschweig Diptych, A 2563, A 3305 & A 3306; Master of the Figdor Deposition, A 1688 & A 2212
Geest, W S de: Wieringa, H W, A 204
Gelder, A de: Poel, E van der, A 117; Russian school? 1st half 18th century, A 116
Gheyn II, J de: Northern Netherlands school ca 1670, A 4478
Giovanni di Paolo: Fiore, J del, A 4001
Giovanni, S di: Giovanni di Francia, A 3432
Gossaert van Mabuse, J: Bosch, J, A 124
Goyen, J van: Knijff, W, C 451

Guardi, F: Longhi, P, A 3405
Haagen, J van der: Northern Netherlands school ca 1660, A 132
Hals, F: Zijl, R van, A 1611
Haringh, D: Haensbergen, J van, A 1440
Heda, G W: Vught, G van, A 2205
Heem, J D de: Heda, W C, A 137
Helst, B van der: Flinck, G, A 582; Ovens, J, A 850
Hemessen, J van: Braunschweig Monogrammist, A 1561 &
 A 1603
Henriquez, B L: MIN Boze, J, A 4320
Hilliard, N: MIN Oliver, I, A 4346 & A 4347
Holbein II, H: Cleve, J van, A 165; Massijs, Q, A 166; Vermeyen,
 J C, A 164; Southern Netherlands school ca 1535-40, A 167
Honthorst, G van: Stomer, M, A 216
Hooch, C C de: Southern Netherlands school ca 1640, A 2575
Hooch, P de: Boursse, E, A 767
Hoogstraten, D van: Verhaert, D, A 989
Hoogstraten, S van: Backer, J A, A 157
Hoskins, J: MIN Cooper, A, A 4303; MIN Dixon, N, A 4312
Houckgeest, G: Vliet, H C van, A 1971
Huchtenburgh, J van: Netscher, Casp, A 183
Jacobsz, D: Dircksz, B, C 405
Jongh, C de: Verburgh, D, A 3112; Northern Netherlands school
 ca 1635, A 3316
Kalf, W: Northern Netherlands school 2d half 17th century,
 A 1882
Ketel, C: Cornelisz van Haarlem, C, A 1241; Key, A Th,
 A 514 & A 515
Key, W: Delff I, J W, A 1460
Keyser, Th de: Eliasz, N, A 698 & A 699; Loo, J van, A 81;
 Netherlands school ca 1620, A 201; Northern Netherlands
 school ca 1640, A 203; Holland school ca 1645, A 202
Koedijck, N: Wieringa, H W, A 204
Krieltjes, G E: Keultjes, G E, A 644
Kruseman, J A: Pieneman, N, A 3466
Laer, P van: Bloemen, P van, A 3478
Laethem, J van: Master of the Magdalene Legend, A 2854
Lanfranco, G: Stomer, M, A 216
Laquy, W J: Holland school 18th or 19th century, A 592
Leyden, L van: Cornelisz van Oostsanen, J, A 976; Gossaert
 van Mabuse, J, A 217; Leyden, A van, A 1691
Leyster, J: Hals, F, A 134
Lievens, J: Flinck, G, A 218; Rembrandt, A 2391
Longhi, A: Ceruti, G, A 3406
Lorenzetti, P: Master of Pietro a Ovile, A 4002
Lotto, L: North Italian school 2d quarter 16th century, A 3411;
 Brescian school 1st half 16th century, A 3035
Lundens, G; MIN Lembke, J Ph, A 4334
Lutma, J: Ketel, C, A 244
Maes, N: Boonen, A, A 1263
Mainardi, S: Master Allegro, A 3007
Mander, K van: Swanenburgh, I C, A 862
Mantegna, A: Zaganelli, B, A 783
Menescardi, G: Zugno, F, A 3435 & A 3436
Mesdach, S: Northern Netherlands school 1630, A 2074
Michelino, D di: Machiavelli, Z, A 3442
Miereveld, M J van: Ravesteyn, J A van, A 259
Moeyaert, N: Backer, J A, A 157
Moillon, L: Beert, O, A 2549
Momper, F de: Goyen, J van, A 952
Momper, J de: Bril, P, A 2672
Monaco, L: Lorenzo di Niccolo, A 4007
Mor van Dashorst, A: Pourbus I, F, A 3065
Moreelse, P: Eliasz, N, A 705; Poelenburgh, C van, A 1747;
 Netherlands school ca 1600, A 1309; Northern Netherlands
 school ca 1635, A 585; MIN Northern Netherlands school?
 ca 1635, A 278
Moucheron, F de: Pynacker, A, A 279
Mura, F de: Diana, G, A 3465
Murant, E: Opperdoes, J P, A 784
Musscher, M van: Vollevens I, J, A 283
Mijtens, J: Northern Netherlands school ca 1670, A 609
Netscher, Casp: Haensbergen, J van, A 1440
Nolpe, P: Neyn, P de, A 2245
Nooms, R: Schellinks, W, A 1393
Oggione, M d': Giampietrino, A 3033
Oliver, I: MIN Hilliard, N, A 4322
Ovens, J: Sandrart, J von, A 56
Palamedesz, A: Hillegaert, P van, A 394
Paolo, G di: Fiore, J del, A 4001
Peeters, B: Northern Netherlands school ca 1690, A 741
Peeters, C: Brueghel I, J, A 2102
Peeters, J: Velde, P van den, A 307
Pereda, A: Northern Netherlands school? 2d half 17th century,
 A 2551
Pieneman, J W: Pieneman, N, A 4270
Pier Francesco Fiorentino: Master of the San Miniato
 Altarpiece, A 3013
Pietersz, A: Pietersz, P, A 865 & C 404
Pollaiuolo, A: Baldovinetti, A, C 1188
Ponte, G a: Master of the Bambino Vispo, A 3979 & A 3980
Potter, P: Netscher, Casp, A 319
Potter, P S: Netscher, Casp, A 319

Pourbus II, F: School of Fontainebleau 3d quarter 16th century,
 A 320
Pourbus, P: Southern Netherlands school ca 1535-40, A 167
Predis, A de: Foppa, V, A 3008
Pynas, Jan S: Northern Netherlands school ca 1610, A 3497
Quast, P J: Bartsius, W, A 2214
Quinkhard, J M: Boonen, A, C 1567 & C 1568
Ravesteyn, J A van: Northern Netherlands school ca 1615,
 A 738; Northern Netherlands school ca 1625, A 328;
 Northern Netherlands school 1633, A 326 & A 327
Rembrandt: Bailly, D, A 945; Bol, F, A 714; Flinck, G, A 1282
Ribera, J: Serodine, G, A 332; Neapolitan school mid-17th
 century, A 3342
Roberti, E de: Ferrarese school 2d half 15th century, A 3418
Rosa, S: Italian school 2d half 17th century, A 4020
Rottenhammer, J: Clerck, H de, A 621
Ruisdael, J I van: Beresteyn, C van, A 785; Northern Netherlands
 school ca 1660, A 132
Ruysch, R: Beyeren, A van, A 355
Rijder, N: Rode, N, A 639
Saenredam, P J: Nickelen, I van, A 360
Saftleven, H: Saenredam, P J, A 1189
Salimbeni, L: Fiore, J del, A 4001
Salviati, F: Bronzino, A, A 3344
Schey, Ph: Netherlands school ca 1615, A 1441
Schiavone, A: Sustris, L, A 3424-A 3427
Schoubroeck, P: Bril, P, A 1314
Schuurman, A M: Monogrammist A S, A 737
Schuylenburgh, C van: Liedts, A, A 854
Scorel, J van: Anthonisz, C, A 1619; Swart van Groningen,
 J, A 669; Zacchia il Vecchio, A 503
Sorgh, H M: Holland 1637, A 3299
Steenwyck, H van: Southern Netherlands school ca 1607, A 740
Steenwyck, P: Vught, G van, A 2205
Stefano di Giovanni: Giovanni di Francia, A 3432
Strozzi, B: Morazzone, P F, A 3433
Teerlink, L: MIN Hilliard, N, A 4323
Teniers II, D: Southern Netherlands school ca 1640, A 2575
Terwesten, M: Tischbein, J V, A 406
Tiepolo, G B: Zugno, F, A 3435 & A 3436
Tischbein, J H: Tischbein, J V, A 406
Troost, C: Boonen, A 1914 & A 1915; Denner, B, A 770
Uccello, P: Machiavelli, Z, A 3442
Uyttenbroeck, M van: Elsheimer, A, A 2650
Valckert, W J van den: Eliasz, N, A 705; Voort, C van der,
 A 1249
Velázquez, D: Mazo, J B M del, A 433; Recco, G B, A 3884
Velde, A van de: Netherlands school ca 1665, A 1979
Velde, E van de: Hillegaert, P van, A 435 & A 607; Venne,
 A P van de, A 434; Vrancx, S, A 2699
Venne, A P van de: Delen, D van, A 3936-A 3942; Hillegaert,
 P van, A 3125
Verboom, A H: Looten, J, A 48
Vermeer, J: Poel, E van der, A 117; Northern Netherlands
 school ca 1660, A 4018
Vinckboons, D: Hillegaert, P van, A 452; Netherlands school
 ca 1620, A 201
Vlieger, S de: Cappelle, J van de, A 453
Vliet, J J van: Holland school ca 1640, A 1248
Vollevens I, J: Wissing, W, A 879
Voort, C van der: Delff, W J, A 953
Vos, M de: Clerck, H de, A 1461
Vrancx, S: Snayers, P, A 857 & A 1555
Vroom, H C: Verwer, A de, A 603
Werff, A van der: Vivien, J, A 4016
Werff, P van der: Liotard, J E, A 2656
Wit, J de: Southern Netherlands school 2d half 17th century,
 A 4021
Witte, E de: Poel, E van der, A 117
Wittel, G A van: Machy, P A de, A 3958
Wijckersloot, J van: Westerbaen, J J, A 1478
Wyllems, W: Wieringa, H W, A 2221
Monogrammist AR: Cleve, M van, A 836
Monogrammist Bart S: Bartsius, W, A 818
Monogrammist DVH: Verhaert, D, A 989
Monogrammist HVB: Burgh, Hendrick van der, A 2720
Monogrammist IGL: Loef, J G, A 1383
Monogrammist IK: Keun, H, A 2681
Monogrammist J V D: Diest, Jer van, A 1389
Monogrammist LWA: Arends, LH, A 3844
Monogrammist T: MIN Thach, N, A 4369
Monogrammist VG: Eertvelt, A van, C 448
Monogrammist WB: Bartsius, W, A 2214
Monogrammist [NN]: Bout, P, A 2223 & A 2224; MIN Jackson II,
 J, A 4330
Master of the Cassoni: Florentine school mid-15th century,
 A 3302

Photograph acknowledgments

By far the largest number of photographs reproduced here were
made by the photography department of the Rijksmuseum,
directed by Beatrice Stokhuyzen and staffed by Marijke van
Wijngaarden, J van Zwol, B Bijl, P Mookhoek and H Bekker.
 In general, photographs of works under the supervision of the
Dienst voor 's Rijks Verspreide Kunstvoorwerpen in The Hague
were provided by the Dienst, whose photographer is R A van der
Zwan, and those of works lent to the Gemeente Musea in
Amsterdam by the photography department of these museums,
staffed by Miss M H Hille, Miss M Korpershoek and P C C van
Roemburg.
 Other sources of photographs that have been drawn upon are:
Amsterdam, Algemeen Handelsblad, fotoredactie: fig 46
—, Associated Correspondents: fig 49
—, Gemeentelijke Archiefdienst, Historisch-Topografische
 Atlas: figs 7, 8 & 12
—, Nationaal Foto Persbureau Stevens & Magielsen: fig 50
—, Publieke Werken, afd Stadsontwikkeling: fig 13
—, Stichting Centraal Projectie- en Lichtbeelden Instituut:
 fig 19
Arnhem, Gemeentemuseum: Arentsz, A, A 1447
—, Rijksmuseum van Volkskunde, Het Nederlands Openlucht-
 museum: Horstok, J P van, A 2204; COST Horst, J, A 4627,
 A 4629, A 4630, A 4632, A 4634, A 4635, A 4636 & A 4638
Capelle aan de IJssel, Fotobureau John Klaver: ROT Werff,
 P van der, A 4507
Dordrecht, Foto Stijns: Cuyp, A, A 1457; Olis, J, A 296
Enschede, Rijksmuseum Twenthe: Utrecht school ca 1435,
 A 2649
Geneva, International Labour Office: Bol, F, A 1577
Gouda, G J Dukker: Bol, F, A 1575, A 1578 & A 1576
—, Foto Bob de Wit: Vivarini, B, A 4235
Groningen, Fotobedrijf Piet Boonstra: Cornelisz van Oostsanen,
 J, A 976; AQU Israels, I L, A 3728; AQU Israels, J, A 3733
The Hague, Foto A Dingjan: Avercamp, H, A 1320; Berchem,
 N, A 27; Hoef, A van, A 1753; Prooyen, A J van, A 1824;
 Provoost, J, A 2570; Saftleven, H, A 362; Teniers II, D, A 400;
 Verschuur I, W, A 1152; Vlieger, S de, A 1777; Weenix, J,
 A 463; Netherlands school ca 1600, A 1309; Northern Nether-
 lands school ca 1590, A 636
Helsinki, Leo Kosonen: Mesdag, H W, A 2938
Leiden, Nederlands Leger- en Wapenmuseum 'Generaal Hoefer':
 Pieneman, J W, A 4270
Malmö, Malmö Museum: fig 15
Middelburg, Ies Lamain: Hengel, H F van, A 1473 & A 1474
Oostvoorne, Foto Barzilay: Burbure, L de, C 534
Rome, Foto Vasari: Windtraken, P W, A 2737 & A 2738
Zeist, Foto Monumentenzorg: Sminck Pitloo, A, A 1117

Addenda

Addenda

Paintings

Lodewijk Franciscus Hendrik Apol

A 4677 Pigs in a sty. *Varkens bij een stal*

Panel 17.3 × 30.4. Signed *Louis Apol f*
PROV Put aside by Mr & Mrs Drucker-Fraser to be used as a present. Acceded with the Drucker-Fraser bequest in 1944

Gerrit Willem Dijsselhof

A 4678 Fish in an aquarium. *Vissen in een aquarium*

Canvas 49.5 × 70. Signed *GWD*
PROV Put aside by Mr & Mrs Drucker-Fraser to be used as a present. Acceded with the Drucker-Fraser bequest in 1944

Paul Joseph Constantin Gabriël

A 4670 Landscape with two trees. *Landschap met twee bomen*

Panel 13.2 × 18.5. Signed *P.J.C.G.*
Inscribed on the verso *A mon Ami H. Hymans, de la part de P.J.C. Gabriël, Bruxelles le 4[?] Janv: 1867*
PROV Bequest of Mrs Th L Laue-Drucker, The Hague, 1974. Received in 1975

A 4669 Farm in the open fields. *Boerderij in open veld*

Canvas 28.5 × 46.5. Signed *Gabriel f*
PROV Same as A 4670

Pierre Victor Galland

Geneva 1822 – 1892 Paris

A 4684 Industry. *De industrie*

Paper on canvas 122 × 187. Sketch
PROV Purchased at the auction of the artist's estate

Isaac Lazerus Israels

A 4679 A young woman looking out over the sea. *Jonge vrouw, uitkijkend over zee*

Cardboard 61.2 × 45. Signed *Isaac Israels*
PROV Put aside by Mr & Mrs Drucker-Fraser to be used as a present. Acceded with the Drucker-Fraser bequest in 1944

B (?) van Kessel

active first quarter 18th century

A 4685 Allegory of peace. *Allegorie op de vrede*

Canvas 112 × 147. Signed *B [?] van Kessel Fecit*
PROV Unknown

Jan Hendrik Neuman

A 4676 Johannes Cornelis van Pappelendam (1810-84). Artist and art dealer. Superintendent of the Van der Hoop Museum. *Kunstenaar en kunsthandelaar. Amanuensis van het Museum Van der Hoop*

Canvas 76.5 × 62.5. Octagonal. Signed and dated *J H Neuman 1876*
PROV Presented by J Schouten, Zeist, 1976

Rembrandt

A 4674 Musical party. *Musicerend gezelschap*

Panel 63.4 × 47.6. Signed and dated *RH 1626*
PROV Purchased from E Speelman gallery, London, 1976, with aid from the Rembrandt Society, the Prince Bernhard Foundation and the Photo Commission
LIT V Bloch, OH 54 (1937) pp 49-53, ill. A Bredius, Rembrandt paintings, London 1937 (2d ed) nr 632. J S Held, Parnassus 9 (1937) pp 36-38, ill. O Benesch, Art Q 3 (1940) p 13, ill. E Kieser, Die Welt als Geschichte 9 (1943) pp 46-54, ill. Van Gelder 1946, p 4, ill. Exhib cat Caravaggio en de Nederlanden, Utrecht-Antwerp 1952, nr 59, ill. Van Gelder 1953, p 284, ill. G Knuttel, Burl Mag 97 (1955) pp 44-49 (not Rembrandt). Idem, Burl Mag 98 (1956) p 260 (not Rembrandt). V Bloch, Burl Mag 97 (1955) pp 259-60. Knuttel 1956, p 240 (not Rembrandt). Bauch 1960, p 138, fig 101. Bauch 1966, nr 97. Gerson 1968, pp 186, 489, fig 18. Haak 1968, p 27, figs 33-33a. Tümpel 1968, nr 10. Bredius & Gerson 1969, nr 632

copy after **Guido Reni**

A 4686 Sleeping putto. *Slapende putto*

Copy after a fresco in the Barberini collection, Rome

Canvas 58 × 53
PROV Unknown

Johannes Daniël Susan

The Hague 1823 – 1843 The Hague

A 4675 Self portrait. *Zelfportret*

Canvas 70 × 58.3. Signed and dated *J D Susan 1839 fec*
PROV Purchased from C Boschma, Leeuwarden, 1976

John Macallan Swan

A 4681 Sleeping lion by night. *Slapende leeuw bij nacht*

Panel 22.8 × 40.6. Signed *J M Swan*
PROV Same as A 4680

A 4680 Polar bears. *IJsberen*

Canvas 79.5 × 17. Signed *J M Swan*
PROV Put aside by Mr & Mrs Drucker-Fraser to be used as a present. Acceded with the Drucker-Fraser bequest in 1944

Daniël Jansz Thievaert

Amsterdam? before 1613 – before 1658 Amsterdam?

A 4668 Theagenes and Chariklea. *Theagenes en Chariklea*

Panel 45.2 × 53. Signed *DT*
PROV Purchased from Mrs G van Marselis Hartsink-Veldhuyzen van Zanten, Haarlem, 1975
LIT J I Kuznetzow, OH 88 (1974) p 178, note 42

Moyses van Uyttenbroeck

A 4673 Pharaoh's daughter discovers Moses in the rush basket. *Farao's dochter vindt Mozes in het biezen mandje*

Panel 73 × 95. Signed *MB f*
PROV Purchased from P de Boer, art dealers, Amsterdam, 1975, as a gift of the Photo Commission

Johannes Martinus Vrolijk

The Hague 1845 – 1894 The Hague

A 4682 A cow with her calf in a meadow. *Een koe met haar kalf in een weide*

Canvas 29 × 43.5. Signed *Jan Vrolijk f 79*
PROV Put aside by Mr & Mrs Drucker-Fraser to be used as a present. Acceded with the Drucker-Fraser bequest in 1944

Hendrik Johannes (JH) Weissenbruch

A 4671 View on a beach. *Strandgezicht*

Panel 17.8 × 24.2. Signed *J.H. Weissenbruch f*
PROV Bequest of Mrs Th L Laue-Drucker, The Hague, 1974. Received in 1975

Monogrammist WHE

Netherlands school ca 1600

C 1583 The Spanish Armada and the English fleet in the roads of Dover. *De Spaanse Armada en de Engelse vloot in het Nauw van Calais*

Gouache on paper 14 × 34.8. Signed *W [?] HE*. Inscribed *Spaensche Armad int iar 1588*
PROV On loan from J A Dillen, Heemstede, since 1975

Netherlands school ca 1660

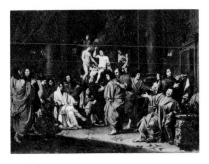

A 4672 The induction of a new member into the band of northern artists in Rome. *Inwijding van een nieuw lid van de Bentveughels te Rome*

Canvas 95.5 × 134
PROV Sale New York, 12 June 1975, lot 184, ill (as Jan van Bijlert)

Northern Netherlands school 2d half 18th century

A 1335 Portrait of a woman in eighteenth-century costume. *Portret van een vrouw in achttiende-eeuwse kleding*

Description on p 671. The photograph reproduced became available after the completion of the main part of the catalogue

Northern Netherlands school ca 1840

A 4687 Portrait of a general. *Portret van een generaal*

Canvas 71 × 54
PROV Unknown

Aquarelles and drawings

Italian school? mid-19th century

A 4683 Young woman in regional
costume. *Jonge vrouw in klederdracht*

Aquarelle 47.5 ×34
PROV Put aside by Mr & Mrs Drucker-
Fraser to be used as a present. Acceded
with the Drucker-Fraser bequest in 1944

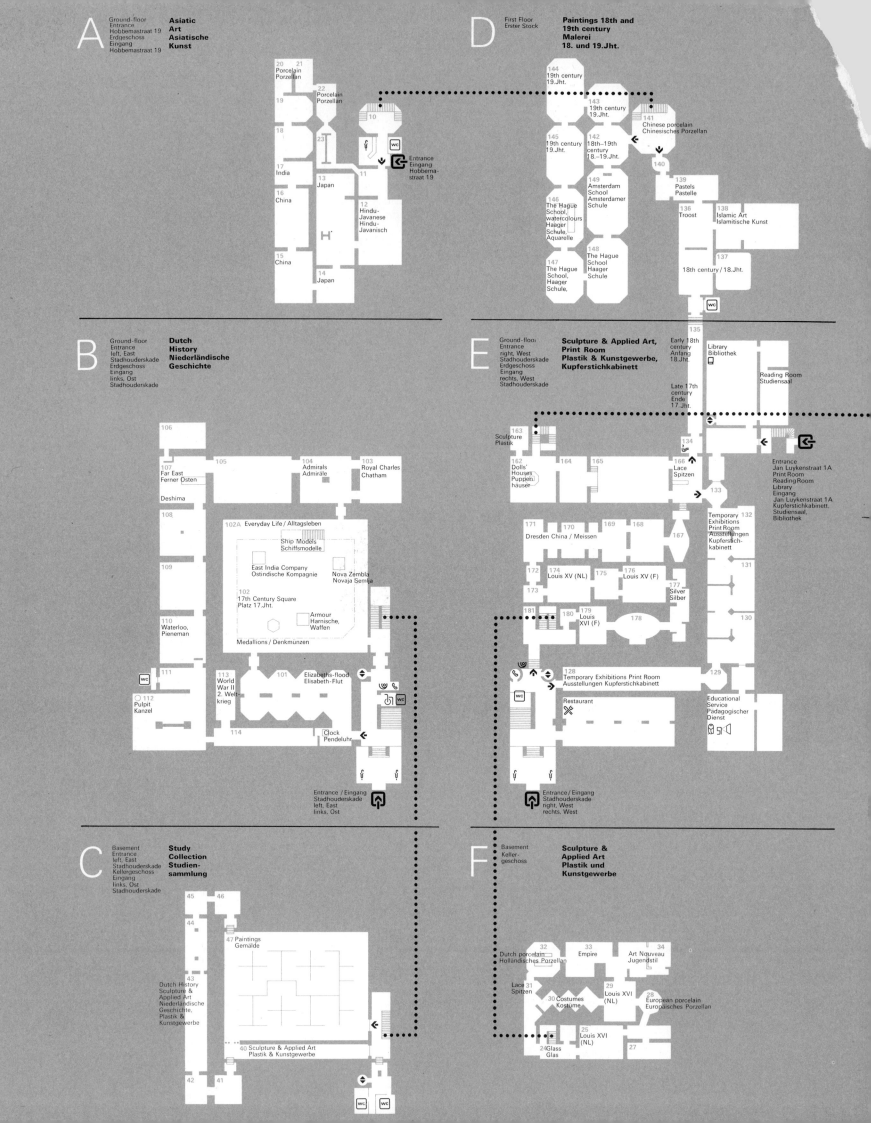

A

Ground-floor
Entrance
Hobbemastraat 19
Erdgeschoss
Eingang
Hobbemastraat 19

**Asiatic
Art
Asiatische
Kunst**

20 21
19 Porcelain
 Porzellan
18
 22 Porcelain
 Porzellan
23
 10
17 India
16 China
 13 Japan
 11
 12 Hindu-
 Javanese
 Hindu-
 Javanisch
15 China
14 Japan

Entrance
Eingang
Hobbema-
straat 19

B

Ground-floor
Entrance
left, East
Stadhouderskade
Erdgeschoss
Eingang
links, Ost
Stadhouderskade

**Dutch
History
Niederländische
Geschichte**

106
107 Far East
 Ferner Osten
 Deshima
108
109
110 Waterloo,
 Pieneman
111
112 Pulpit
 Kanzel
113 World
 War II
 2. Welt-
 krieg
114

105
104 Admirals
 Admiräle
103 Royal Charles
 Chatham

102A Everyday Life / Alltagsleben
 Ship Models
 Schiffsmodelle
 East India Company
 Ostindische Kompagnie
 Nova Zembla
 Novaja Semlja
102 17th Century Square
 Platz 17.Jht.
 Armour
 Harnische,
 Waffen
 Medallions / Denkmünzen

101 Elizabeths-flood
 Elisabeth-Flut

Clock
Pendeluhr

Entrance / Eingang
Stadhouderskade
left, East
links, Ost

C

Basement
Entrance
left, East
Stadhouderskade
Kellergeschoss
Eingang
links, Ost
Stadhouderskade

**Study
Collection
Studien-
sammlung**

45 46
44
47 Paintings
 Gemalde
43 Dutch History
 Sculpture &
 Applied Art
 Niederländische
 Geschichte,
 Plastik &
 Kunstgewerbe
40 Sculpture & Applied Art
 Plastik & Kunstgewerbe
42 41

D

First Floor
Erster Stock

**Paintings 18th and
19th century
Malerei
18. und 19.Jht.**

144 19th century
 19.Jht.
145 19th century
 19.Jht.
143 19th century
 19.Jht.
142 18th–19th
 century
 18.–19.Jht.
141 Chinese porcelain
 Chinesisches Porzellan
140
149 Amsterdam
 School
 Amsterdamer
 Schule
146 The Hague
 School,
 watercolours
 Haager
 Schule,
 Aquarelle
139 Pastels
 Pastelle
136 Troost
138 Islamic Art
 Islamitische Kunst
148 The Hague
 School
 Haager
 Schule
147 The Hague
 School,
 Haager
 Schule,
137 18th century / 18.Jht.

E

Ground-floor
Entrance
right, West
Stadhouderskade
Erdgeschoss
Eingang
rechts, West
Stadhouderskade

**Sculpture & Applied Art,
Print Room
Plastik & Kunstgewerbe,
Kupferstichkabinett**

135

Early 18th
century
Anfang
18.Jht.

Late 17th
century
Ende
17.Jht.

Library
Bibliothek

Reading Room
Studiensaal

163 Sculpture
 Plastik
162 Dolls'
 Houses
 Puppen-
 häuser
164 165
166 Lace
 Spitzen
134
133

Entrance
Jan Luykenstraat 1A
Print Room
Reading Room
Library
Eingang
Jan Luykenstraat 1A
Kupferstichkabinett,
Studiensaal,
Bibliothek

171 170 169 168
Dresden China / Meissen
167
172 174 175 176 Louis XV (F)
 Louis XV (NL)
173
181 180 179 Louis
 XVI (F)
178
Temporary
Exhibitions
Print Room
Ausstellungen
Kupferstich-
kabinett
132
131
130
177 Silver
 Silber

128 Temporary Exhibitions Print Room
 Ausstellungen Kupferstichkabinett
129
Restaurant
Educational
Service
Pädagogischer
Dienst

Entrance / Eingang
Stadhouderskade
right, West
rechts, West

F

Basement
Keller-
geschoss

**Sculpture &
Applied Art
Plastik und
Kunstgewerbe**

32 Dutch porcelain
 Hollandisches Porzellan
33 Empire
34 Art Nouveau
 Jugendstil
31 Lace
 Spitzen
30 Costumes
 Kostüme
29 Louis XVI
 (NL)
28 European porcelain
 Europaisches Porzellan
25 Louis XVI
 (NL)
24 Glass
 Glas
27